ART HISTORY

SECOND EDITION

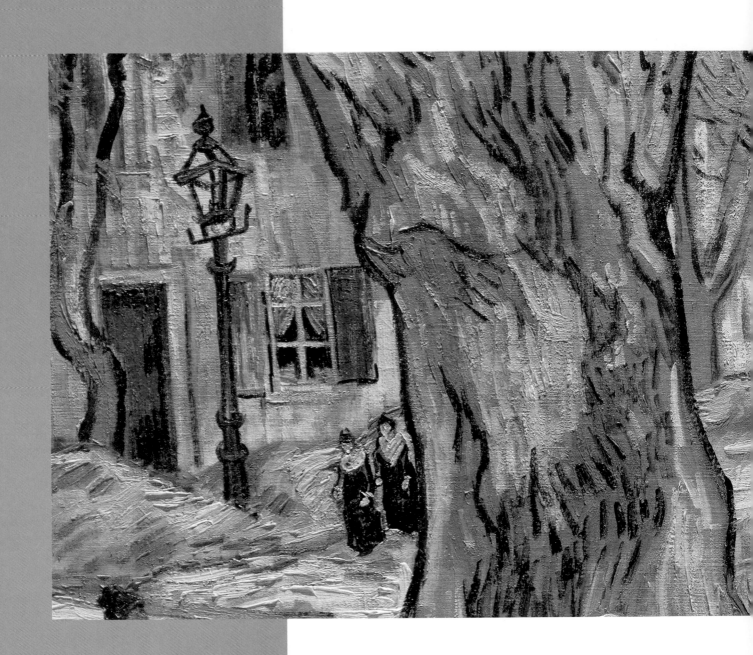

ART HISTORY

SECOND EDITION

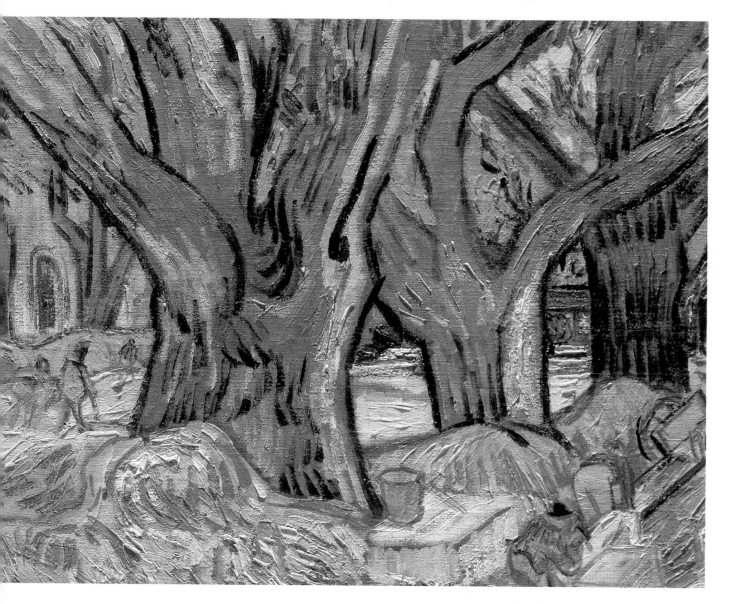

MARILYN STOKSTAD

The University of Kansas

in collaboration with DAVID CATEFORIS

The University of Kansas

with chapters by STEPHEN ADDISS, CHU-TSING LI,
MARYLIN M. RHIE, and CHRISTOPHER D. ROY

PRENTICE HALL, INC., AND HARRY N. ABRAMS, INC., PUBLISHERS

DEDICATED TO MY SISTER, KAREN L. S. LEIDER, AND TO MY NIECE, ANNA J. LEIDER

Publishers: *Mark Magowan, Abrams, and Bud Therien, Prentice Hall*
Project manager and editorial director: *Julia Moore*
Project consultant: *Jean Smith*
Developmental editors: *Mark Getlein, Jean Smith*
Project editor: *Doris Chon*
Copy editor: *Nancy Cohen*
Editorial assistant: *Holly Jennings*
Design and art direction: *Lydia Gershey/Vesica Aphia, Inc.*
Production: *Design 5 Creatives, Thomasina Webb, project manager*
Photo editing, rights and reproduction: *Photosearch, Inc.*
Illustrator: *John McKenna*
Indexers: *Peter and Erica Rooney*
Marketing manager, Prentice Hall: *Sheryl Adams*
Marketing assistant, Prentice Hall: *Jennifer Bryant*
Developmental editor, Prentice Hall: *David Chodoff*
Assistant editor, Prentice Hall: *Kimberly Chastain*
Editorial assistant, Prentice Hall: *Wendy Yurash*

Library of Congress Cataloging-in-Publication Data

Stokstad, Marilyn, 1929–
 Art history / Marilyn Stokstad in collaboration with David Cateforis with chapters by Stephen Addiss . . . [et al.].– 2nd ed.
 p. cm.
 Includes bibliographical references and index.
 ISBN 0–13–091868–7 (HC : combined) —ISBN 0–13–091852–0 (v. 1: PB) —ISBN 0–13–091850–4 (v. 2 : PB)
 1. Art—History. I. Cateforis, David. II. Addiss, Stephen, 1935– III. Title.
 N5300 .S923 2001
 709—dc21

2001000955

Prentice-Hall, Inc.
A Division of Pearson Education
Upper Saddle River, New Jersey 07458

Send inquiries to:
 Marketing Manager
 Humanities & Social Sciences, Prentice Hall, Inc.
 One Lake Street
 Upper Saddle River, N.J. 07458

Printed and bound in Japan
10 9 8 7 6 5 4 3 2 1

First Edition 1995
Revised Edition 1999
Second Edition 2002

Pages 2 and 3: Details of figure 28, Vincent van Gogh. *Large Plane Trees*. 1889. Oil on canvas, 26 x 36^1/$_8$" (73.4 x 91.8 cm).
The Cleveland Museum of Art
Gift of the Hanna Fund, 1947.209

Brief Contents

Preface 6

Acknowledgments 8

Contents 10

Use Notes 17

Starter Kit 18

Introduction 24

Chapter 1 Prehistory and Prehistoric Europe 42

Chapter 2 Art of the Ancient Near East 66

Chapter 3 Art of Ancient Egypt 92

Chapter 4 Aegean Art 128

Chapter 5 Art of Ancient Greece 152

Chapter 6 Etruscan Art and Roman Art 222

Chapter 7 Early Christian, Jewish, and Byzantine Art 288

Chapter 8 Islamic Art 342

Chapter 9 Art of India before 1100 370

Chapter 10 Chinese Art before 1280 400

Chapter 11 Japanese Art before 1392 426

Chapter 12 Art of the Americas before 1300 448

Chapter 13 Art of Ancient Africa 470

Chapter 14 Early Medieval Art in Europe 484

Chapter 15 Romanesque Art 514

Chapter 16 Gothic Art 554

Chapter 17 Early Renaissance Art in Europe 614

Chapter 18 Renaissance Art in Sixteenth-Century Europe 684

Chapter 19 Baroque Art in Europe and North America 756

Chapter 20 Art of India after 1100 824

Chapter 21 Chinese Art after 1280 838

Chapter 22 Japanese Art after 1392 856

Chapter 23 Art of the Americas after 1300 876

Chapter 24 Art of Pacific Cultures 898

Chapter 25 Art of Africa in the Modern Era 914

Chapter 26 Eighteenth-Century Art in Europe and North America 936

Chapter 27 Nineteenth-Century Art in Europe and the United States 978

Chapter 28 The Rise of Modernism in Europe and North America 1058

Chapter 29 The International Avant-Garde since 1945 1124

Glossary Glossary 1

Bibliography Bibliography 1

Index Index 1

Credits Credits 1

Preface

In 1998 I wrote, "I want to thank my many friends and colleagues for welcoming *Art History* into their lives and their classrooms. I knew I wanted a new textbook for my students, but I had no idea how widespread that desire was. In the years since Abrams and Prentice Hall introduced *Art History*, it has exceeded all our hopes for its acceptance." With this new edition, I can only underline my original sentiments.

I believe more than ever that students ought to be able to enjoy their first course in art history. Only if they do will they want to experience and appreciate the visual arts—for the rest of their lives—as offering connection to the most tangible creations of the human imagination. To this end we continue to seek ways to make each edition of *Art History* a more sensitive, engaging, supportive, and accessible learning resource.

Art History **is contextual in its approach and object-based in its execution.** Throughout the text we treat the visual arts not in isolation but within the essential contexts of history, geography, politics, religion, and other humanistic studies, and we carefully define the parameters—social, religious, political, and cultural—that either have constrained or have liberated individual artists.

Art History **reflects the excitement and pleasures of art.** In writing about art's history, we try to express our affection for the subject. Each chapter of the narrative opens with a scene-setting vignette that concentrates on a work of art from that chapter. Set-off **text boxes**, many now illustrated, present interesting, often thought-provoking material. A number of them follow the theme of women in the arts—as artists and as patrons. Others give insights into discoveries and controversies. The discipline of art history is many-dimensional in its possibilities, and *Art History* invites a positive sampling of these possibilities.

We have maintained *Art History*'s comprehensiveness. We reach beyond the Western tradition to include an examination of the arts of other regions and cultures, from their beginnings to the twenty-first century. Acknowledging that the majority of survey courses concentrate on the Western tradition, we have organized the chapters on non-Western arts and cultures so that art can be studied from a global perspective within an integrated sequence of Western and non-Western art. Just as smoothly, non-Western material can be skipped over without losing the thread of the Western narrative.

WHAT'S NEW?

Art History'**s view of art is even more inclusive.** We cover not only the world's most significant paintings and works of sculpture and architecture but also drawings and prints; photographs; works in metal, ceramic, and glass; textiles; jewelry; furniture and aspects of interior design (things that were once considered utilitarian arts). In covering the late twentieth century we include, as well, **new mediums** such as video art and installation art and such temporal arts as Happenings and performance art.

We pay due respect to the canon of great monuments of the history of art. In fact, this edition contains **more canonical works** than the original edition of 1995 and the Revised Edition of 1998, and now includes such works as the fifth-century BCE *Stele of Hegeso* and Dürer's *Self-Portrait* of 1500. Simultaneously, we continue to introduce artists and works not recognized in other surveys. An example is **an expanded representation of Canadian artists** in Chapters 28 and 29 and **the addition of two contemporary artists whose medium is glass.**

Art History **has been updated to include the most recent scholarship, scholarly opinion, technical analysis, archaeological discoveries, and controversies.** Chapter 29 devotes a whole page to recent debates over public funding for the arts, including a review of the events surrounding the 1999 exhibition "Sensation: Young British Artists from the Saatchi Collection." While the text's currency is not always conspicuous, revised opinion has been incorporated into discussions of artworks included in the two previous editions. Examples include the greater attention given to art and architecture of the Middle Byzantine period, especially that in Ukraine and Sicily, in Chapter 7 and the redisposition of figures on the west pediment of the Temple of Zeus at Olympia in Chapter 5.

To explore the role of a work of art within its context, we have added a new feature, The Object Speaks, which focuses in depth on some of the many things a work of art may have to say. At the same time that we stay grounded in the works of art that are, after all, what make art history distinctive among other humanistic disciplines, we emphasize the significance of the work of art.

Recently cleaned and/or restored works of art and architecture have been rephotographed and are now illustrated in their cleaned or restored states. Among the new images of buildings, fresco cycles, panel and easel paintings, and architectural and freestanding sculpture are the Archaic Greek *New York Kouros*, an interior view of the Dome of the Rock in Jerusalem, and Michelangelo's *Pietà*.

We responded to your suggestions for making Art History even more teachable. In this edition, we reorganized material on the Early Renaissance and integrated the graphic arts into the discussion of painting and sculpture. Chapter 18, on sixteenth-century art, draws a greater distinction than before on early- and late-sixteenth-century styles and gives greater attention to the impact of religious turmoil on the arts. In covering the seventeenth century, we resequenced material so that the colonial styles of New England are treated after English art and the art of colonial Mexico appears after the art of Spain. David Cateforis, my colleague at The University of Kansas and a specialist in twentieth-century art, has rewritten Chapters 26 through 29,

from Rococo through the dawn of the twenty-first century. He clarifies many issues and has added scores of illustrations and several text boxes, enriching and elucidating the discussion of art of the modern age.

Although the number of book pages is about the same as for the first two editions, **the text actually is shorter.** This means that more of the **illustrations are larger than ever.**

We have strengthened the pedagogical advantage of *Art History.* When first published, *Art History* was instantly embraced for its groundbreaking use of drawings and diagrams to aid readers in mastering the terminology of art history. The **Elements of Architecture** and **Technique boxes** visually explain how buildings are constructed and how artists use materials to do everything from creating cave paintings to decorating armor to making photographs. New to this edition, for example, are an Elements of Architecture box on timber construction and a Technique box that illustrates fresco painting.

Maps and **timelines** have been rethought and redesigned. Every chapter has at least one map and a timeline, and maps identify every site mentioned in the text. At the end of every chapter, you will now find a summary, called **Parallels**, that lists all major works in that chapter by country, time period, or stylistic category and reminds the reader of works of art from other cultures that are parallel in time. Terms specific to art history are printed in boldface type, which indicates their inclusion in the 900-word **Glossary**. The **Bibliography**, compiled by distinguished art librarian Susan Craig, is specific to this Second Edition.

As much as possible, without distorting the narrative of art history, we have chosen **works of art that are in North American museums, galleries, and collections** so that readers can most easily experience these works directly. This selection includes works from college and university galleries and museums.

More than three-quarters of the illustrations in this edition of Art History are now in color, and there are more drawings and diagrams than ever before. We have added labels to many drawings as well.

Art History **has a Companion Website™** that makes it possible to integrate the art history survey course with the vast power of the Internet. For students, the Stokstad Companion Website™ features Study Guide, Reference, Communication, and Personalization Modules. For instructors, the Companion Website™ has a special Faculty Module and Syllabus Manager.™

In addition, the textbook comes with a **complete ancillary package,** including an interactive CD-ROM with hundreds of images from the book, a student Study Guide, and an Instructors Resource Manual with Test Bank.

IN GRATITUDE

Art History **represents the cumulative efforts of a distinguished group of scholars and educators.** Single authorship of a work such as this is no longer viable, especially because of its global coverage. The work done by Stephen Addiss (Chapters 11 and 22), Chu-tsing Li (Chapters 10 and 21), Marylin M. Rhie (Chapters 9 and 20), and Christopher D. Roy (Chapters 13 and 25) for the original edition of *Art History* is still largely intact. David Cateforis incorporated material from the Revised Edition by Bradford R. Collins in reworking Chapters 26 through 29. As ever, this edition has benefited from the assistance and advice of scores of other teachers and scholars who have generously answered my questions, given recommendations on organization and priorities, and provided specialized critiques. I hope you will enjoy the Second Edition of *Art History* and, as you have done so generously and graciously over the past six years, will continue to share your responses and suggestions with me.

Marilyn Stokstad
Lawrence, Kansas
Spring 2001

Acknowledgments

In the acknowledgments to the original edition, published in 1995, I wrote, "Writing and producing this book has been a far more challenging undertaking than any of us originally thought it would be. Were it not for the editorial and organizational expertise of Julia Moore, we never would have pulled it off. She inspired, orchestrated, and guided the team of editors, researchers, photo editors, designers, and illustrators who contributed their talents to the volume you now hold." In 1998 we revised the original edition in response to suggestions from readers and in order to add more and better illustrations. The success of *Art History* has made it possible to create a full-scale revision in 2001. I want to thank Julia again for her collaboration on this edition and acknowledge the team of editors who worked to refine this book. Special thanks are due to Jean Smith, Nancy Cohen, Doris Chon, Holly Jennings, and Erin Barnett. Reaching back, I want to cite Mark Getlein for his extraordinary care in developing the original chapters on Asian and African art, which are much as they have been in the first two versions of the book. In their work on the original edition, photo researchers Lauren Boucher, Jennifer Bright, Helen Lee, and Catherine Ruello performed miracles in finding the illustrations we needed; and in this edition the team at Photosearch, Inc., working under Abrams' John Crowley, took on this important work. John McKenna's drawings again bring exactly the right mix of information and clarity to the illustration program. Designer Lydia Gershey and Yonah Schurink broke new ground in their design and layout of the original edition and the team at Design 5 Creatives, led by project manager Thomasina Webb, continued the great work in this edition, creating a book that is a joy to use. Sheryl Adams and Alison Pendergast, Prentice Hall marketing managers, have contributed many inspired marketing initiatives. Phil Miller, Charlyce Jones Owen, and Bud Therien at Prentice Hall have been unfailingly supportive.

In these times, no one person should try to write a history of art. Consequently I gathered together a congenial group of scholar-teachers to write the first edition—Stephen Addiss, University of Richmond; Bradford R. Collins, University of South Carolina; Chu-tsing Li, The University of Kansas (ret.); Marylin M. Rhie, Smith College; and Christopher Roy, University of Iowa. In the second edition David Cateforis, The University of Kansas, who specializes in American and twentieth-century art, has joined the team. Art Librarian Susan Craig, head of the Murphy Library of Art and Architecture at The University of Kansas, prepared the bibliography.

Many people reviewed the original edition of *Art History* and have continued to assist with its revision. Every chapter has been read by one or more specialists. For work on the original book, and continuing assistance with the second edition, my thanks go to: Barbara Abou-El-Haj, State University of New York at Binghamton; Jane Aiken, Virginia Polytechnic; Vicki Artimovich, Bellevue Community College; Elizabeth Atherton, El Camino College; Ulkü Bates, Hunter College, City University of New York; Joseph P. Becherer, Grand Rapids Community College; Janet Catherine Berlo, University of Rochester; Roberta Bernstein, State University of New York at Albany; Edward Bleiberg, University of Memphis; Robert Bork, University of Iowa; Daniel Breslauer, The University of Kansas; Ronald Buksbaum, Capital Community Technical College; Petra Ten-Doesschate Chu, Seton Hall University; John Clarke, University of Texas at Austin; Kathleen Cohen, San Jose State University; Robert Cohon, The Nelson-Atkins Museum of Art; Frances Colpitt, University of Texas, San Antonio; Lorelei H. Corcoran, University of Memphis; Nancy Corwin (ret.); Ann G. Crowe, Virginia Commonwealth University; Pamela Decoteau, Southern Illinois University; Susan J. Delaney, Mira Costa College; Walter B. Denny, University of Massachusetts, Amherst; Richard DePuma, University of Iowa; Brian Dursam, University of Miami; Ross Edman, University of Illinois, Chicago; Gerald Eknoian, DeAnza State College; Mary S. Ellett, Randolph-Macon College; Deborah Ellington, North Harris College; James D. Farmer, Virginia Commonwealth University; Craig Felton, Smith College; Mary F. Francey, University of Utah; Joanna Frueh, University of Nevada, Reno; Mark Fullerton, Ohio State University; Jill Leslie Furst; Anna Gonosova, University of California, Irvine; Robert Grigg; Glenn Harcourt, University of Southern California; Sharon J. Hill, Virginia Commonwealth University; Mary Tavener Holmes, New York City; Jeffrey Hughes, Webster University; Paul E. Ivey, University of Arizona; Carol S. Ivory, Washington State University; Nina Kasanof, Sage Junior College of Albany; John F. Kenfield, Rutgers University; Ruth Kolarik, Colorado College; Jeffrey Lang, The University of Kansas; William A. Lozano, Johnson County Community College; Franklin Ludden, Ohio State University (ret.); Lisa F. Lynes, North Idaho College; J. Alexander MacGillivray, Columbia University; Janice Mann, Bucknell University; Michelle Marcus, The Metropolitan Museum of Art; Virginia Marquardt, University of Virginia; Peggy McDowell, University of New Orleans; Sheila McNally, University of Minnesota; Victor H. Miesel, University of Michigan (ret.); Vernon Minor, University of Colorado, Boulder; Anta Montet-White, The University of Kansas (ret.); Anne E. Morganstern, Ohio State University; Robert Munman, University of Illinois, Chicago; William J. Murnane, University of Memphis; Lawrence Nees, University of Delaware; Sara Orel, Truman State University; John G. Pedley, University of Michigan; Elizabeth Pilliod; Nancy H. Ramage, Ithaca College; Patricia Reilly, Santa Clara State University; Ida K. Rigby, San Diego State University; Howard Risatti, Virginia Commonwealth University; Ann M. Roberts, University of Iowa; Katherine Howard Rogers, Oakton Community College; Stanley T. Rolfe, University of Kansas; Wendy W. Roworth, University of Rhode Island; James H. Rubin, State University of New York at Stony Brook; John Russell, Columbia University; Leah Rutchick; Patricia Sands, Pratt Institute; Thomas Sarrantonio, State University of New York at New Paltz; Diane G. Scillia, Kent State University; Linda Seidel, University of Chicago; Nancy Sevcenko, Philadelphia; Tom Shaw, Kean University; Jan Sheridan, Erie Community College; William Sieger, Northeastern Illinois University; Jeffrey Chipps Smith, University of Texas at Austin; Anne Rudloff Stanton, University of Missouri, Columbia; Thomas Sullivan, OSB, Benedictine College (Conception Abbey); Janis Tomlinson, National Academy of Sciences, Washington, D.C.; the late Eleanor Tufts; Dorothy Verkerk, University of North Carolina, Chapel Hill; Roger Ward, The Nelson-Atkins Museum of Art; Mark Weil, Washington University, St. Louis; Alison West, New York City; Randall White, New York University; David Wilkins, University of Pittsburgh; and Linda Woodward, North Harris College.

Others who joined in on the revised edition and have tried to keep me from errors of fact and interpretation—who have shared ideas and course syllabi, read chapters or sections of chapters, and offered suggestions and criticism—include: Janetta Rebold Benton, Pace University; Elizabeth Broun, Smithsonian American Art Museum; Robert G. Calkins, Cornell University; William W. Clark, Queens College, City University of New York; Jaqueline Clipsham; Alessandra Comini, Southern Methodist University; Charles Cuttler, University of Iowa (ret.); Ralph T. Coe, Santa Fe; Patricia Darish; Yvonne R. Dixon, Trinity College; Lois Drewer, Index of Christian Art, Princeton; Charles Eldredge, The University of Kansas; James Enyeart, Santa Fe; Ann Friedman, Rochester; Mary D. Garrard, American University; Paula Gerson, Florida State University; Walter S. Gibson, Case Western Reserve University (ret.); Stephen Goddard, The University of Kansas; Dorothy Glass, State University of New York at Buffalo; the late Jane Hayward, The Cloisters, The Metropolitan Museum of Art; Robert Hoffmann, Smithsonian Institution (ret.); Luke Jordan, University of Kansas; Joseph Lamb, Ohio University; Charles Little, The Metropolitan Museum of Art; Karen Mack; Richard Mann, San Francisco State University; Bob Martin, Arizona State University; Amy McNair, The University of Kansas; Sara Jane Pearman, The Cleveland Museum of Art; Michael Plante, H. Sophie Newcomb Memorial College, Tulane University; John Pultz, The University of Kansas; Virginia Raguin, College of the Holy Cross; Irving Sandler, New York; Pamela Sheingorn, Baruch College, City University of New York; James Seaver, The University of Kansas (ret.); Caryl K. Smith, Muncie; Walter Smith, Ball State University; Lauren Soth, Carleton College; Linda Stone-Ferrier, The University of Kansas; Michael Stoughton, University of Minnesota; Elizabeth Valdez del Alamo, Montclair State College; and Ann S. Zielinski, State University of New York at Plattsburgh (ret.).

Several of the artists included in the book helped with information: Christo and Jeanne-Claude, Wenda Gu, Betye Saar, Miriam Schapiro, and Roger Shimomura.

University of Kansas graduate students taught with each new version and helped me in many ways. Among those who offered special suggestions are Elissa Anderson, Reed Anderson, Sean Barker, Erin Barnett, Heather Jensen, Beverly Joyce, Martha Mundis, Joni Murphy, Carla Tilghman. Graduate research assistants Ted Meadows, Don Sloan, and Jill Vessely provided invaluable help. All have earned my lasting gratitude.

The original book was class tested with students under the direction of these professors: Fred C. Albertson, University of Memphis; Betty J. Crouther, University of Mississippi; Linda M. Gigante, University of Louisville; Jennifer Haley, University of Nebraska, Lincoln; Cynthia Hahn, Florida State University; the late Lawrence R. Hoey, University of Wisconsin, Milwaukee; Delane O. Karalow, Virginia Commonwealth University; Charles R. Mack, University of South Carolina; Brian Madigan, Wayne State University; Meredith Palumbo, Kent State University; Sharon Pruitt, East Carolina State University; J. Michael Taylor, James Madison University; Marcilene K. Wittmer, University of Miami; and Marilyn Wyman, San Jose State University.

As David Cateforis and I reworked the chapters, specialists in many fields continued to answer our questions and share their ideas with us. Our thanks go to many of the people I have already mentioned and to James Adams, Manchester College; Roger Aikin, Creighton University; Anthony Alofsin, University of Texas, Austin; Christiane Andersson, Bucknell University; Kathryn Arnold; Julie Aronson, Cincinnati Art Museum; Larry Beck; Evelyn Bell, San Jose State University; David Binkley, The National Museum of African Art, Smithsonian Institution; Sara Blick, Kenyon College; Judith Bookbinder, University of Massachusetts, Boston; Marta Braun, Ryerson Polytechnic University; Claudia Brown, Arizona State University; Glen R. Brown, Kansas State University; April Clagget, Keene State College; James D'Emilio, University of South Florida; Susan Earle, The University of Kansas; Edmund Eglinski, The University of Kansas; Grace Flam, Salt Lake City Community College; Patrick Frank, The University of Kansas; Randall Griffey, The Nelson-Atkins Museum of Art; Marsha Haufler, The University of Kansas; John Hoopes, The University of Kansas; Marni Kessler, The University of Kansas; Alison Kettering, Carleton College; Wendy Kindred, University of Maine at Fort Kent; Allan T. Kohl, Minneapolis College of Art; Carol H. Krinski, New York University; Aileen Laing, Sweet Briar College; Janet Le Blanc, Clemson University; Laureen Reu Liu, McHenry Country College; Loretta Lorance; Suzaan Boettger; Elizabeth Parker McLachlan, Rutgers University; Judith Mann, St. Louis Art Museum; James Martin, The Nelson-Atkins Museum of Art; Gustav Medicus, Kent State University; Tamara Mikailova, St. Petersburg, Russia, and Macalester College; Winslow Myers, Bancroft School; Amy Ogata, Cleveland Institute of Art; Judith Oliver, Colgate University; Edward Olszewski, Case Western Reserve University; Paul Rehak, Duke University; Lisa Robertson, Cleveland Museum of Art; Barry Rubin, Talmudic College of Florida; Charles Sack, Parsons, Kansas; Jan Schall, The Nelson-Atkins Museum of Art; Raechell Smith, Kansas City Art Institute; Pamela Trimpe, University of Iowa; Richard Turnbull, Fashion Institute of Technology; Lisa Vergara, City University of New York. Special thanks go to Jean Middleton James, Iowa City, who found many a slip of the pen—or computer key—in both the first and the revised editions.

FINAL WORDS

Dean Sally Frost Mason, Associate Dean Carl Strikwerda, and Provost David Shulenburger kindly reduced my teaching duties at the University on two occasions, and the Judith Harris Murphy Funds in The University of Kansas Endowment Association supported my research and travel. My colleagues in the Department of the History of Art have been unfailingly supportive; I have mentioned many of them here. Special thanks are due our Department administrators, Carol Anderson and Maud Morris, for computer assistance. Many friends, as well as colleagues, have endured my enthusiasms and despairs, but I extend my special thanks to Katherine Giele, Nancy and David Dinneen, Charlie and Jane Eldredge, Anta Montet-White, and Katherine Stannard (without whose swimming pool the second edition would never have been finished), and, of course, my very special thanks go to my sister, Karen Leider, and my niece, Anna Leider.

Finally, Paul Gottlieb, who was for twenty years president of Harry N. Abrams, Inc., believed in *Art History* from its inception. With heartfelt thanks for his faith in the project, his unending zeal for the production of valuable and beautiful books, and perhaps especially for his good humor, I express my admiration and gratitude.

Marilyn Stokstad
Lawrence, Kansas
Spring 2001

Contents

Preface 6
Acknowledgments 8
Contents 10
Use Notes 17
Starter Kit 18
Introduction 24

CHAPTER 1 Prehistory and Prehistoric Art in Europe 42

THE PALEOLITHIC PERIOD 44
 The Beginning of Architecture 45
 Sculpture 45
 Cave Art 47
THE NEOLITHIC PERIOD 53
 Rock-Shelter Art 53
 Architecture 55
 Sculpture and Ceramics 66
THE BRONZE AGE 63
THE IRON AGE 64
BOXES
Elements of Architecture
 Post-and-Lintel and Corbel Construction 55
Technique
 Prehistoric Wall Painting 49
 Pottery and Ceramics 62
Text
 The Power of Naming 47
 The Meaning of Prehistoric Cave Paintings 48
 How Early Art Is Dated 54
THE OBJECT SPEAKS: Prehistoric Woman and Man 61

CHAPTER 2 Art of the Ancient Near East 66

THE FERTILE CRESCENT 68
EARLY NEOLITHIC CITIES 69
SUMER 70
AKKAD 76
LAGASH 77
BABYLON AND MARI 78
ASSYRIA 80
NEO-BABYLONIA 83
ELAM 85
ANATOLIA 86
PERSIA 88
BOXES
Technique
 Coining Money 89
Text
 Cuneiform Writing 71
 Gilgamesh 71
 Protection or Theft? 85
 The Fiber Arts 86
THE OBJECT SPEAKS: The Code of Hammurabi 79

CHAPTER 3 Art of Ancient Egypt 92

NEOLITHIC AND PREDYNASTIC EGYPT 94
EARLY DYNASTIC EGYPT 95
 Religious Beliefs 95
 The Palette of Narmer 96
 Representation of the Human Figure 98
THE OLD KINGDOM 99
 Funerary Architecture 99
 Sculpture 104

Tomb Decoration 107
THE MIDDLE KINGDOM 108
 Architecture and Town Planning 108
 Tomb Art and Tomb Construction 109
 Sculpture 112
 Small Objects Found in Tombs 112
THE NEW KINGDOM 113
 Great Temple Complexes 114
 Akhenaten and the Art of the Amarna Period 117
 The Return to Tradition 122
 Books of the Dead 125
THE CONTINUING INFLUENCE OF EGYPTIAN ART 125
BOXES
Elements of Architecture
 Mastaba to Pyramid 100
 Column 102
Technique
 Egyptian Painting and Relief Sculpture 108
 Glassmaking and Egyptian Faience 122
Text
 Egyptian Symbols 96
 Egyptian Myths of Creation 96
 Preserving the Dead 99
 The Seven Wonders of the World 104
 Hieroglyphic, Hieratic, and Demotic Writing 111
 Restoring the Tomb of Nefertari 124
THE OBJECT SPEAKS: The Temples of Rameses II 118

CHAPTER 4 Aegean Art 128

THE AEGEAN WORLD 130
THE CYCLADIC ISLANDS IN THE BRONZE AGE 131
CRETE AND THE MINOAN CIVILIZATION 133
 The Old Palace Period (c. 1900–1700 BCE) 135
 The Second Palace Period (c. 1700–1450 BCE) 137
 The Late Minoan Period (c. 1450–1375 BCE) 141
MAINLAND GREECE AND THE MYCENAEAN CIVILIZATION 142
 Architecture 142
 Sculpture 148
 Metalwork 150
 Ceramics 150
BOXES
Technique
 Aegean Metalwork 136
Text
 The Date Debate 131
 The Wreck at Ulu Burun 131
 The Legend of the Minotaur 134
 The Trojan War 144
 Pioneers of Aegean Archaeology 149
THE OBJECT SPEAKS: The "Mask of Agamemnon" 145

CHAPTER 5 Art of Ancient Greece 152

THE EMERGENCE OF GREEK CIVILIZATION 154
 A Brief History 155
 Religious Beliefs and Sacred Places 156
 Historical Divisions of Greek Art 157
THE GEOMETRIC PERIOD 159
 Ceramic Decoration 159
 Metal Sculpture 160
 The First Greek Temples 160
THE ORIENTALIZING PERIOD 161

THE ARCHAIC PERIOD 161
Temple Architecture 162
Architectural Sculpture 165
Freestanding Sculpture 168
Vase Painting 172
THE CLASSICAL PERIOD IN GREEK ART 177
THE TRANSITIONAL, OR EARLY CLASSICAL, PERIOD 178
Architectural Sculpture 178
Freestanding Sculpture 179
Vase Painting 183
THE FIFTH-CENTURY CLASSICAL PERIOD 185
The Athenian Agora 185
The Acropolis 187
The Parthenon 187
Sculpture and *The Canon* of Polykleitos 196
Stele Sculpture 197
Painting 197
CLASSICAL ART OF THE FOURTH CENTURY 198
Architecture and Architectural Sculpture 199
Sculpture 202
Wall Painting and Mosaics 207
The Art of the Goldsmith 208
THE HELLENISTIC PERIOD 210
Theaters 211
The Corinthian Order in Architecture 211
Sculpture 212
BOXES
Elements of Architecture
Greek Temple Plans 163
The Greek Architectural Orders 164
Technique
Greek Painted Vases 173
Text
Greek and Roman Deities and Heroes 158
Classic *and* Classical 179
*The Discovery and Conservation of the
Riace Warriors* 183
Women Artists in Ancient Greece 209
Realism and Naturalism 218
THE OBJECT SPEAKS: The Parthenon 188

CHAPTER 6 Etruscan Art and Roman Art 222
ETRUSCAN CIVILIZATION 224
The Etruscan City 225
Temples and Their Decoration 226
Tombs 230
Bronze Work 231
ROMAN HISTORY 233
THE REPUBLICAN AND AUGUSTAN PERIODS 236
Architecture 237
Republican Sculpture 239
Augustan Sculpture 241
THE EMPIRE 246
Imperial Architecture 246
Relief Sculpture 254
Portrait Sculpture 257
THE ROMAN CITY AND HOME 260
Domestic Architecture 263
Mosaics 267
Wall Painting 269
THE LATE EMPIRE 274
The Severan Dynasty 274

The Third Century 276
The Tetrarchs 279
Constantine the Great and His Legacy 282
Roman Traditionalism in Art after Constantine 285
BOXES
Elements of Architecture
Arch, Vault, and Dome 228
Roman Architectural Orders 229
Roman Construction 236
Technique
Roman Mosaics 267
Text
Roman Writers on Art 229
Reigns of Significant Roman Emperors 234
Distinctively Roman Gods 234
Roman Funerary Practices 239
The Urban Garden 266
The Position of Roman Women 274
THE OBJECT SPEAKS: *The Unswept Floor* 268

CHAPTER 7 Early Christian, Jewish, and
Byzantine Art 288
JEWS AND CHRISTIANS IN THE ROMAN EMPIRE 290
Early Judaism 291
Early Christianity 291
JEWISH AND EARLY CHRISTIAN ART 292
Painting and Sculpture 293
Architecture and Its Decoration 294
IMPERIAL CHRISTIAN ARCHITECTURE AND ART 297
Architecture and Its Decoration 297
Central-Plan Churches 300
Sculpture 308
EARLY BYZANTINE ART 309
The Church and Its Decoration 310
MIDDLE BYZANTINE ART 323
Architecture and Its Decoration 323
Ivories and Metalwork 333
Manuscripts 336
LATE BYZANTINE ART 337
BOXES
Elements of Architecture
Basilica-Plan and Central-Plan Churches 298
Pendentives and Squinches 311
Multiple-Dome Church Plans 324
Text
Rome, Constantinople, and Christianity 292
Christian Symbols 294
Early Forms of the Book 304
Iconography of the Life of Jesus 306
Iconoclasm 309
THE OBJECT SPEAKS: *The Archangel Michael* 334

CHAPTER 8 Islamic Art 342
ISLAM AND EARLY ISLAMIC SOCIETY 344
ART DURING THE EARLY CALIPHATES 345
Architecture 345
Calligraphy 349
Ceramic and Textile Arts 352
LATER ISLAMIC SOCIETY AND ART 353
Architecture 354
Portable Arts 358
Manuscript Illumination and Calligraphy 365

BOXES

Elements of Architecture

Mosque Plans 351

Arches and Muqarnas 352

Technique

Carpet Making 364

Text

The Life of the Prophet Muhammad 348

CHAPTER 9 Art of India before 1100 370

THE INDIAN SUBCONTINENT 372

INDUS VALLEY CIVILIZATION 373

THE VEDIC PERIOD 375

THE MAURYA PERIOD 377

THE PERIOD OF THE SHUNGAS AND

EARLY ANDHRAS 379

Stupas 379

Buddhist Rock-Cut Halls 382

THE KUSHAN AND LATER ANDHRA PERIOD 383

The Gandhara School 383

The Mathura School 384

The Amaravati School 384

THE GUPTA PERIOD 386

Buddhist Sculpture 386

Painting 386

THE POST-GUPTA PERIOD 388

The Early Northern Temple 388

Monumental Narrative Reliefs 391

The Early Southern Temple 393

THE EARLY MEDIEVAL PERIOD 394

The Monumental Northern Temple 395

The Monumental Southern Temple 396

The *Bhakti* Movement in Art 397

BOXES

Elements of Architecture

Stupas and Temples 381

Text

Buddhism 376

Hinduism 378

Mudras 385

Meaning and Ritual in Hindu Temples and Images 390

CHAPTER 10 Chinese Art before 1280 400

THE MIDDLE KINGDOM 402

NEOLITHIC CULTURES 402

Painted Pottery Cultures 403

Liangzhu Culture 403

BRONZE AGE CHINA 405

Shang Dynasty 405

Zhou Dynasty 406

THE CHINESE EMPIRE: QIN DYNASTY 407

HAN DYNASTY 407

Philosophy and Art 409

Architecture 411

SIX DYNASTIES 411

Painting 412

Calligraphy 413

Buddhist Art and Architecture 413

SUI AND TANG DYNASTIES 414

Buddhist Art and Architecture 416

Figure Painting 418

SONG DYNASTY 419

Philosophy: Neo-Confucianism 419

Northern Song Painting 420

Southern Song Painting and Ceramics 423

BOXES

Elements of Architecture

Pagodas 418

Technique

Piece-Mold Casting 404

Text

Chinese Characters 404

The Silk Road 408

Daoism 409

Confucius and Confucianism 410

CHAPTER 11 Japanese Art before 1392 426

PREHISTORIC JAPAN 428

Jomon Period 428

Yayoi and Kofun Periods 430

ASUKA PERIOD 432

NARA PERIOD 434

HEIAN PERIOD 436

Esoteric Buddhist Art 436

Pure Land Buddhist Art 437

Poetry and Calligraphy 438

Secular Painting 440

KAMAKURA PERIOD 442

Pure Land Buddhist Art 442

Zen Buddhist Art 444

BOXES

Technique

Joined-Wood Sculpture 440

Text

Buddhist Symbols 434

Writing, Language, and Culture 443

Arms and Armor 445

THE OBJECT SPEAKS: *Monk Sewing* 446

CHAPTER 12 Art of the Americas before 1300 448

THE NEW WORLD 450

MESOAMERICA 451

The Olmec 453

Teotihuacan 454

The Maya 457

CENTRAL AMERICA 462

SOUTH AMERICA: THE CENTRAL ANDES 462

The Paracas and Nazca Cultures 463

The Moche Culture 464

NORTH AMERICA 465

The Mound Builders 466

The American Southwest 468

BOXES

Text

The Cosmic Ball Game 451

Maya Record Keeping 458

Technique

Andean Textiles 452

CHAPTER 13 Art of Ancient Africa 470

THE LURE OF ANCIENT AFRICA 472

SAHARAN ROCK ART 473

SUB-SAHARAN CIVILIZATIONS 474

Nok 475

Ife 475

Benin 477

OTHER URBAN CENTERS 479

Djenné 479

Great Zimbabwe 480

BOXES

Text

The Myth of "Primitive" Art	473
Who Made African Art?	477

CHAPTER 14 Early Medieval Art in Europe 484

THE MIDDLE AGES	486
THE BRITISH ISLES AND SCANDINAVIA	487
CHRISTIAN SPAIN	492
LANGOBARD ITALY	495
CAROLINGIAN EUROPE	496
Architecture	497
Books	499
SCANDINAVIA: THE VIKINGS	502
OTTONIAN EUROPE	505
Architecture	506
Sculpture	507
Books	510

BOXES

Text

The Northern Deities	487
The Medieval Scriptorium	490
The Western Church's Definition of Art	496

THE OBJECT SPEAKS:

The Doors of Bishop Bernward	508

CHAPTER 15 Romanesque Art 514

ROMANESQUE CULTURE	516
FRANCE AND NORTHERN SPAIN	517
Architecture	518
Architectural Sculpture	523
Independent Sculpture	529
Wall Painting	530
Books	532
THE NORTH SEA KINGDOMS	534
Timber Architecture and Sculpture	535
Masonry Architecture	537
Books	540
The *Bayeux Tapestry*	540
THE HOLY ROMAN EMPIRE	542
Architecture	544
Metalwork	546
Books	546
ANCIENT ROME AND ROMANESQUE ITALY	549

BOXES

Elements of Architecture

The Romanesque Church Portal	525

Technique

Embroidery Techniques	544

Text

The Crusades	517
The Pilgrim's Journey	518
Timber Construction	535

THE OBJECT SPEAKS: The *Bayeux Tapestry* 543

CHAPTER 16 Gothic Art 554

THE GOTHIC STYLE	556
FRANCE	559
Architecture and Its Decoration	559
Independent Sculpture	579
Book Arts	580
ENGLAND	584
Architecture	584
Book Arts	588
Opus Anglicanum	589

SPAIN	589
Architecture	589
Book Arts	590
Painted Altarpieces	590
GERMANY AND THE HOLY ROMAN EMPIRE	592
Architecture	592
Sculpture	593
ITALY	597
Architecture	597
Sculpture	597
Painting	601

BOXES

Elements of Architecture

Rib Vaulting	561
The Gothic Church	568
The Gothic Castle	587

Technique

Stained-Glass Windows	569
Cennini on Panel Painting	602
Buon Fresco	604

Text

Romance	558
The Black Death	559
Master Builders	586

THE OBJECT SPEAKS: Notre-Dame of Paris 574

CHAPTER 17 Early Renaissance Art in Europe 614

THE RENAISSANCE AND HUMANISM	616
ART OF THE FRENCH DUCAL COURTS	622
Manuscript Illumination	622
Painting and Sculpture for the Chartreuse de Champmol	625
Flamboyant-Style Architecture	626
ART OF FLANDERS	628
First-Generation Panel Painters	629
Second-Generation Panel Painters	635
Luxury Arts	641
THE SPREAD OF THE FLEMISH STYLE	645
The Iberian Peninsula	645
France	646
Germany	646
THE GRAPHIC ARTS	648
ART OF ITALY	649
Architecture and Its Decoration	650
Sculpture	660
Painting	666

BOXES

Technique

Painting on Panel	630
Woodcuts and Engravings on Metal	648

Text

Perspective Systems	621
Italian Artists' Names and Nicknames	622
Women Artists in the Late Middle Ages and the Renaissance	623
Altars and Altarpieces	628
The Printed Book	644
Alberti's Art Theory in the Renaissance	655

THE OBJECT SPEAKS: The Foundling Hospital 653

CHAPTER 18 Renaissance Art in Sixteenth-Century Europe 684

EUROPE IN THE SIXTEENTH CENTURY	686
The Changing Status of Artists	687

THE CLASSICAL PHASE OF THE RENAISSANCE
IN ITALY 687
Three Great Artists of the Classical Phase 688
Architecture in Rome and the Vatican 701
Architecture and Painting in Northern Italy 703
THE RENAISSANCE AND REFORMATION
IN GERMANY 710
Early-Sixteenth-Century Sculpture 711
Early-Sixteenth-Century Painting and Printmaking 714
The Reformation and the Arts 718
LATE RENAISSANCE ART IN ITALY 723
Architecture in Rome and the Vatican 723
Michelangelo and Titian 727
Italian Mannerism 729
Women Painters 733
Painting and Architecture in Venice and the Veneto 734
RENAISSANCE ART IN FRANCE 739
Painting 739
Architecture and Its Decoration 739
RENAISSANCE ART IN SPAIN 742
Architecture 742
Painting 742
RENAISSANCE PAINTING IN THE NETHERLANDS 745
RENAISSANCE ART IN ENGLAND 748
Painting 749
Architecture 753

BOXES
Elements of Architecture
The Renaissance Palace Facade 704
Parts of the Church Facade 725
Technique
Painting on Canvas 707
Text
Great Papal Patrons of the Sixteenth Century 687
The Vitruvian Man 690
The Sistine Ceiling *Restoration* 698
Saint Peter's Basilica 702
Women Patrons of the Arts 709
The Grotto 741
Armor for Royal Games 752
THE OBJECT SPEAKS: *Feast in the House of Levi* 735

CHAPTER 19 Baroque Art in Europe and
North America 756
THE BAROQUE PERIOD 758
ITALY 760
Urban Design, Architecture, and
Architectural Sculpture 760
Independent Sculpture 768
Illusionistic Ceiling Painting 768
Painting on Canvas 774
FRANCE 778
Architecture and Its Decoration at Versailles 778
Painting 782
HABSBURG GERMANY AND AUSTRIA 785
HABSBURG SPAIN 786
Architecture 786
Painting 788
SPANISH COLONIES IN THE AMERICAS 794
THE SOUTHERN NETHERLANDS/FLANDERS 796
THE NORTHERN NETHERLANDS/UNITED
DUTCH REPUBLIC 800
Portraits 802
Views of the World 808
Genre Painting 813

Still Lifes and Flowers Pieces 814
ENGLAND 816
Architecture and Landscape Design 816
ENGLISH COLONIES IN NORTH AMERICA 820
Architecture 820
Painting 821

BOXES
Technique
Etching and Drypoint 808
Text
Science and the Changing Worldview 759
Great Papal Patrons of the Seventeenth Century 760
Caravaggio and the New Realism 775
Grading the Old Masters 778
French Baroque Garden Design 780
Wölfflin's The Principles of Art History 799
The Dutch Art Market 803
The English Court Masque 818
THE OBJECT SPEAKS: Brueghel and Rubens's *Sight* 801

CHAPTER 20 Art of India after 1100 824
LATE MEDIEVAL PERIOD 826
Buddhist Art 826
Jain Art 827
Hindu Art 828
MUGHAL PERIOD 829
Mughal Painting 830
Mughal Architecture 832
Rajput Painting 833
MODERN PERIOD 836

BOXES
Technique
Indian Painting on Paper 832
Text
Foundations of Indian Culture 828

CHAPTER 21 Chinese Art after 1280 838
THE MONGOL INVASIONS 840
YUAN DYNASTY 841
MING DYNASTY 845
Court and Professional Painting 845
Decorative Arts and Gardens 846
Architecture and City Planning 848
Literati Painting 848
QING DYNASTY 851
Orthodox Painting 853
Individualist Painting 853
THE MODERN PERIOD 854

BOXES
Technique
Formats of Chinese Painting 844
Text
The Foundations of Chinese Culture 841
Marco Polo 842
The Secret of Porcelain 846
Geomancy, Cosmology, and Chinese Architecture 850

CHAPTER 22 Japanese Art after 1392 856
MUROMACHI PERIOD 858
Ink Painting 859
The Zen Dry Garden 861
MOMOYAMA PERIOD 862
Architecture 863
Kano School Decorative Painting 863
The Tea Ceremony 864

EDO PERIOD 866
 The Tea Ceremony 866
 Rimpa School Painting 867
 Nanga School 868
 Zen Painting 870
 Maruyama-Shijo School Painting 870
 Ukiyo-e: Pictures of the Floating World 872
THE MEIJI AND MODERN PERIODS 873
■ BOXES
Elements of Architecture
 Shoin Design 865
Technique
 Lacquer 868
 Japanese Woodblock Prints 871
Text
 Foundations of Japanese Culture 859
 Inside a Writing Box 869

CHAPTER 23 Art of the Americas after 1300 876
INDIGENOUS AMERICAN ART 878
MEXICO AND SOUTH AMERICA 879
 The Aztec Empire 879
 The Inka Empire 881
NORTH AMERICA 884
 Eastern Woodlands and the Great Plains 884
 The Northwest Coast 888
 The Southwest 892
OTHER CONTEMPORARY NATIVE AMERICAN ARTISTS 895
■ BOXES
Technique
 Basketry 885
Elements of Architecture
 Inka Masonry 883
Text
 Foundations of Civilizations in the Americas 879
 Navajo Night Chant 894
■ THE OBJECT SPEAKS: Hamatsa mask 890

CHAPTER 24 Art of Pacific Cultures 898
THE PEOPLING OF THE PACIFIC 900
AUSTRALIA 901
MELANESIA 902
 Papua New Guinea 903
 Irian Jaya 904
 New Ireland 904
MICRONESIA 905
POLYNESIA 906
 Easter Island 906
 Marquesas Islands 906
 Hawaiian Islands 906
 New Zealand 908
RECENT ART IN OCEANIA 910
■ BOXES
Text
 Paul Gauguin on Oceanic Art 906
 Art and Science: The First Voyage of Captain Cook 910

CHAPTER 25 Art of Africa in the Modern Era 914
TRADITIONAL AND CONTEMPORARY AFRICA 916
CHILDREN AND THE CONTINUITY OF LIFE 919
 Initiation 920

THE SPIRIT WORLD 922
LEADERSHIP 926
DEATH AND ANCESTORS 929
CONTEMPORARY ART 931
■ BOXES
Text
 Foundations of African Cultures 917
 African Furniture and the Art Deco Style 918
 Numumusow and West African Ceramics 933

CHAPTER 26 Eighteenth-Century Art in Europe and North America 936
THE ENLIGHTENMENT AND ITS REVOLUTIONS 938
THE ROCOCO STYLE IN EUROPE 939
 Architecture and Its Decoration in Germany and Austria 940
 Painting in France 943
 Decorative Arts and Sculpture 946
ART IN ITALY 949
 Art of the Grand Tour 949
 Neoclassicism in Rome 952
REVIVALS AND ROMANTICISM IN BRITAIN 953
 Classical Revival in Architecture and Landscaping 953
 Gothic Revival in Architecture and Its Decoration 956
 Neoclassicism in Architecture and the Decorative Arts 956
 Painting 959
 The Satiric Spirit 959
 Portraiture 960
 The Romance of Science 961
 History Painting 961
 Romantic Painting 964
ART IN FRANCE 966
 Architecture 966
 Painting and Sculpture 968
ART IN NORTH AMERICA 973
 Architecture 973
 Painting 974
■ BOXES
 Academies and Academy Exhibitions 944
 Women and Academies 950
 Iron as a Building Material 962
■ THE OBJECT SPEAKS: Georgian Silver 958

CHAPTER 27 Nineteenth-Century Art in Europe and the United States 978
EUROPE AND THE UNITED STATES IN THE NINETEENTH CENTURY 980
 Early-Nineteenth-Century Art: Neoclassicism and Romanticism 981
 Late-Nineteenth-Century Art: Realism and Antirealism 981
NEOCLASSICISM AND ROMANTICISM IN FRANCE 982
 David and His Students 982
 Romantic Painting 984
 Romantic Sculpture 990
ROMANTICISM IN SPAIN 991
ROMANTIC LANDSCAPE PAINTING IN EUROPE 993
NATURALISTIC, ROMANTIC, AND NEOCLASSICAL AMERICAN ART 996
 Landscape and Genre Painting 997
 Sculpture 998
REVIVAL STYLES IN ARCHITECTURE BEFORE 1850 1000
EARLY PHOTOGRAPHY IN EUROPE 1002

NEW MATERIALS AND TECHNOLOGY IN ARCHITECTURE AT MIDCENTURY	1006
FRENCH ACADEMIC ART AND ARCHITECTURE	1007
FRENCH NATURALISM AND REALISM AND THEIR SPREAD	1009
French Naturalism	1009
French Realism	1011
Naturalism and Realism outside France	1013
LATE-NINETEENTH-CENTURY ART IN BRITAIN	1014
IMPRESSIONISM	1018
Later Impressionism	1027
POST-IMPRESSIONISM	1030
Symbolism in Painting	1036
Late-Nineteenth-Century French Sculpture	1039
Art Nouveau	1041
ART IN THE UNITED STATES	1042
Neoclassical Sculpture	1042
Landscape Painting and Photography	1044
Civil War Photography and Sculpture	1046
Post-Civil War Realism	1047
Urban Photography	1049
Religious Art	1051
Architecture	1052

BOXES
Technique
Lithography	989
How Photography Works	1004

Text
The Print Revivals	1017
Artistic Allusions in Manet's Art	1018
Japonisme	1020

THE OBJECT SPEAKS: *Raft of the "Medusa"* | 986

CHAPTER 28 The Rise of Modernism in Europe and North America 1058
EUROPE AND THE UNITED STATES IN THE EARLY TWENTIETH CENTURY	1060
EARLY MODERNIST TENDENCIES IN EUROPE	1061
The Late Flowering of Art Nouveau	1061
The Fauves	1063
Die Brücke	1065
Independent Expressionists	1066
Der Blaue Reiter	1068
Early Modernist Sculpture	1071
CUBISM IN EUROPE	1072
Picasso's Early Art	1072
Analytic Cubism	1075
Synthetic Cubism	1077
Responses to Cubism	1078
EARLY MODERNIST TENDENCIES IN THE UNITED STATES	1082
EARLY MODERN ARCHITECTURE	1083
American Modernism	1086
The American Skyscraper	1087
European Modernism	1087
MODERNISM IN EUROPE BETWEEN THE WARS	1089
Utilitarian Art Forms in Russia	1090
Rationalism in the Netherlands	1092
Classicism and Purism in France	1094
Bauhaus Art in Germany	1096
Dada	1099
Surrealism	1102
Modernism in Sculpture	1106
ART AND ARCHITECTURE IN THE UNITED STATES BETWEEN THE WARS	1107

Precisionism	1108
American Scene Painting and Photography	1108
The Harlem Renaissance	1112
Abstraction	1113
Architecture	1115
Art in Mexico between the Wars	1117
EARLY MODERN ART IN CANADA	1119

BOXES
Elements of Architecture
The Skyscraper	1088
The International Style	1094

Text
Suppression of the Avant-Garde in Germany	1097
Federal Patronage for American Art during the Depression	1109

THE OBJECT SPEAKS: *Portrait of a German Officer* | 1084

CHAPTER 29 The International Avant-Garde since 1945 1124
THE WORLD SINCE 1945	1126
The "Mainstream" Crosses the Atlantic	1127
POSTWAR EUROPEAN ART	1127
ABSTRACT EXPRESSIONISM	1130
The Formative Phase	1130
Action Painting	1131
Color Field Painting	1134
Sculpture of the New York School	1135
The Second Generation of Abstract Expressionism	1137
ALTERNATIVES TO ABSTRACT EXPRESSIONISM	1137
Return to the Figure	1138
Happenings	1138
Assemblage	1140
Pop Art	1142
Post-Painterly Abstraction and Op Art	1145
Minimalism and Post-Minimalism	1146
Conceptual and Performance Art	1148
Postwar American Photography	1150
The Rise of American Craft Art	1152
FROM MODERNISM TO POSTMODERNISM	1153
Architecture	1154
Earthworks and Site-Specific Sculpture	1159
Feminist Art	1162
POSTMODERNISM	1165
Neo-Expressionism	1165
Neo-Conceptualism	1168
Later Feminist Art	1170
The Persistence of Modernism	1170
Recent Craft Art	1172
The Return to the Body	1173
Public Art	1177
Installation and Video Art	1181

BOXES
Text
The Idea of the Mainstream	1128
Appropriation	1166
Recent Controversies over Public Funding for the Arts	1175

THE OBJECT SPEAKS: *The Dinner Party* | 1163

Glossary	Glossary 1
Bibliography	Bibliography 1
Index	Index 1
Credits	Credits 1

Use Notes

The various features of this book reinforce each other, helping the reader to become comfortable with terminology and concepts that are specific to art history.

Starter Kit and Introduction The Starter Kit is a highly concise primer of basic concepts and tools. The outer margins of the Starter Kit pages are tinted to make them easy to find. The Introduction is an invitation to the many pleasures of art history.

Captions There are two kinds of captions in this book: short and long. Short captions identify information specific to the work of art or architecture illustrated:

> artist (when known)
> title or descriptive name of work
> date
> original location (if moved to a museum or other site)
> material or materials a work is made of
> size (height before width) in feet and inches, with
> centimeters and meters in parentheses
> present location

The order of these elements varies, depending on the type of work illustrated. Dimensions are not given for architecture, for most wall paintings, or for architectural sculpture. Some captions have one or more lines of small print below the identification section of the caption that gives museum or collection information. This is rarely required reading.

Long captions contain information that complements the narrative of the main text.

Definitions of Terms You will encounter the basic terms of art history in three places:

> IN THE TEXT, where words appearing in **boldface** type are defined, or glossed, at their first use. Some terms are explained more than once, especially those that experience shows are hard to remember.

> IN BOXED FEATURES on technique and other subjects and in Elements of Architecture boxes, where labeled drawings and diagrams visually reinforce the use of terms.

> IN THE GLOSSARY at the end of the volume, which contains all the words in **boldface** type in the text and boxes. The Glossary begins on page Glossary 1, and the outer margins are tinted to make the Glossary easy to find.

Maps, Timelines, and Parallels At the beginning of each chapter you will find a map with all the places mentioned in the chapter. Above the map, a timeline runs from the earliest through the latest years covered in that chapter.

Parallels, a table at the end of every chapter, lists, in the left column, key artworks in that chapter in chronological order and, in the right column, major works from other cultures of about the same time. Parallels offer a selection of simultaneous art events for comparison without suggesting that there are direct connections between them.

Boxes Special material that complements, enhances, explains, or extends the text is set off in three types of tinted boxes. Elements of Architecture boxes clarify specifically architectural features, such as "Space-Spanning Construction Devices" in the Starter Kit (page 22). Technique boxes (see "Lost-Wax Casting," page 21) amplify the methodology by which a type of artwork is created. Other boxes treat special-interest material related to the text.

Bibliography The bibliography at the end of this book beginning on page Bibliography 1 contains books in English, organized by general works and by chapter, that are basic to the study of art history today, as well as works cited in the text.

Dates, Abbreviations, and Other Conventions This book uses the designations BCE and CE, abbreviations for "before the Common Era" and "Common Era," instead of BC ("before Christ") and AD ("Anno Domini," "the year of our Lord"). The first century BCE is the period from 99 BCE to 1 BCE; the first century CE is from the year 1 CE to 99 CE. Similarly, the second century BCE is the period from 199 BCE to 100 BCE; the second century CE extends from 100 CE to 199 CE.

100's	99–1	1–99	100's
second century BCE	first century BCE	first century CE	second century CE

Circa ("about" or "approximately") is used with dates, spelled out in the text and abbreviated to "c." in the captions, when an exact date is not yet verified.

An illustration is called a "figure," or "fig." Thus, figure 6-70 is the seventieth numbered illustration in Chapter 6. Figures 1 through 28 are in the Introduction. There are two types of figures: photographs of artworks or of models, and line drawings. Drawings are used when a work cannot be photographed or when a diagram or simple drawing is the clearest way to illustrate an object or a place.

When introducing artists, we use the words *active* and *documented* with dates, in addition to "b." (for "born") and "d." (for "died"). "Active" means that an artist worked during the years given. "Documented" means that documents link the person to that date.

Accents are used for words in French, German, Italian, and Spanish only.

With few exceptions, names of museums and other cultural bodies in Western European countries are given in the form used in that country.

Titles of Works of Art Most paintings and works of sculpture created in Europe and North America in the past 500 years have been given formal titles, either by the artist or by critics and art historians. Such formal titles are printed in italics. In other traditions and cultures, a single title is not important or even recognized. In this book we use formal descriptive titles of artworks where titles are not established. If a work is best known by its non-English title, such as Manet's *Le Dejeuner sur l'Herbe (The Luncheon on the Grass)*, the original language precedes the translation.

Starter Kit

The Starter Kit contains basic information and concepts that underlie and support the study of art history, which concerns itself with the visual arts—traditionally painting and drawing, sculpture, prints, and architecture. It presents the vocabulary used to classify and describe art objects and is therefore indispensable to the student of art history. Use the Starter Kit as a quick reference guide to understanding terms you will encounter again and again in reading *Art History* and in experiencing art directly.

Let us begin with the basic properties of art. In concrete, nonphilosophical terms, a work of art has two components: FORM and CONTENT. It is also described and categorized according to STYLE and MEDIUM.

FORM

Referring to purely visual aspects of art and architecture, the term *form* encompasses qualities of LINE, COLOR, TEXTURE, SPATIAL ATTRIBUTES, and COMPOSITION. When art historians use the term *formal* they mean "relating to form." These qualities all are known as FORMAL ELEMENTS.

Line is an element—usually drawn or painted—that defines shape with a more-or-less continuous mark. In art historical writing, the word *linear* suggests an emphasis on line. Line can be real, as when the line is visible, or it may be imaginary, as when the movement of the eyes over the surface of the work of art follows a path that suggests a line or lines. The outline, edge, or silhouette of an object is perceived as line. Qualities of line range from angular to curvy (called curvilinear), from delicate to bold, from solid to sketchy.

Color has several attributes. These include HUE, VALUE, and SATURATION.

> HUE is what we think of when we hear the word *color*. Red, yellow, and blue are PRIMARY HUES (colors) because the SECONDARY COLORS of orange, green, and purple are made by combining red and yellow, yellow and blue, and red and blue, respectively. Red, orange, and yellow are regarded as warm colors, colors that advance toward us. Green, blue, and purple, which seem to recede, are called cool colors.

> VALUE is the relative degree of lightness or darkness of a given color and is created by the amount of light reflected from an object's surface. A dark green has a deeper value than a light green, for example. In black-and-white reproductions of colored objects, you see only value, and some artworks—for example, a drawing made with black ink—possesses only value, not hue or saturation.

> SATURATION, also referred to sometimes as INTENSITY, is a color's quality of brightness or dullness. A color described as highly saturated looks vivid and pure; a hue of low saturation may look a little muddy.

Texture, another attribute of form, is the tactile (or touch-perceived) quality of a surface. It is experienced and described with words such as *smooth, polished, rough, grainy, pitted, oily*, and the like. Texture relates to two aspects of an art object: the texture of the artwork's actual surface and the texture of the implied but imaginary surface of the object that the work represents.

Spatial attributes include SPACE, MASS, and VOLUME.

> SPACE is what contains objects. It may be actual and three-dimensional, as it is with sculpture and architecture, or it may be represented illusionistically in two dimensions, as when artists represent recession into the distance on walls, paper, or canvas.

> MASS and VOLUME are properties of three-dimensional things. Mass is matter—whether sculpture or architecture—that takes up space; it can be either solid or hollow. Volume is the space that mass organizes or defines by, for example, enclosing or partitioning it.

Composition is the organization, or disposition, of form in a work of art. PICTORIAL DEPTH (spatial recession) is a specialized aspect of composition in which the three-dimensional world is represented in two dimensions on a flat surface, or PICTURE PLANE. The area "behind" the picture plane is called the PICTURE SPACE and conventionally contains three "zones": FOREGROUND, MIDDLE GROUND, and BACKGROUND. Perpendicular to the picture plane is the GROUND PLANE.

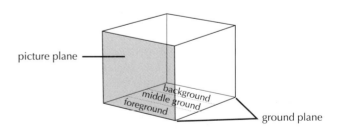

Diagram of picture space

Various techniques for conveying a sense of pictorial depth have been devised and preferred by artists in different cultures and at different times. A number of them are diagrammed here. In Western art, the use of various systems of PERSPECTIVE has created highly convincing illusions of recession into space. In other cultures, perspective is not the most favored way to treat objects in space.

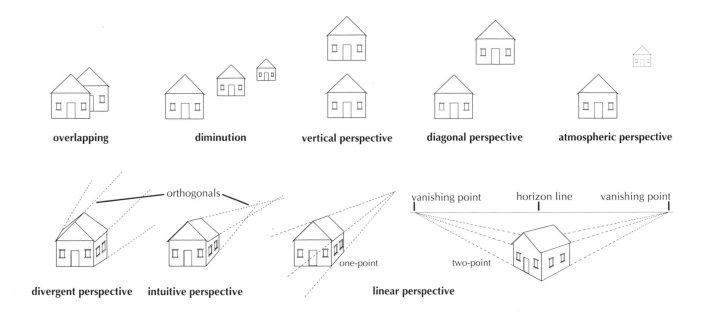

Pictorial devices for depicting recession in space

The top row shows several comparatively simple devices, including OVERLAPPING, in which partially covered elements are meant to be seen as located behind those covering them, and DIMINUTION, in which smaller elements are to be perceived as being farther away than larger ones. In VERTICAL and DIAGONAL PERSPECTIVE, elements are stacked vertically or diagonally, with the higher elements intended to be perceived as deeper in space. Another way of suggesting depth is through ATMOS-PHERIC PERSPECTIVE, which depicts objects in the far distance, often in bluish gray hues, with less clarity than nearer objects and treats sky as paler near the horizon than higher up. In the lower row, DIVERGENT PERSPECTIVE, in which forms widen slightly and lines diverge as they recede in space, was used by East Asian artists. INTUITIVE PERSPECTIVE, used in some late medieval European art, takes the opposite approach: forms become narrower and converge the farther they are from the viewer, approximating the optical experience of spatial recession. LINEAR PERSPECTIVE, also called SCIENTIFIC, MATHEMATICAL, ONE-POINT, and RENAISSANCE PERSPECTIVE, is an elaboration and standardization of intuitive perspective and was developed in fifteenth-century Italy. It uses mathematical formulas to construct illusionistic images in which all elements are shaped by imaginary lines called ORTHOGONALS that converge in one or more VANISHING POINTS on a HORIZON LINE. Linear perspective is the system that most people living in Western cultures think of as perspective. Because it is the visual code they are accustomed to reading, they accept as "truth" the distortions it imposes. One of these distortions is FORESHORTENING, in which, for instance, the soles of the feet in the foreground are the largest elements of a figure lying on the ground.

CONTENT

Content is a term that embraces non-formal aspects of works of art, aspects that impart meaning. Content includes SUBJECT MATTER, which is, quite simply, what the artist is representing, even when what we see are strictly formal elements—lines and colors without recognizable imagery. *REPRESENTATIONAL ART* and *NONREPRESENTIONAL* (or *NONOBJECTIVE*) *ART* are terms used to indicate whether subject matter is or is not recognizable. David Smith's *Cubi XIX*, seen in figure 5, is an example of nonrepresentational art.

Content also includes the ideas contained in a work. Content may comprise the social, political, and economic CONTEXTS in which a work was created, the INTENTION of the artist, the RECEPTION of the work by the beholder (the audience), and ultimately the MEANINGS of the work of art to both artist and audience.

The study of subject matter is ICONOGRAPHY (literally, "the writing of images"). The iconographer asks, What are we looking at? Because so many artists have used visual symbols to represent or identify concepts and ideas, iconography includes the fascinating study of SYMBOLS and SYMBOLISM.

STYLE

Expressed very broadly, style is the combination of form and content that makes a work distinctive. STYLISTIC ANALY-SIS is one of art history's most developed practices, because it is how art historians identify works that are unsigned or whose history is unknown and how they group and classify artworks. This book will help make you sensitive to distinctions of style. For example, you can learn the ways in which French paintings in the Baroque style are distinguishable from Roman Baroque paintings, or how to

recognize the difference between Roman and Greek portrait heads. ARTISTIC STYLES fall in three major categories: PERIOD STYLE, REGIONAL STYLE, and FORMALIST STYLE.

Period style describes the common traits detectable in works of art and architecture from a certain time (and, usually, culture). For example, Roman portrait sculpture is distinguishable according to whether it was created during the Roman Republican era, at the height of the Empire, or in the time of the late Empire.

Regional style refers to stylistic traits that persist in a geographic region. An art historian whose specialty is medieval art can recognize French style through many successive medieval periods, even though individual objects may appear to the untrained eye to have been created in, say, Germany or the Low Countries.

Formalist style is not a common term in the literature of art, but it is a convenient way to present stylistic traits that are grounded in formal considerations. REALISM, NATURALISM, IDEALIZATION, and EXPRESSIONISM are often-found names for styles.

> REALISM is the attempt to depict objects as they are in actual, visible reality. Figure 2, *Flower Piece with Curtain*, is a good example of realism.

> NATURALISM is a style of depiction in which the physical appearance of the rendered image in nature is the primary inspiration. A work in a naturalistic style resembles the original, but not with the same exactitude and literalness as a work in a realistic style. The *Medici Venus* (fig. 7) is naturalistic in this sense.

> IDEALIZATION strives to realize in visual form a concept of perfection embedded in a culture's value system. The *Medici Venus* (fig. 7) just cited as naturalistic is also idealized.

> EXPRESSIONISM refers to styles in which the artist uses exaggeration of form and expression to appeal directly to the beholder's subjective emotional responses. The Hellenistic sculpture *Laocoön* (fig. 24) and van Gogh's *Large Plane Trees* (fig. 28) are both expressionistic.

Artists and artworks that are related by period, place, and style are linked by the term SCHOOL. In art history, the word *school* has several meanings. The designation *school of* is sometimes used for works that are not attributable but that show strong stylistic similarities to a known artist (for example, school of Rubens. A term such as *Sienese school* means that the work shows traits common in art from Siena, Italy, during the period being discussed. *Follower of* most often suggests a second-generation artist working in a variant style of the named artist. *Workshop of* implies that a work was created by an artist or artists trained in the workshop of an established

artist. *Attributed to*, like a question mark next to an artist's name, means that there is some uncertainty as to whether the work is by that artist.

MEDIUM

What is meant by *medium* or *mediums* (the plural we use in this book to distinguish the word from print and electronic news media) is the material or materials from which an object is made. Broader even than medium is the distinction between art forms that are TWO-DIMENSIONAL and THREE-DIMENSIONAL.

Two-dimensional arts include PAINTING, DRAWING, THE GRAPHIC ARTS (also called PRINTS), and PHOTOGRAPHY. In short, these are arts that are made on a flat surface. Three-dimensional arts are SCULPTURE, ARCHITECTURE, and many ORNAMENTAL and FUNCTIONAL ARTS.

The visual arts' traditional mediums have been painting, drawing, graphic arts, sculpture, and architecture. As the study of art history has become more inclusive, other mediums have come within its sphere: photography and the ephemeral arts, furniture, works of ceramic and glass, metalwork, fiber arts, folk and vernacular art, as well as works that mix mediums. More recently, the study of popular arts, often referred to as visual culture, is emerging as a dimension of art history.

Painting includes WALL PAINTING and FRESCO, ILLUMINATION (the decoration of books with paintings), PANEL PAINTING (painting on wood panels) and painting on canvas, miniature painting (small-scale painting), and HANDSCROLL and HANGING SCROLL painting. Paint is pigment mixed with a liquid vehicle, or binder. Various kinds of paint and painting are explained throughout this book in Technique boxes.

Drawing encompasses SKETCHES (quick visual notes for larger drawings or paintings), STUDIES (more carefully drawn analyses of details or entire compositions), drawings as complete artworks in themselves, and CARTOONS (full-scale drawings made in preparation for work in another medium, such as fresco). Drawings are essentially linear in nature and are made with such materials as ink, charcoal, crayon, and lead pencil.

Graphic arts are the printed arts—images that are reproducible. They are usually works of art on paper. The graphic arts traditionally include WOODCUT, WOOD ENGRAVING, ETCHING, DRYPOINT, METAL ENGRAVING, and LITHOGRAPHY.

Sculpture is three-dimensional art that is CARVED, MODELED, CAST, or ASSEMBLED. Carved sculpture is reductive in the sense that the image is created by taking away material. In fact, wood, stone, and ivory can be carved into sculpture only because they are not pliant, malleable materials. Modeled sculpture is considered additive, meaning that the object is built up from a material, such as clay, that is soft enough to be molded and shaped. Metal sculpture is usually cast (see "Lost-Wax Casting," page 21) or is assembled by welding or a similar means of permanent joining.

TECHNIQUE
LOST-WAX CASTING

The lost-wax casting process (also called *cire perdue*, the French term) has been used for many centuries. It probably started in Egypt. By 200 BCE the technique was known in China and ancient Mesopotamia and was soon after used by the Benin peoples in Africa. It spread to ancient Greece sometime in the sixth century BCE and was widespread in Europe until the eighteenth century, when a piece-mold process came to predominate. The usual metal is bronze, an alloy of copper and tin, or sometimes brass, an alloy of copper and zinc.

The progression of drawings here shows the steps used by Benin sculptors. A heat-resistant "core" of clay (approximating the shape of the sculpture-to-be (and eventually becoming the hollow inside the sculpture) was covered by a layer of wax about the thickness of the final sculpture. The sculptor carved the details in the wax. Rods and a pouring cup made of wax were attached to the model. A thin layer of fine, damp sand was pressed very firmly into the surface of the wax model, and then model, rods, and cup were encased in thick layers of clay. When the clay was completely dry, the mold was heated to melt out the wax. The mold was then turned upside down to receive the molten metal, which for the Benin was brass, heated to the point of liquification. The cast was placed in the ground. When the metal was completely cool, the outside clay cast and the inside core were broken up and removed, leaving the cast brass sculpture. Details were polished to finish the piece of sculpture, which could not be duplicated because the mold had been destroyed in the process.

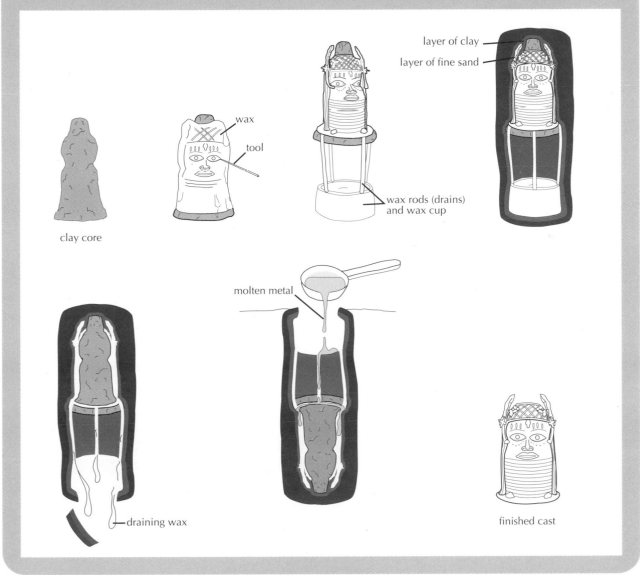

clay core

wax

tool

wax rods (drains) and wax cup

layer of clay

layer of fine sand

molten metal

draining wax

finished cast

ELEMENTS OF ARCHITECTURE

Space-Spanning Construction Devices

Gravity pulls on everything, presenting great challenges to the need to cover spaces. The purpose of the spanning element is to transfer weight to the ground. The simplest space-spanning device is post-and-lintel construction, in which uprights are spanned by a horizontal element. However, if not flexible, a horizontal element over a wide span breaks under the pressure of its own weight and the weight it carries.

Corbeling, the building up of overlapping stones, is another simple method for transferring weight to the ground. Arches, round or pointed, span space. Vaults, which are essentially extended arches, move weight out from the center of the covered space and down through the corners. The cantilever is a variant of post-and-lintel construction. When concrete is reinforced with steel or iron rods, the inherent brittleness of cement and stone is overcome because of metal's flexible qualities. The concrete can then span much more space and bear heavier loads. Suspension works to counter the effect of gravity by lifting the spanning element upward. Trusses of wood or metal are relatively lightweight spanners but cannot bear heavy loads. Large-scale modern construction is chiefly steel frame and relies on steel's properties of strength and flexibility to bear great loads. The balloon frame, an American innovation, is based in post-and-lintel principles and exploits the lightweight, flexible properties of wood.

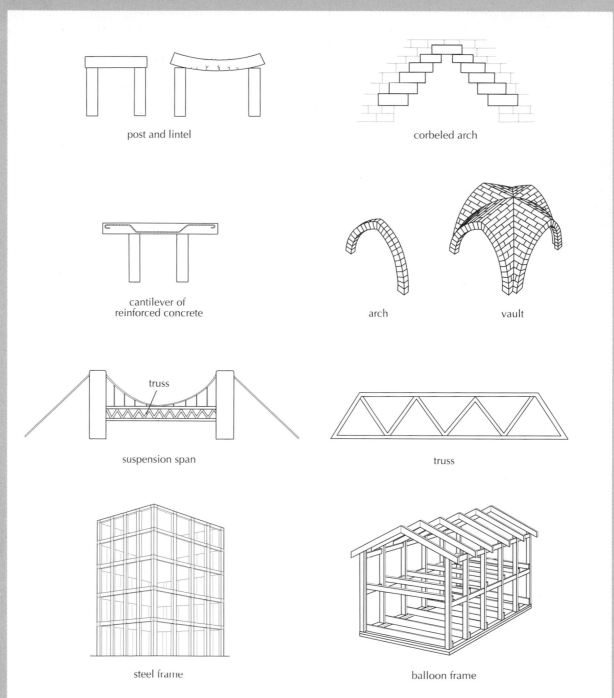

post and lintel

corbeled arch

cantilever of reinforced concrete

arch

vault

truss

suspension span

truss

steel frame

balloon frame

Sculpture is either FREESTANDING (that is, not attached) or in RELIEF. Relief sculpture projects from the background surface of which it is a part. HIGH RELIEF sculpture projects far from its background; LOW RELIEF sculpture is only slightly raised; and SUNKEN RELIEF, found mainly in Egyptian art, is carved into the surface, with the highest part of the relief being the flat surface.

Mixed medium includes categories such as COLLAGE and ASSEMBLAGE, in which two or more mediums are combined to create the artwork. One of the mediums may be paint, but does not have to be.

Ephemeral arts include such chiefly modern categories as performance art, Happenings, earthworks, cinema, video art, and computer art. Common to all of them is the temporal aspect of the work: the art is viewable for a finite period of time, then disappears forever, is in a constant state of change, or must be replayed to be experienced again.

Architecture is three-dimensional, highly spatial, functional, and closely bound with technology and materials. An example of the relationship among technology, materials, and function is how space is spanned (see "Space-Spanning Construction Devices," page 22). Several types of two-dimensional graphic devices are commonly used to enable the visualization of a building. These architectural graphics include PLANS, ELEVATIONS, SECTIONS, and CUTAWAYS.

PLANS depict a structure's masses and voids, presenting a view from above—as if the building had been sliced horizontally at about waist height.

plan

ELEVATIONS show exterior sides of a building as if seen from a moderate distance without any perspective distortion.

elevation

SECTIONS reveal a building as if it had been cut by an imaginary slicer from top to bottom.

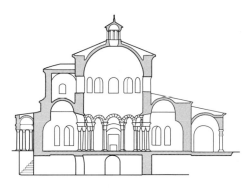

section

CUTAWAY DRAWINGS show both inside and outside elements from an oblique angle.

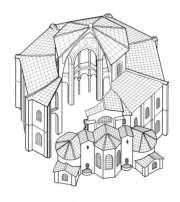

cutaway

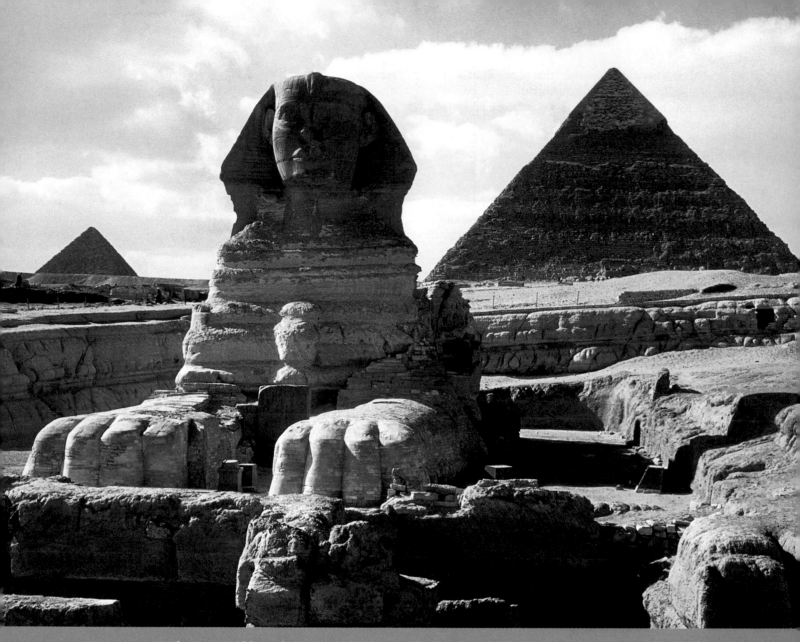

1. **The Great Sphinx, Giza**, Egypt. Dynasty 4, c. 2613–2494 BCE. Sandstone, height approx. 65' (19.8 m)

Introduction

Crouching in front of the pyramids of Egypt and carved from the living rock of the Giza plateau, the Great Sphinx is one of the best-known monuments in the world (fig. 1). By placing the head of the ancient Egyptian king Khafra on the body of a huge lion, the sculptors joined human intelligence and animal strength in a single image to evoke the superhuman power of the ruler. For some 4,600 years the Sphinx has defied encroaching desert sands and other assaults of nature; today it also must withstand the human-made sprawl of urban Cairo and the impact of air pollution. The Sphinx, in its majesty, symbolizes mysterious wisdom and dreams of permanence, of immortality. But is such a monument a work of art? Does it matter that the people who carved the Sphinx—unlike today's independent, individualistic artists—followed time-honored, formulaic conventions and the precise instructions of their priests? No matter how viewers of the time may have labeled it, today most people would answer, "Certainly it is art. Human imagination conceived this amazing creature, and human skill gave material form to the concept of man-lion. Using imagination and skill to create huge, simplified shapes, the creators have defined the idea of awesome grandeur and have created a work of art." *But what is art?*

WHAT IS ART?

The answer to the seemingly simple question is in fact multifaceted. Common definitions of art usually refer to the product of some combination of skill, training, and observation. But the definition of art also depends upon what is created, when it was created, how it was created, the intention of the creator and the anticipated "role" of the creation, perhaps who commissioned it, and certainly the response of the viewer—both at the historical time it was created and today. It is the role of art history, which we'll look at in more detail below, to help us with these complexities.

When we become captivated by the mysteriousness of a creation such as the Sphinx, art history can help us understand its striking imagery and meaning; the artwork's total cultural context—that is, the social, economic, and political situation of the historical period in which it was produced; the belief systems, rituals, and myths (the philosophy and religion) of the time; the relationships to other arts (music, drama, literature, dance); the technology making the art possible. Art history, unlike other humanistic studies, remains grounded in material objects that are the tangible expression of the ideas—and ideals—of a culture. Thus, art history is distinctive because it puts the primary focus on the art object even as it explores the context of its culture, because art does not simply reflect history but also participates in it. Art historians know, for example, that someone had to learn to read Egyptian hieroglyphs to tell us that we are looking at the face of a king on the Sphinx. By studying the translations of these hieroglyphs, they could study the historical period in which it was made and learn about the king's earthly power, the culture's belief in an afterlife, and the overwhelming cultural importance of ceremony—all defined and expressed by the monumental Sphinx.

Works of exceptional physical beauty—however *beauty* may be defined—can speak to us over great expanses of time and space, but the study of art history can greatly enhance our experience of art by helping us to formulate the kinds of questions that enable us to appreciate for ourselves the material culture of our own and other times. But while grappling with the question of what art is, we are inevitably drawn into another question whose answer is almost always culturally specific: *What is beauty?*

WHAT IS BEAUTY?

Historically, beauty has quite literally been "in the eye of the beholder." Beauty has been expressed in a variety of **styles**, or manners of representation. Some times and places have valued as beautiful styles of art that are realistic, or **naturalistic**—art that has a surface reality because the artists appear to have recorded, with greater or lesser accuracy, exactly what they saw. Naturalism and **abstraction**—the transformation of visible forms into patterns that suggest the original—are opposite approaches to representing beauty. In abstraction through **idealization**, for example, artists represent beauty not as it is but as they think it *should* be. So what is beauty? Different cultures have defined it as something that brings pleasure to the senses or to the mind or to the spirit, and the way that

2. Adriaen van der Spelt and Frans van Mieris. *Flower Piece with Curtain*. 1658. Oil on panel, 18¼ x 25¼" (46.5 x 64 cm). The Art Institute of Chicago
Wirt D. Walker Fund

various peoples have represented beauty can tell us a great deal about their cultures and values.

NATURE OR ART?

Beauty can be expressed in many ways—in the natural beauty of huge old trees or in the created beauty of a painting of those trees (see fig. 28, "The Object Speaks: *Large Plane Trees*"). In the ancient world, the Greek philosopher Aristotle (384–322 BCE) evaluated works of art on the basis of *mimesis* ("imitation"), that is, how faithfully artists recorded what they saw in the natural world. But we need to be aware that when artists working in a naturalistic style make images that seem like untouched snapshots of actual objects, their skill can also render lifelike such fictions as a unicorn or the Wicked Witch of the West—or a being with the body of a lion and the head of a king.

Like many people today, ancient Greeks enjoyed the work of especially skillful naturalistic artists (the Greek word for art, *tekne*, is the source of the English word *technique*; the word *art* comes from the Latin word *ars*, or "skill"). Their admiration for naturalistic depiction is illustrated in a famous story about a competition between rival Greek painters named Zeuxis and Parrhasios in the late fifth century BCE. Zeuxis painted a picture of grapes so accurately that birds flew down to peck at them. Then Parrhasios took his turn, and when Zeuxis asked his rival to remove the curtain hanging over the picture, Parrhasios gleefully pointed out that the curtain was his painting. Zeuxis agreed that Parrhasios won the competition since he, Zeuxis, had fooled only birds but Parrhasios had tricked an intelligent fellow artist.

In the seventeenth century, painter Adriaen van der Spelt (1630–73) and his artist friend Frans van Mieris (1635–81), paid homage to the story of Parrhasios's curtain with their painting of blue satin drapery drawn aside to show a garland of flowers (fig. 2). More than a tour-de-force of eye-fooling naturalism, the work is an

3. Edward Weston. *Succulent*. 1930. Gelatin silver print, 7½ x 9½" (19.1 x 24 cm). Collection Center for Creative Photography, The University of Arizona, Tucson
© 1981 Center for Creative Photography, Arizona Board of Regents

intellectual delight. The artists not only re-created Parrhasios's curtain illusion but also included a reference to another Greek legend, which was popular in the fourth century BCE, that told of Pausias, who painted the exquisite floral garlands made by a young woman, Glykera. This second story raises the troubling and possibly unanswerable question of who was the true artist—the painter who copied nature in his art or the garland maker who made works of art out of nature. The seventeenth-century patrons—the people who bought such paintings—knew those stories and appreciated the artists' classical references as well as their skill in drawing and manipulating colors on canvas.

The flower garland also symbolizes the passage of time and the fleeting quality of human riches. The brilliant red and white tulip, the most desirable and expensive flower of the time—symbolizes wealth and power. Yet insects creep out of it, and a butterfly—fragile and transitory—hovers above the flower. Today, after studying the painting in its cultural context, we, too, understand that it is much more than a simple flower piece, the type of still life with flowers popular in the Netherlands in van der Spelt's and Mieris's time.

Just as Dutch flower pieces were ideal expressions of naturalism then, so today modern photography seems like a perfect medium for expressing the natural beauty of plants, especially when they are selected and captured at perfect moments in their life cycles. In his photograph *Succulents*, Edward Weston (1886–1958) did just that by using straightforward camera work, without manipulating the film in the darkroom (fig. 3). Aristotle might have appreciated this example of *mimesis*, but Weston did more than accurately portray his subject; he made photography an **expressionistic** medium by perfecting the close-up view to evoke an emotional response. He argued that although the camera sees more than the human eye, the quality of the image depends not on the camera, but on the choices made by the photographer-artist.

Many people even today think that naturalism represents the highest accomplishment in art. But not everyone agrees. First to argue persuasively that observation alone produced "mere likeness" was the Italian master Leonardo da Vinci (1452–1519), who said that the painter who copied the external forms of nature was acting only as a mirror. He believed that the true artist should engage in intellectual activity of a higher order and attempt to capture the inner life—the energy and power—of a subject. In the twentieth century, Georgia

4. Georgia O'Keeffe. *Red Canna*. 1924. Oil on canvas mounted on Masonite, 36 x 29⅞" (91.44 x 75.88 cm). The University of Arizona Museum of Art, Tucson

5. David Smith.
Cubi XIX.
1964. Stainless
steel, 9'5 3/8" x
1'9 3/4" x 1'8"
(2.88 x 0.55 x
0.51 m). Tate
Gallery, London

O'Keeffe (1887–1986), like van der Spelt and Weston, studied living plants; however, when she painted the canna lily she, like Leonardo, sought to capture the flower's essence (fig. 4). By painting the canna lily's organic energy, she created a new abstract beauty, conveying in paint the pure vigor of its life force.

Furthest of all from naturalism or the Greek concept of *mimesis* are the pure geometric creations of polished stainless steel made by David Smith (1906–65). His *Cubi* works, such as the sculpture in figure 5, are usually called **nonrepresentational** art—art so abstract that it does not represent the natural world. With works like *Cubis*, it is important to distinguish between subject matter and content, or meaning. Abstract art has both subject matter and meaning. Nonrepresentational art does not have subject matter but it does have meaning, which is a product of the interaction between the artist's intention and the viewer's interpretation. Some viewers may see *Cubis* as giant excrescences, for example, mechanistic plants sprung from the core of an unyielding earth, a reflection of today's mechanistic society that challenges the natural forms of trees and hills. Because meaning can change

over time, one goal of contextual art history, which this book exemplifies, is to identify the factors that produce a work, to determine what it probably meant for the artist and the original audience, and to acknowledge that no interpretation is definitive: Again, such visions are in the "eye of the beholder."

THE IDEA OF THE IDEAL

In contrast to Aristotle, an earlier Greek philosopher, Plato (428–348/7 BCE), had looked beyond nature for a definition of art. In his view even the greatest work of art was only a shadow of the material world, several times removed from reality. Physical beauty for Plato's followers depended on the harmony created by symmetry and proportion, on a rational, even mathematical, view of the world. The contemplation of such ideal physical beauty eventually leads the viewer to a new kind of artistic truth to be found in the realm of pure idea. Let us take a simple example from architecture: the carving at the top of a column called the capital. A popular type, known as Corinthian order, which first began to appear in ancient

6. Corinthian capital from the *tholos* at Epidaurus.
c. 350 BCE. Archaeological Museum, Epidaurus, Greece

Greece about 450 BCE, has an inverted bell shape surrounded by acanthus leaves (fig. 6). Although inspired by the appearance of natural vegetation, the sculptors who carved the leaves have eliminated blemishes and arranged the leaves symmetrically. In short, they have created ideal leaves by first looking at nature and then carving the essence of the form, the Platonic ideal of foliage. No insect has ever nibbled at such a timelessly perfect, ideal leaf.

To achieve Plato's ideal images and represent things "as they ought to be" in a triumph of human reason over nature, the sculptors eliminated all irregularities and instead sought perfect balance and harmony. The term *classical*, which refers to both the period in ancient Greek history when this type of idealism emerged and to the art of ancient Greece and Rome in general, has come to be used broadly as a synonym for the peak of perfection in any period. Classical sculpture and painting established ideals that have inspired Western art ever since.

For all recorded times and in most places, one of the subjects artists have frequently chosen to express the sense of beauty is woman. We can see how the different concepts of art and beauty we have mentioned play out by comparing the way that three different arts, in three different ages and parts of the world, have depicted women.

BEAUTIFUL WOMEN

Classical idealism pervades the image of Venus, goddess of love, even in a Roman copy of a Greek statue like the *Medici Venus* (fig. 7). Clearly the artist had the skill to represent a woman as she actually appeared but instead chose to generalize her form and adhere to the classical canon (rule) of proportions. In so doing, the sculptor has created a universal image, an ideal woman rather than a specific woman.

Very different from the classical ideal is the abstract vision of woman seen in a woodblock print by Japanese artist Kitagawa Utamaro (1753–1806). His *Woman*

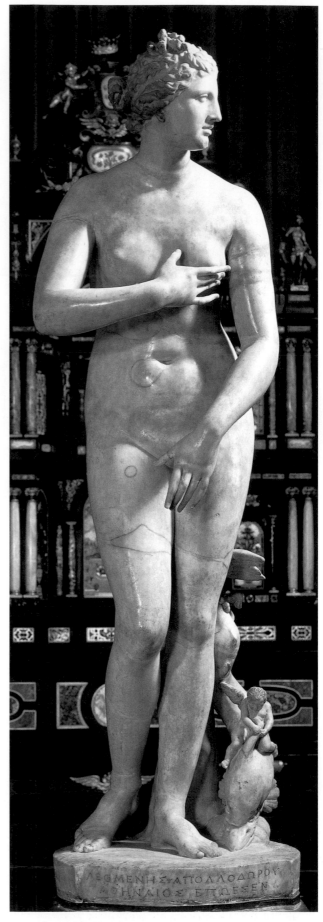

7. *Medici Venus*. Roman copy of a 1st century BCE Greek statue. Marble, height 5' (1.53 m) without base. Galleria degli Uffizi, Florence, Italy

8. Kitagawa Utamaro. *Woman at the Height of Her Beauty*. Mid-1790s. Color woodblock print, 15⅛ x 10" (38.5 x 25.5 cm). Spencer Museum of Art, The University of Kansas, Lawrence

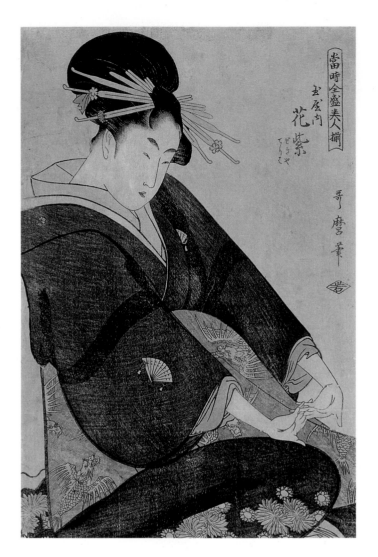

at the Height of Her Beauty (fig. 8) reflects a complex society regulated by convention and ritual in its stylization. Simplified shapes suggest underlying human forms, although the woman's dress and hairstyle defy the laws of nature. Rich textiles turn her body into an abstract pattern, and pins hold her hair in elaborate shapes. Utamaro rendered the decorative silks and carved pins meticulously, but he depicted the woman's face with a few sweeping lines. The elaboration of surface detail combined with an effort to capture the essence of form is characteristic of abstract art of Utamaro's time and place.

How different from either of these ideas of physical beauty can be the perception and representation of spiritual beauty. A fifteenth-century bronze sculpture from India represents Punitavati, a beautiful and generous woman who was deeply devoted to the Hindu god Shiva. Abandoned by her miserly husband because she gave food to beggars, Punitavati offered her beauty to Shiva. Shiva accepted her offering and, in taking her loveliness, turned her into an emaciated, fanged hag (fig. 9). According to legend, Punitavati, with clanging cymbals, provides the music for Shiva as he keeps the universe in motion by dancing the cosmic dance of destruction and creation. The bronze sculpture, although it depicts Punitavati's hideous appearance realistically, is beautiful both in its formal qualities as a work of art and in its message of generosity and sacrifice.

BEAUTY IN ARCHITECTURE

The ways that artists depict beauty in their representations of nature and human beings may seem obvious. But how does an artist represent beauty in architecture?

For thousands of years, people have sought to build what they hoped would be magnificent and permanent structures—buildings such as the Cathedral of the Apostle James in Santiago de Compostela, Spain. In the twelfth century, the author of a guidebook for pilgrims going to the shrine of the saint described the perfection of the building: its fine construction, spaciousness, and proportions ("In the church there is indeed not a single crack, nor any damage to be found; it is wonderfully built, large, spacious, well-lighted; of fitting size, harmonious in width, length, and height; held to be admirable and beautiful in execution"); its form ("And furthermore

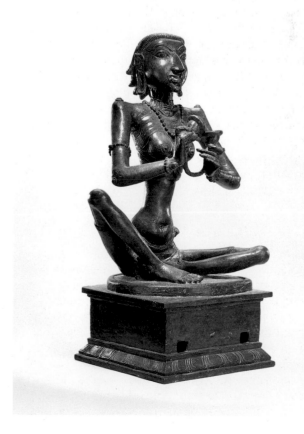

9. *Punitavati (Karaikkalammaiyar)*, Shiva saint, from Karaikka, India. 15th century. Bronze, height 16¼" (41.3 cm). The Nelson-Atkins Museum of Art, Kansas City, Missouri

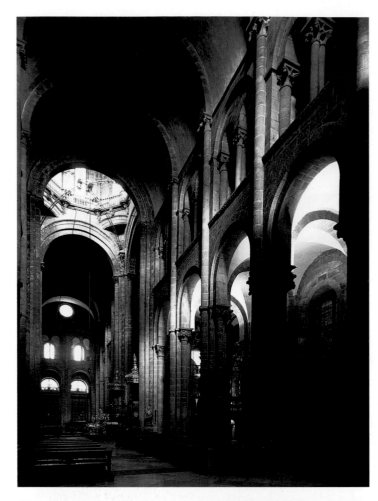

it is built with two stories like a royal palace"); and its effect on visitors ("For he who visits the galleries, if sad when he ascends, once he has seen the preeminent beauty of this temple, rejoices and is filled with gladness"). After nearly a thousand years, the building continues to shelter and dignify the rituals of the Christian religion and to affirm the ancient guidebook's evaluation of its beauty—its ability to bring pleasure to the senses, mind, and spirit (fig. 10).

WHY DO WE NEED ART?

The person who wrote of a building bringing gladness to the viewer reminds us of the importance of beauty in human life. Biologists account for the human desire for art in other terms. They explain that human beings have very large brains that demand stimulation. Curious, active, and inventive, we humans constantly explore, and in so doing invent things that appeal to our senses—fine arts, fine food, fine scents, and fine music. So far, we have mostly considered art in terms of seeking beauty, but there are other reasons deeply rooted in the human experience that create needs for art. For one, humans also speculate on the nature of things and the meaning of life. Visually and verbally, we constantly communicate with each other; in our need to understand and our need to communicate, the arts serve a vital function.

ART AND THE SEARCH FOR MEANING

Throughout history, art has played an important part in our search for the meaning of the human experience. In an effort to understand the world and our place in it, people create rituals that they believe will provide links with unseen powers and also with the past and the future. Believers employ special apparatus in their rituals, such as candles, incense, statues, masks, and various containers. But these utensils are works of art in the eyes of outsiders who do not know—or care—about their intended use and original significance.

Rituals are part of all belief systems, including religions such as Christianity. For Catholic Christians, a complex rite enacted at a consecrated altar changes ordinary wine into the blood of Christ; for Protestants, the wine remains the symbol of that blood; but for both, communication between God and humans becomes possible through the ritual enactment of Jesus' Last Supper with his friends and disciples. The chalice, the vessel for the sacramental wine, plays a central role and today is usually seen as a ritual object. But if a chalice is taken from its place on the altar and set in a different context, it may just as well be viewed purely as a work of art.

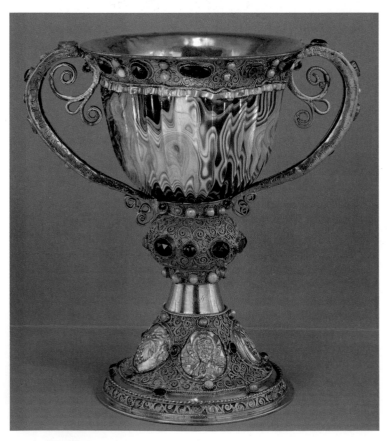

10. **Cathedral of the Apostle James, Santiago de Compostela**, Spain. 1078–1122. View toward the crossing.
Achim Bednorz, Cologne

11. **Chalice of Abbot Suger**, from Abbey Church of Saint-Denis, France. Composite of elements from Ptolemaic Egypt (2nd–1st century BCE) and 12th-century France. 1137–40. Cup: sardonyx; mounts: silver gilt, adorned with filigree, semiprecious stones, pearls, glass insets, and opaque white glass. 7½ x 4¼" (19 x 10.8 cm). National Gallery of Art, Washington, D.C.

Much of the art that moves us most deeply today was originally created as an expression of spiritual experience and an object of devotion. Consider, for example, the so-called *Chalice of Abbot Suger* (fig. 11). In twelfth-century France, Abbot Suger, head of the monastery dedicated to Saint Denis near Paris, found an ancient vase in the storage chests of the abbey. He ordered his goldsmiths to add a foot, a rim, and handles as well as semiprecious stones and medallions to the vase, turning it into a chalice to be used at the altar of the church that was the birthplace of Gothic architecture. Today Suger's chalice no longer functions in the liturgy of the Mass. It has taken on a new secular life, enshrined as a precious work of art in a museum. Instead of linking the congregation with God, now it links the modern viewer with the past, the Middle Ages of some 850 years ago.

Profoundly stirring religious art continues to be made, however. James Hampton's *Throne of the Third Heaven of the Nations' Millennium General Assembly* (fig. 12) is such a work, called by the art critic Robert Hughes the "finest piece of visionary art produced by an American." Hampton (1909–64) worked as a janitor to support himself while, in a rented garage, he built this monument to his faith. In rising tiers, thrones and altars have been prepared for Jesus and Moses, with references to the New Testament on the right and to the Old Testament on the left. Hampton labeled and described everything, even inventing his own language to express his visions. On one of many placards he wrote his credo: "Where there is no vision, the people perish" (Proverbs 29:18). Yet he made this fabulous assemblage out of discarded furniture, flashbulbs, Kraft paper, and all sorts of refuse tacked together and wrapped in gold and silver aluminum foil and purple tissue paper. How can such worthless materials be turned into such an exalted work of art? Today we recognize that the genius of the artist transcends any material.

Works of art from many cultures may speak to us across the vastness of time and space. The Yoruba people of Africa, like people in other times and places, have used art objects to communicate with their gods (fig. 13). This sculpture, carved by the Yoruba master Olowe of Ise (d. 1938), may seem to be just a woman with a child on her back holding an ornate covered cup, but like Suger's chalice, this cup has an importance not immediately apparent to the outsider. It is a divination bowl, made to hold the objects used in ceremonies in which people call on the god Olodumare (or Olorun) to reveal their destiny. The child suggests the life-giving power of women and the idea that all creation rests on women's energy. Men and women help the woman support the bowl, and more women link arms in a ritual dance on the cover. The richly decorative and symbolic wood carving, even when isolated in a museum case, reminds us of those people seeking to learn from Olodumare, the god of destiny, certainty, and order.

Like the divination bowl, many of the expressions that we regard as art were originally meant for other purposes; some were intended to achieve social, political, and educational ends.

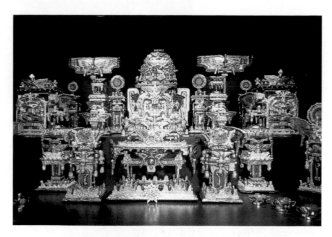

12. James Hampton. *Throne of the Third Heaven of the Nations' Millennium General Assembly*.
c. 1950–64. Gold and silver aluminum foil, colored Kraft paper, and plastic sheets over wood, paperboard, and glass, 10'6" x 27' x 14'6" (3.2 x 8.23 x 4.42 m). National Museum of American Art, Smithsonian Institution, Washington, D.C.

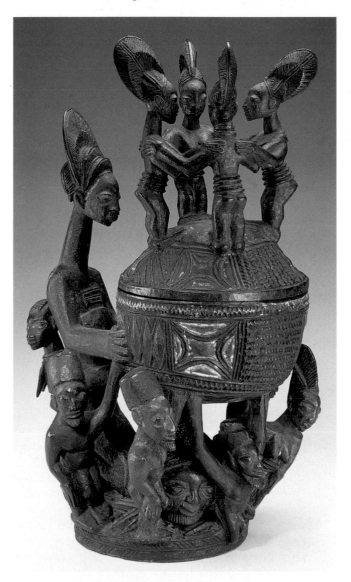

13. Olowe of Ise. Divination bowl. c. 1925. Wood and pigment, diameter 25 1/16" (63.7 cm). National Museum of African Art, Smithsonian Institution, Washington, D.C. Bequest of William A. McCarty-Cooper, 91-10-1

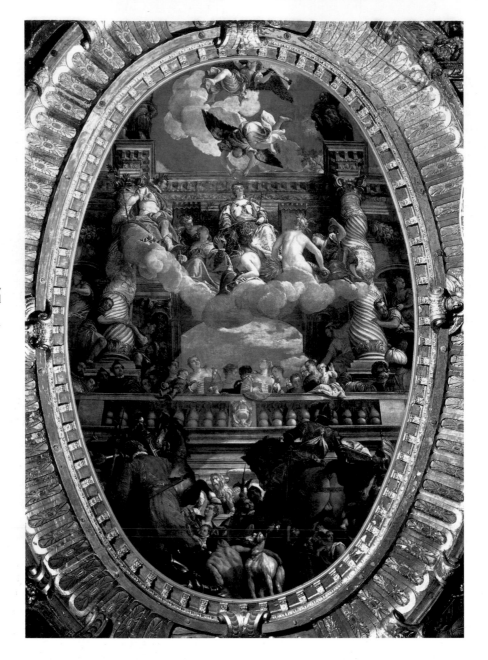

14. Veronese. *The Triumph of Venice*, fresco in the Council Chamber, Palazzo Ducale, Venice, Italy

ART AND THE SOCIAL CONTEXT

The visual arts are among the most sophisticated forms of human communication, at once shaping and being shaped by their social context. Artists may unconsciously interpret their times, but they may also be enlisted to consciously serve social ends in ways that range from heavy-handed propaganda to subtle suggestion. From ancient Egyptian priests to elected officials today, religious and political leaders have understood the educational and motivational value of the visual arts.

How governments—that is, civic leaders—can use the power of art to strengthen the unity that nourishes society was well illustrated in sixteenth-century Venice. There, city officials ordered Veronese (Paolo Caliari, 1528–88) and his assistants to fill the ceiling of the Council Chamber in the ruler's palace with a huge and colorful painting, *The Triumph of Venice* (fig. 14). Their contract with the artist survives, proclaiming their intention. They wanted a painting that showed their beloved Venice surrounded by peace, abundance, fame, happiness, honor, security, and freedom—all in vivid colors

and idealized forms. Veronese complied by painting the city personified as a mature, beautiful, and splendidly robed woman enthroned between the towers of the arsenal, a building where ships were built for worldwide trade, the source of the city's wealth and power. Veronese painted enthusiastic crowds of cheering citizens, while personifications of Fame blow trumpets and Victory crowns Venice with a wreath. Supporting this happy throng, bound prisoners and piles of armor attest to Venetian military power. The Lion of Venice—the symbol of the city and its patron, Saint Mark—oversees the triumph. Veronese has created a splendid propaganda piece as well as a work of art. Although Veronese created his work to serve the purposes of his patron, his artistic vision was as individualistic as that of James Hampton, whose art was purely a form of self-expression.

WHO ARE ARTISTS?

We have focused so far on works of art. But what of the artists who make them? How artists have viewed themselves and been viewed by their contemporaries has changed dramatically over time. In Western art,

artists were first considered artisans or craftspeople. Ancient Greeks and Romans, for example, considered artists to rank among the skilled workers; they admired the creations, but not the creators. People in the Middle Ages went to the opposite extreme and attributed especially fine works of art to angels or to Saint Luke. Artists continued to be seen as craftspeople—admired, often prosperous, but not particularly special—until the Renaissance, when artists such as Leonardo da Vinci proclaimed themselves to be geniuses with singular God-given abilities.

A little after Leonardo's declaration, the Italian painter Il Guercino (Giovanni Francesco Barbieri, 1591–1666) synthesized the idea that saints and angels make art with the concept that human painters have unique gifts. In his painting *Saint Luke Displaying a Painting of the Virgin* (fig. 15), Guercino portrays the evangelist who was regarded as the patron saint of artists because, Christians widely believed, he himself had painted a portrait of the Virgin Mary holding the Christ Child. In Guercino's work, Luke, seated before just such a painting and assisted by an angel, holds his palette and brushes. A book, a quill pen, and an inkpot decorated with a statue of an ox (Saint Luke's symbol) rest on a table, reminders of his status as an evangelist. Guercino seems to say that if Saint Luke is a divinely endowed artist, then surely all other artists share in this special power and status. This image of the artist as an inspired genius has largely continued into the twenty-first century.

Because art is often a communal creation, we sometimes need to use the plural of the word: *artists*. Even after the idea of "specially endowed" creators emerged, numerous artists continued to see themselves, as they had in many historical periods, as craftspeople led by the head of a workshop, and oftentimes artwork continued to be a team effort. In the eighteenth century, for example, Utamaro's color woodblock prints (see fig. 8) were the product of a number of people working together. Utamaro painted pictures for his assistants to transfer to blocks of wood. They carved the lines and areas to be colored, covered the surface with ink or colors, and then transferred the image to paper; nevertheless, Utamaro—as the one who conceived the work—is the "creative center."

The same spirit is evident today in the complex glassworks of American artist Dale Chihuly (b. 1941). His team of artist-craftspeople is skilled in the ancient art of glassmaking, but Chihuly remains the controlling mind and imagination. Once created, many of his multipart pieces are transformed every time they are assembled; they take on a new life in accordance with the will of every owner. The viewer/owner thus becomes part of the creative team. Made in 1990, *Violet Persian Set with Red Lip Wraps* (fig. 16) has twenty separate pieces, and the person who assembles them determines the composition. Artist and patron thus unite in an ever-changing act of creation.

Whether artists work individually or communally, even the most brilliant ones typically spend years in study and apprenticeship. In his painting *The Drawing Lesson*, Dutch artist Jan Steen (1626–79) takes us into an artist's studio where two people—a boy apprentice and a young

15. Il Guercino. *Saint Luke Displaying a Painting of the Virgin*. 1652–53. Oil on canvas, 7'3" x 5'11" (2.21 x 1.81 m). The Nelson-Atkins Museum of Art, Kansas City, Missouri
Purchase (F83-55)

16. Dale Chihuly. *Violet Persian Set with Red Lip Wraps*. 1990. Glass, 26 x 30 x 25" (66 x 76.2 x 63.5 cm). Spencer Museum of Art, The University of Kansas, Lawrence
Peter T. Bohan Acquisition Fund

17. **Jan Steen.** *The Drawing Lesson*. 1665. Oil on wood, 19⅜ x 16¼" (49.3 x 41 cm). The J. Paul Getty Museum, Los Angeles, California

woman—are learning the rudiments of their art. The pupil has been drawing from sculpture and plaster casts because women were not permitted to work from nude models (fig. 17). *The Drawing Lesson* records contemporary educational practice and is a valuable record of an artist's workplace in the seventeenth century.

Even mature artists considered among history's greatest continued to learn from each other. Before Rembrandt van Rijn (1606–69), for example, painted *The Last Supper* (fig. 18), he carefully studied Leonardo da Vinci's late-fifteenth-century painting of the same subject (fig. 19). Since he never went to Italy, Rembrandt could only have known the Italian master's great mural painting from a print. Rembrandt copied the image in hard red chalk, and also made detailed studies. Later he reworked the drawing in a softer chalk, assimilating Leonardo's lessons but revising the composition and the mood of the original. With heavy overdrawing,

18. **Rembrandt van Rijn.** *The Last Supper*, after Leonardo da Vinci's fresco. Mid-1630s. Drawing in red chalks, 14⅜ x 18¾" (36.5 x 47.5 cm). The Metropolitan Museum of Art, New York
Robert Lehman Collection, 1975 (1975.1.794)

Rembrandt re-created the scene, shifting Jesus' position and expression. With a few strokes and smudges of chalk, he created a composition that now reflected the Baroque style of his time: Classical symmetry has given way to asymmetry; shadows loom; highly expressive figures fill a compressed space. The drawing is more than an academic exercise; it is a sincere tribute from one great master to another. Rembrandt must have been pleased with his version of Leonardo's masterpiece because he signed his drawing boldly in the right-hand corner.

WHAT IS A PATRON?

As we have seen, the person or group who commissions or supports a work of art—the patron—can have significant impact on it. The Sphinx (see fig. 1) was "designed" by the conventions of priests in ancient Egypt; the content of Veronese's *Triumph of Venice* (see fig. 14) was determined by that city's government; Chihuly's glassworks (see fig. 16) are assembled according to the collector's specifications, desires, wishes, or whims. Although some artists work independently, hoping to sell their work on the open market, throughout art history both individuals and institutions have acted as patrons of the arts. Patrons very often have been essential factors in the development of arts, but all too often have been overlooked when we study the history of art. Today, not only individuals but also museums, other institutions, and national governments (for example, the United States, through the National Endowment for the Arts) provide support for the arts.

INDIVIDUAL PATRONS

People who are not artists often want to be involved with art, and patrons of art constitute a very special audience for artists. Many collectors truly love works of art, but some who collect art do so to enhance their own prestige, creating for themselves an aura of power and importance. Patrons vicariously participate in the creation of a work when they provide economic support to the artist. Such individual patronage can spring from a cordial relationship between a patron and an artist, as is evident in an early-fifteenth-century manuscript illustration in which the author, Christine de Pisan, presents her work to Isabeau, the Queen of France. Christine, a widow who supported her family by writing, hired painters and

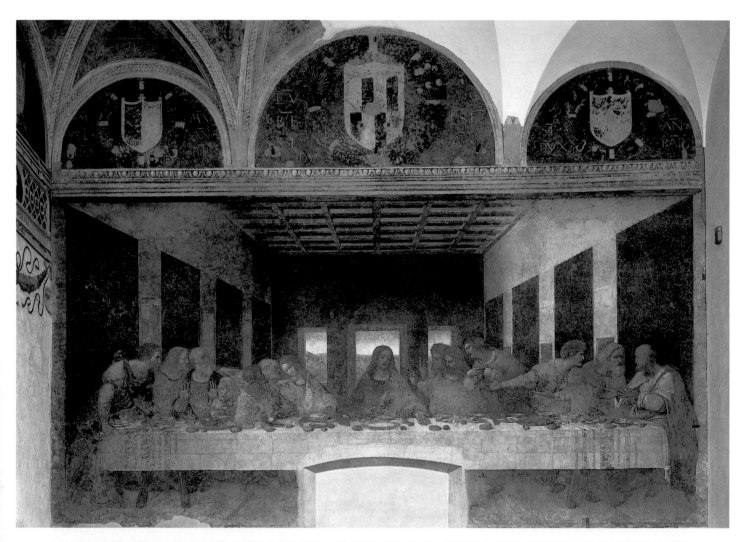

19. Leonardo. *The Last Supper*, wall painting in the refectory, Monastery of Santa Maria delle Grazie, Milan, Italy 1495–98. Tempera and oil on plaster, 15'2" x 28'10" (4.6 x 8.8 m)

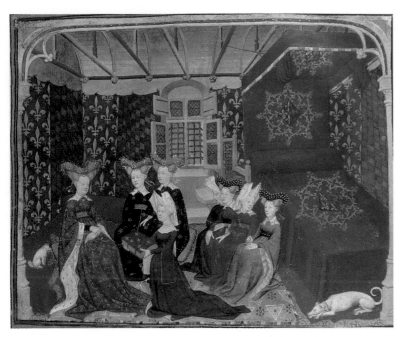

20. *Christine Presenting Her Book to the Queen of France*. 1410–15. Tempera and gold on vellum, image approx. 5½ x 6¾" (14 x 17 cm). The British Library, London.
MS. Hartley 4431, folio 3

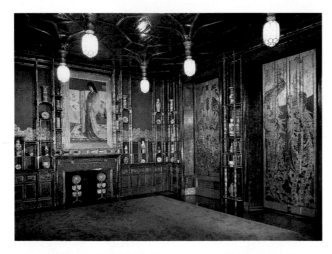

21. James McNeill Whistler. *Harmony in Blue and Gold*. The Peacock Room, northeast corner, from a house owned by Frederick Leyland, London. 1876–77. Oil paint and metal leaf on canvas, leather, and wood, 13'11⅞" x 33'2" x 19'11½" (4.26 x 10.11 x 6.83 m). Freer Gallery of Art, Smithsonian Institution, Washington, D.C. (04.61)

scribes to copy, illustrate, and decorate her books. She especially admired the painting of a woman named Anastaise, whose work she considered unsurpassed in the city of Paris. Queen Isabeau was Christine's patron; Christine was Anastaise's patron; and all the women seen in the painting were patrons of the brilliant textile workers who supplied the brocades for their gowns, the tapestries for the wall, and the embroideries for the bed (fig. 20).

Relations between artists and patrons do not always prove to be as congenial as Christine portrayed them.

Patrons may change their minds and sometimes fail to pay their bills. Artists may ignore their patron's wishes, to the dismay of everyone. In the late nineteenth century, the Liverpool shipping magnate Frederick Leyland asked James McNeill Whistler (1834–1903), an American painter living in London, what color to paint the shutters in the dining room where he planned to hang Whistler's painting *The Princess from the Land of Porcelain*. The room had been decorated with expensive embossed and gilded leather and finely crafted shelves to show off Leyland's blue-and-white porcelain. Whistler, inspired by the Japanese theme of his own painting as well as by the Asian porcelain, painted the window shutters with splendid turquoise, blue, and gold peacocks. But he did not stop there: While Leland was away, Whistler painted the entire room, covering the gilded leather on the walls with turquoise peacock feathers (fig. 21). Leyland was shocked and angry at what seemed to him to be wanton destruction of the room. Luckily, he did not destroy Whistler's "Peacock Room" (which Whistler called simply *Harmony in Blue and Gold*), for it is an extraordinary example of total interior design.

INSTITUTIONAL PATRONAGE: MUSEUMS AND CIVIC BODIES

From the earliest times, people have gathered and preserved precious objects that conveyed the idea of power and prestige. Today both private and public museums are major patrons, collectors, and preservers of art. Curators of such collections acquire works of art for their museums and often assist patrons in obtaining especially fine pieces, although the idea of what is best and what is worth collecting and preserving changes from one generation to another. For example, the collection of abstract and nonrepresentational art formed by members of the Guggenheim family was once considered so radical that few people—and certainly no civic or governmental group—would have considered the art worth collecting at all. Today the collection fills more than one major museum.

Frank Lloyd Wright's Solomon R. Guggenheim Museum (fig. 22), with its snail-like, continuous spiral ramp, is a suitably avant-garde home for the collection in New York City. Sited on Fifth Avenue, beside the public green space of Central Park and surrounded on the other three sides by relentless quadrangles of the city buildings, the Guggenheim Museum challenges and relieves the inhumanity of the modern city. The Guggenheim Foundation recently opened another home for art, in Bilbao, Spain, designed by Frank Gehry, a leader of the twenty-first-century avant-garde in architecture. As both Guggenheim museums show, such structures can do more than house collections; they can be works of art themselves.

Civic sponsorship of art is epitomized by the citizens of fifth-century BCE Athens, a Greek city-state where the people practiced an early form of democracy. Led by the statesman and general Pericles, the Athenians defeated the Persians, then rebuilt Athens's civic and religious

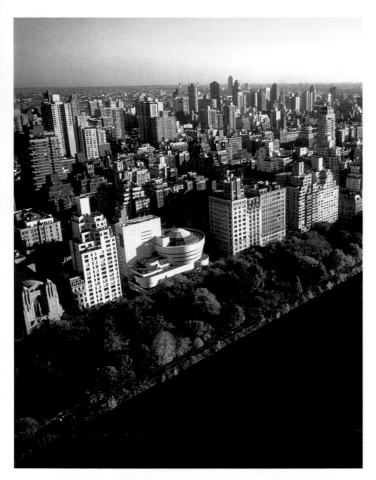

22. **Frank Lloyd Wright. Solomon R. Guggenheim Museum, New York City**. 1956–59. Aerial view

23. **Lawrence Alma-Tadema. *Pheidias and the Frieze of the Parthenon, Athens***. 1868. Oil on canvas, 29³/₅ x 42¹/₃" (75.3 x 108 cm). Birmingham City Museum and Art Gallery, England 118-23

center, the Acropolis, as a tribute to the goddess Athena and a testament to the glory of Athens. In figure 23, a nineteenth-century British artist, Sir Lawrence Alma-Tadema, conveys the accomplishment of the Athenian architects, sculptors, and painters, who were led by the artist Pheidias. Alma-Tadema imagines the moment when Pheidias showed the sculpted and painted frieze at the top of the wall of the Temple of Athena (the Parthenon) to Pericles and a privileged group of Athenian citizens—his civic sponsors. We can also see civic sponsorship today in the architecture, including the museums, of most modern national capitals and in the wide variety of public monuments around the world.

WHAT IS ART HISTORY TODAY?

Compared to art itself, art history as a field of study is a relatively recent phenomenon; many art historians consider the first art history book to be the 1550 publication *Lives of the Most Excellent Italian Architects, Painters and Sculptors*, by the Italian artist and writer Giorgio Vasari. As the name implies, *art history* combines two very different special studies—the study of an individual work of art outside time and place (formal analysis and even art appreciation) and the study of art in its historical context (the primary approach taken in this book). The scope of art history is immense: It shows how people have represented their world and how they have expressed their ideas and ideals. As a result, art history today draws on many other disciplines and diverse methodologies.

Art history as a humanistic discipline adds theoretical and contextual studies to the formal analysis of works of art. Art historians draw on biography to learn about artists' lives; social history to understand the economic and political forces shaping artists, their patrons, and their public; and the history of ideas to gain an understanding of the intellectual currents influencing artists' work (see "The Object Speaks: *Large Plane Trees*," page 41). They also study the history of other arts—including music, drama, and literature—to gain a richer sense of the context of the visual arts. Their work results in an understanding of the **iconography** (the narrative and allegorical significance) and the context (social history) of the artwork.

Today art historians study a wider range of artworks than ever before, and many reject the idea of a fixed canon of superior pieces. The distinction between elite fine arts and popular utilitarian arts has become blurred, and the notion that some mediums, techniques, or subjects are better than others has almost disappeared. This is one of the most telling characteristics of art history today, along with the breadth of studies it now encompasses and its changing attitude to challenges such as preservation and restoration.

At the most sophisticated level, the intense study of individual art objects is known as **connoisseurship**. Through years of close contact with and study of the formal qualities that make up various styles in art, the connoisseur learns to recognize authenticity and quality. The connoisseur places an unknown work with related pieces, attributing it to a period, a place, and even to an artist. Today such experts also make use of all the scientific tests available to them, but ultimately they depend on their visual memory and their skills in formal analysis.

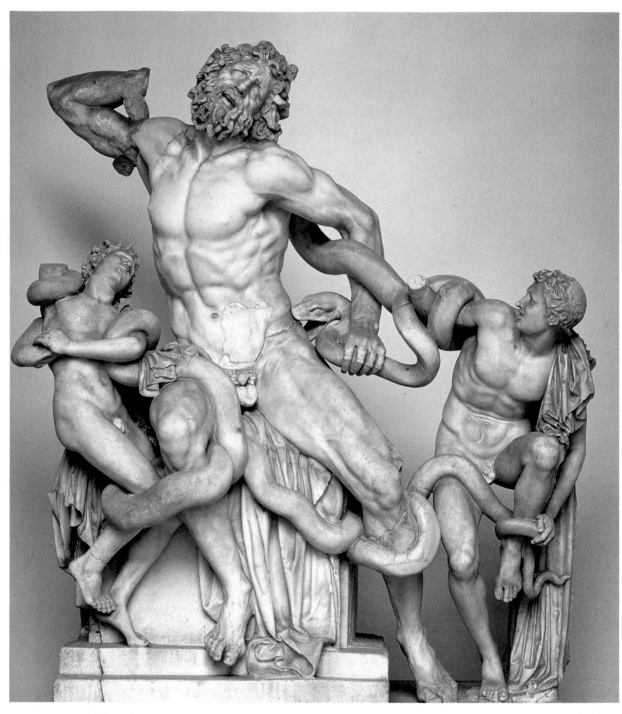

24. Hagesandros, Polydoros, and Athanadoros of Rhodes. *Laocoön and His Sons*, as restored today. Probably the original of 1st century CE or a Roman copy of the 1st century CE. Marble, height 8' (2.44 m). Musei Vaticani, Museo Pio Clementino, Cortile Ottagono, Rome, Italy

Such intense study of the history of art is also enhanced by the work of anthropologists and archaeologists, who study the wide range of material culture produced by a society. Archaeologists often have the excitement of finding new and wonderful objects as they reconstruct the social context of the works. They do not, however, single out individual works of perceived excellence, produced for an elite culture, for special attention.

Even as methodological sophistication and technological advances soar in art history today, art historians and other viewers are faced with some special challenges of interpretation, especially regarding works that have been damaged or restored. As we try to understand such works of art, we must remain quizzical and flexible; damaged artworks may have had large parts replaced—the legs of a marble figure or a section of wall in a mural painting, for example. Many of the works seen in this book have been restored, and many have recently been cleaned. Let's look more closely at some of the challenges those issues pose to art historians today.

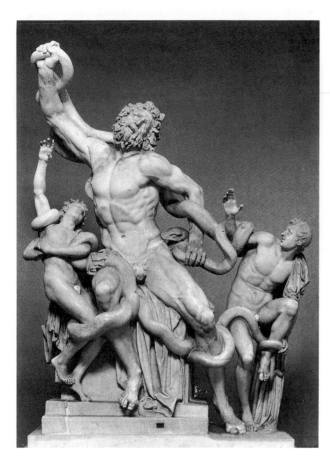

25. Hagesandros, Polydoros, and Athanadoros of Rhodes. *Laocoön and His Sons*, in an earlier restoration

DEFENDING ENDANGERED OBJECTS

Art historians must be concerned with natural and human-caused threats to works of art. In some cases, the threats result from well-meaning actions. The dangers inherent in restoration, for example, are blatantly illustrated by what happened during two restorations, hundreds of years apart, of the renowned sculpture *Laocoön and His Sons*.

Laocoön was a priest who warned the Trojans of an invasion by the Greeks in Homer's account of the Trojan War. Although he told the truth, the goddess Athena, who took the Greeks' side in the war, dispatched serpents to strangle him and his sons. A tragic hero, Laocoön represents a virtuous man destroyed by unjust forces. In the powerful ancient Greek sculpture, his features twist in agony, and the muscles of his and his sons' superhuman torsos and arms extend and knot as they struggle (figs. 24 and 25). When the sculpture was discovered in Rome in 1506, artists such as Michelangelo rushed to see it, and it inspired many artists to develop a heroic style. The pope acquired it for the papal collection, and it can still be seen in the Vatican Museums.

In piecing together the past of this one work, we know that mistakes were made during an early restoration. The broken pieces of the *Laocoön* group first were reassembled with figures flinging their arms out in the melodramatic fashion seen in figure 25—this was the

sculpture the Renaissance and Baroque artists knew. Modern conservation methods, however, have produced a different image and with it a changed mood (fig. 24). Arms turn back upon the bodies, making a compact composition that internalizes the men's agony. This version speaks directly to a self-centered twenty-first century. We can only wonder if twenty-fifth-century art historians will re-create yet another *Laocoön*.

Restoration of works like *Laocoön* is intended to conserve precious art. But throughout the world, other human acts intentionally or mindlessly threaten works of art and architecture—and this is not a recent problem. Egyptian tombs were plundered and vandalized many hundreds of years ago—and such theft continues to this day. Objects of cultural and artistic value are being poached from official and unofficial excavation sites around the world, then sold illegally.

In industrialized regions of the world, emissions from cars, trucks, buses, and factories accrue in corrosive rain that damages and sometimes literally destroys the works of art and architecture on which it falls. For art, however, war is by far the most destructive of all human enterprises. History is filled with examples of plundered works of art that, as spoils of war, were taken elsewhere and paraded and protected. But countless numbers of churches, synagogues, mosques, temples, and shrines have been burned, bombed, and stripped of decoration in the name of winning a war or confirming an ideology. So much has been lost—especially in modern times, with weapons of mass destruction—that is absolutely irrecoverable.

Individuals are sometimes moved to deface works of art, but nature itself can be equally capricious: Floods, hurricanes, tornadoes, avalanches, mudslides, and earthquakes all damage and destroy priceless treasures. For example, an earthquake on the morning of September 27, 1997, convulsed the small Italian town of Assisi, where Saint Francis was born and where he founded the Franciscan order. It shook nearly to pieces the thirteenth-century Basilica of Saint Francis of Assisi—one of the richest repositories of Italian Gothic and Early Renaissance wall painting—causing great damage to architecture and paintings.

In all the examples mentioned, art historians have played a role in trying to protect the treasures that are the cultural heritage of us all. But they play another role that also affects our cultural heritage: helping to increase our understanding of the social and political factors that contribute to the artwork's context.

UNCOVERING SOCIOPOLITICAL INTENTIONS

Because art history considers the role and intention of artists, art historians have explored—but not always discovered—whether the sculpture of Laocoön, for example, had a political impact in its own time. As we have seen, artists throughout history have been used to promote the political and educational agendas of powerful patrons, but modern artists are often independent-minded, astute commentators in their own right. Art history needs to

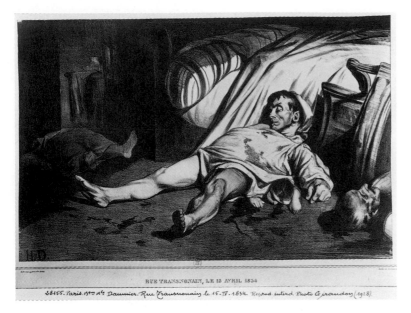

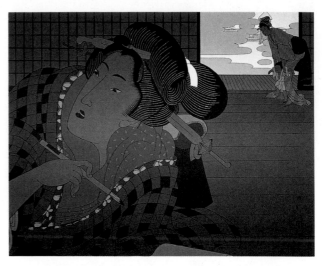

26. Honoré Daumier. *Rue Transonain, Le 15 Avril 1834.* Lithograph, 11 x 17 3/8" (28 x 44 cm). Bibliothèque Nationale, Paris

27. Roger Shimomura. *Diary* **(Minidoka Series #3).** 1978. Acrylic on canvas, 4'11 7/8" x 6'1/16" (1.52 x 1.83 m). Spencer Museum of Art, The University of Kansas, Lawrence

look at these motivations too. For example, among Honoré Daumier's most powerful critiques of the French government is his print *Rue Transonain, Le 15 Avril 1834* (fig. 26). During a period of urban unrest, the French National Guard fired on unarmed citizens, killing fourteen people. For his depiction of the massacre, Daumier used lithography—a cheap new means of illustration. He was not thinking in terms of an enduring historical record, but rather of a medium that would enable him to spread his message as widely as possible. Daumier's political commentary created such horror and revulsion that the government ordered all copies of the print to be gathered up and destroyed. As this example shows, art historians need to consider not just the historical context but also the political content and the medium of a work of art to have a complete understanding of it.

Another, more recent, work with a powerful sociopolitical message is a reminder to those of us in the twenty-first century who may not know or may have forgotten that American citizens of Japanese ancestry were removed from their homes and confined in internment camps during World War II. Roger Shimomura (b. 1939) in 1978 painted *Diary*, recalling his grandmother's record of the family's experience in one such camp in Idaho (fig. 27). Shimomura has painted his grandmother writing in her diary, while he (the toddler) and his mother stand by an open door—a door that does not signify freedom but opens on to a field bounded by barbed wire. In this painting—a commentary on twentieth-century discrimination and injustice—Shimomura combines two formal traditions—the Japanese art of color woodblock prints and American Pop art—to create a personal style that expresses his own dual culture.

Art historians must examine such sociopolitical factors as critical aspects of the historical context of works of art. But what is our responsibility as viewers?

WHAT IS THE VIEWER'S RESPONSI-BILITY? We as viewers enter into an agreement with artists, who in turn make special demands on us. We re-create the works of art for ourselves as we bring to them our own experiences, our intelligence, even our prejudices. Without our participation, artworks are only chunks of stone or painted canvas. But we must also remember that styles change with time and place. From extreme realism at one end of the spectrum to entirely nonrepresentational art at the other—from van der Spelt and van Mieris's *Flower Piece with Curtain* (see fig. 2) to Smith's *Cubi* (see fig. 5)—artists have worked with varying degrees of naturalism, idealism, and abstraction. The challenge for the student of art history is to discover not only how but also why those styles evolved, and ultimately what of significance can be learned from that evolution.

Our involvement with art may be casual or intense, naive or sophisticated. At first we may simply react instinctively to a painting or building or photograph, but this level of "feeling" about art—"I know what I like"—can never be fully satisfying. Because as viewers we participate in the re-creation of a work of art, its meaning changes from individual to individual, from era to era. Once we welcome the arts into our lives, we have a ready source of sustenance and challenge that grows, changes, mellows, and enriches our daily experience. The Starter Kit, which begins on page 18, introduces us to many of the tools of art history, but no matter how much we study or read about art and artists, eventually we return to the contemplation of an original work itself, for art such as Vincent van Gogh's *Large Plane Trees* (fig. 28, "The Object Speaks") is the tangible evidence of the ever-questing human spirit.

THE OBJECT SPEAKS

LARGE PLANE TREES

In Vincent van Gogh's *Large Plane Trees*, huge trees writhe upward from an undulating earth as tiny men labor to repair a street in the southern French town of Saint-Rémy. The painting depicts an ordinary scene in an ordinary little town. Although the canvas is unsigned, stylistic and technical analysis confirms its attribution to the Post-Impressionist master Vincent van Gogh (1853–90). *Large Plane Trees* now hangs in The Cleveland Museum of Art. Museum curators, who study and care for works of art, have analyzed its physical condition and formed opinions about its quality. They have also traced its **provenance** (the history of its ownership) from the time the painting left the artist's studio until the day it entered their collection).

What *Large Plane Trees* says to us depends upon who we are. Art historians and art critics looking at this painting from the perspectives of their own specialties and approaches to the study of art's history can and do see many different meanings. Thus, this art object speaks in various ways.

Some art historians have looked at the work through the prism of the biographical facts of van Gogh's life. At the time he painted *Large Plane Trees*, he was suffering from depression and living in an asylum in Saint-Rémy. His brother, Theo, an art dealer in Paris, supported him and saved Vincent's letters, including two that mention this work. Archival research—study in libraries that have original documents, such as letters—is an essential part of art history.

Art historians steeped in the work of Sigmund Freud (1856–1939)—whose psychoanalytic theory addresses creativity, the unconscious mind, and art as expressions of repressed feelings—will find in this painting images infused with psychoanalytic meaning. The painting, despite its light, bright colors, might seem to suggest something ominous in the uneasy relationship between the looming trees and tiny people.

In contrast to Freud's search into the individual psyche, the political philosopher Karl Marx (1818–83) saw human beings as products of their economic environment. Marxist art critics might see in van Gogh's life and art a reflection of Marx's critique of humanity's over-concern with material values: van Gogh worked early in his life as a lay minister, identified with the underclass, and never achieved material success. This painting might also speak to such art critics of the economic structures that transform an unsalable nineteenth-century painting into a twentieth-century status symbol for the wealthy elite. Similarly, feminist art critics would challenge how the worth of a painting is determined and question the assumption that a painting by van Gogh should bring a higher price than a painting by Georgia O'Keeffe (see fig. 4).

Works of art can also be approached from a purely theoretical point of view. Early in the twentieth century, the Swiss linguist Ferdinand de Saussure (1857–1913) developed Structuralist theory, which defines language as a system of arbitrary signs. Painting, too, can be treated as a language in which the marks of the artist (the lines and colors) replace words. In the 1960s and 1970s, Structuralism evolved into other critical tools to determine what a painting may have to say, such as semiotics (the theory of signs and symbols) and deconstruction.

To the semiologist, *Large Plane Trees* is an arrangement of colored marks on canvas. To decode the message, the critic is not concerned with the artist's meaning or intention but rather with the "signs" van Gogh used. The "correct" interpretation is no longer of interest. Similarly, the deconstructionism of the French philosopher Jacques Derrida (b. 1930) questions all assumptions and frees the viewer from the search for a single, correct interpretation. So many interpretations emerge from the creative interaction between the viewer and the work of art that in the end the artwork is "deconstructed."

Today, critics and art historians have begun to reconsider artworks as tangible objects. Many have turned their attention from pure theory to a contextual or social history of art. Some have even taken up connoisseurship again.

The existence of so many approaches to a work of art may lead us to the conclusion that any idea or opinion is equally valid. But art historians, regardless of their theoretical stance, would argue that the informed mind and eye are absolutely necessary. The creation of works of art remains a uniquely human activity, and knowledge of the history of art is essential if art is to truly speak to us.

28. **Vincent van Gogh.** *Large Plane Trees.* 1889. Oil on canvas, 28 x 351/8" (73.4 x 91.8 cm). The Cleveland Museum of Art
Gift of the Hanna Fund, 1947.209

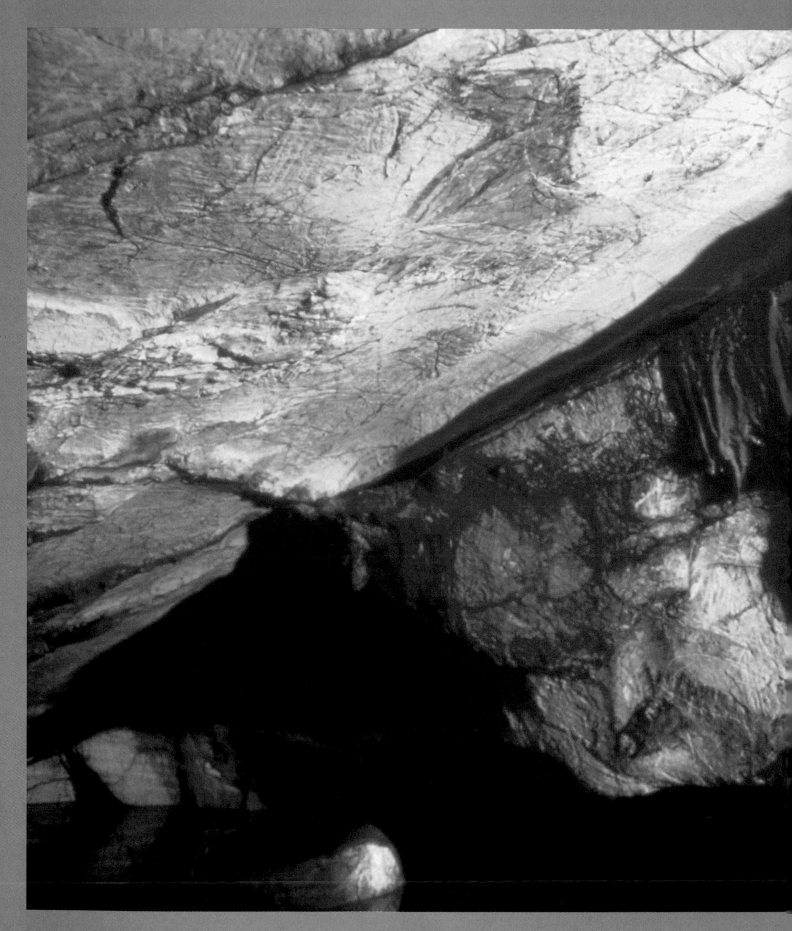

1-1. Wall with horses, Cosquer cave,
Cap Morgiou, France. c. 16,500 BCE.
Charcoal and manganese dioxide on limestone

1
Prehistory and Prehistoric Art in Europe

On July 9, 1991, diver Henri Cosquer set out to explore a small cave at Cap Morgiou, France, which he had first found nearly six years earlier. After swimming through an entrance 120 feet below the surface of the Mediterranean, he followed a narrow, rising tunnel for nearly 600 feet, then bobbed up into the main cavern, above sea level. Looking around, he saw to his amazement something he had missed on his first visit: a human handprint stenciled in red just above the seawater lapping the cave wall. He soon returned with a group of friends, who discovered many more of the prehistoric animal images and human handprints on the walls of this cave (fig. 1-1). The paintings and engravings in the Cosquer cave are the work of artists who spent time in this cave at two different times—27,000 and 18,500 years ago. These images record the interests of prehistoric people living on a hillside above the Mediterranean Sea before the climate change that raised the sea about 360 feet—to where it is today.

Prehistory includes all of human existence before the emergence of writing, but long before that defining moment, people were carving objects, painting images, and creating shelters and other structures. In fact, much of what we know about prehistoric people is based on the art they produced—from the smallest carvings to cave paintings to household wares. These works of prehistoric art and architecture are fascinating in part because they are supremely beautiful and in part because of what they disclose about the people who made them. The sheer artistry and immediacy of the images left by these early ancestors connect us to them as surely as written records link us to those who came later.

Prehistoric art interests art historians, archaeologists, and anthropologists alike. For them, art is only one clue—along with fossils, pollen, and artifacts—to an understanding of early human life and culture. Although they continue to make progress toward understanding when and how these works were created, we will never know *why* some of them were made. The sculpture, paintings, and structures that survive are only a tiny fraction of what was created over a very long span of time. For that reason, the conclusions and interpretations any of us draw from them are only theoretical, making prehistoric art one of the most speculative areas of art history.

TIMELINE 1-1. **Prehistoric Periods in Europe**. The Upper Paleolithic lasted until about 8000 BCE and overlapped the Neolithic as the last Ice Age glaciers receded northward. Metals began to be used in southern Europe during the Neolithic; by about 2300 BCE, the Bronze Age had begun in northern Europe, followed in about 1000 BCE by the Iron Age.

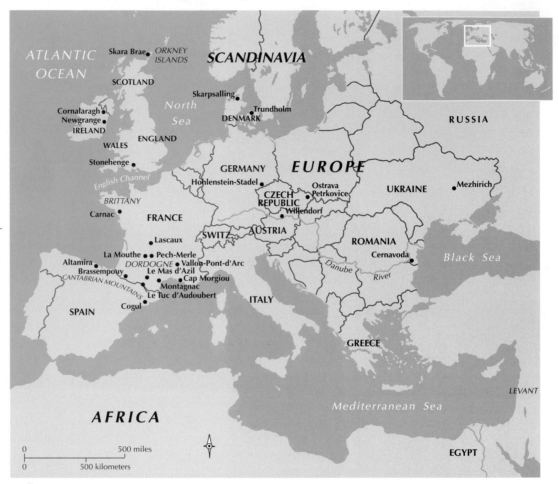

MAP 1-1. **Prehistoric Europe.** As the Ice Age glaciers receded, Paleolithic, Neolithic, Bronze Age, and Iron Age settlements increased from south to north.

THE PALEOLITHIC PERIOD

Archaeological evidence indicates that the earliest upright human species came into being about 4.4 million years ago in Africa. How and when modern humans evolved is the subject of lively debate, but anthropologists now agree that the hominids called *Homo sapiens* ("wise humans") appeared about 200,000 years ago and that the species to which we belong, *Homo sapiens sapiens*, evolved about 120,000 to 100,000 years ago. Modern humans spread across Asia, into Europe, and finally to Australia and the Americas. The most recently developed dating techniques suggest that this vast movement of people took place between 100,000 and 20,000 years ago. Not only did these early modern humans have the ability to travel great distances, but, as curators in the National Museum of Natural History in Washington, D.C., note, they had "aesthetic spirit and questing intellect." This book presents the tangible record of that uniquely human "aesthetic spirit."

Systematic study of prehistory began only about 200 years ago. Struck by the many stone tools, weapons, and figurines found at ancient living sites, those first scholars named the whole period of early human development the "Stone Age." Today's researchers divide the Stone Age into three major periods: the Paleolithic (from the Greek *paleo-*, "old," and *lithos*, "stone"), the Mesolithic (Greek *meso-*, "middle"), and the Neolithic (Greek *neo-*, "new"). The Paleolithic period is itself divided into three phases, Lower, Middle, and Upper, reflecting their relative position in excavated strata, or layers, with Upper being the most recent.

This chapter presents the prehistoric art of Europe (Map 1-1); later chapters consider the prehistoric art of other continents and cultures. The Upper Paleolithic period in Europe began between 42,000 and 37,000 years ago and lasted until the end of the Ice Age, about 9000–8000 BCE (Timeline 1-1). Much of northern Europe was covered by glaciers in the transitional period between the Upper Paleolithic and Neolithic. This period corresponds to the Mesolithic in other parts of the world. The gradual retreat of the ice between about 11,000 and 8,000 years ago introduced a new stone age, that is, Neolithic culture. Although the precise dates for these periods vary from place to place, the divisions are useful as we examine developments in the arts.

In the Upper Paleolithic period, long before the development of writing, our early ancestors created another

,000 BCE

1000 BCE

▲ c. 8000–7000 PALEOLITHIC-NEOLITHIC OVERLAP
▲ c. 8000–2300 NEOLITHIC

▲ c. 2300–1000 BRONZE AGE
c. 1000–IRON AGE ▲

form of communication: the visual arts. Many examples of sculpture, painting, architecture, and other arts have survived the long passage of time to move and challenge us. They may even provide us with insights into the lives and beliefs of their makers. Nevertheless, it is impossible to determine what "art" meant to the people who made it in such early times.

THE BEGINNING OF ARCHITECTURE

People have always found ingenious ways of providing themselves with shelter. Sometimes they occupied the mouth of a cave or fashioned a hut or tent next to a protective cliff. Traditionally, the term *architecture* has been applied to the enclosure of spaces with at least some aesthetic intent, so some people object to its use in connection with prehistoric improvisations. But building even a simple shelter requires a degree of imagination and planning deserving of the name "architecture."

In the Upper Paleolithic period, people in some regions built shelters that were far from simple. Circular or oval huts of light branches and hides might measure as much as 15 to 20 feet in diameter. (Modern tents to accommodate six people vary from 10-by-11-foot ovals to 14-by-7-foot rooms.) Most activities centered around the inside fire pit, or hearth, where food was prepared and tools were fashioned. Larger dwellings might have had more than one hearth and other spaces set aside for different uses—working stone, making clothing, sleeping, and dumping refuse. Some people colored their floors with powdered ocher, a naturally occurring iron ore ranging in color from yellow to red to brown, suggesting a deliberate aesthetic intent.

Remains of Upper Paleolithic dwellings in Russia and Ukraine reveal the ingenuity of people living in those inhospitable northern regions. In the treeless grasslands there, builders created settlements of up to ten houses using the bones of the woolly mammoth, a kind of elephant now extinct (fig. 1-2). One of the best-preserved mammoth-bone villages, discovered in Mezhirich, Ukraine, dates from 16,000–10,000 BCE. Most of its houses were from 13 to 26 feet in diameter, and the largest one, 24 by 33 feet, was cleverly constructed of dozens of mammoth skulls, shoulder blades, pelvic bones, jawbones, and tusks. The long, curving tusks made excellent roof supports and effective arched door openings. The bone framework was probably covered with animal hides and turf. Inside the largest dwelling, archaeologists found fifteen small hearths that still contained ashes and charred bones left by the last occupants.

SCULPTURE

The earliest known works of sculpture are small figures, or figurines, of people and animals and date from as early as 32,000 BCE. Thousands of such figures in bone, ivory, stone, and clay have been found across Europe and Asia. Such self-contained, three-dimensional pieces are examples of

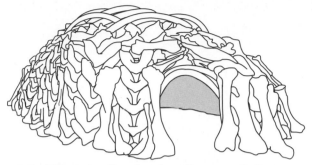

1-2. Reconstruction drawing of mammoth-bone house, from Ukraine. c. 16,000–10,000 BCE

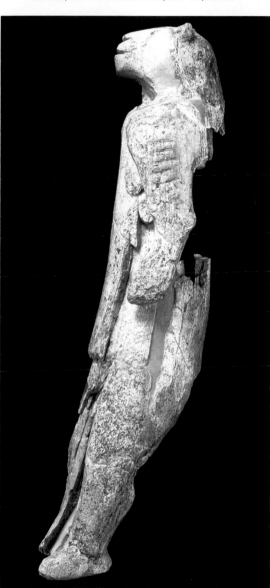

1-3. *Lion-Human*, from Hohlenstein-Stadel, Germany. c. 30,000–26,000 BCE. Mammoth ivory, height 11⅝" (29.6 cm). Ulmer Museum, Ulm, Germany

sculpture in the round. Prehistoric carvers also produced **relief sculpture** in stone, bone, and ivory. In relief sculpture, the surrounding material is carved away to a certain depth, forming a background that sets off the figure.

A human figure carved from mammoth ivory and nearly a foot tall—much larger than most early figurines—was found broken into many pieces at Hohlenstein-Stadel, Germany (fig. 1-3). Astonishingly, the head represents some

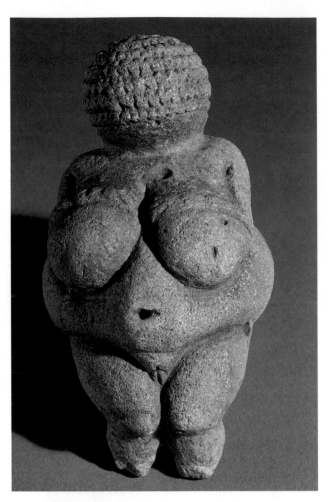

1-4. ***Woman from Willendorf***, Austria. c. 22,000–21,000 BCE. Limestone, height 4³/₈" (11 cm). Naturhistorisches Museum, Vienna

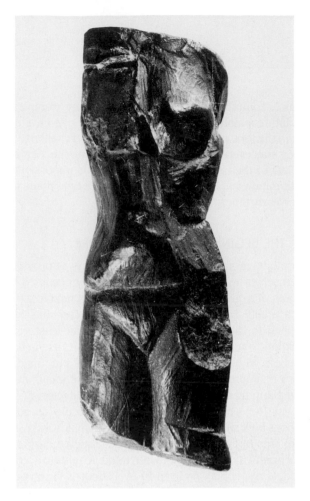

1-5. ***Woman from Ostrava Petrkovice***, Czech Republic. c. 23,000 BCE. Hematite, height 1³/₄" (4.6 cm). Archaeological Institute, Brno

species of cat. Was this lively, powerful figure intended to represent a person wearing a lion mask and taking part in some ritual? Or is this a portrayal of some imagined creature, half human and half beast? One of the few things that can be said with certainty about the *Lion-Human* is that a gifted artist from as long as 30,000 years ago displayed sophisticated thinking to create a creature never seen in nature and considerable technical skill to produce a work that still inspires wonder.

Animals and nude women are the subjects of most small sculpture from the Upper Paleolithic period. The most famous female figure, the *Woman from Willendorf*, Austria (fig. 1-4), dates from about 22,000–21,000 BCE and is only 4³/₈ inches tall. Carved from limestone and originally colored with red ocher, the figure is composed of rounded shapes that convey stability, dignity, and permanence—and incidentally make the work seem much larger than it is. The sculptor carved the stone in a way that conveys the body's fleshiness, exaggerating its female attributes by giving it pendulous breasts, a big belly with deep navel (a natural indentation in the stone), wide hips, and solid thighs. The gender-neutral parts of the body—the face, the arms, the legs—have been reduced to mere vestiges. A pattern signifying hair covers the head.

Another carved figure, found in what is now the Czech Republic, the *Woman from Ostrava Petrkovice*,

presents an entirely different conception of the female form (fig. 1-5). It is less than 2 inches tall and dates from about 23,000 BCE. Archaeologists excavating an oval house stockpiled with flint stone and rough chunks of hematite (the iron oxide ore powdered to make ocher pigment) discovered the figure next to the hearth. Someone at the house had apparently picked up a piece of hematite and shaped it into the figure of a youthful, athletic woman. She stands in an animated pose, with one hip slightly raised and a knee bent as if she were walking.

The hematite woman is so beautiful that one longs to be able to see her face. Perhaps it resembled the one preserved on a fragment from another female figure found in France. This tiny ivory head, known as the *Woman from Brassempouy* (fig. 1-6), dates from about 22,000 BCE. The person who carved it was concerned with those contours necessary to identify the piece as a human head—an egg shape atop a graceful neck, a wide nose, and a strongly defined browline suggesting deep-set eyes. The cap of shoulder-length hair is decorated with a grid pattern perhaps representing curls or braiding, or even a wig or headdress.

This head is an example of **abstraction**: the reduction of shapes and appearances to basic forms that do not faithfully reproduce those of the thing represented. Instead of copying a specific person's face detail by detail, the artist

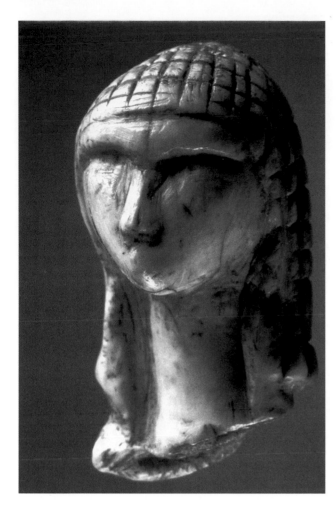

1-6. *Woman from Brassempouy*, Grotte du Pape, Brassempouy, Landes, France. c. 22,000 BCE. Ivory, height 1¼" (3 cm). Musée des Antiquités Nationales, St.-Germain-en-Laye

the tiny face from Brassempouy appeal to our twentieth-century taste for abstraction. Intentionally or not, the artist communicates an essential humanity, even isolated from any cultural context, across the millennia.

Because so many of the surviving human figures from the period are female, some scholars have speculated that prehistoric societies were matriarchal, or dominated by women. Others believe that these female figures, many of them visibly pregnant, reflect concerns with perpetuating the cycles of nature and ensuring the continuing life of people, animals, and vegetation and that they could be fertility symbols. Quite likely, the *Woman from Willendorf*, the *Woman from Brassempouy*, and similar Upper Paleolithic figures did have such a function (see "The Power of Naming," below). But they can also be interpreted as representations of actual women, as expressions of ideal beauty, as erotic images, as ancestor figures, or even as dolls meant to help young girls learn women's roles. Given the diversity of ages and physical types represented in sculpture, the figures could have any or all of these meanings.

CAVE ART

Art in Europe entered a rich and sophisticated phase between about 28,000 and 10,000 BCE, when many images were painted on the walls of caves in southern France and northern Spain. The earliest known site of prehistoric cave paintings created during this period in Europe, discovered in December 1994, is the Chauvet cave near Vallon-Pont-d'Arc in southern France—a tantalizing trove of hundreds of animal and bird paintings. The most dramatic of the Chauvet cave images depict grazing, running, or resting animals. Among the animals represented are the wild horse, the bison, the mammoth, the bear, the panther, the owl, deer, aurochs (extinct ancestors of oxen), the woolly-haired rhino, and the wild goat, or ibex (see fig. 1, in the Introduction). Also included are occasional people, both male and female, many handprints, and hundreds of geometric markings such as

provided only those features common to all of us. This is what is known as a **memory image**, an image that relies on the generic shapes and relationships that readily spring to mind at the mention of an object—in this case, the human head. Although it is impossible to know what motivated the artist to carve them in just this way, the simplified planes of

THE POWER OF NAMING Words are only symbols for ideas. But the very words we invent—or our ancestors invented—reveal a certain view of the world and can shape our thinking. Early people recognized clearly the power of words. In the Old Testament, God gave Adam dominion over the animals and allowed him to name them (Genesis 2:19–20). Today, we still exert the power of naming when we select a name for a baby, call a friend by a complimentary nickname, or use demeaning words to dehumanize those we dislike.

Our ideas about art can also be affected by names, even the ones used in captions in a book. Before the twentieth century, artists usually did not name, or title, their works. Names were eventually supplied by the works' owners or by scholars writing about them and thus may express the cultural prejudices of the labelers or of the times generally.

An excellent example of such distortion is provided by the names early scholars gave to the hundreds of small prehistoric statues of women they found. They dubbed the first of these to be discovered (see fig. 1-4) the "Venus of Willendorf" after the place where it had been found. Using the name of the Roman goddess of love and beauty sent a message that this figure was associated with religious belief, that it represented an ideal of womanhood,

and that it was one of a long line of images of "classical" feminine beauty. In a short time, most similar works of sculpture from the Upper Paleolithic period came to be known as Venus figures. The name was repeated so often that even scholars began to assume that these *had* to be fertility figures and mother goddesses although there is no absolute proof that people once thought these works had religious significance or supernatural powers.

Our ability to understand and interpret works of art creatively is easily compromised by distracting labels. Calling a prehistoric figure a "woman" instead of "Venus" encourages us to think about it in new and different ways.

THE MEANING OF PREHISTORIC CAVE PAINTINGS

What caused people 30,000 or even 15,000 years ago to paint images on the walls of caves? Anthropologists and art historians have devised several theories to explain prehistoric art, but they often tell us as much about the scholars and their times as they do about the art.

The idea that human beings have an inherent desire to decorate themselves and their surroundings—that an aesthetic sense is somehow innate to the human species—found ready acceptance in the nineteenth century. Some artists promoted the idea of "art for art's sake," and many believed that people created art for the sheer love of beauty. Scientists agree that human beings have an aesthetic impulse and take pleasure in pursuing impractical activities, but the effort required to accomplish the great paintings of Lascaux suggests that their creators were motivated by more than simple pleasure.

Early-twentieth-century scholars rejected the idea of art for art's sake. Led by Salomon Reinach, who believed that art fulfills a social function and that aesthetics are culturally relative, they proposed that prehistoric cave paintings might be products both of *totemistic rites* to strengthen clan bonds and of *increase ceremonies* to enhance the fertility of animals depended on for food. In 1903, Reinach suggested that cave paintings were expressions of "sym-pathetic magic." Still encountered in many societies, sympathetic magic relies on two assumptions: first, things that look the same can have a physical influence on each other; and second, things once in contact continue to act upon each other even at great distances. In the case of cave paintings, producing a picture of a bison lying down would ensure that hunters found their prey asleep. Ritual killing of the picture of a bison would guarantee the hunters' triumph over the beast itself.

In the early 1920s, Abbé Henri Breuil took these ideas somewhat further and concluded that cave paintings were early forms of religious expression. Convinced that caves were used as places of worship and the settings for initiation rites, he interpreted them as aids in rituals and in instruction.

In the second half of the twentieth century, scholars tended to base their interpretations on rigorous scientific methods and current social theory. French scholars such as André Leroi-Gourhan and Annette Laming-Emperaire dismissed the "hunting magic" theory because debris from human settlements revealed that the animals used most frequently for food were not the ones traditionally portrayed in caves. These scholars discovered that cave images were often systematically organized, with different animals predominating in different areas of a cave. Although they disagreed on details, Leroi-Gourhan and Laming-Emperaire concluded that cave images are meaningful pictures. As Laming-Emperaire put it, the paintings "might be mythical representations . . . they might be the concrete expression of a very ancient metaphysical system . . . they might be religious, depicting supernatural beings. They might be all these at one and the same time . . ." (Annette Laming-Emperaire, *La signification de l'art rupestre paléolithique*, 1962, pages 236–7). She felt certain that horses, bison, and women suggested "calm, peace, harmony," and were "concerned with love and life."

Researchers continue to discover new cave images and correct earlier errors of fact or interpretation. A restudy of the Altamira cave in the 1980s led Leslie G. Freeman to determine that these artists faithfully represented a herd of bison during the mating season. Instead of being dead, asleep, or disabled—as earlier observers had supposed—the bison on the ground were dust wallowing, common behavior hunters might have seen during the breeding season.

Today, rigorous dating techniques have enhanced our ability to place prehistoric artifacts in time (see "How Early Art Is Dated," page 54), and anthropological studies have extended our knowledge of the cultures out of which cave art emerged. But the discovery of paintings at Cap Morgiou reminds us how great a role chance plays in this rapidly changing field.

grids, circles, and dots. Footprints in the Chauvet cave, left in soft clay by a young boy going to a "room" containing bear skulls, are the oldest human footprints ever documented—charcoal found where he stopped to clean his torch has been dated to about 24,000 BCE.

These caves must have had a special meaning, because people returned to them time after time over many generations, in some cases over thousands of years (see "The Meaning of Prehistoric Cave Paintings," above). The prehistoric artists who worked there must have felt that their art would be of some specific benefit to their communities. Perhaps Upper Paleolithic cave art was the product of rituals intended to gain the favor of supernatural forces. If so, its significance may have had less to do with the finished painting than with the very act of creation. The subterranean galleries were not used as living quarters, but artifacts and footprints suggest that they were gathering places. People may have congregated there to celebrate initiation rites or the sealing of social alliances—just as we gather today for baptisms, bar mitzvahs and bat mitzvahs, weddings, funerals, or town meetings.

The paintings of animals in the Cosquer cave at Cap Morgiou (see fig. 1-1) were created about 16,500 BCE, but the earliest of the handprints found there date from long before, as early as 25,000 BCE. In other caves, painters worked not only in large caverns but also far back in the smallest chambers and recesses, many of which are almost inaccessible today. Small stone lamps found in such caves (see fig. 1-13) indicate that they worked in the dim flicker of light from burning animal fat. Occasional small holes have been found carved into a cave's rock walls. These may have been used to anchor the scaffolding needed for painting the cave's high ceilings and walls.

A cave site at Pech-Merle, in France, appears to have been used and abandoned several times over a period of 5,000 years. Images of animals, handprints, and nearly 600 geometric symbols have been found in thirty different parts of the underground complex. The earliest artists to work in the cave, some 18,000 years ago, specialized in painting horses (fig. 1-7). All of their horses have small, finely detailed heads, heavy bodies, massive extended necks, and legs tapering to almost nothing at

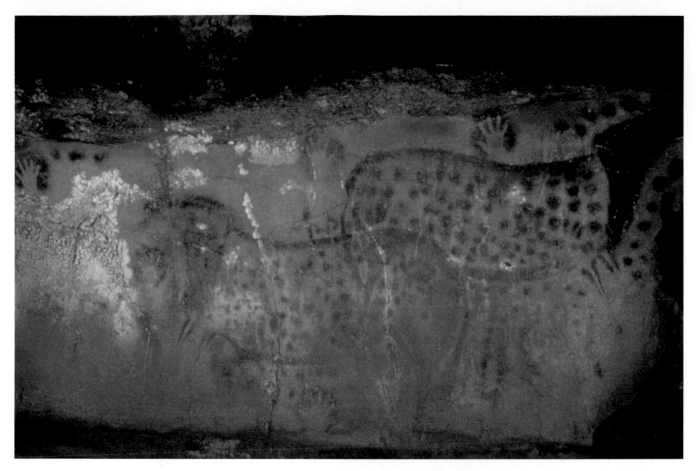

1-7. *Spotted Horses and Human Hands*, Pech-Merle cave, Dordogne, France. Horses c. 16,000 BCE; hands c. 15,000 BCE. Paint on limestone, length approx. 11'2" (3.4 m)

TECHNIQUE

PREHISTORIC WALL PAINTING

In a dark cave in France, working by the light of a flickering lamp fueled with animal fat, an artist places charcoal in his mouth, chews it, diluting it with saliva and water, then spits it out against the wall, using his hand as a stencil. The artist is Michel Lorblanchet, a cave archaeologist. He is showing us how the original artists at Pech-Merle created their magnificent paintings.

Having successfully reproduced a smaller cave painting of animals before, Lorblanchet turned to the best-known and most complex of the Pech-Merle paintings, the one of the spotted horses (see fig. 1-7). He first made a light sketch in charcoal, then painted the horses' outlines using the spitting technique. By turning himself into a human spray can, he produced clear lines on the rough stone surface more easily than he could with a brush. To create the sharpest lines, such as those of the upper hind leg and tail, he simply blew pigment below his hand. He finger-painted the forelegs and the hair on the horses' bellies, and he punched a hole in a piece of leather to make a stencil for the dense, round spots. In some places, he blew a thick pigment through a reed, but in others he applied it with a brush he made by chewing the end of a twig.

Lorblanchet needed thirty-two hours to reproduce the spotted horses. The fact that he could execute such a work in a relatively short time tends to confirm that a single artist—perhaps with an assistant to mix pigments and tend the lamp—created the original. Jean Clottes, who has studied the composition of pigments to date cave painting in

France, thinks that pigments used in a given region remained fairly consistent but that the recipe for the medium—the precise mix of saliva, water, and other liquids used to bind them—varied over time and from place to place.

Although we may never know just what these paintings meant to the artists who produced them, the *process* of creating them must have been rich with significance. Lorblanchet puts it quite eloquently: "Human breath, the most profound expression of a human being, literally breathes life onto a cave wall" (*Archaeology*, November–December 1991, page 30).

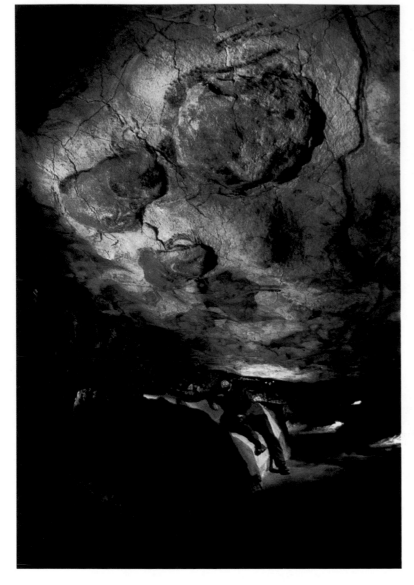

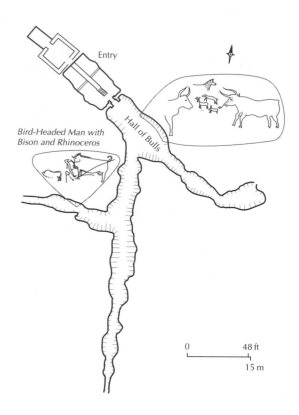

1-9. Plan of Lascaux caves, Dordogne, France

1-8. *Bison*, on the ceiling of a cave at Altamira, Spain. c. 12,000 BCE. Paint on limestone, length approx. 8'3" (2.5 m)

No one knew of the existence of prehistoric cave painting until one day in 1879, when a young girl exploring with her father on the family estate in Altamira crawled through a small opening in the ground and found herself in a cave chamber whose ceiling was covered with painted animals. Her father searched the rest of the cave, then told authorities about the remarkable find. Few people believed that these amazing works could have been done by "primitive" people, and the scientific community declared the paintings a hoax. They were accepted as authentic only in 1902, after many other cave paintings, drawings, and engravings had been discovered at other spots in northern Spain and in France.

the hooves. The horses were then overlaid with bright red circles. Some interpreters see these circles as ordinary spots on the animals' coats, but others see them as representations of rock weapons hurled at the painted horses in a ritual meant to assure success in the hunt.

The handprints on the walls at Pech-Merle and other cave sites were almost certainly not idle graffiti or accidental smudges but were intended to communicate

something. Some are positive images made by simply coating the hand with color pigment and pressing it against the wall. Others are negative images: the surrounding space rather than the hand shape itself is painted. Negative images were made by placing the hand with fingers spread apart against the wall, then spitting or spraying paint around it with a reed blowpipe—an artist's tool found in such caves (see "Prehistoric Wall Painting," page 49). Most of the handprints are small enough to be those of women or even children, yet footprints preserved in the mud floors at other caves show that they were visited by people of all sizes. A series of giant aurochs at Pech-Merle, painted in simple outlines without color, has been dated to a later period, about 15,000 BCE. Sometime afterward, other figures were created near the mouth of the cave by **incising**, or scratching lines into the walls' surface. Thanks to rapid advances in laboratory analysis techniques, it is only a matter of time until all prehistoric wall paintings can be dated more precisely.

The first cave paintings to be discovered and attributed to the Upper Paleolithic period were those at Altamira, near Santander in the Cantabrian Mountains of northern Spain. Scholars recently dated them to about 12,000 BCE. The Altamira artists created sculptural effects by painting the bodies of their animals over and around natural irregularities in the cave's walls and ceilings. To produce the herd of bison on the ceiling of the main cavern (fig. 1-8), they used rich red and brown ochers to paint the large areas of the animals' shoulders, backs, and

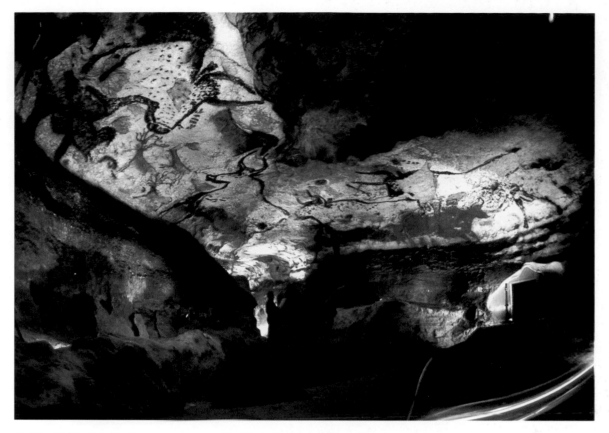

1-10. Hall of Bulls, Lascaux caves. c. 15,000–13,000 BCE. Paint on limestone

Discovered in 1940 and opened to the public after World War II, the prehistoric "museum" at Lascaux soon became one of the most popular tourist sites in France. Too popular, for the many visitors sowed the seeds of the paintings' destruction in the form of heat, humidity, exhaled carbon dioxide, and other insidious contaminants from the outside world. The cave was closed to the public in 1963, so that conservators might battle an aggressive fungus that had attacked the paintings. Eventually they won, but instead of reopening the site, the authorities created a facsimile of it. Visitors at what is called Lascaux II may now view copies of the painted scenes without harming the precious originals.

flanks, then added the details of the legs, tails, heads, and horns in black and brown. They must have observed the bison herd with great care in order to capture the distinctive appearance of the beasts.

The best-known cave paintings are those found in 1940 at Lascaux, in the Dordogne region of southern France, which have been dated to about 15,000–13,000 BCE (fig. 1-9). The Lascaux artists also used the contours of the rock as part of their compositions (fig. 1-10). They painted cows, bulls, horses, and deer along natural ledges, where the smooth, white limestone of the ceiling and upper wall meets a rougher surface below. The animals appear singly, in rows, face to face, tail to tail, and even painted on top of one another. As in other cave paintings, their most characteristic features have been emphasized. Horns, eyes, and hooves are shown as seen from the front, yet heads and bodies are rendered in profile. Even when their poses are exaggerated or distorted, the animals are full of life and energy, and the accuracy in the drawing of their silhouettes, or outlines, is remarkable.

One scene at Lascaux is unusual not only because it includes a human figure but also because it is the only painting in the cave complex that seems to tell a story (fig. 1-11). It was discovered on a wall at the bottom of a

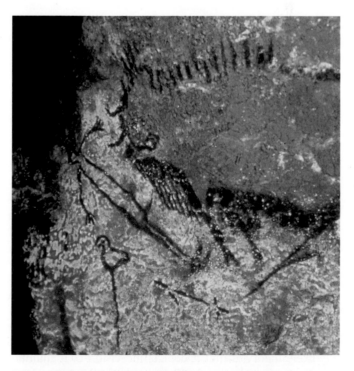

1-11. *Bird-Headed Man with Bison and Rhinoceros*, Lascaux caves. c. 15,000–13,000 BCE. Paint on limestone, length approx. 9' (2.75 m)

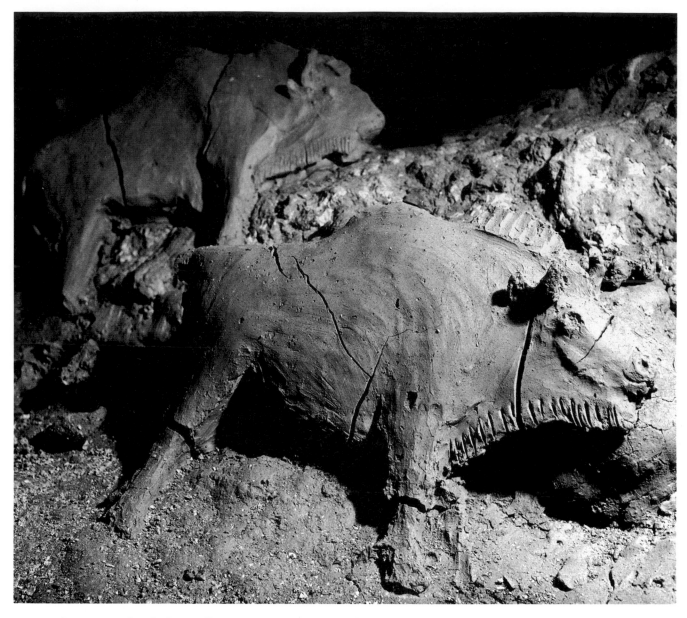

1-12. *Bison*, Le Tuc d'Audoubert, Ariège, France. c. 13,000 BCE. Unbaked clay, length 25" (63.5 cm) and 24" (60.9 cm)

16-foot shaft containing spears and a stone lamp. A figure who could be a hunter, highly stylized but recognizably male and wearing a bird's-head mask, appears to be lying on the ground. A great bison looms above him. Below him lie a staff, or baton, and a spear thrower—a device that allowed hunters to throw farther and with greater force— the outer end of which has been carved in the shape of a bird. The long, diagonal line slanting across the bison's hindquarters is a spear. The bison has been disemboweled and will soon die. To the left of the cleft in the wall is a woolly rhinoceros—possibly the bison's slayer.

What is this scene telling us? Why did the artist portray the man as only a sticklike figure when the bison was rendered with such accurate detail? It may be that the painting illustrates a myth regarding the death of a hero. Perhaps it illustrates an actual event. The most likely theory is that it depicts the vision of a shaman. Shamans were—and still are—people thought to have special powers, an ability to foretell events and assist their people through contact with spirits in the form of

animals or birds. Shamans typically make use of trance states, in which they believe they fly and receive communications from their spirit guides. The images they use to record their visions tend to be abstract, incorporating geometric figures and combinations of human and animal forms such as the bird-headed man in this scene from Lascaux or the lion-headed figure discussed earlier (see fig. 1-3). Some scholars have interpreted the horses with red dots at Pech-Merle as a shamanistic combination of natural and geometric forms.

Caves were sometimes adorned with relief sculpture as well as paintings. In some instances, such as Altamira, an artist simply heightened the resemblance of a natural projecting rock to a familiar animal form. Other reliefs were created by **modeling**, or shaping, the damp clay of the cave's floor. An excellent example of such work in clay from about 13,000 BCE is preserved at Le Tuc d'Audoubert, in the Dordogne region of France. Here the sculptor created two bison leaning against a ridge of rock (fig. 1-12). Although these beasts are modeled in very **high relief** (they extend

1-13. Lamp with ibex design, from La Mouthe cave, Dordogne, France. c. 15,000–13,000 BCE. Engraved stone, 6¾ x 4¾" (17.2 x 12 cm). Musée des Antiquités Nationales, St.-Germain-en-Laye

well forward from the background plane), they display the same conventions as earlier painted ones, with emphasis on the broad masses of the meat-bearing flanks and shoulders. To make the animals even more lifelike, their creator engraved short parallel lines below their necks to represent their shaggy coats. Numerous small footprints found in the clay floor of this cave must have been left by young people, suggesting that initiation rites may have been performed here.

An aesthetic sense and the ability to pose and solve problems are among the characteristics unique to human beings. That these characteristics were richly developed in very early times is evident from Paleolithic artifacts of all kinds. Lamps found in caves provide an example of objects that were both functional and aesthetically pleasing. Some are carved in simple abstract shapes admirably designed to hold oil and wicks and to be easily portable. Others were adorned with engraved images, like one found at La Mouthe, France (fig. 1-13). The creator decorated the underside of this lamp with the image of an ibex. The animal's distinctive head is shown in profile, its sweeping horns reflecting the curved outline of the lamp itself.

Objects such as the ibex lamp were made by people whose survival, up until about 10,000 years ago, depended upon their skill at hunting animals and gathering wild grains and other edible plants. But a change was already under way that would alter human existence forever.

THE NEOLITHIC PERIOD

Today, advances in technology, medicine, transportation, and electronic communication have changed the human experience in a generation. Many thousands of years ago, change came much more slowly. The warming of the climate that brought an end to the Ice Age was so gradual that the people of the time could not have known it was occurring, yet it altered life as dramatically as any changes that have come since. The retreating glaciers exposed large temperate regions, and rising ocean levels changed the shorelines of continents, in some places making islands.

About 6000 BCE, the land bridge connecting England with the rest of Europe disappeared beneath the waters of what are now known as the North Sea and the English Channel. Europe became covered with grassy plains supporting new edible plants and forests that lured great herds of animals, such as deer, farther and farther northward. At the same time, the people in these more hospitable regions were finding ways to enhance their chances of survival. Hunters invented the bow and arrow. Bows were easier to carry and much more accurate at longer range than spears and spear throwers. Dugout boats came into use, opening up new areas for fishing and hunting. With each such advance the standard of living improved.

The changing environment led to a new way of life. People began domesticating animals and cultivating plants. As they gained greater control over their food supply, they established settled communities. None of these changes occurred overnight. Between 10,000 and 5,000 years ago, people along the eastern shore of the Mediterranean began domesticating wild grasses, developing them into more-productive grains such as bread wheat. In this same period, the people of Southeast Asia learned to grow millet and rice and those in the Americas began to cultivate the bottle gourd and eventually corn. Dogs probably first joined with human hunters more than 11,000 years ago, and cattle, goats, and other animals were domesticated later. Large numbers of people became farmers, living in villages and producing more than enough food to support themselves—thus freeing some people in the village to attend to other communal needs. Over time these early societies became increasingly complex. Although most people were still farmers, some of them specialized in political and military affairs, still others in ceremonial practices. The new farming culture gradually spread across Europe, reaching Spain and France by 5000 BCE. Farmers in the Paris region were using plows by 4000 BCE.

These fundamental changes in the prehistoric way of life mark the Neolithic period and occurred in some regions earlier than others. To determine the onset of the Neolithic period in a specific region, archaeologists look for the evidence of three conditions: an organized system of agriculture; animal husbandry, or the maintenance of herds of domesticated animals; and permanent, year-round settlements. By the end of the period, villages were larger, trading had developed among distant regions, and advanced building technology had produced awe-inspiring architecture.

ROCK-SHELTER ART

The period of transition between Paleolithic and Neolithic culture saw the rise of a distinctive art combining geometric forms and schematic images—simplified, diagrammatic renderings—with depictions of people and animals engaged in everyday activities. Artists of the time preferred to paint and engrave such works on easily accessible, shallow rock shelters. In style, technique, and subject matter, these rock-shelter images are quite different from those

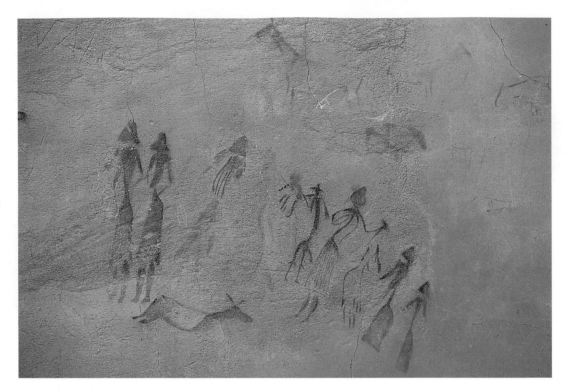

1-14. *People and Animals*, detail of rock-shelter painting, Cogul, Lérida, Spain. c. 4000–2000 BCE

found in Upper Paleolithic cave art. The style is abstract, and the technique is often simple line drawing, with no addition of color. Paintings from this period portray striking new themes: people are depicted in energetic poses, whether engaged in battle, hunting, or possibly dancing. They are found in many places near the Mediterranean coast but are especially numerous, beginning about

6000 BCE, in a region located in northeastern Spain.

At Cogul, in the province of Lérida in Catalonia, the broad surfaces of a rock shelter are decorated with elaborate narrative scenes involving dozens of small figures—men, women, children, animals, even insects (fig. 1-14). They date from between 4000 and 2000 BCE (see "How Early Art Is Dated," below). No specific landscape

HOW EARLY ART IS DATED When Upper Paleolithic cave paintings were first discovered at Altamira, Spain, in 1879, they were promptly rejected as forgeries by the Lisbon Congress on Prehistoric Archaeology. Seven years later, scientists proved that similar paintings discovered in France were indeed thousands of years old because a layer of mineral deposits had built up on top of them. Since those first discoveries, archaeologists have developed increasingly sophisticated ways of dating such finds.

During the twentieth century, archaeologists have primarily used two approaches to determine an artifact's age. **Relative dating** relies on the chronological relationships among objects in either a single excavation or several sites. If archaeologists have determined, for example, that pottery types A, B, and C follow each other chronologically at one site, they can apply that knowledge to another site; even if "type B" is the only pottery present, it can be assigned a relative date. **Absolute dating** aims to determine a precise span of calendar years

in which an artifact was created.

The most accurate method of absolute dating is **radiometric dating**, which measures the degree to which radioactive materials have disintegrated over time. Used for dating organic (plant or animal) materials—including some pigments used in cave paintings—one radiometric method measures a carbon isotope called radiocarbon, or carbon-14, which is constantly replenished in a living organism. When an organism dies, it stops absorbing carbon-14 and starts to lose its store of it at a predictable rate. Under the right circumstances, the amount of carbon-14 remaining in organic material can tell us how long ago an organism died. This method has serious drawbacks for dating works of art, however. Using carbon-14 dating on a carved antler or wood sculpture shows only when the animal died or the tree was cut down, not when the artist created the work, which could have been centuries later. Also, some part of the object must be destroyed to conduct this kind of test—something rarely desirable in a work of art. For this reason, researchers

frequently test organic materials found in the same context as the work of art rather than the work itself.

Radiocarbon dating is most accurate for materials no more than 30,000 to 40,000 years old. **Potassium-argon dating**, which measures the decay of a radioactive potassium isotope into a stable isotope of argon, an inert gas, is most reliable with materials more than a million years old. Two newer techniques have been used since the mid-1980s. **Thermoluminescence dating** measures the irradiation of the crystal structure of a material such as flint or pottery and the soil in which it is found, determined by the luminescence produced when a sample is heated. **Electron spin resonance techniques** involve a magnetic field and microwave irradiation to date a material such as tooth enamel and its surrounding soil.

Recent experiments have helped to date cave paintings with increasing precision. Twelve different radiocarbon-analysis series have determined, for example, that the animal images in the Cosquer cave are 18,500 years old, the handprints 27,000 years old.

Of all the methods for spanning space, **post-and-lintel construction** is the simplest. At its most basic, two uprights (posts) support a horizontal element (**lintel**). There are countless variations, from the trilithons, wood structures, dolmens and other underground burial chambers of prehistory, to Egyptian and Greek stone construction, to medieval timber frame buildings, and even to cast iron and steel construction. Its limitation as a space spanner is the degree of tensile strength, or flexibility, of the lintel material: the more flexible, the greater the span possible. Another early method for creating openings in walls and covering space is **corbeling**, in which rows or layers of stone are laid with the end of each row projecting beyond the row beneath, until opposing layers almost meet and can be capped with a stone that rests across the tops of both layers.

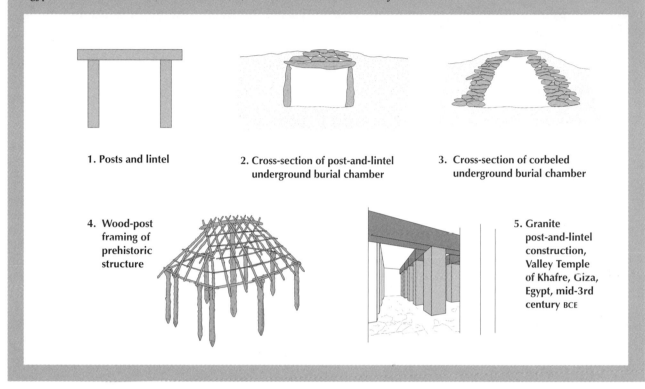

1. Posts and lintel

2. Cross-section of post-and-lintel underground burial chamber

3. Cross-section of corbeled underground burial chamber

4. Wood-post framing of prehistoric structure

5. Granite post-and-lintel construction, Valley Temple of Khafre, Giza, Egypt, mid-3rd century BCE

features are indicated, but occasional painted patterns of animal tracks give the sense of a rocky terrain, like that of the surrounding barren hillsides. In the detail shown here, a number of women are seen gracefully strolling or standing about, some in pairs holding hands. The women's small waists are emphasized by large, pendulous breasts. They wear skirts with scalloped hemlines revealing large calves and sturdy ankles, and all of them appear to have shoulder-length hair. The women stand near several large, long-horned cattle and are surrounded by smaller cattle, the Spanish ibex, red deer, and a pig. A pair of ibexes visible just above the cattle as well as a dog in the foreground are shown leaping forward with legs fully extended. This pose, called a flying gallop, has been used to indicate speed in a running animal from prehistory to the present.

In other paintings at the site, not shown here, some women seem to be looking after children while others carry baskets, gather food, and work the earth with digging sticks. These paintings are more than a record of daily life. They must have had some greater significance, for they were repainted many times over the centuries. Because rock shelters were so accessible, people continued to visit these sites long after their original purpose had been forgotten. At Cogul, in fact, inscriptions in Latin and an early form of Spanish scratched by Roman-era visitors—2,000-year-old graffiti—share the rock wall surfaces with the prehistoric paintings.

ARCHITECTURE

As people adopted a settled, agricultural way of life, they began to build large structures to serve as dwellings, storage spaces, and shelters for their animals. In Europe, timber became abundant after the disappearance of the glaciers, and Neolithic people, like their Paleolithic predecessors, continued to construct buildings out of wood and other plant materials. People clustered their dwellings in villages, and they built large tombs and ritual centers outside their settlements.

Dwellings and Villages. A northern European village probably consisted of three or four long timber buildings, each of them housing forty-five to fifty people. These houses were up to 150 feet long, and they included large granaries, or storage space for the harvest, a necessity in agricultural communities. The structures were rectangular, with a row of posts down the center supporting a ridgepole, a long horizontal beam against which the slanting roof poles were braced (see example 4 in "Post-and-Lintel and Corbel Construction," above). Their walls were probably made of what is known as **wattle and daub**, branches woven in a basketlike pattern, then covered with mud or clay. They were probably roofed with thatch, some plant material such as reeds or straw tied over a framework of poles. Similar structures can still be seen today in some

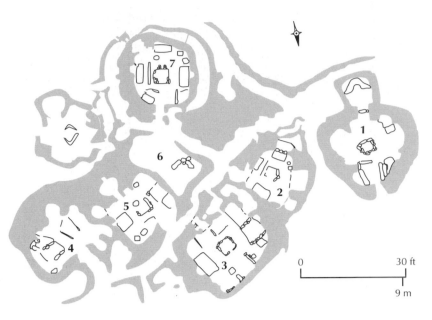

1-15. Plan, village of Skara Brae, Orkney Islands, Scotland. c. 3100–2600 BCE

0 30 ft

9 m

1-16. House interior, Skara Brae (house 7 in fig. 1-15)

regions, serving as animal shelters or even dwellings.

Around 4000 BCE, Neolithic settlers began to locate their communities at sites most easily defended, near rivers, on plateaus, or in swamps. For additional protection, they also frequently surrounded them with wooden walls, earth embankments, and ditches.

A Neolithic settlement has been excellently preserved at Skara Brae, in the Orkney Islands off the northern coast of Scotland (fig. 1-15). This village was constructed of stone, an abundant building material in this austere, treeless region. A long-ago storm buried this seaside village under a layer of sand, and another storm brought it to light again in 1850. The village exposed to view presents a vivid picture of Neolithic life in the far north. In the houses, archaeologists found beds, shelves, stone cooking pots, basins, stone mortars for grinding, and pottery with incised decoration. Comparison of these artifacts with objects from sites farther south and laboratory analysis of the village's organic refuse date the settlement at Skara Brae to between 3100 and 2600 BCE.

The village consists of a compact cluster of dwellings linked together by covered passageways. Each of the houses has a square plan with rounded corners. The largest one measures 20 by 21 feet, the smallest, 13 by 14 feet. Layers of flat stones without mortar form walls, with each layer, or **course**, projecting slightly inward over

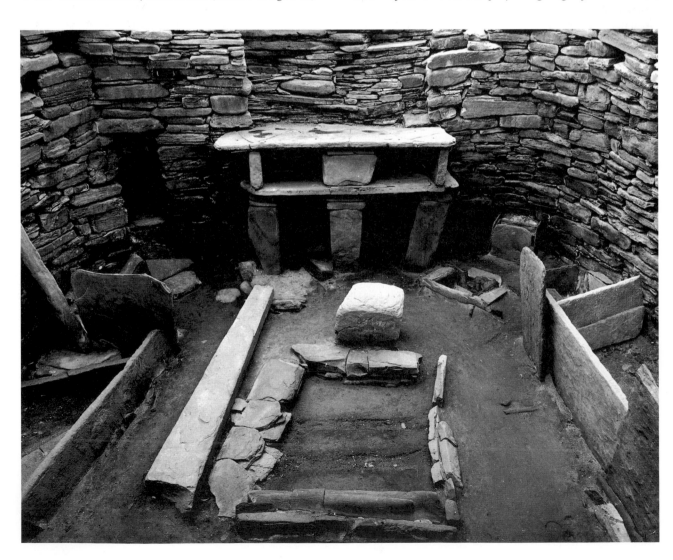

the one below. This type of construction is called **corbeling** (see example 3 in "Post-and-Lintel and Corbel Construction," page 55). In some structures, such inward-sloping walls come together at the top in what is known as a **corbel vault**, but at Skara Brae the walls stopped short of meeting, and the remaining open space was covered with hides or turf. There are smaller corbel-vaulted rooms within the main walls of some of the houses that may have been used for storage. One room, possibly a latrine, has a drain leading out under its wall.

The houses of Skara Brae were well equipped with space-saving built-in furniture. In the room shown (fig. 1-16), a large rectangular hearth with a stone seat at one end occupies the center of the space. Rectangular stone beds, some of them engraved with simple designs, stand against the walls on two sides of the hearth. These box-like beds would probably have been filled with heather "mattresses" and covered with warm furs. In the left corner, a sizable storage room is built into the thick outside wall. Smaller storage niches were provided over each of the beds. Stone tanks lined with clay to make them watertight are partly sunk into the floor. These containers were probably used for live bait, for it is clear that the people at Skara Brae were skilled fisherfolk.

On the back wall is a two-shelf cabinet that is a clear example of what is known as **post-and-lintel construction** (see "Post-and-Lintel and Corbel Construction," page 55). In this structural system, two or more vertical elements (posts) are used to support a bridging horizontal one (**lintel**). The principle has been used throughout history, not only for structures as simple as these shelves but also in huge stone monuments such as Stonehenge (see fig. 1-19) and the temples of Egypt (Chapter 3) and Greece (Chapter 5).

Ceremonial and Tomb Architecture. In western and northern Europe, Neolithic people commonly erected ceremonial structures and tombs using huge stones. In some cases, they had to transport these great stones over long distances. The monuments thus created are examples of what is known as megalithic architecture, the descriptive term derived from the Greek word roots for large (*mega-*) and stone (*lithos*). Architecture formed of such massive elements testifies to a more complex, stratified society than any encountered before. Only strong leaders could have assembled and maintained the required labor force. Skilled "engineers" were needed to devise methods for shaping, transporting, and aligning the stones. Finally, powerful religious figures must have been involved, identifying the society's need for such structures and dictating their design. The accomplishments of the builders of these monuments are all the more impressive considering the short life expectancy of the time—it was uncommon for anyone to survive past the age of thirty. As one anthropologist has noted, these imposing structures were the work of teenagers.

Elaborate megalithic tombs first appeared in the Neolithic period. Some were built for single burials; others consisted of multiple burial chambers. The simplest type of megalithic tomb was the **dolmen**, built on the

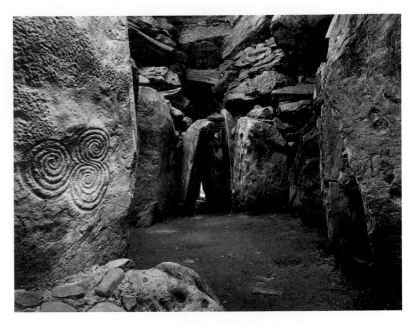

1-17. Tomb interior with corbeling and engraved stones, Newgrange, Ireland. c. 3000–2500 BCE

post-and-lintel principle. The tomb chamber was formed of huge upright stones supporting one or more tablelike rocks, or **capstones**. The structure was then mounded over with smaller rocks and dirt to form an artificial hill. A more imposing structure was the **passage grave**, which was entered by one or more narrow, stone-lined passageways into a large room at the center.

At Newgrange, in Ireland, the mound of an elaborate passage grave (fig. 1-17) originally stood 44 feet tall and measured about 280 feet in diameter. The mound was built of sod and river pebbles and was set off by a circle of decorated standing stones around its perimeter. Its passageway, 62 feet long and lined with standing stones, leads into a three-part chamber with a corbel vault rising to a height of 19 feet. The stones at the entrance and along the passageway are engraved with linear designs, mainly rings, spirals, and diamond shapes. These patterns must have been marked out using strings or compasses, then carved by pecking at the rock surface with tools made of antlers. Such large and richly decorated structures did more than honor the distinguished dead; they were truly public architecture that fostered communal pride and a group identity. As is the case with elaborate funerary monuments built today, their function was both practical and symbolic.

Many megalithic structures were ritual centers serving the people of an entire region. In the Carnac district on the south coast of Brittany, in France, thousands of **menhirs**, or single vertical megaliths, were set up sometime between 4250 and 3750 BCE. They were placed in either circular patterns known as **cromlechs** or straight rows known as **alignments**. More than 3,000 menhirs still stand in 2-mile lines near Ménec (fig. 1-18). Each of these squared-off stones weighs several tons. There are thirteen rows of alignments, their stones graduated in height from about 3 feet on the eastern end to upward of 13 feet toward the west. The east-west orientation of the

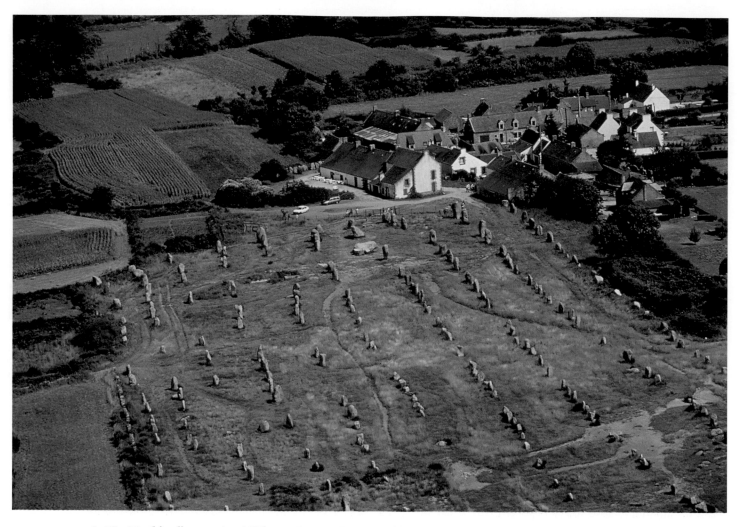

1-18. Menhir alignments at Ménec, Carnac, France. c. 4250–3750 BCE

One legend of Celtic Brittany explains the origin of the Carnac menhirs quite graphically. It relates that a defeated army retreating toward the sea found no ships waiting to carry it to safety. When the desperate warriors turned around and took up their battle stations in preparation for a fight to the death, they were miraculously transformed into stone. Another legend claims that the stones were invading Roman soldiers who were "petrified" in their tracks by a local saint named Cornely.

alignments suggests some connection to the movement of the sun. Neolithic farming people, whose well-being depended on a recurring cycle of sowing, growing, harvesting, and fallow seasons, would have had every reason to worship the sun and do all they could to assure its regular motion through the year. The menhirs at Carnac may well have marked an established procession route for large groups of people celebrating public rites. It is also possible that they were points of reference for careful observation of the sun, moon, and stars.

Of all the megalithic monuments in Europe, the one that has stirred the imagination of the public most strongly is Stonehenge, on Salisbury Plain in southern England (figs. 1-19, 1-20). A **henge** is a circle of stones or posts, often surrounded by a ditch with built-up embankments. Laying out such circles with accuracy would have posed no particular problem. Their architects likely relied on the human compass, a simple but effective surveying method that persisted well into modern times. All that is required is a length of cord either cut or knotted to mark the desired radius of the circle. A person holding one end of the cord is stationed in the center; a co-worker, holding the other end and keeping the cord taut, steps off the circle's circumference. By the time of Stonehenge's construction, cords and ropes were readily available; people, probably women, began working with plant fibers very early. They made ropes, fishing lines, nets, baskets, and even garments using techniques resembling modern macramé and crochet (see "The Fiber Arts," page 86).

Stonehenge is not the largest such circle from the Neolithic period, but its importance to its region is reflected in the fact that it was repeatedly reworked to incorporate new elements, making it one of the most complicated megalithic sites. It is the product of at least four major building phases between about 2750 and 1500 BCE. In the earliest stage, its builders dug a deep, circular ditch, placing the excavated material on the inside rim to form an embankment more than 6 feet high. Digging through the turf, they exposed the chalk substratum characteristic of this part of England, thus creating a brilliant white circle about 330 feet in diameter. An "avenue" from the henge toward the northeast led well outside the embankment to a pointed sarsen megalith—sarsen is a

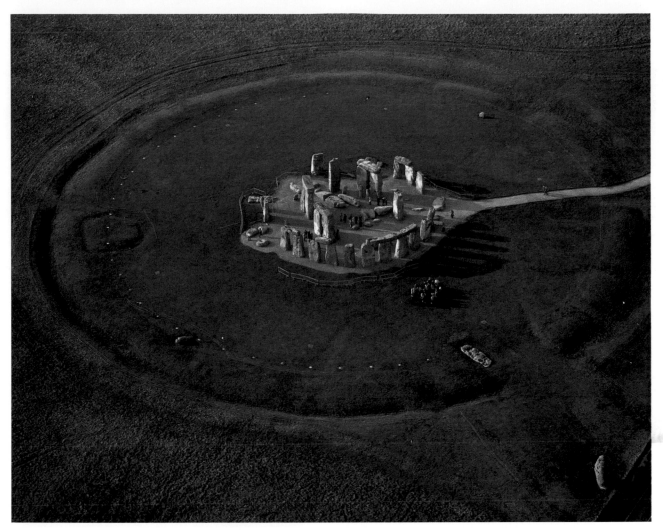

1-19. **Stonehenge**, Salisbury Plain, Wiltshire, England. c. 2750–1500 BCE

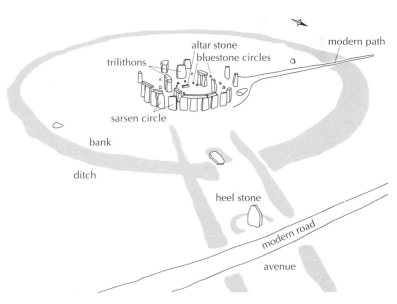

1-20. Diagram of Stonehenge, showing elements discussed here

gray sandstone—brought from a quarry 23 miles away. Today, this so-called heel stone, tapered toward the top and weighing about 35 tons, stands about 16 feet high. The ditches and embankments bordering the approach avenue were constructed somewhat later.

By about 2100 BCE, Stonehenge included all of the internal elements reflected in the drawing shown here (see fig. 1-20). Dominating the center was a horseshoe-shaped arrangement of five sandstone trilithons, or pairs of upright stones topped by lintels. The one at the middle stood considerably taller than the rest, rising to a height of 24 feet, and its lintel was more than 15 feet long and 3 feet thick. This group was surrounded by the so-called sarsen circle, a ring of sandstone uprights weighing up to 50 tons each and standing 20 feet tall. This circle, 106 feet in diameter, was capped by a continuous lintel. The uprights were tapered slightly toward the top, and the gently curved lintel sections were secured by **mortise-and-tenon joints**, a conical projection from one piece fitting into a hole in the next. Just inside the sarsen circle was once a ring of bluestones—worked blocks of a bluish dolerite found only in the mountains of southern Wales,

150 miles away. Why the builders of Stonehenge used this type of stone is one of the many mysteries of Stonehenge. Clearly the stones were highly prized, for centuries later, about 1500 BCE, they were reused to form a smaller horseshoe (inside the trilithons) that encloses the so-called altar stone.

Whoever stood at the exact center of Stonehenge on the morning of the summer solstice 4,000 years ago would have seen the sun rise directly over the heel stone. The observer could then warn people that the sun's strength would shortly begin to wane, that the days would grow shorter and the nights cooler until the country was once more gripped by winter.

Through the ages, many theories have been advanced to explain Stonehenge. (Most of these explanations say more about the times when they were put forward than about Stonehenge.) In the Middle Ages, people thought that Merlin, the magician of the King Arthur legend, built Stonehenge. Later, the site was incorrectly associated with the rituals of the Druids, a Celtic priesthood. Its original function continues to challenge the ingenuity of scholars even today. Because its orientation is related to the movement of the sun, some think it may have been a kind of observatory. Anthropologists suspect that the structure was an important site for major public ceremonies, possibly planting or harvest rituals. Whatever its first role may have been, Stonehenge continues to fascinate the public. Crowds of people still gather there at midsummer to thrill to its mystery. Even if we never learn the original purpose of megalithic structures, the technology developed for building them was a major advance, one that made possible a new kind of architecture and sculpture.

SCULPTURE AND CERAMICS

Having learned how to cut and transport massive blocks of stone, Neolithic sculptors were capable of carving large, freestanding stone figures. Their menhir statues, dating from between 3500 and 2000 BCE, stood 3 to 4 feet high, and all were carved in a similar way. Elements of the human figure reduced to near-geometric forms were incised on all four sides of a single upright block. Faces were usually suggested by a vertical ridge for the nose and a horizontal one for the browline. Incised linear patterns on the sides and backs of such figures have been interpreted as ribs and backbones, but it is possible that they were meant to represent elements of ritual costume or body painting. A menhir statue of a woman found in Montagnac, in southern France (fig. 1-21), has a face composed of a straight nose, a heavy, continuous brow, and protruding eyes. Above the browline she wears a headband. What first appears to be a square jaw and wide, rectangular mouth is actually the outline of a necklace. The woman's hands are raised to cover her breasts, giving her arms a U shape. A belt encircles her waist. Some figures of women have no arms or hands—only breasts and a necklace. Those of men often carry weapons.

In southern France, solitary menhir statues have been discovered on wooded hills and sometimes near tombs or villages. Set on hilly sites, they may have served as "guardians" and signposts for travelers making their way to sacred places. Those in the vicinity of tombs may have served as guardians of the dead. Some female figures found near dwellings are thought to have been household protectors.

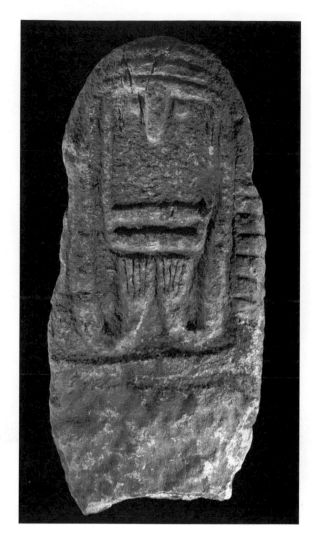

1-21. Menhir statue of a woman, from Montagnac, France. c. 2000 BCE. Limestone, height approx. 33" (85 cm). Musée d'Histoire Naturelle et Préhistoire, Nîmes

Besides working in stone, Neolithic artists also commonly used clay. Their **ceramics—wares** made of baked clay—whether figures of people and animals or vessels, display a high degree of technical skill and aesthetic imagination. This art required a different kind of conceptual leap. In the sculpture previously discussed, artists created their work out of an existing substance, such as stone, bone, or wood. To produce ceramic works, artists had to combine certain substances with clay—bone ash was a common addition—then subject the objects formed of that mixture to high heat for a period of time, thus hardening them and creating an entirely new material. Among the ceramic figures discovered at a pottery-production center in the Danube River valley at Cernavoda, Romania, are a seated man and woman who form a most engaging pair (fig. 1-22, "The Object Speaks"). The artist who made them shaped their bodies out of simple cylinders of clay but managed to pose them in ways that make them seem very true to life.

One of the unresolved puzzles of prehistory is why people in Europe did not produce pottery vessels much earlier. They understood how to harden clay figures by firing them in an oven at high temperatures as early as

THE OBJECT SPEAKS
PREHISTORIC WOMAN AND MAN

For all we know, the artist who created these figures almost 6,000 years ago had nothing particular in mind—people had been modeling clay figures in southeastern Europe for a long time. Perhaps a woman who was making cooking and storage pots out of clay amused herself by fashioning images of the people she saw around her. Perhaps not. That these figures were found in a grave suggests an otherworldly message today.

The Cernavoda woman, spread-hipped and big-bellied, sits directly on the ground, expressive of the mundane world. She exudes stability and fecundity. Her ample hips and thighs seem to ensure the continuity of her family. But in a lively, even elegant, gesture, she joins her hands coquettishly on one knee, raises the knee, curls up her toes, and tilts her head upward. Does she gaze at the skies—the sun or moon and stars? Though earthbound, is she a spiritual figure communing with heaven? In the workaday world, her upwardly tilted head could suggest that she is watching the smoke rising from her hearth, or worrying about holes in her roof, or admiring hanging containers of laboriously gathered drying berries, or gazing adoringly at her partner. We do not know. The Cernavoda man is rather slim, with massive legs and shoulders. He rests his head on his hands in a brooding, pensive pose, evoking for us thoughtfulness, even weariness or sorrow.

These very old figures speak to us in many different ways, not the least of which is the reminder, by their very presence, that men and women not essentially different from us lived and worked, wondered and worried, thousands of years ago. We can interpret the Cernavoda woman and man in many ways, but we cannot know what they meant to their makers or owners. Depending on how they are displayed, we spin out different stories about them. When set facing each other, side by side as they are below, we tend to see them as a couple—a woman and man in a relationship. In fact, we do not know whether the artist conceived them in this way, or even at the same time. For all their visual eloquence, their secrets remain hidden from us.

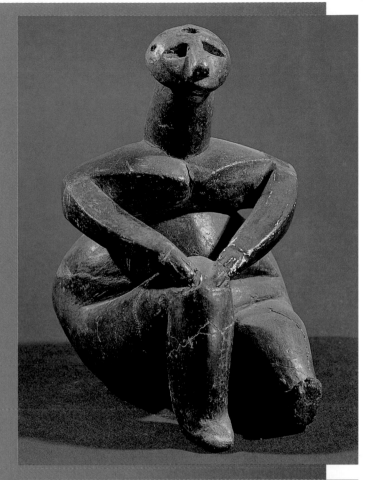

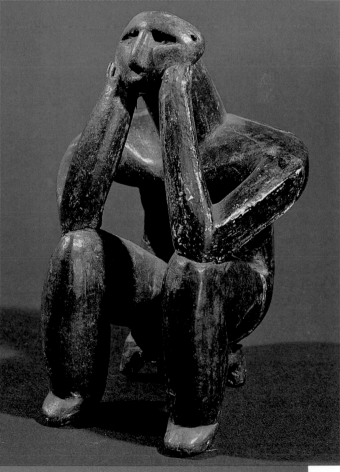

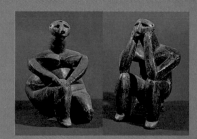

1-22. Figures of a woman and a man, from Cernavoda, Romania. c. 3500 BCE. Ceramic, height 4¹/₂" (11.5 cm). National Historical Museum, Bucharest

The terms *pottery* and *ceramics* may be used interchangeably—and the two often are. The word *ceramics* came into use only in the nineteenth century. Because it covers all baked-clay wares, *ceramics* is technically a more inclusive term than *pottery*.

Pottery includes all baked-clay wares except **porcelain**, which is the most refined product of ceramic technology. Pottery vessels can be formed in several ways. It is possible, though difficult, to raise up the sides from a ball of raw clay. Another method is to coil long rolls of soft, raw clay, stack them on top of each other to form a container, and then smooth them by hand. A third possibility is to simply press the clay over an existing form, a dried gourd for example. By about 4000 BCE, Egyptian potters had developed the potter's wheel, a round, spinning platform on which a lump of clay is placed and then formed with the fingers. Using a potter's wheel, it is relatively simple to produce a uniformly shaped vessel in a very short time. The potter's wheel appeared in the ancient Near East about 3250 BCE and in China about 3000 BCE.

After a pot is formed, it is allowed to dry completely before it is fired. Special ovens for firing ceramics, called **kilns**, have been discovered at prehistoric sites in Europe

dating from as early as 32,000 BCE. For proper firing, the temperature must be maintained at a relatively uniform level. Raw clay becomes porous pottery when heated to at least 500° centigrade. It then holds its shape permanently and will not disintegrate in water. Fired at 800° centigrade, pottery is technically known as earthenware. When subjected to temperatures between 1200° and 1400° centigrade, certain stone elements in the clay vitrify, or become glassy, and the result is a stronger type of ceramics called stoneware.

Pottery is relatively fragile, and new vessels were constantly in demand to replace broken ones, so fragments of low-fired ceramics—fired at the hearth, rather than the hotter kiln—are the most common artifacts found in excavations of prehistoric settlements. Moreover, because pottery disintegrates very slowly, pottery fragments, or **potsherds**, serve as a major key in dating sites and reconstructing human living and trading patterns.

One of the first ways of decorating pottery was simple **incising**—scratching lines into the surface of the clay before it was left to dry. By the dawn of the Bronze Age, about 2300 BCE, vessels were produced in a wide variety of specialized forms and were decorated with great finesse.

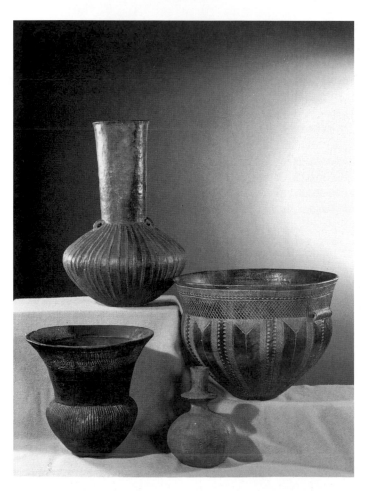

1-23. Vessels, from Denmark. c. 3000–2000 BCE. Ceramic, heights range from 5¾" to 12¼" (14.5 to 31 cm). National Museum, Copenhagen

32,000 BCE. But it was not until about 7000 BCE that they began making vessels using the same technique. Some anthropologists argue that clay is a medium of last resort for vessels. Compared to hollow gourds, wooden bowls, or woven baskets, clay vessels are heavy and quite fragile, and firing them requires considerable expertise.

Excellence in ceramics depends upon the degree to which a given vessel combines domestic utility, visual beauty, and fine execution (see "Pottery and Ceramics," above). A group of bowls from Denmark, made in the third millennium BCE, provides only a hint of the extraordinary achievements of Neolithic artists working in clay (fig. 1-23). Taking their forms from baskets and bags, the earliest pots were round and pouchlike and had built-in loops so that they could be suspended on cords. The earliest pieces in the illustration are the globular bottle with a collar around its neck (bottom center), a form perhaps inspired by eggs or gourd containers, and the flask with loops (top). Even when potters began making pots with flat bottoms that could stand without tipping, they often added hanging loops as part of the design. Some of the ornamentation of these pots, including hatched engraving and stitchlike patterns, seems to reproduce the texture of the baskets and bags that preceded ceramics as containers. It was also possible to decorate clay vessels by impressing stamps into their surface or scratching it with sticks, shells, or toothed implements. Many of these techniques appear to have been used to decorate the flat-bottomed vase with the wide, flaring top (bottom left), a popular type of container that came to be known as a funnel beaker.

The large engraved bowl (center right), found at Skarpsalling, is considered to be the finest piece of northern

Neolithic pottery yet discovered. The potter lightly incised its sides with delicate linear patterns, then rubbed white chalk into the engraved lines so that they would stand out against the dark body of the bowl. Much of the finest art to survive from the Neolithic period is the work of potters; it is an art of the oven and the hearth.

THE BRONZE AGE

Neolithic culture persisted in northern Europe until about 2000 BCE. Metals had made their appearance in the region about 2300 BCE. In southern Europe and the Aegean region, copper, gold, and tin had been mined, worked, and traded even earlier (Chapter 4). Exquisite objects made of **bronze**—an alloy, or mixture, of tin and copper—are frequently found in the settlements and graves of early northern farming communities. The period that follows the introduction of metalworking is commonly called the Bronze Age.

A remarkable sculpture from the Bronze Age in Scandinavia depicts a wheeled horse pulling a cart laden with a large, upright disk commonly thought to represent the sun (fig. 1-24). The work dates from between 1800 and 1600 BCE and was discovered at what is now Trundholm, in Denmark. Horses had been domesticated in Ukraine by about 4000 BCE, but the first evidence of wheeled chariots and wagons designed to exploit the animals' strength dates from about 2000 BCE. Rock engravings in northern Europe show the sun being drawn through the sky by either an animal or a bird—possibly an indication of a widespread sun cult in the region. The Trundholm horse and sun cart could have been rolled from place to place in a ritual reenactment of the sun's passage across the sky.

The valuable materials from which the sculpture was made and the great attention devoted to its details attest to its importance. The horse, cart, and sun were cast in bronze. After two faults in the casting had been repaired, the horse was given its surface finish, and its head and neck were incised with ornamentation. Its eyes were represented as tiny suns. Elaborate and very delicate designs were engraved on its body to suggest a collar and harness. The bronze sun was cast as two disks, both of which were engraved with concentric rings filled with zigzags, circles, spirals, and loops. A thin sheet of beaten gold was then applied to one of the bronze disks and pressed into the incised patterns. Finally, the two disks were joined together by an encircling metal band. The patterns on the horse tend to be geometric and rectilinear, but those of the sun disks are continuous and curvilinear, suggestive of the movement of the sun itself.

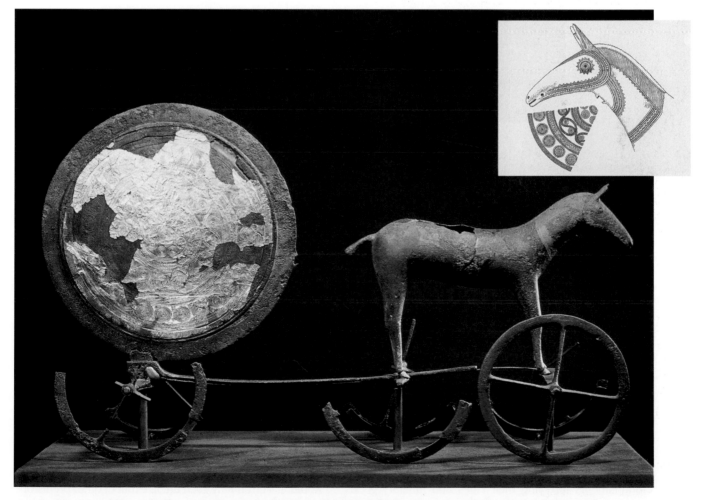

1-24. *Horse and Sun Chariot* and schematic drawing of incised design, from Trundholm, Zealand, Denmark. c. 1800–1600 BCE. Bronze, length 23¼" (59.2 cm). National Museum, Copenhagen

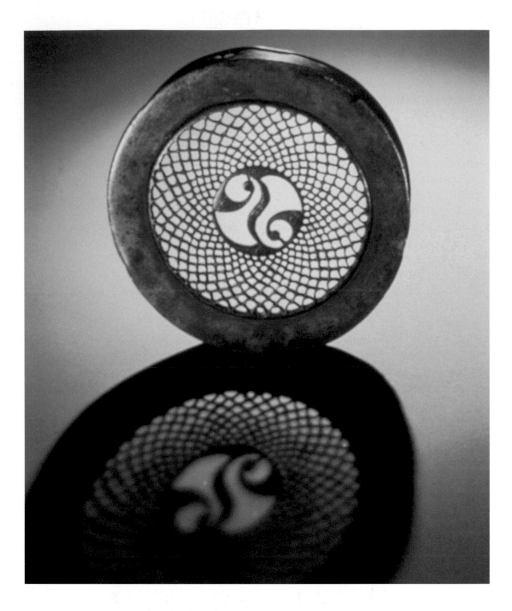

1-25. Openwork box lid, from Cornalaragh, County Monaghan, Ireland. La Tène period, c. 1st century BCE. Bronze, diameter 3" (7.5 cm). National Museum of Ireland, Dublin

THE IRON AGE

By 1000 BCE, iron technology had spread across Europe, although bronze remained the preferred material for luxury items. Cheaper and more readily available than other metals, iron was most commonly used for practical items. The blacksmiths who forged the warriors' swords and the farmers' plowshares held a privileged position among artisans, for they practiced a craft that seemed akin to magic as they transformed iron by heat and hammer work into tools. A hierarchy of metals emerged based on the materials' resistance to corrosion. Gold, as the most permanent and precious metal, ranked first, followed by silver, bronze, and finally practical but rusty iron.

During the Iron Age of the first millennium BCE, Celtic peoples inhabited most of central and western Europe. Celtic artists made a distinctive contribution to the art of the West through their skill in abstract design. Their wooden buildings and sculpture and their colorful woven textiles have disintegrated, but protective **earthworks** such as embankments fortifying their cities and funerary goods such as jewelry, weapons, and tableware have survived.

An **openwork** box lid, in which space is worked into the pattern, in the La Tène style, illustrates the characteristic Celtic style and the continuing use of bronze during this period (fig. 1-25). (*La Tène* refers to a site in Switzerland where discoveries were made of Iron Age artifacts, although this object was found at Cornalaragh, Ireland.) Solid metal and open space play equal roles in the pattern, which consists of a pair of expanding, diagonally symmetrical trumpet-shaped spirals surrounded by lattice. Shapes inspired by compass-drawn spirals, stylized vines, and serpentine dragons seem to change at the blink of an eye, for the artist has eliminated any distinction between figure and background. The openwork trumpets—the forms defined by the absence of material—catch the viewer's attention, yet at the same time the delicate tendrils of solid metal are equally compelling. In Celtic hands, pattern becomes an integral part of the object itself, not an applied decoration.

With the Celts, the prehistoric period in European art comes to an end. Some of what we know about them was recorded by their literate neighbors—the Greeks and Romans. Fortunately, their art, like that of other prehistoric people, survives as direct evidence of their culture.

PARALLELS

PERIOD	ART IN PREHISTORIC EUROPE	ART IN OTHER CULTURES
UPPER PALEOLITHIC c. 40,000–8000 BCE	1. **Chauvet cave** (c. 28,000) 1-3. *Lion-Human* (c. 30,000–26,000) 1-1. *Cosquer cave horses* (c. 16,500) 1-2. *Mammoth-bone house* (c. 16,000–10,000) 1-4. *Woman from Willendorf* (c. 22,000–21,000) 1-7. *Spotted Horses and Human Hands* (c. 16,000) 1-11. *Bird-Headed Man* (c. 15,000–13,000) 1-13. **Lamp with ibex** (c. 15,000–13,000)	
PALEOLITHIC- **NEOLITHIC** c. 8000–7000 BCE		2-3. **Ain Ghazal figure** (c. 7000–6000 BCE), Jordan
NEOLITHIC c. 8000–2300 BCE	1-18. **Menhirs, Carnac** (c. 4250–3750) 1-14. *People and Animals* (c. 4000–2000) 1-22. **Seated woman and man** (c. 3500) 1-16. *Interior, Skara Brae* (c. 3100–2600) 1-17. **Tomb, Newgrange** (c. 3000–2500) 1-23. **Danish ceramic vessels** (c. 3000–2000) 1-19. **Stonehenge** (c. 2750–1500) 1-21. **Menhir woman** (c. 2000)	2-7. **Uruk woman** (c. 3500–3000), Iraq 10-3. *Cong* deity (before 3000), China 3-10. **Great Pyramids** (c. 2601–2515), Egypt 4-3. **Cycladic figure** (c. 2500–2200), Greece
BRONZE AGE c. 2300–1000 BCE	1-24. *Horse and Sun Chariot* (c. 1800–1600) 	9-4. **Harappa torso** (c. 2000), India 4-19. **Funerary mask** (c. 1550–1500), Greece
IRON AGE c. 1000 BCE–	1-25. **Openwork box lid** (1st century) 	10-4. *Fang ding* (c. 12th century), China

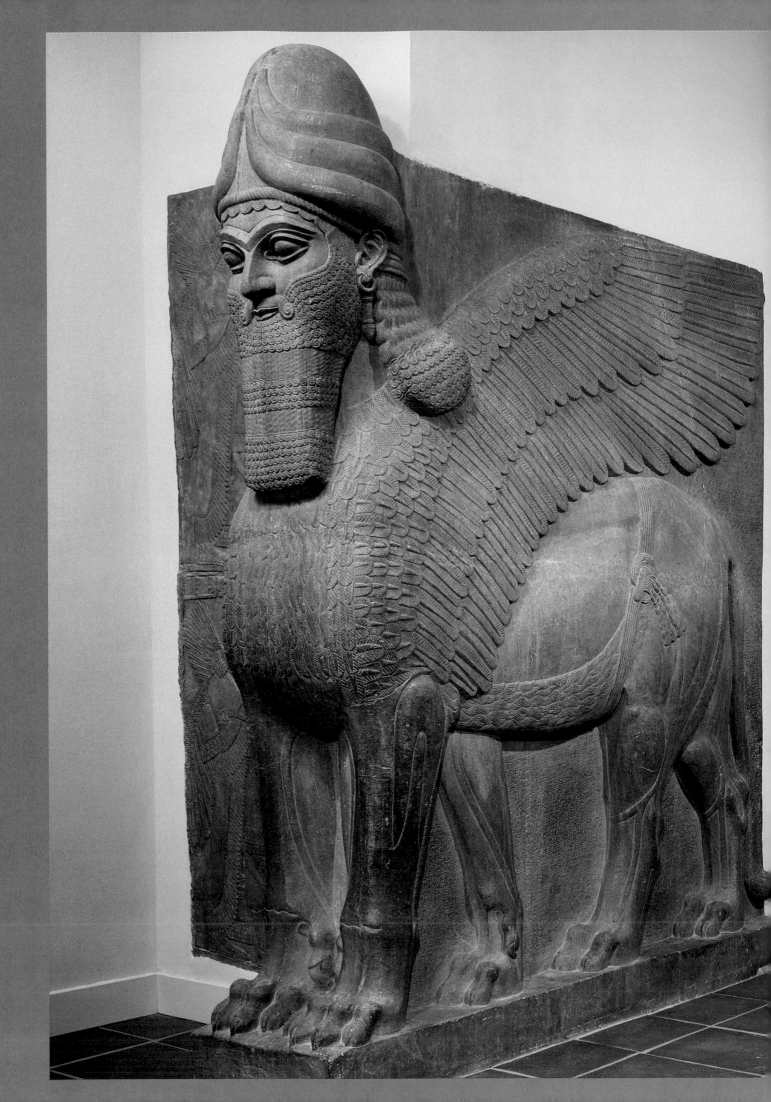

2

Art of the Ancient Near East

Visitors to capital cities like Washington, Paris, and Rome today stroll along broad avenues among huge buildings, dominating gateways, and imposing sculpture. They are experiencing "controlled space," a kind of civic design that rulers and governments—consciously or not—have used since the time of the Assyrian city-state to impress or even intimidate. Ninth-century BCE emissaries to Nimrud, for example, would have encountered breathtaking examples of this ceremonial urbanism, in which the city itself is a stage for the ritual dramas of rulership that reinforce and confirm absolute power. Even from a distance, as they approached the city, these strangers would have seen the vast fortifications and temple where the king acted as intermediary between citizen and god. Following a processional way, they would have passed sculpture extolling the power of the Assyrian armies and then come face-to-face with *lamassus*, extraordinary guardian-protectors of palaces and throne rooms. These creatures may combine the bearded head of a man, the powerful body of a lion or bull, the wings of an eagle, and the horned headdress of a god (fig. 2-1). Often *lamassus* have five legs, so that when seen from the front they appear immobile, but when viewed from the side they seem to be in motion, vigorously striding. *Lamassus'* sheer size—usually large and often twice a person's height— symbolizes the strength of the ruler they defend. Their forceful forms and prominent placement contribute to an architecture of domination. The exquisite detailing of their beards, feathers, and jewels testifies to boundless wealth, which is power. These fantastic composite beasts inspire civic pride and fear. They are works of art with an unmistakable political mission in just one of many cultures that rose and fell in the ancient Near East.

2-1. *Human-Headed Winged Lion (Lamassu),* from the palace of Assurnasirpal II, Nimrud. 883–859 BCE. Limestone, height 10'2" (3.11 m). The Metropolitan Museum of Art, New York

Gift of John D. Rockefeller, Jr., 1932, (32.143.2)

TIMELINE 2-1. **The Ancient Near East.** Beginning about 9000 BCE, early Neolithic civilization arose in the Fertile Crescent. After about 7000 BCE, many different peoples successively conquered and dominated Mesopotamia.

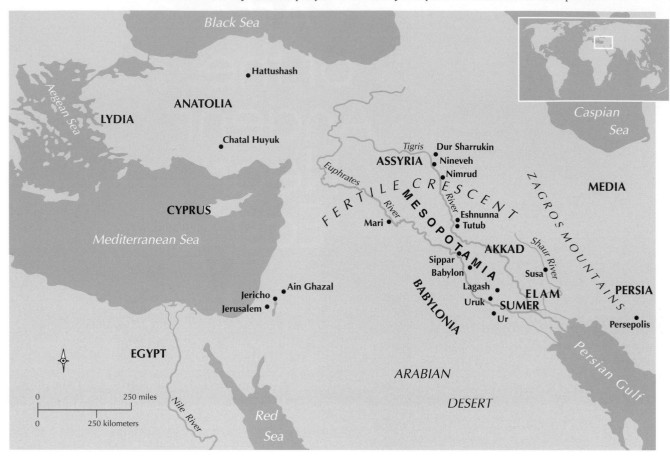

MAP 2-1. **The Ancient Near East.** Ancient Mesopotamia was the Fertile Crescent between the Tigris and Euphrates rivers.

THE FERTILE CRESCENT

Well before farming communities arose in Europe, agriculture emerged in the ancient Near East in an area known as the Fertile Crescent. The "crescent" stretched along the Mediterranean coast through modern Jordan, Israel, Lebanon, and Syria, arched into central Turkey, and descended along the fertile plains between the Tigris and Euphrates rivers (ancient Mesopotamia, the "land between the rivers"), sweeping through Iraq and a slice of western Iran to the Persian Gulf (Map 2-1).

The earliest settled farming communities arose about 9000 BCE, first in the hills above rivers and later in river valleys. In the Near East, agricultural villages gradually evolved into cities, where large populations were separated from outlying rural areas. Mesopotamia's relatively harsh climate, prone to both drought and flood, may have contributed to this change there, as early agriculturists cooperated to construct large-scale systems for controlling their water supply. Trade among distant communities also increased. Farming spread from the Fertile Crescent and reached the Atlantic coast of Europe by about 5000 BCE.

Between 4000 and 3000 BCE, a major cultural shift took place in the Near East. Archaeologists have long believed that this change happened first in southern Mesopotamia, then spread northward. Excavations beginning in 1999, however, strongly suggest that the evolution of agricultural villages and cities occurred simultaneously and independently in the northern and southern regions of the Near East. Prosperous cities and their surrounding territory developed into city-states, each with its own government; eventually, larger kingdoms absorbed these city-states. Urban life and population density gave rise to the development of specialized skills other than those for agricultural work, and social hierarchies evolved. Workshops for milling flour and making bricks, pottery, textiles, and metalware sprang up, and the construction of temples and palaces kept builders and artists busy.

Specialists also emerged to control rituals and the sacred sites. The people of the ancient Near East were polytheistic, worshiping numerous gods and goddesses, and they attributed to them power over human activities and the forces of nature. Each city had a special protective deity, and people believed the fate of the city depended

on the power of that deity. (The names of comparable deities varied over time and place—for example, Inanna, the Sumerian goddess of fertility, love, and war, was equivalent to the Babylonians' Ishtar, the Egyptians' Isis, the Greeks' Aphrodite, and the Romans' Venus.) Large **temple complexes**—clusters of religious, administrative, and service buildings—developed in each city as centers of worship and also as thriving businesses. Religious and political power were closely interrelated.

Mesopotamia's wealth and agricultural resources, as well as its few natural defenses, made it vulnerable to repeated invasions from hostile neighbors and to internal conflicts. Over the centuries, the balance of power shifted between north and south and between local powers and outside invaders (Timeline 2-1). First the Sumerians formed a state in the south. Then for a brief period they were eclipsed by the Akkadians, their neighbors to the north. When invaders from farther north in turn conquered the Akkadians, the Sumerians regained power locally. The Babylonians were next to dominate the south. Later, the center of power shifted to the Assyrians in the north, then back again to Babylonia, called Neo-Babylonia. Throughout this time, important cultural centers arose outside of Mesopotamia as well, such as the newly found excavations in the north, Elam on the plain between the Tigris River and the Zagros Mountains to the east, the Hittite kingdom in Anatolia, and Persia, east of Elam. Beginning in the sixth century BCE, the Achaemenid Persians, a nomadic people from the mountains of modern-day Iran, forged an empire that included not only Mesopotamia but the entire Near East.

EARLY NEOLITHIC CITIES

One of the earliest Near Eastern cities, Jericho, located in today's West Bank territory in Palestine, was home to about 2,000 people by around 7000 BCE. Its houses, made of mud bricks (shaped from clay and dried in the sun), covered 6 acres, an enormous size for that time. Ain Ghazal ("Spring of Gazelles"), just outside present-day Amman, Jordan, was even larger. That settlement, dating from about 7200 to 5000 BCE, occupied 30 acres on terraces stabilized by stone retaining walls. Its houses may have resembled the adobe pueblos that native peoples in the American Southwest began to build more than 7,000 years later (fig. 2-2). The concentration of people and resources in cities such as Jericho and Ain Ghazal was an early step toward the formation of the larger city-states that arose in Mesopotamia and later were common throughout the ancient Near East.

Among the objects recovered from Ain Ghazal are more than thirty painted plaster figures. Fragments suggest that some figures were nearly lifesize (fig. 2-3). Sculptors molded the figures by applying wet plaster to reed-and-cord frames in human shape. The eyes were inset cowrie shells, and small dots of the black, tarlike

2-2. Reconstruction drawing of houses at Ain Ghazal, Jordan. c. 7200–5000 BCE

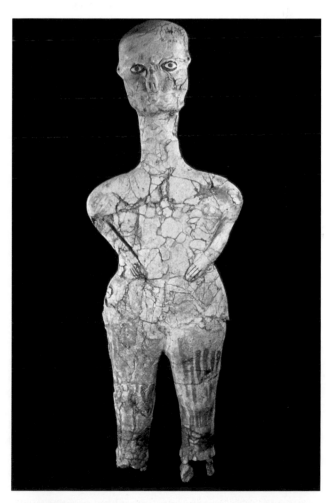

2-3. Figure, from Ain Ghazal, Jordan. c. 7000–6000 BCE. Clay plaster with cowrie shell, bitumen, and paint, height approx. 35" (90 cm). National Museum, Amman, Jordan

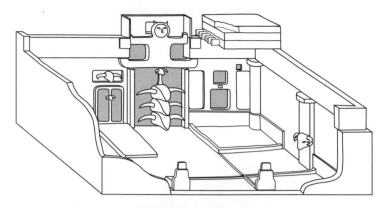

2-4. Composite reconstruction drawing of a shrine room at Chatal Huyuk, Turkey. c. 6500–5500 BCE

Many ancient Near Eastern cities still lie undiscovered. In most cases an archaeological site in a region is signaled by a large mound—known locally as a *tell*, *tepe*, or *huyuk*—that represents the accumulated debris of generations of human habitation. When properly excavated, such mounds yield evidence about the people who inhabited the site. But critical information is lost when treasure hunters, who have no interest in the context in which they find things, loot sites for artifacts to sell on the international art market. Even scientific excavation destroys context, and subsequent investigators are forced to rely on the excavators' detailed records. This is especially true at Chatal Huyuk, which was reburied after it was excavated in the 1950s.

2-5. Reconstruction drawing of the Anu Ziggurat and White Temple, Uruk (modern Warka, Iraq). c. 3100 BCE

substance bitumen—which Near Eastern artists used frequently—formed the pupils. The figures probably wore wigs and clothing and stood upright.

Although agriculture appears to have been the economic mainstay of these new permanent communities, other specialized activities, such as crafts and trade, were also important. Chatal Huyuk, a city in Anatolia with a population of about 5,000 from about 6500 to 5500 BCE, developed a thriving trade in obsidian, a rare, black volcanic glass that was used from Paleolithic into modern times for sharp blades. The inhabitants of Chatal Huyuk lived in single-story buildings densely clustered around shared courtyards, used as garbage dumps. Like other early Near Eastern cities, Chatal Huyuk was easy to defend because it had no streets or open plazas and was protected with continuous, unbroken exterior walls. People moved around by crossing from rooftop to rooftop, entering houses through openings in their roofs.

Many of the interior spaces were elaborately decorated and are assumed to have been shrines (fig. 2-4). Walls were adorned with bold geometric designs, painted

animal scenes, actual animal skulls and horns, and three-dimensional shapes resembling breasts and horned animals. On some walls were depictions of women giving birth to bulls. In one chamber, a leopard-headed woman—portrayed in a high-arched wall area above three large, projecting bulls' heads—braces herself as she gives birth to a ram. Although this dramatic image suggests worship of a fertility goddess, any such interpretation is risky because so little is known about the culture. Like other early Near Eastern settlements, Chatal Huyuk seems to have been abandoned suddenly, for unknown reasons, and never reoccupied.

SUMER

The cities and then city-states that developed along the rivers of southern Mesopotamia between about 3500 and 2340 BCE are known collectively as Sumer. The inhabitants, who had migrated from the north but whose origins are otherwise obscure, are credited with many firsts. Sumerians invented the wagon wheel and plow, cast objects in copper and bronze, and created a system of writing—perhaps their greatest contribution to later civilizations, though recent discoveries indicate that writing developed simultaneously in Egypt (Chapter 3). Sumerians pressed **cuneiform** ("wedge-shaped") **symbols** into clay tablets with a **stylus** (writing stick) to keep business records (see "Cuneiform Writing," page 71). Thousands of Sumerian tablets document the gradual evolution of writing and arithmetic, another tool of commerce, as well as an organized system of justice and the world's first epic literature (see "Gilgamesh," page 71).

The Sumerians' most impressive buildings were **ziggurats**, stepped pyramid structures with a temple or shrine on top. The first such structures may have resulted from repeated rebuilding at a sacred site, with rubble from one structure serving as the foundation for the next; elevating the buildings also protected the shrines from flooding. Whatever the origin of their design, ziggurats towering above the flat plain proclaimed the wealth, prestige, and stability of a city's rulers and glorified its protective gods. Ziggurats functioned symbolically, too, as lofty bridges between the earth and the heavens—a meeting place for humans and their gods. They were given names such as "House of the Mountain" and "Bond between Heaven and Earth," and their temples were known as "waiting rooms" because priests and priestesses waited there for deities to reveal themselves. Ziggurats had impressive exteriors, decorated with elaborate clay **mosaics**—images made by small colored pieces affixed to a hard surface—and reliefs. The gods would have been pleased with all this handiwork, it was said, because they disliked laziness in their people.

Uruk (modern Warka, Iraq), the first independent Sumerian city-state, had two large temple complexes in the 1,000-acre city. One complex was dedicated to Inanna, the goddess of love and war, and the other probably to the sky god Anu. The Anu Ziggurat, built up in stages over the centuries, ultimately rose to a height of about 40 feet. Around 3100 BCE, a whitewashed brick temple was erected on top that modern archaeologists refer to as the White Temple (fig. 2-5). This now-ruined

CUNEIFORM WRITING

Sumerians developed a very early system of writing around 3100 BCE, apparently as an accounting system for goods traded at Uruk. The symbols were **pictographs**, simple pictures incised on moist clay slabs with a pointed tool. Between 2900 and 2400 BCE, the symbols evolved from pictures into phonograms—representations of syllable sounds—thus becoming a true writing system. During the same centuries, scribes adopted a **stylus**, or writing tool, with one triangular end and one pointed end. The stylus could be pressed rapidly into a wet clay tablet to create the increasingly abstract symbols, or characters, of **cuneiform** writing.

This illustration shows examples of the shift from pictograph to cuneiform writing. The drawing of a bowl, which means "bread" and "food" and dates from about 3100 BCE, was reduced by about 2400 BCE to a four-stroke sign, and by about 700 BCE to a highly abstract vertical arrangement. By combining the pictographs and, later, cuneiform signs, writers created composite signs; for example, a composite of the signs for "head" and "food" came to mean "to eat."

Cuneiform writing was a difficult skill, and few people in ancient Mesopotamia mastered it. Some boys attended schools, where they learned to read and write by copying their teachers' lessons, but the small number of girls who learned to read and write probably were tutored at home.

stylus

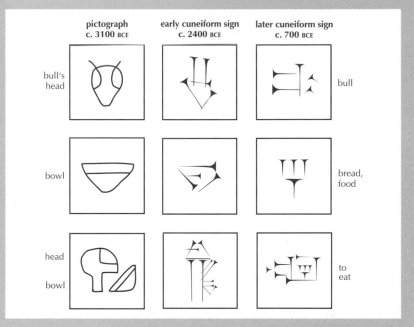

	pictograph c. 3100 BCE	early cuneiform sign c. 2400 BCE	later cuneiform sign c. 700 BCE	
bull's head				bull
bowl				bread, food
head bowl				to eat

GILGAMESH

Among the many thousands of cuneiform tablets excavated thus far in Sumer, fewer than 6,000, containing about 30,000 lines of text, record religious myths, heroic tales, legendary histories, hymns, songs of mourning, and so-called wisdom texts, consisting of essays, debates, proverbs, and fables. These make up the world's oldest written literature, and they tell us much about Sumerian beliefs. Most are written as poetry, and some may have been performed with music.

The best-known literary work of ancient Mesopotamia is the *Epic of Gilgamesh*. Its origins are Sumerian, but only fragments of the Sumerian version survive. The fullest version, written in Akkadian, was found in the library of the Assyrian king Assurbanipal (ruled 669–c. 627 BCE) in Nineveh (modern Kuyunjik, Iraq). It recounts the adventures of Gilgamesh, a legendary Sumerian king of Uruk, and his companion Enkidu. When Enkidu dies, a despondent Gilgamesh sets out to find the secret of eternal life from Utnapishtim and his wife, the only survivors of a great flood sent by the gods to destroy the world, and the only people to whom the gods had granted immortality.

In *Tablet XI*, the *"Flood Tablet,"* Utnapishtim tells this story—with its many striking similarities to the Hebrew Bible's tale of Noah and the Ark. He describes building a huge boat and loading it with "all the seeds of living things," wild and domesticated beasts, and people who knew all the crafts. When the flood strikes:

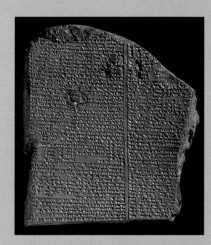

The so-called *Flood Tablet*, Tablet XI, The Epic of Gilgamesh, 2nd millennium BCE.
The British Museum, London

For six days and seven nights
The wind blew, flood and tempest overwhelmed the land;
When the seventh day arrived the tempest, flood and onslaught
Which had struggled like a woman in labour, blew themselves out.
The sea became calm, the *imhullu* wind grew quiet, the flood held back.
I looked at the weather; silence reigned,
For all mankind had returned to clay.
The flood-plain was flat as a roof.
I opened a porthole and light fell on my cheeks.
I bent down, then sat. I wept.

Henrietta McCall. *Mesopotamian Myths*, British Museum Publications in cooperation with University of Texas Press, Austin, 1990. p. 48.

Gilgamesh ultimately abandons his quest for eternal life and returns to Uruk, having accepted his mortality and recognized that the majestic city is his lasting accomplishment.

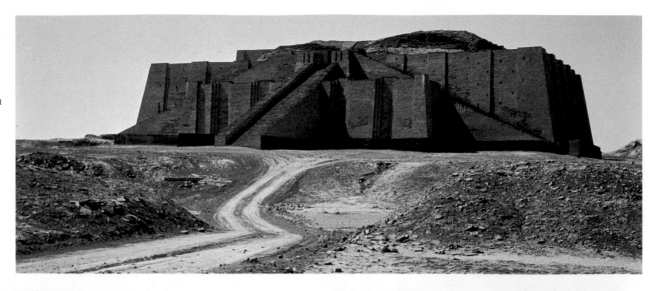

2-6. Nanna Ziggurat, Ur (modern Muqaiyir, Iraq). c. 2100–2050 BCE

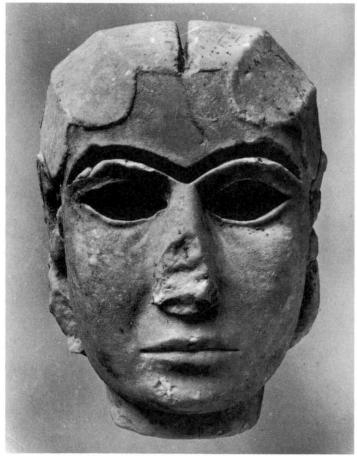

2-7. Face of a woman, from Uruk (modern Warka, Iraq). c. 3500–3000 BCE. Marble, height approx. 8" (20.3 cm). Iraq Museum, Baghdad

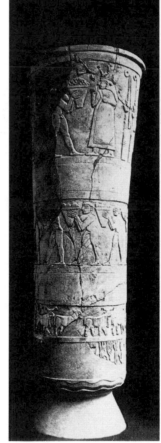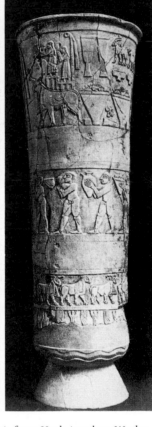

2-8. Carved vase (both sides), from Uruk (modern Warka, Iraq). c. 3500–3000 BCE. Alabaster, height 36" (91 cm). Iraq Museum, Baghdad

structure was a simple rectangle oriented to the points of the compass. An off-center doorway on one of the long sides led into a large chamber containing a raised platform and altar; smaller spaces opened off this main chamber. **Cone mosaic**, a technique apparently invented at Uruk, decorated many courtyards and interior walls in the Inanna and Anu compounds. Thousands of small cones, made of baked clay and brilliantly colored, were pressed like thumbtacks into wet plaster walls to create shimmering, multicolored designs.

South of Uruk lay the city of Ur (modern Muqaiyir, Iraq), the birthplace of the patriarch Abraham, who founded the Hebrew people. About a thousand years after the completion of the White Temple, the people of Ur built a ziggurat dedicated to the moon god Nanna, also called Sin (fig. 2-6). Although located on the site of an earlier temple, this imposing mud-brick structure was elevated by design, not as the result of successive rebuildings. Its base is a rectangle 190 by 130 feet, with three sets of stairs converging at an imposing entrance gate atop the first of what were

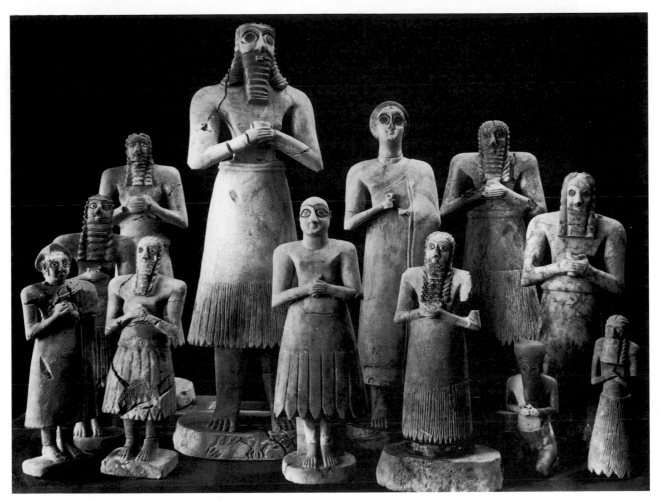

2-9. Votive statues, from the Square Temple, Eshnunna (modern Tell Asmar, Iraq). c. 2900–2600 BCE. Limestone, alabaster, and gypsum, height of largest figure approx. 30" (76.3 cm). The Oriental Institute of The University of Chicago; Iraq Museum, Baghdad

three platforms. Each platform's walls angle outward from top to base, probably to prevent rainwater from forming puddles and eroding the mud-brick pavement below. The first two levels of the ziggurat and their retaining walls have been reconstructed in recent times; little remains of the upper level and temple.

Sculpture of this period was associated with religion, and large statues were commonly placed in temples as objects of devotion. A striking lifesize marble face from Uruk may represent a goddess and once have been part of such an image (fig. 2-7). The face would have been attached to a wooden head on a full-size wooden body. Now stripped of its original facial paint, wig, and **inlaid** (set-in) brows and eyes—probably with shell used for the whites and lapis lazuli for the pupils—it is a stark, white mask. Nevertheless, its compelling stare and sensitively rendered features attest to the skill of Sumerian sculptors.

A tall, carved, alabaster vase found near the temple complex, a group of buildings dedicated to a religious purpose, of Inanna at Uruk (fig. 2-8) shows how Near Eastern sculptors of the time—and for the next 2,500 years—told their stories with great economy and clarity by organizing picture space into **registers**, or bands, and condensing the narrative, much as modern comic-strip artists do. Its lower registers show the natural world, including animals

and plants that medical historians have identified as the pomegranate and the now-extinct silphium, plants used by early people both to control fertility and as fertility symbols. Above them, on a solid **groundline**, rams and ewes alternate, facing right. In the top register, Inanna is accepting an offering from a naked priest.

Size was associated with importance in ancient art, a convention known as **hieratic scale**, and the goddess dominates the scene. The **stylized** figures, which do not conform to natural appearances, are shown simultaneously in side or profile view (heads and legs) and in three-quarter view (torsos), which makes both shoulders visible and increases each figure's breadth. Inanna stands in front of her shrine, indicated by two reed door poles hung with banners. Through the doorway her wealth is displayed, and behind the priest come others who bear offerings. The scene is usually interpreted as the ritual marriage between the goddess and a human during the fall New Year's festival, meant to ensure the fertility of crops, animals, and people, and thus the continued survival of Uruk.

Limestone statues dated to about 2900–2600 BCE from ruins of a temple at Eshnunna (modern Tell Asmar, Iraq) reveal another aspect of Mesopotamian religious art (fig. 2-9). These **votive figures**—images dedicated

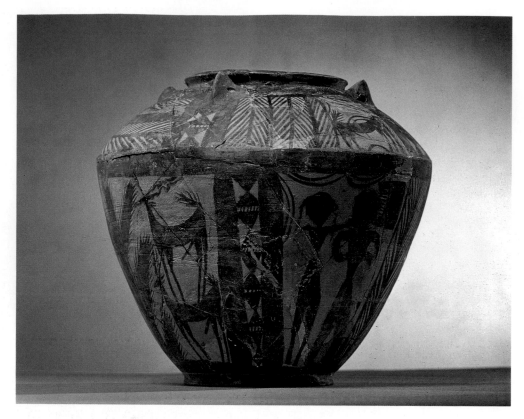

2-10. Scarlet Ware vase, from Tutub (modern Tell Khafajeh, Iraq). c. 3000–2350 BCE. Ceramic, height 11¾" (30 cm). Iraq Museum, Baghdad

The archaeologist's best friend is the potsherd, or piece of broken pottery. Ceramic vessels are easily broken, but the fragments are almost indestructible. Their earliest appearance at a site marks the time when people in the region began producing ceramics. Pottery styles, like automobile designs and clothing fashions today, change over time. Archaeologists are able to determine the chronological order of such changes. By matching the potsherds excavated at a site with the types in this sequence, they can determine the relative date of the site (see "How Early Art Is Dated," page 54).

to the gods—represent an early example of an ancient Near Eastern religious practice: the placement in a shrine of simple, small statues of individual worshipers before a larger, more elaborate image of a god. Anyone who could afford to might commission a self-portrait and dedicate it to a shrine. A simple inscription might identify the figure as "One who offers prayers." Longer inscriptions might recount in detail all the things the donor had accomplished in the god's honor. Cuneiform texts reveal the importance of approaching a god with an attentive gaze, hence the wide-open eyes seen here. Each sculpture served as a stand-in, at perpetual attention, making eye contact, and chanting its donor's praises through eternity.

The sculptors of the Eshnunna statues followed the conventions of Sumerian art—that is, the traditional ways of representing forms with simplified faces and bodies and dress that emphasized the cylindrical shapes. The figures stand solemnly, hands clasped in respect. As with the face of the woman from Uruk, arched brows inlaid with dark shell, stone, or bitumen once emphasized their huge, staring eyes. The male figures, bare-chested and dressed in sheepskin skirts, are stocky and muscular, with heavy legs, large feet, big shoulders, and cylindrical bodies. The two female figures (the tall, regal woman near the center and the smaller woman at

the far left) have somewhat slighter figures but are just as square-shouldered as the men.

The earliest pottery in the Near East dates to about 7000 BCE. Decorated vessels excavated in large numbers from gravesites provide some sense of the development of pottery styles in various regions. One popular type of Sumerian painted ceramic was Scarlet Ware, produced from around 3000 to 2350 BCE (fig. 2-10). Designs on these vessels, predominantly in red with touches of black, were painted with colored mixtures of clay and water. Circles, herringbones, zigzags, diamonds, and other geometric patterns, as well as animal images, were common motifs. The vase pictured here is about a foot tall and includes human figures, which is unusual.

From about 3000 BCE on, Sumerian artisans worked in various metals, including bronze (see Chapter 1) and precious metals, often combining them with other materials. Many of their metal creations were decorated with—or were in the shape of—animals or composite animal-human-bird creatures. A superb example of their skill is a lyre—a kind of harp—from the tomb of King Abargi of Ur (c. 2685 BCE), which combines wood, gold, lapis lazuli imported from Afghanistan, and shell (fig. 2-11). From one end of the lyre projects the three-dimensional head of a bearded bull, intensely lifelike despite the decoratively patterned blue beard.

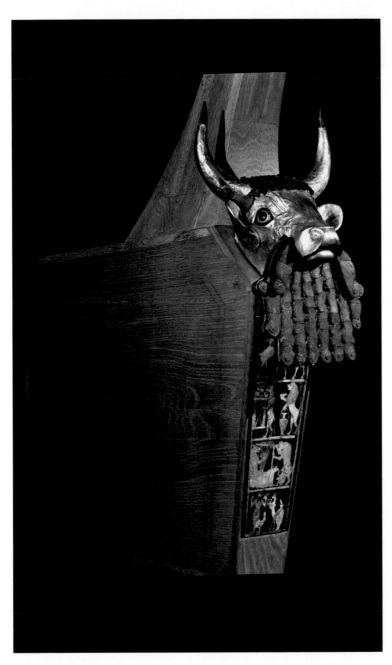

2-11. **Bull lyre**, from the tomb of King Abargi, Ur (modern Muqaiyir, Iraq). c. 2685 BCE. Wood with gold, lapis lazuli, bitumen, and shell, reassembled in modern wood support. University Museum, University of Pennsylvania, Philadelphia

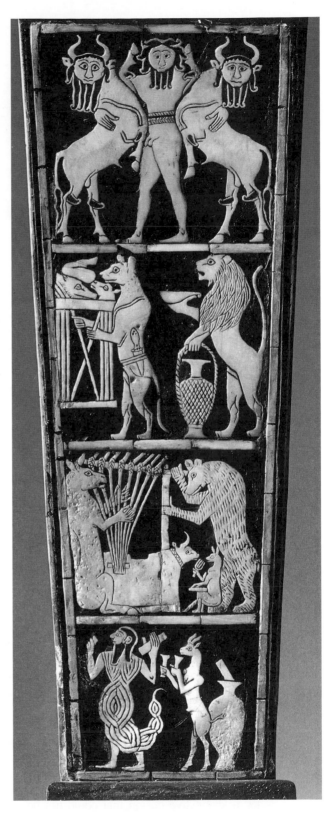

2-12. **Mythological figures**, detail of the sound box of the bull lyre from Ur (fig. 2-11). Wood with shell inlaid in bitumen, 12¼ x 4½" (31.1 x 11 cm)

On the panel below the head, four horizontal registers present scenes executed in shell inlaid in bitumen (fig. 2-12). In the bottom register a scorpion-man holds clappers in his upraised hands. He is attended by a gazelle standing on its hind legs and holding out two tall cups, perhaps filled from the large container from which a ladle protrudes. The scene above this one depicts a trio of animal musicians. A seated donkey plucks the strings of a bull lyre—showing how such instruments were played—while a standing bear braces the instrument's frame and a seated fox plays a small percussion instrument, perhaps a rattle. The next register shows animal

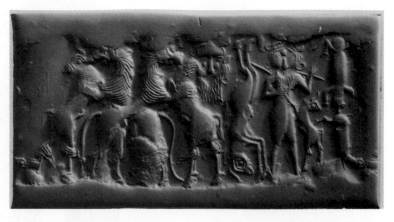

2-13. Cylinder seal from Sumer and its impression. c. 2500 BCE. Marble, height approx. 1¾" (4.5 cm).
The Metropolitan Museum of Art, New York
Gift of Walter Hauser, 1955 (55.65.4)

The distinctive design on the stone cylinder seal on the left belonged to its owner, like a coat of arms in the European Middle Ages or a modern cattle-rancher's brand. When rolled across soft clay applied to the closure to be sealed—a jar lid, the knot securing a bundle, or the door to a room—the cylinder left a raised image, or band of repeated raised images, of the design. Sealing discouraged unauthorized people from secretly gaining access to goods or information.

attendants, also walking erect, bringing food and drink for a feast. On the left a hyena assuming the role of a butcher with a knife in its belt carries a table piled high with pork and mutton. A lion follows with a large wine jug and pouring vessel. In the top panel, facing forward, is an athletic man with long hair and a full beard, naked except for a wide belt, who is clasping two rearing human-headed bulls.

Because the lyre and others like it were found in graves and were used in funeral rites, their imagery probably depicts the fantastic realm of the dead, offerings to the goddess of the underworld, or a funeral banquet. The animals shown are the traditional guardians of the gateway through which the newly dead had to pass. Cuneiform tablets preserve songs of mourning from Sumer, which may have been chanted by priests to lyre music at funerals. One begins: "Oh, lady, the harp of mourning is placed on the ground"—and indeed this harp was so placed in a king's grave.

About the time written records appeared, Sumerians developed stamps and seals for identifying documents and establishing property ownership. At first, Sumerians used simple clay stamps with designs **incised** (cut) into one surface to sign documents and to mark the clay sealing container lids and doorways to storage rooms. Pressed against a damp clay surface, the stamp left a mirror image of its distinctive design that could not be easily altered once dry. Around 3400 BCE, temple record keepers redesigned the stamp seal in the form of a cylinder. Sumerian **cylinder seals**, usually less than 2 inches high, were made of a hard stone, such as marble, so that the tiny, elaborate scenes carved into them would not wear away. The scene in figure 2-13 includes rearing lions fighting with a human-headed bull and a stag on the left, and a hunter on the right—perhaps a spoils-of-the-hunt depiction or an example of the Near Eastern practice of showing leaders protecting their people from both human and animal enemies as well as exerting control over the natural world.

AKKAD During Sumerian domination, a people known as the Akkadians settled to the north of Uruk and adopted Sumerian culture. Unlike the Sumerians, the Akkadians spoke a Semitic language (a language in the same family as Arabic and Hebrew). Under the powerful military and political figure Sargon I (ruled c. 2332–2279 BCE), they conquered the Sumerian cities and most of Mesopotamia. For more than half a century, Sargon ruled this empire from his capital at Akkad, whose actual site is yet to be discovered. As "King of the Four Quarters of the World," Sargon assumed broad earthly powers and also elevated himself to the status of a god, a precedent followed by later Akkadian rulers.

Enheduanna, the daughter of Sargon I, was a major public figure who combined the roles of princess, priestess, politician, poet, and prophet and wielded exceptional power. During her lifetime, she was considered the embodiment of the goddess Ningal, wife of the moon god Nanna, and after her death she herself may have been elevated to the status of goddess. She was apparently the only person to hold the office of high priestess for the ziggurats of both Nanna and Anu, Sumer's two most prestigious gods. She began the tradition of princesses serving as high priestesses, and she complemented her father's political consolidation of his empire by uniting religious authority within it. Her hymns in praise of Sargon and Inanna are among the earliest literary works whose author's name is known. She is memorialized on several cylinder seals, as well as on an inscribed alabaster disk that bears her picture (fig. 2-14). The figures carved in **high relief** in a band across the middle of this disk are participating in a ritual at the base of a ziggurat, seen at the far left. A nude priest pours ceremonial liquid from a pitcher onto an offering stand. The tall figure behind him, wearing a flounced robe and priestess's headdress, is presumed to be Enheduanna. She and the two figures to her right, probably priests with shaven heads, each raise one hand in a gesture of reverent greeting. The disk shape of this work is unique and may have to do with its dedication to the moon god.

2-14. ***Disk of Enheduanna***, from Ur (modern Muqaiyir, Iraq). c. 2300 BCE. Alabaster, diameter approx. 10" (25.4 cm). University Museum, University of Pennsylvania, Philadelphia

An inscription on the back of the disk reads: "Enheduanna, priestess of the moon god, [wife] of the moon god, child of Sargon the king of the universe, in Ishtar's temple of Ur she built [an altar] and named it . . . Offering Table of Heaven" (adapted from William W. Hallo, "Enheduanna," *Harvard Magazine*, May–June 1994, page 48).

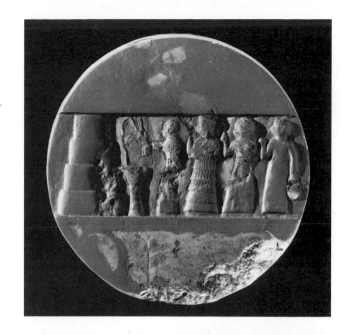

The concept of imperial authority was literally carved in stone in the *Stele of Naramsin* (fig. 2-15). This 6½-foot-high **stele**, or upright stone slab, commemorates a military victory of Naramsin, Sargon's grandson. It is an early example of a work of art created to celebrate the achievements of an individual ruler. The sculptors used the stele's pointed shape, accommodating the carved mountain, as a dynamic part of the **composition** (the arrangement of elements in the work), but in a sharp break with visual tradition, they replaced the horizontal registers with wavy groundlines. The images stand on their own, with no explanatory inscription, but the godlike king is immediately recognizable. Watched over by three solar deities, symbolized by the rayed suns in the sky, Naramsin ascends a mountain wearing the horned crown associated with deities. He stands at the dramatic center of the scene, closest to the mountaintop, silhouetted against the sky. His greater size is in hieratic relationship to his soldiers, who follow at regular intervals, passing conquered enemy forces sprawled in death or begging for mercy. Both the king and his warriors hold their weapons upright. Although this stele depicts Akkadians in triumph, they managed to dominate the region for only about another half century.

LAGASH

About 2180 BCE, the Akkadian Empire fell under attack by the Guti, a mountain people from the northeast. The Guti controlled most of the Mesopotamian plain for a brief time, then the Sumerians regained control of their own region and Akkad. But one large Sumerian city-state remained independent during the period of Guti control: Lagash (modern Telloh, Iraq), on the Tigris River in the southeast, under the ruler Gudea. Gudea built and restored many temples, in which he placed votive statues representing himself as governor and as the embodiment of just rule. The statues are made of diorite, a very hard stone that was difficult to work, prompting sculptors to use compact, simplified forms for the portraits. Twenty of these figures survive, making

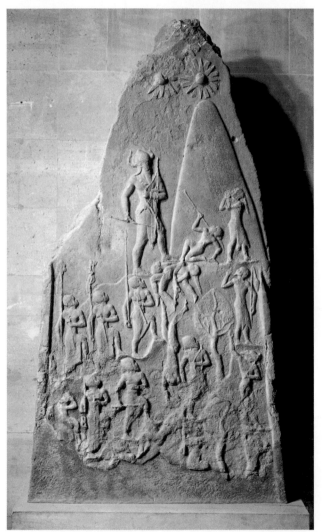

2-15. ***Stele of Naramsin***. c. 2254–2218 BCE. Limestone, height 6'6" (1.98 m). Musée du Louvre, Paris

This stele probably came originally from Sippar, an Akkadian city on the Euphrates River, in what is now Iraq. It was not discovered at Sippar, however, but at the Elamite city of Susa (modern Shush, Iran), some 300 miles to the southeast. Raiders from Elam presumably took it there as booty in the twelfth century BCE.

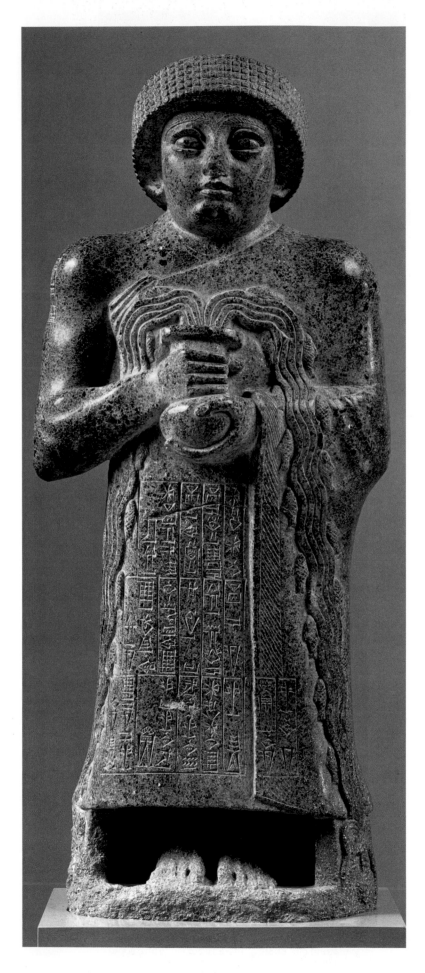

2-16. **Votive statue of Gudea**, from Lagash (modern Telloh, Iraq). c. 2120 BCE. Diorite, height 29" (73.7 cm). Musée du Louvre, Paris

Gudea's face a familiar one in ancient Near Eastern art.

Images of Gudea present him as a strong, peaceful, pious ruler worthy of divine favor. Whether he is shown sitting or standing, he wears a garment similar to that of the female votive figures from Eshnunna, which provides ample space for long cuneiform inscriptions (fig. 2-16). Here the text relates that Gudea, who holds a vessel from which life-giving water flows in two streams filled with leaping fish, dedicated himself, the statue, and its temple to the goddess Geshtinanna, the divine poet and interpreter of dreams. This imposing statue is **monumental**—that is, it gives an impression of grandeur—although it is only 2½ feet tall. The sculptor's treatment of the human body, as in other Mesopotamian figures, emphasizes its power centers: the eyes, head, and smoothly muscled chest and arms. Gudea's face, below the sheepskin hat, is youthful and serene, and the eyes—oversized and wide open, the better to return the gaze of the deity—express intense concentration.

BABYLON AND MARI For more than 300 years, periods of political turmoil alternated with periods of stable government in Mesopotamia. The Amorites, a Semitic-speaking people from the Arabian Desert, to the west, eventually reunited Sumer under Hammurabi (ruled 1792–1750 BCE), whose capital city was Babylon and whose subjects were called Babylonians. Among Hammurabi's achievements was a written legal code that listed the laws of his realm and the penalties for breaking them (fig. 2-17, "The Object Speaks").

As kingship and empire became increasingly important, palace architecture overshadowed temple architecture. The great palace of another Amorite king, Hammurabi's contemporary Zimrilim (ruled 1779–1757 BCE), reflects this trend. Zimrilim's capital city, Mari, was strategically located on the Euphrates River about 250 miles northwest of Babylon. It prospered from commercial traffic on the river and was notable for its well-built houses, sophisticated sanitation system, and bronze-working industry. The palace boasted an enormous courtyard paved in alabaster, several temples and shrines, hundreds of other rooms and courtyards, and a notable art collection. Zimrilim and Hammurabi had once been allies, but in 1757 BCE Hammurabi marched against Mari and destroyed Zimrilim's palace. From the palace, a few **murals**—large paintings or decorations affixed directly to the wall—have survived, providing rare examples of a fragile ancient Near Eastern art form.

The subjects of the murals range from geometric patterns decorating the royal family's quarters to military and religious scenes in the administrative areas. One, in the palace's main courtyard, shows Zimrilim receiving his authority from Ishtar, the Babylonian goddess of war,

THE OBJECT SPEAKS

THE CODE OF HAMMURABI

Hammurabi made his capital, Babylon, the intellectual and cultural center of the ancient Near East. One of his greatest accomplishments was the first systematic codification of his people's rights, duties, and punishments for wrongdoing, which was engraved on the *Stele of Hammurabi* (fig. 2-17). This black basalt stele—in effect, a megalith—speaks to us both as a work of art that depicts a legendary event and as a historical document that records a conversation about justice between god and man.

At the top of the stele, we see Hammurabi on a mountaintop, indicated by three flat tiers on which Shamash, the sun god and god of justice, rests his feet. Hammurabi listens respectfully, standing in an attitude of prayer. Shamash sits on a backless throne, dressed in a long flounced robe and crowned by a conical horned cap. Flames rise from his shoulders, and he holds additional symbols of his power—the measuring rod and the rope circle—as he gives the law to the King Hammurabi, the intermediary between the god and the people. From there, the laws themselves flow forth in horizontal bands of exquisitely engraved cuneiform signs. The idea of god-given laws engraved on stone tables is a long-standing tradition in the ancient Near East: in another example, Moses, the Lawgiver of Israel, received the Ten Commandments on two stone tablets from God on Mount Sinai (Exodus 32:19).

A prologue on the front of the stele lists the temples Hammurabi has restored, and an epilogue on the back glorifies Hammurabi as a peacemaker, but most of the stele was clearly intended to ensure uniform treatment of people throughout his kingdom. In the introductory section of the stele's long cuneiform inscription, Hammurabi declared that with this code of law he intended "to cause justice to prevail in the land and to destroy the wicked and the evil, that the strong might not oppress the weak nor the weak the strong." Most of the 300 or so entries that follow deal with commercial and property matters. Only sixty-eight relate to domestic problems, and a mere twenty deal with physical assault.

Punishments are based on the wealth, class, and gender of the parties—the rights of the wealthy are favored over the poor, freemen over slaves, men over women. The death penalty is frequently decreed for crimes such as stealing from a temple or palace, helping a slave to escape, or insubordination in the army. Trial by water and fire could also be imposed, as when an adulterous woman and her lover were to be thrown into the water (those who did not drown were deemed innocent) or a woman who committed incest with her son was to be burned (an incestuous man was only banished). Although some of the punishments seem excessive to us today, we recognize that Hammurabi was breaking new ground in his attempt to create a society regulated by published laws rather than the whims of judges or rulers.

2-17. *Stele of Hammurabi*, from Susa (modern Shush, Iran). c. 1792–1750 BCE. Basalt, height of stele approx. 7' (2.13 m), height of relief 28" (71.1 cm). Musée du Louvre, Paris

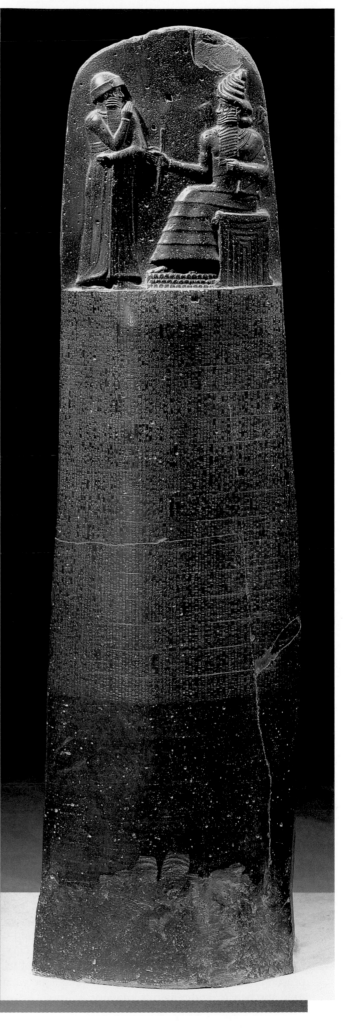

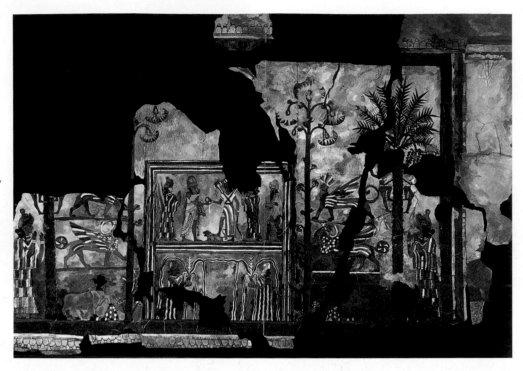

2-18. *Investiture of Zimrilim*,
facsimile of a wall painting on mud plaster from the palace at Mari (modern Tell Hariri, Iraq), Court 106. Before c. 1750 BCE. Height 5'5" (1.7 m). Musée du Louvre, Paris

fertility, and love (fig. 2-18). The central panels, devoted to the investiture ceremony, are organized in the formal, symmetrical style familiar in earlier Sumerian art. In the framed upper register, the goddess, holding weapons and resting her foot on a lion—all emblems of power—extends the rod and the ring, symbols of rule, to the king. Below, two goddesses, holding tall plants in red vases, are surrounded by streams of water that flow from the vases—a theme familiar from the Gudea statue (see fig. 2-16). Flanking these two panels are towering aloelike plants with fan-shaped, stylized foliage; three tiers of animals, mythical and otherwise—bulls, winged lions, and crowned, human-headed winged creatures; date palms being climbed by two fruit pickers; and finally two gigantic goddesses, hands raised in approval. Eye-catching checked and striped patterning throughout the mural makes its surface sparkle. The colors have darkened considerably over time, but they probably included blue, orange, red, brown, and white.

ASSYRIA

After centuries of struggle among Sumer, Akkad, Lagash, and Mari in southern Mesopotamia, a people called the Assyrians rose to dominance in northern Mesopotamia. They were very powerful by about 1400 BCE, and after about 1000 BCE they began to conquer neighboring regions. By the end of the ninth century BCE, they controlled most of Mesopotamia, and by the early seventh century BCE they had extended their influence as far west as Egypt. Soon afterward they succumbed to internal weakness and external enemies, and by 600 BCE their empire had collapsed.

Assyrian rulers built huge palaces atop high platforms inside the different fortified cities that served at one time or another as the Assyrian capital. They decorated these palaces with scenes of victorious battles, presentations of tribute to the king, combat between men and beasts, and religious imagery.

During his reign (883–859 BCE), Assurnasirpal II established his capital at Nimrud, on the east bank of the Tigris River, and undertook an ambitious building program. His architects fortified the city with mud-brick walls 5 miles long and 42 feet high, and his engineers constructed a canal that irrigated fields and provided water for the expanded population of the city. According to an inscription commemorating the event, Assurnasirpal gave a banquet for 69,574 people to celebrate the dedication of the new capital in 879 BCE. Most of the buildings in Nimrud were made from mud bricks, but limestone and alabaster—more impressive and durable—were used for architectural decorations. *Lamassu* guardian figures flanked the major portals (see fig. 2-1), and panels covered the walls with scenes carved in low relief of the king participating in religious rituals, war campaigns, and hunting expeditions.

In a vivid lion-hunting scene (fig. 2-19), Assurnasirpal II stands in a chariot pulled by galloping horses and draws his bow against an attacking lion that already has four arrows protruding from its body. Another beast, pierced by arrows, lies on the ground. This was probably a ceremonial hunt, in which the king, protected by men with swords and shields, rode back and forth killing animals as they were released one by one into an enclosed area. The immediacy of this image marks a shift in Mesopotamian art away from a sense of timelessness and toward visual narrative. As in many earlier works, *Assurnasirpal II Killing Lions* shows a man confronting wild beasts. Unlike earlier works, however, the man is not part of nature, standing among animals as their equal, but has assumed dominion over nature. There is no question in this scene who will prevail.

Sargon II (ruled 721–706 BCE) built a new Assyrian capital (fig. 2-20) at Dur Sharrukin (modern Khorsabad, Iraq). At the northwest side, a walled **citadel**, or fortress, containing 200 rooms and thirty courtyards, straddled the

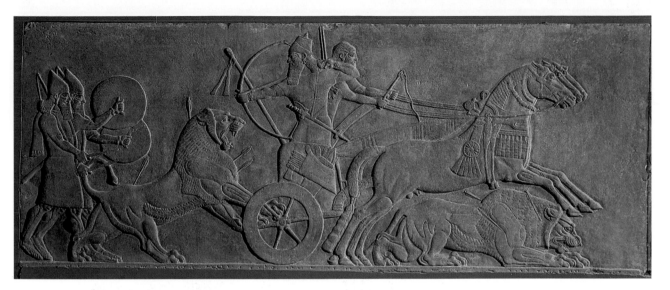

2-19. *Assurnasirpal II Killing Lions*, from the palace complex of Assurnasirpal II, Nimrud, Iraq. c. 850 BCE. Alabaster, height approx. 39" (99.1 cm). The British Museum, London

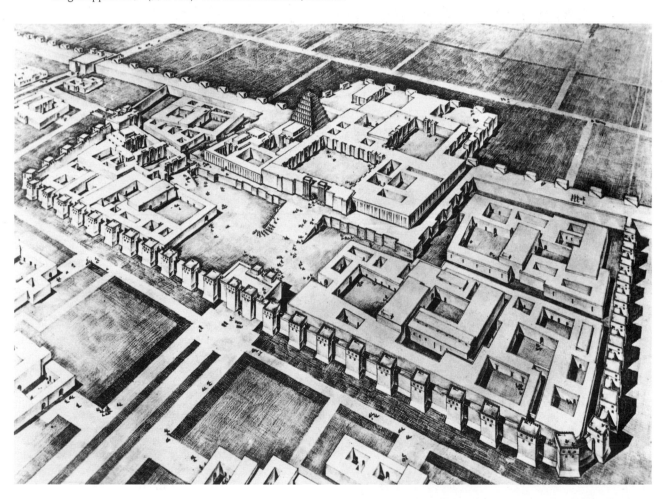

2-20. Reconstruction drawing of the citadel and palace complex of Sargon II, Dur Sharrukin (modern Khorsabad, Iraq). c. 721–706 BCE

city wall. The **palace complex** (the group of buildings where the ruler governed and resided), behind the citadel on a raised, fortified platform about 52 feet high, demonstrates the use of art as propaganda to support political power. Guarded by two towers, it was accessible only by a wide ramp leading up from an open square, around which the residences of important government and religious officials were clustered. Beyond the ramp was the main courtyard, with service buildings on the right and temples on the left. The heart of the palace, protected by a reinforced wall with only two small, off-center doors, lay past the main courtyard. Within the inner compound was a second courtyard, lined with narrative relief panels showing tribute bearers, that functioned as an audience hall. Visitors would have entered the king's throne room from this courtyard through a stone gate flanked by

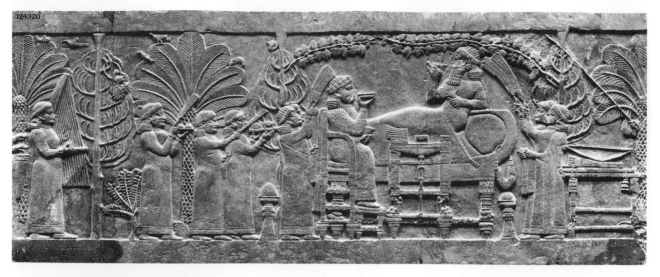

2-21. *Assurbanipal and His Queen in the Garden*, from the palace at Nineveh (modern Kuyunjik, Iraq). c. 647 BCE. Alabaster, height approx. 21" (53.3 cm). The British Museum, London

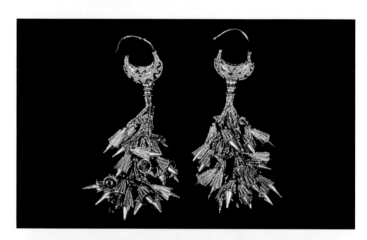

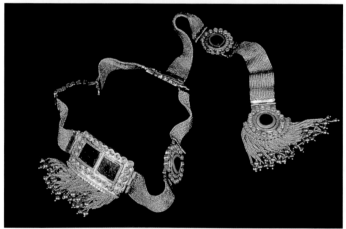

colossal guardian figures even larger than Assurnasirpal's (see fig. 2-1).

The ziggurat at Dur Sharrukin towered in an open space between the temple complex and the palace, declaring the might of Assyria's kings and symbolizing their claim to empire. It probably had seven levels, each about 18 feet high and painted a different color. The four levels still remaining were once white, black, blue, and red. Instead of separate flights of stairs between the levels, a single, squared-off spiral ramp rose continuously along the exterior from the base.

Assurbanipal (ruled 669–c. 627 BCE), king of the Assyrians three generations after Sargon II, established his capital at Nineveh (modern Kuyunjik, Iraq). His palace was decorated with alabaster panels carved with pictorial narratives in low relief. Most show the king and his subjects in battle and hunting, but there are occasional scenes of palace life. One panel shows the king and queen in a pleasure garden (fig. 2-21). The king reclines on a couch, and the queen sits in a chair at his feet. Some servants arrive with trays of food, while others wave whisks to protect the royal couple from insects. This apparently tranquil domestic scene is actually a victory celebration. The king's weapons (sword, bow, and quiver of arrows) are on the table behind him, and the severed head of his vanquished enemy hangs upside down from a tree at the far left. It was common during this period to display the heads and corpses of enemies as a form of psychological warfare, and Assurbanipal's generals would have sent him the head as a trophy.

Although much Assyrian art is relief carving, other arts were developing. One of the most spectacular archaeological finds in the Near East was the discovery, beginning in 1988, of more than a thousand pieces of gold jewelry weighing more than 125 pounds; they were found in three Assyrian royal tombs at Nimrud. The work dates from the ninth and eighth centuries BCE (fig. 2-22).

2-22. Earrings, crown, and rosettes, from the tomb of Queen Yabay, Nimrud, Iraq. Late 8th century BCE. Gold. Iraq Museum, Baghdad

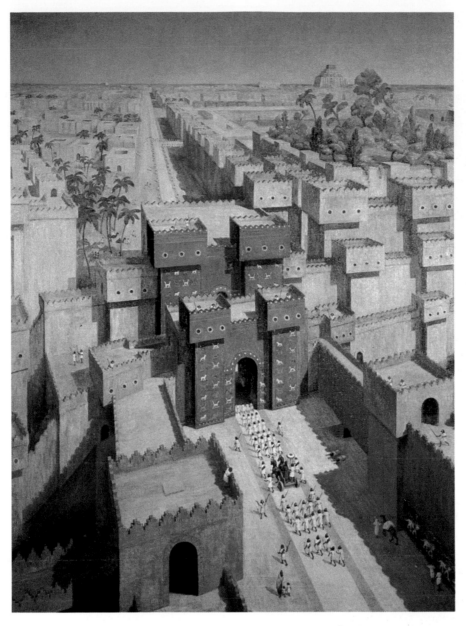

2-23. Reconstruction drawing of Babylon in the 6th century BCE. The Oriental Institute of The University of Chicago

In this view, the palace of Nebuchadnezzar II, with its famous Hanging Gardens, can be seen just behind and to the right of the Ishtar Gate, to the west of the Processional Way. The Marduk Ziggurat looms up in the far distance on the east bank of the Euphrates River. This structure was at times believed to be the biblical Tower of Babel—Bab-il was an early form of the city's name.

The refinement and superb artistry of the crowns, necklaces, bracelets, armbands, ankle bracelets, and other ornaments recovered from these tombs accord with the richly carved surfaces of Assyrian stone sculpture.

NEO-BABYLONIA

At the end of the seventh century BCE, the Medes, a people from Media, now western Iran, and the Scythians (see page 209) from the frigid regions of modern Russia and Ukraine invaded the northern and eastern parts of Assyria. Meanwhile, under a new royal dynasty, the Babylonians reasserted themselves. This Neo-Babylonian kingdom began attacking Assyrian cities in 615 BCE and formed a treaty with the Medes. In 612 BCE, the allied army captured Nineveh. When the dust settled, Assyria was no more. The Medes controlled a swath of land below the Black and Caspian seas, and the Neo-Babylonians controlled a region that stretched from modern Turkey to northern Arabia and from Mesopotamia to the Mediterranean Sea.

The most famous Neo-Babylonian ruler was Nebuchadnezzar II (ruled 604–562 BCE), notorious today for his suppression of the Jews, as recorded in the Hebrew Bible Book of Daniel. A great patron of architecture, he built temples dedicated to the Babylonian gods throughout his realm and transformed Babylon—the cultural, political, and economic hub of his empire—into one of the most splendid cities of its day. Babylon straddled the Euphrates River, its two sections joined by a bridge. The older, eastern sector was traversed by the Processional Way, the route taken by religious processions honoring the city's patron god, Marduk (fig. 2-23). This street of large stone slabs set in a bed of bitumen was up to 66 feet wide at some points. It ran from the Euphrates bridge past the temple district and palaces to end at the Ishtar Gate, the ceremonial entrance to the city. The walls on either side of the route were faced with dark blue bricks that were **glazed**—a film of glass placed over the bricks was fired in a process that had begun about 1600 BCE. Against that blue background, specially molded turquoise, blue, and gold-colored bricks formed images of striding lions, symbols of the goddess Ishtar. The walls and towers along the Processional Way were topped with notches, or **crenellation**.

The double-arched Ishtar Gate, a symbol of Babylonian power, was guarded by four crenellated towers. It is decorated with tiers of the dragons sacred to Marduk and the

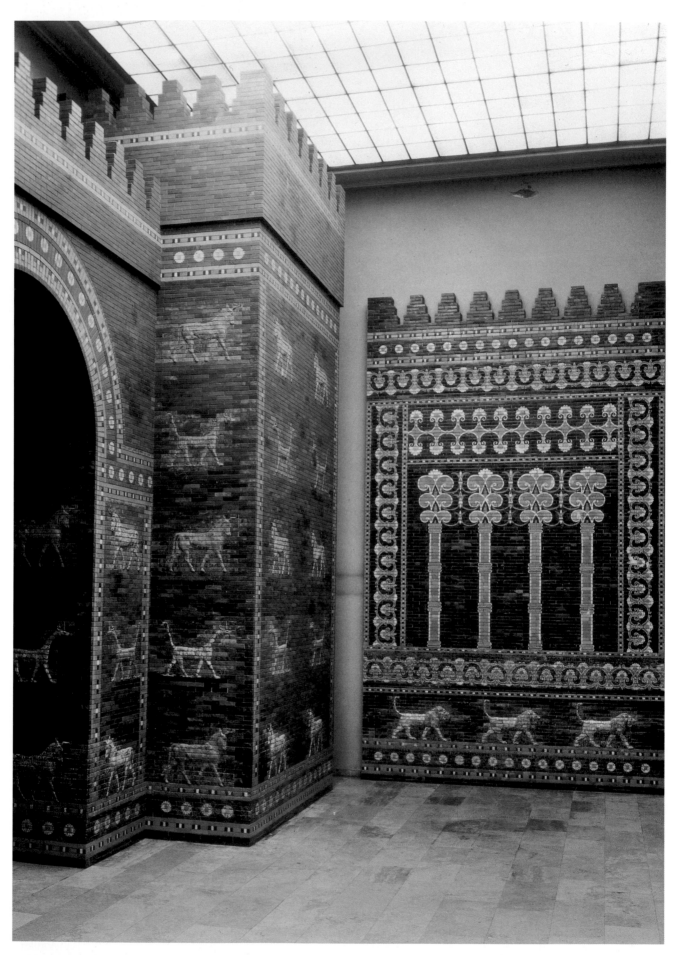

2-24. Ishtar Gate and throne room wall, from Babylon (Iraq). c. 575 BCE. Glazed brick, height originally 40' (12.2 m) with towers rising 100' (30.5 m). Vorderasiatisches Museum, Staatliche Museen zu Berlin, Preussischer Kulturbesitz

bulls with blue horns and tails associated with other deities. Now reconstructed inside one of the Berlin State Museums, the Ishtar Gate is installed next to a panel from the throne room in Nebuchadnezzar's nearby palace (fig. 2-24). In this fragment, lions walk beneath stylized palm trees. Among Babylon's other marvels—none of which survives—were the city's walls, its fabled terraced and irrigated Hanging Gardens (see "The Seven Wonders of the World," page 104), and the Marduk Ziggurat. All that remains of this ziggurat, which ancient documents describe as painted white, black, crimson, blue, orange, silver, and gold, is the outline of its base and traces of the lower stairs.

Outside of Mesopotamia, other cultures—those in Elam, Anatolia, and Persia among them—developed and flourished. Each had an impact on Mesopotamia before one of them, Persia, eventually overwhelmed it.

ELAM

The strip of fertile plain known as Elam, between the Tigris River and the Zagros Mountains to the east (in present-day Iran), was a flourishing farming region by 7000 BCE. About this time, the city of Susa, later the capital of an Elamite kingdom, was established on the Shaur River. Elam had close cultural ties to Mesopotamia, but the two regions were often in conflict. In the twelfth century BCE, Elamite invaders looted art treasures from Mesopotamia and carried them back to Susa (see "Protection or Theft?," below).

About 4000 BCE, Susa was a center of pottery production. Twentieth-century excavations there uncovered nearly 8,000 finely formed and painted vessels (beakers, bowls, and jars), as well as coarse domestic **wares**. The fine wares have thin, fragile shells that suggest they were not meant for everyday use. Decorations painted in brown glaze on pale yellow clay are sometimes purely geometric but are more often a graceful combination of geometric designs and stylized natural forms, mainly from the animal world, expertly balanced between repetition and variation.

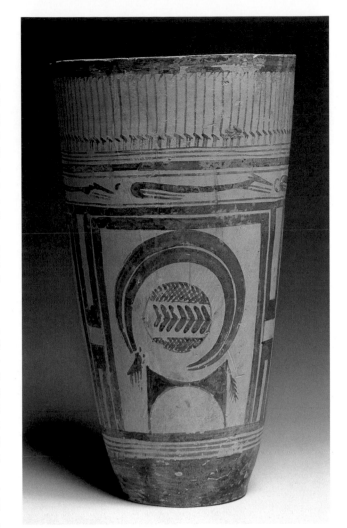

2-25. Beaker, from Susa (modern Shush, Iran). c. 4000 BCE. Ceramic, painted in brown glaze, height 11¼" (28.6 cm). Musée du Louvre, Paris

One handleless cup, or beaker, nearly a foot tall and weighing about 8 pounds, presents a pair of ibexes (only one of which is visible here) that has been reduced to pure geometric form (fig. 2-25). On each side, the great

PROTECTION OR THEFT?

Some of the most bitter resentments spawned by war—whether in Mesopotamia in the twelfth century BCE or in our own time—have involved the "liberation" by the victors of objects of great value to the people from whom they were taken. Museums around the world hold works either snatched by invading armies or acquired as a result of conquest. Two historically priceless objects unearthed in Elamite Susa, for example—the Akkadian *Stele of Naramsin* (see fig. 2-15) and the Babylonian *Stele of Hammurabi* (see fig. 2-17)—were not Elamite at all but were Mesopotamian. Both had been brought there as military trophies by an Elamite king, who added an inscription to the *Stele of Naramsin* explaining that he had merely "protected" it.

The same rationale has been used in modern times to justify the removal of countless works from their cultural contexts. The Rosetta Stone, the key to the modern decipherment of Egyptian hieroglyphics, was discovered in Egypt by French troops in 1799, fell into British hands when they forced the French from Egypt, and ultimately ended up in the British Museum in London (see page 190). In the early nineteenth century, the British Lord Elgin removed renowned Classical Greek reliefs from the Parthenon in Athens with the blessing of the Ottoman authorities who governed Greece at the time (see fig. 5-42). Although his actions may indeed have protected the reliefs from neglect and the ravages of the Greek war of independence, they have remained installed, like the Rosetta Stone, in the British Museum (see page 111), despite continuing protests from Greece. The Ishtar Gate from Babylon (see fig. 2-24) is now in a museum in Germany. Many German collections include works that were similarly "protected" at the end of World War II and are surfacing now. In the United States, Native Americans are increasingly vocal in their demands that artifacts and human remains collected by anthropologists and archaeologists be returned to them. "To the victor," it is said, "belong the spoils." It continues to be a matter of passionate debate whether this notion is appropriate in the case of revered cultural artifacts.

THE FIBER ARTS

Fragments of fired clay impressed with cloth have been dated to 25,000 BCE, showing that fiber arts, including various weaving and knotting techniques, vie with ceramics as the earliest evidence of human creative and technical skill. Since prehistoric times, weaving appears to have been women's work—probably because women, with primary responsibility for child care, could spin and weave in the home no matter how frequently they were interrupted by the needs of their families. Men as shepherds and farmers produced the raw materials for spinning and as merchants distributed the fabrics not needed by the family. Early Assyrian cuneiform tablets preserve the correspondence between merchants traveling by caravan and their wives, who were running the production end of the business back home and complaining about late payments and changed orders. It is no coincidence that the *Woman Spinning* (see fig. 2-26) is a woman.

The production of textiles is complex. First, thread must be produced: fibers gathered from plants (such as flax for linen cloth or hemp for rope) or from animals (wool from sheep, goats, and camels or hair from humans and horses) are cleaned, combed, and sorted. Only then can they be twisted and drawn out under tension—that is, spun—into the long, strong, flexible fibers needed for textiles or cords. Spinning tools include a long, sticklike spindle to gather the spun fibers, a whorl (weight) to help rotate the spindle, and a distaff (a word still used to describe women and their work) to hold the raw materials. Because textiles are fragile and rapidly decompose, the indestructible stone or fired-clay spindle whorls are usually the only surviving evidence of thread making.

Weaving begins on a loom. Warp threads are laid out at right angles to weft threads, which are passed over and under the warp. In the earliest, vertical looms, warp threads hung from a beam, their tension created either by wrapping them around a lower beam (a tapestry loom) or by tying them to heavy stones (a warp-weighted loom, such as the woman from Susa would have used). Although weaving was usually a home industry, in palaces and temples slave women staffed large shops, specializing as spinners, warpers, weavers, and finishers.

The fiber arts also include various nonweaving techniques—cording for ropes and strings; netting for traps, fish nets, and hair nets; knotting for macramé and carpets; sprang (a looping technique like cat's cradle); and single-hook work or crocheting (knitting with two needles came relatively late).

Early fiber artists depended on the natural color of their materials and on natural dyes from the earth (ochers) and from plants (madder for red, woad, an herb, and indigo for blue, and safflower and saffron crocus for yellow). The ancients combined color and techniques to create a great variety of fiber arts: Egyptians seem to have preferred white linen for their garments, elaborately folded and pleated. Minoans created multicolored patterned fabrics with fancy edgings. Greeks perfected pictorial tapestries. The people of the ancient Near East used woven and dyed patterns and also developed knotted pile (the so-called Persian carpet) and felt (a cloth of fibers bound by heat and pressure, not spinning, weaving, or knitting).

sweep of the animals' horns encloses a small circular motif, or **roundel**, containing what might be a leaf pattern or a line of birds in flight. A narrow band above the ibexes shows short-haired, long-nosed dogs at rest. In the wide top band, stately wading birds stand motionless.

Susa's ingenious artisans produced a gray bitumen-based compound that could be molded while soft and carved when hard. From this compound, which still defies laboratory analysis, they made a variety of practical and decorative objects. An especially fine example shows an important-looking woman adorned with many ornaments (fig. 2-26). Her hair is elegantly styled, and her garment has a patterned border. She sits barefoot and cross-legged on a lion-footed stool covered with sheepskin, spinning thread with a large spindle (see "The Fiber Arts," above). A fish lies on an offering stand in front of her, together with six round objects (perhaps fruit). A young servant stands behind the woman, fanning her. At the lower right hand corner of the fragment is what appears to be a portion of a long, flounced garment such as deities are frequently shown wearing, which might indicate the presence of a god or goddess to whom the offering is being made.

ANATOLIA

Anatolia, before the rise of the Assyrians, had been home to several independent cultures that resisted Mesopotamian domination. The most powerful of them was the Hittite civilization, whose founders had moved into the mountains and plateaus of central Anatolia from the east. They established their capital at Hattushash (near modern Boghazkeui, Turkey) about 1600 BCE. It was destroyed about 1200 BCE. Through trade and conquest, the Hittites created an empire that stretched along the coast of the Mediterranean Sea in the area of modern Syria and Lebanon, bringing them into conflict with the Egyptian Empire, which was expanding into the same region from the south (Chapter 3). They also made incursions into Mesopotamia.

The Hittites were apparently the first people to work in iron, which they used for war chariot fittings and weapons for soldiers, sickles and plowshares for farmers, and chisels and hammers for sculptors and masons. They are noted for the artistry of their fine metalwork and for their imposing palace citadels with double walls and fortified gateways.

The foundations and base walls of the Hittite stronghold at Hattushash, which date to about 1400–1300 BCE, were constructed of stone supplied from local quarries, but the upper walls, stairways, and walkways were finished in brick. The blocks of stone used to frame doorways were decorated in high relief with a variety of guardian figures—some of them 7-foot-tall, half-human–half-animal creatures, others naturalistically rendered animals like the lions shown here (fig. 2-27). These sculpted figures were part of the building, and the

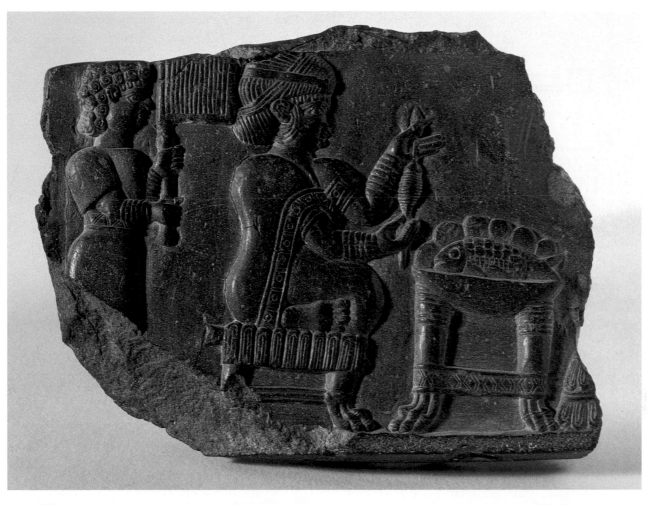

2-26. *Woman Spinning*, from Susa (modern Shush, Iran). c. 8th–7th century BCE. Bitumen compound, 3⅝ x 5⅛" (9.2 x 13 cm). Musée du Louvre, Paris

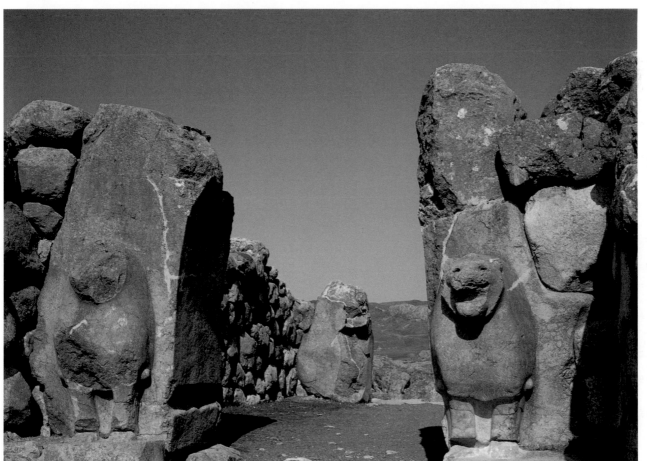

2-27. Lion Gate, Hattushash (near modern Boghazkeui, Turkey). c. 1400 BCE. Limestone

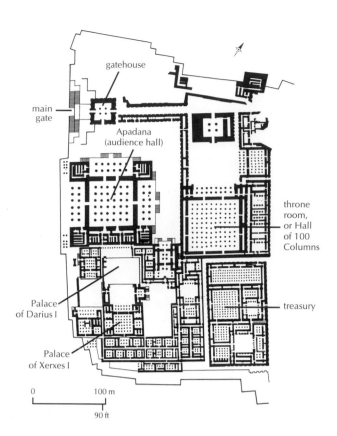

boulders-becoming-creatures on the so-called Lion Gate harmonize with the colossal scale of this construction. Despite extreme weathering, the lions have endured over the millennia and still possess a sense of vigor and permanence.

PERSIA

In the sixth century BCE, the Persians, a formerly nomadic, Indo-European–speaking people related to the Medes, began to seize power. From the region of Parsa, or Persis (modern Fars, Iran) southeast of Susa, they eventually overwhelmed Mesopotamia and the rest of the ancient Near East and established a vast empire. The rulers of this new empire traced their

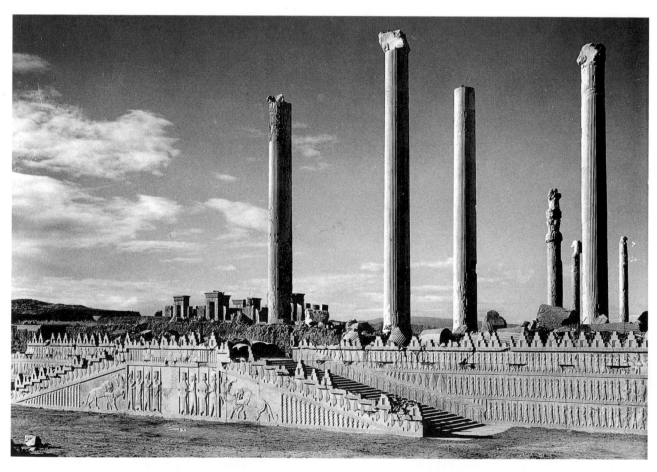

2-29. Apadana (audience hall) of Darius and Xerxes, ceremonial complex, Persepolis, Iran. 518–c. 460 BCE

The central stair displays reliefs of animal combat and tiered ranks of royal guards, the "10,000 Immortals," and delegations of tribute bearers. The figures cover the walls with repeated patterns. Unlike the bellicose Assyrian reliefs, however, Persian sculpture emphasizes the extent of the empire and the economic prosperity under Persian rule. The elegant drawing, calculated compositions, and sleek modeling of figures reflect the Persians' knowledge of Greek art and perhaps the use of Greek artists.

ancestry to a semilegendary Persian king named Achaemenes and consequently are known as the Achaemenids. Their dramatic expansion began in 559 BCE with the ascension of a remarkable leader, Cyrus II (called the Great, ruled 559–530 BCE). By the time of his death the Persian Empire included Babylonia; Media, which stretched across present-day northern Iran through Anatolia; and some of the Aegean islands far to the west. Conquests continued, and when Darius I (ruled 521–486 BCE), the son of a government official, took the throne, he could proclaim: "I am Darius, great King, King of Kings, King of countries, King of this earth."

Darius, like many powerful rulers, created monuments as visible symbols of his authority. He made Susa his first capital and commissioned a 32-acre administrative compound to be built there. In about 518 BCE, he began construction of Parsa, a new capital in the Persian homeland in the Zagros highlands. Today this city, known as Persepolis, the name the Greeks gave it, is one of the best-preserved ancient sites in the Near East (fig. 2-28). Darius imported materials, workers, and artists from all over his empire for his building projects. He even ordered work to be executed in Egypt and transported to his capital. The result was a new style of art that combined many different cultural traditions, including Persian, Mede, Mesopotamian, Egyptian, and Greek. This artistic integration reflects Darius's far-reaching political strategy.

In Assyrian fashion, the imperial complex at Persepolis was set on a raised platform and laid out on a rectangular **grid**, or system of crossed lines. The platform was 40 feet high and measured 1,500 by 900 feet. It was accessible only from a single ramp made of wide, shallow steps that allowed horsemen to ride up rather than dismount and climb on foot. Darius lived to see the erection of only a treasury, the Apadana (audience hall), and a very small palace for himself on the platform. The Apadana, set above the rest of the complex on a second terrace (fig. 2-29), had open porches on three sides and a square hall large enough to hold several thousand people. Darius's son Xerxes I (ruled 485–465 BCE) added a sprawling palace complex for himself, enlarged the treasury building, and began a vast new public reception space, the Hall of 100 Columns.

Sculpture at Persepolis displayed the unity and economic prosperity of the empire rather than the heroic exploits of its rulers. In a central relief, Darius holds an audience while his son and heir, Xerxes, listens from

TECHNIQUE
COINING MONEY

Long before the invention of coins, people used gold, silver, bronze, and copper as mediums of exchange, but each piece had to be weighed to establish its exact value. The Lydians of western Anatolia began to produce metal coins in standard weights in the seventh century BCE, adapting the seal—a Sumerian invention—to designate their value. Until about 525 BCE, coins bore an image on one side only. The beautiful early coin here, minted during the reign of the Lydian king Croesus (ruled 560–546 BCE), is stamped with the heads and forelegs of a bull and lion in low relief. The reverse has only a squarish depression left by the punch used to force the metal into the mold.

To make two-faced coins, the ancients used a punch and anvil, each of which held a die, or mold, incised with the design to be impressed in the coin. A metal blank weighing the exact amount of the denomination was placed over the anvil die, containing the design for the "head" (obverse) of the coin. The punch, with the die of the "tail" (reverse) design, was placed on top of the metal blank and struck with a mallet. Beginning in the reign of Darius I, kings' portraits appeared on coins, proclaiming the ruler's control of the coin of the realm—a custom that has continued throughout the world in coins such as the American Lincoln pennies and Roosevelt dimes. Because we often know approximately when ancient monarchs ruled, coins discovered in an archaeological excavation help to date the objects around them.

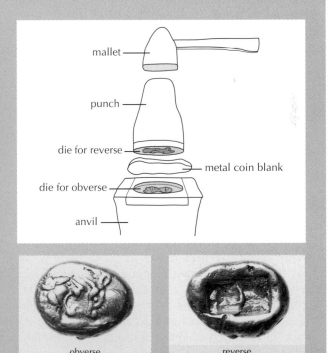

obverse reverse

Front and back of a gold coin first minted under Croesus, king of Lydia. 560–546 BCE. Heberden Coin Room, Ashmolean Museum, Oxford

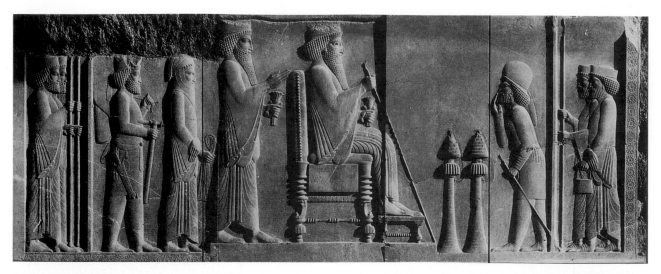

2-30. ***Darius and Xerxes Receiving Tribute***, detail of a relief from the stairway leading to the Apadana, ceremonial complex, Persepolis, Iran. 491–486 BCE. Limestone, height 8'4" (2.54 m). Iranbastan Museum, Teheran

behind the throne (fig. 2-30). Such panels would have looked quite different when they were freshly painted in rich tones of deep blue, scarlet, green, purple, and turquoise, with metal objects such as Darius's crown and necklace covered in **gold leaf**, sheets of hammered gold.

The Persians' decorative arts—including ornamented weapons, domestic wares, horse trappings, and jewelry—demonstrate high levels of technical and artistic sophistication. The Persians also created a refined coinage, with miniature low-relief portraits of rulers, so that coins, in addition to their function as economic standards, served as propaganda, carrying the ruler's portrait throughout the empire. The Persians had learned to mint standard coinage from the Lydians of western Anatolia after Cyrus the Great defeated Lydia's fabulously wealthy King Croesus in 546 BCE (see "Coining Money," page 89). Croesus's wealth—the source of the lasting expression "rich as Croesus"—had made Lydia an attractive target for an aggressive empire builder like Cyrus. A Persian coin, the gold daric, named for Darius and first minted during his regime (fig. 2-31), is among the most valuable coins in the world today. Commonly called an "archer," it shows the well-armed emperor wearing his crown and carrying a lance in his right hand; he lunges forward as if he had just let fly an arrow from his bow.

At its height, the Persian Empire extended from Africa to India. From their spectacular capital, Darius in 490 BCE and Xerxes in 480 BCE sent their armies west to conquer Greece, but mainland Greeks successfully resisted the armies of the Achaemenids, preventing them from advancing into Europe (Chapter 5). And it was a Greek who ultimately put an end to their empire. In 334 BCE, Alexander the Great of Macedonia crossed into Anatolia

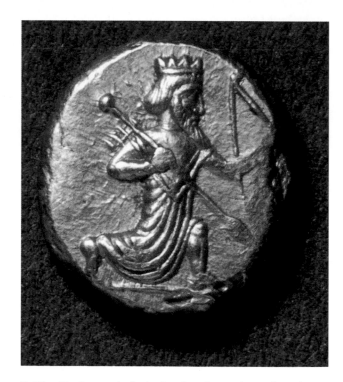

2-31. Daric, a coin first minted under Darius I of Persia. 4th century BCE. Gold. Heberden Coin Room, Ashmolean Museum, Oxford

and swept through Mesopotamia, defeating Darius III and nearly laying waste the magnificent Persepolis in 331 BCE. Although the Persian Empire was at an end, the art style unified there during the Achaemenid period clearly shows its links with Greece as well as with Egypt, which may have been heavily influenced by Mesopotamian culture.

PARALLELS

CULTURES	ART IN THE ANCIENT NEAR EAST	ART IN OTHER CULTURES
EARLY NEOLITHIC c. 9000 BCE–	**2-3. Ain Ghazal figure** (c. 7000–6000) **2-4. Chatal Huyuk shrine** (c. 6500–5500)	
ELAM c. 7000–600 BCE	**2-26.** *Woman Spinning* (c. 8th–7th century) **2-25. Susa beaker** (c. 4000)	**1-14.** *Women and Animals* (c. 4000–2000), Spain
SUMER c. 3500–2340 BCE	**2-7. Uruk woman** (c. 3500–3000) **2-8. Uruk vase** (c. 3500–3000) **2-5. Anu Ziggurat** (c. 3100) **2-10. Scarlet Ware** (c. 3000–2350) **2-9. Votive statues** (c. 2900–2600) **2-11. Bull lyre** (c. 2685) **2-13. Sumerian cylinder seal** (c. 2500)	**1-19. Stonehenge** (c. 2750–1500), England **3-10. Great Pyramids** (c. 2613–2494), Egypt **10-3.** *Cong* deity (before 3000), China
AKKAD c. 2340–2180 BCE	**2-14.** *Disk of Enheduanna* (c. 2300) **2-15.** *Stele of Naramsin* (c. 2254–2218)	**4-3. Cycladic figure** (c. 2500–2200), Greece
LAGASH c. 2150 BCE	**2-16. Gudea** (c. 2120)	
BABYLONIA, MARI c. 1792–1750 BCE	**2-17.** *Stele of Hammurabi* (c. 1792–1750) **2-18.** *Investiture of Zimrilim* (before c. 1750)	**13-1.** *Cattle Gathered next to a Group of Huts* (c. 2500–1500), Africa
HITTITE (ANATOLIA) c. 1600–1200 BCE	**2-27. Lion Gate** (c. 1400)	**4-19. Funerary mask** (c. 1600–1550), Greece **3-38.** *Nefertiti* (c. 1348–1335/6), Egypt
ASSYRIA c. 1000–612 BCE	**2-19.** *Assurnasirpal II* (c. 850) **2-1.** *Lamassu* (883-859) **2-20. Dur Sharrukin complex** (c. 721–706) **2-21.** *Assurbanipal and Queen* (c. 647)	**5-5. Dipylon vase** (c. 750), Greece
NEO-BABYLONIA c. 612–539 BCE	**2-24. Ishtar Gate** (c. 575)	**5-26.** *Suicide of Ajax* (c. 540), Greece
PERSIA c. 559–331 BCE	**2-29. Apadana of Darius and Xerxes** (518–c. 460) **2-30.** *Darius and Xerxes Receiving Tribute* (491–486) **2-31. Daric Persian coin** (4th century)	**5-18.** *Anavysos Kouros* (c. 525), Greece **5-39. Acropolis** (447–438), Greece

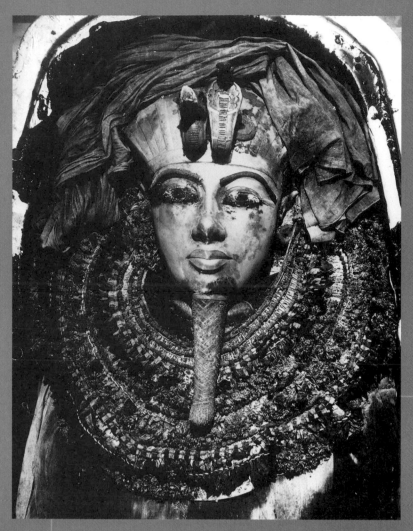

3-1. Funerary mask of Tutankhamun
(Dynasty 18, ruled c. 1336–1327 BCE), from the tomb of Tutankhamun, Valley of the Kings, Deir el-Bahri, photographed the day it was discovered—October 28, 1925

On February 16, 1923, *The Times* of London cabled *The New York Times* with intriguing archaeological news: "This has been, perhaps, the most extraordinary day in the whole history of Egyptian excavation. Whatever one may have guessed or imagined of the secret of Tut-ankh-Amen's tomb, they [sic] surely cannot have dreamed the truth as now revealed. The entrance today was made into the sealed chamber of the tomb of Tut-ankh-Amen, and yet another door opened beyond that. No eyes have seen the King, but to practical certainty we know that he lies there close at hand in all his original state, undisturbed." And indeed he did. A collar of dried flowers and beads covered the chest portion of the mask, and a linen scarf was draped around the head (figs 3-1, 3-2). The mask had been placed over the upper part of the young king's mummified body, which was enclosed in three coffins nested like a set of Russian dolls. These coffins were placed in a quartzite box that was itself encased within three gilt wooden shrines, each larger than the last. The innermost coffin, made of solid gold, is illustrated in figure 3-41. Tutankhamun's burial chamber was not the only royal tomb to survive unpillaged to the twentieth century, but it is by far the richest find.

Since ancient times, tombs have tempted looters, driven by simple greed; more recently, they also have attracted archaeologists and historians, motivated by scholarly interest. The first large-scale "archaeological" expedition in history landed in Egypt with the armies of Napoleon in 1798. The French commander, who went to investigate digging a canal between the Mediterranean and Red seas, clearly sensed that he might find great riches sheltered there, for he took with him some 200 French scholars to study ancient sites. Napoleon's military adventure ended in failure, but his scholars eventually published thirty-six richly illustrated volumes of their findings, unleashing a craze for all things Egyptian.

Popular fascination with this ancient African culture has not dimmed since Napoleon's time. Newspaper headlines around the world continue to herald major archaeological findings there, such as the 1995 discovery of a huge, unlooted burial complex near Thebes believed to hold the remains of many of Rameses II's fifty-two sons. In September 2000, Egyptian archaeologists again made the front pages of the world's newspapers when they announced the spectacular discovery of more than a hundred mummies—some from about 500 BCE and most from the time of the Roman occupation of Egypt—in a huge burial site about 230 miles southwest of Cairo. Called the Valley of the Golden Mummies, the cemetery was first published in 1999 when 105 mummies were discovered in the first four tombs to be opened. The director of excavations for the government of Egypt, Dr. Zahi Hawass, believes that as many as 10,000 mummies will eventually come to light from the Valley.

3
Art of Ancient Egypt

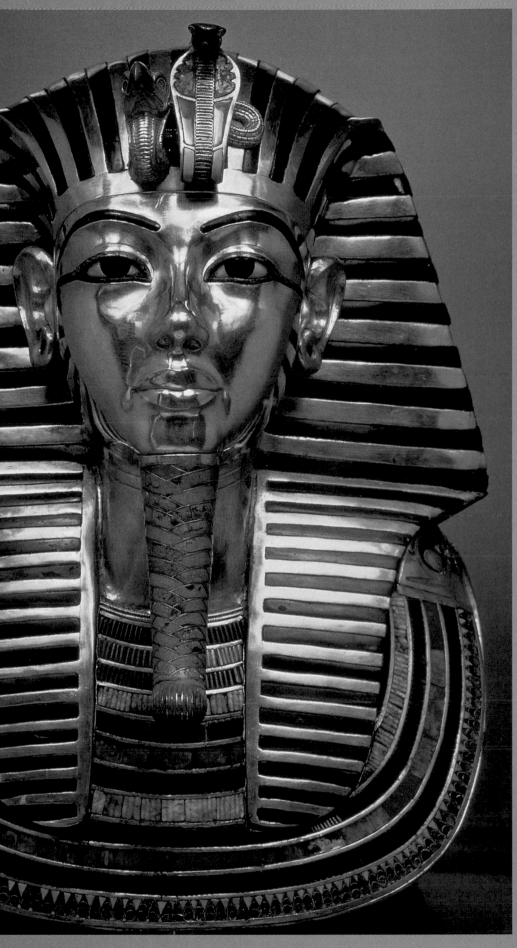

3-2. Funerary mask of Tutankhamun
Dynasty 18, c. 1327 BCE. Gold inlaid with glass and semiprecious
stones. Height 21¼" (54.5 cm). Egyptian Museum, Cairo

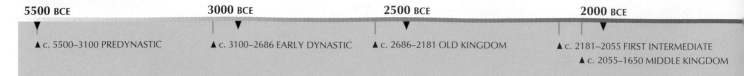

5500 BCE	3000 BCE	2500 BCE	2000 BCE
▲ c. 5500–3100 PREDYNASTIC	▲ c. 3100–2686 EARLY DYNASTIC	▲ c. 2686–2181 OLD KINGDOM	▲ c. 2181–2055 FIRST INTERMEDIATE
			▲ c. 2055–1650 MIDDLE KINGDOM

TIMELINE 3-1. Ancient Egypt. Neolithic culture began in ancient Egypt about 5500 BCE. The country was unified about 3100 BCE by the legendary King Narmer, who founded the first of the thirty dynasties established before the end of the Late Period, in 332 BCE, when Egypt was occupied by Ptolemaic Greek, then Roman rulers.

MAP 3-1. Ancient Egypt. About 3150 BCE the legendary King Menes united Upper (southern) Egypt and Lower (northern) Egypt.

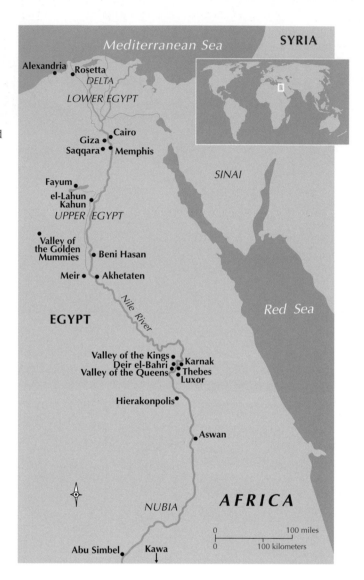

NEOLITHIC AND PREDYNASTIC EGYPT

The Greek traveler and historian Herodotus, writing in the fifth century BCE, remarked that "Egypt is the gift of the Nile." This great river, the longest in the world, winds northward from equatorial Africa and flows through Egypt in a relatively straight line to the Mediterranean (Map 3-1). There it forms a broad delta before emptying into the sea. Before it was dammed in the twentieth century CE at Aswan, the lower (northern) Nile, swollen with the runoff of heavy seasonal rains in the south, overflowed its banks for several months each year. Every time the floodwaters receded, they left behind a new layer of rich silt, making the valley and delta a fertile and attractive habitat for early people.

By about 8000 BCE, the valley's inhabitants had become relatively sedentary, living off the abundant fish, game, and wild plants. Not until about 5500 BCE did they adopt the agricultural, village life associated with Neolithic culture (Chapter 1). At that time, the climate of North Africa grew increasingly dry. To ensure an adequate supply of water, the early agriculturalists along the Nile cooperated to control the river's flow. As in Mesopotamia, this common challenge led riverside settlements to form alliances, and, over time, these rudimentary federations expanded by conquering and absorbing weaker communities. By about 3500 BCE, there were several larger states, or chiefdoms, in the lower Nile Valley.

The Predynastic period, roughly 5500 to 3100 BCE (Timeline 3-1), saw significant social and political transition

preceding the unification of Egypt under a single ruler and the formation of dynasties, in which members of the same family inherited Egypt's throne. During this period, a new dimension of leadership emerged, and political control was bolstered by the rulers' claims of divine powers. Their subjects, in turn, expected such leaders to protect them not only from outside aggression but also from natural catastrophes such as droughts and insect plagues. A royal ritual, the *heb sed* or *sed* festival, held in the thirtieth year of the living king's reign, was thought to renew and reaffirm his power. As part of the ceremony, the king ran a race on a specially built track to demonstrate his physical fitness. Then, enthroned and wearing the *sed* robe, he received his courtiers while the gods wished him "life, stability, dominion, and happiness."

The surviving art of the Predynastic period consists chiefly of ceramic figurines, decorated pottery, and reliefs carved on stone plaques and pieces of ivory. A few examples of Predynastic wall painting—lively scenes filled with small figures of people and animals—were found in what was either a temple or a tomb at Hierakonpolis, in Upper Egypt. This Predynastic town of mud-brick houses distributed over about 100 acres was once home to as many as 10,000 people.

A buff-colored pottery jar found at Hierakonpolis, dating from about 3500–3400 BCE, is decorated with a dark reddish-brown river scene (fig. 3-3). Zigzags around the jar's mouth symbolize the waters of the Nile, upon which floats a boomerang-shaped boat with two deck cabins and palm fronds affixed to a pole on the prow. A row of vertical strokes along the bottom of the hull represents oars. These lines and strokes are a kind of **abstract** visual shorthand. We recognize what they stand for even though the forms they represent are simplified to their essence. Two figures of nearly equal size, a man and a woman, stand on the roof of the cabin on the left. The woman arches her long arms over her head in a gesture that may be an expression of mourning, while the man beside her and a smaller figure atop the other cabin reach out toward her. Perhaps this is a funeral barge.

EARLY DYNASTIC EGYPT

About 3100 BCE, Egypt became a consolidated state. According to legend, the country had previously evolved into two major kingdoms—the Two Lands—Upper Egypt in the south and Lower Egypt in the north. A powerful ruler from Upper Egypt, referred to in an ancient document as "Menes king–Menes god," finally conquered Lower Egypt and merged the Two Lands into a single kingdom. Modern Egyptologists, experts on the history and culture of ancient Egypt, suspect that the unification process was more gradual than the legend would have us believe.

In the third century BCE, an Egyptian priest and historian named Manetho used temple records to compile a

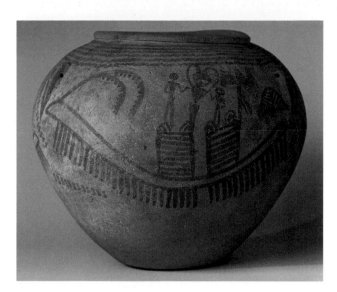

3-3. Jar with river scene, from Hierakonpolis. Predynastic, c. 3500–3400 BCE. Painted clay, 7 x 8¼" (17.5 x 20.9 cm). The Brooklyn Museum
Excavations of H. deMorgan 1907–8 (09.889.400)

chronological list of Egypt's rulers since the most ancient times. He grouped the kings into dynasties and included the length of each king's reign. Although scholars do not agree on all the dates, this dynastic chronology is still the accepted guide to ancient Egypt's long history. Manetho listed thirty dynasties that ruled the country between about 3100 and 332 BCE, when Egypt was conquered by the Greeks. Egyptologists have grouped these dynasties into larger periods reflecting broad historical developments from the Predynastic period through the New Kingdom (ending 1069 BCE). The dating system and the spelling of Egyptian names and places used in this book are those followed by the British Museum.

RELIGIOUS BELIEFS

Herodotus thought the Egyptians the most religious people he had ever encountered. Religious beliefs permeate Egyptian art of all periods, so we need some knowledge of them to understand the art.

Egypt's rulers were divine kings, sons of the sun god Ra (or Re). They rejoined their father at death and rode with him in the solar boat as it made its daily journey across the sky. Egyptians considered their kings to be their link to the invisible gods of the universe. To please the gods and ensure their continuing goodwill toward the state, Egypt's kings built them splendid temples and provided for priests to maintain them. The priests saw to it that statues of the gods, placed deep in the innermost rooms of their temples, were never without fresh food and clothing. The many gods and goddesses were depicted in various forms, some as human beings, others as animals, and still others as humans with animal

EGYPTIAN SYMBOLS

Symbolic of kingship, the crowned figure is everywhere in Egyptian art. Another pervasive image is the cobra, "she who rears up," which was equated with the sun, the king, and some deities and often included in headdress.

The god Horus, king of the earth and a force for good, is represented most characteristically as a falcon. Horus's eyes *(wedjat)* were regarded as symbolic of the sun and moon. The *wedjat* here is the solar eye. The *ankh* is symbolic of everlasting life. The scarab beetle was associated with the creator god Atum and the rising sun.

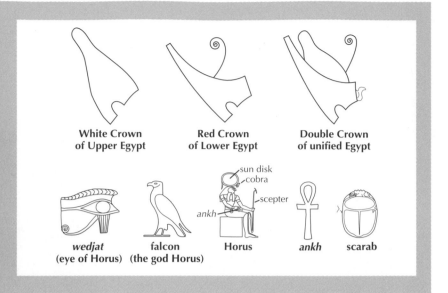

White Crown of Upper Egypt Red Crown of Lower Egypt Double Crown of unified Egypt

wedjat (eye of Horus) falcon (the god Horus) Horus — sun disk, cobra, scepter, ankh *ankh* scarab

EGYPTIAN MYTHS OF CREATION

Herodotus's contention that the Egyptians were obsessively religious is supported by the large number of gods in ancient Egyptian documents—even the River Nile was revered as a god. Early Egyptian creation myths introduce many of the earliest and most important deities in Egypt's pantheon.

One myth, focusing on the origins of the gods, relates that the sun god Ra—or Ra-Atum—shaped himself out of the waters of chaos, or unformed matter, and emerged seated atop a mound of sand hardened by his own rays. By spitting—or ejaculating—he then created the gods of wetness and dryness, Tefnut and Shu, who in turn begat the male Geb (earth) and the female Nut (sky). Geb and Nut produced two sons, Osiris

and Seth—the gods of goodness and evil, respectively—and two daughters, the goddesses Isis and Nephthys (Isis can be seen in figure 3-42). Taking Isis as his wife, Osiris became king of Egypt. His envious brother, Seth, promptly killed Osiris, hacked his body to pieces, and snatched the throne for himself. Isis and her sister, Nephthys, gathered up the scattered remains and, with the help of the god Anubis (a jackal), patched Osiris back together. Despite her husband's mutilated condition, Isis somehow managed to conceive a son—Horus, another power for good capable of guarding the interests of Egypt. Horus defeated Seth and became king of the earth, while Osiris retired to the underworld as overseer of the realm of the dead (see fig. 3-43).

Several myths explain the creation of human beings. In one, Ra lost

an eye but, unperturbed, replaced it with a new one. When the old eye was found, it began to cry, angered that it was no longer of any use. Ra created human beings from its tears. In another myth, favored by the people of Memphis, their local god Ptah created humankind on his potter's wheel.

By the Early Dynastic period, Egypt's kings were revered as gods in human form, a belief accounted for a thousand years later by a New Kingdom practice. As part of the annual *opet* festival, celebrating the flooding of the Nile, a procession carried statues of the god Amun and his wife, Mut, and son, Khons, from the temple at Karnak to their alternate temple at Luxor. Inscriptions in the processional colonnade record that, while at Luxor, the all-powerful god miraculously conceived a future ruler of Egypt.

heads. Osiris, for example, the god of the dead, regularly appears in human form wrapped in linen as a mummy. His wife, Isis, and their son the sky god Horus are human, but Horus was often depicted as having a human body and the head of a falcon. The sun god Ra appears at some times as a cobra, at other times as a scarab beetle (see "Egyptian Symbols," above).

Certain gods took on different forms over time and sometimes were worshiped in different regions under different names. In the New Kingdom at Thebes, for example, the creator god Amun and the sun god Ra were venerated as the single deity Amun-Ra. Everywhere else in Egypt in this period, the two continued to be thought of as separate gods. At the heart of Egyptian religion are stories that explain how the world, the gods, and human beings came into being (see "Egyptian Myths of Creation," above).

Egyptian religious beliefs reflect an ordered cosmos. The movements of heavenly bodies, the workings

of gods, and the humblest of human activities were all thought to be part of a grand design of balance and harmony. Death was to be feared only by those who lived in such a way as to disrupt that harmony; upright souls could be confident that their spirits would live on eternally.

THE PALETTE OF NARMER

The first king, named Narmer (Dynasty 1, ruled c. 3100 BCE), is known from a slab of mudstone (a kind of shale), the *Palette of Narmer* (fig. 3-4), found at Hierakonpolis. It is carved in low relief on both sides with scenes and identifying inscriptions. The ruler's name appears on both sides in **pictographs**, or picture writing, in a small square at the top: a horizontal fish *(nar)* above a vertical chisel *(mer)*. The cow heads on each side of his name symbolize the protective goddess Hathor.

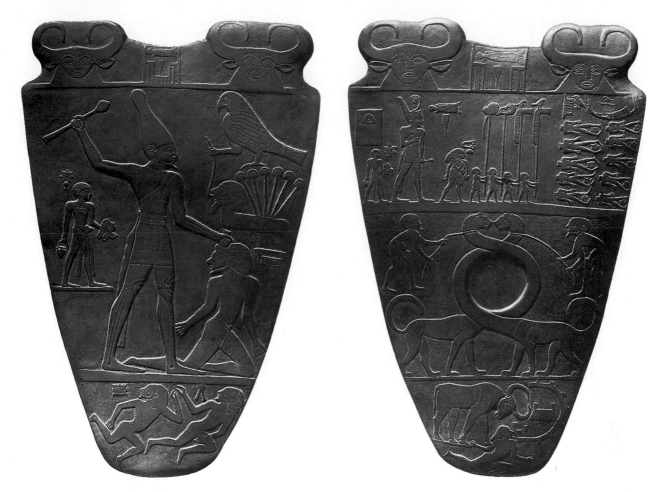

3-4. *Palette of Narmer*, from Hierakonpolis. Dynasty 1, c. 3000 BCE. Mudstone, height 25" (63.5 cm). Egyptian Museum, Cairo

Palettes, flat stones with a circular depression on one side, were common utensils of the time, used for grinding eye paint. Both men and women painted their eyelids to help prevent infections in the eyes and perhaps to reduce the glare of the sun, much as football players today blacken their cheekbones before a game. The *Palette of Narmer* has the same form as these common objects but is much larger. It and other large palettes decorated with animals, birds, and occasionally human figures probably had a ceremonial function.

King Narmer appears as the main character in the various scenes on the palette. Images of conquest proclaim him to be the great unifier, protector, and leader of the Egyptian people. **Hieratic scale** signals the status of individuals and groups in this highly stratified society, so, as in the *Stele of Naramsin* (see fig. 2-15), the ruler is larger than other human figures on the palette to indicate his importance and divine status. Narmer wears the White Crown of Upper Egypt, and from his waistband hangs a ceremonial bull's tail, signifying strength. He is barefoot, suggesting that this is a symbolic representation of a hero's preordained victory over evil. An attendant standing behind Narmer holds his sandals. Above Narmer's kneeling foe, the god Horus—a falcon with a human hand—holds a rope tied around the neck of a man whose head is beside stylized **papyrus**, a plant that grew in profusion along the lower Nile. This combination of symbols again makes clear that Lower Egypt has been tamed. In the bottom register (fig. 3-4, left), below Narmer's feet,

two of his enemies are sprawled on the ground, just as they fell when they were killed.

On the other side of the palette (fig. 3-4, right), Narmer is shown in the top register wearing the Red Crown of Lower Egypt, making clear that he now rules both lands. Here his name—the fish and chisel—appears not only in the rectangle at the top but also next to his head. With his sandal-bearer again in attendance, he marches behind his minister of state and four men carrying standards that may symbolize different regions of the country. Before them, under the watchful eye of Horus, lie the enemy dead. The decapitated bodies have been placed in two neat rows, their heads between their feet.

In the center register, the elongated necks of two feline creatures, each held on a leash by an attendant, curve gracefully around the rim of the cup of the palette. The intertwining of their necks is possibly another reference to the union of the Two Lands. In the bottom register, a bull menaces a fallen foe outside the walls of a fortress. The bull, an animal known for its strength and virility, may symbolize the king. The images affirm the absolute power of the ruler over the entire country of Egypt.

The images carved on the palette are strong and direct, and although scholars disagree about some of their specific meanings, their overall message is clear: a king named Narmer rules over the unified land of Egypt with a strong hand. Narmer's palette is particularly important because of the way it uses pictographs and symbols. Moreover, it provides very early examples of

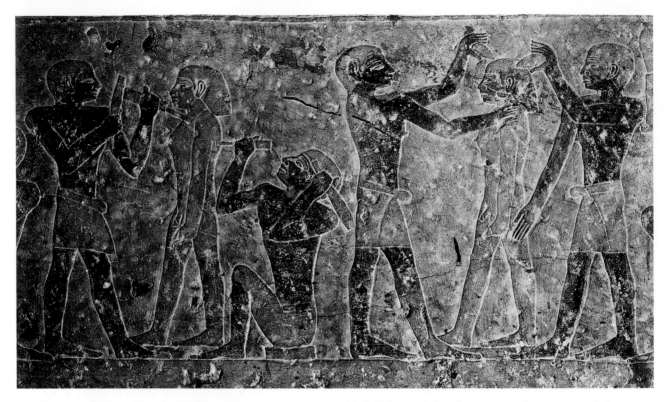

3-5. *Sculptors at Work*, relief from Saqqara. Dynasty 5, c. 2494–2345 BCE. Painted stone. Egyptian Museum, Cairo

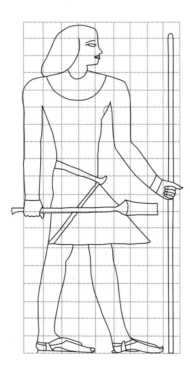

3-6. **An Egyptian canon of proportions for representing the human body**

This canon sets the height of the male body from heel to hairline at 18 times the width of the fist, which is 1 unit wide. Thus, there are 18 squares between the heels and the hairline. As they must, according to the canon, the knees align with the fifth line up, the elbows with the twelfth, and the junction of the neck and shoulders with the sixteenth.

the unusual way Egyptian artists solved the problem of depicting the human form in the two-dimensional arts of relief sculpture and painting.

REPRESENTATION OF THE HUMAN FIGURE

Forceful and easy to comprehend, the images on the Narmer palette present a king's exploits as he wished them to be remembered. For the next several thousand years, much of Egyptian art was created to meet the demand of royal patrons for similarly graphic, indestructible testimonies to their glory.

Many of the figures on the palette are shown in poses that would be impossible to assume in real life. By Narmer's time, Egyptian artists, using the memory image, the generic form that suggests a specific object, had arrived at a unique way of drawing the human figure. The Egyptians' aim was to represent each part of the body from the most characteristic angle. Heads are shown in profile, to best capture the subject's identifying features. Eyes, however, are most expressive when seen from the front, so artists rendered the eyes in these profile heads in frontal view. Artists showed shoulders as though from the front, but at the waist they twisted the figure 90 degrees to show hips, legs, and feet in profile. If both hands were to be shown in front of a figure, artists routinely lengthened the farther arm so both arms would be visible. Unless the degree of action demanded otherwise, they placed one foot in front of the other on the **groundline**, showing both feet from the inside, each with a high-arched instep and a single, large toe. This artistic tradition, or convention, was followed especially in the depiction of royalty and other dignitaries, and it persisted until the fourth century BCE. Persons of lesser social rank engaged in active tasks tend to be represented more naturally (compare the figure of Narmer with those of his standard-bearers in figure 3-4, right). Similarly, long-standing conventions governed the depiction of animals, insects, inanimate objects, landscape, and architecture. Flies, for example, are always shown from above, bees from the side.

In three-dimensional sculpture, figures could be constructed as they are in life. A painted relief from the funerary complex at Saqqara shows that artists working in two dimensions were perfectly capable of drawing figures from the side (fig. 3-5). It shows a pair of sculptors putting the finishing touches on statues. The "living" sculptors are

portrayed in the conventional twisted pose, while the statues appear in full profile, as they would in reality.

Just as Egyptian artists adhered to artificial convention in posing figures, they also proportioned figures in accordance with an ideal image of the human form, following an established **canon of proportions**. The ratios between a figure's height and all of its component parts were clearly prescribed. They were calculated as multiples of a specific unit of measure, such as the width of the closed fist.

The specific measure employed and the proportions derived from it varied slightly over time, but the underlying concept and the means by which it was implemented did not. Having determined the size of a desired figure, the artist first covered the area the figure was to occupy with a grid made up of a fixed number of squares (fig. 3-6). If the width of the fist was the canon's basic unit of measure, the artist saw to it that each hand was one square wide. Knowing that the knee should fall a prescribed number of squares above the groundline, the waist x number of squares above the knee, and so on simplified the process of sizing the figure. The grid itself was covered up as the work progressed.

THE OLD KINGDOM

The Old Kingdom (c. 2686–2181 BCE) was a time of social cohesion and political stability despite the climate changes that made droughts and insect plagues increasingly common and the occasional military excursions to defend the country's borders. The expanding wealth of ruling families of the period is reflected in the size and complexity of the tomb structures they commissioned for themselves. Court sculptors were regularly called upon to create lifesize, even colossal royal portraits in stone. Kings were not the only patrons of the arts, however. Numerous government officials also could afford to have tombs decorated with elaborate carvings.

FUNERARY ARCHITECTURE

Ancient Egyptians believed that an essential part of every human personality is its life force, or spirit, called the **ka**, which lived on after the death of the body, forever engaged in the activities it had enjoyed in its former existence. The *ka* needed a body to live in, but in the absence of one of flesh and blood, a sculpted likeness was adequate. It was especially important to provide a comfortable home for the *ka* of a departed king, so that even in the afterlife it would continue to ensure the well-being of the Egyptian state.

To fulfill the requirements of the *ka*, Egyptians developed elaborate funerary practices. They preserved the bodies of the dead with care and placed them in burial chambers filled with all the supplies and furnishings the *ka* might require throughout eternity (see "Preserving the Dead," below). The quantity and value of these grave goods were so great that looters routinely plundered tombs, even in ancient times.

In Early Dynastic Egypt, the most common tomb structure was the **mastaba**, a flat-topped, one-story building with slanted walls erected above an underground burial chamber (see "Mastaba to Pyramid," page 100). Mastabas were customarily constructed of mud brick, but toward the end of Dynasty 3, more incorporated cut stone, at least as an exterior facing, or **veneer**. In its simplest form, the mastaba contained a **serdab**, a small, sealed room housing the *ka* statue of the deceased, and a chapel designed to receive mourning relatives with their offerings.

PRESERVING THE DEAD

Egyptians developed mummification techniques to ensure that the *ka*, or life force, could live on in the body in the afterlife. Whenever possible, a portrait statue was provided as an alternative, in case the mummy disintegrated (see fig. 3-12). The world's fascination with Egyptian mummies has a long history. In the Middle Ages and into the eighteenth century, Europeans prized pulverized mummy remains and swallowed them in various solutions, believing them to be of great medicinal value. One of the first concerns of the Egyptian National Antiquities Service after its founding in the second half of the nineteenth century was how to prevent people from stealing and destroying ancient human remains, as well as mummies of hundreds of thousands of cats and millions of ibises.

No ancient recipes for preserving the dead have been found, but the basic process seems clear enough from images found in tombs, the descriptions of later Greek writers such as Herodotus and Plutarch, scientific analysis of mummies, and modern experiments. By the time of the New Kingdom, the routine was roughly as follows. The dead body was taken to a mortuary, a special structure used exclusively for embalming. Under the supervision of a priest, workers removed the brains, generally through the nose, and emptied the body cavity through an incision in the left side. They then placed the body and major internal organs in a vat of natron, a naturally occurring salt, to steep for a month or more. This preservative caused the skin to blacken, so workers often dyed it later to restore some color, using red ocher for a man, yellow ocher for a woman. They then packed the body cavity with clean linen, provided by the family of the deceased and soaked in various herbs and ointments. They wrapped the major organs in separate packets, putting them either in special containers to be placed in the tomb chamber or into the body again.

Workers next wound the trunk and each of the limbs separately with cloth strips, then wrapped the whole body in a shroud. They then wound it in additional layers of cloth to produce the familiar mummy shape. The linen winders often inserted good luck charms and other smaller objects among the wrappings. If the family supplied a Book of the Dead (see fig. 3-43), a selection of magic spells meant to help the deceased survive a "last judgment" and win everlasting life, it was tucked between the mummy's legs.

ELEMENTS OF ARCHITECTURE

Mastaba to Pyramid

As the gateway to the afterlife for Egyptian kings and members of the royal court, the Egyptian burial structure began as a low rectangular mastaba with an internal *serdab* (the room where the *ka* statue was placed) and chapel, then a mastaba with attached chapel and *serdab* (not shown). Later, mastaba forms of decreasing size were stacked over an underground burial chamber to form the stepped pyramid. The culmination of the Egyptian burial chamber is the pyramid, in which the actual burial site may be within the pyramid—not below ground—with false chambers, false doors, and confusing passageways to foil potential tomb robbers.

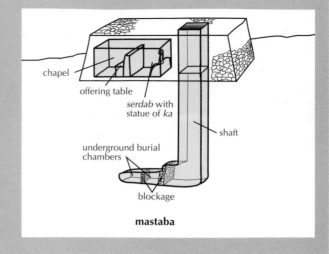

mastaba

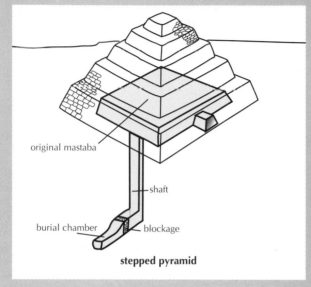

stepped pyramid

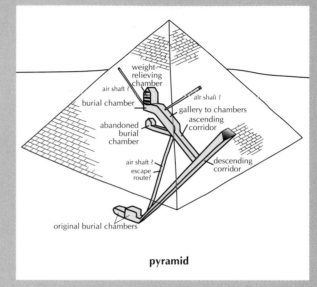

pyramid

A vertical shaft dropped from the top of the mastaba down to the actual burial chamber, where the remains of the deceased reposed in a **sarcophagus**, or stone coffin, surrounded by appropriate grave goods. This chamber was sealed off after interment. Many such structures had numerous underground burial chambers to accommodate whole families, and mastaba burial remained the standard for Egyptian royalty for centuries.

The kings of Dynasties 3 and 4 were the first to devote huge sums to the design, construction, and decoration of more extensive aboveground funerary complexes. These structures tended to be grouped together in a **necropolis**—literally, a "city of the dead"—at the edge of the desert on the west bank of the Nile, for the land of the dead was believed to be in the direction of the setting sun. Two of the most extensive of these early necropolises are at Saqqara and Giza, just outside modern Cairo.

Djoser's Funerary Complex at Saqqara. For his tomb complex at Saqqara, King Djoser (Dynasty 3, ruled c. 2667–2648 BCE) commissioned the earliest known monumental architecture in Egypt (fig. 3-7). The designer of the complex was the prime minister, Imhotep. His name, together with the king's, is inscribed on the base of Djoser's *ka* statue in the *serdab* of the funerary temple to

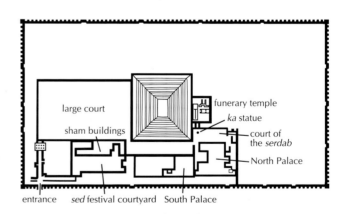

3-7. Plan of Djoser's funerary complex, Saqqara.
Dynasty 3, c. 2667–2648

Situated on a level terrace, this huge commemorative complex—some 1,800 feet (544 meters) long by 900 feet (277 meters) wide—was designed as a replica in stone of the wood, brick, and reed buildings of Djoser's actual palace compound. The enclosing wall had fifteen gates, only one of which was functional. Inside the wall, the stepped pyramid dominated the complex. Underground apartments copied the layout and appearance of rooms in the royal palace.

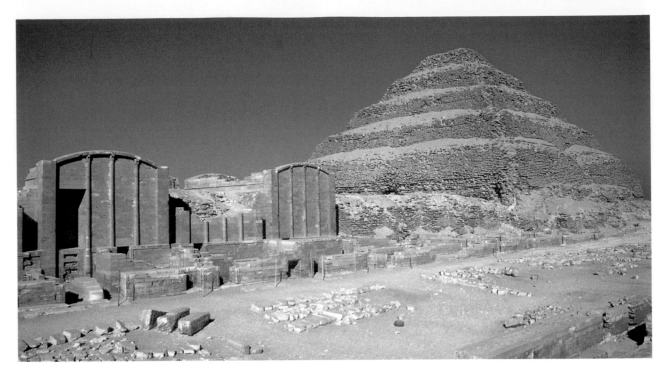

3-8. Stepped pyramid (six-stepped mastaba) of Djoser, Saqqara. Limestone, height 204' (62 m)

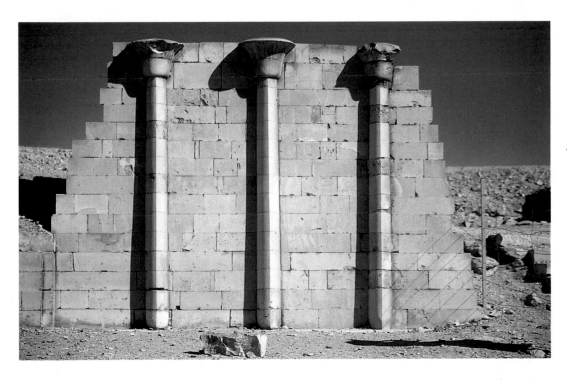

3-9. **Wall of the North Palace**, with engaged columns in the form of papyrus blossoms. Funerary complex of Djoser, Saqqara

the north of the tomb. He is thus the first architect in history known by name. Born into a prominent family, Imhotep was highly educated and served as one of Djoser's chief advisers on affairs of state. It appears that he first planned Djoser's tomb as a single-story mastaba, then later decided to enlarge upon the concept (figs. 3-8, 3-9). In the end, what he produced was a stepped pyramid with six mastabalike elements of decreasing size placed on top of each other (see "Mastaba to Pyramid," page 100). Although the final structure resembles the **ziggurats** of Mesopotamia, it differs in both its intention (as a stairway to the stars and to the sun god Ra) and its purpose of protecting a tomb. Djoser's imposing structure was originally faced with a veneer of limestone. A 92-foot shaft descended from the peak to a granite-lined burial vault.

The adjacent funerary temple, where priests performed their final rituals before placing the king's mummified body in its tomb, was also used for continuing worship of the dead king. In the form of his *ka* statue, Djoser intended to observe these devotions through two peepholes in the wall between the *serdab* and the funerary chapel. To the east of the pyramid were sham buildings—exquisitely carved masonry shells filled with debris—representing chapels, palaces with courtyards, and other structures. They were provided so that the dead king could continue to observe the *sed* rituals that had ensured his long reign. His spirit could await the start of the ceremonies in a pavilion near the entrance to the complex in its southeast corner. The running trials of the *sed* festival took place in a long outdoor

A **column** is a cylindrical, upright pillar that traditionally has three sections: a **base**, a **shaft**, and a top, called a **capital**. Most columns are freestanding and are used to support weight, usually a roof. When used decoratively and attached to a wall, a column is referred to as an **engaged column** or **attached column** (see fig. 3-9). A **colonnade** is a row of columns supporting a horizontal member.

Egyptians used columns, with and without bases, in their **temple complexes**, often in forms based on river plants, especially lotus and **papyrus**.

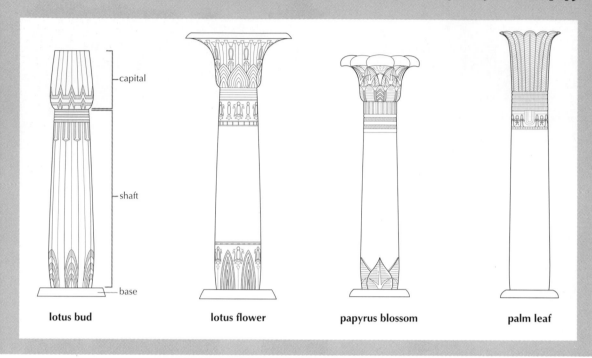

| lotus bud | lotus flower | papyrus blossom | palm leaf |

court-yard within the complex. After proving himself, the living king would proceed first to the South Palace then to the North Palace, to be symbolically crowned once again as king of Egypt's Two Lands.

Imhotep's architecture employs the most elemental structural techniques and the purest geometric forms. Although most of the stone wall surfaces were left plain, in some places he made effective use of **columns**. Some of these are plain except for **fluting**, but others take the form of stylized plants. The **engaged columns** spaced along and attached to the exterior walls of the North Palace, for example, resemble stalks of papyrus. Stylized papyrus blossoms serve as their **capitals**. These columns may have been patterned after the bundled papyrus stalks early Egyptian builders used to reinforce mud walls, and they symbolized Lower Egypt. By contrast, the architectural decorations of the South Palace featured the flowering sedge and the lotus—plants symbolic of Upper Egypt (see "Column," above).

The Pyramids at Giza. The architectural form most closely identified with Egypt is the true pyramid with a square base and four sloping triangular faces. The first such structures were erected in Dynasty 4. The angled sides of the pyramids may have been meant to represent the slanting rays of the sun, for inscriptions on the walls of pyramid tombs built in Dynasties 5 and 6 tell of deceased kings climbing up the rays to join the sun god Ra.

Egypt's most famous funerary structures are the three great pyramid tombs at Giza (fig. 3-10). These were built by the Dynasty 4 kings Khufu (ruled c. 2589–2566 BCE), Khafra (ruled c. 2558–2532 BCE), and Menkaura (ruled c. 2532–2503 BCE). The Greeks were so impressed by these huge, shining monuments—*pyramid* is a Greek term—that they numbered them among the world's architectural marvels (see "The Seven Wonders of the World," page 104). The early Egyptians referred to the pyramids as "Horizon of Khufu," "Great Is Khafra," and "Divine Is Menkaura," thus acknowledging the desire of these rulers to commemorate themselves as divine beings. The oldest and largest of the Giza pyramids is that of Khufu, which covers 13 acres at its base and rises to a height of about 450 feet in its deteriorated state. It was originally finished with a thick veneer of polished limestone that lifted its apex some 30 feet above the present summit, to almost 481 feet. The pyramid of Khafra, the only one of the three that still has a little of its veneer at the top, is slightly smaller than Khufu's. Menkaura's is considerably smaller than the other two and had a polished red granite base.

The site was carefully planned to follow the sun's east-west path. Next to each of the pyramids was a funerary temple connected by causeway, or elevated road, to a valley temple on the bank of the Nile (fig. 3-11). When a king died, his body was ferried across the Nile from the royal palace to his valley temple, where it

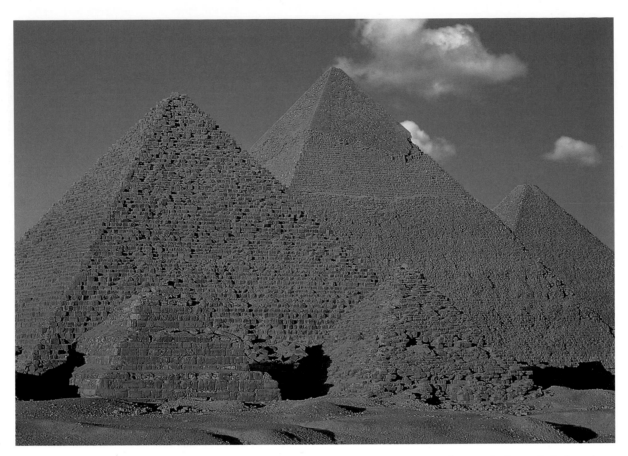

3-10. Great Pyramids, Giza. Dynasty 4, c. 2613–2494 BCE. Erected by (from left) Menkaura, Khafra, and Khufu (the three ruled 2589–2503 BCE). Granite and limestone, height of pyramid of Khufu 450' (137 m)

The designers of the pyramids tried to ensure that the king and his tomb "home" would never be disturbed. Khufu's builders placed his tomb chamber in the very heart of the mountain of masonry, at the end of a long, narrow, steeply rising passageway, sealed off after the king's burial by a 50-ton stone block. Three false passageways, either calculated to mislead or the result of changes in plans as construction progressed, obscured the location of the tomb. Despite such precautions, early looters managed to penetrate to the tomb chamber and make off with Khufu's funeral treasure. For many centuries, it was not known that the pyramids were the tombs of early Egyptian rulers. One theory was that they had been gigantic silos for storing grain during periods of drought and famine.

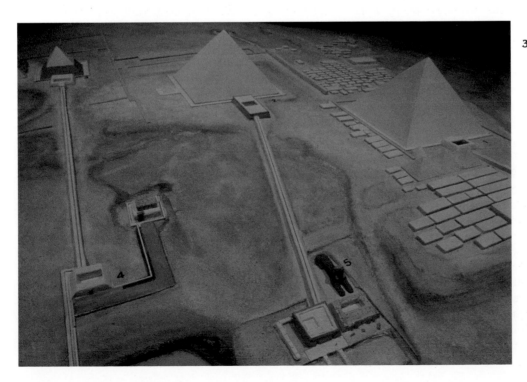

3-11. Model of the Giza plateau, showing from left to right the temples and pyramids of Menkaura, Khafra, and Khufu.

Prepared for the exhibition "The Sphinx and the Pyramids: One Hundred Years of American Archaeology at Giza," held in 1998 at the Harvard University Semitic Museum. Harvard University Semitic Museum, Cambridge, Massachusetts

Just as guidebooks today publicize sights travelers must not miss, Greek writers in the second century BCE heralded the Seven Wonders of the World. The oldest of these "wonders"—and the only one reasonably intact today—is the trio of pyramids at Giza (see fig. 3-10), built during Dynasty 4 (c. 2613–2494 BCE). The next oldest, the so-called Hanging Gardens built for Nebuchadnezzar II in Babylon in the sixth century BCE (see fig. 2-23), had disappeared long before it made the list, although sections believed to be its foundations have been excavated. The other wonders can only be imagined from written descriptions, sculptural fragments, and archaeological reconstructions: the temple of the goddess Artemis at Ephesos, from the sixth century BCE; the statue of the god Zeus at Olympia by Pheidias, about 430 BCE; the Mausoleum at Halikarnassos, fourth century BCE (figure 5-57 shows a conjectural reconstruction); the Colossus of Rhodes, a bronze statue of the sun god Helios the height of a ten-story building, completed in 282 BCE (our own word *colossal* comes from this Greek term for an enormous human statue); and the lighthouse that guarded the port at Alexandria, in Egypt, built about 290 BCE, more than four times as tall as the Colossus. Today, underwater archaeologists working off the north coast of Egypt are raising the ancient port piece by piece and believe they have spotted large stones of the lighthouse.

was received with elaborate ceremonies. It was then carried up the causeway to his funerary temple and placed in its chapel. There family members presented it with offerings of food and drink, and priests performed the rite known as the "opening of the mouth," in which the deceased's spirit consumed a meal. Then the body was entombed in a vault deep inside the pyramid. Khafra's funerary complex is the best preserved today. His valley temple was constructed of massive blocks of red granite with a polished alabaster floor, which reflected the *ka* statue of the king.

Constructing a pyramid was a formidable undertaking. A huge labor force had to be assembled, housed, and fed. Most of the cut stone blocks—each weighing an average of 2.5 tons—used in building the Giza complex were quarried either on the site or nearby. Teams of workers transported them by sheer muscle power, at times employing small logs as rollers or pouring water on sand to create a slippery surface over which they could drag the blocks on sleds.

Scholars and engineers have put forward various theories about the method used to raise the pyramids. Some have been tested in computerized projections and a few in actual buildings attempted on a small but representative scale. The most efficient means of getting the stones into position might have been to build a temporary, gently sloping ramp around the body of the pyramid as it grew higher. The ramp might then be dismantled as the slabs of the stone veneer were laid from the top down. Clearly the architects who oversaw the building of such massive structures were capable of the most sophisticated mathematical calculations, for there was no room for trial and error. They had to make certain that the huge foundation layer was absolutely level and that the angle of each of the slanting sides remained constant so that the stones would meet precisely in the center at the top. They carefully oriented the pyramids to the points of the compass and may have incorporated other symbolic astronomical calculations as well. These immense monuments reflect not only the desire of a trio of kings to attain immortality but also the strength of the Egyptians' belief that a deceased ruler continued to affect the well-being of the state and his people from beyond the grave.

SCULPTURE

As was the custom, Khafra commissioned various stone portraits of himself to perpetuate his memory for all time. In his roughly lifesize *ka* statue, one of about twenty discovered inside his valley temple, he was portrayed as an enthroned king (fig. 3-12). His most famous portrait is the Great Sphinx, a colossal monument some 65 feet tall just behind the valley temple; it combines his head with the long body of a crouching lion.

In his *ka* statue, Khafra sits erect on a simple but elegant lion throne. Horus perches on the back of the throne, protectively enfolding the king's head with his wings. Lions—symbols of regal authority—form the throne's legs, and the intertwined lotus and papyrus plants beneath the seat symbolize the king's power over Upper and Lower Egypt. Khafra wears the traditional royal costume: a short, pleated kilt, a linen headdress with the cobra symbol of Ra, and a false beard symbolic of royalty. The figure conveys a strong sense of dignity, calm, and above all permanence; its compactness—the arms pressed tight to the body, the body firmly anchored in the block—ensured a lasting alternative home for the king's *ka*. The statue was carved in an unusual stone, northosite gneiss, imported from Nubia. This stone produces a rare optical effect: in sunlight, it glows a deep blue, the celestial color of Horus. Through skylights in the valley temple, the sun would have illuminated the alabaster floor and the figure, creating a blue radiance.

When carving such a statue, Egyptian sculptors approached each face of the block as though they were simply carving a relief. A master drew the image full face on the front of the block and in profile on the side. Sculptors cut straight back from each drawing, removing the superfluous stone and literally "blocking out" the figure. Then the three-dimensional shapes were refined, surface details were added, and finally the statue was polished and painted.

Dignity, calm, and permanence also characterize the beautiful double portrait of Khafra's son King Menkaura and a queen, probably Khamerernebty II (fig. 3-13). But the sculptor's handling of the composition of this work, discovered in Menkaura's valley temple, makes it far less austere than Khafra's *ka* statue. The couple's separate

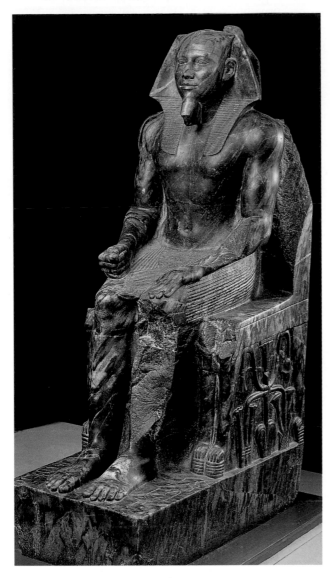

3-12. *Khafra*, from Giza. Dynasty 4, c. 2500 BCE. Northosite gneiss, height 5'6⅛" (1.68 m). Egyptian Museum, Cairo

figures, close in size, form a single unit, tied together by the stone out of which they emerge. They are further united by the queen's symbolic gesture of embrace. Her right hand emerges from behind to lie gently against his ribs, and her left hand rests on his upper arm. The king, depicted in accordance with the Egyptian ideal as an athletic, youthful figure nude to the waist and wearing the royal kilt and headcloth, stands in a typically Egyptian balanced pose with one foot in front of the other, his arms straight at his sides, and his fists tightly clenched. His equally youthful queen echoes his striding pose, but with a smaller step forward. The sculptor exercised remarkable skill in rendering her sheer, close-fitting garment, which clearly reveals the curves of her body. The time-consuming task of polishing this double statue was never completed, indicating that the work may have been undertaken only a few years before Menkaura's death in about 2503 BCE. However, traces of red paint remain on the king's face, ears, and neck (male figures were traditionally painted red), as do traces of black on the queen's hair.

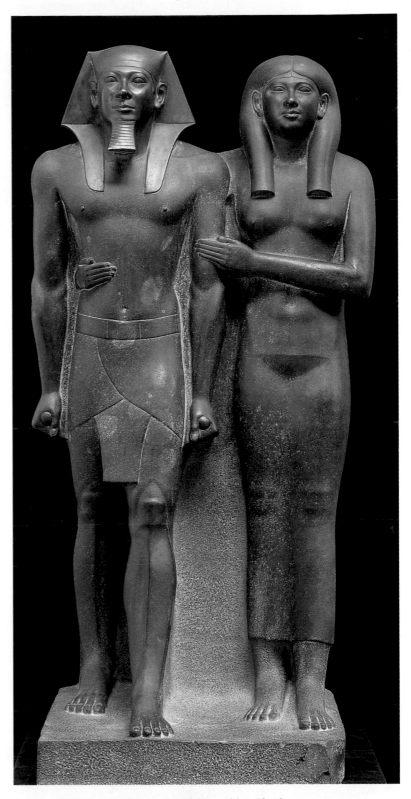

3-13. *Menkaura and a Queen*, perhaps his wife Khamerernebty, from Giza. Dynasty 4, c. 2500 BCE. Graywacke with traces of red and black paint, height 54½" (142.3 cm). Museum of Fine Arts, Boston
Harvard University–MFA Expedition

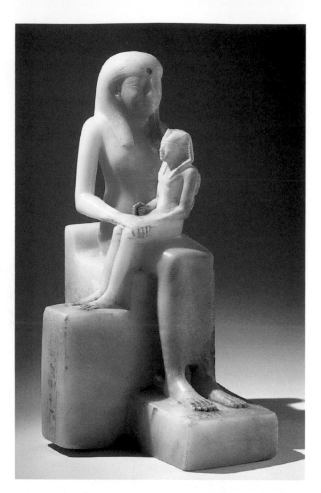

3-14. *Pepy II and His Mother, Queen Merye-ankhnes.* Dynasty 6, c. 2278–2184 BCE. Calcite, height 15¼" (39.2 cm). The Brooklyn Museum

Charles Edwin Wilbour Fund (39.119)

A type of royal portraiture that appeared in Dynasty 6 (c. 2345–2181 BCE) is seen in figure 3-14. In this statue, the figure of Pepy II (ruled c. 2278–2184 BCE), wearing the royal kilt and headdress but reduced to the size of a child, is seated on his mother's lap. The work thus pays homage to Queen Merye-ankhnes, who wears a vulture-skin headdress linking her to the goddess Nekhbet and proclaiming her of royal blood. The queen is inscribed "Mother of the King of Upper and Lower Egypt, the god's daughter, the revered one, beloved of Khum Ankhnesmerye." If Pepy II inherited the throne at the age of six, as Manetho claimed, then the queen may have acted as regent until he was old enough to rule alone. The sculptor placed the king at a right angle to his mother, thus providing two "frontal" views—the queen facing forward, the king to the side. In another break with convention, he freed the queen's arms and legs from the stone block of the throne, giving her figure greater independence.

Old Kingdom sculptors were commissioned to produce portraits not only of kings but also of less prominent people. Such works—for example, *Seated Scribe*, from early in Dynasty 5 (fig. 3-15)—are usually more lively and

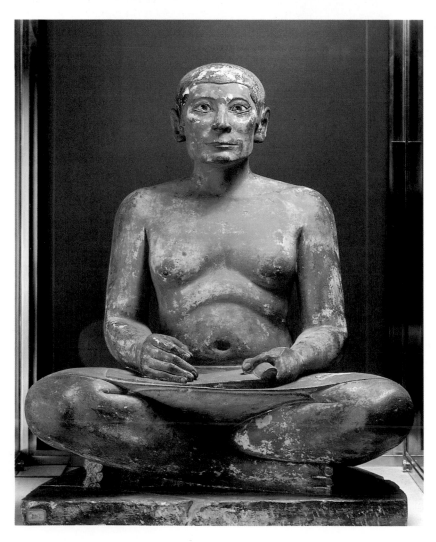

3-15. *Seated Scribe*, from the tomb of Kai, Saqqara. Dynasty 5, c. 2494–2345 BCE. Painted limestone with inlaid eyes of rock crystal, calcite, and magnesite mounted in copper, height 21" (53 cm). Musée du Louvre, Paris

Egyptian scribes began training in childhood. Theirs was a strenuously guarded profession, its skills generally passed down from father to son. Some girls learned to read and write, and although careers as scribes seem generally to have been closed to them, there is a Middle Kingdom word meaning "female scribe." Would-be scribes were required to learn not only reading and writing but also arithmetic, algebra, religion, and law. The studies were demanding, but the rewards were great. A comment found in an exercise tablet, probably copied from a book of instruction, offers encouragement: "Become a scribe so that your limbs remain smooth and your hands soft, and you can wear white and walk like a man of standing whom [even] courtiers will greet" (cited in Strouhal, page 216). A high-ranking scribe with a reputation as a great scholar could hope to be appointed to one of several "houses of life," where lay and priestly scribes copied, compiled, studied, and repaired valuable sacred and scientific texts. Completed texts were placed in related institutions called "houses of books," some of the earliest known libraries.

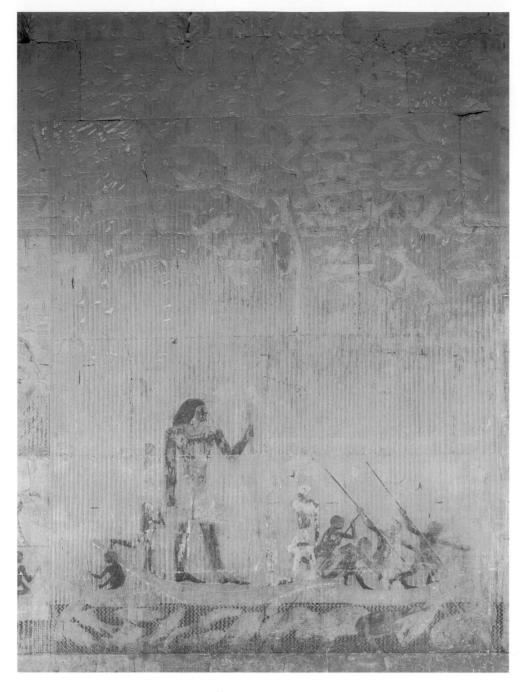

3-16. *Ti Watching a Hippopotamus Hunt*, from the tomb of Ti, Saqqara. Dynasty 5, c. 2494–2345 BCE. Painted limestone relief, height approx. 45" (114.3 cm)

This relief forms part of the decoration of a mastaba tomb discovered by the French archaeologist Auguste Mariette in 1865. Among Mariette's many other famous finds was the *ka* statue of Khafra (see fig. 3-12). A pioneer Egyptologist, Mariette was a man of great heart, intellect, and diverse talents. It was he who provided the composer Giuseppe Verdi with the scenario for the opera *Aida*, set in ancient Egypt. He pressed the Egyptians to establish the National Antiquities Scrvice to protect, preserve, and study the country's art monuments. In gratitude, they later placed a statue of him in the new Egyptian Museum in Cairo. At his death, his remains were brought back to his beloved Egypt for burial.

less formal than royal portraits. This statue was found in the tomb of a vizier (comparable to a prime minister) named Kai, and there is some evidence that *Seated Scribe* may be a portrait of Kai himself. The scribe's sedentary vocation has made his body soft and a little flabby. He sits holding a papyrus scroll partially unrolled on his lap, his right hand clasping a now-lost reed pen, and his face reveals a lively intelligence. Because the pupils are slightly off-center in the irises, the eyes give the illusion of being in motion, almost to be seeking eye contact. Other early Dynasty 5 statues found at Saqqara have a similar round head and face, alert expression, and cap of close-cropped hair.

TOMB DECORATION

To provide the *ka* with the most pleasant possible living quarters for eternity, wealthy families often had the interior walls and ceilings of their tombs decorated with paintings and reliefs (see "Egyptian Painting and Relief Sculpture," page 108). Much of this decoration was symbolic or religious, especially in royal tombs, but it could also include a wide variety of everyday scenes recounting momentous events in the life of the deceased or showing the deceased engaged in routine activities. Tombs therefore provide a wealth of information about ancient Egyptian culture.

A scene in the large mastaba of a Dynasty 5 government official named Ti—a commoner who had achieved great power at court and amassed sufficient wealth to build an elaborate home for his immortal spirit—shows him watching a hippopotamus hunt (fig. 3-16). The artists who created this painted limestone relief employed a number of established conventions. They depicted the river as if seen from above, rendering it as a band of parallel wavy lines below the boats. The creatures in the river, however—fish, a crocodile, and hippopotamuses—are shown in profile for easy identification. The shallow boats carrying Ti and his men skim along the surface of the water unhampered by the papyrus stalks, shown as parallel

EGYPTIAN PAINTING AND RELIEF SCULPTURE

Painting usually relies for its effect on color and line, and relief sculpture usually depends on the play of light and shadow alone—but in Egypt, relief sculpture was also painted. The walls and closely spaced columns of Egyptian tombs and temples provided large surfaces for decoration, and nearly every inch was adorned with colorful figural scenes and hieroglyphic texts. Up until Dynasty 18 (c. 1550–1295 BCE), the only colors used were black, white, red, yellow, blue, and green. They were never mixed. Modeling might be indicated by overpainting lines in a contrasting color but never by shading the basic color pigment. In time, more colors were added, but the primacy of line was never challenged. Compositionally, with very few exceptions, figures, scenes, and texts were presented in bands, or registers. Usually the base line at the bottom of each register represented the ground, but determining the sequence of images can be problematic because it could run horizontally or vertically.

The preliminary steps in the creation of paintings and relief carvings were virtually identical. Surfaces to be painted had to be smooth, so in some cases a coat of plaster was applied. The next step was to lay out the registers with painted lines and draw the appropriate grid (see fig. 3-6). In this remarkable photograph of a wall in the unfinished Dynasty 18 tomb of Horemheb in the Valley of the Kings, the red base lines and horizontals of the grid are clearly visible. The general shapes of the hieroglyphs have also been sketched in red. The preparatory drawings from which carvers worked were black. Egyptian artists worked in

teams, and each member had a particular skill. The sculptor who executed the carving on the right was following someone else's drawing. Had there been time to finish the tomb, other hands would have smoothed the surface of this limestone relief, and still others would have made fresh drawings to guide the artists assigned to paint it.

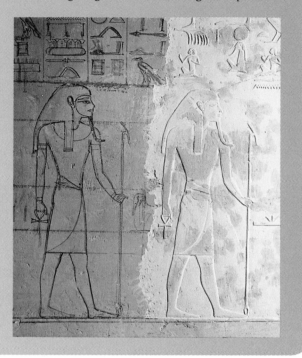

vertical lines, that choke the marshy edges of the river. At the top of the panel, where Egyptian convention often placed background scenes, several animals are seen stalking birds among the papyrus leaves and flowers. The erect figure of Ti, rendered in the traditional twisted pose, looms over this teeming Nile environment. The actual hunters, being of lesser rank and engaged in more strenuous activities, are rendered more realistically.

In Egyptian art, as in that of the ancient Near East, scenes showing a ruler hunting wild animals illustrated the power to maintain order and balance. By dynastic times, hunting had become primarily a showy pastime for the nobility. The hippopotamus hunt, however, was more than simple sport. Hippos tended to wander into fields, damaging crops, and killing them was an official duty of members of the court. Furthermore, it was believed that the companions of Seth, the god of darkness, disguised themselves as hippopotamuses. Tomb depictions of such hunts therefore illustrated not only the valor of the deceased but also the triumph of good over evil.

THE MIDDLE KINGDOM

The collapse of the Old Kingdom, with its long succession of kings ruling the whole of Egypt, was followed by roughly 150 years of political turmoil traditionally referred to as the First Intermediate period. About 2055 BCE, Mentuhotep II (Dynasty 11, ruled c. 2055–2004 BCE), from Thebes, finally reunited

the country. He and his successors reasserted royal power, but beginning with the next dynasty, about 1985 BCE, political authority became less centralized. Provincial governors claimed increasing powers for themselves, effectively limiting the king's responsibility to such national concerns as the defense of Egypt's frontiers. It was during the Middle Kingdom that Egypt's kings began maintaining standing armies to patrol the country's borders, especially its southern reaches in lower Nubia, south of modern Aswan.

Another royal responsibility was the planning and construction of large-scale water-management projects, though regional administrators and the farmers themselves supervised irrigation locally. In this period, Egypt's farmers enjoyed relatively liberal rights, even though they were required to turn over most of what they produced to the nobles or priests who owned the land they worked. Those who failed to meet prescribed annual yields were subject to harsh punishments.

ARCHITECTURE AND TOWN PLANNING

Although Egyptians used durable materials in the construction of tombs, they built their own dwellings with simple mud bricks, which have either disintegrated over time or been carried away by farmers as fertilizer, leaving only the foundations. Archaeologists have developed a map of the remains of Kahun, a town built by Senusret II

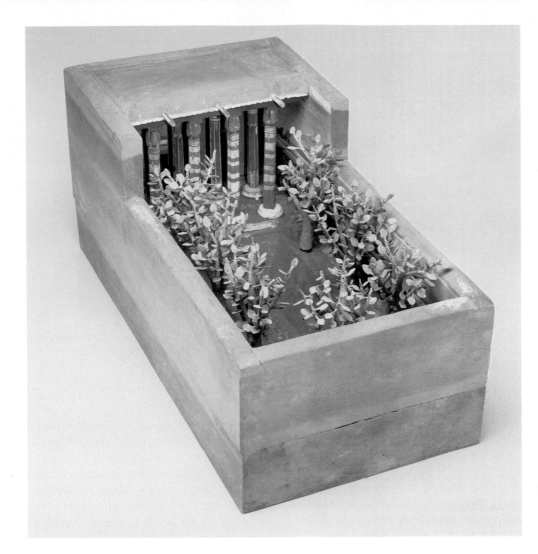

33-18. **Model of a house and garden**, from tomb of Meketra, Thebes. Dynasty 11, c. 2125–2055 BCE. Painted and plastered wood and copper, length 33" (87 cm). The Metropolitan Museum of Art, New York

Purchase, Rogers Fund and Edward S. Harkness Gift, 1920 (20.3.13)

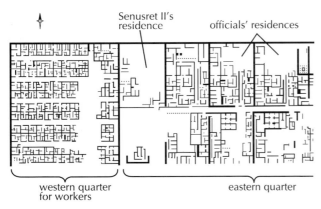

Senusret II's residence

officials' residences

western quarter for workers

eastern quarter

3-17. Plan of the northern section of Kahun, built during the reign of Senusret II near modern el-Lahun. Dynasty 12, c. 1880–1874 BCE

(Dynasty 12, ruled c. 1880–1874 BCE) for the many officials, priests, and workers in his court, that offers a unique view of the Middle Kingdom's social structure (fig. 3-17).

The town's design—streets laid out in a mainly east-west orientation, with rectangular blocks divided into lots for homes and other buildings—reflects three distinct economic and social levels. Appropriately, Senusret's own semifortified residence occupied the highest ground and fronted a large open square. The district to the east of his palace, connected to the square by a wide avenue, was occupied by priests, court officials, and their families. Their houses were large and comfortable, with private living quarters and public rooms grouped around central courtyards. The largest had as many as seventy rooms spread out over half an acre. Workers were housed in the western district, set off from the rest of the town by a solid wall. Their families made do with small, five-room row houses built back to back along narrow streets.

TOMB ART AND TOMB CONSTRUCTION

Tomb art reveals much about domestic life in the Middle Kingdom. Wall paintings, reliefs, and even small models of houses and farm buildings—complete with figurines of workers and animals—reproduce everyday scenes on the estates of the deceased. Many of these models survive because they were made of inexpensive materials of no interest to early grave robbers. One from Thebes, made of wood, plaster, and copper about 2125–2055 BCE, reproduces a portion of a house and garden (fig. 3-18). The flat-roofed structure opens into a walled garden through a **portico**, or columned porch, having columns with bound stems and stylized lotus flowers. The garden has a central pool flanked by sycamore trees. Although water was precious and only the wealthy could afford their own backyard source, some pools, lined with masonry and stocked with water lilies and fish, were so large that a small boat might be kept at the edge for fishing.

During Dynasties 11 and 12, members of the nobility and high-level officials frequently commissioned

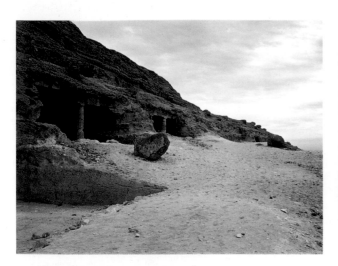

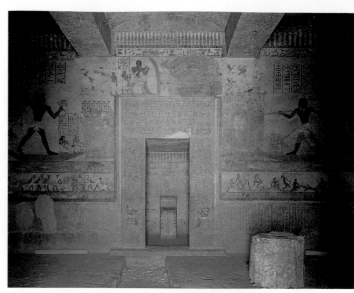

3-19. Rock-cut tombs, Beni Hasan. Dynasty 12, c. 1985–1795 BCE. At the left is the entrance to the tomb of a provincial governor and commander-in-chief

3-20. Interior of rock-cut tomb of Khnumhotep, Beni Hasan. Dynasty 12, c. 1985–1795 BCE

rock-cut tombs—burial places hollowed out of the faces of cliffs—such as those in the necropolis at Beni Hasan on the east bank of the Nile. The various chambers of such tombs and their ornamental columns, lintels, false doors, and niches were all carved out of solid rock (fig. 3-19). Each one was therefore like a single, complex piece of sculpture, attesting to the great skill of its designers and carvers. A typical Beni Hasan tomb included an entrance portico, a main hall, and a shrine with a burial chamber under the offering chapel. Rock-cut tombs at other spots along the Nile exhibit variations on this simple plan. The walls of rock-cut tombs were commonly painted.

In the Dynasty 12 tomb of the local lord Khnumhotep at Beni Hasan, a statue of the deceased once stood in the central niche of the shrine in the rear wall. Among the well-preserved paintings are some spirited depictions of

life on his farms (fig. 3-20). Paintings on the walls at each side of the opening show Khnumhotep, in a boat in the marshes, hunting birds and spearing fish. Above the door, he traps birds in a net. Smaller figures of his sons and his servants assist him. The composition is symmetrical, with panels of figures and inscriptions laid out on a horizontal-vertical grid focused on the niche with its *ka* statue. Originally, the opening would have been closed off by wooden doors. In the outer room, funeral rites and the ongoing cult rituals for Khnumhotep were performed. Representations of these activities on the tomb walls ensured their continuance for all time.

Likewise, funeral offerings represented in statues and paintings would be available for the deceased's use through eternity. On a funeral **stele** of Amenemhat I (fig. 3-21), a table heaped with food is watched over by a

3-21. Funerary Stele of Amenemhat I, from Assasif. Dynasty 11, 2055–1985 BCE. Painted limestone, 11 x 15" (30 x 50 cm). Egyptian Museum, Cairo. The Metropolitan Museum of Art, New York Excavation 1915-16

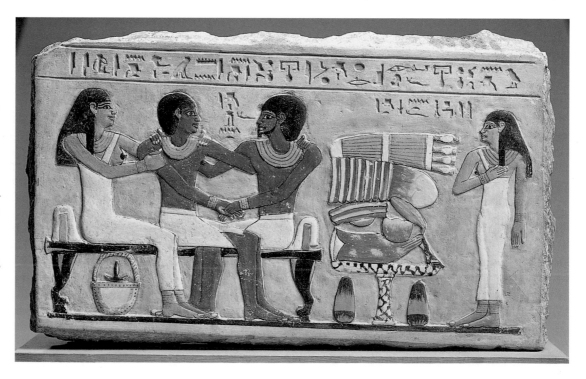

HIERO-GLYPHIC, HIERATIC, AND DEMOTIC WRITING

Ancient Egyptians developed three types of writing that are known today by the names the Greeks gave them.

The earliest system the Egyptians used for inscriptions employed a large number of symbols called hieroglyphs (from the Greek *hieros*, "sacred," and *glyphein*, "to carve"). As their name suggests, the Greeks believed they had religious significance. Some of these symbols were simple pictures of creatures or objects, or pictographs, similar to those used by the Sumerians (Chapter 2). Others were phonograms, or signs representing spoken sounds.

For record keeping, correspondence, and manuscripts of all sorts, the earliest scribes must also have used this system of signs. In time, however, they developed a simplified version of hieroglyphs that could be written more quickly in lines of script on papyrus scrolls. This type of writing is called hieratic, another term derived from the Greek word for "sacred." Even after this script was perfected, inscriptions in reliefs or paintings and on ceremonial objects continued to be written in hieroglyphics.

The third type of writing came into use only in the eighth century BCE, as written communication ceased to be restricted to priests and scribes. It was a simplified, cursive form of hieratic writing that was less formal and easier to master; the Greeks referred to it as demotic writing (from demos, "the people"). From this time on, all three systems were in use, each for its own specific purpose: religious documents were written in hieratic, inscriptions on monuments in hieroglyphics, and all other texts in demotic script.

The Egyptian language gradually died out after centuries of foreign rule, beginning with the arrival of the Greeks in 332 BCE. Modern scholars therefore had to decipher three types of writing in a long-forgotten language. The key was a fragment of a stone stele, dated 196 BCE, which was called the Rosetta Stone for the area of the delta where one of Napoleon's officers discovered it in 1799 CE. On it, a decree issued by the priests at Memphis honoring Ptolemy V (ruled c. 205–180 BCE) had been carved in hieroglyphics, demotic, and Greek. Even with the Greek translation, the two Egyptian texts were incomprehensible until 1818, when Thomas Young, an English physician interested in ancient Egypt, linked some of the hieroglyphs to specific names in the Greek version. A short time later, French scholar Jean-François Champollion located the names Ptolemy and Cleopatra in both of the Egyptian scripts. Having thereby determined the phonetic symbols for P, T, O, and L in demotic, he was able to slowly build up an "alphabet" of hieroglyphs, and by 1822 he had deciphered the two Egyptian texts. Thanks to him, Egyptologists are able to read ancient Egyptian documents and inscriptions as they come to light.

The Rosetta Stone with its three tiers of writing, from top to bottom: hieroglyphic, demotic, and Greek. The British Museum, London

Hieroglyphic signs for the letters P, T, O, and L, which were Champollion's clues to deciphering the Rosetta Stone, plus M, Y, and S: Ptolmys.

3-22. *Face of King Senusret III*. Dynasty 12, 1874–1855 BCE. Red quartzite, height 6½" (16.5 cm). The Metropolitan Museum of Art, New York

Purchase, Edward S. Harkness Gift, 1926 (26.7.1394)

young woman named Hapi. The family sits together on a lion-legged bench. Everyone wears green jewelry and white linen garments, produced by Amenemhat's wife Queen Iji and Hapi (see "The Fiber Arts," page 86). Amenemhat I (at the right) and his son Antel link arms and clasp hands while Iji holds her son's arm and shoulder with a firm but tender gesture. The **hieroglyphs**, or symbols, identify everyone and preserve their prayers to the god Osiris (see "Hieroglyphic, Hieratic, and Demotic Writing," page 111).

SCULPTURE

Royal portraits are less intimate than nonofficial portraits. Nevertheless, portraits from the Middle Kingdom do not always exhibit the idealized rigidity of earlier examples. Some express a special awareness of the hardship and fragility of human existence. A statue of Senusret III (Dynasty 12, ruled c. 1874–1855 BCE) reflects this new sensibility (fig. 3-22). Senusret was a dynamic king and successful general who led four military expeditions into Nubia, overhauled the central administration at home, and did much toward regaining control over the country's increasingly independent nobles. His portrait statue seems to reflect not only his achievements but also something of his personality and his inner thoughts.

He appears to be a man wise in the ways of the world but lonely, saddened, and burdened by the weight of his responsibilities.

Old Kingdom figures such as *Khafra* (see fig. 3-12) gaze into eternity confident and serene, whereas *Senusret III* shows a monarch preoccupied and emotionally drained. Deep creases line his sagging cheeks, his eyes are sunken, his eyelids droop, and his jaw is sternly set. Intended or not, this image betrays a pessimistic view of life, a degree of distrust similar to that reflected in the advice given by Amenemhat I, this Senusret's great-great-grandfather and the founder of his dynasty, to his son Senusret I (cited in Breasted, page 231):

> Fill not thy heart with a brother,
> Know not a friend,
> Nor make for thyself intimates, . . .
> When thou sleepest, guard for thyself thine own
> heart;
> For a man has no people [supporters],
> In the day of evil.

SMALL OBJECTS FOUND IN TOMBS

Middle Kingdom art of all kinds and in all mediums, from official portrait statues such as that of Senusret III to the least-imposing symbolic objects and delicate bits of jewelry, exhibits the desire of the period's artists for well-observed, accurate detail. A hippopotamus figurine discovered in the Dynasty 12 tomb of a governor named Senbi, for example, has all the characteristics of the beast itself: the rotund body on stubby legs, the massive head with protruding eyes, the tiny ears and distinctive nostrils (fig. 3-23). The figurine is an example of Egyptian **faience**, with its distinctive lustrous glaze (see "Glass-making and Egyptian Faience," page 122). The artist made the hippo the watery blue of its river habitat, then painted lotus blossoms on its flanks, jaws, and head, giving the impression that the creature is standing in a tangle of aquatic plants. Such figures were often placed in tombs so that the deceased might engage in an eternal hippopotamus hunt, enjoying the sense of moral triumph that entailed (see the discussion of *Ti Watching a Hippopotamus Hunt*, fig. 3-16).

The simple beauty of this faience hippopotamus contrasts sharply with the intricate splendor of a pectoral, or chest ornament, found at el-Lahun (fig. 3-24). Executed in gold and inlaid with semiprecious stones, it was discovered in the funerary complex of Senusret II, in the tomb of the king's daughter Sithathoryunet. The pectoral's design incorporates the name of Senusret II and a number of familiar symbols. Two Horus falcons perch on its base, and above their heads is a pair of coiled cobras, symbols of Ra, wearing the *ankh*, the symbol of life. Between the two cobras, a **cartouche**—an oval formed by a loop of rope—contains the hieroglyphs of the king's name. The sun disk of Ra appears at the top, and a scarab beetle, another symbol of Ra suggestive of rebirth, is at the bottom. Below the cartouche, a kneeling male figure helps the falcons support a double arch of notched palm ribs, a hieroglyphic

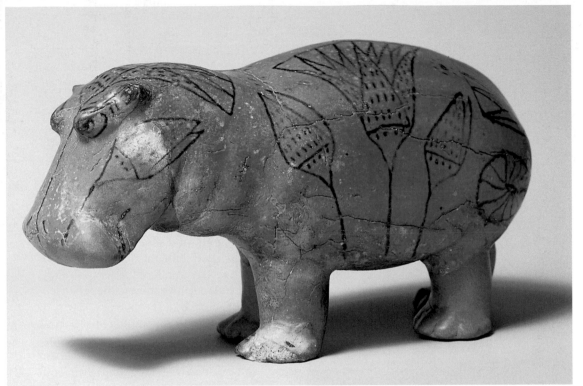

3-23. Hippopotamus, from the tomb of Senbi (Tomb B.3), Meir. Dynasty 12, c. 1985–1795 BCE. Faience, length 7⅞" (20 cm). The Metropolitan Museum of Art, New York

Gift of Edward S. Harkness, 1917 (17.9.1)

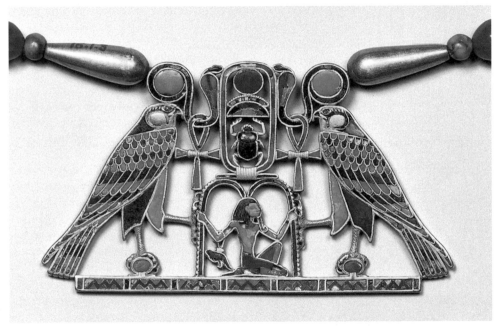

3-24. Pectoral of Senusret II, from the tomb of Princess Sithathoryunet, el-Lahun. Dynasty 12, c. 1880–1874 BCE. Gold and semiprecious stones, length 3¼" (8.2 cm). The Metropolitan Museum of Art, New York

Purchase, Rogers Fund and Henry Walters Gift, 1916 (16.1.3)

symbol meaning "millions of years." Decoded, the pectoral's combination of images yields the message: "May the sun god give eternal life to Senusret II."

THE NEW KINGDOM During the Second Intermediate period—another turbulent interruption in the succession of dynasties ruling a unified country—an eastern Mediterranean people called the Hyksos invaded Egypt's northernmost regions. Finally, during Dynasty 18 (c. 1550–1295), the early rulers of the New Kingdom (c. 1550–1069 BCE) regained control of the entire Nile region from Nubia in the south to the Mediterranean in the north, restoring the country's political and economic strength. Roughly a century later, one of the same dynasty's most dynamic

kings, Thutmose III (ruled c. 1479–1425 BCE), extended Egypt's influence along the eastern Mediterranean coast as far as the region of modern Syria. His accomplishment was the result of fifteen or more military campaigns and his own skill at diplomacy. Thutmose III was the first ruler to refer to himself as "pharaoh," a term that simply meant "great house." Egyptians used it in the same way that people say "the White House" to mean the current United States president. The successors of Thutmose III continued to use the term, and it ultimately found its way into the Hebrew Bible—and modern usage—as the name for the kings of Egypt.

By the beginning of the fourteenth century BCE, the most powerful Near Eastern kings acknowledged the rulers of Egypt as their equals. Marriages contracted

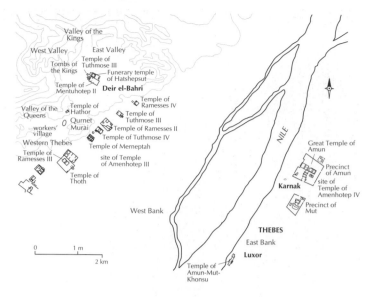

3-25. Map of the Thebes district

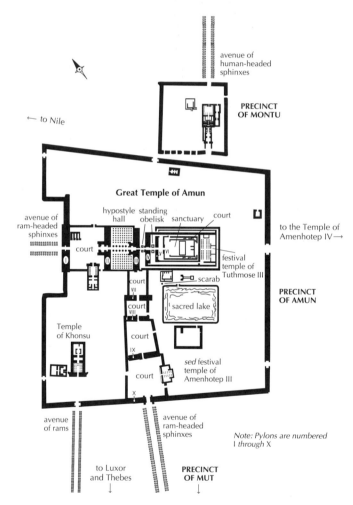

3-26. Plan of the Great Temple of Amun, Karnak. New Kingdom, c. 1295–1186 BCE

The Karnak site had been an active religious center for more than 2,000 years before these structures were erected on it. Over the nearly 500 years of the New Kingdom, successive kings busily renovated and expanded the Amun temple. Later rulers added pylons, courtyards, hypostyle halls, statues, and temples or shrines to other deities to the east, west, and south of the main temple until the complex covered about 60 acres, an area as large as a dozen football fields. In this ongoing process, it was common to demolish older structures and use their materials in new construction.

between Egypt's ruling families and Near Eastern royalty helped to forge a generally cooperative network of kingdoms in the region, stimulating trade and securing mutual aid at times of natural disaster and outside threats to established borders. Over time, however, Egyptian influence beyond the Nile diminished, and the power of Egypt's kings began to wane.

GREAT TEMPLE COMPLEXES

At the height of the New Kingdom, rulers undertook extensive building programs along the entire length of the Nile. Their palaces, forts, and administrative centers disappeared long ago, but remnants of temples and tombs of this great age have endured. Even as ruins, Egyptian architecture and sculpture attest to the expanded powers and political triumphs of the builders. Early in this period, the priests of the god Amun in Thebes, Egypt's capital city through most of the New Kingdom, had gained such dominance that worship of the Theban triad of deities—Amun, his wife Mut, and their son Khons—had spread throughout the country. Temples to these and other gods were a major focus of royal art patronage, as were tombs and temples erected to glorify the kings themselves.

Temples to the Gods at Karnak and Luxor. Two temple districts consecrated primarily to the worship of Amun, Mut, and Khons arose near Thebes—one at Karnak to the north and the other at Luxor to the south (fig. 3-25). Little of the earliest construction at Karnak survives, but the remains of New Kingdom additions to the Great Temple of Amun still dominate the landscape (fig. 3-26). Access to the heart of the temple, a sanctuary containing the statue of Amun, was through a principal courtyard, a **hypostyle hall**—a vast hall filled with columns—and a number of smaller halls and courts. Massive gateways, called **pylons**, set off each of these separate elements. The greater part of Pylons II through VI and the areas behind them were renovated or newly built and embellished with colorful wall reliefs between the reigns of Thutmose I (Dynasty 18, ruled c. 1504–1492 BCE) and Rameses II (Dynasty 19, ruled c. 1279–1213 BCE). A sacred lake to the south of the temple, where the king and priests might undergo ritual purification before entering the temple, was also added during this period. Behind the sanctuary of Amun, Thutmose III erected a court and festival temple to his own glory. Amenhotep III (Dynasty 18, ruled 1390–1352 BCE) later placed a large stone statue of Khepri, the scarab beetle symbolic of the rising sun and everlasting life, next to the sacred lake.

Only kings and priests were allowed to enter the sanctuary of Amun. The priests washed the god's statue every morning and clothed it in a new garment. Twice a day, they provided it with tempting meals. The god was thought to derive nourishment from the spirit of the food, which the priests then removed and ate themselves. Ordinary people entered only as far as the forecourts of the hypostyle halls, where they found themselves surrounded by inscriptions and images of kings and the god on columns and walls. During religious festivals, however,

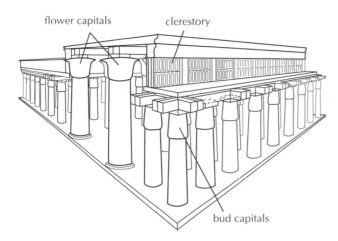

flower capitals clerestory

bud capitals

3-27. Reconstruction drawing of the hypostyle hall, Great Temple of Amun, Karnak. Dynasty 19, c. 1295–1186 BCE

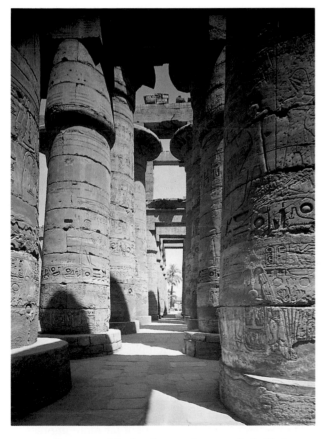

3-28. Flower and bud columns, hypostyle hall, Great Temple of Amun, Karnak

they lined the waterways along which statues of the gods were carried in ceremonial boats. At such times they were permitted to submit petitions to the priests for requests they wished the gods to grant.

Between Pylons II and III at Karnak stands the enormous hypostyle hall erected in the reigns of the Dynasty 19 rulers Sety I (ruled c. 1294–1279 BCE) and his son Rameses II (ruled c. 1279–1213 BCE). Called the "Temple of the Spirit of Sety, Beloved of Ptah in the House of Amun," it may have been used for royal coronation ceremonies. Rameses II referred to it in more mundane

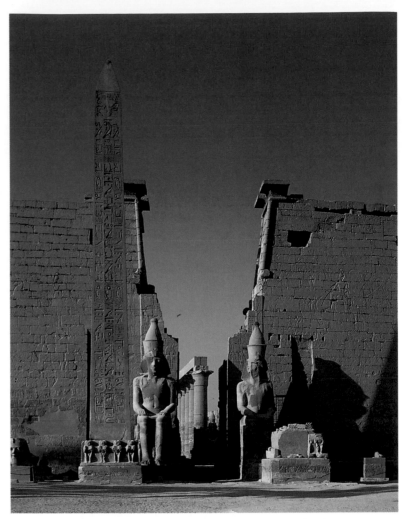

3-29. Pylon of Rameses II with obelisk in the foreground, Temple of Amun, Mut, and Khons, Luxor. Dynasty 19, c. 1279–1213 BCE

terms as "the place where the common people extol the name of his majesty." The hall was 340 feet wide and 170 feet long. Its 134 closely spaced columns supported a stepped roof of flat stones, the center section of which rose some 30 feet higher than the rest (figs. 3-27, 3-28). The columns supporting this higher part of the roof are 66 feet tall and 12 feet in diameter, with massive lotus flower capitals. The smaller columns on each side have lotus bud capitals that must have seemed to march off forever into the darkness.

In each of the side walls of the higher center section was a long row of window openings, creating what is known as a **clerestory**. These openings were filled with stone grillwork, so they cannot have provided much light, but they did permit a cooling flow of air through the hall. Despite the dimness of the interior, artists were required to cover nearly every inch of the columns, walls, and cross-beams with reliefs.

The sacred district at Luxor was already the site of a splendid temple complex by the thirteenth century BCE. Rameses II further enlarged the complex with the addition of a pylon and a **peristyle court**, or open courtyard ringed with columns and covered walkways (fig. 3-29). In front of his pylon stood two colossal statues of the king and a pair of **obelisks**—slender, slightly tapered square shafts of stone capped by a pyramid-

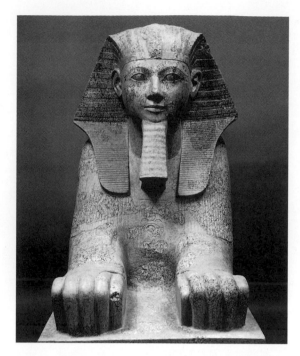

3-30. *Hatshepsut as Sphinx*, from Deir el-Bahri. Dynasty 18, c. 1473–1458 BCE. Red granite, height 5'4" (1.64 m). The Metropolitan Museum of Art, New York

Rogers Fund, 1931 (31.3.166)

Of the Egyptian queens who went down in history as "living gods" themselves and not merely "wives of gods," Hatshepsut may well have been the most commanding. Among the reliefs in her funerary temple at Deir el-Bahri (see fig. 3-31), she placed—just as a male king might have—a depiction of her divine birth. There she is portrayed as the daughter of her earthly mother, Queen Ahmose, and the god Amun. She also honored her real father, Thutmose I, by dedicating a chapel to him in her temple.

shaped block called a **pyramidion**. The faces of the pylon are ornamented with reliefs detailing the king's military exploits. The walls of the courtyard present additional reliefs of Rameses, shown together with various deities, his wife, seventeen of his sons, and other royal children, some hundred of whom he had by eight official wives and numerous concubines during his sixty-seven-year reign.

Temples for Rulers: Hatshepsut and Rameses II. The dynamic female ruler Hatshepsut (Dynasty 18, ruled c. 1473–1458 BCE) is a notable figure in a period otherwise dominated by male warrior-kings. Besides Hatshepsut, three other queens ruled Egypt—the little-known Sobekneferu and Tusret, and, much later, the notorious Cleopatra. The daughter of Thutmose I, Hatshepsut married her half brother, who then reigned for fourteen years as Thutmose II. When he died, she became regent for his underage son—Thutmose III—born to one of his concubines. Hatshepsut had herself declared king by the priests of Amun, a maneuver that prevented Thutmose III from assuming the throne for twenty years. In art, she

was represented in all the ways a male ruler would have been, even as a human-headed sphinx (fig. 3-30), and she was called "His Majesty." Sculpted portraits show her in the traditional royal trappings: kilt, linen head-cloth, broad beaded collar, false beard, and bull's tail hanging from her waist.

Hatshepsut's closest adviser, a courtier named Senenmut, was instrumental in carrying out her ambitious building program. Her most innovative undertaking was her own funerary temple at Deir el-Bahri (fig. 3-31). The structure was not intended to be her tomb; Hatshepsut was to be buried, like other New Kingdom rulers, in a necropolis known as the Valley of the Kings, about half a mile to the northwest (see fig. 3-25). Her funerary temple was magnificently positioned against high cliffs and oriented toward the Great Temple of Amun at Karnak, some miles away on the east bank of the Nile. The complex follows an **axial** plan—that is, all of its separate elements are symmetrically arranged along a dominant center line (fig. 3-32). A causeway lined with sphinxes once ran from a valley temple on the Nile, since destroyed, to the first level of the complex, a huge open space before a long row of columns, or **colonnade**. From there, visitors ascended a long, straight ramp flanked by pools of water to the second level. At the ends of the columned porticos on this level were shrines to Anubis and Hathor. Relief scenes and inscriptions in the south portico depict Hatshepsut's expedition to Punt, an exotic, half-legendary kingdom probably located on the Red Sea or the Gulf of Aden, to bring back rare myrrh trees for the temple's terraces. The uppermost level of the temple consisted of another colonnade fronted by colossal royal statues, and behind this a large hypostyle hall with chapels dedicated to Hatshepsut, her father, and the gods Amun and Ra-Horakhty—the power of the sun at dawn and dusk. Centered in the hall's back wall was the entrance to the temple's innermost sanctuary. This small chamber was cut deep into the cliff in the manner of Middle Kingdom rock-cut tombs.

Hatshepsut's funerary temple, with its lively alternating of open spaces and grandiose architectural forms, projects an imposing image of authority. In its day, its remarkable union of nature and architecture, with many different levels and contrasting textures—water, stone columns, trees, and cliffs—made it far more impressive than the bleak expanse of stone ruins and sand that confronts the visitor today.

Under Rameses II (Dynasty 19, ruled c. 1279–1213 BCE) Egypt became a mighty empire. Rameses was a bold military commander and an effective political strategist. In about 1259 BCE, he secured a peace agreement with the Hittites, a rival power centered in Anatolia (Chapter 2) that had tried to expand its borders to the west and south at the Egyptians' expense. He twice reaffirmed that agreement later in his reign by marrying Hittite princesses.

In the course of his long and prosperous reign, Rameses II initiated building projects on a scale rivaling the Old Kingdom pyramids at Giza (figs. 3-33, 3-34, 3-35, in "The Object Speaks"). The most awe-inspiring of his

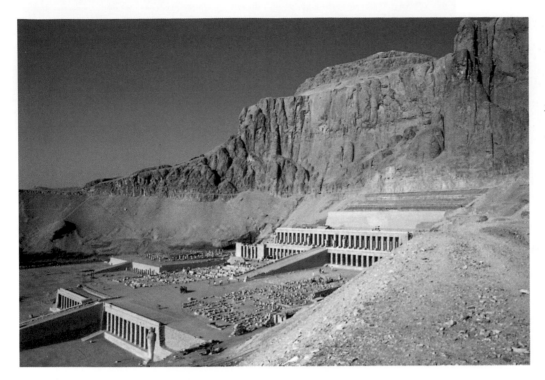

3-31. Funerary temple of Hatshepsut, Deir el-Bahri. Dynasty 18, c. 1473–1458 BCE.

At the far left, ramp and base of the funerary temple of Mentuhotep III. Dynasty 11, c. 2004–1992 BCE

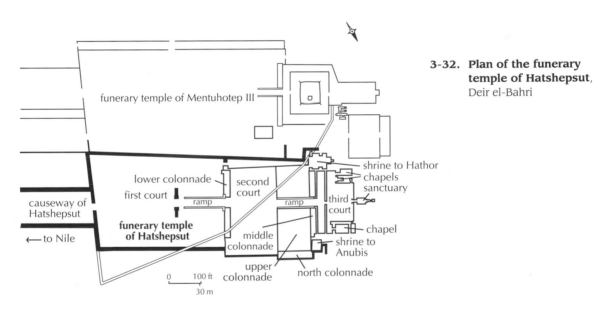

3-32. Plan of the funerary temple of Hatshepsut, Deir el-Bahri

funerary temple of Mentuhotep III

lower colonnade

first court

second court

causeway of Hatshepsut

ramp

← to Nile

funerary temple of Hatshepsut

middle colonnade

upper colonnade

ramp

third court

north colonnade

shrine to Hathor
chapels
sanctuary

chapel

shrine to Anubis

0 100 ft

30 m

many architectural monuments is found at Abu Simbel in Nubia, Egypt's southernmost region. There Rameses ordered the construction of two temples, a large one to himself and a smaller one to his chief wife, Nefertari. They were carved out of the face of a cliff in the manner of a rock-cut tomb but far surpass earlier temples created in this way. The dominant feature of Rameses' temple is a row of four colossal seated statues of the king himself, each more than 65 feet tall. Large figures of Nefertari and other family members stand next to his feet, but they do not even reach the height of the king's giant stone knees. The interior of the temple stretches back some 160 feet and was oriented in such a way that on the most important day of the Egyptian calendar the first rays of the rising sun shot through its entire depth to illuminate a row of four statues—the king and the gods Amun, Ptah, and Ra-Horakhty—placed against the back wall. The front of the smaller nearby temple to Nefertari is adorned with six statues 33 feet tall, two of the queen wearing the headdress of Hathor, and four of her husband, Rameses II.

AKHENATEN AND THE ART OF THE AMARNA PERIOD

The most unusual ruler in the history of ancient Egypt was Amenhotep IV, who came to the throne about 1352 BCE (Dynasty 18). In his seventeen-year reign, he radically transformed the political, spiritual, and cultural life of the

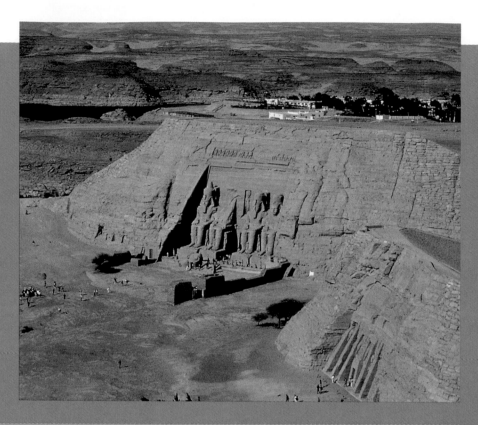

3-33. Temples of Rameses II (left) **and Nefertari** (right), **Abu Simbel**. Dynasty 19, c. 1279–1213 BCE

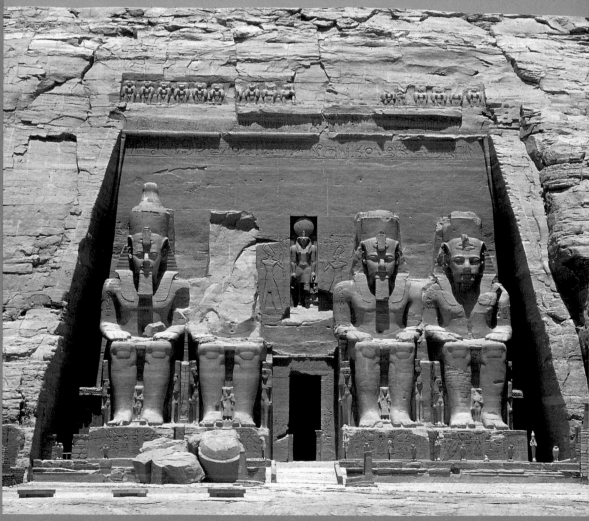

3-34. Temple of Rameses II, Abu Simbel. Dynasty 19, c. 1279–1213 BCE

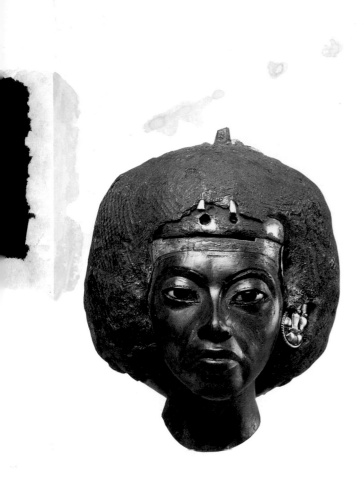

3-37. *Queen Tiy*, from Kom Medinet el-Ghurab (near el-Lahun). Dynasty 18, c. 1352 BCE. Yew, ebony, glass, silver, gold, lapis lazuli, cloth, clay, and wax, height 3³/₄" (9.4 cm). Staatliche Museen zu Berlin, Preussischer Kulturbesitz, Ägyptisches Museum

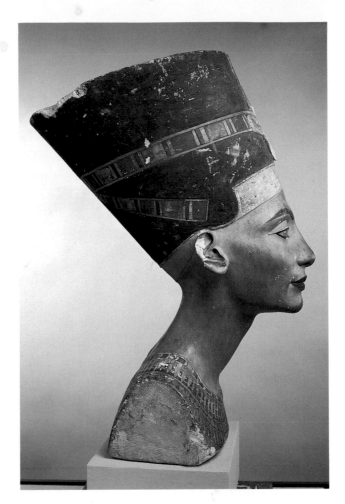

3-38. *Nefertiti*, from Akhetaten (modern Tell el-Amarna). Dynasty 18, c. 1352–1336 BCE. Painted limestone, height 20" (51 cm). Staatliche Museen zu Berlin, Preussischer Kulturbesitz, Ägyptisches Museum

This famous head was discovered, along with various drawings and other items relating to commissions for the royal family, in the studio of the sculptor Thutmose at Akhetaten, the capital city during the Amarna period. Bust portraits, consisting solely of the head and shoulders, were rare in New Kingdom art. Scholars believe that Thutmose may have made this one as a finished model to follow in sculpting or painting other images of his patron. From depictions of sculptors at work, we know that some statues were made in parts and then assembled, but there is no indication that this head was meant to be attached to a body.

silver headdress covered with gold cobras and gold jewelry. Later, when her son had come to power and established his new solar religion, the portrait was altered. A brown cap covered with glass beads was placed over the funeral headdress. A plumed crown, perhaps similar to the one worn by Nefertari (see fig. 3-42), rose above the cap (the attachment is still visible). The entire sculpture would have been about one-third lifesize.

Tiy's portrait contrasts sharply with a head of Nefertiti in which her refined, regular features, long neck, and heavy-lidded eyes appear almost too perfect to be real (fig. 3-38). Part of the beauty of this head is the result of the artist's dramatic use of color. The hues of the blue headdress and its colorful band are repeated in the rich red, blue, green, and gold of the jewelry. The queen's brows, eyelids, cheeks, and lips are heightened with color, as they no doubt were with cosmetics in real life. Whether or not Nefertiti's beauty is exaggerated, phrases used by her subjects when referring to her—"Fair of Face," "Mistress of Happiness," "Great of Love," or "Endowed with Favors"—tend to support the artist's vision.

Glassmaking also flourished in the Amarna period. The craft could only be practiced by artists working for the king, and Akhenaten's new capital had its own glass-making workshops. A fish-shaped bottle produced there was meant to hold scented oil (fig. 3-39). It is an example

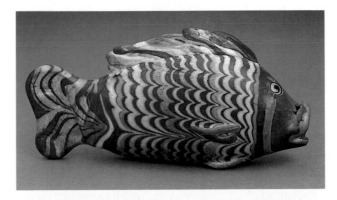

3-39. **Fish-shaped bottle**, from Akhetaten (modern Tell el-Amarna). Dynasty 18, c. 1352–1336 BCE. Core glass, length 5¹/₈" (13 cm). The British Museum, London

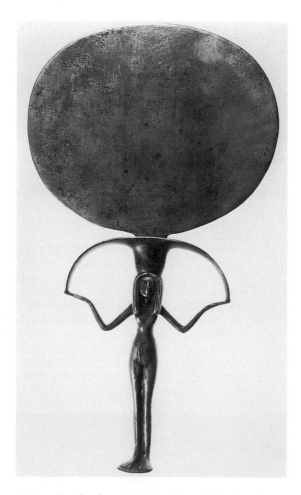

3-40. Hand mirror. Dynasty 18, c. 1550–1295 BCE. Bronze, height 9³⁄₄" (24.6 cm). The Brooklyn Museum

Charles Edwin Wilbour Fund (37.365E)

scales, created by heating small rods of white and orange glass to the point that they fused to the body and could be manipulated with a pointed tool. The fish that lent its shape to the bottle has been identified as a bolti, a species that carries its eggs in its mouth and spits out its offspring when they hatch. It was therefore a common symbol for birth and regeneration, especially the sort of self-generation that Akhenaten attributed to the sun disk Aten.

Domestic objects routinely placed in tombs as grave goods often had similar symbolic significance. One such item is a hand mirror, less than 10 inches tall, discovered in a Dynasty 18 tomb (fig. 3-40). Its handle is formed by the figure of a slender young woman, probably a dancer, balancing a giant lotus blossom on her head. Her arms reach out to support the flower's elongated sepals, forming with them a highly decorative shape. The mirror itself is a metal disk polished to a high gloss to create a reflecting surface. On one level, the young woman can be thought of as an attendant obediently holding the mirror for the person wishing to gaze in it. But she might also be interpreted as a fertility goddess supporting the sun disk. This elegant luxury item could have been placed in the tomb to symbolize the blessings of Aten and the hope that the deceased would live eternally in peace.

THE RETURN TO TRADITION

Akhenaten's new religion and revolutionary ideas regarding the conduct appropriate for royalty outlived him by only a few years. His successors—it is not clear how they were related to him—had brief and troubled reigns, and the priesthood of Amun quickly regained its former power. The young king Tutankhaten (Dynasty 18, ruled c. 1336–1327 BCE) returned to traditional religious beliefs, changing his name to Tutankhamun. He also turned his back on Akhenaten's new city and moved his court to Thebes.

The Royal Tombs of Tutankhamun and Nefertari.

Tutankhamun died quite young and was buried in the Valley of the Kings. Remarkably, although early looters did rob

of what is known as core glass, which refers to the early technique used in its manufacture (see "Glassmaking and Egyptian Faience," above). Its body was created from glass tinted with cobalt, a dark blue metallic oxide. The surface was then decorated with swags resembling fish

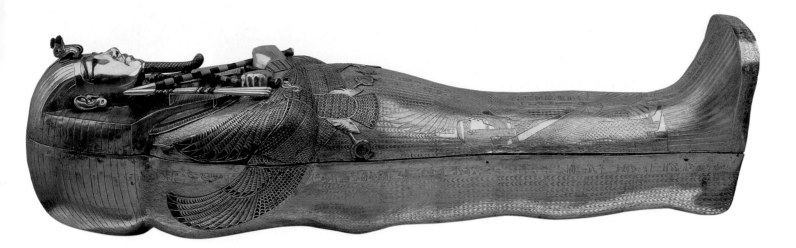

3-41. Inner coffin of Tutankhamun's sarcophagus, from the tomb of Tutankhamun, Valley of the Kings, near Deir el-Bahri. Dynasty 18, c. 1336–1327 BCE. Gold inlaid with glass and semiprecious stones, height 6' ⁷/₈" (1.85 m). Egyptian Museum, Cairo

The English archaeologist Howard Carter had worked in Egypt for more than twenty years before he undertook a last expedition, sponsored by the wealthy British amateur Egyptologist Lord Carnarvon, after World War I. In November 1922 Carter discovered the entrance to the tomb of King Tutankhamun, the only Dynasty 18 royal burial place then still unidentified. His workers cleared their way down to its antechamber, which was found to contain unbelievable treasures: jewelry, textiles, gold-covered furniture, a carved and inlaid throne, four gold chariots, and other precious objects. In February 1923, they pierced through the wall separating the anteroom from the actual burial chamber, and in early January of the following year—having taken great care to catalog all the intervening riches and prepare for their safe removal—they finally reached the king's astonishing sarcophagus. Figure 3-1 shows Tutankhamun's funerary mask as it was first photographed in October 1925.

the tomb complex, his sealed inner tomb chamber was never plundered, and when it was opened in the 1920s its incredible riches were discovered just as they had been left. His body lay inside three nested coffins that identified him with Osiris, the god of the dead. The innermost coffin, in the shape of a mummy, is the richest of the three, for it is made of several hundred pounds of solid gold (fig. 3-41). Its surface is decorated with colored glass and semiprecious gemstones, as well as finely incised linear designs and hieroglyphic inscriptions. The king holds a crook and a flail—an implement used in threshing grain. Both symbols were closely associated with Osiris and were a traditional part of the royal regalia at the time. The king's features as reproduced on the coffin are those of a very young man. Even though they may not reflect Tutankhamun's actual appearance, the unusually full lips and thin-bridged nose hint at the continued influence of the Amarna period style and its dedication to actual appearances.

By royal standards, Tutankhamun's tomb was small and simply decorated. One of the most lavish tombs to be discovered so far is that of Nefertari, the principal wife of Rameses II. In one of the tomb's many beautiful, large-figured wall paintings, Nefertari offers jars of per-fumed ointment to the goddess Isis (fig. 3-42). The queen wears the vulture-skin headdress of royalty, a royal collar, and a long, semitransparent white linen gown. Isis, seated on her throne behind a table heaped with offerings, holds a long scepter in her left hand, the

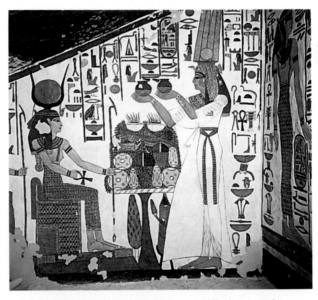

3-42. Queen Nefertari Making an Offering to Isis, wall painting in the tomb of Nefertari, Valley of the Queens, near Deir el-Bahri. Dynasty 19, c. 1279–1213 BCE

RESTORING THE TOMB OF NEFERTARI The tomb of Queen Nefertari, wife of Rameses II (Dynasty 19, ruled c. 1279–1213 BCE), was discovered in the Valley of the Queens, near Deir el-Bahri, in 1904 CE. Although it had been looted of everything that could be carried away, it still had splendid wall paintings of the deceased queen in the company of the gods (see fig. 3-42).

Egypt's dry climate and the care with which most tombs were sealed ensured that many such paintings remained in excellent condition for thousands of years, but the ones in Nefertari's tomb began to deteriorate soon after they were completed. Conservators have theorized that the walls were left damp when priests sealed the tomb, so that salts from the plaster leached to the surface, loosening the layer of pigment over time and causing it to flake. The dampness also allowed fungi to attack the paint. Disintegration accelerated dramatically when the tomb was opened to visitors. The crowds brought with them humidity, dirt, and bacteria, causing such damage by 1940 that the tomb was closed to the public.

In 1968, the Egyptian National Antiquities Service and the Getty Conservation Institute in Santa Monica, California, undertook a multimillion-dollar conservation project to save the tomb's decorations. Painting restorers Paolo and Laura Mora were commissioned to supervise a team of Italian and Egyptian conservators. Their first priority was to stop the paint from flaking and the plaster from crumbling any further. Over the course of a year, their crew applied more than 10,000 "bandages" made of Japanese mulberry-pulp paper to the tomb's interior surfaces.

Once the paint and plaster had been stabilized, the restorers could begin their real work. Their goal was to salvage every flake of paint they could from these 3,000-year-old works. They carefully cleaned the paintings with cotton swabs dipped in distilled water. Using hypodermic needles and a special resin glue, they were able to reattach small spots of loose plaster or pigment. Larger detached areas were removed whole, cleaned, then glued back in place. In the past, conservators commonly recreated and replaced lost sections with conjectural painting of their

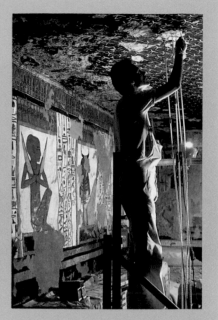

Getty Conservation Institute conservator S. Rickerby at work in Chamber K, tomb of Nefertari, Valley of the Queens, near Deir el-Bahri

own, but restorers today prefer simply to make such gaps less obvious by shading them in tones matched to adjacent work. This was the procedure used in Nefertari's tomb.

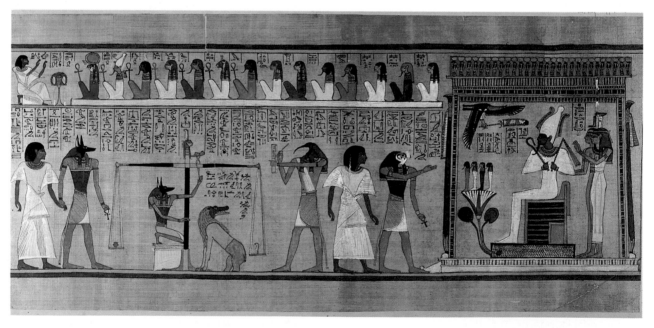

3-43. *Judgment before Osiris*, illustration from a Book of the Dead. Dynasty 19, c. 1285 BCE. Painted papyrus, height 15⅝" (39.8 cm). The British Museum, London

Osiris, the god of the underworld, appears on the right, enthroned in a richly ornamented pavilion, or chapel, in the "Hall of the Two Truths." Here the souls of the deceased were thought to be subjected to a "last judgment" to determine whether they were worthy of eternal life. Osiris was traditionally depicted as a mummified man wrapped in a white linen shroud. His other trappings are those of an Egyptian king. He wears the double crown, incorporating those of both Upper and Lower Egypt, a false beard, and a wide beaded collar, and he brandishes the symbolic crook and flail in front of his chest. The figure in the center combining a man's body with the head of an ibis, a wading bird related to the heron, is the god Thoth. He here functions as a sort of court stenographer—appropriately, for he was revered as the inventor of hieroglyphic writing.

ankh in her right. She too wears the vulture headdress, but hers is surmounted by the horns of Hathor framing a sun disk, clear indications of her divinity. The artists responsible for decorating the tomb, in the Valley of the Queens near Deir el-Bahri, worked in a new style diverging very subtly but distinctively from earlier conventions. The outline drawing and use of clear colors reflect traditional practices, but quite new is the slight modeling of the body forms by small changes of hue to increase their appearance of three-dimensionality. The skin color of these women is much darker than that conventionally used for females in earlier periods, and lightly brushed-in shading makes their eyes and lips stand out more than before (see "Restoring the Tomb of Nefertari," page 124). The tomb's artists used particular care in placing the hieroglyphic inscriptions around these figures, creating an unusually harmonious overall design.

BOOKS OF THE DEAD

By the time of the New Kingdom, the Egyptians had come to believe that only a person free from sin could enjoy an afterlife. The dead were thought to undergo a "last judgment" consisting of two tests presided over by Osiris and supervised by jackal-headed Anubis, the overseer of funerals and cemeteries. The deceased were first questioned by a delegation of deities about their behavior in life. Then their hearts, which the Egyptians believed to be the seat of the soul, were weighed on a scale against an ostrich feather, the symbol of Maat, goddess of truth.

These beliefs gave rise to a funerary practice especially popular among the nonroyal classes. Family members would commission papyrus scrolls containing magical texts or spells to help the dead survive the tests, and they had the embalmers place the scrolls among the wrappings of their loved ones' mummified bodies. Early collectors of Egyptian artifacts referred to such scrolls, often beautifully illustrated, as Books of the Dead. The books varied considerably in content. A scene created for a man named Hunefer (Dynasty 19) shows him at three successive stages in his induction into the afterlife (fig. 3-43). At the left, Anubis leads him by the hand to the spot where he will weigh his heart, contained in a tiny jar, against the "feather of Truth." Maat herself appears atop the balancing arm of the scales wearing the feather as a headdress. A monster—part crocodile, part lion, and part hippopotamus—watches eagerly for a sign from the ibis-headed god Thoth, who prepares to record the result of the weighing. That creature is Ammit, the dreaded "Eater of the Dead."

But the "Eater" is left to go hungry. Hunefer passes the test, and on the right Horus presents him to Osiris. The god of the underworld sits on a throne floating on a lake of natron, the substance used to preserve the flesh of the deceased from decay (see "Preserving the Dead," page 99). The four sons of Horus, each of whom was entrusted with the care of one of the deceased's vital organs, stand atop a huge lotus blossom rising up out of the lake. The goddesses Nephthys and Isis stand behind

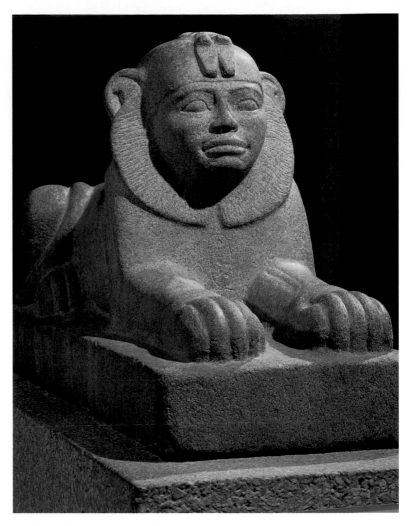

3-44. Sphinx of Taharqo, from Temple T, Kawa, Nubia. Dynasty 25, c. 690–664 BCE. Height 29³/₈" (74.7 cm). The British Museum, London

the throne, supporting the god's left arm with a tender gesture similar to the one seen in the Old Kingdom sculpture of Menkaura and his queen (see fig. 3-13). In the top register, Hunefer makes his appearance in the afterlife, kneeling before the nine gods of Heliopolis—the sacred city of the sun god Ra—and five personifications of life-sustaining principles.

THE CONTINUING INFLUENCE OF EGYPTIAN ART

The Late Period in Egypt (c. 747–332 BCE) saw the country and its art in the hands and service of foreigners. Nubians, Persians, Macedonians, Greeks, and Romans were all attracted to Egypt's riches and seduced by its art. In the seventh century BCE, the Nubians of Dynasty 25 controlled Egypt. Their art adopted the types and forms of earlier traditional Egyptian art. The royal sphinx of Taharqo (ruled c. 690–664 BCE), from Nubia (fig. 3-44), has a head with individualized Nubian features, an Egyptian king's headdress, and a lion's body, combining Egyptian formality with a realistic portrait of a Nubian ruler.

Three centuries later, in 332 BCE, Egypt was conquered by the Macedonian Greeks under Alexander the Great. After Alexander's death, his generals divided up the empire, with the Greek ruler Ptolemy eventually taking Egypt and initiating the Ptolemaic dynasty (c. 305–30 BCE). In 30 BCE, with the death of Cleopatra, the Romans succeeded the Ptolemies as Egypt's rulers. Fertile Egypt became Rome's breadbasket and thus the granary of Europe.

Not surprisingly, the style of painting of the time is **classical**—it reflects the conventions of Greek and Roman, not Egyptian, art. The most representative examples of this very late Egyptian art are the so-called Fayum portraits, painted faces on panels inserted into mummy wrappings. Well into Egypt's Roman period, the tradition of mummifying the dead continued; hundreds of mummies and mummy portraits from that time have been found in the Fayum region of Lower Egypt, The bodies were wrapped in linen strips, with a Roman-style portrait, painted on a wood panel in **encaustic** (hot colored wax), inserted over the face (fig. 3-45). Although great staring eyes invariably dominate the images, the artists recorded individual features and often captured something of the personality of the deceased. Though part of the essentially Egyptian mummy, the Fayum portraits belong more to the history of Roman and Western European art than to Egyptian art, and we shall meet them again in Chapter 6.

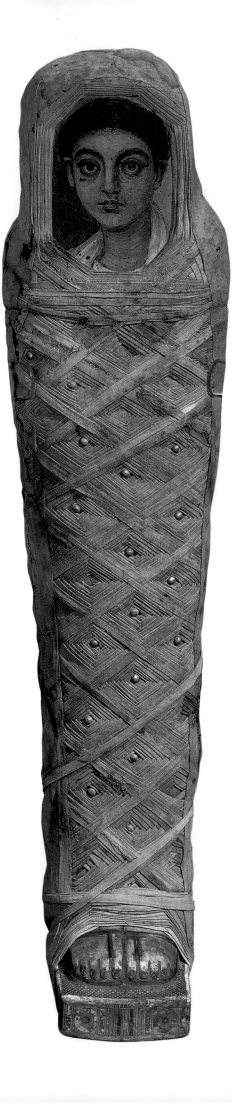

3-45. Mummy wrapping of a young boy, from Hawara. Roman period, c. 100–120 CE. Linen wrappings with gilded stucco buttons and inserted portrait in encaustic on wood, height of mummy 52 ³/₈" (133 cm); portrait 9¹/₂ x 6¹/₂" (24 x 16.5 cm). The British Museum, London

PARALLELS

PERIOD	ART IN ANCIENT EGYPT	ART IN OTHER CULTURES
PREDYNASTIC C. 5500–3100 BCE	**3-3.** Jar with river scene (c. 3500–3400)	**2-25.** Susa beaker (c. 4000), Elam
EARLY DYNASTIC C. 3100–2686 BCE	**3-4.** *Palette of Narmer* (c. 3000)	**2-5.** Anu Ziggurat (c. 3100), Sumer **1-16.** Skara Brae house interior (c. 3100–2600), Scotland
OLD KINGDOM C. 2686–2181 BCE	**3-8.** Djoser pyramid (c. 2667–2648) **3-10.** Giza pyramids (c. 2613–2494) **3-13.** *Menkaura and a Queen* (c. 2500) **3-15.** *Seated Scribe* (c. 2494–2345) **3-16.** *Ti Watching a Hippopotamus Hunt* (c. 2494–2345)	**2-9.** Votive statues (c. 2900–2600), Sumer **1-19.** Stonehenge (c. 2750–1500), England **2-11.** Bull lyre (c. 2685), Sumer **4-3.** Cycladic figures (c. 2500–2200), Greece **13-1.** *Cattle Gathered* (c. 2500–1500), Africa **2-15.** *Stele of Naramsin* (c. 2254–2218), Akkad
FIRST INTERMEDIATE C. 2181–2055 BCE		**2-16.** Votive Statue of Gudea (c. 2120), Lagash
MIDDLE KINGDOM C. 2055–1650 BCE	**3-19.** Rock-cut tombs, Beni Hasan (c. 1985–1795) **3-22.** *Face of King Senusret III* (c. 1860) **3-23.** Hippopotamus (c. 1985–1795)	**9-4.** Harappa torso (c. 2000), India **2-17.** *Stele of Hammurabi* (c. 1792–1750), Babylonia
SECOND INTERMEDIATE C. 1650–1550 BCE		
NEW KINGDOM C. 1550–1069 BCE	**3-30.** *Hatshepsut as Sphinx* (c. 1473–1458) **3-37.** *Queen Tiy* (c.1352) **3-36.** *Akhenaten and His Family* (1352–1336) **3-38.** *Nefertiti* (c. 1352–1336) **3-2.** Mask of Tutankhamun (c. 1336–1327) **3-26.** Karnak temples (c. 1295–1186) **3-43.** *Judgment before Osiris* (c. 1285) **3-33.** Abu Simbel temples (c. 1279–1213)	**4-19.** Funerary mask (c.1550–1500), Greece **2-28.** Lion gate (c. 1400), Anatolia **10-4.** *Fang ding* (c. 12th century), China
THIRD INTERMEDIATE C. 1069–747 BCE		
LATE PERIOD C. 747–332 BCE	**3-44.** Taharqo sphinx (c. 690–664) 	**6-8.** Cerveteri sarcophagus (c. 520), Italy **2-29.** Apadana of Darius and Xerxes (518–c. 460), Iran **5-1.** *Discus Thrower* (c. 450), Greece **5-42.** Acropolis, Athens (447–438), Greece
PTOLEMAIC C. 332–30 BCE		**5-86.** *Aphrodite of Melos* (c. 150), Greece
ROMAN C. 30 BCE–395 CE	**3-45.** Mummy of boy (c. 100–120 CE) 	**6-12.** Pont du Gard (late 1st century CE), France **6-31.** Colosseum (72–80 CE), Italy

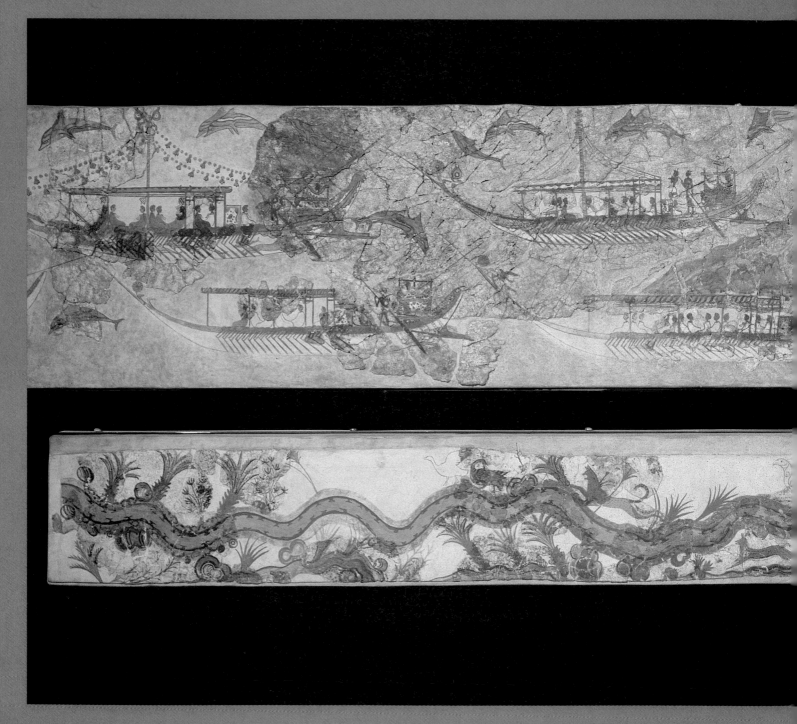

4-1. "Flotilla" fresco, from Room 5 of West House, Akrotiri, Thera, Second Palace period, c. 1650 BCE. National Archaeological Museum, Athens

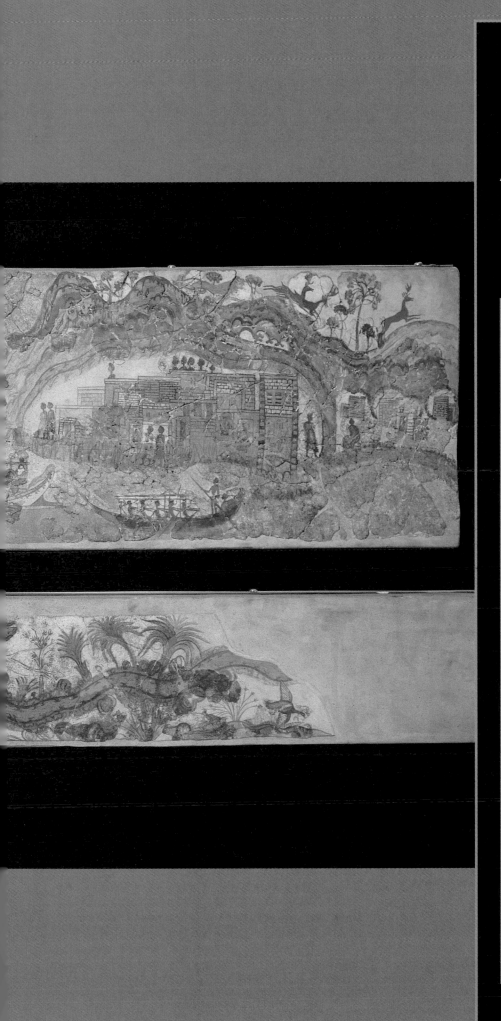

4 Aegean Art

Glorious pink, blue, and gold mountains flicker in the brilliant sunlight. Graceful boats glide on calm seas past islands and leaping dolphins. Picturesquely tiered villages line the shore, with people lounging on terraces and rooftops. Is this description a travel agency's advertisement for the ideal vacation spot? No—but it could be. The words describe the very old painting you scc here (fig. 4-1) from the port of Akrotiri on the island of Thera, one of the Cycladic Islands in the southern Aegean Sea. Today, Thera is called Santorini, a romantic and popular tourist destination. Akrotiri and the paradise depicted in this painting ended suddenly more than 3,500 years ago, when the volcano that formed the island Thera erupted and blew the top of the mountain off, spewing pumice that filled and sealed every crevice of Akrotiri—fortunately, after the residents had fled.

The discovery of Akrotiri in 1967 was among the most significant archaeological events of the second half of the twentieth century, and its excavation is still under way. We have much to learn about the cultures that took root on the Cycladic Islands and elsewhere in the Aegean, a region that is part of modern-day Greece. Every unearthed clue helps, because only one of the three written languages used there has been decoded. For now, we depend mainly on excavated works of art and architecture like this painting for our knowledge of life in the Aegean world.

▲ c. 3000–2000 AEGEAN BRONZE AGE
▲ c. 3000–1600 CYCLADIC CULTURE
▲ c. 3000–1375 MINOAN CULTURE
▲ c. 3000–1000 HELLADIC CULTURE

TIMELINE 4-1. **The Aegean World.** During the Bronze Age in the Aegean, three cultures flourished: the Cycladic, the Minoan, and the Helladic, including the Mycenaean.

MAP 4-1. **The Aegean World.** The three main cultures in the ancient Aegean were the Cycladic, in the Cyclades; the Minoan, on Thera and Crete; and the Helladic, including the Mycenaean, on the mainland.

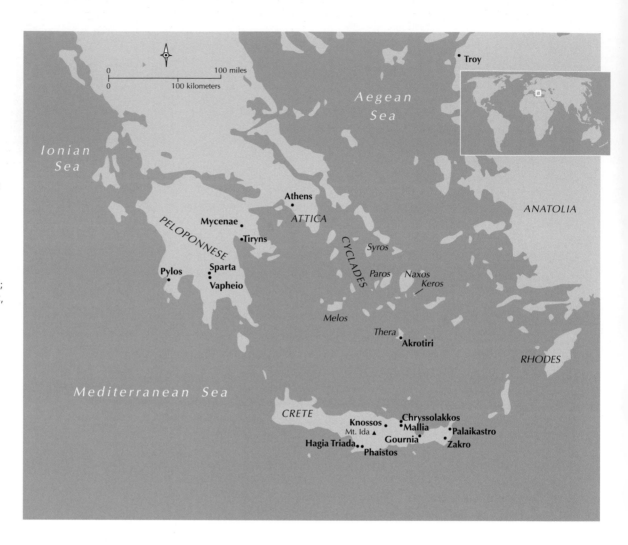

THE AEGEAN WORLD

Before 3000 BCE until about 1100 BCE, three early European cultures flourished simultaneously in the Aegean region: on a cluster of small islands called the Cyclades; on other islands in the Aegean Sea and Crete, which is in the eastern Mediterranean Sea; and on the mainland (Map 4-1). Scholars of these cultures have studied their grave sites, ruined architectural complexes, fortresses, and tombs. In recent years, archaeologists and art historians have also collaborated with researchers in such areas of study as the history of trade and climate change to provide an ever clearer picture of Aegean society.

Although the Aegean people were primarily farmers and herders, their lives were influenced by their proximity to the sea, and they were excellent seafarers. The sea provided an important link not only between the mainland and the islands but also to the world beyond. Egypt and the civilizations of the Near East were especially important trading partners (see "The Wreck at Ulu Burun," page 131).

One of the hallmarks of Aegean society from about 3000 to 1000 BCE was the use of bronze. Bronze, an alloy superior to pure copper for making weapons and tools, gave its name to the period, which is known as the Aegean Bronze Age. Using the metal ores they imported from Europe, Arabia, and Anatolia, the Aegean people created exquisite objects of bronze that became prized for export.

Probably the thorniest problem in Aegean archaeology is that of dating the finds (see "The Date Debate," page 131). Archaeologists have developed a relative dating system for the Aegean Bronze Age, but assigning absolute dates to specific sites and objects continues to be difficult and controversial. You may therefore encounter in other sources different dates than those given for objects shown here and should expect dating to change in the future. All dates are only approximations.

1500 BCE 1000 BCE

▲ c. 1900–1700 MINOAN OLD PALACE ▲ c. 1400–1100 MYCENAEAN CULTURE
 ▲ c. 1700–1450 MINOAN SECOND PALACE
 ▲ c. 1450–1375 LATE MINOAN

THE WRECK AT ULU BURUN

Shipwrecks offer vast amounts of information about the material culture—and the arts—of ancient societies whose contact with the rest of the world was by sea. The wreck of a trading vessel thought to have sunk between 1400 and 1350 BCE and discovered in the vicinity of Ulu Burun, off the southern coast of modern Turkey near the city of Kas demon-strates such ships' varied cargo: it carried metals, bronze weapons and tools, aromatic resin used in incense and perfume, fruits and spices, jewelry and beads, African ebony, ivory tusks, ostrich eggs, raw blocks of blue glass for use in faience and glassmaking, and ceramic wares made by potters from the Near East, mainland Greece, and Cyprus. Among the many gold objects was a scarab associated with Nefertiti, the wife of the Egyptian ruler Akhenaten (Chapter 3).

Its varied cargo suggests that this trading vessel cruised from port to port, loading and unloading goods as it went. It is tempting to see this vessel as evidence of Aegean entre-preneurship, but some scholars believe that Aegean foreign trade, like that in Egypt, was conducted exclusively as exchange between courts by palace officials.

Our study of Aegean art focuses on three Bronze Age cultures, beginning about 3000 BCE and ending about 1100 BCE (Timeline 4-1): Cycladic (on the islands of the Cyclades); Old Palace, Second Palace, and Late Minoan (on Crete and Thera); and Mycenaean, or Helladic (in mainland Greece).

THE CYCLADIC ISLANDS IN THE BRONZE AGE

A thriving late Neolithic and early Bronze Age culture existed on the Cycladic Islands, where people engaged in agriculture, herding, some crafts, and trade. They used local stone to build and fortify their towns and hillside burial chambers. Because they left no written records and their origins remain obscure, their art is a major source of information about them, as is the case with other Neolithic cultures. From about 6000 BCE on, Cycladic artists used a coarse, poor-quality local clay to make a variety of objects. Some 3,000 years later, they continued to produce relatively crude but often engaging ceramic figurines of humans and animals, as well as domestic and ceremonial wares.

Among the more unusual products of Cycladic potters were objects that reminded archaeologists of frying pans. These strange, unidentifiable pieces were made of **terra-cotta**, an orange-brown, low-fired clay, and were ornamented with **stylized** designs, either painted or

THE DATE DEBATE

Controversy has raged over the dating of Aegean objects almost since they were first excavated. New evidence is challenging established ideas of what happened when in the Aegean. The debate is far from over.

Because two of the three scripts used in the region still cannot be read, archaeologists have used changes in pottery styles to construct a chronology based on **relative dating** for the Aegean Bronze Age. A relative chronology indicates how old objects are in relation to each other but cannot assign them absolute dates. Influenced by the division of Egyptian history into Old, Middle, and New Kingdoms, Sir Arthur Evans, the British archaeologist who discovered and excavated the architectural complex at Knossos, used ceramic finds from different excavation levels to devise a similar chronological framework for Crete. He divided Minoan culture into three periods: Early Minoan, Middle Minoan, and Late Minoan, not terms used in this book. Today, Early Minoan and Middle Minoan are called the Palace Period. Later archaeologists extended this system to the Cyclades and the Helladic mainland.

Fortunately, historical records going back to the third millennium BCE have survived from the Near East and Egypt. By the careful cross-cultural referencing of lucky finds—datable foreign trade goods at undated Aegean sites or undated Aegean trade goods in datable foreign contexts—scholars are now able to assign dates to the relative chronology's periods, with a view toward **absolute date** chronology. **Radiometric**, or carbon-14, **dating** is increasingly useful as a method for dating Aegean organic material, though some dates can be determined only within a span of two or three centuries.

After decades of painstaking work establishing a chronology for the Aegean, archaeologists generally agreed that a huge volcanic explosion on the Cycladic island of Thera had thoroughly devastated Minoan civilization on Crete, only 60 miles to the south, around 1450 BCE. New evidence—namely, tree rings from Ireland and California and traces of volcanic ash in ice cores from Greenland—puts the date of the Thera eruption in the 1630s or 1620s BCE. This discovery leaves Minoan and Mycenaean dating in serious disarray—off by centuries. The chronologies for Aegean civilizations and their trading partners—particularly Egypt—must be revised.

How has this controversy affected the dating of Minoan and Mycenaean art works illustrated in this chapter? Sometimes you will find Evans's periods cited without attached dates. While experts ponder the evidence, the rest of us must rely on the conventional best-guess dates.

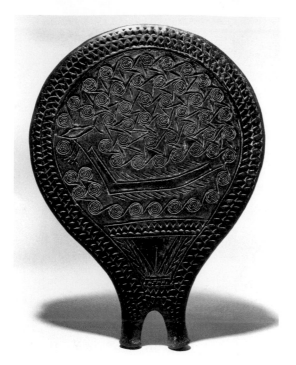

4-2. **"Frying pan,"** from Syros, Cyclades. c. 2500–2200 BCE. Terra-cotta, diameter 11" (28 cm), depth 2⅜" (6 cm). National Archaeological Museum, Athens

incised before firing. The elaborate decoration on one side of a piece from the island of Syros, dated about 2500–2200 BCE, consists of a wide, geometric border encircling a scene showing a boat on a sea of waves depicted as linked spirals (fig. 4-2). With its long hull and banks of oars, the boat resembles those seen in Neolithic Egyptian art from Hierakonpolis (see fig. 3-3). The large fish to the left might be a carved prow ornament. In the triangular area set off below the scene, the artist incised a symbol for the female pubic area. The function of these "frying pan" objects is unknown. Perhaps they had some magical association with pregnancy and childbirth, as well as death, for they are most often found at grave sites.

The Cyclades, especially the islands of Naxos and Paros, had ample supplies of a fine and durable white marble that became a popular medium for sculptors. Out of it they created a unique type of nude figure ranging from a few inches to about 5 feet tall. These figures are often found lying on graves. To shape the stone, sculptors used scrapers and chisels made of obsidian from the island of Melos and polishing stones of emery from Naxos. The introduction of metal tools may have made it possible for them to carve on a larger scale, but perhaps because the stone fractured easily, they continued to limit themselves to simplified sculptural forms.

A few male figurines have been found, including depictions of musicians and acrobats, but they are greatly outnumbered by representations of women. The earliest female figures had simple, violinlike shapes. From these, a more familiar type evolved, by 2500 BCE, that has become the best-known type of Cycladic art (fig. 4-3). Compared with Egyptian statues from the same time (see fig. 3-13), the Cycladic marbles appear to many modern eyes like pared-down, elegant renderings of the figure. With their

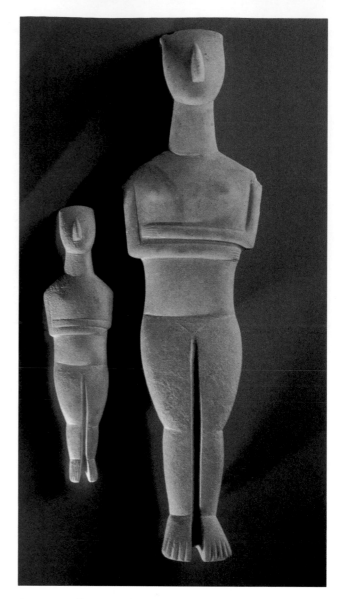

4-3. **Two figures of women,** from the Cyclades. c. 2500–2200 BCE. Marble, heights 13" (33 cm) and 25" (63.4 cm). Museum of Cycladic Art, Athens
Courtesy of the N. P. Goulandris Foundation

simple contours, the female statuettes shown here seem not far removed from the marble slabs out of which they were carved. Their tilted-back heads, folded arms, and down-pointed toes suggest that the figures were intended to lie on their backs, as if asleep or dead. Anatomical detail has been kept to a minimum; the body's natural articulations at the hips, knees, and ankles are indicated by lines, and the pubic area is marked with a lightly incised triangle. These statues originally had painted facial features, hair, and ornaments in black, red, and blue.

The *Seated Harp Player* of roughly the same period is fully developed **sculpture in the round** (fig. 4-4), yet its body shape is just as simplified as that of the female figurines. The figure has been reduced to its geometric essentials, yet with careful attention to those elements that best characterize an actual musician. The harpist sits on a high-backed chair with a splayed base, head tilted back as if singing, knees and feet apart for stability, and arms raised, bracing the instrument with one hand while plucking its strings with the other. So expressive is the pose that we can almost hear the song.

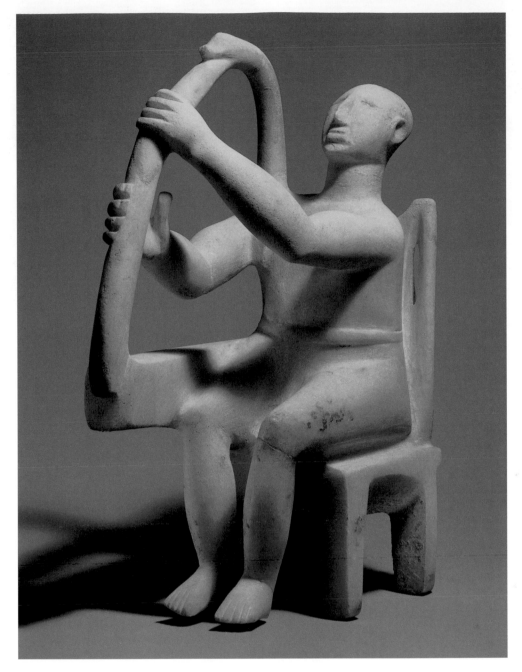

4-4. *Seated Harp Player*, from Keros, Cyclades. 3rd millennium BCE. Marble, height 11½"
(29.2 cm). The Metropolitan Museum of Art, New York
Rogers Fund, 1947, (47.100.1)

Some Cycladic figures have been found in and around graves, but many have no archaeological context. Although their specific use and meaning are unclear, one interpretation is that they were used for worship in the home and then buried with their owners, often after having been symbolically broken as part of the funeral ritual. According to this theory, the larger statues were set up for communal worship, either as representations of the supernatural or as **votive figures**.

CRETE AND THE MINOAN CIVILIZATION

By 3000 BCE, Bronze Age people lived on the island of Crete. A distinctive culture flourished on Crete between about 1900 BCE and 1375 BCE, which Sir Arthur Evans (see "Pioneers of Aegean Archaeology,"

page 149) called Minoan. The name *Minoan* comes from the legend of Minos, a king who ruled from Knossos, the island's ancient capital (see "The Legend of the Minotaur," page 134).

Crete is the largest of the Aegean and eastern Mediterranean islands, 150 miles long and 36 miles wide. It was economically self-sufficient, producing its own grains, olives and other fruits, and cattle and sheep. But because it lacked the ores necessary for bronze production, it was forced to look outward. Crete took advantage of its many safe harbors and its location to become a wealthy sea power, trading with mainland Greece, Egypt, the Near East, and Anatolia.

Archaeological discoveries suggest that in Minoan belief three goddesses controlled various aspects of the natural world. These deities may also have been the

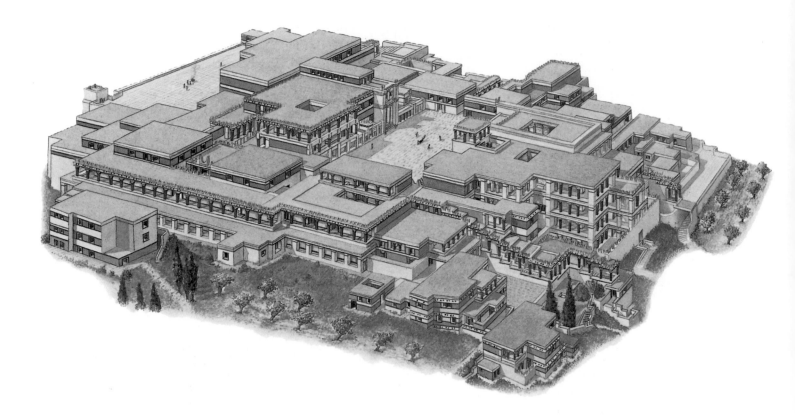

4-5. **Plan and reconstruction of the palace complex, Knossos**, Crete. Site occupied 2000–1375 BCE; complex begun in Old Palace period (c. 1900–1700 BCE); complex rebuilt after earthquakes and fires during Second Palace period (c. 1700–1450 BCE); final destruction c. 1375 BCE.

ancestors of the later Greek goddesses Demeter, Artemis, and Athena (Chapter 5). Female images found in graves and palace shrines may represent goddesses, priestesses, or female worshipers.

Although a number of written records from the period are preserved, the two earliest forms of Minoan writing, called hieroglyphic and Linear A, continue to defy translation. The surviving documents in a later script, Linear B—a very early form of Greek imported from the mainland—have proven to be valuable administrative records and inventories that give an insight into Minoan material culture.

Beginning in the third millennium BCE, the Minoans built and maintained (rebuilding after earthquakes and

THE LEGEND OF THE MINOTAUR According to Greek legend, the half-man-half-bull Minotaur was the son of the wife of King Minos of Crete and a bull belonging to the sea god Poseidon. The monster lived in the so-called Labyrinth, a maze. To satisfy the Minotaur's appetite for human flesh and to keep him tranquil, King Minos ordered the city of Athens, which he ruled, to pay him a yearly tribute tax of fourteen young men and women. Theseus, the son of King Aegeus of Athens, vowed to free his people from this grisly burden by slaying the monster.

He set out for Crete with the doomed young Athenians, promising his father that on his return voyage he would replace his ship's black sails with white ones as a signal of victory. In the manner of ancient heroes, Theseus won the heart of Crete's princess Ariadne, who gave him a sword with which to kill the Minotaur and a spindle of thread to mark the path he took into the Labyrinth. Theseus defeated the Minotaur, followed his trail of thread back out of the maze, and sailed off to Athens with Ariadne and the relieved Athenians. Along the way, his ship put into port on the island of Naxos, where Theseus had a change of heart and left Ariadne behind as she lay sleeping. In his haste to return home, he neglected to raise the white sails. When Aegeus saw the black-sailed ship approaching, he drowned himself in the sea that now bears his name. Theseus thus became king of Athens.

Such psychologically complex myths have long inspired European artists. In William Shakespeare's *A Midsummer Night's Dream*, the play-within-the-play celebrates the marriage of Theseus to an Amazon queen. The plight of Theseus's abandoned lover Ariadne—who finds comfort in the arms of the Greek god Dionysos—is the plot of a 1912 opera by Richard Strauss. Also in the last century, Pablo Picasso used the Minotaur in his art as a symbol of the Spanish dictator Francisco Franco and the horrors of the Spanish Civil War.

fires) great architectural complexes. Excavators in the nineteenth century CE called these complexes "palaces," an inaccurate term because *palaces* imply *kings*, and we do not know the sociopolitical structure of the society. The term *palaces* is still commonly used, and we will use it in this chapter. A number of these sites have been excavated and provide a wealth of art and information.

The walls of early Minoan buildings were made of rubble and mud bricks faced with cut and finished local stone. This was the first use of **dressed stone** as a building material in the Aegean. Columns and other interior elements were made of wood. Both in palaces and in buildings in the surrounding towns, timber appears to have been used for framing and bracing walls; its strength and flexibility would have minimized damage from the earthquakes still common to the area. Nevertheless, a major earthquake about 1700 BCE damaged several building sites, including the important palaces at Knossos and Phaistos. The structures were then repaired and enlarged, and the two resulting new complexes shared a number of features. Multistoried, flat-roofed, and with many columns, they were designed to maximize light, air, and adaptability, as well as to define access and circulation patterns. Daylight and fresh air entered through staggered levels, open stairwells, and strategically placed air shafts and light wells.

Suites of rooms lay around a spacious rectangular courtyard from which corridors and staircases led to other courtyards, private rooms and apartments, administrative and ritual areas, storerooms, and baths. Walls generally were coated with plaster, and some were painted with murals. Floors were either plaster, plaster mixed with pebbles, stone, wood, or beaten earth. The residential quarters had many luxuries: sunlit courtyards, richly colored murals, and sophisticated plumbing systems (at Knossos, a network of terra-cotta pipes was laid below ground). Clusters of workshops in and around the palace complexes formed commercial centers. Storeroom walls were lined with enormous clay jars for oil and wine, and in their floors stone-lined pits from earlier structures had been designed for the storage of grain. The huge scale of the centralized management of foodstuffs became apparent when excavators at Knossos found in a single storeroom enough ceramic jars to hold 20,000 gallons of olive oil.

THE OLD PALACE PERIOD (c. 1900–1700 BCE)

Minoan civilization remained very much a mystery until British archaeologist Sir Arthur Evans discovered the buried ruins of the architectural complex at Knossos, on Crete's north coast, in 1900 CE (fig. 4-5). Evans spent the rest of his life excavating and reconstructing the buildings he had found (see "Pioneers of Aegean Archaeology," page 149). The site had been occupied in the Neolithic period, then built over with a succession of Bronze Age buildings.

Minoan builders seem sensitive to natural settings, for their structures often focus on special landscape features, such as the sacred Mount Ida. The palace complex

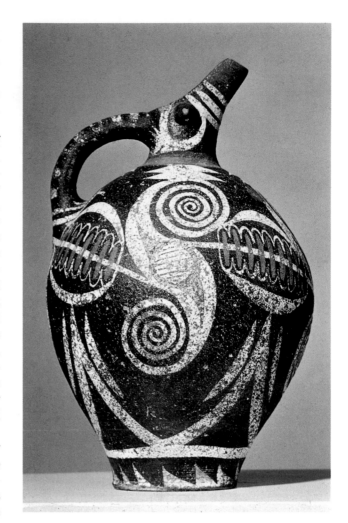

4-6. Kamares Ware jug, from Phaistos, Crete. Old Palace period, c. 2000–1900 BCE. Ceramic, height 10⅝" (27 cm). Archaeological Museum, Iraklion, Crete

itself had a squarish plan and a large central courtyard. Causeways and corridors led from outside to the central courtyard or to special areas such as granaries or storage pits. The complex often had a theater or performance area. Around the central court, independent units were made up of eight or nine suites of rooms. Each suite consisted of a forecourt with light well, a hall with a stepped lustral basin, a room with a hearth, and a series of service rooms. Such suites might belong to a family or serve a special business or government function.

The complex also included workshops that attest to the centralization there of large-scale manufacturing. During the Old Palace period, Minoans developed extraordinarily sophisticated metalwork and elegant new types of ceramics, spurred in part by the introduction of the potter's wheel early in the second millennium BCE. One type is called Kamares Ware, after the cave on Mount Ida overlooking the palace complex at Phaistos, in southern Crete, where it was first discovered. The hallmarks of this select ware—so sought-after that it was exported as far away as Egypt and Syria—were its extremely thin walls, its use of color, and its graceful, stylized, painted decoration. An example from about 2000–1900 BCE has a globular body and a "beaked" pouring spout (fig. 4-6). Decorated with

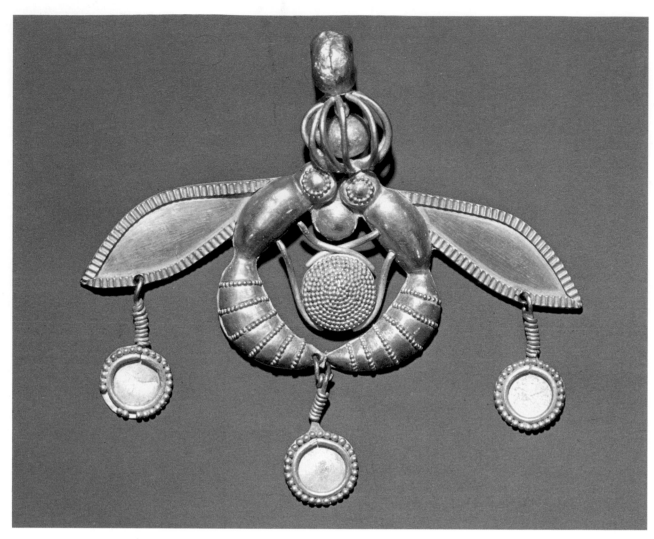

4-7. Pendant of gold bees, from Chryssolakkos, near Mallia, Crete. Old Palace period, c. 1700 BCE. Gold, height approx. 1¹³/₁₆" (4.6 cm). Archaeological Museum, Iraklion, Crete

TECHNIQUE

AEGEAN METALWORK

Aegean artists imported gold to create exquisite luxury goods. Their techniques included **lost-wax casting**, **inlay**, **filigree**, *repoussé* (embossing), **granulation**, **niello**, and **gilding**. The *Vapheio Cup* (see fig. 4-16) and the funerary mask (see fig. 4-19) are examples of *repoussé*, in which the artist gently hammered out relief forms from the back of a thin sheet of gold. Experienced goldsmiths may have done simple designs freehand or used standard wood forms or punches. For more elaborate decorations they would first have sculpted the entire relief design in wood or clay and then used this form as a mold for the gold sheet.

Minoan jewelers were especially skilled at decorating their goldwork with minute granules, or balls, of gold fused to the surfaces, as seen on the bees pendant above. They learned the technique of granulation from Syrian metalsmiths, demonstrating the extensive contact among artists of the time. The technique was only recently rediscovered after nearly a thousand years. The major mystery was how the granules were attached, since all modern solders—heated metal alloys used as adhesives—melted and overwhelmed the tiny gold globules. The ancient smiths are now believed to have used a complex copper-based solder that fused strongly but nearly invisibly.

The artists who created the Mycenaean dagger blade (see fig. 4-26) not only inlaid one metal into another but also employed a special technique called niello, still a common method of metal decoration. Powdered nigellum—a black alloy of lead, silver, and copper with sulfur—was rubbed into very fine engraved lines in the object being decorated, then fused to the surrounding metal with heat. The lines appear to be black drawings.

Gilding, the application of gold to an object made of some other material, was a technically demanding process by which paper-thin sheets of hammered gold called **gold leaf** (or, if very thin, gold foil) were meticulously affixed to the surface to be gilded. This was done with amazing delicacy for the now-bare stone surface of the *Harvester Vase* (see fig. 4-10) and the wooden horns of the bull's-head rhyton (see fig. 4-11).

brown, red, and creamy white pigments on a black body, the jug has rounded contours complemented by bold, curving forms derived from plant life.

Matching Kamares Ware in sophistication is early Minoan goldwork (see "Aegean Metalwork," page 136). By about 1700 BCE, Aegean metalworkers were producing decorative objects rivaling those of Near Eastern jewelers, whose techniques they seem to have borrowed (see fig. 2-22). For a necklace pendant in gold found at Chryssolakkos (fig. 4-7), the artist arched a pair of bees (or perhaps wasps) around a honeycomb of gold granules, providing their sleek bodies with a single pair of outspread wings—a visual "two in one." The pendant hangs from a spiderlike form, with what appear to be long legs encircling a tiny gold ball. Small disks dangle from the ends of the wings and the point where the insects' bodies meet. The simplified geometric patterns and shapes well convey the insects' actual appearance.

THE SECOND PALACE PERIOD
(c. 1700–1450 BCE)

The "old palace" at Knossos, erected about 1900 BCE, formed the core of an elaborate new one built after a terrible earthquake shook Crete about 1700 BCE and destroyed Knossos. The Minoans rebuilt at Knossos and elsewhere, inaugurating the Second Palace period and the flowering of Minoan art. In its heyday, the palace complex covered six acres (see fig. 4-5). Because double-ax motifs were used in its architectural decoration, the Knossos palace was referred to in later Greek legends as the Labyrinth, meaning the "House of the Double Axes" (Greek *labrys*, "double ax"). The layout of the complex seemed so dauntingly complicated that the word *labyrinth* came to mean "maze."

The layout provided the complex with its own internal security system: a baffling array of doors leading to unfamiliar rooms, stairs, and yet more corridors. Admittance could be denied by blocking corridors, and some rooms were accessible only from upper terraces. In short, the building was a warren of halls, stairs, dead ends, and suites—truly a labyrinth. Close analysis, however, shows that the builders had laid out the complex on a square grid following predetermined principles and that the apparently confusing layout was caused in part by earthquake destruction and rebuilding over the centuries.

In typical Minoan fashion, the rebuilt Knossos complex of religious, residential, manufacturing, and warehouse spaces was organized around a large central courtyard. A few steps led from the central courtyard down into the so-called Throne Room to the west, and a grand staircase on the east side descended to the Hall of the Double Axes, an unusually grand example of a Minoan hall (Evans gave the rooms their misleading but romantic names). This hall and others were supported by the uniquely Minoan-type wood columns that became standard in Aegean palace architecture. The tree trunks from which the columns were made were inverted so that they tapered toward the bottom. Thus, the top, supporting massive roof beams and a broad flattened capital, was wider than the bottom (fig. 4-8).

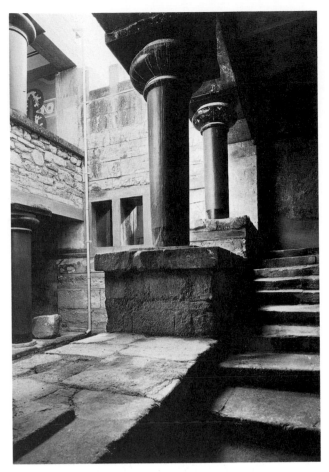

4-8. Court with staircase reconstructed by Sir Arthur Evans, leading to the southeast residential quarter, palace complex, Knossos, Crete

The hundreds of tapered, cushion-capitaled columns of the palace were made of wood and painted bright colors, especially red, yellow, and black. Evans's restorers installed concrete replicas of columns, capitals, and lintels based on ceramic house models and paintings from the Minoan Second Palace period. Today's archaeologists might not attempt such wholesale reconstruction without absolutely authentic documentation, and they would make certain that reconstructed elements could never be mistaken for the originals.

The suites, following Minoan Old Palace tradition, were arranged around a central space rather than along a long axis, as we have seen in Egypt and will see in Mycenae (page 147). During the Second Palace period, suites functioned as archives, business centers, and residences. Some must also have had a religious function, though the temples, shrines, and elaborate tombs seen in Egypt are not found in Minoan architecture.

Surviving Minoan sculpture consists mainly of small, finely executed religious works in wood, ivory, precious metals, stone, and faience. Female figurines holding serpents were fashioned on Crete as far back as 6000 BCE and may have been associated with water, regenerative power, and protection of the home. The *Woman or Goddess with Snakes* from the palace at Knossos is intriguing both as a ritual object and as a work of art.

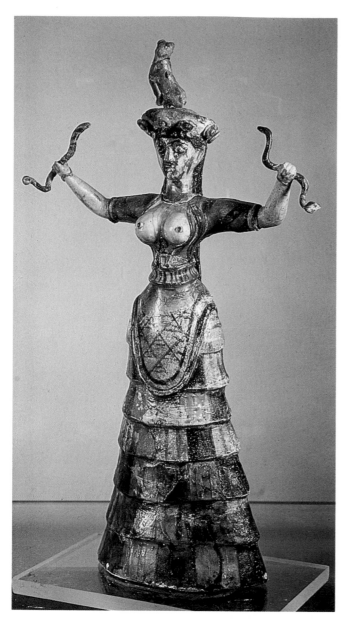

4-9. *Woman or Goddess with Snakes*, from the palace complex, Knossos, Crete. Second Palace period, c. 1600–1550 BCE. Faience, height 11⅝" (29.5 cm). Archaeological Museum, Iraklion, Crete

This faience figurine was found with other ceremonial objects in a pit in one of Knossos's storerooms. Bare-breasted, arms extended, and brandishing a snake in each hand, the woman is a commanding presence (fig. 4-9). A leopard or a cat (perhaps a symbol of royalty, perhaps protective) is poised on her crown, which is ornamented with circles. This shapely figure is dressed in a fitted, open bodice with an apron over a typically Minoan flounced skirt. A wide belt cinches the waist. The red, blue, and green geometric patterning on her clothing reflects the Minoan weavers' preference for bright colors, patterns, and fancy edgings. Realistic elements and formal, stylized ones combine to create a figure that is both lively and dauntingly, almost hypnotically powerful—a combination that has led scholars to disagree whether statues such as this one represent deities or their human attendants.

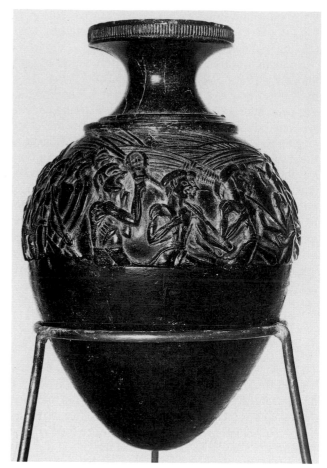

4-10. *Harvester Vase*, from Hagia Triada, Crete. Second Palace period, c. 1650–1450 BCE. Steatite, diameter 4½" (11.3 cm). Archaeological Museum, Iraklion, Crete

Almost certainly of ritual significance are the stone vases and **rhytons**—vessels used for pouring liquids during sacred ceremonies—that Minoans carved from steatite (a greenish or brown soapstone). These pieces were all found in fragments, suggesting that they were ritually broken. One of the treasures of Minoan art is the *Harvester Vase,* an egg-shaped rhyton barely 4½ inches in diameter (fig. 4-10). It may have been covered with **gold leaf,** or sheets of hammered gold (see "Aegean Metalwork," page 136). A rowdy procession of twenty-seven men has been crowded onto its curving surface. The piece is exceptional for the freedom with which the figures occupy three-dimensional space, overlapping and jostling one another instead of marching in orderly single file across the surface in the manner of Near Eastern or Egyptian art. Also new is the exuberance of this scene, especially the emotions shown on the men's faces. They march and chant to the beat of a sistrum—a rattlelike percussion instrument—played by a man who seems to sing at the top of his lungs. The uneven arrangement of elements reinforces the boisterousness of the scene. The men have large, coarse features and sinewy bodies so thin that their ribs stick out. Archaeologists have interpreted the scene as a spring planting or fall harvest festival, a religious procession, a dance, a crowd of warriors, or a gang of forced laborers.

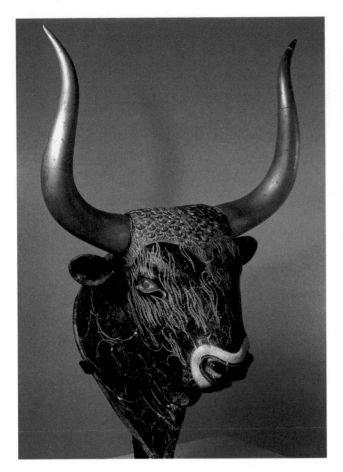

4-11. Bull's-head rhyton, from the palace complex, Knossos, Crete. Second Palace period, c. 1550–1450 BCE. Steatite with shell, rock crystal, and red jasper, the gilt-wood horns restored, height 12" (30.5 cm). Archaeological Museum, Iraklion, Crete

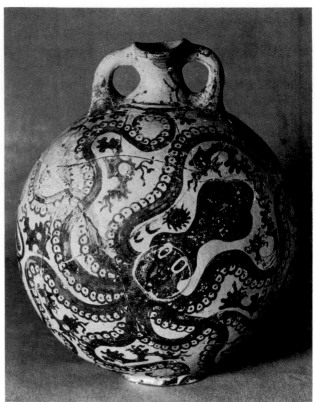

4-12. *Octopus Flask*, from Palaikastro, Crete. Second Palace period, c. 1500–1450 BCE. Marine Style ceramic, height 11" (28 cm). Archaeological Museum, Iraklion, Crete

Depictions of bulls appear quite often in Minoan art, rendered with an intensity not seen since the prehistoric cave paintings at Altamira and Lascaux (Chapter 1), and rhytons were also made in the form of a bull's head. Although many early cultures associated their gods with powerful animals, neither their images nor later myths offer any proof that the Minoans worshiped a bull god. According to later Greek legend, for example, King Minos kept the bull-man called the Minotaur captive in his palace, but the creature was not an object of religious veneration (see "The Legend of the Minotaur," page 134). The sculptor of a bull's head rhyton found at Knossos used a block of greenish-black steatite to create an image that approaches animal portraiture in its decorative detailing (fig. 4-11). Lightly engraved lines, filled with white powder to make them visible, indicate the animal's coat: short, curly hair on top of the head, longer shaggy strands on the sides, and circular patterns along the neck to suggest its dappled coloring. White bands of shell outline the nostrils, and painted rock crystal and red jasper form the eyes. The horns, now restored, were made of wood covered with gold leaf. Bull's-head rhytons were used for pouring ritual fluids—water, wine, or perhaps even blood. Liquid was poured into a hole in the neck and flowed out from the mouth.

Minoan potters also created more modest vessels. The ceramic arts, so splendidly demonstrated in Old Palace Kamares Ware, continued throughout the Second Palace period. In fact, archaeologists have established the chronology of Minoan art based on the ceramics found in excavations.

Some of the most striking ceramics were done in what is called the Marine Style because of the depiction of sea life painted on their surfaces. In a stoppered bottle of this style known as the *Octopus Flask*, made about 1500–1450 BCE (fig. 4-12), the painter celebrates Crete's sea power, then at its height. Like microscopic life teeming in a drop of pond water, sea creatures float around an octopus's tangled tentacles. The decoration on the Kamares Ware jug (see fig. 4-6) reinforces the solidity of its surface, but here the pottery skin seems to dissolve. The painter captured the grace and energy of natural forms while presenting them as a stylized design in harmony with the vessel's spherical shape.

Minoan painters also worked on a larger scale, covering the walls of palace rooms with geometric borders, views of nature, and scenes of human activity. Murals can be painted on either a still-wet plaster (**buon fresco**) surface or a dry one (**fresco secco**). The wet technique binds pigments well to the wall, but forces the painter to work very quickly. On a dry wall, the painter need not hurry, but the pigments tend to flake off in time. Minoans used both techniques. Their preferred colors were red, yellow, black, white, green, and blue. Like Egyptian painters, Minoan artists filled in the outlines of their figures and objects with unshaded areas of pure color. But after that, the resemblance stops.

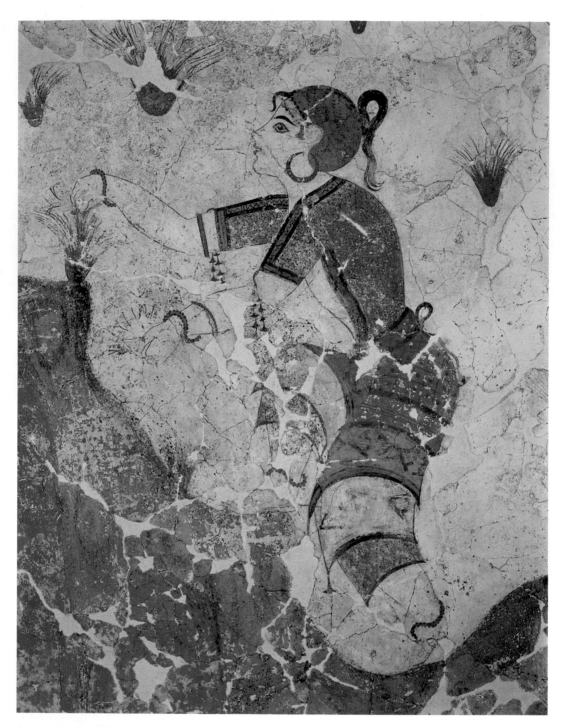

4-13. *Young Girl Gathering Crocus Flowers*, detail of wall painting, Room 3 of House Xeste 3, Akrotiri, Thera. Second Palace period, c. 1700–1450 BCE

Minoan wall painting displays elegant drawing, linear contours filled with bright colors, a preference for profile or full-faced views, and a stylization that turns natural forms into decorative patterns yet keenly observes the appearance of the human body in motion. Those conventions can be seen in the vivid murals at Akrotiri, on the island Thera (see fig. 4-1). Along with other Minoan cultural influences, the art of wall painting seems to have spread to both the Cyclades and mainland Greece. Thera was so heavily under Crete's influence at this time that it was virtually an outpost of Minoan culture.

The paintings in residences at Akrotiri demonstrate a

highly decorative sense, both in color selection and in surface detail. Some of the subjects there also occur in the art of Crete, but others are new. One of the houses, for example, has rooms dedicated to young women's initiation ceremonies. In the detail shown here, a young woman picks purple fall saffron crocus, valuable for its use as a yellow dye, as a flavoring for food, and as a medicinal plant to alleviate menstrual cramps (fig. 4-13). The girl wears the typically colorful Minoan flounced skirt with a short-sleeved, open-breasted bodice, large earrings, and bracelets. She still has the shaved head, fringe of hair, and long ponytail of a child, but the light

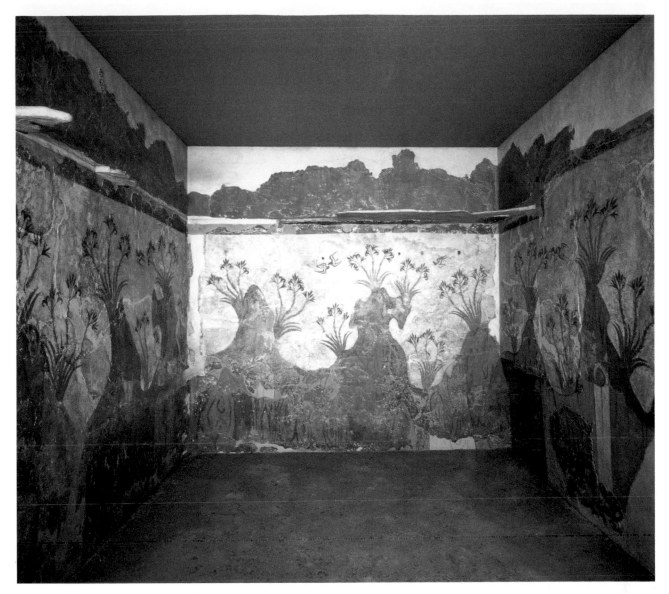

4-14. *Landscape*, wall painting with areas of modern reconstruction, from Akrotiri, Thera. Before 1630–1500 BCE. National Archaeological Museum, Athens

blue color of her scalp indicates that the hair is beginning to grow out. On another wall, not shown here, girls present their flowers to an older seated women who is flanked by a blue Nubian monkey and a griffin (half lion–half eagle). Surely the woman is a goddess receiving her devotees, and the room had a special ceremonial use.

In another house, an artist has created a pure landscape of hills, rocks, and flowers (fig. 4-14). This mural is unlike anything previously encountered in ancient art. A viewer standing in the center of the room is surrounded by orange, rose, and blue rocky hillocks sprouting oversized deep red lilies. Swallows, represented by a few deft lines, swoop above and around the flowers. The artist unifies the rhythmic flow of the undulating landscape, the stylized patterning imposed on the natural forms, and the decorative use of bright colors alternating with darker neutral tones, which were perhaps meant to represent areas of shadow. The colors—pinks, blues, yellows—may seem fanciful to us; however, sailors today who know the area well attest to

their accuracy: the artist recorded the actual colors of Thera's wet rocks in the sunshine. The impression is one of organic life and growth, a celebration of the natural world symbolized by the lilies. How different is this art—which captures a zesty joy of life—from the cool, static elegance of Egyptian painting.

LATE MINOAN PERIOD (c. 1450–1375 BCE)

About 1450 BCE, a conquering people from mainland Greece, known as Mycenaeans (see page 142), arrived in Crete. They occupied the buildings at Knossos and elsewhere until a final catastrophe and the destruction of Knossos about 1375 BCE caused them to abandon the site. While on Crete, they adopted Minoan art with such enthusiasm that sometimes experts disagree over the identity of the artists—were they Minoans working for Mycenaeans or Mycenaeans taught by, or copying, Minoans?

At Knossos, one of the most famous and best-preserved paintings depicts bull leaping. The restored

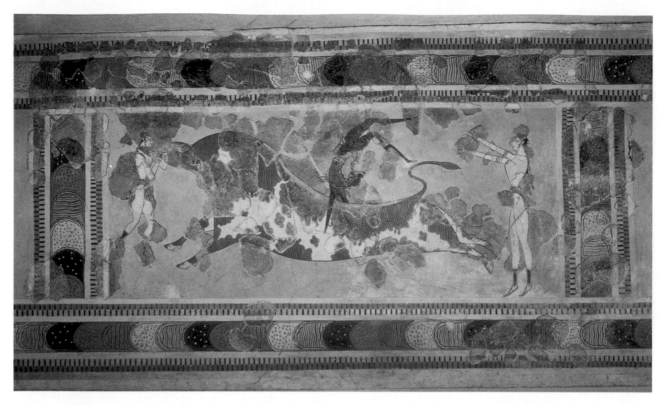

4-15. *Bull Leaping*, wall painting with areas of modern reconstruction, from the palace complex, Knossos, Crete. Late Minoan period, c. 1450–1375 BCE. Height approx. 24½" (62.3 cm). Archaeological Museum, Iraklion, Crete

Careful sifting during excavation preserved many fragments of the paintings that once covered the palace walls. The pieces were painstakingly sorted and cleaned by restorers and reassembled into puzzle pictures that often had more pieces missing than found. The next step was to fill in the gaps with colors similar to the original ones, but lighter and grayer in tone, to make obvious which portions were restored while enabling the eye to read and enjoy the image.

panel is one of a group of paintings with bulls as subjects from a room in the palace's east wing. The action may represent an initiation or fertility ritual (fig. 4-15). *Bull Leaping* shows three scantily clad, youthful figures around a gigantic dappled bull, charging in the flying-gallop pose. The pale-skinned person at the right—probably a woman— is prepared to catch the dark-skinned man in the midst of his leap, and the pale-skinned woman at the left grasps the bull by its horns, perhaps to begin her own vault. The bull's thundering power and sinuous grace are masterfully rendered although the flying-gallop pose is not true to life. Framing the action are variegated overlapping ovals (the so-called chariot-wheel motif) set within striped bands.

The skills of other Minoan artists, particularly metal-smiths, made them highly sought after in mainland Greece. Two magnificent gold cups found in a large tomb at Vapheio, on the Greek mainland south of Sparta, were made sometime between 1650 and 1450 BCE, either by Minoan artists or by local ones trained in Minoan style and techniques. One cup is shown here (fig. 4-16). The relief designs were executed in **repoussé**—the technique of hammering from the back of the sheet. The handles were attached with rivets, and the cups were then lined with sheet gold. In the scenes that circle the cups, men are depicted trying to capture bulls in various ways. On this one, a half-nude man has roped a bull's hind leg. The figures dominate the landscape, which literally bulges with a muscular vitality that belies the cups' small size— they are only 3½ inches tall. The depiction of olive trees could indicate that the scene is a sacred grove and that

these are illustrations of exploits in some long-lost heroic tale rather than commonplace herding scenes.

The Mycenaean invaders appear to have continued to use Crete as a base for many years. But by 1400 BCE the center of political and cultural power in the Aegean had shifted to mainland Greece, which at that time was home to wealthy warrior-kings.

MAINLAND GREECE AND THE MYCENAEAN CIVILIZATION

Archaeologists use the term *Helladic* (from *Hellas*, the Greek name for Greece) to designate the Aegean Bronze Age on mainland Greece. The Helladic period extends from about 3000 to 1000 BCE, concurrent with the Cycladic and Minoan periods. In the early part of the Aegean Bronze Age, Greek-speaking peoples moved into the mainland. They brought advanced metalworking, ceramic, and architectural techniques, and they displaced the indigenous Neolithic culture. When Minoan culture declined after about 1500 BCE, a late Helladic mainland culture known as Mycenaean, after the city of Mycenae, rose to dominance in the Aegean region.

ARCHITECTURE

The Citadel at Mycenae. Later Greek writers recalled the fortified city of Mycenae (fig. 4-17), located near the east coast of the Peloponnese peninsula in southern Greece, as the home of the leader of the Greek army that

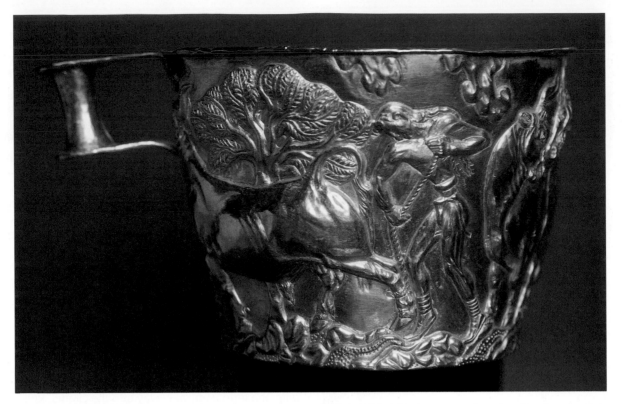

4-16. *Vapheio Cup*, found near Sparta, Greece. c. 1650–1450 BCE. Gold, height 3½" (8.9 cm). National Archaeological Museum, Athens

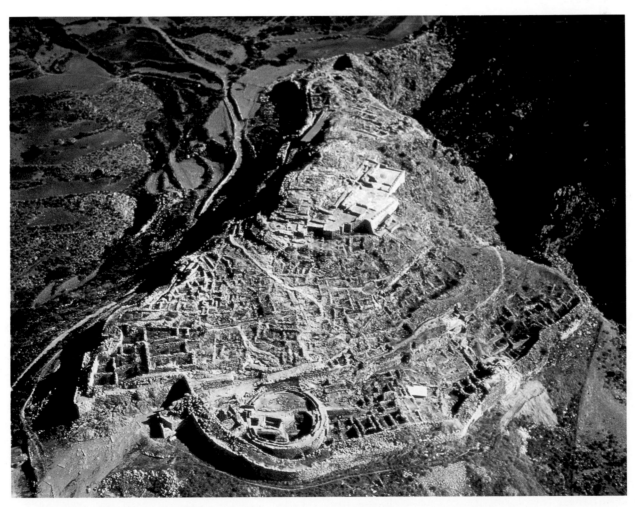

4-17. Citadel, Mycenae, Greece. Site occupied c. 1600–1200 BCE; walls built c. 1340, 1250, 1200 BCE

The citadel's hilltop position, the grave circle at the bottom center of the photograph, and the circuit walls are clearly visible. The Lion Gate (see fig. 4-18) is at the lower left. The megaron floor and bases of columns and walls are at the top of the hill, at the upper center of the photograph.

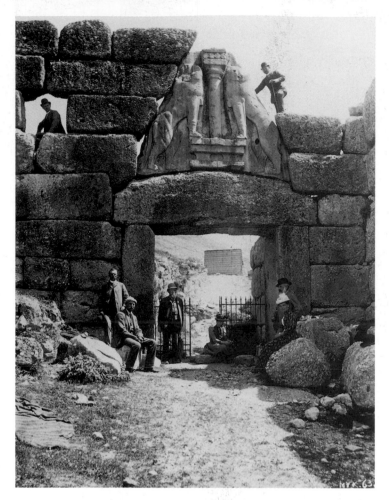

conquered the great city of Troy (see "The Trojan War," below). Even today, the monumental gateway to the **citadel** at Mycenae (fig. 4-18) is an impressive reminder of the city's warlike past. The gate itself dates from about 1250 BCE, perhaps a century later than the first of the citadel's **ring walls**, or surrounding walls. Although formed of megaliths, this gate is very different in purpose and style from other megalithic structures of the time—Stonehenge, for example (see fig. 1-19). The basic architecture of this gate is post-and-lintel construction with a **relieving arch** above. The corbel arch "relieved" the lintel of the weight of the wall that rose above it to a height of about 50 feet. As in Near Eastern citadels, the gate was provided with guardian figures. The Mycenaean sculptors carved a pair of lions nearly 9½ feet tall on a triangular panel filling the opening above the lintel. Their now-missing heads were made separately—of stone, wood, bronze, or gold—then fastened into holes in the stone. The two animals, one on each side of a Minoan-style column, stand facing each other, their forepaws resting on Minoan-style stone altars. From this gate, the formal entranceway into the citadel, known as the Great Ramp, led up the hillside to the king's palace.

Tombs assumed much greater prominence for Helladic period culture of the mainland than for the Minoans, and ultimately they became the most architecturally sophisticated monuments of the entire Aegean period. The earliest burials were in shaft graves. The Mycenean ruling families laid out their dead in opulent costumes and jewelry and surrounded them with ceremonial weapons, gold and silver wares, and other articles indicative of their high status, wealth, and power (fig. 4-19, "The Object Speaks"). By about 1600 BCE, kings and princes on the mainland had

4-18. Lion Gate, Mycenae. C. 1250 BCE. Limestone relief, height of sculpture approx. 9'6" (2.9 m)

In this historic photograph, Heinrich Schliemann, director of the excavation, stands to the left of the gate and his second wife and partner in archaeology, Sophia, sits to the right.

THE TROJAN WAR

The legend of the Trojan War and its aftermath held a central place in the imagination of ancient people. It inspired, sometime before 700 BCE, the great epics of the Greek poet Homer—the *Iliad* and the *Odyssey*—and provided later poets and artists with rich subject matter.

According to the legend, a woman's infidelity caused the war. While on a visit to the city of Sparta in the Peloponnese, in southern Greece, young Paris, the son of King Priam of Troy, fell in love with Helen, a human daughter of Zeus who was the wife of the Spartan king Menelaus. With the help of Aphrodite, the goddess of love, Helen and Paris fled to Troy, a rich city in northwestern Asia Minor. The angry Greeks dispatched ships and a huge army to bring Helen back. Led by Agamemnon, king of Mycenae and the brother of Menelaus, the Greek forces laid siege to Troy. The two sides were deadlocked for ten years, until a ruse devised by the

Greek warrior Odysseus enabled the Greeks to win: the Greeks pretended to give up the siege and built a huge wooden horse to leave behind as a parting gift to the goddess Athena, or so they led the Trojans to believe. In fact, Greek warriors were hidden inside the wooden horse. After the Trojans pulled the horse inside the gates of Troy, the Greeks slipped out and opened the gates to their comrades, who slaughtered the Trojans and burned the city.

This legend probably originated with a real attack on a coastal city of Asia Minor by mainland Greeks during the late Bronze Age. Tales of the conflict, modified over the centuries, endured in a tradition of oral poetry until Homer wrote them down.

Like the Greeks, the Romans found inspiration in the legendary struggle at Troy. Seeking heroic origins for themselves, they claimed descent from Aeneas, a Trojan warrior. As recounted in the *Aeneid*, an epic by the Roman poet Virgil (70–19 BCE), Aeneas

and his followers escaped from Troy and found their way to Italy.

As early as the seventeenth century CE, adventurers began searching for Troy. In the early nineteenth century, the Englishman Charles MacLaren and the American Frank Calvert both concluded that the remains of the legendary city might be found at the Hissarlik Mound in northwestern Turkey. Excavated first by Heinrich Schliemann (see "Pioneers of Aegean Archaeology," page 149) in 1872–90 and by an American team under Carl Blegen in the 1930s, this relatively small mound—less than 700 feet across—contained the "stacked" remains of at least nine successive cities, the earliest of which dates to at least 3000 BCE. The most recent hypothesis is that so-called Troy 6 (the city six levels down), which flourished between about 1800 and 1300 BCE, was the Troy of Homeric legend; its substantially reinforced fortifications suggest that was threatened by a powerful enemy.

THE OBJECT SPEAKS

THE "MASK OF AGAMEMNON"

"I have gazed on the face of Agamemnon," archaeologist Heinrich Schliemann supposedly telegraphed a Greek newspaper in late 1876. His words to the king of Greece, while more enthusiastic, were also more guarded: Schliemann expressed his great joy at having found the tombs of Agamemnon and his family, the House of Atreus. Just as Schliemann had followed clues in Homer's epics to discover Troy (see "Pioneers of Aegean Archaeology," page 149), so had he tracked the words of the second-century BCE Greek geographer Pausanias to the citadel at Mycenae, which Schliemann believed to be the home of Agamemnon, the commander-in-chief of the Greek forces against Troy (see "The Trojan War," opposite). Among the 30 pounds of gold objects he found in the royal graves were five death masks, and one of these golden treasures (fig. 4-19) seemed to him to be the face of Homer's hero. Even today, the gold mask that so moved Schliemann exerts a nearly hypnotic power. But is the face Agamemnon's—if there was such a person—and does it say anything to us about him, and about Schliemann?

In fact, we now know this golden mask has nothing to do with the heroes of the Trojan War. Research shows that the Mycenae graves are about 300 years older than Schliemann believed and the burial practices were different from those described by Homer. Still, the image is so commanding that we sense it nevertheless is a hero's face. However, the characteristics that make it seem so gallant—such as the handlebar moustache and large ears—have caused some scholars to question its authenticity.

Controversies surrounding the mask surfaced about thirty years ago and were raised again in the July–August 1999 issue of *Archaeology*, which asked, "Is Schliemann Mask a Fake?" Some scholars today maintain that the mask is just what Schliemann claimed: a treasure he discovered in a royal tomb at Mycenae. Scholars at the opposite extreme disagree. Noting that this mask is significantly different from the others found at the site, they contend that Schliemann had some of the features added to make the mask appear more heroic to viewers of his day.

Regardless of what future researchers may learn about this mask, several facts are indisputable. First, for Schliemann it was a symbol of the Mycenaean culture he had hoped to find—and of the new world of archaeology he in fact opened up with his discoveries. Second, the image of this face—whoever's it may be—has the power to move us to this day.

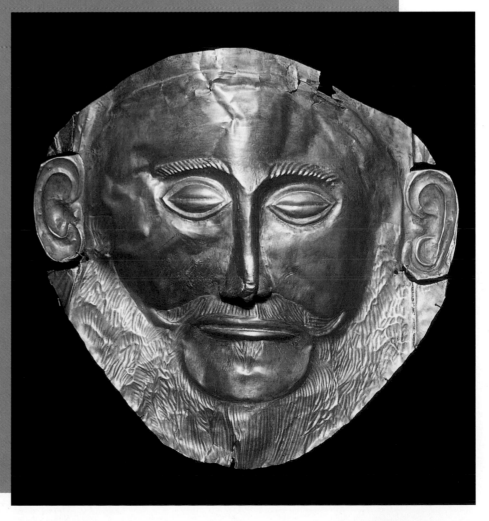

4-19. *"Mask of Agamemnon,"* funerary mask, from the royal tombs, Grave Circle A, at Mycenae, Greece. c. 1600–1550 BCE. Gold, height approx. 12" (35 cm). National Archaeological Museum, Athens

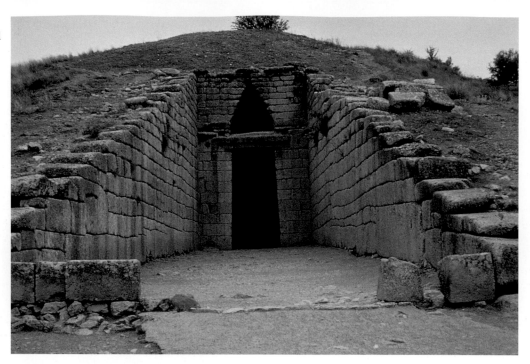

4-20. *Tholos*, **the so-called Treasury of Atreus**, Mycenae, Greece. c. 1300–1200 BCE

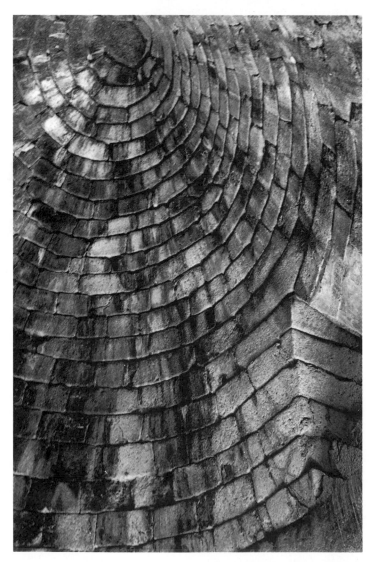

4-21. Corbeled vault, interior of the so-called Treasury of Atreus. Limestone, height of vault approx. 43' (13 m), diameter 47'6" (14.48 m)

This great beehive tomb, which remained half buried until it was excavated by Christos Stamatakis in 1878, is neither a storage space for treasures nor likely to be connected to Atreus, the father of the kings Menelaus and Agamemnon, the king who led the campaign against Troy in Homer's *Iliad*. For more than a thousand years, this Mycenaean tomb remained the largest uninterrupted interior space built in Europe. The first European structure to exceed it in size was the Pantheon in Rome (Chapter 6), built in the first century BCE.

More than a hundred such tombs have been found on mainland Greece, nine of them in the vicinity of Mycenae. Most of the tombs have been robbed. Possibly the most impressive is the so-called Treasury of Atreus (fig. 4-20), which dates from about 1300 to 1200 BCE. The structure is an example of **cyclopean construction**, so called because it was believed that only the race of giants known as the Cyclopes could have moved its massive stones. A walled passageway through the earthen mound covering the tomb, about 120 feet long and 20 feet wide and open to the sky, led to the tomb's entrance facade. The original entrance was 34 feet high and the door was 18 feet high, faced with bronze plaques and flanked by engaged, upward-tapering columns of green Egyptian porphyry (a type of stone) incised with geometric bands and **chevrons**—inverted Vs—filled with **running spirals**, a favored Aegean motif seen in earlier Cycladic and Minoan art. The section above the lintel had smaller engaged columns on each side, and the relieving triangle was disguised behind a red-and-green engraved marble panel. The main tomb chamber (fig. 4-21) is a circular room 47½ feet in diameter and 43 feet high. It is roofed with a **corbel vault** built up in regular **courses**, or layers, of **ashlar**—squared stones—smoothly leaning inward and carefully calculated to meet in a single capstone at the peak, a remarkable engineering feat.

begun building large aboveground burial places commonly referred to as **beehive tombs** because of their rounded, conical shape. In their round plan, beehive tombs are somewhat similar to the prehistoric European megalithic tombs, such as the one at Newgrange, Ireland (see fig. 1-17).

The Citadel at Tiryns. The builders of the citadel at Tiryns (fig. 4-22), about 10 miles from Mycenae and near the coast, made up for the site's lack of natural defenses by drawing heavily on their knowledge of military strategy. Homer referred to the resulting fortress as "Tiryns of the Great Walls." Its ring wall was about 20 feet thick, and the inner palace walls were similarly massive. The main entrance gate was approached along a narrow ramp that wound clockwise along the ring wall, forcing attacking soldiers to approach with their right sides exposed to the defenders on top of the wall (they carried their shields on their left arms). If the attackers reached the entrance, they still had to fight their way through a series of inner fortified gates. Corbel-vaulted casemates, or rooms and passages within the thickness of the ring walls, provided space for storing arms and sheltering soldiers or towns-people seeking safety within the citadel (fig. 4-23). In the unlikely event that the citadel gate was breached, the people inside could fight attackers from openings in the casemates.

As in all Mycenean citadels, the ruler's residence at Tiryns had a large audience hall called a **megaron**, or

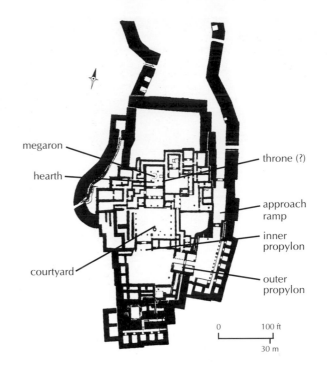

4-22. Plan of the citadel at Tiryns, Greece. Site occupied c. 1600–1200 BCE; fortified c. 1365 BCE

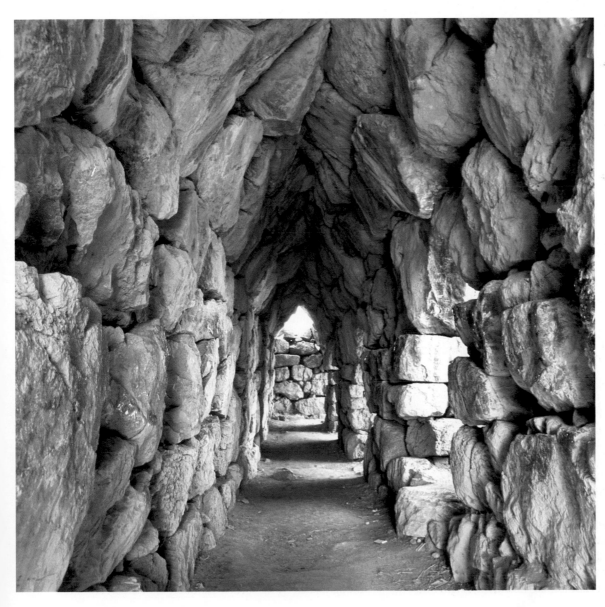

4-23. Corbel-vaulted casemate inside the ring wall of the citadel at Tiryns. c. 1365 BCE

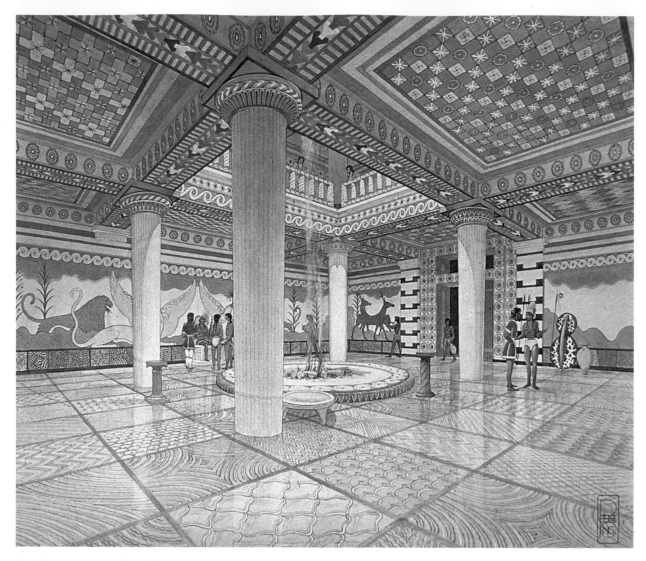

4-24. **Reconstruction drawing of the megaron in the palace at Pylos**, Greece. c. 1300–1200 BCE. Drawing in Antonopouleion Archaeological Museum, Pylos

"great room." The main courtyard led to a porch, a vestibule, and then to the great room—a much more direct approach than the complex corridors imposed on visitors in a Minoan palace. In the typical megaron plan, four large columns around a central hearth supported the ceiling. The roof section above the hearth was either raised or open to admit light and air and permit smoke to escape. Architectural historians surmise that the megaron eventually came to be specifically associated with royalty. The later Greeks therefore adapted its form when building temples, which they saw as earthly palaces for their gods.

The Palace at Pylos. Tiryns required heavy defense works because of its proximity to the sea and its location on a flat plain. The people of Pylos, in the extreme southwest of the Peloponnese, perhaps felt that their more remote and defensible location made them less vulnerable to military attack. The palace at Pylos, built about 1300–1200 BCE, followed the megaron plan and was built on a raised site without fortifications. Set behind a porch and vestibule facing the courtyard, the Pylos megaron was a magnificent display of architectural and decorative prowess. The reconstructed view provided here (fig. 4-24) shows how the combined throne room and audience

hall, with fluted, upward-swelling Minoan-type columns supporting heavy ceiling beams, might have looked when new. Every inch was painted—the floors, ceilings, beams, and door frames with brightly colored abstract designs, and the walls with large mythical animals and highly stylized plant and landscape forms.

Linear B clay tablets found in the ruins of the palace include an inventory of the palace furnishings that indicates they were as elegant as the architecture. The listing on one tablet reads: "One ebony chair with golden back decorated with birds; and a footstool decorated with ivory pomegranates. One ebony chair with ivory back carved with a pair of finials and with a man's figure and heifers; one footstool, ebony inlaid with ivory and pomegranates." It may be that the people of Pylos should have taken greater care to protect themselves. Within a century of its construction, the palace was destroyed by fires, apparently set during the violent upheavals that brought about the collapse of Mycenaean Greek dominance.

SCULPTURE

Mainland artists saw Minoan art acquired through trade. Perhaps they even worked side by side with Minoan artists brought back by the Greek conquerors of Crete. A carved

4-25. *Two Women with a Child*, found in the palace at Mycenae, Greece. c. 1400–1200 BCE. Ivory, height 2¾" (7.5 cm). National Archaeological Museum, Athens

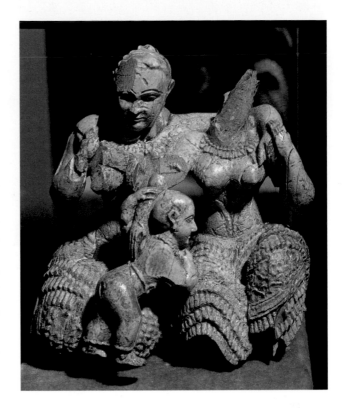

ivory group of two women and a child (fig. 4-25), less than 3 inches high and found in the palace shrine at Mycenae, appears to be a product of Minoan-Mycenaean artistic exchange. Dating from about 1400–1200 BCE, the miniature exhibits carefully observed natural forms, an intricately interlocked composition, and finely detailed rendering. The group is carved entirely in the round—top and bottom as well as back and front. It is an object to be held in the hand and manipulated. Because there are no clues to the identity or the significance of the group, we might easily interpret it as generational—with grandmother, mother, and child—but the figures could just as well represent two nymphs or devotees attending a child god. In either case, the mood of affection and tenderness among the three is unmistakable, and, tiny as it is, the sculpture counters the militaristic vein of so much Mycenaean art.

PIONEERS OF AEGEAN ARCHAEOLOGY The pioneering figure in the modern study of Aegean civilization was Heinrich Schliemann (1822–90 CE), who was inspired by Homer's epic tales, the *Iliad* and the *Odyssey* (see page 144). Born in Germany but an American citizen after 1869, he was the son of an impoverished minister, from whom he inherited a love of literature and languages. Yet Schliemann was forced by economic circumstances to follow a commercial course of study and to enter the business world—as a grocer's apprentice—in 1836. Largely self-educated, he worked hard, grew rich, and retired in 1863 to pursue his lifelong dream of becoming an archaeologist. Between 1865 and 1868, he studied archaeology and Greek in Paris; in 1869, he began conducting fieldwork in Greece and Turkey.

Scholars of that time considered Homer's stories pure fiction, but by studying the descriptions of geography in the *Iliad*, Schliemann located a multilayered site at Hissarlik, in modern Turkey, whose sixth level down is now generally accepted as being Homer's Troy (see "The Trojan War," page 144).

After his success at Hissarlik, Schliemann pursued his hunch that the grave sites of Homer's Greek royal family would be found inside the citadel at Mycenae. He did find opulent burials in shaft graves uncovered near the Lion Gate (see figs. 4-18, 4-19), but later data proved the graves to be too early to contain the bodies of Atreus, Agamemnon, and their relatives—if these legendary figures ever existed. Nevertheless, scholars today accept the possibility that some Homeric legends are based on actual events.

In 1887, Schliemann tried unsuccessfully to buy a site on the island of

Crete where he hoped to find the palace of the legendary King Minos. That discovery fell to a British archaeologist, Sir Arthur Evans (1851–1941), who led the excavation of the palace at Knossos between 1900 and 1905 (see fig. 4-5). It was Evans who gave the name *Minoan*—after King Minos—to Bronze Age culture on Crete. His chief focus was early Minoan writing. He also made a first attempt to establish an absolute chronology for Minoan art, basing his conjectures on datable Egyptian artifacts found in the ruins on Crete and on Minoan finds in Egypt. Later scholars have revised and refined his datings.

Men were not the only energetic researchers in the field in those days. Sophia Schliemann contributed much to her husband's work, and American archaeologist Harriet Boyd Hawes (1871–1945)—assisted by Edith Hall—was responsible for the discovery and excavation of Gournia, which is one of the best-preserved Bronze Age sites in Crete. She published her findings in 1908.

American archaeologist Harriet Boyd Hawes, photographed on Crete in 1902.

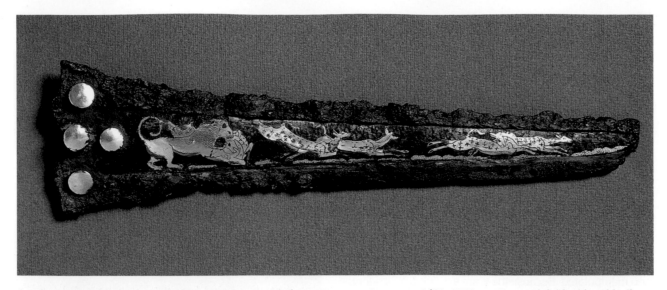

4-26. Dagger blade, from Shaft Grave IV, Grave Circle A, Mycenae, Greece. c. 1600–1550 BCE. Bronze inlaid with gold, silver, and copper, length 9⅜" (23.8 cm). National Archaeological Museum, Athens

METALWORK

The beehive tombs at Mycenae had been looted long before archaeologist Heinrich Schliemann arrived in the 1870s CE to search for Homeric Greece, but the contents of the shaft graves he excavated—constructed about 300 years before the beehive tombs—reflect even earlier mainland culture (see "Pioneers of Aegean Archaeology," page 149). Shaft graves were vertical pits 20 to 25 feet deep. In Mycenae, the royal graves were enclosed in a circle of standing stone slabs. Magnificent gold and bronze swords, daggers, masks, jewelry, and drinking cups were often buried with members of the elite. As in the tombs of Egyptian royalty, some of the men were found wearing masks of gold or a silver-gold alloy called electrum, as if to preserve their heroic features forever (see fig. 4-19, "The Object Speaks").

Also found in one of the shaft graves at Mycenae were three bronze dagger blades decorated with inlaid scenes.

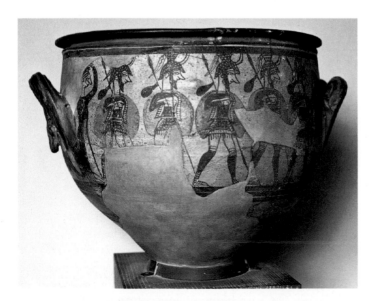

4-27. Warrior Vase, from Mycenae, Greece. c. 1300–1100 BCE. Ceramic, height 16" (41 cm). National Archaeological Museum, Athens

The Mycenaean artist cut shapes out of different-colored metals—copper, silver, and gold—then inlaid them in the bronze blades, then added the fine details in niello (see "Aegean Metalwork," page 136). In the *Iliad*, Homer's epic poem about the Trojan War written sometime before 700 BCE, the poet describes similar decoration on Agamemnon's armor and Achilles' shield. The decoration on the blade shown here, depicting men with shields battling three lions, is typically Aegean in the animated and naturalistic treatment of the figures (fig. 4-26). Interestingly, the scene on another blade found at the site, showing a leopard attacking ducks in a papyrus swamp, reflects Egyptian influence.

CERAMICS

In the final phase of the Helladic period, Mycenaean potters created highly refined ceramics in uniform sizes and shapes. Although their vessels were superior to most earlier wares in terms of technique, the decorations applied to them were often highly stylized. A narrative scene ornaments the Mycenaean *Warrior Vase*, dating from about 1300–1100 BCE (fig. 4-27). On the side shown here, a woman at the far left bids farewell to a group of helmeted men marching off to the right with beribboned lances and large shields. The vibrant energy of the *Harvester Vase* or the *Vapheio Cup* has changed in this scene to the regular rhythm inspired by marching men. The only indication of the woman's emotions is the symbolic gesture of an arm raised to her head, and the figures of the men are seemingly interchangeable parts in a rigidly disciplined war machine.

Mycenaean civilization did not have a long history. By 1200 BCE, more aggressive invaders were crossing into mainland Greece, and within a century they had taken control of the major cities and citadels. The period between about 1100 and 900 BCE was a kind of "dark age" in the Aegean, marked by political, economic, and artistic instability and upheaval. But a new culture was forming, one that looked back to the exploits of the Helladic warrior-kings as the glories of a heroic age while setting the stage for a new Greek civilization.

PARALLELS

PERIOD	ART IN THE AEGEAN	ART IN OTHER CULTURES
CYCLADIC c. 3000–1600 BCE	**4-2.** **"Frying pan"** (c. 2500–2200) **4-3.** **Cycladic woman figure** (c. 2500–2200) **4-4.** *Harp Player* (3rd millennium)	**1-19.** **Stonehenge** (c. 2750–1500), England **3-10.** **Great Pyramids** (c. 2613–2494), Egypt **3-13.** *Menkaura and a Queen* (c. 2500), Egypt **2-16.** **Gudea** (c. 2120), Lagash **2-6.** **Nanna Ziggurat** (c. 2100–2050), Iraq **11-2.** **Jomon vessel** (c. 2000), Japan **9-4.** **Harappa torso** (c. 2000), India
MINOAN **OLD PALACE** c. 1900–1700 BCE	**4-6.** **Kamares Ware** (c. 2000–1900) **4-7.** **Bee pendant** (c. 1700)	**1-24.** *Horse and Sun Chariot* (c. 1800–1600), Denmark **3-24.** *Senusret II pectoral* (c. 1880–1874), Egypt **3-22.** *Face of King Senusret III* (1874–1855), Egypt **2-17.** *Stele of Hammurabi* (c. 1792–1750), Susa
MINOAN SECOND **PALACE** c. 1700–1450 BCE	**4-5.** **Knossos palace** (c. 1700–1450) **4-9.** *Woman or Goddess with Snakes* (c. 1600–1550) **4-10.** *Harvester Vase* (c. 1650–1450) **4-14.** *Landscape* (before 1630–1500) **4-11.** **Bull's head rhyton** (c. 1550–1450) **4-12.** *Octopus Flask* (c. 1500–1450)	
LATE MINOAN c. 1450–1375 BCE	**4-15.** *Bull Leaping* (c. 1450-1375) 	
MYCENAEAN c. 1400–1100 BCE	**4-16.** *Vapheio Cup* (c. 1650–1450) **4-17.** **Mycenae citadel** (c. 1600–1200) **4-19.** **Funerary mask** (c.1600–1550) **4-25.** *Two Women* (c. 1400–1200) **4-23.** **Tiryns citadel** (c. 1365) **4-20.** *Tholos "Treasury"* (c. 1300–1200) **4-27.** *Warrior Vase* (c. 1300–1100) **4-18.** **Lion Gate** (c. 1250)	**2-27.** **Lion Gate** (c. 1400), Turkey **3-37.** *Queen Tiy* (c. 1352), Egypt **3-36.** *Akhenaten and His Family* (c. 1352–1336), Egypt **3-38.** *Nefertiti* (c. 1352–1336), Egypt **3-1.** **Tutankhamun mask** (c. 1336–1327), Egypt **3-29.** **Pylon of Rameses II** (c. 1279–1213), Egypt

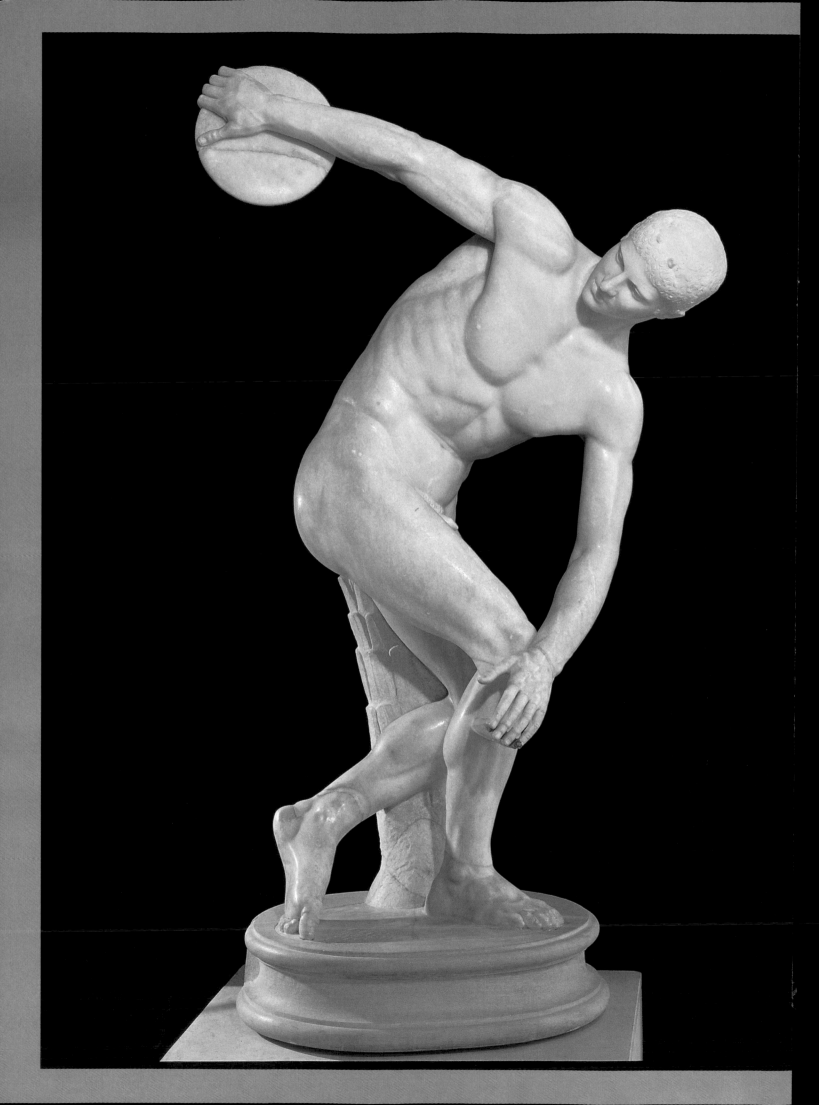

5-1. **Myron.** *Discus Thrower (Diskobolos)*,
Roman copy after the original bronze of c. 450 BCE.
Marble, height 5'1" (1.54 m). Museo Nazionale
Romano, Rome

A sense of awe fills the stadium when the athletes recognized as the fastest runners in the world enter for the second day of competition. With the opening ceremonies behind them, each runner has only one goal: to win—to earn recognition as the best, to take home the award, the praise, the championship. The runners have come from near and far, as will the wrestlers and riders, the discus throwers and long jumpers, the boxers and javelin hurlers who will compete.

This competition took place more than 2,000 years ago, but the scene seems comfortably familiar. Every four years, then as now, the best athletes were to come together. Attention would shift from political confrontation to physical competition, to individual human beings who seemed able to surpass even their own abilities in the glorious pursuit of an ideal. Yet beyond those common elements lie striking differences between Olympics past and present. At those first Olympian Games, the athletes gathered on sacred ground near Olympia, in modern-day Greece, to pay tribute to the supreme god, Zeus, and his wife, Hera. The first day's ceremonies were religious rituals, and the awards were crowns of wild olives. The winners' deeds were celebrated by poets long after their victories, and the greatest of the athletes might well live the rest of their lives at public expense. They were idealized for centuries in extraordinary Greek sculpture, such as the *Discus Thrower*, originally created in bronze by Myron about 450 BCE (fig. 5-1). The Olympian Games were so significant that many Greeks date the beginning of their history as a nation to the first Games, traditionally said to have been held in 776 BCE. (The Roman emperor Theodosius banned the Games in 394 CE, and they were not resumed until 1896.) In recognition of the original Games, the modern Olympics begin with the lighting of a flame from a torch ignited by the sun at Olympia that is carried by relay to that year's site—an appropriate metaphor for the way the light of inspiration was carried from ancient Greece throughout the Western world.

▲ c. 1000–900 PROTO-GEOMETRIC

▲ c. 700– 600 ORIENTALIZING

▲ c. 900– 700 GEOMETRIC

▲ c. 600–480 ARCHAIC

TIMELINE 5-1. Art Periods in Ancient Greece. After the waning of the Mycenaean culture, Greek styles between 900 and 480 BCE were dominated by the Geometric, Orientalizing, and Archaic. After the Transitional, or Early Classical, period, Greece entered the Fifth- and Fourth-Century Classical periods, until about 320 BCE, when the style known as Hellenistic spread throughout the Greek Empire.

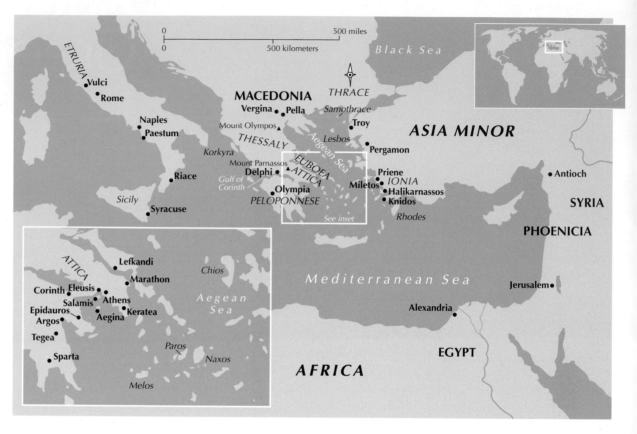

MAP 5-1. Ancient Greece. During the Hellenistic period, Greek influence extended beyond mainland Greece to Macedonia, Egypt, and Asia Minor.

THE EMERGENCE OF GREEK CIVILIZATION

"Man is the measure of all things," concluded Greek sages, and Greeks carved those words on a temple at one of their sacred sites, the Temple of Apollo at Delphi. Supremely self-aware and self-confident, the Greeks developed this concept of human supremacy and responsibility into a worldview that demanded a new visual expression in art. Artists studied human beings intensely, then distilled their newfound knowledge to capture in their art works the essence of *humanity*—a term that, by the Greeks' definition, applied only to those who spoke Greek; they considered those who could not speak Greek "barbarians."

Ancient Greece was a mountainous land of spectacular natural beauty. Olive trees and grapevines grew on the steep hillsides, producing oil and wine, but with little good farmland the Greeks turned to commerce to supply their needs. In towns, skilled artisans provided metal and ceramic wares to exchange abroad for grain and raw materials. Greek merchant ships carried pots, olive oil, and bronzes from Athens, Corinth, and Aegina around the Mediterranean Sea. The Greek cultural orbit included mainland Greece with the Peloponnese in the south and Macedonia in the north, the Aegean islands, and the western coast of Asia Minor (Map 5-1). Greek colonies in Italy, Sicily, and Asia Minor rapidly became powerful independent commercial and cultural centers themselves, but they remained tied to the homeland by common language, traditions, religion, and history.

More than 2,000 years have passed since the artists and architects of ancient Greece worked, yet their achievements continue to have a profound influence. Their legacy is especially remarkable given their relatively small numbers, the almost constant warfare that beset them, and the often harsh economic conditions of the time. Greek artists sought a level of perfection that led them continually to improve upon their past accomplishments through changes in style and approach. For this reason, the history of Greek art contrasts dramatically with that of Egyptian art, where the desire for permanence and continuity induced artists to maintain artistic conventions for nearly 3,000 years. In the comparatively short time span from around 900 BCE to about 100 BCE,

Greek artists explored a succession of new ideas to produce a body of work in every medium—from pottery and painting to sculpture and architecture—that exhibits a clear stylistic and technical direction toward representing the visual world as we see it. The periods into which ancient Greek art is traditionally divided (see page 157) reflect the definable stages in this stylistic progression rather than political developments.

The Greeks contributed more to posterity than their art. Their customs, institutions, and ideas have had an enduring influence in many parts of the world. Countries that highly esteem athletic prowess reflect an ancient Greek ideal. Systems of higher education in the United States and Europe also owe much to ancient Greek models. Many important Western philosophies, especially regarding the individual human being, have conceptual roots in ancient Greece. Perhaps most significant, representative governments throughout the world today owe a debt to ancient Greek experiments in democracy.

A BRIEF HISTORY

Following the collapse of Mycenaean dominance about 1100 BCE, the Aegean region experienced a period of disorganization during which most prior cultural developments, including writing, were destroyed or forgotten. The mainland, the Aegean islands, and the coastal areas of Asia Minor were left open to new waves of migrating peoples. Although nothing is known for certain of their origins or the dates of their arrivals, some of these immigrants may have brought Iron Age technology to these regions.

The mountains and sea that divide the lands of the region also divided the people. By about 900 BCE, the inhabitants of the Aegean region established small, distinct groups in valleys, on coastal plains, and on islands, living in self-sufficient, close-knit communities but all speaking some form of the same language. It was these people, a fusion of new migrants and earlier inhabitants, who came to be called Greeks. From these independent communities, Greeks in the ninth and eighth centuries BCE developed the city-state (polis), an autonomous region having a city—Athens, Corinth, Sparta—as its political, economic, religious, and cultural center. Each was independent, deciding its own form of government, securing its own economic support, and managing its own domestic and foreign affairs. The power of these city-states initially depended at least as much on their manufacturing and commercial skills as on their military might. In the seventh century BCE, the Greeks adopted two sophisticated new tools from Asia Minor, coins and alphabetic writing, opening the way for success in commerce and literature.

Among the emerging city-states, Corinth, located on major land and sea trade routes, was one of the oldest and most powerful. By the sixth century BCE, Athens, located in Attica on the east coast of the mainland, began to assume both commercial and cultural preeminence. In 594 BCE, the poet and patriot Solon became the political leader of Athens. He developed a judiciary and a constitutional government with a popular assembly and a council. By the end of the sixth century BCE, Athens had a representative government in which every community (or deme, hence "democracy") had its own assembly and magistrates. All citizens participated in the assembly and all had an equal right to own private property, to exercise freedom of speech, to vote and hold public office, and to serve in the army or navy. Citizenship, however, remained an elite male prerogative. The census of 309 BCE in Athens listed 21,000 citizens, 10,000 foreign residents, and 400,000 others—that is, women, children, and slaves. In spite of the exclusive and intensely patriarchal nature of citizenship, the idea of citizens with rights and responsibilities was an important new concept in governance. Only in Sparta did a warrior aristocracy retain power. (The Greek cities of Asia Minor, controlled by the Persian Empire under Darius, did not fare well politically at this time; see Chapter 2.)

At the beginning of the fifth century BCE, the Greek cities of Asia Minor led by Miletos (page 199) revolted against Persia, initiating a period of warfare between Greeks and Persians. In 490 BCE, at the Greek mainland city of Marathon, the Athenians drove off Darius's Persian army (today's marathon races still recall the feat of the man who ran the 26 miles from Marathon to Athens with news of victory and dropped dead from exhaustion as he gasped out his words). Ten years later, the Persians again invaded Greece and even destroyed Athens. But the Athenians were skilled mariners, and they had a small but formidable navy. They destroyed the Persian fleet at Salamis in 479 BCE. Athens emerged from the Persian wars as the leader of the city-states.

The victorious Greeks turned to rebuilding their cities and self-confidently celebrating Greek culture. Pericles, who dominated Athenian politics from mid-century until his death in 429 BCE, rebuilt the city and the temples on the Acropolis. Athens's artistic achievements during that period have been unrivaled in the Western world. Not all Greeks applauded the Athenians, however. In 431 BCE, a war broke out that only ended in 404 with the collapse of Athens and the victory of Sparta. In the fourth century BCE, a new force appeared in the north—Macedonia.

In 359 BCE, a crafty and energetic warrior, Philip II, came to the throne of Macedonia. In 338, he defeated Athens and rapidly conquered the other cities. When he was assassinated two years later, he left his kingdom to his twenty-year-old son, Alexander. Alexander, whom history calls "the Great," rapidly consolidated his power and then led a united Greece in a war of revenge and conquest against the Persians. In 334 BCE, he crushed the Persian army and conquered Syria and Phoenicia. By 331, he had occupied Egypt and founded the seaport he named Alexandria; the astute Egyptian priests of Amun recognized him as the son of a god, an idea he readily adopted.

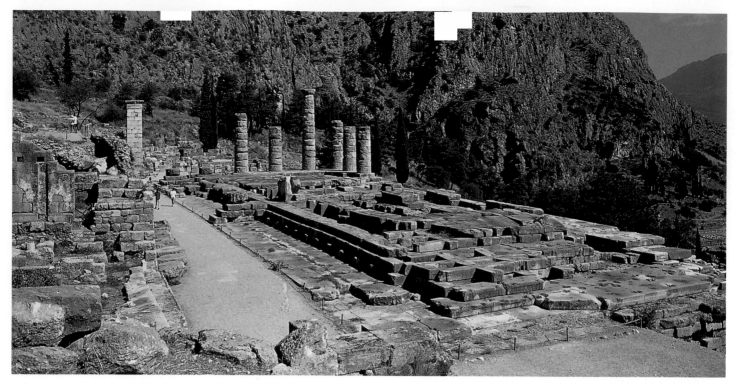

5-2. Sanctuary of Apollo, Delphi. 6th–3rd century BCE

This sacred home of the Greek god Apollo was built on the site of a sixth-century BCE temple destroyed in an earthquake; at a crevice here, the god was believed to communicate with humans through a woman medium called the Pythia. To prepare herself to receive his messages, she chewed sacred laurel leaves and drank water from the sacred Kassotis Spring, both of which are thought to have induced hallucinations. She then sat over the crevice on a three-legged stool. When she received the god's response to a petitioner's question, she conveyed it in often cryptic and ambiguous language. The Greeks attributed many twists of fate to misinterpretations of the Pythia's statements. When, for example, King Croesus of Lydia in Asia Minor (Chapter 2) came to Delphi in the mid-sixth century BCE to consult Apollo about his military plans, he received the message that he would cross a river and destroy a great kingdom. Ironically, the kingdom he destroyed was his own, when his troops crossed the Halys River and were wiped out by the Persians.

That same year, Alexander reached the Persian capital of Persepolis (Chapter 2), where his troops accidentally burned down the palace. He then continued east until he reached India in 326 BCE. Finally his troops refused to go any farther, and on the way home Alexander died of fever in 323. He was only thirty-three years old.

Alexander did not live long enough to consolidate his empire, and his generals divided the lands among themselves. Egypt, ruled by the Ptolemies, became especially rich and powerful (Chapter 3). These Hellenistic rulers in Egypt became patrons of arts and sciences, and their principal city, Alexandria, with its great library, became a center for the study of mathematics, geography, and medicine. Pergamon, Antioch, Jerusalem, and Athens all flourished under their own rulers in the fourth and third centuries BCE.

RELIGIOUS BELIEFS AND SACRED PLACES

Knowledge of Greek history is important to understanding its arts; knowledge of its religious beliefs is indispensable. The creation of the world, according to ancient Greek legend, involved a battle between the earth gods, called Titans or Giants, and the sky gods. The victors were the sky gods, whose home was believed to be atop Mount Olympos in the northeast corner of the Greek mainland. The Greeks saw their gods as immortal and endowed with supernatural powers, but, more than peoples of the ancient Near East and the Egyptians had, they visualized them in human form and attributed to them human weaknesses and emotions. Among the most important Olympian deities were the ruling god and goddess, Zeus and Hera; Apollo, god of healing, arts, and the sun; Poseidon, god of the sea; Ares, god of war; Aphrodite, goddess of love; Artemis, goddess of hunting and the moon; and Athena, the powerful goddess of wisdom who governed several other important aspects of human life (see "Greek and Roman Deities and Heroes," page 158).

In addition to Mount Olympos, many sites throughout Greece, called **sanctuaries**, were thought to be sacred to one or more gods. Local people enclosed the sanctuaries with walls and designated them as sacred ground. The earliest sanctuaries had one or more outdoor altars or shrines and a sacred natural element such as a tree, a rock, or a spring. As additional buildings were added over time, a sanctuary might become a palatial home for the gods, called a **temenos**, with one or more temples, several **treasuries** for storing valuable offerings, various monuments and statues, housing for priests and visitors, an outdoor dance floor or permanent theater for ritual performances and literary competitions, and a **stadium** for athletic events. The Sanctuary of Hera and Zeus near Olympia, in the western Peloponnese, housed an extensive athletic facility with training rooms and arenas for track-and-field events. It was here that athletic competitions, prototypes of today's Olympic Games, were held.

The Sanctuary of Apollo at Delphi is located on a high plateau in the shadow of Mount Parnassos (fig. 5-2). In this

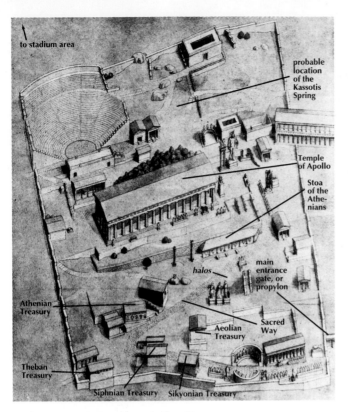

to stadium area

probable
location
of the
Kassotis
Spring

Temple
of Apollo

Stoa
of the
Athe-
nians

halos

main
entrance
gate, or
propylon

Athenian
Treasury

Aeolian
Treasury

Sacred
Way

Theban
Treasury

Siphnian Treasury Sikyonian Treasury

5-3. Reconstruction drawing of the Sanctuary of Apollo, Delphi. c. 400 BCE

rugged mountain site, according to Greek myth, the sky was attached to the *omphalos* (navel) of the earth by an umbilical cord. Here too, it was said, Apollo fought and killed the Python, the serpent son of the earth goddess Ge, who guarded his mother's nearby shrine. This myth may be a metaphorical account of the conquest of early Bronze Age people of Greece, whose religion centered on female earth deities, by a wave of new settlers who believed in a supreme male sky god. From very early times, the sanctuary at Delphi was renowned as an **oracle**, a place where a god (Apollo) was believed to communicate with humans by means of cryptic messages delivered through a human intermediary, or medium (the Pythia). The Greeks and their leaders routinely sought advice at oracles, and even foreign rulers requested help at Delphi.

Delphi was the site of the Pythian Games, named for the female medium there. This festival, like the Olympian Games, attracted participants from all over Greece. The principal events were both the athletic contests and the music, dance, and poetry competitions in honor of Apollo. As at Olympia, hundreds of statues dedicated to the victors of the competitions filled the sanctuary grounds, a kind of Pythian Games hall of fame (see fig. 5-34).

A reconstruction drawing of the Sanctuary of Apollo as it looked about 400 BCE (fig. 5-3) shows that the main temple, performance and athletic areas, and other buildings and monuments cleverly made full use of limited space on the hillside. After visitors climbed the steep path up the lower slopes of Parnassos, they entered the sanctuary by a ceremonial gate in the southeast corner. From there they zigzagged up the Sacred Way, so named because it was the route of religious processions during festivals. Moving past the numerous treasuries and memorials built by Greece's various city-states (see fig. 5-13), they soon arrived at the

long **colonnade** of the Temple of Apollo. This structure, built about 530 BCE on the ruins of an earlier temple, remained standing until it was destroyed by an earthquake in 373 BCE. Below the temple was a **stoa**, a columned pavilion open on three sides, built by the people of Athens. There visitors rested, talked, or watched ceremonial dancing on an outdoor pavement called a ***halos***. At the top of the sanctuary hill was a stadium area for athletic games.

Greek sanctuaries are quite different from the religious complexes of the ancient Egyptians (see, for example, the funerary complex of Hatshepsut, figs. 3-31, 3-32). Egyptian builders dramatized the power of gods or god-rulers by placing their temples at the ends of long, straight, processional ways. The Greeks, in contrast, treated each building and monument within a *temenos* as an independent element to be integrated with the natural features of the site. It is tempting to draw a parallel between this manner of organizing space and the way Greeks organized themselves politically. Every structure, like every Greek citizen, was a unique entity meant to be encountered separately within its own environment while being closely allied with other entities in a larger scheme of common purpose.

HISTORICAL DIVISIONS OF GREEK ART

The names of major periods of Greek art (Timeline 5-1) have remained standard even though changing interpretations have led some art historians to question their appropriateness. The primary source of information about Greek art before the seventh century BCE is pottery, and the Geometric period (c. 900–700 BCE) owes its name to the geometric, or rectilinear, forms with which artists of the time decorated ceramic vessels. The Orientalizing period (c. 700–600 BCE) is named for the apparent influence of Egyptian and Near Eastern art on Greek pottery of that time, spread through trading contacts as well as the travels of artists themselves. The name of the third period, *Archaic*, meaning "old" or "old-fashioned," stresses a presumed contrast between the art of that time (c. 600–480 BCE) and the art of the following Classical period, which once was thought to be the most admirable and highly developed—a view that no longer prevails among art historians.

The Classical period has been subdivided into three phases: the Transitional, or Early Classical, from about 480 to 450 BCE; the Fifth-Century Classical, from about 450 to the end of the fifth century BCE; and the Fourth-Century Classical, from about 400 to about 320 BCE. Art historians still use these subdivisions as convenient chronological markers but no longer see them as chapters in a story detailing the "rise and decline" of the Classical style. For this reason, the neutral terms *Fifth-Century* and *Fourth-Century* have largely replaced the formerly conventional terms *High* and *Late Classical,* with their implication of a peak of achievement followed by a decline.

The name of the final period of Greek art, *Hellenistic*, means "Greek-like." Hellenistic art was produced throughout the eastern Mediterranean world as non-Greek people

GREEK AND ROMAN DEITIES AND HEROES

The ancient Greeks had many deities, and myths about them varied over time. Many deities had several forms, or manifestations. Athena, for example, was revered as a goddess of wisdom, a warrior goddess, a goddess of victory, and a goddess of purity and maidenhood, among others. The Romans later adopted the Greek deities but sometimes attributed to them slightly different characteristics. What follows is a simplified list of the major Greek deities and heroes, with their Roman names in parentheses when they exist. The list includes some of the most important characteristics of each deity or hero, which often identify them in art.

According to the most widespread legend, twelve major sky gods and goddesses established themselves in palatial splendor on Mount Olympos in northeastern Greece after defeating the earth deities, called Giants or Titans, for control of the earth and sky.

THE FIVE CHILDREN OF EARTH AND SKY

Zeus (Jupiter), supreme deity. Mature, bearded man; holds scepter or lightning bolt; eagle and oak tree are sacred to him.

Hera (Juno), goddess of marriage. Sister/wife of Zeus. Mature woman; cow and peacock are sacred to her.

Hestia (Vesta), goddess of the hearth. Sister of Zeus. Her sacred flame burned in communal hearths.

Poseidon (Neptune), god of the sea. Holds a three-pronged spear; horse is sacred to him.

Hades (Pluto), god of the underworld, the dead, and wealth. His helmet makes the wearer invisible.

THE SEVEN SKY GODS, OFFSPRING OF THE FIRST FIVE

Ares (Mars), god of war. Son of Zeus and Hera. Wears armor; vulture and dog are sacred to him.

Hephaistos (Vulcan), god of the forge, fire, and metal handicrafts. Son of Hera (in some myths, also of Zeus); husband of Aphrodite. Lame, sometimes ugly; wears blacksmith's apron, carries hammer.

Apollo (Phoebus), god of the sun, light, truth, music, archery, and healing. Sometimes identified with Helios (the Sun), who rides a chariot across the daytime sky. Son of Zeus and Leto (a descendant of Earth); brother of Artemis. Carries bow and arrows or sometimes lyre; dolphin and laurel are sacred to him.

Artemis (Diana), goddess of the hunt, wild animals, and the moon. Sometimes identified with Selene (the Moon), who rides a chariot or oxcart across the night sky. Daughter of Zeus and Leto; sister of Apollo. Carries bow and arrows, is accompanied by hunting dogs; deer and cypress are sacred to her.

Athena (Minerva), goddess of wisdom, war, victory, the city, and civilization. Daughter of Zeus; sprang fully grown from his head. Wears helmet and carries shield and spear; owl and olive trees are sacred to her.

Aphrodite (Venus), goddess of love. Daughter of Zeus and the water nymph Dione; alternatively, daughter of Poseidon, born of his sperm mixed with sea foam; wife of Hephaistos. Myrtle, dove, sparrow, and swan are sacred to her.

Hermes (Mercury), messenger of the gods, god of fertility and luck, guide of the dead to the underworld, and god of thieves, commerce, and the marketplace. Son of Zeus and Maia, the daughter of Atlas, a Giant who supports the sky on his shoulders. Wears winged sandals and hat; carries caduceus, a wand with two snakes entwined around it.

OTHER IMPORTANT DEITIES

Demeter (Ceres), goddess of grain and agriculture.

Persephone (Proserpina), goddess of fertility and queen of the underworld. Wife of Hades; daughter of Demeter.

Dionysos (Bacchus), god of wine, the grape harvest, and inspiration. Shown surrounded by grapevines and grape clusters; carries a wine cup. His female followers are called maenads (Bacchantes).

Eros (Cupid), god of love. In some myths, the son of Aphrodite. Shown as an infant or young boy, sometimes winged; carries bow and arrows.

Eos (Aurora), goddess of dawn.

Ge, goddess of the earth; mother of the Titans.

Asklepios (Aesculapius), god of healing.

Amphitrite, goddess of the sea. Wife of Poseidon.

Pan, protector of shepherds, god of the wilderness and of music. Half man, half goat, he carries panpipes.

Nike, goddess of victory. Often shown winged and flying.

IMPORTANT HUMAN HEROES

Herakles (Hercules). A man of great and diverse strengths; granted immortality for his achievements, including the Twelve Labors.

Perseus. Killed Medusa, the snake-haired monster.

Theseus. Killed the Minotaur, a bull-monster that ate young men and maidens in a labyrinth in the palace of King Minos of Crete (see "The Legend of the Minotaur," page 134).

HEROES OF THE TROJAN WAR

Among the Greeks: Agamemnon (Greek commander-in-chief), Odysseus (Ulysses), Achilles, Patroclus, and Ajax.

Among the Trojans: Paris, Hector, Priam, Sarpedon, and Aeneas (progenitor of the Romans).

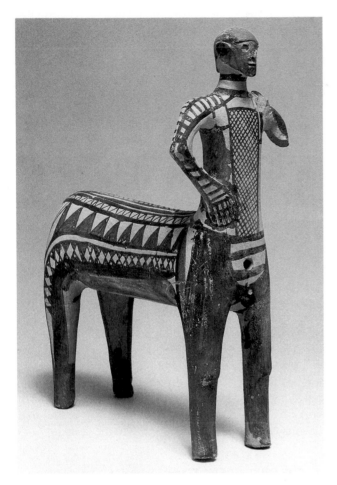

5-4. Centaur, from Lefkandi, Euboea. Late 10th century BCE. Terra-cotta, height 14⅛" (36 cm). Archaeological Museum, Eretria

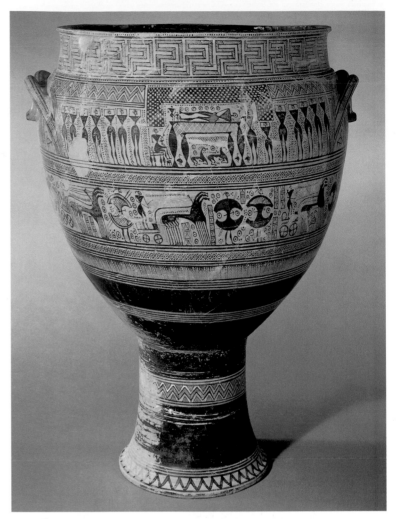

5-5. Funerary vase, from the Dipylon Cemetery, Athens. c. 750 BCE. Terra-cotta, height 42⅝" (108 cm). The Metropolitan Museum of Art, New York
Rogers Fund, 1914 (14.130.14)

gradually became imbued with Greek culture under Alexander and his successors. The history and art of ancient Greece end with the fall of Egypt, the last bastion of Hellenistic rule, to the Romans in 31 BCE.

THE GEOMETRIC PERIOD

The first appearance of a specifically Greek style of vase painting, as opposed to Minoan or Mycenaean, dates to about 1050 BCE. This style—known as Proto-Geometric because it anticipated the Geometric style—was characterized by linear motifs, such as spirals, diamonds, and **cross-hatching**, rather than the stylized plants, birds, and sea creatures characteristic of Minoan vase painting. The Geometric style proper, an extremely complex form of decoration, became widespread after about 900 BCE in all types of art and endured until about 700 BCE.

CERAMIC DECORATION

A striking ceramic figure of a half-horse, half-human creature called a centaur dates to the end of the tenth century BCE (fig. 5-4). This figure exemplifies two aspects of the Proto-Geometric style: the use of geometric forms in painted decoration, and the reduction of human and animal body parts in sculptural works to simple geometric solids such as cubes, pyramids, cylinders, and spheres. The figure is unusual, however, because of its size (more than a foot tall) and because its hollow body was formed like a vase on a potter's wheel. The artist added solid legs, arms, and a tail (now missing) to this body and painted on the bold, abstract designs with **slip**, a mixture of water and clay. The slip fired to dark brown, standing out against the lighter color of the unslipped portions of the figure. Centaurs, prominent in Greek mythology, had both a good and a bad side and may have symbolized the similar dual nature of humans. This centaur, discovered in a cemetery, had been deliberately broken into two pieces that were buried in adjacent graves. Clearly, the object had special significance for the people buried in the graves or their mourners.

Large funerary vases discovered in the ancient cemetery of Athens just outside the Dipylon Gate, once the main western entrance into the city, exemplify the complex decoration typical of the Geometric style proper. For the first time, human beings are depicted as part of a narrative. The pot illustrated here, a grave marker dated about 750 BCE, provides a detailed record of the funerary rituals—including the relatively new Greek practice of cremation—for an important man (fig. 5-5). The body of the deceased is

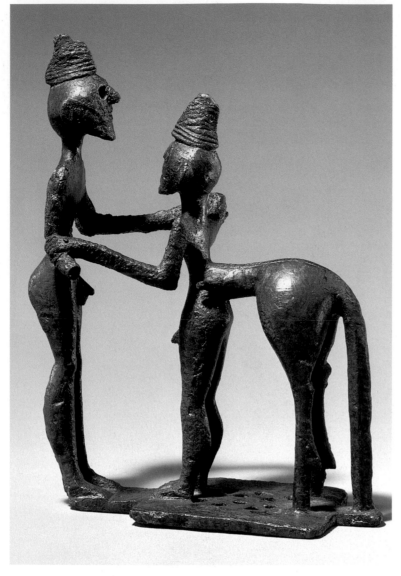

5-6. *Man and Centaur*, perhaps from Olympia. c. 750 BCE. Bronze, height 4⁵/₁₆" (11.1 cm). The Metropolitan Museum of Art, New York
Gift of J. Pierpont Morgan, 1917 (17.190.2072)

placed on its side on a funeral bier, about to be cremated, at the center of the top **register** of the vase. Male and female figures stand on each side of the body, their arms raised and both hands placed on top of their heads in a gesture interpreted as expressing anguish—it suggests that the mourners are literally tearing their hair out with grief. In the bottom register, horse-drawn chariots and foot soldiers, who look like walking shields with tiny antlike heads and muscular legs, form a well-ordered procession.

The abstract forms used to represent human figures on this pot—triangles for torsos; more triangles for the heads in profile; round dots for eyes; long, thin rectangles for arms; tiny waists; and long legs with bulging thigh and calf muscles—are typical of the Geometric style. Figures are shown in either full-frontal or full-profile views that emphasize flat patterns and outline shapes. No attempt has been made to create the illusion of three-dimensional forms occupying real space. The artist has nevertheless communicated a deep sense of human loss by exploiting

the rigidity, solemnity, and strong rhythmic accents of the carefully arranged elements.

Egyptian funerary art reflected the belief that the dead, in the afterworld, could continue to engage in activities they enjoyed while alive. Greek funerary art, in contrast, focused on the emotional reactions of the survivors, not the fate of the dead. The scene of human mourning on this pot contains no supernatural beings, nor any identifiable reference to an afterlife that might have provided solace for the bereaved. According to the Greeks, the deceased entered a place of mystery and obscurity that humans could not define precisely.

METAL SCULPTURE

Greek artists of the Geometric period produced many figurines of wood, ivory, clay, and especially cast bronze. These small statues of humans and animals are similar to those painted on pots. A tiny bronze of this type, *Man and Centaur*, dates to about 750 BCE (fig. 5-6). The two figures confront each other after the man has stabbed the centaur. The sculptor reduced the body parts of the figures to simple geometric shapes, arranging them in a composition of solid forms and open, or **negative, spaces** that makes the piece pleasing from every view. Most such works have been found in sanctuaries, suggesting that they may have been votive offerings to the gods.

THE FIRST GREEK TEMPLES

Greeks worshiped at outdoor altars within walled sanctuaries; their temples sheltered a statue of a god. Few ancient Greek temples remain standing today. Stone foundations define their rectangular shape, and their appearance has been pieced together largely from fallen columns, broken lintels, and fragments of sculpture lying where they fell centuries ago. Walls and roofs constructed of mud brick and wood have disappeared.

Small ceramic models, such as one from the eighth century BCE found in the Sanctuary of Hera near Argos, give some idea how these temples might have looked (fig. 5-7). The rectangular structure has a door at one end sheltered by a projecting **porch** supported on two sturdy posts. The steeply pitched roof forms a triangular area, or **gable**, in the **facade**, or front wall, that is pierced by an opening directly above the door. The abstract designs painted on the roof and side walls are similar to those used on other Geometric period ceramics; whether they reflect the way temples were actually decorated is not known.

Temple interiors followed an enduring basic plan adapted from the Mycenaean palace **megaron** (compare fig. 4-24 with plan [a] in "Greek Temple Plans," page 163). The large audience hall of the megaron became the main room of the temple, called the **cella**, or **naos**. In the center of this room, where the hearth would have been in the megaron, stood a statue of the god to whom the temple was dedicated. The small reception area that preceded the audience hall in the megaron became the temple's vestibule, called the **pronaos**.

THE ORIENTALIZING PERIOD

By the seventh century BCE, vase painters in major pottery centers in Greece had moved away from the dense linear decoration of the Geometric style. They now created more open compositions built around large motifs that included real and imaginary animals, abstract plant forms, and human figures. The source of these motifs can be traced to the arts of the Near East, Asia Minor, and Egypt. Greek painters did not simply copy the work of Eastern artists, however. Instead, they drew on work in a variety of mediums—including sculpture, metalwork, and textiles—to invent an entirely new approach to vase painting.

The Orientalizing style began in Corinth, a port city where luxury wares from Eastern cultures could be seen. The new style is evident in a Corinthian **olpe**, or wide-mouthed pitcher, dating to about 600 BCE, which has silhouetted creatures striding in horizontal bands against a light background with stylized flower forms called **rosettes** (fig. 5-8). An example of the **black-figure** pottery style, it is decorated with dark shapes of lions, a serpent, and composite creatures against a background of very pale buff, the natural color of the Corinthian clay (see "Greek Painted Vases," page 173). The artist incised fine details inside the silhouetted shapes with a sharp tool and added touches of white and reddish purple **gloss**, or clay slip mixed with metallic color pigments, to enhance the design.

THE ARCHAIC PERIOD

During the Archaic period, from about 600 to 480 BCE, the Greek city-states on the mainland, on the Aegean islands, and in the colonies grew and flourished. Athens, which had lagged behind the other city-states in population and economic development in the seventh century BCE, began moving artistically, commercially, and politically to the forefront.

The Greek arts developed rapidly during the Archaic period. In literature, the poet Sappho on the island of Lesbos was writing poetry that would inspire the geographer Strabo, near the end of the millennium, to write: "Never within human memory has there been a woman to compare with her as a poet." On another island, the semilegendary slave Aesop was relating animal fables that became lasting elements in Western culture. Artists shared in the growing prosperity of the city-states by competing for lucrative commissions from city councils and wealthy individuals, who sponsored the building of temples, shrines, government buildings, **monumental** (large-scale) sculpture, and fine ceramic wares. During this period, potters and vase painters began to sign their works.

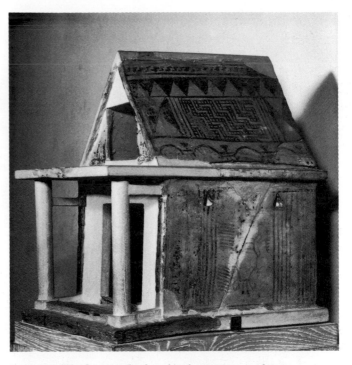

5-7. Model of a temple, found in the Sanctuary of Hera, Argos. Mid-8th century BCE. Terra-cotta, length 14¹⁄₂" (36.8 cm). National Archaeological Museum, Athens

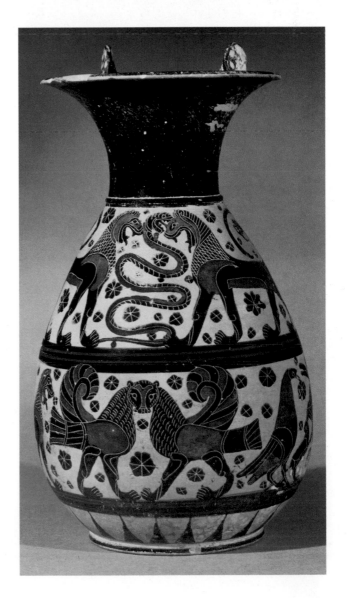

5-8. Pitcher (olpe), from Corinth. c. 600 BCE. Ceramic with black-figure decoration, height 11¹⁄₂" (30 cm). The British Museum, London

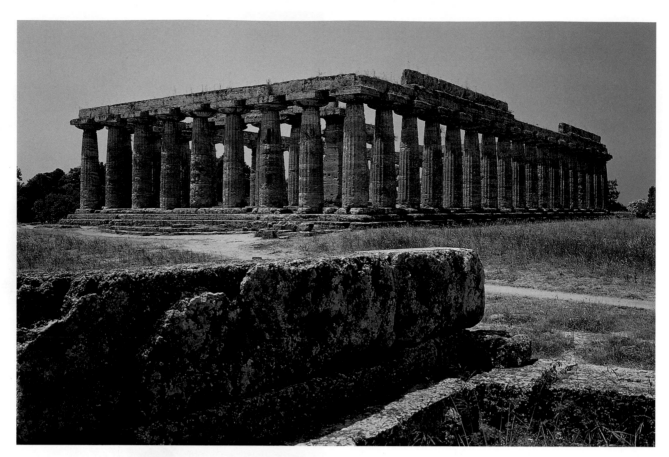

5-9. **Temple of Hera I, Paestum**, Italy. c. 550 BCE

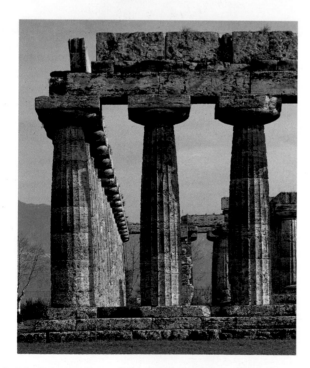

5-10. **Corner view of the Temple of Hera I, Paestum**

TEMPLE ARCHITECTURE

As Greek temples grew steadily in size and complexity over the centuries, stone and marble replaced the earlier mud-brick and wood construction. A number of standardized plans evolved, ranging from simple one-room structures with columned porches to buildings with double porches surrounded by columns (see "Greek Temple Plans," page 163). Builders also experimented with the design of temple **elevations**—the arrangement, proportions, and appearance of the columns and the entablatures. Two standardized elevation designs emerged during the Archaic period: the **Doric order** and the **Ionic order**. The **Corinthian order**, a variant of the Ionic order, developed later (see "The Greek Architectural Orders," page 164).

Paestum, the Greek colony of Poseidonica established in the seventh century BCE about 50 miles south of the modern city of Naples, Italy, contains some well-preserved early Greek temples. The earliest standing temple there, built about 550 BCE, was dedicated to Hera, the wife of Zeus (fig. 5-9). It is known today as Hera I to distinguish it from a second temple to Hera built adjacent to it about a century later.

Hera I is a large, rectangular, stone **post-and-lintel** structure with a stepped foundation supporting a **peristyle**, a row of columns that surrounds the cella on all four sides. This single peristyle plan is called a **peripteral** temple (see "Greek Temple Plans," page 163). Columns consist of **base**, **shaft**, and **capital** and stand on the **stylobate**. The peristyle of Hera I originally supported a tall lintel area called the **entablature**. The roof rested on the **cornice**, the slightly projecting topmost element of the entablature. At each end, the horizontal cornice of the entablature and the **raking** (slanted) **cornices** of the roof defined a triangular gable called the **pediment**.

ELEMENTS OF ARCHITECTURE

Greek Temple Plans

The simplest early temples consist of a single room, the **cella**, or **naos**. Side walls ending in attached **pillars (anta)** may project forward to frame two columns **in antis** (literally, "between the pillars"), as seen in plan (a). An **amphiprostyle** temple (b) has a row of columns (**colonnade**) at the front and back ends of the structure, not on the sides, forming porticos, or covered entrance porches, at the front and back. If the colonnade runs around all four sides of the building, forming a **peristyle**, the temple is **peripteral** (c and d). Plan (c), the Temple of Hera I at Paestum, Italy, shows a pronaos and an **adyton**, an unlit inner chamber. Plan (d), the Parthenon, has an adyton and an **opithodomos**, enclosed porch at the back. The **stylobate** is the top step of the **stereobate**, or layered foundation.

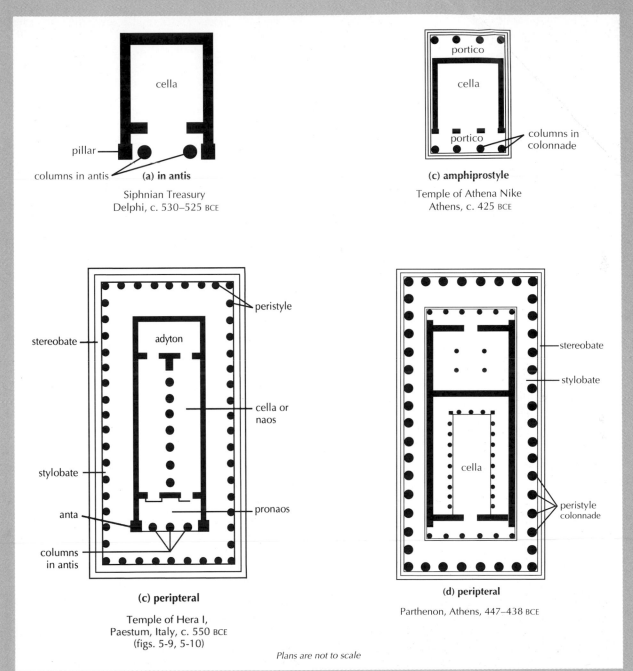

(a) **in antis**
Siphnian Treasury
Delphi, c. 530–525 BCE

(c) **amphiprostyle**
Temple of Athena Nike
Athens, c. 425 BCE

(c) **peripteral**
Temple of Hera I,
Paestum, Italy, c. 550 BCE
(figs. 5-9, 5-10)

(d) **peripteral**
Parthenon, Athens, 447–438 BCE

Plans are not to scale

The elevation design of Hera I illustrates the early form of the Doric order, including columns with fluted shafts resting without bases directly on the stylobate (fig. 5-10). Capitals are made up of three distinct parts: the necking that makes the transition from the shaft, the round **echinus**, and the square **abacus**. A three-part entablature consists of a plain, flat band, called the **architrave**, topped by a decorated band, called the **frieze**, and capped with a cornice. In the Doric frieze, flat areas called **metopes** alternate with projecting blocks with three vertical grooves called **triglyphs**. The metopes were usually either painted or carved in relief and then painted. No sculpture has survived, but fragments of terra-cotta eave decorations painted in bright colors have been found in the rubble of Hera I.

ELEMENTS OF ARCHITECTURE

The Greek Architectural Orders

The three classical Greek architectural orders are the Doric, the Ionic, and the Corinthian. The Doric and Ionic orders were well developed by about 600 BCE. The Doric order is the oldest and plainest of the three orders. The Ionic order is named after Ionia, a region occupied by Greeks on the west coast of Asia Minor and the islands off the coast. The Corinthian order, a variation of the Ionic, began to appear around 450 BCE and was initially used by the Greeks in interiors. Later, the Romans appropriated the Corinthian order and elaborated it, as we shall see in Chapter 6. Greek orders—and later Roman orders—are known as classical orders. Each order is made up of a system of interdependent parts whose proportions are based on mathematical ratios. *No element of an order could be changed without producing a corresponding change in other elements.*

The basic components of the Greek orders are the **column** and the **entablature**, which function as post and lintel. All types of columns have a **shaft** and a **capital**; some also have a **base**. The shafts are formed of round sections, or **drums**, which are joined inside by metal pegs. In Greek temple architecture, columns stand on the **stylobate**, the "floor" of the temple; the levels below the stylobate form the **stereobate**.

The **Doric order** shaft rises directly from the stylobate, without a base. The shaft is **fluted**, or channeled, with sharp edges. At the top of the shaft and part of the capital is the **necking**, which provides a transition to the capital. The Doric capital itself has three parts: the necking, the rounded **echinus**, and the tabletlike **abacus**. The entablature includes the **architrave**, the distinctive **frieze** of **triglyphs** and **metopes**, and the **cornice**, the topmost, projecting horizontal element. The roofline may have decorative waterspouts and terminal decorative elements called **acroterion**.

The **Ionic order** has more elongated proportions than the Doric, its height being about nine times the diameter of the column at its base, as opposed to the Doric column's five-and-a-half– or seven-to-one ratio. The flutes on the columns are deeper and closer together and are separated by flat surfaces called **fillets**. The **capital** has a distinctive scrolled **volute**; the entablature has a three-panel architave, continuous frieze, and the addition of decorative moldings.

The **Corinthian order** was originally developed by the Greeks for use in interiors but came to be used on temple exteriors as well. Its elaborate capitals are sheathed with stylized **acanthus** leaves that rise from a convex band called the **astragal**.

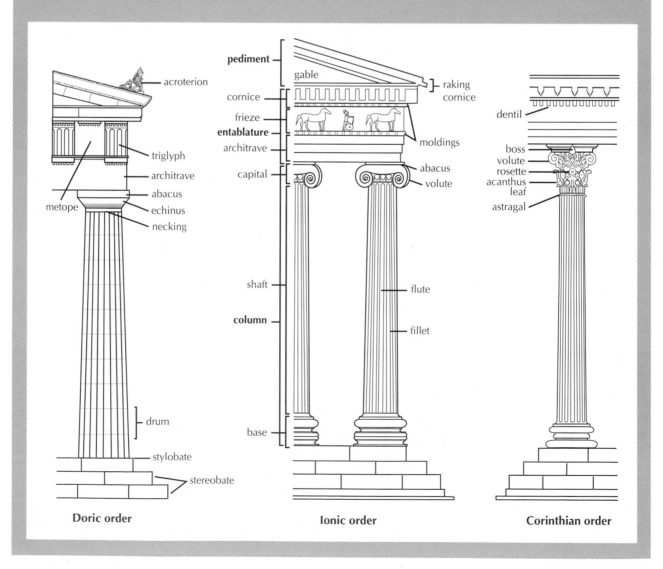

Doric order
- acroterion
- triglyph
- architrave
- abacus
- echinus
- necking
- metope
- drum
- stylobate
- stereobate

Ionic order
- pediment
- gable
- cornice
- frieze
- entablature
- architrave
- capital
- raking cornice
- moldings
- abacus
- volute
- shaft
- flute
- column
- fillet
- base

Corinthian order
- dentil
- boss
- volute
- rosette
- acanthus leaf
- astragal

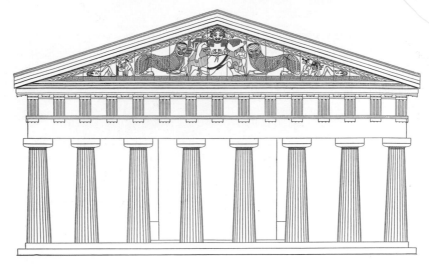

5-11. **Reconstruction of the west pediment of the Temple of Artemis, Korkyra** (Corfu), after G. Rodenwaldt. c. 600–580 BCE

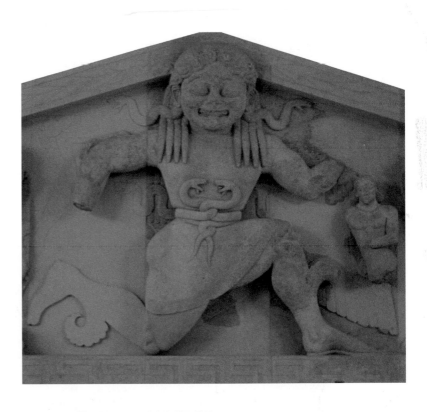

5-12. ***Gorgon Medusa***, detail of sculpture from the west pediment of the Temple of Artemis, Korkyra. c. 580 BCE. Limestone, height of pediment at the center 9'2" (2.79 m). Archaeological Museum, Korkyra (Corfu)

Ancient Greeks would have seen the image of Medusa at the center of this pediment as both menacing and protective. According to legend, countless people tried to kill this monster, only to die because they looked at her face. The Greek hero Perseus, instructed and armed by Athena, succeeded because he beheaded her while looking only at her reflection in his polished shield. Thus, the Medusa head became a popular decoration for Greek armor. See, for example, the shield of Ajax in figure 5-26.

The builders created an especially robust column, only about four times as high as its maximum diameter, topped with a widely flaring capital. This design creates an impression of great stability and permanence but is rather ponderous. As the column shafts rise, they swell in the middle and contract again toward the top, a refinement known as **entasis**. This subtle adjustment gives a sense of energy and upward lift. In a local variation, Hera I has an uneven number of columns—nine—across the short ends of the peristyle, placing a column instead of a space at the center of the ends. The entrance to the pronaos also has a central column, and a row of columns runs down the center of the wide cella to help support the ceiling and roof. The unusual two-aisle, two-door arrangement leading to the **adyton**, the small room at the end of the cella proper, suggests that the temple may have housed both a statue of Hera and that of a second deity, possibly Zeus, her consort.

ARCHITECTURAL SCULPTURE

As Greek temples grew larger and more complex, sculptural decoration took on increased importance. Among the earliest surviving examples of Greek pedimental sculpture are fragments of the ruined Doric order Temple of Artemis on the island of Korkyra (Corfu) off the northwest coast of the mainland, which date to about 580 BCE (fig. 5-11). The figures in this sculpture were carved on separate slabs, then installed in the pediment space. They stand in such **high relief** from the background plane that they actually break through the architectural frame, which was more than 9 feet tall at the peak. At the center is the rampaging snake-haired Medusa (fig. 5-12), one of three winged female monsters called Gorgons. Medusa had the power to turn humans to stone if they should look upon her face, and in this sculpture she fixes viewers with huge glaring eyes as if to work her dreadful

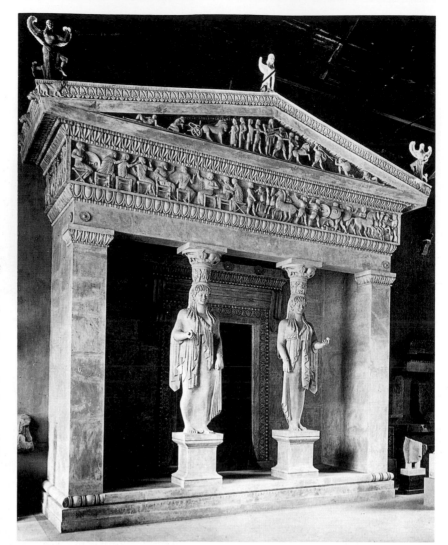

5-13. Reconstruction of the Treasury of the Siphnians, Delphi, using fragments found in the Sanctuary of Apollo. c. 530–525 BCE. Marble

This old reconstruction has been dismantled, and the fragments of the treasury's sculpture are exhibited separately at the Archaeological Museum, Delphi. There should have been a frontal four-horse chariot on the pediment and more chariots on the frieze. The photograph is useful, however, in providing an idea of how elegant and richly ornamented this small treasury building at Delphi was in its original state. The figure sculpture and decorative moldings were probably once painted in strong colors, mainly dark blue, bright red, and white, with touches of yellow to resemble gold. The people who commissioned this treasury were from Siphnos, an island in the Aegean Sea just southwest of the Cyclades.

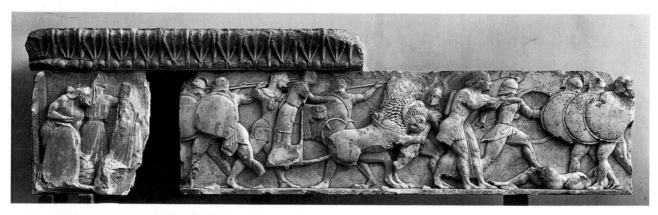

5-14. *Battle between the Gods and the Giants*, fragments of the north frieze of the Treasury of the Siphnians, from the Sanctuary of Apollo, Delphi. c. 530–525 BCE. Marble, height 26" (66 cm). Archaeological Museum, Delphi

magic on them. The much smaller figures flanking Medusa are the flying horse Pegasus on the left (only part of his rump and tail remain) and the giant Chrysaor on the right. These were Medusa's posthumous children (whose father was Poseidon), born from the blood that gushed from her neck after she was beheaded by the legendary hero Perseus. The felines crouching next to them literally bump their heads against the raking cornices of the roof. Dying human warriors lie on the ends of the pediment, their heads tucked into its corners and their knees rising with its sloping sides.

An especially noteworthy collaboration between builder and sculptor can still be seen in the small but luxurious Treasury of the Siphnians, built in the Sanctuary of Apollo at Delphi between about 530 and 525 BCE and housed today in the museum at Delphi. An old reconstruction of the facade of this building, now dismantled, shows a pronaos with two **caryatids**—columns carved in the form of draped women—set flush with the ends of the side walls, which were reinforced by square pillars, or **antae** (fig. 5-13). (This type of temple plan is called **in antis**, meaning "between the

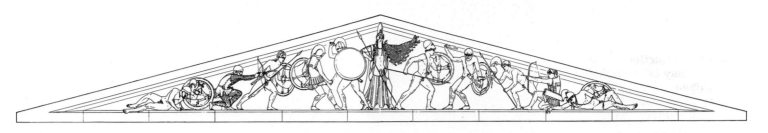

5-15. Reconstruction drawing of the east pediment of the Temple of Aphaia, Aegina. c. 480 BCE

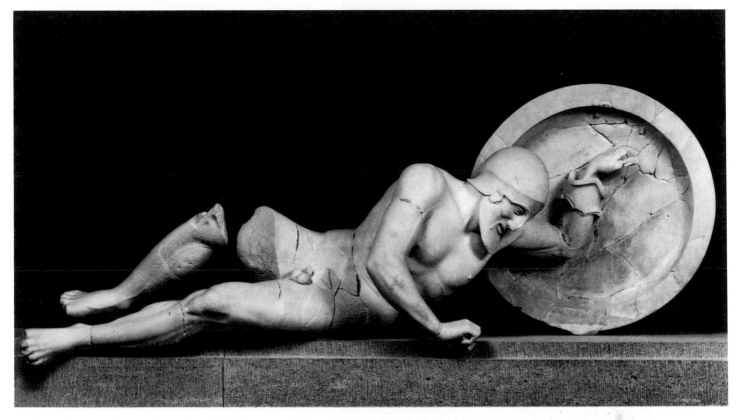

5-16. *Dying Warrior*, sculpture from the left corner of the east pediment of the Temple of Aphaia, Aegina. c. 480 BCE. Marble, length 6' (1.83 m). Staatliche Antikensammlungen und Glyptothek, Munich

pillars"; see "Greek Temple Plans," plan (a), page 163.) The stately caryatids, with their finely pleated, flowing garments, are raised on **pedestals** and balance elaborately carved capitals on their heads. The capitals support a tall entablature conforming to the Ionic order, which features a plain, or three-panel, architrave and a continuous carved frieze, set off by richly carved moldings (see "The Greek Architectural Orders," page 164).

Both the continuous frieze and the pediments of the Siphnian Treasury were originally filled with relief sculpture. A surviving section of the frieze from the building's north side, which shows a scene from the legendary battle between the Gods and the Giants, is one of the earliest known examples of a trend in Greek relief sculpture toward a more natural representation of space (fig. 5-14). To give a sense of three dimensions, the sculptor placed some figures behind others, overlapping as many as three of them and varying the depth of the relief. Countering any sense of deep recession, all the figures were made the same height with their feet on the same **groundline**.

The long pediments of Greek temples provided a perfect stage for storytelling, but the triangular pediment created a problem in composition. The sculptor of the east pediment of the Doric Temple of Aphaia at Aegina (fig. 5-15), dated about 480 BCE, provided a creative solution that became a design standard, appearing with variations throughout the fifth century BCE. The subject of the pediment, rendered in fully three-dimensional figures, is the sack of Troy. Fallen warriors fill the angles at both ends of the pediment base (fig. 5-16), while others crouch, lunge, and reel, rising in height toward an image of Athena as warrior goddess under the peak of the roof. The erect goddess, larger than the other figures and flanked by two defenders facing approaching opponents, dominates the center of the scene and stabilizes the entire composition.

Among the best-preserved fragments from this pedimental scene is the *Dying Warrior* from the far left corner, a tragic but noble figure struggling to rise while dying (fig. 5-16). This figure originally would have been painted and fitted with authentic bronze accessories, heightening the sense of reality it conveys. Fully exploiting the difficult framework of the pediment corner, the sculptor portrayed the soldier's uptilted, twisted form turning in space, capturing his agony and vulnerability. The subtle modeling of

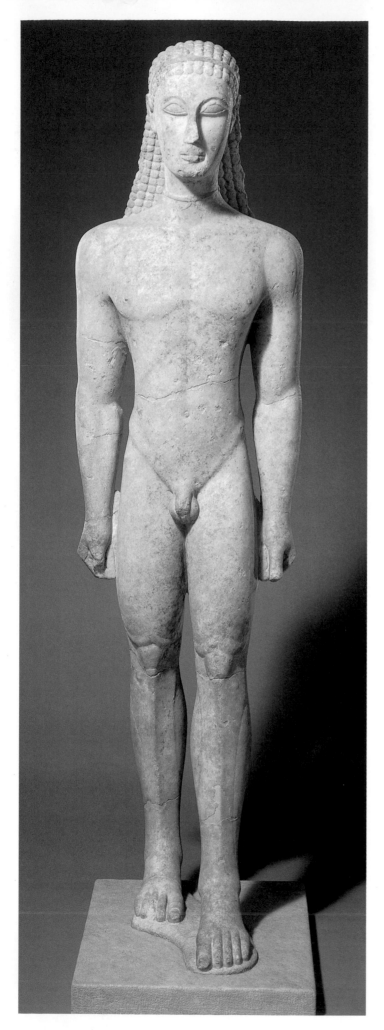

the body conveys the softness of human flesh, which is contrasted with the hard, metallic geometry of the shield and helmet.

FREESTANDING SCULPTURE

In addition to decorating temple architecture, sculptors of the Archaic period created a new type of large, freestanding statue made of wood, terra-cotta, or white marble from the islands of Paros and Naxos. Frequently lifesize or larger, these figures usually were standing or striding. They were brightly painted and sometimes bore inscriptions indicating that they had been commissioned by individual men or women for a commemorative purpose. They have been found marking graves and in sanctuaries, where they lined the sacred way from the entrance to the main temple.

A female statue of this type is called a **kore** (plural *korai*), Greek for "young woman," and a male statue is called a **kouros** (plural *kouroi*), Greek for "young man." Archaic *korai*, always clothed, probably represented deities, priestesses, and nymphs, young female immortals who served as attendants to gods. *Kouroi*, nearly always nude, have been variously identified as gods, warriors, and victorious athletes. Because the Greeks associated young, athletic males with fertility and family continuity, the figures may have been symbolic ancestor figures. Pliny the Elder, a Roman naturalist and historian of the first century CE, believed that some of them portrayed famous athletes. He wrote:

> It was not customary to make effigies [portraits] of men unless, through some illustrious cause, they were worthy of having their memory perpetuated; the first example was a victory in the sacred contest, especially at Olympia, where it was the custom to dedicate statues of all who had been victorious; and in the case of those who had been winners there three times they moulded [sculpted] a likeness from the actual features of the person, which they call "icons" (*Naturalis Historia* 34.16-17, cited in Pollitt, page 30).

A *kouros* dating about 580 BCE (fig. 5-17) recalls the pose and proportions of Egyptian sculpture, such as the statue of Menkaura (see fig. 3-13). Like Egyptian figures, this young Greek, shown frontally, has arms rigidly at his sides, fists clenched, and one leg slightly in front of the other. However, Greek artists of the Archaic period did not share the Egyptian obsession with permanence; they cut away all stone from around the body and introduced variations in appearance from figure to figure. Greek statues may be suggestive of the marble block from which they were carved, but they have a notable athletic quality quite unlike Egyptian statues. Here the artist delineated

5-17. New York Kouros, from Attica. c. 580 BCE. Marble, height 6'4" (1.93 m). The Metropolitan Museum of Art, New York
Fletcher Fund, 1932 (32.11.1)

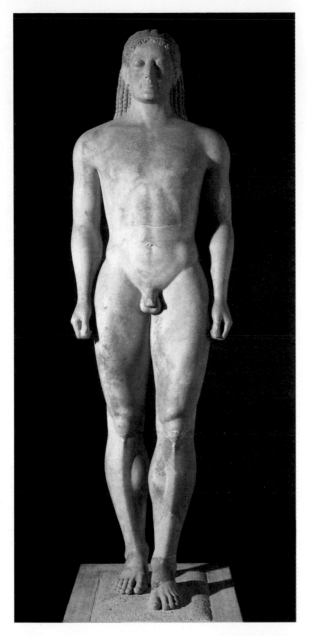

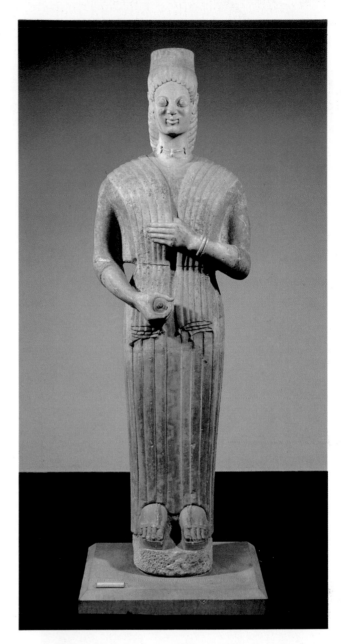

5-18. *Anavysos Kouros*, perhaps young Kroisos, from a cemetery at Anavysos, near Athens. c. 525 BCE. Marble with remnants of paint, height 6'4" (1.93 m). National Archaeological Museum, Athens

5-19. *Berlin Kore*, from a cemetery at Keratea, near Athens. 570–560 BCE. Marble with remnants of red paint, height 6'3" (1.9 m). Staatliche Museen zu Berlin, Antikensammlung, Altes Museum, Berlin-Mitte

the figure's anatomy with ridges and grooves that form geometric patterns. The head is ovoid, with heavy features and schematized hair evenly knotted into tufts and tied back with a narrow ribbon. The eyes are relatively large and wide open, and the mouth forms a characteristic closed-lip smile known as the **Archaic smile**, used to enliven the expressions of figures. In Egyptian sculpture, male figures were always at least partially clothed, wearing articles associated with their status, such as the headdresses, beaded pectorals, and kilts that identified kings. The total nudity of the Greek *kouroi*, in contrast, removes them from a specific time, place, or social class; the nude figure is like the gods but is a fully human shape.

The powerful, rounded body of a *kouros* known as the *Anavysos Kouros*, dated about 530 BCE clearly shows the

increasing interest of artists and their patrons in a more life-like rendering of the human figure (fig. 5-18). The pose, wiglike hair, and Archaic smile echo the earlier style of *kouroi*, but the massive torso and limbs have greater anatomical accuracy suggesting heroic strength. The statue, a grave monument to a fallen war hero, has been associated with a base inscribed: "Stop and grieve at the tomb of the dead Kroisos, slain by wild Ares [god of war] in the front rank of battle." The viewer would have been inspired to emulate Kroisos's noble actions and heroic character.

The first Archaic *korai* are equally impressive. An early *kore* known as the *Berlin Kore*, found in a cemetery at Keratea and dated about 570–560 BCE, stands more than 6 feet tall (fig. 5-19). The erect, immobile pose and full-bodied figure—accentuated by a crown and thick-

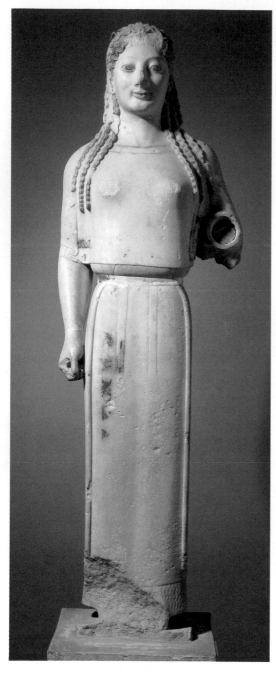

5-20. *Peplos Kore*, from the Acropolis, Athens.
c. 530 BCE. Marble, height 48" (123 cm).
Acropolis Museum, Athens

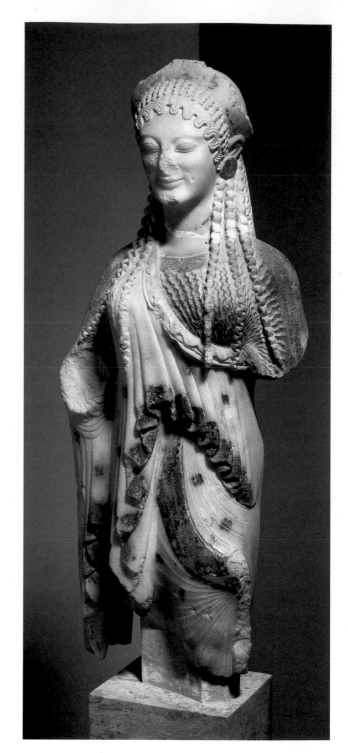

5-21. *Kore*, **from Chios (?)**. C. 520 BCE. Marble, height
21⁷/₈" (56.6 cm). Acropolis Museum, Athens

soled clogs—seem appropriate to a goddess, although
the statue may represent a priestess or an attendant. The
thick robe and tassled cloak over her shoulders fall in
regularly spaced, parallel folds like the fluting on a Greek
column, further emphasizing the stately appearance.
Traces of red—perhaps the red clay used to make thin
sheets of gold adhere—indicate that the robe was once
painted or gilded. The figure holds a pomegranate in her
right hand, an **attribute** (identifying symbol) of Perse-
phone, who was abducted by Hades, the god of the
underworld (see fig. 5-66).

The *Peplos Kore* (fig. 5-20), which dates to about 530
BCE, is named for its distinctive and characteristic garment,

called a ***peplos***—a draped rectangle of cloth, usually
wool, folded over at the top, pinned at the shoulders, and
belted to give a bloused effect. The *Peplos Kore* has the
same motionless, vertical pose of the earlier *kore* but is
a more rounded, feminine figure. Its bare arms and head
convey a greater sense of soft flesh covering a real bone
structure, and its smile and hair are somewhat more
individualized and less conventionalized. The figure once
wore a metal crown and earrings and has traces of
encaustic painting, a mixture of pigments and hot wax
that left a shiny, hard surface when it cooled.

The *Peplos Kore*, was recovered from debris on the
Acropolis of Athens (see page 187), where many votive

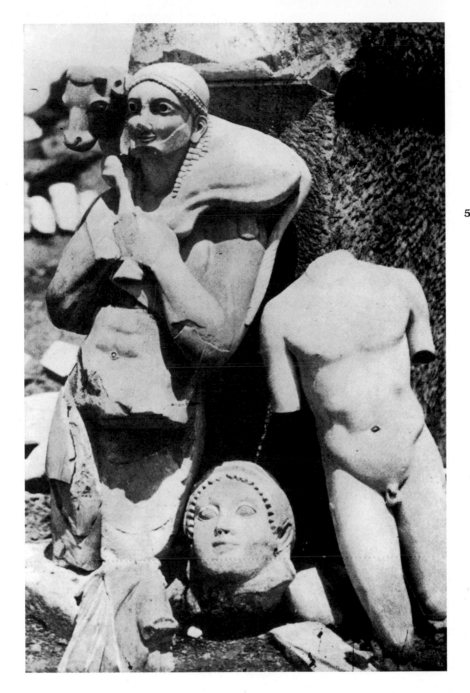

5-22. *Calf Bearer (Moschophoros)*, from the Acropolis, Athens. c. 560 BCE. Marble, height 5'5" (1.65 m). Acropolis Museum, Athens

This photograph, made soon after the *Calf Bearer*'s excavation on the Acropolis, includes *Kritian Boy* (fig. 5-33) at the right.

and commemorative statues were placed in the sanctuary, but few have survived. When the Persians sacked the city in 480 BCE, they destroyed the sculpture there; the fragments were later used as fill in the reconstruction of the Acropolis after the Athenian victory the following year.

Another *kore* (fig. 5-21), dating to about 520 BCE, may have been made by a sculptor from Chios, an island off the coast of Asia Minor. Although the arms and legs of this figure have been lost and its face has been damaged, it is impressive for its rich drapery and the large amount of paint that still adheres to it. Like the *Anavysos Kouros* (see fig. 5-18) and the *Peplos Kore*, it reflects a trend toward increasingly lifelike anatomical depiction that would peak in the fifth century BCE. The *kore* wears a garment called a **chiton**; like the *peplos* but fuller, it was a relatively lightweight rectangle of cloth pinned along the shoulders. It originated in Ionia on the coast of Asia Minor but became popular throughout Greece. Over it, a cloak called a **himation** was draped diagonally and fastened

on one shoulder. The elaborate hairstyle and abundance of jewelry add to the opulent effect. A close look at what remains of the figure's legs reveals a rounded thigh showing clearly through the thin fabric of the *chiton*.

Not all Archaic statues followed the conventional *kouros* or *kore* models for standing figures. A different type is the *Calf Bearer (Moschophoros)* (fig. 5-22). This statue, from about 560 BCE, was also found in the rubble of the Acropolis, in the Sanctuary of Athena. It probably represents a priest or worshiper carrying an animal intended for sacrifice on the altar of a deity. The figure's smile, tufted hairdo, and wide-open eyes with large irises and semicircular eyebrows all reflect the Archaic style. Its short-cropped beard is similar to that of other statues of the period depicting men in active poses, but the gauze-thin robe is unusual. The sculptor has rendered the calf with perceptive detail, capturing its almost dazed look and the twisted position in which its captor holds its legs.

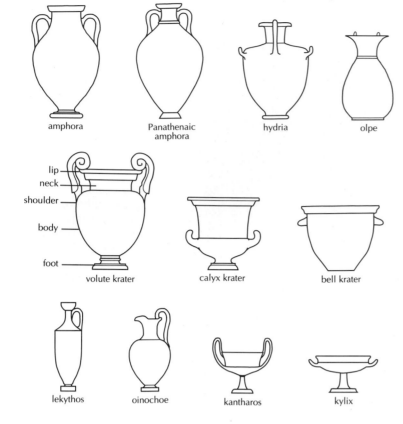

5-23. **Standard shapes of Greek vessels**

Labels in figure: amphora, Panathenaic amphora, hydria, olpe; lip, neck, shoulder, body, foot, volute krater, calyx krater, bell krater; lekythos, oinochoe, kantharos, kylix

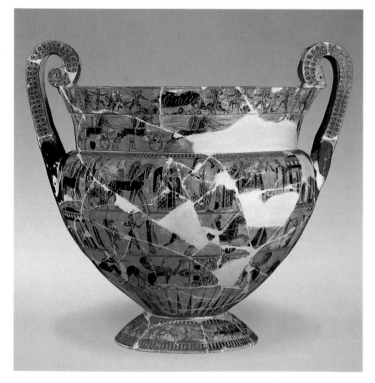

5-24. **Ergotimos (potter) and Kleitias (painter).** *François Vase*. C. 570 BCE. Black-figure decoration on a volute krater. Ceramic, height of volute krater 26" (66 cm). Museo Archeològico Nazionale, Florence

This large mixing bowl was made and decorated by Athenian artists but discovered in an Etruscan tomb. The Etruscans, who lived in central Italy, greatly admired and collected Greek pottery. Not only did they import vases, but they also may have brought in Greek artists to teach their local artists.

VASE PAINTING

Greek potters created only a few vessel forms, but each one combined beauty with a specific utilitarian function (fig. 5-23). The artists who painted the pots, which were often richly decorated, had to accommodate their work to these fixed shapes. During the Archaic period, Athens became the dominant center for pottery manufacture and trade in Greece. Athenian painters adopted the Corinthian black-figure techniques, which became the principal mode of decoration throughout Greece in the sixth century BCE. At first, Athenian painters retained the horizontal banded composition that was characteristic of the Geometric period. An important transitional work, the *François Vase*, illustrates the style (fig. 5-24). This vase, which dates about 570 BCE, is a **volute krater**—a large vessel with scroll-shaped, or volute, handles—which was used for mixing the traditional Greek drink of wine and water. The *François Vase* (discovered by an archaeologist named François) is one of the earliest known vessels signed by both the potter who made it (Ergotimos) and the painter who decorated it (Kleitias).

Kleitias was a great storyteller: this vessel, decorated with approximately 200 human and animal figures, identified with inscriptions, provides an important pictorial and literary record. The main narrative scene, which occupies the third band down from the top and encircles the whole vase, is the marriage of Peleus, the king of Thessaly, and Thetis, a sea nymph, who were the parents of Achilles. In the segment seen in figure 5-24, Peleus stands in front of his palace, greeting the Olympian gods, who are arriving at the marriage ceremony in a grand procession of chariots. The scenes on the neck of the vessel show, from the top down: the hunt for the dangerous Kalydonian Boar, led by the hero Meleager, and the funeral games in honor of Patroclus, Achilles' close friend who died in the Trojan War. On the body of the krater, below Peleus and Thetis, is a depiction of the ambush of the Trojan prince Troilus by Achilles. The Orientalizing style (see fig. 5-8) is still evident in the next band down, decorated with deer, griffins, and plant forms. On the foot of the vessel, very small warriors battle long-necked cranes, illustrating a story dating back to Homer. There are only three bands of pure geometric design—one of elongated triangles radiating up from the foot of the vessel and two narrow bands of looped decoration on the foot.

Over time, Athenian vase painters continued to decrease the number of bands and increase the size of figures until a single scene, usually one on a side, covered the vessel. A mid-sixth-century BCE **amphora**—a large, all-purpose storage jar—illustrates this development (fig. 5-25). The decoration on this vessel, a depiction of the wine god Dionysos with **maenads**, his female worshipers, has been attributed to an anonymous artist called the Amasis Painter, because work of this distinctive style was first recognized on vessels signed by a prolific potter named Amasis. Most of the Amasis Painter's work is found on small vessels, so this handsome amphora is an exception.

In the scene shown here, two maenads, arms around each other's shoulders, skip forward to present their

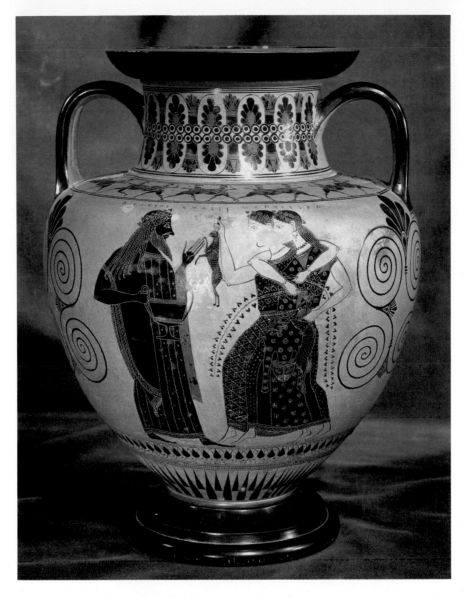

5-25. Amasis Painter. *Dionysos with Maenads.* C. 540 BCE. Black-figure decoration on an amphora. Ceramic, height of amphora 13" (33.3 cm). Bibliothèque Nationale, Paris

TECHNIQUE

GREEK PAINTED VASES

The three main types of Greek painted vase decoration are **black-figure**, **red-figure**, and **white-ground**. Sometimes tasks were divided between potters and painters. To create their works, painters used a complex procedure that involved preparing **slips** (mixtures of clay and water), applying slips to different areas of the vessel in varying thicknesses, and carefully manipulating the firing process in a **kiln**, or closed oven, to control the amount of oxygen reaching the vessel. If all went as planned (and sometimes it didn't), the designs painted in slip, which could barely be seen on the clay pot before firing, emerged afterward in the desired range of colors.

The firing process for both black-figure and red-figure painting involved three stages. In the first, a large amount of oxygen was allowed into the kiln, which "fixed" the whole vessel in one overall color that depended on the composition of the clay used. In the second, or "reduction," stage, the oxygen in the kiln was reduced to a minimum, turning the whole vessel black, and the temperature was raised to the point at which the slip partially vitrified (became glasslike). In the third phase, oxygen was allowed back into the kiln, turning the unslipped areas red. The partially vitrified slipped areas, sealed against the oxygen, remained black.

In black-figure painting, artists painted designs—figures, objects, or abstract motifs—in silhouette on the clay vessel. Then, using a sharp tool called a **stylus**, they cut through the slip to the body of the vessel to incise linear details within the silhouettes. In red-figure painting, the approach was reversed, and the background around the designs was painted with the slip. The linear details inside the shapes were also painted with the same slip, instead of being incised. In both techniques, artists often enhanced their work with touches of white and reddish purple **gloss**, metallic pigments mixed with slip.

White-ground vases became popular in the Fifth-Century Classical period. The white ground was created by painting the vessel with a highly refined, purified clay slip that turned white during the firing. The design elements were added to the white ground using either the black- or red-figure technique. After firing, the artists frequently painted on details and areas of bright and pastel hues using **tempera**, a paint made from egg yolks, water, and pigments. Because the tempera paints were fragile, these colors flaked off easily, and few perfect examples have survived.

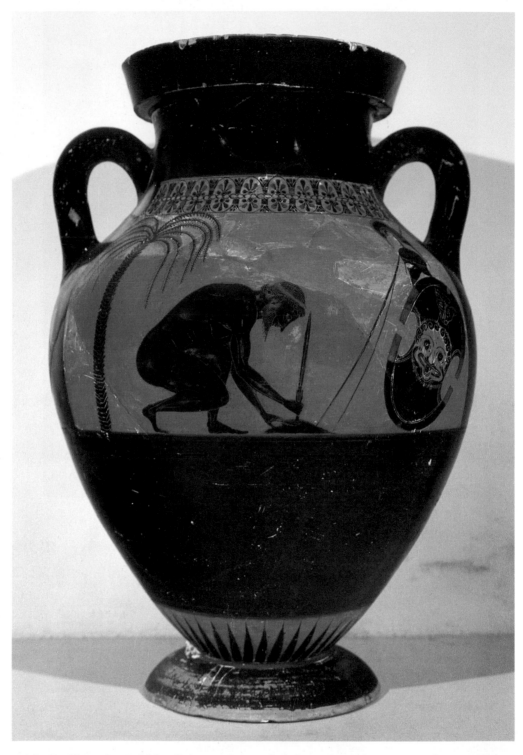

5-26. Exekias. *The Suicide of Ajax*, c. 540 BCE. Black-figure decoration on an amphora. Ceramic, height of amphora 27" (69 cm). Château-Musée, Boulogne-sur-Mer, France

offerings—a long-eared rabbit and a small deer, signifying power over nature—to Dionysos. The maenad holding the deer wears the skin of a spotted panther (or leopard), its head still attached, draped over her shoulders and secured with a belt at her waist. The god, an imposing, richly dressed figure, clasps a large **kantharos** (wine cup). This encounter between humans and a god appears to be a joyful, celebratory occasion rather than one of reverence or fear. The Amasis Painter favored strong shapes and patterns, generally disregarding conventions for making figures appear to occupy real space, and emphasized fine details, such as the large, delicate

petal and spiral designs below each handle, the figures' meticulously arranged hair, and the bold patterns on their clothing.

The finest of all Athenian artists of the mid-sixth century BCE, Exekias, signed many of his vessels as both potter and painter. Exekias took his subjects from Greek history, matching painted composition to vessel shape with great sensitivity. A scene on an amphora, *The Suicide of Ajax* (fig. 5-26), recounts an episode from the Trojan War (see "The Trojan War," page 144). Ajax was a fearless Greek warrior, second only to Achilles in bravery. After the death of Achilles, however, the Greeks bestowed his armor on Odysseus rather than Ajax. Distraught by this humiliation—compounded by his family ties to Achilles, who was his cousin—Ajax killed himself. Other artists showed the great warrior either dying or already dead, but Exekias has captured the story's most poignant moment, showing Ajax preparing to die. He has set aside his helmet, shield, and spear and crouches beneath a tree, planting his sword upright in a mound of dirt so that he can fall upon it. The painting exemplifies the quiet beauty and perfect equilibrium for which Exekias's works are so admired today. Two upright elements—the tree on the left and the shield on the right—frame and balance the figure of Ajax, their in-curving lines echoing the swelling shape of the amphora and the rounding of the hero's powerful back as he bends forward. The whole composition focuses the viewer's attention on the head of Ajax and his intense concentration as he pats down the earth to secure the sword. He will not fail in his suicide.

Not all subjects used for ceramics involved gods and heroes. A handsome example of black-figure decoration, painted about 510 BCE on an Athenian **hydria**, or water jug, by an artist who signed the work with the initials "A.D.," gives interesting insight into everyday Greek city life as well as a view of an important public building in use (fig. 5-27). Most women in ancient Greece were confined to their homes, so their daily trip to the communal well, or fountain house, would have been an important event. At a fountain house, in the shade of a Doric-columned porch, three women patiently fill hydriae like the one on which they are painted. A fourth balances her empty jug on her head as she waits, while a fifth woman, without a jug, appears to be waving a greeting to someone. The women's skin is painted white, a convention for female figures found also in Egyptian and Minoan art. Incising and touches of reddish purple paint create fine details in the architecture and in the figures' clothing and hair.

The composition of this vase painting is a fine balance of vertical, horizontal, rectangular, and rounded elements. The Doric columns, the decorative vertical borders, and even the streams of water flowing from the animal-head spigots echo the upright figures of the women. The wide black band forming the groundline, the architrave above the colonnade, and the left-to-right movement of the horse-drawn chariots across the shoulder area of the hydria emphasize the horizontal, friezelike arrangement of the women across the body of the pot. This geometric framework is softened by the

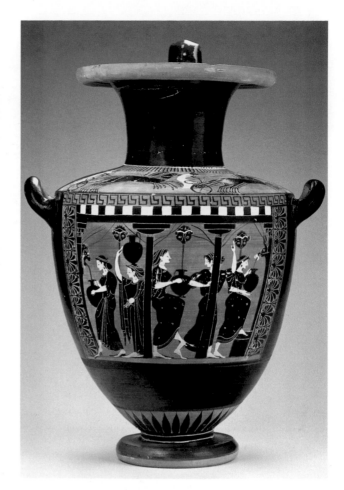

5-27. "A.D." Painter. *Women at a Fountain House.* 520–510 BCE. Black-figure decoration on a hydria. Ceramic, height of hydria 20⅞" (53 cm). Museum of Fine Arts, Boston

William Francis Warden Fund

rounded contours of the female bodies, the globular water vessels, the circular **palmettes** (fan-shaped petal designs) framing the main scene, and the arching bodies of the galloping horses on the shoulder.

In the last third of the sixth century BCE, while "A.D." and others were still creating handsome black-figure wares, some pottery painters turned away from this meticulous process to a variation called **red-figure** decoration (see "Greek Painted Vases," page 173). This new method, as its name suggests, resulted in vessels with red figures against a black background, the opposite of black-figure painting. In red-figure wares, the dark slip was painted on as background around the outlined figures, which were left unpainted. Details were drawn on the figures with a fine brush dipped in the slip. The result was a lustrous dark vessel with light-colored figures and dark details. The greater freedom and flexibility of painting rather than engraving the details led artists to adopt it widely in a relatively short time.

One of the best-known artists specializing in the red-figure technique was the Athenian Euphronios, who was praised especially for his study of human anatomy. His rendering of the *Death of Sarpedon*, about 515 BCE, is painted on a **calyx krater**, so called because its handles

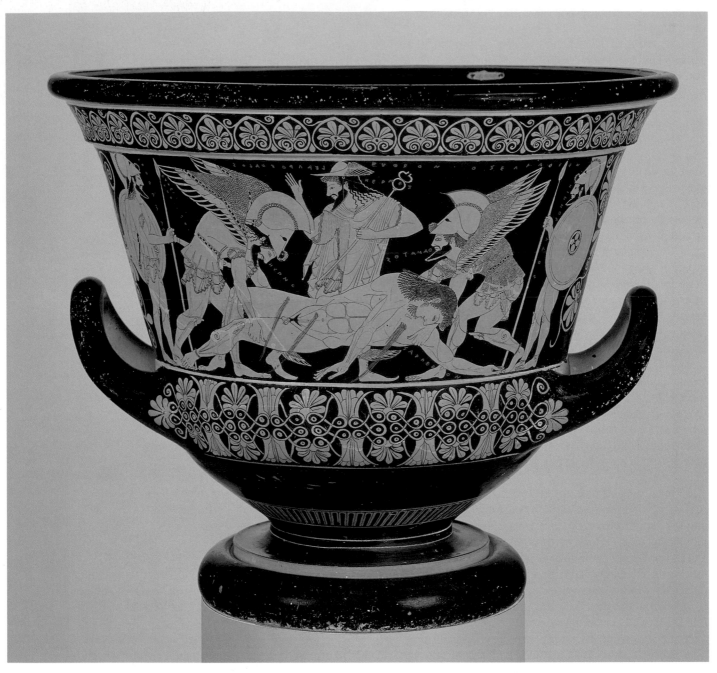

5-28. Euphronios (painter) and Euxitheos (potter). *Death of Sarpedon.* C. 515 BCE. Red-figure decoration on a calyx krater. Ceramic, height of krater 18" (45.7 cm). The Metropolitan Museum of Art, New York

Purchase, Gift of Darius Ogden Mills, Gift of J. Pierpont Morgan, and Bequest of Joseph H. Durkee, by exchange, 1972 (1972.11.10)

curve up like a flower calyx (fig. 5-28). According to Homer's *Iliad*, Sarpedon, a son of Zeus and a mortal woman, was killed by the Greek warrior Patroclus while fighting for the Trojans. Euphronios shows the winged figures of Hypnos (Sleep) and Thanatos (Death) carrying the dead warrior from the battlefield. Watching over the scene is Hermes, the messenger of the gods, identified by his winged hat and caduceus, a staff with coiled snakes. Hermes is there in another important role, as the guide who leads the dead to the netherworld.

Euphronios, like the painter "A.D.," created a perfectly balanced composition of verticals and horizontals that take the shape of the vessel into account. The bands of decoration above and below the scene echo the long horizontal of the dead fighter's body, which seems to levitate in the gentle grasp of its bearers, and the inward-curving lines of the handles mirror the arching backs of Hypnos and Thanatos. The upright figures of the lance-bearers on each side and Hermes in the center counterbalance the horizontal elements of the composition. The painter,

while conveying a sense of the mass and energy of the subjects, also portrayed amazingly fine details of their clothing, musculature, and facial features with the fine tip of a brush. Euphronios created the impression of real space around the figures by **foreshortening** body forms and limbs—Sarpedon's left leg, for example—so that they appear to be coming toward or receding from the viewer. Euphronios understood anatomy and rendered bodies accurately and sympathetically.

Athens was as famous for its metalwork as it was for ceramics. A **kylix**, or drinking cup, illustrates the work in a foundry (fig. 5-29). The artist, called the Foundry Painter, presents all the workings of a contemporary foundry for casting lifesize and monumental bronze figures. The artist successfully organized this scene within the flaring space that extends upward from the foot of the vessel. The circle that marks the attachment of the foot to the vessel serves as the groundline for all the figures. The walls of the workshop are filled with hanging tools and other foundry paraphernalia: hammers, an ax and saw, molds of a human foot and hand, and several sketches. These sketches include one of a horse, some of human heads, and three of human figures in different poses.

On the section shown in figure 5-29, a worker wearing what looks like a modern-day construction helmet squats to tend the furnace on the left. The man in the center, perhaps the supervisor, leans on a staff, while a third worker assembles the already-cast parts of a leaping figure that is braced against a molded support. The unattached head lies between his feet. The scene continues past the handles, where more workers are shown putting the finishing touches on a larger-than-lifesize striding warrior figure. This painting provides clear evidence that the Greeks were creating large bronze statues in active poses—in marked contrast to the static pose of the Archaic *kouroi*—as early as the first decades of the fifth century BCE. Unfortunately, no examples of these early bronze figures have yet been found.

5-29. Foundry Painter. *A Bronze Foundry*, red-figure decoration on a kylix from Vulci, Italy. 490–480 BCE. Ceramic, diameter of kylix 12" (31 cm). Staatliche Museen zu Berlin, Preussischer Kulturbesitz, Antikensammlung

THE CLASSICAL PERIOD IN GREEK ART

Over the brief span of the next 160 years, the Greeks would establish an ideal of beauty that, remarkably, has endured in the Western world to this day. This period of Greek art, known as the Classical, is framed by two major events: the defeat of the Persians in 479 BCE and the death of Alexander the Great in 323 BCE. Art historians today divide the period into three phases, based on the formal qualities of the art: the Transitional, or Early, period (c. 480–450 BCE); the mature Fifth-Century Classical period (c. 450–400 BCE, formerly called the Golden Age or the High Classical period); and the late Fourth-Century Classical period (c. 400–323 BCE). The speed of change in this short span is among the most extraordinary characteristics of Greek art.

Scholars have characterized Greek Classical art as being based on three general concepts: humanism, rationalism, and idealism. The ancient Greeks believed the maxims they had carved on the Temple of Apollo and followed their injunctions in their art: "Man is the measure of all things," that is, seek an ideal based on the human form; "Know thyself," seek the inner significance of forms; and "Nothing in excess," reproduce only essential forms. In their full embrace of the first concept, humanism, the Greeks even imagined that their gods looked like perfect human beings. Apollo, for example, exemplified the Greek ideal: his body and mind in balance, he was athlete and musician, healer and sun god, leader of the Muses.

Yet in their judgment of humanity, and as reflected in their art, the Greeks valued reason over emotion. Practicing the faith in rationality expressed by their philosophers Sophocles, Plato, and Aristotle, and convinced that logic and reason underlie natural processes, the Greeks saw all aspects of life, including the arts, as having meaning and pattern; nothing happens by accident. Rationalism provided an intellectual structure for the arts, as can be seen in the creation of the orders in architecture and the canon of proportions in sculpture (see page 202). The great Greek artists and architects were not only practitioners but theoreticians as well. In the fifth century BCE, the sculptor Polykleitos and the architect Iktinos both wrote books on the theory underlying their practice.

Unlike artists in Egypt and the ancient Near East, Greek artists did not rely on memory images. And even more than the artists of Crete, they grounded their art in close observation of nature. Only after meticulous study of the particular did they begin to generalize, searching within each form for its universal ideal: rather than portray their models in their actual, individual detail, they sought to distill their essence. In so generalizing, they developed a system of perfect mathematical proportions.

In this way, humanism and rationalism produced the idealism that characterizes Classical Greek art, an idealism that for them encompassed the True, the Good, and the Beautiful. Greek artists of the fifth and fourth centuries BCE established a benchmark for art against which succeeding generations of artists and patrons in the Western world have since measured quality (see "*Classic and Classical*," page 179).

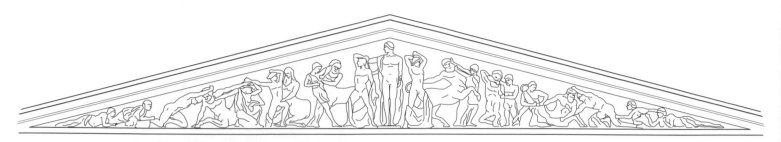

5-30. Reconstruction drawing of the west pediment of the Temple of Zeus, Olympia. C. 470–456 BCE

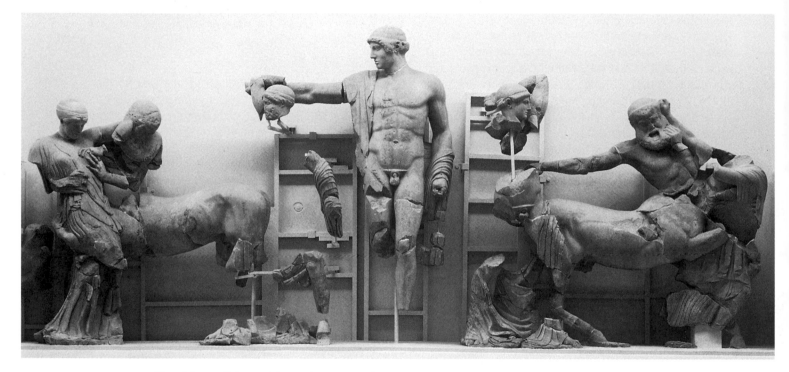

5-31. *Apollo with Battling Lapiths and Centaurs*, fragments of sculpture from the west pediment of the Temple of Zeus, Olympia. C. 460 BCE. Marble, height of Apollo 10'2" (3.1 m). Archaeological Museum, Olympia

THE TRANSITIONAL OR EARLY CLASSICAL PERIOD

In the early decades of the fifth century BCE, the Greek city-states, which for several centuries had developed relatively unimpeded by external powers, faced a formidable threat to their independence from the expanding Persian Empire. Cyrus the Great of Persia had incorporated the Greek cities of Ionia in Asia Minor into his empire in 546 BCE. After several failed invasions, in 480 BCE the Persians penetrated Greece with a large force and destroyed many cities, including Athens. In a series of encounters—at Thermopylae and Plataea on land and in the straits of Salamis at sea—an alliance of Greek city-states led by Athens and Sparta repulsed the invasion. By 479 BCE, the stalwart armies and formidable navies of the Greeks had triumphed over their enemies, and the victors turned to the task of rebuilding their devastated cities.

Some scholars have argued that the Greeks' success against the Persians imbued them with a self-confidence that accelerated the development of Greek art, inspiring artists to seek new and more effective ways to express their cities' accomplishments. In any case, the period that followed the Persian Wars, extending from about 480 to about 450 BCE, saw the emergence of a new art: Artists tried to portray the human figure in painting with greater accuracy and at the same time sought universal forms.

ARCHITECTURAL SCULPTURE

Just a few years after the Persians had been routed, the citizens of Olympia began a new Doric temple to Zeus in the Sanctuary of Hera and Zeus. The temple was

completed between 470 and 456 BCE. Today the massive temple base, fallen columns, and almost all the metope and pediment sculpture remains, monumental even in ruins. Although the temple was of local stone, it was decorated with sculpture of imported marble, and, appropriately for its Olympian setting, the themes demonstrated the power of the gods Zeus, Apollo, and Athena.

The freestanding sculpture that once adorned the west pediment (fig. 5-30) shows Apollo helping the Lapiths, a clan from Thessaly, in their battle with the centaurs. This legendary battle erupted after the centaurs drank too much wine at the wedding feast of the Lapith king and tried to carry off the Lapith women. Apollo stands calmly at the center of the scene, quelling the disturbance by simply raising his arm (fig. 5-31). The rising, falling, triangular composition fills the awkward pediment space. The contrast of angular forms with turning, twisting action poses dramatizes the physical struggle. In contrast, the majestic figure of Apollo celebrates the triumph of reason over passion and civilization over barbarism.

The metope reliefs of the temple illustrated the Twelve Labors imposed by King Eurystheus of Tiryns on Herakles. The hero, with the aid of the gods and his own phenomenal strength, accomplished these seemingly impossible tasks, thereby earning immortality. One of the labors was to steal gold apples from the garden of the Hesperides, the nymphs who guarded the apple trees. To do this, Herakles enlisted the aid of the giant Atlas, whose job was to hold up the heavens. Herakles offered to take on this job himself while Atlas fetched the apples for him. In the episode shown here (fig. 5-32), Herakles is at the center with the heavens on his shoulders. Atlas, on the right, holds out the gold apples to him. As we can see, and Atlas cannot, the human Herakles is backed, literally, by the goddess Athena, who effortlessly supports the sky with one hand. The artist has balanced the erect, frontal view of the heavily clothed Athena with profile views of the two nude male figures. Carved in high relief, the figures reflect a strong interest in realism. Even the rather severe columnlike figure of the goddess suggests the flesh of her body pressing through the graceful fall of heavy drapery.

FREESTANDING SCULPTURE

In the remarkably short time of only a few generations, Greek sculptors had moved far from the rigid, frontal presentation of the human figure embodied in the Archaic *kouroi*. One of the earliest and finest extant freestanding marble figures to exhibit more natural, lifelike

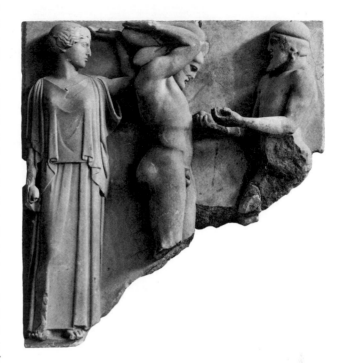

5-32. *Athena, Herakles, and Atlas*, metope relief from the frieze of the Temple of Zeus, Olympia. c. 460 BCE. Marble, height 5'3" (1.59 m). Archaeological Museum, Olympia

The Greeks believed Herakles was the founder of the Olympian Games, held every four years at Olympia beginning in 776 BCE. Supposedly, Herakles drew up the rules for the Games and decided that the stadium should be 600 feet long. The contests had a strong religious aspect, and the victors were rewarded with olive branches from the Sacred Grove of the gods instead of gold, silver, or bronze medals. The Olympian Games came to be so highly regarded that the city-states suspended all political activities while the Games were in progress. The Games ended in 394 CE, when they were banned by the Christian emperor Theodosius. The discovery and excavation of the site of the sanctuary at Olympia in the late nineteenth century stimulated great interest in the Games, inspiring the French baron Pierre de Coubertin to revive them on an international scale. The first modern Olympic Games were held in Athens in 1896.

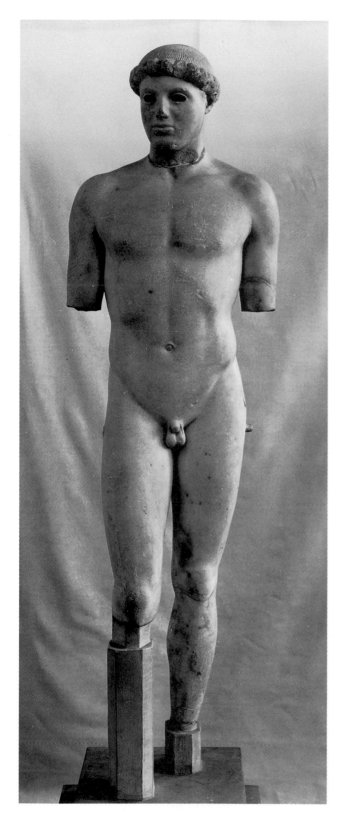 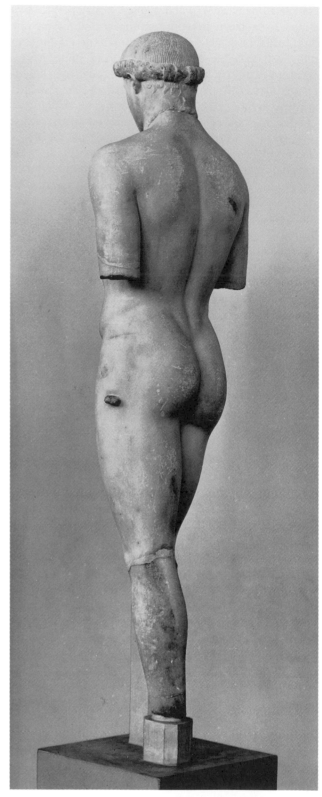

5-33. *Kritian Boy*, from Acropolis, Athens. c. 480 BCE. Marble, height 46" (116 cm). Acropolis Museum, Athens

qualities is the *Kritian Boy* of about 480 BCE (fig. 5-33). The damaged figure, excavated from the debris on the Athenian Acropolis, was thought by its finders to be by the Greek sculptor Kritios, whose work they knew only from Roman copies. A youthful athlete, the boy strikes an easy pose quite unlike the rigid, evenly balanced pose of Archaic

kouroi. The boy's weight rests on his left leg, and his right leg bends slightly at the knee. A noticeable curve in his spine counters the slight shifting of his hips and a subtle drop of one of his shoulders. The slight turn of the head invites the spectator to follow his gaze and move around the figure, admiring the small marble statue from every

angle. The boy's solemn expression lacks any trace of the "Archaic smile." The *Kritian Boy* is truly a transition between the Archaic *kouroi* and the ideal figures to come. Sometimes the art of the Transitional period is called the Severe Style.

A major problem for anyone trying to create a free-standing statue is to assure that it will not fall over. Solving this problem requires a familiarity with the ability of sculptural materials to maintain equilibrium under various conditions. At the end of the Archaic period, a new technique for **hollow-casting** bronze was developed. This technique created a far more flexible medium than solid marble or other stone and became the medium of choice for Greek sculptors. Although it is possible to create freestanding figures with outstretched arms and legs far apart in stone, hollow-cast bronze more easily permits vigorous and even off-balance action poses. After the introduction of the new technique, the figure in action became a popular subject among the ancient Greeks. Sculptors sought to craft poses that seemed to capture a natural feeling of continuing movement rather than an arbitrary moment frozen in time.

Unfortunately, foundries began almost immediately to recycle metal from old statues into new works, so few original Greek bronzes have survived. A spectacular lifesize bronze, the *Charioteer* (fig. 5-34), cast in the 470s BCE, was saved from the metal scavengers only because it was buried during a major earthquake in 373 BCE. Archaeologists found it in its original location in the Sanctuary of Apollo at Delphi, along with fragments of a bronze chariot and horses. According to its inscription, it commemorates a victory by a driver in the Pythian Games of 478 or 474 BCE. Pliny the Elder wrote that three-time winners in Greek competitions had their features memorialized in statues, and faces in the Transitional period often have a sullen look. If the *Kritian Boy* seems solemn, the *Charioteer* seems to pout. His head turns slightly to one side. His rather intimidating expression is enhanced by glittering, colored-glass eyes and fine silver eyelashes. His features suggest an idealized conception of youthful male appearance. The *Charioteer* stands erect; his long robe with its almost columnar fluting, is the epitome of elegance. The folds of the robe fall in a natural way, varying in width and depth, and the whole garment seems capable of swaying and rippling with the charioteer's movement. The feet, with their closely observed toes, toenails, and swelled veins over the instep, are so realistic that they seem to have been cast from molds made from the feet of a living person.

The sea as well as the earth has protected ancient bronzes. In 1972 CE, divers recovered a pair of larger-than-lifesize bronze figures from the seabed off the coast from Riace, Italy. Known as the Riace *Warriors* or *Warriors A* and *B*, they date about 460–450 BCE. Just what mishap sent them to the bottom is not known, but meticulous conservators have restored them to their original condition (see "The Discovery and Conservation of the Riace *Warriors*," page 183). *Warrior A* reveals a striking balance between idealized anatomical forms and naturalistic

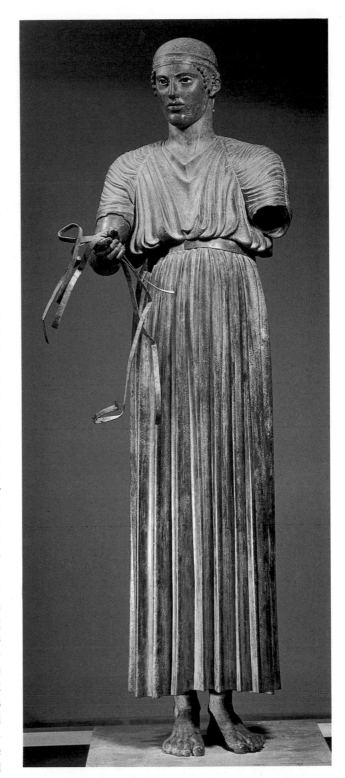

5-34. *Charioteer*, from the Sanctuary of Apollo, Delphi. c. 477 BCE. Bronze, height 5'11" (1.8 m). Archaeological Museum, Delphi

The setting of a work of art affects the impression it makes. Today, this stunning figure is exhibited on a low base in the peaceful surroundings of a museum, isolated from other works and spotlighted for close examination. Its effect would have been very different in its original outdoor location, standing in a horse-drawn chariot atop a tall monument. Viewers in ancient times, tired from the steep climb to the sanctuary and jostled by crowds of fellow pilgrims, could have absorbed only its overall effect, not the fine details of the face, robe, and body visible to today's viewers.

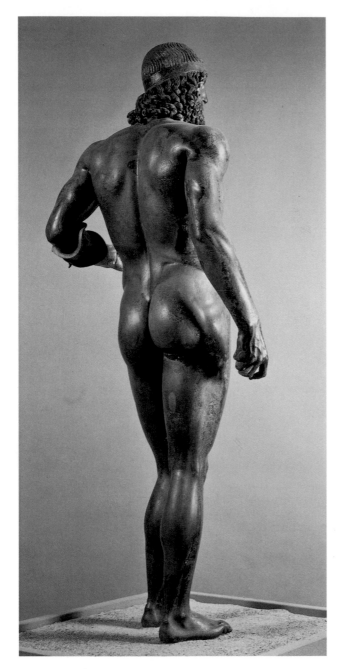
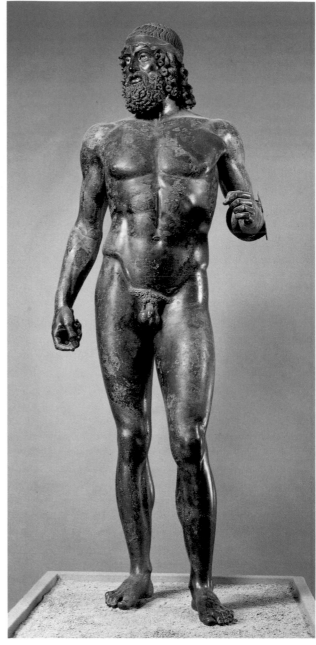

5-35. *Warrior A*, found in the sea off Riace, Italy. c. 460–450 BCE. Bronze with bone and glass eyes, silver teeth, and copper lips and nipples, height 6'8" (2.03 m). Museo Archeològico Nazionale, Reggio Calabria, Italy

details (fig. 5-35). The supple athletic musculature suggests a youthfulness belied by the maturity of the face. Minutely detailed touches—the navel, the swelling veins in the backs of the hands, and the strand-by-strand rendering of the hair—are also in marked contrast to the idealized, youthful smoothness of the rest of the body. The sculptor heightened these lifelike effects by inserting eyeballs of bone and colored glass, applying eyelashes and eyebrows of separately cast, fine strands of bronze, insetting the lips and nipples with pinkish copper, and

plating the teeth that show between the parted lips with silver. The man held a shield (parts are still visible) on his left arm and a spear in his right hand and was probably part of a monument commemorating a military victory, perhaps against the Persians.

At about the same time, the *Discus Thrower* (*Diskobolos*), reproduced at the beginning of this chapter, was created in bronze by the sculptor Myron (see fig. 5-1). It is known today only from Roman copies in marble, but in its original form it must have been as lifelike

THE DISCOVERY AND CONSERVATION OF THE RIACE WARRIORS In 1972, a scuba diver in the Ionian Sea near the beach resort of Riace, Italy, found what appeared to be a human elbow and upper arm protruding from sand about 25 feet beneath the sea. Taking a closer look, he discovered that the arm was made of metal, not flesh, and was part of a large statue. He soon uncovered a second statue nearby.

Experienced underwater salvagers raised the statues: bronze warriors more than 6 feet tall, complete in every respect, except for swords, shields, and one helmet. But after centuries underwater, the *Warriors* were corroded and covered with accretions, as the illustration shows. The clay cores from the casting process were still inside the bronzes, adding to the deterioration by absorbing lime and sea salts. To restore the *Warriors*, conservators first removed all the exterior corrosion and lime encrustations using surgeon's scalpels, pneumatic drills with 3-millimeter heads, and high-technology equipment such as sonar (sound-wave) probes and micro-sanders. Then they painstakingly removed the clay core through existing holes in the heads and feet using hooks, scoops, jets of distilled water, and concentrated solutions of peroxide. Finally, they cleaned the figures thoroughly by soaking them in solvents and sealed them with a fixa-tive specially designed for use on metals (see fig. 5-35).

Since the *Warriors* were put on view in 1980, conservators have taken additional steps to assure their preservation. In 1993, for example, a sonar probe mounted with two miniature video cameras found and blasted loose with sound waves the clay remaining inside the statues, which was then flushed out with water.

How did the *Warriors* end up at sea? They were probably on a ship bound from or to a Greek colony at the tip of Italy in ancient times and—as there was no evidence of a shipwreck in the vicinity of the find—must have accidentally slipped off the deck in rough seas or been deliberately jettisoned.

Back of *Warrior A* from Riace prior to conservation. Museo Archeològico Nazionale, Reggio Calabria, Italy

in its details as *Warrior A* from Riace. Like a sports photographer, Myron caught the athlete at a critical moment, the breathless instant before the concentrated energy of his body will unwind to propel the discus into space. His muscular torso is coiled tightly into a forward arch, and his powerful throwing arm is poised at the top of his backswing. Myron earned the adulation of his contemporaries, and it is interesting that he was as warmly admired for a sculpture that has not survived—a bronze cow—as for the *Discus Thrower*.

VASE PAINTING

Vase painters continued to work with the red-figure technique throughout the fifth century BCE, refining their styles and experimenting with new compositions. Among the outstanding vase painters of the Transitional period was the prolific Pan Painter, who was inspired by the less heroic myths of the gods to create an admirable body of red-figure works. The artist's name comes from a work involving the god Pan on one side of

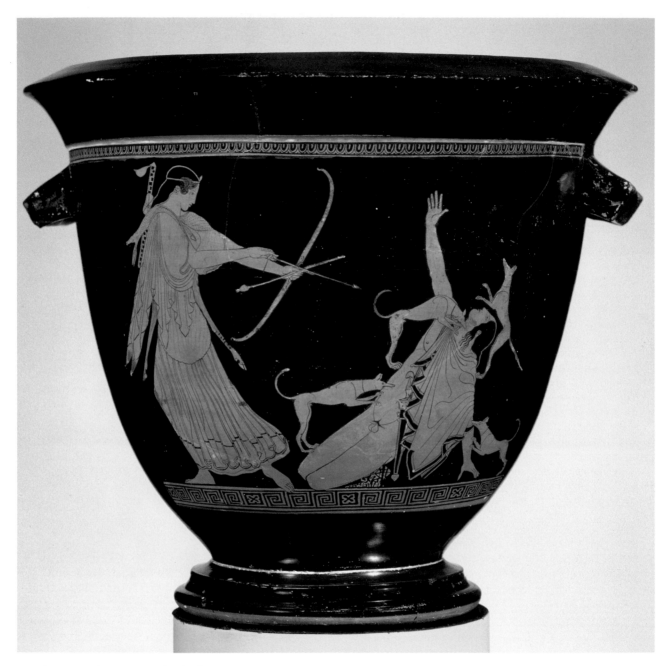

5-36. Pan Painter. *Artemis Slaying Actaeon*. C. 470 BCE. Red-figure decoration on a bell krater. Ceramic, height of krater 14⅝" (37 cm). Museum of Fine Arts, Boston

James Fund and by Special Contribution

a bell-shaped krater that dates to about 470 BCE. The other side of this krater shows *Artemis Slaying Actaeon* (fig. 5-36). Actaeon, while out hunting, happened upon Artemis, the goddess of the hunt, taking a bath. The enraged goddess caused Actaeon's own dogs to mistake him for a stag and attack him. The Pan Painter shows Artemis herself about to finish off the unlucky hunter with an arrow from her bow. The angry goddess and the fallen Actaeon each form roughly triangular shapes that conform to the flaring shape of the vessel. The scene is so dramatically rendered that one does not immediately notice the slender, graceful lines of the figures and the delicately detailed draperies that are the hallmarks of the Pan Painter's style.

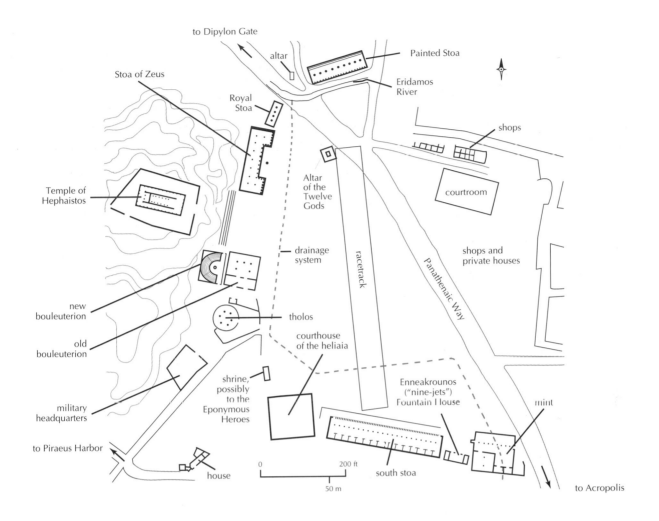

To Dipylon Gate · altar · Painted Stoa · Stoa of Zeus · Eridamos River · Royal Stoa · shops · Temple of Hephaistos · Altar of the Twelve Gods · courtroom · shops and private houses · drainage system · racetrack · Panathenaic Way · new bouleuterion · tholos · old bouleuterion · courthouse of the heliaia · shrine, possibly to the Eponymous Heroes · Enneakrounos ("nine-jets") Fountain House · mint · military headquarters · to Piraeus Harbor · house · 0 · 200 ft · 50 m · south stoa · to Acropolis

5-37. Plan of the Agora (marketplace), Athens. c. 400 BCE

THE FIFTH-CENTURY CLASSICAL PERIOD

The mature Classical period of Greek art, from about 450 to 400 BCE, corresponds roughly to an extended period of conflict between Sparta and Athens. The two had emerged as the leading city-states in the Greek world in the wake of the Persian Wars. Sparta dominated the Peloponnese and much of the rest of mainland Greece. Athens dominated the Aegean and became the wealthy and influential center of a maritime empire. The series of conflicts known as the Peloponnesian Wars (461–445 BCE and 431–404 BCE) ended with the defeat of Athens.

Except for a few brief interludes, Pericles, a dynamic, charismatic leader, dominated Athenian politics and culture from 462 BCE until his death in 429 BCE. Although comedy writers of the time sometimes mocked him, calling him "Zeus" and "the Olympian" because of his haughty personality, he led Athens to its greatest wealth and influence. He instituted political reforms that greatly increased the scope of Athenian democracy. And he was a great patron of the arts—supporting the use of Athenian wealth for the adornment of the city and encouraging artists to promote a public image of peace, prosperity,

and power. He brought new splendor to the sanctuaries of the gods who protected Athens and rebuilt much of the Acropolis, which had been laid waste by the Persians in 480 BCE. Pericles said of his city and its accomplishments that "future generations will marvel at us, as the present age marvels at us now." It was a prophecy he himself helped fulfill.

Athens originated as a Neolithic **acropolis**, or city on a hill (*akro* means "high" and *polis* means "city"). The flat-topped hill that was the original site of the city later served as a fortress and religious sanctuary. As the city grew, the Acropolis became the religious and ceremonial center devoted primarily to the goddess Athena, the city's patron and protector (see pages 188–189). The lower town, enclosed by a protective **ring wall**, became the residential and business center. In Athens, as in most cities of ancient Greece, commercial, civic, and social life revolved around the marketplace, or **agora**.

THE ATHENIAN AGORA

The Athenian Agora, at the foot of the Acropolis (fig. 5-37), began as an open space where farmers and

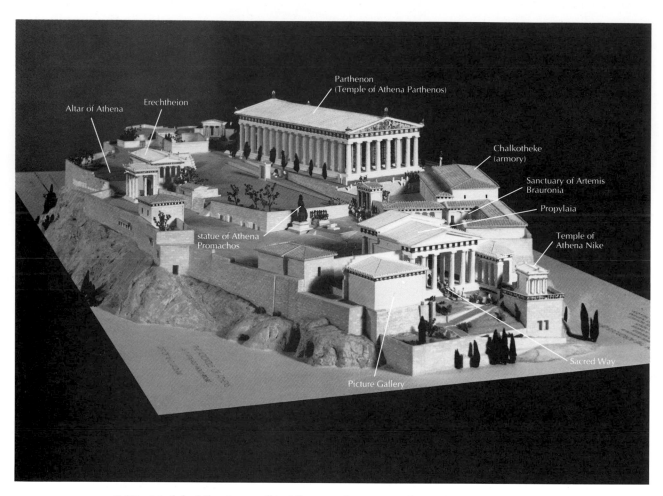

5-38. Model of the Acropolis, Athens, c. 400 BCE. Royal Ontario Museum, Toronto

artisans displayed their wares. Over time, public and private structures were erected on both sides of the Panathenaic Way, a ceremonial road used during an important festival in honor of Athena. A stone drainage system was installed to prevent flooding, and a large fountain house (see fig. 5-27) was built to provide water for surrounding homes, administrative buildings, and shops. By 400 BCE, the Agora contained several religious and administrative structures and even a small racetrack. The temple to Hephaistos, the god of the forge, so appropriate for an area where craftspeople gathered, was a fine Doric building. The Agora also had the city mint, its military headquarters, and two buildings devoted to court business.

Large stoas offered protection from the sun and rain, providing a place for strolling and talking business, politics, or philosophy. In design the stoa, a distinctively Greek structure found nearly everywhere people gathered, ranged from a simple roof held up by columns to a

substantial, sometimes architecturally impressive, building with two stories and shops along one side.

While city business could be, and often was, conducted in the stoas, agora districts also came to include buildings with specific administrative functions. In the Athenian Agora, the 500-member *boule*, or council, met in a building called the *bouleuterion*. This structure, built before 450 BCE, was laid out on a simple rectangular plan with a vestibule and large meeting room. Near the end of the fifth century BCE, a new *bouleuterion* was constructed to the west of the old one. This too had a rectangular plan. The interior, however, may have had permanent tiered seating arranged in an ascending semicircle around a ground-level **podium**, or raised platform, as in the outdoor theaters of the time. Nearby was a small, round building with six columns supporting a conical roof, a type of structure known as a ***tholos***. Built about 465 BCE, this *tholos* was the meeting place of the fifty-member executive committee of the *boule*. The committee

members dined there at the city's expense, and, rotating the responsibility among themselves, a few of them always spent the night there to be available for any pressing business that might arise.

Private houses surrounded the Agora. Compared with the often grand public buildings, houses of the fifth century BCE in Athens were rarely more than simple rectangular structures of **stucco**-faced mud brick with wooden posts and lintels supporting roofs of terra-cotta tiles. Rooms were small and included a dayroom in which women could sew, weave, and do other chores, a dining room with couches for reclining around a table, a kitchen, bedrooms, and occasionally an indoor bathroom. Where space was not at a premium, houses sometimes opened onto small courtyards or porches.

THE ACROPOLIS

After Persian troops destroyed the Acropolis in 480 BCE, the Athenians vowed to keep it in ruins as a memorial. Later Pericles convinced them to rebuild it to a new magnificence. He argued that this project honored the gods, especially Athena, who had helped the Greeks defeat the Persians. But Pericles also hoped to create a visual expression of Athenian values and civic pride that would glorify his city and bolster its status as the capital of the empire he was instrumental in building. He placed his close friend Pheidias, a renowned sculptor, in charge of the rebuilding and assembled under him the most talented artists and artisans in Athens and its surrounding countryside.

The cost and labor involved in this undertaking were staggering. Quantities of gold, ivory, and exotic woods had to be imported. Some 22,000 tons of marble had to be transported 10 miles from mountain quarries to city workshops. Pericles was severely criticized by his political opponents for this extravagance, but it never cost him popular support. In fact, many working-class Athenians—laborers, carpenters, masons, sculptors, and the carters and merchants who kept them supplied and fed—benefited from his expenditures.

Work on the Acropolis continued after Pericles' death and was completed by the end of the fifth century BCE (fig. 5-38). Visitors to the Acropolis in 400 BCE would have climbed a steep ramp on the west side of the hill to the sanctuary entrance, perhaps pausing to admire the small, marble temple dedicated to Athena Nike (Athena as the goddess of victory in war), poised on a projection of rock above the ramp. After passing through an impressive porticoed gatehouse called the Propylaia, they would have seen a huge bronze figure of Athena Promachos (the Defender). This statue, designed and executed by Pheidias between about 465 and 455 BCE, showed the goddess bearing a spear. Sailors entering Athens's port of Piraeus, about 10 miles away, could see the sun reflected off the helmet and spear tip. Behind this statue was a walled precinct that enclosed the Erechtheion, a temple dedicated to several deities.

Religious buildings and votive statues filled the hilltop. A large stoa with projecting wings was dedicated to Artemis Brauronia (the protector of wild animals).

Beyond this stoa on the right stood the largest building on the Acropolis, looming above the precinct wall that enclosed it. This was the Parthenon, a temple dedicated to Athena Parthenos (the Virgin Athena). Visitors approached the temple from its northwest corner. The cella of the Parthenon faced east, so visitors walked along the north side of the temple past an outdoor altar to Athena to reach the temple's entrance. With permission from the priests, they would have climbed the east steps of the Parthenon to look into the cella and see a colossal gold and ivory statue of Athena, created by Pheidias and installed in the temple in 432 BCE.

The Parthenon. Sometime around 490 BCE, Athenians began work on a temple to Athena Parthenos that was still unfinished when the Persians sacked the Acropolis a decade later. Kimon of Athens then hired the architect Kallikrates to begin rebuilding on the old site. Work was halted briefly then resumed in 447 BCE by Pericles, who commissioned the architect Iktinos to design a larger temple using the existing foundation and stone elements. No expense was spared on this elegant new home for Athena. The finest white marble was used throughout, even on the roof, in place of the more usual terra-cotta tiles.

The planning and execution of the Parthenon required extraordinary mathematical and mechanical skills and would have been impossible without a large contingent of distinguished architects and builders, as well as talented sculptors and painters. The result is thus as much a testament to the administrative skills as to the artistic vision of Pheidias, who supervised the entire project. The building was completed in 438 BCE, and its sculptural decoration, designed by Pheidias and executed by himself and other sculptors in his workshop, was completed in 432 BCE, when the pedimental sculpture was placed (figs. 5-39, 5-40, 5-41, "The Object Speaks").

The extensive decoration of the Parthenon strongly reflects Pheidias's unifying vision despite being the product of many individuals. A coherent, stylistic whole, the sculptural decoration conveys a number of political and ideological themes: the triumph of the democratic Greek city-states over Persia's imperial forces, the preeminence of Athens thanks to the favor of Athena, and the triumph of an enlightened Greek civilization over despotism and barbarism.

Like the pediments of most temples, including the Temple of Aphaia at Aegina (see fig. 5-15), those of the Parthenon were filled with sculpture in the round, set on the deep shelves of the cornice and secured to the wall with metal pins. Unfortunately, much of the Parthenon's pedimental sculpture has been damaged or lost over the centuries. Using the locations of the pinholes, scholars nevertheless have been able to determine the placement of surviving statues and infer the poses of missing ones. The west pediment sculpture, facing the entrance to the Acropolis, illustrated the contest that Athena won over the sea god Poseidon for rule over the Athenians. The east pediment figures, above the entrance to the cella, illustrated the birth of Athena, fully grown and clad in armor, from the brow of her father, Zeus.

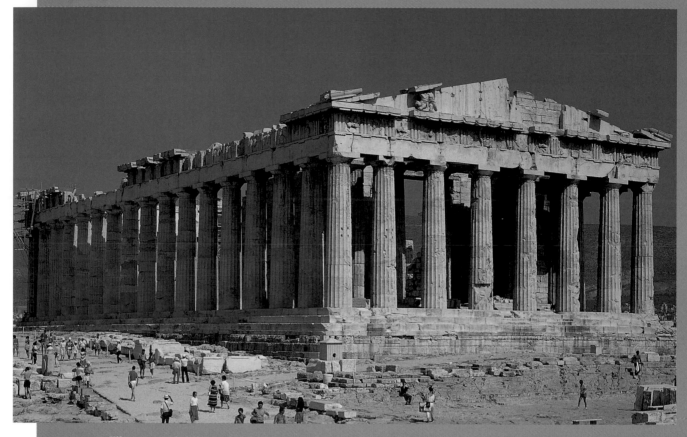

5-39. **Kallikrates and Iktinos. Parthenon, Acropolis,** Athens. 447–438 BCE. View from the northwest

What creates the Parthenon's sense of harmony and balance? One key is an aesthetics of number, which determines its perfect proportions—especially the ratio of 4:9 in breath to length and in the relationship of column diameter to space between columns. Just as important to the overall effect are subtle refinements of design, including the slightly arched base and entablature, the very subtle swelling of the soaring columns, and the narrowing of the space between the corner columns and the others in the colonnade. This aesthetic control of space is the essence of architecture, as opposed to mere building. The significance of their achievement was clear to its builders—Iktinos even wrote a book on the proportions of his masterpiece.

The Parthenon, a symbol of Athenian aspirations and creativity, rises triumphantly above the Acropolis (fig. 5-39). The sculptor Pheidias, the architects Iktinos and Kallikrates, teams of skillful stonecutters, and the political leader Pericles joined to create a building whose perfection has been recognized through the ages. This temple of the Goddess of Wisdom spoke eloquently to fifth-century BCE Greeks of independence, self-confidence, and justifiable pride—through the excellence of its materials and craftwork, the rationality of its simple and elegant post-and-lintel structure, and the subtle yet ennobling messages of its sculpture. Today, we continue to be captivated by the gleaming marble ruin of the Parthenon, the building that has shaped our ideas about Greek civilization, about the importance of architecture as a human endeavor, and also about the very notion of the possibility of perfectibility. Its form, even when regarded abstractly, is an icon for democratic values and independent thought.

When the Parthenon was built, Athens was the capital of a powerful, independent city-state. For Pericles, Athens was the model of all Greek cities; the Parthenon was the perfected, ideal Doric temple. Isolated like a work of sculpture, with the rock of the Acropolis as its base, the Parthenon is both an abstract form—a block of columns—and at the same time the essence of shelter: an earthly home for Athena, the patron goddess, who is represented in the temple by her cult statue. During the splendid Panathenaic procession held every four years, young women would climb the Acropolis, bringing with them a new *peplos* to present to Athena. In the Parthenon, Pheidias's ivory Athena was dressed in sheets of gold. It shone inside the Parthenon like an epiphany, while the procession wound around the building, both in reality and in a timeless marble frieze (see figs. 5-44–46).

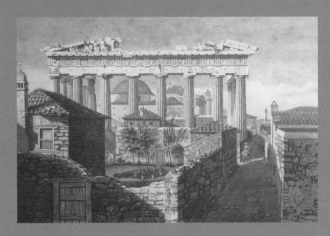

5-40. **William Pars. The Parthenon when it contained a mosque.** Drawn in 1765 and published in James Stuart and Nicholas Reve, *The Antiquities of Athens* (London, 1789)

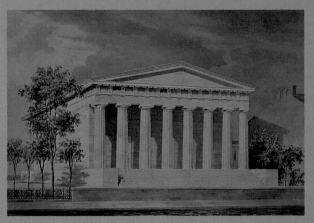

5-41. **William Strickland. The Second Bank of the United States, Philadelphia.** 1818–24. Watercolor by A. J. Davis. Avery Architecture and Fine Arts Library, Columbia University, New York

For the ancient Greeks the Parthenon symbolized Athens, its power and wealth, its glorious victory over foreign invaders, and its position of leadership at home. Over the centuries, very different people reacting to very different circumstances found that the temple could likewise express their ideals. They imbued it with meaning and messages that might have shocked the original builders. Over its long life, the Parthenon has been a Christian church dedicated to the Virgin Mary, an Islamic mosque (fig. 5-40), a Turkish munitions storage facility, an archaeological site, and a major tourist attraction. To many people through the ages, it remained silent, but in the eighteenth century CE, in the period known as the Enlightenment, the Parthenon found its voice again. British architects James Stuart and Nicholas Revett made the first careful drawings of the building in the mid-eighteenth century, which they published as *The Antiquities of Athens*, in 1789. People reacted to the Parthenon's harmonious proportions, subtle details, and rational relationship of part to part, even in drawings. The building came to exemplify, in architectural terms, human and humane values. In the nineteenth century, the Parthenon became a symbol of honesty, heroism, and civic virtue, of the highest ideals in art and politics, a model for national monuments, government buildings, and even homes.

Architectural messages, like any communications, may be subject to surprising interpretations. One of the most remarkable reincarnations of the Parthenon can still be seen in southern Germany. In 1821, Prince Ludwig of Bavaria, wishing to build a monument to German unity and heroism (and the defeat of Napoleon), commissioned Leo von Klenze to build a replica of the Parthenon on a bluff overlooking the Danube River near Regensburg. At the same time, the Scots began their Parthenon in Edinburgh, the "Athens of the North," but ran out of funds in 1829, leaving only isolated Doric columns supporting the entablature.

Nineteenth-century Americans dignified their democratic, mercantile culture by adapting the Parthenon's form to government, business, and even domestic buildings. Not only was the simplicity of the Doric order considered appropriate but it also was the cheapest order to build. The first quotation of the Parthenon in the United States was William Strickland's Second Bank of the United States in Philadelphia (1818–24), whose porch is an exact copy of the Parthenon—but three-fifths the actual size (fig. 5-41). In the 1830s and 1840s, the Greek Revival style spread across the United States. In Washington, D.C., Robert Mills used the Parthenon's Doric colonnade for the porches of the U.S. Patent Office in 1835–40. At Berry Hill (1842–44), near Halifax, Virginia, a beautiful plantation was given a Doric, Parthenon-like veranda.

The Parthenon continued to speak into the twentieth century. Its columns and pediment became a universal image, like the Great Pyramids of Egypt, that was used and reused in popular culture. In Nashville, Tennessee, for example, the Parthenon became a temple of tourism, first as a state fair building, then as rebuilt in concrete in 1941. The Parthenon even has an intriguing half-life in postmodern buildings and decorative arts.

When the notable architect Le Corbusier sought to create an architecture for the twentieth century, he turned for inspiration to the still-vibrant temple of the goddess of wisdom's clean lines, simple forms, and mathematical ratios. Le Corbusier called the Parthenon "ruthless, flawless," and wrote, "There is nothing to equal it in the architecture of the entire world and all the ages . . ." (Le Corbusier, *Vers une architecture*, 1923).

The Parthenon still speaks to those in the twenty-first century who listen.

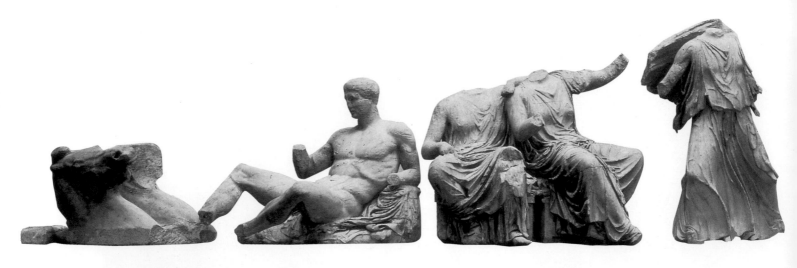

5-42. Photographic mock-up of the east pediment of the Parthenon (using photographs of the extant marble sculpture c. 438–432 BCE). The gap in the center represents the space that would have been occupied by the missing sculpture.

At the beginning of the nineteenth century, Thomas Bruce, the British earl of Elgin and ambassador to Constantinople, acquired much of the surviving sculpture from the Parthenon, which was being used for military purposes. He shipped it back to London in 1801 to decorate a lavish mansion for himself and his wife. By the time he returned to England a few years later, his wife had left him and the ancient treasures were at the center of a financial dispute. Finally, he sold the sculpture for a very low price. Referred to as the *Elgin Marbles*, most of the sculpture is now in the British Museum, including all the elements seen here except the torso of *Selene*, which is in the Acropolis Museum, Athens. The Greek government has tried unsuccessfully in recent times to have the *Elgin Marbles* returned.

The statues from the east pediment are the best preserved of the two groups (fig. 5-42). Flanking the missing central figures—probably Zeus seated on a throne with the just-born adult Athena standing at his side—were groups of three goddesses followed by single reclining male figures. In the left corner was the sun god Apollo in his chariot and in the right corner was the moon goddess Selene in hers. The reclining male nude on the left has been identified as both Herakles and Dionysos. His easy pose conforms to the slope of the pediment without a hint of awkwardness. The standing female figure just to the left of center is Iris, messenger of the gods, already spreading the news of Athena's birth. The three female figures on the right side, two sitting upright and one reclining, were once thought to be the Three Fates, whom the Greeks believed appeared at the birth of a child and determined its destiny. Most art historians now think that they are goddesses, perhaps Hestia (a sister of Zeus and the goddess of the hearth), Aphrodite, and her mother, Dione (one of Zeus's many consorts). These monumental interlocked figures seem to be awakening from a deep sleep, slowly rousing from languor to mental alertness. The sculptor, whether Pheidias or someone working in the Pheidian style, expertly rendered the female form beneath the fall of draperies. The clinging fabric both covers and reveals, creating circular patterns rippling with a life of their own over torsos, breasts, and knees and uniting the three figures into a single mass.

The Athenians intended their temple to surpass the Temple of Zeus at Olympia (see fig. 5-30), and they succeeded. The Parthenon was large in every dimension, built entirely of fine marble. It held a spectacular gold and ivory cult statue of Athena about 40 feet high and had two sculptured friezes encircling it, one above the outer peristyle and another atop the cella wall inside (see fig. 5-44). The Doric frieze on the exterior was decorated with ninety-two metope reliefs, fourteen on each end and thirty-two along each side. These reliefs depicted legendary battles, symbolized by combat between two representative figures of each: a Lapith against a centaur; a god against a Giant; a Greek against a Trojan; a Greek against an Amazon, a member of the mythical tribe of female warriors sometimes said to be the daughters of the war god Ares.

Among the best-preserved metope reliefs are those from the south side, including several depicting the battle between the Lapiths and the centaurs. The panel shown here (fig. 5-43)—with its choice of a perfect moment of pause within a fluid action, its reduction of forms to their most characteristic essentials, and its choice of a single, timeless image to stand for an entire historical episode—captures the essence of Fifth-Century Classical art. So dramatic is the **X**-shaped composition that we easily accept its visual contradictions. Like the *Discus Thrower* (see fig. 5-1), the Lapith is caught at an instant of total equilibrium. What should be a grueling tug-of-war between a man and a man-beast appears instead as an athletic ballet choreographed to show off the Lapith warrior's muscles and graceful movements against the implausible backdrop of his carefully draped cloak. Like Greek sculptors of earlier periods, those of the Fifth-Century Classical style were masters of representing hard muscles but soft flesh. As noted earlier (see

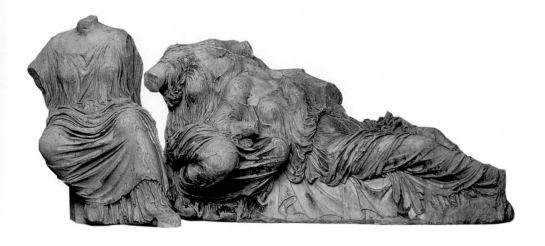

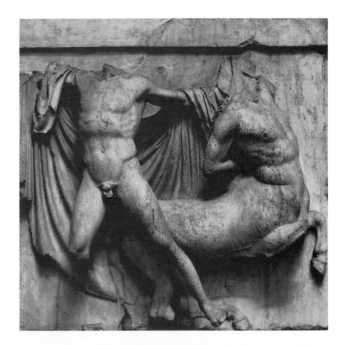

5-43. *Lapith Fighting a Centaur*, metope relief from the Doric frieze on the south side of the Parthenon. c. 440s BCE. Marble, height 56" (1.42 m). The British Museum, London

fig. 5-31), the legend of the Lapiths and centaurs may have symbolized the triumph of reason over animal passion.

Enclosed within the Parthenon's Doric order peristyle, the body of the temple consists of a cella, opening to the east, and an unconnected auxiliary space opening to the west. Short colonnades in front of each entrance support an entablature with an Ionic order frieze in relief that extends along both sides of the temple, for a total frieze length of 525 feet (fig. 5-44). The subject of this frieze is a procession celebrating the festival that took place in Athens every four years, when the women of the city wove a new wool *peplos* and carried it to the Acropolis to clothe an ancient wooden cult statue of Athena. The frieze culminated with the presentation of the new robe to Athena. A new interpretation suggested that the girl holding the *peplos* is to become a human sacrifice, a tribute to the role Athenian women played in saving the city. Current opinion favors the traditional interpretation, for the east facade presents a totally integrated program of images—the birth of the goddess in the pediment, her honoring by the citizens who present her with the newly woven *peplos*, and—seen through the doors—the glorious ivory and gold figure of Athena herself, the cult image. The Panathenaic procession began just outside the city walls in a cemetery, where people assembled among the grave monuments of their ancestors (see fig. 5-52). They then marched into the city through the Dipylon Gate, across the busy Agora along the Panathenaic Way, and up the ramp to the Acropolis. From the Propylaia, they moved onto the Sacred Way and completed their journey at Athena's altar.

In Pheidias's portrayal of this major ceremony, the figures—skilled riders managing powerful steeds, for

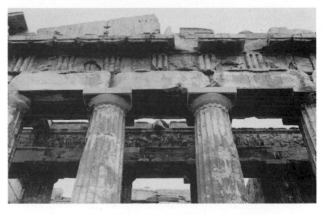

5-44. View of the outer Doric and inner Ionic friezes at the west end of the Parthenon. c. 440s–430s BCE

In the Doric metopes, Greeks, led by Theseus, battle Amazons. In the Ionic frieze at the top of the cella wall, horsemen are being organized by marshals.

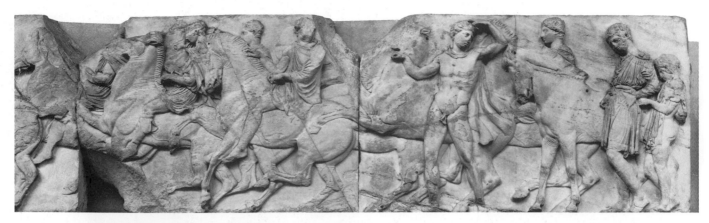

5-45. *Horsemen*, detail of the Procession, from the Ionic frieze on the north side of the Parthenon. c. 438–432 BCE. Marble, height 41³/₄" (106 cm). The British Museum, London

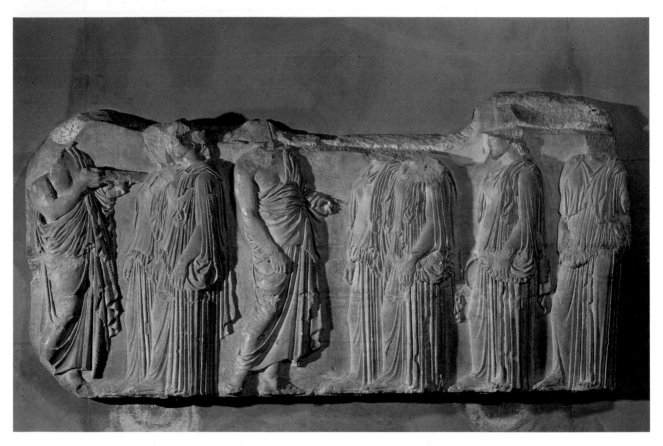

5-46. *Marshals and Young Women*, detail of the Procession, from the Ionic frieze on the east side of the Parthenon. c. 438–432 BCE. Marble, height 43" (109 cm). Musée du Louvre, Paris

example (fig. 5-45), or graceful but physically sturdy young walkers (fig. 5-46)—seem to be representative types, ideal inhabitants of a successful city-state. The underlying message of the frieze as a whole is that the Athenians are a healthy, vigorous people, enjoying individual rights but united in a democratic civic body looked upon with favor by the gods. The people were inseparable from and symbolic of the city itself.

As with the metope relief of the *Lapith Fighting a Centaur* (see fig. 5-43), viewers of the processional frieze easily accept its disproportions, spatial incongruities, and such implausible compositional features as all the animal and human figures standing on the same groundline, and upright men and women being as tall as rearing horses. Carefully planned rhythmic variations—changes in the speed of the participants in the procession as it winds around the walls—contribute to the effectiveness of the frieze: horses plunge ahead at full gallop; women proceed with a slow, stately step; parade marshals pause to look back at the progress of those behind them; and human-looking deities rest on conveniently placed benches as they await the arrival of the marchers. In executing the frieze, the sculptors took into account the spectators' low viewpoint and the

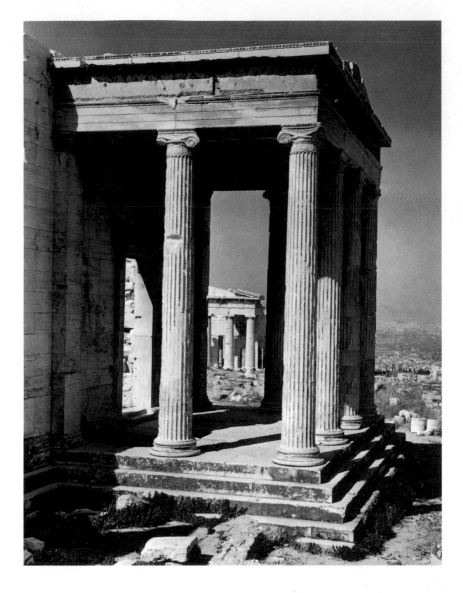

5-47. Mnesikles. Erechtheion, Acropolis, Athens. 430s–405 BCE. View of north porch

dim lighting inside the peristyle. They carved the top of the frieze band in higher relief than the lower part, thus tilting the figures out to catch the reflected light from the pavement and permit a clearer reading of the action. The subtleties in the sculpture may not have been as evident to Athenians in the fifth century BCE as they are now, because the frieze, seen at the top of a high wall and between columns, originally was completely painted. The background was dark blue and the figures were in contrasting red and ocher, accented with glittering gold and real metal details such as bronze bridles and bits on the horses.

The Erechtheion. Upon completion of the Parthenon, Pericles commissioned an architect named Mnesikles to design a monumental gatehouse, the Propylaia. Work began on it in 437 and stopped in 432 BCE, with the structure still incomplete. The Propylaia had no sculptural decoration, but its north wing was the earliest known *museum* (meaning "home of the Muses"), a gallery built specifically to house a collection of paintings for public view.

Mnesikles also designed the Erechtheion, the second-largest structure erected on the Acropolis under Pericles' building program (fig. 5-47). Work began on it in the 430s and ended in 405 BCE, just before the fall of Athens to Sparta. Its asymmetrical plan and several levels reflect its multiple functions in housing many different shrines, and also conform to the sharply sloping terrain on which it was located. The mythical contest between the sea god Poseidon and Athena for patronage over Athens was said to have occurred within the Erechtheion precinct. During this contest, Poseidon struck a rock with his trident (three-pronged harpoon), bringing forth a spout of water. Athena gave the olive tree and won. The Athenians enclosed what they believed to be this sacred rock, bearing the marks of the trident, in the Erechtheion's north porch. Another area housed a sacred spring dedicated to Erechtheus, a legendary king of Athens, during whose reign the goddess Demeter was said to have instructed the Athenians in the agricultural arts. The Erechtheion also contained a memorial to the legendary founder of Athens, Kekrops, half man and half serpent, who acted as judge in the contest between Athena and Poseidon. And it housed the wooden cult statue of Athena that was the center of the Panathenaic festival.

The Erechtheion had porches on the north, east, and south sides. Architects agree that the north porch has the most perfect interpretation of the Ionic order, and they have copied the columns and capitals, the carved moldings, and the proportions and details of the door ever since the eighteenth-century discovery of Greek art. The Porch of the

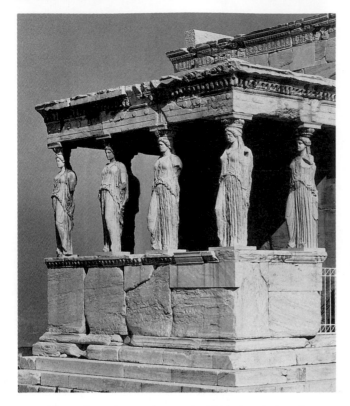

the knee, rests on the ball of the foot. The three caryatids on the left have their right legs engaged, and the three on the right have their left legs engaged, creating a sense of closure, symmetry, and rhythm. The vertical fall of the drapery on the engaged side resembles the fluting of a column shaft and provides a sense of stability, whereas the bent leg gives an impression of relaxed grace and effortless support. The hair of each caryatid falls in a loose but massive knot around its neck, a device that strengthens the weakest point in the sculpture while appearing entirely natural.

The Temple of Athena Nike. The Temple of Athena Nike (Athena as the goddess of victory in war), located on a bastion south of the Propylaia, was designed and built about 425 BCE, probably by Kallikrates (fig. 5-49). It is an Ionic order temple built on an **amphiprostyle** plan, that is, with a porch at each end (see "Greek Temple Plans," page 163). The porch facing out over the city is **blind**, with no entrance to the cella. Reduced to rubble during the Turkish occupation of Greece in the seventeenth century CE, the temple has since been rebuilt. Its diminutive size, about 27 by 19 feet, and refined Ionic decoration are in marked contrast to the massive Doric Propylaia adjacent to it. Between 410 and 407 BCE, the temple was surrounded by a **parapet**, or low wall, faced with sculptured panels depicting Athena presiding over her winged attendants, called Victories, as they prepared for a celebration. The parapet no longer exists, but some of the panels from it have survived. One of the most admired is of *Nike (Victory) Adjusting Her Sandal* (fig. 5-50).

Maidens (fig. 5-48), on the south side facing the Parthenon, is even more famous. Raised on a high base, its six stately caryatids with simple Doric capitals support an Ionic entablature made up of bands of carved molding. In a pose characteristic of Classical figures, each caryatid's weight is supported on one engaged leg, while the free leg, bent at

5-48. (above) **Porch of the Maidens (Caryatid Porch), Erechtheion,** Acropolis, Athens. 421–405 BCE

5-49. Kallikrates. Temple of Athena Nike, Acropolis, Athens. C. 425 BCE

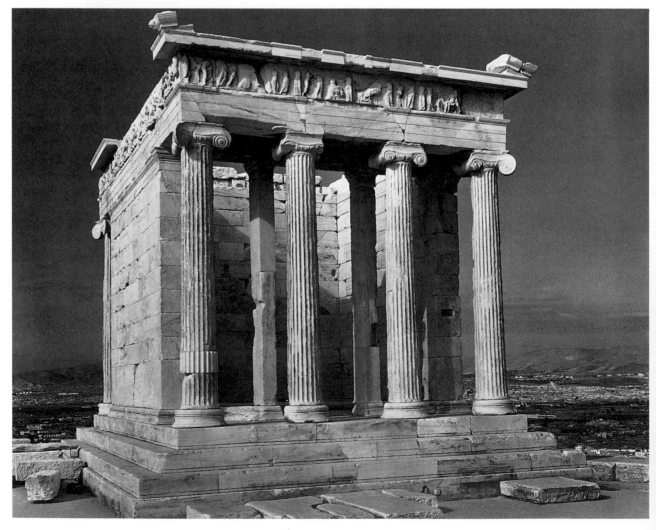

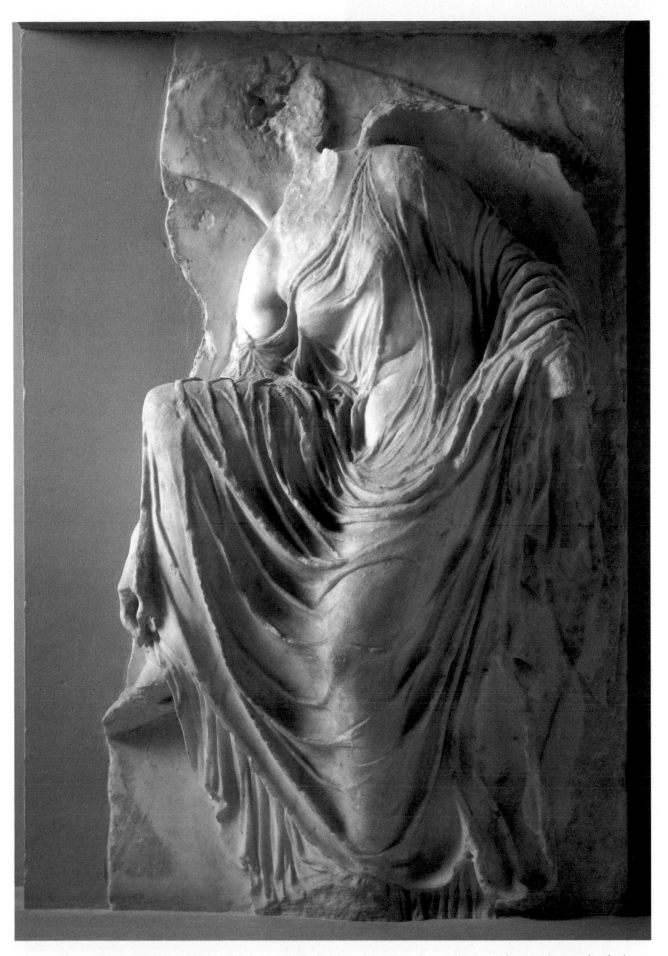

5-50. *Nike (Victory) Adjusting Her Sandal*, fragment of relief decoration from the parapet (now destroyed), Temple of Athena
Nike, Acropolis, Athens. Last quarter of the 5th century BCE. Marble, height 42" (107 cm). Acropolis Museum, Athens

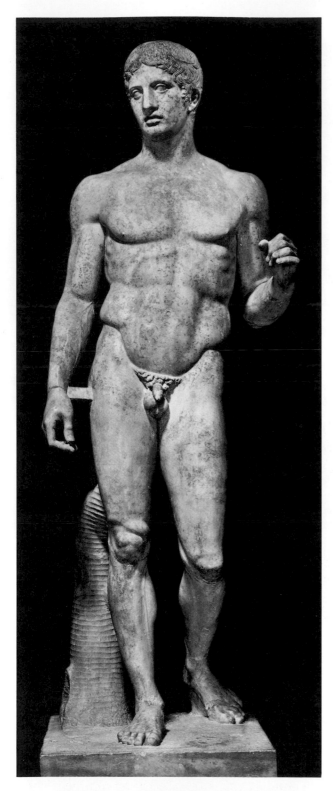

5-51. Polykleitos. *Spear Bearer (Doryphoros)*, Roman copy after the original bronze of c. 450–440 BCE. Marble, height 6'6" (2 m); tree trunk and brace strut are Roman additions. Museo Archeològico Nazionale, Naples

The figure bends forward gracefully, causing her ample *chiton* to slip off one shoulder. Her large wings, one open and one closed, effectively balance this unstable pose. Unlike the decorative swirls of heavy fabric covering the Parthenon goddesses or the weighty pleats of the robes of the Erechtheion caryatids, the textile covering this *Nike* appears delicate and light, clinging to her body like wet silk, one of the most discreetly erotic images in ancient art.

SCULPTURE AND THE CANON OF POLYKLEITOS

Just as Greek architects defined and followed a set of standards for ideal temple design, Greek sculptors sought an ideal of human beauty. Studying human appearances closely, the sculptors of the Fifth-Century Classical period selected those attributes they considered the most desirable, such as regular facial features, smooth skin, and particular body proportions, and combined them into a single ideal of physical perfection. The quest for the ideal, as we have noted, was seen also in fifth-century BCE rationalists' philosophy that all objects in the physical world were reflections of ideal forms that could be discovered through reason.

The best-known art theorist of the Classical period was the sculptor Polykleitos of Argos. About 450 BCE he developed a set of rules for constructing the ideal human figure, which he set down in a treatise called *The Canon* (*kanon* is Greek for "measure," "rule," or "law"). To illustrate his theory, Polykleitos created a larger-than-lifesize bronze statue, the *Spear Bearer* (*Doryphoros*). Neither the treatise nor the original statue has survived, but both were widely discussed in the writings of his contemporaries, and later Roman artists made copies in stone and marble of the *Spear Bearer* (fig. 5-51). By studying the most exact of these copies, or **replicas**, scholars have tried to determine the set of measurements that defined the ideal proportions in Polykleitos's canon. The canon included a system of ratios between a basic unit and the length of various body parts. Some studies suggest that his basic unit may have been the length of the figure's index finger or the width of its hand across the knuckles; others suggest that it was the height of the head from chin to hairline. The canon also included guidelines for *symmetria* ("commensurability"), by which Polykleitos meant the relationship of body parts to one another. In the statue he made to illustrate his book, he explored not only proportions but also the relationship of weight-bearing and relaxed legs and arms in a perfectly balanced figure. The cross-balancing of supporting and free elements in a figure is sometimes referred to as **contrapposto**. In true Classical fashion, Polykleitos also balanced careful observation and generalization to create an ideal figure.

The marble replica of the *Spear Bearer* illustrated here shows a male athlete, perfectly balanced with the whole weight of the upper body supported over the straight (engaged) right leg. The left leg is bent at the knee, with the left foot poised on the ball of the foot, suggesting preceding and succeeding movement. The pattern of tension and relaxation is reversed in the arrangement of the arms, with the right relaxed on the engaged side and the left bent to support the weight of the (missing) spear. This dynamically balanced body pose—characteristic of Fifth-Century Classical standing figure sculpture—differs somewhat from that of the *Kritian Boy* (see fig. 5-33) of a generation earlier. The tilt of the hipline in the *Spear Bearer* is a little more pronounced to accommodate the raising of the left foot onto its ball, and the head is turned toward the same side as the engaged leg.

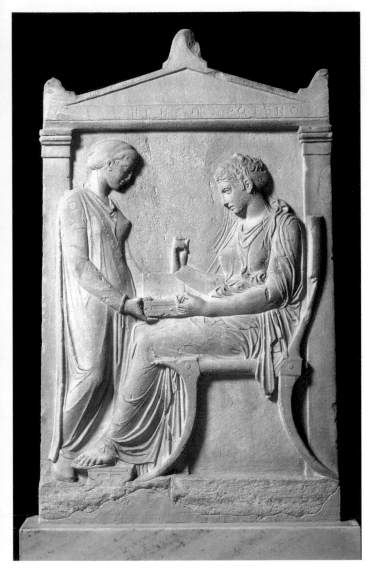

5-52. *Grave Stele of Hegeso*. c. 410–400 BCE. Marble, height 5'9" (1.5 m). National Archaeological Museum, Athens

A comparison of the *Spear Bearer* to the *Warrior A* from Riace (see fig. 5-35) is also informative. The treatment of the torso and groin is quite similar in both, and their poses are nearly identical, except for the slightly different positions of the unengaged left legs and the fact that the heel of the *Spear Bearer* is raised. *Warrior A* seems to stand still in alert relaxation. The *Spear Bearer* appears to have paused before stepping forward.

To Polykleitos and others in the fifth century BCE, the Beautiful was synonymous with the Good. He sought a mathematical definition of the Beautiful as it applied to the human figure, aspiring to make it possible to replicate human perfection in the tangible form of sculpture.

STELE SCULPTURE

Another kind of freestanding monument was used in the Archaic and the Fifth-Century Classical periods in Greece—the upright stone slab, or **stele** (plural stelai), carved in low relief with the image of the person to be remembered. Athenians had not used private memorial

stelai since the end of the sixth century BCE, when such personal monuments were banned. But during the third quarter of the fifth century they began to erect stelai in cemeteries again. Instead of images of warriors or athletes, however, the Classical stelai represent departures or domestic scenes that very often feature women. Although respectable women played no role in politics or civic life, the presence of many fine tombstones of women suggests that they held a respected position in the family.

The *Grave Stele of Hegeso* depicts a beautifully dressed woman seated in an elegant chair, her feet on a footstool (fig. 5-52). She selects jewels (a necklace indicated in paint) from a box presented by her maid. The composition is entirely inward turning, not only in the gaze and gestures focused on the jewels but also in the way the vertical fall of the maid's drapery and the curve of Hegeso's chair seem to enclose and frame the figures. Although their faces and bodies are as idealized as the Parthenon maidens', the two women take on some individuality through accessory details of costume and hairstyle. The simplicity of the maid's tunic and hair contrasts with the luxurious dress and partially veiled, flowing hair of Hegeso. The sculptor has carved both women as part of the living spectators' space in front of a simple temple-fronted gravestone. The artist does not invade the private world of women, and Hegeso's stele and many others like it could be set up in the public cemetery with no loss of privacy or dignity to its subjects.

The imagery and mood of the stele were also found in painted ceramics, especially on the **lekythoi** (slim vessels; singular lekythos) used in graveside ceremonies, as markers and offerings. However, Athenians again banned private funeral monuments at the end of the fourth century (317 BCE).

PAINTING

Painted ceramics continued to be a major art form throughout the Classical period. A new style of **white-ground** decoration grew in popularity in the 460s BCE. White backgrounds had been applied on black-figure vases as early as the seventh century BCE, but the white-ground techniques of the fifth century BCE were far more complex than those earlier efforts (see "Greek Painted Vases," page 173). Characterized by dominantly white backgrounds and outlined or drawn imagery, white-ground painted pottery was a specialty of Athens' potters. Artists used both black-figure and red-figure techniques, and soon they began to enhance the fired vessel with a full range of colors using **tempera** paint, an opaque, water-based medium mixed with glue or egg white. This fragile decoration deteriorated easily and for that reason seems to have been favored for funerary, votive, and similarly non-utilitarian vessels.

The tall, slender, one-handled white-ground lekythos was used to pour liquids during religious rituals, and funerary lekythoi have been found both in and on tombs. Some convey grief and loss with a scene of a departing figure bidding farewell, while others depict a grave stele draped with garlands. Still others show scenes of the

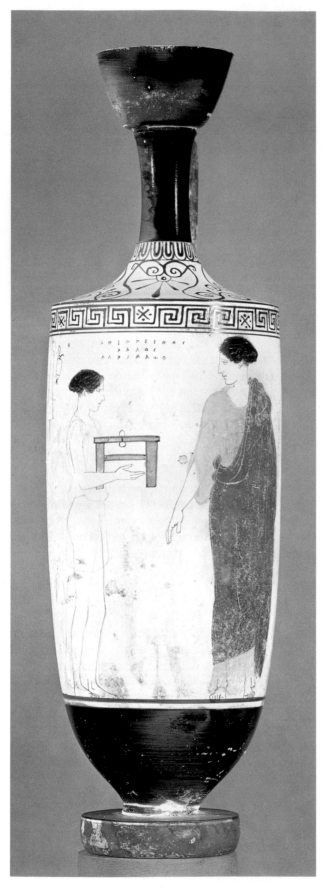

5-53. Style of Achilles Painter. *Woman and Maid*.
c. 450–440 BCE. White-ground and black-figure
decoration on a lekythos. Ceramic, with additional
painting in tempera, height of lekythos 15 1/8"
(38.4 cm). Museum of Fine Arts, Boston
Francis Bartlett Fund

dead person once again in the prime of life and engaged in a seemingly everyday activity, but scrutiny reveals that the images are imbued with signs of separation and loss.

A white-ground lekythos, dated about 450–440 BCE and in the style of the Achilles Painter (an anonymous artist known from his painting of Achilles), shows a young servant girl carrying a stool for a small chest of valuables to a well-dressed woman of regal bearing, the dead person whom the vessel memorializes (fig. 5-53). Like the *Grave Stele of Hegeso*, the scene contains no overt signs of grief, but a quiet sadness pervades it. The two figures seem to inhabit different worlds, and their glances just fail to meet. White-figure painting must have echoed the style of contemporary paintings on walls and panels, but no examples of those have survived for comparison.

Other painting was found in settings such as the Painted Stoa (see fig. 5-37, top center). It was built on the north side of the Athenian Agora about 460 BCE, and was so called because it was decorated with paintings by the most famous artists of the time, including Polygnotos of Thasos (active c. 475–450 BCE). Nothing survives of Polygnotos's work, but his contemporaries praised his talents for creating the illusion of spatial recession in landscapes, rendering female figures clothed in transparent draperies, and conveying through facial expressions the full range of human emotions. Ancient writers describe his paintings enthusiastically, but nothing remains for us to see.

CLASSICAL ART OF THE FOURTH CENTURY

After the Spartans defeated Athens in 404 BCE, they set up a pro-Spartan government led by Kritias. This government was so oppressive that within a year the Athenians rebelled against it, killed Kritias, and restored democracy. Athens recovered its independence and its economy revived, but it never regained its dominant political and military status. Sparta failed to establish a lasting preeminence over the rest of Greece, and the city-states again began to struggle among themselves. Although Athens had lost its empire, it retained its reputation as a center of artistic and intellectual accomplishment. In 387 BCE, the great philosopher-teacher Plato founded a school just outside Athens, as Plato's student Aristotle did later. Among Aristotle's students was young Alexander of Macedon, known to history as Alexander the Great.

The work of Greek artists during the fourth century BCE exhibits a high level of creativity and technical accomplishment. Changing political conditions never seriously dampened the Greek creative spirit. Indeed, the artists of the second half of the century in particular experimented widely with new subjects and styles. Although they observed the basic Classical approach to composition and form, they no longer adhered rigidly to its conventions. Their innovations were supported by a sophisticated and diverse new group of patrons, including the Macedonian courts of Philip and Alexander, wealthy aristocrats in Asia Minor, and foreign rulers anxious to import Greek wares and, sometimes, Greek artists.

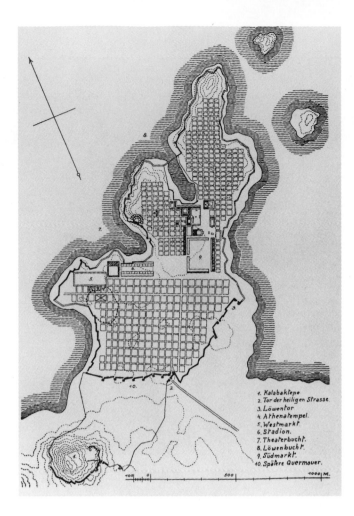

5-54. Plan of Miletos, with original coastline

1. Kalabaktepe
2. Tor der heiligen Strasse.
3. Löwentor.
4. Athenatempel.
5. Westmarkt.
6. Stadion.
7. Theaterbucht.
8. Löwenbuch t.
9. Südmarkt.
10. Spätere Quermauer.

ARCHITECTURE AND ARCHITECTURAL SCULPTURE

Despite the instability of the fourth century BCE, Greek cities undertook innovative architectural projects. Architects developed variations on the Classical ideal in urban planning, temple design, and the design of two increasingly popular structures, the *tholos* and the monumental tomb. In contrast to the previous century, much of this activity took place outside of Athens and even in areas beyond mainland Greece, notably in Asia Minor.

The Orthogonal City Plan. In older Greek cities such as Athens, which grew up on the site of an ancient **citadel**, buildings and streets developed irregularly according to the needs of their inhabitants and the requirements of the terrain. As early as the eighth century BCE, however, builders in some western Greek settlements began to implement a rigid, mathematical concept of urban development based on the **orthogonal** (right-angled) **plan**. New cities or rebuilt sections in old cities were laid out on straight, evenly spaced parallel streets that intersected at right angles to create rectangular blocks. These blocks, or plats, were then subdivided into identical building plots. The orthogonal plan probably originated in Egypt, where it was used early in the second millennium BCE at such sites as el-Lahun (see fig. 3-17).

During the Classical period, Greek architects promoted the orthogonal system as an ideal for city planning. Hippodamos of Miletos, a major urban planner of the fifth century BCE, had views on the city philosophically

akin to those of Socrates and aesthetically akin to those of Polykleitos. All three believed that humans could arrive at a model of perfection through reason. According to Hippodamos, who seems to have been more concerned with abstract principles of order than with the human individual, the ideal city should be divided into three zones—sacred, public, and private—and limited to 10,000 citizens divided into three classes—artists, farmers, and soldiers. The basic Hippodamian plat was a square 600 feet on each side, divided into quarters. Each quarter was subdivided into six rectangular building plots measuring 100 by 150 feet on a side, a scheme still widely used in Western cities and suburbs today.

Many Greek cities with orthogonal plans were laid out on relatively flat land that posed few obstacles to regularity. Miletos, in Asia Minor, for example, was redesigned by Hippodamos after its partial destruction by the Persians (fig. 5-54). Later the orthogonal plan was applied on less-hospitable terrain, such as that of Priene, which lies across the plain from Miletos on a rugged hillside. In this case, the city's planners made no attempt to accommodate their grid to the irregular mountainside, so some streets are in fact stairs.

The Tholos. Buildings with a circular plan had a long history in Greece going back to Mycenaean beehive tombs (see fig. 4-20). In later times various types of *tholoi*, or circular-plan buildings, were erected. Some were shrines or monuments and some, like the fifth-century BCE *tholos* in the Athens Agora (see fig. 5-37), were administrative buildings. However, the function of many, such as a *tholos* built

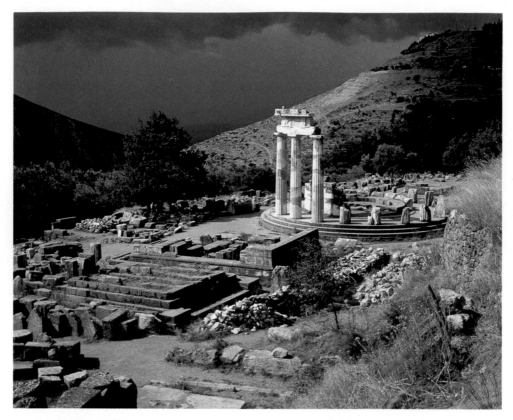

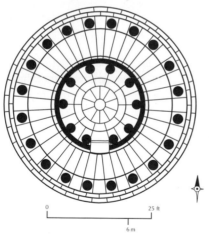

5-55. *Tholos*, Sanctuary of Athena Pronaia, Delphi.
c. 400 BCE

Often the term following the name *Athena* is an epithet, or title, identifying one of the goddess's many roles in ancient Greek belief. For example, as patron of craftspeople, she was referred to as *Athena Ergane* ("Athena of the Worker"). As guardian of the city-states, she was *Athena Polias*. The term *Pronaia* in this sanctuary name simply means "in front of the temples," referring to the sanctuary's location preceding the Temple of Apollo higher up on the mountainside.

5-56. Plan and section of the *tholos*, Sanctuary of Athena Pronaia, Delphi

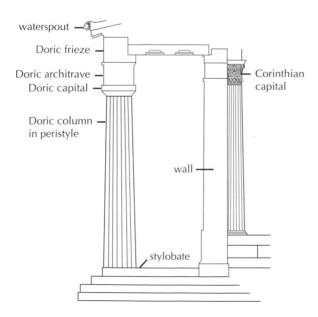

waterspout

Doric frieze

Doric architrave

Doric capital

Corinthian capital

Doric column in peristyle

wall

stylobate

shortly after 400 BCE in the Sanctuary of Athena Pronaia at Delphi, is unknown (figs. 5-55, 5-56). Theodoros, the presumed architect, was from Phokaia in Asia Minor. The exterior was of the Doric order, as seen from the three columns and a piece of the entablature that have been restored. Other remnants suggest that the interior featured a ring of columns with capitals carved to resemble the curling leaves of the acanthus plant. This type of capital came to be called Corinthian in Roman times (see "The Greek Architectural Orders," page 164). It had been used on roof-supporting columns in temple interiors since the mid-fifth century BCE, but was not used on building exteriors until the Hellenistic period, more than a hundred years later.

The Monumental Tomb. Monumental tombs might be designed as large, showy memorials to their wealthy owners. One such tomb was built for Mausolos, prince of Karia, at Halikarnassos in Asia Minor. This monument

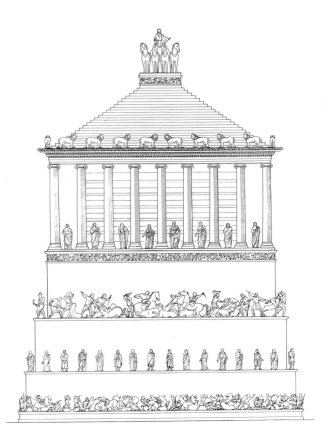

5-57. Reconstruction drawing of the Mausoleum (tomb of Mausolos), Halikarnassos (modern Bodrum, Turkey). c. 353 BCE

Later writers describe the building and its sculpture in frustratingly inexact detail. Consequently, many archaeologists have tried to reconstruct the appearance of the monument. This illustration shows the most likely possibilities.

(fig. 5-57) was so spectacular that later writers glorified it as one of the Seven Wonders of the World. Mausolos, whose name has given us the term **mausoleum** (a large burial structure), was the Persian governor of the region. He admired Greek culture and brought to his court from Greece writers, entertainers, and artists, as well as the greatest sculptors to decorate his tomb. The structure was completed after his death in 353 BCE under the direction of his wife, Artemisia, who was rumored to have drunk her dead husband's ashes mixed with wine.

A preserved male statue from the tomb was long believed to be of Mausolos himself (fig. 5-58). The man's broad face, long, thick hair, short beard and moustache, and stocky body could represent the features of a particular individual, but it is more likely that the statue represents a new heroic ideal—a glorification of experience, maturity, and intellect over youthful physical beauty and athletic vigor. The heavy swathing of drapery drawn into a thick mass around the waist reveals the underlying body forms while providing the necessary bulk to make the figure impressive to a viewer at the bottom of the monument.

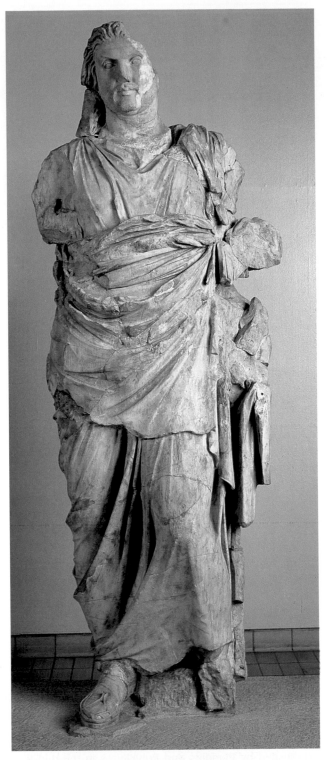

5-58. *Mausolos (?)*, from the Mausoleum (tomb of Mausolos), Halikarnassos. Marble, height 9'10" (3 m). The British Museum, London

The foundation, many scattered stones, and fragments of sculpture and moldings that are now in various museums are what remains of Mausolos's tomb, which was destroyed in the Middle Ages. Although early descriptions are often ambiguous, the structure probably stood about 150 feet high and rose from a base measuring 126 by 105 feet. The elevation consisted of three main sections: a plain-surfaced podium, a colonnaded section in

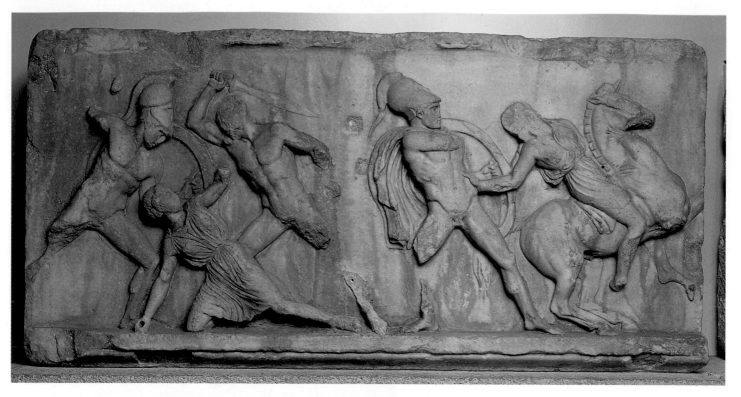

5-59. Panel from the Amazon frieze, south side of the Mausoleum at Halikarnassos. Mid-4th century BCE. The British Museum, London

the Ionic order, and a stepped roof. The roof section measured about 24 feet high and was topped with marble statues of a four-horse chariot and driver. The exterior decoration consisted of Ionic friezes and an estimated 250 freestanding statues, lifesize or larger, including more than 50 lions. The friezes were carved in relief with battle scenes of Lapiths against centaurs and Greeks against Amazons (fig. 5-59). According to the reconstruction of the monument in figure 5-57, statues of Mausolos's relatives and ancestors stood between the columns in the colonnade; statues of hunters killing lions, boars, and deer encircled the next level down; below them was a circle of unidentified standing figures; and around the base was depicted a battle between Greeks and Persians. Originally, all the sculptural elements of the tomb were painted.

SCULPTURE

Throughout the fifth century BCE, sculptors carefully maintained the equilibrium between simplicity and ornament that is fundamental to Greek Classical art. Standards established by Pheidias and Polykleitos in the mid-fifth century BCE for the ideal proportions and idealized forms of the human figure had generally been accepted by the next generation of artists. Fourth-century BCE artists, on the other hand, challenged and modified those standards. The artists of mainland Greece, in particular, developed a new canon of proportions for male figures—now 8 or more "heads" tall rather than the 6½- or 7-head height of earlier works. The calm, noble detachment characteristic of earlier figures gave way to more sensitively rendered images of men and women with expressions of wistful introspection, dreaminess, or even fleeting anxiety. Patrons lost some of their interest in images of mighty Olympian gods and legendary heroes and acquired a

taste for depictions of minor deities in lighthearted moments. This period also saw the earliest depictions of fully nude women in major works of art.

The fourth century BCE was dominated by three sculptors—Praxiteles, Skopas, and Lysippos. Praxiteles was active in Athens from about 370 to 335 BCE or later. According to the Greek traveler Pausanias, writing in the second century CE, Praxiteles' "Hermes of stone who carries the infant Dionysos" stood in the Temple of Hera at Olympia. Just such a sculpture in marble, depicting the messenger god Hermes teasing the baby Dionysos with a bunch of grapes, was discovered in the ruins of the ancient Temple of Hera in the Sanctuary of Hera and Zeus at Olympia (fig. 5-60). Archaeologists accepted *Hermes and the Infant Dionysos* as an authentic work by Praxiteles until recent studies indicated that it is probably a very good fourth-century BCE Roman or Hellenistic copy of an original made by Praxiteles or his followers.

The sculpture remains an excellent example that reflects a number of differences between Praxiteles' style and that of the late fifth century. His *Hermes* has a smaller head and a more youthful body than Polykleitos's *Spear Bearer*, and its off-balance, **S**-curve pose, requiring the figure to lean on a post, contrasts clearly with that of the earlier work (see fig. 5-51). This sculptor also created a sensuous play of light over the figure's surface. The gleam of the smoothly finished flesh contrasts with the textured quality of the crumpled draperies and the rough locks of hair, even on the baby's head. Surely owed to Praxiteles is the humanized treatment of the subject—two gods, one a loving adult and the other a playful child, caught in a moment of absorbed companionship. The interaction of the two across real space through gestures and glances creates an overall effect far different from

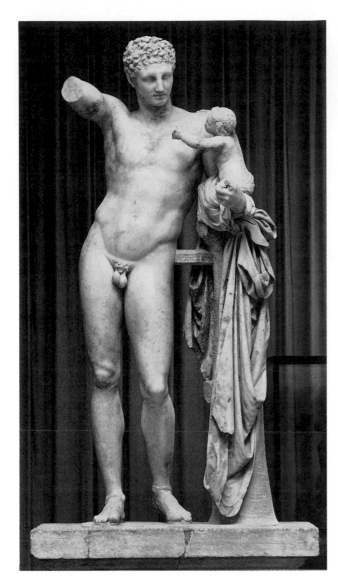

5-60. Praxiteles or his followers. *Hermes and the Infant Dionysos*, probably a Hellenistic or Roman copy after a 4th-century BCE original. Marble, with remnants of red paint on the lips and hair, height 7'1" (2.16 m). Archaeological Museum, Olympia

Discovered in the rubble of the ruined Temple of Hera at Olympia in 1875, this statue is now widely accepted as a very good Roman or Hellenistic copy. Support for this conclusion comes from certain elements typical of Roman sculpture: Hermes' sandals, which recent studies suggest are not accurate for a fourth-century BCE date; the supporting element of crumpled fabric covering a tree stump; and the use of a reinforcing strut, or brace, between Hermes' hip and the tree stump.

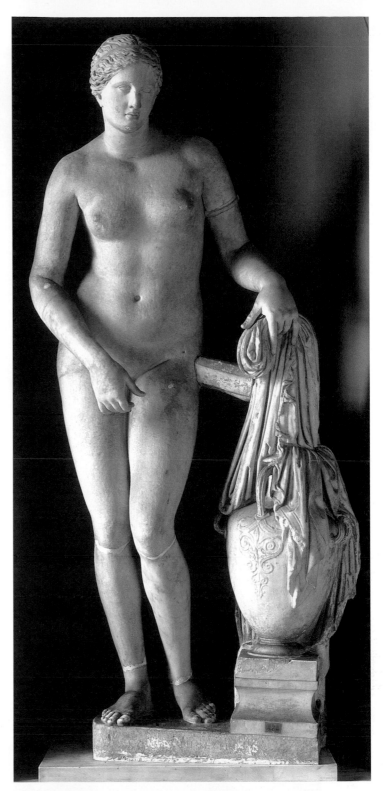

5-61. Praxiteles. *Aphrodite of Knidos*, composite of two similar Roman copies after the original marble of c. 350 BCE. Marble, height 6'8" (2.03 m). Musei Vaticani, Museo Pio Clementino, Gabinetto delle Maschere, Rome

The head of this figure is from one Roman copy, the body from another. Seventeenth- and eighteenth-century CE restorers added the nose, the neck, the right forearm and hand, most of the left arm, and the feet and parts of the legs. This kind of restoration would rarely be undertaken today, but it was frequently done and considered quite acceptable in the past, when archaeologists were trying to put together a body of work documenting the appearances of lost Greek statues. It was also done to create a piece suitable for sale to a private individual or for display in a museum.

that of the austere Olympian deities of the fifth century BCE on the pediments and metopes of the Temple of Zeus (see figs. 5-31, 5-32), near where the work was found.

Around 350 BCE, Praxiteles created a statue of Aphrodite for the city of Knidos in Asia Minor. Although artists of the fifth century BCE had begun to hint boldly at the naked female body beneath tissue-thin drapery, as in *Nike Adjusting Her Sandal* (see fig. 5-50), this *Aphrodite* was apparently the first statue by a well-known Greek sculptor to depict a fully nude woman, and it set a new standard (fig. 5-61). Although nudity among athletic young men

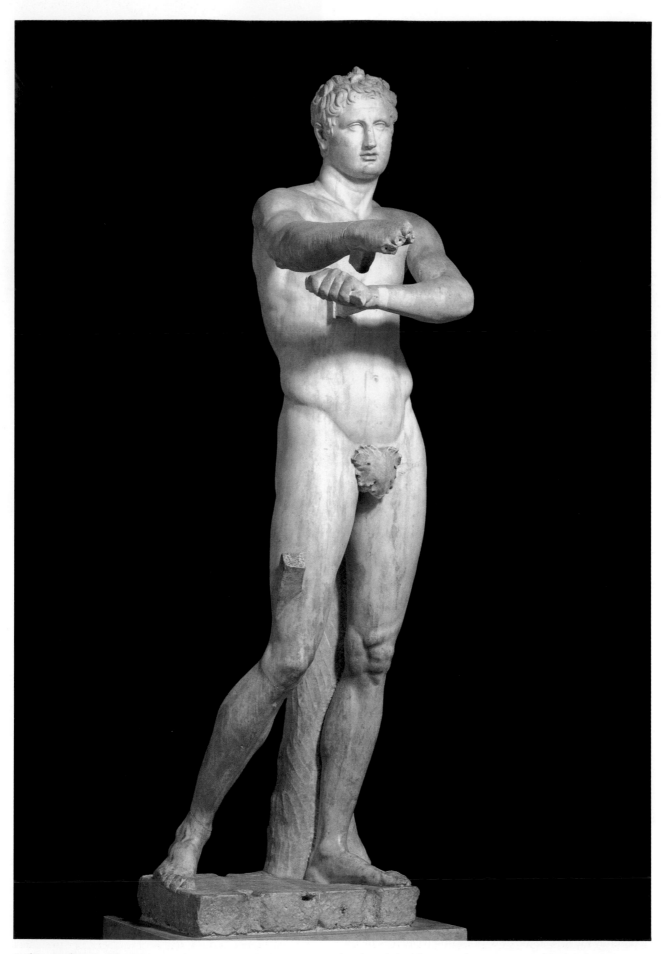

5-62. Lysippos. *The Scraper (Apoxyomenos)*, Roman copy after the original bronze of c. 330 BCE. Marble, height 6'9"
(2.06 m). Musei Vaticani, Museo Pio Clementino, Gabinetto dell'Apoxyomenos, Rome

was admired in Greek society, among women it had been considered a sign of low character. The eventual wide acceptance of female nudes in large statuary may be related to the gradual merging of the Greeks' concept of their goddess Aphrodite with some of the characteristics of the Phoenician goddess Astarte (the Babylonian Ishtar), who was nearly always shown nude in Near Eastern art.

In the version of the statue seen here, actually a composite of two Roman copies, the goddess is preparing to take a bath, with a water jug and her discarded clothing at her side. Her right arm and hand extend in what appears at first glance to be a gesture of modesty but in fact only emphasizes her nakedness. The bracelet on her left arm has a similar effect. Her well-toned body, with its square shoulders, thick waist, and slim hips, conveys a sense of athletic strength. She leans forward slightly with one knee in front of the other in a seductive pose that emphasizes the swelling forms of her thighs and abdomen.

Writers of the time relate that Praxiteles' original statue was of such enchanting beauty that it served as a public model of high moral value. According to an old legend, the sculpture was so realistic that Aphrodite herself made a journey to Knidos to see it and cried out in shock, "Where did Praxiteles see me naked?" The Knidians were so proud of their *Aphrodite* that they placed it in an open shrine where people could view it from every side. Hellenistic and Roman copies probably numbered in the hundreds, and nearly fifty survive in various collections today.

Skopas, another artist who was greatly admired in ancient times, had a brilliant career as both sculptor and architect that took him around the Greek world. Unfortunately, little survives, either originals or copies, that can be reliably attributed to him, even though early writers credited him with one whole side of the sculptural decoration of Mausolos's tomb. If the literary accounts are accurate, Skopas introduced a new style of sculpture admired in its time and influential in the following Hellenistic period. In relief compositions, he favored very active, dramatic poses over balanced, harmonious ones, and he was especially noted for the expression of emotion in the faces and gestures of his figures. The typical Skopas head conveys intensity with its deep-set eyes, heavy brow, slightly parted lips, and a gaze that seems to look far into the future.

The third of the fourth-century BCE masters, the sculptor Lysippos, is unique in that many details of his life are known. He claimed to be entirely self-taught and asserted that "nature" was his only model, but he must have received training in the technical aspects of his profession in the vicinity of his home, near Corinth. Although he expressed great admiration for Polykleitos, his own figures reflect a different set of proportions than those of the fifth-century BCE master, with small heads and slender bodies like those of Praxiteles. For his famous work *The Scraper* (*Apoxyomenos*), known today only from Roman copies, he chose a typical Classical subject, a nude male athlete, but treated it in an unusual way (fig. 5-62). Instead of a figure actively engaged in a sport or standing in the Classical shallow **S** curve, Lysippos depicted a young man methodically removing oil and dirt from his body with a scraping tool called a strigil.

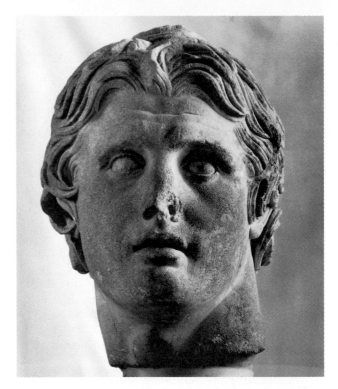

5-63. *Alexander the Great*, head from a Hellenistic copy (c. 200 BCE) of a statue, possibly after a 4th-century BCE original by Lysippos. Marble fragment, height 16¹/8" (41 cm). Archaeological Museum, Istanbul, Turkey

Judging from the athlete's expression, his thoughts are far from his mundane task. His deep-set eyes, dreamy stare, heavy forehead, and tousled hair may reflect the influence of Skopas.

The Scraper, tall and slender with a relatively small head, makes a telling comparison with Polykleitos's *Spear Bearer* (see fig. 5-51). Not only does it reflect a different canon of proportions, but the figure's weight is also more evenly distributed between the engaged leg and the free one, with the free foot almost flat on the ground. The legs are also in a wider stance to counterbalance the outstretched arms. The *Spear Bearer* is contained within fairly simple, compact contours and oriented to a frontal view. In contrast, the arms of *The Scraper* break free into the surrounding space, requiring the viewer to move around the statue to absorb its full aspect. Roman authors, who may have been describing the bronze original rather than a copy, remarked on the subtle modeling of *The Scraper's* elongated body and the spatial extension of its pose.

Lysippos was widely known and admired for his monumental statues of Zeus, which may be why he was summoned to do a portrait of Alexander the Great. Lysippos portrayed Alexander as a full-length standing figure with an upraised arm holding a scepter, just as he is believed to have posed Zeus, though none of these statues still exists.

A head found at Pergamon that was once part of a standing figure is believed to be from one of several copies of Lysippos's original of Alexander (fig. 5-63). It depicts a ruggedly handsome, heavy-featured young man with a large Adam's apple and short, tousled hair. The treatment of the hair may be a visual reference to the mythical hero Herakles, who killed the Nemean Lion as his First Labor and is often portrayed wearing its head and pelt as a hooded cloak. Alexander would have felt great kinship

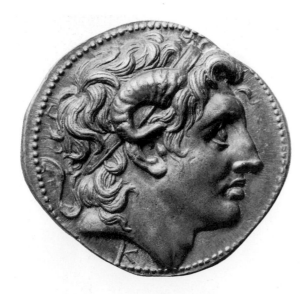

5-64. *Alexander the Great*, 4-drachma coin issued by Lysimachos of Thrace. 306–281 BCE. Silver, diameter 1⅛" (30 mm). The British Museum, London

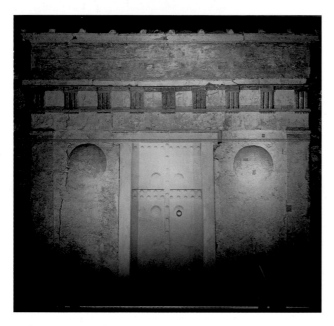

5-65. Facade of Tomb II, so-called Tomb of Philip, Vergina, Macedonia. Second half of the 4th century BCE. Fresco, height 18'2½" x 3'9⅝" (5.56 x 1.16 m)

The facade illustrates the Greeks' use of color to enhance architectural details.

5-66. *Abduction of Persephone*, detail of a wall painting in Tomb I (Small Tomb), Vergina, Macedonia. c. 366 BCE. Height approx. 39½" (100.3 cm)

In the legend, Persephone was picking flowers in Eleusis, near Athens, when Hades, god of the underworld, kidnapped her. The king of Eleusis provided a home for Persephone's grieving mother, Demeter, the goddess of grain, as she searched for her lost daughter. In return for this kindness, Demeter taught the Eleusians to grow grain. Eventually Zeus interceded, and Hades allowed Persephone to divide her time between the earth and the underworld. Her comings and goings accounted for the change in seasons—fertile summer when she lived with her mother, the dead of winter when she lived with her husband. The Greeks built a sanctuary on the spot where they believed Persephone entered the underworld, and an extremely influential cult developed around Demeter and Persephone, a "mystery cult" comparable to that of Isis and Osiris in Egypt. Unlike most sanctuaries, the Sanctuary of Demeter and Persephone at Eleusis was under the private control of two aristocratic families and closed to all but initiated worshipers. Cult members were forbidden on pain of death to describe what happened inside the walls, and any outsider found trying to enter illegally would have been killed. None of the cult's activities—the Mysteries of Eleusis—was ever revealed, but they probably involved a ritual reenactment of Persephone's abduction and descent into the underworld and her return to earth.

with Herakles, whose acts of bravery and strength earned him immortality. The Pergamon head was not meant to be entirely true to life. The artist rendered certain features in an idealized manner to convey a specific message about the subject. The deep-set eyes are unfocused and meditative, and the low forehead is heavily lined, as though the figure were contemplating decisions of great consequence and waiting to receive divine advice.

According to the Roman-era historian Plutarch, Lysippos depicted Alexander in a characteristic meditative pose, "with his face turned upward toward the sky, just as Alexander himself was accustomed to gaze, turning his neck gently to one side" (cited in Pollitt, page 20). Because this description fits the marble head from Pergamon and others like it so well, they have been thought to be copies of the Alexander statue. On the other hand, the heads could also be viewed as conventional, idealized "types" created by Lyssipos rather than identifiable portraits of Alexander. A reasonably reliable image of Alexander is found on a coin issued by Lysimachos, king of Thrace, in the late fourth and early third centuries BCE (fig. 5-64). It shows Alexander in profile wearing the curled ram's-horn headdress that identifies him as the

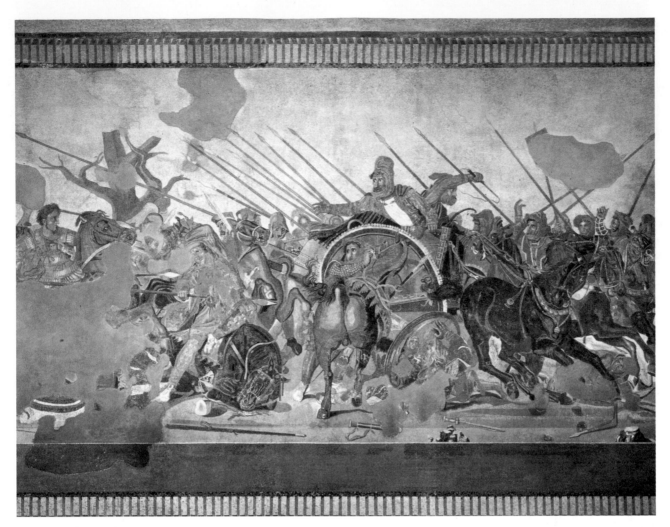

5-67. *Alexander the Great Confronts Darius III at the Battle of Issos*, from Pompeii. Roman mosaic copy after a Greek painting of c. 310 BCE, perhaps by Philoxenos or Helen of Egypt. Museo Archeològico Nazionale, Naples

Greek-Egyptian god Zeus-Amun. The portrait has the same low forehead, high-bridged nose, large lips, and thick neck as the Pergamon head.

WALL PAINTING AND MOSAICS

Greek painting has so far been discussed only in terms of pottery decoration because little remains of paintings in other mediums. Excavations in the 1970s CE have enriched our knowledge of fourth-century BCE painting. At Vergina (modern-day Aigai), in Macedonia, two intact tombs were found in a large mound called the Great Tumulus. Dated from **potsherds** (broken ceramics) to around the middle of the fourth century BCE, both tombs were decorated with wall paintings. The larger of the tombs (Tomb II), which contained a rich casket, armor, and golden wreaths, may be that of Alexander's father, Philip II, although the identification has recently been questioned. Tomb II has a remarkable entrance wall, with well-preserved Doric architecture (fig. 5-65). The bright colors of the original paint remain. Such treatment in reds and blue must be imagined when looking at Greek buildings, beautiful as the marble, shed of its paint, may seem today.

A mural in the smaller of the tombs (Tomb I) depicts the kidnapping of Persephone by Hades (fig. 5-66). Even in its deteriorated state, the *Abduction of Persephone* is clearly the work of an outstanding artist. Hades has just snatched Persephone and is carrying her off to the underworld to be his wife and queen. The convincing twists of the figures, the foreshortened view of the huge wheels of the chariot, and the swirl of draperies capture the story's action, conveying the intensity of the struggle and the violent emotions it has provoked. Hades, with his determined expression, contrasts strikingly with the young Persephone, who evokes pity with her helpless gestures. The subject, certainly appropriate for a tomb painting, may be a metaphor for rebirth, the changing seasons, the cycle of life and death. This mural, with its vigorous drawing style, complex foreshortening, and dynamic brushwork, proves claims by early observers such as Pliny the Elder that Greek painters were skilled in capturing the appearance of the real world. It also contradicts the view often held before its discovery that dramatic, dynamic figural representation in Greek art was confined to Hellenistic sculpture of the third to first century BCE.

Roman patrons in the second century BCE and later greatly admired Greek murals and commissioned copies, as either wall paintings or mosaics, to decorate their homes. These copies provide another source of evidence about fourth-century BCE Greek painting. Together with evidence from red-figure vase painting, they indicate a growing taste for dramatic narrative subjects. A second-century BCE mosaic, *Alexander the Great Confronts Darius III at the Battle of Issos* (fig. 5-67), was based on an original

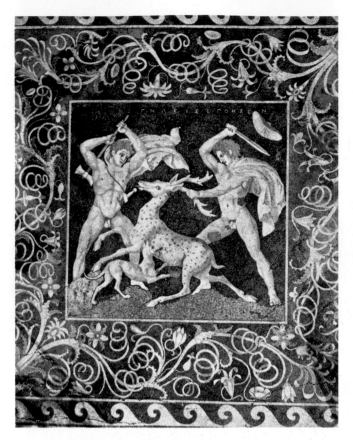

5-68. Gnosis. *Stag Hunt*, detail of mosaic floor decoration from Pella, Macedonia. 300 BCE. Pebbles, height 10'2" (3.1 m). Archaeological Museum, Pella. Signed at top: "Gnosis made it"

5-69. Earrings. C. 330–300 BCE. Hollow-cast gold, height 2³/₈" (6 cm). The Metropolitan Musem of Art, New York
Harris Brisbane Dick Fund, 1937 (37.11.9–10)

wall painting of about 310 BCE. Pliny the Elder attributed the original to Philoxenos of Eretria; a recent theory claimed it was by a well-known woman painter, Helen of Egypt (see "Women Artists in Ancient Greece," page 209). Like the *Abduction of Persephone*, this scene is one of violent action, gestures, and radical foreshortening, all devised to elicit the viewer's response to a dramatic situation. Astride a horse at the left, his hair blowing free and his neck bare, Alexander challenges the helmeted and armored Persian leader, who stretches out his arm in a gesture of defeat and apprehension as his charioteer whisks him back toward safety in the Persian ranks. Presumably in close imitation of the original painting, the mosaicist created the illusion of solid figures through **modeling**, mimicking the play of light on three-dimensional surfaces by touching protrusions with highlights and shading undercut areas and areas in shadow. The same techniques were used in the *Abduction of Persephone*, but the mosaic's condition makes them difficult to see in a photographic reproduction.

The great interest of fourth-century BCE artists in creating a believable illusion of the real world was the subject of anecdotes repeated by later writers (see Introduction, page 000). One popular legend involved a floral designer, a woman named Glykera—widely praised for the artistry with which she wove blossoms and greenery into wreaths, swags, and garlands for religious processions and festivals—and Pausias, the foremost painter of the day. Pausias challenged Glykera to a contest, claiming that he could paint a picture of one

of her complex works that would appear as lifelike to the spectator as her real one. According to the legend, he succeeded. It is not surprising, although perhaps unfair, that the opulent floral borders so popular in later Greek painting and mosaics are described as "Pausian" rather than "Glykeran."

A mosaic floor from a palace at Pella in Macedonia provides an example of a Pausian design. Dated about 300 BCE, the floor features a series of framed hunting scenes, such as the *Stag Hunt* (fig. 5-68), prominently signed by an artist named Gnosis. Blossoms, leaves, spiraling tendrils, and twisting, undulating stems frame this scene, echoing the linear patterns formed by the hunters, the dog, and the struggling stag. The over-lifesize human and animal figures are accurately drawn and modeled in light and shade. The dog's front legs are expertly foreshortened to create the illusion that the animal is turning at a sharp angle into the picture. The work is all the more impressive because it was not made with uniformly cut marble in different colors but with a carefully selected assortment of natural pebbles. The background was formed of dark stones, and the figures and floral designs were made of light-colored stones. The smallest pebbles were used to create the delicate shading and subtle details.

THE ART OF THE GOLDSMITH

The work of Greek goldsmiths, which gained international popularity in the Classical period, followed the same stylistic trends and achieved the same high standards of technique and execution found in the other art mediums.

A specialty of Greek goldsmiths was the design of earrings in the form of tiny works of sculpture. They were often placed on the ears of marble statues of goddesses, but they adorned real ears as well. An earring designed as the youth Ganymede in the grasp of an

Although comparatively few artists in ancient Greece were women, there is evidence that women artists worked in many mediums. Ancient writers noted women painters—Pliny the Elder, for example, listed Aristarete, Eirene, Iaia, Kalypso, Olympias, and Timarete. Helen, a painter from Egypt who had been taught by her father, is known to have worked in the fourth century BCE. and may have been responsible for

the original wall painting of *Alexander the Great at the Battle of Issos* (see fig. 5-67).

Greek women excelled in creating narrative or pictorial tapestries. They also worked in pottery-making workshops. The hydria here, dating from about 450 BCE, shows a woman artist in such a workshop, but her status is ambiguous. The composition focuses on the male painters, who are being approached by Nikes bearing wreaths symbolizing victory in an artistic competition. A well-

dressed woman sits on a raised dais, painting the largest vase in the workshop. She is isolated from the other artists and is not part of the awards ceremony. Perhaps women were excluded from public artistic competitions, as they were from athletics. Another interpretation, however, is that the woman is the head of this workshop. Secure in her own status, she may have encouraged her assistants to enter contests to further their careers and bring glory to the workshop as a whole.

A Vase Painter and Assistants Crowned by Athena and Victories, composite photograph of the red-figure decoration on a hydria from Athens. c. 450 BCE. Private collection

eagle (Zeus) (fig. 5-69), dated about 330–300 BCE, is both a charming decoration and a technical tour de force. Slightly more than 2 inches high, it was hollow-cast using the **lost-wax** process, no doubt to make it light on the ear. Despite its small size, the earring conveys all the drama of its subject. Action subjects like this, with the depiction of swift movement through space, were to become a hallmark of Hellenistic art.

Greek goldsmiths' work was especially admired by the Scythians, a once-nomadic people from northern Asia who themselves had an ancient tradition of outstanding goldwork. An elaborate example of Greek artistry, a large, gold pectoral dating from the fourth century BCE, was found in a Scythian chief's tomb in the Caucasus Mountains of Russia (fig. 5-70). A series of four gold **torques**,

5-70. Pectoral, from the tomb of a Scythian at Ordzhonikidze, Russia. 4th century BCE. Gold, diameter 12" (30.6 cm). Historical Museum, Kiev

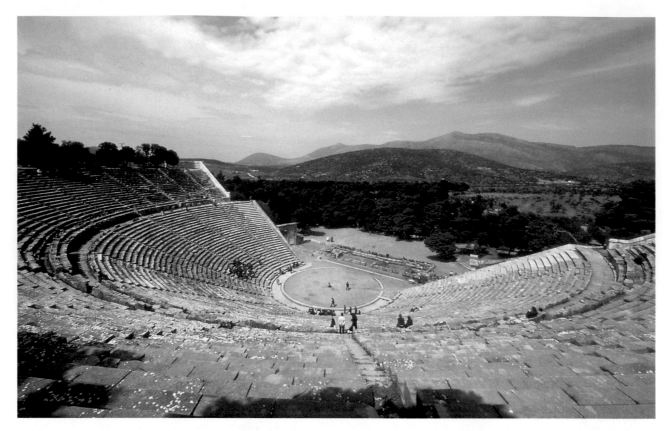

5-71. Theater, Epidauros. Early 3rd century BCE and later

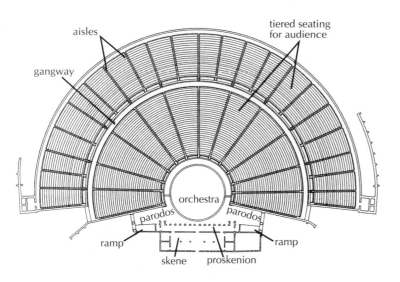

5-72. Plan of the theater at Epidauros

or neckpieces, of increasing diameter separates each of the sections. The upper and lower bands have figures, and the center one contains a stylized floral design that strongly resembles the floral border on the Pella floor (see fig. 5-68). In the pectoral's top band, the artist re-created a typical scene of Scythian daily life. At the center, two men are making a cloth shirt, while at the right another man milks a goat. Around them are cows and horses with their nursing calves and foals, all portrayed with great naturalistic detail. In contrast, the bottom band is devoted to a Near Eastern theme of animal combat, with griffinlike beasts attacking a group of horses. Is there a lesson here—that the domestication of animals is justified because it offers them protection from the dangers of the wild?

THE HELLENISTIC PERIOD When Alexander died unexpectedly in 323 BCE, he left a vast empire with no administrative structure and no accepted successor. Almost at once his generals turned against one another, local leaders tried to regain their lost autonomy, and the empire began to break apart. The Greek city-states formed a new mutual-protection league but never again achieved significant power. Democracy survived in form but not substance in governments dominated by local rulers.

By the early third century BCE, three major powers had emerged out of the chaos, ruled by three of Alexander's generals and their heirs: Antigonus, Ptolemy, and Seleucus. The Antigonids controlled Macedonia and mainland Greece; the Ptolemies ruled Egypt; and the Seleucids controlled Asia Minor, Mesopotamia, and Persia. Over the course of the second and first centuries BCE, these kingdoms succumbed to the growing empire centered in Rome. Ptolemaic Egypt endured the longest, almost two and one-half centuries. The death in 30 BCE of its last ruler, the remarkable Cleopatra, marks the end of the Hellenistic period.

Alexander's lasting legacy was the spread of Greek culture far beyond its original borders. The Ptolemaic capital, Alexandria in Egypt, a prosperous seaport known for its lighthouse (another of the Seven Wonders of the World, according to ancient writers), emerged as a great Hellenistic center of learning and the arts. Its library is estimated to have contained 700,000 papyrus and parchment scrolls.

Artists of the Hellenistic period had a vision noticeably different from that of their predecessors. Where

earlier artists sought the ideal and the general, Hellenistic artists sought the individual and the specific. They turned increasingly away from the heroic to the everyday, from gods to mortals, from aloof serenity to individual emotion, and from drama to melodramatic pathos. A trend introduced in the fourth century BCE—the appeal to the senses through lustrous or glittering surface treatments and to the emotions with dramatic subjects and poses—became more pronounced. Even the architecture of the Hellenistic period largely reflected the contemporary taste for high drama.

THEATERS

In ancient Greece, the theater was more than mere entertainment; it was a vehicle for the communal expression of religious belief through music, poetry, and dance. In very early times, theater performances took place on the hard-packed dirt or stone-surfaced pavement of an outdoor threshing floor (*halos*)—the same type of floor later incorporated into religious sanctuaries (see fig. 5-3). Whenever feasible, dramas were also presented facing a steep hill that served as elevated seating for a kind of natural theater. Eventually such sites were made into permanent open-air auditoriums. At first, tiers of seats were simply cut into the side of the hill. Later, builders improved them with stone.

During the fifth century BCE, the plays usually were tragedies in verse based on popular myths and were performed at a festival dedicated to Dionysos. At this time, the three great Greek tragedians—Aeschylus, Sophocles, and Euripides—were creating the dramas that would define tragedy for centuries. Many theaters were built in the fourth century BCE, including those on the side of the Athenian Acropolis and in the sanctuary at Delphi, also for the performance of music and dance during the festival of Dionysos. Because theaters were used continuously and frequently modified over many centuries, no early theaters have survived in their original form.

The early third century BCE theater at Epidauros presents a good example of the characteristics of the fully realized theater (figs. 5-71, 5-72). A semicircle of tiered seats built into the hillside overlooked the circular performance area, called the orchestra, at the center of which was an altar to Dionysos. Rising behind the orchestra was a two-tiered stage structure made up of the vertical *skene* (scene)—an architectural backdrop for performances that also screened the backstage area from view—and the *proskenion* (**proscenium**), a raised platform in front of the *skene* that was increasingly used over time as an extension of the orchestra. Ramps connecting the *proskenion* with lateral passageways (*parodoi*; singular *parodos*) provided access to the stage for performers. Steps gave the audience access to the fifty-five rows of seats and divided the seating area into uniform wedge-shaped sections. The tiers of seats above the wide corridor, or gangway, were added at a much later date. This design provided uninterrupted sight lines and good acoustics and allowed for efficient entrance and exit of the 12,000 spectators. No better design has ever been created.

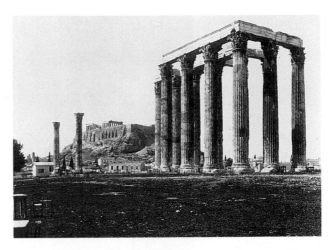

5-73. Temple of the Olympian Zeus, Athens. Building and rebuilding phases: foundation mid-6th century BCE; temple designed by Cossutius, begun 175 BCE, left unfinished 164 BCE, completed 132 CE using Cossutius's design

THE CORINTHIAN ORDER IN ARCHITECTURE

During the Hellenistic period there was increasing innovation in public architecture. A variant of the Ionic order featuring a tall, slender column with an elaborate foliate capital, for example, began to challenge the dominance of the Doric and Ionic orders on building exteriors. Invented in the late fifth century BCE and called Corinthian by later Romans, this highly decorative carved capital had previously been used only indoors, as in the *tholos* at Delphi (see fig. 5-55). Today, the Corinthian variant is routinely treated as a third Greek order (see "the Greek Architectural Orders," page 164). In the Corinthian column, the echinus becomes an unfluted extension of the column shaft set off by a collar molding called an **astragal**. From the astragal sprout curly acanthus leaves and coiled flower spikes. The molded abacus often has a central floral motif. Unlike the more standardized Doric and Ionic capitals, the Corinthian capital has many possible variations; only the foliage is required. The Corinthian entablature, like the Ionic, has a stepped-out architrave and a continuous frieze. It also has even more bands of carved moldings, often including a line of blocks called **dentils**. The Corinthian design became a lasting symbol of elegance and refinement that is still used on banks, churches, and office buildings.

The Corinthian order Temple of the Olympian Zeus, located in the lower city of Athens at the foot of the Acropolis, was commissioned by the Seleucid ruler Antiochus IV and was designed by the Roman architect Cossutius in the second century BCE (fig. 5-73). The temple's unusually large foundation, measuring 135 by 354 feet, is that of an earlier temple dating to the mid-sixth century BCE. Work on the Cossutius design halted in 164 BCE and was not completed until three centuries later under Roman rule, by Hadrian. The temple's great Corinthian columns may be the second-century BCE originals or Roman replicas of them. The peristyle soars 57 feet above the stylobate. Viewed through its columns, the Parthenon seems modest in comparison. But for all its height and luxurious decoration, the new

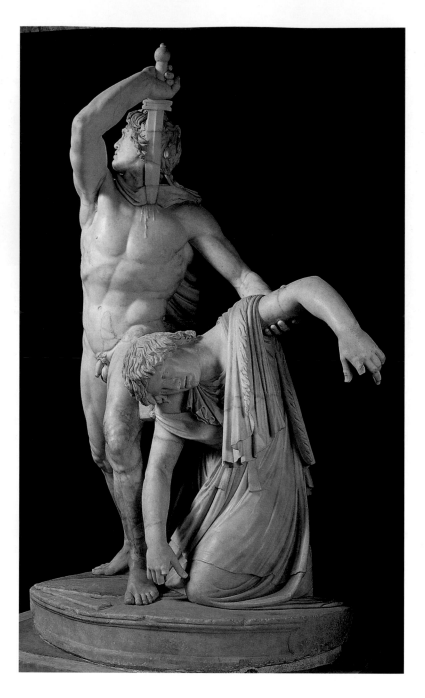

5-74. *Gallic Chieftain Killing His Wife and Himself*, Roman copy after the original bronze of c. 220 BCE. Marble, height 6'11" (2.1 m). Museo Nazionale Romano, Rome

temple followed long-established design norms. It stood on a three-stepped base, it had an enclosed room or series of rooms surrounded by a screen of columns, and its proportions and details followed traditional standards. Quite simply, it is a Greek temple grown very large.

SCULPTURE

Hellenistic sculptors produced an enormous variety of work in a wide range of materials, techniques, and styles. The period was marked by two broad and conflicting trends. One (sometimes called anti-Classical) led away from Classical models and toward experimentation with new forms and subjects; the other led back to Classical models, with artists selecting aspects of certain favored works by fourth-century BCE sculptors and incorporating them into new styles. The radical anti-Classical style was practiced in Pergamon and other eastern centers of Greek culture.

The Pergamene Style. The kingdom of Pergamon, a breakaway state within the Seleucid realm, established itself in the early third century BCE in western Asia Minor. The capital, Pergamon, quickly became a leading center of arts patronage and the hub of a new sculptural style that had far-reaching influence throughout the Hellenistic period. This new style is illustrated by sculpture from a monument commemorating the victory in 230 BCE of Attalos I (ruled 241–197 BCE) over the Gauls, a Celtic people. The monument extols the dignity and heroism of the defeated enemies. These figures of Gauls, originally in bronze but known today only from Roman copies in marble, were mounted on a large pedestal. One group depicts the murder-suicide of the Gallic chieftain and his wife (fig. 5-74) and the slow demise of a wounded soldier-trumpeter (fig. 5-75). Their wiry, unkempt hair and the trumpeter's twisted neck ring, or torque (the Celtic battle dress), identify them as "barbarians." The artist has sought to arouse the viewer's admiration and pity for his

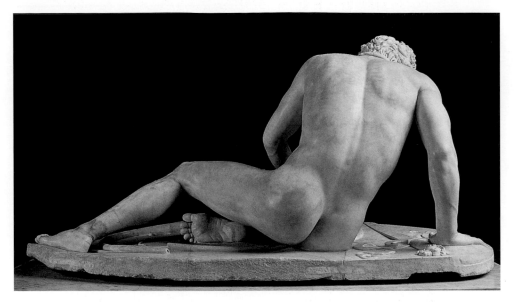

5-75. Epigonos (?). *Dying Gallic Trumpeter*, Roman copy after the original bronze of c. 220 BCE. Marble, lifesize. Museo Capitolino, Rome

The marble sculpture was found in Julius Caesar's garden in Rome. The bronze originals were made for the Sanctuary of Athena in Pergamon. Pliny wrote that Epigonos "surpassed others with his Trumpeter."

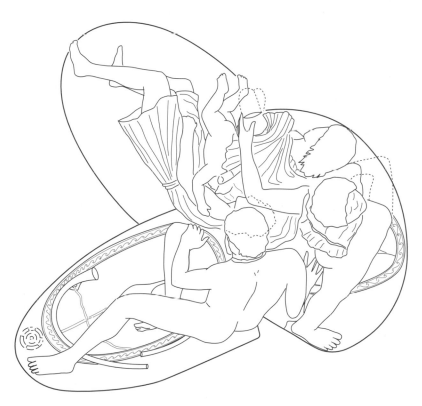

5-76. Reconstruction of monument of *Dying Gallic Trumpeter*, *Chieftain and Wife*, and *Mother and Child*, from Pergamon; from Eugenio Polito, *I Galati Vinti* (Milan: Electa, 1999)

subjects. The chieftain, for example, still supports his dead wife as he plunges the sword into his own breast. The trumpeter, fatally injured, struggles to rise, but the slight bowing of his supporting right arm and his unseeing downcast gaze indicate that he is on the point of death. This kind of deliberate attempt to elicit a specific emotional response in the viewer is known as **expressionism**, and it was to become a characteristic of Hellenistic art.

The marble copies of these works are now separated, but originally they formed part of an interlocked, multi-figured group on a raised base that could have been viewed and appreciated from every angle (fig. 5-76). Pliny the Elder described a work like the *Dying Gallic Trumpeter*, attributing it to an artist named Epigonos. Recent research indicates that Epigonos probably knew the early-fifth-century BCE sculpture of the Temple of Aphaia at Aegina, which included the *Dying Warrior* (see fig. 5-16), and could

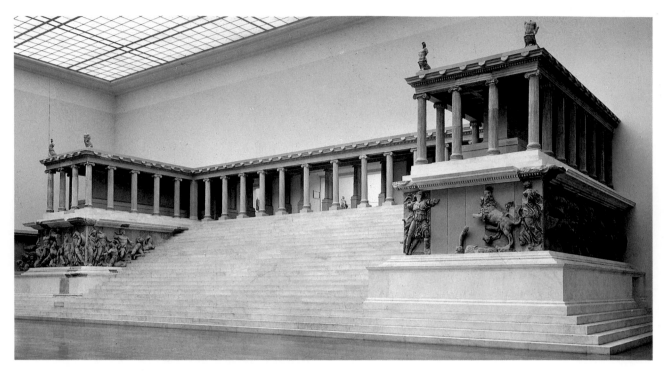

5-77. Reconstructed west front of the altar from Pergamon. c. 166–156 BCE. Marble. Staatliche Museen zu Berlin, Antikensammlung, Pergamonmuseum

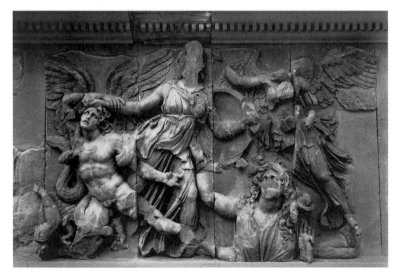

5-78. *Athena Attacking the Giants*, detail of the frieze from the east front of the altar from Pergamon. Marble, frieze height 7'6" (2.3 m). Staatliche Museen zu Berlin, Antikensammlung, Pergamonmuseum

have had it in mind when he created his own works.

The style and approach of the works in the monument to the defeated Gauls became more pronounced and dramatic in later works, culminating in the decorative frieze on the base of the great altar at Pergamon (fig. 5-77). The wings and staircase to the entrance of the courtyard in which the altar stood have been reconstructed inside a Berlin museum from fragments from the site. The original altar complex was a single-story structure with an Ionic colonnade raised on a high podium reached by a monumental staircase 68 feet wide and nearly 30 feet deep. The running frieze decoration, probably executed during the

reign of Eumenes II (197–159 BCE), depicts the battle between the Gods and the Giants, a mythical struggle that the Greeks are thought to have used as a metaphor for Pergamon's victory over the Gauls.

The frieze was about 7½ feet high, tapering along the steps to just a few inches. The Greek gods fight not only human-looking Giants, but also hybrids emerging from the bowels of the earth. In a detail of the frieze (fig. 5-78), the goddess Athena at the left has grabbed the hair of a winged male monster and forced him to his knees. Inscriptions along the base of the sculpture identify him as Alkyoneos, a son of the earth goddess Ge, who rises from the ground on the right in fear as she reaches toward Athena, pleading for her son's life. At the far right, a winged Nike rushes to Athena's assistance.

The figures in the Pergamon frieze not only fill the sculptural space, they break out of their architectural boundaries and invade the spectators' space. They crawl out of the frieze onto the steps, where visitors had to pass them on their way up to the shrine. Many consider this theatrical and complex interaction of space and form to be a benchmark of the Hellenistic style, just as they consider the balanced restraint of the Parthenon sculpture to be the epitome of the Fifth-Century Classical style. Where fifth-century BCE artists sought horizontal and vertical equilibrium and control, the Pergamene artists sought to balance opposing forces in three-dimensional space along diagonal lines. The Classical preference for smooth, sculpted surfaces reflecting a clear, even light has been replaced by a preference for dramatic contrasts of light and shade playing over complex forms carved in high relief with deep undercutting. The composure and stability

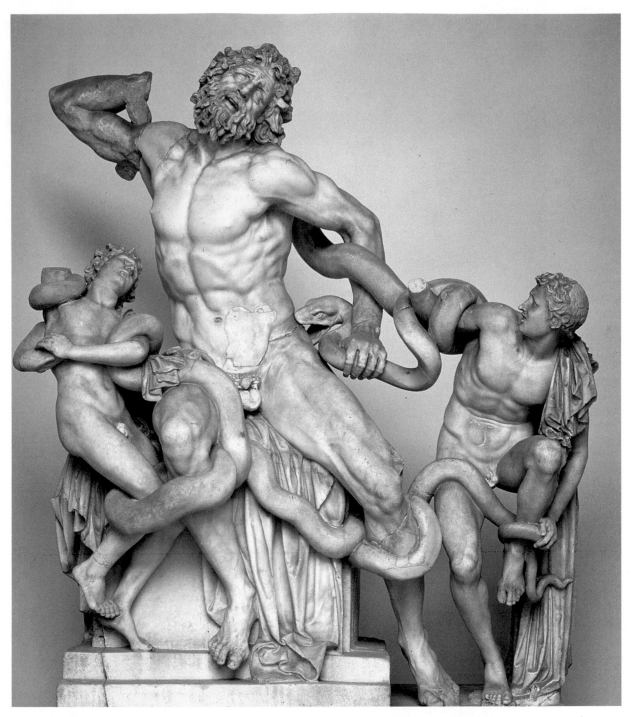

5-79. Hagesandros, Polydoros, and Athanadoros of Rhodes. *Laocoön and His Sons*, probably the original of the 1st century CE or a Roman copy of the 1st century CE. Marble, height 8' (2.44 m). Musei Vaticani, Museo Pio Clementino, Cortile Ottagono, Rome

admired in the Classical style have given way to extreme expressions of pain, stress, wild anger, fear, and despair. In the Fifth-Century Classical style, figures stood remote in their own space. In the fourth century BCE, they reached out into their immediate environment. In the Hellenistic period, they impose themselves, often forcefully, on the spectator. Whereas the Classical artist asked only for an intellectual commitment, the Hellenistic artist demanded that the viewer empathize with the depicted scene.

Pergamene artists may have inspired the work of Hagesandros, Polydoros, and Athanadoros, three sculptors on the island of Rhodes named by Pliny the Elder as the creators of the famed *Laocoön and His Sons* (fig. 5-79). This

work, in the collection of the Vatican since it was discovered in Rome in 1506, has been assumed by many art historians to be the original version from the second or first century BCE, although others argue that it is a brilliant copy commissioned by an admiring Roman patron. The complex sculptural composition illustrates an episode from the Trojan War. The Trojans' priest Laocoön warned them not to take the giant wooden horse (within which were concealed Greeks warriors) inside their walls. The gods who supported the Greeks in the war retaliated by sending serpents from the sea to destroy Laocoön and his sons as they walked along the shore. The struggling figures, anguished faces, intricate diagonal movements, and skillful unification

5-80. *Nike (Victory) of Samothrace*, from the Sanctuary of the Great Gods, Samothrace. c. 190 BCE (?). Marble, height 8' (2.44 m). Musée du Louvre, Paris

The wind-whipped costume and raised wings of this Victory indicate that she has just alighted on the prow of the stone ship that formed the original base of the statue. The work probably commemorated an important naval victory, perhaps the Rhodian triumph over the Seleucid king Antiochus III in 190 BCE. The Nike, lacking its head and arms, and a fragment of its ship base were discovered in the ruins of the Sanctuary of the Great Gods by a French explorer in 1863 (additional fragments were discovered later). Soon after, it entered the collection of the Louvre Museum in Paris. Poised high on the landing of the grand staircase, this famous Hellenistic sculpture continues to catch the eye and the imagination of thousands of museum visitors.

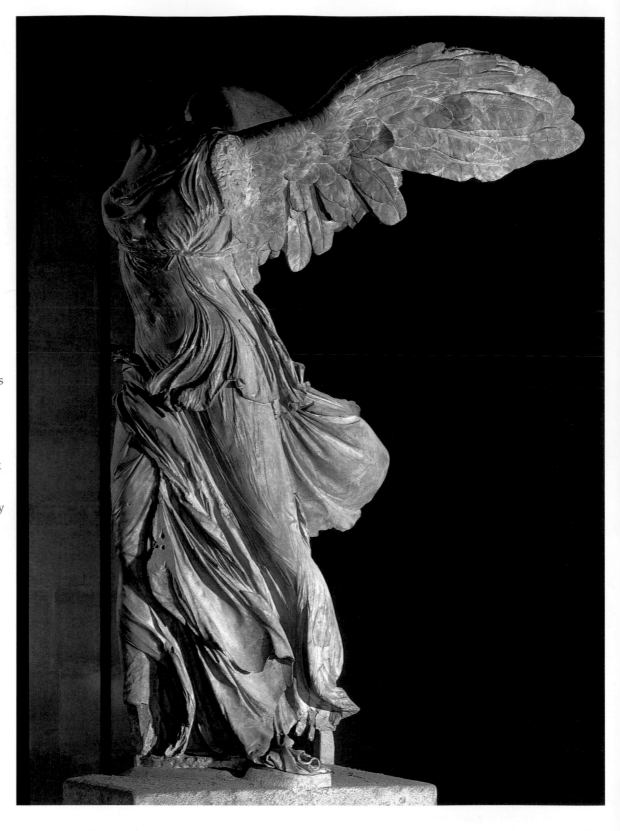

of diverse forces in a complex composition all suggest a strong relationship between Rhodian and Pergamene sculptors. Unlike the monument to the conquered Gauls, the *Laocoön* was composed to be seen from the front, within a short distance. As a result, although sculpted in the round, the three figures appear as very high relief and are more like the relief sculpture on the altar from Pergamon.

The *Nike (Victory) of Samothrace* (fig. 5-80) is more theatrical still. In its original setting—in a hillside niche high above the city of Samothrace and perhaps drenched with spray from a fountain—this huge goddess of victory must have reminded the Samothracians of the god in Greek plays who descends from heaven to determine the outcome of the drama. The fact that victory in real life does often seem miraculous makes this image of a goddess alighting suddenly on a ship breathtakingly appropriate for a war memorial. The forward momentum of the *Nike*'s heavy body is balanced by the powerful backward thrust of her enormous wings. The large, open movements of the figure, the strong contrasts of light and dark on the deeply

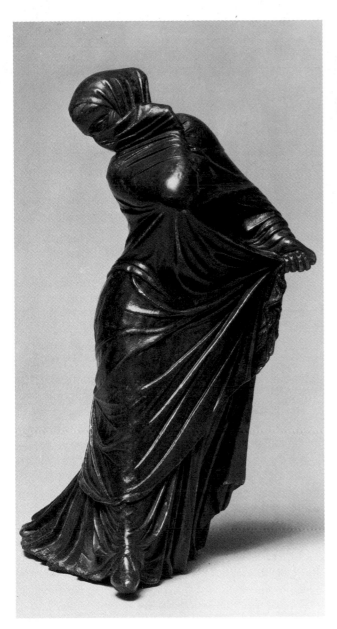

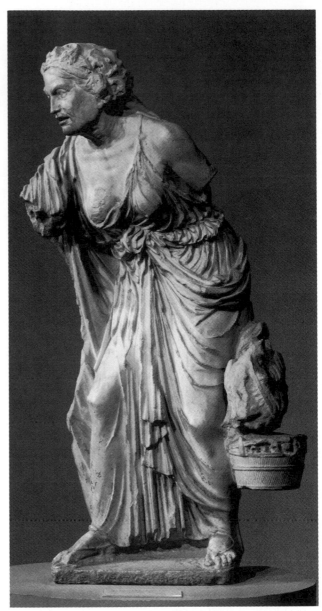

5-81. *Veiled and Masked Dancer*. Late 3rd or 2nd century BCE. Bronze, height 8¹/₈" (20.7 cm). The Metropolitan Museum of Art, New York
Bequest of Walter C. Baker, 1971 (1972.118.95)

5-82. *Old Woman*. 2nd century BCE. Marble, height 49¹/₂" (125.7 cm). The Metropolitan Museum of Art, New York
Rogers Fund, 1909 (09.39)

sculpted forms, and the contrasting textures of feathers, fabric, and skin typify the finest Hellenistic art.

Although "huge," "enormous," and "larger-than-life" are terms correctly applied to much Hellenistic sculpture, artists of the time also created fine works on a small scale. The grace, dignity, and energy of the 8-foot-tall *Nike of Samothrace* can also be found in a bronze about 8 inches tall (fig. 5-81). This figure of a heavily veiled and masked dancing woman twists sensually under the gauzy, layered fabric in a complex spiral movement. The dancer clearly represents an artful professional performer. Private patrons must have delighted in such intimate works, which were made in large numbers and featured a wide variety of subjects and treatments. This bronze would have been costly, but many such graceful figurines were produced in inexpensive terra-cotta from preshaped

molds and would have been accessible to almost anyone.

The appeal to the emotions in the sculpture signals a social change between the Classical and Hellenistic periods. In contrast to the Classical world, which was characterized by relative cultural unity and social homogeneity, the Hellenistic world was varied and multicultural. In this environment, artists turned from idealism, the quest for perfect form, to realism, the attempt to portray the world as they saw it (see "Realism and Naturalism," page 218). Portraiture, for example, became popular during the Hellenistic period, as did the representation of people from every level of society. Patrons were fascinated by depictions of unusual physical types as well as of ordinary individuals.

A marble statue a little over 4 feet tall of an old woman, once called *Market Woman* (fig. 5-82), may represent more

than a peasant woman on her way to the agora with three chickens and a basket of vegetables. Despite the bunched and untidy way the figure's dress hangs, it appears to be of an elegant design and made of fine fabric. Her hair too bears some semblance of a once-careful arrangement. These characteristics, along with the woman's sagging lower jaw, unfocused stare, and lack of concern for her exposed breasts, have led some to speculate that she represents an aging, dissolute follower of the wine god Dionysos on her way to make an offering. Whether an aging peasant or a Dionysian celebrant, the subject of this work is the antithesis of the *Nike of Samothrace*. Yet, in formal terms, both sculpted figures are expressionistic. Both stretch out assertively into the space around them, both demand an emotional response from the viewer, and both display technical virtuosity in the rendering of forms and textures. They are closer to each other stylistically than either is to the *Nike Adjusting Her Sandal* or the *Aphrodite of Knidos* (see figs. 5-50, 5-61).

The Classical Alternative. Not all Hellenistic artists followed the trend toward realism and expressionism that characterized the artists of Pergamon and Rhodes. Some turned to the past, creating an eclectic style by reexamining and borrowing elements from earlier Classical styles and combining them with new elements. Certain popular sculptors, no doubt encouraged by patrons nostalgic for the past, looked back especially to Praxiteles and Lysippos for their models. This renewed interest in the style of the fourth century BCE is exemplified by the *Aphrodite of Melos* (fig. 5-83), found on the island of Melos by French excavators in the early nineteenth century CE. The sculpture was intended by its maker to recall the *Aphrodite* of Praxiteles

(see fig. 5-61), and indeed the head with its dreamy gaze is very Praxitelean. The figure has the heavier proportions of Fifth-Century Classical sculpture, but the twisting stance and the strong projection of the knee are typical of Hellenistic art. The drapery around the lower part of the body also has the rich, three-dimensional quality associated with the Hellenistic sculpture of Rhodes and Pergamon. The juxtaposition of flesh and drapery, which seems about to slip off the figure entirely, adds a note of erotic tension.

The standing male nude also continued to fascinate artists and patrons. The larger-than-lifesize *Hellenistic Ruler* (fig. 5-84, page 220) reflects the heroic figure types favored for official and religious sculpture. The figure recalls the descriptions of Lysippos's *Zeus* and *Alexander the Great*. Certainly the elongated body proportions and small head resemble Lysippos's *The Scraper* (see fig. 5-62). Yet the Hellenistic exaggeration overrides the lingering suggestions of Classical heroism and idealism. The overdeveloped musculature of this figure, the individualized features of the jowly face, and the arrogant pose suggest the unbridled power of an earthly ruler who saw himself as divine.

By the end of the first century BCE, the influence of Greek painting, sculpture, and architecture had spread to the artistic communities of the emerging Roman civilization. Roman patrons and artists maintained their enthusiasm for Greek art into Early Christian and Byzantine times. Indeed, so strong was the urge to emulate the great Greek artists that, as we have seen throughout this chapter, much of our knowledge of Greek achievements comes from Roman replicas of Greek art works and descriptions of Greek art by Roman-era writers.

The Greeks themselves, for all their admiration for works of art, never held artists in high regard. As Plutarch, a Greek commentator of the first century CE,

5-83. *Aphrodite of Melos* (also called *Venus de Milo*). C. 150 BCE. Marble, height 6'10" (2.1 m). Musée du Louvre, Paris

The original appearance of this famous statue's missing arms has been much debated. When it was dug up in a field in 1820, some broken pieces found with it (now lost) indicated that the figure was holding out an apple in its right hand. Many judged these fragments to be part of a later restoration, not part of the original statue. Another theory is that Aphrodite was admiring herself in the highly polished shield of the war god Ares, an image that was popular in the second century BCE. This theoretical "restoration" would explain the pronounced **S**-curve of the pose and the otherwise unnatural forward projection of the knee.

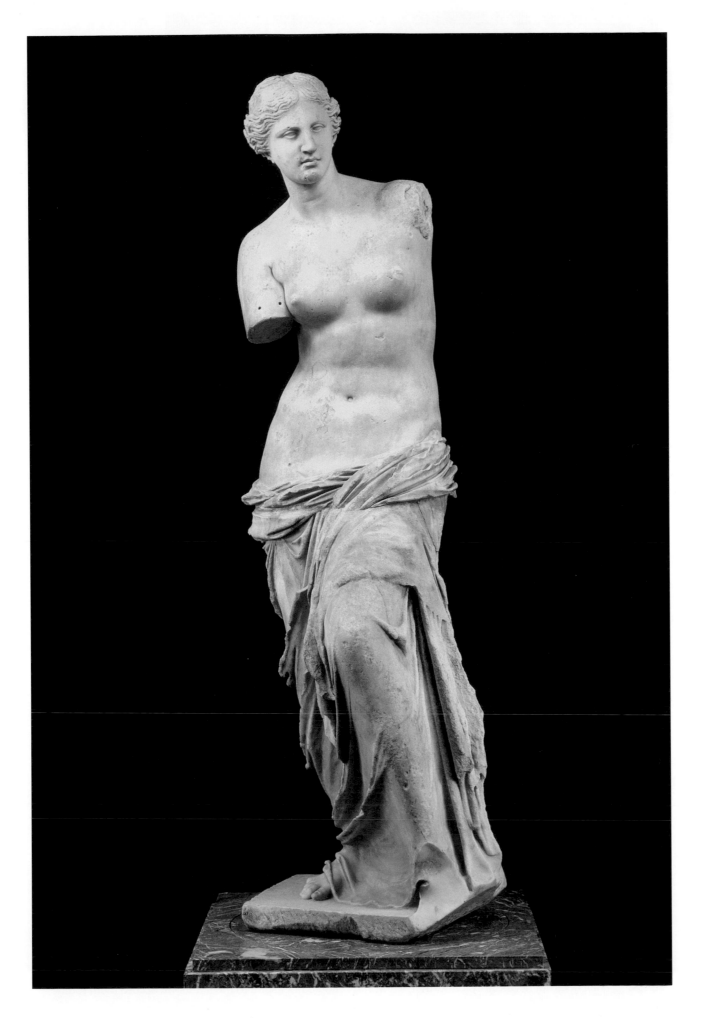

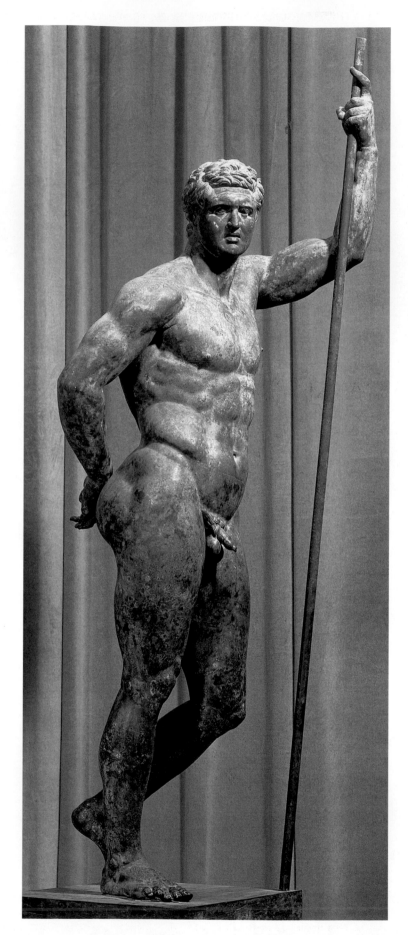

5-84. *Hellenistic Ruler.* c. 150–140 BCE. Bronze, height 7'9" (2.37 m). Museo Nazionale Romano, Rome

wrote: "No gifted young man, upon seeing the Zeus of Pheidias at Olympia, ever wanted to be Pheidias nor, upon seeing the Hera at Argos, ever wanted to be Polykleitos. . . . For it does not necessarily follow that, if a work is delightful because of its gracefulness, the man who made it is worthy of our serious regard" (quoted in Pollitt, page 227). Sculptors and painters, for all their genius, could not aspire to the status we accord them today.

PARALLELS

PERIOD	ART IN ANCIENT GREECE	ART IN OTHER CULTURES
GEOMETRIC c. 900–700 BCE	5-4. *Centaur* (10th cent.) 5-5. *Dipylon vase* (c. 750) 5-6. *Man and Centaur* (c. 750)	12-2. Olmec pyramids (900–600), Mesoamerica 12-3. Olmec head (900–500), Mesoamerica
ORIENTALIZING c. 700–600 BCE	5-8. Corinthian pitcher (c. 600)	
ARCHAIC c. 600–480 BCE	5-11. Temple of Artemis, Korkyra (c. 600–580) 5-9. Hera I, Paestum (c. 550) 5-13. Siphnian Treasury, Delphi (c. 530–525) 5-17. *New York Kouros* (c. 580) 5-24. *François Vase* (c. 570) 5-26. Exekias. *The Suicide of Ajax* (c. 540) 5-28. Euxitheos and Euphronius. *Death of Sarpedon* (c. 515) 5-16. *Dying Warrior* (c. 480)	6-5. *Apollo* from Veii (c. 500), Tuscany 6-1. *She-Wolf* (c. 500–480), Tuscany 2-29. Persepolis Apadana (518–460), Iran 13-3. Nok head (c. 500 BCE–200 CE), Africa
TRANSITIONAL, OR EARLY CLASSICAL c. 480–450 BCE	5-33. *Kritian Boy* (c. 480) 5-34. *Charioteer* (c. 477) 5-30. Temple of Zeus, Olympia (c. 470–456) 5-36. Pan Painter. *Artemis Slaying Actaeon* (c. 470) 5-31. *Apollo with Battling Lapiths and Centaurs* (c. 460) 5-35. *Warrior A* (c. 460–450)	
FIFTH-CENTURY CLASSICAL c. 450–400 BCE	5-1. Myron. *Discus Thrower* (c. 450) 5-51. Polykleitos. *Spear Bearer* (c. 450–440) 5-39. Kallikrates and Iktinos. Parthenon (447–438), friezes (c. 438–432) 5-47. Mnesikles. Erechtheion (430s–405) 5-50. *Nike Adjusting Her Sandal* (last quarter 5th cent.)	
FOURTH-CENTURY CLASSICAL c. 400–320 BCE	5-57. Mausoleum, Halikarnassos (c. 353) 5-61. Praxiteles. *Aphrodite of Knidos* (c. 350) 5-62. Lysippos. *The Scraper* (c. 330) 5-63. *Alexander the Great* (copy c. 200) 5-65. Tomb II facade (2nd half of 4th cent.) 5-67. *Alexander the Great Confronts Darius III at the Battle of Issos* (c. 310)	2-31. Daric coin (4th cent.), Persia
HELLENISTIC c. 320–30 BCE	5-71. Epidauros theater (early 3rd cent.) 5-75. *Dying Gallic Trumpeter* (c. 220) 5-80. *Nike of Samothrace* (c. 190?) 5-77. Pergamon altar (c. 166–156) 5-79. *Laocoön and His Sons* (2nd or 1st cent.) 5-83. *Aphrodite of Melos* (c. 150)	9-8. Sanchi stupa (3rd cent.), India 9-1. Ashokan pillar (c. 246), India 10-1. Qin soldiers (c. 210), China 12-16. Nazca earth drawing (200 BCE–200 CE), Peru 6-18. *Aulus Metellus* (late 2nd cent.), Rome 6-22. *Ara Pacis* (copy c. 1st cent.), Rome 6-62. *Initiation Rites of the Cult of Bacchus* (c. 50), Rome

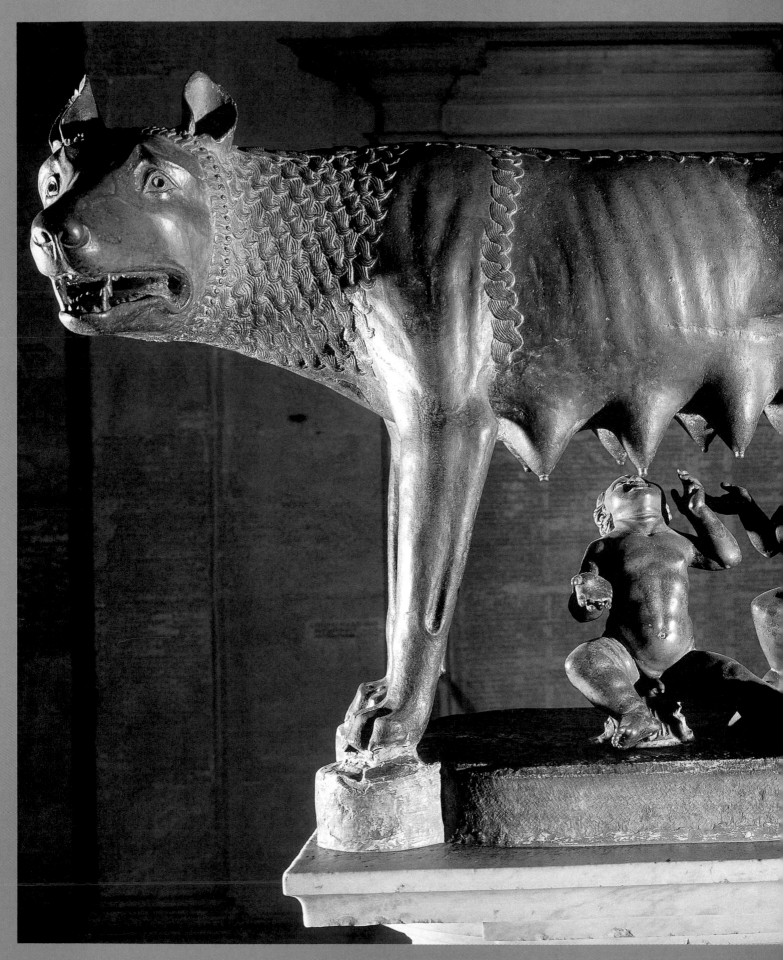

6-1. *She-Wolf.* c. 500 BCE. Bronze, glass-paste eyes, height 33½" (85 cm). Museo Capitolino, Rome

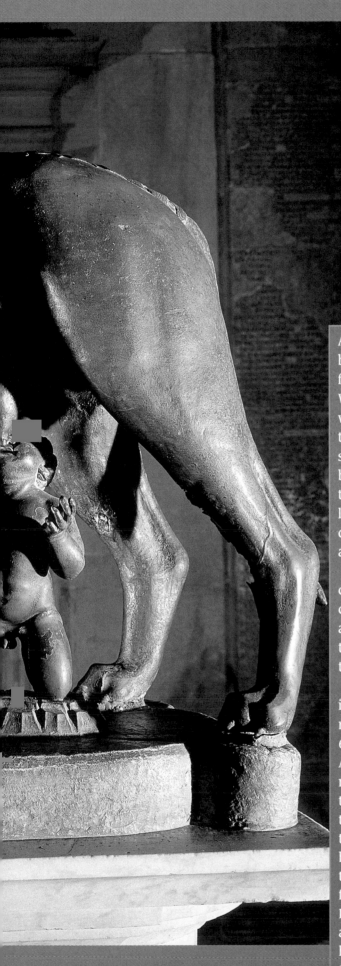

6
Etruscan Art and Roman Art

A ferocious she-wolf turns toward us with a vicious snarl. Her tense body, thin flanks, and protruding ribs contrast with her heavy, milk-filled teats. Incongruously, she suckles two active, chubby little boys. We are looking at the most famous symbol of Rome, the legendary wolf who nourished and saved the city's founder, Romulus, and his twin brother, Remus (fig. 6-1). According to a Roman legend, the twin sons of the god Mars and a mortal woman were left to die on the banks of the Tiber River by their wicked uncle. A she-wolf discovered the infants and nursed them in place of her own pups; the twins were later raised by a shepherd. When they reached adulthood, the twins decided to build a city near the spot where the wolf had rescued them, according to tradition, in the year 753 BCE.

This composite sculptural group of wolf and boys suggests the complexities of art history on the Italian peninsula. An early people called Etruscans created the bronze wolf about 500 BCE, and Romans added the sculpture of children to it in the late fifteenth or early sixteenth century CE. This figure is thus a fitting image for the way that the themes and styles of the Etruscans and the later Romans combined.

We know that a statue of a wolf—and sometimes even a live wolf in a cage—stood on the Capitoline Hill, the governmental and religious center of ancient Rome. But whether the wolf in figure 6-1 is the same sculpture that Romans saw then is far from certain. According to tradition, the original bronze wolf was struck by lightning and buried. The documented history of this *She-Wolf* begins in the tenth century CE, when it was rediscovered and placed outside the Lateran Palace, the home of the pope. At that time, statues of two small men stood under the wolf, personifying the alliance between the Romans and their former enemies from central Italy, the Sabines. But in the later Middle Ages, people mistook the figures for children and identified the sculpture with the founding of Rome. During the Renaissance, Romans wanted more specific imagery and added the twins we see here. Pope Sixtus IV (papacy after 1471 CE) had the sculpture moved from his palace to the Capitoline Hill; today, the *She-Wolf* maintains her wary pose in a museum there.

TIMELINE 6-1. **The Etruscan and Roman Worlds.** The Etruscans controlled the Italian peninsula until the Romans defeated them in 509 BCE. Roman kings unified Italy during their nearly 500-year reign. The emperors, beginning with Augustus in 27 BCE, first expanded the Roman Empire until it extended to Britain, then saw it contract until it weakened and was permanently split in 395 CE.

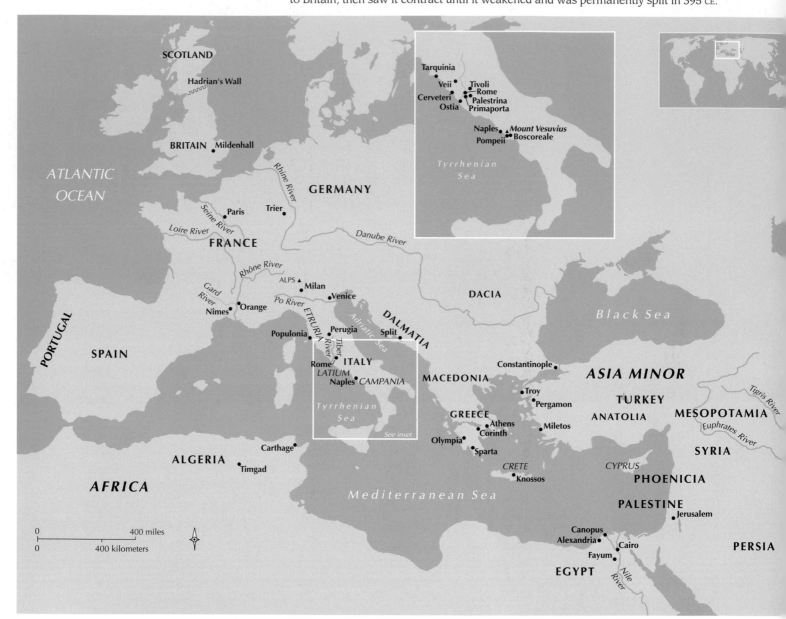

ETRUSCAN CIVILIZATION

The boot-shaped Italian peninsula, shielded to the north by the Alps, juts into the Mediterranean Sea. At the end of the Bronze Age (about 1000 BCE), a central European people known as the Villanovans occupied the northern and western regions of Italy, and central Italy was home to a variety of people who spoke a closely related group of Italic languages, Latin among them. Beginning about 750 BCE, Greeks too established colonies in Italy and in Sicily. Between the seventh and sixth century BCE, the people known as the Etruscans, probably related to the Villanovans, gained control of northern and much of central Italy, an area known as Etruria (modern Tuscany).

The Etruscans' wealth came from Etruria's fertile soil and abundance of metal ore. Noted as both farmers and metalworkers, the Etruscans were also sailors and merchants, and they exploited their resources in trade with the Greeks and with the people of Phoenicia (modern Lebanon). Although Etruscan artists knew and drew inspiration from Greek and Near Eastern sources, they never slavishly copied what they admired. Instead, they assimilated these influences and created a distinctive Etruscan style. Organized into a loose federation of a dozen cities, the Etruscans reached the height of their power in the sixth century BCE, when they expanded into the Po River valley to the north and the Campania region to the south.

MAP 6-1. (opposite)
The Roman Republic and Empire. After defeating the Etruscans in 509 BCE, Rome became a republic. It reached its greatest area by the time of Julius Caesar's death in 46 BCE. The Roman Empire began in 27 BCE, extended its borders from the Euphrates River to Scotland under Trajan in 106 CE, but was permanently split into the Eastern and Western Empires in 395 CE.

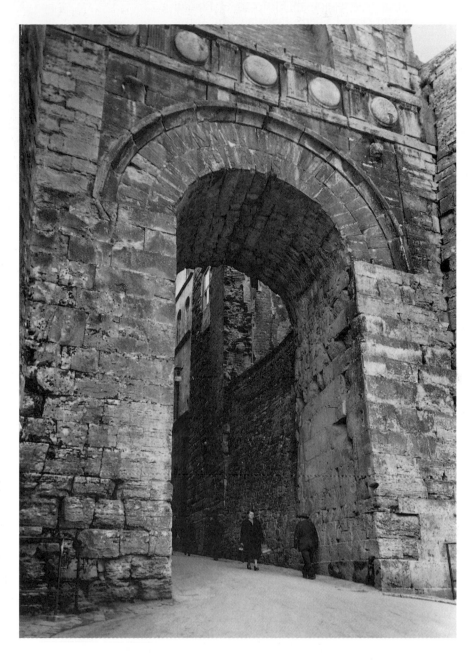

6-2. Porta Augusta, Perugia, Italy. 2nd century BCE

At the same time, the Latin-speaking inhabitants of Rome began to develop into a formidable power. For a time, kings of Etruscan lineage ruled them, but in 509 BCE the dynamic Romans overthrew the kings and formed a republic at Rome (Timeline 6-1). The Etruscans' power was in decline by the fifth century BCE, and they were absorbed by the Roman Republic at the end of the third century BCE, by which time the Romans had steadily expanded their realm in many directions. They had unified Italy and, after defeating Carthage, their rival in the western Mediterranean, had established an empire that encompassed the entire Mediterranean region (Map 6-1).

THE ETRUSCAN CITY

The Etruscan city was laid out on a grid plan, like cities in Egypt and Greece but with a difference. Two main streets—one usually running north-south and the other east-west—divided the city into quarters. The intersection of these streets was the town's business center. Because the Etruscans created house-shaped funerary urns and also decorated the interiors of tombs to resemble houses, we know that within these quadrants their houses were built around a central courtyard (or **atrium**) open to the sky with a shallow pool fed by rainwater.

Walls with protective gates and towers surrounded the cities. As a city's population grew, its boundaries expanded and building lots were added as needed outside the walls. The second-century BCE city gate of Perugia, called the Porta Augusta, is one of the few surviving examples of Etruscan monumental architecture (fig. 6-2). A tunnel-like passageway between two huge towers, this gate is significant for anticipating the Romans' use of the

round arch, which is here extended to create a semi-circular **barrel vault** over the passageway.

The round arch was not an Etruscan or Roman invention—ancient Near Eastern, Egyptian, and Greek builders had been familiar with it—but the Etruscans and Romans were the first to make widespread use of it (see "Arch, Vault, and Dome," page 228). Unlike the **corbel arch**, in which overhanging **courses** of masonry meet at the top, the round arch is formed by precisely cut, wedge-shaped stone blocks called **voussoirs**. In the Porta Augusta, a square frame surmounted by a horizontal decorative element resembling an **entablature** sets off the arch, which consists of a double row of *voussoirs*. The decorative section is lined with a row of circular panels, or **roundels**, alternating with rectangular, columnlike uprights called **pilasters**. The effect is reminiscent of the **triglyphs** and **metopes** of a Greek Doric frieze.

TEMPLES AND THEIR DECORATION

From early on, the Etruscans incorporated Greek deities and heroes into their pantheon. They also may have adapted from ancient Mesopotamians the use of divination to predict future events. Beyond this and their burial practices (revealed by the findings in their tombs, discussed below), we know little about their religious beliefs. Only a few foundations of Etruscan temples remain. Knowledge of the temples' appearance comes from ceramic **votive** models and from the writings of the Roman architect Vitruvius, who sometime between 46 and 39 BCE compiled descriptions of Etruscan and Roman architecture (see "Roman Writers on Art," page 229). His account indicates that Etruscan temples (fig. 6-3) were built on a platform called a **podium** and had a single flight of steps leading up to a front porch from a courtyard or open city square. Columns and an entablature supported the section of roof that projected over the porch. The ground plan was almost square and was divided equally between porch and interior space (fig. 6-4). Often, as in figure 6-4, the interior space was separated into three rooms that probably housed cult statues.

Etruscans built their temples with mud-brick walls. The columns and entablatures were made of wood or a quarried volcanic rock called tufa, which hardens upon exposure to the air. The columns' bases, shafts (which were sometimes fluted), and capitals could resemble those of either the Greek Doric or the Greek Ionic orders, and the entablature might have a frieze resembling that of the Doric order (not seen in the model). Vitruvius used the term *Tuscan order* for the variation that resembled the Doric order, with an unfluted shaft and a simplified base, capital, and entablature (see "Roman Architectural Orders," page 229). Although Etruscan temples were simple in form, they were embellished with dazzling displays of painting and terra-cotta sculpture. The temple roof, rather than the pediment, served as a base for large statue groups.

Etruscan artists excelled at making huge terra-cotta figures, a task of great technical difficulty. A splendid example is a lifesize figure of Apollo (fig. 6-5). Dating

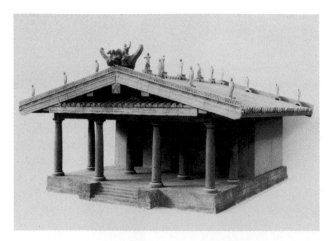

6-3. Reconstruction of an Etruscan temple, based on descriptions by Vitruvius. University of Rome, Istituto di Etruscologia e Antichità Italiche

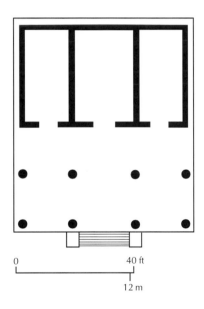

6-4. Plan of an Etruscan temple, based on descriptions by Vitruvius

from about 500 BCE and originally part of a four-figure scene depicting one of the labors of Hercules (Greek Herakles), the figure comes from the temple at Veii. The four figures depicted Apollo and Hercules fighting for possession of a deer sacred to Diana, while she and Mercury looked on (see "Greek and Roman Deities and Heroes," page 158). Apollo is shown striding as if he had just stepped over the decorative scrolled element that helps support the sculpture. The representation of the god chasing Hercules along the **ridgepole** of the temple roof defies the logical relationship of sculpture to architecture seen in Greek pedimental and frieze sculpture. The Etruscans seemed willing to sacrifice structural logic for lively action in their art.

The well-developed body and the **Archaic smile** of the *Apollo* from Veii clearly demonstrate that Etruscan sculptors were familiar with Greek Archaic *kouroi*. Despite those similarities, a comparison of the *Apollo* and

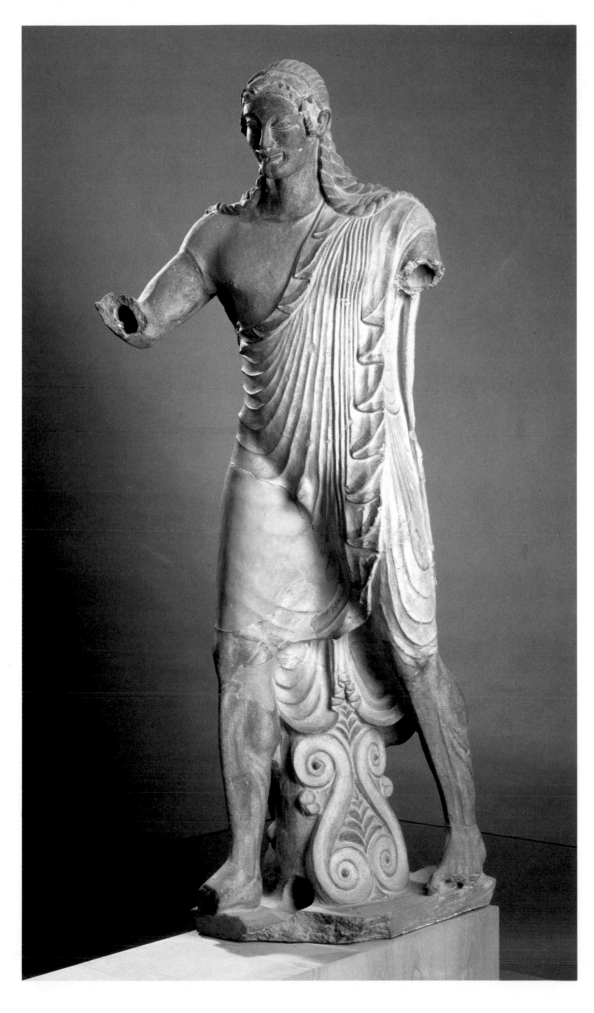

6-5. *Apollo*, from Veii. c. 500 BCE. Painted terra-cotta, height 5'10" (1.8 m). Museo Nazionale di Villa Giulia, Rome

This lifesize figure is made of terra-cotta ("baked clay"), the same material used for pottery containers. Making and firing a large clay sculpture such as this one requires great technical skill. The artist must know how to construct the figure so that it does not collapse under its own weight while the clay is still wet and must know how to precisely regulate the temperature in a large kiln for a long period of time. Etruscan terra-cotta artists must have been well known, for some of their names have come down to us, including that of a sculptor from Veii called Vulca, in whose workshop this *Apollo* may have been created.

ELEMENTS OF ARCHITECTURE

Arch, Vault, and Dome

The first true arch used in Western architecture is the round arch. When extended, the round arch becomes a barrel vault. The round arch and barrel vault were known and were put to limited use by Mesopotamians and Egyptians long before the Etruscans began their experiments. But it was the Romans who realized the potential strength and versatility of these architectural features and exploited them to the fullest degree.

The **round arch** displaces most of the weight, or downward thrust (see arrows on diagrams), of the masonry above it to its curving sides and transmits that weight to the supporting uprights (door or window **jambs**, **columns**, or **piers**), and from there to the ground. Arches may require added support, called **buttressing**, from adjacent masonry elements. Brick or cut-stone arches are formed by fitting together wedge-shaped pieces, called **voussoirs**, until they meet and are locked together at the top center by the final piece, called the **keystone**. Until the mortar between the bricks or stones dries, an arch is held in place by wooden scaffolding, called **centering**. The inside surface of the arch is called the ***intrados***, the outside curve of the arch the ***extrados***. The points from which the curves of the arch rise, called **springings**, are often reinforced by masonry **imposts**. The wall areas adjacent to the curves of the arch are **spandrels**. In a succession of arches, called an **arcade**, the space encompassed by each arch and its supports is called a **bay**.

The **barrel vault** is constructed in the same manner as the round arch. The outside pressure exerted by the curving sides of the barrel vault requires buttressing within or outside the supporting walls. When two barrel-vaulted spaces intersect each other at the same level, the result is a **groin vault**, or **cross vault**. The Romans used the groin vault to construct some of their grandest interior spaces, and they made the round arch the basis for their great freestanding **triumphal arches**.

A third type of vault brought to technical perfection by the Romans is the hemispheric **dome**. The rim of the dome is supported on a circular wall, as in the Pantheon (see figs. 6-35, 6-36). This wall is called a **drum** when it is raised on top of a main structure. Sometimes a circular opening, called an **oculus**, is left at the top.

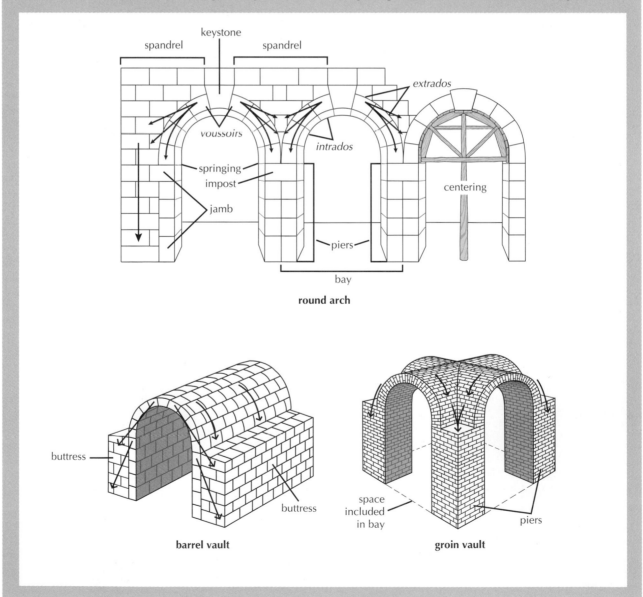

round arch

barrel vault

groin vault

Only one book specifically on architecture and the arts survives from antiquity—all our other written sources consist of digressions and insertions in works on other subjects. That one book, Vitruvius's *Ten Books of Architecture*, written for Augustus in the first century CE, is a practical handbook for builders that discusses such things as laying out cities, siting buildings, and using the Greek architectural orders. Vitruvius argued for appropriateness and rationality in architecture, and his definition of Greek architectural terms is invaluable. Vitruvius also made significant contributions to art theory, including studies on proportion.

Pliny the Elder (c. 23–79 CE) wrote a vast encyclopedia of "facts, histories, and observations," known as *Naturalis Historia* (*The Natural History*). He often included discussions of art and architecture, and he used works of art to make his points—for example, sculpture to illustrate essays on stones and metals. Pliny's scientific turn of mind led to his death, for he was overcome while observing the eruption of Mount Vesuvius, the same eruption that buried Pompeii. His nephew Pliny the Younger (c. 61–113 CE), a voluminous letter writer, added to our knowledge of Roman domestic architecture with his meticulous description of villas and gardens.

Valuable bits of information can also be found in books by travelers and historians. Pausanias, a second-century CE Greek traveler, wrote descriptions of Greece that are basic sources on Greek art and artists. Flavius Josephus (c. 37–100 CE), a historian of the Flavians, wrote in his *Jewish Wars* a description of the triumph of Titus that includes a description of the treasures looted from the Temple of Solomon in Jerusalem (see fig. 6-38).

As an **iconographical** resource, *Metamorphoses* by the poet Ovid (43 BCE–17 CE) provided themes for artists in his own time and ever since. Ovid recorded Greek and Roman myths, stories of interactions between gods and mortals, and amazing transformations (metamorphoses)—for example, Daphne turning into a laurel tree to escape Apollo. Ovid is best known for his love poetry; his last book, *Ars Amatoria* (*The Art of Seduction*), may have caused his downfall. In any event, Augustus banished him from Rome in 8 CE.

For anyone interested in the theoretical basis of art, a knowledge of the philosopher Plotinus (c. 205–70 CE) is essential. In the *Enneads*, he discussed the relationship of *phantasia* (imagination and intuition) and *mimesis* (imitation of the natural world) in the creation of art. His emphasis on imagination and intuition and his theory of hierarchies leading from dull matter to the ultimate and immaterial, understood in aesthetic terms as pure light and color, had a profound influence on art theory.

Perhaps the best-known—and most pungent—comments on art and artists remain those of the Greek writer Plutarch (c. 46–after 119 CE), who opined that one may admire the art but not the artist, and the Roman poet Virgil (70–19 BCE), who in the *Aeneid* wrote that the Greeks practice the arts, but it is the role of Romans to rule, for their skill lies in government, not art.

The Etruscans and Romans adapted Greek architectural orders to their own tastes and uses (see "The Greek Architectural Orders," page 164).

The Etruscans modified the Greek Doric order by adding a base to the column. The Romans derived the sturdy, unfluted **Tuscan order** from the Greek Doric order by way of Etruscan models. They created the **Composite order** by incorporating the volute motif of the Greek Ionic capital with other forms from the Greek Corinthian. In this diagram, the two Roman orders are shown on **pedestals**, which consist of a **plinth**, a **dado**, and a **cornice**.

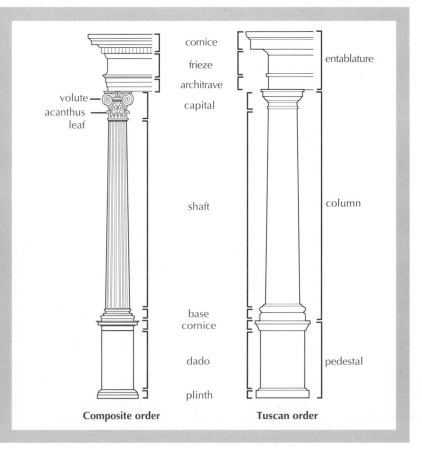

Composite order **Tuscan order**

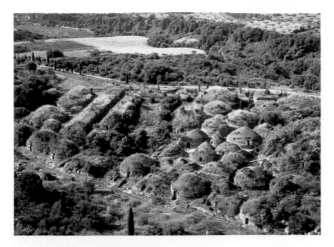

6-6. Etruscan cemetery of La Banditaccia, Cerveteri.
7th–4th century BCE

the nearly contemporary Greek *Anavysos Kouros* (see fig. 5-18) reveals telling differences. Unlike the Greek figure, the body of the Etruscan *Apollo* is partially concealed by a robe that cascades in knife-edged pleats to his knees. The forward-moving pose of the Etruscan statue also has a vigor that is only hinted at in the balanced stance of the Greek figure. This implied energy expressed in purposeful movement is characteristic of both Etruscan sculpture and Etruscan tomb painting.

TOMBS

Etruscan beliefs about the afterlife may have been somewhat similar to those of the Egyptians. Unlike the Egyptians, however, the Etruscans favored cremation; nevertheless, they clearly thought of tombs as homes for the dead. The Etruscan cemetery of La Banditaccia at Cerveteri (fig. 6-6) was laid out like a small town, with "streets" running between the grave mounds. The tomb chambers were partially or entirely excavated below the ground, and some were hewn out of bedrock. They were roofed over, sometimes with corbel vaulting, and covered with dirt and stones.

Some tombs were carved out of the rock to resemble rooms in a house. The Tomb of the Reliefs, for example, has a flat ceiling supported by square, stone posts (fig. 6-7). Its walls were plastered and painted, and it was fully furnished. Couches were carved from stone, but most of the furnishings were simulated in **stucco**, a slow-drying type of plaster that can be easily molded and carved. Pots, jugs, robes, axes, and other items were carved into the posts to look like real objects hanging on hooks. Rendered in **low relief** at the bottom of the post just left of center is the family dog. As these details suggest, the Etruscans made every effort to provide earthly comforts for their dead, but tomb decorations also sometimes

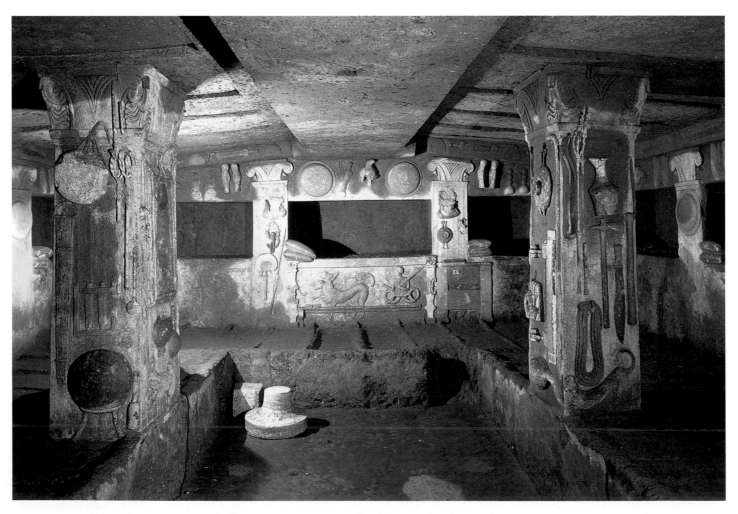

6-7. Burial chamber, Tomb of the Reliefs, Cerveteri. 3rd century BCE

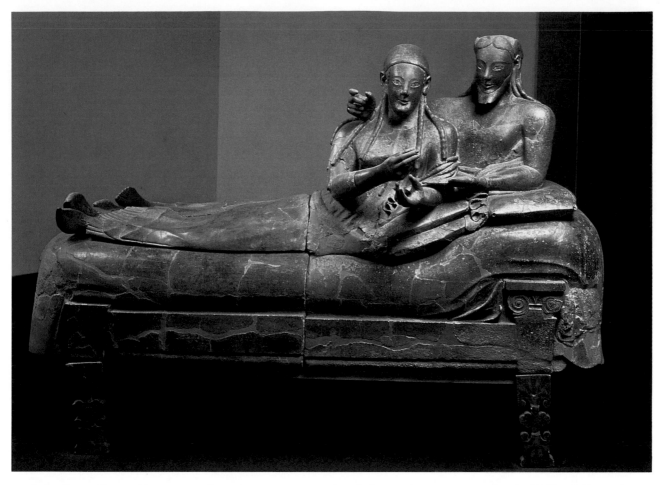

6-8. Sarcophagus, from Cerveteri. c. 520 BCE. Terra-cotta, length 6'7" (2.06 m). Museo Nazionale di Villa Giulia, Rome

included frightening creatures from Etruscan mythology. On the back wall of the Tomb of the Reliefs is another kind of dog—a beast with many heads—that probably represents Cerberus, the guardian of the gates of the underworld, an appropriate funerary image.

Sarcophagi, or coffins, often made entirely of terra-cotta, also might have provided a domestic touch. In an example from Cerveteri, about 520 BCE (fig. 6-8), a husband and wife are shown reclining comfortably on a couch. Rather than seeing a somber memorial to the dead, we find two lively, happy individuals rendered in sufficient detail to convey current hair and clothing styles. These genial hosts, with their smooth conventionalized body forms and faces, their uptilted, almond-shaped eyes, and their benign smiles, gesture as if to communicate something important to the living viewer—perhaps an invitation to dine with them for eternity. Portrait coffins like this one evolved from earlier terra-cotta cinerary jars with sculpted heads of the dead person whose ashes they held.

Brightly colored paintings of convivial scenes of feasting, dancing, musical performances, athletic contests, hunting, fishing, and other pleasures often decorated tomb walls. Many of these murals are faded and flaking, but those in the tombs at Tarquinia are well preserved. In a detail of a painted frieze in the Tomb of the Lionesses, from about 480–470 BCE, a young man and woman engage in an energetic dance to the music of a double flute (fig. 6-9, page 232). These and other figures are grouped around the walls within a carefully arranged setting of stylized trees, birds, fish, animals, and architectural elements. Unlike Greek tomb paintings, women are portrayed as active participants. The Etruscan painters had a remarkable ability to suggest that their subjects inhabit a bright, tangible world just beyond the tomb walls. Rather than enacting the formal rituals of death, the dancers and musicians are performing exuberantly.

BRONZE WORK

The skill of Etruscan bronze workers was widely acknowledged in ancient times. Especially impressive are the few examples of large-scale **sculpture in the round** that survived the wholesale recycling of bronze objects over the centuries. One of these bronzes portrays a female wolf (see fig. 6-1). The animal is at the same time ferocious and an object of sympathy. The naturalistic rendering of her body contrasts with the decorative, stylized rendering of the tightly curled molded and incised ruff of fur around her neck and along her spine. The glass-paste eyes that add so much to the dynamism of the figure were inserted after the sculpture was finished.

After Etruria fell to Rome, the work of Etruscan artists continued to be held in high regard by Roman patrons. Etruscan bronze workers and other artists went to work for the Romans, often making the distinction

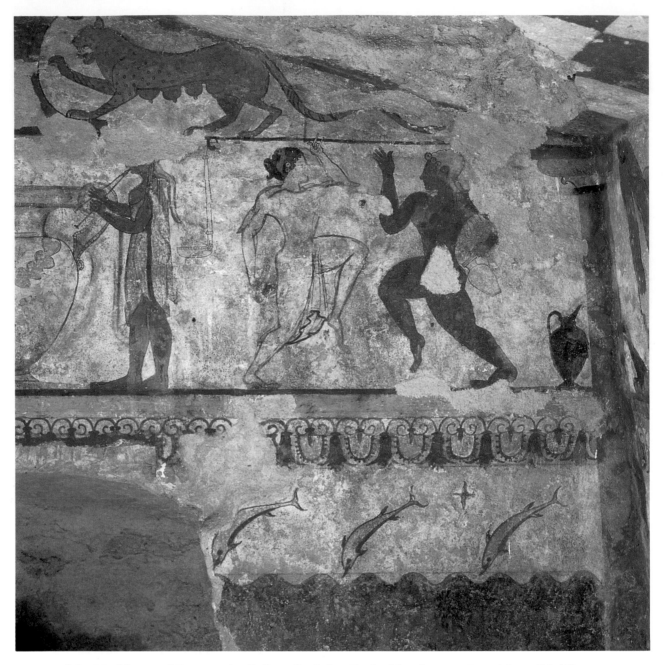

6-9. *Musicians and Dancers*, detail of a wall painting, Tomb of the Lionesses, Tarquinia. c. 480–470 BCE

between Etruscan and early Roman art moot. A head that was once part of a bronze statue of a man may be an example of an important Roman commission (fig. 6-10). Often alleged to be a portrait of Lucius Junius Brutus, the founder (in 509 BCE) and first consul of the Roman Republic, the head traditionally has been dated about 300 BCE, long after Brutus's death. Although it may represent an unknown Roman dignitary of the day, it could also be an imaginary portrait of the ancient hero. The rendering of the strong, broad face with its heavy brows, firmly set lips, and wide-open eyes (made of painted ivory) is scrupulously detailed. The sculptor seems also to have sought to convey the psychological complexity of the subject, showing him as a somewhat world-weary man who nevertheless projects strong character and great strength of purpose.

Etruscan bronze workers also created small items for either funerary or domestic use, such as a bronze

mirror from about 350 BCE (fig. 6-11). The subject of the decoration engraved on the back is a winged man, identified by the inscription as the Greek priest Calchas, who accompanied the Greek army under Agamemnon to Troy (see "The Trojan War," page 144). According to Homer, the Greeks consulted Calchas when they were uncertain about the gods' will or how to secure their favor in the war. Greeks, Etruscans, and Romans all believed that the appearance of animal entrails could reveal the future, and here Calchas is shown bending over a table, intently studying the liver of a sacrificed animal. The engraving may refer to an incident in which Calchas, called upon to determine why the Greek fleet had been left becalmed on its way to Troy, told Agamemnon that he had to sacrifice his daughter Iphigenia. According to another legend, Calchas retired after the war to his vineyards, where he died laughing,

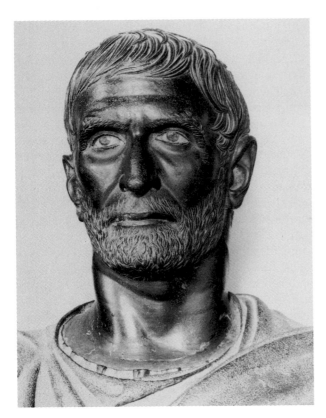

6-10. Head of a man. c. 300 BCE. Bronze, eyes of painted ivory, height 12½" (31.8 cm). Palazzo dei Conservatori, Rome

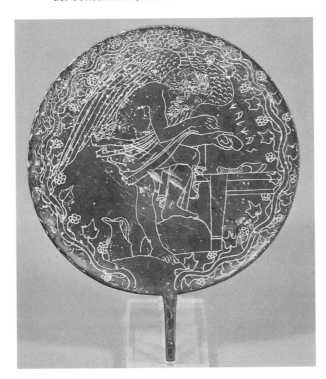

6-11. Mirror. c. 350 BCE. Engraved bronze, diameter 6" (15.3 cm). Musei Vaticani, Museo Gregoriano Etrusco, Rome

The back of this mirror depicts an Etruscan method of predicting the future from the appearance of the entrails and organs, especially the liver, of sacrificed animals. Diviners (prophets) not only would interpret what they saw in the entrails as good or bad omens but also would suggest a course of action.

and so fulfilled the prophecy that he would not live to drink his own wine. Perhaps alluding to this story, the artist has shown Calchas surrounded by grapevines and with a jug at his feet. The complex pose, the naturalistic suggestions of a rocky setting, and the pull and twist of drapery that emphasizes the figure's three-dimensionality convey a sense of realism.

ROMAN HISTORY

After the formation of the Roman Republic in 509 BCE, the Romans expanded the borders of their realm through near-continuous warfare. At its greatest extent, in the early second century CE, the Roman Empire reached from the Euphrates River in southwest Asia to Scotland. The vast territory ringed the Mediterranean Sea—*mare nostrum*, or "our sea," the Romans called it. As the Romans absorbed the peoples they conquered, they imposed on them a legal, administrative, and cultural structure that endured for some five centuries—in the eastern Mediterranean until the fifteenth century CE—and left a lasting mark on the civilizations that emerged in Europe.

These conquering peoples saw themselves, not surprisingly, in heroic terms and attributed heroic origins to their ancestors. According to one popular legend rendered in epic verse by the poet Virgil (70–19 BCE) in the *Aeneid*, the Roman people were the offspring of Aeneas, a Trojan who was the mortal son of the goddess Venus. Thanks to his mother's intervention with Jupiter, Aeneas and some companions escaped from burning Troy and made their way to Italy. There they settled at the mouth of the Tiber. Their sons were the Romans, the people who in fulfillment of a promise by Jupiter to Venus were destined to rule the world. Another popular legend told the story of Rome's founding by Romulus and Remus, the twin sons of Mars, the god of war (see fig. 6-1).

Archaeologists and historians have developed a more mundane picture of Rome's origins. In Neolithic times, groups of people who spoke a common language—Latin—settled in permanent villages on the plains of Latium, south of the Tiber River, as well as on the Palatine, one of the seven hills that would eventually become Rome. These first settlements were little more than clusters of small, round huts, but by the sixth century BCE Rome had developed into a major transportation hub and trading center.

Early Rome was governed by kings and an advisory body of leading citizens called the Senate. The population fell into two classes: a wealthy and powerful upper class, the patricians, and a lower class, the plebeians. The last kings of Rome were members of an Etruscan family, the Tarquins. In 509 BCE, Roman aristocrats overthrew the last Tarquin king and began the Roman Republic, which was to last about 450 years as an oligarchy, or government by the few. By the Republican period, nearly a million people lived in Rome.

During the fifth century BCE, through alliance and conquest, Rome began to incorporate neighboring territories in Italy, and by 275 BCE Rome controlled the entire Italian peninsula. Then, after more than a century of conflict

known as the Punic Wars (264–146 BCE), the Romans defeated the Carthaginians, destroying Carthage, the Phoenician city on the north coast of Africa, and gaining control of the western Mediterranean. By the mid-second century BCE, they had taken Macedonia and Greece, and by 44 BCE they had conquered most of Gaul (modern France) as well as the eastern Mediterranean (see Map 6-1).

During this period of expansion, Rome changed from an essentially agricultural society to a commercial and political power. In 46 BCE, the Roman general Julius Caesar emerged victorious over his rivals, assumed autocratic powers, and ruled Rome until his assassination in 44 BCE. The conflicts that followed Caesar's death ended within a few years with the unquestioned control of his grandnephew and heir, Octavian, over Rome and all its possessions.

Although Octavian continued the forms of Republican government, he retained real authority for himself. In 27 BCE, he was granted the title "Augustus," which came to mean "supreme ruler" (and by which we will now call him); he is known to history as the first emperor of Rome (see "Reigns of Significant Roman Emperors," left). The Augustan era was firmly grounded in the Roman Republic and at the same time introduced a new style that established Roman imperial art. Assisted by his astute and pragmatic second wife, Livia, Augustus proved to be an incomparable administrator. He brought opposing factions under his control and established efficient rule throughout the empire. In 12 CE, he was given the title "Pontifex Maximus" ("High Priest") and so became the empire's highest religious official as well as political leader. During his lifetime, Augustus laid the foundation for an extended period of stability, internal peace, and economic prosperity known as the *Pax Romana* ("Roman Peace"), which lasted nearly 200 years. After his death in 14 CE, the Senate ordered Augustus to be venerated as a god.

Augustus's successor was his stepson Tiberius, and in acknowledgment of the lineage of both—Augustus from *Julius* Caesar and Tiberius from his father, Tiberius *Claudius* Nero, Livia's first husband—the dynasty is known as the Julio-Claudian (14–68 CE). Although the family produced some capable administrators, the times were marked by suspicion, intrigue, and terror in Rome. The dynasty ended with the reign of the despotic, capricious, and art-loving Nero. A brief period of civil war followed Nero's death in 68 CE, until an astute general, Vespasian, seized control of the government. This Flavian dynasty ruled from 69 to 96 CE. The Flavians restored the imperial finances and stabilized the empire's frontiers, but during the autocratic reign of the last Flavian, Domitian, intrigue and terror returned to the capital.

Five very competent rulers, known as the Five Good Emperors, succeeded the Flavians and oversaw a long period of stability and prosperity between 96 CE and 180 CE. Instead of depending on the vagaries of fate (or genetics) to produce intelligent heirs, each emperor selected an able administrator to follow him and "adopted" his successor. Italy and the provinces flourished equally, and official and private patronage of the arts increased. Under Trajan, the empire reached its greatest extent, when he conquered Dacia (roughly modern Romania) in 106 CE (see Map 6-1). Hadrian then consolidated the empire's borders and imposed far-reaching social, administrative, and military reforms. Hadrian was well educated and widely traveled, and his admiration for Greek culture spurred new building programs and art patronage throughout the empire.

Conquering and maintaining a vast empire required not only inspired leadership and tactics but also careful planning, massive logistical support, and great administrative skill. Some of Rome's most enduring contributions to Western civilization—its system of law, its governmental and administrative structures, and its sophisticated civil engineering and architecture—reflect these qualities.

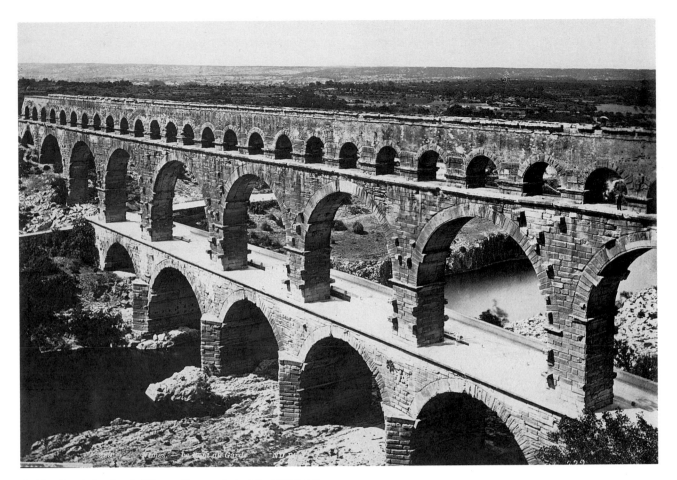

6-12. Pont du Gard, Nîmes, France. Late 1st century BCE

The 900-foot span rising 180 feet above the Gard River was originally an aqueduct that brought water from springs 30 miles to the north, providing 100 gallons of water a day for every person in Nîmes. Its three stacked walls with regularly spaced openings, or arcades, exemplify the simplest use of the arch as a structural element. The thick base arcade supports a roadbed approximately 20 feet wide. The arches of the second arcade are narrower than the first and are set at one side of the roadbed. The narrow third arcade supports the water trough, with three arches for every one below. The Pont du Gard is still in use as a bridge for pedestrians.

To facilitate the development and administration of the empire, as well as to make city life comfortable and attractive to its citizens, the Roman government undertook building programs of unprecedented scale and complexity, mandating the construction of central administrative and legal centers (**forums** and **basilicas**), recreational facilities (racetracks, **stadiums**), theaters, public baths, roads, bridges, **aqueducts**, middle-class housing, and even new towns. To accomplish these tasks without sacrificing beauty, efficiency, and human well-being, Roman builders and architects developed rational plans using easily worked but durable materials and highly sophisticated engineering methods (see "Roman Construction," page 236). The architect Vitruvius described these accomplishments in his *Ten Books of Architecture* (see "Roman Writers on Art," page 229).

To move their armies about efficiently, speed communications between Rome and the farthest reaches of the empire, and promote commerce, the Romans built a vast and sophisticated network of roads and bridges. Many modern European highways still follow the lines laid down by Roman engineers, and Roman-era foundations underlie the streets of many cities. Roman bridges are still in use, and remnants of Roman aqueducts need only repairs and connecting links to enable them to function again. The Pont du Gard, near Nîmes, in southern France, for example, is a powerful reminder of Rome's rapid spread and enduring impact (fig. 6-12). Entirely functional, the aqueduct conveys the balance, proportion, and rhythmic harmony of a great work of art and fits naturally into the landscape, a reflection of the Romans' attitude toward the land.

Despite their urbanity, Romans liked to portray themselves as simple country folk who had never lost their love of nature. The middle classes enjoyed their town-home gardens, wealthy city dwellers maintained rural estates, and Roman emperors had country villas that were both functioning farms and places of recreation. Wealthy Romans even brought nature indoors by commissioning artists to paint landscapes on the interior walls of their homes.

Like the Etruscans, the Romans admired Greek art. Historians have even suggested that although Rome conquered the Hellenistic world, Greek culture conquered

The Romans were pragmatic, and their practicality extended from recognizing and exploiting undeveloped potential in construction methods and physical materials to organizing large-scale building works. Their exploitation of the arch and the vault is typical of their adapt-and-improve approach. Their innovative use of **concrete**, beginning in the first century BCE, was a technological breakthrough of the greatest importance.

Roman concrete consisted of powdered lime, sand (in particular, a volcanic sand called *pozzolana* found in abundance near Pompeii), and various types of rubble, such as small rocks and broken pottery. Mixing in water caused a chemical reaction that blended the materials, which hardened as they dried into a strong, solid mass. At first, concrete was used mainly for poured foundations, but with technical advances it became indispensable

for the construction of walls, arches, and vaults for ever-larger buildings. In the earliest concrete wall construction, workers filled a framework of rough stones with concrete. Soon they developed a technique known as *opus reticulatum*, in which the framework is a diagonal web of smallish, pyramidal bricks set in a cross pattern.

Concrete-based construction freed the Romans from the limits of right-angle forms and comparatively short spans. With this freedom, Roman builders pushed the established limits of architecture, creating some very large and highly original spaces, many based on the curve.

Concrete's one weakness was that it absorbed moisture, so builders covered exposed concrete surfaces with a **veneer**, or facing, of finer materials, such as marble, stone, stucco, or painted plaster. Thus, an essential difference between Greek and Roman architecture is that Greek buildings reveal the building material itself, whereas Roman buildings show only the applied surface.

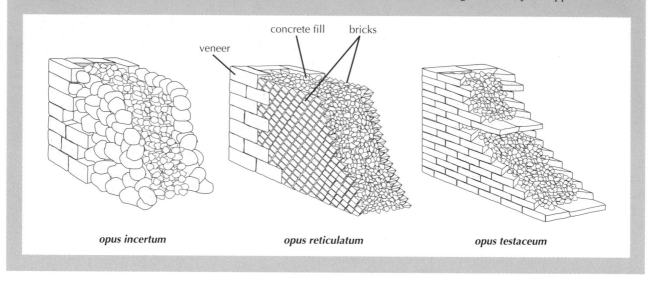

opus incertum *opus reticulatum* *opus testaceum*

Rome. The Romans used Greek designs and Greek orders in their architecture, imported Greek art, and employed Greek artists. In 146 BCE, for example, they stripped the Greek city of Corinth of its art treasures and shipped them back to Rome. Ironically, this love of Greek art was not accompanied by admiration for its artists. In Rome, as in Greece, professional artists were generally considered little more than skilled laborers.

Although the Romans had gods of their own (see "Distinctively Roman Gods," page 234), like the Etruscans they too adopted many Greek gods and myths (this chapter uses the Roman form of Greek names) and assimilated Greek religious beliefs and practices into a form of state religion. To the Greek pantheon they added their own deified emperors, in part to maintain the allegiance of the culturally diverse populations of the empire. Worship of ancient gods mingled with homage to past rulers, and oaths of allegiance to the living ruler made the official religion a political duty—increasingly ritualized, perfunctory, and distant from the everyday life of the average person. As a result, many Romans

adopted the more personal religious beliefs of the people they had conquered, the so-called mystery religions. Worship of Isis and Osiris from Egypt, Cybele (the Great Mother) from Anatolia, the hero-god Mithras from Persia, and the single, all-powerful God of Judaism and Christianity from Palestine challenged the Roman establishment. These unauthorized religions flourished alongside the state religion, with its Olympian deities and deified emperors, despite occasional government efforts to suppress them.

THE REPUBLICAN AND AUGUSTAN PERIODS

During the centuries of the Republic, Roman arts reflected Etruscan influences, but the expansion of the empire brought Romans wider exposure to the arts of other cultures. Under those diverse influences, Roman art became increasingly eclectic. It continued its transformation in tandem with the political transition represented by the reign of Augustus (27 BCE–14 CE), an emperor in fact who

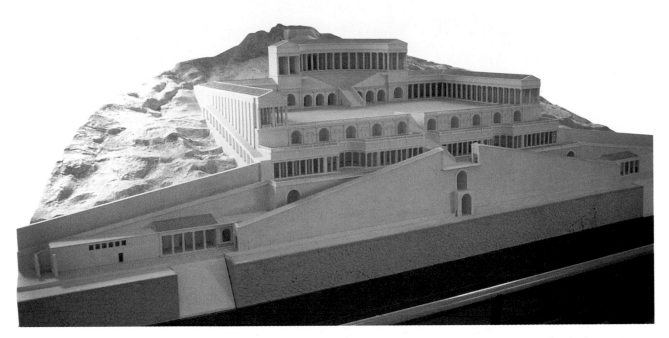

6-13. Model of the Sanctuary of Fortuna Primigenia, Palestrina, Italy. Begun c. 100 BCE. Museo Archeologico Nazionale, Italy

paid lip service to the Senate and always ruled with power voted to him by the Senate. During this period, some of the arts, such as architecture, evolved slowly while others, such as sculpture, underwent dramatic change.

ARCHITECTURE

Although Roman architects built temples, palaces, and tombs for the rich and powerful, they also had to satisfy the needs of ordinary people efficiently and inexpensively. To do so, they created new building types and construction techniques.

Roman architects relied heavily on the round arch and vault. Beginning in the second century BCE, they also created new forms using **concrete** (see "Roman Construction," opposite). In contrast to stone—which was expensive, time-consuming to quarry, and difficult to transport—the brick, rubble, and cement components of concrete were cheap, light, and easily transported. Building stone structures required highly skilled workers, but a large, semiskilled workforce directed by a few experienced supervisors could construct brick and concrete buildings, saving stone and marble for surfaces.

The remains of the Sanctuary of Fortuna Primigenia, an example of Roman Republican architectural planning and concrete construction at its most creative (fig. 6-13), were discovered after World War II by teams clearing the rubble from bombings of Palestrina (ancient Praeneste), about 16 miles southeast of Rome. The sanctuary, dedicated to the goddess of fate and chance, was begun

about 100 BCE and was grander than any building in Rome in its time. Its design and size show the clear influence of Hellenistic architecture, especially the colossal scale of buildings in cities such as Pergamon (see fig. 5-77). Built of concrete covered with a **veneer** (or thin coat) of stucco and finely cut limestone, the seven vaulted platforms or terraces of the Sanctuary of Fortuna covered a steep hillside. Worshipers ascended long ramps, then staircases to successively higher levels. Especially effective is the way enclosed ramps open onto the fourth terrace, which has a central stair with flanking colonnades and symmetrically placed **exedrae**, or semicircular niches. On the sixth level, **arcades** (series of arches) and colonnades form three sides of a large square, which is open on the fourth side to the distant view. Finally, from the seventh level, a huge, theaterlike, semicircular colonnaded pavilion is reached by a broad semicircular staircase. Behind this pavilion was a small **_tholos_**—the actual temple to Fortuna—hiding the ancient rock-cut cave where acts of divination took place. The overall **axial** plan—directing the movement of people from the terraces up the semicircular staircase, through the portico, to the tiny _tholos_ temple, to the cave—brings to mind great Egyptian temples, such as that of Hatshepsut at Deir el-Bahri (see fig. 3-31).

More typical of Roman religious architecture than such a sanctuary were urban temples built in commercial centers. A small, rectangular temple in Rome, nearly contemporary with the Sanctuary of Fortuna Primigenia, stands on its raised platform, or podium, beside the Tiber

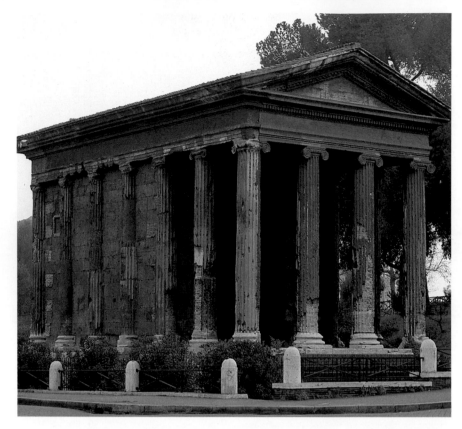

6-14. **Temple perhaps dedicated to Portunus, Forum Boarium (Cattle Market), Rome**. Late 2nd century BCE

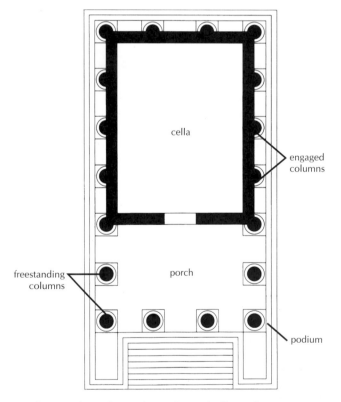

freestanding columns

cella

engaged columns

porch

podium

6-15. Plan of temple perhaps dedicated to Portunus

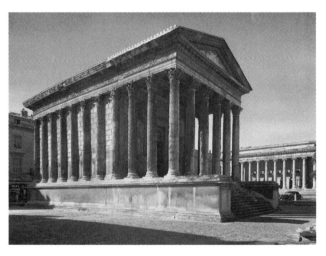

6-16. Maison Carrée, Nîmes, France. c. 20 BCE

porch and **engaged** (set into the wall) around the cella. The entablature above the columns on the porch continues around the cella as a decorative frieze. The plan of this structure resembles that of a **peripteral** temple, but because the columns around the cella are engaged it is called pseudo-peripteral. This design, with variations in the orders used with it, is typical of Roman temples.

Early imperial temples, such as the one known as the Maison Carrée ("Square House"), are simply larger and much more richly decorated versions of the so-called Temple of Portunus (fig. 6-16). Built in the forum at Nîmes, France, about 20 BCE and later dedicated to the grandsons of Augustus, the Maison Carrée differs from its prototype only in its size and its use of the opulent Corinthian order. This most elaborate order seems

River (figs. 6-14, 6-15). It may have been dedicated to Portunus, the god of harbors and ports. With a rectangular **cella** and a porch at one end reached by a single flight of steps, this late-second-century BCE temple echoes the Greek **prostyle** plan, with a colonnade across the entrance. The Ionic columns are freestanding on the

Like the Etruscans, the early Romans generally cremated their dead, and they placed the ashes in special cinerary urns or vases. Unlike the Etruscans, however, they did not provide an earthly domestic setting for their deceased. Instead, they frequently kept the ash containers—along with family documents and busts and casts from death masks of their ancestors—on view in their homes, often in a room called the *tablinum* at one end of the atrium.

In Rome, related individuals or members of social clubs and other organizations established private group cemeteries. When a group had used up the cemetery's ground-level space, they tunneled underground to create a **catacomb**. The tunnels extended from one edge of the cemetery property to the other, like streets, and descended to another level as space filled up. The tunnels were lined with niches for urns and busts of the dead and opened into small side chambers called *cubicula*. Over time, a catacomb became a true **necropolis**, or city of the dead. Aboveground the Romans built funeral basilicas where they held banquets to honor the dead.

The Romans revered their ancestors and kept death masks as a way of remembering them. Pliny the Elder, writing in the first century CE, describes this practice: "Wax impressions of the face were set out on separate chests [at home], so that they might serve as the portraits which were carried in family funeral processions, and thus, when anyone died, the entire roll of his ancestors, all who ever existed, was present" (*Naturalis Historia* 35.6–7). The wax death masks were sometimes cast in plaster, and sculptors might be commissioned to create bust portraits of the dead. Sculptors might also be asked to create imaginary portraits of illustrious, long-dead ancestors to be displayed in the *tablinum* and carried in funeral processions.

appropriate for the city of Nîmes, which is located in what was one of the richest provinces of the empire. The temple summarizes the character of Roman religious architecture: technologically advanced but conservative in design, perfectly proportioned and elegant in sculptural detail. (These qualities appealed to the future American president and amateur architect Thomas Jefferson, who visited Nîmes and was said to have found inspiration in the Maison Carrée for his own designs for buildings in the new state of Virginia.)

The Romans also continued the Greek tradition of building large outdoor theaters against suitable hillsides. A well-preserved theater still stands in Orange, north of Nîmes (fig. 6-17). The seating resembles a Greek theater, but the orchestra, which in Greek theaters is circular and is part of the performance area, has here been reduced to a semicircle. A raised stage with an elaborate enclosing wall faces the audience. Built during the reign of Augustus in the first century BCE, the theater could hold 7,000 spectators. In its heyday, the plain masonry of the wall, 335 feet long and 123½ feet high, was disguised with columns and pediments and had a niche for a statue of the emperor. Unlike Greek theaters, in which the surrounding environment is part of the setting, this theater isolated audience and actors in an entirely architectural environment.

REPUBLICAN SCULPTURE

Sculptors of the Republican period sought to create believable images based on careful observations of their surroundings. The convention of rendering accurate and faithful portraits of individuals, called **verism**, may be derived from Roman ancestor veneration and the practice of making death masks of deceased relatives (see "Roman Funerary Practices," above). In any case, patrons in the Republican period clearly admired veristic portraits, and it is not surprising that they often turned to

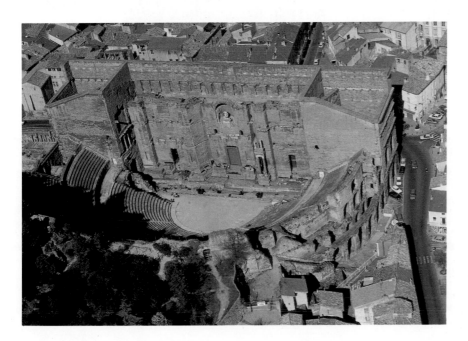

6-17. Roman theater, Orange, France. 1st century BCE

Plays are staged here today, so this Roman theater is still used for its original purpose.

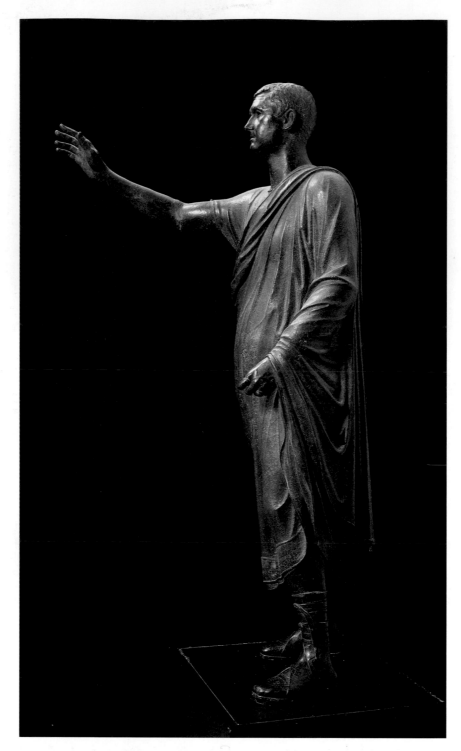

6-18. *Aulus Metellus*, found near Perugia. Late 2nd or early 1st century BCE. Bronze, height 5'11" (1.8 m). Museo Archeològico Nazionale, Florence

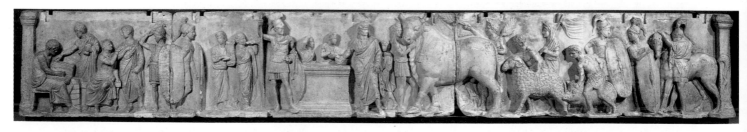

6-19. *Taking of the Roman Census*, frieze from a large base for statuary, possibly from the Temple of Neptune, Rome. C. 70 BCE. Marble, height 32" (81.3 cm). Musée du Louvre, Paris

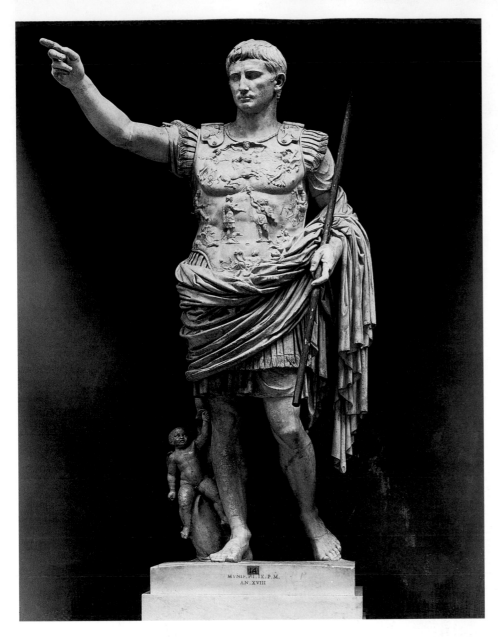

6-20. *Augustus of Primaporta*. Early 1st century CE (perhaps a copy of a bronze statue of c. 20 BCE). Marble, height 6'8" (2.03 m). Musei Vaticani, Braccio Nuovo, Rome

The popularity of the portrait type seen in the *Augustus of Primaporta* may be due to its sophisticated combination of Greek idealism and Roman individuality—in effect, a new Augustan ideal. This was the most popular image of the emperor. A catalogue of Augustan portraits published in 1993 listed 148 replicas in sculpture, including this one, plus six done as cameos—more than double the number of any other image. The original portrait sculpture may have marked the beginning of Octavian's rule as Augustus in 27 BCE, since the earliest known replica is securely dated before 25 BCE.

skilled Etruscan artists to execute them. The lifesize bronze portrait of *Aulus Metellus*—the Roman official's name is inscribed on the hem of his garment in Etruscan letters (fig. 6-18)—dates to the late second or early first century BCE. The statue, known from early times as *The Orator*, depicts the man addressing a gathering, his arm outstretched and slightly raised, a pose expressive of authority and persuasiveness. The orator wears sturdy laced leather boots and the folded and draped garment called a toga, both characteristic of a Roman official. According to Pliny the Elder, large statues like this were often placed atop columns as memorials to the individuals portrayed.

Historical events in ancient Rome were often recorded in relief sculpture. Among the earliest historical reliefs discovered in Rome is a long marble panel dating from the early first century BCE, the *Taking of the Roman Census* (fig. 6-19). This panel may have been part of a base for a statue in the Temple of Neptune. The left half of the panel shows the official registration of citizens; the right half shows a *lustrum*, a purification ceremony with the ritual sacrifice of animals. In this case, a bull, a sheep, and a large pig are being led in a procession to the altar

of Mars, at the center. The sculptor's desire to convey specific events and subjects in accurate detail overrode concerns for balanced composition.

AUGUSTAN SCULPTURE

Drawing inspiration from Etruscan and Greek art as well as Republican traditions, Roman artists of the Augustan age created a new style—a Roman form of idealism specifically grounded in the appearance of the everyday world. They enriched the art of portraiture in both official images and representations of private individuals; they recorded contemporary historical events on commemorative arches, columns, and mausoleums erected in public places; and they contributed unabashedly to Roman imperial propaganda.

The *Augustus of Primaporta* (fig. 6-20), discovered in the villa belonging to Augustus's wife, Livia, at Primaporta, demonstrates the creative assimilation of earlier sculptural traditions into a new context. In its idealization of a specific ruler and his prowess, the sculpture also illustrates the use of imperial portraiture for political propaganda. The sculptor of this larger-than-life marble statue eloquently

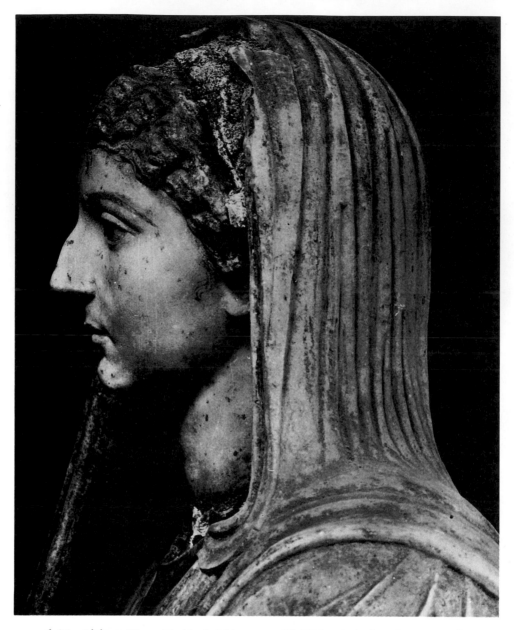

6-21. *Livia*. C. 20 BCE. Marble, height approx. 15" (38.5 cm). Antiquarium, Pompeii

adapted the orator's gesture of *Aulus Metellus* (see fig. 6-18) and combined it with the pose and ideal proportions developed by the Greek Polykleitos and exemplified in his *Spear Bearer* (see fig. 5-51). Mythological imagery exalts Augustus's position. Cupid, son of the goddess Venus, rides a dolphin next to the emperor's right leg, a reference to the claim of the emperor's family, the Julians, to descent from the goddess Venus through her human son Aeneas. Although Augustus wears a cuirass (torso armor) and holds a commander's baton, his feet are bare, suggesting to some scholars his elevation to divine status (**apotheosis**) after death.

This imposing statue creates a recognizable image of Augustus, yet it is far removed from the intensely individualized portrait that was popular during the Republican period. Augustus was in his late seventies when he died, but in his portrait sculpture he is always a vigorous young ruler. This statue was found in the atrium of Livia's house, facing the door and, in effect, greeting the guests. Whether depicting Augustus as a general praising his troops or as a peacetime leader speaking words of encouragement to his people, the sculpture projects the image of a benign ruler, touched by the gods, who governs by reason and persuasion, not autocratic power.

Augustus's wife, Livia, was a strong and resourceful woman who remained by his side for more than fifty years. For both, this was a second marriage. Augustus had married his first wife for political reasons and divorced her after the birth of what would be his only child, Julia. By her first husband Livia had two children, Tiberius (who would become the second emperor of Rome) and Drusus. A portrait bust of Livia, dated about 20 BCE, reveals a woman with strong features in the realistic tradition of Roman portraits (fig. 6-21).

The combination of realism and idealism in Augustan sculpture is clear in the Ara Pacis, the Altar of

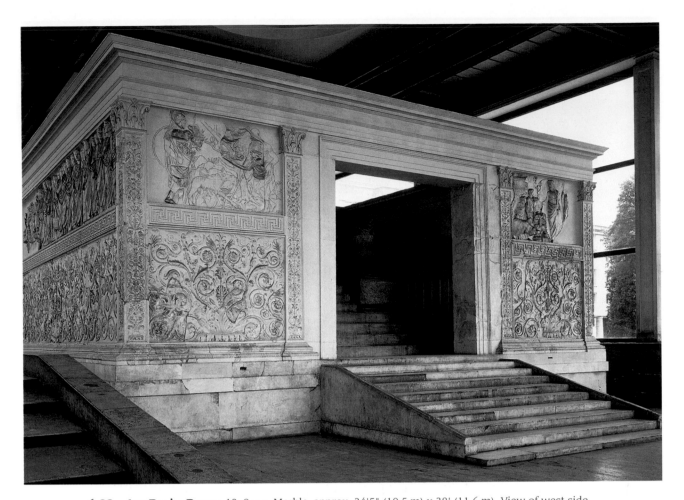

6-22. Ara Pacis, Rome. 13–9 BCE. Marble, approx. 34'5" (10.5 m) x 38' (11.6 m). View of west side

In its original location, in the Campus Martius (Plain of Mars) beside the Tiber River, the Ara Pacis was aligned with a giant sundial that used an Egyptian obelisk as its pointer, suggesting that Augustus controlled not just Egypt but time itself. On the fall equinox (the time of Augustus's conception), the shadow of the obelisk pointed to the open door of the enclosure wall, on which sculptured panels depicted the first rulers of Rome—the warrior-king Romulus on the left and the second king, Numa Pompilius, who founded traditional religious practices and first sacrificed to Peace, on the right. The Ara Pacis thus celebrates Augustus as both a warrior and a peacemaker. The theme of time is almost as important as that of peace. The monument was begun when Augustus was fifty (13 BCE) and was dedicated on Livia's fiftieth birthday (9 BCE). In 1937–38 CE, the Italian premier Mussolini reconstructed the Ara Pacis in its present location, closer to the Tiber than originally.

Augustan Peace (fig. 6-22). The altar, begun in 13 BCE and dedicated in 9 BCE, commemorates Augustus's triumphal return to Rome after establishing Roman rule in Gaul. The walled rectangular enclosure with the altar inside is approached by a flight of steep stairs on the west. Its decoration is a thoughtful union of portraiture and allegory, religion and politics, the private and the public. On the inner walls, garlands of flowers suspended in **swags**, or loops, from *bucrania* (ox skulls) surround the altar. The ox skulls symbolize sacrificial offerings, and the garlands, which unrealistically include flowering plants from every season, signify continuous peace.

Decorative allegory gives way to Roman realism on the exterior side walls of the enclosure, where sculptors depicted the just-completed procession with its double lines of senators (on the north) and imperial family members (on the south). Here recognizable people wait for other ceremonies to begin. At the head of the line on the south side of the altar is Augustus (not illustrated), with members of his family waiting behind him (fig. 6-23, page 244). Unlike the Greek sculptors who created an ideal procession for the Parthenon frieze (see fig. 5-46), the Roman sculptors of the Ara Pacis depicted actual individuals participating in a specific event at a known time. To suggest a double line of marchers in space, they varied the height of the relief, with the closest elements in high relief and those farther back in increasingly lower relief. They draw us, as spectators, into the event by making the feet of the nearest figures project from the architectural groundline into our space.

Moving from this procession, with its immediacy and naturalness, to the east and west ends of the enclosure wall, we find panels of quite a different character, an allegory of Peace and War in two complementary pairs of images. On the west front (see fig. 6-22), in the center of

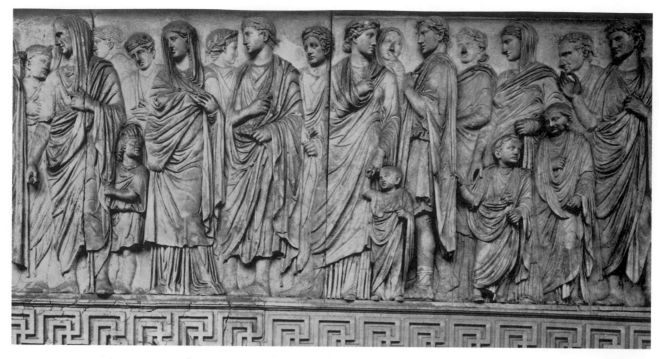

6-23. *Imperial Procession*, detail of a relief on the south side of the Ara Pacis. Height 5'2" (1.6 m)

The middle-aged man with the shrouded head at the far left is Marcus Agrippa, who would have been Augustus's successor had he not died in 12 CE. The bored but well-behaved youngster pulling at Agrippa's robe—and being restrained gently by the hand of the man behind him—is probably Agrippa's son Gaius Caesar. The heavily swathed woman next to Agrippa on the right may be Augustus's wife, Livia, followed by the elder of her two sons, Tiberius, who would become the next emperor. Behind Tiberius is Antonia, the niece of Augustus, looking back at her husband, Drusus, Livia's younger son. She grasps the hand of Germanicus, one of her younger children. Behind their uncle Drusus are Gnaeus and Domitia, children of Antonia's older sister, who can be seen standing quietly beside them. The depiction of children in an official relief was new to the Augustan period and reflects Augustus's desire to promote private family life.

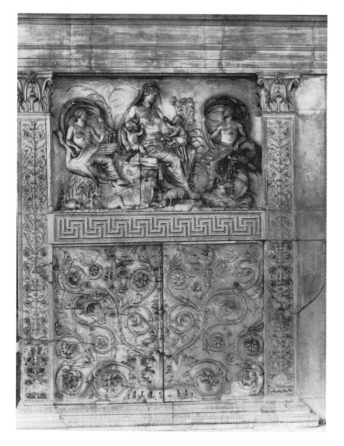

the top left-hand panel, is Romulus (the belligerent first king of Rome), and in the top right-hand panel is Numa Pompilius (the peacemaking second king). On the east side (fig. 6-24) are personifications (symbols in human form) of war and peace—Roma (the triumphant empire) and Pax (the goddess of peace), or Tellus. Augustus and Livia stood on the south side, between Numa and Pax, suggesting to the Roman citizens that they brought peace and prosperity to the empire.

In the best-preserved panel, figure 6-24, the goddess Pax, who is also understood to be *Tellus Mater*, or Mother Earth, nurtures the Roman people, represented by the two chubby babies in her arms. She is accompanied by two young women with billowing veils, one seated on the back of a flying swan, the other reclining on a sea monster. They are personifications of the sea wind and the land wind. The sea wind, symbolized by the sea monster and waves, would have reminded Augustus's contemporaries of Rome's dominion over the Mediterranean; the land wind, symbolized by the swan, the jug of fresh water, and the vegetation, would have suggested the fertility of Roman farms. The underlying theme of a peaceful, abundant Earth is reinforced by the flowers

6-24. *Allegory of Peace*, relief on the east side of the Ara Pacis. Height 5'2" (1.6 m)

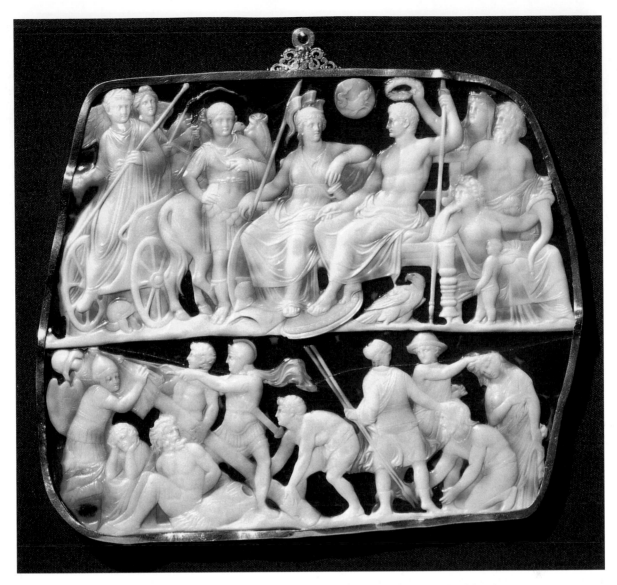

6-25. *Gemma Augustea*. Early 1st century CE. Onyx, 7½ x 9" (19 x 23 cm). Kunsthistorisches Museum, Vienna

and foliage in the background and the domesticated animals in the foreground.

Although the inclusion in this panel of features from the natural world—sky, water, rocks, and foliage—represents a Roman contribution to monumental sculpture, the idealized figures themselves are clearly drawn from Greek sources. The artists have conveyed a sense of three-dimensionality and volume by turning the figures in space and wrapping them in revealing draperies. The scene is framed by Corinthian pilasters supporting a simple entablature. A wide **molding** with a Greek key pattern (**meander**) joins the pilasters and divides the wall into two horizontal segments. Stylized vine and flower forms cover the lower panels. More foliage overlays the pilasters, culminating in the acanthus-covered capitals. The delicacy and minute detail with which these spiraling vegetal forms are rendered are characteristic of Roman decorative sculpture.

Exquisite skill characterizes all the arts of the Augustan period. A large onyx **cameo** (a gemstone carved in low relief) known as the *Gemma Augustea* carries the scene of the apotheosis of Augustus after his death in 14 CE (fig. 6-25). The emperor, crowned with a victor's wreath, sits at the center right of the upper register. He has assumed the identity of Jupiter, the king of the gods; an eagle, sacred to Jupiter, stands at his feet. Sitting next to him is a personification of Rome that has Livia's features. The sea goat in the roundel between them may represent Capricorn, the emperor's zodiac sign. Tiberius, the adopted son of Augustus, holds a lance and steps out of a chariot at the left. Returning victorious from the German front, he will assume the imperial throne as the designated heir of Augustus. Below this realm of godly rulers is the earth, where Roman soldiers are raising a trophy—a post or standard on which armor captured from the defeated enemy is displayed. The cowering, shackled barbarians on the bottom right wait to be tied to this trophy. The *Gemma Augustea* brilliantly combines idealized, heroic figures of a kind characteristic of Classical Greek art with recognizable portraits, the dramatic action of Hellenistic art, and a purely Roman realism in the depiction of historical events.

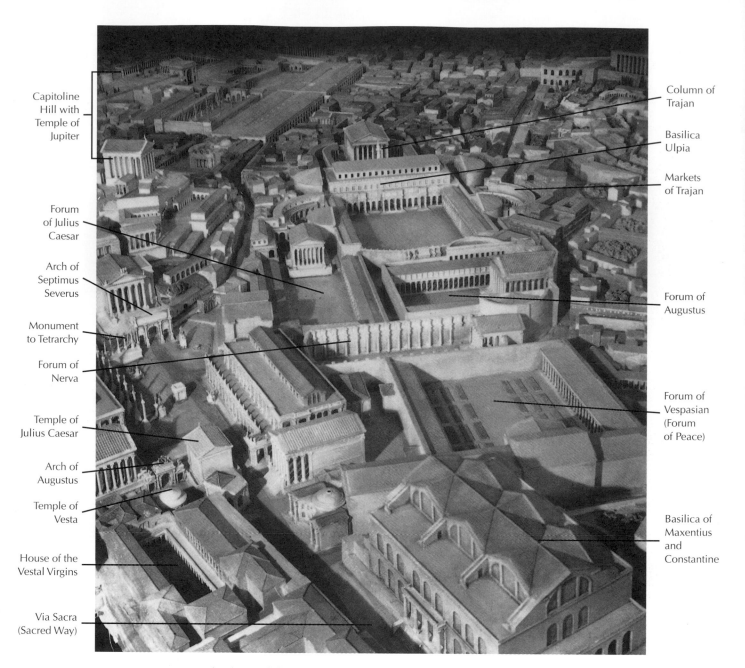

Capitoline Hill with Temple of Jupiter

Column of Trajan

Basilica Ulpia

Markets of Trajan

Forum of Julius Caesar

Arch of Septimus Severus

Monument to Tetrarchy

Forum of Nerva

Temple of Julius Caesar

Arch of Augustus

Temple of Vesta

House of the Vestal Virgins

Via Sacra (Sacred Way)

Forum of Augustus

Forum of Vespasian (Forum of Peace)

Basilica of Maxentius and Constantine

6-26. Model of the Imperial Forums, Rome. C. 46 BCE–325 CE

THE EMPIRE As the scene on the *Gemma Augustea* illustrates, Tiberius stepped into the vacancy left by the death of Augustus. As we have noted, the Julio-Claudian dynasty ended with the forced suicide of Nero in 68 CE. The Flavians, practical military men, restored confidence and ruled for the rest of the first century CE. Then, from 96 to 180 CE, the "Five Good Emperors"—Nerva, Trajan, Hadrian, Antoninus Pius, and Marcus Aurelius—gave Rome an era of stability. Unfortunately, Marcus Aurelius broke the tradition of adoption and left his son, Commodus, to inherit the throne. Within twelve years, Commodus destroyed the government his predecessors had so carefully built.

IMPERIAL ARCHITECTURE

The Romans believed that their rule extended to the ends of the Western world, but the city of Rome remained the heart and nerve center of the empire. During his long and peaceful reign, Augustus paved the city's old Republican Forum, restored its temples and basilicas, and built the first Imperial Forum. These projects marked the beginning of a continuing effort to transform the capital itself into a magnificent monument to imperial rule. While Augustus's claim of having turned Rome into a city of marble is exaggerated, he certainly began the process of creating a monumental civic center. Such grand structures as the Imperial Forums, the Colosseum, the Circus Maximus (a track for chariot races), the Pantheon, and aqueducts rose amid the temples, baths, warehouses, and homes in the city center.

A twentieth-century model of the Imperial Forums makes apparent the city's dense building plan (fig. 6-26). The last and largest Imperial Forum was begun by Trajan in 110–13 CE and finished by Hadrian about 117 CE on a

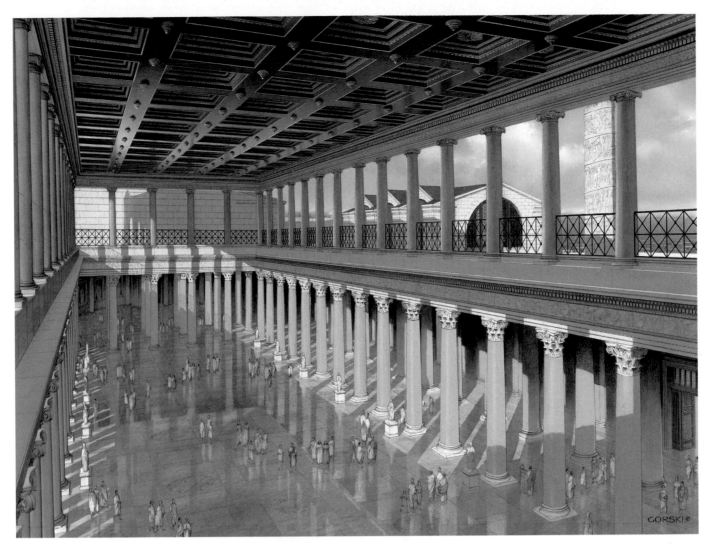

6-27. Restored perspective view of the central hall, Basilica Ulpia, Rome. 113 CE. Drawn by Gilbert Gorski

large piece of property next to the earlier forums of Augustus and Julius Caesar. For this major undertaking, Trajan chose a Greek architect, Apollodorus of Damascus. A straight, central axis leads from the Forum of Augustus through a triple-arched gate surmounted by a bronze chariot group into a large, colonnaded square with a statue of Trajan on horseback at its center. Closing off the courtyard at the north end was the Basilica Ulpia, dedicated in 113 CE and named for the family to which Trajan belonged.

A basilica was a large, rectangular building with a rounded extension, called an **apse**, at each end. A general-purpose administrative structure, it could be adapted to many uses. The Basilica Ulpia was a court of law, but other basilicas served as imperial audience chambers, army drill halls, and schools. The basilica design provided a large interior space with easy access in and out. The Basilica Ulpia was 385 feet long and 182 feet wide (not including the apses), with doors on the long sides. The interior space consisted of a large central area (the **nave**) flanked by two colonnaded aisles surmounted by open galleries (fig. 6-27). The central space

was taller than the surrounding galleries and was lit directly by an open gallery in the space normally occupied by a **clerestory** (upper nave wall with windows). The timber truss roof had a span of about 80 feet. The two apses, one at each end of the building, provided imposing settings for judges when the court was in session.

Behind the Basilica Ulpia stood twin libraries built to house the emperor's large collections of Latin and Greek manuscripts. These buildings flanked an open court and the great spiral column that became Trajan's tomb (Hadrian placed his predecessor's ashes in the base). The column commemorated Trajan's victory over the Dacians and was erected either with the Basilica Ulpia about 113 CE or by Hadrian after Trajan's death in 117 CE. The Temple of the Divine Trajan stands opposite the Basilica Ulpia, forming the fourth side of the court and closing off the end of the forum. Hadrian ordered the temple built after Trajan's death and apotheosis.

The relief decoration on the Column of Trajan spirals upward in a band that would stretch almost 656 feet if unfurled. Like a giant version of the scrolls housed in the libraries next to it, the column is a continuous pictorial

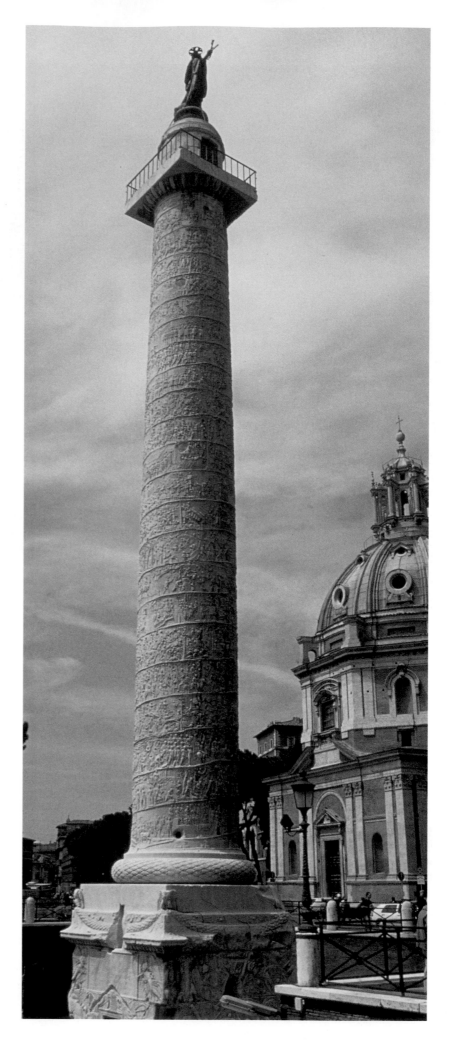

6-28. Column of Trajan, Rome.
113–16 or after 117 CE.
Marble, overall height with
base 125' (38 m), column
alone 97'8" (29.77 m)

The height of the column,
100 Roman feet (97'8"),
may have recorded the depth
of the excavation required to
build the Forum of Trajan.
The column had been topped
by a gilded bronze statue of
Trajan, which was replaced in
1587 CE, by order of Pope
Sixtus V, with the statue of
Saint Peter seen today.
Trajan's ashes were interred
in the base in a golden urn.

6-29. Main hall, Markets of Trajan, Rome. 100–12 CE

narrative of the Dacian campaign (fig. 6-28). This remarkable sculpture involved carving more than 2,500 individual figures linked by landscape, architecture, and the recurring figure of Trajan. The artist took care to make the scroll legible. The narrative band slowly expands from about 3 feet in height at the bottom, near the viewer, to 4 feet at the top of the column, where it is farther from view. The natural and architectural elements in the scenes have been kept small to emphasize the important figures.

During the site preparation for the forum, part of a commercial district had to be razed and excavated. To make up for the loss, Trajan ordered the construction of a handsome public market. The market, comparable in size to a large modern shopping mall, had more than 150 individual shops on several levels and included a large groin-vaulted main hall (fig. 6-29). In compliance with a building code that was put into effect after a disastrous fire in 64 CE, the market, like all Roman buildings of the time, had masonry construction—brick-faced concrete, with only some detailing in stone and wood.

An idea of the splendor of the forum and markets can be gained from another of Trajan's projects in the provinces, a market on the south side of Miletos (in modern Turkey). Markets were an essential part of city life, and improving them with splendid buildings was a way for wealthy families or rulers to gain popular favor. Only

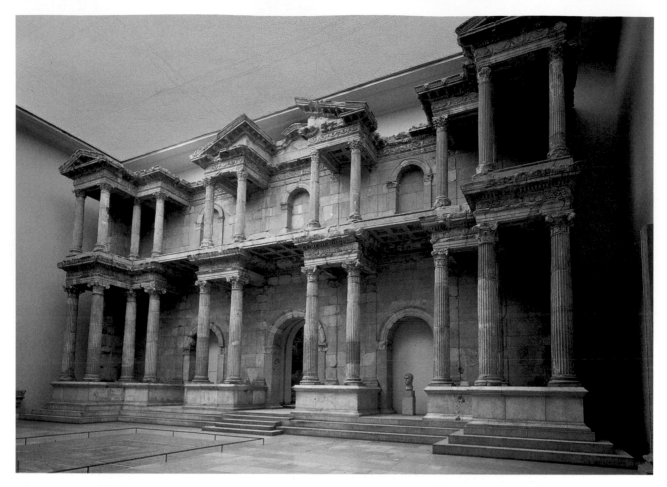

6-30. Market Gate, from Miletos (Turkey). c. 120 CE. Staatliche Museen zu Berlin, Preussischer Kulturbesitz, Antikensammlung

the core of Trajan's Miletos market survives. The gate (fig. 6-30) was added in about 120 CE during the reign of Hadrian. The gate has three arched openings screened by a series of paired columns. On the lower level, the columns are in the Composite order, with capitals formed by superimposing Ionic volutes on Corinthian capitals (see "Roman Architectural Orders," page 229). These Composite columns support short sections of entablature with carved friezes that in turn support the platformlike base of the second level. The shorter Corinthian columns and entablatures on the second level repeat the design of the lower level, except that the two center pairings support a **broken pediment**, which consists of the ends of a typical triangular pediment without a middle section. Such an elaborate building was not necessary for the market's operations—rather, it is symbolic architecture: architecture as propaganda for the power and glory of Rome. The intention of the patrons of structures like the gate at Miletos was to impress the populace.

Life in the city could be festive and exciting. In a way, Romans were as sports-mad as modern Americans, and the Flavian emperors catered to their taste by building the Colosseum, Rome's greatest arena (fig. 6-31). Construction on the arena began under Vespasian in 72 CE and was completed under Titus, who dedicated it in 80 CE as the Flavian Amphitheater. The name "Colosseum," by which it came to be known, was derived from a gigantic statue of Nero called the *Colossus* standing

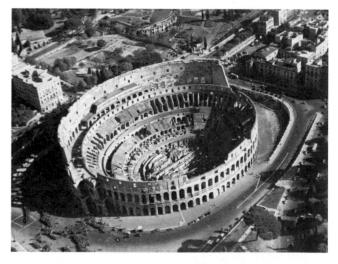

6-31. Colosseum, Rome. 72–80 CE

In July 2000, after a lapse of 1,500 years, audiences again paid to see performances at the Colosseum. A stage built to cover 4,300 square feet of the original 29,000-foot arena, part of a restoration and protection project, enabled an audience of 700 people to see adaptations of three ancient Greek tragedies by Sophocles where 70,000 once watched gladiators and beasts in mortal combat.

next to it. But *Colosseum* is a most appropriate description of this enormous entertainment center. It is an oval, measuring 615 by 510 feet, with a floor 280 by 175 feet, and it is 159 feet high. Roman audiences watched a variety of athletic events and spectacles, including animal hunts, fights to the death between gladiators or between gladiators and wild animals, performances of trained animals and acrobats, and even mock sea battles, for which the arena could be flooded. The opening performances in 80 CE lasted 100 days, during which time it was claimed that 9,000 wild animals and 2,000 gladiators died for the amusement of the spectators.

The floor of the Colosseum was laid over a foundation of service rooms and tunnels that provided an area for the athletes, performers, animals, and equipment. This floor was covered by sand, or *arena* in Latin, hence the English term "arena." Some 55,000 spectators could easily move through the seventy-six entrance doors to the three levels of seats and the standing area at the top. Each had an uninterrupted view of the spectacle below. Stadiums today are still based on this efficient plan. The Colosseum derived its oval shape—the amphitheater—from the idea of two theaters placed facing each other. Ascending tiers of seats were laid over barrel-vaulted access corridors and entrance tunnels connecting the ring corridors to the ramps and seats on each level (fig. 6-32). The intersection of the barrel-vaulted entrance tunnels and the ring corridors created what are called **groin vaults** (see "Arch, Vault, and Dome," page 226). The walls on the top level of the arena supported a huge awning that could shade the seating areas. Sailors who had experience in handling ropes, pulleys, and large expanses of canvas worked the apparatus that extended the sun screen.

The curving, outer wall of the Colosseum consists of three levels of arcades surmounted by a wall-like **attic** (top) **story**. Each arch in the arcades is framed by engaged columns. Entablaturelike friezes mark the divisions between levels (fig. 6-33). Each level also uses a different architectural order, increasing in complexity from bottom to top: the plain Tuscan order on the ground level, the Ionic on the second level, the Corinthian on the third, and Corinthian pilasters on the fourth. The attic story is broken by small, square windows, which originally alternated with gilded bronze shield-shaped ornaments called **cartouches**. The cartouches were supported on brackets that are still in place and can be seen in the illustration. Engaged Corinthian pilasters above the Corinthian columns of the third level support another row of corbels beneath the projecting cornice. All of these elements are purely decorative and serve no structural function. As we saw in the Porta Augusta (see fig. 6-2), the addition of

6-32. Colosseum. View of a radial passage with barrel and groin vaulting

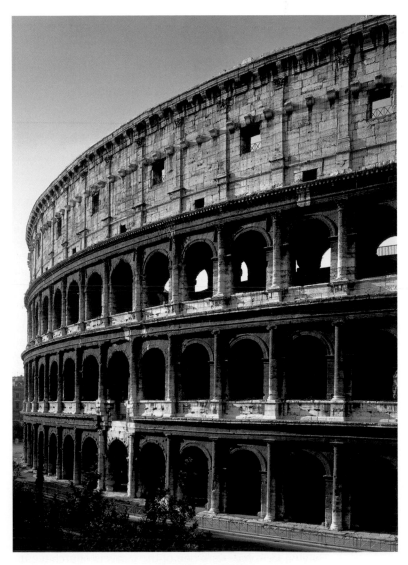

6-33. Colosseum

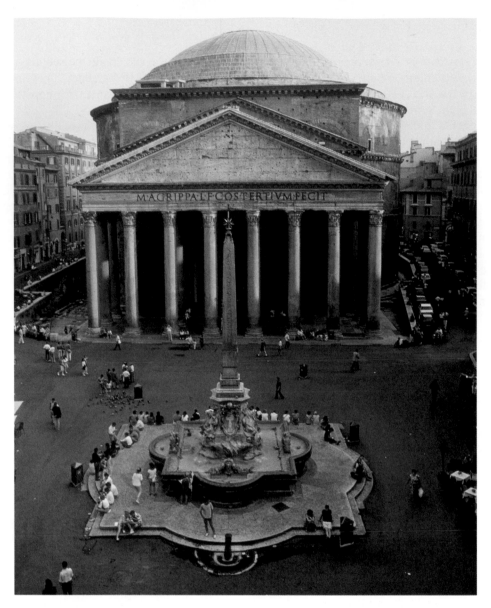

6-34. Pantheon, Rome. 125–28 CE

Originally the Pantheon stood on a podium and was approached by stairs from a colonnaded square. The difference in height of the street levels of ancient and modern Rome can be seen at the left side of the photograph. Although this magnificent monument was designed and constructed entirely during the reign of the emperor Hadrian, the long inscription on the architrave states that it was built by "Marcus Agrippa, son of Lucius, who was consul three times." Agrippa, the son-in-law and valued adviser of Augustus, was responsible for building on this site in 27–25 BCE a temple to all the gods, a pantheon, which later burned. Agrippa died in 12 BCE, but Hadrian, who had a strong sense of history, placed Agrippa's name on the facade in a grand gesture to the memory of the illustrious consul rather than using the new building to memorialize himself. Septimius Severus and Caracalla restored the Pantheon in 202 CE. Attachment holes in the pediment indicate the placement of sculpture, perhaps an eagle.

post-and-lintel decoration to arched structures was an Etruscan innovation. The systematic use of the orders in a logical succession from sturdy Tuscan to lighter Ionic to decorative Corinthian follows a tradition inherited from Hellenistic architecture. This orderly, dignified, and visually satisfying way of organizing the facades of large buildings is still popular. Unfortunately, much of the Colosseum was dismantled as a source of marble, metal fittings, and materials for later buildings.

Perhaps the most remarkable ancient building surviving in Rome—and one of the marvels of architecture in any age—is a temple to the Olympian gods called the Pantheon (literally "all the gods"). It was completed under the patronage of Hadrian between 125 and 128 CE on the site of an earlier temple that had been erected in 27 BCE to commemorate the defeat of Anthony and Cleopatra but had burned in 110 CE.

The approach to the temple gives little suggestion of its original appearance. Centuries of dirt and street construction hide its podium and stairs. Nor is there any hint of what lies beyond the entrance porch, which resembles the facade of a typical Roman temple (fig. 6-34). Behind this porch is a giant rotunda with 20-foot-thick walls that rise nearly 75 feet. The walls support a bowl-shaped

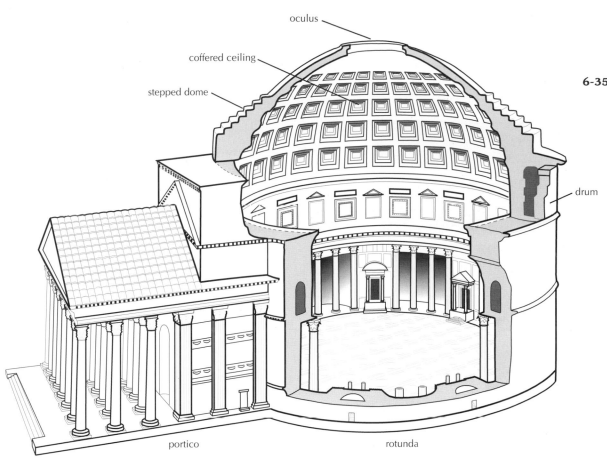

oculus

coffered ceiling

stepped dome

drum

portico

rotunda

6-35. Reconstruction drawing of the Pantheon

Ammianus Marcellinus described the Pantheon in 357 CE as being "rounded like the boundary of the horizon, and vaulted with a beautiful loftiness." Although the Pantheon has inspired hundreds—perhaps thousands—of faithful copies, inventive variants, and eclectic borrowings over the centuries, only recently have the true complexity and the innovative engineering of its construction been fully understood.

dome that is 143 feet in diameter and 143 feet from the floor at its summit (fig. 6-35). Standing at the center of this nearly spherical temple, the visitor feels isolated from the outside world and intensely aware of the shape and tangibility of the space itself rather than the enclosing architectural surfaces. The eye is drawn upward over the circular patterns made by the sunken panels, or **coffers**, in the dome's ceiling to the light entering the 29-foot-wide *oculus*, or central opening (fig. 6-36). Through this opening, the sun pours on clear days; rain falls on wet ones, then drains off as planned by the original engineer; and the occasional bird flies in. The empty, luminous space imparts a sense of apotheosis, a feeling that one could rise buoyantly upward to escape the spherical hollow of the building and commune with the gods.

The simple shape of the Pantheon's dome belies its sophisticated design and engineering. Marble veneer disguises the internal brick arches and concrete structure. The interior walls, which form the **drum** that both supports and buttresses the dome, are disguised by two tiers of architectural detail and richly colored marble (more than half of the original decoration survives)—a wealth of columns, *exedrae*, pilasters, and entablatures. The wall is punctuated by seven niches—rectangular alternating

6-36. Dome of the Pantheon with light from the *oculus* on its coffered ceiling

with semicircular—that originally held statues of gods. This simple repetition of square against circle, which was established on a large scale by the juxtaposition of the rectilinear portico against the rotunda, is found throughout the building. The square, boxlike coffers inside the dome, which help lighten the weight of the masonry, may once have contained gilded bronze **rosettes** or stars suggesting the heavens. In 609 CE, Pope Boniface IV dedicated the Pantheon as the Christian church of Saint Mary and the Martyrs, thus ensuring its survival through the Middle Ages—which brought about the destruction of pagan temples—and to this day.

RELIEF SCULPTURE

Official commissions created the finest Roman art. Among the most admirable is a distinctive Roman structure, the **triumphal arch**. Part architecture, part sculpture, this freestanding arch commemorates a triumph, or formal victory celebration, during which a victorious general or emperor paraded with his troops, captives, and booty through the city after a significant campaign. When Domitian assumed the throne in 81 CE, for example, he immediately commissioned a triumphal arch to honor the capture of Jerusalem in 70 CE by his brother and deified predecessor, Titus (fig. 6-37). The Arch of Titus, constructed of concrete and faced with marble, is essentially a freestanding gateway whose passage is covered by a barrel vault. Originally the whole arch served as a giant base, 50 feet tall, for a statue of a four-horse chariot and driver, a typical triumphal symbol. Applied to the faces of the arch are columns in the Composite order supporting an entablature. The inscription on the attic story declares that the Senate and the Roman people erected the monument to honor Titus.

Titus's capture of Jerusalem ended a fierce campaign to crush a revolt of the Jews in Palestine. The Romans sacked and destroyed the Second Temple in Jerusalem, carried off its sacred treasures, then displayed them in a triumphal procession in Rome. An eyewitness, Jewish historian Josephus (*The Jewish War*), described Titus's triumphal procession:

> The most interesting of all were the spoils seized from the Temple of Jerusalem: a gold table weighing many talents, and a lampstand, also made of gold, which was made in a form different from that which we usually employ. For there was a central shaft fastened to the base; then spandrels [branches] extended from this in an arrangement which rather resembled the shape of a trident, and on the end of each of these spandrels a lamp was forged. There were seven of these, emphasizing the honor accorded the number seven among the Jews. The law of the Jews [Ark of the Covenant] was borne along after these as the last of the spoils . . . Vespasian drove along behind [it] . . . and Titus followed him; Domitian rode beside them, dressed in a dazzling fashion and riding a horse which was worth seeing.

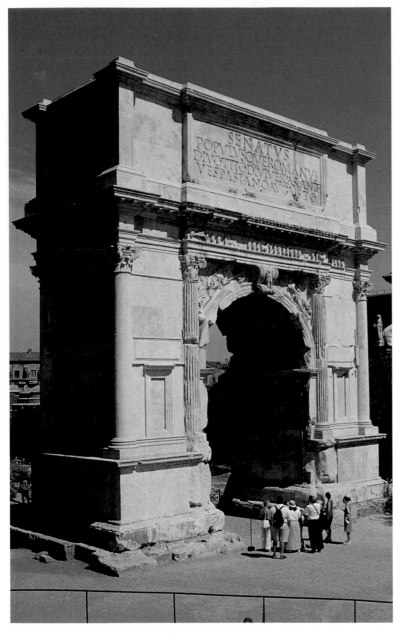

6-37. Arch of Titus, Rome. C. 81 CE. Concrete and white marble, height 50' (15 m)

The dedication inscribed across the tall attic story above the arch opening reads: "The Senate and the Roman People to the Deified Titus Flavius Vespasianus Augustus, son of the Deified Vespasian." The Romans typically recorded historic occasions and identified monuments with solemn prose and beautiful inscriptions in stone. The sculptors' use of elegant Roman capital letters—perfectly sized and spaced to be read from a distance and cut with sharp terminals (serifs) to catch the light—established a standard that calligraphers and alphabet designers still follow.

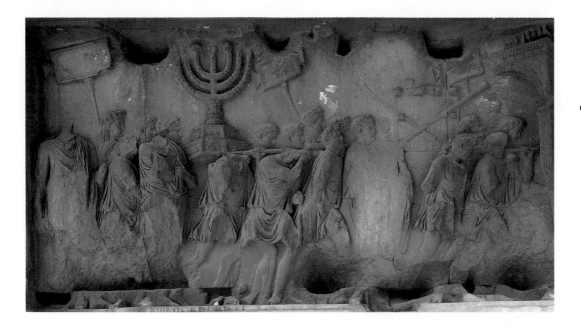

6-38. Spoils from the Temple of Solomon, Jerusalem, relief in the passageway of the Arch of Titus. Marble, height 6'8" (2.03 m)

The reliefs on the inside walls of the arch, capturing the drama of the occasion, depict Titus's soldiers flaunting this booty as they carry it through the streets of Rome (fig. 6-38). The viewer can sense the press of that boisterous, disorderly crowd and might expect at any moment to hear the soldiers and onlookers shouting and chanting.

The mood of the procession depicted in these reliefs contrasts with the relaxed but formal solemnity of the procession portrayed on the Ara Pacis (see fig. 6-23). Like the sculptors of the Ara Pacis, the sculptors of the Arch of Titus showed the spatial relationships among figures by rendering close elements in higher relief than those more distant. A **menorah**, or seven-branched lamp holder (the lampstand described by Josephus), from the Temple of Jerusalem dominates the scene. Reflecting their concern for representing objects as well as people in a believable manner, the sculptors rendered this menorah as if seen from the low point of view of a spectator at the event, and they have positioned the arch on the right through which the procession is about to pass on a diagonal. Using a technique also encountered on the Ara Pacis, the sculptors have undercut the foreground figures and have used low relief for the figures in the background. The panel on the other side of the arch interior shows Titus riding in his chariot as a participant in the ceremonies. On the vaulted ceiling, which shows his apotheosis, an eagle carries him skyward to join the gods.

Sculptors further refined the art of pictorial narrative in the next century, as we see when we revisit the Column of Trajan (see fig. 6-28). The scene at the beginning of the spiral (fig. 6-39), at the bottom of the column, shows Trajan's army crossing the Danube River on a pontoon bridge as the campaign gets under way. A giant river god, the personification of the Danube, supports the bridge of boats.

6-39. Romans Crossing the Danube and Building a Fort, detail of the lowest part of the Column of Trajan. 113–16 CE, or after 117. Marble, height of the spiral band approx. 36" (91 cm)

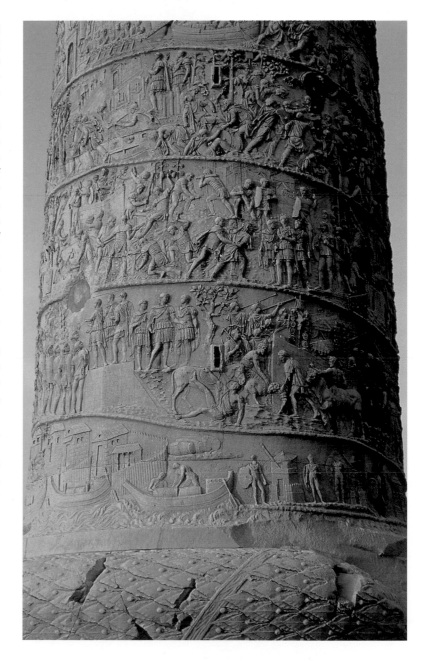

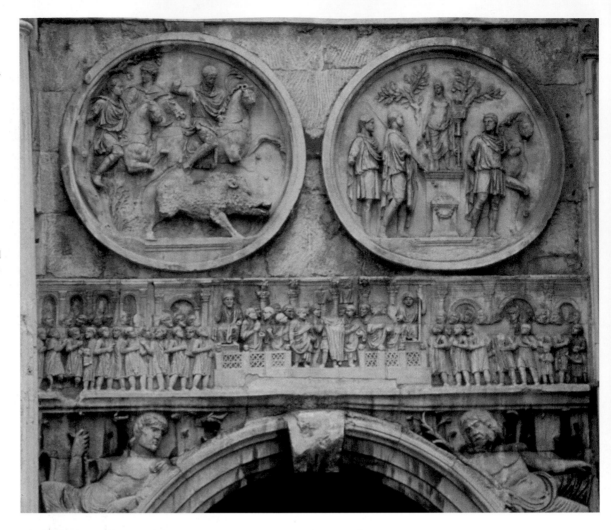

6-40. *Hadrian Hunting Boar and Sacrificing to Apollo*, roundels made for a monument to Hadrian and reused on the Arch of Constantine. Sculpture c.130–38 CE. Marble, roundel diameter 40" (102 cm)

In the fourth century CE, Emperor Constantine had the roundels removed from the Hadrian monument, had Hadrian's head recarved with his own or his father's features, and placed them on his own triumphal arch (see fig. 6-79).

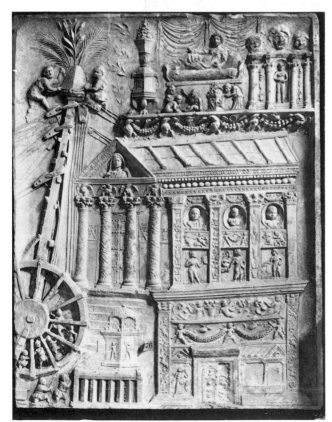

6-41. *Mausoleum under Construction*, relief from the tomb of the Haterius family, Via Labicana, Rome. Late 1st century CE. Marble, height 41" (104 cm). Musei Vaticani, Museo Gregoriano Profano, ex Lateranese, Rome

In the scene above, soldiers have begun constructing a battlefield headquarters in Dacia from which the men on the frontiers will receive orders, food, and weapons. Throughout the narrative—which is a spectacular piece of imperial propaganda—Trajan is portrayed as a strong, stable and efficient commander of a well-run army, but his barbarian enemies are shown as pathetically disorganized and desperate. The hardships of war—death, destruction, and the suffering of innocent people—are ignored, and, of course, the Romans never lose a battle.

Trajan's successor, Hadrian, also used monumental sculpture to vaunt his accomplishments. Several large, circular reliefs, or roundels—originally part of a monument that no longer exists—contain images designed to affirm his imperial stature and right to rule (fig. 6-40). In the scene on the left, he demonstrates his courage and physical prowess in a boar hunt. Other roundels, not included here, show him confronting a bear and a lion. At the right, in a show of piety and appreciation to the gods for their support of his endeavors, Hadrian makes a sacrificial offering to Apollo at an outdoor altar. As did the sculptors of the Column of Trajan, the sculptors of these roundels included elements of a natural landscape setting but kept them relatively small, using them to frame the proportionally larger figures. The idealized heads, form-enhancing drapery, and graceful yet energetic movement of the figures owe a distant debt to the works of Praxiteles and Lysippos (Chapter 5), but the well-observed details of the features and the bits of

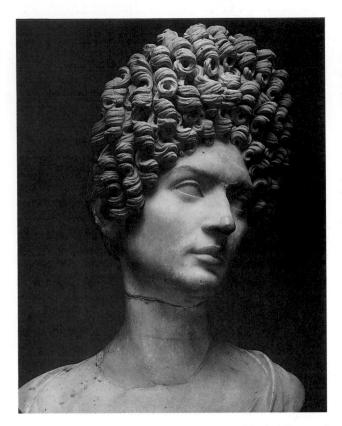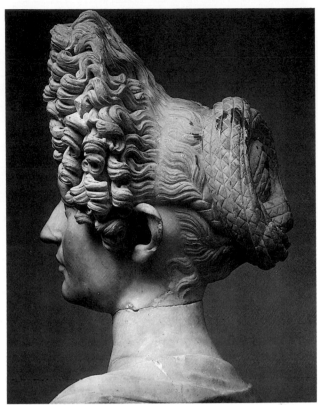

6-42. *Young Flavian Woman*. c. 90 CE. Marble, height 25" (65.5 cm). Museo Capitolino, Rome

The typical Flavian hairstyle seen on this woman and the older woman in figure 6-43 required a patient hairdresser handy with a curling iron and with a special knack for turning the back of the head into an intricate basketweave of braids. Male writers loved to scoff at the results. Martial described the style precisely as "a globe of hair." Statius spoke of "the glory of woman's lofty front, her storied hair." And Juvenal waxed comically poetic: "See her from the front; she is Andromache [an epic heroine]. From behind she looks half the size—a different woman you would think" (cited in Balsdon, page 256).

landscape are characteristically Roman. Much of the sculpture of the mid-second century CE shows the influence of Hadrian's love of Greek art, and for a time Roman artists achieved a level of idealized figural depiction close to that of Classical Greece.

Not all Roman sculpture was as sophisticated as the imperial reliefs. Lesser artists worked for less affluent patrons. A relief on the mausoleum of the plebeian Haterius family (fig. 6-41) shows a gigantic, human-powered crane at the left being maneuvered into place over the still-unfinished mausoleum. Funerary reliefs typically honor the dead with portraits, garlands, and narrative themes—sometimes of mythological figures, sometimes of biographical scenes associated with the deceased. Because this relief commemorates the construction of the mausoleum itself, some scholars believe that the deceased may have been an architect or a builder. The mausoleum under construction is an encyclopedia of decorative motifs—**egg-and-dart** moldings, garlands looped in swags, busts in shell-shaped niches, symmetrical vegetal reliefs, and robust Corinthian columns, heavily carved with spiraling garlands. The sculptor sacrificed clarity in order to convey as much information as possible.

The sculptors and patrons responsible for the reliefs on the Haterius family tomb were probably relatively unsophisticated, though quite clear about what they wanted. The sculptural style that emerged from such commissions was characterized by crowded compositions and deeply undercut forms, stocky figures, and detailed but visually unrealistic images.

PORTRAIT SCULPTURE

Roman patrons demanded likenesses in their portraits. However, sometimes they preferred some idealization of the sitter and at other times wanted an exact image. The portrait of a young Flavian woman, whose identity is not known (fig. 6-42), exemplifies the idealized portrait type, in the manner of the *Augustus of Primaporta* (see fig. 6-20). The well-observed, recognizable features—a strong nose and jaw, heavy brows, deep-set eyes, and a long neck contrast with the smoothly rendered flesh and soft, full lips. (The portrait suggests the retouched fashion photos of today.) The hair is piled high in an extraordinary mass of ringlets in the latest court fashion. Executing the head required skillful chiseling and drill-work, a technique for rapidly cutting deep grooves with straight sides, as was done here to render the holes in the center of the curls. The overall effect, from a distance, is very lifelike. The play of natural light over the more subtly sculpted surfaces gives the illusion of being reflected

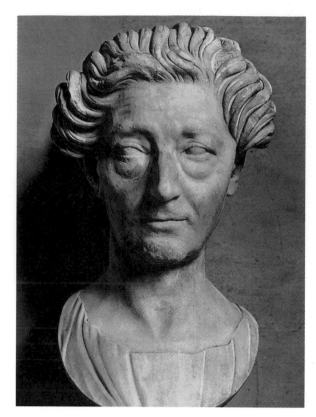

6-43. *Middle-Aged Flavian Woman*. Late 1st century CE. Marble, height 9¹/₂" (24.1 cm). Musei Vaticani, Museo Gregoriano Profano, ex Lateranese, Rome

off real skin and hair, yet closer inspection reveals a portrayal too perfect to be real.

A more realistic approach, exemplified by a bust of an older woman (fig. 6-43), reflects a revival of the verist style popular in the Republican period. Comic writers of the Flavian era liked to satirize older women who vainly sought to preserve their youthful looks, but the subject of this portrait, though she too wore her hair in the latest style, was apparently not preoccupied with her appearance. The work she commissioned shows her just as she appeared in her own mirror, with all the signs of age recorded on her face.

In contrast to the Roman taste for realism, Hadrian preferred and commissioned an idealized style. The widely traveled emperor admired Greek sculpture but had also seen the arts of other cultures. He liked to combine his favorite images in new works. A remarkable example of how styles could be merged is a portrait of his handsome young friend Antinous, who drowned in the Nile in 130 CE (fig. 6-44). Hadrian ordered that Antinous be deified and become the object of a cult. Represented in sculpture as an ideally beautiful youth, Antinous remains clearly recognizable with distinctive facial features and a slightly flabby body. He assumes the pose of an Egyptian king wearing the royal kilt and headdress. This **syncretic** image, with its combination of Greek, Roman, and Egyptian elements, is distinctly unsettling, for all its sleek perfection.

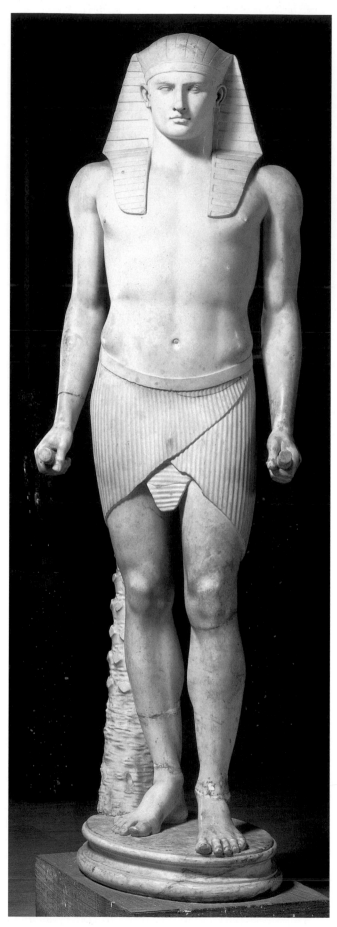

6-44. *Antinous*, from Hadrian's Villa at Tivoli. c. 130–38 CE. Marble, height 8' (2.41m)
Museo Gregoriano Egizio, Rome

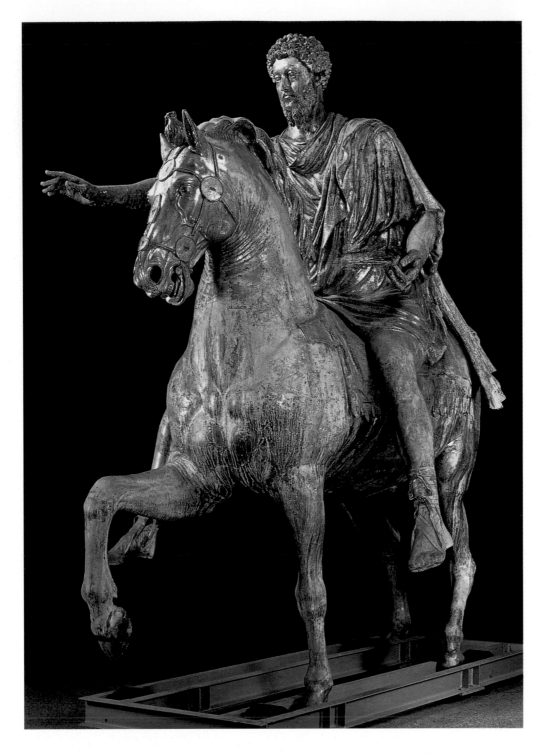

6-45. Equestrian statue of Marcus Aurelius (after restoration). c. 176 CE. Bronze, originally gilded, height of statue 11'6" (3.5 m). Museo Capitolino, Rome

Between 1187 and 1538, this statue stood in the piazza fronting the palace and church of Saint John Lateran in Rome. In January 1538, Pope Paul III had it moved to the Capitoline Hill. After being removed from its base for cleaning and restoration work some years ago, it was taken inside the Capitoline Museum to protect it from air pollution, and a copy replaced it in the piazza.

Imperial portraits—realistic or not—contain an element of propaganda. Marcus Aurelius, like Hadrian, was a successful military commander who was equally proud of his intellectual attainments. In a lucky error—or twist of fortune—a gilded bronze equestrian statue of the emperor (fig. 6-45) came early but mistakenly to be revered as a statue of Constantine, known in the Middle Ages as the first Christian emperor. Consequently the statue escaped being melted down, a fate that befell all other bronze equestrian statues from antiquity. The emperor is dressed as a military commander in a tunic and short, heavy cloak. The raised foreleg of his horse once trampled a crouching barbarian. Marcus Aurelius's head, with its thick, curly hair and full beard (a style that was begun by Hadrian to enhance his intellectual image), resembles the traditional "philosopher" portraits of the Republican period. The emperor wears no armor and carries no weapons; like Egyptian kings, he conquers effortlessly by the will of the gods. And like his illustrious predecessor Augustus, he reaches out to the people in a persuasive, beneficent gesture.

It is difficult to create an equestrian portrait in which the rider stands out as the dominant figure without making the horse look too small. The sculptor of this statue found a balance acceptable to viewers of the time and, in doing so, created a model for later artists. The horse's high-arched neck, massive head, and short body suggest that it is from a Spanish breed of strong, compact, agile animals prized as war steeds.

Marcus Aurelius was succeeded as emperor by his son Commodus, a man lacking political skill, administrative

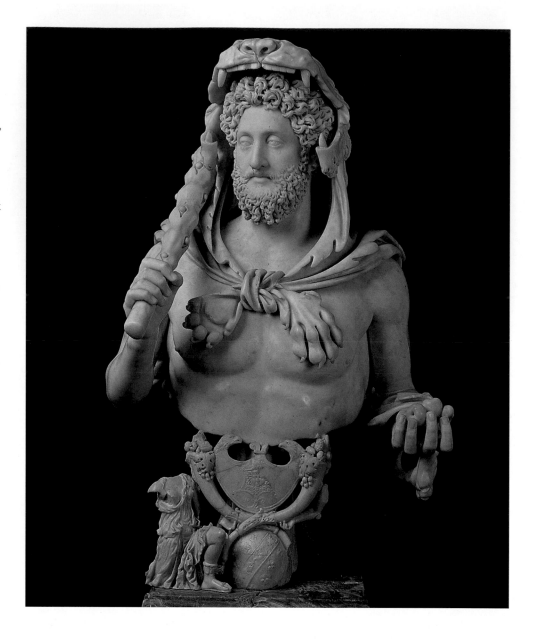

6-46. *Commodus as Hercules*, from Esquiline Hill, Rome. c. 191–2 CE. Marble, height 46½" (118 cm). Palazzo dei Conservatori, Rome

The emperor Commodus was not just decadent—he was probably insane. He claimed at various times to be the reincarnation of Hercules and the incarnation of the god Jupiter, and he even appeared in public as a gladiator. He ordered the months of the Roman year to be renamed after him and changed the name of Rome to Colonia Commodiana. When he proposed to assume the consulship dressed and armed as a gladiator, his associates, including his mistress, arranged to have him strangled in his bath by a wrestling partner. In this portrait, the emperor is shown in the guise of Hercules, adorned with references to the hero's legendary labors: his club, the skin and head of the Nemean Lion, and the golden apples from the garden of the Hesperides.

competence, and intellectual distinction. During his unfortunate reign (180–92 CE), he devoted himself to luxury and frivolous pursuits. He did, however, attract some of the finest artists of the day for his commissions. A marble bust of Commodus posing as Hercules reflects his character (fig. 6-46). The sculptor's sensitive modeling and expert drillwork exploit the play of light and shadow on the figure and bring out the textures of the hair, beard, facial features, and drapery. The portrait conveys the illusion of life and movement, but it also captures its subject's weakness. The foolishness of the man comes through in his pretentious assumption of the attributes of Hercules.

THE ROMAN CITY AND HOME

Through good times and bad, individual Romans—like people everywhere at any time—tried to live a decent or even comfortable life with adequate shelter, food, and clothing. Their poets and historians tell us that Romans were genuinely attached to the land, but they were essentially city dwellers. Today their cities and towns, houses, apartments, and country villas evoke the ancient Roman way of life with amazing clarity through the efforts of the modern archaeologists who have excavated them.

Such archaeological sites as Pompeii, Timgad, Ostia, and Tivoli, as well as those in Rome itself, illustrate different kinds of Roman cities and lifestyles. The affluent southern Italian city of Pompeii was a thriving center of about 20,000 inhabitants on the day in 79 CE that Mount Vesuvius erupted, burying it under more than 20 feet of volcanic ash. An ancient village that had grown and spread over many centuries, Pompeii lacked the gridlike regularity of newer, planned Roman cities (as we will see at Timgad), but its layout is typical of cities that grew over time. Temples and government buildings surrounded a main square, or forum; shops and houses lined straight paved streets; and a protective wall enclosed the heart of the city. The forum was the center of civic life in Roman towns and cities, as the agora was in Greek cities. Business was conducted in its basilicas and pavilions, religious duties performed in its temples,

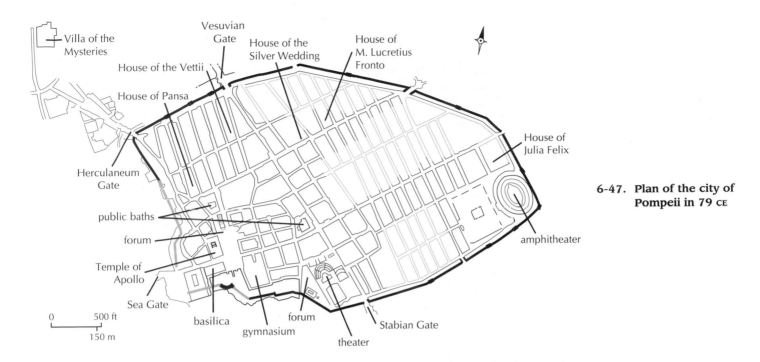

6-47. Plan of the city of Pompeii in 79 CE

Villa of the Mysteries
Vesuvian Gate
House of the Silver Wedding
House of M. Lucretius Fronto
House of the Vettii
House of Pansa
Herculaneum Gate
House of Julia Felix
public baths
forum
Temple of Apollo
Sea Gate
basilica
gymnasium
forum
theater
Stabian Gate
amphitheater

0 500 ft
150 m

6-48. Hadrian's Wall, Great Britain. 2nd century CE. View from near Housesteads, England

and speeches presented in its open square. For recreation, people went to the nearby baths or to events in the theater or amphitheater (fig. 6-47).

The people of Pompeii lived in houses behind or above rows of shops. Even upper-class homes—gracious private residences with gardens—often had street-level shops. If there was no shop, the wall facing the street was usually broken only by a door, for the Romans emphasized the interior rather than the exterior in their domestic architecture.

In contrast to a city like Pompeii, which sprawled as it grew from its ancient, village origins, newer cities followed a design based on Roman army camps. The Roman army skillfully built sturdy walls and forts at outposts throughout the empire. Hadrian's Wall, in northern Britain, is a singularly well preserved example of these structures (fig. 6-48). This stone barrier snakes from coast to coast across a narrow (80-mile-wide) part of Britain, creating a symbolic as well as a physical boundary between Roman territory and that of the "barbarian" Picts and Scots to the north. Seventeen large camps housed forces ready to respond to any trouble. These camps were laid out in a grid, with two main streets crossing at right angles dividing them into quarters; the commander's headquarters was located at their intersection.

Roman architects who designed frontier towns, new cities, and forts or who expanded and rebuilt existing ones based the urban plan on the layout of the army camp. Adopting the grid plan of the Etruscan and later

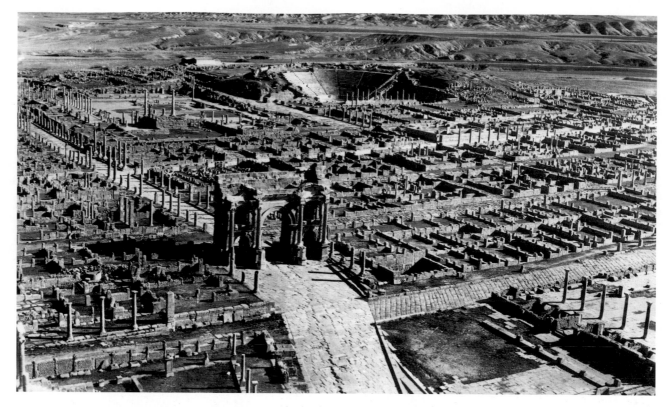

6-49. Ruins of Timgad, Algeria. Begun c. 100 CE

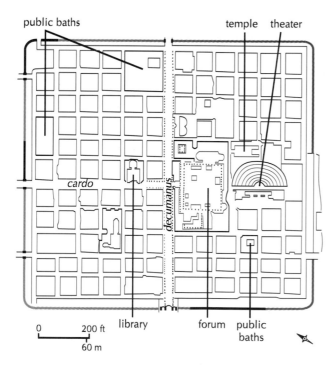

6-50. Plan of Timgad

Greek cities, they divided towns into four quarters defined by intersecting north-south and east-west avenues, called, respectively, the *decumanus* and the *cardo* by modern archaeologists. The forum and other public buildings were located at this intersection, just as the commander's headquarters had been in a camp. Terrain and climate had little effect on the symmetry of this simple, efficient plan. It remained much the same throughout the empire.

Some of the new towns designed along these lines in the outlying reaches of the empire were built by the imperial administration for the soldiers who had defended its borders. For example, in North Africa, Trajan founded a new town for retired soldiers and their families at Timgad (in modern Algeria). Timgad was once home to 15,000 people (fig. 6-49).

Timgad covered about 30 acres with two main streets dividing the grid into four equal districts with a central forum. Amenities included a theater, a library, and several public baths. An elaborate arch marked the main entrance to the town and the beginning of a colonnaded avenue. The streets were paved with precisely cut and fitted ashlar blocks (fig. 6-50).

Another city type can be seen in the remains of Ostia, the port of ancient Rome, a commercial city with a population of 100,000 at its height, during the empire. Laid out for the convenience of merchants and traders with a very long main street paralleling the Tiber River, Ostia had large public squares, shops, and a special square for the seventy large businesses that had their headquarters there. Mosaic floors, designed with appropriate traders' emblems, identified each office. A temple to the imperial

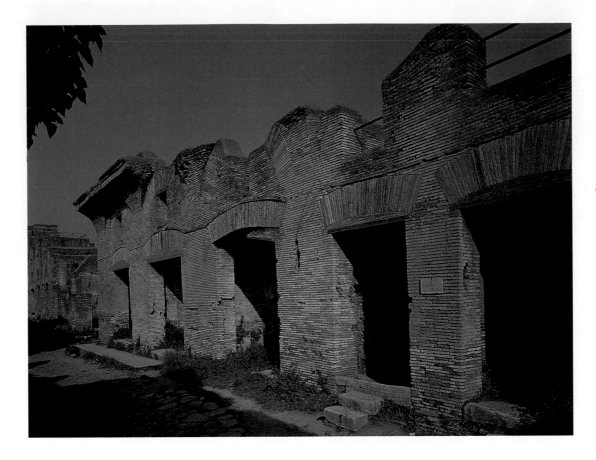

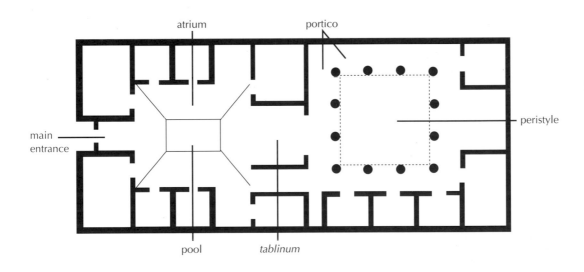

atrium

portico

6-52. **Plan of a typical Roman house**

peristyle

main entrance

pool

tablinum

grain supply (which was worshiped like a god) stood in the center of the square.

Much of the housing in a Roman city such as Ostia consisted of brick apartment blocks (fig. 6-51), referred to as *insulae* ("islands"). These apartment buildings with their internal courtyards, multiple floors, narrow staircases, and occasional overhanging balconies give a better picture of typical Roman city life than the luxurious villas of Pompeii (see fig. 6-59), although Ostia had a garden-filled section too. Although most of the apartments might seem cramped to us, Roman city dwellers—then as now—were social creatures who lived much of their lives in public markets, squares, theaters, baths, and neighborhood bars. The city dweller returned to the *insulae* to sleep, perhaps to eat. Even women enjoyed a public life outside the home—a marked contrast to the circumscribed lives of Greek women.

DOMESTIC ARCHITECTURE

A Roman house usually consisted of small rooms laid out symmetrically around one or two open courts (fig. 6-52). From the entrance, a corridor led to the atrium, a large space with a shallow pool or cistern for catching

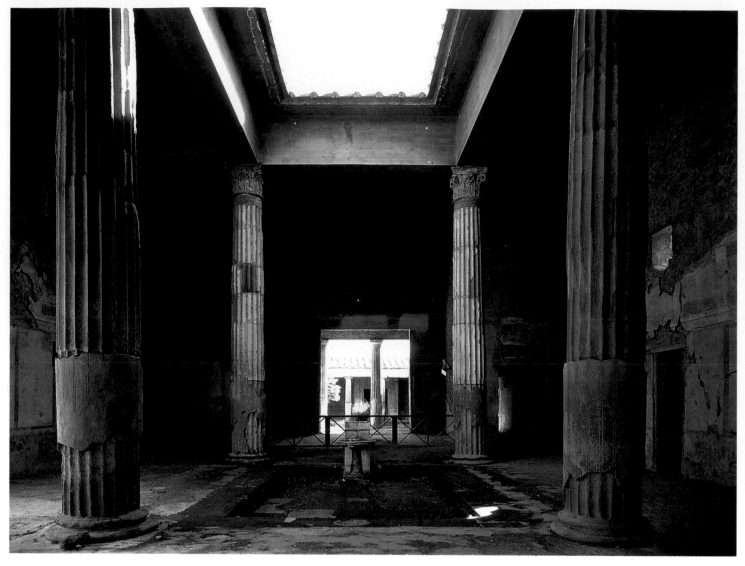

6-53. Atrium, House of the Silver Wedding, Pompeii. Early 1st century CE

Ancient Roman houses excavated at Pompeii and elsewhere are usually simply given numbers by archaeologists or (if known) named after the families or individuals who once lived in them. This house received its unusual name as a commemorative gesture. It was excavated in 1893, the year of the silver wedding anniversary of Italy's King Humbert and his wife, Margaret of Savoy, who had supported archaeological fieldwork at Pompeii.

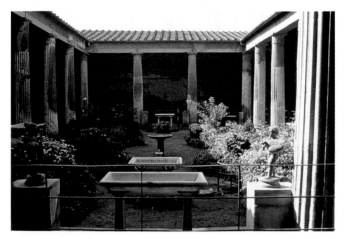

6-54. Peristyle garden, House of the Vettii, Pompeii. Mid-1st century CE

rainwater (fig. 6-53). This organization of the front part of the house—the centrally located atrium surrounded by small rooms—originated with the Etruscans. Beyond the atrium, in a reception room called the **tablinum**, where the head of the household conferred with clients, portrait busts of the family's ancestors might be displayed. In large houses, the *tablinum* opened onto a peristyle, a garden surrounded by a colonnaded walkway or portico. The most private areas—such as the dining room, the family sitting room, bedrooms, the kitchen, and servants' quarters—usually were entered from the peristyle.

The nature-loving Romans softened the regularity of their homes with beautifully planted gardens (see "The Urban Garden," page 266). Larger residences often had both fruit and vegetable gardens. In Pompeii, where the mild southern climate permitted gardens to flourish year-round, the peristyle was often turned into an outdoor living room with painted walls, fountains, and sculpture, as in the mid-first-century CE House of the Vettii (fig. 6-54).

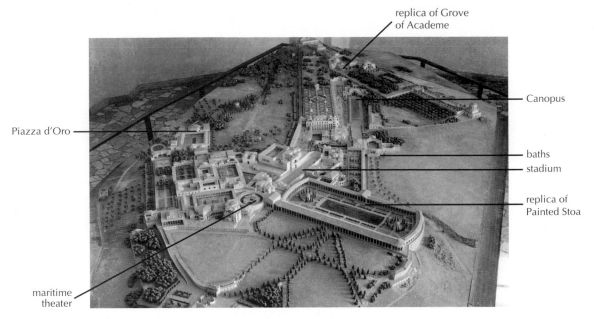

replica of Grove
of Academe

Canopus

baths

stadium

replica of
Painted Stoa

Piazza d'Oro

maritime
theater

6-55. Model of Hadrian's Villa, Tivoli. C. 135 CE

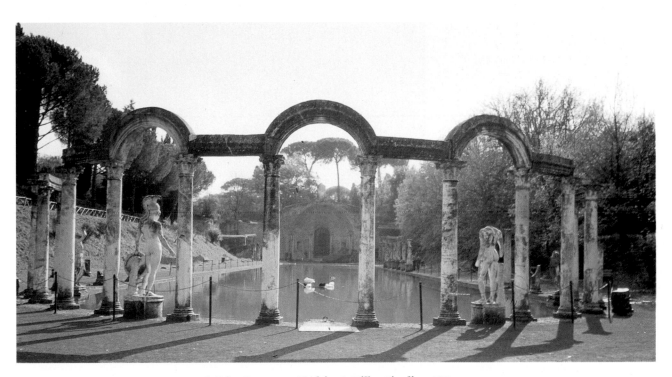

6-56. Canopus, Hadrian's Villa, Tivoli. C. 135 CE

To imagine Roman life at its most luxurious, however, one must go to Tivoli, a little more than 20 miles from Rome. Here, Hadrian, a great patron whose undertakings extended beyond public architecture, instructed his architects to re-create his favorite places throughout the empire in fantasy rather than actuality. In his splendid villa, he could pretend to enjoy the Athenian Grove of Academe where Plato had founded his academy, the Painted Stoa from the Athenian Agora, and buildings of the Ptolemaic capital of Alexandria, Egypt. Hadrian's Villa was not a single building but an architectural complex of many buildings, lakes, and gardens spread over half a square mile (fig. 6-55). Each section had its own inner logic, and each took advantage of natural land formations and attractive views. The individual buildings were not large, but they were extremely complex, challenging the ingenuity of Roman builders and engineers, who exploited to the fullest the flexibility offered by concrete and vaulted construction. Walls and floors had veneers of marble and travertine or exquisite mosaics and paintings. Landscapes with pools, fountains, and gardens turned the villa into a place of sensuous delight. An area with a long reflecting pool, called the Canopus after a site near Alexandria, was framed by a colonnade with alternating semicircular and straight entablatures (fig. 6-56). Copies of famous Greek statues, and sometimes even the originals, filled the spaces between the columns. So great was Hadrian's love of Greek sculpture that he even had the caryatids of the Erechtheion (see fig. 5-48) replicated for his pleasure palace.

THE URBAN GARDEN

The remains of urban gardens preserved in the volcanic fallout at Pompeii have been the focus of a decades-long study by archaeologist Wilhelmina Jashemski. Her work has revealed much about the layout of ancient Roman gardens and the plants cultivated in them. Early archaeologists, searching for more tangible remains, usually destroyed evidence of gardens, but in 1973 Jashemski and her colleagues had the opportunity to work on the previously undisturbed **peristyle** garden—a planted interior court enclosed by columns—of the House of G. Polybius in Pompeii. Workers first removed layers of debris and volcanic material to expose the level of the soil as it was before the eruption in 79 CE. They then collected samples of pollen, seeds, and other organic material and carefully injected plaster into underground root cavities to make casts for later study. These materials enabled botanists to identify the types of plants and trees cultivated in the garden, to estimate their size, and to determine where they had been planted.

The evidence from this and other excavations indicates that most urban gardens served a practical function. They were planted with fruit- and nut-bearing trees and occasionally with olive trees. Only the great luxury gardens were rigidly landscaped. Most gardens were randomly planted or, at best, arranged in irregular rows. Some houses had both peristyle gardens and separate vegetable gardens.

The garden in the house of Polybius was surrounded on three sides by a **portico**, which protected a large cistern on one side that supplied the house and garden with water. Young lemon trees in pots lined the fourth side of the garden, and nail holes in the wall above the pots indicated that the trees had been espaliered—pruned and trained to grow flat against a support—a practice still in use today. Fig, cherry, and pear trees filled the garden space, and traces of a fruit-picking ladder, wide at the bottom and narrow at the top to fit among the branches, was found on

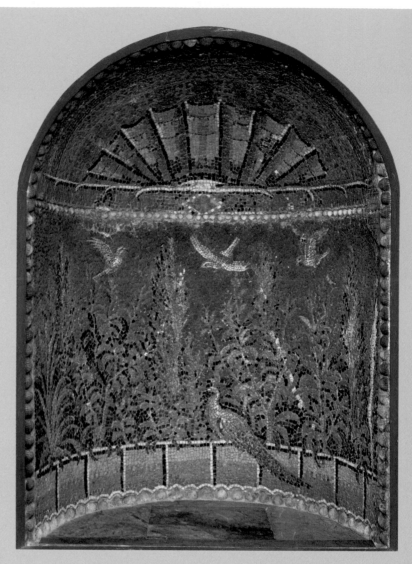

Wall niche, from a garden in Pompeii. Mid-1st century CE. Mosaic, 43³/4 x 31¹/2" (111 x 80 cm). Fitzwilliam Museum, University of Cambridge, England

the site. This evidence suggests that the garden was a densely planted orchard similar to the one painted on the dining-room walls of the villa of Empress Livia in Primaporta (see fig. 6-61).

An aqueduct built during the reign of Augustus had given Pompeii's residents access to a reliable and plentiful supply of water, eliminating their dependence on wells and rainwater basins and allowing them to add to their gardens pools, fountains, and flowering plants that needed heavy watering. In contrast to the earlier, unordered plantings, formal gardens with low, clipped borders and plantings of ivy, ornamental boxwood, laurel, myrtle, acanthus, and rosemary—all mentioned by writers of the time—became fashionable. There is also evidence of topiary work, the clipping of shrubs and hedges into fanciful shapes. Sculpture and purely decorative fountains became popular. The peristyle garden of the House of the Vettii, for example, had more than a dozen fountain statues jetting water into marble basins (see fig. 6-54). In the most elegant peristyles, mosaic decorations covered the floors, walls, and even the fountains. Some of the earliest wall mosaics, such as the one illustrated here, were created as backdrops for fountains.

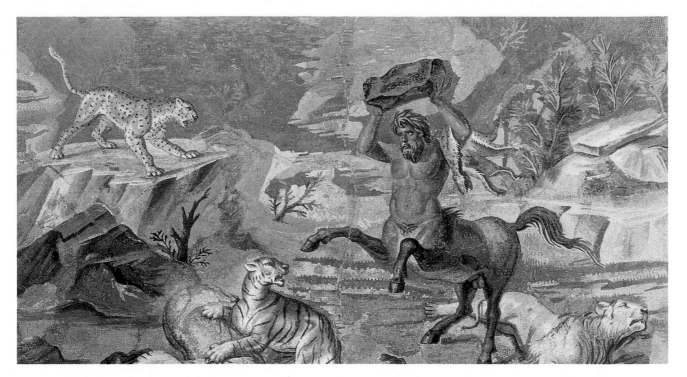

6-57. *Battle of Centaurs and Wild Beasts*, from Hadrian's Villa, Tivoli. c. 118–28 CE. Mosaic, 23 x 36" (58.4 x 91.4 cm). Staatliche Museen zu Berlin, Preussischer Kulturbesitz, Antikensammlung

This floor mosaic may be a copy of a much-admired painting of a fight between centaurs and wild animals done by the late-fifth-century BCE Greek artist Zeuxis.

Hadrian did more than copy his favorite cities; he also added to them. For example, he finished the Temple of the Olympian Zeus in Athens and dedicated it in 132 CE (see fig. 5-73). He also built a library, a stoa, and an aqueduct for the Athenians and according to Pausanias placed a statue of himself inside the Parthenon.

MOSAICS

Pictorial mosaics covered the floors of fine houses, villas, and public buildings throughout the empire. Working with very small ***tesserae*** (cubes of glass or stone) and a wide range of colors, mosaicists achieved remarkable illusionistic effects (see "Roman Mosaics," below). The ***emblemata***, or panels, from a floor mosaic from Hadrian's Villa at Tivoli illustrate extraordinary artistry (fig. 6-57). In a rocky landscape with only a few bits of greenery, a desperate male centaur raises a large boulder over his head to crush a tiger that has attacked and severely wounded a female centaur. Two other felines apparently took part in the attack—the white leopard on the rocks to the left and the dead lion at the feet of the male centaur. The mosaicist rendered the figures with three-dimensional shading, **foreshortening**, and a great sensitivity to a range of figure types, including human torsos and powerful animals, living and dead, in a variety of poses.

TECHNIQUE
ROMAN MOSAICS

Mosaics were used widely in Hellenistic times and became enormously popular for decorating homes in the Roman period. **Mosaic** designs were created with pebbles or with small, regularly shaped pieces of colored stone and marble, called ***tesserae***. The stones were pressed into a kind of soft cement called grout. When the stones were firmly set, the spaces between them were also filled with cement. After the surface dried, it was cleaned and polished. At first, mosaics were used mainly as durable, water-resistant coverings on floors and pavements. They were done in a narrow range of colors depending on the natural color of the stone—often earth tones or black or some other dark color on a light background. When mosaics began to appear on walls at outdoor fountains, a wide range of colors was used (see "The Urban Garden," page 266). So accomplished were some mosaicists that they could create works that looked like paintings. In fact, at the request of patrons, they often copied well-known paintings employing a technique in which very small *tesserae*, in all the needed colors, were laid down in irregular, curving lines that very effectively mimicked painted brushstrokes.

Mosaic production was made more efficient by the development of ***emblemata*** (the plural of *emblema*, "central design"). These small mosaic compositions were created in the artist's workshop in square or rectangular trays. They could be made in advance, carried to a work site, and inserted into a floor otherwise decorated with a simple background mosaic in a plain or geometric pattern.

THE UNSWEPT FLOOR

In his twenty-book work of comic genius, *Satyricon*, the first-century CE Roman satirist Petronius created one of the all-time fantastic dinner parties. *Trimalchio's Feast* (*Cena Trimalchionis*, Book 15) exposes the newly rich Trimalchio, who entertains his friends at a lavish banquet where he shows off his extraordinary wealth but also his boorish ignorance and bad manners. Unlike the Greeks, whose banquets were quite private affairs, reflecting their more spare material culture, Romans such as Trimalchio used such occasions to display their possessions. When dishes are broken, Trimalchio orders his servants to sweep them away with the rubbish on the floor.

In *The Unswept Floor* mosaic, the remains of fine food from a party such as Trimalchio's—from lobster claws to cherry pits—litter the floor (fig. 6-58). In the dining room where this segment was found, mosaics covered the floor along three walls. Because Romans arranged their dining rooms with three-person couches on three sides of a square table, the family and guests would have seen the fictive remains of past gourmet pleasures under their couches. Such a festive Roman dinner might have begun with appetizers of eggs, shellfish, dormice, and olives; continued with as many as seven courses, including a whole roasted pig (or ostrich, crane, or peacock), veal, and several kinds of fish; and ended with dessert of snails, nuts, shellfish, and fruit.

If art speaks to and of the ideals of a society, what does it mean that wealthy Romans commemorated their table scraps in mosaics of the greatest subtlety and skill? Is this a form of conspicuous consumption, proof positive that the owner of this house gave lavish banquets and hosted guests who had the kind of sophisticated humor that could appreciate *Trimalchio's Feast*? The Romans did in fact place a high value on displaying their wealth and taste in the semipublic rooms and gardens of their houses and villas, and they did so through their possessions, especially their art collections. *The Unswept Floor* is but one of a very large number of Roman copies of great Greek mosaics and paintings, such as *Alexander the Great Confronts Darius III* (see fig. 5-67), and sculptures such as Myron's *Discus Thrower* (see fig. 5-1). Julius Caesar owned a version of the *Dying Gallic Trumpeter* (see fig. 5-75); a *Laocöon* (see fig. 5-79) belonged to Nero; and a copy of Polykleitos's *Spear Bearer* (see fig. 5-51) was in the baths at Hadrian's Villa.

In the case of *The Unswept Floor*, Herakleitos, a second-century CE Greek mosaicist living in Rome, made this copy of an illusionistic painting by the renowned second-century BCE Pergamene artist Sosos. Consequently, the guests reclining on their banquet couches could have displayed their knowledge of the history of art—of the notable precedents for the trash on the floor.

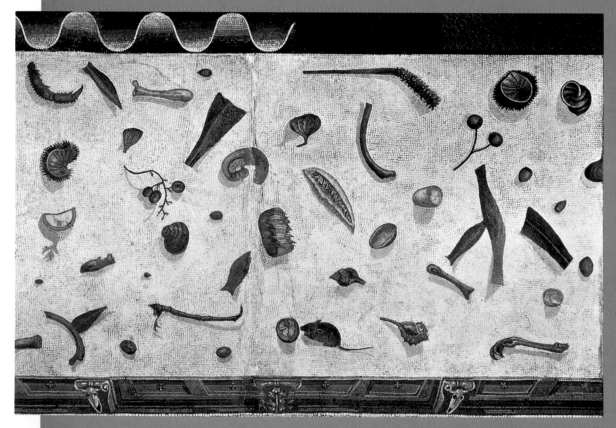

6-58. Herakleitos. *The Unswept Floor*, mosaic variant of a 2nd-century BCE painting by Sosos of Pergamon. 2nd century CE. Musei Vaticani, Museo Gregoriano Profano, ex Lateranese, Rome

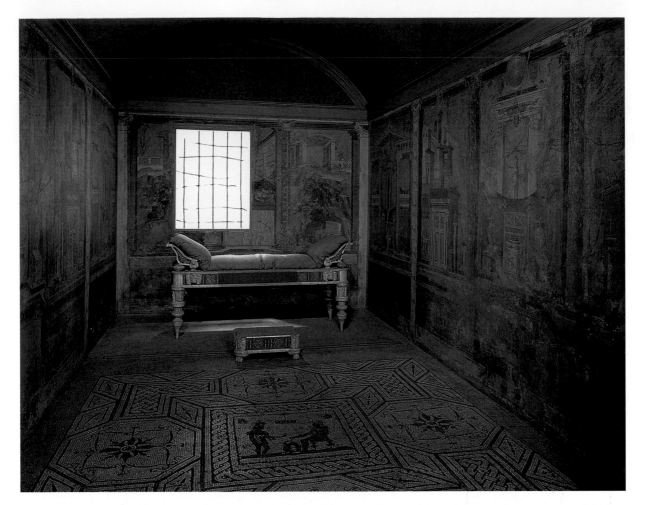

6-59. Reconstructed bedroom, from the House of Publius Fannius Synistor, Boscoreale, near Pompeii. Late 1st century CE, with later furnishings. The Metropolitan Museum of Art, New York

Rogers Fund, 1903 (03.14.13)

Although the elements in the room are from a variety of places and dates, they give a sense of how the original furnished room might have looked. The floor mosaic, found near Rome, dates to the second century CE. At its center is an image of a priest offering a basket with a snake to a cult image of Isis. The couch and footstool, which are inlaid with bone and glass, date from the first century CE. The wall paintings, original to the Boscoreale villa, may have been inspired by theater scene painting.

Artists created these fine mosaic image panels in their workshops. The *emblemata* were then set into a larger area already bordered by geometric patterns in mosaic. The mosaic floor in the reconstructed room in The Metropolitan Museum of Art in New York (see fig. 6-59) has a typical mosaic floor with a small image panel and many abstract designs in black and white. Image panels in floors usually reflected the purpose of the room. A dining room, for example, might have an *Unswept Floor* (fig. 6-58, "The Object Speaks"), with table scraps re-created in meticulous detail, even to the shadows they cast, and a mouse foraging among them.

WALL PAINTING

Many fine wall paintings have come to light through excavations, first in Pompeii and other communities surrounding Mount Vesuvius, near Naples, and more recently in and around Rome. The interior walls of Roman houses were plain, smooth plaster surfaces with few architectural features. On these invitingly empty spaces, artists painted decorations using pigment in a solution of lime and soap, sometimes with a little wax. After the painting was finished, they polished it with a special metal, glass, or stone burnisher and then buffed the surface with a cloth.

In the earliest paintings (200–80 BCE), artists attempted to produce the illusion of thin slabs of colored marble covering the walls, which were set off by actual architectural moldings and columns. By about 80 BCE, they began to extend the space of a room visually with painted scenes of figures on a shallow "stage" or with a landscape or cityscape. Architectural details such as columns were painted rather than made of molded plaster. As time passed, this painted architecture became increasingly fanciful. Solid-colored walls were decorated with slender, whimsical architectural and floral details and small, delicate vignettes.

The walls of a room from a villa at Boscoreale near Pompeii (reconstructed in The Metropolitan Museum, New York) open onto a fantastic urban panorama (fig. 6-59). The wall surfaces seem to dissolve behind columns and lintels, which frame a maze of floating architectural forms creating purely visual effects, like the backdrops of a stage. Indeed, the theater may have inspired this kind

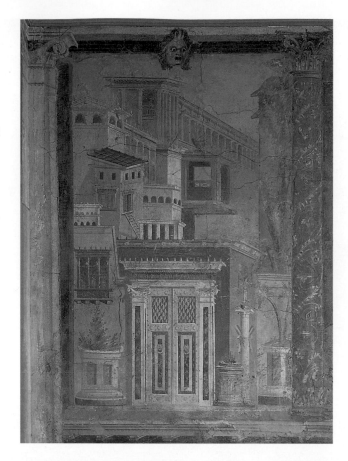

6-60. *Cityscape*, detail of a wall painting from a bedroom in the House of Publius Fannius Synistor, Boscoreale. Late 1st century CE. The Metropolitan Museum of Art, New York
Rogers Fund, 1903 (03.14.13)

6-61. *Garden Scene*, detail of a wall painting from the Villa of Livia at Primaporta, near Rome. Late 1st century BCE. Museo Nazionale Romano, Rome

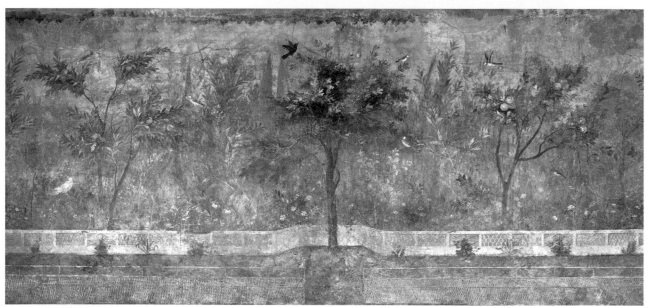

of decoration, as details in the room suggest. For example, on the rear wall, next to the window, is a painting of a grotto, the traditional setting for satyr plays, dramatic interludes about the half-man, half-goat followers of Bacchus. On the side walls, paintings of theatrical masks hang from the lintels.

One section shows a complex jumble of buildings with balconies, windows, arcades, and roofs at different levels, as well as a magnificent colonnade (fig. 6-60). The artist has used **intuitive perspective** admirably to create a general impression of real space. The architectural details follow diagonal lines that the eye interprets as parallel lines receding into the distance, and objects meant to be perceived as far away from the surface plane of the wall are shown slightly smaller than those intended to appear nearby.

The dining-room walls of the Villa of Livia at Primaporta exemplify yet another approach to creating a sense of expanded space (fig. 6-61). Instead of rendering a stage set or a cityscape, the artist "painted away" the wall surfaces to create the illusion of being on a porch or pavilion looking out over a low, paneled wall into an orchard of heavily laden fruit trees. These and the flowering shrubs are filled with a variety of wonderfully observed birds.

During the first century CE, landscape painters became especially accomplished. Pliny the Elder wrote in *Naturalis Historia* (35.116–17) of

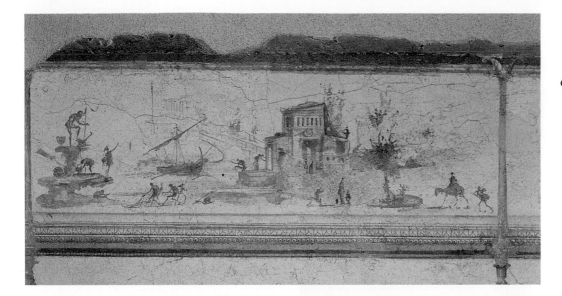

6-62. *Seascape*, detail of a wall painting from Villa Farnesina, Rome. Late 1st century CE.

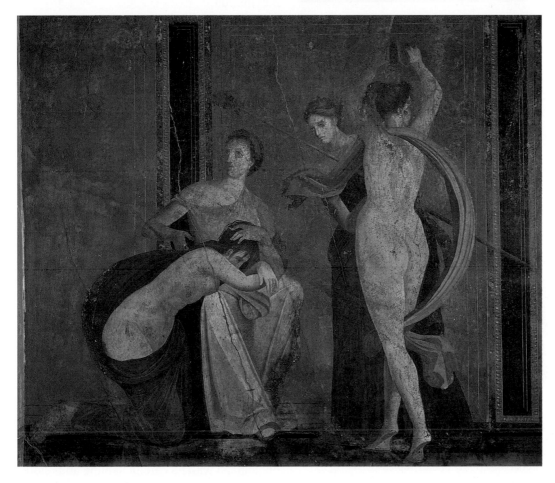

6-63. *Initiation Rites of the Cult of Bacchus (?)*, detail of a wall painting in the Villa of the Mysteries, Pompeii. c. 50 BCE

that most delightful technique of painting walls with representations of villas, porticoes and landscape gardens, woods, groves, hills, pools, channels, rivers, coastlines—in fact, every sort of thing which one might want, and also various representations of people within them walking or sailing . . . and also fishing, fowling, or hunting or even harvesting the wine-grapes.

In such paintings, the overall effect is one of wonder-invoking nature, an idealized view of the world, rendered with free, fluid brushwork and delicate color. A painting from the Villa Farnesina, in Rome (fig. 6-62), depicts the *locus amoenus*, the "lovely place" extolled by Roman poets, where people lived effortlessly in union with the land. Here two conventions create the illusion of space: distant objects are rendered proportionally smaller than near objects, and the colors become slightly grayer near the horizon, an effect called **atmospheric perspective**, which reproduces the tendency of distant objects to appear hazy, especially in seascapes.

In addition to landscapes and city views, other subjects that appeared in Roman art included historical and mythological scenes, exquisitely rendered **still lifes** (compositions of inanimate objects), and portraits. One of the most famous painted rooms in Roman art is in the so-called Villa of the Mysteries at Pompeii (fig. 6-63). The rites of mystery religions were often performed in private homes as well as in special buildings or temples, and this

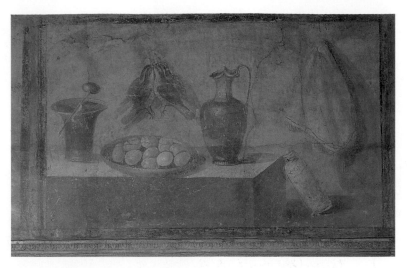

6-64. ***Still Life***, detail of a wall painting from the House of Julia Felix, Pompeii. Late 1st century CE. Museo Archeològico Nazionale, Naples

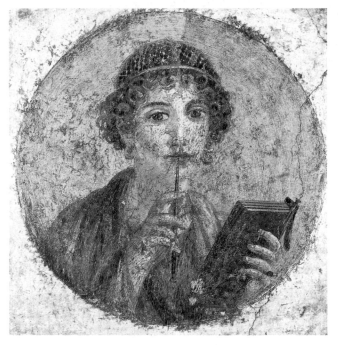

6-65. ***Young Woman Writing***, detail of a wall painting, from Pompeii. Late 1st century CE. Diameter 14⅝" (37 cm). Museo Archeològico Nazionale, Naples

The fashionable young woman seems to be pondering what she will write about with her stylus on the beribboned writing tablet that she holds in her other hand. Romans used pointed styluses to engrave letters on thin, wax-coated ivory or wood tablets in much the way we might use a hand-held computer; errors could be easily smoothed over. When a text or letter was considered ready, it was copied onto expensive papyrus or parchment. Tablets like these were also used by schoolchildren for their homework.

room, at the corner of a suburban villa, must have been a shrine or meeting place for such a cult. A reminder of the wide variety of religious practices tolerated by the Romans, the murals depict initiation rites—probably into the cult of Bacchus, who was the god of vegetation and fertility as well as wine and was one of the most important deities in Pompeii. The entirely painted architectural setting consists of a "marble" **dado** (the lower part of a wall) and, around the top of the wall, an elegant frieze supported by pilasters. The action takes place on a shallow "stage" along the top of the dado, with a background of brilliant, deep red (now known as Pompeian red) that was very popular with Roman painters. The scene unfolds around the entire room, depicting a succession of events that culminate in the acceptance of an initiate into the cult.

In the portion of the room seen here, a priestess (on the left) prepares to reveal draped cult objects, a winged figure whips a female initiate lying across the lap of another woman, and a devotee dances with cymbals, perhaps to drown out the initiate's cries. According to another interpretation, the dancing figure is the initiate herself, who has risen to dance with joy at the conclusion of her trials. The whole scene may show a purification ritual meant to bring enlightenment and blissful union with the god.

Wall painting also depicted more mundane subject matter. A still-life panel from the House of Julia Felix in Pompeii (fig. 6-64) depicts everyday domestic wares and the makings of a meal—eggs and recently caught game birds. Items have been carefully arranged to give the composition clarity and balance. The focus is on the round plate filled with eggs and the household containers that flank it. The towel on a hook on the right of the painting and the bottle tilted against the end of the shelf echo the pyramidal shape of the birds above the plate. A strong, clear light floods the picture from the left, casting shadows and enhancing the illusion of real objects in real space.

Portraits, sometimes imaginary ones, also became popular. A late-first-century CE **tondo** (circular panel) from Pompeii contains the portrait *Young Woman Writing* (fig. 6-65). The sitter has regular features and curly hair caught in a golden net. As in a modern studio portrait photograph with its careful lighting and retouching, the young woman may be somewhat idealized. Following a popular convention, she nibbles on the tip of her stylus. Her sweet mien and clear-eyed but unfocused and contemplative gaze suggest that she is in the throes of composition. The paintings in Pompeii reveal much about the lives of women during this period (see "The Position of Roman Women," page 274). Some, like Julia Felix, were the owners of houses where paintings were found. Others were the subjects of the paintings, shown as rich and poor, young and old, employed as business managers and domestic workers.

Just as architecture became increasingly grand, even grandiose, during the first 150 years of the Roman Empire, so, too, did the decorative wall painting in houses become ever more elaborate. In the House of M. Lucretius

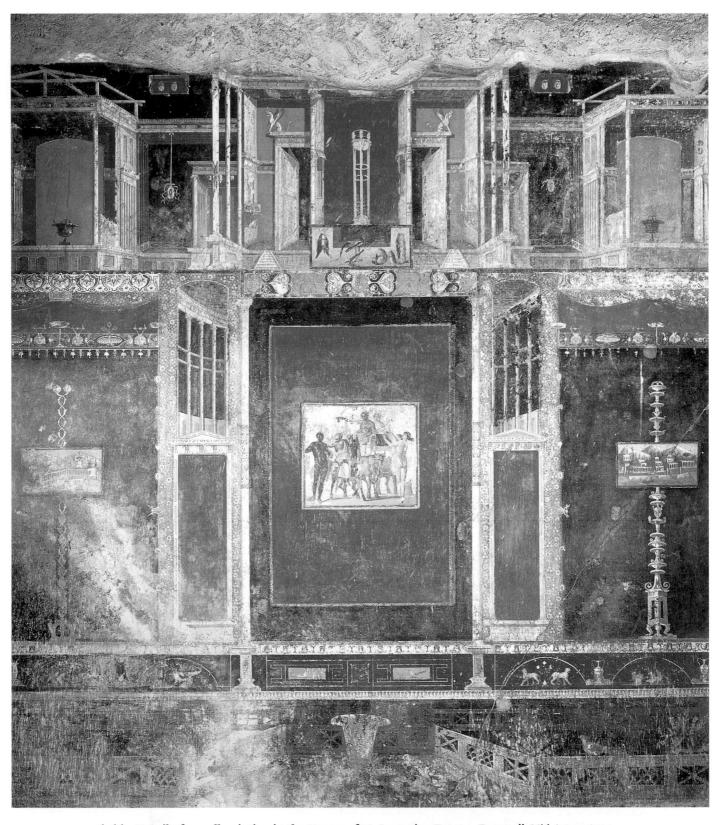

6-66. Detail of a wall painting in the House of M. Lucretius Fronto, Pompeii. Mid-1st century CE

Fronto in Pompeii, from the mid-first century CE (fig. 6-66), the artist painted a room with panels of black and red, bordered with architectural moldings. These architectural elements have no logic, and for all their playing with perspective, they fail to create any significant illusion of depth. Rectangular pictures seem to be mounted on the black and red panels. The scene with figures in the center is flanked by two small simulated window openings protected by grilles. The two pictures of villas in landscapes appear to float in front of intricate bronze easels.

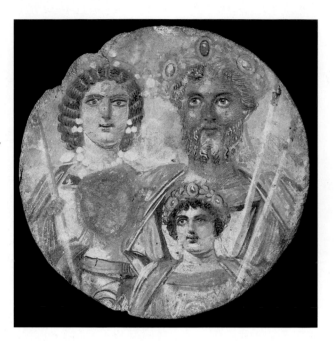

6-67. *Septimius Severus, Julia Domna, and Their Children, Caracalla and Geta*, from Fayum, Egypt. c. 200 CE. Painted wood, diameter 14" (35.6 cm). Staatliche Museen zu Berlin, Preussischer Kulturbesitz, Antikensammlung

THE LATE EMPIRE

The comfortable life suggested by the wall paintings in Roman villas was, within a century, to be challenged by hard times. The reign of Commodus at the end of the second century CE marked the beginning of a period of political and economic decline. Barbarian groups pressed on Rome's frontiers, and many crossed the borders and settled within them, disrupting provincial governments. As strains spread throughout the empire, imperial rule became increasingly authoritarian. Eventually the army controlled the government, and the Imperial Guards set up and deposed rulers almost at will, often selecting candidates from among poorly educated, power-hungry provincial leaders in their own ranks.

THE SEVERAN DYNASTY

Despite the pressures of political and economic change, the arts continued to flourish under the Severan emperors (193–235 CE) who succeeded Commodus. Septimius Severus (ruled 193–211 CE) and his Syrian wife, Julia Domna, restored public buildings, commissioned official portraits, and made some splendid additions to the old Republican Forum, including the transformation of the House of the Vestal Virgins, who served the Temple of Vesta, into a large, luxurious residence. Their sons, Caracalla and Geta, succeeded Septimus Severus as co-emperors in 211 CE, but in 212 CE, Caracalla murdered Geta and ruled alone until he in turn was murdered by his successor in 217 CE.

THE POSITION OF ROMAN WOMEN

If we were to judge from the conflicting accounts of Roman writers, Roman women were either shockingly wicked and willful, totally preoccupied with clothes, hairstyles, and social events, or well-educated, talented, and active members of family and society. In ancient Rome, as in the contemporary world, sin sold better than saintliness, and for that reason written attacks on women by their male contemporaries must be viewed with some reservation. In fact, careful study has shown that Roman women were far freer and more engaged in society than their Greek counterparts.

Many women received a formal education, and a well-educated woman was as admired as a well-educated man. Although many educated women became physicians, shopkeepers, and even overseers in such male-dominated businesses as shipbuilding, education was valued primarily for the desirable status it imparted.

Ovid (43 BCE–17 CE) advised all young women to read both the Greek classics and contemporary Roman literature, including his own, of course. Women conversant with political and cultural affairs and with a reputation for good conversation enjoyed the praise and admiration of some male writers. A few women even took

up literature themselves. A woman named Julia Balbilla was respected for her poetry. Another, Sulpicia, a writer of elegies, was accepted into male literary circles. Her works were recommended by the author Martial to men and women alike. The younger Agrippina, sister of the emperor Caligula and mother of Nero, wrote a history of her illustrious family.

Women were also encouraged to become accomplished singers, instrumentalists, and even dancers—as long as they did not perform publicly. Almost nothing appears in literature about women in the visual arts, no doubt because artists were not highly regarded.

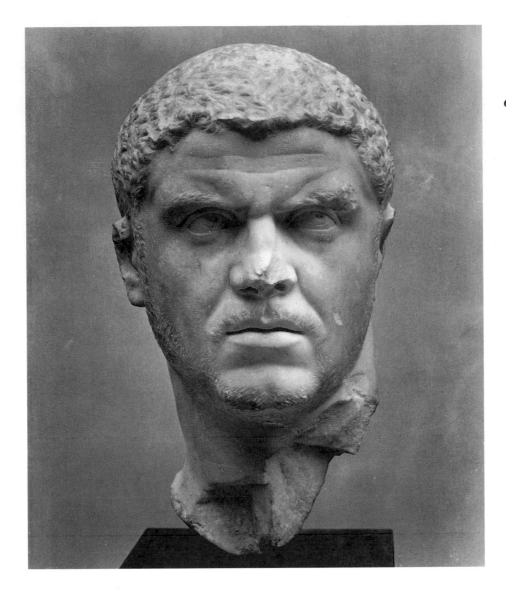

6-68. *Caracalla*. Early 3rd century CE. Marble, height 14½" (36.2 cm). The Metropolitan Museum of Art, New York

Samuel D. Lee Fund, 1940 (40.11.1A)

The emperor Caracalla (ruled 211–17 CE) was consistently represented with a malignant, scowling expression, a convention meant to convey a particular message to the viewer: The emperor was a hard-as-nails, battle-toughened military man, a lethal opponent ready to defend himself and his empire.

A portrait of the family of Septimius Severus provides insight into both the history of the Severan dynasty and early-third-century CE painting (fig. 6-67). The work is in the highly formal style of the Fayum region in northwestern Egypt, and it may be a souvenir of an imperial visit to Egypt. The emperor, clearly identified by his distinctive divided beard and curled moustache, wears an enormous crown. Next to him is the empress Julia Domna, portrayed with similarly recognizable features—full face, large nose, and masses of waving hair. Their two sons, Geta (who has been scratched out) and Caracalla, stand in front of them. Perhaps because we know that he grew up to be a ruthless dictator, little Caracalla looks like a disagreeable child. After murdering his brother, perhaps with Julia Domna's help, Caracalla issued a decree to abolish every reference to Geta. Clearly the owners of this painting complied and scraped off Geta's face. The work emphasized the trappings of imperial wealth and power—crowns, jewels, and direct forceful expressions—rather than attempting any psychological study. The rather hard drawing style, with its broadly brushed-in colors, contrasts markedly with the illusionism of earlier portraits, such as the *Young Woman Writing*.

Emperor Caracalla emerges from his adult portraits as a man of chilling and calculating ruthlessness. In the example shown here (fig. 6-68), the sculptor has enhanced the intensity of the emperor's expression by producing strong contrasts of light and dark with careful chiseling and drillwork. Even the marble eyes have been drilled and engraved to catch the light in a way that makes them glitter. The contrast between this style and that of the portraits of Augustus is a telling reflection of the changing character of imperial rule. Augustus presented himself as the first among equals, ruling by persuasion; Caracalla revealed himself as a no-nonsense ruler of iron-fisted determination.

The year before his death in 211 CE, Septimius Severus had begun a popular public-works project, the construction of magnificent new public baths on the southeast side of Rome. His son and successor, Caracalla, completed and inaugurated the baths in 216–17 CE, and they are known by his name. For the Romans, baths were recreational and educational centers, not simply places to wash, and emperors built large bathing complexes to gain public favor. Baths were luxurious buildings whose brick and concrete structures were hidden under a sheath of colorful marble and mosaic.

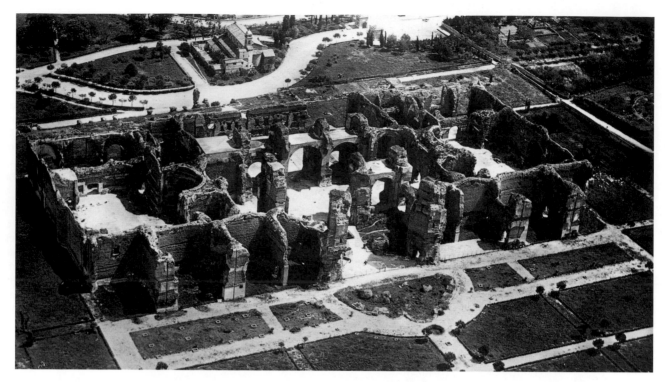

6-69. Baths of Caracalla, Rome. C. 211–17 CE

Although well-to-do people usually had private baths in their homes, women and men enjoyed the pleasures of socializing at public baths—but not together. In some cities, women and men had separate bathhouses, but it was also common for them to share one facility at different times of the day. Everyone—from nobles to working people—was allowed to use the public baths. Men had access to the full range of facilities, including hot, warm, and cold baths, moist- and dry-heat chambers (like saunas), pools for swimming, and outdoor areas for sunbathing or exercising in the nude. Women generally refrained from using very hot baths, dry-heat chambers, and the outdoor areas. Libraries provided study and reading facilities.

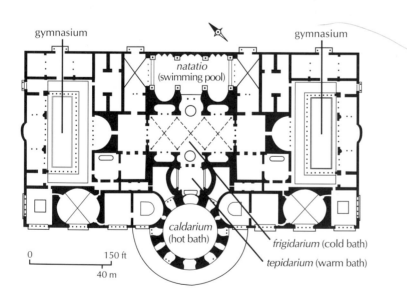

6-70. Plan of the Baths of Caracalla

The Baths of Caracalla (fig. 6-69) were laid out on a strictly symmetrical plan. The bathing facilities were grouped in the center of the main building to make efficient use of the below-ground furnaces that heated them and to allow bathers to move comfortably from hot to cold pools and finish with a swim (fig. 6-70). Many other facilities—exercise rooms, shops, latrines, and dressing rooms—were housed on each side of the bathing block. The baths alone covered 5 acres. The entire complex, which included gardens, a stadium, libraries, a painting gallery, auditoriums, and huge water reservoirs, covered an area of 50 acres and inspired later buildings when large crowds had to be accommodated (fig. 6-71).

THE THIRD CENTURY

The successors of the Severan emperors—the more than two dozen so-called soldier-emperors who attempted to rule the empire for the next seventy years—continued to favor the style of Caracalla's portraits. The sculptor of a bust of Philip the Arab (ruled 244–49 CE), for example, first modeled the broad structure of the emperor's head, then used both chisel and drill to deepen shadows and heighten the effects of light in the furrows of the face and the stiff folds of the drapery (fig. 6-72). Tiny flicks of the chisel suggest the texture of hair and beard. The overall

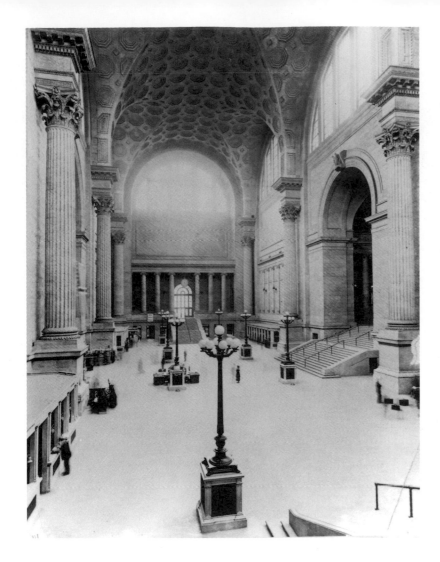

6-71. McKim, Mead, and White, architects. Waiting room, interior of New York City's Pennsylvania Railroad Station. 1906–10; demolished 1963

The design of this railroad terminal was based on the Baths of Caracalla.

impact of the work depends on the effects of light and the imagination of the spectator as much as on the carved stone itself. Nevertheless, this portrait does not convey the same malevolent energy as Caracalla's portraits. Philip seems tense and worried, suggesting that he was a troubled man in troubled times. What comes through from Philip's twisted brow, sidelong upward glance, quizzical lips, and tightened jaw muscles is a sense of guile, deceit, and fear. Philip had been the head of the Imperial Guard, but he murdered his predecessor and was murdered himself after only five years.

During the turmoil of the third century CE, Roman artists emphasized the symbolic or general qualities of their subjects and expressed them in increasingly simplified, geometric forms. Despite this trend toward abstraction, the earlier tradition of slightly idealized but realistic portraiture was slow to die out, probably because it showed patrons as they wanted to be remembered. In the engraved gold-glass of a woman with her son and daughter, the so-called *Family of Vunnerius Keramus* (fig. 6-73, page 278), the subjects are rendered as individuals, although the artist has emphasized their great almond-shaped eyes. The work seems to reflect

6-72. *Philip the Arab*. 244–49 CE. Marble, height 26" (71.1 cm). Musei Vaticani, Braccio Nuovo, Rome

6-73. *Family of Vunnerius Keramus.* C. 250 CE. Engraved gold leaf sealed between glass, diameter 2³⁄₈" (6 cm). Museo Civico dell'Età Cristiana, Brescia

This gold-glass medallion of a mother, son, and daughter could have been made in Alexandria, Egypt, any time between the early third and the mid-fifth centuries CE. It is inscribed "Bounneri Kerami" in Alexandrian Greek—perhaps the signature of the artist. The medallion was later placed in the eighth-century Brescia cross (see fig. 14-9).

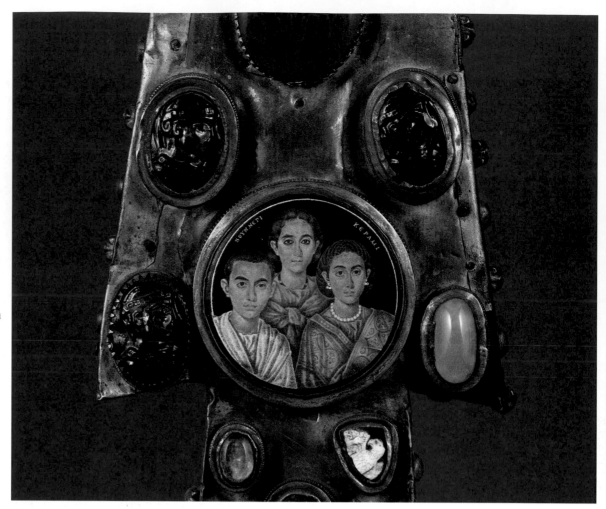

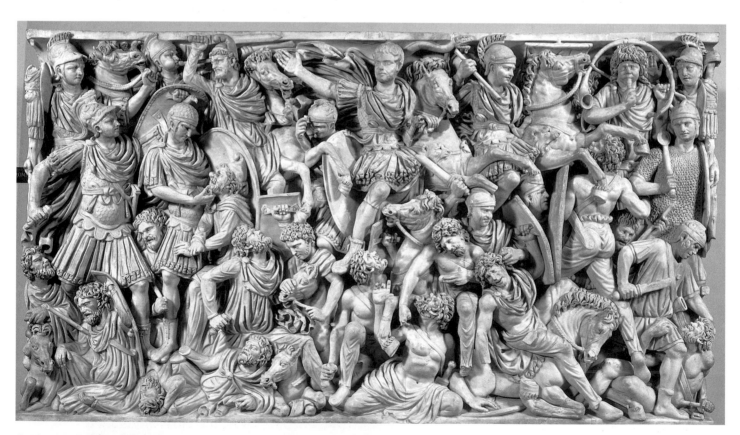

6-74. *Battle between the Romans and the Barbarians*, detail of the *Ludovisi Battle Sarcophagus*, found near Rome. c. 250 CE. Marble, height approx. 5' (1.52 m). Museo Nazionale Romano, Rome

the advice of Philostratus, who, writing in the late third century CE, commented:

> The person who would properly master this art [of painting] must also be a keen observer of human nature and must be capable of discerning the signs of people's characters even though they are silent; he should be able to discern what is revealed in the expression of the eyes, what is found in the character of the brows, and, to state the point briefly, whatever indicates the condition of the mind. (Quoted in Pollitt, pages 224–25)

The *Family of Vunnerius Keramus* portrait was engraved on a sheet of gold leaf and sealed between two layers of glass. This fragile, delicate medium, often used for the bottoms of glass bowls or cups, seems appropriate for an age of material insecurity and emotional intensity. This glowing portrait was inserted by a later Christian owner as the central jewel in an eighth-century cross (see fig. 14-9).

Although portraits and narrative reliefs were the major forms of public sculpture during the second and third centuries CE, changing funerary practices—a shift from cremation to burial—led to a growing demand for funerary sculpture. Wealthy Romans commissioned elegant marble sarcophagi to be placed in their tombs. Workshops throughout the empire produced thousands of these sarcophagi, which were carved with reliefs that ranged in complexity from simple geometric or floral ornament to scenes involving large numbers of figures. The subjects of the elaborate reliefs varied widely. Some included events from the life of the deceased; some showed dramatic scenes from Greek mythology and drama.

A sarcophagus known as the *Ludovisi Battle Sarcophagus* (after a seventeenth-century owner) dates about 250 CE (fig. 6-74). Romans triumph over barbarians in a style that has roots in the sculptural traditions of Hellenistic Pergamon. The artist has made no attempt to create a realistic spatial environment. The Romans at the top of the panel are efficiently dispatching the barbarians—clearly identifiable by their heavy, twisted locks and scraggly beards—who lie fallen, dying, or beaten at the bottom of the panel. The bareheaded young Roman commander, with his gesture of victory, recalls the equestrian statue of Marcus Aurelius (see fig. 6-45).

THE TETRARCHS

The half century of anarchy, power struggles, and inept rule by the soldier-emperors that had begun with the death of Alexander Severus (ruled 222–35 CE), the last in the Severan line, ended with the rise to power of Diocletian (ruled 284–305 CE). This brilliant politician and general reversed the empire's declining fortunes, but he also initiated an increasingly autocratic form of rule, and the social structure of the empire became increasingly rigid.

To distribute the task of defending and administering the empire and to assure an orderly succession, in 286 CE

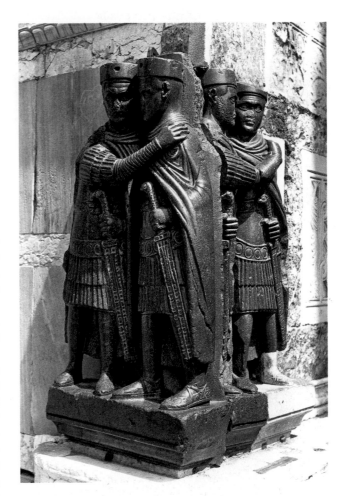

6-75. *The Tetrarchs*. c. 300 CE. Porphyry, height of figures 51" (129 cm). From Constantinople; installed in the Middle Ages at the corner of the facade of the Cathedral of Saint Mark, Venice

Diocletian divided the empire in two. With the title of "Augustus" he would rule in the East, while another Augustus, Maximian, would rule in the West. Then, in 293 CE, he devised a form of government called a tetrarchy, or "rule of four," in which each Augustus designated a subordinate and heir, who held the title of "Caesar." Although Diocletian intended that on the death or retirement of an Augustus, his Caesar would replace him and name a new Caesar, the plan failed when Diocletian tried to implement it.

Sculpture depicting the tetrarchs, about 300 CE, documents a turn in art toward abstraction and symbolic representation (fig. 6-75). The four figures—two with beards, probably the senior Augusti, and two clean-shaven, probably the Caesars—are nearly identical. Dressed in military garb and clasping swords at their sides, they embrace each other in a show of imperial unity, proclaiming a kind of peace through concerted strength and vigilance. As a piece of propaganda and a summary of the state of affairs at the time, it is unsurpassed. The sculpture is made of porphyry, a purple stone from Egypt reserved for imperial use. The hardness of the stone, which makes it difficult to carve, and perhaps the sculptor's familiarity with Egyptian artistic conventions,

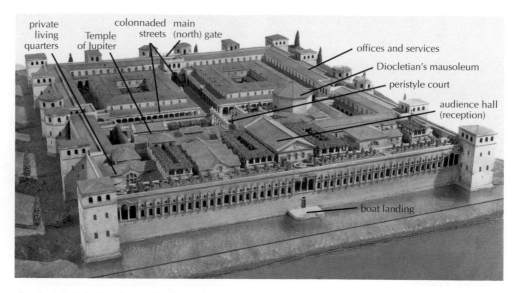

private living quarters
Temple of Jupiter
colonnaded streets
main (north) gate
offices and services
Diocletian's mausoleum
peristyle court
audience hall (reception)
boat landing

6-76. Model of Palace of Diocletian, Split, Croatia. c. 300 CE. Museo della Civiltà Romana, Rome

6-77. Peristyle court, Palace of Diocletian

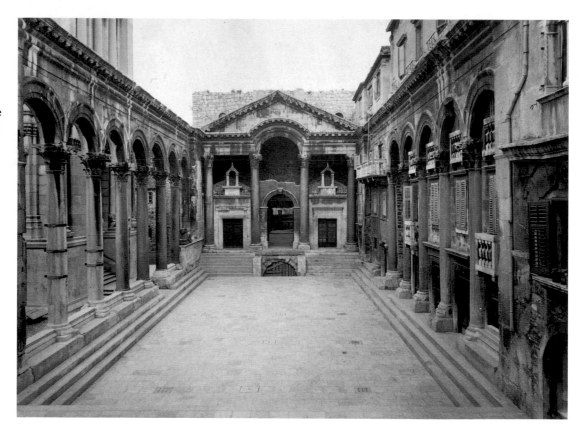

may have contributed to the extremely abstract style of the work. The most striking features of *The Tetrarchs*—the simplification of natural forms to geometric shapes, the disregard for normal human proportions, and the emphasis on a message or idea—appear often in Roman art by the end of the third century. The sculpture may have been made in Egypt and moved to Constantinople after 330 CE. Christian Crusaders who looted Constantinople in 1204 CE took the statue to Venice, where they placed it on the Cathedral of Saint Mark.

Architecture also changed under Diocletian's patronage. Earlier great palaces such as Hadrian's Villa often had been as extensive and as semipublic as the Minoan palace at Knossos. Diocletian broke with this tradition by building a huge and well-fortified imperial residence at Split on the Dalmatian coast after he retired from active rule (fig. 6-76). Revolutionary in design, the structure recalls the compact, regular plan of a Roman army camp rather than the irregular, sprawling design of Hadrian's Villa. The palace consisted of a rectangular enclosure 650

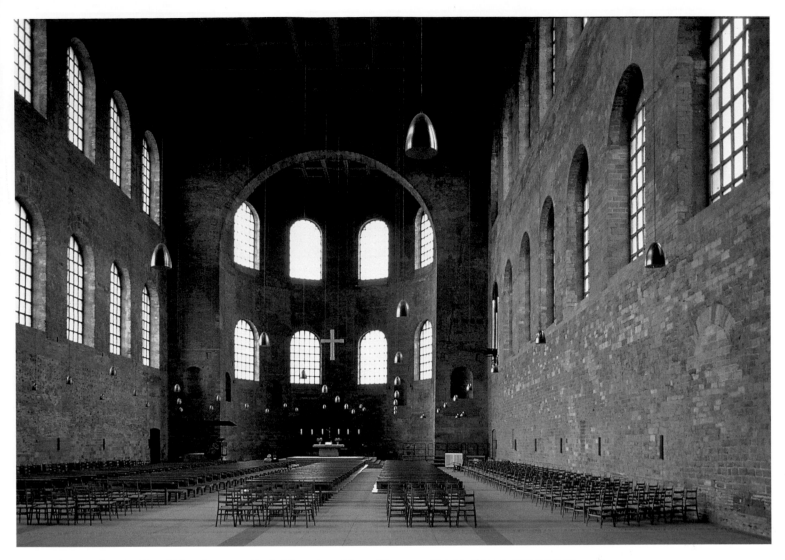

6-78. The Basilica, Trier, Germany. Early 4th century. View of the nave. Height of room 100' (30.5 m)

Only the left wall and apse survive from the original Roman building. The basilica became part of the bishop's palace during the medieval period.

by 550 feet, surrounded by a wall and crossed by two colonnaded streets that divided it into quarters, each with a specific function. The emperor's residential complex, which included the reception hall on the main, north-south axis of the palace, faced the sea. Ships bearing supplies or providing transport for the emperor tied up at the narrow landing stage. The support staff lived and worked in buildings near the main gate. A colonnaded avenue extended from this entrance to a peristyle court that ended in a grand facade with an enormous arched doorway where Diocletian made his ceremonial appearances (fig. 6-77). Like the Canopus at Hadrian's Villa, the columns of the peristyle court supported arches rather than entablatures (see fig. 6-56). On one side of the court, the arcade opened onto Diocletian's mausoleum; on the other side, it opened onto the Temple of Jupiter.

The tetrarchs ruled the empire from administrative headquarters in Milan, Italy; Trier, Germany; Thessaloniki, in Macedonia; and Nicomedia, in Asia Minor. In Trier, Constantius Chlorus (Augustus, 293–306 CE) and

his son Constantine fortified the city with walls and a monumental gate. They built public amenities such as baths and a palace with a huge audience hall, known as the Basilica (fig. 6-78). This early-fourth-century CE building's large size and simple plan and structure exemplify the architecture of the tetrarchs: imposing buildings that would impress their subjects.

The Basilica is a large rectangular building, 190 by 95 feet, with a single apse opposite the door. Brick walls, originally stuccoed on the outside and covered with marble veneer inside, are pierced by two rows of arched windows. The flat roof, 100 feet above the floor, covers both the nave and the apse. In a concession to the northern climate, the building was centrally heated with hot air flowing under the floor. The windows of the apse create an interesting optical effect. They are slightly smaller and set higher than the windows in the hall, so they create the illusion of greater distance and make the tetrarch enthroned in the apse appear larger than life. This simple interior with its focus on the apse inspired later Christian builders.

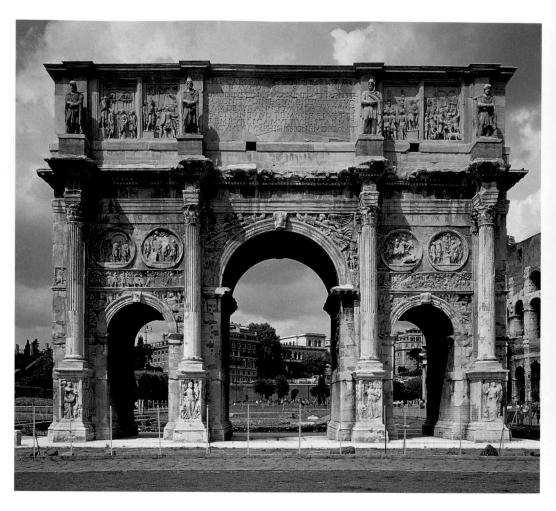

6-79. Arch of Constantine, Rome.
312–15 CE (dedicated July 25, 315)

This massive, triple-arched monument to Emperor Constantine's victory over Maxentius in 312 CE is a wonder of recycled sculpture. On the attic story, flanking the inscription over the central arch, are relief panels taken from a monument celebrating the victory of Marcus Aurelius over the Germans in 174 CE. On the attached piers framing these panels are large statues of prisoners made to celebrate Trajan's victory over the Dacians in the early second century CE. On the inner walls of the central arch (not seen here) are reliefs commemorating Trajan's conquest of Dacia. Over each of the side arches are pairs of giant roundels taken from a monument to Hadrian (see fig. 6-40). The rest of the decoration is contemporary with the arch.

CONSTANTINE THE GREAT AND HIS LEGACY

In 305 CE Diocletian abdicated and forced his fellow Augustus, Maximian, to do so too. The orderly succession he had hoped for failed to occur, and a struggle for position and advantage almost immediately ensued. Two main contenders emerged in the western empire: Maximian's son Maxentius and Constantine I, son of Tetrarch Constantius Chlorus. Constantine emerged victorious in 312 after defeating Maxentius at the Battle of the Milvian Bridge, at the entrance to Rome. According to tradition, Constantine had a vision the night before the battle in which he saw a flaming cross in the sky and heard these words: "In this sign you shall conquer." The next morning he ordered that his army's shields and standards be inscribed with the monogram *XP* (the Greek letters *chi* and *rho*, standing for *Christos*). The victorious Constantine then showed his gratitude by ending the persecution of Christians and recognizing Christianity as a lawful religion. (He may also have been influenced in that decision by his mother, Helen, a devout Christian—later canonized—who played an important part in his career.) In fact, *chi* and *rho* used together had long been an abbreviation of the Greek word *chrestos*, meaning "auspicious," which may have been the reason Constantine used the monogram. Whatever his motivation, in 313 CE, together with Licinius, who ruled the East, Constantine issued the Edict of Milan, a model of religious toleration:

With sound and most upright reasoning . . . we resolved that authority be refused to no one to follow and choose the observance or form of worship that Christians use, and that authority be granted to each one to give his mind to that form of worship which he deems suitable to himself, to the intent that the Divinity . . . may in all things afford us his wonted care and generosity. (Eusebius, *Ecclesiastical History* 10.5.5)

The Edict of Milan granted freedom to all religious groups, not just Christians. Constantine, however, remained the Pontifex Maximus of Rome's state religion and also reaffirmed his devotion during his reign to the military's favorite god, Mithras, and to the Invincible Sun, *Sol Invictus*, a manifestation of Helios Apollo, the sun god.

In 324 CE Constantine defeated Licinius, his last rival; he would rule as sole emperor until his death in 337. He made the port city of Byzantium the new Rome and renamed it Constantinople (modern Istanbul, in Turkey). After Constantinople was dedicated in 330, Rome, which had already ceased to be the seat of government in the West, further declined in importance.

The Arch of Constantine. In Rome, next to the Colosseum, the Senate erected a memorial to Constantine's victory over Maxentius (fig. 6-79), a huge, triple arch that

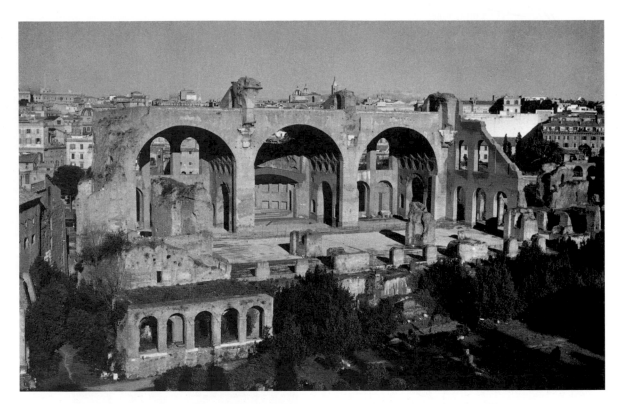

6-80. Plan and isometric projection of the Basilica of Maxentius and Constantine (Basilica Nova), Rome. 306–13 CE

The original plan for the basilica called for a single entrance on the southeast side, facing a single apse on the northwest. After building had begun, Constantine's architects added another entrance from the Via Sacra (Sacred Way) on the southwest and another apse opposite it across the nave. The effect was to dilute the focus on the original apse, which held the gigantic statue of the emperor (see fig. 6-82).

dwarfs the nearby Arch of Titus (see fig. 6-37). Its three barrel-vaulted passageways are flanked by columns on high pedestals and surmounted by a large attic story with elaborate sculptural decoration and a traditional laudatory inscription: "To the Emperor Constantine from the Senate and the Roman People. Since through divine inspiration and great wisdom he has delivered the state from the tyrant and his party by his army and noble arms, [we] dedicate this arch, decorated with triumphal insignia." The "triumphal insignia" were in part looted from earlier monuments made for Constantine's illustrious predecessors, the Good Emperors Trajan, Hadrian, and Marcus Aurelius. The reused items visually transferred the old Roman virtues of strength, courage, and piety associated with these earlier emperors to Constantine. New reliefs made for the arch recount the story of his victory and symbolize his power and generosity.

Although these new reliefs reflect the long-standing Roman affection for depicting important events with realistic detail, they nevertheless represent a significant change in style, approach, and subject matter that distinguishes them from the reused elements in the arch. The stocky, mostly frontal, look-alike figures are compressed by the buildings of the forum into the foreground plane. The arrangement and appearance of the uniform and undifferentiated participants below the enthroned Constantine clearly isolate the new emperor and connect him visually with his illustrious predeces-

sors on each side. This two-dimensional, hierarchical approach and abstract style are far removed from the realism of earlier imperial reliefs. This style, with its emphasis on authority, ritual, and symbolic meaning rather than outward form, was adopted by the emerging Christian Church. Constantinian art thus bridges the art of the Classical world and the art of the Middle Ages (roughly 476 to 1453 CE).

The Basilica of Maxentius and Constantine. Constantine's rival, Maxentius, who controlled Rome throughout his short reign (ruled 306–12), ordered the repair of many buildings there and had others built. His most impressive undertaking was a huge new basilica just southeast of the Imperial Forums called the Basilica Nova, or New Basilica. Now known as the Basilica of Maxentius and Constantine, this was the last important imperial government building erected in Rome. It functioned, like all basilicas, as an administrative center and provided a magnificent setting for the emperor when he appeared as supreme judge. Earlier basilicas, such as Trajan's Basilica Ulpia (see fig. 6-27), had been columnar halls, but Maxentius ordered his engineers to create the kind of large, unbroken, vaulted space found in public baths (fig. 6-80). The central hall was covered with groin vaults, and the side aisles were covered with lower barrel vaults. These vaults acted as buttresses, or projecting supports, for the central groin vault and allowed generous window openings in

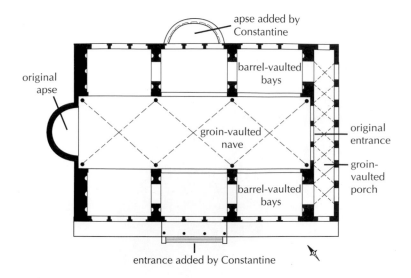

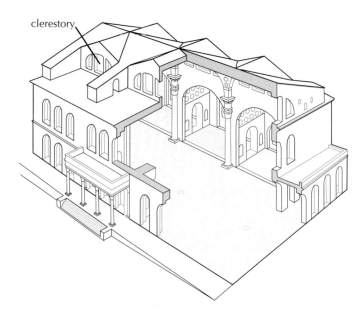

6-81. Basilica of Maxentius and Constantine (Basilica Nova)

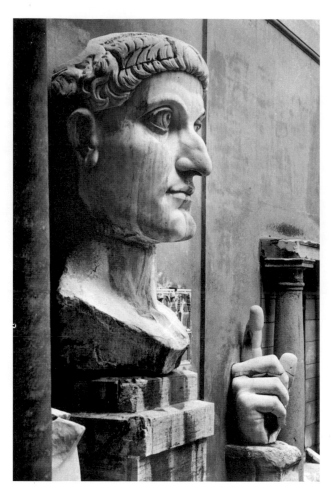

6-82. *Constantine the Great*, from the Basilica of Maxentius and Constantine, Rome. 325–26 CE. Marble, height of head 8'6" (2.6 m). Palazzo dei Conservatori, Rome

These fragments came from a statue of the seated emperor. The original sculpture combined marble and probably bronze supported on a core of wood and bricks. Only a few marble fragments survive—the head, a hand, a knee, an elbow, and a foot. The body might have been made of either colored stone or of bronze on a scaffold of wood and bricks sheathed in bronze. This statue, although made of less expensive materials, must have been as awe-inspiring as the gigantic ivory and gold-clad statues of Zeus at Olympia and Athena on the Acropolis in Athens, made in the fifth century BCE. Constantine was a master at the use of portrait statues to spread imperial propaganda.

the clerestory areas over the side walls. Three of these brick-and-concrete barrel vaults still loom over the streets of modern Rome (fig. 6-81). The basilica originally measured 300 by 215 feet and the vaults of the central nave rose to a height of 114 feet. A groin-vaulted porch extended across the short side and sheltered a triple entrance to the central hall. At the opposite end of the long axis of the hall was an apse of the same width, which acted as a focal point for the building. The directional focus along a central axis from entrance to apse was adopted by Christians for use in churches.

Constantine, seeking to impress the people of Rome with visible symbols of his authority, put his own stamp on projects Maxentius had started. He changed the orientation of the Basilica Nova by adding an imposing new entrance in the center of the long side facing the Via Sacra and a giant apse facing it across the three aisles. He finished the building in 306–13.

Constantine also commissioned a colossal, 30-foot portrait statue of himself and had it placed in the original

apse (fig. 6-82). On a wooden frame, the sculptor combined the head, chest, arms, and legs carved of white marble with bronze drapery. This statue was a permanent stand-in for the emperor, representing him whenever the conduct of business legally required his presence. The sculpture combines features of traditional Roman portraiture with the abstract qualities evident in *The Tetrarchs* (see fig. 6-75). The defining characteristics of Constantine's face—his heavy jaw, hooked nose, and jutting chin—have been incorporated into a rigid, symmetrical pattern in which other features, such as his eyes, eyebrows, and hair, have

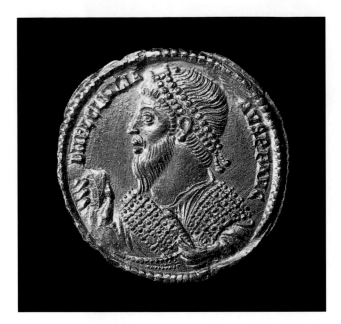

6-83. *Julian the Apostate*, coin issued 361–63 CE. Gold. The British Museum, London

been simplified into repeated geometric arcs. The result is a work that projects imperial power and dignity with no hint of human frailty or imperfection.

ROMAN TRADITIONALISM IN ART AFTER CONSTANTINE

Constantine was baptized formally into the Christian religion on his deathbed in 337 CE. All three of his sons were his heirs, and civil war broke out after his death. The old imperial religion revived during the reign of Constantius II's successor, Julian (361–63 CE), known by Christians as Julian the Apostate ("Religious Defector"). A follower of Mithras, Julian did not ban Christianity but tried to undermine it by adapting some of its liturgical devices and charitable practices into the worship of the traditional gods. He had himself portrayed on coins as a bearded scholar-philosopher (fig. 6-83), a portrait convention also favored by his illustrious predecessors Hadrian and Marcus Aurelius.

Christian emperors succeeded Julian. By the end of the fourth century CE, Christianity had become the official religion of the empire, and non-Christians had become targets of persecution. Many people resisted this shift and tried to revive classical culture. Among the champions of paganism were the Roman patricians Quintus Aurelius Symmachus and Virius Nicomachus Flavianus. A famous ivory **diptych**—a pair of panels attached with hinges—attests to the close relationship between their families, perhaps through marriage, as well as to their firmly held beliefs. One family's name is inscribed at the top of each panel. On the panel inscribed *Symmachorum* (fig. 6-84), a stately, elegantly attired priestess burns incense at a beautifully decorated altar. She is assisted by a small child, and the event takes place out of doors under an oak tree, sacred to Jupiter. The Roman ivory

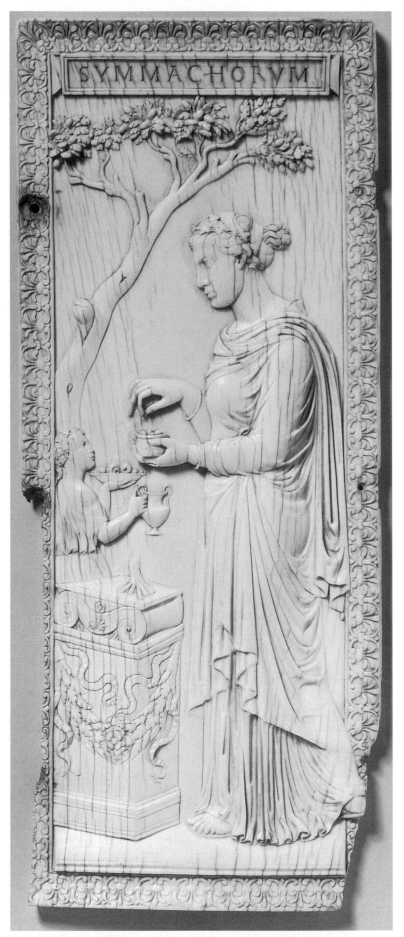

6-84. *Priestess of Bacchus* (?), right panel of a diptych. c. 390–401 CE. Ivory, 11¾ x 5½" (29.9 x 14 cm). Victoria and Albert Museum, London

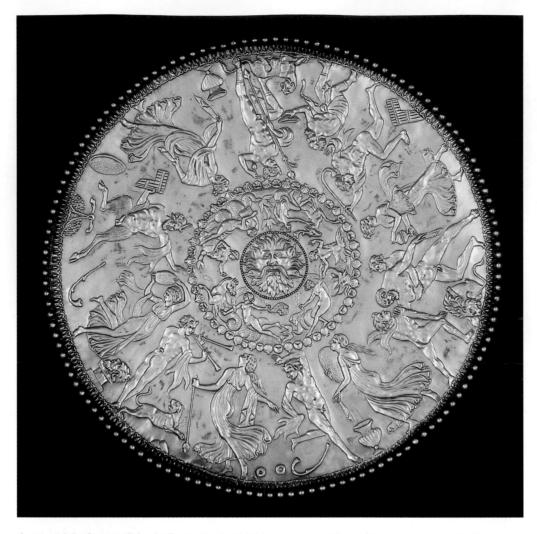

6-85. Dish, from Mildenhall, England. Mid-4th century CE. Silver, diameter approx. 24" (61 cm). The British Museum, London

carvers of the fourth century were extremely skillful, and their wares were widely admired and commissioned by pagans and Christians alike. For conservative patrons like the Nicomachus and Symmachus families, they imitated the Augustan style effortlessly. The exquisite rendering of the drapery and foliage recalls the reliefs of the Ara Pacis (see fig. 6-23).

Classical subject matter remained attractive to artists and patrons, and imperial repression could not immediately extinguish it. Even such great Christian thinkers as the fourth-century CE bishop and saint Gregory of Nazianzus spoke out in support of the right of the people to appreciate and enjoy their classical heritage, so long as they were not seduced by it to return to pagan practices. As a result, stories of the ancient gods and heroes entered the secular realm as lively, visually delightful, and even erotic decorative elements. The style and subject matter of the art reflect a society in transition.

A large silver platter dating from the mid-fourth century CE shows how themes involving Bacchus continued to provide artists with the opportunity to create elaborate figural compositions displaying the nude or lightly draped human body in complex, dynamic poses (fig. 6-85). The Bacchic revelers whirl, leap, and sway in a dance to the piping of satyrs around a circular central medallion. In

this centerpiece, the head of the sea god Oceanus is ringed by nude females frolicking in the waves with fantastic sea creatures. In the outer circle, Bacchus is the one stable element. Wine bottles on his shoulder and at his feet and one foot on the haunches of his panther, he listens to a male follower begging for another drink. Only a few figures away, the pitifully drunken hero Hercules has lost his lion-skin mantle and collapsed in a stupor into the supporting arms of two satyrs. The detail, clarity, and liveliness of this platter reflect the work of a skillful artist. Deeply engraved lines emphasize the contours of the subtly modeled bodies, echoing the technique of undercutting used to add depth to figures in stone and marble reliefs and suggesting a connection between silver working and relief sculpture.

The platter was found in a cache of silver near Mildenhall, England. Such opulent items were often hidden or buried to protect them from theft and looting, a sign of the breakdown of the long Roman peace. Even as Roman authority gave way to local rule by powerful barbarian tribes in much of the West, many people continued to appreciate classical learning and to treasure Greek and Roman art. In the East, classical traditions and styles endured to become an important element of Byzantine art.

PARALLELS

PERIOD	ETRUSCAN AND ROMAN ART	ART IN OTHER CULTURES
ETRUSCAN 700–509 BCE	**6-8.** Cerveteri sarcophagus (c. 520 BCE) **6-1.** *She-Wolf* (c. 500 BCE) **6-5.** Veii *Apollo* (c. 500 BCE) **6-2.** Porta Augusta (2nd cent. BCE)	**3-44.** **Taharqo sphinx** (c. 690–664 BCE), Egypt **2-24.** **Ishtar Gate** (c. 575 BCE), Neo-Babylonia **5-9.** **Temple of Hera** (c. 550 BCE), Italy **5-26.** Exekias. *Suicide of Ajax* (c. 540 BCE), Greece **5-20.** *Peplos Kore* (c. 530 BCE), Greece **5-13.** **Siphnian Treasury** (c. 530–525 BCE), Greece **5-18.** *Anavysos Kouros* (c. 525 BCE), Greece
REPUBLICAN 509–27 BCE	**6-11.** **Bronze mirror** (c. 350 BCE) **6-10.** **Head of a man** (c. 300 BCE)	**2-29.** **Apadana of Darius and Xerxes** (518–c. 460 BCE), Persia
AUGUSTAN 27 BCE–14 CE	**6-18.** *Aulus Metellus* (late 2nd/1st cent. BCE) **6-13.** **Sanctuary of Fortuna Primigenia** (begun c. 100 BCE) **6-12.** *Pont du Gard* (late 1st cent. BCE) **6-61.** *Garden Scene* (late 1st cent. BCE) **6-63.** *Initiation Rites of the Cult of Bacchus* (?) (c. 50 BCE) **6-16.** Maison Carrée (c. 20 BCE) **6-20.** *Augustus of Primaporta* (c. 20 BCE) **6-22.** *Ara Pacis* (13–9 BCE)	**2-30.** *Darius and Xerxes Receiving Tribute* (491–486 BCE), Persia **5-33.** *Kritian Boy* (c. 480 BCE), Greece **5-1.** Myron. *Discus Thrower* (c. 450 BCE), Greece **5-39.** Kallikrates and Iktinos. Parthenon (447–438 BCE), Greece **5-61.** Praxiteles. *Aphrodite of Knidos* (c. 350 BCE), Greece **9-8.** **Sanchi stupa** (3rd cent. BCE), India **10-1.** **Qin soldiers** (c. 210 BCE), China **5-77.** **Pergamon altar** (c. 166–156 BCE), Greece **5-83.** *Aphrodite of Milos* (c. 150 BCE), Greece
IMPERIAL 14–180 CE	**6-26.** **Imperial Forums** (c. 46 BCE–325 CE) **6-54.** **House of the Vettii** (mid-1st cent. CE) **6-31.** **Colosseum** (72–80 CE) **6-37.** **Arch of Titus** (c. 81 CE) **6-60.** *Cityscape* (late 1st cent. CE) **6-65.** *Young Woman Writing* (late 1st cent. CE) **6-49.** **Timgad** (begun c. 100 CE) **6-28.** **Column of Trajan** (113–16 or after 117 CE) **6-30.** **Miletos gate** (c. 120 CE) **6-34.** **Pantheon** (125–28 CE) **6-55.** **Hadrian's Villa** (c. 135 CE) **6-45.** *Marcus Aurelius* (c. 176 CE)	**3-45.** **Mummy of boy** (100–120 CE), Egypt
LATE EMPIRE 180 CE–395 CE	**6-46.** *Commodus as Hercules* (c. 191–2 CE) **6-67.** **Fayum portrait** (c. 200 CE) **6-69.** **Baths of Caracalla** (c. 211–17 CE) **6-74.** *Ludovisi Battle Sarcophagus* (c. 250 CE) **6-78.** **Trier Basilica** (early 4th cent. CE) **6-81.** **Basilica of Maxentius and Constantine** (306–13 CE) **6-79.** **Arch of Constantine** (312–15 CE) **6-84.** *Priestess of Bacchus* (?) diptych (c. 390–401 CE)	**7-3.** *Menorahs and Ark of the Covenant* (3rd cent. CE), Rome **7-5.** **Synagogue** (244–45 CE), Dura-Europos **7-6.** *Good Shepherd, Orants, and Story of Jonah* (4th cent. CE), Rome

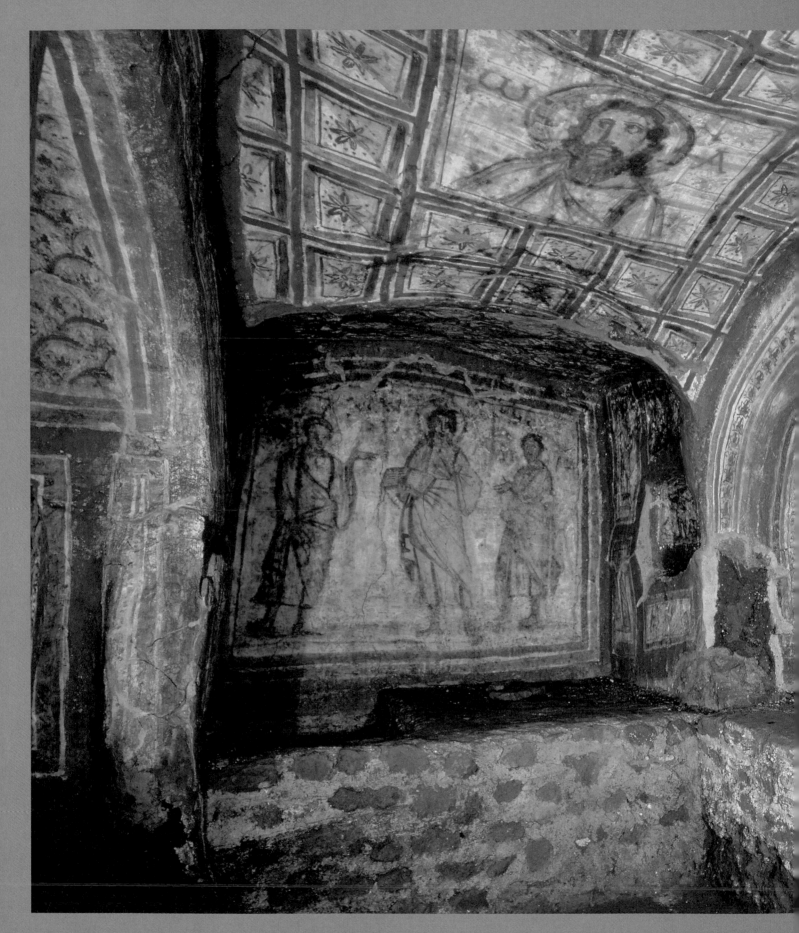

7-1. *Cubiculum* of Leonis,
Catacomb of Commodilla, near Rome.
Late 4th century

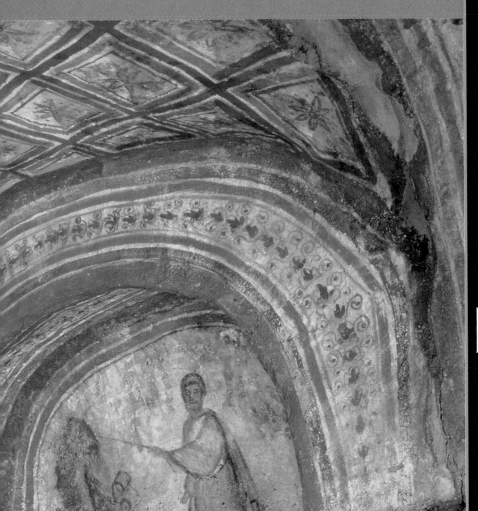

7
Early
Christian,
Jewish,
and
Byzantine
Art

In ancient Rome, gravediggers were the architects of the underground. Where subsoil conditions were right—the tufa around Rome, for example—they tunneled out streets and houses in a city of the dead—a necropolis—with as many as five underground levels. Working in dark, narrow galleries as much as 70 feet below the surface, they dug out corridors, shelves, and small burial rooms to create catacombs. Above-ground, the gravediggers acted as the cemeteries' guards and gardeners. Some of them may have been painters, too, for even the earliest catacombs had some pictorial decoration—initially very simple inscriptions and symbols.

Cemeteries were always built outside the city walls, so that the dead would not defile the city, but they were not secret or ever used as hiding places—such stories are products of the nineteenth-century romantic imagination. Burial in catacombs became common in the early third century CE and ended by about 500. Although Rome's Christian catacombs are the most famous today, people of other faiths—Jews, devotees of Isis, followers of Bacchus and other mystery religions, pagan traditionalists—were interred in their own communal catacombs, which were decorated with symbols of their faiths.

In the third century CE, catacombs were painted with images of salvation based on prayers for the dead. By the fourth century, painting had become even more elaborate, as in this catacomb near the tomb of Saint Paul on the road to Ostia, which depicts New Testament saints with a particular connection to Rome (fig. 7-1). In the center of a small burial room's ceiling, between *alpha* and *omega*—the Greek letters signifying the beginning and end—the head of Christ appears in a circle (a halo). Facing the door is Christ with the Roman martyrs Felix (d. 274) and Adauctus (d. 303). At the right, a painting depicts Peter in the hours before the cock crowed, denying that he knew Jesus (Matthew 26:74–75). On the left, Peter miraculously brings forth water from a rock in Rome's Mamertine Prison to baptize his fellow prisoners and jailers. Here the painter has copied the traditional Jewish scene of Moses striking water from the rock (Exodus 17:1–7); were it not for the painting's Christian context, it would be indistinguishable from Jewish art.

TIMELINE 7-1. Early Christian and Byzantine Worlds. Early Christianity, first documented about 70–100 CE, took root and spread during the time of the Roman Empire. The Byzantine era is traditionally divided into Early, Middle, and Late periods.

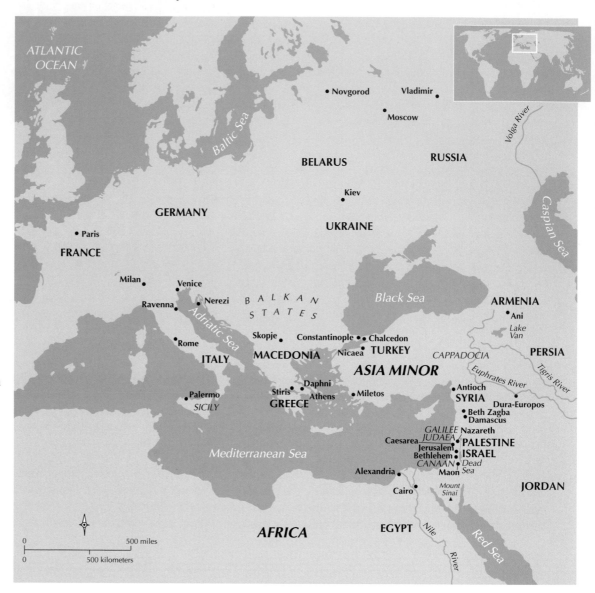

MAP 7-1. Early Christian, Jewish, and Byzantine Worlds. The eastern Mediterranean lands of Canaan and Judaea were centers of Jewish settlement. Rome was a major center of early Christianity. Byzantine culture took root in Constantinople and flourished throughout the Eastern Roman, or Byzantine, Empire and extended into northern areas such as Russia and Ukraine.

JEWS AND CHRISTIANS IN THE ROMAN EMPIRE

Three religions that arose in the Near East dominate the spiritual life of the Western world: Judaism, Christianity, and Islam. All three religions are monotheistic; followers hold that only one god created and rules the universe. Traditional Jews believe that God made a covenant, or pact, with their ancestors, the Hebrews, and that they are God's chosen people. They await the coming of a savior, the Messiah, "the anointed one." Traditional Christians believe that Jesus of Nazareth was that Messiah (the appellation "Christ" is derived from the Greek term meaning "Messiah"). They believe that God took human form, preached among men and women, and suffered execution, then rose from the dead and ascended to heaven after establishing the Christian Church under the leadership of the apostles (his closest disciples). Muslims, while accepting the Hebrew prophets and Jesus as divinely inspired, believe Muhammad to be God's (Allah's) last and greatest prophet, the Messenger of God through whom Islam was revealed some six centuries after Jesus' lifetime. All three are "religions of the book," that is, they have written records of God's will and words: the Hebrew Scriptures; the Christian Bible, which includes the Hebrew Scriptures as its Old Testament as well as the Christian New Testament; and the Muslim Koran, believed to be the Word of God revealed in Arabic directly to Muhammad through the archangel Gabriel. Jewish and Early Christian art and Byzantine art, including some of the later art of the Eastern Orthodox Church, are considered in this chapter (Timeline 7-1). Islamic art is discussed in Chapter 8.

EARLY JUDAISM

The Jewish people trace their origin to the Semitic people called the Hebrews, who lived in the land of Canaan. Canaan, known from the second century CE by the Roman name "Palestine," was located along the Mediterranean Sea (Map 7-1). According to the Torah, the first five books of the Hebrew Scriptures, God promised the patriarch Abraham that Canaan would be a homeland for the Jewish people (Genesis 17:8), a belief that remains important among Jews to this day.

Jewish settlement of Canaan probably began sometime in the second millennium BCE. According to Exodus, the second book of the Torah, the prophet Moses led the Hebrews out of slavery in Egypt to the promised land of Canaan. At one crucial point during the journey, Moses climbed alone to the top of Mount Sinai, where God gave him the Ten Commandments, the cornerstone of Jewish law. The commandments, inscribed on tablets, were kept in a gold-covered wooden box, the Ark of the Covenant.

In the tenth century BCE, the Jewish king Solomon built a temple in Jerusalem to house the Ark of the Covenant. He sent to nearby Phoenicia for cedar, cypress, and sandalwood, and for a superb artisan to supervise construction of the Temple (later known as the First Temple) (Chronicles 2:2–15). The Temple consisted of courtyards, two bronze pillars, an entrance hall, a main hall, and the Holy of Holies, the innermost chamber that housed the Ark and its guardian **cherubim**, or attendant angels (perhaps resembling the winged guardians of Assyria, seen in figure 2-1). The Temple was the spiritual center of Jewish life.

In 586 BCE, the Babylonians, under King Nebuchadnezzar II, conquered Jerusalem. They destroyed the Temple, exiled the Jews, and carried off the Ark of the Covenant. When Cyrus the Great of Persia conquered Babylonia in 539 BCE, he permitted the Jews to return to their homeland and rebuild the Temple in Jerusalem (the Second Temple). But from that time forward, Canaan existed primarily under foreign rule; eventually, it became part of the Roman Empire. Herod the Great, the king of Judaea (ruled 37–4 BCE), restored the Temple, but in 70 CE, Roman forces led by the general and future emperor Titus destroyed the Herodian temple and all of Jerusalem (Chapter 6). The Jews dispersed and established communities throughout the Roman Empire. The site of the Temple is now occupied by a Muslim shrine (Chapter 8).

EARLY CHRISTIANITY

Christians believe in one God manifest in three persons: the Trinity of Father (God), Son (Jesus Christ), and Holy Spirit. According to Christian belief, Jesus was the son of God (the Incarnation) by a human mother, the Virgin Mary. His ministry on earth ended when he was executed by being nailed to a cross (the Crucifixion). He rose from the dead (the Resurrection) and ascended into heaven (the Ascension). Christian belief, especially about the Trinity, was formalized at the first ecumenical council of the Christian Church, called by Constantine I at Nicaea (modern Iznik, Turkey) in 325.

The life and teachings of Jesus of Nazareth, who was born sometime between 8 and 4 BCE and was crucified at the age of thirty-three, were recorded between about 70 and 100 CE in the New Testament books attributed to the Four Evangelists: Matthew, Mark, Luke, and John. These books are known as the Gospels (from an Old English translation of a Latin word derived from the Greek *euangelion*, "good news"). In addition to the Gospels, the New Testament includes an account of the Acts of the Apostles (one book) and the Epistles, twenty-one letters of advice and encouragement to Christian communities in cities and towns in Greece, Asia Minor, and other parts of the Roman Empire. Thirteen of these letters are attributed to a Jewish convert, Saul, who took the Christian name "Paul." The twenty-seventh and final book is the Apocalypse (the Revelation), a series of enigmatic visions and prophecies concerning the eventual triumph of God at the end of the world, written about 95 CE.

Jesus was born during the reign of Emperor Augustus (ruled 27 BCE–14 CE), when Herod the Great ruled the Jewish kingdom of Judaea as a Roman protectorate. Following Herod's death in 4 BCE, Judaea came under direct Roman rule, leading to widespread political and social unrest and religious dissent. Tiberius (ruled 14–37 CE) was emperor during the three-year period in which Jesus is thought to have preached. Jesus' arrest and crucifixion probably occurred not long after the Roman Pontius Pilate was appointed administrator of Judaea in 26 CE.

The Gospels' sometimes conflicting accounts relate that Jesus was a descendant of the Jewish royal house of King David and that he was born in Bethlehem in Judaea, where his mother, Mary, and her husband, Joseph, had gone to be registered in the Roman census. He grew up in Nazareth in Galilee (in what is now northern Israel), where Joseph was a carpenter. At the age of thirty, Jesus gathered a group of disciples, male and female, preaching love and charity, a personal relationship with God, the forgiveness of sins, and the promise of life after death.

Jesus limited his ministry primarily to Jews; the apostles, as well as later followers such as Paul, took Jesus' teachings to non-Jews. Despite sporadic persecutions, Christianity persisted and spread throughout the Roman Empire, although the government did not formally recognize the religion until 313. As well-educated, upper-class Romans joined the Church during its first century of rapid growth, they instituted an increasingly elaborate organizational structure and ever more sophisticated doctrine.

Christian communities were organized by geographical units, along the lines of Roman provincial governments. Senior Church officials called bishops served as

ROME, CONSTANTINOPLE, AND CHRISTIANITY

The balance of power in the Roman-Byzantine world and the composition of the empire shifted continually. Constantine I (ruled 306–37) defeated his rivals and became sole emperor of the Roman Empire in 324. In 330, he moved the empire's capital from Rome to Byzantium, a city located at the intersection of Europe and Asia. The site offered great advantages in military defense and trade. The new capital, renamed Constantinople, was the seat of the Roman Empire until 395, when the empire split permanently in two, becoming the Western (Roman) Empire and the Eastern (Byzantine) Empire. Despite the cultural division between the Latin-speaking West, where urban society was the product of comparatively recent imperial conquest, and the Greek-speaking East, heir to much older civilizations, the Byzantines always called themselves Romans and their empire the Eastern Roman Empire.

What remained of the greatly weakened Roman Empire in the West ended in 476, crumbling under the continual onslaught of Germanic invaders. Constantinople succeeded Rome as the center of power and culture. At its greatest extent, in the sixth century, the Byzantine Empire included most of the area around the Mediterranean, including northern Africa, the Levant, Anatolia, all of Greece, much of Italy, and a small part of Spain. The Byzantine Empire lasted until 1453, when Constantinople became an Islamic capital under the Ottoman Turks.

The relationship of church and state in the Roman-Byzantine world was complex. When the empire divided in the late fourth century, the Christian Church developed two branches, Eastern and Western. Despite centuries of disagreement over doctrine and jurisdiction, the Church did not officially split until 1054, resulting in the Western, or Catholic, Church and the Eastern, or Orthodox, Church. The Western Church, led by the pope, has been centered throughout most of its history in Rome. The patriarch of Constantinople has headed the Eastern Church, which, over time, has developed along regional lines, with several national patriarchs as semi-autonomous leaders.

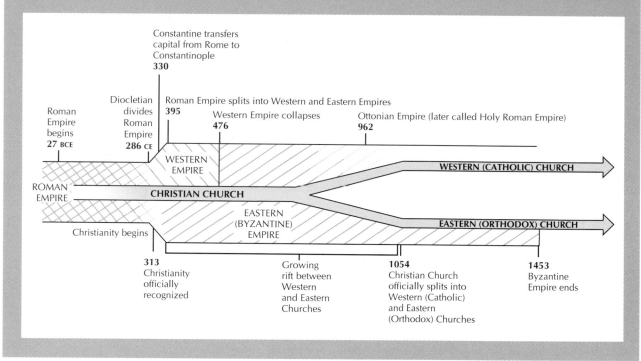

governors of dioceses made up of smaller units, parishes, headed by priests. Bishops' headquarters—known as sees, or seats—were often in Roman provincial capitals. (A bishop's church is a cathedral, a word derived from the Latin *cathedra*, which means "chair" but took on the meaning "bishop's throne.") Archbishops administered several sees. The archbishops of Jerusalem, Rome, Constantinople, Alexandria, and Antioch (in southern Turkey) were the most important. The bishop of Rome eventually became head of the Western Church, holding the title "pope." The bishop of Constantinople became the head, or patriarch, of the Eastern Church. In spite of tensions between East and West, the Church remained united until 1054, when the Western pope and Eastern patriarch declared one another to be in error, and the Church split in two. Since this schism, the pope has been the supreme authority in the Western, Catholic Church, and the patri-arch, with his metropolitans (equivalent to archbishops), has governed the Eastern, Orthodox Church. (See "Rome, Constantinople, and Christianity," above.)

JEWISH ART AND EARLY CHRISTIAN ART

Jewish law forbade the making of images that might be worshiped as idols. In early Judaism this prohibition against representational art was applied primarily to sculpture in the round. Jewish art combined both Near Eastern and classical Greek and Roman elements to depict Jewish subject matter, both symbolic and narrative. Because Christianity claimed to have arisen out of Judaism, its art incorporated many symbols and narrative representations from the Hebrew Scriptures and other Jewish sources. Christian rites prompted the development of special buildings—churches

and baptistries—as well as specialized apparatus, and Christians began to use the visual arts to instruct the laity as well as to glorify God. Almost no examples of specifically Christian art exist before the early third century, and even then it drew its styles and imagery from Jewish and classical traditions. In this process, known as **syncretism**, artists assimilate images from other traditions, giving them new meanings; such borrowings can be unconscious or quite deliberate. For example, **orant** figures—worshipers with arms outstretched—can be pagan, Jewish, or Christian, depending on the context in which they occur.

Perhaps the most important of these syncretic images is the **Good Shepherd**. In pagan art, he was Hermes the shepherd or Orpheus among the animals, but Jews and Christians saw him as the Good Shepherd of the Twenty-third Psalm: "The Lord is my shepherd; there is nothing I lack" (Psalms 23:1).

PAINTING AND SCULPTURE

Jews lived in communities dispersed throughout the Roman Empire, and most of the earliest surviving examples of Jewish art date from the Hellenistic and Roman periods. Six Jewish catacombs (see "Roman Funerary Practices," page 239), discovered just outside the city of Rome and in use from the first to fourth century CE, display wall paintings with Jewish themes. In one example, from the third century CE, two **menorahs**, or seven-branched lamps, flank the long-lost Ark of the Covenant (fig. 7-2). The conspicuous representation on the Arch of Titus in Rome (see fig. 6-38) of the menorah looted from the Second Temple of Jerusalem kept the memory of these treasures alive.

Christians, too, used catacombs for burials and funeral services even before Constantine I (ruled 306–37) granted their religion official recognition. In the Christian Catacomb of Commodilla, dating from the fourth century, long rectangular niches in the walls, called *loculi*, each held two or three bodies (see fig. 7-1). Affluent families created small rooms, or *cubicula*, off the main passages to house *sarcophagi*. The *cubicula* were hewn out of the soft tufa, a volcanic rock, then plastered and painted with imagery related to their owners' religious beliefs. The finest Early Christian catacomb paintings resemble murals in houses such as those preserved at Rome and Pompeii (see figs. 6-61, 6-62); however, the aesthetic quality of the painting is secondary to the message it conveys.

Communal Christian worship focused on the central "mystery," or miracle, of the Incarnation and the promise of salvation. At its core was the ritual consumption of bread and wine, identified as the body and blood of Jesus, which Jesus had inaugurated at the Last Supper, a Passover meal with his disciples. Around these acts developed an elaborate religious ceremony, or liturgy, called the Eucharist (also known as Holy Communion or Mass). Christians adopted the grapevine and grape cluster of the Roman god Bacchus to symbolize the wine of the Eucharist and the blood of Christ (see "Christian Symbols," page 294).

One fourth-century Roman catacomb contained remains, or relics, of Saints Pietro and Marcellino, two third-century Christians martyred for their faith. Here, the

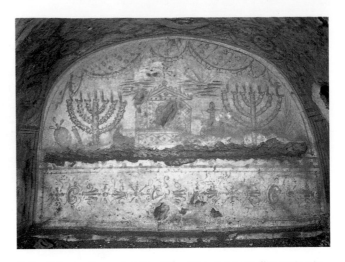

7-2. ***Menorahs and Ark of the Covenant***, wall painting in a Jewish catacomb, Villa Torlonia, Rome. 3rd century

The menorah form probably derives from the ancient Near Eastern Tree of Life, symbolizing for the Jewish people both the end of exile and the paradise to come.

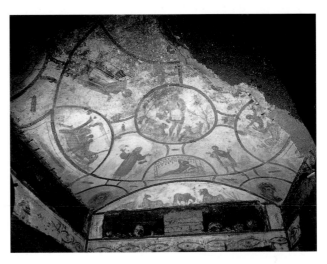

7-3. ***Good Shepherd***, ***Orants***, and ***Story of Jonah***, painted ceiling of the Catacomb of Saints Pietro and Marcellino, Rome. 4th century

ceiling of a *cubiculum* is partitioned by a central **medallion**, or round ornament, and four **lunettes**, semicircular wall areas framed by an arch (fig. 7-3). At the center is a Good Shepherd, whose pose has roots in Greek sculpture. In its new context, the image was a reminder of Jesus' promise: "I am the good shepherd. A good shepherd lays down his life for the sheep" (John 10:11). The semicircular compartments at the ends of the arms of the cross tell the Old Testament story of Jonah and the sea monster (Jonah 1–2), in which God caused Jonah to be thrown overboard in a storm, swallowed by a monster, and released, repentant and unscathed, three days later. Christians reinterpreted this story as a parable of Christ's death and resurrection—and hence of the everlasting life awaiting true believers—and it was a popular subject in Christian catacombs. On the left, Jonah is thrown from the boat; on the right, the monster spews him up; and at the center, Jonah reclines in the shade of a gourd vine, a symbol of paradise. Orants, figures with upraised hands in the ancient gesture of prayer, stand between the lunettes.

CHRISTIAN SYMBOLS

Symbols have always played an integral role in Christian art. Some were devised just for Christianity, but most were borrowed from pagan and Jewish traditions and were adapted for Christian use.

Dove

The Old Testament dove is a symbol of purity, representing peace when it is shown bearing an olive branch. In Christian art, a white dove is the symbolic embodiment of the Holy Spirit and is often shown descending from heaven, sometimes haloed and radiating celestial light.

Fish

The fish was one of the earliest symbols for Jesus Christ. Because of its association with baptism in water, it came to stand for all Christians. Fish are sometimes depicted with bread and wine to represent the Eucharist.

Lamb (Sheep)

The lamb, an ancient sacrificial animal, symbolizes Jesus' sacrifice on the cross as the Lamb of God, its pouring blood redeeming the sins of the world. The Lamb of God (*Agnus Dei* in Latin) may appear holding a cross-shaped scepter and/or a victory banner with a cross (signifying Christ's resurrection). The lamb sometimes stands on a cosmic rainbow or a mountaintop. A flock of sheep represents the apostles—or all Christians—cared for by their Good Shepherd, Jesus Christ.

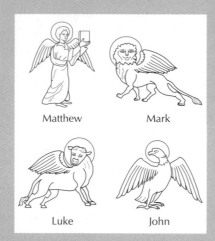

Matthew Mark
Luke John

Four Evangelists

The evangelists who wrote the New Testament Gospels are traditionally associated with the following creatures: Saint Matthew, a man (or angel); Saint Mark, a lion; Saint Luke, an ox; and Saint John, an eagle. These emblems derive from visionary biblical texts and may be depicted either as the saints' **attributes** (identifying accessories) or their embodiments (stand-ins for the saints themselves).

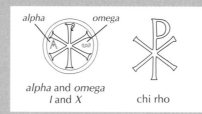

alpha omega

alpha and omega
I and X

chi rho

Monograms

Alpha (the first letter of the Greek alphabet) and *omega* (the last) signify God as the beginning and end of all things. This symbolic device was popular from Early Christian times through the Middle Ages. *Alpha* and *omega* often flank the abbreviation IX or XP. The initials *I* and *X* are the first letters of Jesus and *Christ* in Greek. The initials *XP*, known as the *chi rho*, were the first two letters of the word *Christos*. These emblems are sometimes enclosed by a halo or wreath of victory.

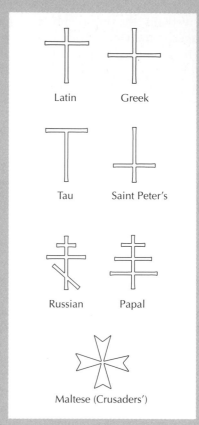

Latin Greek

Tau Saint Peter's

Russian Papal

Maltese (Crusaders')

Cross

The primary Christian emblem, the cross, symbolizes the suffering and triumph of Jesus' crucifixion and resurrection as Christ. It also stands for Jesus Christ himself, as well as the Christian religion as a whole. Crosses have taken various forms at different times and places, the two most common in Christian art being the Latin and Greek.

Sculpture that is clearly Christian is even rarer than painting from before the time of Constantine. What there is consists mainly of small statues and reliefs, many of them Good Shepherd images. A remarkable set of small marble figures, probably made in the third century in Asia Minor, also depicts the Jonah story (fig. 7-4); their function is unknown. Carved of a fine marble, they illustrate the biblical story with the same literalness and enthusiasm as the paintings on the catacomb ceiling.

ARCHITECTURE AND ITS DECORATION

The variety of religious buildings found in modern Syria at the abandoned Roman outpost of Dura-Europos, a Hellenistic fortress taken over by the Romans in 165 CE, illustrates the cosmopolitan character of frontier Roman society, as well as places of worship, in the second and third centuries. Although Dura-Europos was destroyed in 256 CE by Persian forces, important parts of the

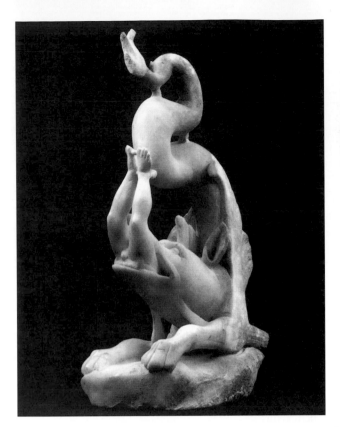
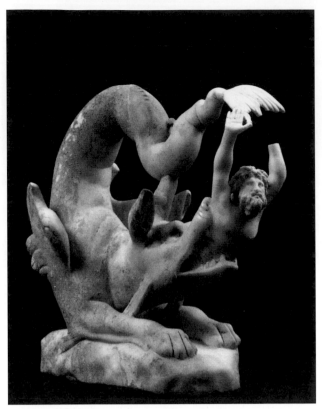

7-4. ***Jonah Swallowed*** **and** ***Jonah Cast Up***, two statuettes of a group from the eastern Mediterranean, probably Asia Minor. Probably 3rd century. Marble, heights 20⁵/₁₆" (51.6 cm) and 16" (40.6 cm). The Cleveland Museum of Art
John L. Severance Fund, 65.237, 65.238

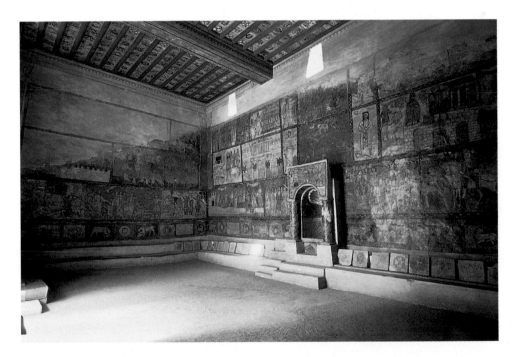

7-5. Wall with Torah niche, from a house-synagogue, Dura-Europos, Syria. 244–45. Tempera on plaster, section approx. 40' (12.19m) long. Reconstructed in the National Museum, Damascus, Syria

stronghold have been excavated, including a Jewish **house-synagogue**, a Christian **house-church**, shrines to the Persian gods Mithras and Zoroaster, and temples to Greek and Roman gods, including Zeus, Artemis, and Adonis. The Jewish and Christian structures were preserved because they had been built against the inside wall of the southwest rampart. When the desperate citizens attempted to strengthen this fortification in futile preparation for the final attack, they buried these buildings. The entire site was abandoned and was rediscovered only in 1920 by a French army officer.

Jewish Places of Worship. Some Jewish places of worship, or synagogues, were located in private homes, or in buildings originally constructed as homes. The first Dura-Europos synagogue, built like a house, consisted of an assembly hall with a niche for the Torah scrolls, a separate alcove for women, and a courtyard. After a remodeling of the building, completed in 244–45 CE, men and women shared the hall, and residential rooms were added. Two architectural features distinguished the assembly hall: a bench along its walls and a niche for the Torah scrolls (fig. 7-5).

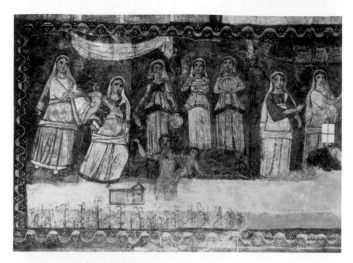

7-6. Finding of the Baby Moses, detail of a wall painting from a house-synagogue, Dura-Europos, Syria. Second half of 3rd century. Copy in tempera on plaster. Yale University Art Gallery, New Haven, Connecticut
Dura-Europus Collection

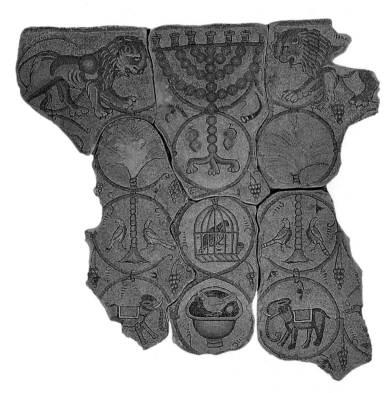

7-7. Mosaic synagogue floor, from Maon (Menois). c. 530. The Israel Museum, Jerusalem

In addition to house-synagogues, Jews built synagogues designed, as were Christian churches, on the model of the ancient Roman **basilica**. A typical basilica synagogue had a central **nave**; an **aisle** on both sides, separated from the nave by a line of columns; a mosaic floor; a semicircular **apse** in the wall facing Jerusalem; and perhaps an atrium and porch, or **narthex**. A Torah was kept in a shrine in the apse.

Synagogues contained little representational sculpture because of the prohibition against praying to images

or idols, but paintings and mosaics often decorated walls and floors. Jewish representational painting flourished in the third century, as seen in the murals that covered the Dura-Europos house-synagogue's interior. Narrative and symbolic scenes depicting events from Jewish history unfold in three registers of framed panels. The work of more than one artist, they are done in a style in which static, almost two-dimensional figures seem to float against a neutral background. *Finding of the Baby Moses* (fig. 7-6) illustrates what took place after Moses' mother set him afloat in a reed basket in the shallows of the Nile in an attempt to save him from the pharaoh's decree that all Jewish male infants be put to death (Exodus 1:8–2:10): The pharaoh's daughter finds him and claims him as her own child. The painting shows the story unfolding in a continuous narrative set in a narrow foreground space. At the right, the princess sees the child hidden in the bulrushes; at the center, she wades nude into the water to save him; and at the left, she hands him to a nurse (actually his own mother). The frontal poses, strong outlines, and flat colors are distinctive pictorial devices; they are, in fact, features of later Byzantine art, which perhaps derived from works such as this.

Among the mosaics that decorated early Jewish places of worship, a fragment of a mosaic floor from a sixth-century synagogue at Maon (Menois) features traditional Jewish symbols along with a variety of stylized plants, birds, and animals (fig. 7-7). Two lions of Judah flank a menorah. Beneath it is the ram's horn (*shofar*) blown on ceremonial occasions and three citrons (*etrogs*) used to celebrate the harvest festival of Sukkoth. Other Sukkoth emblems—including palm trees and the *lulov*, a sheaf of palm, myrtle, and willow branches and an *etrog*—symbolize the bounty of the earth and unity of all Jews. The variety of placid animals may represent the universal peace prophesied by Isaiah (11:6–9; 65:25). The pairing of images around a central element—as in the birds flanking the palm trees or the lions facing the menorah—is characteristic of Near Eastern art. The grapevine forming circular medallions as a frame for the images was popular in Roman mosaics.

Christian House-Churches. The Dura-Europos house-church, about 300 yards from the synagogue, reminds us that Christians first gathered in the homes of members of the community. The church was a typical Roman house, with rooms around a courtyard and a second-floor apartment for the owner. A small red cross painted above the main entrance alerted Christians that the building was a gathering place. Two of the five ground-floor rooms—a large assembly hall (made by eliminating a wall dividing two rooms) and a room with a water tank—were clearly for Christian use. The other rooms are undifferentiated from residential chambers.

Opening off the courtyard, the room with the water tank must have been the **baptistry**, a special place for the baptismal rite. One end of the room had a niche equipped with a water basin, above which were images of the Good Shepherd and of Adam and Eve (fig. 7-8). These murals reminded new Christians that humanity fell from grace when the first man and woman disobeyed God and ate

fruit from the tree of knowledge offered to them by an evil serpent. But the Good Shepherd (Jesus Christ) came to earth to carry his sheep (Christians) to salvation and eternal life. Baptism washed away sin, leaving the initiate reborn as a member of the community of the faithful.

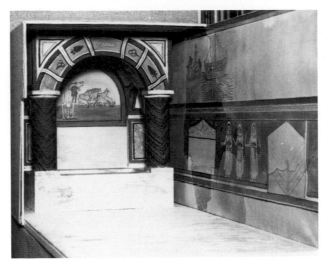

7-8. Small-scale model of walls and baptismal font, from the baptistry of a Christian house-church, Dura-Europos, Syria. c. 240. Yale University Art Gallery, New Haven, Connecticut
Dura-Europos Collection

IMPERIAL CHRISTIAN ARCHITECTURE AND ART

In 313, Constantine I issued the Edict of Milan, granting all people in the Roman Empire freedom to worship whatever god they wished. This religious toleration, combined with Constantine's active support of Christianity (though he himself did not convert until just before his death), allowed Christianity to enter a new phase, developing a sophisticated philosophical and ethical system that incorporated many ideas from Greek and Roman thought. Church scholars edited and commented on the Bible, and the papal secretary who would become Saint Jerome (c. 347–420) undertook a new translation from Hebrew, Greek, and Latin versions into Latin, the language of the Western Church. Completed about 404, this so-called Vulgate became the official version of the Bible. (The term *Vulgate* derives from the same Latin word as *vulgar*, meaning "common" or "popular.") Christians also gained political influence in this period. The Christian writer Lactantius (c. 240–320), for example, tutored Constantine I's son Crispus; and Eusebius (c. 260–c. 339), bishop of Caesarea, was a trusted imperial adviser from about 315 to 339. These transformations in the philosophical and political arenas coincided with a dramatic increase in size and splendor of Christian architecture.

ARCHITECTURE AND ITS DECORATION

Christian congregations needed large, well-lit spaces for their worship. The basilica suited perfectly. The nave with aisles on the two long sides created a space for processions (see "Basilica-Plan and Central-Plan Churches," page 296). If the clergy needed to partition space, they used screens or curtains—for example, around the **altar** or in aisles. The entrance was on a short end of the basilica, facing the apse and the place where the altar stood, the same place that in a pagan basilica was reserved for the judge or presiding official.

Basilica-Plan Churches. After Constantine consolidated imperial power, uniting the West and East around 324, he began a vast building program that included Christian churches. Among these was a residence, a church, and a baptistry for the bishop of Rome (the pope) on the site of the imperial Lateran palace. The church of Saint John Lateran remains the cathedral of Rome, although the pope's residence has since the thirteenth century been the Vatican. Perhaps as early as 320, the emperor also ordered the construction of a large new basilica to replace the second-century monument marking the place where Christians believed Saint Peter (c. 64 CE) was buried. The new basilica—now known as Old Saint Peter's because it was completely replaced by a new building in the sixteenth

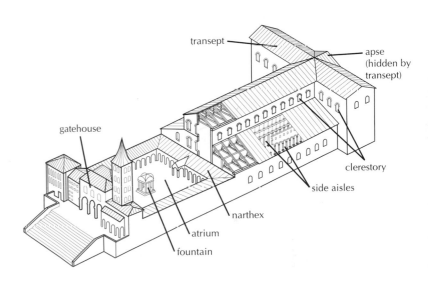

7-9. Reconstruction drawing of Old Saint Peter's basilica, Rome. c. 320–27; atrium added in later 4th century. Approx. 394' (120 m) long and 210' (64 m) wide

century—would protect the tomb of Peter, whom Christ had designated as the leader of the Church, and make the site accessible to the faithful. As the church of Saint Peter and his successors, it established a model for churches just as the bishop of Rome gained authority over all other bishops. Our knowledge of Old Saint Peter's is based on written descriptions, drawings made before and while it was being dismantled, the study of other churches inspired by it, and modern archaeological excavations at the site (fig. 7-9).

Old Saint Peter's was an unusual basilica church in having double side aisles instead of one aisle on each side of the nave. A narthex across the width of the building protected five doorways—a large, central portal into the nave and two portals on each side opening directly to each of the four side aisles. Open wood rafters roofed the nave and aisles. Columns supporting an entablature lined

ELEMENTS OF ARCHITECTURE

Basilica-Plan and Central-Plan Churches

The forms of early Christian buildings were based on two classical prototypes: rectangular Roman basilicas (see fig. 6-27) and round-domed structures—rotundas—such as the Pantheon (see figs. 6-34, 6-35). As in Old Saint Peter's in Rome (see fig. 7-9), **basilica-plan** churches are characterized by an **atrium**, or forecourt, which leads to the **narthex**, a porch spanning one of the building's short ends. Doorways—known collectively as the church's **portal**—lead from the narthex into a long central area called a **nave**. The high-ceilinged nave is separated from aisles on either side by rows of columns. The nave is lit by windows along its upper story—called a clerestory—that rises above the side aisles' roofs. At the opposite end of the nave from the narthex is a semicircular projection, the **apse**. The apse is the building's symbolic core, where the altar, raised on a platform, is located.

Sometimes there is also a **transept**, a horizontal wing that crosses the nave in front of the apse (see fig. 7-9). The transept was developed for early Christian churches that were pilgrimage sites to provide space for large numbers of people near the altar and its relics.

Central-plan structures were first used by Christians as tombs, baptism centers (**baptistries**), and shrines to martyrs (*martyria*). The **Greek-cross plan**, in which two similarly sized "arms" intersect at their centers, is a type of central plan. Instead of the longitudinal axis of basilica-plan churches, which draws worshipers forward toward the apse, central-plan churches such as Ravenna's San Vitale (see figs. 7-26, 7-27) have a more vertical axis. This makes the **dome**, which is a symbolic "vault of heaven," a natural focus over the main worship area. Like secular basilicas, central-plan churches generally have an atrium, a narthex, and an apse. The **naos** is the space containing the central dome, sanctuary, and apse.

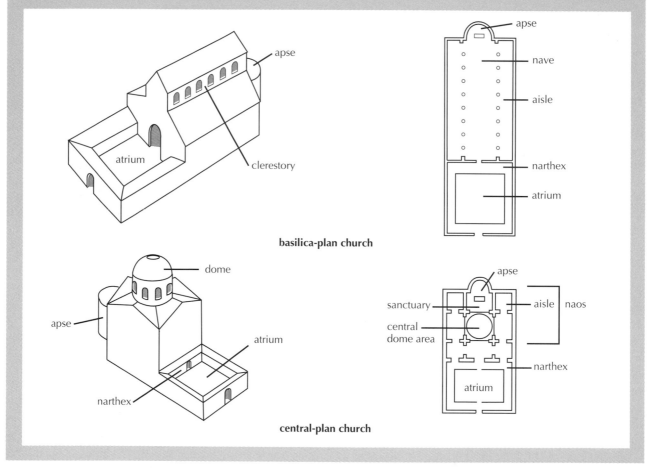

basilica-plan church

central-plan church

the nave, forming what is called a **nave colonnade**. The row of columns between the side aisles supported a series of round arches. Constantine's architects devised a new element for the basilica plan. At the **apsidal** end of the nave and aisles, they added a **transept**, which crossed in front of the apse, projecting a **T** form that anticipated the later **Latin-cross** church plan (see "Basilica-Plan and Central-Plan Churches," above). This area provided additional space near the tomb for pilgrims.

Saint Peter's bones supposedly lie below, marked in the nave by a permanent, pavilionlike structure supported on four columns called a *ciborium*. Catacombs

lay beneath the church, and over time a large **crypt**, or underground vault, was used for the burial of popes. Sarcophagi and tombs eventually also lined the side aisles. Old Saint Peter's thus served a variety of functions. It was a congregational church, a pilgrimage shrine commemorating Peter's martyrdom and containing his relics, and a burial site. Old Saint Peter's could hold at least 14,000 worshipers, and it remained the largest Christian church until the eleventh century.

Most early Christian churches have been rebuilt, some many times, but the Church of Santa Sabina in Rome, constructed by Bishop Peter of Illyria between 422 and 432,

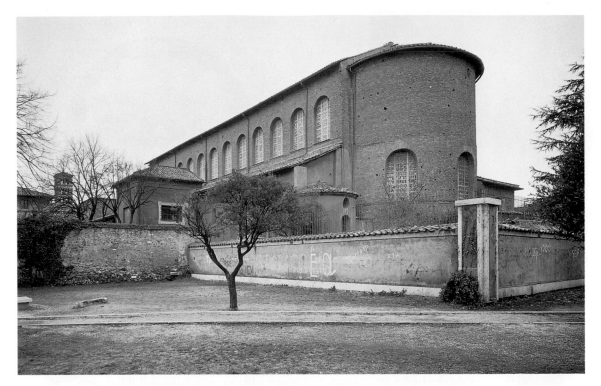

7-10. Church of Santa Sabina, Rome. 422–32

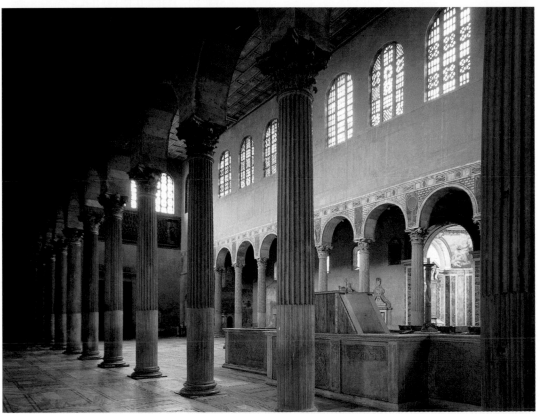

7-11. Interior, Church of Santa Sabina. View toward the east

appears much as it did in the fifth century (fig. 7-10). The basic elements of the basilica church are clearly visible inside and out: a nave with side aisles, lit by **clerestory** windows, ending in a rounded apse. (Compare Roman secular basilicas, such as the Basilica Ulpia [see fig. 6-27] and the Basilica at Trier [see fig. 6-78].) Santa Sabina's exterior, typical of the time, is severe brickwork. In contrast, the interior displays a wealth of marble veneer and twenty-four fluted marble columns with Corinthian capitals acquired from a second-century building (fig. 7-11). (Material reused from pagan buildings is known as *spolia*, Latin for "spoils.") The columns support round arches, creating a **nave arcade**, in contrast to a nave colonnade. The **spandrels** are inlaid with marble images of the chalice and paten (the plate that holds the bread)—the essential equipment for the Eucharistic rite that took place at the altar. The decoration of the upper walls is lost, and a paneled ceiling covers the rafter roof. The **triforium**, the blind wall between the arcade and the clerestory, typically had paintings or mosaics with scenes from the Old Testament or the Gospels.

Triforium mosaic panels still survive in the Church of Santa Maria Maggiore (Saint Mary the Great), which was built between 432 and 440. The church was the first to be dedicated to the Virgin Mary after the Council of Ephesus

7-12. *Parting of Lot and Abraham*, mosaic in the nave arcade, Church of Santa Maria Maggiore, Rome. 432–40. Panel approx. 4'11" x 6'8" (1.2 x 2 m)

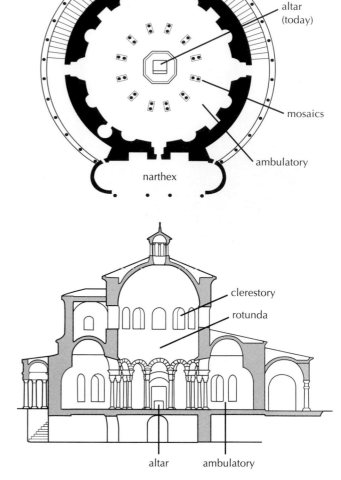

7-13. **Plan and section of the Church of Santa Costanza, Rome**. c. 338–50

in 431 declared her to be *Theotokos*, Bearer of God. The mosaics of the Church of Santa Maria Maggiore reflect a renewed interest in the earlier classicizing style of Roman art that arose during the reign of Pope Sixtus III (432–40). The mosaics along the nave walls, in framed panels high above the worshipers, illustrate Old Testament stories of the Jewish patriarchs and heroes—Abraham, Jacob, Moses, and Joshua—whom Christians believe foretold the coming of Christ and his activities on earth. These panels were not merely didactic—that is, they were not simply intended to instruct the congregation. Instead, like most of the decorations in great Christian churches from this time forward, they were also meant to praise God through their splendor, to make churches symbolic embodiments of the Heavenly Jerusalem that awaits believers.

Some of the most effective, "legible" compositions are those in which a few large figures dominate the space, as in the *Parting of Lot and Abraham* (fig. 7-12), a story told in the first book of the Hebrew Scriptures (Genesis 13:1–12). The people of Abraham and his nephew Lot, dwelling together, had grown too numerous, so the two agreed to separate and lead their followers in different directions. On the right, Lot and his daughters turn toward the land of Jordan, while Abraham and his wife stay in the land of Canaan. This parting is significant to both Jews and Christians because Abraham was the founder of Israel and an ancestor of Jesus.

In this mosaic, the toga-clad men share a parting look as they gather their robes about them and turn decisively away from each other. The space between them in the center of the composition emphasizes their irreversible decision to part. Clusters of heads in the background represent Abraham's and Lot's followers, an artistic convention used effectively here. References to the earlier Roman illusionistic style can be seen in the solid three-dimensional rendering of foreground figures, the hint of perspective in the building, and the landscape setting, with its flocks

of sheep, bit of foliage, and touches of blue sky. The mosaic was created with small cubes of marble and glass *tesserae* set closely together. The use of graduated colors creates shading from light to dark, producing three-dimensional effects that are offset by strong outlines. These outlines, coupled with the sheen of the gold *tesserae*, tend to flatten the forms.

CENTRAL-PLAN CHURCHES

A second type of ancient building—the *tholos*, a round structure with a central plan and vertical axis—also served Christian builders for tombs, martyrs' churches, and baptistries (see "Basilica-Plan and Central-Plan Churches," page 298). One of the earliest surviving central-plan Christian buildings is the mausoleum of Constantina, the daughter of Constantine, which was built outside the walls of Rome just before 350 (fig. 7-13). The mausoleum was consecrated as a church in 1256 and is now dedicated to Santa Costanza (the Italian form of the Christian princess's name). The building consists of a tall **rotunda** with an encircling **barrel-vaulted** passageway called an **ambulatory** (fig. 7-14). A double ring of paired columns with Composite capitals and richly molded entablature blocks supports the arcade and dome. The building's interior was entirely sheathed in mosaics and fine marble.

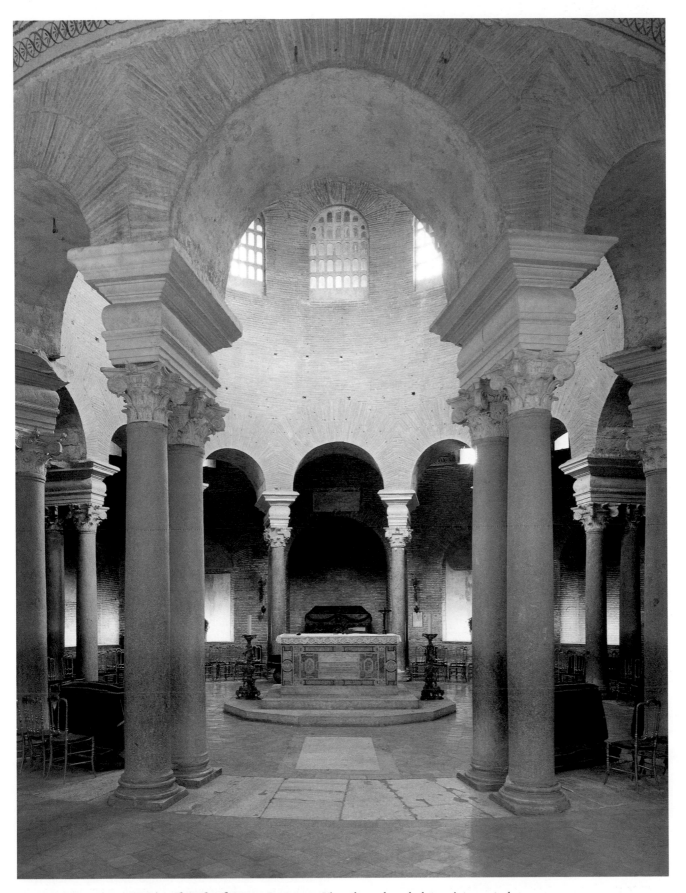

7-14. Church of Santa Costanza. View through ambulatory into central space

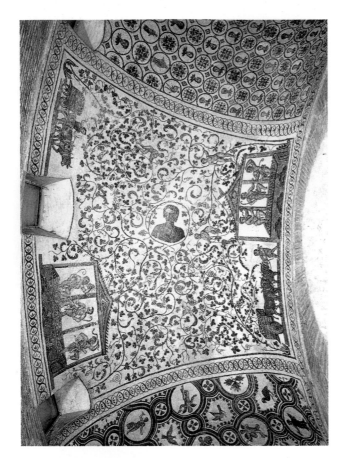

7-15. *Harvesting of Grapes*, mosaic in the ambulatory vault, Church of Santa Costanza

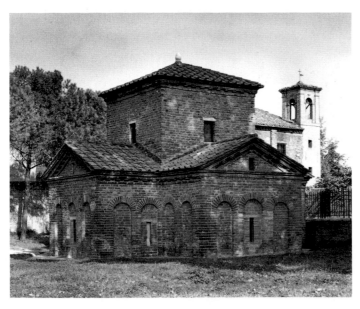

7-16. Mausoleum of Galla Placidia, Ravenna, Italy. c. 425–26

Mosaics in the ambulatory vault recall the catacombs' syncretic images. One section, for example, is covered with a tangle of grapevines filled with ***putti***—naked male child-angels, or cherubs, derived from classical art—who vie with the birds to harvest the grapes (fig. 7-15). Along the bottom edges on each side, *putti* drive wagonloads of grapes toward pavilions covering large vats in which more *putti* trample the grapes into juice. The technique, subject, and style are Roman, but the meaning has been altered. The scene would have been familiar to the pagan followers of Bacchus, but in a Christian context the wine became the wine of the Eucharist. For Constantina, the scene probably evoked only one—Christian—interpretation; her pagan husband, however, may have recognized the double allusion.

Constantine had planned to build his tomb in the cemetery of Saints Pietro and Marcellino in Rome, but after making Constantinople the center of government, he decided to build a funerary church there. The building, dedicated to the Holy Apostles, has not survived, but descriptions remain to tell us that it had the form of an equal-armed cross, a form known as the **Greek cross**, and it inspired a famous copy in the West, the Cathedral of Saint Mark in Venice (see fig. 7-39). Having dedicated the building to the apostles, Constantine provided **cenotaphs** (memorial tombs) for them. (Later, relics of the apostles were gathered in the church, making it a true ***martyrium***.) He placed his own tomb in the center, in effect elevating himself to the position of thirteenth apostle.

As Rome's political importance dwindled, that of the northern Italian cities of Milan and Ravenna grew. In 395, Emperor Theodosius I split the Roman Empire into eastern and western divisions, each ruled by one of his sons: Arcadius (ruled 383–408) assumed complete control of the Eastern Empire, based in Constantinople; heading the Western Roman Empire, Honorius (ruled 395–423) first established himself at the new capital of Milan. When Germanic settlers laid siege to Milan in 402, Honorius moved his capital to the east coast of Italy at Ravenna, whose naval base, Classis (modern Classe), had been important since the early days of the empire. In addition to military security, Ravenna offered direct access by sea to Constantinople. Ravenna flourished under Roman rule, and when Italy fell in 476 to the Ostrogoths from the East, the city became one of their headquarters. It still contains a remarkable group of well-preserved fifth- and sixth-century buildings.

One of the earliest surviving Christian structures in Ravenna is a funerary chapel attached to the church of the imperial palace (now Santa Croce, meaning "Holy Cross"). Built about 425–26, the chapel was constructed when Honorius's half sister, Galla Placidia, was regent (ruled 425–c. 440) in the West for her son. The chapel came to be called the Mausoleum of Galla Placidia because she and her family were once believed to be buried there (fig. 7-16). This small building is **cruciform**, or cross-shaped; a barrel vault covers of each of its arms, and a **pendentive dome**—a dome continuous with its **pendentives**—covers the space at the intersection of the arms (see "Pendentives and Squinches," page 311). **Blind arcading**—a series of decorative arches applied to a solid wall—tall slit windows, and

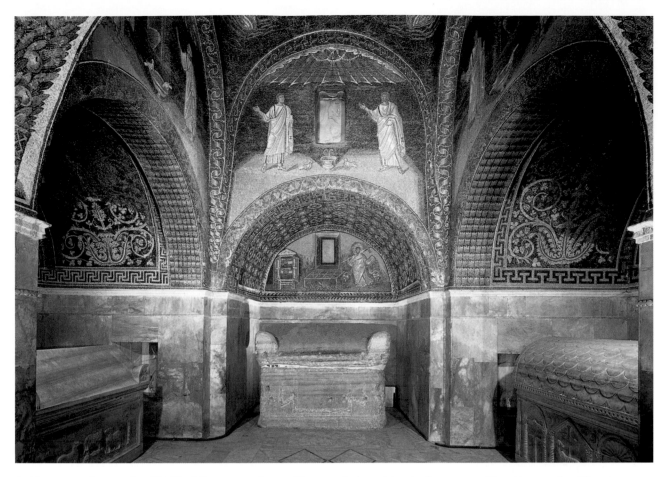

7-17. Mausoleum of Galla Placidia, eastern bays with sarcophagus niches in the arms and lunette mosaic of the *Martyrdom of Saint Lawrence*

a simple **cornice** are the only decorations on the exterior. The vaults covering the arms of the cross have been hidden from view on the outside by sloping, tile-covered roofs.

The interior of the chapel contrasts markedly with the exterior, a transition designed to simulate the passage from the real world into a supernatural one (fig. 7-17). The worshiper looking from the western entrance across to the eastern bay of the chapel sees a brilliant, abstract pattern of mosaic suggesting a starry sky filling the barrel vault. Panels of veined marble sheath the walls below. Bands of luxuriant foliage and floral designs derived from funerary garlands cover the four central arches, and the walls above them are filled with the figures of standing apostles, gesturing like orators. Doves flanking a small fountain between the apostles symbolize eternal life in heaven. In the lunette below, a mosaic depicts the third-century martyrdom of Saint Lawrence, to whom the building may have been dedicated. The saint holds a cross and gestures toward the fire and metal grill, on which he was literally roasted (so becoming the patron saint of bakers). At the left stands a tall cabinet containing the Gospels, signifying the faith for which he died (see a detail showing the contents of the cabinet in "Early Forms of the Book," page 304).

Opposite Saint Lawrence, in a lunette over the entrance portal, is a mosaic of the *Good Shepherd* (fig. 7-18). A comparison of this version with a fourth-century depiction of the same subject (see fig. 7-3) reveals significant changes in content and design. The Ravenna

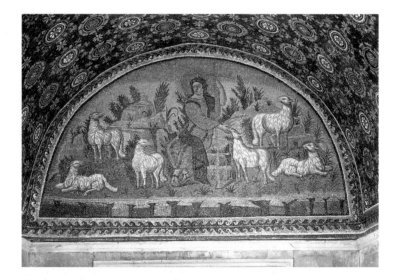

7-18. *Good Shepherd*, mosaic in the lunette over the west entrance, Mausoleum of Galla Placidia

EARLY FORMS OF THE BOOK

Since people began to write some 5,000 years ago, they have kept records on a variety of materials, including clay or wax tablets, pieces of broken pottery, papyrus, animal skins, and finally paper. Books have taken two forms: scroll and **codex**.

Scribes made scrolls from sheets of papyrus glued end to end or from thin sheets of cleaned, scraped, and trimmed sheep- or calfskin, a material known as **parchment** or, when softer and lighter, **vellum**. Each end of the scroll was attached to a rod; the reader slowly unfurled the scroll from one rod to the other. Scrolls could be written to be read either horizontally or vertically.

At the end of the first century CE, the more practical and manageable codex (plural codices)—sheets bound together like the modern book—replaced the scroll. The basic unit of the codex was the eight-leaf quire, made by folding a large sheet of parchment twice, cutting the edges free, then sewing the sheets together up the center.

Until the invention of printing in the fifteenth century, all books were **manuscripts**—that is, written by hand. Manuscripts often included illustrations, but techniques for combining pictures and text varied: Some illustrations were simply above or below the text, but others were within the text or set off with frames. Illustrations in books came to be called **miniatures**, from *minium*, the Latin word for a reddish lead pigment. Manuscripts decorated with gold and colors were said to be **illuminated**. Manuscript illumination became increasingly specialized during the European Middle Ages, with some experts doing only borders, others decorating initials, others painting pictures, and still others applying gold leaf.

Heavy covers in the form of wooden boards covered with leather kept the sheets of a codex flat. Very opulent manuscripts sometimes had covers decorated with precious metals, jewels, ivory, and enamels. The thickness and weight of parchment and vellum made it impractical to produce a very large manuscript, such as an entire Bible, in a single volume. As a result, individual sections were made into separate books. The Gospels, the Psalms, and the first five books of the Old Testament (the Pentateuch), for example, were often bound individually. These weighty tomes were stored flat on shelves in cabinets like the one holding the Gospels shown here and visible in the mosaic of Saint Lawrence in the Mausoleum of Galla Placidia (see fig. 7-17).

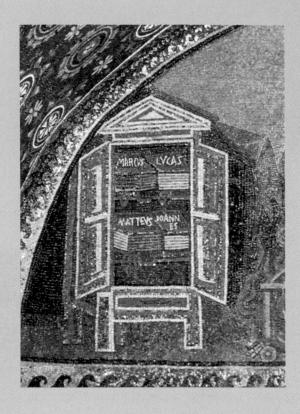

Bookstand with the Gospels in codex form, detail of a mosaic in the eastern lunette, Mausoleum of Galla Placidia, Ravenna, Italy. c. 425–26 (see fig. 7-17)

mosaic contains many familiar classical elements, such as illusionistic shading suggesting a single light source acting on solid forms, and an intimation of landscape in rocks and foliage. The conception of Jesus the shepherd, however, has changed. In the fourth-century painting, he was a simple shepherd boy carrying an animal on his shoulders; in this mosaic, he is a young adult with a golden halo, wearing imperial robes of gold and purple and holding a long, golden staff that ends in a cross instead of a shepherd's crook. The stylized elements of a natural landscape are arranged more rigidly than before. Individual plants at regular intervals fill the spaces between animals, and the rocks are stepped back into a shallow space that rises from the foreground plane and ends in foliage. The rocky band at the bottom of the lunette scene, resembling a cliff face riddled with clefts, separates the divine image from worshipers.

Just as the political role of Ravenna changed in the fourth and fifth centuries, so did the religious belief of its leaders. The early Christian Church faced many philosophical and doctrinal controversies, some of which resulted in serious splits, called schisms, within the Church. When this happened, its leaders gathered in church councils to decide on the orthodox, or official, position and denounce others as heretical. They rejected, for example, Arianism and Monophysitism, two early

forms of Christianity that questioned the doctrine of the Trinity. Arianism, named after Arius (c. 250–336), a church official in Alexandria, held that Jesus was coeternal with God but not fully divine, having been made by God. The first church council, called by Constantine at Nicaea in 325, declared the doctrine of the Trinity to be orthodox and denounced Arianism as heretical. Monophysites took the opposite viewpoint from Arians. They believed that Jesus was an entirely divine being even while on earth. Attempting to address this belief, the Council of Chalcedon, near Constantinople, in 451 declared Jesus to be of two natures—human and divine—united in one. This declaration did not put an end to Monophysitism, which remained strong in Egypt, Syria, Palestine, and Armenia in Asia Minor.

In Ravenna, two baptistries still stand as witness to these disputes: the Baptistry of the Orthodox and the Baptistry of the Arians. The Baptistry of the Orthodox was constructed next to the cathedral of Ravenna in the early fourth century. It was renovated and refurbished between 450 and 460, the wooden ceiling replaced with a dome and splendid interior decoration added in marble, stucco, and mosaic (fig. 7-19). On the clerestory level, an arcade springing from columns with large **impost** blocks repeats blind arcading below. Each main arch contains three arches framing a window.

Flanking the windows are figures of Old Testament prophets in stucco relief surmounted by pediments containing shell motifs. The pediment above the figure to the left of each window is round, whereas that on the right is pointed. The main arcading acts visually to turn the domed ceiling into a huge canopy tethered to the imposts of the columns.

In the dome itself, concentric rings of decoration draw the eye upward to a central image: the baptism of Jesus by John the Baptist, the forerunner of Jesus. The lowest ring depicts fantastic architecture, similar to Roman wall painting. Eight circular niches contain alternating altars holding gospel books and empty thrones under *ciboria*. The empty thrones symbolize the throne that awaits Christ's Second Coming (Matthew 25:31–36), his return to earth before Judgment Day. In the next ring, toga-clad apostles stand holding their crowns, the rewards of martyrdom; stylized golden plant forms divide the deep blue ground between them. Although the figures cast dark shadows on the pale green grass, their cloudlike robes, shot through with golden rays, give them an otherworldly presence. The landscape setting of the Baptism of Jesus in the central **tondo**—a circular image—exhibits classical roots, and the personification of the Jordan River recalls pagan imagery. The background, however, is not the blue of the earthly sky but the

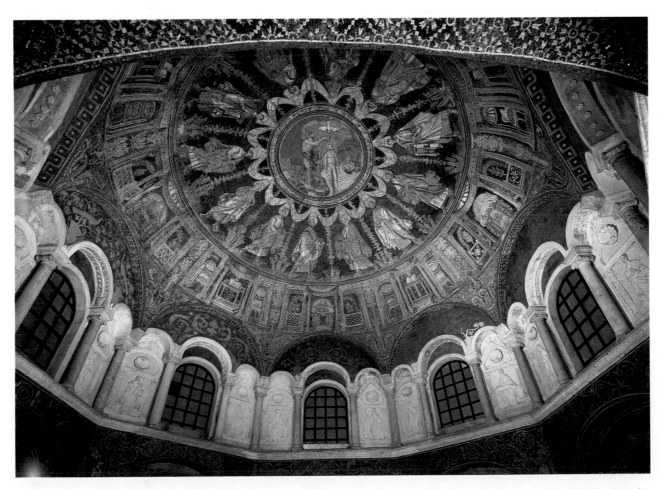

7-19. Clerestory and dome, Baptistry of the Orthodox, Ravenna, Italy. Early 5th century; dome remodeled c. 450–60

ICONOGRAPHY OF THE LIFE OF JESUS

Iconography is the study of subject matter in art. It involves identifying both what a work of art represents—its literal meaning—and the deeper significance of what is represented—its symbolic meaning. Events about the life of Jesus, grouped in "cycles," form the basis of Christian iconography. What follows is an outline of those cycles and the main events of each.

THE INCARNATION CYCLE AND THE CHILDHOOD OF JESUS

This cycle contains events surrounding the conception, birth, and youth of Jesus.

The Annunciation: The archangel Gabriel informs the Virgin Mary that God has chosen her to bear his son. A dove represents the Holy Spirit, Mary's miraculous conception of Jesus through the Holy Spirit.

The Visitation: Mary visits her older cousin Elizabeth, who is pregnant with the future Saint John the Baptist. Elizabeth is the first to acknowledge the divinity of the child Mary is carrying. The two women rejoice.

The Nativity: Jesus is born to Mary in Bethlehem. The Holy Family—Jesus, Mary, and her husband, Joseph—is shown in a stable, or, in Byzantine art, in a cave.

The Annunciation to the Shepherds and **The Adoration of the Shepherds**: An angel announces Jesus' birth to humble shepherds. They hasten to Bethlehem to honor him.

The Adoration of the Magi: The Magi—wise men from the East—follow a bright star to Bethlehem to honor Jesus as King of the Jews, presenting him with precious gifts: gold (symbolizing kingship), frankincense (a fragrant wood, symbolizing divinity), and myrrh (perfumed oil symbolizing death). In the European Middle Ages, the Magi were identified as three kings.

The Massacre of the Innocents and **The Flight into Egypt**: An angel warns Joseph that Herod, king of Judaea—to eliminate the threat of a newborn rival king—plans to murder all the male babies in Bethlehem. The Holy Family flees to Egypt.

The Presentation in the Temple: Mary and Joseph bring the infant Jesus to the Temple in Jerusalem, where he is presented to the high priest. It is prophesied that Jesus will redeem humankind but that Mary will suffer great sorrow.

Jesus among the Doctors: In Jerusalem for the celebration of Passover, Joseph and Mary find the twelve-year-old Jesus in serious discussion with Temple scholars. This is seen as a sign of his coming ministry.

THE PUBLIC MINISTRY CYCLE

In this cycle Jesus preaches his message.

The Baptism: At age thirty Jesus is baptized by John the Baptist in the Jordan River. He sees the Holy Spirit and hears a heavenly voice proclaiming him God's son. This marks the beginning of his ministry.

The Calling of Matthew: Passing by the customhouse, Jesus sees Matthew, a tax collector, to whom he says, "Follow me." Matthew complies, becoming one of the apostles.

Jesus and the Samaritan Woman at the Well: On his way from Judaea to Galilee, Jesus rests by a spring called Jacob's Well. Contrary to custom, he speaks directly to a woman, a Samaritan (a people despised by the Jews), asking her for a drink from the well. Jesus teaches that he alone can satisfy spiritual thirst.

Jesus Walking on the Water: The apostles, in a storm-tossed boat, see Jesus walking toward them on the water. Peter tries to go out to meet Jesus, but begins to sink. Jesus saves him and chides him for his lack of faith.

The Raising of Lazarus: Jesus brings his friend Lazarus back to life four days after his death. Lazarus emerges from the tomb wrapped in his shroud.

The Delivery of the Keys to Peter: Jesus designates Peter as his successor, symbolically turning over to him the keys to the kingdom of heaven.

The Transfiguration: Jesus reveals his divinity on Mount Tabor in Galilee as his closest disciples—Peter, James, and John the Evangelist—look on. A cloud overshadows them, and a heavenly voice proclaims Jesus to be God's son.

The Cleansing of the Temple: Jesus, in anger at the desecration, drives money changers and animal traders from the Temple.

THE PASSION CYCLE

This cycle contains events surrounding Jesus' death and resurrection. (*Passio* is Latin for "suffering.")

The Entry into Jerusalem: Jesus, riding a donkey, and his disciples enter Jerusalem in triumph. Crowds honor them, spreading clothes and palm fronds in their path.

The Last Supper: During the Passover seder, Jesus reveals his impending death to his disciples. Instructing them to drink wine (his blood) and eat bread (his body) in remembrance of him, he lays the foundation for the Christian Eucharist (Mass).

Jesus Washing the Apostles' Feet: After the Last Supper, Jesus humbly washes the apostles' feet to set an example of humility. Peter, embarrassed, protests.

The Agony in the Garden: In the Garden of Gethsemane on the Mount

of Olives, Jesus struggles between his human fear of pain and death and his divine strength to overcome them (*agon* is Greek for "contest"). An angelic messenger bolsters his courage. The apostles sleep nearby, oblivious.

The Betrayal (The Arrest): Judas Iscariot, one of the apostles, accepts a bribe to point Jesus out to his enemies. Judas brings an armed crowd to Gethsemane. He kisses Jesus, a prearranged signal. Peter makes a futile attempt to defend Jesus from the Roman soldiers who seize him.

The Denial of Peter: Jesus is brought to the palace of the Jewish high priest, Caiaphas, to be interrogated for claiming to be the Messiah. Peter follows, and there, three times before the cock crows, denies knowing Jesus, as Jesus predicted he would.

Jesus before Pilate: Condemned by the Jewish court for the blasphemy of calling himself the Messiah, Jesus is then sent to the Roman civil court to be tried for treason for calling himself the King of the Jews. Although both Roman governors, Herod and Pontius Pilate, find him innocent, the crowd demands his execution. Pilate washes his hands before the crowd to signify that Jesus' blood is on their hands, not his.

The Flagellation (The Scourging): Jesus is whipped by his Roman captors, an act traditional before crucifixions.

Jesus Crowned with Thorns (The Mocking of Jesus): Pilate's soldiers torment Jesus. They dress him in royal robes, crown him with thorns, and kneel before him, sarcastically hailing him as King of the Jews.

The Bearing of the Cross (The Road to Calvary): Jesus bears the cross of his crucifixion from Pilate's house to Golgotha, where he is executed. Medieval artists depicted this

event and its accompanying incidents in fourteen images known today as the Stations of the Cross: (1) Jesus is condemned to death; (2) Jesus picks up the cross; (3) Jesus falls for the first time; (4) Jesus meets his grieving mother; (5) Simon of Cyrene is forced to help Jesus carry the cross; (6) Veronica wipes Jesus' face with her veil; (7) Jesus falls again; (8) Jesus admonishes the women of Jerusalem; (9) Jesus falls a third time; (10) Jesus is stripped; (11) Jesus is nailed to the cross; (12) Jesus dies on the cross; (13) Jesus is taken down from the cross; (14) Jesus is entombed.

The Crucifixion: The earliest representations of the Crucifixion are abstract, showing either a cross alone or a cross and a lamb. Later depictions include some or all of the following narrative details: two criminals (one penitent, the other not), are crucified on either side of Jesus; the Virgin Mary, John the Evangelist, Mary Magdalen, and other followers mourn at the foot of the cross; Roman soldiers torment Jesus—one extends a pole with a sponge soaked with vinegar instead of water for him to drink, another, required to prove the criminal is dead before sundown, stabs him in the side with a spear, and others gamble for his clothes; a skull identifies the execution ground as Golgotha, "the place of the skull," where Adam was buried. The association symbolizes the promise of redemption: the blood flowing from Jesus' wounds will wash away Adam's Original Sin.

The Descent from the Cross (The Deposition): Jesus' followers take his body down from the cross. Joseph of Arimathea and Nicodemus wrap it in linen with myrrh and aloe. Also present are the grief-stricken Virgin, John the Evangelist, and sometimes Mary Magdalen, other disciples, and angels.

The Lamentation (*Pietà* or *Vesperbild*): Jesus' sorrowful followers gather around his body in a group

expressing grief. An image of the Virgin mourning alone with Jesus across her lap is known in Italian as a ***pietà*** (from the Latin *pietas*, "pity") or, in German, a *Vesperbild* (the image for evening prayer).

The Entombment: Jesus' mother and friends place his body in the tomb provided by Joseph of Arimathea. This is done hastily because of the approaching Jewish Sabbath.

The Descent into Limbo (The Anastasis): No longer in mortal form, Jesus, now called Christ, descends into limbo, on the borders of hell, to free deserving souls, among them Adam, Eve, and Moses.

The Resurrection: Three days after his death, Christ leaves his tomb while the soldiers guarding it sleep.

The Marys at the Tomb (The Holy Women at the Sepulcher): Christ's female followers—usually including Mary Magdalen and the mother of the apostle James, also named Mary—discover his empty tomb. An angel announces Christ's resurrection. The soldiers guarding the tomb sleep.

***Noli Me Tangere* ("Do Not Touch Me"), The Supper at Emmaus,** and **The Incredulity of Thomas**: Christ makes a series of appearances to his followers in the forty days after his resurrection. He first appears to Mary Magdalen, who thinks he is a gardener. She reaches out to him, but he warns her not to touch him. In the Supper at Emmaus, he shares a meal with his apostles. In the Incredulity of Thomas, Christ invites the doubting apostle to touch the wound in his side to convince Thomas of his resurrection.

The Ascension: Christ ascends to heaven from the Mount of Olives, disappearing in a cloud. His disciples, often accompanied by the Virgin, watch.

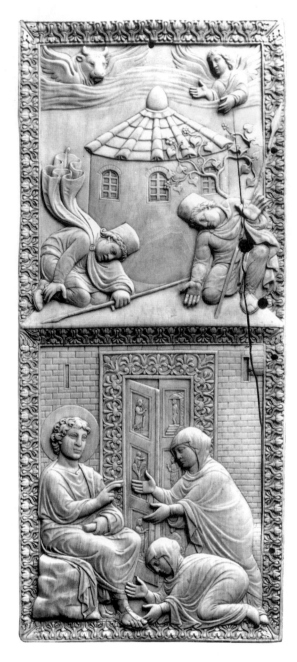

7-20. ***Resurrection and Angel with Two Marys at the Tomb***, panel of a diptych, found in Rome. c. 400. Ivory, 14½ x 5⅜" (37 x 13.5 cm). Castello Sforzesco, Milan

names of people to be remembered with prayers during Mass. An ivory panel found in Rome and dating to about 400 may have been an early example of this practice (fig. 7-20). The top register shows the moment of Christ's resurrection in both symbolic and narrative terms. While the soldiers guarding his tomb sleep, the evangelists Luke (represented by the ox in the upper left) and Matthew (represented by the man in the upper right) acknowledge the event from the clouds. The bottom register shows the moment when Mary, mother of the apostle James, and Mary Magdalen learn from a young man whose "appearance was like lightning and . . . clothing was white as snow" (Matthew 28:1–6) that the tomb is empty. The top panels of the carved doors of the tomb show the Raising of Lazarus, the Gospel story in which Jesus brings a man back to life to prove his divine power. In the top right door panel, the shrouded Lazarus emerges from his tomb, symbolizing the Christian promise of life after death. The varied natural poses of the figures, the solid modeling of the bodies beneath their drapery, the architectural details of the tomb, and the decorative framing patterns all indicate the classical roots of this work, which in its theme is completely Christian.

Monumental stone sculpture can be studied in sarcophagi such as the elaborately carved *Sarcophagus of Junius Bassus* (fig. 7-21). Junius Bassus was a Roman official who, as the inscription here tells us, was "newly baptized" and died on August 25, 359, at the age of forty-two. The front panel has two registers divided by columns into shallow spaces of equal width. On the top level, the columns are surmounted by an entablature incised with the inscription. On the bottom register, columns support alternating triangular and arched gables. Fragments of architecture, furniture, and foliage suggest the earthly setting for each scene. In the center of both registers, columns carved with *putti* producing wine frame the triumphal Christ. In the upper register, he appears as a teacher-philosopher flanked by Saints Peter and Paul. In a reference to the pagan past, Christ in this scene rests his feet on the head of Aeolus, the god of the winds in classical mythology, shown with a veil billowing behind him. To Christians, Aeolus personified the skies, so that Christ is meant to be seen as seated above, in heaven, where he is giving the Christian Law to his disciples, imitating the Hebrew Scriptures' account of God dispensing the Law to Moses. In the bottom register, Jesus makes his triumphal entry into Jerusalem.

The earliest Christian art, such as that in catacomb paintings and on the *Sarcophagus of Junius Bassus*, unites the imagery of Old and New Testaments in elaborate allegories, called **typological** exegesis. That is, Old Testament themes illuminate events in the New Testament. On the top left, Abraham, the first Hebrew patriarch, learns that he has passed the test of faith and need not sacrifice his son Isaac. Christians saw in this story a prophetic sign of God's sacrifice of his son, Jesus, on the cross. In the next frame to the right, the apostle Peter has just been arrested for preaching after the death of Jesus. On the upper right side are two scenes from Christ's Passion (see "Iconography of the Life of Jesus," pages 306-7),

gold of paradise. Already in the mid-fifth century, artists working for the Christian Church had begun to reinterpret and transform Roman naturalism into an abstract style better suited to their patrons' spiritual goals.

SCULPTURE

In sculpture, as in architecture, Christians adapted Roman forms for their own needs. Commemorative ivory **diptychs**—two carved panels hinged together—originated with Roman politicians elected to the post of consul, who sent to friends and colleagues notices of that event, and, later, other events, inscribed in wax on the inner sides of a pair of carved ivory panels (see fig. 6-84). Christians adapted the practice for religious use by at least the fifth century, inscribing a diptych with the

his arrest and his appearance before Pontius Pilate, who is about to wash his hands, symbolizing that he denies responsibility for Jesus' death. In the lower left frame, God tests the faith of Job, who provides a model for the sufferings of Christian martyrs. Next, Adam and Eve have set in motion the entire Christian story. Lured by the serpent, they have eaten the forbidden fruit, have become conscious of their nakedness, and are trying to hide their genitals with leaves. This fall from grace will be redeemed by Christ. Two frames to the right, the story of Daniel saved by God from the lions prefigures Christ's resurrection. In the last frame, Paul is arrested. The images in the upper central frame of Paul and Peter, whose martyrdoms in Rome led to the power of the Roman Church, also represent the continuing power of Christ and his disciples.

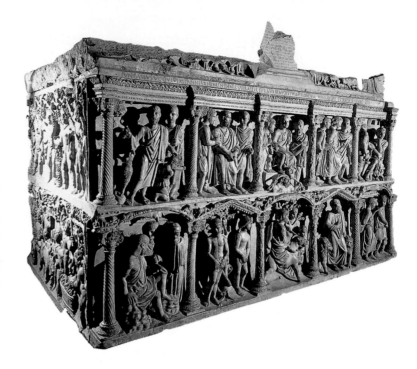

7-21. *Sarcophagus of Junius Bassus.* c. 359. Marble, 4 x 8' (1.2 x 2.4 m). Grottoes of Saint Peter, Vatican, Rome

EARLY BYZANTINE ART

The Byzantine artistic tradition was, in the words of one scholar, "monumental, kaleidoscopic, constantly open to fashion, energizing and far-reaching" (Beckwith, page 344). Byzantine art can be thought of broadly as the art of Constantinople (whose ancient name, before Constantine renamed it after himself, was Byzantium) and the regions under its influence from the fifth through the fifteenth century, as well as the art centered in Ukraine and Russia in the fifteenth and sixteenth centuries. In this chapter, we focus on Byzantine art's three "golden ages." The Early Byzantine period, most closely associated with the reign of Emperor Justinian I (527–65), dates from the fifth cen-

tury until 726, the onset of the iconoclastic controversy that led to the destruction of religious images (see "Iconoclasm," below). The Middle Byzantine period began in 843, when Empress Theodora (c. 810–62) reinstated the veneration of icons, and lasted until 1204, when Christian Crusaders from the West occupied Constantinople. The Late Byzantine period began with the restoration of Byzantine rule in 1261 and ended, in Constantinople and

ICONOCLASM Christianity, like Judaism and Islam, has always been uneasy with the power of religious images. The early Church feared that the faithful would worship the works of art themselves instead of what they represented. This discomfort grew into a major controversy in the Eastern Church as images increasingly replaced holy relics as objects of devotion from the late sixth century on. Many **icons** were believed to have been created miraculously, and all were thought to have magical protective and healing powers. Prayer rituals came to include prostration before images surrounded by candles, practices that seemed to some dangerously close to idol worship.

In 726 Emperor Leo III launched a campaign of **iconoclasm** ("image breaking"), decreeing that all religious images were idols and should be destroyed. In the decades that followed, Iconoclasts undertook widespread destruction of devotional

pictures of Jesus Christ, the Virgin Mary, and the saints. Those who defended devotional images (Iconodules) were persecuted. The veneration of images was briefly restored under Empress Irene following the Second Council of Nicaea in 787, but the Iconoclasts regained power in 814. In 843 Empress Theodora, widow of Theophilus, the last of the iconoclastic emperors, reversed her husband's policy.

While the Iconoclasts held power, they enhanced imperial authority at the expense of the Church by undermining the untaxed wealth and prestige of monasteries, whose great collections of devotional art drew thousands of worshipers. They also increased tensions between the Eastern Church and the papacy, which defended the veneration of images and refused to acknowledge the emperor's authority to ban it. The Iconoclasts claimed that representations of Jesus Christ, because they portrayed him as human, promoted

heresy by separating his divine from his human nature or by misrepresenting the two natures as one. Iconodules countered that upon assuming human form as Jesus, God took on all human characteristics, including visibility. According to this view, images of Christ, testifying to that visibility, demonstrate faith in his dual nature and not, as the Iconoclasts claimed, denial of it: "How, indeed, can the Son of God be acknowledged to have been a man like us . . . if he cannot, like us, be depicted?" (Saint Theodore the Studite, cited in Snyder, page 128).

Those who defended images made a distinction between veneration—a respect for icons as representations of sacred personages—and worship of icons as embodiments of divinity, or idols. Moreover, they saw image making not only as an effective teaching tool but also as a humble parallel to the divine act of creation, when "God created man in his image" (Genesis 1:27).

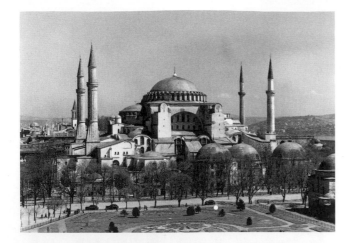

7-22. Anthemius of Tralles and Isidorus of Miletus. Church of Hagia Sophia, Istanbul, Turkey. 532–37. View from the southwest

The body of the original church is now surrounded by later additions, including the minarets built after 1453 under the Ottoman Turks. Today the structure houses a museum.

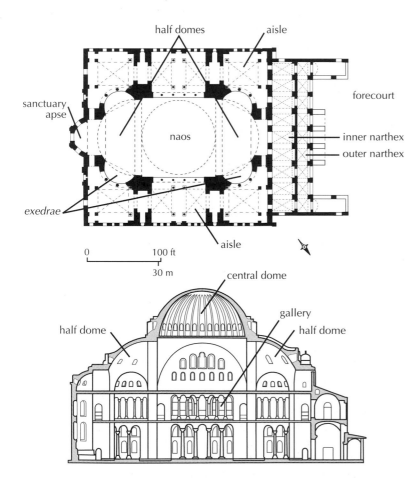

7-23. Plan and section of the Church of Hagia Sophia

the Eastern Empire prospered. Constantinople remained secure behind massive walls defended by the imperial army and navy. Its control of land and sea routes between Europe and Asia made many of its people wealthy. The patronage of the affluent citizenry, as well as that of the imperial family, made the city an artistic center. Greek literature, science, and philosophy continued to be taught in its schools. Influences from the regions under the empire's control—Syria, Palestine, Egypt, Persia, and Greece—gradually combined to create a distinctive Byzantine culture.

In the sixth century, Byzantine political power, wealth, and culture reached its height under Emperor Justinian, ably seconded by Empress Theodora (c. 500–48). Imperial forces held northern Africa, Sicily, much of Italy, and part of Spain. Ravenna became the empire's administrative capital in the West, and Rome's power declined, though Rome would remain under nominal Byzantine control until the eighth century. The pope remained head of the Western Church; however, the Byzantine policy of caesaropapism, whereby the emperor was head of both church and state, required that the pope pay homage to the powers in Constantinople (see "Rome, Constantinople, and Christianity," page 292). As Slavs and Bulgars moved into the Balkan peninsula in southeastern Europe, they, too, came under Constantinople's sway. Only on the frontier with the Persian Empire to the east did Byzantine armies falter, and there Justinian bought peace with tribute. To centralize his government and impose a uniform legal system throughout the empire, Justinian began a thorough compilation of Roman law known as the Justinian Code. Written in Latin, this code was the foundation for the later legal systems of Europe.

THE CHURCH AND ITS DECORATION

Constantinople. Justinian and Theodora embarked on a building and renovation campaign in Constantinople that overshadowed any in the city since the reign of Constantine two centuries earlier. Their massive undertaking would more than restore the city, half of which had been destroyed by rioters in 532, but little remains of their architectural projects or of the old imperial capital itself. A magnificent exception is the Church of Hagia Sophia ("Holy Wisdom," fig. 7-22). It replaced a fourth-century Hagia Sophia destroyed when crowds at the hippodrome, a racetrack beside the imperial palace, took to the streets and, spurred on by Justinian's foes, set fire to the church. The empress Theodora, a brilliant, politically shrewd woman, is said to have goaded Justinian to resist the rioters by saying, "Purple makes a fine shroud"—meaning that she would rather die an empress (purple was the royal color) than flee for her life. Taking up her words as a battle cry, imperial forces crushed the rebels and restored order.

Justinian chose two scholar-theoreticians, Anthemius of Tralles and Isidorus of Miletus (Miletos), to rebuild the church as an embodiment of imperial power and Christian glory. Anthemius was a specialist in geometry and optics,

its realm, with the empire's fall to Ottoman Turks in 1453. However, Late Byzantine art continued to flourish through the sixteenth century in Ukraine and Russia, which succeeded Constantinople as the center of the Eastern Orthodox Church after the empire's collapse.

During the fifth and sixth centuries, while invasions and religious controversy wracked the Italian peninsula,

Pendentives and squinches are two methods of supporting a round dome or its drum over a square opening. They convert the square formed by walls or arches into a circle. A squinch is formed by a wood or masonry beam that is itself supported by an arch or a series of corbeled arches that give it a nichelike or trumpet shape. The first set of squinches converts the square to an octagon, and additional squinches may be inserted as needed. In Islamic architecture, squinches are multiplied until they take on the stalactite form known as *muqarnas*. Pendentives are mathematically and structurally much more sophisticated. Spherical triangles of masonry are based on a dome (see fig. 7-24). Curving inward and around, they rise from the supporting pier to form the circular rim of a smaller dome whose diameter is the width of the bay to be covered. A drum (a wall) may be inserted between the pendentives and the dome.

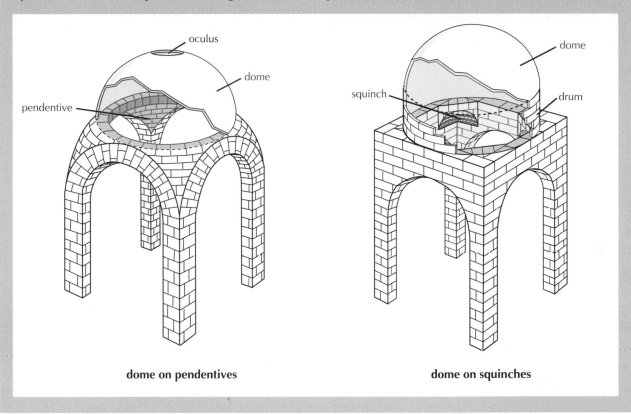

dome on pendentives

dome on squinches

and Isidorus a specialist in physics who had also studied vaulting. They developed a daring and magnificent design. The dome of the church provided a vast, golden, light-filled canopy high above a processional space for the many priests and members of the imperial court who assembled there to celebrate the Eucharist.

The new Hagia Sophia was not constructed by the miraculous intervention of angels, as was rumored, but by mortal builders in only five years (532–37). The architects, engineers, and masons who built it benefited from the accumulated experience of a long tradition of great architecture. Procopius of Caesarea, who chronicled Justinian's reign, claimed poetically that Hagia Sophia's gigantic dome seemed to hang suspended on a "golden chain from Heaven." Legend has it that Justinian himself, aware that architecture can be a potent symbol of earthly power, compared his accomplishment with that of the legendary builder of the First Temple in Jerusalem, saying, "Solomon, I have outdone you."

Hagia Sophia is based on a central plan with a dome inscribed in a square (fig. 7-23). To form a longitudinal nave, half domes expand outward from the central dome to connect with the narthex on one end and the half dome of the sanctuary apse on the other. Side aisles flank this central core, called the **naos** in Byzantine architecture; **galleries**, or stories open to and overlooking the naos, are located above the aisles.

The main dome of Hagia Sophia is supported on pendentives, triangular curving vault sections built between the four huge arches that spring from piers at the corners of the dome's square base (see "Pendentives and Squinches," above). The origin of the dome on pendentives, which became the preferred method for supporting domes in Byzantine architecture, is obscure, but Hagia Sophia represents its earliest use in a major building. Here two half domes flanking the main dome rise above *exedrae* with their own smaller half domes at the four corners of the nave. Unlike the Pantheon's dome, which is solid with an **oculus** at the top (see fig. 6-36), Hagia Sophia's dome has a band of forty windows around its base. This daring concept challenged architectural logic by weakening the integrity of the masonry but created the all-important circle of light that makes

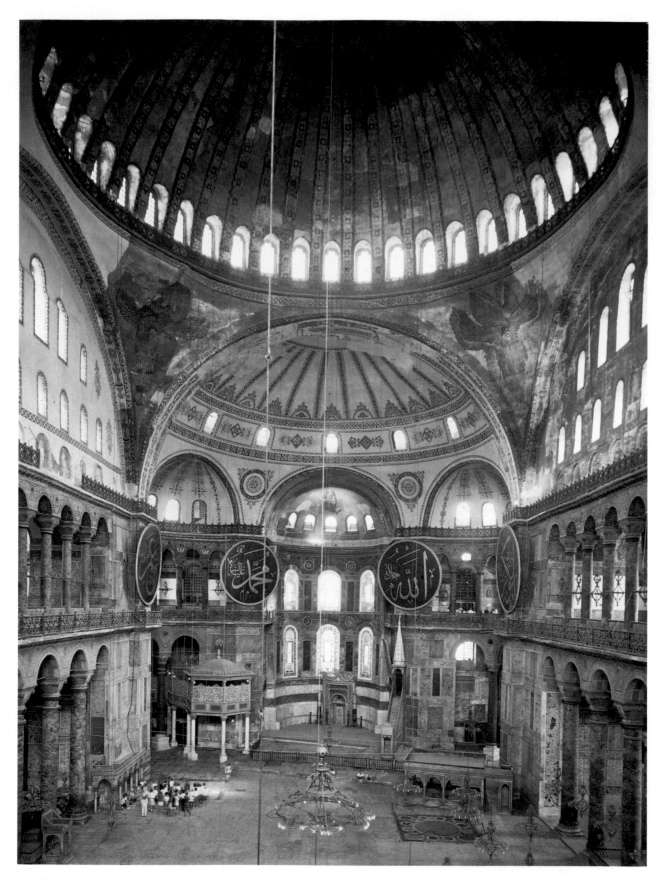

7-24. Church of Hagia Sophia

Hypatius of Ephesus, writing in the mid-sixth century, justified decorating churches in a luxurious manner as a means to inspire piety in the congregation. He wrote: "We, too, permit material adornment in the sanctuaries, not because God considers gold and silver, silken vestments and vessels encrusted with gems to be precious and holy, but because we allow every order of the faithful to be guided in a suitable manner and to be led up to the Godhead, inasmuch as some men are guided even by such things towards the intelligible beauty, and from the abundant light of the sanctuaries to the intelligible and immaterial light" (cited in Mango, page 117). The large medallions were added in the nineteenth century.

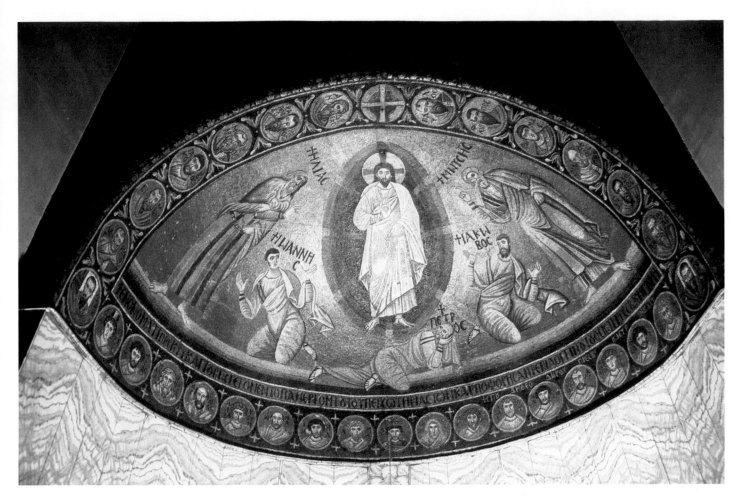

7-25. *Transfiguration of Christ*, mosaic in the apse, Church of the Virgin, Monastery of Saint Catherine, Mount Sinai, Egypt. c. 548–65

the dome appear to float (fig. 7-24). In fact, when the first dome fell in 558, it did so because a **pier** and pendentive shifted and because the dome was too shallow, not because of the windows. Confident of their revised technical methods, the architects designed a steeper dome that put the summit 20 feet higher above the floor. Exterior **buttressing** was added, and although repairs had to be made in 869, 989, and 1346, the church has since withstood the shock of earthquakes.

As in a basilica-plan church, worshipers entered Hagia Sophia through a forecourt and outer and inner narthexes on a central axis. Once through the portals, though, their gaze was drawn by the succession of curving spaces upward and then forward, to the central dome and on to the distant sanctuary. With this inspired design, Anthemius and Isidorus had reconciled an inherent conflict in church architecture between the desire for a symbolically soaring space and the need to focus attention on the altar and the liturgy. The domed design came to be favored by the Eastern Church.

The liturgy used in Hagia Sophia in the sixth century has been lost, but it presumably resembled the rites described in detail for the church in the Middle Byzantine period. Assuming that was the case, the celebration of the Mass took place behind a screen—at Hagia Sophia a crimson curtain embroidered in gold, in later churches

an **iconostasis**, or wall hung with devotional paintings called **icons** ("images" in Greek). The emperor was the only layperson permitted to enter the sanctuary; others stood in the aisles (men) or galleries (women). Processions of clergy moved in a circular path from the sanctuary into the nave and back five or six times during the ritual. The focus of the congregation was the screen and the dome rather than the altar and apse. This upward focus reflects the interest of Byzantine Neoplatonic philosophers, who viewed meditation as a way to rise from the material world to a spiritual state. Worshipers standing on the church floor must have felt just such a spiritual uplift as they gazed at the mosaics of saints, angels, and, in the golden central dome, heaven itself.

The churches of Constantinople were once filled with the products of Justinian's patronage: mosaics, rich furniture, and objects of gold, silver, and silk. Mosaics in the Monastery of Saint Catherine on Mount Sinai in Egypt were the result of such a donation and help us to imagine the splendors of the capital city. The apse mosaic of the monastery's church (fig. 7-25) depicts the Transfiguration on Mount Tabor (see "Iconography of the Life of Jesus," pages 306-7). Dated between 548 and 565, this imposing work shows the transfigured Christ in a triple blue **mandorla**, an almond-shaped halo that surrounds Christ's whole figure, against a golden sky that fills the

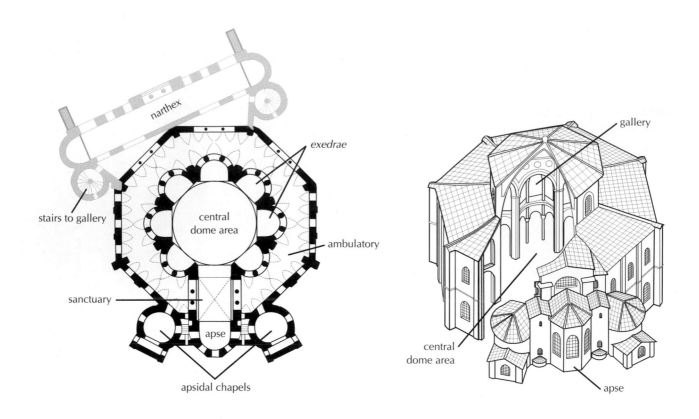

7-26. Plan and cutaway drawing of the Church of San Vitale, Ravenna, Italy. 526–47

half dome of the apse. The figure of Christ emits rays of light, and the standing Old Testament prophets Moses and Elijah affirm his divinity. The astonished apostles—who have fallen to the ground in fear and amazement, while Christ stands calmly in the relaxed pose of a classical orator—are identified as Peter below, John at the left, and James at the right. A supernatural wind seems to catch the ends of their robes, whipping them into curiously jagged shapes. Mount Tabor is suggested only by a narrow strip at the bottom, half green and half reflecting the golden light. This **abstract** rendering contrasts with the continuing classical influence seen in the figures' substantial bodies, revealed by their tightly wrapped drapery.

The formal character of the *Transfiguration of Christ* mosaic reflects an evolving approach to representation that began with imperial Roman art of the third century. As the character of imperial rule changed, the emperor became an increasingly remote figure surrounded by pomp and ceremony. Orators often used terms like *Sacred*, *Majestic*, or *Eternalness* to address him. In official art such as the Arch of Constantine (see fig. 6-79), abstraction displaced the naturalism and idealism of the Greeks. The Roman interest in capturing the visual appearance of the material world fully gave way in Christian art to a new **hieratic**—formally abstract or priestly—style that sought to express essential religious meaning rather than exact external appearance. Attempting to create tangible images that would stand for intangible Christian concepts, artists

rejected the physicality of the real world for a timeless supernatural world. Geometric simplification of forms, an expressionistic abstraction of figures, use of **reverse perspective**, and standardized conventions to portray individuals and events characterized the new style.

Ravenna. In 540, Byzantine forces captured Ravenna from the Arian Christian Ostrogoths who had taken it in 476, and the city became a base for the further conquest of Italy, completed by Justinian I in 553. Much of our knowledge of the art of this turbulent period—from the time of Honorius (emperor of the Western Roman Empire 395–423) through Arian Ostrogothic control to the triumphant victory of the Byzantine Empire—comes from the well-preserved monuments at Ravenna.

In 526, Ecclesius, bishop of Ravenna from 521 to 532, commissioned two new churches, one for the city and one for its port, Classis, as well as other churches and baptistries. With funding from a wealthy local banker, construction began on a central-plan church in Ravenna dedicated to the fourth-century Roman martyr Saint Vitalis and a basilica-plan church in the port dedicated to Saint Apollinaris, the first bishop of Ravenna. The churches were not completed until after Justinian had conquered Ravenna and established it as the administrative capital of Byzantine Italy. The Church of San Vitale was dedicated in 547, followed by the Church of Sant'Apollinare in Classe two years later.

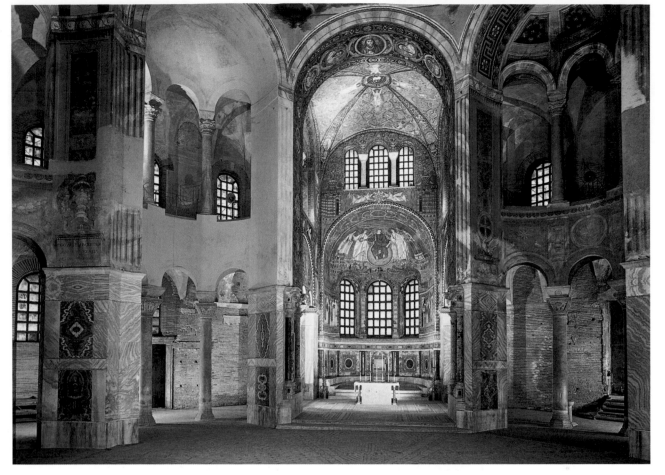

7-27. Church of San Vitale. View across the central space toward the sanctuary apse with mosaic showing Christ enthroned and flanked by Saint Vitalis and Bishop Ecclesius

The design of San Vitale is basically a central-domed octagon extended by ***exedra***-like semicircular bays, surrounded by an ambulatory and gallery, all covered by vaults (fig. 7-26). A rectangular sanctuary and semicircular apse project from one of the sides of the octagon, and circular rooms in typical Byzantine fashion flank the apse. A separate oval narthex, set off-axis, joined church and palace and also led to cylindrical stair towers that gave access to the second-floor gallery. This sophisticated design has distant roots in Roman buildings such as Santa Costanza (see fig. 7-13).

The floor plan of San Vitale only hints at the effect of the complex, interpenetrating interior spaces of the church, an effect that was enhanced by the offset narthex, with its double sets of doors leading into the church. People entering from the right saw only arched openings, whereas those entering from the left approached on axis with the sanctuary, which they saw straight ahead of them. The round dome, hidden on the exterior by an octagonal shell and a tile-covered roof, is a light, strong structure ingeniously created out of interlocking ceramic tubes and mortar. The whole rests on eight squinches and large piers that frame the *exedrae* and the sanctuary. The two-story *exedrae* open through arches into the outer aisles on the ground floor and into galleries on the second floor. They expand the octagonal central space physically and also create an airy, floating sensation, reinforced by the liberal use of gold *tesserae* in the mosaic surface decoration. The architecture dissolves into shimmering light and color.

In the half dome of the sanctuary apse, an image of Christ enthroned is flanked by Saint Vitalis and Bishop Ecclesius, who presents a model of the church to Christ (fig. 7-27). The other sanctuary images relate to its use for the celebration of the Eucharist. Pairs of lambs flanking a cross decorate impost blocks above the intricately interlaced carving of the marble column capitals (visible in figure 7-28, page 316). The lunette on the south wall shows an altar table set with a chalice for wine and two patens, to which the high priest Melchizedek on the right brings an offering of bread, and Abel, on the left, carries a sacrificial lamb (fig. 7-28). Their identities are known from the inscriptions above their heads.

The prophets Isaiah (right) and Moses (left) appear in the spandrels. Moses is shown twice: The lower image depicts the moment when, while tending his sheep, he heard the voice of an angel of God coming from a bush that was burning with a fire that did not destroy it. Just above, Moses is shown reaching down to remove his shoes, a symbolic gesture of respect in the presence of God or on holy ground. In the gallery zone of the sanctuary the Four Evangelists are depicted, two on each wall, and in the vault the Lamb of God supported by four angels appears in a field of vine scrolls.

Justinian and Theodora did not attend the dedication ceremonies for the Church of San Vitale conducted by

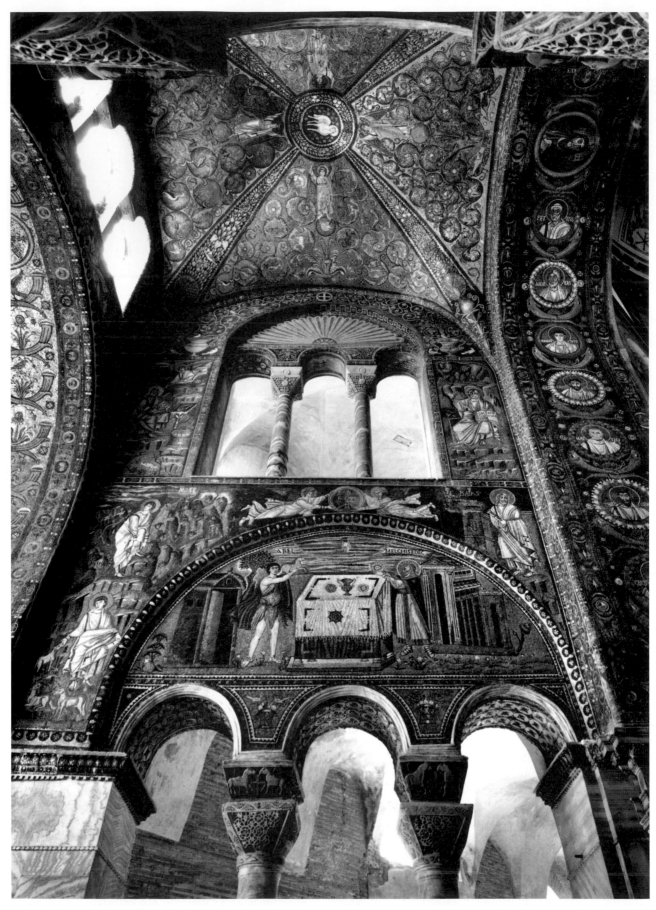

7-28. Church of San Vitale, south wall of the sanctuary, with Abel and Melchizedek in the lunette, Moses and Isaiah in the spandrels, portraits of the evangelists in the gallery zone, and the Lamb of God in the vault

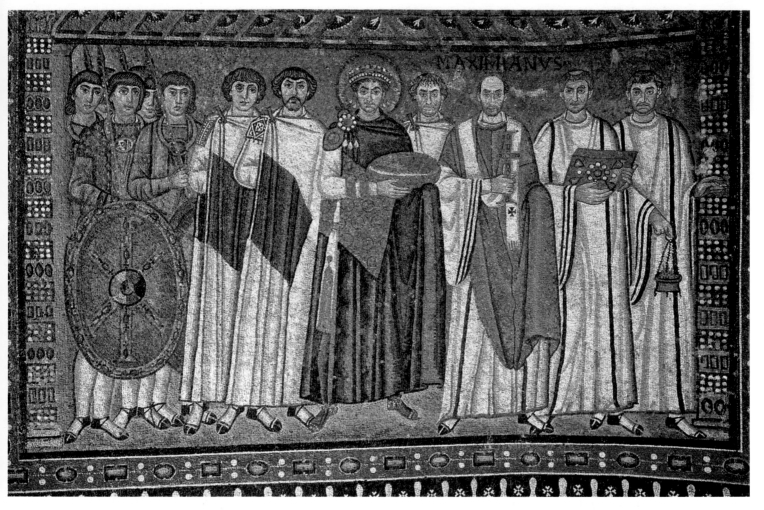

7-29. *Emperor Justinian and His Attendants*, mosaic on north wall of the apse, Church of San Vitale, Ravenna, Italy. c. 547. 8'8" x 12' (2.64 x 3.65 m)

As head of state, Justinian wears a huge jeweled crown and a purple cloak; as head of church, he carries a large golden paten to hold the Host, the symbolic body of Jesus Christ. The Church officials at his left hold a jeweled cross and a gospel book symbolizing Christ and his church. Justinian's soldiers stand behind a shield decorated with the *chi rho*, a monogram of Greek letters standing for "Christ." On the opposite wall, Empress Theodora, also dressed in royal purple, offers a golden chalice for the liturgical wine (see fig. 7-30).

Archbishop Maximianus in 547—they may never have set foot in Ravenna—but two large mosaic panels that face each other across its apse still stand in their stead. Justinian (fig. 7-29), on the north wall, carries a large golden paten for the Host and stands next to Maximianus, who holds a golden, jewel-encrusted cross. The priestly celebrants at the right carry the Gospels, encased in a golden, jeweled book cover, symbolizing the coming of the Word, and a censer containing burning incense to purify the altar prior to the Mass.

On the south wall, Theodora, standing beneath a fluted shell canopy and singled out by a gold halolike disk and elaborate crown, carries a huge golden chalice studded with jewels (fig. 7-30, page 318). She presents the chalice both as an offering for the Mass and as a gift of great value for Christ. With it she emulates the Magi (see "Iconography of the Life of Jesus," pages 306-7), depicted at the bottom of her purple robe, who brought valuable gifts to the infant Jesus. A courtyard fountain stands to the left of the panel and patterned draperies adorn the openings at left and right.

Theodora's huge jeweled and pearl-hung crown nearly dwarfs her delicate features, yet the empress dominates these worldly trappings by the intensity of her gaze.

The mosaic decoration in the Church of San Vitale combines imperial ritual, Old Testament narrative, and Christian liturgical symbolism. The setting around Theodora—the implied shell form, the fluted pedestal, the open door, and the swagged draperies—are classical illusionistic devices, yet the mosaicists deliberately avoid making them space-creating elements. Byzantine artists accepted the idea that objects exist in space, but they no longer conceived pictorial space the way Roman artists had, as a view of the natural world seen through a "window," the **picture plane**, and extending back from it toward a distant horizon. In Byzantine aesthetic theory, invisible rays of sight joined eye and image so that pictorial space extended forward from the picture plane to the eye of the beholder and included the real space between them. Parallel lines appear to diverge as they get farther away and objects seem to tip up in a

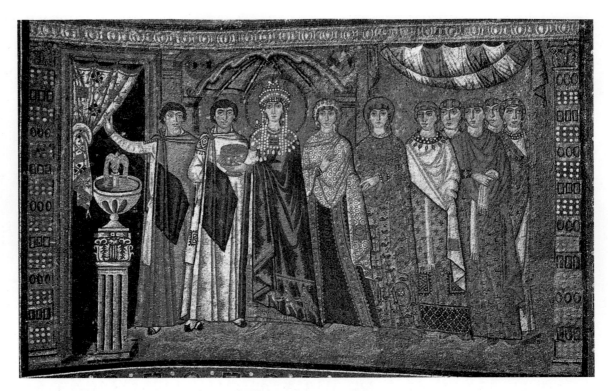

7-30. *Empress Theodora and Her Attendants*, mosaic on south wall of the apse, Church of San Vitale. c. 547. 8'8" x 12' (2.64 x 3.65 m)

The mosaic suggests the richness of Byzantine court costume. Both men and women dressed in layers beginning with a linen or silk tunic, over which men wore another tunic and a long cloak fastened on the right shoulder with a *fibula* (brooch) and decorated with a rectangular panel (*tablion*). Women wore a second, fuller long-sleeved garment over their tunics. Over all their layers, women wore a large rectangular shawl, usually draped over the head. Justinian and Theodora wear imperial purple cloaks with gold-embroidered *tablions* held by *fibulae*. Embroidered in gold at the hem of Theodora's cloak is the scene of the Magi bringing gifts to Jesus. Her elaborate jewelry includes a superhumeral (an item worn on the shoulders) of embroidered and jeweled cloth. A pearled crown, hung with long strands of pearls (thought to protect the wearer from diseases), frames the haunted face of Theodora, who died not long after this mosaic was completed.

representational system known as **reverse perspective**.

Bishop Maximianus consecrated the Church of Sant'Apollinare in Classe in 549. The atrium has disappeared, but the simple geometry of the brick exterior clearly reflects the basilica's interior spaces (fig. 7-31). A narthex entrance spans the full width of the ground floor; a long, tall nave with a clerestory ends in a semicircular apse; and side aisles flank the nave.

Inside, nothing interferes visually with the movement forward from the entrance to the raised sanctuary (fig. 7-32), which extends directly from a triumphal-arch opening into the semicircular apse. The apse mosaic depicts an array of men and sheep in a stylized landscape. In the center, a jeweled cross with the face of Christ at its center symbolizes the Transfiguration—Jesus' revelation of his divinity. The Hand of God and the Old Testament figures Moses and Elijah emerge, legitimizing the newer religion and attesting to the divinity of Christ. The apostles Peter, James, and John—represented here by the three sheep with raised heads—also witness the event. At the center below the cross, Bishop Apollinaris raises his hands in prayer and blessing, an orant. The twelve lambs flanking him represent the apostles. Stalks of blooming lilies, along with tiny trees and other plants, birds, and

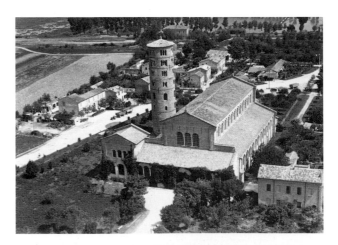

7-31. Church of Sant'Apollinare in Classe (Classis), the former port of Ravenna, Italy. Dedicated 549

oddly shaped rocks, fill the green mountain landscape. Unlike the landscape in the *Good Shepherd* lunette of the Mausoleum of Galla Placidia (see fig. 7-18), these highly stylized forms bear little resemblance to nature. The artists eliminated any suggestion of spatial recession by making the trees and lambs at the top of the golden sky larger than those at the bottom.

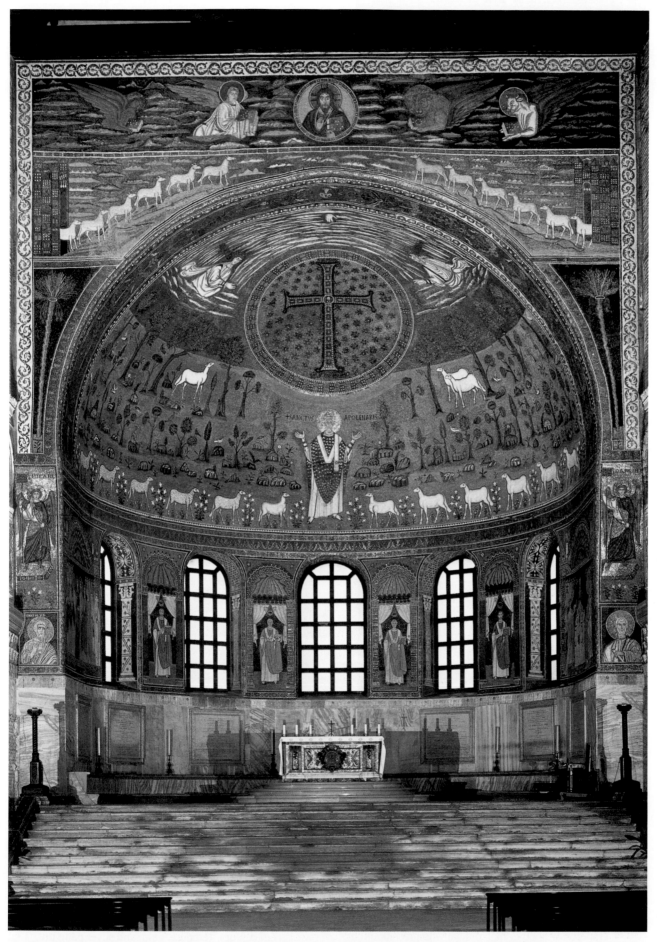

7-32. *The Transfiguration of Christ with Saint Apollinaris, First Bishop of Ravenna*, mosaic in the apse,
Church of Sant'Apollinare in Classe. Apse, 6th century; mosaics above apse, 7th and 9th centuries

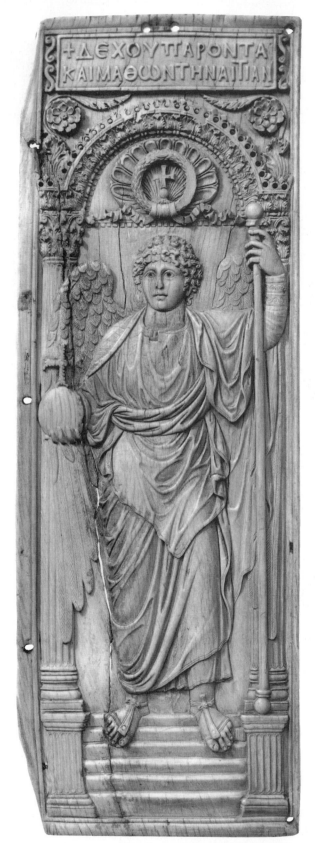

7-33. Archangel Michael, panel of a diptych, probably from the court workshop at Constantinople. Early 6th century. Ivory, 17 x 5¹/₂" (43.3 x 14 cm). The British Museum, London

The lost half of this diptych would have completed the Greek inscription across the top, which begins: "Receive these gifts, and having learned the cause . . . " Perhaps the other panel contained the portrait of the emperor or another high official who presented the panels as a gift to an important colleague, acquaintance, or family member.

7-34. Page with Wild Blackberry, from De Materia Medica, by Pedanius Dioscorides (1st century), copy made and illustrated in Constantinople for Princess Anicia Juliana. c. 512. Tempera on vellum, 15 x 13" (38.1 x 33 cm). Österreichische Nationalbibliothek, Vienna

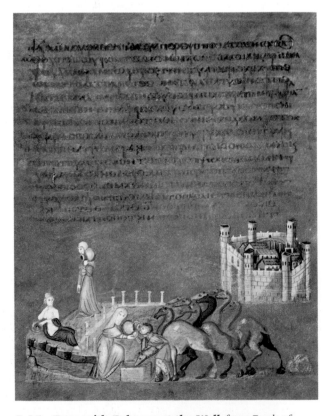

7-35. Page with Rebecca at the Well, from Book of Genesis, probably made in Syria or Palestine. Early 6th century. Tempera, gold, and silver paint on purple-dyed vellum, 13¹/₂ x 9⁷/₈" (33.7 x 25 cm). Österreichische Nationalbibliothek, Vienna

In the mosaics on the wall above the apse, which were added in the seventh and ninth centuries, Christ, now portrayed with a cross inscribed in his halo and flanked by symbols representing the evangelists, blesses and holds the Gospels. Sheep (the apostles) emerge from gateways and climb golden rocks toward their leader and teacher.

Ivories, Manuscripts, and Panel Paintings. The court workshops of Constantinople excelled in the production of carved ivory objects for liturgical use. The panel here depicts the archangel Michael in a classicizing style (fig. 7-33). In his beauty, physical presence, and elegant setting, the archangel is comparable to the priestess of Bacchus in the Symmachus panel (see fig. 6-84). His relation to the architectural space and the frame around him, however, has changed. His heels rest on the top step of a stair that clearly lies behind the columns and pedestals, but the rest of his body projects in front of them. The angel is shown here as a divine messenger, holding a staff of authority in his left hand and a sphere symbolizing worldly power in his right, a message reinforced by repetition: within the arch is a cross-topped orb, framed by a wreath, against the background of a scallop shell. This image floats in an indefinite space, unrelated to either the archangel or the message.

The Byzantine court also sponsored a major *scriptorium* (writing room for scribes—professional document writers) for the production of **manuscripts** (handwritten books). Among these works was a botanical encyclopedia known by its Latin title, *De Materia Medica*, listing the appearance, properties, and medicinal uses of plants. Compiled in the first century CE by a Greek physician named Pedanius Dioscorides (c. 40–90), who probably traveled as a physician with the Roman army, this work was the first systematic treatment of plants. Generations of scribes copied it. The earliest known surviving copy, a **codex** (see "Early Forms of the Book," page 304) from Constantinople dated about 512, was given to Princess Anicia Juliana, whose father had been emperor in the West for a few months in 472. The illustrators transformed a practical reference book in Greek into an exquisitely illustrated work suitable for the imperial library (fig. 7-34). Although Dioscorides' work is secular and pagan, Christians found religious as well as medical significance in the plants it catalogs. For example, the wild blackberry bramble illustrated here came by tradition to represent the burning bush of Moses and the purity of the Virgin Mary.

Byzantine manuscripts often used very costly materials. Although plain sheets of **vellum** (a fine writing surface made from calfskin) and natural pigments were used in this copy of *De Materia Medica*, purple-dyed vellum and gold and silver inks were used in a *Book of Genesis* (fig. 7-35). The book was probably made in Syria or Palestine, and the purple vellum indicates that it may have been done for an imperial patron (costly purple dye, made from the shells of murex mollusks, usually was restricted to imperial use). The Genesis book, like *De Materia Medica*, is in codex form and is written in Greek. Illustrations appear below the text at the bottom of the pages. The illustration of the story of Rebecca at the Well (Genesis 24) shown here appears to be a single scene, but it actually mimics the continuous narrative of a

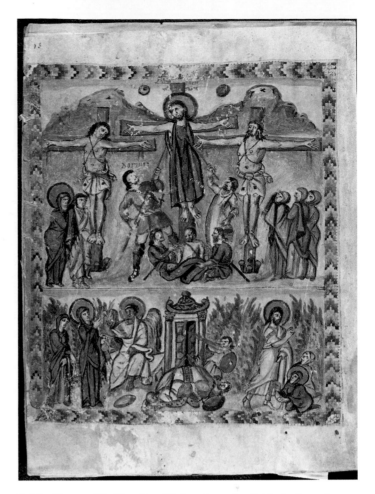

7-36. Page with *The Crucifixion*, from the Rabbula Gospels, from Beth Zagba, Syria. 586. 13½ x 10½" (33.7 x 26.7 cm). Biblioteca Medicea Laurenziana, Florence

scroll. Events that take place at different times in the story follow in succession. Rebecca, the heroine of the story, appears at the left walking away from the walled city of Nahor with a large jug on her shoulder to fetch water. She walks along a miniature colonnaded road toward a spring personified by a reclining pagan water nymph who holds a flowing jar. In the foreground, Rebecca, her jug now full, encounters a thirsty camel driver and offers him water to drink. Unknown to her, he is Abraham's servant Eliezer in search of a bride for Abraham's son Isaac. Her generosity leads to her marriage with Isaac. Although the realistic poses and rounded, full-bodied figures in this painting reflect an earlier Roman painting tradition, the unnatural purple of the background and the glittering metallic letters of the text remove the scene from the mundane world.

An illustrated Gospels, signed by a monk named Rabbula and completed in February 586 at the Monastery of Saint John the Evangelist in Beth Zagba, Syria, provides a near-contemporary example of a quite different approach to religious art. Church murals and mosaics may have inspired its illustrations. They are intended not only to depict biblical events but also to present the Christian story through complex, multileveled symbolism. Besides full-page illustrations like those of the Crucifixion and the Ascension shown here, there are also lively smaller scenes, or **vignettes**, in the margins.

The Crucifixion in the *Rabbula Gospels* presents a detailed picture of Christ's death and resurrection (fig. 7-36).

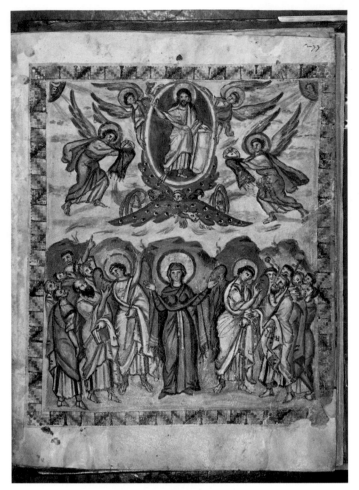

7-37. Page with *The Ascension*, from the Rabbula Gospels

He appears twice, on the cross in the center of the upper register and with the two Marys—the mother of James and Mary Magdalen—at the right in the lower register. The Byzantine Christ is a living king who triumphs over death. He is shown as a mature, bearded figure, not the youthful shepherd depicted in the catacombs (see fig. 7-3). Even on the cross he is dressed in a long, purple robe, called a *colobium*, that signifies his royal status. (In many Byzantine images he also wears a jeweled crown.) At his sides are the repentant and unrepentant thieves who were crucified with him. Beside the thief at the left stand the Virgin and John the Evangelist; beside the thief at the right are the holy women. Soldiers beneath the cross throw dice for Jesus' clothes. A centurion stands on either side of the cross. One of them, Longinus, pierces Jesus' side with a lance; the other, Stephaton, gives him vinegar instead of water to drink from a sponge. The small disks in the heavens represent the sun and moon. In the lower register, directly under Jesus on the cross, stands his tomb, with its open door and stunned or sleeping guards. This scene represents the Resurrection. The angel reassures the holy women at the left, and Christ himself appears to them at the right. All these events (described in Matthew 28) take place in an otherworldly setting indicated by the glowing bands of color in the sky. The austere mountains

behind the crosses give way to the lush foliage of the garden around the tomb. This very complete representation of the orthodox view of the Crucifixion may have been intended to counter the claim of the Monophysites that Christ was entirely divine.

The ascension of Christ into heaven (fig. 7-37) is described in the New Testament: "[A]s they [his apostles] were looking on, he was lifted up, and a cloud took him from their sight" (Acts of the Apostles 1:9). The cloud has been transformed into a mandorla supported by two angels. Two other angels follow, holding victory crowns in fringed cloths. The image directly under the mandorla combines fiery wheels and the four beasts seen by the Hebrew prophet Ezekiel in a vision (Ezekiel 1). The four beasts also appear in the New Testament's Revelations and are associated with the Four Evangelists: Matthew, an angel; Mark, a lion; Luke, an ox; and John, an eagle. Christians interpreted this vision as a precursor of the vision of Judgment Day described in Revelations.

Below this imagery, the Virgin Mary stands calmly in the pose of an orant, while angels at her side confront the astonished apostles. One angel gestures at the departing Christ and the other appears to be offering an explanation of the event to attentive listeners (Acts of the Apostles 1:10–11). The prominence accorded Mary here can be interpreted as a result of her status of *Theotokos*, God-bearer. She may also represent the Christian community on earth, that is, the Church. As we noted earlier, the Christian world at this time was filled with debate over the exact natures of Christ, the Trinity, and the Virgin Mary. Taken as a whole, the *Rabbula Gospels* would provide evidence of the owner's adherence to orthodoxy.

Eastern Christians prayed to Christ, Mary, and the saints while looking at images of them on icons. The first such image was believed to have been a portrait of Jesus that appeared miraculously on the scarf with which his follower Veronica wiped his face along the road to the execution ground. Church doctrine toward the veneration of icons was ambivalent. Key figures of the Eastern Church, such as Basil the Great of Cappadocia (c. 329–79) and John of Damascus (c. 675–749), distinguished between idolatry—the worship of images—and the veneration of an idea or holy person depicted in a work of art. The Eastern Church thus prohibited the worship of icons but accepted them as aids to meditation and prayer. The images were thought to act as intermediaries between worshipers and the holy personages they depicted.

Most early icons were destroyed in the eighth century in a reaction to the veneration of images known as iconoclasm (see "Iconoclasm," page 309), making those that have survived especially precious. A few very beautiful examples were preserved in the Monastery of Saint Catherine on Mount Sinai, among them the *Virgin and Child with Saints and Angels* (fig. 7-38). As *Theotokos*, Mary was viewed as the powerful, ever-forgiving intercessor, or go-between, appealing to her Divine Son for mercy on behalf of repentant worshipers. She was also called the Seat of Wisdom, and many images of the Virgin and Child, like this one, show her holding Jesus on

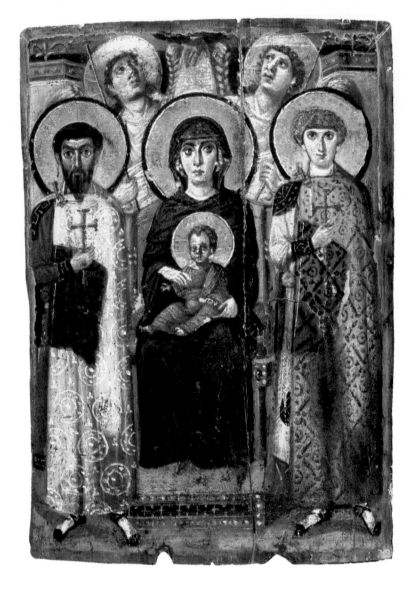

7-38. *Virgin and Child with Saints and Angels*, icon. Second half of 6th century. Encaustic on wood, 27 x 18⅞" (69 x 48 cm). Monastery of Saint Catherine, Mount Sinai, Egypt

her lap in a way that suggests that she represents the throne of Solomon. The Christian warrior-saints Theodore (left) and George (right)—both legendary figures said to have slain dragons, representing the triumph of the Church over the "evil serpent" of paganism—stand at each side, while angels behind them look heavenward. The Christ Child, the Virgin, and the angels were painted with a Roman-derived, illusionistic technique and are almost realistic. The male saints are much more stylized than the other figures; the richly patterned textiles of their cloaks barely hint at the bodies beneath.

MIDDLE BYZANTINE ART

The Iconoclasts, who had ruled for more than a century, lost power in 843, and under new leadership, the Eastern Empire revitalized. Early Byzantine civilization had been centered in lands along the rim of the Mediterranean Sea that had been within the Roman Empire. During the Middle Byzantine period, Constantinople's scope was reduced to what is present-day Turkey and other areas by the Black Sea, the Balkan peninsula including Greece, and southern Italy. The influence of Byzantine culture also extended into Russia, Ukraine, and Venice, Constantinople's trading partner in northeastern Italy, at the head of the Adriatic Sea.

Under the Macedonian dynasty (867–1056) initiated by Basil I, the empire prospered and enjoyed a cultural rebirth. Middle Byzantine art and architecture, visually powerful and stylistically coherent, reflect the strongly spiritual focus of the period's autocratic—and wealthy—leadership. From the mid-eleventh century, however, incursions by other powers on Byzantine territory began to weaken the empire. It stabilized temporarily under the Comnenian dynasty (1081–1185), extending the Middle Byzantine period well into the Western Middle Ages—until 1204, when Christian Crusaders seized Constantinople.

ARCHITECTURE AND ITS DECORATION

Although comparatively few Middle Byzantine churches in Constantinople have survived intact, enough remain to suggest what the city's Christian architecture looked like then. Fortunately, many central-plan domed churches, favored by Byzantine architects, survive beyond the imperial capital, in Ukraine to the northeast and Sicily to

ELEMENTS OF ARCHITECTURE

Multiple-Dome Church Plans

The construction of a huge single dome, such as Hagia Sophia's (see figs. 7-23 and 7-24) presented almost insurmountable technical challenges. Byzantine architects found it more practical to cover large interior spaces with several domes. Justinian's architects devised the five-dome Greek-cross plan, which was copied in the West at Saint Mark's in Venice ([a], and see fig. 7-39). Middle Byzantine builders preferred smaller, more intricate spaces, and multiple-dome churches were very popular. The five domes of the Greek cross would often rise over a nine-bay square (b). The most favored plan was the quincunx, or cross-in-square, in which barrel vaults cover the arms of a Greek cross around a large central dome, with domes or groin vaults filling out the corners of a nine-bay space (c). Often the vaults and secondary domes are smaller than the central dome. Any of these arrangements can be made into an expanded quincunx (d) by additional domed aisles, as at the Cathedral of Saint Sophia in Kiev (see fig. 7-41), or by a second set of four domes, in the Cathedral of Saint Basil in Moscow (see fig. 7-54).

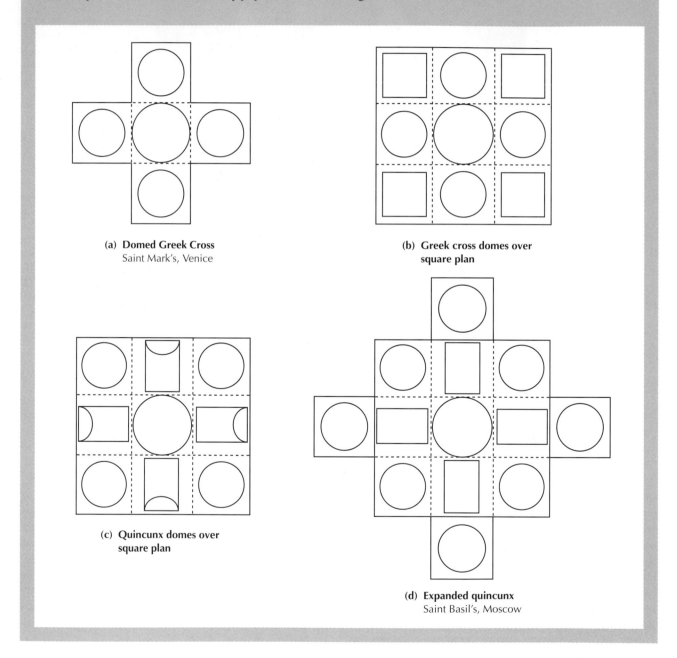

(a) **Domed Greek Cross**
Saint Mark's, Venice

(b) **Greek cross domes over square plan**

(c) **Quincunx domes over square plan**

(d) **Expanded quincunx**
Saint Basil's, Moscow

the southwest, for example. These structures reveal the builders' taste for a multiplicity of geometric forms, verticality, and rich decorative effects both inside and out.

The loss of buildings similarly makes the study of Byzantine domestic architecture almost impossible, but Byzantine palaces must have been spectacular. Descriptions of the imperial palace in Constantinople tell of extraordinarily rich marbles and mosaics, silk hangings, and golden furniture, including a throne surrounded by mechanical singing birds and roaring lions. Palaces and houses evidently followed the pattern established by the Romans of a series of rooms around open courts. The

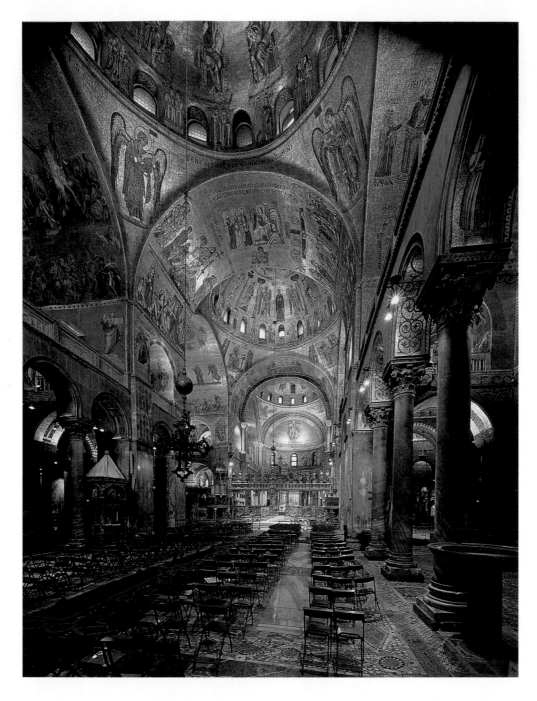

7-39. Cathedral of Saint Mark, Venice. Present building begun 1063. View looking toward apse

This church is the third one built on the site. It was both the palace chapel of the *doge* and the *martyrium* that stored the bones of the patron of Venice, Saint Mark. This great multi-domed structure, consecrated as a cathedral in 1807, has been reworked continually to the present day.

great palace of the Byzantine emperors may have resembled Hadrian's Villa, with different buildings for domestic and governmental functions set in gardens, which were walled off from the city.

Venice. The northeastern Italian city of Venice, set on the Adriatic at the crossroads of Europe and Asia Minor, had been subject to Byzantine rule in the sixth and seventh centuries and, until the tenth century, the city's ruler, the *doge*, had to be ratified by the emperor. At the end of the tenth century, Constantinople granted Venice a special trade status that allowed its merchants to control much of the commercial interchange between the East and the West, which brought the city great wealth and increased its exposure to Eastern cultures, clearly reflected in its art and architecture. One of Venice's great Byzantine monuments is the Cathedral of Saint Mark, which was modeled after the Church of the Holy Apostles in Constantinople.

Venetian architects looked to the Byzantine domed church for inspiration in 1063, when the *doge* commissioned a much larger church to replace the palace chapel. The chapel had served since the ninth century as a *martyrium*, holding the relics of Saint Mark the Apostle, which were brought to Venice from Alexandria in 828. On the chapel's site rose the massive Cathedral of Saint Mark, which has a Greek-cross plan, each square unit of which is covered by a dome (see "Multiple-Dome Church Plans," page 324). There are five great domes in all, separated by barrel vaults and supported by pendentives. Unlike Hagia Sophia, with its flow of space from the narthex through the nave to the apse (see fig. 7-23), Saint Mark's domed compartments produce a complex space with five separate vertical axes (fig. 7-39). Marble covers the lower walls and golden mosaics glimmer above, covering the vaults,

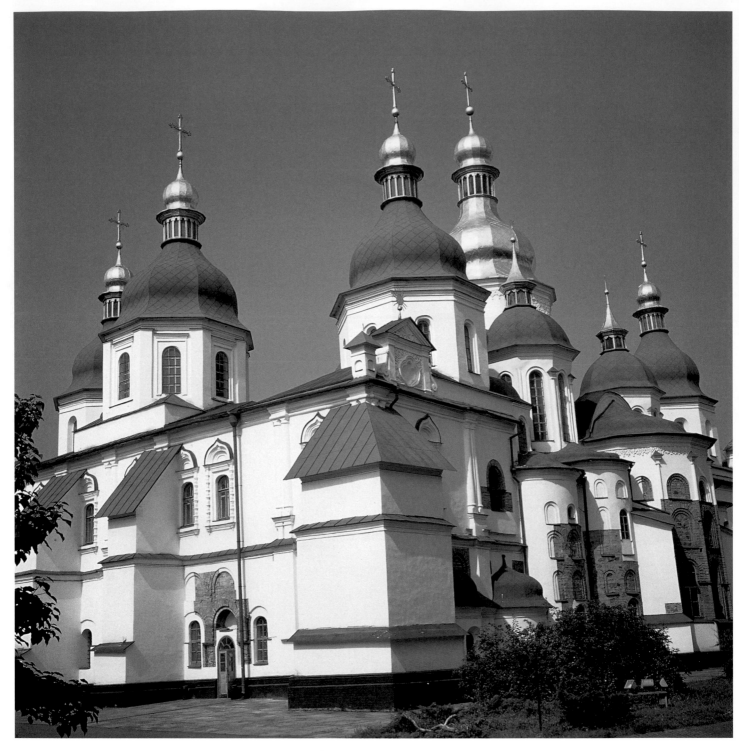

7-40. Cathedral of Santa Sophia, Kiev, Ukraine. c. 1017–37

pendentives, and domes. The dome seen in figure 7-39 depicts the Pentecost, the descent of the Holy Spirit on the apostles. The mosaics were continually reworked and were completed in the sixteenth and seventeenth centuries.

Kiev. As Constantinople turned its gaze to the east, Ukraine, Belarus, and Russia fell under its spell. These lands had been settled by Eastern Slavs in the fifth and sixth centuries, but later were ruled by Swedish Vikings. The Vikings had sailed down the rivers from the Baltic to the Black Sea, establishing forts and trading stations along the way. They traveled as far as Constantinople, where the Byzantine

emperor hired them as his personal bodyguards. In the ninth century, the Viking traders established headquarters in the upper Volga region and in the city of Kiev, which became the capital of the area under their control, known as Kievan Rus.

The first Christian member of the Kievan ruling family was Princess Olga (c. 890–969), who was baptized in Constantinople by the patriarch himself, with the Byzantine emperor as her godfather. Her grandson Grand Prince Vladimir (ruled 980–1015) established Byzantine Christianity as the state religion in 988. Vladimir sealed the pact with the Byzantines by accepting baptism and marrying Anna,

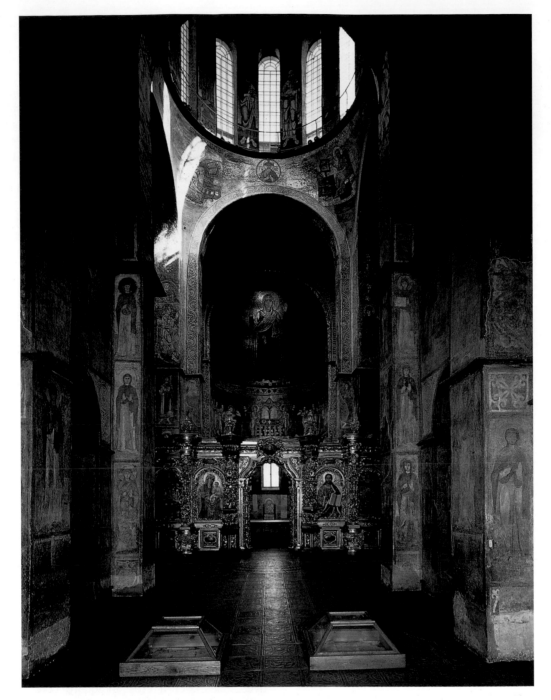

7-41. Interior, Cathedral of Santa Sophia

The view under the dome and into the apse does not convey the quality of the interior as an agglomeration of tall narrow spaces divided by piers whose architectural function is disguised or ignored by elaborate paintings.

the sister of the powerful Emperor Basil II (ruled 976–1025).

Vladimir's son Grand Prince Yaroslav (ruled 1019–54) founded the Cathedral of Santa Sophia in Kiev (fig. 7-40) after the city burned in 1017. The church originally had a typical nine-bay, cross-in-square, or **quincunx**, design (see "Multiple-Dome Church Plans," page 324), but it was expanded to have double side aisles, five apses (whose original brickwork was left free of plaster in the recent restoration), a large central dome, and twelve smaller domes. The small domes were said to represent the twelve apostles gathered around the central dome representing Christ the *Pantokrator*, Ruler of the Universe. The great cen-

tral dome, typical of Middle Byzantine churches, gives the complex silhouette a roughly pyramidal shape. Although the tall drums and pointed, bulbous onion domes on the exterior were added in the seventeenth and eighteenth centuries, they convey the sense of intricate, rising spaces typical of Kievan (and later Russian) architecture.

Inside the church, the central domed space of the **crossing** focuses attention on the nave and the main apse. The many individual bays, each of which is an almost independent vertical unit, create an often confusing and compartmentalized interior (fig. 7-41). The interior walls glow with lavish decoration: mosaics

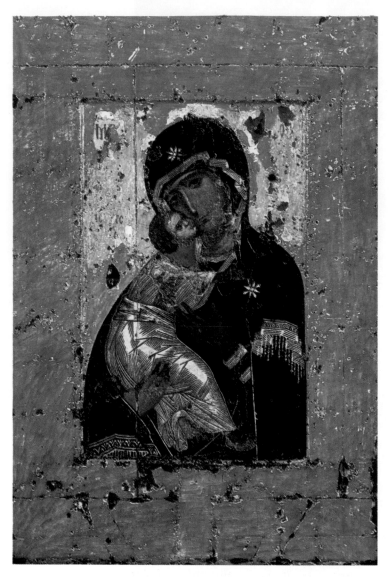

7-42. Virgin of Vladimir, icon, probably from Constantinople. Faces only, 12th century; the rest has been retouched. Tempera on panel, height approx. 31" (78 cm). Tretyakov Gallery, Moscow

powerful political declaration of his own—and the Kievan church's—importance and wealth.

The people of Kievan Rus learned their art by copying and recopying icons brought from Constantinople. One image transported to Kiev was the icon of Mary and Jesus known as the *Virgin of Vladimir* (fig. 7-42), which has been greatly revered since its creation. Its distinctively humanized approach suggests the growing desire, reflected in Byzantine art, for a more immediate and personal religion. (A similar trend began about the same time in the art of Western Europe.) Paintings of this type, known as the Virgin of Compassion, show Mary and the Christ Child pressing their cheeks together and gazing tenderly at each other. The source for this tender image was widely believed to be a portrait painted by the evangelist Luke following a vision he had of the Nativity. Almost from its creation (probably in Constantinople), the *Virgin of Vladimir* was thought to protect the people of the city where it resided. It arrived in Kiev sometime between 1131 and 1136 and was taken to the city of Suzdal and then to Vladimir in 1155. In 1480 it was moved to Moscow, where it graced the Cathedral of the Dormition in the Kremlin. Today, secularized, it is housed in a museum.

In 1169, Prince Andrew of Suzdal (c. 1111–74) sacked Kiev and made Vladimir the capital. Thus weakened, Kiev was unable to withstand the Mongol forces that laid waste to the city in 1240 and controlled Ukraine and much of Russia for more than a century thereafter.

Greece. Although an outpost, Greece lay within the Byzantine Empire in the tenth and eleventh centuries. The two churches of the Monastery of Hosios Loukas, built a few miles from the village of Stiris, Greece, in the tenth and eleventh centuries, are excellent examples of the architecture of the Middle Byzantine age (fig. 7-43). The Church of the Virgin Theotokos, on the right in the plan, is joined to the Katholikon, on the left. Both churches are essentially compact, central-plan structures. The dome of the Theotokos, supported by pendentives, rises over a cross-in-square core; that of the Katholikon, supported by **squinches**, rises over an octagonal core (see "Pendentives and Squinches," page 311). The high central space in the interior of the Katholikon carries the eye of the worshiper upward into the main dome, which soars above a ring of tall arched windows.

Unlike Hagia Sophia, with its clear, sweeping geometric forms, the two churches of Hosios Loukas have a complex variety of forms, including domes, groin vaults, barrel vaults, pendentives, and squinches (the squinches in the Katholikon are the fan shapes supporting the dome and converting the square bay into an octagon). The barrel vaults and tall sanctuary apses with flanking rooms further complicate the space. In the Katholikon, single, double, and triple windows create intricate and unusual patterns of light, illuminating a painting (originally a mosaic) of Christ *Pantokrator* in the center of the main dome. The secondary, sanctuary dome of the Katholikon is decorated with a mosaic of the Lamb of God surrounded by the Twelve Apostles, and the apse half dome has a mosaic of the Virgin and

glitter from the central dome, the apse, and the arches of the crossing, and the remaining surfaces are painted with scenes from the lives of Christ, the Virgin, the apostles Peter and Paul, and the archangels.

The mosaics established an iconographical system that came to be followed in Russian Orthodox churches. The *Pantokrator* fills the center of the dome (not visible above the window-pierced drum in figure 7-41). At a lower level, the apostles stand between the windows of the drum, with the Four Evangelists in the pendentives. The Virgin Mary, in the traditional pose of prayer (an orant figure), seems to float in a golden heaven, filling the half dome and upper wall of the apse. In the mosaic on the wall below the Virgin, Christ, appearing not once but twice, accompanied by angels who act as deacons, celebrates Mass at an altar under a canopy, a theme known as the Communion of the Apostles. He distributes communion to six apostles on each side of the altar. With this extravagant use of costly mosaic, Prince Yaroslav made a

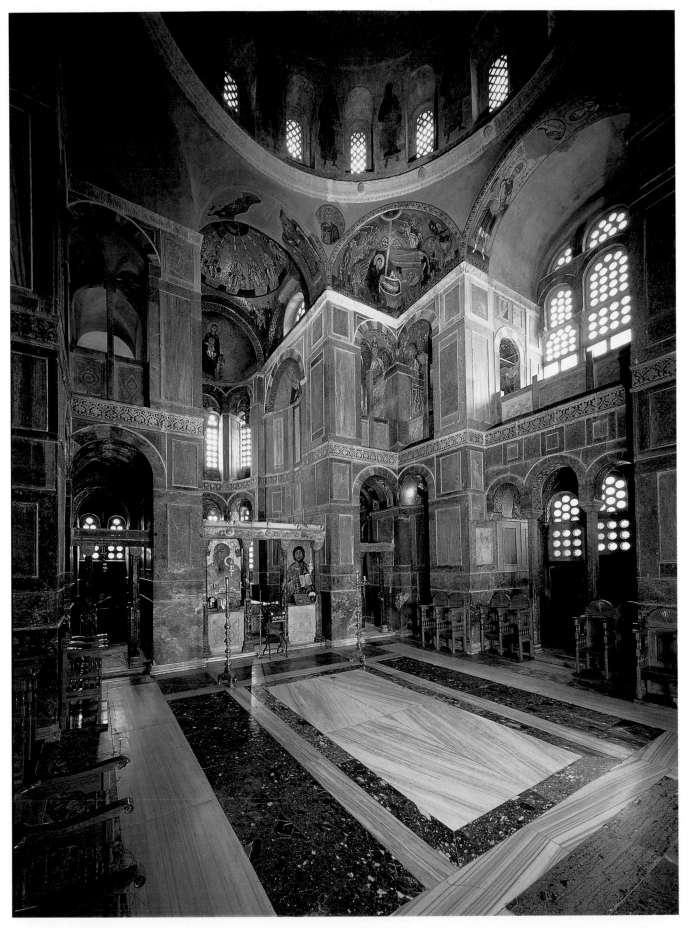

7-43. Central dome and apse, Katholikon, Monastery of Hosios Loukas, near Stiris, Greece. Early 11th century and later

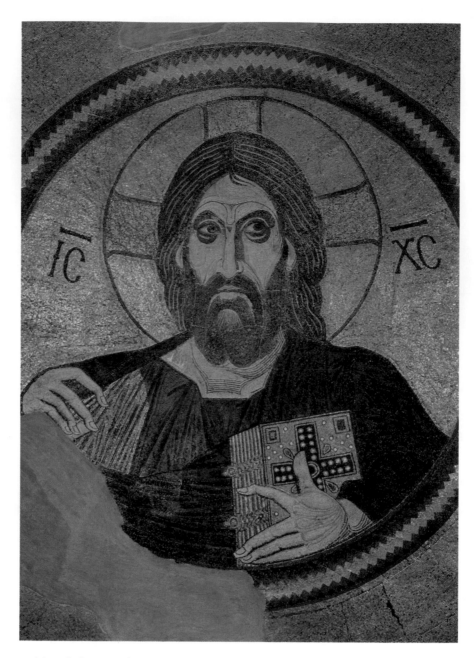

7-44. *Christ Pantokrator*, mosaic in the central dome, Church of the Dormition, Daphni, Greece. Central dome, c. 1080–1100

Child. Scenes from the Old and New Testaments and figures of saints fill the interior with brilliant color and dramatic images.

Eleventh-century mosaicists in Greece looked with renewed interest at models from the past, studying both classical art and the art of Justinian's era. They conceived their compositions in terms of an intellectual rather than a physical ideal. While continuing to represent the human figure and narrative subjects, some artists eliminated all unnecessary details, focusing on the essential elements of a scene to convey its mood and message.

The decoration of the Church of the Dormition at Daphni, near Athens, provides an excellent example of this moving but elegant style. (The term *dormition*—which comes from the Greek and Latin words for "sleep"—refers to the assumption into heaven of the Vir-

gin Mary at the moment of her death.) The *Christ Pantokrator*, a bust-length mosaic portrayal, fills the central dome of the church (fig. 7-44). This awe-inspiring image, hovering in golden glory, combines two persons of the Trinity—father and son, judge and savior. It is a powerful evocation of his promised judgment, with its reward for the faithful and punishment for sinners.

On a wall in the north arm of the church is an image of the Crucifixion (fig. 7-45). Jesus is shown with bowed head and sagging body, his eyes closed in death. Gone is the royal robe of the sixth-century *Rabbula Gospels* (see fig. 7-36); a nearly nude figure hangs on the cross. Also unlike the earlier Crucifixion scene, which depicts many people, some anguished and others indifferent or hostile, this image shows just two mourning figures, Mary and the young apostle John, to whom Jesus had entrusted the

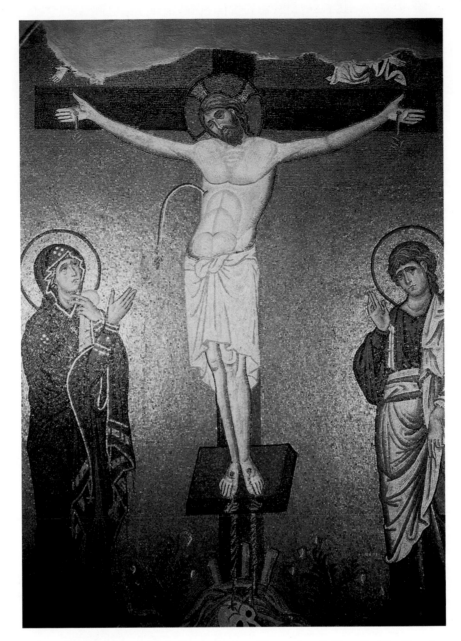

7-45. *Crucifixion*, mosaic in the north arm of the east wall, Church of the Dormition, Daphni, Greece. Late 11th century

care of his mother after his death. The arc of blood and water springing from Jesus' side refers to the Eucharist. The simplification of contours and the reduction of forms to essentials give the image great emotional power. This otherworldly space is a golden universe anchored to the material world by a few flowers, which suggest the promise of new life. The mound of rocks and the skull at the bottom of the cross represent Golgotha, the "place of the skull," a hill outside ancient Jerusalem where Adam was thought to be buried and the Crucifixion was said to have taken place. To the faithful, Jesus Christ was the new Adam sent by God to save humanity through his own sacrifice. As Paul wrote in his First Letter to the Corinthians: "For just as in Adam all die, so too in Christ shall all be brought to life" (1 Corinthians 15:22). The timelessness and simplicity of this image were meant to

aid the Christian worshiper seeking to achieve a mystical union with the divine through prayer and meditation.

Sicily. Other notable mosaics were created during this period on the island of Sicily, a crossroads of Byzantine, Muslim, and European cultures. Muslims had ruled Sicily from 827 to the end of the eleventh century, when it fell to the Normans, descendants of the Viking settlers of northern France. The Norman Roger II, count of Sicily (ruled 1105–30), was crowned king of Sicily in Palermo in 1130 and ruled until 1154. The pope, who assumed ecclesiastical jurisdiction over Sicily for "God and Saint Peter," endorsed Norman rule. In the first half of the twelfth century, Sicily became one of the richest and most enlightened kingdoms in Europe. Roger extended religious toleration to the kingdom's diverse population, which

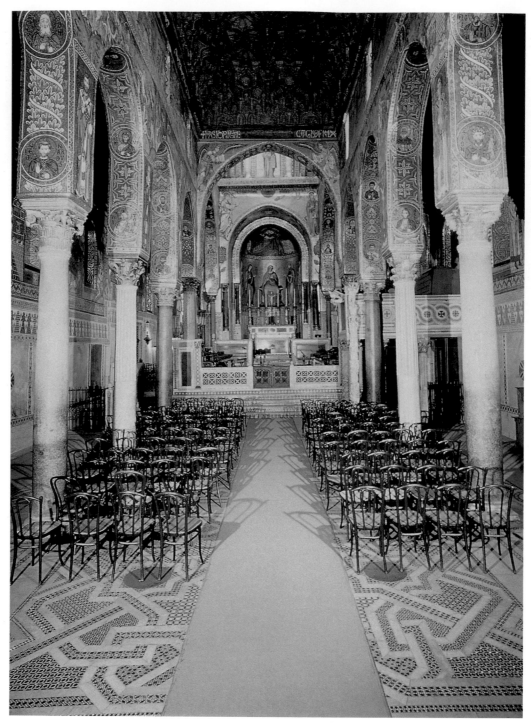

7-46. Palatine Chapel,
Palermo, Sicily.
Mid-12th century.
View toward the east

included western Europeans, Greeks, Arabs, and Jews. He involved all factions in his government, permitted everyone to participate equally in the kingdom's economy, and issued official documents in Latin, Greek, and Arabic.

Roger's court in his capital of Palermo was a brilliant mixture of Norman, Muslim, and Byzantine cultures, as reflected in the Palatine (palace) Chapel there. The Western-style basilica-plan church has a Byzantine dome on squinches over the crossing, an Islamic-style timber ceiling in the nave, lower walls and a floor of inlaid marble, and upper walls decorated with mosaic—the diverse elements dramatically combining into an exotic whole (fig. 7-46). A blessing Christ holding an open book fills the half dome of the apse; a Christ *Pantokrator* surrounded by

angels, the dome; the Annunciation, the arches of the crossing. The mosaics in the transept (seen at the right) have scenes from the Gospels, with the Nativity and shepherds on the end wall. In contrast to the focus on strictly essential forms seen in the mosaics at Daphni, the artists here seem to have been absorbed in depicting anecdotal details, so that well-proportioned figures clothed in form-defining garments might also have draperies with patterns of geometric folds and jagged, flying ends bearing no relation to gravity. Instead of modeling forms with subtle tonal gradations, the artists often relied on strong juxtapositions of light and dark areas. The style and some iconographical details are Byzantine, but the excited narrative energy is Western.

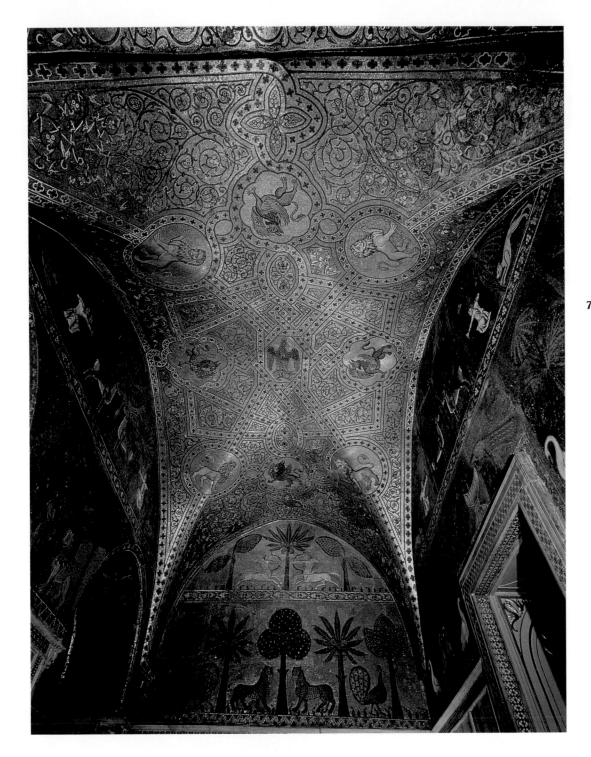

7-47. Chamber of King Roger, Norman Palace, Palermo, Sicily. Mid-12th century

A room in the Norman Palace in Palermo, made for William I (ruled 1154–66) although known as King Roger's chamber, gives an idea of domestic Byzantine interior decoration (fig. 7-47). The floor and lower walls have individual marble panels framed by strips inlaid with geometric patterns of colored stones. Columns with patterned marble shafts add to the decoration rather than form necessary supports. Mosaics cover the upper walls and vault. Against a continuous gold surface are two registers of highly stylized trees and paired lions, leopards, peacocks, centaurs, and hunters. The interior glistens with reflected light and color. The idea of a garden room, so popular in Roman houses, remains, but the artists have turned it into a stylized fantasy on nature—a world as formalized as the rituals that had come to dominate life in the imperial and royal courts.

IVORIES AND METALWORK

During the second Byzantine golden age, artists of impeccable ability and high aesthetic sensibility produced small luxury items of a personal nature for members of the court as well as for the Church. Many of these items were commissioned by rulers and high secular and church functionaries as official gifts for one another. As such, they had to be portable, sturdy, and exquisitely refined. In style these works tended to combine classical elements with iconic compositions,

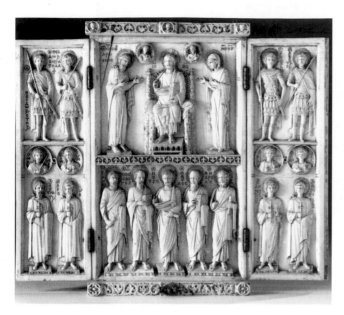

7-48. *Harbaville Triptych.* Mid-11th century. Ivory, closed 11 x 9½" (28 x 24.1 cm); open 11 x 19" (28 x 48.2 cm). Musée du Louvre, Paris

successfully joining simple beauty and religious meaning. Such a piece is the *Harbaville Triptych*, dating from the mid-eleventh century (fig. 7-48). This small ivory devotional piece represents Christ in the upper center panel flanked by Mary and Saint John the Baptist acting as intercessors on behalf of worshipers; this group, known as Deesis, was an important new theme. The figures in the other panels (wings) are military saints and martyrs. All the figures exist in a neutral space given definition only by the small bases under the feet of the saints and by Christ's throne. Although conceived as essentially frontal and rigid, the figures have rounded shoulders, thighs, and knees that suggest physical substance beneath a linear, decorative drapery. Beautiful as the carved ivory seems to us, the triptych was likely to have been brightly painted and gilded, as microscopic examination of other Middle Byzantine ivories has revealed tiny grains of pigment in red, blue, green, black, white, and gold.

The refined taste and skillful work that characterize the arts of the tenth through twelfth centuries were also expressed in precious materials such as silver and gold. A silver-gilt and enamel icon of the archangel Michael was one of the prizes the Crusaders took back to Venice in 1204, after sacking Constantinople. The icon was presumably made in the late tenth or early eleventh century in an imperial workshop (fig. 7-49, "The Object Speaks"). The angel's head and hands, executed in relief, are surrounded by intricate relief and enamel decoration. Halo, wings, and garments are in jewels, colored glass, and delicate **cloisonné**, and the outer frame, added later, is inset with enamel **roundels**. The colorful brilliance of the patterned setting removes the image from the physical world, although the archangel appears here in essentially the same frontal pose and with the same idealized and timeless youthfulness with which he was portrayed in a

THE OBJECT SPEAKS
THE ARCHANGEL MICHAEL

Icons speak to us today from computer screens—tiny images leading us from function to function in increasingly sophisticated hierarchies. Allusive images formed of light and color, these icons—like the religious **icons** ("images" in Greek) that came before—speak to those who almost intuitively understand their suggestive form of communicating.

The earliest icons had a mostly religious purpose—they were holy images that mediated between people and their God. Icons in the early Church were thought to be miracle workers, capable even of defending their petitioners from evil. An icon made more than a thousand years ago, possibly from the front and back covers of a book, depicts the archangel Michael (fig. 7-49). The Protector of the Chosen, who defends his people from Satan and conducts their souls to God, Michael is mentioned in Jewish, Christian, and Islamic scriptures. On the front of this icon, Michael blesses petitioners with upraised hand; on the back is a relief in silver of the Cross, symbolizing Christ's victory over death.

When it was created, this icon would have spoken to believers of how archangels and angels mediate between God and humans—as when they announced Jesus' birth or mourned his death. Immaterial, they occupy no space; their presence is felt, not seen. They are known intuitively, not by human reason.

Intuitive understanding is the core of Christian mysticism, according to the sixth-century theologian Dionysus the Pseudo-Areopagite. As he explained, humans may, in stages, leave their sensory perception of the material world and rational thought and move to a mystical union with God. In icons, enamels, mosaics, and stained glass, artists tried to convey a sense of the divine with colored light, representing how matter becomes pure color and light as it becomes immaterial. Believers thus would have interpreted the *Archangel Michael* as an image formed by the golden light of heaven—his presence is felt; his body is immaterial. When believers then and now behold icons like the *Archangel Michael*, they intuit the image of the Heavenly Jerusalem.

7-49. *Archangel Michael,* icon. Late 10th or early 11th century. Silver gilt with enamel, 19 x 14" (48 x 36 cm). Treasury of the Cathedral of Saint Mark, Venice

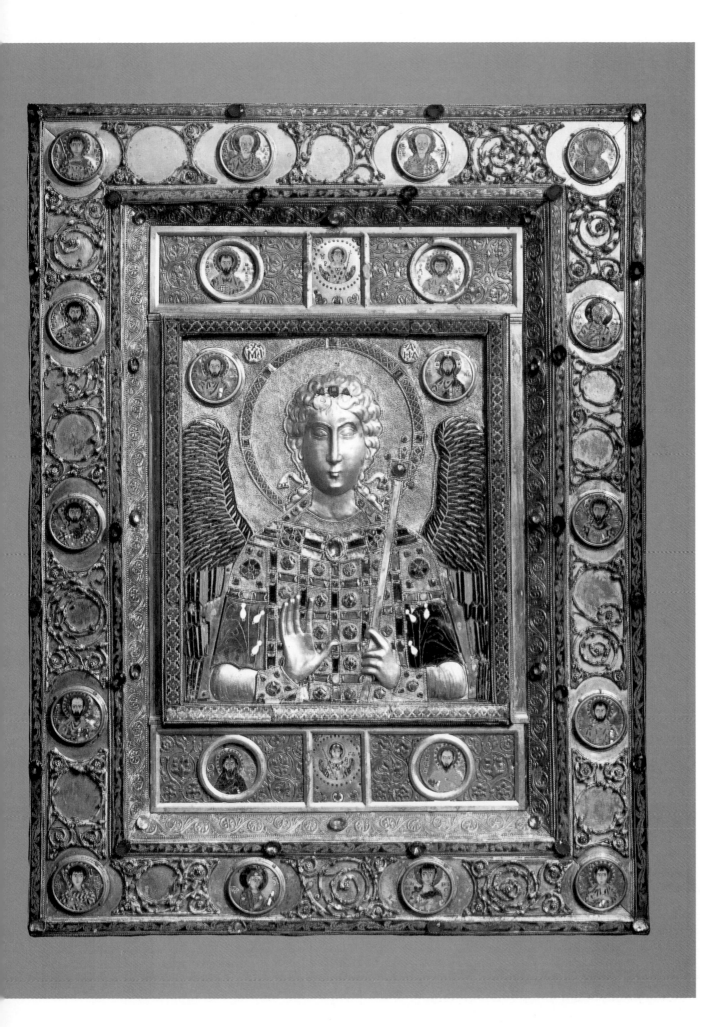

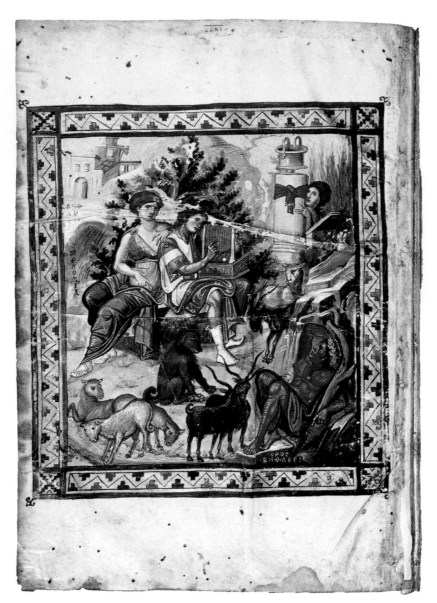

7-50. Page with *David the Psalmist*, from the *Paris Psalter*. Second half of the 10th century. Paint on vellum, sheet size 14 x 10 1/2" (35.6 x 26 cm). Bibliothèque Nationale, Paris

About a third of the Old Testament was written in poetry, and among its most famous poems are those in the Book of Psalms. According to ancient tradition, the author of the Psalms was Israel's King David, who, as a young shepherd and musician, saved the people by killing the Philistine giant Goliath. In Christian times, the Psalms were copied into a book called a psalter, used for private reading and meditation. *Psalm* and *psalter* come from a word referring to the sound or action of playing a stringed instrument called the psaltery.

sixth-century ivory panel (see fig. 7-33). The image exists on a lofty plane where light and color supplant form, and material substance becomes pure spirit.

MANUSCRIPTS

Several luxuriously illustrated manuscripts have survived from the second Byzantine golden age. As was true of the artists who decorated church interiors, the illustrators of these manuscripts combined intense religious expression, aristocratic elegance, and a heightened appreciation of rich decorative forms. The *Paris Psalter* from the second half of the tenth century is one example (fig. 7-50). Like the earlier *Rabbula Gospels* (see figs. 7-36, 7-37), the psalter (a version of the Psalms) includes scenes set off in frames on pages without text. Fourteen full-page paintings illustrate the *Paris Psalter*, the first of which depicts David, traditionally the author

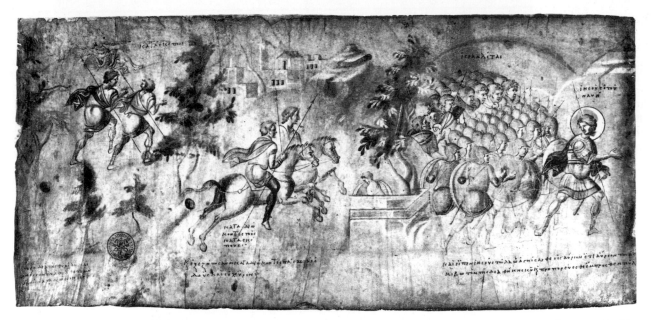

7-51. **Page with *Joshua Leading the Israelites*,** from the *Joshua Roll*, made in Constantinople. c. 950. Vellum scroll with brown ink and colored washes, height 12½" (32.4 cm). Biblioteca Apostolica Vaticana, Rome

of the Old Testament's Book of Psalms. The illuminators turned to earlier classical illustrations as source material. The idealized, massive, three-dimensional figures reside in a receding space with lush foliage and a meandering stream that seem directly transported from ancient Rome. The architecture of the city and the ribbon-tied memorial column also derive from conventions in Greek and Roman funerary art, and in the ancient manner, the illustrator has personified abstract ideas and landscape features. Melody, a female figure, leans casually on David's shoulder, while another woman, perhaps the wood nymph Echo, peeks out from behind the column. The reclining youth in the lower foreground is a personification of Mount Bethlehem, as we learn from his inscription. The image of the dog watching over the sheep and goats while his master strums the harp suggests the classical subject of Orpheus charming wild animals with music. The subtle modeling of forms, the integration of the figures into a three-dimensional space, and the use of **atmospheric perspective** all enhance the classical flavor of the painting.

The *Joshua Roll* (fig. 7-51), a tenth-century manuscript in scroll form, reflects an approach different from that of the *Paris Psalter*, though both are believed to have been created in a Constantinople *scriptorium*. The illustrators worked on plain vellum, using colored inks—black, brown, blue, and red with white and gold—to convey the exploits of Moses' successor, Joshua, the Old Testament hero of the Battle of Jericho (Joshua 6:1–20), who conquered the promised land and whom the Byzantines thought foreshadowed their victories against the Muslims. In the section shown here, the events described in the text are depicted in a continuous landscape that recedes from the large foreground figures to distant cities and landforms. Strategically placed labels within

the pictures identify the figures. The main character, Joshua, is at the far right. Crowned with a halo, unhelmeted but wearing upper-body armor, he leads his soldiers toward the Jordan River. The scroll in its original form would have rolled out in a continuous narrative like an ancient Roman victory column.

LATE BYZANTINE ART

The third great age of Byzantine art began in 1261, after the Byzantines expelled the Christian Crusaders who had occupied the capital and the empire for nearly sixty years. Although the empire had been weakened and its realm decreased to small areas of the Balkans and Greece, its arts underwent a resurgence. The patronage of emperors, wealthy courtiers, and the Church stimulated renewed church building. In this new work, the physical requirements of the clergy and the liturgy took precedence over costly interior decorations. The buildings, nevertheless, often reflect excellent construction skills and elegant and refined design.

New ambulatory aisles, narthexes, and side chapels were added to many small, existing churches. Among these is the former Church of the Monastery of Christ in Chora, Constantinople, now the Kariye Camii Museum. The expansion of this church was one of several projects that Theodore Metochites, the administrator of the Imperial Treasury at Constantinople, sponsored between 1315 and 1321. A humanist, poet, and scientist, Metochites became a monk in this monastery sometime after 1330. To its church he added a two-story annex on the north side, two narthexes on the west side, and a funerary chapel on the south side. These structures contain the most impressive interior decorations remaining in Constantinople from the Late Byzantine period. The

7-52. Funerary chapel, Church of the Monastery of Christ in Chora (now Kariye Camii Museum), Istanbul, Turkey. c. 1315–21

funerary chapel is entirely painted (fig. 7-52) with themes appropriate to such a setting—for example, the Last Judgment, painted on the vault of the nave, and the Anastasis, Christ's descent into limbo to rescue Adam, Eve, and other virtuous people from Satan, depicted in the half dome of the apse. Large figures of the church fathers (a group of especially revered early Christian writers of the history and teachings of the Church), saints, and martyrs line the walls below. Sarcophagi, surmounted by portraits of the deceased, once stood in side niches. ***Trompe l'oeil*** ("fool the eye") painting simulates marble paneling in the **dado**.

The *Anastasis* fills the funerary chapel's apse vault (fig. 7-53). Christ appears as a savior in white, moving with such force that even his star-studded mandorla has been set awry. He has trampled down the doors of hell; tied Satan into a helpless bundle; and shattered locks, chains, and bolts, which lie scattered over the ground. He drags the elderly Adam and Eve from their open sarcophagi with such force that their bodies seem airborne. Behind him are Old Testament prophets and kings, as well as his cousin John the Baptist.

Architecture of the Late Byzantine style flourished in the fifteenth and sixteenth centuries outside the borders of the empire in regions that had adopted Eastern Orthodox Christianity. After Constantinople's fall to the Ottoman Turks in 1453, leadership of the Orthodox Church shifted to Russia. Russian rulers declared Moscow to be the third Rome and themselves the heirs of Caesar (czars). Russian preference for complexity and verticality combined with Byzantine architecture in a spectacular style epitomized by the Cathedral of Saint Basil the Blessed in Moscow (fig. 7-54). The first Russian czar, Ivan IV, known as the Terrible (1530–84), commissioned the church, and the architects Barma and Postnik designed and built it between 1555 and 1561. Instead of a central dome, the architects employed a typical Russian form called a ***shater*** (a steeply pitched, tentlike roof form, designed to keep dangerously large accumulations of snow from forming). It is surrounded by eight chapels, each with its own dome seeming to grow budlike from the slender stalk of a very tall drum. The multiplications of shapes and sizes and the layering of the surfaces with geometric relief elements all distract visitors from the underlying plan—a nine-bay, cross-in-square, or quincunx, design surrounded by four more chapels, all on a podium approached by a covered stair (see "Multiple-Dome Church Plans," page 324). This spectacular church shows the evolution of Byzantine architecture into a distinct style that later typified Eastern Orthodox churches in Russia and elsewhere, including the United States.

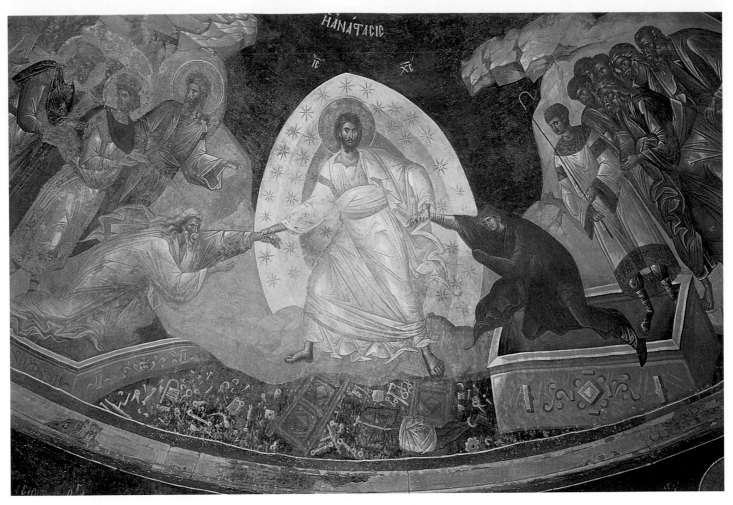

7-53. *Anastasis*, painting in the apse of the funerary chapel, Church of the Monastery of Christ in Chora

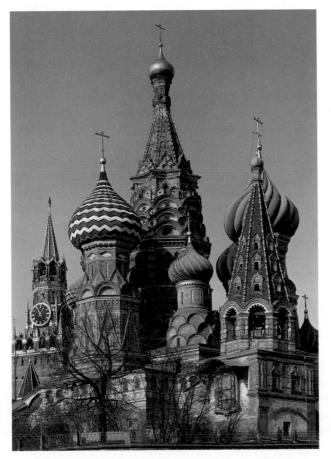

7-54. Barma and Postnik. Cathedral of Saint Basil the Blessed, Moscow. 1555–61

Like most mid-sixteenth-century Russian churches, the entire exterior of Saint Basil's was originally painted white, and the domes were gilded. The bright colors we see today were added by later generations. The name of the church also changed over time. It was originally dedicated to the Intercession of the Virgin Mary, a reflection of the veneration of Mary in the Eastern Church.

7-55. Andrey Rublyov. *The Old Testament Trinity (Three Angels Visiting Abraham)*, icon. c. 1410–20. Tempera on panel, 55½ x 44½" (141 x 113 cm). Tretyakov Gallery, Moscow

Representing the dogma of the Trinity—one God in three beings—was a great challenge to artists. One solution was to depict God as three identical individuals. Rublyov used that convention to illustrate the Old Testament story of the Hebrew patriarch Abraham and his wife, Sarah, who entertained three strangers who were divine beings.

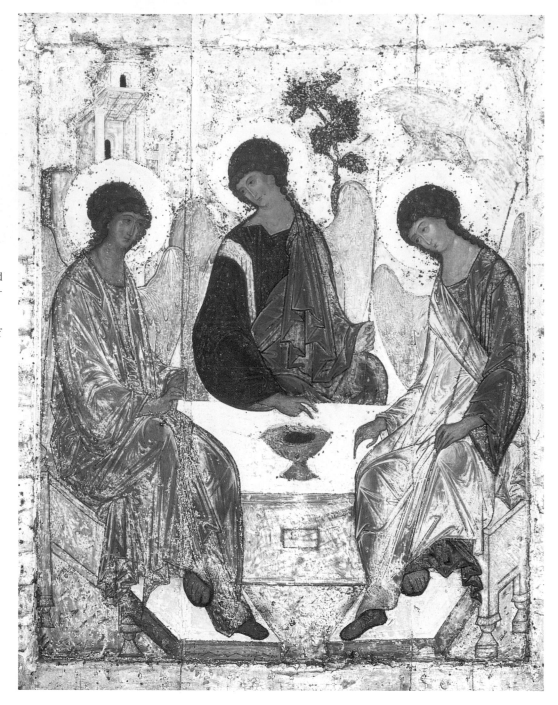

The practice of venerating icons continued in the Late Byzantine period. A remarkable icon from this time is *The Old Testament Trinity (Three Angels Visiting Abraham)*, a large panel created between 1410 and 1420 by the famed artist-monk Andrey Rublyov (fig. 7-55). It was commissioned in honor of the abbot Sergius of the Trinity-Sergius Monastery, near Moscow. This icon clearly illustrates how Late Byzantine artists relied on mathematical conventions to create ideal figures, as did the ancient Greeks, thus giving their work remarkable consistency. Unlike the Greeks, who based their formulas on close observation of nature, Byzantine artists invented an ideal geometry and depicted human forms and features according to it. Here, as is often the case, the circle forms the underlying geometric figure, emphasized by the form of the haloed heads. Despite the for-

mulaic, somewhat uniform approach, talented artists like Rublyov managed to create a personal expressive style. He relied on typical conventions—simple contours, elongation of the body, and a focus on a limited number of figures—to capture the sense of the spiritual in his work, yet distinguished his art by imbuing it with a sweet, poetic ambience. In this artist's hands, the Byzantine style took on new life. The Byzantine tradition would carry on in the art of the Eastern Orthodox Church and continues to this day in Russian icon painting. But in Constantinople, the three golden ages of Byzantine art—and the empire itself—came to a decisive end in 1453. When the forces of the Ottoman sultan Muhammad II overran the capital, the Eastern Empire became part of the Islamic world, with its own very rich aesthetic heritage.

PARALLELS

PERIOD	EARLY CHRISTIAN, JEWISH, BYZANTINE ART	ART IN OTHER CULTURES
EARLY JEWISH PERIOD	7-2. *Menorahs and Ark* (3rd cent.) 7-5. *Dura-Europos synagogue* (244–45) 7-6. *Finding of the Baby Moses* (second half 3rd cent.)	6-31. Colosseum (72–80), Italy 3-45. Mummy of boy (c. 100–120), Egypt 13-3. Nok head (500 BCE–200 CE), Nigeria
EARLY CHRISTIAN C. 100– 6TH CENTURY	7-1. Leonis *cubiculum* (late 4th cent.) 7-3. *Good Shepherd* (4th cent.)	6-27. Basilica Ulpia (113), Italy 6-58. *Unswept Floor* (2nd cent.), Italy 9-13. *Standing Buddha* (c. 2nd–3rd cent.), India
IMPERIAL CHRISTIAN 313–476	7-9. Old Saint Peter's (c. 320–27) 7-13. Santa Costanza (c. 338–50) 7-21. *Sarcophacus of Junius Bassus* (c. 359) 7-20. *Resurrection and Angel with Two Marys at the Tomb* (c. 400) 7-10. Santa Sabina (422–32) 7-17. Mausoleum of Galla Placidia (c. 425–26) 7-12. *Parting of Lot and Abraham* (432–40)	6-84. *Priestess* diptych (c. 390–401), Italy 9-17. Ajanta murals (c. 475), India 12-6. Temple of the Feathered Serpent (after 350), Mexico
EARLY BYZANTINE 5TH CENTURY–726	7-33. *Archangel Michael* (early 6th cent.) 7-35. *Book of Genesis* (early 6th cent.) 7-26. San Vitale (526–47) 7-22. Hagia Sophia (532–37) 7-31. Church of Sant'Apollinare (dedicated 549) 7-25. *Transfiguration*, St. Catherine (c. 548–65) 7-36. *Rabbula Gospels* (586) 7-38. *Virgin and Child with Saints and Angels* (later 6th cent.)	11-4. *Haniwa* (6th cent.), Japan 8-2. Dome of the Rock (c. 687–91), Jerusalem
MIDDLE BYZANTINE 843–1204	7-49. *Archangel Michael* (late 10th/early 11th cent.) 7-51. *Joshua Roll* (c. 950) 7-50. *Paris Psalter* (mid-10th cent.) 7-43. Hosios Loukas (early 11th cent.) 7-40. Santa Sophia (c. 1017–37) 7-48. *Harbaville Triptych* (mid-11th cent.) 7-39. Cathedral of Saint Mark (begun 1063) 7-44. *Christ Pantokrator* (c. 1080–1100) 7-45. *Crucifixion* (late 11th cent.) 7-42. *Virgin of Vladimir* (12th cent.) 7-46. Palatine Chapel (mid-12th cent.)	14-17. *Utrecht Psalter* (c. 825–50), Netherlands 11-1. Byodo-in (c. 1053), Japan 12-13. Chacmool (9th–13th cent.), Mexico 15-33. Speyer Cathedral (c. 1030–early 1100s), Germany 15-40. Pisa Cathedral (begun 1063), Italy 15-32. *Bayeux Tapestry* (c. 1066–77), France 9-28. *Shiva Nataraja* (12th cent.), India 16-6. Chartres Cathedral (c. 1134–1220), France 16-22. Notre Dame, Paris (begun 1163), France 12-23. Anasazi seed jar (c. 1150), North America
LATE BYZANTINE 1261–16TH CENTURY	7-52. Church, Christ in Chora (c. 1315–21) 7-55. *The Old Testament Trinity (Three Angels Visiting Abraham)* (c. 1410–20)	13-4. Ife head (c. 1200–1300), Nigeria 13-10. Great Friday Mosque (13th cent.), Mali 16-69. Giotto. *Virgin and Child* (1310), Italy

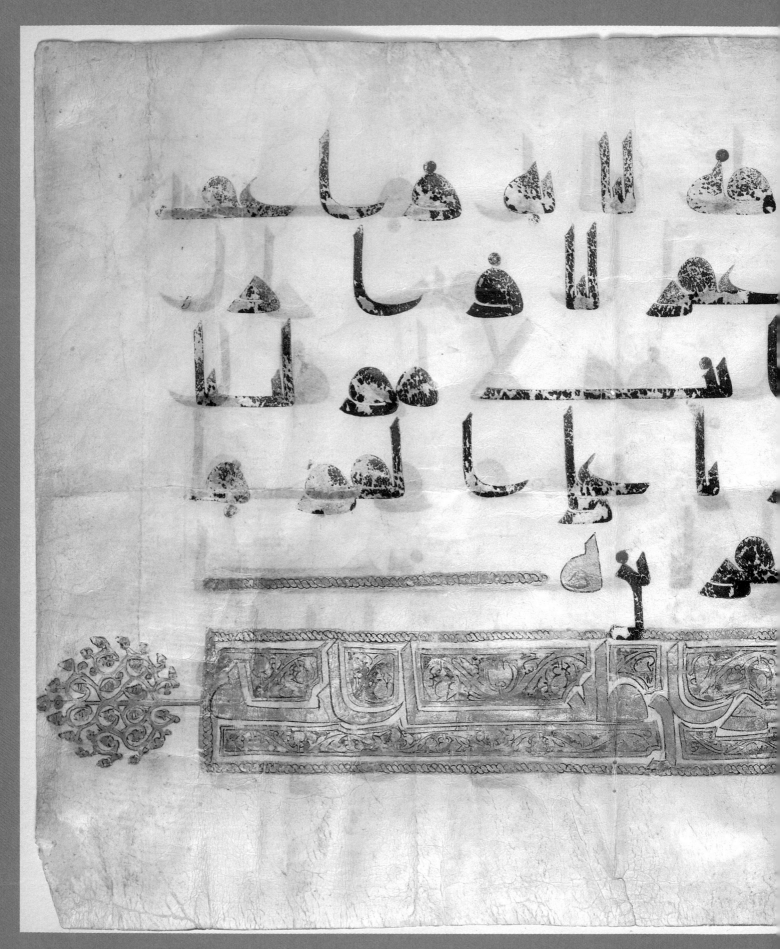

8-1. Page from Koran (*surah* 47:36) in kufic script, from Syria.
9th century. Ink, pigments, and gold on vellum, 9³/₈ x 13¹/₈"
(23.8 x 33.3 cm). The Metropolitan Museum of Art, New York
Rogers Fund, 1937 (37.99.2)

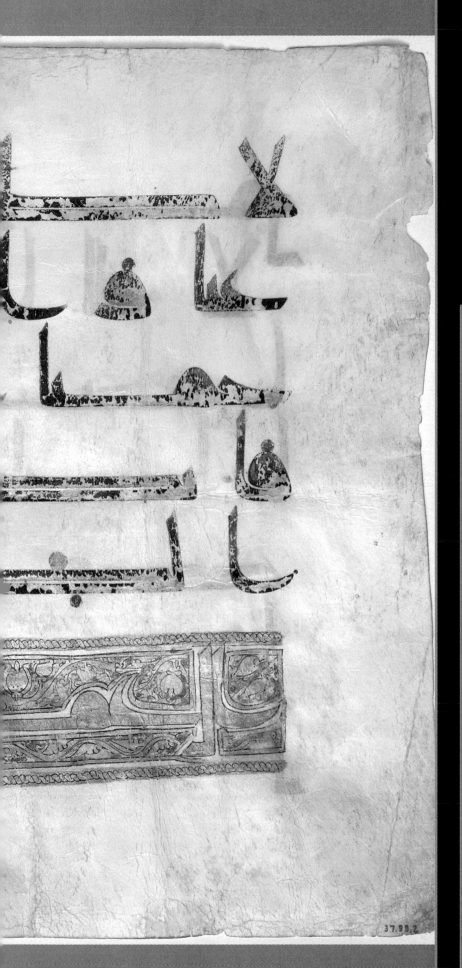

8
Islamic Art

During the holy month of Ramadan in 610 CE, a merchant named al-Amin ("the Trusted One") sought solitude in a cave on Mount Hira, a few miles north of Mecca, in Arabia. On that night, "The Night of Power and Excellence," the angel Gabriel is believed to have appeared to him and commanded him to recite revelations from God. In that moment, the merchant al-Amin became the Messenger of God, Muhammad. The revelations dictated by Gabriel at Mecca were the foundation of the religion called Islam ("submission to God's will"), whose adherents are referred to as Muslims ("those who have submitted to God"). Today, nearly a billion Muslims turn five times a day toward Mecca to pray.

The Word of God revealed to Muhammad was recorded in the book known as the Koran ("Recitation"). To transcribe these revelations, scribes adopted Arabic script wherever Islam spread, and the very act of transcribing the Koran became sacred. To accomplish this holy task, which is summarized in the ancient Arabic expression "Purity of writing is purity of the soul," scribes developed **calligraphy**, the art of writing, to an extraordinary degree (fig. 8-1). A prohibition against depicting representational images in religious art, as well as the naturally decorative nature of Arabic script, led to the use of calligraphic decoration on religious architecture, carpets, ceramics, and handwritten documents. Perhaps the foremost characteristic of Islamic religious art, wherever it is found in the world and among every race, is the presence of beautiful writing, used for reading, for prayer, and for decoration.

TIMELINE 8-1. The Islamic World. After the early Caliphs, rapid geographical expansion and internal rivalries led to the formation of powerful independent dynasties, some of which lasted for centuries.

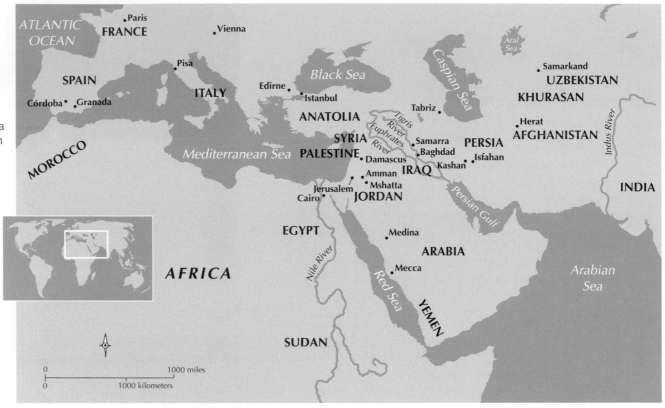

MAP 8-1.
The Islamic World.
Within 200 years of its founding in 610 CE, the Islamic world expanded from Mecca to India in the east, to Spain in the northwest, and to Africa in the south.

ISLAM AND EARLY ISLAMIC SOCIETY

Islam spread rapidly after its founding, encompassing much of North Africa, the Middle East, and Southeast Asia. The art of this vast region draws its distinctive character both from Islam itself and from the diverse cultural traditions of the world's Muslims. Because Islam discouraged the use of figurative images, particularly in religious contexts—unlike Christian art—Islamic artists developed a rich vocabulary of **aniconic**, or nonfigural, ornament that is a hallmark of Islamic work. This vocabulary includes complex geometric patterns and the scrolling vines known outside the Islamic world as **arabesques**. Figural representation, to the extent it was permitted (which varied from time to time and place to place), first developed most prominently in regions with strong pre-Islamic figural traditions, such as those that had been under the control of the Roman and Byzantine empires. Stylized forms for representing animals and plants developed in the regions that had been under the control of the Sassanian dynasty of Persia (modern Iran), the heirs of the artistic traditions of the ancient Near East, who ruled from 226 to 641. Because the Arabian birthplace of Islam

had little art, these Persian and Roman-Byzantine influences shaped Islamic art in its formative centuries.

Much of Islamic art can be seen as an interplay between pure abstraction and organic form. For Muslims, abstraction helps free the mind from the contemplation of material form, opening it to the enormity of the divine presence. Islamic artists excelled in surface decoration, using repeated and expanding patterns to suggest timelessness and infinite extension. Shimmering surfaces created by dense, highly controlled patterning are characteristic of much later Islamic art, including architecture, carpet making, calligraphy, and book illustration.

Muslims date the beginning of their history to the flight of the Prophet Muhammad from Mecca to Medina—an exodus called in Arabic the *hijra*—in 622 (see "The Life of the Prophet Muhammad," pages 346–7). Over the next decade Muhammad succeeded in uniting the warring clans of Arabia under the banner of Islam. Following the Prophet's death in 632, four of his closest associates assumed the title of "caliph" ("successor"): Abu Bakr (ruled 633–34), Umar (ruled 634–44), Uthman (ruled 644–56), and finally Ali (ruled 656–61). According to tradition, during the time of Uthman, the Koran assumed its final form.

The accession of Ali provoked a power struggle that led to his assassination—and resulted in enduring divisions within Islam. Followers of Ali, known as Shiites, regard him as the Prophet's rightful successor and the first three caliphs as illegitimate. Sunni Muslims, in contrast, recognize all of the first four caliphs as "rightly guided." Ali was succeeded by his rival Muawiya (ruled 661–80), a close relative of Uthman and the founder of the Umayyad dynasty (661–750).

Beginning in the seventh century, Islam expanded dramatically. In just two decades, seemingly unstoppable Muslim armies conquered the Sassanian Persian Empire, Egypt, and the Byzantine provinces of Syria and Palestine. By the early eighth century, under the Umayyads, they had reached India, conquered all of North Africa and Spain, and penetrated France to within 100 miles of Paris before being turned back (Map 8-1). In Muslim-conquered lands, the circumstances of Christians and Jews who did not convert to Islam was neither uniform nor consistent. In general, as "People of the Book"—followers of a monotheistic religion based on a revealed scripture—they enjoyed a protected status. However, they were also subject to a special tax and restrictions on dress and employment.

Islam has proven a remarkably adaptable faith. Part of that adaptability is due to its emphasis on the believer's direct, personal relationship with God through prayer, along with a corresponding lack of ceremonial paraphernalia. Every Muslim must observe the Five Pillars, or duties, of faith. The most important of these is the statement of faith: "There is no god but God and Muhammad is his messenger." Next come ritual prayer five times a day, charity to the poor, fasting during the month of Ramadan, and a pilgrimage to Mecca—Muhammad's birthplace and the site of the Kaaba, Islam's holiest structure—once in a lifetime for those able to undertake it.

Muslims are expected to participate in congregational worship at a **mosque** (*masjid* in Arabic) on Fridays. When not at a mosque, the faithful simply kneel wherever they are to pray, facing the Kaaba in Mecca. The Prophet Muhammad himself lived simply and advised his companions not to waste their resources on elaborate architecture. Instead, he instructed and led them in prayer in a mud-brick structure, now known as the Mosque of the Prophet, adjacent to his home in Medina. This was a square enclosure with verandas supported by palm-tree trunks that framed a large courtyard. Muhammad spoke from a low platform on the south veranda. This simple arrangement—a walled courtyard with a separate space on one side housing a **minbar** (pulpit) for the *imam* (prayer leader)—became the model for the design of later mosques.

ART DURING THE EARLY CALIPHATES

The caliphs of the aggressively expansionist Umayyad dynasty ruled from their capital at Damascus (in modern Syria). They were essentially desert chieftains who had scant interest in fostering the arts except for architecture and poetry, which had been held in high esteem among Arabs since pre-Islamic times. The building of shrines and mosques throughout the empire in this period represented both the authority of the new rulers and the growing acceptance of Islam. The caliphs of the Abbasid dynasty, who replaced the Umayyads in 750 and ruled until 1258 (Timeline 8-1), governed in the grand manner of ancient Persian emperors from their capitals at Baghdad and Samarra (in modern Iraq). Their long and cosmopolitan reign saw achievements in medicine, mathematics, the natural sciences, philosophy, literature, music, and art. They were generally tolerant of the ethnically diverse populations in the territories they subjugated and admired the cultural traditions of Byzantium, Persia, India, and China. (The early art of India is discussed in Chapter 9 and that of China in Chapter 10.)

ARCHITECTURE

As Islam spread, architects adapted freely from Roman, Christian, and Persian models, which include the basilica, the *martyrium*, the peristyle house, and the palace audience hall. The Dome of the Rock in Jerusalem (figs. 8-2, 8-3, page 346), built about 687–91, is the oldest surviving Islamic sanctuary and is today the holiest site in Islam after Mecca and Medina. The building stands on the platform of the Temple Mount (Mount Moriah) and encloses a rock outcropping that has also long been sacred to the Jews, who identify it as the site on which Abraham prepared to sacrifice his son Isaac. Jews, Christians, and Muslims associate the site with the creation of Adam and the Temple built by Solomon. Muslims also identify it as the site from which Muhammad, led by the angel Gabriel, ascended to heaven in the Night Journey, passing through the spheres of heaven to the presence of God.

The Dome of the Rock was built by Syrian artisans trained in the Byzantine tradition, and its centralized plan—an octagon within an octagon—derived from both Early Christian and Byzantine architecture. Unlike its Byzantine models, however, with their plain exteriors, the Dome of the Rock, crowned with a golden dome that dominates the Jerusalem skyline, is opulently decorated with tiles outside and marble veneer and mosaics inside. A dome on a tall **drum** pierced with windows and supported by an **arcade** composed of alternating **piers** and **columns**—two columns to one pier in the outer ring, three to one in the inner—covers the central space

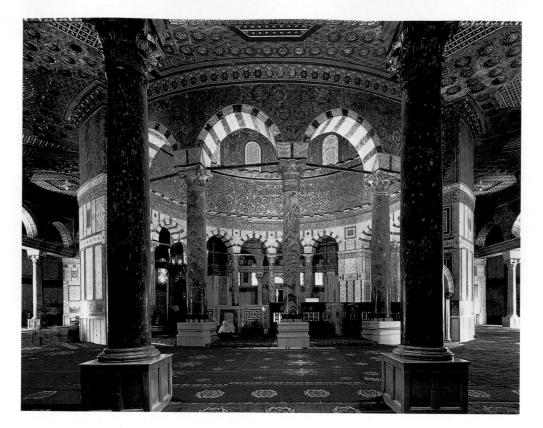

8-2. Dome of the Rock, Jerusalem, Israel. Interior. c. 687–91

The gilt wooden beams in the outer ambulatory are not visible. The carpets and ceiling are modern but probably reflect the original patrons' intention.

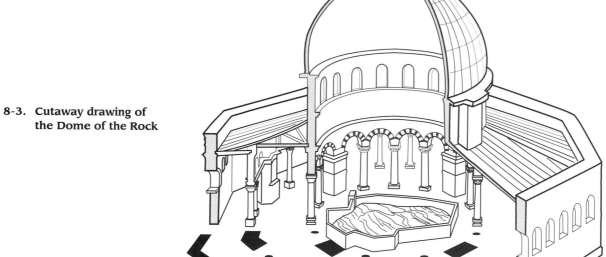

8-3. Cutaway drawing of the Dome of the Rock

containing the rock. Concentric **aisles (ambulatories)** permit the devout visitor to circumambulate the rock. Inscriptions from the Koran interspersed with passages from other texts and commentary, including information about the building, form a **frieze** around the inner wall. The pilgrim must walk around the central space first clockwise and then counterclockwise to read the inscriptions in gold mosaic on turquoise green ground. These texts are the first use of monumental Koranic inscriptions in architectural decoration. Below the frieze, the walls are covered with pale marble, whose veining creates abstract symmetrical patterns, and columns with shafts of gray patterned marble and gilded capitals. Above the calligraphic frieze is another mosaic frieze depicting thick, symmetrical vine scrolls and trees in turquoise, blue, and green, embellished with imitation jewels, over a gold ground. The mosaics are thought to represent both the gardens of Paradise and trophies of Muslim victories offered to God. The focal point of the building, remarkably enough, is not the decorative program—or

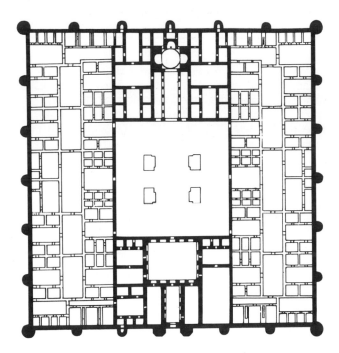

8-4. Plan of the palace, Mshatta, Jordan. Begun 740s

even something that can be seen. From the entrance one sees only pure light streaming down to the unseen rock, surrounded by color and pattern. After penetrating the space, the viewer/worshiper realizes that the light falls on the precious rock, and in a sense re-creates the passage of Muhammad to the heavens.

The Umayyad caliphs, disregarding the Prophet's advice about architectural austerity, built for themselves palatial hunting retreats on the edge of the desert. With profuse interior decoration depicting exotic human and animal subjects in stucco, mosaic, and paint, some had swimming pools, baths, and domed, private rooms. One of the later desert palaces was begun in the 740s at Mshatta (near present-day Amman, Jordan). Although never completed, this square, stone-walled complex is nevertheless impressively monumental (fig. 8-4). It measured about 470 feet on each side, and its outer walls and gates were guarded by towers and bastions reminiscent of a Roman fort. The space was divided roughly into thirds, with the center section containing a huge courtyard. The main spaces were a mosque and a domed, **basilica-plan** audience hall that was flanked by four private apartments, or *bayts*. *Bayts* grouped around small courtyards, for the use of the caliph's relatives and guests, occupied the remainder of the building.

Unique among surviving palaces, Mshatta was decorated with a frieze that extended in a band about 16 feet high across the base of its facade. This frieze was divided by a zigzag molding into triangular compartments, each punctuated by a large **rosette** carved in high relief (fig. 8-5). The compartments were filled with intricate carvings in low relief that included interlacing scrolls inhabited by birds and other animals (there were no animals on the mosque side of the building), urns, and candlesticks. Beneath one of the rosettes, two facing lions drink from an urn from which grows the Tree of Life, an ancient Persian motif.

8-5. Frieze, detail of facade, palace, Mshatta. Stone. Staatliche Museen zu Berlin, Preussischer Kulturbesitz, Museum für Islamische Kunst

The mosque was and is the Muslim place for communal worship, and its characteristic elements developed during the Umayyad period (see "Mosque Plans," page 351). The earliest mosques were very simple, modeled on Muhammad's house. The mosque's large rectangular enclosure is divided between a courtyard and a simple columnar hall (the prayer hall), laid out so that worshipers face Mecca when they pray. Designating the direction of Mecca are the **qibla** wall and its **mihrab** (a niche); the plan of identical repeated bays and aisles can easily be extended as congregations grow.

The origin and significance of the *mihrab* are debated, but the *mihrab* is within the tradition of niches that signifies a holy place—the shrine for the Torah scrolls in a synagogue, the frame for the sculpture of gods or ancestors in Roman architecture, the apse in a church. The **maqsura**, an enclosure in front of the *mihrab* for the ruler and other dignitaries, became a feature of the principal congregational mosque after an assassination attempt on the ruler. The *minbar*, or pulpit/throne, stands by the *mihrab* as the place for the prayer leader and a symbol of authority (for a fourteenth-century example, see fig. 8-14). **Minarets**, towers from which the *muezzins*, or criers, call the faithful to prayer, rise outside the mosque as a symbol of Islam's presence in a city.

When the Abbasids overthrew the Umayyads in 750, a survivor of the Umayyad dynasty, Abd ar-Rahman I

Muhammad, the prophet of Islam, was born about 570 in Mecca, a major pilgrimage center in west-central Arabia, to a prominent family that traced its ancestry to Ishmael, son of the biblical patriarch Abraham. Orphaned as a small child, Muhammad spent his early years among the Beduin, desert nomads. When he returned to Mecca, he became a trader's agent, accompanying caravans across the desert. At the age of twenty-five he married his employer, Khadija, a well-to-do, forty-year-old widow, and they had six children.

After Muhammad received revelations from God in 610, the first to accept him as Prophet was his wife. Other early converts included members of his clan and a few friends, among them the first four successors, or caliphs, who led the faithful after Muhammad's death. As the number of converts grew, Muhammad encountered increasing opposition from Mecca's ruling clans, including some leaders of his own clan. They objected to both his religious teachings and the threat his teachings posed to the trade that accompanied Mecca's status as a pilgrimage site. In 622 Muhammad and his companions fled Mecca and settled in the oasis town of Yathrib, which the Muslims renamed Medina, the Prophet's City. It is to this event, called the *hijra* ("emigration"), that Muslims date the beginning of their history. After years of fighting, Muhammad and his fol-

lowers won control of Mecca in 630 with an army of 10,000, and its inhabitants converted to Islam. The Kaaba, a shrine in the courtyard of Mecca's Great Mosque, became the sacred center of Islam; it is toward this one-room, cube-shaped stone structure, traditionally thought to have been built as a sanctuary by Abraham and Ishmael on a foundation laid by Adam, that Muslims around the globe still turn to pray. Shortly after the conquest of Mecca, Islam spread throughout Arabia.

Muhammad married eleven times. (Muslim law allows men four coequal wives at once, although the Prophet was permitted more.) Some of these marriages were political and others were to provide for women in need—a social duty in a society in which clan feuds killed many men. Within the framework of Islam, women gained rights where they had had none before. Their degree of freedom depended greatly on the time and the place, and many were significant sponsors of architecture programs.

Muhammad is reputed to have been a vigorous, good-looking man for whom the world was a fragrant paradise. One of his wives, Aisha, provided much of the information available about his personal life. "People used to ask [Aisha] how the Prophet lived at home. Like an ordinary man, she answered. He would sweep the house, stitch his own clothes, mend his own sandals, water the camels, milk the goats, help the servants at their work, and eat his

meals with them; and he would go fetch a thing we needed from the market" (cited in Glassé, page 281).

After making a farewell pilgrimage to Mecca, Muhammad died in Medina in 632. According to his wishes, he was buried in his house, in Aisha's room, where he breathed his last. His tomb is a major pilgrimage site. A generation after his death his revelations, which he continued to receive throughout his life, were assembled in 114 chapters, called *surahs*, organized from longest to shortest, each *surah* divided into verses. This is the sacred scripture of Islam, called the Koran ("Recitation"), which is the core of the faith. Another body of work, the Hadith ("Account"), compiled over the centuries, contains sayings of the Prophet, anecdotes about him, and additional revelations. The Koran and the Hadith are the foundation of Islamic law, guiding the lives of nearly a billion Muslims around the world today.

Muslims consider Muhammad to be the last in a succession of prophets, or messengers of God, that includes Adam, Abraham, Ishmael, Moses, and Jesus. Like Judaism and Christianity but unlike other religions prevalent in Arabia at the time, Islam is monotheistic, recognizing only a single, all-powerful deity. Muhammad's teaching emphasized the all-pervading immateriality of God and banned idol worship.

This painting shows Muhammad traveling by camel to a desert market fair to seek the support of a powerful

(ruled 756–88), fled across North Africa into southern Spain (known as al-Andalus in Arabic), where, with the support of Syrian Muslim settlers, he established himself as the provincial ruler, or *emir*. While the caliphs of the Abbasid dynasty ruled the eastern Islamic world from Baghdad for five centuries, the Umayyads continued their dynasty in Spain from their capital in Córdoba for the next three centuries (756–1031). The Umayyads were noted patrons of the arts, and one of the finest surviving examples of Umayyad architecture, the Great Mosque of Córdoba, thus is in Spain. (see figs. 8-6, 8-7)

In 785, the Umayyad conquerors began building the Córdoba mosque on the site of a Christian church. Later rulers expanded the building three times, and today the walls enclose an area about 620 by 460 feet, about a third of which is the courtyard, the Patio of the Orange Trees. Inside, the proliferation of pattern in the repeated columns

and arches and the double flying arches is almost disorienting. The marble columns and capitals in the **hypostyle** prayer hall were recycled from the ruins of classical buildings in the region, which had been a wealthy Roman province (fig. 8-6, page 350). Two tiers of arches, one over the other, surmount these columns; the upper tier springs from rectangular posts that rise from the columns. This double-tiered design, which was widely imitated, effectively increases the height of the interior space and provides excellent air circulation. The distinctively shaped **horseshoe arches**—a form known from Roman times and favored by the Visigoths, Spain's pre-Islamic rulers—came to be closely associated with Islamic architecture in the West (see "Arches and *Muqarnas*," page 352). Another distinctive feature of these arches, also adopted from Roman and Byzantine precedents, is the alternation of pale stone and red brick **voussoirs** forming the curved arch.

uncle for his religious movement as well as to make converts among the fairgoers. He is accompanied by two close associates, the merchant Abu Bakr and the young warrior Ali. Abu Bakr, the first caliph, was the father of Muhammad's wife Aisha. Ali, husband of Muhammad's daughter Fatima, was the fourth caliph. The power struggle that ended in his death led to the rise of the Shiite sect. Although the faces of Abu Bakr and Ali are shown, that of Muhammad, in keeping with the Islamic injunction against idolatry and the making of idols, is not. The degree of representation permitted in Islamic art varied from place to place and from period to period depending in part on the strictness with which the injunction against idol making was interpreted and the purpose a work of art was to serve. This example suggests what the Ottoman court at the end of the sixteenth century considered acceptable for an illustration of its type.

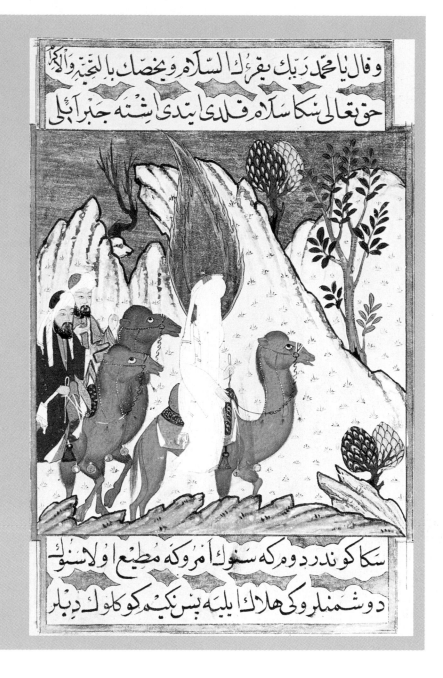

The Prophet Muhammad and His Companions Traveling to the Fair, from a copy of the 14th-century *Siyar-i Nabi* (*Life of the Prophet*) of al-Zarir, Istanbul, Turkey. 1594. Pigments and gold on paper, 10⅝ x 15" (27 x 38 cm). New York Public Library, New York Spencer Collection

In the final century of Umayyad rule, Córdoba emerged as a major commercial and intellectual hub and a flourishing center for the arts. It surpassed Christian European cities economically and in science, literature, and philosophy. Beginning with Abd ar-Rahman III (ruled 912–61), the Umayyads boldly claimed the title of "caliph." Al-Hakam II (ruled 961–76) made the Great Mosque a focus of his patronage, commissioning costly and luxurious renovations that disturbed many of his subjects. The caliph attempted to answer their objections to paying for such ostentation with an inscription giving thanks to God, who "helped him in the building of this eternal place, with the goal of making this mosque more spacious for his subjects, something which both he and they greatly wanted" (cited in Dodds, page 23). Among al-Hakam's renovations was a new *mihrab* with three bays in front of it. The melon-shaped, ribbed dome over one bay seems to float over a web of intersecting arches that rise from polylobed, intersecting arches rather than supporting piers (fig. 8-7, page 350). Lushly patterned mosaics with inscriptions, geometric motifs, and stylized vegetation clothe the domes in brilliant color and gold.

CALLIGRAPHY

The Arabic language and script have held a unique position in Islamic society and art from the beginning. As the language of the Koran and Muslim liturgy, Arabic has been a powerful unifying force within Islam. Because reverence for the Koran as the Word of God extended also to the act of writing it, generations of extraordinary scribes made Arabic calligraphy one of the glories of Islam. Arabic script is written from right to left, and each of its letters takes one of three forms depending on its position in a word. With its rhythmic interplay between verticals and horizontals, the system lends itself to many variations.

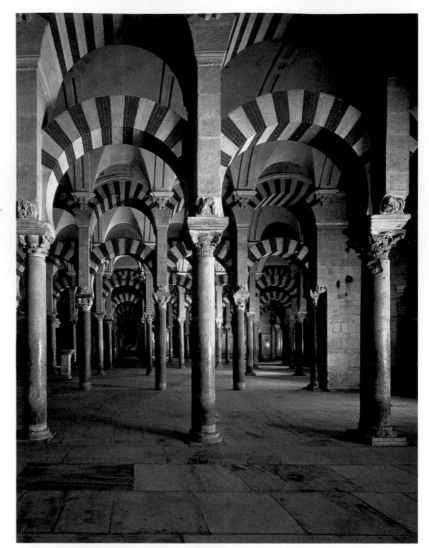

8-6. Prayer hall, Great Mosque, Córdoba, Spain. Begun 785–86, extension of 987

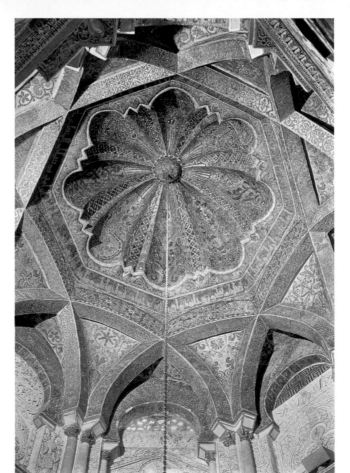

8-7. Dome in front of the *mihrab*, **Great Mosque**. 965

ELEMENTS OF ARCHITECTURE

Mosque Plans

The earliest mosques were pillared **hypostyle halls** such as the Great Mosque at Córdoba (see fig. 8-6). Approached through an open courtyard, the *sahn*, their interiors are divided by rows of columns leading, at the far end, to the **mihrab** niche of a **qibla** wall, which is oriented toward Mecca.

A second type, the **four-*iwan* mosque**, was originally associated with **madrasas** (schools for advanced study). The *iwans*—monumental barrel-vaulted halls with wide-open, arched entrances—faced each other across a central *sahn*; related structures spread out behind and around the *iwans*. Four-*iwan* mosques were most developed in Persia, in buildings like Isfahan's Masjid-i Jami (see fig. 8-12).

Central-plan mosques, such as the Selimiye Cami at Edirne (see fig. 8-15), were derived from Istanbul's Hagia Sophia (see fig. 7-22) and are typical of Ottoman Turkish architecture. Central-plan interiors are dominated by a large domed space uninterrupted by structural supports. Worship is directed, as in other mosques, toward a *qibla* wall and its *mihrab* opposite the entrance.

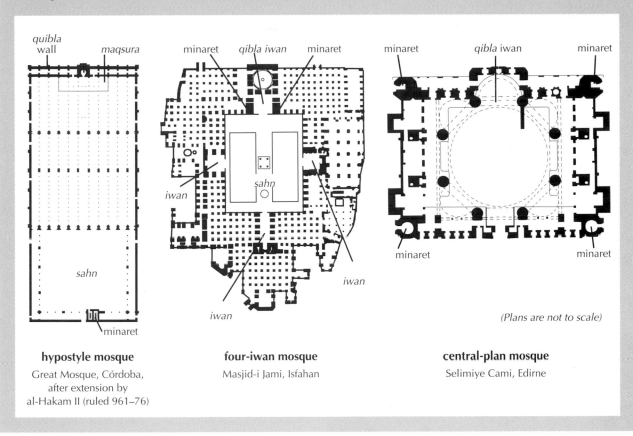

hypostyle mosque
Great Mosque, Córdoba, after extension by al-Hakam II (ruled 961–76)

four-iwan mosque
Masjid-i Jami, Isfahan

(Plans are not to scale)

central-plan mosque
Selimiye Cami, Edirne

Writing pervades Islamic art. In addition to manuscripts, decorative writing is prominent in architecture and on smaller-scale objects made of metal, glass, cloth, ceramic, and wood. The earliest scripts, called kufic (from the city of Kufa in modern Iraq), were angular and evolved from inscriptions on stone monuments. Kufic scripts were especially suitable for carved or woven inscriptions, as well as those on coins and other metalware; they are still used for Koran chapter headings. Most early Korans had only three to five lines per page and customarily had large letters because two readers shared one book (although they would have known the text by heart). A page from a ninth-century Syrian Koran exemplifies a style common from the eighth to the tenth century (see fig. 8-1). Red diacritical marks (pronunciation guides) accent the dark brown ink. Horizontals are elongated, and fat-bodied letters are also emphasized. The chapter heading is set against an ornate gold band that contrasts with the simplicity of the letters.

Because calligraphy was an honored occupation, calligraphers enjoyed the highest status of all artists in Islamic society. Included in their numbers were a few princes and women. Their training was long and arduous, and their work usually anonymous. Not until the later Islamic centuries did it become common for calligraphers to sign their work, and even then only the most accomplished were allowed this privilege. Apprentice scribes had to learn secret formulas for inks and paints, become skilled in the proper ways to sit, breathe, and manipulate their tools, and develop their individual specialties. They also had to absorb the complex literary traditions and number symbolism that had developed.

The Koran was usually written on **vellum**, very fine calfskin. Paper, a Chinese invention, was first imported into the Islamic realm in the mid-eighth century. Muslims subsequently learned how to make high-quality, rag-based paper and established their own paper mills. Among the most influential calligraphers in this process was a woman named Shuhda. By the tenth century, more than twenty cursive scripts had come into use. They were standardized by Ibn Muqla (d. 940), an Abbasid minister, who fixed the proportions of the letters in each and devised a method for teaching calligraphy that is still in use. By about 1000, paper had largely replaced vellum and parchment, encouraging

Islamic builders used a number of innovative structural devices. Among these were two arch forms, the horseshoe arch (see fig. 8-6) and the pointed arch (see fig. 8-13). There are many variations of each, some of which disguise their structural function beneath complex decoration.

Structurally, a **muqarna** is simply a **squinch** (see "Pendentives and Squinches," page 311). *Muqarnas* are used in multiples (see fig. 8-11) as interlocking, load-bearing, niche-shaped vaulting units. Over time they became increasingly ornamental and appear as intricately faceted surfaces. They are frequently used to vault *mihrabs* and, on a larger scale, to support and to form domes.

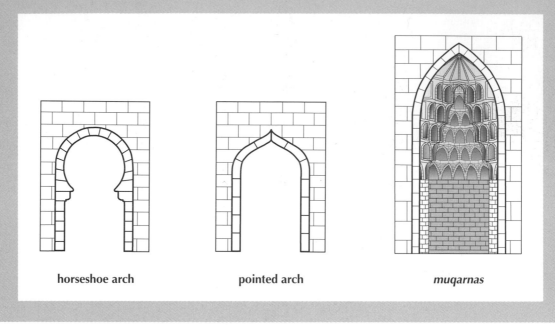

horseshoe arch pointed arch *muqarnas*

8-8. Bowl with kufic border, from Samarkand, Uzbekistan. 9th–10th century. Earthenware with slip, pigment, and lead glaze, diameter 14½" (37 cm). Musée du Louvre, Paris

The white ground of this piece imitated prized Chinese porcelains made of fine white kaolin clay. Both Samarkand and Khurasan were connected to the Silk Road (Chapter 10), the great caravan route to China, and were influenced by Chinese culture.

the proliferation of increasingly elaborate and decorative cursive scripts, which generally superseded kufic by the thirteenth century. The great calligrapher Yaqut al-Mustasim (d. 1299), the Turkish secretary of the last Abbasid caliph, codified six basic calligraphic styles, including *thuluth* (see fig. 8-19), *naskhi* (see the illustration in "The Life of the Prophet Muhammad," pages 348–9), and *muhaqqaq* (see fig. 8-13, outer frame). Al-Mustasim reputedly made more than 1,000 copies of the Koran.

CERAMIC AND TEXTILE ARTS

Kufic-style letters were used effectively as the only decoration on a type of white pottery made in the ninth and tenth centuries in and around Khurasan (a region also known as Nishapur, in modern northeastern Iran) and Samarkand (in modern Uzbekistan in Central Asia). Now known as Samarkand ware, it was the ancestor of a ware produced until fairly recently by Central Asian peasants. In the example here, a bowl of medium quality, clear lead glaze was applied over a black inscription on a white slip-painted ground (fig. 8-8). The letters have been elongated to fill the bowl's rim, stressing their vertical elements. The inscription translates: "Knowledge, the beginning of it is bitter to taste, but the end is sweeter than honey," an apt choice for tableware. Inscriptions on Samarkand ware provide a storehouse of such popular sayings.

A kufic inscription also appears on a tenth-century piece of silk from Khurasan (fig. 8-9): "Glory and happiness

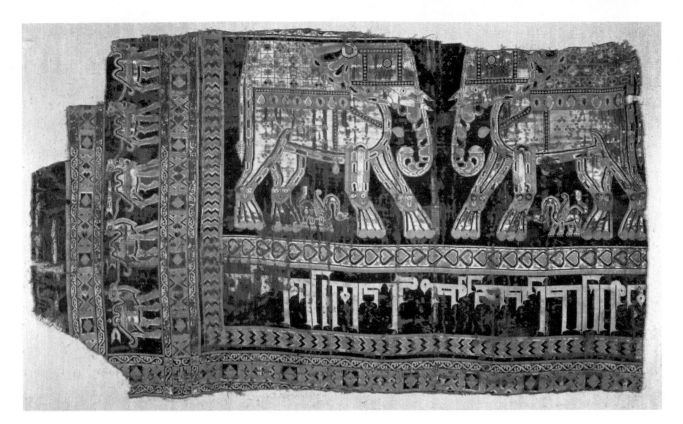

8-9. Textile with elephants and camels, from Khurasan, Persia (Iran). c. 960. Dyed silk, largest fragment 20½ x 37" (94 x 52 cm). Musée du Louvre, Paris

Silk textiles were both sought-after luxury items and a medium of economic exchange. Government-controlled factories, known as *tiraz*, produced cloth for the court as well as for official gifts and payments. A number of fine Islamic fabrics have been preserved in the treasuries of medieval European churches, where they were used for priests' ceremonial robes, altar cloths, and covers for Christian saints' relics.

to the Commander Abu Mansur Bukhtakin, may God prolong his prosperity." Such good wishes were common in Islamic art, appearing as generic blessings on ordinary goods sold in the marketplace or, as here, personalized for the patron. Texts can sometimes help determine where and when a work was made, but they can also be frustratingly uninformative when little is known about the patron. Stylistic comparisons—in this case with other textiles, with the way similar subjects appear in other mediums, and with other kufic inscriptions—reveal more than the inscription alone.

This fragment shows two elephants with rich ornamental coverings facing each other on a dark red ground, each with a mythical griffin between its feet. A caravan of two-humped, Bactrian camels linked with rope moves up the left side, part of the elaborately patterned borders. The inscription at the bottom is upside-down, suggesting that the missing portion of the textile was the mirror image of the surviving fragment, with another pair of elephants joined back-to-back to this pair. The weavers used a complicated loom to produce repeated patterns. The technique and design derive from the sumptuous pattern-woven silks of Sassanian Persia. The Persian weavers had, in turn, adapted Chinese silk technology to the Sassanian taste for paired heraldic beasts and other Near Eastern imagery. This tradition, with modifications—the depiction of animals, for example, became less naturalistic—continued after the Islamic conquest of Persia.

LATER ISLAMIC SOCIETY AND ART

The Abbasid caliphate began its slow disintegration in the ninth century, and thereafter power in the Islamic world became fragmented among more or less independent regional rulers. During the eleventh century, the Seljuks, a Turkic people who had served as soldiers for the Abbasid caliphs and converted to Islam in the tenth century, became the virtual rulers of the Abbasid empire. The Seljuks united Persia and most of Mesopotamia, establishing a dynasty that endured from 1037/38 to 1194. A branch of the dynasty, the Seljuk of Rum, ruled much of Anatolia (Turkey) from the late eleventh to the beginning of the fourteenth century. In the early thirteenth century, the Mongols—non-Muslims led by Jenghiz Khan (ruled 1206–27) and his successors—swept out of central Asia, captured Baghdad in 1258, and encountered weak resistance until they reached Egypt. There the young Mamluk dynasty (1250–1517), founded by descendants of slave soldiers (*mamluk* means "slave"), firmly defeated them. In the west, Islamic control of Spain gradually succumbed to expanding Christian forces and ended altogether in 1492.

With the breakdown of Seljuk power in Anatolia at the end of the thirteenth century, another group of Muslim Turks seized power in the early fourteenth century in the northwestern part of that region, having migrated there from their homeland in central Asia. Known as the Ottomans, after an early leader named Osman, they

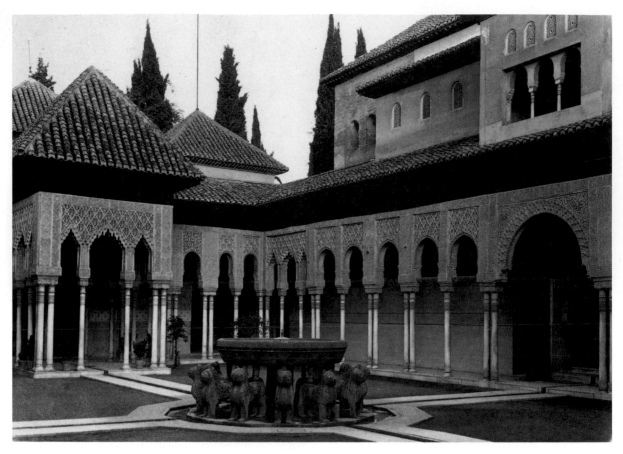

8-10. Court of the Lions, Palace of the Lions, Alhambra, Granada, Spain. Completed c. 1370–80

Granada, with its ample water supply, had long been known as a city of gardens. The twelve stone lions in the fountain in the center of this court were salvaged from the ruins of an earlier palatial complex on the Alhambra hill. Commentators of the time praised this complex, with its pools, fountains, and gardens.

pushed their territorial boundaries westward and, in spite of setbacks inflicted by the Mongols, ultimately created an empire that extended over Anatolia, western Persia, Iraq, Syria, Palestine, western Arabia (including Mecca and Medina), India, Southeast Asia, North Africa (including Egypt and the Sudan), and much of eastern Europe. In 1453, they captured Constantinople (renaming it Istanbul) and brought the Byzantine Empire to an end. The Ottoman Empire lasted until 1918. Another dynasty, the Safavids, established a Shiite state in Persia in the early years of the sixteenth century.

Although Islam remained a dominant and unifying force throughout these developments, the history of later Islamic society and art reflects largely regional phenomena. Only a few works have been selected to characterize the art of Islam, and they by no means provide a history of Islamic art.

ARCHITECTURE

For many people in the West, the Alhambra in Granada, Spain, typifies the beauty and luxury of Islamic palace architecture. To the conquering Christians at the end of the fifteenth century, the Alhambra represented the epitome of luxury. This fortified hilltop palace complex was the seat of the Nasrids (1232–1492), the last Spanish

Muslim dynasty, whose territory had shrunk to the region around Granada in southeastern Spain. The Alhambra remained fairly intact in part because it represented the defeat of Islam to the victorious Christian monarchs, who restored, maintained, and occupied it as much for its commemorative value as for its beauty.

The Alhambra exemplifies the growing regionalism in Islamic art. The founder of the Nasrid dynasty began the complex in 1238 on the site of a pre-Islamic fortress. Successive rulers expanded it, and it took its present form in the fourteenth century. Literally a small town extending for about half a mile along the crest of a high hill overlooking Granada, it included government buildings, royal residences, gates, mosques, baths, servants' quarters, barracks, stables, a mint, workshops, and gardens.

The Alhambra was a sophisticated pleasure palace, an attempt to create paradise on earth. Although the buildings offered views to the valley and mountains, the architecture of the Alhambra also turned inward toward its lush courtyard gardens—the Muslim vision of paradise as a well-watered, walled garden (the English word *paradise* comes from the Persian term for an enclosed park, *faradis*). The so-called Palace of the Lions in the Alhambra was a private retreat built by Muhammad V (ruled 1362–91) in the late fourteenth century. At its heart is the Court of the Lions, a rectangular courtyard named

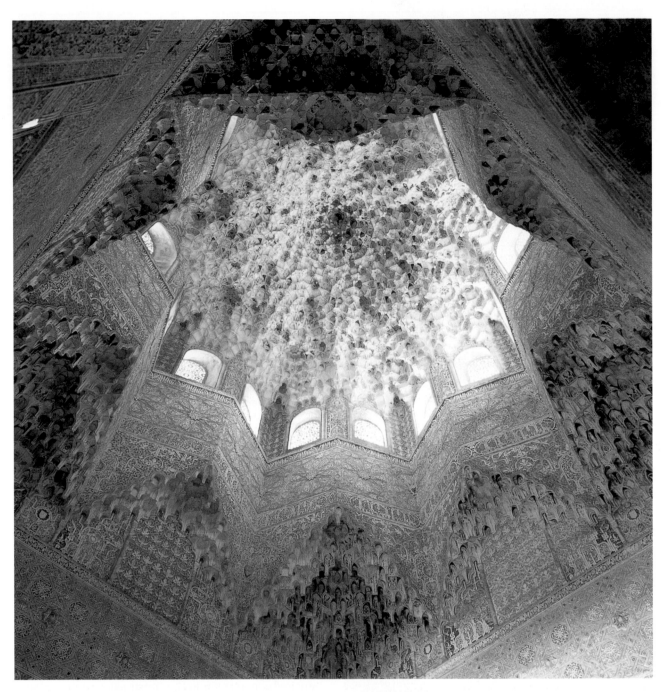

8-11. *Muqarnas* **dome, Hall of the Abencerrajes, Palace of the Lions, Alhambra**. c. 1370–80

for a marble fountain surrounded by stone lions (fig. 8-10). Although sanded today, the Court of the Lions was originally a garden, probably planted with aromatic shrubs, flowers, and small citrus trees between the water channels that radiate from the central Lion Fountain. Second-floor *miradors*—projecting rooms with windows on three sides—overlook the courtyard. One *mirador* looks out onto a large, lower garden and the plain below.

Four pavilions used for dining and performances of music, poetry, and dance open onto the Court of the Lions. One of these, the two-storied Hall of the Abencerrajes on the south side, was designed as a winter music room. Like the other pavilions (all of which had good acoustics), it is covered by a remarkable ceiling (fig. 8-11). The star-shaped vault is formed by a honeycomb of clustered **squinches** called *muqarnas* and also rests on *muqarnas* (see "Arches and *Muqarnas*," page 352). The effect is like architectural lace—material form made immaterial.

In the eastern Islamic world, the Seljuk rulers also proved themselves enlightened patrons of the arts. As builders of religious architecture, they introduced a new mosque plan, the **four-*iwan* mosque**. In this plan, *iwans*, which are large, rectangular, vaulted halls with monumental arched openings, face each other across a courtyard. Reflecting the influence of Sufism, a literary and philosophical movement that arose in the late tenth and early eleventh centuries, *iwans* may represent symbolic gateways between outside and inside, open and closed, the material and the spiritual.

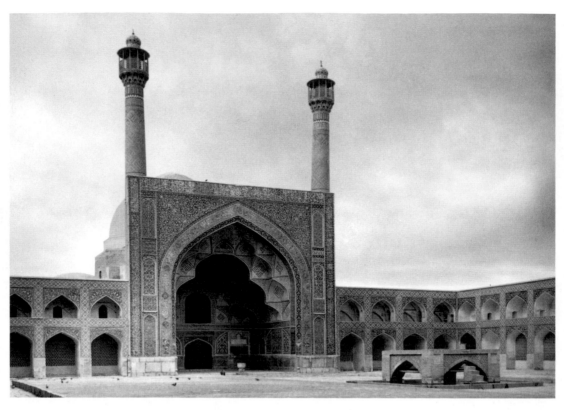

8-12. Courtyard, Masjid-i Jami (Great Mosque), Isfahan, Persia (Iran). 11th–18th century. View from the northeast

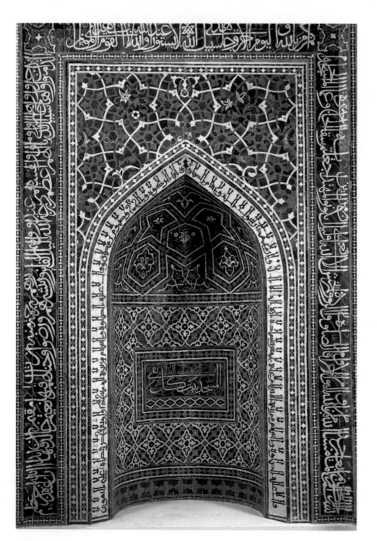

Iwans first appeared in **madrasas**, schools for advanced study that were the precursors of the modern university. Beginning in the eleventh century, Muslim rulers and wealthy individuals endowed hundreds of these institutions as acts of pious charity, and many are still in existence. The four-*iwan* mosque may have evolved from the need to provide separate quarters for four schools of thought within *madrasas*.

The Masjid-i Jami (Great Mosque) in the center of the Seljuk capital of Isfahan (in modern Iran) was originally a hypostyle mosque. In the late eleventh century, it was refurbished with two great brick domes, and in the twelfth century with four *iwans* and a monumental gate flanked by paired minarets (fig. 8-12). Construction continued sporadically on this mosque into the eighteenth century, but it retained its basic four-*iwan* layout, which became standard in Persia. The massive *qibla iwan*, on the southwest side, is a twelfth-century structure with fourteenth-century *muqarnas* and seventeenth-century exterior tilework and

8-13. Tile mosaic *mihrab*, from the Madrasa Imami, Isfahan, Persia (Iran). c. 1354 (restored). Glazed and painted ceramic, 11'3" x 7'6" (3.43 x 2.29 m). The Metropolitan Museum of Art, New York
Harris Brisbane Dick Fund (39.20)

One of the three Koranic inscriptions on this *mihrab* dates it to approximately 1354. Note the combination of decorated kufic (inner inscription) and cursive *muhaqqaq* (outer inscription) scripts. The outer inscription tells of the duties of believers and the heavenly rewards for the builders of mosques. The next (kufic) gives the Five Pillars of Islam. The center panel says: "The mosque is the house of every pious person."

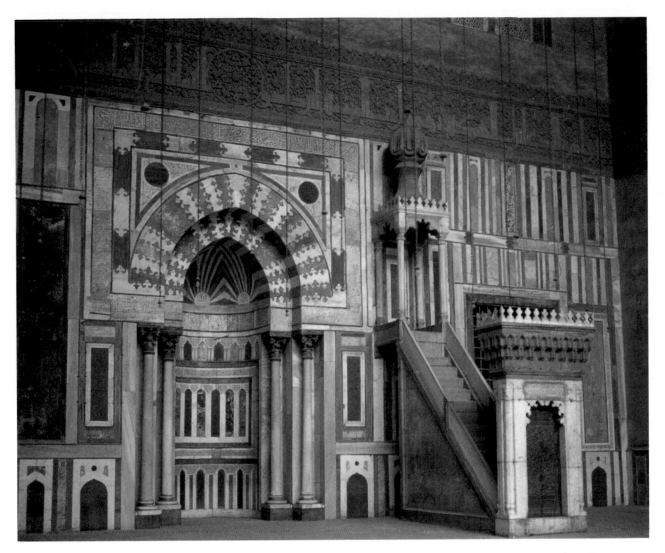

8-14. *Qibla* **wall with** *mihrab* **and** *minbar*, main *iwan* (vaulted chamber) in a mosque, Sultan Hasan *madrasa-mausoleum-mosque*, Cairo, Egypt. 1356–63

minarets. The brick masonry on the interior of the *iwans* is unadorned; the facades, however, are sheathed in brilliant blue architectural tilework—a typically Islamic feature for which this monument is justly famous.

A fourteenth-century tile mosaic *mihrab* originally from a *madrasa* in Isfahan but now in the Metropolitan Museum of Art in New York is one of the finest examples of early architectural ceramic decoration in Islamic art (fig. 8-13). More than 11 feet tall, it was made by painstakingly cutting each piece of tile individually, including the pieces making up the letters on the curving surface of the niche. The color scheme—white against turquoise and cobalt blue with accents of dark yellow and green—was typical of this type of decoration, as were the harmonious dense, contrasting patterns of organic and geometric forms.

A *madrasa*-mausoleum-mosque complex built in the mid-fourteenth century by the Mamluk sultan Hasan in Cairo, Egypt, shows Seljuk influence (fig. 8-14). The *iwans* in this structure functioned as classrooms, and students were housed in neighboring rooms. Hasan's

domed tomb lies beyond the *qibla* wall of the largest of the four *iwans*, which served as the mosque for the entire complex. The walls and vaulting inside this main *iwan* are unornamented except for a wide stucco frieze band. Originally painted, this band combines calligraphy and intricate carved scrollwork. The *qibla* wall has marble panels and a double-arched recessed *mihrab* with slender columns supporting pointed arches (see "Arches and *Muqarnas*," page 352). Marble inlays create blue, red, and white stripes on the *voussoirs*, a fanciful echo of the brick and stone *voussoirs* of Umayyad architecture (see fig. 8-6). Except for its elaborately carved door, the throne-like *minbar* at the right is made of carved stone instead of the usual wood.

Farther to the west, the rulers of the Ottoman Empire, after conquering Constantinople, converted the church of Hagia Sophia there into a mosque, framing it with two graceful Turkish-style minarets in the fifteenth century and two more in the sixteenth century. Calligraphic roundels with the names of Allah, Muhammad, and the early caliphs were added in the mid-nineteenth century to the

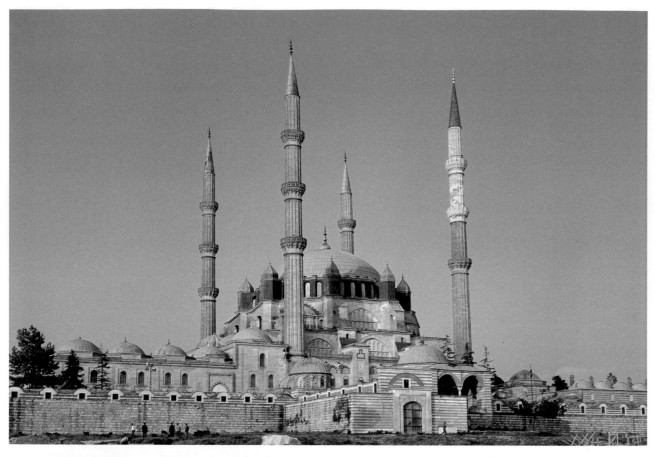

8-15. Sinan. Selimiye Cami (Mosque of Selim), Edirne, Turkey. 1570–74

The minarets that pierce the sky around the prayer hall of this mosque, their sleek, fluted walls and needle-nosed spires soaring to more than 295 feet, are only 12½ feet in diameter at the base, an impressive feat of engineering. Only royal mosques were permitted multiple minarets, and more than two was highly unusual.

interior (see figs. 7-22, 7-24). Inspired by this great Byzantine structure, Ottoman architects developed a domed, **central-plan** mosque. The finest example of this new form was the work of the architect Sinan (c. 1489–1588). Sinan began his career in the army and was chief engineer during the Ottoman campaign and siege of Vienna (1526–29). He rose through the ranks to become chief architect for Suleyman (known as "the Lawgiver" and "the Magnificent"), the tenth Ottoman sultan (ruled 1520–66). Suleyman, whose reign marked the height of Ottoman power, sponsored a building program on a scale not seen since the glory days of the Roman Empire. Sinan is credited with more than 300 imperial commissions, including palaces, *madrasas* and Koran schools, burial chapels, public kitchens and hospitals, caravansaries—way stations for caravans—treasure houses, baths, bridges, viaducts, and 124 large and small mosques.

Sinan's crowning accomplishment, completed when he was at least eighty, was a mosque he designed at the provincial capital of Edirne for Suleyman's son Selim II (ruled 1566–74) in the third quarter of the sixteenth century (fig. 8-15). The gigantic spherical dome that tops this structure is more than 102 feet in diameter, larger than the dome of Hagia Sophia. It crowns a building of great geometric complexity on the exterior and complete coherence

on the interior, a space at once soaring and serene. In addition to the mosque, the complex housed a *madrasa* and other educational buildings, a burial ground, a hospital, and charity kitchens, as well as the income-producing covered market and baths. Framed by the vertical lines of four minarets, the mosque shifts from square to octagon to circle as it moves upward and inward. Raised on a base at the city's edge, it dominates the skyline.

The interior seems superficially very much like Hagia Sophia's: an open expanse under a vast dome floating on a ring of light (fig. 8-16). The mosque, however, is a true central-plan structure and lacks Hagia Sophia's longitudinal pull from entrance to sanctuary. A small fountain covered by a *muezzin* platform emphasizes this centralization. The arches supporting the dome spring from eight enormous piers topped with *muqarnas*. Smaller half-domes between the piers define the corners of a square. Windows at every level flood the interior's cream-colored stone, restrained tile decoration, and softly glowing carpets with light.

PORTABLE ARTS

Islamic society was cosmopolitan, with considerable trade, pilgrimage, and other movement of people fostering

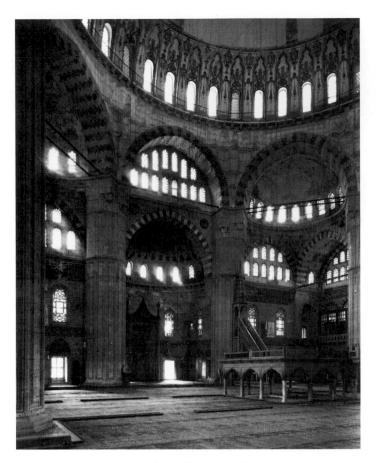

8-16. Selimiye Cami

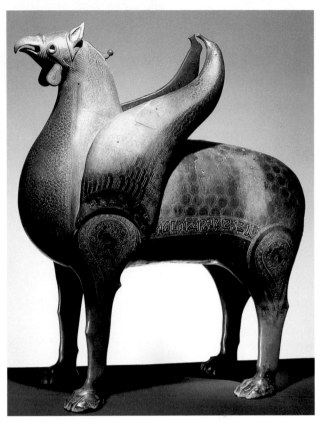

8-17. Griffin, from the Islamic Mediterranean, probably Fatimid Egypt. 11th century. Bronze, height 42¹/₈" (107 cm). Museo dell'Opera del Duomo, Pisa

the circulation of goods. In this context, portable objects such as textiles and books assumed greater cultural importance than buildings, and decorated objects were valued as much for the status they bestowed as for their usefulness.

Metal. Islamic metalworkers inherited the techniques of their Roman, Byzantine, and Sassanian predecessors, applying them to new forms, such as incense burners and water pitchers in the shape of birds. An example of this delight in fanciful bronze work is an unusually large and stylized griffin, perhaps originally a fountain spout (fig. 8-17). Now in Pisa, Italy, it is probably Fatimid (Egyptian) work, and it may have arrived as booty from Pisan victories over the Egyptian fleet in 1087. The Pisans displayed it atop their cathedral from about 1100 to 1828. Made of cast bronze, it is decorated with incised feathers, scales, and silk trappings. The decoration on the creature's thighs includes animals in medallions; the bands across its chest and back are embellished with kufic lettering and scale and circle patterns.

The Islamic world was administered by educated leaders who often commissioned personalized containers—emblems of their class—for their pens, ink, and blotting sand. One such container, an inlaid brass box, was the possession of Majd al-Mulk al-Muzaffar, the grand vizier, or chief minister, of Khurasan in the early thirteenth century (fig. 8-18). An artist named Shazi

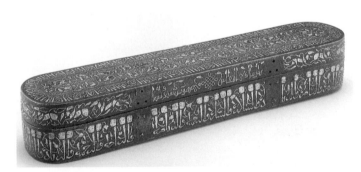

8-18. Shazi. Pen box, from Persia (Iran) or Afghanistan. 1210–11. Brass with silver and copper; height 2", length 12⁵/₈", width 2¹/₂" (5 x 31.4 x 6.4 cm). Freer Gallery of Art, Smithsonian Institution, Washington, D.C. (36.7)

The inscriptions on this box include some twenty honorific phrases extolling its owner, al-Mulk. The inscription in *naskhi* script on the lid calls him the "luminous star of Islam." The largest inscription, written in animated *naskhi* (an animated script is one with human or animal forms in it), asked twenty-four blessings for him from God. Shazi, the designer of the box, signed and dated it in animated kufic on the side of the lid, making it one of the earliest signed works in Islamic art. Al-Mulk enjoyed his box for only ten years; he was killed by Mongol invaders in 1221.

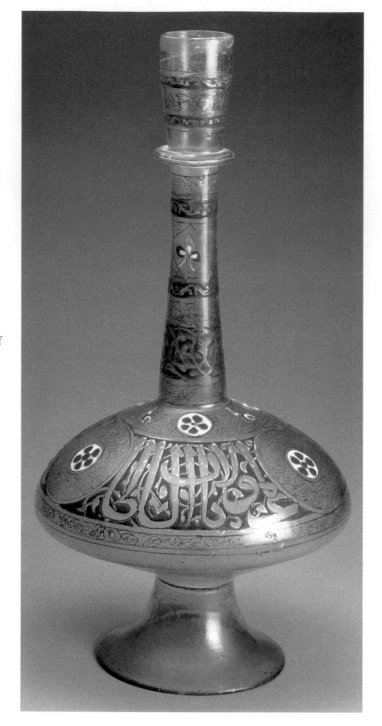

8-19. **Bottle**, from Syria. Mid-14th century. Blown glass with enamel and gilding, 19¹/₂ x 9¹/₂" (49.7 x 24.8 cm). Freer Gallery of Art, Smithsonian Institution, Washington, D.C. (34.20)

cast, engraved, embossed, and inlaid the box with consummate skill. Scrolls, interlacing designs, and human and animal figures enliven its calligraphic inscriptions. All these elements, animate as well as inanimate, seem to be engaged in lively conversation. That a work of such quality was made of brass rather than a costlier metal may seem odd. A severe silver shortage in the mid-twelfth century had prompted the development of inlaid brass pieces like this one that used the more precious metal sparingly. Humbler brass ware would have been available in the marketplace to those of more modest means than the vizier.

Glass. Glass, according to the twelfth-century poet al-Hariri, is "congealed of air, condensed of sunbeam motes, molded of the light of the open plain, or peeled from a white pearl" (cited in Jenkins, page 3). Made with the most ordinary of ingredients—sand and ash—glass is the most ethereal of materials. It first appeared roughly 4,000 years ago, and the tools and techniques for making it have changed little in the past 2,000 years. Like their counterparts working in metal, Islamic glassmakers generally adapted earlier practices to new forms. They were particularly innovative in the application of enameled decoration in gold and various colors.

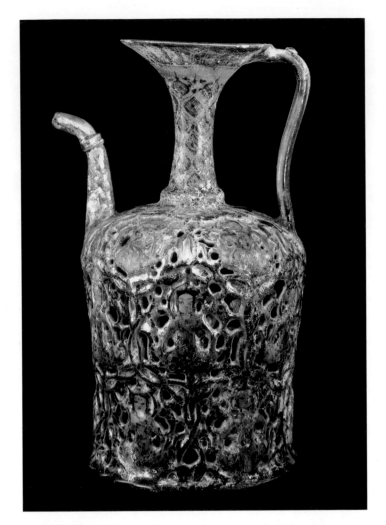

8-20. Ewer, from Kashan, Persia (Iran). Early 13th century. Glazed and painted fritware, height 11¹³⁄₁₆" (30 cm). The al-Sabah Collection, Kuwait

Fritware was used to make beads in ancient Egypt and may have been rediscovered there by Islamic potters searching for a substitute for Chinese porcelain. Its components were one part white clay, ten parts quartz, and one part quartz fused with soda, which produced a brittle, white ware when fired. The colors on this double-walled ewer and others like it were produced by applying mineral glazes over black painted detailing. The deep blue comes from cobalt and the turquoise from copper. Luster, a thin, transparent glaze with a metallic sheen, was applied over the colored glazes.

A tall, elegant enameled bottle from the mid-fourteenth century exemplifies their skill (fig. 8-19). One of several objects either given by Mamluk rulers to the Rasulid rulers of Yemen (southern Arabia) or ordered by the Rasulids from Mamluk workshops in Syria, it bears a large inscription naming and honoring a Rasulid sultan in *thuluth*—a popular Mamluk cursive script—and the Rasulid insignia, a five-petaled red rosette.

Ceramics. Ceramicists in the city of Kashan developed a distinctive pottery in the thirteenth century. Painted underglaze bowls and jugs were decorated with curling vines and leaves painted in black on white and then glazed with a shiny turquoise glaze. In this elaborate double-walled ewer (fig. 8-20), the artisan has pierced and painted the outer shell with a tangle of vines surrounding seated human figures. Glazes of translucent turquoise and luster (a metallic glaze that creates the appearance of precious metal) then cover the painting.

Textiles. The tradition of silk weaving that passed from Sassanian Persia to Islamic artisans in the early Islamic period (see fig. 8-9) was kept alive in Muslim Spain, where it was both economically and culturally important.

8-21. Banner of Las Navas de Tolosa, detail of center panel, from southern Spain. 1212–50. Silk tapestry-weave with gilt parchment, 10'9⅞" x 7'2⅝" (3.3 x 2.2 m). Museo de Telas Medievales, Monasterio de Santa Maria la Real de Las Huelgas, Burgos, Spain. Patrimonio Nacional

This banner was a trophy of King Ferdinand III, who gave it to Las Huelgas, the Cistercian convent outside Burgos, the capital city of Old Castile and the burial place of the royal family. This illustration shows only a detail of the center section of the textile. The calligraphic panels continue down the sides, and a second panel crosses the top. Eight lobes with gold crescents and white inscribed parchment medallions form the lower edge of the banner.

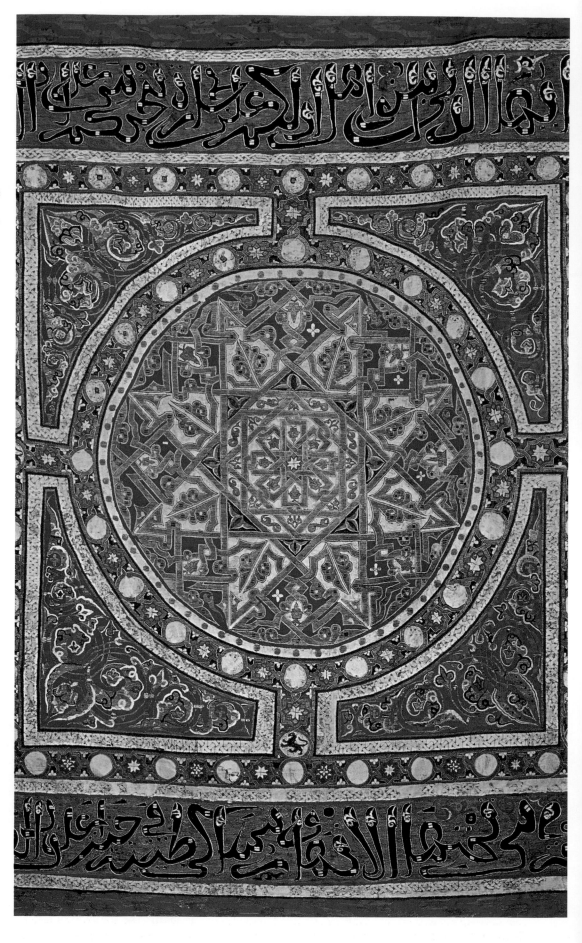

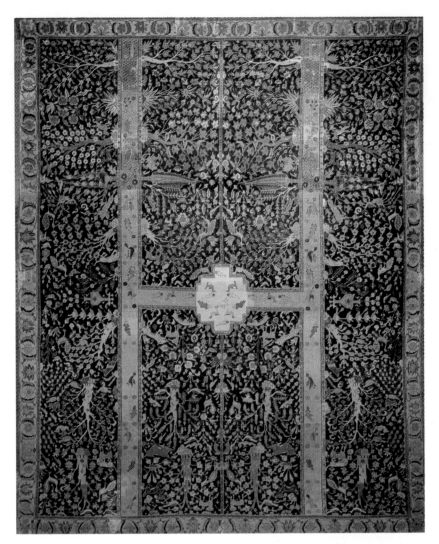

8-22. Garden carpet, from central Persia (Iran). Second half of 17th century. Woolen pile, cotton warps, cotton and wool wefts, 17'5" x 14'2" (5.31 x 4.32 m). The Burrell Collection, Glasgow Museums, Scotland

Spanish designs reflect a new aesthetic, with an emphasis beginning in the thirteenth century on architecture-like forms. An eight-pointed star forms the center of a magnificent silk and gold banner (fig. 8-21). The calligraphic panels continue down the sides and a second panel crosses the top. Eight lobes with gold crescents and white inscribed parchment medallions form the lower edge of the banner. In part, the text reads: "You shall believe in God and His Messenger. . . . He will forgive you your sins and admit you to gardens underneath which rivers flow, and to dwelling places goodly in Gardens of Eden; that is the mighty triumph."

Since the late Middle Ages, carpets have been the Islamic art form best known in Europe. Knotted rugs (see "Carpet Making," page 364) from Persia, Turkey, and elsewhere were so highly prized among Westerners that they were often displayed on tables rather than floors. Persian taste favored intricate, elegant designs that evoked the gardens of paradise. Written accounts indicate that such designs appeared on Persian carpets as early as the seventh century. In one fabled royal carpet,

garden paths were rendered in real gold, leaves were modeled with emeralds, and highlights on flowers, fruits, and birds were created from pearls and other jewels.

A typical garden carpet shows a bird's-eye view of an enclosed park. One such carpet from the second half of the seventeenth century depicts a garden irrigated by an H–shaped system of channels. In the middle is a basin filled with floating plants, fish, and birds (fig. 8-22). All kinds of animals and birds, some resting and others hunting, inhabit the dense forests of leafy trees and blooming shrubs represented in profile along the water channels, roots directed toward the water. The very finest carpets, like this, woven of cotton and wool or silk and wool in royal workshops, were status symbols in the Islamic world.

Rugs and mats have long been used for Muslim prayer, which involves repeated kneeling and touching of the forehead to the floor. Many mosques were literally "carpeted" with wool-pile rugs received as pious donations; wealthy patrons gave large prayer rugs (note, for example, the rugs on the floor of the Selimiye Cami in figure 8-16).

TECHNIQUE

CARPET MAKING

Because textiles, especially floor coverings, are destroyed through use, very few carpets from before the sixteenth century have survived. There are two basic types of carpets: flat-weaves and pile, or knotted. Both can be made on either vertical or horizontal frames. The best-known flat-weaves today are Turkish kilims, which are typically woven in wool with bold, geometric patterns and sometimes with embroidered details. Kilim weaving is done in the **tapestry** technique (see diagram, a).

Knotted carpets are an ancient invention. The oldest known example, excavated in Siberia and dating to the fourth or fifth century BCE, has designs evocative of Achaemenid Persian art, suggesting that the technique may have originated in ancient Persia. In knotted carpets, the pile—the plush, thickly tufted surface—is made by tying colored strands of yarn, usually wool but occasionally silk for deluxe carpets, onto the vertical elements (**warp**) of a yarn grid (b or c). These knotted loops are later trimmed and sheared to form the plush surface of the carpet. Rows of knots alternate with flat-woven rows (**weft**) that hold the carpet together. The weft is usually an undyed yarn and is hidden by the colored knots. Two common tying techniques are the symmetrical Turkish knot, which works well for straight-line designs (b), and the asymmetrical Persian knot, used for rendering curvilinear patterns (c). The greater the number of knots, the denser and more durable the pile. The finest carpets have a hundred knots per square inch, each one tied separately by hand.

Although royal workshops produced the most luxurious carpets (see fig. 8-22), most knotted rugs have traditionally been made in tents and homes. Carpets were woven by either women or men, depending on local custom. The photograph in this box shows two women, sisters in Ganakkale province in Turkey, weaving a large carpet in a typical Turkish pattern. The woman in the foreground pushes a row of knots tightly against the row below it with a wood comb called a beater. The other woman pulls a dark red weft yarn against the warp threads before tying a knot. Working between September and May, these women may weave five carpets, tying up to 5,000 knots a day. Generally, an older woman works with a young girl, who learns the art of carpet weaving at the loom and eventually passes it on to the next generation.

a. Kilim weaving pattern used in flat-weaving

b. Turkish knots, used typically in Anatolia (Turkey) to make pile, or knotted, carpets

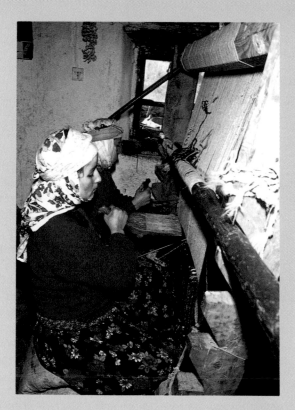

c. Persian knots, favored by Persian carpet makers

MANUSCRIPT ILLUMINATION AND CALLIGRAPHY

The art of book production flourished in the later Islamic centuries. Islam's emphasis on the study of the Koran created a high level of literacy among both women and men in Muslim societies. Books on a wide range of secular as well as religious subjects were available, although even books modestly copied on paper were fairly costly. Libraries, often associated with *madrasas*, were endowed by members of the educated elite. Books made for royal patrons had luxurious bindings and highly embellished pages, the result of workshop collaboration between noted calligraphers and illustrators. New scripts were developed for new literary forms.

The **illuminators**, or manuscript illustrators, of Mamluk Egypt executed intricate nonfigural geometric designs for Korans. Geometric and botanical ornamentation achieved unprecedented sumptuousness and mathematical complexity. As in contemporary architectural decoration, strict underlying geometric organization combined with luxurious all-over patterning. In an impressive frontispiece originally paired with its mirror image on the facing left page, energy radiates from a sixteen-pointed starburst, filling the central square (fig. 8-23). The surrounding ovals and medallions are filled with interlacing foliage and stylized flowers that provide a backdrop for the Word of God. The page's resemblance to court carpets was not coincidental. Designers worked in more than one medium, leaving the execution of their efforts to specialized artisans.

In addition to religious works, scribes copied and recopied famous secular texts—scientific treatises, manuals of all kinds, fiction, and especially poetry. Painters supplied illustrations for these books, and they also created individual small-scale paintings—**miniatures**—that were collected by the wealthy and placed in albums. One of the great royal centers of miniature painting was at Herat in Khurasan (in modern Iran). A school of painting and calligraphy was founded there in the early fifteenth century under the cultured patronage of the Turkic Timurid dynasty (1370–1507). Prince Baysonghur held court in Herat. A great patron of painting and calligraphy, he commissioned superb illuminated manuscripts. The story of the Sassanian prince Bahram Gur, told in poems known as *Haft Paykar (Seven Portraits)* by the twelfth-century Persian mystic poet Nizami, was a favorite. The painting of Bahram Gur and the Indian Princess of the Black Pavilion illustrates the lyrical idealism that characterizes the Timurid style (fig. 8-24, page 366). The round, impassive faces of the amorous couple and their servants are part of this idealization.

Although the scene takes place at night (Bahram Gur married seven princesses, one for each night of the week), the colors are clear and bright without a trace of shadows. The night sky with stars and moon and the two tall candles in the pavilion signal the viewer that it is nighttime. The black pavilion is represented in shades of gray with an interior decorated with brilliant blue tiles. Through a central opening a garden in bloom can be seen, and in the foreground a stream of silver water

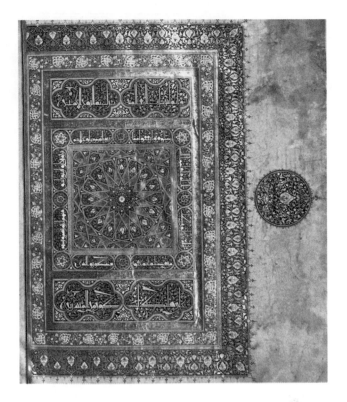

8-23. Koran frontispiece (right half of two-page spread), from Cairo, Egypt. c. 1368. Ink, pigments, and gold on paper, 24 x 18" (61 x 45.7 cm). National Library, Cairo. Ms. 7

The Koran to which this page belonged was donated in 1369 by Sultan Shaban to the *madrasa* established by his mother. Throughout the manuscript, as here, is evidence of close collaboration between illuminator and scribe.

runs into a silver pool (the silver has tarnished to black). The representation of setting, people, and objects from their most characteristic viewpoints is also typical of Timurid painting. The pavilion, tiled walls and step, huge pillow, and items on trays are seen straight on, while the floor, pool, platform, and bed are seen from a bird's-eye view. The viewpoint for the people and the things they carry, as well as the trays already in place, seems somewhere between the two extremes. Obviously, Timurid artists delighted in the representation of intricate decorative details; especially noteworthy are the representation of tiles and fabrics and the glimpse of the garden.

In the second half of the fifteenth century, the leader of the Herat school was Kamal al-Din Bihzad (c. 1440–1514). When the Safavids supplanted the Timurids and established their capital at Tabriz in northwestern Persia in 1506, Bihzad moved to Tabriz and briefly resumed his career there. Bihzad's paintings done around 1494 to illustrate the *Khamsa (Five Poems)*, also written by Nizami, demonstrate his ability to render human activity convincingly. He set his scenes within complex, stagelike architectural spaces that are stylized according to Timurid conventions, creating a visual balance between activity

8-24. *Bahram Gur Visiting One of His Wives, an Indian Princess*, from a copy of Nizami's 12th-century *Haft Paykar (Seven Portraits)*, Herat, Khurasan, Persia (Iran). late 1420s. Color and gilt on paper, height 8⅝", width 4⅝". The Metropolitan Museum of Art, New York

Gift of Alexander Smith Cochran, 1913 (13.228.13)

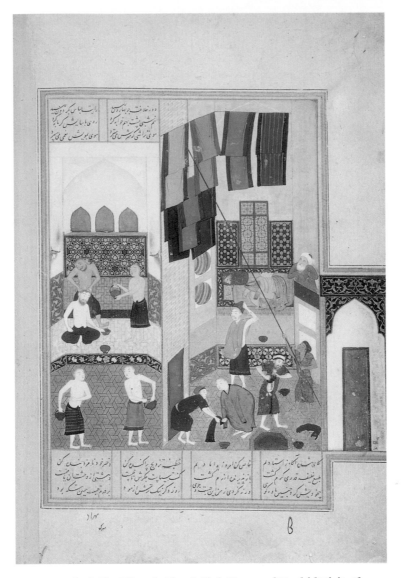

8-25. Kamal al-Din Bihzad. *The Caliph Harun al-Rashid Visits the Turkish Bath*, from a copy of the 12th-century *Khamsa (Five Poems)* of Nizami, Herat, Khurasan, Persia (Iran). c. 1494. Ink and pigments on paper, approx. 7 x 6" (17.8 x 15.3 cm). The British Library, London
Oriental and India Office Collections (Ms. Or. 6810, fol. 27v)

Despite early warnings against it as a place for the dangerous indulgence of the pleasures of the flesh, the bathhouse *(hammam)*, adapted from Roman and Hellenistic predecessors, became an important social center in much of the Islamic world. The remains of an eighth-century *hammam* are still standing in Jordan, and a twelfth-century *hammam* is still in use in Damascus. *Hammams* had a small entrance to keep in the heat, which was supplied by ducts running under the floors. The main room had pipes in the wall with steam vents. Unlike the Romans, who bathed and swam in pools of water, Muslims preferred to splash themselves from basins, and floors were slanted for drainage. A *hammam* was frequently located near a mosque, part of the commercial complex provided by the patron to generate income for the mosque's upkeep.

and architecture. In *The Caliph Harun al-Rashid Visits the Turkish Bath* (fig. 8-25), the bathhouse, its tiled entrance leading to a high-ceilinged dressing room with brick walls, provides the structuring element. Attendants wash long, blue towels and hang them to dry on overhead clotheslines. A worker reaches for one of the towels with a long pole, and a client prepares to wrap himself discreetly in a towel before removing his outer garments. The blue door on the left leads to a room where the caliph is being groomed by his barber while attendants bring buckets of water for his bath. The asymmetrical composition depends on a balanced placement of colors and architectural ornaments within each section.

This combination of abstract setting with realism in figures and details continued into the sixteenth century. The Ottoman Turks in Anatolia adopted the style for their miniatures, enhancing the decorative aspects with an intensity of religious feeling, as in the painting of

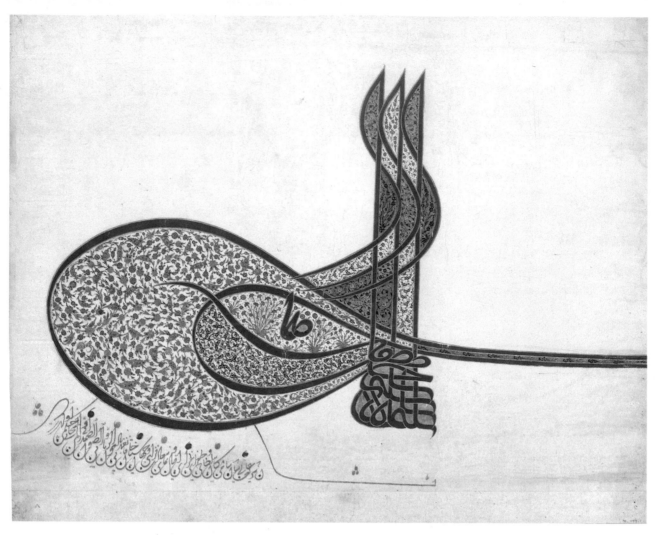

8-26. Illuminated *tugra* of Sultan Suleyman, from Istanbul,
Turkey. c. 1555–60. Ink, paint, and gold on paper, removed
from a *firman* and trimmed to 20¹/₂ x 25³/₈" (52 x 64.5 cm).
The Metropolitan Museum of Art, New York
Rogers Fund, 1938 (38.149.1)

Muhammad (see page 349) in which the Prophet appears
as a white wraithlike shadow riding a realistic camel
through a stylized landscape. At the Ottoman court of Sul-
tan Suleyman in Constantinople, the imperial workshops
also produced remarkable illuminated manuscripts. In
addition, following a practice begun by the Seljuks and
Mamluks, the Ottomans put calligraphy to another, political
use, developing the design of imperial emblems—*tugras*—
into a specialized art form. Ottoman *tugras* combined the
ruler's name with the title *khan* ("lord"), his father's name,
and the motto "Eternally Victorious" into an unvarying
monogram. *Tugras* symbolized the authority of the sultan
and of those select officials who were also granted an
emblem. They appeared on seals, coins, and buildings, as
well as on official documents called *firmans*, imperial
edicts supplementing Muslim law.

Suleyman issued hundreds of *firmans*. A high court
official affixed Suleyman's *tugra* to the top of official scrolls
and employed specialist calligraphers and illuminators
for documents, such as imperial grants to charitable
projects, that required particularly fancy *tugras*. The *tugra*
shown here (fig. 8-26) is from a document endowing an

institution in Jerusalem that had been established by
Suleyman's wife, Sultana Hurrem.

Tugras on paper were always outlined in black or
blue with three long, vertical strokes (*tug* means "horse-
tail") to the right of two horizontal teardrops, one inside
the other. Early *tugras* were purely calligraphic, but dec-
orative fill patterns became fashionable in the sixteenth
century. Fill decoration became more naturalistic by the
1550s and in later centuries spilled outside the emblems'
boundary lines. Figure 8-26 shows a rare, oversized *tugra*
that required more than the usual skill to execute. The
sweeping, fluid line had to be drawn with perfect control
according to set proportions, and a mistake meant start-
ing over. The color scheme of the delicate floral interlace
enclosed in the body of the *tugra* was inspired by Chinese
blue-and-white ceramics; similar designs appear on
Ottoman ceramics and textiles.

The Ottoman *tugra* is a sophisticated merging of
abstraction with naturalism, boldness with delicacy,
political power with informed patronage, and function—
both utilitarian and symbolic—with adornment. As such,
it is a fitting conclusion for this brief survey of Islamic art.

PARALLELS

PERIOD	ISLAMIC ART	ART IN OTHER CULTURES
EARLY CALIPHS 633–61		
UMAYYAD CALIPHS 661–750, 756–1031	**8-2. Dome of the Rock** (c. 687–91) **8-4. Mshatta palace** (c. 740) **8-6. Great Mosque**, Córdoba (begun 785–6) 	
ABBASID, NASRID, SELJUK, MAMLUK, TIMRUD, CALIPHS 750–1570	**8-1. Koran page** (Abbasid, 9th cent.) **8-8. Kufic bowl**, Samarkand (Abbasid, 9th–10th cent.) **8-9. Textile**, Khurasan (Abbasid, c. 960) **8-17. Griffin** (Fatimid, 11th cent.) **8-18. Pen box**, Khurasan (Abbasid, 1210–11) **8-12. Masjid-i Jami (Great Mosque,)** Isfahan (Seljuk, 11th–18th cent.) **8-21. Banner of Las Navas de Tolosa,** Spain (Nasrid, 1212–50) **8-20. Ewer, Kashan** (Seljuk, early 13th cent.) **8-13. Mosaic** *mihrab*, Isfahan (Seljuk, c. 1354) **8-14.** *Qibla* **wall**, Cairo (Mamluk, 1356–63) **8-19. Bottle, Syria** (Mamluk, mid-14th cent.) **8-23. Koran frontispiece** (Mamluk, c. 1368) **8-10. Palace of the Lions**, Alhambra (Nasrid, c. 1370–80) **8-25.** *Khamsa* **page** (Timurid, c. 1494)	**7-51.** *Joshua Roll* (c. 950), Turkey **7-49.** *Archangel Michael* (late 10th / early 11th cent.), Italy **9-28.** *Shiva Nataraja* (c. 1000), India **7-39. Cathedral of Saint Mark** (begun 1063), Italy **15-32.** *Bayeux Tapestry* (c. 1066–77), France **7-42.** *Virgin of Vladimir* (12th cent.), Russia **12-23. Anasazi jar** (1100–1300), US **16-6. Chartres Cathedral** (c. 1134–1220), **16-69.** Giotto. *Virgin and Child* (1310), Italy **7-52. Christ in Chora** (c. 1315–21), Turkey **7-53.** *Anastasis* (c. 1315–21), Turkey
OTTOMAN EMPIRE 1290–1918	**8-26. Suleyman** *tugra*, Turkey (c. 1555–60) **8-15. Selimye Cami, Edirne** **(Mosque of Selim)** (1570–74) **8-22. Garden carpet**, Persia (second half 17th cent.)	**7-54. Cathedral of St. Basil the Blessed** (1555–61), Russia

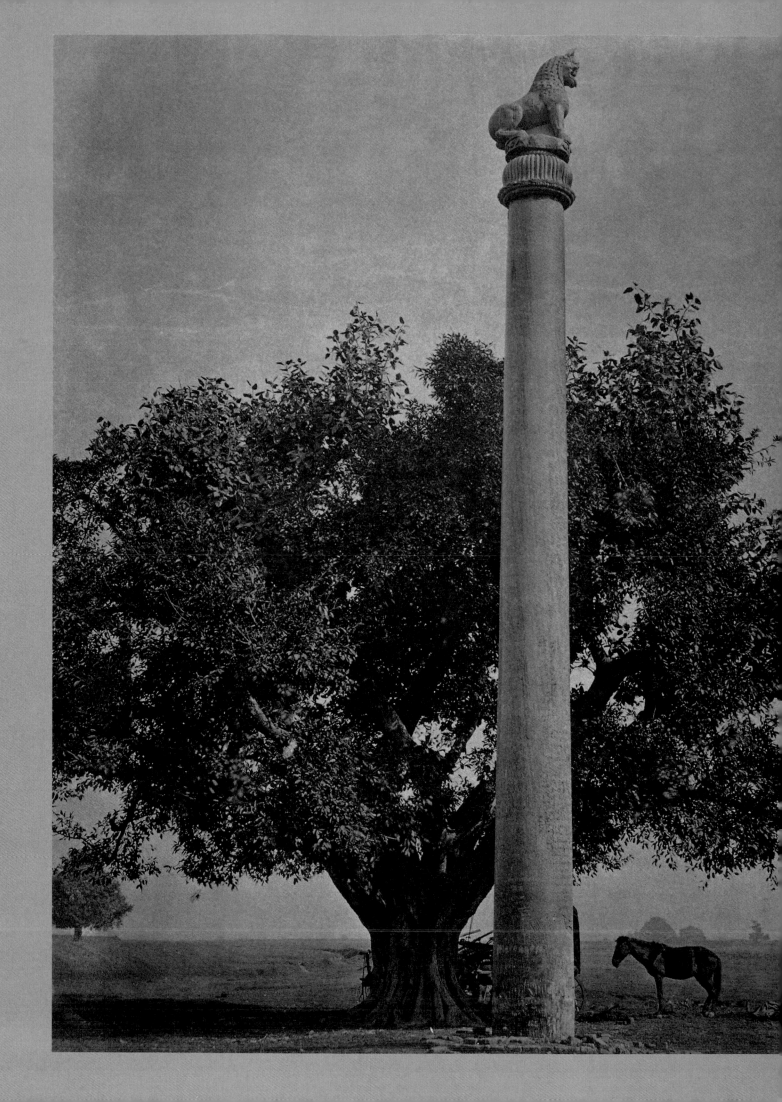

9

Art of India before 1100

The ruler Ashoka was stunned by grief and remorse as he looked across the battlefield. In the custom of his dynasty, he had gone to war, expanding his empire until he had conquered many of the peoples of the Indian subcontinent. Now, in 261 BCE, after the final battle in his conquest of the northern states, he was suddenly—unexpectedly—shocked by the horror of the suffering he had caused. In the traditional account, it is said that only one form on the battlefield moved, the stooped figure of a Buddhist monk slowly making his way through the carnage. Watching this spectral figure, Ashoka abruptly turned the moment of triumph into one of renunciation. Decrying violence and warfare, he vowed to become a *chakravartin* ("world-conquering ruler"), not through the force of arms but through spreading the teachings of the Buddha and helping to establish Buddhism as a major religion of his realm. Although there is no absolute proof that Ashoka him-self converted to Buddhism, from that moment on he set a noble example by living his belief in nonviolence and kindness to all beings.

In his impassioned propagation of Buddhism, Ashoka stimulated an intensely rich period of art. He erected and dedicated monuments to the Buddha throughout his empire—shrines, monasteries, sculp-ture, and the columns known as Ashokan pillars (fig. 9-1). In his missionary ardor, he sent delegates throughout the Indian subcontinent and to countries as distant as Syria, Egypt, and Greece.

TIMELINE 9-1. **Major Early Cultural Periods of the Indian Subcontinent.** A continuous Indian artistic tradition extended from the very early Indus Valley civilizations through the Early Medieval period.

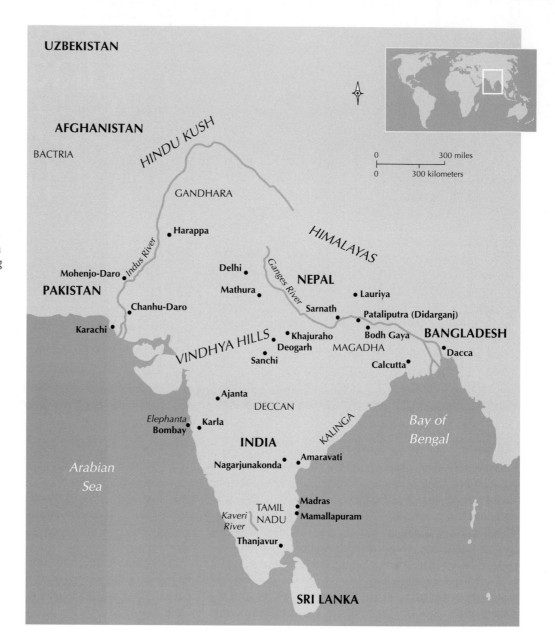

MAP 9-1. **The Indian Subcontinent.** The Vindhya Hills are a natural feature dividing North and South India.

THE INDIAN SUBCONTINENT

The South Asian subcontinent, or Indian subcontinent, as it is commonly called, is a peninsular region that includes the present-day countries of India, southeastern Afghanistan, Pakistan, Nepal, Bangladesh, and Sri Lanka (Map 9-1). From the beginning, these areas have been home to societies whose cultures are closely linked and remarkably constant. (South Asia is distinct from Southeast Asia, which includes Brunei, Burma [Myanmar], Cambodia [Kampuchea], Laos, Malaysia, the Philippines, Singapore, Thailand, and Vietnam.) Present-day India is approximately one-third the size of the United States. A low mountain range, the Vindhya Hills, acts as a kind of natural division that demarcates North India and South India, which are of approximately equal size. On the northern border rises the protective barrier of the Himalayas, the world's tallest mountains. To the northwest are other mountains through whose passes came invasions and immigrations that profoundly affected the civilization of the subcontinent. Over these passes, too, wound the major trade routes that linked the Indian subcontinent by land to the rest of Asia and to Europe. Surrounded on the remaining sides by oceans, the subcontinent has also been connected to the world since ancient times by maritime trade, and during much of

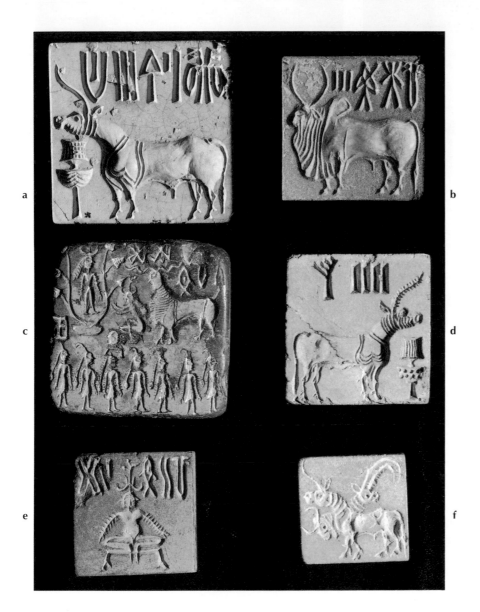

9-2. Seal impressions: a., d. horned animal; b. buffalo; c. sacrificial rite to a goddess (?); e. yogi; f. three-headed animal. Indus Valley civilization, c. 2500–1500 BCE. Seals: steatite, each approx. 1¼ x 1¼" (3.2 x 3.2 cm)

The more than 2,000 small seals and impressions that have been found offer an intriguing window on the Indus Valley civilization. Usually carved from steatite stone, the seals were coated with alkali and then fired to produce a lustrous, white surface. A perforated knob on the back of each may have been for suspending them. The most popular subjects are animals, most commonly a one-horned bovine standing before an altarlike object (a, d). Animals on Indus Valley seals are often portrayed with remarkable naturalism, their taut, well-modeled surfaces implying their underlying skeletons. The function of the seals, beyond sealing packets, remains enigmatic, and the pictographic script that is so prominent in the impressions has yet to be deciphered.

the period under discussion here it formed part of a coastal trading network that extended from eastern Africa to China.

Differences in language, climate, and terrain within India have fostered distinct regional and cultural characteristics and artistic traditions. However, despite such regional diversity, several overarching traits tend to unite Indian art. Most evident is a distinctive sense of beauty, with voluptuous forms and a profusion of ornament, texture, and color. Visual abundance is considered auspicious, and it reflects a belief in the generosity and favor of the gods. Another characteristic is the pervasive symbolism that enriches all Indian arts with intellectual and emotional layers. Third, and perhaps most important, is an emphasis on capturing the vibrant quality of a world seen as infused with the dynamics of the divine. Gods and humans, ideas and abstractions, are given tactile, sensuous forms, radiant with inner spirit.

INDUS VALLEY CIVILIZATION

The earliest civilization of South Asia was nurtured in the lower reaches of the Indus River, in present-day Pakistan and in northwestern India (Timeline 9-1). Known as the Indus Valley or Harappan civilization (after Harappa, the first-discovered site), it flourished from approximately 2700 to 1500 BCE, or during roughly the same time as the Old Kingdom period of Egypt, the Minoan civilization of the Aegean, and the dynasties of Ur and Babylon in Mesopotamia. Indeed, it is considered along with Egypt and Mesopotamia one of the world's earliest urban river-valley civilizations.

It was the chance discovery in the late nineteenth century of some small seals like those in figure 9-2 that provided the first clue that an ancient civilization had existed in this region. The seals appeared to be related to, but not the same as, seals known from ancient

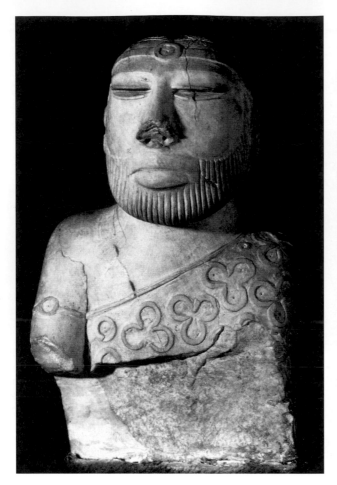

9-3. Bust of a man, from Mohenjo-Daro. Indus Valley civilization, c. 2000 BCE. Limestone, height 6⁷/₈" (17.5 cm). National Museum of Pakistan, Karachi

9-4. Torso, from Harappa. Indus Valley civilization, c. 2000 BCE. Red sandstone, height 3³/₄" (9.5 cm). National Museum, New Delhi

Mesopotamia (see fig. 2-13). Excavations begun in the 1920s and continuing into the present subsequently uncovered a number of major urban areas at points along the lower Indus River, including Harappa, Mohenjo-Daro, and Chanhu-Daro.

The ancient cities of the Indus Valley resemble each other in design and construction, suggesting a coherent culture. At Mohenjo-Daro, the best preserved of the sites, archaeologists discovered an elevated **citadel** area, presumably containing important government structures, surrounded by a wall about 50 feet high. Among the buildings is the so-called Great Bath, a large, watertight pool that may have been used for ritual purposes. Stretching out below this elevated area was the city, arranged in a gridlike plan with wide avenues and narrower side streets. Its houses, often two stories high, were generally built around a central courtyard. Like other Indus Valley cities, Mohenjo-Daro was constructed of fired brick, in contrast to the less-durable sun-dried brick used in other cultures of the time. The city included a network of covered drainage systems that channeled away waste and rainwater. Clearly the technical and engineering skills of this civilization were highly advanced. At its peak, about 2500 to 2000 BCE, Mohenjo-Daro was approximately 6 to 7 square miles in size and had a population of about 20,000 to 50,000.

Although little is known about the Indus Valley civilization, motifs on the seals as well as the few art works that have been discovered strongly suggest continuities with later South Asian cultures. Seal (e) in figure 9-2, for example, depicts a man in the meditative posture associated in Indian culture with a yogi, one who seeks mental and physical purification and self-control, usually for spiritual purposes. In seal (c), persons with elaborate headgear in a row or procession observe a figure standing in a tree—possibly a goddess—and a kneeling worshiper. This scene may offer some insight into the religious or ritual customs of Indus Valley people, whose deities may have been ancient prototypes of later Indian gods and goddesses.

Numerous **terra-cotta** figurines and a few stone and bronze statuettes have been found in the Indus Valley. They reveal a confident maturity of artistic conception and technique. Two main styles appear: one is related to Mesopotamian art in its motifs and rather abstract rendering, while the other foreshadows the later Indian artistic tradition in its sensuous naturalism.

The bust of a man in figure 9-3 is an example of the Mesopotamian style. The man's garment is patterned with a **trefoil**, or three-lobed, motif also found in Mesopotamian art. Although the striated beard and the smooth, planar surfaces of the face resemble the

9-5. *Large Painted Jar with Border Containing Birds*, from Chanhu-Daro. Indus Valley civilization, c. 2400–2000 BCE. Reddish buff clay, height 9⁷/₈" (25 cm). Museum of Fine Arts, Boston

Joint Expedition of the American School of Indic and Iranian Studies and the Museum of Fine Arts, Boston

Mesopotamian treatment of the head, distinctive physical traits emerge, including a low forehead, a broad nose, thick lips, and large, wide eyes. These traits may well record something of the appearance of the Indus Valley peoples. The depressions of the trefoil pattern were originally filled with red paste and the eyes inlaid with shell. The narrow band encircling the head falls in back into two long strands and may be an indication of rank. Certainly with its formal pose and simplified, geometric form the statue conveys a commanding human presence.

A nude male torso found at Harappa is an example of the contrasting naturalistic style (fig. 9-4). Less than 4 inches tall, it is one of the most extraordinary portrayals of the human form to survive from any early civilization. In contrast to the more athletic male ideal developed in ancient Greece, this sculpture emphasizes the soft texture of the human body and the subtle nuances of muscular form. The abdomen is relaxed in the manner of a yogi able to control his breath. With these characteristics the Harappa torso forecasts the essential aesthetic attributes of later Indian sculpture.

No wall paintings from the Indus Valley civilization have yet been found, but there are remains of handsome painted ceramic vessels (fig. 9-5). Formed on a potter's wheel and fired at high temperatures, the vessels are quite large and generally have a rounded bottom. They are typically decorated with several zones of bold, linear designs painted in black slip. Flower, leaf, bird, and fish motifs predominate. The elegant vessel here, for example, is decorated with peacocks poised gracefully among leafy branches in the upper zone and rows of leaves formed by a series of intersecting circles in the lower zone. Such geometric patterning is typical of Indus Valley decoration.

The reasons for the demise of this flourishing civilization are not yet understood. All we know is that apparently around 1500 BCE—possibly because of climate changes, a series of natural disasters, or invasions—the cities of the Indus Valley civilization declined, and over the next thousand years predominantly rural societies evolved.

THE VEDIC PERIOD

The centuries between the demise of the Indus Valley civilization and the rise of the first unified empire in the late fourth century BCE are generally referred to as the Vedic period. Named for the Vedas, a body of sacred writings that took shape over these centuries, the Vedic period witnessed profound changes in social structure and the formation of three of the four major enduring religions of India—Hinduism, Buddhism, and Jainism.

The period is marked by the dominance of Indo-European Aryans, a pastoral, seminomadic warrior people believed to have entered India sometime around 1500 BCE from the northwest. Gradually they supplanted the indigenous populations that had created the Indus Valley urban centers. The Aryans brought a language called Sanskrit, a hierarchical social order, and religious practices that centered on the propitiation of gods through fire sacrifice. The earliest of the Vedas, dating from the first centuries of Aryan presence, consist of hymns to such Aryan gods as the divine king Indra—the Vedic counterpart of the later Greek god Zeus. The importance of the fire sacrifice, overseen by a powerful priesthood, and religiously sanctioned social classes persisted through the Vedic period. At some point, the class structure became hereditary and immutable, with lasting consequences for Indian society.

During the latter part of this period, from about 800 BCE, the Upanishads were composed. These metaphysical texts examine the meanings of the earlier, more cryptic Vedic hymns. They focus on the relationship between the individual soul, or *atman*, and the universal soul, or Brahman, as well as on other concepts central to subsequent Indian philosophy. One is the assertion that the material world is illusory and that only Brahman is real and eternal. Another holds that our existence is cyclical and that beings are caught in *samsara*, a relentless cycle of birth, life, death, and rebirth. Believers aspire to attain liberation from *samsara* and to unite individual *atman* with the eternal universal Brahman.

The latter portion of the Vedic period also saw the flowering of India's epic literature, written in the melodious and complex Sanskrit language. By around 400 BCE, the eighteen-volume *Mahabharata*, the longest epic in world literature, and the *Ramayana*, the most popular and enduring religious epic in India and Southeast Asia, were taking shape. These texts, the cornerstones of Indian literature, relate histories of gods and humans that bring the philosophical ideas of the Vedas to a more accessible and popular level.

In this stimulating religious, philosophical, and literary climate numerous religious communities arose. The most influential teachers of these times were Shakyamuni Buddha and Mahavira. The Buddha, or "enlightened one," lived and taught in India around 500 BCE; his teachings form the basis of the Buddhist religion (see "Buddhism," below). Mahavira (c. 599–527 BCE), regarded as the last of twenty-four highly purified superbeings

BUDDHISM The Buddhist religion developed from the teachings of Shakyamuni Buddha, who lived from about 563 to 483 BCE in the present-day regions of Nepal and central India. At his birth, it is believed, seers foretold that the infant prince, named Siddhartha Gautama, would become either a *chakravartin*—a "world-conquering ruler"—or a *buddha*—a "fully enlightened being." Hoping for a ruler like himself, Siddhartha's father tried to surround his son with pleasure and shield him from pain. Yet the prince was eventually exposed to the sufferings of old age, sickness, and death—the inevitable fate of all mortal beings. Deeply troubled by the human condition, Siddhartha at age twenty-nine left the palace, his family, and his inheritance to live as an ascetic in the wilderness. After six years of meditation, he attained complete enlightenment near Bodh Gaya, India.

Following his enlightenment, the Buddha ("Enlightened One") gave his first teaching in the Deer Park at Sarnath. Here he expounded the Four Noble Truths, which are the foundation of Buddhism: (1) life is suffering; (2) this suffering has a cause, which is ignorance; (3) this ignorance can be overcome and extinguished; (4) the way to overcome this ignorance is by following the eightfold path of right view, right resolve, right speech, right action, right livelihood, right effort, right mindfulness, and right concentration. After the Buddha's death at the age of eighty, his many disciples developed his teachings and established the world's oldest monastic institutions.

A *buddha* is not a god but rather one who sees the ultimate nature of the world and is therefore no longer subject to *samsara*, the cycle of birth, death, and rebirth that otherwise holds us in its grip, whether we are born into the world of the gods, humans, animals, tortured spirits, or hell beings.

The early form of Buddhism, known as Theravada or Hinayana, stresses self-cultivation for the purpose of attaining *nirvana*, which is the extinction of *samsara* for oneself; Theravada Buddhism has continued mainly in southern India, Sri Lanka, and Southeast Asia. Within 500 years of the Buddha's death, another form of Buddhism, known as Mahayana, became popular mainly in northern India; it eventually flourished in China (as Chan), Korea, Japan (as Zen), and Tibet (as Vajrayana). Compassion for all beings is the foundation of Mahayana Buddhism, whose goal is not *nirvana* for oneself but buddhahood (enlightenment) for every being throughout the universe. Mahayana Buddhism recognizes *buddhas* other than Shakyamuni from the past, present, and future. One such is Maitreya, the next *buddha* to appear on earth. Another is Amitabha Buddha, the Buddha of Infinite Light and Infinite Life (that is, incorporating all space and time), who dwells in a paradise known as the Western Pure Land. Amitabha Buddha became particularly popular in East Asia. Mahayana Buddhism also developed the category of *bodhisattvas* ("those whose essence is wisdom"), saintly beings who are on the brink of achieving buddhahood but have vowed to help others achieve buddhahood before crossing over themselves.

In art, *bodhisattvas* and *buddhas* are most clearly distinguished by their clothing and adornments: *bodhisattvas* wear the princely garb of India, while *buddhas* wear monks' robes. In Hinduism a deity may dwell in its image, but in Buddhism portrayals of *buddhas* and *bodhisattvas* are recognized as purely symbolic, and no spirit is believed to reside within.

called pathfinders (*tirthankaras*), was the founder of the Jain religion. Both Shakyamuni Buddha and Mahavira espoused some basic Upanishadic tenets, such as the cyclical nature of existence and the need for liberation from the material world. However, they rejected the authority of the Vedas, and with it the legitimacy of the fire sacrifice and the hereditary class structure of Vedic society, with its powerful, exclusive priesthood. In contrast, Buddhism and Jainism were open to all, regardless of social position.

Buddhism became a vigorous force in South Asia and provided the impetus for much of the major art created between the third century BCE and the fifth century CE. The Vedic tradition, meanwhile, continued to evolve, emerging later as Hinduism, a loose term that encompasses the many religious forms that resulted from the mingling of Vedic culture with indigenous beliefs (see "Hinduism," page 378).

THE MAURYA PERIOD After about 700 BCE, cities again began to appear on the subcontinent, especially in the north, where numerous kingdoms arose. For most of its subsequent history, India was a shifting mosaic of regional dynastic kingdoms. From time to time, however, a particularly powerful dynasty formed an empire. The first of these was the Maurya dynasty (c. 322–185 BCE), which extended its rule over all but the southernmost portion of the subcontinent.

The art of the Maurya period reflects an age of heroes and the rise to prominence of Buddhism, which became the official state religion under the greatest king of the dynasty, Ashoka (ruled c. 273–232 BCE). At this time emerged the ideal of upholding *dharma*, the divinely ordained moral law believed to keep the universe from falling into chaos. The authority of *dharma* seems fully embodied in a lifesize statue found at Didarganj, near the Maurya capital of Pataliputra (fig. 9-6). The statue probably represents a **yakshi**, a spirit associated with the productive forces of nature. With its large breasts and pelvis, the figure embodies the association of female beauty with procreative abundance, bounty, and auspiciousness—qualities that in turn reflect the generosity of the gods and the workings of *dharma* in the world.

Sculpted from fine-grained sandstone, the statue conveys the *yakshi*'s authority through the frontal rigor of her pose, the massive volumes of her form, and the strong, linear patterning of her ornaments and dress. Alleviating and counterbalancing this hierarchical formality are her soft, youthful face, the precise definition of prominent features such as the stomach muscles, and the polished sheen of her exposed flesh. This lustrous polish, the technique of which is a lost secret, is a special feature of Mauryan sculpture.

In addition to depictions of popular deities like the *yakshis* and their male counterparts, **yakshas**, the Maurya period is known for art associated with the imperial sponsorship of Buddhism. Emperor Ashoka, grandson of the dynasty's founder, is considered one of India's greatest rulers. Among the monuments he erected to Buddhism

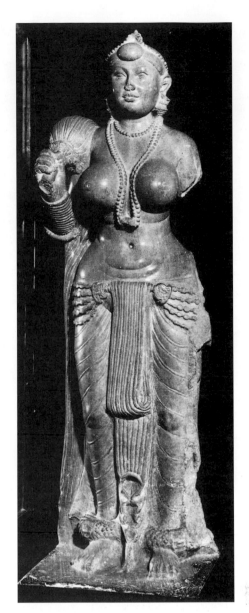

9-6. *Yakshi Holding a Fly Whisk*, from Didarganj, Patna, Bihar, India. Maurya period, c. 250 BCE. Polished sandstone, height 5'4¼" (1.63 m). Patna Museum, Patna

Discovered near the ancient Maurya capital of Pataliputra, this sculpture has become one of the most famous works of Indian art. Holding a fly whisk in her raised right hand, the *yakshi* wears only a long shawl and a skirtlike cloth. The cloth rests low on her hips, held in place by a girdle. Subtly sculpted parallel creases indicate that it is gathered closely about her legs. The ends, drawn back up over the girdle, cascade down to her feet in a broad, central loop of flowing folds ending in a zigzag of hems. Draped low over her back, the shawl passes through the crook of her arm and then flows to the ground. (The missing left side of the shawl probably mirrored this motion.) The *yakshi*'s jewelry is prominent. A double strand of pearls hangs between her breasts, its shape echoing and emphasizing the voluptuous curves of her body. Another strand of pearls encircles her neck. She wears a simple tiara, plug earrings, and rows of bangles. The nubbled tubes about her ankles probably represent anklets made of beaten gold. Her hair is bound in a large bun in back, and a small bun sits on her forehead. This hairstyle appears again in Indian sculpture of the later Kushan period (c. second century CE).

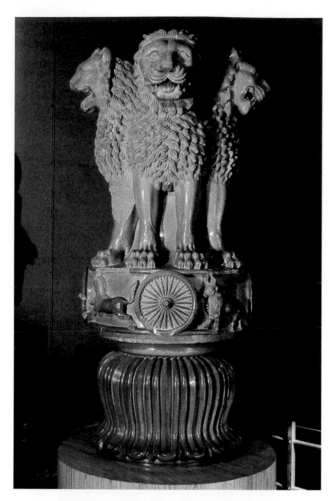

9-7. Lion capital, from an Ashokan pillar at Sarnath, Uttar Pradesh, India. Maurya period, c. 250 BCE. Polished sandstone, height 7' (2.13 m). Archaeological Museum, Sarnath

throughout his empire were monolithic **pillars** set up primarily at sites related to events in the Buddha's life.

Pillars had been used as flag-bearing standards in India since earliest times. The creators of the Ashokan pillars seem to have adapted this already-ancient form to the symbolism of Indian creation myths and the new religion of Buddhism. The fully developed Ashokan pillar, a slightly tapered sandstone **shaft**, usually rested on a stone foundation slab sunk more than 10 feet into the ground and rose to a height of around 50 feet (see fig. 9-1). On it were carved inscriptions relating to rules of *dharma* that Vedic kings were enjoined to uphold but that many later Buddhists interpreted as also referring to Buddhist teachings or exhorting the Buddhist community to unity. At the top, carved from a separate block of sandstone, an elaborate **capital** bore animal sculpture. Both shaft and capital were given the characteristic Maurya polish. Scholars believe that the pillars symbolized the **axis mundi**, or "axis of the world," joining earth with the cosmos. It represented the vital link between the human and celestial realms, and through it the cosmic order was impressed onto the terrestrial world.

The capital in figure 9-7 originally crowned the pillar erected at Sarnath in northeast India, the site of the Buddha's first teaching. The lowest portion represents the down-turned petals of a lotus blossom. Because the lotus flower emerges from murky waters without any mud sticking to its petals, it symbolizes the presence of divine purity in the imperfect world. Above the lotus is an **abacus** (the slab forming the top of a capital) embellished with **low-relief** carvings of wheels, called *chakras*, alternating with four different animals: lion, horse, bull, and elephant. The animals may symbolize the four great rivers of the world, which are mentioned in Indian creation myths. Standing on this abacus are four back-to-back lions.

HINDUISM Hinduism is not one integral religion but many related sects. Each sect considers its particular deity supreme, and each deity is revealed and depicted in multiple ways. In Vaishnavism, for example, the supreme deity is Vishnu, who manifests himself in the world in ten major incarnations. In Shaivism it is Shiva, who has numerous, complex, and apparently contradictory aspects. In Shaktism, the Goddess, Devi—a deity worshiped under many different names and in various manifestations—has forms indicative of beauty, wealth, and auspiciousness, but also forms of wrath, pestilence, and power. Indeed, she can be more powerful than the male gods.

The Hindu sects all draw upon the texts of the Vedas, which are believed to be sacred revelation. Of critical importance is ritual sacrifice, in which offerings are placed into fire in the belief that they will carry to the gods prayers, most often seeking *moksha*, or liberation from *samsara*, the endless cycle of birth, death, and rebirth. As purity is deemed essential to effective sacrifice, priests (considered more pure than others) perform the ceremonies for other Hindus.

Hindus believe that every action has a purpose and consequences. Desire for the fruits of our actions keeps us trapped in *samsara*. But if our actions are offerings to a god, their fruits too will belong to the deity—meaning that we act not out of selfish desire, but for the god's sake. The most compelling expression of these beliefs occurs in the *Bhagavad Gita*, a section of the *Mahabharata*, where Krishna, an incarnation of Vishnu, reveals them as truths to the warrior Arjuna on the battlefield.

Hindu deities are believed to arise from a state of being called Brahman, or Formless One, into a Subtle Body stage. From the Subtle Body emanates our world of space-time and all that it contains. Into this world the deity then manifests itself in Gross Body form to help living beings. These three stages of a deity's emanation from One to the Many—Formless One, Subtle Body, and Gross Body—underlie much Hindu art and architecture.

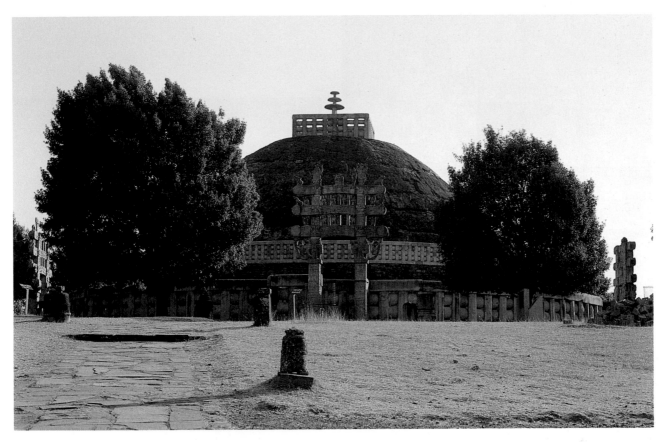

9-8. Great Stupa, Sanchi, Madhya Pradesh, India. Founded 3rd century BCE, enlarged c. 150–50 BCE

Facing the four cardinal directions, the lions may be emblematic of the universal nature of Buddhism. Their roar might be compared to the speech of the Buddha that spreads far and wide. The lions may also refer to the Buddha himself, who is known as "the lion of the Shakya clan" (the clan into which the Buddha was born as prince). The lions originally supported a great copper wheel, now lost. A universal Buddhist symbol, the wheel refers to Buddhist teaching, for with his sermon at Sarnath the Buddha "set the wheel of the doctrine [*dharma*] in motion."

Their formal, heraldic pose imbues the lions with something of the monumental quality evident in the statue of the *yakshi* of the same period. We also find the same strong patterning of realistic elements: Veins and tendons stand out on the legs; the claws are large and powerful; the mane is richly textured; and the jaws have a loose and fluttering edge.

THE PERIOD OF THE SHUNGAS AND EARLY ANDHRAS

With the demise of the Maurya Empire, India returned to local rule by regional dynasties. Between the second century BCE and the early first century CE, the most important of these dynasties were the Shunga in central India and the early Andhra in South India. During this period, Buddhism continued to be the main inspiration for art, and some of the most magnificent early Buddhist structures were created.

STUPAS

Probably no early Buddhist structure is more famous than the Great Stupa at Sanchi in central India (fig. 9-8). Originally built by King Ashoka in the Maurya period, the Great Stupa was part of a large monastery complex crowning a hill. During the mid-second century BCE the stupa was enlarged to its present size, and the surrounding stone railing was constructed. About 100 years later, elaborately carved stone gateways were added to the railing.

Stupas—religious monuments enclosing a relic chamber—are fundamental to Buddhism (see "Stupas and Temples," page 381). The first stupas were constructed to house the Buddha's remains after his cremation. At that time (c. 483 BCE), the relics were divided into eight portions and placed in eight **reliquaries**. Each reliquary was then encased in its own burial mound, called a stupa. In the mid-third century BCE King Ashoka opened the original eight stupas and divided their relics among many more stupas, probably including the one at Sanchi. Since the early stupas held actual remains of the Buddha, they were venerated as his body and, by extension, his enlightenment and attainment of *nirvana*—liberation from rebirth. The method of veneration was, and still is, to circumambulate, or walk around, the stupa in a clockwise direction, following the sun's path across the sky. Stupas are open to all for private worship.

A stupa may be small and plain or large and elaborate. Its form may vary from region to region, but its

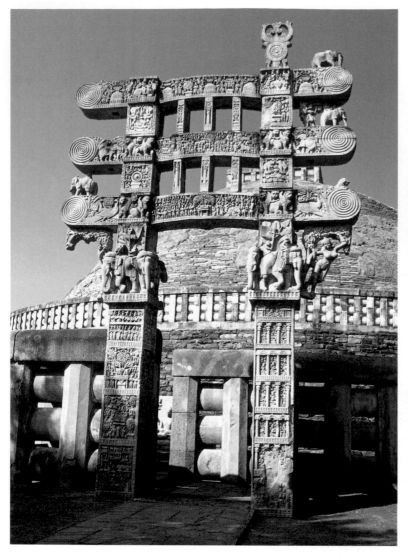

9-9. **East *torana* of the Great Stupa at Sanchi**. Early Andhra period, mid-1st century BCE. Stone, height 35' (10.66 m)

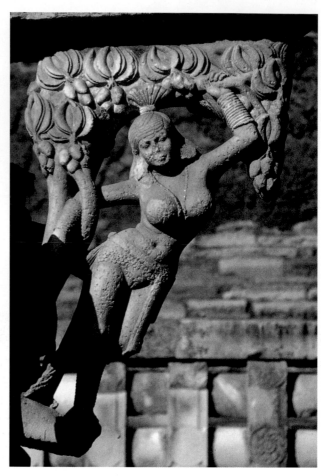

9-10. ***Yakshi* bracket figure**, on the east *torana* of the Great Stupa at Sanchi. Stone, height approx. 60" (152.4 cm)

symbolic meaning remains virtually the same, and its plan is a carefully calculated ***mandala***, or diagram of the cosmos as it is envisioned in Buddhism. The Great Stupa at Sanchi is a representative of the early central Indian type. Its solid, hemispherical **dome** was built up from rubble and dirt, faced with **dressed stone**, then covered with a shining white plaster made from lime and powdered seashells. The dome—echoing the arc of the sky—sits on a raised base. Around the perimeter is a walkway enclosed by a railing and approached by a pair of staircases. As is often true in religious architecture, the railing provides a physical and symbolic boundary between an inner, sacred area and the outer, profane world. On top of the dome, another stone railing, square in shape, defines the abode of the gods atop the cosmic mountain. It encloses the top of a mast bearing three stone disks, or "umbrellas," of decreasing size. These disks have been interpreted in various ways. They may refer to the Buddhist concept of the three realms of exis-

tence—desire, form, and formlessness. The mast itself is an *axis mundi*, connecting the cosmic waters below the earth with the celestial realm above it and anchoring everything in its proper place.

An 11-foot-tall stone railing rings the entire stupa, enclosing another, wider, circumambulatory path at ground level. Carved with octagonal uprights and lens-shaped crossbars, it probably simulates the wooden railings of the time. This design pervaded early Indian art, appearing in relief sculpture and as architectural ornament. Four stone gateways, or ***toranas***, punctuate the railing (fig. 9-9). Set at the four cardinal directions, the *toranas* symbolize the Buddhist cosmos. According to an inscription, they were sculpted by ivory carvers from the nearby town of Vidisha. The only elements of the Great Stupa at Sanchi to be ornamented with sculpture, the *toranas* rise to a height of 35 feet. Their square posts are carved with symbols and scenes drawn mostly from the Buddha's life and his past lives. Vines, lotuses,

geese, and mythical animals decorate the sides, while guardians sculpted on the lowest panel of each inner side protect the entrance. The "capitals" above the posts consist of four back-to-back elephants on the north and east gates, dwarfs on the south gate, and lions on the west gate. The capitals in turn support a three-tiered superstructure whose posts and crossbars are elaborately carved with still more symbols and scenes and studded with freestanding sculpture depicting such subjects as *yakshis* and *yakshas*, riders on real and mythical animals, and the Buddhist wheel. As in all known early Buddhist art, the Buddha himself is not shown in human form. Instead, he is represented by symbols such as his footprints, an empty "enlightenment" seat, or a stupa.

Forming a bracket between each capital and the lowest crossbar is a sculpture of a *yakshi* (fig. 9-10). These *yakshis* are some of the finest female figures in Indian art, and they make an instructive comparison with the *yakshi* of the Maurya period (see fig. 9-6). The earlier figure was distinguished by a formal, somewhat rigid pose, an emphasis on realistic details, and a clear distinction between clothed and nude parts of the body. In contrast, the Sanchi *yakshi* leans daringly into space with casual abandon, supported by one leg as the other charmingly crosses behind. Her thin, diaphanous garment is noticeable only by its hems, and so she appears almost nude, which emphasizes her form. The band pulling gently at her abdomen accentuates the suppleness of her flesh. The swelling, arching curves of her body evoke this deity's procreative and bountiful essence. As the personification of the waters, she is the source of life. Here she symbolizes the sap of the tree, which flowers at her touch.

ELEMENTS OF ARCHITECTURE

Stupas and Temples

Buddhist architecture in South Asia consists mainly of stupas and temples, often at monastic complexes containing **viharas** (monks' cells and common areas). These monuments may be either structural—built up from the ground—or rock-cut—hewn out of a mountainside. Stupas derive from burial mounds and contain relics beneath a solid, dome-shaped core. A major stupa is surrounded by a railing that creates a sacred path for ritual circumambulation at ground level. This railing is punctuated by gateways called **toranas**, aligned with the cardinal points; access is through the eastern *torana*. The stupa sits on a round or square terrace; stairs lead to an upper circumambulatory path around the platform's edge. On top of the stupa's dome a railing defines a square, from the center of which rises a mast supporting tiers of disk-shaped "umbrellas."

Hindu architecture in South Asia consists mainly of temples, either structural or rock-cut, executed in a number of styles and dedicated to a vast range of deities. The two general Hindu temple types are the northern and southern styles—corresponding to North India and South India, respectively. Within these broad categories is great stylistic diversity, though all are raised on plinths and dominated by their superstructures, towers called **shikharas** in the North and **vimanas** in the South. *Shikharas* are crowned by **amalakas**, vimanas by large **capstones**. Inside, a series of **mandapas** (halls) leads to an inner sanctuary, the **garbhagriha**, which contains a sacred image. An *axis mundi* runs vertically up from the cosmic waters below the earth, through the *garbhagriha*'s image, and out through the top of the tower.

Jain architecture consists mainly of structural and rock-cut monasteries and temples that have much in common with their Buddhist and Hindu counterparts. Buddhist, Hindu, and Jain temples may share a site.

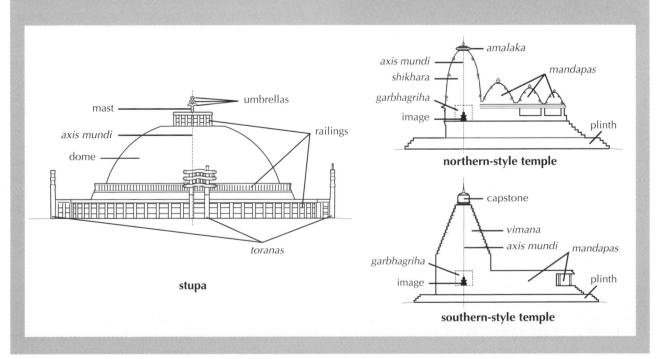

stupa

northern-style temple

southern-style temple

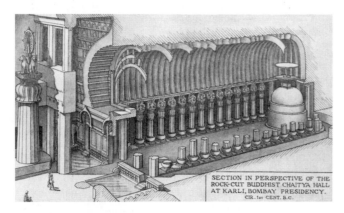

9-11. Section of the *chaitya* hall at Karla, Maharashtra, India. Early Andhra period, second half of 1st century BCE

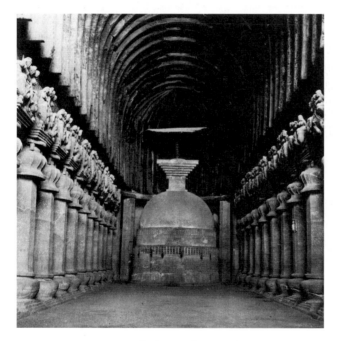

9-12. *Chaitya* hall at Karla

The profusion of designs, symbols, scenes, and figures carved on all sides of the gateways to the Great Stupa not only relates the history and lore of Buddhism but also represents the teeming life of the world and the gods.

BUDDHIST ROCK-CUT HALLS

From ancient times, caves have been considered hallowed places in India, for they were frequently the abode of holy ones and ascetics. Around the second century BCE, Buddhist monks began to hew caves for their own use out of the stone plateaus in the region of south-central India

known as the Deccan. The exteriors and interiors were carved from top to bottom like great pieces of sculpture, with all details completely finished in stone. To enter one of these remarkable halls is to feel transported to an otherworldly, sacred space. The energy of the living rock, the mysterious atmosphere created by the dark recess, the echo that magnifies the smallest sound—all combine to promote a state of heightened awareness.

The monastic community made two types of rock-cut halls. One was the **vihara**, used for the monks' living quarters, and the other was the **chaitya**, meaning "sacred," which usually enshrined a stupa. A *chaitya* hall at Karla, dating from around the latter half of the first century BCE, is the largest and most fully developed example of these early Buddhist works (figs. 9-11, 9-12). At the entrance, columns once supported a balcony, in front of which a pair of Ashokan-type pillars stood. The walls of the vestibule are carved in relief with rows of small balcony railings and arched windows, simulating the facade of a great multistoried palace. At the base of the side walls, enormous statues of elephants seem to be supporting the entire structure on their backs. Dominating the upper portion of the main facade is a large horseshoe-shaped opening called a sun window or *chaitya* window, which provides the hall's main source of light. The window was originally fitted with a carved wood screen, some of which remains, that filtered the light streaming inside.

Three entrances pierce the main facade. The two side entrances are each approached through a shallow pool of water, which symbolically purifies visitors as it washes their dusty feet. Flanking the entrances are sculpted panels of **mithuna** couples, amorous male and female figures that evoke the harmony and fertility of life. The interior hall, 123 feet long, has a 46-foot-high ceiling carved in the form of a **barrel vault** ornamented with arching wooden ribs. Both the interior and exterior of the hall were once brightly painted. A wide central aisle and two narrower side aisles lead to the stupa in the **apse** at the far end.

The closely spaced columns that separate the side aisles from the main aisle are unlike any known in the West, and they are important examples in the long and complex evolution of the many Indian styles. The base resembles a large pot set on a stepped pyramid of planks. From this potlike form rises a massive octagonal shaft. Crowning the shaft, a bell-shaped lotus capital supports an inverted pyramid of planks, which serves in turn as a platform for sculpture. The statues facing the main aisle depict pairs of kneeling elephants, each bearing a *mithuna* couple; those facing the side aisles depict pairs of horses also bearing couples. These figures, the only sculpture within this austere hall, represent the nobility coming to pay homage at the temple. The pillars around the apse are plain, and the stupa is simple. A railing motif ornaments the base; the dome was once topped with wooden "umbrella" disks, only one of which remains. Like nearly everything in the cave, the stupa is carved from the living rock. Although much less ornate than the stupa at Sanchi, its symbolism is the same.

THE KUSHAN AND LATER ANDHRA PERIODS

Around the first century CE the regions of present-day Afghanistan, Pakistan, and North India came under the control of the Kushans, a nomadic people from Central Asia. The beginning of the long reign of their most illustrious king, Kanishka, is variously dated from 78 to 143 CE. Kanishka's patronage supported the building of many stupas and Buddhist monasteries.

Buddhism during this period underwent a profound evolution that resulted in the form known as Mahayana, or Great Vehicle (see "Buddhism," page 376). This vital new movement, which was to sweep most of northern India and eastern Asia, probably inspired the first depictions of the Buddha himself in art. (Previously, as in the Great Stupa at Sanchi, the Buddha had been indicated solely by symbols.) The two earliest schools of representation arose in the Gandhara region in the northwest (present-day Pakistan and Afghanistan) and in the famous religious center of Mathura in central India. Both of these areas were ruled by the Kushans. Slightly later, a third school, known as the Amaravati school after its most famous site, developed to the south under the Andhra dynasty, which ruled much of southern and central India from the second century BCE through the second century CE.

While all three schools cultivated distinct styles, they shared a basic visual language, or **iconography**, in which the Buddha is readily recognized by certain characteristics. He wears a monk's robe called a **sanghati**, a long length of cloth draped over the left shoulder and around the body. The Buddha is said to have had thirty-two major distinguishing marks, called **lakshana**, some of which also passed into the iconography (see "Buddhist Symbols," page 432). These include a golden-colored body, long arms that reached to his knees, the impression of a wheel (*chakra*) on the palms of his hands and the soles of his feet, and the **urna**—a tuft of white hair between his eyebrows. Because he had been a prince in his youth and had worn the customary heavy earrings, his earlobes are usually shown elongated. The top of his head is said to have had a protuberance called an **ushnisha**, which in images often resembles a bun or topknot and symbolizes his enlightenment.

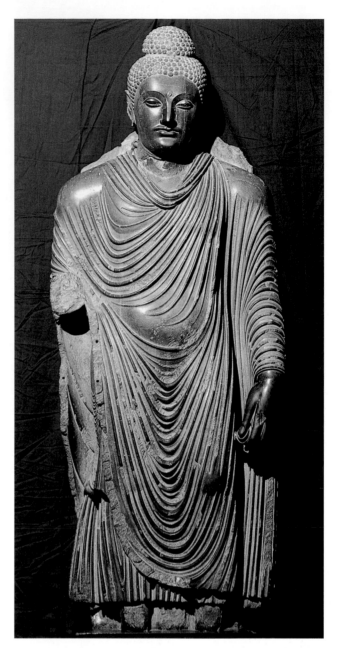

9-13. *Standing Buddha*, from Gandhara (Pakistan). Kushan period, c. 2nd–3rd century CE. Schist, height 7'6" (2.28 m). Lahore Museum, Lahore

THE GANDHARA SCHOOL

A typical image from the Gandhara school portrays the Buddha as a superhuman figure, more powerful and heroic than an ordinary human (fig. 9-13). This over-life-size Buddha dates to the fully developed stage of the Gandhara style around the third century CE. It is carved from schist, a fine-grained dark stone. The Buddha's body, revealed through the folds of the garment, is broad and massive, with heavy shoulders and limbs and a well-defined torso. His left knee bends gently, suggesting a slightly relaxed posture.

The treatment of the *sanghati* is especially characteristic of the Gandhara manner. Tight, riblike folds alternate with delicate creases, setting up a clear, rhythmic pattern of heavy and shallow lines. On the upper part of the figure, the folds break asymmetrically along the left arm; on the lower part, they drape in a symmetric **U** shape. The strong tension of the folds suggests life and power within the image. This complex fold pattern resembles the treatment of togas on certain Roman statues (see fig. 6-18), and it exerted a strong influence on portrayals of the Buddha in Central and East Asia. The Gandhara region's relations with the Hellenistic world may have led to this strongly Western style in its art. Pockets of Hellenistic culture had thrived in neighboring Bactria (present-day northern Afghanistan and southern Uzbekistan) since the fourth century BCE, when the Greeks under Alexander the Great reached the borders of India. Also, Gandhara's position near the

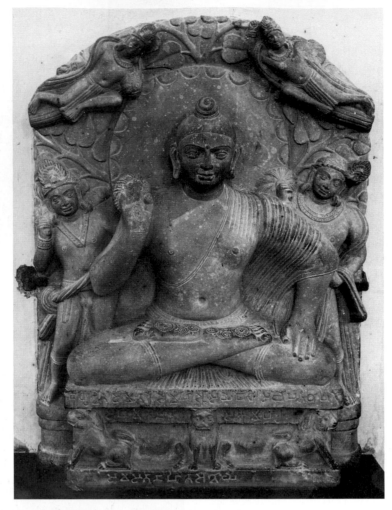

9-14. *Buddha and Attendants*, from Katra Keshavdev, Mathura, Madhya Pradesh, India. Kushan period, c. late 1st–early 2nd century CE. Red sandstone, height 27¼" (69.2 cm). Government Museum, Mathura

East-West trade routes appears to have stimulated contact with Roman culture in the Near East during the early centuries of the first millennium CE.

THE MATHURA SCHOOL

The second major school of Buddhist art in the Kushan period, that at Mathura, was not allied with the Hellenistic-Roman tradition. Instead, its style evolved from representations of *yakshas*, the indigenous male nature deities. Images produced at Mathura during the early days of the school may be the first representations of the Buddha to appear in art.

The **stele** in figure 9-14 is one of the finest of the early Mathura images. Carved in **high relief** from a block of red sandstone, it depicts a seated Buddha with two attendants. The Buddha sits in a yogic posture on a pedestal supported by lions. His right hand is raised in a symbolic gesture meaning "have no fear." Images of the Buddha rely on a repertoire of such gestures, called **mudras**, to communicate certain ideas, such as teaching, meditation, or the attaining of enlightenment (see "Mudras," page 385). The Buddha's *urna*, his *ushnisha*, and the impressions of wheels on his palms and soles are all clearly visible in this figure. Behind his head is

a large, circular halo; the scallop points of its border represent radiating light. Behind the halo are branches of the pipal tree, the tree under which the Buddha was seated when he achieved enlightenment. Two celestial beings hover above.

As in the Gandhara school, the Mathura work gives a powerful impression of the Buddha. Yet this Buddha's riveting outward gaze and alert posture impart a more intense, concentrated energy. The robe is pulled tightly over the body, allowing the fleshy form to be seen as almost nude. Where the pleats of the *sanghati* appear, such as over the left arm and fanning out between the legs, they are depicted abstractly through compact parallel formations of ridges with an **incised** line in the center of each ridge. This characteristic Mathura tendency to abstraction also appears in the face, whose features take on geometric shapes, as in the rounded forms of the widely opened eyes. Nevertheless, the torso with its subtle and soft modeling is strongly naturalistic.

THE AMARAVATI SCHOOL

Events from the Buddha's life were popular subjects in the reliefs decorating stupas and Buddhist temples. One example from Nagarjunakonda, a site of the Amaravati

MUDRAS

Mudras (Sanskrit word for "signs") are ancient symbolic hand gestures that are regarded as physical expressions of different states of being. In Buddhist art, they function iconographically. *Mudras* also are used during meditation to release these energies. Following are the most common *mudras* in Asian art.

Dharmachakra mudra

The gesture of teaching, setting the *chakra* (wheel) of the *dharma* (law, or doctrine) in motion. Hands are at chest level.

Dhyana mudra

A gesture of meditation and balance, symbolizing the path toward enlightenment. Hands are in the lap, the lower representing *maya*, the physical world of illusion, the upper representing *nirvana*, enlightenment and release from the world.

Vitarka mudra

This variant of *dharmachakra mudra* stands for intellectual debate. Each hand forms this gesture, the right at shoulder level, pointing downward, and the left at hip level, pointing upward.

Abhaya mudra

The gesture of reassurance, blessing, and protection, this *mudra* means "have no fear." The right hand is at shoulder level, palm outward.

Bhumisparsha mudra

This gesture calls upon the earth to witness Shakyamuni Buddha's enlightenment at Bodh Gaya. A seated figure's right hand reaches toward the ground, palm inward.

Varada mudra

The gesture of charity, symbolizing the fulfillment of all wishes. Alone, this *mudra* is made with the right hand; when combined with *abhaya mudra* in standing *buddha* figures, the left hand is shown in *varada mudra*.

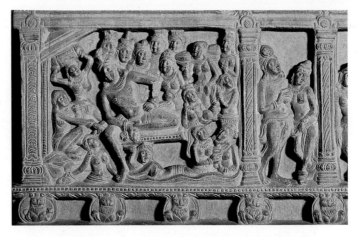

9-15. *Siddhartha in the Palace*, detail of a relief from Nagarjunakonda, Andhra Pradesh, India. Later Andhra period, c. 3rd century CE. Limestone. National Museum, New Delhi

In his *Buddhacharita*, a long poem about the life of the Buddha, the great Indian poet Ashvagosha (c. 100 CE) describes Prince Siddhartha's life in the palace: "The monarch [Siddhartha's father], reflecting that the prince must see nothing untoward that might agitate his mind, assigned him a dwelling in the upper storeys of the palace and did not allow him access to the ground. Then in the pavilions, white as the clouds of autumn, with apartments suited to each season and resembling heavenly mansions come down to earth, he passed the time with the noble music of singing-women." Later, during an outing, a series of unexpected encounters confronts Siddhartha with the nature of mortality. Deeply shaken, he cannot bring himself to respond to the perfumed entreaties of the women who greet him on his return: "For what rational being would stand or sit or lie at ease, still less laugh, when he knows of old age, disease and death?" In this relief, the prince, though surrounded by women in the pleasure garden, seems already to bear the sober demeanor of these thoughts, which were profoundly to affect not only his life, but the world.

(Translated by E. H. Johnston)

school in the south, depicts a scene from the Buddha's life when he was Prince Siddhartha, before his renunciation and subsequent quest for enlightenment (fig. 9-15). Carved in low relief, the panel reveals a scene of pleasure around a pool of water. Gathered around Siddhartha, the largest figure and the only male, are some of the palace women. One holds his foot, entreating him to come into the water; another sits with legs drawn up on the nearby rock; others lean over his shoulder or fix their hair; one comes into the scene with a box of jewels on her head. The panel is framed by decorated columns, crouching lions, and amorous *mithuna* couples. (One of these couples is visible at the right of the illustration.) The scene is skillfully orchestrated to revolve around the prince as the main focus of all eyes. Typical of the southern school, the figures are slighter than those of the Gandhara and Mathura schools. They are sinuous and mobile, even while at rest. The rhythmic nuances of the limbs and varied postures not only create interest in the activity of each individual but also engender a light and joyous effect.

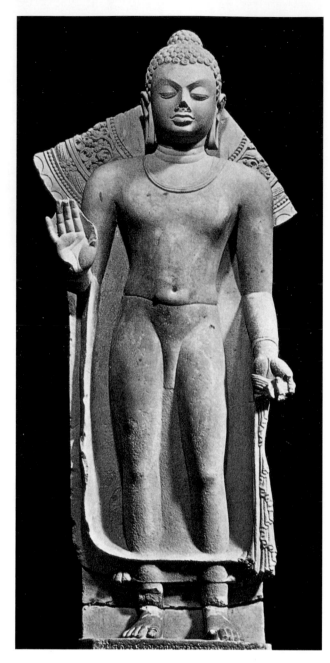

9-16. *Standing Buddha*, from Sarnath, Uttar Pradesh, India. Gupta period, 474 CE. Chunar sandstone, height 6'4" (1.93 m). Archaeological Museum, Sarnath

THE GUPTA PERIOD

The Guptas, who founded a dynasty in the eastern region of central India known as Magadha, expanded their territories during the fourth century to form an empire that encompassed northern and much of southern India. Although Gupta power prevailed for only about 130 years (c. 320–450 CE) before the dynasty's collapse around 500 CE, the influence of Gupta culture was felt for centuries.

The Gupta period is renowned for the flourishing artistic and literary culture that brought forth some of India's most widely admired sculpture and painting. During this time, Buddhism reached its greatest influence in India, although Hinduism, supported by the Gupta monarchs, began to rise in popularity.

BUDDHIST SCULPTURE

Two schools of Buddhist sculpture reached their artistic peak during the second half of the fifth century and dominated in northern India: the Mathura, one of the major schools of the earlier Kushan period, and the school at Sarnath.

The standing Buddha in figure 9-16 embodies the fully developed Sarnath Gupta style. Carved from fine-grained sandstone, the figure stands in a mildly relaxed pose, the body clearly visible through a clinging robe. This plain *sanghati*, portrayed with none of the creases and folds so prominent in the Kushan period images, is distinctive of the Sarnath school. Its effect is to concentrate attention on the perfected form of the body, which emerges in high relief. The body is graceful and slight, with broad shoulders and a well-proportioned torso. Only a few lines of the garment at the neck, waist, and hems interrupt the purity of its subtly shaped surfaces; the face, smooth and ovoid, has the same refined elegance. The downcast eyes suggest otherworldly introspection, yet the gentle, open posture maintains a human link. Behind the head are the remains of a large, circular halo. Carved in concentric circles of pearls and foliage, it would have contrasted dramatically with the plain surfaces of the figure.

The Sarnath Gupta style reveals the Buddha in perfection and equilibrium. He is not represented as a superhuman presence but as a being whose spiritual purity is evidenced by, and fused with, his physical purity, one whose nature blends that of the fully enlightened with that of the fully human.

PAINTING

The Gupta aesthetic also found expression in painting. Some of the finest surviving works are murals from the Buddhist rock-cut halls of Ajanta, in the western Deccan region of India (fig. 9-17). Under a local dynasty, many caves were carved around 475 CE, including Cave I, a large *vihara* hall with monks' chambers around the sides and a Buddha shrine chamber in the back. The walls of the central court were covered with murals painted in **fresco** technique, with mineral pigments on a prepared plaster surface. Some of these paintings depict episodes from the

During the first to third century CE, each of the three major schools of Buddhist art developed its own distinct idiom for expressing the complex imagery of Buddhism and depicting the image of the Buddha. The Gandhara and Amaravati schools declined over the ensuing centuries, mainly due to the demise of the major dynasties that had supported their Buddhist establishments. However, the schools of central India, including the school of Mathura, continued to develop, and from them came the next major development in Indian Buddhist art.

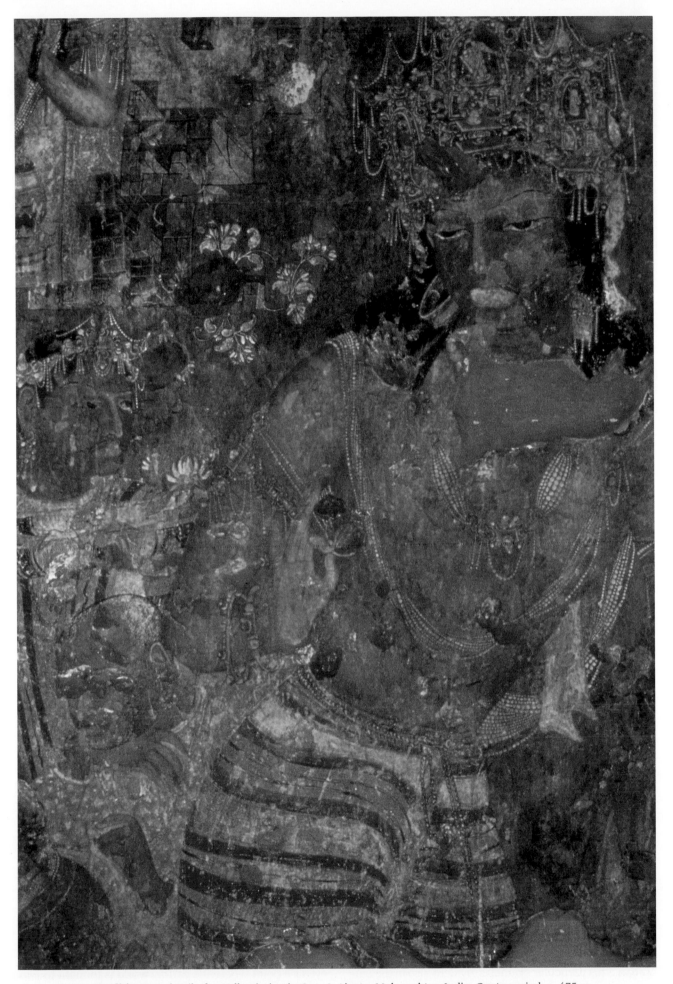

9-17. *Bodhisattva*, detail of a wall painting in Cave I, Ajanta, Maharashtra, India. Gupta period, c. 475 CE

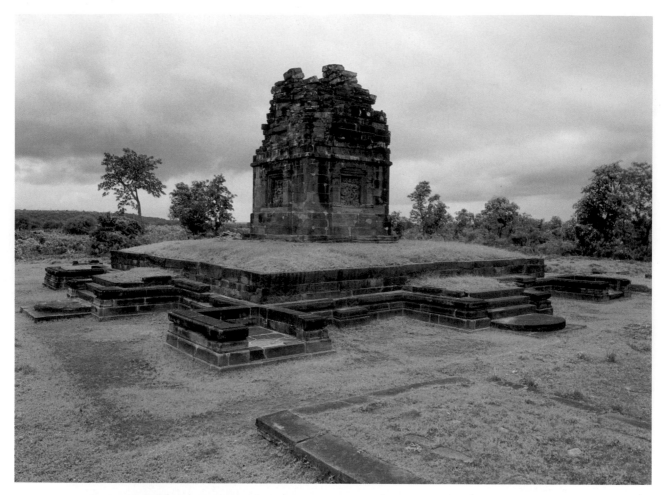

9-18. Vishnu Temple at Deogarh, Uttar Pradesh, India. Post-Gupta period, c. 530 CE

Buddha's past lives. Flanking the entrance to the shrine are two large *bodhisattvas*, one of which is seen in figure 9-17.

Bodhisattvas are enlightened beings who postpone *nirvana* and buddhahood to help others achieve enlightenment. They are distinguished from *buddhas* in art by their princely garments. The *bodhisattva* here is lavishly adorned with delicate ornaments. He wears a complicated crown with many tiny pearl festoons, large earrings, long necklaces of twisted pearl strands, armbands, and bracelets. A striped cloth covers his lower body. The graceful bending posture and serene gaze impart a sympathetic attitude. His spiritual power is suggested by his large size in comparison with the surrounding figures.

The naturalistic style balances outline and softly graded color tones. Outline drawing, always a major ingredient of Indian painting, clearly defines shapes; tonal gradations impart the illusion of three-dimensional form, with lighter tones used for protruding parts such as the nose, brows, shoulders, and chest muscles. Together with the details of the jewels, these highlighted areas resonate against the subdued tonality of the figure and the somber, flower-strewn background. Sophisticated, realistic detail is balanced, in typical Gupta fashion, by the languorous human form. In no other known examples of Indian painting do *bodhisattvas* appear so graciously divine yet at the same time so palpably human. This particular synthesis, evident also in the Sarnath statue, is the special Gupta artistic achievement.

THE POST-GUPTA PERIOD

Although the Gupta dynasty came to an end around 500 CE, its influence—in both religion and the arts—lingered until the mid-seventh century. While Buddhism had flourished in India during the fifth century, Hinduism, sponsored by Gupta monarchs, began its ascent toward eventual domination of Indian religious life. Hindu temples and sculpture of the Hindu gods, though known earlier, increasingly appeared during the Gupta period and the post-Gupta era.

THE EARLY NORTHERN TEMPLE

The Hindu temple developed many different forms throughout India, but it can be classified broadly into two types, northern and southern. The northern type is chiefly distinguished by a superstructure called a **shikhara** (see "Stupas and Temples," page 381). The *shikhara* rises as a solid mass above the flat stone ceiling and windowless walls of the sanctum, or **garbhagriha**, which houses an image of the temple's deity. As it rises, it curves inward in a mathematically determined ratio. (In mathematical terms, the *shikhara* is a paraboloid.) Crowning the top is a circular, cushionlike element called an **amalaka**, which means "sunburst." From the *amalaka* a **finial** takes the eye to a point where the earthly world is thought to join the cosmic world. An imaginary *axis mundi* penetrates the

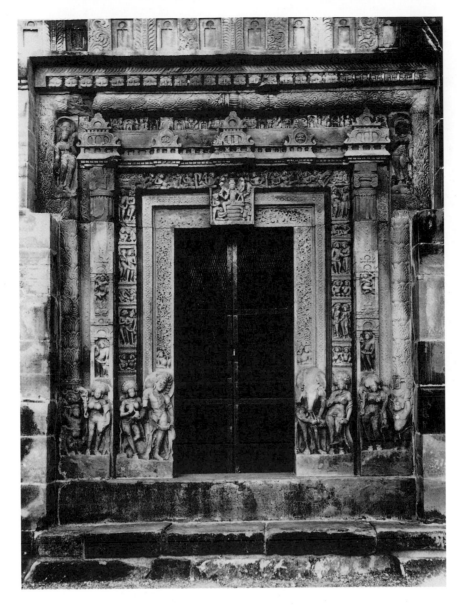

9-19. Doorway of the Vishnu Temple at Deogarh

entire temple, running from the point of the finial, through the exact center of the *amalaka* and *shikhara*, down through the center of the *garbhagriha* and its image, finally passing through the base of the temple and into the earth below. In this way the temple becomes a conduit between the celestial realms and the earth. This theme, familiar from Ashokan pillars and Buddhist stupas, is carried out with elaborate exactitude in Hindu temples, and it is one of the most important elements underlying their form and function (see "Meaning and Ritual in Hindu Temples and Images," page 390).

One of the earliest northern-style temples is the temple of Vishnu at Deogarh in central India, which dates from around 530 CE (fig. 9-18). Much of the *shikhara* has crumbled away, so we cannot determine its original shape with precision. Nevertheless, it was clearly a massive, solid structure built of large cut stones. It would have given the impression of a mountain, which is one of several metaphoric meanings of a Hindu temple. This early temple has only one chamber, the *garbhagriha*, which corresponds to the center of a sacred diagram called a *mandala* on which the entire temple site is patterned. As the deity's residence, the *garbhagriha* is likened to a sacred

cavern within the "cosmic mountain" of the temple.

The entrance to a Hindu temple is elaborate and meaningful. The doorway at Deogarh is well preserved and an excellent example (fig. 9-19). Because the entrance takes a worshiper from the mundane world into the sacred, stepping over a threshold is considered a purifying act. Two river goddesses, one on each upper corner of the **lintel**, symbolize the purifying waters flowing down over the entrance. These imaginary waters also provide symbolic nourishment for the vines and flowers decorating some of the vertical **jambs**. The innermost vines sprout from the navel of a dwarf, one of the popular motifs in Indian art. *Mithuna* couples and small replicas of the temple line other jambs. At the bottom, male and female guardians flank the doorway. Above the door, in the center, is a small image of the god Vishnu, to whom the temple is dedicated.

Large panels sculpted in relief with images of Vishnu appear as "windows" on the temple's exterior. These elaborately framed panels do not function literally to let light *into* the temple; they function symbolically to let the light of the deity *out* of the temple to be seen by those outside. The panels thus symbolize the third phase of Vishnu's threefold emanation from Brahman, the Formless One,

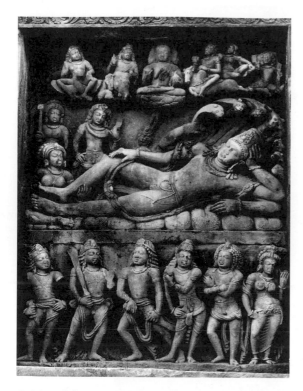

9-20. *Vishnu Narayana on the Cosmic Waters*, relief panel in the Vishnu Temple at Deogarh. Stone c. 530 CE

into our physical world. (For a discussion of the emanation of Hindu deities, see "Hinduism," page 378.)

One panel depicts Vishnu Lying on the Cosmic Waters at the beginning of creation (fig. 9-20). This vision represents the Subtle Body, or second, stage of the deity's emanation. Vishnu sleeps on the serpent of infinity, Ananta, whose body coils endlessly into space. Stirred by his female aspect (*shakti*, or female energy), personified here by the goddess Lakshmi, seen holding his foot, Vishnu dreams the universe into existence. From his navel springs a lotus (shown in this relief behind Vishnu), and the unfolding of space-time begins. The first being to be created is Brahma (not to be confused with Brahman), who appears here as the central, four-headed figure in the row of gods portrayed above the reclining Vishnu. Brahma turns himself into the universe of space and time by thinking, "May I become Many."

The sculptor has depicted Vishnu as a large, resplendent figure with four arms. His size and his many arms connote his omnipotence. He is lightly garbed but richly ornamented. The ideal of the Gupta style persists in the smooth, perfected shape of the body and in the lavishly detailed jewelry, including Vishnu's characteristic cylindrical crown. The four rightmost figures in the frieze below personify Vishnu's powers. They stand ready to fight the appearance of evil, represented at the left of the

MEANING AND RITUAL IN HINDU TEMPLES AND IMAGES

The Hindu temple is one of the most complex and meaningful architectural forms in Asian art. Age-old symbols and ritual functions are embedded not only in a structure's many parts but also in the process of construction itself. Patron, priest, and architect worked as a team to ensure the sanctity of the structure from start to finish. No artist or artisan was more highly revered in ancient Indian society than the architect, who could oversee the construction of an abode in which a deity would dwell.

For a god to take up residence, however, everything had to be done properly in exacting detail. By the sixth century CE, the necessary procedures had been recorded in texts called the *Silpa Shastra*. First, an auspicious site was chosen; a site near water was especially favored, for water makes the earth fruitful. Next, the ground was prepared in an elaborate process that took several years: spirits already inhabiting the site were invited to leave; the ground was planted and harvested through two seasons; then cows—sacred beasts since the Indus Valley civilization—were pastured there to lend their potency to the site. When construction began, each phase was accompanied by ritual to ensure its purity and sanctity.

All Hindu temples are built on a mystical plan known as a **mandala**, a schematic design of a sacred realm or space—specifically, the *mandala* of the Cosmic Man (Vastupurusha *mandala*), the primordial progenitor of the human species. His body, fallen on earth, is imagined as superimposed on the *mandala* design; together, they form the base on which the temple rises. The Vastupurusha *mandala* always takes the form of a square subdivided into a number of equal squares (usually sixty-four) surrounding a central square. The central square represents Brahman, the primordial, unmanifest Formless One. This square corresponds to the temple's sanctum, the windowless *garbhagriha*, or "womb chamber." The nature of Brahman is clear, pure light; that we perceive the *garbhagriha* as dark is considered a testament to our deluded nature. The surrounding squares belong to lesser deities, while the outermost compartments hold protector gods. These compartments are usually represented by the enclosing wall of a temple compound.

The *garbhagriha* houses the temple's main image—most commonly a stone, bronze, or wood statue of Vishnu, Shiva, or Devi. The image is made with the understanding that the god will inhabit it. To ensure perfection, its proportions follow a set canon, and rituals surround its making. When the image is completed, a priest recites *mantras*, or mystic syllables, that bring the deity into the image. The belief that a deity is literally present is not taken lightly. Even in India today, any image "under worship"—whether it be in a temple or a field, an ancient work or a modern piece—will be respected and not taken from the people who worship it.

A Hindu temple is a place for individual devotion, not congregational worship. It is the place where a devotee can make offerings to one or more deities and be in the presence of the god who is embodied in the image in the *garbhagriha*. Worship generally consists of prayers and offerings such as food and flowers or water and oil for the image, but it can also be much more elaborate, including dancing and ritual sacrifices.

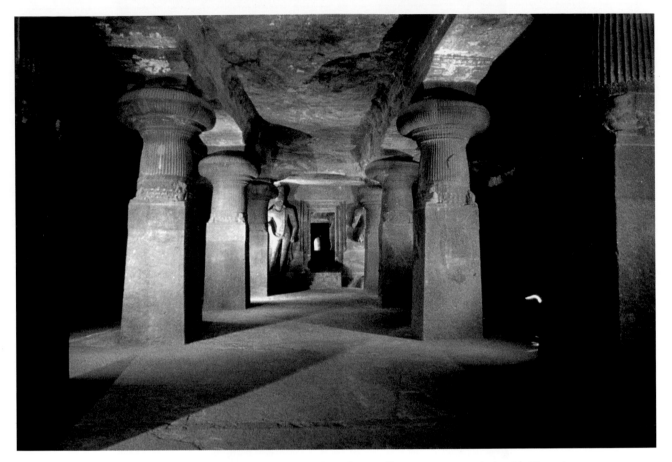

9-21. Cave-Temple of Shiva at Elephanta, Maharashtra, India. Post-Gupta period, mid-6th century CE. View along the east-west axis to the *lingam* shrine

frieze by two demons who threaten to kill Brahma and jeopardize all creation.

The birth of the universe and the appearance of evil are thus portrayed here in three clearly organized **registers**. Typical of Indian religious and artistic expression, these momentous events are set before our eyes not in terms of abstract symbols but as a drama acted out by gods in superhuman form. The birth of the universe is imagined not as a "big bang" of infinitesimal particles from a supercondensed black hole but as a lotus unfolding from the navel of Vishnu.

MONUMENTAL NARRATIVE RELIEFS

Another major Hindu god, Shiva, was known in Vedic times as Rudra, "the howler." He was "the wild red hunter" who protected beasts and inhabited the forests. Shiva, which means "benign," exhibits a wide range of aspects or forms, both gentle and wild: he is the Great Yogi who dwells for vast periods of time in meditation in the Himalayas; he is also the Husband par excellence who makes love to the goddess Parvati for eons at a time; he is the Slayer of Demons; and he is the Cosmic Dancer who dances the destruction and re-creation of the world. Shiva assumes such seemingly contradictory natures purposefully, to make us question reality.

Many of these forms of Shiva appear in the monu-mental relief panels adorning the Cave-Temple of Shiva carved in the mid-sixth century on the island of Elephanta off the coast of Bombay in western India. The cave-temple is complex in layout and conception, per-haps to reflect the nature of Shiva. While most temples have one entrance, this temple offers three—one facing north, one east, and one west. The interior, impressive in its size and grandeur, is designed along two main axes, one running north-south, the other east-west. The three entrances provide the only source of light, and the result-ing cross- and back-lighting effects add to the sense of the cave as a place of mysterious, almost confusing complexity. A worshiper is thrown off-balance—fit preparation for a meeting with Shiva, the most unpre-dictable of the Hindu gods.

Along the east-west axis, large pillars cut from the living rock appear to support the low ceiling and its beams, although, as with all architectural elements in a cave-temple, they are not structural (fig. 9-21). The pil-lars form orderly rows, but the rows are hard to discern within the framework of the cave shape, which is neither square nor longitudinal, but overlapping *mandalas* that create a symmetric yet irregular space. The pillars are an important aesthetic component of the cave. Each has an unadorned, square base rising to nearly half its total height. Above is a circular column, which has a curved contour and a billowing "cushion" capital. Both column

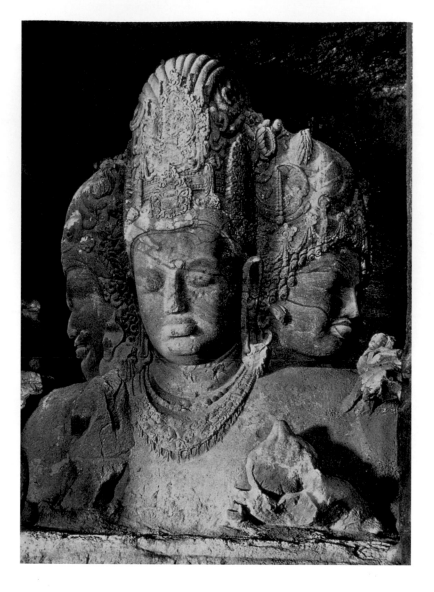

9-22. *Eternal Shiva*, rock-cut relief in the Cave-Temple of Shiva at Elephanta. Mid-6th century CE. Height approx. 11' (3.4 m)

and capital are delicately **fluted**, adding a surprising refinement to these otherwise sturdy forms. The focus of the east-west axis is a square ***lingam* shrine**, shown here at the center of the illustration. Each of its four entrances is flanked by a pair of colossal standing guardian figures. In the center of the shrine is the *lingam*, the phallic symbol of Shiva. The *lingam* represents the presence of Shiva as the unmanifest Formless One, or Brahman. It symbolizes both his erotic nature and his aspect as the Great Yogi who controls his seed. The *lingam* is synonymous with Shiva and is seen in nearly every Shiva temple and shrine.

The focus of the north-south axis, in contrast, is a relief on the south wall depicting Shiva in his Subtle Body, the second stage of the threefold emanation. A huge bust of the deity represents his Sadashiva, or Eternal Shiva, aspect (fig. 9-22). Three heads are shown resting upon the broad shoulders of the upper body, but five heads are implied: the fourth in back and the fifth, never depicted, on top. The heads summarize Shiva's fivefold nature as creator (back), protector (left shoulder), destroyer (right shoulder), obscurer (front), and releaser (top). The head in the front depicts Shiva deep in introspection. The massiveness of the broad head, the large eyes barely delineated, and the mouth with its heavy lower lip suggest the god's serious depths. Lordly and majestic, he easily supports his huge crown, intricately carved with designs and jewels, and the matted, piled-up hair of a yogi. On his left shoulder, his protector nature is depicted as female, with curled hair and a pearl-festooned crown. On his right shoulder, his wrathful, destroyer nature wears a fierce expression, and snakes encircle his neck.

Like the relief panels at the temple to Vishnu in Deogarh (see fig. 9-20), the reliefs at Elephanta are early examples of the Hindu monumental narrative tradition. Measuring 11 feet in height, they are set in recessed niches, one on either side of each of the three entrances and three on the south wall. The panels portray the range of Shiva's powers and some of his different aspects, presented in the context of narratives that help devotees understand his nature. Taken as a whole, the reliefs represent the third stage of emanation, the Gross Body manifestation of Shiva in our world. Indian artists often convey the many aspects or essential nature of a deity through multiple heads or arms—which they do with such convincing naturalism that we readily accept the additions. Here, for example, the artist has united three heads onto a single body so skillfully that we still relate to the statue as an essentially human presence.

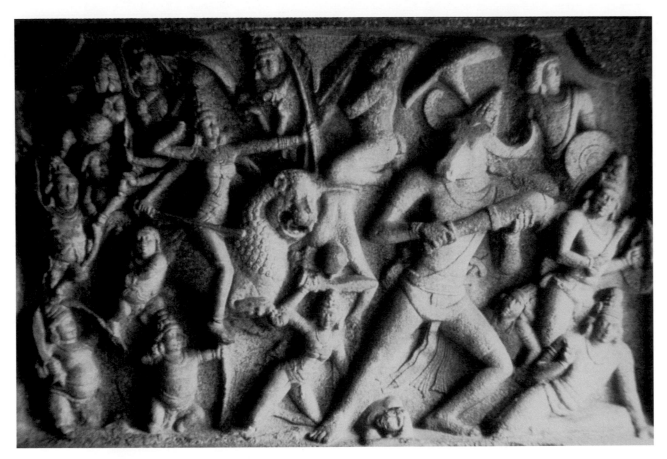

9-23. *Durga Mahishasura-mardini (Durga as Slayer of the Buffalo Demon)*, rock-cut relief, Mamallapuram, Tamil Nadu, India. Pallava period, c. mid-7th century CE. Granite, height approx. 9' (2.7 m)

The third great Hindu deity is Devi, a designation covering many deities who embody the feminine. In general, Devi represents the power of *shakti*, a divine energy understood as feminine. *Shakti* is needed to overcome the demons of our afflictions, such as ignorance and pride. Among the most widely worshiped goddesses are Lakshmi, goddess of wealth and beauty, and Durga, the warrior goddess.

Durga is the essence of the conquering powers of the gods. A large relief at Mamallapuram, near Madras, in southeastern India, depicts Durga in her popular form as the slayer of Mahishasura, the buffalo demon (fig. 9-23). Triumphantly riding her lion, a symbol of her *shakti*, the eight-armed Durga battles the demon. His huge figure with its human body and buffalo head is shown lunging to the right, fleeing her onslaught as his warriors fall to the ground. Accompanied by energetic, dwarfish warriors, victorious Durga, though small, sits erect and alert, flashing her weapons. The moods of victory and defeat are clearly distinguished between the left and right sides of the panel. The artist clarifies the drama by focusing our attention on the two principal actors. Surrounding figures play secondary roles that support the main action, adding visual interest and variety.

Stylistically, this and other panels at Mamallapuram represent the final flowering of the Indian monumental relief tradition. Here, as elsewhere, the reliefs portray stories of the gods and goddesses, whose heroic deeds unfold before our eyes. Executed under the dynasty of the Pallavas, which flourished in southern India from the seventh to ninth century CE, this panel illustrates the gentle, simplified figure style characteristic of Pallava sculpture. Figures tend to be slim and elegant with little ornament, and the rhythms of line and form have a graceful, unifying, and humanizing charm.

THE EARLY SOUTHERN TEMPLE

The coastal city of Mamallapuram was also a major temple site under the Pallavas. Along the shore are many large granite boulders and cliffs, and from these the Pallava stonecutters carved reliefs, halls, and temples. Among the most interesting Pallava creations is a group of temples known as the Five Rathas, which preserve a sequence of early architectural styles. As with other rock-cut temples, the Five Rathas were probably carved in the style of contemporary wood or brick structures that have long since disappeared.

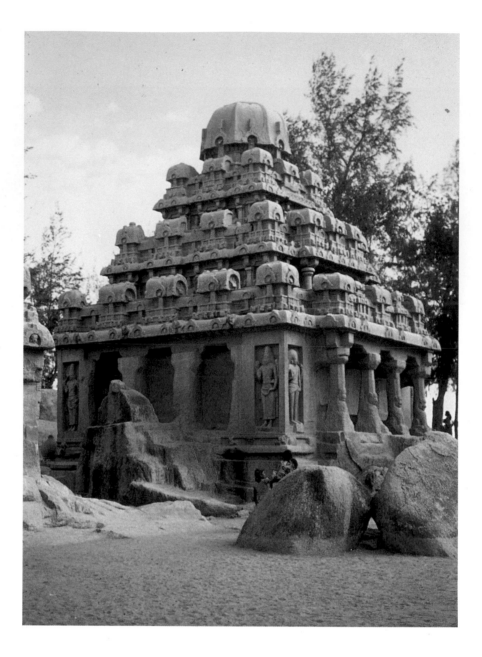

9-24. Dharmaraja Ratha, Mamallapuram, Tamil Nadu, India. Pallava period, c. mid-7th century CE

One of this group, the Dharmaraja Ratha, epitomizes the early southern-style temple (fig. 9-24). Though strikingly different in appearance from the northern style, it uses the same symbolism to link the heavens and earth and it, too, is based on a *mandala*. The temple, square in plan, remains unfinished, and the *garbhagriha* usually found inside was never hollowed out. On the lower portion, only the columns and niches have been carved. The use of a single deity in each niche forecasts the main trend in temple sculpture in the centuries ahead: the tradition of narrative reliefs began dying out, and the stories they told became concentrated in statues of individual deities, which conjure up entire mythological episodes through characteristic poses and a few symbolic objects.

Southern and northern temples are most clearly distinguished by their superstructures. The Dharmaraja Ratha does not culminate in the paraboloid of the northern *shikhara* but in a pyramidal tower called a **vimana**. Each story of the *vimana* is articulated by a **cornice** and carries a row of miniature shrines. Both shrines and

cornices are decorated with a window motif from which faces peer. The shrines not only demarcate each story but also provide loftiness for this palace for a god. Crowning the *vimana* is a dome-shaped octagonal **capstone** quite different from the *amalaka* of the northern style.

During the centuries that followed, both northern- and southern-style temples developed into complex, monumental forms, but their basic structure and symbolism remained the same as those we have seen in these simple, early examples at Deogarh and Mamallapuram.

THE EARLY MEDIEVAL PERIOD

During the Early Medieval period, which extends roughly from the mid-seventh through the eleventh century, many small kingdoms and dynasties flourished. Some were relatively long-lived, such as the Pallavas and Cholas in the south and the Palas in the northeast. Though Buddhism remained strong in a few areas—notably under the Palas—it generally declined, while the Hindu gods Vishnu,

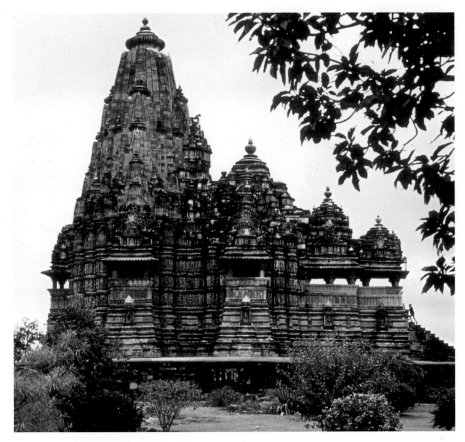

9-25. **Kandariya Mahadeva temple, Khajuraho**, Madhya Pradesh, India. Chandella dynasty, Early Medieval period, c. 1000 CE

Shiva, and the Goddess (mainly Durga) grew increasingly popular. Local kings rivaled each other in the building of temples to their favored deity, and many complicated and subtle variations of the Hindu temple emerged with astounding rapidity in different regions. By around 1000 CE the Hindu temple had reached unparalleled heights of grandeur and engineering.

THE MONUMENTAL NORTHERN TEMPLE

The Kandariya Mahadeva, a temple dedicated to Shiva at Khajuraho, in central India, was probably built by a ruler of the Chandella dynasty in the late tenth or early eleventh century (fig. 9-25). Khajuraho was the capital and main temple site for the Chandellas, who constructed more than eighty temples there, about twenty-five of which are well preserved. The Kandariya Mahadeva temple is in the northern style, with a *shikhara* rising over its *garbhagriha*. Larger, more extensively ornamented, and expanded through the addition of halls on the front and porches to the sides and back, the temple seems at first glance to have little in common with its precursor at Deogarh (see fig. 9-18). Actually, however, the basic elements and their symbolism remain unchanged.

As at Deogarh, the temple rests on a stone terrace that sets off a sacred space from the mundane world. A steep flight of stairs at the front (to the right in the illustration) leads to a series of three halls (distinguished on the outside by three pyramidal roofs) preceding the *garbhagriha*. Called **mandapas**, the halls symbolize the Subtle Body stage of the threefold emanation. They serve as spaces for ritual, such as dances performed for the deity, and for the presentation of offerings. The temple is built of stone blocks using only **post-and-lintel construction**. Because vault and arch techniques are not used, the interior spaces are not large.

The exterior has a strong sculptural presence, its massiveness suggesting a "cosmic mountain" composed of ornately carved stone. The *shikhara* rises more than 100 feet over the *garbhagriha* and is crowned by a small *amalaka*. The *shikhara* is bolstered by the many smaller *shikhara* motifs bundled around it. This decorative scheme adds a complex richness to the surface, but it also obscures the shape of the main *shikhara*, which is slender, with a swift and impetuous upward movement. The roofs of the *mandapas* contribute to the impression of rapid ascent by growing progressively taller as they near the *shikhara*.

Despite its apparent complexity, the temple has a clear structure and unified composition. The towers of the superstructure are separated from the lower portion by strong horizontal **moldings** and by the open spaces over the *mandapas* and porches. The moldings and rows of sculpture adorning the lower part of the temple create a horizontal emphasis that stabilizes the vertical thrust of the superstructure. Three rows of sculpture—some

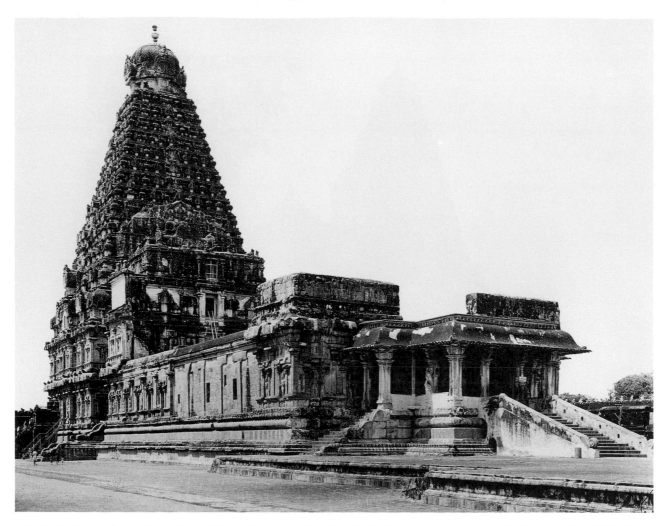

9-26. Rajarajeshvara Temple to Shiva, Thanjavur, Tamil Nadu, India. Chola dynasty, Early Medieval period, 1003–10 CE

600 figures—are integrated into the exterior walls. Approximately 3 feet tall and carved in high relief, the sculptures depict gods and goddesses, some in erotic postures. They are thought to express Shiva's divine bliss, the manifestation of his presence within, and the transformation of one to many.

In addition to its horizontal emphasis, the lower portion of the temple is characterized by a verticality created by protruding and receding elements. Their visual impact is similar to that of engaged columns and buttresses, and they account for much of the rich texture of the exterior. The porches, two on each side and one in the back, contribute to the complexity by outwardly expanding the ground plan, yet their curved bases also reinforce the sweeping vertical movements that unify the entire structure.

THE MONUMENTAL SOUTHERN TEMPLE

The Cholas, who superseded the Pallavas in the mid-ninth century, founded a dynasty that governed most of the far south well into the late thirteenth century. The Chola dynasty reached its peak during the reign of Rajaraja I (ruled 985–1014 CE). As an expression of gratitude for his many victories in battle, Rajaraja built the Rajarajeshvara Temple to Shiva in his capital, Thanjavur

(Tanjore). Known alternatively as the Brihadeshvara, this temple is the supreme achievement of the southern style of Hindu architecture (fig. 9-26). It stands within a huge, walled compound near the banks of the Kaveri River. Though smaller shrines dot the compound, the Rajarajeshvara dominates the area.

Clarity of design, a formal balance of parts, and refined decor contribute to the Rajarajeshvara's majesty. Rising to an astonishing height of 216 feet, this temple was probably the tallest structure in India in its time. Like the Kandariya Mahadeva temple at Khajuraho, the Rajarajeshvara has a longitudinal axis and greatly expanded dimensions, especially with regard to its superstructure. Typical of the southern style, the *mandapa* halls at the front of the Rajarajeshvara have flat roofs, as opposed to the pyramidal roofs of the northern style.

The base of the *vimana*, which houses the *garbhagriha*, rises for two stories, with each story emphatically articulated by a large cornice. The exterior walls are ornamented with niches, each of which holds a single statue, usually depicting a form of Shiva. The clear, regular, and wide spacing of the niches imparts a calm balance and formality to the lower portion of the temple, in marked contrast to the irregular, concave-convex rhythms of the northern style.

The *vimana* of the Rajarajeshvara is a four-sided, hollow pyramid that rises for thirteen stories. Each story is decorated with miniature shrines, window motifs, and robust dwarf figures who seem to be holding up the next story. Because these sculptural elements are not large in the overall scale of the *vimana*, they appear well integrated into the surface and do not obscure the thrusting shape. This is quite different from the effect of the small *shikhara* motifs on the *shikhara* of the Kandariya Mahadeva temple. Notice also that in the earlier southern style as embodied in the Dharmaraja Ratha (see fig. 9-24), the shrines on the *vimana* were much larger in proportion to the whole and thus each appeared to be nearly as prominent as the *vimana*'s overall shape.

Because the Rajarajeshvara *vimana* is not obscured by its decorative motifs, it forcefully ascends skyward. At the top is an octagonal dome-shaped capstone similar to the one that crowned the earlier southern-style temple. This huge capstone is exactly the same size as the *garbhagriha* housed thirteen stories directly below. It thus evokes the shrine a final time before the point separating the worldly from the cosmic sphere above.

THE BHAKTI MOVEMENT IN ART

Throughout the Early Medieval period two major religious movements were developing that affected Hindu practice and its art: the tantric, or esoteric, and the *bhakti*, or devotional. Although both movements evolved throughout India, the influence of tantric sects appeared during this period primarily in the art of the north, while the *bhakti* movements found artistic expression mostly in the south.

The *bhakti* devotional movement was based on ideas expressed in ancient texts, especially the *Bhagavad Gita*. *Bhakti* revolves around the ideal relationship between humans and deities. According to *bhakti*, it is the gods who create *maya*, or illusion, in which we are all trapped. They also reveal truth to those who truly love them and whose minds are open to them. Rather than focusing on ritual and the performance of *dharma* according to the Vedas, *bhakti* stresses an intimate, personal, and loving relation with god, and the complete devotion and surrender to god. Inspired and influenced by *bhakti*, southern artists produced some of India's greatest and most humanistic works, as revealed in the few remaining paintings and in the famous bronze works of sculpture.

Rajaraja's building of the Rajarajeshvara was in part a reflection of the fervent movement of Shiva *bhakti* that had reached its peak by that time. The corridors of the circumambulatory passages around its *garbhagriha* were originally adorned with frescoes. Overpainted later, they were only recently rediscovered. One painting apparently depicts the ruler Rajaraja himself, not as a warrior or majestic king on his throne, but as a simple mendicant humbly standing behind his religious teacher (fig. 9-27). With his white beard and dark skin, the aged teacher contrasts with the youthful, bronze-skinned king. The position of the two suggests that the king

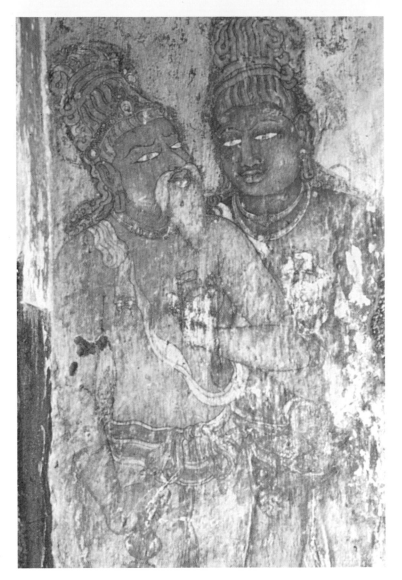

9-27. *Rajaraja I and His Teacher*, detail of a wall painting in the Rajarajeshvara Temple to Shiva. Chola dynasty, Early Medieval period, c. 1010 CE

treats the saintly teacher, who in the devotee's or *bhakta*'s view is equated with god, with intimacy and respect. Both figures allude to their devotion to Shiva by holding a small flower as an offering, and both emulate Shiva in their appearance by wearing their hair in the "ascetic locks" of Shiva in his Great Yogi aspect.

The portrayal does not represent individuals so much as a contrast of types: the old and the youthful, the teacher and the devotee, the saint and the king—the highest religious and worldly models, respectively—united as followers of Shiva. Line is the essence of the painting. With strength and grace, the even, skillfully executed line defines the boldly simple forms and features. There is no excessive detail, very little shading, and no highlighting such as we saw in the Gupta paintings at Ajanta (see fig. 9-17). A cool, sedate calm infuses the monumental figures, but the power of line also invigorates them with a sense of strength and inner life.

Perhaps no sculpture is more representative of Chola bronzes than the statues of Shiva Nataraja, or Dancing Shiva. The dance of Shiva is a dance of cosmic proportions, signifying the universe's cycle of death and rebirth;

9-28. *Shiva Nataraja*, from Thanjavur, Tamil Nadu. Chola dynasty, 12th century CE. Bronze, 32" (81.25 cm). National Museum of India, New Delhi

The fervent religious devotion of the *bhakti* movement was fueled in no small part by the sublime writings of a series of poet-saints who lived in the south of India. One of them, Appar, who lived from the late sixth to mid-seventh century CE, wrote this tender, personal vision of the Shiva Nataraja. The ash the poem refers to is one of many symbols associated with the deity. In penance for having lopped off one of the five heads of Brahma, the first created being, Shiva smeared his body with ashes and went about as a beggar.

> If you could see
> the arch of his brow,
> the budding smile
> on lips red as the kovvai fruit,
> cool matted hair,
> the milk-white ash on coral skin,
> and the sweet golden foot
> raised up in dance,
> then even human birth on this wide earth
> would become a thing worth having.

(Translated by Indira Vishvanathan Peterson)

it is also a dance for each individual, signifying the liberation of the believer through Shiva's compassion. In the iconography of the Nataraja, perfected over the centuries, this sculpture shows Shiva with four arms dancing on the prostrate body of Apasmaru, a dwarf figure who symbolizes "becoming" and whom Shiva controls (fig. 9-28). Shiva's extended left hand holds a ball of fire; a circle of fire rings the god as well. The fire is emblematic of the destruction of *samsara* and the physical universe as well as the destruction of *maya* and our ego-centered perceptions. Shiva's back right hand holds a drum; its beat represents the irrevocable rhythms of creation and destruction, birth and death. His front right arm gestures the "have no fear" mudra (see "Mudras," page 385). The front left arm, gracefully stretched across his body with the hand pointing to his raised foot, signifies the promise of liberation.

The artist has rendered the complex pose with great clarity. The central axis, which aligns the nose, navel, and insole of the weight-bearing foot, maintains the figure's equilibrium while the remaining limbs asymmetrically extend far to each side. Shiva wears a short loincloth, a ribbon tied above his waist, and delicately tooled ornaments. The scant clothing reveals his perfected form with its broad shoulders tapering to a supple waist. The jewelry is restrained and the detail does not detract from the beauty of the body.

The deity does not appear self-absorbed and introspective as he did in the Eternal Shiva relief at Elephanta (see fig. 9-22). He turns to face the viewer, appearing lordly and aloof yet fully aware of his benevolent role as he generously displays himself for the devotee. Like the Sarnath Gupta Buddha (see fig. 9-16), the Chola Nataraja Shiva presents a characteristically Indian synthesis of the godly and the human, this time expressing the *bhakti* belief in the importance of an intimate relationship with a lordly god through whose compassion one is saved. The earlier Hindu emphasis on ritual and the depiction of the heroic feats of the gods is subsumed into the all-encompassing, humanizing factor of grace.

The *bhakti* movement spread during the ensuing Late Medieval period into North India. However, during this period a new religious culture penetrated the subcontinent: Turkic, Persian, and Afghan invaders had been crossing the northwest passes into India since the tenth century, bringing with them Islam and its rich artistic tradition. New religious forms eventually evolved from Islam's long and complex interaction with the peoples of the subcontinent, and so too arose uniquely Indian forms of Islamic art, adding yet another dimension to India's artistic heritage.

PERIOD	ART IN INDIA BEFORE 1100	ART IN OTHER CULTURES
INDUS VALLEY c. 2700–1500 BCE	9-2. **Seals** (c. 2500–1500) 9-5. **Painted jar** (c. 2400–2000) 9-3. **Mohenjo-Daro bust** (c. 2000) 9-4. **Harappa torso** (c. 2000)	2-13. Sumerian cylinder seal (c. 2500 BCE), 3-13. *Menkaura and a Queen* (c. 2500), Egypt 2-17. *Stele of Hammurabi* (1792–1750 BCE), Babylonia 4-9. *Woman or Goddess with Snakes* (c. 1600–1550), Knossos
VEDIC c. 1500–322 BCE		2-27. Lion Gate (c. 1400), Anatolia 3-38. *Nefertiti* (c. 1352–1336), Egypt 5-39. Parthenon (447–438), Greece
MAURYA c. 322–185 BCE	9-6. *Yakshi Holding a Fly Whisk* (c. 250) 9-7. **Lion capital** (c. 250) 9-1. **Ashokan pillar** (246)	5-75. *Dying Gallic Trumpeter* (c. 220), Greece
SHUNGA/ EARLY ANDHRA c. 185 BCE–72 CE	9-8. **Great Stupa, Sanchi** (3rd cent. CE, 150–50) 9-12. *Chaitya* **hall, Karla** (Second half 1st cent. BCE)	5-77. *Pergamon altar* (c. 166–156 BCE), Greece 5-83. *Aphrodite of Melos* (c. 150 BCE), Greece 6-63. *Initiation Rites of the Cult of Bacchus* (c. 50 BCE), Italy 6-22. *Ara Pacis* (13–9 BCE), Italy
KUSHAN/ LATER ANDHRA c. 30–433 CE	9-13. *Standing Buddha*, Gandhara (c. 2nd–3rd cent. CE) 9-15. *Siddhartha in the Palace* (c. 3rd cent. CE)	6-45. **Equestrian statue of Marcus Aurelius** (c. 176 CE), Italy 7-5. **Dura-Europos synagogue** (244–45 CE) 7-9. **Old Saint Peter's** (c. 320–27 CE), Italy
GUPTA c. 320–500 CE	9-16. *Standing Buddha*, Sarnath (474) 9-17. *Bodhisattva* (c. 475)	7-17. **Mausoleum of Galla Placidia** (c. 425–26 CE), Italy 7-18. *Good Shepherd* (c. 425–26 CE), Italy
POST-GUPTA c. 500–650 CE	9-20. *Vishnu Narayana* (c. 530) 9-21. **Shiva cave-temple, Elephanta** (mid-6th cent.)	7-22. **Hagia Sophia** (532–37 CE), Turkey 7-36. *Rabbula Gospels* (586 CE), Syria 11-4. *Haniwa* (c. 6th cent. CE), Japan
EARLY MEDIEVAL c. 650–1200 CE	9-23. *Durga Mahishasura-mardini* (*Durga as Slayer of the Buffalo Demon*) (mid-7th cent.) 9-25. **Kandariya Mahadeva temple, Khajuraho** (c. 1000) 9-26. **Rajarajeshvara temple to Shiva, Thanjavur** (1003–10) 9-27. *Rajaraja I and His Teacher* (c. 1010) 9-28. *Shiva Nataraja* (12th cent.)	8-2. **Dome of the Rock** (687–91 CE), **Jerusalem** 8-6. **Great Mosque, Córdoba** (785–86 CE), Spain 14-12. **Charlemagne's chapel** (792–805 CE), Germany 7-39. **Saint Mark's, Venice** (begun 1063 CE), Italy 15-32. *Bayeux Tapestry* (c. 1066–77 CE), France

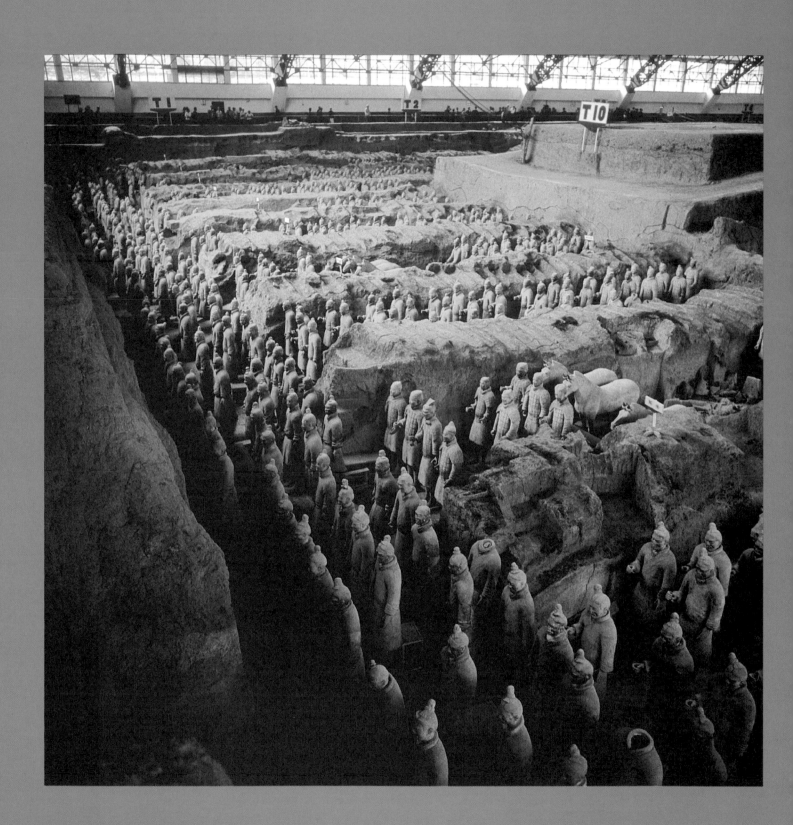

10
Chinese Art before 1280

10-1. **Soldiers**, from the mausoleum of Emperor Shihuangdi, Lintong, Shaanxi. Qin dynasty, c. 210 BCE. Earthenware, lifesize

As long as anyone could remember, the huge mound in China's Shaanxi province in northern China had been part of the landscape. No one dreamed that an astonishing treasure lay beneath the surface until one day in 1974 when peasants digging a well accidentally brought to light the first hint of the riches. When archaeologists began to excavate the mound, they were stunned by what they found: a vast underground army of more than 7,000 lifesize clay soldiers and horses standing in military formation, facing east, ready for battle (fig. 10-1). Originally painted in vivid colors, they emerged from the earth a ghostly gray. For more than 2,000 years, while the tumultuous history of China unfolded overhead, they had guarded the tomb of Emperor Shihuangdi, the ruthless ruler who first united the states of China into an empire, the Qin dynasty.

In 1990, a road-building crew in central China accidentally uncovered an even richer vault, containing perhaps tens of thousands of terra-cotta figures. Although excavations there are barely under way, the artifacts so far uncovered are exceptional both in artistic quality and in what they tell us about life—and death—during the Han dynasty, about 100 years later than the Qin find.

China has had a long-standing traditional interest in and respect for antiquity, but archaeology is a relatively young discipline there. Only since the 1920s have scholars methodically dug into the layers of history that lie buried at thousands of sites across the country. Yet in that short period so much has been unearthed that ancient Chinese history has been rewritten many times.

TIMELINE 10-1. Major Periods in China before 1280. The cultural history of China, though marked by changes of ruling dynasties, goes back unbroken some 8,000 years.

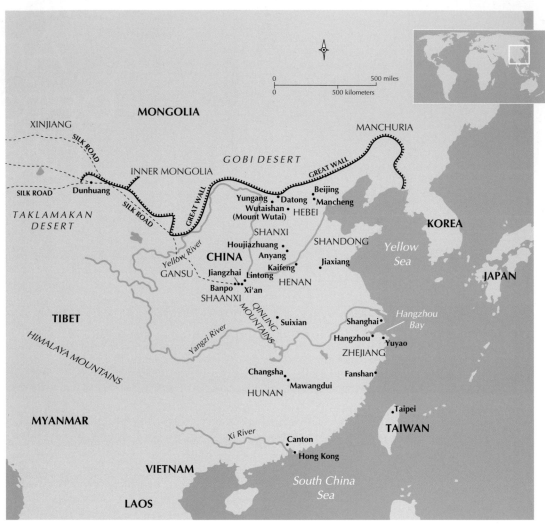

MAP 10-1. China before 1280. The heart of China is crossed by three great rivers—the Yellow, Yangzi, and Xi—and is divided into northern and southern regions by the Qinling Mountains.

THE MIDDLE KINGDOM

Among the cultures of the world, China is distinguished by its long, uninterrupted development, now traced back some 8,000 years. From Qin, pronounced "chin," comes our name for the country the Chinese call the Middle Kingdom, the country in the center of the world. Modern China occupies a large landmass in the center of Asia, covering an area slightly larger than the continental United States. Within its borders lives one-fifth of the human race.

The historical and cultural heart of China—sometimes called Inner China—is the land watered by its three great rivers, the Yellow, the Yangzi, and the Xi (Map 10-1). The Qinling Mountains divide Inner China into north and south, regions with strikingly different climates, cultures, and historical fates. In the south, the Yangzi River flows through lush green hills to the fertile plains of the delta. Along the southern coastline, rich with natural harbors, arose China's port cities, the focus of a vast maritime trading network. The Yellow River, nicknamed "China's

Sorrow" because of its disastrous floods, winds through the north. The north country is a dry land of steppe and desert, hot in the summer and lashed by cold winds in the winter. Over its vast and vulnerable frontier have come the nomadic invaders that are a recurring theme in Chinese history, as well as caravans and emissaries from Central Asia, India, Persia, and, eventually, Europe.

NEOLITHIC CULTURES

Early archaeological evidence led scholars to believe that agriculture, the cornerstone technology of the Neolithic period, made its way to China from the ancient Near East. More recent findings, however, have shown that agriculture based on rice and millet arose independently in East Asia before 5000 BCE and that knowledge of Near Eastern grains followed some 2,000 years later. One of the clearest signs of Neolithic culture in China is the vigorous emergence of towns and cities (Timeline 10-1). At Jiangzhai, near modern Xi'an, for example, the foundations of more than

▲ c. 221–206 BCE QIN DYNASTY ▲ c. 589–617 SUI DYNASTY
▲ c. 206 BCE–220 CE HAN DYNASTY ▲ c. 618–907 TANG DYNASTY
▲ c. 220–579 SIX DYNASTIES ▲ c. 960–1279 SONG DYNASTY

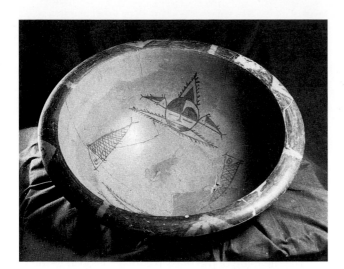

10-2. Bowl, from Banpo, near Xi'an, Shaanxi. Neolithic period, Yangshao culture, 5000–4000 BCE. Painted pottery, height 7" (17.8 cm). Banpo Museum

100 dwellings have been discovered surrounding the remains of a community center, a cemetery, and a kiln. Dated to about 4000 BCE, the ruins point to the existence of a highly developed early society. Elsewhere in China, the foundations of the earliest known palace have been uncovered and dated to about 2000 BCE.

PAINTED POTTERY CULTURES

In China, as in other places, distinctive forms of Neolithic pottery identify different cultures. One of the most interesting objects thus far recovered is a shallow red bowl with a turned-out rim (fig. 10-2). Found in the village of Banpo near the Yellow River, it was crafted sometime between 5000 and 4000 BCE. The bowl is an artifact of the Yangshao culture, one of the most important of the so called Painted Pottery cultures of Neolithic China. Although the potter's wheel had not yet been developed, the bowl is perfectly round and its surfaces are highly polished, bearing witness to a distinctly advanced technology. The decorations are especially intriguing. The marks on the rim may be among the earliest evidence of the beginnings of writing in China, which had been fully developed by the time the first definitive examples appeared in the later Bronze Age.

Inside the bowl, a pair of stylized fish suggests that fishing was an important activity for the villagers. The image between the two fish represents a human face with four more fish, one on each side. Although there is no certain interpretation of the image, it probably served some magical purpose. Perhaps it is a depiction of an ancestral figure who could assure an abundant catch, for worship of ancestors and nature spirits was a fundamental element of later Chinese beliefs.

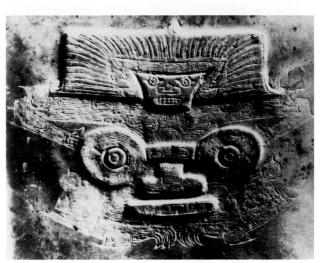

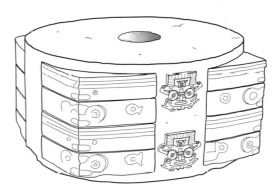

Schematic drawing of a _cong_

10-3. Image of a deity, detail from a _cong_ recovered from Tomb 12, Fanshan, Yuyao, Zhejiang. Neolithic period, Liangzhu culture, before 3000 BCE. Jade, 3½ x 6⅞" (8.8 x 17.5 cm). Zhejiang Provincial Museum, Hangzhou

The _cong_ is one of the most prevalent and mysterious of early Chinese jade shapes. Originating in the Neolithic era, it continued to play a prominent role in burials through the Shang and Zhou dynasties. Many scholars believe that the _cong_ was connected with the practice of contacting the spirit world. They suggest that the circle symbolized heaven; the square, earth; and the hollow, the axis connecting these two realms. The animals found carved on many _cong_ may have portrayed the priest's helpers or alter egos.

LIANGZHU CULTURE

Banpo lies near the great bend in the Yellow River, in the area traditionally regarded as the cradle of Chinese civilization—but archaeological finds have revealed that Neolithic cultures arose over a far broader area. Recent excavations in sites more than 800 miles away, near the Hangzhou Bay, in the southeastern coastal region, have turned up half-human, half-animal images more than 5,000 years old (fig. 10-3). Large, round eyes linked by a

PIECE-MOLD CASTING

The early **piece-mold** technique for bronze casting is more complex than the **lost-wax** process developed in the ancient Mediterranean and Near East. Although we do not know the exact steps ancient Chinese artists followed, we can deduce the general procedure for casting a simple vessel.

First, a model of the bronze-to-be was made of clay and dried. To create the mold, damp clay was pressed onto the model; after the clay dried, it was cut away in pieces, which were keyed for later reassembly and then fired. The model itself was shaved down to serve as the core for the mold. The pieces of the mold were reassembled around the core and held in place by bronze spacers, which locked the core in position and ensured an even casting space. The reassembled mold was then covered with another layer of clay, and a spue, or pouring duct, was cut into the clay to receive the molten metal. A riser duct may also have been cut to allow the hot gases to escape. Molten bronze was then poured into the mold. When the metal had cooled, the mold was broken apart with a hammer. Finally, the vessel could be burnished—a long process that involved scouring the surface with increasingly fine abrasives.

bar like the frames of eyeglasses, a flat nose, and a rectangular mouth protrude slightly from the background pattern of wirelike lines. Above the forehead, a second, smaller face grimaces from under a huge headdress. The image is one of eight carved in **low relief** on the outside of a large jade *cong*, an object resembling a cylindrical tube encased in a rectangular block. This *cong* must have been an object of great importance, for it was found near the head of a person buried in a large tomb at the top of a mound that served as an altar. Hundreds of jade objects have been recovered from this mound, which measures about 66 feet square and rises in three levels.

The intricacy of the carving shows the technical sophistication of this jade-working culture, named the Liangzhu, which seems to have emerged around 4000 BCE. Jade, a stone cherished by the Chinese throughout their history, is extremely hard and is difficult to carve. Liangzhu artists must have used sand as an abrasive to slowly grind the stone down, but we can only wonder at how they produced such fine work.

The meaning of the masklike image is open to interpretation. Its combination of human and animal features seems to show how the ancient Chinese imagined supernatural beings, either deities or dead ancestors. Strikingly similar masks later formed the primary decorative motif of Bronze Age ritual objects. Still later, Chinese historians began referring to the ancient mask motif as **taotie**, but its original meaning had already been lost. The jade carving here seems to be a forerunner of this most central and mysterious image. It suggests that eventually the various Neolithic cultures of China merged to form a single culture, despite their separate origins thousands of miles apart.

CHINESE CHARACTERS

Each word in Chinese is represented by its own unique picture, called a character or **calligraph**. Some characters originated as **pictographs**, images that mean what they depict. Writing reforms over the centuries have often disguised the resemblance, but if we place modern characters next to their oracle-bone ancestors, the picture comes back into focus:

	water	horse	moon	child	tree	mountain
ancient	𡿨	馬	⺆	子	木	⛰
modern	水	馬	月	子	木	山

Other characters are **ideographs**, pictures that represent abstract concepts or ideas:

sun	+	moon	=	bright
日		月		明
woman	+	child	=	good
女		子		好

Most characters were formed by combining a radical, which gives the field of meaning, with a phonetic, which originally hinted at pronunciation. For example, words that have to do with water have the character for "water" 水 abbreviated to three strokes 氵 as their radical. Thus "to bathe" 沐, pronounced *mu*, consists of the water radical and the phonetic 木, which by itself means "tree" and is also pronounced *mu*. Here are other "water" characters. Notice that the connection to water is not always literal.

river	sea	weep	pure, clear	extinguish, destroy
河	海	泣	清	滅

These phonetic borrowings took place centuries ago. Many words have shifted in pronunciation, and for this and other reasons there is no way to tell how a character is pronounced or what it means just by looking at it. While at first this may seem like a disadvantage, in the case of Chinese it is actually a strength. Spoken Chinese has many dialects. Some are so far apart in sound as to be virtually different languages. But while speakers of different dialects cannot understand each other, they can still communicate through writing, for no matter how they say a word, they write it with the same character. Writing has thus played an important role in maintaining the unity of Chinese civilization through the centuries.

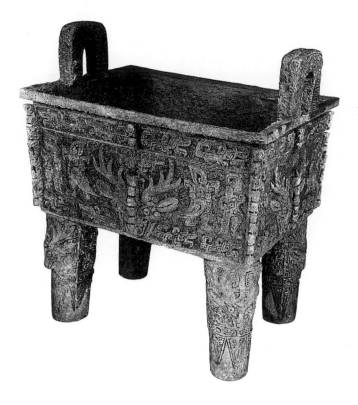

10-4. *Fang ding*, from Tomb 1004, Houjiazhuang, Anyang, Henan. Shang dynasty, Anyang period, c. 12th century BCE. Bronze, height 24½" (62.2 cm). Academia Sinica, Taipei, Taiwan

BRONZE AGE CHINA

China entered its Bronze Age in the second millennium BCE. As with agriculture, scholars at first theorized that the technology had been imported from the Near East. It is now clear, however, that bronze casting using the **piece-mold casting** technique arose independently in China, where it attained an unparalleled level of excellence (see "Piece-Mold Casting," page 404).

SHANG DYNASTY

Traditional Chinese histories tell of three Bronze Age dynasties: the Xia, the Shang, and the Zhou. Modern scholars had tended to dismiss the Xia and Shang as legendary, but recent archaeological discoveries have now fully established the historical existence of the Shang (c. 1700–1100 BCE) and point strongly to the historical existence of the Xia as well.

Shang kings ruled from a succession of capitals in the Yellow River valley, where archaeologists have found walled cities, palaces, and vast royal tombs. Their state was surrounded by numerous other states—some rivals, others clients—and their culture spread widely. Society seems to have been highly stratified, with a ruling group that had the bronze technology needed to make weapons. They maintained their authority in part by claiming power as intermediaries between the supernatural and human realms. The chief Shang deity, Shangdi, may have been a sort of Great Ancestor. Nature and fertility spirits were also honored, and regular sacrifices were believed necessary to keep the spirits of dead ancestors alive so that they might help the living.

Shang priests communicated with the supernatural world through **oracle** bones. An animal bone or piece of tortoiseshell was inscribed with a question and heated until it cracked, then the crack was interpreted as an answer. Oracle bones, many of which have been recovered and deciphered, contain the earliest known form of Chinese writing, a script fully recognizable as the ancestor of the system still in use today (see "Chinese Characters," page 404).

Ritual Bronzes. Shang tombs reveal a warrior culture of great splendor and violence. Many humans and animals were sacrificed to accompany the deceased. In one tomb, for example, chariots were found with the skeletons of their horses and drivers; in another, dozens of human skeletons lined the approaches to the central burial chamber. Above all, the tombs contain thousands of jade, ivory, and lacquer objects, gold and silver ornaments, and bronze vessels. The enormous scale of Shang burials illustrates the great wealth of the civilization and the power of a ruling class able to consign such great quantities of treasure to the earth, as well as this culture's reverence for the dead.

Bronze vessels are the most admired and studied of Shang artifacts. Like oracle bones and jade objects, they were connected with shamanistic practices, serving as containers for ritual offerings of food and wine. A basic repertoire of about thirty shapes evolved. Some shapes clearly derive from earlier pottery forms, others seem to reproduce wooden containers, while still others are purely sculptural and take the form of fantastic composite animals.

The illustrated bronze *fang ding*, a square vessel with four legs, is one of hundreds of vessels recovered from the royal tombs near the last of the Shang capitals, Yin, present-day Anyang (fig. 10-4). Weighing more than 240 pounds, it is one of the largest Shang bronzes ever

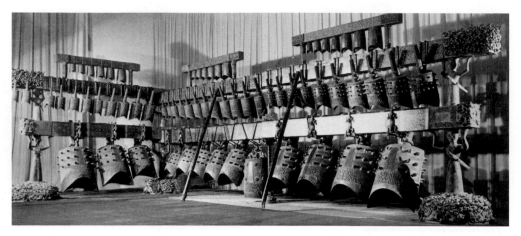

10-5. Set of sixty-five bells, from the tomb of Marquis Yi of Zeng, Suixian, Hubei. Zhou dynasty, 433 BCE. Bronze, with bronze and timber frame, frame height 9' (2.74 m), length 25' (7.62 m). Hubei Provincial Museum, Wuhan

recovered. In typical Shang style, its surface is decorated with a complex array of images based on animal forms. The *taotie*, usually so prominent, does not appear. Instead, a large deer's head adorns the center of each side, and images of deer are repeated on all four legs. The rest of the surface is filled with images resembling birds, dragons, and other fantastic creatures. Such images seem to be related to the hunting life of the Shang, but their deeper significance is unknown. Sometimes strange, sometimes fearsome, Shang creatures seem always to have a sense of mystery, evoking the Shang attitude toward the supernatural world.

ZHOU DYNASTY

Around 1100 BCE, the Shang were conquered by the Zhou, from western China. During the Zhou dynasty (1100–221 BCE), a feudal society developed, with nobles related to the king ruling over numerous small states. (Zhou nobility are customarily ranked in English by such titles as duke and marquis.) The supreme deity became known as Tian, or Heaven, and the king ruled as the Son of Heaven. Heaven remained the personal cult of China's sovereigns until the end of imperial rule in the early twentieth century.

The first 300 years of this longest Chinese dynasty were generally stable and peaceful. In 771 BCE, however, the Zhou suffered defeat at the hands of a nomadic tribe in the west. Although they quickly established a new capital to the east, their authority had been crippled, and the later Eastern Zhou period was a troubled one. States grew increasingly independent, giving the Zhou kings merely nominal allegiance. Smaller states were swallowed up by their larger neighbors. During the time historians call the Spring and Autumn period (770–476 BCE), ten or twelve states, later reduced to seven, emerged as powers.

During the ensuing Warring States period (402–221 BCE), intrigue, treachery, and increasingly ruthless warfare became routine.

Against this background of constant social unrest, China's great philosophers arose—such thinkers as Confucius, Laozi, and Mozi. Traditional histories speak of China's "one hundred schools" of philosophy, indicating a shift of focus from the supernatural to the human world. Nevertheless, elaborate burials on an even larger scale than before reflected the continuation of traditional beliefs.

Ritual bronze objects continued to play an important role during the Zhou dynasty, and new forms developed. One of the most spectacular recent discoveries is a carillon of sixty-five bronze bells arranged in a formation 25 feet long (fig. 10-5), found in the tomb of Marquis Yi of the state of Zeng. Each bell is precisely calibrated to sound two tones—one when struck at the center, another when struck nearer the rim. The bells are arranged in scale patterns in a variety of registers, and several musicians would have moved around the carillon, striking the bells in the appointed order.

Music may well have played a part in rituals for communicating with the supernatural, for the *taotie* typically appears on the front and back of each bell. The image is now much more intricate and stylized, partly in response to the refinement available with the **lost-wax casting** process, which had replaced the older piece-mold technique. On the coffin of the marquis are painted guardian warriors with half-human, half-animal attributes. The marquis, who died in 433 BCE, must have been a great lover of music, for among the more than 15,000 objects recovered from his tomb were many musical instruments. Zeng was one of the smallest and shortest-lived states of the Eastern Zhou, but the contents of this tomb, in quantity and quality, attest to the high level of its culture.

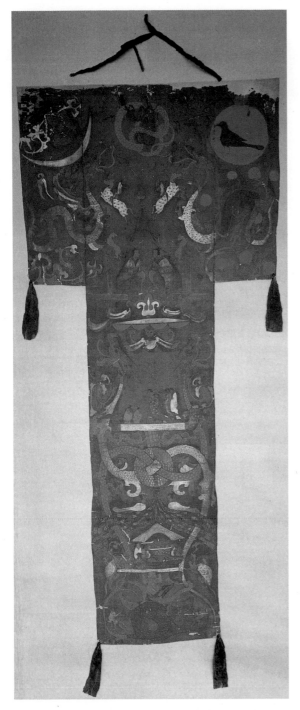

10-6. Painted banner, from the tomb of the wife of the Marquis of Dai, Mawangdui, Changsha, Hunan. Han dynasty, c. 160 BCE. Colors on silk, height 6'8½" (2.05 m). Hunan Provincial Museum, Changsha

THE CHINESE EMPIRE: QIN DYNASTY

Toward the middle of the third century BCE, the state of Qin launched military campaigns that led to its triumph over the other states by 221 BCE. For the first time in its history, China was united under a single ruler. This first emperor of Qin, Shihuangdi, a man of exceptional ability, power, and ruthlessness, was fearful of both assassination and rebellion. Throughout his life, he sought ways to attain immortality. Even before uniting China, he began his own **mausoleum** at Lintong, in Shaanxi province. This project continued throughout his life and after his death, until rebellion abruptly ended the dynasty in 206 BCE. Since that time, the mound over the mausoleum has always been visible, but not until its accidental discovery in 1974 was the army of clay soldiers and horses even imagined (see fig. 10-1). Modeled from clay and then fired, the figures claim a prominent place in the great tradition of Chinese ceramic art. Individualized faces and meticulously rendered uniforms and armor demonstrate the sculptors' skill. Literary sources suggest that the tomb itself, which has not yet been opened, reproduces the world as it was known to the Qin, with stars overhead and rivers and mountains below. Thus did the tomb's architects try literally to ensure that the underworld—the world of souls and spirits—would match the human world.

Qin rule was harsh and repressive. Laws were based on a totalitarian philosophy called legalism, and all other philosophies were banned, their scholars executed, and their books burned. Yet the Qin also established the mechanisms of centralized bureaucracy that molded China both politically and culturally into a single entity. Under the Qin, the country was divided into provinces and prefectures, the writing system and coinage were standardized, roads were built to link different parts of the country with the capital, and battlements on the northern frontier were connected to form the Great Wall. China's rulers to the present day have followed the administrative framework first laid down by the Qin.

HAN DYNASTY

The commander who overthrew the Qin became the next emperor and founded the Han dynasty (206 BCE–220 CE). During this period the Chinese enjoyed a peaceful, prosperous, and stable life. Borders were extended and secured, and Chinese control over strategic stretches of Central Asia led to the opening of the Silk Road, a land route that linked China by trade all the way to Rome (see "The Silk Road," page 408).

The early Han dynasty marks the twilight of China's so-called mythocentric age, when people believed in a close relationship between the human and supernatural worlds, reflected in all the art we have looked at so far. From this time comes one of the most important works in Chinese art, a **T**-shaped silk banner that summarizes this early worldview (fig. 10-6). Found in the tomb of a noblewoman on the outskirts of present-day Changsha, the banner dates from the second century BCE and is

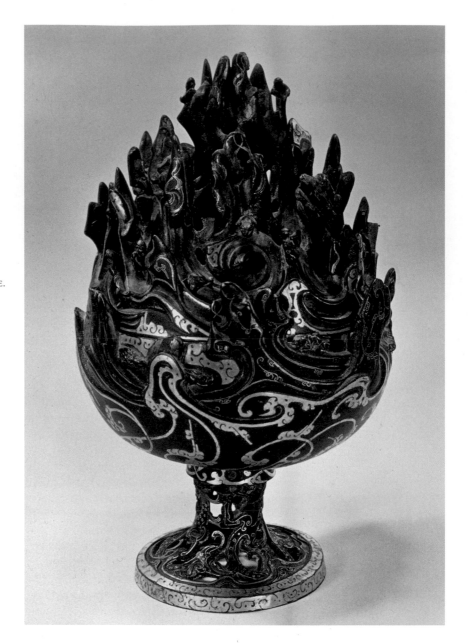

10-7. Incense burner, from the tomb of Prince Liu Sheng, Mancheng, Hebei. Han dynasty, 113 BCE. Bronze with gold inlay, height 10½" (26 cm). Hebei Provincial Museum, Shijiazhuang

THE SILK ROAD At its height, in the second century CE, the Silk Road was the longest road in the world, a 5,000-mile network of caravan routes from the Han capital of Luoyang on the Yellow River to Rome. The Western market for Chinese luxury goods such as silk and lacquer seemed limitless. For these goods, Westerners paid in gold and silver and sometimes exchanged their own commodities, including silver and gold vessels and glass wares, as well as transmitting ideas and religious objects, especially Buddhist icons.

The journey began at the Jade Gate (Yumen), at the westernmost end of the Great Wall, where Chinese merchants turned their goods over to Central Asian traders. Goods would change hands many more times before reaching the Mediterranean. Caravans headed first for the desert oasis of Dunhuang. Here northern and southern routes diverged to skirt the vast Taklamakan Desert. Farther west than the area shown in Map 10-1, at Khotan, in western China, travelers on the southern route could turn off toward a mountain pass into Kashmir, in northern India. Or they could continue on, meeting up with the northern route at Kashgar, on the western border of the Taklamakan, before proceeding over the Pamir Mountains into present-day Afghanistan. There, travelers could turn off into the Kushan Empire that stretched down into India, or they could continue on west through present-day Uzbekistan, Iran, and Iraq, arriving finally at Antioch, in Syria, on the coast of the Mediterranean. From there, land and sea routes led on to Rome.

Sections of the Silk Road were used throughout history by traders, travelers, conquerors, emissaries, pilgrims, missionaries, explorers, and adventurers. But only twice in history was the entire length of it open, with relatively safe passage likely from end to end. The first time was during the days of the Han dynasty and the Roman Empire. The second was during the thirteenth and fourteenth centuries, when the route lay within the borders of the vast Mongol Empire.

DAOISM

Daoism is a kind of nature mysticism that brings together many ancient Chinese ideas regarding humankind and the universe. One of its first philosophers is said to have been a contemporary of Confucius (551–479 BCE) named Laozi, who is credited with writing a slim volume called the *Daodejing*, or *The Way and Its Power*. Later, a philosopher named Zhuangzi (369–286 BCE) took up many of the same ideas in a book that is known simply by his name, *Zhuangzi*. Together the two texts formed a body of ideas that crystallized into a school of thought during the Han period.

A *dao* is a way or path. The *Dao* is the Ultimate Way, the Way of the universe. The Way cannot be named or described, but it can be hinted at. It is like water. Nothing is more flexible and yielding, yet water can wear down the hardest stone. Water flows downward, seeking the lowest ground. Similarly, a Daoist sage seeks a quiet life, humble and hidden, unconcerned with worldly success. The Way is great precisely because it is small. In fact, it is nothing, yet nothing turns out to be essential (cited in Cleary, page 14):

When the potter's wheel makes a pot
the use of the pot
is precisely where there is nothing.

To recover the Way, we must unlearn. We must return to a state of nature. To follow the Way, we must practice *wu wei*, or nondoing. "Strive for nonstriving," advises the *Daodejing*.

All our attempts at asserting our egos, at making things happen, are like swimming against a current and thus ultimately futile, even harmful. If we let the current carry us, however, we will travel far. Similarly, a life that follows the Way will be a life of pure effectiveness, accomplishing much with little effort.

It is often said that the Chinese are Confucians in public and Daoists in private, and the two approaches do seem to balance each other. Confucianism is a rational political philosophy that emphasizes morality, conformity, duty, and self-discipline. Daoism is an intuitive philosophy that emphasizes individualism, nonconformity, and a return to nature. If a Confucian education molded scholars outwardly into responsible, ethical officials, Daoism provided some breathing room for the artist and poet inside.

painted with scenes representing the three levels of the universe: heaven, earth, and the underworld.

The heavenly realm is shown at the top, in the crossbar of the T. In the upper right corner is the sun, inhabited by a mythical crow; in the upper left, a mythical toad stands on a crescent moon. Between them is a primordial deity shown as a man with a long serpent's tail—a Han imagining of the Great Ancestor. Dragons and other celestial creatures swarm below.

A gate, indicated by two upside-down Ts and guarded by two seated figures, stands where the horizontal of heaven meets the banner's long, vertical stem. Two intertwined dragons loop through a circular jade piece known as a **bi**, itself usually a symbol of heaven, dividing this vertical segment into two areas. The portion above the *bi* represents the earthly realm. Here, the deceased woman and her three attendants stand on a platform while two kneeling figures offer gifts. The lower portion represents the underworld. Silk draperies and a stone chime hanging from the *bi* form a canopy for the platform below. Like the bronze bells we saw earlier, stone chimes were ceremonial instruments dating from Zhou times. On the platform, ritual bronze vessels contain food and wine for the deceased, just as they did in Shang tombs. The squat, muscular man holding up the platform stands in turn on a pair of fish whose bodies form another *bi*. The fish and the other strange creatures in this section are inhabitants of the underworld.

PHILOSOPHY AND ART

The Han dynasty marked not only the end of the mythocentric age but also the beginning of a new age. During this dynasty, Daoism and Confucianism, two of the many philosophies formulated during the troubled times of the Eastern Zhou, became central in Chinese thought. Their influence since then has been continuous and fundamental.

Daoism and Nature. Daoism emphasizes the close relationship between humans and nature. It is concerned with bringing the individual life into harmony with the *Dao*, or Way, of the universe (see "Daoism," above). For some a secular, philosophical path, Daoism on a popular level developed into an organized religion, absorbing many traditional shamanistic folk practices and the search for immortality.

Immortality was as intriguing to Han rulers as it had been to the first emperor of Qin. Daoist adepts experimented endlessly with diet, physical exercise, and other techniques in the belief that immortal life could be achieved on earth. A popular Daoist legend told of the Isles of the Immortals in the Eastern Sea, depicted on a bronze incense burner from the tomb of Prince Liu Sheng, who died in 113 BCE (fig. 10-7). Around the bowl, gold inlay outlines the stylized waves of the sea. Above them rises the mountainous island, busy with birds, animals, and people who had discovered the secret of immortality. Technically, this exquisite piece represents the ultimate development of the long tradition of bronze casting in China.

Confucianism and the State. In contrast to the metaphysical focus of Daoism, Confucianism is concerned with the human world, and its goal is the attainment of peace. To this end, it proposes an ethical system based on correct relationships among people. Beginning with self-discipline in the individual, Confucianism goes on to achieve correct relationships with the family, including ancestors, then, in ever-widening circles, with friends

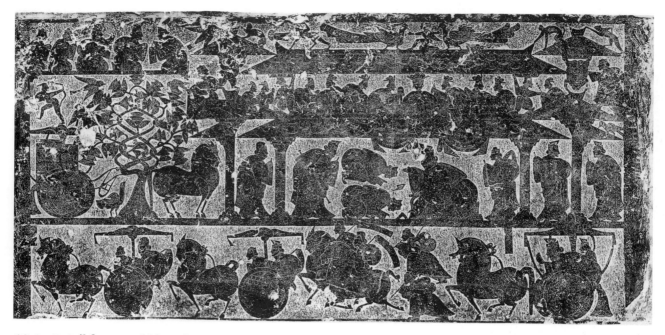

10-8. Detail from a rubbing of a stone relief in the Wu family shrine (Wuliangci), Jiaxiang, Shandong. Han dynasty, 151 CE., 27½ x 66½" (70 x 169 cm)

and others all the way up to the emperor (see "Confucius and Confucianism," below).

Emphasis on social order and respect for authority made Confucianism especially attractive to Han rulers, who were eager to distance themselves from the disastrous legalism of the Qin. The Han emperor Wu (ruled 141–87 BCE) made Confucianism the official imperial philosophy, and it remained the state ideology of China for more than 2,000 years, until the end of imperial rule in the twentieth century. Once institutionalized, Confucianism took on so many ritu-

als that it too eventually assumed the form and force of a religion. Han philosophers contributed to this process by infusing Confucianism with traditional Chinese cosmology. They emphasized the Zhou idea, taken up by Confucius, that the emperor ruled by the mandate of heaven. Heaven itself was reconceived more abstractly as the moral force underlying the universe. Thus the moral system of Confucian society became a reflection of the universal order.

Confucian subjects turn up frequently in Han art. Among the most famous examples are the reliefs from

CONFUCIUS AND CONFUCIANISM Confucius was born in 551 BCE in the state of Lu, roughly present-day Shandong province, into a declining aristocratic family. While still in his teens he set his heart on becoming a scholar; by his early twenties he had begun to teach.

By Confucius's lifetime, warfare for supremacy among the various states of China had begun, and the traditional social fabric seemed to be breaking down. Looking back to the early Zhou dynasty as a sort of golden age, Confucius thought about how a just and harmonious society could again emerge. For many years he sought a ruler who would put his ideas into effect, but to no avail. Frustrated, he spent his final years teaching. After his death in 479 BCE, his sayings were collected by his disciples and their followers into a

book known in English as the Analects, which is the only record of his words.

At the heart of Confucian thought is the concept of *ren*, or human-heartedness. *Ren* emphasizes morality and empathy as the basic standards for all human interaction. The virtue of *ren* is most fully realized in the Confucian ideal of the *junzi*, or gentleman. Originally indicating noble birth, the term was redirected to mean one who through education and self-cultivation had become a superior person, right-thinking and right-acting in all situations. A *junzi* is the opposite of a petty or small-minded person. His characteristics include moderation, inner integrity, self-control, loyalty, reciprocity, and altruism. His primary concern is justice.

Together with human-heartedness

and justice, Confucius emphasized *li*, or etiquette. *Li* includes scrupulous everyday manners as well as ritual, ceremony, protocol—all of the formalities of social interaction. Such forms, Confucius felt, choreographed life so that an entire society moved in harmony. *Ren* and *li* operate in the realm of the Five Constant Relationships that define Confucian society: parent and child, husband and wife, elder sibling and younger sibling, elder friend and younger friend, ruler and subject. Deference to age is clearly built into this view, as is the deference to authority that made Confucianism popular with emperors. Yet responsibilities flow the other way as well: the duty of a ruler is to earn the loyalty of subjects, of a husband to earn the respect of his wife, of age to guide youth wisely.

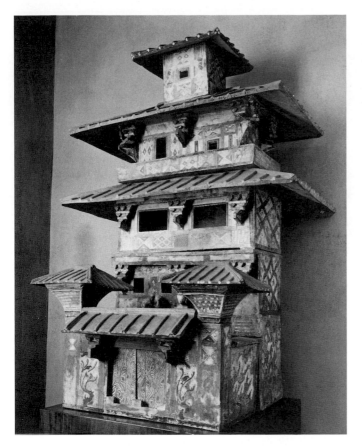

10-9. Tomb model of a house. Eastern Han dynasty, 1st century CE. Painted earthenware, 52 x 33½ x 27" (132.1 x 85.1 x 68.6 cm). The Nelson-Atkins Museum of Art, Kansas City, Missouri

Purchase, Nelson Trust (33–521)

the Wu family shrines built in 151 CE in Jiaxiang. Carved and engraved in low relief on stone slabs, the scenes were meant to teach such basic Confucian themes as respect for the emperor, filial piety, and wifely devotion. Daoist motifs also appear, as do figures from traditional myths and legends. Such mixed **iconography** is characteristic of Han art.

One relief shows a two-story building, with women in the upper floor and men in the lower (fig. 10-8). The central figures in both floors are receiving visitors, some of whom bear gifts. The scene seems to depict homage to the first emperor of the Han dynasty, indicated by his larger size. The birds and small figures on the roof may represent mythical creatures and immortals, while to the left the legendary archer Yi shoots at one of the sun-crows. (Myths tell how Yi shot all but one of the ten crows of the ten suns so that the earth would not dry out.) Across the lower register, a procession brings more dignitaries to the reception.

When compared to the Han dynasty banner (see fig. 10-6), this late Han relief clearly shows the change that took place in the Chinese worldview in the span of 300 years. The banner places equal emphasis on heaven, earth, and the underworld; human beings are dwarfed by a great swarming of supernatural creatures and divine beings. In the Wu shrine, the focus is clearly on the human realm. The composition conveys the importance of the emperor as the holder of the mandate of heaven and illustrates the fundamental Confucian themes of social order and decorum.

ARCHITECTURE

Contemporary literary sources are eloquent on the wonders of the Han capital. Unfortunately, nothing of Han architecture remains except ceramic models. One model of a house found in a tomb, where it was provided for the dead to use in the afterlife, represents a typical Han dwelling (fig. 10-9). Its four stories are crowned with a watchtower and face a small walled courtyard. Pigs and oxen probably occupied the ground floor, while the family lived in the upper stories.

Aside from the multilevel construction, the most interesting feature of the house is the **bracketing** system supporting the rather broad eaves of its tiled roofs. Bracketing became a standard element of East Asian architecture, not only in private homes but more typically in palaces and temples. Another interesting aspect of the model is the elaborate painting on the exterior walls. Much of the painting is purely decorative, though some of it illustrates structural features such as posts and lintels. Still other images evoke the world outdoors: Notice the trees flanking the gateway with crows perched in their branches. Literary sources describe the walls of Han palaces as decorated with paint and lacquer and also inlaid with precious metals and stones.

SIX DYNASTIES

With the fall of the Han dynasty in 220 CE, China splintered into three warring kingdoms. In 280 CE the empire was briefly reunited, but invasions by nomadic peoples from Central Asia, a source of trouble throughout Chinese history, soon forced the court to flee south. For the next three centuries, northern and southern China developed separately. In the north, sixteen kingdoms carved out by invaders rose and fell before giving way to a succession of largely foreign dynasties. Warfare was commonplace. Tens of thousands of Chinese fled south, where six short-lived dynasties succeeded each other in an age of almost constant turmoil broadly known as the Six Dynasties period or the period of the Southern and Northern dynasties (220–579 CE).

In such chaos, the Confucian system lost much influence. In the south especially, many intellectuals—the creators and custodians of China's high culture—turned to Daoism, which contained a strong escapist element. Educated to serve the government, they increasingly withdrew from public life. They wandered the landscape, drank, wrote poems, practiced calligraphy, and expressed their disdain for the world through willfully eccentric behavior.

The rarefied intellectual escape route of Daoism was available only to the educated elite. Far more people sought answers in the magic and superstitions of Daoism in its religious form. Though weak and disorganized,

10-10. Attributed to Gu Kaizhi. Detail of *Admonitions of the Imperial Instructress to Court Ladies*. Six Dynasties period, c. 344–406 CE. Handscroll, ink and colors on silk, 9½" x 11'6" (24.8 cm x 3.5 m). The British Museum, London

the southern courts continued to patronize traditional Chinese culture, and Confucianism remained the official doctrine. Yet ultimately it was a new influence, Buddhism, that brought the greatest comfort to the troubled China of the Six Dynasties.

PAINTING

Although few paintings survive from the Six Dynasties, abundant descriptions in literary sources make clear that the period was an important one for painting. Landscape, later a major theme of Chinese art, first appeared as a subject during this era. For Daoists, wandering through China's countryside was a source of spiritual refreshment. Painters and scholars of the Six Dynasties found that wandering in the mind's eye through a painted landscape could serve the same purpose. This new emphasis on the spiritual value of painting contrasted with the Confucian view, which had emphasized art's moral and didactic uses.

Reflections on the tradition of painting also inspired the first works on theory and aesthetics. One of the earliest and most succinct formulations of the ideals of Chinese painting are the six principles set out by the scholar Xie He (c. 500–c. 535). The first two principles in particular offer valuable insight to the spirit in which China's painters worked.

The first principle announces that "spirit consonance" imbues a painting with "life's movement." This "spirit" is the Daoist *qi*, the breath that animates all creation, the energy that flows through all things. When a painting has *qi*, it will be alive with inner essence, not merely outward resemblance. Artists must cultivate their own spirit so that this universal energy flows through them and infuses their work. The second principle recognizes that brushstrokes are the "bones" of a picture, its primary structural element. The Chinese judge a painting

above all by the quality of its brushwork. Each brushstroke is a vehicle of expression; it is through the vitality of a painter's brushwork that "spirit consonance" makes itself felt. We can sense this attitude already in the rapid, confident brushstrokes that outline the figures of the Han banner and again in the more controlled, rhythmical lines of one of the most important of the very few works surviving from this period, a painted scroll known as *Admonitions of the Imperial Instructress to Court Ladies*. Attributed to the painter Gu Kaizhi (c. 344–406 CE), it alternates illustrations and text to relate seven Confucian stories of wifely virtue from Chinese history.

The first illustration depicts the courage of Lady Feng (fig. 10-10). An escaped circus bear rushes toward her husband, a Han emperor, who is filled with fear. Behind his throne, two female servants have turned to run away. Before him, two male attendants, themselves on the verge of panic, try to fend off the bear with spears. Only Lady Feng is calm as she rushes forward to place herself between the beast and the emperor.

The style of the painting is typical of the fourth century. The figures are drawn with a brush in a thin, even-width line, and a few outlined areas are filled with color. Facial features, especially those of the men, are quite well depicted. Movement and emotion are shown through conventions such as the bands flowing from Lady Feng's dress, indicating that she is rushing forward, and the upturned strings on both sides of the emperor's head, suggesting his fear. There is no hint of a setting; instead, the artist relies on careful placement of the figures to create a sense of depth.

The painting is on silk, a Chinese material with origins in the remote past. Silk was typically woven in bands about 12 inches wide and up to 20 or 30 feet long. Early Chinese painters thus developed the format used here, the **handscroll**—a long, narrow, horizontal composition, compact enough to be held in the hands when

10-11. Wang Xizhi. Portion of a letter from the *Feng Ju* album. Six Dynasties period, mid-4th century CE. Ink on paper, 9¹/₂ x 18¹/₂" (24.7 x 46.8 cm). National Palace Museum, Taipei, Taiwan

The stamped calligraphs that appear on Chinese art works are seals—personal emblems. The use of seals dates from the Zhou dynasty, and to this day seals traditionally employ the archaic characters, known appropriately as "seal script," of the Zhou or Qin. Cut in stone, a seal may state a formal, given name, or it may state any of the numerous personal names that China's painters and writers adopted throughout their lives. A treasured work of art often bears not only the seal of its maker but also those of collectors and admirers through the centuries. In the Chinese view, these do not disfigure the work but add another layer of interest. This sample of Wang Xizhi's calligraphy, for example, bears the seals of two Song dynasty emperors, a Song official, a famous collector of the sixteenth century, and two emperors of the Qing dynasty of the eighteenth and nineteenth centuries.

rolled up. Handscrolls are intimate works, meant to be viewed by only two or three people at a time. They were not displayed completely unrolled as we commonly see them today in museums. Rather, viewers would open a scroll and savor it slowly from right to left, displaying only a foot or two at a time.

CALLIGRAPHY

The emphasis on the expressive quality and structural importance of brushstrokes finds its purest embodiment in **calligraphy**. The same brushes are used for both painting and calligraphy, and a relationship between them was recognized as early as Han times. In his teachings, Confucius had extolled the importance of the pursuit of knowledge and the arts. Among the visual arts, painting was felt to reflect moral concerns, while calligraphy was believed to reveal the style and character of the writer.

Calligraphy is regarded as one of the highest forms of expression in China. For more than 2,000 years, China's literati ("educated"), all of them Confucian scholars, have enjoyed being connoisseurs and practitioners of this abstract art. During the fourth century, calligraphy came to full maturity. The most important practitioner of the day was Wang Xizhi (c. 303–61 CE), whose works have served as models of excellence for all subsequent generations. The example here comes from a letter, now somewhat damaged and mounted as part of an album, known as *Feng Ju* (fig. 10-11).

Feng Ju is an example of "walking" style, which is neither too formal nor too free but is done in a relaxed, easygoing manner. Brushstrokes vary in width and length, creating rhythmic vitality. Individual characters remain distinct, yet within each character the strokes are run together and simplified as the brush moves from one to the other without lifting off the page. The effect is fluid and graceful, yet still strong and dynamic. It was Wang Xizhi who first made this an officially accepted style, to be learned along with other styles.

BUDDHIST ART AND ARCHITECTURE

Buddhism originated in India during the fifth century BCE (Chapter 9), then gradually spread north into Central Asia. With the opening of the Silk Road during the Han dynasty, its influence reached China. To the Chinese of the Six Dynasties, beset by constant warfare and social devastation, Buddhism offered consolation in life and the promise of salvation after death. The faith spread throughout the country to all social levels, first in the north, where many of the invaders promoted it as the official religion, then slightly later in the south, where it found its first great patron in the emperor Liang Wu Di (ruled 502–49 CE). Thousands of temples and monasteries were built, and many people became monks and nuns.

Almost nothing remains in China of the Buddhist architecture of the Six Dynasties, but we can see what it must have looked like in the Japanese temple Horyu-ji (see fig. 11-6), which was based on Chinese models of this period. The slender forms and linear grace of Horyu-ji have much in common with the figures in Gu Kaizhi's handscroll, and they indicate the delicate, almost weightless style cultivated in southern China.

The most impressive works of Buddhist art surviving from the Six Dynasties are the hundreds of northern rock-cut caves that line the Silk Road between Xinjiang in Central Asia and the Yellow River valley. Both the caves and the sculpture that fill them were carved from the solid rock of the cliffs. Small caves high above the ground were retreats for monks and pilgrims, while larger caves at the base of the cliffs were wayside shrines and temples.

The caves at Yungang, in Shanxi province in central China, contain many examples of the earliest phase of

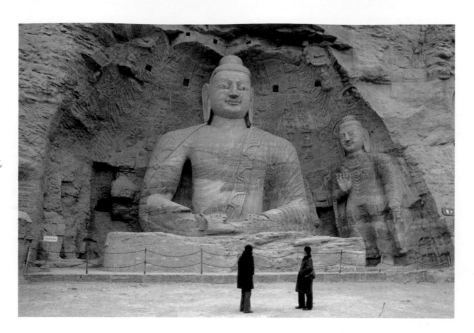

10-12. **Seated Buddha, Cave 20, Yungang, Datong**, Shanxi. Northern Wei dynasty, c. 460 CE. Stone, height 45' (13.7 m)

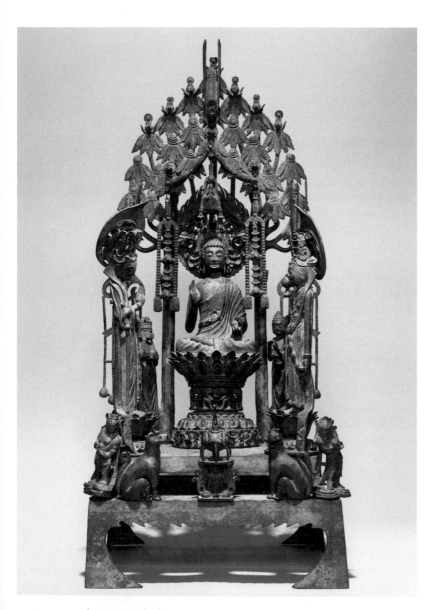

10-13. **Altar to Amitabha Buddha**. Sui dynasty, 593 CE. Bronze, height 30⅛" (76.5 cm). Museum of Fine Arts, Boston
Gift of Mrs. W. Scott Fitz (22.407) and Gift of Edward Holmes Jackson in memory of his mother, Mrs. W. Scott Fitz (47.1407–1412)

Buddhist sculpture in China, including the monumental seated Buddha in Cave 20 (fig. 10-12). The figure was carved in the latter part of the fifth century by imperial decree of a ruler of the Northern Wei dynasty (386–535 CE), the longest-lived and most stable of the northern kingdoms. Most Wei rulers were avid patrons of Buddhism, and under their rule the religion made its greatest advances in the north.

The front part of the cave has crumbled away, and the 45-foot statue, now exposed to the open air, is clearly visible from a distance. The elongated ears, protuberance on the head (*ushnisha*), and monk's robe (*sanghati*) are traditional attributes of the Buddha. The masklike face, full torso, massive shoulders, and shallow, stylized drapery indicate strong Central Asian influence. The overall effect of this colossus is remote and even austere, less human than the more sensuous expression of the early traditions in India. The image of the Buddha became increasingly formal and unearthly as it traveled east from its origins, reflecting a fundamental difference in the way the Chinese and the Indians visualize their deities.

SUI AND TANG DYNASTIES

In 589 CE, a general from the last of the northern dynasties replaced a child emperor and established a dynasty of his own, the Sui. Defeating all opposition, he molded China into a centralized empire as it had been in Han times. The new emperor was a devout Buddhist, and his reunification of China coincided with a fusion of the several styles of Buddhist sculpture that had developed. This new style is seen in a bronze altar to Amitabha Buddha (fig. 10-13), one of the many buddhas espoused by Mahayana Buddhism. Amitabha dwelled in the Western Pure Land, a paradise into which his faithful followers were promised rebirth. With its comparatively simple message of salvation, the Pure Land sect eventually became the most popular form of Buddhism in China and one of the most popular in Japan (see fig. 11-1).

The altar depicts Amitabha in his paradise, seated on a lotus throne beneath a canopy of trees. Each leaf

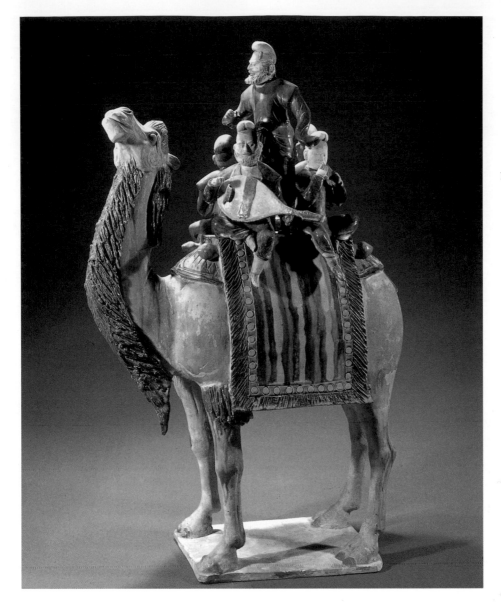

10-14. *Camel Carrying a Group of Musicians*, from a tomb near Xi'an, Shanxi. Tang dynasty, c. mid-8th century CE. Earthenware with three-color glaze, height 26⅛" (66.5 cm). Museum of Chinese History, Beijing

cluster is set with jewels. Seven celestial nymphs sit on the topmost clusters, and ropes of "pearls" hang from the tree trunks. Behind Amitabha's head is a halo of flames. To his left, the **bodhisattva** Guanyin holds a pomegranate; to his right, another *bodhisattva* clasps his hands in prayer. Behind are four disciples who first preached the teachings of the Buddha. On the lower level, an incense burner is flanked by seated dogs and two smaller *bodhisattvas*. Focusing on Amitabha's benign expression and filled with objects symbolizing his power, the altar combines the sensuality of Indian styles, the schematic abstraction of Central Asian art, and the Chinese emphasis on linear grace and rhythm into a harmonious new style.

The short-lived Sui dynasty fell in 617 CE, but in reunifying the empire it paved the way for one of the greatest dynasties in Chinese history, the Tang (618–907 CE). Even today many Chinese living abroad still call themselves "Tang people." To them, Tang implies that part of the Chinese character that is strong and vigorous (especially in military power), noble and idealistic, but also realistic and pragmatic.

Under a series of ambitious and forceful emperors, Chinese control again reached over Central Asia. As in Han times, goods, ideas, and influence flowed across the Silk Road. In the South China Sea, Arab and Persian ships carried on a lively trade with coastal cities. Chinese cultural influence in East Asia was so important that Japan and Korea sent thousands of students to study Chinese civilization.

Cosmopolitan and tolerant, Tang China was confident in itself and curious about the world. Many foreigners came to the splendid new capital, Chang'an (present-day Xi'an), and they are often depicted in the art of the period. A ceramic statue of a camel carrying a troupe of musicians reflects the Tang fascination with the "exotic" Turkic cultures of Central Asia (fig. 10-14). The three bearded musicians (one with his back to us) are Central Asian, while the two smooth-shaven ones are Han Chinese. Two-humped Bactrian camels, themselves exotic Central Asian "visitors," were beasts of burden in the caravans that crisscrossed the Silk Road. The motif of musicians on camelback seems to have been popular in the Tang dynasty, for it also appears in some paintings.

Stylistically, the statue reveals a new interest in **naturalism**, an important trend in both painting and sculpture. Compared to the rigid, staring ceramic soldiers of the first emperor of Qin, the Tang group is alive

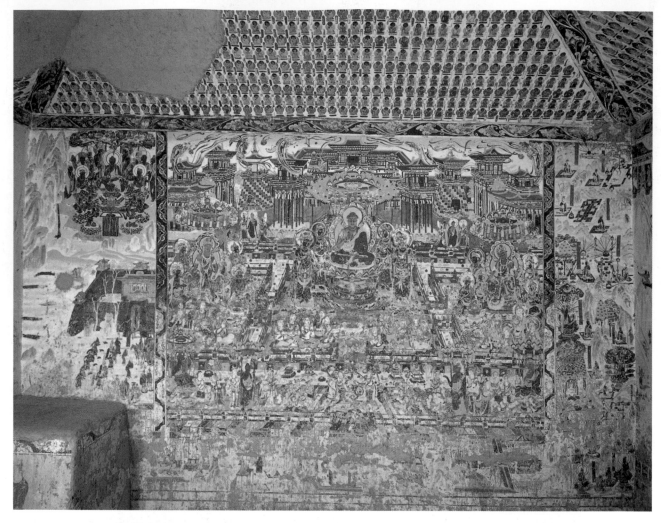

10-15. *The Western Paradise of Amitabha Buddha*, detail of a wall painting in Cave 217, Dunhuang, Gansu. Tang dynasty, c. 750 CE. 10'2" x 16' (3.1 x 4.86 m)

with gesture and expression. The majestic camel throws its head back; the musicians are vividly captured in mid-performance. Ceramic figurines such as this, produced by the thousands for Tang tombs, offer a glimpse into the gorgeous variety of Tang life. The statue's three-color **glaze** technique was a specialty of Tang ceramicists. The glazes—usually chosen from a restricted palette of amber, yellow, green, and white—were splashed freely and allowed to run over the surface during firing to convey a feeling of spontaneity. The technique seems symbolic of Tang culture itself in its robust, colorful, and cosmopolitan expressiveness.

BUDDHIST ART AND ARCHITECTURE

Buddhism reached its greatest development in China during the Tang dynasty. From emperors and empresses to common peasants, virtually the entire country adopted the Buddhist faith. A Tang vision of the most popular sect, Pure Land, was expressed in a wall painting from a cave in Dunhuang (fig. 10-15). A major stop along the Silk Road, Dunhuang has some 500 caves carved out of its sandy cliffs, all filled with painted clay sculpture and decorated with wall paintings from floor to ceiling. The site was worked on continuously from the

fifth to the fourteenth century, a period of almost a thousand years. Rarely in art's history do we have the opportunity to study such an extended period of stylistic and iconographic evolution in one place.

In the detail shown here, Amitabha Buddha is seated in the center, surrounded by four *bodhisattvas*, who serve as his messengers to the world. Two other groups of *bodhisattvas* are clustered at the right and left. In the foreground, musicians and dancers create a heavenly atmosphere. In the background, great halls and towers rise. The artist has imagined the Western Paradise in terms of the grandeur of Tang palaces. Indeed, the lavish entertainment could just as easily be taking place at the imperial court. This worldly vision of paradise, recorded with great attention to naturalism in the architectural setting, contrasts tellingly with the simple portrayal in the earlier Sui altarpiece (see fig. 10-13), and it gives us our best visualization of the splendor of Tang civilization at a time when Chang'an was probably the greatest city in the world.

The early Tang emperors proclaimed a policy of religious tolerance, but during the ninth century a conservative reaction set in. Confucianism was reasserted and Buddhism was briefly persecuted as a "foreign" religion. Thousands of temples, shrines, and monasteries were destroyed and innumerable bronze statues melted down.

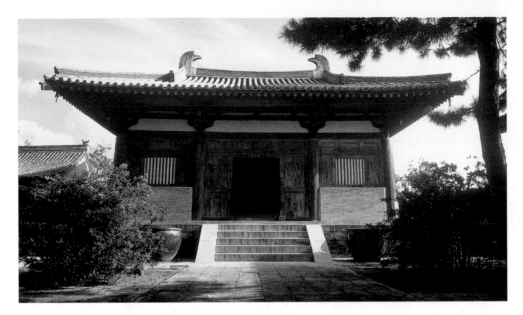

10-16. **Nanchan Temple, Wutaishan**, Shanxi. Tang dynasty, 782 CE

Nevertheless, several Buddhist structures survive from the Tang dynasty, one of which, the Nanchan Temple, is the earliest surviving example of important Chinese architecture.

Nanchan Temple. Of the few structures earlier than 1400 to have survived, the Nanchan Temple is the most significant, for it shows characteristics of both temples and palaces of the Tang dynasty (fig. 10-16). Located on Mount Wutai in the eastern part of Shanxi province, this small hall was constructed in 782 CE. The tiled roof, first seen in the Han tomb model (see fig. 10-9), has taken on a curved silhouette. Quite subtle here, this curve became increasingly pronounced in later centuries. The very broad overhanging eaves are supported by a correspondingly elaborate bracketing system.

Also typical is the **bay** system of construction, in which a cubic unit of space, a bay, is formed by four posts and their lintels. The bay functioned in Chinese architecture as a sort of module, a basic unit of construction. To create larger structures, an architect multiplied the number of bays. Thus the Nanchan Temple—modest in scope with three bays—gives an idea of the vast, multistoried palaces of the Tang depicted in such paintings as the one from Dunhuang.

Great Wild Goose Pagoda. Another important monument of Tang architecture is the Great Wild Goose Pagoda at the Ci'en Temple in Xi'an, the Tang capital (fig. 10-17). The temple was constructed in 645 CE for the famous monk Xuanzang on his return from a sixteen-year pilgrimage to India. At Ci'en Temple, Xuanzang taught and translated the materials he had brought back with him.

The **pagoda**, a typical East Asian Buddhist structure, originated in the Indian Buddhist **stupa**, the elaborated burial mound that housed relics of the Buddha (see "Pagodas," page 418). In India the stupa had developed a multistoried form in the Gandhara region under the Kushan dynasty (c. 50–250 CE). In China this form blended with a traditional Han watchtower to produce the pagoda. Built entirely in masonry, the Great Wild Goose Pagoda nevertheless imitates the wooden architecture of the time. The walls are decorated in low relief to resemble

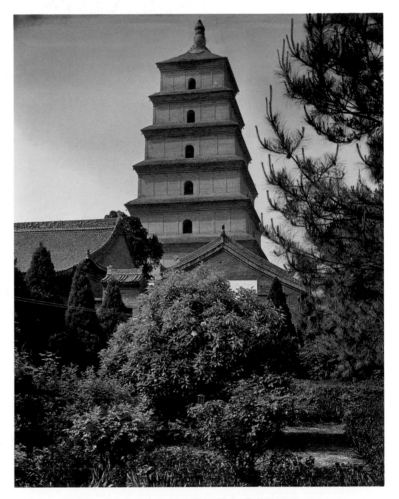

10-17. **Great Wild Goose Pagoda at Ci'en Temple, Xi'an**, Shanxi. Tang dynasty, first erected 645 CE; rebuilt mid-8th century CE

bays, and bracket systems are reproduced under the projecting roofs of each story. Although modified and repaired in later times (its seven stories were originally five, and a new **finial** has been added), the pagoda still preserves the essence of Tang architecture in its simplicity, symmetry, proportions, and grace.

Pagodas are the most characteristic of East Asian architectural forms. Originally associated with Buddhism, **pagodas** developed from Indian **stupas** as Buddhism spread northeastward along the Silk Road. Stupas merged with the watchtowers of Han dynasty China in multistoried stone structures with projecting tiled roofs. This transformation culminated in wooden pagodas with upward-curving roofs supported by elaborate **bracketing** in China, Korea, and Japan. Buddhist pagodas retain the *axis mundi* masts of stupas. Like their South Asian prototypes, early East Asian pagodas were symbolic rather than enclosing structures; they were solid, with small devotional spaces hollowed out. Later examples often provided access to the ground floor and sometimes to upper levels. The layout and construction of pagodas, as well as the number and curve of their roofs, vary depending on the time and place.

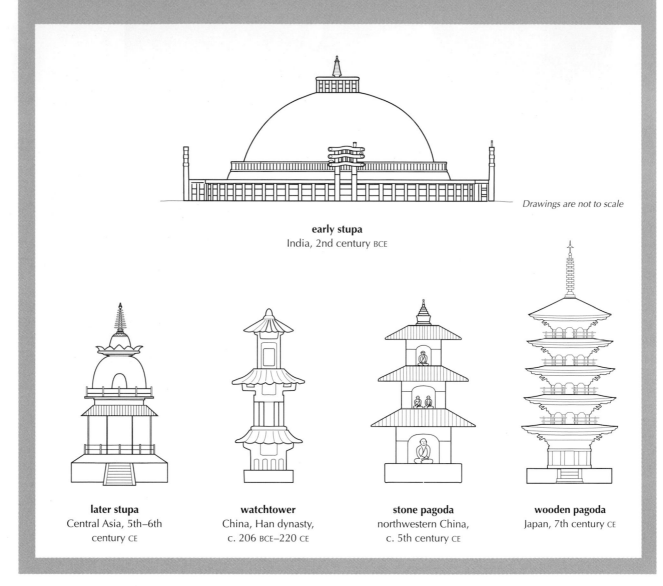

Drawings are not to scale

early stupa
India, 2nd century BCE

later stupa
Central Asia, 5th–6th
century CE

watchtower
China, Han dynasty,
c. 206 BCE–220 CE

stone pagoda
northwestern China,
c. 5th century CE

wooden pagoda
Japan, 7th century CE

FIGURE PAINTING

Later artists looking back on their heritage recognized the Tang dynasty as China's great age of figure painting. Unfortunately, very few scroll paintings that can be definitely identified as Tang still exist. We can get some idea of the character of Tang figure painting from the wall paintings of Dunhuang (see fig. 10-15). Another way to savor the particular flavor of Tang painting is to look at copies made by later Song dynasty artists, which are far better preserved. An outstanding example of this practice is *Ladies Preparing Newly Woven Silk*, attributed to Huizong (ruled 1101–25 CE), the last emperor of the Northern Song dynasty (fig. 10-18). A long handscroll in several sections, it depicts the activities of court women as they weave and iron silk. An inscription on the scroll informs us that the painting is a copy of a famous work by Zhang Xuan, an eighth-century painter known for his depictions of women at the Tang court. The original no longer exists, so we cannot know how faithful the copy is. Still, its refined lines and bright colors seem to share not only the grace and simplicity of Tang sculpture and architecture but also the quiet beauty characteristic of Tang painting.

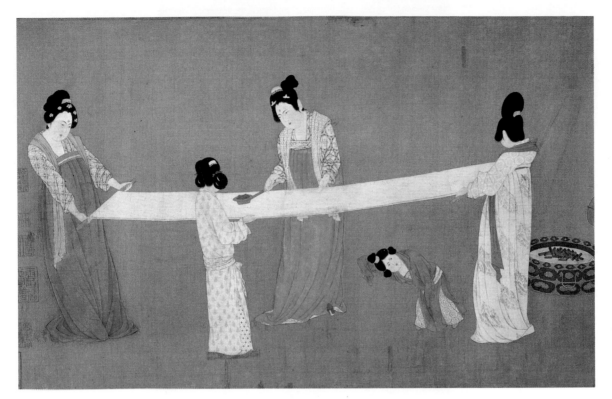

10-18. Attributed to Emperor Huizong. Detail of *Ladies Preparing Newly Woven Silk*, copy after a lost Tang dynasty painting by Zhang Xuan. Northern Song dynasty, early 12th century CE. Handscroll, ink and colors on silk, 14½ x 57½" (36.8 x 145.5 cm). Museum of Fine Arts, Boston

Chinese and Japanese Special Fund

Confucius said of himself, "I merely transmit, I do not create; I love and revere the ancients." In this spirit, Chinese painters regularly copied paintings of earlier masters. Painters made copies both to absorb the lessons of their great predecessors and to perpetuate the achievements of the past. In later centuries, painters took up the practice of regularly executing a work "in the manner of" some particularly revered ancient master. This was at once an act of homage, a declaration of artistic allegiance, and a way of reinforcing a personal connection with the past.

SONG DYNASTY

A brief period of disintegration followed the fall of the Tang dynasty before China was again united, this time under the Song dynasty (960–1279 CE), which established a new capital at Bianjing (present-day Kaifeng), near the Yellow River. In contrast to the outgoing confidence of the Tang, the mood during the Song was more introspective, a reflection of China's weakened military situation. In 1126 the Jurchen tribes of Manchuria invaded China, sacked the capital, and took possession of much of the northern part of the country. Song forces withdrew south and established a new capital at Hangzhou. From this point on, the dynasty is known as Southern Song (1127–1279 CE), with the first portion called in retrospect Northern Song (960–1126 CE).

Although China's territory had diminished, its wealth had increased because of advances in agriculture, commerce, and technology begun under the Tang. Patronage was plentiful, and the arts flourished. Song culture is noted for its highly refined taste and intellectual grandeur. Where the Tang had reveled in exoticism, eagerly absorbing influences from Persia, India, and Central Asia, Song culture was more self-consciously Chinese. Philosophy experienced its most creative era since the "one hundred schools" of the Zhou. Song scholarship was brilliant, especially in history, and its poetry is noted for its depth. But the finest expressions of the Song are in art, especially painting and ceramics.

PHILOSOPHY: NEO-CONFUCIANISM

Song philosophers continued the process, begun during the Tang, of restoring Confucianism to dominance. In strengthening Confucian thought, philosophers drew on Daoism and especially Buddhism, even as they openly rejected Buddhism itself as foreign. These innovations provided Confucianism with a metaphysical aspect it had previously lacked, allowing it to propose a more satisfying, all-embracing explanation of the universe. This new synthesis of China's three main paths of thought is called Neo-Confucianism.

Neo-Confucianism teaches that the universe consists of two interacting forces known as *li* (principle or idea) and *qi* (matter). All pine trees, for example, consist

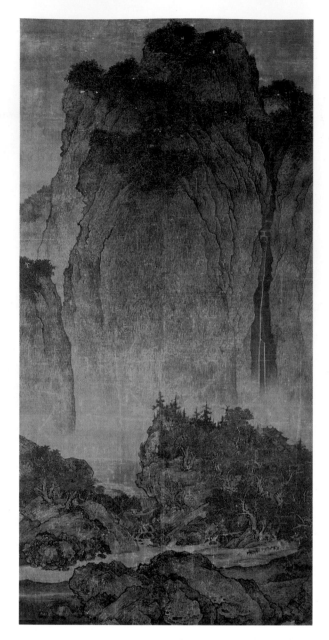

10-19. Fan Kuan. *Travelers among Mountains and Streams*. Northern Song dynasty, early 11th century CE. Hanging scroll, ink and colors on silk, height 6'9½" (2.06 m). National Palace Museum, Taipei, Taiwan

of an underlying *li* we might call "Pine Tree Idea" brought into the material world through *qi*. All the *li* of the universe, including humans, are but aspects of an eternal first principle known as the Great Ultimate, which is completely present in every object. Our task as human beings is to rid our *qi* of impurities through education and self-cultivation so that our *li* may realize its oneness with the Great Ultimate. This lifelong process resembles the striving to attain buddhahood, and if we persist in our attempts, one day we will be enlightened—the term itself comes directly from Buddhism.

NORTHERN SONG PAINTING

The Neo-Confucian ideas found visual expression in art, especially in landscape, which became the most highly esteemed subject for painting. Northern Song artists studied nature closely to master its many appearances—the way each species of tree grew, the distinctive character of each rock formation, the changes of the

seasons, the myriad birds, blossoms, and insects. This passion for realistic detail was the artist's form of self-cultivation: Mastering outward forms showed an understanding of the principles behind them.

Yet despite the convincing accumulation of detail, the paintings do not record a specific site. The artist's goal was to paint the eternal essence of mountain-ness, for example, not to reproduce the appearance of a particular mountain. Painting a landscape required an artist to orchestrate his cumulative understanding of *li* in all its aspects—mountains and rocks, streams and waterfalls, trees and grasses, clouds and mist. A landscape painting thus expressed the desire for the spiritual communion with nature that was the key to enlightenment. As the tradition progressed, landscape also became a vehicle for conveying human emotions, even for speaking indirectly of one's own deepest feelings.

In the earliest times, art reflected the mythocentric worldview of the ancient Chinese. During the period when the three religions dominated people's lives, there

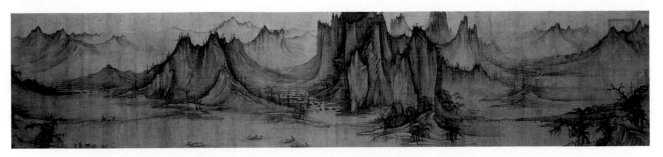

10-20. Xu Daoning. Detail of *Fishing in a Mountain Stream*. Northern Song dynasty, mid-11th century CE. Handscroll, ink on silk, 19" x 6'10" (48.9 cm x 2.09 m). The Nelson-Atkins Museum of Art, Kansas City, Missouri
Purchase, Nelson Trust (33–1559)

was a major shift in which religious images and human actions became the most important subjects. The choice of landscape as the chief means of expression, reflecting the general Chinese desire to avoid direct depiction of the human condition and to show things instead in a symbolic manner, was the second great shift in the focus of Chinese art. The major form of Chinese artistic expression thus moved from the mythical, through the religious and ethical, and finally to the philosophical and aesthetic.

One of the first great masters of Song landscape was the eleventh-century painter Fan Kuan (active c. 990–1030 CE), whose surviving major work, *Travelers among Mountains and Streams*, is generally regarded as one of the greatest monuments in the history of Chinese art (fig. 10-19). The work is physically large—almost 7 feet high—but the sense of monumentality also radiates from the composition itself, which makes its impression even when much reduced.

The composition unfolds in three stages, comparable to the three acts of a drama. At the bottom a large, low-lying group of rocks, taking up about one-eighth of the picture surface, establishes the extreme foreground. The rest of the landscape pushes back from this point. In anticipating the shape and substance of the mountains to come, the rocks introduce the main theme of the work, much as the first act of a drama introduces the principal characters. In the middle ground, travelers and their mules are coming from the right. They are somewhat startling, for we suddenly realize our human scale—how small we are, how vast nature is. This middle ground takes up twice as much picture surface as the foreground, and, like the second act of a play, shows variation and development. Instead of a solid mass, the rocks here are separated into two groups by a waterfall spanned by a bridge. In the hills to the right, the rooftops of a temple stand out above the trees.

Mist veils the transition to the background, with the result that the mountain looms suddenly. This background area, almost twice as large as the foreground and middle ground combined, is the climactic third act of the drama. As our eyes begin their ascent, the mountain solidifies. Its ponderous weight increases as it billows upward, finally bursting into the sprays of energetic brushstrokes that describe the scrubby growth on top. To the right, a slender waterfall plummets, not to balance the powerful upward thrust of the mountain but simply to enhance it by

contrast. The whole painting, then, conveys the feeling of climbing a high mountain, leaving the human world behind to come face to face with the Great Ultimate in a spiritual communion.

All the elements are depicted with precise detail and in proper scale. Jagged brushstrokes describe the contours of rocks and trees and express their rugged character. Layers of short, staccato strokes (called "raindrop texture" in Chinese) accurately mimic the texture of the rock surface. Spatial recession from foreground through middle ground to background is logically and convincingly handled, if not yet quite continuous.

Although it contains realistic details, the landscape represents no specific place. In its forms, the artist expresses the ideal forms behind appearances; in the rational, ordered composition, he expresses the intelligence of the universe. The arrangement of the mountains, with the central peak flanked by lesser peaks on each side, seems to reflect both the ancient Confucian notion of social hierarchy, with the emperor flanked by his ministers, and the Buddhist motif of the Buddha with *bodhisattvas* at his side. The landscape, a view of nature uncorrupted by human habitation, expresses a kind of Daoist ideal. Thus we find the three strains of Chinese thought united, much as they are in Neo-Confucianism itself.

The ability of Chinese landscape painters to take us out of ourselves and to let us wander freely through their sites is closely linked to the avoidance of perspective as it is understood in the West. Fifteenth-century European painters, searching for fidelity to appearances, developed a "scientific" system for recording exactly the view that could be seen from a single, fixed vantage point. The goal of Chinese painting is precisely to get away from such limits and show a totality beyond what we are normally given to see. If we can imagine the ideal for centuries of Western painters as a photograph, which shows only what can be seen from a fixed viewpoint, we can imagine the ideal for Chinese artists as a film camera aloft in a balloon: distant, all-seeing, and mobile.

The sense of shifting perspective is clearest in the handscroll, where our vantage point changes constantly as we move through the painting. One of the finest handscrolls to survive from the Northern Song is *Fishing in a Mountain Stream* (fig. 10-20), a 7-foot-long painting executed in the middle of the eleventh century by Xu Daoning

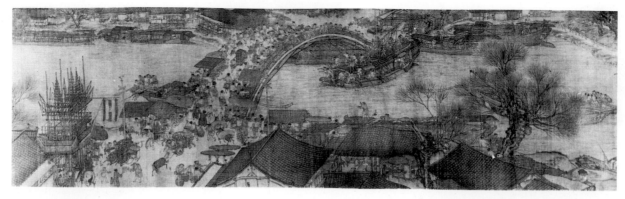

10-21. Zhang Zeduan. Detail of *Spring Festival on the River*. Northern Song dynasty, early 12th century CE. Handscroll, ink and colors on silk, 9½" x 7'4" (24.8 cm x 2.28 m). The Palace Museum, Beijing

(c. 970–c. 1052 CE). Starting from a thatched hut in the right foreground, we follow a path that leads to a broad, open view of a deep vista dissolving into distant mists and mountain peaks. (Remember that viewers observed only a small section of the scroll at a time. To mimic the effect, use two pieces of paper to frame a small viewing area, then move them slowly leftward.) Crossing over a small footbridge, we are brought back to the foreground with the beginning of a central group of high mountains that show extraordinary shapes. Again our path winds back along the bank, and we have a spectacular view of the highest peaks from another small footbridge the artist has placed for us. At the far side of the bridge, we find ourselves looking up into a deep valley, where a stream lures our eyes far into the distance. We can imagine ourselves resting for a moment in the small pavilion the artist offers us halfway up the valley on the right. Or perhaps we may spend some time with the fishers in their boats as the valley gives way to a second, smaller group of mountains, serving both as an echo of the spectacular central group and as a transition to the painting's finale, a broad, open vista. As we cross the bridge here, we meet travelers coming toward us, who will have our experience in reverse. Gazing out into the distance and reflecting on our journey, we again feel that sense of communion with nature that is the goal of Chinese artistic expression.

Such handscrolls have no counterpart in the Western visual arts and are often compared instead to the tradition of Western music, especially symphonic compositions. Both are generated from opening motifs that are developed and varied, both are revealed over time, and in both our sense of the overall structure relies on memory, for we do not see the scroll or hear the composition all at once.

The Northern Song fascination with precision extended to details within landscape. The emperor Huizong, whose copy of *Ladies Preparing Newly Woven Silk* was seen in figure 10-18, gathered around himself a group of court painters who shared his passion for quiet, exquisitely detailed, delicately colored paintings of birds and flowers. Other painters specialized in domestic and wild animals, still others in palaces and buildings. One of the most spectacular products of this passion for observation is *Spring Festival on the River*, a long handscroll painted in the first quarter of the twelfth century by Zhang Zeduan, an artist connected to the court (fig. 10-21).

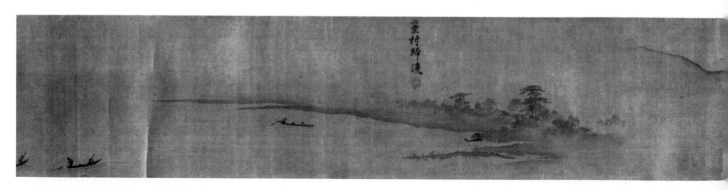

10-22. Xia Gui. Detail of *Twelve Views from a Thatched Hut*. Southern Song dynasty, early 13th century CE. Handscroll, ink on silk, height 11" (28 cm), length of extant portion 7'7½" (2.31 m). The Nelson-Atkins Museum of Art, Kansas City, Missouri
Purchase, Nelson Trust (32-159/2)

Beyond its considerable visual delights, the painting is also an invaluable record of daily life in the Song capital.

The painting is set on the day of a festival, when local inhabitants and visitors from the countryside thronged the streets. One high point is the scene reproduced here, which takes place at the Rainbow Bridge. The large boat to the right is probably bringing goods from the southern part of China up the Grand Canal that ran through the city at that time. The sailors are preparing to pass beneath the bridge by lowering the sail and taking down the mast. Excited figures on ship and shore gesture wildly, shouting orders and advice, while a noisy crowd gathers at the bridge railing to watch. Stalls on the bridge are selling food and other merchandise; wine shops and eating places line the banks of the canal. Everyone is on the move. Some people are busy carrying goods, some are shopping, some are simply enjoying themselves. Each figure is splendidly animated and full of purpose; the buildings and boats are perfect in every detail—the artist's knowledge of this bustling world was indeed encyclopedic.

Little is known about the painter Zhang Zeduan other than that he was a member of the scholar-official class, the highly educated elite of imperial China. Interestingly, some of Zhang Zeduan's peers were already beginning to cultivate quite a different attitude toward painting as a form of artistic expression, one that placed overt skill at the lowest end of the scale of values. This emerging scholarly aesthetic later came to dominate Chinese thinking about art, with the result that only in the twentieth century has *Spring Festival* again found an audience willing to hold it in the highest esteem.

SOUTHERN SONG PAINTING AND CERAMICS

Landscape painting took a very different course after the fall of the north and the removal of the court to its new capital in the south, Hangzhou. This new sensibility is reflected in the extant portion of *Twelve Views from a Thatched Hut* (fig. 10-22) by Xia Gui (c. 1180–1230 CE), a member of the newly established Academy of Painters. In general, academy members continued to favor such subjects as birds and flowers in the highly refined, elegantly colored court style patronized earlier by Huizong. Xia Gui, however, was interested in landscape and cultivated his own style. Only the last four of the twelve views that originally made up this long hand-scroll have survived, but they are enough to illustrate the unique quality of his approach.

In sharp contrast to the majestic, austere landscapes of the Northern Song painters, Xia Gui presents an intimate and lyrical view of nature. Subtly modulated, perfectly controlled ink washes evoke a landscape veiled in mist, while a few deft brushstrokes suffice to indicate the details showing through—the grasses growing by the bank, the fishers at their work, the trees laden with moisture, the two bent-backed figures carrying their heavy load along the path that skirts the hill. Simplified forms, stark contrasts of light and dark, asymmetrical composition, and great expanses of blank space suggest a fleeting world that can be captured only in glimpses. The intangible is somehow more real than the tangible. By limiting himself to a few essential details, the painter evokes a deep feeling for what lies beyond.

This development in Song painting from the rational and intellectual to the emotional and intuitive, from the tangible to the intangible, had a parallel in philosophy. During the late twelfth century a new school of Neo-Confucianism called School of the Mind insisted that self-cultivation could be achieved through contemplation, which might lead to sudden enlightenment. The idea of sudden enlightenment may have come from Chan Buddhism, better known in the West by its Japanese name, Zen. Chan Buddhists rejected such formal paths to enlightenment as scripture, knowledge, and ritual in favor of meditation and techniques designed to "short-circuit" the rational mind. Xia Gui's painting seems also to follow this intuitive approach.

The subtle and sophisticated paintings of the Song were created for a highly cultivated audience equally discerning in other arts such as ceramics. Building on the considerable accomplishments of the Tang, Song potters achieved a technical and aesthetic perfection that has

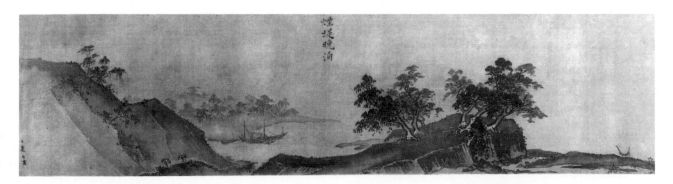

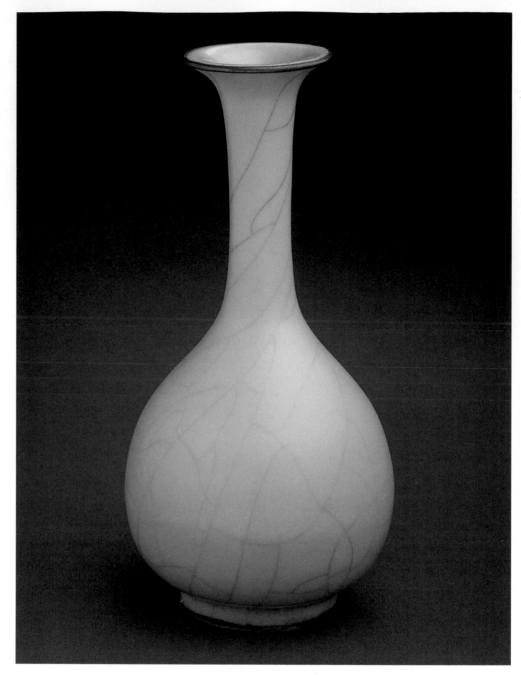

10-23. Guan Ware vase. Southern Song dynasty, 13th century CE. Porcelaneous stoneware with crackled glaze, height 6⅝" (16.8 cm). Percival David Foundation of Chinese Art, London

made their wares models of excellence throughout the world. Like their painter contemporaries, Song potters turned away from the exuberance of Tang styles to create more quietly beautiful pieces.

The most highly prized of the many types of Song ceramics is Guan Ware, made mainly for imperial use (fig. 10-23). The everted lip, high neck, and rounded body of this simple vase show a strong sense of harmony. Aided by a lustrous white glaze, the form flows without break from base to lip. The piece has an introspective quality as eloquent as the blank spaces in Xia Gui's painting. The aesthetic of the Song is most evident in the crackle pattern that spreads over the surface. The crackle technique was probably discovered accidentally, but it came to be used deliberately in some of the finest Song

wares. In the play of irregular, spontaneous crackles over a perfectly regular, perfectly planned form we can sense the same spirit that hovers behind the self-effacing virtuosity and freely intuitive insights of Xia Gui's landscape.

In 1279 the Southern Song dynasty fell to the conquering forces of the Mongol leader Kublai Khan. China was subsumed into the vast Mongol Empire. Mongol rulers founded the Yuan dynasty (1279–1368 CE), setting up their capital in the northeast in what is now Beijing. Yet the cultural center of China remained in the south, in the cities that rose to prominence during the Song. This separation of political and cultural centers, coupled with a lasting resentment of "barbarian" rule, created the climate for later developments in the arts.

PERIOD	ART IN CHINA BEFORE 1280	ART IN OTHER CULTURES
NEOLITHIC c. 5000–2000 BCE	10-2. Yangshao bowl (5000–4000 BCE) 10-3. Liangzhu *cong* (before 3000 BCE)	2-25. Susa beaker (c. 4000 BCE), Iran 3-4. *Palette of Narmer* (c. 3000 BCE), Egypt 3-10. Giza pyramids (c. 2613–2494 BCE), Egypt 9-4. Harappa torso (c. 2000 BCE), India
BRONZE AGE c. 1700–221 BCE	10-4. *Fang ding* (c. 12th cent. BCE)	5-39. Parthenon (447–438 BCE), Greece 5-1. *Discus Thrower* (c. 450 BCE), Greece
QIN DYNASTY c. 221–206 BCE	10-1. Qin soldiers (c. 210 BCE)	5-74. *Gallic Chieftain Killing His Wife and Himself* (c. 220 BCE), Greece
HAN DYNASTY c. 206 BCE–220 CE	10-6. Painted banner (c. 160 BCE) 10-8. Wu shrine relief (151 CE) 10-9. Model of Han house (1st cent. CE)	6-22. Ara Pacis (13–9 BCE), Italy 6-28. Column of Trajan (113–16 or after 117 CE), Italy
SIX DYNASTIES c. 220–579 CE	10-10. Gu. *Admonitions of the Imperial Instructress to Court Ladies* (c. 344–406 CE) 10-11. Wang. *Feng Ju* calligraphy (mid-4th cent. CE) 10-12. Seated Buddha (c. 460 CE)	7-5. Dura-Europos synagogue (244–45 CE), Syria 9-17. Ajanta *Bodhisattva* (c. 475 CE), India 7-22. Hagia Sophia (532–37 CE), Turkey 11-4. *Haniwa* (6th cent. CE), Japan
SUI DYNASTY c. 589–617 CE	10-13. Amitabha Buddha altar (593 CE)	
TANG DYNASTY c. 618–907 CE	10-14. *Camel Carrying a Group of Musicians* (c. mid-8th cent. CE) 10-15. *The Western Paradise of Amitabha Buddha* (c. 750 CE) 10-16. Nanchan Temple (782 CE) 10-17. Great Wild Goose Pagoda (rebuilt mid-8th cent. CE)	8-6. Córdoba mosque (785–86 CE), Spain 14-12. Charlemagne's chapel (792–805 CE), Germany 14-17. *Utrecht Psalter* (c. 825–50 CE), Netherlands
SONG DYNASTY c. 960–1279 CE	10-19. Fan. *Travelers among Mountains and Streams* (early 11th cent. CE) 10-21. Zhang. *Spring Festival on the River* (early 12th cent. CE) 10-22. *Twelve Views from a Thatched Hut* (early 13th cent. CE) 10-23. Guan Ware vase (13th cent. CE)	7-39. Cathedral of Saint Mark (begun 1063 CE), Italy 15-32. *Bayeux Tapestry* (c. 1066–77 CE), France 9-28. *Shiva Nataraja* (12th cent. CE), India 16-6. Chartres Cathedral (c. 1134–1220 CE), France 12-23. Anasazi seed jar (1150 CE), North America

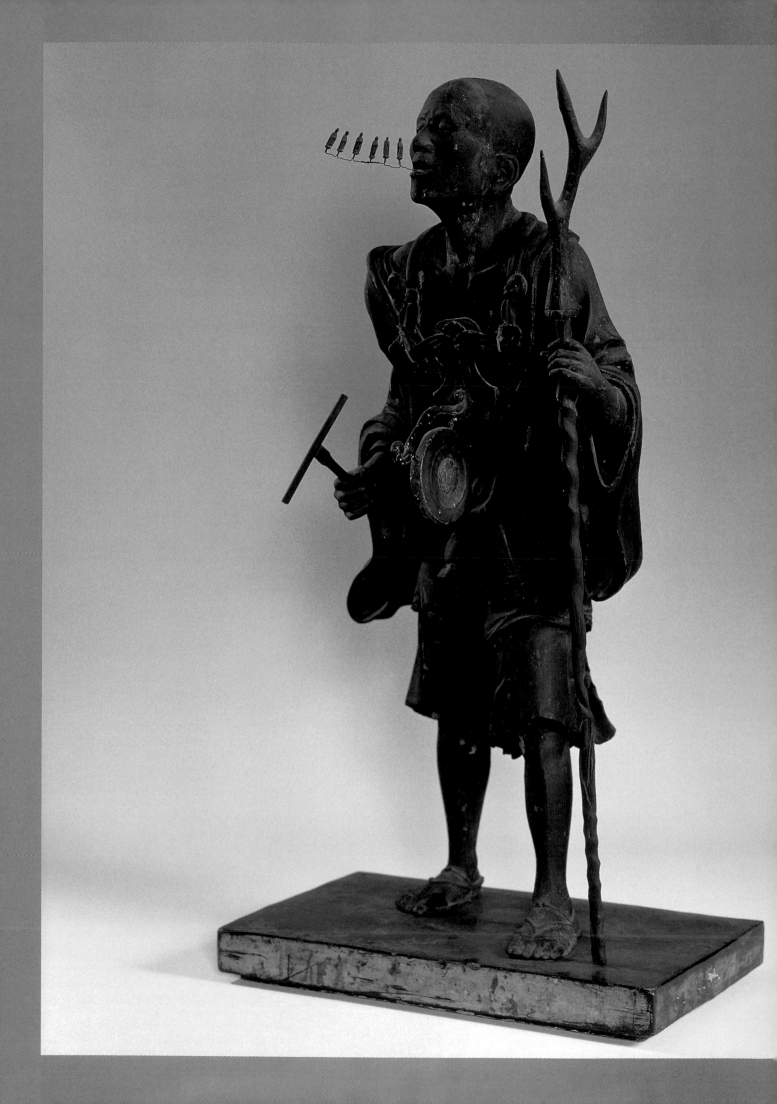

11
Japanese Art before 1392

Rising militarism, political turbulence, and the excesses of the imperial court marked the beginning of the eleventh century in Japan. To many Japanese of the late Heian and Kamakura eras (Timeline 11-1), the unsettled times seemed to confirm the coming of *Mappo*, a long-prophesied dark age of spiritual degeneration. Japanese of all classes reacted by increasingly turning to the promise of simple salvation extended by Pure Land Buddhism, which had spread from China by way of Korea. The religion held that merely by chanting *Namu Amida Butsu*, hailing the Buddha Amida (the Japanese version of Amitabha Buddha), the faithful would be reborn into the Western Pure Land paradise over which he presided.

The practice had been spread throughout Japan by traveling monks such as the charismatic Kuya (903–72 CE), who encouraged people to chant by going through the countryside singing.

Believers would have immediately recognized Kuya in this thirteenth-century statue by Kosho (fig. 11-1): The traveling clothes, the small gong, the staff topped by deer horns (symbolic of his slaying a deer, whose death converted him to Buddhism), clearly identify the monk, whose sweetly intense expression gives this sculpture a radiant sense of faith. As for Kuya's chant, Kosho's solution to the challenge of putting words into sculptural form was simple but brilliant: He carved six small buddhas emerging from Kuya's mouth, one for each of the six syllables *Na-mu-A-mi-da-Buts(u)* (the final *u* is not articulated). Believers would have understood that these six small buddhas embodied the Pure Land chant.

In combining the realistic portrait of Kuya with the abstract representation of the chant, this statue reveals the tolerance of—even preference for—paradox in Japanese art.

11-1. Kosho. *Kuya Preaching*. Kamakura period, before 1207. Painted wood, height 46½" (117.5 cm). Rokuhara Mitsu-ji, Kyoto

TIMELINE 11-1. **Japan before 1392.** Prehistoric cultures gave way to a settled agricultural way of life. Beginning about 550 CE, Japan experienced several periods of intense cultural transformation: Asuka, Nara, Heian, and Kamakura.

MAP 11-1. **Japan before 1392.** Melting glaciers at the end of the Ice Age in Japan 15,000 years ago raised the sea level and formed the four main islands of Japan: Hokkaido, Honshu, Shikoku, and Kyushu.

PREHISTORIC JAPAN

The earliest traces of human habitation in Japan are at least 30,000 years old. At that time the four islands that comprise the country today were still linked to the East Asian landmass, forming a ring from Siberia to Korea around the present-day Sea of Japan, which was then a lake. With the end of the last Ice Age there, some 15,000 years ago, melting glaciers caused the sea level to rise, gradually submerging the lowland links and creating the islands as we know them today (Map 11-1). Sometime after, Paleolithic peoples gave way to Neolithic hunter-gatherers, who crafted stone tools and gradually developed the ability to make and use ceramics. Recent scientific dating methods have shown some works of Japanese pottery to date earlier than 10,000 BCE, making them the oldest now known.

JOMON PERIOD

The Jomon period (c. 12,000–300 BCE) is named for the patterns on much of the pottery produced during this time, which were made by pressing cord onto damp clay (*jomon* means "cord markings"). Jomon people were able to develop an unusually sophisticated hunting-gathering culture in part because their island setting protected them from large-scale invasions and also because of their abundant food supply. Around 5000 BCE, agriculture emerged with the planting and harvesting of beans and gourds. Some 4,000 years later, the Jomon began to cultivate rice, but nevertheless remained primarily a hunting-gathering society that used stone tools and weapons. People lived in small communities, usually with fewer than ten or twelve dwellings, and

300 BCE			300 CE	500 BCE	700 CE	900 CE	1100 CE	1200 CE	1400 CE

▲ c. 300 BCE–300 CE YAYOI ▲ c. 300–552 CE KOFUN ▲ c. 552–646 ASUKA ▲ c. 794–1185 HEIAN ▲ c. 1185–1392 KAMAKURA

▲ c. 646–794 NARA

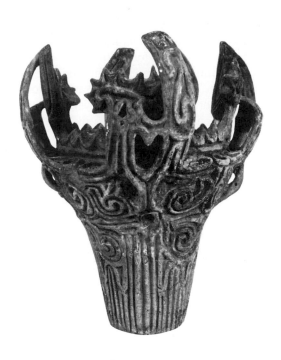

11-2. Vessel, from the Asahi Mound, Toyama Prefecture. Jomon period, c. 2000 BCE. Low-fired ceramic, height 14 3/4" (37.4 cm). Collection of Tokyo University

11-3. *Dogu*, from Kurokoma, Yamanashi Prefecture. Jomon period, c. 2000 BCE. Low-fired earthenware, height 10" (25.2 cm). Tokyo National Museum

seem to have enjoyed a peaceful life, giving them the opportunity to develop their artistry for even such practical endeavors as ceramics.

Jomon ceramics may have begun in imitation of reed baskets, as many early examples suggest. Other early Jomon pots have pointed bottoms. Judging from burn marks along the sides, they must have been planted firmly into soft earth or sand, then used for cooking. Applying fire to the sides rather than the bottom allowed the vessels to heat more fully and evenly. Still other early vessels were crafted with straight sides and flat bottoms, a shape that was useful for storage as well as cooking and eventually became the norm. Jomon usually crafted their vessels by building them up with coils of clay, then firing them in bonfires at relatively low temperatures. Researchers think that Jomon pottery was made by women, as was the practice in most early societies, especially before the use of the potter's wheel.

During the middle Jomon period (2500–1500 BCE), pottery reached a high degree of creativity. By this time communities were somewhat larger, and each family may have wanted its ceramic vessels to have a unique design. The basic form remained the straight-sided cooking or storage jar, but the rim now took on spectacular, flamboyant shapes, as seen in one example from the Asahi Mound (fig. 11-2). Middle Jomon potters made full use of the tactile quality of clay, bending and twisting it as well as **incising** and applying designs. They favored asymmetrical shapes, although certain elements in the geometric patterns are repeated. Some designs may have had specific meanings, but the lavishly creative vessels also display a playful artistic spirit. Rather than working toward practical goals (such as better firing techniques or more useful shapes), Jomon potters seem to have been simply enjoying to the full their imaginative vision.

The people of the middle and late Jomon periods also used clay to fashion small humanoid figures. These figures were never fully realistic but rather were distorted into fascinating shapes. Called ***dogu***, they tend to have large faces, small arms and hands, and compact bodies. Some of the later *dogu* seem to be wearing round goggles over their eyes. Others have heart-shaped faces. One of the finest, from Kurokoma, has a face remarkably like a cat's (fig. 11-3). The slit eyes and mouth have a haunting quality, as does the gesture of one hand touching the chest. The marks on the face, neck, and shoulders suggest tattooing and were probably incised with a bamboo stick. The raised area behind the face may indicate a Jomon hairstyle.

The purpose of Jomon *dogu* remains unknown, but most scholars believe that they were effigies, figures

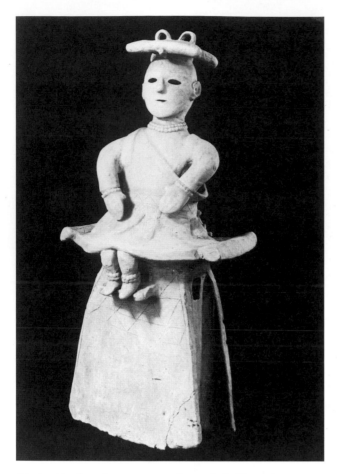

11-4. *Haniwa*, from Kyoto. Kofun period, 6th century CE. Earthenware, height 27" (68.5 cm). Tokyo National Museum

There have been many theories as to the function of *haniwa*. The figures seem to have served as some kind of link between the world of the dead, over which they were placed, and the world of the living, from which they could be viewed. This figure has been identified as a seated female shaman, wearing a robe, belt, and necklace and carrying a mirror at her waist. In early Japan, shamans acted as agents between the natural and the supernatural worlds, just as *haniwa* figures were links between the living and the dead.

representing the owner or someone else, and that they manifested a kind of sympathetic magic. Jomon people may have believed, for example, that they could transfer an illness or other unhappy experience to a *dogu*, then break it to destroy the misfortune. So many of these figures were deliberately broken and discarded that this theory has gained acceptance, but *dogu* may have had different functions at different times. Regardless of their purpose, the images still retain a powerful sense of magic thousands of years after their creation.

YAYOI AND KOFUN PERIODS

During the Yayoi (c. 300 BCE–300 CE) and Kofun (c. 300–552 CE) eras, several features of Japanese culture became firmly established. Most important of these was

the transformation of Japan into an agricultural nation, with rice cultivation becoming widespread. This momentous change was stimulated by the arrival of immigrants from Korea, who brought with them more complex forms of society and government.

As it did elsewhere in the world, the shift from hunting and gathering to agriculture brought profound social changes, including larger permanent settlements, the division of labor into agricultural and nonagricultural tasks, more hierarchical forms of social organization, and a more centralized government. The emergence of a class structure can be dated to the Yayoi period, as can the development of metal technology. Bronze was used to create weapons as well as ceremonial objects such as bells. Iron knives were developed later in this period, eventually replacing stone tools in everyday life.

Yayoi people lived in thatched houses with sunken floors and stored their food in raised granaries. The granary architecture, with its use of natural wood and thatched roofs, reflects the Japanese appreciation of natural materials, and the style of these raised granaries persisted in the architectural designs of shrines in later centuries (see fig. 11-5).

The trend toward centralization of government became more pronounced during the ensuing Kofun, or "old tombs," period, named for the large royal tombs that were built then. With the emergence of a more complex social order, the veneration of leaders grew into the beginnings of an imperial system. Still in existence today in Japan, this system eventually equated the emperor (or, very rarely, empress) with deities such as the sun goddess. When an emperor died, chamber tombs were constructed following Korean examples. Various grave goods were placed inside the tomb chambers, including large amounts of pottery, presumably to pacify the spirits of the dead and to serve them in their next life. Many Korean potters came to Japan in the fifth century CE, bringing their knowledge of finishing techniques and improved kilns. Their new form of gray-green pottery was first used for ceremonial purposes in Japan and later entered daily life.

The Japanese government has never allowed the major sacred tombs to be excavated, but much is known about the mortuary practices of Kofun-era Japan. Some of the huge tombs of the fifth and sixth centuries CE were constructed in a shape resembling a large keyhole and surrounded by **moats** dug to preserve the sacred land from commoners. Tomb sites might extend over more than 400 acres, with artificial hills built over the tombs themselves. On the top of the hills were placed ceramic works of sculpture called **haniwa**.

The first *haniwa* were simple cylinders that may have held jars with ceremonial offerings. Gradually these cylinders came to be made in the shapes of ceremonial objects, houses, and boats. Still later, living creatures were added to the repertoire of *haniwa* subjects, including birds, deer, dogs, monkeys, cows, and horses. Finally, *haniwa* in human shapes were crafted, including males and females of all types, professions, and classes (fig. 11-4).

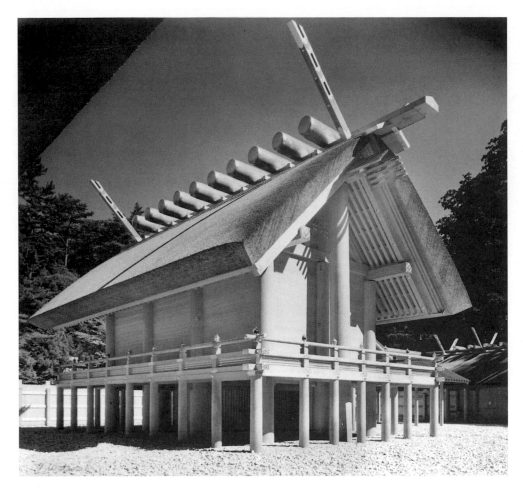

11-5. Inner shrine, Ise, Mie Prefecture. Yayoi period, early 1st century CE; last rebuilt 1993

Haniwa illustrate several enduring characteristics of Japanese aesthetic taste. Unlike Chinese tomb ceramics, which were often beautifully glazed, *haniwa* were left unglazed to reveal their clay bodies. Nor do *haniwa* show the interest in technical skill seen in Chinese ceramics. Instead, their makers explored the expressive potentials of simple and bold form. *Haniwa* shapes are never perfectly symmetrical; the slightly off-center placement of the eye slits, the irregular cylindrical bodies, and the unequal arms give them great life and individuality. No one knows what purpose *haniwa* served. The popular theory that they were intended as tomb guardians is weakened by their origin as cylinders and by the mundane subjects they portray. Indeed, they seem to represent every aspect of Kofun-period society. They may also reflect some of the beliefs of Shinto.

Shinto is often described as the indigenous religion of Japan, but whether it was originally a religion in the usual sense of the word is debatable. Perhaps Shinto is most accurately characterized as a loose confederation of beliefs in deities (*kami*). These *kami* were thought to inhabit many different aspects of nature, including particularly hoary and magnificent trees, rocks, waterfalls, and living creatures such as deer. Shinto also represents the ancient beliefs of the Japanese in purification through ritual use of water. Later, in response to the arrival of Buddhism in the sixth century CE, Shinto became somewhat more systematized, with shrines, a hierarchy of deities, and more strictly regulated ceremonies. Nevertheless, even today in many parts of Japan a **torii**, or wooden gateway, is the only sign that a place is sacred. Nature itself, not the gateway, is venerated.

One of the great Shinto monuments is the shrine at Ise, on the coast southwest of Tokyo (fig. 11-5), dedicated to the sun goddess, the legendary progenitor of Japan's imperial family. Visited by millions of pilgrims each year, this exquisitely proportioned shrine has been ritually rebuilt at twenty-year intervals for nearly 2,000 years (most recently in 1993) in exactly the same ancient Japanese style by expert carpenters who have been trained in this task since childhood. In this way, the temple preserves some features of Yayoi-era granaries and—like Japanese culture itself—is both ancient and endlessly new.

The Ise shrine has many aspects that are typical of Shinto architecture, including wooden piles raising the building off the ground, a thatched roof held in place by horizontal logs, the use of unpainted cypress wood, and the overall feeling of natural simplicity rather than overwhelming size or elaborate decoration. Only members of the imperial family and a few Shinto priests are

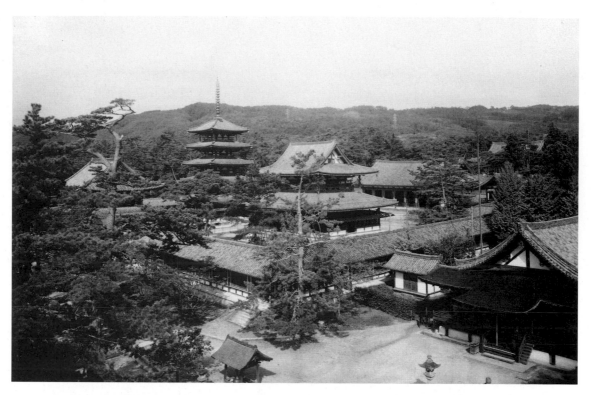

11-6. Main compound, Horyu-ji, Nara Prefecture. Asuka period, 7th century CE

allowed inside the fourfold enclosure housing the sacred shrine. The shrine in turn houses the three sacred symbols of Shinto—a sword, a mirror, and a jewel.

ASUKA PERIOD

Japan has experienced several periods of intense cultural transformation. Perhaps the greatest time of change was the Asuka period (552–646 CE). During a single century, new forms of philosophy, medicine, music, foods, clothing, agricultural methods, city planning, and arts and architecture were introduced into Japan from Korea and China. The three most significant introductions, however, were Buddhism, a centralized governmental structure, and a system of writing. Each was adopted and gradually modified to suit Japanese conditions, and each has had an enduring legacy.

Buddhism reached Japan in Mahayana form, with its many *buddhas* and *bodhisattvas* (see "Buddhism," page 376). After being accepted by the imperial family, it was soon adopted as a state religion. Buddhism represented not only different gods than Shinto but an entirely new concept of religion itself. Where Shinto had found deities in beautiful and imposing natural areas, Buddhist worship was focused in temples. At first this change must have seemed strange, for the Chinese-influenced architecture and elaborate iconography introduced by Buddhism (see "Buddhist Symbols," page 434) contrasted sharply with the simple and natural aesthetics of earlier Japan. Yet Buddhism offered a rich cosmology with profound teachings of meditation and enlighten-

ment. Moreover, the new religion was accompanied by many highly developed aspects of continental Asian culture, including new methods of painting and sculpture.

The most significant surviving early Japanese temple is Horyu-ji, located on Japan's central plains not far from Nara. The temple was founded in 607 CE by Prince Shotoku (574–622 CE), who ruled Japan as a regent and became the most influential early proponent of Buddhism. Rebuilt after a fire in 670, Horyu-ji is the oldest wooden temple in the world. It is so famous that visitors are often surprised at its modest size. Yet its just proportions and human scale, together with the artistic treasures it contains, make Horyu-ji an enduringly beautiful monument to the early Buddhist faith of Japan.

The main compound of Horyu-ji consists of a rectangular courtyard surrounded by covered corridors, one of which contains a gateway. Within the compound are only two buildings, the ***kondo***, or golden hall, and a five-story **pagoda**. The simple layout of the compound is asymmetrical, yet the large *kondo* is perfectly balanced by the tall, slender pagoda (fig. 11-6). The *kondo* is filled with Buddhist images and is used for worship and ceremonies. The pagoda serves as a reliquary and is not entered. Other monastery buildings lie outside the main compound, including an outer gate, a lecture hall, a repository for sacred texts, a belfry, and dormitories for monks.

Among the many treasures still preserved in Horyu-ji is a miniature shrine decorated with paintings in lacquer. It is known as the Tamamushi Shrine after the

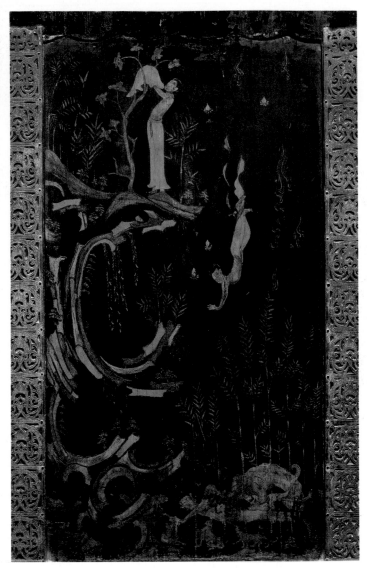

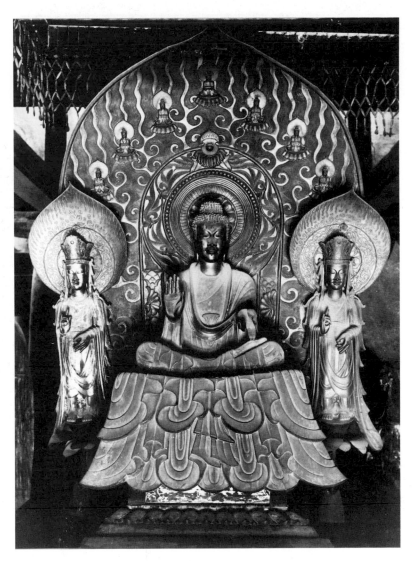

11-7. *Hungry Tigress Jataka*, panel of the Tamamushi Shrine, Horyu-ji. Asuka period, c. 650 CE. Lacquer on wood, height of shrine 7'7½" (2.33 m). Horyu-ji Treasure House

11-8. Tori Busshi. *Shaka Triad*, in the *kondo*, Horyu-ji. Asuka period, c. 623 CE. Gilt bronze, height of seated figure 34½" (87.5 cm)

tamamushi beetle, whose iridescent wings were originally affixed to the shrine to make it glitter, much like mother-of-pearl. There has been some debate whether the shrine was made in Korea, in Japan, or perhaps by Korean artisans in Japan. The question of whether it is, in fact, a "Japanese" work of art misses the point that Buddhism was so international at that time that matters of nationality were irrelevant.

The Tamamushi Shrine is a replica of an even more ancient palace-form building, and its architectural details preserve a tradition predating Horyu-ji itself. Its paintings are among the few two-dimensional works of art to survive from the Asuka period. Most celebrated among them are two that illustrate *jataka* tales, stories about former lives of the Buddha. One depicts the future Buddha nobly sacrificing his life in order to feed his body to a starving tigress and her cubs (fig. 11-7). The tigers

are at first too weak to eat him, so he must jump off a cliff to break open his flesh. The anonymous artist has created a full narrative within a single frame. The graceful form of the Buddha appears three times, harmonized by the curves of the rocky cliff and tall sprigs of bamboo. First, he hangs his shirt on a tree, then he dives downward onto the rocks, and finally he is devoured by the starving animals. The elegantly slender renditions of the figure and the somewhat abstract treatment of the cliff, trees, and bamboo represent an international Buddhist style largely shared during this time by China, Korea, and Japan. These illustrations for the *jataka* tales helped spread Buddhism in Japan.

Another example of the international style of early Buddhist art at Horyu-ji is the sculpture called the *Shaka Triad*, by Tori Busshi (fig. 11-8). (Shaka is the Japanese name for Shakyamuni, the historical Buddha.) Tori

Busshi was a third-generation Japanese, whose grandfather had emigrated to Japan from China as part of an influx of craftspeople and artists. The *Shaka Triad* reflects the strong influence of Chinese art of the Northern Wei dynasty (see fig. 10-12). The frontal pose, the outsized face and hands, and the linear treatment of the drapery all suggest that Tori Busshi was well aware of earlier continental models, while the fine bronze casting of the figures shows his advanced technical skill. The *Shaka Triad* and the Tamamushi Shrine reveal how quickly Buddhist art became an important feature of Japanese culture. During an age when Japan was being unified under an imperial system, Buddhism introduced a form of compassionate idealism that is clearly expressed in its art.

NARA PERIOD

The Nara period (646–794 CE) is named for Japan's first permanent imperial capital. Previously, when an emperor died, his capital was considered tainted, and for reasons of purification (and perhaps also of politics) his successor usually selected a new site. With the emergence of a complex, Chinese-style government, however, this custom was no longer practical. By establishing a

BUDDHIST SYMBOLS A few of the most important Buddhist symbols, which have myriad variations, are described here in their most generalized forms.

Lotus flower: Usually shown as a white water lily, the lotus (Sanskrit, *padma*) symbolizes spiritual purity, the wholeness of creation, and cosmic harmony. The flower's stem is an *axis mundi*.

Lotus throne: Buddhas are frequently shown seated on an open lotus, either single or double, a representation of *nirvana*.

Chakra: An ancient sun symbol, the wheel (*chakra*) symbolizes both the various states of existence (the Wheel of Life) and the Buddhist doctrine (the Wheel of the Law). A *chakra*'s exact meaning depends on how many spokes it has.

Marks of a buddha: A buddha is distinguished by thirty-two physical attributes (*lakshanas*). Among them are a bulge on top of the head (*ushnisha*), a tuft of hair between the eyebrows (*urna*), elongated earlobes, and thousand-spoked *chakras* on the soles of the feet.

Mandala: *Mandalas* are diagrams of cosmic realms, representing order and meaning within the spiritual universe. They may be simple or complex, three- or two-dimensional, in a wide array of forms—such as an Indian stupa (see fig. 9-8) or a Womb World *mandala* (see fig. 11-10), an early Japanese type.

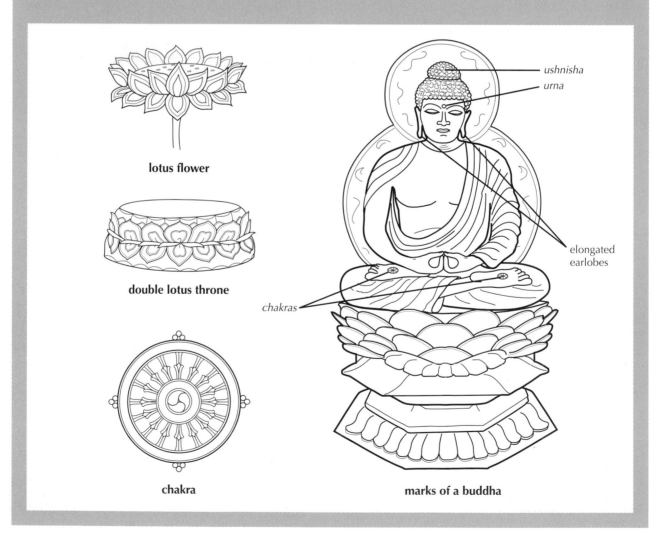

lotus flower

double lotus throne

chakra

ushnisha

urna

elongated earlobes

chakras

marks of a buddha

permanent capital in Nara, the Japanese were able to enter a new era of growth and consolidation. Nara swelled to a population of perhaps 200,000 people. During this period the imperial system solidified into an effective government that could withstand the powerful aristocratic families that had traditionally dominated the political world.

One positive result of strong central authority was the construction in Nara of magnificent Buddhist temples and monasteries that dwarfed those built previously. Even today a large area of Nara is a park where numerous temples preserve magnificent Nara-period art and architecture. The grandest of these temples, Todai-ji, is so large that the area surrounding only one of its pagodas could accommodate the entire main compound of Horyu-ji. When it was built, and for a thousand years thereafter, Todai-ji was the largest wooden structure in the world. Not all the monuments of Nara are Buddhist. There also are several Shinto shrines, and deer wander freely, reflecting Japan's Shinto heritage.

Buddhism and Shinto have coexisted quite comfortably in Japan over the ages. One seeks enlightenment, the other purification, and since these ideals did not clash, neither did the two forms of religion. Although there were occasional attempts to promote one over the other, more often they were seen as complementary, and to this day most Japanese see nothing inconsistent about having Shinto weddings and Buddhist funerals.

While Shinto became more formalized during the Nara period, Buddhism advanced to become the single most significant element in Japanese culture. One important method for transmitting Buddhism in Japan was through the copying of Buddhist sacred texts, the *sutras*. They were believed to be so beneficial and magical that occasionally a single word would be cut out from a *sutra* and worn as an amulet. Someone with hearing problems, for example, might use the word for "ear."

Copying the words of the Buddha was considered an effective act of worship by the nobility; it also enabled Japanese courtiers as well as clerics to become familiar with the Chinese system of writing—with both secular and religious results. During this period, the first histories of Japan were written, strongly modeled upon Chinese precedents, and the first collection of Japanese poetry, the *Manyoshu*, was compiled. The *Manyoshu* includes Buddhist verse, but the majority of the poems are secular, including many love songs in the five-line *tanka* form, such as this example by the late-seventh-century courtier Hitomaro (all translations from Japanese are by Stephen Addiss unless otherwise noted):

> Did those
> who lived in past ages
> lie sleepless
> as I do tonight
> longing for my beloved?

Unlike the poetry, most other art of the Nara period is sacred, with a robust splendor that testifies to the fervent belief and great energy of early Japanese Buddhists. Some of the finest Buddhist paintings of the late seventh

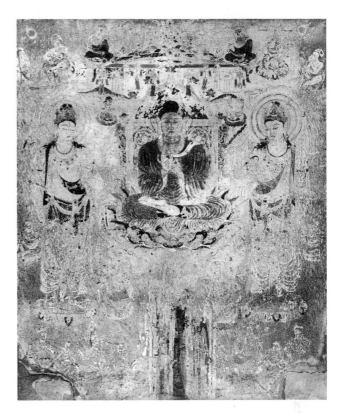

11-9. ***Amida Buddha***, fresco in the *kondo*, Horyu-ji. Nara period, c. 700 CE. Ink and colors (now severely damaged), 10'3" x 8'6" (3.13 x 2.6 m)

century were preserved in Japan on the walls of the golden hall of Horyu-ji until a fire in 1949 defaced and partially destroyed them. Fortunately, they had been thoroughly documented before the fire in a series of color photographs. These murals represent what many scholars believe to be the golden age of Buddhist painting, an era that embraces the Tang dynasty in China (618–907 CE), the United Silla period in Korea (668–935 CE), and the Nara period in Japan.

One of the finest of the Horyu-ji murals is thought to represent Amida, the Buddha of the Western Paradise (fig. 11-9). Delineated in the thin, even brushstrokes known as iron-wire lines, Amida's body is rounded, his face is fully fleshed and serene, and his hands form the ***dharmachakra*** ("revealing the Buddhist law") *mudra* (see "Mudras," page 385). Instead of the somewhat abstract style of the Asuka period, there is now a greater emphasis on realistic detail and body weight in the figure. The parallel folds of drapery show the enduring influence of the Gandhara style current in India 500 years earlier (see fig. 9-13), but the face is fully East Asian in contour and spirit.

The Nara period was an age of great belief, and Buddhism permeated the upper levels of society. Indeed, one of the few empresses in Japanese history wanted to cede her throne to a Buddhist monk. Her advisers and other influential courtiers became extremely worried, and they finally decided to move the capital away from Nara, where they felt Buddhist influence had become overpowering. The move of the capital to Kyoto marked the end of the Nara period.

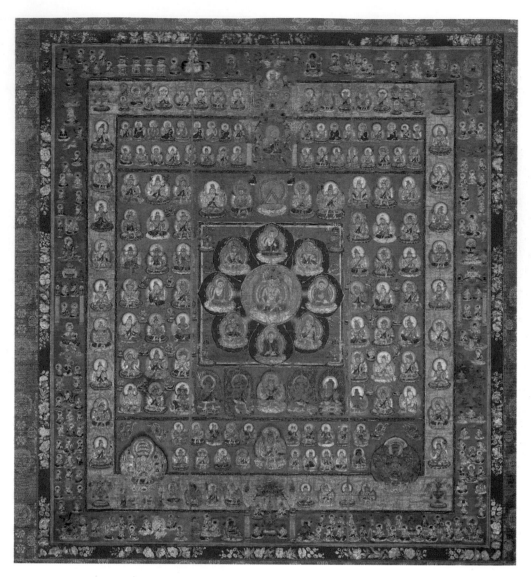

11-10. Womb World *mandala*, To-ji, Kyoto. Heian period, late 9th century CE. Hanging scroll, colors on silk, 6' x 5'1½" (1.83 x 1.54 m)

Mandalas are used not only in teaching but also as vehicles for practice. A monk, initiated into secret teachings, may meditate upon and assume the gestures of each deity depicted in the *mandala*, gradually working out from the center, so that he absorbs some of each deity's powers. The monk may also recite magical phrases called *mantras* as an aid to meditation. The goal is to achieve enlightenment through the powers of the different forms of the Buddha. *Mandalas* are created in sculptural and architectural forms as well as in paintings. Their integration of the two most basic shapes, the circle and the square, is an expression of the principles of ancient geomancy (divining by means of lines and figures) as well as Buddhist cosmology.

HEIAN PERIOD

The Japanese fully absorbed and transformed the influences from China and Korea during the Heian period (794–1185 CE). Generally peaceful conditions contributed to a new air of self-reliance on the part of the Japanese. The imperial government severed ties to China in the mid-ninth century and was sustained by support from aristocratic families. An efficient method of writing the Japanese language was developed, and the rise of vernacular literature generated such masterpieces as the world's first novel, Lady Murasaki's *Tale of Genji*. During these four centuries of splendor and refinement, two major religious sects emerged: first Esoteric Buddhism and later Pure Land Buddhism.

ESOTERIC BUDDHIST ART

With the removal of the capital to Kyoto, the older Nara temples lost their influence. Soon two new Esoteric sects of Buddhism, named Tendai and Shingon, grew to dominate Japanese religious life. Strongly influenced by polytheistic religions such as Hinduism, Esoteric Buddhism included a daunting number of deities, each with magical powers. The historical Buddha was no longer very important.

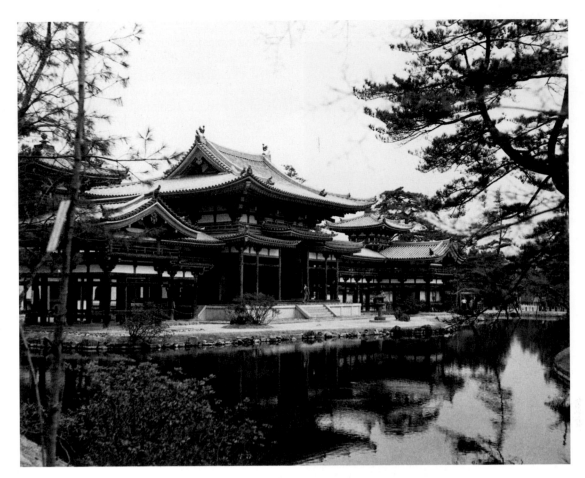

11-11. Byodo-in, Uji, Kyoto Prefecture. Heian period, c. 1053 CE

Instead, the universal Buddha (called Dainichi, "Great Sun," in Japanese) was believed to preside over the universe. He was accompanied by buddhas and *bodhisattvas*, as well as guardian deities who formed fierce counterparts to the more benign gods.

Esoteric Buddhism is hierarchical, and its deities have complex relationships to one another. Learning all the different gods and their interrelationships was assisted greatly by works of art, especially **mandalas**, cosmic diagrams of the universe that portray the deities in schematic order. The Womb World *mandala* from To-ji, for example, is entirely filled with depictions of gods. Dainichi is at the center, surrounded by buddhas of the four directions (fig. 11-10). Other deities, including some with multiple heads and limbs, branch out in diagrammatical order, each with a specific symbol of power. To believers, the *mandala* represents an ultimate reality beyond the visible world.

Perhaps the most striking attribute of many Esoteric Buddhist images is their sense of spiritual force and potency, especially in depictions of the wrathful deities, which are often surrounded by flames. Esoteric Buddhism, with its intricate theology and complex doctrines, was a religion for the educated aristocracy, not for the masses. Its network of deities, hierarchy, and ritual found a parallel in the elaborate social divisions of the Heian court.

PURE LAND BUDDHIST ART

During the latter half of the Heian period, a rising military class threatened the peace and tranquility of court life. The beginning of the eleventh century was also the time for which the decline of Buddhism (*Mappo*) had been prophesied. In these uncertain years, many Japanese were ready for another form of Buddhism that would offer a more direct means of salvation than the elaborate rituals of the Esoteric sects.

Pure Land Buddhism, although it had existed in Japan earlier, now came to prominence. It taught that the Western Paradise (the Pure Land) of the Amida Buddha could be reached through nothing more than faith. In its ultimate form, Pure Land Buddhism held that the mere chanting of a *mantra*—the phrase *Namu Amida Butsu* ("Hail to Amida Buddha")—would lead to rebirth in Amida's paradise. This doctrine soon swept throughout Japan. Spread by traveling monks who took the chant to all parts of the country (see fig. 11-1), it appealed to people of all levels of education and sophistication. Pure Land Buddhism has remained the most popular form of Buddhism in Japan ever since.

One of the most beautiful temples of Pure Land Buddhism is the Byodo-in, located in the Uji Mountains not far from Kyoto (fig. 11-11). The temple itself was originally

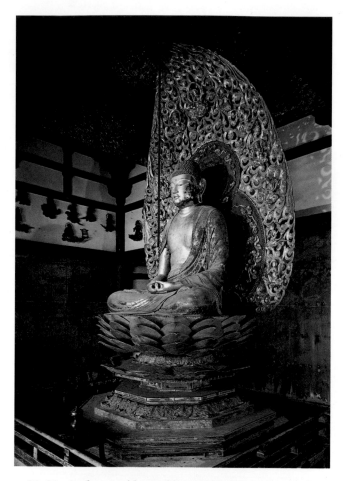

11-12. Jocho. *Amida Buddha*, Byodo-in. Heian period, c. 1053 CE. Gold leaf and lacquer on wood, height 9'8" (2.95 m)

a secular palace created to suggest the palace of Amida in the Western Paradise. It was built for a member of the powerful Fujiwara family who served as the leading counselor to the emperor. After the counselor's death in the year 1052, the palace was converted into a temple. The Byodo-in is often called Phoenix Hall, not only for the pair of phoenix images on its roof but also because the shape of the building itself suggests the mythical bird. The lightness of its thin columns gives the Byodo-in a sense of airiness, as though the entire temple could easily rise up through the sky to Amida's Western Paradise. The hall rests gently in front of an artificial pond created in the shape of the Sanskrit letter *A*, the sacred symbol for Amida.

The Byodo-in's central image of Amida, carved by the master sculptor Jocho (d. 1057), exemplifies the serenity and compassion of the Buddha who welcomes the souls of all believers to his paradise (fig. 11-12). When reflected in the water of the pond before it, the Amida image seems to shimmer in its private mountain retreat. The figure was not carved from a single block of wood like earlier sculpture but from several blocks in Jocho's new **joined-wood** method of construction (see "Joined-Wood Sculpture," page 440). This technique

allowed sculptors to create larger but lighter portrayals of buddhas and *bodhisattvas* for the many temples constructed and dedicated to the Pure Land faith. It also reaffirmed the Japanese love of wood, which during the Heian period became the major medium for sculpture.

Surrounding the Amida on the walls of the Byodo-in are smaller wooden figures of *bodhisattvas* and angels, some playing musical instruments. Everything about the Byodo-in was designed to suggest the paradise that awaits the believer after death. Its remarkable state of preservation after more than 900 years allows visitors to experience the late-Heian-period religious ideal at its most splendid.

POETRY AND CALLIGRAPHY

While Buddhism pervaded the Heian era, a refined secular culture also arose at court that has never been equaled in Japan. Gradually over the course of four centuries, the influence from China waned. Although court nobles continued to write many poems in Chinese, both men and women wrote in the new kana script of their native language (see "Writing, Language, and Culture," page 443). With its simple, flowing symbols interspersed with more complex Chinese characters, the new writing system allowed Japanese poets to create an asymmetrical calligraphy quite unlike that of China.

Refinement was greatly valued among the Heian-period aristocracy. A woman would be admired merely for the way she arranged the twelve layers of her robes by color, or a man for knowing which kind of incense was being burned. Much of court culture was centered upon the sophisticated expression of human love through the five-line *tanka*. A courtier leaving his beloved at dawn would send her a poem wrapped around a single flower still wet with dew. If his words or his calligraphy were less than stylish, however, he would not be welcome to visit her again. In turn, if she could not reply with equal elegance, he might not wish to repeat their amorous interlude. Society was ruled by taste, and pity any man or woman at court who was not accomplished in several forms of art.

During the later Heian period, the finest *tanka* were gathered in anthologies. The poems in one famous early anthology, the *Thirty-Six Immortal Poets*, are still known to educated Japanese today. This anthology was produced in sets of albums called the *Ishiyama-gire*. These albums consist of *tanka* written elegantly on high-quality papers decorated with painting, block printing, scattered gold and silver, and sometimes paper collage. The page shown here reproduces two *tanka* by the courtier Ki no Tsurayuki (fig. 11-13). Both poems express sadness for:

> Until yesterday
> I could meet her,
> But today she is gone—
> Like clouds over the mountain
> She has been wafted away.

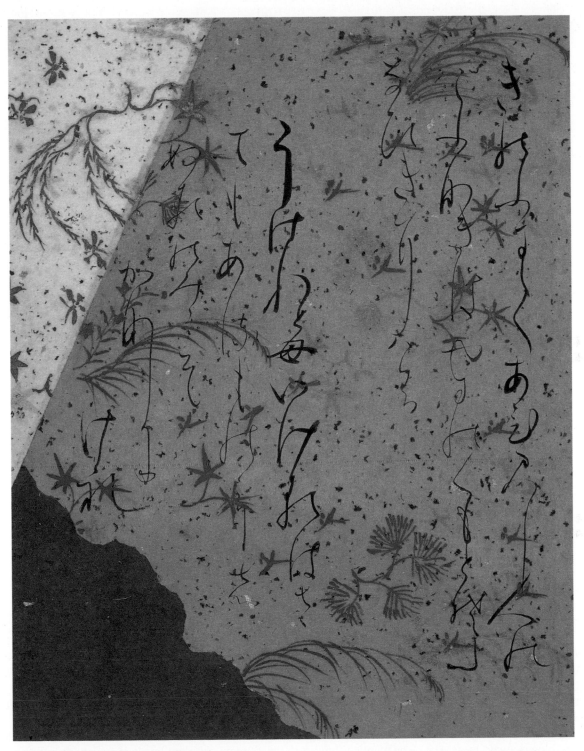

11-13. Album leaf from the *Ishiyama-gire*. Heian period, early 12th century CE. Ink with gold and silver on decorated and collaged paper, 8 x 6³⁄₈" (20.3 x 16.1 cm). Freer Gallery of Art, Smithsonian Institution, Washington, D.C. (F1969.4)

JOINED-WOOD SCULPTURE

Wood is a temperamental medium, as sculptors who work with it quickly learn. Cut from a living, sap-filled tree, it takes many years to dry thoroughly. The outside dries first, then the inside gradually yields its moisture. As the core dries, however, the resulting shifts in tension can open up gaping cracks. A large statue carved from a single solid block thus runs the risk of splitting as it ages—especially if it has been painted or lacquered, which interferes with the wood's natural "breathing."

One strategy adopted by Japanese sculptors to prevent cracking was to split a completed statue into several pieces, hollow them out, then fit them back together. A more effective method was the **joined-wood** technique. Here the design for a statue was divided into sections, each of which was carved from a separate block. These sections were then hollowed out and assembled. By using multiple blocks, sculptors could produce larger images than they could from any single block. Moreover, statue sections could be created by teams of carvers, some of whom became specialists in certain parts, such as hands or crossed legs or lotus thrones. Through this cooperative approach, large statues could be produced with great efficiency to meet a growing demand.

The spiky, flowing calligraphy and the patterning of the papers, the rich use of gold, and the suggestions of natural imagery match the elegance of the poetry, epitomizing courtly Japanese taste.

Although the style of Japanese calligraphy such as that in the *Ishiyama-gire* was considered "women's hand," it is not known how much of the calligraphy of the time was actually written by women. It is certain, however, that women were a vital force in Heian society. Although the place of women in Japanese society was to decline in later periods, they contributed greatly to the art at the Heian court.

SECULAR PAINTING

Women were noted for both their poetry and their prose, including diaries, mythical tales, and courtly romances. Lady Murasaki transposed the life-style of the Heian court into fiction in the first known novel, *The Tale of Genji*, at the beginning of the eleventh century. She wrote in Japanese at a time when men still wrote prose primarily in Chinese, and her work remains one of Japan's—and the world's—great novels. Underlying the story of the love affairs of Prince Genji and his companions is the Japanese conception of fleeting pleasures and ultimate sadness in life, an echo of the Buddhist view of the vanity of earthly pleasures.

One of the earliest extant secular paintings from Japan is a series of scenes from *The Tale of Genji*, painted in the twelfth century by unknown artists in "women's hand" painting style. This style was characterized by delicate lines, strong if sometimes muted colors, and asymmetrical compositions usually viewed from above through invisible, "blown-away" roofs. The *Genji* paintings have a refined, subtle emotional impact. They generally show court figures in architectural settings, with the frequent addition of natural elements, such as sections of gardens, that help to represent the mood of the scene. Thus a blossoming cherry tree appears in a scene of happiness, while unkempt weeds appear in a depiction of loneliness. Such correspondence between nature and human emotion is an enduring feature of Japanese poetry and art.

The figures in *The Tale of Genji* paintings do not show their emotions directly on their faces, which are simply rendered with the fewest possible lines. Instead, their feelings are conveyed by colors, poses, and the total composition of the scenes. One evocative scene portrays a seemingly happy Prince Genji holding a baby boy borne by his wife, Nyosan. In fact, the baby was fathered by another court noble. Since Genji himself has not been faithful to Nyosan, who appears in profile below him, he cannot complain; meanwhile the true father of the child has died, unable to acknowledge his only son (fig. 11-14). The irony is even greater because Genji himself is the illegitimate son of an emperor. Thus what should be a joyful scene has undercurrents that lend it a sense of irony and sorrow.

One might expect a painting of such an emotional scene to focus on the people involved. Instead, they are rendered in rather small size, and the scene is dominated by a screen that effectively squeezes Genji and his wife into a corner. This composition deliberately represents how their positions in courtly society have forced them into this unfortunate situation. In typical Heian style, Genji expresses his emotion by murmuring a poem:

How will he respond,
The pine growing on the mountain peak,
When he is asked who planted the seed?

The Tale of Genji scroll represents courtly life as interpreted through refined sensibilities and the "women's hand" style of painting. Heian painters also cultivated a contrasting "men's hand" style. Characterized by strong ink play and lively brushwork, it most often depicts subjects outside the court. One of the masterpieces of this style is *Frolicking Animals*, a set of scrolls satirizing the life of many different levels of society. Painted entirely in ink, the scrolls are attributed to Toba Sojo, the abbot of a Buddhist temple, and they represent the humor of Japanese art to the full.

In one scene, a frog is seated as a buddha upon an altar while a monkey dressed as a monk prays proudly to him; in other scenes frogs, donkeys, foxes, and rabbits are shown playing, swimming, and wrestling, with one frog boasting of his prowess when he flings a rabbit to the ground (fig. 11-15). Playful and irreverent though it may be, the quality of the painting is remarkable. Each line is

11-14. Scene from *The Tale of Genji*. Heian period, 12th century CE. Handscroll, ink and colors on paper, 8 5/8 x 18 7/8" (21.9 x 47.9 cm). Tokugawa Art Museum, Nagoya

Twenty chapters from *The Tale of Genji* have come down to us in illustrated scrolls such as this one. Scholars assume, however, that the entire novel of fifty-four chapters must have been written out and illustrated—a truly monumental project. Each scroll seems to have been produced by a team of artists. One was the calligrapher, most likely a member of the nobility. Another was the master painter, who outlined two or three illustrations per chapter in fine brushstrokes and indicated the color scheme. Next, colorists went to work, applying layer after layer of color to build up patterns and textures. After they had finished, the master painter returned to reinforce outlines and apply the finishing touches, among them the details of the faces.

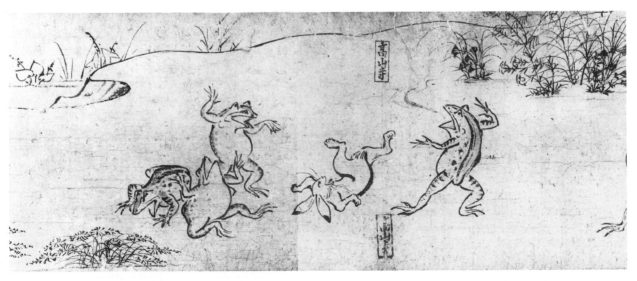

11-15. Attributed to Toba Sojo. Detail of *Frolicking Animals*. Heian period, 12th century CE. Handscroll, ink on paper, height 12" (30.5 cm). Kozan-ji, Kyoto

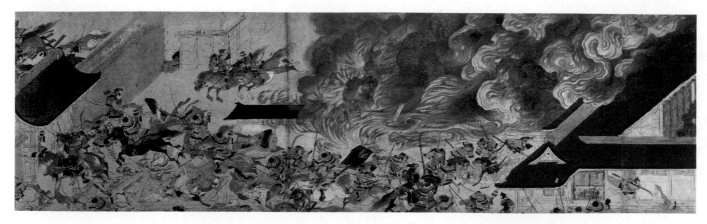

11-16. Detail of *Night Attack on the Sanjo Palace*. Kamakura period, late 13th century CE. Handscroll, ink and colors on paper, height 16¼" (41.3 cm). Museum of Fine Arts, Boston
Fenollosa-Weld Collection

The battles between the Minamoto and Taira clans were fought primarily by mounted and armored warriors, who used both bows and arrows and the finest swords. In the year 1060, some 500 Minamoto rebels opposed to the retired emperor Go-Shirakawa carried out a daring raid on the Sanjo Palace. In a surprise attack in the middle of the night, they abducted the emperor. The scene was one of great carnage, much of it caused by the burning of the wooden palace. Despite the drama of the scene, this was not the decisive moment in the war. The Minamoto rebels would eventually lose more important battles to their Taira enemies. Yet Minamoto forces, heirs to those who carried out this raid, would eventually prove victorious, destroying the Taira clan in 1185.

brisk and lively, and there are no strokes of the brush other than those needed to depict each scene. Unlike the *Genji* scroll, there is no text to *Frolicking Animals*, and we must make our own interpretations of the people and events being satirized. Nevertheless, the visual humor is so lively and succinct that we can recognize not only the Japanese of the twelfth century, but perhaps also ourselves.

KAMAKURA PERIOD

The courtiers of the Heian era became so engrossed in their own refinement that they neglected their responsibilities for governing the country. Clans of warriors—samurai—from outside the capital grew increasingly strong. Drawn into the factional conflicts of the imperial court, samurai leaders soon became the real powers in Japan.

The two most powerful warrior clans were the Minamoto and the Taira, whose battles for domination became famous not only in medieval Japanese history but also in literature and art. One of the great painted handscrolls depicting these battles is *Night Attack on the Sanjo Palace* (fig. 11-16). Painted perhaps 200 years after the actual event, the scroll conveys a sense of eyewitness reporting even though the anonymous artist had to imagine the scene from verbal (and at best semifactual) descriptions. The style of the painting includes some of the brisk and lively linework of *Frolicking Animals* and

also traces of the more refined brushwork, use of color, and bird's-eye viewpoint of *The Tale of Genji* scroll. The main element, however, is the savage depiction of warfare (see "Arms and Armor," page 445). Unlike the *Genji* scroll, *Night Attack* is full of action: flames engulf the palace, horses charge, warriors behead their enemies, court ladies try to hide, and a sense of energy and violence is conveyed with great sweep and power. The era of poetic refinement was now over in Japan, and the new world of the samurai began to dominate the secular arts.

The Kamakura era (1185–1392 CE) began when Minamoto Yoritomo (1147–99) defeated his Taira rivals and assumed power as shogun (general-in-chief). To resist the softening effects of courtly life in Kyoto, he established his military capital in Kamakura. While paying respect to the emperor, Yoritomo kept both military and political power for himself. He thus began a tradition of rule by shogun that lasted in various forms until 1868.

PURE LAND BUDDHIST ART

During the early Kamakura period, Pure Land Buddhism remained the most influential form of religion and was expressed in sculpture such as *Kuya* by Kosho, a master of the new naturalistic style that evolved at this time (see fig. 11-1). Just as the *Night Attack* revealed the political turbulence of the period through its vivid colors and

WRITING, LANGUAGE, AND CULTURE

Chinese culture enjoyed great prestige in East Asia. Written Chinese served as an international language of scholarship and cultivation, much as Latin did in medieval Europe. Educated Koreans, for example, wrote almost exclusively in Chinese until the fifteenth century CE. In Japan, Chinese continued to be used for certain kinds of writing, such as philosophical and legal texts, into the nineteenth century.

When it came to writing their own language, the Japanese initially borrowed Chinese characters, or kanji. Differences between the Chinese and Japanese languages made this system extremely unwieldy, so during the ninth century CE two syllabaries, or kana, were developed from simplified Chinese characters. (A syllabary is a system in which each symbol stands for a syllable.) Katakana, now generally used for foreign words, consists of mostly angular symbols, while the more frequently used hiragana has graceful, cursive symbols.

Japanese written in kana was known as "women's hand," possibly because prestigious scholarly writing still emphasized Chinese, which women were rarely taught. Yet Japan had an ancient and highly valued poetic tradition of its own, and women as well as men were praised as poets from earliest times. So while women rarely became scholars, they were often authors. During the Heian period kana were used to create a large body of literature, written either by women or sometimes for women by men.

A charming poem originated in Heian times to teach the new writing system. In two stanzas of four lines each, it uses almost all of the syllable sounds of spoken Japanese and thus almost every kana symbol. It was memorized as we would recite our ABCs. The first stanza translates as:

Although flowers glow with color
They are quickly fallen,
And who in this world of ours
Is free from change?
(Translation by Earl Miner)

Like Chinese, Japanese is written in columns from top to bottom and across the page from right to left. (Following this logic, Chinese and Japanese narrative paintings also read from right to left.) Below is the stanza written three ways. At the right, it appears in katakana glossed with the original phonetic value of each symbol. (Modern pronunciation has shifted slightly.) In the center, the stanza appears in flowing hiragana. To the left is the mixture of kanji and kana that eventually became standard. This alternating rhythm of simple kana symbols and more complex Chinese characters gives a special flavor to Japanese calligraphy.

常ならむ
我世誰ぞ
散りぬるを
色は匂へど

つねならむ
わかよたれそ
ちりぬるを
いろはにほへと

I-ro ha-ni-ho-he-to
Chi-ri-nu-ru-wo
Wa-ka-yo-ta-re-so
Tsu-ne-na-ra-mu

kanji and kana **hiragana** **katakana**

forceful style, Kamakura-era portraiture saw a new emphasis on realism, including the use of crystal eyes in sculpture for the first time. Perhaps the warriors had a taste for realism, for many sculptors and painters of the Kamakura period became expert in depicting faces, forms, and drapery with great attention to naturalistic detail. As we have seen, Kosho took on the more difficult task of representing in three dimensions not only the person of the famous monk Kuya but also his chant.

Pure Land Buddhism taught that even one sincere invocation of the sacred chant could lead the most wicked sinner to the Western Paradise. Paintings called *raigo* (literally "welcoming approach") were created depicting the Amida Buddha, accompanied by *bodhisattvas*, coming down to earth to welcome the soul of the dying believer. Golden cords were often attached to

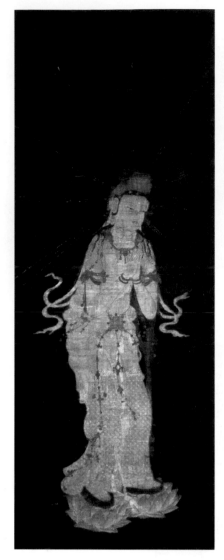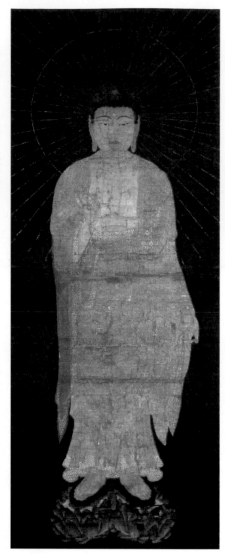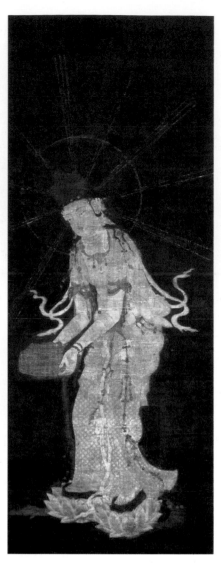

11-17. ***Descent of the Amida Trinity***, *raigo* triptych. Kamakura period, late 13th century CE. Ink and colors with cut gold on silk; each scroll 54 x 19 ½" (137.2 x 50.2 cm). The Art Institute of Chicago

Kate S. Buckingham Collection, 1929.855–1929.857

these paintings, which were taken to the homes of the dying. A person near death held on to these cords, hoping that Amida would escort the soul directly to paradise.

Raigo paintings are quite different in style from the complex *mandalas* and fierce guardian deities of Esoteric Buddhism. Like Jocho's sculpture of Amida at the Byodo-in, they radiate warmth and compassion. One magnificent *raigo*, a set of three paintings, portrays Amida Buddha and two *bodhisattvas* not only with gold paint but also with slivers of gold leaf cut in elaborate patterning to suggest the radiance of their draperies (fig. 11-17). The sparkle of the gold over the figures is heightened by the darkening of the silk behind them, so that the deities seem to come forth from the surface of the painting. In the flickering light of oil lamps and torches, *raigo* paintings would have glistened and gleamed in magical splendor in a temple or a dying person's home.

In every form of Buddhism paintings and sculpture became vitally important elements in religious teaching

and belief. In their own time they were not considered works of art but rather visible manifestations of faith.

ZEN BUDDHIST ART

Toward the latter part of the Kamakura period, Zen Buddhism, the last major form to reach Japan, appeared. Zen was already highly developed in China, where it was known as Chan, but it had been slow to reach Japan because of the interruption of relations between the two countries during the Heian period. But during the Kamakura era, both visiting Chinese and returning Japanese monks brought Zen to Japan. It would have a lasting impact on Japanese arts.

In some ways, Zen resembles the original teachings of the historical Buddha. It differed from both Esoteric and Pure Land Buddhism in emphasizing that individuals must reach their own enlightenment through meditation, without the help of deities or magical chants. It especially appealed to the self-disciplined spirit

ARMS AND ARMOR Battles such as the one depicted in *Night Attack on the Sanjo Palace* (see fig. 11-16) were fought largely by archers on horseback. Samurai archers charged the enemy at full gallop and loosed their arrows just before they wheeled away. The scroll clearly shows their distinctive bow, with its asymmetrically placed handgrip. The lower portion of the bow is shorter than the upper so it can clear the horse's neck. The samurai wear a long, curved sword at the waist.

By the tenth century, Japanese swordsmiths had perfected techniques for crafting their legendarily sharp swords. Sword makers face a fundamental difficulty: Steel hard enough to hold a razor-sharp edge is brittle and breaks easily, but steel resilient enough to withstand rough use is too soft to hold a keen edge. The Japanese ingeniously forged a blade from up to four strengths of steel, cradling a hard cutting edge in a less brittle support.

Samurai armor, illustrated here, was made of overlapping iron and lacquered leather scales, punched with holes and laced together with leather thongs and brightly colored silk braids. The principal piece wrapped around the chest, left side, and back. Padded shoulder straps hooked it back to front. A separate piece of armor was tied to the body to protect the right side. The upper legs were protected by a skirt of four panels attached to the body armor, while two large rectangular panels tied on with cords guarded the arms. The helmet was made of iron plates riveted together. From it hung a neckguard flared sharply outward to protect the face from arrows shot at close range as the samurai wheeled away from an attack.

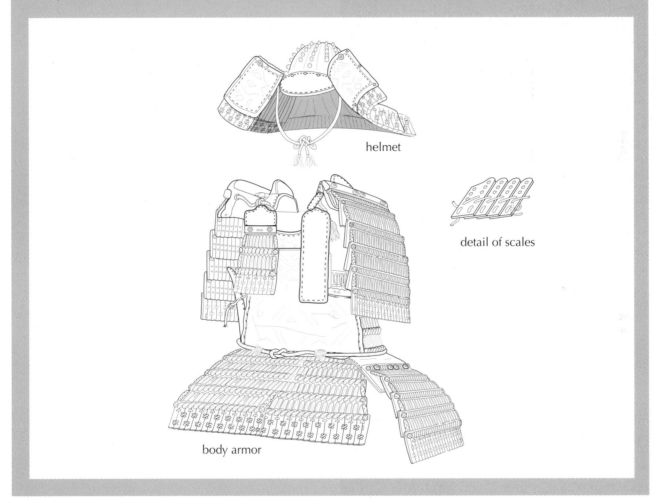

helmet

detail of scales

body armor

oof samurai warriors, who were not satisfied with the older forms of Buddhism connected with the Japanese court.

Zen temples were usually built in the mountains rather than in large cities. An abbot named Kao Ninga at an early Zen temple was a pioneer in the kind of rough and simple ink painting that so directly expresses the Zen spirit. We can see this style in a remarkable ink portrait of a monk sewing his robe (fig. 11-18, "The Object Speaks: Monk Sewing," page 446). Buddhist prelates of other sects undoubtedly had assistants to take care of such mundane tasks as repairing a robe, but in Zen Buddhism each monk, no matter how advanced, is expected to do all tasks for himself. Toward the end of the fourteenth century, Zen's spirit of self-reliance began to dominate many aspects of Japanese culture.

As the Kamakura era ended, the seeds of the future were planted: Control of rule by the warrior class and Zen values had become established as the leading forces in Japanese life and art.

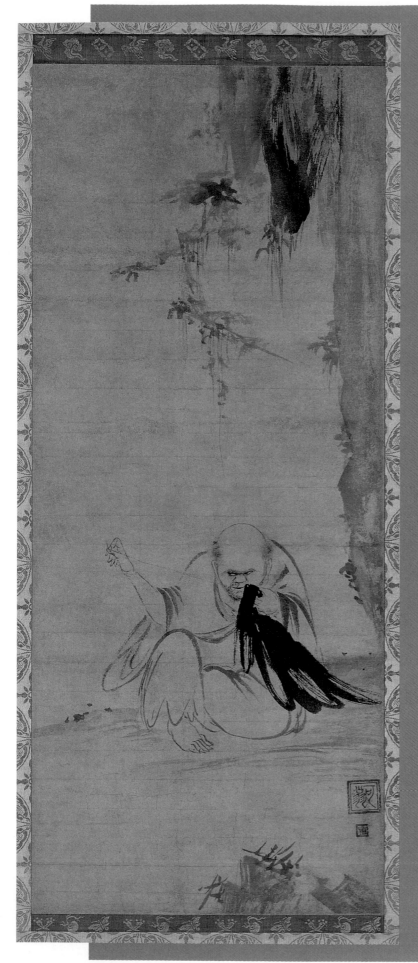

THE OBJECT SPEAKS

MONK SEWING

In the early thirteenth century CE, a statue such as Kosho's *Kuya Speaking* (see fig. 11-1) epitomized the faith expressed in Pure Land Buddhist art. At the very same time, Zen Buddhism was being introduced into Japan from China, and within a century its art communicated a far different message. Whereas Kuya had wandered the countryside, inviting the faithful to chant the name of Amida Buddha and relying on the generosity of believers to support him, Zen monks lived settled lives in monasteries—usually up in the mountains. They had no need of contributions from the court or from believers.

Then, as today, Japanese Zen monks grew and cooked their own food, cleaned their temples, and were as responsible for their daily lives as for their own enlightenment. In addition to formal meditation, they practiced *genjo koan*, taking an ordinary circumstance in their immediate world, such as mending a garment, as an object of meditation. Thus, a painting such as *Monk Sewing* (fig. 11-18), which bears the seals of the Buddhist priest-painter Kao Ninga (active mid-fourteenth century), would have spoken clearly to viewers of a commitment to a life of simplicity and responsibility for oneself. It was and is still so effective because it has the blunt style, strong sense of focus, and visual intensity of the finest Zen paintings. The almost humorous compression of the monk's face, coupled with the position of the darker robe, focuses our attention on his eyes, which then lead us out to his hand pulling the needle. We are drawn into the activity of the painting rather than merely sitting back and enjoying it as a work of art. This sense of intense activity within daily life, involving us directly with the painter and the subject, is a feature of the best Zen figure paintings.

11-18. **Attributed to Kao Ninga.** *Monk Sewing*. Kamakura period, early 14th century. Ink on paper, 32 7/8 x 13 1/2" (83.5 x 35.4 cm). The Cleveland Museum of Art
John L. Severance Fund (62.163)

PARALLELS

PERIOD	JAPANESE ART BEFORE 1392	ART IN OTHER CULTURES
JOMON c. 12,000–300 BCE	**11-2. Asahi vessel** (c. 2000 BCE) **11-3.** *Dogu* (c. 2000 BCE)	9-5. *Large Painted Jar with Border Containing Birds* (c. 2400–2000 BCE), India 4-6. **Kamares Ware** (c. 2000–1900 BCE), Greece
YAYOI c. 300 BCE–300 CE	**11-5. Inner shrine, Ise** (early 1st cent. CE)	6-14. **Portunas (?) temple** (late 2nd cent. BCE), Italy
KOFUN c. 300–552 CE	**11-4.** *Haniwa* (6th cent. CE)	9-17. *Bodhisattva* (c. 475 CE), India 7-22. **Hagia Sophia** (532–37 CE), Turkey
ASUKA c. 552–646 CE	**11-6. Horyu-ji** (7th cent. CE) **11-8. Tori Busshi.** *Shaka Triad* (c. 623 CE)	7-36. *Rabbula Gospels* (586 CE), Syria 10-13. **Amitabha altar** (593 CE), China
NARA c. 646–794 CE	**11-9.** *Amida Buddha* (c. 700 CE)	8-2. **Dome of the Rock** (c. 687–91 CE), Jerusalem
HEIAN c. 794–1185 CE	**11-10. Womb World** *mandala* (late 9th cent. CE) **11-11. Byodo-in, Uji** (c. 1053 CE) **11-12. Jocho.** *Amida Buddha* (c. 1053 CE) **11-14.** *The Tale of Genji* (12th cent. CE)	14-17. *Utrecht Psalter* (c. 825–50 CE), Netherlands 7-39. **Cathedral of Saint Mark** (begun 1063 CE), Italy 12-23. **Anasazi seed jar** (c. 1150 CE), North America
KAMAKURA c. 1185–1392 CE	**11-1.** *Kuya Preaching* (before 1207 CE) **11-17.** *Descent of the Amida Trinity* (late 13th cent. CE) **11-18. Kao.** *Monk Sewing* (early 14th cent. CE)	12-1. **Pueblo Bonito** (c. 900–1230 CE), North America 16-6. **Chartres Cathedral** (c. 1134–1220 CE), France 7-42. *Virgin of Vladimir* (12th cent. CE), Russia

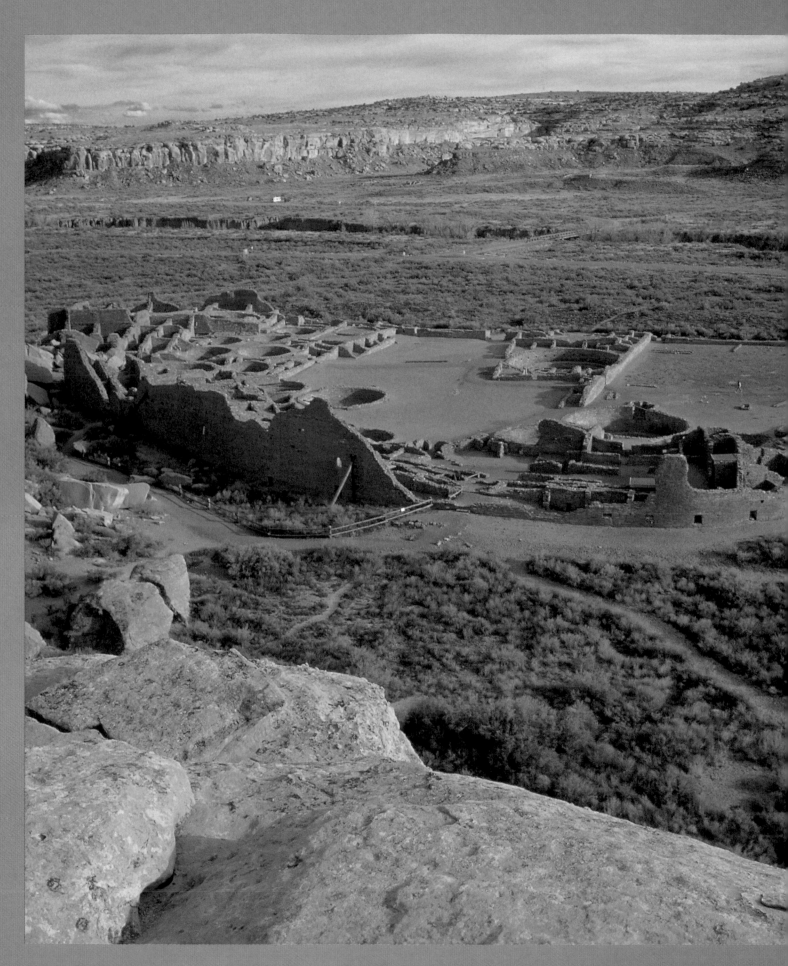

12-1. Pueblo Bonito, Chaco Canyon,
New Mexico. Anasazi culture, c. 900–1230 CE

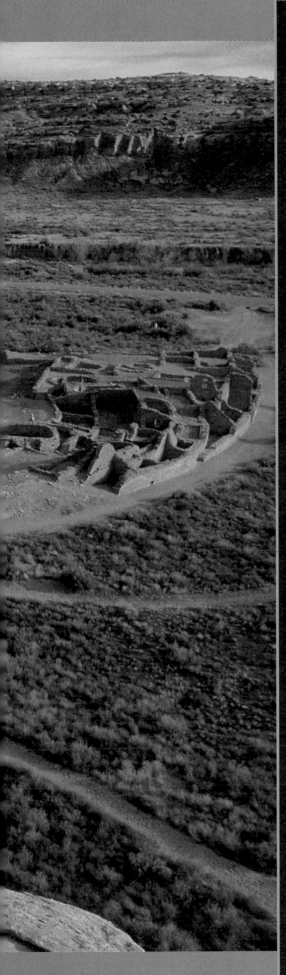

12
Art of the Americas before 1300

We know—because there are written records—how Roman imperial architects planned cities such as Timgad in modern Algeria and apartment complexes such as the *insulae* in Ostia, Italy (Chapter 6). But the *pre*historic ruins in New Mexico's Chaco Canyon still only whisper hints of their secrets. As we look across the striking contours of Pueblo Bonito (fig. 12-1), we are seeing the high point of a culture that ended suddenly about 1400 CE for reasons that can only be guessed at.

We know much from archaeological research conducted during the past century: Pueblo Bonito and similar complexes known as great houses were built between about 900 and 1100 CE, dated by analyzing some of the 200,000 trees that were cut with stone axes or burned through, then transported at least 50 miles for use in roofs. Pueblo Bonito covered more than 3 acres, was four or five stories high, and had some 800 rooms, including 30 kivas (subterranean circular rooms used as ceremonial centers). Amazingly, all aspects of construction—including quarrying, timber cutting, and transport—were done without draft animals, wheeled vehicles, or metal tools. Pueblo Bonito stood at the center of a network of wide, straight roads, in some places with curbs and paving, that radiated more than 400 miles to some seventy other communities. The builders made no effort to avoid topographic obstacles; when they encountered cliffs, they ran stairs up them. Almost invisible today, the roads, most probably processional ways, were only recently discovered through aerial photography.

We also know that Chaco Canyon's inhabitants traded food, jewelry, turquoise, and black-and-white pottery known as Cibola. They buried their deceased with carved turquoise, shell, and bead jewelry. They were so sophisticated in astronomy that they built an accurate solar and lunar calendar known as the sun dagger and recorded in petrographs the activities of celestial objects, including what may have been a supernova in the Crab Nebula in 1054 and the passing in 1066 of what was later known as Halley's Comet.

But we don't know who *they* were—the Navajo, who came much later, called them Anasazi ("ancient ones")—or why their magnificent culture ended so suddenly.

▲ c. 1200–400 OLMEC

c. 350 BCE–900 CE MAYA ▲

▲ c. 1000–200 CHAVIN

c. 200 BCE–600 CE NAZCA ▲

▲ c. 1000 BCE–200 CE PARACAS

c. 200 BCE–600 CE MOCHE ▲

TIMELINE 12-1. **Mesoamerica, Central America, and the South American Andes before 1300.** In Mesoamerica, Olmec culture dominated during the Formative/Preclassic period (1500 BCE–300 CE); the Maya and Teotihuacan flourished during the Classic period (300–900 CE); and the Itza rose to prominence during the Postclassic period (900–1500 CE), about the same time that the Diquis culture thrived in Central America. In the Andes, the early Chavin and Paracas cultures were followed by the Nazca and Moche; the major Andean cultural periods before 1300 are categorized as Early Horizon (1000–200 BCE) and Middle Horizon (600–1000 CE).

MAP 12-1. **The Americas.** Between 15,000 and 17,000 years ago, Paleo-Indians moved across North America, then southward through Central America until they reached the Tierra del Fuego region of South America about 12,500 years ago.

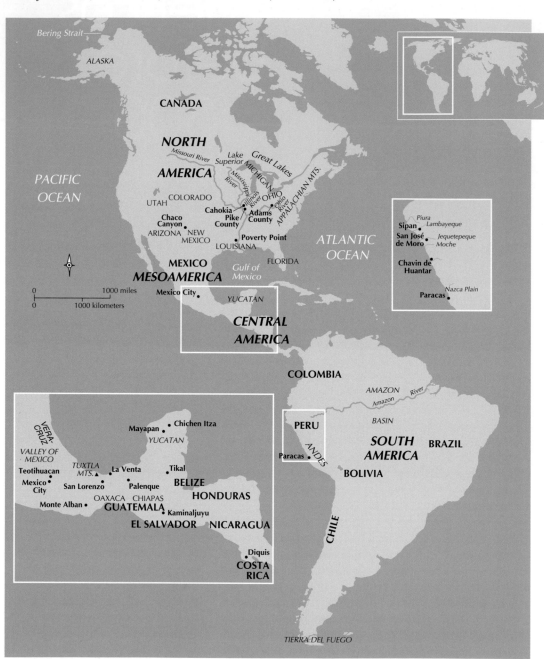

THE NEW WORLD

During the last Ice Age, which began about 2.5 million years ago, glaciers periodically trapped enough of the world's water to lower the level of the oceans and expose land between Asia and North America. At its greatest extent, this land bridge was a vast, rolling plain a thousand miles wide, where grasses, sagebrush, sedge, and groves of scrub willow provided food and shelter for animals and birds.

Although most areas of present-day Alaska and Canada were covered by glaciers during the Ice Age, an ice-free corridor provided access from Asia to the south and east. Sometime before 12,000 years ago, perhaps as early as 20,000 to 30,000 years ago, Paleolithic hunter-gatherers emerged through this corridor and began to spread out into two vast, uninhabited continents (Map 12-1). Between 15,000 and 17,000 years ago, bands of hunters whose tool kits included sophisticated

fluted- and flaked-stone spearheads traveled across most of North America. The earliest uncontested evidence puts humans at the southern end of South America by 12,500 years ago. Although contact between Siberia and Alaska continued after the ice retreated and rising oceans again flooded the Bering Strait, the peoples of the Western Hemisphere, known as Paleo-Indians, were essentially cut off from the peoples of Africa and Eurasia.

In this isolation New World peoples experienced the same transformation from hunting to agriculture that followed the end of the Paleolithic era elsewhere. In many regions they cultivated corn, beans, and squash. Other plants first domesticated in the New World included potatoes, tobacco, cacao (chocolate), tomatoes, and avocados. New World peoples also domesticated many animals: turkeys, guinea pigs, llamas (and their camelid cousins, the alpacas, guanacos, and vicuñas), and, as did the peoples of the Old World, dogs.

As elsewhere, the shift to agriculture in the Americas was accompanied by population growth and, in some places, the rise of hierarchical societies, the appearance of ceremonial centers and towns with monumental architecture, and the development of sculpture, ceramics, and other arts. The peoples of Mesoamerica—the region that extends from central Mexico well into Central America—developed writing, astronomy, a complex and accurate calendar, and a sophisticated system of mathematics. Central and South American peoples had an advanced metallurgy and produced exquisite gold, silver, and copper pieces. The smiths of the Andes, the mountain range along the western coast of South America, began to produce metal weapons and agricultural implements in the first millennium CE, and people elsewhere in the Americas made tools and weapons from such other materials as bone, ivory, stone, wood, and, where it was available, obsidian, a volcanic glass capable of holding a cutting edge as fine as surgical steel. Basketry and, in the Andes, weaving (see "Andean Textiles," page 452) became major art forms.

Later civilizations such as the Aztec, Inka, and Pueblo of the North American Southwest are perhaps more familiar today, but before 1300 CE extraordinary artistic traditions already flourished in many regions in the Americas. This chapter explores the accomplishments of some of the cultures in five of those regions—Mesoamerica, Central America, the central Andes of South America, the southeastern woodlands and great river valleys of North America, and the North American Southwest.

MESO-AMERICA

Ancient Mesoamerica encompasses the area from north of the Valley of Mexico (the location of Mexico City) to modern Belize, Honduras, and western Nicaragua in Central America (see Map 12-1 inset). The region is one of great contrasts, ranging from tropical rain forest to semiarid mountains. Reflecting this physical diversity, the civilizations that arose in Mesoamerica varied, but they were linked by trade and displayed an overall cultural unity. Among their common features are a complex calendrical system based on interlocking 260-day and 365-day cycles, a ritual ball game (see "The Cosmic Ball Game," below), and aspects of the construction of monumental ceremonial centers. Mesoamerican society was sharply divided into elite and commoner classes.

The transition to farming began in Mesoamerica between 7000 and 6000 BCE, and by 3000–2000 BCE settled villages were widespread. Archaeologists traditionally have divided the region's subsequent history into three broad periods: Formative or Preclassic (1500 BCE–300 CE), Classic (300–900 CE), and Postclassic (900–1500 CE). This chronology derives primarily from the archaeology of the Maya—the people of Guatemala and the Yucatan peninsula. The Classic period brackets the time during which the Maya erected dated stone monuments. The term reflects the view of early Mayanists that it was a kind of golden age, the equivalent of the Classical period in ancient Greece. Although this view is no longer current

THE COSMIC BALL GAME

The ritual ball game was one of the defining characteristics of Mesoamerican society. The ball game was generally played on a long, rectangular court with a large, solid, heavy rubber ball. Using their elbows, knees, or hips—but not their hands—heavily padded players directed the ball toward a goal or marker. The rules, the size and shape of the court, the number of players on a team, and the nature of the goal varied. The largest surviving ball court, at Chichen Itza, was about the size of a modern football field. The goals of the Chichen Itza court were large stone rings set in the walls of the court about 25 feet above the field. The game had profound religious and political significance and was a common subject of Mesoamerican art. Players, complete with equipment, appear as figurines and on stone votive sculpture; the game and its attendant rituals were represented in relief sculpture. The movement of the ball represented celestial bodies—the sun, moon, or stars—held aloft and directed by the skill of the players. The ball game was sometimes associated with warfare. Captive warriors might have been made to play the game, and players might have been sacrificed when the stakes were high.

ANDEAN TEXTILES

Textiles were of enormous importance in Andean life, serving significant functions in both private and public events. Specialized fabrics were developed for everything from ritual burial shrouds and shamans' costumes to rope bridges and knotted record-keeping devices. Clothing indicated ethnic group and social status and was customized for certain functions, the most rarefied being royal ceremonial garments made for specific occasions and worn only once. The creation of their textiles, among the most technically complex cloths ever made, consumed a major portion of ancient Andean societies' resources. Weavers and embroiderers used nearly every textile technique known, some of them unique inventions of these cultures. Dyeing technology, too, was an advanced art form in the ancient Andes, with some textiles containing dozens of colors.

Cotton was grown in Peru by 3500 BCE and was the most widely used plant fiber. From about 400 BCE on, animal fibers—superior in warmth and dye absorption—largely replaced cotton in the mountains, where cotton was hard to cultivate. The earliest Peruvian textiles were made by twining, knotting, wrapping, braiding, and looping fibers. Those techniques continued to be used even after the invention of weaving looms in the early second millennium BCE.

For weaving, early Andean peoples developed a simple, portable **backstrap loom** in which the undyed cotton **warp** (lengthwise thread) was looped and stretched between two poles. One pole was tied to a stationary object and the other to a strap circling the waist of the weaver. The weaver controlled the tension of the warp threads by leaning back and forth while threading a **bobbin**, or shuttle, through the warp to create the **weft** (crosswise threads) of camelid fiber, frequently vividly colored, that completely covered the warp.

Tapestry-weaving appeared in Peru around 900 BCE and was the main cloth-making technique for the next thousand or so years. In tapestry, a technique especially suited to representational textiles, the weft does not run the full width of the fabric; each colored section is woven as an independent unit (see illustration). Tapestry was followed by the introduction of **embroidery** on camelid fibers (llama, alpaca, or vicuña hair), the Andean equivalent of wool. (Embroidery on camelid fiber is seen in the Paracas mantle in figure 12-15.)

As much more complex techniques developed, the production of a single textile might involve a dozen processes requiring highly skilled workers. A tunic would have taken approximately 500 hours of work. Some of the most elaborate textiles were woven, unwoven, and rewoven to achieve special effects that were prized for their labor-intensiveness and difficulty of manufacture as well as their beauty. The most finely woven pieces contain a staggering 200 weft threads per square inch (fine European work uses 60–80 threads per inch).

Because of their complexity, deciphering how these textiles were made can be a challenge, and scholars rely on contemporary Andean weavers—inheritors of this tradition—for guidance. Then, as now, textile production was primarily in the hands of women.

Detail of tapestry-weave mantle, from Peru. C. 700–1100 CE. Wool and cotton. The Cleveland Museum of Art

Gift of William R. Carlisle, 56.84

Diagram of toothed tapestry-weaving technique, one of many sophisticated methods used in Andean textiles

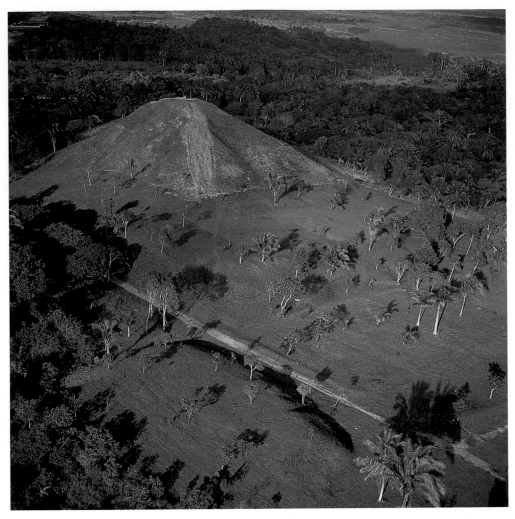

12-2. Great Pyramid and ball court, La Venta, Mexico. Olmec culture, c. 900–600 BCE.
Pyramid height approx. 100' (30 m)

and the periods are only roughly applicable to other cultures of Mesoamerica, the terminology has endured (Timeline 12-1).

THE OLMEC

The first major Mesoamerican art style, that of the Olmec, emerged during the Formative/Preclassic period. In dense vegetation along slow, meandering rivers of the modern Mexican states of Veracruz and Tabasco, the Olmec cleared farmland, drained fields, and raised earth mounds on which they constructed religious and political ceremonial centers. These centers probably housed an elite group of ruler-priests supported by a larger population of farmers who lived in villages of pole-and-thatch houses. The presence at Olmec sites of goods such as obsidian, iron ore, and jade that are not found in the Gulf of Mexico region but come from throughout Mesoamerica indicates that the Olmec participated in extensive long-distance trade. Olmec or Olmec-inspired art has been found as far away as Costa Rica and central Mexico.

The earliest Olmec ceremonial center, at San Lorenzo, flourished from about 1200 to 900 BCE and was abandoned

by 400 BCE. The archaeological findings there include a possible ball court, an architectural feature of other major Olmec sites. Another center, at La Venta, rose to prominence after San Lorenzo declined, thriving from about 900 to 400 BCE. La Venta was built on high ground between rivers. Its most prominent feature, an earth mound known as the Great Pyramid, still rises to a height of about 100 feet (fig. 12-2). This scalloped mound may have been intended to resemble a volcanic mountain, but its present form may simply be the result of erosion after thousands of years of the region's heavy rains. The Great Pyramid stands at the south end of a large, open court, possibly used as a playing field, arranged on a north-south axis and defined by long, low earth mounds. An elaborate drainage system of stone troughs may have been used as part of a ritual honoring a water deity. Many of the physical features of La Venta—including the symmetrical arrangement of earth mounds, platforms, and central open spaces along an axis that was probably determined by astronomical observations—are characteristic of later monumental and ceremonial architecture throughout Mesoamerica. Found buried within the site were carved jade, serpentine stone, and granite artifacts.

Although the Olmec developed no form of written language, their highly descriptive art enables scholars to gain an idea of their beliefs. The Olmec universe had three levels: sky, earth surface, and underworld. A bird monster ruled the sky. The earth surface itself was a female deity—apparently La Venta's principal deity—the repository of wisdom and overseer of surface water as well as land. The underworld—ruled by a fish monster—was a cosmic sea on which the earth surface, including its plants, floated. A vertical axis joining the three levels made a fourth element.

At the beginning, religion seems to have centered on shamanistic practices in which a shaman (a priest or healer) traveled in a trance state through the cosmos with the help of personal animal spirits, usually jaguars but also frogs and birds. Olmec sculpture and ceramics depict humans in the process of taking animal form. As society changed from a hunting base to an agricultural one and natural forces like sun and rain took on greater importance, a new priest class formed, in addition to the shamans, and created rituals to try to control these natural forces.

The Olmec produced an abundance of monumental basalt sculpture, including colossal heads, altars, and seated figures. The huge basalt blocks for the large works of sculpture were quarried at distant sites and transported to San Lorenzo, La Venta, and other centers. Colossal heads ranged in height from 5 to 12 feet and weighed from 5 to more than 20 tons. The heads are portraits of rulers, adult males wearing close-fitting caps with chin straps and large, round earplugs. The fleshy faces have almond-shaped eyes, flat broad noses, thick protruding lips, and downturned mouths. Each face is different, suggesting that they may represent specific individuals. Twelve heads were found at San Lorenzo. All had been mutilated and buried about 900 BCE, about the time the site went into decline. At La Venta, 102 basalt monuments were found (fig. 12-3).

The colossal heads and the subjects depicted on other monumental sculpture suggest that the Olmec elite, like their counterparts in later Mesoamerican civilizations, particularly the Maya, were preoccupied with the commemoration of rulers and historic events. This preoccupation was probably an important factor in the development of calendrical systems, which first appeared around 600 to 500 BCE in areas with strong Olmec influence.

Not long after 400 BCE, forests and swamps began to reclaim Olmec sites, but Olmec civilization had spread widely throughout Mesoamerica and was to have an enduring influence on its successors. As vegetation obscured the defunct Olmec centers of the Mesoamerican Gulf Coast, the Teotihuacan and Maya cultures began to rise. Their greatest achievements would flower during the Classic period, at Teotihuacan in the Valley of Mexico, at Monte Alban in the Valley of Oaxaca, and in the Maya regions of Guatemala and Palenque (Mexico).

TEOTIHUACAN

Teotihuacan is located some 30 miles northeast of present-day Mexico City. Early in the first millennium CE

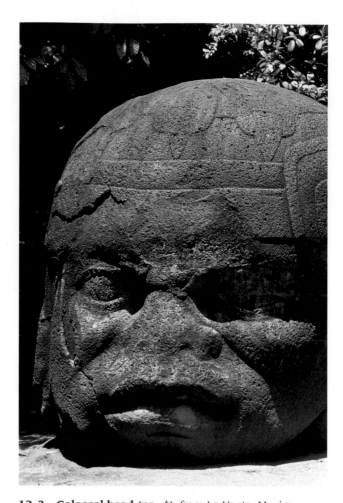

12-3. Colossal head (no. 4), from La Venta, Mexico. Olmec culture, c. 900 BCE. Basalt, height 7'5" (2.26 m). La Venta Park, Villahermosa, Tabasco, Mexico

The naturalistic colossal heads found at La Venta and San Lorenzo are sculpture in the round that measure about 8 feet in diameter. They are carved from basalt boulders that were transported to the Gulf Coast from the Tuxtla Mountains, more than 60 miles inland.

it began a period of rapid growth, and by 200 it had emerged as a significant center of commerce and manufacturing, the first large city-state in the Americas. One reason for its wealth was its control of a source of high-quality obsidian. Goods made at Teotihuacan, including obsidian tools and pottery, were distributed widely throughout Mesoamerica in exchange for luxury items such as the brilliant green feathers of the quetzal bird, used for priestly headdresses, and the spotted fur of the jaguar, used for ceremonial garments. The city's farmers terraced hillsides and drained swamps, and on fertile, reclaimed land they grew the common Mesoamerican staple foods, including corn, squash, and beans. From the fruit of the spiky-leafed maguey plant they fermented pulque, a mildly alcoholic brew still consumed today.

At its height, between 350 and 650 CE, Teotihuacan covered nearly 9 square miles and had a population of about 200,000, making it the largest city in the Americas and one of the largest in the world at that time (figs. 12-4, 12-5). The people of Teotihuacan worshiped two primary

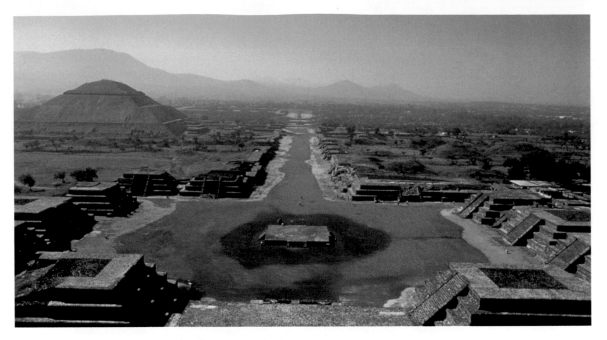

12-4. Ceremonial center of the city of Teotihuacan, Mexico. Teotihuacan culture, c. 500 CE

View from the Pyramid of the Moon toward the Ciudadela and the Temple of the Feathered Serpent. The Pyramid of the Sun is on the middle left.

gods: the goggle-eyed Storm God and the Great Goddess, an earth-surface and groundwater deity.

Sometime in the middle of the eighth century disaster struck Teotihuacan. The ceremonial center burned, and the city went into a permanent decline. Nevertheless, its influence continued as other centers throughout northern Mesoamerica borrowed and transformed its imagery over the next several centuries. The site was never entirely abandoned, however, because it remained a legendary pilgrimage center. The much later Aztec (c. 1300–1525 CE) revered the site, believing it to be the place where the gods created the sun and the moon. Its name, Teotihuacan, is an Aztec word meaning "The City [gathering place] of the Gods."

Teotihuacan's principal monuments include the Pyramid of the Sun and the Pyramid of the Moon. A broad thoroughfare laid out on a north-south axis, extending for more than 3 miles and in places as much as 150 feet wide, bisects the city. Much of the ceremonial center, in a pattern typical of Mesoamerica, is characterized by the symmetrical arrangement of structures around open courts or plazas. The Pyramid of the Sun is east of the main corridor.

The largest of Teotihuacan's architectural monuments, the Pyramid of the Sun is more than 210 feet high and measures about 720 feet on each side at its base, similar in size but not as tall as the largest Egyptian pyramid at Giza. It is built over a four-chambered cave with a spring that may have been the original focus of worship at the site and the source of its prestige. It rises in a series of sloping steps to a flat platform, where a two-room temple once stood. A monumental stone stairway led from level to level up the side of the pyramid to the temple platform. The exterior was faced with stone and stucco and was painted. The Pyramid of the Moon, not quite as large as the Pyramid of the Sun, stands at the

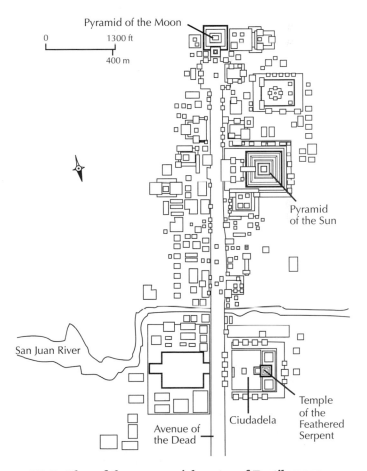

12-5. Plan of the ceremonial center of Teotihuacan

north end of the main avenue, facing a large plaza flanked by smaller, symmetrically placed platforms.

At the southern end of ceremonial center, and at the heart of the city, is the so-called Ciudadela, a vast sunken

12-6. Temple of the Feathered Serpent, the Ciudadela, Teotihuacan, Mexico. Teotihuacan culture, after 350 CE

plaza surrounded by temple platforms. One of the city's principal religious and political centers—the plaza could accommodate more than 60,000 people—it had as its focal point the Temple of the Feathered Serpent. This structure exhibits the ***talud-tablero*** (slope-and-panel) construction that is a hallmark of the Teotihuacan architectural style. The sloping base, or *talud*, of each platform supports a *tablero*, or **entablature**, that rises vertically, is surrounded by a frame, and often was filled with sculptural decoration (fig. 12-6). The Temple of the Feathered Serpent was enlarged several times, and typical of Mesoamerican practice, each enlargement completely enclosed the previous structure.

Archaeological excavations of the temple's early-phase *tableros* and a stairway balustrade have revealed painted reliefs of the Feathered Serpent, the goggle-eyed Storm God, and aquatic shells and snails. Their flat, angular, abstract style is typical of Teotihuacan art and is a marked contrast to the three-dimensional, curvilinear Olmec style. The Storm God has a squarish, stylized head with protruding lips, huge round eyes originally inlaid with obsidian and surrounded by once-colored circles, and large, circular earspools. The fanged serpent heads emerge from an aureole of stylized feathers. The Storm God and the Feathered Serpent may represent alternating

wet and dry seasons or may be symbols of regeneration and cyclical renewal. Mass burials have been found here—in one case, eighty young men dressed as warriors. Archaeologists now suggest that male social groups had formed, with the Storm God and the Feathered Serpent as their patrons.

The residential sections of Teotihuacan fanned out from the city's center. The large palaces of the elite, with as many as forty-five rooms and seven patios, stood nearest the ceremonial center. Artisans, foreign traders, and peasants lived farther away, in simpler compounds. The palaces and more humble homes alike were rectangular one-story structures with high walls, thatched roofs, and suites of rooms arranged symmetrically around open courts. Walls were plastered and, in the homes of the elite, were covered with paintings.

Teotihuacan's artists worked in a true **fresco** technique, applying pigments directly on damp lime plaster. Their painting style, like that for sculpture, was flat, angular, and abstract. Their use of color is subtle—one work may include five shades of red with touches of ocher, green, and blue. A detached fragment of a wall painting, now in the Cleveland Museum of Art, depicts a bloodletting ritual in which an elaborately dressed man impersonating the Storm God enriches and revitalizes the earth (the

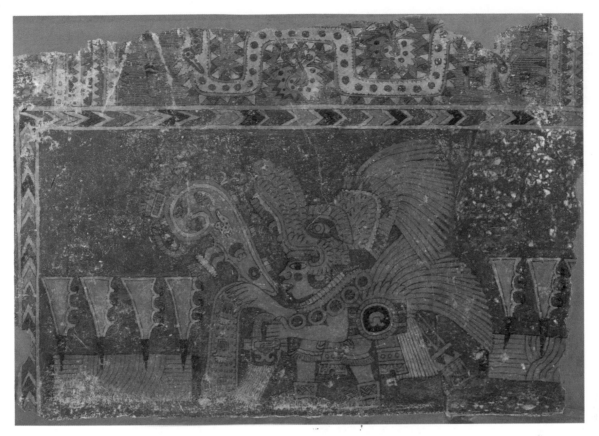

12-7. ***Maguey Bloodletting Ritual***, fragment of a fresco from Teotihuacan, Mexico. Teotihuacan culture, 600–750 CE. Pigment on lime plaster, 32¼ x 45¼" (82 x 116.1 cm). The Cleveland Museum of Art
Purchase from the J. H. Wade Fund (63.252)

The maguey plant supplied the people of Teotihuacan with food; fiber for making clothing, rope, and paper; and the sacramental drink pulque. As this painting indicates, priestly officials used its spikes in rituals to draw their own blood as a sacrifice to the Great Goddess.

Great Goddess) with his own blood (fig. 12-7). The man's Feathered Serpent headdress, decorated with precious quetzal feathers, indicates his high rank. He stands between rectangular plots of earth planted with bloody maguey spines and scatters seeds or drops of blood from his right hand, as indicated by the panel with conventionalized symbols for blood, seeds, and flowers. The **speech scroll** emerging from his open mouth symbolizes his ritual chant. The visual weight accorded the headdress and speech scroll suggests that the man's priestly office and chanted words are essential elements of the ceremony. Such bloodletting rituals were not limited to Teotihuacan but were widespread in Mesoamerica.

THE MAYA

The Maya homeland in Mesoamerica includes Guatemala, the Yucatan peninsula, Belize, and the northwestern part of Honduras. The remarkable civilization created there endured to the time of the Spanish conquest in the early sixteenth century and is still reflected in present-day Maya culture. The ancient Maya are noted for a number of achievements, including finding ways to produce high agricultural yields in the seemingly inhospitable tropical rain forest of the Yucatan. In densely populated cities they built imposing pyramids, temples, palaces, and administrative structures. They developed the most advanced hieroglyphic writing in Mesoamerica and the most sophisticated version of the Mesoamerican calendrical system (see "Maya Record Keeping," page 458). With these tools they documented the accomplishments of their rulers in monumental commemorative **stelai**, in books, on ceramic vessels, and on wall paintings. (Scholars have determined the relationship between the Maya calendar and the European calendar, making it possible to date Maya artifacts with a precision unknown elsewhere in the Americas.) They studied astronomy and the natural cycles of plants and animals and developed the mathematical concepts of zero and place value before they were known in Europe.

An increasingly detailed picture of the Maya has been emerging from recent archaeological research and advances in deciphering their writing. That picture shows a society divided into competing centers, each with a hereditary ruler and an elite class of nobles and priests supported by a large group of farmer-commoners. Rulers established their legitimacy, maintained links with their divine ancestors, and sustained the gods through elaborate rituals, including ball games, bloodletting ceremonies, and human sacrifice. These rituals occurred in the pyramids, temples, and plazas that dominated Maya cities. Rulers commemorated such events and their

Since the rediscovery of the Classic-period Maya sites in the nineteenth century, scholars have puzzled over the meaning of the hieroglyphic writing that abounds in Maya art work. They soon realized that many of the glyphs were numeric notations in a complex calendrical system. In 1894, a German librarian, Ernst Forstermann, deciphered the numbering systems. By the early twentieth century, the calendrical system had been interpreted and approximately correlated with the European calendar. The Maya calendar counts time from a starting date now securely established as August 13, 3114 BCE.

Since the late 1950s scholars have made enormous progress in deciphering Maya writing. Previously, many prominent Mayanists argued that the inscriptions dealt with astronomical and astrological observations, not historical events. This interpretation was in accord with the prevailing view that the Classic-period Maya were a peaceful people ruled by a theocracy of learned priests. The results of the deciphering and archaeological research overturned the earlier view of Maya society and Maya writing. The inscriptions on Maya architecture and **stelai** are almost entirely devoted to historical events. They record the dates of royal marriages, births of heirs, alliances between cities, and great military victories, tying them to astronomical events and propitious periods in the Maya calendar.

Maya writing, like the Maya calendar, is the most advanced in ancient Mesoamerica. About 800 glyphs have been identified. The system combines logographs—symbols representing entire words—and symbols representing syllables in the Maya language.

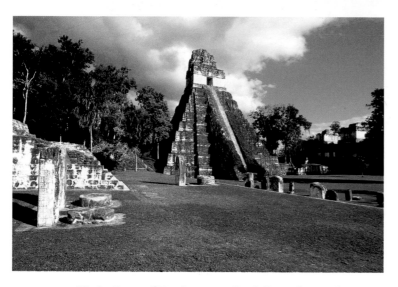

12-8. Base of North Acropolis (left) and Temple I, called the Temple of the Giant Jaguar (tomb of Ah Hasaw), Tikal, Guatemala. Maya culture. North Acropolis, 5th century CE; Temple I, c. 700 CE

examples of the use of architecture for public display and propaganda. Seen from outside and afar, they would have impressed the common people with the power and authority of the elite and the gods they served.

Tikal, in what is now northern Guatemala, was the largest Classic-period Maya city, with a population of as many as 70,000 at its height. Like other Maya cities—and unlike Teotihuacan, with its grid plan—Tikal conformed to the uneven terrain of the rain forest. Plazas, pyramid-temples, ball courts, and other structures stood on high ground connected by elevated roads, or causeways. One major causeway, 80 feet wide, led from the center of the city to outlying residential areas.

Figure 12-8 shows part of the ceremonial core of Tikal. The structure whose base is visible on the left, known as the North Acropolis, dates to the early Classic period. It contained many royal tombs and covers earlier structures that date to the origin of the city, about 500 BCE. The tall pyramid in the center, known as Temple I or the Temple of the Giant Jaguar, faces a companion pyramid, Temple II, across a large plaza. Temple I covers the tomb of the ruler Ah Hasaw (682–c. 727 CE), who began an ambitious expansion of Tikal after a period in the sixth and early seventh centuries CE when there was little new construction at this or other major Maya sites. Under Ah Hasaw and his successors, Tikal's influence grew, with evidence of contacts that extended from highland Mexico to Costa Rica.

From Ah Hasaw's tomb in the limestone bedrock, Temple I rises above the forest canopy to a height of more than 140 feet. Its base has nine layers, probably reflecting the belief that the underworld had nine levels. Priests climbed the steep stone staircase on the exterior to the temple on top, which consists of two long, parallel rooms covered with a steep roof supported by **corbel vaults**. It is typical of Maya enclosed stone structures, which resemble the kind of pole-and-thatch houses the Maya still build in parts of the Yucatan today. The only entrance to the temple was on the long side, facing the plaza and the commemorative stelai erected there. The crest that rises over the roof of the temple, known as a

military exploits on carved stelai. A complex pantheon of deities, many with several manifestations, presided over the Maya universe.

Olmec influence was widespread around 1000–300 BCE in what would come to be the Maya area. The earliest distinctively Maya centers emerged around 350 BCE–300 CE, and Maya civilization reached its peak in the southern lowlands of the Yucatan peninsula (Chiapas, northern Guatemala, Belize, and northwestern Honduras; see Map 12-1, page 450) during the Classic period (300–900 CE). Probably due to increased warfare and growing pressure on agricultural resources, the sites in the southern lowlands were abandoned at the end of the Classic period. The focus of Maya civilization then shifted to the northern Yucatan peninsula during the Postclassic period (900–1500 CE).

Classic-Period Architecture at Tikal and Palenque. The monumental buildings of Maya cities were masterly

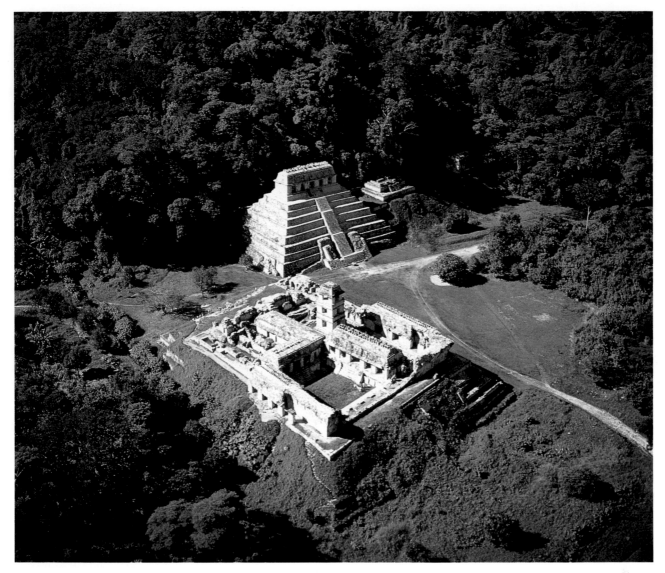

12-9. "Palace" (foreground) and Temple of the Inscriptions (tomb-pyramid of Lord Pacal), Palenque, Mexico. Maya culture, 7th century CE

roof comb, was originally covered with brightly painted sculpture. Archaeological evidence recently raised the possibility that the narrow platforms of the pyramids served as shallow stages for ritual reenactments of mythological narratives.

Palenque, in the Mexican state of Chiapas, rose to prominence in the late Classic period. Hieroglyphic inscriptions record the beginning of its royal dynasty in 431 CE, but the city had only limited regional importance until the ascension of a powerful ruler, Lord Pacal (Maya for "shield"), who ruled from 615 to 683 CE. He and the son who succeeded him commissioned most of the structures visible at Palenque today. As at Tikal, major buildings are grouped on high ground. A northern complex has five temples, two nearby adjacent temples, and a ball court. A central group includes the so-called Palace, the Temple of the Inscriptions, and two other temples (fig. 12-9). A third group of temples lies to the southeast.

The "palace" in the central group—a series of buildings on two levels around three open courts, all on a raised terrace—may have been an administrative rather than a residential complex. The Temple of the Inscriptions next to it is a pyramid that rises about 75 feet. Like Temple I at Tikal, it has nine levels. The shrine on the summit consisted of a portico with five entrances and a three-part, vaulted inner chamber surmounted by a tall roof comb. Its facade still retains much of its stucco sculpture. The inscriptions that give the building its name were carved on the back wall of the portico and the central inner chamber.

In 1952 an archaeologist studying the structure of the Temple of the Inscriptions discovered a corbel-vaulted stairway beneath the summit shrine. This stairway descended almost 80 feet to a small subterranean chamber that contained the undisturbed tomb of Lord Pacal himself, and in it were some remarkable examples of Classic-Period sculpture.

Classic-Period Sculpture. Lord Pacal lay in a monolithic sarcophagus with a lid carved in low relief that showed him balanced between the spirit world and the earth

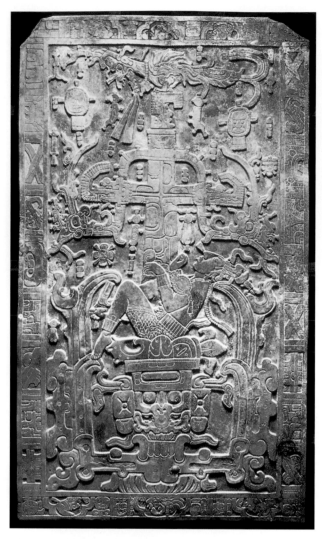

12-10. Sarcophagus lid, in the tomb of Lord Pacal (Shield 2), Temple of the Inscriptions, Palenque, Mexico. Maya culture, c. 683 CE. Limestone, approx. 12'6" x 7' (3.8 x 2.14 m)

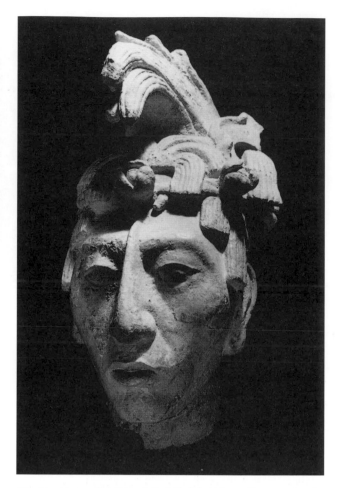

12-11. Portrait of Lord Pacal, from his tomb, Temple of the Inscriptions, Palenque, Mexico. Maya culture, mid-7th century CE. Stucco, height 16⁷/₈" (43 cm). Museo Nacional de Antropología, Mexico City

This portrait of the youthful Lord Pacal may have been placed in his tomb as an offering. Possibly it formed part of the original exterior decoration of the Temple of the Inscriptions.

(fig. 12-10). With knees bent, feet twisted, and face, hands, and torso upraised, he lies on the head of a creature that represents the setting sun. Together they are falling into the jaws of the underworld's monster. The image above him, which ends in the profile head of a god and a fantastic bird, represents the sacred tree of the Maya. Its roots are in the earth, its trunk is in the world, and its branches support the celestial bird in the heavens. The message is one of death and rebirth. Lord Pacal, like the setting sun, will rise again to join the gods after falling into the underworld. Lord Pacal's ancestors, carved on the side of his sarcophagus, witness his death and **apotheosis**. They wear elaborate headdresses and are shown only from the waist up, as though emerging from the earth. Among them are Lord Pacal's parents, Lady White Quetzal and Lord Yellow Jaguar-Parrot, supporting the contention of some scholars that both maternal and paternal lines transmitted royal power among the Maya.

Elite men and women, rather than gods, were the usual subjects of Maya sculpture, and most show rulers dressed as warriors performing religious rituals in elaborate costumes and headdresses. The Maya favored low-relief carving with sharp outlines on flat stone surfaces, but they also excelled at three-dimensional clay and stucco sculpture. A stucco portrait of Lord Pacal found with his sarcophagus shows him as a young man wearing a diadem of jade and flowers (fig. 12-11). His features—sloping forehead and elongated skull (babies' heads bound to produce this shape), large curved nose (enhanced by an ornamental bridge, perhaps of latex), full lips, and open mouth—are characteristic of the Maya ideal of beauty. His long narrow face and jaw are individual characteristics. Traces of pigment indicate that this portrait, like much Maya sculpture, was colorfully painted.

Classic-Period Painting. Artists had high status in Maya society, reflecting in part the great importance of record keeping to the Maya; they chronicled their history in carved and painted inscriptions on stelai, ceramic vessels, and walls and with hieroglyphic writing and illustrations in **codices**—books of folded paper made from the

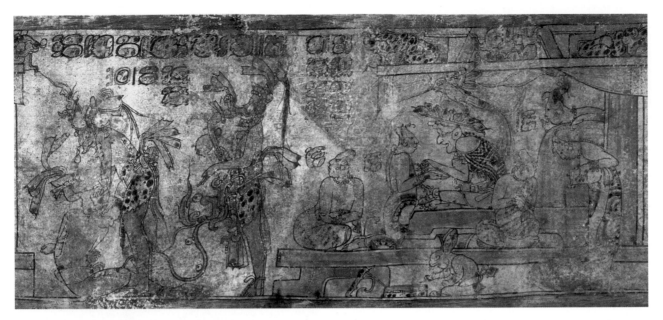

12-12. Cylindrical vessel (composite photograph in the form of a roll-out). Maya culture, 600–900 CE. Painted ceramic, diameter 6¹/₂" (16.6 cm); height 8³/₈" (21.5 cm). The Art Museum, Princeton University, New Jersey

The clay vessel was first covered by a creamy white slip and then painted in light brown washes and dark brown or black lines. The painter may have used turkey feathers to apply the pigments.

maguey plant. Vase painters and scribes were often members of the ruling elite and perhaps included members of the royal family not in the direct line of succession.

Maya painting survives on ceramics and a few large murals; most of the illustrated books have perished, except for a few late examples with astronomical and divinatory information. However, the books' influence is reflected in vases painted in the so-called codex style, which often show a fluid line and elegance similar to that of the manuscripts.

The codex-style painting on a late Classic cylindrical vase (fig. 12-12) may illustrate an episode from the Book of Popol Vuh, the history of the creation of the world and the first people. The protagonists, the mythical Hero Twins, defeat the lords of Xibalba, the Maya underworld, and overcome death. The vessel shows one of the lords of Xibalba, an aged-looking being known to archaeologists as God L, sitting inside a temple on a raised platform. Five female deities attend him. The god ties a wrist cuff on the attendant kneeling before him. Another attendant, seated outside the temple, looks over her shoulder at a scene in which two men sacrifice a bound victim. A rabbit in the foreground writes in a manuscript, reminding us of the Maya obsession with historical records, as well as of the many books now lost. The two men may be the Hero Twins and the bound victim a bystander they sacrificed and then brought back to life to gain the confidence of the Xibalban lords. The inscriptions on the vessel have not been entirely translated. They include a calendar reference to the Death God and to the evening star, which the Maya associated with war and sacrifice.

Postclassic Art. A northern Maya group called the Itza rose to prominence when the focus of Maya civilization shifted northward in the Postclassic period. Their principal center, Chichen Itza, which means "at the mouth of the well of the Itza," grew from a village located near a sacred well. The city flourished from the ninth to the thirteenth century CE, eventually covering about 6 square miles.

One of Chichen Itza's most conspicuous structures is a massive pyramid in the center of a large plaza embellished with figures of the Feathered Serpent (fig. 12-13). A stairway on each side leads to a square, blocky temple on its summit. At the spring and fall equinoxes, the setting sun casts an undulating, serpentlike shadow on the stairway balustrades. Like earlier Maya pyramids, this one has nine levels, but many other features of Chichen Itza are markedly different from earlier sites. The pyramid,

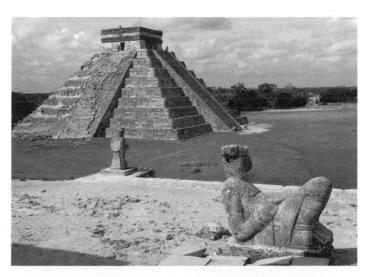

12-13. Pyramid with Chacmool in foreground, Chichen Itza, Yucatan, Mexico. Itza (northern Maya) culture, 9th–13th century CE; Chacmool, 800–1000 CE

for example, is lower and broader than the stepped pyramids of Tikal and Palenque, and Chichen Itza's buildings have wider rooms. Another prominent feature not found at earlier sites is the use of pillars and columns. Chichen Itza has broad, open galleries surrounding courtyards and inventive columns in the form of inverted, descending serpents. Brilliantly colored relief sculpture covered the buildings of Chichen Itza, and paintings of feathered serpents, jaguars, coyotes, eagles, and composite mythological creatures adorned its interior rooms. The surviving works show narrative scenes that emphasize the prowess of warriors and the skill of ritual ballplayers.

Sculpture at Chichen Itza, including the serpent columns and the half-reclining figures known as **Chacmools** (see fig. 12-13), has the sturdy forms, proportions, and angularity of architecture. It lacks the curving forms and subtlety of Classic Maya sculpture. The Chacmools probably represent fallen warriors and were used to receive sacrificial offerings. They were once, inaccurately, considered the archetypal Pre-Columbian sculpture.

After Chichen Itza's decline, Mayapan, on the north coast of the Yucatan, became the principal Maya center. But by the time the Spanish arrived in the early sixteenth century, Mayapan, too, had declined. The Maya people and much of their culture would survive the conquest despite the imposition of Hispanic customs and beliefs. The Maya continue to speak their own languages, to venerate traditional sacred places, and to follow traditional ways.

CENTRAL AMERICA

Unlike their neighbors in Mesoamerica, who lived in complex hierarchical societies, the people of Central America generally lived in extended family groups led by chiefs. A notable example of these small chiefdoms was the Diquis culture, which developed in present-day Costa Rica from about 700 CE to about 1500 CE.

The Diquis occupied fortified villages without monumental architecture or sculpture and seem to have engaged in constant warfare with one another. They nevertheless produced fine featherwork, ceramics, textiles, and gold objects. (The name Costa Rica, which means "rich coast" in Spanish, probably reflects the value the Spanish placed on the gold they found there.)

Metallurgy and the use of gold and copper-gold alloys were widespread in Central America. The technique of **lost-wax casting** probably first appeared in present-day Colombia between 500 and 300 BCE. From there it spread north to the Diquis. The small, exquisite pendant shown in figure 12-14 illustrates the sophisticated design and technical facility of Diquis goldwork. The pendant depicts a male figure wearing bracelets, anklets, and a belt with a snake-headed penis sheath. He plays a drum while holding the tail of a snake in his teeth and its head in his left hand. The wavy forms with serpent heads emerging from his scalp suggest an elaborate headdress, and the creatures emerging from his legs suggest some kind of reptile costume. The inverted triangles on the headdress probably represent birds' tails.

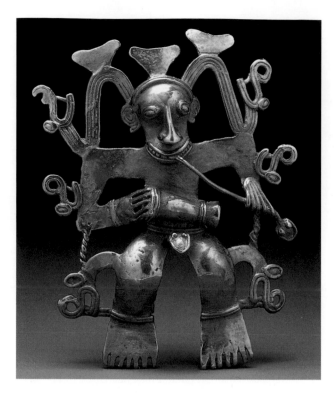

12-14. *Shaman with Drum and Snake*, from Costa Rica. Diquis culture, c. 1000 CE. Gold, 4¼ x 3¼" (10.8 x 8.2 cm). Museos del Banco Central de Costa Rica, San José, Costa Rica

In Diquis mythology serpents and crocodiles inhabited a lower world, humans and birds a higher one. Their art depicts animals and insects as fierce and dangerous. Perhaps the man in the pendant is a shaman transforming himself into a composite serpent-bird or performing a ritual snake dance surrounded by serpents or crocodiles. The scrolls on the sides of his head may represent the shaman's power to hear and understand the speech of animals. Whatever its specific meaning, the pendant evokes a ritual of mediation between earthly and cosmic powers involving music, dance, and costume.

Whether gold figures of this kind were protective amulets or signs of high status, they were certainly more than personal adornment. Shamans and warriors wore gold to inspire fear, perhaps because gold was thought to capture the energy and power of the sun. This energy was also thought to allow shamans to leave their bodies and travel into cosmic realms.

SOUTH AMERICA: THE CENTRAL ANDES

Like Mesoamerica, the central Andes of South America—primarily present-day Peru and Bolivia—saw the development of complex hierarchical societies with rich and varied artistic traditions. The area is one of dramatic contrasts. The narrow coastal plain, bordered by the Pacific Ocean on the west and the abruptly soaring Andes on the east, is one of the driest deserts in the world. Life here depends on the rich marine resources of the Pacific and the rivers that descend from the Andes, forming a series of valley oases from south to north. The Andes themselves are a

region of lofty snowcapped peaks, high grasslands, steep slopes, and deep, fertile river valleys. The high grasslands are home to the Andean camelids—llamas, alpacas, vicuñas, and guanacos—that have served for thousands of years as beasts of burden and a source of wool and meat. The lush eastern slopes of the Andes descend to the tropical rain forest of the Amazon basin.

The earliest evidence of monumental architecture in Peru dates to the third millennium BCE, contemporary with the earliest pyramids in Egypt. (There are no dated monuments; all dates are approximate.) On the coast, sites with ceremonial mounds and plazas were located near the sea. The inhabitants of these centers depended on marine and agricultural resources, farming the floodplains of nearby coastal rivers. Their chief crops were cotton, used to make fishing nets, and gourds, used for floats. Early centers in the highlands consisted of multi-roomed stone-walled structures with sunken central fire pits for burning ritual offerings.

In the second millennium BCE, herding and agriculture became prevalent in the highlands. On the coast, people became increasingly dependent on agriculture. They began to build canal irrigation systems, greatly expanding their food supply. Settlements were moved inland, and large, U-shaped ceremonial complexes with circular sunken plazas were built. These complexes were oriented toward the mountains, the direction of the rising sun and the source of the water that nourished their crops. The shift to irrigation agriculture also corresponded to the spread of pottery and ceramic technology in Peru.

Between about 1000 and 200 BCE an art style associated with the northern highland site of Chavin de Huantar spread through much of the Andes. In Andean chronology, this era is known as the Early Horizon, the first of three so-called horizon periods marked by the widespread influence of a single style (see Timeline 12-1). The political and social forces behind the spread of the Chavin style are not known; many archaeologists suspect that they involved an influential religious cult.

The Chavin site was located on a major trade route between the coast and the Amazon basin, and Chavin art features images of many tropical forest animals. The period was one of artistic and technical innovation in ceramics, metallurgy, and textiles (ceramics, metalware, and textiles all were found in burial sites, reflecting the importance to the Chavin people of burial and the afterlife). These innovations were also expressed in the textiles of the Paracas culture on the south coast of Peru, the art of the Nazca culture there, and the ceramics and metalwork of the Moche culture on the north coast.

THE PARACAS AND NAZCA CULTURES

The Paracas culture of the Peruvian south coast flourished from about 1000 BCE to 200 CE, overlapping the Chavin period. It is best known for its stunning textiles, which were found in cemeteries wrapped in many layers around the dead. Some bodies were wrapped in as many as 200 pieces of cloth.

Weaving is of great antiquity in the central Andes and continues to be among the most prized arts in the region (see "Andean Textiles," page 452). Fine textiles were a source of prestige and wealth, and the production of textiles was an important factor in the domestication of both cotton and llamas. The designs on Paracas textiles include repeated **embroidered** (needlework) figures of warriors, dancers, and composite creatures such as

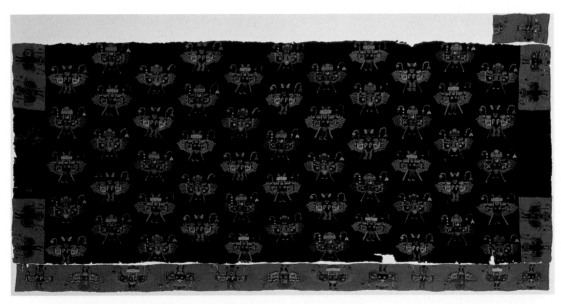

12-15. Mantle with bird impersonators, from the Paracas peninsula, Peru. Paracas culture, c. 50–100 CE. Camelid fiber, plain weave with stem-stitch embroidery, approx. 40" x 7'11" (101 cm x 2.41 m).
Museum of Fine Arts, Boston
Denman Waldo Ross Collection
The stylized figures display the beautiful Paracas sense of color and pattern. The all-directional pattern is also characteristic of Paracas art.

TIMELINE 12-2. **North American Cultures before 1300.** The Adena, Hopewell, and Mississippian cultures settled the Mississippi, Missouri, Illinois, and Ohio river valleys. The Mogollon, Hohokam, and Anasazi cultures developed in the Southwest.

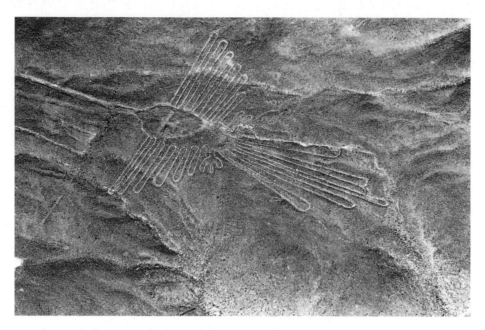

12-16. Earth drawing of a hummingbird, Nazca Plain, southwest Peru. Nazca culture, c. 200 BCE–200 CE. Length approx. 450' (138 m); wingspan approx. 200' (60.5 m)

bird-people (fig. 12-15). Embroiderers used tiny overlapping stitches to create colorful, curvilinear patterns, sometimes using as many as twenty-two different colors within a single figure. The effect of the clashing and contrasting colors and tumbling figures is dazzling.

The Nazca culture, which dominated the south coast of Peru from about 200 BCE to 600 CE, overlapped the Paracas culture. Nazca artisans continued to weave fine fabrics, but they also produced multicolored pottery with painted and modeled images reminiscent of those on Paracas textiles.

The Nazca are probably best known for their colossal earthworks, or **geoglyphs**, which dwarf even the most ambitious twentieth-century environmental sculpture. On great stretches of desert they literally drew in the earth. By removing dark, oxidized stones, they exposed the light underlying stones, then edged the resulting lines with more stones. In this way they created gigantic images—including a hummingbird, a killer whale, a monkey, a spider, a duck, and other birds—similar to those with which they decorated their pottery. They also made abstract patterns and groups of straight, parallel lines that extend for up to 12 miles. The beak of the hummingbird in figure 12-16 consists of two parallel lines, each 120 feet long. Each geoglyph was evidently maintained by a clan. At regular intervals the clans gathered on the plateau in a sort of fair where they traded goods and looked for marriage partners. How the glyphs functioned—perhaps as clan emblems or spirit patrons—is unknown, but the "lines" of stone are wide enough to have been ceremonial walkways.

THE MOCHE CULTURE

The Moche culture dominated the north coast of Peru from the Piura Valley to the Huarmey Valley—a distance of some 370 miles—between about 200 BCE and 600 CE. Moche lords ruled each valley in this region from a ceremonial-administrative center. The largest of these, in the Moche Valley (from which the culture takes its name), contained the so-called Pyramids of the Sun and the Moon. Both pyramids were built entirely of **adobe** bricks. The Pyramid of the Sun, the largest ancient structure in South America, was originally a cross-shaped structure 1,122 feet long by 522 feet wide that rose in a series of terraces to a height of 59 feet. This site had been thought to be the capital of the entire Moche realm, but evidence is accumulating that the Moche were not so centralized.

The Moche were exceptional potters and metalsmiths. They developed ceramic molds, which allowed them to mass-produce some forms. Vessels were made in the shape of naturalistically modeled human beings, animals, and architectural structures. They also created realistic portrait vessels and recorded mythological narratives and ritual scenes in intricate fine-line painting. Similar scenes were painted on the walls of temples and administrative buildings. Moche smiths, the most sophisticated in the central Andes, developed several innovative metal alloys.

The ceramic vessel in figure 12-17 shows a Moche lord sitting in a structure associated with high office. He wears an elaborate headdress and large earspools and

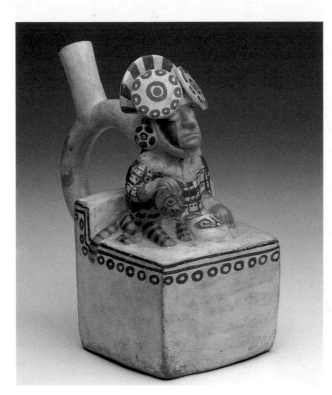

12-17. *Moche Lord with a Feline*, from Moche Valley, Peru. Moche culture, c. 100 BCE–500 CE. Painted ceramic, height 7¹/₂" (19 cm). Art Institute of Chicago
Buckingham Fund, 1955–2281

Behind the figure is the distinctive stirrup-shaped handle and spout. Vessels of this kind, used in Moche rituals, were also treasured as special luxury items and were buried in large quantities with individuals of high status.

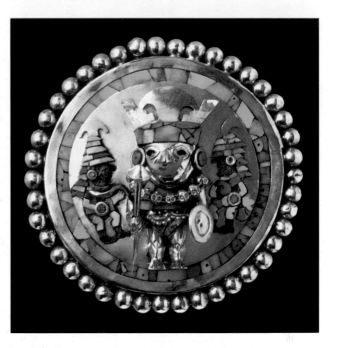

12-18. Earspool, from Sipan, Peru. Moche culture, c. 300 CE. Gold, turquoise, quartz, and shell, diameter approx. 5" (12.7 cm). Bruning Archaeological Museum, Lambayeque, Peru

strokes a cat or perhaps a jaguar cub. The so-called stirrup, or U-shaped spout, appears on many high-quality Moche vessels. Paintings indicate that vessels of this type were used in Moche rituals.

A central theme in Moche iconography is the sacrifice ceremony, in which prisoners captured in battle are sacrificed and several elaborately dressed figures drink their blood. Archaeologists have labeled the principal figure in the ceremony as the Warrior Priest and other important figures as the Bird Priest and the Priestess. The recent discovery of a number of spectacularly rich Moche tombs indicates that the sacrifice ceremony was an actual Moche ritual and that Moche lords assumed the roles of the principal figures. The occupant of a tomb at Sipan, on the northwest coast, was buried with the regalia of the Warrior Priest. In a tomb at the site of San José de Moro, just south of Sipan, an occupant was buried with the regalia of the Priestess.

Among the riches accompanying the Warrior Priest at Sipan was a pair of exquisite gold-and-turquoise earspools, each of which depicts three Moche warriors

(fig. 12-18). The central figure is made of beaten gold and turquoise. He and his companions are adorned with tiny gold-and-turquoise earspools. They wear spectacular gold-and-turquoise headdresses topped with delicate sheets of gold that resemble the crescent-shaped knives used in sacrifices. The crests, like feathered fans of gold, would have swayed in the breeze as the wearer moved. The central figure has a crescent-shaped nose ornament and carries a gold club and shield. A necklace of owl's-head beads strung with gold thread hangs around his shoulders. Many of his anatomical features have been rendered in painstaking detail.

NORTH AMERICA

Compared to the densely inhabited agricultural regions of Mesoamerica and South America, most of North America remained sparsely populated. People lived primarily by hunting, fishing, and gathering edible plants. In the Southeast and in the lands drained by the Mississippi and Missouri river system, a more settled way of life began to emerge, and by around 1000 BCE—in Louisiana as early as 2800 BCE, according to some anthropologists—nomadic hunting and gathering had given way to more settled communities (Timeline 12-2). People cultivated squash, sunflowers, and other plants to supplement their diet of game, fish, and berries. People in the American Southwest began to adopt a sedentary, agricultural life toward the end of the first millennium BCE.

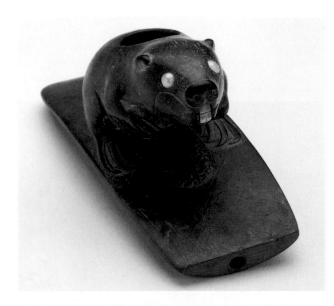

12-19. Beaver effigy platform pipe, from Bedford Mound, Pike County, Illinois. Hopewell culture, c. 100–200 CE. Pipestone, pearl, and bone, length 4¹/₂" (11.4 cm). Gilcrease Museum, Tulsa, Oklahoma

Pipes made by the Hopewell culture may have been used for smoking hallucinatory plants, perhaps during rituals involving the animal carved on the pipe bowl. The shining pearl eyes indicate association with the spirit world.

THE MOUND BUILDERS

Sometime before 1000 BCE, people living in the river valleys of the American East began building monumental earthworks, or mounds, and burying their leaders with valuable grave goods. The earliest of these earthworks, six concentric circles three-fourths of a mile across at Poverty Point in Louisiana, dates to about 1700 BCE. The contents of the burial sites indicate that the people of the Mississippi, Illinois, and Ohio river valleys traded widely with other regions. For example, the burial sites of two mound-building cultures—the Adena (c. 1100 BCE–200 CE) and the Hopewell (c. 100 BCE–500 CE)—contained elaborate and rich grave goods, including jewelry made with copper from Michigan's Upper Peninsula and silhouettes cut in sheets of mica from the Appalachian Mountains. Further evidence of extensive trade is that fine-grained pipestone and the pipes the Hopewell people created from it have been found from Lake Superior to the Gulf of Mexico. Among the items the Hopewell received in exchange for their pipestone and a flintlike stone used for toolmaking were turtle shells and sharks' teeth from Florida.

The Hopewell carved their pipes with realistic representations of forest animals and birds, sometimes with inlaid eyes and teeth of freshwater pearls and bone. In a combination of realism and aesthetic simplification that is exceptionally sophisticated, a beaver crouching on a platform forms the bowl of a pipe found in Illinois (fig. 12-19). As in a modern pipe, the bowl—a hole in the beaver's back—could be filled with dried leaves (the Hopewell may not have grown tobacco), the leaves lighted, and smoke drawn through the hole in the stem. A second way that these pipes were used was to blow smoke inhaled from another vessel through the pipe to envelop the animal carved on it.

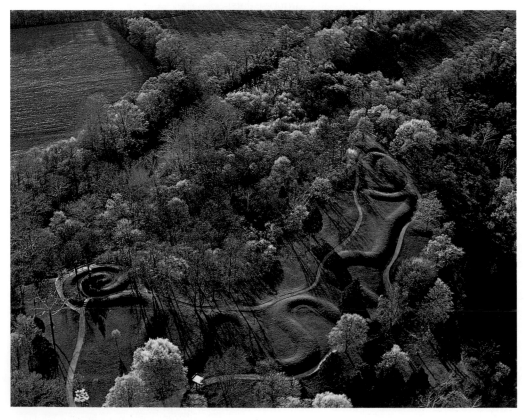

12-20. Great Serpent Mound, Adams County, Ohio. Mississippian culture, c. 1070 CE. Length approx. 1,254' (426.7 m)

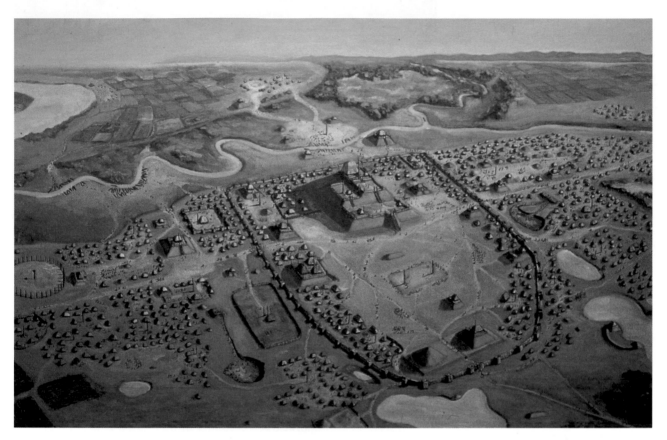

12-21. Reconstruction of central Cahokia, East St. Louis, Illinois. Mississippian culture, c. 1150 CE. East-west length approx. 3 miles (4.5 km), north-south length approx. 2¼ miles (3.6 km); base of great mound, 1,037 x 790' (316 x 241 m), height approx. 100' (30 m). Painting by William R. Iseminger

The people of the Mississippian culture (c. 900–1500 CE) continued the mound-building tradition begun by the earlier North American cultures. One of the most impressive mounds is the Great Serpent Mound in present-day Adams County, Ohio (fig. 12-20). A writhing earthen snake 1,254 feet long and 20 feet wide wriggles along the crest of a ridge overlooking a stream, with its head at the highest point. The serpent appears to open its jaws to swallow an enormous egg formed by a heap of stones. Researchers, using carbon-14 **radiometric dating**, have recently dated the mound at about 1070 CE. Perhaps the people who built it, like those who did the petroglyphs in Chaco Canyon (pages 448/449), were responding to mysterious lights in the sky, such as the Crab Nebula of 1054 or Halley's Comet in 1066.

One major site of Mississippian culture was Cahokia, 16 miles northeast of St. Louis near the juncture of the Illinois, Missouri, and Mississippi rivers (now East St. Louis, Illinois). It was an urban center of 6 square miles that at its height had a population of about 20,000 people, with another 10,000 in the surrounding countryside (figs. 12-21, 12-22). The site's most prominent feature is an enormous earth mound covering 15 acres. The location of the mound and the axis of the ceremonial center it dominated were established during the early part of the city's occupation (c. 900–1050 CE), but most construction occurred later, between about 1050 and 1200. A **stockade**, or fence, of upright wooden posts—a sign of increasing warfare—surrounded the 200-acre core. Within this

barrier the principal mound rose in four stages to a height of about 100 feet. On its summit was a small, conical platform that supported a wood fence and a rectangular temple for the ancestor effigies that represented the soul of the people. In front of the principal mound lay a large, roughly rectangular plaza surrounded by smaller rectangular and conical mounds. In all, the walled enclosure contained more than 500 mounds, platforms, wooden enclosures, and houses. The various earthworks functioned as tombs and as bases for palaces and temples. A conical burial mound, for example, was located next to a platform that may have been used for sacrifices.

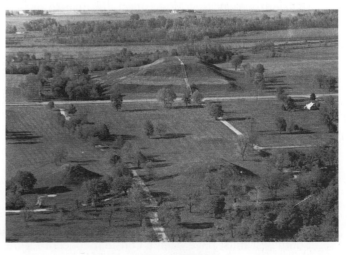

12-22. Cahokia

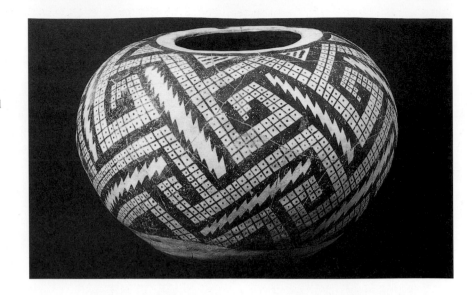

12-23. Seed jar. Anasazi culture, c. 1150 CE. Earthenware and black-and-white pigment, diameter 14½" (36.9 cm). The St. Louis Art Museum, St. Louis, Missouri
Purchase: Funds given by the Children's Art Festival 175:1981

Postholes indicate that wooden **henges** were a feature of Cahokia. The largest, with a diameter of about 420 feet (seen to the extreme left in figure 12-21), had forty-eight posts and was oriented to the cardinal points. Sight lines between a forty-ninth post set east of the center of the enclosure and points on the perimeter enabled native astronomers to determine solstices and equinoxes.

THE AMERICAN SOUTHWEST

The first farming culture emerged around 200 BCE in the arid southwestern region of what is now the United States, which became home to three major early cultures. The Mogollon culture, located in the mountains of west-central New Mexico and east-central Arizona, flourished from circa 200 CE to about 1250 CE. The Hohokam culture, concentrated in central and southern Arizona, emerged around 550 CE and endured until after about 1400 CE. The Hohokam built large-scale irrigation systems with canals that were deep and narrow to reduce evaporation and lined with clay to reduce seepage. The Hohokam shared a number of customs with their Mesoamerican neighbors to the south, including the ritual ball game.

The third southwestern culture, the Anasazi, emerged around 550 CE in the Four Corners region, where Colorado, Utah, Arizona, and New Mexico meet. The Anasazi adopted the irrigation technology of the Hohokam and began building "great houses," elaborate, multistoried, apartmentlike structures with many rooms for specialized purposes, including communal food storage. The largest known Anasazi center was in Chaco Canyon, a canyon of about 30 square miles with nine great houses. The Spanish called such communities *pueblos*, or "towns." (Descendants of the Anasazi, including the Hopi and Zuni Pueblo peoples, still occupy similar communities in the Four Corners area.)

The most extensive great house, Pueblo Bonito (see fig. 12-1), was built in stages between the tenth and mid-thirteenth centuries CE within a perimeter wall that was 1,300 feet long. Securing a steady food supply in the arid Southwest must have been a constant concern for the people of Chaco Canyon. At Pueblo Bonito the number of rooms far exceeds the evidence of human habitation, and many rooms were almost certainly devoted to food storage. It also has more than thirty **kivas**—including two that are more than 60 feet in diameter—attesting to the importance of ritual there. Kivas, with built-in platform seats around the perimeter, were a kind of ritual assembly hall where men performed important rites and instructed youths in their adult rituals and social responsibilities. The top of these circular, underground kivas became part of the floor of the communal plaza. Interlocking pine logs formed a shallow, domelike roof with a hole in the center through which only men entered the kiva by climbing down a ladder. Inside the kiva, in the floor directly under the entrance, a square hole—the "navel of the earth"—symbolized the place where the Anasazi ancestors had emerged from the earth in the mythic "first times."

Women were the potters in Anasazi society. In the eleventh century they perfected a functional, aesthetically pleasing, coil-built earthenware, or low-fired ceramic. This ceramic tradition continues today among the Pueblo peoples of the Southwest. One type of vessel, a wide-mouthed seed jar with a globular body and holes near the rim (fig. 12-23), would have been suspended from roof poles by thongs attached to the holes, out of reach of voracious rodents. The example shown here is decorated with black-and-white checkerboard and zigzag patterns. The patterns conform to the body of the jar, and in spite of their angularity, they enhance its curved shape. The intricate play of dark and light, positive and negative, suggests lightning flashing over a grid of irrigated fields.

Though no one knows for certain what happened to the Anasazi, the population of Chaco Canyon declined during severe drought in the twelfth century, and building at Pueblo Bonito ceased around 1230. Throughout the Americas for the next several hundred years, artistic traditions would continue to emerge, develop, and be transformed as the indigenous peoples of various regions interacted. The sudden incursions of Europeans, beginning in the late fifteenth century, would have dramatic and lasting impact on these civilizations and their art.

PARALLELS

CULTURE	ART OF THE AMERICAS BEFORE 1300	ART IN OTHER CULTURES
OLMEC c. 1200–400 BCE	12-2. **Great Pyramid, La Venta** (c. 900–600 BCE) 12-3. **Colossal head** (c. 900 BCE)	5-4. *Centaur* (10th cent. BCE), Greece 2-1. *Lamassu* (883–859 BCE), Assyria
PARACAS c. 1000 BCE–200 CE	12-15. **Mantle** (c. 50–100 CE)	13-3. **Nok head** (c. 500 BCE–200 CE), Africa
NAZCA c. 200 BCE–600 CE	12-16. **Earth hummingbird** (c. 200 BCE–200 CE)	5-74. *Gallic Chieftain Killing His Wife and Himself* (c. 220 BCE), Greece 9-8. **Great Stupa**, Sanchi (3rd cent. BCE), India
MOCHE c. 200 BCE–600 CE	12-17. *Moche Lord with a Feline* (c. 100 BCE–500 CE) 12-18. **Earspool** (c. 300 CE)	7-3. *Good Shepherd Orants, and Story of Jonah* (4th cent. CE), Italy 9-17. *Bodhisattva*, Ajanta (c. 475 CE), India
HOPEWELL c. 100 BCE–500 CE	12-19. **Beaver effigy platform pipe** (c. 100–200 CE)	6-34. **Pantheon** (125–28 CE), Italy 7-9. **Old St. Peter's** (c. 320–27 CE), Italy
TEOTIHUACAN c. 1–750 CE	12-6. **Feathered Serpent temple** (after 350 CE) 12-4. **City of Teotihuacan** (c. 500 CE) 12-7. *Maguey Bloodletting Ritual* (600–750 CE)	6-49. **Timgad** (begun c. 100 CE), Algeria 11-4. *Haniwa* (6th cent. CE), Japan
MAYA c. 350 BCE–900 CE	12-12. **Cylindrical vessel** (600–900 CE) 12-10. **Lord Pacal sarcophagus** (c. 683 CE) 12-8. **Temple I, Tikal** (c. 700 CE)	7-22. **Hagia Sophia** (532–37 CE), Turkey 8-2. **Dome of the Rock** (687–91 CE), Jerusalem
ANASAZI c. 550–1400 CE	12-1. **Pueblo Bonito, Chaco Canyon** (c. 900–1230 CE) 12-23. **Seed jar** (c. 1150 CE)	8-6. **Córdoba mosque** (begun 785–86 CE), Spain 14-17. *Utrecht Psalter* (c. 825–50), Netherlands 8-8. **Kufic bowl** (9th–10th cent. CE), Uzbekistan
DIQUIS c. 700–1500 CE	12-14. *Shaman with Drum and Snake* (c. 1000 CE)	15-32. *Bayeux Tapestry* (c. 1066–77 CE), France
ITZA c. 9th–13th century CE	12-13. **Chichen Itza plaza** (9th–13th cent. CE)	10-19. Fan. *Travelers among Mountains and Streams* (early 11th cent.), China
MISSISSIPPIAN c. 900–1500 CE	12-20. **Great Serpent Mound, Adams County** (c. 1070 CE) 12-21. **Cahokia** (c. 1150 CE)	7-39. **Cathedral of St. Mark** (begun 1063 CE), Italy

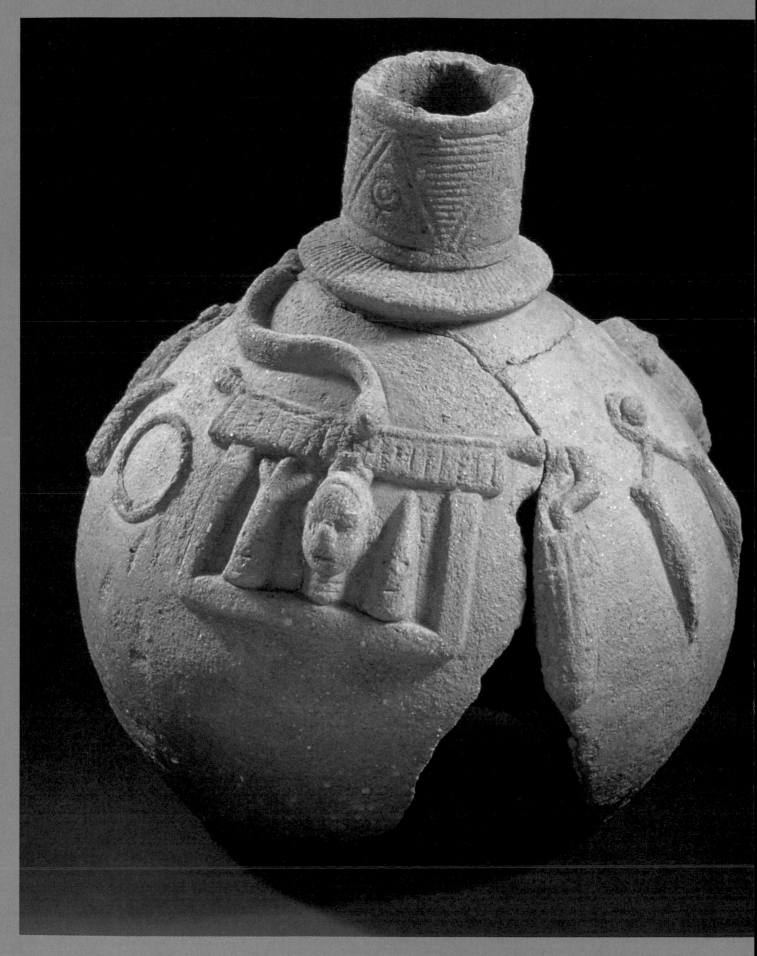

13-1. Ritual vessel, from Ife. Yoruba, 13–14th century. Terra-cotta, height 9¹³/₁₆" (24.9 cm). University Art Museum, Obafemi, Awolowo University, Ife, Nigeria

13
Art of Ancient Africa

The Yoruba people of southwestern Nigeria have traditionally regarded the city of Ife (also known as Ife-Ife) as the "navel of the world," the site of creation, the place where kingship originated when Ife's first ruler, the *oni* Oduduwa, came down from heaven to create earth and then to populate it. By the eleventh century CE, Ife was a lively metropolis and cultural center; today, every one of the many Yoruba cities claims "descent" from Ife.

Ancient Ife was essentially circular, with the *oni*'s palace at the center. Ringed by protective stone walls and moats, Ife was connected to other Yoruba cities by roads that radiated from the center and pierced the city walls at elaborate fortified gateways partially decorated with pavement mosaics created from stones and pottery shards. From these elaborately patterned pavement mosaics, which covered much of Ife's open spaces, came the name for Ife's most artistically cohesive centuries (c. 1000–1400 CE), the Pavement period.

Just as the *oni*'s palace was in a large courtyard in center of Ife, so too were ritual spaces elsewhere in Ife located in paved courtyards with altars. In the center of such a semicircular courtyard, outlined by half-rings of pavement mosaic, archaeologists excavated an exceptional terra-cotta vessel from Ife's Pavement period (fig. 13-1). The jar's bottom had been ritually broken before it was buried, so that liquid offerings (libations) poured into the neck opening would flow into the earth. The objects so elegantly depicted in high relief on the surface of the vessel include what looks like an altar table with three heads under it, the outer two quite abstract and the middle one **naturalistic** in the tradition of freestanding Yoruba portrait heads (see fig. 13-5). The abstraction of the two outside heads may well have been a way of honoring or blessing the central portrait, a practice that survives today among the Yoruba royalty.

TIMELINE 13-1. Art of Ancient Africa. Although most art created in impermanent materials such as wood has been lost, ancient African monuments in stone, terra-cotta, and brass can be found in existing cultural centers.

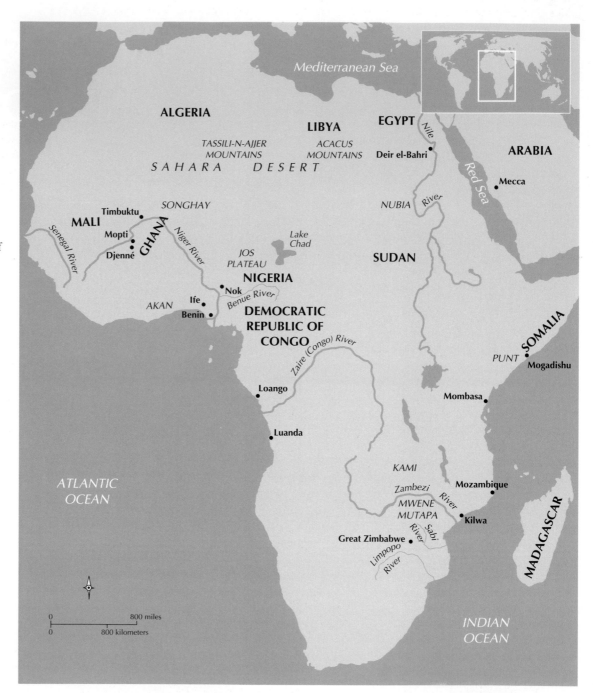

MAP 13-1.

Ancient Africa.
Nearly 5,000 miles from north to south, Africa is the second-largest continent and was the home of some of the earliest and most advanced cultures of the ancient world.

THE LURE OF ANCIENT AFRICA

"I descended [the Nile] with three hundred asses laden with incense, ebony, grain, panthers, ivory, and every good product." Thus the Egyptian envoy Harkhuf described his return from Nubia, the African land to the south of Egypt, in 2300 BCE. The riches of Africa attracted merchants and envoys in ancient times, and trade brought the continent in contact with the rest of the world. Egyptian relations with the rest of the African continent continued through the Hellenistic era and beyond. Phoenicians and Greeks founded dozens of settlements along the Mediterranean coast of North Africa between 1000 and 300 BCE to extend trade routes across the Sahara to the

peoples of Lake Chad and the bend of the Niger River (Map 13-1). When the Romans took control of North Africa, they continued this lucrative trans-Saharan trade. In the seventh and eighth centuries CE, the expanding empire of Islam swept across North Africa, and thereafter Islamic merchants were regular visitors to Bilad al-Sudan, the Land of the Blacks (sub-Saharan Africa). Islamic scholars chronicled the great West African empires of Ghana, Mali, and Songhay, and West African gold financed the flowering of Islamic culture.

East Africa, meanwhile, had been drawn since at least the beginning of the Common Era into the maritime trade that ringed the Indian Ocean and extended east to Indonesia and the South China Sea. Arab, Indian, and Persian ships plied the coastline. A new language, Swahili, evolved from centuries of contact between Arabic-speaking merchants and Bantu-speaking Africans, and great port cities such as Mozambique, Kilwa, Mombasa, and Mogadishu arose.

In the fifteenth century, Europeans—whose hostile relations with Islam had cut them off from Africa for centuries—ventured by ship into the Atlantic Ocean and down the coast of Africa. Finally rediscovering the continent at first hand, they were often astonished by what they found (see "The Myth of 'Primitive' Art," below). "Dear King My Brother," wrote a fifteenth-century Portuguese king to his new trading partner, the king of Benin in West Africa. The Portuguese king's respect was well founded—Benin was vastly more powerful and more wealthy than the small European country that had just stumbled upon it.

As we saw in Chapter 3, Africa was home to one of the world's earliest great civilizations, that of ancient Egypt, and as we saw in Chapter 8, Egypt and the rest of North Africa contributed prominently to the development of Islamic art and culture. This chapter examines the artistic legacy of the rest of ancient Africa, beginning with the early peoples of the Sahara, then turning to other early civilizations (Timeline 13-1).

SAHARAN ROCK ART

Like the Paleolithic inhabitants of Europe, early Africans painted and inscribed an abundance of images on the walls of the caves and rock shelters in which they sought refuge. Rock art has been found all over Africa, in sites ranging from small, isolated shelters to great, cavernous formations. The mountains of the central Sahara—principally the Tassili-n-Ajjer range in the south of present-day Algeria and the Acacus Mountains in present-day Libya—contain images that span a period of thousands of years. They record not only the artistic and cultural development of the peoples who lived in the region, but also the transformation of the Sahara from the fertile grassland it once was to the vast desert we know today.

The earliest images of Saharan rock art are thought to date from at least 8000 BCE, during the transition into a geological period known as the Makalian Wet Phase. At that time the Sahara was a grassy plain, perhaps much like the game-park areas of modern East Africa. Vivid images of hippopotamus, elephant, giraffe, antelope, and other animals incised into rock surfaces testify to the abundant wildlife that roamed the region. Like the cave paintings in Altamira and Lascaux (Chapter 1), these images may have been intended to ensure plentiful game or a successful hunt, or they may have been symbolic of other life-enhancing activities, such as healing or rainmaking.

By 4000 BCE the climate had become more arid, and hunting had given way to herding as the primary life-sustaining activity of the Sahara's inhabitants. Among the most beautiful and complex examples of Saharan rock art created in this period are scenes of sheep, goats,

THE MYTH OF "PRIMITIVE" ART

The word *primitive* was once used by Western art historians to categorize the art of Africa, the art of the Pacific islands, and the indigenous art of the Americas. The term itself means "early," and its very use implies that these civilizations are frozen at an early stage of development, rather than that their cultures have developed along different paths than those of Europe.

The origins of such a label, as well as many historical attitudes, lay with early Christian missionaries, who long described the peoples among whom they worked as "heathen," "barbaric," "ignorant," "tribal," "primitive," and other terms rooted in racism and colonialism. Such usages were extended to these peoples' creations, and "primitive art" became the dominant label for their cultural products.

Criteria that have been used to label a people "primitive" include the use of so-called Stone Age technology, the absence of written histories, and the failure to build great cities. Therefore, the accomplishments of the peoples of Africa, to take just one example, strongly belie this categorization: Africans south of the Sahara have smelted and forged iron since at least 500 BCE, and Africans in many areas made and used high-quality steel for weapons and tools. Many African peoples have recorded their histories in Arabic since at least the tenth century CE. The first European visitors to Africa admired the politically and socially sophisticated urban centers of Benin and Luanda, to name only two of the continent's great cities. Clearly, neither the cultures of ancient Africa nor the art works they produced were "primitive" at all.

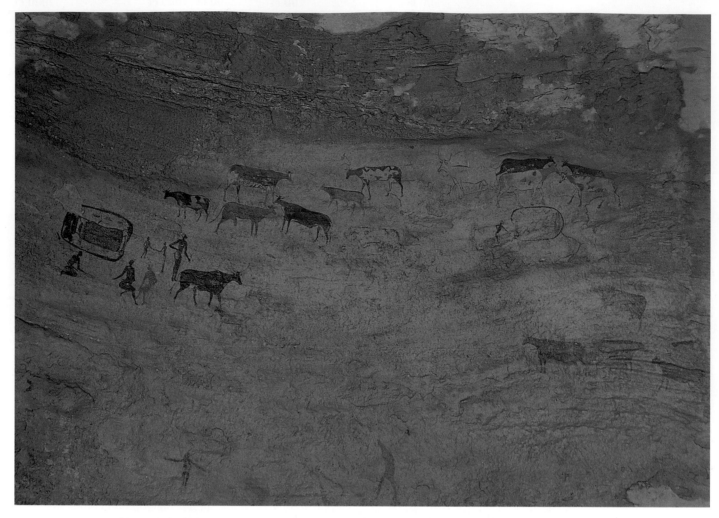

13-2. *Cattle Being Tended*, section of rock-wall painting, Tassili-n-Ajjer, Algeria. c. 2500–1500 BCE

and cattle and of the daily lives of the people who tended them. One such scene, *Cattle Being Tended*, was found at Tassili-n-Ajjer and probably dates from late in the herding period, about 2500–1500 BCE (fig. 13-2). Men and women are gathered in front of their round, thatched houses, the men tending cattle, the women preparing a meal and caring for children. A large herd of cattle, many of them tethered to a long rope, has been driven in from pasture. The cattle shown are quite varied. Some are mottled, while others are white, red, or black. Some have short, thick horns, while others have graceful, lyre-shaped horns. The overlapping forms and the confident placement of near figures low and distant figures high in the picture create a sense of depth and distance.

By 2500–2000 BCE the Sahara was drying and the great game had gone, but other animals were introduced that appear in the rock art. The horse was brought from Egypt by about 1500 BCE and is seen regularly in rock art over the ensuing millennia. The fifth-century BCE Greek historian Herodotus described a chariot-driving people called the Garamante, whose kingdom corresponded roughly to present-day Libya. Rock-art images of horse-drawn chariots bear out his account. Around 600 BCE the camel was introduced into the region from the east, and images of camels were painted on and incised into the rock.

The desiccation of the Sahara coincides with the rise of Egyptian civilization along the Nile Valley to the east.

Similarities have been noted between Egyptian and Saharan motifs, among them images of rams with what appear to be disks between their horns. These similarities have been viewed as evidence of Egyptian influence on the less-developed regions of the Sahara. Yet in light of the great age of Saharan rock art, it seems just as plausible that influence flowed the other way, carried by people who had migrated into the Nile Valley in search of arable land and pasture when the grasslands of the Sahara disappeared.

SUB-SAHARAN CIVILIZATIONS

Saharan peoples presumably migrated southward as well, into the Sudan, the broad belt of grassland that stretches across Africa south of the Sahara desert. They brought with them knowledge of settled agriculture and animal husbandry. The earliest evidence of settled agriculture in the Sudan dates from about 3000 BCE. Toward the middle of the first millennium BCE, at the same time that iron technology was being developed elsewhere in Africa, knowledge of ironworking spread across the Sudan, enabling its inhabitants to create more efficient weapons and farming tools. In the wake of these developments, larger and more complex societies emerged, especially in the fertile basins of Lake Chad in the central Sudan and the Niger and Senegal rivers to the west.

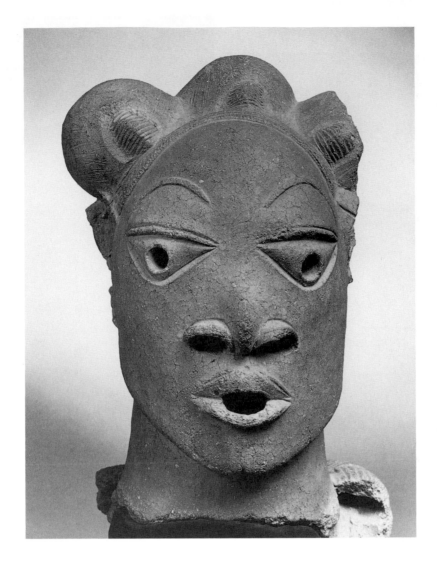

13-3. Head. Nok,
c. 500 BCE–200 CE.
Terra-cotta, height
14³/₁₆" (36 cm).
National Museum,
Lagos, Nigeria

NOK

Some of the earliest evidence of iron technology in sub-Saharan Africa comes from the so-called Nok culture, which arose in the western Sudan, in present-day Nigeria, as early as 500 BCE. The Nok people were farmers who grew grain and oil-bearing seeds, but they were also smelters with the technology for refining ore. Slag and the remains of furnaces have been discovered, along with clay nozzles from the bellows used to fan the fires. The Nok people created the earliest known sculpture of sub-Saharan Africa, producing accomplished terra-cotta figures of human and animal subjects between about 500 BCE and 200 CE.

Nok sculpture was discovered in modern times by tin miners digging in the alluvial deposits on the Jos plateau north of the confluence of the Niger and Benue rivers. Presumably, floods from centuries past had removed the figures from their original contexts, dragged and rolled them along, then redeposited them. This rough treatment scratched and broke many, often leaving only the heads from what must have been complete human figures. Following archaeological convention, scholars gave the name of a nearby village, Nok, to the culture that created these works. Nok-style works of sculpture have since been found in numerous sites over a wide area.

The Nok head shown here (fig. 13-3), slightly larger than lifesize, probably formed part of a complete figure. The triangular or **D**-shaped eyes are characteristic of Nok style and appear also on sculpture of animals. Holes in the pupils, nostrils, and mouth allowed air to pass freely as the figure was fired. Each of the large buns of its elaborate hairstyle is pierced with a hole that may have held ornamental feathers. Other Nok figures boast large quantities of beads and other prestige ornaments. Nok sculpture may represent ordinary people dressed up for a special occasion or may portray people of high status, providing evidence of social stratification in this early farming culture. At the very least, the sculpture provides evidence of considerable technical accomplishment. The skill and artistry it reflects have led many scholars to speculate that Nok culture was built on the achievements of an earlier culture still to be discovered.

IFE

Following the disappearance of the Nok culture, the region of present-day Nigeria remained a vigorous cultural and artistic center. The naturalistic works of sculpture created by the artists of the city of Ife, which arose in the southern, forested part of that region by about 800 CE, are among the most remarkable in art history (see "Who Made African Art?," page 477).

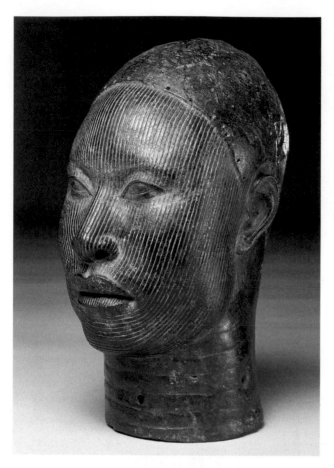

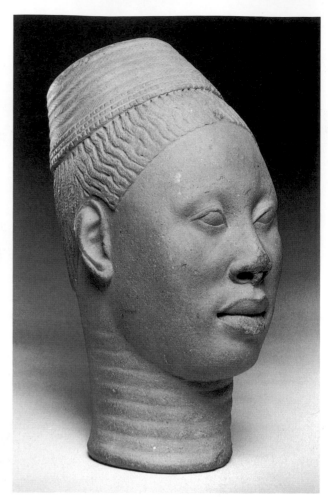

13-4. Head of a king, from Ife. Yoruba, c. 13th century CE. Zinc brass, height 11⁷/₁₆" (29 cm). Museum of Ife Antiquities, Ife, Nigeria

The naturalism of Ife sculpture contradicted everything Europeans thought they knew about African art. The German scholar who "discovered" Ife sculpture in 1910 suggested that it had been created not by Africans but by survivors from the legendary lost island of Atlantis. Later scholars speculated that influence from ancient Greece or Renaissance Europe must have reached Ife. Scientific dating methods, however, finally put such misleading comparisons and prejudices to rest. When naturalism flowered in Ife, the ancient Mediterranean world was long gone and the European Renaissance still to come. In addition, the proportions of the few known full figures are characteristically African, with the head comprising as much as one-quarter of the total height. These proportions probably reflect a belief in the head's importance as the abode of the spirit and the focus of individual identity.

Ife was, and remains, the sacred city of the Yoruba people. A tradition of naturalistic sculpture began there about 1050 CE and flourished for some four centuries. Although the line of Ife kings, or *oni*s, continues unbroken from that time to the present, the knowledge of how these works were used has been lost. When archaeologists showed the sculpture to members of the contemporary *oni*'s court, however, they identified symbols of kingship that had been worn within living memory, indicating that the figures represent rulers.

A lifesize head (fig. 13-4) shows the extraordinary artistry of ancient Ife. The modeling of the flesh is

13-5. Head said to represent the Usurper Lajuwa, from Ife. Yoruba, c. 1200–1300 CE. Terra-cotta, height 12¹⁵/₁₆" (32.8 cm). Museum of Ife Antiquities, Ife, Nigeria

supremely sensitive, especially the subtle transitions around the nose and mouth. The lips are full and delicate, and the eyes are strikingly similar in shape to those of some modern Yoruba. The face is covered with thin, parallel **scarification** patterns (decorations made by scarring). The head was cast of zinc brass using the **lost-wax** technique (see "Lost-Wax Casting," page TK).

Holes along the scalp apparently permitted a crown or perhaps a beaded veil to be attached. Large holes around the base of the neck may have allowed the head itself to be attached to a wooden mannequin for display during memorial services for a deceased *oni*. The mannequin was probably dressed in the *oni*'s robes; the head probably bore his crown. The head could also have been used to display a crown during annual purification and renewal rites.

The artists of ancient Ife also worked in terra-cotta. Unlike their brass counterparts, terra-cotta heads are not fitted for attachments. They were probably placed in shrines devoted to the memory of each dead king. Two of the most famous Ife sculptures were not found by archaeologists but had been preserved through the centuries in the *oni*'s palace. One, a terra-cotta head, is said to represent Lajuwa, a court retainer who usurped the throne by intrigue and impersonation (fig. 13-5). The other, a lifesize copper mask, is said to represent Obalufon, the ruler who introduced bronze casting.

Scholars continue to debate whether the Ife heads are true portraits. Their striking anatomical individuality strongly suggests that they are. The heads, however, all seem to represent men of the same age and seem to embody a similar concept of physical perfection, suggesting that they are **idealized** images. In the recent past, Africans did not produce naturalistic portraits, fearing that they could house malevolent spirits that would harm the soul of the subject. If the Ife heads are portraits, then perhaps the institution of kingship and the need to revere royal ancestors were strong enough to overcome such concerns.

BENIN

Ife was probably the artistic parent of the great city-state of Benin, which arose some 150 miles to the southeast. According to oral histories, the earliest kings of Benin belonged to the Ogiso, or Skyking, dynasty. After a long period of misrule, however, the people of Benin asked the *oni* of Ife for a new ruler. The *oni* sent Prince Oranmiyan, who founded a new dynasty in 1170 CE. Some two centuries later, the fourth king, or *oba*, of Benin decided to start a tradition of memorial sculpture like that of Ife, and he sent to Ife for a master metal caster named Iguegha. The tradition of casting memorial heads for the shrines of royal ancestors endures among the successors of Oranmiyan to this day (fig. 13-6).

Benin came into contact with Portugal in the late fifteenth century CE. The two kingdoms established cordial relations in 1485 and carried on an active trade, at first in ivory and other forest products but eventually in slaves. Benin flourished until 1897, when, in reprisal for the massacre of a party of trade negotiators, British troops sacked and burned the royal palace, sending the *oba* into an exile from which he did not return until 1914. The palace was later rebuilt, and the present-day *oba* continues the dynasty started by Oranmiyan.

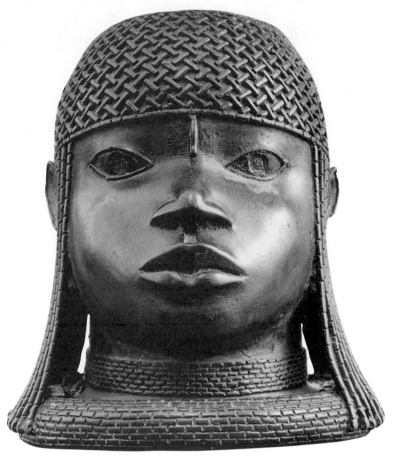

13-6. Memorial head. Benin Early Period, c. 1400–1550 CE. Brass, height 9³⁄₈" (23.4 cm). The Metropolitan Museum of Art, New York

The Michael C. Rockefeller Memorial Collection, Bequest of Nelson A. Rockefeller, 1979 (1979.206.86)

WHO MADE AFRICAN ART? On label after label identifying African art works exhibited in museums, a standard piece of information is missing. Where are the artists' names? Who made this art?

Until quite recently, Westerners tended to see Africa as a single country and not as an immense continent of vastly diverse cultures. Moreover, they perceived artists working in Africa as obedient craftsworkers, bound to styles and images dictated by village elders and producing art that was anonymous and interchangeable.

Over the past several decades, however, these misconceptions have begun to crumble. One of the first non-Africans to understand that African art, as much as European art,

was the work of identifiable artists was the Belgian art historian Frans Olbrechts. During the 1930s, while assembling a group of objects from the present-day Democratic Republic of the Congo for an exhibition, Olbrechts noticed that as many as ten figures had been carved in a very distinctive style. A look at the labels revealed that two of the statues had been collected in the same town, Buli, in eastern Congo. Accordingly, Olbrechts named the unknown African artist the Master of Buli. In the late 1970s, the owners of an object in the style of the Master of Buli identified the artist as Ngongo ya Chintu, of Kateba village. Kateba villagers in turn remembered Ngongo ya Chintu as an artist of great skill.

The story of Ngongo ya Chintu showed clearly that African artists did not work anonymously and that Africans were fully aware of the names of their artists.

Art historians and anthropologists have now identified numerous African artists and compiled catalogs of their work. Certainly we will never know the names of the vast majority of African artists of the past, just as we do not know the names of the sculptors responsible for the portrait busts of ancient Rome or the monumental reliefs of the Hindu temples of South Asia. But, as elsewhere, the greatest artists in Africa were famous and sought after, while innumerable others labored honorably and not at all anonymously.

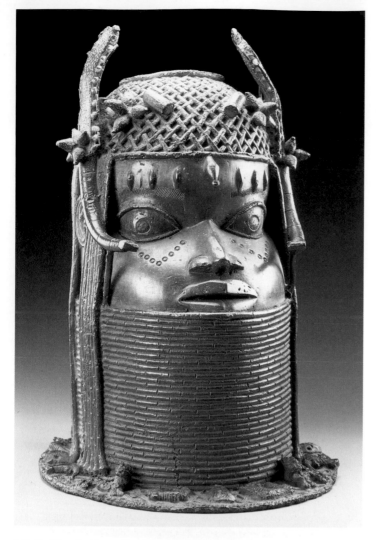

13-7. Head of an *oba* (king). Benin Late Period, c. 1700–1897 CE. Brass, height 17¼" (43.8 cm). Museum für Völkerkunde, Vienna/Musée Dapper, Paris

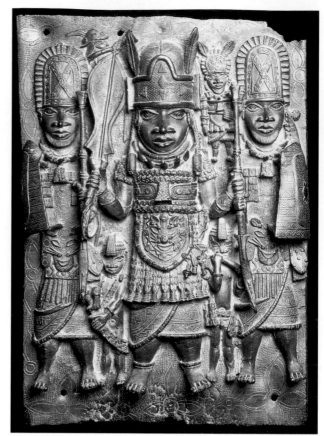

13-8. *General and Officers*. Benin Middle Period, c. 1550–1650 CE. Brass, height 21" (53.5 cm). National Museum, Lagos, Nigeria

The general wears an elaborate appliqué apron depicting the head of a leopard, and the flanking officers wear leopard pelts. Leopards were symbols of royalty in Benin. Live leopards were kept at the royal palace, where they were looked after by a special keeper. Water pitchers in the form of leopards were cast in bronze and placed on altars dedicated to ancestors. An engraving from a European travel book of the sixteenth century depicts a procession of courtiers in Benin led by a pair of magnificent leopards.

The British invaders discovered shrines to deceased *obas* filled with brass heads, bells, and figures. They also found wooden rattles and enormous ivory tusks carved with images of kings, court attendants, and sixteenth-century Portuguese soldiers. The British appropriated the treasure as war booty, making no effort to note which head came from which shrine, thus destroying evidence that would have helped establish the relative age of the heads and determine a chronology for the evolution of Benin style. Nevertheless, scholars have managed to piece together a chronology from other evidence.

Benin brass heads range from small, thinly cast, and naturalistic to large, thickly cast, and highly stylized. The heads that were being made at the time of the British invasion are of the latter variety, as are those being cast today. Many scholars have concluded that the smallest, most naturalistic heads were created during a so-called Early Period (1400–1550 CE), when Benin artists were still heavily influenced by Ife (see fig. 13-6). Heads grew increasingly stylized during the Middle Period (1550–1700 CE). Heads from the ensuing Late Period (1700–1897 CE) are very large and heavy, with angular, stylized features and an elaborate beaded crown (fig. 13-7). A similar crown is still worn by the present-day *oba*. One of the honorifics used for the king is "Great Head": The head leads the

body as the king leads the people. The Benin heads must be visualized on a semicircular platform—an altar to royal heads—surmounted by a large elephant tusk, another symbol of power.

All of the heads include representations of coral-bead necklaces, which formed part of the royal costume. Small and few in number on Early Period heads, the strands of beads increase in number until they conceal the chin during the Middle Period. During the Late Period, the necklaces form a tall, cylindrical mass that greatly increases the weight of the sculpture. Broad, horizontal flanges, or projecting edges, bearing small images cast in low relief ring the base of the Late Period statues, adding still more weight. The increase in size and weight of Benin memorial heads over time may reflect the growing power and wealth flowing to the *oba* from Benin's expanding trade with Europe.

The art of Benin is a royal art, for only the *oba* could commission works in brass. Artisans who served the court lived in a separate quarter of the city and were organized into guilds. Among the most remarkable visual records of

court life are the hundreds of brass plaques, each about 2 feet square, that once decorated the walls and columns of the royal palace. Produced during the Middle Period, the plaques are modeled in relief, sometimes in such high relief that the figures are almost freestanding. An exceptionally detailed plaque (fig. 13-8) shows a general in elaborate military dress holding a spear in one hand and a ceremonial sword in the other. Flanking the general, two officers, whose helmets indicate their rank, brandish spears and shields. Smaller figures appear between the three principal figures, one carrying a sword, another sounding a horn. Above the tip of the general's sword is a small figure of a Portuguese soldier.

Obas also commissioned important works in ivory. One example is a beautiful ornamental mask (fig. 13-9) that represents an *iyoba*, or queen mother. The woman who had borne the previous *oba*'s first male child (and thus the mother of the current *oba*), the *iyoba* ranked as the senior female member of the court. This mask may represent Idia, the first and best-known *iyoba*. Idia was the mother of Esigie, who ruled as *oba* from 1504 to 1550 CE. She is particularly remembered for raising an army and using her magical powers to help her son defeat his enemies.

The mask was carved as a belt ornament and was worn at the *oba*'s waist with an ivory leopard's head and several other plaques. Its pupils were originally inlaid with iron, as were the scarification patterns on the forehead. The necklace represents heads of Portuguese soldiers with beards and flowing hair. Like Idia, the Portuguese helped Esigie expand his kingdom. In the crown, more Portuguese heads alternate with figures of mudfish, which in Benin iconography symbolized Olokun, the Lord of the Great Waters. Mudfish live on the riverbank, mediating between water and land, just as the *oba*, who is viewed as semidivine, mediates between the human world and the supernatural world of Olokun.

OTHER URBAN CENTERS

Ife and Benin were but two of the many cities that arose in ancient Africa. The first European visitors to the West African coast at the end of the fifteenth century were impressed not only by Benin, but also by the cities of Loango and Luanda near the mouth of the Zaire River. Exploring the East African coastline, European ships happened on cosmopolitan cities that had been busily carrying on long-distance trade across the Indian Ocean and as far away as China and Indonesia for hundreds of years.

Important centers also arose in the interior, especially across the central and western Sudan. There, cities and the states that developed around them grew wealthy from the trans-Saharan trade that had linked West Africa to the Mediterranean from at least the first millennium BCE. Indeed, the routes across the desert were probably as old as the desert itself. Among the most significant goods exchanged in this trade were salt from the north and gold from West Africa. Such fabled cities as Mopti, Timbuktu, and Djenné were great centers of commerce, where merchants from all over West Africa met caravans arriving from the Mediterranean.

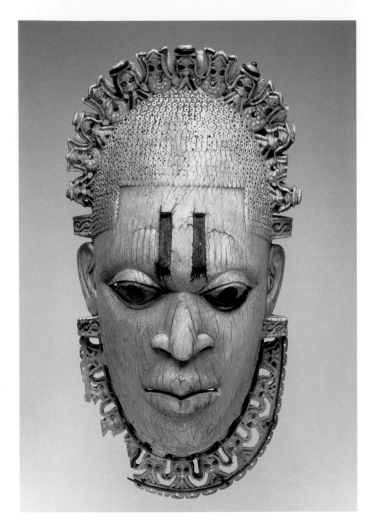

13-9. Mask representing an *iyoba* (queen mother). Benin Middle Period, c. 1550 CE. Ivory, iron, and copper, height 9³⁄₈" (23.4 cm). The Metropolitan Museum of Art, New York
The Michael C. Rockefeller Memorial Collection, Gift of Nelson A. Rockefeller, 1972 (1978.412.323)

DJENNÉ

In 1655, the Islamic writer al-Sadi wrote this description of Djenné:

> This city is large, flourishing, and prosperous; it is rich, blessed, and favoured by the Almighty. . . . Jenne [Djenné] is one of the great markets of the Muslim world. There one meets the salt merchants from the mines of Teghaza and merchants carrying gold from the mines of Bitou. . . . Because of this blessed city, caravans flock to Timbuktu from all points of the horizon. . . . The area around Jenne is fertile and well populated; with numerous markets held there on all the days of the week. It is certain that it contains 7,077 villages very near to one another.
>
> (Translated by Graham Connah in Connah, page 97)

By the time al-Sadi wrote his account, Djenné, in present-day Mali, already had a long history. Archaeologists have determined that the city was established by the third century CE and that by the middle of the ninth century it had become a major urban center. Also by the ninth century,

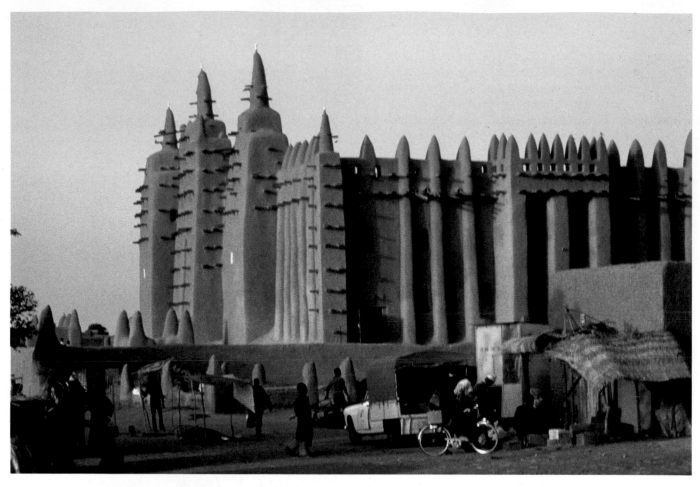

13-10. Great Friday Mosque, Djenné, Mali, showing the eastern and northern facades. Rebuilding of 1907, in the style of 13th-century original

The plan of the mosque is quite irregular. Instead of a rectangle, the building forms a parallelogram. Inside, nine long rows of heavy adobe columns some 33 feet tall run along the north-south axis, supporting a flat ceiling of palm logs. A pointed arch links each column to the next in its row, thereby forming nine east-west archways facing the *mihrab*, the niche that indicates the direction of Mecca. The mosque is augmented by an open courtyard for prayer on the west side, which is enclosed by a great double wall only slightly lower than the walls of the mosque itself.

Islam was becoming an economic and religious force in West Africa, North Africa and the northern terminals of the trans-Saharan trade routes having already been incorporated into the Islamic Empire. Much of what we know about African history from this time on is based on the accounts of Islamic scholars, geographers, and travelers.

When Koi Konboro, the twenty-sixth king of Djenné, converted to Islam in the thirteenth century, he transformed his palace into the first of three successive **mosques** in the city. Like the two that followed, the first mosque was built of **adobe** brick, a sun-dried mixture of clay and straw. With its great surrounding wall and tall towers, it was said to have been more beautiful and more lavishly decorated than the Kaaba, the central shrine of Islam, at Mecca. The mosque eventually attracted the attention of austere Muslim rulers, who objected to its sumptuous furnishings. Among these was the early-nineteenth-century ruler Sekou Amadou, who had it

razed and a far more humble structure erected on a new site. This second mosque was in turn replaced by the current grand mosque, constructed between 1906 and 1907 on the ancient site and in the style of the original. The reconstruction was supervised by the architect Ismaila Traoré, the head of the Djenné guild of masons.

The mosque's eastern, or "marketplace," facade boasts three tall towers (fig. 13-10). The **finials**, or crowning ornaments, at the top of each tower bear ostrich eggs, symbols of fertility and purity. The facade and sides of the mosque are distinguished by tall, narrow, engaged columns, which act as buttresses. These columns are characteristic of West African mosque architecture, and their cumulative rhythmic effect is one of great verticality and grandeur. The most unusual features of West African mosques are the **torons**, wooden beams projecting from the walls. *Torons* provide permanent supports for the scaffolding erected each year so that the exterior of the mosque can be replastered.

GREAT ZIMBABWE

Thousands of miles from Djenné, in southeastern Africa, an extensive trade network developed along the Zambezi, Limpopo, and Sabi rivers. Its purpose was to funnel gold, ivory, and exotic skins to the coastal trading towns that had been built by Arabs and Swahili-speaking Africans. There, the gold and ivory were exchanged for prestige goods, including porcelain, beads, and other manufactured items. Between 1000 and 1500 CE, this trade was largely controlled from a site that was called Great Zimbabwe, home of the Shona people.

13-11. Conical Tower, Great Zimbabwe. c. 1350–1450 CE. Height of tower 30' (9.1 m)

The word *zimbabwe* derives from the Shona term for "venerated houses" or "houses of stone." Scholars agree that the stone buildings at Great Zimbabwe were constructed by ancestors of the present-day people in this region. The earliest construction at the site took advantage of the enormous boulders abundant in the vicinity. Masons incorporated the boulders and used the uniform granite blocks that split naturally from them to build a series of tall enclosing walls high on a hilltop. Each enclosure defined a family's living or ritual space and housed dwellings made of adobe with conical, thatched roofs.

The largest building complex at Great Zimbabwe is located in a broad valley below the hilltop enclosures. Known as Imba Huru, the Big House, the complex is ringed by a masonry wall more than 800 feet long, 32 feet tall, and 17 feet thick at the base. The buildings at Great Zimbabwe were built without mortar; for stability the walls are **battered**, or built so that they slope inward toward the top. Inside the great outer wall are numerous smaller stone enclosures and adobe foundations.

The complex seems to have evolved with very little planning. Additions and extensions were begun as labor and materials were available and need dictated. Over the centuries, the builders grew more skillful, and the later additions are distinguished by **dressed stones**, or smoothly finished stones, laid in fine, even, level **courses**. One of these later additions is a fascinating structure known simply as the Conical Tower (fig. 13-11). Some 18 feet in diameter and 30 feet tall, the tower was originally capped with three courses of ornamental stonework. It may have represented the good harvest and prosperity believed to result from allegiance to the ruler of Great Zimbabwe, for it resembles a present-day Shona granary built large.

13-12. Bird, top part of a monolith, from Great Zimbabwe. c. 1200–1400 CE. Soapstone, height of bird 14½" (36.8 cm); height of monolith 5'4½" (1.64 m). Great Zimbabwe Site Museum, Zimbabwe

Among the many interesting finds at Great Zimbabwe is a series of carved soapstone birds (fig. 13-12). The carvings, which originally crowned tall **monoliths**, seem to depict birds of prey, perhaps eagles. They may, however, represent mythical creatures, for the species cannot be identified. Traditional Shona beliefs include an eagle called *shiri ye denga*, or "bird of heaven," who brings lightning, a metaphor for communication between the heavens and earth. These soapstone birds may have represented such messengers from the spirit world. Recently, the birds and the crocodiles also found decorating such monoliths have been identified as symbols of royalty, expressing the king's power to mediate between his subjects and the supernatural world of spirits.

Although some of the enclosures at Great Zimbabwe were built on hilltops, there is no evidence that they were constructed as fortresses. There are neither openings for weapons to be thrust through nor battlements for warriors to stand on. Instead, the walls and structures seem intended to reflect the wealth and power of the city's rulers. The Big House was probably a royal residence, or palace complex, and other structures housed members of the ruler's family and court. The complex formed the nucleus of a city that radiated for almost a mile in all directions. It is estimated that at the height of its power, in the fourteenth century CE, Great Zimbabwe and its surrounding city housed a population of more than 10,000 people. A large cache of goods containing items of such far-flung origin as Portuguese medallions, Persian pottery, and Chinese porcelain testify to the extent of its trade. Yet beginning in the mid-fifteenth century Great Zimbabwe was gradually abandoned. Its power and control of the lucrative southeast African trade network passed to the Mwene Mutapa and Kami empires a short distance away.

During the twentieth century, the sculpture of traditional African societies—wood carvings of astonishing formal inventiveness and power—have found admirers the world over, becoming virtually synonymous with "African art." Admiration for these art forms was evident in earlier periods as well. In the mid-seventeenth century, for example, a German merchant named Christopher Weickman collected a Yoruba divination board, textiles from the Congo, and swords with nubbly ray-skin sheaths from the Akan, all of which are now housed in a museum in Ulm, Germany. Wood decays rapidly, however, and little of African wood sculpture remains from before the nineteenth century. As a result, much of ancient Africa's artistic heritage has probably been as irretrievably lost as have, for example, the great monuments of wooden architecture of dynastic China. Yet the beauty of ancient African creations in such durable materials as terra-cotta, stone, and bronze bears eloquent witness to the skill of ancient African artists and the splendor of the civilizations in which they worked.

PARALLELS

CULTURE	ART IN ANCIENT AFRICA	ART IN OTHER CULTURES
SAHARA c. 8000–500 BCE	**13-2.** *Cattle Being Tended* (c. 2500–1500 BCE) 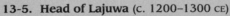	**9-4.** Harappa torso (c. 2000 BCE), India **5-74.** *Gallic Chieftain Killing His Wife and Himself* (c. 220 BCE), Greece
NOK c. 500 BCE–200 CE	**13-3.** Head (c. 500 BCE–200 CE) 	**10-1.** Qin soldiers (c. 210 BCE), China
DJENNÉ c. 200 CE–PRESENT	**13-10.** Great Friday Mosque (13th cent. CE) 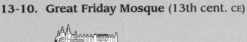	**8-12.** Great Mosque, Isfahan (11th–18th cent. CE), Iran
IFE c. 800 CE–PRESENT	**13-5.** Head of Lajuwa (c. 1200–1300 CE) **13-4.** Head of a king (c. 13th cent. CE) **13-1.** Ritual vessel (13–14th cent. CE)	**7-42.** *Virgin of Vladimir* (12th cent. CE), Russia
GREAT ZIMBABWE c. 1000–1500 CE	**13-12.** Bird (c. 1200–1400 CE) **13-11.** Conical Tower (c. 1350–1450 CE) 	**9-28.** *Shiva Nataraja* (12th cent. CE), India **8-11.** Palace of the Lions, Alhambra (c. 1370-80 CE), Spain
BENIN c. 1170 CE–PRESENT	**13-6.** Memorial head (c. 1400–1550 CE) **13-9.** *Iyoba* mask (c. 1550 CE) **13-8.** *General and Officers* (c. 1550–1650 CE)	**8-15.** Mosque of Selim, Edirne (c. 1570-74 CE), Turkey

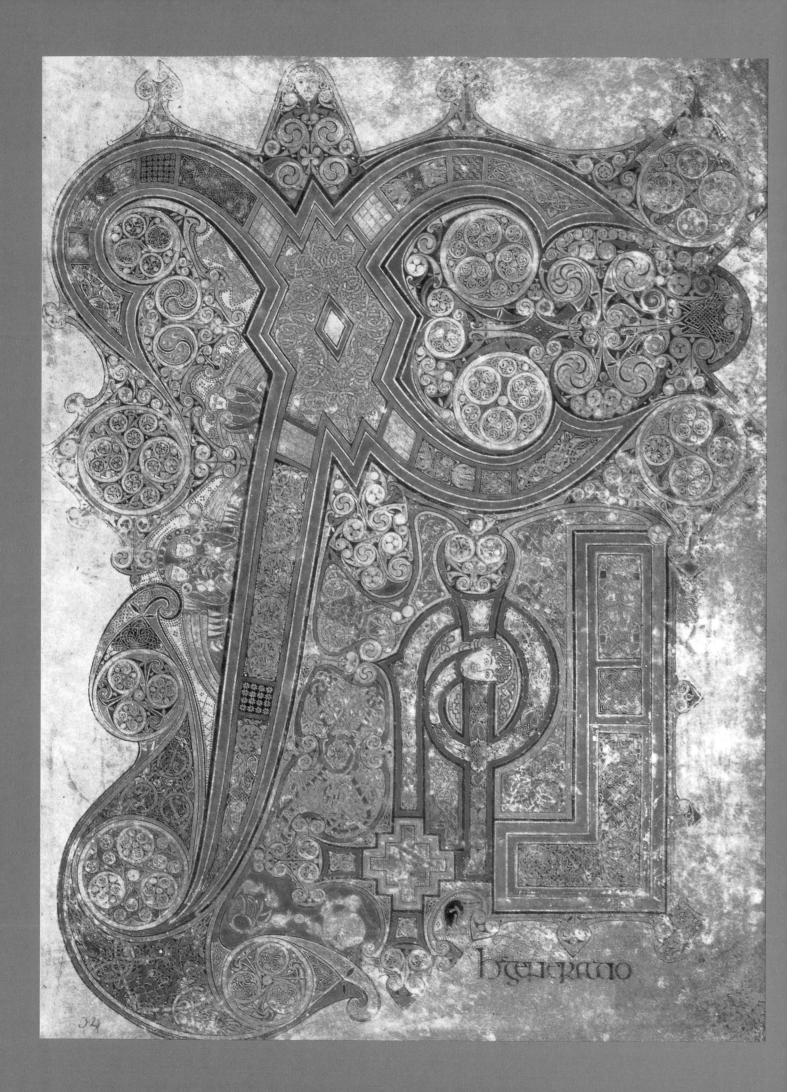

14-1. ***Chi Rho Iota* page**, Book of Matthew, *Book of Kells*, probably made at Iona, Scotland. Late 8th or early 9th century. Oxgall inks and pigments on vellum, 13 x 9½" (33 x 25 cm). The Board of Trinity College, Dublin, MS 58 (A.1.6.), fol. 34v

14 Early Medieval Art in Europe

According to legend, the Irish missionary Colum Cille (c. 521–97, later canonized as Saint Columba) copied a psalter without the permission of its owner, then refused to relinquish his copy. The two declared war over the book, and Colum fled to Iona, an island off the western coast of Scotland, where he established a monastery. Such remote Celtic monasteries stood "among craggy and distant mountains, which looked more like lurking places for robbers and retreats for wild beasts than habitation for men," as the eighth-century Anglo-Saxon historian Bede wrote. Nevertheless, they became seats of scholarship—and, as wealthy, isolated, and undefended sites, victims of Viking attacks beginning in 793 (Lindisfarne) and 795 (Iona).

Despite the repeated Viking attacks, Iona became the center of Celtic Christendom. Its monastery was as famous for its *scriptorium* (a room for producing manuscripts) as for its spirituality. In 806, monks fleeing raids on Iona established a refuge at Kells, on the Irish mainland, and brought with them the work now known as the *Book of Kells*, one of the most admired early medieval books, then and now—though no one knows how much was created at Iona, nor how much, if any, at Kells. To produce this illustrated version of the Book of Matthew entailed a lavish expenditure: Four scribes and three major illuminators worked on it (modern scribes take about a month to complete a comparable page), 185 calves were slaughtered to make the vellum, and the colors for the paintings came from as far away as Afghanistan.

The *Kells* style is especially brilliant in the monogram page (fig. 14-1). The artists have reaffirmed their Celtic heritage in the animal interlace and spirals with which they form the monogram of Christ (the three Greek letters *chi rho iota*) and the words *Christi autem generatio*, the first sentence of Matthew's Gospel. The illuminators outlined each letter, then subdivided the letters into panels filled with interlaced animals and snakes, as well as extraordinary spiral and knot motifs. The spaces between the letters form an equally complex ornamental field, dominated by spirals. In the midst of these abstractions, painters inserted pictorial observations and comments and symbolically referred to Christ many timess—including by his initials, the fish (see "Christian Symbols," page 294), moths (symbols of rebirth), the cross-inscribed wafer of the Eucharist and numerous chalices and goblets, and possibly in two human faces, one at the top of the page and one dotting the *i* of *iota* (in Ireland Jesus is depicted as a blond or redheaded youth). Three angels along the left edge of the *chi*'s stem are reminders that angels surrounded the Holy Family at the time of the Nativity, thus introducing Matthew's story while supporting the monogram of Christ.

In a particularly intriguing image, to the right of the *chi*'s tail two cats pounce on a pair of mice nibbling the Eucharistic wafer, and two more mice torment the vigilant cats. The vignette is a reference to the problem in medieval monasteries of keeping the monks' food and the sacred Host safe from rodents, as well as a metaphor for the struggle between good (cats) and evil (mice).

▲ c. 500–1000 BRITISH ISLES ▲ c. 568–774 LANGOBARD ITALY c. 768–877 CAROLINGIAN EUROPE ▲
▲ c. 500–1000 CHRISTIAN SPAIN
▲ c. 500–1100 SCANDINAVIA

TIMELINE 14-1. **Early Medieval Culture Centers in Europe.** Art of the Early Middle Ages reflects the widely varying cultures in which it was created.

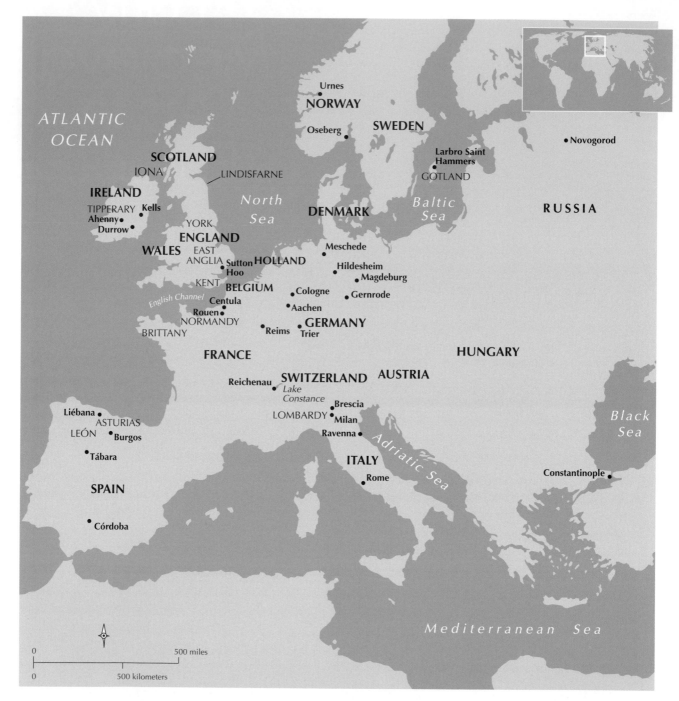

MAP 14-1. **Europe of the Early Middle Ages.** On this map, modern names have been used for medieval regions in northern and western Europe to make sites of cultural works easier to locate.

THE MIDDLE AGES

The roughly 1,000 years of European history between the collapse of the Western Roman Empire in the fifth century and the Renaissance in the fifteenth are known as the Middle Ages, or the medieval period. These terms reflect the view of early historians that this was a dark "middle" age of ignorance, decline,

and barbarism between two golden ages. Although this view no longer prevails—the Middle Ages are now known to have been a period of great richness, complexity, and innovation that gave birth to modern Europe—the terms have endured. Art historians commonly divide the Middle Ages into three periods: early medieval (ending in the early eleventh century), Romanesque (eleventh and

twelfth centuries), and Gothic (extending from the mid-twelfth into the fifteenth century). The terms *Romanesque* and *Gothic* refer to distinctive artistic styles that were prevalent during the periods that bear their names and are discussed in Chapters 15 and 16; in this chapter we shall look at some early medieval art work that overlaps the Romanesque in time but not in style (Timeline 14-1). In this chapter, modern geographical names (Map 14-1) are used for convenience—for example, no such country as Germany or Italy existed before the nineteenth century.

As Roman authority crumbled at the outset of the Middle Ages, it was replaced by strong local leaders—including the leaders of the various tribes (among them the Germanic Franks, Visigoths, Ostrogoths, Saxons, and Norse, as well as the Celts) that had invaded or settled within much of the Roman Empire during the previous centuries. The Church, which remained centered in Rome, also gained influence at this time. The breakdown of central power, the fusion of Germanic, Celtic, and Roman culture, and the unifying influence of Christianity produced distinctive new political, social, and cultural forms. Relationships of patronage and dependence between the powerful—nobles and Church officials—and the less powerful became increasingly important, ultimately giving rise to a type of social organization known as feudalism. A system of mutual support developed between secular leaders and the Church, with secular leaders defending the claims of the Church and the Church validating their rule. The Church emerged as a repository of learning, and Church officials and the nobility became the principal patrons of the arts. The focus of their patronage was the church: its buildings and liturgical equipment, including altars, altar vessels, crosses, candlesticks, and **reliquaries** (containers for holy relics), vestments, art portraying Christian figures and stories, and copies of sacred texts.

As Christianity spread north beyond the borders of what had been the Western Roman Empire, northern artistic traditions similarly worked their way south. Out of a tangled web of themes and styles originating from sources both northern and southern, eastern and western, pagan and Christian, and urban and rural, were born brilliant new artistic styles.

THE BRITISH ISLES AND SCANDINAVIA

When Roman armies first ventured into Britain in 55–54 BCE, it was a well-populated, thriving agricultural land of numerous small communities with close trading links to nearby regions of the European continent. Like the inhabitants of Ireland and much of Roman Gaul (modern France), the Britons were Celts, an ancient European people. (Welsh, Breton—the language of Brittany, in France—and the variants of Gaelic spoken in Ireland, Scotland, and Wales are all Celtic languages.) Following the Roman subjugation of the island in 43 CE, its fortunes rose and fell with those of the empire. Roman Britain experienced a final period of wealth and productivity from about 296 to about 370. Christianity flourished during this period and spread from Britain to Ireland, which was never under Roman control.

Scandinavia, which encompasses the modern countries of Denmark, Norway, and Sweden, was never part of the Roman Empire, either. In the fifth century CE it was a land of small independent agricultural and fishing communities. Most of its inhabitants spoke variants of a

THE NORTHERN DEITIES

Numerous gods, their descendants, mythical places, and attendant animals figured prominently in Pre-Christian legends in Scandinavia. The most well known include the following:

Odin, the supreme god, of wisdom, magic, law, justice, and war. Represented as one-eyed, riding on an eight-legged horse, accompanied by wolves and his two spying ravens. Presided over the Scandinavian world from his palace, Valhalla, in Aasgard, the realm of the gods. Taught people to write with runes and gave them folk wisdom and guides to conduct, such as "The generous and brave get the best out of life."

Frigg, goddess of the home and hearth and Odin's consort.

Thor, son of Odin, god of war and thunder. A huge, popular, boisterous god who protected people and the other gods from the giants. Rode across the heavens in his goat-cart, hurling his hammer and causing thunderstorms (followers wore gold or silver hammer-shaped amulets).

Frey and **Freya**, brother and sister, male and female fertility gods. Associated with boars, stallions, weather, and ships. Required human and animal sacrifices, so had carcasses hung in the trees around their temples.

Loki, fire god. A mischief-maker.

Balder, god of light and joy. Christian missionaries tried to identify him with Christ.

Valkyries, female messengers and ale-bearers of Odin. Descended from gods. Carried Viking warriors who died in battle to Valhalla, where they would enjoy themselves, fighting by day and drinking by night.

Yggdrasil, a great ash tree that supported the Viking universe.

Norns, fates that tended Yggdrasil and foretold the apocalyptic Ragnarok, a Twilight of the Gods when the world of men and gods would be destroyed and a new earth would arise (the basis for Richard Wagner's opera cycle *The Ring of the Neibelungen*).

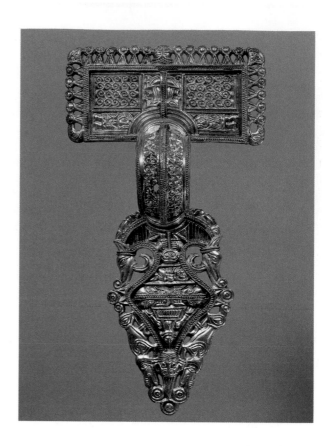

14-2. Gummersmark brooch, Denmark. 6th century. Silver gilt, height 5¾" (14.6 cm). Nationalmuseet, Copenhagen

The faceted surface of this pin seethes with abstract human, animal, and grotesque forms such as the eye-and-beak motif that frames the headplate, the man compressed between dragons just below the bridge element, and the pair of crouching dogs with spiraling tongues that forms the tip of the footplate.

language called Norse and shared a rich mythology with other Germanic peoples. Among other deities, they worshiped Odin, chief of the gods, who protected the courageous in battle and rewarded the fallen by allowing them entrance into Valhalla, the great hall where warriors were received (see "The Northern Deities," page 487).

During the first millennium BCE, trade, warfare, and migration had brought a variety of jewelry, coins, textiles, and other portable objects into northern Europe. Scandinavian artists, who had exhibited a fondness for abstract patterning from early prehistoric times, incorporated the solar disks, spirals, and stylized animals on these objects into their already rich artistic vocabulary (see fig. 1-24). Beginning about 300 CE, Roman influences appeared in the art of Scandinavia. By the fifth century CE, the so-called **animal style** was prevalent there, displaying an impressive array of serpents, four-legged beasts, and squat human forms. Certain underlying principles govern works in this complex style: They are generally symmetrically composed, and they depict animals in their entirety from a variety of perspectives—in profile, from above, and sometimes with their ribs and spinal columns exposed as if they had been x-rayed.

The Gummersmark brooch (fig. 14-2), a large silver-gilt pin, probably one of a pair, was used to fasten a cloak around the wearer's shoulders (see Emperor Justinian's cohorts in fig. 7-29). Dating from the sixth century CE and made in Denmark, this elegant ornament consists of a large, rectangular headplate and a medallionlike, **open-work** footplate connected by an arched bow, which acts as a spring. The artist combines an intricate animal-style design with abstract, geometric motifs, including spirals and beaded bands. Bird heads, human figures, dogs, and

dragons form the footplate. The artist created a glittering surface by faceting the mold from which this piece was cast in a technique called **chip carving**. Earlier, Romans had developed chip carving as a cheap, fast way of decorating molded hardware for military uniforms. The northern artists who adopted the technique carefully crafted each item by hand, turning a process intended for fast production into an art form of great refinement.

The Roman army abandoned Britain in 406 to help defend Gaul against various Germanic peoples crossing the borders into the empire. The historical record for the subsequent period in Britain is sketchy, but it appears that the economy faltered, and large towns lost their commercial function and declined. Powerful Romanized British leaders took control of different areas, vying for dominance with the help of mercenary soldiers from the Continent. These mercenaries—Germanic Angles and Saxons, and Norse Jutes—soon began to operate independently, settling largely in the southeast part of Britain and gradually extending their control northwest across the island. Over the next 200 years, the people under their control adopted Germanic speech and customs, and this fusion of Romanized British and Germanic cultures produced a new Anglo-Saxon culture. By the beginning of the seventh century, rival Anglo-Saxon kingdoms had emerged in Britain, and the arts, which had suffered a serious decline, made a brilliant recovery. Celtic, Roman, Germanic, and Norse influences all contributed to vigorous new styles and techniques.

Anglo-Saxon literature is filled with references to splendid and costly jewelry and military equipment decorated with gold and silver. Leaders rewarded their followers and friends with gold rings and weapons. The

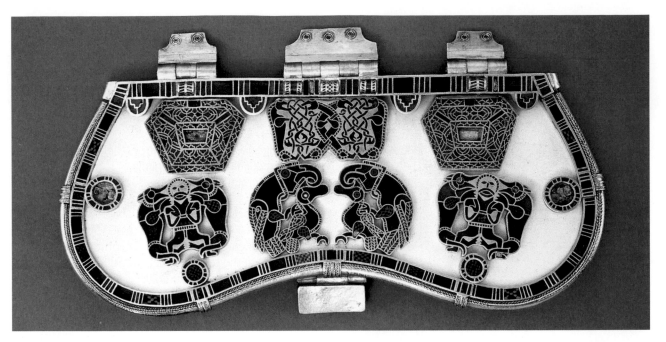

14-3. Purse cover, from the Sutton Hoo burial ship, Suffolk, England. c. 615–30. Cloisonné plaques of gold, garnet, and checked millefiore enamel, length 8" (20.3 cm). The British Museum, London

Only the decorations on this purse cover are original. The lid itself, of a light tan ivory or bone, deteriorated and disappeared centuries ago, and the white backing is a modern replacement. The purse was designed to hang at the waist. A leather pouch held thirty-seven coins, struck in France, the latest dated in the early 630s.

Anglo-Saxon epic *Beowulf*, composed perhaps as early as the seventh century, describes its hero's burial with a hoard of treasure in a grave mound near the sea. Such a burial site, located near the North Sea coast in Suffolk at a site called Sutton Hoo (*hoo* means "hill"), was discovered in 1938. The grave's occupant had been buried in a ship whose traces in the earth were recovered by the careful excavators. The wood—and the body—had disintegrated, and no inscriptions record his name.

The treasures buried with him confirm that he was, in any case, a wealthy and powerful man. His burial ship was 86 feet long. In it were weapons, armor, other equipment for the afterlife, and many luxury items, including a large purse filled with coins. Although the leather of the pouch and the bone or ivory of its lid have disintegrated, the gold and garnet fittings survive (fig. 14-3). The gold frame is set with garnets and blue checkered enamel, forming figures and rectilinear patterns. The upper ornaments, in the same materials, consist of polygons decorated with purely geometrical patterns flanking four animals with interlacing legs and jaws. Below, in the center, large, curved-beaked Swedish hawks attack ducks. Flanking the birds are images of men spread-eagled between two rampant beasts. The theme of a human attacked by or controlling a pair of animals is widespread in ancient Near Eastern art and in the Roman world. The hawks are Swedish, the interlacing animals Germanic, and the polychrome gem style eastern continental—a rich blend of motifs that heralds the complex Hiberno-Saxon style that flourished in England and Ireland (whose Roman name was Hibernia) during the seventh and eighth centuries.

Although the Anglo-Saxons who settled in Britain were pagans, Christianity endured through the fifth and sixth centuries in southwestern England and in Wales, Scotland, and Ireland. Monasteries began to appear in these regions in the late fifth century, and Irish Christians founded influential missions in Scotland and northern England. Some were located in inaccessible places, isolating their monks from the outside world. At many others, however, monks interacted with local Christian communities. The priests in the Christian communities spoke Celtic languages and had some familiarity with Latin. Cut off from Rome, they developed their own liturgical practices, church calendar, and distinctive artistic traditions. Then, in 597, Pope Gregory the Great (papacy 590–604), beginning a vigorous campaign of conversion in Britain, dispatched a mission from Rome to King Ethelbert of Kent, who had a Christian wife. The head of this mission, the monk Augustine (d. 604, canonized as Saint Augustine), became the archbishop of Canterbury in 601. The Roman Christian authorities and the Irish monasteries, although allied in the effort to Christianize the British Isles, came into conflict over their divergent practices. The Roman Church eventually triumphed in bringing British Christianity under its authority and in liturgical and calendrical matters. Local traditions, however, continued to dominate both secular and religious art.

Among the richest art works of the period were the beautifully written, illustrated, and bound manuscripts, especially the gospels, that rested on the altars of churches. They were produced by monks in local monastic workshops called *scriptoria* (see "The Medieval Scriptorium," page 490), which played a leading role in

14-4. **Page with** *Lion,* Gospel of Saint John, *Gospel Book of Durrow,* probably made at Iona, Scotland. c. 675. Ink and tempera on parchment, 9⁵/₈ x 5¹¹/₁₆" (24.5 x 14.5 cm). The Board of Trinity College, Dublin, MS 57 (TCD MS 57 fol. 191v)

diffusing artistic styles and themes. One of the many large, elaborately decorated Gospels of the period is the *Gospel Book of Durrow,* dating to about 675. This manuscript is named for the town in Ireland where it was kept in the late medieval period, but no one knows exactly where it was made. A likely possibility is the monastery founded on Iona by Colum Cille in the sixth century (see page 485). The format and text of the book reflect a knowledge of Roman Christian models, but its decoration is practically an encyclopedia of local design motifs, such as serpents and animals adopted from metalwork like the Sutton Hoo treasure (see fig. 14-3). Each of the four Gospels is introduced by a page with the symbol of the evangelist who wrote it, followed by a page of pure ornament (a carpet page), then decorated letters of the first words of the text (the incipit). In the *Gospel Book of Durrow,* the artist followed early Christian, pre-Vulgate tradition, using the lion, normally the symbol of Saint Mark, for Saint John (fig. 14-4) and Saint John's eagle for Saint Mark. The lion here is a ferocious beast with sharp claws, jagged teeth, curling tail, and wild eye. The stylization of the body is based on Pictish (Scottish) stone carving, rather than on a flesh-and-blood creature. Its eye, tail, and paws and the stylized muscles around hip and shoulder joints are painted yellow to suggest gold. Its head is decorated with a uniform stippled pattern, and the surface of its body is covered with diamond patterns similar to those found in cloisonné. Around the wide border are two types of **ribbon interlace**, a complex pattern of woven and knotted lines that may derive from similar border ornamentation in ancient Greek and Roman mosaics and is commonly found in medieval painting and metalwork. Here, a dotted pattern marks the vertical bands and shifting bright green, red, and yellow coloration adorns the horizontal bands.

Another Gospel book, the *Book of Kells,* described by an eleventh-century observer as "the chief relic [religious

THE MEDIEVAL SCRIPTORIUM

Today books are made with the aid of computer software that can lay out pages, set type, and insert and prepare illustrations. Modern presses can produce hundreds of thousands of identical copies in full color. In Europe in the Middle Ages, however, before the invention there of printing from movable type in the mid-1400s, books were made by hand, one at a time, with ink, pen, brush, and paint. Each one was an important, time-consuming, and expensive undertaking.

Medieval books were usually made by monks and nuns in a workshop called a **scriptorium** (plural **scriptoria**) within the monastery. As the demand for books increased, lay professionals joined the work, and great rulers set up palace workshops supervised by well-known scholars. Books were written on animal skin—either **vellum**, which was fine and soft, or **parchment**, which was heavier and shinier. (Paper did not come into common use in Europe until the early 1400s.) Skins for vellum were cleaned, stripped of hair, and scraped to create a smooth surface for the ink and water-based paints, which themselves required time and experience to prepare. Many pigments—particularly blues and greens—had to be imported and were as costly as semiprecious stones. In early manuscripts, bright yellow was used to suggest gold, but later manuscripts were decorated with real gold leaf or gold paint.

Sometimes work on a book was divided between a scribe, who copied the text, and one or more artists, who did the illustrations, large initials, and other decorations. Although most books were produced anonymously, scribes and illustrators signed and dated their work on the last page, called the **colophon** (see fig. 14-7). One scribe even took the opportunity to warn the reader: "O reader, turn the leaves gently, and keep your fingers away from the letters, for, as the hailstorm ruins the harvest of the land, so does the injurious reader destroy the book and the writing" (cited in Dodwell, page 247).

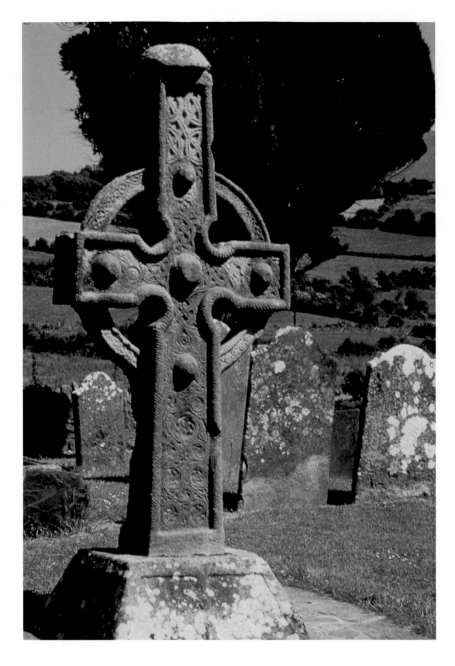

14-5. South Cross, Ahenny, County Tipperary, Ireland. 8th century. Stone

object] of the Western world," is one of the most beautiful, original, and inventive of the surviving Hiberno-Saxon Gospel books. It may have been begun or made at the monastery on Iona in the late eighth century and brought to the monastery at Kells, in Ireland, in the early ninth century.

In the twelfth century, a priest named Gerald of Wales, describing a Hiberno-Saxon Gospel book very much like the *Book of Kells*, wrote: "Fine craftsmanship is all about you, but you might not notice it. Look more keenly at it, and you will penetrate to the very shrine of art. You will make out intricacies, so delicate and subtle, so exact and compact, so full of knots and links, with colors so fresh and vivid, that you might say that all this was the work of an angel, and not of a man" (cited in Henderson, page 195). A close look at perhaps the most celebrated page in the *Book of Kells*—the one from the Book of Matthew (1:18–25) that begins the account of Jesus' birth—reveals what he means (see fig. 14-1). At first glance, the page seems completely abstract, but for

those who would "look more keenly," there is so much more—human and animal forms—in the dense thicket of spiral and interlace patterns derived from metalwork.

Metalwork's influence is seen not only in manuscript illumination, but also in the monumental stone crosses erected in Ireland in the eighth century. In the Irish "high crosses," so called because of their size, a circle encloses the arms of the cross. This Celtic ring has been interpreted as a halo or a glory (a ring of heavenly light), or as a purely practical support for the arms of the cross. The South Cross of Ahenny, in County Tipperary, is an especially well preserved example of this type (fig. 14-5). It seems to have been modeled on metal ceremonial or reliquary crosses, that is, cross-shaped containers for holy relics. It is outlined with **gadrooning** (ropelike, convex molding) and covered with spirals and interlace. The large **bosses** (broochlike projections), which form a cross within the cross, resemble the jewels that were similarly placed on metal crosses.

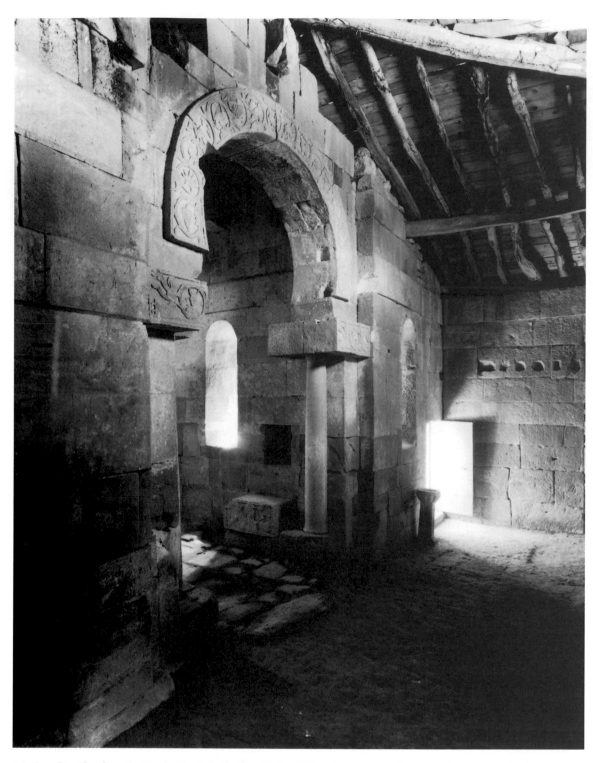

14-6. Church of Santa Maria de Quintanilla de las Viñas, Burgos, Spain. Late 7th century. View from the choir into the apse

CHRISTIAN SPAIN

In the fourth and fifth centuries, as Roman control of western Europe deteriorated, a Germanic tribe known as the Visigoths converted to Arian Christianity (Chapter 7) and migrated across Europe and into Spain. By the sixth century the Visigoths had established themselves as an aristocratic elite ruling the indigenous population. They adopted Latin for writing and in 589 the Western Church's orthodox Christianity. Visigothic metalworkers, following the same late-Roman–Germanic tradition they shared with other Gothic peoples, created magnificent colorful jewelry.

The sixth- and seventh-century churches surviving in Spain are well-preserved examples of Visigothic stone architecture. The Church of Santa Maria de Quintanilla de las Viñas, located near Burgos, was built in the late seventh century. It was originally a **basilica** (see "Basilica-Plan and Central-Plan Churches," page 298)—the nave and two aisles no longer exist—and the aisles opened via narrow doorways into the **choir**. Like a **transept**, this

area, reserved for the clergy, extended the full width of the church. This marked partitioning of the nave from the choir and sanctuary, found in other Spanish churches of the same period, may reflect a change in liturgical practice in which the congregation no longer approached the altar to receive communion.

The Visigothic form of the **horseshoe arch** frames the entrance to the apse at Santa Maria de Quintanilla de las Viñas (fig. 14-6), refuting the popular belief that Islamic architects introduced this form in the eighth century (see the discussion of the Great Mosque of Córdoba in Chapter 8 and figure 8-6). The lowest *voussoirs* jut inward slightly into the apse entrance, supported on **piers** and freestanding columns and large **impost blocks**. The themes of the crisp bands of carving on the arch and impost blocks are found frequently in early Christian art. Above the arch is Christ between Angels. The sun and the moon are on the impost blocks. On the arch is a scrolling vine, the loops of which encircle birds and bunches of grapes, symbolic of the Eucharist. Like the carved decoration on the roughly contemporary South Cross at Ahenny, the style of these low-relief decorations is reminiscent of metalwork.

In 711, Islamic invaders conquered Spain, ending Visigothic rule. With some exceptions, Christians and Jews who did not convert to Islam but acknowledged the authority of the new rulers and paid the taxes required of non-Muslims were left free to follow their own religious practices. Christians in the Arab territories were called Mozarabs (from the Arabic *mustarib*, meaning "would-be Arab"). The conquest resulted in a rich exchange of artistic influences between the Islamic and Christian communities. Christian artists adapted many features of Islamic style to their traditional themes, creating a unique, colorful new style known as Mozarabic; when they migrated to the monasteries of northern Spain, which reverted to Christian rule not long after the initial Islamic invasion, they took this Mozarabic style with them.

In northern Spain, the antagonisms among Muslims, orthodox Christians, and the followers of various heretical Christian sects provided fertile material for writers to explore in religious commentaries. One of the most influential of these was the *Commentary on the Apocalypse* compiled in the eighth century by Beatus, abbot of the Monastery of San Martín at Liébana, in the north Spanish kingdom of Asturias. It is an analysis of the visions set down in the Apocalypse (the Book of Revelation), the book of the New Testament that vividly describes Christ's final, fiery triumph. Beatus's work, an impassioned justification of orthodox beliefs, appealed to Christians in their long struggle against the Muslims. The book was widely read, copied, and illustrated. Two copies from the late tenth century, illustrated in the Mozarabic style, were produced under the direction of the scribe-painter Emeterius, a monk in the workshop of the Monastery of San Salvador at Tábara in the kingdom of León.

The first of these copies was completed in 970 by Emeterius and a scribe-painter named Senior, who identified themselves in the manuscript. Unlike most monastic scribes at this time, Mozarabic scribes usually signed their

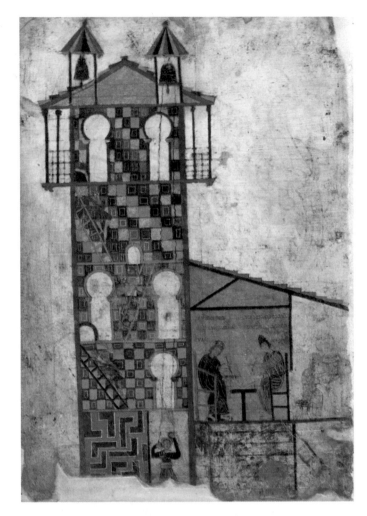

14-7. Emeterius and Senior. Colophon page, *Commentary on the Apocalypse* **by Beatus and** *Commentary on Daniel* **by Jerome**, made for the Monastery of San Salvador at Tábara, León, Spain. Completed July 27, 970. Tempera on parchment, 14¼ x 10⅛" (36.2 x 25.8 cm). Archivo Histórico Nacional, Madrid. MS 1079B f. 167.v

In medieval manuscripts the colophon page provided specific information about the production of a book. In addition to identifying himself and Senior on this colophon, Emeterius praised his teacher, "Magius, priest and monk, the worthy master painter," who had begun the manuscript prior to his death in 968. Emeterius also took the opportunity to comment on the profession of bookmaking: "Thou lofty tower of Tábara made of stone! There, over thy first roof, Emeterius sat for three months bowed down and racked in every limb by the copying. He finished the book on July 27th in the year 1008 (970, by modern dating) at the eighth hour" (cited in Dodwell, page 247).

work, sometimes showed themselves occupied with pen and brush, and occasionally offered the reader their own comments and asides (see "The Medieval Scriptorium," page 490). On the **colophon**, the page at the end of a manuscript or book that identifies its producers, is a picture of the five-story tower of the Tábara monastery and the two-story *scriptorium* attached to it, the earliest known depiction of a medieval *scriptorium* (fig. 14-7). The tower,

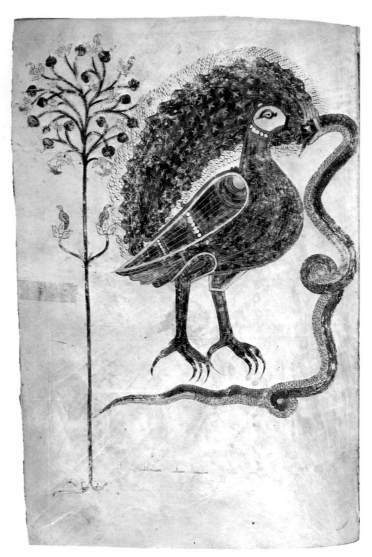

14-8. Emeterius and Ende, with the scribe Senior. Page with *Battle of the Bird and the Serpent*, *Commentary on the Apocalypse* by Beatus and *Commentary on Daniel* by Jerome, made for Abbot Dominicus, probably at the Monastery of San Salvador at Tábara, León, Spain. Completed July 6, 975. Tempera on parchment, 15¾ x 10¼" (40 x 26 cm). Cathedral Library, Gerona, Spain. MS 7[11], fol. 18v

with horseshoe-arched windows, and the workshop have been rendered in a cross section that reveals many details of the interior and exterior simultaneously. In the *scriptorium*, Emeterius on the right and Senior on the left, identified by inscriptions over their heads, are at work at the same small table. A helper in the next room cuts sheets of **parchment** or vellum for book pages. A monk standing inside (or perhaps outside) the ground floor of the tower pulls the ropes to the bell in the turret on the right. Three other men climb ladders between the floors, apparently on their way to the balconies on the top level. Brightly glazed tiles in geometric patterns, a common feature of Islamic architecture, cover what could be the tower's walls.

The other Beatus *Commentary* was produced five years later for a named patron, Abbot Dominicus. The colophon identifies Senior as the scribe for this project. Emeterius and a woman named Ende, who signed herself "painter and servant of God," shared the task of

illustration. A full-page painting from this book shows a peacock grasping a red and orange snake in its beak (fig. 14-8). With abstract shapes and colored enamel recalling Visigothic metalwork, Emeterius and Ende illustrate a metaphorical description of the triumph of Christ over Satan. A bird with a powerful beak and beautiful plumage (Christ) covers itself with mud to trick the snake (Satan). Just when the snake decides the bird is harmless, the creature swiftly attacks and kills it. "So Christ in his Incarnation clothed himself in the impurity of our [human] flesh that through a pious trick he might fool the evil deceiver. . . . [W]ith the word of his mouth [he] slew the venomous killer, the devil" (from the Beatus *Commentary*, cited in Williams, page 95). The Church often used such symbolic stories, or allegories, to translate abstract ideas into concrete events and images, making their implications accessible to almost anyone of any level of education.

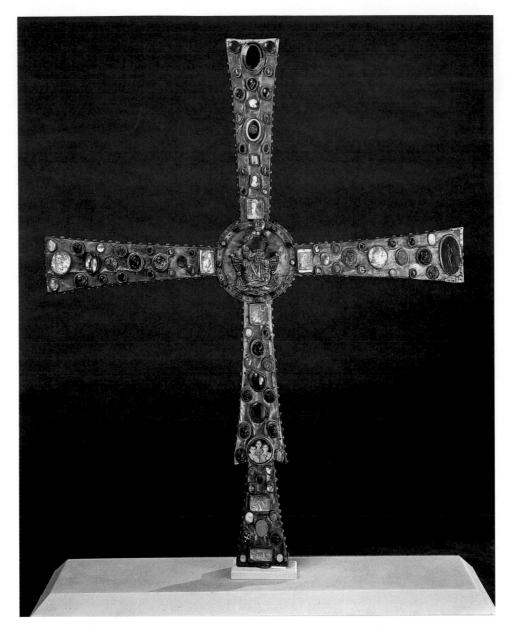

14-9. Cross, from the Church of Saint Giulia, Brescia, Italy. Late 7th–early 9th century. Gilded silver, wood, jewels, glass, cameos, and gold-glass medallion, 50 x 39" (126 x 99 cm). Museo di Santa Giulia, Brescia

LANGOBARD ITALY

The Western Empire did not recover after the disastrous but temporary conquest of Rome by the Visigoths in 410. Gradually the pope replaced the emperor as a temporal as well as spiritual ruler. At the same time, the Byzantines held the important port city of Ravenna and territory along the Adriatic coast against a succession of Germanic invaders. Among those who established short-lived kingdoms in Italy were the Visigoths, who captured Ravenna in 493–553) and established a short-lived kingdom, and the Langobards, who settled in northern and central Italy (568–774).

Most enduring was the Langobard kingdom. The Langobards had moved from their homeland in northern Germany to the Hungarian plain and then traveled west into Italy, where they became a constant threat to Rome. Like other migrating people, the Langobards excelled in fine metalwork and jewelry. A huge jeweled cross in Brescia (east of Milan) shows their love of bright colors and spectacular jewels (fig. 14-9). The cross has a Byzantine form—equal arms widening at the ends joined by a central disc. Gilded silver covers its wooden core. Christ enthroned in a silver jeweled **mandorla**, executed in relief, fills the central disk, and more than 200 jewels, pieces of glass, engraved gems, and antique **cameos** cover the arms. At the bottom of the lower vertical arm is a gold glass medallion inscribed "Bounneri Kerami," a fine example of Roman portraiture (see fig. 6-73). According to tradition, the last Langobard king, Desiderius (ruled 757–74), gave the cross to the Church of

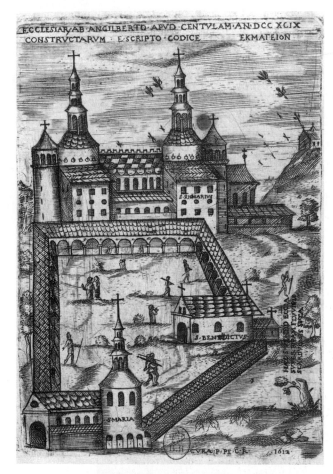

14-10. Abbey Church of Saint Riquier, Monastery of Centula, France, dedicated 799. Engraving dated 1612, after an 11th-century drawing. Bibliothèque Nationale, Paris

church but having the form associated with the Byzantine East, and using engraved jewels and cameos from the ancient world, the cross achieves the effect of "barbarian" splendor.

The Langobards did not create a new integrated Roman-German style. For that we turn to the Carolingian dynasty founded by Charlemagne. King of the Franks, Charlemagne had married the Langobard princess as a diplomatic gesture in 770 but in 771 repudiated her and marched against her father, Desiderius, whom he vanquished in 774. Proclaiming himself king of the Langobards, Charlemagne incorporated the Langobardian kingdom into his growing realm.

CAROLINGIAN EUROPE

A new empire emerged in continental Europe during the second half of the eighth century, forged by the Carolingian dynasty (dynasty from 768, empire 800–77) that was created by Charlemagne, or Charles the Great (*Carolus* is Latin for "Charles"). The Carolingians were Franks, a Germanic people who had settled in northern Gaul by the end of the fifth century. Under Charlemagne (ruled 768–814; crowned emperor 800) the Carolingian realm reached its greatest extent, encompassing western Germany, France, the Langobard kingdom in Italy, and the Low Countries (modern Belgium and Holland). Charlemagne imposed Christianity, sometimes brutally, throughout this territory and promoted Church reform. In 800 Pope Leo III (papacy 795–816), in a ceremony in the Church of Saint Peter (later known as Old Saint Peter's) in Rome, crowned Charlemagne emperor, declaring him to be the rightful successor to Constantine, the first Christian emperor. This endorsement reinforced Charlemagne's authority over his diverse realm and strengthened the bonds between the papacy and secular government in the West.

Charlemagne sought to restore the Western Empire as a Christian state and to revive the arts. On his official seal, Charlemagne inscribed *renovatio Romani imperii* ("The revival of the Roman Empire"). He placed great emphasis on education, gathering around him the finest scholars of the time, and his court, in Aachen, Germany, became the leading intellectual center of

Saint Giulia in Brescia. Scholars cannot agree, and they date the cross variously to the late seventh, eighth, and even early ninth centuries.

The patron who gathered this rich collection of jewels and ordered the cross made intended to glorify it with glowing color—although nearly all the engraved gems (some of which are copies) have pagan subjects. The cross thus typifies this turbulent period in the western European history of art. Made for a Western Christian

THE WESTERN CHURCH'S DEFINITION OF ART

In 787, when the iconoclastic controversy that had raged in the Eastern Empire temporarily ended with the reestablishment of the veneration of icons (discussed in Chapter 7), Charlemagne ordered his scholars to rebut the Eastern Church's position. In the *Caroline Books* (*Libri Carolini*), the Carolingians concluded that artists create visual fictions and that, contrary to pious Byzantine belief, icons are made by human beings. They rejected the supernatural powers attributed by the Eastern Church to icons.

The Western Church took the position that images are precious only if their material is precious (a gold image of Mary is more valuable than a wooden one, although both represent the Mother of God). In the case of ancient works, the value should be based on both the materials and the condition of the piece. Further, although images are not holy or products of divine inspiration, they do have an important educational function. Pope Gregory the Great (papacy 590–604) wrote in a letter: "What scripture is to the educated, images are to the ignorant." Therefore, artists should be well trained, work diligently, use good materials, and follow the best models. "Quality" should be determined by the artists' success in fulfilling their intentions and their patrons' commands.

western Europe. His architects, painters, and sculptors turned to Rome and Ravenna for inspiration, but what they created was a new, northern version of the Imperial Christian style (see "The Western Church's Definition of Art," opposite).

ARCHITECTURE

Charlemagne's biographer, Einhard, reported that the ruler, "beyond all sacred and venerable places . . . loved the church of the holy apostle Peter at Rome." Not surprisingly, Charlemagne's architects turned to Old Saint Peter's, a basilica-plan church with a long nave and side aisles ending in a transept and projecting apse (see fig. 7-9), as a model for his own churches. These churches, however, included purely northern features and were not simply imitations of Roman Christian structures. Among these northern features was a multistory **narthex**, or vestibule, flanked by attached stair towers. Because church entrances traditionally faced west, this type of narthex is called a **westwork**.

The Abbey Church of Saint Riquier, an ancient monastery at Centula in northern France was an example of the Carolingian reworking of the Roman basilica-plan church. Built when Angilbert, a Frankish scholar at Charlemagne's court, was abbot at Centula, it was completed about 799. Destroyed by Viking raids in 845 and 881 and rebuilt, it is known today from archaeological evidence and an engraved copy after a lost eleventh-century drawing of the abbey (fig. 14-10). For the abbey's more than 300 monks, the enclosure between the church and two freestanding chapels may have served as a **cloister**—cloisters are arcaded courtyards, with a well and sometimes with gardens, linking the church and the buildings for the monastic community. A second cloister has also been found. The small, barnlike chapel at the right in the drawing was dedicated to Saint Benedict. The more elaborate structure at the lower left, a basilica with a **rotunda** ringed with chapels, was dedicated to the Virgin and the Twelve Apostles. The interior would have had an altar of the Virgin in the center, an **ambulatory** passageway around it, and altars for each of the apostles against the perimeter walls.

The Church of Saint Riquier followed a basic basilica plan. Excavations have revealed a much longer nave than is indicated in the illustration. Giving equal weight to both ends of the nave are, at the left of the drawing, a multistory westwork including paired towers, a **transept**, and a crossing tower, and, at the right (the east end of the church), a crossing tower that rises over the transept and an extended **chancel** (sanctuary) and apse. The westwork's liturgical function was so important that it served almost as a separate church. At the Church of Saint Riquier, the altar in the westwork was dedicated to Christ the Savior and used on great feast days. The boys' choir sang from its galleries, filling the church with angelic music, and its ground floor had altars with important relics. Later, the westwork held the chapel of the archangel Michael, instead of the Savior, whose altar was moved to the main body of the church. (During the

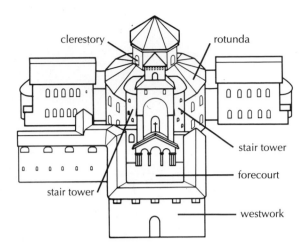

14-11. Reconstruction drawing of the Palace Chapel of Charlemagne, Aachen (Aix-la-Chapelle), Germany. 792–805

Romanesque and Gothic periods, the westwork element would evolve into a twin-towered facade.) The two tall towers, soaring from cylindrical bases through three arcaded levels to cross-topped spires, would have been the building's most striking feature, though their form has been debated. They were apparently made of timber, which, being lighter than masonry, posed fewer problems for tall construction. This vertical emphasis created by the many towers was a northern contribution to Christian architecture.

Remains of Charlemagne's palace complex provide another example of the Carolingian synthesis of Roman Christian and northern styles. Charlemagne, who enjoyed hunting and swimming, built his palace complex amid the forests and natural hot springs of Aachen (Aix-la-Chapelle in French), in the northern part of his empire. He installed his court there about 794, making it his capital. The complex included homes for his circle of advisers and his large family, administrative buildings, the palace school, and workshops supplying all the needs of church and state. An audience hall survives in part, and excavations have revealed the plan of the complex with a monumental gateway and judgment hall. Directly across from the royal audience hall on the north-south axis of the complex stood the Palace Chapel (fig. 14-11). This structure functioned as Charlemagne's private chapel, the church of his imperial court, a **martyrium** for certain precious relics of saints, and, after the emperor's death, the imperial **mausoleum**. To satisfy all these needs, the emperor's architects created a large, central-plan building similar to that of the Church of San Vitale in Ravenna (see fig. 7-26), but added a westwork with a tall, cylindrical stair tower on each side. The chapel originally had a very large, walled forecourt where crowds could assemble. Spiral stairs in the twin towers led to a throne room on the second level that opened onto the chapel rotunda, allowing the emperor to participate in the Mass. Relics were housed above the throne room on the third level.

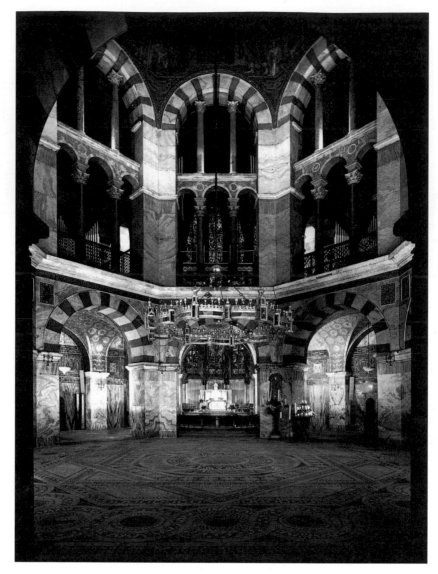

14-12. Palace Chapel of Charlemagne

> Although this sturdily constructed chapel retains its original design and appearance, including the bronze railings, much of its decoration either has been restored or dates from later periods. The Gothic-style chapel seen through the center arches on the ground floor replaced the eighth-century sanctuary apse. The enormous "crown of light" chandelier suspended over the central space was presented to the church by Emperor Frederick Barbarossa in 1168. Extensive renovations took place in the nineteenth century, when the chapel was reconsecrated as the cathedral of Aachen, and in the twentieth century, after it was damaged in World War II.

The core of the chapel is an octagon that rises to a **clerestory** above the **gallery** level (fig. 14-12). An ambulatory aisle surrounds this central core to form a sixteen-sided outer wall. The gallery also opens on the central space through arched openings supported by two tiers of Corinthian columns. Compared to San Vitale, where the central space seems to flow outward from the dome into half domes and the **exedrae**, the Aachen chapel has a clarity created by flat walls and geometric forms. The columns and grilles on the gallery level lie flush with the opening overlooking the central area, screening it from the space beyond. The effect is to create a powerful vertical visual pull from the floor of the central area to the top of the vault. Unlike San Vitale, which is covered by a smooth, round dome, the vault over the Palace Chapel rises from its octagonal base in eight curving masonry segments. Originally the vault had a mosaic depicting the twenty-four Elders of the Apocalypse. The clear division of the structure into parts and the vertical emphasis are both hallmarks of the new style that developed under Charlemagne.

Monastic communities had grown numerous by the early Middle Ages and had spread across Europe. In the early sixth century, Benedict of Nursia (c. 480–547) wrote

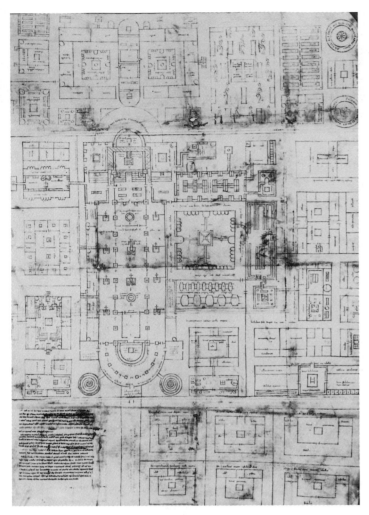

14-13. Plan of the Abbey of Saint Gall (redrawn). c. 817. Original in red ink on parchment, 28 x 44⅛" (71.1 x 112.1 cm). Stiftsbibliothek, St. Gallen, Switzerland. Cod. Sang. 1092

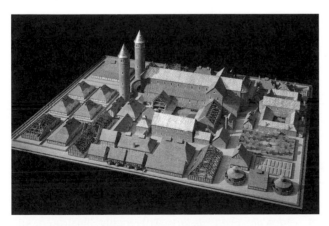

14-14. Model after the Saint Gall monastery plan (see fig. 14-13), constructed by Walter Horn and Ernst Born, 1965

his *Rule for Monasteries*, a set of guidelines for monastic life. Benedictine monasticism quickly became dominant, displacing earlier forms, including the Irish monasticism that had developed in the British Isles. In the early ninth century, Abbot Haito of Reichenau developed a general plan for the construction of monasteries for his colleague

Abbot Gozbert of the Benedictine Abbey of Saint Gall near Lake Constance (in modern Switzerland). The Saint Gall plan (figs. 14-13, 14-14) was drawn on five pieces of parchment sewn together.

This extremely functional plan was widely adopted and can still be seen in many Benedictine monasteries. Central to monastic life were the eight daily services in the church (*Opus dei*, the *Work of God*). Monks entered from the cloister or by stairs directly from their quarters. The church had apses at both ends and a transcpt crossing the nave at the eastern end. Most important was the development of the cloister and complex of monastic buildings surrounding it. The warming room and dormitory above it stood on the east side of the cloister, the refectory (dining hall) on the south, and the cellar (indicated by giant barrels) on the west. Only a chapter house (the administrative center of the monastery where a chapter of the Rule of Saint Benedict was read every day) is missing from the plan; instead, the monks met in the north cloister aisle, next to the church. The Saint Gall plan provides beds for seventy-seven monks in the dormitory and space for thirty-three more monks elsewhere, but only seven seats are indicated in the main latrine. Six beds and refectory seats were reserved for visiting monks. Members of the lay community that inevitably developed outside the walls of a large monastery used the main entryway. In the surrounding buildings, monks pursued their individual tasks. Scribes and painters, for example, spent much of their day in the *scriptorium* studying and copying books, and teachers staffed the monastery's schools and library. Benedictine monasteries generally had two schools, one inside the monastery proper for young monks and novices (those hoping to take vows and become brothers), and another outside for educating the sons of the local nobility.

Saint Benedict had directed that monks extend hospitality to all visitors, and the large building in the upper left of the plan may be a hostel, or inn, for housing them. A porter would have looked after visitors, supplying them from the food produced by the monks. The plan also included a hospice for the poor and an infirmary. A monastery of this size had most of the features of a small town and would have indirectly or directly affected many hundreds of people. Essentially self-supporting, it would have had livestock, barns, agricultural equipment, a bakery and brewery, kitchen gardens (farm fields lay outside the walls), and even a cemetery.

BOOKS

Books played a central role in the efforts of Carolingian rulers to promote learning, propagate Christianity, and standardize Church law and practice. As a result, much of the artistic energy of the period found an outlet in the empire's great *scriptoria*. One of the main tasks of these workshops was to produce authoritative copies of key religious texts, free of the errors that tired, distracted, or confused scribes had introduced over the generations. The scrupulously edited versions of ancient texts that emerged are among the lasting achievements of the

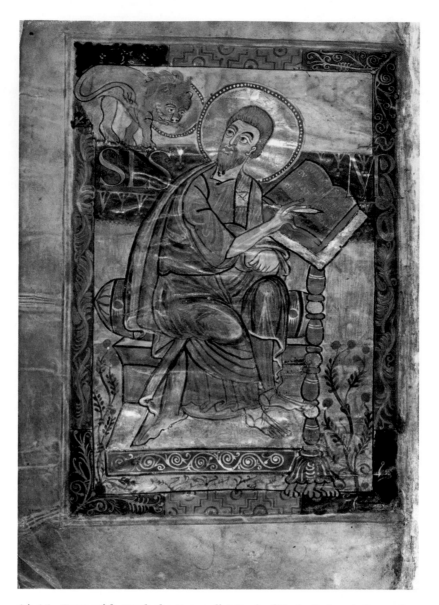

14-15. Page with *Mark the Evangelist*, Book of Mark, *Godescalc Evangelistary*. 781–83. Ink and colors on vellum, 12½ x 8½" (32.1 x 21.8 cm). Bibliothèque Nationale, Paris. MS lat. 1203, fol. 16

Carolingian period. The Anglo-Saxon scholar Alcuin of York, whom Charlemagne called to his court, spent the last eight years of his life producing a corrected copy of the Latin Vulgate Bible. His revision served as the standard text of the Bible for the remainder of the medieval period.

Ordered by Charlemagne to create a simple, legible Latin script, the scribes and scholars developed uniform letters. Capitals (majuscules) based on ancient Roman inscriptions were used for very formal writing, titles and headings, and the finest manuscripts. Minuscules (now called lowercase letters, a modern term from printing) were used for more rapid writing and ordinary texts. This Caroline script is comparatively easy to read, although the scribes did not use punctuation marks or spaces between words.

One of the earliest surviving manuscripts in the new script, produced at Charlemagne's court between 781 and 783, was a collection of selections from the Gospels to be read at Mass, copied by the Frankish scribe Godescalc and known as the *Godescalc Gospel Lectionary* or *Godescalc Evangelistary*. This richly illustrated and sumptuously made book (featuring gold and silver letters and purple-dyed vellum pages) has a full-page portrait of the evangelist at the beginning of each Gospel section. The style of these illustrations suggests that Charlemagne's artists were familiar with the author portraits and illusionistic painting style of imperial Rome that had been preserved in Byzantine manuscripts.

In his portrait, Mark is in the act of writing at a lectern tilted up to display his work (fig. 14-15). He appears to be attending closely to the small haloed lion

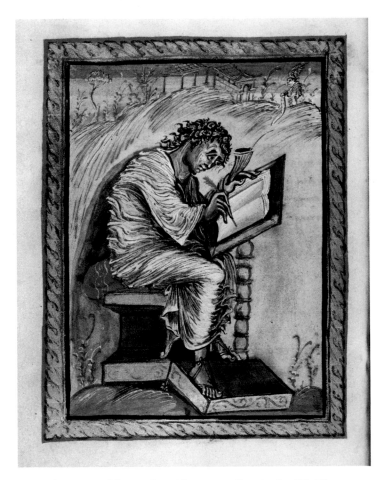

14-16. Page with *Matthew the Evangelist*, Book of Matthew, *Ebbo Gospels.* c. 816–35. Ink, gold, and colors on vellum, 10¼ x 8¾" (26 x 22.2 cm). Bibliothèque Municipale, Epernay, France, MS 1, fol.18v

in the upper left corner, the source of his inspiration and the iconographic symbol by which he is known. The artist has modeled Mark's arms, hips, and knees beneath his garment and rendered the bench and lectern to give a hint of three-dimensional space despite the flat, banded background. Mark's round-shouldered posture and sandaled feet, solidly planted on a platform decorated with a classical spiraling-vine motif, contribute an additional naturalistic touch, which is destroyed by the impossible position of the left knee. Stylized plants set the scene out of doors. Commissioned by Charlemagne and his wife Hildegarde, perhaps to commemorate the baptism of their sons in Rome, the *Godescalc Evangelistary* provided a model for later luxuriously decorated Gospel books.

Louis the Pious, Charlemagne's son and successor, appointed his childhood friend Ebbo as archbishop of Reims. Ebbo was archbishop from 816 to 835, was temporarily disgraced, then returned to rule from 840 to 845. A portrait of Matthew from a Gospel book made for Ebbo, begun after 816 at the Abbey of Hautevillers near Reims, illustrates the unique style that arose there, a medieval expressionism (fig. 14-16). Brilliant drawing in color creates a figure of Matthew that vibrates with intensity, and

the landscape in the background threatens to run off the page, contained only by the golden border. Even the acanthus leaves in the frame seem blown by a violent wind. The artist uses the brush like a pen, focusing attention less on the evangelist's physical appearance than on his inner, spiritual excitement as he hastens to transcribe the Word of God coming to him from the distant angel (Matthew's symbol) in the upper right corner. His head and neck jut out of hunched shoulders, and he grasps his pen and inkhorn. His twisted brow and prominent eyebrows lend his gaze an intense, theatrical quality. As if to echo Matthew's turbulent emotions, the desk, bench, and footstool tilt every which way and the top of the desk seems about to detach itself from the pedestal. Gold highlights the evangelist's hair and robe, the furniture, and the landscape. The accompanying text is written in magnificent golden capitals.

The most famous of all Carolingian manuscripts, the *Utrecht Psalter*, was made in the same *scriptorium*. This volume, which is illustrated with ink drawings, has the same linear vitality as the paintings in the Ebbo Gospel book. A psalter contains the Old Testament Book of Psalms, which does not tell a straightforward story and so is difficult to represent. The *Utrecht Psalter* solves this

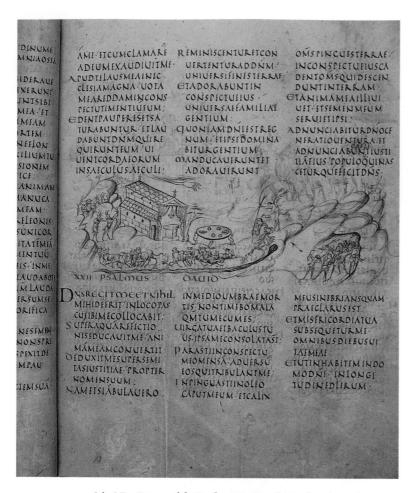

14-17. Page with *Psalm 23*, *Utrecht Psalter.* from Benedictine Abbey at Hautvilliers, France. c. 820–835. Ink on vellum or parchment, 13 x 9⅞" (33 x 25 cm). Universiteitsbibliotheek, Utrecht, Holland, MS 32, fol. 13r

problem by visually interpreting individual words and literary images. In figure 14-17, the words of the well-known Twenty-third Psalm are illustrated literally. "The Lord is my shepherd; I shall not want" (verse 1): The psalmist (traditionally King David) sits in front of a laden table holding a cup (verse 5). He is portrayed as a shepherd in a pasture filled with sheep, goats, and cattle, "beside the still water" (verse 2). Perhaps the stream flows through "the valley of the shadow of death" (verse 4). An angel supports the psalmist with a "rod and staff" and anoints his head (verses 4 and 5). "Thou preparest a table before me in the presence of mine enemies" (verse 5): The enemies gather at the lower right and shoot arrows, but the psalmist and angel ignore them and focus on the table and the House of the Lord, a basilica whose curtains are drawn back to reveal an altar and hanging votive crown: "I will dwell in the house of the Lord forever" (verse 6). Illustrations like this convey the characteristically close association between text and illustration in Carolingian art. The technique has been likened to a game of charades in which each word must be acted out.

The magnificent illustrated manuscripts of the medieval period represented an enormous investment in time, talent, and materials, so it is not surprising that they were often protected with equally magnificent covers. But because these covers were themselves made of valuable materials—ivory, enamelwork, precious metals, and jewels—they were frequently reused or stolen and broken up. The elaborate book cover of gold and jewels shown in figure 14-18 was probably made between 870 and 880 at one of the monastic workshops of Charles the Bald (ruled 840–77), who inherited the portion of Charlemagne's empire that corresponds roughly to modern France after the death of his father, Louis the Pious. It is not known what book it was made for, but sometime before the sixteenth century it became the cover of a Carolingian manuscript known as the *Lindau Gospels*, which was prepared at the Monastery of Saint Gall in the late ninth century.

The Cross and the Crucifixion were common themes for medieval book covers. The Crucifixion scene on the front cover of the *Lindau Gospels* is made of gold with figures in **repoussé** relief surrounded by heavily jeweled frames. Angels hover above the arms of the cross. Over Jesus' head, hiding their faces, are figures representing the sun and moon. The graceful, expressive poses of the mourners who float below the arms of the cross reflect the style of the *Utrecht Psalter* illustrations. Jesus has been modeled in a rounded, naturalistic style suggesting classical influence, but his stiff posture and stylized drapery counter the emotional expressiveness of the other figures. He stands straight and wide-eyed with outstretched arms, announcing his triumph over death and welcoming believers into the faith.

The Carolingian empire had been divided into three parts, ruled by three grandsons of Charlemagne, in 843. Although a few monasteries and secular courts continued to patronize the arts, intellectual and artistic activity slowed. Torn by internal strife and ravaged by Viking invaders, the Carolingian empire came to a bloody and inglorious end in the ninth century.

SCANDINAVIA: THE VIKINGS

Sometime in the late eighth century seafaring bands of Scandinavians known as Vikings (*Viken* originally meant "people from the coves" but came to be synonymous with "raiders" or "pirates") began descending on the rest of Europe. Setting off in flotillas of as many as 350 ships, they explored, plundered, traded with, and colonized a vast area and were an unsettling presence in Europe in the ninth and tenth centuries. Frequently, their targets were isolated, but wealthy, Christian monasteries. The earliest recorded Viking incursions were two devastating attacks: one in 793, on the religious community on Lindisfarne, an island off the northeast coast of England, and another, in 795, at Iona, off Scotland's west coast. In France they destroyed Centula and besieged Paris in 845 and harried the northern and western coasts of Europe for the rest of the century.

The Vikings raided and settled a vast territory, anywhere their ships could sail, stretching from Iceland and Greenland, where they settled in 870 and 985, respectively, to Ireland, England, Scotland, and France; the

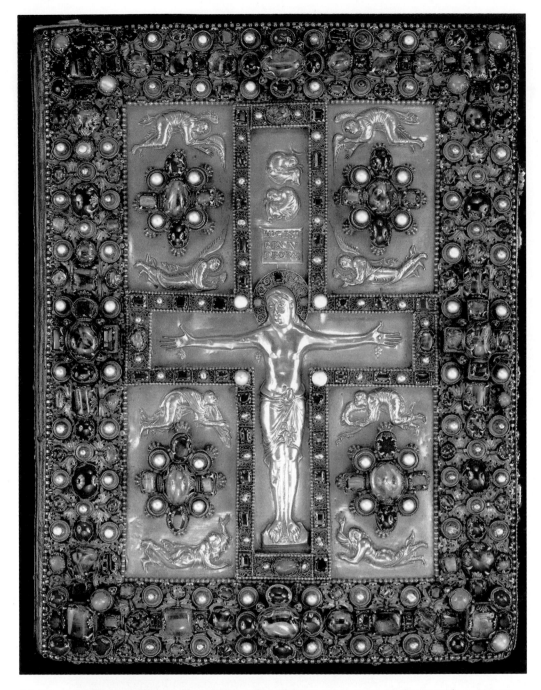

14-18. *Crucifixion with Angels and Mourning Figures*, outer cover, *Lindau Gospels*. c. 870–80. Gold, pearls, and gems, 13³/₄ x 10³/₈" (36.9 x 26.7 cm). The Pierpont Morgan Library, New York, MS 1

The jewels and pearls are arranged in a regular pattern in which pearls and smaller stones frame large jewels. All are raised from the metal plate so that they glow in the light. Gems were simply polished, not faceted, in the Middle Ages.

Viking explorer Leif Eriksson reached North America in 1000. In the early tenth century, the rulers of France bought off Scandinavian raiders (the Normans, or North men) with a large grant of land that became the duchy of Normandy. Some Viking groups also sailed down rivers to the Black Sea and Constantinople, while others, known as Rus, established settlements around Novgorod, one of the earliest cities in what would become Russia.

The Danish king Harold Bluetooth brought Christianity from Europe to Scandinavia in the middle of the ninth century. In Norway, Olaf Haraldsson (c. 995–1030, later canonized Saint Olaf) is credited with converting his people. Olaf accepted Christianity in Rouen, France, while on a Viking expedition. During the eleventh century the religion spread through the rest of the Scandinavian peninsula. Viking raids and the Viking era came to an end.

The Vikings erected large memorial stones both at home and abroad. Those covered mostly with inscriptions are called **rune stones**; those with figural decoration

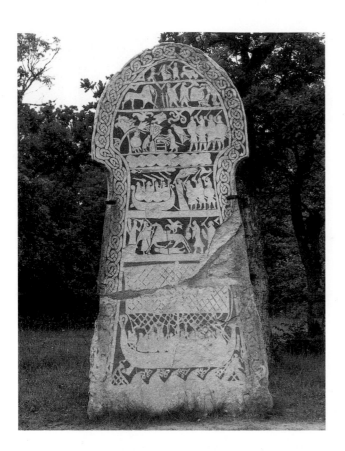

14-19. Memorial stone, Larbro Saint Hammers, Gotland, Sweden. 8th century

Much of what we know about Viking beliefs comes from later writings, especially the *Prose Edda*, compiled in the early thirteenth century by a wealthy Icelandic farmer-poet, Snorri Sturluson (1178–1241), as a guide to Norse religion and a manual for writing poetry. Among the stories he recounts is that of Gudrun and her brothers, Gunnar and Hogni, which may be the subject of the scene in the register just above the large ship on this stone. According to this legend, Gudrun was engaged to King Atli, who was interested in her only for the treasures her brothers had hidden. The scene on the stone—which shows men with raised swords on each side of a horse trampling a fallen victim and a woman with a sword boldly confronting the horse—may illustrate Gudrun and her brothers in battle against Atli. The brothers were captured in this battle and horribly murdered. Gudrun then made peace with Atli and married him, but later avenged her family's honor by serving him the hearts and blood of their children at a feast, following which she and a nephew killed Atli and burned his castle.

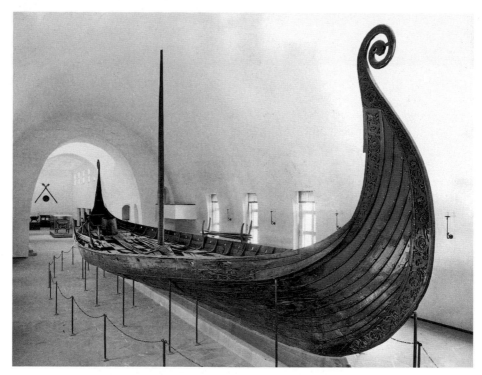

14-20. Burial ship, from Oseberg, Norway. Ship c. 815–20; burial 834. Wood, length 75'6" (23 m). Vikingskiphuset, Universitets Oldsaksamling, Oslo, Norway

This vessel, propelled by both sail and oars, was designed not for ocean voyages but for travel in the relatively calm waters of fjords, narrow coastal inlets. The shelter at the center of this ship was used as the burial chamber for two women, perhaps Queen Aase and a servant. A cart and four sleds, all made of wood with beautifully carved decorations, were stored on board. Fourteen horses, an ox, and three dogs had been sacrificed to accompany the women into the grave. It is also quite possible that one of the women was a willing sacrificial victim for the other, since Viking society believed that a courageous and honorable death was a guarantee of reward in the afterlife.

are called **picture stones**. Runes are twiglike letters of an early Germanic alphabet. Traces of pigments suggest that the memorial stones were originally painted in bright colors. Picture stones from Gotland, an island off the east coast of Sweden, share a common design and a common theme—heroic death in battle and the journey of the dead warriors to Valhalla (see "The Northern Deities," page 487). An eighth-century stone from Larbro Saint Hammers on Gotland has a characteristic "mushroom" shape (fig. 14-19). The scenes are organized into horizontal registers and surrounded by a band of ribbon interlace. In northern art such patterns probably were not merely decorative but carried some symbolic significance. Most of the registers show scenes of battle and scenes from Norse mythology, including rituals associated with the cult of Odin. The third register down, just above a horizontal band of interlace, depicts the ritual hanging of a willing victim in sacrifice to Odin. Directly in front of the hanged man is a burial mound, called the hall of Odin, and above it are symbols of Odin, the eagle and the triple knot.

The bottom panel shows a large Viking ship with a broad sail, intricate rigging, and a full crew sailing over foamy waves. Viking ships typically carried a 970-square-foot sail; the weaving of the sail by women took as long as the building of the ship by men. In good weather a ship could sail 200 miles in a day. In Viking iconography, ships symbolize the dead warrior's passage to Valhalla, and Viking chiefs were sometimes cremated in a ship in the belief that this hastened their ascent.

Women, too, might be honored by a seaworthy burial site. A 75-foot-long ship discovered in Oseberg, Norway, and dated 815–20 served as the vessel for two women on their journey to eternity (fig. 14-20). Although the burial chamber was long ago looted of jewelry and precious objects, the ship itself and the remaining artifacts attest to the wealth and prominence of the ship's owner (probably Queen Aase, since *Oseberg* means "Aase's mound") and have provided insight into the culture of Scandinavia in the early Middle Ages. The Vikings saw their ships as sleek sea serpents—they had represented them as such since prehistoric times—and the prow and stern of the Oseberg ship rise and coil accordingly, the spiraling prow ending with a tiny serpent head. The burial cabin contained empty chests that no doubt once held precious goods, as well as two looms, an indication of the skills of the women. The cabin walls had been covered with tapestries, fragments of which survived. Among the ship's artifacts are examples of wood carving, a major art form. Bands of animal interlace carved in low relief run along the ship's bow and stern. The animals are sturdy, broad-bodied creatures that grip each other with sharp claws.

Images of strange beasts adorned all sorts of Viking belongings—jewelry, houses, tent poles, beds, wagons, sleds—and, later, even churches. Traces of black, white, red, brown, and yellow indicate that the carved wood was painted. Found in the cabin of the Oseberg ship were several wooden animal-head posts about 3 feet long with handles, the purpose of which is unknown (fig. 14-21).

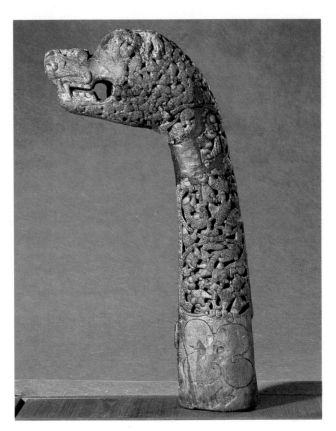

14-21. Post, from the Oseberg burial ship (see fig. 14-20). c. 815–20. Wood, length approx. 36" (92.3 cm). Vikingskiphuset, Universitets Oldsaksamling, Oslo, Norway

Although each is unique in style and design, all represent similar long-necked, grotesque, dog- or catlike creatures with bulging eyes, short muzzles, snarling mouths, and large teeth. These ferocious creatures are encrusted with a writhing mass of delicately carved beasts that clutch at each other with small, clawlike hands. This type of animal interlace, known as "gripping beasts," is a hallmark of Viking ornament. The beasts are organized into roughly circular, interlocking groups surrounded by decorated bands. The faceted cutting emphasizes the flicker of light over the densely carved surfaces. This vigorous style reinforced the tendency toward abstraction in medieval art.

OTTONIAN EUROPE

In the tenth century, a new dynasty arose in the eastern portion of the former Carolingian empire, which corresponded roughly to modern Germany and Austria. A dynasty of Saxon rulers founded by Henry the Fowler (919–36) but known as the Ottonians after its three principal figures, Otto I (ruled 936–73), Otto II (ruled 973–83), and Otto III (regency 983–96, ruled 996–1002). Henry the Fowler secured the territory by defeating the Vikings and the Magyars (Hungarians) in the 930s. Then Otto I gained control of northern Italy by marrying the Langobard queen in 951 and was crowned emperor by the pope in 962. Successors so dominated the papacy and appointments to other high Church offices that this union of Germany and Italy under a German ruler came to be known as the Holy Roman Empire.

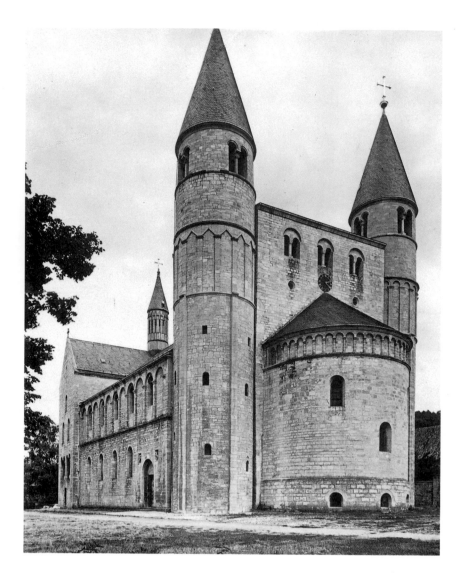

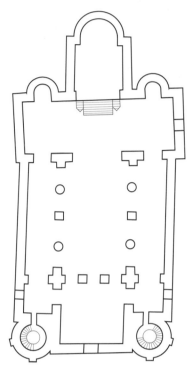

14-22. Church of Saint Cyriakus, Gernrode, Germany. Begun 961; consecrated 973

The apse seen here replaced the original westwork in the late 12th century.

14-23. Plan of the Church of Saint Cyriakus (after Broadley)

ARCHITECTURE

The Ottonian rulers, in keeping with their imperial status, sought to replicate the splendors of the Christian architecture of imperial Rome. The German court in Rome introduced northern architects to Roman architecture. Reinterpreting Roman buildings in their own local materials and time-tested techniques, the builders created a new Ottonian style. Some of their finest churches were also strongly influenced by Carolingian as well as Early Christian and Byzantine architecture.

Most of the great Ottonian buildings burned in their own time or were destroyed in later wars. One that survived was the Church of Saint Cyriakus at Gernrode, Germany (fig. 14-22). The margrave (provincial military governor) Gero founded the convent of Saint Cyriakus and commissioned the church in 961. Following the Ottonian policy of appointing relatives and close associates to important church offices, he made his widowed daughter-in-law the convent's first abbess. The church was designed as a basilica with a westwork (fig. 14-23). The choir and apse rose at the east end over the vaulted crypt. Two entrances on the south provided access to the church from the convent's cloister and dormitories. The towers and westwork that dominate the east and west

ends of the church are reminiscent of similar features at Saint Riquier's. Windows, wall arcades, and **blind arcades** break the severity of the church's exterior.

The interior of Saint Cyriakus (fig. 14-24) has three levels: an arcade separating the nave from the side aisles, a gallery with groups of six arched openings, and a clerestory. The flat ceiling is made of wood and must have been painted. Galleries over aisles were used in Byzantine architecture but rarely in the West. Their function in Ottonian architecture is debated. They may have provided space for choirs as music became more elaborate in the tenth century. They may have held additional altars. They may have been simply a mark of status. The alternation of columns and rectangular piers in Saint Cyriakus creates a rhythmic effect more interesting than that of the uniform colonnades of earlier churches. Saint Cyriakus is also marked by vertical shifts in visual rhythm, with two arches on the nave level surmounted by six arches on the gallery level, surmounted in turn by three windows in the clerestory. This seemingly simple architectural aesthetic, with its rhythmic alternation of heavy and light supports, its balance of rectangular and round forms, and its combination of horizontal and vertical movement, was to inspire architects for the next 300 years, finding full expression in the Romanesque period.

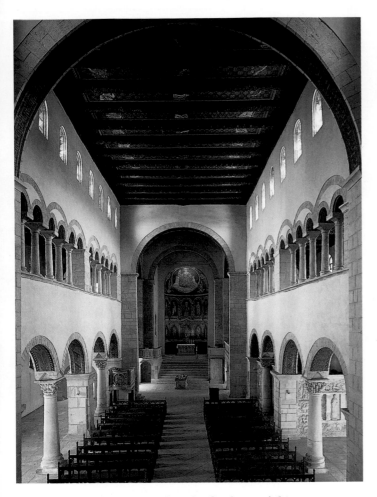

14-24. **Nave, Church of Saint Cyriakus**

SCULPTURE

Carved ivory panels for book covers and **diptychs** and **altarpieces** were among the products of both Carolingian and Ottonian bookmaking workshops. An Ottonian ivory plaque that shows Otto I presenting a model of the Magdeburg Cathedral to Christ may once have been part of the decoration of an altar or pulpit in the cathedral of Magdeburg, which was dedicated in 968 (fig. 14-25). Otto is the small figure holding the church on the left. Saint Maurice, the major saint in Magdeburg, wraps his arm protectively around him. Christ is seated on a wreath, which may represent the heavens, and his feet rest on an arc that may represent the earth. Saint Peter, patron of the church, faces Otto. The solemn dignity and intense concentration of the figures are characteristic of the Ottonian court style.

In the eleventh century under the last of the Ottonian rulers, Henry II and Queen Kunigunde (ruled 1002–24), Ottonian artists, drawing on Roman, Byzantine, and Carolingian models, created large sculpture in wood and bronze that would have a significant influence on later medieval art. An important patron of these sculptural works was Bishop Bernward of Hildesheim, who was himself an artist. His biographer, the monk Thangmar, described Bernward as a skillful goldsmith who closely supervised the artisans working for him. A pair of bronze doors made under his direction for the Abbey Church of

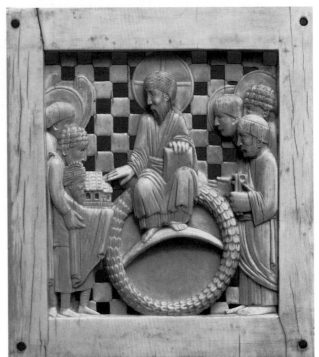

14-25. **Otto I Presenting Magdeburg Cathedral to Christ**, one of a series of 19 ivory plaques known as the *Magdeburg Ivories*. c. 962–73. Ivory, 5 x 4½" (12.7 x 11.4 cm). The Metropolitan Museum of Art, New York

Bequest of George Blumenthal, 1941 (41.100.157)

During the reign of Otto I, Magdeburg was on the edge of a buffer zone between the Ottonian empire and the pagan Slavs. In the 960s, Otto established a religious center there from which he aimed to convert the Slavs. One of the important saints of Magdeburg was Maurice, a Roman Christian commander of African troops who is said to have suffered martyrdom in the third century for refusing to worship in pagan rites. In later times, he was often represented as a dark-skinned African (see fig. 16-52). The warrior-saint appears here presenting both Otto and Magdeburg Cathedral to Christ.

Saint Michael represented the most ambitious and complex bronze-casting project since antiquity (figs. 14-26, 14-27, "The Object Speaks: The Doors of Bishop Bernward," pages 508–9). The bishop had lived for a while in Rome as tutor for Otto III and may have been inspired by the carved wooden doors of the fifth-century Church of Santa Sabina, located near Otto's palace there.

The doors' rectangular panels recall the framed miniatures in Carolingian Gospel books, and the style of the scenes within them is reminiscent of illustrations in works like the *Utrecht Psalter*. Small, extremely active figures populate spacious backgrounds. Architectural elements and features of the landscape are depicted in very low relief, forming little more than a shadowy stage for the actors in each scene. The figures stand out prominently, in varying degrees of relief, with their heads fully modeled in three dimensions. The result is lively and visually stimulating.

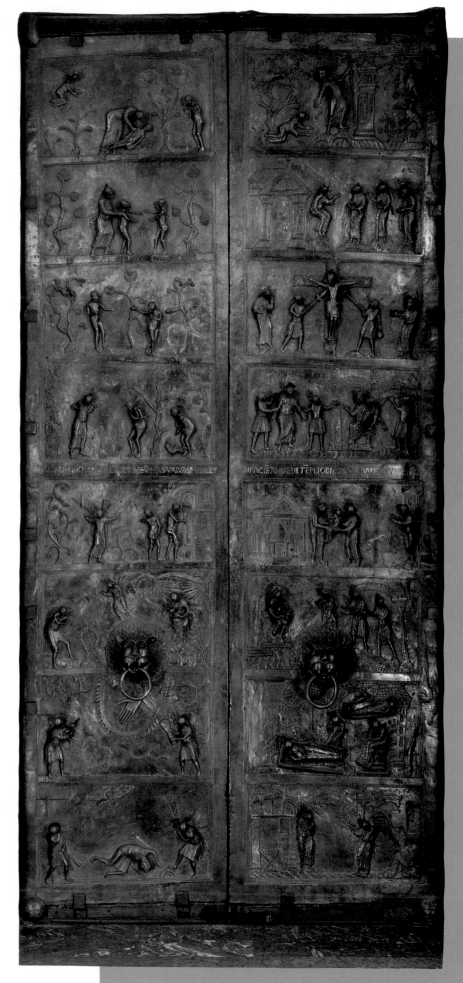

THE DOORS OF BISHOP BERNWARD

The design of the magnificent doors at Bishop Bernward's abbey church in Hildesheim, Germany, (fig. 14-26) anticipated by centuries the great sculptural programs that would decorate the exteriors of European churches in the Romanesque period. The awesome monumentality of the towering doors—nearly triple a person's height—is matched by the intellectual content of their iconography. The doors spoke eloquently to the viewers of the day and still speak to us through a combination of straightforward narrative history and subtle **typological** interrelationships, in which Old Testament themes, on the left, illuminate New Testament events, on the right (fig. 14-27). Bernward, both a scholar and a talented artist, must have designed the iconographical program himself, for only a scholar thoroughly familiar with Christian theology could have conceived it.

The Old Testament history begins in the upper left-hand panel with the Creation and continues downward to depict Adam and Eve's Expulsion from Paradise, their difficult and sorrowful life on earth, and, in the bottom panel, the tragic fratricidal story of their sons, Cain and Abel. The New Testament follows, beginning with the Annunciation at the lower right and reading upward through the early life of Jesus and his mother, Mary, through the Crucifixion to the Resurrection, symbolized by the Marys at the tomb and the meeting of Christ and Mary Magdalen in the garden.

The way the Old Testament prefigured the New in scenes paired across the doors is well illustrated, for example, by the third panels down. On the left, we see the Temptation and Fall of Adam and Eve in the Garden of Eden, believed to be the source of human sin, suffering, and death. This panel is paired on the right with the Crucifixion of Jesus, whose suffering and sacrifice redeemed humankind, atoned for Adam and Eve's Original Sin, and brought the promise of eternal life. Another example is the recurring pairing of "the two Eves": Eve, who caused humanity's Fall and Expulsion from Paradise and whose son Cain committed the first murder, and Mary, the "new Eve," through whose son, Jesus, salvation will be granted. In one of the clearest juxtapositions, in the sixth panel down, Eve and Mary are almost identical figures, each holding her first-born son; thus Cain and Jesus (evil and goodness) are also paired.

14-26. Doors of Bishop Bernward, made for the Abbey Church of Saint Michael, Hildesheim, Germany. 1015. Bronze, height 16'6" (5 m)

LEFT DOOR	THEMATIC	RIGHT DOOR
read down ↓	COMPARISONS	read up ↑
OLD TESTAMENT (Genesis)		NEW TESTAMENT (Gospels)

LIFE IN PARADISE

Creation of Adam	PARADISE LOST vs. PARADISE GAINED	The Ascension	PROMISE OF RETURN TO PARADISE
Eve presented to Adam	GREETINGS	Women at the Tomb	

THE FALL

Temptation and Fall	TREE OF KNOWLEDGE (SIN) vs. TREE OF LIFE (THE CROSS, SALVATION)	The Crucifixion	THE PASSION
Accusation and Judgment of Adam and Eve	JUDGMENT	Judgment of Christ by Pilate	

LIFE IN THE WORLD

Expulsion from Paradise	SEPARATION FROM GOD vs. REUNION WITH GOD	Presentation of Jesus in Temple	INFANCY OF JESUS
Arduous life on earth	FIRSTBORN SONS OF EVE (CAIN) AND MARY (JESUS); POVERTY vs. WEALTH	Gifts of the Magi	

EVE'S CHILDREN

Offerings by Cain (grain) and Abel (lamb)	ABEL'S SACRIFICAL LAMB vs. JESUS, LAMB OF GOD	The Nativity	MARY'S CHILD
Abel murdered by Cain	DESPAIR, SIN, MURDER vs. HOPE AND EVERLASTING LIFE	The Annunciation (Incarnation)	

14-27. Schematic diagram of the message of the Doors of Bishop Bernward

14-28. *Gero Crucifix*, from Cologne Cathedral, Germany. c. 970. Painted and gilded wood, height of figure 6'2" (1.87 m)

This lifesize sculpture is both a crucifix to be suspended over an altar and a special kind of reliquary. A cavity in the back of the head was made to hold a piece of the Host, or communion bread, already consecrated by the priest. Consequently, the figure not only represents the body of the dying Jesus but also contains within it the body of Christ obtained through the Eucharist.

Another treasure of Ottonian sculpture is the *Gero Crucifix*, one of the few large works of carved wood to survive from that period (fig. 14-28). Archbishop Gero of Cologne (served 969–76) commissioned the sculpture and presented it about 970 to his cathedral. The figure of Jesus is more than 6 feet tall and is made of painted and gilded oak. The focus here, following Byzantine models, is on Jesus' suffering. He is shown as a tortured martyr, not, as on the cover of the *Lindau Gospels* (see fig. 14-18), a triumphant hero. The intent is to inspire pity and awe in the viewer. Jesus' broken body sags on the cross and his head falls forward, eyes closed. The straight, linear fall of his golden drapery heightens the impact of his drawn face, emaciated arms and legs, sagging torso, and limp, bloodied hands. In this image of distilled anguish, the miracle and triumph of Resurrection seem distant indeed.

BOOKS

Great variation in style and approach is characteristic of book illustration in the Ottonian period. Artists worked in widely scattered centers, using different models or sources of inspiration. The *Liuthar* (or *Aachen*) *Gospels*, made for Otto III around 1000, is the work of the so-called Liuthar School, named for the scribe or patron responsible for the book. The center of this school was probably a monastic *scriptorium* in the vicinity of Reichenau or Trier. The dedication page of the *Liuthar Gospels* (fig. 14-29) is as much a work of imperial propaganda as the ancient Roman *Gemma Augustea* (see fig. 6-25). It establishes the divine underpinnings of Otto's authority and depicts him as a near-divine being himself. He is shown enthroned in heaven, surrounded by a

mandorla and symbols representing the evangelists. The Hand of God descends from above to place a crown on his head. Otto's arms are extended in an all-embracing gesture, and he holds the Orb of the World surmounted by a cross in his right hand. His throne, in a symbol of his worldly dominion, rests on the crouching Tellus, the personification of earth. In what may be a reference to the dedication on the facing page—"With this book, Otto Augustus, may God invest thy heart"—the evangelists represented by their symbols hold a white banner across the emperor's breast, dividing body, below, from soul (heart and head), above.

On each side of Otto is an emperor bowing his crowned head toward him. These may represent his Ottonian predecessors or subordinate rulers acknowledging his sovereignty. The bannered lances they hold may allude to the Ottonians' most precious relic, the Holy Lance, believed to be the one with which the Roman soldier Longinus pierced Jesus' side. In the lower register, two warriors face two bishops, symbolizing the union of secular and religious power under the emperor.

A second Gospel book made for Otto III in the same *scriptorium* illustrates the painters' narrative skill. In an episode recounted in Chapter 13 of the Gospel according to John (fig. 14-30), Jesus, on the night before his crucifixion, gathers his disciples together to wash their feet. Peter, feeling unworthy, at first protests. The painting shows Jesus in the center, larger than the other figures, extending an elongated arm and hand in blessing toward

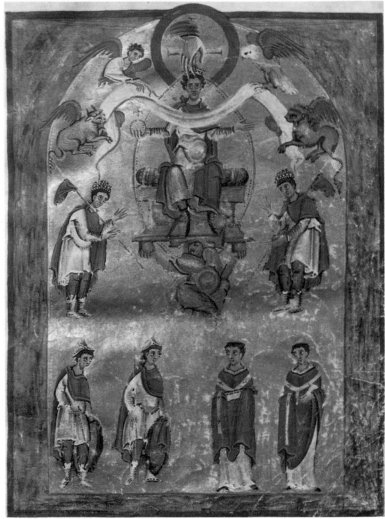

14-29. Page with *Otto III Enthroned*, *Liuthar Gospels (Aachen Gospels)*. c. 1000. Ink and colors on vellum, 10⁷/₈ x 8¹/₂" (27.9 x 21.8 cm). Cathedral Treasury, Aachen

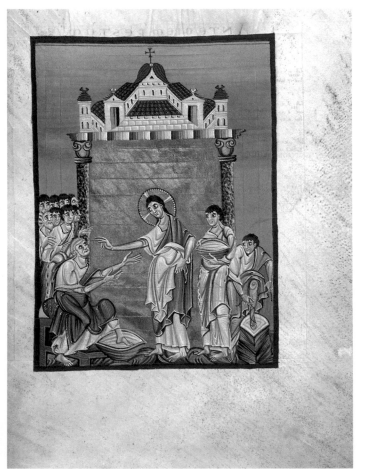

14-30. Page with *Christ Washing the Feet of His Disciples*, *Gospels of Otto III*. c. 1000. Ink and colors on vellum, approx. 8 x 6" (20.5 x 14.5 cm). Staatsbibliothek, Munich (CLM 4453)

The washing of the disciples' feet, as told in John 13, was a human gesture of hospitality, love, and humility as well as a symbolic transfer of spiritual power from Jesus to his "vicars," who would remain on earth after his departure to continue his work. At the time this manuscript was made, both the Byzantine emperor and the Roman pope practiced the ritual of foot-washing once a year, following the model provided by Jesus: "If I, therefore, the master and teacher, have washed your feet, you ought to wash one another's feet" (13:14). The pope still carries out this ritual, washing the feet of twelve priests every Maundy Thursday, the day before Good Friday.

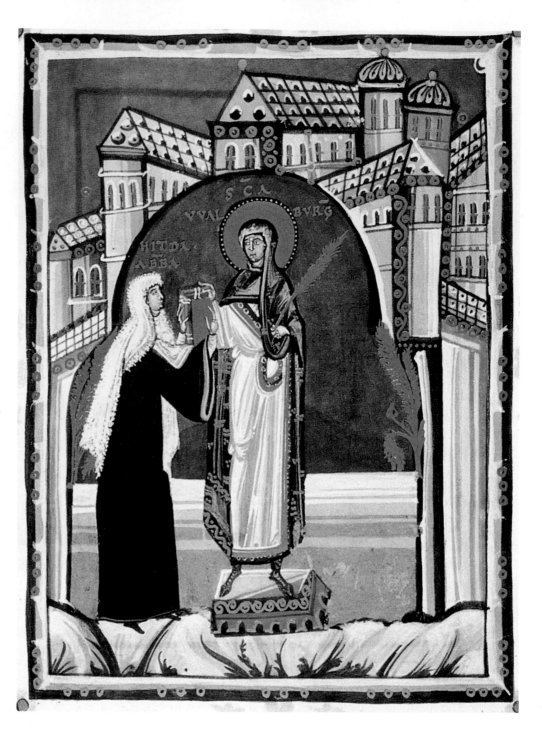

14-31. Presentation page with *Abbess Hitda and Saint Walpurga*, *Hitda Gospels.* Early 11th century. Ink and colors on vellum, 11³⁄₈ x 5⁵⁄₈" (29 x 14.2 cm). Hessische Landes- und-HochschulBibliothek, Darmstadt, Germany

the elderly apostle. Peter, his foot in a basin of water, reaches toward Jesus with similarly elongated arms. Gesture and gaze carry the meaning in Ottonian painting: The two figures fix each other with a wide-eyed stare. A disciple on the far right unbinds his sandals, and another, next to him, carries a basin of water. Eight other disciples look on from the left. The light behind Jesus has turned to gold, which is set off by buildings suggesting the Heavenly Jerusalem.

Elaborate architecture also provides the setting for a very different image, the presentation page of a Gospel book made for Hitda (d. 1041), the abbess of the convent at Meschede, near Cologne, in the early eleventh century. The abbess offers her book to Saint Walpurga, her convent's patron saint (fig. 14-31). The artist has arranged the architecture of the convent in the background to frame the figures and draw attention to their transaction. The size of the convent underscores the abbess's position of authority. The foreground setting—a rocky, uneven strip of ground—is meant to be understood as holy ground, separated from the rest of the world by the huge arch-shaped aura and golden trees that silhouette Saint Walpurga. The painter conveys a sense of spirituality and contained but deeply felt emotion, rather than the austere grandeur of the Ottonian court.

These manuscript paintings summarize the high intellectual and artistic qualities of Ottonian art. Ottonian artists drew inspiration from the past to create a monumental style for a Christian, German-Roman empire. From the groundwork laid during the early medieval period emerged the arts of the Romanesque and Gothic periods in western Europe.

PARALLELS

CULTURAL CENTER	EARLY MEDIEVAL ART IN EUROPE	ART IN OTHER CULTURES

BRITISH ISLES
c. 500–1000

14-3. **Sutton Hoo purse cover** (c. 615–30)
14-4. *Gospel Book of Durrow* (c. 675)
14-5. **South Cross** (8th cent.)

14-1. *Book of Kells* (8th/9th cent.)

SCANDINAVIA
c. 500–1100

14-2. **Gummersmark brooch** (6th cent.)
14-19. **Memorial stone** (8th cent.)
14-20. **Burial ship** (c. 815–20)

CHRISTIAN SPAIN
c. 500–1000

14-6. **Church of Santa Maria de Quintanilla de las Viñas, Burgos** (late 7th cent.)
14-8. **Emeterius and Ende. Beatus and Jerome commentaries** (975)

LANGOBARD ITALY
c. 568–774

14-9. **Brescia cross** (late 7th–early 9th cent.)

CAROLINGIAN EUROPE
c. 768–877

14-15. *Godescalc Evangelistary* (781–83)
14-12. **Palace Chapel of Charlemagne, Aachen** (792–805)

14-10. **Abbey Church of St. Riquier** (799)
14-16. *Ebbo Gospels* (c. 816–35)
14-17. *Utrecht Psalter* (c. 816–35)
14-13. **Abbey of St. Gall** (c. 817)
14-18. *Lindau Gospels* (c. 870–80)

OTTONIAN EUROPE
c. 919–1002

14-22. **Church of Cyriakus, Gernrode** (begun 961)
14-25. *Magdeburg Ivories* (c. 962–73)
14-28. *Gero Crucifix* (c. 970)
14-29. *Liuthar Gospels* (c. 1000)
14-30. *Gospels of Otto III* (c. 1000)
14-26. **Doors of Bishop Bernward, Hildesheim** (1015)

14-31. *Hitda Gospels* (early 11th cent.)

ART IN OTHER CULTURES

7-35. *Book of Genesis* (early 6th cent.), Syria
7-26. **Church of San Vitale** (526–47), Italy
7-22. **Hagia Sophia** (532–37), Turkey
9-21. **Shiva cave-temple** (mid-6th cent.), India
7-36. *Rabbula Gospels* (586), Syria
10-13. **Amitaba altar** (593), China
11-4. *Haniwa* (6th cent.), Japan
11-7. *Shaka Triad* (c. 623), Japan
12-11. **Lord Pacal sarcophagus** (mid-7th cent.), Mexico
8-2. **Dome of the Rock** (687–91), Jerusalem
10-14. *Camel Carrying a Group of Musicians* (c. mid-8th cent.), China
10-17. **Great Wild Goose Pagoda** (mid-8th cent.), China
8-6. **Córdoba mosque** (begun 785/6), Spain
12-13. **Chacmool** (9th–13th cent.), Mexico
11-10. *Mandala* (late 9th cent.), Japan
12-1. **Pueblo Bonito** (c. 900–1230) North America
7-51. *Joshua Roll* (c. 950), Turkey
10-19. Fan. *Travelers among Mountains and Streams* (early 11th cent.), China
8-17. **Griffin** (11th cent.), Islamic Mediterranean

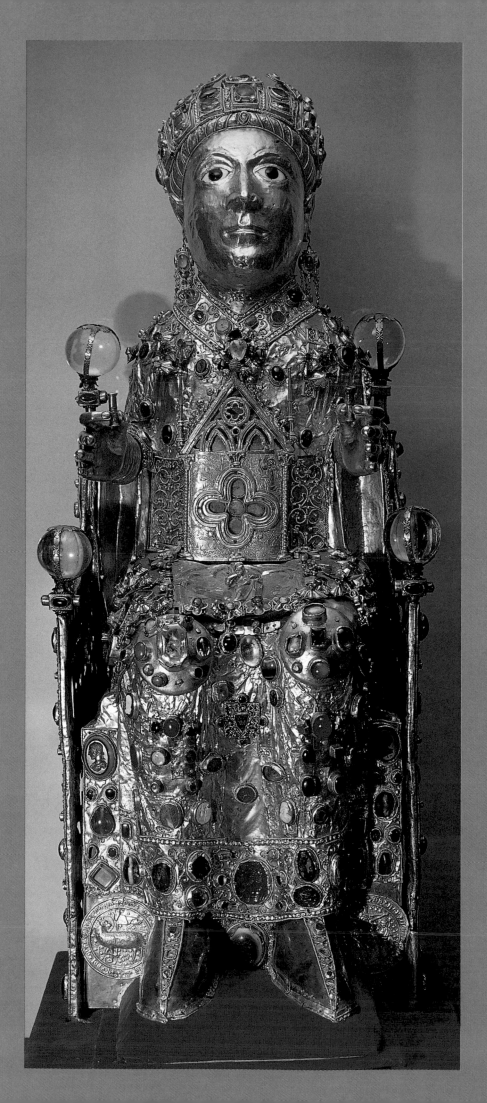

15-1. Reliquary statue of Saint Foy (Saint Faith), made in the Auvergne region, France, for the Abbey Church of Conques, Rouergue, France. Late 10th–11th century. Gold repoussé and gemstones over wood core (incorporating a Roman helmet and Roman cameos; later additions 12th–19th centuries), height 33" (85 cm). Cathedral Treasury, Conques, France

15 ROMAN-ESQUE ART

During the late Middle Ages, people in western Europe once again began to travel in large numbers as traders, soldiers, and Christians on pilgrimages. Pilgrims throughout history have journeyed to holy sites—the ancient Greeks to Delphi, early Christians to Jerusalem and to Rome, Muslims to Mecca—but in the eleventh century, pilgrimages to the holy places of Christendom dramatically increased, despite the great financial and physical hardships they entailed (see "The Pilgrim's Journey," page 518).

As difficult and dangerous as these journeys were, rewards awaited the courageous travelers along the routes, even before they reached their destination. Pilgrims could stop along the way to venerate local saints through their relics and visit the places where miracles were believed to have taken place. Relics—bodies of saints, parts of bodies, or even things owned by saints—were thought to have miraculous powers, and they were kept in richly decorated reliquaries.

Having and displaying the relics of saints so enhanced the prestige and wealth of a community that people went to great lengths to acquire them, not only by purchase but also by theft. In the ninth century, for example, the monks of Conques stole the relics of the child martyr Saint Foy ("Saint Faith") from her shrine at Saint-Agens. Such a theft was called holy robbery, for the new owners insisted that the saint had encouraged them because she wanted to move. The monks of Conques encased their relic—the skull of Saint Foy—in a jewel-bedecked gold statue whose head was made from a Roman parade helmet (fig. 15-1).

To accommodate the faithful and instruct them in Church doctrine, many monasteries on the major pilgrimage routes built large new churches and filled them with sumptuous altars, crosses, and reliquaries. Sculpture and paintings on the walls illustrated important religious stories and doctrines and served to instruct as well as fascinate the faithful. These awe-inspiring works of art and architecture, like most of what has come down to us from the Romanesque period, had a Christian purpose. One monk wrote that by decorating the church "well and gracefully" the artist showed "the beholders something of the likeness of the paradise of God" (Theophilus, page 79).

▲ c. 1066 WILLIAM II OF NORMANDY INVADES ENGLAND c. 1095–99 FIRST CRUSADE ▲

▲ c. 1075 INVESTITURE CONTROVERSY 1098 CISTERCIAN ▲
ORDER FOUNDED

TIMELINE 15-1. The century between 1050 and 1150 in Europe is identified as the Romanesque period.

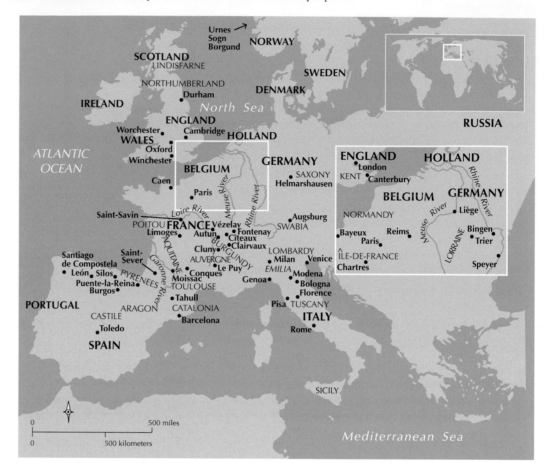

MAP 15-1. Romanesque Art.
The term *Romanesque* is now applied to all the arts in Europe between the mid-eleventh and late-twelfth centuries.

ROMANESQUE CULTURE

Romanesque means "in the Roman manner," and the term applies specifically to an eleventh- and twelfth-century European style. The word was coined in the early nineteenth century to describe European church architecture of the eleventh and twelfth centuries, which displayed the solid masonry walls, rounded arches, and masonry vaults characteristic of imperial Roman buildings. Soon the term was applied to all the arts of the period from roughly the mid-eleventh to the late-twelfth century, even though the art reflects influences from many sources, including the Byzantine and Islamic empires and early medieval Europe, as well as imperial Rome.

At the beginning of the eleventh century, Europe was still divided into many small political and economic units ruled by powerful families. The nations we know today did not exist (Map 15-1). The king of France ruled only a small area around Paris. France had close linguistic and cultural ties to northern Spain. The duke of Normandy (a former Viking who controlled the northwest coast) and the duke of Burgundy paid the French king only token homage. By the end of the twelfth century, however, the lands in the Île-de-France region around Paris were beginning to emerge as the core of a national state. After the Norman conquest of Anglo-Saxon Britain in 1066, the Norman duke became the English king, and England, too, became a nation. In Germany and northern Italy (collectively, the Holy Roman Empire), in contrast, the power of local rulers and towns ultimately prevailed against the attempts of the German emperor to impose a central authority. These regions remained politically fragmented until the nineteenth century. Sicily and southern Italy, previously in the hands of Byzantine and Islamic rulers, fell under the control of the Normans.

Europe remained an agricultural society, with land the primary source of wealth and power. In many regions the feudal system (at its simplest, an exchange of land for service) that had developed in the early Middle Ages governed social and political relations. In this system, a landowning lord granted some of his property to a subordinate, a vassal, offering the vassal protection and receiving in return the vassal's allegiance and promise of military service as an armed knight. Vassals, in turn, could grant part of their holdings to their own vassals.

The economic foundation for this political structure was the manor, an agricultural estate in which peasants worked in exchange for a place to live, food, military protection, and other services from the lord. Feudal estates,

community-based and almost entirely self-sufficient, became hereditary over time. Economic and political power thus came to be distributed through a network of largely inherited but constantly shifting allegiances and obligations that defined relations among lords, vassals, and peasants. Women generally had a subordinate position in this hierarchical, military social system. When necessary, however, aristocratic women took responsibility for managing estates in their male relatives' frequent absences on military missions or pilgrimages. They could also achieve positions of authority and influence as the heads of religious communities. Among peasants and artisans, women and men often worked side by side.

In the early Middle Ages, church and state had forged an often fruitful alliance. Christian rulers helped assure the spread of Christianity throughout Europe and supported monastic communities and Church leaders, who were often their relatives, with grants of land. The Church, in return, provided rulers with crucial social and spiritual support, and it supplied them with educated officials. As a result, secular and religious authority became tightly intertwined. In the eleventh century, the papacy sought to make the Church independent of lay authority and so sparked a conflict known as the Investiture Controversy with secular rulers over the right to "invest" Church officials with the symbols of office.

In the eleventh and twelfth centuries, Christian Europe, previously on the defensive against the expanding forces of Islam, became the aggressor. In Spain the armies of the Christian north were increasingly successful against the Islamic south. In 1095, Pope Urban II, responding to a request for help from the Byzantine emperor, called for a Crusade to retake Jerusalem and the Holy Land (see "The Crusades," below). This First Crusade succeeded in establishing a short-lived Christian state in Palestine. Although subsequent Crusades were, for the most part, military failures, the crusading movement as a whole had far-reaching cultural and economic consequences. The West's direct encounters with the more sophisticated material culture of the Islamic world and the Byzantine Empire created a demand for goods from the East. This in turn helped stimulate trade, and with it the rise of an increasingly urban society. An increase in trade during the eleventh and twelfth centuries promoted the growth of towns, cities, and an urban class of merchants and artisans.

Western scholars rediscovered many classical Greek and Roman texts that had been preserved for centuries in Islamic Spain and the eastern Mediterranean. The combination of intellectual ferment and increased financial resources enabled the arts to flourish. The first universities were established at Bologna (eleventh century) and Paris, Oxford, and Cambridge (twelfth century). This renewed intellectual and artistic activity has been called the twelfth-century "renaissance," a cultural "rebirth." Monastic communities continued to be powerful and influential in Romanesque Europe, as they had been in the early Middle Ages. Some monks and nuns were highly regarded for their religious devotion, for their learning, as well as for the valuable services they provided, including taking care of the sick and destitute, housing travelers, and educating the laity in monastic schools. Because monasteries were major landholders, they were part of the feudal power structure. The children of aristocratic families who joined religious orders also helped forge links between monastic communities and the ruling elite. As life in Benedictine communities grew increasingly comfortable, reform movements arose within the order itself. The first of these reform movements originated in the abbey of Cluny, founded in 910 in present-day east-central France. In the twelfth century, the Cistercians, another monastic order, provided spiritual reform.

FRANCE AND NORTHERN SPAIN

For most of the Romanesque period, power in France was divided among the nobility, the Church, and the kings of the Capetian dynasty, the successors in France to the Carolingians (Chapter 14). Centralized royal power was negligible in the eleventh century; the duchy of Burgundy was stronger than the Crown until the beginning of the twelfth century, when the Capetian kings began to consolidate their authority in the Île-de-France.

THE CRUSADES Despite the schism within the Church (see "Rome, Constantinople, and Christianity," page 292), the emperor in Constantinople turned to the pope for help when his territories were besieged by conquering Turks, a Muslim people from Central Asia. The Western Church responded in 1095 by launching the Crusades, a series of military expeditions against Muslim powers.

This First Crusade, advocated by Pope Urban II (papacy 1088–99) and involving primarily the lesser nobility of France, was the only successful Crusade, concluding with the capture of Jerusalem in 1099. Eventually, in the Fourth Crusade (1202–4), Western Christian Crusaders turned against Eastern Christians as well, plundered Constantinople, and established their own rule there, which was not overturned until 1261.

In Western Europe the eleventh and twelfth centuries saw an explosive growth in the popularity of religious pilgrimages. The rough roads that led to the most popular destinations—the Constantinian churches of Rome, the Church of the Holy Sepulchre in Jerusalem, and the Cathedral of Santiago de Compostela (Saint James at Compostela) in the northwest corner of Spain—were often crowded with pilgrims, who had to contend at times with bandits and dishonest innkeepers and merchants. Journeys could last a year or more.

The stars of the Milky Way, it was said, marked the way to Santiago de Compostela (see fig. 00, Introduction). Still, a guidebook helped, and in the twelfth century the priest Aymery Picaud wrote one for pilgrims on their way to the great shrine through what is now France. In Picaud's time, four main pilgrimage routes crossed France, merging into a single road in Spain at Puente-la-Reina and leading on from there through Burgos and León to Compostela. Conveniently spaced monasteries and churches offered food and lodging. Roads and bridges were maintained by a guild of bridge builders and guarded by the Knights of Santiago.

Picaud described the best-traveled routes and most important shrines to visit along the way. Chartres, for example, housed the tunic that the Virgin was said to have worn when she gave birth to Jesus. At Vézelay were the bones of Saint Mary Magdalen, and at Conques, those of Saint Foy (see fig. 15-1). Churches associated with miraculous cures—Autun, for example, which claimed to house the bones of Saint Lazarus, raised by Jesus from the dead—were filled with the sick and injured praying to be healed.

Like travel guides today, Picaud's book also provided shopping tips, advice on local customs, comments on food and the safety of drinking water, and pocket dictionaries of useful words in the languages the pilgrim would encounter en route. His warnings about the people who prey on travelers seem all too relevant today.

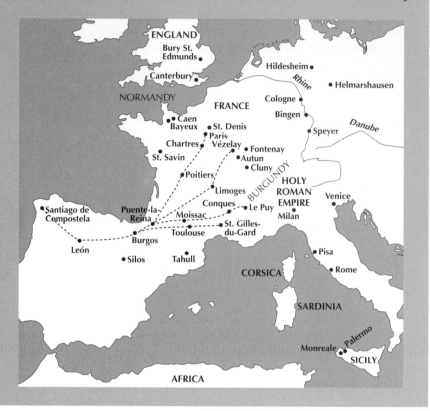

The Iberian peninsula (present-day Spain and Portugal) remained divided between Muslim rulers in the south and Christian rulers in the north. The power of the Christian rulers was growing, however. Their long struggle with the Muslims had heightened their religious fervor, and they joined forces to extend their territory southward throughout the eleventh and twelfth centuries. The Christians in 1085 reconquered the Muslim capital and stronghold Toledo, a center of Islamic and Jewish culture in the kingdom of Castile. Toledo would remain an oasis of concord between Christians, Muslims, and Jews until the early twelfth century. Its scholars played an important role in the transmission of classical writings to the rest of Europe, contributing to the cultural renaissance of the twelfth century.

ARCHITECTURE

The eleventh and twelfth centuries were a period of great building activity in Europe. Castles, manor houses, churches, and monasteries arose everywhere. As one eleventh-century monk noted, "Each people of Christendom rivaled with the other, to see which should worship in the finest buildings. The world shook herself, clothed everywhere in a white garment of churches" (Radulphus Glaber, cited in Holt, *A Documentary History of Art*, I, page 18). That labor and funds should have been committed on such a scale to monumental stone architecture at the same time as the Crusades and in a period of frequent domestic warfare seems extraordinary today. The buildings that still stand, despite the ravages of weather, vandalism, neglect, and war, testify to the power of religious faith and local pride.

In one sense, Romanesque churches were the result of master builders solving the problems associated with each individual project: its site, its purpose, the building materials and work force available, the builders' own knowledge and experience, and the wishes of the patrons providing the funding. The process was slow, often requiring several different masters and teams of masons over the years. The churches nevertheless exhibit an overall unity and coherence, in which each element is part of a geometrically organized, harmonious whole.

Like Carolingian churches, the basic form of the Romanesque church derives from earlier churches inspired by Early Christian **basilicas**. Romanesque builders made

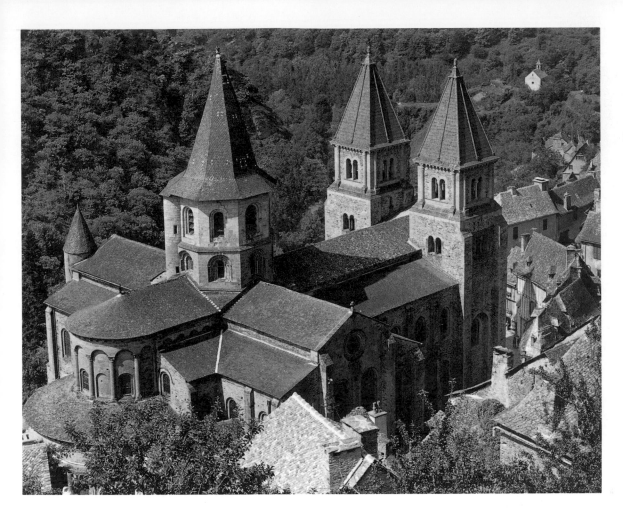

15-2. Abbey Church of Sainte-Foy, Conques, Rouergue, France. Mid-11th–12th century. Western towers rebuilt in the 19th century; crossing tower rib-vaulted in the 14th century, restored in the 19th century. View from the northeast

The contrast of nave and transepts, as well as the apse and lower ambulatory, are clearly seen in this exterior view, which supports a French scholar's characterization of Romanesque architecture as "additive."

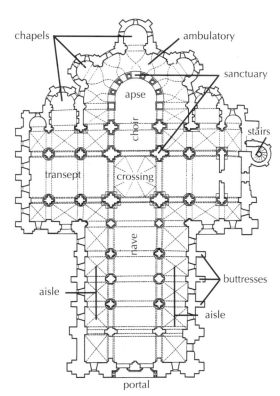

15-3. Plan of Abbey Church of Sainte-Foy

vaults and groin vaults permitted builders more flexibility in laying out interior space (see "Rib Vaulting," page 561). Masonry **buttresses** reinforced walls at critical points. The introduction of an **ambulatory** (walkway) around the apse allowed worshipers to reach additional, radiating chapels and to view relics displayed there. Builders of Romanesque churches emphasized the symbolic importance of towers, especially over the **crossing** and the west facade (the entrance to the church and, by extension, the gateway to paradise). This new form arose along the pilgrimage routes to the Cathedral of Saint James in Santiago de Compostela, in Spain (see "The Pilgrim's Journey, opposite). Pilgrims entering the north transept **portal**—large doorway—(approach from the town was through the south transept portal) found themselves in a space as long as the nave. The builder laid out Saint James's to accommodate hordes of pilgrims, for besides the immense **transept** he created a two-story, barrel-vaulted nave with **galleries** over the side aisles and engaged half columns with foliate capitals inspired by ancient **Corinthian** capitals (see fig. 00, Introduction).

Another pilgrimage church, the Benedictine Abbey Church of Sainte-Foy, perches on a hillside at Conques in south-central France (fig. 15-2). Here pilgrims venerated the golden reliquary containing the remains of a child saint (see fig. 15-1). The original **cruciform** (cross-shaped) plan with a wide, projecting transept was typical of Romanesque pilgrimage churches (fig. 15-3). At the west a portal opens directly into the broad nave. The west portals of the largest churches, such as this, have three doors, the central one leading into the nave and the flanking

several key structural advances and changes in this form. Stone masonry **vaulting** replaced wooden roofs, increasing the protection from fire and improving the acoustics for music. The addition of **ribs**—curved and usually projecting stone members—as structural elements to both barrel

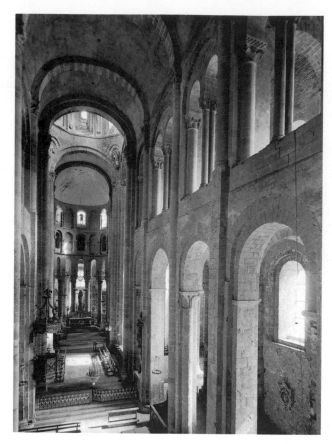

15-4. Nave, Abbey Church of Sainte-Foy. c. 1120

doors into the side aisles. The elongated **sanctuary** encompasses the **choir** and the **apse**, with its surrounding ambulatory and ring of chapels.

The building is made of local sandstone that has weathered to a golden color. Light enters indirectly through windows in the outer walls of the aisles and upper-level galleries (fig. 15-4). The galleries replace the **clerestory** along the side aisles and overlook the nave. Ribbed barrel vaults cover the nave, groin vaulting spans the side aisles, and half-barrel or quadrant vaulting, the arc of which is one-quarter of a circle, covers the galleries. The vaults over the galleries help strengthen the building by carrying the outward thrust of the nave vaults to the outer walls and buttresses.

The solid masonry piers that support the nave arcade have attached half columns on all four sides. This type of support, known as a **compound pier**, gives sculptural form to the interior and was a major contribution of Romanesque builders to architectural structure and aesthetics. Compound piers helped organize the architectural space by marking off the individual square, vaulted bays. Conques's square crossing is lit by an open, octagonal **lantern** tower resting on **squinches**. Light streaming in from the lantern and apse windows acted as a beacon, directing the worshipers' attention forward. During the Middle Ages the laity stood in the nave, separated from the priests and monks, who celebrated Mass in the choir.

Pilgrims arrived at Conques weary after many days of difficult travel through dense woods and mountains,

probably grateful to Saint Foy if they had been protected against bandits on the way. They no doubt paused in front of the west entrance to study its portal sculpture, a notable feature of Romanesque pilgrimage churches. Portal sculpture communicated the core doctrines of the Church to those who came to read its messages. At Conques, the Last Judgment in the **tympanum** (the **lunette** over the doorway) marked the passage from the secular world into the sacred world within the church. Inside, the walls resounded with the music of the plainsong, also called Gregorian chant after Pope Gregory I (papacy 590–604). The Benedictines spent eight-and-a-half to ten hours a day in religious services. Today they still spend two-and-a-half to three hours.

A different Romanesque architecture could be found at the Abbey Church of Cluny in Burgundy, founded in 909 as a reformed Benedictine monastery. Cluny had a special independent status, its abbot answering directly to the pope in Rome rather than to the local bishop and feudal lord. This unique freedom, jealously safeguarded by a series of long-lived and astute abbots, enabled Cluny to become influential and prosperous in the eleventh and early twelfth centuries. Cluniac reform spread to other monasteries within Burgundy, to the rest of France, Italy, Germany, and beyond. Cluny attracted the patronage of successive rulers, as well as the favor of the pope in Rome. By the second half of the eleventh century, there were some 300 monks in the abbey at Cluny alone. Cluny founded more than 200 priories (monasteries dependent on Cluny) in other locations—many along pilgrimage routes—and many more houses were loosely affiliated with it. At the height of its power, 1,450 monasteries answered to the strong central administration of the abbot of Cluny.

Cluniac monks and nuns dedicated themselves to the scholarly and artistic interests of their order. Most important was the celebration of the eight Hours of the Divine Office, including prayers, scripture readings, psalms and hymns, and the Mass, the symbolic rite of the Last Supper, celebrated after the third hour (*terce*). They depended for support on the labor of laymen and laywomen. Cluny's extensive landholdings, coupled with gifts of money and treasure, made it wealthy. Cluny and its affiliates were among the major patrons of art in Western Europe.

The great Hugh de Semur, abbot of Cluny for sixty years (1049–1109), began a new church at Cluny in 1088 with the help of financing from King Alfonso VI of León and Castile in northern Spain (ruled 1065–1109). Known to art historians as Cluny III (because it was the third building at the site), it was the largest church in Europe when it was completed in 1130 (fig. 15-5). Richly carved, painted, and furnished, it was described by a contemporary observer as the work of angels. Music and art were densely interwoven in Cluniac life, shaped by the Cluniac conception of the House of God. The proportions of Cluny III were based on harmonic relationships discussed in ancient Greek musical theory and mathematics. The towering barrel vaulting—98 feet high with a span of about 40 feet in a space more than 450 feet long from end

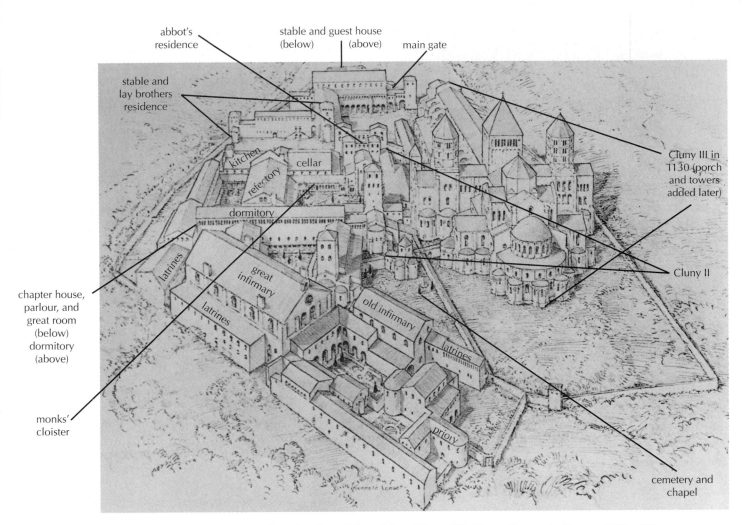

abbot's residence

stable and guest house (below) (above)

main gate

stable and lay brothers residence

kitchen

cellar

refectory

dormitory

latrines

great infirmary

latrines

old infirmary

latrines

chapter house, parlour, and great room (below) dormitory (above)

monks' cloister

priory

Cluny III in 1130 (porch and towers added later)

Cluny II

cemetery and chapel

15-5. Reconstruction drawing of the Abbey (Cluny III), Cluny, Burgundy, France. 1088–1130. View from the east (after Conant)

The Cluny complex expanded to accommodate its increasing responsibilities and number of monks until it was 6,351 feet long. In K. J. Conant's drawing of Cluny III, the abbey church (on the right) dominates the buildings, which are loosely organized around cloisters and courtyards. As at Saint Gall's (see fig. 14-13), the cloisters link buildings and provide private space for the monks; the two principal cloisters—for choir monks and for novices—are to the south (left of the church in the drawing). The abbot's residence, guesthouse, workrooms, and infirmary all have courtyards.

to end—enhanced the sound of the monks' chants. Sculpture, too, picked up the musical theme: Carvings on two surviving column capitals depict personifications of the eight modes of the plainsong. The hallmarks of Cluniac churches were functional design, skillful masonry technique, and the assimilation of elements from Roman and early medieval architecture and sculpture. Individual Cluniac monasteries, however, were free to follow regional traditions and styles; consequently Cluny III was widely influential, though not copied exactly.

Several new religious orders devoted to an austere spirituality arose in the late eleventh and early twelfth centuries. Among these were the Cistercians, another reform group within the Benedictine order. The Cistercians turned away from Cluny's elaborate liturgical practices and emphasis on the arts to a simpler monastic life. The order was founded in the late eleventh century at Cîteaux (*Cistercium* in Latin, hence the order's name), also in Burgundy. Led by the commanding figure of Abbot Bernard of Clairvaux (abbacy 1115–54), the Cistercians thrived on strict mental and physical discipline. They settled and reclaimed vast tracts of wilderness. In time, their enterprises stretched from present-day Russia to Ireland, and by the end of the Middle Ages there were approximately 1,500 Cistercian abbeys, half of which were for women. Although their very success eventually undermined their austerity, they were able for a long time to sustain a way of life devoted to prayer and intellectual pursuits combined with shared manual labor. Like the Cluniacs, however, they depended on the assistance of laypersons.

Early Cistercian architecture reflects the ideals of the order. The Abbey Church of Notre-Dame at Fontenay, begun in 1139, is the oldest surviving Cistercian structure

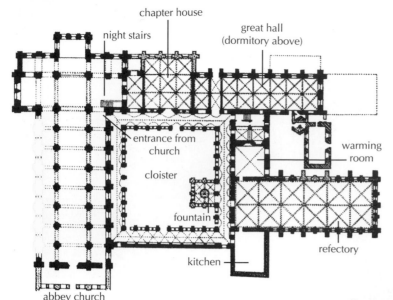

chapter house

night stairs

great hall
(dormitory above)

entrance from
church

cloister

warming
room

fountain

refectory

kitchen

abbey church

15-6. Plan of the Abbey of Notre-Dame, Fontenay,
Burgundy, France. 1139–47

Always practical, the Cistercians made a significant
change to the already very efficient monastery plan.
They placed the refectory parallel to the dormitory
and at a right angle to the cloister walk so that the
two buildings could easily be extended should the
community grow. The cloister fountain was moved
from its usual central location to the side of the clois-
ter directly in front of the refectory, conveniently
located for washing.

15-7. Nave, Abbey Church of Notre-Dame, Fontenay.
1139–47

The pointed arch began to be used in northwestern
Europe in the Romanesque period. It may have derived
from Islamic buildings in southern Europe. Pointed
arches are structurally more stable than round ones,
directing more weight down into the floor instead of
outward to the walls, and they can span greater dis-
tances at greater heights without collapsing. Pointed
arches narrow the eye's focus and draw it upward, an
effect intended to direct thoughts toward heaven.

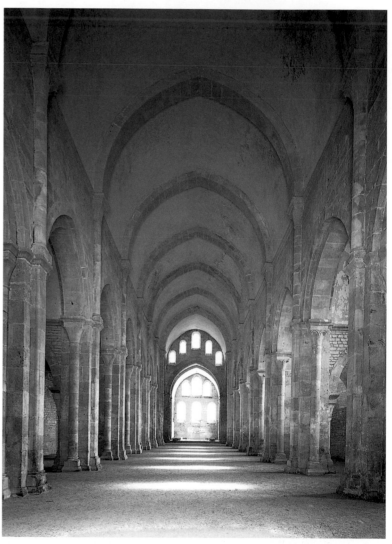

in Burgundy. The abbey has a simple geometric plan (fig.
15-6). The church has a long nave with rectangular
chapels in the square-ended transept arms, and a shal-
low choir with a straight end wall. Lay brothers entered
through the west doorway, monks from the attached
cloister or upstairs dormitory by way of the "night stairs."
Situated far from the distractions of the secular world,
the building made few concessions to the popular taste
for architectural adornment, either outside or inside. In
other ways, however, Fontenay and other Cistercian
monasteries fully reflect the architectural developments
of their time in their masonry, vaulting, and proportions.

The Cistercians relied on harmonious proportions and
fine stonework, not elaborate surface decoration, to
achieve beauty in their architecture (fig. 15-7). A feature of
Fontenay often found in Cistercian architecture is the use
of pointed ribbed vaults over the nave and pointed arches
in the nave arcade and side-aisle bays. Furnishings

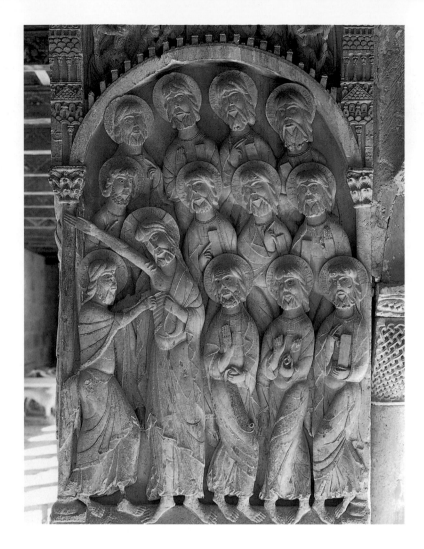

15-8. *Doubting Thomas*, pier in the cloister of the Abbey of Santo Domingo de Silos, Castile, Spain. c. 1100

included little else than altars and candles. The large windows in the end wall, rather than a clerestory, provided light. The sets of triple windows reminded the monks of the Trinity.

This simple architecture spread from the Cistercian homeland in Burgundy to become an international style. From Scotland and Germany to Spain and Italy, Cistercian designs and building techniques varied only slightly. The masonry vaults and harmonious proportions were to be influential in the development of the Gothic style later in the Middle Ages (Chapter 16).

ARCHITECTURAL SCULPTURE

Like Cluny and unlike the severe churches of the Cistercians, many Romanesque churches have a remarkable variety of painting and sculpture. Christ Enthroned in Majesty in heaven may be carved over the entrance or painted in the half-dome of the apse. Stories of Jesus among the people or images of the lives and the miracles of the saints cover the walls; the art also reflects the increasing importance accorded to the Virgin Mary. Depictions of the prophets, kings, and queens of the Old Testament symbolically foretell people and events in the New Testament, but also represented are contemporary bishops, abbots, other noble patrons, and even ordinary folk. A profusion of monsters, animals, plants, geometric ornament, allegorical figures such as Lust and Greed, and depictions of real and imagined buildings surround

the major works of sculpture. The Elect rejoice in heaven with the angels; the Damned suffer in hell, tormented by demons. Biblical and historical tales come alive, along with scenes of everyday life. All these events seem to take place in a contemporary medieval setting.

Superb reliefs embellish the corner piers in the cloister of the Abbey of Santo Domingo de Silos in Castile. One of these illustrates the story, recounted in the Gospel of John (Chapter 20), in which Christ, appearing to his apostles after the crucifixion, invites Thomas to touch his wounds to convince the doubting apostle of his resurrection (fig. 15-8). The composition is expert. Christ is shown larger than his disciples and placed off-center in the left foreground. His outstretched right arm forms a strong diagonal that bisects the space between his haloed head and that of Thomas in the lower left. Thomas's outstretched arm, reaching toward Christ's side, forms an opposing diagonal parallel to the slope between their heads, leading the eye back to Christ's face. The massed presence of the other apostles, bearing witness to the miracle, gives visual weight to the scene through the rhythmic repetition of form. The effect parallels the way the repetition of the nave bays in a Romanesque church culminates in the apse, its symbolic core. The arch that forms a canopy over the apostles' heads is crowned by a **crenellated** wall and towers plus musicians. The sculptors used these lively images from medieval life to frame the biblical story, just as medieval preachers used elements of daily life in their sermons to

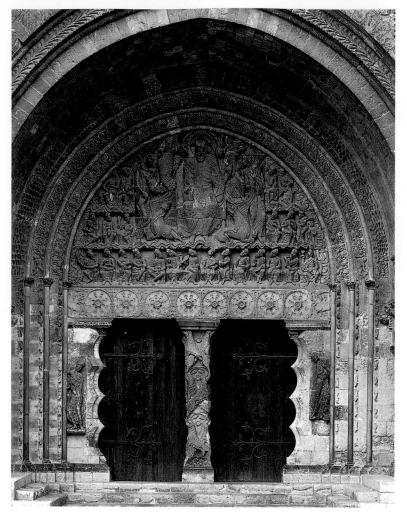

15-9. South portal and porch, Priory Church of Saint-Pierre, Moissac, Toulouse, France. c. 1115–30

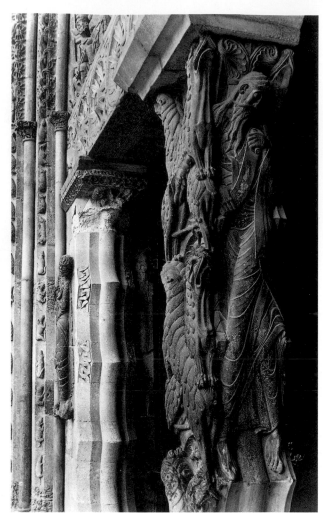

15-10. *Lions and Prophet Jeremiah (?)*, trumeau of the south portal, Priory Church of Saint-Pierre

In a letter to fellow cleric William of Saint-Thierry, Bernard of Clairvaux, leader of the Cistercian order (led 1125–53), objected to what he felt was excessive architectural decoration of Cluniac churches and cloisters. "So many and so marvellous are the varieties of diverse shapes on every hand," he wrote, "that we are more tempted to read in the marble than in our books, and to spend the whole day in wondering at these things rather than in meditating the law of God. For God's sake, if men are not ashamed of these follies, why at least do they not shrink from the expense?" (cited in Davis-Weyer, page 170).

provide a context for biblical messages. The art and literature of the period frequently combined "official" and "popular" themes in this way.

Carved portals are a significant innovation in Romanesque art. These complex works, which combine biblical narrative, legends, folklore, history, and Christian symbolism, represent the first attempt at large-scale architectural sculpture since the end of the Roman Empire. By the early twelfth century, sculpture depicting Christ in Majesty (the Second Coming), the Last Judgment, and the final triumph of good over evil at the Apocalypse could be seen on the portals of churches in northern Spain, southern France, and Burgundy. The churches of Conques and Cluny had carved portals; so did the churches of Saint-Pierre in Moissac in southern France, Saint-Lazare at Autun, and Sainte-Madeleine at Vézelay in Burgundy.

The Cluniac priory of Saint-Pierre at Moissac was a major pilgrimage stop and Cluniac administrative center on the route to Santiago de Compostela. The original shrine at the site was reputed to have existed in the Carolingian period. After joining the congregation of Cluny in 1047, the monastery prospered from the donations of pilgrims and the local nobility, as well as from its control of shipping on the nearby Garonne River. Moissac's monks launched an ambitious building campaign, and much of the sculpture from the cloister (c. 1100) and the church

(1115–30) has survived. The church was completed during the tenure of Abbot Roger (abbacy 1115–31), who commissioned the sculpture on the south portal and porch (fig. 15-9). This sculpture represents a genuine departure from earlier works in both the quantity and the quality of the carving. The sculpture covers the tympanum, the **archivolts** (the curved rows of *voussoirs* outlining the tympanum), and the lintel, door jambs and *trumeau*, and porch walls (see "The Romanesque Church Portal," opposite). The stones still bear traces of the original paint.

The sculpture of Christ in Majesty dominates the huge tympanum. The scene combines images from the description of the Second Coming of Christ in Chapters 4 and 5 of the Apocalypse with others derived from Old Testament prophecies, all filtered through the early twelfth

Doorways of major Romanesque churches are often grand carved **portals**. Wood or metal doors are surrounded by elaborate stone sculpture arranged in zones to fit the architectural elements. The most important imagery is in the semicircular **tympanum** directly over the door lintel, which may be supported by a **pier** called the *trumeau*. **Archivolts**—curved moldings formed by the wedge-form stone *voussoirs* of which the arch is constructed—frame the tympanum. Romanesque archivolts are often decorated with carved geometric patterns or figures. **Spandrels** are the flat areas at the outside upper corners of the tympanum area. On both sides of the doors are **jambs**. These jambs form a shallow porch that leads into the church.

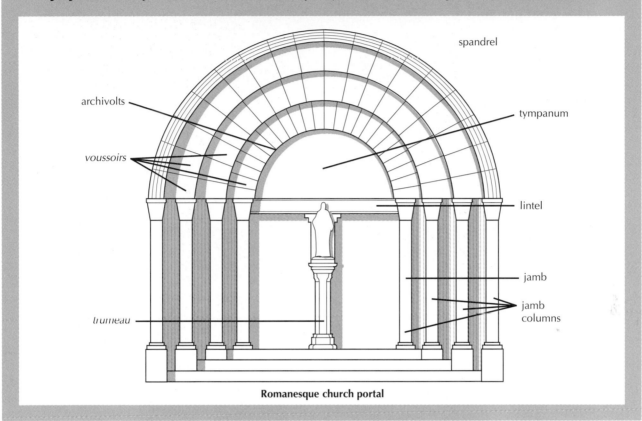

Romanesque church portal

century's view of scripture. A gigantic Christ, like an awe-inspiring Byzantine *Pantokrator* (see fig. 7-44), stares down at the viewer as he blesses and points to the book "sealed with seven seals" (Revelation 5:1). He is enclosed by a mandorla, and a cruciform halo rings his head. Four winged creatures symbolizing the evangelists—Matthew the Man (upper left), Mark the Lion (lower left), Luke the Ox (lower right), and John the Eagle (upper right)—frame Christ on either side, each holding a scroll or book representing his Gospel. Two elongated seraphim (angels) stand one on either side of the central group, each holding a scroll. A band beneath Christ's feet and another passing behind his throne represent the waves of the "sea of glass like crystal" (Revelation 4:6). These define three registers in which sit twenty-four elders with "gold crowns on their heads" in varied poses, each holding either a harp or a gold bowl of incense (Revelation 4:4 and 5:8). According to the medieval view, the elders were the kings and prophets of the Old Testament and, by extension, the ancestors and precursors of Christ.

The figures in the tympanum relief reflect a hierarchy of scale and location. Christ, the largest figure, sits at the top center, the spiritual heart of the scene, surrounded by smaller figures of the evangelists and angels. The elders, farthest from Christ, are roughly one-third his size. Despite this formality and the limitations forced on them by the tympanum's shape, the sculptors created a sense of action by turning and twisting the gesturing figures, shifting their poses off-center, and avoiding rigid symmetry or mirror images. Nonfigural motifs above and below Christ contribute to the dynamic play across the tympanum's surface. The sculptors carved the tympanum from twenty-eight stone blocks of different sizes. The elders were carved one or two per block, whereas the figures of the central group covered one or more blocks as needed. Paint would originally have disguised the join lines. The crowns and incense bowls—described as made of gold in Revelation—may have been gilded. Foliate and geometric ornament covers every surface. Monstrous heads in the lower corners of the tympanum spew ribbon scrolls that run up its periphery. Similar creatures, akin to the beasts seen in the Scandinavian **animal style** of the early Middle Ages (see fig. 14-2), appear at each end of the lintel, their tongues growing into ropes encircling a line of eight acanthus **rosettes**. A similar combination of animals, interlace, and rosettes can also be found in Islamic art. Heraldic beasts and rosettes appeared together on Byzantine and Islamic textiles. Processions of naturalistically depicted rats and rabbits climb the piers on either side of the doors (at the far left in figure 15-10). Halos, crowns, and Christ's throne in the tympanum are adorned with stylized foliage.

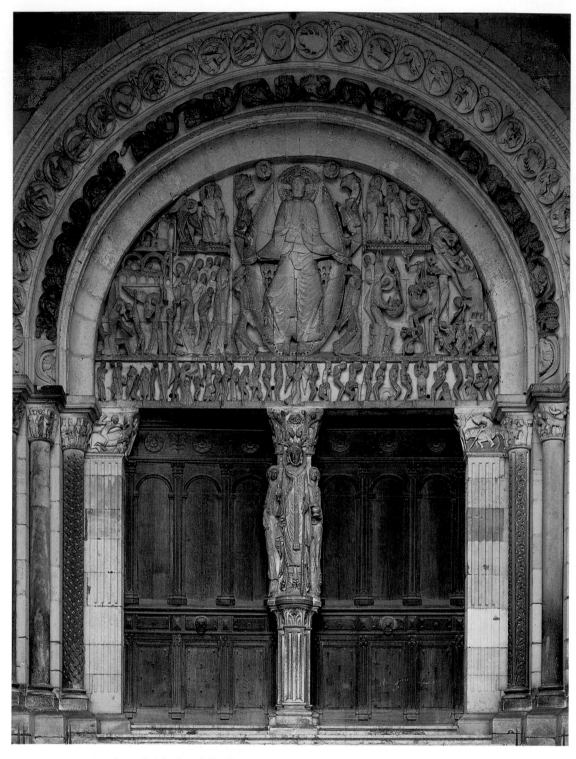

15-11. West portal, Cathedral (originally abbey church) of Saint-Lazare, Autun, Burgundy, France. c. 1120–35/40

Two side jambs and a central *trumeau* support the weight of the lintel and tympanum. Moissac's jambs and trumeau have scalloped profiles (see fig. 15-9). Saint Peter (holding his **attribute**, the key to the gates of heaven) is carved in high relief on the left jamb, the Old Testament prophet Isaiah on the right jamb. Saint Paul is carved on the left side of the *trumeau*, and another Old Testament prophet, usually identified as Jeremiah, is on the right. On the front face of the trumeau are pairs of lions crossing

each other in **X**-patterns. The tall, thin prophet in figure 15-10 twists toward the viewer with his legs crossed. The sculptors placed him skillfully within the constraints of the scalloped trumeau, his head, pelvis, knees, and feet falling on the pointed cusps of the curved forms. On the front of the trumeau the lions' bodies also fit the cusps of the scalloped frame. Between each pair of lions are more rosettes. Such decorative scalloping resembles Islamic art. The sculpture at Moissac was created shortly after the First

Crusade and Europe's resulting encounter with the Islamic art and architecture of the Holy Land. Warriors from the region participated in the Crusade and presumably brought Eastern art objects and ideas home with them.

A very different pictorial style is seen in Burgundy. On the main portal of the Cathedral of Saint-Lazare at Autun (fig. 15-11), Christ has returned to judge the cowering, naked human souls at his feet. The damned writhe in torment at his left, while the saved enjoy serene bliss at his right hand. The inscribed message reads: "May this terror frighten those who are bound by worldly error. It will be true just as the horror of these images indicates" (trans. Petzold). Christ dominates the composition as he did at Moissac. The surrounding figures are thinner and taller than those at Moissac and are arranged in less regular compartmentalized tiers. The overall effect is less consciously balanced than the pattern-filled composition at Moissac. The stylized figures, stretched out and bent at sharp angles, are powerfully expressive, successfully conveying the terrifying urgency of the moment as they swarm around the magisterially detached Christ figure. Delicate weblike engraving on the robes may have derived from metalwork or manuscript illumination.

Angels trumpet the call to the Day of Judgment. Angels also help the departed souls to rise from their tombs and line up to await judgment. In the bottom register, two men at the left carry walking staffs and satchels bearing the cross and a scallop-shell badge, attributes identifying them as pilgrims to Jerusalem and Santiago de Compostela. A pair of giant, pincerlike hands descends at the far right to scoop up a soul (seen at the bottom center in the detail, fig. 15-12). Above these hands, in a scene reminiscent of Egyptian Books of the Dead (see fig. 3-43), the archangel Michael competes with devils as he weighs souls on the scale of good and evil. In the early decades of the twelfth century, Church doctrine came increasingly to stress the role of the Virgin Mary and the saints as intercessors who could plead for mercy on behalf of repentant sinners. The tympanum at Autun shows angels also acting as intercessors. The archangel Michael shelters some souls in the folds of his robe and may be jiggling the scales a bit. Another angel boosts a saved soul into heaven, bypassing the gate and Saint Peter. By far the most riveting players in the drama are the grotesquely decomposed, screaming demons grabbing at terrified souls and trying to cheat by pushing down souls and yanking the scales to favor evil.

A lengthy inscription in the band beneath Christ's feet identifies the Autun tympanum as the work of Gislebertus, who oversaw the sculpture and did much of the work himself. He may have carved a representation of the Magi asleep (fig. 15-13), one of the many capitals in the cathedral illustrating the Bible and the lives of the saints. The ingenious compression of instructive narrative scenes into the geometric confines of column capitals was an important Romanesque contribution to architectural decoration. The underlying form was usually that of the flaring Corinthian capital. Sculptors used undercutting, a technique known since ancient times, to sharpen contours and convey depth.

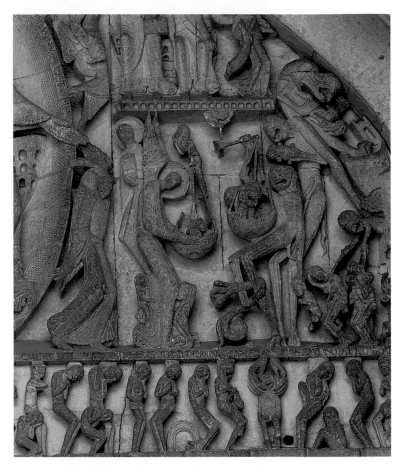

15-12. Gislebertus. *Weighing of Souls*, detail of *Last Judgment* tympanum, Cathedral of Saint-Lazare, Autun

15-13. *The Magi Asleep*, capital from the choir, Cathedral of Saint-Lazare. c. 1120–32. Musée Lapidaire, Autun

The lower half of the capital was carved with stylized acanthus leaves, probably inspired by Roman ruins in Autun.

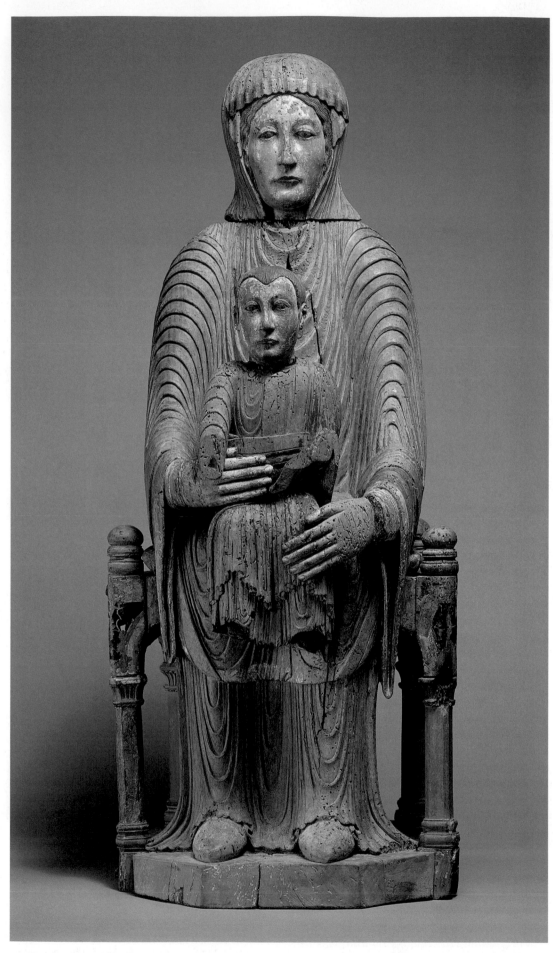

15-14. *Virgin and Child*, from the Auvergne region, France. c. 1150–1200. Oak with polychromy, height
31" (78.7 cm). The Metropolitan Museum of Art, New York
Gift of J. Pierpont Morgan, 1916 (16.32.194)

The Magi Asleep is one in a series of capitals depicting events surrounding the birth of Jesus. Medieval tradition identified the three Magi, or wise men—whom the Gospels say brought gold, frankincense, and myrrh to the newborn Jesus—as the kings Caspar, Melchior, and Balthasar. Caspar, the oldest, is shown bearded here; Melchior has a moustache; and Balthasar, the youngest, is clean-shaven. Later, he is often shown as a black African. The Magi, following heavenly signs, traveled from afar to acknowledge Jesus as King of the Jews. The position of the capital in the choir of the church suggests that it was meant to remind worshipers that they were embarking on a metaphorically parallel journey to find Christ. The slumbering Magi, wearing their identifying crowns, share a bed and blanket. An angel has arrived to hurry them on their way, awakening Melchior and pointing to the Star of Bethlehem, which will guide them. The sculptor's use of two vantage points simultaneously—the Magi and the head of their bed viewed from above, the angel and the foot of the bed seen from the side—communicates the key elements of the story with wonderful economy and clarity.

INDEPENDENT SCULPTURE

Reliquaries, altar frontals, crucifixes, devotional images, and other sculpture filled medieval churches. One form of devotional image that became increasingly popular during the later Romanesque period was that of the Virgin Mary holding the Christ Child on her lap, a type known as the Throne of Wisdom. A well-preserved example in painted wood dates from the second half of the twelfth century (fig. 15-14). Such images were a specialty of the Auvergne region of France, but are found throughout Europe. Mother and Child are frontally erect, as rigid as they are regal. Mary is seated on a thronelike bench symbolizing the lion throne of Solomon, the Old Testament king and symbol of wisdom. She supports Jesus with both hands. The small but adult Jesus holds a book—the Word of God—in his left hand and raises his (now missing) right hand in blessing. To the medieval believer, Christ represented the priesthood, humankind, and God. In Christ, the Wisdom of God became human; in the medieval scholar's language, he is the Word Incarnate. Mary represented the Church. And Mary, as earthly mother and God-bearer (*Theotokos*), gave Jesus his human nature and forms a throne on which he sits in majesty. As a fourteenth-century churchman wrote, "The throne of the true Solomon is the Most Blessed Virgin Mary, in which sat Jesus Christ, the true Wisdom" (trans: Forsyth, p. 27).

Earlier in the Middle Ages, small, individual works of art were generally made of costly materials for royal or aristocratic patrons (see the Brescia cross, fig. 14-9). In the twelfth century, however, when abbeys and local parish churches of more limited means began commissioning hundreds of statues, painted wood became an increasingly common medium. These devotional images were frequently carried in processions both inside and outside the churches. A statue of the Virgin and Child, like the one shown here, could also have played an important role in the liturgical drama performed at the

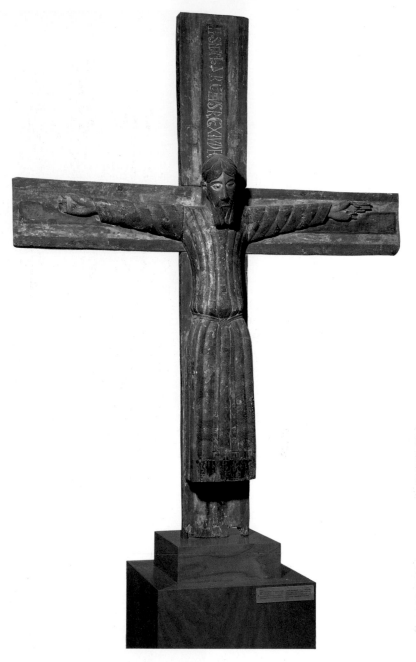

15-15. *Batlló Crucifix*, from the Olot region, Catalonia, Spain. Mid-12th century. Wood with polychromy, height approx. 36" (91 cm). Museu Nacional d'Art de Catalunya, Barcelona

This crucifix was modeled on a famous medieval sculpture called the *Volto Santo* (Holy Face) that had supposedly been brought from Palestine to Italy in the eighth century. Legend had it that the work had been made by Nicodemus, who helped Joseph of Arimathea bury Jesus. Many replicas of the *Volto Santo* still exist.

Feast of the Epiphany, which in the Western Church celebrates the arrival of the Magi to pay homage to the baby Jesus. Participants representing the Magi would act out their journey by searching through the church until they came to the statue. (Some scholars see this as the origin of western European drama.)

The Crucifixion continued to be a primary devotional theme in the Romanesque period. The image of Jesus in the mid-twelfth-century *Batlló Crucifix* from Catalonia (fig. 15-15) derives from Byzantine sources and is quite different from the nearly nude, tortured Jesus of the Ottonian-period *Gero Crucifix* (see fig. 14-28). Jesus'

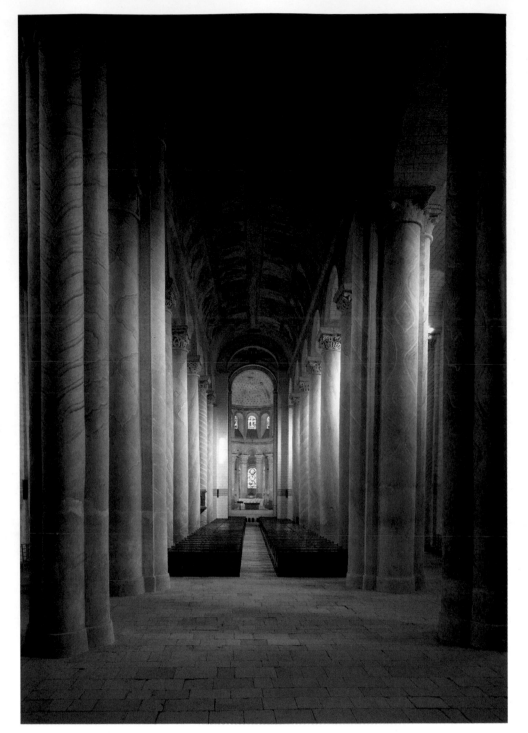

15-16. Nave, Abbey Church of Saint-Savin-sur-Gartempe, Poitou, France. c. 1100

The columns of Saint-Savin, painted to resemble veined marble, support an arcade and barrel vault without intermediate galleries or clerestory windows, a design known as a hall church.

bowed head, downturned mouth, and heavy-lidded eyes convey a sense of deep sadness or contemplation; however, he still wears royal robes that emphasize his kingship (see *Rabbula Gospels*, figs. 7-36, 7-37). He wears a long, medallion-patterned tunic with pseudo-kufic inscriptions—designs meant to resemble Arabic script—on the hem. The garment reflects how valuable silks from Islamic Spain were in Europe at this time. They were widely used as cloths of honor to designate royal and sacred places, appearing, for example, behind rulers' thrones, or as altar coverings and backdrops. Many wooden crucifixes such as this one have survived from the Romanesque period. They were displayed over church altars and, like other devotional statues, were carried in processions.

WALL PAINTING

Throughout Europe paintings on church walls glowed in flickering candlelight amid clouds of incense. Wall painting was subject to the same influences as the other visual arts: The painters were inspired by models available to them locally. Some must have seen examples of Byzantine art. Others had Carolingian or even Early Christian models from manuscripts. During the Romanesque period, painted decoration largely replaced mosaics on the walls of churches. This change occurred, at least partly, because the growing demand by the greater number of churches led to the use of less expensive materials and techniques.

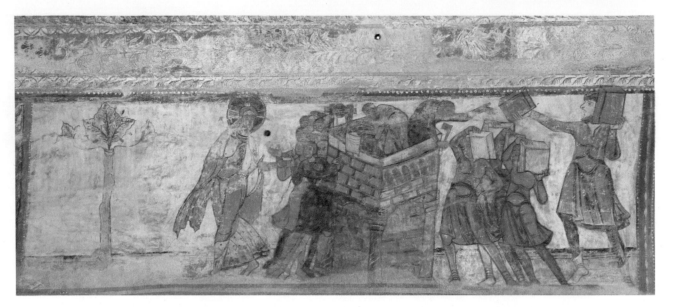

15-17. *Tower of Babel*, detail of painted nave vaulting, Abbey Church of Saint-Savin-sur-Gartempe

One of the most extensive programs of Romanesque wall painting is at the Benedictine Abbey Church of Saint-Savin-sur-Gartempe in the Poitou region of western France. The tunnel-like barrel vault running the length of the nave and choir provides a surface ideally suited to painted decoration (fig. 15-16). The narthex, crypt, and chapels were also painted. Old Testament scenes can be seen in the nave; New Testament scenes and scenes from the lives of two local saints, Savin and Cyprian, appear in the transept, ambulatory, and chapels. The paintings were done about 1100 and may have been inspired primarily by manuscripts. The painters did not use the wet-plaster **fresco** technique favored in Italy for its long-lasting colors, but they did moisten the walls before painting, which allowed some absorption of pigments into the plaster, making them more permanent than paint applied to a dry surface. Consequently, the colors of the vault have a soft, powdery tone in contrast to the richer, more brilliant hues of Byzantine-inspired painting.

Several artists or teams of artists worked in different parts of Saint-Savin. The nave vault suggests the energy of Carolingian artists, like those working for Archbishop Ebbo, and the narrative drama of the Ottonian Hildesheim doors (see figs. 14-16, 14-26). The painters here seem to have immediately followed the masons and used the same scaffolding. Perhaps this intimate involvement with the building process accounts for the vividness with which they portrayed the biblical story of the Tower of Babel (fig. 15-17). According to the account in Genesis (11:1–9), God punished the prideful people who tried to build a tower to heaven by scattering them and making their languages mutually unintelligible. The tower in the painting is a medieval-looking structure, reflecting the practice of depicting legendary events in contemporary settings. Workers haul heavy stone blocks to the tower, lifting them to masons on the top with a hoist. The giant Nimrod, on the far right, simply hands over the blocks. On the far left, God confronts the people. He steps away

from them even as he turns back to chastise them. The scene's dramatic action, large figures, strong outlines, broad areas of color, and simplified modeling all help make it intelligible to a viewer looking up at it in dim light from far below.

Many Romanesque wall paintings survived in churches in the isolated mountain valleys of the Catalonian Pyrenees in northern Spain. In the twentieth century, the paintings were detached from the walls and placed in museums for security. The paintings from the Church of San Clemente in Tahull are now in Barcelona. A magnificently expressive Christ in Majesty filled the curve of the half-dome of the apse (fig. 15-18, page 532). Christ's powerful presence recalls the contemporary sculpture at Moissac and Autun (see figs. 15-9, 15-11), whose sculptors may have been inspired by monumental paintings such as this. The San Clemente Christ illustrates a Romanesque transformation of the Byzantine depiction of Christ *Pantokrator*, ruler and judge of the world (see fig. 7-44). The iconography is traditional. Christ sits within a mandorla; the symbols *alpha* and *omega* are on each side of his head. He holds the open Gospel inscribed *"ego sum lux mundi"* ("I am the light of the world," John 8:12). Four angels, each grasping an evangelist's symbol, float at his sides. At Christ's feet are six apostles, of whom Bartholomew and John are visible here, and the Virgin Mary holding a bowl. Flanking them are columns with stylized capitals and wavy lines indicating marble shafts. The intensity of the colors was created by building up many thin coats of paint, a technique called **glazing**.

The San Clemente Master, as the otherwise anonymous Tahull painter is known, was one of the finest Spanish painters of the Romanesque period. The elongated oval faces, large staring eyes, and long noses, as well as the placement of figures against flat colored bands and the use of heavy outlining, reflect Mozarabic influence (Chapter 14). The prevailing influence, however, was the Byzantine style, which the Tahull painter and other Western artists of the period adapted to their

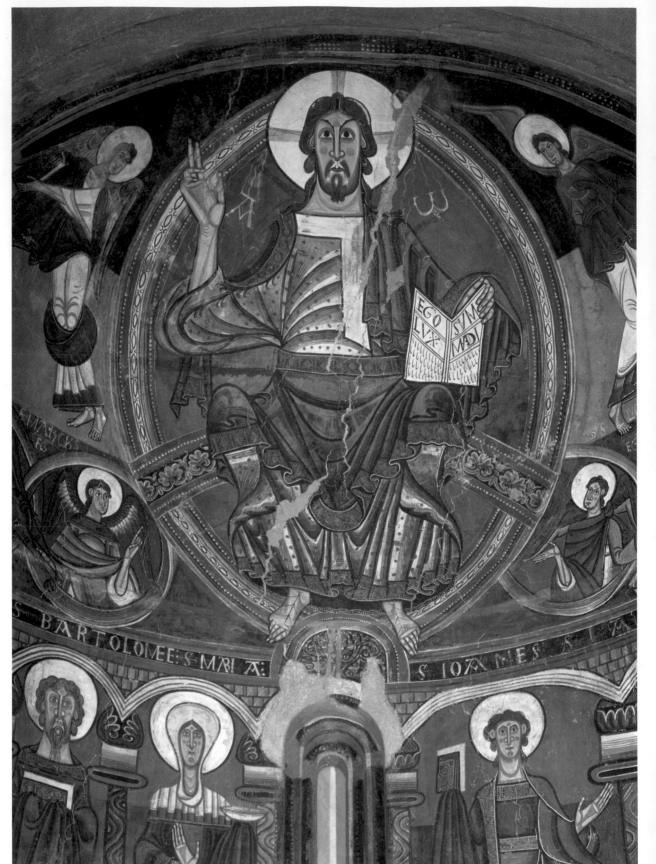

15-18. *Christ in Majesty*, detail of apse painting from the Church of San Clemente, Tahull, Lérida, Spain. c. 1123. Museu Nacional d'Art de Catalunya, Barcelona

own taste for geometric simplicity of form. Faces and figures are strictly frontal and symmetrical. Modeling from light to dark is accomplished through repeated colored lines of varying width in three shades—dark, medium, and light. Details of faces, hair, hands, and muscles are turned into elegant patterns.

BOOKS

As today, illustrated books played a key role in the transmission of artistic styles and other cultural information from one region to another. Like other arts, the output of books increased dramatically in the eleventh and twelfth

quodds suscepto ē cū. Dscūi erat
uerbū umgemeus: gignerā eo
æmus: Sed ut mediaor daretur
nob. pineffabilē grām uerbum
caro factum ē & habitau innobis:
bLECTIO OCTAVA
heloquutussū uob ut
gaudiū meū muob sit:
& gaudium uirm impleatur:
Hoc ē peeptū meū ut diligatis in
uice sicut dilexiuos: Audistis ca
rissimi drīm dicēre discipulis su
is: heloquutussū uob. ut gau
diū meū muob sit & gaudiū uirm
impleatur: Quod ē gaudiū xpi
innob. nisi quod dignat gaudere
de nob: & qd ē gaudiū nrīm qd
dicit implendū nisi à habere con
sortiū: Apt qd beato petro dixe
rat si ñ lauerote non habebis par
tē mecū: Gaudiū g eius innobis
grā ē quā pstitat nob. ipsa ē utiq;
gaudiū nrīm: Sed dehac ille eti
am exaeternitate gaudebat:
quando nos elegit ante mundi
constitutionē: Nee recte possu
mus dicere: quod gaudium eius
plenū non erat: Non enim ds in
pfecte aliquando gaudebat.
sed illud e' gaudiū innob non
erat: quia. nee nos inquib: ē pos
sit iam eramus. nee quando ē ē
punus cū illo ē cepimus: Impse
.aut semp erat: qui nos suos futu
ros certissima suar pscientiae uer
tate gaudebat: EVG. Hoc est
peeptū meū. REd. IN HE APtois.

cū euangluim legeretur: drīm di
cēre: Sidiligitis me mandata mea
seruate. Et ego rogabo patron
meū & alium paraclitū dabit
uob. ut maneat uobcū inæternū:

VDI
VI
MVS
RATRES

15-19. **Page with**
Pentecost, Cluny
Lectionary. Early
12th century. Ink
and tempera on
vellum, 9 x 5"
(23 x 12.5 cm).
Bibliothèque
Nationale, Paris,
MS lat. 2246,
fol. 79v

centuries, despite the labor and materials required to make them. Monastic and convent *scriptoria* continued to be the centers of production, where monks and nuns copied books (see "The Medieval Scriptorium," page 490). The *scriptoria* sometimes also employed lay artisans who might be itinerant, traveling from place to place. Most books had religious subject matter, including scholarly commentaries, lives of saints, collections of letters, and even histories. Liturgical works were often large and lavish; other works were more modest, their embellishment confined to the initial letter of each section of text.

An illuminated **lectionary**, a work containing biblical excerpts arranged according to the Church calendar for reading during Mass, was made for the wealthy monastery of Cluny in the early 1100s. In the page at the beginning of the eighth reading (fig. 15-19), the framed scene illustrates the beginning of the second chapter of the Acts of the Apostles, which recounts how "tongues as of fire" from the Holy Spirit descended on each of the apostles while they were assembled, and they began to speak "in tongues." Christ appears at the top of the picture, and glowing red rays—tongues of fire—stream from the gold

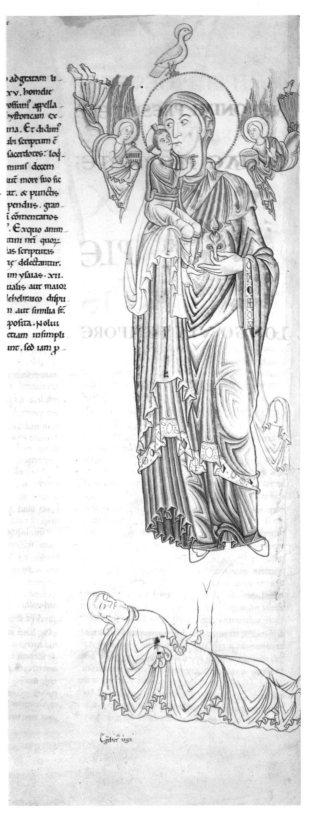

15-20. Page with *The Tree of Jesse*, *Explanatio in Isaiam (Saint Jerome's Commentary on Isaiah),* from the Abbey, Cîteaux, Burgundy, France. c. 1125. Ink and tempera on vellum, 15 x 4¾" (38 x 12 cm). Bibliothèque Municipale, Dijon, France. MS 129, fol. 4v

The Tree of Jesse, a pictorial representation of the genealogy of Jesus, was used to illustrate the Church's doctrine that Christ was both human and divine. The growing importance of devotion to Mary as the mother of God led to an emphasis on her place in this illustrious royal line.

banner draped over him to the heads of the Twelve Apostles below. Just under the picture is a beautifully interlaced *A*, the first letter of the word *audivimus* ("we have been hearing"). The subject—an unusual one for medieval art—may have been chosen as a symbolic reminder of Cluny's direct tie to the papacy. The picture may suggest that, just as the apostles received miraculous powers from Christ, so Cluny derived its power directly from the pope, the heir to the apostle Peter, the monastery's patron saint, who sits holding a gold-covered book in the center of the image. The image of Christ, like the Tahull *Christ in Majesty* (see fig. 15-18), is a reinterpretation of the Byzantine *Pantokrator* type. The faces of the figures have been delicately rendered with green and red highlighting. The drapery seems to fall over fleshy limbs. The illuminator deliberately deemphasized the drama of the supernatural event described in the text, conveying instead the psychological bond among the figures.

Despite their ascetic teachings and austere architecture, the Cistercians produced many elaborately illustrated books early in their history. A symbolic image known as the Tree of Jesse appears on a page from a copy of *Saint Jerome's Commentary on Isaiah* made in the *scriptorium* of the Cistercian mother house at Cîteaux about 1125 (fig. 15-20). Jesse was the father of King David, who was an ancestor of Mary and, through her, of Jesus. The Cistercians were particularly devoted to the Virgin and are credited with popularizing the Tree of Jesse as a device for showing her position as the last link in the genealogy connecting Jesus Christ to the house of David. In the manuscript illustration, *The Tree of Jesse* depicts Jesse asleep, a small tree trunk growing from his body. A monumental Mary, standing on the forking branches of the tree, dwarfs the sleeping patriarch. The Christ Child sits on her right arm, which is swathed in her veil. Following late Byzantine and Romanesque convention, he is portrayed as a miniature adult with his right hand raised in blessing. His cheek presses against Mary's, a display of affection similar to that shown in Byzantine icons like the *Virgin of Vladimir* (see fig. 7-42). Mary holds a flowering sprig from the tree, a symbol for Christ. The building held by the angel on the left refers to Mary as the Christian Church, and the crown held by the angel on the right refers to her as Queen of Heaven. The dove above her halo represents the Holy Spirit. The linear depiction of drapery in **V**-shaped folds and the jeweled hems of Mary's robes reflect Byzantine influence and her elevated status. The subdued colors are in keeping with Cistercian restraint.

THE NORTH SEA KINGDOMS

The North Sea became a Viking waterway in the ninth century (see Chapter 14), linking Norwegian and Danish mariners to the lands around it much as the Mediterranean Sea had served the Romans. Vikings saw the cold and turbulent water as the "whale way" for their ships, not as a barrier, and what began as exploration and raiding expeditions to the British Isles and Normandy soon turned to trade and colonization.

TIMBER CONSTRUCTION

In northern Europe, the standard early building type made good use of the area's plentiful forests: It was typically framed in wood, using either **cruck** or **post-and-lintel** construction. Crucks are pairs of timbers made by cutting a tree trunk with a naturally forked branch to the correct length, then splitting it into a matching pair. Crucks are used as both wall and roof supports, and a series of crucks can be set up to make a long single-aisle building. The more technically advanced post-and-lintel frame consists of a series of paired upright timbers spanned at the top by a horizontal timber. That wooden skeleton supports a triangle of rafters, the sloping beams that form the roof. A post-and-lintel frame divides the inner area into three spaces (in church architecture, a nave and two side aisles), a configuration that eventually influenced masonry architecture. Sometimes the structure would be built on a stone foundation, which protected the wooden frame from rotting in the moist earth. Whichever construction method was used, the building would be finished with wattle-and-daub walls, composed of woven light branches (wattle) covered with clay, mud, or other substance (daub). The roof, made up of a ridgepole, rafters, and eave beams, was covered by shingles, turf, or thatch.

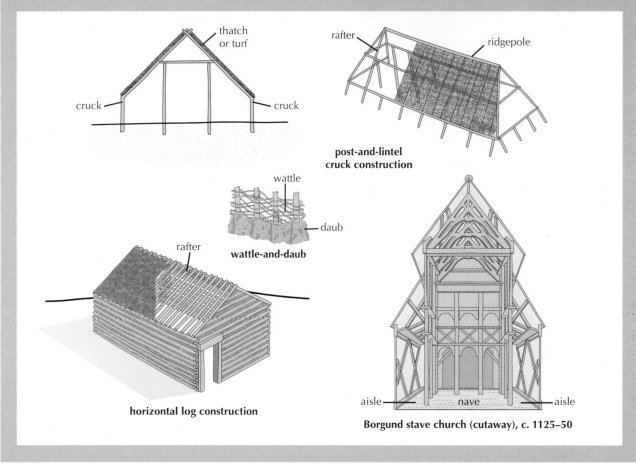

post-and-lintel
cruck construction

wattle-and-daub

horizontal log construction

Borgund stave church (cutaway), c. 1125–50

In the early tenth century, a band of Norse raiders seized the peninsula in northwest France that came to be known as Normandy. In 911, their leader, Rollo, gained recognition as duke of the region from the weak Carolingian king. Within little more than a century, Rollo's successors had transformed Normandy into one of Europe's most powerful feudal domains. The Norman dukes were astute and skillful administrators. They formed a close alliance with the Church, supporting it with grants of land and gaining in return the allegiance of abbots and bishops, many of whom also served as vassals of the duke. When in 1066 Duke William II of Normandy (1035–87) invaded England and, as William the Conqueror, became that country's new king, Norman nobles replaced the Anglo-Saxon nobility there, and England became politically and culturally allied to northern France.

TIMBER ARCHITECTURE AND SCULPTURE

The great forests of northern Europe provided the materials for timber buildings of all kinds. Two forms of timber construction evolved: one that stacked horizontal logs, notched at the ends, to form a rectangular building (the still-popular log cabin), and the vertical plank wall, with timbers set directly in the ground or into a sill (a horizontal beam). Typical buildings had rectangular plans, wattle-and-daub walls, and a turf or thatched roof that was supported in large halls by interior posts (see "Timber Construction," above).

The same basic structure was used for almost all building types—on a large scale for palaces, assembly halls, and churches, on a small scale for huts and family homes, which were shared with domestic animals, including horses and

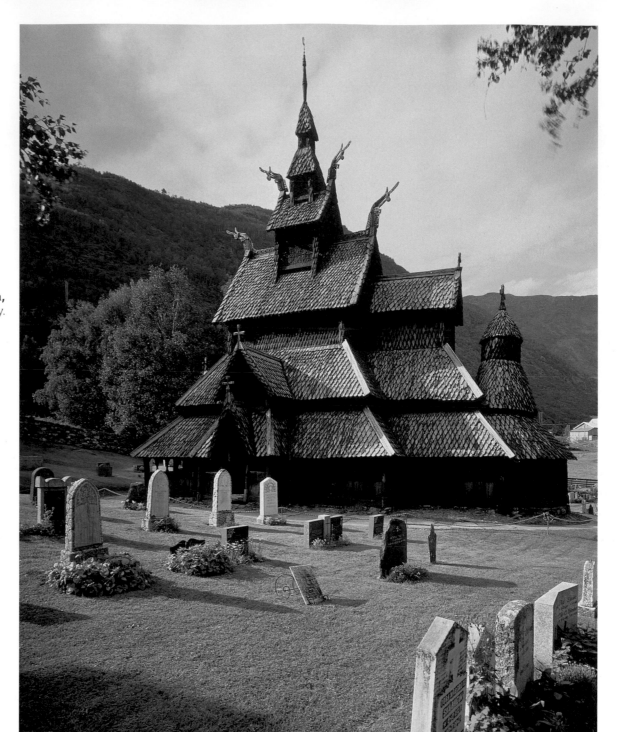

15-21. Borgund stave church, Sogn, Norway. c. 1125–50

cattle. The great hall had a central open hearth and an off-center door to prevent drafts. As defense, people created a kind of fort around residences and trading centers by building massive earthworks topped with palisades.

Subject to decay and fire, timber buildings of the period have largely disappeared, leaving only postholes and other traces in the soil. However, some timber churches—known as stave churches, from the four huge timbers (staves) that form the structural core of the building—survive in Norway. Borgund stave church, of about 1125–50, is one of the finest (fig. 15-21). Four corner staves support the central roof, and additional posts placed within or to the side of the space the corner staves define create the effect of a nave and side aisles, narthex, and choir. A rounded apse covered with a timber tower

is attached to the choir. Upright planks slotted into the sills form the walls. A steep-roofed gallery rings the entire building, and wooden shingles cover the roofs and some walls. Steeply pitched roofs protect the walls from the rain and snow. Openwork timber stages set on the roof ridge create a tower and an overall pyramidal shape. On all the gables—the triangular section at the upper part of the building's end—are crosses and dragons to protect the church and its congregation.

The penchant for carved relief decorations seen on the Oseberg ship (see figs. 14-20, 14-21) endured in the decoration of Scandinavia's earliest churches. The facades of these structures often teem with intricate animal interlace. A church at Urnes, Norway, entirely rebuilt in the twelfth century, still has some remnants of the original

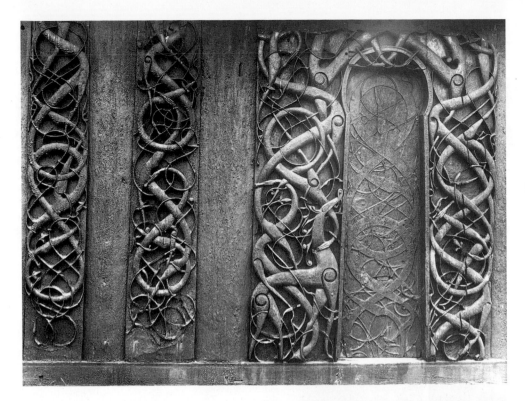

15-22. **Doorway panels, Parish church, Urnes**, Norway. c. 1050–70. Carved wood

eleventh-century carving, including on its doorway (fig. 15-22). Although it did not originate with this church, the style of carvings like these is known as Urnes. The animal interlace in the Urnes style is composed of serpentine creatures snapping at each other, a fusion of the vicious little gripping beasts covering the surface of the Oseberg post and the interlace pattern of the Oseberg ship's bow and stern. The satin-smooth carving of rounded surfaces, the contrast of thick and very thin elements, and the organization of the interlace into harmoniously balanced figure-8 patterns are characteristic of the Urnes style. The effect is one of aesthetic and technical control rather than wild disarray. Works such as the Urnes doorway panels suggest the persistence of Scandinavia's mythological tradition even as Christianity took hold there and demonstrate its enriching influence on the vocabulary of Christian art. The great beast standing at the left of the door, fighting serpents and dragons, came to be associated with the Lion of Judah and with Christ, who fought Satan and the powers of darkness and paganism.

MASONRY ARCHITECTURE

When the British turned from timber architecture to stone and brick, they associated the masonry building—whether church, feasting hall, or castle—with the power and glory of ancient Rome, where those materials had been used. They also appreciated the greater strength and resistance to fire of masonry walls. Not surprisingly, they soon began to experiment with masonry vaults, as can be seen at Durham Castle and Cathedral in northeastern England.

Strategically located on England's northern frontier with Scotland, Durham grew after the Norman Conquest into a great fortified complex with a castle, a monastery, and a cathedral (fig. 15-23). Durham Castle is an excellent example of a Norman fortress. The only way in and out was over a drawbridge, which was controlled from a gatehouse

15-23. **Castle-monastery-cathedral complex, Durham**, Northumberland, England. c. 1075–1100s, plus later alterations and additions

Since 1837, the castle has housed the University of Durham (now joined with the University of Newcastle). The castle was added to and rebuilt over the centuries. The Norman portion extends to the left of the keep. The castle and cathedral share a parklike green. South of the cathedral (lower in the photograph), the cloister with chapterhouse, dormitory (now a library), and kitchens are clearly visible. Houses of the old city cluster around the buildings as they would have in earlier days. Trees, however, would not have been allowed to grow near the approaches to this fortified outpost against the Scots.

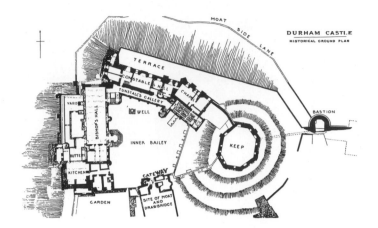

15-24. Plan of Durham Castle

In Norman times, the bishops of Durham lived in a three-story residence. An exterior staircase led from the courtyard (inner bailey) to a single undivided, multipurpose room on the middle floor occupied by the bishop and his principal servants (Constable's Hall and Tunstall's Gallery in the plan). Other people occupied humbler wood structures within the castle complex or outside its walls in the village that served it. The structures at the left date from Gothic times.

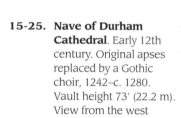

15-25. Nave of Durham Cathedral. Early 12th century. Original apses replaced by a Gothic choir, 1242–c. 1280. Vault height 73' (22.2 m). View from the west

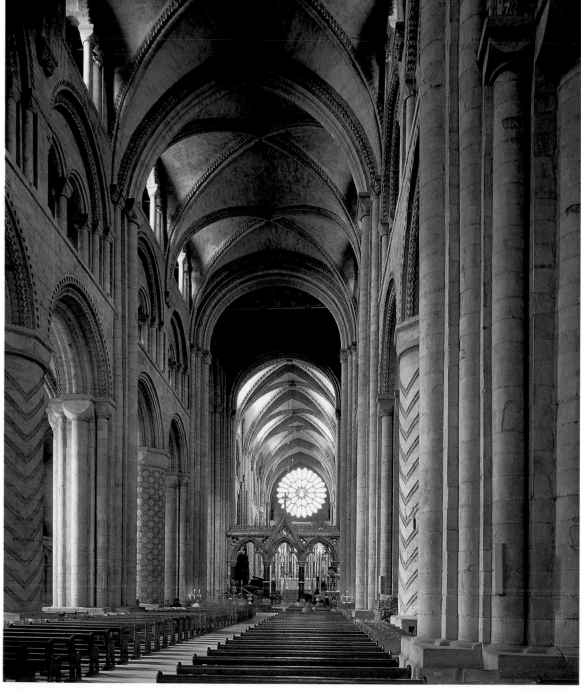

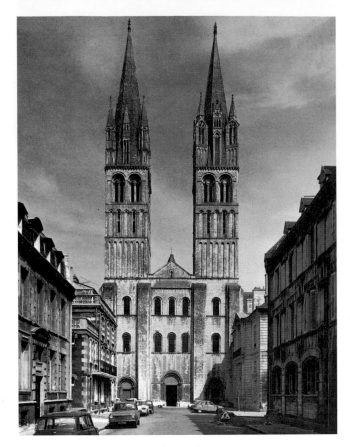

15-26. Church of Saint-Étienne, Caen, Normandy, France.
Begun 1064; facade late 11th century; spires 13th century

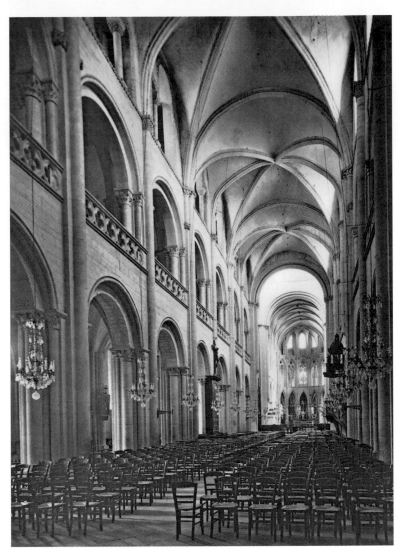

15-27. Nave, Church of Saint-Étienne, Caen

(fig. 15-24). Beyond the gatehouse was the **bailey**, or courtyard. In times of danger, the castle's defenders took up their battle positions in the **keep** (***donjon*** in French), the massive tower to the east of the bailey. At Durham, a stone keep replaced an earlier timber tower. Other buildings, including the great hall in which the bishops conducted their business, extended along the northern rampart overlooking a sheer cliff. The Norman chapel, located between the great hall and the keep, was built about 1075 and may have been the first stone structure in the compound. Medieval fortresses were often surrounded by a defensive water-filled ditch known as a **moat**. At Durham, the Wear River acted as a natural moat, looping around the high, rocky outcrop on which the complex was built.

Durham Cathedral and its adjoining monastery were built to the south of the castle (see fig. 15-23). The cathedral, begun in 1087 and vaulted beginning in 1093, is one of the most impressive medieval churches. Like most buildings that have been in continuous use, it has been altered several times. The visible parts of the towers, for example, are Gothic with eighteenth-century modifications. The cathedral's scale and decor are both ambitious (fig. 15-25). Enormous compound piers alternating with robust columns support the nave arcade. The columns are carved with **chevrons**, spiral fluting, and diamond patterns, and some have scalloped, cushion-shaped capitals. The arcades have round moldings and chevron ornaments. All this ornamentation was originally painted.

Above the cathedral's massive walls rise ribbed vaults. While most builders were still using timber roofs, the masons at Durham developed a new system of vaulting. The typical Romanesque ribbed groin vault (best

seen in Milan, fig. 15-34) used round arches that produced separate, domed spatial units. To create a more unified interior space, the Durham builders divided each bay with two pairs of crisscrossing ribs and so kept the crown of the vault at almost the same height as the keystone of the transverse arches. In the transept they experimented with rectangular rather than square bays, and the earliest quadrant vaults were built there. Between 1093 and 1133, when the project was essentially complete, they developed a system of vaulting that was carried to the Norman homeland in France, perfected in churches such as Saint-Étienne at Caen, in Normandy, then adopted by masons throughout France in the Gothic period (see "Rib Vaulting," page 561).

Saint-Étienne (fig. 15-26) was begun nearly a generation before Durham Cathedral, but work continued there through the century. William, duke of Normandy, had founded the monastery and begun construction of its church by the time of his conquest of England. His queen, Matilda, had already established an abbey for women in Caen. The two churches survived the devastation of Normandy in World War II, and their western towers still dominate the skyline. At Saint-Étienne, the nave wall has a three-part elevation with exceptionally wide arches in the nave arcade (fig. 15-27), which are repeated in the gallery above. At the clerestory level, a third arcade with

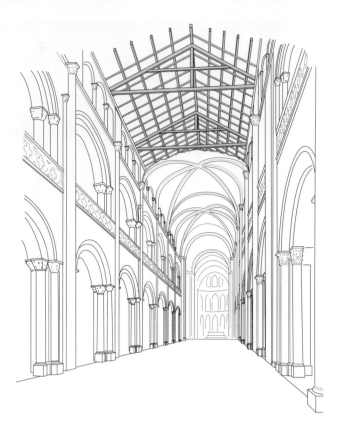

15-28. Diagram of roof and vaulting, Church of Saint-Étienne, Caen

four arches fronts the windows, creating a passageway. Alternating engaged columns and engaged columns backed by pilasters run the full height of the wall, emphasizing the nave's height and creating an interesting rhythmic pattern of heavy and light compound piers down the length of the nave. The side aisles are groin-vaulted. The building was dedicated in 1077.

Saint-Étienne's nave originally had a timber roof, which was replaced by a masonry vault sometime after 1120. The vault has been dated as late as 1130–35. A ribbed groined vault, divided by the addition of a second transverse rib, was raised over double bays (fig. 15-28). This design created square nave bays with six-part ribbed groin vaults—a system adopted by early Gothic builders in the Île-de-France. Soaring height was a Norman architectural goal, continuing the tradition of towers and verticality begun by Carolingian builders (see fig. 14-10). The west facade of Saint-Étienne was constructed at the end of the eleventh century, probably about 1096–1100. Wall buttresses divide the facade into three vertical sections, and small **stringcourses**, unbroken cornicelike moldings, at each window level suggest the three stories of the building's interior. This concept of reflecting in the design of the facade the plan and elevation of the church itself would be adopted by Gothic builders. Norman builders, with their brilliant technical innovations and sophisticated designs, in fact prepared the way for the architectural feats seen in Gothic cathedrals of the twelfth and thirteenth centuries.

BOOKS

The great Anglo-Saxon tradition of book illumination, which declined for a time in the wake of the Norman Conquest, revived after about 1130. The *Worcester Chronicle*

is the earliest known illustrated English history. This record of contemporary events by a monk named John was an addition to a work called *The Chronicle of England*, written by Florence, another monk. The pages shown here concern King Henry I (ruled 1100–35), the second of William the Conqueror's sons to sit on the English throne (fig. 15-29). The text relates a series of dreams the king had on consecutive nights in 1130 in which his subjects demanded tax relief. The illustrations depict the dreams with energetic directness. On the first night, angry farmers confront the sleeping king; on the second, armed knights; and on the third, monks, abbots, and bishops. In the fourth illustration, the king is in a storm at sea and saves himself by promising God to lower taxes for a period of seven years. The *Worcester Chronicle* assured its readers that this story came from a reliable source, the royal physician Grimbald, who appears in the margins next to most scenes.

More characteristic of Romanesque illumination are illustrated psalters. The so-called *Hellmouth* page from a psalter written in Latin and Norman French is one of the masterpieces of English Romanesque art (fig. 15-30). The psalter was produced at a renowned Anglo-Saxon monastic *scriptorium* in Winchester. The vigorous narrative style for which the *scriptorium* was famous had its roots in the style of the ninth-century workshop at Reims that produced the *Utrecht Psalter* (see fig. 14-17). The page depicts the gaping jaws of hell, a traditional Anglo-Saxon subject, one that inspired poetry and drama as well as the vivid descriptions of the terrors and torments of hell with which the clergy enlivened their sermons.

The inscription at the top of the page reads: "Here is hell and the angels who are locking the doors." The ornamental frame that fills the page represents the door to hell. An angel on the left turns the key to the door in the keyhole of the big red doorplate. The frenzy of the Last Judgment, as depicted on the tympanum at Autun (see fig. 15-11), has subsided. Inside the door, the last of the damned are crammed into the mouth of hell, the wide-open jaw of a grotesque double-headed monster. Sharp-beaked birds and fire-breathing dragons sprout from the monster's mane. Hairy, horned demons torment the lost souls, who tumble around in a dark void. Among them are kings and queens with golden crowns and monks with shaved heads, a daring reminder to the clergy of the vulnerability of their own souls.

THE BAYEUX TAPESTRY

The best-known work of Norman art is undoubtedly the *Bayeux Tapestry* (figs. 15-31, 15-32, "The Object Speaks," page 543). This narrative wall hanging, 230 feet long and 20 inches high, documents events surrounding the Norman Conquest of England in 1066. Despite its name, the work is **embroidery**, not tapestry. It was embroidered in eight colors of wool on eight lengths of undyed linen that were then stitched together (see "Embroidery Techniques," page 544). It was made for William the Conqueror's half brother Odo, who was bishop of Bayeux in Normandy and earl of Kent in southern England. Odo commissioned it for

15-29. John of Worcester. Page with *Dream of Henry I*, *Worcester Chronicle*, from Worcester, England. c. 1140. Ink and tempera on vellum, each page 12¾ x 9⅜" (32.5 x 23.7 cm). Corpus Christi College, Oxford (CCC MS 157, pages 382–383)

One of the achievements of Henry's father, William the Conqueror, was a comprehensive census of English property owners, the *Domesday Book*. Compiled into two huge volumes, this document was used to assess taxes and settle property disputes. After Henry, too, raised taxes and encountered protests, a series of visions and a life-threatening storm at sea made him promise a seven-year delay in implementing the higher rate.

15-30. Page with *Hellmouth*, *Winchester Psalter*, from Winchester, England. c. 1150. Ink and tempera on vellum, 12¾ x 9⅛" (32.5 x 23 cm). The British Library, London

There are fascinating parallels between Hellmouth images and the liturgical dramas—known in England as mystery plays—that were performed throughout Europe from the tenth through the sixteenth century. Depictions of the Hellmouth in Romanesque English art were based on the large and expensive stage props used for the hell scenes in mystery plays. Carpenters made the infernal beast's head out of wood, papier-mâché, fabric, and glitter and placed it over a trapdoor onstage. The wide jaws of the most ambitious Hellmouths, operated by winches and cables, opened and closed on the actors. Smoke, flames, foul smells, and loud noises came from within, to the delight of the audience. Hell scenes, with their often scatological humor, were by far the most popular parts of the plays. Performances are still given today.

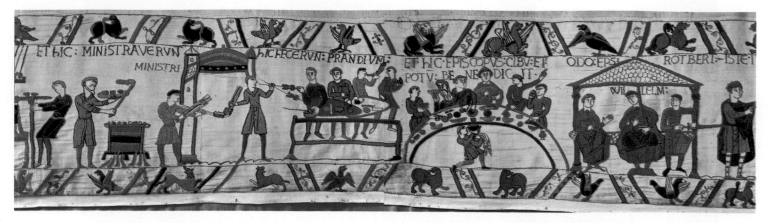

15-31. *Bishop Odo Blessing the Feast*, section 47–48 of the *Bayeux Tapestry*, Norman–Anglo-Saxon embroidery from Canterbury, Kent, England, or Bayeux, Normandy, France. c. 1066–82. Linen with wool, height 20" (50.8 cm). Centre Guillaume le Conquérant, Bayeux, France

Translation of text: ". . . and here the servants (*ministri*) perform their duty. /Here they prepare the meal /and here the bishop blesses the food and drink. Bishop Odo. William. Robert."

his Bayeux Cathedral, and it may have been completed in 1077, in time for the cathedral's consecration. According to an inventory made in 1476, it was "hung round the nave of the church on the Feast of relics" (Rud, page 9). Scholars disagree as to where it was made. Some argue for the famous embroidery workshops of Canterbury, in Kent, and others for Bayeux itself. A Norman probably directed the telling of the story and either an illuminator from a *scriptorium* or a specialist from an embroidery workshop provided drawings. Recent research suggests that the embroiderers were women.

The *Bayeux Tapestry* is a major political document, celebrating William's victory, validating his claim to the English throne, and promoting Odo's interests as a powerful leader himself. Today it is also a treasury of information about Norman and Anglo-Saxon society and technology, with depictions of everything from farming implements to table manners to warfare. The *Bayeux Tapestry* shows broadly gesturing actors on a narrow stage with the clarity and directness of English manuscript illustration. It is laid out in three registers. In the middle register, the central narrative, explained by Latin inscriptions, unfolds in a continuous scroll from left to right. Secondary subjects and decorative motifs adorn the top and bottom registers.

The section illustrated in figure 15-31 shows Odo and William, feasting on the eve of battle. Attendants provide roasted birds on skewers, placing them on a makeshift table of the knights' shields laid over trestles. The diners, summoned by the blowing of a horn, gather at a curved table laden with food and drink. Bishop Odo—seated at the center, head and shoulders above William to his right—blesses the meal while others eat. The kneeling servant in the middle proffers a basin and towel so that the diners may wash their hands. The man on Odo's left points impatiently to the next event, a council of war between William (now the central and tallest figure), Odo, and a third man labeled "Rotbert," probably Robert of Mortain, another of William's half brothers. These men held power after the conquest.

THE HOLY ROMAN EMPIRE In the early eleventh century, the Salian dynasty replaced the Ottonians on the throne of the Holy Roman Empire, which encompassed much of Germany and Langobard Italy (Lombardy). The third Salian emperor, Henry IV (ruled 1056–1106), became embroiled in the dramatic conflict with the papacy known as the Investiture Controversy, which involved the right of lay rulers to "invest" high-ranking clergy with the symbols of their spiritual offices. In 1075, Pope Gregory VII (papacy 1073–85) declared that only the pope and his bishops could appoint bishops, abbots, and other important clergy—meaning that the clergy now depended on the pope, not the emperor. Many German nobles sided with the pope; some sided with the emperor. The controversy divided Germany into many small, competing states. The efforts of Holy Roman emperors of the late twelfth and early thirteenth centuries to reimpose imperial authority failed, and Germany remained divided until the late nineteenth century.

Italy too remained divided. The north, embroiled in the conflict between the papacy and the German emperors, experienced both economic growth and increasing political fragmentation. Toward the end of the eleventh century, towns such as Pisa and Genoa became self-governing municipal corporations known as communes, and by the middle of the twelfth century the major cities and towns of northern and central Italy were independent civic entities, feuding with one another incessantly in a pattern that continued for the next several hundred years. Port cities like Pisa, Genoa, and Venice maintained a thriving Mediterranean trade and also profited from their role in transporting Crusaders and pilgrims to the Holy Land. The great bishops of these urban centers were leading patrons of the arts in the building and furnishing of their cathedrals. In southern Italy and in Sicily, Norman adventurers displaced Islamic and Byzantine rulers in the late eleventh century, retaining control until the end of the twelfth.

Religious and political problems sapped energy and wasted financial resources. Nevertheless, building and the

THE OBJECT SPEAKS

THE BAYEUX TAPESTRY

Rarely has art spoken more vividly than in the *Bayeux Tapestry*, a strip of linen that tells the history of the Norman conquest of England. On October 14, 1066, William, duke of Normandy, after a hard day of fighting, became William the Conqueror, king of England. The story told in embroidery is a straightforward justification of the action, told with the intensity of an eyewitness account: The Anglo-Saxon noble Harold swears his feudal allegiance to William on the most sacred relics of Normandy—the saints of Bayeux and the blood of Christ himself. Betraying his feudal vows, Harold is crowned king of England but, unworthy to be king, he dies at the hands of the Normans.

At the beginning of the *Bayeux* story, Harold is a heroic figure, then events overtake him. After his coronation, cheering crowds celebrate—until a flaming star crosses the sky (fig. 15-32). (We know that it was Halley's Comet, which appeared shortly after Harold's coronation and reached astonishing brightness.) The Anglo-Saxons see it as a portent of disaster; the crowd cringes and gestures at the ball of fire with a flaming tail, and a man rushes to inform the new king. Harold slumps on his throne in the Palace of Westminster. He foresees what is to come: Below his feet is his vision of a ghostly fleet of Norman ships already riding the waves. The last great Viking flotilla has assembled on the Normandy coast.

The narrator was a skillful storyteller who used a staggering number of images. In the fifty surviving scenes are more than 600 human figures; 700 horses, dogs, and other creatures; and 2,000 inch-high letters. Perhaps he or she was assisted by William's half brother, Bishop Odo, who had fought beside William using a club, not a sword, to avoid spilling blood. The tragic drama would have spoken to audiences of Shakespeare's tragedy *Macbeth*—the story of a good man who is overcome by his lust for power and so betrays his king. But the images of this Norman invasion also spoke to people during the darkest days of World War II, when the Allies invaded Nazi-occupied Europe, taking the same route in reverse from England to beaches on the coast of Normandy. Harold or Hitler—the *Bayeux Tapestry* speaks to us of the folly of human greed and ambition and of two battles that changed the course of history.

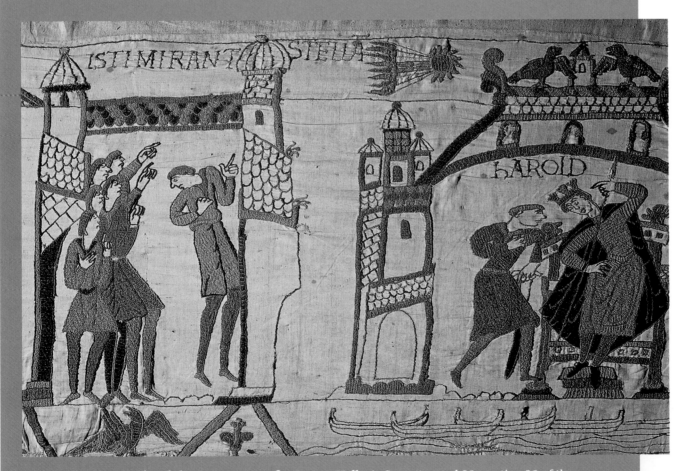

15-32. *Messengers Signal the Appearance of a Comet (Halley's Comet),* panel 32, section 20 of the *Bayeux Tapestry,* Norman–Anglo-Saxon embroidery from Canterbury, Kent, England, or Bayeux, Normandy, France. c. 1066–82. Linen with wool, height 20" (50.8 cm). Centre Guillaume le Conquérant, Bayeux, France

EMBROIDERY TECHNIQUES

The embroiderers of the *Bayeux Tapestry* probably followed drawings provided by a Norman, perhaps even an eyewitness to some of the events depicted. The style of the embroidery, however, is Anglo-Saxon, and the embroiderers were probably women. They worked in tightly twisted wool that was dyed in eight colors with dyes made from plants and minerals. They used only two stitches. The quick, overlapping, linear stem stitch produced a slightly jagged outline. The more time-consuming laid-and-couched work that was used to form blocks of color required three steps. The embroiderer first "laid" a series of long, parallel covering stitches, anchored them with a second layer of regularly spaced crosswise stitches, and finally tacked everything down with tiny "couching" stitches. Some of the tapestry's laid-and-couched work was done in contrasting colors for particular effects. Skin and other light-toned areas were represented by the bare linen cloth that formed the ground of this great work.

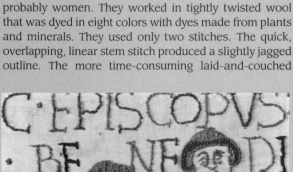
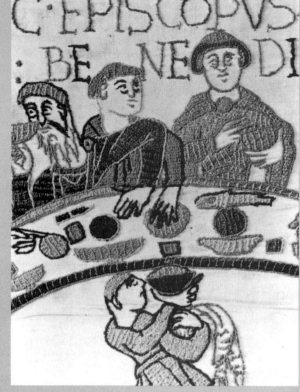

Laid-and-couched work and **stem-stitch techniques** are clearly visible in this detail of figure 15-31. Stem stitching outlines all the solid areas, is used to draw the facial features, and forms the letters of the inscription.

Centre Guillaume le Conquérant, Bayeux

stem stitching

crosswise stitches

laid threads

couching stitches

other arts continued. Carolingian and Ottonian cultural traditions persisted in the German lands during the eleventh and twelfth centuries. Ties between the northern Italian region of Lombardy and Germany also remained strong and provided a source of artistic exchange. Throughout Italy, moreover, artists looked to the still-standing remains of imperial Rome. All these influences shaped the character of the Romanesque style in the Holy Roman Empire.

ARCHITECTURE

The imperial cathedral at Speyer in the Rhine River valley of southwest Germany was a colossal structure that rivaled Cluny in size and magnificence. During the reign of Henry IV, beginning in the 1080s and finishing in 1106, the cathedral building was constructed on the foundations of an Ottonian imperial church. The emperor was fresh from recent successes against the papacy and a German rival, King Rudolf of Swabia, and the monumental rebuilding project was a testament to his power.

A nineteenth-century **lithograph** shows the interior of the Romanesque cathedral (fig. 15-33). Massive compound piers mark each nave bay and support the transverse ribs of the high vault. Lighter, simpler piers mark the aisle bays where two smaller bays cover the distance. This rhythmic alternation of heavy and light piers, first suggested for aesthetic reasons in Ottonian architecture, such as Saint Cyriakus at Gernrode (see fig. 14-24), is regularized in Speyer and became an important design element in Romanesque architecture. The ribbed groin vaults also relieve the stress on the side walls of the building, so that windows can be larger. The result is both a physical and a psychological lightening of the building.

15-33. Interior, Speyer Cathedral, Speyer, Germany, as remodeled c. 1081–1106. Engraving of 1844 by von Bachelier. Kurpfälzisches Museum der Stadt Heidelberg

At roughly the same time, about 1080, construction began in Lombardy, in the city of Milan, on a new Church of Sant'Ambrogio (Saint Ambrose). Milan had been the capital of the Western Roman Empire for a brief period in the fourth century, and the city's first bishop, Ambrose (d. 397), was one of the fathers of the Christian Church. The new church replaced an often-renovated ninth-century church, and the builders reused much of the earlier structure, including the freestanding tenth-century "monks' tower." Lombard Romanesque architecture depended for its austere dignity on harmonious proportions and the restrained use of decorative motifs derived from architectural forms. The simple exterior architectural decoration of wall buttresses and a row of **corbels** (brackets) joined by arches and supporting a molding was carried to Germany, Normandy, and elsewhere by Lombard clerics and masons.

Following an earthquake in 1117, masons rebuilt the church using a technically advanced system of four-part rib vaulting (fig. 15-34). Compound piers support three domed, ribbed groin vaults over the nave, and smaller intermediate piers support the ribbed groin vaulting over the side-aisle bays. In addition to the vaulting system, the builders took other steps to assure the stability of the church. Sant'Ambrogio has a nave that was wider than that of Cluny III (with which it was roughly contemporary), but, at 60 feet, only a little more than half as high. Vaulted galleries buttress the nave, and there are windows only in the outer walls.

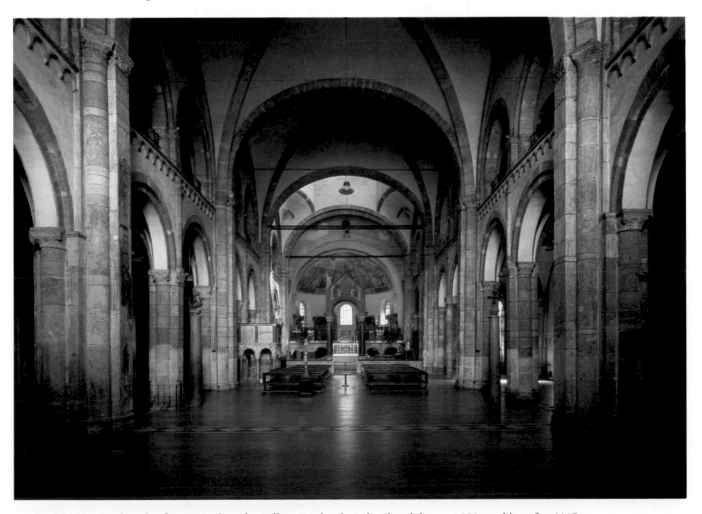

15-34. Nave, Church of Sant'Ambrogio, Milan, Lombardy, Italy. Church begun 1080; vaulting after 1117

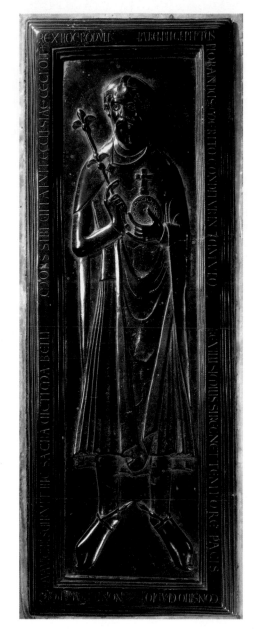

15-35. Tomb cover with effigy of Rudolf of Swabia, from Saxony, Germany. After 1080. Bronze with niello, approx. 6'5½" x 2'2½" (1.97 x 0.68 m). Cathedral, Merseburg, Germany

METALWORK

For centuries, three centers in the West supplied much of the best metalwork for aristocratic and ecclesiastical patrons throughout Europe: German Saxony, the Meuse River valley region (in modern Belgium), and the lower Rhine River valley. The metalworkers in these areas drew on a variety of stylistic sources, including the work of contemporary Byzantine and Italian artists, as well as classical precedents as reinterpreted by their Carolingian forebears.

In the late eleventh century, Saxon metalworkers, already known for their large-scale bronze casting, began making bronze **tomb effigies**, or portraits of the deceased. Thus began a tradition of funerary art that spread throughout Europe and persisted for hundreds of years. The oldest known bronze tomb effigy is that of King Rudolf of Swabia (fig. 15-35), who sided with the pope against Henry IV during the Investiture Controversy. The tomb effigy, made soon after Rudolf's death in battle in 1080, is the work of an artist originally from the Rhine region. Nearly lifesize, it has fine linear detailing in **niello**, an incised design filled with a black alloy. The king's head has been modeled in higher relief than his body. The spurs on his oversized feet identify him as a heroic warrior. In his hands he holds the scepter and cross-surmounted orb, emblems of Christian kingship.

Most work of the time is anonymous, but according to the account books of the Abbey of Helmarshausen in Saxony, an artist named Roger was paid on August 15, 1100, for a portable altar dedicated to Saints Kilian and Liborius. Found preserved in the treasury of the cathedral there, the foot-long, chestlike altar—made of gilt bronze, silver, gemstones, and niello—supports a beautiful altar stone (fig. 15-36). It rests on three-dimensionally modeled animal feet. On one end, in high relief, are two standing saints flanking Christ in Majesty, enthroned on the arc of the heavens. On the front are five apostles, each posed somewhat differently, executed in two-dimensional engraving and niello. Saint Peter sits in the center, holding his key. Roger adapted Byzantine figural conventions to his personal style, and he gave his subjects a sense of life despite their formal setting. He was clearly familiar with classical art, but his geometric treatment of natural forms, his use of decorative surface patterning, and the linear clarity of his composition are departures from the classical aesthetic.

Metalworkers in the Meuse and Rhine valleys excelled in a very different regional style. They were well known for sumptuous small pieces, such as the gilt bronze aquamanile shown here, which was made about 1130 (fig. 15-37). Aquamaniles (from the Latin *aqua*, "water," and *manus*, "hand") were introduced into western Europe from the Islamic East, probably by returning Crusaders. In their homelands, Muslims used aquamaniles for rinsing their hands at meals. In the West, they found their way to church altars, where priests purified themselves by pouring water over their hands. This griffin aquamanile recalls its Islamic prototypes (see fig. 8-17). In its liturgical context, however, the hybrid beast known as a griffin symbolized the dual nature of Christ: divine (half eagle) and human (half lion). Black niello sets off the gleaming gold and silver, and the circular handle echoes the curved forms of the rest of the vessel.

BOOKS

The great Carolingian and Ottoman manuscript tradition continued in the Romanesque period. A painting on an opening page from the earliest illustrated copy of the *Liber Scivias* by Hildegard of Bingen (1098–1179) shows the

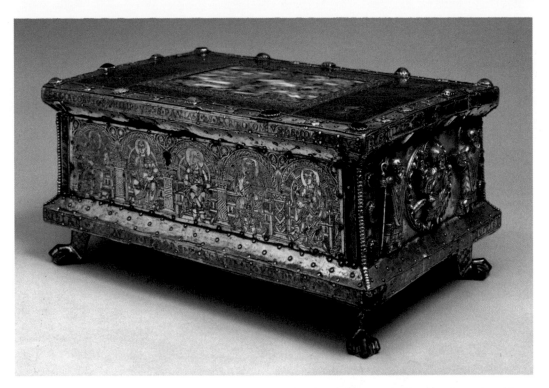

15-36. Roger of Helmarshausen. Portable altar of Saints Kilian and Liborius, from the Abbey, Helmarshausen, Saxony, Germany. c. 1100, with later additions. Silver and gilt bronze, with niello and gemstones, 6½ x 13⅝ x 8⅜" (16.5 x 34.5 x 21 cm). Erzbischöfliches Diözesanmuseum und Domschatzkammer, Paderborn, Germany

Some scholars identify Roger, a monk, with "Theophilus," the pseudonym used by a monk who wrote an artist's handbook, *On Diverse Arts*, about 1100. The book gives detailed instructions for painting, glassmaking, and goldsmithing. In contrast to Abbot Bernard of Clairvaux, "Theophilus" assured artists that "God delights in embellishments" and that artists worked "under the direction and authority of the Holy Spirit." He wrote, "most beloved son, you should not doubt but should believe in full faith that the Spirit of God has filled your heart when you have embellished His house with such great beauty and variety of workmanship . . . Set a limit with pious consideration on what the work is to be, and for whom, as well as on the time, the amount, and the quality of work, and, lest the vice of greed or cupidity should steal in, on the amount of the recompense" (Theophilus, page 43). The last admonishment is a worldly reminder about fair pricing.

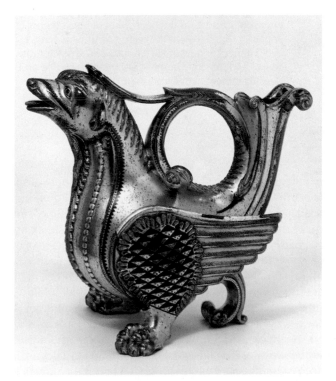

15-37. Griffin aquamanile, in the style of Mosan, Liège (?), Belgium. c. 1130. Gilt bronze, silver, and niello, height 7¼" (18.5 cm). Victoria and Albert Museum, London

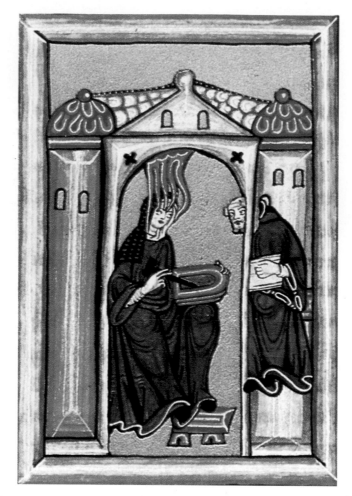

15-38. Facsimile of page with *Hildegard's Vision*, *Liber Scivias.* c. 1150–1200. Original manuscript lost during World War II

The text that accompanies this picture of Hildegard of Bingen reads: "In the year 1141 of the incarnation of Jesus Christ the Son of God, when I was forty-two years and seven months of age, a fiery light, flashing intensely, came from the open vault of heaven and poured through my whole brain. . . . And suddenly I could understand what such books as the psalter, the gospel and the other catholic volumes of the Old and New Testament actually set forth" (*Scivias*, I, 1).

author at work (fig. 15-38). Born into an aristocratic German family, Hildegard transcended the barriers that limited most medieval women, and she became one of the towering figures of her age. Like many women of her class, she entered a convent as a child. Developing into a scholar and a capable administrator, Hildegard began serving as leader of the convent in 1136. In about 1147 she founded a new convent near Bingen. Since childhood she had been subject to what she interpreted as divine visions, and in her forties, with the assistance of the monk Volmar, she began to record them. Her book, *Scivias* (from the Latin *scite vias lucis*, "know the ways of the light"), records her visions. In addition to *Scivias*, Hildegard wrote

treatises on a variety of subjects, including medicine and natural science. Emerging as a major figure in the intellectual life of her time, she corresponded with emperors, popes, and the Cistercian abbot Bernard of Clairvaux.

The opening page of this copy of *Scivias* shows Hildegard receiving a flash of divine insight, represented by the tongues of flame encircling her head. She records the vision on a tablet while Volmar, her scribe, waits in the wings. Stylistic affinities suggest to some art historians that this copy of *Scivias* was made at the *scriptorium* of the Monastery of Saint Matthias in Trier, whose abbot was a friend of Hildegard. Others suggest it was made at Bingen under the direction of Hildegard herself.

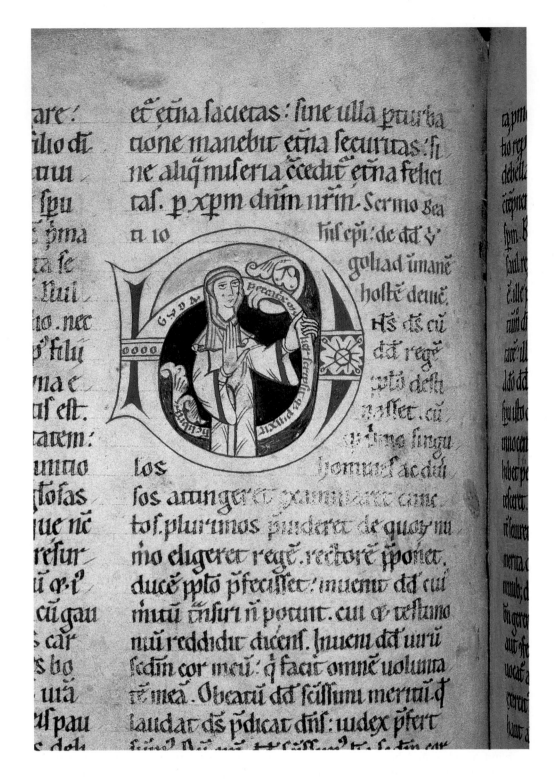

15-39. Page with self-portrait of the nun Guda, *Book of Homilies.* Early 12th century. Ink on parchment. Stadt-und Universitäts-Bibliothek, Frankfurt, Germany. MS. Barth. 42, folio 110v

In the Romanesque period, as earlier in the Middle Ages, women were involved in the production of books as authors, scribes, painters, and patrons. Like Abbess Hitda (see fig. 14-31), the nun Guda, from Westphalia, was a scribe and painter. In a book of homilies, now in Frankfurt, she inserted her self-portrait into the letter *D* and signed "Guda, the sinful woman, wrote and illuminated this book" (fig. 15-39). A simple drawing with colors only in the background spaces, Guda's self-portrait is certainly not a major work of art. The importance of the drawing lies in its demonstration that women were far from anonymous workers in German *scriptoria.* Guda and other nuns played an important role in the production of books in the twelfth century, and this image is the earliest signed self-portrait by a woman in Western Europe.

ANCIENT ROME AND ROMANESQUE ITALY

The spirit of classical Rome reappeared in the Romanesque art of Pisa, Rome, Modena, and other centers in Italy. Pisa, on the west coast of Tuscany, was a great maritime power from the ninth through the thirteenth century. An expansionist republic, it competed with Muslim centers for control of trade in the western Mediterranean. In 1063, Pisa won a decisive victory over Muslim forces, and the jubilant city

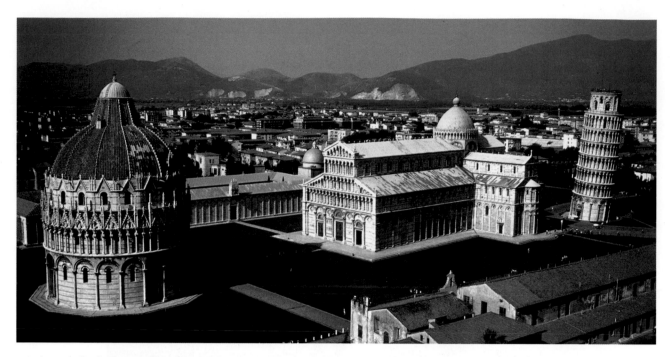

15-40. Cathedral complex, Pisa, Tuscany, Italy. Cathedral begun 1063; baptistry begun 1153; campanile begun 1174; Campo Santo 13th century

When finished in 1350, the Leaning Tower of Pisa stood 179 feet high. The campanile had begun to tilt while still under construction, and today it leans about 13 feet off the perpendicular. In the latest effort to keep it from toppling, engineers filled the base with tons of lead.

soon began constructing an imposing new cathedral dedicated to the Virgin Mary (fig. 15-40). The cathedral complex eventually included the cathedral itself; a **campanile**, or freestanding bell tower, a feature of Italian church architecture since the sixth century (this one now known for obvious reasons as the Leaning Tower); a baptistry; and the Campo Santo (Holy Field), a walled burial ground. The cathedral, designed by the master builder Busketos, was not completed until the late thirteenth century. Its plan is an adaptation on a grand scale of the cruciform basilica. It has a long nave with double side aisles crossed by a projecting transept each of which has aisles and an apse like the nave and main sanctuary. Three portals open onto the nave and side aisles, and a clerestory rises above the side aisles and second-story galleries. A dome covers the crossing. Pilasters, blind arcades, and narrow galleries adorn the five-story, pale-marble facade. An Islamic bronze griffin stood atop the building from about 1100 until 1828 (see fig. 8-17).

The Pisa baptistry, begun in 1153, has arcading and galleries on the lower levels of its exterior that match those on the cathedral (the baptistry's present exterior dome and ornate upper levels came later). The campanile was begun in 1174 by the master Bonanno Pisano. Built on inadequate foundations, it began to lean almost immediately. The cylindrical tower is encased in tier upon tier of marble arcades. This creative reuse of an ancient, classical theme is characteristic of Italian Romanesque art; artists and architects seem always to have been conscious of their Roman past.

Builders in Rome itself looked to revive the past when the city was destroyed in 1084. During the Investiture Controversy, Pope Gregory VII called on the Norman rulers of southern Italy for help when the forces of Emperor Henry IV threatened Rome. However, these erstwhile allies themselves looted and burned the city. Among the architectural victims was the eleventh-century Church of San Clemente. The Benedictines rebuilt the church between 1120 and 1130 as part of a program to restore Rome to its ancient splendor. The new church, built on top of the remains of a sanctuary of Mithras and the eleventh-century church, reflects a conscious effort to reclaim the artistic and spiritual legacy of the early Church (fig. 15-41). However, a number of features mark it as a Romanesque structure. A characteristic of early basilica churches, for example, was a strong horizontal movement down the nave to the sanctuary. In the new San Clemente, rectangular piers interrupt the line of Ionic columns, which had been assembled from ancient Roman buildings. In a configuration that came to be called the Benedictine plan, the nave and the side aisles each end in a semicircular apse. The different sizes of the apses, caused by the difference in the widths of the nave and the narrower side aisles, creates a stepped outline. The apse of the nave followed the outline of the apse of the older structure beneath and was too small to accommodate all the participants in the liturgy of the time. As a result, the choir, defined by the low barrier in the foreground of figure 15-41, was extended into the nave.

Mosaic was a rarely used medium in twelfth-century Europe because it required expensive materials and

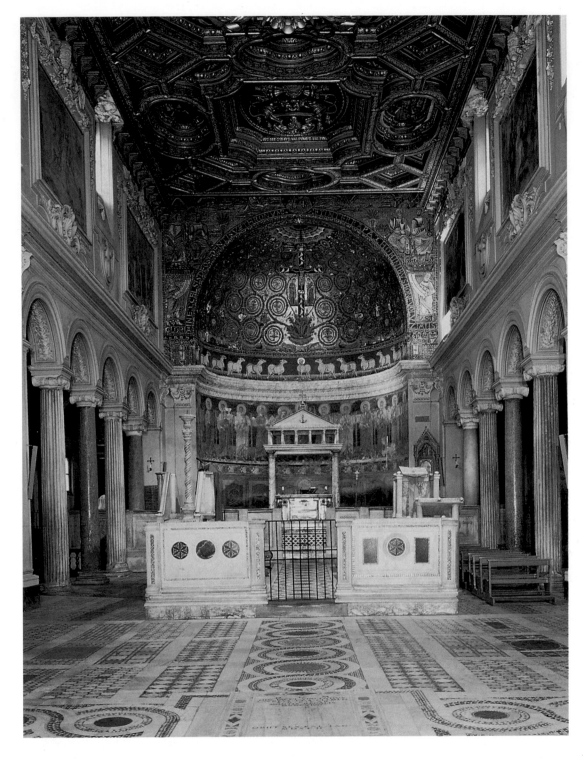

15-41. **Nave, Church of San Clemente, Rome**. c. 1120–30

Ninth-century choir screens were reused from the earlier church on the site. The upper wall and ceiling decoration are eighteenth century. San Clemente contains one of the earliest surviving collections of church furniture: choir stalls, pulpit, lecturn, candlestick, and also the twelfth-century inlaid floor pavement.

specialized artisans. The apse of San Clemente, however, is richly decorated with colored marble inlay and a gold mosaic apse half-dome, another reflection of its builders' desire to recapture the past. The style of the mosaics and the subject matter—a crucified Jesus, his mother, and Saint John, all placed against a vine scroll, and sheep representing the apostles and the Lamb of God—are likewise archaic. As in other Italian churches of the period, inlaid geometric patterns in marble embellish the floors of San Clemente. They are known as Cosmati work, after the family who perfected it. Ninth-century panels with relief sculptures, saved from

the earlier church, form the wall separating the choir from the nave. A **baldachin** (*baldacchino*), or canopy of honor symbolizing the Holy Sepulchre, covers the main altar in the apse.

The spirit of ancient Rome also pervades the sculpture of Romanesque Italy. Horizontal bands of relief on the west facade of Modena Cathedral, in north-central Italy, are among the earliest narrative portal sculpture in Italy (c. 1106–20). Wiligelmus, the sculptor, must have seen the sculpture of ancient sarcophagi and may also have looked at Ottonian carving. He took his subjects from the Old Testament Book of Genesis and included

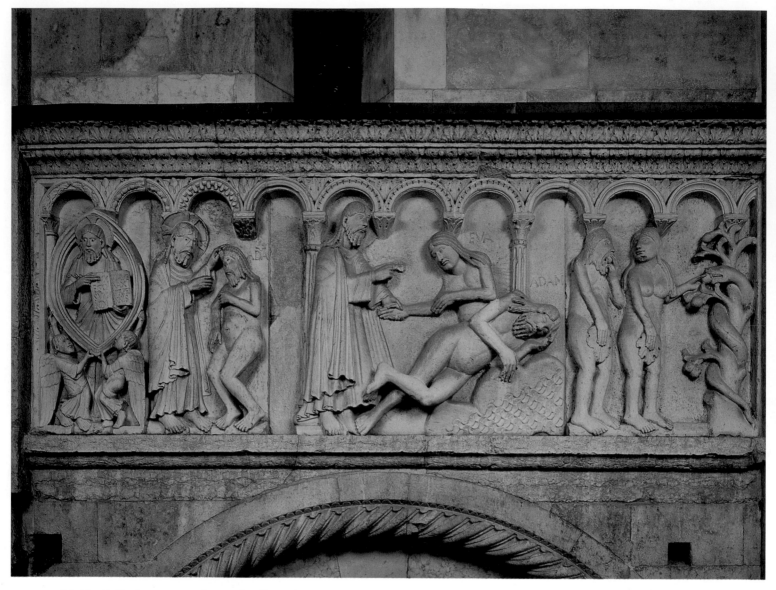

15-42. Wiligelmus. *Creation and Fall*, on the west facade, Modena Cathedral, Emilia, Italy. 1106–20. Height approx. 3' (92 cm)

events from the Creation to the Flood. The panel in figure 15-42 shows the Creation and the Fall of Adam and Eve. On the far left is a half-length God with a cruciform halo, indicating two persons—father and son—framed by a mandorla supported by two angels. The scene to the right shows God bringing Adam to life. Next, he brings forth Eve from Adam's side. On the right, Adam and Eve cover their genitals in shame as they greedily eat the fruit of the forbidden tree, around which the serpent twists.

Wiligelmus's deft carving and undercutting give these low-relief figures a strong three-dimensionality. While most Romanesque sculpture seems controlled by a strong frame or architectural setting, Wiligelmus used the arcade to establish a stagelike setting. Rocks and a tree add to the impression that figures interact with stage props. Wiligelmus's figures, although not particularly graceful, have a sense of life and personality and effectively convey the emotional depth of the narrative. Bright

paint, now almost all lost, must have increased the impact of the sculpture.

An inscription reads: "Among sculptors, your work shines forth, Wiligelmo [Wiligelmus]." This self-confidence turned out to be justified. Wiligelmus's influence can be traced throughout Italy and as far away as the cathedral of Lincoln in England. Wiligelmus, Roger, Gislebertus, and many anonymous women and men of the eleventh and twelfth centuries created a new art that—although based on the Bible and the lives of the saints—focused on human beings, their stories, and their beliefs. The artists worked on a monumental scale in painting, sculpture, and even embroidery, and their art moved from the cloister to the public walls of churches. While they emphasized the spiritual and intellectual concerns of the Christian Church, they also began to observe and record what they saw around them. In so doing they laid the groundwork for the art of the Gothic period.

PARALLELS

REGION	ROMANESQUE ART	ART IN OTHER CULTURES
FRANCE/ NORTHERN SPAIN	**15-1.** *Saint Foy* (late 10th–11th cent)	**7-39.** **Cathedral of Saint Mark** (begun 1063), Italy
	15-2. **Abbey Church of Sainte-Foy, Conques** (mid-11th to 12th cent)	**12-20.** **Great Serpent Mound** (c. 1070), North America
	15-5. **Cluny III** (1088–1130)	**7-44.** *Christ Pantokrator* (c. 1080–1100), Greece
	15-8. *Doubting Thomas* (c. 1100)	**7-42.** *Virgin of Vladimir* (12th cent.), Russia
	15-17. *Tower of Babel* (c. 1100)	**10-21.** Zhang. *Spring Festival on the River* (early 12th cent.), China
	15-16. **Church of Saint-Savin-sur-Gartempe** (c. 1100)	**12-23.** **Anasazi seed jar** (c. 1150), North America
	15-19. *Cluny Lectionary* (early 12th cent.)	**9-28.** *Shiva Nataraja* (12th cent.), India
	15-9. **Priory Church of Saint-Pierre, Moissac** (c. 1115/30)	**11-14.** *The Tale of Genji* (12th cent.), Japan
	15-10. *Lions and Prophet Jeremiah (?)* (c. 1115–30)	
	15-12. *Last Judgment* (c. 1120–35/40)	
	15-18. *Christ in Majesty* (c. 1123)	
	15-20. *The Tree of Jesse* (c. 1125)	
	15-6. **Abbey Church of Notre-Dame, Fontenay** (1139–47)	
	15-14. *Virgin and Child* (c. 1150–1200)	
	15-15. *Batlló Crucifix* (mid-12th cent.)	
NORTH SEA KINGDOMS	**15-22.** **Urnes panels** (c. 1050–70)	
	15-26. **Church of Saint-Étienne, Caen** (begun 1064)	
	15-31. *Bayeux Tapestry* (c. 1066–82)	
	15-23. **Durham castle-monastery-cathedral complex** (c. 1075–1100s)	
	15-29. *Worcester Chronicle* (c.1140)	
	15-30. *Winchester Psalter* (c. 1150)	
	15-21. **Borgund stave church, Sogn** (c. 1125–50)	
HOLY ROMAN EMPIRE	**15-33.** **Speyer Cathedral** (remodeled c. 1081–1106)	
	15-35. **Tomb cover with effigy of Rudolf of Swabia** (after 1080)	
	15-36. **Helmarshausen altar** (c. 1100)	
	15-34. **Church of Sant'Ambrogio, Milan** (after 1117)	
	15-37. **Griffin aquamanile** (c. 1130)	
	15-38. *Hildegard's Vision* (c. 1150–1200)	
	15-39. **Guda self-portrait** (early 12th cent.)	
ROME AND ROMANESQUE ITALY	**15-40.** **Pisa Cathedral complex** (begun 1063)	
	15-41. **Church of San Clemente, Rome** (c. 1120–30)	
	15-42. *Creation and Fall,* (1106–20)	

16 Gothic Art

16-1. Triforium wall of the nave,
Chartres Cathedral,
the Cathedral of Notre-Dame,
Chartres, France. c. 1194–1260

The twelfth-century Abbot Suger of Saint-Denis was, according to his biographer Wil-lelmus, "small of body and family, constrained by twofold smallness, [but] he refused, in his smallness, to be a small man" (cited in Panofsky, page 33). Educated at the monastery of Saint-Denis, near Paris, he rose from modest origins to become a powerful adviser to kings. And he built what many consider the first Gothic structure in Europe.

After Suger was elected abbot of Saint-Denis, he was determined to rebuild its church. Within it were housed the relics of Saint Denis—patron saint of France—and the remains of the kings of the Franks, whose burials had taken place there since the seventh century. Suger waged a successful campaign to gain both royal and popular support for his rebuilding plans. The current building, he pointed out, had become inad-equate. With a touch of exaggeration, he claimed that the crowds of worshipers had become so great that women were being crushed and monks sometimes had to flee with their relics by jumping through windows.

In carrying out his duties, the abbot had traveled widely—in France, the Rhineland, and Italy, including four trips to Rome—and so was familiar with the latest architecture and sculpture of Romanesque Europe. As he began planning the new church, he also turned for inspiration to Church writings, including the writings of a late-fifth-century Greek philosopher known as the Pseudo-Dionysius, who had identified radiant light with divinity. Seeing the name "Dionysius" (Denis), Suger thought he was reading the work of Saint Denis, so Suger not unreasonably adapted the concept of divine lumi-nosity into the redesign of the church dedicated to Saint Denis. Accordingly, when Suger began work on the choir after completing a magnificent Norman-inspired facade and narthex, he created "a circular string of chapels" so that the whole church "would shine with the wonderful and uninterrupted light of most luminous windows, pervad-ing the interior beauty" (cited in Panofsky, page 101).

Although Abbot Suger died before he was able to finish rebuilding Saint-Denis, his presence remained: The cleric had himself portrayed in a sculpture at Christ's feet in the central portal and in a stained-glass window in the apse. Suger is remembered not for these portraits, however, but for his inspired departure from traditional architecture in order to achieve radiant interior light. His innovation led to the widespread use of large stained-glass windows, such as those that bathe the inside walls of Chartres Cathedral with sublime washes of color (fig. 16-1).

▲ 1204 FOURTH CRUSADE 1261 WESTERN CONTROL OF ▲
TAKES CONSTANTINOPLE CONSTANTINOPLE ENDS

TIMELINE 16-1. Gothic Art in Europe. In the two and a half centuries following 1150, known as the Gothic era, Europe underwent a gradual shift toward urbanization and experienced political, religious, and social change.

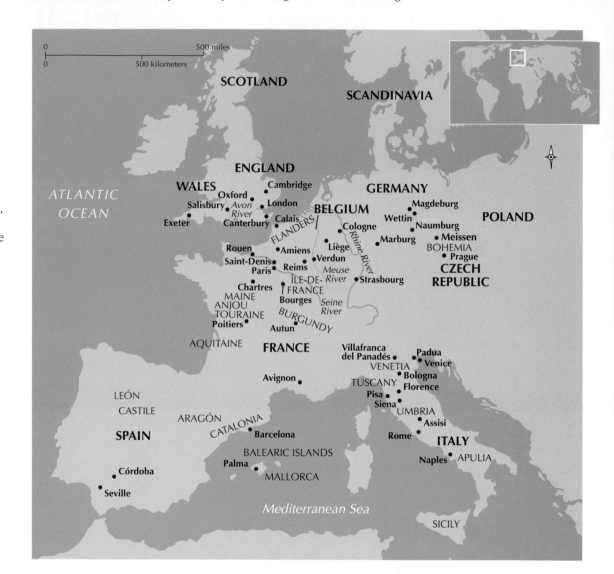

MAP 16-1. Gothic Art in Europe. Gothic art began in the Île-de-France in about 1140 and spread throughout Europe during the next 250 years.

THE GOTHIC STYLE

In the middle of the twelfth century, while builders throughout Europe were working in the Romanesque style, a distinctive new architecture known today as Gothic emerged in the Île-de-France, the French king's domain around Paris (Map 16-1). The appearance there of the new style and building technique coincided with the emergence of the monarchy as a powerful centralizing force in France. From that point, the Gothic style spread, and it prevailed in western European art until about 1400, then lingered for another century in some regions. The term *Gothic* was introduced in the sixteenth century by the Italian artist and historian Giorgio Vasari, who disparagingly attributed the style to the Goths, the Germanic invaders who had destroyed the classical civilization of the Roman Empire that he and his contemporaries so admired. In its own day the Gothic style was simply called modern style or the French style. As it spread from the Île-de-France, it gradually displaced Romanesque forms but took on regional characteristics inspired by those forms. England developed a distinctive national style, which also influenced architectural design in continental Europe. The Gothic style was slow to take hold in Germany but ultimately endured there well into the sixteenth century. Italy proved more resistant to French Gothic elements, and by 1400, Italian artists and builders there sought a return to classical traditions. In the late fourteenth century, the various regional styles of Europe coalesced into what is known as the International Gothic style.

▲ 1309 PAPACY MOVES TO AVIGNON FROM ROME
▲ 1337 HUNDRED YEARS' WAR BEGINS
▲ 1348 BLACK DEATH BEGINS

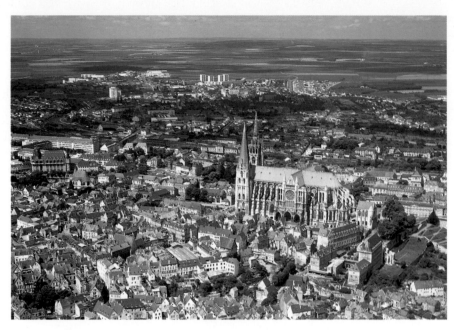

16-2. Chartres Cathedral, the Cathedral of Notre-Dame, Chartres, France.
West facade begun c. 1134; cathedral rebuilt after a fire in 1194 and building continued to 1260; north spire 1507–13. View from the southeast

Chartres was the site of a pre-Christian virgin-goddess cult and one of the oldest and most important Christian shrines in France. Its main treasure was a long piece of linen believed to have been worn by Mary—a gift from the Byzantine empress Irene to Charlemagne, which was donated to the cathedral by King Charles the Bald in 876—that was on display with other relics in a huge basement crypt. The healing powers attributed to this relic and its association with Mary made Chartres a major pilgrimage destination as the cult of the Virgin grew.

Gothic architecture's elegant, soaring buildings, the light, colors, and sense of transparency produced by great expanses of stained glass, and its linear qualities became more pronounced over time. The style was adapted to all types of structures—including town halls, meeting houses, market buildings, residences, and Jewish synagogues, as well as churches and palaces—and its influence extended beyond architecture and architectural sculpture to painting and other mediums.

The people of western Europe experienced both great achievements and great turmoil during the Gothic period. Although Europe remained rural, towns gained increasing prominence. By the late twelfth century, nearly all the major cities in western Europe today were sizable urban centers. The rise of towns stimulated intellectual life, and urban universities supplanted rural monastic schools as centers of learning. The first European university, at Bologna, Italy, was founded in the eleventh century, and important universities in Paris, Cambridge, and Oxford soon followed. The Gothic period saw the flowering of poetry and music as well as philosophy and theology.

As towns grew, they became increasingly important centers of artistic patronage. The production and sale of goods in many towns was controlled by guilds. Merchants and artisans of all types, from bakers to painters, formed these associations to advance their professional interests. Medieval guilds also played an important social role, safeguarding members' political interests, organizing religious celebrations, and looking after members and their families in times of trouble.

A town's walls enclosed streets, wells, market squares, shops, churches, and schools. Homes ranged from humble wood-and-thatch structures to imposing town houses of stone. Although wooden dwellings crowded together made fire an ever-present danger and hygiene was rudimentary at best, towns fostered an energetic civic life and a strong communal identity, reinforced by public projects and ceremonies.

Urban cathedrals, the seats of the ruling bishops, superseded rural monasteries as centers of religious patronage throughout western Europe during the Gothic period. So many of these churches were rebuilt between 1150 and 1400—usually after fires—that the period has been called the age of cathedrals. Cathedral precincts functioned almost as towns within towns. The great churches dominated their surroundings and were central fixtures of urban life (fig. 16-2). Their grandeur inspired

love and admiration; their great expense and the intrusive power of their bishops inspired resentment and fear. The twelfth century witnessed a growth of intense religiosity among the laity, particularly in Italy and France. The same devotional intensity gave rise in the early thirteenth century to two new religious orders, the Franciscans and the Dominicans, whose monks went out into the world to preach and minister to those in need, rather than confining themselves in monasteries.

The Crusades continued throughout the thirteenth century (see "The Crusades," page 517). In 1204, soldiers of the Fourth Crusade who had set out to conquer Egypt from the Muslims instead seized Constantinople—capital of the Byzantine Empire and the center of the Eastern Christian Church—and the city remained under Western control until 1261. The Crusades and the trade that followed from them brought western Europeans into contact with the Byzantine and Islamic worlds, and through them many literary works of classical antiquity, particularly those of Aristotle. These works posed a problem for medieval scholars because they promoted rational inquiry rather than faith as the path to truth, and their conclusions did not always fit comfortably with Church doctrine. A philosophical and theological movement called Scholasticism emerged to reconcile the two belief systems. The Dominican Thomas Aquinas (1225–74), the foremost Scholasticist, used reason to comprehend religion's supernatural aspects and in his writings convincingly integrated scientific rationalism with Christian faith. His work has endured as a basis of Catholic thought to this day.

The Scholastic thinkers applied their system of reasoned analysis to a vast range of subjects. Vincent de Beauvais, a thirteenth-century Parisian Dominican, organized his eighty-volume encyclopedia, *Speculum Maius* (*Greater Mirror*), to include categories of the Natural World, Doctrine, History, and Morality. This all-encompassing intellectual approach had a profound influence on the arts. Like the Scholastics, Gothic master builders saw divine order in geometric relationships and used these relationships as the underpinnings of architectural and sculptural programs. Sculptors and painters created naturalistic forms that reflected the combined idealism and analysis of Scholastic thought. Gothic religious imagery expanded to incorporate a wide range of subjects from the natural world, and like Romanesque imagery its purpose was to instruct and convince the viewer. In the Gothic cathedral, Scholastic logic intermingles with the mysticism of light and color to create for the worshiper the direct, emotional, ecstatic experience of the church as the embodiment of God's house, filled with divine light.

Yet beneath the achievements of the era lay the seeds of disaster. By the middle of the fourteenth century much of Europe was in crisis. Prosperity had fostered population growth, which by about 1300 began to

In the early 1340s rumors began to circulate in Europe of a deadly plague spreading by land and sea from Asia. By 1348 the plague had reached Constantinople, Italy, and France; by the next winter it had struck the British Isles; and by 1350 it had swept across Germany, Poland, and Scandinavia. Successive waves struck again in 1362, 1374, 1383, 1389, and 1400, and new outbreaks continued sporadically over the next centuries, culminating in England's Great Plague of 1665. As much as half the urban population of Florence and Siena died in the summer of 1348, including many promising artists. England was similarly hard hit.

The plague, known as the Black Death, took two forms, both of which killed rapidly. The bubonic form was spread by fleas from rats, the pneumonic form through the air from the lungs of infected victims. To people of the time, ignorant of its causes and powerless to prevent it, the Black Death was a catastrophe. The fourteenth-century Italian writer Giovanni Boccaccio described how "the calamity had instilled such terror in the hearts of men and women that . . . fathers and mothers shunned their children, neither visiting them nor helping them" (cited in Herlihy, page 355). In their panic, some people turned to escapist pleasure seeking, others to religious fanaticism. Many, seeking a scapegoat, turned against Jews, who were massacred in several cities.

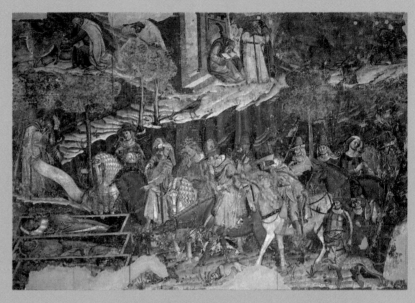

Francesco Traini. *Triumph of Death*, detail of a fresco in the Campo Santo, Pisa. 1325–50

exceed food production, and famines became increasingly common. Peasant revolts began as worsening conditions frustrated rising expectations. In 1337 a prolonged conflict known as the Hundred Years' War (1337–1453) erupted between France and England, devastating much of France. In the middle of the fourteenth century a lethal plague swept northward from Sicily, wiping out as much as 40 percent of Europe's population (see "The Black Death," above). By depleting the labor force, however, the plague gave surviving peasants increased leverage over their landlords and increased the wages of artisans. The Church, too, experienced great strain during the fourteenth century. In 1309 the papal court moved from Rome to Avignon, in southeastern France, where it remained until 1377. From 1378 to 1417, in what is known as the Great Schism, the papacy split, with two contending popes, one in Avignon and one in Rome, claiming legitimacy.

FRANCE The birth and initial flowering of the Gothic style took place in France against the backdrop of the growing power of the French monarchy. Louis VI (ruled 1108–37) and Louis VII (ruled 1137–80) consolidated royal authority over the Île-de-France and began to exert control over powerful nobles in other regions. Before succeeding to the throne, Louis VII had married Eleanor (1122–1204), heir to the region of Aquitaine (southwestern France), the largest and most prosperous feudal domain in western Europe. Eleanor of Aquitaine was one of the great figures of her age. She accompanied Louis on the Second Crusade (1147–49), but the marriage was later annulled by papal decree. Taking her wealthy province with her, Eleanor then married Henry Plantagenet—the soon-to-be King Henry II of England. Henry and Eleanor together controlled more French territory than the French king, although he was technically their feudal overlord. The resulting tangle of conflicting claims eventually culminated in the Hundred Years' War.

The successors to Louis VII continued the consolidation of royal authority and nation building, increasing their domains and privileges at the expense of their vassals and the Church.

ARCHITECTURE AND ITS DECORATION

The political events of the twelfth and thirteenth centuries were accompanied by a burst of church building, often made necessary by the fires that swept through towns. It has been estimated that during the Middle Ages several million tons of stone were quarried to build some eighty cathedrals, 500 large churches, and tens of thousands of parish churches, and that within 100 years some 2,700 churches were built in the Île-de-France region alone. This explosion of cathedral building began at a historic abbey church on the outskirts of Paris.

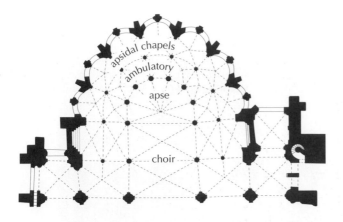

16-3. Plan of the sanctuary, Abbey Church of Saint-Denis, Saint-Denis, France. 1140–44

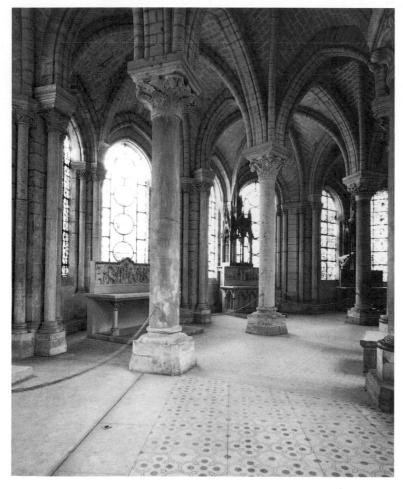

16-4. Ambulatory choir, Abbey Church of Saint-Denis

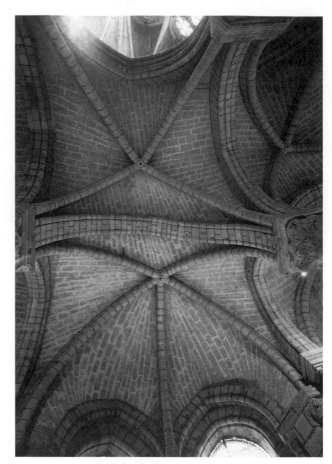

16-5. Ambulatory vaults, Abbey Church of Saint-Denis

Abbey Church of Saint-Denis. The Benedictine monastery of Saint-Denis, a few miles north of central Paris, had great symbolic significance for the French monarchy. It housed the tombs of French kings, regalia of the French Crown, and the relics of Saint Denis, the patron saint of France, who, according to tradition, had been the first bishop of Paris. In the 1130s, under the inspiration of Abbot Suger, construction began on a new abbey church, which is arguably Europe's first Gothic structure.

Suger (1081–1151) was a trusted adviser to both Louis VI and Louis VII, and he governed France as regent when Louis VII and Eleanor of Aquitaine went on crusade.

Suger described his administration of the abbey and the building of the Abbey Church of Saint-Denis in three books. In contrast to the austerity advocated by the Cistercian Abbot Bernard of Clairvaux (Chapter 15), Suger prized magnificent architecture and art. The widely traveled cleric had seen the latest developments in church building, and his design combines elements from many sources. Because the Île-de-France had great Carolingian buildings and little monumental Romanesque architecture, Suger brought in masons and sculptors from other regions. Saint-Denis thus became a center of artistic interchange. Unfortunately for art historians today, Suger did not record the names of the masters he employed, nor information about them and the techniques they used, although he took an active part in the building. He found the huge trees and stone needed on the abbey's own lands. To generate income for the rebuilding, he instituted economic reforms, receiving substantial annual payments from the town's inhabitants and establishing free housing on abbey estates to attract peasants. For additional funds, he turned to the royal coffers and even to fellow clerics.

The first part of the new structure to be completed was the west facade and narthex (1135–40). Here Suger's masons combined Norman facade design like that at

Rib vaulting was one of the chief technical contributions of Romanesque and Gothic builders. Rib vaults are a form of **groin vault** (see "Arch, Vault, and Dome," page 228), in which the ridges (groins) formed by the intersecting vaults may rest on and be covered by curved moldings called ribs. These ribs were usually structural as well as decorative, and they strengthened the joins and helped channel the vaults' thrust outward and downward. The ribs were constructed first and supported the scaffolding of the vault. Ribs developed over time into an intricate masonry "skeleton" filled with an increasingly lightweight masonry "skin," the web of the vault, or webbing. Sophisticated variations on the basic rib vault created the soaring interiors for which Gothic churches are famous.

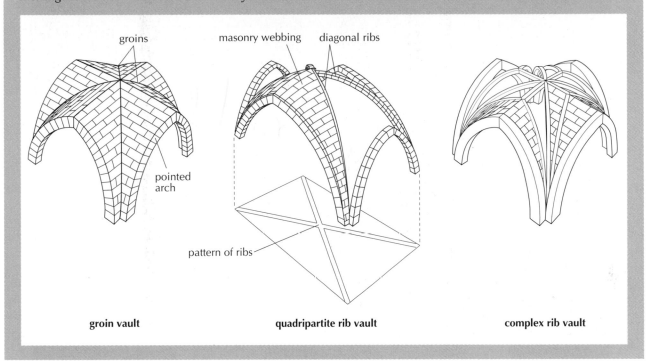

groins

masonry webbing diagonal ribs

pointed arch

pattern of ribs

groin vault quadripartite rib vault complex rib vault

Caen (see fig. 15-26) with the richly sculptured portals of Burgundy, like those at Autun (see fig. 15-11). The east end represented a more stunning change. The choir was completed in three years and three months (1140–44), timing that Abbot Suger found auspicious. The plan of the choir (*chevet* in French) resembled that of a Romanesque pilgrimage church, with a semicircular sanctuary surrounded by an ambulatory from which radiated seven chapels of uniform size (fig. 16-3). All the architectural elements of the choir—ribbed groin vaults springing from round piers, pointed arches, wall buttresses to relieve stress on the walls, and window openings—had already appeared in Romanesque buildings. The dramatic achievement of Suger's master mason was to combine these features into a fully integrated architectural whole that emphasized the open, flowing space. Sanctuary, ambulatory, and chapels opened into one another; walls of stained glass replaced masonry, permitting the light to permeate the interior with color (fig. 16-4). To accomplish this effect, the masons relied on the systematic use of advanced vaulting techniques, the culmination of half a century of experiment and innovation (fig. 16-5; see "Rib Vaulting," above).

The apse of Saint-Denis represented the emergence of a new architectural aesthetic based on line and light. Citing early Christian writings, Suger saw light and color as a means of illuminating the soul and uniting it with

God, a belief he shared with medieval mystics such as Hildegard of Bingen (Chapter 15). For him, the colored lights of gemstones and stained-glass windows and the glint of golden church furnishings at Saint-Denis transformed the material world into the splendor of paradise.

Louis VII and Eleanor of Aquitaine attended the consecration of the new choir on June 14, 1144. Shortly thereafter the impending Second Crusade became the primary recipient of royal resources, leaving Suger without funds to replace the old nave and transept at Saint-Denis. The abbot died in 1151, and his church remained unfinished for another century. (Saint-Denis suffered extensive damage during the French Revolution in the late eighteenth century. Its current condition is the result of nineteenth- and twentieth-century restorations and cleaning.)

The Abbey Church of Saint-Denis became the prototype for a new architecture of space and light based on a highly adaptable skeletal framework constructed from buttressed perimeter walls and an interior vaulting system of pointed-arch masonry ribs. It initiated a period of competitive experimentation in the Île-de-France and surrounding regions that resulted in ever larger churches enclosing increasingly tall interior spaces walled with ever greater expanses of colored glass. These great churches, with their unabashed decorative richness, were part of Abbot Suger's legacy to France.

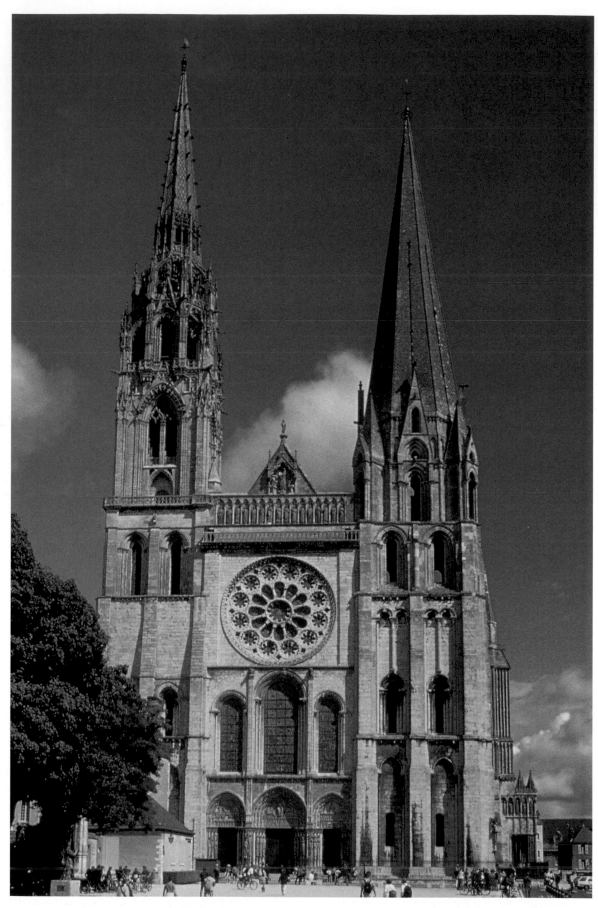

16-6. West facade, Chartres Cathedral, the Cathedral of Notre-Dame, Chartres, France. c. 1134–1220; south tower c. 1160; north tower 1507–13

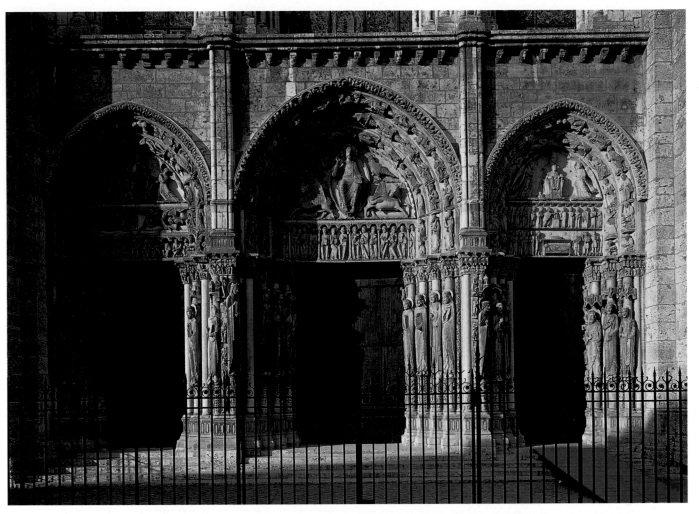

16-7. Royal Portal, west facade, Chartres Cathedral. c. 1145–55

Chartres Cathedral. The great Cathedral of Notre-Dame ("Our Lady," the Virgin Mary) dominates the town of Chartres, southwest of Paris (see fig. 16-2). For many people, Chartres Cathedral is a near-perfect embodiment of spirit in stone and glass. Constructed in several stages beginning in the mid-twelfth century and extending into the mid-thirteenth with later additions such as the north spire in the sixteenth century, the cathedral reflects the transition from an experimental twelfth-century phase to a mature thirteenth-century style. A fire in 1134 that damaged the western facade of an earlier cathedral on the site prompted the building of a new facade, influenced by the early Gothic style at Saint-Denis. After another fire in 1194 destroyed most of the rest of the original structure, a papal representative convinced reluctant local church officials to undertake a massive rebuilding project. He argued that the Virgin permitted the fire because she wanted a new and more beautiful church to be built in her honor (quoted in Von Simson, page 163). A new cathedral was built between approximately 1194 and 1260.

To erect such an enormous building required vast resources—money, raw materials, and skilled labor. Contrary to common perceptions, medieval people often opposed the building of cathedrals because of the burden of new taxes. Nevertheless, cathedral officials pledged all or part of their incomes for three to five years. The church's relics were sent on tour as far away as England to solicit contributions. As the new structure rose higher during the 1220s, the work grew more costly and funds dwindled. When the bishop and canons (cathedral clergy) tried to make up the deficit by raising feudal and commercial taxes, they were driven into exile for four years. The economic privileges claimed by the Church for the cathedral sparked intermittent riots by townspeople and the local nobility throughout the thirteenth century. Despite these tensions, the new cathedral emerged as a work of remarkable balance and harmony, still inspiring today, even to nonbelievers.

From a distance, the most striking features of the west facade are its prominent rose window—the huge circle of stained glass—and two towers and spires (fig. 16-6). The spire on the north tower (left) was added in the early sixteenth century; the spire on the south tower dates from the twelfth century. On closer inspection, the facade's three doorways—the so-called Royal Portal—capture the attention with their sculpture (fig. 16-7). Christ Enthroned in Royal Majesty dominates the central

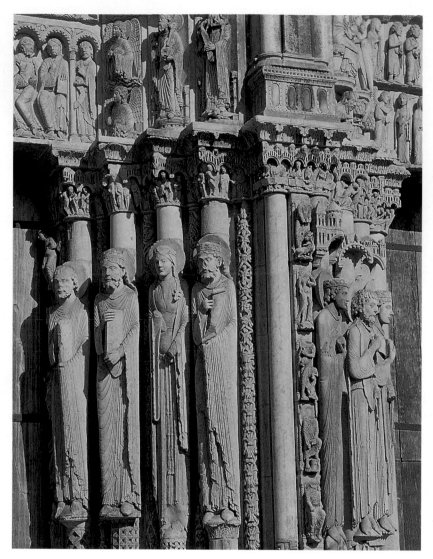

16-8. *Prophets and Ancestors of Christ*, right side, central portal, Royal Portal, Chartres Cathedral. c. 1145–55

tympanum. Flanking the doorways are monumental **column statues**, a form that originated at Saint-Denis. These column statues depict nineteen of the twenty-two Old Testament figures who were seen as precursors of Christ (fig. 16-8). In other biblical references, the builders of Gothic cathedrals identified themselves symbolically with Solomon, the builder of the Temple in Jerusalem, and the depiction of Old Testament kings and queens evokes the close ties between the Church and the French royal house. Because of this relationship, still potent after 600 years, most such figures at other churches were smashed during the French Revolution.

Earlier sculptors had achieved dramatic, dynamic effects by compressing, elongating, and bending figures to fit them into an architectural framework. At Chartres, in contrast, the sculptors sought to pose their high-relief figures naturally and comfortably in their architectural settings. The erect, frontal column statues, with their elongated proportions and vertical drapery, echo the cylindrical shafts from which they emerge. Their heads are finely rendered with idealized features.

Calm and order prevail in the imagery of the Royal Portal, in contrast to the somewhat more crowded imagery at many Romanesque churches, such as those at Moissac (see fig. 15-9) and Autun (see fig. 15-11). Christ in the central tympanum of the Royal Portal appears imposing but more benign and less terrifying than in earlier representations. The Twelve Apostles in the lintel below him and the twenty-four elders in the archivolts above him have been placed according to hierarchical scale—an arrangement by size and location to reflect their relative importance—with little narrative interaction between them. Even in narrative scenes, calm prevails, as in the Ascension of Christ in the tympanum of the left doorway and the enthroned Virgin and Child in the tympanum of the right doorway.

Column statues became standard elements of Gothic church portals, developing from shaftlike reliefs to fully three-dimensional figures that appear to interact with one another as well as with approaching worshipers. A comparison of the column statues of the Royal Portal with those of the south transept portal illustrates this

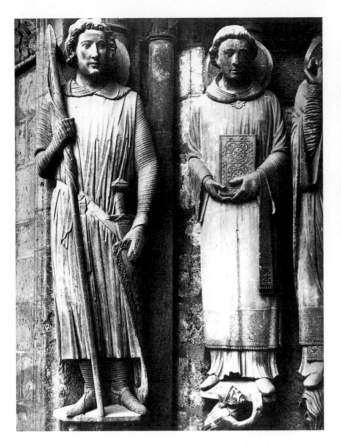

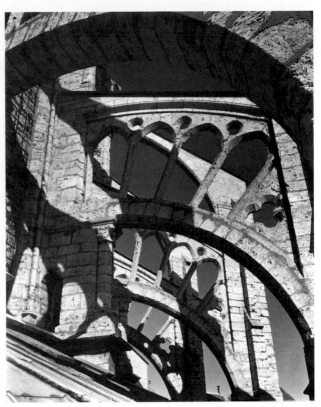

16-9. *Saint Stephen* (right, c. 1210–20) and *Saint Theodore* (left, c. 1230–35), left side, left portal, south transept entrance, Chartres Cathedral

16-10. Flying buttresses, Chartres Cathedral. c. 1200–20

transition. Figure 16-9 shows two column statues from the south transept portal. *Saint Stephen*, on the right, was made between 1210 and 1220; *Saint Theodore*, on the left, between 1230 and 1235. More lifelike than their predecessors, they seem to stand on projecting bases with carved brackets. The bases reinforce the illusion that the figures are free of the architecture to which they are attached. In another change, the dense geometric patterning and stylized foliage around the earlier statues have given way to plain stone.

Saint Stephen, still somewhat cylindrical, is more naturally proportioned than the earlier figures on the west facade. The sculptor has also created a variety of textures to differentiate cloth, embroidery, flesh, and other features. The later *Saint Theodore* reflects its sculptor's attempt to depict a convincingly "alive" figure. The saint is dressed as a contemporary crusader and stands, purposeful but contemplative, with his feet firmly planted and his hips thrust to the side (a pose often called the Gothic S-curve). The meticulous detailing of his expressive face and the textures of his chain mail and surcoat help create a strong sense of physical presence.

Many nearby churches built by local masons about the same time as Chartres Cathedral reflect an earlier style and are relatively dark and squat. Unlike them, Chartres was the work of artisans from areas north and northeast of the town who were accomplished

practitioners of the Gothic style. In the new cathedral they brought together the hallmark Gothic structural devices for the first time: the pointed arch, ribbed groin vaulting, the **flying buttress**, and the *triforium*, now designed as a mid-level passageway (see "The Gothic Church," page 568). The flying buttress, a gracefully arched, skeletal exterior support, counters the outward thrust of the vaulting over the nave and aisles (fig. 16-10). The Gothic *triforium* (which was a flat wall in the basilica church or a gallery in Byzantine and Romanesque architecture) overlooks the nave through an arcaded screen that contributes to the visual unity of the interior (fig. 16-11, page 566). Building on the concept pioneered at Saint-Denis of an elegant masonry shell enclosing a large open space, the masons at Chartres erected a structure with one of the widest naves in Europe and vaults that soar 118 feet above the floor. The enlarged sanctuary, another feature derived from Saint-Denis, occupies one-third of the building (fig. 16-12, page 567). The large and luminous clerestory is filled by pairs of tall, arched windows called **lancets** surmounted by circular windows, or *oculi*, and stained glass covers nearly half the clerestory surfaces. Whereas at a Romanesque pilgrimage church like Sainte-Foy (see fig. 15-4) the worshiper's gaze is drawn forward toward the apse, at Chartres it is drawn upward—to the clerestory windows and the soaring vaults overhead—as well as forward. Relatively little interior architectural decoration

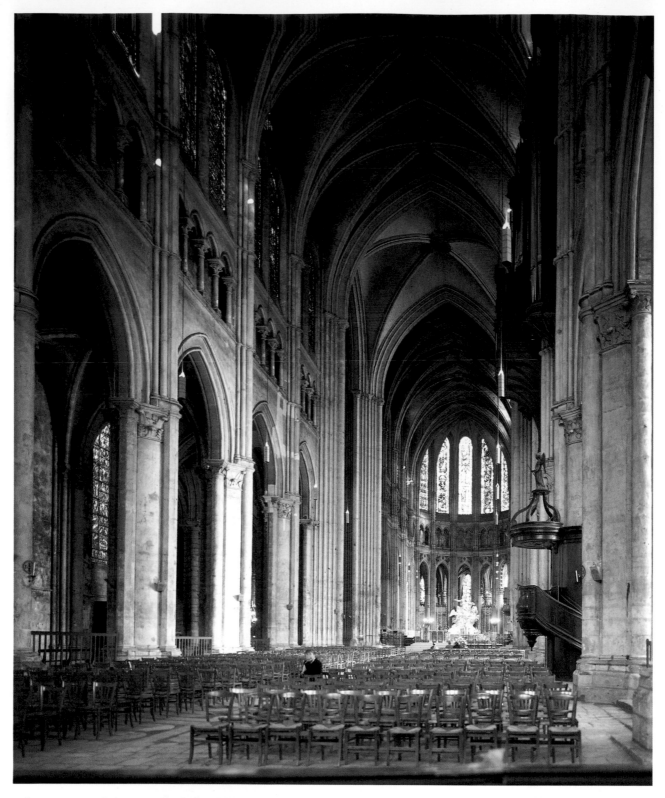

16-11. Nave, Chartres Cathedral. c. 1194–1260

Medieval churches did not have chairs or pews—the only seating was in the choir stalls. In this photograph, chairs have been turned away from the altar in preparation for a dramatic performance to be held in the narthex.

interrupts the visual rhythm of shafts and arches. Four-part vaulting has superseded more complex systems such as that at Durham Cathedral (see fig. 15-25), and the alternating heavy and light piers typical of Romanesque naves such as that at Speyer Cathedral (see fig. 15-33) have been eliminated.

At Chartres, architectural engineering incorporated numerical symbolism, reflecting Scholastic belief that the divine order of the natural world is expressed in its geometry. For example, the number 3, representing the Trinity, is reflected in the equilateral triangle that establishes the three points of the outer edges of the cathedral's buttresses and the keystone of the vault in the nave. Chartres's decorative program also encompasses number symbolism, for example, the number three represents the spiritual world of the Trinity, while the number 4

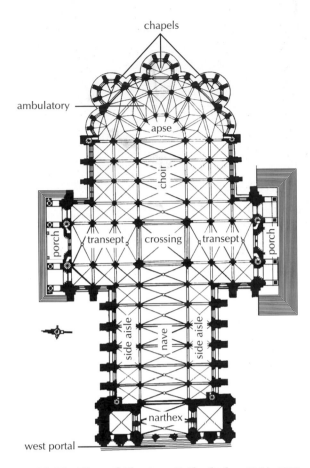

16-12. Plan of Chartres Cathedral. c. 1194–1220

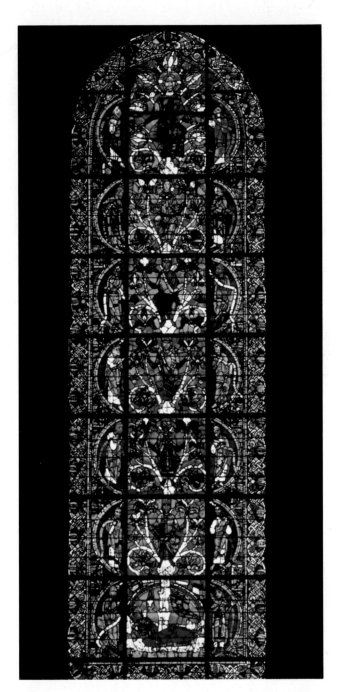

16-13. *Tree of Jesse*, west facade, Chartres Cathedral.
c. 1150–70. Stained glass

represents the material world (the four winds, the four seasons, the four rivers of paradise). Combined, they form the perfect and all-inclusive number 7, expressed in the seven gifts of the Holy Spirit. References to the number seven recur throughout the church imagery. On the west facade, for example, the seven liberal arts surround the image of the Christ Child and Mary, that is, Notre Dame, to whom the church is dedicated. The imagery of Chartres, which emphasizes themes involving Mary, the Old Testament precursors of Christ, and the saints who came after the Incarnation, reflects the entire program of Scholastic thought.

Chartres is unique among French Gothic buildings in that most of its stained-glass windows have survived. The light from these windows changes constantly as sunlight varies with the time of day, the seasons, and the movement of clouds. Stained glass is an expensive and difficult medium, but its effect on the senses and emotions makes the effort worthwhile (see "Stained-Glass Windows," page 569). Chartres was famous for its glass-making workshops, which by 1260 had installed about 22,000 square feet of stained glass in 176 windows. Most of the glass dates between about 1210 and 1250, but a few earlier windows, from around 1150 to 1170, were preserved in the west facade. The iconography of the windows echoes that of the portal sculpture.

Among the twelfth-century works of stained glass in the west wall of the cathedral is the *Tree of Jesse* window (fig. 16-13). The monumental treatment of this subject, much more complex than its depiction in an early twelfth-century Cistercian manuscript (see fig. 15-20), was apparently inspired by a similar window at Saint-Denis. The body of Jesse lies at the base of the tree, and in the branches above him appear, first, four kings of Judaea, Christ's royal ancestors, then the Virgin Mary, and finally Christ himself. Seven doves, symbolizing the seven gifts of the Holy Spirit, encircle Christ, and fourteen prophets stand in the half-moons flanking the tree.

The glass in the *Tree of Jesse* is set within a rectilinear iron armature (visible as silhouetted black lines). In a later work, the *Charlemagne Window* (figs. 16-14, 16-15, page 569), the glass is set within an interlocking

ELEMENTS OF ARCHITECTURE

The Gothic Church

Most large Gothic churches in western Europe were built on the **Latin-cross plan**, with a projecting **transept** marking the transition from **nave** to **sanctuary**. The main entrance **portal** was generally on the west, the **choir** and **apse** on the east. A **narthex** led to the nave and **side aisles**. An **ambulatory** with radiating chapels circled the apse and facilitated the movement of worshipers through the church. Above the nave were a *triforium* passageway and windowed **clerestory**. Narthex, side aisles, ambulatory, and nave usually had **rib vaults** in the Gothic period. Church walls were decorated inside and out with **arcades** of round and pointed arches,

engaged columns and **colonnettes**, and horizontal moldings called **stringcourses**. The roof was supported by a wooden framework. A spire or **crossing** tower above the junction of the transept and nave was usually planned, though often never finished. The **buttress piers** and **flying buttresses** that countered the outward thrusts of the interior vaults were visible on the outside. Portal facades were customarily marked by high, flanking towers or **gabled** porches ornamented with **pinnacles** and **finials**. Architectural sculpture generally covered each portal's **tympanum**, **archivolts**, and **jambs**. A magnificent stained-glass rose window typically formed the centerpiece of the facades. More stained glass filled the tall, pointed **lancet**-shaped aisle and clerestory windows.

Chartres Cathedral

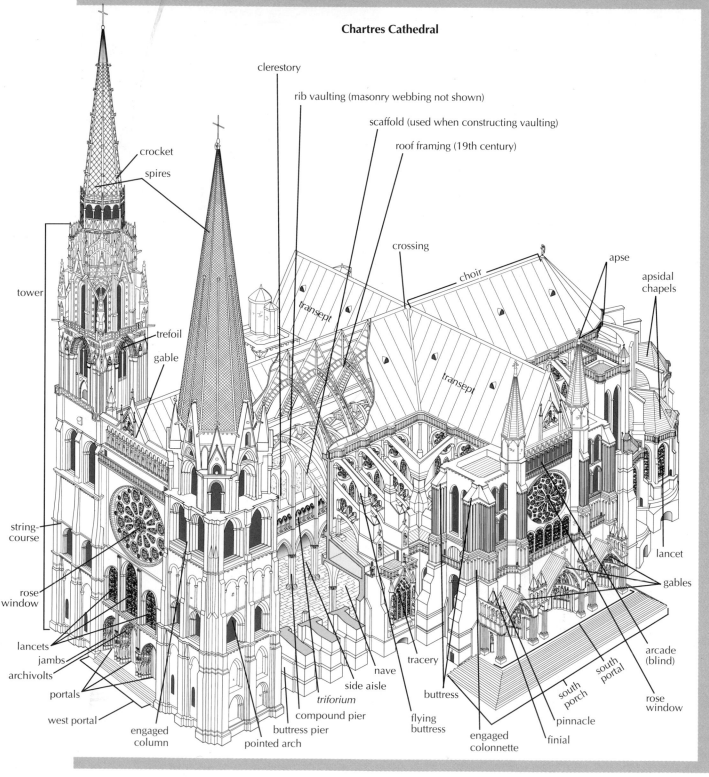

STAINED-GLASS WINDOWS

The basic technique for making colored glass has been known since ancient Egypt. It involves the addition of metallic oxides—cobalt for blue, manganese for red and purple—to a basic formula of sand and ash or lime that is fused at high temperature. Such "stained" glass was used on a small scale in church windows during the Early Christian period and in Carolingian and Ottonian churches. Colored glass sometimes adorned Romanesque churches, but the art form reached a height of sophistication and popularity in the cathedrals and churches of the Gothic era.

Making a stained-glass image was a complex and costly process. A designer first drew a composition on a wood panel the same size as the opening of the window to be filled, noting the colors of each of the elements in it. Glassblowers produced sheets of colored glass, then artisans cut individual pieces from these large sheets and laid them out on the wood template. Painters added details with enamel emulsion, and the glass was reheated to fuse the enamel to it. Finally, the pieces were joined together with narrow lead strips, called **cames**. The assembled pieces were set into iron frames that had been made to fit the window opening.

The colors of twelfth-century glass—mainly reds and blues with touches of dark green, brown, and orange yellow—were so dark as to be nearly opaque, and early uncolored glass was full of impurities. But the demand for stained-glass windows stimulated technical experimentation to achieve new colors and greater purity and transparency. The Cistercians adorned their churches with **grisaille** windows, painting foliage and crosses onto a gray glass, and Gothic artisans developed a clearer material onto which elaborate narrative scenes could be drawn.

By the thirteenth century, many new colors were discovered, some accidentally, such as a sunny yellow produced by the addition of silver oxide. Flashing, in which a layer of one color was fused to a layer of another color, produced an almost infinite range of colors. Blue and yellow, for example, could be combined to make green. In the same way, clear glass could be fused to layers of colored glass in varying thicknesses to produce a range of hues from light to dark. The deep colors of early Gothic stained-glass windows give them a saturated and mysterious brilliance. The richness of some of these colors, particularly blue, has never been surpassed. Pale colors and large areas of *grisaille* glass became increasingly popular from the mid-thirteenth century on, making the windows of later Gothic churches bright and clear by comparison.

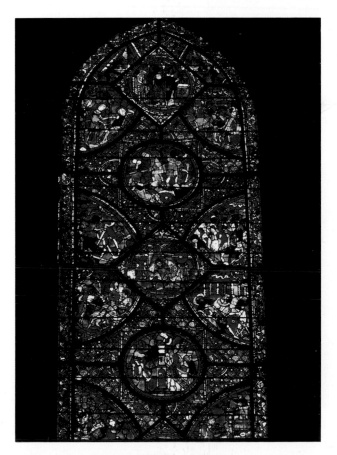

16-15. ***Furrier's Shop***, detail of *Charlemagne Window*

This close-up shows how stained-glass artisans handled form and color. The figures have been reduced to simple shapes and their gestures kept broad to convey meaning from afar. The glass surfaces, however, are painted with fine lines that are invisible from the cathedral's floor. Forms stand out against a lustrous blue ground accented with red. Glowing clear glass serves as white, and violet-pink, green, and yellow complete the palette.

16-14. ***Charlemagne Window***, ambulatory apse, Chartres Cathedral. c. 1210–36. Stained glass

This window depicts scenes from the *Song of Roland*, an epic based on events during the reign of Charlemagne that acquired its final form sometime around 1100. The hero, Roland, is portrayed as an ideal feudal knight, devoted to his lord, his fellow knights, and his faith. Roland was killed fighting Muslims in the Pyrenees Mountains, which lie between France and Spain.

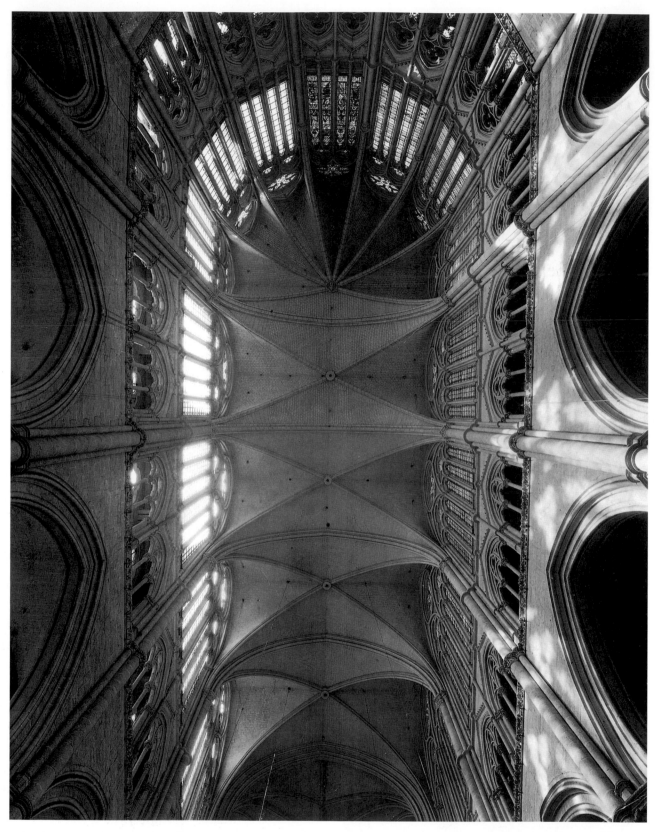

16-16. Vaults, sanctuary, Amiens Cathedral, Cathedral of Notre-Dame, Amiens, France. Upper choir after 1258; vaulted by 1288

framework of medallions so that colored glass and **cames**, the lead strips that join the pieces of glass, work together to make the window imagery more decorative. The medallions contain narrative scenes, each surrounded by a field of stylized flowers, leaves, and geometric patterns. At the base of the *Charlemagne Window* is a scene of a customer buying a cloak in a furrier's shop. The furrier displays a large cloak made of small pelts (perhaps rabbit or squirrel) taken from the chest at the right. The potential buyer has removed one glove and reaches out, perhaps to feel the fur, perhaps to bargain. Several scenes at Chartres—and at other Gothic churches—

show tradespeople, including bakers, wheelwrights, weavers, goldsmiths, and carpenters. These scenes were once thought to have reflected pious donations by local guilds, but recent scholarship suggests that merchants and artisans had not yet been permitted to form guilds and contributed only through the taxes assessed on them by Church officials. The vignettes of tradespeople might thus be a form of Church propaganda, images of an ideal world in which the Church was the center of society and the focus of everyone's work.

Amiens and Reims Cathedrals. As it continued to evolve, Gothic taste favored increasingly sculptural, ornate facades and intricate window **tracery** (geometric decorative patterns molded in stone or wood). Builders across northern France refined the geometry of church plans and elevations and found ways to engineer ever stronger masonry skeletons to support ever larger expanses of stained glass.

The Cathedral of Notre-Dame at Amiens, an important trading and textile-manufacturing center north of Paris, burned in 1218, and as at Chartres, church officials devoted their resources to making its replacement as splendid as possible. Their funding came mainly from the cathedral's rural estates and from important trade fairs. Construction began in 1220 and continued for some seventy years. The result is the supreme architectural statement of elegant Gothic verticality. The nave, only 48 feet wide, soars upward 144 feet. Not only is the nave exceptionally tall, its narrow proportions create an exaggerated sense of height (figs. 16-16, 16-18).

A labyrinth, now destroyed, recorded the names of the master builders at Amiens on the inlaid floor of the nave (see "Master Builders," page 586). This practice honored the mythical Greek hero Daedalus, master builder of the first labyrinth at the palace of King Minos in Crete. The labyrinth identifies Robert de Luzarches (d. 1236) as the builder who established the overall design for the Amiens Cathedral. He was succeeded by Thomas de Cormont, who was followed by his son Renaud. The lower portions of the church were probably substantially complete by around 1240.

The plan of the cathedral of Amiens derived from that of Chartres, with some simple but critical adjustments (fig. 16-17). The narthex was eliminated, while the transept and sanctuary were expanded and the crossing brought forward. The result is a plan that is balanced east and west around the crossing. The elevation of the nave is similarly balanced and compact (fig. 16-18). Chapels of the same size and shape enhance the clarity and regularity of the design. Tracery and **colonnettes** (small columns) unite the *triforium* and the clerestory, which makes up nearly half the height of the nave. Evenly spaced piers with engaged half columns topped by foliage capitals support the arcades. An ornate floral stringcourse below the *triforium* level and a simpler one below the clerestory both run uninterrupted across the otherwise plain wall surfaces and colonnettes, providing a horizontal counterpoint. The vaulting and the light-filled choir date to the second phase of construction,

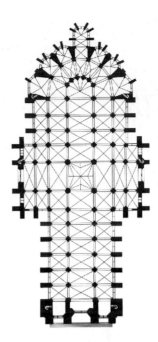

16-17. Robert de Luzarches, Thomas de Cormont, and Renaud de Cormont. Plan of Amiens Cathedral. 1220–88

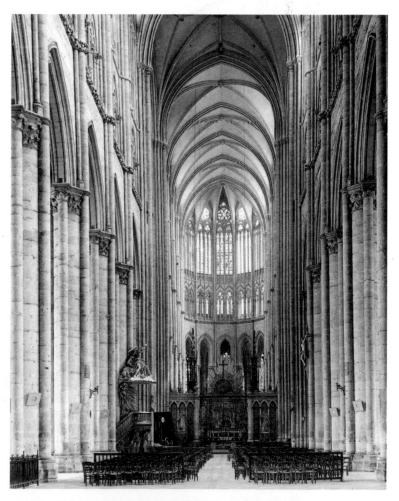

16-18. Nave, Amiens Cathedral. 1220–88; upper choir reworked after 1258

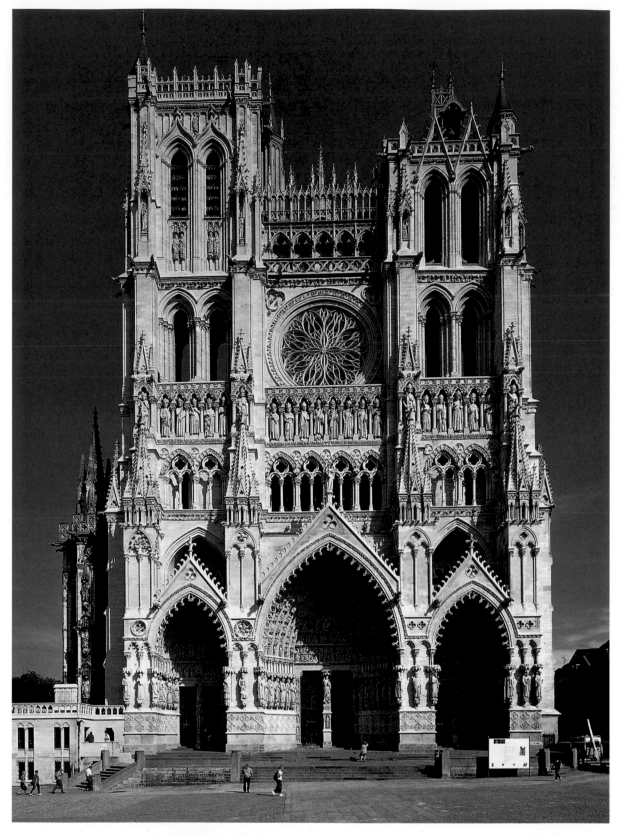

16-19. West facade, Amiens Cathedral. Begun c. 1220–36

directed by Thomas de Cormont, probably after a fire in 1258. The choir is illuminated by large windows subdivided by tracery into slender lancets crowned by **trefoils** (three-lobed designs) and circular windows.

The west front of Amiens reflects several stages of construction (fig. 16-19). The lower levels, designed by

Robert de Luzarches, are the earliest, dating to about 1220–40, but building continued over the centuries. The towers date to the fourteenth and fifteenth centuries, and the tracery in the rose window is also from this later date. Consequently, the facade has a somewhat disjointed appearance, and all its elements do not correspond to the

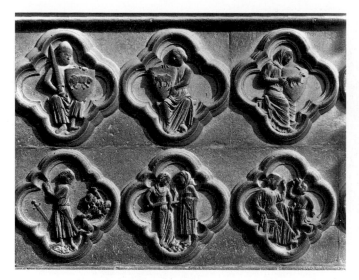

16-20. *Virtues and Vices*, central portal, west entrance, Amiens Cathedral. c. 1220–36

Quatrefoils appeared here as a framing device for the first time and soon became one of the most widespread decorative motifs in Gothic art. In the top row are the Virtues, personified as seated figures. Each holds a shield with an animal on it that symbolizes a particular virtue: the lion for Courage, the cow for Patience, and the lamb for Meekness. Below the Virtues are figures that represent the Vices that correspond to each of the Virtues: a knight dropping his sword and turning to run when a rabbit pops up (Cowardice); a woman on the verge of plunging a sword through a man (Discord); and a woman delivering a swift kick to her servant (Impatience or Injustice).

interior spaces behind them. Design had begun to be detached from structural logic, an indication of the loosening of the traditional ties between architectural planning and the actual building process. This trend led to the elevation of architectural design—as opposed to structural engineering and construction—to a high status by the fifteenth century.

The sculptural program of the west portals of Amiens presents an almost overwhelming array of images. The sculpture was produced rapidly by a large workshop in only fifteen years or so (1220–c. 1236), making it stylistically more uniform than that of the cathedrals of Chartres or Reims. In the mid-thirteenth century, Amiens-trained sculptors carried their style to other parts of Europe, especially Castile (Spain) and Italy.

Worshipers approaching the main entrance encountered figures of apostles and saints lined up along the door jambs and projecting buttresses, as were seen at Chartres. At Amiens something new captures the attention. On the base below the figures, at eye-level, are **quatrefoils** (four-lobed medallions) containing relief sculpture illustrating Good and Evil in daily life (fig. 16-20), the seasons and labors of the months, the lives of the saints, and biblical stories. High above, in the tympanum and archivolts of the central portal, the history of humanity ends in the Last Judgment. The left portal sculpture illustrates the life of Saint Firmin, an early bishop of Amiens and the town's patron saint; those on

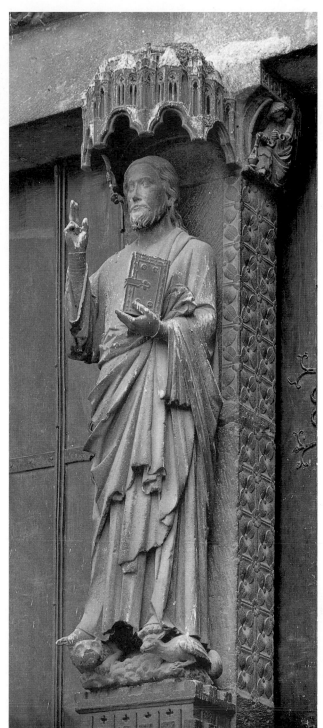

16-21. *Beau Dieu*, trumeau, central portal, west façade, Amiens Cathedral. c. 1220–36

the right portal are dedicated to Mary and her coronation as Queen of Heaven.

A sculpture of Christ as the *Beau Dieu* ("Noble" or "Beautiful" "God"), the kindly teacher-priest bestowing his blessing on the faithful (fig. 16-21), adorns the **trumeau** of the central portal. This exceptionally fine sculpture may have been the work of the master of the Amiens workshop himself. The broad contours of the heavy drapery wrapped around Christ's right hip and bunched over his left arm lead the eye up to the Gospel book he holds and past it to his face, which is that of a young king. He stands on a lion and a dragonlike creature

NOTRE-DAME OF PARIS

Think of Gothic architecture. Chances are, the image that springs to mind is the Cathedral of Notre-Dame of Paris. Just as this structure rivals the Eiffel Tower as the symbol of Paris itself, Notre-Dame is the vision of what a Gothic cathedral should look like. In fact, the Notre-Dame we see today began as an early Gothic building that bridged the period between Abbot Suger's rebuilding of the Abbey Church of Saint-Denis and the thirteenth-century Chartres Cathedral. On this site—a small island in the Seine River called the Île de la Cité, where the Parisii people who gave the city its name first settled— Pope Alexander III set the building cornerstone in 1163. Construction was far enough along for the altar to be consecrated twenty years later. The nave, rising to 115 feet, dates to 1180–1200. The west facade, whose tympana (like that of the north portal) are dedicated to Mary (*Notre Dame*) dates to 1200–50. By this time, the massive walls and buttresses and six-part vaults, adopted from Norman Romanesque architecture, must have seemed very old-fashioned. After 1225, new masters modernized and lightened the building by reworking the clerestory into the large double-lancet and rose windows

we see today. Notre-Dame had the first true flying buttresses, although those seen at the right of the photograph, rising dramatically to support the high vault of the choir, result from later Gothic remodeling. (The 290-foot spire over the crossing is the work of the nineteenth-century architect Eugène-Emmanuel Viollet-le-Duc.)

Throughout its history, Notre-Dame has spoken so powerfully that people in each age have embraced it as a symbol of their most passionate beliefs. For example, French revolutionaries decapitated the statues associated with deposed nobility and transformed the cathedral into the secular Temple of Reason (1793–95). Soon afterward, Notre-Dame returned to Christian use, and in 1804 Napoleon crowned himself emperor at its altar. Notre-Dame was also where Paris celebrated its liberation from the Nazis in August 1944. Today, boats filled with tourists drift under the bridges spanning the Seine and circle the Île de la Cité to admire the beautiful cathedral. Notre-Dame so resonates with life and history that it has become more than a house of worship and work of art; it expresses so many aspirations of Western culture even as it inspires affection and awe at a universal level.

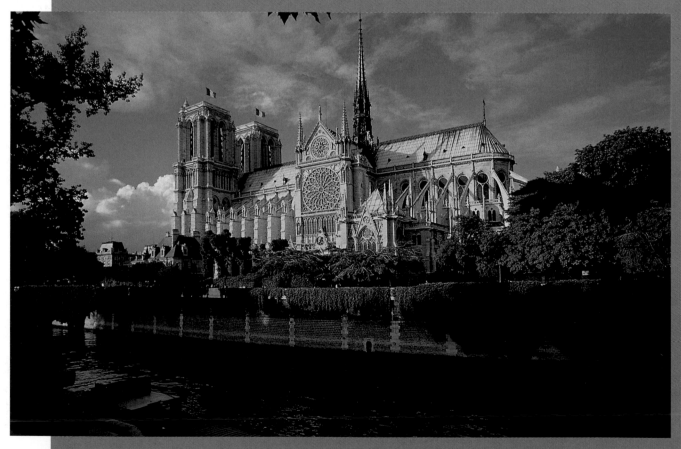

16-22. Cathedral of Notre-Dame, Paris. Begun 1163; choir chapels 1270s; spire 19th-century replacement. View from the south

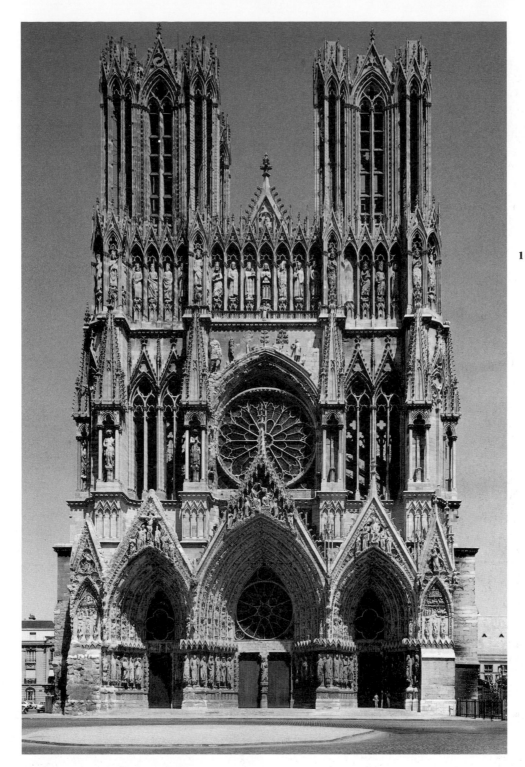

16-23. West facade, Reims Cathedral, Cathedral of Notre-Dame, Reims, France. Rebuilding begun c. 1211 after fire in 1210; facade 1230s was largely unfinished by 1287; towers left unfinished in 1311; additional work 1406–28

The cathedral was restored in the sixteenth century and again in the nineteenth and twentieth centuries. During World War I it withstood bombardment by some 3,000 shells, an eloquent testimony to the skills of its builders. It was recently cleaned.

called a basilisk, symbolizing his kingship and his triumph over evil and death. With its clear, solid forms, elegantly cascading robes, and interplay of close observation with idealization, the *Beau Dieu* embodies the Amiens style and the Gothic spirit.

In the Church hierarchy, the bishop of Amiens was subordinate to the archbishop of Reims, a town northeast of Paris. Politically the archbishop also had great power, for the French kings were crowned in his cathedral, though they were buried at Saint-Denis. Reims, like Saint-Denis, had been a cultural and educational center since Carolingian times. As at Chartres and Amiens, the community at Reims, led by the clerics responsible for the building, began to erect a new cathedral after a fire destroyed an earlier church. And as at Chartres, the expense of the project

sparked local opposition, with revolts in the 1230s twice driving the archbishop and canons into exile. Construction of the cathedrals of Chartres, Amiens, and Reims overlapped, and the artisans at each site borrowed ideas from and influenced one another.

Many believe the Cathedral of Notre-Dame at Reims to be the most beautiful of all Gothic cathedrals, surpassing even Chartres and Notre-Dame of Paris (fig. 16-22, "The Object Speaks: Notre-Dame of Paris"). The cornerstone at Reims was laid in 1211 and work continued on it throughout the century. Its master builders, their names recorded in the cathedral labyrinth, were Jean d'Orbais, Jean le Loup, Gaucher de Reims, and Bernard de Soissons.

The magnificent west facade at Reims was built from 1254 through 1287 and left unfinished in 1311 (fig. 16-23).

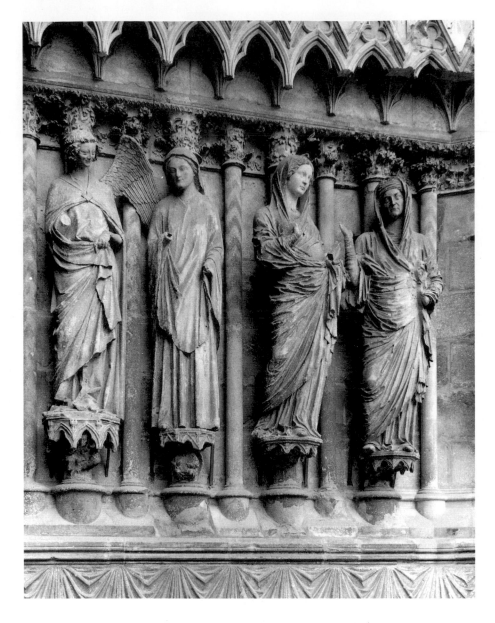

16-24. *Annunciation* (left pair: Mary [right] c. 1245, angel [left] c. 1255) and *Visitation* (right pair: Mary [left] and Elizabeth [right] c. 1230), right side, central portal, west facade, Reims Cathedral

16-25. *Saint Joseph*, left side, central portal, west facade, Reims Cathedral. c. 1255

Scratched onto the column behind Joseph's head are a crescent and four lines. These masons' marks, called setting marks, were used to position a piece of sculpture during installation. A crescent mark indicates the left side of the central doorway, and four lines indicate the fourth in a series. The work site for such an enormous project would have been filled with dressed and undressed stone blocks, carved slabs in various stages of completion, and work crews hauling and hoisting the finished pieces into place.

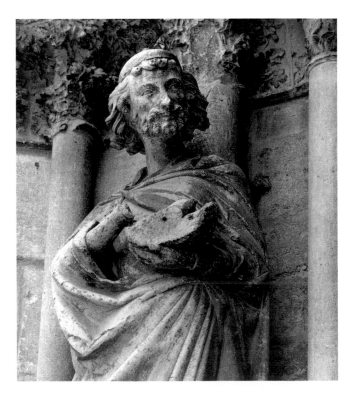

Its massive gabled portals project forward, rising higher than those at Amiens. Their soaring peaks, the middle one reaching to the center of the rose window, help to unify the facade. Large windows fill the portal tympana, displacing the sculpture usually found there. The deep porches are encrusted with sculpture that reflects changes in plan, iconography, and sculpture workshops. In a departure from tradition, Mary rather than Christ dominates the central portal, a reflection of the growing popularity of her cult. The enormous rose window, the focal point of the facade, fills the entire clerestory level. The towers were later additions, as was the row of carved figures that runs from the base of one tower to the other above the rose window. This "gallery of kings" is the only strictly horizontal element of the facade. Its subject matter is appropriate for a coronation church.

Different workshops and individuals worked at Reims over a period of several decades. Further complicating matters, a number of the works of sculpture have been moved from their original locations, creating sometimes abrupt stylistic shifts. A group of four figures on the right jamb of the central portal of the western front illustrates three of the Reims styles (fig. 16-24).

The pair on the right is the work of the "Classical Shop," which was active beginning in about the 1230s and most of whose work is at the east and north sides of the building. The subject of the pair is the Visitation, in which Mary (left), pregnant with Jesus, visits her older cousin Elizabeth (right), who is pregnant with John the Baptist. The sculptors drew on classical sources, to which they had perhaps been exposed indirectly through earlier Mosan metalwork (see fig. 16-50) or directly in the form of local examples of ancient works (Reims had been an important Roman center). The heavy figures have the same solidity seen in Roman portrayals of noblewomen, and Mary's full face, gently waving hair, and heavy mantle recall imperial portrait statuary. The contrast between the features of the young Mary and the older Elizabeth is also reminiscent of the contrast between two Flavian portrait heads, one of a young woman and the other of a middle-aged woman (see figs. 6-42, 6-43). The Reims sculptors used deftly modeled drapery not only to provide volumetric substance that stresses the theme of pregnancy but also to create a stance in which a weight shift with one bent knee allows the figures to seem to turn toward each other. The new freedom, movement, and sense of relationship implied in the sculpture inspired later Gothic artists toward ever greater realism.

The pair on the left of figure 16-24 illustrates the Annunciation; the archangel Gabriel (left) announces to Mary (right) that she will bear Jesus. The Mary in this pair, quiet and graceful, with a slender body, restrained gestures, and refined features, contrasts markedly with the bold tangibility of the Visitation Mary to the right. The drapery style and certain other details resemble those of Amiens, suggesting that those who made this pair—and much of the other sculpture of the west entrance—may also have worked at Amiens.

The figure of the angel Gabriel illustrates yet a third style, the work of a sculptor known today as the Joseph Master or the Master of the Smiling Angels. This artist created tall, gracefully swaying figures that suggest the fashionable refinement associated with the Parisian court in the 1250s (see fig. 16-33). The facial features of Gabriel—and of Saint Joseph, on the opposite side of the doorway (fig. 16-25)—are typical: a small, almost triangular head with a broad brow and pointed chin has short, wavy hair; long, puffy, almond-shaped eyes under arching brows; a well-shaped nose; and thin lips curving into a slight smile. Voluminous drapery drawn into elegant folds by the movement and gestures of the figures adds to the impression of aristocratic grace. This engaging style was imitated from Paris to Prague, as elegance and refinement became a guiding force in later Gothic sculpture and painting.

The architectural plan of Reims (fig. 16-26), like that of Amiens, was adapted from Chartres. The nave is longer in proportion to the choir, so the building lacks the perfect balance of Amiens. The three-part elevation and ribbed vault are familiar, too (fig. 16-27). The carvings on the capitals in the nave are notable for their variety, naturalism, and quality. Unlike the idealized foliage of

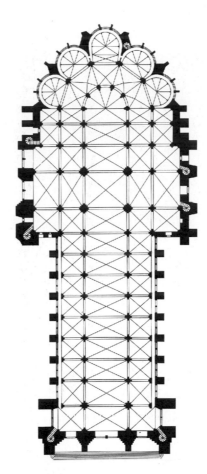

16-26. Plan of Reims Cathedral. 1211–60

16-27. Nave, Reims Cathedral. 1211–60

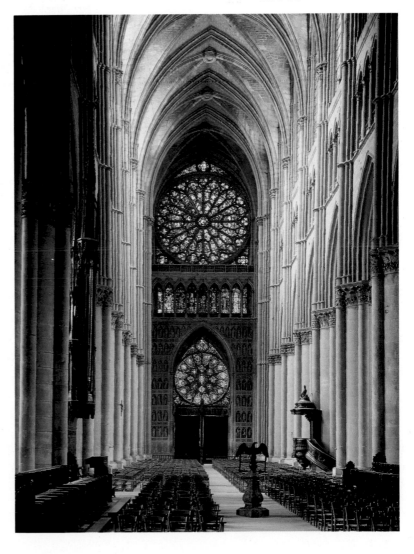

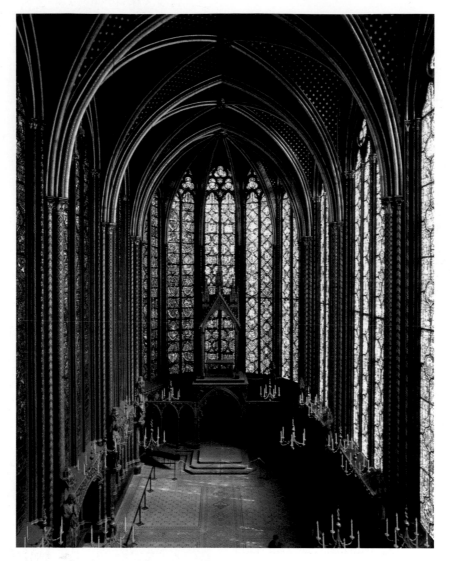

16-28. Interior, upper chapel, the Sainte-Chapelle, Paris. 1243–48

Louis IX avidly collected relics of the Passion, some of which became available in the aftermath of the Crusaders' sack of Constantinople. Those that Louis acquired were supposedly the crown of thorns that had been placed on Jesus' head before the Crucifixion, a bit of the metal lance tip that pierced his side, the vinegar-soaked sponge offered to wet his lips, a nail used in the Crucifixion, and a fragment of the True Cross. The king is depicted in the Sainte-Chapelle's stained glass walking out barefoot to demonstrate his piety and humility when his treasures arrived in Paris.

Amiens, the Reims carvings depict recognizable plants and figures. The remarkable sculpture and stained glass of the west wall complement the clerestory and choir. A great rose window in the clerestory, a row of lancets at the *triforium* level, and windows over the portals replace the stone of wall and tympana. Visually the wall "dissolves" in colored light. This great expanse of glass was made possible by **bar tracery**, a technique perfected at Reims, in which thin stone strips, called **mullions**, form a lacy matrix for the glass, replacing the older practice in which glass was inserted directly into window openings. Reims's wall of glass is anchored visually by a masonry screen around the doorway. Here ranks of carved Old Testament prophets and ancestors serve as moral guides for the newly crowned monarchs who faced them after coronation ceremonies.

The Sainte-Chapelle in Paris. In 1243 construction began on a new palace chapel in Paris to house Louis IX's prized collection of relics from Christ's Passion. The Sainte-Chapelle was finished in 1248, and soon thereafter Louis (ruled 1226–70) departed for Egypt on the Seventh Crusade. This exquisite structure epitomizes a new Gothic style known as Rayonnant ("radiant" or "radiating" in French) because of its radiating bar tracery, like that at Reims; it is also known as the Court style because of its association with Paris and the royal court. The hallmarks of the style include daring engineering, the proliferation of bar tracery, exquisite sculpture and painting, and vast expanses of stained glass.

Originally part of the king's palace, the Sainte-Chapelle is located in the present-day administrative complex in the center of Paris. Intended to house precious

relics, it resembles a giant reliquary itself, one made of stone and glass instead of gold and gems. It was built in two stories, with a ground-level chapel accessible from a courtyard and a private upper chapel entered from the royal residence. The ground-level chapel has narrow side aisles, but the upper level is a single room with a western porch and a rounded east wall. Entering the upper level after climbing up the narrow spiral stairs from the lower level is like emerging into a kaleidoscopic jewel box (fig. 16-28). The ratio of glass to stone is higher here than in any other Gothic structure, for the walls have been reduced to clusters of slender painted colonnettes framing tall windows filled with brilliant color. Bar tracery in the windows is echoed in the blind arcading and tracery of the **dado**, the decoration on the lower walls at floor level. The dado's surfaces are richly patterned in red, blue, and gilt so that stone and glass seem to merge in the multicolored light. Painted statues of the Twelve Apostles stand between window sections, linking the dado and the stained glass. The windows contain narrative and symbolic scenes. Those in the curve of the sanctuary behind the altar and relics, for example, illustrate the Nativity and Passion of Christ, the Tree of Jesse, and the life of Saint John the Baptist. The story of Louis's acquisition of his relics is told in one of the bays, and the Last Judgment appeared in the original rose window on the west.

Later Gothic Architecture. Beginning in the late thirteenth century, France began to suffer from overpopulation and economic decline, followed in the fourteenth century by the devastation of the Hundred Years' War and the plague (see "The Black Death," page 559). Large-scale construction gradually ceased, ending the great age of cathedral building. The Gothic style continued to develop, however, in smaller churches, municipal and commercial buildings, and private residences. Many of these later buildings were covered with elaborate decoration in the new Flamboyant ("flaming" in French) style, named for the repeated flamelike patterns of its tracery. Flamboyant may have reflected an English architectural style known as Decorated (see fig. 16-39). New window tracery was added to many earlier churches in this period, as at Amiens (see fig. 16-19), and a Flamboyant north spire, built between 1507 and 1513, was even added to the west facade of Chartres (see fig. 16-6).

INDEPENDENT SCULPTURE

Gothic sculptors found a lucrative new outlet for their work in the growing demand among wealthy patrons for small religious statues intended for homes and personal chapels or as donations to favorite churches. Busy urban workshops produced large quantities of statuettes and reliefs in wood, ivory, and precious metals, often decorated with enamel and gemstones. Much of this art was related to the cult of the Virgin Mary.

Among the treasures of the Abbey Church of Saint-Denis is a silver-gilt image, slightly over 2 feet tall, of a standing Virgin and Child (fig. 16-29), an excellent

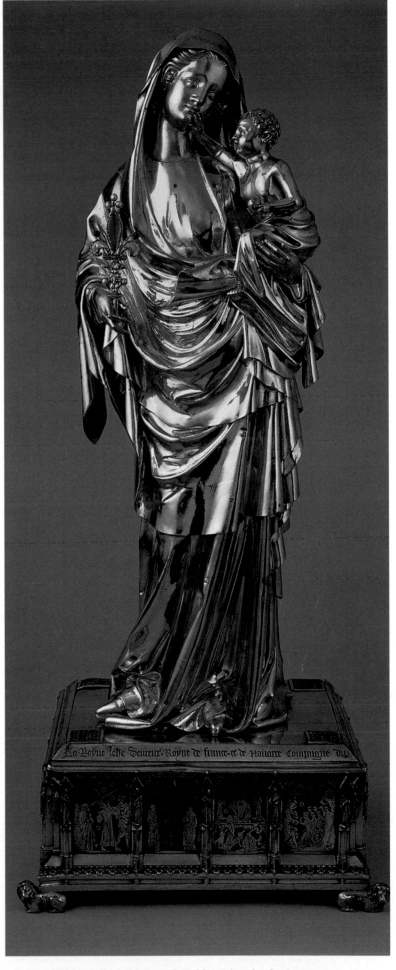

16-29. *Virgin and Child*, from the Abbey Church of Saint-Denis. c. 1339. Silver gilt and enamel, height 27⅛" (69 cm). Musée du Louvre, Paris

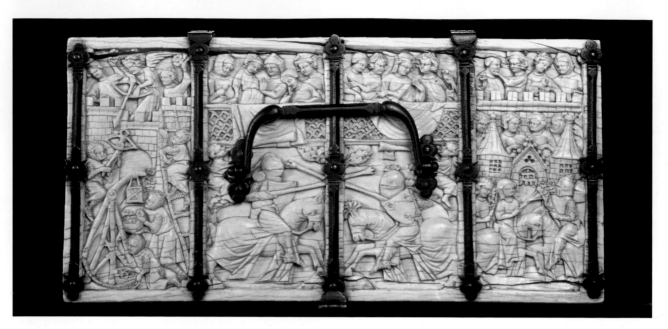

16-30. *Attack on the Castle of Love*, lid of a jewelry box, from Paris. c. 1330–50. Ivory casket with iron mounts, panel 4^1/$_2$ x 9^{11}/$_{16}$" (11.5 x 24.6 cm). Walters Art Gallery, Baltimore

The god of love (upper left) shoots his arrows; knights and ladies throw flowers as missiles and joust with flowers (right).

example of such works. An inscription on the base bears the date 1339 and the name of Queen Jeanne d'Evreux, wife of Charles IV of France (ruled 1322–28). The Virgin holds her son in her left arm, her weight on her left leg, creating the graceful S-curve pose that was a stylistic signature of the period. Fluid drapery with the consistency of heavy silk covers her body. She holds a scepter topped with a large enameled and jeweled *fleur-de-lis,* the heraldic symbol of French royalty, and she originally wore a crown. The scepter served as a reliquary for hairs said to be from Mary's head. Despite this figure's clear association with royalty, Mary's simple clothing and sweet, youthful face anticipate a type of imagery that emerged in the later fourteenth and fifteenth centuries in northern France, Flanders, and Germany: the ideally beautiful mother. The Christ Child, clutching an apple in one hand and reaching with the other to touch his mother's lips, is more babylike in his proportions and gestures than in earlier depictions. Still, prophets and scenes of Christ's Passion in enamel cover the statue's simple rectangular base, a reminder of the suffering to come.

In addition to devotional or moralizing subjects, there was a strong market for objects with secular subjects taken from popular literature. Themes drawn from the poetry of the troubadours (see "Romance," page 558) decorated women's jewelry boxes, combs, and mirror cases. A casket for jewelry made in a Paris workshop around 1330–50 provides a delightful example of such a work (fig. 16-30). Its ivory panels depict scenes of love, including vignettes from the King Arthur legend. The central sections of the lid shown here depict a tournament. Such mock battles, designed to keep knights fit for war, had become one of the chief royal and aristocratic entertainments of the day. In the scene on the lid, women of the court, accompanied by their hunting falcons,

watch with great interest as two jousting knights, visors down and lances set, charge to the blare of trumpets played by young boys. In the scene on the left, ardent knights assault the Castle of Love, firing roses from crossbows and a catapult. Love, in the form of a winged boy, aids the women defenders, aiming a giant "Cupid's arrow" at the attackers. The action concludes in the scene on the right, where the tournament's victor and his lady love meet in a playful joust of their own.

BOOK ARTS

France gained renown in the thirteenth and fourteenth centuries not only for its new architectural style but also for its book arts. These works ranged from lodge books, practical manuals for artisans, to elaborate devotional works illustrated with exquisite miniatures.

Lodge books were an important tool of the master mason and his workshop, or lodge. Compiled by heads of workshops, lodge books provided visual instruction and inspiration for apprentices and assistants. Since the drawings received hard use, few have survived. One of the most famous architect's collections is the early-thirteenth-century sketchbook of Villard de Honnecourt, a well-traveled master mason who recorded a variety of images and architectural techniques. A section labeled "help in drawing figures according to the lessons taught by the art of geometry" (fig. 16-31) illustrates the use of geometric shapes to form images and how to copy and enlarge images by superimposing geometric shapes over them as guides.

The production of high-quality manuscripts flourished in Paris during the reign of Louis IX, whose royal library was renowned. Queen Blanche of Castile, Louis's mother and granddaughter of Eleanor of Aquitaine,

16-31. Villard de Honnecourt. Sheet of drawings with geometric figures and ornaments, from Paris. 1220–35. Ink on vellum, 9¼ x 6" (23.5 x 15.2 cm). Bibliothèque Nationale, Paris

served as regent of France (1226–34) until he came of age. She and the teenage king appear on the dedication page (fig. 16-32) of a Moralized Bible—one in which selected passages of the Old and New Testaments are paired to give an allegorical, or moralized, interpretation. The royal pair sits against a solid gold background under trilobed arches. Below them a scholar-monk dictates to a scribe. The ornate thrones of Louis and his mother and the buildings atop the arches suggest that the figures are inside a royal palace, and in fact it would not have been unusual for the queen to have housed scholar, scribe, and illuminator while they were executing her commission during her regency. Interestingly, only the slightly oversized heads of the queen and king preserve a sense of hierarchical scale. The scribe, in the lower right, is working on a page with a column of

16-32. Page with *Louis IX and Queen Blanche of Castile*, Moralized Bible, from Paris. 1226–34. Ink, tempera, and gold leaf on vellum, 15 x 10½" (38 x 26.6 cm). The Pierpont Morgan Library, New York
M.240, f.8

Thin sheets of gold leaf were painstakingly attached to the vellum and then polished to a high sheen with a tool called a burnisher. Gold was applied to paintings before pigments.

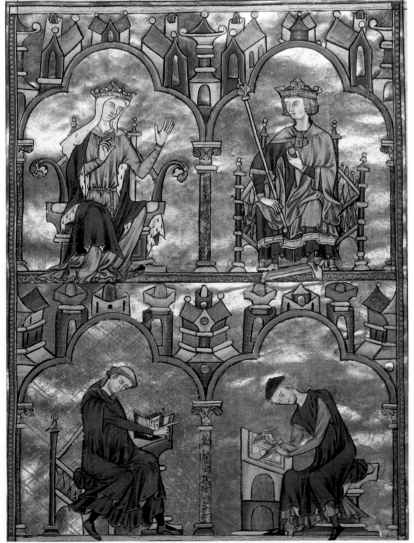

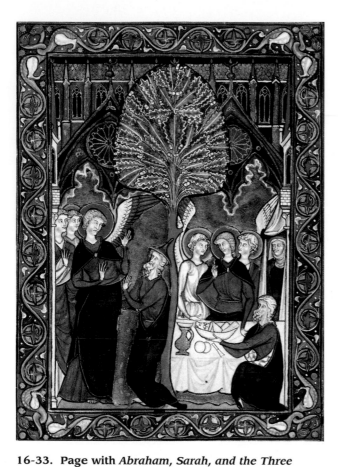

16-33. Page with *Abraham, Sarah, and the Three Strangers*, *Psalter of Saint Louis*, from Paris. 1253–70. Ink, tempera, and gold leaf on vellum, 5 x 3¹/₂" (13.6 x 8.7 cm). Bibliothèque Nationale, Paris

The Court style had enormous influence throughout northern Europe, spread by illuminators who flocked to Paris from other regions. There they joined workshops affiliated with the Confrérie de Saint-Jean ("Guild of Saint John"), supervised by university officials who controlled the production and distribution of manuscripts.

rest. On the right, he offers the men a meal prepared by his wife, Sarah, who stands in the entryway of their tent on the far right. God says that Sarah will soon bear a child, and she laughs because she and Abraham are old. But God replies, "Is anything too marvelous for the Lord to do?" (18:14). She later gives birth to Isaac, whose name comes from the Hebrew word for "laughter." Christians in the Middle Ages viewed the three strangers in this story as symbols of the Trinity and believed that God's promise to Sarah was a precursor of the Annunciation to Mary.

The architectural background in this painting establishes a narrow stage space in which the story unfolds. Wavy clouds float within the arches under the gables. The imaginatively rendered oak tree establishes the location of the story and separates the two scenes. The gesture of the central haloed figure in the scene on the right and Sarah's presence in the entry of the tent indicate that we are viewing the moment of divine promise. This new spatial sense, as well as the depiction of a tree with oak leaves and acorns, reflects a tentative move toward the representation of the natural world that will gain momentum in the following centuries.

By the late thirteenth century, literacy had begun to spread among laypeople. Private prayer books became popular among those who could afford them. Because such books contained special prayers to be recited at the eight canonical "hours" between morning and night, these books came to be called Books of Hours. The material in them was excerpted from a larger liturgical book called a breviary, which contained all the canonical offices (Psalms, readings, and prayers) used by priests in celebrating Mass. Books of Hours were usually devoted to the Virgin, but they could be personalized for particular patrons with prayers to other saints, a calendar of saints' feast days and other Church events, and even other offices, such as that said for the dead. During the fourteenth century a richly decorated Book of Hours, like jewelry, would have been among a noble person's most important portable possessions.

A tiny, exquisite Book of Hours given by Charles IV to his queen, Jeanne d'Evreux, shortly after their marriage in 1325 is the work of an illuminator named Jean Pucelle (fig. 16-34). Instead of the intense colors used by earlier illuminators, Pucelle worked in a technique called **grisaille**—monochromatic painting in shades of gray with faint touches of color (see also "Stained-Glass Windows," page 569)—that emphasized his accomplished drawing. The book combines two narrative cycles. One, the Hours of the Virgin, juxtaposes scenes from the Infancy and Passion of Christ, a form known as the Joys and Sorrows of the Virgin. The other is a collection of scenes from the life of Saint Louis (King Louis IX), whose new cult was understandably popular at court. In the pages shown here, the joy of the *Annunciation* on the right is paired with the sorrow of the *Betrayal and Arrest of Christ* on the left. Queen Jeanne appears in the initial below the *Annunciation*, kneeling before a lectern and reading from her Book of Hours. This inclusion of the patron in prayer within a scene, a practice that continued in monumental painting and sculpture

roundels for illustrations. This format of manuscript illustration—used on the pages that follow the Bible's dedication page—derives from stained-glass lancets, with their columns of images in medallions (see fig. 16-28). The illuminators also show their debt to stained-glass in their use of glowing red and blue and reflective gold surfaces.

The *Psalter of Saint Louis* (the king was canonized in 1297) defines the Court style in manuscript illumination. The book, containing seventy-eight full-page illuminations, was created for Louis IX's private devotions sometime between 1253 and 1270. The illustrations fall at the back of the book, preceded by Psalms and other readings unrelated to them. Intricate scrolled borders and a background of Rayonnant architectural features modeled on the Sainte-Chapelle frame the narratives. Figures are rendered in an elongated, linear style. One page (fig. 16-33) illustrates two scenes from the Old Testament story of Abraham, Sarah, and the Three Strangers (Genesis 18). On the left, Abraham greets God, who has appeared to him as three strangers, and invites him to

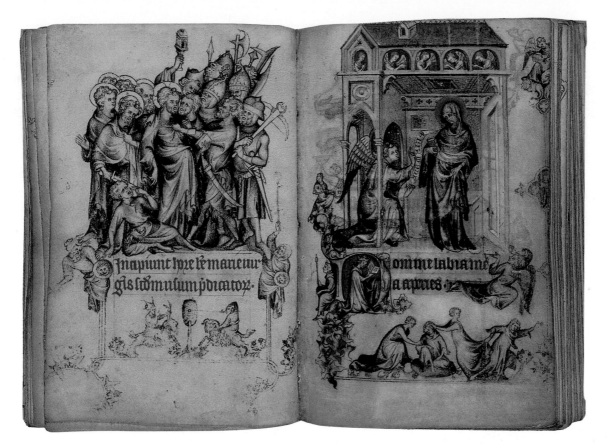

16-34. Jean Pucelle. Pages with *Betrayal and Arrest of Christ*, folio 15v. (left), and *Annunciation*, folio 16r. (right), *Book of Hours of Jeanne d'Evreux*, from Paris. c. 1325–28. *Grisaille* and color on vellum, each page 3¹/₂ x 2¹/₄" (8.2 cm x 5.6 cm). The Metropolitan Museum of Art, New York

The Cloisters Collection, 1954 (54.1.2)

This book was precious to the queen, who mentioned it in her will; she named its illuminator, an unusual tribute.

in the fifteenth century, conveyed the idea that the scenes were visions inspired by meditation rather than records of historical events. In this case, the young queen would presumably have identified with Mary's joy at Gabriel's message.

In the *Annunciation* Mary is shown receiving the archangel Gabriel in her Gothic-style home as rejoicing angels look on from windows under the eaves. The group of romping children at the bottom of the page (known as the *bas-de-page* in French) at first glance seems to echo the joy of the angels. Scholars have determined, however, that the children are playing "froggy in the middle," a game in which one child was tagged by the others (a symbolic reference to the Mocking of Christ). The game thus evokes a darker mood, foreshadowing Jesus' death even as his life is beginning. In the Betrayal scene on the left page, the disciple Judas Iscariot embraces Jesus, thus identifying him to the soldiers who have come to seize him and setting in motion the events that lead to the Crucifixion. Peter, on the left, realizing the danger, draws his sword to defend Jesus and slices off the ear of one of the soldiers. The *bas-de-page* on this side shows "knights" riding goats and jousting at a barrel stuck on a pole, a spoof of military training that is perhaps a comment on the valor of the soldiers assaulting Jesus.

Pucelle's work represents a sophisticated synthesis of French, English, and Italian painting traditions. From English illuminators he borrowed the merging of Christian narrative with allegory, the use of foliate borders filled with real and grotesque creatures (instead of the standard French vine scrolls), and his lively *bas-de-page* illustrations. His presentation of space, with figures placed within coherent architectural settings, apparently reflects his firsthand knowledge of developments in painting in Siena, Italy (for a slightly later example, see fig. 16-65). Pucelle also adapted to manuscript illumination the Parisian Court style in sculpture, with its softly modeled, voluminous draperies gathered around tall, elegantly curved figures with curly hair and broad foreheads. For instance, Jesus on the left page in figure 16-34 and Mary on the right stand in the swaying S-curve pose typical of Court-style works in other mediums, such as the Virgin and Child from Saint-Denis (see fig. 16-29). Similarly, the earnest face of the Annunciation archangel resembles that of the smiling Annunciation archangel at Reims (see fig. 16-24).

The thirteenth and fourteenth centuries saw the growing use of book margins for fresh and unusual images. Often drawn by illustrators who specialized in this kind of work, marginal imagery was a world of its own, interacting in unexpected ways with the main images and

16-35. Page with *Fox Seizing a Rooster*, *Book of Hours of Jeanne d'Evreux*. The Metropolitan Museum of Art, New York

The Cloisters Collection, 1954 (54.1.2 f. 46)

"The Fox," according to a medieval bestiary, "never runs straight but goes on his way with tortuous windings. He is a fraudulent and ingenious animal. When he is hungry and nothing turns up for him to devour, he rolls himself in red mud so that he looks as if he were stained with blood. Then he throws himself on the ground and holds his breath. The birds, seeing that he is not breathing, think he is dead and come down to sit on him. As you can guess, he grabs them and gobbles them up. The Devil has this same nature" (cited in Schrader, page 24). Bestiaries, an English specialty, were popular compilations of animal lore that were sometimes, as here, made into Christian moral tales. Some of these fables or their characterizations survive in present-day folklore, such as this familiar view of the fox as a cunning trickster.

text, and often deliberately obscure or ambiguous. Visual puns on the main image or text abound. There are also humorous corrections of scribes' errors, pictures of hybrid monsters, erotic and scatological scenes, and charming depictions of ordinary activities and folklore that may or may not have functioned as ironic commentaries on what was going on elsewhere on the page. In addition to the *bas-de-page* scenes, the *Book of Hours of Jeanne d'Evreux* contains other minute but vivid marginalia, such as a fox capturing a rooster (fig. 16-35).

ENGLAND

The Plantagenet dynasty, founded by Henry II and Eleanor of Aquitaine in 1154, ruled England until 1485. Under Plantagenet rule, the thirteenth century was marked by conflicts between the king and England's feudal barons over their respective rights. In 1215, King John (ruled 1199–1216), under compulsion from powerful barons, set his seal to the draft of the Magna Carta (Latin for "Great Charter"), which laid out feudal rights and dues and became an important document in the eventual development of British common law. The thirteenth century also saw the annexation of the western territory of Wales and the settlement of long-standing border disputes with Scotland. In the mid-fourteenth century, the Black Death ravaged England as it did the rest of Europe. During the Hundred

Years' War (1337–1453), English kings claimed the French throne and by 1429 controlled most of France, but after a number of reversals they were driven from all their holdings in France except Calais.

Late medieval England was characterized by rural villages and bustling market towns, all dominated by the great city of London. England's two universities, Oxford and Cambridge, dominated intellectual life. A rich store of Middle English literature survives, including the brilliant social commentary of the *Canterbury Tales*, by Geoffrey Chaucer (c. 1342–1400). Many of the Plantagenet kings, especially Henry III (ruled 1216–72), were great patrons of the arts.

ARCHITECTURE

Gothic architecture in England was strongly influenced by Cistercian and Norman Romanesque architecture as well as by French master builders like William of Sens, who directed the rebuilding of Canterbury Cathedral, in southeastern England, between 1174 and 1178 (see "Master Builders," page 586). English cathedral builders were less concerned with height than their French counterparts, and they constructed long, broad naves, Romanesque-type galleries, and clerestory-level passageways. Walls retained a Romanesque solidity.

Salisbury Cathedral, because it was built in a relatively short period of time, has a consistency of style that makes it an ideal representative of English Gothic architecture (fig. 16-36). The cathedral, in southern England, was begun in 1220 and nearly finished by 1258, an unusually short period for such an undertaking. The west facade was completed by 1265. The huge crossing tower and its 400-foot spire are fourteenth-century additions, as are the flying buttresses that were added to stabilize the tower. Typically English is the parklike setting (the cathedral close) and attached cloister and chapter house for the cathedral clergy. The thirteenth-century structure seems to hug the earth, more akin to Fontenay (see fig. 15-7), built a century earlier, than to the contemporary Amiens Cathedral in France.

In contrast to French cathedral facades, which suggest the entrance to paradise with their mighty towers flanking deep portals, English facades like the one at Salisbury suggest the jeweled wall of paradise itself. The small flanking towers of the west front project beyond the side walls and buttresses, giving the facade an increased width that was underscored by tier upon tier of blind tracery and arcaded niches. Lancet windows grouped in twos, threes, and fives introduce a vertical element.

Typical of English cathedrals, Salisbury has wide projecting transepts (double transepts, in this case), a square apse, and a spacious sanctuary (fig. 16-37). The interior reflects enduring Norman traditions, with its heavy walls and tall nave arcade surmounted by a short gallery and a clerestory with simple lancet windows (fig. 16-38). The emphasis on the horizontal movement of the arcades, unbroken by colonnettes in the unusually restrained nave, directs worshipers' attention forward to

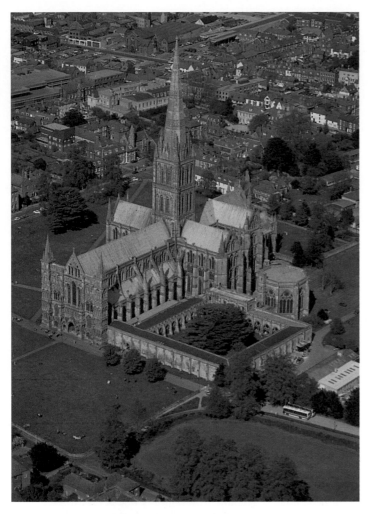

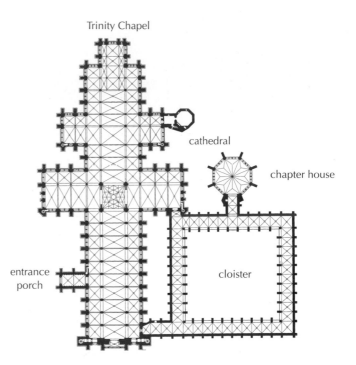

16-37. Plan of Salisbury Cathedral

16-36. Salisbury Cathedral, Salisbury, Wiltshire, England. 1220–58; west facade 1265; spire c. 1320–30; cloister and chapter house 1263–84

The original cathedral had been built within the hilltop castle complex of a Norman lord. In 1217, Bishop Richard Poore petitioned the pope to relocate the church, claiming the wind howled so loudly there that the clergy could not hear themselves say Mass. A more pressing concern was probably his desire to escape the lord's control; Pope Innocent III (papacy 1198–1216) had only recently lifted a six-year ban on church services throughout England and Wales after King John (ruled 1199–1216) agreed to acknowledge the Church's sovereignty. The bishop himself laid out the town of Salisbury (from the Saxon *Searisbyrig,* meaning "Caesar's burg," or town) after the cathedral was under way. Material carted down from the old church was used in the cathedral, along with dark, fossil-filled Purbeck stone from quarries in southern England and stone from Caen. The building was abandoned and vandalized during the Protestant Reformation in England initiated by King Henry VIII (ruled 1509–47). In the eighteenth century, the English architect James Wyatt, called the Destroyer, subjected it to radical renovations, during which the remaining stained glass and figure sculpture were removed or rearranged. Similar campaigns to refurbish medieval churches were common at the time. The motives of the restorers were complex and their results far from our notions of historical authenticity today.

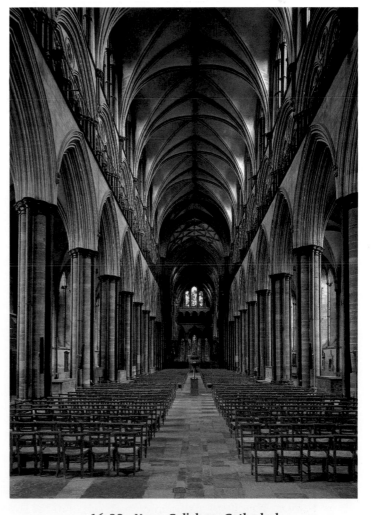

16-38. Nave, Salisbury Cathedral

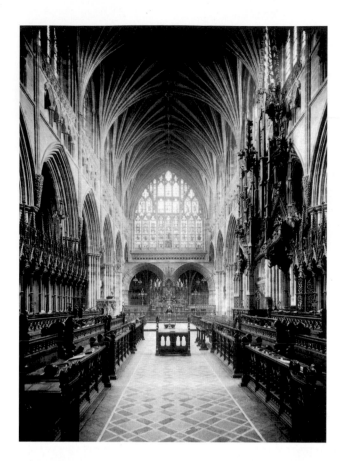

the altar, rather than upward into the vaults. Reminiscent of Romanesque interiors is the use of color in the stonework: The shafts supporting the four-part rib vaults are made of a darker stone that contrasts with the lighter stone of the rest of the interior. The stonework was originally painted and gilded as well as carved.

Just as the Rayonnant style was emerging in France at mid-century, English designers were developing a new Gothic style of their own that has come to be known as the Decorated style (a nineteenth-century term). At Salisbury the tall, elegant spire and the octagonal chapter house with huge traceried windows were built in the Decorated style. This change in taste has been credited to King Henry III's ambition to surpass his brother-in-law, Louis IX of France, as a royal patron of the arts.

A splendid example of this new style is Exeter Cathedral, in southwest England. After the Norman Conquest in 1066, a Norman church replaced an earlier structure, and it, in

16-39. Sanctuary, Exeter Cathedral, Exeter, Devon, England. c. 1270–1366

The Gothic choir stalls and bishop's throne illustrate the skill of the English wood carvers and carpenters. Exeter has some of the finest surviving medieval furniture.

MASTER BUILDERS

"At the beginning of the fifth year [of the rebuilding of England's Canterbury Cathedral], suddenly by the collapse of beams beneath his feet, [master William of Sens] fell to the ground amid a shower of falling masonry and timber from . . . fifty feet or more. . . . On the master craftsman alone fell the wrath of God—or the machinations of the Devil" (Brother Gervase, Canterbury, twelfth century, cited in Andrews, page 20).

Master masons oversaw all aspects of church construction in the Middle Ages, from design and structural engineering to decoration. The job presented formidable logistical challenges, especially at great cathedral sites. The master mason at Chartres coordinated the work of roughly 400 people scattered, with their equipment and supplies, at many locations, from distant stone quarries to high scaffolding. This workforce set in place some 200 blocks of stone each day.

Master masons gained in prestige during the thirteenth century as they increasingly differentiated themselves from the laborers working under them. In the words of Nicolas de Biard, a thirteenth-century Dominican preacher, "The master masons, holding measuring rod and gloves in their hands, say to others: 'Cut here,' and they do not work; nevertheless they receive the greater fees" (cited in Frisch, page 55). By the standards of their time they were well read; they traveled widely. They knew both aristocrats and high Church officials, and they earned as much as knights. From the thirteenth century on, in what was then an exceptional honor, masters were buried, along with patrons and bishops, in the cathedrals they built. The tomb sculpture of a master mason named Hugues Libergier in the Reims Cathedral portrays him, attended by angels, as a well-dressed figure with his tools and a model of the cathedral. The names of more than 3,000 master masons are known today. In some cases their names were prominently inscribed in the labyrinths on cathedral floors.

The illustration here shows a master—right-angle and compass in hand—conferring with his royal patron while workers carve a capital, hoist stones with a winch, cut a block, level a course of masonry using a plumb rule (a board with a line and a weight), and lay dressed stones in place. Masters and their crews moved constantly from site to site, and several masters contributed to a single building. A master's training was rigorous but not standardized, so close study of subtle differences in construction techniques can reveal the hand of specific individuals. Fewer than 100 master builders are estimated to have been responsible for all the major architectural projects around Paris during the century-long building boom there, some of them working on parts of as many as forty churches. Funding shortages and technical delays, such as the need to let mortar harden for three to six months, made construction sporadic.

Page with *King Henry III Supervising the Works*, copy of an illustration from a 13th-century English manuscript; original in The British Library, London

ELEMENTS OF ARCHITECTURE

The Gothic Castle

A typical Gothic castle was a defensible, enclosed structure that combined fortifications and living quarters for the lord, his family, and those defending them. It was built on raised ground and sometimes included a **moat** (ditch), filled with water and crossed by a bridge; **ramparts** (heavy walls), which were freestanding or built against earth embankments; **parapets**, walls into which towers were set; a **keep**, or **donjon**, a tower that was the most secure place within the compound; and a great hall where the rulers and their closest associates lived. The **bailey**, a large open courtyard in the center, contained wooden structures such as living quarters and stables, as well as a stone chapel. The castle complex was defended by a wooden **stockade**, or fence, outside the moat; inside the stockade lay **lists**, areas where knightly combats were staged. The main entrance was approached by a wide bridge, which passed through moat gateways called **barbicans**, ending in a drawbridge and then an iron **portcullis**, a grating set into the doorway that could be lowered as defense. Elsewhere, small doors called **posterns** provided secret access for the castle's inhabitants. Ramparts and walls were topped by stone **battlements** designed to screen defenders standing on the **parapet walks** while they aimed weapons through notched **crenellations**. Covered parapet walks and miniature towers called **turrets** lay along the castle's more secure perimeter walls.

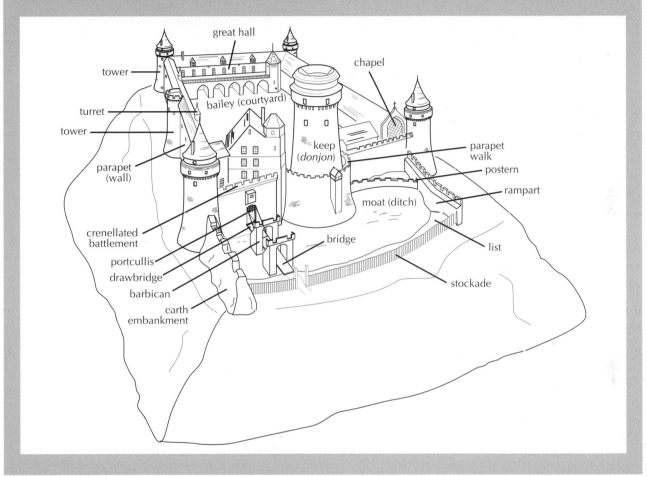

turn, was rebuilt beginning about 1270. When the cathedral was redesigned and vaulted in the first half of the fourteenth century, its interior was turned into a dazzling stone forest of arch moldings and vault ribs (fig. 16-39). From diamond-shaped piers (partly hidden by Gothic choir stalls in the illustration), covered with colonnettes, rise massed moldings that make the arcade seem to ripple. Bundled colonnettes spring from ornate **corbels** between the arches to support conical clusters of thirteen ribs that meet at the summit of the vault, a modest 69 feet above the floor. The basic structure here is the four-part vault with intersecting cross-ribs, but the designer added purely decorative ribs, called **tiercerons**, between the supporting ribs to create a richer linear pattern. Elaborately carved knobs known as **bosses** punctuate the intersections where ribs meet. Large clerestory lancets with bar-tracery mullions illuminate the 300-foot-long nave. Unpolished gray marble shafts, yellow sandstone arches, and a white French stone used in the upper walls add color to the many-rayed space.

Although Gothic architectural style is most studied in cathedrals and other church buildings, it also is seen in such secular structures as castles, which during the turbulent Middle Ages were necessary fortress-residences. Castles evolved during the Romanesque and Gothic periods from enclosed and fortified strongholds to elaborate defended residential complexes from which aristocrats ruled their domains. Usually sited on a promontory or similar defensive height, British castles had many elements in common with continental ones (see "The Gothic Castle," above).

16-40. Page with *Psalm 1 (Beatus Vir)*, *Windmill Psalter*, from London. c. 1270–80. Ink, pigments, and gold on vellum, each page 12¾ x 8¾" (32.3 x 22.2 cm). The Pierpont Morgan Library, New York
M.102, f. 1v-2

BOOK ARTS

In France book production had become centralized in the professional **scriptoria** of Paris, and its main patrons were the universities and the court. In thirteenth-century England, by contrast, the traditional centers of production—far-flung rural monasteries that had produced such twelfth-century work as the beautiful *Winchester Psalter* (see fig. 15-30)—continued to dominate the book arts. Toward the close of the thirteenth century, however, secular workshops became increasingly active, reflecting a demand for books from newly literate landowners, townspeople, and students. These people read books, both in English and in Latin, for entertainment and general knowledge as well as for prayer. The fourteenth century was a golden age of manuscript production in England, as the thirteenth century had been in France. Among the delights of English Gothic manuscripts are their imaginative marginalia (pictures in margins of pages).

The dazzling artistry and delight in ambiguities that had marked earlier Anglo-Saxon manuscript illumination reappeared in the *Windmill Psalter* (c. 1270–80), so-called because of a windmill at the top of the initial *E* at the beginning of Psalm 1 (fig. 16-40). The Psalm begins with the words *"Beatus vir qui non abiit"* ("Happy those who do not follow the counsel [of the wicked]," Psalm 1:1). The letter *B*, the first letter of the Psalm, fills the left page, and an *E*, the second letter, occupies the top of the right page. The rest of the opening words appear on a banner carried by an angel at the bottom of the *E*. The *B* outlines a densely interlaced Tree of Jesse. The *E* is formed from large tendrils that escape from delicate background vegetation to support characters in the story of the Judgment of Solomon. The story, seen as a prefiguration of the Last Judgment, relates how two women (at the right) claiming the same baby came before King Solomon (on the crossbar) to settle their dispute. He ordered a guard to slice the baby in half with his sword and give each woman her share. This trick exposed the real mother, who hastened to give up her claim in order to save the baby's life.

Charming images appear among the pages' foliage, many of them visual puns on the text. For example, the large windmill at the top of the initial *E* illustrates the statement in the Psalm that the wicked would not survive the Judgment but would be "like chaff driven by the wind" (Psalm 1:4). Imagery such as this would have stimulated contemplation of the inner meanings of the text's familiar messages.

16-41. *Life of the Virgin*, back of the Chichester-Constable chasuble, from a set of vestments embroidered in *opus anglicanum*, from southern England. 1330–50. Red velvet with silk and metallic thread and seed pearls; length 5'6" (164 cm), width 30" (76 cm). The Metropolitan Museum of Art, New York

Fletcher Fund, 1927 (2.7 162.1)

(fig. 16-41) is embroidered with scenes from the Life of the Virgin—from the bottom, the Annunciation, the Adoration of the Magi, and the Coronation of the Virgin—arranged in three registers on its back. Cusped, crocketed S-shaped arches, twisting branches sprouting oak leaves, seed-pearl acorns, and animal faces define each register. The star and crescent moon in the Coronation of the Virgin scene, heraldic emblems of the royal family, suggest that the chasuble may have been made under the patronage of Edward III (ruled 1327–77). The embroidery was done in split stitch with fine gradations of colored silk forming the images as subtly as painting (see "Embroidery Techniques," page 544). Where gold threads were laid and couched, the effect is like the burnished gold-leaf backgrounds of manuscript illuminations. During the celebration of the Mass, garments of *opus anglicanum* would have glinted in the candlelight amid the other treasures of the altar. So heavy did such gold and bejeweled garments become, however, that their wearers often needed help to move.

SPAIN

The Christian Reconquest of Muslim Spain gained momentum in the thirteenth century, first under Ferdinand III (ruled 1217–52), then under Alfonso X "the Wise" (ruled 1252–84), king of the newly unified northern realm of León and Castile. In the east, the union of Aragón with Catalonia created a prosperous realm that benefited from expanding Mediterranean trade. Christian rulers were initially tolerant of the Muslim and Jewish populations that came under their control, but this tolerance would give way in the late fifteenth century to a drive toward religious conformity. Like other European lands in the fourteenth century, Spain was ravaged by rebellion, war, and plague.

From the twelfth century on, the art of Christian Spain reflects the growing influence of foreign styles, particularly those of France and Italy. Patrons often brought in master masons, sculptors, and painters from these regions to direct or execute important projects. Local artisans adapted the new influences and combined them with local traditions to create a recognizably Spanish Gothic style.

OPUS ANGLICANUM

Since Anglo-Saxon times, the English were famous for their embroidery. From the thirteenth through the sixteenth centuries the pictorial needlework in colored silk and gold thread of English embroiderers, both men and women, gained such renown that it came to be referred to by the Latin term *opus anglicanum* ("English work"). Among the collectors of this luxurious textile art was the pope in Rome, who had more than 100 pieces. The names of several prominent embroiderers are known, such as Mabel of Bury Saint Edmunds, who worked for Henry III in the thirteenth century, but few can be connected to specific works.

Opus anglicanum was employed for banners, court dress, and other secular uses, as well as for the vestments worn by the clergy during Mass. A mid-fourteenth-century vestment known as the Chichester-Constable chasuble

ARCHITECTURE

While most of the great thirteenth-century churches of Castile and León were inspired by French Gothic architecture—and some even had French masons working on their structure and sculpture—to the east, Catalonia and the Balearic Islands developed their own distinctive Catalán Gothic style. Mallorca, the largest of the Balearic Islands and a major center of Mediterranean trade, had been captured from the Muslims in 1229 by James I of Aragón (ruled 1214–76); he converted the mosque at its capital, Palma, into a church. His son initiated the construction of a new cathedral in 1306. The structure has an imposing, fortresslike exterior dominated by closely packed wall buttresses at the continuous line of chapels along the outer aisles. The tall nave, supported by flying buttresses (every third buttress on the exterior), soars to

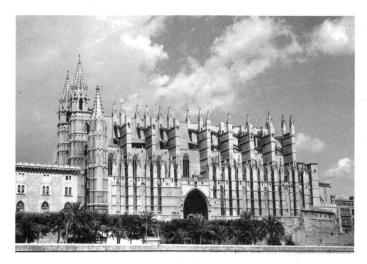

16-42. Cathedral of Palma, Mallorca, Balearic Islands, Spain. Begun 1306. View from the south

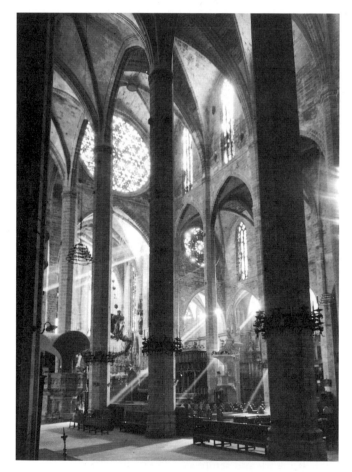

16-43. Nave and side aisle, Palma Cathedral

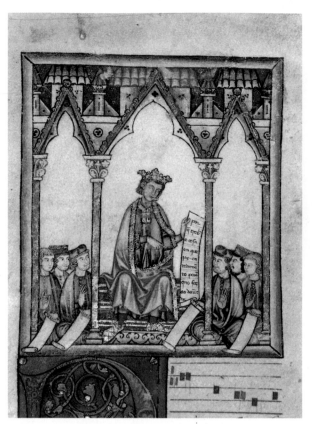

16-44. Page with *Alfonso the Wise*, *Cantigas de Santa María*, from Castile, Spain. Mid- to late-13th century. Ink, pigments, and gold on vellum. El Escorial, Real Biblioteca de San Lorenzo, Madrid

BOOK ARTS

King Alfonso X of Castile was known as a patron of the arts who maintained a brilliant court of poets, scholars, artists, and musicians during the mid-thirteenth century. He promoted the use of local vernacular languages instead of Latin in his realm for everything from religious literature and history to legal codes and translations of important Arabic scientific texts. He was a poet and musician himself, compiling and setting to music a collection of poems, some of them his own, devoted to the Virgin Mary. An illustration from this manuscript, the *Cantigas de Santa María (Songs of Saint Mary)*, shows Alfonso as poet-musician above one of his own songs (fig. 16-44). Like Queen Blanche and King Louis in the French Court–style Moralized Bible seen earlier (see fig. 16-32), Alfonso is shown seated in a Gothic building. He holds a copy of his poetry, which he presents to admiring courtiers.

PAINTED ALTARPIECES

Large-scale paintings on or just behind church altars, called **altarpieces**, began to appear in the thirteenth century and came into use throughout Europe thereafter. While manuscript illumination and stained glass, and to some extent the fiber arts of embroidery and tapestry,

the amazing height of 143 feet; the side-aisle vaults rise to more than 94 feet (figs. 16-42, 16-43). These tall side aisles, combined with slender polygonal piers in the nave arcade, create a unified interior space. Large windows in the clerestory and both eastern and western nave walls flood the interior with light.

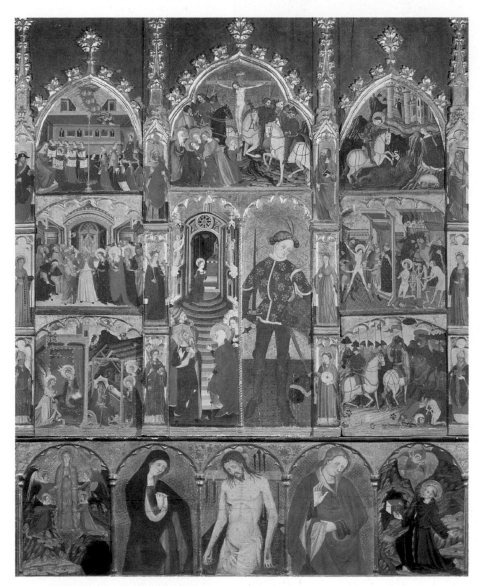

16-45. **Luis Borrassá.** *Virgin and Saint George*, altarpiece in Church of San Francisco, Villafranca del Panadés, Barcelona. c. 1399. Tempera on wood panel

The contract for another of Borrassá's altarpieces, dated 1402, specifies its subject matter in detail as well as its dimensions and shape. The contract requires the use of high-quality materials and calls for delivery in six months, with payment at specified stages upon inspection of work in progress. It holds the painter responsible for all stages of production "according to what is customary in other beautiful [altarpieces]" (cited in Binski, page 52).

remained the most important forms of two-dimensional art, altarpieces, murals, and smaller paintings on wood panels became increasingly important in the thirteenth century. Professional painters worked for both individual and institutional patrons. Many were members of painting dynasties that lasted for generations, and some had wide-ranging responsibilities at court.

One of the major figures in late medieval Spanish painting was Luis Borrassá (1360–1426). From a Catalán family of painters, he worked for the court of Aragón early in his career, probably in the style favored by the French-born queen. Sometime during the 1380s he set up a workshop in the Catalán capital of Barcelona.

Among the altarpieces attributed to him is the *Virgin and Saint George* made for the Church of San Francisco at Villafranca del Panadés (fig. 16-45). This work is a distinctively Spanish-type altarpiece called a ***retablo***, which consists of an enormous wooden framework—taking up the whole wall behind an altar—that is filled with either painted or carved narrative scenes. The depiction of space and the lively narrative scenes in the panels of the *Virgin and Saint George* reflect the influence of the painting style that had developed in Tuscany, in northern Italy, but the realistic details, elegant drawing, and rich colors are characteristically Catalán. Borrassá's synthesis of foreign artistic influences reflects the development of the

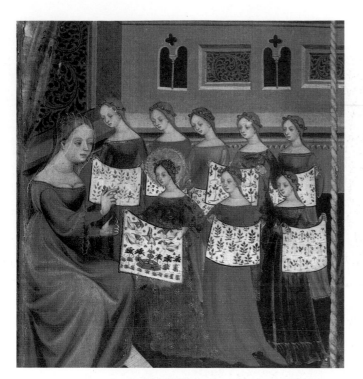

16-46. Luis Borrassá. *Education of the Virgin*, detail from *Virgin and Saint George* altarpiece

A new type of church, the **hall church**, developed in thirteenth-century Germany in response to the increasing importance of sermons in church services. The hall church featured a nave and side aisles with vaults of the same height, creating a spacious and open interior that could accommodate the large crowds drawn by charismatic preachers. The flexible design of these great halls was also widely adopted for civic and residential buildings.

The Church of Saint Elizabeth at Marburg, near Cologne in Germany, built between 1233 and 1283, was popular as a pilgrimage site and as a funerary chapel for the local nobility. The earliest example of a hall church in Germany, Saint Elizabeth's has a beautiful simplicity and purity of line. Light from two stories of tall windows fills the interior, unimpeded by nave arcades, galleries, or *triforia* (fig. 16-47). The exterior has a similar verticality and geometric clarity.

The Gothic style was also adopted for Jewish religious structures. The oldest functioning synagogue in Europe, Prague's Altneuschul ("Old-New Synagogue"), replaced a synagogue of 1230–40 in the third quarter of the thirteenth century (fig. 16-48). One of two principal synagogues serving the Jews of Prague, it reflects the geometric clarity and regularity of Gothic architecture and

courtly International Gothic style that emerged in much of Europe about the beginning of the fourteenth century.

The panel depicting the *Education of the Virgin* (fig. 16-46) shows Mary among a group of fourteenth-century Spanish girls presenting their embroidery for a teacher's approval. All except Mary have produced the assigned floral design. Mary instead has stitched the enclosed garden of Paradise where five golden-winged angels flutter around the Fountain of Life. Embroidery is such an important art that even the child Mary has learned to do it.

GERMANY AND THE HOLY ROMAN EMPIRE

In contrast to England and France, which were becoming strong national states, by about the middle of the thirteenth century Germany had developed into a decentralized conglomeration of independent principalities, bishoprics, and even independent cities. The Holy Roman Empire, weakened by prolonged struggle with the papacy and with German princes, had ceased to be a significant power. Its Italian holdings had established their independence, and Holy Roman emperors—now elected by German princes—had only nominal authority over a loose union of Germanic states. Each emperor in turn held court from his own state. Charles IV (ruled 1355–78), for example, who was also king of Bohemia, ruled from the Bohemian city of Prague, which he helped develop into a great city. Indeed, the emperors exhibited their greatest powers as patrons of the arts, promoting local traditions as well as the spread of the French Court style and the International Gothic style that followed it.

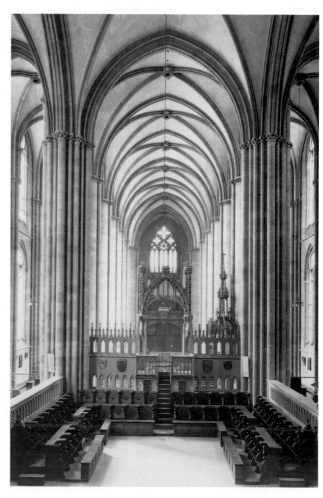

16-47. Nave, Church of Saint Elizabeth, Marburg, Germany. 1233–83

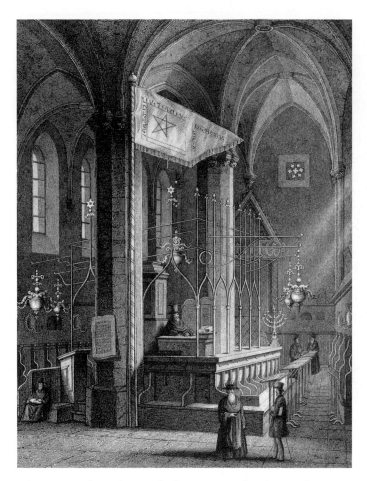

16-48. Interior, Altneuschul, Prague, Bohemia (Czech Republic). c. late 13th century; *bimah* after 1483; later additions and alterations. Engraving from *Das Historisches Prag in 25 Stahlstichen*, 1864

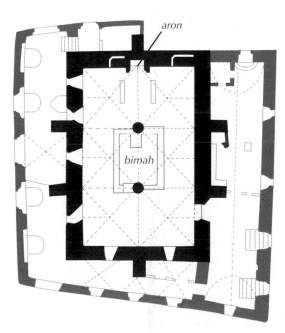

16-49. Plan of Altneuschul

demonstrates the adaptability of the Gothic hall-church design for non-Christian use (fig. 16-49). Like a hall church, the vaults of the synagogue are all the same height. Unlike a church, with its nave and side aisles, the Altneuschul has two aisles with three bays each. The bays have four-part vaulting with a decorative fifth rib.

Because of sporadic repression, Jewish communities in the cities of northern Europe tended to be small throughout the Middle Ages. Towns often imposed restrictions on the building of synagogues, requiring, for example, that they be lower than churches. Since local guilds controlled the building trades in most towns, Christian workers usually worked on Jewish construction projects. Franciscans may have built the Altneuschul for the Jewish community.

The medieval synagogue was both a place of prayer and a communal center of learning and inspiration where men gathered to read and discuss the Torah. The synagogue had two focal points, the *aron*, or shrine for the Torah scrolls, and a raised reading platform called the *bimah*. Worshipers faced the *aron*, which was located on the east wall, in the direction of Jerusalem. The *bimah* stood in the center of the hall. The pedimented *aron* of the Altneuschul can be seen in figure 16-48, partially obscured by a fifteenth-century openwork partition around the *bimah*, which straddled the two center bays. The synagogue's single entrance was placed off-center in a corner bay at the west end. Candles along the walls and in overhead chandeliers supplemented natural light from twelve large windows. The interior was also originally adorned with murals (the large, richly decorated Torah case shown on the *bimah* table was made later). Men worshiped and studied in the principal space; women were sequestered in annexes on the north and west sides.

SCULPTURE

One of the creative centers of Europe since the eleventh century had been the region known as the Mosan (from the Meuse River, in today's Belgium), with centers in Liège and Verdun, and the closely related Rhine River valley. Nicholas of Verdun, a pivotal figure in the early development of Gothic sculpture, influenced both French and German art through his work well into the thirteenth century. Born in the Meuse River valley between Flanders and Germany, he was heir to the great Mosan metalworking tradition (see fig. 15-37). Nicholas worked for a number of important German patrons, including the archbishop of Cologne, for whom he created a magnificent reliquary (c. 1190–1205/10) to hold what were believed to be relics of the Three Magi (fig. 16-50, page 594). Called the *Shrine of the Three Kings*, the reliquary resembles a basilica, a traditional reliquary form that evolved to reflect changes in church architecture. It is made of gilded bronze and silver with gemstones and dark blue enamel that accentuate its architectonic details. Mosan classicism reached new heights in this work. Figures are fully and naturalistically modeled in bronze **repoussé**. The Magi and Virgin are on the front end, and figures of prophets and the apostles fill the

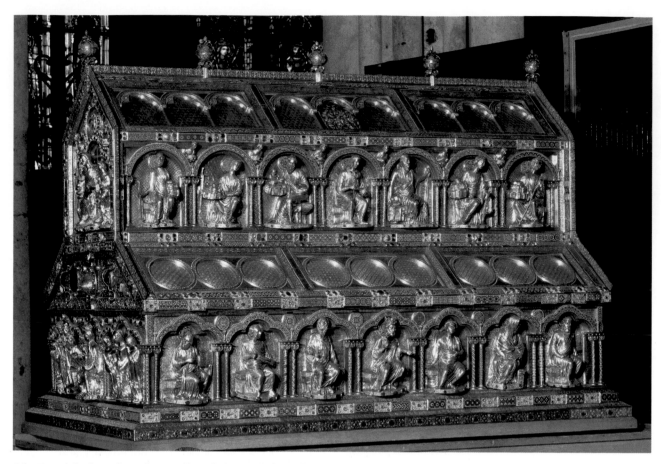

16-50. Nicholas of Verdun and workshop. *Shrine of the Three Kings*. c. 1190–c. 1205/10. Silver and gilded bronze with enamel and gemstones, 5'8" x 6' x 3'8" (1.73 x 1.83 x 1.12 m). Cathedral Treasury, Cologne, Germany

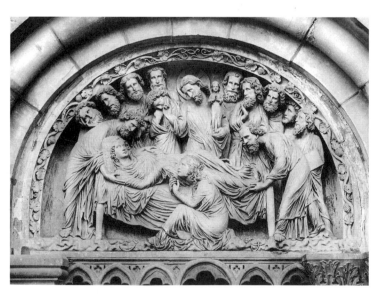

16-51. *Dormition of the Virgin*, south transept portal tympanum, Strasbourg Cathedral, Strasbourg, France. c. 1230

niches in the two levels of arcading on the sides. The work combines robust, expressively mobile sculptural forms with a jeweler's exquisite ornamental detailing to create an opulent, monumental setting for its precious contents.

Nicholas and his fellow goldsmiths inspired a new classicizing style in architectural sculpture, seen, for example, in the works by the "Classical Shop" at Reims (see fig. 16-24) and the sculpture in the south transept facade at the cathedral in Strasbourg (a border city variously claimed by France and Germany over the centuries). Although the works on the Strasbourg facade reflect this classicizing style, they also have an emotional expressiveness that is characteristic of much German medieval sculpture. A relief depicting the death and assumption of Mary, a subject known as the Dormition (Sleep) of the Virgin, fills the tympanum of the south transept portal (fig. 16-51). Mary lies on her deathbed, but Christ has received her soul, the doll-like figure in his arms, and will carry it directly to heaven, where she will be enthroned next to him. The scene is filled with dynamically expressive figures with large heads and short bodies clothed in fluid drapery that envelops their rounded limbs. Deeply undercut, the large figures stand out dramatically in the crowded scene, their grief vividly rendered.

In addition to such emotional expressionism, a powerful current of naturalism ran through German Gothic sculpture. Some works—among them a famous statue of Saint Maurice, produced about 1240–50, from Magdeburg Cathedral—may even have been based on living models instead of idealized types (fig. 16-52). Magdeburg Cathedral, in north-central Germany, had been built on the site of an earlier church dedicated to Saint Maurice, and his relics were preserved there. Maurice, the leader of a

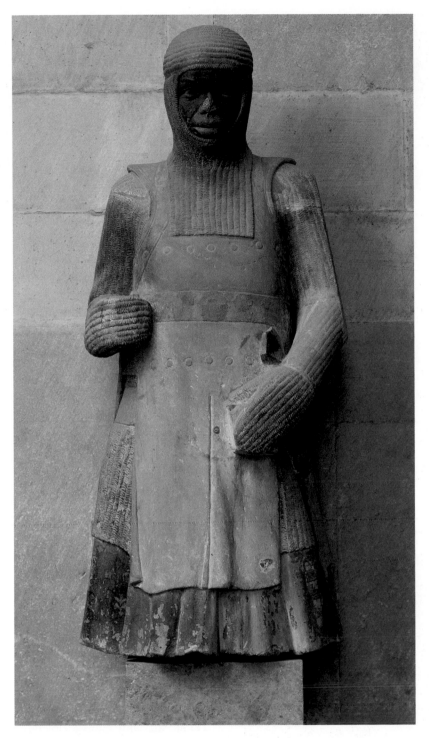

16-52. *Saint Maurice*, Magdeburg Cathedral, Magdeburg, Germany.
c. 1240–50. Dark sandstone with traces of polychromy

group of Egyptian Christians in the Roman army in Gaul, was martyred together with his troops in 286. The crusading knights of the Middle Ages viewed him and other warrior-saints as models of the crusading spirit, and he was a favorite saint of military aristocrats. Because he came from Egypt, Maurice was commonly portrayed with black African features. Dressed in a full suit of chain mail covered by a sleeveless coat of leather, this Saint Maurice represents a distinctly different ideal of warrior-ship and manhood than does the *Saint Theodore* from

Chartres (see fig. 16-9), which is nearly contemporary.

Another exceptional sculptor worked in a naturalistic style for the bishop of Wettin, Dietrich II, on the decoration of a new chapel-sanctuary built at the west end of Naumburg Cathedral about 1245–60. Dietrich, a member of the ruling family of Naumburg, had lifesize statues of twelve ancestors who were patrons of the church placed on pedestals around the chapel—in effect, securing their perpetual attendance at Mass. Among them are representations of Ekkehard of Meissen and his Polish-born

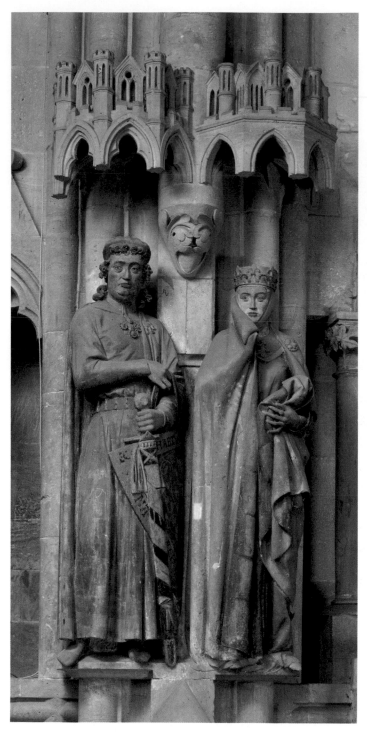

16-53. *Ekkehard and Uta*, west chapel sanctuary, Naumburg Cathedral, Naumburg, Germany. c. 1245–60. Stone, originally polychromed, approx. 6'2" (1.88 m)

wife, Uta (fig. 16-53). Although long dead when these statues were carved, they seem extraordinarily lifelike and individualized. Ekkehard appears as a proud warrior and no-nonsense administrator, while Uta, coolly elegant, artfully draws her cloak to her cheek. Traces of pigment indicate that the figures were originally painted.

The ordeals of the fourteenth century—famines, wars, and plagues—helped inspire a mystical religiosity that emphasized both ecstatic joy and extreme suffering.

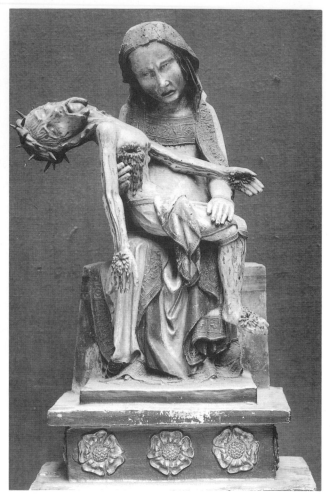

16-54. *Vesperbild*, from Middle Rhine region, Germany. c. 1330. Wood, height 34½" (88.4 cm). Landesmuseum, Bonn, Germany

The joys and sorrows of Mary became important themes, represented expressionistically in German Gothic art with almost cloying sweetness in Nativity depictions and excruciatingly graphic physical suffering in portrayals of the Crucifixion and the Lamentation. Devotional images, known as *Andachtsbilder* in German, inspired the worshiper to contemplate Jesus' first and last hours, especially during evening prayers, vespers (giving rise to the term *Vesperbild* for the image of Mary mourning her son). Through such religious exercises, worshipers hoped to achieve understanding of the divine and union with God. In the well-known example shown here (fig. 16-54), blood gushes from the hideous rosettes that are the wounds of an emaciated Jesus. The Virgin's face conveys the intensity of her ordeal, mingling horror, shock, pity, and grief. Such images had a profound impact on later art, both within Germany and beyond.

ITALY The thirteenth century was a period of political division and economic expansion for the Italian peninsula and its neighboring islands. With the death of Holy Roman Emperor Frederick II (ruled 1220–50), Germany and the empire ceased to be an important factor in Italian politics and culture, and France and Spain began to vie for control of Sicily and southern Italy. In northern and central Italy, the prolonged conflict between the papacy and the empire had created two political factions: the pro-papacy Guelphs and the pro-imperial Ghibellines. Northern Italy was dominated by several independent and wealthy city-states controlled by a few powerful families. These cities were subject to chronic internal factional strife as well as conflict with one another.

The papacy had emerged from its conflict with the Holy Roman Empire as a significant international force. But its temporal success weakened its spiritual authority and brought it into conflict with the growing power of the kings of France and England. In 1309, after the election of a French pope, the papal court moved from Rome to Avignon, in southern France. During the Great Schism of 1378 to 1417, there were two rival lines of popes, one in Rome and one in Avignon, each claiming legitimacy.

Great wealth and a growing individualism promoted arts patronage in northern Italy. It was here that artisans began to emerge as artists in the modern sense, both in their own eyes and the eyes of patrons. Although their methods and working conditions remained largely unchanged, artisans in Italy now belonged to powerful urban guilds and contracted freely with wealthy townspeople and nobles and with civic and religious bodies. Their ambitious, self-aware art reflects their economic and social freedom.

ARCHITECTURE

Italian Gothic architecture developed from earlier Italian Romanesque architecture in a way that only marginally reflects the influence of the French Gothic style. Rather than the complex narrative sculptural programs typical of French Gothic facades, the decorative focus is on the doors themselves and, inside, on furnishings such as pulpits, tomb monuments, and baptismal fonts.

Florence erected a colossal cathedral (*duomo*) in the fourteenth century (fig. 16-55, page 598). The building has a long and complex history. The original plan, by Arnolfo di Cambio (c. 1245–1302), was approved in 1294, but political unrest brought construction to a halt until 1357. Several modifications of the design were made, and Florence Cathedral assumed much of its present appearance between 1357 and 1378. The west facade was rebuilt again in the sixteenth century. The facade was given its veneer of white and green marble in the nineteenth century to coordinate with that of the nearby Romanesque Baptistry of San Giovanni.

The cathedral's spacious, square-bayed nave (fig. 16-56, page 598) is approximately as tall as the nave at Amiens (see fig. 16-18) but is three times as wide, giving it a radically different appearance. Here, well-proportioned

form is more important than light. The tall nave arcade, harkening back to single-storied imperial Christian designs, has a short clerestory with a single oculus in each bay and no triforium. The regular procession of four-part ribbed vaults springing from composite piers, however, clearly reflects northern Gothic influence. When the vaults began to crack under their own weight in 1366, unsightly iron tie bars had to be installed to hold them together. Builders in northern Europe solved this problem with exterior buttressing.

Sculptors and painters rather than masons were often responsible for designing Italian architecture, and as the plan of Florence Cathedral reflects, they tended to be more concerned with pure design than with engineering (fig. 16-57, page 598). The long nave ends in an octagonal domed crossing, as wide as the nave and side aisles, from which the apse and transept arms extend. In basic architectural terms, this is a central-plan church grafted onto a basilica-plan church. It symbolically creates a Dome of Heaven over the crossing, where the main altar is located, and separates it from the worldly realm of the congregation in the nave. The great ribbed dome, so fundamental to this abstract conception, could not be built when it was planned in 1365. Not until 1420 did Filippo Brunelleschi solve the engineering problems involved in constructing it.

SCULPTURE

In the first half of the thirteenth century, Holy Roman Emperor Frederick II fostered a classical revival at his court in southern Italy that is often compared to Charlemagne's undertakings in the early ninth century. The revival stimulated a trend toward greater naturalism in Italian Gothic sculpture that paralleled a similar trend in the north. A leading early exemplar of the trend was Nicola Pisano (active c. 1258–78), who came from the southern town of Apulia, where imperial patronage was still strong. An inscription on a freestanding marble pulpit (fig. 16-58, page 599) in the Pisa Baptistry (see fig. 15-40) identifies it as Nicola's earliest work in northern Italy. The inscription reads: "In the year 1260 Nicola Pisano carved this noble work. May so gifted a hand be praised as it deserves." The six-sided structure is open on one side for a stairway. It is supported by columns topped with leafy Corinthian capitals and standing figures flanking Gothic trefoil arches. A center column stands on a high base carved with crouching figures and domestic animals. Every second outer column rests on the back of a shaggy-maned lion guarding its prey. The format, style, and technique of Roman sarcophagus reliefs—readily accessible in the burial ground near the cathedral—may have inspired the carving on the pulpit's upper panels. The panels illustrate New Testament subjects, each treated as an independent composition unrelated to the others.

The Nativity cycle panel (fig. 16-59, page 599) illustrates three scenes—the Annunciation, the Nativity, and the Adoration of the Shepherds—within a shallow space. The reclining Virgin dominates the middle of the

16-55. Arnolfo di Cambio, Francesco Talenti, Andrea Orcagna, and others. Florence Cathedral, Florence. Begun 1296; redesigned 1357 and 1366; drum and dome by Brunelleschi, 1420–36; campanile by Giotto, Andrea Pisano, and Francesco Talenti, c.1334–50.

The Romanesque Baptistry of San Giovanni stands in front of the *duomo*. In the distance, near the Arno River, is the Church of Santa Croce.

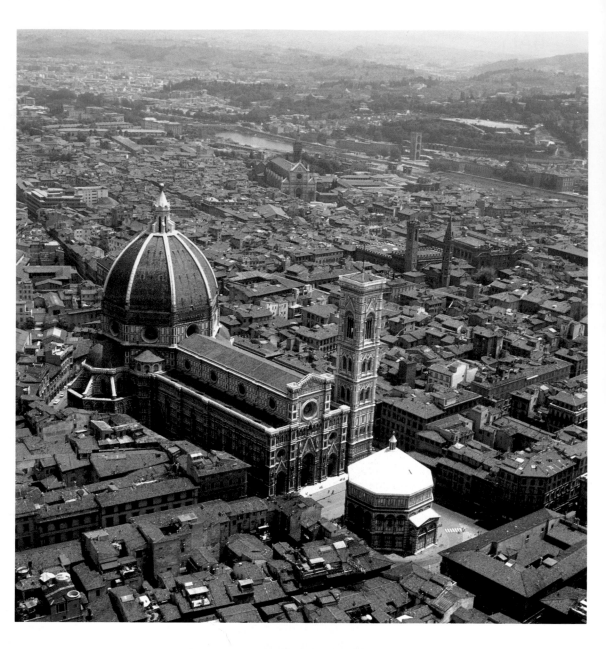

16-56. Nave, Florence Cathedral. 1357–78

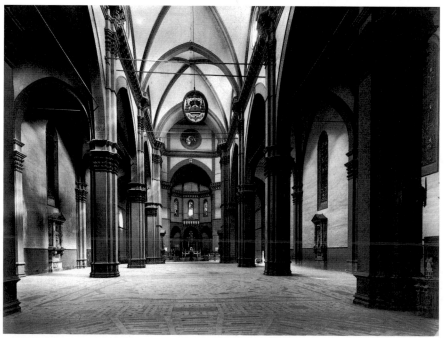

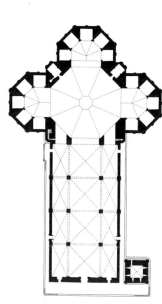

16-57. Plan of Florence Cathedral. 1357–78

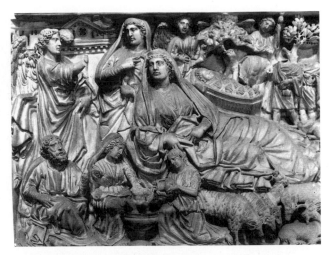

16-59. Nicola Pisano. *Nativity*, detail of pulpit, Baptistry, Pisa. Marble, 33½ x 44½" (85 x 113 cm)

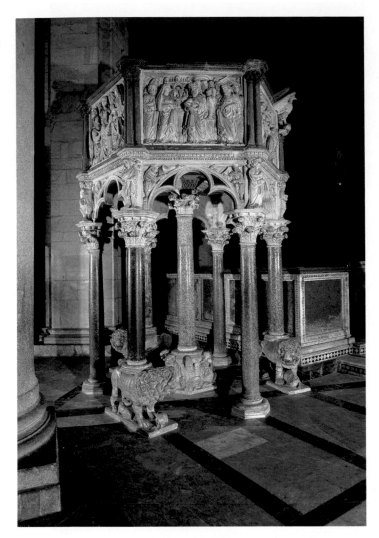

16-58. Nicola Pisano. Pulpit, Baptistry, Pisa. 1260. Marble; height approx. 15' (4.6 m)

The scene of the Presentation is clearly visible on the pulpit.

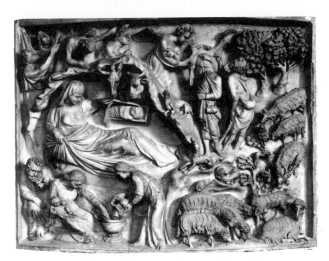

16-60. Giovanni Pisano. *Nativity*, detail of pulpit, Pisa Cathedral, Pisa. 1302–10. Marble, 34⅜ x 43" (87.2 x 109.2 cm)

composition. In the foreground, midwives wash the infant Jesus as Joseph looks on. In the upper left is the Annunciation, with the archangel Gabriel and the Virgin. The scene in the upper right combines the Adoration with the Annunciation to the Shepherds. The composition leads the eye from group to group back to the focal point in the center, the reclining and regally detached Mother of God. The sculptural treatment of the deeply cut, full-bodied forms is quite classical, as are their heavy, placid faces; the congested layout and the use of hierarchical scale are not.

Nicola's son Giovanni (active in Italy c. 1265–1314; he may also have worked or studied in France) assisted his father in his later projects and emerged as a versatile artist in his own right near the end of the thirteenth century. Between 1302 and 1310, Giovanni created a pulpit for Pisa Cathedral that is similar to his father's in conception and general approach but is significantly different in style and execution. Giovanni's graceful, animated Nativity figures inhabit an uptilted, deeply carved space (fig. 16-60). In place of Nicola's impassive Roman matron, Giovanni depicts a slender young Virgin, sheltered

by a shell-like cave, gazing delightedly at her baby. Below her, a midwife who doubted the virgin birth has her withered hand restored by dipping it into the baby Jesus' bath water. Angelic onlookers in the upper left have replaced the Annunciation. Sheep, shepherds, and angels spiral up from the landscape with trees and sheep at the right. Dynamic where Nicola's was static, the scene pulses with energy.

Another Italian sculptor called Pisano but unrelated to Giovanni and Nicola, Andrea Pisano (active c. 1320s–48), in 1330 was awarded the prestigious commission for a pair of gilded bronze doors for the Florentine Baptistry of San Giovanni. Completed within six years, the doors are decorated with twenty-eight scenes from the life of John the Baptist (San Giovanni) set in quatrefoils (fig. 16-61, page 600). Surrounding the doors are lush vine scrolls filled with flowers, fruits, and birds, cast in bronze and applied to the doorway's lintel and jambs. The figures within the quatrefoils are in the monumental classicizing style then current in Florentine painting. The individual scenes are elegantly natural, and the

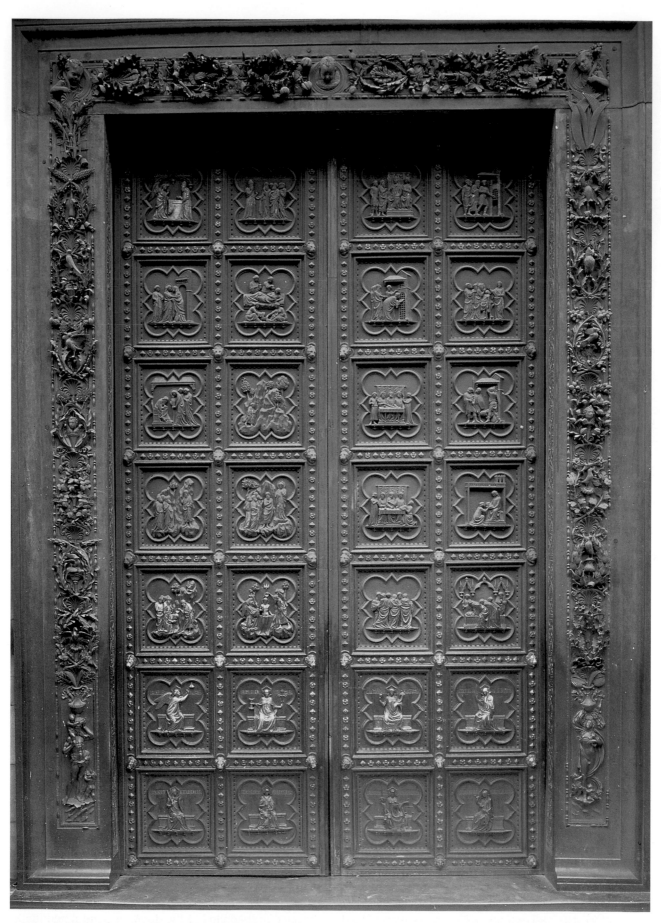

16-61. Andrea Pisano. *Life of John the Baptist*, south doors, Baptistry of San Giovanni, Florence. 1330–36. Gilded bronze

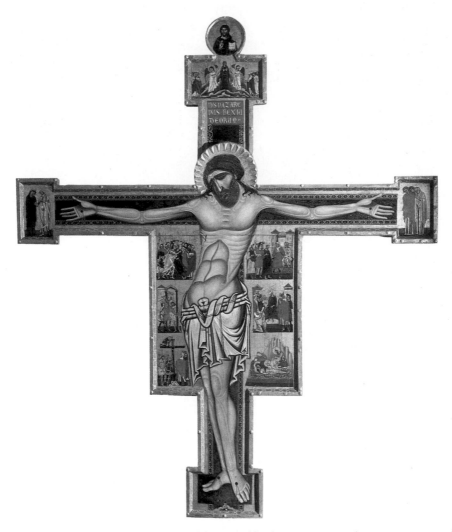

16-62. Coppo di Marcovaldo. *Crucifix*, from Tuscany, Italy.
c. 1250–1300. Tempera and gold on wood panel, 9'7³/₈" x
8'1¼" (2.93 x 2.47 m). Pinacoteca, San Gimignano, Italy

figures' placement and modeling create a remarkable illusion of three-dimensionality, but the overall effect of the repeated barbed quatrefoils is two-dimensional and decorative.

PAINTING

Wall painting, common elsewhere in Europe, became a preeminent art form in Italy. Painting on wood panels also surged in popularity (see "Cennini on Panel Painting," page 602). Altarpieces were commissioned not just for the main altars of cathedrals but for secondary altars, parish churches, and private chapels as well. This growing demand reflected the new sources of patronage created by Italy's burgeoning urban society. Art proclaimed a patron's status as much as it did his or her piety.

The capture of Constantinople by Crusaders in 1204 had brought an influx of Byzantine art and artists to Italy, influencing Italian painters of the thirteenth and fourteenth centuries to varying degrees. This influence appears strongly in the emotionalism of a large wooden crucifix attributed to the Florentine painter Coppo di Marcovaldo and dated about 1250–1300 (fig. 16-62). Instead of the *Christus triumphans* type common in earlier Italo-Byzantine painting, Coppo has represented the *Christus patiens*, or suffering Christ, with closed eyes and bleeding, slumped body (see figs. 7-45, 14-28). The six scenes at the sides of Christ's body tell the Passion story. Such historiated crucifixes were mounted on the **rood screens** (partitions holding the rood, or cross) that hid sanctuary rituals from worshipers (as depicted in figure 16-70). Some were painted on the back, too, suggesting that they were carried in religious processions.

Two very important schools of Italian Gothic painting emerged in Siena and Florence, rivals in this as in everything else. Siena's foremost painter was Duccio di Buoninsegna (active 1278–1318), whose synthesis of Byzantine and northern Gothic influences transformed the tradition in which he worked. Duccio and his studio painted the grand *Maestà* ("Majesty") *Altarpiece* for the

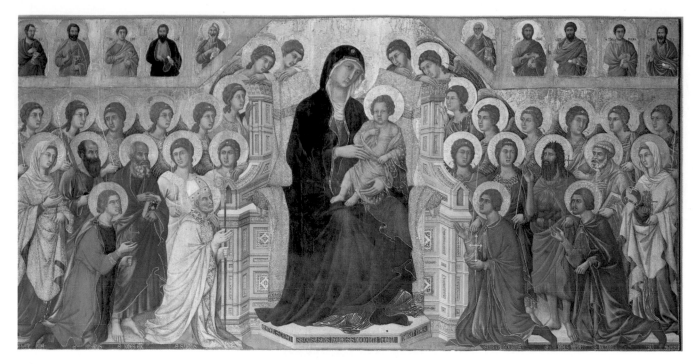

16-63. Duccio di Buoninsegna. *Virgin and Child in Majesty*, main panel of *Maestà Altarpiece*, from Siena Cathedral. 1308–11. Tempera and gold on wood panel, 7' x 13'6¼" (2.13 x 3.96 m). Museo dell'Opera del Duomo, Siena

"On the day that it was carried to the [cathedral] the shops were shut, and the bishop conducted a great and devout company of priests and friars in solemn procession, accompanied by . . . all the officers of the commune, and all the people, and one after another the worthiest with lighted candles in their hands took places near the picture, and behind came the women and children with great devotion. And they accompanied the said picture up to the [cathedral], making the procession around the Campo [square], as is the custom, all the bells ringing joyously, out of reverence for so noble a picture as is this" (Holt, page 69).

TECHNIQUE

CENNINI ON PANEL PAINTING

Cennino Cennini's *Il Libro dell' Arte* (*The Handbook of the Crafts*), a compendium of early fifteenth-century Florentine artistic techniques, includes step-by-step instructions for making panel paintings: The wood for these paintings, he specified, should be fine-grained, free of blemishes, and thoroughly seasoned by slow drying. The first step in preparing a panel for painting is to cover its surface with clean white linen strips soaked in a **gesso** made from gypsum, a task best done on a dry, windy day. Gesso provides a ground, or surface, on which to paint. Cennini specified that at least nine layers should be applied, with a minimum of two-and-a-half days' drying time between layers, depending on the weather. The gessoed surface should then be burnished until it resembles ivory. The artist can now sketch the composition of the work with charcoal made from burned willow twigs. At this point, advised the author, "When you have finished drawing your figure, especially if it is in a very valuable [altarpiece], so that you are counting on profit and reputation from it, leave it alone for a few days, going back to it now and then to look it over and improve it wherever it still needs something . . . (and bear in mind that you may copy and examine things done by other good masters; that it is no shame to you)" (cited in Thompson, page 75). The final version of the design should be inked in with a fine squirrel-hair brush, and the charcoal brushed off with a feather. Gold leaf should be affixed on a humid day over a reddish clay ground called bole, the tissue-thin sheets carefully glued down with a mixture of fine powdered clay and egg white, and burnished with a gemstone or the tooth of a carnivorous animal. Punched and incised patterning should be added to the gold leaf later.

Italian painters at this time worked in a type of paint known as **tempera**, powdered pigments mixed most often with egg yolk, a little water, and an occasional touch of glue. Apprentices were kept busy grinding and mixing paints according to their masters' recipes, setting them out for more senior painters in wooden bowls or shell dishes.

Cennini specified a detailed and highly formulaic painting process. Faces, for example, were always to be done last, with flesh tones applied over two coats of a light greenish pigment and highlighted with touches of red and white. The finished painting was to be given a layer of varnish to protect it and enhance its colors. Reflecting the increasing specialization that developed in the thirteenth century, Cennini assumed that an elaborate frame would have been produced by someone else according to the painter's specifications and brought fully assembled to the studio.

Cennini claimed that panel painting was a gentleman's job, but given its laborious complexity, that was wishful thinking. The claim does, however, reflect the rising social status of painters.

16-64. Plan of front and back of *Maestà Altarpiece*

Duccio's *Maestà Altarpiece* was removed from the cathedral's main altar in 1505. In 1771, the altarpiece was cut up to make it salable. Over the years, sections were dispersed, appearing later at auctions or in museums and private collections. The value of the panels remaining in Siena was finally recognized, and they were placed in the cathedral museum there in 1878.

main altar of Siena Cathedral—dedicated, like the town itself, to the Virgin—between 1308 and 1311 (fig. 16-63). Creating this altarpiece was an arduous undertaking. The work was large—the central panel alone was 7 by 13 feet—and it had to be painted on both sides because the main altar stood in the center of the sanctuary.

Because the *Maestà* was broken up in the eighteenth century, the power and beauty of Duccio's original work must be imagined today from its scattered parts (fig. 16-64). The main scene, depicting the *Virgin and Child in Majesty*, was once accompanied above and below by narrative scenes from the Life of the Virgin and the Infancy of Christ. On the back were scenes from the Life and Passion of Christ. The brilliant palette and ornate **punchwork**—tooled designs in gold leaf—are characteristically Sienese. Duccio has combined a softened Italo-Byzantine figure style with the linear grace and the easy relationship between figures and their settings characteristic of the later northern Gothic style. This subtle blending of northern and southern elements can be seen in the haloed ranks around Mary's architectonic throne (which represents both the Church and its specific embodiment, Siena Cathedral). The central, most holy figures retain an iconic Byzantine solemnity and immobility, but those adoring them reflect a more naturalistic, courtly style that became the hallmark of the Sienese school for years to come.

Simone Martini, a practitioner (active 1315–44) of the style pioneered by Duccio, may have been among Duccio's assistants on the *Maestà*. In 1333, Martini painted an outstanding altarpiece depicting the Annunciation (fig. 16-65) for Siena Cathedral. This exquisite work, with its lavish punchwork, reflects a love of ornamental detail. The elegant figures, robed in fluttering

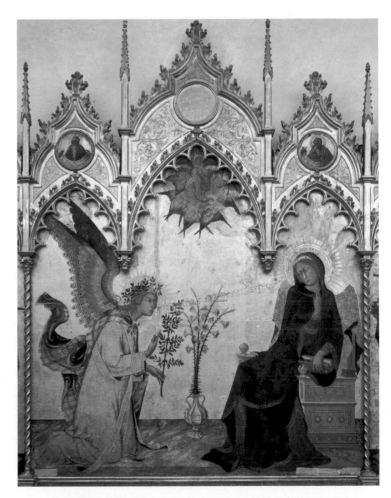

16-65. Simone Martini. *Annunciation*, center panel of altarpiece from Siena Cathedral. 1333. Tempera and gold on wood panel; 19th-century frame, 10' x 8'9" (3.05 x 2.67 m). Galleria degli Uffizi, Florence

The altarpiece's side panels depict saints and prophets. They were done by Lippo Memmi, Simone's brother-in-law and assistant.

TECHNIQUE
BUON FRESCO

Buon ("true") **fresco** ("fresh") wall painting on wet plaster was an Italian specialty, derived from Byzantine techniques and distinguished from **fresco secco** ("dry" fresco). The two methods were commonly used together in Italy.

The advantage of *buon fresco* was its durability. A chemical reaction occurred as the painted plaster dried that bonded the pigments into the wall surface. *Fresco secco*, in contrast, tended to flake off over time. The chief disadvantage of *buon fresco* was that it had to be done quickly and in sections. The painter plastered and painted only as much as could be completed in a day. Each section was thus known as a **giornata**, or day's work. The size of a *giornata* varied according to the complexity of the painting within it. A face, for instance, could occupy an entire day, whereas large areas of sky could be painted quite rapidly. A wall to be frescoed was first prepared with a rough, thick undercoat of plaster (*arriccio*). When this was dry, assistants copied the artist's composition onto it with sticks of charcoal, with the artist making any necessary adjustments. These drawings, known as **sinopia**, were often beautifully executed. Painting proceeded in irregularly shaped sections conforming to the contours of major figures and objects, with painters working from the top down so that drips fell on unfinished portions. Assistants covered one section at a time with a fresh, thin coat of very fine plaster, called *intonaco*, over the *sinopia*, and when this was "set" but not dry, pigments mixed with water were painted on. Blue areas, as well as details, were usually painted afterward in tempera using the *fresco secco* method.

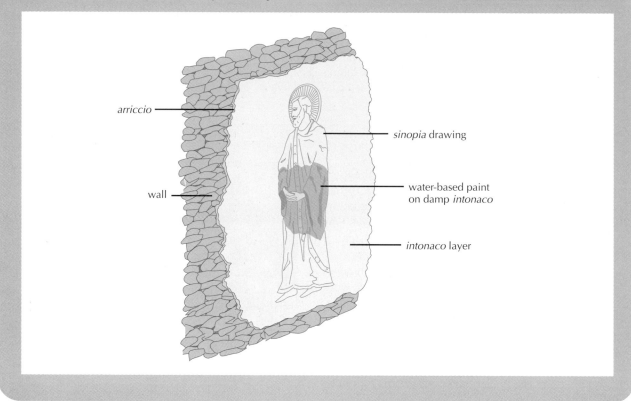

arriccio

sinopia drawing

wall

water-based paint on damp *intonaco*

intonaco layer

draperies and silhouetted against a flat gold ground, seem weightless. Reflecting the Marian literature of his day, the painter focused on the psychological impact of the Annunciation on a young and very human Mary. Gabriel has just appeared, his plaid-lined cloak swirling about him as he kneels in front of the Virgin. The words of his salutation—"Hail, favored one! The Lord is with you"—run from his mouth to her ear. Interrupted while reading the Bible in her room, Mary recoils in shock and fear from this gorgeous apparition. Only essential elements occupy the emotionally charged space. In addition to the two figures, these include Gabriel's olive-branch crown and scepter (emblems of triumph and peace), Mary's thronelike seat (an allusion to her future status as Queen of Heaven), the vase of white lilies (a symbol of her purity), and the dove of the Holy Spirit surrounded by cherubim. Mary's face harks back to

Byzantine conventions, but the stylized elegance of her body, seen in the deft curve of her recoiling form, the folds of her rich robe, and her upraised right hand, are characteristic of the Italian Gothic court style. Soon after finishing the *Annunciation*, Simone Martini was summoned to southern France to head a workshop at the papal court in Avignon (he had worked earlier for the French king of Sicily and Naples). His Sienese reformulation of the French Gothic style would contribute to the development of the International Gothic style at the turn of the century.

The Lorenzetti brothers, Pietro (active c. 1306–45) and Ambrogio (active c. 1319–47), worked in a more robust style that dominated Sienese painting during the second quarter of the fourteenth century. One of Pietro's outstanding works was a **triptych**, the *Birth of the Virgin* (fig. 16-66), painted in 1335–42 for one of the cathedral's

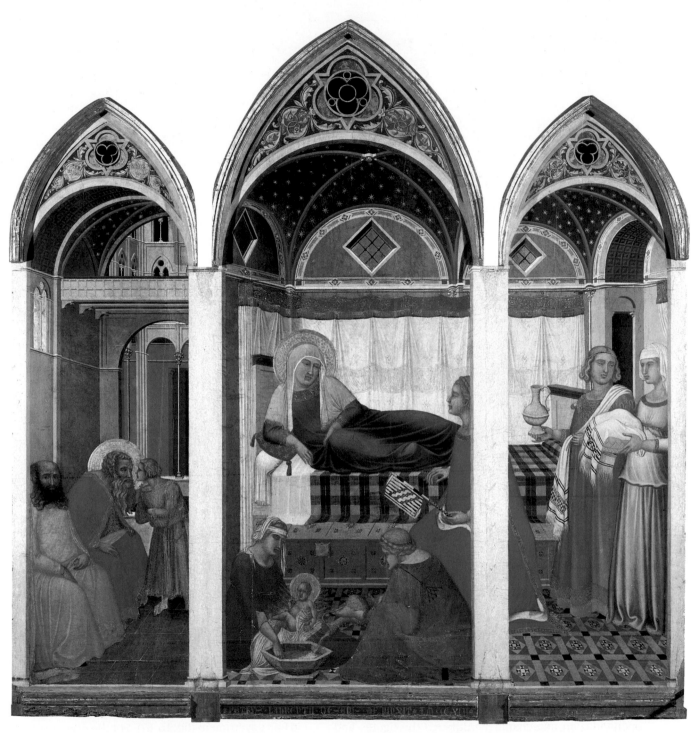

16-66. Pietro Lorenzetti. *Birth of the Virgin*, from Siena Cathedral. c. 1335–42. Tempera and gold on wood panel; frame partially replaced; 6'1½" x 5'11½" (1.88 x 1.82 m). Museo dell'Opera del Duomo, Siena

The illusion of space would have been greater in the original altarpiece. Columns supporting the arches would have emphasized the sense of looking through a window into two rooms.

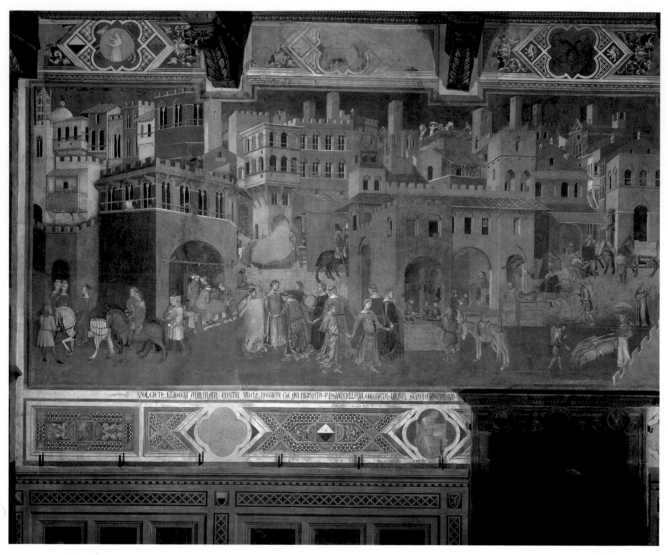

16-67. Ambrogio Lorenzetti. *Allegory of Good Government in the City* and *Allegory of Good Government in the Country*, frescoes in the Sala della Pace, Palazzo Pubblico, Siena. 1338–40

secondary altars. In striking contrast to Simone Martini's *Annunciation*, Pietro's ample figures people a well-furnished scene. The only supernatural elements here are the gold halos identifying the baby Mary and her parents, Anna and Joachim. The painter has attempted to create the illusion of an interior space seen through the "windows" of a triple-arched frame. The center and right windows open into a single room, and the left window opens into an antechamber. Although the figures and the architecture are on different scales, Pietro has conveyed a convincing sense of space through an intuitive system of perspective. The lines of floor tiles, the chest, and the plaid bedcover, for example, appear to converge as they recede. Thematically, the Virgin's birth is depicted as a forerunner of the birth of Jesus, with elements that echo those of Nativity scenes: the mother reclines on a bed, midwives bathe the newborn, the elderly father sits off to one side, and three people bearing gifts appear at the right. The gift-bearers are local women with simple offerings of bread and wine (an allusion to the Eucharist) instead of kings bearing treasures. Anna wears the

royal color purple, and gold-starred vaulting forms a heavenly canopy.

A few years earlier, in 1338, the Siena city council commissioned Pietro's brother Ambrogio to paint in fresco (see "*Buon Fresco*," page 604) a room called the Sala della Pace ("Chamber of Peace") in the Palazzo Pubblico (city hall). The allegorical theme chosen for the walls was the contrast between the effects on people's lives of good and bad government (fig. 16-67). For the *Allegory of Good Government in the City*, and in tribute to his patrons, Ambrogio created an idealized but recognizable portrait of Siena and its immediate environs. The cathedral dome and the distinctive striped **campanile** are visible in the upper left-hand corner. Above the gateway dividing city from country is perched the statue of the wolf suckling Romulus and Remus, the legendary founders of Rome, identifying it as Siena's Porta Romana. Hovering outside the gate is an allegory of Security as a woman clad only in a wisp of transparent drapery, a scroll in one hand and a miniature gallows complete with a hanged man in the other. The scroll bids those entering the city to come in

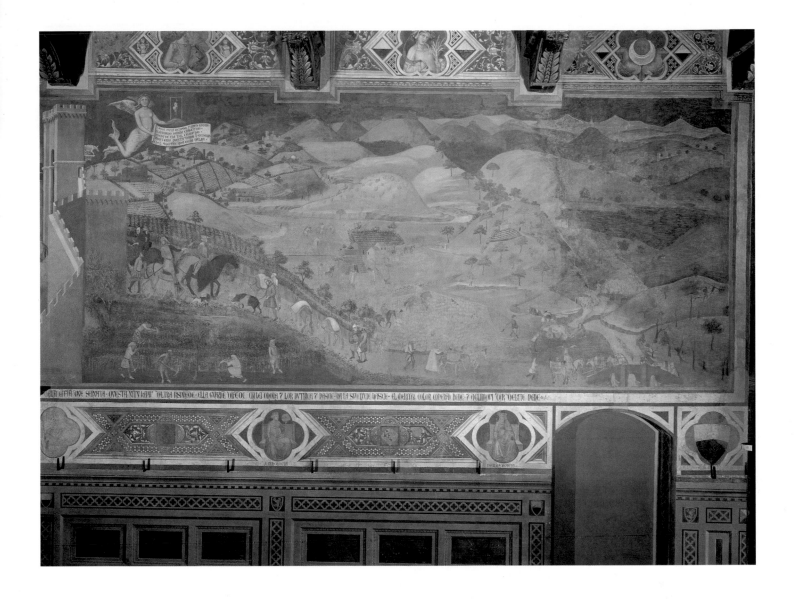

peace, and the gallows is a reminder of the consequences of not doing so.

Ambrogio's achievement in this fresco was twofold. First, he maintained an overall visual coherence despite the shifts in vantage point and scale, helping to keep all parts of the flowing composition intelligible. Second, he created a feeling of natural scale in the relationship between figures and environment. From the women dancing to a tambourine outside a shoemaker's shop to the contented peasants tending fertile fields and lush vineyards, the work conveys a powerful vision of an orderly society, of peace and plenty at this particular time and place. Sadly, famine, poverty, and disease overcame Siena just a few years after this work was completed.

In Florence, the transformation of the Italo-Byzantine style began somewhat earlier than in Siena. Duccio's Florentine counterpart was an older painter named Cenni di Pepi (active c. 1272–1302), better known by his nickname, Cimabue. He is believed to have painted the *Virgin and Child Enthroned* (fig. 16-68, page 608) in about 1280 for the main altar of the Church of Santa Trinità ("Holy Trinity") in Florence. At almost 12 feet high, this enormous panel painting seems to have set a precedent

for monumental altarpieces. In it, Cimabue follows the Byzantine iconography of the Virgin Pointing the Way. The Virgin sits surrounded by saints, angels, and Old Testament prophets. She holds the infant Jesus in her lap and points to him as the path to salvation.

Cimabue employed Byzantine formulas in determining the proportions of his figures, the placement of their features, and even the tilts of their haloed heads. Mary's huge throne, painted to resemble gilded bronze with inset enamels and gems, provides an architectural framework for the figures. To render her drapery and that of the infant Jesus, Cimabue used the Italo-Byzantine technique of highlighting drapery with thin lines of gold to indicate divinity, as in Mary's blue cloak. The vantage point suspends the viewer in space in front of the image, simultaneously looking down on the projecting elements of the throne and Mary's lap while looking straight on at the prophets at the base of the throne and the splendid angels at each side. These interesting spatial ambiguities, the subtle asymmetries throughout the composition, the Virgin's thoughtful, engaging gaze, and the well-observed faces of the old men are all departures from tradition that enliven the picture. Cimabue's concern for spatial

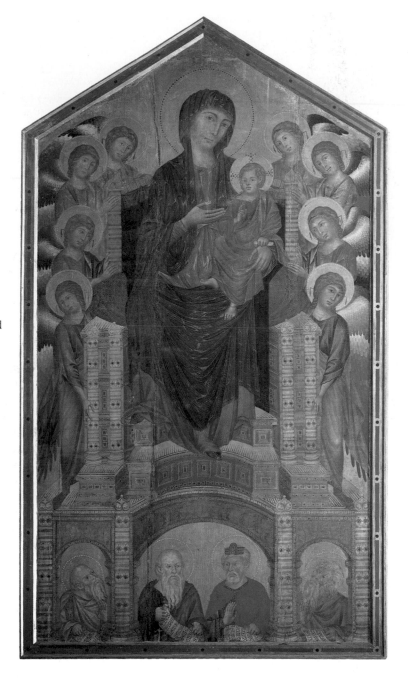

16-68. Cimabue. *Virgin and Child Enthroned*, from the Church of Santa Trinità, Florence. c. 1280. Tempera and gold on wood panel, 11'7½" x 7'4" (3.53 x 2.2 m). Galleria degli Uffizi, Florence

volumes, solid forms, and warmly naturalistic human figures contributed to the course of later Italian painting.

According to the sixteenth-century chronicler Vasari, Cimabue discovered a talented shepherd boy, Giotto di Bondone, and taught him how to paint. Then, "Giotto obscured the fame of Cimabue, as a great light outshines a lesser." Vasari also credited Giotto (active c. 1300–37) with "setting art upon the path that may be called the true one [for he] learned to draw accurately from life and thus put an end to the crude Greek [i.e., Italo-Byzantine] manner" (trans. J. C. and P. Bondanella). The painter and commentator Cennino Cennini (c. 1370–1440), writing in the late fourteenth century, was struck by the accessibility and modernity of Giotto's art, which, though it retained traces of the "Greek manner," was moving toward the depiction of a humanized world anchored in three-dimensional form.

Compared to Cimabue's *Virgin and Child Enthroned*, Giotto's painting of the same subject (fig. 16-69), done about 1310 for the Church of the Ognissanti ("All Saints") in Florence, exhibits a groundbreaking spatial consistency and sculptural solidity while retaining certain of Cimabue's conventions. The central and largely symmetrical composition, the rendering of the angels' wings, and Mary's Byzantine facial type all reflect Cimabue's influence. Gone, however, are her modestly inclined head and delicate gold-lined drapery. This colossal and mountainlike Mary seems to burst forth from her slender Gothic **baldachin**. Giotto has imbued the picture with an unprecedented physical immediacy, despite his retention of hierarchical scale, the formal, enthroned image type, and a flat, gold ground. By rendering the play of light and shadow across their substantial forms, he has created the sense that his figures are fully three-dimensional beings inhabiting real space.

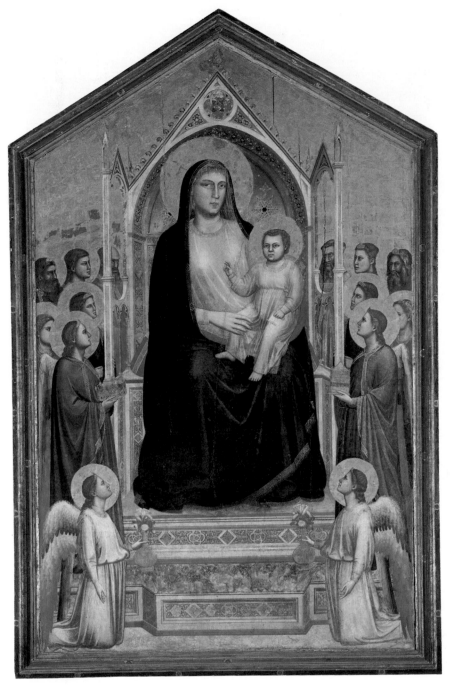

16-69. Giotto di Bondone. *Virgin and Child Enthroned*, from the Church of the Ognissanti, Florence. c. 1310. Tempera and gold on wood panel, 10'8" x 6'8¼" (3.53 x 2.05 m). Galleria degli Uffizi, Florence

Giotto may have collaborated on murals at the prestigious Church of San Francesco in Assisi, the home of Saint Francis (c. 1181–1226), founder of the Franciscan order. Saint Francis's message of simple, humble devotion, direct experience of God, and love for all creatures was gaining followers throughout western Europe and had a powerful impact on thirteenth-century Italian literature and art. The Church of San Francesco, the Franciscans' mother church, was consecrated by the pope in 1253, and the Franciscans commissioned many works to adorn it. Among those who worked there were Simone Martini, Pietro Lorenzetti, Cimabue, and perhaps some unidentified artists from Rome.

The *Life of Saint Francis*, in the upper church at San Francesco, was apparently among the last of the fresco cycles to be completed there. Scholars differ on whether they were painted by the young Giotto as early as

1295–1301 or by his followers as late as 1330; many have adopted the neutral designation of the artist as the Saint Francis Master; others see in these paintings the influence of Roman masters such as Pietro Cavallini (c. 1240/50–1330s). One scene, the *Miracle of the Crib at Greccio*, depicts the legendary story of Saint Francis making the first crèche, a Christmas tableau representing the birth of Jesus, in the church at Greccio. The artist of this scene has made great strides in depicting a convincing space with freely moving solid figures. The fresco documents the way the sanctuary of an early Franciscan church looked and the observances that took place within it. A large wooden historiated crucifix similar to the one by Coppo di Marcovaldo (see fig. 16-62) has been suspended from a stand on top of the rood screen. It has been reinforced by cross-bracing on the back and tilted forward to hover over worshipers in the nave. A high pulpit

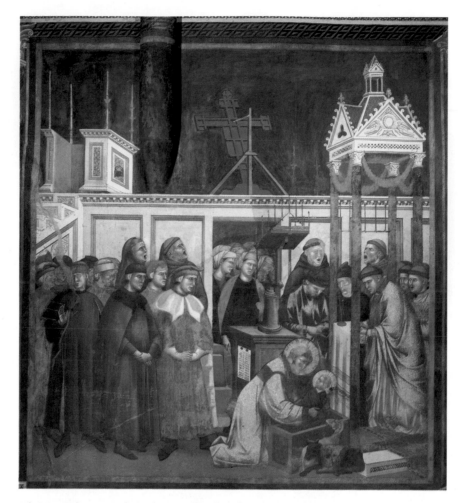

16-70. Saint Francis Master. *Miracle of the Crib at Greccio*, fresco in upper church of San Francesco, Assisi, Italy. c. 1295–1301/30

Saint Francis, born Giovanni Bernadone (c. 1181–1226), was the educated son of a rich cloth merchant. After an early career as a soldier, he dedicated himself to God. Embracing poverty, he lived as a wandering preacher. Contemporaries described him as an innocent eccentric. The Franciscan order began after he and his followers gained the recognition of the pope. Two years before his death, he experienced the stigmata, wounds in his hands and feet like those of the crucified Christ. This panel, on a lower nave wall, survived the disastrous earthquake that wracked Assisi on September 26, 1997.

with candlesticks at its corners rises over the screen at the left. Other small but telling touches include a seasonal liturgical calendar posted on the lectern, foliage swags decorating a Gothic baldachin, and the singing monks. Saint Francis, in the foreground, reverently places a statue of the Holy Infant in a plain, boxlike crib next to representations of various animals that might have been present at his birth (fig. 16-70). Richly dressed people—presumably patrons of the church—stand at the left, while women—normally excluded from the sanctuary—look on through an opening in the screen.

Giotto's masterpiece is the frescoed interior of another church, the Arena Chapel, for the Scrovegni family in Padua (fig. 16-71), painted about 1305. While working at the Church of Saint Anthony in Padua, Giotto was approached by a local merchant, Enrico Scrovegni, to decorate a new family chapel. The chapel, named for a nearby ancient Roman arena, is a simple, barrel-vaulted room.

Giotto covered the entrance wall with a scene of the Last Judgment. He subdivided the side walls with a dado of allegorical *grisaille* paintings of the Virtues and Vices, from which rise vertical bands containing quatrefoil portrait medallions. The medallions are set within a framework painted to resemble marble inlay and carved relief. The central band of medallions spans the vault, crossing a brilliant lapis blue, star-spangled sky in which large portrait disks float like glowing moons. Set into this framework are rectangular narrative scenes juxtaposing the life of the Virgin with that of Jesus. Both the individual scenes and the overall program display Giotto's genius for distilling a complex narrative into a coherent visual experience. Among Giotto's achievements was his ability to model form with color. He rendered his bulky figures as pure color masses, painting the deepest shadows with the most intense hues and highlighting shapes with lighter shades mixed with white. These sculpturally

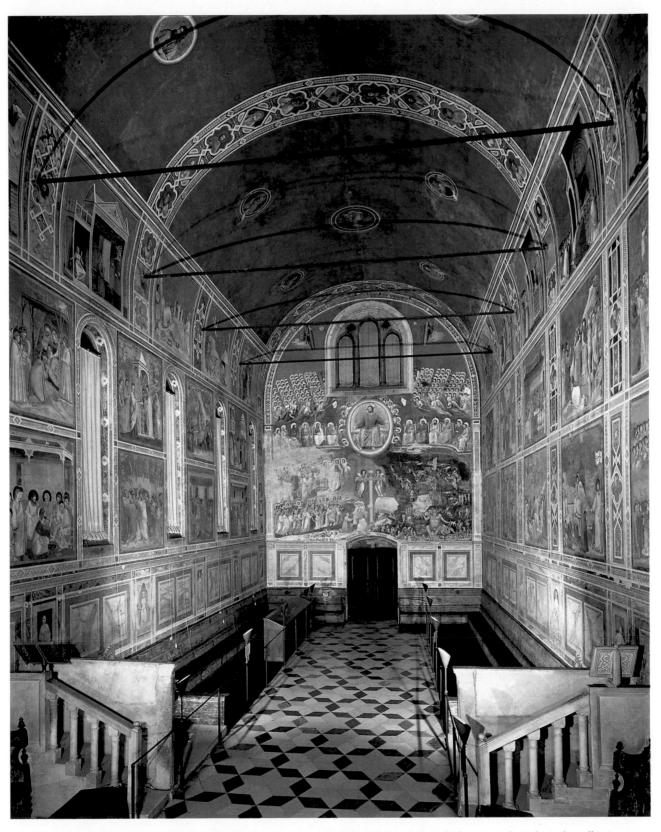

16-71. Giotto di Bondone. *Last Judgment* on west wall, *Life of Christ and the Virgin* on north and south walls, Arena (Scrovegni) Chapel, Padua. 1305–6

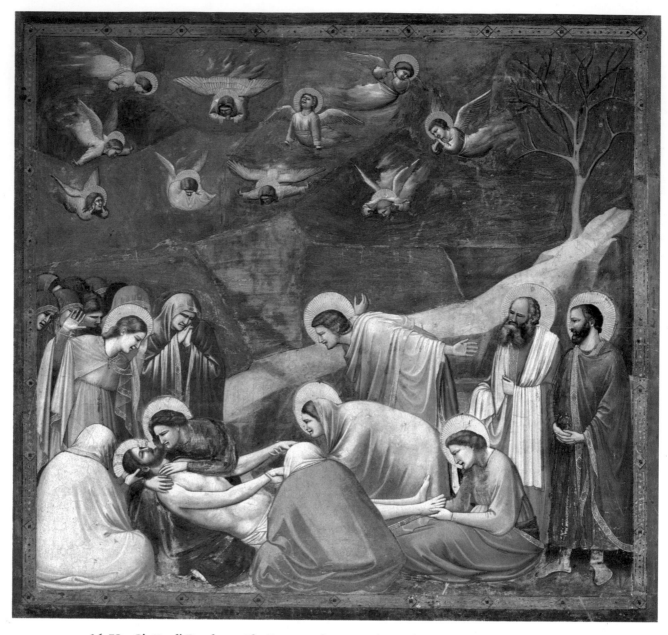

16-72. Giotto di Bondone. *The Lamentation*. 1305–6. Fresco in the Arena (Scrovegni) Chapel

modeled figures enabled Giotto to convey a sense of depth in landscape settings without relying on the traditional convention of an architectural framework, although he did make use of that convention.

In the moving work *The Lamentation* (fig. 16-72), in the lowest register of the Arena Chapel, Giotto focused the composition for maximum emotional effect off-center, on the faces of Mary and the dead Jesus. A great downward-swooping ridge—its barrenness emphasized by a single dry tree, a medieval symbol of death—carries the psychological weight of the scene to its expressive core. Mourning angels hovering overhead mirror the anguish of Jesus' followers. The stricken Virgin communes with her dead son with mute intensity, while John the Evangelist flings his arms back in convulsive despair and other figures hunch over the corpse. Instead of symbolic sorrow, Giotto conveys real human suffering, drawing the viewer into the circle of personal grief. The

direct, emotional appeal of his art, as well as its deliberate plainness, embodies Franciscan values.

While Sienese painting was a key contributor to the development of the International Gothic style, Florentine painting in the style originated by Giotto and kept alive by his pupils and their followers was fundamental to the development over the next two centuries of Italian Renaissance art. Before these movements, however, came the disastrous last sixty years of the fourteenth century, during which the world of the Italian city-states—which had seemed so full of promise in Ambrogio Lorenzetti's *Good Government* frescoes—was transformed into uncertainty and desolation by epidemics of the plague. Yet as dark as those days must have seemed to the men and women living through them, beneath the surface profound, unstoppable changes were taking place. In a relatively short span of time, the European Middle Ages gave way to what is known as the Renaissance.

PARALLELS

REGION	GOTHIC ART	ART OF OTHER CULTURES

FRANCE

16-3. **Abbey Church of Saint-Denis** (1140–44)
16-22. **Notre-Dame, Paris** (begun 1163)
16-1. **Chartres Cathedral** (c. 1194–1260)

16-14. *Charlemagne Window* (c. 1210–36)
16-16. **Cathedral of Notre-Dame, Amiens** (1220–88)
16-20. *Virtues and Vices* (c. 1220–36)
16-23. **Cathedral of Notre-Dame, Reims** (begun 1230s)
16-24. *Annunciation* and *Visitation* (begun c. 1230)
16-28. **Sainte-Chapelle, Paris** (1243–48)
16-33. *Psalter of Saint Louis* (1253–70)
16-34. Pucelle. *Book of Hours* (c. 1325–28)
16-29. *Virgin and Child*, **Saint-Denis** (c. 1339)

ENGLAND

16-36. **Salisbury Cathedral** (1220–58)

16-39. **Exeter Cathedral** (c. 1270–1366)
16-40. *Windmill Psalter* (c. 1270–80)
16-41. **Chichester-Constable chasuble** (1330–50)

SPAIN

16-44. *Cantigas de Santa María* (mid- to late-13th cent.)
16-42. **Cathedral of Palma, Mallorca** (begun 1306)

16-45. Borrassá. *Virgin and Saint George* altarpiece (c. 1399)

GERMANY, HOLY ROMAN EMPIRE

16-50. Nicholas of Verdun and workshop. *Shrine of the Three Kings* (c. 1190–c. 1205/10)
16-51. *Dormition of the Virgin* (c. 1230)
16-47. **Church of Saint Elizabeth, Marburg** (1233–83)
16-53. *Ekkehard and Uta* (c. 1245–60)
16-54. *Vesperbild* (c. 1330)

ITALY

16-58. N. Pisano, Pulpit, Pisa Baptistry (1260)
16-68. Cimabue. *Virgin and Child Enthroned* (c. 1280)
16-55. **Florence Cathedral** (begun 1296)
16-60. G. Pisano. Nativity pulpit, Pisa Cathedral (1302–10)
16-71. Giotto. Arena (Scrovegni) Chapel frescoes (1305–6)
16-63. Duccio. *Maestà Altarpiece* (1308–11)
16-69. Giotto. *Virgin and Child Enthroned* (c. 1310)

16-61. A. Pisano. Baptistry doors, Florence (1330–36)
16-65. Martini. *Annunciation* (1333)
16-66. P. Lorenzetti. *Birth of the Virgin* (c. 1335–42)
16-67. A. Lorenzetti. *Allegory of Good Government* (1338–40)

ART OF OTHER CULTURES

7-42. *Virgin of Vladimir* (12th cent.), Russia
9-28. *Shiva Nataraja* (12th cent.), India
11-14. *The Tale of Genji* (12th cent.), Japan
10-21. Zhang. *Spring Festival on the River* (early 12th cent.), China
12-23. **Anasazi seed jar** (c. 1150), North America
12-21. **Cahokia** (c. 1150), North America
8-18. **Abbasid pen box** (1210–11), Khurasan
13-4. **Head of king** (c. 13th cent.), Ife
10-23. **Guan Ware vase** (13th cent.), China
11-17. *Raigo* triptych (13th cent.) Japan
13-11. **Conical tower** (1350–1450), Great Zimbabwe
8-14. Mamluk *qibla* wall (1356–63), Egypt

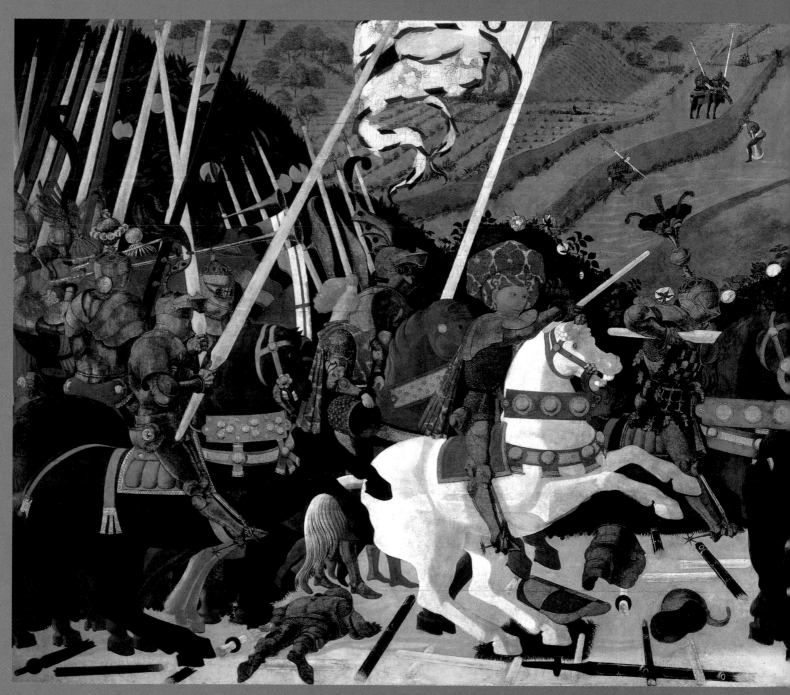

17-1. Paolo Uccello. *The Battle of San Romano*. 1430s (?).
Tempera on wood panel, approx. 6' x 10'7" (1.83 x 3.23
m). National Gallery, London. Reproduced by courtesy of
the Trustees

17
Early Renaissance Art in Europe

The combat we see before us could take place only in our dreams. Under an elegantly fluttering banner, knights battle but do not bleed. When dying, they join rows of broken lances—all arranged to show off a new, more realistic way of depicting space, linear perspective, that made objects seem to recede into the distance. The Battle of San Romano, in 1432, was no great Florentine victory, but the Florentine general was a devoted ally of the powerful Medici family, who commissioned an eccentric painter nicknamed Paolo Uccello ("Paul of the Birds") to create this painting (fig. 17-1) and two other splendid battle scenes. Uccello's war paintings are a pageant glorifying men-at-arms for merchant princes.

The three paintings were moved in the 1450s into a new Medici palace, where, with their gilt frames, they presented a continuous tableau more than 30 feet long: A battle rages across a shallow stage, defined by the debris of warfare, arranged in the neat pattern required by linear perspective and backed by a forest and hills that look like a tapestry. But can we believe in the serious intent of the knights in glittering armor who seem to be riding hobbyhorses? Even the peasants ignore the mayhem and go about their work in the vineyards.

In recording a current event, Uccello produced a ritualized view of history, yet at the same time paid homage to the past and future—to the past in the embroiderylike, decorative heroics of a long-gone chivalric age, and to the future in the manipulation of the new science of perspective. The details of the brilliantly decorative frieze also carry meaning. Even though orange trees do not grow near San Romano, the ones here are in full fruit, their rich orange balls glowing against the dark foliage. They are a not very subtle reference to the artist's patron: The orange, called mala medica ("medicinal apple"), was a pun on the Medici name and formed the family's coat of arms.

The sixteenth-century artist, courtier, and historian Giorgio Vasari devoted a chapter to Paolo Uccello in his book Lives of the Painters. He described him as a man so obsessed with the study of perspective that he neglected his painting, his family, and even his beloved birds, until he finally became "solitary, eccentric, melancholy, and impoverished" (page 79). His wife declared that he stayed at his desk all night, searching for the vanishing points of perspective, and when she called him to bed, Paolo used to say to her: "Oh, what a sweet thing this perspective is!" (page 83)

(translation by J.C. and P. Bondanella, Oxford, 1991)

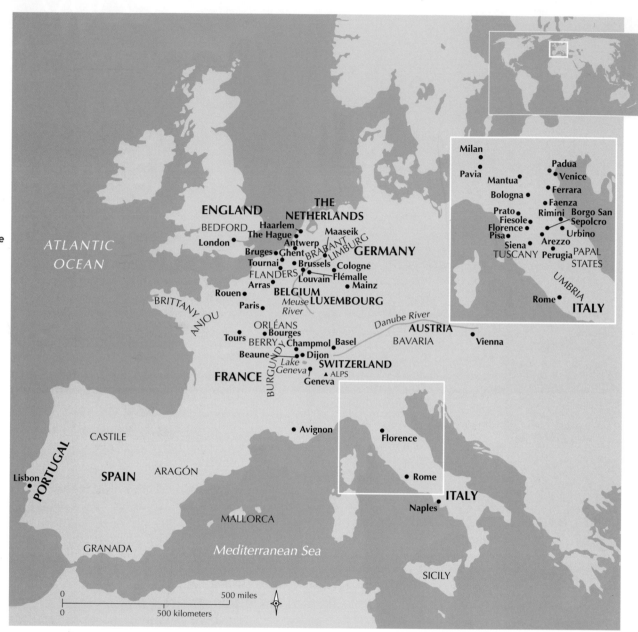

1400	1420	1440

▲ 1430s ALBERTI WRITES *ON ARCHITECTURE*; PUBLISHED IN 1485

1445 GUTENBERG ▲ PRINTS FIRST BOOK

TIMELINE 17-1. Early Renaissance Europe. The fifteenth century in Europe was an intense period of transformation, aided by the introduction of printing, the growth of cities, and a rapid secularization of whole societies.

MAP 17-1. Early Renaissance Europe. The Renaissance flourished first in northern Europe, then in Italy.

THE RENAISSANCE AND HUMANISM

In western Europe, many of the developments of the late Middle Ages, such as urbanization, intellectualism, and vigorous artistic patronage, reached maturity in the fifteenth century. Underlying these changes was the economic growth in the late fourteenth century that gave rise to a prosperous middle class of merchants and bankers. Unlike the hereditary aristocracy that had dominated society through the late Middle Ages, these businesspeople had attained their place in the world through personal achievement. In the early fifteenth century, the newly rich middle class supported

scholarship, literature, and the arts. Their generous patronage resulted in the explosion of learning and creativity known as the Renaissance. Artists and patrons, especially in Italy, began to appreciate classical thought and art, as well as the natural world.

The characterization of the period as a renaissance (from the French word for "rebirth") originated with fourteenth-century scholars like the great humanist and poet Petrarch. Petrarch looked back at the thousand years extending from the collapse of the Roman Empire to his own time and determined that history fell into three distinct periods: The ancient classical world, a time of high human achievement, was followed by a decline during

▲ 1452 HAPSBURGS BEGIN RULE
OF HOLY ROMAN EMPIRE

▲ 1453 HUNDRED YEARS' WAR ENDS

▲ 1469–92 LORENZO DE' MEDICI RULES FLORENCE

▲ 1492–98 COLUMBUS DISCOVERS THE
WEST INDIES AND SOUTH AMERICA

1498 SAVANAROLA EXECUTED ▲

the Middle Ages, or "dark ages." The third period was the modern world—his own era—a revival, a rebirth, a renaissance, when humanity began to emerge from an intellectual and cultural stagnation and scholars again appreciated the achievements of the ancients. For all our differences, we still live in Petrarch's modern period—a time when human beings, their deeds, and their beliefs have primary importance. But today, we view the past differently. Unlike fourteenth-century scholars, we understand history as a gradual unfolding of events, changing over time. We can see now that the modern worldview that emerged during the fourteenth century was based on continuity and change through the preceding centuries.

Humanism, a nineteenth-century term, is used narrowly to designate the revival of classical learning and literature. More generally, in fourteenth- and fifteenth-century western Europe, humanism embodied a worldview that focused on human beings; an education that perfected individuals through the study of past models of civic and personal virtue; a value system that emphasized personal effort and responsibility; and a physically or intellectually active life that was directed at a common good as well as individual nobility. To this end, the Greek and Latin languages had to be mastered so that classical literature—history, biography, poetry, letters, orations—could be studied.

For Petrarch and his contemporaries in Italy, the defining element of the age was an appreciation of Greek and Roman writers. In fact, throughout the Middle Ages, classical texts had been essential for scholars—from the monks in Charlemagne's eighth-century monasteries, who preserved the books, to the students who mastered them in the universities that arose in the twelfth and thirteenth centuries in Italy, France, and England. Especially important to the Renaissance was the balance of faith and reason addressed by philosophers in the twelfth century and achieved by the Scholasticist Thomas Aquinas in the *Summa theologica* of 1267–73, which still forms the basis of Roman Catholic philosophy. Scholasticism underlay such literary works as the *Divine Comedy* of Dante—who with literary figures like Petrarch and Boccaccio and the artists Cimabue (active c. 1272–1302), Duccio (active 1278–1318), and Giotto (1266/7–1337) fueled the cultural explosion of fourteenth-century Italy.

In literature Petrarch was a towering figure of change, a poet whose love lyrics were written not in Latin but for the first time in the spoken language of his own time. A similar role was played in painting by the Florentine Giotto di Bondone, who observed the people around him and captured their gestures and emotions in deeply moving mural paintings. Essentially a Gothic artist, Giotto created massive three-dimensional figures,

modeled by a natural and consistent light and depicted in a shallow yet clearly defined space. One of art's great storytellers, Giotto made biblical events and their theological implications immediately understandable to the new patrons of art in northern Italy—merchants and bankers like Enrico Scrovegni of Padua, who commissioned Giotto to decorate a chapel dedicated in 1305 to the Virgin of Charity and the Virgin of the Annunciation (fig. 17-2, page 618). As viewers look toward the altar they see the story of Mary and Joseph unfolding before them in a series of rectangular panels.

Both Giotto's narrative skills and his awareness of the medieval tradition of **typology**—in which earlier Old Testament events foreshadow the New Testament—are apparent in the paintings of the chapel (fig. 17-3, page 619). The life of the Virgin Mary begins the series. Events in the life and ministry of Jesus circle the chapel in the middle **register**, while scenes of the Passion (the arrest, trial, and Crucifixion of Jesus) fill the lowest register. Thus, the first miracle, when Jesus changes water to wine during the wedding feast at Cana (recalling that his blood will become the wine of the Eucharist, or Communion), is followed by the raising of Lazarus (a reference to his own Resurrection). Below, the Lamentation over the body of Jesus by those closest to him leads to the Resurrection, indicated by angels at the empty tomb and his appearance to Mary Magdalen in the *Noli Me Tangere* ("Do not touch me"). The juxtaposition of dead and live trees in the two scenes becomes a telling detail of death and resurrection. Giotto used only a few large figures and essential props in settings that never distract by their intricate detail. The scenes are reminiscent of the *tableaux vivants* ("living pictures," in which people dressed in costume re-created poses from familiar works of art) that were played out in the piazza in front of the chapel in Padua.

Outside Italy, interest in the natural world manifested itself in the detailed observation and recording of nature. Artists depicted birds, plants, and animals with breathtaking accuracy. They observed that the sky is more colorful straight above than at the horizon, and they painted it that way and so developed **aerial perspective**. They, like Giotto, emphasized three-dimensional modeling of forms with light and shadow.

Along with the desire for accurate depiction came a new interest in individual personalities. Fifteenth-century portraits have an astonishingly lifelike quality, combining careful—sometimes even unflattering—description with an uncanny sense of vitality. In a number of religious paintings, even the saints and angels seem to be portraits. Indeed, individuality became important in every sphere. More names of artists survive from the fifteenth century, for example, than in the entire

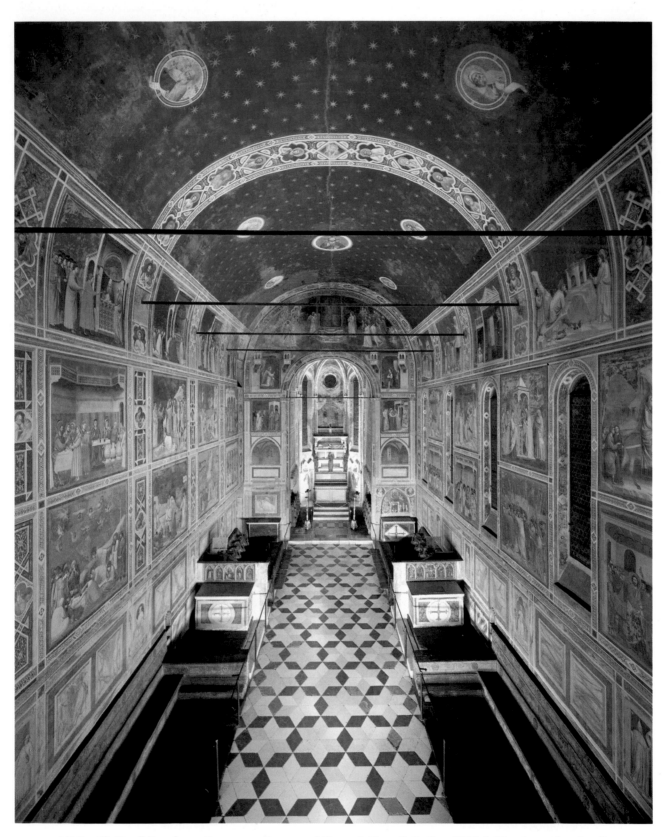

17-2. Giotto di Bondone. Frescoes, Scrovegni (Arena) Chapel, Padua. 1305–6. View toward east wall

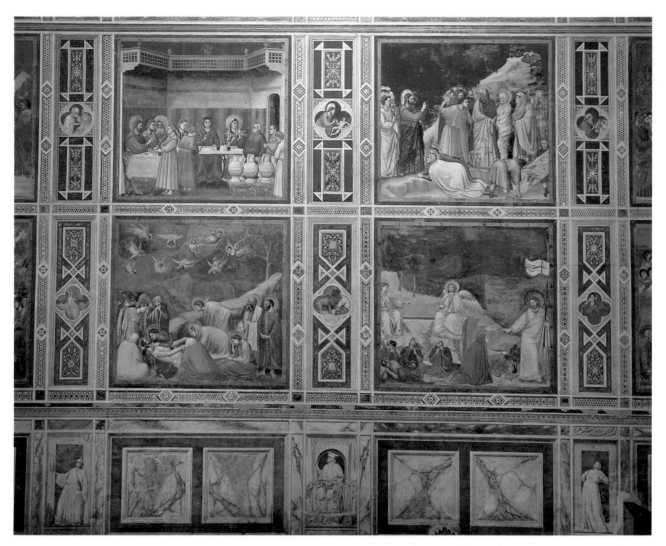

17-3. Giotto di Bondone. *Marriage at Cana, Raising of Lazarus, Resurrection* **and** *Noli Me Tangere,* **and** *Lamentation* (clockwise), frescoes on north wall of Scrovegni (Arena) Chapel, Padua. 1305–6

span from the beginning of the Common Era to the year 1400. A similar observation might be made in nearly every other field.

One reason for this new emphasis on individuality was the humanist interest not only in antiquity but also in people. Humanists sought the physical and literary records of the ancient world—assembling libraries, collecting sculpture and fragments of architecture, and beginning archaeological investigations of ancient Rome—so that they could understand an imagined golden age in order to achieve personal freedom and dignity for everyone in their own time. Their aim was to live a rich, noble, and productive life within the framework of Christianity. Needless to say, the humanist ideal was seldom achieved. Nevertheless, these people extended education to the laity, investigated the natural world, and subjected philosophical and theological positions to logical scrutiny. They constantly invented new ways to extend humans' intellectual and physical reach.

The rise of humanism did not signify a decline in the importance of Christian belief. In fact, an intense Christian spirituality continued to inspire and pervade most European art through the fifteenth century and long after. But despite the enormous importance of Christian faith, the established Western Church was plagued with problems in the fifteenth century. Its hierarchy was bitterly criticized for a number of practices, including a perceived indifference to the needs of common people. These strains within the Western Church exemplified the skepticism of the Renaissance mind. In the next century, they would give birth to the Protestant Reformation.

While wealthy and sophisticated men in the highest ranks of the clergy—bishops, cardinals, and the pope himself—and the royal and aristocratic courts continued to play major roles in the support of the arts, increasingly the urban lay public sought to express personal and civic pride by sponsoring secular architecture, sculpted monuments, and paintings directed toward the community, as well as town houses, fine furnishings, and portraits of family members. The commonsense values of the merchants formed a solid underpinning for humanist theories and enthusiasms.

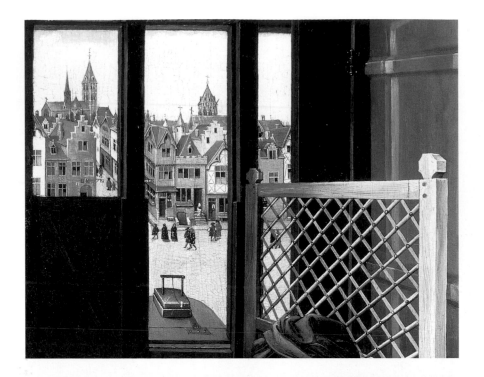

17-4. Robert Campin. *Joseph in His Carpentry Shop*, detail of right wing of the *Mérode Altarpiece (Triptych of the Annunciation)*, fig. 17-11. c. 1425–28. Oil on wood panel, approx. 25³⁄₈ x 10⁷⁄₈" (64.5 x 27.6 cm). The Metropolitan Museum of Art, New York

The Cloisters Collection, 1956 (56.70)

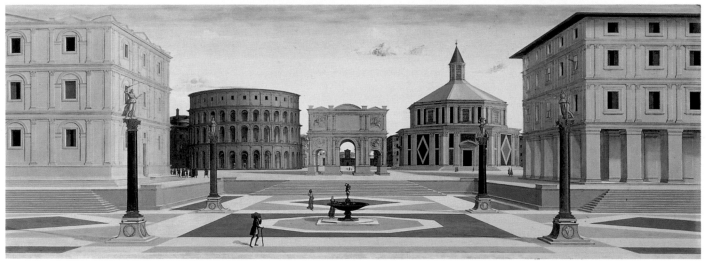

17-5. Anonymous. *Ideal City with a Fountain and Statues of the Virtues*. c. 1500. Oil on wood panel, 2'6¹⁄₂" x 7'1⁵⁄₈" (0.77 x 2.17 m). Walters Art Gallery, Baltimore

Two ideal cities, as seen through contemporary eyes, exemplify the fifteenth-century view as it emerged in northern and southern Europe. In Robert Campin's *Mérode Altarpiece* (see fig. 17-11), windows in Joseph's carpentry shop open onto a view of a prosperous Flemish city (fig. 17-4). Tall, well-kept houses crowd around churches, whose towers dominate the skyline. People gather in the open market square, walk up a major thoroughfare, and enter the shops, whose open doors and windows suggest security as well as commercial activity. The tall, narrow buildings recall the picturesque look of a medieval town; and the painter, with detailed realism, represents the architecture and people as a visual record.

The ideal Italian city depicted by an anonymous north Italian painter in figure 17-5 is based on different assumptions. Walking through this balanced and harmonious piazza would feel quite different from dropping in on one of the Flemish shops. The Italian cityscape—with its classical references and precise linear perspective (see "Renaissance Perspective Systems," opposite)—invites us, instead, to contemplate the look and clarity of a well-ordered civic life. Cubical palaces flank a vast square closed off by three buildings that recall the Roman Colosseum, Constantine's triumphal arch, and the Florentine Baptistry. In the center of the piazza, a woman draws water from a splendid community well, evidence of the ruler's (or town council's) generosity in providing fresh water for the citizens.

These images of two ideal cities present us with different but congenial aspects of fifteenth-century life and art: the observable reality and bustle of human activity viewed from an artisan's workshop, its spaces suggested through an observed, intuitive atmosphere, as compared to the orderly city controlled by a benevolent government

RENAISSANCE PERSPECTIVE SYSTEMS

The humanists' scientific study of the natural world and their belief that "man is the measure of all things" led to the invention of a mathematical system enabling artists to represent the visible world in a convincingly illusionistic way. This system—known variously as mathematical, linear, or one-point perspective—was first demonstrated by the architect Filippo Brunelleschi about 1420. In 1435 Leon Battista Alberti codified mathematical perspective in his treatise *De pictura* (*On Painting*), making a standardized, somewhat simplified method available to a larger number of draftspeople, painters, and relief sculptors. One artist, Paolo Uccello (1397–1475), devoted his life to the study of perspective (see fig. 17-1).

These artists considered the picture's surface a flat plane that intersected the viewer's field of vision at a right angle. In Alberti's highly artificial system, a one-eyed viewer was to stand at a prescribed distance from a work, dead center. From this fixed vantage point everything in a picture appeared to recede into the distance at the same rate, following imaginary lines called **orthogonals** that met at a single vanishing point on the horizon. Using orthogonals as a guide, artists could distort—or **foreshorten**—objects, replicating the optical illusion that things appear smaller and closer together the farther away they are from us. Despite its limitations, mathematical perspective extends pictorial space into real space, providing the viewer with a direct, almost physical connection to the picture. It creates a compelling, even exaggerated sense of depth.

Early Renaissance artists following Alberti's system relied on a number of mechanical methods. Many constructed devices with peepholes through which they sighted the figure or object to be represented. They used mathematical formulas to translate three-dimensional forms onto the picture plane, which they overlaid with a grid to provide reference points, or emphasized the orthogonals by including linear forms, such as tiled floors and buildings, in the composition. As Italian artists became more comfortable with mathematical perspective over the course of the fifteenth century, they came to rely less on peepholes, formulas, and linear forms. Many artists adopted multiple vanishing points, which gave their work a more relaxed, less tunnel-like feeling.

In the north, artists such as Jan van Eyck refined **intuitive perspective** to approximate the appearance of things growing smaller and closer together in the distance, coupling it with **atmospheric**, or aerial, **perspective**. This technique—applied to the landscape scenes that were a northern specialty—was based on the observation that haze in the atmosphere causes distant elements to appear less distinct and less colorful, the sky to become paler as it nears the horizon, and the distant landscape to turn to a bluish gray. Among southern artists, Leonardo da Vinci made extensive use of atmospheric perspective, while in the north, the German artist Albrecht Dürer adopted the Italian system of mathematical perspective toward the end of the fifteenth century (Chapter 18).

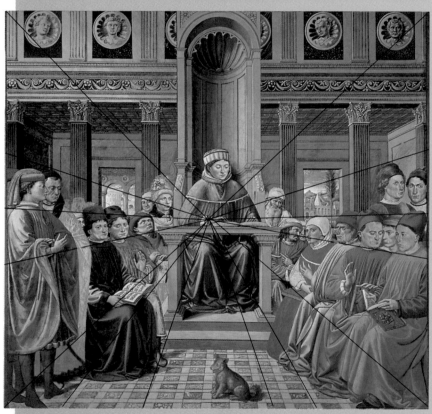

Benozzo Gozzoli. *Saint Augustine Reading Rhetoric in Rome*, fresco in the choir of the Church of Sant'Agostino, San Gimignano, Italy.1464–5

In the 1460s Benozzo Gozzoli (1421–97) began to paint scenes from the life of Saint Augustine for the church dedicated to him in the Tuscan hill town of San Gimignano. In this painting, he shows his debt to Alberti's theories of perspective, from the coffered ceiling to the tiled floor. Gozzoli's use of strict one-point perspective here also suggests the orderliness and rationality of Augustine's thought. Distant views flank the thronelike seat of the professor-saint, while rows of solemn students at either side of Augustine's desk fill a foreground space that is carefully defined by classical columns and friezes. Only the small dog at the saint's feet breaks the driving force of one-point perspective in the pattern of the floor tiles.

depicted in a logical, intellectual construct of linear perspective. One has a warm picturesqueness, while the other suggests a cool, balanced, unachievable ideal. To explore how these two images were forged, we will begin in the powerful courts of French royalty, whose patronage supported and in fact spread the early Renaissance style in northern Europe.

ART OF THE FRENCH DUCAL COURTS

In the late Middle Ages, French kings, with their capital in Paris, began to emerge as the powerful rulers of a national state. Nevertheless, in the fourteenth and fifteenth centuries, their royal authority was constrained by the nobles who controlled large territories outside the Paris region. Some of these nobles were even powerful enough to pursue their own policies independently of the king. Many of the great dukes were members of the royal family, although their interests rarely coincided with those of the king. One strong unifying factor was the threat of a common enemy: England, whose kings held large territories in western France and repeatedly fought France between 1337 and 1453 in a series of conflicts known as the Hundred Years' War.

While the French king held court in Paris, the most powerful of the dukes held even more splendid courts in their own capitals. Through much of the fourteenth century, these centers were arbiters of taste for most of Europe. From the last decades of the fourteenth century up to the 1420s, French court patronage was especially influential in northern Europe. The French king and his relatives the dukes of Anjou, Berry, and Burgundy employed not only local artists but also gifted painters and sculptors from the Low Countries (present-day Belgium, Luxembourg, and the Netherlands; Map 17-1). In the south of France, a truly international style emerged at the papal court at Avignon, where artists from Italy, France, and Flanders worked side by side. Of major importance in the creation and spread of the new International Gothic style was the construction and decoration of a monastery and funeral chapel at Champmol near Dijon, for the duke of Burgundy (see pages 625–26).

The International Gothic style, the prevailing manner of the late fourteenth century, is characterized by gracefully posed figures, sweet facial expressions, and naturalistic details, including carefully rendered costumes and textile patterns, presented in a palette of bright and pastel colors with liberal touches of gold. The International Gothic style was so universally appealing that patrons throughout Europe continued to commission such works throughout the fifteenth century.

MANUSCRIPT ILLUMINATION

Many nobles collected illustrated manuscripts, and in the late fourteenth century workshops in France and the Netherlands produced outstanding manuscripts for them. Besides religious texts, secular writings such as herbals (encyclopedias of plants), health manuals, and both ancient and contemporary works of history and literature were in great demand.

The painters in the Netherlands and Burgundy, skilled at creating an illusion of reality, increasingly influenced France and the **illumination**, or illustration, of books at the beginning of the fifteenth century. Women artists gained increasing importance too (see "Women Artists in the Late Middle Ages and the Renaissance," opposite). The most famous Netherlandish illuminators of the time were three brothers—Paul, Herman, and Jean—commonly known as the Limbourg brothers. In the fifteenth century, people were known by their first names, often followed by a reference to their place of origin, parentage, or occupation (see "Italian Artists' Names and Nicknames," below). The name used by the three Limbourg brothers, for example, refers to their home region. (Similarly, Jan van Eyck means "Jan from [the town of] Eyck." This chapter uses the forms of artists' names as they most commonly appear today.)

WOMEN ARTISTS IN THE LATE MIDDLE AGES AND THE RENAISSANCE

Medieval and Renaissance women artists typically learned to paint from their husbands and fathers because formal apprenticeships were not open to them. Noblewomen, who were often educated in convents, learned to draw, paint, and embroider. One of the earliest examples of a signed work by a woman painter is a tenth-century manuscript of the Apocalypse illustrated in Spain by a woman named Ende, who describes herself as "painter and helper of God." In Germany, women began to sign their work in the twelfth century. For example, a collection of sermons was decorated by a nun named Guda, who not only signed her work but also included a self-portrait, one of the earliest in Western art.

Jeanne de Montbaston and her husband, Richart, worked together as book illuminators under the auspices of the University of Paris in the fourteenth century. After Richart's death, Jeanne continued the workshop and, following the custom of the time, was sworn in as a *libraire* (publisher) by the university in 1353. In the fifteenth century, women could be admitted to the guilds in some cities, including the Flemish towns of Ghent, Bruges, and Antwerp, and by the 1480s one-quarter of the painters' guild of Bruges was female.

Particularly talented women received commissions of the highest order. Bourgot, the daughter of the miniaturist Jean le Noir, illuminated books for Charles V of France and Jean, Duke of Berry. Christine de Pisan (1365–c. 1430), a well-known writer patronized by Philip the Bold of Burgundy and Queen Isabeau of France, described the work of an illuminator named Anastaise, "who is so learned and skillful in painting manuscript borders and miniature backgrounds that one cannot find an artisan . . . who can surpass her . . . nor whose work is more highly esteemed" (*Le Livre de la Cité des Dames*, I.41.4, translated by Earl J. Richards).

In a French edition of a book by the Italian author Boccaccio entitled *Concerning Famous Women*, presented to Philip the Bold in 1403, the anonymous illuminator shows Thamyris, an artist of antiquity, at work in her studio. She is depicted in fifteenth-century dress, painting an image of the Virgin and Child. At the right, an assistant grinds and mixes the colors Thamyris will need to complete her painting. In the foreground, her brushes and paints are laid out conveniently on a table.

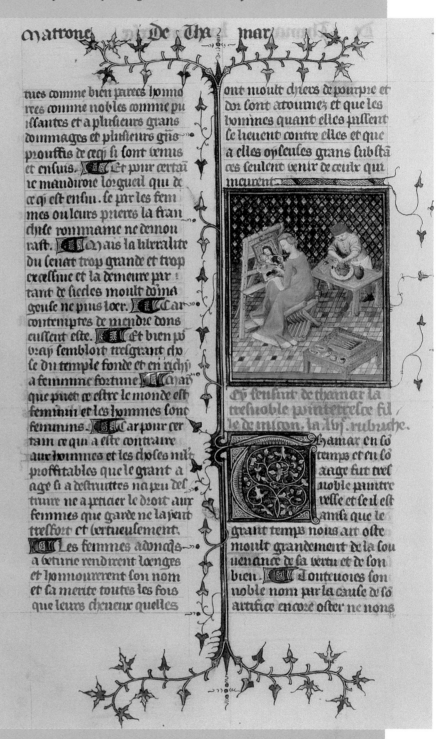

Detail of page with *Thamyris*, from Giovanni Boccaccio's *De Claris Mulieribus (Concerning Famous Women).* 1402. Ink and tempera on vellum. Bibliothèque Nationale de France, Paris

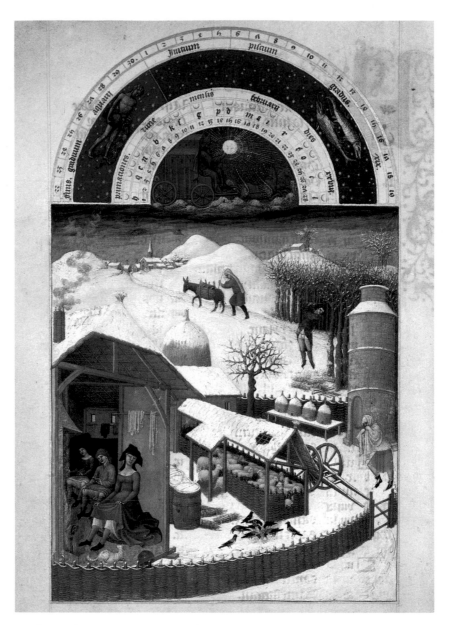

17-6. **Paul, Herman, and Jean Limbourg. Page with *February*,** *Très Riches Heures*. 1413–16. Colors and ink on parchment, 8⅞ x 5⅜" (22.5 x 13.7 cm). Musée Condé, Chantilly, France

The Limbourg brothers are first recorded as apprentice goldsmiths in Paris around 1390. About 1404 they entered the service of the duke of Berry, for whom they produced their major work, the so-called *Très Riches Heures (Very Sumptuous Hours)*, between 1413 and 1416. For the calendar section of this Book of Hours—a selection of prayers and readings keyed to daily prayer and meditation—the Limbourgs created full-page paintings to introduce each month, with subjects including both peasant labors and aristocratic pleasures. Like most European artists of the time, the Limbourgs showed the laboring classes in a light acceptable to aristocrats—that is, happily working for their benefit. But the Limbourgs also showed peasants enjoying their own pleasures. Haymakers on the *August* page shed their clothes to take a swim in a stream, and *September* grape pickers pause

to savor the sweet fruit they are gathering. In the *February* page (fig. 17-6), farm people relax cozily before a blazing fire. This farm looks comfortable and well maintained, with timber-framed buildings, a row of beehives, a sheepfold, and tidy woven wattle fences. In the distance are a village and church.

Most remarkably, the artists convey the feeling of cold winter weather: the breath of the bundled-up worker turning to steam as he blows on his hands, the leaden sky and bare trees, the snow covering the landscape, and the comforting smoke curling from the farmhouse chimney. The painting employs several International Gothic conventions: the high placement of the horizon line, the small size of trees and buildings in relation to people, and the cutaway view of the house showing both interior and exterior. The muted palette is

sparked with touches of yellowish orange, blue, and a patch of bright red on the man's turban at the lower left. The landscape recedes continuously from foreground to middle ground to background. An elaborate calendar device, with the chariot of the sun and the zodiac symbols, fills the upper part of the page.

PAINTING AND SCULPTURE FOR THE CHARTREUSE DE CHAMPMOL

One of the most lavish projects of Philip the Bold, the duke of Burgundy (ruled 1363–1404) and son of the French king, was the Carthusian monastery, or *chartreuse* ("charterhouse"), founded in 1385 at Champmol, near his capital at Dijon. Its church was intended to house his family's tombs. A Carthusian monastery was particularly expensive to maintain because the Carthusians lived a solitary life as a brotherhood, in effect a brotherhood of hermits. Carthusians did not provide for themselves by farming or other physical work but were dedicated to prayer and solitary meditation. The brothers were expected to pray at all hours for the souls of Philip and his family.

Philip commissioned the Flemish sculptor Jean de Marville (active 1366–89) to direct the sculptural decoration of the monastery. At Jean's death in 1389, he was succeeded by his assistant Claus Sluter (1379–1406), from Haarlem, in Holland. Although much of this splendid complex was destroyed 400 years later during the French Revolution, the quality of Sluter's work can still be seen on the Well of Moses, a monumental sculpted well at the center of the main cloister (fig. 17-7). Begun in 1395, the sculpture was unfinished at Sluter's death. A pier rose from the water to support a large freestanding Crucifixion, with figures of the Virgin Mary, Mary Magdalen, and John the Evangelist. Forming a pedestal for the Crucifixion group are lifesize stone figures of Old Testament men who either foretold the coming of Christ or were in some sense his precursors: Moses (the ancient Hebrew prophet and lawgiver), David (king of Israel and an ancestor of Jesus), and the prophets Jeremiah, Zechariah, Daniel, and Isaiah. These images and their texts must have been based on two contemporary plays, *The Trial of Jesus* and *The Procession of Prophets*.

Sluter depicted the Old Testament figures as physically and psychologically distinct individuals. Moses' sad old eyes blaze out from a memorable face entirely covered with a fine web of wrinkles. Even his horns—traditionally given to him because of a mistranslation in the Latin Bible—are wrinkled. A mane of curling hair and a beard cascade over his heavy shoulders and chest, and an enormous cloak envelops his body. Beside him stands David, in the voluminous robes of a medieval king, the personification of nobility. The drapery, with its deep folds creating dark pockets of shadow, is an innovation of Sluter's. While its heavy sculptural masses conceal the body beneath, its strong highlights and shadows visually define the body's volumes. With these vigorous, imposing, and highly individualized figures, Sluter transcended the limits of the International Gothic style and introduced a new style in northern sculpture.

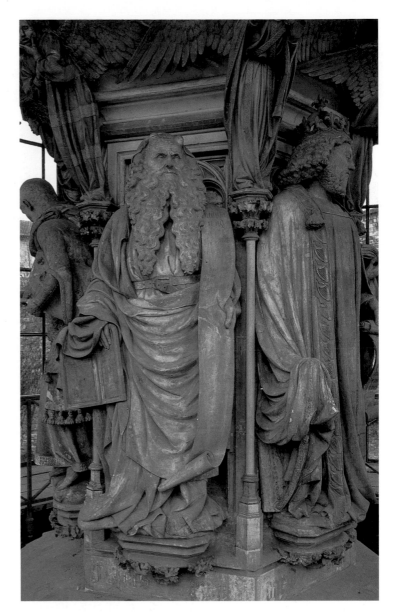

17-7. **Claus Sluter. Well of Moses**, detail of Moses and David, from the Chartreuse de Champmol, Dijon, France. 1395–1406. Limestone with traces of paint, height of figures 5'8" (1.69 m)

The sculpture's original details included metal used for buckles and even eyeglasses. It was also painted: Moses wore a gold mantle with a blue lining over a red tunic; David's gold mantle had a painted lining of ermine, and his blue tunic was covered with gold stars and wide bands of ornament.

Between 1394 and 1399, the duke also ordered a large altarpiece for the Chartreuse de Champmol (see "Altars and Altarpieces," page 628). This was a **triptych**, a work in three panels, hinged together side by side so that the two side panels, or **wings**, fold over the central one (for an example of a carved altarpiece in a church, see fig. 18-31). Jacques de Baerze, a wood carver, executed the central panel with the Crucifixion in carved reliefs. Melchior Broederlam painted the exteriors of the two protective wings, illustrating scenes from the Life of the

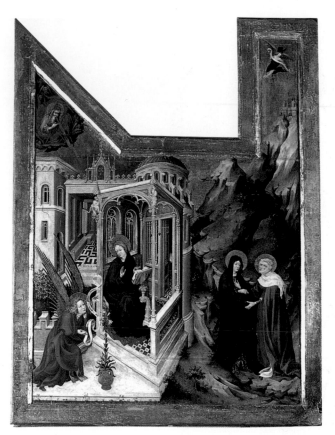
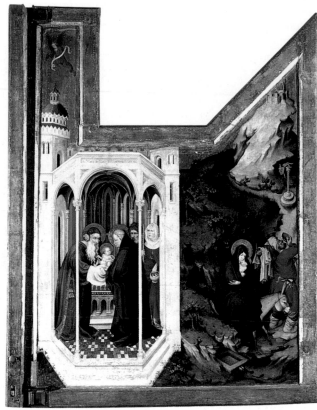

17-8. Melchior Broederlam. *Annunciation and Visitation* (left); ***Presentation in the Temple and Flight into Egypt*** (right), wings of an altarpiece for the Chartreuse de Champmol. 1394–99. Oil on wood panel, 5'5³/4" x 4'1¹/4" (1.67 x 1.25 m). Musée des Beaux-Arts, Dijon

Virgin and the Infancy of Christ (fig. 17-8). The events take place in both architectural and landscape settings that fill the panels. In International Gothic fashion, both interior and exterior of the building are shown, and the floors are tilted up to give clear views of the action. The landscapes have been arranged to lead the eye up from the foreground and into the distance along a rising ground plane. Despite the imaginative architecture, fantasy mountains, miniature trees, and solid gold sky, the artist has created a sense of light and air around solid figures.

On the left wing, in the *Annunciation*, under the benign eyes of God, the archangel Gabriel greets Mary with the news of her impending motherhood. A door leads into the dark interior of the tall pink rotunda meant to represent the Temple of Jerusalem, a symbol of the Old Law, where, according to legend, Mary was an attendant prior to her marriage to Joseph. A tiny enclosed garden and a pot of lilies are symbols of Mary's virginity. In the *Visitation*, just outside the temple walls, the now-pregnant Mary greets her older cousin Elizabeth, who is also pregnant and will soon give birth to John the Baptist. On the right wing, in the *Presentation in the Temple*, Mary and Joseph have brought the newborn Jesus to the temple for the Jewish purification rite, where the priest Simeon takes him in his arms to bless him (Luke 2:25–32). At the far right, the Holy Family flees into Egypt to escape King Herod's order that all Jewish male infants be killed. The family travels along treacherous terrain similar to that in the *Visitation* scene. Much of the detail

comes not from New Testament accounts but from legends. Reflecting a new humanizing element creeping into art, Joseph drinks from a flask and carries the family belongings over his shoulder. The statue of a pagan god, visible at the upper right, breaks and tumbles from its pedestal as the Christ Child approaches. Typical of paintings of this period, every detail has meaning.

FLAMBOYANT-STYLE ARCHITECTURE

The great age of cathedral building that had begun about 1150 was over by the end of the fourteenth century, but the growing urban population needed more parish churches and a wide variety of secular buildings. The richest patrons commissioned sculptors to cover their buildings with elaborate decoration inspired by Gothic architectural sculpture and by their increased interest in the realistic depiction of nature, such as ivy and hawthorn leaves. Called the Flamboyant ("flaming" in French) style because of its repeated, twisted, flamelike shapes, this intricate, elegant decoration covered new buildings and was added to older buildings being modernized with spires, porches, or window **tracery**.

The facade of the Church of Saint-Maclou in Rouen, which was begun after a fund-raising campaign in 1432 and dedicated in 1521, perhaps designed by the Paris architect Pierre Robin, is an outstanding example of the Flamboyant style (fig. 17-9). The projecting porch bends to enfold the facade of the church in a screen of tracery.

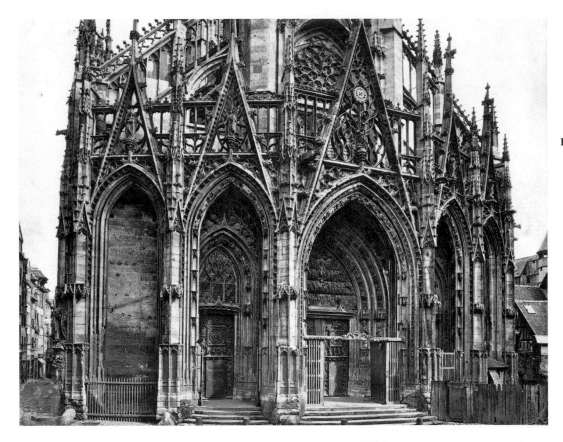

17-9. West facade, Church of Saint-Maclou, Rouen, Normandy, France. Dedicated 1521; facade c. 1500–14

Sunlight on the flame-shaped openings casts flickering, changing shadows across the intentionally complex surface. **Crockets**, small knobby leaflike ornaments that line the steep **gables** and slender **buttresses**, break every defining line. In the Flamboyant style, decoration sometimes seems divorced from structure. Load-bearing walls and buttresses often have stone overlays; traceried **pinnacles**, gables, and S-curve **moldings** combine with a profusion of ornament in geometric and natural shapes, all to dizzying effect. The interior of such a church, filled with light from huge windows of *grisaille* glass, can be seen in the *Hours of Mary of Burgundy* (see fig. 17-23).

The house of the fabulously wealthy merchant Jacques Coeur in Bourges, in central France, built at great expense between 1443 and 1451, reflects the popularity of the Flamboyant style for secular architecture (fig. 17-10). The rambling, palatial house has many rooms of varying sizes on different levels, all arranged around an open courtyard. Spiral stairs in octagonal towers give access to the rooms. **Tympana** over doors indicate the function of the rooms within; for example, over the door to the kitchen a cook stirs the contents of a large bowl. Flamboyant decoration enriches the **cornices**, **balustrades**, windows, and gables. Among the carved decorations are puns on the patron's surname, Coeur ("heart" in French). The house was also Jacques Coeur's place of business, so it had large storerooms for goods and a strong room for treasure. (A well-stocked merchant's shop can be seen in a painting of Saint Eloy; see fig. 17-18.)

17-10. Interior courtyard, house of Jacques Coeur, Bourges, France. 1443–51

Illuminated manuscripts, such as that of Christine de Pisan (see fig. 20, Introduction), give some indication of the interior richness of a palace or town house owned by a wealthy family. The architecture was often painted and the walls were hung with rich and colorful tapestries. Furnishings were also covered with tapestry and embroideries. Glass windows might be enriched with stained-glass inserts illustrating coats of arms.

The altar in a Christian church symbolizes both the table of Jesus' Last Supper and the tombs of Christ and the saints. The altar, whether on leglike supports or a block of stone, has named parts: the top surface is the **mensa**, and the support is the **stipes**. The front surface of a block altar is the **antependium**. Relics of the church's patron saint may be placed in a reliquary on the altar, beneath the floor on which the altar rests, or even within the altar itself.

Altarpieces are painted or carved constructions placed at the back of the mensa or behind the altar in a way that makes altar and altarpiece appear to be visually joined. Their original purpose was to identify the saint or the mystery to which the altar was dedicated. Over time, the altarpiece evolved from a low panel to a large and elaborate architectonic structure filled with images and protected by movable wings that function like shutters. An altarpiece may have a firm base, called a **predella**, decorated with images. A winged altarpiece can be a **diptych**, in which two panels are hinged in the middle (see fig. 17-28); a **triptych**, in which two wings fold over a center section (see fig. 17-11); or a **polyptych**, in which sets of wings can be opened and closed in different arrangements according to specific liturgical uses through the church year (see fig. 17-16). Wings bear images, usually painted, on both sides. The wings and center section are sometimes decorated with sculpture.

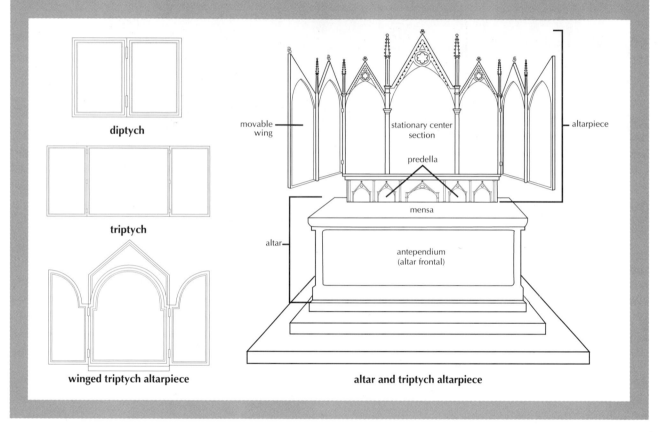

diptych

triptych

winged triptych altarpiece

movable wing — stationary center section — altarpiece

predella

mensa

altar —

antependium (altar frontal)

altar and triptych altarpiece

ART OF FLANDERS

The southern Netherlands, known as Flanders (today's Belgium and northeastern France), became the leading center of painting outside Italy in the fifteenth century. Flanders, with its major seaport at Bruges, was the commercial power of northern Europe, rivaled in southern Europe by the Italian city-states of Milan, Florence, and Venice. The chief sources of Flemish wealth were the wool trade and the manufacture of fine fabrics. Most professionals belonged to a powerful local guild—an association of people engaged in the same business or craft. Guilds oversaw nearly every aspect of their members' lives, and high-ranking guild members served on town councils and helped run city governments.

Artists might work independently in their own studios without the sponsorship of an influential patron, but they had to belong to a local guild. Experienced artists who moved from one city to another usually had to work as assistants in a local workshop until they met the requirements for guild membership. Different kinds of artists belonged to different guilds. Painters, for example, joined the Guild of Saint Luke, the guild of the physicians and pharmacists, because painters used the same techniques of grinding and mixing raw ingredients for their pigments and varnishes that physicians and pharmacists used to prepare salves and potions.

Civic groups, town councils, and wealthy merchants were important art patrons in the Netherlands, where the cities were self-governing, largely independent of the landed nobility. The diversity of clientele encouraged artists to experiment with new types of images—with outstanding results. The dukes of Burgundy also ruled the Netherlands, and they provided stability and money for the arts to flourish there. Throughout most of the fifteenth century, Flemish art and artists were greatly

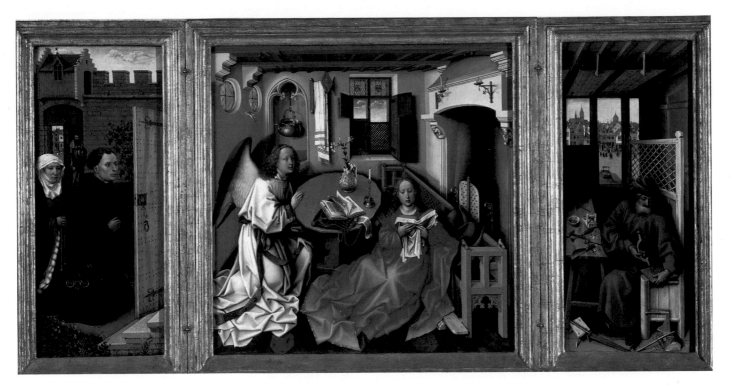

17-11. Robert Campin. *Mérode Altarpiece (Triptych of the Annunciation)* (open). c. 1425–28. Oil on wood panel, center 25¼ x 24⅞" (64.1 x 63.2 cm); each wing approx. 25⅜ x 10¾" (64.5 x 27.6 cm). The Metropolitan Museum of Art, New York

The Cloisters Collection, 1956 (56.70)

admired; artists from abroad studied Flemish works, and their influence spread throughout Europe, including Italy. Only at the end of the fifteenth century did a general preference for the Netherlandish painting style give way to a taste for the new styles of art and architecture developing in Italy.

FIRST-GENERATION PANEL PAINTERS

The Flemish style originated in manuscript illumination of the late fourteenth century, when artists began to create full-page scenes set off with frames that functioned almost as windows looking into rooms or out onto landscapes with distant horizons. Artists also designed tapestries and stained glass, and painted on wood **panels** (see "Painting on Panel," page 630). Tapestries had the greatest value and prestige, but panel painting became increasingly important. Like the manuscript illuminations before them, the panel paintings provided a window onto a scene, which fifteenth-century Flemish painters typically rendered with keen attention to individual features—whether of people, human-made objects, or the natural world—in works laden with symbolic meaning.

The most outstanding exponents of the new Flemish style were Robert Campin (documented from 1406; d. 1444), Jan van Eyck (c. 1370/90–1441), and Rogier van der Weyden (c. 1399–1464). Scholars have been able to piece together sketchy biographies for these artists from contracts, court records, account books, and references

to their work by contemporaries. Reasonable attributions of a number of paintings have been made to each of them, but written evidence is limited. Signatures are rarely found on fifteenth-century paintings, in part because artists customarily signed the frames, which usually have been lost.

The paintings of Robert Campin (formerly known as the Master of Flémalle, after a pair of panel paintings once thought to have come from the Abbey of Flémalle) reflect the Netherlandish taste for lively narrative and a bold three-dimensional treatment of figures reminiscent of the sculptural style of Claus Sluter. About 1425–28, Campin painted an altarpiece now known as the *Mérode Altarpiece* from the name of later owners. Slightly over 2 feet tall and about 4 feet wide with the wings open, it probably was made to be placed on the altar of a small private chapel (fig. 17-11). By depicting the Annunciation inside a Flemish home, Campin turned common household objects into religious symbols. The lilies in the **majolica** (glazed earthenware) pitcher on the table, for example, which symbolize Mary's virginity, were a traditional element of Annunciation imagery (see fig. 17-8). The white towel and hanging waterpot in the niche symbolize Mary's purity and her role as the vessel for the Incarnation of God. These accouterments of a middle-class home now have a religiously sanctioned status. Such objects are often referred to as "hidden" symbols because they are treated as an ordinary part of the scene, but their religious meanings would have been widely understood by contemporary people.

PAINTING ON PANEL

For works ranging from enormous altarpieces to small portraits, wood **panels** were favored by fifteenth-century European painters and their patrons. First the wood surface was sanded to make it smooth, then the panel was coated—in Italy with **gesso**, a fine solution of plaster, and in northern Europe with a solution of chalk. These coatings soaked into and closed the pores of the wood. Fine linen was often glued over the whole surface or over the joining lines on large panels made of two or more pieces of wood. The cloth was then also coated with gesso or chalk.

Once the surface was ready, the artist could paint on it with pigments held in water (**tempera** painting) or **oil**. Italian artists favored tempera, using it almost exclusively for panel painting until the end of the fifteenth century. Northern European artists preferred the oil technique that

Flemish painters so skillfully exploited. Tempera had to be applied in a very precise manner, because it dried almost as quickly as it was laid down. Shading had to be done with careful overlying strokes in varied tones. Because tempera is opaque—light striking its surface does not penetrate to lower layers of color and reflect back—the resulting surface was matte, or dull, and had to be varnished to give it sheen.

Oil paint, on the other hand, took much longer to dry, and errors could be corrected while it was still wet. Oil could also be made translucent by applying it in very thin layers, called **glazes**. Light striking a surface built up of glazes penetrates to the lower layers and is reflected back, creating a glow from within. In both tempera and oil the desired result in the fifteenth century was a smooth surface that betrayed no brushstrokes.

Unfortunately, the precise meanings are not always clear today. The central panel may simply portray Gabriel telling Mary that she will be the Mother of Christ. Another interpretation suggests that the painting shows the moment immediately following Mary's acceptance of her destiny. A rush of wind riffles the book pages and snuffs the candle as a tiny figure of Christ carrying a cross descends on a ray of light. Having accepted the miracle of the Incarnation (God assuming human form), Mary reads her Bible while sitting humbly on the footrest of the long bench as a symbol of her submission to God's will. But another interpretation of the scene suggests that it represents the moment just prior to the Annunciation. In this view, Mary is not yet aware of Gabriel's presence, and the rushing wind is the result of the angel's rapid entry into the room, where he appears before her half kneeling and raising his hand in salutation.

The complex treatment of light in the *Mérode Altarpiece* was an innovation of the Flemish painters. The strongest illumination comes from an unseen source at the upper left in front of the **picture plane**, as if the sun entered through a miraculously transparent wall that allows the viewer to observe the scene. In addition, a few rays enter the round window at the left as the vehicle for the Christ Child's descent. More light comes from the window at the rear of the room, and areas of reflected light can also be detected.

Campin maintained the spatial conventions typical of the International Gothic style; the abrupt recession of the bench toward the back of the room, the sharply uplifted floor and tabletop, and the disproportionate relationship between the figures and the architectural space create an inescapable impression of instability. In an otherwise intense effort to mirror the real world, this treatment of space may be a conscious remnant of medieval style, serving the symbolic purpose of visually detaching the religious realm from the world of the viewers. Unlike figures by such International Gothic painters as the Limbourg brothers (see fig. 17-6), the

Virgin and Gabriel are massive rather than slender, and their abundant draperies increase the impression of their material weight.

Although in the biblical account Joseph and Mary were not married at the time of the Annunciation, this house clearly belongs to Joseph, shown in his carpentry shop on the right. A prosperous Flemish city can be seen through the shop window, with people going about their business unaware of the drama taking place inside the carpenter's home. One clue indicates that this is not an everyday scene: The shop, displaying carpentry wares— mousetraps, in this case—should be on the ground floor, but its window opens from the second floor. The significance of the mousetraps would have been recognized by knowledgeable people in the fifteenth century as Saint Augustine's reference to Christ as the bait in a trap set by God to catch Satan. Joseph is drilling holes in a small board that may be a drainboard for wine making, symbolizing the central rite of the Church, the Eucharist.

Joseph's house opens onto a garden planted with a rosebush, which alludes to the Virgin and also to the Passion. It has been suggested that the man standing behind the open entrance gate, clutching his hat in one hand and a document in the other, may be a self-portrait of the artist. Alternatively, the figure may represent an Old Testament prophet, because rich costumes like his often denoted high-ranking Jews of the Bible. Kneeling in front of the open door to the house are the donors of the altarpiece. They appear to observe the Annunciation through the door, but their gazes seem unfocused. The garden where they kneel is unrelated spatially to the chamber where the Annunciation takes place, suggesting that the scene is a vision induced by their prayers. Such a presentation, often used by Flemish artists, allowed the donors of a religious work to appear in the same space and time—and often on the same scale—as the figures of the saints represented.

Campin's contemporary Jan van Eyck was a trusted official in the court of the duke of Burgundy as well as a

painter. Nothing is known of Jan's youth or training, but he was born sometime between 1370 and 1390 in Maaseik, on the Maas (Meuse) River, now in Belgium on the present-day border between Belgium and the Netherlands. He was from a family of artists, including two brothers, Lambert and Hubert, and a sister, Margareta, whom sixteenth-century Flemish writers still remembered with praise. The earliest references to Jan are in 1422 in The Hague, where he was probably involved in the renovation of a castle. He was appointed painter to Philip the Good, the duke of Burgundy, in Bruges on May 19, 1425. His appointment papers state that he had been hired because of his skillfulness in the art of painting, that the duke had heard about Jan's talent from people in his service, and that the duke himself recognized those qualities in Jan van Eyck. The special friendship that developed between the duke and his painter is a matter of record.

Although there are a number of contemporary accounts of Jan's activities, the only reference to specific art works is to two portraits of Princess Isabella of Portugal, which he painted in that country in 1429 and sent back to Philip in Flanders. Philip and Isabella were married in 1430. The duke alluded to Jan's remarkable technical skills in a letter of 1434–35, saying that he could find no other painters equal to his taste or so excellent in art and science. Part of the secret of Jan's "science" was his technique of painting with oil glazes on wood panel. So brilliant were the results of his experiments that Jan has been mistakenly credited with being the inventor of **oil painting**. Actually, the medium had been known for several centuries, and medieval painters had used oil paint to decorate stone, metal, and occasionally plaster walls.

For his paintings on wood panel, Jan built up the images in transparent oil layers, a procedure called **glazing**. His technique permitted a precise, objective description of what he saw, with tiny, carefully applied brushstrokes so well blended that they are only visible at very close range. Other northern European artists of the period worked in the oil medium, although oil and **tempera** were still combined in some paintings, and tempera was used for painting on canvas (see "Painting on Panel," opposite).

Jan's earliest surviving known work, the *Ghent Altarpiece,* was completed in 1432 for a wealthy official of Ghent and his wife. The complexities of this altarpiece can be challenging intellectually and emotionally. The brilliantly painted interior of the altarpiece presents the adoration of the Lamb of God. Above are an enthroned figure of God, the Virgin Mary, John the Baptist, angel musicians, and Adam and Eve (see fig. 17-62).

Jan's *Annunciation* (fig. 17-12), a small independent panel, is an excellent example of the Flemish desire to paint more than the eye can see and almost more than the mind can grasp. We can enjoy the painting for its visual characteristics—the drawing, colors, and arrangement of shapes—but we need information about the painting's cultural context to understand it fully. *The Annunciation* takes place in a richly appointed church, not

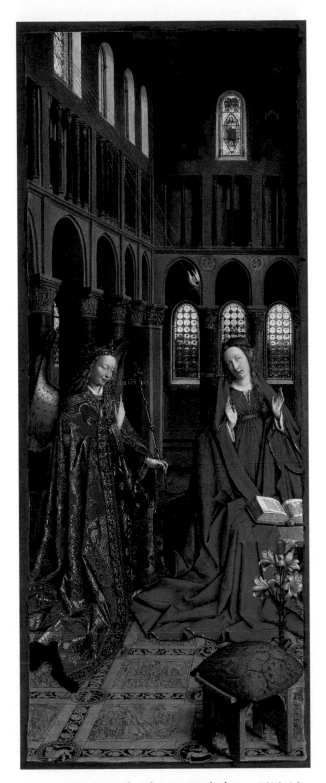

17-12. Jan van Eyck. ***The Annunciation***. c. 1434–36. Oil on canvas, transferred from wood panel, painted surface 35³⁄₈ x 13⁷⁄₈" (90.2 x 34.1 cm). National Gallery of Art, Washington, D.C.

Andrew W. Mellon Collection 1937.1.39

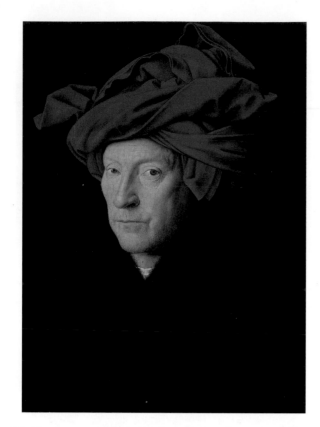

17-13. Jan van Eyck. *Man in a Red Turban*. 1433. Oil on wood panel, 10⅛ x 7⅜" (25.7 x 18.7 cm). The National Gallery, London

Mary's house, as we saw in Robert Campin's painting. Gabriel, a richly robed youth with splendid multicolored wings, has interrupted Mary's reading. The two figures gesture gracefully upward toward a dove flying down through beams of gold. As the angel Gabriel tells the Virgin Mary that she will bear the Son of God, Jesus Christ, golden letters floating from their lips capture their words, "Hail, full of grace" and "Behold the handmaiden of the Lord." The story is recounted in the Gospel of Luke (1:26–38). In the painting every detail has a meaning. The dove symbolizes the Holy Spirit; the white lilies are symbols of Mary. The signs of the zodiac in the floor tiles indicate the traditional date of the Annunciation, March 25. The one stained-glass window representing God rises above the three windows enclosing Mary and representing the Trinity of Father, Son, and Holy Spirit.

Man in a Red Turban of 1433 (fig. 17-13) is widely believed to be Jan's self-portrait, partly because of the strong sense of personality it projects, partly because the frame, signed and dated by him, also bears his personal motto, *Als ich chan* ("The best that I am capable of doing"). This motto, derived from classical sources, is a telling illustration of the humanist spirit of the age and the confident expression of an artist who knows his capabilities and is proud to display them. If the *Man in a Red Turban* is, indeed, the face of Jan van Eyck, it shows his physical appearance as if in a magnifying mirror— every wrinkle and scar, the stubble of a day's growth of

beard on the chin and cheeks, and the tiny reflections of light from a studio window in the pupils of the eyes. The outward gaze of the subject is new in portraiture, and it suggests the subject's increased sense of pride as he seems to catch the viewer's eye.

Jan's best-known painting today is an elaborate portrait of a couple, traditionally identified as Giovanni Arnolfini and his wife, Giovanna Cenami (fig. 17-14). This fascinating work has been, and continues to be, subject to a number of interpretations, most of which suggest that it represents a wedding or betrothal. One remarkable detail is the artist's inscription below the mirror on the back wall: *Johannes de eyck fuit hic 1434* ("Jan van Eyck was here, 1434"). Normally, a work of art in fifteenth-century Flanders would have been signed "Jan van Eyck made this." The wording here specifically refers to a witness to a legal document, and indeed, two witnesses to the scene are reflected in the mirror, a man in a red turban—perhaps the artist—and one other. The man in the portrait, identified by early sources as a member of an Italian merchant family living in Flanders, the Arnolfini, holds the right hand of the woman in his left (symbolizing a marriage between people of different classes) and raises his right to swear to the truth of his statements before the two onlookers. In the fifteenth century, a marriage was rarely celebrated with a religious ceremony. The couple signed a legal contract before two witnesses, after which the bride's dowry might be paid and gifts exchanged. However, it has been suggested that, instead of a wedding, the painting might be a pictorial "power of attorney," by which the husband states that his wife may act on his behalf in his absence.

Whatever event the painting depicts, the artist has juxtaposed the secular and the religious in a work that seems to have several levels of meaning. On the man's side of the painting, the room opens to the outdoors, the external world in which men function, while the woman is silhouetted against the domestic interior, with its allusions to the roles of wife and mother. The couple is surrounded by emblems of wealth, piety, and married life. The convex mirror reflecting the entire room and its occupants is a luxury object described in many inventories of the time, but it may also symbolize the all-seeing eye of God, before whom the man swears his oath. The **roundels** decorating its frame depict the Passion of Christ, a reminder of Christian redemption.

Many other details have religious significance, suggesting the piety of the couple: the crystal prayer beads on the wall; the image of Saint Margaret, protector of women in childbirth, carved on the top of a high-backed chair next to the bed; and the single burning candle in the chandelier, which may be a symbol of Christ's presence. But the candle can also represent a nuptial taper or a sign that a legal event is being recorded. The fruits shown at the left, seemingly placed there to ripen in the sun, may allude to fertility in a marriage and also to the Fall of Adam and Eve in the Garden of Eden. The small dog may simply be a pet, but it serves also as a symbol of fidelity, and its rare breed—affenpinscher—suggests wealth. The discovery of a document proving that Arnolfini married

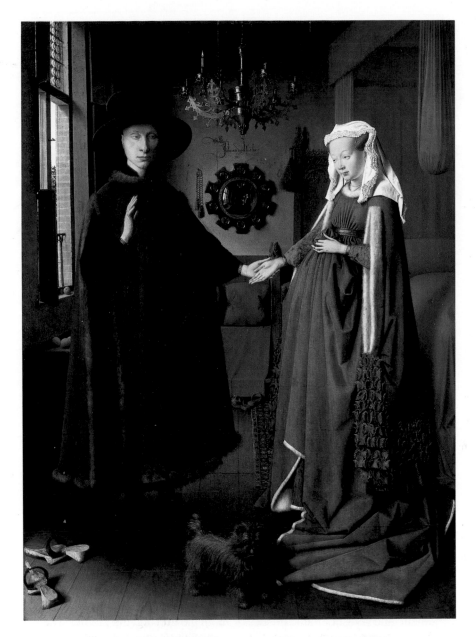

17-14. Jan van Eyck. *Portrait of Giovanni Arnolfini (?) and His Wife, Giovanna Cenami (?)*. 1434. Oil on wood panel, 33 x 22½" (83.8 x 57.2 cm). The National Gallery, London

The merchant class copied the fashions of the court, and a beautifully furnished room containing a large bed hung with rich draperies was often a home's primary public space, not a private retreat. According to a later inventory description of this painting, the original frame (now lost) was inscribed with a quotation from Ovid, a Roman poet known for his celebration of romantic love. The woman wears an aristocratic costume, a fur-lined overdress with a long train. Fashion dictated that the robe be gathered up and held in front of the abdomen, giving an appearance of pregnancy. This ideal of feminine beauty emphasized women's potential fertility.

in 1447, thirteen years after this painting and six years after Jan's death, adds to the mystery.

One of the most enigmatic of the major early Flemish artists is Rogier van der Weyden. Although his biography has been pieced together from documentary sources, not a single existing work of art bears his name or has an entirely undisputed connection with him. He was thought at one time to be identical with the Master of Flémalle, but evidence now suggests that he studied under Robert Campin, which would explain the similarities in their painting styles. Even his relationship with Campin is not altogether certain, however. At the peak of his career, Rogier maintained a large workshop in Brussels, to which apprentices and shop assistants came from as far away as Italy to study.

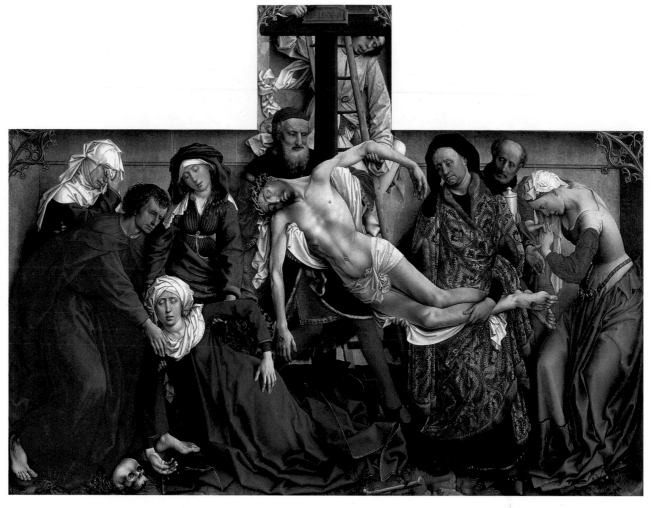

17-15. Rogier van der Weyden. *Deposition*, from an altarpiece commissioned by the Crossbowmen's Guild, Louvain, Brabant, Belgium. c. 1442. Oil on wood panel, 7'2⅝" x 8'7⅛" (2.2 x 2.62 m). Museo del Prado, Madrid

To establish the thematic and stylistic characteristics for Rogier's art, scholars have turned to a painting of the Deposition, the central panel of an altarpiece that once had wings painted with the Four Evangelists—Matthew, Mark, Luke, and John—and Christ's Resurrection (fig. 17-15). The altarpiece was commissioned by the Louvain Crossbowmen's Guild sometime before 1443, the date of the earliest known copy after it by another artist.

The Deposition was a popular theme in the fifteenth century because of its dramatic, personally engaging character. Like a *tableau vivant*, the act of removing Jesus' body from the Cross is set on a shallow stage closed off by a wood backdrop that has been **gilded**, or covered with a thin overlay of gold. The solid, three-dimensional figures seem to press forward toward the viewer's space, forcing the viewer to identify with the grief of Jesus' friends—made palpably real by their portraitlike faces and elements of contemporary dress—as they tenderly and sorrowfully remove his body from the Cross for burial. Rogier has arranged Jesus, the lifesize corpse at the center of the composition, in a graceful curve, echoed by the form of the fainting Virgin, thereby increasing the viewer's emotional identification with

both the Son and the Mother. The artist's compassionate sensibility is especially evident in the gestures of John the Evangelist, who supports the Virgin at the left, and Jesus' friend Mary Magdalen, who wrings her hands in anguish at the right. Many scholars see Rogier's emotionalism as a tie with the Gothic past, but it can also be interpreted as an example of fifteenth-century humanism in its concern for individual expressions of emotion. Although united by their sorrow, the mourning figures react in personal ways.

Rogier's choice of color and pattern balances and enhances his composition. For example, the complexity of the gold brocade worn by Joseph of Arimathea, who offered his new tomb for the burial, and the contorted pose and vivid dress of Mary Magdalen increase the visual impact of the right side of the panel and counter the larger number of figures at the left. The palette of subtle, slightly muted colors is sparked with red and white accents to focus the viewer's attention on the main subject. The whites of the winding cloth and the tunic of the youth on the ladder set off Jesus' pale body, as the white headdress and neck shawl emphasize the ashen face of Mary.

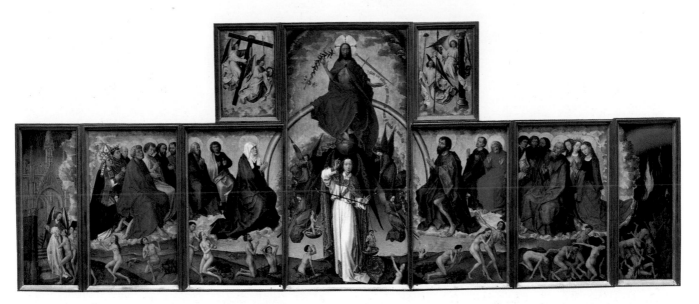

17-16. **Rogier van der Weyden.** *Last Judgment Altarpiece* (open). After 1443. Oil on wood panel, open 7'4⅝" x 17'11" (2.25 x 5.46 m). Musée de l'Hôtel-Dieu, Beaune, France

Rogier painted his largest and most elaborate work, the altarpiece of the *Last Judgment*, for a hospital in Beaune founded by the chancellor of the duke of Burgundy (fig. 17-16). Whether Rogier painted this altarpiece before or after he made a trip to Rome for the Jubilee of 1450 is debated by scholars. He would have known the Last Judgments so common in medieval churches, but he could also have been inspired by the paintings and mosaics in Rome. The tall, straight figure of the archangel Michael, dressed in a white robe and priest's cope (a ceremonial cloak), dominates the center of the wide **polyptych** (multiple-panel work) as he weighs souls under the direct order of Christ, who sits on the arc of a giant rainbow above him. The Virgin Mary and John the Baptist kneel at either end of the rainbow. Behind them on each side, six apostles, then men at the left (the right side of Christ) and women at the right witness the scene. The cloudy gold background serves, as it did in medieval art, to signify events in the heavenly realm or in a time remote from that of the viewer.

The bodily resurrection takes place on a narrow, barren strip of earth that runs across the bottom of all but the outer panels. Men and women climb out of their tombs, turning in different directions as they react to the call to Judgment. The scale of justice held by Michael tips in an unexpected direction; instead of Good weighing more than Bad, the Saved Soul has become pure spirit and rises, while the Damned one sinks, weighed down by unrepented sins. The Damned throw themselves into the flaming pit of hell; those moving to the left (the right hand of Christ)—notably far less numerous—are greeted by the archangel Gabriel at the shining Gate of Heaven, depicted as Gothic architecture.

In his portraiture, Rogier balanced a Flemish love of detailed individuality with a flattering **idealization** of the features of men and women. In *Portrait of a Lady,* dated about 1460, Rogier transformed an ordinary young woman into a vision of exquisite but remote beauty (fig. 17-17, page 636). Her long, almond-shape eyes, regular features, and smooth translucent skin characterize women in portraits attributed to Rogier. He popularized the half-length pose that includes the woman's high waistline and clasped hands, which he used for images of the Virgin and Child that often formed **diptychs** (two-panel works) with small portraits of this type. The woman is pious and humble, wealthy but proper and modest. The portrait expresses the complex and often contradictory attitudes of the new middle-class patrons of the arts, who balanced pride in their achievements with appropriate modesty.

SECOND-GENERATION PANEL PAINTERS

The extraordinary accomplishments of Robert Campin, Jan van Eyck, and Rogier van der Weyden attracted many followers in Flanders. The work of this second generation of Flemish painters was simpler, more direct, and easier to understand than that of their predecessors. These artists produced high-quality work of great emotional power, and they were in large part responsible for the rapid spread of the Flemish style through Europe.

Among the most interesting of the second-generation painters was Petrus Christus (documented from 1444–c. 1475/76). Nothing is known of his life before 1444, when he became a citizen of Bruges. Although many paintings attributed to him resemble the work of Jan van Eyck, they probably did not know each other, because Jan died three years before Christus's arrival in Bruges.

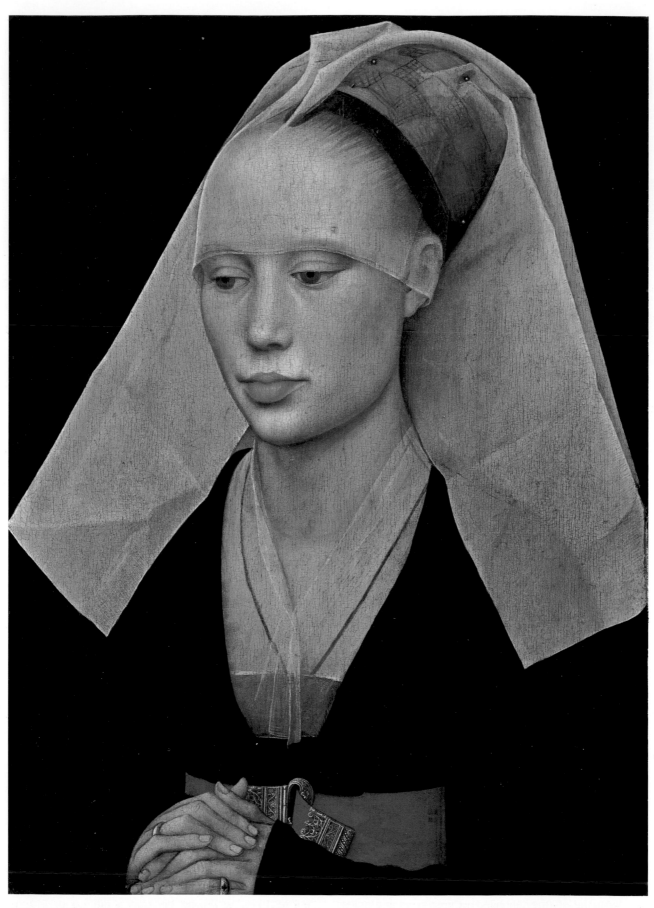

17-17. Rogier van der Weyden. *Portrait of a Lady*. c. 1460. Oil and tempera on wood panel, 14¹/₁₆ x 10⁵/₈" (37 x 27 cm). National Gallery of Art, Washington, D.C.

Andrew W. Mellon Collection

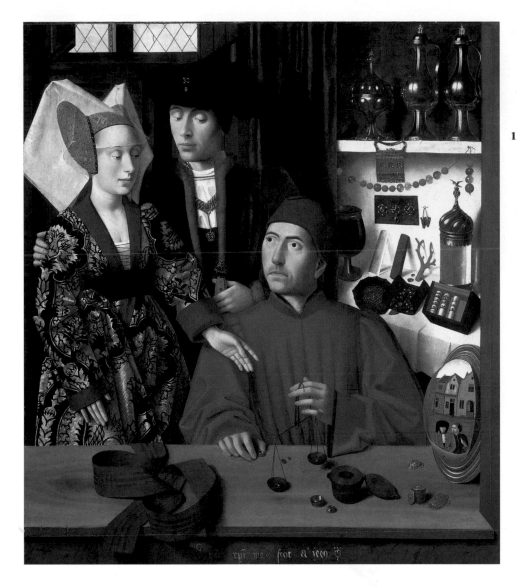

17-18. Petrus Christus. *Saint Eloy (Eligius) in His Shop*. 1449. Oil on oak panel, 38⅝ x 33½" (98 x 85 cm). The Metropolitan Museum of Art, New York

Robert Lehman Collection, 1975 (1975.1.110)

The artist signed and dated his work on the house reflected in the mirror.

In 1449 Christus painted *Saint Eloy (Eligius) in His Shop* (fig. 17-18). Eloy, a seventh-century ecclesiastic, goldsmith, and mintmaster for the French court, used his wealth to ransom Christian captives, according to legend. He became the patron saint of metalworkers. Here he weighs a jeweled ring, as a handsome couple looks on. This may be a specific betrothal or wedding portrait. Certainly the painting contains elaborate messages, and all the objects can be identified. The coins are Burgundian gold ducats and gold "angels" of Henry VI of England (ruled 1422–61, 1470–71), and on the bottom shelf are a box of rings, two bags with precious stones, and pearls. Behind them stands a crystal reliquary with a gold dome and a ruby and amethyst pelican. Many of the objects on the shelves had a protective function—for example, the red coral and the serpents' tongues (fossilized sharks' teeth) hanging above the coral could ward off the evil eye, and the coconut cup at the left neutralized poison. Slabs of porphyry and rock crystal were "touchstones," used to test gold and precious stones, such as the pendant and two brooches of gold with pearls and precious stones pinned to a dark fabric. Rosary beads and a belt end (similar to the one worn in

Rogier's *Portrait*) hang from the top shelf, where two silver flagons and a covered cup stand.

The young couple are certainly aristocrats: The man wears a badge identifying him as a member of the court of the duke of Gelders; the young woman, dressed in Italian gold brocade, has no jewelry but wears the double horned headdress fashionable at mid-century and worn by the ladies of the queen of France (see fig. 00, Introduction).

As in Jan's *Portrait of Giovanni Arnolfini* (see fig. 17-14), a convex mirror extends the viewer's field of vision, in this instance to the street outside, where two men appear. One holds a falcon. All the figures are dressed stylishly, for the court of Burgundy set the fashions for much of Europe. Whether or not the reflected image has symbolic meaning, the mirror had a practical value in allowing the goldsmith to note the approach of a potential customer.

An outstanding Haarlem painter who moved south to Flanders, Dirck Bouts (documented from 1457; d. 1475), became the official painter of the city of Louvain in 1468. His mature style shows a strong debt to Jan van Eyck and, especially, Rogier van der Weyden, but not at the expense of his own clear-cut individuality. Bouts was

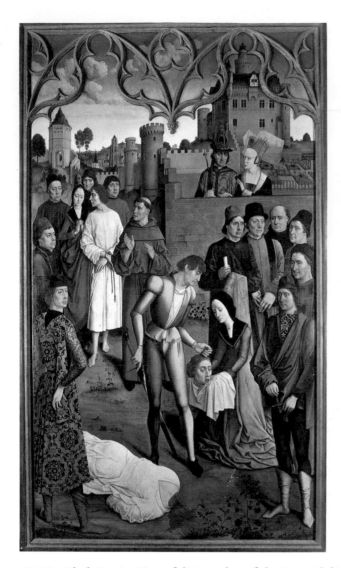 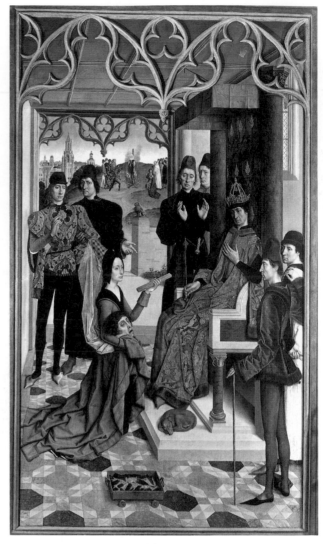

17-19. Dirck Bouts. *Wrongful Execution of the Count* (left), and companion piece, ***Justice of Otto III*** (right). 1470–75. Oil on wood panel, each 12'11" x 6'7½" (3.9 x 2 m). Musées Royaux des Beaux-Arts de Belgique, Brussels, Belgium

an excellent storyteller, skillful in direct narration rather than complex symbolism. His best-known works today are two remaining panels (fig. 17-19) from a set of four on the subject of justice. Such paintings were often commissioned for display in municipal buildings, and the town council of Louvain had ordered this set from Bouts for the city hall. The subject of the panels was a fictional twelfth-century story about a real-life emperor. In a continuous narrative in the left panel, *Wrongful Execution of the Count*, the empress falsely accuses a count of a sexual impropriety. Otto III tries and convicts the count, who is beheaded. In the right panel, *Justice of Otto III*, the widowed countess successfully endures a trial by ordeal to prove her husband's innocence. She kneels unscathed before the repentant emperor, holding her husband's head on her right arm and a red-hot iron bar in her left hand. In the far distance, the evil empress is executed by burning at the stake.

Dirck Bouts's work is notable for its spacious outdoor settings. Carefully adjusting the scale of his figures to the landscape and architecture, the artist created an illusion of space that recedes continuously and gradually from the picture plane to the far horizon. For this effect, he employed devices such as walkways, walls, and winding roads along which characters in the scene are placed. Bouts's figures are extraordinarily tall and slender and have little or no facial expression. Bouts is credited as the inventor of a type of official group portrait in which individuals are integrated into a narrative scene with fictional or religious characters, so the Louvain justice panels, with their distinctly individualized protagonists, may have been a vehicle for a group portrait of the town council.

By far the most successful of the second-generation Flemish school painters was Hans Memling. Memling combines the intellectual depth and virtuoso rendering of his predecessors with a delicacy of feeling and exquisite grace. Memling was born in one of the German states about 1430–35. He may have worked in Rogier van der Weyden's Brussels workshop in the 1460s, for Rogier's style remained the dominant influence on his art. Soon after Rogier's death in 1464, Memling moved to

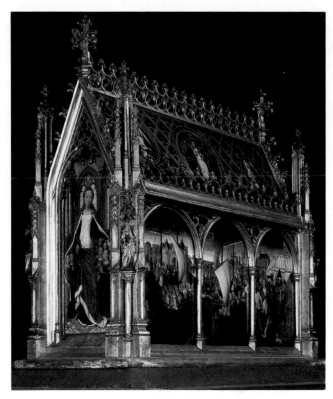

17-20. Hans Memling. Saint Ursula reliquary. 1489. Painted and gilded oak, 34 x 36 x 13" (86.4 x 91.4 x 33 cm). Memling Museum, Hospital of Saint John, Bruges, Belgium

The reliquary was commissioned presumably by the two women dressed in the white habits and black hoods worn by hospital sisters and depicted on the end of the reliquary not visible here. One hypothesis is that they are Jossine van Dudzeele and Anna van den Moortele, two administrators of the hospital where the church-shaped chest has remained continuously for more than five centuries. The story of Ursula, murdered in the fourth century by Huns in Cologne after she returned from a visit to Rome, is told on the six side panels. Shown from the left: the pope bidding Ursula good-bye at the port of Rome; the murder of her female companions in Cologne harbor; and Ursula's own death. On the "roof" are roundels with musician angels flanking the Coronation of the Virgin. At the corners are carved saints, and on the end is Saint Ursula in the doorway of the "church," sheltering her followers under her mantle. In early stories, Ursula was accompanied on her trip by ten maidens. By the tenth century, however, she had become the leader of 11,000 women martyrs.

Bruges, where he worked until his death in 1494. Memling had an international clientele, and his style was widely emulated both at home and abroad.

Among the works securely assigned to Memling is a large wooden **reliquary**, a container for the sacred relics of Saint Ursula, in the form of a Gothic chapel (fig. 17-20). It was made in 1489 for the Hospital of Saint John in

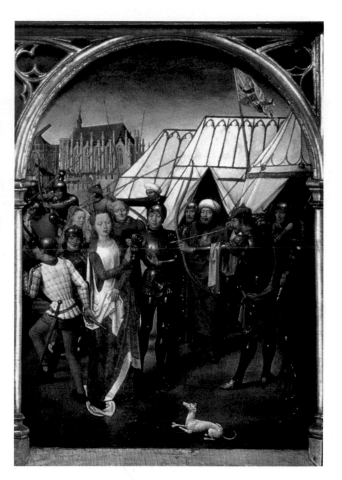

17-21. Hans Memling. *Martyrdom of Saint Ursula*, detail of the Saint Ursula reliquary. Panel 13¾ x 10" (35 x 25.3 cm)

Bruges, now a museum of Memling's works. The painting illustrates the story of Saint Ursula's martyrdom. According to legend, Ursula, the daughter of the Christian king of Brittany, in France, was betrothed to a pagan English prince. She requested a three-year delay in the marriage to travel with 11,000 virgin attendants to Rome, during which time her husband-to-be was to convert to Christianity. On the trip home, the women stopped in Cologne, which had been taken over by Attila the Hun and his nomadic warriors from Central Asia. They murdered her companions, and when Ursula rejected an offer of marriage, they killed her as well, with an arrow through the heart (fig. 17-21). Although the events supposedly took place in the fourth century, Memling has set them in contemporary Cologne: The city's Gothic cathedral, under construction, looms in the background of the *Martyrdom of Saint Ursula* panel. Memling created this deep space as a foil for his idealized female martyr, a calm aristocratic figure amid active men-at-arms. The surface pattern and intricately arranged folds of the drapery draw our attention to her.

Hugo van der Goes (c. 1440–82) united the intellectualism of Jan van Eyck and the emotionalism of Rogier van Weyden in an entirely new style. Hugo's major work was an exceptionally large altarpiece, exceeding 8 feet in height, commissioned by an Italian living in Bruges,

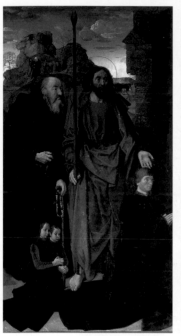
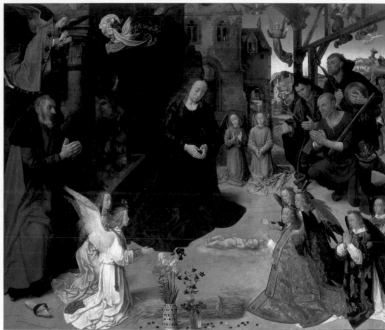
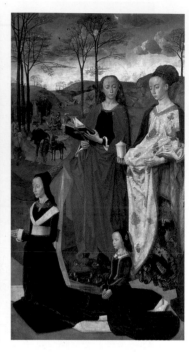

17-22. Hugo van der Goes. *Portinari Altarpiece* (open). c. 1474–76. Tempera and oil on wood panel; center 8'3½" x 10' (2.53 x 3.01 m), wings each 8'3½" x 4'7½" (2.53 x 1.41 m). Galleria degli Uffizi, Florence

Tommaso Portinari, who managed the Medici bank there (fig. 17-22). Painted in Flanders, probably between 1474 and 1476, the triptych was transported to Italy and installed in 1483 in the Portinari family chapel in the Church of Sant'Egidio, in Florence, where it had a profound impact on Florentine painters such as Ghirlandaio. Tommaso, his wife, Maria Baroncelli, and their three eldest children are portrayed kneeling in prayer on the wings, their patron saints behind them. On the left wing, looming larger than life behind Tommaso and his son Antonio, are their name saints, Thomas and Anthony. The younger son, Pigello, born in 1474, was apparently added after the original composition was set and has no patron saint. On the right wing, Maria and her daughter Margherita are presented by Saints Mary Magdalen and Margaret. The theme of the altarpiece is the Nativity, with the central panel representing the Adoration of the newborn Child by Mary and Joseph, a host of angels, and the shepherds who have rushed in from the fields. In the middle ground of the wings are scenes that precede the Adoration. Winding their way through the winter landscape are two groups headed for Bethlehem, Jesus' birthplace. On the left wing, Mary and Joseph travel to their native city to take part in a census ordered by the region's Roman ruler. Near term in her pregnancy, Mary has dismounted from her donkey and staggers before it, supported by Joseph. On the right wing, a servant of the

Three Magi, who are coming to honor the awaited Savior, is asking directions from a poor man. The continuous landscape across the wings and central panel is the finest evocation of cold, barren winter since the Limbourg brothers' *February* (see fig. 17-6).

Hugo's technique is firmly grounded in the terrestrial world despite the visionary subjects. Meadows and woods are painted leaf by leaf and petal by petal. He noted, too, that the farther away colors are, the more muted they seem; he therefore painted more-distant objects with a grayish or bluish cast and the sky paler toward the horizon, an effect called **atmospheric perspective** (see "Renaissance Perspective Systems," page 621).

Although Hugo's brilliant palette and meticulous accuracy recall Jan van Eyck and the intense but controlled feelings suggest the emotional content of Rogier van der Weyden's works, the composition and interpretation of the altarpiece are entirely Hugo's. The huge figures of Joseph, Mary, and the shepherds dominating the central panel are the same size as the patron saints on the wings, in contrast to the Portinari family and angels. Hugo uses color as well as the gestures and gazes of the figures to focus our eyes on the center panel, where the mystery of the Incarnation takes place. Instead of lying swaddled in a manger or in his mother's arms, the Child rests naked and vulnerable on the barren ground with rays of light emanating from his body. The source of

this image was the visionary writing of the Swedish mystic Bridget (declared a saint in 1391), composed about 1360–70, which specifically mentions Mary kneeling to adore the Child immediately after giving birth.

The foreground still life of ceramic pharmacy jar (*albarello*), glass, flowers, and wheat has multiple meanings. The glass vessel symbolizes the entry of the Christ Child into the Virgin's womb without destroying her virginity, the way light passes through glass without breaking it. The *albarello* is decorated with vines and grapes, alluding to the wine of Communion at the Eucharist, which represents the Blood of Christ. The wheat sheaf refers both to the location of the event at Bethlehem, which in Hebrew means "house of bread," and to the Host, or bread, at Communion, which represents the Body of Christ. Even a little flower has a meaning. The majolica *albarello* holds a red lily for the Blood of Christ and three irises—white for purity and purple for Christ's royal ancestry. The three irises may refer to the Trinity of Father (God), Son (Jesus), and Holy Ghost. The iris, or "little sword," also refers to Simeon's prophetic words to Mary at the Presentation in the Temple: "And you yourself a sword will pierce so that the thoughts of many hearts may be revealed" (Luke 2:35). The three irises together with the seven blue columbines in a glass (the Virgin Mary) remind the viewer of the Virgin's future sorrows. Scattered on the ground are violets, symbolizing humility. Hugo's artistic vision goes far beyond this formal religious symbolism. For example, the shepherds, who stand in unaffected awe before the miraculous event, are among the most sympathetically rendered images of common people to be found in the art of this period. The portraits of the children are among the most sensitive studies of children's features.

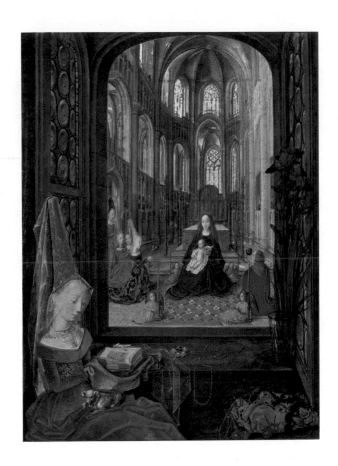

17-23. Mary of Burgundy Painter. Page with *Mary at Her Devotions*, in *Hours of Mary of Burgundy*. Before 1482. Colors and ink on parchment, 7½ x 5¼" (19.1 x 13.3 cm). Österreichische Nationalbibliothek, Vienna

LUXURY ARTS

The rise in popularity of panel painting in the fifteenth century did not diminish the production of richly illustrated books for wealthy patrons (see "The Printed Book," page 644). Not surprisingly, developments in manuscript illumination were similar to those in panel painting, although in miniature. Each scene was a tiny image of the world rendered in microscopic detail. Complexity of composition and ornateness of decoration were commonplace, with the framed image surrounded by a fantasy of vines, flowers, insects, animals, shellfish, or other objects painted as if seen under a magnifying glass. Ghent and Bruges were major centers of this exquisite art, and one of the finest practitioners was an anonymous artist known as the Mary of Burgundy Painter from a Book of Hours traditionally thought to have been made for Mary—the daughter and only heir of Charles the Bold, the duke of Burgundy—who married Maximilian of Austria. The manuscript dates to sometime prior to Mary's early death, in 1482 (fig. 17-23).

In the Book of Hours frontispiece, the painter has attained a new complexity in treating pictorial space; we look not only through the "window" of the illustration's frame but through another window in the wall of the room depicted in the painting. The young Mary of Burgundy appears twice: once seated in the foreground, reading from her Book of Hours; and again in the background, in a vision inspired by her reading, kneeling with attendants before the Virgin and Child in a church. On the window ledge is an exquisite still life—a rosary (symbol of Mary's devotion), carnations (symbolizing the nails of the Crucifixion), and a glass vase holding purple irises (having the same meaning as in the *Portinari Altarpiece*). The artist has skillfully executed the filmy veil covering Mary's hat, the transparent glass vase, and the bull's-eye panes of the window, circular panes whose center "lump" was formed by the glassblower's pipe. The spatial recession leads the eye into the far reaches of the church interior, past the Virgin and the gilded altarpiece in the sanctuary to two people conversing in the far distance at the left. Within an illumination in a book only 7½ by 5¼ inches in size, reality and vision have been rendered equally tangible, as if captured by a Jan van Eyck or a Robert Campin on a large panel.

The lavish detail with which textiles are depicted in all these Flemish works reflects their great importance to fifteenth-century society. A remarkable example of Flemish fiber arts is a sumptuous embroidered cope now in

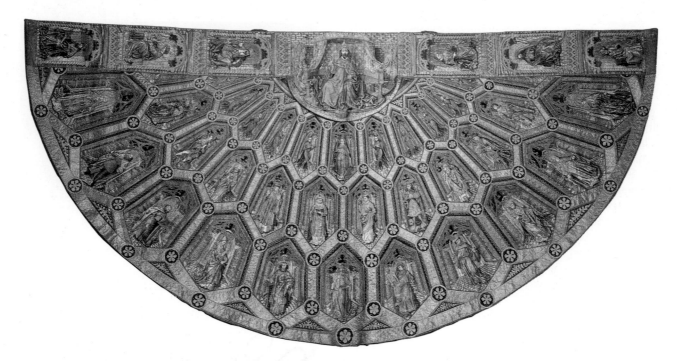

17-24. Cope of the Order of the Golden Fleece. Flemish, mid-15th century. Cloth with gold and colored silk embroidery, 5'4 9/16" x 10'9 5/16" (1.64 x 3.3 m). Imperial Treasury, Vienna

The Order of the Golden Fleece was an honorary fraternity founded by Duke Philip the Good of Burgundy in 1430 with twenty-three knights chosen for their moral character and bravery. Religious services were an integral part of the order's meetings, and opulent liturgical and clerical objects were created for the purpose. The insignia of the order, worn by each knight, were a collar (chain) formed of stylized flints and flames from which hung a tiny golden fleece, the ram's skin taken by Jason and the Argonauts. These insignia were the property of the order and had to be returned at the member's death. The gold ram referred to the Greek legend of Jason, who went off on his ship *Argo* to search for the Golden Fleece, the wool of a magical ram that had been sacrificed to Zeus.

the Imperial Treasury in Vienna (fig. 17-24). (To view the full effect of a cope, see the angels at the right in the center panel of the *Portinari Altarpiece,* fig. 17-22.) The surface of this vestment is divided into compartments, with the standing figure of a saint in each one. At the top of the cloak's back, as if presiding over the standing saints, is an enthroned figure of Christ, flanked by scholar-saints in their studies. The designer of this out-standing piece of needlework was clearly familiar with contemporary Flemish painting, and the embroiderers were able to copy the preliminary drawings with great precision. The particular stitch used here is a kind of couching, consisting of double gold threads tacked down with unevenly spaced colored silk threads to create an iridescent effect.

In the fifteenth and sixteenth centuries, Flemish tap-estry making was considered the best in Europe. Major weaving centers at Brussels, Tournai, and Arras produced intricately designed wall hangings for royal and aristo-cratic patrons, important church officials, and even town councils. Among the most common subjects were foliage and flower patterns, scenes from the lives of the saints, and themes from classical mythology and history. Tapes-tries provided both insulation and luxurious decoration for the stone walls of castles, churches, and municipal buildings. Often they were woven for specific places or for festive occasions such as weddings, coronations, and

other public events. Many were given as diplomatic gifts, and the wealth of individuals can often be judged from the number of tapestries listed in their household inventories. Some of the finest surviving weavings were originally in royal chambers. In one early-fifteenth-century painting, tapestries can be seen hanging on the walls in the private rooms where the French queen Isabeau of Bavaria accepts a bound manuscript from the author Christine de Pisan (see fig. 20, Introduction). More sumptuous woven and embroidered textiles covered the queen's bed and were sewn into robes for her and the ladies-in-waiting who are gathered with her.

One of the best-known tapestry suites (now in The Metropolitan Museum of Art, New York) is the *Hunt of the Unicorn*. The unicorn, a mythological horselike animal with cloven hooves, a goat's beard, and a single long twisted horn, appears in stories from ancient India, the Near East, and Greece. The creature was said to be supernaturally swift and, in medieval belief, could only be captured by a young virgin, to whom it came willingly. Thus, it became a symbol of the Incarnation, with Christ as the unicorn captured by the Virgin Mary, and also a metaphor for romantic love, suitable as a subject for wedding tapestries.

Each piece in the suite exhibits many people and animals in a dense field of trees and flowers, with a dis-tant view of a castle, as in the *Unicorn at the Fountain*

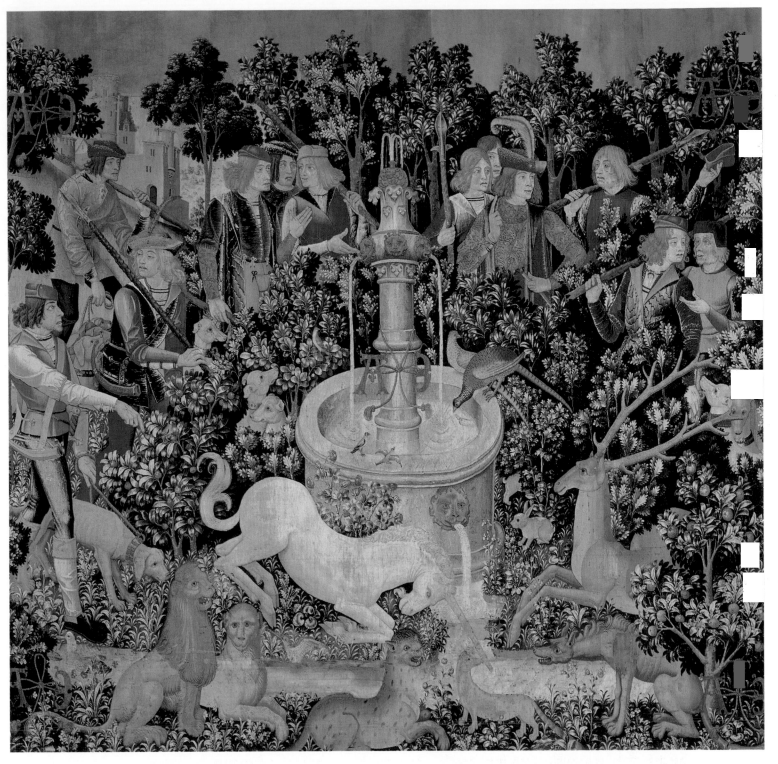

17-25. ***Unicorn at the Fountain***, from the *Hunt of the Unicorn* tapestry series. c. 1498–1500. Wool, silk, and metal thread (13–21 warp threads per inch), 12'1" x 12'5" (3.68 x 3.78 m). The Metropolitan Museum of Art, New York

Gift of John D. Rockefeller, the Cloisters Collection (37.80.2)

The price of a tapestry depended on the materials used. Rarely was a fine, commissioned series woven only with wool; instead, tapestry producers enhanced it to varying degrees with silk, silver, and gold threads. The richest kind of tapestry was made almost entirely of silk and gold. Because silver and gold threads were made of silk wrapped with real metal, people later burned many tapestries to retrieve the precious materials. As a result, few royal tapestries in France survived the French Revolution. Many existing works show obvious signs, however, that the metallic threads were painstakingly pulled out in order to get the gold but preserve the tapestries.

(fig. 17-25). The letters *A* and *E*, hanging by a cord from the fountain, may be a reference to the first and last letters of Anne of Brittany's name or the first and last letters of her motto, *À ma vie* ("By my life," a kind of pledge). The unusually fine condition of the piece allows us to appreciate its rich coloration and the subtlety in modeling the faces, creating tonal variations in the animals' fur, and depicting reflections in the water.

THE PRINTED BOOK

The explosion of learning in Europe in the fifteenth century precipitated experiments in faster and cheaper ways to produce books than copying them by hand. The earliest printed books were **block books**, for which each page of text, with or without illustrations, was cut in relief on a single block of wood, which could be repeatedly inked and printed. The process was greatly simplified by the development—first achieved in the workshop of Johann Gutenberg in Mainz, Germany—of movable-type printing, in which individual, carved letters could be locked together, inked, and printed onto paper by a mechanical press. More than forty copies of Gutenberg's Bible, printed in 1456, still exist. With the invention of this fast way to make identical books, the intellectual and spiritual life of Europe changed forever, as did the arts. Use of the new technique spread quickly: As early as 1465, two German printers were working in Italy, and by the 1470s there were presses in France, Flanders, Holland, and Spain. England got its first printing press when William Caxton, who had been a cloth merchant in Bruges, returned to London in 1476 to launch England's first publishing house.

The finest of all early books was *Hypnerotomachia Poliphili* (*The Love-Dream Struggle of Poliphilo*). This charming romantic allegory tells of the search of Poliphilo through exotic places for his lost love, Polia. The book, written in the 1460s or 1470s by Fra Francesco Colonna, was published in 1499 by the noted Venetian printer Aldo Manuzio (Aldus Manutius), who had established a press in Venice in 1490 (often called the Aldine Press). Many historians of book printing consider Aldo's *Hypnerotomachia* to be the most beautiful book ever produced, from the standpoint of type and page design. The woodcut illustrations in the *Hypnerotomachia*, such as the *Garden of Love*, incorporate

linear pespective and pseudoclassical structures that would influence future architects.

Although woodcuts, constantly refined and increasingly complex, would remain a popular medium of book illustration for centuries to come, books also came to be illustrated with engravings. The innovations in printing at the end of the 1400s held great promise for the spread of knowledge and ideas in the following century.

Fra Francesco Colonna. Page with *Garden of Love*, *Hypnerotomachia Poliphili*, published by Aldo Manuzio (Aldus Manutius), Venice, 1499. Woodcut, image 5$\frac{1}{8}$ x 5$\frac{1}{8}$" (13.5 x 13.5 cm). The Pierpont Morgan Library, New York
PML 373

Because of its religious connotations, the unicorn was an important animal in the medieval **bestiary**, an encyclopedia of real and imaginary animals that gave information of both moral and practical value. For example, the unicorn's horn (in fact, the narwhale's horn) was thought to be an antidote to poison. Thus, the unicorn purifies the water by dipping its horn into it. Other woodland creatures included here have symbolic meanings as well. For instance, lions, ancient symbols of power, represent valor, faith, courage, and mercy; the stag is a symbol of Christian resurrection and a protector against poisonous serpents and evil in general; and the gentle, intelligent leopard was said to breathe perfume. Not surprisingly, the rabbits symbolize fertility and the

dogs fidelity. The pair of pheasants is an emblem of human love and marriage, and the goldfinch is another symbol of fertility. Only the ducks swimming away have no known message.

The plants, flowers, and trees in the tapestry, identifiable from their botanically correct depictions, reinforce the theme of protective and curative powers. Each has both religious and secular meanings, but the theme of marriage, in particular, is referred to by the presence of such plants as the strawberry, a common symbol of sexual love; the pomegranate, for fertility; the pansy, for remembrance; and the periwinkle, a cure for spiteful feelings and jealousy. The trees include oak for fidelity, beech for nobility, holly for protection against evil, hawthorn for the power of love, and orange for fertility. The parklike setting with its prominent fountain is rooted in the biblical love poem the Song of Songs (4:12, 13, 15–16): "You are an enclosed garden, my sister, my bride, an enclosed garden, a fountain sealed. You are a park that puts forth pomegranates, with all choice fruits. . . . You are a garden fountain, a well of water flowing fresh from Lebanon. Let my lover come to his garden and eat its choice fruits."

In contrast to the elegant intellectualism of the unicorn tapestries is the so-called Monkey Cup (fig. 17-26). The cup seems almost too rich to touch, but it is a perfectly functional drinking vessel. Unlike medieval enamel, with its carefully separated colors, the enamel here was applied like paint to the silver cup. The sophistication of the enamel technique contrasts with the earthy theme of the decoration, where monkeys—actually tailless Barbary apes—steal a peddler's satchel and play wickedly in the curling foliage. The colors—black, white, and gold—were the heraldic colors of Charles's father, Philip the Good, the duke of Burgundy (ruled 1419–67), whose court set the fashion in clothes, manners, entertainment, and fine dining, as well as art and pageantry, throughout Europe.

THE SPREAD OF THE FLEMISH STYLE

Flemish art—its complex and provocative symbolism, its realism and atmospheric space, its brilliant colors and sensuous textures—delighted wealthy patrons and well-educated courtiers both inside and outside of Flanders. At first, Flemish artists were imported to foreign courts; then many artists from outside Flanders went to study there. Flemish manuscripts, tapestries, altarpieces, and portraits began appearing in palaces and chapels throughout Europe. As the art works spread, local artists were able to learn Flemish oil painting techniques and emulate the Flemish style, until by the later years of the fifteenth century, distinctive regional variations of Flemish art could be found throughout Europe, from the Atlantic Ocean to the Danube.

THE IBERIAN PENINSULA

Many Flemish paintings and artists traveled to the Iberian peninsula (modern Spain and Portugal), where they

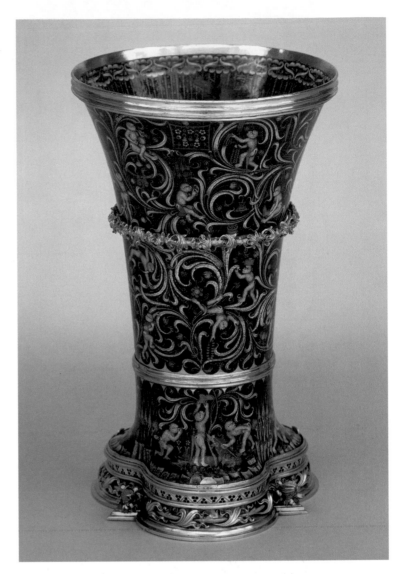

17-26. Beaker, known as the Monkey Cup, from Flanders. 2nd quarter of 15th century. Silver, silver gilt, and painted enamel, height 7⁷⁄₈" (20 cm), diameter 4⁵⁄₈" (11.7 cm). The Metropolitan Museum, New York

The Cloisters Collection, 1952 (52.50)

were held in high esteem. Queen Isabella of Castile, for example, preferred Flemish painting to all other styles. Local painters such as Nuño Gonçalvez (active 1450–91), a major artist connected with the court of Portugal, quickly absorbed the Flemish style. Among his inspirations was Jan van Eyck, who had visited Portugal to paint the portrait of a princess who was a candidate for marriage to the duke of Burgundy.

Gonçalvez's intense interest in detail, monumental figures, and rich colors reflect Jan's influence—although his portraiture, for which he was renowned, was closer in the sense of a severe or simpler style to Dirck Bouts's and Hans Memling's than to Jan's. Gonçalvez's only securely attributed works are six panels from a large altarpiece made for the Convent of Saint Vincent de Fora in Lisbon between 1471 and 1481. The altarpiece, whose central scene may have been carved, may have been created to commemorate a Portuguese crusade against the Muslims in Morocco undertaken in 1471 under Saint

17-27. Nuño Gonçalvez. *Saint Vincent with the Portuguese Royal Family*, panel from the *Altarpiece of Saint Vincent.* c. 1471–81. Oil on wood panel, 6'9¾" x 4'2⅝" (2.07 x 1.28 m). Museu Nacional de Arte Antiga, Lisbon

Joan of Arc to lead a crusade to return him to the throne. Although Joan was burned at the stake in 1431, the revitalized French forces captured Paris in 1436 and by 1453 had driven the English from French lands. In 1461 Louis XI succeeded his father, Charles VII, as king of France. Under his rule the French royal court again became a major source of patronage for the arts.

The leading court artist of the period, Jean Fouquet (c. 1420–81), was born in Tours and may have trained in Paris as an illuminator. He probably traveled to Italy in about 1445, but by about 1450 he was back in Tours, a renowned painter. He painted Charles VII, the royal family, and courtiers, and he illustrated manuscripts and designed tombs. Fouquet knew contemporary Italian architectural decoration, and he was also strongly influenced by Flemish realism. Among the court officials painted by Fouquet is Étienne Chevalier, the treasurer of France under Charles VII, for whom he painted a diptych showing Chevalier praying to the Virgin and Child (fig. 17-28). According to an inscription, the painting was made to fulfill a vow made by Chevalier to the king's much-loved and respected mistress, Agnès Sorel, who died in 1450. Sorel, whom contemporaries described as a highly moral, extremely pious woman, was probably the model for the Virgin, her features taken from her death mask, which is still preserved.

Chevalier, who kneels in prayer with clasped hands and a meditative gaze, wears a *houppelande*, the voluminous costume of the time. Fouquet has followed the Flemish manner in depicting the courtier's ruddy features with the truthful detail of a reflection in a mirror; his accuracy is confirmed by other known portraits. Chevalier is presented to the Virgin by his name saint, Stephen ("Étienne" in French), whose features are also distinctive enough to have been a portrait. According to legend and biblical accounts, Stephen, a deacon in the early Christian Church in Jerusalem, was the first Christian martyr, stoned to death for defending his beliefs. Here the saint wears liturgical, or ritual, vestments and carries a large stone on a closed Gospel book. A trickle of blood can be seen on his tonsure, the shaved head adopted as a sign of humility by male members of religious orders. The two figures are shown in a large hall decorated with marble paneling and classical **pilasters**. Fouquet has arranged the figures in an unusual spatial setting, with the diagonal lines of the wall and uptilted tile floor receding toward an unseen vanishing point at the right. Despite his debt to Flemish realism and his nod to Italian architectural forms and to linear perspective, Fouquet's somewhat austere style is uniquely his own.

Vincent's standard. In one of the two largest panels (fig. 17-27), Saint Vincent, magnificent in red and gold vestments, stands in a tightly packed group of people, with members of the royal family at the front and courtiers forming a solid block across the rear. With the exception of the idealized features of the saint, all are portraits: At the right, King Alfonso V kneels before Saint Vincent, while his young son and his deceased uncle, Henry the Navigator, look on. Alfonso and his son rest their hands on their swords; Henry's hands are tented in prayer. At the left, Alfonso's deceased wife and mother hold rosaries. The appearance of Saint Vincent is clearly a vision, brought on by the intense prayers of the individuals around him.

FRANCE

France and England's centuries-long struggle for power and territory continued well into the fifteenth century. When Charles VI of France died in 1422, England claimed the throne for his nine-month-old grandson, Henry VI of England. The infant king's uncle, the duke of Bedford, then assumed control of the French royal territories as regent, with the support of the duke of Burgundy. Charles VII, the late French king's son, had been exiled, inspiring

GERMANY

In the Holy Roman Empire, a loose confederation of primarily Germanic states that lasted as the Habsburg Empire until the early twentieth century, two major stylistic strains of art existed simultaneously during the first half of the fifteenth century. One continued the International Gothic style with increased prettiness, softness, and sweetness of expression. The other was an intense

17-28. Jean Fouquet. *Étienne Chevalier and Saint Stephen*, left wing of the ***Melun Diptych***. c. 1450. Oil on wood panel, 36½ x 33½" (92.7 x 85.5 cm). Staatliche Museen zu Berlin, Preussischer Kulturbesitz, Gemäldegalerie. ***Virgin and Child***, right wing of the ***Melun Diptych***. c. 1451. Oil on wood panel, 37¼ x 33½" (94.5 x 85.5 cm). Koninklijk Museum voor Schone Kunsten, Antwerp, Belgium

The diptych was separated long ago and the two paintings went to collections in different countries. They are reunited on this page.

17-29. Konrad Witz. *Miraculous Draft of Fish*, from an altarpiece from the Cathedral of Saint Peter, Geneva, Switzerland. 1444. Oil on wood panel, 4'3" x 5'1" (1.29 x 1.55 m). Musée d'Art et d'Histoire, Geneva

investigation and detailed description of the physical world. The major exponent of the latter style was Konrad Witz (documented from 1434; d. 1445/46). Witz, a native of what is now southern Germany, was drawn, like many artists, to Basel (in modern Switzerland), where the numerous Church officials were a rich source of patronage. Witz's last large commission before his early death (probably from the plague) was an altarpiece dedicated to Saint Peter for the Cathedral of Saint Peter in Geneva, the wings of which he signed and dated in 1444. In the *Miraculous Draft of Fish* (fig. 17-29), a scene from the life of the apostle Peter, the Flemish influence can be perceived in the handling of drapery and in details of the landscape setting that ultimately engages our attention. The painter has created an identifiable topographical portrayal of Lake Geneva, with its dark mountain rising

TECHNIQUE
WOODCUTS AND ENGRAVINGS ON METAL

Woodcuts are made by drawing on the smooth surface of a block of fine-grained wood, then cutting away all the areas around the lines with a sharp tool called a gouge, leaving the lines in **high relief**. When the block's surface is inked and a piece of paper pressed down hard on it, the ink on the relief areas transfers to the paper to create a reverse image. The effects can be varied by making thicker and thinner lines, and shading can be achieved by placing the lines closer or farther apart. Sometimes the resulting black-and-white images were then painted by hand.

Engraving on metal requires a technique called **intaglio**, in which the lines are cut into the plate with tools called gravers or **burins**. The engraver then carefully burnishes the plate to ensure a clean, sharp image. Ink is applied over the whole plate and forced down into the lines, then the plate's surface is carefully wiped clean of the excess ink. When paper and plate are held tightly together by a press, the ink in the lines transfers to the paper.

Woodblocks and metal plates could be used repeatedly to make nearly identical images. If the lines of the block or plate wore down, the artists could repair them. Printing large numbers of identical prints of a single version, called an **edition**, was usually a team effort in a busy workshop. One artist would make the drawing.

Sometimes it was drawn directly on the block or plate with ink, in reverse of its printed direction, sometimes on paper to be transferred in reverse onto the plate or block by another person, who then cut the lines. Others would ink and print the images. Prints often were inscribed with the names and occupations (usually given in Latin, and frequently abbreviated) of those who carried out these various tasks. The following are some of the most common inscriptions (Hind, volume 2, page 26):

> *Sculpsit (sculp., sc.), sculptor*: engraved or cut, engraver or cutter
> *Fecit (fec., f.)*: literally "made"; engraved or cut, engraver or cutter
> *Pinxit (pinx.), pictor*: painted, painter
> *Delineavit (delin.), delineator*: drew, draftsperson

In the illustration of books, the plates or blocks would be reused to print later editions and even adapted for use in other books. A set of blocks or plates for illustrations was a valuable commodity often sold by one workshop to another. Early in publishing, there were no copyright laws, and many entrepreneurs simply had their workers copy book illustrations onto woodblocks and cut them for their own publications.

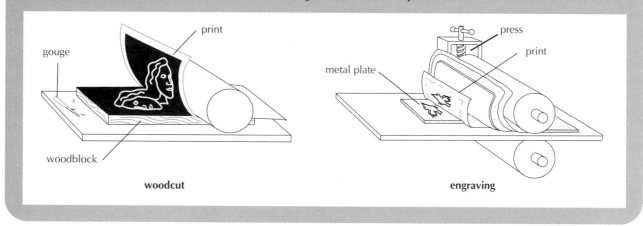

gouge · print · woodblock · **woodcut**

metal plate · press · print · **engraving**

on the far shore behind Jesus and the snow-covered Alps shining in the distance. Witz records every nuance of light and water—the rippling surface, the reflections of boats, figures, and buildings, even the lake bottom. Peter's body and legs, visible through the water, are distorted by the refraction. The floating clouds above create shifting light and dark passages over the water. Witz, perhaps for the first time in European art, recorded and captured the appearance and spirit of nature.

THE GRAPHIC ARTS

Printmaking emerged in Europe with the increased local manufacture of paper at the end of the fourteenth century. Paper had been made in China as early as the second century, and small amounts were imported into Europe from the eighth century on. Paper was made in Europe from the twelfth century on, but it was rare and expensive. By the beginning of the fifteenth century, however, commercial paper mills in nearly every European country were turning out large supplies, making paper fairly inexpensive to use for printing. **Woodblocks** cut in relief had long been used to print designs on cloth, but only in the fifteenth century did the printing of images and texts on paper and the production of books in multiple copies of a single **edition**, or version, begin to replace the copying of each book by hand. Soon both handwritten and printed books were illustrated with printed images. Printed books and single-sheet printed images were sometimes embellished with **watercolor paints**.

Single-sheet prints in the **woodcut** and **engraving** techniques were made in large quantities in the early decades of the fifteenth century (see "Woodcuts and Engravings on Metal," above). Initially, woodcuts were made primarily by woodworkers with no training in drawing, but soon artists began to draw the images for them to cut from the block. Simply executed devotional images sold as souvenirs to pilgrims at holy sites were popular, such as *Saint Christopher* (found in the Carthusian Monastery of Buxheim, in southern Germany), dated 1423, one of the earliest woodcuts to survive (fig. 17-30). Saint Christopher, patron saint of travelers,

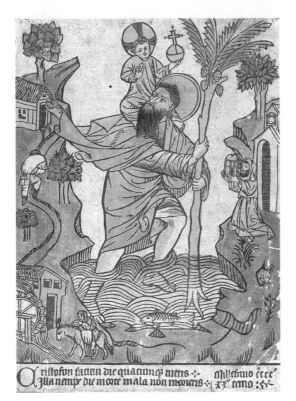

17-30. *The Buxheim Saint Christopher*. 1423. Hand-colored woodcut, The John Rylands University Library. Courtesy of the Director and Librarian, The John Rylands University Library of Manchester, England

carries the Christ Child across the river; in this image his efforts are witnessed by a monk at the monastery door. Not all prints were made for religious purposes, or even for sale. Some artists seem to have made them as personal studies, in the manner of drawings, or for use in their shops as models.

Engravings, by contrast, seem to have developed from the metalworking techniques of goldsmiths and armorers. When paper became relatively plentiful around 1400, these artisans began to make impressions of the designs they were engraving on metal by rubbing the lines with lampblack and pressing paper over them. German artist Martin Schongauer (1430/50–91), who learned engraving from his goldsmith father, was an immensely skillful printmaker who excelled in drawing and the difficult technique of shading from deep blacks to faintest grays. One of his best-known prints today is the *Temptation of Saint Anthony*, engraved about 1480–90 (fig. 17-31). Schongauer illustrated the original biblical meaning of *temptation*, expressed in the Latin word *tentatio,* as a physical assault rather than a subtle inducement. Wildly acrobatic, slithery, spiky demons lift Anthony up off the ground to torment and terrify him in midair. The engraver intensified the horror of the moment by condensing the action into a swirling vortex of figures beating, scratching, poking, tugging, and no doubt shrieking at the stoical saint, who remains impervious to all by reason of his faith.

During the fifteenth century, printmaking flourished in Italy, as it did in northern Europe, but did so with the special regard for the sculpture and literature of classical antiquity that marked the Renaissance in Italy.

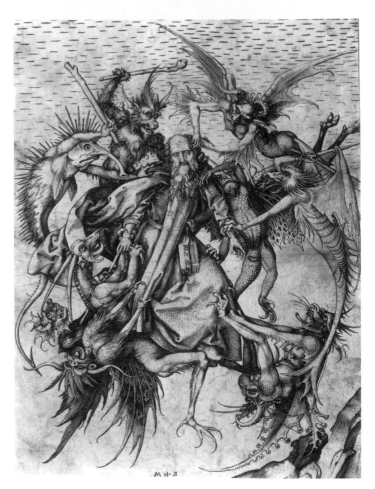

17-31. Martin Schongauer. *Temptation of Saint Anthony*. c. 1480–90. Engraving, 12¼ x 9" (31.1 x 22.9 cm). The Metropolitan Museum of Art, New York

Rogers Fund, 1920 (20.5.2)

ART OF ITALY

By the end of the Middle Ages, the most important Italian cultural centers were north of Rome at Florence, Pisa, Milan, Venice, and the smaller duchies of Mantua, Ferrara, and Urbino. Much of the power and art patronage was in the hands of wealthy families: the Medici in Florence, the Visconti and Sforza in Milan, the Gonzaga in Mantua, the Este in Ferrara, and the Montefeltro in Urbino. Cities grew in wealth and independence as people moved to them from the countryside in unprecedented numbers, and commerce became increasingly important. In some of the Italian states a noble lineage was no longer necessary for—nor did it guarantee—political and economic success. Now money conferred status, and a shrewd business or political leader could become very powerful. Patronage of the arts was an important public activity with political overtones. As one Florentine merchant, Giovanni Rucellai, succinctly noted, he supported the arts "because they serve the glory of God, the honour of the city, and the commemoration of myself" (cited in Baxandall, page 2).

The Medici of Florence were leaders in intellectual and artistic patronage, as they were in business—and their city was the cradle of the Italian Renaissance. Cosimo de' Medici the Elder (1389–1464) founded an academy devoted to the study of the classics, especially the works of Plato and his followers, the Neoplatonists.

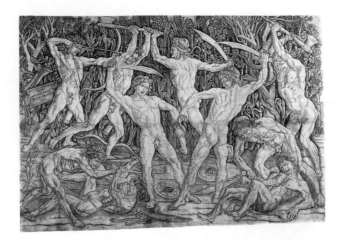

17-32. Antonio del Pollaiuolo. *Battle of the Nudes.*
c. 1465–70. Engraving, 15⅛ x 23¼" (38.3 x 59 cm).
Cincinnati Art Museum, Ohio

Bequest of Herbert Greer French. 1943.118

Neoplatonism sharply distinguishes between the spiritual (the ideal or Idea) and the carnal (Matter) and argues that the latter can be overcome by severe discipline and denial of the world of the senses. Writers, philosophers, and musicians dominated the Medici Neoplatonic circle. Few architects, sculptors, or painters were included, however, for although some artists had studied Latin or Greek, most had learned their craft in apprenticeships and thus were still considered little more than manual laborers. Nevertheless, interest in the ancient world rapidly spread beyond the Medici circle to artists and craftspeople, who sought to reflect the new interests of their patrons in their work. Gradually, artists began to see themselves as more than artisans and society recognized their best works as achievements of a very high order.

Artists, like humanist scholars, turned to classical antiquity for inspiration. Because few examples of ancient Roman painting were known in the fifteenth century, Renaissance painters looked to Roman sculpture and literature. Despite this interest in antiquity, fifteenth-century Italian painting and sculpture continued to be predominantly Christian. Secular works were rare until the second half of the century, and even these were chiefly portraits. Allegorical and mythological themes also appeared in the latter decades as patrons began to collect art for their personal enjoyment. The male nude became an acceptable subject in Renaissance art, mainly in religious images—Adam, Jesus on the cross, and martyrdoms of saints such as Sebastian. Other than representations of Eve or an occasional allegorical or mythological figure such as Venus, female nudes were rare until the end of the century.

The Florentine goldsmith and sculptor Antonio del Pollaiuolo's *Battle of the Nudes* (fig. 17-32), an engraving, illustrates many of these interests: the study of classical sculpture, anatomical research that leads to greater realism, as well as the artist's technical skill. Pollaiuolo may have intended this, his only known—but highly influential—print, as a study in composition involving the human figure in action. The naked men fighting each other ferociously against a tapestrylike background of foliage seem to have been drawn from a single model in a variety of poses, many of which were taken from classical sources. Like the artist's *Hercules and Antaeus* (see fig. 17-55), much of the engraving's fascination lies in how it depicts muscles of the male body reacting under tension.

Like their Flemish counterparts, Italian painters and sculptors moved gradually toward a greater precision in rendering the illusion of physical reality. They did so in a more analytical way than the Flemings had, with the goal of achieving correct but perfected generic figures set within a rationally, rather than visually, defined space. Painters and relief sculptors developed a mathematical system of linear perspective to achieve the illusion of continuously receding space (see "Renaissance Perspective Systems," page 621), just as Italian architects came to apply abstract, mathematically derived design principles to their plans and elevations.

ARCHITECTURE AND ITS DECORATION

Travelers from across the Alps in the mid-fifteenth century found Italian cities very different in appearance from their northern counterparts. In Florence, for example, they did not find church spires piercing the sky, but a skyline dominated, as it still is today, by the enormous mass of the cathedral dome rising above low houses, smaller churches, and the blocklike palaces and towers of the wealthy, all of which had minimal exterior decoration.

Florence. The major civic project of the early years of the fifteenth century was to complete the Florence Cathedral, begun in the late thirteenth century and continued intermittently during the fourteenth century. As early as 1367, its architects had envisioned a very tall dome to span the huge interior space of the **crossing**, but they lacked the engineering know-how to construct it. When interest in completing the cathedral revived, around 1407, the technical solution was proposed by a young sculptor-turned-architect, Filippo Brunelleschi (1377–1446). Brunelleschi's intended career as a sculptor had ended with his failure to win a competition in 1402 to design bronze doors for the Baptistry of San Giovanni, opposite the cathedral (see fig. 17-49). Brunelleschi declined a role as assistant on that project and traveled to Rome, probably with his sculptor friend Donatello, where he studied ancient Roman sculpture and architecture.

Brunelleschi, whose father had been involved in the original plans for the cathedral dome in 1367, advised constructing first a tall **drum**, or cylindrical base. The drum was finished in 1410, and in 1417 Brunelleschi was commissioned to design the dome itself (fig. 17-33). Work began in 1420 and was completed by 1471. A revolutionary feat of engineering, the dome is a double shell of masonry that combines Gothic and Renaissance elements. Gothic construction is based on the **pointed arch**, using stone shafts, or **ribs**, to support the **vault**, or ceiling. The octagonal outer shell is essentially a structure of this type, supported on ribs and in a pointed-arch

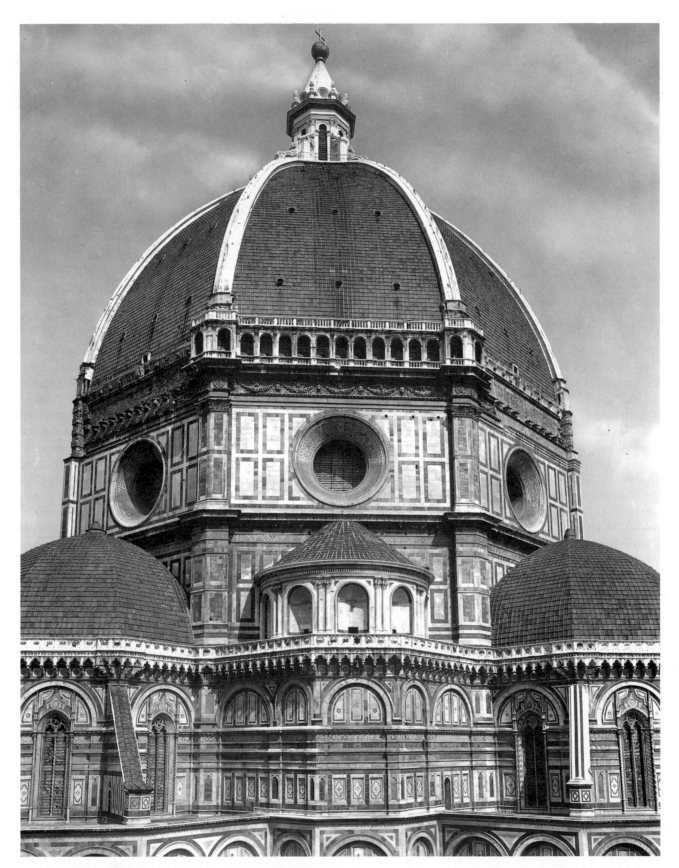

17-33. Filippo Brunelleschi. Dome of Florence Cathedral. 1417–36; lantern completed 1471

The cathedral dome was a source of immense local pride from the moment of its completion. Renaissance architect and theorist Leon Battista Alberti described it as rising "above the skies, large enough to cover all the peoples of Tuscany with its shadow" (cited in Goldwater and Treves, page 33). While Brunelleschi maintained the Gothic pointed-arch profile of the dome established in the fourteenth century, he devised an advanced construction technique that was more efficient, less costly, and safer than earlier systems. An arcaded gallery he planned to install at the top of the tall drum was never built, however. In 1507 Baccio d'Agnolo won a competition to design the gallery, using supports installed on the drum nearly a century earlier. The first of the eight sections, seen here, was completed in 1515.

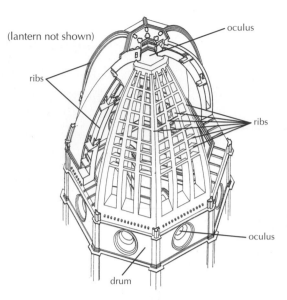

(lantern not shown)

oculus

ribs

ribs

oculus

drum

17-34. Cutaway drawing of Brunelleschi's dome, Florence Cathedral. (Drawing by P. Sanpaolesi)

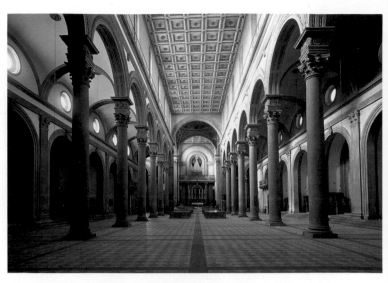

17-36. Filippo Brunelleschi. Nave, Church of San Lorenzo, Florence. c. 1421–28, 1442–46

profile; however, like Roman domes, it is cut at the top with an **oculus** (opening) and is surmounted by a **lantern**, a crowning structure made up of Roman architectural forms. The dome's 138-foot diameter would have necessitated the use of **centering**, temporary wooden construction supports that were costly and even dangerous. Therefore, Brunelleschi devised machinery to hoist building materials as needed and invented an ingenious system by which each portion of the structure reinforced the next one as the dome was built up **course**, or layer, by course. The reinforcing elements were vertical marble ribs and horizontal sandstone rings connected with iron rods, with the whole reinforced by oak staves and beams tying rib to rib (fig. 17-34). The inner and outer shells were also linked internally by a system of arches. When completed, this self-buttressed unit required no external support to keep it standing.

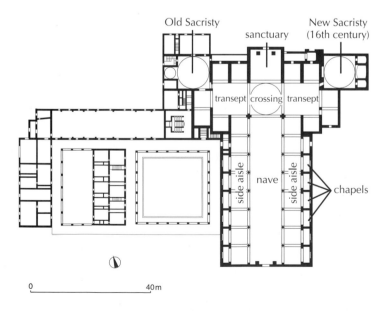

Old Sacristy

sanctuary

New Sacristy (16th century)

transept | crossing | transept

side aisle | nave | side aisle

chapels

0 40m

17-37. Plan of the Church of San Lorenzo, including later additions and modifications

The cathedral dome was a triumph of engineering and construction technique for Brunelleschi, who was a pioneer in Renaissance architectural design. Other commissions came quickly after the cathedral-dome project, and Brunelleschi's innovative designs were well received by Florentine patrons. He designed a foundling hospital for the city in 1419 (fig. 17-35, "The Object Speaks: The Foundling Hospital," opposite). From about 1418 until his death, in 1446, Brunelleschi was involved in projects for the Medici. For the Medici's parish Church of San Lorenzo, he designed a **sacristy** (a room where ritual attire and vessels are kept) as a burial chapel for Giovanni de Bicci de' Medici and his wife. Completed in 1425, it today is called the Old Sacristy to distinguish it from one built in the sixteenth century. Brunelleschi also went to work on the church itself, replacing the eleventh-century basilica. The precise history of this second project is obscured by interruptions in the construction and later alterations. Brunelleschi may have conceived the plans for the new church at the same time as he designed the sacristy in 1421 or perhaps as late as about 1425.

The Church of San Lorenzo has a basilican plan, with a long **nave**, flanked by single side aisles opening into shallow side chapels (fig. 17-36). A short **transept** and square crossing lead to a square sanctuary flanked by chapels opening off the transept. Projecting from the left transept, as one faces the altar, is Brunelleschi's sacristy and the Medici tomb. Brunelleschi may have left the project as early as 1428—certainly by 1442—leaving others to carry out his design.

San Lorenzo is unusual in its mathematical regularity and symmetry. Brunelleschi based his plan on a square, traditionally medieval, module—a basic unit of measure that could be multiplied or divided and applied to every element of the design. The result was a series of clear, rational interior spaces in harmony with one another. Brunelleschi's modular system was also carried through in the proportions of the church's interior elevation (fig. 17-37). Ornamental details, all in a classical style, were carved in **pietra serena**, a grayish stone

THE OBJECT SPEAKS

THE FOUNDLING HOSPITAL

Decorated with blue-and-white medallions bearing images of swaddled babies, this ancient orphanage in one of the world's most beautiful public spaces, Florence's Piazza della Santissima Annunziata, echoes the long-ago cries of children. Built in 1444, the Foundling Hospital, the Ospedale degli Innocenti, was the first of its kind—although the need to care for abandoned children went back to the thirteenth century with the explosive growth of city populations and consequent social disruption. Care of the helpless and destitute had been the responsibility of families, the village, and the Church, but in 1419 the Guild of Silk Manufacturers and Goldsmiths in Florence undertook an unprecedented public service: It established a public orphanage and commissioned the brilliant young architect Filippo Brunelleschi to build it (fig. 17-35) next to the Church of the Santissima Annunizata ("Holiest Annunciation"), which housed a miracle-working painting of the Annunciation.

Brunelleschi created a building that paid homage to traditional forms while introducing what came to be known as Renaissance style. Traditionally, a charitable foundation's building had a portico open to the street to provide shelter. Brunelleschi built an arcade of hitherto unimagined lightness and elegance, using smooth round columns and richly carved Corinthianesque capitals—his own interpretation of a Classical order. The underlying mathematical basis for his design creates a sense of classical harmony. Each bay of the arcade encloses a cube of space defined by the 10-braccia (20-foot) height of the columns and diameter of the arches.

Hemispherical **pendentive domes**, half again as high as the columns, cover the cubes. The bays at the end of the arcade are slightly larger than the rest, creating a subtle frame for the composition. Brunelleschi defined the perfect squares and circles of his building with dark gray stone (*pietra serena*) against plain white walls. His training as a goldsmith and sculptor served him well as he led his artisans to carve crisp, elegantly detailed capitals and moldings for the *loggia*.

A later addition to the building seems eminently suitable: Andrea della Robbia's glazed **terra-cotta** medallions in the **spandrels** of the arches. Brunelleschi may have intended to divide the triangular spaces with pilasters to create a pattern that would harmonize with the pedimented windows above. If so, they were never executed. Instead, about 1487 Andrea della Robbia, who had inherited the family firm and its secret glazing formulas from his uncle Luca, created blue-and-white glazed medallions that signified the building's function. The babies in swaddling clothes, one in each medallion, are among the most beloved images of Florence.

The medallions seem to embody the human side of Renaissance humanism, reminding viewers that the city's wealthiest guild, led by its most powerful citizen, Cosimo de' Medici, cared for the most helpless members of society. Perhaps the Foundling Hospital spoke to fifteenth-century Florentines of an increased sense of social responsibility. Or perhaps, by so publicly demonstrating social concerns, the wealthy guild that sponsored it solicited the approval and support of the lower classes in the cutthroat power politics of the day.

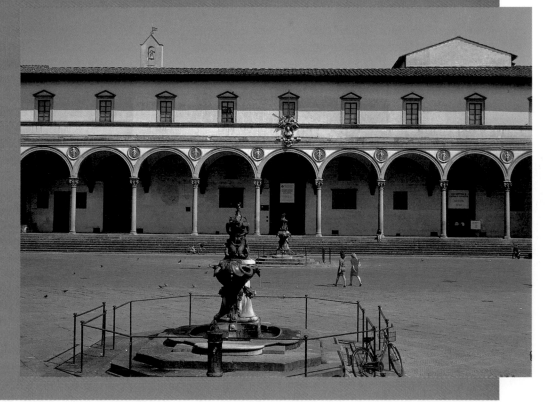

17-35. Filippo Brunelleschi. Foundling Hospital, Florence, Italy. Designed 1419; built 1421–44

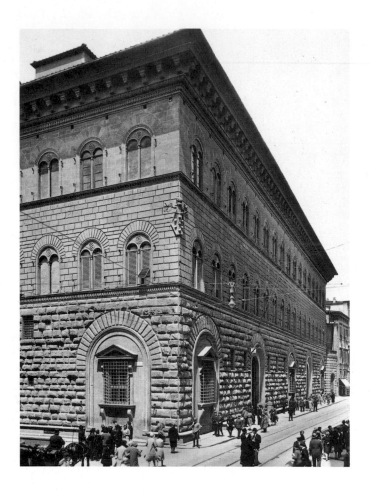

17-38. Michelozzo di Bartolommeo. Palazzo Medici-Riccardi, Florence. Begun 1444

Cosimo de' Medici the Elder decided to build a new palace not just to provide more living space for his family. He also incorporated into the plans offices and storage rooms for conducting his business affairs. For the palace site, he chose the Via de' Gori at the corner of the Via Larga, the widest city street at that time. Despite his practical reasons for constructing a large residence and the fact that he chose simplicity and austerity over grandeur in the exterior design, his detractors commented and gossiped. As one exaggerated: "[Cosimo] has begun a palace which throws even the Colosseum at Rome into the shade."

that became synonymous with Brunelleschi's interiors. Below the plain **clerestory** (upper-story wall of windows) with its unobtrusive openings, the arches of the nave arcade are carried on tall, slender **Corinthian** columns made even taller by the insertion of a favored Brunelleschian device, an **impost block** between the column **capital** and the springing of the round arches. The arcade is repeated in the outer walls of the side aisles in the arched openings to the chapels surmounted by arched **lunettes**. Flattened architectural forms in *pietra serena* articulate the wall surfaces, and each **bay** is covered by its own shallow vault. The square crossing is covered by a hemispherical dome, the nave and transept by flat ceilings. San Lorenzo was an experimental building combining old and new elements, but Brunelleschi's rational approach, unique sense of order, and innovative incorporation of classical motifs were inspirations to later Renaissance architects, many of whom learned from his work firsthand by completing his unfinished projects.

Brunelleschi's role in the Medici palace (now known as the Palazzo Medici-Riccardi) in Florence, begun in 1444, is unclear. According to the sixteenth-century painter, architect, and biographer Giorgio Vasari, Brunelleschi's model for the *palazzo* (palace) was rejected as too grand by Cosimo de' Medici the Elder, who later hired Michelozzo di Bartolommeo (1396–1474), whom most scholars have accepted as the designer of the building. In any case, the palace established a tradition for Italian town houses that, with interesting variations, remained the norm for a century (fig. 17-38). The plain exterior was in keeping with political and religious thinking in Florence, which was strongly influenced by Christian ideals of poverty and charity. Like many other European cities, Florence had sumptuary laws, which forbade ostentatious displays of wealth—but they were often ignored. Under Florentine law, for example, private homes were limited to a dozen rooms; Cosimo, however, acquired and demolished twenty small houses to provide the site for his new residence. The house was more than a dwelling place; it symbolized the family and established the family's place in society.

Huge in scale (each story is more than 20 feet high), with fine proportions and details, the building was constructed around a central courtyard surrounded by a ***loggia***, or covered gallery. On one side, the ground floor originally opened through large, round arches onto the street and provided a *loggia* for the family business. These arches were walled up in the sixteenth century

Alberti's books on painting, sculpture, and architecture present the first coherent exposition of aesthetic theory since classical Rome. Leon Battista Alberti developed his ideas in three books: *De pictura* (*On Painting*), 1435; *De statua* (*On Sculpture*), written in the 1440s and published later; and *De re aedificatoria* (*On Architecture*), finished in 1452 and published in 1485. He dedicated *On Painting* to the architect Brunelleschi. In it he expounded his ideas that painting is the most important of the three arts and that narrative painting, especially allegory, is the highest form of painting.

Painting, he wrote, should be the product of the intellect, not a craft, and the artists' skill rather than costly materials should determine the value. Alberti developed and codified Brunelleschi's rules of perspective into a mathematical system for representing three dimensions on a two-dimensional surface. The goal he articulated is to make an image resemble a "view through a window," the view being the image represented and the window, the picture plane. Artists should be intelligent, educated, and, he argued, of high moral character. To achieve these high goals, the artist should not only imitate nature but also improve upon it. Similarly, *On Sculpture* analyzed the ideal proportions of the human figure.

Alberti's *On Architecture*, which he worked on from the 1430s until 1452, was the first such book since the Roman architect Vitruvius's *On Architecture*, written in the first century. Alberti adopted Vitruvius's definition of fine architecture as embodying strength, utility, and beauty, and he supplemented his theoretical discussions with classical references and evidence from archaeology. He developed a specific vocabulary for discussing architecture. For example, he further defined the Vitruvian "hierarchy of orders" of architecture— Tuscan, Doric, Ionic, and Corinthian— and added a fifth, "Italic" order, known today as Composite.

and given windows designed by Michelangelo. The facade of large, **rusticated** stone blocks—that is, with their outer faces left rough, typical of Florentine town house exteriors—was derived from fortifications. On the palace facade, the stories are clearly set off from each other by the change in the stone surfaces from very rough at the ground level to almost smooth on the third. The Medici palace inaugurated a new monumentality and regularity of plan in residential urban architecture.

The relationship of the facade to the body of the building behind it was a continuing challenge for Italian Renaissance architects. Early in his architectural career, Leon Battista Alberti (1404–72), a humanist turned architect and author (see "Alberti's Art Theory in the Renaissance," above), devised a facade—begun in 1455 but never finished—to be the unifying front for a planned merger of eight adjacent houses in Florence acquired by Giovanni Rucellai (fig. 17-39). Alberti's design, influenced in its basic approach by the Palazzo Medici, was a simple rectangular front suggesting a coherent, cubical three-story building capped with an overhanging cornice, the heavy, projecting horizontal molding at the top of the wall. The double windows under round arches were a feature of Michelozzo's Palazzo Medici, but other aspects of the facade were entirely new. Inspired by the ancient Colosseum in Rome, Alberti articulated the surface of the lightly rusticated wall with a horizontal-vertical pattern of pilasters and **architraves** that superimposed the classically inspired orders: Doric on the ground floor, floral rather than Ionic on the second, and Corinthian on the third (see "The Renaissance Palace Facade," page 704). The Palazzo Rucellai provided a visual lesson for local architects in the use of classical elements and mathematical proportions, and Alberti's enthusiasm for classicism and his architectural projects in other cities were catalysts for the spread of the Renaissance movement. Later, Alberti worked in Mantua and other north Italian cities.

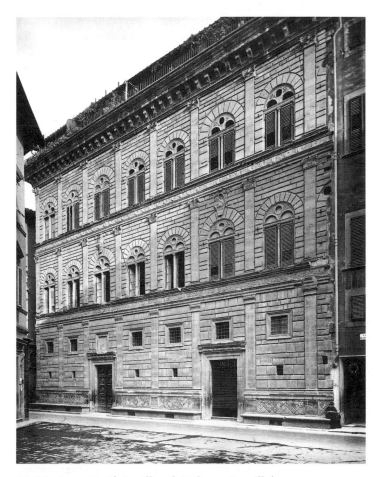

17-39. Leon Battista Alberti. Palazzo Rucellai, Florence. 1455–70

Mantua, Prato, and Urbino. In the second half of the fifteenth century, the classicizing ideas of artists like Brunelleschi began to expand from Florence to the rest of Italy, combining with local styles to form the distinctive Italian Renaissance. Renaissance ideas were often spread by artists who trained or worked in Florence, then traveled to other cities to work, either temporarily or permanently—including Donatello (Padua, Siena), Alberti (Mantua, Rimini, Rome), Piero della Francesca (Urbino, Ferrara, Rome), Uccello (Venice, Urbino, Padua), Giuliano da Sangallo (Rome), and Botticelli (Rome). Northern Italy embraced the new classical ideas swiftly, with the ducal courts at Mantua and Urbino taking the lead. The Republic of Venice and the city of Padua, which Venice had controlled since 1404, also emerged as innovative art centers in the last quarter of the century.

The spread of Renaissance architectural style beyond Florence was due in significant part to Leon Battista Alberti, who traveled widely, wrote on architecture, and expounded his views to potential patrons. In 1470 the ruler of Mantua, Ludovico Gonzaga, commissioned Alberti to enlarge the small Church of Sant'Andrea, which housed a sacred relic believed to be the actual blood of Jesus. To satisfy his patron's desire for a sizable building to handle crowds coming to see the relic, Alberti proposed to build an "Etruscan temple." Work began on the new church in 1472, but Alberti died that summer. Construction went forward slowly, at first according to his original plan, but it was finally completed only at the end of the eighteenth century. Thus, it is not always clear which elements belong to Alberti's original design.

The **Latin-cross plan** (fig. 17-40)—a nave more than 55 feet wide intersected by a transept of equal width; a square, domed crossing; and a rectangular sanctuary on axis with the nave—is certainly in keeping with Alberti's ideas. Alberti was responsible, too, for the barrel-vaulted chapels the same height as the nave and the low chapel niches carved out of the huge piers supporting the barrel vault of the nave. His dome, however, would not have been perforated and would not have been raised on a drum, as this one finally was.

Alberti's design for the facade of Sant'Andrea (fig. 17-41) fuses a classical temple front and triumphal arch, but the facade now has a clear volume of its own, which sets it off visually from the building behind. Two sets of colossal Corinthian pilasters articulate the porch face. Those flanking the barrel-vaulted triumphal-arch entrance are two stories high, whereas the others, raised on pedestals, run through three stories to support the entablature and pediment of the temple form. The arch itself has lateral barrel-vaulted spaces opening through two-story arches on the left and right.

Neither the simplicity of the plan nor the complexity of the facade hints at the grandeur of Sant'Andrea's interior (fig. 17-42). Its immense barrel-vaulted nave extended on each side by tall chapels was inspired by the monumental interiors of such ancient ruins as the Basilica of Maxentius and Constantine in the Roman Forum. In this clear reference to Roman imperial art put to fully Christian use, Alberti created a building of such

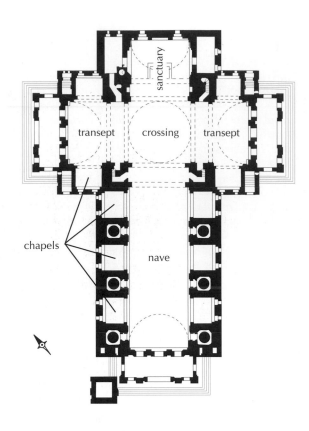

17-40. Leon Battista Alberti. Plan of the Church of Sant'Andrea, Mantua. Designed 1470

colossal scale, spatial unity, and successful expression of Christian humanist ideals that it affected architectural design for centuries.

Another fifteenth-century Florentine architect whose work influenced developments in the sixteenth century was Giuliano da Sangallo (c. 1443–1516). From 1464 to 1472, he worked in Rome, where he produced a number of meticulous drawings after the city's ancient monuments, many of which are known today only from his work. Back in Florence, he became a favorite of Lorenzo the Magnificent, a great humanist and patron of the arts. Soon after completing a country villa for Lorenzo, Giuliano submitted a model for a votive church (a church built as a special offering to a saint) that was to house a painting of the Virgin that a child in 1484 claimed had come to life. The painting was to be relocated from its site on the wall of the town prison to the new church, to be named Santa Maria delle Carceri ("Saint Mary of the Prisons"), in Prato, near Florence. Giuliano began work on it in 1485.

Although the need to accommodate processions and the gathering of congregations made the long nave of a basilica almost a necessity for local churches, the votive church became a natural subject for Renaissance experimentation with the central plan. The existing tradition of **central-plan** churches extended back to the Early Christian *martyrium* (a round shrine to a martyred saint) and perhaps ultimately to the Classical *tholos*, or round temple. Alberti in his treatise on architecture had spoken

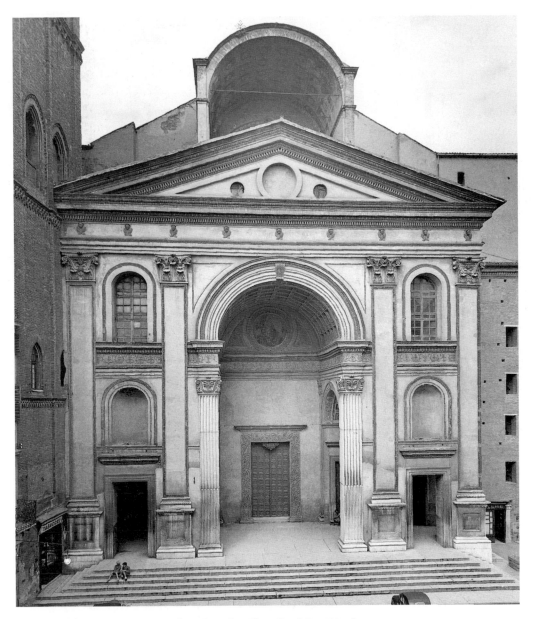

17-41. Facade, Church of Sant'Andrea

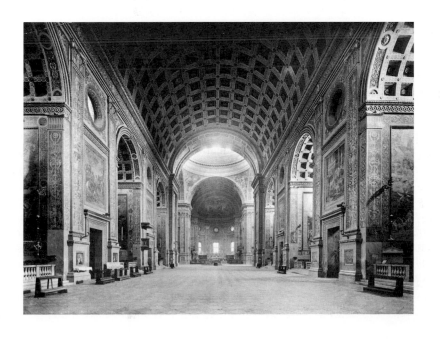

17-42. Nave, Church of Sant'Andrea.
Vault width 60' (18.3 m)

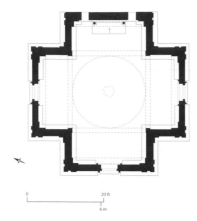

17-43. Giuliano da Sangallo. Plan of the Church of Santa Maria delle Carceri, Prato. Before 1485

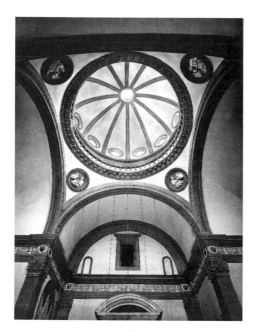

17-44. Interior view of dome, Church of Santa Maria delle Carceri. 1485–92

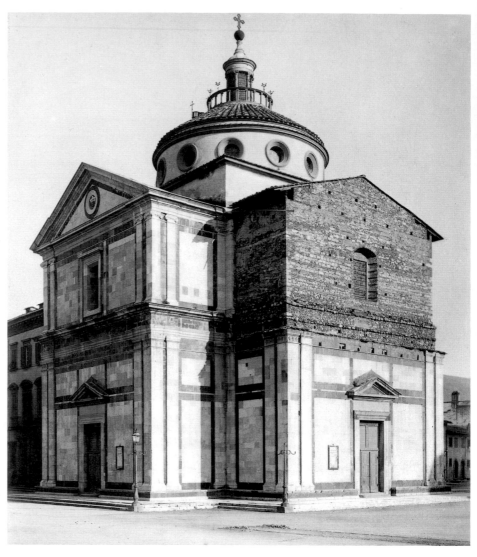

17-45. Church of Santa Maria delle Carceri

of the central plan as an ideal, derived from the humanist belief that the circle was a symbol of divine perfection and that both the circle inscribed in a square and the cross inscribed in a circle were symbols of the cosmos. Thus, Giuliano's Church of Santa Maria delle Carceri, built on Alberti's ideal **Greek-cross plan**, is one of the finest early Renaissance examples of humanist symbolism in architectural design (fig. 17-43). It is also the first Renaissance church with a true central plan; Brunelleschi's earlier experiment in the Old Sacristy of San Lorenzo, for example, was for an attached structure, and Alberti's Greek-cross plan was never actually built. Drawing on his knowledge of Brunelleschi's works, Giuliano created a square, dome-covered central space extended in each direction by arms whose length was one-half the width of the central space. The arms are covered by barrel vaults extended from the round arches supporting the dome. Giuliano raised his dome on a short, round drum that increased the amount of natural light entering the church. He also articulated the interior walls and the twelve-ribbed dome and drum with *pietra serena* (fig. 17-44). The exterior of the dome is capped with a conical roof and a tall lantern in Brunelleschian fashion.

The exterior of the church is a marvel of Renaissance clarity and order (fig. 17-45). To understand the designer's intention one has but to look at the buildings represented in a painting by Piero della Francesca in Arezzo (see fig. 17-66). Giuliano's ground-floor system of slim Doric pilasters clustered at the corners is repeated in the Ionic order on the shorter upper level, as

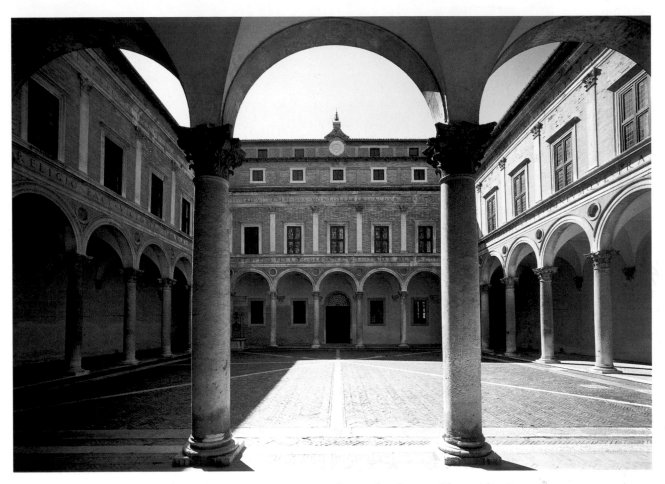

17-46. **Luciano Laurana. Courtyard, Ducal Palace, Urbino**. 1465–79

if the entablature of a small temple had been surmounted with a second, smaller one. The church was entirely finished in 1494 except for installation of the fine green- and white-marble veneer above the first story. In the 1880s, one section of the upper level was veneered; however, the philosophy of present-day conservation requires that the rest of the building be left in rough stone, as it is today.

East of Florence lay another outstanding artistic center, the court of Urbino, which, under the patronage of Federico da Montefeltro, attracted the finest artists of the day. Construction of Federico's ducal palace (*palazzo ducale*) had begun about 1450, and in 1468 Federico hired Luciano Laurana, who had been an assistant on the project, to direct the work. Among Laurana's major contributions were closing the courtyard with a fourth wing and redesigning the courtyard facades (fig. 17-46). The result is a superbly rational solution to the problems of courtyard elevation design, particularly the awkward juncture of the arcades at the four corners. The ground-level portico on each side has arches supported by columns; the corner angles are bridged with piers having

engaged columns on the arcade sides and pilasters facing the courtyard. This arrangement avoided the awkward visual effect of two arches springing from a single column and gave the corner a greater sense of stability. The **Composite** capital (Corinthian with added Ionic **volutes**) was used, perhaps for the first time, on the ground level. Corinthian pilasters flank the windows in the story above, forming divisions that repeat the bays of the portico. (The two short upper stories were added later.) The plain architrave faces were engraved with inscriptions identifying Federico and lauding his many humanistic virtues. Not visible in the illustration is an innovative feature that became standard in palace courtyard design: the monumental staircase from the courtyard to the main floor.

The interior of the ducal palace likewise reflected its patron's embrace of new Renaissance ideas and interest in classical antiquity. In creating luxurious home furnishings and interior decorations for educated clients such as Federico, Italian craft artists found freedom to experiment with new subjects, treatments, and techniques. Among these was the creation of ***trompe l'oeil***

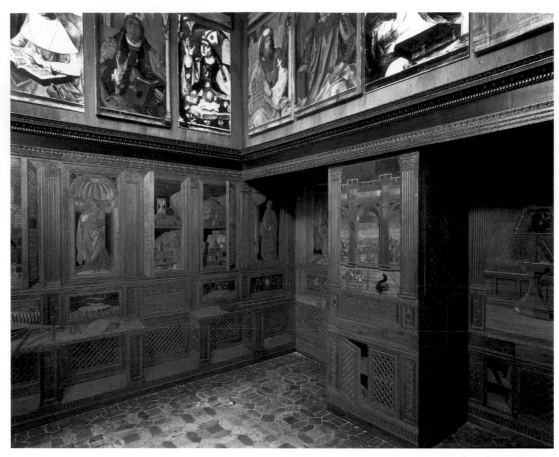

17-47. *Studiolo* **of Federico da Montefeltro, Ducal Palace, Urbino.** 1470s. Intarsia, height 7'3" (2.21 m)

Paintings of great scholars by Justus of Ghent and others have been moved to museums and replaced by photographs.

("fool-the-eye") effects, which had become more convincing with the development of linear perspective. *Trompe l'oeil,* commonly used in painting, was carried to its ultimate expression in **intarsia** (wood inlay) decoration, exemplified by the walls of Federico da Montefeltro's *studiolo,* a room for his private collection of fine books and art objects (fig. 17-47).

The elaborate scene in the small room is created entirely of wood inlaid on flat surfaces with scrupulously applied linear perspective and **foreshortening** (a contraction of forms that supports the overall perspectival system). Each detail is rendered in *trompe l'oeil* design: the illusionistic pilasters, carved cupboards with latticed doors, niches with statues, paintings, and built-in tables. Prominent is the prudent and industrious squirrel, a Renaissance symbol of the ideal ruler, which Federico da Montefeltro was considered to be. A large window looks out onto an elegant marble *loggia* with a distant view of the countryside through its arches; and the shelves, cupboards, and tables are filled with all manner of fascinating things—scientific instruments, books, even the duke's armor hanging like a suit in a closet. On the walls above were paintings by Italian, Spanish, and Flemish artists.

SCULPTURE

In the early fifteenth century, the two most important sculptural commissions in Florence were the exterior decoration of the Church of Orsanmichele and the new bronze doors for the Florence Cathedral Baptistry. Orsanmichele, once an open-arcaded market, was both the municipal granary and a shrine for the local guilds. After its ground floor was walled up near the end of the fourteenth century, each of the twelve niches on the outside of the building was assigned to a guild, which was to commission a large figure of its patron saint or saints to stand there.

Nanni di Banco (c. 1385–1421), son of a sculptor in the Florence Cathedral workshop, produced statues for three of Orsanmichele's niches in his short but brilliant career. The *Four Crowned Martyrs* was commissioned about 1410–13 by the stone carvers' and woodworkers' guild, to which Nanni himself belonged (fig. 17-48). These martyrs, according to legend, were third-century Christian sculptors executed for refusing to make an image of a Roman god. Although the architectural setting resembles a small-scale Gothic chapel, Nanni's figures—with their solid bodies, heavy, form-revealing togas, and stylized hair and beards—have the appearance of ancient Roman sculpture. Standing in a semicircle with forward feet and drapery protruding beyond the floor of the niche, the saints convey a sense of realism. They appear to be four individuals talking together. In the relief panels below, showing the four sculptors at work, the forms have a similar solid vigor. Both figures and objects have been deeply **undercut** to cast shadows and enhance the illusion of three-dimensionality.

In 1402, a competition had been held to determine who would design bronze relief panels for a new set of doors for the north side of the Florence Baptistry of San Giovanni. The commission was awarded to Lorenzo Ghiberti (1381?–1455), a young artist trained as a painter,

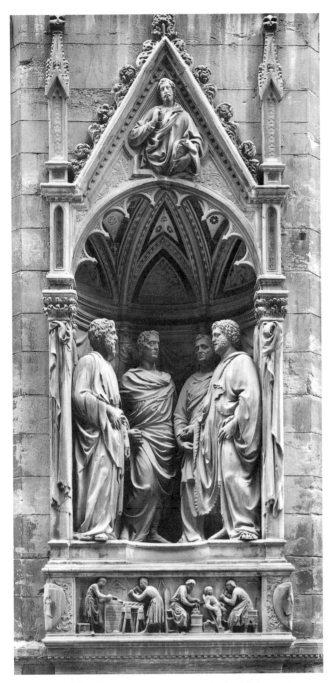

17-48. Nanni di Banco. *Four Crowned Martyrs*. c. 1410–13. Marble, height of figures 6' (1.83 m). Orsanmichele, Florence (photographed before removal of figures)

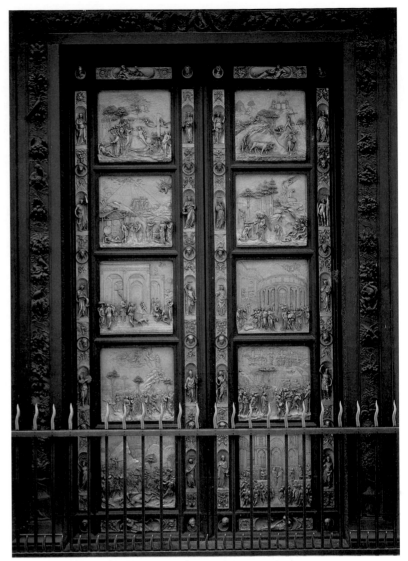

17-49. Lorenzo Ghiberti. Gates of Paradise (East Doors), Baptistry of San Giovanni, Florence. 1425–52. Gilt bronze, height 15' (4.57 m). Museo dell'Opera del Duomo, Florence

The door panels, commissioned by the Wool Manufacturers' Guild, contain ten Old Testament scenes, from the Creation to the reign of Solomon. The upper left panel depicts the Creation, Temptation, and Expulsion of Adam and Eve from Eden. The murder of Abel by his brother, Cain, follows in the upper right panel, succeeded in the same left-right paired order by the Flood and the drunkenness of Noah, Abraham sacrificing Isaac, the story of Jacob and Esau, Joseph sold into slavery by his brothers, Moses receiving the Tablets of the Law, Joshua and the fall of Jericho, David and Goliath, and finally Solomon and the Queen of Sheba. Ghiberti, whose bust portrait appears at the lower right corner of *Jacob and Esau*, wrote in his *Commentaries* (c. 1450–55): "I strove to imitate nature as clearly as I could, and with all the perspective I could produce, to have excellent compositions with many figures."

at the very beginning of his career. His panels were such a success that in 1425 he was awarded the commission for another set of doors for the east side of the Baptistry. Those doors, installed in 1452, were reportedly said by Michelangelo to be worthy of being the Gates of Paradise (fig. 17-49). Overall gilding unifies the ten large, square reliefs. Ghiberti organized the space either by a system of linear perspective, approximating the one described by Alberti in his 1435 treatise on painting (see "Renaissance Perspective Systems," page 621) or by a series of arches or rocks or trees leading the eye into the distance. Foreground figures are grouped in the lower third of the

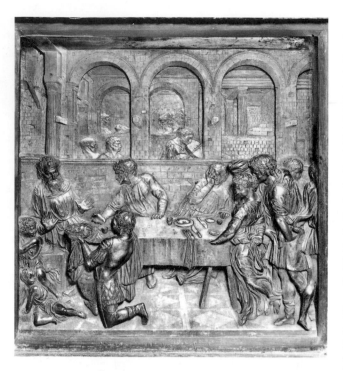

17-50. Donatello. *Feast of Herod*, panel of baptismal font, from the Siena Cathedral Baptistry. c. mid-1420s. Gilt bronze, 23½ x 23½" (59.7 x 59.7 cm)

In illustrating the biblical story of Salome's dance before her stepfather, Herod Antipas, and her morbid request to be rewarded with the head of John the Baptist on a platter (Mark 6:21–28), Donatello showed Herod's palace as a series of three chambers parallel in space. Although he established a **vanishing point**, the central point where the lines of the architecture converge, he placed the focus of action and emotion—the presentation of the severed head of John the Baptist—in the left foreground, leaving the central axis of the composition empty. As a result, the eye is led past horrified spectators and disinterested musicians to the prison where the beheading took place, then back to the scene in which John's head is carried forward. Donatello demonstrated the fifteenth-century artists' new interest in the individual as he recorded the different reactions to the appalling trophy.

Donatello stands out from all the other artists because he constantly explored human emotions and expressions, the formal problems inherent in representing his visions and insights, and the technical problems posed by various mediums, from bronze and marble to polychromed wood. In bronze sculpture, he achieved several "firsts"—the first lifesize male nude since antiquity (*David*, fig. 17-51) and the first lifesize bronze equestrian portrait (*Gattamelata*, see fig. 17-53) since classical Rome.

The sculpture of *David* has been the subject of continuous inquiry and speculation, since nothing is known about the circumstances of its creation. It is first recorded in 1469 in the courtyard of the Medici palace, where it stood on a base engraved with an inscription extolling Florentine heroism and virtue. This inscription supports the suggestion that it celebrated the triumph of the Florentines over the Milanese in 1428. Although the statue clearly draws on the Classical tradition of heroic nudity, this sensuous, adolescent boy in jaunty rose-trimmed shepherd's hat and boots has long piqued interest in its meaning. In one interpretation, the boy's angular pose, his underdeveloped torso, and the sensation of his wavering between childish interests and adult responsibility heighten his heroism in taking on the giant and outwitting him. With Goliath's severed head now under his feet, David seems to have lost interest in warfare and to be retreating into his dreams.

As Donatello's career drew to a close, his style underwent a profound change, becoming more emotionally expressive. His *Mary Magdalen* of about 1455 shows the saint known for her physical beauty as an emaciated, vacant-eyed hermit clothed by her own hair (fig. 17-52). Few can look at this figure without a wrenching reaction to the physical deterioration of aging and years of self-denial. Nothing is left for her but an ecstatic vision of the hereafter. Despite Donatello's total rejection of Classical form in this figure, the powerful force of the Magdalen's personality makes this a masterpiece of Renaissance imagery.

If one image were to characterize the Italian Renaissance, surely the most appropriate would be the *condottieri* ("commanders")—soldiers of fortune—the brilliant

panel, while the other figures decrease gradually in size, suggesting deep space. In some panels, the tall buildings suggest ancient Roman architecture and illustrate the emerging antiquarian tone in Renaissance art.

The great genius of early Italian Renaissance sculpture was Donatello (Donato di Niccolò de Betto di Bardi, c. 1386–1466), one of the most influential figures of the century in Italy. During his long and vigorous career, he executed each commission as if it were a new experiment in expression. Donatello took a remarkably pictorial approach to relief sculpture. He developed a technique for creating the impression of very deep space by combining the new linear perspective with the ancient Roman technique of varying heights of relief—high relief for foreground figures and very low relief, sometimes approaching engraving, for the background. The *Feast of Herod* (fig. 17-50), a gilded bronze panel made for the baptismal font in the Siena Cathedral Baptistry in the mid-1420s, illustrates this technique. As in the relief sculpted below Nanni's *Four Crowned Martyrs* (see fig. 17-48), the contours of the foreground figures have been undercut to emphasize their mass, while figures beyond the foreground are in progressively lower relief. The lines of the brickwork and many other architectural features are incised rather than carved. Donatello used classical architecture to establish a space implied by linear perspective, yet he avoided the artificiality of precise geometric perspective by handling some peripheral areas more intuitively. The result is a spatial setting in relief sculpture as believable as any illusionistic painting.

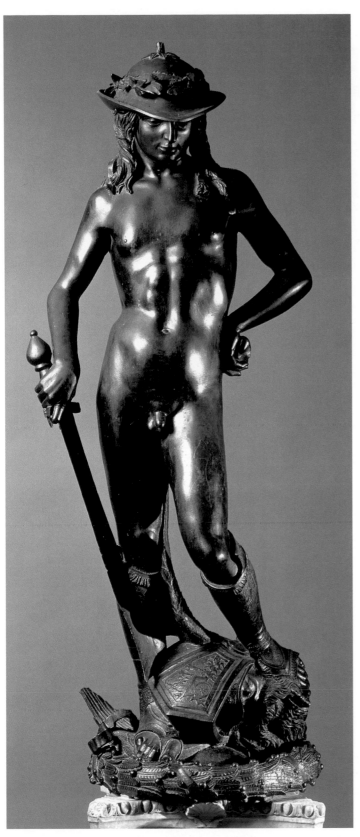

17-51. Donatello. *David*. Dated as early as
c. 1420 and as late as the 1460s. Bronze, height
5'2¼" (1.58 m). Museo Nazionale del Bargello,
Florence

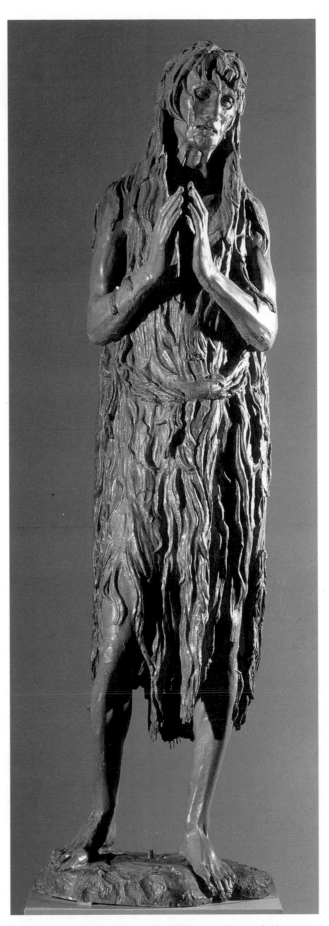

17-52. Donatello. *Mary Magdalen*. c. 1455. Polychromy
and gilt on wood, height 6'2" (1.88 m). Museo
dell'Opera del Duomo, Florence

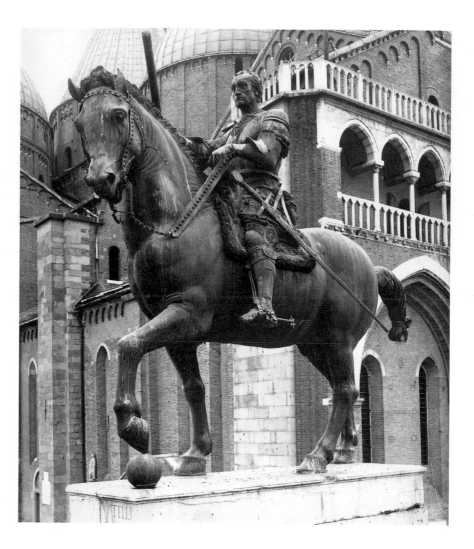

17-53. Donatello. Equestrian monument of Erasmo da Narni (Gattamelata), Piazza del Santo, Padua. 1443–53. Bronze, height approx. 12'2" (3.71 m)

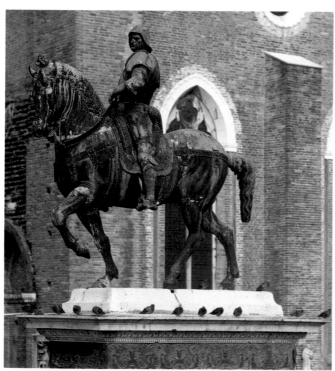

17-54. Andrea del Verrocchio. Equestrian monument of Bartolommeo Colleoni, Campo Santi Giovanni e Paolo, Venice. Clay model 1486–88; cast after 1490; placed 1496. Bronze, height approx. 13' (4 m)

generals who organized the armies and fought for any city-state willing to pay. Two magnificent and characteristic examples stand in Padua and Venice, monuments to the tenacity and leadership of Erasmo da Narni (fig. 17-53) and Bartolommeo Colleoni (see fig. 17-54).

In 1443, Donatello was called to Padua to execute the equestrian statue commemorating the Venetian general Erasmo da Narni, nicknamed Gattamelata ("Honeyed Cat," a reference to his mother, Melania Gattelli). Donatello's sources for this statue were two surviving Roman bronze equestrian portraits, one (now lost) in the north Italian city of Pavia, the other of the emperor Marcus Aurelius, which the sculptor certainly saw and probably sketched during his youthful stay in Rome. Viewed from a distance, this man-animal juggernaut, installed on a high marble base in front of the Church of Sant'Antonio, seems capable of thrusting forward at the first threat. Seen up close, however, the man's sunken cheeks, sagging jaw, ropy neck, and stern but sad expression suggest a warrior now grown old and tired from the constant need for military vigilance and rapid response.

During the decade that he remained in Padua, Donatello executed other commissions for the Church of Sant'Antonio, including a bronze crucifix and reliefs for

the high altar. His presence in the city introduced Renaissance ideas to northeastern Italy and gave rise to a new Paduan school of painting and sculpture. The expressionism of Donatello's late work inspired some artists to add psychological intensity even in public monuments. In the early 1480s, the Florentine painter and sculptor Andrea del Verrocchio (1435–88) was commissioned to produce an equestrian memorial to another Venetian general, Bartolommeo Colleoni (d. 1475), this time in Venice itself (fig. 17-54). In contrast to the tragic overtones communicated by Donatello's *Gattamelata*, the impression conveyed by the tense forms of Verrocchio's equestrian monument is one of vitality and brutal energy. The general's determination is clearly expressed in his clenched jaw and staring eyes. The taut muscles of the horse, fiercely erect posture of the rider, and complex interaction of the two make this image of will and domination a singularly compelling monument.

Small Bronzes. Sculptors in the fifteenth century worked not only on a monumental scale for the public sphere; they also created small works, each designed to inspire the mind and delight the eye of its private owner. The enthusiasm of European collectors in the latter part of the fifteenth century for small, easily transported bronzes contributed to the spread of classical taste. Antonio del Pollaiuolo, ambitious and multitalented— a goldsmith, embroiderer, printmaker (see fig. 17-32), sculptor, and painter—came to the Medici court in Florence about 1460 as a painter. His sculpted works were mostly small bronzes, such as his *Hercules and Antaeus* of about 1475 (fig. 17-55). This study of complex interlocking figures has an explosive energy that can best be appreciated by viewing it from every angle—it is meant to be held in the hand and turned. Statuettes of religious subjects were still popular, but humanist art patrons began to collect bronzes of Greek and Roman subjects like this one. Many sculptors, especially those trained as goldsmiths, began to cast small copies after well-known Classical works. Some artists also executed original designs *all'antica* ("in the antique style"). Although there were outright forgeries of antiquities at this time, works in the antique manner were intended simply to appeal to a cultivated humanist taste.

Works in Ceramic. Italian sculptors did not limit themselves to the traditional materials of wood, stone and marble, and bronze. They also returned to **terra-cotta**, a clay medium whose popularity in Italy went back to Etruscan and ancient Roman times. Techniques of working with and firing clay had been kept alive by the ceramics industry and by a few sculptors, especially in northern Italy.

Typical of the period's ceramics manufacture in shape and decoration is the *albarello* (fig. 17-56), a jar designed especially for pharmacies: The tall concave shape made it easy to remove from a line of jars on pharmacy shelves, and the lip at the rim helped secure the cord that tied a parchment cover over the mouth. Sometimes the name of the owner or the contents of the jar were inscribed on a band around the center (this jar held

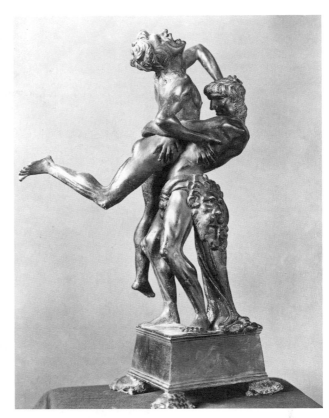

17-55. Antonio del Pollaiuolo. *Hercules and Antaeus*. c. 1475. Bronze, height with base 18" (45.7 cm). Museo Nazionale del Bargello, Florence

Among the many courageous acts by which Hercules gained immortality was the slaying of the evil Antaeus in a wrestling match by lifting him off the earth, the source of the giant's great physical power. Hercules had been attacked by Antaeus, the son of the earth goddess Ge (or Gaia), on his search for a garden that produced pure gold apples. The sculpture is a remarkable study of pain and struggle.

17-56. *Albarello*, cylindrical pharmacy jar, from Faenza. c. 1480. Glazed ceramic, height 12⅜" (31.5 cm). Getty Museum, Los Angeles
Getty .84.DE.104

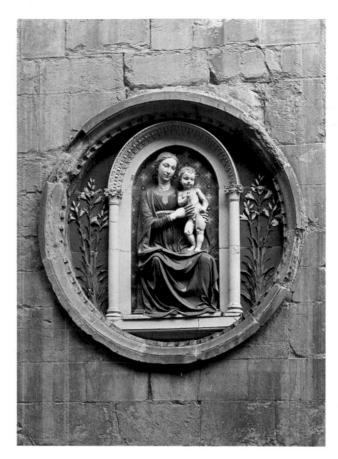

17-57. Luca della Robbia. *Madonna and Child with Lilies*. c. 1455–60. Enameled terra-cotta, diameter approx. 6' (1.83 m). Orsanmichele, Florence.

syrup of lemon juice). The jars were glazed white and decorated in deep rich colors—orange, blue, green, and purple. The technique for making this lustrous, tin-glazed earthenware had been developed by Islamic potters and then by Christian potters in Spain. It spread to Italy from the Spanish island of Mallorca—known in Italian as Majorca, which gave rise to the term *majolica* to describe such wares. From the fourteenth through the sixteenth century, Faenza, in northern Italy, was a leading center of majolica production. The painted decoration of broad scrolling leaves (known as "Gothic leaves"), seen here, is characteristic of the fifteenth century.

Ceramic—using very cheap, easy-to-work material (clay)—was also used to supply the ever-increasing demand for architectural sculpture. Luca della Robbia (1399/1400–1482), although an accomplished sculptor in marble, began to experiment in 1441–42 with tin glazing to make his ceramic sculpture both weatherproof and decorative. As his inexpensive and rapidly produced sculpture gained an immediate popularity, he added color to the traditional white glaze. His workshop even made molds so that a particularly popular work could be replicated many times. Luca favored a limited palette of clear blues, greens, and pale yellows with a great deal of white, as seen in his *Madonna and Child with Lilies* of about 1455–60, on Orsanmichele (fig. 17-57). The elegant

and lyrical della Robbia style was continued by Luca's nephew Andrea and his children long after Luca's death. The family workshop produced standard decorative forms such as image-framing swags and wreaths of fruit and foliage that are still popular today.

PAINTING

Italian patrons generally commissioned murals and large altarpieces for their local churches and smaller panel paintings for their private chapels. Artists experienced in **fresco**, mural painting on wet plaster, were in great demand and traveled widely to execute wall and ceiling decorations. Italian panel painters showed little interest in oil painting, for the most part using tempera even for their largest works until the last decades of the century, when Venetians began to use the oil medium for major panel paintings.

International Gothic–style Painting. The new Renaissance style in painting—with its solid, volumetric forms, perspectively defined space, and references to classical antiquity—did not immediately displace the International Gothic. One of the important painters who retained International Gothic elements in their work was Gentile da Fabriano (c. 1385–1427), who in 1423

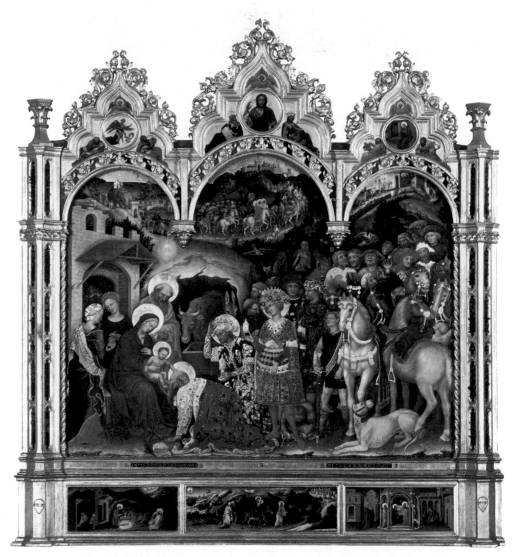

17-58. Gentile da Fabriano. *Adoration of the Magi*, altarpiece for the Strozzi family chapel, Church of Santa Trinità, Florence. 1423. Tempera and gold on wood panel, 9'10" x 9'3" (3 x 2.85 m). Galleria degli Uffizi, Florence

completed the *Adoration of the Magi* (fig. 17-58), a large altarpiece commissioned by the Strozzi family, the wealthiest family in Florence, for their chapel in the Church of Santa Trinità in Florence. Among the International Gothic elements are the steeply rising ground plane, graceful figural poses, brightly colored costumes and textile patterns, glinting gold accents, and naturalistic rendering of the details of the setting. But Gentile's landscape, with its endless procession of people winding from the far distance toward Bethlehem to worship the Christ Child, also is related to the northern landscape tradition seen in Broederlam's altarpiece for the Chartreuse de Champmol (see fig. 17-8). Also like northern works, Gentile's painting celebrates the riches of the Magi (and the Strozzi patrons) as well as their piety.

Fresco Painting. The most innovative of the early Italian Renaissance painters was Tommaso di Ser Giovanni di Mone Cassai (1401–28), nicknamed Masaccio (see "Italian Artists' Names and Nicknames," page 622). In his short career of less than a decade, he established a new direction in Florentine painting, much as Giotto had a century earlier. The exact chronology of his works is uncertain and perhaps not important, since they were all painted within about eight years. His fresco of the Trinity in the Church of Santa Maria Novella in Florence has been dated as early as 1425 and as late as 1427/28 (fig. 17-59, page 668). The *Trinity* was meant to give the illusion of a stone funerary monument and altar table set below a deep **aedicula** (framed niche) in the wall. The praying donors in front of the pilasters are probably Domenico

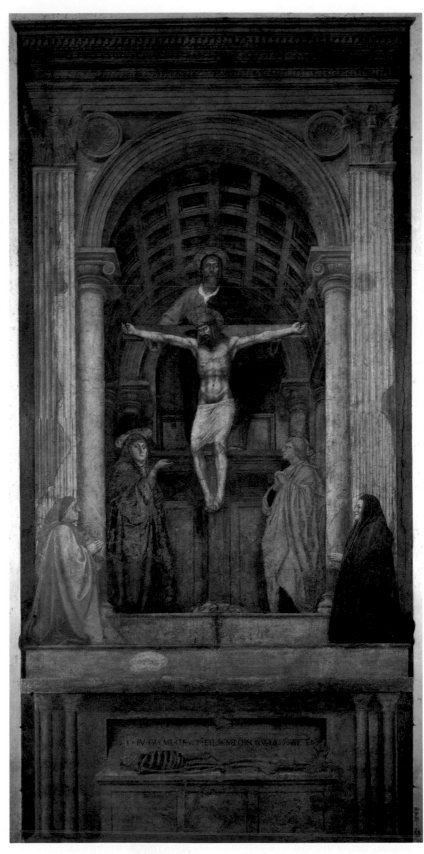

17-59. Masaccio. *Trinity with the Virgin, Saint John the Evangelist, and Donors*, fresco in the Church of Santa Maria Novella, Florence. c. 1425–27/28. 21' x 10'5" (6.4 x 3.2 m)

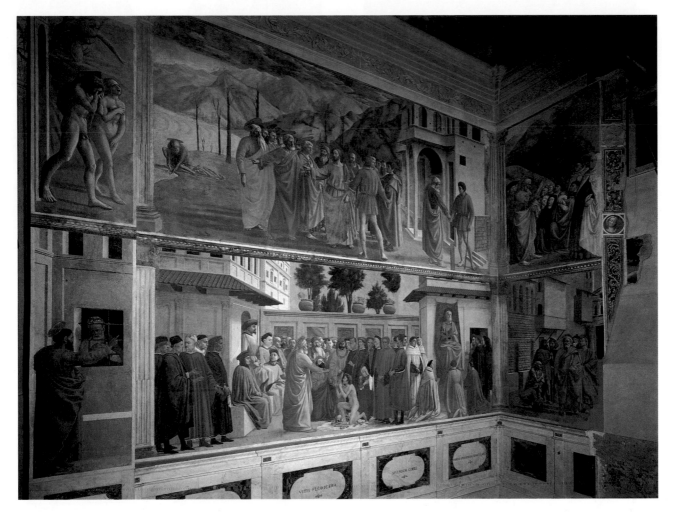

17-60. Interior of the Brancacci Chapel, Church of Santa Maria del Carmine, Florence, with frescoes by Masaccio and Masolino (1424–27) and Filippino Lippi (c. 1482–84)

Lenzi and his wife, whose tombstone lay in front of the painting. The red robes of the male donor at the left signify that he was a member of the governing council of Florence.

Masaccio created the unusual *trompe l'oeil* effect of looking up into a barrel-vaulted niche through precisely rendered linear perspective. The eye-level of an adult viewer determined the horizon line on which the vanishing point was centered, just above the base of the cross. The painting demonstrates Masaccio's intimate knowledge of both Brunelleschi's perspective experiments and his architectural style (see fig. 17-36). The painted architecture is an unusual combination of Classical orders; on the wall surface Corinthian pilasters support a plain architrave below a cornice, while inside the niche Renaissance variations on Ionic columns support arches on all four sides. The Trinity is represented by Jesus on the Cross, the dove of the Holy Spirit poised in downward flight above his tilted halo, and God the Father, who stands behind the Cross on a high platform apparently supported on the rear columns. The "source" of the consistent illumination modeling the figures with light and shadow lies in front of the picture, casting

reflections on the **coffers**, or sunken panels, of the ceiling. As in many scenes of the Crucifixion, Jesus is flanked by the Virgin Mary and John the Evangelist, who contemplate the scene. Mary gazes calmly out at us, her raised hand presenting the Trinity. Below, in an open sarcophagus, is a skeleton, a grim reminder that death awaits us all and that our only hope is redemption and life in the hereafter through Christian belief. The inscription above the skeleton reads: "I was once that which you are, and what I am you also will be."

Masaccio's brief career reached its height in his collaboration with a painter known as Masolino (1383–after 1435) on the fresco decoration of the Brancacci Chapel in the Church of Santa Maria del Carmine in Florence (fig. 17-60). The project was ill-fated, however: The painters never finished their work—Masolino left in 1425 for Hungary, and Masaccio left in 1427 or 1428 for Rome, where he died in 1428—and the patron, Brancacci, was exiled in 1435. Eventually, another Florentine painter, Filippino Lippi, finished the painting in the 1480s. The chapel was originally dedicated to Saint Peter, and most frescoes illustrate events in his life.

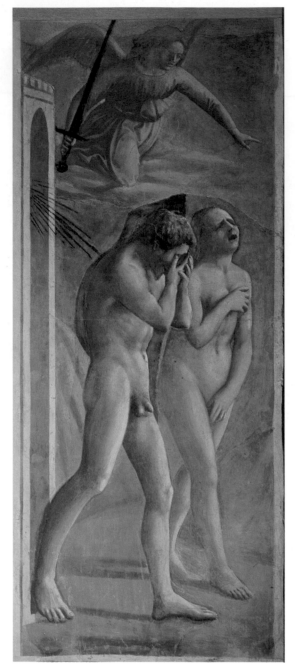

17-61. Masaccio. *The Expulsion from Paradise*, fresco in the Brancacci Chapel. c. 1427

Cleaning and restoration of the Brancacci Chapel paintings revealed the remarkable speed and skill with which Masaccio worked. He painted Adam and Eve in four *giornate* (each *giornata* of fresh plaster representing a day's work). Working from the top down and left to right, he painted the angel on the first day; on the second day, only the portal; the magnificent figure of Adam on the third day; and Eve on the fourth day.

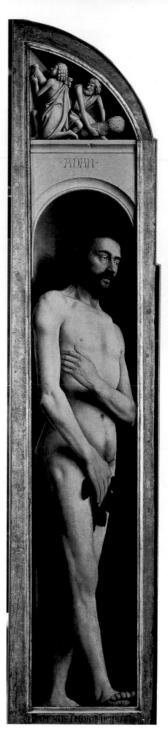
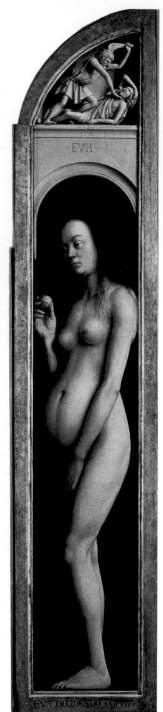

17-62. Jan van Eyck. *Adam and Eve*, details of the open *Ghent Altarpiece*, from the Cathedral of Saint-Bavo, Ghent, Flanders (Belgium). 1432. Oil on wood panel, 11'5¾" x 7'6¾" (3.5 x 2.3 m) © IRPA-KIK, Brussels

Jan depicts Adam and Eve after the Fall, trying to cover their almost shocking nakedness, Eve holding the forbidden fruit. Above their heads, painted as if carved in stone, is the terrible consequence of the first couple's disobedience to God: Their son Cain commits the first murder by killing his brother, Abel. Only the sacrifice of Christ, depicted in a panel of the altarpiece not seen here, will redeem their sin.

A comparison of the nearly contemporary figures of Adam and Eve as painted by Masaccio (fig. 17-61) and Jan van Eyck (fig. 17-62) clarifies the differences between the artists of Florence and Bruges, and between fifteenth-century Italian and Flemish painting generally. Masaccio worked in fresco, Jan in oil. Both had studied nude human figures and worked in a realistic style, but Jan captured every detail, every nuance of the surfaces of the figures while Masaccio represented the mass of the bodies formed by their underlying structure. Both painters represented figures modeled by light—Jan used an intense, single-source, raking light, Masaccio, a more generalized

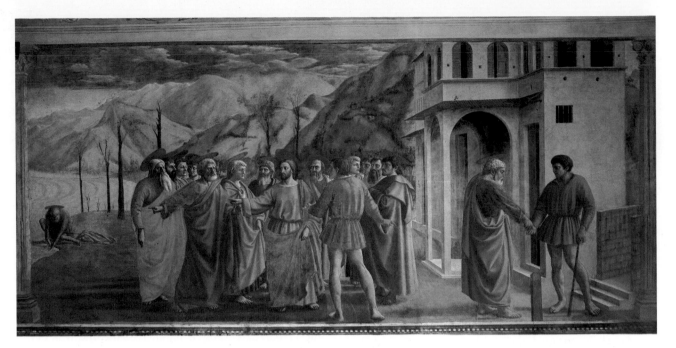

17-63. Masaccio. *Tribute Money*, fresco in the Brancacci Chapel. c. 1427. 7'6½" x 19'7" (2.3 x 6 m)

> Much valuable new information about the Brancacci Chapel frescoes was discovered during the course of a cleaning and restoration carried out between 1984 and 1990. Art historians now have a more accurate picture of how the frescoes were done and in what sequence, as well as which artist did what. One interesting discovery was that all of the figures in the *Tribute Money*, except those of the temple tax collector, originally had gold-leaf halos, several of which had flaked off. Rather than silhouette the heads against flat gold circles in the medieval manner, Masaccio conceived of the halo as a gold disk hovering in space above each head and subjected it to perspective foreshortening depending on the position of the figure.

but still focused illumination. Jan focused on the traditional Christian wrongdoing and on the forbidden fruit—the essence of the Fall. Masaccio was concerned with the psychology of individual humans who have been cast mourning and protesting out of Paradise. Jan painted Adam and Eve as if they were ordinary people he had seen in the market in Bruges. Masaccio captured the essence of humanity thrown naked into the world.

Masaccio's most innovative painting is the *Tribute Money* (fig. 17-63), completed about 1427, rendered in a continuous narrative of three scenes within one setting. The painting illustrates an incident in which a collector of the Jewish temple taxes (tribute money) demands payment from Peter, shown in the central group with Jesus and the other disciples (Matthew 17:24–27). Although Jesus opposes the tax, he instructs Peter to "go to the sea, drop in a hook, and take the first fish that comes up," which Peter does at the far left. In the fish's mouth is a coin worth twice the tax demanded, which Peter gives to the tax collector at the far right. The tribute story was significant for Florentines because in 1427, to raise money for defense against military aggression, the city enacted a graduated tax, based on the ability to pay.

The *Tribute Money* is remarkable for its integration of figures, architecture, and landscape into a consistent whole. The group of Jesus and his disciples forms a clear central focus, from which the landscape seems to recede naturally into the far distance. To create this illusion, Masaccio used linear perspective in the depiction of the house, and then reinforced it by diminishing the sizes of the barren trees and reducing Peter's size at the left. At the vanishing point established by the lines of the house is the head of Jesus. A second vanishing point determines

the steps and stone rail at the right. Cleaning of the fresco in 1984–90 revealed that the painting was done in thirty-two *giornate* and also that Masaccio used atmospheric perspective in the distant landscape, where mountains fade from grayish green to grayish white and the houses and trees on their slopes are loosely sketched.

Masaccio modeled the foreground figures with strong highlights and cast their long shadows on the ground toward the left, implying a light source at the far right, as if the scene were lit by the actual window in the rear wall of the Brancacci Chapel. Not only does the lighting give the forms sculptural definition, but the colors vary in tone according to the strength of the illumination. Masaccio used a wide range of hues—pale pink, mauve, gold, seafoam, apple green, peach—and a sophisticated color technique in which Andrew's green robe is shaded with red instead of darker green. Another discovery after the cleaning was that—allowing for the differences between rapidly applied water-based colors in fresco versus slow-drying oil—the wealth of linear details such as tiles, walls, and landscape before they were obscured by dirt and overpainting was much closer to that of Masaccio's northern European contemporaries than previously thought. In contrast to Jan van Eyck's figure style, however, Masaccio's exhibits an intimate knowledge of Roman sculpture.

Stylistic innovations take time to be fully accepted, and Masaccio's genius for depicting weight and volume, consistent lighting, and spatial integration was best appreciated by a later generation. Many important sixteenth-century Italian artists, including Michelangelo, studied and sketched from Masaccio's Brancacci Chapel frescoes. In the meantime, painting in Florence after

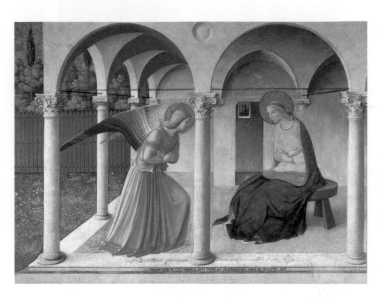

17-64. Fra Angelico. *Annunciation*, fresco in Cell No. 3, east corridor, Monastery of San Marco, Florence. c. 1441–45. Image 6'1½" x 5'2" (1.87 x 1.57 m)

Fra Angelico's humility was legendary. He had left the completion of the San Marco frescoes to his assistants in 1445 to answer a summons to Rome by Pope Eugene IV, who was looking for a new archbishop of Florence. The current vicar of San Marco, Antonino Pierozzi, was finally appointed to the post in January 1446. When Pierozzi was proposed for canonization in the early sixteenth century, several people testified that Pope Eugene's first choice for archbishop had been Fra Angelico, who declined the honor and suggested his Dominican brother Antonino.

Masaccio's death developed along lines somewhat different from that of the *Tribute Money* or *Trinity*, as other artists experimented in their own ways of conveying the illusion of a believably receding space.

The tradition of covering walls with paintings in fresco continued through the century. One of the most extensive projects was the decoration of the Dominican Monastery of San Marco in Florence between 1435 and 1445 led by Fra Angelico ("The Angelic Brother"). Born Guido di Pietro (c. 1395/1400–55) and known to his peers as Fra Giovanni da Fiesole, Fra Angelico earned his nickname through his piety as well as his painting. He is documented as a painter in Florence in 1417–18 and he continued to be a very active painter after taking his vows as a Dominican monk in nearby Fiesole between 1418 and about 1421. Fra Angelico went to work at the Vatican in Rome in 1445, and the frescoes at San Marco were completed by his assistants several years later.

Each monk's cell in the monastery had a painting to inspire meditation. In one cell off the east corridor of the upper floor Fra Angelico painted the *Annunciation* (fig. 17-64). The painting reflects its location. The arched frame echoes the curvature of the cell wall, and the plain white interior of the illusionistic space appears almost to be a nichelike extension of the cell's space. The effect is that of looking through a window onto a scene taking place in the cloister portico. In the painting, the ceiling is supported by the wall on one side and by slender Ionic columns on the other, a building technique Fra Angelico

would have known from the *loggia* of Brunelleschi's Foundling Hospital (see fig. 17-35). The edge of the porch, the base of the first column, and the lines of the bench establish a linear perspective. Gabriel and Mary are slender, graceful figures with glowing draperies. The natural light falling from the left models the forms, but a supernatural radiance lights Gabriel's hands and face and creates a spotlight effect on the back wall. The scene is a vision within a vision; Saint Dominic appears at the left in prayer, giving rise to the vision of the Annunciation, while the whole may be seen as a vision of the resident monk.

Another notable Florentine fresco, *The Last Supper*, is the best-known work of Andrea del Castagno (c. 1417/19–57). He worked for a time in Venice before returning to Florence to paint it, in 1447, in the refectory of the convent of the Benedictine nuns, Sant'Apollonia (fig. 17-65). Extending 32 feet across the end wall of the dining room and rising 15 feet high, the fresco gives the illusion of a raised alcove where Jesus and his disciples are eating their meal as if at a head table. Rather than the humble "upper room" where the biblical event took place, the setting resembles a royal audience hall with sumptuous marble panels and inlays. The *trompe l'oeil* effect is aided by a focal point on the head and shoulders of the sleeping young disciple John. Some of the lines of the architecture converge here, while others merely come close; a few converge elsewhere. Thus, Andrea appears to have adjusted many of the perspectival elements intuitively to create a more believable spatial representation.

Above the *Last Supper* and completely ignoring the illusion of a room cut into the wall, Andrea painted the Entombment and Resurrection of Christ. An unfortunate accident, when these paintings were damaged by water and had to be removed from the wall, provided a fascinating insight into the working methods of a mural painter. The **sinopia**, or sketch made on the wall before painters begin work, was recovered in the process of restoring the murals. By comparing the drawings and the final paintings, even in their damaged state, one can see the careful preparation necessary before frescoes were begun—as well as the amount of freedom the painter had to change and improve, to improvise and refine, his original concept.

Piero della Francesca (c. 1406/12–92) worked in Florence in the 1430s before settling down in his native Borgo San Sepolcro, a Tuscan hill town under papal control. He knew current thinking in art and art theory—including Brunelleschi's system of spatial illusion and linear perspective, Masaccio's powerful modeling of forms and atmospheric perspective, and Alberti's theoretical treatises. Piero was one of the few practicing artists who also wrote about his own theories. Not surprisingly, in his treatise on perspective he emphasized the geometry and the volumetric construction of forms and spaces that were so apparent in his own work.

From about 1454 to 1458, he was in Arezzo, where he decorated the Bacci Chapel of the Church of San Francesco with a cycle of frescoes illustrating the Legend

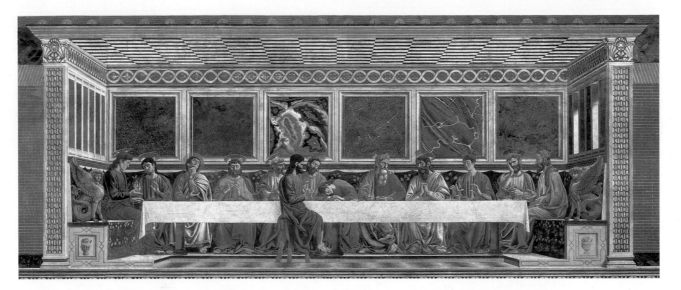

17-65. Andrea del Castagno. *Last Supper*, fresco in the refectory, Convent of Sant'Apollonia, Florence. 1447. Approx. 15' x 32' (4.6 x 9.8 m)

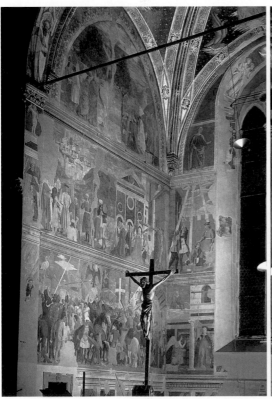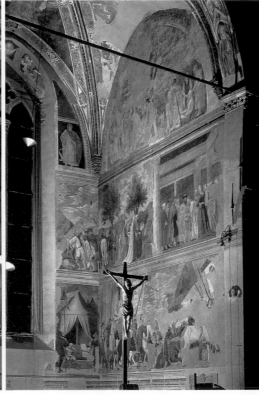

17-66. Piero della Francesca. View of the Bacci Chapel, Church of San Francesco, Arezzo. 1454–58

of the True Cross (fig. 17-66), the cross on which Jesus was crucified. The lunettes at the top display the beginning and end of the story—the death of Adam and the adoration of the Cross. In the center section at the right, the Queen of Sheba visits Solomon (the Cross miraculously appears to her); at the left, Helena (mother of Constantine, the first Christian Roman emperor) discovers and proves the authenticity of the Cross, whose touch resurrects a man being carried to his tomb. The small scenes by the window show the burial of the Cross after the Crucifixion and the torture of the Jew who knew its hiding place. The battle scenes at the bottom illustrate Constantine's defeat of his rival Maxentius with the help of the Cross, and the recovery of the Cross from the Persian ruler Chosroes, who had stolen it and built it into his throne. The small scenes show Constantine's dream, in

which he foresaw victory under a flaming cross (right), and the Annunciation (left). The Annunciation reaffirms Mary's role in making God flesh, beginning the process of redemption that culminates in the Crucifixion.

Piero's analytical modeling and perspectival projection result in a highly believable illusion of space around his monumental figures. He reduced his figures to cylindrical and ovoid shapes and painted the clothing and other details of the setting with muted colors. Particularly remarkable are the foreshortening of figures and objects—shortening the lines of forms seen head-on to align them with the overall perspective system—such as the cross at the right, and the anatomical accuracy of the revived youth's nude figure. Unlike many of his contemporaries, however, Piero gave his figures no expression of human emotion.

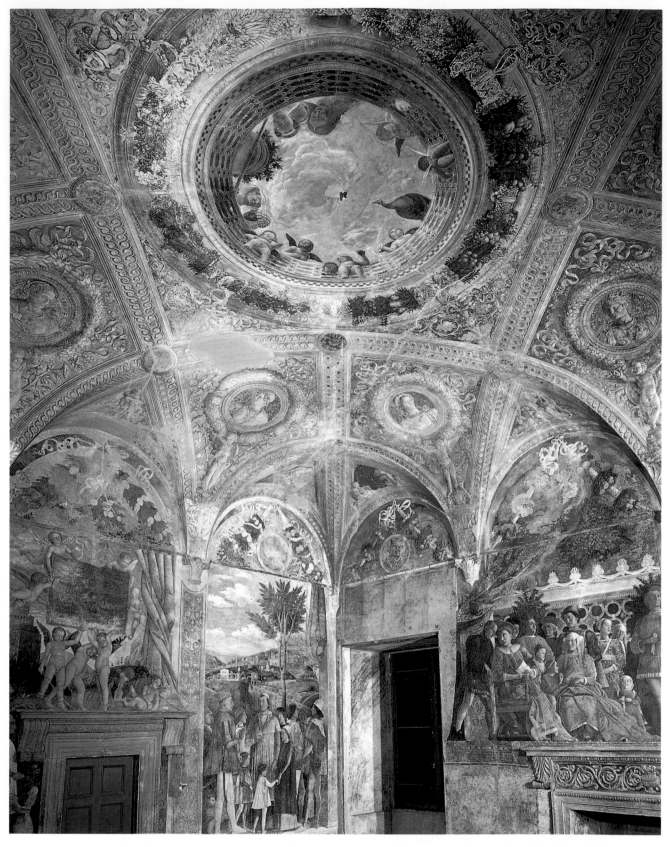

17-67. Andrea Mantegna. Frescoes in the Camera Picta, Ducal Palace, Mantua. 1465–74

One of the most influential fifteenth-century painters born and working outside Florence was Andrea Mantegna (1431–1506) of Padua, to the north. Mantegna entered the painters' guild at the age of fifteen. The greatest influence on the young artist was the sculptor Donatello, who arrived in Padua in 1443 for a decade of work there. By the time Donatello left, Mantegna had fully absorbed the sculptor's Florentine linear-perspective system, which he pushed to its limits with experiments in radical perspective views and the foreshortening of figures. In 1459 Mantegna went to work for Ludovico Gonzaga, the ruler of Mantua, and he continued to work for the Gonzaga family for the rest of his life although he made trips to Florence and Pisa in the 1460s and to Rome

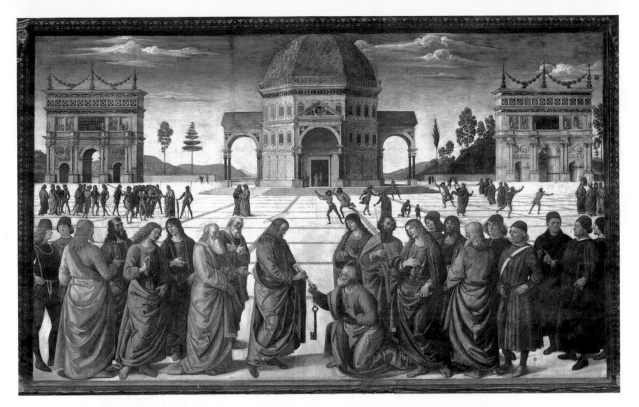

17-68. Perugino. *Delivery of the Keys to Saint Peter*, fresco on the right wall of the Sistine Chapel, Vatican, Rome. 1482. 11'5½" x 18'8½" (3.48 x 5.70 m)

Modern eyes accustomed to gigantic parking lots would not find a large open space in the middle of a city extraordinary, but in the fifteenth century this great piazza was purely the product of artistic imagination. A real piazza this size would have been very impractical. In summer sun or winter wind and rain, such spaces would have been extremely unpleasant for a pedestrian population, but, more important, no city could afford such extravagant use of valuable land within its walls.

in 1488–90. In Mantua the artist became a member of the humanist circle, whose interests in classical literature and archaeology he shared. He often signed his name using Greek letters.

Mantegna's mature style is characterized by the virtuosity of his use of perspective, his skillful integration of figures into their settings, and his love of naturalistic details. His finest works are the frescoes of the Camera Picta ("Painted Room"), a tower chamber in Gonzaga's ducal palace, which Mantegna decorated between 1465 and 1474. On the domed ceiling, the artist painted a tour de force of radical perspective called *di sotto in sù* ("seen from directly below"), which began a long tradition of illusionistic ceiling painting (fig. 17-67). The room appears to be open to a cloud-filled sky through a large oculus in a simulated marble- and mosaic-covered vault. On each side of a precariously balanced planter, three young women and an exotically turbaned African man peer over a marble balustrade into the room below. A fourth young woman in a veil looks dreamily upward. Joined by a large peacock, several **putti** play around the balustrade.

Rome's establishment as a Renaissance center of the arts was greatly aided by Pope Sixtus IV's decision to call to the city the best artists he could find to decorate the walls of his newly built Sistine Chapel. The resolution in 1417 of the Great Schism in the Western Church had secured the papacy in Rome, precipitating the restoration of not only the Vatican but the city as a whole. Among the artists who went to Rome was Pietro Vannucci, called Perugino (c. 1450–1523). Originally from near

the town of Perugia in Umbria, Perugino had been working in Florence since 1472 and left there in 1481 to work on the Sistine wall frescoes. His contribution, *Delivery of the Keys to Saint Peter* (fig. 17-68), portrayed the event that provided biblical support for the supremacy of papal authority, Christ's giving the keys to the kingdom of heaven to the apostle Peter (Matthew 16:19), who became the first bishop of Rome.

Delivery of the Keys is a remarkable work in carefully studied linear perspective that reveals much about Renaissance ideas and ideals. In a light-filled piazza whose banded paving stones provide a geometric grid for perspectival recession, the figures stand like chess pieces on the squares, scaled to size according to their distance from the picture plane and modeled by a consistent light source from the upper left. Horizontally, the composition is divided between the lower frieze of massive figures and the band of widely spaced buildings above. Vertically, it is divided by the open space at the center between Christ and Peter and by the symmetrical architectural forms on each side of this central axis. Triumphal arches inspired by ancient Rome frame the church and focus the attention on the center of the composition, where the vital key is being transferred. The carefully calibrated scene is softened by the subdued colors, the distant idealized landscape and cloudy skies, and the variety of the figures' positions. Perugino's painting is, among other things, a representation of Alberti's ideal city, described in his treatise on architecture as having a "temple" (that is, a church) at the very center of a great

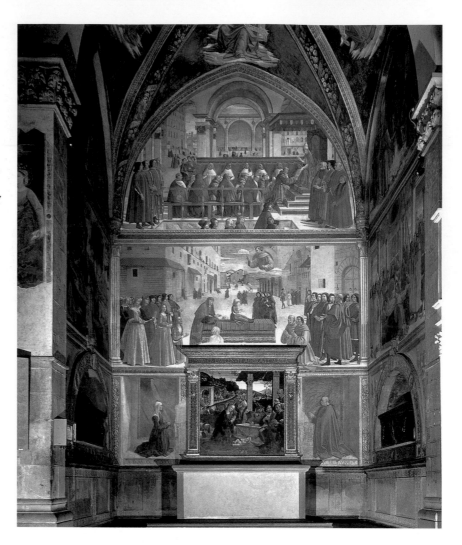

17-69. Domenico Ghirlandaio. View of the Sassetti Chapel, Church of Santa Trinità, Florence. 1482–86, altarpiece 1485

open space raised on a dais and separate from any other buildings that might obstruct its view. His ideal church had a central plan, illustrated here as a domed octagon.

In Florence, the most important painting workshop of the later fifteenth century was that of the painter Domenico di Tommaso Bigordi (1449–94), known as Domenico Ghirlandaio ("Garland Maker"), a nickname adopted by his father, a goldsmith noted for his floral wreaths. A specialist in narrative cycles, Ghirlandaio reinterpreted the art of earlier fifteenth-century painters into a popular visual language of great descriptive immediacy. Flemish painting, seen in Florence after about 1450, had considerable impact on his style; Ghirlandaio's 1485 altarpiece, *The Nativity with Shepherd,* was inspired by Hugo's *Portinari Altarpiece* (see fig. 17-22), which Tommaso Portinari had sent home to Florence from Bruges in 1483, just two years earlier.

Among Ghirlandaio's finest total compositions were frescoes of the life of Saint Francis created between 1482 and 1486 for the Sassetti family burial chapel in the Church of Santa Trinità, Florence (fig. 17-69). In the uppermost tier of paintings, Pope Honorius confirms the Franciscan order. Ghirlandaio transferred the event from thirteenth-century Rome to the Florence of his own day, painting views of the city and portraits of Florentines, taking delight in local color and anecdotes. Perhaps Renaissance painters represented events from the distant past in contemporary terms to emphasize their current relevance, or perhaps they and their patrons simply loved to see themselves in their fine clothes acting out the dramas in the cities of which they were justifiably proud.

Painting in Tempera and Oil. In 1472–73, Piero della Francesca went to the court of Federico da Montefeltro at Urbino, for whom he painted a pair of pendant, or companion, portraits of Federico and his recently deceased wife, Battista Sforza (fig. 17-70). The small panels, painted in tempera in light colors, resemble Flemish painting in their detail and luminosity, their record of surfaces and textures, and their vast landscapes. In the traditional Italian fashion, the figures are portrayed in strict profile, as remote from the viewer as icons. The profile format also allowed for an accurate recording of Federico's likeness without emphasizing two disfiguring scars—the loss of his right eye and his broken nose—from a sword blow. His good left eye is shown, and the angular profile of his nose seems like a distinctive familial trait. Typically, Piero emphasized the underlying geometry of the forms, rendering the figures with an absolute stillness. Dressed in the most elegant fashion, Battista and Federico are silhouetted against a distant view recalling the hilly landscape around Urbino. The portraits may have been hinged as a diptych, since the landscape appears to be nearly continuous across the two panels. The influence of Flemish art also is strong in the careful observation of Battista's jewels and in the well-observed atmospheric perspective. Piero used another northern European device in the harbor view near the

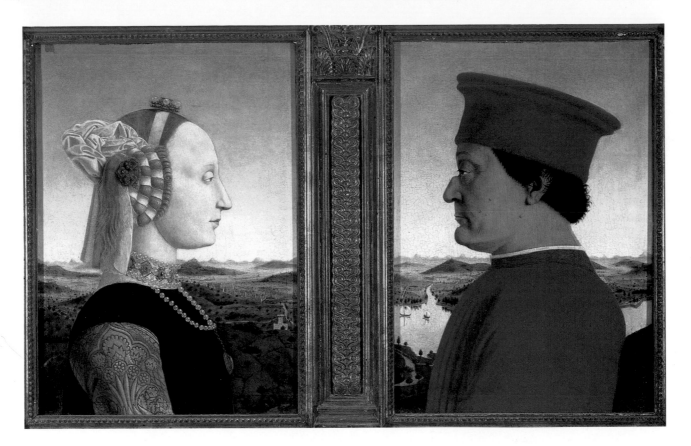

17-70. Piero della Francesca. *Battista Sforza* **(left) and** *Federico da Montefeltro* **(right).** 1472–73. Oil on wood panel, cach 18½ x 13" (47 x 33 cm). Galleria degli Uffizi, Florence

center of Federico's panel: The water narrows into a river and leads the eye into the distant landscape.

In contrast to their northern counterparts, Italian panel painters tended to use tempera rather than oil paint throughout the fifteenth century, but oil painting would soon become dominant. An early example of oil painting is a splendid birth tray—a popular item in Florence, it held gifts of candy and fruit for new mothers—painted by Giovanni di Ser Giovanni (1407–86). The younger brother of Masaccio, Giovanni specialized in small paintings of the Virgin and Child for tabernacles, marriage chests, and birth trays and also designed wood inlay. He was commissioned to paint this tray by Cosimo de' Medici, who gave it to his daughter-in-law, Lucrezia Tornabuoni, in 1449 to honor of the birth of her son Lorenzo (fig. 17-71). The back of the wooden disk carried the parents' coats of arms; the front depicted the Triumph of Fame, a theme that proved to be appropriate for little Lorenzo, who grew up to become Lorenzo "the Magnificent" (1449–92). Lucrezia would have hung the birth tray in her private apartment as a memento of the birth of the heir to a great dynasty.

Sandro Botticelli (1445–1510), too, created some of his most popular paintings under the patronage of the Medici. Botticelli had worked as an assistant to Filipino Lippi and in the studio of Verrocchio; like most artists in the second half of the fifteenth century, he had learned to draw and paint sculptural figures that were modeled by light from a consistent source and placed in a setting rendered with strict linear perspective. An outstanding portraitist, he often included recognizable contemporary figures among the saints and angels in religious paintings. He worked in Florence, then went to Rome,

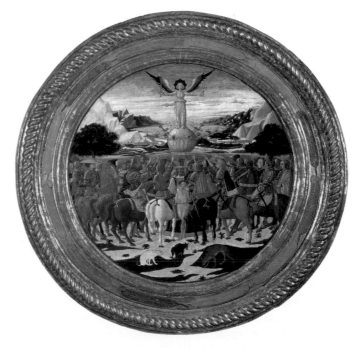

17-71. Giovanni di Ser Giovanni (called lo Scheggia). *The Triumph of Fame,* **birth tray of Lorenzo de' Medici.** 1449. Tempera, silver, and gold on wood, overall diameter 36½" (92.7 cm). The Metropolitan Museum of Art, New York

one of the many artists called to decorate the Sistine Chapel.

In 1481, after returning to Florence from Rome, Botticelli entered a new phase of his career. Like other artists working for patrons steeped in classical scholarship and humanistic speculation, Botticelli was exposed to a

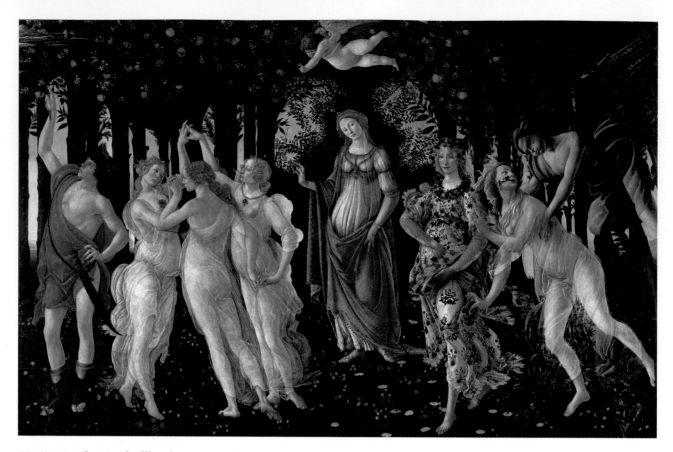

17-72. Sandro Botticelli. *Primavera*. c. 1482. Tempera on wood panel, 6'8" x 10'4" (2.03 x 3.15 m). Galleria degli Uffizi, Florence

philosophy of beauty—as well as to the examples of ancient art in their collections. For the Medici, Botticelli produced secular paintings of mythological subjects inspired by ancient works and by contemporary Neoplatonic thought, including *Primavera*, or *Spring* (fig. 17-72), and *The Birth of Venus* (see fig. 17-73).

The overall appearance of *Primavera* recalls Flemish tapestries, which were popular in Italy at the time. The decorative quality of the painting is deceptive, however, for it is a highly complex allegory, interweaving Neoplatonic ideas with esoteric references to classical sources. Neoplatonic philosophers and poets conceived of Venus, the goddess of love, as having two natures, one terrestrial and the other celestial. The first ruled over earthly, human love and the second over universal love, making her a classical equivalent of the Virgin Mary. *Primavera* was painted at the time of a Medici wedding, so it may have been intended as a painting on the theme of love and fertility in marriage. Silhouetted and framed by an arching view through the trees at the center of *Primavera* is Venus. She is flanked on the right by Flora, a Roman goddess of flowers and fertility, and on the left by the Three Graces. Her son, Cupid, hovers above, playfully aiming an arrow at the Graces. At the far right is the wind god, Zephyr, in pursuit of the nymph Chloris, his breath causing her to sprout flowers from her mouth. At the far left, the messenger god, Mercury, uses his characteristic snake-wrapped wand, the caduceus, to dispel a patch of gray clouds drifting in Venus's direction. He is the sign of the month of May, and he looks out of the painting and onto summer. Venus, clothed in contemporary costume and wearing a marriage wreath on her head, here represents her terrestrial nature, governing marital love. She stands in a grove of orange trees (a Medici symbol) weighted down with lush fruit, suggesting human fertility; Cupid embodies romantic desire, and as practiced in central Italy in ancient times, the goddess Flora's festival had definite sexual overtones.

Several years later, some of the same mythological figures reappeared in Botticelli's *Birth of Venus* (fig. 17-73), whose central image, a type known as the modest Venus, is based on an antique statue of Venus in the Medici collection. The classical goddess of love and beauty, born of sea foam, floats ashore on a scallop shell, gracefully arranging her hands and hair to hide—or enhance—her sexuality. Blown by the wind, Zephyr (and his love, the nymph Chloris), and welcomed by a devotee holding a garment embroidered with flowers, Venus arrives at her earthly home. The circumstances of this commission are uncertain, but the links between this painting and *Primavera* inspired Neoplatonic debate about the meaning of the "two Venuses"—one sacred, one profane (see fig. 7, Introduction).

Botticelli's later career was affected by a profound spiritual crisis. While Botticelli was creating his mythologies, a Dominican monk, Fra Girolamo Savonarola (ruled 1494–98), had begun to preach impassioned sermons denouncing the worldliness of Florence. Many Florentines reacted with orgies of self-recrimination, and processions of weeping penitents wound through the streets. Botticelli, too, fell into a state of religious fervor. In a dramatic gesture of repentance, he burned many of his earlier paintings and began to produce highly emotional pictures pervaded by an intense religiosity.

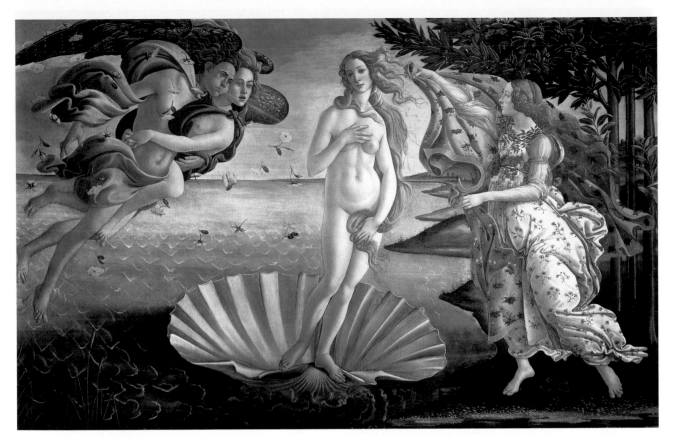

17-73. Sandro Botticelli. *The Birth of Venus*. c. 1484–86. Tempera on canvas, 5'8⁷/₈" x 9'1⁷/₈" (1.8 x 2.8 m). Galleria degli Uffizi, Florence

In 1500, when many people feared that the end of the world was imminent, Botticelli painted the *Mystic Nativity* (fig. 17-74), his only signed and dated painting. Botticelli's Nativity takes place in a rocky, forested landscape whose cave-stable follows the tradition of the Eastern Orthodox (Byzantine) Church, while the timber shed in front recalls the Western iconographic tradition. In the center of the painting, the Virgin Mary kneels in adoration of the Christ Child, who lies on the earth, as recorded in the vision of the fourteenth-century mystic Bridget (see also Hugo van der Goes's *Portinari Altarpiece*, fig. 17-22, which would have been a familiar precedent). Joseph crouches and hides his face, while the ox and the ass bow their heads to the Holy Child. The shepherds at the right and the Magi at the left also kneel before the Holy Family. A circle of singing angels holding golden crowns and laurel branches flies jubilantly above the central scene. Tiny devils, vanquished by the coming of Christ, try to escape from the bottom of the picture.

The most unusual element of the painting is the frieze of wrestling figures below the Holy Family. The men are ancient classical philosophers, who ceremonially struggle with angels. Each of the three pairs holds an olive branch and a scroll, as do the angels circling above,

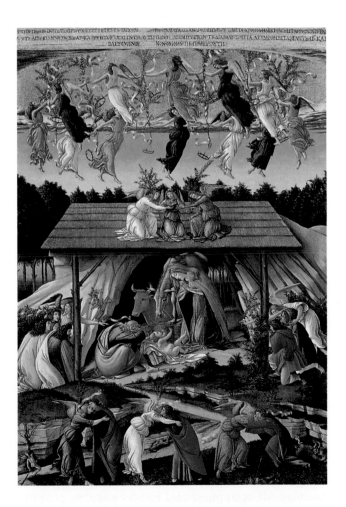

17-74. Sandro Botticelli. *Mystic Nativity*. 1500. Oil on canvas, 42 x 29½" (106.7 x 74.9 cm). The National Gallery, London

This is the only work signed and dated by Botticelli (in Greek): "I Alessandro made this picture at the conclusion of the 1500th year" (National Gallery, Washington, D.C. files).

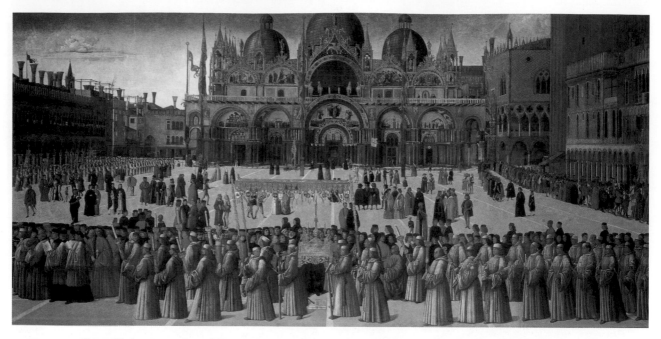

17-75. Gentile Bellini. *Procession of the Relic of the True Cross before the Church of Saint Mark.* 1496. Oil on canvas, 10'7" x 14' (3.23 x 4.27 m). Galleria dell'Accademia, Venice

Every year on the Feast of Saint Mark (April 25) the Confraternity of Saint John the Evangelist (one of six major confraternities in Venice) carried the miracle-working relic of the True Cross in a procession through the square in front of the Church of Saint Mark, seen in the background. The relic, in a gold reliquary under a canopy, is surrounded by marchers with giant candles, led by a choir, and followed at the far right by the *doge* (the city's ruler) and other officials. The painting commemorates the miraculous recovery of a sick child whose father, the man in red kneeling to the right of the relic, prayed for help as the relic passed by.

whose scrolls are inscribed with the words: "Glory to God in the Highest; peace on earth to men of good will." In fifteenth-century Florence, Palm Sunday, the festival of Christ the King, was called Olive Sunday and olive branches, symbols of peace, rather than palms were carried in processions. The inscription at the top of the painting reads (in Greek): "I Alessandro made this picture at the conclusion of . . . [a millennium and a half], according to the 11th chapter of Saint John in the second woe of the Apocalypse, during the loosing of the devil for three and a half years, then he will be bound in the 12th chapter and we shall see [missing word] as in this picture." The references are to the Book of Revelation, chapter 11, which describes woes to come, and Revelation 12, which includes the vision of a woman crowned with stars and clothed by the sun, taken by Christians as a prophesy of the Virgin Mary, and the description of the defeat of Satan. Thus, in this painting Christ has come to save humankind in spite of the troubles Botticelli saw all around him. Savonarola had been burned at the stake only two years before Botticelli painted this picture. By the end of his own life, Botticelli had given up painting altogether.

Oil Painting in Venice. In the last quarter of the fifteenth century, Venice—once a center of Byzantine art—emerged as a major artistic center of Renaissance painting. From the late 1470s on, the domes of the Church of Saint Mark dominated the city center, and the rich colors of its glowing mosaics captured painters' imaginations. Venetian painters embraced the oil medium for both panel and canvas painting, probably introduced by Antonello da Messina (c. 1430–79), an influential Sicilian painter who had studied in Flanders

before working in Venice. The most important Venetian artists of this period were two brothers, Gentile (c. 1429–1507) and Giovanni (c. 1430–1516) Bellini, whose father, Jacopo (active c. 1423–70), also was a central figure in Venetian art. Jacopo, who had worked for a short time in Florence, was a theorist who produced books of drawings in which he experimented with linear perspective. Andrea Mantegna was also part of this circle, for he had married Jacopo's daughter in 1453.

Gentile Bellini celebrated the daily life of the city in large, lively narratives, such as the *Procession of the Relic of the True Cross before the Church of Saint Mark* (fig. 17-75). The painting of 1496 depicted an event that had occurred fifty-two years earlier: During a procession in which a relic of the True Cross was carried through Venice's Saint Mark's Piazza, a miraculous healing occurred, which was attributed to the relic. Gentile rendered the cityscape with great accuracy and detail.

His brother, Giovanni, amazed and attracted patrons with his artistic virtuosity for almost sixty years. *Virgin and Child Enthroned with Saints Francis, John the Baptist, Job, Dominic, Sebastian, and Louis of Toulouse* (fig. 17-76), painted about 1478 for the Church of San Giobbe (Saint Job), exhibits a dramatic perspectival view up into a vaulted apse. Certainly Giovanni knew his father's perspective drawings well, and he may also have been influenced by his brother-in-law Mantegna's early experiments in radical foreshortening and the use of a low vanishing point. In Giovanni's painting, the vanishing point for the rapidly converging lines of the architecture lies at the center, on the feet of the lute-playing angel. Also, the pose of Saint Sebastian, his body pierced by arrows, at the right recalls a famous *Saint Sebastian* by Mantegna. Giovanni has

17-76. Giovanni Bellini. *Virgin and Child Enthroned with Saints Francis, John the Baptist, Job, Dominic, Sebastian, and Louis of Toulouse*, from the Church of San Giobbe, Venice. c. 1478. Oil on wood panel, 15'4" x 8'4" (4.67 x 2.54 m). Galleria dell'Accademia, Venice

Art historians have given a special name, *sacra conversazione* ("holy conversation"), to this type of composition showing saints, angels, and sometimes even the painting's donors in the same pictorial space with the enthroned Virgin and Child. Despite the name, no conversation or other interaction among the figures takes place in a literal sense. Instead, the individuals portrayed are joined in a mystical and eternal communion occurring outside of time, in which the viewer is invited to share.

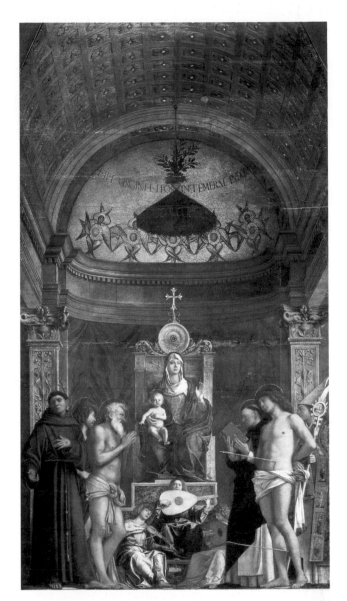

placed his figures in a Classical architectural interior with a coffered barrel vault, reminiscent of Masaccio's *Trinity* (see fig. 17-59). The gold mosaic, with its identifying inscription and stylized **seraphim** (angels of the highest rank), recalls the art of the Byzantine Empire in the eastern Mediterranean and the long tradition of Byzantine-inspired painting and mosaics produced in Venice.

Giovanni Bellini demonstrates the intense investigation and recording of nature associated with the early Renaissance. His early painting of *Saint Francis in Ecstasy* (fig. 17-77), painted in the 1470s, illustrates his command of an almost Flemish realism. The saint stands in communion with nature, bathed in early morning sunlight, his outspread hands showing the **stigmata** (the miraculous appearance of Christ's wounds on the saint's body). Francis had moved to a cave in the barren wilderness in his search for communion with God, but in this landscape, the fields blossom and flocks of animals graze. The grape arbor over his desk and the leafy tree toward which he directs his gaze add to an atmosphere of sylvan delight. True to fifteenth-century religious art, however, Bellini unites Old and New Testament themes to associate Francis with Moses and Christ: The tree symbolizes the burning bush; the stream, the miraculous spring brought forth by Moses; the grapevine and the stigmata, Christ's sacrifice. The crane and donkey represent the monastic virtue of patience. The detailed realism, luminous colors, and symbolic elements suggest Flemish art, but the golden light suffusing the painting is associated with Venice, a city of mist, reflections, and above all, color.

Giovanni's career spanned the second half of the fifteenth century, but he produced many of his greatest paintings in the early years of the sixteenth, when his work matured into a grand, simplified, idealized style. Although his work is often discussed with that of Leonardo da Vinci in the sixteenth century, it seems fitting to end our consideration of the first phase of Renaissance painting in Italy with Giovanni Bellini as an important and influential bridge to the future.

17-77. Giovanni Bellini. *Saint Francis in Ecstasy.*
1470s. Oil and tempera on wood panel, 49 x 55⅞" (125 x 142 cm). The Frick Collection, New York

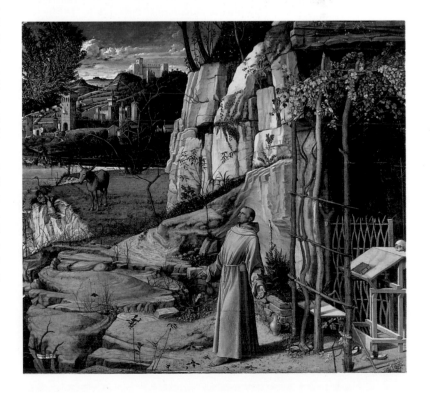

PARALLELS

REGION	RENAISSANCE ART	ART IN OTHER CULTURES
ITALY	**17-2.** Giotto. Scrovegni (Arena) Chapel, Padua (1305–6)	**20-3.** *Kalpa Sutra* (c. 1375–1400), India
	17-48. Nanni. *Four Crowned Martyrs* (c. 1410–13)	**21-6.** Ming flask (c. 1426–35), China
	17-33. Brunelleschi. Florence Cathedral Dome (1417–36)	**22-2.** Bunsei. *Landscape* (mid-15th cent.), Japan
	17-35. Brunelleschi. Foundling Hospital, Florence (1419–44)	**22-4.** Ikkyu. *Calligraphy* (mid-15th cent.), Japan
	17-51. Donatello. *David* (c. 1420–60s)	**23-5.** Aztec *Mother Goddess* (15th cent.), Mexico
		23-9. Inka llama (15th cent.), Bolivia (?)
		23-8. Inka tunic (15th cent.), Peru
		22-5. Ryoan-ji garden (c. 1480), Japan
	17-36. Brunelleschi. Church of San Lorenzo, Florence (c. 1421–46)	**21-9.** Shen Zhou. *Poet on a Mountain Top* (c. 1500), China
	17-58. Fabriano. *Adoration of the Magi* (1423)	
	17-50. Donatello. *Feast of Herod* (mid-1420s)	
	17-49. Ghiberti. Gates of Paradise, Baptistry of San Giovanni, Florence (1425–52)	
	17-59. Masaccio. *Trinity with the Virgin, Saint John the Evangelist, and Donors* (c. 1425–27/28)	
	17-61. Masaccio. *The Expulsion from Paradise* (c. 1427)	
	17-63. Masaccio. *Tribute Money* (c. 1427)	
	17-1. Uccello. *Battle of San Romano* (1430s[?])	
	17-64. Fra Angelico. *Annunciation* (c. 1441–45)	
	17-53. Donatello. *Gattamelata* (1443–53)	
	17-38. Bartolommeo. Palazzo Medici-Riccardi, Florence (begun 1444)	
	17-65. Castagno. *Last Supper* (1447)	
	17-71. lo Scheggia. Birth tray of Lorenzo de' Medici (1449)	
	17-66. Piero della Francesca. Bacci Chapel, Arezzo (1454–58)	
	17-39. Alberti. Palazzo Rucellai, Florence (1455–70)	
	17-52. Donatello. *Mary Magdalen* (c. 1455)	
	17-57. Della Robbia. *Madonna and Child with Lilies* (c. 1455–60)	
	17-67. Mantegna. Camera Picta frescoes (1465–74)	
	17-32. Pollaiuolo. *Battle of the Nudes* (c. 1465–70)	
	17-46. Laurana. Ducal Palace, Urbino (1465–79)	
	17-40. Alberti. Church of Sant'Andrea, Mantua (designed 1470)	
	17-47. *Studiolo*, Urbino (1470s)	
	17-77. Giovanni Bellini. *St. Francis in Ecstasy* (1470s)	
	17-70. Piero della Francesca. *Battista Sforza* (1472–73)	
	17-55. Pollaiuolo. *Hercules and Antaeus* (c. 1475)	
	17-76. Giovanni Bellini. *Virgin and Child Enthroned* (c. 1478)	
	17-69. Ghirlandaio. Sassetti Chapel, Florence (1482–86)	
	17-56. Faenza *albarello* (c. 1480)	
	17-68. Perugino. *Delivery of the Keys to Saint Peter* (1482)	
	17-72. Botticelli. *Primavera* (c. 1482)	
	17-73. Botticelli. *The Birth of Venus* (c. 1484–86)	
	17-43. Sangallo. Santa Maria delle Carceri, Prato (before 1485)	

REGION	RENAISSANCE ART
	17-54. Verrocchio. Equestrian monument of Bartolommeo Colleoni (c. 1486–96)
	17-75. Gentile Bellini. *Procession of the Relic of the True Cross* (1496)
	17-74. Botticelli. *Mystic Nativity* (1500)
	17-5. *Ideal City with a Fountain and Statues of the Virtues* (c. 1500)
FLANDERS	**17-4.** Campin. *Mérode Altarpiece* (c. 1425–28)
	17-62. Van Eyck. *Adam* (1432)
	17-13. Van Eyck. *Man in a Red Turban* (1433)
	17-14. Van Eyck. Arnolfini wedding portrait (1434)
	17-12. Van Eyck. *The Annunciation* (c. 1434–36)
	17-15. Van der Weyden. *Deposition* (c. 1442)
	17-16. Van der Weyden. *Last Judgment Altarpiece* (after 1443)
	17-18. Christus. *St. Eloy (Eligius) in His Shop* (1449)
	17-24. Golden Fleece cope (mid-15th cent.)
	17-26. Monkey Cup (mid-15th cent.)
	17-17. Van der Weyden. *Portrait of a Lady* (c. 1460)
	17-19. Bouts. *Wrongful Execution of the Count* (1470–75)
	17-22. Van der Goes. *Portinari Altarpiece* (c. 1474–76)
	17-23. Mary of Burgundy Painter. *Mary at Her Devotions* (before 1482)
	17-20. Memling. St. Ursula reliquary (1489)
GERMANY	**17-30.** *The Buxheim St. Christopher* (1423)
	17-29. Witz. *Miraculous Draft of Fish* (1444)
	17-31. Schongauer. *Temptation of St. Anthony* (c. 1480–90)
FRANCE	**17-8.** Broederlam. *Annunciation and Visitation* (1394–99)
	17-7. Sluter. Well of Moses (1395–1406)
	17-6. Limbourg brothers. *Très Riches Heures* (1413–16)
	17-9. Church of Saint-Maclou, Rouen (1436–1521)
	17-10. Jacques Coeur house, Bourges (1443–51)
	17-28. Fouquet. *Melun Diptych* (c. 1450)
	17-25. *Hunt of the Unicorn* tapestry (c. 1498–1500)
IBERIA	**17-27.** Gonçalvez. *Altarpiece of St. Vincent* (c. 1471–81)

Io già faclo ūgozo īquesto steto
chome fa lacqua agacti ilonbardia
over daltro paese ch'essi chesisia
cha forza luetre apicha soctolmeto

La barba alcielo ellamemoria sento
īsullo scrignio elpecto fo darpia
elpennel sopraluiso tuctavia
melfa gocciando ū richo pauimeto

E lobbi entrati miso nella peccia
e fo delcul p̄ chotrapeso groppa
e passi seza gliochi muouo īuano

Dimāzi misalluga lachorteccia
ep̄ piegarsi adietro sragroppa
e tēdomi comarcho soriano

po fallace e strano
surgie iludicio ch̄ lamete porta
ch̄ mal si tra p̄ cerboctana torta

lamia pictura morta
di fedi orma giouanni elmio onore
nō sēdo īloco bō ne io pictore

18
Renaissance Art in Sixteenth-Century Europe

18-1. **Michelangelo. Sonnet with a self-portrait of the artist in the right margin, painting the ceiling over his head.** c. 1510. Pen and ink on paper, 11 x 7" (39 x 27.5 cm). Casa Buonarroti, Florence, Italy
Archivo Buonarotti vol. XII, fol. 11

Rarely before the nineteenth century did artists express in writing their reactions to a commission. But Michelangelo was not just an artist—he was a poet as well, and he described in a sonnet for his friend Giovanni da Pistoia (fig. 18-1) his discomfort as he clung to a scaffold, painting the ceiling of the pope's chapel:

> This miserable job has given me a goitre like the cats in Lombardy get from the water there—
> or somewhere else. . . .
> Beard to the sky, I feel my seat of memory rests on a hump. . . . Brush splatterings make a
> mosaic pavement of my face.
> My loins have moved into my guts. As a counterweight, I stick my bum out like a horse's rump.
> Without the aid of eyes to steer their way, my feet take aimless steps.
> Stretched taut in front, my skin meets up behind as I bend backward like a Syrian bow.
> Just as a gun that's bent will never find its mark, so, waywardly I shoot false judgements . . .
> from my mind.
> Giovanni, take up my cause, defend both my dead painting and my reputation.
> I'm in a poor state and I'm not a painter. (Hughes, page 132)

Earlier, Michelangelo had successfully begun a large commission for Florence Cathedral, but Pope Julius II (papacy 1503–13) ordered him to stop that project and go immediately to Rome to work on a spectacular tomb-monument Julius planned for himself. Michelangelo had barely begun the new project when the pope changed his mind and ordered him to paint the Sistine Chapel ceiling instead (see fig. 18-13).

Michelangelo considered himself a sculptor—"I'm not a painter," he wrote bluntly at the end of his sonnet—but the strong-minded pope forced Michelangelo to paint against his will, and Michelangelo was not the sort to do anything halfway: He mastered the fresco technique and, despite his physical misery as he stood on a scaffold, painting the ceiling just above him, managed to achieve the desired visual effects for viewers standing on the floor far below. Not only did he create a masterpiece of religious art, but his *Sistine Ceiling* also established a new and extraordinarily powerful style in Renaissance painting.

1500	1520	1540

▲ 1517 LUTHER PROTESTS CHURCH'S ▲ ▲ 1519–56 CHARLES V IS HOLY ROMAN EMPEROR ▲ 1534 JESUIT ORDER FOUNDED;
 SALE OF INDULGENCES CHURCH OF ENGLAND SEPARATES
 ▲ 1522 FIRST CIRCUM- ▲ ▲ 1527 CHARLES V FROM ROMAN CHURCH
 NAVIGATION OF EARTH ORDERS SACK OF ROME

TIMELINE 18-1. **Sixteenth-Century Europe.** The century of the Renaissance was marked by exploration, major territorial wars, challenges to the Church, and the steady advance of secularization.

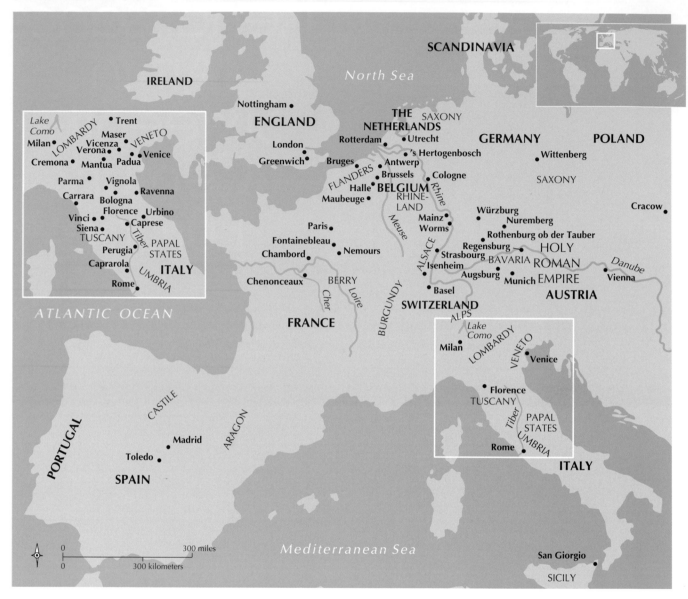

EUROPE IN THE SIXTEENTH CENTURY

The sixteenth century was an age of social, intellectual, and religious ferment that transformed European culture; it was also marked by continual warfare triggered by the expansionist ambitions of the continent's various rulers. The humanism of the fourteenth and fifteenth centuries, with its medieval roots and its often uncritical acceptance of the authority of classical texts, slowly gave way to a spirit of discovery that led Europeans to explore new ideas, the natural world, and lands previously unknown to them. The use of the printing press caused an explosion in the number of books available, spreading new ideas through the publication in translation of ancient and contemporary texts, broadening the horizons of educated Europeans,

and enabling more people to learn to read. Travel became more common, and much moreso than in earlier centuries, artists and their work became mobile; consequently, artistic styles became less regional and more "international (Timeline 18-1)."

At the start of the sixteenth century, England, France, and Portugal were national states under strong monarchs (Map 18-1). Central Europe (Germany) was divided into dozens of free cities and territories ruled by nobles, but even states as powerful as Saxony and Bavaria acknowledged the overlordship of the Habsburg (Holy Roman) Empire, the greatest power in Europe. Charles V, elected Holy Roman Emperor in 1519, added Spain, the Netherlands, and vast territories in the Americas to the realm. Italy, which was divided into many small states, was a diplomatic and military battlefield where

▲ 1550 VASARI'S *LIVES* PUBLISHED

▲ 1558 ELIZABETH I QUEEN OF ENGLAND

▲ 1576 DUTCH UNITE
AGAINST SPANISH RULE

▲ 1588 ENGLISH DEFEAT SPANISH
NAVY IN SPANISH ARMADA

1598 EDIT OF NANTES TOLERATES PROTESTANTS IN FRANCE ▲

MAP 18-1. (opposite)
Sixteenth-Century Europe. The sixteenth century in Europe was a period of dramatic political, intellectual, religious, and artistic change, which became known as the Renaissance.

the Italian states, Habsburg Spain, France, and the papacy warred against each other in shifting alliances for much of the century. The popes themselves behaved like secular princes, using diplomacy and military force to regain control over the Papal States in central Italy and in some cases even to establish their families as hereditary rulers. The popes' incessant demands for money, particularly to finance the rebuilding of Saint Peter's (as well as their self-aggrandizing construction and art projects and luxurious life-styles) aggravated the religious dissent that had long been developing, especially north of the Alps, and contributed greatly to the rise of Protestantism.

The political maneuvering of Pope Clement VII (papacy 1523–34), a Medici, led to a direct clash with

GREAT PAPAL PATRONS OF THE SIXTEENTH CENTURY

Alexander VI (Borgia) papacy 1492–1503
Julius II (della Rovere) papacy 1503–13
Leo X (Medici) papacy 1513–21
Clement VII (Medici) papacy 1523–34
Paul III (Farnese) papacy 1534–49

Holy Roman Emperor Charles V. In May 1527, Charles's German mercenary troops attacked Rome, beginning a six-month orgy of killing, looting, and burning. The Sack of Rome, as it is called, shook the sense of stability and humanistic confidence that until then had characterized the Renaissance and sent many artists fleeing the ruined city. Nevertheless, Charles led the Catholic forces, and in 1530 the Clement VII crowned him emperor in Bologna.

THE CHANGING STATUS OF ARTISTS

Although only rare sixteenth-century artists like Michelangelo made public their feelings about their commissions, many others recorded their activities in private diaries, notebooks, and letters that have come down to us. In addition, contemporary writers reported on everything about artists, from their physical appearance to their personal reputation. Giorgio Vasari's *Lives of the Most Excellent Italian Architects, Painters and Sculptors*—the first art history book—appeared in 1550.

Sixteenth-century patrons valued artists highly and rewarded them well, not only with generous commissions but sometimes even with high social status (Charles V, for example, knighted the painter Titian). Some painters and sculptors became entrepreneurs, selling prints of their works on the side. The sale of prints was a means by which reputations and styles became widely known, and a few artists of stature became international celebrities. With their new fame and independence, the most successful artists could decide which commissions to accept or reject.

During this period, artists argued that the conception of a painting, sculpture, or work of architecture was a liberal—rather than a manual—art that required education in the classics and mathematics. The artist could express as much through painted, sculptural, and architectural forms as the poet could with words or the musician with melody. The myth of the divinely inspired creative genius—which arose during the Renaissance—is still with us today. The newly elevated status of artists worked against women's participation in the visual arts, however, because genius was then believed to be reserved for men. Few women had access to the humanistic education required for the sophisticated, often esoteric, subject matter used in paintings or to the studio practice necessary to draw nude figures in foreshortened poses. Furthermore, an artist could not achieve international status without traveling extensively and frequently relocating to follow commissions. Still, women artists were active in Europe despite the obstacles to their entering *any* profession.

THE CLASSICAL PHASE OF THE RENAISSANCE IN ITALY

Italian art from the 1490s to about the time of the Sack of Rome—characterized by self-confident humanism, admiration of classical art, and a prevailing sense of stability and order—has been called variously the High Renaissance, the Imperial Style, and the classical phase of the Renaissance. Outstanding Italian artists, trained and practicing in Rome, Florence, and northern Italy, also worked in other Italian cities and in Spain, France, Germany, and the Netherlands, spreading Renaissance humanism and the Italian Renaissance style throughout Europe.

Two important developments at the turn of the sixteenth century affected the arts in Italy: In painting, the use of tempera gave way to the more flexible oil technique, and commissions from private sources increased. Artists no longer depended on the patronage of the Church or royalty, as many patrons in Italy and other European countries amassed wealth and became avid collectors of paintings and small bronzes, as well as coins, minerals and fossils from the natural world, and antiquities.

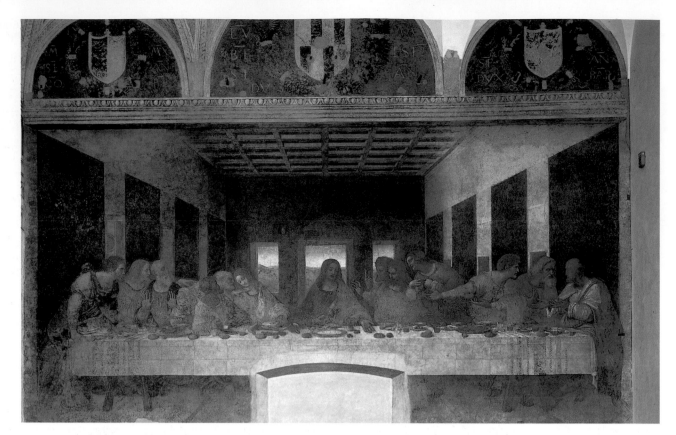

18-2. Leonardo. *The Last Supper*, wall painting in the refectory of the Monastery of Santa Maria delle Grazie, Milan, Italy. 1495–98. Tempera and oil on plaster, 13'2" x 29'10" (4.19 x 9.09 m)

Instead of painting in fresco, Leonardo devised an experimental technique for this mural. Hoping to achieve the freedom and flexibility of painting on wood panel, he worked directly on dry *intonaco*—a thin layer of smooth plaster—with an oil-and-tempera paint whose formula is unknown. The result was disastrous. Within a short time, the painting began to deteriorate, and by the middle of the sixteenth century its figures could be seen only with difficulty. In the seventeenth century, the monks saw no harm in cutting a doorway through the lower center of the composition. Since then the work has barely survived, despite many attempts to halt its deterioration and restore its original appearance. The painting narrowly escaped complete destruction in World War II, when the refectory was bombed to rubble around its heavily sandbagged wall. The most recent restoration began in 1979. The coats of arms at the top are those of patron Ludovico Sforza, the duke of Milan (ruled 1476–99), and his wife, Beatrice.

THREE GREAT ARTISTS OF THE CLASSICAL PHASE

Florence's great fifteenth-century art works and tradition of arts patronage attracted a stream of young artists to the city, which has been considered the cradle of the Italian Renaissance since Vasari labeled it such in 1550. The frescoes in the Brancacci Chapel there (see fig. 17-60) inspired young artists, who went to study Masaccio's solid, monumental figures and eloquent facial features, poses, and gestures. For example, the young Michelangelo's sketches of the chapel frescoes clearly show the importance of Masaccio on his developing style. Along with Michelangelo, Leonardo and Raphael—together, the three leading artists of the classical phase of the Italian Renaissance—began their careers in Florence, although they soon moved to other centers of patronage and their influence spread far beyond that city.

Leonardo da Vinci. Leonardo da Vinci (1452–1519) was twelve or thirteen when his family moved to Florence from the Tuscan village of Vinci. He was apprenticed to the shop of the painter and sculptor Verrocchio until about 1476. After a few years on his own, Leonardo traveled to Milan in 1481 or 1482 to work for the court of the ruling Sforza family.

He spent much of his time in Milan on military and civil engineering projects, including an urban-renewal plan for the city, but he also created one of the monuments of Renaissance art there: At Duke Ludovico Sforza's request, Leonardo painted *The Last Supper* (fig. 18-2) in the refectory, or dining hall, of the Monastery of Santa Maria delle Grazie in Milan between 1495 and 1498. In fictive space defined by a **coffered** ceiling and four pairs of tapestries that seem to extend the refectory into another room, Jesus and his disciples are seated at a long table placed parallel to the **picture plane** and to the living diners seated below. The stagelike space recedes from the table to three windows on the back wall, where the vanishing point of the **one-point perspective** lies behind Jesus' head. Jesus' outstretched arms form a pyramid at the center, and the disciples are grouped in threes on each side. As a narrative, the scene captures the moment when Jesus tells his companions that one of them will betray him. They react with shock, disbelief, and horror. Judas, clutching his money bag in the shadows to the left of Jesus, has recoiled so suddenly that he has upset the salt dish, a bad omen. Leonardo

was an acute observer of human beings and his art vividly expressed human emotion.

On another level, *The Last Supper* is a symbolic evocation of both Jesus' coming sacrifice for the salvation of humankind and the institution of the ritual of the Mass. Breaking with traditional representations of the subject, such as the one by Andrea del Castagno (see fig. 17-65), Leonardo placed the traitor Judas in the first triad to the left of Jesus, with the young John the Evangelist and the elderly Peter, rather than isolating him on the opposite side of the table. Judas, Peter, and John were each to play an essential role in Jesus' mission: Judas to set in motion the events leading to Jesus' sacrifice; Peter to lead the Church after Jesus' death; and John, the visionary, to foretell the Second Coming and the Last Judgment in the Apocalypse. By arranging the disciples and architectural elements into four groups of three, Leonardo incorporated a medieval tradition of numerical symbolism. He eliminated another symbolic element—the halo—and substituted the natural light from a triple window framing Jesus' head (compare Rembrandt's reworking of the composition, fig. 18, Introduction).

The painting's careful geometry, the convergence of its perspective lines, the stability of its pyramidal forms, and Jesus' calm demeanor amid the commotion all reinforce a sense of order. The work's qualities of stability, calm, and timelessness, coupled with the established Renaissance forms modeled after those of classical sculpture, characterize the art of the Renaissance at the beginning of the sixteenth century.

Leonardo returned to Florence in 1498, when the French, who had invaded Italy in 1494, claimed Milan. (Two years later they captured Leonardo's Milanese patron, Ludovico Sforza, who remained imprisoned until his death in 1508.) About 1500, Leonardo produced a large drawing of the *Virgin and Saint Anne with the Christ Child and the Young John the Baptist* (fig. 18-3). This work was once thought to be a full-scale model, called a **cartoon**, for a major painting, but no known painting can be associated with it. Scholars today believe it to be a finished work—perhaps one of the drawings artists often made as gifts in the sixteenth century. Mary sits on the knee of her mother, Anne, and turns to the right to hold the Christ Child, who strains away from her to reach toward his cousin, the young John the Baptist. Leonardo created the illusion of high relief by modeling the figures with strongly contrasted light and shadow, a technique called **chiaroscuro** (Italian for "light-dark"). Carefully placed highlights create a circular movement rather than a central focus, which retains the individual importance of each figure while also making each of them an integral part of the whole. This effect is emphasized by the figures' complex interactions, which are suggested by their exquisitely tender expressions, particularly those of Saint Anne and the Virgin.

Between about 1503 and 1506, Leonardo painted the renowned portrait known as *Mona Lisa* (fig. 18-4), which

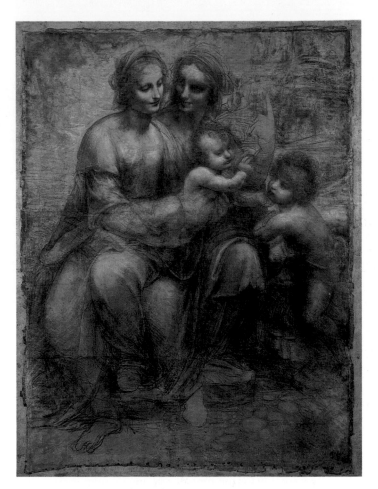

18-3. Leonardo. *Virgin and Saint Anne with the Christ Child and the Young John the Baptist*. c. 1500–1501. Charcoal heightened with white on brown paper, 54⁷/₈ x 39⁷/₈" (139 x 101 cm). The National Gallery, London

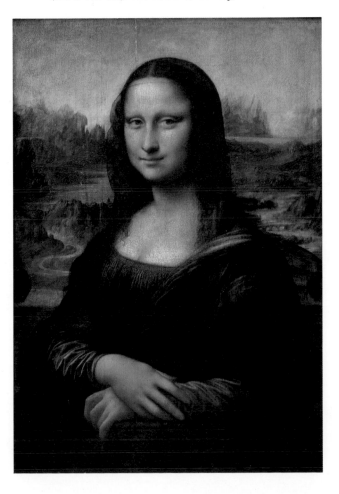

18-4. Leonardo. *Mona Lisa*. c. 1503–6. Oil on wood panel, 38¹/₂ x 21" (97.8 x 53.3 cm). Musée du Louvre, Paris

Artists throughout history have turned to geometric shapes and mathematical proportions to seek the ideal representation of the human form. Leonardo da Vinci, and before him Vitruvius, equated the ideal man with both circle and square. Ancient Egyptian artists laid out square grids as aids to design. Medieval artists adapted a variety of figures, from triangles to pentagrams. The Byzantines used circles swung from the bridge of the nose to create face, head, and halo.

The first-century BCE Roman architect and engineer Vitruvius, in his ten-volume *De architectura (On Architecture),* wrote: "For if a man be placed flat on his back, with his hands and feet extended, and a pair of compasses centered at his navel, the fingers and toes of his two hands and feet will touch the circumference of a circle described therefrom. And just as the human body yields a circular outline, so too a square figure may be found from it. For if we measure the distance from the soles of the feet to the top of the head, and then apply that measure to the outstretched arms, the breadth will be found to be the same as the height" (Book III, Chapter 1, Section 2). Vitruvius determined that the body should be eight heads high. Leonardo added his own observations in the reversed writing he always used for his notebooks when he created his well-known diagram for the ideal male figure, called the *Vitruvian Man.*

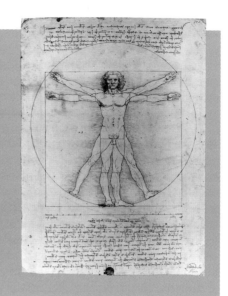

Leonardo. *Vitruvian Man.* c. 1487–90. Ink, approx. 13¹/₂ x 9⁵/₈" (34.3 x 24.5 cm). Galleria dell'Accademia, Venice

he kept with him for the rest of his life. The subject may have been twenty-four-year-old Lisa Gherardini del Giocondo, the wife of a prominent merchant in Florence. Remarkably for the time, the young woman is portrayed without any jewelry, not even a ring. The solid pyramidal form of her half-length figure is silhouetted against distant mountains, whose desolate grandeur reinforces the painting's mysterious atmosphere. Mona Lisa's expression has been called enigmatic because her gentle smile is not accompanied by the warmth one would expect to see in her eyes. The contemporary fashion for plucked eyebrows and a shaved hairline to increase the height of the forehead adds to her arresting appearance. Perhaps most unsettling is the bold and slightly flirtatious way her gaze has shifted toward the right to look straight out at the viewer. The implied challenge of her direct stare, combined with her apparent serenity and inner strength, has made the *Mona Lisa* one of the most popular and best-known works in the history of art.

A fiercely debated topic in Renaissance Italy was the question of the superiority of painting or sculpture. Leonardo insisted on the supremacy of painting as the best and most complete means of creating an illusion of the natural world while Michelangelo argued for sculpture. Yet in creating a painted illusion, Leonardo considered color to be secondary to the depiction of sculptural volume, which he achieved through his virtuosity in highlighting and shading. He also unified his compositions by covering them with a thin, lightly tinted varnish, which resulted in a smoky overall haze called **sfumato**. Because early evening light tends to produce a similar effect naturally, Leonardo considered dusk the finest time of day and recommended that painters set up their studios in a courtyard with black walls and a linen sheet stretched overhead to reproduce twilight.

Leonardo's fame as an artist is based on only a few works, for his many interests took him away from painting.

Unlike his humanist contemporaries, he was not particularly interested in classical literature or archaeology. Instead, his passions were mathematics, engineering, and the natural world; he compiled volumes of detailed drawings and notes on anatomy, botany, geology, meteorology, architectural design, and mechanics. In his drawings of human figures, he sought not only the precise details of anatomy but also the geometric basis of perfect proportions (see "The Vitruvian Man," above). Leonardo returned to Milan in 1508 and lived there until 1513. He also lived for a time in the Vatican at the invitation of Pope Leo X, but there is no evidence that he produced any art during his stay. In 1516, he accepted the French king Francis I's invitation to relocate to France as an adviser on architecture. He lived there until his death in 1519.

Raphael. In 1504, Raphael (Raffaello Santi or Sanzio, 1483–1520) arrived in Florence from his native Urbino. He had studied in Perugia with the leading artist of that city, Perugino (see fig. 17-68). Raphael quickly became successful in Florence, especially with paintings of the Virgin and Child, such as *The Small Cowper Madonna* (named for a modern owner) of about 1505 (fig. 18-5). Already a superb painter technically, Raphael must have studied Leonardo's work to achieve the simple grandeur of these monumental shapes, idealized faces, figure-enhancing draperies, and rich colors. The forms are modeled solidly but softly by the clear, even light that pervades the outdoor setting, which is derived from views of his hometown. Raphael painted at least seventeen Madonnas, several portraits, and a number of other works in the short time he spent in Florence, but his greatest achievements were to come during the dozen years he spent in Rome.

Raphael left Florence about 1508 for Rome, where Pope Julius II put him to work almost immediately

18-5. Raphael. *The Small Cowper Madonna*.
c. 1505. Oil on wood panel, 23³/₈ x 17³/₈"
(59.5 x 44.1 cm). National Gallery of Art,
Washington, D.C.
Widener Collection

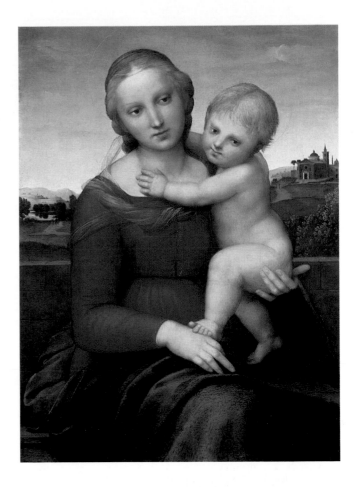

decorating rooms (*stanze*, singular *stanza*) in the papal
apartments. In the library, Raphael painted the four
branches of knowledge as conceived in the sixteenth
century: religion (the *Disputà*, depicting the dispute over
the true presence of Christ in the Communion bread),
philosophy (the *School of Athens*), poetry (*Parnassus*,
home of the Muses), and law (the *Cardinal Virtues under
Justice*). The shape of the walls and vault of the room
itself inspired the composition of the paintings—the arc
of clouds intersected by Christ's mandorla in the *Disputà*,
for example, or the receding arches and vaults in the
School of Athens. For all their serene idealism, the figures
break classical conventions in their foreshortened **con-
trapposto** poses. In the *Disputà*, theologians and Church
officials discuss the meaning of the Eucharist (fig. 18-6).
Above them, the three Persons of the Trinity, flanked by
the apostles, fill the upper half of the painting. The Host
in its monstrance, silhouetted against the sky, rests on
the altar, where Pope Julius's name appears in the
embroidered altar frontal.

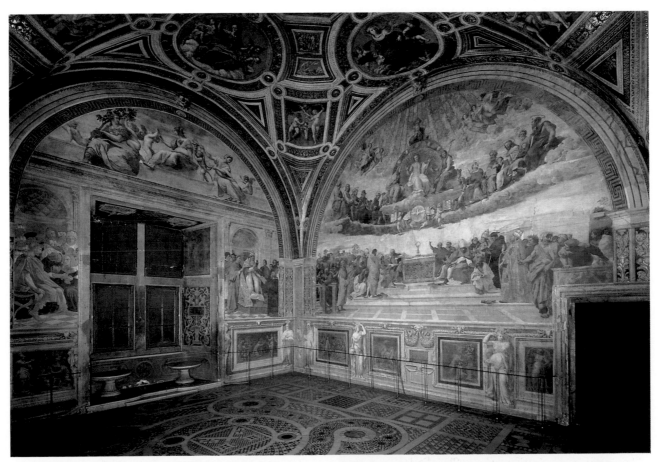

18-6. Raphael. *Disputà*, fresco in the Stanza della Segnatura, Vatican, Rome. 1510–11. 19 x 27' (5.79 x 8.24 m)

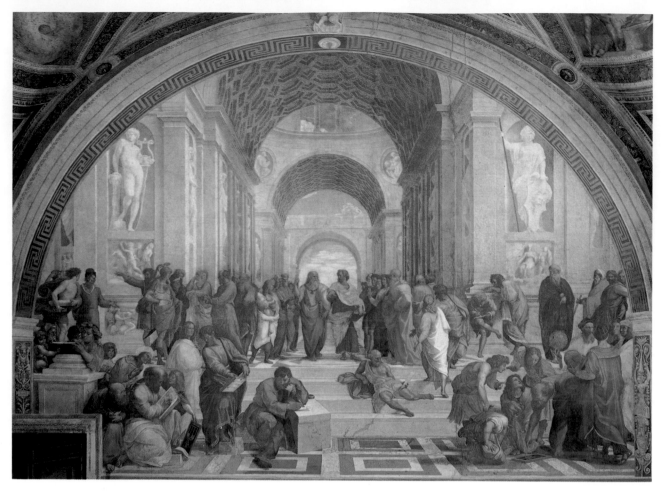

18-7. Raphael. *School of Athens*, fresco in the Stanza della Segnatura, Vatican, Rome. c. 1510–11. 19 x 27' (5.79 x 8.24 m)

Raphael gave many of the figures in his imaginary gathering of philosophers the features of his friends and colleagues. Plato, standing immediately to the left of the central axis and pointing to the sky, was said to have been modeled after Leonardo da Vinci; Euclid, shown inscribing a slate with a compass at the lower right, was a portrait of Raphael's friend the architect Donato Bramante. Michelangelo, who was at work on the *Sistine Ceiling* only steps away from the *stanza* where Raphael was painting his fresco, is shown as the solitary figure at the lower left center, leaning on a block of marble and sketching, in a pose reminiscent of the figures of sibyls and prophets on his great ceiling. Raphael's own features are represented on the second figure from the front group at the far right, as the face of a young man listening to a discourse by the astronomer Ptolemy.

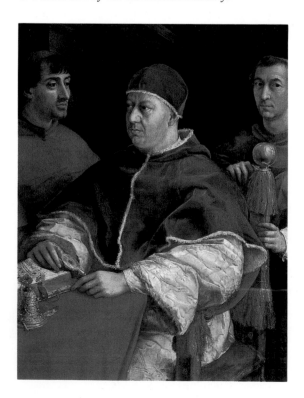

Raphael's most outstanding achievement in the papal rooms was the *School of Athens* (fig. 18-7), painted about 1510–11, which seems to summarize the ideals of the Renaissance papacy in its grand conception of harmoniously arranged forms and rational space, as well as the calm dignity of its figures. Indeed, if the learned Julius II did not actually devise the subjects painted, he certainly must have approved them.

Viewed through a *trompe l'oeil* arch, the Greek philosophers Plato and Aristotle are silhouetted against the sky—the natural world—and command our attention. At the left, Plato holds his book *Timaeus*—in which creation is seen in terms of geometry, and humanity encompasses and explains the universe—and gestures upward to the heavens as the ultimate source of his philosophy. Aristotle, with his outstretched hand palm down, seems to emphasize the importance of gathering

18-8. Raphael. *Leo X with Cardinals Giulio de' Medici and Luigi de' Rossi*. c. 1518. Oil on wood panel, 5'5⅝"x 3'10⅞" (1.54 x 1.19 m). Galleria degli Uffizi, Florence

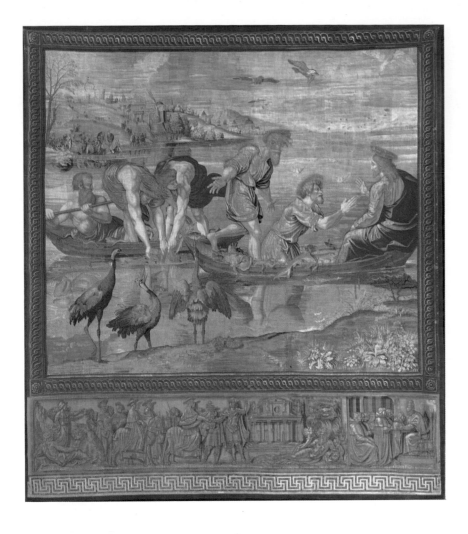

18-9. Shop of Pieter van Aelst, Brussels, after Raphael's cartoon. *Miraculous Draft of Fishes*, from the Acts of the Apostles series; lower border, two incidents from the life of Giovanni de' Medici, later Pope Leo X. Woven 1517, installed 1519 in the Sistine Chapel. Wool and silk with silver-gilt threads, 15'11⅚" x 14'5⅚" (4.90 x 4.41 m). Musei Vaticani, Pinacoteca, Rome

Raphael's Acts of the Apostles cartoons were used as the models for several sets of tapestries woven in the van Aelst shop, including one for Francis I of France. In 1630, the Flemish painter Peter Paul Rubens (Chapter 19) discovered seven of the ten original cartoons in the home of a van Aelst heir and convinced his patron Charles I of England to buy them. Still part of the royal collection today, they are exhibited at the Victoria and Albert Museum in London. The tapestries themselves were dispersed after the Sack of Rome in 1527, later returned, dispersed again during the Napoleonic Wars, purchased by a private collector in 1808, and returned to the Vatican as a gift that year. They are now displayed in the Raphael Room of the Vatican Painting Gallery.

empirical knowledge from observing the material world. Looking down from niches in the walls are depictions of a sculpted Apollo, the god of sunlight, rationality, poetry, music, and the fine arts, and Minerva, the goddess of wisdom and the mechanical arts. Around Plato and Aristotle are mathematicians, naturalists, astronomers, geographers, and other philosophers debating and demonstrating their theories to onlookers and to each other. The scene, flooded with a clear, even light from a single source, takes place in an immense barrel-vaulted interior possibly inspired by the new design for Saint Peter's, then being rebuilt. The grandeur of the building is matched by the monumental dignity of the philosophers themselves, each of whom has a distinct physical and intellectual presence. Despite the variety and energy of the poses and gestures, these striking individuals are organized into a dynamic unity by the sweeping arcs of the composition.

Raphael continued to work for Julius II's successor, Leo X (papacy 1513–21), as director of all archaeological and architectural projects in Rome. Raphael's portrait of Leo X (fig. 18-8) depicts the pope as a great collector of books, and indeed, Leo (born Giovanni de' Medici) was already planning a new Medici library in Florence (see fig. 18-17). Leo's driving ambition was the advancement of the Medici family, and Raphael's painting is, in effect, a dynastic group portrait. Facing the pope at the left is his cousin Giulio, Cardinal de' Medici; behind him stands Luigi de' Rossi, another relative he had made cardinal. Dressed in splendid brocades and enthroned in a velvet chair, the pope looks up from a richly illuminated fourteenth-century manuscript that he has been examining with a magnifying glass. Raphael carefully depicted the contrasting textures and surfaces in the picture, including the visual distortion caused by the magnifying glass on the book page. The polished brass knob on the pope's chair reflects the window and Raphael's self-portrait. In these telling details, Raphael acknowledges his debt—despite great stylistic differences—to the fifteenth-century Flemish artist Jan van Eyck and his followers (Chapter 17).

At about the same time, Raphael painted cartoons of themes from the Acts of the Apostles to be made into tapestries to cover the **dado** (lower wall) below the fifteenth-century wall paintings of the Sistine Chapel. For the production of tapestries, which were woven in workshops in France and Flanders and were extremely expensive, artists made charcoal drawings, then painted over them with glue-based colors for the weavers to match. The first tapestry in Raphael's series was the *Miraculous Draft of Fishes*, combined with Christ's calling of his apostles Peter, Andrew, James, and John, who had been fishing on the Sea of Galilee (Matthew 4:18-22) (fig. 18-9). Today, the Sistine Chapel dado is painted with *trompe l'oeil* draperies (see fig. 18-12), and the papal tapestries are used only occasionally.

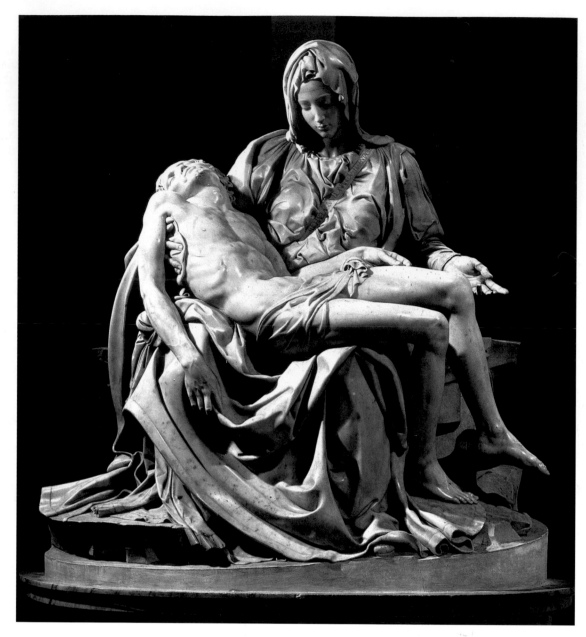

18-10. Michelangelo. *Pietà*, from Old Saint Peter's. c. 1500. Marble, height 5'8½" (1.74 m). Saint Peter's, Vatican, Rome

Raphael died after a brief illness in 1520, at the age of thirty-seven. After a state funeral, he was buried in the ancient Roman Pantheon, originally a classical temple to the gods of Rome, but then a Christian church dedicated to the Virgin Mary. His unfinished painting of the *Transfiguration of Christ* was placed over his tomb.

Michelangelo. Michelangelo Buonarroti (1475–1564) was born in the Tuscan town of Caprese, grew up in Florence, and spent his long career working there and in Rome. At thirteen, he was apprenticed to Ghirlandaio, in whose workshop he learned the rudiments of fresco painting and studied drawings of classical monuments. Soon the talented youth joined the household of Lorenzo the Magnificent, head of the ruling Medici family, where he came into contact with the Neoplatonic philosophers and studied sculpture with Bertoldo di Giovanni, a pupil of Donatello. Bertoldo worked primarily in bronze, and Michelangelo later claimed that he had taught himself to carve marble by studying the Medici collection of classical statues. After Lorenzo died in 1492, Michelangelo traveled to Venice and Bologna, then returned to Florence, where he fell under the spell of the charismatic preacher Fra Girolamo Savonarola. The preacher's execution for heresy in 1498 had a traumatic effect on Michelangelo, who said in his old age that he could still hear the sound of Savonarola's voice.

Michelangelo's major early work at the turn of the century was a *pietà*, commissioned by a French cardinal and installed as a tomb monument in Old Saint Peter's in the Vatican (fig. 18-10). *Pietàs*—works in which the Virgin supports and mourns the dead Jesus—had long been popular in northern Europe but were rare in Italian art at the time. Michelangelo traveled to the marble quarries at

Carrara in central Italy to select the block from which to make this large work, a practice he was to follow for nearly all of his sculpture. His choice of stone was important, for Michelangelo envisioned the statue as already existing within the marble and needing only to be "set free" from it. He later wrote in his Sonnet 15 (1536–47): "The greatest artist has no conception which a single block of marble does not potentially contain within its mass, but only a hand obedient to the mind can penetrate to this image."

Michelangelo's *Pietà* is a very young Virgin of heroic stature holding the lifeless, smaller body of her grown son. The seeming inconsistencies of age and size are countered, however, by the sweetness of expression, the finely finished surfaces, and the softly modeled forms. Michelangelo's compelling vision of beauty is meant to be seen up close, from directly in front of the statue and on the statue's own level, so that the viewer can look into Jesus' face. The twenty-five-year-old artist is said to have slipped into Old Saint Peter's at night to sign the finished sculpture, to answer the many questions about its creator.

In 1501, Michelangelo accepted a commission for a statue of the biblical David (fig. 18-11) to be placed high atop a buttress of the Florence Cathedral. When it was finished in 1504, the *David* was so admired that the city council placed it in the square next to the seat of Florence's government instead. Although Michelangelo's *David* embodies the athletic ideal of antiquity in its muscular nudity, the emotional power of its expression and concentrated gaze is entirely new. Unlike Donatello's bronze *David* (see fig. 17-51), this is not a triumphant hero with the head of the giant Goliath under his feet. Instead, slingshot over his shoulder and a rock in his right hand, Michelangelo's *David* frowns and stares into space, seemingly preparing himself psychologically for the danger ahead. Here the male nude implies, as it had in classical antiquity, heroic or even divine qualities. No match for his opponent in experience, weaponry, or physical strength, David represents the power of right over might—a perfect emblematic figure for the Florentines, who recently had fought the forces of Milan, Siena, and Pisa.

Despite Michelangelo's contractual commitment to the Florence Cathedral for statues of the apostles, in 1505 Pope Julius II, who saw Michelangelo as his equal in mental power and dedication and thus as an ideal collaborator in the artistic aggrandizement of the papacy, arranged for him to come to Rome. The sculptor's first undertaking, the pope's tomb, was set aside in 1506 when Julius ordered Michelangelo to redecorate the ceiling of the Sistine Chapel (fig. 18-12, page 696).

Julius's initial order for the ceiling was simple: *trompe l'oeil* coffers to replace the original star-spangled blue ceiling. Later he wanted the Twelve Apostles seated on thrones to be painted in the triangular **spandrels**, the walls between the **lunettes** framing the windows. When Michelangelo objected to the limitations of Julius's plan, the pope told him to paint whatever he liked. This he presumably did, although a commission of this importance probably involved some supervision by the pope and perhaps also an adviser in theology.

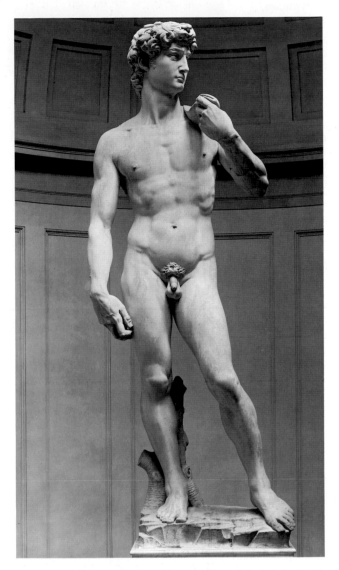

18-11. Michelangelo. *David*. 1501–4. Marble, height 13'5" (4.09 m). Galleria dell'Accademia, Florence

Michelangelo's most famous sculpture was cut from an 18-foot-tall marble block damaged by another sculptor during the 1460s. After studying the block carefully and deciding that it could be salvaged, Michelangelo made a small model in wax, then sketched the contours of the figure as they would appear from the front on one face of the marble. Then, according to his friend and biographer Vasari, he chiseled in from the drawn-on surface, as if making a figure in very high relief. The completed statue took four days to move on tree-trunk rollers down the narrow streets of Florence from Michelangelo's workshop to its location outside the Palazzo Vecchio (the town hall). In 1504, the Florentines gilded the tree stump and added a gilded wreath to the head and a belt of twenty-eight gilt-bronze leaves. In 1837, the statue was replaced by a copy made to scale and moved into the museum of the Florence Academy.

18-12. Interior, Sistine Chapel, Vatican, Rome. Built 1475–81

Named after its builder, Pope Sixtus (Sisto) IV, the chapel is slightly more than 130 feet long and about 143½ feet wide, approximately the same measurements recorded in the Old Testament for the Temple of Solomon. The floor mosaic was recut from the colored stones used in the floor of an earlier papal chapel. The plain walls were painted in fresco between 1481 and 1483 with scenes from the lives of Moses and Jesus by Perugino, Botticelli, Ghirlandaio, and others. Below these are *trompe l'oeil* painted draperies, where Raphael's tapestries illustrating the Acts of the Apostles once hung (see fig. 18-9). Michelangelo's famous ceiling frescoes begin with the lunette scenes above the windows (see fig. 18-13). On the end above the altar is his *Last Judgment* (see fig. 18-48).

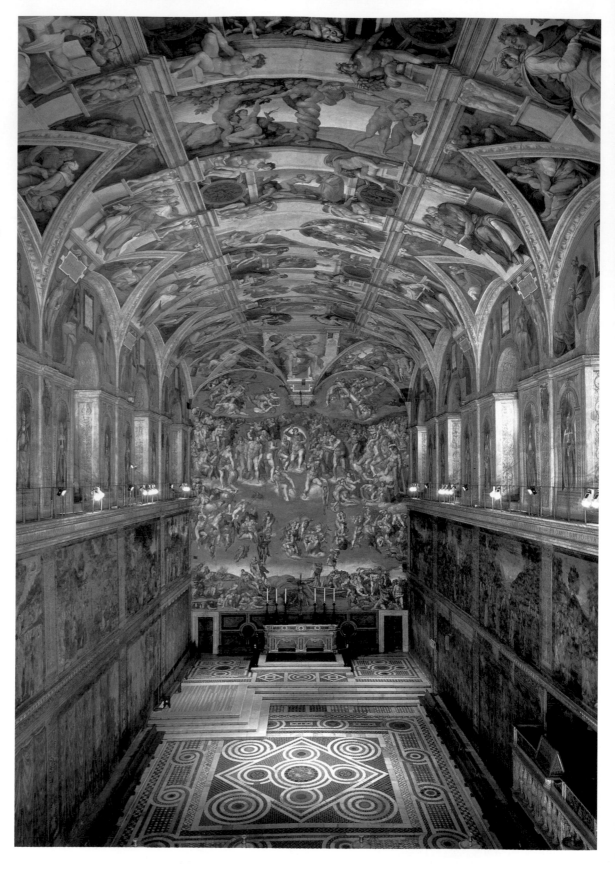

In Michelangelo's final composition, illusionistic marble architecture establishes a framework for the figures on the vault of the chapel (fig. 18-13). Running completely around the ceiling is a painted **cornice** with projections supported by short **pilasters** decorated with the figures of nude little boys, called *putti*. Set among these projections are figures of Old Testament prophets and classical sibyls (female prophets) who were believed to have foretold Jesus' birth. Seated on the cornice projections are heroic figures of nude young men, called *ignudi* (singular *ignudo*), holding sashes attached to large gold medallions. Rising behind the *ignudi*, shallow bands of fictive stone span the center of the ceiling and divide it into compartments in which are painted scenes of the Creation, the Fall, and the Flood. The narrative sequence begins over the altar and ends near the chapel entrance (fig. 18-14). God's earliest acts of creation are therefore closest to the altar, the Creation of Eve at the center of

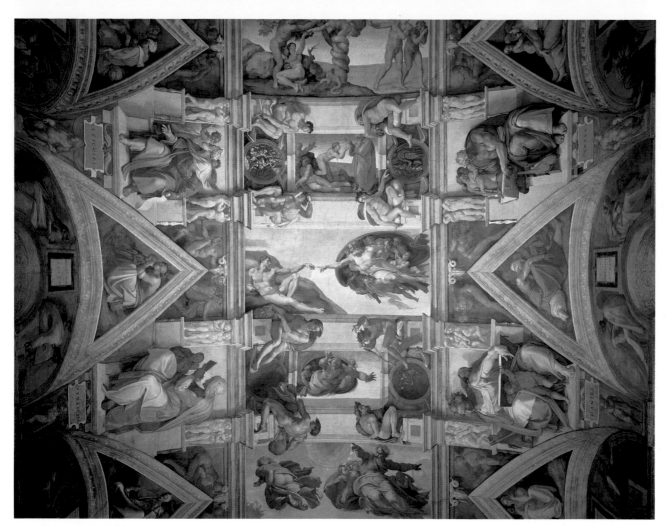

18-13. **Michelangelo.** *Sistine Ceiling*, frescoes in the Sistine Chapel. Top to bottom: *Expulsion* (center); *Creation of Eve*, with *Ezekiel* (left) and *Cumaean Sibyl* (right); *Creation of Adam*; *God Gathering the Waters*, with *Persian Sibyl* (left) and *Daniel* (right); and *God Creating the Sun, Moon, and Planets*. 1508–12. The spandrels and lunettes depict the ancestors of Jesus.

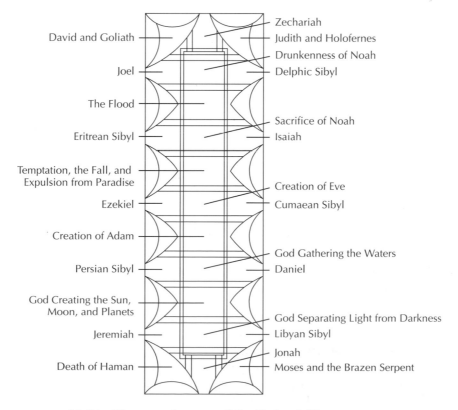

David and Goliath	Zechariah
	Judith and Holofernes
	Drunkenness of Noah
Joel	Delphic Sibyl
The Flood	
	Sacrifice of Noah
Eritrean Sibyl	Isaiah
Temptation, the Fall, and Expulsion from Paradise	
	Creation of Eve
Ezekiel	Cumaean Sibyl
Creation of Adam	
	God Gathering the Waters
Persian Sibyl	Daniel
God Creating the Sun, Moon, and Planets	
	God Separating Light from Darkness
Jeremiah	Libyan Sibyl
	Jonah
Death of Haman	Moses and the Brazen Serpent

18-14. Diagram of scenes of the *Sistine Ceiling*.

The cleaning of frescoes on the walls of the Sistine Chapel, done in the 1960s and 1970s, was so successful that in 1980 a single **lunette** from Michelangelo's ceiling decoration was cleaned as a test. Underneath layers of soot and dust was found color so brilliant and so different from the long-accepted dusky appearance of the ceiling that conservators summoned their courage and proposed a major restoration of the entire ceiling. The work was completed in the winter of 1989, and the *Last Judgment* over the altar was completed in the spring of 1994.

Although the restorers proceeded with great caution and frequently consulted with other experts in the field, the cleaning created serious controversy. The greatest fear was that the work was moving ahead too rapidly for absolute safety. Another concern was that the ceiling's final appearance might not resemble its original state. Some scholars, convinced that Michelangelo had

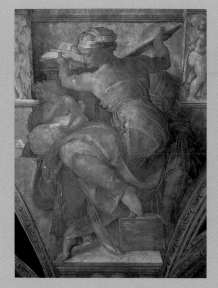 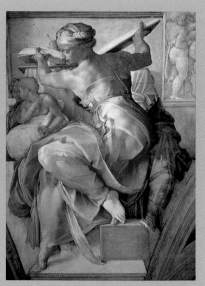

Michelangelo. *Libyan Sibyl*, fresco in the Sistine Chapel, Vatican, Rome. 1511–12. On the left, the fresco before cleaning; on the right, as it appears today

reworked the surface of the fresco after it had dried to tone down the colors, feared that cleaning would remove those finishing touches. In the end, the breathtaking colors that the cleaning revealed forced scholars to thoroughly revise their understanding of Michelangelo's art and the development of sixteenth-century Italian painting. We will never know for certain if some subtleties were lost in the cleaning, and only time will tell if this restoration has prolonged the life of Michelangelo's great work.

the ceiling, followed by the imperfect actions of humanity: the Temptation, the Fall, the Expulsion from Paradise, and God's eventual destruction of all people except Noah and his family by the Flood. The triangular spandrels contain paintings of the ancestors of Jesus; each is flanked by mirror-image nudes in reclining and seated poses. At the apex of each spandrel-triangle is a *bucranium*, or ox skull, a **motif** (a repeated figure in a design) that appears in ancient Roman paintings and reliefs.

According to discoveries during the most recent restoration (see "The Sistine Ceiling Restoration," above), Michelangelo worked on the ceiling in two stages, beginning in the late summer or fall of 1508 and moving from the chapel's entrance toward the altar, in reverse of the narrative sequence. The first half of the ceiling up to the Creation of Eve was unveiled in August 1511 and the second half in October 1512. His style became broader and the composition simpler as he progressed.

Perhaps the most familiar scene is the Creation of Adam. Here Michelangelo depicts the moment when God charges the languorous Adam with the spark of life. As if to echo the biblical text, Adam's heroic body and pose mirror those of God, in whose image he has been created. Directly below Adam is an *ignudo* grasping a bundle of oak leaves and giant acorns, which refer to Pope Julius's family name (della Rovere, or "of the oak") and possibly also to a passage in the Old Testament prophecy of Isaiah (61:3), "They will be called oaks of justice, planted by the Lord to show his glory."

Michelangelo's first papal sculpture commission, the tomb of Julius II, still incomplete at Julius's death in 1513, was to plague him and his patrons for forty years. In 1505, he presented his first designs to the pope for a huge free-standing rectangular structure crowned by the pope's sarcophagus and covered with more than forty statues and reliefs in marble and bronze. But after a year of preliminary work on the tomb, Michelangelo angrily left for Florence the day before the cornerstone was laid for the new Saint Peter's; he later explained that Julius had halted the tomb project to divert money toward building the church. After Julius died, his heirs offered the sculptor a new contract and a larger payment for a more elaborate tomb but soon began to cut back on the expense and size. At this time, between 1513 and 1515, Michelangelo created *Moses* (fig. 18-15), the only sculpture from the original design to be incorporated into the final, much-reduced monument to Julius II. No longer an actual tomb—Julius was buried elsewhere—the monument was installed in 1545, after decades of wrangling, in the Church of San Pietro in Vincoli, Rome. In the original design, the *Moses* was to have been one of four seated figures subordinate to several groups, including a Madonna and Child flanked by saints. The pope was to have been supported by angels atop a sarcophagus. In the final configuration, however, the eloquent *Moses* becomes the focus of the monument and a stand-in for the long-dead pope.

After Leo X succeeded Julius in 1513 and the Medici regained power in Florence in 1515, Michelangelo was

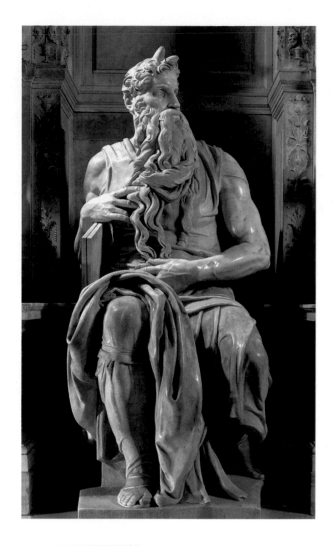

18-15. Michelangelo. *Moses*, Tomb of Julius II. c. 1513–15. Marble, height 7'8½" (2.35 m). Church of San Pietro in Vincoli, Rome

made chief architect for Medici family projects at the Church of San Lorenzo in Florence—including a new chapel for the tombs of Lorenzo the Magnificent, Giuliano, and two younger dukes, also named Lorenzo and Giuliano, ordered in 1519. The older men's tombs were never built, but the unfinished tombs for the younger relatives were placed on opposite side walls of the so-called New Sacristy (the Old Sacristy, by Filippo Brunelleschi, is at the other end of the transept).

In the New Sacristy, each of the two monuments consists of an idealized portrait of the deceased, who turns to face the family's ancestral tomb (fig. 18-16). The men are dressed in a sixteenth-century interpretation of classical armor and seated in niches above pseudo-classical sarcophagi. Balanced precariously atop the sarcophagi are male and female figures representing the times of day. Their positions would not seem so unsettling had reclining figures of river gods been installed below them, as originally planned. Giuliano, Duke of Nemours, represents the Active Life, and his sarcophagus figures are allegories of Night and Day. Night is accompanied by her symbols: a star and crescent moon on her tiara; poppies, which induce sleep; and an owl under the arch of her leg. The huge mask at her back may allude to Death, since Sleep and Death were said to be the children of Night.

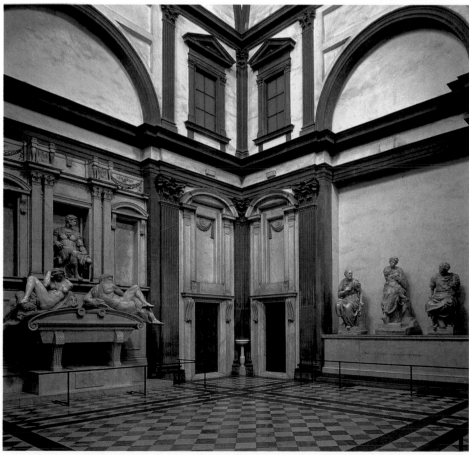

18-16. Michelangelo. Tombs of Giuliano (bareheaded) **and Lorenzo de' Medici** (helmeted). 1519–34. Marble, each 22'9" x 15'3" (6.94 x 4.65 m). Medici Chapel (New Sacristy), Church of San Lorenzo, Florence

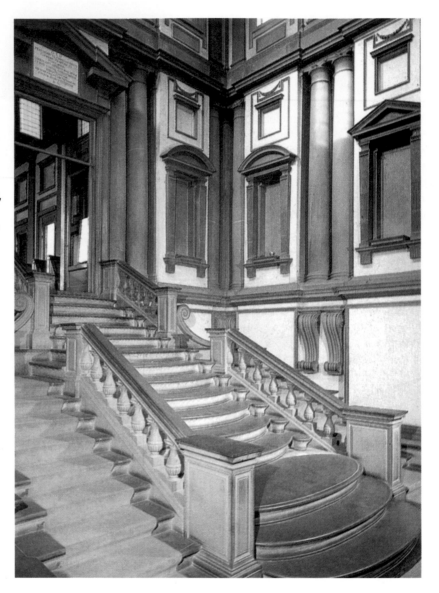

18-17. Michelangelo. Vestibule of the Laurentian Library, Monastery of San Lorenzo, Florence. 1524–33; staircase completed 1559

Lorenzo, representing Contemplative Life, is supported by Dawn and Evening. The allegorical figures for the empty niches that flank the tombs were never carved. The walls of the sacristy are articulated with Brunelleschian *pietra serena* **pilasters** and **architraves** in the Corinthian order.

The figures of the dukes are finely finished, but the times of day are notable for their contrasting areas of rough and polished marble, a characteristic of the artist's mature work that some Michelangelo specialists call his *nonfinito* ("unfinished") quality, suggesting that he had begun to view his artistic creations as symbols of human imperfection (see fig. 18-49). Indeed, Michelangelo's poetry often expressed his belief that humans could achieve perfection only in death.

Construction went forward slowly at San Lorenzo, where Michelangelo was also working on the Laurentian Library, above the monastery's dormitories. He designed a grand staircase leading up to the library from a vestibule off the monastery's main cloister (fig. 18-17). The structure's spatial proportions are somewhat unsettling: The tall vestibule is taken up almost entirely by a staircase cascading like a waterfall, its central flight of large oval steps flanked by narrower flights of rectangular steps that, at the outer edge, form seats with every other step until they join the main flight two-thirds of the way up. The architectural details are equally unconventional: Paired columns do not support an **entablature** but are simply embedded in the walls on the second-floor level; enormous **volute** brackets, capable of bearing great weight, are merely attached to the wall, supporting nothing. Michelangelo at one point described this project as "a certain stair that comes back to my mind as in a dream," and the strange and potent effects do indeed suggest a dreamlike imagining brought to physical reality. In its perturbing power and its use of architectural elements purely for their expressive, rather than functional, qualities, the Laurentian Library staircase is a remarkable precursor of the Mannerist style (see page 728) and would be an inspiration to the next generation of artists.

Ongoing political struggles in Florence interrupted Michelangelo's work. In 1534, detested by the new duke of Florence and fearing for his life, Michelangelo returned to Rome, where he settled permanently. He had

left the New Sacristy and Laurentian Library unfinished, but the library stair was completed by others according to his designs by 1559; the Medici chapel was never finished. Michelangelo's artistic style continued to evolve throughout his career in sculpture, painting, and architecture, and he produced significant works until his death in 1564. We will return to him later in this chapter to examine his further development and his direct influence on artists of the later sixteenth century.

ARCHITECTURE IN ROME AND THE VATICAN

The French invasion of Italy in 1494 was just the beginning of what were to be four decades of war. France, Spain, and the Holy Roman Empire all had designs on Italy, primarily the northern and southernmost territories. The political turmoil that beset Florence, Milan, and other northern cities left Rome as Italy's most active artistic and intellectual center. The election of Julius II in 1503 had begun a resurgence of the power of the papacy. During the ten years of his reign, he fought wars and formed alliances to consolidate his power. But he also enlisted the artists Bramante, Raphael, and Michelangelo as architects to carry out his vision of revitalizing Rome and the Vatican, the pope's residence, as the center of a new Christian art based on classical forms and principles.

Inspired by the achievements of their fifteenth-century predecessors as well as monuments of antiquity, architects working in Rome created a new ideal classical style typified by Bramante. The first-century Roman architect and engineer Vitruvius's treatise on classical architecture (see "The Vitruvian Man," page 690) became an important source for sixteenth-century Italian architects. Although most commissions were for religious architecture, opportunities also arose to build urban palaces and large country villas.

One of the leaders of the new Renaissance style in architecture was Donato Bramante (1444–1514). Born near Urbino and trained as a painter, Bramante turned to architectural design early in his career. A church attributed to him, the Church of San Bernardino near Urbino, can be seen in the landscape background of Raphael's *The Small Cowper Madonna* (see fig. 18-5). About 1481, he became attached to the Sforza court in Milan, where he would have known Leonardo da Vinci. In 1499, Bramante settled in Rome, but work came slowly. The architect was nearing sixty when Queen Isabella and King Ferdinand of Spain commissioned him to design a small shrine over the spot in Rome where the apostle Peter was believed to have been crucified (fig. 18-18). In this tiny building, known as the Tempietto ("Little Temple"), Bramante created a Renaissance interpretation of the principles of Vitruvius and the fifteenth-century architect Leon Battista Alberti, from the stepped base to the Doric columns and frieze (Vitruvius had advised that the Doric order be used for temples to gods of particularly forceful character) to the elegant balustrade. The tall **drum**, or circular wall, supporting a hemispheric dome (rebuilt) and the centralized plan recall early Christian shrines built over martyrs' relics, as well as ancient Roman circular temples.

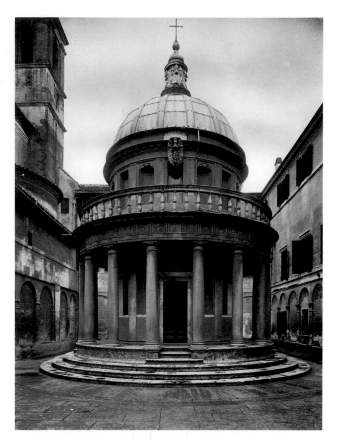

18-18. Donato Bramante. Tempietto, Church of San Pietro in Montorio, Rome. 1502–10; dome and lantern are 17th-century restorations

Especially notable is the sculptural effect of the building's exterior, with its deep wall niches creating contrasts of light and shadow and Doric frieze of carved papal emblems. Bramante's design called for a circular cloister around the church, but it was never built.

Shortly after Julius II's election as pope in 1503, he commissioned Bramante to renovate the Vatican Palace. Julius also appointed him chief architect of a project to replace Saint Peter's Basilica in the Vatican and laid the cornerstone on April 18, 1506. Bramante again looked to the past for his design for Saint Peter's. The plan—a **Greek cross** in a square—resembles traditional Byzantine domed churches, and the central dome was inspired by the ancient Roman Pantheon; at about 131 feet, it was almost as wide. Construction had barely begun when Julius died, and Bramante himself died the next year, in 1514. Raphael replaced Bramante as papal architect with responsibility for building Saint Peter's, but he died in 1520. After a series of popes and architects and revisions, the new Saint Peter's was still far from completion when Michelangelo took over the project in 1546 (see "Saint Peter's Basilica," page 702).

Sixteenth-century Rome was more than a city of churches and public monuments. Wealthy families, many of whom had connections with the pope or the cardinals—the "princes of the Church"—commissioned architects to design residences to enhance their prestige (see "The Renaissance Palace Facade," page 704). For example, Cardinal Alessandro Farnese (who became

SAINT PETER'S BASILICA

The history of Saint Peter's in Rome is an interesting case of the effects of individual and institutional demands on the practical congregational needs of a major religious building. The original church was built in the fourth century CE by Constantine, the first Christian Roman emperor, to mark the grave of the apostle Peter, the first bishop of Rome and therefore the first pope. Because the site was considered the holiest in Europe, Constantine's architect had to build a structure large enough to house Saint Peter's tomb and to accommodate the crowds of pilgrims who came to visit it. To provide a platform for the church, a huge terrace was cut into the side of the Vatican Hill, across the Tiber River from the city. Here Constantine's architect erected a **basilica**, a type of Roman building used for law courts, markets, and other public gathering places, with a long central chamber, or **nave**, double-flanking side aisles set off by **colonnades**, and an **apse**, or large nichelike recess, set into the wall opposite the main door. To allow large numbers of visitors to approach the shrine at the front of the apse, a new feature was added: a **transept**, or long rectangular area perpendicular to the top of the nave. The rest of the church was, in effect, a covered cemetery, carpeted with the tombs of believers who wanted to be buried near the apostle's grave. In front of the church was a walled forecourt, or **atrium**. When it was built, Constantine's basilica, as befitted an imperial commission, was one of the largest buildings in the world (interior length 368 feet; width 190 feet), and for more than a thousand years it was the most important pilgrim shrine in Europe.

In 1506, Pope Julius II (papacy 1503–13) made the astonishing decision to demolish the Constantinian basilica, which had fallen into disrepair, and to replace it with a new building. That anyone, even a pope, had the nerve to pull down such a venerated building is an indication of the extraordinary sense of assurance of the age—and of Julius himself. To design and build the new church, the pope appointed Donato Bramante. Bramante envisioned the new Saint Peter's as a central-plan building, in this case a **Greek cross** (with four arms of equal length) crowned by an enormous dome. This design was intended to continue the tradition of domed and round *martyria*. In Renaissance thinking, the central plan and dome symbolized the perfection of God.

The deaths of pope and architect in 1513 and 1514 put a temporary halt to the project. Successive plans by Raphael, Antonio da Sangallo, and others changed the Greek cross to a **Latin cross** (with three shorter arms and one long one) to provide the church with a full-length nave. However, when Michelangelo was appointed architect in 1546, he returned to the Greek-cross plan. Michelangelo simplified Bramante's design to create a single, unified space covered with a hemispherical dome. The dome was finally completed some years after Michelangelo's death by Giacomo della Porta, who retained Michelangelo's basic design but gave the dome a taller profile.

By the early seventeenth century, the needs of the basilica had changed. During the Counter-Reformation, the Church emphasized congregational worship, so more space was needed for people and processions. To expand the church—and to make it more closely resemble Old Saint Peter's—Pope Paul V in 1606 commissioned the architect Carlo Maderno to change Michelangelo's Greek-cross plan to a Latin-cross plan. Maderno extended the nave to its final length of slightly more than 636 feet and added a new facade, thus completing Saint Peter's as it is today. Later in the seventeenth century, the sculptor and architect Gianlorenzo Bernini changed the square in front of the basilica by surrounding it with a great colonnade (see fig. 19-3).

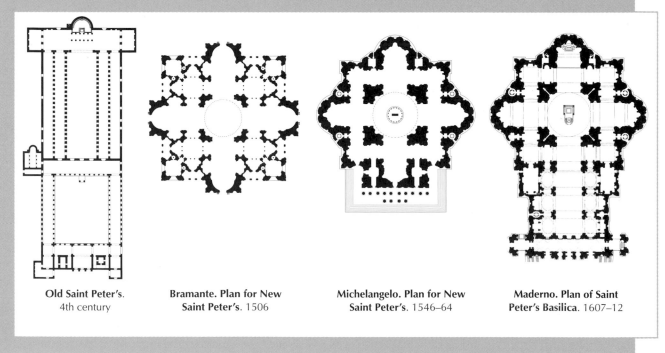

Old Saint Peter's. 4th century

Bramante. Plan for New Saint Peter's. 1506

Michelangelo. Plan for New Saint Peter's. 1546–64

Maderno. Plan of Saint Peter's Basilica. 1607–12

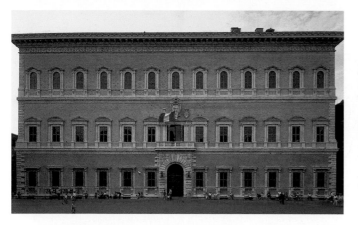

18-19. Antonio da Sangallo the Younger and Michelangelo. Palazzo Farnese, Rome. 1517–50

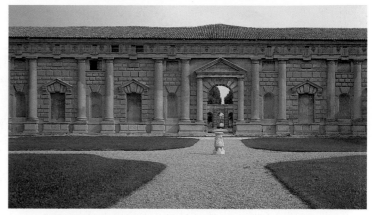

18-20. Giulio Romano. Courtyard facade, Palazzo del Tè, Mantua. 1525–32

Pope Paul III in 1534) set Antonio da Sangallo the Younger (1484–1546) the task of rebuilding the Palazzo Farnese into the largest, finest palace in Rome. The main facade of the great rectangular building faces a public square (fig. 18-19). At the opposite side, a **loggia** overlooked a garden and the Tiber River. When Sangallo died, the pope turned work on the Palazzo Farnese over to Michelangelo, who added focus to the building by emphasizing the portal. He also increased the height of the top story, redesigned the inner courtyard, and capped the building with a magnificent cornice. The principal reception room was painted by Annibale Carracci at the end of the century (see fig. 19-13). (The building continues its distinguished life today as the French Embassy.)

ARCHITECTURE AND PAINTING IN NORTHERN ITALY

While Rome ranked as Italy's preeminent arts center at the beginning of the sixteenth century, wealthy and powerful families in northern Italy also patronized the arts and letters, just as the Montefeltros had in Urbino and the Gonzagas had in Mantua during the fifteenth century. Their architects created fanciful structures and their painters developed a new colorful, illusionistic style—witty, elegant, and finely executed art designed to appeal to the jaded taste of the intellectual elite of Mantua, Parma, and Venice.

Giulio Romano. In Mantua, Federigo Gonzaga (ruled 1519–40) continued the family tradition of patronage when in 1524 he lured a Roman architect and follower of Raphael, Giulio Romano (c. 1492–1546), to Mantua to create a pleasure palace for him.

The Palazzo del Tè (fig. 18-20) is not serious architecture and was never meant to be. It was built for Federigo's enjoyment. He and his erudite friends would have known proper orders and proportions so well that they could appreciate this travesty of classical ideals—visual jokes such as lintels masquerading as arches. The building itself is skillfully constructed, and fine craft abounds in its details. Later architects and scholars have studied the palace, with its sophisticated humor and exquisite craft, as a precursor to Mannerism (see page 728).

Giulio Romano devoted more space in his design to gardens, pools, and stables than he did to living—and

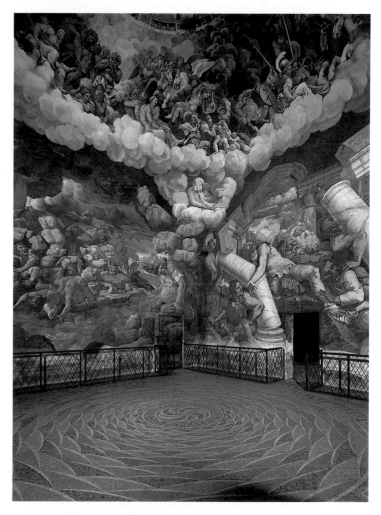

18-21. Giulio Romano. *Fall of the Giants*, fresco in the Sala dei Giganti, Palazzo del Tè. 1530–32

party—space, and he continued his witty play on the classics in the decoration of the two principal rooms. One, dedicated to the loves of the gods, depicted the marriage of Cupid and Psyche. The other room is a remarkable feat of *trompe l'oeil* painting in which the entire building seems to be collapsing about the viewer as the gods defeat the Giants (fig. 18-21). Here Giulio Romano accepted the challenge Andrea Mantegna had laid down when he painted the Camera Picta of the Gonzaga palace (see fig. 17-67) for Federigo's grandfather:

ELEMENTS OF ARCHITECTURE

The Renaissance Palace Facade

Wealthy and noble families in Renaissance Italy built magnificent city palaces. More than just being large and luxurious private homes, the palaces were designed, often by the best architects of the time (see "Alberti's Art Theory in the Renaissance," page 655), to look imposing and even intimidating. The **facade**, or front face of a building, offers broad clues to what lies behind it: Its huge central door suggests power; rough, **rusticated** stonework hints of strength and castle fortifications; precious marbles or carvings connote wealth; a **cartouche**, perhaps with a family coat of arms, is an emphatic identity symbol.

Most Renaissance palaces used architectural elements derived from ancient Greek and Roman buildings—**columns** and **pilasters** in the Doric, Ionic, and/or Corinthian orders, decorated **entablatures**; and other such pieces—in a style known as **classicism**. The example illustrated here, the Palazzo Farnese in Rome, was built for the Farneses, one of whom, Cardinal Alessandro Farnese, became Pope Paul III in 1534. Designed by Sangallo the Younger, Michelangelo, and Giacomo della Porta, this immense building stands at the head of and dominates a broad open public square, or **piazza**. The palace's three stories are clearly defined by two horizontal bands of stonework, or **stringcourses**. A many-layered molded **cornice** encloses the facade like a weighty crown. The **moldings**, cornice, and entablatures are decorated with

classical **motifs** and with the lilies that form the Farnese family coat of arms.

The massive central door is emphasized by elaborate rusticated stonework (as are the building's corners, where the shaped stones are known as **quoins**) and is surmounted by a balcony suitable for ceremonial appearances, over which is set the cartouche with the Farnese arms. Windows are treated differently on each story: On the ground floor, the twelve windows sit on **brackets**. The story directly above is known in Italy as the *piano nobile*, or first floor (Americans would call it the second floor), which contains the grandest rooms. Its twelve windows are decorated with alternating triangular and arched **pediments**, supported by pairs of **engaged** half **columns** in the Corinthian order. The second floor (or American third floor) has thirteen windows, all with triangular pediments whose supporting Ionic half columns are set on brackets echoing those under the windows on the ground floor.

Renaissance city palaces, in general, were oriented inward, away from the noisy streets. Many contained open-air courtyards (see fig. 17-46), also designed with classical elements. The courtyard of the Palazzo Farnese has a *loggia* fronted by an **arcade** at the ground level. Its classical engaged columns and pilasters present all the usual parts: pedestal, base, shaft, and capital. The progression of orders from the lowest to the highest story mirrors the appearance of the orders in ancient Rome: Doric, Ionic, and Corinthian.

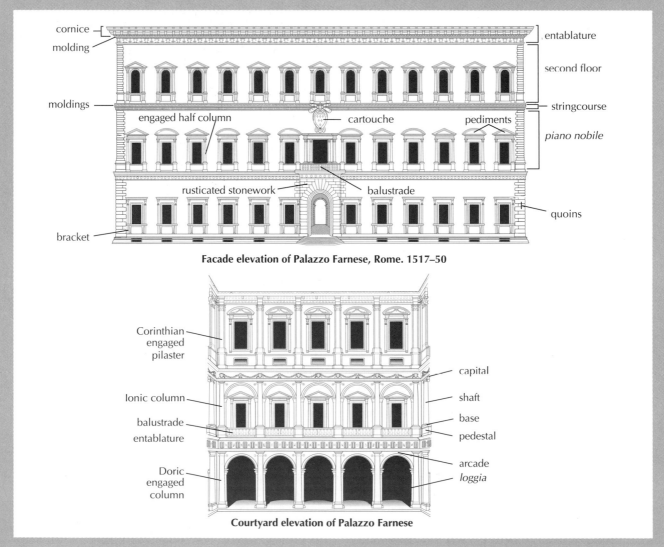

Facade elevation of Palazzo Farnese, Rome. 1517–50

Courtyard elevation of Palazzo Farnese

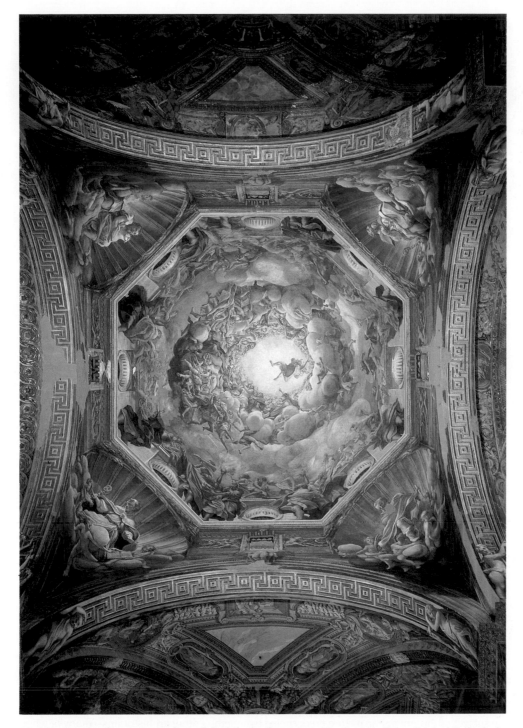

18-22. Correggio. *Assumption of the Virgin*, fresco in main dome interior, Parma Cathedral, Italy. c. 1526–30. Diameter of base of dome approx. 36' (11 m)

He painted away the very architecture. Like the building itself, the mural paintings display brilliant craft in the service of lighthearted, even superficial, goals: to distract, amuse, and enchant the viewer.

At about the same time that Giulio Romano was building and decorating the Palazzo del Tè in Mantua, in nearby Parma an equally skillful master, Correggio, was creating just as theatrical effects through dramatic foreshortening in the Parma Cathedral dome.

Correggio. In his brief but prolific career, Correggio (Antonio Allegri, 1494–1534) produced most of his work

for patrons in Parma and Mantua. Correggio's great work, the *Assumption of the Virgin* (fig. 18-22), a fresco painted between 1526 and 1530 in the dome of Parma Cathedral, distantly recalls the illusionism of Mantegna's ceiling in the Gonzaga palace, but Leonardo clearly inspired Correggio's use of softly modeled forms, spotlighting effects of illumination, and slightly hazy overall appearance. Correggio also assimilated Raphael's idealism as he developed his personal style. In the *Assumption*, Correggio created a dazzling illusion: The architecture of the dome seems to dissolve and the forms seem to explode through the building, drawing the viewer up into

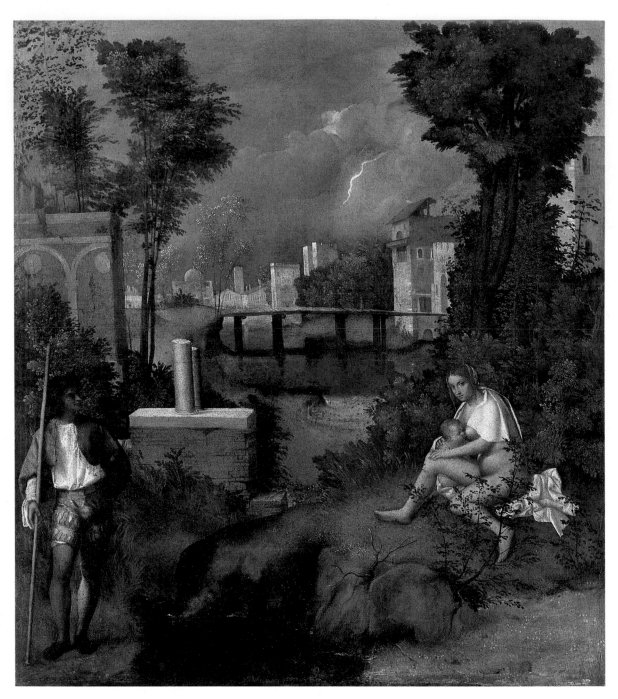

18-23. Giorgione. *The Tempest*. c. 1510. Oil on canvas, 31 x 28 ³⁄₄" (79.4 x 73 cm). Galleria dell'Accademia, Venice

The subject of this enigmatic picture preoccupied twentieth-century art historians—many of whom came up with well-reasoned possible solutions to the mystery. However, the painting's subject seems not to have particularly intrigued sixteenth-century observers, one of whom described it matter-of-factly in 1530 as a small landscape in a storm with a Gypsy woman and a soldier.

the swirling vortex of saints and angels who rush upward, amid billowing clouds, to accompany the Virgin as she soars into heaven. Correggio's painting of the sensuous flesh and clinging draperies of the figures in warm colors contrasts with the spirituality of the theme, which is the Virgin's miraculous transport to heaven at the moment of her death. The viewer's strongest impression is of a powerful, spiraling upward motion of alternating cool clouds and warm, sensuous figures. Illusionistic painting directly derived from this work

became a hallmark of ceiling decoration in Italy in the following century.

Giorgione. The idealized style and oil painting technique, initiated by the Bellini family in the late fifteenth century (see figs. 17-75, 17-76, 17-77), were developed further by sixteenth-century painters in Venice. Venetians were the first Italians to use oils for painting on both wood panel and canvas (see "Painting on Canvas," opposite), and oil paint was particularly suited to the rich color

The technique of painting on canvas was fully developed by the late fifteenth century and canvas paintings were common, although—being less durable than paintings on wood panel—few good examples survive. From contracts and payment accounts, most of these paintings—chiefly in **tempera** on linen—appear to have been decorations for private homes. Many may have served as inexpensive substitutes for tapestries, but records show that small, framed pictures of various subjects were also common. Canvas paintings, less costly than frescoes, were clearly considered less important until the Venetians began to exploit the technique of painting with **oils** on canvas in the late fifteenth century.

The Venetians were also the first to use large canvas paintings instead of frescoes for wall decoration, probably because of humidity problems. Painting on canvas allowed artists to complete the work in their studios, then carry the rolls of canvas to the location where they were to be installed. Because oils dried slowly, errors could be corrected and changes made easily during the work. Thus, the flexibility of the canvas support, coupled with the radiance and depth of oil-suspended color pigments, eventually made oil painting on canvas the almost universally preferred medium.

A recent scientific study of Titian's paintings revealed that he ground his pigments much finer than had earlier wood-panel painters. The complicated process by which he produced many of his works began with a charcoal drawing on the prime coat of lead white that was used to seal the pores and smooth the surface of the rather coarse Venetian canvas. The artist then built up the forms with fine glazes of color laid on with brushes, sometimes in as many as ten to fifteen layers. Because patrons customarily paid for paintings according to the painting's size and how richly the paint was applied, thinly painted works may reflect the patron's finances rather than the artist's choice of technique.

and lighting effects employed by Giorgione and Titian, two of the city's major painters of the sixteenth century. (Two others, Veronese and Tintoretto, will be discussed later in this chapter.)

The career of Giorgione (Giorgio da Castelfranco, c. 1478–1510) was brief—he died from the plague—and most scholars accept only four or five paintings as entirely by his hand. Nevertheless, his importance to Venetian painting is critical, as he introduced enigmatic pastoral themes, sensuous nude figures, and, above all, an appreciation of nature in landscape painting. His early life and training are undocumented, but his work suggests that he studied with Giovanni Bellini. Perhaps Leonardo da Vinci's subtle lighting system and mysterious, intensely observed landscapes also inspired him.

Giorgione's most famous work, called today *The Tempest* (fig. 18-23), was painted shortly before his death. Simply trying to understand what is happening in the picture piques our interest. At the right, a woman is seated on the ground, nude except for the end of a long white cloth thrown over her shoulders. Her nudity seems maternal rather than erotic as she nurses the baby at her side. Across the dark, rock-edged spring stands a man wearing the uniform of a German mercenary soldier. His head is turned toward the woman, but he appears to have paused for a moment before continuing to turn toward the viewer. X rays of the painting show that Giorgione altered his composition while he was still at work on it—the woman on the right was originally balanced by another woman on the left. The spring between the figures feeds a lake surrounded by substantial houses, and in the far distance a bolt of lightning splits the darkening sky. Indeed, the artist's attention seems focused on the landscape and the unruly elements of nature rather than on the figures. The painting of the nude as an inexplicable subject and the dominance of the landscape are typical of Giorgione.

Some scholars have theorized that Giorgione approached his work as many modern-day artists do,

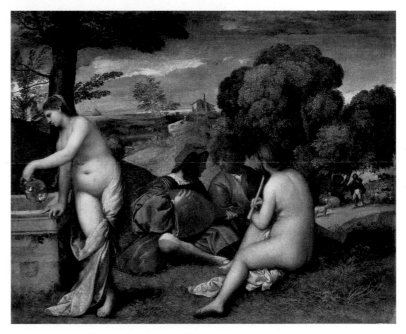

18-24. Titian and Giorgione. *The Pastoral Concert*. c. 1508. Oil on canvas, 43 x 54" (109 x 137 cm). Musée du Louvre, Paris

expressing private impulses in his paintings. Although he may have painted *The Tempest* for purely personal reasons, most of Giorgione's known works were of traditional subjects, produced on commission for clients: portraits, altarpieces, and paintings on the exteriors of Venetian buildings. When commissioned in 1507 to paint the exterior of the Fondaco dei Tedeschi, the warehouse and offices of German merchants in Venice, Giorgione hired Titian (Tiziano Vecelli, c. 1485–1576) as an assistant. For the next three years before Giorgione's untimely death, the two artists' careers were closely bound together.

The painting known as *The Pastoral Concert* (fig. 18-24) has been attributed to both Giorgione and Titian. As in Giorgione's *The Tempest*, the idyllic, fertile landscape,

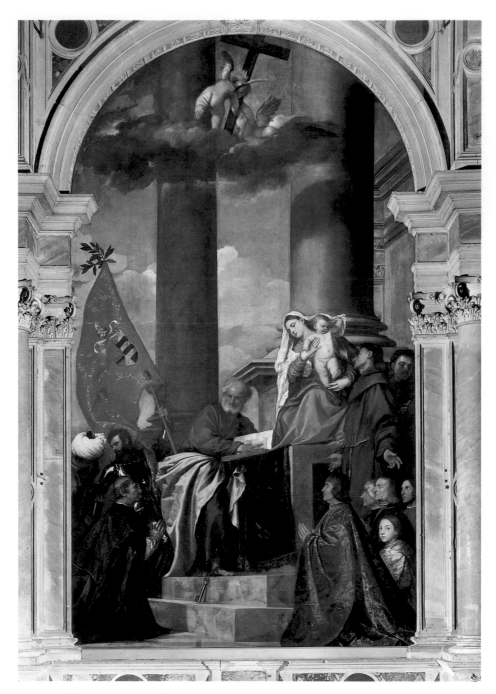

18-25. Titian. *Pesaro Madonna*. 1519–26. Oil on canvas, 15'11" x 8'10" (4.85 x 2.69 m).
Pesaro Chapel, Santa Maria Gloriosa dei Frari, Venice

here bathed in golden, hazy late-afternoon sunlight, seems to be the true subject of the painting. In this mythic world, a few humans appear to idle away their time. Two men—an aristocratic musician in rich red silks and a barefoot peasant in homespun cloth—turn toward each other, ignoring the two women in front of them. One woman plays a pipe and the other pours water into a well, oblivious of the swaths of white drapery sliding to the ground and enhancing rather than hiding their nudity. In the middle ground, the sunlight catches a shepherd and his animals near lush woodland; in the distance, a few buildings and wispy trees break the horizon line. Nothing happens. Like poetry, the painting evokes a mood, a golden age of love and innocence

recalled in ancient Roman pastoral poetry. Such poetic painting is new in the history of art, and *The Pastoral Concert* had a profound influence on later painters who saw and reinterpreted it (see fig. 27-53).

Titian. Everything about Titian's life is obscure, including his birth. His age was given at his death in 1576 as 103 (a figure now considered to have been exaggerated). He supposedly began an apprenticeship as a mosaicist, then studied painting under Gentile and Giovanni Bellini. His first documented work, the Fondaco dei Tedeschi frescoes with Giorgione, completed in 1508, has been destroyed except for a fragment of a Giorgionesque female nude preserved in the Accademia Museum of Venice. Whatever

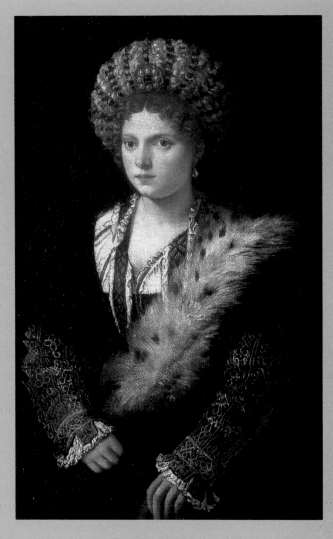

Titian. *Isabella d'Este*. 1534–36. Oil on canvas, 40⅛ x 25³/₁₆" (102 x 64.1 cm). Kunsthistorisches Museum, Vienna

Titian's work was like before then, he had completely absorbed Giorgione's style by the time Giorgione died two years later, and Titian completed Giorgione's work. Titian was made official painter to the Republic of Venice when Giovanni Bellini died in 1516.

In 1519, Jacopo Pesaro, commander of the papal fleet that had defeated the Turks in 1502, commissioned Titian to commemorate the victory in a votive altarpiece for the Franciscan Church of Santa Maria Gloriosa dei Frari in Venice. Titian worked on the painting for seven years and changed the concept three times before he finally came up with a revolutionary composition: He created an asymmetrical setting of huge columns on high bases soaring right out of the frame (fig. 18-25). Into this architectural setting, he placed the Virgin and Child on a high throne at one side and arranged saints and the Pesaro family at the sides and below on a diagonal axis, crossing at the central figure of Saint Peter. The red of Francesco Pesaro's brocade garment and of the banner

diagonally across sets up a contrast of primary colors against Saint Peter's blue tunic and yellow mantle and the red and blue draperies of the Virgin. Saint Maurice (behind Jacopo at the left) holds the banner with the coat of arms of the pope, and a cowering Turkish captive reminds the viewer of the Christian victory. Light floods in from above, illuminating not only the faces but also the great columns, where *putti* in the clouds carry a cross. Titian was famous for his mastery of light and color even in his own day, but this altarpiece demonstrates that he also could draw and model as solidly as any Florentine. The composition, perfectly balanced but built on diagonals, presages the art of the seventeenth century.

In 1529, Titian, who was well known outside Venice, began a long professional relationship with Emperor Charles V, who vowed to let no one else paint his portrait. Shortly after being knighted by Charles in 1533, Titian was commissioned to paint a portrait of Isabella d'Este (see "Women Patrons of the Arts," above). Isabella

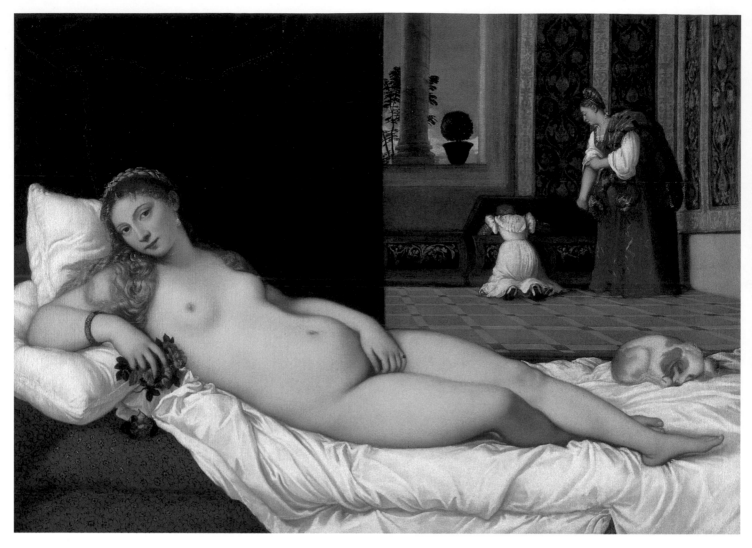

18-26. Titian. *Venus of Urbino*. c. 1538. Oil on canvas, 3'11" x 5'5" (1.19 x 1.65 m). Galleria degli Uffizi, Florence

was past sixty when Titian portrayed her in 1534–36, but she asked to appear as she had in her twenties. A true magician of portraiture, Titian was able to satisfy her wish by referring to an early portrait by another artist while also conveying the mature Isabella's strength, self-confidence, and energy.

No photograph can convey the vibrancy of Titian's paint surfaces, which he built up in layers of pure colors, chiefly red, white, yellow, and black. According to a contemporary, Titian could make "an excellent figure appear in four brushstrokes." His technique was admirably suited to the creation of female nudes, whose flesh seems to glow with an incandescent light. Paintings of nude reclining women became especially popular in sophisticated court circles, where male patrons could enjoy and appreciate the "Venuses" under the cloak of respectable classical mythology. Typical of such paintings is the *Venus* Titan painted about 1538 for the duke of Urbino (fig. 18-26). The sensuous quality of this work suggests that Titian was as inspired by flesh-and-blood beauty as by any source from mythology or the history of art. Here, a beautiful Venetian courtesan—whose gestures seem deliberately provocative—stretches languidly on her couch in a spacious palace, white sheets and pillows setting off her glowing flesh and golden hair. A spaniel, symbolic of fidelity, sleeping at her feet and maids assembling her clothing in the background lend a comfortable domestic air. The *Venus of Urbino* inspired artists as distant in time as Manet (see fig. 27-54).

THE RENAISSANCE AND REFORMATION IN GERMANY

Through carefully calculated dynastic marriages, inheritance, and some good luck, the Holy Roman Emperor Charles V (ruled 1519–56, also crowned Charles I of Spain) reigned over lands from the North Sea to the Mediterranean. In the northern territories, including Germany, the arts flourished from the last decades of the fifteenth century up to the 1520s. After that, religious upheavals and iconoclastic (image-smashing) purges of religious images took a toll.

Typical of the German cities with strong business, trade, and publishing interests was Nuremberg. The

18-27. Albrecht Dürer House, Nuremberg, Germany. Before damage in 1944 and subsequent restoration

middle class emerged as traders, merchants, and bankers accumulated self-made, rather than inherited, wealth. An entrepreneurial artist like Albrecht Dürer—whose workshop was a major commercial success—could now afford to live in a large, comfortable house (fig. 18-27), typical of the middle-class residences that were rising in Nuremberg. The city had an active group of humanists and internationally renowned artists with large workshops. Hans Krug (d. 1519) and his sons Hans the Younger and Ludwig had a typical gold and silver workshop, producing marvelous display pieces for the wealthy, such as this silver-gilt apple cup (fig. 18-28). A technical tour de force, the cup has a style that looks back toward the detailed naturalism of the fifteenth century and forward to the technical virtuosity of Mannerism (see page 728). Sculpture, painting, and architecture flourished in other northern centers as well, including Strasbourg, Isenheim, Würzburg, and Cracow.

EARLY-SIXTEENTH-CENTURY SCULPTURE

Fifteenth-century German sculpture had been closely related to that of France and Flanders, but in the sixteenth century German sculpture gradually began to show the influence of the Italian Renaissance style. Although German sculptors worked in every medium, they produced some of their finest and most original work during the period in limewood. They generally gilded and painted these wooden images, until Tilman Riemenschneider (c. 1460–1531) introduced a natural wood finish.

Tilman Riemenschneider. After about 1500, Riemenschneider had the largest workshop in Würzburg, a shop that included specialists in every medium of sculpture. Riemenschneider attracted patrons from other cities, and in 1501 signed a contract for one of his major creations, the *Altarpiece of the Holy Blood*, for the Sankt

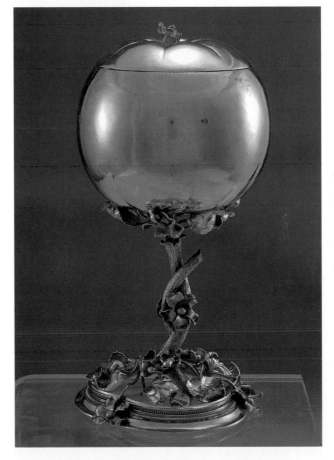

18-28. Workshop of Hans Krug (?). "Apple Cup." c. 1510–15. Gilt silver, height 53 ⅓" (21 cm). Germanisches Nationalmuseum, Nuremberg

In this covered cup made about 1510, the gleaming round apple, whose stem forms the handle of the lid, balances on a leafy branch that forms the stem and base of the cup. Artists worked together to produce such works—one drawing designs, another making the models, and others creating the final piece in metal. This cup may be based on drawings by Albrecht Dürer.

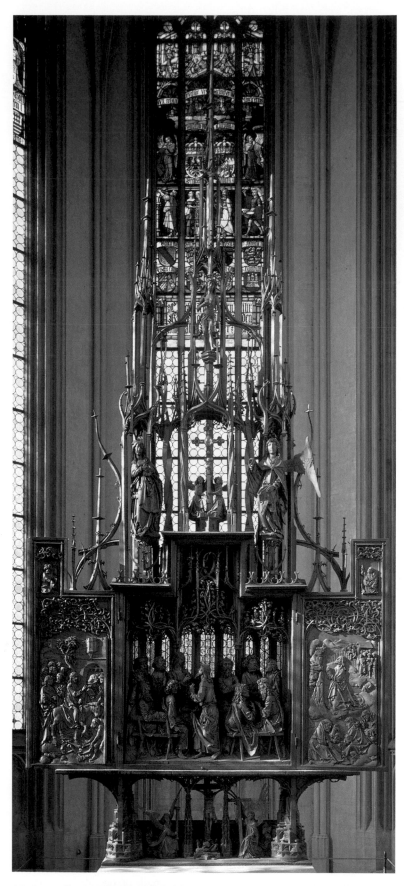

18-29. Tilman Riemenschneider. *Last Supper*, center of the *Altarpiece of the Holy Blood*. c. 1499–1505. Limewood, glass, height of tallest figure 39" (99.1 cm); height of altar 29'6" (9 m). Sankt Jakobskirche, Rothenburg ob der Tauber, Germany

Jakobskirche (Church of Saint James) in Rothenburg ob der Tauber, where a relic said to be a drop of Jesus' blood was preserved. As completed, the limewood construction stood nearly 30 feet high. A specialist in architectural shrines had begun work on the frame in 1499, and Riemenschneider was to provide the figures to go within this frame. The relative value of their contributions to their contemporaries can be judged by the fact that the frame carver was paid fifty florins, almost as much as Riemenschneider's sixty. In the main scene of the altarpiece, the *Last Supper* (fig. 18-29), Riemenschneider depicted the moment of Jesus' revelation that one of his followers would betray him. Unlike Leonardo, Riemenschneider composed his group with Jesus off-center at the left and his disciples seated around him. Judas, at the center, looks stricken as he holds the money bag to which he will soon add the thirty pieces of silver he received for his betrayal. As the event is described in the Gospel of John (13:21–30), the apostles look puzzled by the news that a traitor is among them, and Jesus extends a morsel of food to Judas, signifying that he is the one destined to set in motion the events leading to Jesus' death. The youngest apostle, John, is asleep with his head on Jesus' lap, following a medieval tradition derived from John 13:23, where "one of his disciples, the one whom Jesus loved," is described as "reclining at Jesus' side." One of the figures in front points down toward the **predella**, where the Crucifixion is depicted, and the altar, the symbolic table of the Last Supper.

Rather than creating individual portraits, Riemenschneider simply repeated a limited number of types. His figures have large heads, prominent features, sharp cheekbones, sagging jowls, baggy eyes, and elaborate hair treatments with thick wavy locks and deeply drilled curls. The muscles, tendons, and raised veins of their hands and feet are especially lifelike. Riemenschneider's assistants copied figures and even different modes of drapery either from drawings or from other carved examples. Here, the deeply hollowed folds and active patterning of the drapery create strong highlights and dark shadows that unify the figures and the intricate carving of the framework. The scene is set in three-dimensional space, with actual benches for the figures to rest on and windows at the rear glazed with real bull's-eye glass. Natural light from the church's windows illuminates the scene, so that the effects change with the time of day and weather.

In addition to producing an enormous number of religious images for churches, Riemenschneider was politically active in the city's government. However, his career ended with the Peasants' War of 1525; his support of the peasants, who rose up against their feudal overlords because of economic and religious oppression, led to a fine and imprisonment just six years before his death.

Veit Stoss. Riemenschneider's contemporary Veit Stoss (c. 1438–1533) spent most of the years 1477–96 in Cracow, Poland, where he became wealthy from his sculpture and architectural commissions, as well as from financial investments. After returning to his native

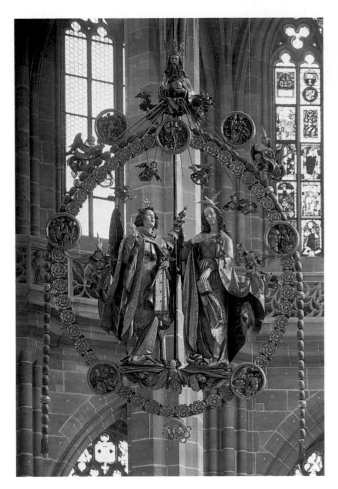

18-30. Veit Stoss. *Annunciation and Virgin of the Rosary*, 1517–18. Painted and gilt limewood, 12'2" x 10'6" (3.71 x 3.20 m). Church of Saint Lawrence, Nuremberg

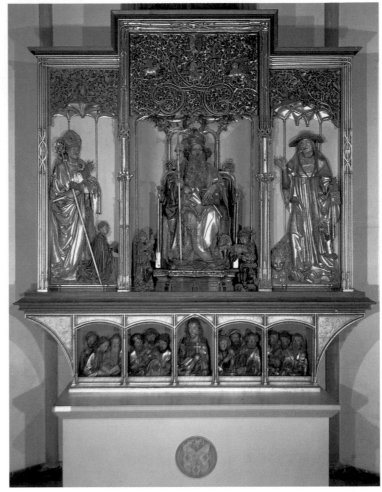

18-31. Nikolaus Hagenauer. *Saint Anthony Enthroned between Saints Augustine and Jerome*, shrine of the *Isenheim Altarpiece*. c. 1505. Painted and gilt limewood, center panel 9'9½" x 10'9" (2.98 x 3.28 m); predella 2'5½" x 11'2" (0.75 x 3.4 m)

Nuremberg, he began to specialize in limewood sculpture, probably because established artists already dominated commissions in other mediums. He had a small shop whose output was characterized by an easily recognizable style expressing a taste for German realism. Stoss's unpainted limewood works show a special appreciation for the wood itself, which he exploited for its inherent colorations, grain patterns, and range of surface finishes.

Stoss carved the *Annunciation and Virgin of the Rosary* (fig. 18-30), one of the loveliest images in German art, for the choir of the Church of Saint Lawrence in Nuremberg in 1517–18. Gabriel's Annunciation to Mary takes place within a wreath of roses symbolizing the prayers of the rosary. Disks are carved with scenes of the Joys of the Virgin, to which are added her Dormition and Coronation. Mary and Gabriel are adored and supported by angels. Their dignified figures are encased in elaborate crinkled and fluttering drapery that seems to blend with the delicate angels and to cause the entire work to float like an apparition in the upper reaches of the choir. The sculpture continues the expressive, mystical

tradition prevalent since the Middle Ages in the art of Germany, where the recitation of prayers to the Virgin known as the rosary had become an important part of personal devotion.

Nikolaus Hagenauer. Prayer continued to provide solace and relief to the ill before the advent of modern medicine. In 1505, the Strasbourg sculptor Nikolaus Hagenauer (active 1493–1530s) carved images of Saint Anthony, Saint Jerome, and Saint Augustine for an altarpiece for the Abbey of Saint Anthony in Isenheim, whose hospital specialized in the care of patients with skin diseases, including the plague and leprosy (fig. 18-31). The donor of this piece, Jean d'Orliac, and two men offering a cock and a piglet are depicted kneeling at the feet of the saints—tiny figures, as befits their subordinate status. In the predella below, Jesus and the apostles bless the altar, Host, and assembled patients in the hospital. The limewood sculpture was painted in lifelike colors and the shrine itself was gilded to enhance its resemblance to a precious reliquary. Later, Matthias Grünewald painted a wood-paneled altarpiece to cover the shrine (see figs. 18-32, 18-33).

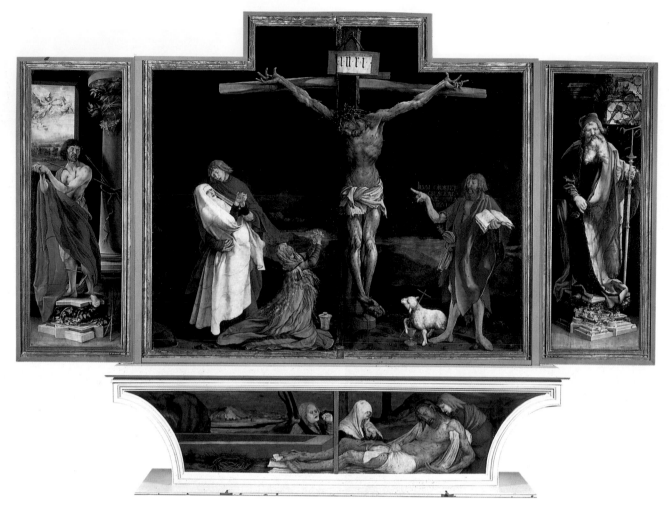

18-32. Matthias Grünewald. *Isenheim Altarpiece* (closed), from the Community of Saint Anthony, Isenheim, Alsace, France. Center panels: *Crucifixion*; predella: *Lamentation*; side panels: Saints Sebastian (left) and Anthony Abbot (right). c. 1510–15. Oil on wood panel, center panels 9'9½" x 10'9" (2.97 x 3.28 m) overall, each wing 8'2½" x 3'½" (2.49 x 0.93 m), predella 2'5½" x 11'2" (0.75 x 3.4 m). Musée d'Unterlinden, Colmar, France

EARLY-SIXTEENTH-CENTURY PAINTING AND PRINTMAKING

German art during the first decades of the sixteenth century was dominated by two very different artists, Matthias Gothardt (known as Matthias Grünewald) and Albrecht Dürer. Grünewald's unique style expressed the continuing currents of medieval German mysticism and emotionalism, while Dürer's intense observation of the natural world represented the scientific Renaissance interest in empirical observation, perspective, and the use of a reasoned canon of proportions for depicting the human figure.

Matthias Grünewald. As an artist in the court of the archbishop of Mainz, Matthias Grünewald (c. 1480–1528) worked as an architect and hydraulic engineer as well as a painter. The work for which Grünewald is best known today, the *Isenheim Altarpiece* (figs. 18-32, 18-33, 18-34), created around 1510–15, illustrates the same intensity of religious feeling that motivated the religious reform movement that would soon sweep Germany. It was created to protect the shrine by Nikolaus Hagenauer

(see fig. 18-31) at the Abbey of Saint Anthony in Isenheim and commemorates the abbey's patron saint, the fourth-century hermit Anthony of Egypt (also known as Anthony Abbot). Patients at the abbey's hospital gazed upon it as they prayed for recovery.

Although the altarpiece is no longer mounted in its original frame to cover the shrine, it is nevertheless monumentally impressive in size and complexity. In their original juxtaposition, the wings and carved wooden shrine complemented one another, the inner sculpture seeming to bring the surrounding paintings to life, and the painted wings protecting the precious carvings. Grünewald painted one set of fixed wings and two sets of movable ones, plus one set of sliding panels to cover the predella, so that the altarpiece could be exhibited in different configurations depending upon the Church calendar.

On weekdays, when the altarpiece was closed, viewers saw a shocking image of the Crucifixion in a darkened landscape, a Lamentation below it on the predella, and lifesize figures of Saints Sebastian and Anthony Abbot—saints associated with the plague—standing on *trompe l'oeil* pedestals on the fixed wings

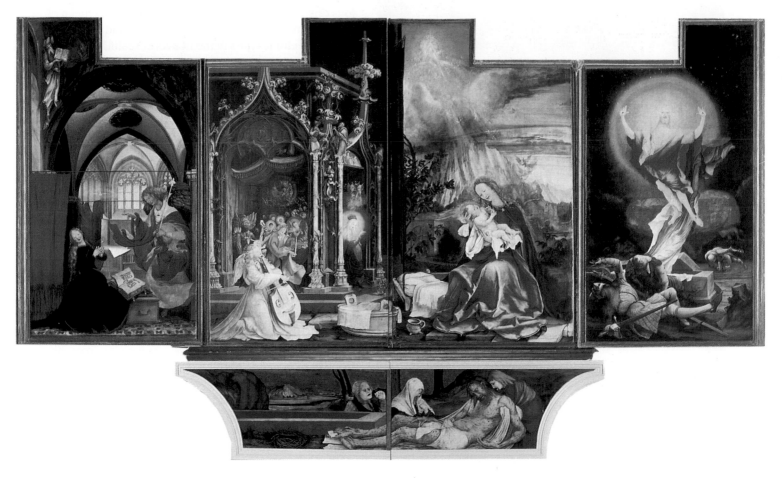

18-33. *Isenheim Altarpiece*, first opening. Left to right: *Annunciation, Virgin and Child with Angels, Resurrection.* c. 1510–15. Oil on wood panel, center panel 9'9½" x 10'9" (2.97 x 3.28 m), each wing 9'9½" x 8'5"

(see fig.18-32). Grünewald represented in the most horrific details the tortured body of Jesus, covered with gashes from being beaten and pierced by the thorns used to form a crown for his head. His ashen body, open mouth, and blue lips indicate that he is dead; in fact, he appears already to be decaying, an effect enhanced by the palette of putrescent green, yellow, and purplish red. A ghostlike Virgin Mary has collapsed in the arms of an emaciated John the Evangelist, and Mary Magdalen has fallen in anguish to her knees; her clasped hands with outstretched fingers seem to echo Jesus' fingers, cramped in rigor mortis. At the right, John the Baptist points at Jesus and repeats his prophecy, "He shall increase." The Baptist and the lamb holding a cross and bleeding from its breast into a golden chalice allude to the Christian rites of baptism and the Eucharist and to Christ as the Lamb of God. In the predella below, Jesus' bereaved mother and friends prepare his body for burial, which must have been a common sight in the abbey's hospital.

In contrast to these grim scenes, the altarpiece when first opened displays Christian events of great joy—the Annunciation, the Nativity, and the Resurrection—expressed in vivid reds and golds accented with

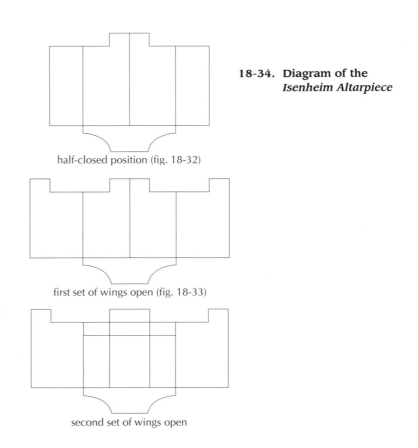

18-34. Diagram of the *Isenheim Altarpiece*

half-closed position (fig. 18-32)

first set of wings open (fig. 18-33)

second set of wings open

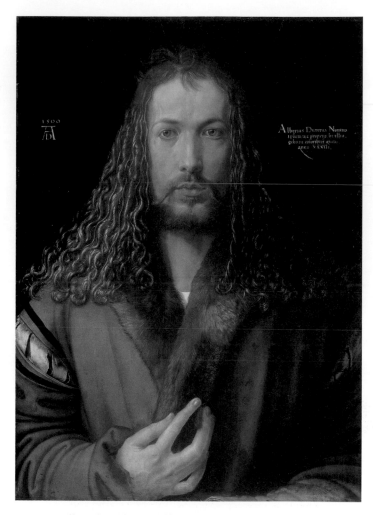

18-35. Albrecht Dürer. *Self-Portrait*. 1500. Oil on wood panel, 25⅝ x 18⅞" (65.1 x 48.2 cm). Alte Pinakothek, Munich

visionary tradition, the new mother adores her miraculous Child while envisioning her own future as Queen of Heaven amid angels and cherubs. Grünewald illustrated a range of ethnic types in the heavenly realm, as well as three distinct types of angels seen in the foreground—young, mature, and a feathered hybrid with a birdlike crest on its human head. Perhaps this was intended to emphasize the global dominion of the Church, whose missionary efforts were expanding as a result of European exploration. The panels are also filled with symbolic and narrative imagery related to the Annunciation. For example, the Virgin and Child are surrounded by Marian symbols: the enclosed garden, the white towel on the tub, and the clear glass cruet behind it, which signify Mary's virginity; the waterpot next to the tub, which alludes both to purity and to childbirth; and the fig tree in the background, suggesting the Virgin Birth, since figs were thought to bear fruit without pollination. The bush of red roses at the right alludes not only to Mary but also to the Passion of Jesus, thus recalling the Crucifixion on the outer wings and providing a transition to the Resurrection on the right wing. There, the shock of Christ's explosive emergence from his stone sarcophagus tumbles the guards about, and his new state of being—no longer material but not yet entirely spiritual—is vibrantly evident in his dissolving, translucent figure.

The second opening of the altarpiece—with the center panels opened to reveal Hagenauer's sculpture, was reserved for the special festivals of Saint Anthony, who has the place of honor in the sculpture and is flanked by the scholarly saints Augustine and Jerome. The wings in this second opening (or third view) of the altarpiece are painted with the temptation of Saint Anthony by horrible demons and the meeting of Saint Anthony with the hermit Saint Paul in a fantastic forested wasteland.

Grünewald's artistic career was damaged by his personal identification with and active support of the peasants in the Peasants' War in 1525. He left Mainz and spent his last years in Halle, whose ruler was a longtime patron of Grünewald's contemporary Albrecht Dürer.

Albrecht Dürer. Studious, analytical, observant, and meticulous—but as self-absorbed and difficult as Michelangelo—Albrecht Dürer (1471–1528) was one of eighteen children of a Nuremberg goldsmith. After an apprenticeship in goldworking and after 1486 in painting, stained-glass design, and especially the making of woodcuts, in the spring of 1490 Dürer began traveling to extend his education and gain experience as an artist. Dürer worked until early 1494 in Basel, Switzerland, providing drawings for woodcut illustrations for books published there.

His first trip to Italy, in 1494–95, clearly imparted to him both the idealism associated with art there and the concept of the artist as an independent creative genius, as Dürer showed in a self-portrait of 1500 (fig. 18-35). He represents himself as an idealized, even Christ-like, figure in a severely frontal pose, meeting the viewer's eyes like an icon. His rich fur-lined robes and flowing locks of

high-keyed pink, lemon, and white (see fig. 18-33). Unlike the awful darkness of the Crucifixion, the inner scenes are illuminated with clear natural daylight, phosphorescent auras and halos, and the glitter of stars in a night sky. Fully aware of contemporary formal achievements in Italy, Grünewald created the illusion of three-dimensional space and volumetric figures, and he abstracted, simplified, and idealized the forms. Unlike Italian Renaissance painters, however, his aim was to strike the heart rather than the mind and to evoke sympathy rather than to create an intellectual ideal. Underlying this deliberate attempt to arouse an emotional response in the viewer is a complex religious symbolism, undoubtedly the result of close collaboration with his monastic patrons.

The *Annunciation* on the left wing illustrates a special liturgy called the Golden Mass, which celebrated the divine motherhood of the Virgin. The Mass included a staged reenactment of the angel's visit to her, as well as readings from the story of the Annunciation (Luke 1:26–38) and the Old Testament prophecy of the Savior's birth (Isaiah 7:14–15), which is inscribed in Latin on the pages of the Virgin's open book.

The central panels show the heavenly and earthly realms joined in one space. In a variation on the northern

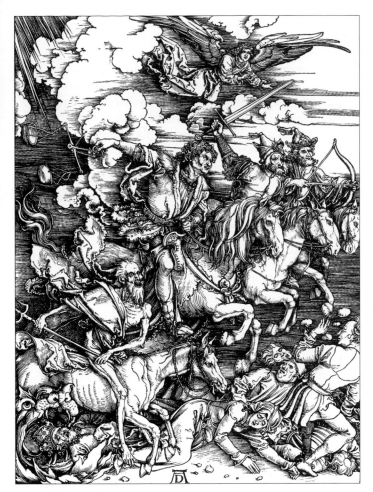

18-36. **Albrecht Dürer.** *Four Horsemen of the Apocalypse*, from *The Apocalypse*. 1497–98. Woodcut, 15½ x 11⅛" (39.4 x 28.3 cm). The Metropolitan Museum of Art, New York

Gift of Junius S. Morgan, 1919 (19.73.209)

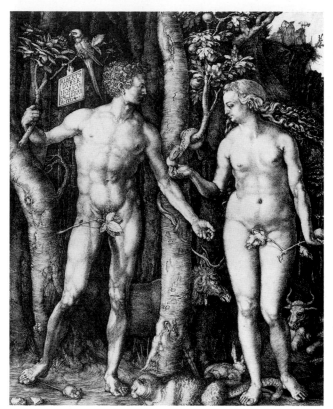

18-37. **Albrecht Dürer.** *Adam and Eve*. 1504. Engraving, 9⅞ x 7⅝" (25.1 x 19.4 cm). Philadelphia Museum of Art

Purchased: Lisa Nora Elkins Fund

curly hair create a monumental equilateral triangle, the timeless symbol of unity.

Back in Nuremberg, Dürer began to publish his own prints to bolster his income, and ultimately it was these prints, not his paintings, that made his fortune. His first major publication, *The Apocalypse*, appeared simultaneously in German and Latin editions in 1497–98 and consisted of a woodcut title page and fourteen full-page illustrations with the text printed on the back of each. The best known of the woodcuts is the *Four Horsemen of the Apocalypse* (fig. 18-36), based on figures described in Revelation 6:1–8: a crowned rider, armed with a bow, on a white horse (Conquest); a rider with a sword, on a red horse (War); a rider with a set of scales, on a black horse (Plague and Famine); and a rider on a sickly pale horse (Death).

Dürer probably did not cut his own woodblocks but employed a skilled carver who followed his drawings faithfully. Dürer's dynamic figures show affinities with the *Temptation of Saint Anthony* (see fig. 17-31) by Martin Schongauer, whom he admired, and he adapted for woodcut Schongauer's technique for shading **engravings**, using a complex pattern of lines that model the

forms with highlights against the tonal ground. Dürer's early training is evident in his meticulous attention to detail, decorative cloud and drapery patterns, and foreground filled with large, active figures, typical of late-fifteenth-century art.

Perhaps as early as the summer of 1494, Dürer began to experiment with engravings, cutting the plates himself with artistry equal to Schongauer's (Chapter 17). His growing interest in Italian art and theoretical investigations is reflected in his 1504 engraving *Adam and Eve* (fig. 18-37), which represents his first documented use of a canon of ideal human proportions based on Roman copies of Greek sculpture that he may have seen in Italy. As idealized as the human figures may be, the flora and fauna are recorded with typically northern European naturalistic detail. Dürer embedded the landscape with symbolic content related to the medieval theory that after Adam and Eve disobeyed God, they and their descendants became vulnerable to imbalances in body fluids that altered human temperament: An excess of black bile from the liver produced melancholy, despair, and greed; yellow bile caused anger, pride, and impatience; phlegm in the lungs resulted in a lack of emotion,

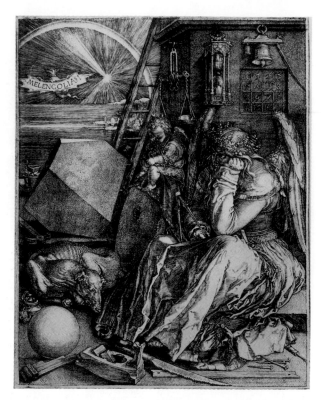

18-38. Albrecht Dürer. *Melencolia I*. 1514. Engraving, 9³/₈ x 7¹/₂" (23.8 x 18.9 cm). Victoria and Albert Museum, London

lethargy, and disinterest; and an excess of blood made a person unusually optimistic but also compulsively interested in pleasures of the flesh. These four human temperaments, or personalities, are symbolized here by the melancholy elk, the choleric cat, the phlegmatic ox, and the sensual rabbit. The mouse is a symbol of Satan (see mousetraps in fig. 17-4), whose earthly power, already manifest in the Garden of Eden, was capable of bringing perfect human beings to a life of woe through their own bad choices. The parrot may symbolize false wisdom, since it speaks but can only repeat mindlessly what is said to it. Dürer's pride in his engraving can be seen in the prominence of his signature—a placard bearing his full name and date hung on a branch of the Tree of Life.

Dürer's familiarity with Italian art was greatly enhanced by a second, more leisurely trip over the Alps in 1505–6. Thereafter, he seems to have resolved to reform the art of his own country by publishing theoretical writings and manuals that discussed Renaissance problems of perspective, ideal human proportions, and the techniques of painting. Between 1513 and 1515, Dürer created what are known today as his master prints—three engravings that are in many ways an engraver's showpiece, demonstrating his skill at implying color, texture, and space by black line alone. The prints represent the active and the contemplative Christian life (*Knight, Death and the Devil* and *Saint Jerome in His Study*) and the frustrated creativity of the secular life (*Melencolia I*, fig. 18-38).

Melencolia I seems to reflect the self-doubt that beset Dürer after he returned from Italy, caught up in the spirit of the Italian Renaissance, with its humanist ideals of the artist as a divinely inspired creator. Here Dürer created a superhuman figure caught in mental turmoil and brooding listlessly, surrounded by tools and symbols of the arts and humanities, while a bat, inscribed "Melencolia I," flits through the night. The melancholic person was thought to live under the influence of black bile—the bodily fluid associated with things dry and cold, the earth, evening, autumn, age, and the vices of greed and despair—and the main figure's pose can be seen as that of one in deep thought as well as of sloth, weariness, and despair. In this engraving, Dürer seems to brood on the futility of art and the fleeting nature of human life. In its despair, the work foreshadows the effects of the religious turmoil, social upheaval, and civil war soon to sweep northern Europe.

THE REFORMATION AND THE ARTS

Many dissident movements had shaken but not destroyed the Church over its history. Some led to great controversy and outright war, but the unity and authority of the Church always prevailed—until the sixteenth century. Then, against a backdrop of broad dissatisfaction with financial abuses and lavish lifestyles among the clergy, religious reformers began to challenge specific Church practices and beliefs, especially Julius II's sale of indulgences—the Church's forgiveness of sins and insurance of salvation in return for a financial contribution—to finance the rebuilding of Saint Peter's. From their protests, the reformers came to be called Protestants, and their search for Church reform gave rise to a movement called the Reformation.

Two of the most important reformers in the early sixteenth century were themselves Catholic priests and trained theologians, Desiderius Erasmus of Rotterdam (1466?–1536) in Holland and Martin Luther (1483–1546) in Germany. Indeed, the Reformation may be dated to the issuing in 1517 of Luther's Ninety-Five Theses, which called for Church reform. Among his concerns were the practice of selling indulgences and the excessive veneration of saints and their relics, which he considered superstitious, even pagan. The reformers questioned not only Church teaching but also the pope's supremacy, and in time the Protestants had to break away from Rome. Instead of looking to an official church, they emphasized individual faith and regarded the Bible as the ultimate religious authority. The Church condemned Luther in 1521.

The reform movement was immeasurably aided by the widespread use of the printing press. The Bible and other Christian writings, translated into German, were readily available to laypeople, many of whom now could read. Improved communications resulting from printed materials allowed scholars throughout Europe to debate religious matters and to influence many people. The wide circulation of Luther's writings—especially his German translation of the Bible and his works maintaining that salvation comes through faith alone—eventually led

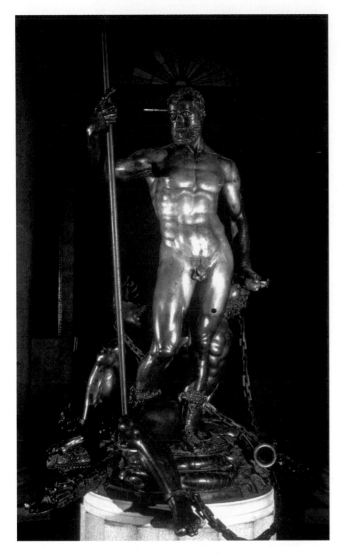

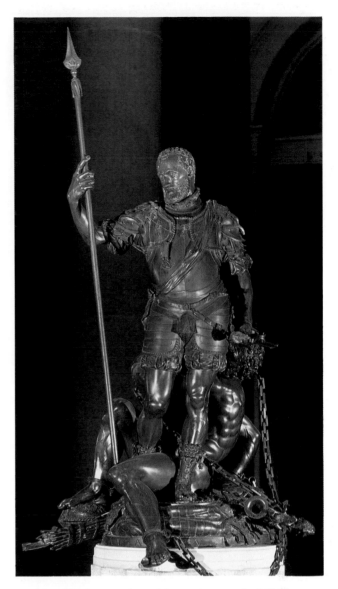

18-39. Leone Leoni. *Charles V Triumphing over Fury,* **without armor**. c. 1549–55. Bronze, height to top of head 5'8" (1.74 m). Museo del Prado, Madrid

18-40. *Charles V Triumphing over Fury,* **in full armor**

to the establishment of the Protestant Church in Germany. Meanwhile in Switzerland, John Calvin (1509–64) led another Protestant revolt, and in England, King Henry VIII (ruled 1509–47) also broke with Rome. By the end of the sixteenth century, some form of Protestantism prevailed throughout northern Europe.

Protestantism did not come easily to northern Europe, which was wracked by decades of religious civil war. Leading the Catholic cause, Emperor Charles V battled the Protestant forces in Germany from 1546 to 1555. During this turbulent time, one of the emperor's favorite artists, Leone Leoni (1509–90), created a lifesize bronze sculpture, *Charles V Triumphing over Fury,* which was cast between 1549 and 1555. Leone depicted Charles as a Herculean, heroic nude, an idealized warrior in classical guise (fig. 18-39). He also provided armor that was cast separately and could be added (fig. 18-40) or removed from the figure. The idea of portraying the

emperor as an idealized nude figure in the classical mode, convertible into a contemporary portrait by dressing it in armor, is a kind of intellectual conceit typical of sixteenth-century art.

Yet Leone's portrayal of a victorious Charles proved premature. After years of armed resistance, at a meeting of the provincial legislature of Augsburg in 1555, the emperor was forced to accommodate the Protestant Reformation in his lands. The terms of the peace dictated that local rulers select the religion of their subjects, furthering the establishment of Protestantism. Tired of the strain of government and prematurely aged, Charles abdicated in 1556 and retired to a monastery in Spain, where he died two years later. His son Philip II inherited Spain and the Spanish colonies; the Austrian branch of the dynasty lasted into the twentieth century.

The years of political and religious strife had a grave impact on artists and their art. Early on, some artists,

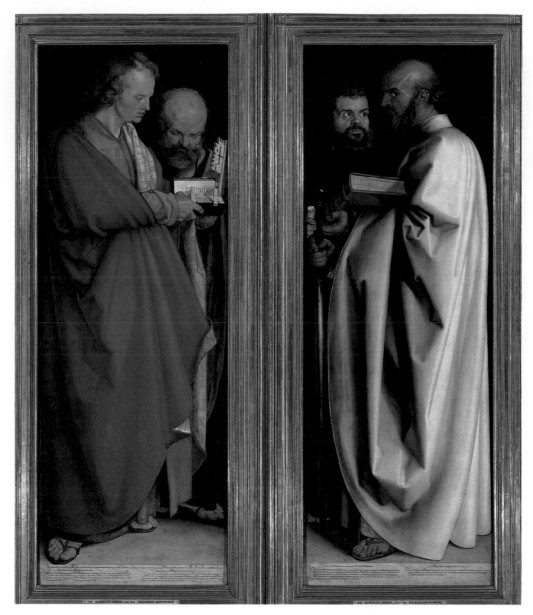

18-41. Albrecht Dürer. *Four Apostles*. 1526. Oil on wood panel, each panel 7'1/2" x 2'6"
(2.15 x 0.76 m). Alte Pinakothek, Munich

such as Riemenschneider, found their careers at an end because of their sympathies for rebels and reformers. Later, as Protestantism took hold, artists who supported the Roman Catholic Church left their homes to seek patronage abroad.

One tragic consequence of the Reformation was the destruction of religious art, an outgrowth of Luther's objections to excessive devotion to religious imagery—although Luther, who saw the educational value of art, never supported iconoclasm. In some areas, Protestant zealots smashed sculpture and stained-glass windows and destroyed or whitewashed religious paintings to rid the churches of what they considered to be idolatrous images. With the sudden loss of patronage for religious art in the newly Protestant lands, many artists turned to portraiture and other secular subjects, including moralizing depictions of human folly and weaknesses. The popularity of these themes stimulated a free market for which

artists created works of their own invention that were sold through dealers or by word of mouth.

Albrecht Dürer. Dürer admired the writings of Martin Luther and had hoped to engrave a portrait of him, as he had other important Reformation thinkers. In 1526, the artist openly professed his belief in Lutheranism in a pair of inscribed panels commonly referred to as the *Four Apostles* (fig. 18-41). The paintings show the apostles John, Peter, Mark, and Paul in an arrangement that suggests the rise of Protestantism. On the left panel, the elderly Peter, the first pope, holds up his key to the Church but seems to shrink behind the young John, Luther's favorite evangelist. On the right panel, Mark is nearly hidden behind Paul, whose teachings and epistles were greatly admired by the Protestants. Long inscriptions below the figures (not legible here) warn the viewer not to be led astray by "false prophets" but to heed the words

18-42. **Lucas Cranach the Elder.** *Martin Luther as Junker Jörg.* c. 1521. Oil on wood panel, 20½ x 13⅝" (52.1 x 34.6 cm). Kunstmuseum, Weimar, Germany

of the New Testament. Also included are excerpts from the letters of Peter, John, and Paul and the Gospel of Mark from Luther's German translation of the New Testament.

Dürer presented the panels to the city of Nuremberg, which had already adopted Lutheranism as its official religion. The work was surely meant to demonstrate that a Protestant art was possible. Earlier, the artist had written: "For a Christian would no more be led to superstition by a picture or effigy than an honest man to commit murder because he carries a weapon by his side. He must indeed be an unthinking man who would worship picture, wood, or stone. A picture therefore brings more good than harm, when it is honourably, artistically, and well made" (cited in Snyder, page 347).

Lucas Cranach the Elder. Martin Luther's favorite painter and one of Dürer's friends, Lucas Cranach the Elder (1472–1553), had moved his workshop to Wittenberg in 1504, after a number of years in Vienna. In addition to the humanist milieu of its university, Wittenberg offered the patronage of the Saxon court. Appointed court painter in 1505, Cranach created woodcuts, altarpieces, and many portraits. One of the most interesting among Cranach's roughly fifty portraits of Luther is *Martin Luther as Junker Jörg* (fig. 18-42). It was painted after the reformer's excommunication by Pope Leo X in early 1521—and after rulers of the German states met in Worms and declared Luther's ideas heresy and Luther himself an outlaw to be captured and handed over to Emperor Charles V. Smuggled out of Worms by Saxon agents, Luther returned to Wittenberg wearing a black beard and mustache, disguised as a knight named Jörg, or George. The painting shows him in this disguise.

Albrecht Altdorfer. Landscape, with or without figures, was an important new category of imagery after the Reformation. Among the most accomplished German landscape painters of the period was Albrecht Altdorfer (c. 1480–1538), who also undertook civic construction projects. He probably received his early training in Bavaria from his painter father, then became a citizen in 1505 of the city of Regensburg, in the Danube River Valley, where he remained for the rest of his life and whose portrayal became his specialty. In his paintings, Altdorfer often depicted religious and historical subjects in magnificent landscapes. The artist's varied talents are barely hinted at by the single work illustrated here, his *Danube Landscape* of about 1525 (fig. 18-43, page 722), a fine example of pure landscape painting—one without a narrative subject or human figures, unusual for the time. A small work on vellum laid down on a wood panel, the *Landscape* seems to be a minutely detailed view of the natural terrain, but a close inspection reveals an inescapable picturesqueness—far more poetic and mysterious than Dürer's scientifically observed views of nature—in the low mountains, gigantic lacy pines, neatly contoured shrubberies, and fairyland castle with red-roofed towers at the end of a winding path. The eerily glowing yellow-white horizon below roiling gray and blue clouds in a sky that takes up more than half the composition suggests otherworldly scenes.

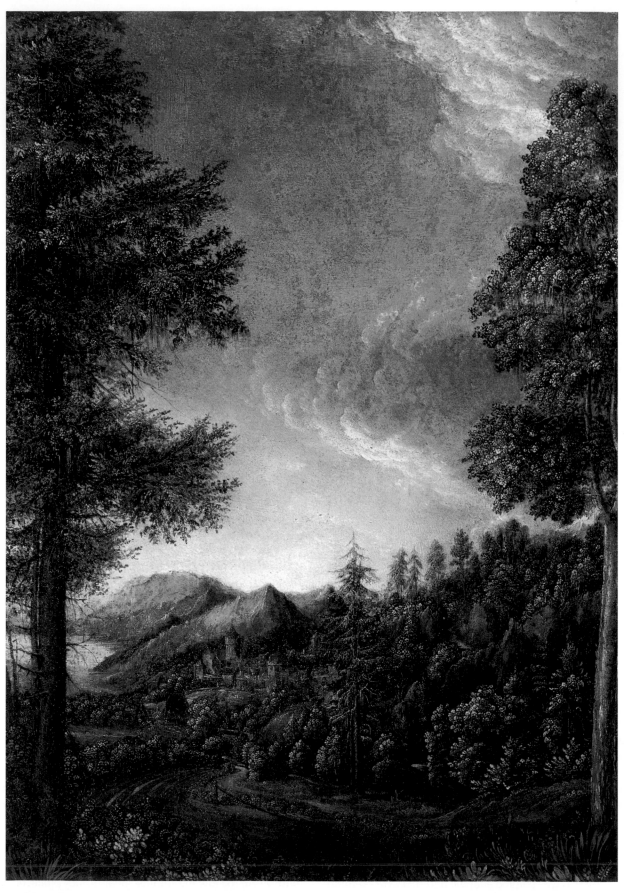

18-43. **Albrecht Altdorfer.** *Danube Landscape*. c. 1525. Oil on vellum on wood panel, 12 x 8¹/₂" (30.5 x 22.2 cm). Alte Pinakothek, Munich

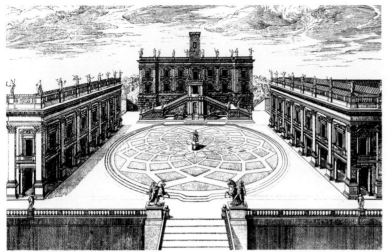

18-44. Étienne Dupérac. *Piazza del Campidoglio, Rome*, engraving after design of Michelangelo. 1569. Gabinetto Nazionale delle Stampe, Rome

Flanking the entrance to the piazza are the so-called *Dioscuri*, two ancient Roman statues moved to the Capitol by Paul III, along with the bronze *Marcus Aurelius*, an imperial Roman equestrian statue, which was installed at the center of the piazza. At the back of the piazza is the Palazzo Senatorio, whose double-ramp grand staircase is thought to have been designed by Michelangelo and built 1545–1605. At the right is the Palazzo dei Conservatori, with a new facade designed by Michelangelo and built 1563–84; facing it is the Palazzo Nuovo, which was built 1603–55 to match the Conservatori. The pavement was executed in 1944 following Michelangelo's design.

LATE RENAISSANCE ART IN ITALY

Although it remained staunchly Catholic, the Protestant Reformation had profound repercussions in Italy. It drove the Catholic Church not only to launch a fight against Protestantism but also to seek internal reform and renewal—a movement that became known as the Counter-Reformation. It also inspired the papacy to promote the Church's preeminence by undertaking an extensive program of building and art commissions. Under such patronage, the art of the Italian Late Renaissance, including a style known as Mannerism, flourished in the second half of the sixteenth century.

Another stimulus for the papal building campaign and arts patronage was brought not by Protestant but by Catholic forces. Pope Clement VII's shifting allegiance in the political struggles between France and the Holy Roman Empire had spurred Emperor Charles V to sack Rome in 1527, leaving the city in ruins. Clement also miscalculated the threat to the Church and to papal authority posed by the Protestant Reformation, and his failure to address the issues raised by the reformers enabled the movement to spread. His successor was a rich and worldly Roman noble, Alessandro Farnese, who was elected Pope Paul III (papacy 1534–49). He was the first pope to grapple directly with the rise of Protestantism, and he vigorously pursued Church reform. In 1536, he appointed a commission to investigate charges of corruption within the Church. He also convened the Council of Trent (1545–63) to define Catholic dogma, initiate disciplinary reforms, and regulate training of clerics.

Pope Paul III addressed Protestantism not only through reform, but also through repression and censorship. In 1542, he instituted the Inquisition, a papal office that sought out heretics for interrogation, trial, and sentencing. The enforcement of religious unity extended to the arts, which had to conform to guidelines issued by the Council of Trent. Traditional images of Christ and the saints continued to be used to inspire and educate, but art was scrutinized for traces of heresy and profanity. The new rules limited what could be represented in Christian art and led to the destruction of some works. At the same time, art became a powerful weapon of propaganda, especially in the hands of members of the Society of Jesus, a new religious order founded by the Spanish noble Ignatius of Loyola (1491–1556) and confirmed by Paul III in 1540. The Jesuits, dedicated to piety, education, and missionary work, spread worldwide from Il Gesù, their headquarters church in Rome (see fig. 18-47). They came to lead the Counter-Reformation movement and the revival of the Catholic Church.

ARCHITECTURE IN ROME AND THE VATICAN

Paul III set out to restore not only the Roman Catholic Church but also Roman Catholic architecture. He aimed to restore the heart of the city of Rome by rebuilding the Capitoline Hill as well as continuing work on Saint Peter's. His commissions include some of the glories of the Late Italian Renaissance.

Michelangelo. After fleeing Florence in 1534, Michelangelo resettled in Rome. Among the projects in which Paul III involved him was the redesign of the Capitoline Hill, the buildings and piazza that were once the citadel of Republican Rome. The buildings covering the irregular site had fallen into disrepair, and the pope saw its renovation as a symbol of both his spiritual and his secular power. Scholars still debate Michelangelo's role in the Capitoline project, although some have connected the granting of Roman citizenship to him in 1537 with his taking charge of the work. Preserved accounts mention the artist by name only twice: In 1539, he advised reshaping the base for the ancient Roman statue of Marcus Aurelius; in 1563, payment was made "to execute the orders of master Michelangelo Buonarroti in the building of the Campidoglio." Michelangelo's comprehensive plan for what is surely among the most beautiful urban-renewal projects of all time was documented in contemporary prints (fig. 18-44); the Piazza del Campidoglio today closely resembles the plan, even though it was not finished until the seventeenth century, and Michelangelo's exquisite star design in the pavement was not installed until the twentieth century.

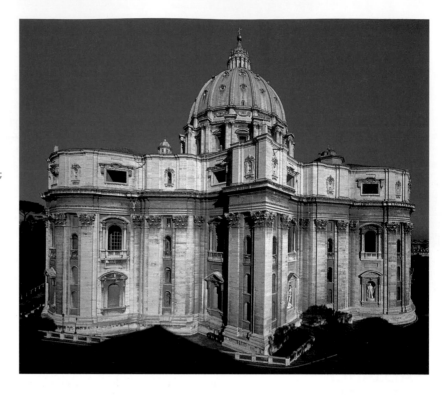

18-45. Michelangelo. Saint Peter's Basilica, Vatican. c. 1546–64; dome completed 1590 by Giacomo della Porta; lantern 1590–93. View from the southwest

Another of Paul III's ambitions was to complete the new Saint Peter's, a project that had been under way for forty years. When he appointed Michelangelo architect of the project in 1546, Michelangelo was well aware of the work done by his predecessors—from Bramante to Raphael to Antonio da Sangallo the Younger—since the laying of the cornerstone in 1506. The seventy-one-year-old sculptor, confident of his architectural expertise, demanded the right to deal directly with the pope, rather than through a committee of construction deputies. Michelangelo further shocked the deputies—but not the pope—by tearing down or canceling parts of Sangallo's design and returning to Bramante's central plan, long associated with Christian *martyria*. Seventeenth-century additions and renovations dramatically changed the original plan of the church and the appearance of its interior, but Michelangelo's Saint Peter's (fig. 18-45) still can be seen in the contrasting forms of the flat and angled walls and the three **hemicycles** (semicircular structures), whose colossal pilasters, **blind windows** (having no openings), and niches form the sanctuary of the church. The level above the heavy entablature was later given windows of a different shape. How Michelangelo would have built the great dome is not known; most scholars believe that he would have made it hemispherical. The dome that was erected by Giacomo della Porta in 1588–90 retains Michelangelo's basic design: a segmented dome with regularly spaced openings, resting on a high drum with **pedimented** windows between paired columns, and surmounted by a tall **lantern** reminiscent of Bramante's Tempietto. Della Porta's major changes were raising the dome height, narrowing its segmental bands, and changing the shape of its openings. (See "Saint Peter's Basilica," page 702.)

Vignola. Michelangelo alone could not satisfy the demand for architects. One young artist who helped meet that need was Giacomo Barozzi (1507–73), known as Vignola after his native town. He worked in Rome in the late 1530s surveying ancient Roman monuments and providing illustrations for an edition of Vitruvius, then worked from 1541 to 1543 in France with Francesco Primaticcio at the Château of Fontainebleau. After returning to Rome, he secured the patronage of the Farnese family.

Vignola profited from the Counter-Reformation program of church building. The Church's new emphasis on individual, emotional, congregational participation brought a focus on sermons and music; it also required churches to have—instead of the complex interiors of medieval and earlier Renaissance churches—wide naves and unobstructed views of the altar to accommodate worshipers. Ignatius of Loyola, founder of the Jesuit order, was determined to build its headquarters church in Rome under these precepts, but he did not live to see it finished. The cornerstone was laid in 1540, but construction of the large new Church of Il Gesù did not begin until 1568, as the Jesuits had to raise considerable funds. Cardinal Alessandro Farnese (Paul III's namesake and grandson) donated funds to the project in 1561 and selected as architect Vignola, famed as a builder and theoretician for his book on architecture. After Vignola died in 1573, Giacomo della Porta finished the dome and facade of Il Gesù.

Il Gesù was admirably suited for its congregational purpose. Vignola designed a wide, barrel-vaulted nave, shallow connected side chapels but not aisles, and short transepts that did not extend beyond the line of the outer walls—enabling all worshipers to gather in the central space; a single huge apse and dome over the crossing (fig. 18-46) directed their attention to the altar. The building fit compactly into the city block—a requirement that now often overrode the desire to orient a church east-west. The facade design emphasized the central portal with classical pilasters, engaged columns and pediments, and volutes scrolling out to hide the buttresses of the central vault and to link the tall central section with the lower sides (fig. 18-47). As finally built by Giacomo della Porta, the facade

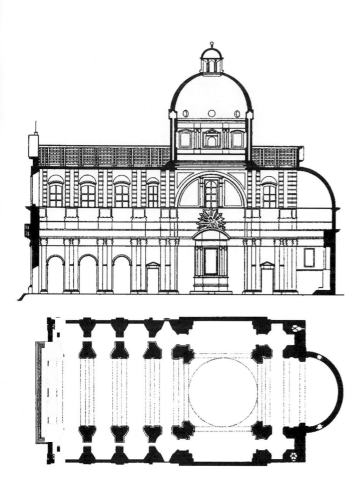

18-46. Plan and section of the Church of Il Gesù, Rome. Cornerstone laid 1540; building begun on Giacomo da Vignola's design in 1568; completed by Giacomo della Porta in 1584

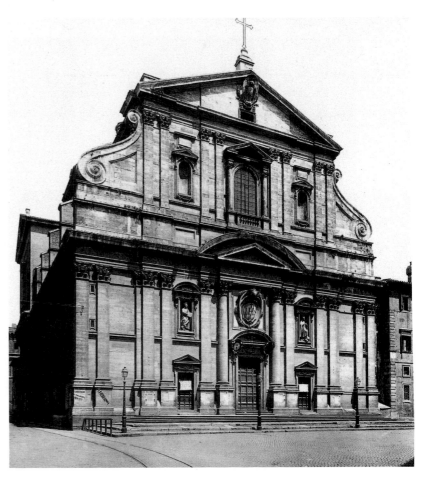

18-47. Vignola and della Porta. Facade of the Church of Il Gesù

ELEMENTS OF ARCHITECTURE

Parts of the Church Facade

Giacomo da Vignola and Giacomo della Porta's facade for Il Gesù (see fig. 18-47), of about 1575–84, like Renaissance and Mannerist buildings, is firmly grounded in the clean articulation and vocabulary of classical architecture. Il Gesù's facade employs the **colossal order** and uses huge **volutes** to aid the transition from the wide lower stories to the narrower upper level. Verticality is also emphasized by the large double pediment that rises from the wide entablature and pushes into the transition zone between stories; by the repetition of triangular pedimental forms (above the *aedicula* window and in the crowning **gable**); by the rising effect of the volutes; and most obviously by the massing of upward-moving forms at the center of the facade. Cartouches, cornices, and **niches** provide concave and convex rhythms across the middle zone.

Giacomo da Vignola and Giacomo della Porta. Facade elevation of the Church of Il Gesù, Rome. c. 1575–84

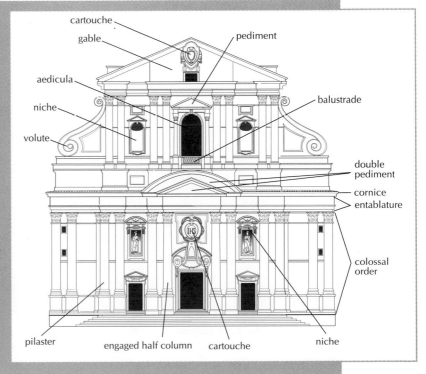

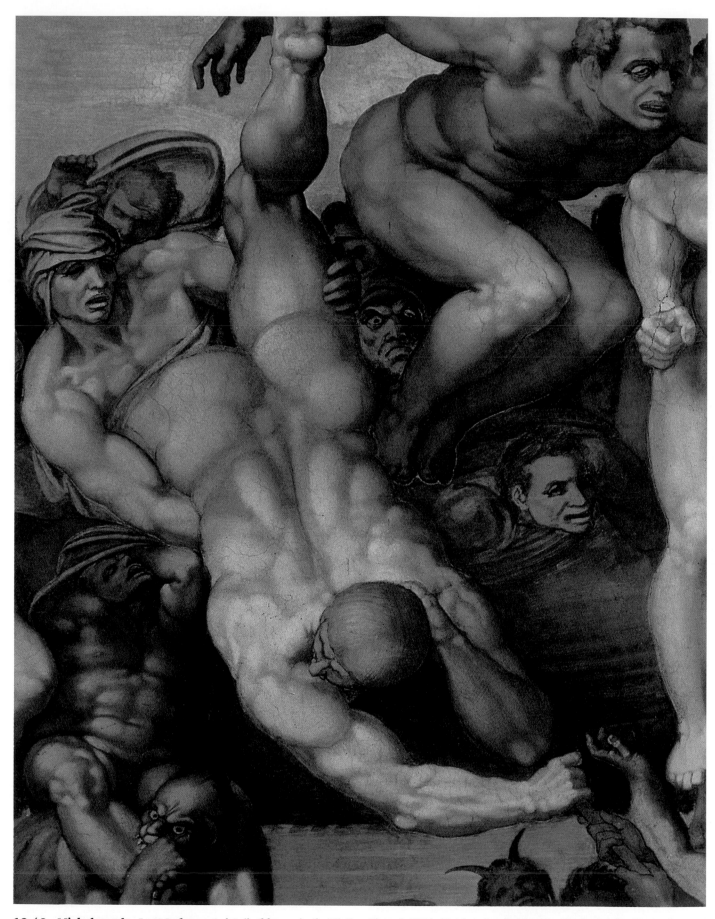

18-48. Michelangelo. *Last Judgment*, detail of fresco in the Sistine Chapel. 1536–41 (cleaning finished in 1994). Height 48' (14.6 m)

design, in its verticality and centrality, would have significant influence on church design well into the next century (see "Parts of the Church Facade," page 725). The facade abandoned the early Renaissance grid of classical pilasters and entablatures (see fig. 17-41) for a two-story design of paired **colossal order** columns that reflected and tied together the two stories of the nave elevation. Each of these stories was further subdivided by **moldings**, niches, and windows. The entrance of the church, with its central portal and tall window, became the focus of the composition. Pediments at every level break into the level above, leading the eye upward to the **cartouches** with coats of arms. Both Cardinal Farnese, the patron, and the Jesuits (whose arms entail the monogram of Christ, IHS) are commemorated here on the facade.

MICHELANGELO AND TITIAN

Over the course of their lengthy careers, Michelangelo and Titian continued to explore their art's expressive potential. In their late work, they discovered new stylistic directions that would inspire succeeding generations of artists. A quarter of a century after finishing the *Sistine Ceiling* (see fig. 18-13), Michelangelo began to paint again in the Sistine Chapel. Although only in his fifties, he complained bitterly of feeling old, but he accepted the important and demanding task of painting the *Last Judgment* on the 48-foot-high end wall above the chapel altar (fig. 18-48). The *Last Judgment*, painted between 1536 and 1541, was the first major commission of Pope Paul III.

Abandoning the clearly organized medieval conceptions of the Last Judgment, in which the Saved are neatly separated from the Damned, Michelangelo painted a writhing swarm of rising and falling humanity. At the left, the dead are dragged from their graves and pushed up into a vortex of figures around Christ, who wields his arm like a sword of justice. The shrinking Virgin represents a change from Gothic tradition, where she sat enthroned beside, and equal in size to, her son. Despite the efforts of several saints to save them at the last minute, the rejected souls are plunged toward hell on the right, leaving the Elect and still-unjudged in a dazed, almost uncomprehending state. To the right of Christ's feet is Saint Bartholomew, who in legend was martyred by being skinned alive, holding his flayed skin, the face of which is painted with Michelangelo's own distorted features. On the lowest level of the mural is the gaping, fiery entrance to hell, toward which Charon, the ferryman of the dead to the underworld, propels his craft. From the beginning, conservative clergy criticized the painting for its nudity and ordered bits of drapery to be added after Michelangelo's death. The painting was long interpreted as a grim and constant reminder to the celebrants of the Mass—the pope and his cardinals—that ultimately they would be judged for their deeds. However, the brilliant colors revealed by recent cleaning seem to contradict the grim message.

Michelangelo was an intense man who alternated between periods of depression and frenzied activity. He was difficult and often arrogant, yet he was devoted to

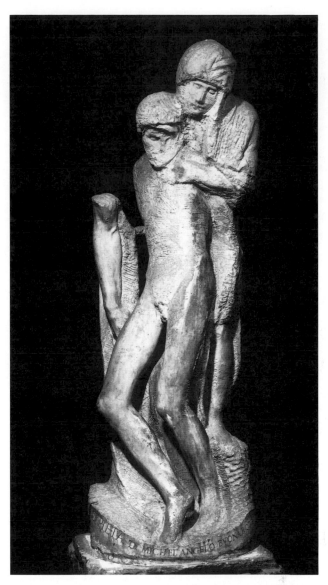

18-49. Michelangelo. *Pietà* (known as the *Rondanini Pietà*). 1555–64. Marble, height 5'3³⁄₈" (1.61 m). Castello Sforzesco, Milan

Shortly before his death in 1564, Michelangelo resumed work on this sculpture group, which he had begun some years earlier. He cut down the massive figure of Jesus, merging the figure's now elongated form with that of the Virgin, who seems to carry her dead son upward toward heaven.

his friends and helpful to young artists. He believed that his art was divinely inspired; later in life, he became deeply absorbed in religion and dedicated himself chiefly to religious works.

Michelangelo's last days were occupied by an unfinished composition now known, from the name of a modern owner, as the *Rondanini Pietà* (fig. 18-49). The *Rondanini Pietà* is the final artistic expression of a lonely, disillusioned, and physically debilitated man who struggled to end his life as he had lived it—working with his mind and his hands. In his youth, the stone had released the *Pietà* in Old Saint Peter's as a perfect, exquisitely finished work (see fig. 18-10), but this block resisted his best efforts to shape it. The ongoing struggle between artist

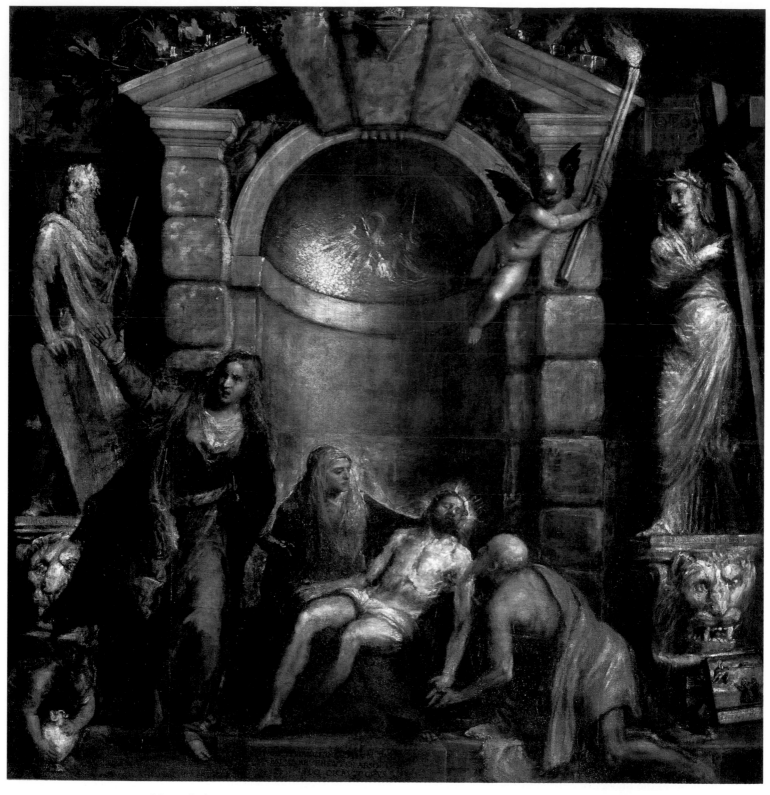

18-50. Titian. *Pietà*. c. 1570–76. Oil on canvas, 11'7¹/₂" x 11'5¹/₂" (3.5 x 3.5 m). Galleria dell'Accademia, Venice

and medium is nowhere more apparent than in this moving example of Michelangelo's *nonfinito* creations. In his late work, Michelangelo subverted Renaissance ideals of human perfectability and denied his own youthful idealism, uncovering new forms that mirrored the tensions in Europe during the second half of the sixteenth century.

Like Michelangelo, Titian in his late work sought the essence of the form and idea, not the surface perfection of his youthful works. In 1570, he began a painting for his own tomb, a *pietà* that was left unfinished at his death in 1576 (fig. 18-50). Against a monumental arched niche, the Virgin mourns her son. The figures emerge out of darkness, their forms defined by the sweeping brushstrokes that Titian painted with complete freedom and confidence. These elderly artists, secure in the techniques gained over decades of masterful craft, could abandon

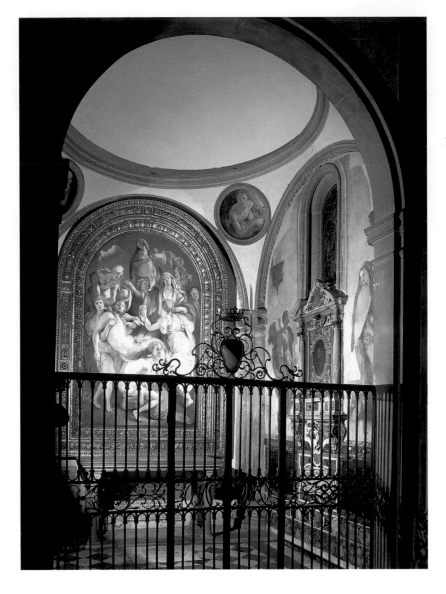

18-51. **Capponi Chapel, Church of Santa Felicità, Florence**. Chapel by Filippo Brunelleschi, 1419–23; paintings by Pontormo, 1525–28

the knowledge of a lifetime as they attempted to express ultimate truths through art.

ITALIAN MANNERISM

The term *Mannerism* comes from the Italian *maniera*, a word used in the sixteenth century suggesting intellectually intricate subjects, highly skilled techniques, and art concerned with beauty for its own sake. Any attempt to define Mannerism as a single style is futile, but certain characteristics occur regularly: extraordinary virtuosity; sophisticated, elegant compositions; and fearless manipulations or distortions of accepted formal conventions. Artists created irrational spatial effects and figures with elongated proportions, exaggerated poses, and enigmatic gestures and expressions. Some artists favored obscure, unsettling, and often erotic imagery; unusual colors and juxtapositions; and unfathomable secondary scenes. Mannerist sculptors exaggerated body forms and poses and preferred small size, the use of precious metals, and displays of extraordinary technical skill. Mannerist architecture defied the conventional use of the Classical orders and uniformity and rationality in designs.

Mannerism, which was stimulated and supported by court patronage, began in Florence and Rome about 1520—first in painting, then in other mediums—and spread to other locations as artists traveled. Mannerist artists admired the great artists of the earlier generation: Leonardo da Vinci, Raphael, and Michelangelo, whose late style was a direct source of inspiration. Mannerism has been seen as an artistic expression of the unsettled political and religious conditions in Europe and also as an elegant, intriguing art created for sophisticated courtiers. Furthermore, a formal relationship between new art styles and aesthetic theories began to appear at this time—especially the elevation of "grace" as an ideal.

Painting. The first wave of Mannerist painters emerged in Florence in the 1520s. The frescoes and altarpiece created by Jacopo da Pontormo (1494–1557) between 1525 and 1528 for the hundred-year-old Capponi Chapel in the Church of Santa Felicità in Florence are clearly Mannerist in style (fig. 18-51). Open on two sides, the chapel creates the effect of a *loggia* in which frescoes depict the Annunciation. The Virgin accepts the angel's message but also seems to have a vision of her future sorrow as she sees her son's body lowered from the Cross in the

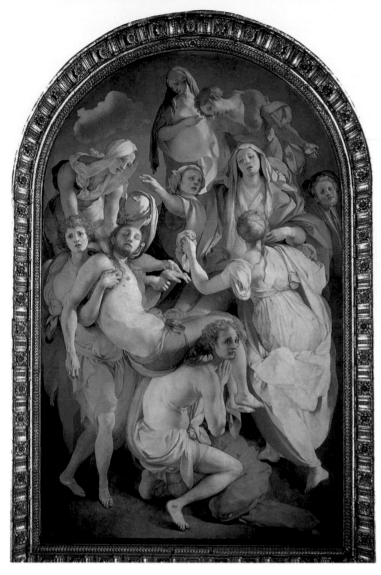

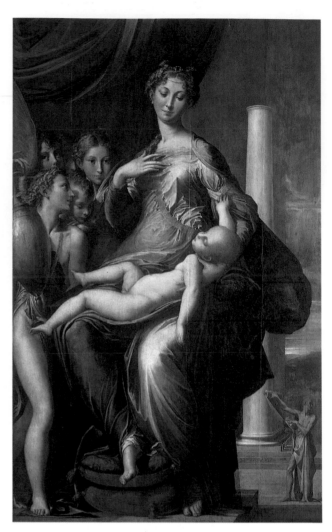

18-52. Pontormo. *Entombment*. 1525–28. Oil on wood panel, 10'3" x 6'4" (3.12 x 1.93 m). Altarpiece in Capponi Chapel, Church of Santa Felicità, Florence

18-53. Parmigianino. *Madonna with the Long Neck*. c. 1535. Oil on wood panel, 7'1" x 4'4" (2.16 x 1.32 m). Galleria degli Uffizi, Florence

Entombment altarpiece (fig. 18-52). Pontormo's ambiguous composition in the altarpiece enhances the visionary quality of the painting. The rocky ground and cloudy sky give little sense of location in space, and some figures press into the viewer's space, while others seem to levitate or stand on a ring of boulders. Pontormo chose a moment just after Jesus' removal from the Cross, when the youths who have lowered him have paused to regain their hold. The emotional atmosphere of the scene is expressed in the odd poses, drastic shifts in scale, and unusual costumes, but perhaps most poignantly in the use of secondary color and colors shot through with contrasting colors, like iridescent silks. The palette is predominantly blue and pink with accents of olive green, gray, scarlet, and creamy white. The overall tone of the picture is set by the color treatment of the crouching youth, whose skintight bright pink shirt is shaded in iridescent, pale gray-green.

Parmigianino (Francesco Mazzola, 1503–40) created equally intriguing variations on the classical style. Until he left his native Parma in 1524 for Rome, the strongest influence on his work had been Correggio. In Rome, Parmigianino met Mannerists Rosso Fiorentino

and Giulio Romano, and he also studied the work of Raphael and Michelangelo. He assimilated what he saw into a distinctive style of Mannerism, calm but strangely unsettling. After the Sack of Rome, he moved back to Parma. Dating around 1535 is an unfinished painting known as the *Madonna with the Long Neck* (fig. 18-53). The elongated figure of the Madonna, whose massive legs and lower torso contrast with her narrow shoulders and long neck, resembles the large metal vase inexplicably being carried by the youth at the left. The Madonna's neck also seems to echo the very tall white columns, having no more substance than theater sets in the middle distance. The painting has been interpreted as an abstract conception of beauty that compares the female body to the forms of classical columns and vases. Like Pontormo, Parmigianino presents a well-known image in a manner calculated to unsettle viewers. Are the young people at the left grown-up cherubs or wingless angels? Is the man with the scroll at the right an architect or an Old Testament prophet, perhaps Isaiah, who foretold the birth of Christ? The painting challenges the viewer's intellect while it exerts its strange appeal to aesthetic sensibility.

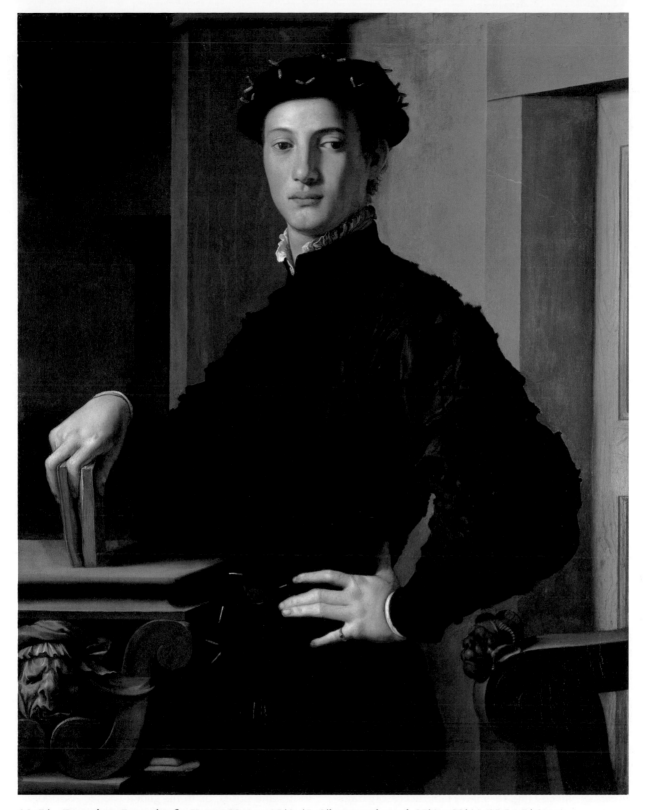

18-54. **Bronzino.** *Portrait of a Young Man*. c. 1540–45. Oil on wood panel, 37½ x 29½" (95.5 x 74.9 cm).
The Metropolitan Museum of Art, New York
The H. O. Havemayer Collection (29.100.16)

Bronzino (Agnolo di Cosimo, 1503–72), whose nickname means "Copper-Colored" (just as we might call someone Red), was born near Florence. About 1522, he became Pontormo's assistant. In 1530, he established his own workshop, though he continued to work occasionally with Pontormo on large projects. In 1540, Bronzino became the court painter to the Medici. Although he was a versatile artist who produced altarpieces, fresco decorations, and tapestry designs over his long career, he is best known today for his portraits in the courtly Mannerist style. Bronzino's virtuosity in rendering costumes and settings creates a rather cold and formal effect, but the self-contained demeanor of his subjects admirably conveys their haughty personalities. The *Portrait of a Young Man* (fig. 18-54) demonstrates Bronzino's characteristic portrayal of his subjects as intelligent,

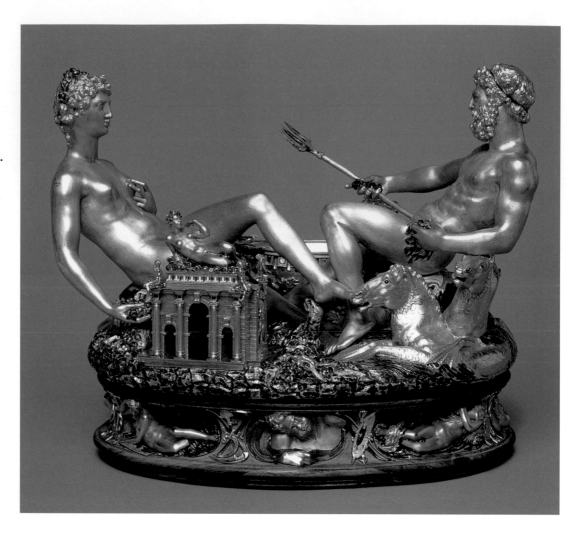

18-55. Benvenuto Cellini. *Saltcellar of Francis I*. 1539–43. Gold with enamel, 10¼ x 13⅛" (26 x 33.3 cm). Kunsthistorisches Museum, Vienna

aloof, elegant, and self-assured. The youth toys with a book, suggesting his scholarly interests, but his walleyed stare creates a slightly unsettling effect and seems to associate his portrait with the carved masks surrounding him.

Sculpture. Two sculptors exemplify the Mannerist style: Benvenuto Cellini and Giovanni da Bologna, well-traveled artists who represent the internationalism of the sixteenth century. The Florentine goldsmith and sculptor Benvenuto Cellini (1500–1571), who wrote an autobiography and a handbook for artists, traveled to the French king's court at Fontainebleau, where he made the famous *Saltcellar of Francis I* (fig. 18-55)—a table accessory transformed into an elegant sculptural ornament by fanciful imagery and superb execution in gold and enamel. The Roman sea god Neptune, representing the source of salt, sits next to a tiny boat-shaped container that carries the seasoning, while a personification of Earth guards the plant-derived pepper, contained in the triumphal arch to her right. Representations of the seasons and the times of day on the base refer to both daily meal schedules and festive seasonal celebrations. The two main figures, their poses mirroring each other with one bent and one straight leg, lean away from each other at impossible angles yet are connected and visually balanced by glances and gestures. Their supple, elongated bodies and small heads reflect the Mannerist conventions of artists like Parmigianino.

In the second half of the sixteenth century, probably the most influential sculptor in Italy was Jean de Boulogne, better known by his Italian name, Giovanni da Bologna (1529–1608). Born in Flanders, he settled by 1557 in Florence, where both the Medici family and the sizable Netherlandish community there were his patrons. He not only influenced a later generation of Italian sculptors, he also spread the Mannerist style to the north through artists who came to study his work. Although greatly influenced by Michelangelo, Giovanni was generally more concerned than his predecessor with graceful forms and poses, as in his gilded-bronze *Astronomy*, or *Venus Urania* (fig. 18-56), of about 1573. The figure's identity is suggested by the astronomical device on the base of the plinth. Designed with a classical prototype of Venus in mind, the sculptor twisted Venus's upper torso and arms to the far right and extended her neck in the opposite direction so that her chin was over her right shoulder, straining the limits of the human body. Consequently, Giovanni's statuette may be seen from any viewpoint. The elaborate coiffure of tight ringlets and the detailed engraving of drapery texture contrast strikingly with the smooth, gleaming flesh of Venus's body. Following the common practice for cast-metal sculpture, Giovanni replicated this stauette several times for different patrons.

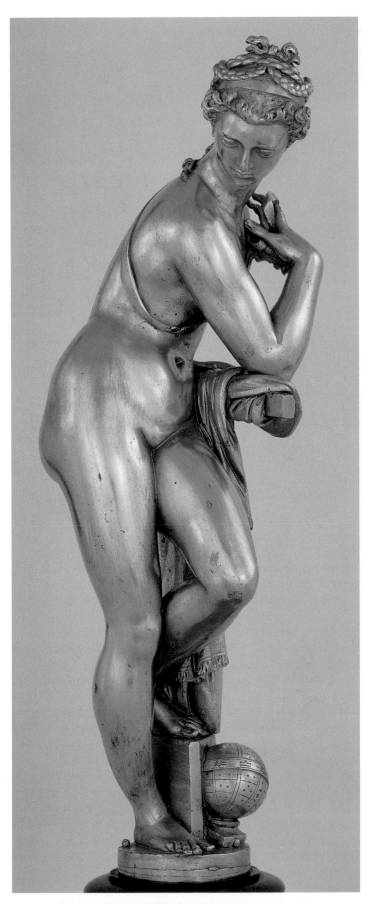

18-56. Giovanni da Bologna. *Astronomy*, or *Venus Urania*. c. 1573. Bronze gilt, height 15¼" (38.8 cm). Kunsthistorisches Museum, Vienna

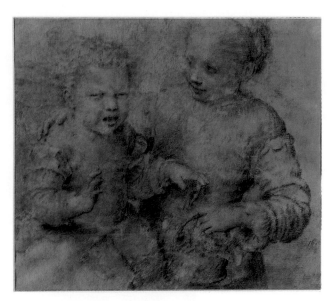

18-57. Sofonisba Anguissola. *Child Bitten by a Crayfish*. c. 1558. Black chalk on paper, 12⅜ x 13⅜" (31.5 x 34 cm). Galleria Nazionale de Capodimonte, Naples

WOMEN PAINTERS

Northern Italy, more than any other part of the peninsula, produced a number of gifted woman artists. Sofonisba Anguissola (1527–1625), born into a noble family in Cremona, was unusual in that she was not the daughter of an artist. Her father gave all his children a humanistic education and encouraged them to pursue careers in literature, music, and especially painting. He consulted Michelangelo about Sofonisba's artistic talents in 1557, asking for a drawing that she might copy and return to be critiqued. Michelangelo not only obliged but also set another task for young Anguissola; she was to send him a drawing of a crying boy. Her sketch of a girl comforting a small boy, wailing because a crayfish is biting his finger (fig. 18-57), so impressed Michelangelo that he gave it as a gift to his closest friend, who later presented it to Cosimo I de' Medici.

In 1560, Anguissola accepted the invitation of the queen of Spain to become an official court painter, a post she held for twenty years. In a 1582 Spanish inventory, Anguissola is described as "an excellent painter of portraits above all the painters of this time"—extraordinary praise in a court that patronized Titian. Unfortunately, most of Anguissola's Spanish works were lost in a seventeenth-century palace fire.

Another northern Italian city, Bologna, was hospitable to accomplished women and boasted in the latter half of the century some two dozen women painters and sculptors, as well as a number of women scholars who lectured at the university. There, Lavinia Fontana (1552–1614) learned to paint from her father, a Bolognese follower of Raphael. By the 1570s, she was a highly respected painter of narratives as well as of portraits, the more usual field for women artists of the time. Her success was so well rewarded, in fact, that her husband, the painter Gian Paolo Zappi, eventually gave up

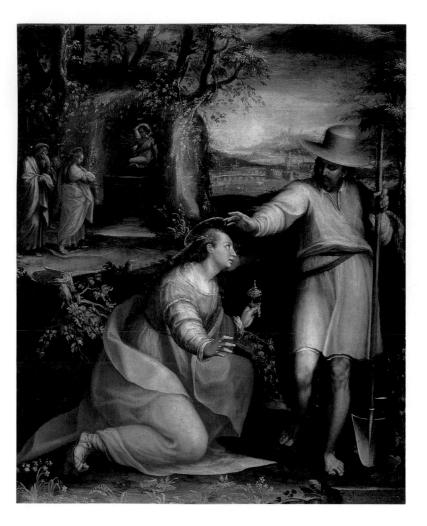

18-58. Lavinia Fontana. *Noli Me Tangere*. 1581. Oil on canvas, 47³/₈ x 36⁵/₈" (120.3 x 93 cm). Galleria degli Uffizi, Florence

his own painting career to care for their large family and help his wife with such technical aspects of her work as framing. While still in her twenties, Fontana painted the *Noli Me Tangere* (fig. 18-58), illustrating the biblical story of Christ revealing himself before his Ascension to Mary Magdalen (Mark 16:9, John 20:17). The Latin title of the painting means "Don't touch me," Christ's words when she moved to embrace him, explaining that he now existed in a new form somewhere between physical and spiritual and had not yet joined his Father in Heaven. Christ's costume refers to the passage in the Gospel of John that says that the Magdalen at first mistook Christ for a gardener.

In 1603 Fontana moved to Rome as an official painter to the papal court. She also soon came to the attention of the Habsburgs, who paid large sums for her work. In 1611, she was honored with a commemorative medal portraying her as a dignified, elegantly coiffed woman on one side and as an intensely preoccupied artist with rolled-up sleeves and wild, uncombed hair on the other.

PAINTING AND ARCHITECTURE IN VENICE AND THE VENETO

Rather than the cool, formal, technical perfection sought by the Mannerists, painters in Venice expanded upon the techniques initiated there by Giorgione and Titian,

concerning themselves above all with color, light, and expressively loose brushwork. The Veneto region, the part of northeastern Italy ruled by Venice, also gave rise to new directions in architecture under Palladio, the dominant architect of the latter half of the century.

Painting. Paolo Caliari (1528–88) took his nickname—Veronese—from his hometown, Verona, but he worked mainly in Venice. His paintings are nearly synonymous today with the popular image of Venice as a splendid city of pleasure and pageantry sustained by a nominally republican government and great mercantile wealth. Veronese's elaborate architectural settings and costumes, still lifes, anecdotal vignettes, and other everyday details, often unconnected with the main subject, proved immensely appealing to Venetian patrons. His vision of the glorious Venice reached an apogee in the ceiling of the council chamber in the ducal palace (fig. 14, Introduction).

Veronese's most famous work is the painting now called *Feast in the House of Levi* (fig. 18-59, "The Object Speaks," opposite), painted in 1573 for the Dominican Monastery of Santi Giovanni e Paolo. At first glance, the subject of the painting seems to be architecture and only secondarily the figures within the space. An enormous *loggia* framed by colossal triumphal arches and reached by balustraded stairs symbolizes Levi's house. Beyond the *loggia* an imaginary city of white marble gleams.

THE OBJECT SPEAKS

FEAST IN THE HOUSE OF LEVI

Jesus among his disciples at the Last Supper was an image that spoke powerfully to believers during the sixteenth century. So it was not unusual when, in 1573, the highly esteemed painter Veronese revealed an enormous canvas that seemed at first glance to depict this scene—Jesus, indeed, is in the center of the painting, with his followers (fig. 18-59). But the church officials of Venice were shocked and offended—some of them by Veronese's grandiose portrayal of the subject in the midst of splendor and pageantry, others by the impiety of placing near Jesus a host of extremely unsavory characters. Veronese was called before the Inquisition to explain his reasons for including such extraneous details as a man picking his teeth, scruffy dogs, a parrot, and foreign soldiers. Veronese claimed the painting depicted the Feast in the House of Simon, a small dinner shortly before Jesus' final entry into Jerusalem. Veronese boldly justified his actions by saying: "We painters take the same license the poets and the jesters take I paint pictures as I see fit and as well as my talent permits" (from the record of the inquiry, cited in Holt, volume 2, pages 68, 69). Such artistic autonomy was unheard-of at that time, and his defense fell on unsympathetic ears. He was told to change the painting.

Accordingly, Veronese changed the picture's title so that it referred to another banquet, given by the tax collector Levi, whom Jesus had called to follow him. Thus, the "buffoons, drunkards . . . and similar vulgarities" (cited in Holt, volume 2, page 68) remained, and Veronese noted his new source—Luke, Chapter 5—on the balustrade. That Gospel reads that "Levi gave a great banquet for him [Jesus] in his house, and a large crowd of tax collectors and others were at table with them" (Luke 5:29). In changing the declared subject of the painting, Veronese also had modest revenge on the Inquisitors: When Jesus was criticized for associating with such people, he replied, "I have not come to call the righteous to repentance but sinners" (Luke 5:32).

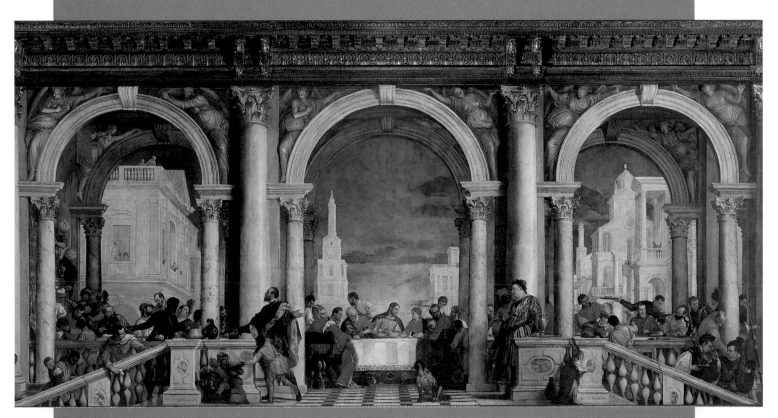

18-59. Veronese. *Feast in the House of Levi,* from the refectory of the Dominican Monastery of Santi Giovanni e Paolo, Venice. 1573. Oil on canvas, 18'3" x 42' (5.56 x 12.8 m). Galleria dell'Accademia, Venice

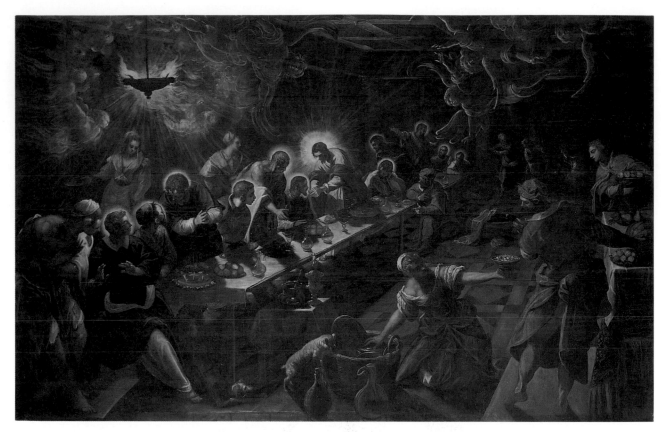

18-60. Tintoretto. *The Last Supper*. 1592–94. Oil on canvas, 12' x 18'8" (3.7 x 5.7 m). Church of San Giorgio Maggiore, Venice

Tintoretto, who had a large workshop, often developed a composition by creating a small-scale model like a miniature stage set, which he populated with wax figures. He then adjusted the positions of the figures and the lighting until he was satisfied with the entire scene. Using a grid of horizontal and vertical threads placed in front of this model, he could easily sketch the composition onto squared paper for his assistants to copy onto a large canvas. His assistants also primed the canvas, blocking in the areas of dark and light, before the artist himself, free to concentrate on the most difficult passages, finished the painting. This efficient working method allowed Tintoretto to produce a large number of paintings in all sizes.

Within this grand setting, realistic figures in splendid costumes assume exaggerated, theatrical poses. The huge size of the painting allowed Veronese to include the sort of anecdotal vignettes beloved by the Venetians—the parrots, monkeys, and Germans—but detested by the Inquisitors, who saw in them profane undertones.

Another Venetian master, Jacopo Robusti (1518–94), called Tintoretto ("Little Dyer") because his father was a dyer, worked in a style that developed from, and exaggerated, the techniques of Titian, in whose shop he reportedly apprenticed. Tintoretto's goal, declared on a sign in his studio, was to combine his master's color with the drawing of Michelangelo. Like Veronese, Tintoretto often received commissions to decorate huge interior spaces. He painted *The Last Supper* (fig. 18-60) for the choir of the Church of San Giorgio Maggiore, a building designed by Palladio (see fig. 18-61). Comparison with Leonardo da Vinci's painting of almost a century earlier is instructive (see fig. 18-2). Instead of Leonardo's closed and logical space with massive figures reacting in individual ways to Jesus' statement, Tintoretto's view is from a corner, with the vanishing point on a high horizon line at the far right side. The table, coffered ceiling, and inlaid floor all seem to plunge dramatically into the distance. The figures, although still large bodies modeled by flowing draperies,

turn and move in a continuous serpentine line that unites apostles, servants, and angels. Tintoretto used two light sources: one real, the other supernatural. Light streams from the oil lamp flaring dangerously over the near end of the table; angels seem to swirl out from the flame and smoke. A second light emanates from Jesus himself and is repeated in the glow of the apostles' halos. The mood of intense spirituality is enhanced by deep colors flashed with bright highlights, as well as by the elongated figures—treatments that reflect both the Byzantine art of Venice and the Mannerist aesthetic. The still lifes on the tables and the homey detail of a cat and basket emphasize the reality of the viewers' experience. At the same time, the deep chiaroscuro and brilliant dazzling lights catching forms in near-total darkness enhance the convincingly otherworldly atmosphere. The interpretation of the Last Supper also has changed—unlike Leonardo's more secular emphasis on personal betrayal, Tintoretto has returned to the institution of the Eucharist: Jesus offers bread and wine, a model for the priest administering the sacraments at the altar next to the painting.

The speed with which Tintoretto drew and painted was the subject of comment in his own time, and the brilliance and immediacy so admired today (his slashing brushwork was fully appreciated by the gestural painters

of the twentieth century) were derided as evidence of carelessness. His rapid production may be attributed to the efficiency of his working methods: Tintoretto had a large workshop of assistants and he usually provided only the original conception, the beginning drawings, and the final brilliant colors of the finished painting. Tintoretto's workshop included members of his family—of his eight children, four became artists. His eldest, Marietta Robusti, worked with him as a portrait painter, and two or perhaps three of his sons also joined the shop. Another daughter, famous for her needlework, became a nun. Marietta, in spite of her fame and many commissions, stayed in her father's shop until she died, at the age of thirty. So skillfully did she capture her father's style and technique that today art historians cannot be certain which paintings are hers.

Architecture. Just as Veronese and Tintoretto expanded upon the rich Venetian tradition of oil painting established by Giorgione and Titian, Andrea Palladio dominated architecture during the second half of the century by expanding upon principles of Alberti and of ancient Roman architecture. His work—whether a villa, palace, or church—was characterized by harmonious symmetry and a rejection of ornamentation.

Born Andrea di Pietro della Gondola (1508–80), probably in Padua, the artist began his career as a stonecutter. After moving to Vicenza, he was hired by the noble humanist scholar and amateur architect Giangiorgio Trissino, who nicknamed him Palladio, for the Greek goddess of wisdom, Pallas Athena, and the fourth-century Roman writer Palladius. Palladio learned Latin at Trissino's small academy and accompanied his benefactor on three trips to Rome, where he made drawings of Roman monuments. Over the years, he became involved in several publishing ventures, including a guide to Roman antiquities, an illustrated edition of Vitruvius, and books on architecture that for centuries would be valuable resources for architectural design.

By 1559, when he settled in Venice, Palladio was one of the foremost architects of Italy. In 1565, he undertook a major architectural commission: the monastery Church of San Giorgio Maggiore (fig. 18-61). His design for the Renaissance facade to the traditional basilica-plan elevation—a wide lower level fronting the nave and side aisles surmounted by a narrower front for the nave clerestory—is ingenious. Inspired by Alberti's solution for Sant'Andrea in Mantua (see fig. 17-41), Palladio created the illusion of two temple fronts of different heights and widths, one set inside the other. At the center, colossal columns on high pedestals, or bases, support an entablature and pediment that front the narrower clerestory level of the church. The lower temple front, which covers the triple-aisle width and slanted side-aisle roofs, consists of pilasters supporting an entablature and pediment running behind the columns of the taller clerestory front. Palladio retained Alberti's motif of the triumphal-arch entrance. Although the facade was not built until after the architect's death, his original design was followed. The interior of San Giorgio (fig. 18-62) is

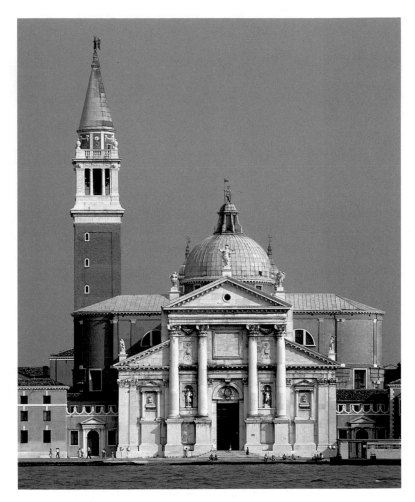

18-61. Palladio. Church of San Giorgio Maggiore, Venice. 1565–80; campanile 1791

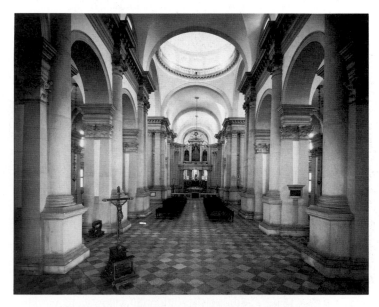

18-62. Nave, Church of San Giorgio Maggiore

a fine example of Palladio's harmoniously balanced geometry, expressed here in strong verticals and powerful arcs. The tall engaged columns and shorter pairs of pilasters of the nave arcade echo the two levels of orders on the facade, thus unifying the building's exterior and interior.

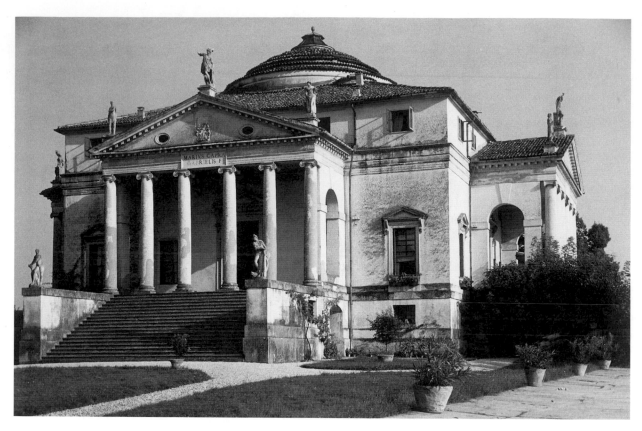

18-63. Palladio. Villa Rotunda (Villa Capra), Vicenza, Italy. 1560s

18-64. Plan of the Villa Rotunda. c. 1550

Palladio was a scholar and an architectural theorist as well
as a designer of buildings. His books on architecture provided
ideal plans for country estates, using proportions derived
from ancient Roman structures. Despite their theoretical bent,
his writings were often more practical than earlier treatises.
Perhaps his early experience as a stonemason provided him
with the knowledge and self-confidence to approach technical
problems and discuss them as clearly as he did theories
of ideal proportion and uses of the classical orders. By the
eighteenth century, Palladio's *Four Books of Architecture* had
been included in the library of most educated people. Thomas
Jefferson had one of the first copies in America.

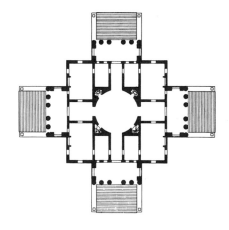

Palladio's versatility can best be seen in numerous vil-
las built early in his career. In the 1560s, he started his
most famous and influential villa just outside Vicenza
(fig. 18-63). Although traditionally villas were working
farms, Palladio designed this one as a retreat for relaxation
(a party house). To afford views of the countryside, he
placed an Ionic order porch on each face of the building,
with a wide staircase leading up to it. The main living
quarters are on the second level, as is usual in European
palace architecture, and the lower level is reserved for the
kitchen, storage, and other utility rooms. Upon its com-
pletion in 1569, the villa was dubbed the Villa Rotunda

because it had been inspired by another rotunda (or round
hall), the Roman Pantheon; after its purchase in 1591 by
the Capra family, it became known as the Villa Capra. The
villa plan (fig. 18-64) shows the geometric clarity of Palla-
dio's conception: a circle inscribed in a small square inside
a larger square, with symmetrical rectangular compart-
ments and identical rectangular projections from each of
its faces. The use of a central dome on a domestic build-
ing was a daring innovation that effectively secularized
the dome. The Villa Rotunda was the first of what was to
become a long tradition of domed country houses, partic-
ularly in England and the United States.

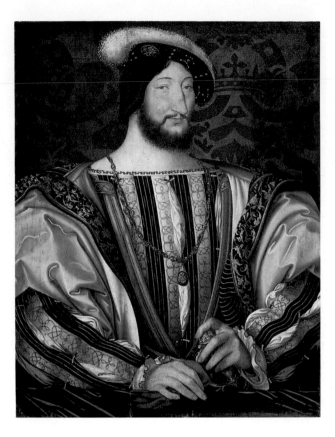

18-65. Jean Clouet. *Francis I.*
1525–30. Oil and tempera on wood panel, 37¾ x 29⅛" (95.9 x 74 cm). Musée du Louvre, Paris

RENAISSANCE ART IN FRANCE

The French had exerted military power in Italy since the end of the fifteenth century; Italian Renaissance art, in turn, exerted its aesthetic power over the French. The greatest French patron of Italian artists was Francis I (ruled 1515–47). Immediately after his ascent to the throne, Francis showed his desire to "modernize" the French court by acquiring the versatile talents of Leonardo da Vinci, who moved to France at his invitation in 1516 to advise on royal architectural projects. In 1526, Francis began a major campaign of supporting the arts, which he sustained throughout his reign, despite the distraction of continual warring against his brother-in-law, Emperor Charles V, to expand French territory. Under his patronage, an Italian-inspired Renaissance blossomed in France.

PAINTING

The Flemish-born artist Jean Clouet (c. 1485–c. 1540) found great favor as Francis's portraitist. Clouet's origins are obscure, but he was in France as early as 1509 and in 1530 moved to Paris as principal court painter. In his official portrait of the king (fig. 18-65), Clouet softened Francis's distinctive features but did not completely idealize them. The king's thick neck seems at odds with the delicately worked costume of silk, satin, velvet, jewels, and gold embroidery, and his shoulders are broadened by elaborate, puffy sleeves to more than fill the panel, much as parade armor turned scrawny men into giants.

In creating such official portraits, artists sketched the subject, then painted a prototype that, upon approval, was the model for numerous replicas for diplomatic and family purposes. The clothing and jewels could be painted separately; lent to the artists by the subjects, they were sometimes modeled by a servant.

ARCHITECTURE AND ITS DECORATION

With the enthusiasm of Francis for things Italian and the widening distribution of Italian books on architecture, the Italian Renaissance style began to appear in French construction. Builders of elegant rural palaces, called **châteaux**, were quick to introduce Italianate decoration on otherwise Gothic buildings, but French architects soon adapted classical principles of building design as well. The king also began renovation of royal properties. Having chosen as his primary residence the medieval hunting lodge at Fontainebleau, Francis began transforming it into a grand palace. Most of the exterior structure was altered or destroyed by later renovations, but parts of the interior decoration, mainly the work of artists and artisans from Italy, have been preserved and restored. The first artistic director at Fontainebleau, the Mannerist painter Rosso Fiorentino (d. 1540), arrived in 1530. Francesco Primaticcio (1504–70), who had worked with Giulio Romano in Mantua, joined him in 1532 and succeeded him in 1540.

Following ancient tradition, the king maintained an official mistress—Anne, the duchess of Étampes, who was in residence at Fontainebleau. Among Primaticcio's

18-66. Primaticcio. Stucco and wall painting, Chamber of the Duchess of Étampes, Château of Fontainebleau, France. 1540s

Primaticcio worked on the decoration of Fontainebleau from 1532 until his death in 1570. During that time, he also commissioned and imported a large number of copies and casts of original Roman sculpture, from the newly discovered *Laocoön* to the relief decoration on the Column of Trajan. These works provided an invaluable visual source of figures and techniques for the northern artists employed on the Fontainebleau project.

(below)
18-67. Pierre Lescot. West wing of the Cour Carré, Palais du Louvre, Paris. Begun 1546

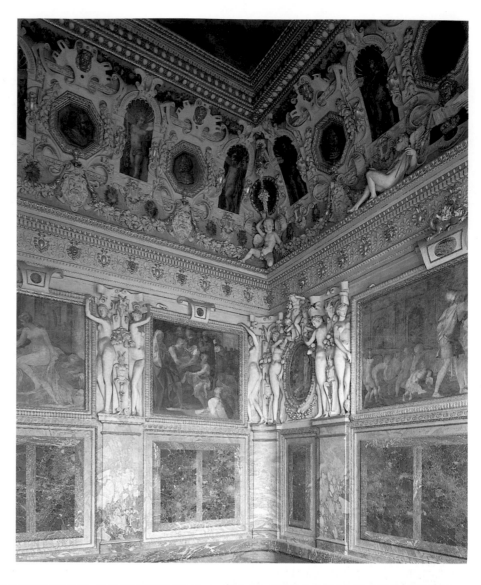

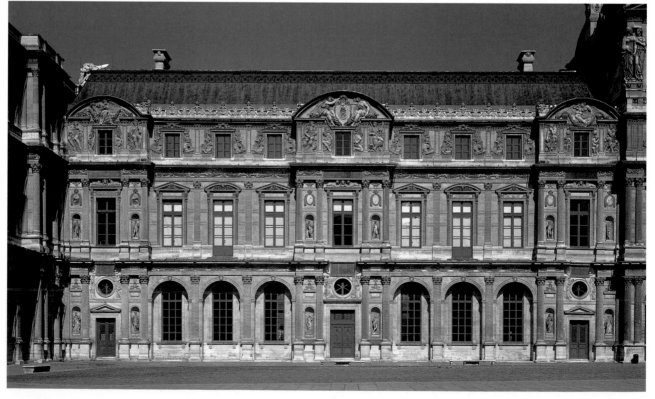

THE GROTTO Of all the enchanting features of the Renaissance garden, none is more intriguing than a grotto, a recess typically constructed of irregular stones and shells and covered with fictive foliage and slime to suggest a natural cave. The fancifully decorated grotto usually included a spring, pool, fountain, or other waterworks. Sculpture of earth giants might support its walls, and depictions of nymphs might suggest the source of the water that nourished the garden. Great Renaissance gardens had at least one grotto where one could commune with nymphs and Muses and escape the summer heat. Alberti recommended that the contrived grotto be covered "with green wax, in imitation of mossy Slime which we always see in moist grottoes" (Alberti, *On Architecture*, 9.4).

The Great Grotto of the Boboli Gardens of the Pitti Palace in Florence, designed by Bernardo Buontalenti in 1583 and constructed in 1587–93, contained four marble captives (originally conceived for the tomb of Pope Julius II) carved by Michelangelo and, in its inner cave, a 1592 copy of the *Venus* by Giovanni da Bologna (see fig. 18-56).

Flowing water operated fountains, hydraulic organs, and other devices, such as mechanical birds that fluttered their wings and chirped or sang, filling the grotto with noise, if not music. Water jets concealed in the floor, stairs, or crevasses in the rockwork could be turned on by the owner to drench his guests, to the great amusement of all. Two of the most charming garden grottoes were designed by Bernard Palissy for Catherine de Medici, Queen of France, at the Château of Écouten (1570–72) and in the Tuileries Gardens in Paris (1563). Palissy's grottoes were made entirely of glazed ceramic, including fish and crayfish seeming to swim in the pool and reptiles slithering or creeping over mossy rocks—all of which glistened with water and surely achieved Alberti's ideal Slime.

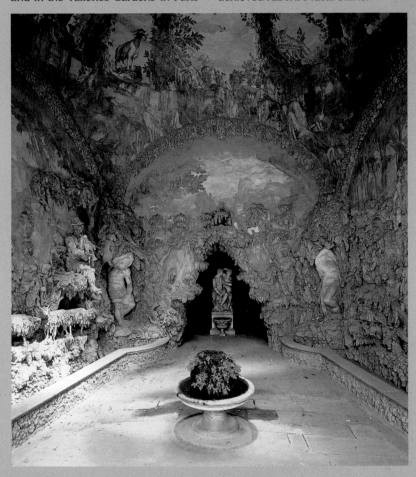

Bernardo Buontalenti. The Great Grotto, Boboli Gardens, Pitti Palace, Florence. 1583–93

first projects was the redecoration of Anne's rooms and the stair leading to them (fig. 18-66). The artist combined woodworking, stucco relief, and fresco painting in his complex but lighthearted and graceful interior design. The lithe figures of stucco nymphs, with their long necks and small heads, recall Parmigianino's painting style (see fig.18-53). Their spiraling postures are playfully sexual. The wall surface is almost overwhelmed with garlands, mythological figures, and Roman architectural ornament, yet the visual effect is extraordinarily confident and joyous. The first School of Fontainebleau, as this Italian phase of the palace decoration is called, established a tradition of Mannerism in painting and interior design that spread to other centers in France and the Netherlands.

Paris at midcentury saw the birth of a more classical style. In 1546, the king decided to modernize the Louvre, a medieval castle in Paris. The work began with the replacement of the west wing of the square court, the Cour Carré (fig. 18-67), by the architect Pierre Lescot (c. 1515–78). Working with the sculptor Jean Goujon (1510–68), Lescot designed a building incorporating Renaissance ideals of balance and regularity with classical architectural details and rich sculptural decoration. **Turrets** with pointed roofs gave way to discreetly rounded arches, breaking the line of the facade. Classical pilasters and entablatures replaced Gothic buttresses and **stringcourses**. Pediments topped a round-arched arcade on the ground floor, suggesting an Italian *loggia*. The final effect of the building, with its rectangular windows and sumptuous decoration, is elegantly French.

Gardens played an important role in architectural designs. Usually intended to be viewed from the owners' principal rooms on the main (second) floor, Renaissance gardens had regular plantings, often in intricate patterns enlivened by sculpture and sometimes witty surprises such as trick fountains. For the gardens of the proposed Tuileries Palace facing the Louvre, Bernard Palissy (1510–89) created an earthenware grotto in 1567. It was

18-68. Attributed to Bernard Palissy. Oval plate in *"style rustique."* 1570–80/90 (?). Polychromed tin and glazed earthenware, length 20½" (52 cm). Musée du Louvre, Paris

18-69. Juan Bautista de Toledo and Juan de Herrera. El Escorial, Madrid. 1563–84. Detail from an anonymous 18th-century painting

decorated entirely with glazed ceramic rocks, shells, crumbling statues, water creatures, a cat stalking birds, ferns, and garlands of fruits and vegetation—all reportedly made from casts of actual creatures and plants. In 1563, Palissy had been appointed the court's "inventor of rustic figurines." He also was called the Huguenot potter because of his Protestant faith and was repeatedly arrested during a period of persecution of Protestants. He died in prison, and at about the same time, his Tuileries grotto was destroyed. We can imagine its appearance from the distinctive ceramic platters decorated in high relief with plants, reptiles, and insects in the same style and technique as was the grotto (fig. 18-68). Existing examples are best called Palissy-style works, however,

because their authenticity is nearly impossible to prove. His designs were copied until the seventeenth century, and pieces in his style are still made today.

RENAISSANCE ART IN SPAIN

Philip II, the only son of Holy Roman Emperor Charles V and Isabella of Portugal, became the king of Spain, the Netherlands, and the Americas, as well as ruler of Milan, Burgundy, and Naples, when his father abdicated. He preferred Spain as his permanent residence. From an early age, Philip was a serious art collector: For more than half a century, he patronized and supported artists in Spain and abroad. During his long reign (1556–98), the zenith of Spanish power, Spain halted the advance of Islam in the Mediterranean and secured control of much of the Americas. Despite enormous effort and wealth, however, Philip could not suppress the revolt of the northern Netherlands, nor could he prevail in his war against the English, who destroyed his navy, the famous Spanish Armada, in 1588.

ARCHITECTURE

Philip built El Escorial (fig. 18-69), the great monastery-palace complex outside Madrid, partly to comply with his father's direction to construct a "pantheon" in which all Spanish kings might be buried and partly to house his court and government. The basic plan was a collaboration between Philip and Juan Bautista de Toledo (d. 1567), Michelangelo's supervisor of work at Saint Peter's from 1546 to 1548, summoned from Italy in 1559. Juan Bautista's design reflected his indoctrination in Bramante's classical principles in Rome, but the king himself dictated its severity and size, and El Escorial's grandeur comes from its large size, excellent masonry, and fine proportions.

The complex includes not only the royal residence but also the Royal Monastery of San Lorenzo, a school, a library, and a church whose crypt served as the royal burial chamber. In 1572, Juan Bautista's original assistant, Juan de Herrera, was appointed architect and immediately changed the design, adding second stories on all wings and breaking the horizontality of the main facade with a central frontispiece that resembled superimposed temple fronts. Before beginning the church in the center of the complex, Philip solicited the advice of Italian architects—including Vignola and Palladio. The final design combined ideas that Philip approved and Herrera carried out. Although not a replica of any Italian design, the building embodies Italian classicism in its geometric clarity and symmetry and the use of superimposed orders on the temple-front facade.

PAINTING

The most famous painter in Spain in the last quarter of the sixteenth century was the Greek painter Domenikos Theotokopoulos (1541–1614), who arrived in 1577 after working for ten years in Italy. El Greco ("The Greek"), as he is called, was trained as an icon painter in the Byzantine

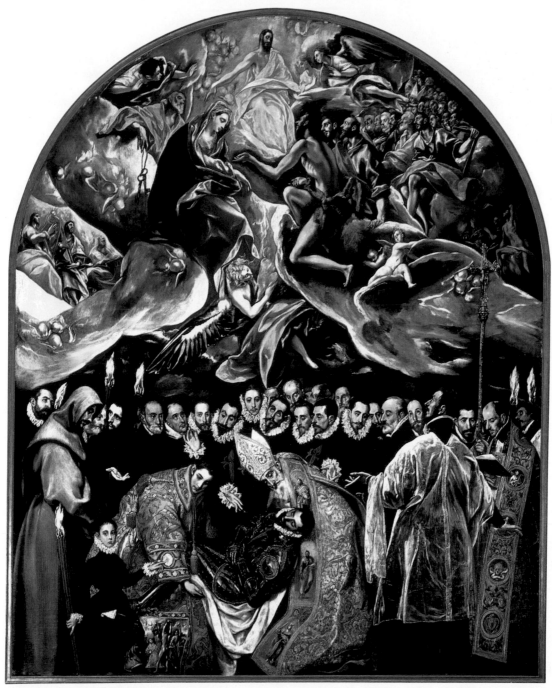

18-70. El Greco. *Burial of Count Orgaz*. 1586. Oil on canvas, 16' x 11'10" (4.88 x 3.61 m). Church of Santo Tomé, Toledo, Spain.

manner in his native Crete, then under Venetian rule. In about 1566, he went to Venice and entered Titian's shop, but he must also have closely studied the paintings of Tintoretto and Veronese. From about 1570 to 1577, he worked in Rome, apparently without finding sufficient patronage. Probably encouraged by Spanish Church officials he met in Rome, El Greco settled in Toledo, in central Spain, where he soon received major commissions. He had apparently hoped for a court appointment, but Philip II disliked the one large painting he had commissioned from the artist for El Escorial and never gave him work again. Toledo was an important cultural center, and El Greco joined the circle of humanist scholars who dominated its intellectual life.

An intense religious revival was under way in Spain, expressed in the impassioned preaching of Ignatius of Loyola, as well as in the poetry of the two great Spanish mystics, Saint Teresa of Ávila (1515–82) and her follower Saint John of the Cross (1542–91). El Greco's style—rooted in Byzantine religious art but strongly reflecting Venetian artists' rich colors and loose brushwork—expressed in paint the intense spirituality of these mystics.

In 1586, the Orgaz family commissioned El Greco to paint a large altarpiece honoring an illustrious fourteenth-century ancestor, Count Orgaz. The count had been a great benefactor of the Church, and at his funeral Saints Augustine and Stephen were said to have appeared and lowered his body into his tomb as his soul simultaneously was seen ascending to heaven. In El Greco's painting the *Burial of Count Orgaz* (fig. 18-70), the miraculous burial takes place slightly off-center in the foreground, while an angel lifts Orgaz's tiny ghostly soul along the central axis through the heavenly hosts toward the enthroned Christ at the apex of the canvas.

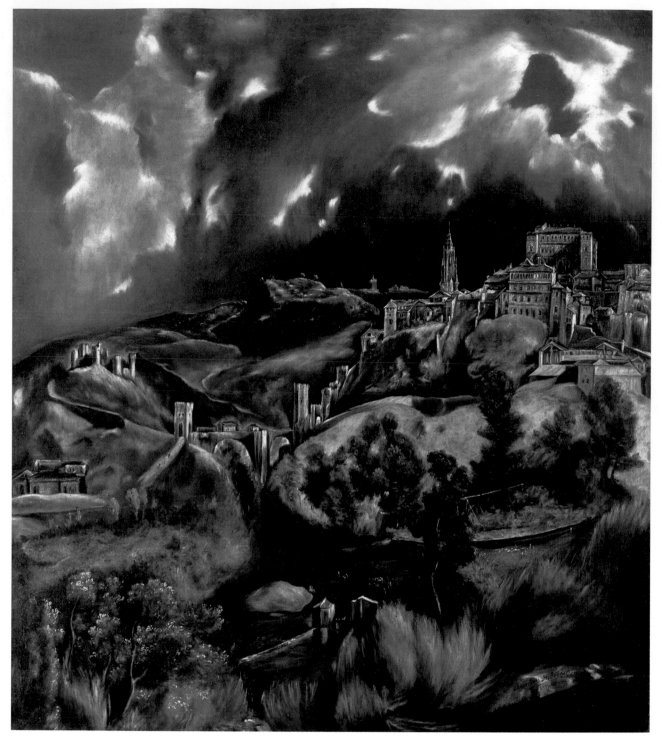

18-71. El Greco. *View of Toledo.* c. 1610. Oil on canvas, 47³/₄ x 42³/₄" (121 x 109 cm). The Metropolitan Museum of Art, New York

The H. O. Havemeyer Collection. Bequest of Mrs. H. O. Havemeyer, 1929 (29.100.6)

El Greco filled the space around the burial scene with a group portrait of the local aristocracy and religious notables. He placed his own eight-year-old son at the lower left next to Saint Stephen and signed the painting on the boy's white kerchief. El Greco may also have put his own features on the man just above the saint's head, the only one who looks straight out at the viewer.

In composing the painting, El Greco used a Mannerist device reminiscent of Pontormo, filling up the pictorial field with figures and eliminating specific reference to the spatial setting (see fig. 18-52). Yet he has distinguished between heaven and earth by the elongation of

the heavenly figures and the light emanating from Christ, who sheds an otherworldly luminescence quite unlike the natural light below. The two realms are connected, however, by the descent of the light from heaven to strike the priestly figure in the white vestment at the lower right.

Late in his life, El Greco painted one of his rare landscapes, *View of Toledo* (fig. 18-71), a topographical cityscape transformed into a mystical illusion by a stormy sky and a narrowly restricted palette of greens and grays. This conception is very different from Altdorfer's peaceful, idealized *Danube Landscape* of nearly a century earlier (see fig. 18-43). If any precedent comes to

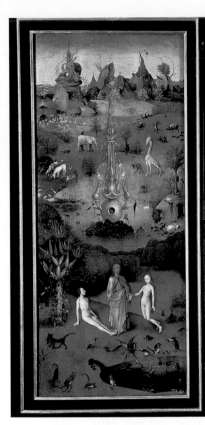
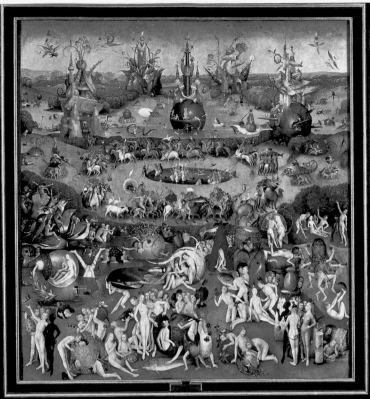
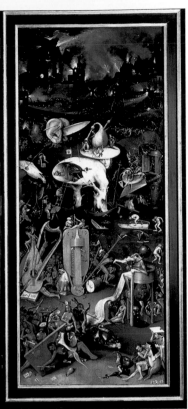

18-72. Hieronymus Bosch. *Garden of Earthly Delights*. c. 1505–15. Oil on wood panel, center panel 7'2½" x 6'4¾" (2.20 x 1.95 m), each wing 7'2½" x 3'2" (2.20 x 0.97 m). Museo del Prado, Madrid

This work was commissioned by an aristocrat for his Brussels town house, and the artist's choice of a triptych format, which suggests an altarpiece, may have been an understated irony. As a secular work, the *Garden of Earthly Delights* may well have inspired lively discussion and even ribald comment, much as it does today in its museum setting. Despite—or perhaps because of—its bizarre subject matter, the triptych was copied in 1566 into tapestry versions, one (now in El Escorial, Madrid) for a cardinal and another for Francis I. At least one painted copy was made as well. Bosch's original triptych was sold at the onset of the Netherlands's revolt and sent in 1568 to Spain, where it entered the collection of Philip II.

mind, it is the lightning-rent sky and prestorm atmosphere in Giorgione's *The Tempest* (see fig. 18-23). In El Greco's painting, the precisely accurate portrayal of Toledo's geography and architecture seems to have been overridden by the artist's desire to convey his emotional response to the city, his adopted home.

RENAISSANCE PAINTING IN THE NETHERLANDS

In the Netherlands, a region that included Holland and Belgium, the sixteenth century was an age of bitter religious and political conflict. Despite the opposition of Charles V, who instituted book burnings and, in 1522, the Inquisition, the Protestant Reformation took hold in the northern provinces. Seeds of unrest were sown still deeper over the course of the century by continued religious persecution, economic hardship, and control by a distant king—Charles's son Philip II, in Spain. A long battle for independence began with a revolt in 1568 and lasted until Spain relinquished all claims to the region eighty years later. But as early as 1579, when the seven northern Protestant provinces declared themselves the United Provinces, the discord split the Netherlands, eventually dividing it along religious lines into Holland and Belgium.

Even with the turmoil, the Netherlanders found the resources to pay for art. Strong, affluent art centers, such as Utrecht, developed in the north. In addition to painting, textile arts flourished in the Netherlands. Antwerp and Brussels were both centers of tapestry weaving and received such commissions as the Sistine Chapel tapestries, for which Raphael provided the cartoons (see fig. 18-9). Although the Roman Catholic Church continued to commission works of art, the religious controversies led Netherlandish artists to seek private patrons. A market existed for small paintings of secular subjects that were both decorative and interesting conversation pieces for homes. Certain subjects were so popular later in the century that some artists became specialists, rapidly producing variations on a particular theme, with the help of assistants.

Hieronymus Bosch. One of the greatest of the Netherlandish painters is Hieronymus Bosch (1450–1516), whose work depicts a world of fantastic imagination associated with medieval art. A superb colorist and technical virtuoso, Bosch spent his career in the town whose name he adopted, 's Hertogenbosch, near the German border. Bosch's religious devotion is certain, and his range of subjects shows that he was well educated; a man of many talents, he was also a hydraulic engineer who designed fountains and civic waterworks.

Challenging and unsettling paintings such as Bosch's triptych *Garden of Earthly Delights* (fig. 18-72)

have led modern critics to label him scholar, mystic, and social critic. There are many interpretations of the *Garden*, but a few broad conclusions can be drawn. The subject of the overall work is sin—that is, the Christian belief in human beings' natural state of sinfulness and their inability to save themselves from its consequences. Because only the damned are shown in the Last Judgment on the right, the work seems to caution that damnation is the natural outcome of a life lived in ignorance and folly, that people ensure their damnation through their self centered pursuit of pleasures of the flesh—the sins of gluttony, lust, avarice, and sloth.

The introduction of Adam and Eve, at the left, is brought about by Christ but is watched by the owl of perverted wisdom. Appearing repeatedly, the owl symbolizes both wisdom and folly—a concept as important as sin to the northern humanists, who believed in the power of education: People would choose the right way if they knew it. Here the owl is in a fantastic plant in a lake from which vicious creatures creep out into the world. Bosch seems obsessed with hybrid forms, unnatural unions in the world. In the central panel, the earth teems with revelers, monstrous birds, and fruits symbolic of fertility and sexual abandon. In hell, the sensual pleasures—eating, drinking, music, and dancing—are turned into elements of torture in a dark world of fire and ice. At the right, for example, a central creature with stump legs watches his own stomach filled with lost souls in a tavern on the road to hell.

One interesting interpretation of the central panel proposes that it is a parable on human salvation in which the practice of alchemy—the process that sought to turn common metals into gold—parallels Christ's power to convert human dross into spiritual gold. In this theory, the bizarre fountain at the center of the lake in the middle distance can be seen as an alchemical "marrying chamber," complete with the glass vessels for collecting the vapors of distillation. The central pool is the setting where the power of the seductive woman—a relatively new theme in the fifteenth century—is presented: Women frolic alluringly in the pool while men dance and ride madly, trying to attract them. In this strange garden, men are slaves to their own lust.

One critic wrote about 1600 that the triptych was known as *The Strawberry Plant* because it resembled the "vanity and glory and the passing taste of strawberries or the strawberry plant and its pleasant odor that is hardly remembered once it has passed." Luscious fruits with sexual symbolism—strawberries, cherries, grapes, and pomegranates—appear everywhere in the *Garden*, serving as food, as shelter, and even as a boat. Therefore, the subject of sin is reinforced by the suggestion that life is as fleeting and insubstantial as the taste of a strawberry.

Caterina van Hemessen. With a style profoundly different from Bosch's, Caterina van Hemessen (1528–87) of Antwerp developed an illustrious international reputation. She had learned to paint from her father, the Flemish Mannerist Jan Sanders van Hemessen, with whom she collaborated on large commissions, but her

18-73. Caterina van Hemessen. *Self-Portrait*. 1548. Oil on wood panel, 12¼ x 9¼" (31.1 x 23.5 cm). Öffentliche Kunstsammlung, Basel, Switzerland

The panel on the easel already has its frame. Catherine holds a small palette and brushes and steadies her right hand with a mahlstick, an essential tool for an artist doing fine, detailed work.

quiet realism and skilled rendering had roots in the classical Renaissance style—stylistic tendencies brought back to the Netherlands by painters who had visited Italy. To maintain the focus on the foreground subject, Caterina painted her portrait backgrounds in an even, dark color on which she identified her subject and the subject's age, and signed and dated the work. In her *Self-Portrait* (fig. 18-73), the inscription reads: "I Caterina van Hemessen painted myself in 1548. Her age 20." In delineating her own features, Caterina presented a serious young person without personal vanity yet seemingly already self-assured about her artistic abilities. During her early career, spent in Antwerp, she became a favored court artist to Mary of Hungary, regent of the Netherlands and sister of Emperor Charles V, for whom she painted not only portraits but also religious works. In 1554, Caterina married the organist of Antwerp Cathedral, and the couple accompanied Mary to Spain after she ceased to be regent in 1556. Unfortunately, Caterina's Spanish works have not survived or cannot be securely attributed to her.

Pieter Bruegel the Elder. So popular did the works of Hieronymus Bosch remain that, nearly half a century

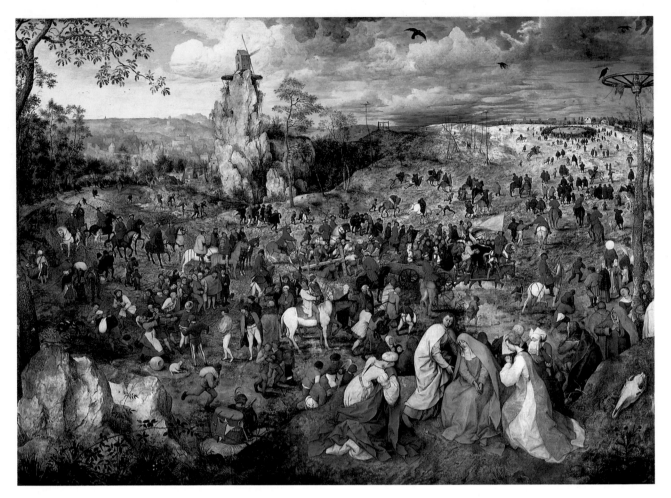

18-74. Pieter Bruegel the Elder. *Carrying of the Cross*. 1564. Oil on wood panel, 4'3/4" x 5'7" (1.23 x 1.7 m).
Kunsthistorisches Museum, Vienna

after his death, Pieter Bruegel (c. 1525–69) began his career by imitating Bosch's work. Fortunately, Bruegel's talents went far beyond those of an ordinary copyist, but like his predecessor he often painted large narrative works crowded with figures and chose moralizing or satirical subject matter. Nothing is known of his early training, but shortly after entering the Antwerp Guild in 1551, he spent time in Bologna and Rome, where he studied Michelangelo's *Sistine Ceiling* and other works in the Vatican.

Bruegel maintained a shop in Antwerp from 1554 until 1563, then moved to Brussels. His style and subjects found great favor with local scholars, merchants, and bankers, who appreciated the beautifully painted, artfully composed works that also reflected contemporary social, political, and religious conditions. Bruegel visited country fairs to sketch the farmers and townspeople who became the focus of his paintings, whether religious or secular. He depicted characters not as unique individuals but as well-observed types whose universality makes them familiar even today. Nevertheless, Bruegel presented Flemish farmers so vividly and sympathetically while also exposing their faults that the middle-class artist earned the nickname Peasant Bruegel.

True to his Mannerist heritage, Bruegel adopted Mannerist tricks of composition. The main subject of his pictures is often deliberately hidden or disguised by being placed in the distance or amid a teeming crowd of figures, as in the *Carrying of the Cross* (fig. 18-74) of 1564. At first glance, the large figures—Saint John and the three Marys—near the picture plane at the lower right seem to be the subject, but they are in fact secondary to the main event: Jesus carrying his Cross to Golgotha. To find Jesus, the viewer must visually enter the painting and search for the principal action while being constantly distracted by smaller dramas going on among the crowd milling about the large open field or surging around the dire events central to the painting. Bruegel's panoramic scene is carefully composed to guide our eye in swirling, circular orbits that expand, contract, and intersect. Part of this movement is accomplished by carefully placed bright red patches, the coats of guards trying to control the crowd. The figure of Jesus is finally discovered at the center of the painting. Far in the distance, on a hill caught by a beam of light in the darkening sky, people are gathering early to get a good place in the circle around the spot where the crosses will be set up—illustrating Bruegel's cynical view of crowd

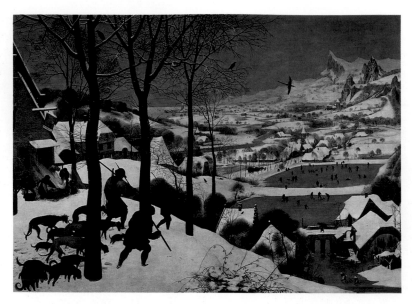

18-75. Pieter Bruegel the Elder. *Return of the Hunters*. 1565. Oil on wood panel, 3'10½" x 5'3¾" (1.18 x 1.61 m). Kunsthistorisches Museum, Vienna

psychology. The landscape recedes skillfully and apparently naturally toward the distant horizon, except for the tall rock outcropping near the center with a wooden windmill on top. The exaggerated shape of the rock is a convention of sixteenth-century northern European landscapes, but the enigmatic windmill suggests the ambiguities of Italian Mannerism.

Bruegel was one of the great landscape painters of all time. His ability to depict nature in all seasons, and in all moods, shines forth in his **cycles**—series of paintings on a single allegorical subject such as the Five Senses or the Seasons, frequently commissioned as decorations for elegant Netherlandish homes. Bruegel's *Return of the Hunters* (fig. 18-75) of 1565 is one of a cycle of six panels, each representing two months of the year. In this November–December scene, Bruegel has captured the atmosphere of the damp, cold winter, with its early nightfall, in the same way that his compatriots the Limbourgs did 150 years earlier in the *February* calendar illustration for the duke of Berry (see fig. 17-6). At first, the *Hunters* appears neutral and realistic, but the sharp plunge into space, the juxtaposition of near and far without middle ground, is typically Mannerist. The viewer seems to hover with the birds slightly above the ground, looking down first on the busy foreground scene, then suddenly across the valley to the snow-covered village and frozen ponds. The main subjects of the painting, the hunters, have their backs turned and do not reveal their feelings as they slog through the snow, trailed by their dogs. They pass an inn, at the left, where a worker moves a table to receive the pig others are singeing in a fire before butchering it. But this is clearly not an accidental image; it is a slice of everyday life faithfully reproduced within the carefully calculated composition. The sharp diagonals, both on the picture plane and as lines receding into space, are countered by the pointed gables and roofs at the lower right as well as by the jagged mountain peaks linking the valley and the skyline along the right edge. Their rhythms are deliberately slowed and stabilized by a balance of vertical tree trunks and horizontal rectangles of water frozen over in the distance.

As a depiction of Netherlandish history, this scene represents a relative calm before the storm. Three years after it was painted, the anguished struggle of the northern provinces for independence from Spain began. Pieter the Elder died young in 1569, leaving two children, Pieter the Younger and Jan, both of whom became successful painters in the next century. The dynasty continued with Jan's son Jan the Younger. (In the seventeenth century, the spelling of the family name was changed from Bruegel to Brueghel.)

RENAISSANCE ART IN ENGLAND

England, in contrast to continental Europe, was economically and politically stable enough to again provide sustained support for the arts during the Tudor dynasty in the sixteenth century. Henry VIII was known for his love of music (he was himself a composer of considerable accomplishment), but he also competed with the wealthy, sophisticated courts of Francis I and Charles V in the visual arts. Direct contacts with Italy became difficult after Henry's break with the Roman Catholic Church in 1534, and the Tudors favored Netherlandish and German artists.

English architects fared better than English painters, developing a style that incorporated classical features as seen in illustrated architectural handbooks rather than through direct Italian influence. The first architectural manual in English, published in 1563, was written by John Shute, who had spent time in Italy. Also available were stylebooks and treatises by Flemish, French, and German architects, as well as a number of books on architectural design by the Italian architect Sebastiano Serlio.

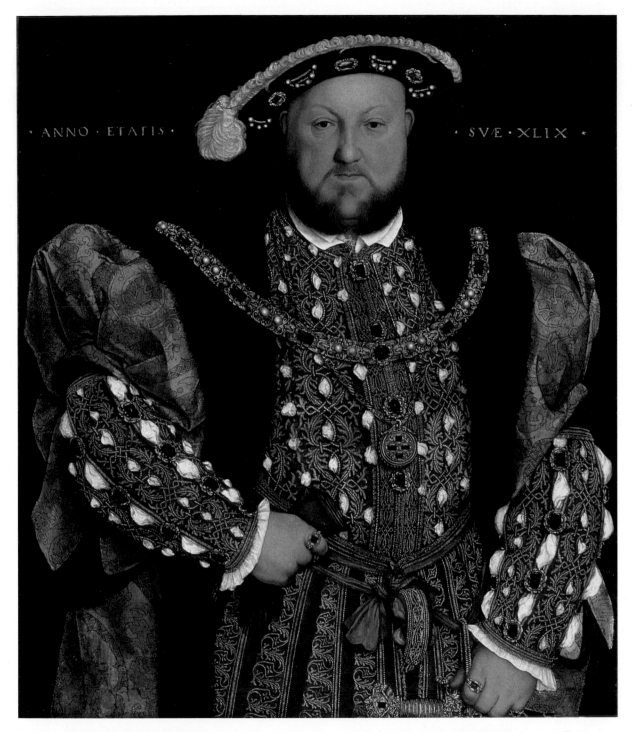

· ANNO · ETATIS · · SVÆ · XLIX ·

18-76. Hans Holbein the Younger. *Henry VIII*. 1540. Oil on wood panel, 32½ x 29½" (82.6 x 75 cm). Galleria Nazionale d'Arte Antica, Rome

Holbein used the English king's great size to advantage for this official portrait, enhancing Henry's majestic figure with embroidered cloth, fur, and jewelry to create one of the most imposing images of power in the history of art. He is dressed for his wedding to his fourth wife, Anne of Cleves, on April 5, 1540.

PAINTING

A remarkable record of the appearance of Tudor monarchs survives in portraiture. Hans Holbein the Younger (c. 1497–1543), a German-born painter, shaped the taste of the English court. He first visited London from 1526 to 1528 and was introduced by the Dutch scholar Erasmus to the humanist circle around the statesman Thomas More. He returned to England in 1532 and was appointed court painter to Henry VIII about four years later. One of Holbein's official portraits of Henry (fig. 18-76), shown at age forty-nine according to the inscription on the dark blue-green background, was painted in 1540, although the king's dress and appearance had already been established in an earlier prototype based on sketches of his features. Henry, who envied Francis I

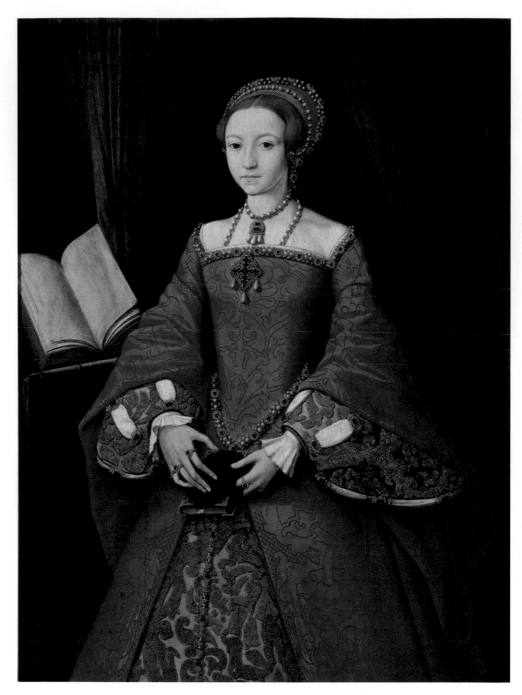

18-77. Unknown, attributed to William Scrots. *Elizabeth I when Princess.* c. 1559.
Oil on oak panel, 42³/₄ x 32¹/₄" (109 x 81.8 cm). The Royal Collection, Windsor Castle,
Windsor, England
(RCIN 404444, OM 46 WC 2010)

and attempted to outdo him in every way, imitated French fashions and even copied the French king's beard. Henry's huge frame—he was well over 6 feet tall and had a 54-inch waist in his maturity—is covered by the latest style of dress: a short puffed-sleeve coat of heavy brocade trimmed in dark fur; a narrow, stiff white collar fastened at the front; and a doublet, encrusted with gemstones and gold braid, that was slit to expose his silk shirt.

Holbein was not the highest-paid painter in Henry VIII's court. That status belonged to a Flemish woman named Levina Bening Teerling, who worked in England for thirty years. Her anonymity in England is an art-historical mystery. At Henry's invitation to become "King's Paintrix," she and her husband arrived in London in 1545 from Bruges, where her father was a leading manuscript illuminator. She maintained her court appointment until her death around 1576, in the reign of Elizabeth I. Because Levina was the granddaughter and daughter of Flemish manuscript illuminators, she is assumed to have painted mainly miniature portraits or scenes on vellum and ivory. One lifesize portrait frequently attributed to her—but by no means securely—depicts Elizabeth Tudor as a young princess (fig. 18-77). Elizabeth's pearled headcap, an adaptation of the so-called French hood popularized by her mother, Anne

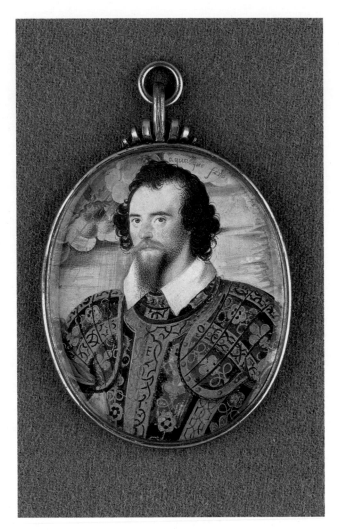

18-78. Nicholas Hilliard. *George Clifford, 3rd Earl of Cumberland (1558–1605)*. c. 1595. Watercolor on vellum on card, oval 2³/₄ x 2³/₁₆" (7.1 x 5.8 cm). The Nelson-Atkins Museum of Art, Kansas City, Missouri

Gift of Mr. and Mrs. John W. Starr through the Starr Foundation. F58-60/188

Boleyn, is set back to expose her famous red hair. Her brocaded outer dress, worn over a rigid hoop, is split to expose an underskirt of cut velvet. Although her features are softened by youth and no doubt are idealized as well, her long, high-bridged nose and the fullness below her small lower lip give her a distinctive appearance. The prominently displayed books were no doubt included to signify Elizabeth's well-known love of learning.

About the time Elizabeth sat for this portrait, in 1551, her half brother, the Protestant Edward VI, was king, and her half sister, the Catholic Mary Tudor, was next in line for the throne. When she gained the throne in 1553, Queen Mary quickly reinstated Catholic practice, and in July 1554 she married the future King Philip II of Spain. She died four years later, and the Protestant princess Elizabeth assumed the throne. So effective was Elizabeth's rule (1558–1603) that the last decades of the sixteenth century in England are called the Elizabethan age.

In 1570, while Levina Teerling was still active at Elizabeth's court, Nicholas Hilliard (1547–1619) arrived in London from southwest England to pursue a career as a jeweler, goldsmith, and painter of miniatures. Hilliard never received a court appointment but worked instead on commission, creating miniature portraits of the queen and court notables, including George Clifford, third earl of Cumberland (fig. 18-78). This former admiral was a regular participant in the tilts (jousts) and festivals celebrating the anniversary of Elizabeth I's ascent to the throne. In Hilliard's miniature, Cumberland wears a richly engraved and gold-inlaid suit of armor, forged for his first appearance, in 1583, at the tilts (see "Armor for Royal Games," page 752). Hilliard had a special talent for giving his male subjects an appropriate air of courtly jauntiness. Cumberland, a man of about thirty with a stylish beard, mustache, and curled hair, is humanized by his direct gaze and unconcealed receding hairline. Cumberland's motto, "I bear lightning and water," is inscribed on a stormy sky, with a lightning bolt in the form of a **caduceus** (the symbolic staff with two entwined snakes), one of his emblems.

ARMOR FOR ROYAL GAMES

The medieval tradition of tilting, or jousting, competitions at English festivals and public celebrations continued during Renaissance times. Perhaps the most famous of these, the Accession Day Tilts were held annually to celebrate the anniversary of Elizabeth I's coronation. The gentlemen of the court, dressed in armor made especially for the occasion, rode their horses from opposite directions, trying to strike each other with long lances. Each pair of competitors galloped past each other six times, and the judges rated their performances the way boxers are awarded points today. Breaking a competitor's lance was comparable to a knockout.

The elegant armor worn by George Clifford, third earl of Cumberland, at the Accession Day Tilts has been preserved in a nearly complete state in the collection of The Metropolitan Museum of Art in New York. In honor of the queen, the armor's surface was decorated with engraved Tudor roses and back-to-back capital *E*s. As the Queen's Champion from 1590 on, Clifford also wore her jeweled glove attached to his helmet as he met all comers in the courtyard of Whitehall Palace in London.

Made by Jacob Halder in the royal armories at Greenwich, the 60-pound suit of armor is recorded in the sixteenth-century Almain Armourers Album along with its "exchange pieces." These allowed the owner to vary his appearance by changing mitts, side pieces, or leg protectors, and also provided backup pieces if one were damaged.

Jacob Halder. Armor of George Clifford, 3rd Earl of Cumberland, made in the royal workshop at Greenwich, England. c. 1580–85. Steel and gold, height 5'9½" (1.77 m). The Metropolitan Museum of Art, New York
Munsey Fund, 1932 (32.130.6)

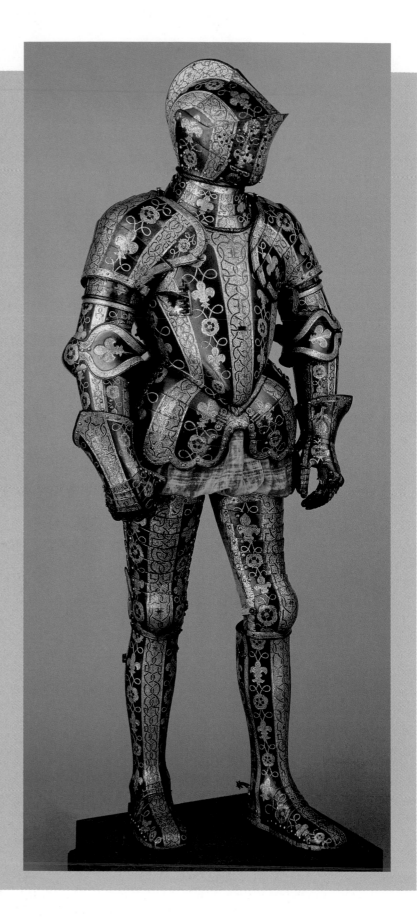

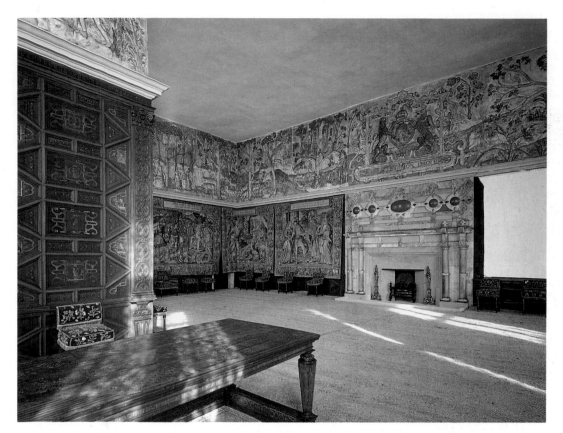

18-79. Robert Smythson. High Great Chamber, Hardwick Hall, Shrewsbury, England. 1591–97

Elizabeth, Countess of Shrewsbury, who commissioned Smythson, participated actively in the design of her houses. (For example, she embellished the roofline with her initials, *ES*, in letters 4 feet tall.) This room was designed to accommodate sixteenth-century Brussels tapestries telling the story of Ulysses, which she had bought in 1587. Other decorations include painted plaster sculpture around the top of the walls by Abraham Smith on mythological themes, a carved and inlaid fireplace, and seventeenth-century Farthingale chairs. Rush matting covers the floor.

ARCHITECTURE

In the years after his 1534 break with the Roman Catholic Church, Henry VIII, as the newly declared head of the Church of England, dissolved the monastic communities in England, seized their land, and sold or gave it to favored courtiers. Many properties were bought by speculators who divided and resold them. To increase support for the Tudor dynasty, Henry and his successors created a new nobility by granting titles to rich landowners and officials. To display their wealth and status, many of these newly created aristocrats embarked on extensive building projects after about 1550. They built lavish country residences, which sometimes surpassed the French châteaux in size and grandeur.

One of the grandest of all the Elizabethan houses was Hardwick Hall, the home of Elizabeth, Countess of Shrewsbury, known as Bess of Hardwick. The redoubtable countess—who inherited riches from all four of her deceased husbands—employed Robert Smythson (c. 1535–1614), the first English Renaissance professional architect, to build Hardwick Hall between 1591 and 1597, when she was in her seventies. At this time, Elizabethan architecture still reflected the Perpendicular style seen in Oxford colleges, with its severe walls and broad expanses

of glass, although designers modernized the forms by replacing medieval ornament with classical details learned from architectural handbooks and pattern books. But Smythson's—and Bess's—plan for Hardwick was new. The medieval great hall became a two-story entrance hall, with other rooms arranged symmetrically around it—a nod to classical balance. A sequence of rooms leads to a grand stair up to the Long Gallery and High Great Chamber on the second floor (fig. 18-79), where the owners received guests, entertained, and sometimes dined. The hall had enormous windows, ornate fireplaces, and richly sculptured and painted friezes around the room.

Under Protestant patronage, art work was less overtly religious than that of the Catholic Church, but with grand palaces and portraits, the Protestants carried on the tradition of using the visual arts to promote a cause, to educate, and to glorify—just as the Catholic Church had over the centuries used great churches and religious art for their didactic as well as aesthetic values. While Protestantism had become firmly established, the effects of the Reformation and the Counter-Reformation would continue to reverberate in the arts of the following century throughout Europe and, across the Atlantic, in America.

COUNTRY	SIXTEENTH-CENTURY ART IN EUROPE	ART IN OTHER CULTURES
ITALY	18-2. Leonardo. *The Last Supper* (1495–98)	21-9. Shen Zhou. *Poet on a Mountain Top* (c. 1500), China
	18-10. Michelangelo. *Pietà* (c. 1500)	21-5. Qiu Ying. *Spring Dawn in the Han Palace* (early 16th cent.), China
	18-3. Leonardo. *Virgin and St. Anne with the Christ Child and the Young John the Baptist* (c. 1500–1501)	23-2. *Codex Mendoza* (16th cent.), Mexico
	18-11. Michelangelo. *David* (1501–4)	20-8. *Gita Govinda* (c. 1525–50), India
		22-7. Kano Eitoku. Juko-in screens (c. 1563–73), Japan
	18-18. Bramante. Tempietto, Rome (1502–10)	20-5. *Hamza-nama* (c. 1567–82), India
	18-4. Leonardo. *Mona Lisa* (c. 1503–6)	
	18-5. Raphael. *The Small Cowper Madonna* (c. 1505)	
	18-24. Titian, Giorgione. *The Pastoral Concert* (c. 1508)	
	18-13. Michelangelo. *Sistine Ceiling* (1508–12)	
	18-23. Giorgione. *The Tempest* (c. 1510)	
	18-6. Raphael. *Disputà* (1510–11)	
	18-7. Raphael. *School of Athens* (1510–11)	
	18-15. Michelangelo. *Moses* (c. 1513–15)	
	18-9. *Miraculous Draft of Fishes* tapestry (1517)	
	18-19. Palazzo Farnese, Rome (1517–50)	
	18-8. Raphael. *Leo X with Cardinals Giulio de' Medici and Luigi de' Rossi* (c. 1518)	
	18-25. Titian. *Pesaro Madonna* (1519–26)	
	18-16. Michelangelo. Medici tombs, Florence (1519–34)	
	18-22. Correggio. *Assumption of the Virgin* (c. 1526–36)	
	18-17. Michelangelo. Laurentian Library, Florence (1524–33)	
	18-52. Pontormo. *Entombment* (1525–28)	
	18-20. Romano. Palazzo del Tè, Mantua (1525–32)	
	18-21. Romano. *Fall of the Giants* (1530–32)	
	18-53. Parmigianino. *Madonna with the Long Neck* (c. 1535)	
	18-48. Michelangelo. *Last Judgment* (1536–41)	
	18-26. Titian. *Venus of Urbino* (c. 1538)	
	18-55. Cellini. *Saltcellar of Francis I* (1539–43)	
	18-54. Bronzino. *Portrait of a Young Man* (c. 1540–45)	
	18-45. Michelangelo. St. Peter's, Vatican, Rome (c. 1546–64)	
	18-39. Leoni. *Charles V Triumphing over Fury* (1549–55)	
	18-49. Michelangelo. *Rondanini Pietà* (1555–64)	
	18-57. Anguissola. *Child Bitten by a Crayfish* (c. 1558)	
	18-61. Palladio. S. Giorgio Maggiore, Venice (1565–80)	
	18-63. Palladio. Villa Rotunda, Vicenza (1560s)	
	18-56. Bologna. *Astronomy, or Venus Urania* (c. 1573)	
	18-59. Veronese. *Feast in the House of Levi* (1573)	
	18-47. Vignola, della Porta. Il Gesù, Rome (c. 1568–84)	
	18-50. Titian. *Pietà* (1576)	
	18-58. Fontana. *Noli Me Tangere* (1581)	
	18-60. Tintoretto. *The Last Supper* (1592–94)	
GERMANY	18-27. Dürer House, Nuremberg	
	18-36. Dürer. *Four Horsemen of the Apocalypse* (1497–98)	
	18-29. Riemenschneider. *Last Supper* (c. 1499–1505)	
	18-35. Dürer. *Self-Portrait* (1500)	
	18-28. *"Apple Cup"* (c. 1510–15)	
	18-37. Dürer. *Adam and Eve* (1504)	
	18-31. Hagenauer. *St. Anthony Enthroned between Saints Augustine and Jerome* (c. 1505)	

COUNTRY	SIXTEENTH-CENTURY ART IN EUROPE

18-32. *Grünewald. Isenheim Altarpiece* (c. 1510–15)

18-38. Dürer. *Melencolia I* (1514)
18-30. Stoss. *Annunciation and Virgin of the Rosary* (1517–18)
18-42. Cranach the Elder. *Martin Luther as Junker Jörg* (c. 1521)
18-43. Altdorfer. *Danube Landscape* (c. 1525)
18-41. Dürer. *Four Apostles* (1526)

NETHERLANDS **18-72.** Bosch. *Garden of Earthly Delights* (c. 1505–15)

18-73. Van Hemessen. *Self-Portrait* (1548)
18-74. Bruegel the Elder. *Carrying of the Cross* (1564)
18-75. Bruegel the Elder. *Return of the Hunters* (1565)

FRANCE **18-65.** Clouet. *Francis I* (1525–30)

18-66. Primaticcio. Fontainebleau wall painting (1540s)
18-67. Lescot. Cour Carré, Paris (begun 1546)
18-68. Palissy (?). Oval plate (1570–80/90?)

SPAIN **18-69.** Bautista de Toledo, Herrera. El Escorial, Madrid (1563–84)
18-70. El Greco. *Burial of Count Orgaz* (1586)
18-71. El Greco. *View of Toledo* (c. 1610)

ENGLAND **18-76.** Holbein the Younger. *Henry VIII* (1540)

18-77. Teerling (?). *Elizabeth I* (c. 1551)
18-78. Hilliard. *George Clifford, 3rd Earl of Cumberland* (c. 1595)
18-79. Smythson. Hardwick Hall, Shrewsbury (1591–97)

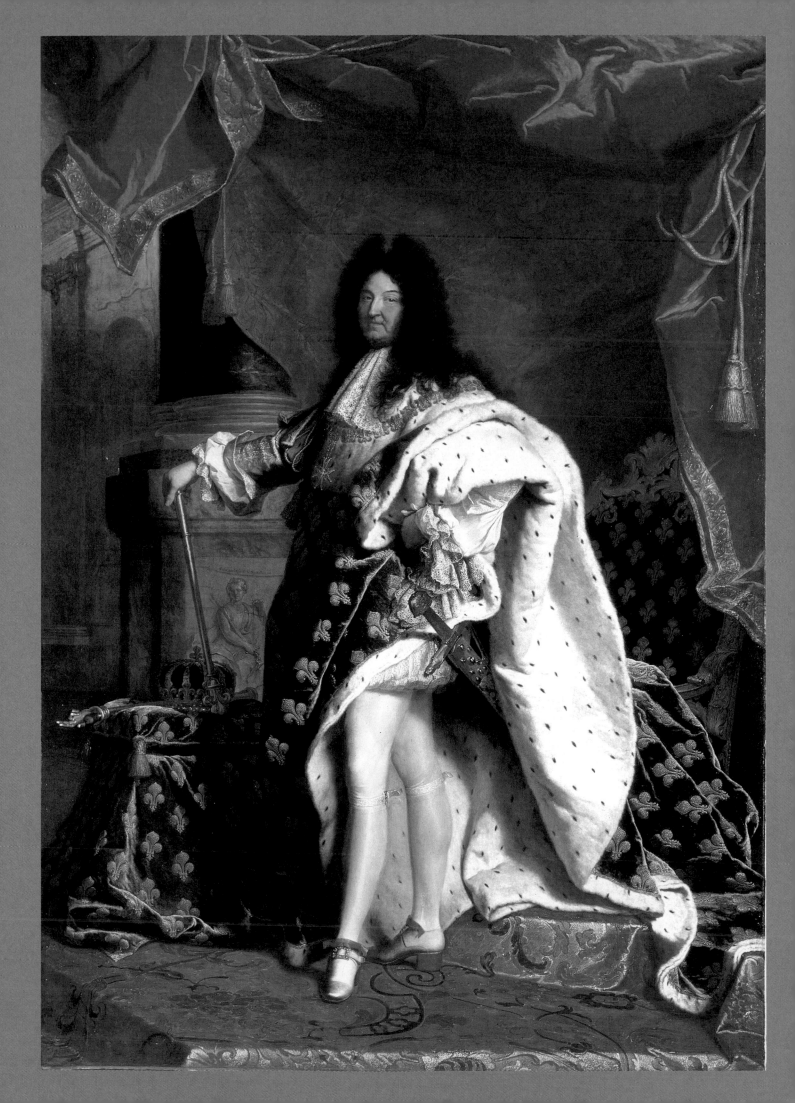

19

Baroque Art in Europe and North America

19-1. **Hyacinthe Rigaud.** *Louis XIV*. 1701. Oil on canvas, 9'2" x 7'10 ¾" (2.79 x 2.4 m). Musée du Louvre, Paris

In Hyacinthe Rigaud's 1701 portrait of Louis XIV (fig. 19-1), the richly costumed monarch known as le Roi Soleil ("the Sun King") is presented to us by an unseen hand that pulls aside a huge billowing curtain. Showing off his elegant legs, of which he was quite proud, the sixty-three-year-old French monarch poses in an elaborate robe of state, decorated with gold *fleurs-de-lis* and white ermine, and he wears the red-heeled built-up shoes he had invented to compensate for his short stature. At first glance, the face under the huge wig seems almost incidental to the overall grandeur. Yet the directness of Louis XIV's gaze makes him movingly human despite the pompous pose and the overwhelming magnificence that surrounds him. Rigaud's genius in portraiture was always to capture a good likeness while idealizing his subjects' less attractive features and giving minute attention to the virtuoso rendering of textures and materials of the costume and setting.

Louis XIV had ordered this portrait as a gift for his grandson Philip, but when Rigaud finished the painting, Louis liked it so much that he kept it. Three years later, Louis ordered a copy from Rigaud to give his grandson, now Philip V of Spain (ruled 1700–46). The request for copies of portraits was not unusual, for the royal and aristocratic families of Europe were linked through marriage, and paintings made appropriate gifts for relatives. Rigaud's workshop produced between thirty and forty portraits a year. His portraits varied in price according to whether the entire figure was painted from life or whether Rigaud merely added a portrait head to a stock figure in a composition he had designed for his workshop to execute.

Rigaud's long career spanned a time of great change in Western art. Not only did new manners of representation emerge, but where art had once been under the patronage of the Church and the aristocracy, a kind of broad-based commercialism arose that was reflected both by portrait workshops such as Rigaud's and by the thousands of still-life and landscape painters producing works for the many households that could now afford them. These changes of the seventeenth and eighteenth centuries—the Baroque period in Europe—took place in a cultural context in which individuals and organizations were grappling with the effects of religious upheaval, economic growth, colonial expansion, political turbulence, and a dramatic explosion of scientific knowledge.

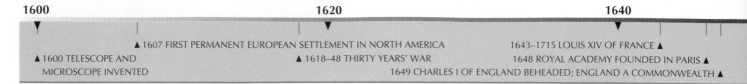

1600	1620	1640

▲ 1607 FIRST PERMANENT EUROPEAN SETTLEMENT IN NORTH AMERICA 1643–1715 LOUIS XIV OF FRANCE ▲

▲ 1600 TELESCOPE AND ▲ 1618–48 THIRTY YEARS' WAR 1648 ROYAL ACADEMY FOUNDED IN PARIS ▲
MICROSCOPE INVENTED 1649 CHARLES I OF ENGLAND BEHEADED; ENGLAND A COMMONWEALTH ▲

TIMELINE 19-1. The Seventeenth Century in Europe and North America. Scientific inventions and observations and national wars motivated by religious differences mark the seventeenth century in Europe.

**MAP 19-1.
The Seventeenth Century in Europe.** Protestantism dominated in northern Europe, while Roman Catholicism remained strong after the Counter-Reformation in southern Europe.

THE BAROQUE PERIOD

By the seventeenth century, Protestantism was established firmly and irrevocably in much of northern Europe (Map 19-1). The permanent division within Europe between Roman Catholicism and Protestantism had a critical effect on European art. In response to the Protestant Reformation of the early sixteenth century, the Roman Catholic Church had embarked in the 1540s on a program of renewal that came to be known as the Counter-Reformation. As part of the program that came to fruition in the seventeenth century, the Church used art to encourage piety among the faithful and to persuade those it regarded as heretics to return to the fold. Counter-Reformation art was intended to be both doctrinally correct and visually and emotionally appealing so that it could influence the largest possible audience. Both the Catholic Church and the Catholic nobility supported ambitious building and decoration projects to achieve these ends.

Civic projects—buildings, sculpture, and paintings—were also undertaken to support varied political positions throughout Europe. Private patrons too continued to

SCIENCE AND THE CHANGING WORLDVIEW

Investigations of the natural world that had begun during the Renaissance changed the way people of the seventeenth and eighteenth centuries—including artists—saw the world. Some of the new discoveries brought a sense of the grand scale of the universe without, while others focused on the minute complexity of the world within. As frames of reference expanded and contracted, artists found new ways to mirror these changing perspectives in their own works.

The philosophers Francis Bacon (1561–1626) of England and René Descartes (1596–1650) of France established a new, scientific method of studying the world by insisting on scrupulous objectivity and logical reasoning. Bacon proposed that facts be established by observation and tested by controlled experiments. Descartes argued for the deductive method of reasoning, in which a conclusion was arrived at logically from basic premises—the most fundamental example being "I think, therefore I am." Seventeenth-century scientists continued to believe that God had created matter, the basis of all things, and that their discoveries simply amplified human understanding of Creation, adding to God's glory. Church authorities, however, often disagreed.

In 1543, the Polish scholar Nicolaus Copernicus (1473–1543) published *On the Revolutions of the Heavenly Spheres*, which contradicted the long-held view that Earth is the center of the universe (the Ptolemaic theory) by arguing that Earth and other planets revolve around the Sun. The Church viewed the Copernican theory as a challenge to its doctrines and put *On the Revolutions of the Heavenly Spheres* on its Index of Prohibited Books in 1616. At the beginning of the seventeenth century, Johannes Kepler (1571–1630), the court mathematician and astronomer to Holy Roman Emperor Rudolf II, demonstrated that the planets revolve around the Sun in elliptical orbits. Kepler noted a number of interrelated dynamic geometric patterns in the universe, the overall design of which he believed was an expression of divine order.

Galileo Galilei (1564–1642), an astronomer, mathematician, and physicist, was the first to develop the telescope as a tool for observing the heavens. His findings provided further confirmation of the Copernican theory, but since the Church prohibited teaching that theory, Galileo was tried for heresy by the Inquisition. Under duress, he publicly recanted his views, although at the end of his trial, according to legend, he muttered, "Nevertheless it [Earth] does move." As the first person to see the craters of the moon through a telescope, Galileo began the exploration of space that led humans to take their first steps on the moon in 1969.

Seventeenth-century science explored not only the vastness of outer space but also the smallest elements of inner space, thanks to the invention of the microscope by the Dutch lens maker and amateur scientist Antoni van Leeuwenhoek (1632–1723). Although embroiderers, textile inspectors, manuscript illuminators, and painters had long used magnifying glasses in their work, Leeuwenhoek perfected grinding techniques and increased the power of his lenses far beyond what those uses required. Ultimately, he was able to study the inner workings of plants and animals and even see microorganisms. Early scientists learned to draw or depended on artists to draw the images revealed by the microscope for further study and publication. Not until the discovery of photography in the nineteenth century could scientists communicate their discoveries without an artist's help.

commission works of art. Economic growth in most European countries helped create a large, affluent middle class eager to build and furnish fine houses and even palaces. By the late seventeenth century, the European colonies of North and South America were firmly established, creating new markets for art and architecture. Building projects in Europe and the Americas ranged from enormous churches and palaces to stage sets for plays and ballets, while painting and sculpture varied from large religious works and history paintings to portraits, still lifes, and **genre**, or scenes of everyday life. At the same time, scientific advances compelled people to question their worldview. Of great importance was the growing understanding that Earth was not the center of the universe but was a planet revolving around the Sun, although the astronomer Galileo was forced to disavow his theories as heretical in 1633 (see "Science and the Changing Worldview," above).

The style that emerged in Europe during this time is called Baroque, a word that has come to designate certain formal characteristics of art as well as a period in the history of art lasting from the end of the sixteenth into the eighteenth century. Baroque, as a formal style, is characterized by open compositions in which elements are placed or seem to move diagonally in space. A loose, free technique using rich colors and dramatic contrasts of light and dark produces what one critic called an "absolute unity" of form. (Many of these formal characteristics can be seen in other nonclassical styles, like Hellenistic Greek and Roman styles, such as figure 25, Introduction.)

Seventeenth-century art was, above all, **naturalistic**. So admired was the quality of visual verisimilitude that many painters and sculptors aimed to reproduce nature without any improvements—certainly without the idealization of classical and Renaissance styles. The English leader Oliver Cromwell supposedly demanded

that his portrait be painted "warts and all." This desire for realism was inspired in part by the growing interest in the natural sciences: Biological sciences added to the artists' knowledge of human and animal anatomy and botany; physics and astronomy changed their concept of space and light. The new understanding of the relationship of Earth and the Sun reaffirmed the expressive power of light, not as an abstract emanation of the divine, as in the Middle Ages, but as a natural phenomenon to be treated with realism and drama.

Artists achieved spectacular technical virtuosity in every medium. Painters manipulated their mediums from the thinnest **glazes** to heavy **impasto** (thickly applied pigments), taking pleasure in the very quality of the material. The leading artists organized their studios into veritable picture factories, without an apparent diminution of quality, for their delight in technical skill permeated their studios and artisan workshops. Artists were admired for the originality of a concept or design, and their shops produced paintings on demand—including copy after copy of popular themes or portraits. The respect for the "original," or first edition, is a modern concept; at that time, an image might be painted in several versions and more than once, but the appreciation for and importance of the work were in no way lessened as long as it was finely crafted.

The role of art's viewer also changed, with a strong personal involvement in art work increasingly expected of the observer. Earlier, Renaissance painters and patrons had been fascinated with the visual possibilities of perspective, but even such displays as Mantegna's ceiling fresco at Mantua (see fig. 17-67) remained an intellectual conceit. Seventeenth-century masters, on the other hand, treated viewers as participants in the art work, and the space of the work included the world beyond the frame. In one example, Gianlorenzo Bernini's *David* hurls a rock at the giant Goliath, who seems to be standing behind the viewer (see fig. 19-10). In another, Diego Velázquez—in one of the finest imaginary spaces of all—paints himself painting his subject, reflected in a mirror that just misses the image of the viewer (see fig. 19-39).

Spectators were expected to be emotionally as well as intellectually involved in art. In Catholic countries, representations of horrifying scenes of martyrdom or the passionate spiritual life of a mystic in religious ecstasy inspired a renewed faith. In Protestant countries, images of civic parades and city views inspired pride in accomplishment. Viewers participated in art like audiences in a theater—vicariously but completely—as the work of art

reached out visually and emotionally to draw them into its orbit. The seventeenth-century French critic Roger de Piles described this exchange when he wrote: "True painting . . . calls to us; and has so powerful an effect, that we cannot help coming near it, as if it had something to tell us" (quoted in Puttfarken, page 55).

ITALY The patronage of the papal court and the Roman nobility dominated much of Italian art from the late sixteenth to the late seventeenth century. Major architectural projects were undertaken in Rome during this period, both to glorify the Church and to improve the city. Pope Sixtus V (papacy 1585–90) had begun the renewal by cutting long straight avenues through the city to link the major pilgrimage churches with one another and with the main gates of Rome. A major intersection created by two of Sixtus's new avenues was adorned by four fountains, one at each corner, decorated by statues, and in the seventeenth century, a church (see fig. 19-6) was erected at this crossroad. Sixtus also ordered open spaces—**piazzas**—cleared in front of the churches and marked each site with an Egyptian **obelisk**—a four-sided, tapered shaft ending in a pyramid—that had survived from ancient Rome. (His chief architect, Domenico Fontana, performed remarkable feats of engineering to move the huge monoliths.) Unchallengeable power and vast financial resources were required to carry out such an extensive plan of urban renewal. The Counter-Reformation popes had great wealth, although eventually they nearly bankrupted the Church with their building programs. Sixtus also began to renovate the Vatican and its library, completed the dome of Saint Peter's Basilica (see "Saint Peter's Basilica," page 702), built splendid palaces, and reopened one of the ancient aqueducts to stabilize the city's water supply. Several of Sixtus V's successors, especially Urban VIII (papacy 1623–44), were also vigorous patrons of art and architecture (see "Great Papal Patrons of the Seventeenth Century," left).

URBAN DESIGN, ARCHITECTURE, AND ARCHITECTURAL SCULPTURE

A goal of the Counter-Reformation was to embellish the Church through splendid church building. The Renaissance ideal of the **central-plan church** continued to be used for the shrines of saints, but Counter-Reformation thinking called for churches with long, wide **naves** to accommodate large congregations and the processional entry of the clergy at the Mass. In the sixteenth century, the decoration of new churches had been generally austere, but seventeenth- and eighteenth-century taste favored opulent and spectacular visual effects to heighten the emotional involvement of worshipers.

Saint Peter's Basilica in the Vatican. Half a century after Michelangelo had returned Saint Peter's Basilica to Bramante's original vision of a central-plan building, Pope Paul V (papacy 1605–21) commissioned Carlo Maderno (1556–1629) to provide the church with a longer nave

GREAT PAPAL PATRONS OF THE SEVENTEENTH CENTURY

Paul V (Borghese)	papacy	1605–21
Urban VIII (Barberini)	papacy	1623–44
Innocent X (Pamphili)	papacy	1644–55
Alexander VII (Chigi)	papacy	1655–67

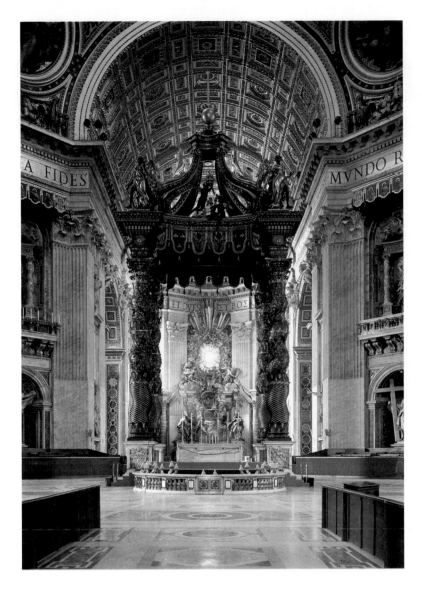

19-2. Gianlorenzo Bernini. *Baldacchino*. 1624–33. Gilt bronze, height approx. 100' (30.48 m). Chair of Peter shrine. 1657–66. Gilt bronze, marble, stucco, and glass. Pier decorations. 1627–41. Gilt bronze and marble. Crossing, Saint Peter's Basilica, Vatican, Rome

and a new facade (see fig. 19-3). Construction began in 1607, and everything but the facade bell towers was completed by 1615 (see "Saint Peter's Basilica," page 702). In essence, Maderno took the concept of Il Gesù's facade (see fig. 18-47 and "Parts of the Church Facade," page 727) and enhanced its scale to befit the most important church of the Catholic world. Saint Peter's facade, like Il Gesù's, "steps out" in three progressively projecting planes: from the corners to the doorways flanking the central entrance area, then the entrance area, then the central doorway itself. Similarly, the colossal orders connecting the first and second stories are flat **pilasters** at the corners but are fully round columns where they flank the doorways. These columns support a continuous **entablature** that also steps out—following the columns—as it moves toward the central door, which is surmounted by a triangular **pediment**. Similar to the Gesù facade, the pediment provides a vertical thrust, as does the superimposition of pilasters on the relatively narrow attic story above the entablature.

When Maderno died in 1629, he was succeeded as Vatican architect by his collaborator of five years, Gianlorenzo

Bernini (1598–1680). Bernini was born in Naples, but his family had moved to Rome about 1605. Taught by his father, Gianlorenzo was already a proficient marble sculptor by the age of eight. Part of his training involved sketching the Vatican collection of ancient sculpture, such as *Laocoön and His Sons* (see fig. 24, Introduction), as well as the many examples of Renaissance painting in the papal palace. Throughout his life, Bernini admired antique art and considered himself a classicist, but today we consider his art a breakthrough that takes us from the Renaissance into the Baroque style.

When Urban VIII was elected pope in 1623, he unhesitatingly gave the young Bernini the demanding task of designing an enormous bronze **baldachin**, or canopy, for the high altar of Saint Peter's. The church was so large that a dramatic focus on the altar was essential. The resulting *baldacchino* (fig. 19-2), completed in 1633, stands almost 100 feet high and exemplifies the Baroque artists' desire to combine architecture and sculpture— and sometimes painting as well—so that works no longer fit into a single category or medium. The twisted columns symbolize the union of Old and New Testaments—the

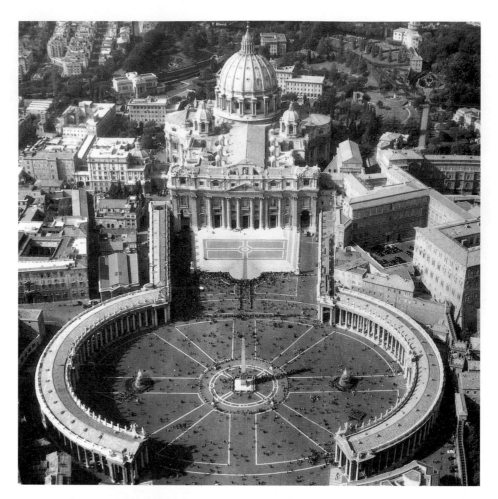

19-3. Saint Peter's Basilica and Piazza, Vatican, Rome. Carlo Maderno, facade, 1607–26; Gianlorenzo Bernini, piazza design, c. 1656–57

Perhaps only a Baroque artist of Bernini's talents could have unified the many artistic periods and styles that come together in Saint Peter's Basilica (starting with Bramante's original design for the building in the sixteenth century). The basilica in no way suggests a piecing together of parts made by different builders at different times, but rather presents itself as a triumphal unity of all the parts in one coherent whole.

vine of the Eucharist climbing the columns of the Temple of Solomon. The fanciful **Composite capitals**, combining elements of both the Ionic and the Corinthian orders, support an entablature with a crowning element topped with an orb (a sphere representing the universe) and a cross (symbolizing the reign of Christ). Figures of angels and *putti* decorate the entablature, which is hung with tasseled panels in imitation of a cloth canopy. These symbolic elements, both architectural and sculptural, not only mark the site of the tomb of Saint Peter but also serve as a monument to Urban VIII and his family, the Barberini, whose emblems—including honeybees and suns on the tasseled panels, and laurel leaves on the climbing vines—are prominently displayed.

Between 1627 and 1641, Bernini and several other sculptors, again combining architecture and sculpture, rebuilt Bramante's **crossing piers** as giant **reliquaries**. Statues of Saints Helena, Veronica, Andrew, and Longinus stand in niches below alcoves containing their relics, to the left and right of the *baldacchino*. Visible through

the *baldacchino*'s columns in the apse of the church is another reliquary: the gilded stone, bronze, and stucco shrine made by Bernini between 1657 and 1666 for the ancient wooden throne thought to have been used by Saint Peter as the first bishop of Rome. The Chair of Peter symbolized the direct descent of Christian authority from Peter to the current pope, a belief rejected by Protestants and therefore deliberately emphasized in Counter-Reformation Catholicism. In Bernini's work, the chair is carried by four theologians and is lifted farther by a surge of gilded clouds moving upward to the Holy Spirit in the form of a dove adored by angels. Gilt-bronze rays around a stained-glass panel depicting a dove are lit from a window. The light penetrating the church from this window and reflected back by the gilding creates a dazzling effect—the sort that present-day artists achieve by resorting to electric spotlights.

At approximately the same time that he was at work on the Chair of Peter, Bernini designed and supervised the building of a colonnade to form a huge double piazza

in front of the entrance to Saint Peter's (fig. 19-3). The open space that he had to work with was irregular, and an Egyptian obelisk and a fountain already in place (part of Sixtus V's plan for Rome) had to be incorporated into the overall plan. Bernini's remarkable design frames the oval piazza with two enormous curved **porticoes**, or covered walkways, supported by Doric columns. These curved porticoes are connected to two straight porticoes, which lead up a slight incline to the two ends of the church facade. Bernini spoke of his conception as representing the "motherly arms of the Church" reaching out to the world. He had intended to build a third section of the colonnade closing the side of the piazza facing the church so that pilgrims, after crossing the Tiber River bridge and passing through narrow streets, would suddenly emerge into the enormous open space before the church. Even without the final colonnade section, the great church, colonnade, and piazza with its towering obelisk and monumental fountains—Bernini added the second one to balance the first—are an awe-inspiring vision.

The Church of San Carlo alle Quattro Fontane. The intersection of two of the major avenues created under the new Counter-Reformation city plan inspired planners to add a special emphasis there, with fountains marking each of the four corners of the crossing. In 1634, the Trinitarian monks decided to build a new church at the site and awarded the commission for San Carlo alle Quattro Fontane (Saint Charles at the Four Fountains) to Francesco Borromini (1599–1667). Borromini, a nephew of architect Carlo Maderno, had arrived in Rome in 1619 from northern Italy, to enter his uncle's workshop. Later, he worked under Bernini's supervision on the decoration of Saint Peter's, and some details of the *Baldacchino* are now attributed to him, but San Carlo was his first independent commission. From 1638 to 1641, he planned and constructed the body of this small church, although he did not receive the commission for its facade until 1665. Unfinished at Borromini's death, the church was nevertheless completed according to his design.

San Carlo stands on a narrow tract, with one corner cut off to accommodate one of the four fountains that gives the church its name. To fit the irregular site, Borromini created an elongated central-plan interior space with undulating walls (fig. 19-4), whose powerful, sweeping curves create an unexpected feeling of movement, as if the walls were heaving in and out. Robust pairs of columns support a massive entablature, over which an oval dome seems to float. The **coffers** (inset panels in geometric shapes) filling the interior of the dome form an eccentric honeycomb of crosses, elongated hexagons, and octagons (fig. 19-5). These coffers decrease sharply in size as they approach the apex, or highest point, so that the dome appears to be inflating.

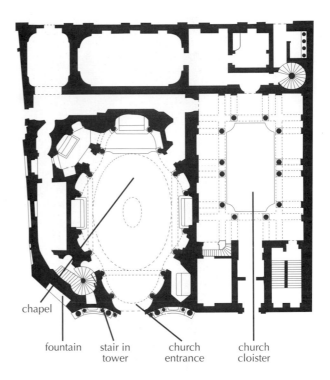

chapel
fountain · stair in tower · church entrance · church cloister

19-4. Francesco Borromini. Plan of the Church of San Carlo alle Quattro Fontane, Rome. 1638–41

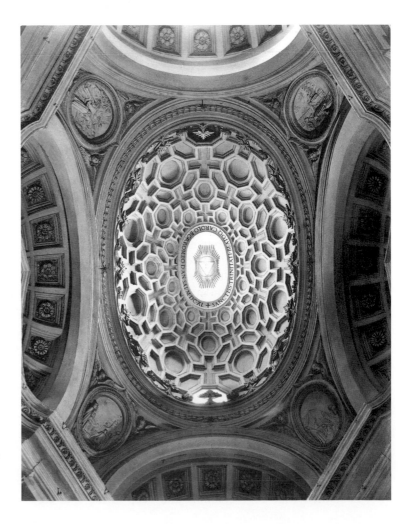

19-5. Dome interior, Church of San Carlo alle Quattro Fontane. 1638–41

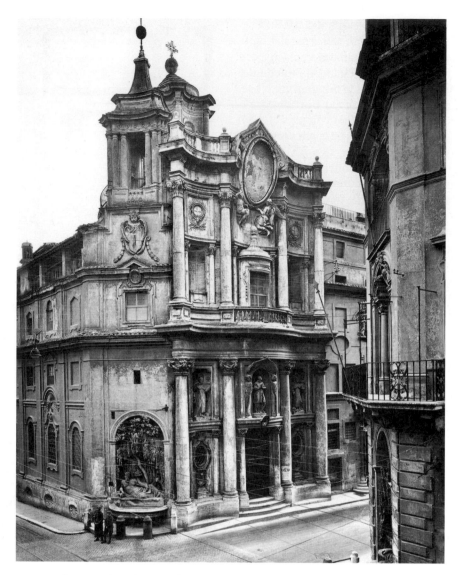

19-6. Facade, Church of San Carlo alle Quattro Fontane. 1665–67

It is difficult today to appreciate how audacious Borromini's design for this small church was. In it he abandoned the modular system of planning taken for granted by every architect since Brunelleschi (see figs. 17-33, 17-34) and worked instead from an overriding geometric scheme, the ideal, domed, central-plan church. Moreover, his treatment of the architectural elements as if they were malleable was unprecedented. Borromini's contemporaries understood immediately what an extraordinary innovation the church represented; the Trinitarian monks who had commissioned it received requests for plans from visitors from all over Europe. Although Borromini's invention had little influence on the architecture of classically minded Rome, it was widely imitated in northern Italy and beyond the Alps.

Borromini's design for San Carlo's facade (fig. 19-6), done more than two decades later, was as innovative as his plan for its interior had been. He turned the building's front into an undulating, sculpture-filled screen punctuated with large columns and deep niches that create dramatic effects of light and shadow. Borromini also gave his facade a strong vertical thrust in the center by placing over the tall doorway a statue-filled niche, then a windowed niche covered with a pointed canopy, then a giant **cartouche** (an oval or circular decorative element) held up by angels carved in such high relief that they appear to hover in front of the wall. The entire facade is crowned with a **balustrade** and the sharply pointed frame of the cartouche. Borromini's facade was enthusiastically imitated in northern Italy and especially in northern and eastern Europe.

Piazza Navona. Rome's Piazza Navona, a popular site for festivals and celebrations, became another center of urban renewal with the election of Innocent X as pope (papacy 1644–55). Both the palace and parish church of his family, the Pamphilis, fronted on the piazza, which had been the site of a stadium built by Emperor Domitian in 86 CE and still retains the shape of the ancient stadium's racetrack. The stadium, in ruins, had been

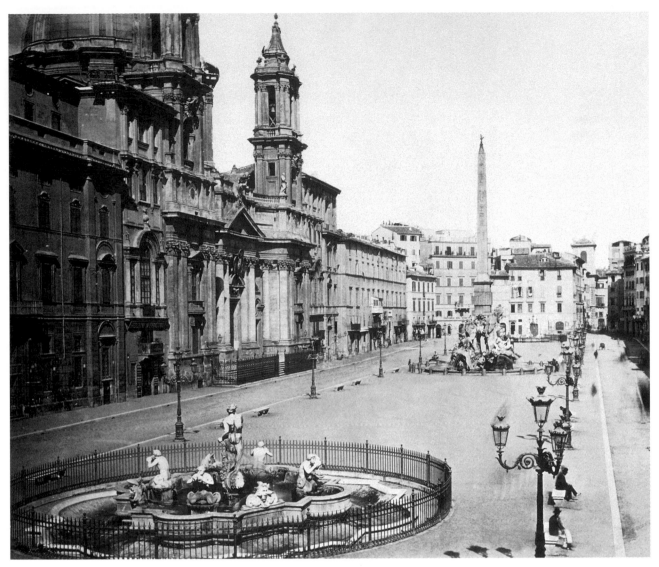

19-7. Piazza Navona, Rome. In middle ground, Gianlorenzo Bernini's Four Rivers Fountain. 1648–51. Travertine and marble. To the left of the fountain, Francesco Borromini's Church of Sant'Agnese. 1653–57. In the foreground, Giacomo della Porta's fountain of 1576.

used for festivals during the Middle Ages and as a marketplace since 1477. A modest shrine to Sant'Agnese stood on the site of her martyrdom.

The Pamphilis enlarged their palace in 1644–50 and in 1652 decided to rebuild their parish church, the Church of Sant'Agnese. Girolamo and Carlo Rainaldi won the original commission, and in 1653–57 Francesco Borromini designed the facade, conceiving a plan that unites church and piazza (fig. 19-7). The facade sweeps inward from two flanking towers to a monumental portal approached by broad stairs. The inward curve of the facade brings the dome nearer the entrance than usual, making it clearly visible from the piazza. The templelike design of columns and pediment around the door also leads the eye to the steeply rising dome on its tall drum. The church truly dominates the urban space.

The south end of the piazza was already graced by a 1576 fountain by Giacomo della Porta. After some skillful maneuvering, Gianlorenzo Bernini, who was at his most ingenious in his fountain designs, won the commission

for a second monumental fountain in the center. Bernini, who had been publicly disgraced in 1646 when a bell tower he had begun for Saint Peter's threatened to collapse, had not been invited to compete for the fountain's design. The contest was won by Borromini, who originated the fountain's theme of the Four Rivers and brought in the water supply for it in 1647. With the collusion of a papal relative, however, the pope saw Bernini's design. Pope Innocent X was so impressed that Bernini took over the project the next year, and Bernini's assistants carved the figures after his designs.

Executed in marble and **travertine**, a porous stone that is less costly and more easily worked than marble, the now famed Fountain of the Four Rivers was completed in 1651. In the center is a rocky hill covered with animals and vegetation, from which flow the four great rivers of the world, each representing a continent and personified by a colossal figure: the Nile (Africa), covering his head; the Ganges (Asia), at the left; the Danube (Europe), at the right; and the Rio de la Plata (Americas),

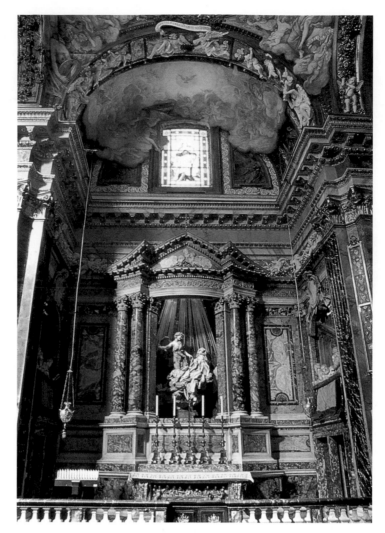

19-8. Gianlorenzo Bernini. Cornaro Chapel, Church of Santa Maria della Vittoria, Rome. 1642–52

not visible in the photograph. The central rock formation supports a Roman imitation of an Egyptian obelisk, topped by a dove, the emblem of the pope's family and also of peace and the Trinity. The installation of the obelisk—which weighs many tons—over the grotto, a hidden collecting pool that feeds the rivers, was a technical marvel that reversed Bernini's disgrace over the bell-tower incident. Two years after the completion of the major fountain, Bernini altered della Porta's fountain by replacing the principal figure (1653). In 1878, a third fountain, depicting Neptune and an octopuslike sea monster, was built at the north end of Piazza Navona.

Cornaro Chapel. Even after Bernini's appointment as Vatican architect in 1629, he was able to accept outside commissions by virtue of his large workshop. Beginning in 1642, he worked on designs for the decoration of the funerary chapel of Cardinal Federigo Cornaro (fig. 19-8) in the Church of Santa Maria della Vittoria, which had been designed by Carlo Maderno. Like Il Gesù (see fig. 18-46), the church had a single nave with shallow side chapels. The chapel of the Cornaro family was dedicated to Saint Teresa of Ávila, and near the high altar Bernini

designed a rich and theatrical setting for a scene depicting Teresa's vision of the angel of the Lord. From 1642 to 1652, Bernini covered the walls with colored marble panels, crowned with a projecting **cornice** supported by marble pilasters. Above the cornice on the back wall, the curved ceiling surrounding the window appears to dissolve into a painted vision of clouds and angels. Kneeling at what appear to be balconies on both sides of the chapel are portrait statues of Federigo, his deceased father, and six cardinals of the Cornaro family. The figures are informally posed and naturalistically portrayed. Two are reading from their prayer books, others converse, and one leans out from his seat, apparently to look at someone entering the chapel.

Framed by columns in a huge oval niche above the altar, Bernini's marble group *Saint Teresa of Ávila in Ecstasy* (fig. 19-9), created between 1645 and 1652, represents a vision described by the Spanish mystic in which an angel pierced her body repeatedly with an arrow, transporting her to a state of religious ecstasy, a sense of oneness with God. Teresa and the angel, who seem to float upward on moisture-laden clouds, are cut from a heavy mass of solid marble supported on a hidden

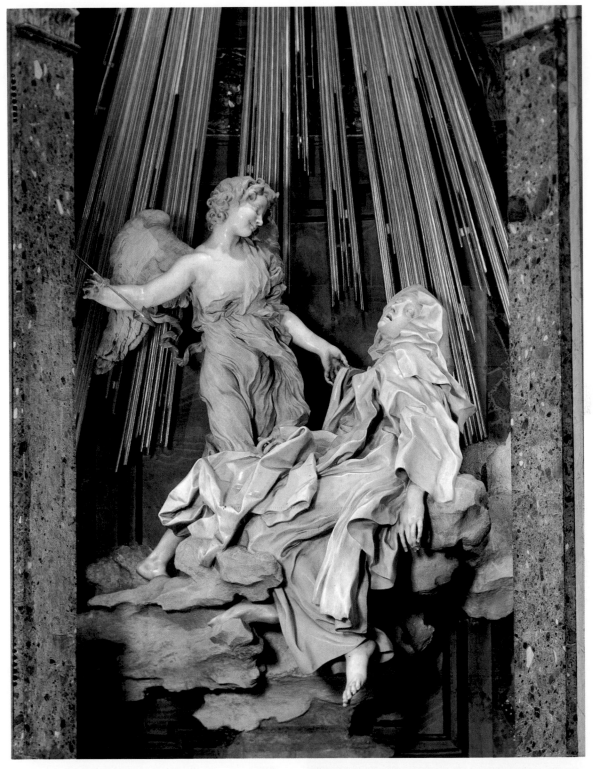

19-9. Gianlorenzo Bernini. *Saint Teresa of Ávila in Ecstasy*. 1645–52. Marble, height of the group 11'6" (3.5 m). Cornaro Chapel, Church of Santa Maria della Vittoria

pedestal and by metal bars sunk deep into the chapel wall. Bernini's skill at capturing the movements and emotions of these figures is matched by his virtuosity in simulating different textures and colors in the pure white medium of marble; the angel's gauzy, clinging draperies seem silken in contrast with Teresa's heavy woolen robe, the habit of her order. Yet Bernini effectively used the configuration of the garment's folds to convey the swooning, sensuous body beneath, even though only Teresa's face, hands, and bare feet are actually visible. The descending rays of light are of gilt bronze illuminated from above by a hidden window. Bernini's complex, theatrical interplay of the various levels of illusion in the chapel, which invites the beholder to identify with Teresa's emotion, was imitated by sculptors throughout Europe.

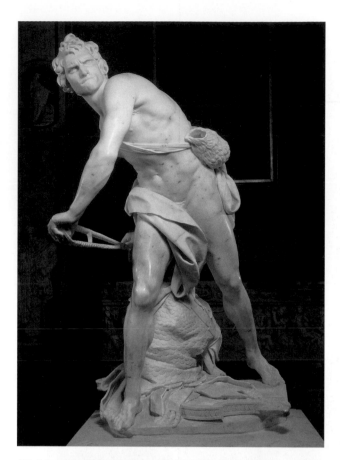

19-10. Gianlorenzo Bernini. *David*. 1623. Marble, height 5'7" (1.7 m). Galleria Borghese, Rome

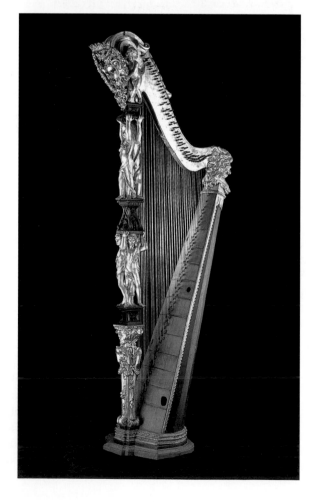

INDEPENDENT SCULPTURE

Bernini first became famous as a sculptor, and he continued to work as a sculptor throughout his career, for both the papacy and private clients. His *David* (fig. 19-10), made for a nephew of Pope Paul V in 1623, introduced a new type of three-dimensional composition that intrudes forcefully on the viewer's space. Inspired by the athletic figures Annibale Carracci had painted on a palace ceiling some twenty years earlier (see, for example, the Giant preparing to heave a boulder at the far end of figure 19-13), Bernini's *David* bends at the waist and twists far to one side, ready to launch the lethal rock. Unlike Michelangelo's cool and self-confident youth (see fig. 18-11), this more mature *David*, with his lean, sinewy body, is all tension and determination, a frame of mind emphasized by his ferocious expression, tightly clenched mouth, and straining muscles. Bernini's energetic, twisting figure includes the surrounding space as part of the composition by implying the presence of an unseen adversary somewhere behind the viewer. Thus, the viewer becomes part of the action that is taking place at that very moment. This immediacy and the inclusion of the viewer in the work of art represent an important new direction for art.

A remarkable piece of sculpture in wood, the Barberini Harp (fig. 19-11), was carved by someone working in the circle of Bernini, probably about the time of the election of Cardinal Maffeo Barberini as Pope Urban VIII in 1623. (The harp is first mentioned in the family archives in 1631.) The harp was a functional instrument with a range of more than three octaves. The carved and gilded pillar is divided into three sections by painted black pedestals: At the bottom is a herm of a satyr decorated with the heraldic Barberini bees; in the center, two seminude youths; and at the top, *putti* whose lion skins refer to the classical hero Hercules, a model for the Barberini leaders. In a second reference to Hercules, the harp's curving neck ends with a lion's head. The top of the pillar is carved with the Barberini coat of arms, three bees, to which a crown and the collar of the Order of the Golden Fleece, the most highly valued continental order of chivalry, were later added (in 1671, the queen of Spain awarded the honor to Urban VIII's namesake, Maffeo Barberini). The harp was clearly prized by the family, since they saw fit to turn it into a memorial to the Golden Fleece.

ILLUSIONISTIC CEILING PAINTING

Theatricality, intricacy, and the opening of space reached an apogee in Baroque ceiling decoration, closely allied with architecture. Baroque ceiling decoration went far beyond Michelangelo's *Sistine Ceiling* (see fig. 18-13) or

19-11. Barberini Harp. c. 1623–24, 1671. Wood, with gilt and black paint, 5'10⁷/₈" x 3'11¼" (1.8 x 1.2 m). Museo Nazionale degli Strumenti Musicali, Rome. Inv. 790

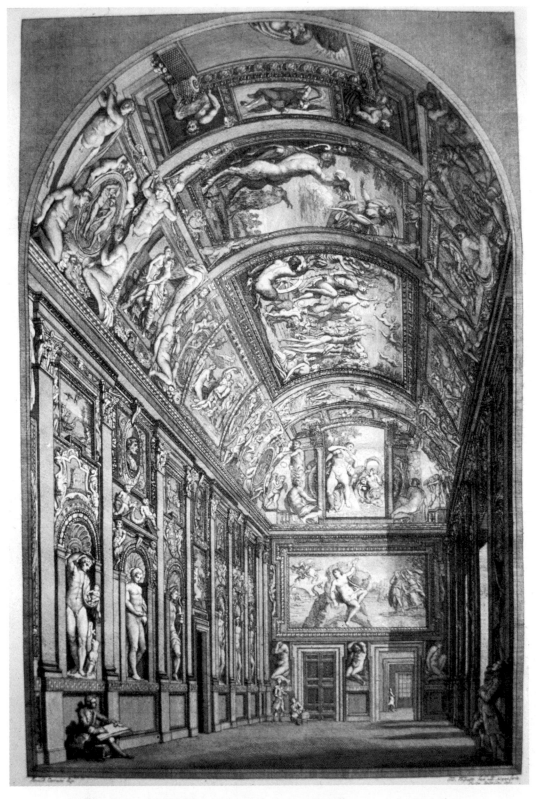

19-12. Giovanni Volpato. *View of the Farnese Gallery.* c. 1770. Engraving

even Correggio's dome (see fig. 18-22). Many Baroque ceiling projects were done entirely in **trompe l'oeil** painting, and some were complex constructions combining architecture, painting, and stucco sculpture. These grand illusionistic projects were carried out on the domes and vaults of churches, civic buildings, palaces, and villas.

Annibale Carracci. The major monument of early Baroque classicism was a ceiling painted for the Farnese family in the last years of the sixteenth century. In 1597, to celebrate the wedding of Duke Ranuccio Farnese of Parma, the Farneses decided to redecorate the **galleria** ("great hall") of their immense Roman palace (fig. 19-12). Cardinal Odarico Farnese commissioned Annibale

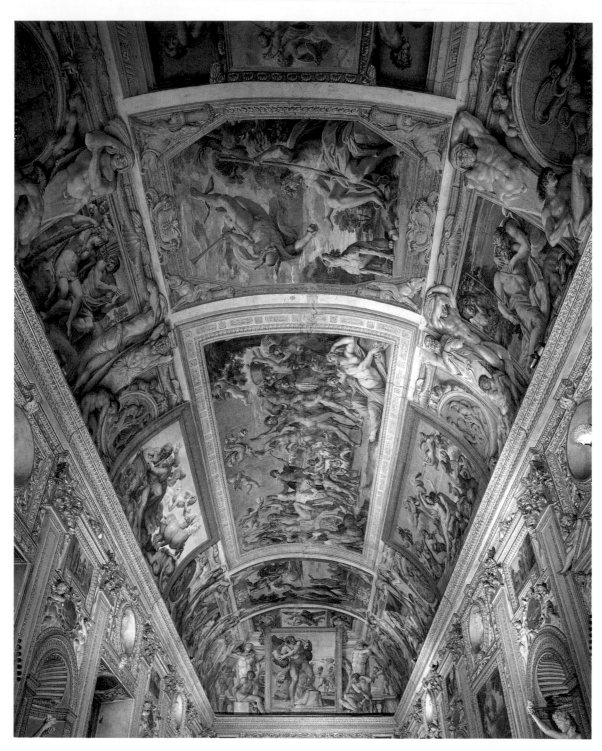

19-13. Annibale Carracci. Ceiling fresco of main gallery, Palazzo Farnese, Rome. 1597–1601

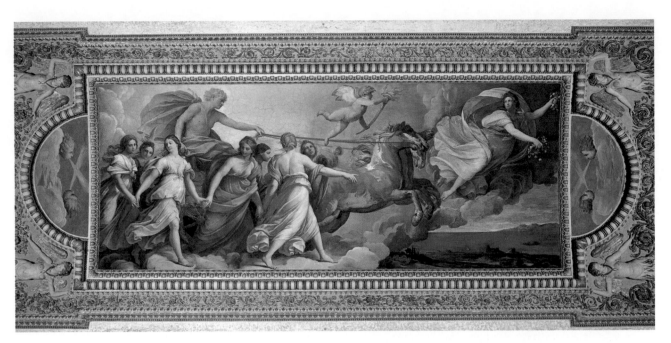

19-14. Guido Reni. *Aurora*, ceiling fresco in Casino Rospigliosi, Rome. 1613–14

Carracci (1560–1609) to do the work. Annibale was a noted painter and the cofounder of an art academy in Bologna with his cousin Ludovico. At the academy, students were expected to study the art of the past—that is, Renaissance painting and antique classical sculpture—as well as nature. The Bolognese painters placed a high value on drawing, complex figure compositions, narrative skills, and technical expertise in both oil and fresco painting. Annibale was assisted on the ceiling project by his brother Agostino (1557–1602), who also worked briefly in Rome.

The Farnese ceiling (fig. 19-13) is an exuberant tribute to earthly love, expressed in mythological scenes. Its primary image, set in the center of the vault, is *The Triumph of Bacchus and Ariadne*, a joyous procession celebrating the wine god Bacchus's love for Ariadne, a woman whom he rescued after her lover, Theseus, abandoned her. In his ceiling painting, Carracci created the illusion of framed paintings, stone sculpture, bronze medallions, and *ignudi* (nude youths) in an architectural framework—all inspired by Michelangelo's *Sistine Ceiling*. The figure types, true to their source, are heroic, muscular, and drawn with precise anatomical accuracy. But instead of Michelangelo's cool illumination and intellectual detachment, the Farnese ceiling glows with a warm light that recalls the work of the Venetian painters Titian and Veronese and seems buoyant with optimism. The ceiling was highly admired and became famous almost immediately. The Farnese family, proud of the gallery, generously allowed young artists to sketch the figures there, so that Carracci's masterpiece influenced Italian art well into the following century.

Guido Reni. The most important Italian Baroque classicist after Annibale Carracci was the Bolognese artist Guido Reni (1575–1642), who briefly studied at the Carracci academy in 1595. Shortly after 1600, Reni made his first trip to Rome, where he worked intermittently before returning to Bologna in 1614. In 1613–14, he decorated the ceiling of a garden house (*casino* in Italian) at a palace in Rome with his most famous work, *Aurora* (fig. 19-14). The fresco emulates the illusionistic framed mythological scenes on the Farnese ceiling, although Reni made no effort to relate his painting's space to that of the room. Indeed, *Aurora* appears to be a framed oil painting incongruously attached to the ceiling. The composition itself, however, is Baroque classicism at its most lyrical. Apollo is shown driving the sun chariot, escorted by Cupid and the Seasons and led by the flying figure of Aurora, goddess of the dawn. The measured, processional staging and idealized forms seem to have been derived from an antique relief, and the precise drawing owes much to Annibale Carracci and academic training. But the graceful figures, the harmonious rhythms of gesture and drapery, and the intense color are all Reni's own.

Pietro da Cortona. Pietro Berrettini (1596–1669), called Pietro da Cortona after his hometown, carried the development of the Baroque ceiling away from classicism into a more Baroque direction. Trained in Florence, the artist was commissioned in the early 1630s by the Barberini family of Pope Urban VIII to decorate the ceiling of the audience hall of their Roman palace. Pietro's great fresco there, *Triumph of the Barberini*, the glorification of Urban's papacy, became

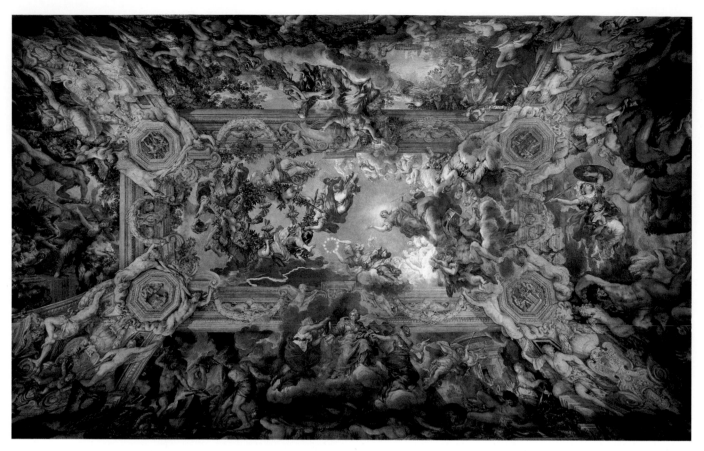

19-15. Pietro da Cortona. *Triumph of the Barberini*, ceiling fresco in the Gran Salone, Palazzo Barberini, Rome. 1632–39

a model for a succession of Baroque illusionistic palace ceilings throughout Europe (fig. 19-15). Its subject is an elaborate **allegory**, or symbolic representation, of the virtues of the papal family. Just below the center of the vault, seated at the top of a pyramid of clouds and figures personifying Time and the Fates, Divine Providence gestures toward three giant bees surrounded by a huge laurel wreath (both Barberini emblems) carried by Faith, Hope, and Charity. Immortality offers a crown of stars, while other symbolic figures present the crossed keys and the triple-tiered crown of the papacy. Around these figures are scenes of Roman gods and goddesses, who demonstrate the pope's virtues by triumphing over the vices.

Pietro, like Annibale Carracci, framed his mythological scenes with painted architecture, but in contrast to Annibale's neat separations and careful framing, Pietro partly concealed his setting with an overlay of shells, masks, garlands, and figures, which unifies the vast illusionistic space. Instead of Annibale's warm, nearly even light, Pietro's sporadic illumination, with its bursts of brilliance alternating with deep shadows, fuses the ceiling into a dense but unified whole.

Giovanni Battista Gaulli. The ultimate illusionistic Baroque ceiling is *Triumph of the Name of Jesus* (fig. 19-16), which fills the vault of Il Gesù (see fig. 18-47). In the 1560s, Giacomo da Vignola had designed an austere interior for Il Gesù, but when the Jesuits renovated their church a century later, they commissioned a religious allegory to cover the nave's plain ceiling. Giovanni Battista Gaulli (1639–1709) designed and executed the spectacular illusion between 1672 and 1685, combining sculpture and painting to eliminate the presence of architecture. It is impossible to see which figures are three-dimensional and which are painted, and some paintings are on panels that extend over the actual architecture. Gaulli, who arrived in Rome from Genoa in 1657, had worked in his youth for Bernini, from whom he absorbed a taste for drama and for multimedia effects. The elderly Bernini, who worshiped daily at Il Gesù, may well have offered his personal advice to his former assistant, and Gaulli was certainly familiar with other illusionistic paintings in Rome as well, including Pietro da Cortona's Barberini ceiling.

Gaulli's astonishing creation went beyond anything that had preceded it in unifying architecture, sculpture, and painting. Every element is dedicated to creating the illusion that clouds and angels have floated down through an opening in the church's vault into the upper reaches of the nave. The figures are projected as if seen from below, and the whole composition is focused off-center on the golden aura around the letters *IHS*, the monogram of Jesus and the insignia of the Jesuits. The subject is, in fact, a Last Judgment, with the Elect rising joyfully toward the name of God and the Damned plummeting through the ceiling toward the nave floor. The sweeping inclusion in the work of the space of the nave, the powerful and exciting appeal to the viewer's emotions, and the nearly total unity of visual effect have never been surpassed.

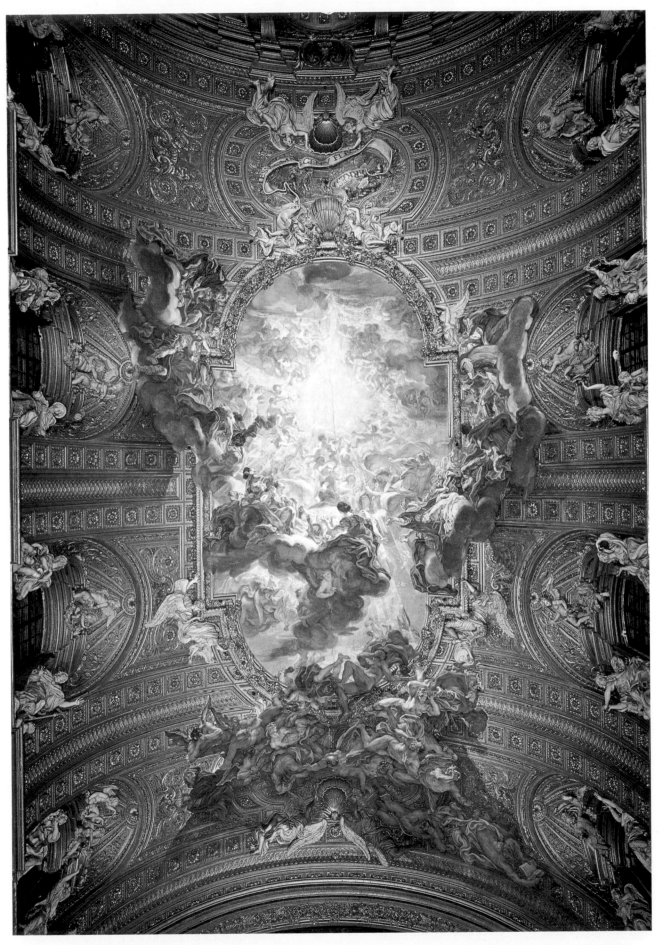

19-16. Giovanni Battista Gaulli. *Triumph of the Name of Jesus*, ceiling fresco with stucco figures in the vault of the Church of Il Gesù, Rome. 1672–85

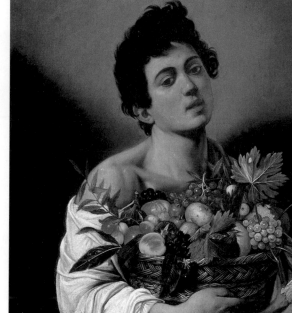

19-17. Caravaggio. *Boy with a Basket of Fruit.* c. 1593–4 Oil on canvas, 27½ x 26⅜" (70 x 67 cm). Galleria Borghese, Rome

PAINTING ON CANVAS

Il Guercino. In painting, the Baroque classicism exemplified by Carracci's Farnese ceiling and Guido Reni's *Aurora* was the logical development of mature Renaissance styles with roots in classical antiquity. This style was also popular for altarpieces and other painting on canvas. Il Guercino ("The Little Squinter," Giovanni Francesco Barbieri, 1591–1666) painted *Saint Luke Displaying a Painting of the Virgin* (fig. 15, Introduction) for the high altar of the Franciscan church in Reggio nell'Emilia, near Bologna. In keeping with the desire for greater naturalism and contemporary relevance in religious art, Luke's symbol as an evangelist, the ox, has become a paperweight; and the painting of the Virgin and Child on Luke's easel copies a Byzantine icon believed by the Bolognese to have been painted by Luke himself. Although Protestants ridiculed the idea that paintings by Luke existed, Catholics staunchly defended their authenticity. Guercino's painting, then, is both an homage to the patron saint of painters and a defense of the miracle-working Madonna di San Luca in his hometown. The classical architecture and idealized figures typify Bolognese academic art.

Caravaggio. A more naturalistic tendency was introduced by Carracci's younger contemporary Michelangelo Merisi (1571–1610), known as Caravaggio after his birthplace, a town in the northern Italian region of Lombardy. A realistic style together with careful drawing and an interest in still life, unusual at the time, characterized Lombard art. The young painter demonstrated those interests in his first known paintings after he arrived late in 1592 in Rome, where he was employed in the studio of the Cavaliere d'Arpino as a specialist in the painting of fruit and vegetables. When he began to paint on his own, he continued to paint still lifes but also included half-length figures, as in the *Boy with a Basket of Fruit* (fig.

19-17). By this time, his reputation had grown to the extent that an agent offered to market his pictures.

Caravaggio painted for a small circle of sophisticated Roman patrons. His subjects from this early period include still lifes and low-life scenes featuring fortune-tellers, cardsharps, and street urchins dressed as musicians or mythological figures. The figures in these pictures tend to be large, brightly lit, and set close to the picture plane.

Most of his commissions after 1600 were religious, and reactions to them were mixed. On occasion, his powerful, sometimes brutal, naturalism was rejected by patrons as unsuitable to the subject's dignity. Caravaggio's approach has been likened to the preaching of Filippo Neri (1515–95), a priest and noted mystic of the Counter-Reformation who founded a Roman religious group called the Congregation of the Oratory and was later canonized. Neri, called the Apostle of Rome, focused his missionary efforts on the people there, for whom he strove to make Christian history and doctrine understandable and meaningful. Caravaggio, too, interpreted his religious subjects directly and dramatically, combining intensely observed forms, poses, and expressions with strong effects of light and color. In the technique known as **tenebrism**, forms emerge from a dark background into a strong light that often falls from a single source outside the painting; the effect is that of a modern spotlight (see "Caravaggio and the New Realism," opposite).

Caravaggio's first public commission, paintings for the Contarelli Chapel in the Church of San Luigi dei Francesi, included the *Calling of Saint Matthew* (fig. 19-18), painted about 1599–1600. The painting depicts Jesus

(opposite page)
19-18. Caravaggio. *Calling of Saint Matthew.* 1599–1600. Oil on canvas, 11'1" x 11'5" (3.22 x 3.4 m). Contarelli Chapel, Church of San Luigi dei Francesi, Rome

CARAVAGGIO AND THE NEW REALISM

For decades after his death, Caravaggio was viewed as an "evil genius" and an "omen of the ruin and demise of painting" for his painting "without study . . . with nothing but nature before him, which he simply copied in his amazing way" (Carducho, *Dialogues on Painting*, Madrid, 1633, in Enggass and Brown, pp. 173–74). But with the passage of another forty years, he was recognized as a great innovator who reintroduced realism into art and developed new, dramatic lighting effects, now known as **tenebrism**. The art historian Giovanni Bellori wrote in his *Lives of the Painters* (1672):

Caravaggio (for he was now generally called by the name of his native town) was making himself more and more notable for the color scheme which he was introducing, not soft and sparingly tinted as before, but reinforced throughout with bold shadows and a great deal of black to give relief to the forms. He went so far in this manner of working that he never brought his figures out into the daylight, but placed them in the dark brown atmosphere of a closed room, using a high light that descended vertically over the principal parts of the bodies while leaving the remainder in shadow in order to give force through a strong contrast of light and dark. The painters then in Rome were greatly impressed by his novelty and the younger ones especially gathered around him and praised him as the only true imitator of nature The old painters who were accustomed to the old ways were shocked at the new concern for nature, and they did not cease to decry Caravaggio and his manner. They spread it about that he did not know how to come out of the cellar and that, poor in invention and design, lacking in decorum and art, he painted all his figures in one light and on one plane without gradations.

There is no question that Caravaggio advanced the art of painting because he came upon the scene at a time when realism was not much in fashion and when figures were made according to convention and manner and satisfied more the taste for gracefulness than for truth. Thus by avoiding all prettiness and vanity in his color, Caravaggio strengthened his tones and gave them blood and flesh. In this way he induced his fellow painters to work from nature

(Bellori, *Lives of the Painters*, Rome, 1672, in Enggass and Brown, pp. 79, 83)

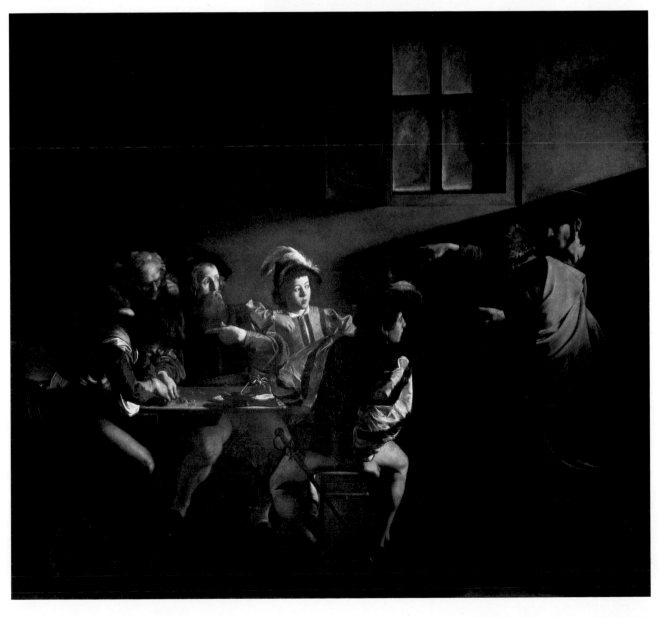

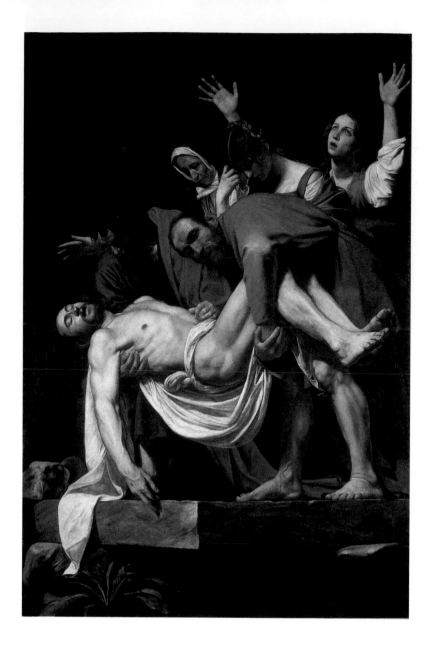

19-19. Caravaggio. *Entombment*, from the Vittrici Chapel, Church of Santa Maria in Vallicella, Rome. 1603–4. Oil on canvas, 9'10⅛" x 6'7¹⁵/₁₆" (3 x 2.03 m). Musei Vaticani, Pinacoteca, Rome

The *Entombment* was one of many paintings confiscated from Rome's churches and taken to Paris during the French occupation by Napoleon's troops in 1798 and 1808–14. It was one of the few to be returned after 1815 through the negotiations of Pius VII and his agents, who were assisted greatly by the Neoclassical sculptor Antonio Canova, a favorite of Napoleon. The decision was made not to return the works to their original churches and chapels but instead to assemble them in a gallery where the general public could enjoy them. Today, Caravaggio's painting is one of the most important in the collections of the Vatican Museums.

calling Levi, the tax collector, to join his apostles (Mark 2:14). Levi sits at a table, counting out gold coins for a boy at the left, surrounded by overdressed young men in plumed hats, velvet doublets, and satin shirts. Nearly hidden behind the cloaked apostle Peter, at the right, the gaunt-faced Jesus points dramatically at Levi, a gesture that is repeated by the tax collector's surprised response of pointing to himself. An intense raking light enters the painting from a high, unseen source at the right and spotlights the faces of the men. For all of his naturalism, Caravaggio also used antique and Renaissance sources. Jesus' outstretched arm, for example, recalls God's gesture giving life to Adam in Michelangelo's *Creation of Adam* on the *Sistine Ceiling* (see fig. 18-13), now restated as Jesus' command to Levi to begin a new life by becoming his disciple Matthew.

The emotional power of Baroque naturalism combines with a solemn, classical monumentality in Caravaggio's *Entombment* (fig. 19-19), painted in 1603–4 for a chapel in Santa Maria in Vallicella, the church of Neri's Congregation of the Oratory. With almost physical force, the size and immediacy of this painting strike the viewer, whose perspective is from within the burial pit into which Jesus'

lifeless body is to be lowered. The figures form a large off-center triangle, within which angular elements are repeated: the projecting edge of the stone slab; Jesus' bent legs; the akimbo arm, bunched coat, and knock-kneed stance of the man on the right; and even the spaces between the spread fingers of the raised hands. The Virgin and Mary Magdalen barely intrude on the scene, which, through the careful placing of the light, focuses on the dead Jesus, the sturdy-legged laborer supporting his body at the right, and the young John the Evangelist at the triangle's apex.

Despite the great esteem in which Caravaggio was held as an artist, his violent temper repeatedly got him into trouble. During the last decade of his life, he was frequently arrested, generally for minor offenses: throwing a plate of artichokes at a waiter, carrying arms illegally, street brawling. In 1606, however, he killed a man in a fight over a tennis match and had to flee Rome. He went first to Naples, then to Malta, finding work in both places. The Knights of Malta awarded him the cross of their religious and military order in July 1608, but in October he was imprisoned for insulting one of their number, and again he had to flee. The aggrieved knight's agents

tracked him to Naples in the spring of 1610 and severely wounded him; the artist recovered and fled north to Port'Ercole, where he died of a fever on July 18, 1610, just short of his thirty-ninth birthday. Caravaggio's naturalism and tenebrist lighting influenced nearly every important European artist of the seventeenth century.

Artemisia Gentileschi. One of Caravaggio's most successful Italian followers was Artemisia Gentileschi (1593–c. 1652/3), whose international reputation helped spread the Caravaggesque style beyond Rome. Born in Rome, Artemisia first studied and worked under her father, himself a follower of Caravaggio. In 1616, she moved to Florence, where she worked for the grand duke of Tuscany and was elected, at the age of twenty-three, to the Florentine Academy of Design. As a resident of Florence and member of the academy, Artemisia was well aware of the city's identification with the Jewish hero David and heroine Judith (both subjects of sculpture by Donatello and Michelangelo). In one of several versions of Judith triumphant over the Assyrian general Holofernes (fig. 19-20), Artemisia brilliantly uses Baroque naturalism and tenebrist effects, dramatically showing Judith still holding the bloody sword and hiding the candle's light as her maid stuffs the general's head into a sack.

Throughout her life, Artemisia painted images of heroic and abused women—Judith, Susanna, Bathsheba, Esther—and she also became a famous portrait painter. In 1630, she painted *La Pittura*, an allegorical self-portrait (fig. 19-21). The image of a woman with palette and

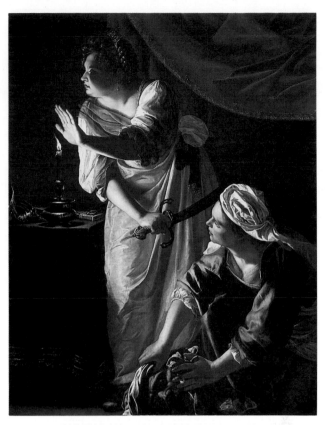

19-20. Artemisia Gentileschi. *Judith and Maidservant with the Head of Holofernes*. 1625. Oil on canvas, 6'1/2" x 4'7" (1.84 x 1.41 m). The Detroit Institute of Arts

Gift of Leslie H. Green

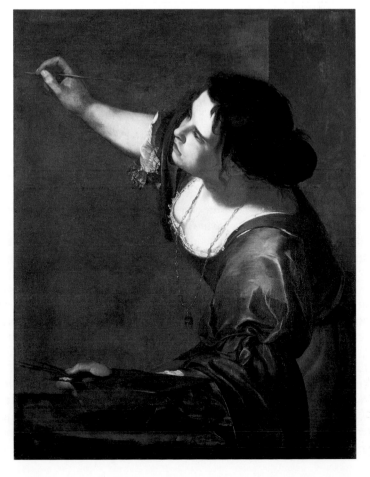

19-21. Artemisia Gentileschi. *La Pittura*. 1630. Oil on canvas, 38 x 29" (96.5 x 73.7 cm). The Royal Collection, Windsor Castle, Windsor, England

(RCIN 405551, ML 49 BP 2652)

The members of the French Royal Academy of Painting and Sculpture considered ancient classical art to be the standard by which contemporary art should be judged. By the 1680s, however, younger artists of the Academy began to argue that modern art might equal and even surpass the art of the ancients. A debate arose over the relative merits of drawing and color in painting. The conservatives argued that drawing was superior to color because drawing appealed to the mind, while color appealed to the senses. They saw Nicolas Poussin as embodying perfectly the classical principles of subject and design. But the young artists who admired the vivid colors of Titian, Veronese, and Rubens claimed that painting should deceive the eye, and since color achieves this deception more convincingly than drawing, application of color should be valued over drawing. The two positions were called *poussinistes* (in honor of Poussin) and *rubénistes* (for Rubens).

The portrait painter and critic Roger de Piles (1635–1709) took up the cause of the *rubénistes* in a series of pamphlets. In *The Principles of Painting*, Piles evaluated the most important painters on a scale of 0 to 20. He gave no score higher than 18, since no mortal artist could achieve perfection. Caravaggio received the lowest grade, a 0 in expression and 6 in drawing, while Michelangelo and Leonardo both got a 4 in color and Rembrandt a 6 in drawing.

If we convert Piles's grades to the traditional scale of 90% = A, 80% = B, and so forth, most of the painters we have studied don't do very well. Raphael and Rubens get As, but no one gets a B; Van Dyck comes close with a C+. Poussin and Titian earn solid Cs, while Rembrandt slips by with a C-. Leonardo gets a D, and Michelangelo, Dürer, and Caravaggio all are resounding failures in Piles's view.

brushes, richly dressed, and wearing a gold necklace with a mask pendant comes from a popular sourcebook for such images, the *Iconologia*, by Cesare Ripa (1593), which maintains that the mask imitates the human face, as painting imitates nature. The gold chain symbolizes "the continuity and interlocking nature of painting, each man learning from his master and continuing his master's achievements in the next generation" (cited in E. Maser, no. 197). Thus, Artemisia's self-portrait not only commemorates her profession but also pays tribute to her father.

FRANCE

The early seventeenth century was a difficult period in France, marked by almost continuous foreign and civil wars. The assassination of King Henri IV in 1610 left France in the hands of the queen, Marie de' Medici (regency 1610–17), as regent for her nine-year-old son, Louis XIII (ruled 1610–43). When Louis came of age, the brilliant and unscrupulous Cardinal Richelieu became chief minister and set about increasing the power of the Crown at the expense of the French nobility. The death of Louis XIII again left France with a child king, the five-year-old Louis XIV (ruled 1643–1715). His mother, Anne of Austria, became regent, with the assistance of another powerful minister, Cardinal Mazarin. At Mazarin's death in 1661, Louis XIV (see fig. 19-1) began his long personal reign, assisted by yet another able minister, Jean-Baptiste Colbert.

An absolute monarch whose reign was the longest in European history, Louis XIV expanded royal art patronage, making the French court the envy of every ruler in Europe. In 1635, Cardinal Richelieu had founded the French Royal Academy to compile a definitive dictionary and grammar of the French language. In 1648, the Royal Academy of Painting and Sculpture was founded, which, as reorganized by Colbert in 1663, maintained strict control over the arts (see "Grading the Old Masters," above). Although it was not the first European arts academy, none before it had exerted such dictatorial authority—an authority that lasted in France until the late nineteenth century. Membership in the Academy assured an artist of royal and civic commissions and financial success, but many talented artists did well outside it.

ARCHITECTURE AND ITS DECORATION AT VERSAILLES

French architecture developed along classical lines in the second half of the seventeenth century under the influence of François Mansart (1598–1666) and Louis Le Vau (1612–70). When the Royal Academy of Architecture was founded in 1671, its members developed guidelines for architectural design based on the belief that mathematics was the true basis of beauty. Their chief sources for ideal models were the books of Vitruvius (see "The Vitruvian Man," page 690), Vignola (see figs. 18-46, 18-47), and Palladio (see figs. 18-61, 18-63).

In 1668, Louis XIV began to enlarge the small château built by Louis XIII at Versailles, not far from Paris. Louis eventually required his court of 20,000 nobles to live in Versailles; 5,000 lived in the palace itself, together with 14,000 servants and military staff members. The town had another 30,000 residents, most of whom were employed by the palace. The designers of the palace and park complex at Versailles (fig. 19-22) were Le Vau, Charles Le Brun (1619–90), who oversaw the interior decoration, and André Le Nôtre (1613–1700), who planned the gardens (see "French Baroque Garden Design," page 780). For both political and sentimental reasons, the old Versailles château was left standing, and the new building went up around it. This project consisted of two phases: the first additions by Le Vau, begun in 1668; and an enlargement completed after Le Vau's death by his successor, Jules Hardouin-Mansart (1646–1708), from 1670 to 1685.

Hardouin-Mansart was responsible for the addition of the long lateral wings and the renovation of Le Vau's central block on the garden side to match these wings (fig. 19-23). The three-story elevation has a lightly **rusticated** ground floor, a main floor lined with enormous

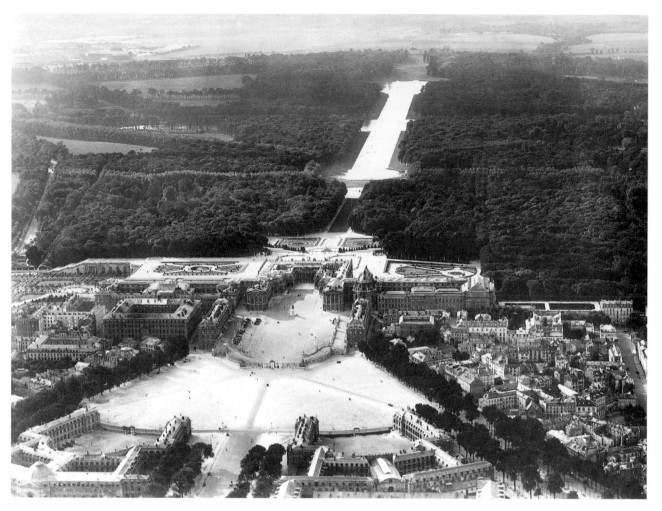

19-22. Louis Le Vau and Jules Hardouin-Mansart. Palais de Versailles, Versailles, Francc. 1668–85. Gardens by André Le Nôtre

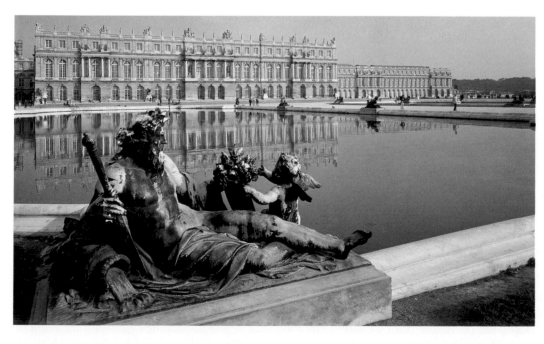

19-23. Central block of the garden facade, Palais de Versailles

FRENCH BAROQUE GARDEN DESIGN

Wealthy landowners would commission garden designers to transform their large properties into gardens extending over many acres; the challenge for garden designers was to unify diverse elements—buildings, pools, monuments, plantings, natural land formations—into a coherent whole. At Versailles, André Le Nôtre imposed order upon the vast expanses of palace gardens and park by using broad, straight avenues radiating from a series of round focal points. He succeeded so thoroughly that his plan inspired generations of urban designers as well as landscape architects.

In Le Nôtre's hands, the palace terrain became an extraordinary work of art and a visual delight for its inhabitants. Neatly contained stretches of lawn and broad, straight vistas seemed to stretch to the horizon, while the formal gardens became an exercise in precise geometry. The Versailles gardens are classically harmonious in their symmetrical, geometric design but Baroque in their vast size and extension into the surrounding countryside, where the gardens thickened into woods cut by straight avenues.

The most formal gardens lay nearest the palace, and plantings became progressively less elaborate and larger in scale as the distance from the palace increased. Broad, intersecting paths separated reflecting pools and planting beds, which are called embroidered **parterres** for their colorful patterns of flowers outlined with trimmed hedges. After the formal zone of parterres came lawns, large fountains on terraces, and trees planted in thickets to conceal features such as an open-air ballroom and a colonnade. Statues carved by at least seventy sculptors also adorned the park. A mile-long canal, crossed by a second canal nearly as large, marked the main axis of the garden. Fourteen waterwheels brought the water from the river to supply the canals and the park's 1,400 fountains. Only the fountains near the palace played all day; the others were turned on when the king approached.

At the north of the secondary canal, a smaller pavilion-palace, the Trianon, was built in 1669. To satisfy the king's love of flowers year-round, the gardens of the Trianon were bedded out with blooming plants shipped in by the navy from the south; even in midwinter, the king and his guests could stroll through a summer garden. The gardener is said to have had nearly 2 million flowerpots at his disposal. The fruit and vegetable garden that supplied the palace in 1677–83 is now the National School of Horticulture. In the eighteenth century, Louis XV added greenhouses and a botanical garden. Another royal retreat, the Little Trianon, was added in 1761 and given in 1774 to Louis XVI's queen, Marie Antoinette. Reflecting a new delight in unspoiled nature, in 1785 a miniature village in a "natural" landscape was constructed there for the queen, where she and the ladies of the court relaxed by pretending to be shepherdesses and milkmaids.

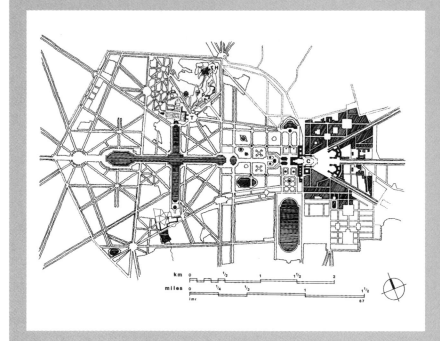

Louis Le Vau and André Le Nôtre. Plan of the Palais de Versailles, Versailles, France. c. 1661–1785. Drawing by Leland M. Roth after Delagrive's engraving of 1746

arched windows separated by Ionic pilasters, an attic level whose rectangular windows are also flanked by pilasters, and a flat, terraced roof. The overall design is a sensitive balance of horizontals and verticals relieved by a restrained overlay of regularly spaced projecting blocks with open, colonnaded porches.

In his renovation of Le Vau's center-block facade, Hardouin-Mansart enclosed the previously open gallery on the main level, which is about 240 feet long. He achieved architectural symmetry by lining the interior wall opposite the windows with Venetian glass mirrors—extremely expensive in the seventeenth century—the same size and shape as the arched windows, thus creating the famed Hall of Mirrors (fig. 19-24). The mirrors reflect the natural light from the windows and give the impression of an even larger space. In a tribute to Carracci's Farnese ceiling (see fig. 19-13), Le Brun decorated the vaulted ceiling with paintings glorifying the reign of Louis XIV. In 1642, Le Brun had studied in Italy, where he came under the influence of the classical style of his

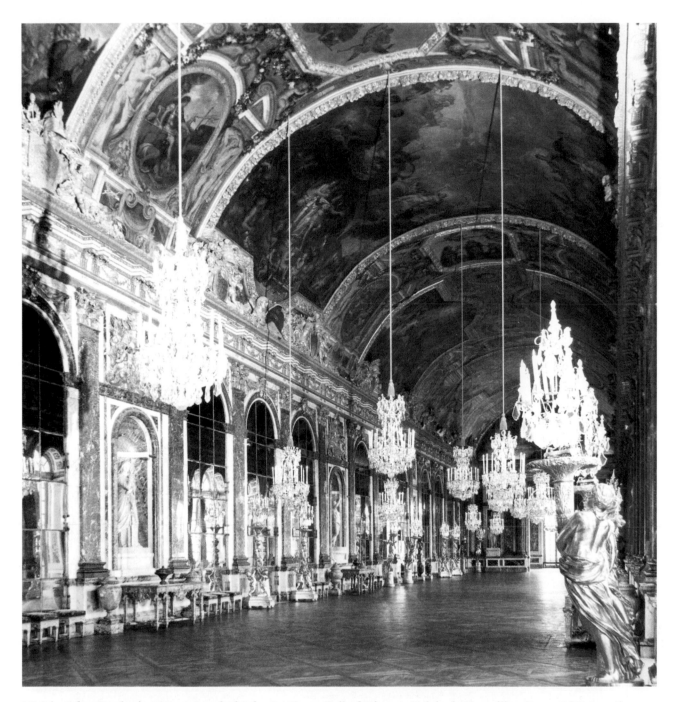

19-24. Jules Hardouin-Mansart and Charles Le Brun. Hall of Mirrors, Palais de Versailles. Begun 1678. Length approx. 240'

In the seventeenth century, mirrors and clear window glass were enormously expensive. To furnish the Hall of Mirrors, hundreds of glass panels of manageable size had to be assembled into the proper shape and attached to one another with glazing bars, which became part of the decorative pattern of the vast room.

compatriot Nicolas Poussin, discussed later in this chapter. Stylistically, Le Brun tempered the more exuberant Baroque ceilings he had seen in Rome with Poussin's classicism in his spectacular decorations. The underlying theme for the design and decoration of the palace was the glorification of the king as Apollo the Sun God, with whom Louis identified. Louis XIV thought of the duties of kingship, including its pageantry, as a solemn performance, so it is most appropriate that Rigaud's portrait presents him on a raised, stagelike platform, with a theatrical curtain

(see fig. 19-1). Versailles was the splendid stage on which the king played this grandiose drama.

In the seventeenth century, French taste in sculpture tended to favor classicizing works inspired by antiquity and the Italian Renaissance. A highly favored sculptor in this classical style, François Girardon (1628–1715), had studied the monuments of classical antiquity in Rome in the 1640s. He had worked with Le Vau and Le Brun before he began working to decorate Versailles. In keeping with the repeated identification of Louis XIV with

Apollo, he created the sculpture group *Apollo Attended by the Nymphs of Thetis* (fig. 19-25), executed about 1666–75, to be displayed in a classical arched niche in the Grotto of Thetis (fig. 19-26), a formal, triple-arched pavilion named after a sea nymph beloved by the Sun god (see "The Grotto," page 741). The original setting was destroyed in 1684, and today the sculpture group stands in the eighteenth-century grotto seen in figure 19-25. In the center—the group Girardon created—Apollo is attended by the nymphs of Thetis after his long journey across the heavens. At each side, Tritons, figures by Thomas Regnaudin (c. 1622-1706), rub down Apollo's horses, which were carved by the Marsy family workshop. In 1776, Louis XVI had the painter Hubert Robert design a "natural" rocky cavern for Girardon's sculpture.

PAINTING

French seventeenth-century painting was much affected by developments in Italian art. The lingering Mannerism of the sixteenth century gave way as early as the 1620s to Baroque classicism and Caravaggism—the use of strong **chiaroscuro** (tenebrism) and raking light, and the placement of large-scale figures in the foreground.

Georges de La Tour. One of Caravaggio's most important followers in France, Georges de La Tour (1593–1652), received major royal and ducal commissions and became court painter to King Louis XIII in 1639. La Tour may have traveled to Italy in 1614–16, and in the 1620s

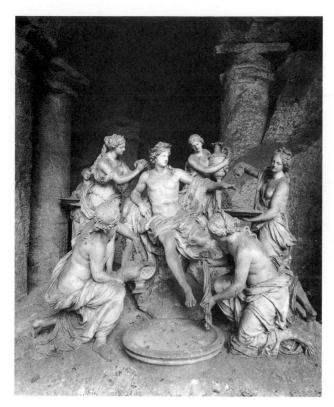

19-25. François Girardon. *Apollo Attended by the Nymphs of Thetis*, from the Grotto of Thetis, Palais de Versailles, Versailles, France. c. 1666–72. Marble, lifesize. Grotto by Hubert Robert in 1776; sculpture reinstalled in a different configuration in 1778

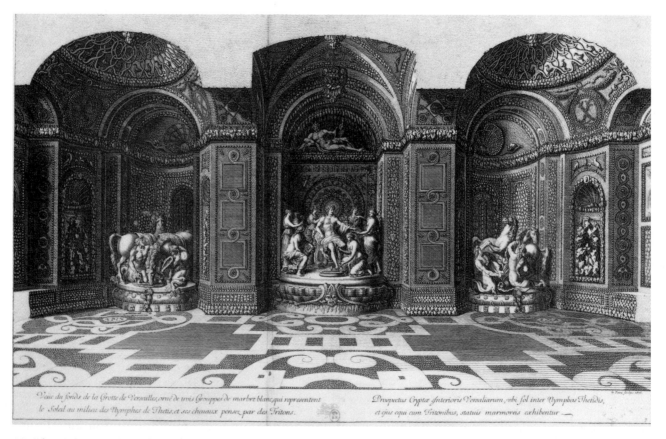

19-26. Jean Lepautre. *The Grotto of Thetis*. 1676. Engraving by Jean Lepautre showing the original setting (destroyed in 1684) of *Apollo Attended by the Nymphs of Thetis*. Bibliothèque Nationale de France, Paris

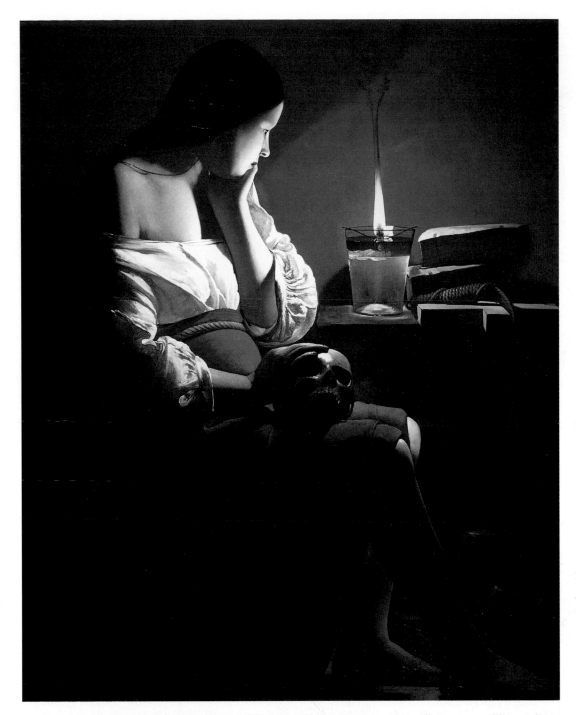

19-27. Georges de La Tour. *Magdalen with the Smoking Flame*. c. 1640. Oil on canvas, 46¼ x 36⅛"
(117 x 91.8 cm). Los Angeles County Museum of Art
Gift of the Ahmanson Foundation

he almost certainly visited the Netherlands, where Caravaggio's style was being enthusiastically emulated. Like Caravaggio, La Tour filled the foreground of his canvases with monumental figures, but in place of Caravaggio's detailed naturalism he used a simplified setting and a light source within the picture so intense that it often seems to be his real subject. In *Magdalen with the Smoking Flame* (fig. 19-27), as in many of his paintings, the light emanates from a candle. The hand and skull act as devices to establish a foreground plane, and the compression of the figure within the pictorial space lends a

sense of intimacy. The light is the unifying element of the painting and conveys the mood. Mary Magdalen has put aside her rich clothing and jewels and meditates on the frailty and vanity of human life.

Claude Lorrain and Nicolas Poussin. The painters Claude Gellée (called Claude Lorrain, or simply Claude, 1600–1682) and Nicolas Poussin (1594–1665) worked for French patrons and significantly influenced other French artists, although they both pursued their careers in Italy. Claude and Poussin were classicists in that neither

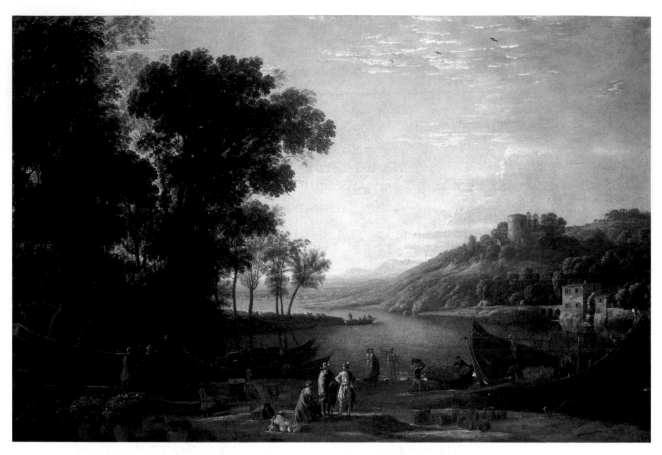

19-28. Claude Lorrain. *Landscape with Merchants*. c. 1630. Oil on canvas, 38¼ x 56½" (97.2 x 143.6 cm). National Gallery of Art, Washington, D.C.
Samuel H. Kress Collection

recorded nature as he found it but instead organized natural elements and figures into idealized compositions. Both were influenced by Annibale Carracci and to some extent by Venetian painting, yet each evolved an unmistakable personal style that conveyed an entirely different mood from that of their sources and from each other.

Claude went to Rome in 1613 and studied with a specialist in harbor paintings, which inspired his later enthusiasm for that subject. He dedicated himself to painting landscapes and harbor views with small figures that activated the space and provided a narrative subject. He was fascinated with light, and his works are often studies of the effect of the rising or setting sun on colors and the atmosphere. His working method included making many sketches from nature, which he later referred to while composing in his studio. A favorite and much imitated device was to place one or two large objects in the foreground—a tree, building, or hill—past which the viewer's eye enters the scene and proceeds, often by zigzag paths, into the distance.

In his *Landscape with Merchants* (fig. 19-28), of about 1630, Claude presents an idyllic scene in which elegant men proffer handsome goods to passersby as the sun rises on a serene world. Past the framing device of huge trees in the left and busy foreground, the eye moves unimpeded into the open middle ground over gleaming water to arrive at a mill and waterwheel, then on to a hilltop

tower illuminated by the rising sun. Along the shore is a walled city, luminous in the early morning haze. Pale blue mountains provide a final closure in the far distance.

Like Claude, Poussin created landscapes with figures, but to different effect. His paintings are the epitome of the orderly, arranged, classical landscape. In his *Landscape with Saint John on Patmos* (fig. 19-29), from 1640, Poussin created a consistent perspective progression from the picture plane back into the distance through a clearly defined foreground, middle ground, and background. These zones are marked by alternating sunlight and shade, as well as by their architectural elements. Huge, tumbled classical ruins fill the foreground and overshadow the evangelist, who concentrates on his writing of the Book of Revelation. In the middle distance are a ruined temple and an obclisk, and the round building in the distant city is Hadrian's Tomb, which Poussin knew from Rome. Precisely placed trees, hills, mountains, water, and even clouds take on a solidity of form that seems almost as structural as architecture. The reclining evangelist and the eagle, his symbol, seem almost incidental to this perfect landscape. The triumph of the rational mind takes on moral overtones. The subject of Poussin's painting is in effect the balance and order of nature rather than the story of John the Evangelist.

In the second half of the seventeenth century, the French Academy took Poussin's paintings and notes on

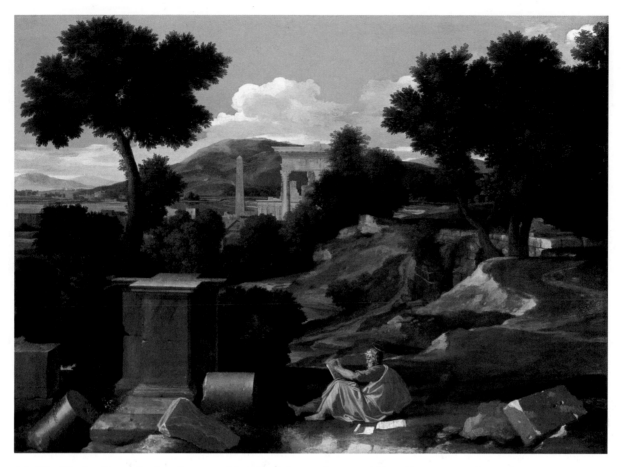

19-29. Nicolas Poussin. *Landscape with Saint John on Patmos*. 1640. Oil on canvas, 40 x 53½" (101.8 x 136.3 cm). The Art Institute of Chicago

A. A. Munger Collection, 1930.500

painting as a final authority. Thereafter, whether as a model to be followed or one to be reacted against, Poussin influenced French art.

Hyacinthe Rigaud. Hyacinthe Rigaud (1659–1743), trained by his painter father, won the Royal Academy's prestigious **Prix de Rome** in 1682, which would have paid his expenses for study at the Academy's villa in Rome. Rigaud rejected the prize, however, and opened his own Paris studio. After painting a portrait of Louis XIV's brother in 1688, he became a favorite of the king himself. One of his best-known portraits—one representing the height of royal propaganda—is the one he painted of the Sun King in 1701, with which we opened the chapter (see fig. 19-1). Although he was well known and popular—and quite influential on later French portraitists—Rigaud was far removed from both the classicizing and the Caravaggesque influences at work on other French artists of the time.

HABSBURG GERMANY AND AUSTRIA What had begun as a Germanic Holy Roman Empire had by the early sixteenth century expanded through inheritance and marriage across a broad swath of Europe (Chapter 18). But even an intelligent and dedicated ruler like the Habsburg Charles V, who had been

elected emperor in 1519, could not manage the affairs of and maintain control over such a vast territory. In 1556 he abdicated, dividing the empire, and he died two years later. He left Spain and its American colonies, the Netherlands, Burgundy, Milan, and the Kingdom of Naples and Sicily to his son Philip II. The Holy Roman Empire (Germany and Austria) went to his brother Ferdinand.

The arts suffered in seventeenth-century Germanic lands during and after the Protestant Reformation. The Habsburg emperors ruled their territories from Vienna in Austria, but much of German-speaking Europe remained divided into small units in which local rulers decided on the religion of their territory. Catholicism prevailed in southern and western Germany, including Bavaria and the Rhineland, and in Austria, while the north was Lutheran. Wars over religion ravaged the land, absorbing available money. When peace finally returned in the eighteenth century, Catholic Austria and Bavaria (southern Germany) saw a remarkable burst of building activity, including the creation and refurbishing of churches and palaces with exuberant interior decoration. Emperor Charles VI (ruled 1711–40) inspired building in his capital, Vienna, and throughout Austria.

Church architecture looked to Italian Baroque developments, which were then added to German medieval forms such as the westwork, a tall west front, and bell towers. With these elements, German Baroque architects

19-30. Jakob Prandtauer. Benedictine Monastery Church, Melk, Austria. 1702–36

gave their churches an especially strong vertical emphasis. Important secular projects were also undertaken, as princes throughout Germany began building smaller versions of Louis XIV's palace and garden complex at Versailles. One of the most imposing buildings of this period is the Benedictine Abbey of Melk, built high on a promontory overlooking the Danube River upstream from Vienna. It combines church, monastery, library, and—true to the Benedictine tradition of hospitality— guest quarters that evolved into a splendid palace to house the traveling court (fig. 19-30). The architect, Jakob Prandtauer (1660–1726), oversaw its construction from 1702 to 1736 on a site where there had been a Benedictine monastery since the eleventh century. Seen from the river, the monastery appears to be a huge twin-towered church. But the church is flanked by two long (1,050 feet) parallel wings, one of which contains a grand hall and the other, the monastery's library. The wings are joined at the lower level by a section with a curving facade forming a terrace overlooking the river in front of the church. Large windows and open galleries take advantage of the river view, while colossal pilasters and high bulbous-dome towers emphasize the building's verticality. As an ancient foundation enjoying imperial patronage, the monastery was expected to provide lodging for traveling princes and other dignitaries. Its grand and palacelike appearance—especially the interior (fig. 19-31)—was appropriate to that function.

HABSBURG SPAIN

The Spanish Habsburg kings—Philip III (ruled 1598–1621), Philip IV (ruled 1621–65), and Charles II (ruled 1665–1700)—reigned over an increasingly weakening empire during a rich period for painting and literature that concealed a profound economic and political decline. Agriculture, industry, and trade suffered, and after repeated local rebellions Portugal reestablished its independence in 1640. The Kingdom of Naples remained in a constant state of revolt. After eighty years of war, the Protestant northern Netherlands—which had formed the United Dutch Republic—definitively gained independence in 1648. Amsterdam grew into one of the wealthiest cities of Europe, and the Dutch Republic became an increasingly serious threat to Spanish trade and colonial possessions. Meanwhile, the Catholic southern Netherlands (Flanders) stagnated under Spanish and then Austrian Habsburg rule. (Flanders did not declare its independence until 1798, when it took the name Belgium from the original tribe of Belgae.) Furthermore, what had seemed an endless flow of gold and silver from the Americas diminished, as precious-metal production in Bolivia and Mexico lessened. Attempting to defend the Roman Catholic Church and their empire on all fronts, Spanish kings squandered their resources and finally went bankrupt in 1692. Nevertheless, despite the decline of the Habsburgs' Spanish empire, seventeenth-century writers and artists produced much of what is considered the greatest Spanish literature and art, and the century is often called the Spanish Golden Age.

ARCHITECTURE

Turning away from the severity displayed in the sixteenth-century El Escorial monastery-palace (see fig. 18-69), Spanish architects again embraced the lavish decoration that had characterized their art since the fourteenth century. The profusion of ornament typical of Moorish and Gothic architecture in Spain swept back into fashion in

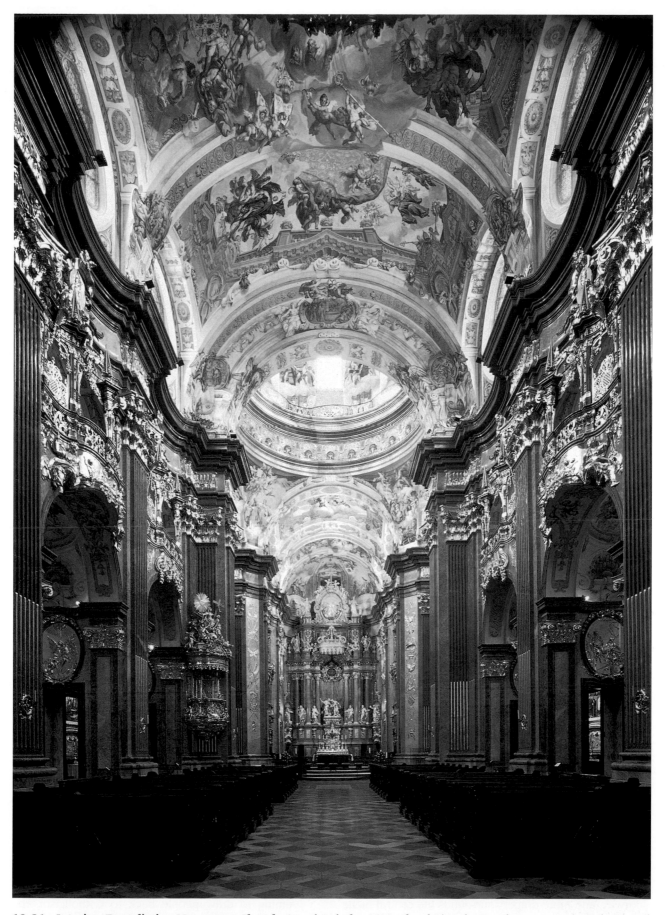

19-31. Interior, Benedictine Monastery Church. Completed after 1738, after designs by Prandtauer, Antonio Beduzzi, and Joseph Munggenast

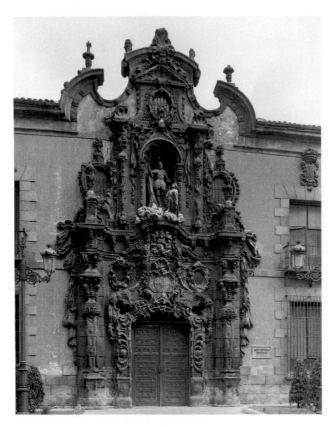

19-32. Pedro de Ribera. Portal of the Hospicio de San Fernando, Madrid. 1722

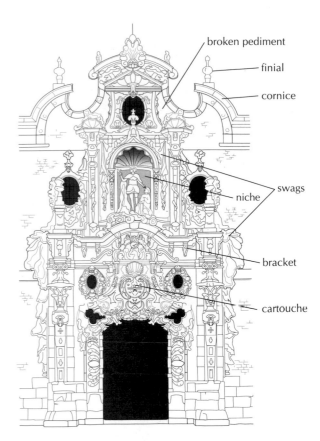

19-33. Diagram of the Portal of the Hospicio de San Fernando

the work of a family of architects and sculptors named Churriguera, first in huge **retablos** (altarpieces), then in **portals**, and finally in entire buildings. Once called Churrigueresque but now known as Ultra-Baroque or Late Baroque, the style found its most exuberant expression in the work of eighteenth-century architects such as Pedro de Ribera (c. 1681–1742) and in the architecture of colonial Mexico and Peru.

Ribera's 1722 facade for the Hospicio de San Fernando is typical (figs. 19-32, 19-33). The street facade is a severe brick structure with an extraordinarily exuberant sculpted portal, which is as much like a painting as architecture becomes. Although the architect used classical elements (among them cornices, **brackets**, pedestals, **volutes**, **finials**, **swags**, and niches) in the portal and organized them symmetrically, the parts run together in a wild profusion of theatrical hollows and projections, large forms (such as the **broken pediment** at the roofline), and small details. Like a huge altarpiece, the portal soars upward. The structural forms of classical architecture are transformed into projecting and receding layers overlaid with foliage. Carved curtains loop back as if to reveal the doorway, and more drapery surrounds the central niche with the figure of the hospital's patron saint, Ferdinand. This florid style was carried by the *conquistadores* to the Americas, where it formed the basis of a splendid colonial architecture (see fig. 19-43).

PAINTING

The primary influence on Spanish painting in the fifteenth century had been the art of Flanders; in the sixteenth, it had been the art of Florence and Rome. Seventeenth-century Spanish painting, profoundly influenced by Caravaggio's powerful art, was characterized by an ecstatic religiosity combined with intense realism whose surface details emerge from the deep shadows of tenebrism. This influence is not surprising, since the Kingdom of Naples was ruled by Spanish monarchs, and contact between Naples and the Iberian peninsula was strong and productive.

Jusepe de Ribera. First to Rome, then to Naples went the young Spanish painter Jusepe de Ribera (c. 1591–1652), also known as Lo Spagnoletto ("the Little Spaniard"). Ribera combined the classical and Caravaggesque styles he had learned in Rome, and after settling in Naples in 1620, created a new Neapolitan—and eventually Spanish—style: Ribera became the link extending from Caravaggio in Italy to two major painters in Spain, Zurbarán and Velázquez.

Aiming to draw people back to Catholicism, the Church ordered art depicting heroic martyrs who had endured shocking torments as witness to their faith or who, like Teresa in ecstasy, reinforced the importance of personal religious experience and intuitive knowledge. A

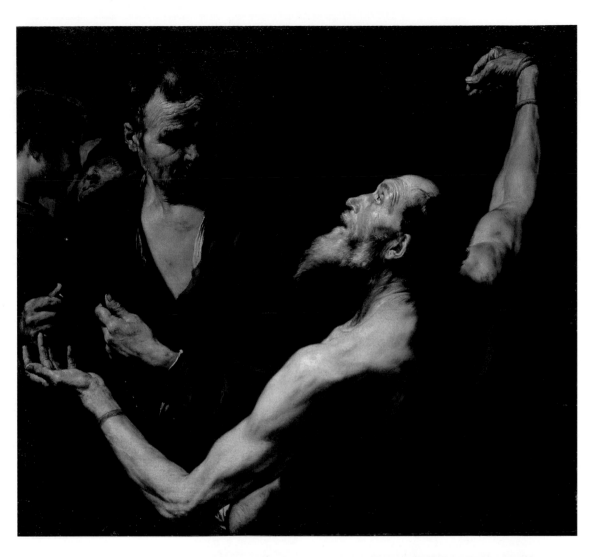

19-34. Jusepe de Ribera. *Martyrdom of Saint Bartholomew.* 1634. Oil on canvas, 41¼" x 44⅞" (105 x 114 cm). National Gallery of Art, Washington, D.C.

Gift of the 50th Anniversary Gift Committee

striking response to this call is Ribera's painting of Bartholomew, an apostle who was martyred by being skinned alive (fig. 19-34). Here Ribera highlighted the intensely realistic aged faces with dramatic Caravaggesque tenebrism. The bound Bartholomew looks heavenward as his executioner tests the knife that he will soon use on his still-living victim.

Francisco de Zurbarán. Equally horrifying in its depiction of martyrdom, but represented with understated control, is the 1628 painting of *Saint Serapion* (fig. 19-35) by Francisco de Zurbarán (1598–1664). Little is known of his early years before 1625, but Zurbarán was greatly influenced by the Caravaggesque taste prevalent in Seville, a major city in southwestern Spain, where he worked. From it he evolved his own distinctive style, incorporating a Spanish taste for abstract design.

Zurbabán was closely associated with the monastic orders for which he executed his major commissions. In the painting shown here, he portrays the martyrdom of

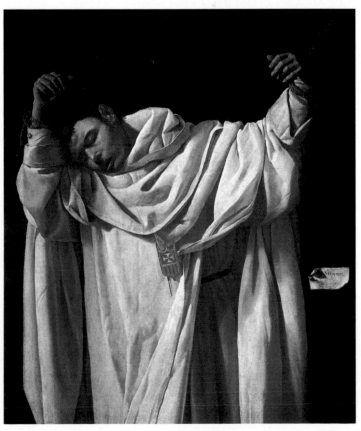

19-35. Francisco de Zurbarán. *Saint Serapion.* 1628. Oil on canvas, 47½ x 40¾" (120.7 x 103.5 cm). Wadsworth Atheneum, Hartford, Connecticut

Ella Gallup Sumner and Mary Catlin Sumner Collection

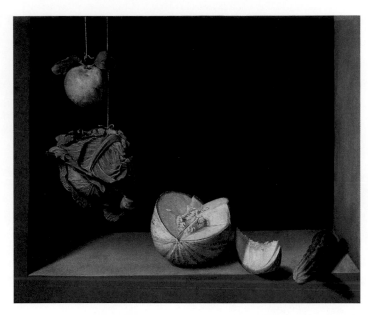

19-36. Juan Sánchez Cotán. *Still Life with Quince, Cabbage, Melon, and Cucumber*. c. 1602. Oil on canvas, 27⅛ x 33¼" (68.8 x 84.4 cm). San Diego Museum of Art

Gift of Anne R. and Amy Putnam

Serapion, who was a member of the thirteenth-century Mercedarians, a Spanish order founded to rescue the Christian prisoners of the Spanish Moors. Following the vows of his order, Serapion sacrificed himself in exchange for Christian captives. The dead man's pallor, his rough hands, and the coarse ropes emerge from the off-white of his creased Mercedarian habit, its folds carefully arranged in a pattern of highlights and varying depths of shadow. The only colors are the red and gold of the insignia. The effect of this composition, almost timeless in its stillness, is that of a tragic still life.

Juan Sánchez Cotán. Late in the sixteenth century, Spanish artists developed a significant interest in paintings of artfully arranged objects rendered with intense attention to detail. Juan Sánchez Cotán (1561–1627) was one of the earliest painters of these pure still lifes in Spain. His *Still Life with Quince, Cabbage, Melon, and Cucumber* (fig. 19-36), of about 1602, is a prime example of the characteristic Spanish *trompe l'oeil* rendering of an artificially composed still life. Sánchez Cotán's composition plays off the irregular, curved shapes of the fruits

19-37. Diego Velázquez. *Water Carrier of Seville*. c. 1619. Oil on canvas, 42 x 31¾" (106.7 x 81 cm). Wellington Museum, London

In the hot climate of Seville, Spain, where this painting was made, water vendors walked the streets selling cool drinks from large clay jars like the one in the foreground. In this scene, the clarity and purity of the water are proudly attested to by its seller, who offers the customer a sample poured into a glass goblet. The jug contents were usually sweetened by the addition of a piece of fresh fruit or a sprinkle of aromatic herbs.

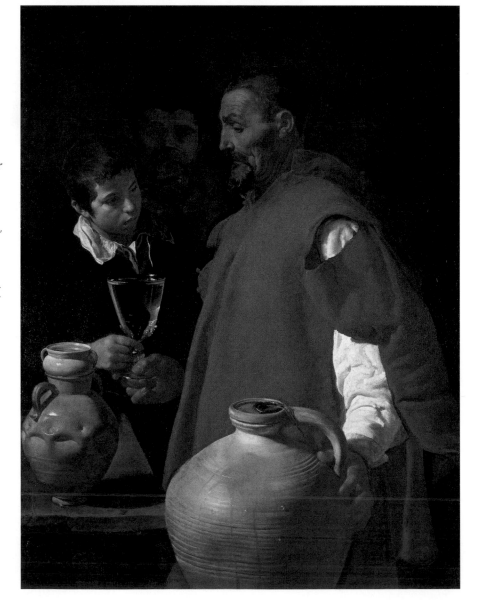

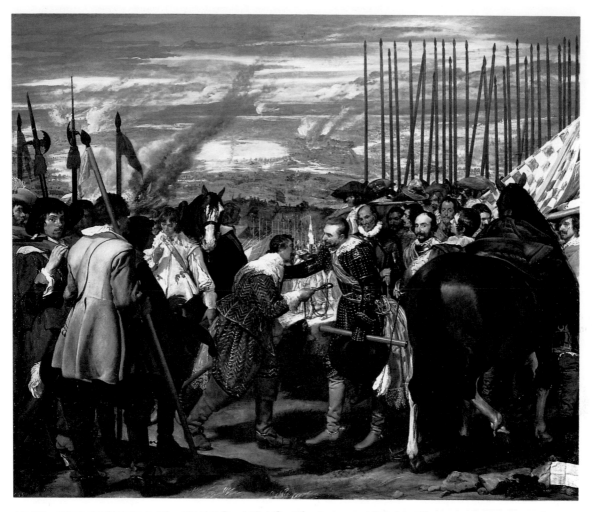

19-38. Diego Velázquez. *The Surrender at Breda (The Lances)*. 1634–35. Oil on canvas, 10'1" x 10'4" (3.1 x 3.16 m). Museo del Prado, Madrid

and vegetables against the angular geometry of the setting. His precisely ordered subjects, suspended from strings in a long arc from the upper left to the lower right, are set in a strong light against an impenetrable dark background. This highly artificial arrangement exemplifies a Spanish fascination with spatial ambiguity; it is not clear whether the seemingly airless space is a wall niche or a window ledge, or why these objects have been arranged in this way.

Diego Velázquez. Diego Rodríguez de Silva y Velázquez (1599–1660), the greatest painter to emerge from the Caravaggesque school of Seville and one of the most acclaimed painters of all time, entered Seville's painters' guild in 1617. Like Ribera, he was influenced at the beginning of his career by Caravaggesque tenebrism and naturalism. During his early years, he painted figural works set in taverns, markets, and kitchens, showing still lifes of various foods and kitchen utensils. Velázquez was devoted to studying and sketching from life, and the model for the superb *Water Carrier of Seville* (fig. 19-37), of about 1619, was a well-known Sevillian water seller. Like Sánchez Cotán, Velázquez arranged the elements of his paintings with almost mathematical rigor. The objects and figures allow the artist to exhibit his virtuosity

in rendering sculptural volumes and contrasting textures illuminated by dramatic natural light, which reacts to the surfaces: reflecting off the glazed waterpot at the left and the **matte**-, or dull-, finished jug in the foreground; being absorbed by the rough wool and dense velvet of the costumes; and reflecting, being refracted, and passing through the clear glass and the waterdrops on the jug's surface.

In 1623, Velázquez moved to Madrid, where he became court painter to young King Philip IV, a comfortable position that he maintained until his death in 1660. The artist's style evolved subtly but significantly over his long career. The Flemish painter Peter Paul Rubens, during a 1628–29 diplomatic visit to the Spanish court, convinced the king that Velázquez should visit Italy, which Velázquez did in 1629–31 and again in 1649–51. Velázquez was profoundly influenced by Italian painting of that time, especially in narratives with complex figure compositions.

In his great history painting *The Surrender at Breda* (fig. 19-38), Velázquez treated the theme of triumph and conquest in an entirely new way, unlike the traditional gloating military propaganda. Years earlier, in 1625, the duke of Alba, the Spanish governor, had defeated the Dutch at Breda. In Velázquez's imagination, the opposing

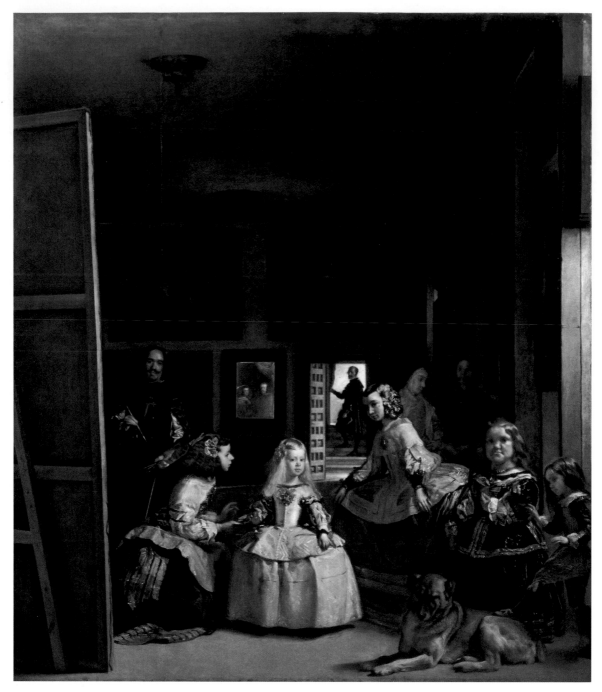

19-39. Diego Velázquez. *Las Meninas (The Maids of Honor)*. 1656. Oil on canvas, 10'5" x 9'1/2" (3.18 x 2.76 m). Museo del Prado, Madrid

armies stand on a hilltop overlooking a vast valley where the city of Breda burns and soldiers are still deployed. The Dutch commander, Justin of Nassau, hands over the keys of Breda to the victorious Spanish commander, Ambrosio Spinola. The entire exchange seems extraordinarily gracious; the painting represents a courtly ideal of gentle-manly conduct. The victors stand at attention, holding their densely packed lances upright—giving the painting its popular name, *The Lances*—while the defeated Dutch, a motley group, stand out of order, with pikes and banners drooping.

In *The Surrender at Breda*, Velázquez displays his ability to arrange a large number of figures into an effective narrative composition. Portraitlike faces, meaningful gestures, and brilliant control of color and texture convince us of the reality of the scene. The landscape painting is almost startling. Across the huge canvas, Velázquez painted an entirely imaginary Netherlands in greens and blues worked with flowing, liquid brushstrokes. The silvery light forms a background for dramatically silhouetted figures and weapons. Velázquez revealed a breadth and intensity unsurpassed in his century that would inspire modern artists from Manet to Picasso.

Although complex compositions were characteristic of many Velázquez paintings, perhaps his most striking and enigmatic work is the enormous multiple portrait, nearly 10 1/2 feet tall and 9 feet wide, known as *Las Meninas (The Maids of Honor)* (fig. 19-39). Painted in 1656,

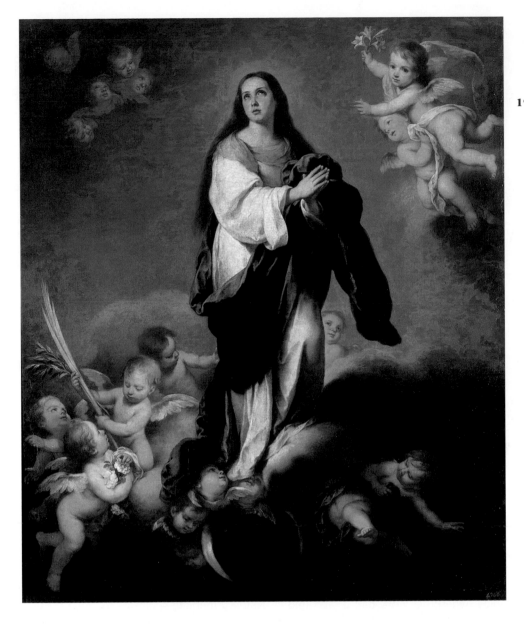

19-40. Bartolomé Esteban Murillo. *The Esquilache Immaculate Conception*. c. 1645–50. Oil on canvas, 7'8" x 6'5" (2.35 x 1.96 m). State Hermitage Museum, St. Petersburg, Russia

near the end of the artist's life, this painting continues to challenge the viewer. Like Caravaggio's *Entombment* (see fig. 19-19), it draws the viewer directly into its action, for the viewer is standing, apparently, in the space occupied by King Philip and his queen, whose reflections can be seen in the large mirror on the back wall. The central focus, however, is on the couple's five-year-old daughter, the *infanta* (princess) Margarita, surrounded by her attendants, most of whom are identifiable portraits.

A cleaning of *Las Meninas* in 1984 revealed much about Velázquez's methods. He used a minimum of underdrawing, building up his forms with layers of loosely applied paint and finishing off the surfaces with dashing highlights in white, lemon yellow, and pale orange. Velázquez tried to depict the optical properties of light rather than using it to model volumes in the classical manner. While his technique captures the appearance of light on surfaces, at close inspection his forms dissolve into a maze of individual strokes of paint.

No consensus exists today on the meaning of this monumental painting. It is more than a portrait of the princess and her attendants. It is also a painting of the king and queen stepping into the artist's studio and a self-portrait of Velázquez standing at his easel. But more than that, *Las Meninas* seems to have been a personal statement in its own day, not a true court portrait. Throughout his life, Velázquez had sought respect and acclaim for himself and for the art of painting. Here, dressed as a courtier, the Order of Santiago on his chest and the keys of the palace in his sash, Velázquez proclaimed the dignity and importance of painting as one of the liberal arts.

Bartolomé Esteban Murillo. One of the most popular painters in his day and for the next 200 years, Bartolomé Esteban Murillo (1617–82) was reevaluated at the end of the twentieth century and his art again found adherents, who respected his rich colors and skillful technique. Murillo specialized in painting the Virgin Mary and in rendering the Immaculate Conception (fig. 19-40), the controversial idea that Mary was born free from original sin. Although the Immaculate Conception became Church dogma only in 1854, the concept, as well as

19-41. Atrial cross. Before 1556. Stone, height 11'3"
(3.45 m). Chapel of the Indians, Basilica of
Guadalupe, Mexico City

devotion to Mary, became widespread during the seventeenth and eighteenth centuries. Murillo lived and worked in Seville, which was a center for trade with the Spanish colonies, where his work had a profound influence on art and religious iconography. Counter-Reformation authorities had provided specific instructions for artists such as Murillo painting the Virgin: Mary was to be dressed in blue and white, hands folded in prayer, as she is carried upward by angels, sometimes in large flocks. She may be surrounded by an unearthly light ("clothed in the sun") and may stand on a crescent moon. Angels often carry palms and symbols of the Virgin, such as a mirror, fountain, roses, and lilies and may vanquish the old serpent, Satan.

The Church exported many paintings by Murillo, Zurbarán, and others to the New World. When the native population began to visualize the Christian story, paintings such as Murillo's *The Esquilache Immaculate Conception* provided the imagery.

SPANISH COLONIES IN THE AMERICAS The Spanish colonization of the Americas dates to 1519, when Hernán Cortés arrived off the coast of Mexico from the Spanish colony in Cuba. Within two years, after forging alliances with enemies of the dominant Aztec people, Cortés succeeded in taking

the Aztec capital, Tenochtitlan (Mexico City). Over the next several years, Spanish forces established Mexico as a colony of Spain. In 1532, Francisco Pizarro, following Cortés's example, led an expedition to the land of the Inka, in Peru (see Map 23-1). Hearing that the Inka ruler Atahualpa, freshly victorious in the war of succession that followed the death of his father, was preparing to enter the Inka capital, Cuzco, Pizarro pressed inland to intercept him. He and his men seized Atahualpa, held him for a huge ransom in gold, then treacherously strangled him. They marched on Cuzco and seized it in 1533. The conquest was followed by a period of disorder, with Inka rebellions and struggles among the *conquistadores* that did not end until about 1550. In both Mexico and Peru, the Native American populations declined sharply after the conquest because of the exploitative policies of the conquerors and the ravages of diseases they brought with them, like smallpox, against which the indigenous people had no immunity.

In the wake of the conquest, the European conquerors suppressed local beliefs and practices and imposed Roman Catholicism throughout Spanish America. Native American temples were torn down, and churches were erected in their place (see fig. 23-6). The early work of conversion fell to the Franciscan, Dominican, and Augustinian religious orders. Several missionaries were so appalled by the conquerors' treatment of the people they called Indians that they petitioned the Spanish king to improve their condition.

In the course of Native Americans' conversion to Roman Catholicism, their own symbolism was to some extent absorbed into Christian symbolism. This process can be seen in the huge early colonial **atrial crosses**, so called because they were located in church **atriums**, where large numbers of converts gathered for education in their new faith. Missionaries recruited Native American sculptors to carve these crosses. One sixteenth-century atrial cross, now in the Basilica of Guadalupe in Mexico City, suggests pre-Hispanic sculpture in its stark form and rich surface symbols, even though the individual images were probably copied from illustrated books brought by the missionaries (fig. 19-41). The work is made from two large blocks of stone that are entirely covered with low-relief images known as the Arms of Christ, the "weapons" Christ used to defeat the devil. Jesus' Crown of Thorns hangs like a necklace around the cross bar, and with the Holy Shroud, which also wraps the arms, it frames the image of the Holy Face (the impression on the cloth with which Veronica wiped Jesus' face). Blood gushes forth where huge nails pierce the ends of the cross. Symbols of regeneration, such as winged **cherub** heads and pomegranates, surround the inscription at the top of the cross.

The cross itself suggests an ancient Mesoamerican symbol, the World Tree or Tree of Life. The image of blood sacrifice also resonates with indigenous beliefs. Like the statue of the Aztec earth mother Coatlicue (see fig. 23-5), the cross is composed of many individual elements that seem compressed to make a shape other than their own, the dense low relief combining into a single

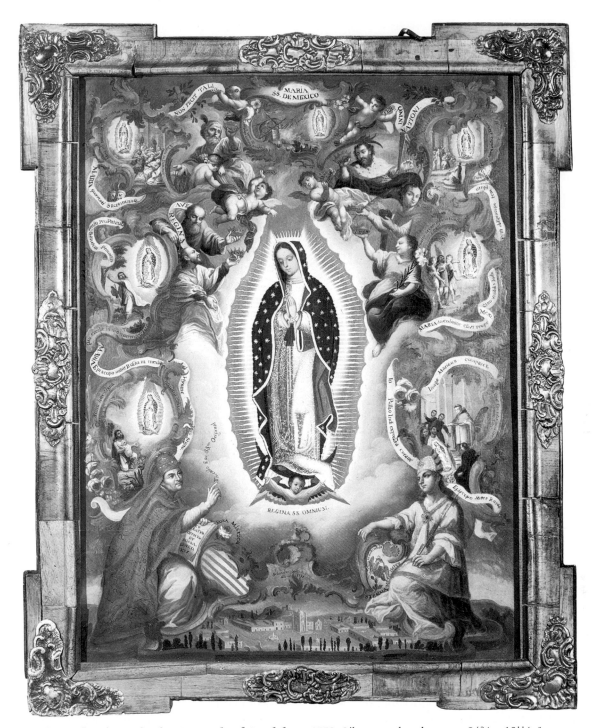

19-42. Sebastian Salcedo. *Our Lady of Guadalupe*. 1779. Oil on panel and copper, 24³/₄ x 18¹¹/₁₆"
(62.9 x 47.5 cm). Denver Art Museum
Museum Purchase with funds contributed by Mr. and Mrs. George G. Anderman and an anonymous donor

massive form. Simplified traditional Christian imagery is clearly visible in the work, although it may not yet have had much meaning or emotional resonance for the artists who put it there.

Converts in Mexico gained their own patron saint after the Virgin Mary was believed to have appeared as an Indian to an Indian named Juan Diego in 1531. Mary is said to have asked that a church be built on a hill where the goddess Coatlicue had once been worshiped. As evidence of this vision, Juan Diego brought the archbishop flowers that the Virgin had caused to bloom, wrapped in a cloak. When he opened his bundle, the cloak bore the image of a dark-skinned Virgin Mary, an image that, light-skinned, was popular in Spain and known as the Virgin of the Immaculate Conception. The site of the vision was renamed Guadalupe, after Our Lady of Guadalupe in Spain, and became a venerated pilgrimage center. In 1754, the pope declared the Virgin of Guadalupe the patron saint of the Americas, seen here (fig. 19-42) in an eighteenth-century work by the painter Sebastian Salcedo.

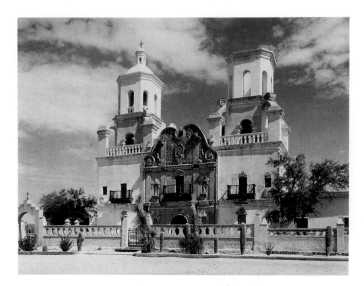

19-43. Mission San Xavier del Bac, near Tucson, Arizona. 1784–97. Arizona Historial Society, Tucson
(Ash #41446)

Spanish colonial builders quite naturally tried to replicate the architecture of their native country in their adopted lands. In the colonies of North America's Southwest, the builders of one of the finest examples of mission architecture, San Xavier del Bac, near Tucson, Arizona (fig. 19-43), looked to Spain for its inspiration. The Jesuit priest Eusebio Kino began laying the foundations in 1700, using stone quarried locally by Native Americans of the Pima nation. The desert site had already been laid out with irrigation ditches, and Father Kino wrote in his reports that there would be running water in every room and workshop of the new mission, but the building never proceeded. The mission site was turned over to the Franciscans in 1768, after King Charles III ousted the Jesuit order from Spain and its colonies and asserted royal control over Spanish churches. Father Kino's vision was realized by the Spanish Franciscan missionary and master builder Juan Bautista Velderrain (d. 1790), who arrived at the mission in 1776.

The huge church, 99 feet long with a domed crossing and flanking bell towers, was unusual for the area in being built of brick and mortar rather than adobe, which is made of earth and straw. The basic structure was finished by the time of Velderrain's death, in 1790, and the exterior decoration was completed by 1797 under the supervision of his successor. It is generally accepted that the Spanish artists who executed the elaborate exterior, as well as the fine interior paintings and sculpture, were from central Mexico; nearly thirty artists may have been living at the mission in 1795. Although the San Xavier facade is far from a copy, the focus on the central entrance area, with its Spanish Baroque decoration, is clearly in the tradition of the earlier eighteenth-century work of Pedro de Ribera in Madrid (see fig. 19-32). The mission was dedicated to Saint Francis Xavier, whose statue once stood at the apex of the portal decoration. In the niches are statues of four female saints tentatively identified as Lucy, Cecilia, Barbara, and Catherine of Siena. Hidden in the sculpted mass

is one humorous element: a cat confronting a mouse, which inspired a local Pima saying: "When the cat catches the mouse, the end of the world will come" (cited in Chinn and McCarty, page 12). (Spanish colonial art is discussed in more detail in Chapter 23.)

THE SOUTHERN NETHERLANDS/ FLANDERS

After a period of relative autonomy from 1598 to 1621 under a Habsburg regent, Flanders, the southern—and predominantly Catholic—part of the Netherlands, returned to direct Spanish rule (until declaring independence in 1798). Antwerp, the capital city and major arts center, gradually recovered from the turmoil of the sixteenth century, and artists of great talent flourished there, establishing international reputations that brought them important commissions from foreign patrons. During the seventeenth century, however, the port silted up and trade fell off, until finally the city was financially destroyed.

Peter Paul Rubens. Peter Paul Rubens (1577–1640), whose painting has become synonymous with Flemish Baroque, was born in Germany, where his father, a Protestant, had fled from his native Antwerp to escape religious persecution. In 1587, after her husband's death, Rubens's mother and her children returned to Antwerp and to Catholicism. After a youth spent in poverty, Rubens decided in his late teens to become an artist. He was accepted into the Antwerp painters' guild at age twenty-one, a testament to his energy, intelligence, and determination.

In 1600, Rubens left for Italy, taking with him a pupil, whose father may have paid for the trip. While he was in Venice, his work came to the attention of an agent for the duke of Mantua, and Rubens was offered a court post. His activities on behalf of the duke over the next eight years did much to prepare him for the rest of his long and successful career. Surprisingly, other than designs for court entertainments and occasional portraits, the duke never acquired a single original work of art by Rubens. Instead, he had him copy famous paintings in collections all over Italy to add to the ducal collection.

Rubens visited every major Italian city, went to Madrid as the duke's emissary, and spent two extended periods in Rome, where he studied the great works of Roman antiquity and the Italian Renaissance. While in Italy, Rubens studied the work of two contemporaries, Caravaggio and Annibale Carracci. Hearing of Caravaggio's death in 1610, Rubens encouraged the duke of Mantua to buy the artist's painting *Death of the Virgin*, which had been rejected by the patron because of the shocking realism of its portrayal of the Virgin's dead body. The duke refused; later Rubens arranged the purchase of another Caravaggio painting by an Antwerp church.

In 1608, Rubens returned to Antwerp, where he accepted employment from the Habsburg governors of Flanders and, shortly afterward, married Isabella Brant. Rubens built a mansion with a large studio between 1610 and 1615 (it was restored and opened as a museum in

1946). The dining room gives an idea of the princely surroundings Rubens enjoyed (fig. 19-44). Light from a many-armed brass chandelier would have fallen on the massive furniture, carved mantel and door frames, and tiled floor and fireback. The embossed and gilded leather wall hangings provided a luxurious background for Rubens's collection of some 300 paintings. The collection was dispersed, but the paintings in the house today are typical. A nephew left a description of a typical day: Rubens ate very little during the day, finished work about 5 P.M., then rode horseback for exercise; he usually invited friends to dine with him, and after dinner everyone moved to the upstairs living room for conversation. The living room permitted access to a gallery overlooking Rubens's huge studio, a room designed to house what became virtually a painting factory. An oversized door accommodated large paintings and led to the splendid formal garden.

Rubens's first major commission in Antwerp was a large canvas **triptych** for the main altar of the Church of Saint Walpurga, *The Raising of the Cross* (fig. 19-45), painted in 1610–11. Unlike earlier triptychs, where the side panels contained related but independent images, the wings here extend the action of the central scene and surrounding landscape across the vertical framing. At the center, Herculean figures strain to haul upright the wooden cross with Jesus already stretched upon it. At the

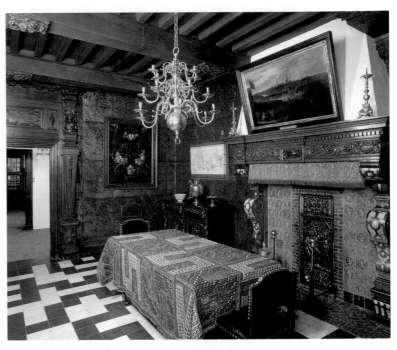

19-44. House of Peter Paul Rubens, Antwerp, Belgium. 1610–15. View of the dining room

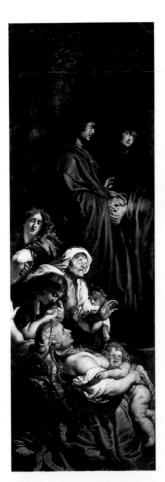
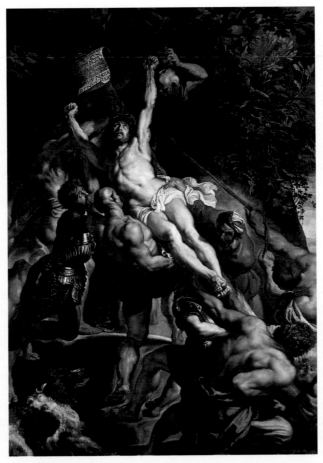
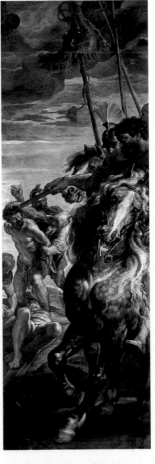

19-45. Peter Paul Rubens. *The Raising of the Cross*, from the Church of Saint Walpurga, Antwerp, Belgium. 1610–11. Oil on canvas, center panel 15'1⁷/₈" x 11'1¹/₂" (4.62 x 3.39 m); each wing 15'1⁷/₈" x 4'11" (4.62 x 1.52 m). Cathedral of Our Lady, Antwerp ©IRPA-KIK, Brussels

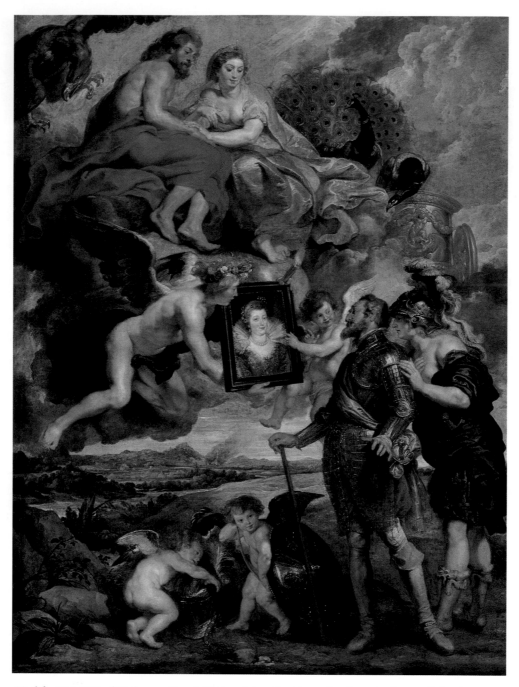

19-46. Peter Paul Rubens. *Henri IV Receiving the Portrait of Marie de' Medici.* 1621–25.
Oil on canvas, 12'11⅛" x 9'8⅛" (3.94 x 2.95 m). Musée du Louvre, Paris

left, the followers of Jesus join in mourning, and at the right, indifferent soldiers supervise the execution. Culminating in this work are all the drama and intense emotion of Caravaggio and the virtuoso technique of Annibale Carracci, transformed and reinterpreted according to Rubens's own unique ideal of thematic and formal unity. The heroic nude figures, dramatic lighting effects, dynamic diagonal composition, and intense emotions show his debt to Italian art, but the rich colors and surface realism, with minute attention given to varied textures and forms, belong to his native Flemish tradition (see "Wölfflin's The Principles of Art History," opposite).

Rubens had created a powerful, expressive visual language that was as appropriate for the secular rulers who engaged him as it was for the Catholic Church.

Moreover, his intelligence, courtly manners, and personal charm made him a valuable and trusted courtier to his royal patrons, who included Philip IV of Spain, Queen-Regent Marie de' Medici of France, and Charles I of England. In 1630, while Rubens was in England on a peace mission, Charles I knighted him and commissioned him to decorate the ceiling of the new Banqueting House at Whitehall Palace, London (see fig. 19-69). There, he painted the apotheosis of James I (Charles's father and predecessor) and the glorification of the Stuart dynasty he had founded.

In 1621, Marie de' Medici, who had been regent for her son Louis XIII, asked Rubens to paint the story of her life, to glorify her role in ruling France and also to commemorate the founding of the new Bourbon royal dynasty. In

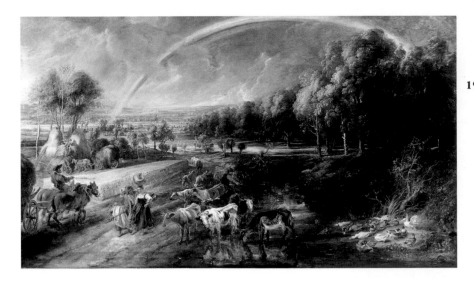

19-47. Peter Paul Rubens. *Landscape with Rainbow.* c. 1635. Oil on panel, 4'5¾" x 7'9⅛" (1.36 x 2.36 m). Wallace Collection, London

twenty-four paintings, Rubens portrayed Marie's life and political career as one continuous triumph overseen by the gods. In fact, Marie and her husband, Henri, appear as companions of the Roman gods themselves.

In the painting depicting the royal engagement (fig. 19-46), Henri IV falls in love at once with Marie's portrait, shown to him by Cupid and Hymen, the god of marriage, while the supreme Roman god, Jupiter, and his wife, Juno, look down from the clouds. Henri, wearing his steel breastplate and silhouetted against a landscape in which the smoke of a battle lingers in the distance, is encouraged by a personification of France to abandon war for love, as *putti* play with the rest of his armor. The sustained visual excitement of these enormous canvases makes them not only important works of art but also political propaganda of the highest order.

For all the grandeur of his commissioned paintings, Rubens was a sensitive, innovative painter, as the works he created for his own pleasure clearly demonstrate. One of his greatest joys was his country home, Castle Steen, a working farm with gardens, fields, woods, and streams. Steen furnished subjects for several pastoral paintings, such as *Landscape with Rainbow* (fig. 19-47), of about 1635. The atmosphere after a storm is nearly palpable, with the sun breaking through clouds and the air still moisture-laden, as farmworkers resume their labors. These magnificent landscapes had a significant impact on later painting.

Rubens had by no means "retired" to Castle Steen, however; he continued to live in Antwerp and accept large commissions from clients all over Europe. He employed dozens of assistants, many of whom were, or became, important painters in their own right. Using workshop assistants was standard practice for a major artist, but Rubens was particularly methodical, training or hiring specialists in costumes, still lifes, landscapes, portraiture, and animal painting who together could complete a work from Rubens's detailed sketches.

Anthony Van Dyck. One of Rubens's collaborators, Anthony Van Dyck (1599–1641), had an illustrious independent career as a portraitist. Son of an Antwerp silk merchant, he was listed as a pupil of the dean of Antwerp's Guild of Saint Luke at age ten. He had his own studio and roster of pupils at age sixteen but was not made a member of the guild until 1618, the year after he began his association with Rubens as a painter of heads. The need to blend his work seamlessly with that of Rubens enhanced Van Dyck's technical skill; the elegance and aristocratic refinement of his own work expressed his artistic character. After a trip to the English court of James I (ruled Great Britain 1603–25) in 1620, Van Dyck traveled to Italy and worked as a portrait painter to the nobility for seven years before returning to Antwerp. In 1632, he returned to England as the court painter to Charles I (ruled 1625–49), by whom he was

WÖLFFLIN'S THE PRINCIPLES OF ART HISTORY In 1915, Swiss art historian Heinrich Wölfflin published a book called *The Principles of Art History*. In it, he described five pairs of characteristics based on style (formal qualities) that he used to distinguish between Renaissance and Baroque art—and, by extension, between any "classical" and "nonclassical" style, such as Classical Greek art versus Hellenistic art. His ideas can be a useful tool for learning the rudiments of formal analysis. Wölfflin compared and contrasted the paintings of Raphael and Rubens to illustrate and clarify his principles.

1. *Linear vs. painterly*: sharp outline drawing and sculptural modeling vs. loose, free brushwork and emphasis on color
2. *Plane vs. depth*: elements arranged parallel to the picture plane vs. diagonal recession in depth
3. *Closed form vs. open form*: self-contained composition closely related to the picture frame vs. figures spilling over and beyond the frame
4. *Multiplicity vs. unity*: each element being free and complete but all being coordinated within the frame vs. elements interlocking to create a single, total effect
5. *Clarity vs. unclearness*: clear and intellectually understandable vs. suggestive and intuitive.

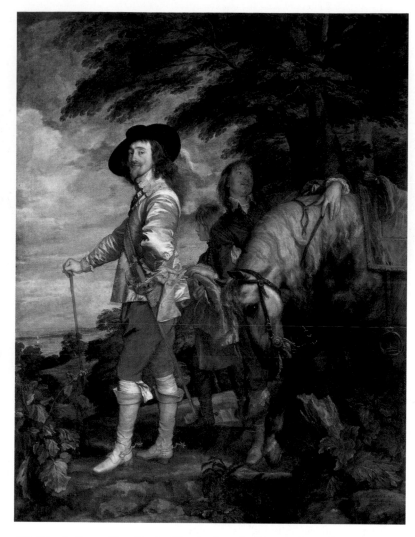

19-48. Anthony Van Dyck. *Charles I at the Hunt*. 1635. Oil on canvas, 8'11" x 6'11" (2.75 x 2.14 m). Musée du Louvre, Paris

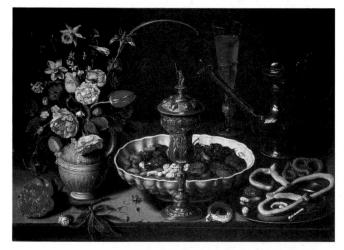

19-50. Clara Peeters. *Still Life with Flowers, Goblet, Dried Fruit, and Pretzels*. 1611. Oil on panel, 19¾ x 25¼" (50.2 x 64.1 cm). Museo del Prado, Madrid

Like many breakfast pieces, this painting features a pile of pretzels among the elegant tablewares. The salty, twisted bread was called pretzel (from the Latin *pretiola*, meaning "small reward") because it was invented by southern German monks to reward children who had learned their prayers: The twisted shape represented the crossed arms of a child praying.

knighted and given a studio, a summer home, and a large salary.

Van Dyck's many portraits of the royal family provide a sympathetic record of their features, especially those of King Charles. In *Charles I at the Hunt* (fig. 19-48), of 1635, Van Dyck was able, by clever manipulation of the setting, to portray the king truthfully and yet as a quietly imposing figure. Dressed casually for the hunt and standing on a bluff overlooking a distant view, Charles is shown as being taller than his pages and even than his horse, since its head is down and its heavy body is partly off the canvas. The viewer's gaze is diverted from the king's delicate and rather short frame to his pleasant features, framed by his jauntily cocked cavalier's hat. As if in decorous homage, the tree branches bow gracefully toward him, echoing the circular lines of the hat.

Jan Brueghel. Yet another painter working with Rubens, Jan Brueghel (1568–1625), painted settings rather than portraits. Brueghel and Rubens's allegory of the five senses—five paintings illustrating sight, hearing, touch, taste, and smell—in effect invited the viewer to wander in an imaginary space and to enjoy an amazing collection of works of art and scientific equipment (fig. 19-49, "The Object Speaks: Brueghel and Rubens's Sight"). This remarkable painting is a display, a virtual inventory, and a summary of the wealth, scholarship, and connoisseurship created through the patronage of the Habsburg rulers of the Spanish Netherlands.

Clara Peeters. A contemporary of Van Dyck in Antwerp who was not associated with Rubens, Clara Peeters (1594–c. 1657), an early still-life specialist, was a prodigy whose career seems to have begun before she was fourteen. She married in Antwerp and was a guild member there, but she may have previously spent time in Holland. Of some fifty paintings now attributed to her (more than thirty were signed), many are of the type called **breakfast pieces**, showing a table set for a meal of bread and fruit. She was one of the first artists to use flowers and food together in a still life. As in her *Still Life with Flowers, Goblet, Dried Fruit, and Pretzels* (fig. 19-50), of 1611, Peeters arranged rich tableware and food against neutral, almost black backgrounds, the better to emphasize the fall of light over the contrasting surface textures. The luxurious goblet and bowl contrast with the simple pewterware, as do the flowers with the pretzels. The pretzels, piled high on the pewter tray, are a particularly interesting Baroque element, with their complex multiple curves.

THE NORTHERN NETHERLANDS/ UNITED DUTCH REPUBLIC

Led by William of Orange, the Netherlands' Protestant northern provinces (today's Holland) rebelled against Spain in 1568, joining together as the United Provinces in 1579 to begin a long struggle for independence. The king of Spain considered the Dutch heretical rebels but finally, in 1648, what was by then the United Dutch Republic joined Spain, the Vatican, the Holy

THE OBJECT SPEAKS

BRUEGHEL AND RUBENS'S SIGHT

In 1599, the Habsburg Spanish princess Isabel Clara Eugenia married the Habsburg Austrian archduke Albert, uniting two branches of the family in the monarchy of the Habsburg Netherlands. These rulers were great patrons of the arts and sciences and were friends of artists—especially Peter Paul Rubens. Their interests and generous arts patronage were abundantly displayed in five allegorical paintings of the senses by Rubens and Jan Brueghel. The two artists were neighbors and frequently collaborated, Rubens rendering the figures and Brueghel creating allegorical settings for them.

Of the five paintings in the series, *Sight* (fig. 19-50) is the most splendid; it is almost an illustrated catalog of the ducal collection. Gathered in a huge vaulted room are paintings, sculpture, furniture, objects in gold and silver, and scientific equipment—all under the magnificent double-headed eagle emblems of the Habsburgs. We explore the painting *Sight* inch by inch, as if reading a book or a palace inventory. There on the table are Brueghel's copies of Rubens's portraits of Archduke Albert and Princess Isabel Clara Eugenia;

another portrait of the duke is on the floor. Besides the portraits, we can find Rubens's *Daniel in the Lions' Den* (upper left corner), *The Lion and Tiger Hunt* (top center), and *The Drunken Silenus* (lower right), as well as the popular subject *Madonna and Child in a Wreath of Flowers* (far right), for which Rubens painted the Madonna and Brueghel created the wreath. Brueghel also included Raphael's *Saint Cecilia* (behind the globe) and Titian's *Venus and Psyche* (over the door).

In the foreground, the classical goddess Venus, attended by Cupid (both painted by Rubens), has put aside her mirror to contemplate Jan Brueghel's painting *The Blind Leading the Blind* (on the floor in the back). Venus is surrounded by the equipment needed to see and to study: The huge globe at the right and the sphere with its gleaming rings at the upper left symbolize the extent of humanistic learning. In symbolism that speaks to viewers of our day as clearly as it did those of its own, the books and prints, ruler, compasses, magnifying glass, and the more complex astrolabe, telescope, and eyeglasses refer to spiritual blindness—to those who look but do not see.

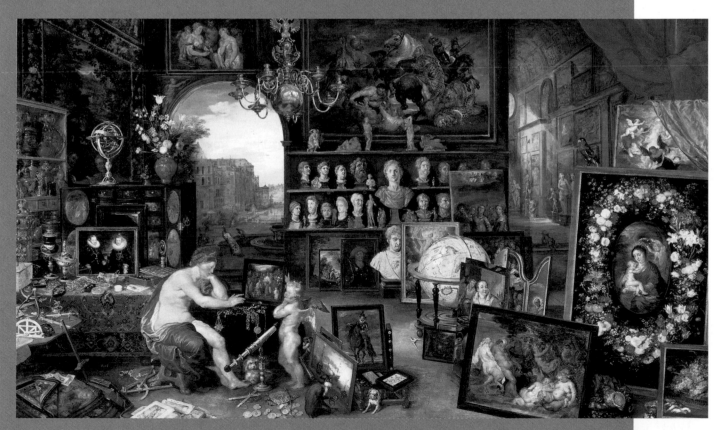

19-49. Jan Brueghel and Peter Paul Rubens. *Sight*, from Allegories of the Five Senses. c. 1617–18. Oil on wood panel, 25⅝ x 43" (65 x 109 cm). Museo del Prado, Madrid

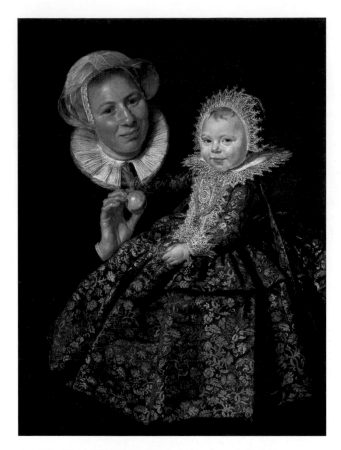

19-51. Frans Hals. *Catharina Hooft and Her Nurse*. c. 1620. Oil on canvas, 33¾ x 25½" (85.7 x 64.8 cm). Staatliche Museen zu Berlin, Preussischer Kulturbesitz, Gëmaldegalerie

Roman Empire, and France on equal footing in peace negotiations. The Hague was the capital city and the preferred residence of the House of Orange, but Amsterdam was the true center of power, because of its sea trade and the enterprise of its merchants, who made the city an international commercial center. The House of Orange was not notable for its patronage of the arts, but patronage improved significantly under Prince Frederick Henry (ruled 1625–47), and Dutch artists found many other eager patrons among the prosperous middle class in Amsterdam, Leiden, Haarlem, Delft, and Utrecht.

The Dutch delighted in depictions of themselves and their country's landscape, cities, and domestic life, not to mention beautiful and interesting objects (see "The Dutch Art Market," opposite). A well-educated people, the Dutch were also fascinated by history, mythology, the Bible, new scientific discoveries, commercial expansion abroad, and colonial exploration.

PORTRAITS

Dutch Baroque portraiture took many forms, ranging from single portraits in sparsely furnished settings to allegorical depictions of people in elaborate costumes with appropriate symbols. Although the accurate portrayal of facial features and costumes was the most important gauge of a portrait's success, Dutch painters went

beyond pure description to convey a sense of their subjects' personalities. Group portraiture that documented the membership of corporate organizations was a Dutch specialty. These large canvases, filled with many individuals who shared the cost of the commission, challenged painters to present a coherent, interesting composition that nevertheless gave equal attention to each individual portrait.

Frans Hals. Frans Hals (c. 1581/85–1666), the leading painter of Haarlem, studied with the Flemish Mannerist Karel van Mander, but little is certain about Hals's work before 1616. He had by then developed a style grounded in the Netherlandish love of realism and inspired by the Caravaggesque style, yet it was far from a slavish copy of that style. Like Velázquez, he tried to re-create the optical effects of light on the shapes and textures of objects. He painted boldly, with slashing strokes and angular patches of paint; when seen at a distance, all the colors merge into solid forms over which a flickering light seems to move. In Hals's hands, this seemingly effortless technique suggests a boundless joy in life.

In his painting *Catharina Hooft and Her Nurse* (fig. 19-51), of about 1620, Hals captured the vitality of a gesture and a fleeting moment in time. While the portrait records for posterity the great pride of the parents in their child and their wealth, it is much more than a study of rich fabrics, laces, and expensive toys (a golden rattle). Hals depicted the heartwarming delight of the child, who seems to be acknowledging the viewer as a loving family member while her doting nurse tries to distract her with an apple.

In contrast to this intimate individual portrait are Hals's official group portraits, such as his *Officers of the Haarlem Militia Company of Saint Adrian* (fig. 19-52), of about 1627. Less imaginative artists had arranged their sitters in neat rows to depict every face clearly. Instead, Hals's dynamic composition turned the group portrait into a lively social event, even while maintaining a strong underlying geometry of diagonal lines—gestures, banners, and sashes—balanced by the stabilizing perpendiculars of table, window, tall glass, and striped banner. The black suits and hats make the white ruffs and sashes of rose, white, and blue even more brilliant.

Judith Leyster. The most successful of Hals's contemporaries was Judith Leyster (c. 1609–60). In fact, one painting long praised as one of Hals's finest works was recently discovered to be by Leyster when a cleaning revealed her distinctive signature, the monogram *JL* with a star, in reference to her surname, which means "pole star," taken from the name of her family's Haarlem brewery.

Although almost nothing is known of her early years, in 1628–29 she was with her family in Utrecht, where she very likely encountered artists who had traveled to Italy and fallen under the spell of Caravaggio. Leyster's work shows clear echoes of her exposure to the Utrecht painters who had enthusiastically adopted the Italian master's naturalism, the dramatic tenebrist lighting

Visitors to the Netherlands in the seventeenth century noted the great popularity of art, not just among aristocrats but also among merchants and working people. Peter Mundy, an English traveler, wrote in 1640: "As For the art off Painting and the affection off the people to Pictures, I thincke none other goe beeyond them, there having bin in this Country Many excellent Men in thatt Facullty, some att presentt, as Rimbrantt, etts. [etc.] All in generall striving to adorne their houses, especially the outer or street roome, with costly peeces, Butchers and bakers not much inferiour in their shoppes, which are Fairely sett Forth, yea many tymes blacksmithes, Coblers, etts., will have some picture or other by their Forge and in their stalle. Such is the generall Notion, enclination and delight that these Countrie Native[s] have to Paintings" (cited in Temple, page 70).

This taste for art stimulated a free market for paintings that functioned like other commodity markets. Without Church patronage and with limited civic and private commissions, artists had to compete to capture the interest of their public by painting on speculation. Naturally, specialists in particularly popular types of images were likely to be financially successful, and what most Dutch patrons wanted were paintings of themselves, their country, their homes, and the life around them. It was hard to make a living as an artist, and many artists had other jobs, such as tavern keeping and art dealing, to make ends meet. In some cases, the artist was more entrepreneur than art maker, running a "stable" of painters who made copy after copy of original works to sell.

The great demand for art gave rise to an especially active market for engravings and etchings, both for original compositions and for copies after paintings, since one copperplate could produce hundreds of impressions, and worn-out plates could be reworked and used again. Although most prints sold for modest prices, Rembrandt's etching *Christ Healing the Sick* (1649) was already known in 1711 as the Hundred-Guilder Print, because of the then-unheard-of price that one patron had paid for an impression of it.

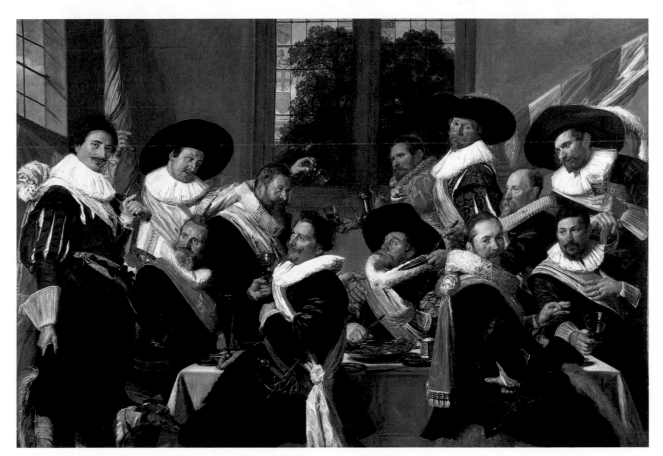

19-52. Frans Hals. *Officers of the Haarlem Militia Company of Saint Adrian*. c. 1627. Oil on canvas, 6' x 8'8" (1.83 x 2.67 m). Frans Halsmuseum, Haarlem

Hals painted at least six group portraits of civic-guard organizations, including two for the Company of Saint Adrian. The company, made up of several guard units, was charged with the military protection of Haarlem whenever needed. Officers came from the upper middle class and held their commissions for three years, whereas the ordinary guards were tradespeople and craftworkers. Each company was organized like a guild, under the patronage of a saint. When the men were not on war alert, the company functioned as a fraternal order, holding archery competitions, taking part in city processions, and maintaining an altar in the local church. (See also fig. 19-54.)

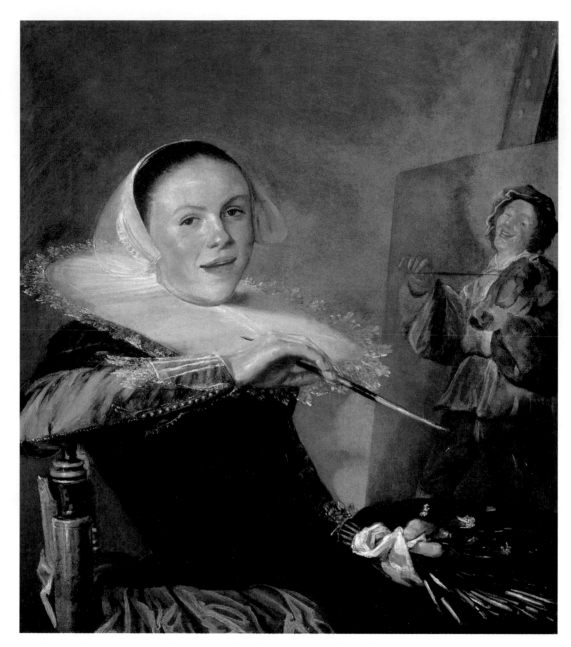

19-53. Judith Leyster. *Self-Portrait*. 1635. Oil on canvas, 29³/₈ x 25⁵/₈" (72.3 x 65.3 cm).
National Gallery of Art, Washington, D.C.
Gift of Mr. and Mrs. Robert Woods Bliss

effects, the large figures pressed into the foreground plane, and, especially, the theatrically presented everyday themes. In 1631, Leyster signed as a witness at the baptism in Haarlem of one of Frans Hals's children, which has led to the probably incorrect conclusion that she was Hals's pupil. Leyster may have worked in his shop, however, since she entered Haarlem's Guild of Saint Luke only in 1633. Membership allowed her to take pupils into her studio, and her competitive relationship with Frans Hals around that time is made clear by the complaint she lodged against him in 1635 for luring away one of her apprentices.

Leyster is known primarily for her informal scenes of daily life, which often carry an underlying moralistic theme. In her lively *Self-Portrait* of 1635 (fig. 19-53), the artist has paused momentarily in her work to look back, as if the viewer had just entered the room. Her elegant dress and the fine chair in which she sits are symbols of her success as an artist whose popularity was based on the very type of painting under way on her easel. Her subject, a man playing a violin, may be a visual pun on the painter with palette and brush. So that the viewer would immediately see the difference between her painted portrait and the painted painting, she varied her technique, executing the image on her easel more loosely. The narrow range of colors sensitively dispersed in the composition and the warm spotlighting are typical of Leyster's mature style.

Rembrandt van Rijn. Rembrandt van Rijn (1606–69) was the most important painter working in Amsterdam in the seventeenth century and is now revered as one of the great artists of all time. Rembrandt was one of nine children born in Leiden to a miller and his wife. Rembrandt

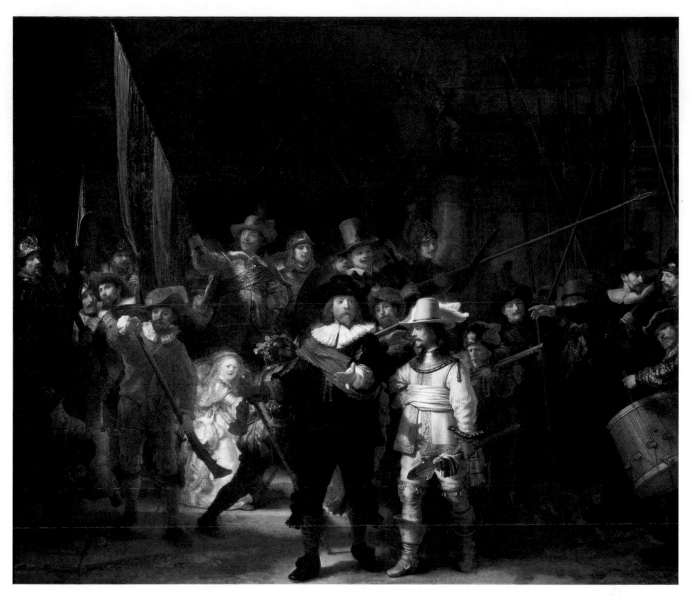

19-54. Rembrandt van Rijn. *Captain Frans Banning Cocq Mustering His Company (The Night Watch)*. 1642. Oil on canvas, 11'11" x 14'4" (3.63 x 4.37 m) (cut down from the original size). Rijksmuseum, Amsterdam

was sent to the University of Leiden in 1620 at age fourteen, but within a few months he dropped out to study painting. From 1621 to about 1624, he was apprenticed to a Leiden artist, then worked briefly in Amsterdam. He returned to Leiden in 1625 as a painter of religious pictures. In 1631 or 1632, he returned to Amsterdam and broadened his repertoire to include mythological paintings, landscapes, and figure studies, but his primary source of income was portraiture. His work quickly attracted the interest of the secretary to Prince Frederick Henry, whose favorite artist was Peter Paul Rubens. Knowing this, Rembrandt studied Rubens's work and incorporated some of his compositional ideas in a series of paintings for the prince on the subject of the Passion of Christ (c. 1632–40). His study of Leonardo's *Last Supper*, based on an engraving, probably dates to this period in the 1630s (fig. 18, Introduction).

Prolific and popular with Amsterdam clientele, Rembrandt ran a busy studio producing works that sold for high prices. His large workshop and the many pupils who imitated his manner have made it difficult for scholars to define his body of work, and many paintings formerly attributed to him have recently been assigned to other artists. Rembrandt's mature work reflected his new environment, his study of science and nature, and the broadening of his artistic vocabulary by the study of Italian Renaissance art, chiefly from engraved copies. In 1639, he purchased a large house, which he filled with art and an enormous supply of studio props, such as costumes, weapons, and stuffed animals.

In 1642, Rembrandt was one of several artists commissioned by a wealthy civic-guard company to create large group portraits of its members for its new meeting hall. The result, *Captain Frans Banning Cocq Mustering His Company* (fig. 19-54), is considered one of Rembrandt's finest works. Because of the dense layer of grime and darkened varnish on it and its dark background architecture, this painting was once thought to

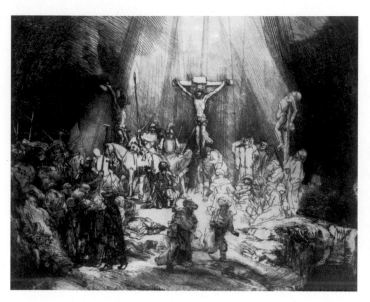

19-55. Rembrandt van Rijn. *Three Crosses* **(first state)**. 1663. Drypoint and engraving, 15¹⁄₆ x 17³⁄₄" (38.5 x 45 cm). Rijksmuseum, Amsterdam

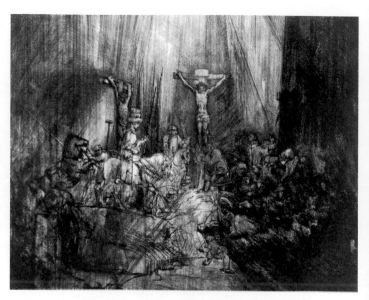

19-56. Rembrandt van Rijn. *Three Crosses* **(fourth state)**. 1663. Drypoint and engraving, 15¹⁄₆ x 17³⁄₄" (38.5 x 45 cm). The Metropolitan Museum of Art, New York

Gift of Felix M. Warburg and his family, 1941 (41.1.33)

be a night scene and was therefore called *The Night Watch*. After recent cleaning and restoration, it now exhibits a natural golden light that sets afire the palette of rich colors—browns, blues, olive green, orange, and red—around a central core of lemon yellow in the costume of a lieutenant. To the dramatic group composition, showing a company forming for a parade in an Amsterdam street, Rembrandt added several colorful but seemingly unnecessary figures. While the officers stride purposefully forward, the rest of the men and several mischievous children mill about. The young girl at the left, carrying a chicken and wearing a money pouch, is so unusual that attempts have been made to find symbolic or ironic meaning. From the earliest days of his career, however, Rembrandt was devoted to sketching people he encountered in the streets. The figure may simply add lively touches of interesting local color to heighten the excitement of the scene.

Rembrandt was second only to Albrecht Dürer (see figs. 18-36–18-38) in his enthusiasm for printmaking as an important art form with its own aesthetic qualities and expressiveness. His interest focused on **etching**, a relatively minor medium at the time, which uses acid to inscribe a design on metal plates. His earliest line etchings date from 1627. About a decade later, he began to experiment with additions in the **drypoint** technique, in which the artist uses a sharp needle to scratch shallow lines in a plate (see "Etching and Drypoint," page 808). Because etching and drypoint allow the artist to work directly on the plate, the style of the finished print has the relatively free and spontaneous character of a drawing. Rembrandt's commitment to the full exploitation of the medium is indicated by the fact that in these works he alone carried the creative process through, from the preparation of the plate to its inking and printing, and he constantly experimented with the technique, with methods of inking, and with papers for printing.

Rembrandt experienced a deepening religiousness that was based on his personal study of the Bible and perhaps also on his association with the pacifist Mennonite sect, whose spirit pervades his treatment of religious themes, from gentle mysticism to soul searching to belief in ultimate forgiveness. These expressions can be studied in a series of prints, *Three Crosses*, that comes down to us in four states, or stages, of the engraving process. Rembrandt tried to capture the moment described in the Gospels when, during the Crucifixion, darkness covered the earth and Jesus cried out, "Father, into thy hands I commend my spirit." In the first state (fig. 19-55), the centurion kneels in front of the cross while other terrified people run from the scene. The Virgin Mary and John share the light flooding down from heaven. By the fourth state (fig. 19-56), Rembrandt has completely reworked and reinterpreted the theme. In each version, the shattered hill of Golgotha dominates the foreground, but now a mass of vertical lines, echoing the rigid body of Jesus, fills the space, obliterates the shower of light, and virtually eliminates the former image, including even Mary and Jesus' friends. The horseman holding a lance now faces Jesus. Compared with the first state, the composition is more compact, the individual elements are simplified, and the emotions are intensified. The first state is a detailed rendering of the scene in realistic terms; the fourth state, a reduction of the event to its essence. The composition revolves in an oval of half-light around the base of the cross, and the viewer's attention is drawn to the figures of Jesus and the people, in mute confrontation. In *Three Crosses*, Rembrandt defined the mystery of Christianity in Jesus' sacrifice, presented in realistic terms but as something beyond rational explanation. In Rembrandt's late works, realism relates to the spirit of inner meaning, not of surface details. The eternal battles of dark and light, doom and salvation, evil and good—all seem to be waged anew.

Rembrandt remained a popular artist and teacher, but he was continually plagued by financial problems. He painted ever more brilliantly in a unique manner that distilled a lifetime of study and contemplation of life and human personalities. His sensitivity to the human condition is perhaps nowhere more powerfully expressed than in his *Self-Portrait* of 1659 (fig. 19-57). Among his other late achievements is *The Jewish Bride* (fig. 19-58), of about 1665. This portrait may refer to the marriage of Isaac and Rebecca or some other loving biblical couple. As in *Captain Frans Banning Cocq Mustering His Company*, the monumental figures emerge from a dark architectural background, perhaps a garden wall and portico, with the warm light suffusing the scene and setting the reds and golds of their costumes aglow. In comparison with Jan van Eyck's emotionally neutral *Portrait of Giovanni Arnolfini and His Wife, Giovanna Cenami (?)* of the early fifteenth century (see fig. 17-14), where the meaning of the picture relied heavily on its

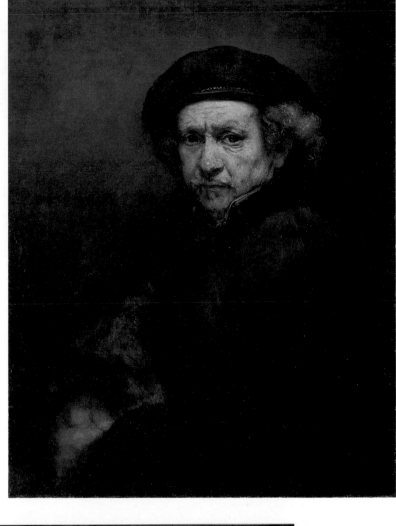

19-57. Rembrandt van Rijn. *Self-Portrait*. 1659. Oil on canvas, 33¼ x 26" (84 x 66 cm). National Gallery of Art, Washington, D.C.
Andrew W. Mellon Collection

19-58. Rembrandt van Rijn. *The Jewish Bride*. c. 1665. Oil on canvas, 3'11¾" x 5'5½" (1.21 x 1.65 m). Rijksmuseum, Amsterdam

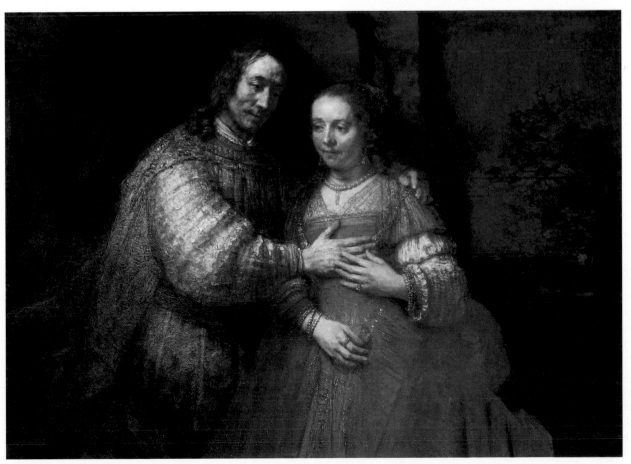

TECHNIQUE

ETCHING AND DRYPOINT

Etching with acid on metal was used to decorate armor and other metal wares before it became a printmaking medium. The earliest etchings for that purpose were made in Germany in the early 1500s, and Albrecht Dürer experimented with the technique briefly, but Rembrandt was the first artist to popularize etching as a major form of artistic expression.

In the etching process, a metal plate is coated on both sides with an acid-resistant varnish. Then, instead of laboriously cutting the lines of the desired image directly into the plate, the artist draws through the varnish with a sharp needle to expose the metal. The plate is then covered with acid, which eats into the metal exposed by the drawn lines. By controlling the amount of time the acid stays on different parts of the plate, the artist can make fine, shallow lines or heavy, deep ones. The varnish covering the plate is removed before an impression is taken. If a change needs to be made, the lines can be "erased" with a sharp metal scraper. Accidental scratches are eliminated by burnishing (polishing).

Another technique for registering images on a metal plate is called **drypoint**. A sharp needle is used to scratch lines in the metal, but there are two major differences in technique between the process of engraving and that of drypoint (see "Woodcuts and Engravings on Metal," page 648). The engraving tool, or **burin**, is held straight and throws up equal amounts of metal, called burr, on both sides of the line, but the drypoint needle is held at a slight slant and throws up most of the burr on one side. Also, in engraving the metal burr is scraped off and the plate polished to yield a clean, sharp groove to hold the ink for printing. In drypoint, the burr is left in place, and it, rather than the groove, holds the ink. The rich black appearance of drypoint lines when printed is impossible to achieve with engraving or etching. Drypoint burr is fragile, and only a few prints—a dozen or fewer—can be made before it flattens and loses its character. Rembrandt's earliest prints were pure etchings, but later he enriched his prints with drypoint to achieve greater tonal richness.

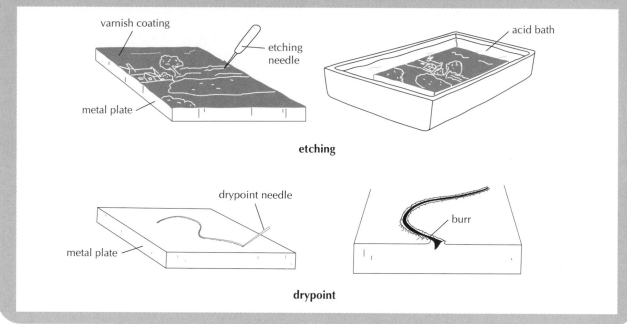

etching

drypoint

symbolic setting, the significance of *The Jewish Bride* is emotional, conveyed by loving expressions and gestures, such as the groom tenderly touching his bride's breast, an ancient symbol of fertility.

VIEWS OF THE WORLD

The Dutch loved the landscapes and vast skies of their own country, but those who painted them were not slaves to nature as they found it. The artists were never afraid to remake a scene by rearranging, adding, or subtracting to give their compositions formal organization or a desired mood. Starting in the 1620s, view painters generally adhered to a convention in which little color was used beyond browns, grays, and beiges. After 1650, they tended to be more individualistic in their styles, but nearly all brought a broader range of colors into play. One continuing motif was the emphasis on cloud-filled expanses

of sky dominating a relatively narrow horizontal band of earth below. Paintings of architectural interiors also achieved great popularity in the Baroque period and seem to have been painted for their own beauty, just as exterior views of the land, cities, and harbors were.

Emanuel de Witte. Emanuel de Witte (1617–92) of Rotterdam specialized in architectural interiors, first in Delft in 1640 and then in Amsterdam after settling there permanently in 1652. Although many of his interiors were composites of features from several locations combined in one idealized architectural view, de Witte also painted faithful portraits of actual buildings. One of these is his *Portuguese Synagogue, Amsterdam* (fig. 19-59), of 1680. The synagogue, which still stands and is one of the most impressive buildings in Amsterdam, is shown here as a rectangular hall divided into one wide central aisle with narrow side aisles, each covered with a wooden barrel

vault resting on lintels supported by columns. De Witte's shift of the viewpoint slightly to one side has created an interesting spatial composition, and strong contrasts of light and shade add dramatic movement to the simple interior. The caped figure in the foreground and the dogs provide a sense of scale for the architecture and add human interest.

Today, the painting is interesting both as a record of seventeenth-century synagogue architecture and as evidence of Dutch religious tolerance in an age when Jews were often persecuted. Ousted from Spain and Portugal in the late fifteenth and early sixteenth centuries, many Jews had settled first in Flanders and then in the Netherlands. The Jews in Amsterdam enjoyed religious and personal freedom, and their synagogue was considered one of the outstanding sights of the city.

Aelbert Cuyp. From a family of artists, Aelbert Cuyp (1620–91) of Dordrecht specialized early in his career in view painting. Cuyp first worked in the older, nearly monochromatic convention for recording the Dutch countryside and waterways. About 1645, his style evolved to include a wider range of colors while also moving toward more idealized scenes drenched with a warm golden light, such as his *Maas at Dordrecht* (fig. 19-60), painted about 1660. This dramatic change has been attributed to Cuyp's contact with Utrecht painters who were influenced by contemporary landscape painting in Italy, especially the works of the French expatriate Claude Lorrain (see fig. 19-28). However, unlike the Italian and French artists who preferred religious, historical, or other narrative themes expressed through the figures inhabiting the landscape, Cuyp and other Dutch painters represented the country as they saw it, although in its

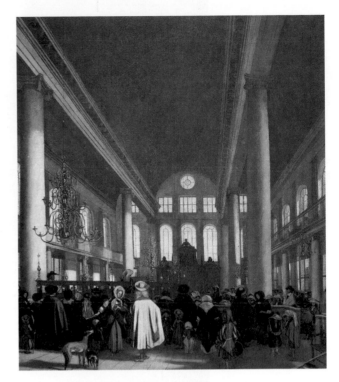

19-59. Emanuel de Witte. *Portuguese Synagogue, Amsterdam*. 1680. Oil on canvas, 43½" x 39" (110.5 x 99.1 cm). Rijksmuseum, Amsterdam.

Architect Daniel Stalpaert built the synagogue in 1670–75

most pleasant aspects. At Dordrecht, the wide, deep harbor of the Maas River was always filled with cargo ships and military vessels, and Cuyp's seascapes express pride in the city's contribution to the United Dutch Republic's prosperity, independence, and peaceful life.

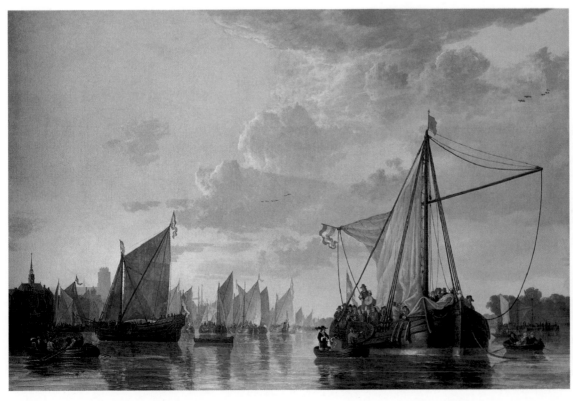

19-60. Aelbert Cuyp. *Maas at Dordrecht*. c. 1660. Oil on canvas, 3'9¼" x 5'7" (1.15 x 1.70 m). National Gallery of Art, Washington, D.C.

Andrew W. Mellon Collection

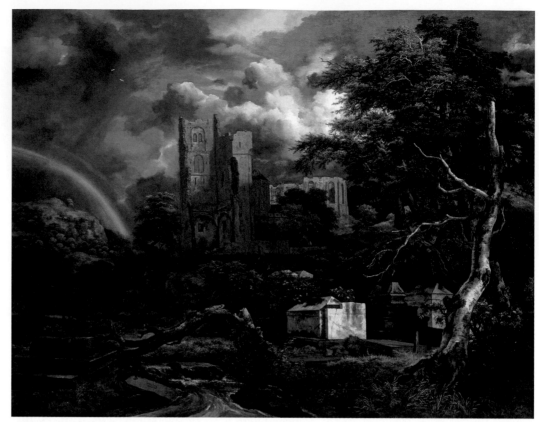

19-61. Jacob van Ruisdael. *The Jewish Cemetery.* 1655–60. Oil on canvas, 4'6" x 6'2½" (1.42 x 1.89 m). The Detroit Institute of Arts

Gift of Julius H. Haass in memory of his brother Dr. Ernest W. Haass

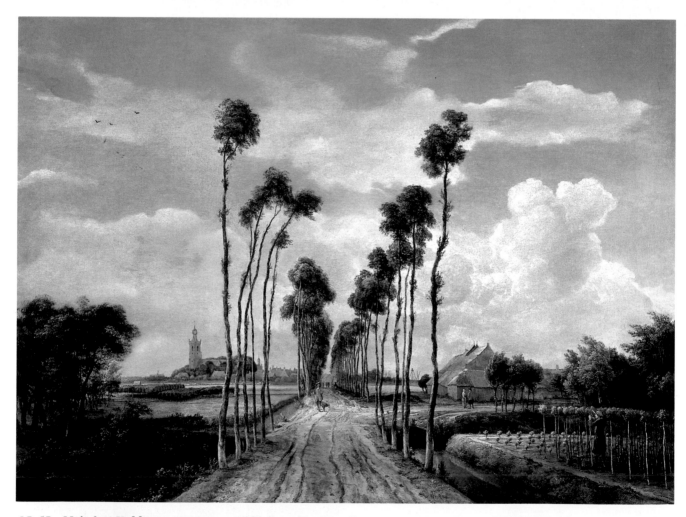

19-62. Meindert Hobbema. *Avenue at Middelharnis.* 1689. Oil on canvas, 40¾ x 55½" (104 x 141 cm). The National Gallery, London

The power of nature is challenged by a people who have captured their land not from a human rival but from the sea itself. They are constantly aware of the mighty forces of wind and water ever ready to reclaim it.

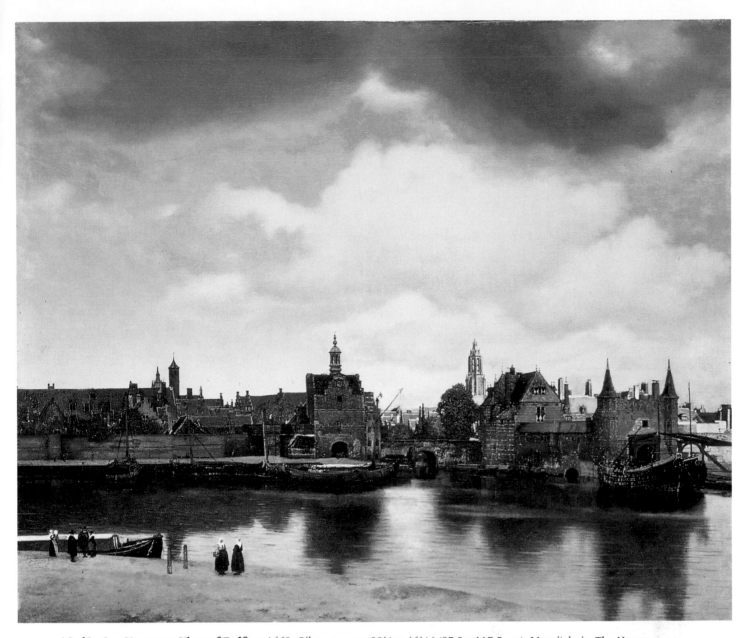

19-63. Jan Vermeer. *View of Delft*. c. 1662. Oil on canvas, 38½ x 46¼" (97.8 x 117.5 cm). Mauritshuis, The Hague
The Johan Maurits van Nassau Foundation

Jacob van Ruisdael. The Haarlem landscape specialist Jacob van Ruisdael (1628/29–82) was especially adept at both the invention of dramatic compositions and the projection of moods in his canvases. His *Jewish Cemetery* (fig. 19-61), of 1655–60, is a thought-provoking view of silent tombs, crumbling ruins, and stormy landscape, with a rainbow set against dark, scudding clouds. Ruisdael was greatly concerned with spiritual meanings of the landscape, which he expressed in his choice of such environmental factors as the time of day, the weather, the appearance of the sky, or the abstract patterning of sun and shade. The barren tree points its branches at the tombs. Here the tombs, ruins, and fallen and blasted trees suggest an allegory of transience. The melancholy mood is mitigated by the rainbow, a traditional symbol of renewal and hope.

Meindert Hobbema. Ruisdael's popularity drew many pupils to his workshop, the most successful of whom was Meindert Hobbema (1638–1709), who studied with him from 1657 to 1660. Although there are many similarities to

Ruisdael's style in Hobbema's earlier paintings, his mature work moved away from the melancholy and dramatic moods of his master. Hobbema's love of the peaceful, orderly beauty of the civilized Dutch countryside is exemplified by one of his best-known paintings, *Avenue at Middelharnis* (fig. 19-62)—the rational art of a country physically constructed by its people. In contrast with the broad horizontal orientation of many Dutch landscapes, Hobbema's composition draws the viewer into the picture and down the rutted, sandy road toward the distant village of Middelharnis in a compelling demonstration of one-point perspective.

Jan Vermeer. Jan (Johannes) Vermeer (1632–75) of Delft, an innkeeper and art dealer who painted only for local patrons, entered the Delft artists' guild in 1653. Meticulous in his technique, with a unique compositional approach and painting style, Vermeer produced only a small number of works.

Vermeer's *View of Delft* (fig. 19-63) is no simple cityscape. Although Vermeer convinces the viewer of its

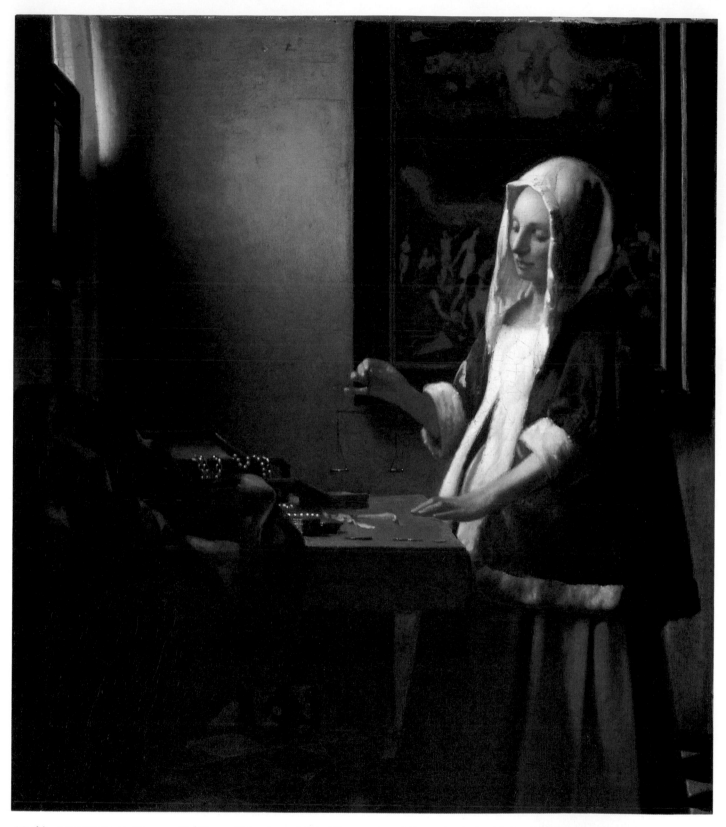

19-64. **Jan Vermeer.** *Woman Holding a Balance*. c. 1664. Oil on canvas, 16¾ x 15" (42.5 x 38.1 cm). National Gallery of Art, Washington, D.C.
Widener Collection, 1942

authenticity, he does not paint a photographic reproduction of the scene; he moves buildings around to create an ideal composition. As he also does with paintings of interior scenes, he endows the city with a timeless stability created by the careful placement of the buildings, the quiet atmosphere, and the clear, even light. Vermeer may have experimented with the mechanical device known as the **camera obscura** (Chapter 27), not as a method of reproducing the image but as another tool in the visual analysis of the landscape. The camera obscura

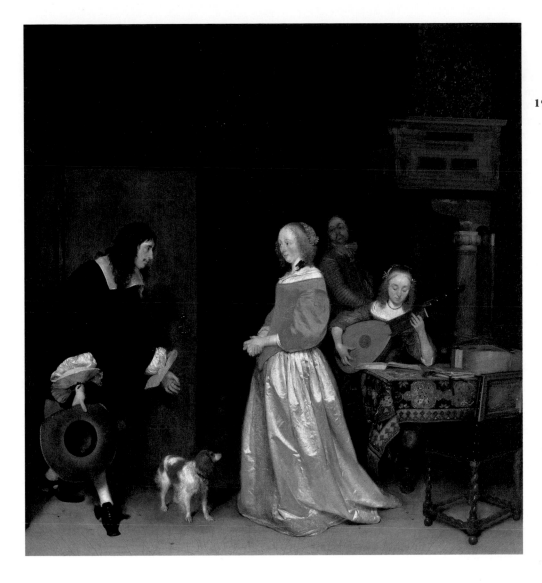

19-65. **Gerard Ter Borch.** *The Suitor's Visit*. c. 1658. Oil on canvas, 32¹⁄₂ x 29⁵⁄₈" (82.6 x 75.3 cm). National Gallery of Art, Washington, D.C.

Andrew W. Mellon Collection

would have enhanced optical distortions that led to the "beading" of highlights, which creates the illusion of brilliant light but does not dissolve the underlying form.

GENRE PAINTING

Another popular art form among the Dutch was the genre painting. Generally painted for private patrons, these works depict scenes of contemporary daily life. Continuing a long Netherlandish tradition, genre paintings of the Baroque period were often laden with symbolic references, although their meaning is not always clear.

Jan Vermeer. Vermeer worked in the genre tradition as well as the landscape form but he surpassed categorization. His genre paintings are frequently enigmatic scenes of women in their homes, alone or with a servant, who are occupied with some cultivated activity, such as writing, reading letters, or playing a musical instrument.

Of the fewer than forty canvases securely attributed to Vermeer, most are of a similar type—quiet interior scenes, low-key in color, and asymmetrical but strongly geometric in organization. Vermeer achieved his effects through a consistent architectonic construction of space

in which every object adds to the clarity and balance of the composition. An even light from a window often gives solidity to the figures and objects in a room. All emotion is subdued, as Vermeer evokes the stillness of meditation. Even the brushwork is so controlled that it becomes invisible, except when he paints reflected light as tiny droplets of color.

In *Woman Holding a Balance* (fig. 19-64), perfect balance creates a monumental composition and a moment of supreme stillness. The woman contemplates the balance and so calls our attention to the act of weighing and judging. Her hand and the scale are central, but directly over her, on the wall of the room, hangs a large painting of the Last Judgment. Thus, Vermeer's painting becomes a metaphor for eternal judgment. The woman's moment of quiet introspection before she touches gold or pearls also recalls the **vanitas** theme of the transience of life, allowing the painter to comment on the ephemeral quality of material things.

Gerard Ter Borch. Gerard Ter Borch (1617–81) was renowned for his exquisite rendition of lace, velvet, and especially satin, a skill he demonstrated in a work traditionally known as *The Suitor's Visit* (fig. 19-65), painted about 1658. It shows a well-dressed man bowing gracefully

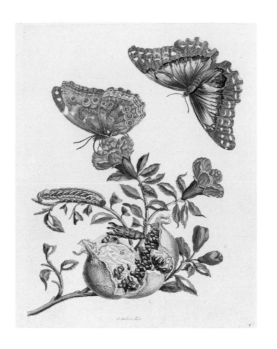

19-66. Maria Sibylla Merian. Plate 9 from *Dissertation in Insect Generations and Metamorphosis in Surinam*. 1719. Hand-colored engraving, 18⁷/₈ x 13" (47.9 x 33 cm). National Museum of Women in the Arts, Washington, D.C.

Gift of Wallace and Wilhelmina Holladay

to an elegant woman dressed in white satin who stands in a sumptuously furnished room in which another woman plays a lute. The painting appears to represent a prosperous gentleman paying a call on a lady of equal social status, possibly a courtship scene. The dog in the painting and the musician seem to be simply part of the scene, but we are already familiar with the dog as a symbol of fidelity, and stringed instruments were said to symbolize, through their tuning, the harmony of souls and thus, possibly, a loving relationship.

Jan Steen. Jan Steen (1626–79), whose larger brush-strokes contrast with the meticulous treatment of Ter Borch, used scenes of everyday life to portray moral tales, illustrate proverbs and folk sayings, or make puns to amuse the spectator. Steen owned a brewery for several years, and from 1670 until his death he kept a tavern in Leiden; he probably found inspiration and models all about him. Steen was influenced early in his career by Frans Hals, and his work in turn influenced a **school**, or circle of artists working in a related style, of Dutch artists who emulated his style and subjects.

Jan Steen's paintings of children are especially remarkable, for he captured not only their childish physiques but also their fleeting moods and expressions. His ability to capture such transitory dispositions was well expressed in his painting *The Drawing Lesson* (fig. 17, Introduction). Here, a youthful apprentice observes the master artist correct an example of drawing—a skill widely believed to be the foundation of art.

STILL LIFES AND FLOWER PIECES

The term ***still life*** for paintings of artfully arranged objects on a table comes from the Dutch *stilleven*, a word coined about 1650. The Dutch were so proud of their artists' still-life paintings that they presented one to the French queen Marie de' Medici when she made a state visit to Amsterdam. A still-life painting might carry

moralizing connotations and commonly was a *vanitas*, reminding viewers of the transience of life, material possessions, and even art.

Still-life paintings in which cut-flower arrangements predominate are often referred to as **flower pieces**. Significant advances were made in botany during the Baroque period through the application of orderly scientific methods, and objective observation was greatly improved by the invention of the microscope in 1674 (see "Science and the Changing Worldview," page 759). The Dutch were also major growers and exporters of flowers, especially tulips, which appear in nearly every flower piece in dozens of exquisite variations.

Maria Sibylla Merian. Before the invention of photography, scientific investigations relied entirely on drawn and painted illustrations, and researchers hired artists to accompany them on field trips. Maria Sibylla Merian (1647–1717) was unusual in making noteworthy contributions as both researcher and artist. German by birth and Dutch by training, Merian was once described by a Dutch contemporary as a painter of flowers, fruit, birds, worms, flies, mosquitoes, spiders, "and other filth." At the time, it was believed that insects emerged spontaneously from the soil, but Merian's research on the life cycles of insects proved otherwise, findings she published in 1679 and 1683 as *The Wonderful Transformation of Caterpillars and (Their) Singular Plant Nourishment*. In 1699, Amsterdam subsidized Merian's research on plants and insects in the Dutch colony of Surinam in South America; her results were published as *Dissertation in Insect Generations and Metamorphosis in Surinam*, illustrated with sixty large plates engraved after her watercolors (fig. 19-66). Each plate is scientifically precise, accurate, and informative, presenting insects in various stages of development, along with the plants they live on.

Rachel Ruysch. The Dutch tradition of flower painting peaked in the long career of Rachel Ruysch (1664–1750)

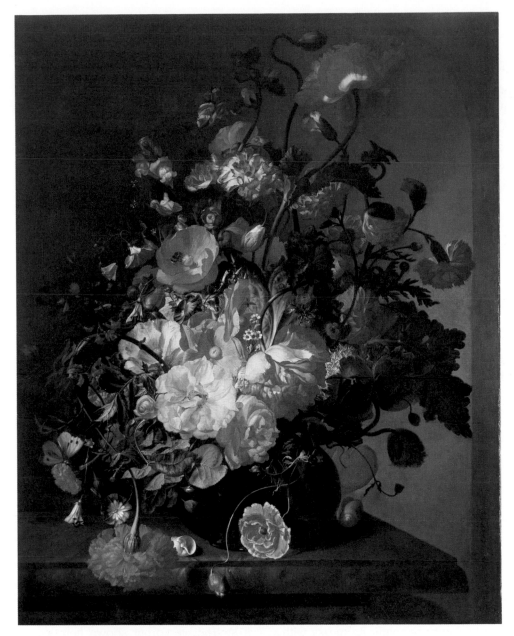

19-67. **Rachel Ruysch.** *Flower Still Life*. After 1700. Oil on canvas, 30 x 24" (76.2 x 61 cm).
The Toledo Museum of Art, Ohio

Purchased with funds from the Libbey Endowment. Gift of Edward Drummond Libbey

Flower painting was a much-admired specialty in the seventeenth- and eighteenth-
century Netherlands. Such paintings were almost never straightforward depictions
of actual fresh flowers. Instead, artists made color sketches of fresh examples of each
type of flower and studied scientifically accurate color illustrations in botanical
publications. Using their sketches and notebooks, in the studio they would compose
bouquets of perfect specimens of a variety of flowers that could never be found
blooming at the same time. The short life of blooming flowers was a poignant
reminder of the fleeting nature of beauty and of human life.

of Amsterdam. Her flower pieces were highly prized for their sensitive, free-form arrangements and their unusual and beautiful color harmonies. During her seventy-year career, she became one of the most sought-after and highest-paid still-life painters in Europe—her paintings brought twice what Rembrandt's did. In her *Flower Still Life* (fig. 19-67), painted after 1700, Ruysch placed the container at the center of the canvas's width, then created an asymmetrical floral arrangement of pale oranges, pinks, and yellows rising from lower left to top right of the picture, offset by the strong diagonal of the tabletop. To further balance the painting, she placed highlighted blossoms and leaves against the dark left half of the canvas and silhouetted them against the light wall area on the right. Ruysch often emphasized the beauty of curving flower stems and enlivened her compositions

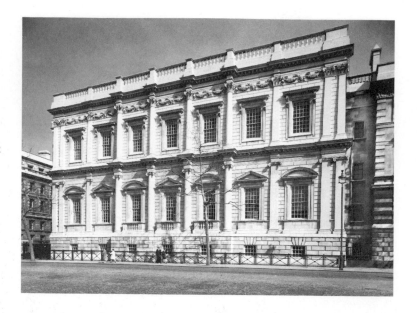

19-68. Inigo Jones. Banqueting House, Whitehall Palace, London. 1619–22

with interesting additions, such as casually placed pieces of fruit or insects, in this case a large gray moth (lower left) and two snail shells.

ENGLAND

England and Scotland came under the same rule in 1603 with the ascent to the English throne of James VI of Scotland, who reigned over Great Britain as James I (ruled 1603–25). James increased the royal patronage of British artists, especially in literature and architecture. William Shakespeare wrote *Macbeth*, featuring the king's legendary ancestor Banquo, in tribute to the new royal family, and it was performed at court in December 1606. James's son Charles I was also an important collector and patron of painting.

However, religious and political tensions erupted into civil wars that began in 1642 and that cost Charles his throne and his life in 1649. Much of the rest of the Baroque period in England was politically uneasy, with a succession of republican and monarchical rulers who alternately supported Protestantism or Catholicism. The Protestant course was ensured by the Glorious Revolution of 1689, the bloodless overthrow of the Catholic king James II by his Protestant son-in-law and daughter, William and Mary, who ruled jointly until Mary's death in 1694. William (the Dutch great-grandson of William of Orange, who had led the Netherlands' independence movement) ruled on his own until his death in 1702. He was succeeded by Mary's sister Anne (ruled 1702–14).

ARCHITECTURE AND LANDSCAPE DESIGN

In sculpture and painting, the English court patronized primarily foreign artists and sought mainly portraiture. The field of architecture, however, was dominated in the seventeenth century by two Englishmen, Inigo Jones and Christopher Wren. They replaced the country's long-lived Gothic style with a classical one and were followed in the classicist mode by another English architect, John Vanbrugh. Major change in **landscape architecture** took place during the eighteenth century, led by the innovative designer Lancelot "Capability" Brown.

Inigo Jones. In the early seventeenth century, the architect Inigo Jones (1573–1652) introduced to the English throne his version of Renaissance classicism, an architectural design based on the style of the Renaissance architect Andrea Palladio (see figs. 18-61, 18-63). Jones had studied Palladio's work in Venice, and Jones's copy of Palladio's *Four Books of Architecture* (which has been preserved) is filled with his notes. Jones was appointed surveyor-general in 1615 and was commissioned to design the Queen's House in Greenwich and the Banqueting House for the royal palace of Whitehall.

The Whitehall Banqueting House (fig. 19-68), built in 1619–22 to replace an earlier one destroyed by fire, was used for court ceremonies and entertainments such as popular masques (see "The English Court Masque," page 818). The west front shown here, consisting of what appeared to be two upper stories with superimposed Ionic and Composite orders raised over a plain basement level, exemplifies the understated elegance of Jones's interpretation of Palladian design. **Pilasters** flank the end **bays** (vertical divisions), and engaged columns subtly emphasize the three bays at the center. These vertical elements are repeated in the balustrade along the roofline. A rhythmic effect was created in varying window treatments from triangular and **segmental** (semicircular) **pediments** on the first level to cornices with volute (scroll-form) brackets on the second. The sculpted garlands just below the roofline add an unexpected decorative touch, as does the use of a different-color stone—pale golden, light brown, and white—for each story (no longer visible after the building was refaced in uniformly white Portland stone).

Despite the two stories presented on the exterior, the interior of the Whitehall Banqueting House (fig. 19-69) is actually one large hall divided by a balcony; it has antechambers at each end. Ionic pilasters suggest a colonnade but do not impinge on the ideal, double-cube

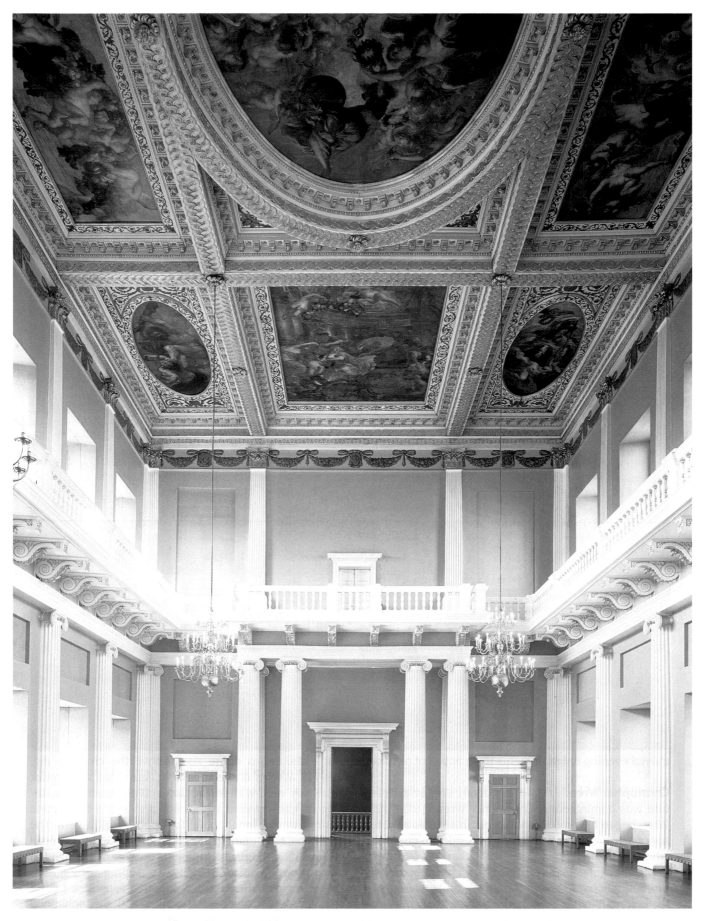

19-69. Interior, Banqueting House, Whitehall Palace. Ceiling paintings of the apotheosis of King James and the glorification of the Stuart monarchy by Peter Paul Rubens. 1630–35

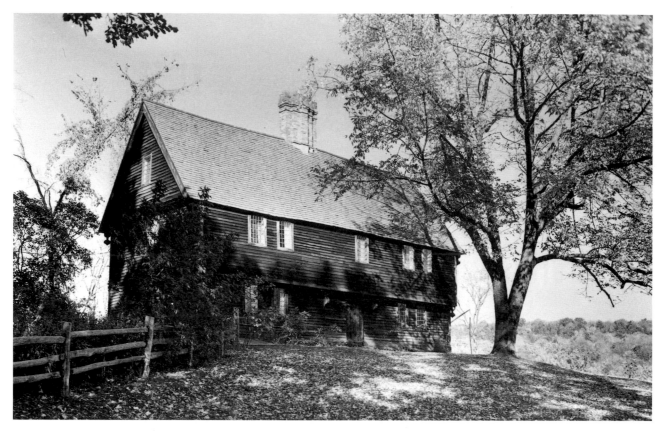

19-73. Parson Capen House, Topsfield, Massachusetts. 1683

Lancelot "Capability" Brown. Blenheim's grounds originally comprised a practical kitchen garden, an avenue of elm trees, and another garden. In the 1760s, the grounds were redesigned by Lancelot "Capability" Brown (1716–83) according to his radical new style of landscape architecture. In contrast to the geometric rigor of the French garden, Brown's designs appeared to be both informal and natural. At Blenheim, Brown dammed the small river flowing by the palace to form two lakes and a rockwork cascade, then created sweeping lawns and artfully arranged trees. The formal gardens in the French style now seen at each side of Blenheim's center block were added in the twentieth century.

ENGLISH COLONIES IN NORTH AMERICA

In the seventeenth century, the art of North America reflected the tastes of the European countries that ruled the colonies, especially, on the eastern coast, England. Not surprisingly, much of the colonial art was done by immigrant artists, and styles often lagged behind the European mainstream. Colonial life was still hard in the 1600s, and few could afford to think of fine houses and art collections; the Puritans, the religious dissenters who had left England and settled in the Northeast beginning in 1620, wanted only the simplest functional buildings for homes and churches. Architecture responded more quickly than sculpture, painting, and craft arts in the

development of native styles. Although by the last decades of the seventeenth century a market for fine furniture and portraits had developed, unfortunately but understandably native artists of outstanding talent often found it advantageous to resettle in Europe.

ARCHITECTURE

Early architecture in the British North American colonies tended to derive from European provincial timber construction with medieval roots. Wood, so easily obtained in the Northeast, was used to create the same kinds of houses and churches then being built in rural England (as well as in Holland and France, which also had colonies in North America). In seventeenth-century New England, for example, many buildings reflected the adaptation of contemporary English country buildings, which were so appropriate to the severe North American winters—framed-timber construction with steep roofs, massive central fireplaces and chimneys, overhanging upper stories, and small windows with tiny panes of glass. Following a time-honored tradition, walls consisted of wooden frames filled with **wattle and daub** (woven branches packed with clay), or brick in more expensive homes. Instead of leaving this construction exposed, as was common in Europe, colonists usually weatherproofed it with horizontal plank siding, called **clapboard**. The Parson Capen House in Topsfield,

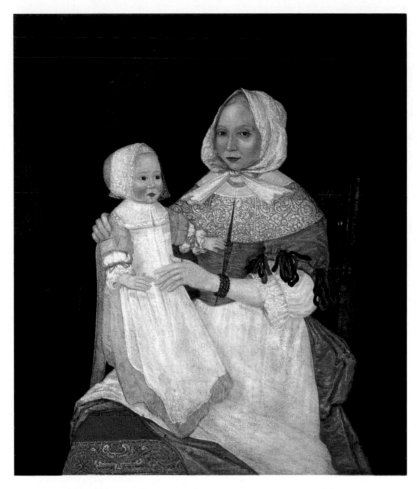

19-74. Anonymous ("Freake Painter"). *Mrs. Freake and Baby Mary.*
c. 1674. Oil on canvas, 42¼ x 36¼" (108 x 92.1 cm). Worcester
Museum of Art, Worcester, Massachusetts
Gift of Mr. and Mrs. Albert W. Rice

Massachusetts (fig. 19-73), built in 1683, is a well-preserved example. The earliest homes generally consisted of a single "great room" and fireplace, but the Capen House has two stories, each with two rooms flanking the central fireplace and chimney. The main fireplace was the center of domestic life; all the cooking was done there, and the firelight provided illumination for reading and sewing.

PAINTING

Painting and sculpture had to wait for more settled and affluent times in the colonies. For a long time, the only works of sculpture were carved or engraved tombstones. Painting, too, was sponsored as a necessary part of family record keeping—not for the sake of art or vanity—and portraits done by itinerant "face painters," also called **limners**, have a charm and sincerity that appeal to the modern eye. The anonymous painter of *Mrs. Freake and Baby Mary* (fig. 19-74), dated about 1674, seems to have known Dutch portraiture, probably through engraved copies that were imported and sold in the colonies. Even though the Freake painter was clearly self-taught and lacked skills in illusionistic, three-dimensional composition, this portrait has much in common with Frans Hals's *Catharina Hooft and Her Nurse* (see fig. 19-51), especially in its spirit, in the care given to minute details of costuming, and in the focus on large figures in the foreground. Maternal pride in an infant and hope for her future are universals that seem to apply to little Mary as well as to Catharina, even though their worlds were far apart.

COUNTRY	BAROQUE AND EARLY AMERICAN ART	ART IN OTHER CULTURES
ITALY	19-13. Carracci. Farnese palace ceiling, Rome (1597–1601) 19-17. Caravaggio. *Boy with a Basket of Fruit* (1593–4) 19-18. Caravaggio. *Calling of Saint Matthew* (c. 1599–1600) 19-19. Caravaggio. *Entombment* (1603–4) 19-14. Reni. *Aurora* (1613–14) 19-10. Bernini. *David* (1623) 19-11. Barberini harp (c. 1623–24, 1671) 19-2. Bernini. *Baldacchino* (1624–33) 19-20. Gentileschi. *Judith and Maidservant with the Head of Holofernes* (1625) 19-21. Gentileschi. *La Pittura* (1630) 19-15. Cortona. *Triumph of the Barberini* (1632–39) 19-4. Borromini. San Carlo, Rome (1638–41) 19-8. Bernini. Cornaro Chapel, Rome (1642–52) 19-9. Bernini. *St. Teresa of Ávila in Ecstasy* (1645–52) 19-7. Bernini. Four Rivers Fountain, Rome (1648–51) 19-3. Bernini. St. Peter's Piazza, Rome (c. 1656–57) 19-16. Gaulli. *Triumph of the Name of Jesus* (1672–85) 19-12. Volpato. *View of the Farnese Gallery* (c. 1770)	21-10. Dong Qichang. *The Qingbian Mountains* (1617), China 20-6. *Jahangir-nama* (c. 1620), India 22-9. Koetsu. Teabowl (early 17th cent.), Japan 20-7. Taj Mahal (c. 1632–48), India 25-12. Kuba portrait (mid-17th cent.), Congo 22-10. Sotatsu. Screens (17th cent.), Japan 21-11. Wang Hui. *A Thousand Peaks and Myriad Ravines* (1693), China 23-19. Taos Pueblo (c. 1700), North America 21-12. Shitao. *Landscape* (c. 1700), China
FRANCE	19-28. Claude. *Landscape with Merchants* (c. 1630) 19-27. La Tour. *Magdalen with the Smoking Flame* (c. 1640) 19-29. Poussin. *Landscape with St. John on Patmos* (1640) 19-25. Girardon. *Apollo Attended by the Nymphs of Thetis* (c. 1666–72) 19-22. Le Vau and Hardouin-Mansart. Palais de Versailles, Versailles (1668–85) 19-24. Hardouin-Mansart and Le Brun. Hall of Mirrors, Versailles (begun 1678) 19-1. Rigaud. *Louis XIV* (1701)	
HABSBURG GERMANY, AUSTRIA	19-30. Prandtauer. Melk monastery (1702–36)	
HABSBURG SPAIN	19-36. Sánchez Cotán. *Still Life With Quince, Cabbage, Melon, and Cucumber* (c. 1602) 19-37. Velázquez. *Water Carrier of Seville* (c. 1619) 19-35. Zurbarán. *St. Serapion* (1628) 19-34. J. de Ribera. *Martyrdom of St. Bartholomew* (1634) 19-38. Velázquez. *The Lances* (1634–35) 19-40. Murillo. *The Esquilache Immaculate Conception* (c. 1645–50) 19-39. Velázquez. *Las Meninas* (1656) 19-32. P. de Ribera. Hospicio de San Fernando, Madrid (1722)	

COUNTRY	BAROQUE AND EARLY AMERICAN ART
NORTH AMERICA	19-41. **Atrial cross, Mexico** (before 1556)
	19-74. *Mrs. Freake and Baby Mary* (c. 1674)
	19-73. **Capen House, Massachusetts** (1683)
	19-42. Salcedo. *Our Lady of Guadalupe,* Mexico (1779)
	19-43. **San Xavier del Bac, Arizona** (1784–97)
SOUTHERN NETHERLANDS/ FLANDERS	19-45. Rubens. *The Raising of the Cross* (1610–11)
	19-44. **Rubens House, Antwerp** (1610–15)
	19-50. Peeters. *Still Life with Flowers, Goblet, Dried Fruit, and Pretzels* (1611)
	19-49. Brueghel, Rubens. *Sight* (c. 1617–18)
	19-46. Rubens. *Henri IV Receiving the Portrait of Marie de' Medici* (1621–25)
	19-47. Rubens. *Landscape with Rainbow* (c. 1635)
	19-48. Van Dyck. *Charles I at the Hunt* (1635)
NORTHERN NETHERLANDS/ DUTCH REPUBLIC	19-51. Hals. *Catharina Hooft and Her Nurse* (c. 1620)
	19-52. Hals. *Officers of the Haarlem Militia Company of Saint Adrian* (c. 1627)
	19-53. Leyster. *Self-Portrait* (1635)
	19-54. Rembrandt. *The Night Watch* (1642)
	19-61. Ruisdael. *The Jewish Cemetery* (1655–60)
	19-65. Ter Borch. *The Suitor's Visit* (c. 1658)
	19-57. Rembrandt. *Self-Portrait* (1659)
	19-60. Cuyp. *Maas at Dordrecht* (c. 1660)
	19-63. Vermeer. *View of Delft* (c. 1662)
	19-55. Rembrandt. *Three Crosses* (etchings) (1663)
	19-64. Vermeer. *Woman Holding a Balance* (c. 1664)
	19-58. Rembrandt. *The Jewish Bride* (c. 1665)
	19-59. De Witte. *Portuguese Synagogue, Amsterdam* (1680)
	19-62. Hobbema. *Avenue at Middelharnis* (1689)
	19-67. Ruysch. *Flower Still Life* (after 1700)
	19-66. Merian. *Dissertation in Insect Generations and Metamorphosis in Surinam* (1719)
ENGLAND	19-68. Jones. **Banqueting House, London** (1619–22)
	19-69. Rubens. **Interior ceiling paintings, Banqueting House, London** (1630–35)
	19-70. **Wren. St. Paul's, London** (1675–1710)
	19-72. **Vanbrugh. Blenheim Palace, Woodstock** (1705–21)

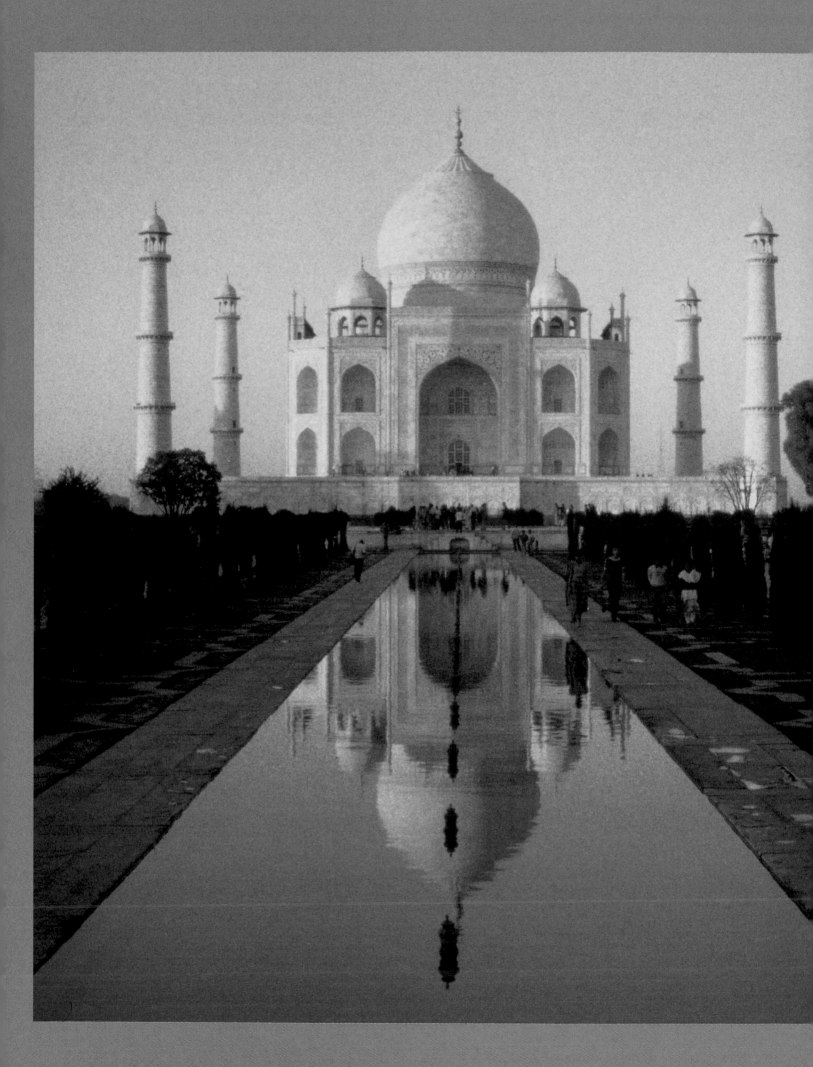

20-1. **Taj Mahal, Agra**, India. Mughal period,
Mughal, reign of Shah Jahan, c. 1632-48

Visitors catch their breath. Ethereal, weightless, the building before them barely seems to touch the ground. Its reflection shimmers in the pools of the garden meant to evoke a vision of paradise as described in the Koran, the holy book of Islam. Its facades are delicately inlaid with inscriptions and arabesques in semiprecious stones—carnelian, agate, coral, turquoise, garnet, lapis, and jasper. Above, its luminous, white marble dome reflects each shift in light, flushing rose at dawn, dissolving in its own brilliance in the noonday sun.

One of the most celebrated buildings in the world, the Taj Mahal (fig. 20-1) was built in the seventeenth century by the Mughal ruler Shah Jahan as a mausoleum for his favorite wife, Mumtaz-i-Mahal, who died in childbirth. A dynasty of Central Asian origin, the Mughals were the most successful of the many Islamic groups that established themselves in India beginning in the tenth century. Under their patronage, Persian and Central Asian influences mingled with older traditions of the South Asian subcontinent, adding yet another dimension to the already ancient and complex artistic heritage of India.

1100	1200	1300	1400	1500

▲ c. 1100–1526 LATE MEDIEVAL PERIOD

▲ 1206 TURKIC DYNASTIES RULE PARTS OF NORTHERN INDIA

▲ 1408 BABUR, FIRST MUGHAL EMPEROR, BEGINS RULE

TIMELINE 20-1. **India after 1100.** Much of the Indian subcontinent was occupied by outside powers for nearly 750 years.

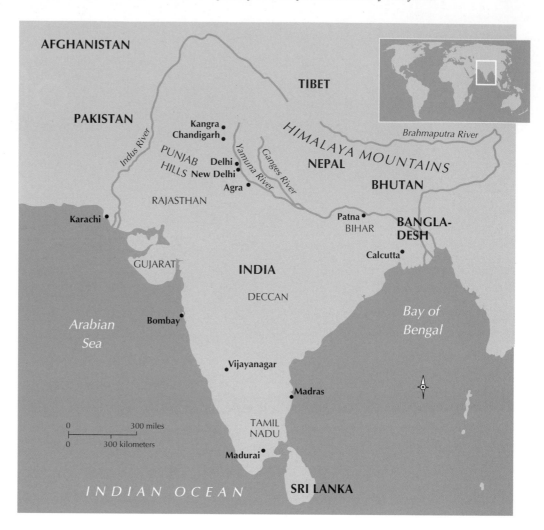

MAP 20-1. **India after 1100.** Throughout its history, the Indian subcontinent was subject to continual invasion that caused the borders of its kingdoms to contract and expand until the establishment of modern-day India in the twentieth century.

LATE MEDIEVAL PERIOD

By 1100 India was already among the world's oldest civilizations (see "Foundations of Indian Culture," page 828). The art that survives from its earlier periods is almost exclusively sacred, most of it inspired by the three principal religions: Buddhism, Hinduism, and Jainism. At the start of the Late Medieval period, which extends roughly from 1100 to 1526, these three religions continued as the principal focus for Indian art, even as invaders from the northwest began to establish the new religious culture of Islam.

BUDDHIST ART

After many centuries of prominence, Buddhism had been in decline as a cultural force in India since the seventh century. By the Late Medieval period, the principal Buddhist centers were concentrated in the northeast, in the kingdom ruled by the Pala dynasty. There, in great monastic universities that attracted monks from as far away as China, Korea, and Japan, was cultivated a form of Buddhism known as Tantric (Vajrayana) Mahayana.

The practices of Tantric Buddhism, which included techniques for visualizing deities, encouraged the development of **iconographic** images such as the gilt-bronze sculpture of the **bodhisattva** Avalokiteshvara in figure 20-2. *Bodhisattvas* are beings who are well advanced on the path to buddhahood (enlightenment), the goal of Mahayana Buddhists, and who have vowed out of compassion to help others achieve enlightenment. Avalokiteshvara, the *bodhisattva* of greatest compassion, whose vow is to forgo buddhahood until all others become buddhas, became the most popular of these saintly beings in India and in East Asia.

Characteristic of *bodhisattvas*, he is distinguished in art by his princely garments, unlike a buddha, who wears a monk's robes. Avalokiteshvara is specifically recognized by the lotus flower he holds and by the presence in his crown of his "parent" buddha, in this case Amitabha, buddha of the Western Pure Land (the Buddhist paradise). Other marks of Avalokiteshvara's extraordinary status are the third eye (symbolizing the ability to see in miraculous ways) and the wheel on his palm (signifying the ability to teach the Buddhist truth).

1600 1700 1800 1900 2000 CE

▲ c. 1658 UNIFIED MUGHAL EMPIRE IN NORTHERN INDIA

▲ c. 1757 BRITISH SOVEREIGNTY FULLY ESTABLISHED

▲ c. 1949 INDIA BECOMES
INDEPENDENT
NATION

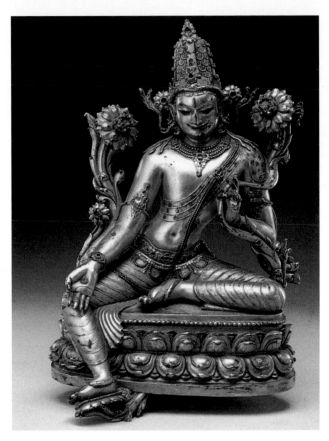

20-2. ***The Bodhisattva Avalokiteshvara***, from Kurkihar, Bihar, central India. Late Medieval period, Pala dynasty, 12th century. Gilt-bronze, height 10" (25.5 cm). Patna Museum, Patna

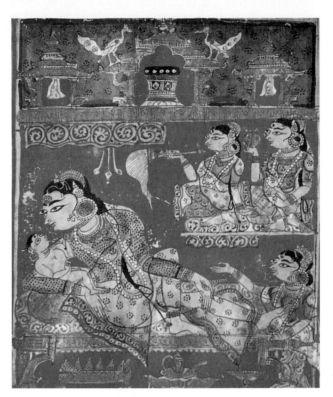

20-3. **Detail of a leaf with** *The Birth of Mahavira*, from the *Kalpa Sutra*. Late Medieval period, western Indian school (probably Gujarat), c. 1375–1400. Gouache on paper, 3⅜ x 3" (8.5 x 7.6 cm). Prince of Wales Museum, Bombay

Avalokiteshvara is shown here in the posture of relaxed ease known as the royal pose. One leg angles down; the other is drawn up onto the lotus seat, itself considered an emblem of spiritual purity. His body bends gracefully, if a bit stiffly, to one side. The chest scarf and lower garment cling to his body, fully revealing its shape. Delicate floral patterns enliven the textiles, and closely set parallel folds provide a wiry, linear tension that contrasts with the hard but silken surfaces of the body. Linear energy continues in the sweep of the tightly pleated hem emerging from under the right thigh, the sinuous lotus stalks on each side, and the fluttering ribbons of the elaborate crown. A profusion of details and varied textures creates an ornate effect—the lavish jewelry, the looped hair piled high and cascading over the shoulders, the ripe blossoms, the rich layers of the lotus seat. Though still friendly and human, the image is somewhat formalized. The features of the face, where we instinctively look for a human echo, are treated abstractly, and despite its reassuring smile, the statue's expression remains remote. Through richness of ornament and tension of line, this style expresses the heightened power of a perfected being.

With the fall of the Pala dynasty to Turkic invaders in 1199, the last centers of Buddhism in northern India collapsed, and the monks dispersed, mainly into Nepal and Tibet (see Map 20-1). From that time, Tibet has remained the principal stronghold of Tantric Buddhist practice and its arts. The artistic style perfected under the Palas, however, became an influential international style throughout East and Southeast Asia.

JAIN ART

The Jain religion traces its roots to a spiritual leader called Mahavira (c. 599–527 BCE), whom it regards as the final in a series of twenty-four saviors known as pathfinders, or *tirthankaras*. Devotees seek through purification to become worthy of rebirth in the heaven of the pathfinders, a zone of pure existence at the zenith of the universe. Jain monks live a life of austerity, and even laypersons avoid killing any living creature.

As Islamic, or Muslim, territorial control over northern India expanded, non-Islamic religions resorted to more private forms of artistic expression, such as illustrating sacred texts, rather than public activities, such as building temples. In these circumstances, the Jains of western India, primarily in the region of Gujarat, created many stunningly illustrated manuscripts, such as this *Kalpa Sutra*, which explicates the lives of the pathfinders (fig. 20-3). Produced during the late fourteenth century, it

is one of the first Jain manuscripts on paper rather than palm leaf, which had previously been used.

With great economy, the illustration, inserted between blocks of Sanskrit text, depicts the birth of Mahavira. He is shown cradled in his mother's arms as she reclines in her bed under a canopy connoting royalty, attended by three ladies-in-waiting. Decorative pavilions and a shrine with peacocks on the roof suggest a luxurious palace setting. Everything appears two-dimensional against the brilliant red or blue ground. Vibrant colors and crisp outlines impart an energy to the painting that suggests the arrival of the divine in the mundane world. Transparent garments with variegated designs reveal the swelling curves of the figures, whose alert postures and gestures convey a sense of the importance and excitement of the event. Strangely exaggerated features, such as the protruding eyes, contribute to the air of the extraordinary. With its angles and tense curves, the drawing is closely linked to the aesthetics of Sanskrit **calligraphy**, and the effect is as if the words themselves had suddenly flared into color and image.

HINDU ART

During the Early Medieval period Hinduism became the dominant religious tradition of India. With the increasing popularity of Hindu sects came the rapid development of Hindu temples. Spurred by the ambitious building programs of wealthy rulers, well-formulated regional styles had evolved by about 1000 CE. The most spectacular structures of the era were monumental, with a complexity and grandeur of proportion unequaled even in later Indian art.

During the Late Medieval period the emphasis on monumental individual temples gave way to the building of vast **temple complexes** and more moderately scaled yet more richly ornamented individual temples. These developments took place largely in the south of India, for temple building in the north virtually ceased with the consolidation of Islamic rule there from the beginning of the thirteenth century. The mightiest of the southern Hindu kingdoms was Vijayanagar (c. 1350–1565), whose rulers successfully countered the southward progress of

FOUNDA-TIONS OF INDIAN CULTURE The earliest civilization on the Indian subcontinent flourished toward the end of the third millennium BCE along the Indus River in present-day Pakistan. Remains of its expertly engineered brick cities have been uncovered, together with works of art that intriguingly suggest spiritual practices and reveal artistic traits known in later Indian culture.

The abrupt demise of the Indus Valley civilization during the mid-second millennium BCE coincides with (and may be related to) the arrival from the northwest of a semi-nomadic warrior people known as the Indo-European Aryans. Over the next millennium they were influential in formulating the new civilization that gradually emerged. The most important Aryan contributions to this new civilization included the Sanskrit language and the sacred texts called the Vedas. The evolution of Vedic thought under the influence of indigenous Indian beliefs culminated in the mystical, philosophical texts called the Upanishads, which took shape sometime after 800 BCE.

The Upanishads teach that the material world is illusory; only Brahman, the universal soul, is real and eternal. We—that is, our individual souls—are trapped in this illusion in a relentless cycle of birth, death, and

rebirth. The ultimate goal of religious life is to liberate ourselves from this cycle and to unite our individual soul with Brahman.

Buddhism and Jainism are two of the many religions that developed in the climate of Upanishadic thought. Buddhism is based on the teachings of Shakyamuni Buddha, who lived in central India about 500 BCE; Jainism was shaped about the same time around the followers of the spiritual leader Mahavira. Both religions acknowledged the cyclical nature of existence and taught a means of liberation from it, but they rejected the authority, rituals, and social strictures of Vedic religion. Whereas the Vedic religion was in the hands of a hereditary priestly class, Buddhist and Jain communities welcomed all members of society, which gave them great appeal. The Vedic tradition eventually evolved into the many sects now collectively known as Hinduism.

Politically, India through most of its history was a mosaic of regional dynastic kingdoms, but from time to time, empires emerged that unified large parts of the subcontinent. The first was the Maurya dynasty (c. 322–185 BCE), whose great king Ashoka patronized Buddhism. From this time Buddhist doctrines spread widely and its artistic traditions were established.

In the first century CE the Kushans, a Central Asian people, created an empire extending from present-day Afghanistan down into central India. Buddhism prospered under Kanishka, the most powerful Kushan king, and spread into Central Asia and to East Asia.

At this time, under the evolving thought of Mahayana Buddhism, traditions first evolved for depicting the image of the Buddha in art.

Later, under the Gupta dynasty (c. 320–500 CE) in central India, Buddhist art and culture reached their high point. However, Gupta monarchs also patronized the Hindu religion, which from this time grew to become the dominant Indian religious tradition, with its emphasis on the great gods Vishnu (the Creator), Shiva (the Destroyer), and the Goddess—all with multiple forms.

During the long Medieval period, which lasted from about 650 to 1526 CE, numerous regional dynasties prevailed, some quite powerful and long-lasting. During the early part of this period, to roughly 1100, Buddhism continued to decline as a cultural force, while artistic achievement under Hinduism soared. Hindu temples, in particular, developed monumental and complex forms that were rich in symbolism and ritual function, with each region of India producing its own variation.

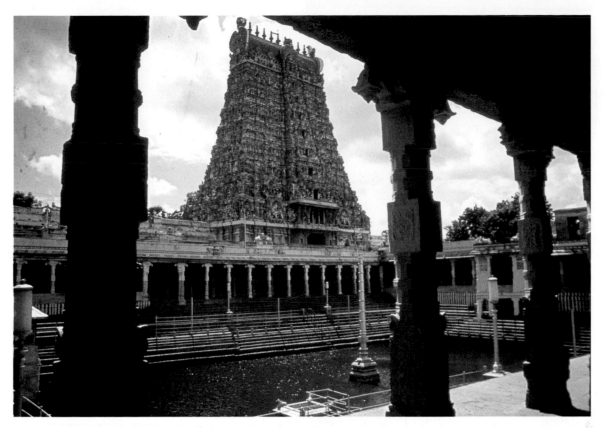

20-4. Outer *gopura* of the Minakshi-Sundareshvara Temple, Madurai, Tamil Nadu, South India. Late Medieval period, Nayak dynasty, mostly 13th to mid-17th century

Islamic forces for more than 200 years. Viewing themselves as defenders and preservers of Hindu faith and culture, Vijayanagar kings lavished donations on sacred shrines. Under the patronage of the Vijayanagar and their successors, the Nayaks, the principal monuments of later Hindu architecture were created.

The enormous temple complex at Madurai, one of the capitals of the Nayaks, is an example of this late, fervent expression of Hindu faith. Founded around the thirteenth century, it is dedicated to the goddess Minakshi (the local name for Parvati, the consort of the god Shiva) and to Sundareshvara (the local name for Shiva himself). The temple complex stands in the center of the city and is the focus of Madurai life. At its heart are the two oldest shrines, one to Minakshi and the other to Sundareshvara. Successive additions over the centuries gradually expanded the complex around these small shrines and came to dominate the visual landscape of the city. The most dramatic features of this and similar "temple cities" of the south were the thousand-pillar halls, large ritual-bathing pools, and especially entrance gateways, called **gopuras**, which tower above the temple site and the surrounding city like modern skyscrapers (fig. 20-4).

Gopuras proliferated as a temple city grew, necessitating new and bigger enclosing walls, and thus new gateways. Successive rulers, often seeking to outdo their predecessors, donated taller and taller *gopuras*. As a result, the tallest structures in temple cities are often at the periphery, rather than at the central temples, which are sometimes totally overwhelmed. The temple complex at Madurai has eleven *gopuras*, the largest well over 100 feet tall.

Formally, the *gopura* has its roots in the **vimana**, the pyramidal tower characteristic of the seventh-century southern temple style. As the *gopura* evolved, it took on the graceful concave silhouette shown here. The exterior is embellished with thousands of sculpted figures, evoking a teeming world of gods and goddesses. Inside, stairs lead to the top for an extraordinary view.

MUGHAL PERIOD

Islam first touched the South Asian subcontinent in the eighth century, when Arab armies captured a small territory near the Indus River. Later, beginning around 1000, Turkic factions from Central Asia, relatively recent converts to Islam, began military campaigns into North India, at first purely for plunder, then seeking territorial control. From 1206, various Turkic dynasties ruled portions of the subcontinent from the northern city of Delhi. These sultanates, as they are known, constructed forts, **mausoleums**, monuments, and **mosques**. Although these early dynasties left their mark, it was the Mughal dynasty that made the most inspired and lasting contribution to the art of India.

The Mughals, too, came from Central Asia. Babur (ruled 1494–1530), the first Mughal emperor, emphasized his Turkic heritage, though he had equally impressive Mongol ancestry. After some initial conquests in

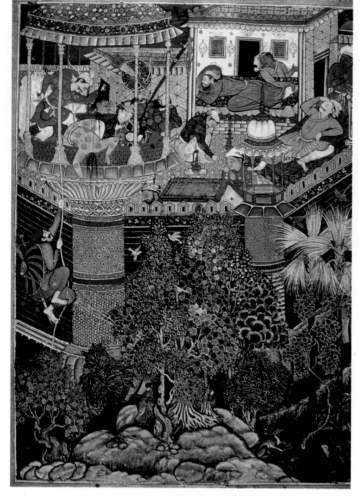

20-5. Page with *Hamza's Spies Scale the Fortress*, from the *Hamza-nama*, North India. Mughal period, Mughal, reign of Akbar, c. 1567–82. Gouache on cotton, 30 x 24" (76 x 61 cm). Museum of Applied Arts, Vienna

Central Asia, he amassed an empire stretching from Afghanistan to Delhi, which he conquered in 1526. Akbar (ruled 1556–1605), the third ruler, extended Mughal control over most of North India, and under Akbar and his two successors, Jahangir and Shah Jahan, northern India was generally unified as the Mughal Empire by 1658.

MUGHAL PAINTING

Probably no one had more control over the solidification of the Mughal Empire and the creation of Mughal art than the emperor Akbar. A dynamic, humane, and just leader, Akbar was an avid enthusiast of religious discourse and the arts, especially painting. He created an imperial **atelier** (workshop) of painters, which he placed under the direction of two artists from the Persian court. Learning from these two masters, the Indian painters of the atelier soon transformed Persian styles into the more vigorous, naturalistic styles that mark the Mughal school (see "Indian Painting on Paper," page 832).

One of the most famous and extraordinary works produced in Akbar's atelier is an illustrated manuscript of the *Hamza-nama*, a Persian classic about the adventures of Hamza, uncle of the Prophet Muhammad. Painted on cotton cloth, each illustration is more than 2½ feet high.

The entire project gathered 1,400 illustrations into twelve volumes and took fifteen years to complete.

One illustration shows Hamza's spies scaling a fortress wall and surprising some men as they sleep (fig. 20-5). One man climbs a rope; another has already beheaded a figure in yellow and lifts his head aloft—realistic details are never avoided in paintings from the Mughal atelier. The receding lines of the architecture, viewed from a slightly elevated vantage point, provide a reasonably three-dimensional setting. Yet the sense of depth is boldly undercut by the richly variegated geometric patterns of the tilework, which are painted as though they had been set flat on the page. Contrasting with the flat geometric patterns are the large human figures, whose rounded forms and softened contours create a convincing sense of volume. The energy exuded by the figures is also characteristic of painting under Akbar—even the sleepers seem active. This robust, naturalistic figure style is quite different from the linear style seen earlier in Jain manuscripts (see fig. 20-3) and even from the Persian styles that inspired Mughal paintings.

Nearly as prominent as the architectural setting with its vivid human adventure is the sensuous landscape in the foreground, where monkeys, foxes, and birds inhabit a grove of trees that shimmer and glow against the darkened background like precious gems. The treatment of the gold-edged leaves at first calls to mind the patterned geometry of the tilework, yet a closer look reveals a skillful naturalism born of careful observation. Each tree species is carefully distinguished—by the way its trunk grows, the way its branches twist, the shape and veining of its leaves, the silhouette of its overall form. Pink and blue rocks with lumpy, softly outlined forms add still further interest to this painting, whose every inch is full of intriguing elements.

Painting from the reign of Jahangir (ruled 1605–27) presents a different tone. Like his father, Jahangir admired painting and, if anything, paid even more attention to his atelier. Indeed, he boasted that he could recognize the hand of each of his artists even in collaborative paintings, which were common. Unlike Akbar, however, Jahangir preferred the courtly life to the adventurous one, and paintings produced for him reflect his subdued and refined tastes and his admiration for realistic detail.

One such painting is *Jahangir in Darbar* (fig. 20-6). The work, probably part of a series on Jahangir's reign, shows the emperor holding an audience, or *darbar*, at court. Jahangir himself is depicted at top center, seated on a balcony under a canopy. Members of his court, including his son, the future emperor Shah Jahan, stand somewhat stiffly to each side. The audience, too, is divided along the central axis, with figures lined up in profile or three-quarter view. In the foreground, an elephant and a horse complete the symmetrical format.

Jahangir insisted on fidelity in portraiture, including his own in old age. The figures in the audience are a medley of portraits, possibly taken from albums meticulously kept by the court artists. Some represent people known to have died before Jahangir's reign, so the painting may represent a symbolic gathering rather than an

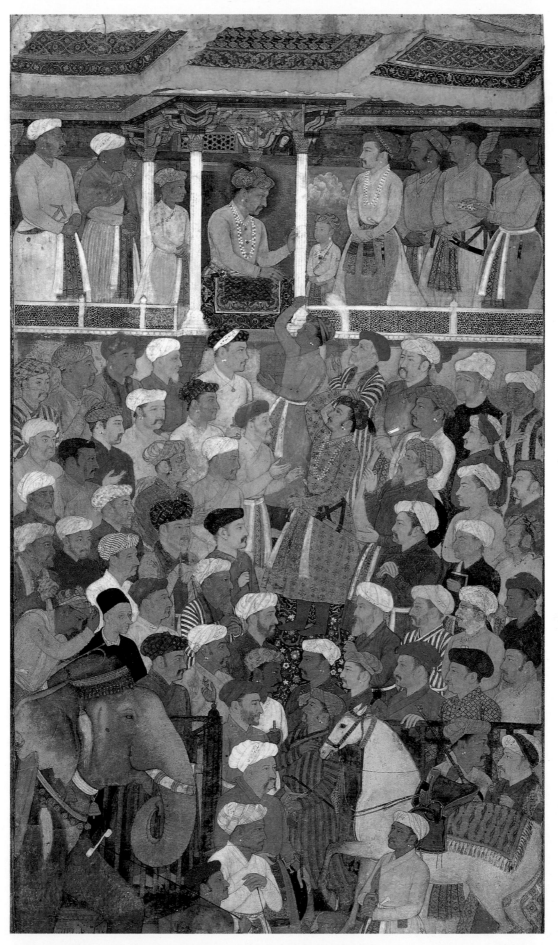

20-6. Abul Hasan and Manohar. Page with *Jahangir in Darbar*, from the *Jahangir-nama*, North India. Mughal period, Mughal, reign of Jahangir, c. 1620. Gouache on paper, 13⅝ x 7⅝" (34.5 x 19.5 cm). Museum of Fine Arts, Boston

Frances Bartlett Donation of 1912 and Picture Fund

actual event. Standing out amid the bright array of garments is the black robe of a Jesuit priest from Europe. Both Akbar and Jahangir were known for their interest in things foreign, and many foreigners flocked to the courts of these open-minded rulers. The scene is formal, the composition static, and the treatment generally two-dimensional. Nevertheless, the sensitively rendered portraits and the fresh colors, with their varied range of pastel tones, provide the aura of a keenly observed, exquisitely idealized reality that marks the finest paintings of Jahangir's time.

MUGHAL ARCHITECTURE

Mughal architects were heir to a 300-year-old tradition of Islamic building in India. The Delhi sultans who preceded them had great forts housing government and court buildings. Their architects had introduced two fundamental Islamic structures, the mosque and the tomb, along with construction based on the arch and the dome. (Earlier Indian architecture had been based primarily on post-and-lintel construction.) They had also drawn freely on Indian architecture, borrowing both decorative and structural elements to create a variety of hybrid styles, and had especially benefited from the centuries-old Indian virtuosity in stone carving and masonry. The Mughals followed in this tradition, synthesizing Indian, Persian, and Central Asian elements for their forts, palaces, mosques, tombs, and **cenotaphs** (tombs or monuments to someone whose remains are actually somewhere else). Mughal architectural style culminated in the most famous of all Indian Islamic structures, the Taj Mahal.

The Taj Mahal is sited on the bank of the Yamuna River at Agra, in northern India. Built between 1632 and 1648, it was commissioned as a mausoleum for his wife by the emperor Shah Jahan (ruled 1628–58), who is believed to have taken a major part in overseeing its design and construction.

Visually, the Taj Mahal never fails to impress (see fig. 20-1). As visitors enter through a monumental, hall-like gate, the tomb looms before them across a spacious garden set with long reflecting pools. Measuring some 1,000 by 1,900 feet, the garden is unobtrusively divided into quadrants planted with trees and flowers and framed by broad walkways and stone inlaid in geometric patterns. In Shah Jahan's time, fruit trees and cypresses—symbolic of life and death, respectively—lined the walkways, and fountains played in the shallow pools. One can imagine the melodies of court musicians that wafted through the garden. Truly, the senses were beguiled in this earthly evocation of paradise.

Set toward the rear of the garden, the tomb is flanked by two smaller structures not visible here, one a mosque and the other, its mirror image, a resting hall. They share a broad base with the tomb and serve visually as stabilizing elements. Like the entrance hall, they are made mostly of red sandstone, rendering even more startling the full glory of the tomb's white marble. The tomb is raised higher than these structures on its own marble platform. At each corner of the platform, a **minaret**, or slender tower, defines the surrounding space. The minarets' three levels correspond to those of the tomb, creating a bond between them. Crowning each minaret is a **chattri**, or pavilion. Traditional embellishments of Indian palaces, *chattris* quickly passed into the vocabulary of Indian Islamic

TECHNIQUE

INDIAN PAINTING ON PAPER

Before the fourteenth century most painting in India had been made on walls or palm leaves. With the introduction of paper, Indian artists adapted painting techniques from Persia and over the ensuing centuries produced jewel-toned works of surpassing beauty on paper.

Painters usually began their training early. As young apprentices, they learned to make brushes and grind pigments. Brushes were made from the curved hairs of a squirrel's tail, arranged to taper from a thick base to a single hair at the tip. Paint came from pigments of vegetables and minerals—lapis lazuli to make blue, malachite for pale green—that were ground to a paste with water, then bound with a solution of gum from the acacia plant. Paper, too, was made by hand. Fibers of cotton and jute were crushed to a pulp, poured onto a woven mat, dried, and then burnished with a smooth piece of agate, often to a glossy finish.

Artists frequently worked from a collection of sketches belonging to a master painter's atelier. Sometimes, to transfer the drawing to a blank sheet beneath, sketches were pricked with small, closely spaced holes that were then daubed with wet color. The dots were connected into outlines, and the process of painting began.

First, the painter applied a thin wash of a chalk-based white, which sealed the surface of the paper while allowing the underlying sketch to show through. Next, outlines were filled with thick washes of brilliant, opaque, unmodulated color. When the colors were dry, the painting was laid facedown on a smooth marble surface and burnished with a rounded agate stone, rubbing first up and down, then side to side. The indirect pressure against the marble polished the pigments to a high luster. Then outlines, details, and modeling—depending on the style—were added with a fine brush.

Sometimes certain details were purposely left for last, such as the eyes, which were said to bring the painting to life. Along more practical lines, gold and raised details were applied when the painting was nearly finished. Gold paint, made from pulverized, 24-karat gold leaf bound with acacia gum, was applied with a brush and burnished to a high shine. Raised details such as the pearls of a necklace were made with thick, white chalk-based paint, with each pearl a single droplet hardened into a tiny raised mound.

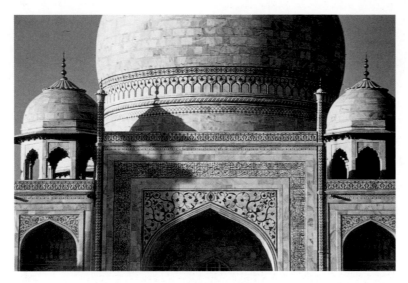

20-7. Taj Mahal, Agra, India. Mughal period, Mughal, reign of Shah Jahan, c. 1632–48

Inside, the Taj Mahal invokes the *hasht behisht*, or "eight paradises," a plan named for the eight small chambers that ring the interior—one at each corner and one behind each *iwan*. In two stories (for a total of sixteen chambers), the rooms ring the octagonal central area, which rises the full two stories to a domed ceiling that is lower than the outer dome. In this central chamber, surrounded by a finely carved octagonal openwork marble screen, are the exquisite inlaid cenotaphs of Shah Jahan and his wife, whose actual tombs lie in the crypt below.

architecture, where they appear prominently. Minarets occur in architecture throughout the Islamic world; from their heights, the faithful are called to prayer.

A lucid geometric symmetry pervades the tomb. It is basically square, but its **chamfered**, or sliced-off, corners create a subtle octagon. Measured to the base of the **finial** (the spire at the top), the tomb is almost exactly as tall as it is wide. Each facade is identical, with a central ***iwan*** flanked by two stories of smaller *iwans*. (A typical feature of eastern Islamic architecture, an *iwan* is a vaulted opening with an arched portal.) By creating voids in the facades, these *iwans* contribute markedly to the building's sense of weightlessness. On the roof, four octagonal *chattris*, one at each corner, create a visual transition to the lofty, bulbous dome, the crowning element that lends special power to this structure. Framed but not obscured by the *chattris*, the dome rises more gracefully and is lifted higher by its **drum** than in earlier Mughal tombs, allowing the swelling curves and lyrical lines of its beautifully proportioned, surprisingly large form to emerge with perfect clarity.

The pristine surfaces of the Taj Mahal are embellished with utmost subtlety. The sides of the platform are carved in relief with a **blind arcade** motif, and carved relief panels of flowers adorn the base of the building. The portals are framed with verses from the Koran inlaid in black marble, while the **spandrels** are decorated with floral **arabesques** inlaid in colored semiprecious stones, a technique known by its Italian name, ***pietra dura*** (fig.

20-7). Not strong enough to detract from the overall purity of the white marble, the embellishments enliven the surfaces of this impressive yet delicate masterpiece.

RAJPUT PAINTING

Outside of the Mughal strongholds at Delhi and Agra, much of northern India was governed regionally by local Hindu princes, descendants of the so-called Rajput warrior clans, who were allowed to keep their lands in return for allegiance to the Mughals. Like the Mughals, Rajput princes frequently supported painters at their courts, and in these settings, free from Mughal influence, a variety of strong, indigenous Indian painting styles were perpetuated.

The Hindu devotional movement known as *bhakti*, which had done much to spread the faith in the south from around the seventh century, experienced a revival in the north beginning in the Late Medieval period. As it had earlier in the south, *bhakti* inspired an outpouring of poetic literature, this time devoted especially to Krishna, the popular human incarnation of the god Vishnu. Most renowned is the *Gita Govinda*, a cycle of rhapsodic poems about the love between God and humans expressed metaphorically through the love between the young Krishna and the cowherd Radha.

The illustration here is from a manuscript of the *Gita Govinda* produced in the region of Rajasthan about 1525–50. The blue god Krishna sits in dalliance with a

20-8. Page with *Krishna and the Gopis*, from the *Gita Govinda*, Rajasthan, India. Mughal period, Rajput, c. 1525–50. Gouache on paper, 4⁷/₈ x 7¹/₂" (12.3 x 19 cm). Prince of Wales Museum, Bombay

The lyrical poem *Gita Govinda*, by the poet-saint Jayadeva, was probably written in eastern India during the latter half of the twelfth century. The episode illustrated here occurs early in the relationship of Radha and Krishna, which in the poem is a metaphor for the connection between humans and god. The poem traces the progress of their love through separation, reconciliation, and fulfillment. Intensely sensuous imagery characterizes the entire poem, as in the final song, when Krishna welcomes Radha to his bed (Narayana is the name of Vishnu in his role as cosmic creator):

> Leave lotus footprints on my bed of tender shoots, loving Radha!
> Let my place be ravaged by your tender feet!
> > Narayana is faithful now. Love me Radhika!
>
> I stroke your feet with my lotus hand—you have come far.
> Set your golden anklet on my bed like the sun.
> > Narayana is faithful now. Love me Radhika!
>
> Consent to my love. Let elixir pour from your face!
> To end our separation I bare my chest of the silk that bars your breast.
> > Narayana is faithful now. Love me Radhika!

> (Translated by Barbara Stoller Miller)

group of cowherd women. Standing with her maid and consumed with love for Krishna, Radha peers through the trees, overcome by jealousy. Her feelings are indicated by the cool blue color behind her, while the crimson red behind the Krishna grouping suggests passion (fig. 20-8). The curving stalks and bold patterns of the flowering vines and trees express not only the exuberance of springtime, when the story unfolds, but also the heightened emotional tensions of the scene. Birds, trees, and flowers are brilliant as fireworks against the black, hilly landscape edged in an undulating white line. As in the Jain manuscript earlier (see fig. 20-3), all the figures are of a single type, with plump faces in profile and oversized eyes. Yet the resilient line of the drawing gives them life,

and the variety of textile patterns provides some individuality. The intensity and resolute flatness of the scene seem to thrust all of its energy outward, irrevocably engaging the viewer in the drama.

Quite a different mood pervades *Hour of Cowdust*, a work from the Kangra school in the Punjab Hills, foothills of the Himalayas north of Delhi (fig. 20-9). Painted around 1790, some 250 years later than the previous work, it shows the influence of Mughal naturalism on the later schools of Indian painting. The theme is again Krishna. Wearing his peacock crown, garland of flowers, and yellow garment—all traditional iconography of Krishna-Vishnu—he returns to the village with his fellow cowherds and their cattle. All eyes are upon him as he plays his flute,

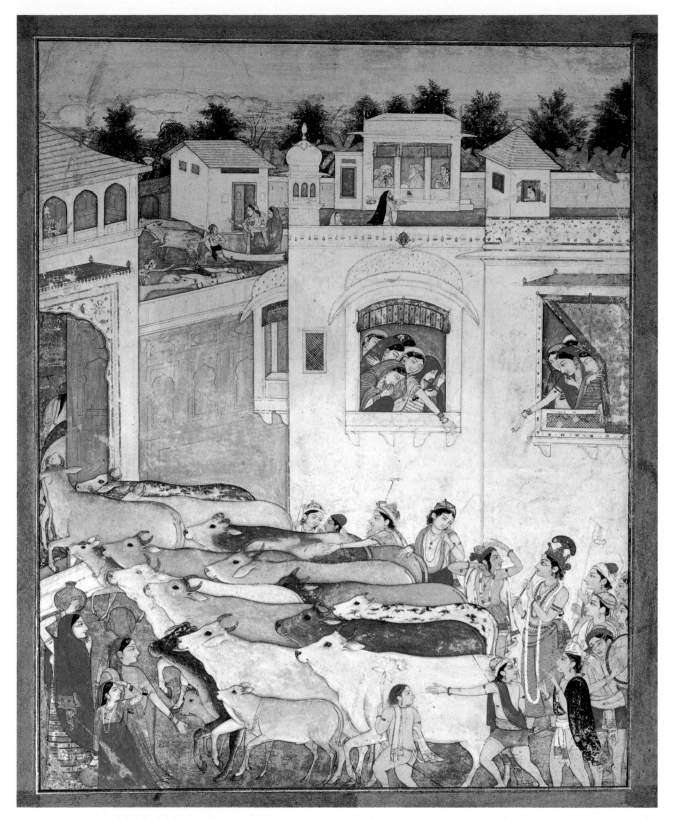

20-9. *Hour of Cowdust*, from Punjab Hills, India. Mughal period, Rajput, Kangra school, c. 1790. Gouache on paper, 10¾ x 8½" (27.2 x 21.5 cm). Museum of Fine Arts, Boston
Denman W. Ross Collection

said to enchant all who heard it. Women with water jugs on their heads turn to look; others lean from windows to watch and call out to him. We are drawn into this charming village scene by the diagonal movements of the cows as they surge through the gate and into the courtyard beyond. Pastel houses and walls create a sense of space, and in the distance we glimpse other villagers going about their work or peacefully sitting in their houses. A rim of dark trees softens the horizon, and an atmospheric sky completes the aura of enchanted naturalism. Again, all the figures are similar in type, this time with a perfection of proportion and a gentle, lyrical movement that complement the idealism of the setting. The scene embodies the sublime purity and grace of the divine, which, as in so much Indian art, is evoked into our human world to coexist with us as one.

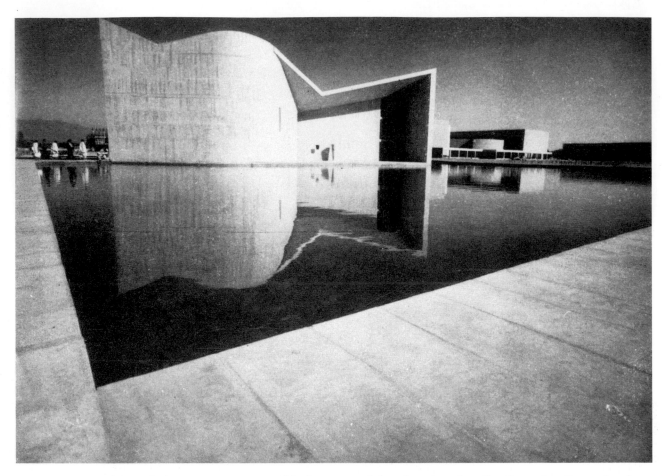

20-10. B. P. Mathur and Pierre Jeanneret. Gandhi Bhavan, Punjab University, Chandigarh, North India. Modern period, 1959–61

MODERN PERIOD By the time *Hour of Cowdust* was painted, India's regional princes had reasserted themselves, and the vast Mughal Empire had shrunk to a small area around Delhi. At the same time, a new power, Britain, was making itself felt, inaugurating a markedly different period in Indian history. First under the mercantile interests of the British East India Company in the seventeenth century, and then under the direct control of the British government as a part of the British Empire in the eighteenth, India was brought forcefully into contact with the West and its culture.

The political concerns of the British Empire extended even to the arts, especially architecture. Over the course of the nineteenth century, the great cities of India, such as Calcutta, Madras, and Bombay, took on a European aspect as British architects built in the revivalist styles favored in England (Chapter 26). During the late nineteenth and early twentieth centuries, architects made an effort to incorporate Indian, usually Mughal, elements into their work. But the results were superficial or overly fantastic and consisted largely of adding ornamental forms such as *chattris* to fundamentally European buildings. The most telling imperial gesture came in the 1920s with the construction of a new, Western-style capital city at New Delhi.

At the same time that the British were experimenting with Indian aesthetics, Indian artists were infusing into their own work Western styles and techniques. One example of this new synthesis is the Gandhi Bhavan at Punjab University in Chandigarh, in North India (fig. 20-10). Used for both lectures and prayer, the hall was designed in the late 1950s by Indian architect B. P. Mathur in collaboration with Pierre Jeanneret, cousin of the French modernist architect Le Corbusier (Chapter 28), whose version of the International Style had been influential in India.

The Gandhi Bhavan's three-part, pinwheel plan, abstract sculptural qualities, and fluid use of planes reflect the modern vision of the International Style. Yet other factors speak directly to India's heritage. The merging of sharp, brusque angles with lyrical curves recalls the linear tensions of the ancient Sanskrit alphabet. The pools surrounding the building evoke Mughal tombs, some of which were similarly laid out on terraces surrounded by water, as well as the ritual-bathing pools of Hindu temples. Yet the abstract style is free of specific religious associations.

The irregular stone structure, its smooth surfaces punctuated by only a few apertures, shimmers in the bright Indian sunlight like an apparition of pure form in our ordinary world. Caught between sky, earth, and water, it fittingly evokes the pulsating qualities of a world seen as imbued with divine essence, the world that has always been at the heart of Indian art.

PARALLELS

PERIOD	INDIAN ART	ART IN OTHER CULTURES
LATE MEDIEVAL c. 1100–1526	**20-2.** *The Bodhisattva Avalokiteshvara* (12th cent.) **20-4.** Minakshi-Sundareshvara Temple (begun 13th cent.) **20-3.** *Kalpa Sutra* (c. 1375–1400)	**21-6.** Ming flask (c. 1426–35), China **17-14.** Van Eyck. Arnolfini wedding portrait (1434), Belgium **18-2.** Leonardo. *Last Supper* (1495–98), Italy **18-11.** Michelangelo. *David* (1501–4), Italy
MUGHAL c. 1526– 18th CENTURY	**20-8.** *Gita Govinda* (c. 1525–50) **20-5.** *Hamza-nama* (c. 1567–82) **20-6.** *Jahangir-nama* (c. 1620) **20-7.** Taj Mahal (c. 1632–48) **20-9.** *Hour of Cowdust* (c. 1790)	**19-3.** Bernini. St. Peter's Square (1607–15), Italy **19-53.** Leyster. *Self-Portrait* (1635), Netherlands **19-57.** Rembrandt. *Self-Portrait* (1659), Netherlands **23-19.** Taos Pueblo (rebuilt c. 1700), North America **26-48.** David. *Oath of the Horatii* (1784–85), France
MODERN c. 18th CENTURY– PRESENT	**20-10.** Mathur and Jeanneret. Gandhi Bhavan (1959–61) 	**22-1.** Hokusai. *Great Wave* (c. 1831), Japan **25-15.** Dogon mask (20th cent.), Mali **28-42.** Gilbert. Woolworth Bldg. (1911–13), US **21-13.** Wu. *Pine Spirit* (1984), China

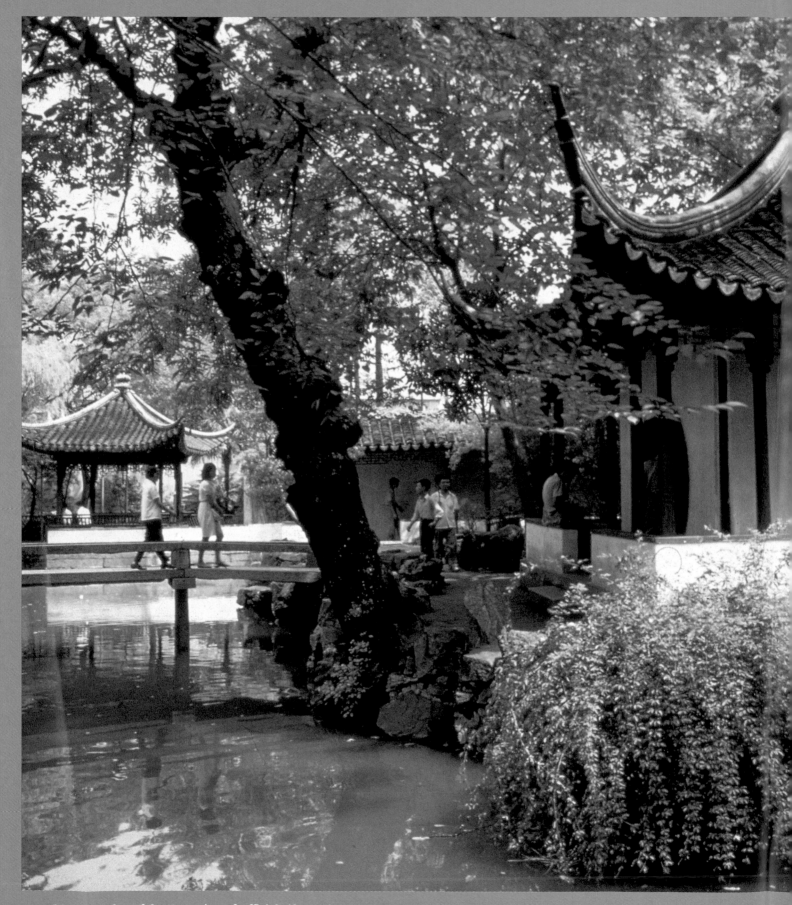

21-1. **Garden of the Cessation of Official Life, Suzhou,**
Jiangsu. Ming dynasty, early 16th century

Early in the sixteenth century, an official in Beijing, frustrated after serving in the capital for many years without promotion, returned to his home near Shanghai. Taking an ancient poem, "The Song of Leisurely Living," for his model, he began to build a garden. He called his retreat the Garden of the Cessation of Official Life (fig. 21-1) to indicate that he had exchanged his career as a bureaucrat for a life of leisure. By leisure, he meant that he could now dedicate himself to calligraphy, poetry, and painting, the three arts dear to scholars in China.

The scholar class of imperial China was a phenomenon unique in the world, the product of an examination system designed to recruit the finest minds in the country for government service. Instituted during the Tang dynasty (618–907) and based on even earlier traditions, the civil service examinations were excruciatingly difficult, but for the tiny percentage that passed at the highest level, the rewards were prestige, position, power, and wealth. During the Song dynasty (960–1279) the examinations were expanded and regularized, and more than half of all government positions came to be filled by scholars.

Steeped in the classic texts of philosophy, literature, and history, China's scholars—known as literati—shared a common bond in education and outlook. Their lives typically moved between the philosophical poles of Confucianism and Daoism (see "Foundations of Chinese Culture," page 841). Following the former, they became officials to fulfill their obligation to the world; pulled by the latter, they retreated from society in order to come to terms with nature and the universe: to create a garden, to write poetry, to paint.

Under a series of remarkably cultivated emperors, the literati reached the height of their influence during the Song dynasty. Their world was about to change dramatically, however, with lasting results for Chinese art.

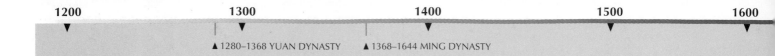

TIMELINE 21-1. China after 1280. After the Mongols invaded China, Kublai Khan established the Yuan dynasty in 1280. Imperial rule continued under the Ming and Qing dynasties that followed until the twentieth century.

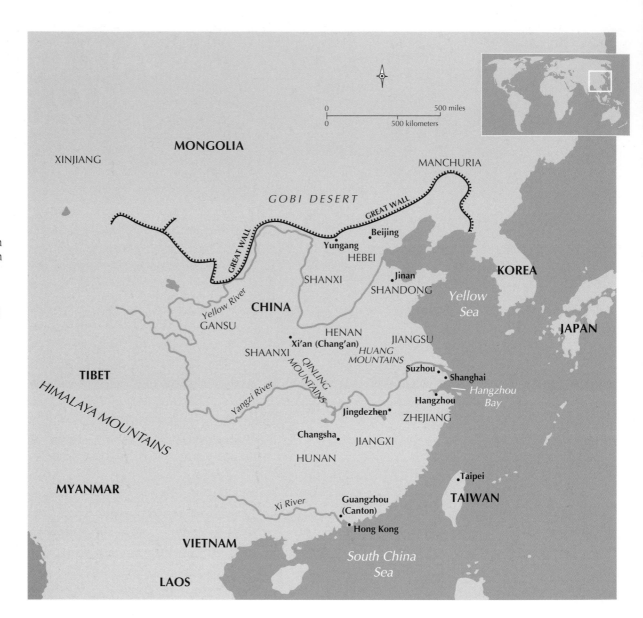

MAP 21-1. China after 1280.
The Qinling Mountains divide China into northern and southern regions with distinctively different climates and cultures.

THE MONGOL INVASIONS

At the beginning of the thirteenth century the Mongols, a nomadic people from the steppelands north of China, began to amass an empire. Led first by Jenghiz Khan (c. 1162–1227), then by his sons and grandsons, they swept westward into central Europe and overran Islamic lands from Central Asia through present-day Iraq. To the east, they quickly captured northern China, and in 1279, led by Kublai Khan, they conquered southern China as well. Grandson of the mighty Jenghiz, Kublai proclaimed himself emperor of China and founder of the Yuan dynasty (1280–1368) (Timeline 21-1).

The Mongol invasions were traumatic, and their effect on China was long lasting. During the Song dynasty, China had grown increasingly reflective. Rejecting foreign ideas and influences, intellectuals had focused on defining the qualities that constituted true "Chinese-ness." They had drawn a clear distinction between their own people, whom they characterized as gentle, erudite, and sophisticated, and the "barbarians" outside China's borders, whom they believed to be crude, wild, and uncultured. Now, faced with the reality of barbarian occupation, China's inward gaze intensified in spiritual resistance. For centuries to come, long after the Mongols had gone, leading scholars continued to seek intellectually more

FOUNDATIONS OF CHINESE CULTURE

Chinese culture is distinguished by its long and continuous development. Between 7000 and 2000 BCE a variety of Neolithic cultures flourished across China. Through long interaction these cultures became increasingly similar, and they eventually gave rise to the three Bronze Age dynastic states with which Chinese history traditionally begins: the legendary Xia, the Shang (c. 1700–1100 BCE), and the Zhou (1100–221 BCE).

The Shang developed traditions of casting ritual vessels in bronze, working jade in ceremonial shapes, and writing consistently in scripts that directly evolved into the modern Chinese written language. Society was stratified, and the ruling group maintained its authority in part by claiming power as shamans, intermediaries between the human and spirit worlds. Shamanistic practices are responsible for the earliest known examples of Chinese writing. Under the Zhou a feudal society developed, with nobles related to the king ruling over numerous small states. During the latter part of the Zhou dynasty, states began to vie for supremacy through intrigue and increasingly ruthless warfare. The collapse of social order inspired China's first philosophers, who largely concerned themselves with the pragmatic question of how to bring about a stable society.

In 221 BCE rulers of the state of Qin triumphed over the remaining states, unifying China as an empire for the first time. The Qin created the mechanisms of China's centralized bureaucracy, but their rule was harsh and the dynasty was quickly overthrown. During the ensuing Han dynasty (206 BCE–220 CE), China at last knew peace and prosperity. Confucianism was made the official state ideology, in the process assuming the form and force of a religion. Developed from the thought of Confucius (551–479 BCE), one of the many philosophers of the Zhou, Confucianism is an ethical system for the management of society based on establishing correct relationships among people. Providing a counterweight was Daoism, which also came into its own during the Han dynasty. Based on the thought of Laozi, a possibly legendary contemporary of Confucius, and the philosopher Zhuangzi (369–286 BCE), Daoism is a kind of nature mysticism that seeks to harmonize the individual with the *Dao*, or Way, of the Universe. Confucianism and Daoism have remained central to Chinese thought—the one addressing the public realm of duty and conformity, the other the private world of individualism and creativity.

Following the collapse of the Han dynasty, China experienced a centuries-long period of disunity (220–589 CE). Invaders from the north and west established numerous kingdoms and dynasties, while a series of six precarious Chinese dynasties held sway in the south. Buddhism, which had begun to filter over trade routes from India during the Han dynasty, now spread widely. The period also witnessed the economic and cultural development of the south (all previous dynasties had ruled from the north).

China was reunited under the Sui dynasty (589–617 CE), which quickly overreached itself and fell to the Tang (618–907 CE), one of the most successful dynasties in Chinese history. Strong and confident, Tang China fascinated and, in turn, was fascinated by the cultures around it. Caravans streamed across Central Asia to the capital, Chang'an, then the largest city in the world. Japan and Korea sent thousands of students to study Chinese culture, and Buddhism reached the height of its influence before a period of persecution signaled the start of its decline.

The mood of the Song dynasty (960–1279 CE) was quite different. The martial vigor of the Tang gave way to a culture of increasing refinement and sophistication, and Tang openness to foreign influences was replaced by a conscious cultivation of China's own traditions. In art, landscape painting emerged as the most esteemed genre, capable of expressing both philosophical and personal concerns. With the fall of the north to invaders in 1126, the Song court set up a new capital in the south, which became the cultural and economic center of the country.

challenging, philosophically more profound, and artistically more subtle expressions of all that could be identified as authentically Chinese.

YUAN DYNASTY

The Mongols established their capital in the northern city now known as Beijing (Map 21-1). The cultural centers of China, however, remained the great cities of the south, where the Song court had been located for the previous 150 years. Combined with the tensions of Yuan rule, this separation of China's political and cultural centers created a new situation dynamic in the arts.

Throughout most of Chinese history, the imperial court had set the tone for artistic taste; artisans attached to the court produced architecture, paintings, gardens, and objects of jade, lacquer, ceramics, and silk especially for imperial use. Over the centuries, painters and calligraphers gradually moved higher up the social scale, for these "arts of the brush" were often practiced as well by scholars and even emperors, whose high status reflected positively on whatever interested them. With the establishment of an imperial painting academy during the Song dynasty, painters finally achieved a status equal to that of court officials. For the literati, painting came to

be grouped with **calligraphy** and poetry as the trio of accomplishments suited to members of the cultural elite.

But while the literati elevated the status of painting by virtue of practicing it, they also began to develop their own ideas of what painting should be. Not needing to earn an income from their art, they cultivated an amateur ideal in which personal expression counted for more than "mere" professional skill. They created for themselves a status as artists totally separate from and superior to professional painters, whose art they felt was inherently compromised, since it was done to please others, and impure, since it was tainted by money.

The conditions of Yuan rule now encouraged a clear distinction between court taste, ministered to by professional artists and artisans, and literati taste. The Yuan continued the imperial role as patron of the arts, commissioning buildings, murals, gardens, paintings, and decorative arts. Western visitors such as the Italian Marco Polo were impressed by the magnificence of the Yuan court (see "Marco Polo," below). But scholars, profoundly alienated from the new government, took no notice of these accomplishments, and thus wrote nothing about them. Nor did Yuan rulers have much use for scholars, especially those from the south. The civil service examinations were abolished, and the highest government positions were bestowed, instead, on Mongols and their foreign allies. Scholars now tended to turn inward, to search for solutions of their own and to try to express themselves in personal and symbolic terms.

Typical of this trend is Zhao Mengfu (1254–1322), a descendant of the imperial line of Song. Unlike many scholars of his time, he eventually chose to serve the Yuan government and was made a high official. A painter, calligrapher, and poet, all of the first rank, Zhao was especially known for his carefully rendered paintings of horses. But he also cultivated another manner, most famous in his landmark painting, *Autumn Colors on the Qiao and Hua Mountains* (fig. 21-2).

Zhao painted this work for a friend whose ancestors came from Jinan, the present-day capital of Shandong

21-2. Zhao Mengfu. Section of *Autumn Colors on the Qiao and Hua Mountains*. Yuan dynasty, 1296. Handscroll, ink and color on paper, 11¼ x 36¾" (28.6 x 93.3 cm). National Palace Museum, Taipei, Taiwan

province, and the painting supposedly depicts the landscape there. Yet the mountains and trees are not painted in the accomplished naturalism of Zhao's own time but rather in the archaic yet oddly elegant manner of the earlier Tang dynasty. The Tang dynasty was a great era in Chinese history, when the country was both militarily strong and culturally vibrant. Through his painting Zhao evoked a nostalgia not only for his friend's distant homeland but also for China's past.

This educated taste for the "spirit of the antiquity" became an important aspect of **literati painting** in later periods. Also typical of literati taste are the unassuming brushwork, the subtle colors sparingly used (many literati paintings forgo color altogether), the use of landscape to convey personal meaning, and even the intended audience—a close friend. The literati did not paint for public display but for each other. They favored small formats such as **handscrolls**, **hanging scrolls**, or **album leaves** (book pages), which could easily be taken to show to friends or to share at small gatherings (see "Formats of Chinese Painting," page 844).

Of the considerable number of Yuan painters who took up Zhao's ideas, several became models for later generations. One such was Ni Zan (1308–74), whose

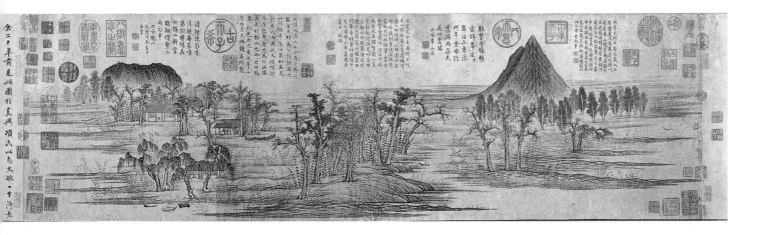

most famous surviving painting is *The Rongxi Studio* (fig. 21-3). Done entirely in ink, the painting depicts the lake region in Ni's home district. Mountains, rocks, trees, and a pavilion are sketched with a minimum of detail using a dry brush technique—a technique in which the brush is not fully loaded with ink but rather about to run out, so that white paper "breathes" through the ragged strokes. The result is a painting with a light touch and a sense of simplicity and purity. Literati styles were believed to reflect the painter's personality. Ni's spare, dry style became associated with a noble spirit, and many later painters adopted it or paid homage to it.

Ni Zan was one of those eccentrics whose behavior has become legendary in the history of Chinese art. In his early years he was one of the richest men in the region, the owner of a large estate. His pride and his aloofness from daily affairs often got him into trouble with the authorities. His cleanliness was notorious. In addition to washing himself several times daily, he also ordered his servants to wash the trees in his garden and to clean the furniture after his guests had left. He was said to be so unworldly that late in life he gave away most of his possessions and lived as a hermit in a boat, wandering on rivers and lakes.

21-3. Ni Zan. *The Rongxi Studio*. Yuan dynasty, 1372. Hanging scroll, ink on paper, height 29³/₈" (74.6 cm). National Palace Museum, Taipei, Taiwan

The idea that a painting is not done to capture a likeness or to satisfy others but is executed freely and carelessly for the artist's own amusement is at the heart of the literati aesthetic. Ni Zan once wrote this comment on a painting: "What I call painting does not exceed the joy of careless sketching with a brush. I do not seek formal likeness but do it simply for my own amusement. Recently I was rambling about and came to a town. The people asked for my pictures, but wanted them exactly according to their own desires and to represent a specific occasion. [When I could not satisfy them,] they went away insulting, scolding, and cursing in every possible way. What a shame! But how can one scold a eunuch for not growing a beard?" (cited in Bush and Shih, page 266).

TECHNIQUE

FORMATS OF CHINESE PAINTING

With the exception of large wall paintings that typically decorated palaces, temples, and tombs, most Chinese paintings were done in ink and water-based colors on silk or paper. Finished works were generally mounted on silk as a **handscroll**, a **hanging scroll**, or leaves in an **album**.

An album comprises a set of paintings of identical size mounted in an accordion-fold book. (A single painting from an album is called an **album leaf**.) The paintings in an album are usually related in subject, such as various views of a famous site or a series of scenes glimpsed on one trip.

Album-sized paintings might also be mounted as a handscroll, a horizontal format generally about 12 inches high and anywhere from a few feet to dozens of feet long. More typically, however, a handscroll would be a single continuous painting. Handscrolls were not meant to be displayed all at once, the way they are commonly presented today in museums. Rather, they were unrolled only occasionally, to be savored in much the same spirit as we might put a favorite film in the VCR. Placing the scroll on a flat surface such as a table, a viewer would unroll it a foot or two at a time, moving gradually through the entire scroll from right to left, lingering over favorite details. The scroll was then rolled up and returned to its box until the next viewing.

Like handscrolls, hanging scrolls were not displayed permanently but were taken out for a limited time—a day, a week, a season. Unlike a handscroll, however, the painting on a hanging scroll was viewed as a whole, unrolled and put up on a wall, with the roller at the lower end acting as a weight to help the scroll hang flat. Although some hanging scrolls are quite large, they are still fundamentally intimate works, not intended for display in a public place.

Creating a scroll was a time-consuming and exacting process. The painting was first backed with paper to strengthen it. Next, strips of paper-backed silk were pasted to the top, bottom, and sides, framing the painting on all four sides. Additional silk pieces were added to extend the scroll horizontally or vertically, depending on the format. The assembled scroll was then backed again with paper and fitted with a half-round dowel, or wooden rod, at the top (of a hanging scroll) or right end (of a handscroll), with ribbons for hanging and tying, and with a wooden roller at the other end. Hanging scrolls were often fashioned from several patterns of silk, and a variety of piecing formats were developed and codified. On a handscroll, a painting was generally preceded by a panel giving the work's title and often followed by a long panel bearing **colophons**—inscriptions related to the work, such as poems in its praise or comments by its owners over the centuries. A scroll would be remounted periodically to better preserve it, and colophons and inscriptions would be preserved in each remounting.

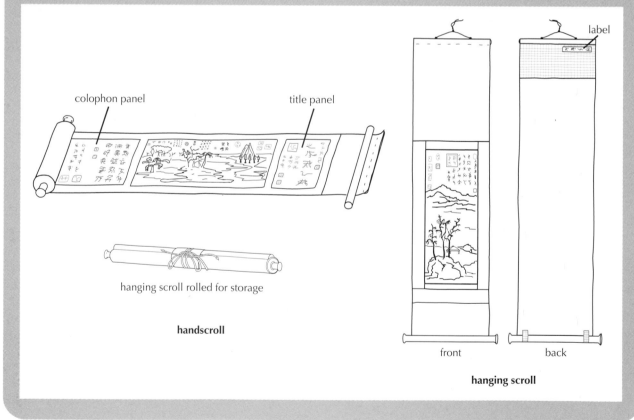

colophon panel

title panel

hanging scroll rolled for storage

handscroll

label

front

back

hanging scroll

Whether these stories are true or not, they were important elements of Ni's legacy to later painters, for Ni's life as well as his art served as a model. The painting of the literati was bound up with certain views about what constituted an appropriate life. The ideal, as embodied by Ni Zan and others, was of a brilliantly gifted scholar whose spirit was too refined for the dusty world of government service and who thus preferred to live as a recluse, or as one who had retired after having become frustrated by a brief stint as an official.

21-4. Yin Hong. *Hundreds of Birds Admiring the Peacocks*. Ming dynasty, c. late 15th–early 16th century. Hanging scroll, ink and color on silk, 7'10½" x 6'5" (2.4 x 1.96 m). The Cleveland Museum of Art

Purchase from the J. H. Wade Fund, 74.31

MING DYNASTY

The founder of the next dynasty, the Ming (1368–1644), came from a family of poor uneducated peasants. As he rose through the ranks in the army, he enlisted the help of scholars to gain power and solidify his following. Once he had driven the Mongols from Beijing and firmly established himself as emperor, however, he grew to distrust intellectuals. His rule was despotic, even ruthless. Throughout the nearly 300 years of Ming rule, most emperors shared his attitude, so although the civil service examinations were reinstated, scholars remained alienated from the government they were trained to serve.

COURT AND PROFESSIONAL PAINTING

The contrast between the luxurious world of the court and the austere ideals of the literati continued through the Ming dynasty. A typical example of Ming court taste is *Hundreds of Birds Admiring the Peacocks*, a large painting on silk by Yin Hong, an artist active during the late fifteenth and early sixteenth centuries (fig. 21-4). A pupil of some well-known courtiers, Yin most probably served in the court at Beijing. The painting is an example of the birds-and-flowers **genre**, which had been popular with artists of the Song academy. Here the subject takes on symbolic

21-5. Qiu Ying. Section of *Spring Dawn in the Han Palace*. Ming dynasty, first half of the 16th century. Handscroll, ink and color on silk, 1' x 18'¹³/₁₆" (0.30 x 5.7 m). National Palace Museum, Taipei, Taiwan

meaning, with the homage of the birds to the peacocks representing the homage of court officials to the emperor. The decorative style goes back to Song academy models as well, although the large format and multiplication of details are traits of the Ming.

The preeminent professional painter in the Ming period was Qiu Ying (1494–1552), who lived in Suzhou, a prosperous southern city. He inspired generations of imitators with exceptional works, such as a long handscroll known as *Spring Dawn in the Han Palace* (fig. 21-5). The painting is based on Tang dynasty depictions of women in the court of the Han dynasty (206 BCE–220 CE). While in the service of a well-known collector, Qiu Ying had the opportunity to study many Tang paintings, whose artists usually concentrated on the figures, leaving out the background entirely. Qiu's graceful and elegant figures—although modeled after those in Tang works—are portrayed in a setting of palace buildings, engaging in such pastimes as chess, music, calligraphy, and painting. With its antique subject matter, refined technique, and flawless taste in color and composition, *Spring Dawn in the Han Palace* brought professional painting to a new high point.

DECORATIVE ARTS AND GARDENS

Qiu Ying painted to satisfy his patrons in Suzhou. The cities of the south were becoming wealthy, and newly rich merchants collected paintings, antiques, and art objects. The court, too, was prosperous and patronized the arts on a lavish scale. In such a setting, the decorative arts thrived.

Like the Song dynasty before it, the Ming has become famous the world over for its exquisite ceramics, especially **porcelain** (see "The Secret of Porcelain," below). The imperial **kilns** in Jingdezhen, in Jiangxi province, became the most renowned center for porcelain not only in all of China but eventually in all the world. Particularly noteworthy are the blue-and-white wares produced there during the ten-year reign of the ruler known as the Xuande emperor (ruled 1425–35), such as the flask in figure 21-6. The subtle shape, the refined yet vigorous decoration of dragons writhing in the sea, and the flawless **glazing** embody the high achievement of Ming artisans.

Chinese furniture, made mainly for domestic use, reached the height of its development in the sixteenth

THE SECRET OF PORCELAIN Marco Polo, it is said, was the one who named a new type of ceramic he found in China. Its translucent purity reminded him of the smooth whiteness of the cowry shell, *porcellana* in Italian. **Porcelain** is made from kaolin, an extremely refined white clay, and petuntse, a variety of the mineral feldspar. When properly combined and fired at a sufficiently high temperature, the two materials fuse into a glasslike, translucent ceramic that is far stronger than it looks.

Porcelaneous stoneware, fired at lower temperatures, was known in China by the seventh century, but true porcelain emerged during the Song dynasty. To create blue-and-white porcelain such as the flask in figure 21-6, blue pigment was made from cobalt oxide, finely ground and mixed with water. The decoration was painted directly onto the unfired porcelain vessel, then a layer of clear glaze was applied over it. (In this technique, known as underglazing, the pattern is painted beneath the glaze.) After firing, the piece emerged from the kiln with a clear blue design set sharply against a snowy white background.

Entranced with the exquisite properties of porcelain, European potters tried for centuries to duplicate it. The technique was finally discovered in 1708 by Johann Friedrich Böttger in Dresden, Germany, who tried—but failed—to keep it a secret.

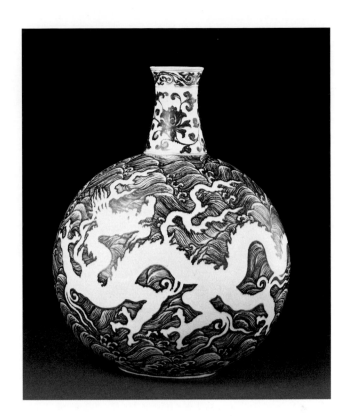

21-6. Flask. Ming dynasty, c. 1426–35. Porcelain with blue underglaze decoration. Palace Museum, Beijing

Dragons have featured prominently in Chinese folklore from earliest times—Neolithic examples have been found painted on pottery and carved in jade. In Bronze Age China, dragons came to be associated with powerful and sudden manifestations of nature, such as wind, thunder, and lightning. At the same time, dragons became associated with superior beings such as virtuous rulers and sages. With the emergence of China's first firmly established empire during the Han dynasty, the dragon was appropriated as an imperial symbol, and it remained so throughout Chinese history. Dragon sightings were duly recorded and considered auspicious. Yet even the Son of Heaven could not monopolize the dragon. During the Tang and Song dynasties the practice arose of painting pictures of dragons to pray for rain, and for Chan (Zen) Buddhists, the dragon was a symbol of sudden enlightenment.

and seventeenth centuries. Characteristic of Chinese furniture, the chair in figure 21-7 is constructed without the use of glue or nails. Instead, pieces fit together based on the principle of the **mortise-and-tenon joint**, in which a projecting element (tenon) on one piece fits snugly into a cavity (mortise) on another. Each piece of the chair is carved, as opposed to being bent or twisted, and the joints are crafted with great precision. The patterns of the wood grain provide subtle interest unmarred by any painting or other embellishment. The style, like that of Chinese architecture, is one of simplicity, clarity, symmetry, and balance. The effect is formal and dignified but natural and simple—virtues central to the Chinese view of proper human conduct as well.

The art of landscape gardening also reached a high point during the Ming dynasty, as many literati surrounded their homes with gardens. The most famous gardens were created in the southern cities of the Yangzi River (Chang Jiang) delta, especially Suzhou. The largest surviving garden of the era is the Garden of the Cessation of Official Life, with which this chapter opened (see fig. 21-1). Although modified and reconstructed many times through the centuries, it still reflects many of the basic ideas of the original Ming owner. About a third of the 3-acre garden is devoted to water through artificially created brooks and ponds. The landscape is dotted with pavilions, kiosks, libraries, studios, and corridors. Many of the buildings have poetic names, such as Rain Listening Pavilion and Bridge of the Small Flying Rainbow.

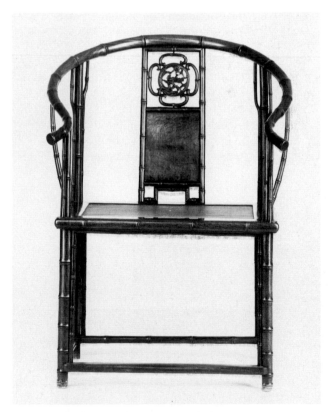

21-7. Armchair. Ming dynasty, l6th–17th century. Huanghuali wood (hardwood), 39³⁄₈ x 27¹⁄₄ x 20" (100 x 69.2 x 50.8 cm). The Nelson-Atkins Museum of Art, Kansas City, Missouri
Purchase, Nelson Trust (46-78/1)

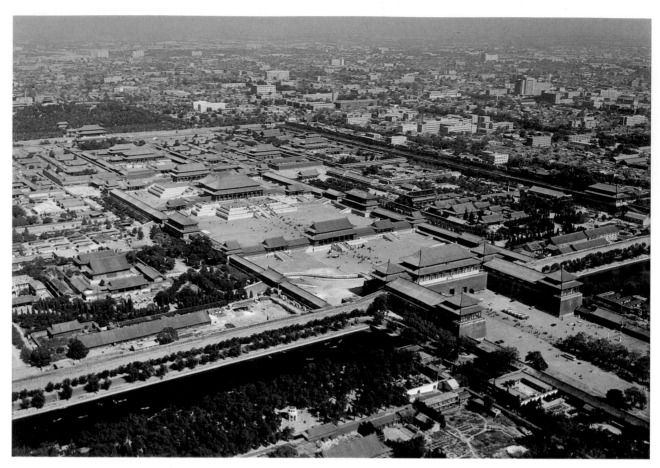

21-8. The Forbidden City, now the Palace Museum, Beijing. Mostly Ming dynasty. View from the southwest

ARCHITECTURE AND CITY PLANNING

Centuries of warfare and destruction have left very few Chinese architectural monuments intact. The most important remaining example of traditional Chinese architecture is the Forbidden City, the imperial palace compound in Beijing, whose principal buildings were constructed during the Ming dynasty (fig. 21-8).

The basic plan of Beijing was the work of the Mongols, who laid out their capital city according to traditional Chinese principles. City planning began early in China—in the seventh century, in the case of Chang'an (present-day Xi'an), the capital of the Sui and Tang emperors (see "Geomancy, Cosmology, and Chinese Architecture," page 850). The walled city of Chang'an was laid out on a rectangular grid, with evenly spaced streets that ran north-south and east-west. At the northern end stood a walled imperial complex.

Beijing, too, was developed as a walled, rectangular city with streets laid out in a grid. The palace enclosure occupied the center of the northern part of the city, which was reserved for the Mongols. Chinese lived in the southern third of the city. Later Ming and Qing emperors preserved this division, with officials living in the northern or Inner City and commoners living in the southern or Outer City. Under the third Ming emperor, Yongle (ruled 1402–24), the Forbidden City was rebuilt as we see it today.

The approach to the Forbidden City was impressive,

and it was meant to be. Visitors entered through the Meridian Gate, a monumental U-shaped gate (at the right in fig. 21-8). Inside the Meridian Gate a broad courtyard is crossed by a bow-shaped waterway that is spanned by five arched marble bridges. At the opposite end of the courtyard is the Gate of Supreme Harmony, opening onto an even larger courtyard that houses three ceremonial halls raised on a broad platform. First is the Hall of Supreme Harmony, where, on the most important state occasions, the emperor was seated on his throne, facing south. Beyond is the smaller Hall of Central Harmony, then the Hall of Protecting Harmony. Behind these vast ceremonial spaces, still on the central axis, is the inner court, again with a progression of three buildings, this time more intimate in scale. In its balance and symmetry the plan of the Forbidden City reflects ancient Chinese beliefs about the harmony of the universe, and it emphasizes the emperor's role as the Son of Heaven, whose duty was to maintain the cosmic order from his throne in the middle of the world.

LITERATI PAINTING

In the south, especially in the district of Suzhou, literati painting remained the dominant trend. One of the major literati figures from the Ming period is Shen Zhou (1427–1509), who had no desire to enter government service and spent most of his life in Suzhou. He studied the

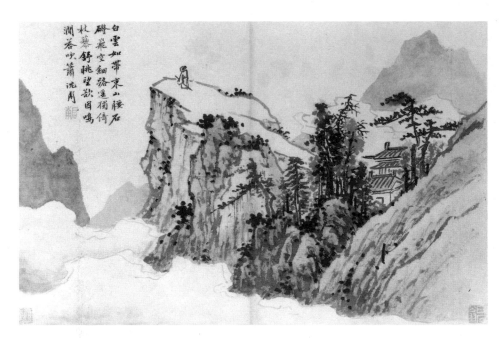

21-9. Shen Zhou. *Poet on a Mountain Top*, leaf from an album of landscapes; painting mounted as part of a handscroll. Ming dynasty, c. 1500. Ink and color on paper, 15¼ x 23¾" (38.1 x 60.2 cm). The Nelson-Atkins Museum of Art, Kansas City, Missouri Purchase, Nelson Trust (46-51/2)

The poem at the upper left reads:

> White clouds like a belt encircle the mountain's waist
>
> A stone ledge flying in space and the far thin road.
>
> I lean alone on my bramble staff and gazing contented into space
>
> Wish the sounding torrent would answer to your flute.

(Translated by Richard Edwards, cited in *Eight Dynasties of Chinese Paintings*, page 185)

Shen Zhou composed the poem and the inscription, written at the time he painted the album. The style of the calligraphy, like the style of the painting, is informal, relaxed, and straightforward—qualities that were believed to reflect the artist's character and personality.

Yuan painters avidly and tried to recapture their spirit in such works as *Poet on a Mountain Top* (fig. 21-9). Although the style of the painting recalls the freedom and simplicity of Ni Zan (see fig. 21-3), the motif of a poet surveying the landscape from a mountain plateau is Shen's creation.

In earlier landscape paintings, human figures were typically shown dwarfed by the grandeur of nature. Travelers might be seen scuttling along a narrow path by a stream, while overhead towered mountains whose peaks conversed with the clouds and whose heights were inaccessible. Here, the poet has climbed the mountain and dominates the landscape. Even the clouds are beneath him. Before his gaze, a poem hangs in the air, as though he were projecting his thoughts. The painting reflects Ming philosophy, which held that the mind, not the physical world, was the basis for reality. With its perfect synthesis of poetry, calligraphy, and painting, and its harmony of mind and landscape, *Poet on a Mountain Top* represents the essence of literati painting.

The ideas underlying literati painting found their most influential expression in the writings of Dong Qichang (1555–1636). A high official in the late Ming dynasty, Dong Qichang embodied the literati tradition as poet, calligrapher, and painter. He developed a view of Chinese art history that divided painters into two opposing schools, northern and southern. The names have nothing to do with geography—a painter from the south might well be classed as northern—but reflect a parallel Dong drew to the northern and southern schools of Chan (Zen) Buddhism in China. The southern school of Chan, founded by the eccentric monk Huineng (638–713), was unorthodox, radical, and innovative; the northern school was traditional and conservative. Similarly, Dong's two schools of painters represented conservative and progressive traditions. In Dong's view the conservative northern school was dominated by professional painters whose academic, often decorative style emphasized technical skill. In contrast, the progressive southern school

GEOMANCY, COSMOLOGY, AND CHINESE ARCHITECTURE

Geomancy is a form of divination that looks for signs in the topography of the earth. In China it has been known from ancient times as *feng shui*, or "wind and water." Still practiced today, *feng shui* assesses *qi*, the primal energy that is believed to flow through creation, to determine whether a site is suitably auspicious for building. *Feng shui* also advises on improving a site's *qi* through landscaping, planting, creating waterways, and building temples and pagodas.

One important task of *feng shui* in the past was selecting auspicious sites for imperial tombs. These were traditionally set in a landscape of hills and winding paths, protected from harmful spiritual forces by a hill to the rear and a winding waterway crossed by arched bridges in front. *Feng shui* was also called on to find and enhance sites for homes, towns, and, especially, imperial cities. The Forbidden City, for example, is "protected" by a hill outside the north wall and a bow-shaped watercourse just inside the entrance.

The layout of imperial buildings was as important as their site and reflected ancient principles of cosmology—ideas about the structure and workings of the universe. Since the Zhou dynasty (1100–221 BCE) the emperor had ruled as the Son of Heaven. If he was worthy and right-acting, it was believed, all would go well in nature and the cosmos. But if he was not, cosmic signs, natural disasters, and human rebellions would make clear that Heaven had withdrawn his dynasty's mandate to rule—traditional histories explained the downfall of a dynasty in just these terms.

Architecture played a major role in expressing this link between imperial and cosmic order. As early as Zhou times, cities were oriented on a north-south axis and built as a collection of enclosures surrounded by a defensive wall. The first imperial city of which we have any substantial knowledge, however, is Chang'an, the capital of the Tang dynasty (618–907 CE). Chang'an was a walled city laid out on a rectangular grid measuring 5 miles by 6 miles. At the north end was an imperial enclosure. The palace within faced south, symbolic of the emperor looking out over his city and, by extension, his realm. This orientation was already traditional by Tang times. Chinese rulers—and Chinese buildings—had always turned their backs to the north, whence came evil spirits. Confucius even framed his admiration for one early Zhou ruler by saying that all he needed to do to govern was to assume a respectful position and face south, so attuned was he to Heaven's way.

A complex of government buildings stood in front of the imperial compound, and from them a 500-foot-wide avenue led to the city's principal southern gate. The city streets ran north-south and east-west. Each of the resulting 108 blocks was like a miniature city, with its own interior streets, surrounding walls, and gates that were locked at night. Two large markets to the east and west were open at specified hours. Such was the prestige of China during the Tang dynasty that the Japanese modeled their imperial capitals at Nara (built in 710 CE) and Heian (Kyoto, built in 794 CE) on Chang'an, though without the surrounding walls.

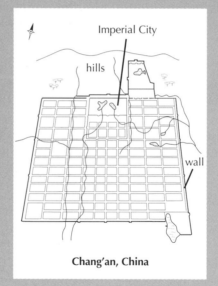

Chang'an, China

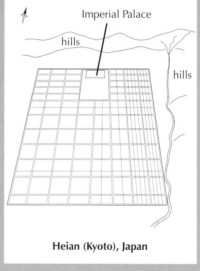

Heian (Kyoto), Japan

preferred ink to color and free brushwork to meticulous detail. Its painters aimed for poetry and personal expression. In promoting this theory, Dong gave his unlimited sanction to literati painting, which he positioned as the culmination of the southern school, and he fundamentally influenced the way the Chinese viewed their own tradition.

Dong Qichang summarized his views on the proper training for literati painters in the famous statement "Read ten thousand books and walk ten thousand miles." By this he meant that one must first study the works of the great masters, then follow "heaven and earth," the world of nature. These studies prepared the way for greater self-expression through brush and ink, the goal of literati painting. Dong's views rested on an awareness that a painting of scenery and the actual scenery are two very different things. The excellence of a painting does not lie in its degree of resemblance to reality—that gap can never be bridged—but in its expressive power. The expressive language of painting is inherently abstract and lies in its nature as a construction of brushstrokes. For example, in a painting of a rock, the rock itself is not expressive; rather, the brushstrokes that add up to "rock" are expressive.

With such thinking Dong brought painting close to the realm of calligraphy, which had long been considered the highest form of artistic expression in China. More than a thousand years before Dong's time, a body of critical terms and theories had evolved to discuss calligraphy in light of the formal and expressive properties of brushwork and

composition. Dong introduced some of these terms—ideas such as opening and closing, rising and falling, and void and solid—to the criticism of painting.

Dong's theories are fully embodied in his painting *The Qingbian Mountains* (fig. 21-10). According to Dong's own inscription, the painting was based on a work by the tenth-century artist Dong Yuan. Dong Qichang's style, however, is quite different from the masters he admired. Although there is some indication of foreground, middle ground, and distant mountains, the space is ambiguous, as if all the elements were compressed to the surface of the picture. With this flattening of space, the trees, rocks, and mountains become more readily legible in a second way, as semiabstract forms made of brushstrokes.

Six trees diagonally arranged on a boulder define the extreme foreground and announce themes that the rest of the painting repeats, varies, and develops. The tree on the left, with its outstretched branches and full foliage, is echoed first in the shape of another tree just across the river and again in a tree farther up and toward the left. The tallest tree of the foreground grouping anticipates the high peak that towers in the distance almost directly above it. The forms of the smaller foreground trees, especially the one with dark leaves, are repeated in numerous variations across the painting. At the same time, the simple and ordinary-looking boulder in the foreground is transformed in the conglomeration of rocks, ridges, hills, and mountains above. This double reading, both abstract and representational, parallels the work's double nature as a painting of a landscape and an interpretation of a traditional landscape painting.

The influence of Dong Qichang on the development of Chinese painting of later periods cannot be overstated. Indeed, nearly all Chinese painters since the early seventeenth century have reflected his ideas in one way or another.

QING DYNASTY

In 1644, when the armies of the Manchu people to the northeast of China marched into Beijing, many Chinese reacted as though the world had come to an end. However, the situation turned out to be quite different from the Mongol invasions three centuries earlier. The Manchu had already adopted many Chinese customs and institutions before their conquest. After gaining control of all of China, they showed great respect for Chinese tradition. In art, all the major trends of the late Ming dynasty continued almost without interruption into the Manchu, or Qing, dynasty (1644–1911).

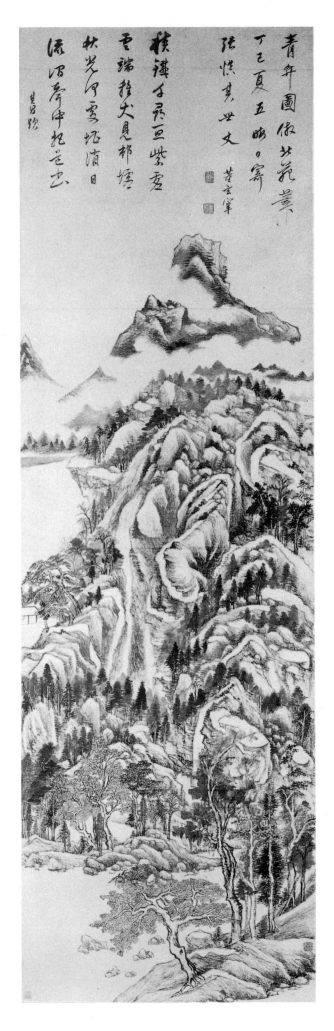

21-10. **Dong Qichang.** *The Qingbian Mountains.* Ming dynasty, 1617. Hanging scroll, ink on paper, 21'8" x 7'4 3/8" (6.72 x 2.25 m). The Cleveland Museum of Art
Leonard C. Hanna, Jr., Bequest, 80.10

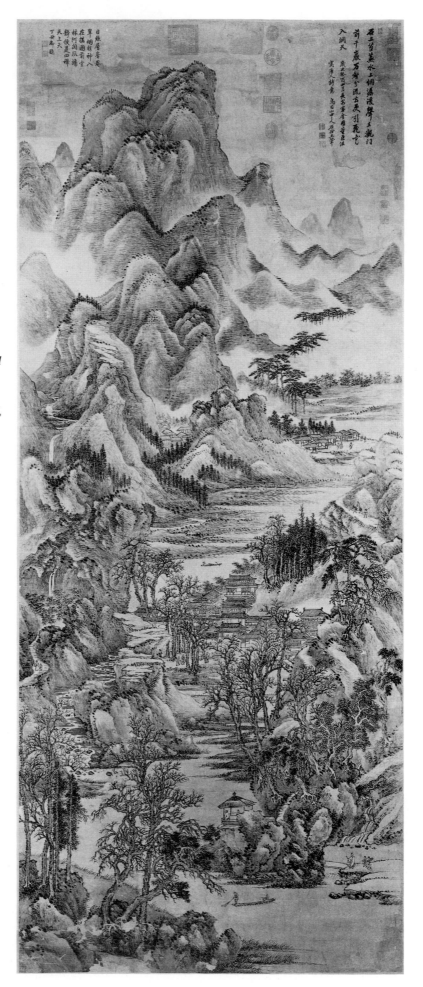

21-11. Wang Hui. *A Thousand Peaks and Myriad Ravines.* Qing dynasty, 1693. Hanging scroll, ink on paper, 8'2¹/₂" x 3'4¹/₂" (2.54 x 1.03 m). National Palace Museum, Taipei, Taiwan

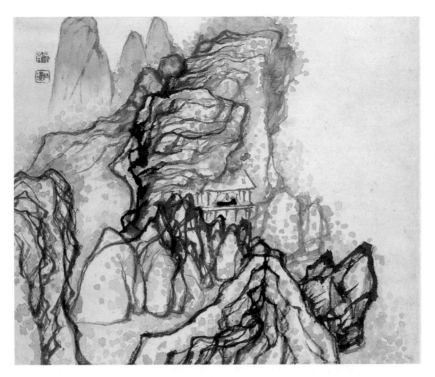

21-12. Shitao. *Landscape*, leaf from an album of landscapes. Qing dynasty, c. 1700. Ink and color on paper, 9½ x 11" (24.1 x 28 cm)

Collection C. C. Wang family

ORTHODOX PAINTING

Literati painting was by now established as the dominant tradition; it had become orthodox. Scholars followed Dong Qichang's recommendation and based their approach on the study of past masters, and they painted large numbers of works in the manner of Song and Yuan artists as a way of expressing their learning, technique, and taste.

The grand, symphonic composition *A Thousand Peaks and Myriad Ravines* (fig. 21-11), painted by Wang Hui (1632–1717) in 1693, exemplifies all the basic elements of Chinese landscape painting: mountains, rivers, waterfalls, trees, rocks, temples, pavilions, houses, bridges, boats, wandering scholars, fishers—the familiar and much loved cast of actors from a tradition now many centuries old. At the upper right corner, the artist has written:

> Moss and weeds cover the rocks and mist hovers
> over the water.
> The sound of dripping water is heard in front of the
> temple gate.
> Through a thousand peaks and myriad ravines the
> spring flows,
> And brings the flying flowers into the sacred caves.

> In the fourth month of the year 1693, in an inn in the capital, I painted this based on a Tang dynasty poem in the manner of [the painters] Dong [Yuan] and Ju [ran].

> (Translated by Chu-tsing Li)

This inscription shares Wang Hui's complex thoughts as he painted this work. In his mind were both the lines of the Tang dynasty poet Li Cheng, which offered the subject, and the paintings of the tenth-century masters Dong

Yuan and Juran, which inspired his style. The temple the poem asks us to imagine is nestled on the right bank in the middle distance, but the painting shows us the scene from afar, as when a film camera pulls slowly away from some small human drama until its actors can barely be distinguished from the great flow of nature. Giving viewers the experience of dissolving their individual identity in the cosmic flow had been a goal of Chinese landscape painting since its first era of greatness during the Song dynasty.

All the Qing emperors of the late seventeenth and eighteenth centuries were painters themselves. They collected literati painting, and their conservative taste was shaped mainly by artists such as Wang Hui. Thus literati painting, long associated with reclusive scholars, ultimately became an academic style practiced at court.

INDIVIDUALIST PAINTING

In the long run, the Manchu conquest was not a great shock for China as a whole. But its first few decades were both traumatic and dangerous for those who were loyal—or worse, related—to the Ming. Some committed suicide, while others sought refuge in monasteries or wandered the countryside. Among them were several painters who expressed their anger, defiance, frustration, and melancholy in their art. They took Dong Qichang's idea of painting as an expression of the artist's personal feelings very seriously and cultivated highly original styles. These painters have become known as the individualists.

One of the individualists was Shitao (1642–1707), who was descended from the first Ming emperor and who took refuge in Buddhist temples when the dynasty fell. In his later life he brought his painting to the brink of abstraction in such works as *Landscape* (fig. 21-12). A monk sits in a small hut, looking out onto mountains that seem to be in

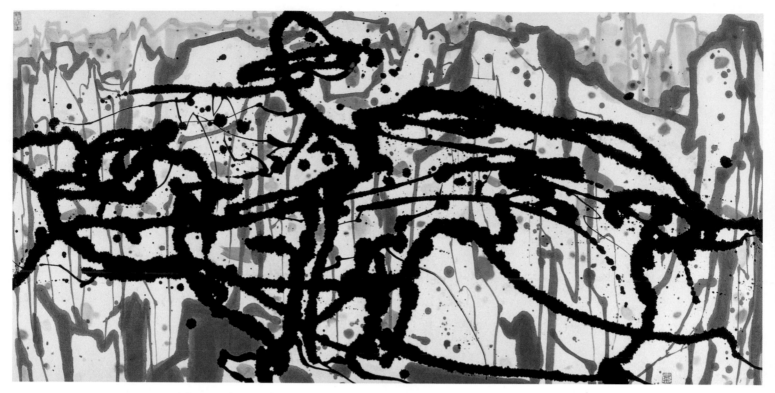

21-13. **Wu Guanzhong.** *Pine Spirit*. 1984. Ink and color on paper, 2'3⅝" x 5'3½" (0.70 x 1.61 m). Spencer Museum of Art, The University of Kansas, Lawrence

Gift of the E. Rhodes and Leonard B. Carpenter Foundation

turmoil. Dots, used for centuries to indicate vegetation on rocks, here seem to have taken on a life of their own. The rocks also seem alive—about to swallow up the monk and his hut. Throughout his life Shitao continued to identify himself with the fallen Ming, and he felt that his secure world had turned to chaos with the Manchu conquest.

THE MODERN PERIOD In the mid- and late nineteenth century, China was shaken from centuries of complacency by a series of crushing military defeats by Western powers and Japan. Only then did the government finally realize that these new rivals were not like the Mongols of the thirteenth century. China was no longer at the center of the world, a civilized country surrounded by "barbarians." Spiritual resistance was no longer enough to solve the problems brought on by change. New ideas from Japan and the West began to filter in, and the demand arose for political and cultural reforms. In 1911 the Qing dynasty was overthrown, ending 2,000 years of imperial rule, and China was reconceived as a republic.

During the first decades of the twentieth century Chinese artists traveled to Japan and Europe to study Western art. Returning to China, many sought to introduce the ideas and techniques they had learned and explored ways to synthesize the Chinese and the Western traditions. After the establishment of the present-day Communist government in 1949, individual artistic freedom

was curtailed as the arts were pressed into the service of the state and its vision of a new social order. After 1979, however, cultural attitudes began to relax, and Chinese painters again pursued their own paths.

One artist who emerged during the 1980s as a leader in Chinese painting is Wu Guanzhong (b. 1919). Combining his French artistic training and Chinese background, Wu Guanzhong has developed a semiabstract style to depict scenes from the Chinese landscape. His usual method is to make preliminary sketches on site, then, back in his studio, to develop them into free interpretations based on his feeling and vision. An example of his work, *Pine Spirit*, depicts a scene in the Huang (Yellow) Mountains (fig. 21-13). The technique, with its sweeping gestures of paint, is clearly linked to Abstract Expressionism, an influential Western movement of the post–World War II years (Chapter 29); yet the painting also claims a place in the long tradition of Chinese landscape as exemplified by such masters as Shitao.

Like all aspects of Chinese society, Chinese art has felt the strong impact of Western influence, and the question remains whether Chinese artists will absorb Western ideas without losing their traditional identity. Interestingly, landscape remains the most popular subject, as it has been for more than a thousand years. Using the techniques and methods of the West, China's painters still seek spiritual communion with nature through their art as a means to come to terms with human life and the world.

PARALLELS

PERIOD	CHINESE ART	ART IN OTHER CULTURES
YUAN DYNASTY 1280–1368	**21-2. Zhao Mengfu.** *Autumn Colors on the Qiao and Hua Mountains* (1296) **21-3. Ni Zan.** *The Rongxi Studio* (1372) 	**24-1. Ancestor figures** (c. 1000–1500), Polynesia **20-4. Minakshi-Sundareshvara Temple** (begun 13th cent.), India
MING DYNASTY 1368–1644	**21-6. Ming flask** (c. 1426–35) **21-4. Yin Hong.** *Hundreds of Birds Admiring the Peacocks* (c. late 15th–early 16th cent.) **21-9. Shen Zhou.** *Poet on a Mountain Top* (c. 1500) **21-5. Qiu Ying.** *Spring Dawn in the Han Palace* (early 16th cent.) **21-8. Forbidden City, Beijing** (mostly Ming) **21-1. Cessation of Official Life garden** (early 16th cent.) **21-7. Ming armchair** (16th–17th cent.) **21-10. Dong Qichang.** *The Qingbian Mountains* (1617)	**17-14. Van Eyck. Arnolfini wedding portrait** (1434), Belgium **18-2. Leonardo.** *Last Supper* (1495-98), Italy **18-11. Michelangelo.** *David* (1501–4), Italy **22-7. Juko-in screens** (c. 1563–73), Japan **18-70. El Greco.** *Burial of Count Orgaz* (1586), Spain **19-3. Bernini. St. Peter's Piazza** (1607), Italy **20-7. Taj Mahal** (c. 1632–48), India
QING DYNASTY 1644–1911	**21-11. Wang Hui.** *A Thousand Peaks and Myriad Ravines* (1693) **21-12. Shitao.** *Landscape* (c. 1700) 	**23-19. Taos Pueblo** (c. 1700), North America **28-21. Picasso.** *Les Demoiselles d'Avignon* (1907), France **28-41. Gilbert. Woolworth Bldg.** (1911–13), US
MODERN PERIOD 1911–PRESENT	**21-13. Wu Guanzhong.** *Pine Spirit* (1984) 	

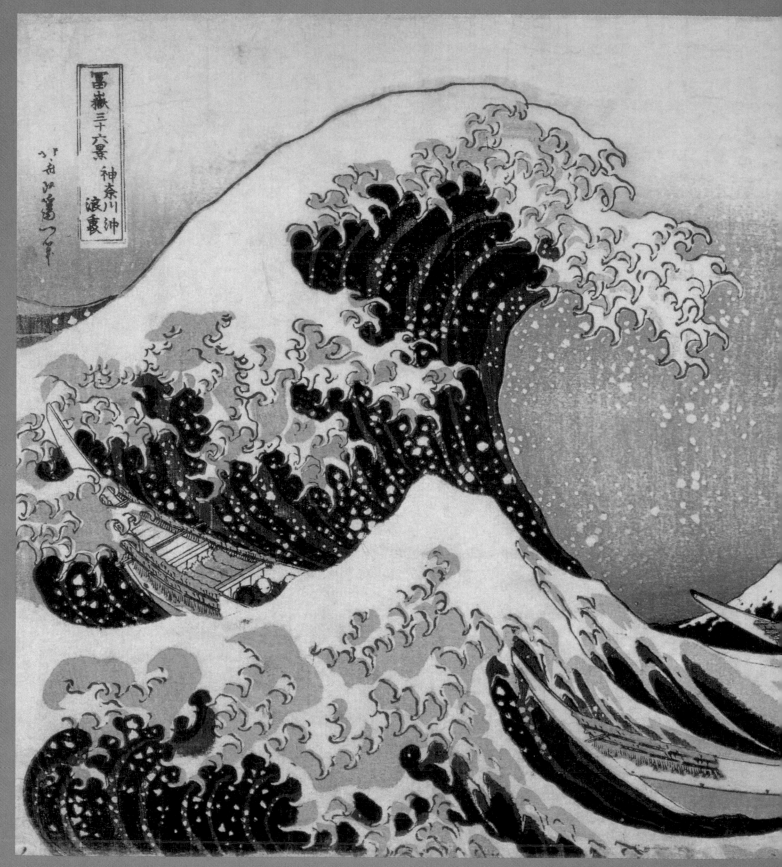

22-1. Katsushika Hokusai. *The Great Wave.* Edo period, c. 1831. Polychrome woodblock print on paper, $9\frac{7}{8}$ x $14\frac{5}{8}$" (25 x 37.1 cm). Honolulu Academy of Arts, Honolulu, Hawaii

James A. Michener Collection (HAA 13, 695)

22
Japanese Art after 1392

The great wave rears up like a dragon with claws of foam, ready to crash down on the figures huddled in the boat below. Exactly at the point of imminent disaster, but far in the distance, rises Japan's most sacred peak, Mount Fuji, whose slopes, we suddenly realize, swing up like waves and whose snowy crown is like foam—comparisons the artist makes clear in the wave nearest us, caught just at the moment of greatest resemblance.

If one were forced to choose a single work of art to represent Japan, at least in the world's eye, it would have to be this woodblock print, popularly known as *The Great Wave*, by Katsushika Hokusai (fig. 22-1). Taken from his series called *Thirty-Six Views of Fuji*, it has inspired countless imitations and witty parodies, yet its forceful composition remains ever fresh.

Today, Japanese color woodblock prints of the eightennth and nineteenth centuries are collected avidly around the world, but in their own day they were barely considered art. Commercially produced by the hundreds for ordinary people to buy, they were the fleeting secular souvenirs of their era, one of the most fascinating in Japanese history. Not until the twentieth century would the West experience anything like the pluralistic cultural atmosphere, in which so many diverse groups participate in and contribute to a common culture, as the one that produced *The Great Wave*.

▲ 1392–1568 MUROMACHI ▲ 1568–1603 MOMOYAMA

▲ 1603–1868 EDO

TIMELINE 22-1. Japan after 1392. Japan's centuries of isolation ended with the Meiji Restoration in 1868, ushering in the modern era.

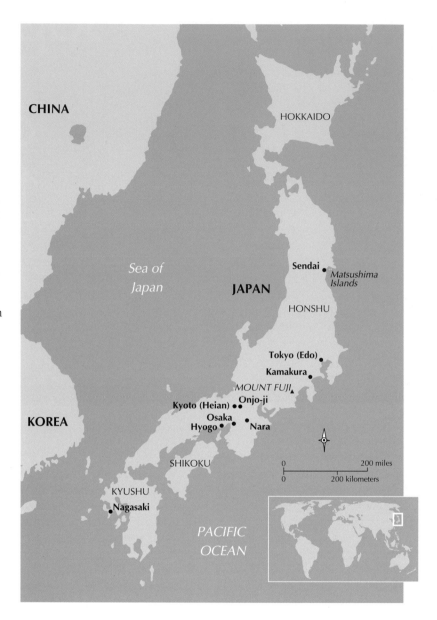

MAP 22-1. Japan after 1392. Ideas and artistic influences from the Asian continent flowed to Japan before and after the island nation's self-imposed isolation from the 17th to the 19th century.

MUROMACHI PERIOD

By the year 1392, Japanese art had already developed a long and rich history (see "Foundations of Japanese Culture," opposite). Beginning with prehistoric pottery and tomb art, then expanding through cultural influences from China and Korea, Japanese visual expression reached high levels of sophistication in both religious and secular arts. Very early in the tradition, a particularly Japanese aesthetic emerged, including a love of natural materials, a taste for asymmetry, a sense of humor, and a tolerance for qualities that may seem paradoxical or contradictory—characteristics that continue to distinguish Japanese art, appearing and re-appearing in ever-changing guises.

By the end of the twelfth century, the political and cultural dominance of the emperor and his court had given way to rule by warriors, or samurai, under the leadership of the shogun, the general-in-chief. In 1338 the Ashikaga family gained control of the shogunate and moved its headquarters to the Muromachi district in Kyoto. In 1392 they reunited northern and southern Japan and retained their grasp on the office for more than 150 years. The Muromachi period after the reunion (1392–1568) is also known as the Ashikaga era (Timeline 22-1).

The Muromachi period is especially marked by the ascendance of Zen Buddhism, whose austere ideals particularly appealed to the highly disciplined samurai.

▲ 1868–PRESENT MEIJI, MODERN

FOUNDATIONS OF JAPANESE CULTURE

With the end of the last Ice Age roughly 15,000 years ago, rising sea levels submerged the lowlands connecting Japan to the Asian landmass, creating the chain of islands we know today as Japan (see Map 22-1). Not long afterward, early Paleolithic cultures gave way to a Neolithic culture known as Jomon (c. 12,000–300 BCE), after its characteristic cord-marked pottery. During the Jomon period, a sophisticated hunter-gatherer culture developed. Agriculture supplemented hunting and gathering by around 5000 BCE, and rice cultivation began some 4,000 years later.

A fully settled agricultural society emerged during the Yayoi period (c. 300 BCE–300 CE), accompanied by hierarchical social organization and more-centralized forms of government. As people learned to manufacture bronze and iron, use of those metals became widespread. Yayoi architecture, with its unpainted wood and thatched roofs, already showed the Japanese affinity for natural materials and clean lines, and the style of Yayoi granaries in particular persisted in the design of shrines in later centuries. The trend toward centralization continued during the Kofun period (c. 300–552 CE), an era characterized by the construction of large royal tombs, following the Korean practice. Veneration of leaders grew into the beginnings of the imperial system that has lasted to the present day.

The Asuka era (552–646 CE) began with a century of profound change as elements of Chinese civilization flooded into Japan, initially through the intermediary of Korea. The three most significant Chinese contributions to the developing Japanese culture were Buddhism (with its attendant art and architecture), a system of writing, and the structures of a centralized bureaucracy. The earliest extant Buddhist temple compound in Japan—the oldest currently existing wooden building in the world—dates from this period.

The arrival of Buddhism also prompted some formalization of Shinto, the loose collection of indigenous Japanese beliefs and practices. Shinto is a shamanistic religion that emphasizes ceremonial purification. Its rituals include the invocation and appeasement of spirits, including those of the recently dead. Many Shinto deities are thought to inhabit various aspects of nature, such as particularly magnificent trees, rocks, and waterfalls, and living creatures such as deer. Shinto and Buddhism have in common an intense awareness of transience, and as their goals are complementary—purification in the case of Shinto, enlightment in the case of Buddhism—they have generally existed comfortably alongside each other to the present day.

The Nara period (646–794 CE) takes its name from Japan's first permanently established imperial capital. During this time the founding works of Japanese literature were compiled, among them an important collection of poetry called the *Manyoshu*. Buddhism advanced to become the most important force in Japanese culture. Its influence at court grew so great as to become worrisome, and in 794 the emperor moved the capital from Nara to Heian-kyo (present-day Kyoto), far from powerful monasteries.

During the Heian period (794–1185), an extremely refined court culture thrived, embodied today in an exquisite legacy of poetry, calligraphy, and painting. An efficient method for writing the Japanese language was developed, and with it a woman at the court wrote the world's first novel, *The Tale of Genji*. Esoteric Buddhism, as hierarchical and intricate as the aristocratic world of the court, became popular.

The end of the Heian period was marked by civil warfare as regional warrior (samurai) clans were drawn into the factional conflicts at court. Pure Land Buddhism, with its simple message of salvation, offered consolation to many in these troubled times. In 1185 the Minamoto clan defeated their arch rivals, the Taira, and their leader, Minamoto Yoritomo, assumed the position of shogun (general-in-chief). While paying respects to the emperor, Minamoto Yoritomo kept actual military and political power to himself, setting up his own capital in Kamakura. The Kamakura era (1185–1392) began a tradition of rule by shogun that lasted in various forms until 1868.

While Pure Land Buddhism, which had spread widely during the latter part of the Heian period (794–1185), remained popular, Zen, patronized by the samurai, became the dominant cultural force in Japan.

INK PAINTING

Several forms of visual art flourished during the Muromachi period, but **ink painting**—monochrome painting in black ink and its diluted grays—reigned supreme. Muromachi ink painting was heavily influenced by the aesthetics of Zen, yet it also marked a shift away from the earlier Zen painting tradition. As Zen moved from an "outsider" sect to the chosen sect of the ruling group, the fierce intensity of earlier masters gave way to a more subtle and refined approach. And whereas earlier Zen artists had concentrated on rough-hewn depictions of Zen figures such as monks and teachers, now Chinese-style landscapes became the most important theme. The monk-artist Shubun (active 1414–63) is regarded as the first great master of the ink landscape. Unfortunately, no works survive that can be proven to be his. Two

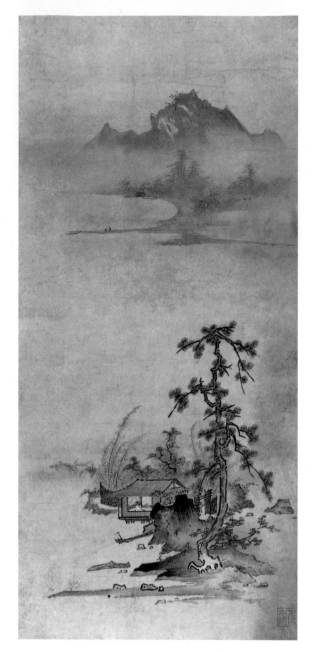

22-2. Bunsei. *Landscape*. Muromachi period, mid-15th century. Hanging scroll, ink and light colors on paper, 28³/₄ x 13" (73.2 x 33 cm). Museum of Fine Arts, Boston

Special Chinese and Japanese Fund

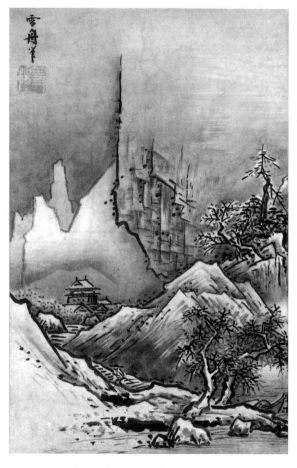

22-3. Sesshu. *Winter Landscape*. Muromachi period, c. 1470s. Ink on paper, 18¹/₄ x 11¹/₂" (46.3 x 29.3 cm). Tokyo National Museum

landscapes by Shubun's pupil Bunsei (active c. 1450–60) have survived, however. In the one shown here (fig. 22-2), the foreground reveals a spit of rocky land with an overlapping series of motifs—a spiky pine tree, a craggy rock, a poet seated in a hermitage, and a brushwood fence holding back a small garden of trees and bamboo. In the middle ground is space—emptiness, the void.

We are expected to "read" the empty paper as representing water, for subtle tones of gray ink suggest the presence of a few people fishing from their boats near the distant shore. The two parts of the painting seem to echo each other across a vast expanse, just as nature echoes the human spirit in Japanese art. The painting illustrates well the pure, lonely, and ultimately serene spirit of the Zen-influenced poetic landscape tradition.

Ink painting soon took on a different spirit. Zen monks painted—just as their Western counterparts illuminated manuscripts—but gave away their art works. By the turn of the sixteenth century, temples were asked for so many paintings that they formed ateliers staffed by monks who specialized in art rather than religious ritual or teaching. Some painters even found they could survive on their own as professional artists. Nevertheless, many of the leading masters remained monks, at least in name, including the most famous of them all, Sesshu (1420–1506). Although he lived his entire life as a monk, Sesshu devoted himself primarily to painting. Like Bunsei, he learned from the tradition of Shubun, but he also had the opportunity to visit China in 1467. Sesshu traveled extensively there, viewing the scenery, stopping at Zen monasteries, and seeing

seems to cut the composition in half. Sharp, jagged brushstrokes delineate a series of rocky hills, where a lone figure makes his way to a Zen monastery. Instead of a gradual recession into space, flat overlapping planes seem to slice the composition into crystalline facets. The white of the paper is left to indicate snow, while the sky is suggested by tones of gray. The few trees cling desperately to the rocky land, and the harsh chill of winter is boldly expressed.

A third important artist of the Muromachi period was a monk named Ikkyu (1394–1481). A genuine eccentric and one of the most famous Zen masters in Japanese history, Ikkyu derided the Zen of his day, writing, "The temples are rich but Zen is declining, there are only false teachers, no true teachers." Ikkyu recognized that success was distorting the spirit of Zen. Originally, Zen had been a form of counterculture for those who were not satisfied with prevailing ways. Now, however, Zen monks acted as government advisers, teachers, and even leaders of merchant missions to China. Although true Zen masters were able to withstand all outside pressures, many monks became involved with political matters, with factional disputes among the temples, or with their reputations as poets or artists. Ikkyu did not hesitate to mock what he regarded as "false Zen." He even paraded through the streets with a wooden sword, claiming that his sword would be as much use to a samurai as false Zen to a monk.

Ikkyu was very involved in the arts, although he treated traditional forms with extreme freedom. His **calligraphy**, which is especially admired, has a spirit of spontaneity. To write out the classic Buddhist couplet "Abjure evil, practice only the good," he created a pair of single-line scrolls (fig. 22-4). At the top of each scroll, Ikkyu began with standard script, in which each stroke of a character is separate and distinct. As he moved down the columns, he grew more excited and wrote in increasingly cursive script, until finally his frenzied brush did not leave the paper at all. This calligraphy displays the intensity that is the hallmark of Zen.

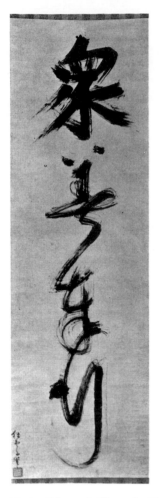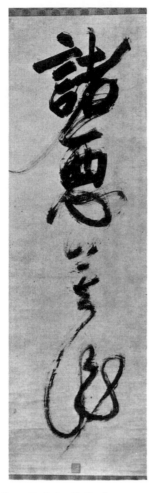

22-4. Ikkyu. *Calligraphy Pair*, from Daitoku-ji, Kyoto. Muromachi period, c. mid-15th century. Ink on paper, each 10'2⁷⁄₈" x 1'4¹⁄₂" (3.12 x 0.42 m)

THE ZEN DRY GARDEN

One of the most renowned Zen creations in Japan is the "dry garden" at the temple of Ryoan-ji in Kyoto. There is a record of a famous cherry tree at this spot, so the completely severe nature of the garden may have come about sometime after its founding in the late fifteenth century. Nevertheless, today the garden is celebrated for its serene sense of space and emptiness. Fifteen rocks are set in a long rectangle of raked white gravel. Temple verandas border the garden on the north and east sides, while clay-and-tile walls define the south and west. Only a part of the larger grounds of Ryoan-ji, the garden has provoked much interest, curiosity, and numerous attempts to "explain" it. Some people see the rocks as land and the gravel as sea. Others imagine animal forms in certain of the rock groupings. However, perhaps it is best to see the rocks and gravel as . . . rocks and gravel. The asymmetrical balance in the placement of the rocks

whatever Chinese paintings he could. He does not seem to have had access to works by contemporary **literati** masters such as Shen Zhou (see fig. 21-9) but saw instead the works of professional painters. Sesshu later claimed that he learned nothing from Chinese artists, but only from the mountains and rivers he had seen. When Sesshu returned from China, he found his homeland rent by the Onin Wars, which devastated the capital of Kyoto. Japan was to be torn apart by further civil warfare for the next hundred years. The refined art patronized by a secure society in peacetime was no longer possible. Instead, the violent new spirit of the times sounded its disturbing note, even in the peaceful world of landscape painting.

This new spirit is evident in Sesshu's *Winter Landscape*, which makes full use of the forceful style that he developed (fig. 22-3). A cliff descending from the mist

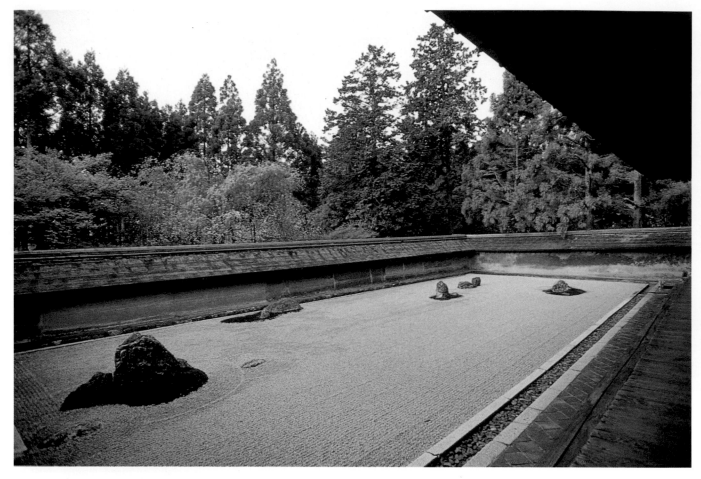

22-5. Stone and gravel garden, Ryoan-ji, Kyoto. Muromachi period, c. 1480

The American composer John Cage once exclaimed that every stone at Ryoan-ji was in just the right place. He then said, "and every other place would also be just right." His remark is thoroughly Zen in spirit. There are many ways to experience Ryoan-ji. For example, we can imagine the rocks as having different visual "pulls" that relate them to one another. Yet there is also enough space between them to give each one a sense of self-sufficiency and permanence.

and the austere beauty of the raked gravel have led many people to meditation (fig. 22-5).

The Muromachi period is the only time an entire culture was strongly influenced by Zen, and the results were mixed. On one hand, works such as Ryoan-ji were created that continue to inspire people to the present day. On the other, the very success of Zen led to a secularization and professionalization of the arts that masters such as Ikkyu found intolerable.

MOMOYAMA PERIOD

The civil wars sweeping Japan laid bare the basic flaw in the Ashikaga system, which was that samurai were primarily loyal to their own feudal lord, or *daimyo*, rather than to the central government. Battles between feudal clans grew more frequent, and it became clear that only a *daimyo* powerful and bold enough to unite the entire country could control Japan. As the Muromachi period drew to a close, three leaders emerged who would change the course of Japanese history.

The first of these leaders was Oda Nobunaga (1534–82), who marched his army into Kyoto in 1568, signaling the end of the Ashikaga family as a major force in Japanese politics. A ruthless warrior, Nobunaga went so far as to destroy a Buddhist monastery because the monks refused to join his forces. Yet he was also a patron of the most rarefied and refined arts. Assassinated in the midst of one of his military campaigns, Nobunaga was succeeded by the military commander Toyotomi Hideyoshi (1536/37–98), who soon gained complete power in Japan. He, too, patronized the arts when not leading his army, and he considered culture a vital adjunct to his rule. Hideyoshi, however, was overly ambitious. He believed that he could conquer both Korea and China, and he wasted much of his resources on two ill-fated invasions. A stable government finally emerged in 1600 with the triumph of a third leader, Tokugawa Ieyasu (1543–1616), who established his shogunate in 1603. But despite its turbulence, the era of Nobunaga and Hideyoshi, known as the Momoyama period (1568–1603), was one of the most creative eras in Japanese history.

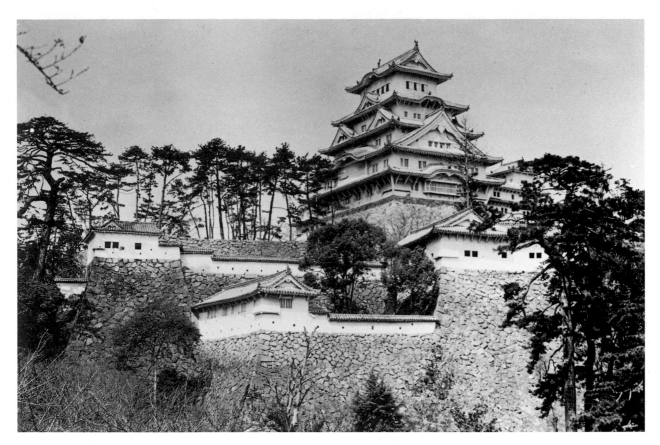

22-6. Himeji Castle, Hyogo, near Osaka. Momoyama period, 1601–9

ARCHITECTURE

Today the very word *Momoyama* conjures up images of bold warriors, luxurious palaces, screens shimmering with **gold leaf**, and magnificent ceramics. The Momoyama period was also the era when Europeans first made an impact in Japan. A few Portuguese explorers had arrived at the end of the Muromachi era in 1543, and traders and missionaries were quick to follow. It was only with the rise of Nobunaga, however, that Westerners were able to extend their activities beyond the ports of Kyushu, Japan's southernmost island. Nobunaga welcomed foreign traders, who brought him various products, the most important of which were firearms.

European muskets and cannons soon changed the nature of Japanese warfare and even influenced Japanese art. In response to the new weapons, monumental fortified castles were built in the late sixteenth century. Some were eventually lost to warfare or torn down by victorious enemies, and others have been extensively altered over the years. One of the most beautiful of the surviving castles is Himeji, not far from the city of Osaka (fig. 22-6). Rising high on a hill above the plains, Himeji has been given the name White Heron. To reach the upper fortress, visitors must follow angular paths beneath steep walls, climbing from one area to the next past stone ramparts and through narrow fortified gates, all the while feeling as though lost in a maze, with no sense of direction or progress. At the main building, a further climb up a series of narrow ladders leads to the uppermost chamber. There, the footsore visitor is rewarded with a stunning 360-degree view of the surrounding countryside. The sense of power is overwhelming.

KANO SCHOOL DECORATIVE PAINTING

Castles such as Himeji were sumptuously decorated, offering artists unprecedented opportunities to work on a grand scale. Large murals on *fusuma*—paper-covered sliding doors—were particular features of Momoyama design, as were folding screens with gold-leaf backgrounds, whose glistening surfaces not only conveyed light within the castle rooms but also vividly demonstrated the wealth of the warrior leaders. Temples, too, commissioned large-scale paintings for their rebuilding projects after the devastation of the civil wars.

The Momoyama period produced a number of artists who were equally adept at decorative golden screens and broadly brushed *fusuma* paintings. Daitoku-ji, a celebrated Zen monastery in Kyoto, has a number of subtemples that are treasure troves of Japanese art. One, the Juko-in, possesses *fusuma* by Kano Eitoku (1543–90), one of the most brilliant painters from the professional school of artists

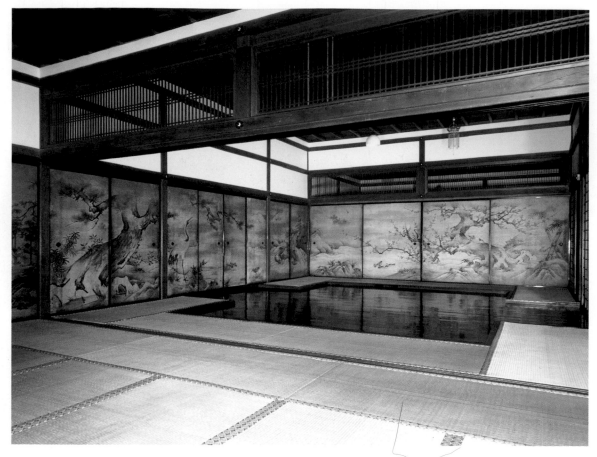

22-7. Kano Eitoku. *Fusuma* **depicting pine and cranes** (left) **and plum tree** (right), **from the central room of the Juko-in, Daitoku-ji, Kyoto**. Momoyama period, c. 1563–73. Ink and gold on paper, height 5'9⅛" (1.76 m)

founded by the Kano family and patronized by government leaders for several centuries. Founded in the Muromachi period, the Kano school combined training in the ink-painting tradition with new skills in decorative subjects and styles. The illustration here shows two of the three walls of *fusuma* panels painted when the artist was in his mid-twenties (fig. 22-7). To the left, the subject is the familiar Kano school theme of cranes and pines, both symbols of long life; to the right is a great gnarled plum tree, symbol of spring. The trees are so massive they seem to extend far beyond the panels. An island rounding both walls of the far corner provides a focus for the outreaching trees. Ingeniously, it belongs to both compositions at the same time, thus uniting them into an organic whole. Eitoku's vigorous use of brush and ink, his powerfully jagged outlines, and his dramatic compositions all hark back to the style of Sesshu, but the bold new sense of scale in his works is a leading characteristic of the Momoyama period.

THE TEA CEREMONY

Japanese art is never one-sided. Along with castles, golden screens, and massive *fusuma* paintings there was an equal interest during the Momoyama period in the quiet, the restrained, and the natural. This was expressed primarily through the tea ceremony.

"Tea ceremony" is an unsatisfactory way to express *cha no yu*, the Japanese ritual drinking of tea, but there is no counterpart in Western culture, so this phrase has come into common use. Tea itself had been introduced to Japan from the Asian continent hundreds of years earlier. At first tea was molded into cakes and boiled. However, the advent of Zen in the late Kamakura period (1185–1392) brought to Japan a different way of preparing tea, with the leaves crushed into powder and then whisked in bowls with hot water. Tea was used by Zen monks as a slight stimulant to aid meditation, and it also was considered a form of medicine.

The most famous tea master in Japanese history was Sen no Rikyu (1521–91). He conceived of the tea ceremony as an intimate gathering in which a few people would enter a small rustic room, drink tea carefully prepared in front of them by their host, and quietly discuss the tea utensils or a Zen scroll hanging on the wall. He did a great deal to establish the aesthetic of modesty, refinement, and rusticity that permitted the tearoom to serve as a respite from the busy and sometimes violent world outside. A traditional tearoom is quite small and simple. It is made of natural materials such as bamboo and wood, with mud walls, paper windows, and a floor covered with **tatami** mats—mats of woven straw. One tearoom that preserves Rikyu's design is named Tai-an (fig. 22-8). Built in 1582, it is distinguished by its tiny door (guests must

22-8. Sen no Rikyu. Tai-an tearoom, Myoki-an Temple, Kyoto. Momoyama period, 1582

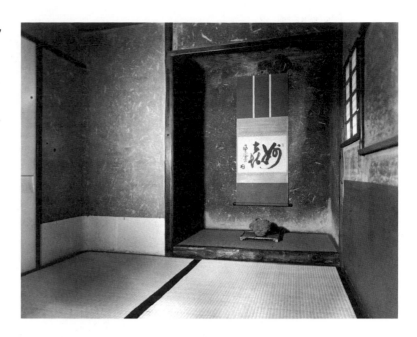

crawl to enter) and its alcove, or **tokonoma**, where a Zen scroll or a simple flower arrangement may be displayed. At first glance, the room seems symmetrical. But the disposition of the *tatami* mats does not match the spacing of the *tokonoma*, providing a subtle undercurrent of irregularity. A longer look reveals a blend of simple elegance and rusticity. The walls seem scratched and worn with age, but the *tatami* are replaced frequently to keep them clean and fresh. The mood is quiet; the light is muted and diffused through three small paper windows. Above all, there is a sense of spatial clarity. All nonessentials have been eliminated, so there is nothing to distract from focused attention. The tearoom aesthetic became an important element in Japanese culture, influencing secular architecture through its simple and evocative form (see "Shoin Design," below).

ELEMENTS OF ARCHITECTURE
Shoin Design

Of the many expressions of Japanese taste that reached great refinement in the Momoyama period, *shoin* architecture has had perhaps the most enduring influence. *Shoin* are upper-class residences that combine a number of traditional features in more-or-less standard ways, always asymmetically. These features are wide verandas; wood posts as framing and defining decorative elements; woven straw **tatami** mats as floor and ceiling covering; several shallow alcoves for prescribed purposes; **fusuma** (sliding doors) as fields for painting or textured surfaces; and **shoji** screens—wood frames covered with translucent rice paper. The *shoin* illustrated here was built in 1601 as a guest hall, called Kojo-in, at the great Onjo-ji monastery. *Tatami, shoji*, alcoves, and asymmetry are still seen in Japanese interiors today.

In the original *shoin*, one of the alcoves would contain a hanging scroll, an arrangement of flowers, or a large painted screen. Seated in front of that alcove, called **tokonoma**, the owner of the house would receive guests, who could contemplate the object above the head of their host. Another alcove contained staggered shelves, often for writing instruments. A writing space fitted with a low writing desk was on the veranda side of a room, with *shoji* that could open to the outside.

The architectural harmony of *shoin*, like virtually all Japanese buildings, was based on the mathematics of proportions and on the proportionate disposition of basic units, or modules. The modules were the **bay**, reckoned as the distance from the center of one post to the center of another, and the *tatami*. Room area in Japan is still expressed in terms of the number of *tatami* mats, so that, for example, a room may be described as a seven-mat room. Although varying slightly from region to region, the size of a single *tatami* is about 3 feet by 6 feet.

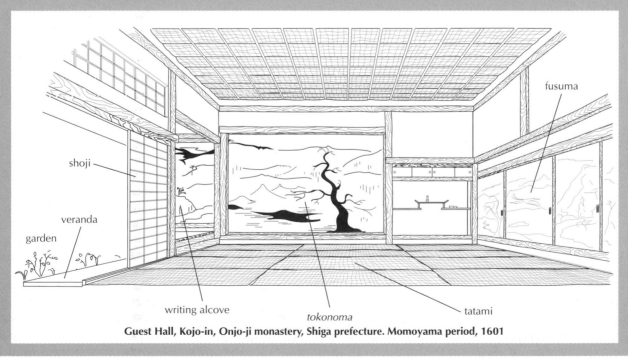

Guest Hall, Kojo-in, Onjo-ji monastery, Shiga prefecture. Momoyama period, 1601

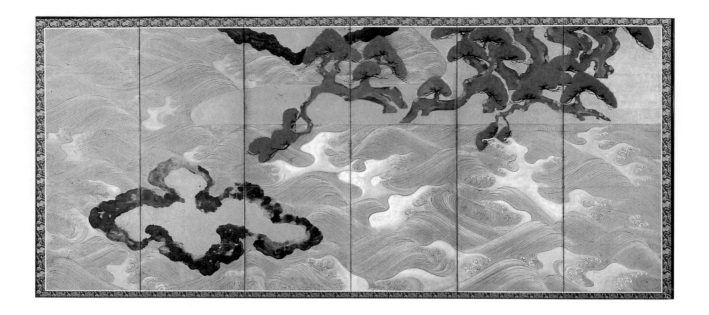

EDO PERIOD

Three years after Tokugawa Ieyasu gained control of Japan, he proclaimed himself shogun. His family's control of the shogunate was to last more than 250 years, a span of time known as the Edo period (1603–1868) or the Tokugawa era.

Under the rule of the Tokugawa family, peace and prosperity came to Japan at the price of an increasingly rigid and often repressive form of government. The problem of potentially rebellious *daimyo* was solved by ordering all feudal lords to spend either half of each year or every other year in the new capital of Edo (present-day Tokyo), where their wives and children were sometimes required to live permanently. Zen Buddhism was supplanted as the prevailing intellectual force by a form of neo-Confucianism, a philosophy formulated in Song-dynasty China that emphasized loyalty to the state. More drastically, Japan was soon closed off from the rest of the world by its suspicious government. Japanese were forbidden to travel abroad, and with the exception of small Chinese and Dutch trading communities on an island off the southern port of Nagasaki, foreigners were not permitted in Japan.

Edo society was officially divided into four classes. Samurai officials constituted the highest class, followed by farmers, artisans, and finally merchants. As time went on, however, merchants began to control the money supply, and in Japan's increasingly mercantile economy they soon reached a high, if unofficial, position. Reading and writing became widespread at all levels of society. Many segments of the population—samurai, merchants, intellectuals, and even townspeople—were now able to patronize artists, and a pluralistic cultural atmosphere developed unlike anything Japan had experienced before.

THE TEA CEREMONY

The rebuilding of temples continued during the first decades of the Edo period, and for this purpose government officials, monks, and wealthy merchants needed to cooperate. The tea ceremony was one way that people

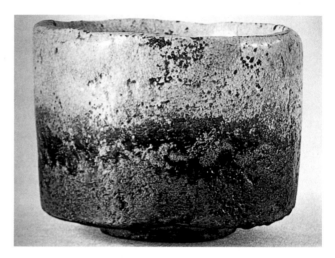

22-9. Hon'ami Koetsu. Teabowl, called *Mount Fuji*. Edo period, early 17th century. *Raku* ware, height 3⅜" (8.5 cm). Sakai Collection, Tokyo

A specialized vocabulary developed to allow connoisseurs to discuss the subtle aesthetics of tea. A favorite term was *sabi*, which summoned up the particular beauty to be found in stillness or even deprivation. *Sabi* was borrowed from the critical vocabulary of poetry, where it was first established as a positive ideal by the early-thirteenth-century poet Fujiwara Shunzei. Other virtues were *wabi*, conveying a sense of great loneliness or a humble (and admirable) shabbiness, and *shibui*, meaning plain and astringent.

of different classes could come together for intimate conversations. Every utensil connected with tea, including the waterpot, the kettle, the bamboo spoon, the whisk, the tea caddy, and, above all, the teabowl, came to be appreciated for their aesthetic qualities, and many works of art were created for use in *cha no yu*.

The age-old Japanese admiration for the natural and the asymmetrical found full expression in tea ceramics. Korean-style bowls made by humble farmers for their rice were suddenly considered the epitome of refined taste. Tea masters even went so far as to advise rural

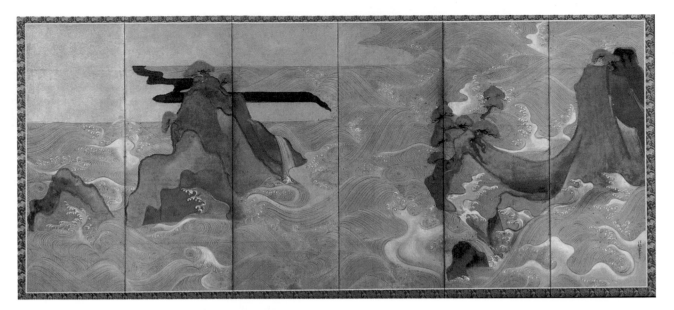

22-10. Tawaraya Sotatsu. Pair of six-panel screens, known as the Matsushima screens. Edo period, 17th century. Ink, mineral colors, and gold leaf on paper; each screen 4'9⅞" x 11'8½" (1.52 x 3.56 m). Freer Gallery of Art, Smithsonian Institution, Washington, D.C. (F1906.231 & 232)

The six-panel screen format was a triumph of scale and practicality. Each panel consisted of a light wood frame surrounding a latticework interior covered with several layers of paper. Over this foundation was pasted a high-quality paper, silk, or gold-leaf ground, ready to be painted by the finest artists. Held together with ingenious paper hinges, a screen could be folded for storage or transportation, resulting in a mural-size painting light enough to be carried by a single person, ready to be displayed as needed.

potters in Japan to create imperfect shapes. But not every misshapen bowl would be admired. An extremely subtle sense of beauty developed that took into consideration such factors as how well a teabowl fit into the hands, how subtly the shape and texture of the bowl appealed to the eye, and who had previously used and admired it. For this purpose, the inscribed box became almost as important as the ceramic that fit within it, and if a bowl had been given a name by a leading tea master, it was especially treasured by later generations.

One of the finest teabowls extant is named *Mount Fuji* after Japan's most sacred peak (fig. 22-9). (Mount Fuji itself is depicted in figure 22-1.) An example of **raku** ware—a hand-built, low-fired ceramic developed especially for use in the tea ceremony—the bowl was crafted by Hon'ami Koetsu (1558–1637), a leading cultural figure of the early Edo period. Koetsu was most famous as a calligrapher, but he was also a painter, lacquer designer, poet, landscape gardener, connoisseur of swords, and potter. With its small foot, straight sides, slightly irregular shape, and crackled texture, this bowl exemplifies tea taste. In its rough exterior we sense directly the two elements of earth and fire that create pottery. Merely looking at it suggests the feeling one would get from holding it, warm with tea, cupped in one's hands.

RIMPA SCHOOL PAINTING

One of Koetsu's friends was the painter Tawaraya Sotatsu (active c. 1600–40), with whom he collaborated on several magnificent handscrolls. Sotatsu is considered the first great painter of the Rimpa school, a grouping of

artists with similar tastes rather than a formal school such as the Kano school. Rimpa masters excelled in decorative designs of strong expressive force, and they frequently worked in several mediums.

Sotatsu painted some of the finest golden screens that have survived. The splendid pair here depict the celebrated islands of Matsushima near the northern city of Sendai (fig. 22-10). Working in a boldly decorative style, the artist has created asymmetrical and almost abstract patterns of waves, pines, and island forms. On the screen to the right, mountainous islands echo the swing and sweep of the waves, with stylized gold clouds in the upper left. The screen on the left continues the gold clouds until they become a sand spit from which twisted pines grow. Their branches seem to lean toward a strange island in the lower left, composed of an organic, amoebalike form in gold surrounded by mottled ink. This mottled effect was a specialty of Rimpa school painters.

As one of the "three famous beautiful views of Japan," Matsushima was often depicted in art. Most painters, however, emphasized the large number of pine-covered islands that make the area famous. Sotatsu's genius was to simplify and dramatize the scene, as though the viewer were passing the islands in a boat on the roiling waters. Strong, basic mineral colors dominate, and the sparkling two-dimensional richness of the gold leaf contrasts dramatically with the three-dimensional movement of the waves.

The second great master of the Rimpa school was Ogata Korin (1658–1716). Korin copied many designs after Sotatsu in homage to the master, but he also originated many remarkable works of his own, including colorful

22-11. Ogata Korin. Lacquer box for writing implements. Edo period, late 17th–early 18th century. Lacquer, lead, silver, and mother-of-pearl, 5⅝ x 10¾ x 7¾" (14.2 x 27.4 x 19.7 cm). Tokyo National Museum

golden screens, monochrome scrolls, and paintings in glaze on his brother Kenzan's pottery. He also designed some highly prized works in **lacquer** (see "Lacquer," below). One famous example (fig. 22-11) is a writing box, a lidded container designed to hold tools and materials for calligraphy (see "Inside a Writing Box," opposite). Korin's design for this black lacquer box sets a motif of irises and a plank bridge in a dramatic combination of mother-of-pearl, silver, lead, and gold lacquer. For Japanese viewers

the decoration immediately recalls a famous passage from the tenth-century *Tales of Ise*, a classic of Japanese literature. A nobleman poet, having left his wife in the capital, pauses at a place called Eight Bridges, where a river branches into eight streams, each covered with a plank bridge. Irises are in full bloom, and his traveling companions urge the poet to write a *tanka*—a five-line, thirty-one-syllable poem—beginning each line with a syllable from the word *ka.ki.tsu.ba.ta* ("iris"). The poet responds (substituting *ha* for *ba*):

> **Ka**ragoromo
> **ki**tsutsu narenishi
> **tsu**ma shi areba
> **ha**rubaru kinuru
> **ta**bi o shi zo omou.

> When I remember
> my wife, fond and familiar
> as my courtly robe,
> I feel how far and distant
> my travels have taken me.
> (Translated by Stephen Addiss)

The poem brought tears to all their eyes, and the scene became so famous that any painting of a group of irises, with or without a plank bridge, immediately calls it to mind.

NANGA SCHOOL PAINTING

Rimpa artists such as Sotatsu and Korin are considered quintessentially Japanese in spirit, both in the expressive

TECHNIQUE

LACQUER

Lacquer is derived in Asia from the sap of the lacquer tree, *Rhus verniciflua*. The tree is indigenous to China, where examples of lacquerware have been found dating back to the Neolithic period. Knowledge of lacquer spread early to Korea and Japan, and the tree came to be grown commercially throughout East Asia.

Gathered by tapping into a tree and letting the sap flow into a container, in much the same way as maple syrup, lacquer is then strained to remove impurities and heated to evaporate excess moisture. The thickened sap can be colored with vegetable or mineral dyes and lasts for several years if carefully stored. Applied in thin coats to a surface such as wood or leather, lacquer hardens into a smooth, glasslike, protective coating that is waterproof, heat and acid resistant, and airtight. Lacquer's practical qualities made it ideal for storage containers and vessels for food and drink. In Japan the leather scales of samurai armor were coated in lacquer, as were leather saddles. In China, Korea, and Japan the decorative potential of lacquer was brought to exquisite perfection in the manufacture of expensive luxury items.

The creation of a piece of lacquer is a painstaking process that can take a sequence of specialized craftsworkers several years. First, the item is fashioned of wood and sanded to a flawlessly smooth finish. Next, layers of lacquer are built up. In order to dry properly, lacquer must be applied in extremely thin coats. (If the lacquer is applied too thickly, the lacquer's exterior surface dries first, forming an airtight seal that prevents the lacquer below from ever drying.) Optimal temperature and humidity are also essential to drying, and craftsworkers quickly learned to control them artificially. Up to thirty coats of lacquer, each dried and polished before the next is brushed on, are required to build up a substantial layer.

Many techniques were developed for decorating lacquer. Particularly in China, lacquer was often applied to a thickness of up to 300 coats, then elaborately carved in low relief—dishes, containers, and even pieces of furniture were executed in carved lacquer. In Japan and Korea, **inlay** with mother-of-pearl and precious metals was brought to a high point of refinement. Japanese artisans also perfected a variety of methods known collectively as **maki-e** ("sprinkled design") that embedded flaked or powdered gold or silver in a still-damp coat of lacquer—somewhat like a very sophisticated version of the technique of decorating with glitter on glue.

power of their art and in their use of poetic themes from Japan's past. Other painters, however, responded to the new Confucian atmosphere by taking up some of the ideas of the literati painters of China. These painters are grouped together as the Nanga ("Southern") school. Nanga was not a school in the sense of a professional workshop or a family tradition. Rather, it took its name from the southern school of amateur artists described by the Chinese literati theorist Dong Qichang (Chapter 21). Educated in the Confucian mold, Nanga masters were individuals and often individualists, creating their own variations of literati painting from unique blendings of Chinese models, Japanese aesthetics, and personal brushwork. They were often experts at calligraphy and poetry as well as painting, but one, Uragami Gyokudo (1745–1820), was even more famous as a musician, an expert on a seven-string Chinese zither called the *qin*. Most instruments are played for entertainment or ceremonial purposes, but the *qin* has so deep and soft a sound that it is played only for oneself or a close friend. Its music becomes a kind of meditation, and for Gyokudo it opened a way to commune with nature and his own inner spirit.

Gyokudo was a hereditary samurai official, but midway through his life he resigned from his position and spent seventeen years wandering through Japan, absorbing the beauty of its scenery, writing poems, playing music, and beginning to paint. During his later years Gyokudo produced many of the strongest and most individualistic paintings in Japanese history, although they were not appreciated by people during his lifetime. *Geese Aslant in the High Wind* is a leaf from an album Gyokudo painted in 1817, three years before his death (fig. 22-12). The creative power in this painting is remarkable. The wind seems to have the force of a hurricane, sweeping the tree branches and the geese into swirls of action. The

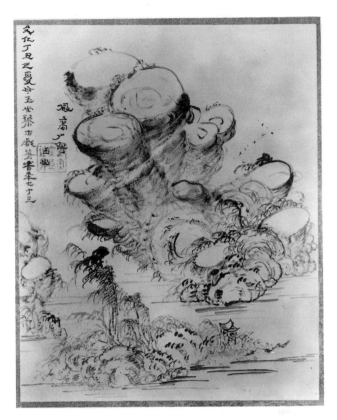

22-12. Uragami Gyokudo. *Geese Aslant in the High Wind*. Edo period, 1817. Ink and light colors on paper, 12³⁄₁₆ x 9⁷⁄₈" (31 x 25 cm). Takemoto Collection, Aichi

greatest force comes from within the land itself, which mushrooms out and bursts forth in peaks and plateaus as though an inner volcano were erupting.

The style of the painting derives from the Chinese literati tradition, with layers of calligraphic brushwork

INSIDE A WRITING BOX

The interior of the writing box shown in figure 22-11 is fitted with compartments for holding an ink stick, an ink stone, brushes, an eyedropper, and paper—tools and materials not only for writing but also for **ink painting**.

Ink sticks are made by burning wood or oil inside a container. Soot deposited by the smoke is collected, bound into a paste with resin, heated for several hours, kneaded and pounded, then pressed into small stick-shaped or cake-shaped molds to harden. Molds are often carved to produce an ink stick (or ink cake) decorated in low relief. The tools of writing and painting are also beautiful objects in their own right.

Fresh ink is made for each writing or painting session by grinding the hard, dry ink stick in water against a fine-grained stone. A typical ink stone has a shallow well at one end sloping up to a grinding surface at the other. The artist fills the well with water from a waterpot. The ink stick, held vertically, is dipped into the well to pick up a small amount of water, then is rubbed in a circular motion firmly on the grinding surface. The process is repeated until enough ink has been prepared. Grinding ink is viewed as a meditative task, time for collecting one's thoughts and concentrating on the painting or calligraphy ahead.

Brushes are made from animal hairs set in simple bamboo or hollow-reed handles. Brushes taper to a fine point that responds with great sensitivity to any shift in pressure. Although great painters and calligraphers do eventually develop their own styles of holding and using the brush, all begin by learning the basic position for writing. The brush is held vertically, grasped firmly between the thumb and first two fingers, with the fourth and fifth fingers often resting against the handle for more subtle control.

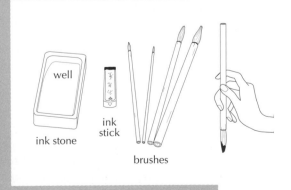

well

ink stone

ink stick

brushes

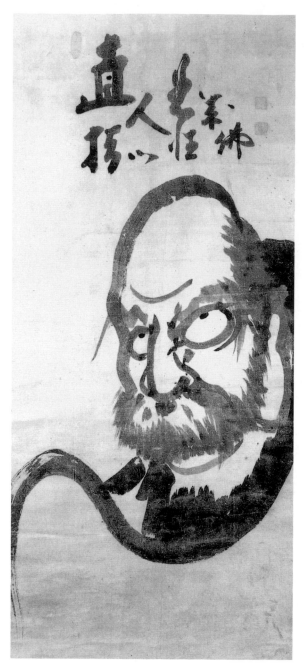

22-13. Hakuin Ekaku. *Bodhidharma Meditating*. Edo period, 18th century. Ink on paper, 49½ x 21¾" (125.7 x 55.3 cm). On extended loan to the Spencer Museum of Art, University of Kansas, Lawrence

Hakuin had his first enlightenment experience while meditating upon the koan (mysterious Zen riddle) about *mu*. One day a monk asked a Chinese Zen master, "Does a dog have the *buddha* nature?" Although Buddhist doctrine teaches that all living beings have *buddha* nature, the master answered, "*Mu*," meaning "has not" or "nothingness." The riddle of this answer became a problem that Zen masters gave their students as a focus for meditation. With no logical answer possible, monks were forced to go beyond the rational mind and penetrate more deeply into their own being. Hakuin, after months of meditation, reached a point where he felt "as though frozen in a sheet of ice." He then happened to hear the sound of the temple bell, and "it was as though the sheet of ice had been smashed." Later, as a teacher, Hakuin invented a koan of his own that has since become famous: "What is the sound of one hand clapping?"

building up the forms of mountains, trees, and the solitary human habitation. But the inner vision is unique to Gyokudo. In his artistic world, humans do not control nature but can exult in its power and grandeur. Gyokudo's art may have been too strong for most people in his own day, but in our violent century he has come to be appreciated as a great artist.

ZEN PAINTING

Deprived of the support of the government and samurai officials, who now favored neo-Confucianism, Zen initially went into something of a decline during the Edo period. In the early eighteenth century, however, it was revived by a monk named Hakuin Ekaku (1685–1769), who had been born in a small village not far from Mount Fuji and resolved to become a monk after hearing a fire-and-brimstone sermon in his youth. For years he traveled around Japan seeking out the strictest Zen teachers. After a series of enlightenment experiences, he eventually became an important teacher himself.

In his later years Hakuin turned more and more to painting and calligraphy as forms of Zen expression and teaching. Since the government no longer sponsored Zen, Hakuin reached out to ordinary people, and many of his paintings portray everyday subjects that would be easily understood by farmers and merchants. The paintings from his sixties have great charm and humor, and by his eighties he was creating works of astonishing force. Hakuin's favorite subject was Bodhidharma, the semilegendary Indian monk who had begun the Zen tradition in China (fig. 22-13). Here he has portrayed the wide-eyed Bodhidharma during his nine years of meditation in front of a temple wall in China. Intensity, concentration, and spiritual depth are conveyed by broad and forceful brushstrokes. The inscription is the ultimate Zen message, attributed to Bodhidharma himself: "Pointing directly to the human heart, see your own nature and become Buddha."

Hakuin's pupils followed his lead in communicating their vision through brushwork. The Zen figure once again became the primary subject of Zen painting, and the painters were again Zen masters rather than primarily artists.

MARUYAMA-SHIJO SCHOOL PAINTING

Zen paintings were given away to all those who wished them, including poor farmers as well as artisans, merchants, and samurai. Many merchants, however, were more concerned with displaying their increasing wealth than with spiritual matters, and their aspirations fueled a steady demand for golden screens and other decorative works of art. One school that arose to satisfy this demand was the Maruyama-Shijo school, formed in Kyoto by Maruyama Okyo (1733–95). Okyo had studied Western-style "perspective pictures" in his youth, and he was able in his mature works to incorporate shading and perspective into a decorative style, creating a sense of volume that was new to East Asian painting. Okyo's new style proved very

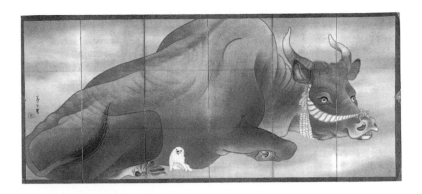

22-14. Nagasawa Rosetsu. *Bull and Puppy*. Edo period, 18th century. One of a pair of six-panel screens, ink and gold wash on paper, 5'7¼" x 12'3" (1.70 x 3.75 m). Los Angeles County Museum of Art

Joe and Etsuko Price Collection

popular in Kyoto, and it soon spread to Osaka and Edo (present-day Tokyo) as well. The subjects of Maruyama-Shijo painting were seldom difficult to understand. Instead of legendary Chinese themes, Maruyama-Shijo painters portrayed the birds, animals, hills, trees, farmers, and townsfolk of Japan. Although highly educated people might make a point of preferring Nanga painting, Maruyama-Shijo works were perfectly suited to the taste of the emerging upper middle class.

The leading pupil of Okyo was Nagasawa Rosetsu (1754–99), a painter of great natural talent who added his own boldness and humor to the Maruyama-Shijo tradition. Rosetsu delighted in surprising his viewers with odd juxtapositions and unusual compositions. One of his finest works is a pair of screens, the left depicting a bull and a puppy (fig.

22-14). The bull is so immense that it fills almost the entire six panels of the screen and still cannot be contained at the top, left, and bottom. The puppy, white against the dark gray of the bull, helps to emphasize the huge size of the bull by its own smallness. The puppy's relaxed and informal pose, looking happily right out at the viewer, gives this powerful painting a humorous touch that increases its charm.

In earlier centuries, when works of art were created largely under aristocratic or religious patronage, Rosetsu's painting might have seemed too mundane. In the Edo

TECHNIQUE

JAPANESE WOODBLOCK PRINTS

Ukiyo-e ("pictures of the floating world," as these woodblock prints are called in Japanese) represent the combined expertise of three people: the artist, the carver, and the printer. Coordinating and funding the endeavor was a publisher, who commissioned the project and distributed the prints to stores or itinerant peddlers, who would sell them.

The artist supplied the master drawing for the print, executing its outlines with brush and ink on tissue-thin paper. Colors might be indicated, but more often they were understood or decided on later. The drawing was passed on to the carver, who pasted it facedown on a hardwood block, preferably cherrywood, so that the outlines showed through the paper in reverse. A light coating of oil might be brushed on to make the paper more transparent, allowing the drawing to stand out with maximum clarity. The carver then cut around the lines of the drawing with a sharp knife, always working in the same direction as the original brushstrokes. The rest of the block was chiseled away, leaving the outlines standing in relief. This block, which reproduced the master drawing, was called the **key block**. If the print was to be **polychrome**, having multiple colors, prints made from the key block were in turn pasted facedown on blocks that would be used as guides for the carver of the color blocks. Each color generally required a separate block, although both sides of a block might be used for economy.

Once the blocks were completed, the printer took over. Paper for printing was covered lightly with animal glue (gelatin). A few hours before printing, the paper was lightly moistened so that it would take ink and color well. Water-based ink or color was brushed over the block, and the paper placed on top and rubbed with a smooth, padded device called a baren, until the design was completely transferred. The key block was printed first, then the colors one by one. Each block was carved with two small marks called **registration marks**, in exactly the same place in the margins, outside of the image area— an L in one corner, and a straight line in another. By aligning the paper with these marks before letting it fall over the block, the printer ensured that the colors would be placed correctly within the outlines. One of the most characteristic effects of later Japanese prints is a grading of color from dark to pale. This was achieved by wiping some of the color from the block before printing, or by moistening the block and then applying the color gradually with an unevenly loaded brush—a brush loaded on one side with full-strength color and on the other with diluted color.

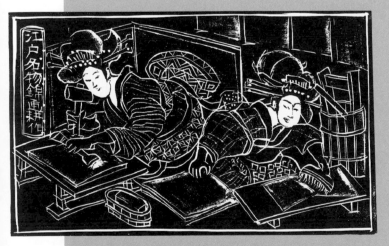

An early-20th-century woodblock showing two women cutting and inking blocks

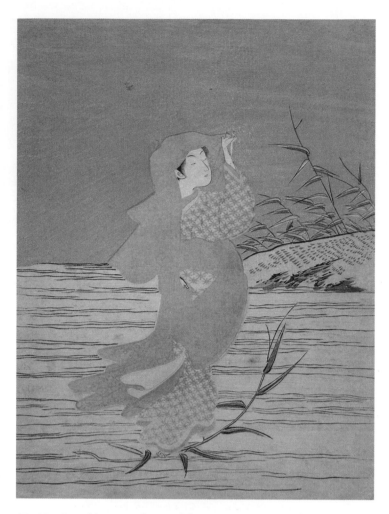

22-15. Suzuki Harunobu. *Geisha as Daruma Crossing the Sea.*
Edo period, mid-18th century. Color woodcut, 10⅞ x 8¼"
(27.6 x 21 cm). Philadelphia Museum of Art
Gift of Mrs. Emile Geyelin, in memory of Anne Hampton Barnes

period, however, the taste for art had spread so widely through the populace that no single group of patrons could control the cultural climate. Everyday subjects like farm animals were painted as often as Zen subjects or symbolic themes from China. In the hands of a master such as Rosetsu, plebeian subject matter could become simultaneously delightful and monumental, equally pleasing to viewers with or without much education or artistic background.

UKIYO-E: PICTURES OF THE FLOATING WORLD

Not only did newly wealthy merchants patronize painters in the middle and later Edo period, but even artisans and tradespeople could purchase works of art. Especially in the new capital of Edo, bustling with commerce and cultural activities, people savored the delights of their peaceful society. Buddhism had long preached that pleasures were fleeting; the cherry tree, which blossoms so briefly, became the symbol for the transience of earthly beauty and joy. Commoners in the Edo period did not dispute this transience, but they took a new attitude:

Let's enjoy it to the full as long as it lasts. Thus the Buddhist phrase *ukiyo* ("floating world") became positive rather than negative.

There was no world more transient than that of the pleasure quarters, set up in specified areas of every major city. Here were found restaurants, bathhouses, and brothels. The heroes of the day were no longer famous samurai or aristocratic poets. Instead, swashbuckling actors and beautiful courtesans were admired. These paragons of pleasure soon became immortalized in paintings and—because paintings were often too expensive for common people—in **woodblock** prints known as *ukiyo-e*, "pictures of the floating world" (see "Japanese Woodblock Prints," page 871).

At first prints were made in black and white, then colored by hand when the public so desired. The first artist to design prints to be printed in many colors was Suzuki Harunobu (1724–70). His exquisite portrayals of feminine beauty quickly became so popular that soon every artist was designing multicolored *nishiki-e* ("brocade pictures").

One print that displays Harunobu's charm and wit is *Geisha as Daruma Crossing the Sea* (fig. 22-15). Harunobu has portrayed a young woman in a red cloak crossing the water on a reed, a clear reference to one of the legends about Bodhidharma, known in Japan as Daruma. To see a young woman peering ahead to the other shore, rather than a grizzled Zen master staring off into space, must have greatly amused the Japanese populace. There was also another layer of meaning in this image because geishas were sometimes compared to Buddhist teachers or deities in their ability to bring ecstasy, akin to enlightenment, to humans. Harunobu's print suggests these meanings, but it also succeeds simply as a portrait of a beautiful woman, with the gently curving lines of drapery suggesting the delicate feminine form beneath.

The second great subject of *ukiyo-e* were the actors of the new form of popular theater known as kabuki. Because women had been banned from the stage after a series of scandalous incidents, male actors took both male and female roles. Much as people today buy posters of their favorite sports, music, or movie stars, so, too, in the Edo period people clamored for images of their feminine and masculine ideals.

During the nineteenth century, landscape joined courtesans and actors as a major theme—not the idealized landscape of China, but the actual sights of Japan. The two great masters of landscape prints were Utagawa Hiroshige (1797–1858) and Katsushika Hokusai (1760–1849). Hiroshige's *Fifty-Three Stations of the Tokaido* and Hokusai's *Thirty-Six Views of Fuji* became the most successful sets of graphic art the world has known. The woodblocks were printed and printed again until they wore out. They were then recarved, and still more copies were printed. This process continued for decades, and thousands of prints from the two series are still extant.

The Great Wave (see fig. 22-1) is the most famous of the scenes from *Thirty-Six Views of Fuji*. Hokusai was already in his seventies, with a fifty-year career behind

him, when he designed this image. Such was his modesty that he felt that his Fuji series was only the beginning of his creativity, and he wrote that if he could live until he was 100, he would finally learn how to become an artist.

When seen in Europe and America, these and other Japanese prints were immediately acclaimed, and they strongly influenced late-nineteenth- and early-twentieth-century Western art (Chapter 27). *Japonisme*, or "japonism," became the vogue, and Hokusai and Hiroshige became as famous in the West as in Japan. Indeed, their art was taken more seriously in the West; the first book on Hokusai was published in France, and it has been estimated that by the early twentieth century more than 90 percent of Japanese prints had been sold to Western collectors. Only within the past fifty years have Japanese museums and connoisseurs fully realized the stature of this "plebeian" form of art.

THE MEIJI AND MODERN PERIODS

Pressure from the West for entry into Japan mounted dramatically in the mid-nineteenth century, and in 1853 the policy of national seclusion was ended. Resulting tensions precipitated the downfall of the Tokugawa shogunate, however, and in 1868 the emperor was formally restored to power, an event known as the Meiji Restoration. The court moved from Kyoto to Edo, which was renamed Tokyo, meaning "Eastern Capital."

The Meiji period marked a major change for Japan. After its long isolation Japan was deluged by the influx of the West. Western education, governmental systems, clothing, medicine, industrialization, and technology were all adopted rapidly into Japanese culture. Teachers of sculpture and oil painting were imported from Italy, while adventurous Japanese artists traveled to Europe and America to study.

Japan's people have always been eager to be up-to-date while at the same time preserving the heritage of the past. Even in the hasty scrambling to become a modern industrialized country, Japan did not lose its sense of tradition, and traditional arts continued to be created even in the days of the strongest Western influence. In modern Japan, artists still choose whether to work in an East Asian style, a Western style, or some combination of the two. Just as Japanese art in earlier periods had both Chinese style and native traditions, so Japanese art today has both Western and native aspects.

Perhaps the most lively contemporary art is ceramics. Japan has retained a widespread appreciation for pottery. Many people still practice the traditional arts of the tea ceremony and flower arranging, both of which require ceramic vessels, and most people would like to own at least one fine ceramic piece. In this atmosphere many potters can earn a comfortable living by making art ceramics, an opportunity not available in other countries. Some ceramists continue to create *raku* teabowls and other traditional wares, while others experiment with new styles and new techniques. Figure 22-16 shows the work of four contemporary potters, from left to right,

22-16. From left: Miyashita Zenji, Morino Hiroaki, Tsujimura Shiro, Ito Sekisui. Four ceramic vessels. Modern period, after 1970. Spencer Museum of Art, University of Kansas, Lawrence
Gift of the Friends of the Art Museum/Helen Foresman Spencer Art Acquisition Fund

Miyashita Zenji (b. 1939), Morino Hiroaki (b. 1934), Tsujimura Shiro (b. 1947), and Ito Sekisui (b. 1941).

Miyashita Zenji, who lives in Kyoto, spends a great deal of time on each piece. He creates the initial form by constructing an undulating shape out of pieces of cardboard, then builds up the surface with clay of many different colors, using torn paper to create irregular shapes. When fired, the varied colors of the clay seem to form a landscape, with layers of mountains leading up to the sky. Miyashita's work is modern in shape, yet also traditional in its evocation of nature.

Morino Hiroaki's works are often abstract and sculptural, without any functional use. He has also made vases, however, and they showcase his ability to create designs in glaze that are wonderfully quirky and playful. His favorite colors of red and black bring out the asymmetrical strength of his compositions, the products of a lively individual artistic personality.

Tsujimura Shiro lives in the mountains outside Nara and makes pottery in personal variations on traditional shapes. He values the rough texture of country clay and the natural ash glaze that occurs with wood firing, and he creates jars, vases, bowls, and cups with rough exteriors covered by rivulets of flowing green glaze that are often truly spectacular. Tsujimura's pieces are always functional, and part of their beauty comes from their suitability for holding food, flowers, or tea.

Ito Sekisui represents the fifth generation of a family of potters. Sekisui demonstrates the Japanese love of natural materials by presenting the essential nature of fired clay in his works. The shapes of his bowls and pots are beautifully balanced with simple clean lines; no ornament detracts from their fluent geometric purity. The warm tan, orange, and reddish colors of the clay reveal themselves

22-17. Chuichi Fujii.
Untitled '90. Modern period, 1990. Cedar wood, height 7'5½" (2.3 m). Hara Museum of Contemporary Art, Tokyo

in irregularly flowing and changing tones created by allowing different levels of oxygen into the kiln when firing.

These four artists represent the high level of contemporary ceramics in Japan, which is supported by a broad spectrum of educated and enthusiastic collectors and admirers. There is also strong public interest in contemporary painting, prints, calligraphy, textiles, lacquer, architecture, and sculpture.

One of the most adventurous and original sculptors currently working is Chuichi Fujii (b. 1941). Born into a family of sculptors in wood, Fujii found himself as a young artist more interested in the new materials of plastic, steel, and glass. However, in his mid-thirties he took stock of his progress and decided to begin again, this time with wood. At first he carved and cut into the wood, but he soon realized that he wanted to allow the material to express its own natural spirit, so he devised an ingenious new technique that preserved the individuality of each log while making of it something new. As Fujii explains it, he first studies the log to come to terms with its basic shape and to decide how far he can "push to the limit the log's balancing point with the floor" (Howard N. Fox, *A Primal Spirit: Ten Contemporary Japanese Sculptors.* Exh. cat., Los Angeles County Museum of Art, 1990, page 63). Next, he inserts hooks into the log and runs wires between them. Every day he tightens the wires, over a period of months

gradually pulling the log into a new shape. When he has bent the log to the shape he envisioned, Fujii makes a cut and sees whether his sculpture will stand. If he has miscalculated, he discards the work and begins again.

Here, Fujii has created a circle, one of the most basic forms in nature but never before seen in such a thick tree trunk (fig. 22-17). The work strongly suggests the *enso,* the circle that Zen monks painted to express the universe, the all, the void, the moon—and even a tea cake. Yet Fujii does not try to proclaim his links with Japanese culture. He says that while his works may seem to have some connections with traditional Japanese arts, he is not conscious of them. He acknowledges, however, that people carry their own cultures inside them, and he claims that all Japanese have had "the experience of sensing with their skin the fragrance of a tree. Without saying it, the Japanese understand that a tree has warmth; I believe it breathes air, it cries" (Fox, page 63).

Fujii's sculpture testifies to the depth of an artistic tradition that has continued to produce visually exciting works for 14,000 years. He has achieved something entirely new, yet his work also embodies the love of asymmetry, respect for natural materials, and dramatic simplicity encountered throughout the history of Japanese art. Whatever the future of art in Japan, these principles will undoubtedly continue to lead to new combinations of tradition and creativity.

PARALLELS

PERIOD	JAPANESE ART	ART IN OTHER CULTURES
MUROMACHI 1392–1568	**22-2. Bunsei.** *Landscape* (mid-15th cent.) **22-4. Ikkyu.** *Calligraphy Pair* (c. mid-15th cent.) **22-3. Sesshu.** *Winter Landscape* (c. 1470s) **22-5. Ryoan-ji garden, Kyoto** (c. 1480)	**17-14. Van Eyck.** Arnolfini portrait (1434), Belgium **18-2. Leonardo.** *Last Supper* (1495–98), Italy **18-11. Michelangelo.** *David* (1501–4), Italy **20-8.** *Gita Govinda* (c. 1525–50), India
MOMOYAMA 1568–1603	**22-7. Eitoku.** Juko-in screens (c. 1563–73) **22-8. Rikyu.** Tai-an tearoom (1582) **22-6. Himeji Castle, Hyogo** (1601–9)	**20-5.** *Hamza-nama* (c. 1567–82), India **18-70. El Greco.** *Burial of Count Orgaz* (1586), Spain
EDO 1603–1868	**22-9. Koetsu.** *Mount Fuji* teabowl (early 17th cent.) **22-10. Sotatsu.** Matsushima screens (17th cent.) **22-11. Korin.** Lacquer box (late 17th–early 18th cent.) **22-13. Hakuin.** *Bodhidharma Meditating* (18th cent.) **22-14. Rosetsu.** *Bull and Puppy* (18th cent.) **22-15. Harunobu.** *Geisha as Daruma Crossing the Sea* (mid-18th cent.) **22-12. Gyokudo.** *Geese Aslant in the High Wind* (1817) **22-1. Hokusai.** *Great Wave* (c. 1831)	**20-7. Taj Mahal** (c. 1632–48), India **19-53. Leyster.** *Self-Portrait* (1635), Netherlands **23-19. Taos Pueblo** (c. 1700), North America **26-48. David.** *Oath of the Horatii* (1784–85), France **27-43. Bonheur.** *Plowing in the Niverais: The Dressing of the Vines* (1849), France **27-53. Manet.** *Le Déjeuner sur l'Herbe* (1863), France
MEIJI, MODERN 1868–PRESENT	**22-16. Ceramic vessels** (after 1970) **22-17. Fujii.** *Untitled '90* (1990)	**27-91. Eakins.** *Gross Clinic* (1875), US **27-66. Cézanne.** *Mont Sainte-Victoire* (c. 1885–87), France **28-21. Picasso.** Les *Demoiselles d'Avignon* (1907), France **28-41. Gilbert.** Woolworth Bldg. New York City (1911–13), US

23-1. **A view of the world**, page from *Codex Fejervary-Mayer*. Aztec or Mixtec, c. 1400–1519/21. Paint on animal hide, each page 6⅞ x 6⅞" (17.5 x 17.5 cm), total length 13'3" (4.04 m). The National Museums and Galleries on Merseyside, Liverpool, England

23
Art of the Americas after 1300

Early in November 1519, the army of the Spanish conquistador Hernán Cortés beheld for the first time the great Aztec capital of Tenochtitlan. The shimmering city, which seemed to be floating on the water, was built on islands in the middle of Lake Texcoco in the Valley of Mexico, linked by broad causeways to the mainland. One of Cortés's companions later recalled the wonder the Spanish felt at that moment: "When we saw so many cities and villages built on the water and other great towns and that straight and level causeway going towards [Tenochtitlan], we were amazed . . . on account of the great towers and [temples] and buildings rising from the water, and all built of masonry. And some of our soldiers even asked whether the things that we saw were not a dream" (cited in Berdan, page 1).

The startling vision that riveted Cortés's soldiers was indeed real, a city of stone built on islands—a city that held many treasures and many mysteries. Much of the period before the conquistadores' arrival remains enigmatic, but a rare manuscript that survived the Spanish Conquest of Mexico depicts the preconquest worldview of the native peoples. At the center of the image here is the ancient fire god Xiuhtecutli (fig. 23-1). Radiating from him are the four directions—each associated with a specific color, a deity, and a tree with a bird in its branches. In each corner, to the right of a U-shaped band, is an attribute of Tezcatlipoca, the Smoking Mirror, an omnipotent, primal deity who could see humankind's thoughts and deeds—in the upper right a head, in the upper left an arm, in the lower left a foot, and in the lower right bones. Streams of blood flow from these attributes to the fire god in the center. Such images are filled with important, symbolically coded information—even the dots refer to the number of days in one aspect of the Mesoamerican calendar—and they were integral parts of the culture of the Americas.

1300	1400	1500	1600

▲ c. 1300– EASTERN WOODLANDS CULTURE ▲ c. 1400–1519/21 AZTEC EMPIRE AT ITS HEIGHT ▲ c. 1519–24 CORTÉS CONQUERS AZTEC EMPIRE
▲ AFTER c. 2500 BCE– NORTHWEST COAST CULTURE
▲ AFTER c. 200 CE– SOUTHWEST CULTURE ▲ c. 1438–1532 INKA EMPIRE AT ITS HEIGHT
▲ AFTER c. 1000– GREAT PLAINS CULTURE ▲ c. 1532 PIZARRO CONQUERS INKA EMPIRE

TIMELINE 23-1. **The Americas after 1300.** The two most powerful indigenous empires in Mesoamerica and South America after 1300 were the Aztec and the Inka. (Aztec civilization arose about 1135 CE, Inka as early as 800 CE.) Native North American cultures go back to the second millennium BCE, and major regional peoples continue their cultural heritage today.

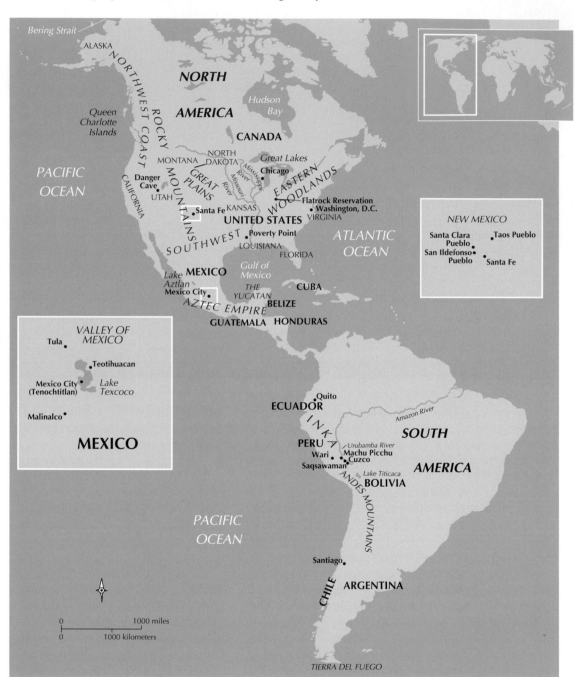

MAP 23-1. **The Americas after 1300.** Diverse peoples spread throughout the Americas, each shaping a distinct culture in the area it settled.

INDIGENOUS AMERICAN ART

When the first European explorers and conquerors arrived in 1519, the Western Hemisphere was already inhabited from the Arctic Circle to Tierra del Fuego by peoples with long and complex histories and rich and varied cultural traditions (see "Foundations of Civilization in the Americas," opposite). This chapter focuses on the arts of the indigenous peoples of Mesoamerica, Andean South America, and North America (Map 23-1) just prior to and in the wake of their encounter with an expansionist Europe.

Although art was central to their lives, the peoples of the Americas set aside no special objects as "works of art." Some objects were essentially utilitarian and others had ritual uses and symbolic associations, but people drew no

FOUNDATIONS OF CIVILIZATION IN THE AMERICAS

Humans first arrived in the Western Hemisphere between 20,000 and 30,000 years ago by way of a land bridge in the Bering region that connected Asia and North America during the last Ice Age. By 12,000 years ago they had spread over both North and South America and in many regions developed a settled, agricultural way of life. In Mesoamerica, in the Andean region of South America, and for a time in what is now the southeastern United States, they developed hierarchical, urban societies with monumental architecture and elaborate artistic traditions.

Mesoamerica extends from north of the Valley of Mexico into Central America. The civilizations that arose there shared a number of features, including writing, a complex calendrical system, a ritual ball game, and several deities and religious beliefs. Their religious practices included blood and human sacrifice. The earliest Mesoamerican civilization, that of the Olmec, flourished between about 1200 and 400 BCE. The so-called Mesoamerican Classic Period, during which rulers built hundreds of cities with large buildings, monumental sculptures, and with hieroglyphic writing recorded their deeds in astronomical and ritual contexts, lasted from about 300 to 900 CE. Two cultures were dominant during this period: the Maya and Teotihuacan.

Maya civilization dominated the area now occupied by southern Mexico, Guatemala, Belize, and northwestern Honduras. The Maya developed Mesoamerica's most sophisticated writing and calendrical systems and built large cities with monumental buildings and sculpture. The city of Teotihuacan, which exerted widespread influence throughout Mesoamerica, dominated the Valley of Mexico. New cultures and forms of government followed, stimulating another cultural florescence in the northern Yucatan Peninsula and the highlands of Guatemala. In the thirteenth century, the Aztec settled and soon dominated the Valley of Mexico. To the south, the Inka, heirs to an equally lengthy and complex cultural legacy—including the great civilizations of Chavin, Moche, Nasca, Paracas, and Wari—controlled the entire Andean region by the end of the fifteenth century.

In North America, the people of what is now the southeastern United States adopted a settled way of life by around the end of the second millennium BCE and began building monumental **earthworks** as early as 1700 BCE at Poverty Point, Louisiana. The people of the American Southwest developed a settled, agricultural way of life during the first millennium CE. By around 550 CE the Anasazi—the forebears of the modern Pueblo peoples—began building multistoried, apartmentlike structures with many specialized rooms.

distinctions between art and other aspects of material culture or between the fine arts and the decorative arts. Understanding Native American art thus requires an understanding of the cultural context in which it was made, a context that in many cases has been lost to time or to the disruptions of the European conquest. Fortunately, art history and archaeology have helped recover at least some of that lost context.

MEXICO AND SOUTH AMERICA

Two great empires—the Aztec in Mexico and the Inka in South America—rose to prominence in the fifteenth century at about the same time that European adventurers began to explore the oceans in search of new trade routes to Asia (Timeline 23-1). In the encounter that followed, the Aztec and Inka empires were destroyed.

THE AZTEC EMPIRE

The Mexica people who lived in the remarkable city that Cortés found in the early sixteenth century were then rulers of much of the land that took their name, Mexico. Their rise to power had been recent and swift. Only 400 years earlier, according to their own legends, they had been a nomadic people living northwest of the Valley of Mexico on the shores of the mythological Lake Aztlan (the source of the word Aztec, by which they are commonly known).

At the urging of their patron god, Huitzilopochtli, the Aztec began a long migration away from Lake Aztlan, arriving in the Valley of Mexico in the thirteenth century. Driven from place to place, they eventually ended up in the marshes on the edge of Lake Texcoco. There they settled on an island where they had seen an eagle perching on a prickly pear cactus (tenochtli), a sign that Huitzilopochtli told them would mark the end of their wandering. They called the place Tenochtitlan. The city grew on a collection of islands linked by canals.

Through a series of alliances and royal marriages, the Aztec rose to prominence, emerging less than a century before the arrival of Cortés as the head of a powerful alliance and the dominant power in the valley. Only then did they begin the aggressive expansion that brought them tribute from all over central Mexico and transformed Tenochtitlan into the glittering capital that so impressed the invading Spanish.

Aztec society was divided into roughly three classes: an elite of rulers and nobles, a middle class of professional merchants and luxury artisans, and a lower class of farmers and laborers. Aztec religion was based on a complex pantheon that combined the Aztec deities with more ancient ones that had long been worshiped in central Mexico. According to Aztec belief, the gods had

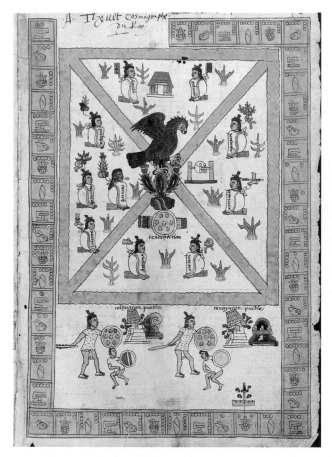

23-2. *The Founding of Tenochtitlan*, page from *Codex Mendoza*. Aztec, 16th century. Ink and color on paper, 12³/₈ x 8⁷/₁₆" (21.5 x 31.5 cm). The Bodleian Library, Oxford

MS. Arch Selden. A.1.fol. 2r

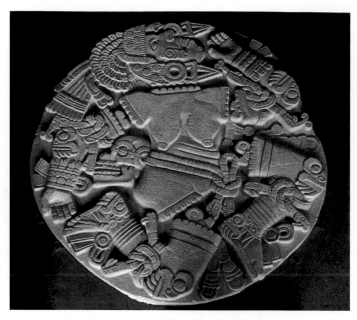

23-3. *The Moon Goddess Coyolxauhqui ("She of the Golden Bells")*, from the Sacred Precinct of the Museo Templo Mayor, Tenochtitlan. Aztec, 1469 (?). Stone, diameter 10'10" (3.33 m). Museo Templo Mayor, Mexico City

This disk was discovered in 1978 by workers from a utility company who were excavating at a street corner in central Mexico City.

created the current universe at the ancient city of Teotihuacan in the Valley of Mexico. Its continued existence depended on human actions, including rituals of bloodletting and human sacrifice. The end of each round of fifty-two years in the Mesoamerican calendar was a particularly dangerous time, requiring a special fire-lighting ritual. Sacrificial victims sustained the sun god, Huitzilopochtli, in his daily course through the sky. Huitzilopochtli was the son of the earth mother Coatlicue. When Coatlicue conceived Huitzilopochtli by holding within her chest a ball of hummingbird feathers (the soul of a fallen warrior) that had dropped from the sky, her other children—the stars and the moon—jealously conspired to kill her. When they attacked, Huitzilopochtli emerged from his mother's body fully grown and armed, drove off his half brothers, and destroyed his half sister, the moon goddess Coyolxauhqui. As the sun born from the mother earth, Huitzilopochtli every day at dawn must again fight off the darkness, killing the stars (his 400 brothers) and the moon (his sister).

Most Aztec books were destroyed in the wake of the Spanish Conquest, but the work of Aztec scribes appears in several documents created for Spanish administrators afterward. The first page of the *Codex Mendoza*, prepared

for the Spanish viceroy in the sixteenth century, can be interpreted as an idealized representation of both the city of Tenochtitlan and its sacred ceremonial precinct (fig. 23-2). An eagle perched on a prickly pear cactus—the symbol of the city—fills the center of the page. Waterways divide the city into four quarters, which are further subdivided into wards, as represented by the seated figures. The victorious warriors at the bottom of the page represent Aztec conquests.

The focal point of the sacred precinct—probably symbolized in figure 23-2 by the temple or house at the top of the page—was the Great Pyramid, a 130-foot-high stepped double pyramid with dual temples on top, one of which was dedicated to Huitzilopochtli and the other to Tlaloc, the god of rain and fertility. Two steep staircases led up the west face of this structure from the plaza in front of it. Sacrificial victims climbed these stairs to the Temple of Huitzilopochtli, where several priests threw them over a stone and another quickly cut open their chests and pulled out their still-throbbing hearts. Their bodies were then rolled down the stairs and dismembered. Thousands of severed heads were said to have been kept on a skull rack in the plaza, represented in figure 23-2 by the rack with a single skull to the right of the eagle. During the winter rainy season the sun rose behind the Temple of Tlaloc, and during the dry season it rose behind the Temple of Huitzilopochtli. The double temple thus united two natural forces, sun and rain, or fire and water. During the spring and autumn equinoxes, the sun rose between the two temples, illuminating the Temple of Quetzalcoatl, the feathered serpent, an

ancient creator god associated with the calendar, civilization, and the arts.

Sculpture of serpents and serpent heads on the Great Pyramid in Tenochtitlan associated it with the Hill of the Serpent, where Huitzilopochtli slew the moon goddess Coyolxauhqui. A huge circular relief of the dismembered goddess once lay at the foot of the temple stairs, as if the enraged and triumphant Huitzilopochtli had cast her there like a sacrificial victim (fig. 23-3). Her torso is in the center, surrounded by her head and limbs. A rope around her waist is attached to a skull. She has bells on her cheeks and balls of down in her hair. She wears a magnificent headdress and has distinctive ear ornaments composed of disks, rectangles, and triangles. The sculpture is two-dimensional in concept with a deeply cut background.

Like other Mesoamerican peoples, the Aztec intended their temples to resemble mountains. They also carved shrines and temples directly into the mountains surrounding the Valley of Mexico. A steep flight of stairs leads up to one such temple carved into the side of a mountain at Malinalco (fig. 23-4). The formidable entrance, meant to resemble the open mouth of the earth monster, leads into a circular room; the thatched roof is modern. If the temple itself is a mountain, surely this space is a symbolic cave, the womb of the earth. A pit for blood sacrifices opens into the heart of the mountain. A semicircular bench around the room is carved with stylized eagle and jaguar skins, symbols of two Aztec military orders, suggesting that members of those orders performed rites here.

The Spanish built their own capital, Mexico City, over the ruins of Tenochtitlan and built a cathedral on the site of Tenochtitlan's sacred precinct. An imposing statue of Coatlicue, mother of Huitzilopochtli, was found near the cathedral during excavations there in the late eighteenth century (fig. 23-5). One of the sixteenth-century conquistadores described seeing such a statue covered with blood inside the Temple of Huitzilopochtli, where it would have stood high above the disk of the vanquished Coyolxauhqui. *Coatlicue* means "she of the serpent skirt," and this broad-shouldered figure with clawed hands and feet has a skirt of twisted snakes. A pair of serpents, symbols of gushing blood, rise from her neck to form her head. Their eyes are her eyes; their fangs, her tusks. The writhing serpents of her skirt also form her body. Around her stump of a neck hangs a necklace of sacrificial offerings—hands, hearts, and a dangling skull. Despite the surface intricacy, the sculpture's simple, bold, and blocky forms create a single visual whole. The colors with which it was originally painted would have heightened its dramatic impact.

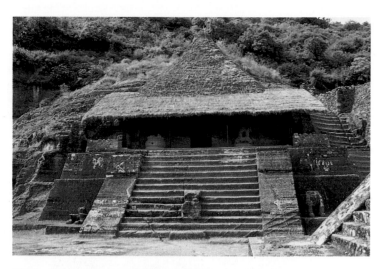

23-4. Rock-cut sanctuary, Malinalco, Mexico. Aztec, 15th century; modern thatched roof

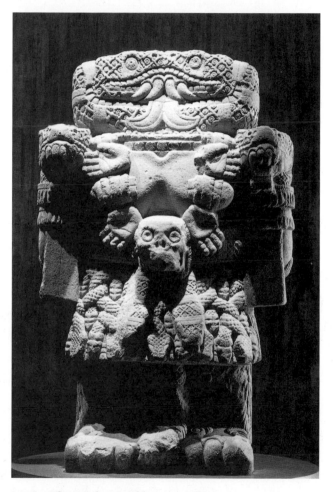

23-5. *The Mother Goddess, Coatlicue*. Aztec, 15th century. Stone, height 8'6" (2.65 m). Museo Nacional de Antropología, Mexico City

THE INKA EMPIRE

At the beginning of the sixteenth century the Inka Empire was one of the largest states in the world, rivaling China in size. It extended more than 2,600 miles along western South America, encompassing most of modern Peru, Ecuador, Bolivia, and northern Chile and reaching into modern Argentina. Like the Aztec Empire, its rise had been recent and swift.

The Inka called their empire the Land of the Four Quarters. At its center was their capital, Cuzco, "the navel of the world," located high in the Andes Mountains. The early history of the Inka is obscure. The Cuzco region had

23-6. Walls of the Temple of the Sun, below the Church of Santo Domingo, Cuzco, Peru. Inka, 15th century

The curving lower wall formed part of the Inka Temple of the Sun, also known as the Golden Enclosure or Court of Gold (*Coricancha*). Extending from this ritual center were shrines, radiating out in forty-one lines.

been under the control of the earlier Wari Empire, and the Inka state was probably one of many small competing kingdoms that emerged in the highlands in the wake of the Wari collapse. In the fifteenth century the Inka began suddenly and rapidly to expand, and they subdued most of their vast domain—through conquest, alliance, and intimidation—by 1500. To hold their linguistically and ethnically diverse empire together, the Inka relied on an overarching state religion, a hierarchical bureaucracy, and various forms of labor taxation, in which the payment was a set amount of time spent performing tasks for the state. Agricultural lands were divided into three categories: those for the gods, which supported priests and religious authorities; those for the ruler and the state; and those for the local population itself. As part of their labor tax, people were required to work the lands of the gods and the state for part of each year. In return the state provided gifts through their local leaders and sponsored lavish ritual entertainments. Men served periodically on public-works projects—building roads and terracing hillsides, for example—and in the army. The Inka also moved whole communities to best exploit the resources of the empire. Ranks of storehouses at Inka administrative centers assured the state's ability to feed its armies and supply the people working for it. No Andean civilization ever developed writing, but the Inka kept detailed accounts on knotted and colored cords.

To move their armies and speed transport and communication within the empire, the Inka built more than 23,000 miles of roads. These varied from 50-foot-wide thoroughfares to 3-foot-wide paths. Two main north-south roads, one along the coast and the other through the highlands, were linked by east-west roads. Travelers went on foot, using llamas as pack animals. Stairways helped travelers negotiate steep mountain slopes, and rope suspension bridges allowed them to cross river gorges. The main road on the Pacific coast, a desert region, had walls to protect it from blowing sand. All along the roads, the Inka built administrative centers, storehouses, and roadside lodgings. These lodgings—more than a thousand have been found—were spaced a day's journey apart. A relay system of waiting runners could carry messages between Cuzco and the farthest reaches of the empire in about a week.

Cuzco, a capital of great splendor, was home to the Inka, as the ruler of the Inka Empire was called, and the extended ruling group. The city, which may have been laid out to resemble a giant puma, was a showcase of the finest Inka masonry, some of which can still be seen in the modern city. The walls of its most magnificent structure, the Temple of the Sun, served as the foundation for the Spanish colonial Church of Santo Domingo (fig. 23-6). Within the Temple of the Sun was a gold-adorned room dedicated to the sun and another, adorned with silver, dedicated to the moon.

Inka masonry has survived earthquakes that have destroyed or seriously damaged later structures. Fine Inka masonry consisted of either rectangular blocks, as in figure 23-6, or irregular polygonal blocks. Both types were ground so that adjoining blocks fit tightly together without mortar (see "Inka Masonry," opposite). The blocks might be slightly **beveled** (cut at an angle) so that the stones had a pillowed form and each block retained its identity, or they might, as in figure 23-6, be smoothed into a continuous flowing surface in which the individual blocks form part of a seamless whole. Inka structures had gabled, thatched roofs. Doors, windows, and niches were trapezoid shaped, narrower at the top than the bottom. The effort expended on building by the Inka was prodigious. Erecting the temple fortress of Saqsawaman in Cuzco, for example, was reputed to have occupied 30,000 workers for many decades.

Machu Picchu, one of the most spectacular archaeological sites in the world, provides an excellent example of Inka architectural planning (fig. 23-7). At 9,000 feet above sea level, it straddles a ridge between two high peaks in the eastern slopes of the Andes and looks down on the Urubamba River. Stone buildings, today lacking only their thatched roofs, occupy terraces around central plazas, and narrow agricultural terraces descend into the valley. The site, near the eastern limits of the empire, was the estate of the Inka Pachacuti (ruled 1438–71). Its temples and carved sacred stones suggest that it also had an important religious function. Special stones, left natural, were set up in courtyard shrines.

The production of fine textiles is of ancient origin in the Andes, and textiles were one of the primary forms of

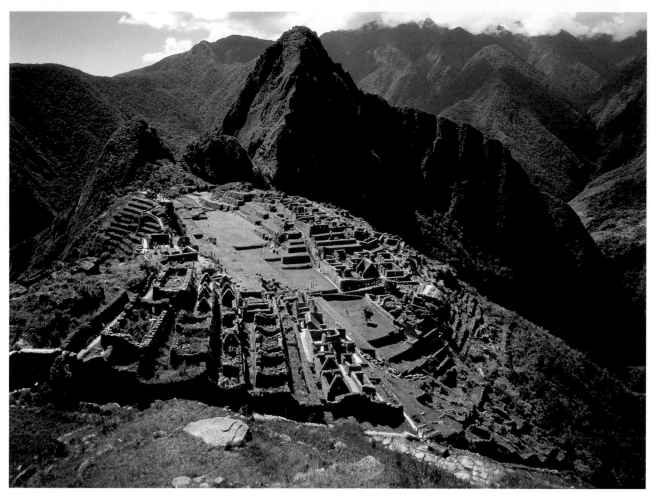

23-7. Machu Picchu, Peru. Inka, 1450–1530

ELEMENTS OF ARCHITECTURE

Inka Masonry

Working with the simplest of tools—mainly heavy stone hammers—and using no mortar, Inka builders created stonework of great refinement and durability: roads and bridges that linked the entire empire, built-up terraces for growing crops, and structures both simple and elaborate. At Machu Picchu (fig. 23-7), all buildings and terraces within its 3-square-mile extent were made of granite, the hard stone occurring at the site. Commoners' houses and some walls were constructed of irregular stones that were carefully fitted together. Some walls and certain domestic and religious structures were erected using squared-off, smooth-surfaced stones laid in even rows. At a few Inka sites, the stones used in construction were boulder-size: up to 27 feet tall.

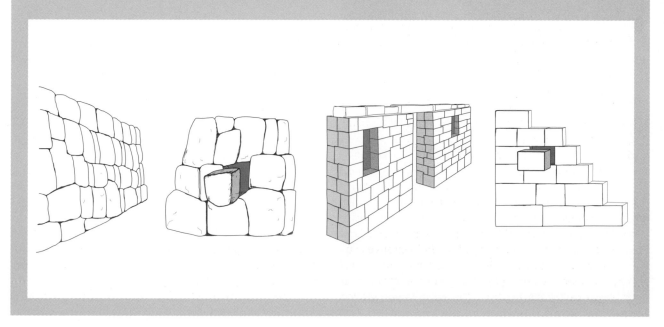

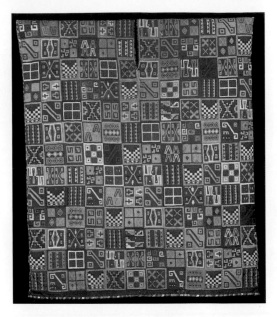

23-8. Tunic, from Peru. Inka, c. 1500. Wool and cotton, 35⁷/₈ x 30" (91 x 76.5 cm). Dumbarton Oaks Research Library and Collections, Washington, D.C.

Inka textile patterns and colors were standardized, like European heraldry or the uniforms of today's sports teams, to convey information at a glance.

23-9. Llama, from Bolivia or Peru, found near Lake Titicaca, Bolivia. Inka, 15th century. Cast silver with gold and cinnabar, 9 x 8¹/₂ x 1³/₄" (22.9 x 21.6 x 4.4 cm). American Museum of Natural History, New York

Trans. #5003

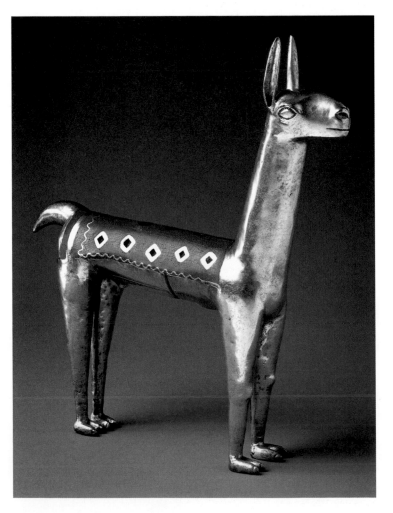

wealth for the Inka. One kind of labor taxation was the required manufacture of fibers and cloth, and textiles as well as agricultural products filled Inka storehouses. Cloth was deemed a fitting offering for the gods, so fine garments were draped around golden statues, and three-dimensional images were constructed of cloth. The patterns and designs on garments were not simply decorative but also carried important symbolic messages, including indications of a person's ethnic identity and social rank. Each square in the tunic shown in figure 23-8 represents a miniature tunic, but the meaning of the individual patterns is not yet completely understood. The four-part **motifs** may refer to the Land of the Four Quarters. The checkerboard pattern designated military officers and royal escorts. The meaning of the diagonal key motif is not known, but it is often found on tunics with horizontal border stripes.

The Spanish, who under the conquistador Francisco Pizarro conquered the Inka Empire in 1532, were far more interested in the Inka's vast quantities of gold and silver objects than in their cloth. Whatever they found, they melted down to enrich themselves and the royal coffers of Spain. The Inka, in contrast, valued gold and silver not as precious metals in themselves but because they saw in them symbols of the sun and the moon. They are said to have called gold the sweat of the sun and silver the tears of the moon. Some small figures, buried as offerings, escaped the conquerors' treasure hunt. The small llama shown in figure 23-9 was found near Lake Titicaca. The llama was thought to have a special connection with the sun, with rain, and with fertility, and one was sacrificed to the sun every morning and evening in Cuzco. Also in the capital, a white llama was kept as the symbol of the Inka. Dressed in a red tunic and wearing gold jewelry, this llama passed through the streets during April celebrations. According to Spanish commentators, these processions included lifesize gold and silver images of llamas, people, and gods.

NORTH AMERICA

In America north of Mexico, many different peoples (all with very different cultures) were established, from the upper reaches of Canada and Alaska to the southern tip of Florida. We look at only four areas: the Eastern Woodlands and the Great Plains, the Northwest Coast, and the Southwest. Much of the art produced in North America was small, portable, fragile, and impermanent, and until recently its aesthetic quality was unappreciated.

EASTERN WOODLANDS AND THE GREAT PLAINS

Forest-covered eastern North America was first settled by early peoples who had built great **earthworks** and cities, established widespread trading networks, and buried their leaders with treasures of copper and mica before being eradicated by famine, warfare, or disease. New groups then moved into the Eastern Woodlands, establishing settlements from the Hudson Bay to the Gulf of Mexico and from the Atlantic coast to the Mississippi

Basketry

Basketry is the weaving of reeds, grasses, and other materials to form containers. In North America the earliest evidence of basketwork, found in Danger Cave, Utah, dates to as early as 8400 BCE. Over the subsequent centuries, Native American women, notably in California and the Southwest, developed basketry into an art form that combined utility with great beauty.

There are three principal basket-making techniques: **coiling**, **twining**, and **plaiting**. Coiling involves sewing together a spiraling foundation of rods with some other material. Twining involves sewing together a vertical **warp** of rods. Plaiting involves weaving strips over and under each other.

The coiled basket shown here was made by the Pomo of California. According to Pomo legend, the earth was dark until their ancestral hero stole the sun and brought it to earth in a basket. He hung the basket first just over the horizon, but, dissatisfied with the light it gave, he kept suspending it in different places across the dome of the sky. He repeats this process every day, which is why the sun moves across the sky from east to west. In the Pomo basket the structure of coiled willow and bracken fern root produces a spiral surface into which the artist worked sparkling pieces of clamshell, trade beads, and the soft tufts of woodpecker and quail feathers. The underlying basket, the glittering shells, and the soft, moving feathers make this an exquisite container. Such baskets were treasured possessions, cremated with their owners at death.

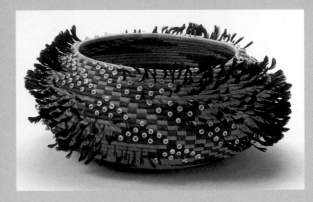

Feathered Bowl. Pomo, c. 1877. Willow, bulrush, fern, feather, shells, glass beads. Height 5½" (14 cm), diameter 12" (36.5 cm). Philbrook Museum, Tulsa, Oklahoma
Clark Field Collection (1948.39.37)

and Missouri river watersheds. The Native American peoples of the Eastern Woodlands supported themselves by a combination of hunting and agriculture. They lived in villages and cultivated corn, squash, and beans. They used flexible, waterproof birch bark to construct their homes and their canoes, which were extremely functional watercraft. They reestablished extensive trade routes using the rivers and the Great Lakes.

The arrival in the seventeenth century on the Atlantic coast of a few boatloads of Europeans seeking religious freedom and a new life in no way resembled Cortés's and Pizarro's bloody conquests of the Aztec and Inka empires. Trade with the settlers gave the Woodlands peoples access to things they valued. They exchanged furs for such useful items as metal kettles and needles, cloth, and beads. They prized objects and materials with bright sparkling and reflecting surfaces, such as mirrors, glass, and polished metal, which to them had spiritual values.

Woodlands peoples had long made wampum—belts and strings of cylindrical purple and white shell beads. The Iroquois and Delaware, both Woodlands peoples, used wampum to keep records (the beads' purple patterns served as memory devices) and exchanged it to conclude treaties: Wampum strings and belts had the power of legal agreement and also symbolized a moral order.

Woodlands art focused on personal adornment—tattoos, body paint, elaborate dress—and fragile arts such as **quillwork**. Quillwork involved soaking porcupine and bird quills to soften them, then working them into rectilinear, ornamental surface patterns on deerskin clothing and on birch-bark artifacts like baskets and boxes. A Sioux legend recounts how a mythical ancestor, Doublewoman ("double" because she was both beautiful and ugly, benign and dangerous), appeared to a woman in a dream and taught her the art of quillwork. As the legend

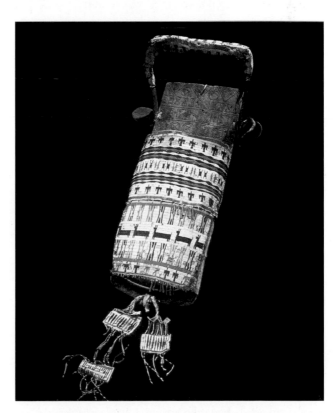

23-10. Baby carrier, from the Upper Missouri River area. Eastern Sioux, 19th century. Board, buckskin, porcupine quill, length 31" (78.8 cm). Smithsonian Institution Libraries, Washington, D.C.

suggests, quillwork was a woman's art form, as was basketry (see "Basketry," above). The Sioux baby carrier shown in figure 23-10 is richly decorated with symbols of protection and well-being, including bands of antelopes in profile and thunderbirds with their heads turned and tails

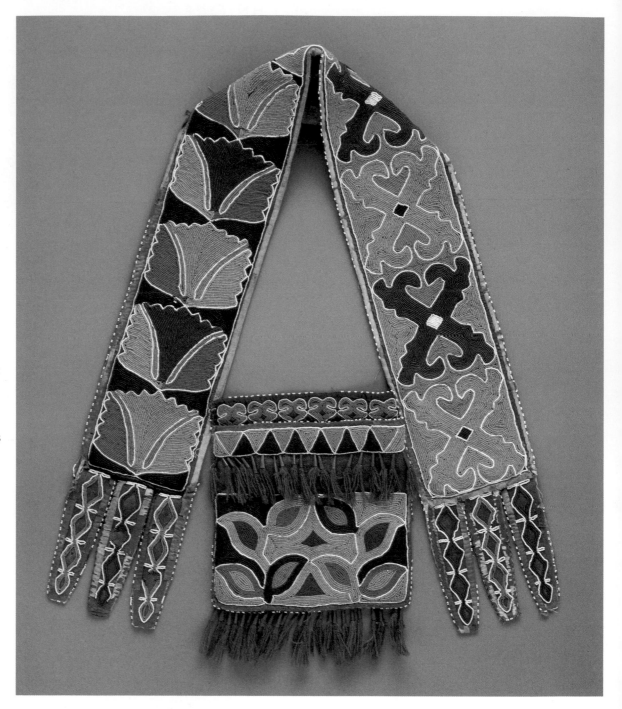

23-11. Shoulder bag, from Kansas. Delaware, c. 1860. Wool fabric, cotton fabric and thread, silk ribbon, and glass beads, 23 x 7³/4" (58.5 x 19.8 cm). The Detroit Institute of Arts

Founders Society Purchase (81.216)

Brilliant bags such as this one were worn by men at public intertribal events.

outspread. (The thunderbird was an especially beneficent symbol, thought to be capable of protecting against both human and supernatural adversaries.)

In spite of the use of shell beads in wampum, decorative **beadwork** did not become commonplace until after European contact. In the late eighteenth century, Native American artists began to acquire European colored glass beads, and in the nineteenth century they favored the tiny seed beads from Venice and Bohemia. Early beadwork mimicked the patterns and colors of quillwork—in some places in the nineteenth century it even replaced quillwork—but beadwork came to incorporate European design in a process known as **reintegration**. About 1830 Canadian nuns introduced Native American artists to embroidered European floral designs, and the embroiderers began to adapt European needlework techniques and patterns from European garments into their own work.

Some of the functional aspects of those garments were transformed into purely decorative motifs; a pocket, for example, would be replaced by an area of beadwork in the *form* of a pocket. A shoulder bag from Kansas, made by a Delaware woman, exemplifies the evolution of beadwork design (fig. 23-11): In contrast to the rectilinear patterns of quillwork, this Delaware bag is covered with curvilinear plant motifs. White lines outline brilliant pink and blue leaf-shaped forms, heightening the intensity of the colors, and colors alternate within repeated patterns.

Over time, the Woodlands people were pushed westward by European settlers. They eventually reached an area of prairie grasslands now known as the Great Plains. In this sparsely inhabited region they adopted a nomadic life-style based on the wild, free-roaming herds of horses descended from horses introduced by the Spanish. A distinctive Plains culture flourished from about 1700 to about

1870. The Plains peoples domesticated horses and, armed with rifles acquired through trade, became hunters and warriors. They also traded with Europeans for equipment and the highly prized beads.

The nomadic Plains peoples hunted buffalo for food as well as for hides from which they created clothing and a light, portable dwelling known as a **tepee** (fig. 23-12), which was well designed to withstand the wind, dust, and rain of the prairies. The framework of a tepee consisted of a stable frame of three or four long poles, filled out with about twenty additional poles, in a roughly egg-shaped plan. The framework was covered with hides (or, later, with canvas) to form an almost conical structure that leaned slightly in the direction of the prevailing west wind. The hides were specially prepared to make them flexible and waterproof. A typical tepee required about eighteen hides, the largest about thirty-eight hides. An opening at the top served as a smoke hole for the central hearth. The flap-covered door and smoke hole usually faced east, away from the wind. An inner lining covered the lower part of the walls and the perimeter of the floor to protect the occupants from drafts. When packed to be dragged by a horse to another location, the tepee served as a platform for transporting other possessions as well. When the Blackfoot gathered in the summer for their ceremonial Sun Dance, they formed their hundreds of tepees into a circle a mile in circumference. The Sioux encamped in two half circles—one for the sky people and one for the earth people—divided along an east-west axis.

Tepees were the property and responsibility of women, who raised them at new encampments and lowered them when the group moved on. Blackfoot women could set up their huge tepees in less than an hour. Women

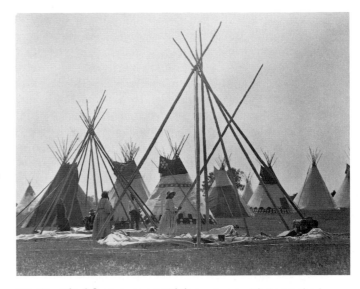

23-12. Blackfoot women raising a tepee. Photographed c. 1900. Montana Historical Society, Helena

painted, embroidered, quilled, and beaded tepee linings, backrests, clothing, and equipment. The patterns with which tepees were decorated, as well as their proportions and colors, varied from Native American nation to nation. In general, the bottom was covered with a group's traditional motifs and the center section with personal images.

Plains men recorded their exploits in symbolic and narrative form in paintings on tepee linings and covers and on buffalo-hide robes. The earliest known painted buffalo-hide robe illustrates a battle fought in 1797 by the Mandan of North Dakota and their allies against the Sioux (fig. 23-13). The painter, trying to capture the full extent

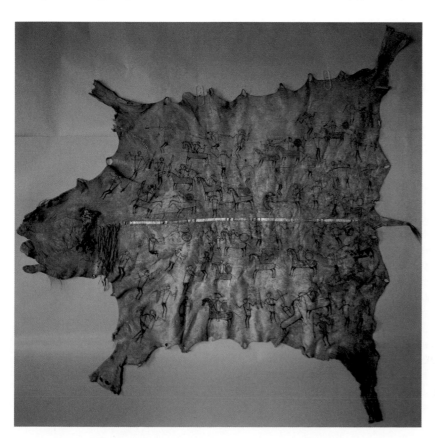

23-13. Battle-scene hide painting, from North Dakota. Mandan, 1797–1800. Tanned buffalo hide, dyed porcupine quills, and black, red, green, yellow, and brown pigment, 7'10" x 8'6" (2.44 x 2.65 m). Peabody Museum of Archaeology, Harvard University, Cambridge, Massachusetts

(99-12-10/53121)

This robe, collected in 1804 by Meriwether Lewis and William Clark on their 1804–6 expedition into western lands acquired by the United States in the Louisiana Purchase, is the earliest documented example of Plains painting. It was one of a number of Native American art works that Lewis and Clark sent to President Thomas Jefferson. Jefferson displayed the robe in the entrance hall of his home at Monticello, Virginia.

of a conflict in which five nations took part, shows a party of warriors in twenty-two separate episodes. Their leader appears with a pipe and wears an elaborate eagle-feather headdress. The party is armed with bows and arrows, lances, clubs, and flintlock rifles. The lively stick figures of the warriors have rectangular torsos and tiny round heads. Details of equipment and emblems of rank—headdresses, sashes, shields, feathered lances, powder horns for the rifles—are accurately depicted. Horses are shown in profile with stick legs and **C**-shaped hooves; some have clipped manes, others have flowing manes. The figures stand out clearly against the light-colored background of the buffalo hide; to make them, the painter pressed lines into the hide, then added black, red, green, yellow, and brown pigments. A strip of colored porcupine quills runs down the spine. The robe would have been worn draped over the shoulders of the powerful warrior whose deeds it commemorates. As he moved, the painted horses and warriors would have come alive, transforming him into a living representation of his exploits.

Life on the Great Plains changed abruptly in 1869, when the Euro-Americans finished the transcontinental railway linking the coasts of the United States and providing easy access to Native American lands. By 1885 Euro-American hunters had killed off the buffalo, and soon ranchers and then farmers moved into the plains. The Euro-Americans forcibly settled the outnumbered and outgunned Native Americans on reservations, land considered worthless until the later discovery of oil there.

THE NORTHWEST COAST

From southern Alaska to northern California, the Pacific coast of North America is a region of unusually abundant resources. Its many rivers fill each year with salmon returning to spawn. Harvested and dried, the fish could sustain large populations throughout the year. The peoples of the Northwest Coast—among them the Tlingit, the Haida, and the Kwakiutl—exploited this abundance to develop a complex and distinctive way of life in which the arts played a central role.

Northwest Coast peoples lived in extended family groups in large, elaborately decorated communal houses made of massive timbers and thick planks. Family groups claimed descent from a mythic animal or animal-human ancestor. Social rank within and between related families was based on genealogical closeness to the mythic ancestor. Chiefs, who were in the most direct line of descent from the ancestor, administered a family's spiritual and material resources. Chiefs validated their status and garnered prestige for themselves and their families by holding ritual feasts in which they gave valuable gifts to the invited guests. Shamans, who were sometimes also chiefs, mediated between the human and spirit worlds. A family derived its name and the right to use certain animals and spirits as totemic emblems, or crests, from its mythic ancestor. These emblems appeared prominently in Northwest Coast art, notably in carved house crests and the tall, freestanding poles erected to memorialize dead chiefs.

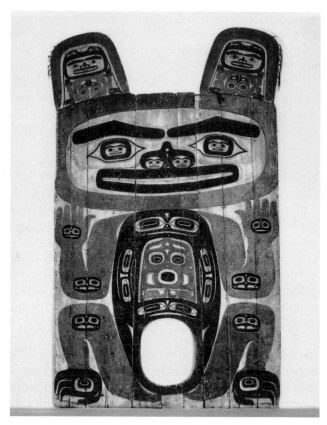

23-14. Grizzly bear house-partition screen, from the house of Chief Shakes of Wrangell, Canada. Tlingit, c. 1840. Cedar, native paint, and human hair, 15 x 8' (4.57 x 2.74 m). Denver Art Museum

Purchase from Altmen Antiques (1951.315)

Carved and painted house-partition screens separated a chief's quarters from the rest of a communal house. The screen shown in figure 23-14 came from the house of Chief Shakes of Wrangell (d. 1916), whose family crest was the bear. The image of a rearing grizzly painted on the screen is itself made up of smaller bears and bear heads that appear in its ears, eyes, nostrils, joints, paws, and body. The images within the image enrich the monumental symmetrical design. The oval door opening is a symbolic vagina; passing through it reenacts the birth of the family from its ancestral spirit.

Blankets and other textiles produced by the Chilkat Tlingit had great prestige throughout the Northwest Coast (fig. 23-15). Chilkat men created the patterns, which they drew on boards, and women did the weaving. The blankets are made from shredded cedar bark wrapped with mountain-goat wool. The weavers did not use looms; instead, they hung **warp** threads from a rod and twisted colored threads back and forth through them to make the pattern. The ends of the warp formed the fringe at the bottom of the blanket.

The small face in the center of the blanket shown here represents the body of a stylized creature, perhaps a sea bear (a fur seal) or a standing eagle. On top of the body are the creature's large eyes; below it and to the sides are its legs and claws. Characteristic of Northwest

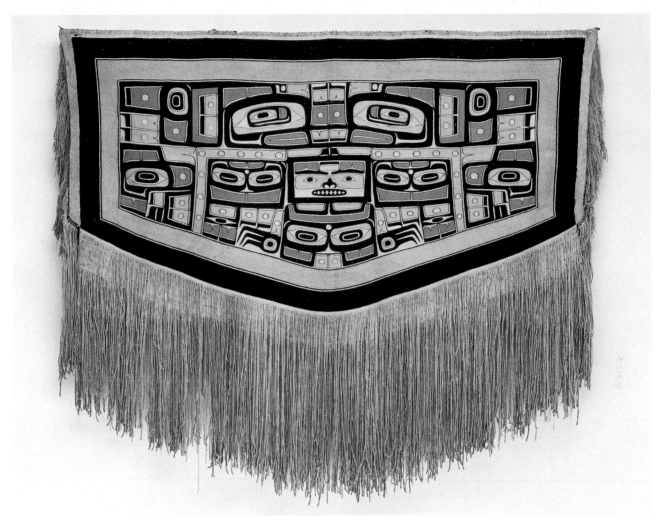

23-15. Chilkat blanket. Tlingit, before 1928. Mountain-goat wool and shredded cedar bark, 4'7⅛" x 5'3¾" (1.56 m across top). American Museum of Natural History, New York

Trans. #3804

painting and weaving, the images are composed of two basic elements: the **ovoid**, a slightly bent rectangle with rounded corners, and the **formline**, a continuous, shape-defining line. Here, subtly swelling black formlines define shapes with gentle curves, ovoids, and rectangular **C** shapes. When the blanket was worn, its two-dimensional forms would have become three-dimensional, with the dramatic central figure curving over the wearer's back and the intricate side panels crossing over his shoulders and chest.

Many Native American cultures stage ritual dance ceremonies to call upon guardian spirits. The participants in Northwest Coast dance ceremonies wore elaborate costumes and striking carved wooden masks. Among the most elaborate masks were those used by the Kwakiutl in their Winter Ceremony for initiating members into the shamanistic Hamatsa society (figs. 23-16, 23-17, "The Object Speaks: Hamatsa Masks," pages 890-891). The dance reenacted the taming of Hamatsa, a people-eating spirit, and his three attendant bird spirits. Magnificent

carved and painted masks transformed the dancers into Hamatsa and the bird attendants, who searched for victims to eat. Strings allowed the dancers to manipulate the masks so that the beaks opened and snapped shut with spectacular effect.

The contemporary Canadian Haida artist Bill Reid (1920–98) has sought to sustain and revitalize the traditions of Northwest Coast art in his work. Trained as a wood carver, painter, and jeweler, Reid revived the art of carving dugout canoes and totem poles in the Haida homeland of Haida Gwaii—"Islands of the People"— known on maps today as the Queen Charlotte Islands. Late in life he began to create large-scale sculpture in bronze. With their black patina, these works recall traditional Haida carvings in argillite, a shiny black stone. One of them, *The Spirit of Haida Gwaii*, now stands outside the Canadian Embassy in Washington, D.C. This sculpture, which Reid views as a metaphor for modern Canada's multicultural society, depicts a collection of figures from the natural and mythic worlds struggling to

THE OBJECT SPEAKS

HAMATSA MASKS

During the harsh winter season, when spirits are thought to be most powerful, many northern people seek spiritual renewal through their ancient rituals—including the potlach, or ceremonial gift giving, and the initiation of new members into the prestigious Hamatsa Society. With snapping beaks and cries of *"Hap! Hap! Hap!"* ("Eat! Eat! Eat!"), Hamatsa, the people-eating spirit of the north, and his three assistants—horrible masked monster birds—begin their wild, ritual dance (fig. 23-16). The dancing birds threaten and even attack the Kwakiutl people who gather for the Winter Ceremony.

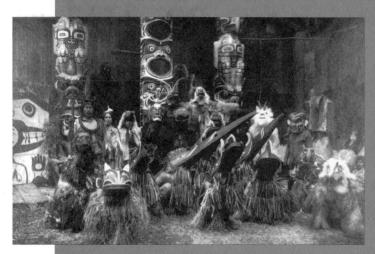

23-16. Edward S. Curtis. Hamatsa dancers, Kwakiutl, Canada. Photographed 1914. Smithsonian Institution Libraries, Washington, D.C.

The photographer Edward S. Curtis (1868–1952) devoted thirty years to documenting the lives of Native Americans. This photograph shows participants in a film he made about the Kwakiutl. For the film, his Native American assistant, Richard Hunt, borrowed family heirlooms and commissioned many new pieces from the finest Kwakiutl artists. Most of the pieces are now in museum collections. The photograph shows carved and painted posts, masked dancers (including those representing people-eating birds), a chief at the left (holding a speaker's staff and wearing a cedar neck ring), and spectators at the right.

In the Winter Ceremony, youths are captured, taught the Hamatsa lore and rituals, and then in a spectacular theater-dance performance are "tamed" and brought back into civilized life. All the members of the community, including singers, gather in the main room of the great house, which is divided by a painted screen (see fig. 23-14). The audience members fully participate in the performance; in early times, they brought containers of blood so that when the bird-dancers attacked them, they could appear to bleed and have flesh torn away.

Whistles from behind the screen announce the arrival of the Hamatsa (danced by an initiate), who enters through the central hole in the screen in a flesh-craving frenzy. Wearing hemlock, a symbol of the spirit world, he crouches and dances wildly with outstretched arms as attendants try to control him. He disappears but returns again, now wearing red cedar and dancing upright. Finally tamed, a full member of society, he even dances with the women.

Then the masked bird dancers appear—first Raven-of-the-North-End-of-the-World, then Crooked-Beak-of-the-End-of-the-World, and finally the untranslatable Huxshukw, who cracks open skulls with his beak and eats the brains of his victims. Snapping their beaks, these masters of illusion enter the room backward, their masks pointed up as though the birds are looking skyward. They move slowly counterclockwise around the floor. At each change in the music they crouch, snap their beaks, and let out their wild cries of *Hap! Hap! Hap!* Essential to the ritual dances are the huge carved and painted wooden masks, articulated and operated by strings worked by the dancers. Among the finest masks are those by Willie Seaweed (1873–1967), a Kwakiutl chief (fig. 23-17), whose brilliant colors and exuberantly decorative carving style determined the direction of twentieth-century Kwakiutl sculpture.

The Canadian government, abetted by missionaries, outlawed the Winter Ceremony and potlaches in 1885, claiming the event was injurious to health, encouraged prostitution, endangered children's education, damaged the economy, and was cannibalistic. But the Kwakiutl refused to give up their "oldest and best" festival—one that spoke powerfully to them in many ways, establishing social rank and playing an important role in arranging marriages. By 1936 the government and the missionaries, who called the Kwakiutl "incorrigible," gave up. But not until 1951 could the Kwakiutl people gather for winter ceremonies, including the initiation rites of the Hamatsa Society.

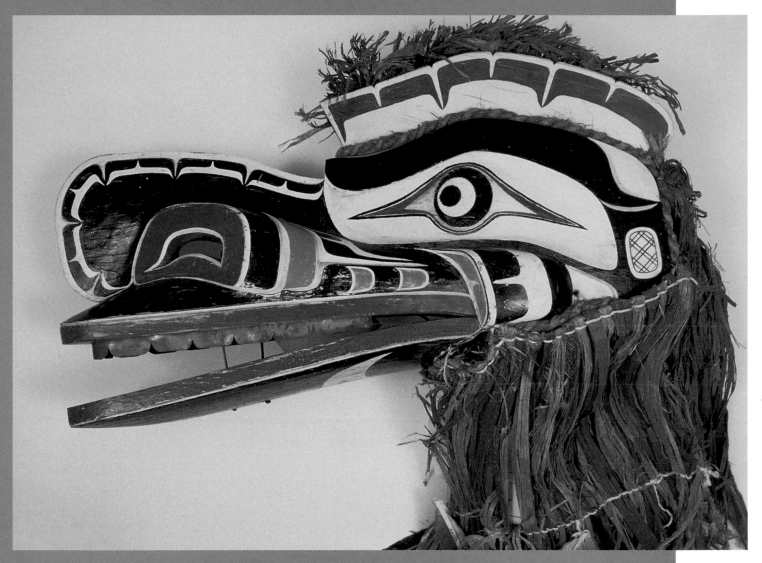

23-17. Attributed to Willie Seaweed. Kwakwaka'wakw Bird mask, from Alert Bay, Canada. Prior to 1951. Cedar wood, cedar bark, feathers, and fiber, 10 x 72 x 15" (25.4 x 183 x 38.1 cm). Collection of the Museum of Anthropology, Vancouver, Canada

(A6120)

The name *Seaweed* is an anglicization of the Kwakiutl name *Siwid*, meaning "Paddling Canoe," "Recipient of Paddling," or "Paddled To"—referring to a great chief to whose potlaches guests paddle from afar. Willie Seaweed was not only the chief of his clan, but a great orator, singer, and tribal historian who kept the tradition of the potlach alive during years of government repression.

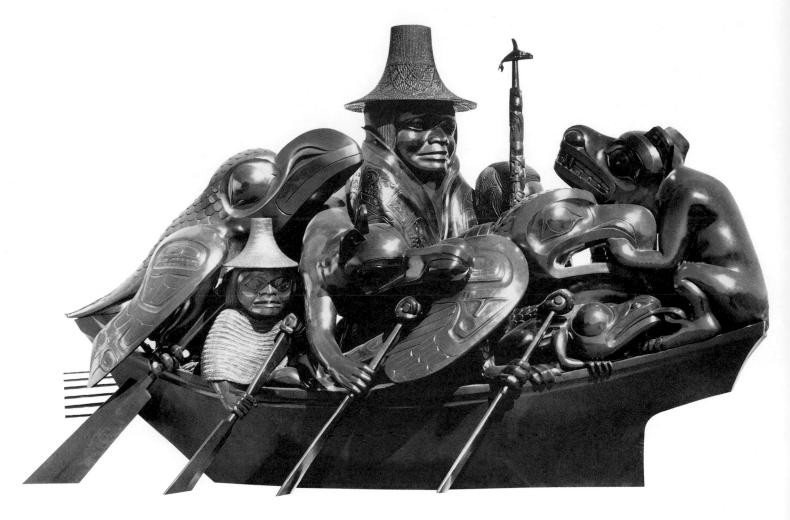

23-18. Bill Reid. *The Spirit of Haida Gwaii*. Haida, 1991. Bronze, approx. 13 x 20' (4 x 6 m). Canadian Embassy, Washington, D.C.

paddle forward in a canoe (fig. 23-18). The dominant figure in the center is a shaman in a spruce-root basket hat and Chilkat blanket holding a speaker's pole, a staff that gives him the right to speak with authority. In the prow, the place reserved for the chief in a war canoe, is the Bear. The Bear faces backward rather than forward, however, and is bitten by the Eagle, with formline-patterned wings. The Eagle, in turn, is bitten by the Seawolf. The Eagle and the Seawolf, together with the man behind them, nevertheless continue paddling. In the stern, steering the canoe, is the Raven, the trickster in Haida mythology. The Raven is assisted by Mousewoman, the traditional guide and escort of humans in the spirit realms. On the other side, not visible here, are the Bear mother and her twins, the Beaver, and the Dogfish Woman. According to Reid, the work represents a "mythological and environmental lifeboat," where "the entire family of living things . . . whatever their differences, . . . are paddling together in one boat, headed in one direction."

THE SOUTHWEST

The Native American peoples of the southwestern United States include the Pueblo (village-dwelling) groups and the Navajo. The Pueblo groups are heirs to the ancient Anasazi and Hohokam cultures, which developed a settled, agricultural way of life around 550 CE. The Anasazi built the many large, multistoried, apartmentlike villages and cliff dwellings whose ruins are found throughout northern Arizona and New Mexico. The Navajo, who moved into the region about the eleventh century or later, developed a semisedentary way of life based on agriculture and, after the introduction of sheep by the Spanish, sheepherding. Both groups succeeded in maintaining many of their traditions despite first Spanish and then Euro-American encroachments. Their arts reflect the adaptation of traditional forms to new technologies, new mediums, and the influences of the dominant American culture that surrounds them.

The Pueblos. Some Pueblo villages, like those of their Anasazi forebears, consist of multistoried, apartmentlike dwellings of considerable architectural interest. One of these, Taos Pueblo, shown here in a photograph by Laura Gilpin, is located in north-central New Mexico (fig. 23-19). The northernmost of the surviving Pueblo communities, Taos once served as a trading center between Plains and Pueblo peoples. It burned in 1690 but was rebuilt about 1700 and has often been modified since. "Great houses," multifamily dwellings, stand on either side of Taos Creek, rising in a stepped fashion to form a series of roof terraces. The houses border a plaza that opens toward the neighboring mountains. The plaza and roof terraces are centers of communal life and ceremony.

Pottery traditionally was a woman's art among Pueblo peoples, whose wares were made by **coiling** and other hand-building techniques, then fired at low temperature in wood bonfires. The best-known twentieth-century Pueblo potter is Maria Montoya Martinez (1887–1980) of San Ildefonso Pueblo in New Mexico. Inspired by prehistoric **blackware** pottery that was unearthed at nearby archaeological excavations, she and her husband, Julian Martinez (1885–1943), developed a distinctive new ware decorated with **matte** (nongloss) black forms on a lustrous black background (fig. 23-20). Maria made pots covered with a **slip** that was then burnished. Using additional slip, Julian painted the pots with designs that combined traditional Pueblo imagery and the then fashionable Euro-American Art Deco style. After firing, the burnished ground became a lustrous black and the slip painting retained a matte surface. Production of blackware in San Ildefonso had begun with Maria as potter and Julian as painter; by the 1930s, however, family members and friends all participated. Maria signed all the works so the entire community would profit from the market's appreciation of the Martinezes' skill.

In the 1930s Anglo-American art teachers and dealers worked with Native Americans of the Southwest to create a distinctive, stereotypical "Indian" style in several mediums—including jewelry, pottery, weaving, and painting—to appeal to tourists and collectors. A leader in this effort was Dorothy Dunn, who taught painting in the Santa Fe Indian School, a government high school

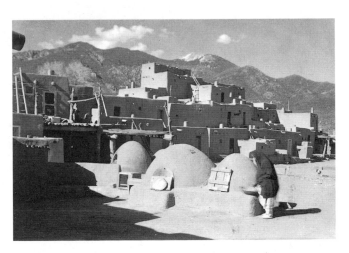

23-19. Laura Gilpin. Taos Pueblo. Tewa. Taos, New Mexico. Photographed 1947. Amon Carter Museum, Fort Worth, Texas

© 1979
Laura Gilpin Collection (neg. # 2528.1)

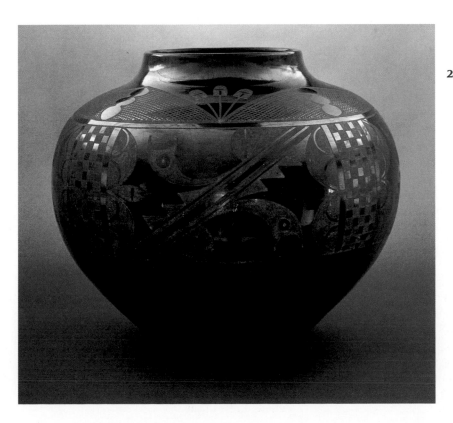

23-20. Maria Montoya Martinez and Julian Martinez. Blackware storage jar, from San Ildefonso Pueblo, New Mexico. c. 1942. Ceramic, height 18¾" (47.6 cm), diameter 22½" (57.1 cm). Museum of Indian Arts and Culture/Laboratory of Anthropology, Museum of New Mexico, Santa Fe

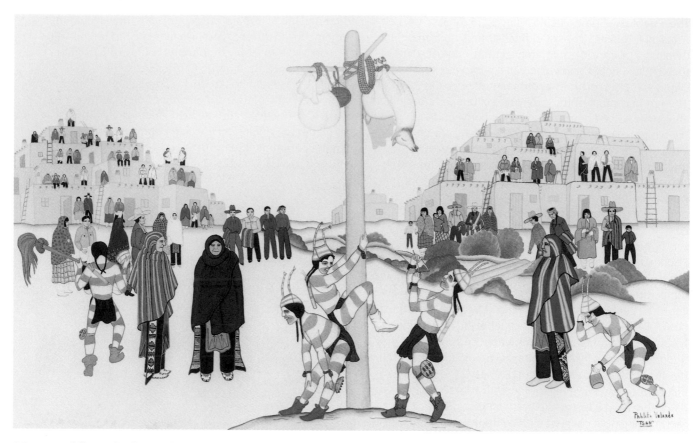

23-21. Pablita Velarde. *Koshares of Taos*, from Santa Clara Pueblo, New Mexico. 1946–47. Watercolor on paper, 13⅞ x 22⅜"
(35.3 x 56.9 cm). Philbrook Museum of Art, Tulsa, Oklahoma
Museum Purchase (1947.37)

in New Mexico, from 1932 to 1937. Dunn inspired her students to create a painting style that combined the outline drawing and flat colors of folk art, the decorative qualities of Art Deco, and "Indian" subject matter and came to be known as the Studio School. Restrictive as the school was, Dunn's success made painting a viable occupation for young Native American artists.

Pablita Velarde (b. 1918), a 1936 graduate of Dorothy Dunn's school, was only a teenager when one of her paintings was selected for exhibition at the Chicago World's Fair in 1933. Velarde, from Santa Clara Pueblo in New Mexico, began to document Pueblo ways of life as her work matured. *Koshares of Taos* (fig. 23-21) illustrates a moment during a ceremony celebrating the winter solstice when *koshares*, or clowns, take over the plaza from the *kachinas*—the supernatural counterparts of animals, natural phenomena like clouds, and geological features

like mountains—who are central to traditional Pueblo religion. *Kachinas* become manifest in the human dancers who impersonate them during the winter solstice ceremony, as well as in the small figures known as *kachina* dolls that are given to children. Velarde's painting combines bold, flat colors and a simplified decorative line with European perspective to produce a kind of Art Deco abstraction.

The Navajos. Navajo women are renowned for their skill as weavers. According to Navajo mythology, the universe itself is a kind of weaving, spun by Spider Woman out of sacred cosmic materials. Spider Woman taught the art of weaving to Changing Woman (a mother earth figure who constantly changes through the seasons), who in turn taught it to Navajo women. The earliest Navajo blankets have simple horizontal stripes,

NAVAJO NIGHT CHANT This chant accompanies the creation of a sand painting during a Navajo curing ceremony. It is sung toward the end of the ceremony and indicates the restoration of inner harmony and balance.

In beauty (happily) I walk.
With beauty before me I walk.
With beauty behind me I walk.
With beauty below me I walk.
With beauty above me I walk.
With beauty all around me
 I walk.

It is finished (again) in beauty.
It is finished in beauty.

(cited in Washington Mathews,
*American Museum of Natural
History Memoir*, no. 6,
New York, 1902, page 145)

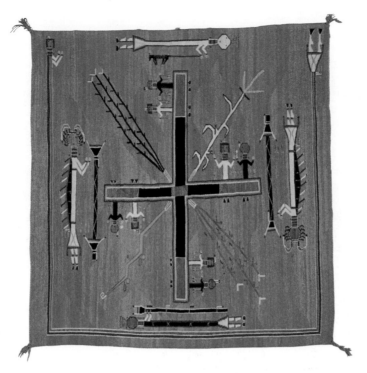

23-22. Hosteen Klah. *Whirling Log Ceremony*, sand painting, tapestry by Mrs. Sam Manuelito. Navajo, c. 1925. Wool, 5'5" x 5'10" (1.69 x 1.82 m). Heard Museum, Phoenix, Arizona

like those of their Pueblo neighbors, and are limited to the white, black, and brown colors of natural sheep's wool. Over time, the weavers developed finer techniques and introduced more intricate patterns. In the mid-nineteenth century, they began unraveling the fibers from commercially manufactured and dyed blankets and reusing them in their own work. By 1870–90 they were weaving spectacular blankets that were valued as prestige items among the Plains peoples as well as Euro-American collectors.

Another traditional Navajo art, sand painting, is the exclusive province of men. Sand paintings are made to the accompaniment of chants by shaman-singers in the course of healing and blessing ceremonies and have great sacred significance (see "Navajo Night Chant," opposite). The paintings depict mythic heroes and events; as ritual art they follow prescribed rules and patterns that ensure their power. To make them, the singer dribbles pulverized colored stones, pollen, flowers, and other natural colors over a hide or sand ground. The rituals are intended to restore harmony to the world and so to achieve cures. The paintings are not meant for public display and are destroyed by nightfall of the day on which they are made.

In 1919 a respected shaman-singer named Hosteen Klah (1867–1937) began to incorporate sand-painting images into weavings, breaking with the traditional prohibition against making them permanent. Many Navajos took offense at Klah both for recording the sacred images and for doing so in a woman's art form. Klah had learned to weave from his mother and sister. Gender roles were strict among Native Americans, but some superior artists began to break down the barriers. Klah's work was ultimately accepted because of his great skill and prestige. His *Whirling Log Ceremony* sand painting, which was woven into a tapestry (fig. 23-22), depicts a part of the Navajo creation myth in which the Holy People divide the world into four parts, create the Earth Surface People (humans), and bring forth corn, beans, squash, and tobacco, the four sacred plants. The Holy People surround the image, and a male-female pair of humans stands in each of the four quarters defined by the central cross. The guardian figure of Rainbow Maiden encloses the scene on three sides. The open side represents the east. Like all Navajo artists, Hosteen Klah hoped that the excellence of the work would make it pleasing to the spirits. Recently shaman-singers started making permanent sand paintings on boards for sale, but they always introduce slight errors in them to render them ceremonially harmless.

OTHER CONTEMPORARY NATIVE AMERICAN ARTISTS The Institute of American Indian Arts (IAIA), founded in 1962 in Santa Fe and attended by Native American students from all over North America, replaced Dorthy Dunn's Studio School in the later years of the twentieth century. Staffed by major Native American artists, the school encourages the incorporation of indigenous ideals in the arts without creating an

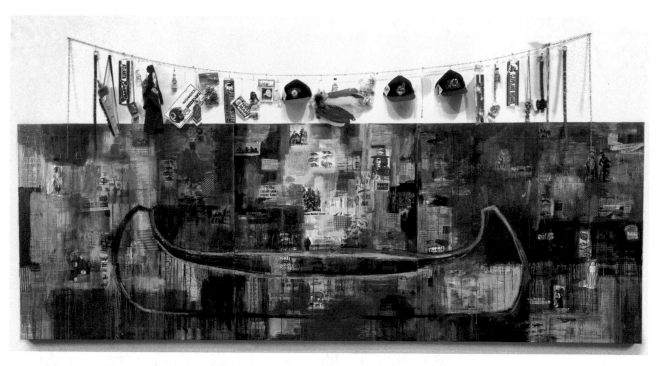

23-23. Jaune Quick-to-See Smith. *Trade (Gifts for Trading Land with White People).* Salish-Cree-Shoshone, 1992. Oil and collage on canvas, with other materials, 5' x 14'2" (1.56 x 4.42 m). Collection of the Chrysler Museum, Norfolk, Virginia

93.2. Courtesy Steinbaum Krauss Collection, New York City

official "style." As alumni achieved distinction and the IAIA museum in Santa Fe established a reputation for excellence, the institute led Native American art into the mainstream of contemporary art.

Many Native American artists today seek to move beyond the occasionally self-conscious revival of traditional forms to a broader art that acknowledges and mediates among the complex cultural forces shaping their lives. One exemplar of this trend is Jaune Quick-to-See Smith (b. 1940), who was raised on Flatrock Reservation in Montana and traces her descent to the Salish of the Northwest Coast, the Shoshone of southern California, and the Cree, a northern woodlands and plateau people. Quick-to-See Smith described the multiple influences on her work this way: "Inhabited landscape is the continuous theme in my work. Pictogram forms from Europe, the Amur, the Americas; color from beadwork, parfleches [rawhide], the landscape; paint application from Cobra art, New York Expressionism, primitive art; composition from Kandinsky, Klee, or Byzantine art provide some of the sources for my work. Study of the wild horse ranges, western plants and animals, and ancient sites feed my imagination and dreams. This is how I reach out and strike

new horizons while I reach back and forge my past" (*Women of Sweetgrass*, page 97).

During the United States' quincentennial celebration of Columbus's arrival in the Americas—in her words, the beginning of "the age of tourism"—Quick-to-See Smith created paintings and collages of great formal beauty that also confronted viewers with their own, perhaps unwitting, stereotypes (fig. 23-23). In *Trade (Gifts for Trading Land with White People),* a stately canoe floats over a richly colored and textured field, which on closer inspection proves to be a dense collage of clippings from Native American newspapers. Wide swatches and rivulets of red, yellow, green, and white cascade over the newspaper collage. On a chain above the painting is a collection of Native American cultural artifacts—tomahawks, beaded belts, feather headdresses—and memorabilia for sports teams like the Atlanta Braves, the Washington Redskins, and the Cleveland Indians, names that many Native Americans find offensive. Surely, the painting suggests, Native Americans could trade these goods to retrieve their lost lands, just as European settlers traded trinkets with Native Americans to acquire the lands in the first place.

PARALLELS

CULTURE	INDIGENOUS AMERICAN ART	ART IN OTHER CULTURES
AZTEC EMPIRE c. 1400–1519/21	23-1. *Codex Fejervary-Mayer* (c. 1400–1521) 23-4. **Malinalco sanctuary** (15th cent.) 23-3. *The Moon Goddess Coyolxauhqui* (1469[?]) 23-5. *The Mother Goddess, Coatlicue* (15th cent.) 23-2. *Codex Mendoza* (16th cent.)	17-14. **Van Eyck. Arnolfini wedding portrait** (1434), Belgium 22-5. **Ryoan-ji garden** (c. 1480), Japan 18-2. **Leonardo.** *Last Supper* (1495–98), Italy 17-25. *Unicorn* **tapestry** (1498–1500), France 21-9. **Shen Zhou.** *Poet on a Mountain Top* (c. 1500), China 20-8. *Gita Govinda* (c. 1525–50), India 18-11. **Michelangelo.** *David* (1501–4), Italy 21-6. **Ming flask** (c. 1426–35), China 20-7. **Taj Mahal** (c. 1632–48), India 22-1. **Hokusai.** *The Great Wave* (c. 1831), Japan 27-54. **Manet.** *Le Déjeuner sur l'Herbe* (1863), France 25-17. **Ijo ancestor screen** (19th cent.), Nigeria 24-14. **Kakalia.** *Royal Symbols* **quilt** (1978), Hawaii 25-11. **Ashanti** *kente* **cloth** (20th cent.), Ghana Hawaii 25-4. **Bwa performance mask** (1984), Burkina Faso 24-6. *Mbis* **spirit poles** (c.1960), Irian Jaya 25-20. **Odundo.** *Asymmetrical Angled Piece* (1991), Kenya 25-19. **Ouattara.** *Nok Culture* (1993), Côte d'Ivoire
INKA EMPIRE c. 1438–1532	23-6. **Temple of the Sun** (15th cent.), Cuzco 23-9. **Llama** (15th cent.) 23-7. **Machu Picchu** (1450–1530) 23-8. **Tunic** (c. 1500)	
EASTERN WOODLANDS	23-13. **Mandan hide painting** (1797–1800) 23-10. **Eastern Sioux baby carrier** (19th cent.)	
GREAT PLAINS	23-11. **Delaware shoulder bag** (c. 1860) 23-12. **Blackfoot tepee** (c. 1900)	
NORTHWEST COAST	23-14. **Tlingit screen** (c. 1840) 23-15. **Kwakiutl Hamatsa dancers** (1914) 23-17. **Tlingit Chilkat blanket** (before 1928) 23-16. **Kwakiutl mask** (before 1954)	
SOUTHWEST	23-19. **Taos Pueblo, New Mexico** (rebuilt 1700) 23-22. **Klah. Navajo.** *Whirling Log Ceremony* (c. 1925) 23-20. **Martinez and Martinez. San Ildefonso. Blackware jar** (c. 1942) 23-21. **Velarde. Santa Clara.** *Koshares of Taos* (1946–47) 23-23. **Smith. Salish-Cree-Shoshone.** *Trade (Gifts for Trading Land with White People)* (1992)	

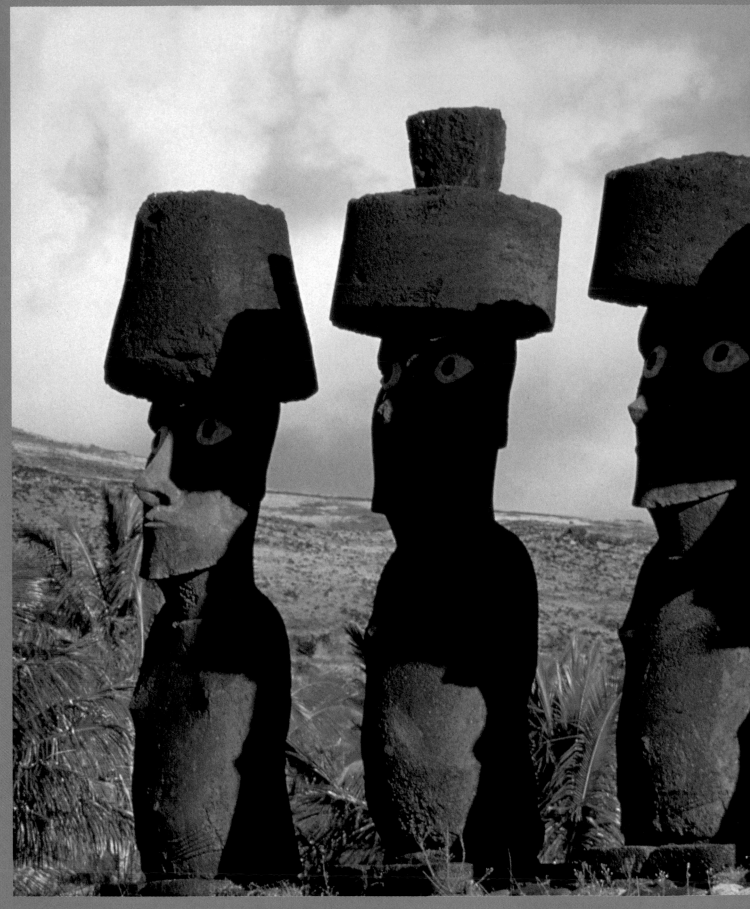

24-1. *Moai* **ancestor figures (?),** Ahu Nau Nau, Easter Island, Polynesia.
c. 1000–1500, restored 1978. Volcanic stone (tufa), average
height approx. 36' (11 m)

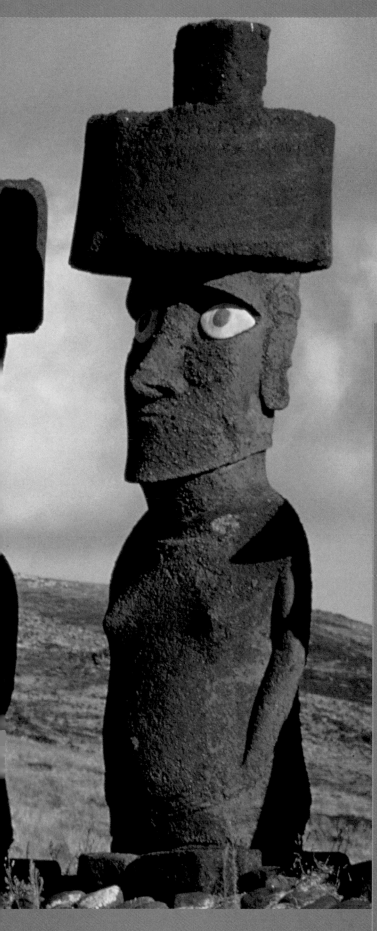

24
Art of Pacific Cultures

"In the middle of the Great Ocean, in a region where no one ever passes, there is a mysterious and isolated island; there is no land in the vicinity and, for more than eight hundred leagues in all directions, empty and moving vastness surrounds it. It is planted with tall, monstrous statues, the work of some now-vanished race, and its past remains an enigma" (Pierre Loti, *L'Île de Pâques*, 1872).

The early travelers who successfully reached the islands that lie in the Pacific Ocean found far more than the mysterious, "monstrous" statues of Easter Island (fig. 24-1). Those islands, which came to be described as simple paradises by romantic European and American visitors, have in fact supported widely differing ecosystems, peoples, and cultures for thousands of years. Over that span of time, their inhabitants have developed complex belief systems that have encouraged a rich, visionary life. And they have expressed their beliefs in concrete form—in ritual objects, masks, and the enrichment of their material environment.

The nineteenth-century explorers who set out from the Northern Hemisphere for the vastness of the Pacific had to rely on the earliest maps of the region, about a hundred years old, which showed only an uncertain location for an unknown "continent" that mapmakers believed extended to the South Pole. For them, as for us, maps created a view of the world—usually one that put their users' origins at its center. European medieval maps, for example, placed Jerusalem in the center; later cartographers focused on Rome. Westerners are so accustomed to thinking of a world grid originating at an observatory in Greenwich, England, or to imagining a map with the United States as the center of the world that other images are almost inconceivable. From a Northern Hemisphere point of view, the great landmasses of Australia, New Guinea, and New Zealand become lands "down under," sliding off under the globe, remote from our part of the world. But a simple shift of viewpoint—or a map in which the vast Pacific Ocean forms the center of a composition—suddenly marginalizes the Americas, and Europe disappears altogether.

TIMELINE 24-1. The Pacific Cultures. Populated by peoples from Southeast Asia beginning about 50,000 years ago, the four main cultural-geographic groups of Oceania were settled at different times and rates.

MAP 24-1. Pacific Cultural-Geographic Regions. The Pacific cultures are found in four vast areas: Australia, Melanesia, Micronesia, and Polynesia.

THE PEOPLING OF THE PACIFIC

On a map with the Pacific Ocean as its center, only the peripheries of the great landmasses of Asia and the Americas appear. The immense, watery region of Oceania consists of four cultural-geographic areas: Australia, Melanesia, Micronesia, and Polynesia (see Map 24-1). Australia includes the island continent as well as the island of Tasmania to the southeast. Melanesia (meaning "black islands," a reference to the dark skin color of its inhabitants) includes New Guinea and the string of islands that extends eastward from it as far as Fiji and New Caledonia. Micronesia ("small islands"), to the north of Melanesia, is a region of small islands, including the Marianas. Polynesia ("many islands") is scattered over a huge, triangular region defined by New Zealand in the south, Easter Island in the east, and the Hawaiian Islands to the north. The last region on earth to be inhabited by humans, Polynesia covers some 7.7 million square miles, of which fewer than 130,000 square

miles are dry land—and most of that is New Zealand. Melanesia and Micronesia are also known as Near Oceania, and Polynesia as Far Oceania.

Australia, Tasmania, and New Guinea formed a single continent during the last Ice Age, which began some 2.5 million years ago. About 50,000 years ago, when the sea level was about 330 feet lower than it is today, people moved to this continent from Southeast Asia, making at least part of the journey over open water. Some 27,000 years ago they were settled on the large islands north and east of New Guinea as far as San Cristobal, but they ventured no farther for another 25,000 years. By about 4000 BCE—possibly as early as 7000 BCE—the people of Melanesia were raising pigs and cultivating taro, a plant with edible rootstocks. As the glaciers melted, the sea level rose, flooding low-lying coastal land. By around 4000 BCE a 70-mile-wide waterway, now called the Torres Strait, separated New Guinea from Australia, whose people retained a hunting and gathering way of life into the twentieth century.

24-2. *Mimis and Kangaroo*, prehistoric rock art, Oenpelli, Arnhem Land, Australia. Older painting 16,000–7000 BCE. Red and yellow ocher and white pipe clay

The settling of the rest of the islands of Melanesia and the westernmost islands of Polynesia—Samoa and Tonga—coincided with the spread of the seafaring Lapita culture, named for a site in New Caledonia, after about 1500 BCE. The Lapita people were farmers and fisherfolk who lived in often large coastal villages, probably cultivated taro and yams, and produced a distinctive style of pottery. They were skilled shipbuilders and navigators and engaged in interisland trade. Over time the Lapita culture lost its widespread cohesion and evolved into various local forms. Polynesian culture apparently emerged in the eastern Lapita region on the islands of Tonga and Samoa. Around the beginning of the first millennium CE, daring Polynesian seafarers, probably in double-hulled sailing canoes, began settling the scattered islands of Far Oceania and eastern Micronesia. Voyaging over open water, sometimes for thousands of miles, they reached Hawaii and Easter Island after about 500 CE and settled New Zealand by about 800/900–1200 CE.

In this vast and diverse Pacific region, the arts display enormous variety and are generally closely linked to a community's ritual and religious life. In this context, the visual arts were often just one strand in a rich weave that also included music, dance, and oral literature.

AUSTRALIA

The aboriginal inhabitants of Australia, or Aborigines, were nomadic hunter-gatherers closely attuned to the varied environments in which they lived until European settlers disrupted their way of life. The Aborigines had a complex social organization and a rich mythology that was vividly represented in the arts. As early as 18,000 years ago they were painting images on rocks and caves in western Arnhem Land, which is on the northern coast of Australia. One such painting contains a later image superimposed on an earlier one (fig. 24-2). The earlier painting is of skinny, sticklike humans that the Aborigines call *mimis* (ancestral spirits). Over the *mimis* is a kangaroo rendered in the distinctive **x-ray style**, in which the artist drew important bones and internal organs—including the spinal column, other bones, the heart, and the stomach—over the silhouetted form of the animal. In the picture shown here, all four of the kangaroo's legs have been drawn, and the ears have been placed symmetrically on top of its head. In some images both eyes appear in the head, which is shown in profile. The x-ray style was still prevalent in western Arnhem Land when European settlers arrived in the nineteenth century.

Another aboriginal art form, bark painting, has continued from prehistoric times to the present day. Paintings in ocher and clay on eucalyptus bark, created in a ritual context, were used to help maintain and transmit cultural traditions from generation to generation. These paintings reduced complex stories and ideas to essentials and served as memory aids upon which elders could elaborate.

Bark paintings from northeastern Arnhem Land are entirely filled with elaborate narrative compositions in delicate striping and **cross-hatching**. The Aborigines do not reveal the full meaning of these works to outsiders, but in general they depict origin myths. According to their beliefs, the world and its inhabitants were created in the Dream Time. The myths also explain the formation of important features of the landscape, of climatic phenomena like the monsoon season, and of aboriginal social groupings: In the beginning, the world was flat, but

24-4. Fragments of a large Lapita jar, from Venumbo, Reef Santa Cruz Island, Solomon Islands, Melanesia. c. 1200–1100 BCE. Clay, height of human face approx. 1 1/2" (4 cm)

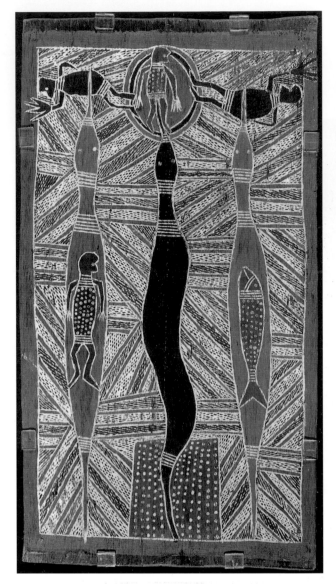

24-3. Mawalan Marika. *The Wawalag Sisters and the Rainbow Serpent*. 1959. Ochers on eucalyptus bark, 18 3/4 x 10 1/8" (48 x 26 cm). Collection, Art Gallery of Western Australia, Perth

The sisters dance outside their home in an attempt to escape the Rainbow Serpent's wrath. The serpent slithers out of his hole at the bottom of the bark. It has already devoured a human and a fish.

animals and the ancestral beings shaped it into mountains, sand hills, creeks, and water holes. Animals became the totemic ancestors of human groups, and the places associated with them became sacred sites. The paintings and the rituals associated with them are meant to restore contact with the Dream Time.

Aboriginal artists continue to work in time-honored and ritually sanctioned ways. In one origin myth, depicted in a bark painting by Mawalan Marika (1908–67), the first humans, the Wawalag Sisters (seen at the top of figure 24-3), walked about with their digging sticks, singing, dancing, naming things, and populating the land with their children. But they offended the Rainbow Serpent, a

symbol of the monsoon rains that bring both fertility and destruction. The serpent swallowed the sisters and designated the place where their descendants were to perform the Wawalag rituals. Aboriginal artists today may paint with acrylic paint on canvas instead of with ocher, clay, and charcoal on rock and eucalyptus bark, but their imagery has remained relatively constant, and their explanations of their work provide insight into the meaning of prehistoric images.

MELANESIA

Exceptional seafarers spread the Lapita culture throughout the islands of Melanesia beginning around 1500 BCE. They brought with them the plants and animals that colonizers needed for food, thus spreading agricultural practices through the islands. They also carried with them the distinctive ceramics whose remnants today enable us to trace the extent of their travels. Lapita potters, probably women, produced dishes, platters, bowls, and jars. Sometimes they covered their wares with a red **slip**, and they often decorated them with bands of **incised** and stamped geometric patterns—dots, lines, and hatching—heightened with white lime. Most of the decoration was entirely geometric, but some was figurative. The human face that appears on one example (fig. 24-4) is among the earliest representations of a human being in Oceanic art. Over time Lapita pottery evolved into a variety of regional styles in Melanesia, but in western Polynesia, the heartland of Polynesian culture and the easternmost part of the Lapita range, the making of pottery ceased altogether by between 100 and 300 CE.

In Melanesia, as in Australia, the arts were intimately involved with belief and provided a means for communicating with supernatural forces. Rituals and ritual arts were primarily the province of men, who devoted a great

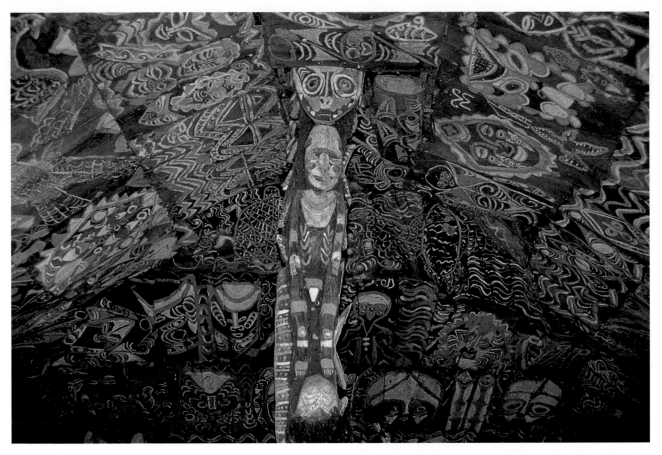

24-5. Detail of *tamberan* house, Sepik River, Papua New Guinea, New Guinea. Abelam, 20th century. Carved and painted wood, with ocher pigments on clay ground

deal of time to both. In some societies most of the adult males were able to make ritual objects. Women, although barred from ritual arts, gained prestige for themselves and their families through their skill in the production of other kinds of goods. To be effective, ritual objects had to be well made, but they were often allowed to deteriorate after they had served their ceremonial function.

PAPUA NEW GUINEA

New Guinea, the largest island in Melanesia (and at 1,500 miles long and 1,000 miles wide, the second-largest island in the world), is today divided between two countries. The eastern half of the island is part of the present-day nation of Papua New Guinea; the western half is Irian Jaya, a province of present-day Indonesia. Located near the equator and with mountains that rise to 16,000 feet, the island's diverse environments range from tropical rain forest to grasslands to snow-covered peaks.

The Abelam, who live in the foothills of the mountains on the north side of Papua New Guinea, raise pigs and cultivate yams, taro, bananas, and sago palms. In traditional Abelam society, people live in extended families or clans in hamlets. Wealth among the Abelam is measured in pigs, but men gain status from participation in a yam cult that has a central place in Abelam society and in the iconography of its art and architecture. The yams that are the focus of this cult—some of which reach an extraordinary 12 feet in length—are associated with clan ancestors and the potency of their growers. Village leaders renew their relationship with the forces of nature that yams represent during the Long Yam Festival, which is held at harvest time and involves processions, masked figures, singing, and the ritual exchange of the finest yams.

An Abelam hamlet includes sleeping houses, cooking houses, storehouses for yams, a central space for rituals, and a *tamberan* house. In this ceremonial structure, *tamberans*, the images and objects associated with the yam cult and with clan identity, are kept hidden from women and uninitiated boys. Men of the clan gather in the *tamberan* house to organize rituals and conduct community business. In the past, they also planned raids. The prestige of a hamlet is linked to the quality of its *tamberan* house and the size of its yams. Constructed on a frame of poles and rafters and roofed with split cane and thatch, *tamberan* houses have been as much as 280 feet long and more than 40 feet wide. The ridgepole is set at an angle, making one end higher than the other, and the roof extends forward in an overhanging peak that is braced by a carved pole. The entrance facade is thus a large, in-folded triangular form, elaborately painted and carved (fig. 24-5). Panels are painted in red, ocher, white, and black with the faces of a clan's ancestral spirits. The

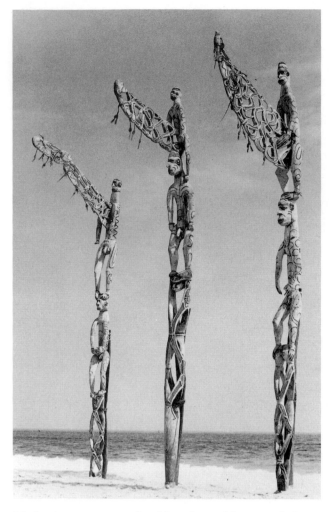

24-6. Asmat ancestral spirit poles (mbis), Faretsj River, Irian Jaya, Indonesia, New Guinea. c. 1960. Wood, paint, palm leaves, and fiber, height approx. 18' (5.48 m). Photograph in The Metropolitan Museum of Art, New York

The Michael C. Rockefeller Memorial Collection, Gift of Nelson A. Rockefeller and Mrs. Mary C. Rockefeller, 1965 (1978.412. 1248-50)

Abelam believe the paint itself has magical qualities. The effectiveness of the images is thought to depend in part on accurate reproduction, and master painters direct the work of younger initiates. Regular, ritual repainting revitalizes the images and ensures their continued potency. Every stage in the construction of a *tamberan* house is accompanied by ceremonies, which are held in the early morning while women and boys are still asleep. The completion of a house is celebrated with elaborate fertility rituals and an all-night dance. Women participate in these inaugural ceremonies and are allowed to enter the new house, which afterward is ritually cleansed and closed to them.

IRIAN JAYA

The Asmat, who live in the grasslands on the southwest coast of Irian Jaya, were known in the past as warriors and headhunters. They believe that a mythic hero carved

their ancestors from trees, and to honor the dead they erect memorial poles covered with elaborate sculpture (fig. 24-6). The poles are known as *mbis*, and the rituals surrounding them are intended to reestablish the balance between life and death. The Asmat believe that *mbis* house the souls of the recent dead, and they place them in front of the village men's house so the souls can observe the rituals there. After the *mbis* ceremonies, the poles are abandoned and allowed to deteriorate.

In the past, once the poles had been carved, villagers would organize a headhunting expedition so that they could place an enemy head in a cavity at the base of each pole. The base, with its abstract voids for enemy heads, represents the twisting roots of the banyan tree. Above the base, figures representing tribal ancestors support figures of the recent dead. The bent pose of the figures associates them with the praying mantis, a symbol of headhunting; another symbol of headhunting seen in *mbis* is birds breaking open nuts. The large, lacy phalluses emerging from the figures at the top of the poles symbolize male fertility, and the surface decoration suggests tattoos and scarification (patterned scars), common body ornamentation in Melanesia.

NEW IRELAND

The people of the central part of the island of New Ireland, which is one of the large easternmost islands of the nation of Papua New Guinea, are known for their *malanggan* ceremonies, elaborate funerary rituals for which striking painted carvings and masks are made. *Malanggans* involve an entire community as well as its neighbors and serve to validate social relations and property claims.

Because preparations are costly and time consuming, *malanggans* are often delayed for several months or even years after a death and might commemorate more than one person. Although preparations are hidden from women and children, everyone participates in the actual ceremonies. Arrangements begin with the selection of trees to be used for the *malanggan* carvings. In a ceremony marked by a feast of taro and pork, the logs are cut, transported, and ritually pierced. Once the carvings are finished, they are dried in the communal men's house, polished, and then displayed in a *malanggan* house in the village *malanggan* enclosure. Here the figures are painted and eyes made of sea snail shell are inserted. The works displayed in a *malanggan* house include figures on poles and freestanding sculpture representing ancestors and the honored dead, as well as masks and ritual dance equipment. They are accorded great respect for the duration of the ceremony, then allowed to decay.

Another ritual, the *tatanua* dance, assures male power, and men avoid contact with women for six weeks beforehand. *Tatanua* masks, worn for the dance, represent the spirits of the dead (fig. 24-7). The helmetlike masks are carved and painted with simple, repetitive motifs such as ladders, zigzags, and stylized feathers. The paint is applied in a ritually specified order: first lime white for magic spells; then red ocher to recall the

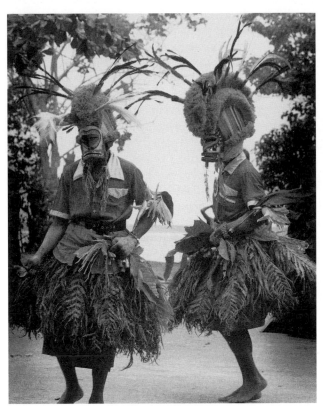

24-7. Dancers wearing *tatanua* masks, Pinikindu Village, central New Ireland, Papua New Guinea, New Guinea. 1979. Masks: wood, vegetable fibers, trade cloth, and pigments, approx. 17 x 13" (43 x 33 cm)

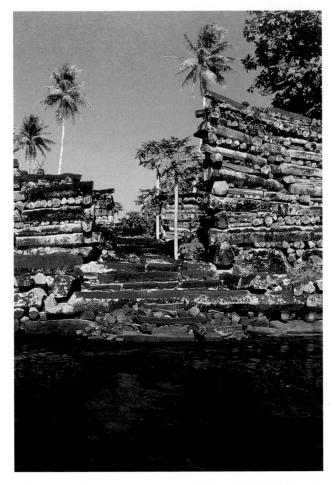

24-8. Royal mortuary compound, Nan Madol, Pohnpei, Federated States of Micronesia. c.1200/1300–c.1500/1600. Basalt blocks, wall height up to 25' (7.62 m)

spirits of those who died violently; then black from charcoal or burned nuts, a symbol of warfare; and finally yellow and blue from vegetable materials. The magnificent crest of plant fiber is a different color on the right and the left sides, perhaps a reflection of a long-ago hairstyle in which the hair was cut short and left naturally black on one side and dyed yellow and allowed to grow long on the other. The contrasting sides of the masks allow dancers to present a different appearance by turning from side to side. A good performance of the *tatanua* dance is considered a demonstration of strength, while a mistake can bring laughter and humiliation.

MICRONESIA Over the centuries the people of Oceania erected monumental stone architecture and carvings in a number of places. In some cases, in Polynesia for example, widely scattered structures share enough characteristics to suggest that they spring from a common origin. Others appear to be unique. The site of Nan Madol, on the southeast coast of Pohnpei in Micronesia, is the largest and one of the most remarkable stone complexes in Oceania. It and a similar, smaller complex on another island nearby are also apparently without precedent. At one time Nan Madol was home to as many as 1,000

people, but it was deserted by the time Europeans discovered it in the nineteenth century.

Pohnpei, today the location of the Federated States of Micronesia's capital city, Palikir, is a mountainous tropical island with cliffs of prismatic basalt. By the thirteenth century CE the island's inhabitants were evidently living in a hierarchical society ruled by a powerful chief with the resources to harness sufficient labor for a monumental undertaking. Nan Madol, which covers some 170 acres, consists of 92 small artificial islands set within a network of canals. Most of the islands are oriented northeast-southwest, receiving the benefit of the cooling prevailing winds. Seawalls and breakwaters 15 feet high and 35 feet thick protect Nan Madol from the ocean. Openings in the breakwaters gave canoes access to the ocean and allowed seawater to flow in and out with the tides, flushing clean the canals. The islands and structures of Nan Madol are built of prismatic basalt "logs" stacked in alternating **courses** (rows or layers). Through ingenious technology the logs were split from their source by alternately heating the base of a basalt cliff with fire and dousing it with water.

The royal mortuary compound, which once dominated the southeast side of Nan Madol (fig. 24-8), has walls rising in subtle upward and outward curves to a

height of 25 feet. To achieve the sweeping, rising lines, the builders increased the number of stones in the **header** courses (the courses with the ends of the stones laid facing out along the wall) relative to the **stretcher** courses (the courses with the lengths of the stones laid parallel to the wall) as they came to the corners and entryways. The plan of the structure consists simply of progressively higher rectangles within rectangles—the outer walls leading by steps up to interior walls that lead up to a center courtyard with a small, cubical tomb.

POLYNESIA

The settlers of the far-flung islands of Polynesia quickly developed distinctive cultural traditions but also retained linguistic and cultural affinities that reflect their common origin. Traditional Polynesian society was generally far more stratified than Melanesian society, and Polynesian art objects served as important indicators of rank and status. Reflecting this function, they tended to be more permanent than art objects in Melanesia, and they often were handed down as heirlooms from generation to generation. European colonization had a profoundly disruptive effect on society and art in Polynesia, as elsewhere in Oceania, which stemmed, ironically, from the very high regard the outsiders felt for the art they found. European artists and collectors admired Polynesian art and purchased it avidly, but in so doing totally altered the context in which much of it was produced (see "Paul Gauguin on Oceanic Art," below).

EASTER ISLAND

Easter Island, the most remote and isolated island in Polynesia, is also the site of Polynesia's most impressive sculpture. Stone temples, or *marae*, with stone altar platforms, or *ahu*, are common throughout Polynesia. Most of the *ahu* are built near the coast, parallel to the shore. About 900 CE, Easter Islanders began to erect huge stone figures on *ahu*, perhaps as memorials to dead chiefs. Nearly 1,000 of the figures, called *moai*, have been found, including some unfinished in the quarries where they were being made. Carved from tufa, a yellowish brown volcanic stone, most are about 36 feet tall, but one unfinished figure measures almost 70 feet. In 1978 several figures were restored to their original condition, with red tufa topknots on their heads and white coral eyes with stone pupils (see fig. 24-1). The heads have deep-set eyes under a prominent browridge; a long, concave, pointed nose; a small mouth with pursed lips; and an angular chin. The extremely elongated earlobes have parallel engraved lines that suggest ear ornaments. The figures have schematically indicated breastbones and pectorals, and small arms with hands pressed close to the sides, but no legs.

Easter Islanders stopped erecting *moai* around 1500 and apparently entered a period of warfare among themselves, possibly because overpopulation was straining the island's available resources. Most of the *moai* were knocked down and destroyed during this period. The island's indigenous population, which may at one time have consisted of as many as 10,000 people, was nearly eradicated in the nineteenth century by Peruvian slave traders. The smallpox and tuberculosis they brought with them precipitated an epidemic that left only about 600 inhabitants alive on Easter Island.

MARQUESAS ISLANDS

Warfare was common in Polynesia and involved hand-to-hand combat. Warriors dressed to intimidate and to convey their rank and status, so weapons, shields, and regalia tended to be especially splendid. A 5-foot-long ironwood war club from the Marquesas Islands (fig. 24-9) is lavishly decorated, with a Janus-like double face at the end. More faces appear within these faces. The high arching eyebrows frame sunburst eyes whose pupils are tiny faces. Other patterns seem inspired by human eyes and noses. The overlay of low relief and engraved patterns suggests tattooing, a highly developed art in Polynesia (see fig. 24-12).

HAWAIIAN ISLANDS

Until about 1200 CE the Hawaiian Islands remained in contact with other parts of Polynesia; thereafter they were isolated, and rigidly stratified Hawaiian society was

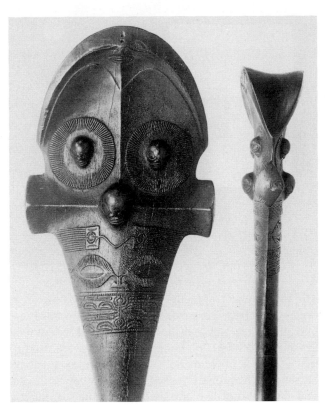

24-9. War club, from the Marquesas Islands, Polynesia. Early 19th century. Ironwood, length approx. 5' (1.52 m). Peabody Essex Museum, Salem, Massachusetts

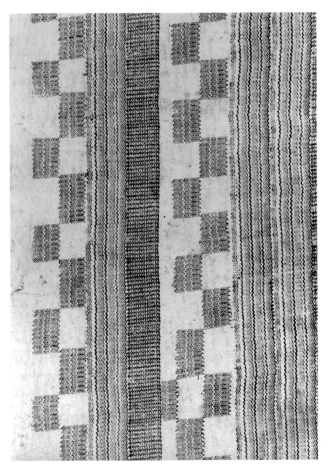

24-10. Skirt originally belonging to Queen Kamamalu, Hawaii. 1823–24. Paper mulberry (wauke) bark, stamped patterns, 12'3"x 5'6" (3.77 x 1.7 m). Bishop Museum, Honolulu

Gift of Evangeline Priscilla Starbuck, 1927 (C.209)

divided into several independent chiefdoms. By 1810 one ruler, Kamehameha I (c. 1758–1819), had consolidated the islands into a unified kingdom, but Hawaii's isolation had already come to an end with the 1778 arrival of the English explorer Captain James Cook. Throughout the nineteenth century the influence of United States missionaries and economic interests increased, and Hawaii's traditional religion and culture declined. The United States annexed Hawaii in 1898, and the territory became a state in 1959.

Decorated bark cloth and featherwork, found elsewhere in Polynesia, were highly developed in Hawaii. Bark cloth, commonly known as **tapa** (*kapa* in Hawaiian), is made by pounding together moist strips of the inner bark of certain trees, particularly the mulberry tree. The cloth makers, usually women, used mallets with incised patterns that left impressions in the cloth. Like a watermark in paper, these impressions can be seen when the cloth is held up to the light. Fine bark cloth was dyed and decorated in red or black with repeated geometric patterns laboriously made with tiny bamboo stamps. One favorite design consists of parallel rows of **chevrons** printed close together in sets or spaced in

rows. The cloth could also be worked into a kind of **appliqué**, in which a layer of cutout patterns, usually in red, was beaten onto a light-colored backing sheet. The traditional Hawaiian women's dress consisted of a sheet of bark cloth worn wrapped around the body either below or above the breasts. The example shown here (fig. 24-10) belonged to Queen Kamamalu. Such garments were highly prized and were considered to be an appropriate diplomatic gift. The queen took bark-cloth garments with her when she and King Kamehameha II made a state visit to London in 1823.

The Hawaiians prized featherwork even more highly than fine bark cloth. Feather cloaks, helmets, capes, blankets, and garlands (leis) conveyed special status and prestige, and only wealthy chiefs could command the resources to make them. Tall feather pompons (*kahili*) mounted on long slender sticks symbolized royalty. And the images of the gods that Hawaiian warriors carried into battle were made of light, basketlike structures covered with feathers. Feather garments, made following strict ritual guidelines, consisted of bundles of feathers tied in overlapping rows to a foundation of plant-fiber netting. Yellow feathers, which came from the Hawaiian

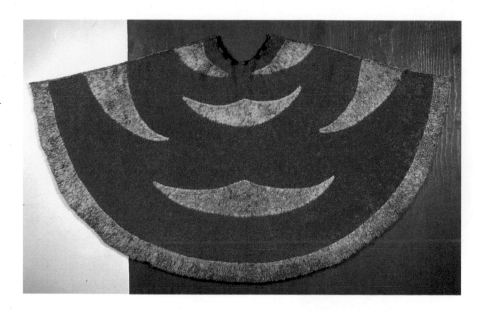

24-11. Feather cloak, known as the Kearny Cloak, Hawaii. c. 1843. Red, yellow, and black feathers, *olona* cordage, and netting, length 55¾" (143 cm). Bishop Museum, Honolulu

Hawaiian chiefs wore feather cloaks into battle, making them prized war trophies as well as highly regarded diplomatic gifts. King Kamehameha III (ruled 1825–54) presented this cloak to Commodore Lawrence Kearny, commander of the U.S. frigate *Constellation*.

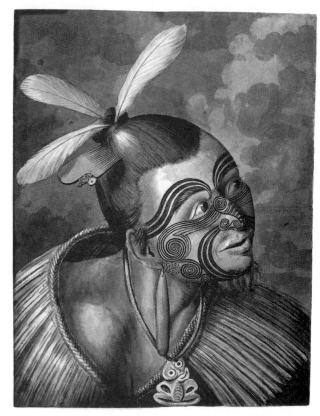

24-12. Sydney Parkinson. *Portrait of a Maori*. 1769. Wash drawing, 15½ x 11⅝" (39.37 x 29.46 cm), later engraved and published as plate XVI in Parkinson's *Journal*, 1773. The British Library, London

Add MS 23920 f.55

honey eater bird, were extremely valuable because one bird produced only seven or eight suitable feathers. Some 80,000 to 90,000 honey eater birds were used to make King Kamehameha I's full-length royal cloak. Lesser men had to be satisfied with short capes. Cloaks and capes hung like upside-down funnels from the wearer's shoulders, creating a sensuously textured and colored abstract design. The typical cloak was red (the color of the gods) with a yellow border and sometimes a narrow decorative neckband. The symmetrically arranged geometric decoration in the example shown here (fig. 24-11) falls on the wearer's front and back; the paired crescents on the edge join when the garment is closed to match the forms on the back. Captain Cook, impressed by the "beauty and magnificence" of Hawaiian featherwork, compared it to "the thickest and richest velvet" (*Voyage*, 1784, volume 2, page 206; volume 3, page 136).

NEW ZEALAND

New Zealand was the last part of Polynesia to be settled. The first inhabitants had arrived by about the tenth century, and their descendants, the Maori, numbered in the hundreds of thousands by the time of European contact in the seventeenth and eighteenth centuries. Captain Cook, before he landed in Hawaii, led a British scientific expedition to the Pacific that explored the coast of New Zealand in 1769. Sydney Parkinson (1745?–71), an artist on the expedition, documented aspects of Maori life and art at the time (see "Art and Science: The First Voyage of Captain Cook," page 916). An unsigned drawing by Parkinson (fig. 24-12) shows a Maori with facial tattoos (*moko*) wearing a headdress with feathers, a comb, and a *hei-tiki* (a carved pendant of a human figure).

Combs similar to the one in the drawing can still be found in New Zealand. The long ear pendant is probably made of greenstone, a form of jade found on New

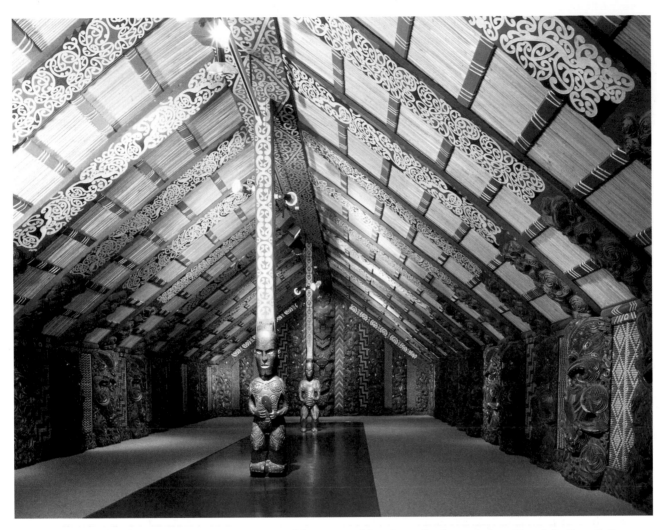

24-13. Raharuhi Rukupo, master carver. Te-Hau-ki-Turanga (Maori meetinghouse), from Manutuke Poverty Bay, New Zealand. 1842–43, restored in 1935. Wood, shell, grass, flax, and pigments. The Museum of New Zealand Te Papa Tongarewa, Wellington

Neg. B18358

Zealand's South Island that varies in color from off-white to very dark green. The Maori considered greenstone to have supernatural powers. The *hei-tiki* hanging on a cord around the man's neck would have been among his most precious possessions. Such *tiki* figures, which represented legendary heroes or ancestor figures, gained power from their association with powerful people. The *tiki* in this illustration has an almost embryonic appearance, with its large tilted head, huge eyes, and seated posture. Some *tiki* had large eyes of inlaid shell.

The art of tattoo was widespread and ancient in Oceania; bone tattoo chisels have even been found in Lapita sites. Maori men generally had tattoos on the face and on the lower body between the waist and the knees. Women were tattooed around the mouth and on the chin. The typical design of men's facial tattoos, like the striking one shown here, consisted of broad, curving parallel lines from nose to chin and over the eyebrows to the ears. Small spiral patterns adorned the cheeks and nose. Additional spirals or other patterns were placed on the forehead and chin and in front of the ears. A formal, bilateral symmetry controlled the design. Maori men

considered their *moko* designs to be so personal that they sometimes signed documents with them. Ancestor carvings in Maori meetinghouses also have distinctive *moko*. According to Maori mythology, tattooing, as well as weaving and carving, was brought to them from the underworld, the realm of the Goddess of Childbirth. *Moko* might thus have a birth-death symbolism that links the living with their ancestors.

The Maori are especially known for their wood carving, which is characterized by a combination of massive underlying forms with delicate surface ornament. This art form found expression in small works like the *hei-tiki* in Parkinson's drawing as well as in the sculpture that adorned storehouses and meetinghouses in Maori hilltop villages. The meetinghouse in particular became a focal point of local tradition under the influence of one built in 1842–43 by Raharuhi Rukupo as a memorial to his brother (fig. 24-13). Rukupo, who was an artist, diplomat, warrior, priest, and early convert to Christianity, built the house with a team of eighteen wood carvers. Although they used European metal tools, they worked in the technique and style of traditional carving done

with stone tools. They finished the carved wood by rubbing it with a combination of red clay and shark-liver oil to produce a rich, brownish-red color.

The whole structure symbolizes the sky father. The ridgepole is his backbone, the rafters are his ribs, and the slanting **bargeboards**—the boards attached to the projecting end of the **gable**—are his outstretched enfolding arms. His head and face are carved at the peak of the roof. The curvilinear patterns on the rafters were made with a silhouetting technique. Artists first painted the rafters white, then outlined the patterns, and finally painted the background red or black, leaving the patterns in white. Characteristically Maori is the *koru* pattern, a curling stalk with a bulb at the end that is said to resemble the young tree fern.

Relief figures of ancestors—Raharuhi Rukupo in-cluded a portrait of himself among them—cover the support poles, wall planks, and the lower ends of the rafters. The ancestors, in effect, support the house. They were thought to take an active interest in community affairs and to participate in the discussions held in the meetinghouse. Like the *hei-tiki* in figure 24-12, the figures have large heads. Flattened to fit within the building planks and covered all over with spirals, parallel and hatched lines, and tattoo patterns, they face the viewer head on with glittering eyes of blue-green inlaid shell. Their tongues stick out in defiance from their grimacing mouths, and they squat in the posture of the war dance.

Lattice panels made by women fill the spaces between the wall planks. Because ritual prohibitions, or taboos, prevented women from entering the meetinghouse, they worked from the outside and wove the panels from the back. They created the black, white, and orange patterns from grass, flax, and flat slats. Each pattern has a symbolic meaning: chevrons represent the teeth of the monster Taniwha; steps represent the stairs of heaven climbed by the hero-god Tawhaki; and diamonds represent the flounder.

Considered a national treasure by the Maori, this meetinghouse was restored in 1935 by Maori artists from remote areas who knew the old, traditional methods. It was moved to the Museum of New Zealand.

RECENT ART IN OCEANIA

Many contemporary artists in Oceania, in a process anthropologists call reintegration, have responded to the impact of European culture by adapting traditional themes and subjects to new mediums and techniques. The work of a Hawaiian quilt maker and an Australian aboriginal painter provide two examples of the striking and challenging results of this process.

Missionaries introduced fabric patchwork and quilting to the Hawaiian Islands in 1820, and Hawaiian women were soon making distinctive, multilayered stitched quilts. Over time, as cloth became increasingly available, the new arts replaced bark cloth in prestige, and today they are held in high esteem. Quilts are brought out for display and given as gifts to mark holidays and rites of passage such as weddings, anniversaries, and funerals. They are also important gifts for establishing bonds between individuals and communities.

Royal Symbols, by contemporary quilter Deborah (Kepola) U. Kakalia, is a luxurious quilt with a two-color pattern reminiscent of bark-cloth design (fig. 24-14). It combines heraldic imagery from both Polynesian and European sources to communicate the artist's proud sense of cultural identity. The crowns, the rectangular feather standards (*kahili*) in the corners, and the boldly contrasting red and yellow colors—derived from traditional featherwork—are symbols of the Hawaiian monarchy, even though the crowns have been adapted from those worn by European royalty. The *kahili* are ancient Hawaiian symbols of authority and rule, and the eight arches arranged in a cross in the center symbolize the uniting of Hawaii's eight inhabited islands into a

ART AND SCIENCE: THE FIRST VOYAGE OF CAPTAIN COOK

The ship *Endeavour*, under the command of Captain James Cook, a skilled geographer and navigator, sailed from Plymouth, England, in August 1768 on a scientific expedition to the Pacific Ocean. On board—in addition to a research team of astronomers, botanists, and other scientists—were two artists, Sydney Parkinson, a young Scottish botanical drafter, and Alexander Buchan, a painter of landscapes and portraits. At that time drawings and paintings served science the way photographs and documentary films and videotapes do today, recording, as Cook wrote, "a better idea . . . than can be expressed by word . . ." (*Journal*, 1773).

The *Endeavour* sailed west to Brazil, then south around South America's Cape Horn, and westward across the Pacific Ocean to Tahiti, where Buchan died. The ship went on to explore New Zealand, Tasmania, Australia, and the Great Barrier Reef before returning to England in July 1771, by sailing westward and around Africa's southern tip, the Cape of Good Hope.

Parkinson, frequently working with decaying specimens in cramped quarters on rough seas or plagued by insects, completed more than 1,300 drawings and paintings. His watercolors of plants are especially outstanding. Although he could not replace Buchan as a portrait painter, he did make a few sketches and wash drawings of people, among them drawings of the Maori that provide valuable evidence of their traditional way of life (see fig. 24-12).

He died on the return journey, on January 21, 1771. In addition to fulfilling his duties as expedition artist, Parkinson, like the other expedition members, had kept a journal, which was later published.

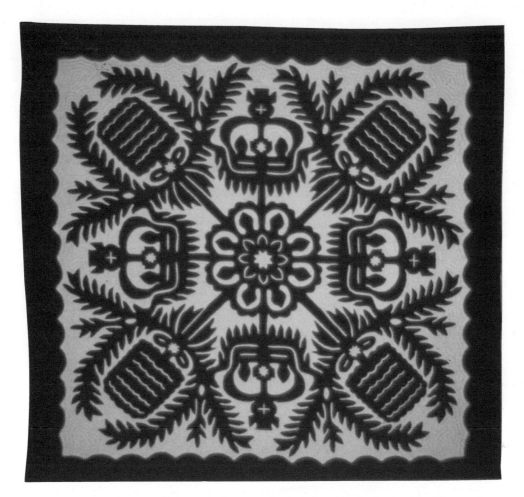

24-14. **Deborah (Kepola) U. Kakalia.** *Royal Symbols*. 1978. Quilt of cotton fabric and synthetic batting, appliqué, and contour stitching, 6'6¼" x 6'4½" (1.98 x 1.96 m). Courtesy of Joyce D. Hammond, Joyce D. Hammond Collection

single Christian kingdom. The quilt's design, construction, and strong color contrasts are typically Hawaiian. The artist created the design the way children create paper snowflakes, by folding a piece of red fabric into eight triangular layers, cutting out the pattern, and then unfolding it. The red fabric was then sewn onto a yellow background and quilted with a technique known as contour stitching, in which the quilter follows the outlines of the design layer with parallel rows of tiny stitches. This technique, while effectively securing the layers of fabric and batting together, also creates a pattern that quilters liken to breaking waves.

In Australia, Aborigine artists have adopted canvas and acrylic paint for rendering imagery traditionally associated with more ephemeral mediums like bark, body, and sand painting. Sand painting is an ancient ritual art form that involves creating large colored designs on the ground. These paintings are done with red and yellow ochers, seeds, and feathers arranged on the earth in dots and other symbolic patterns. They are used to convey tribal lore to young initiates. Led by an art teacher named Geoff Bardon, who introduced new mediums, a group of Aborigines expert in sand painting formed an art cooperative in 1971 in Papunya, in central Australia. Their success in transforming their ephemeral art into a

salable commodity encouraged community elders to allow others, including women, to try their hand at painting, which soon became an economic mainstay for many aboriginal groups in the region.

Clifford Possum Tjapaltjarri (b. 1934), a founder of the Papunya cooperative who gained an international reputation after an exhibition of his paintings in 1988, works with his canvases on the floor, using traditional patterns and colors, as well as touches of blue. The superimposed layers of concentric circles and undulating lines and dots in a painting like *Man's Love Story* (fig. 24-15, page 918) create an effect of shifting colors and lights. The painting seems entirely abstract, but it actually conveys a complex narrative involving two mythical ancestors. One of these men came to Papunya in search of honey ants; the white **U** shape on the left represents him seated in front of a water hole with an ants' nest, represented by the concentric circles. His digging stick lies to his right, and white sugary leaves lie to his left. The straight white "journey line" represents his trek from the west. The second man, represented by the brown-and-white U-shaped form, came from the east, leaving footprints, and sat down by another water hole nearby. He began to spin a hair string (a string made from human hair) on a spindle (the form leaning toward the upper right of the painting)

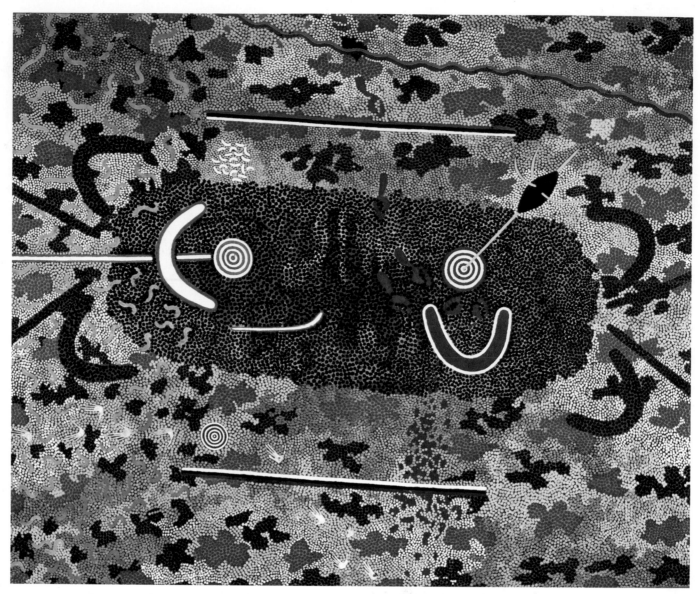

24-15. Clifford Possum Tjapaltjarri. *Man's Love Story*. 1978. Synthetic polymer paint on canvas, 6'11¾" x 8'4¼" (2.15 x 2.57 m). Art Gallery of South Australia, Adelaide

Visual Arts Board of the Australia Council Contemporary Art Purchase Grant, 1980

but was distracted by thoughts of the woman he loved, who belonged to a kinship group into which he could not marry. When she approached, he let his hair string blow away (represented by the brown flecks below him) and lost all his work. Four women (the dotted **U** shapes) from the group into which he could marry came with their digging sticks and sat around the two men. Rich symbolism fills other areas of the painting: The white footprints are those of another ancestral figure following a woman, and the wavy line at the top is the path of yet another ancestor. The black, dotted oval area indicates the site where young men were taught this story. The long horizontal bars are mirages. The wiggly shapes represent caterpillars, and the dots represent seeds, both forms of food.

The point of view of this work may be that of someone looking up from beneath the surface of the earth rather than looking down from above. Possum first painted the landscape features and the impressions left on the earth by the figures—their tracks, direction lines, and the **U**-shaped marks they left when sitting. Then, working carefully, dot by dot, he captured the vast expanse and shimmering light of the arid landscape. The painting's resemblance to modern Western painting styles like Abstract Expressionism, **gestural** painting, pointillism, or Color Field painting (Chapter 29) is accidental. Possum's work remains deeply embedded in the mythic, narrative traditions of his people. Although few artifacts remain from prehistoric times on the Pacific islands, throughout recorded history artists such as Possum have worked with remarkable robustness, freshness, and continuity. They have consistently created arts that express the deepest meanings of their culture.

PARALLELS

REGION	PACIFIC ART	ART OF OTHER CULTURES
AUSTRALIA	**24-2.** *Mimis and Kangaroo* (16,000–7000 BCE), Arnhem Land	**1-10.** Lascaux cave paintings (c. 15,000–13,000 BCE), France
	24-3. Marika. *The Wawalag Sisters and the Rainbow Serpent* (1959)	**1-19.** Stonehenge (c. 2750–1500 BCE), England
	24-15. Tjapaltjarri. *Man's Love Story* (1978)	**18-11.** Michelangelo. *David* (1501–4), Italy
		20-7. Taj Mahal (c. 1632–48), India
		23-19. Taos Pueblo (rebuilt c. 1700), North America
		26-48. David. *Oath of the Horatii* (1784–85), France
MELANESIA	**24-4.** Lapita jar (c. 1200–1100 BCE), Solomon Islands	**23-16.** Tlingit screen (c. 1840), North America
	24-5. *Tamberan* house (20th cent.), Papua New Guinea	**28-21.** Picasso. *Les Demoiselles d'Avignon* (1907), France
	24-6. *Mbis* (c. 1960), Irian Jaya	**23-15.** Kwakiutl mask (c. 1914), North America
	24-7. *Tatanua* masks (1979), New Ireland	**23-21.** Velarde. *Koshares of Taos* (1946–47), North America
		25-4. Bwa masks (1984), Burkina Faso
		25-1. Ashanti finial (20th cent.), Ghana
		25-11. Ashanti *kente* cloth (20th cent.), Ghana
MICRONESIA	**24-8.** Mortuary compound (c. 1200–1600), Pohnpei	
POLYNESIA	**24-1.** Ancestor figures (c. 1000–1500), Easter Island	
	24-12. Parkinson. *Portrait of a Maori* (1769), New Zealand	
	24-9. War club (early 19th cent.), Marquesas Islands	
	24-10. Queen Kamamalu's skirt (1823–24), Hawaii	
	24-13. Rukupo. Maori meetinghouse (1842–43), New Zealand	
	24-11. Kearny Cloak (c. 1843), Hawaii	
	24-14. Kakalia. *Royal Symbols* quilt (1978), Hawaii	

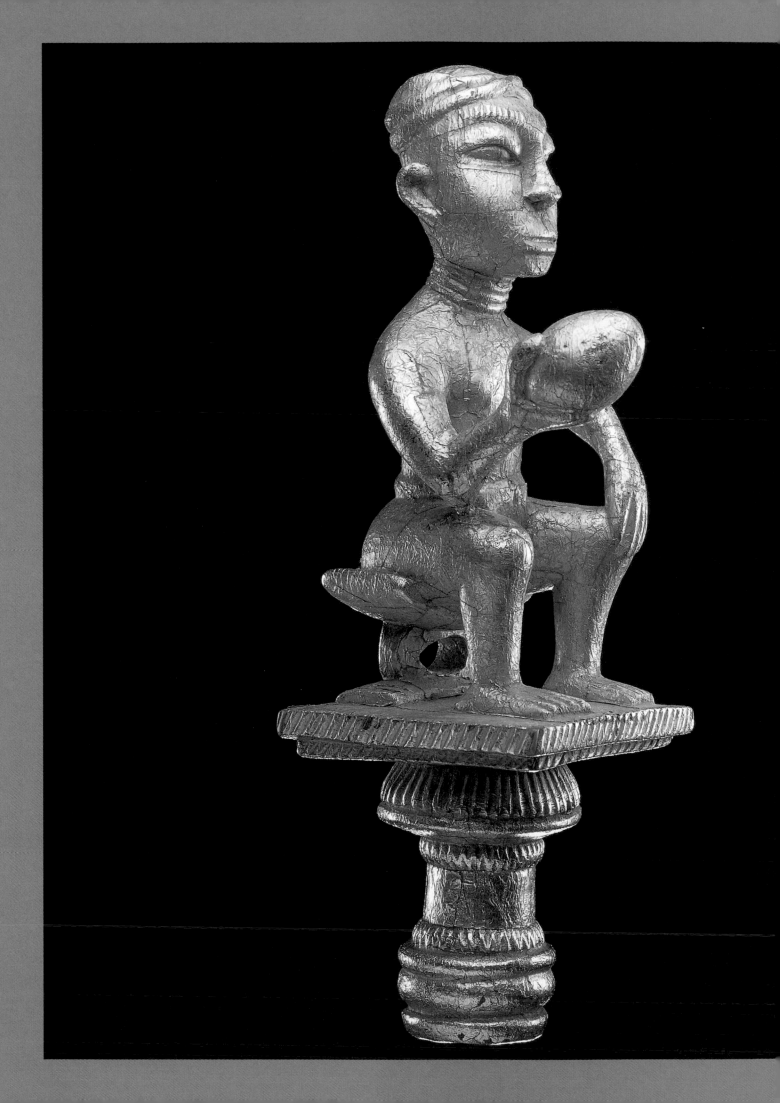

25
Art of Africa in the Modern Era

25-1. **Kojo Bonsu (?). Finial of a spokesperson's staff** *(okyeame poma)*, from Ghana. Ashanti culture, 1960s–70s. Wood and gold, height 11" (28.57 cm). Musée Barbier-Mueller, Geneva

Political power is like an egg, says an Ashanti proverb. Grasp it too tightly and it will shatter in your hand; hold it too loosely and it will slip from your fingers. Whenever the okyeame, or spokesperson, for one twentieth-century Ashanti ruler was conferring with that ruler or communicating the ruler's words to others, he held a staff with this symbolic caution on the use and abuse of power prominently displayed on the gold-leaf–covered finial (fig. 25-1).

If we are to attempt to understand African art such as this staff on its own terms, we must first restore it to life. As with the art of so many periods and societies, we must take it out of the glass cases of the museums where we usually encounter it and imagine the art work playing its vital role in a human community.

▲ c. 1400— EUROPEAN PRESENCE IN SUB-SAHARAN AFRICA

TIMELINE 25-1. **Africa in the Modern Era.** The last six hundred years in Africa were dominated by European control, which ended in the second half of the twentieth century.

MAP 25-1. **Africa in the Modern Era.** The vast continent of Africa is home to many countries and many cultures.

TRADITIONAL AND CONTEMPORARY AFRICA

The second-largest continent in the world, Africa is a land of enormous diversity (Map 25-1). Geographically, it ranges from vast deserts to tropical rain forest, from flat grasslands to spectacular mountains and dramatic rift valleys. Human diversity in Africa is equally impressive. More than 1,000 languages have been identified, grouped by scholars into five major linguistic families. Various languages represent unique cultures, with their own history, customs, and art forms.

Before the nineteenth century, the most important outside influence to pervade Africa had been the religious culture of Islam, which spread gradually and largely peacefully through much of West Africa and along the East African coast (see "Foundations of African Cultures," opposite). The modern era, in contrast, begins with the European exploration and subsequent colonization

c. 1914 MOST OF AFRICA UNDER FOREIGN CONTROL ▲

c. 1950 MOST COLONIES GRANTED INDEPENDENCE ▲

FOUNDATIONS OF AFRICAN CULTURES

Africa was the site of one of the great civilizations of the ancient world, that of Egypt, which arose along the fertile banks of the Nile River over the course of the fourth millennium BCE and lasted for some 3,000 years. Egypt's rise coincided with the emergence of the Sahara, the largest desert in the world, from the formerly lush grasslands of northern Africa. Some of the oldest known African art, images inscribed and painted in the mountains of the central Sahara beginning around 8000 BCE, bears witness to this gradual transformation as well as to the lives of the pastoral peoples who once lived in the region.

As the grassland dried, its populations migrated in search of pasture and arable land. Many probably made their way to the Sudan, the broad band of savanna south of the Sahara. During the sixth century BCE, knowledge of iron smelting spread across the Sudan, enabling larger and more complex societies to emerge. One such society was the iron-working Nok culture, which arose in present-day Nigeria around 500 BCE and lasted until about 200 CE. Terra-cotta figures created by Nok artists are the earliest known sculpture from sub-Saharan Africa.

Farther south in present-day Nigeria, a remarkable culture developed in the city of Ife, which rose to prominence around 800 CE. There, from roughly 1000 to 1400, a tradition of naturalistic sculpture in bronze and terra-cotta flourished. Ife was, and remains, the sacred city of the Yoruba people. According to legend, Ife artists brought the techniques of bronze casting to the kingdom of Benin to the southeast. From 1400 through the nineteenth century Benin artists in the service of the court created numerous works in bronze, at first in the naturalistic style of Ife, then in an increasingly stylized and elaborate manner.

With the Arab conquest of North Africa during the seventh and eighth centuries, Islamic travelers and merchants became regular visitors to the Sudan. Largely through their writings, we know of the powerful West African empires of Ghana and Mali, which flourished successively from the fourth through the sixteenth centuries along the great bend in the Niger River. Both grew wealthy by controlling the flow of African gold and forest products into the lucrative trans-Sahara trade. The city of Djenné, in Mali, served not only as a commercial hub but also as a prominent center of Islam.

Peoples along the coast of East Africa, meanwhile, since before the Common Era had participated in a maritime trade network that ringed the Indian Ocean and extended east to the islands of Indonesia. Over time, trading settlements arose along the coastline, peopled by Arab, Persian, and Indian merchants as well as Africans. By the thirteenth century these settlements were important port cities, and a new language, Swahili, had developed from the longtime mingling of Arabic with local African languages. Peoples of the interior organized extensive trade networks to funnel goods to these ports. From 1000 to 1500 many of these interior routes were controlled by the Shona people from the site called Great Zimbabwe. The extensive stone palace compound there stood in the center of a city of some 10,000 at its height. Numerous cities and kingdoms, often of great wealth and opulence, greeted the astonished eyes of the first European visitors to Africa at the end of the fifteenth century.

of the African continent, developments that brought traditional African societies into sudden and traumatic contact with the "modern" world that Europe had largely created.

European ships first visited sub-Saharan Africa in the fifteenth century. For the next several hundred years, however, European contact with Africa was almost entirely limited to coastal areas, where trade, including the tragic slave trade, was carried out. During the nineteenth century, as the slave trade was gradually eliminated, European explorers began to investigate the unmapped African interior. They were soon followed by Christian missionaries, whose reports greatly fueled popular interest in the continent. Drawn by the potential wealth of Africa's natural resources, European governments began to seek territorial concessions from African rulers. Diplomacy soon gave way to force, and toward the end of the century, competition among rival powers fueled the so-called scramble for Africa, with European governments racing to lay claim to whatever portion of the continent they were powerful enough to take. By 1914 virtually all of Africa had fallen under colonial rule.

In the years following World War I, nationalistic movements arose across Africa. Their leaders generally did not advocate a return to earlier forms of political organization but rather demanded the transformation of colonial divisions into Western-style nation-states governed by Africans. From 1945 through the mid-1970s one colony after another gained its independence, and the present-day map of modern African nations took shape.

Change has been brought about by contact between one people and another since the beginning of time, and art in Africa has both affected and been affected by such contacts. During the early twentieth century, the art of traditional African societies played a pivotal role in revitalizing the Western art tradition (see "African Furniture and the Art Deco Style," page 918). The formal inventiveness and expressive power of African sculpture were sources of inspiration for European artists trying to rethink strategies of representation. And contemporary

AFRICAN FURNITURE AND THE ART DECO STYLE

In some African cultures, elaborate stools or chairs were created not only to indicate their owners' status but also to serve as altars for their souls after death. Thrones and other important seats in Africa are often carved from a single block of wood. This is the case with a chair taken from the Ngombe people, who live along the Congo River. The back is cantilevered out from the seat, which is in turn supported by four massive, braced legs. The rich surface decoration consists of European brass carpet tacks and darker iron tacks arranged in parallel lines and diamond patterns. The use of the tacks (imported goods) indicates that the owner had access to the extensive trade routes linking people of the inland forest to people of the coast. Both copper and iron were precious materials in central Africa; they were used as currency long before contact with Europe, and they were associated with both high social status and spirituality. The chair was thus an object of both beauty and power.

France began to colonize Africa in the late nineteenth century, and African objects were brought to France by soldiers, administrators, and adventurers. Colonial expositions held in France in 1919 and 1923 displayed trophies from the newly vanquished territories, including household objects and art works from African courts. Just as painters and sculptors such as Picasso and Matisse were inspired by the formal power of African masks, the French designer Pierre Legrain (1889–1929) recognized the aesthetic excellence of African furniture. Legrain made a fairly faithful reproduction of this Ngombe chair but adapted the simple, elegant forms of other African furniture to French taste. His Africa-inspired pieces appeared in the definitive 1925 exhibition, "Exposition Internationale des Arts Décoratifs et Industriels Modernes," where the term *Art Deco* was coined to describe the geometric quality of many of the objects displayed there.

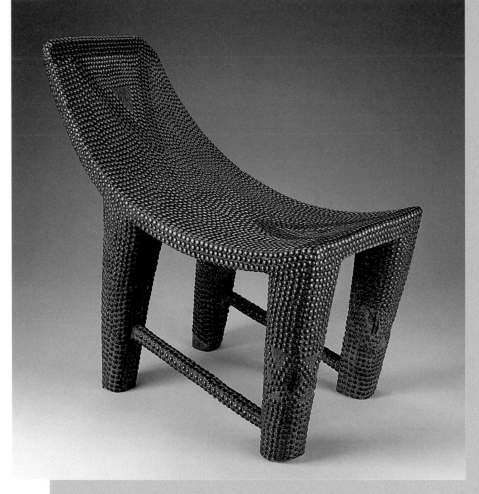

Chair, from Democratic Republic of Congo. Ngombe culture, 20th century. Wood, brass, and iron tacks, height at tallest point 25⅝" (65.1 cm). National Museum of African Art, Washington, D.C. Museum Purchases, 90-4-1

African artists, especially those from major urban centers, who have come of age in the postcolonial culture that mingles European and African elements, can draw easily on the influences from many cultures, both African and non-African. They have established a firm place in the lively international art scene along with their European, American, and Asian counterparts, and their work is shown as readily in Paris, Tokyo, and Los Angeles as it is in the African cities of Abidjan, Kinshasa, and Dakar.

From the time of the first European explorations and continuing through the colonial era, quantities of art from traditional African societies were shipped back to Western museums—not art museums, at first, but museums of natural history or ethnography, which exhibited the works as curious artifacts of "primitive" cultures. Toward the end of the nineteenth century, however, profound changes in Western thinking about art gradually led people to appreciate the aesthetic qualities of traditional African "artifacts" and finally to embrace them fully as art. Art museums, both in Africa and in the West, began to collect African art seriously and methodically. Together with the living arts of traditional peoples today, these collections afford us a rich sampling of African art in the modern era.

Many traditional societies persist in Africa, both within and across contemporary political borders, and art continues to play a vital role in the spiritual and social life of the community. It is used to express Africans' ideas

about their relation to their world and as a tool to help them survive in a difficult and unpredictable environment. This chapter explores African art in light of how it addresses some of the fundamental concerns of human existence. Those concerns—rather than geographical region or time frame—form the backdrop against which we look at art works in this chapter, as African art cannot be divorced from its cultural and social contexts.

CHILDREN AND THE CONTINUITY OF LIFE

Among the most fundamental of human concerns is the continuation of life from one generation to the next. In traditional societies children are especially important: Not only do they represent the future of the family and the community, but they also provide a form of "social security," guaranteeing that parents will have someone to care for them when they are old.

In the often harsh and unpredictable climates of Africa, human life can be fragile. In some areas half of all infants die before the age of five, and the average life expectancy may be as low as forty years. In these areas women may bear many children in hopes that a few will survive into adulthood, and failure to have children is a disaster for a wife, her husband, and her husband's lineage. It is very unusual for a man to be blamed as the cause of infertility, so women who have had difficulty bearing children appeal for help with special offerings or prayers, often involving the use of art.

The Mossi people of Burkina Faso, in West Africa, carve a small wooden figure called *biiga*, or "child," as a plaything for little girls (fig. 25-2). The girls feed and bathe the figures and change their clothes, just as they see their mothers caring for younger siblings. At this level the figures are no more than simple dolls. Like many children's dolls around the world, they show ideals of mature beauty, including elaborate hairstyles, lovely clothing, and developed breasts. The *biiga* shown here wears its hair just as little Mossi girls do, with a long lock projecting over the face. (A married woman, in contrast, wears her lock in back.)

Other aspects of the doll, however, reveal a more complex meaning. The elongated breasts recall the practice of stretching by massaging to encourage lactation, and they mark the doll as the mother of many children. The scars that radiate from the navel mimic those applied to Mossi women following the birth of their first child. Thus, although the doll is called a child, it actually represents the ideal Mossi woman, one who has achieved the goal of providing children to continue her husband's lineage.

Mossi girls do not outgrow their dolls as one would a childhood plaything. When a young woman marries, she brings the doll with her to her husband's home to serve as an aid to fertility. If she has difficulty in bearing her first child, she carries the doll on her back just as she would a baby. When she gives birth, the doll is placed on a new, clean mat just before the infant is placed there, and when she nurses, she places the doll against her breast for a moment before the newborn receives nourishment.

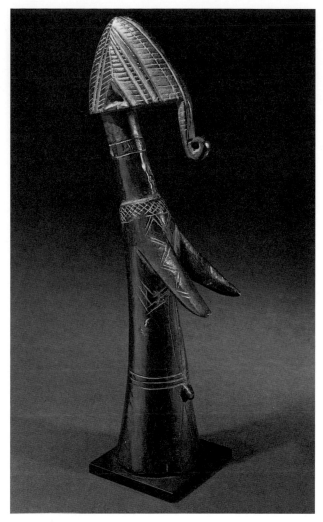

25-2. Doll (*biiga*), from Burkina Faso. Mossi culture, mid-20th century. Wood, height 11¼" (28.57 cm). Collection Thomas G. B. Wheelock

The Yoruba people of Nigeria have one of the highest rates of twin births in the world. The birth of twins is a joyful occasion, yet it is troubling as well, for twins are more delicate than single babies, and one or both may well die. Many African peoples believe that a dead child continues its life in a spirit world and that the parents' care and affection may reach it there, often through the medium of art. When a Yoruba twin dies, the parents consult a diviner, a specialist in ritual and spiritual practices, who may tell them that an image of a twin, or *ere ibeji*, must be carved (see fig. 25-3).

The mother cares for the "birth" of this image by sending the artist food while the figure is being carved. When the image is finished, she brings the artist gifts. Then, carrying the figure as she would a living child, she dances home accompanied by the singing of neighborhood women. She places the figure in a shrine in her bedroom and lavishes care upon it, feeding it, dressing it with beautiful textiles and jewelry, anointing it with cosmetic oils. The Yoruba believe that the spirit of a dead twin thus honored may bring its parents wealth and good luck.

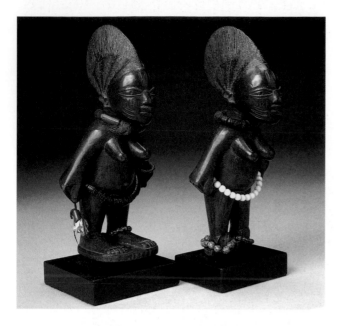

25-3. Akiode (?). Twin figures (*ere ibeji*), from Nigeria. Yoruba culture, 20th century. Wood, height 7 7/8" (20 cm). The University of Iowa Museum of Art, Iowa City
The Stanley Collection

As with other African sculpture, patterns of use result in particular signs of wear. The facial features of *ere ibeji* are often worn down or even obliterated by repeated feedings and washings. Camwood powder applied as a cosmetic builds to a thick crust in areas that are rarely handled, and the blue indigo dye regularly applied to the hair eventually builds to a thin layer.

The twins in figure 25-3 are female. They may be the work of the Yoruba artist Akiode, who died in 1936. Like most objects that Africans produce to encourage the birth and growth of children, the figures emphasize health and well-being. They have beautiful, glossy surfaces, rings of fat as evidence that they are well fed, and the marks of mature adulthood that will one day be achieved. They represent hope for the future, for survival, and for prosperity.

INITIATION

Eventually, an adolescent must leave behind the world of children and take his or her place in the adult world. In contemporary Western societies, initiation into the adult world is extended over several years and punctuated by numerous rites, such as being confirmed in a religion, earning a driver's license, graduating from high school, and reaching the age of majority. All of these steps involve acquiring the spiritual and worldly knowledge Western society deems necessary and accepting the corresponding responsibilities. In other societies, initiation is more concentrated, and the acquisition of knowledge may be supplemented by physical tests and trials of endurance to prove that the candidate is equal to the hardships of adult life.

The Bwa people of central Burkina Faso initiate young men and women into adulthood following the onset of puberty. The initiates are first separated from younger playmates by being "kidnapped" by older relatives, though their disappearance is explained in the community by saying that they have been devoured by wild beasts. The initiates are stripped of their clothing and made to sleep on the ground without blankets. Isolated from the community, they are taught about the world of nature spirits and about the wooden masks that represent them.

The initiates have watched these masks in performance every month of their lives. Now, for the first time, they learn that the masks are made of wood and are worn by their older brothers and cousins. They learn of the spirit each mask represents, and they memorize the story of each spirit's encounter with the founding ancestors of the clan. They learn how to construct costumes from hemp to be worn with the masks, and they learn the songs and instruments that accompany the masks in performance. Only the boys wear each mask in turn and learn the dance steps that express the character and personality it represents. Returning to the community, the initiates display their new knowledge in a public ceremony. Each boy performs with one of the masks, while the girls sing the accompanying songs. At the end of the mask ceremony the young men and young women rejoin their families as adults, ready to marry, to start farms, and to begin families of their own.

Most Bwa masks depict spirits that have taken an animal form, such as crocodile, hyena, hawk, or serpent. Others represent spirits in human form. Among the most spectacular masks, however, are those crowned with a tall, narrow plank (fig. 25-4), which are entirely **abstract** and represent spirits that have taken neither human nor animal form. The graphic patterns that cover these masks are easily recognized by the initiated. The white crescent at the top represents the quarter moon, under which the initiation is held. The white triangles below represent bull roarers—sacred sound makers that are swung around the head on a long cord to re-create spirit voices. The large central **X** represents the scar that every initiated Bwa wears as a mark of devotion. The horizontal zigzags at the bottom represent the path of ancestors and symbolize adherence to ancestral ways. That the path is difficult to follow is clearly conveyed. The curving red hook that projects in front of the face is said to represent the beak of the hornbill, a bird associated with the supernatural world and believed to be an intermediary between the living and the dead. Through abstract patterns, the mask conveys a message about the proper moral conduct of life with all the symbolic clarity and immediacy of a traffic signal.

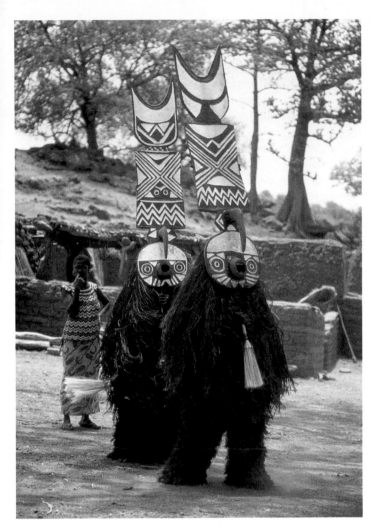

25-4. Two masks in performance, from Dossi, Burkina Faso. Bwa culture, 1984. Wood, mineral pigments, and fiber, height approx. 7' (2.13 m)

The Bwa have been making and using such masks since well before Burkina Faso achieved its independence in 1960. We might assume their use is centuries old, but in this case, the masks are a comparatively recent innovation. The elders of the Bwa family who own these masks state that they, like all Bwa, once followed the cult of the spirit of Do, who is represented by masks made of leaves. In the last quarter of the nineteenth century the Bwa were the targets of slave raiders from the north and east. Their response to this new danger was to acquire wooden masks from their neighbors, for such masks seemed a more effective and powerful way of communicating with spirits who could help them. Thus, faced with a new form of adversity, the Bwa sought a new tradition to cope with it.

Among the Mende people of Sierra Leone, in West Africa, the initiation of young girls into adulthood is organized by a society of older women called Sande. The initiation culminates with a ritual bath in a river, after which the girls return to the village to meet their future husbands. At the ceremony the Sande women wear black gloves and stockings, black costumes of shredded raffia fibers that cover the entire body, and black masks called *nowo* (fig. 25-5).

With its high and glossy forehead, plaited hairstyle decorated with combs, and creases of abundance around the neck, the mask represents the Mende ideal of female

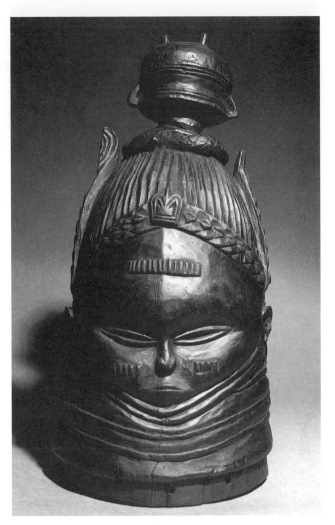

25-5. Female Ancestral Mask (Nowo), from Sierra Leone. Mende culture, c. 1906. Wood, height 18 7/8 x 8 3/5" (47.7 x 21.9 cm). The Baltimore Museum of Art

Gift of Dr. Joseph H. Seipp, Jr. (#BMA 1975.69.0001)

beauty. The meanings of the mask are complex. One scholar has shown that the entire mask can be compared to the chrysalis of a certain African butterfly, with the creases in particular representing the segments of the chrysalis. Thus, the young woman entering adulthood is like a beautiful butterfly emerging from its ugly chrysalis. The comparison extends even further, for just as the butterfly feeds on the toxic sap of the milkweed to make itself poisonous to predatory birds, so the medicine of Sande is believed to protect the young women from danger. The creases may also refer to concentric waves radiating outward as the mask emerges from calm waters to appear among humankind, just as the initiates rise from the river to take their place as members of the adult community.

A ceremony of initiation may accompany the achievement of other types of membership as well. Among the Lega people, who live in the dense forests between the headwaters of the Congo River and the great lakes of East Africa, the political system is based on a voluntary association called *bwami*, which comprises six levels or grades. Some 80 percent of all male Lega belong to *bwami*, and all aspire to the highest grade. Women can belong to *bwami* as well, although not at a higher grade than their husbands.

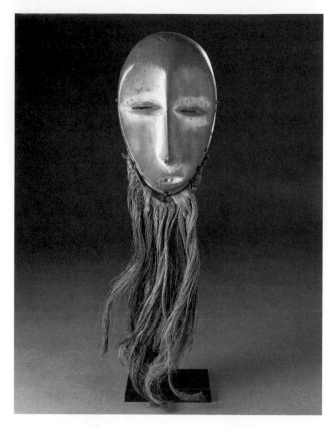

25-6. *Bwami* mask, from Democratic Republic of Congo. Lega culture, early 20th century. Wood, kaolin, and hemp fibers, height 7⅝" (19.3 cm). The University of Iowa Museum of Art, Iowa City

The Stanley Collection

Promotion from one grade of *bwami* to the next takes many years. It is based not only on a candidate's character but also on his or her ability to pay the initiation fees, which increase dramatically with each grade. No candidate for any level of *bwami* can pay the fees alone; all must depend on the help of relatives to provide the necessary cowrie shells, goats, wild game, palm oil, clothing, and trade goods. Candidates who are in conflict with their relatives will never be successful in securing such support and thus will never achieve their highest goals. The ambitions of the Lega to move from one level of *bwami* to the next encourage a harmonious and well-ordered community, for all must stay on good terms if they are to advance. The association promotes a lifelong growth in moral character and an ever-deepening understanding of the relationship of the individual to the community.

Bwami initiations are held in the plaza at the center of the community in the presence of all members. Dances and songs are performed, and the values and ideals of the appropriate grade are explained through proverbs and sayings. These standards are illustrated by natural or crafted objects, which are presented to the initiate as signs of membership. At the highest two levels of *bwami*, such objects include masks and sculpted figures.

The mask in figure 25-6 is associated with *yananio*, the second-highest grade of *bwami*. Typical of Lega masks, the head is fashioned as an oval into which is carved a concave, heart-shaped face with narrow, raised features.

The masks are often colored white with clay and fitted with a beard made of hemp fibers. Too small to cover the face, they are displayed in other ways—held in the palm of a hand, for example, or attached to a thigh. Each means of display recalls a different value or saying, so that one mask may convey a variety of meanings. For example, held by the beard and slung over the shoulder, this mask represents "courage," for it reminds the Lega of a disastrous retreat from an enemy village during which many Lega men were slain from behind.

THE SPIRIT WORLD

Why does one child fall ill and die while its twin remains healthy? Why does one year bring rain and a bountiful crop, while the next brings drought and famine? All people everywhere confront such fundamental and troubling questions. For traditional African societies the answers are often thought to lie in the workings of spirits. Spirits are believed to inhabit the fields that produce crops, the river that provides fish, the forest that is home to game, the land that must be cleared in order to build a new village. A family, too, includes spirits—those of its ancestors as well as those of children yet unborn. In the blessing or curse of these myriad surrounding spirits lies the difference between success and failure in life.

To communicate with these all-important spirits, African societies usually rely on a specialist in ritual—the person known elsewhere in the world as priest, minister, rabbi, pastor, *imam*, or shaman. Whatever his or her title, the ritual specialist serves as an essential link between the supernatural and human worlds, opening the lines of communication through such techniques as prayer, sacrifice, offerings, magic, and divination. Each African people has its own name for this specialist, but for simplicity we can refer to them all as diviners. Art often plays an important role in dealings with the spirit world, for art can make the invisible visible, giving identity and personality to what is abstract and intangible.

To the Lobi people of Burkina Faso, the spirits of nature are known as *thila* (singular *thil*), and they are believed to control every aspect of life. Indeed, their power is so pervasive that they may be considered the true rulers of the community. Lobi houses may be widely scattered over miles of dry West African savanna but are considered a community when they acknowledge the same *thil* and agree to regulate their society by its rules, called *zoser*. Such rules bear comparison to those binding many religious communities around the world and may include a prohibition against killing or eating the meat of a certain animal, sleeping on a certain type of mat, or wearing a certain pattern or cloth. Totally averse to any form of kingship or centralized authority, the Lobi have no other system of rule but *zoser*.

Thila are normally believed to be invisible. When adversity strikes, however, the Lobi may consult a diviner, who may prescribe the carving of a wooden figure called a *boteba* (fig. 25-7). A *boteba* gives a *thil* physical form. More than simply a carving, a *boteba* is thought of as a living being who can see, move, and communicate with other *boteba* and with its owner. The owner of a *boteba*

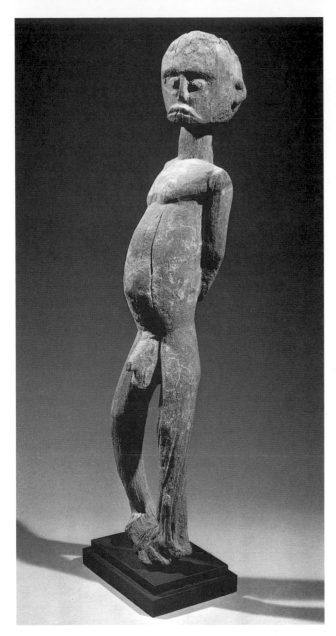

25-7. Spirit figure (*boteba*), from Burkina Faso. Lobi culture, 19th century. Wood, height 30 11/16" (78 cm). Collection Kerchache, Paris

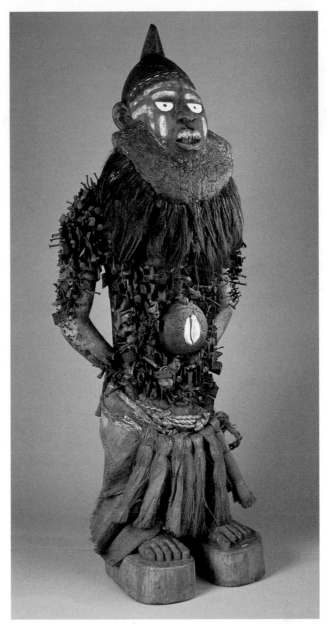

25-8. Power figure (*nkisi nkonde*), from Democratic Republic of Congo. Kongo culture, 19th century. Wood, nails, pins, blades, and other materials, height 44" (111.7 cm). The Field Museum, Chicago
Acquisition A109979 c

can thus address the spirit it gives form to directly, seeking its protection or aid.

Each *thil* has a particular skill that its representative *boteba* conveys through pose or expression. A *boteba* carved with an expression of terrible anger, for example, represents a *thil* whose skill is to frighten off evil forces. The *boteba* in figure 25-7 is carved in the characteristic Lobi pose of mourning, with its hands clasped tightly behind its back and its head turned to one side. This *boteba* mourns so that its owner may not be saddened by misfortune. Like a spiritual decoy, it takes on the burden of grief that might otherwise have come to the owner. Shrines may hold dozens of *boteba* figures, each one contributing its own unique skill to the family or community.

Among the most potent images of power in African art are the *nkisi*, or spirit, figures made by the Kongo and Songye peoples of Congo. The best known of these are the large wooden *nkonde*, which bristle with nails, pins, blades, and other sharp objects (fig. 25-8). An *nkisi nkonde*

Nkisi nkonde provide a dramatic example of the ways in which works of African sculpture are transformed by use. When first carved, the figure is "neutral," with no particular significance or use. Magical materials applied by a diviner transform the figure into a powerful being, at the same time modifying its form. Each client who activates that power further modifies the statue. While the object is empowered, nails may also be removed as part of a healing or oath-taking process. And when the figure's particular powers are no longer needed, the additions may all be stripped away to be replaced with different magical materials that give the same figure a new function. The result is that many hands play a role in creating the work of art we see in a museum. The person we are likely to label as the "artist" is only the initial creator. Many others modify the work, and in their hands the figure becomes a visual document of the history of the conflicts and afflictions that have threatened the community.

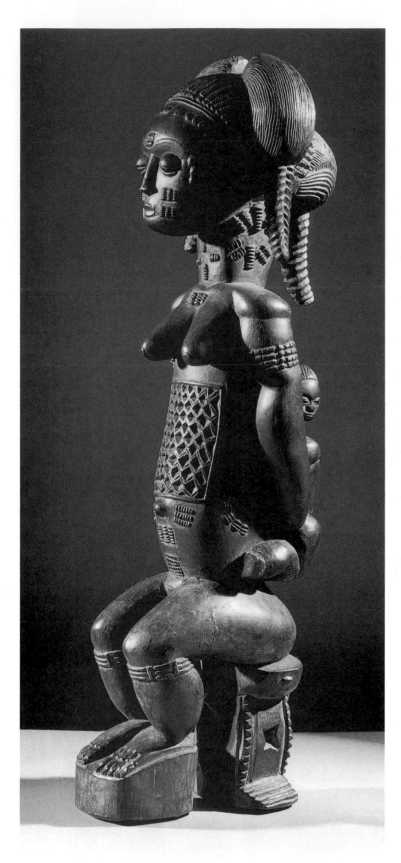

25-9. Spirit spouse (*blolo bla*), from Côte d'Ivoire. Baule culture, early 20th century. Wood, height 17⅛" (43.5 cm). University Museum, University of Pennsylvania, Philadelphia

begins its life as a simple, unadorned wooden figure that may be purchased from a carver at a market or commissioned by a diviner on behalf of a client who has encountered some adversity or faces an important turning point. Drawing on vast knowledge, the diviner prescribes magical/medicinal ingredients, called *bilongo*, specific to the client's problem. These *bilongo* are added to the figure, either mixed with white clay and plastered directly onto the body or suspended in a packet from the neck or waist.

The *bilongo* transform the *nkonde* into a living being with frightful powers, ready to attack the forces of evil on behalf of a human client. *Bilongo* ingredients are drawn from plants, animals, and minerals, and may include human hair, nail clippings, and other materials. Each ingredient has a unique role. Some bring the figure to life by embodying the spirit of an ancestor or a soul trapped by a malevolent power. Others endow the figure with distinctive powers or focus the powers in a particular direction, often through metaphor. For example, the Kongo admire the quickness and agility of a particular species of mouse. Tufts of this mouse's hair included in the *bilongo* act as a metaphor for quickness, ensuring that the *nkisi nkonde* will act rapidly when its powers are activated.

To activate the powers, clients drive in a nail or other pointed object to get the *nkonde*'s attention and prick it into action. An *nkisi nkonde* may serve many private and public functions. Two warring villages might agree to end their conflict by swearing an oath of peace in the presence of the *nkonde* and then driving a nail into it to seal the agreement. Two merchants might agree to a partnership by driving two small nails into the figure side by side and then make their pact binding by wrapping the nails together with a stout cord. Someone accused of a crime might swear his innocence and drive in a nail, asking the *nkonde* to destroy him if he lied. A mother might invoke the power of the *nkonde* to heal her sick children. The objects driven into the *nkonde* may also operate metaphorically. For example, the Kongo use a broad blade called a *baaku* to cut into palm trees, releasing sap that will eventually be fermented into palm wine. The word *baaku* derives from the word *baaka*, which means both "extract" and "destroy." Thus tiny replicas of *baaku* driven into the *nkonde* are believed to destroy those who use evil power.

The word *nkonde* shares a stem with *konda*, meaning "to hunt," for the figure is quick to hunt down a client's enemies and destroy them. The *nkonde* here stands in a pose called *pakalala*, a stance of alertness like that of a wrestler challenging an opponent in the ring. Other *nkonde* figures hold a knife or spear in an upraised hand, ready to strike or attack.

Some African peoples conceive of the spirit world as a parallel realm in which spirits may have families, attend markets, live in villages, and possess personalities complete with faults and virtues. The Baule people in Côte d'Ivoire believe that each of us lived in the spirit world before we were born. While there, we had a spirit spouse, whom we left behind when we entered this life. A person who has difficulty assuming his or her gender-specific role as an adult Baule—a man who has not married or

achieved his expected status in life, for example, or a woman who has not borne children—may dream of his or her spirit spouse.

For such a person, the diviner may prescribe the carving of an image of the spirit spouse (fig. 25-9). A man has a female figure (*blolo bla*) carved; a woman has a male figure (*blolo bian*) carved. The figures display the most admired and desirable marks of beauty so that the spirit spouses may be encouraged to enter and inhabit them. Spirit spouse figures are broadly naturalistic, with swelling, fully rounded musculature and careful attention to details of hairstyle, jewelry, and scarification patterns. They may be carved standing in a quiet, dignified pose or seated on a traditional throne. The throne contributes to the status of the figure and thus acts as an added incentive for the spirit to take up residence there. The owner keeps the figure in his or her room, dressing it in beautiful textiles and jewelry, washing it, anointing it with oil, feeding it, and caressing it. The Baule hope that by caring for and pleasing their spirit spouse a balance may be restored that will free their human life to unfold smoothly.

While nature spirits are often portrayed in African art, major deities are generally considered to be far removed from the everyday lives of humans and are thus rarely depicted. Such is the case with Olodumare, also known as Olorun, the creator god of the Yoruba people of southwestern Nigeria. According to Yoruba myth, Olodumare withdrew from the earth when he was insulted by one of his eight children. When the children later sought him out to ask him to restore order on earth, they found him sitting beneath a palm tree. Olodumare refused to return, although he did consent to give humanity some tools of divination so that they could learn his will indirectly.

The Yoruba have a sizable pantheon of lesser gods, or *orisha*, who serve as intermediaries between Olodumare and his creation. One that is commonly represented in art is Eshu, also called Elegba, the messenger of the gods. Eshu is a trickster, a capricious and mischievous god who loves nothing better than to throw a wrench into the works just when everything is going well. The Yoruba acknowledge that all humans may slip up disastrously (and hilariously) when it is most important not to, and thus all must recognize and pay tribute to Eshu.

Eshu is associated with two eternal sources of human conflict, sex and money, and is usually portrayed with a long hairstyle, because the Yoruba consider long hair to represent excess libidinous energy and unrestrained sexuality. Figures of Eshu are usually adorned with long strands of cowrie shells, a traditional African currency. Shrines to Eshu are erected wherever there is the potential for encounters that lead to conflict, especially at crossroads, in markets, or in front of banks. Eshu's followers hope that their offerings will persuade the god to spare them the pitfalls he places in front of others.

Eshu is intriguingly ambivalent and may be represented as male or female, as a young prankster or a wise old man. The dance staff here beautifully embodies the dual nature of Eshu (fig. 25-10). To the left he is depicted as a boy blowing loud noises on a whistle just to annoy his elders—a gleefully antisocial act of defiance. To the right

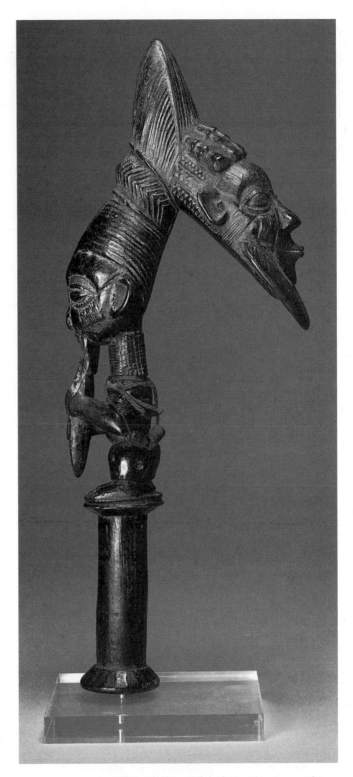

25-10. Dance staff depicting Eshu, from Nigeria. Yoruba culture, 20th century. Wood, height 17" (43.2 cm). The University of Iowa Museum of Art, Iowa City
The Stanley Collection

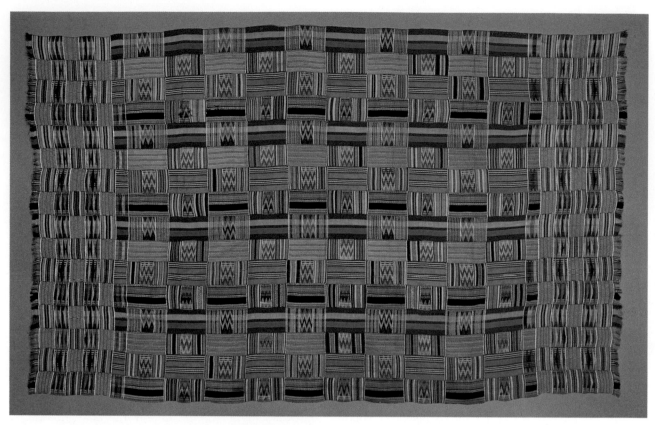

25-11. *Kente* **cloth**, from Ghana. Ashanti culture, 20th century. Silk, 6'10 9/16" x 4'3 9/16" (2.09 x 1.30 m). National Museum of African Art and National Museum of Natural History, Washington, D.C.

Purchased with funds provided by the Smithsonian Collections Acquisition Program, 1983–85, EJ 10583

he is shown as a wise old man, with wrinkles and a beard. The two faces are joined at the hair, which is drawn up into a long phallic knot. The heads crown a dance wand meant to be carried in performance by priests and followers of Eshu, whose bodies the god is believed to enter during worship.

LEADERSHIP

As in societies throughout the world, art in Africa is used to identify those who hold power, to validate their right to kingship or their authority as representatives of the family or community, and to communicate the rules for moral behavior that must be obeyed by all members of the society. The gold-and-wood spokesperson's staff with which this chapter opened is an example of the art of leadership (see fig. 25-1). It belongs to the culture of the Ashanti peoples of Ghana, in West Africa. The Ashanti greatly admire fine language—one of their adages is, "We speak to the wise man in proverbs, not in plain speech"—and consequently their governing system includes the special post of spokesperson to the ruler. Since about 1900 these advisers have carried staffs of office such as the one pictured here. The carved figure at the top illustrates a story that may have multiple meanings when told by a witty owner. This staff was probably carved in the 1960s or 1970s by Kojo Bonsu. The son of Osei Bonsu (1900–1976), a

famous carver, Kojo Bonsu lives in the Ashanti city of Kumasi and continues to carve prolifically.

The Ashanti use gold not only for objects, such as the staff, that are reserved for the use of rulers, but also for jewelry, as do other peoples of the region. But for the Ashanti, gold was long a major source of power; they traded it first via intermediaries across the Sahara to the Mediterranean world, then later directly to Europeans on the West African coast.

The Ashanti are also renowned for the beauty of their woven textiles, called **kente** (fig. 25-11). Weaving was introduced in the sixteenth century from Sudan. The weavers were, traditionally, men. Ashanti weavers work on small, light, horizontal looms that produce long, narrow strips of cloth. They begin by laying out the long **warp** threads in a brightly colored pattern. Today the threads are likely to be rayon. Formerly, however, they were silk, which the Ashanti produced by unraveling Chinese cloth obtained through European trade. **Weft** threads are woven through the warp to produce complex patterns, including double weaves in which the front and back of the cloth display different patterns. The long strips produced by the loom are then cut to size and sewn together to form large rectangles of finished *kente* cloth.

Kente cloth was originally reserved for state regalia. A man wore a single huge piece, about 6 to 7 feet by 12 to 13 feet, wrapped like a toga with no belt and the right shoulder

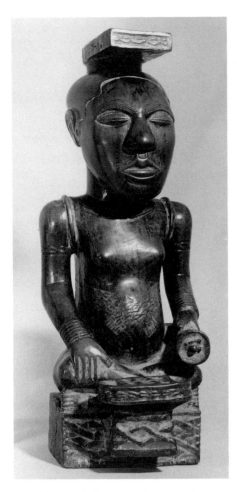

25-12. Royal portrait figure (*ndop*) of Shyaam a-Mbul a-Ngwoong, from Democratic Republic of Congo. Baluba culture, Kuba kingdom, 18th-century copy of a mid-17th-century figure. Wood, height 21⅜" (54.5 cm). Museum of Mankind, London

bare. Women wore two pieces—a skirt and a shawl. The *kente* cloth shown here began with a warp pattern that alternates red, green, and yellow. The pattern is known as *oyokoman ogya da mu*, meaning "there is a fire between two factions of the Oyoko clan," and refers to the civil war that followed the death of the Ashanti king Osai Tutu in about 1730. Traditionally, only the king of the Ashanti was allowed to wear this pattern. Other complex patterns were reserved for the royal family or members of the court. Commoners who dared to wear a restricted pattern were severely punished. In present-day Ghana the wearing of *kente* and other traditional textiles has been encouraged, and patterns are no longer restricted to a particular person or group.

The Kuba people of the Democratic Republic of Congo have produced elaborate and sophisticated political art since at least the seventeenth century. Kuba kings were memorialized by portrait sculpture called *ndop* (fig. 25-12). While the king was alive, his *ndop* was believed to house his double, a counterpart of his soul. After his death the portrait was believed to embody his spirit, which was thought to have power over the fertility both of the land and of his subjects. Together, the twenty-two known *ndop* span almost 400 years of Kuba history.

Kuba sculptors did not try to capture a physical likeness of each king. Indeed, several of the portraits seem interchangeable. Rather, each king is identified by an icon, called *ibol*, carved as part of the dais on which he is seated. The *ibol* refers to a skill for which the king was noted or an important event that took place during his lifetime. The *ndop* in figure 25-12 portrays the seventeenth-century king Shyaam a-Mbul a-Ngwoong, founder of the Kuba kingdom. Carved on the front of his dais is a board for playing mancala, a game he is said to have introduced to the Kuba. Icons of other kings include an anvil for a king who was a skilled blacksmith, a slave girl for a king who married beneath his rank, and a rooster for a twentieth-century king who was exceptionally vigilant.

Kuba *ndop* figures also feature carved representations of royal regalia, including a wide belt of cowrie shells crossing the torso. Below the cowries is a braided belt that can never be untied, symbolizing the ability of the wearer to keep the secrets of the kingdom. Cowrie-shell bands worn on the biceps are called *mabiim*. Commoners are allowed to wear two bands; members of the royal family wear nine. The brass rings depicted on the forearms may be worn only by the king and his mother. The ornaments over each shoulder are made of cloth-covered cane. They represent hippopotamus teeth, and they reflect the prestige that accrues to a hunter of that large animal. Finally, all of the Kuba king figures wear a distinctive cap with a projecting bill. The bill reminds the Kuba of the story of a dispute that arose between the sons of their creator god in which members of one faction identified themselves by wearing the blade of a hoe balanced on their heads.

The kings of the Yoruba people manifested their power through the large, complex palaces in which they lived. In a typical palace plan, the principal rooms opened onto a veranda with elaborately carved posts fronting a courtyard. Dense, highly descriptive figure carving also covered the doors. The finest architectural sculptor of modern times was Olowe of Ise, who carved doors and veranda posts for the rulers of the Ekiti-Yoruba kingdoms in southwestern Nigeria.

The door of the royal palace in Ikere (fig. 25-13, page 928) illustrates Olowe's artistry. Its asymmetrical composition combines narrative and symbolic scenes in horizontal rectangular panels. Tall figures carved in profile end in heads facing out to confront the viewer. Their long necks and elaborate hairstyles make them appear even taller, unlike typical Yoruba sculpture, which uses short static figures. The figures are in such high relief that the upper portions are actually carved in the round. The figures move energetically against an underlying decorative pattern, and the entire surface of the doors is also painted.

Olowe seems to have worked from the early 1900s until his death in 1938. Although he was famous throughout Yorubaland and called upon by patrons as distant as 60 miles from his home, few records of his activities remain, and only one European, Philip Allison, wrote of meeting him and watching him work. Allison described Olowe carving the iron-hard African oak "as easily as [he would] a calabash [gourd]."

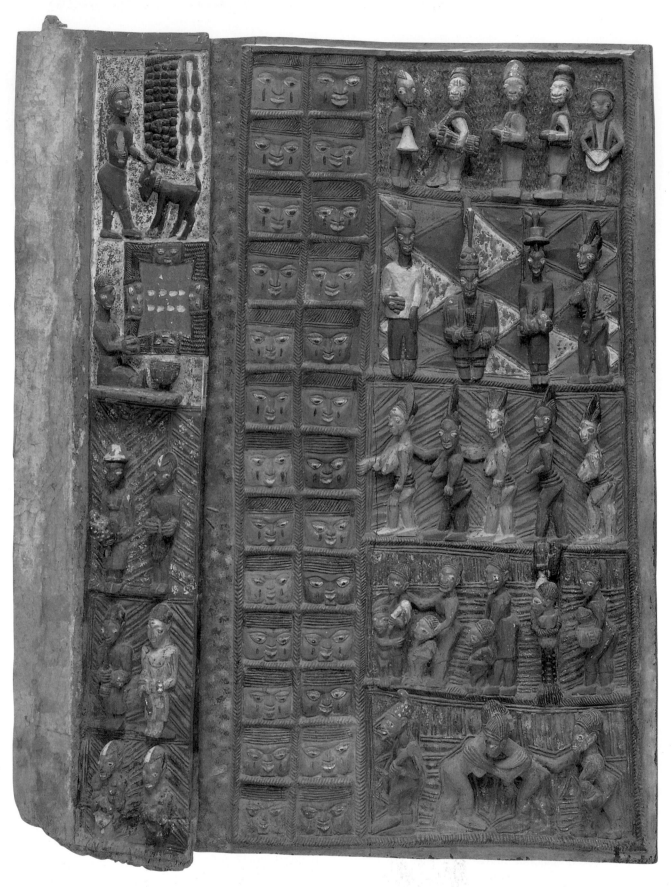

25-13. Olowe of Ise. Door from royal palace in Ikere, Nigeria. Yoruba culture, c. 1925. Wood, pigment, height 6'2⅞" (1.9 m). The Detroit Institute of the Arts

Acc. 1997.80.A &.B. Gift of Bethea and Irwin Green in honor of the 20th anniversary of the Department of African, Oceanic and New World Cultures

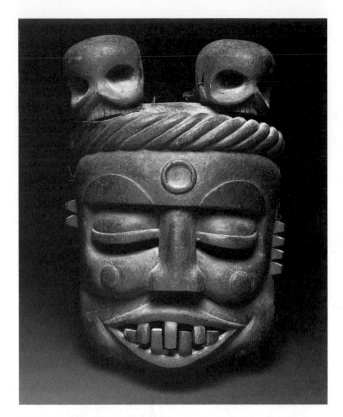

25-14. Ekpo mask, from Nigeria. Anang Ibibio culture, late 1930s. Wood, height 23⅝" (60 cm). Musée Barbier-Mueller, Geneva

This mask embodies many characteristics the Ibibio find repulsive or frightening, such as swollen features, matte black skin, and large, uneven teeth. The pair of skulls atop the head are potent death imagery. The circular scar on the forehead and the ropelike headband indicate membership in the diviner's cult, *idiong*, whose members were particularly feared for their supernatural power. The mask is in the style of the Otoro clan from the Ikot Abia Osom area near the city of Ikot Ekpene.

Not all African peoples centralized power in a single ruler. Most of the peoples of southeastern Nigeria, for example, depended on a council of male elders or on a men's voluntary association to provide order in the life of the community. The Anang Ibibio people of Nigeria were formerly ruled by a men's society called Ekpo. Ekpo expressed its power in part through art, especially large, dark, purposely frightening masks (fig. 25-14). In most rituals involving masks, it is "the mask," not the person wearing it, who takes the action. Such masks were worn by the younger members of the society when they were sent out to punish transgressors. Accompanied by assistants bearing torches, the mask would emerge from the Ekpo meetinghouse at night and proceed directly to the guilty person's house, where a punishment of beating or even execution might be meted out. The identity of the executioner was concealed by the mask, which identified him as an impersonal representative of Ekpo in much the same way that a uniform makes clear that a police officer represents the authority of the state.

25-15. *Kanaga* mask, from Mali. Dogon culture, early 20th century. Wood, height 45¼" (115 cm). Musée Barbier-Mueller, Geneva

DEATH AND ANCESTORS

In the traditional African view, death is not an end but a transition—the leaving behind of one phase of life and the beginning of another. Just as ceremonies mark the initiation of young men and women into the community of adults, so they mark the initiation of the newly dead into the community of spirits. Like the rites of initiation into adulthood, death begins with a separation from the community, in this case the community of the living. A period of isolation and trial follows, during which the newly dead spirit may, for example, journey to the land of ancestors. Finally, the deceased is reintegrated into a community, this time the community of ancestral spirits. The living who preserve the memory of the deceased may appeal to his or her spirit to intercede on their behalf with nature spirits or to prevent the spirits of the dead from using their powers to harm.

Among the Dogon people of Mali, in West Africa, a collective funeral rite with masks (fig. 25-15) is held every twelve to thirteen years, a ceremony called *dama*, meaning "forbidden" or "dangerous." During *dama*, masks perform to the sound of gunfire to drive the soul of the

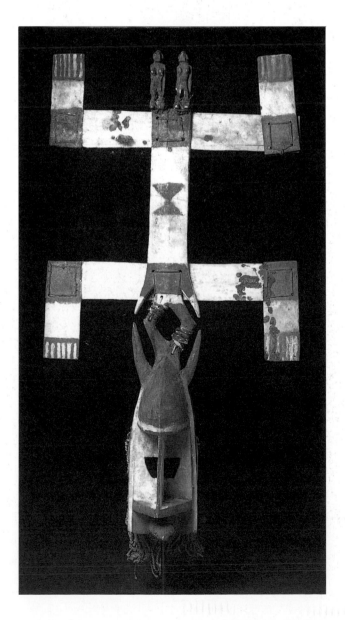

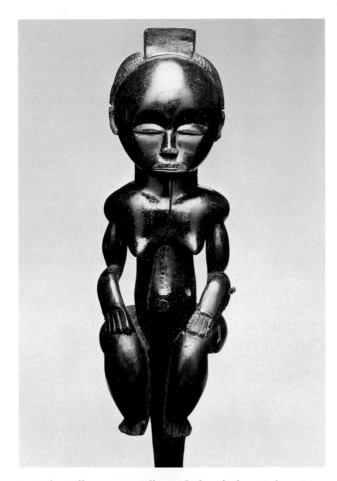

25-16. Reliquary guardian (*nlo byeri*), from Gabon. Fang culture, 19th century. Wood, height 16⅞" (43 cm). Musée Dapper, Paris

deceased from the village. Among the most common masks is the *kanaga*, shown in figure 25-15, whose rectangular face supports a superstructure of planks that depict a woman, bird, or lizard with splayed legs.

For a deceased man, men from the community later engage in a mock battle on the roof of his home and participate in ritual hunts; for a deceased woman, the women of the community smash her cooking vessels on the threshold of her home. These portions of *dama* are reminders of human activities the deceased will no longer engage in. The *dama* may last as long as six days and include the performance of hundreds of masks. Because a *dama* is so costly, it is performed for several deceased elders, both male and female, at the same time.

The Fang people, who live near the Atlantic coast from southern Cameroon through Rio Muni and into northern Gabon, follow an ancestral religion in which the long bones and skulls of ancestors who have performed great deeds are collected after burial and placed together in a cylindrical bark container called *nsekh o byeri*, which a family would carry when it migrated. Deeds thus honored include killing an elephant, being the first to trade with Europeans, bearing an especially large number of children, or founding a particular lineage or community. On top of the container the Fang

place a wooden figure called *nlo byeri*, which represents the ancestors and guards their relics from malevolent spirit forces (fig. 25-16). *Nlo byeri* are carved in a naturalistic style, with carefully arranged hairstyles, fully rounded torsos, and heavily muscled legs and arms. Frequent applications of cleansing and purifying palm oil produce a rich, glossy black surface.

The strong symmetry of the statue is especially notable. The layout of Fang villages is also symmetrical, with pairs of houses facing each other across a single long street. At each end of the street is a large public meetinghouse. The Fang immigrated to the area they now occupy during the early nineteenth century. The experience was disruptive and disorienting, and Fang culture thus emphasizes the necessity of imposing order on a disorderly world. Many civilizations have recognized the power of symmetry to express permanence and stability (see, for example, the Forbidden City in Beijing, China, fig. 21-8).

Internally, the Fang strive to achieve a balance between the opposing forces of chaos and order, male and female, pure and impure, powerful and weak. They value an attitude of quiet composure, of reflection and tranquillity. These qualities are embodied in the powerful symmetry of the *nlo byeri* here, which communicates the calm and wisdom of the ancestor while also instilling awe and fear in those not initiated into the Fang religion.

Among the most complex funerary art in Africa are the memorial ancestral screens made during the nineteenth century by the Ijo people of southeast Nigeria (fig. 25-17). The Ijo live on the Atlantic coast, and with their great canoes formerly mediated the trade between European ships anchored offshore and communities in the interior of Nigeria. During that time groups of Ijo men organized themselves into economic associations called canoe houses, and the heads of canoe houses had much power and status in the community. When the head of a canoe house died, a screen such as the one in figure 25-17 was made in his memory. The Ijo call these screens *duen fobara*, meaning "foreheads of the dead." (The forehead was believed to be the seat of power and the source of success.) The screens are made of pieces of wood and cane that were joined, nailed, bound, and pegged together. The assembly technique is unusual, because most African sculpture is carved from a single piece of wood.

Although each screen commemorates a specific individual, the central figure was not intended as a physical likeness. Instead, as is common in Africa, identity was communicated through attributes of status, such as masks, weapons, or headdresses that the deceased had the right to wear or display. The central figure of the example here wears a hat that distinguishes him as a member of an important men's society called Peri. He is flanked by assistants, followers, or supporters of the canoe house, who are portrayed on a smaller scale. All three figures originally held weapons or other symbols of aggressiveness and status. Other extant screens include smaller heads attached to the top of the frame, perhaps wearing masks that the deceased had commissioned, and

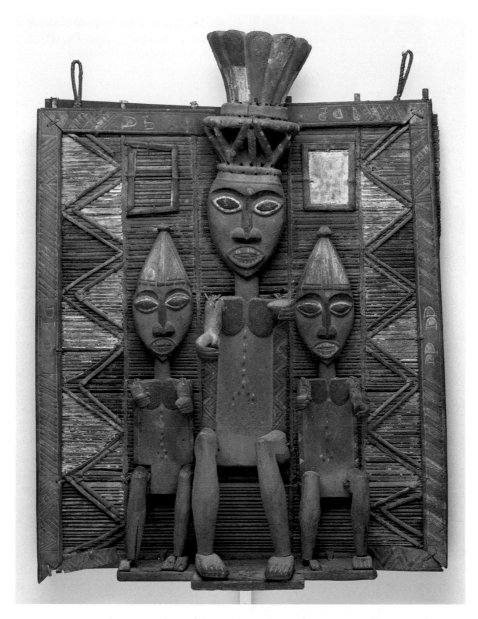

25-17. **Ancestral screen (*duen fobara*)**, from Abonnema village, Nigeria. Kalabari group, Ijo culture, 19th century. The Minneapolis Institute of Arts

representations of the severed heads of defeated enemies at the feet of the figures.

Memorial screens were placed in the ancestral altars of the canoe house, where they provided a dwelling for the spirit of the dead, who was believed to continue to participate in the affairs of the house after his death, ensuring its success in trade and war.

CONTEMPORARY ART The photograph in this chapter of the Bwa masks in performance (see fig. 25-4) was taken in 1984. Even as you read this chapter, new costumes are being made for this year's performance, in which the same two masks will participate. Many traditional communities continue their art in contemporary Africa. But these communities do not live as if in a museum, re-creating the forms of the past as though nothing had

changed. As new experiences pose new challenges or offer new opportunities, art changes with them.

Perhaps the most obvious change in traditional African art has been in the adaptation of modern materials to traditional forms. Other peoples have similarly made use of European textiles, plastics, metal, and even Christmas tree ornaments to enhance the visual impact of their art. Some Yoruba, for example, have used photographs and bright-colored, imported plastic children's dolls in place of the traditional *ere ibeji*, the images of twins shown in figure 25-3. The Guro people of Côte d'Ivoire, continue to commission delicate masks dressed with costly textiles and other materials. But now they paint them with oil-based enamel paints, endowing the traditional form with a new range and brilliance of color. The Guro have also added inscriptions in French and depictions of contemporary figures to sculptural

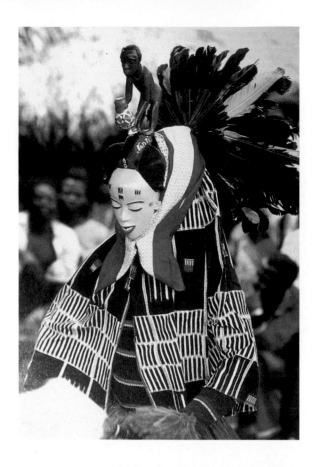

25-18. Spirit mask in performance, from Côte d'Ivoire. Guro culture, 1983. Polychrome wood, height approx. 18" (45.72 cm)

forms that have persisted since before the colonial period (fig. 25-18).

Throughout the colonial period and especially during the years following World War II, Europeans established schools in Africa to train talented artists in the mediums and techniques of European art. In the postcolonial era, numerous African artists have studied in Europe and the United States, and many have become known internationally through exhibits in galleries and museums.

One such artist is Ouattara (b. 1957), represented here by *Nok Culture* (fig. 25-19). Ouattara's background exemplifies the fertile cross-cultural influences that shape the outlook of contemporary urban Africans. Born in Côte d'Ivoire, he received both formal French schooling and traditional African spiritual schooling. His father practiced both Western-style surgery and traditional African healing. At nineteen Ouattara moved to Paris to absorb firsthand the modern art of Europe. He currently lives and works in New York, Paris, and Abidjan. In paintings such as *Nok Culture*, Ouattara draws on his entire experience, synthesizing Western and African influences.

Nok Culture is dense with allusions to Africa's artistic and spiritual heritage. Its name refers to a culture that thrived in Nigeria from about 500 BCE to 200 CE and whose naturalistic works of terra-cotta sculpture are the earliest known figurative art from sub-Saharan Africa. Here, thickly applied paint has built up a surface reminiscent of the painted adobe walls of rural architecture. Tonalities of earth browns, black, and white appear frequently in traditional African art, especially in textiles. The conical horns at the upper corners evoke the ancestral shrines common in rural communities as well as the buttresses of West African adobe mosques. The **motif** of concentric circles at the center of the composition looks much like the traditional bull-roarer sound maker used to summon spirits. Suspended in a window that opens into the painting is a lesson board of the type used by Muslim students in Koranic schools. On the board appear Arabic writing, graphic patterns from African initiation rituals, and symbols from the Christian, ancient Egyptian, and mystical Hebrew traditions—a vivid if cryptic evocation of the many spiritual currents that run together in Africa.

Another art that has brought contemporary African artists to international attention is ceramics. Traditionally, most African pottery has been made by women (see "Numumusow and West African Ceramics," page 933). In some West African societies, potters were married to blacksmiths, both husband and wife making products that take raw ingredients from the earth and transform them

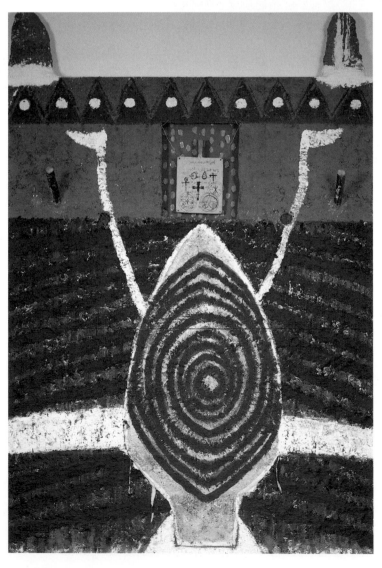

25-19. Ouattara. *Nok Culture*. 1993. Acrylic and mixed mediums on wood, 9'8½" x 6'7¾" (2.96 x 2.03 m). Collection of the artist

NUMUMUSOW AND WEST AFRICAN CERAMICS

In many West African cultures, fired ceramics are made exclusively by women. Among the Mende people of Mali, Burkina Faso, Guinea, and Côte d'Ivoire, potters are *numumusow*, female members of *numu* lineages, and hold an important place in society. Women from these families may resolve disputes and initiate girls; their husbands, fathers, and sons are the sculptors and blacksmiths of the Mende.

Numumusow make a wide selection of vessels, including huge storage jars. The shapes of these pots reflect their intended use, from wide bowls and cooking pots to narrow-necked stoppered water bottles, from large storage vessels to small eating dishes. The *numumusow* form the soft and sticky clay by coiling and modeling with their fingers. They decorate their vessels by burnishing (polishing), by engraving, by adding pellets or coils of clay, or by coloring with slip (a wash of colored clay). The vessels are fired at low temperatures in a shallow pit or in the open, producing a ware that can be used to cook over an open fire without breaking.

Even though most urban Africans use metal and plastic dishes and cookware today, large earthenware jars still keep water cool and clean in areas where refrigeration is expensive. In the past, water-storage jars were public display pieces, standing near the entrance to the house, where a guest would be offered a drink of cool water as an essential part of hospitality. Mende vessels for drinking water are often decorated with incised lines and molded ridges. On older wares such as this example, raised images of figures or lizards might have referred to Mende myths or to philosophical concepts.

Jar, from Bamana, Mali. Mende culture, 20th century. Earthenware, 23½ x 18¾" (59.7 x 47.6 cm). The Nelson-Atkins Museum of Art, Kansas City, Missouri
Purchase: The George H. and Elizabeth O. Davis Fund

by fire. These couples lived apart from the community both physically and socially, respected for their skills yet feared for the intimate contact they had with the powers of earth and fire.

Today, making pottery has enabled many women from traditional communities to attain a measure of economic independence. In Nigeria it is not uncommon to see large trucks stopped at a potters' village, loading up pots to be transported to distant markets. The women do not usually share their pottery income with the male head of the family but keep it to buy food for themselves and their children. In one large pottery community in Ilorin, a northern city of the Yoruba people in Nigeria, women have subcontracted the dreary and physically demanding tasks

25-20. Magdalene Odundo. *Asymmetrical Angled Piece.* 1991.
Reduced red clay, height 17" (43.18 cm). Collection of Werner
Muensterberger

of gathering raw clay and fuel to local men so that they can concentrate on forming their wares, for which there is a great demand. In this way they control much of the local economy.

Nourished by this long tradition, some women have achieved broader recognition as artists. One is Magdalene Odundo (b. 1950), whose work displays the flawless surfaces of traditional Kenyan pottery (fig. 25-20). Indeed, she forms her pots using the same coiling technique that her Kenyan ancestors used. Like Ouattara, Odundo draws her inspiration from a tremendous variety of sources, both African and non-African. In the workshops she presents at colleges and art schools she shows hundreds of slides of pottery. She begins with images of Kenyan potters and pottery, then quickly moves on to pottery from the Middle

East, China and Japan, and ancient North and South America. Odundo works in England, teaches in Europe and the United States, and shows her art through a well-known international dealer. Yet the power of traditional African forms is abundantly evident in the elegant pot illustrated here.

The painter Ouattara probably speaks for most contemporary artists around the world when he says, "[M]y vision is not based only on a country or a continent, it's beyond geography or what you see on a map, it's much more than that. Even though I localize it to make it understood better, it's wider than that. It refers to the cosmos" (cited in McEvilley, page 81). In his emphasis on the inherent spirituality of art, Ouattara voices what is most enduring about the African tradition.

PARALLELS

REGION	AFRICAN ART	ART OF OTHER CULTURES
BURKINA FASO	25-7. **Lobi spirit figure** (19th cent.) 25-2. **Mossi doll** (mid-20th cent.) 25-4. **Bwa masks** (1984)	20-7. **Taj Mahal** (c. 1632–48), India 22-1. **Hokusai.** *The Great Wave* (c. 1831), Japan 28-68. **Dalí.** *The Persistence of Memory* (1831), Spain 23-16. **Tlingit screen** (c. 1840), North America 27-44. **Bonheur.** *Plowing in the Nivernais* (1849), France
CÔTE D'IVOIRE	25-9. **Baule spirit spouse** (early 20th cent.) 25-18. **Guro spirit mask** (early 1980s) 25-19. **Ouattara,** *Nok Culture* (1993)	28-5. **Matisse.** *Woman with the Hat* (1905), France 28-39. **Wright. Robie House** (1906–9), US 28-21. **Picasso.** *Les Demoiselles d'Avignon* (1907), France 28-14. **Marc.** *Blue Horses* (1911), Germany 23-15. **Kwakiutl mask** (c. 1914), North America
GABON	25-16. **Fang reliquary guardian** (19th cent.)	23-22. **Klah.** *Whirling Log* (c. 1925), North America 28-75. **Lange.** *Migrant Mother, Nipomo, California* (1936), US 23-20. **Martinez. Blackware jar** (c. 1942), North America
GHANA	25-1. **Ashanti finial** (20th cent.) 25-11. **Ashanti** *kente* **cloth** (20th cent.)	24-6. *Mbis* (c. 1960), Irian Jaya 24-14. **Kakalia.** *Royal Symbols* quilt (1978), Hawaii 24-7. *Tatanua* masks (1979), New Ireland 22-17. **Fujii.** *Untitled '90* (1990), Japan
KENYA	25-20. **Odundo.** *Assymetrical Angled Piece* (1991)	
MALI	25-15. **Dogon** *kanaga* **mask** (early 20th cent.)	
NIGERIA	25-17. **Ijo ancestor screen** (19th cent.) 25-3. **Yoruba twin figures** (20th cent.) 25-10. **Yoruba dance staff** (20th cent.) 25-13. **Olowe. Yoruba door** (c. 1925) 25-14. **Anang Ibibio Ekpo mask** (late 1930s)	
SIERRA LEONE	25-5. **Mende** *nowo* **mask** (20th cent.)	
DEMOCRATIC REPUBLIC OF CONGO	25-12. **Kuba royal portrait figure** (mid-17th cent.) 25-8. **Kongo power figure** (19th cent.) 25-6. **Lega** *bwami* **mask** (early 20th cent.)	

26
Eighteenth-Century Art in Europe and North America

26-1. John Singleton Copley. *Samuel Adams*.
c. 1770–72. Oil on canvas, 50 x 40"
(127 x 102.2 cm). Museum of Fine Arts,
Boston

Deposited by the City of Boston

On March 5, 1770, a street fight broke out between several dozen residents of Boston and a squad of British soldiers. The British fired into the crowd, killing three men and wounding eight others, two of whom later died. Dubbed the Boston Massacre by anti-British patriots, the event was one of many that led to the Revolutionary War of 1775–83, which won independence from Britain for the thirteen American colonies.

The day after the Boston Massacre, Samuel Adams, a member of the Massachusetts legislature, demanded that the royal governor, Thomas Hutchinson, expel British troops from the city—a confrontation that Boston painter John Singleton Copley immortalized in oil paint (fig. 26-1). Adams, conservatively dressed in a brown suit and waistcoat, stands before a table and looks sternly out at the viewer, who occupies the place of Governor Hutchinson. With his left hand, Adams points to the charter and seal granted to Massachusetts by King William and Queen Mary; in his right, he grasps a petition prepared by the aggrieved citizens of Boston.

The vivid realism of Copley's style makes the lifesize figure of Adams seem almost to be standing before us. Adams's head and hands, dramatically lit, surge out of the darkness with a sense of immediacy appropriate to the urgency of his errand. The legislator's defiant stance and emphatic gesture convey the moral force of his demands, which are impelled not by emotion but by reason. The charter to which he points insists on the rule of law, and the classical columns behind him connote republican virtue and rationality—important values of the Enlightenment, the major philosophical movement of eighteenth-century Europe as well as Colonial America. Enlightenment political philosophy provided the ideological basis for the American Revolution, which Adams ardently supported.

TIMELINE 26-1. Europe and North America in the Eighteenth Century. With the birth of democracies and republics and the rise of industrialization, this century marks the beginning of the modern era.

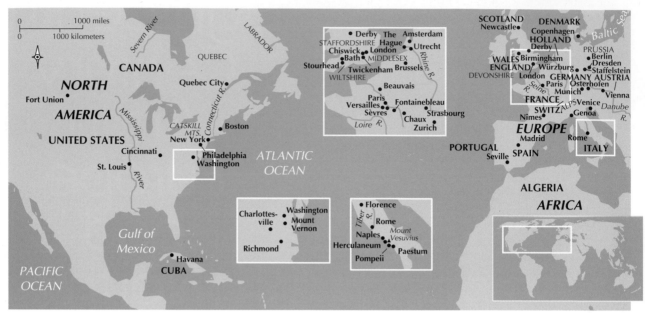

MAP 26-1.
Europe and North America in the Eighteenth Century. During the eighteenth century, three major artistic styles—Rococo, Neoclassicism, and Romanticism—flourished in Europe and North America.

THE ENLIGHTENMENT AND ITS REVOLUTIONS

The eighteenth century marks a great divide in Western history. When the century opened, the West was still semifeudal economically and politically. Wealth and power were centered in an aristocratic elite, who owned or controlled the land worked by the largest and poorest class, the farmers. In between was a small middle class composed of doctors, lawyers, shopkeepers, artisans, and merchants—most of whom depended for their livelihood on the patronage of the rich. Only those involved in overseas trade operated outside the agrarian system, but even they aspired to membership in the landed aristocracy.

By the end of the century, the situation had changed dramatically (Timeline 26.-1). A new source of wealth—industrial manufacture—was being developed, and social visionaries expected industry not only to expand the middle class but also to provide a better material existence for all classes, an interest that extended beyond purely economic concerns. What became known as the Industrial Revolution was complemented by a revolution in politics, spurred by a new philosophy that conceived of all white men (some thinkers included women and minorities) as deserving of equal rights and opportunities. The American Revolution of 1776 and the French Revolution of 1789 were the seismic results of this dramatically new concept.

Developments in politics and economics were themselves manifestations of a broader philosophical revolution: the Enlightenment. The Enlightenment was a radically new synthesis of ideas about humanity, reason, nature, and God that had arisen during the Renaissance and during classical Greek and Roman times. What distinguished the Enlightenment proper from its antecedents was the late-seventeenth- and early-eighteenth-century thinkers' generally optimistic view that humanity and its institutions could be reformed, if not perfected. Bernard de Fontenelle, a French popularizer of seventeenth-century scientific discoveries, writing in 1702, anticipated "a century which will become more enlightened day by day, so that all previous centuries will be lost in darkness by comparison." At the end of the seventeenth and beginning of the eighteenth century, such hopes were expressed by a handful of thinkers; after 1740, the number and power of such voices grew, so that their views increasingly dominated every sphere of intellectual life, including that of the European courts. The most prominent and influential of these thinkers, called philosophes (to distinguish their practical concerns from the purely academic ones of philosophers), included Jean-Jacques Rousseau, Denis Diderot, Thomas Jefferson, Benjamin Franklin, and Immanuel Kant.

The philosophes and their supporters did not agree on all matters. Perhaps the matter that most unified these thinkers was the question of the purpose of humanity. Rejecting conventional notions that men and women were here to serve God or the ruling class, the philosophes insisted that humans were born to serve themselves, to pursue their own happiness and fulfillment. The purpose of the State, they agreed, was to facilitate this pursuit. Despite the pessimism of some and the reservations of others, Enlightenment thinkers were generally optimistic that men and women, when set free from their political and religious shackles, could be expected to act both rationally and morally. Thus, in pursuing their own happiness, they would promote the happiness of others.

Nature, like humanity, was generally seen as both rational and good. The natural world, whether a pure

mechanism or the creation of a beneficent deity, was amenable to human understanding and, therefore, control. Once the laws governing the natural and human realms were determined, they could be harnessed for our greater happiness. From this concept flowed the inextricably intertwined industrial and political revolutions that marked the end of the century.

Three artistic styles prevailed during the Enlightenment, but the most characteristic was Neoclassicism. In essence, Neoclassicism (*neo* means "new") presents classical subject matter—mythological or historical—in a style derived from classical Greek and Roman sources. Some Neoclassical art was conceived to please the senses, some to teach moral lessons. In its didactic manifestations—usually **history paintings**—Neoclassicism was one of the chief vehicles for conveying Enlightenment ideals.

The Neoclassical style arose in part in reaction to the dominant style of the early eighteenth century, known as Rococo. The term *rococo* was coined by critics who combined the Portuguese word *barroco* (which refers to an irregularly shaped pearl and is the source of the word *baroque*) and the French word *rocaille* (the artificial shell or rock ornament popular for gardens) to describe the refined, fanciful, and often playful style that became fashionable in France at the end of the seventeenth century and spread throughout Europe in the eighteenth century.

While the terms *Rococo* and *Neoclassicism* identify distinct artistic styles—the one complex and sensuous, the other simple and restrained—a third term applied to later eighteenth-century art, *Romanticism*, describes not only a style but also an attitude. Romanticism is chiefly concerned with imagination and the emotions, and it is often understood as a reaction against the Enlightenment focus on rationality. Romanticism celebrates the individual and the subjective rather than the universal and the objective. The movement takes its name from the medieval romances—novellas, stories, and poems written in Romance (Latin-derived) languages—that provided many of its themes. Thus, the term *Romantic* suggests something fantastic or novelistic, perhaps set in a remote time or place, infused by a poetic or even melancholic spirit.

Many works of art of the later eighteenth and early nineteenth centuries combined elements of Neoclassicism and Romanticism. Indeed, because a sense of remoteness in time or place characterizes both Neoclassical and Romantic art, some scholars argue that Neoclassicism is a subcategory of Romanticism.

THE ROCOCO STYLE IN EUROPE

The Rococo style is characterized by pastel colors, delicately curving forms, dainty figures, and a lighthearted mood. It may be seen partly as a reaction at all levels of society, even among kings and bishops, against the art identified with the formality and rigidity of seventeenth-century court life. The movement began in French

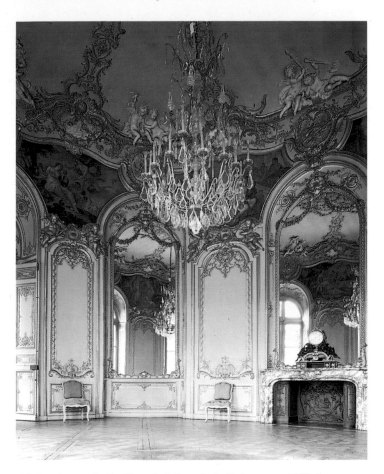

26-2. Germain Boffrand. Salon de la Princesse, Hôtel de Soubise, Paris. Begun 1732

architectural decoration at the end of Louis XIV's reign (ruled 1643–1715) and quickly spread across Europe (Map 26-1). The duke of Orléans, regent for the boy-king Louis XV (ruled 1715–74), made his home in Paris, and the rest of the court—delighted to escape the palace at Versailles—also moved there and built elegant town houses (in French, *hôtels*), whose smaller rooms dictated new designs for layout, furniture, and décor. They became the lavish settings for intimate and fashionable intellectual gatherings and entertainments, called salons, that were hosted by accomplished, educated women of the upper class whose names are still known today—Mesdames de Staël, de La Fayette, de Sévigné, and du Châtelet being among the most familiar. The Salon de la Princesse in the Hôtel de Soubise in Paris (fig. 26-2), designed by Germain Boffrand (1667–1754) beginning in 1732, is typical of the delicacy and lightness seen in French Rococo *hôtel* design during the 1730s. Interior designs for palaces and churches built on traditional Baroque plans were also animated by the Rococo spirit, especially in Germany and Austria. In occasional small-scale buildings, the Rococo style was also successfully applied to architectural planning.

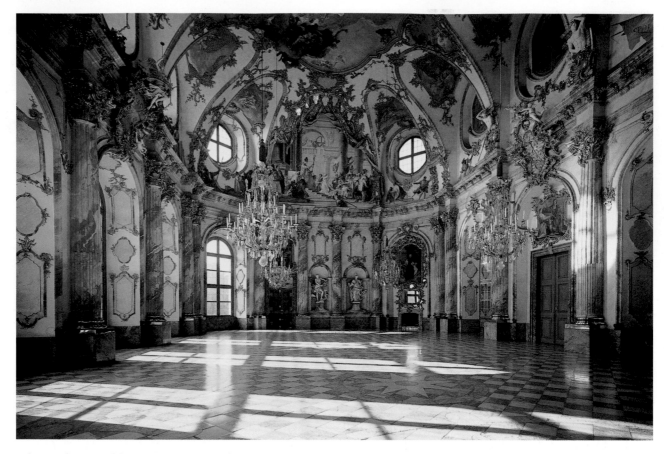

26-3. Johann Balthasar Neumann. Kaisersaal (Imperial Hall), Residenz, Würzburg, Bavaria, Germany. 1719–44. Fresco by Giovanni Battista Tiepolo. 1751–52 (see fig. 26-4)

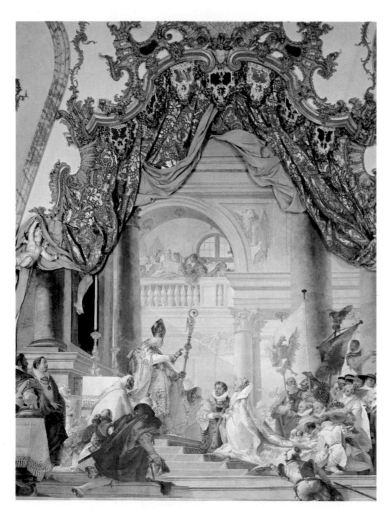

Typical Rococo elements in architectural decoration were **arabesques**, **S** shapes, **C** shapes, reverse-**C** shapes, **volutes**, and naturalistic plant forms. The glitter of silver or gold against expanses of white or pastel color, the visual confusion of mirror reflections, delicate ornament in sculpted stucco, carved wood panels called *boiseries*, and inlaid wood designs on furniture and floors were all part of the new look. In residential settings, pictorial themes were often taken from classical love stories, and sculpted ornaments were rarely devoid of **putti**, cupids, and clouds.

ARCHITECTURE AND ITS DECORATION IN GERMANY AND AUSTRIA

A major architectural project influenced by the new Rococo style was the Residenz, a splendid palace that Johann Balthasar Neumann (1687–1753) created for the prince-bishop of Würzburg from 1719 to 1744. The oval Kaisersaal, or Imperial Hall (fig. 26-3), illustrates Neumann's great triumph in planning and decoration. Although the clarity of the plan, the size and proportions of the marble columns, and the large windows recall the Hall of Mirrors at Versailles (see fig. 19-24) the decoration of the Kaisersaal, with its white-and-gold color scheme and its profusion of delicately curved forms, embodies the Rococo spirit. Here one can see the earliest development

26-4. Giovanni Battista Tiepolo. *The Marriage of the Emperor Frederick and Beatrice of Burgundy*, fresco in the Kaisersaal (Imperial Hall), Residenz. 1751–52

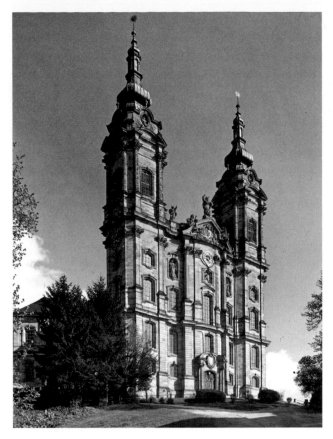

26-5. Johann Balthasar Neumann. Church of the Vierzehnheiligen, near Staffelstein, Germany. 1743–72

In the center of the nave of the Church of the Vierzehnheiligen (Fourteen Auxiliary Saints), an elaborate shrine was built over the spot where, in the fifteenth century, a shepherd had visions of the Christ Child surrounded by saints. The saints came to be known as the Holy Helpers because they assisted people in need.

of Neumann's aesthetic of interior design that culminated in his final project, the Church of the Vierzehnheiligen (Fourteen Auxiliary Saints) near Staffelstein (see fig. 26-7).

Neumann's collaborator on the Residenz was a brilliant Venetian painter, Giovanni Battista Tiepolo (1696–1770), who began to work there in 1750. Venice by the early eighteenth century had surpassed Rome as an artistic center, and Tiepolo was acclaimed internationally for his confident and optimistic expression of the illusionistic fresco painting pioneered by sixteenth-century Venetians such as Veronese. Tiepolo's work in the Kaisersaal—three scenes glorifying the twelfth-century crusader-emperor Frederick Barbarossa, who had been a patron of the bishop of Würzburg—is a superb example of his architectural painting. *The Marriage of the Emperor Frederick and Beatrice of Burgundy* (fig. 26-4) is presented as if it were theater, with painted and gilded stucco curtains drawn back to reveal the sumptuous costumes and splendid setting of an imperial wedding. Like Veronese's grand conceptions (see fig. 18-59), Tiepolo's spectacle is populated with an assortment of character types, presented in dazzling light and sun-drenched colors with the assured hand of a virtuoso. Against the opulence of their surroundings, these heroic figures behave with the utmost decorum and, the artist suggests, nobility of purpose.

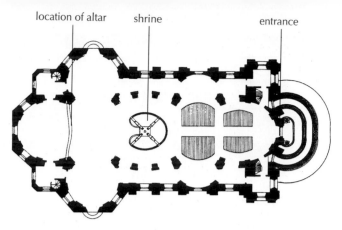

26-6. Plan of the Church of the Vierzehnheiligen. c. 1743

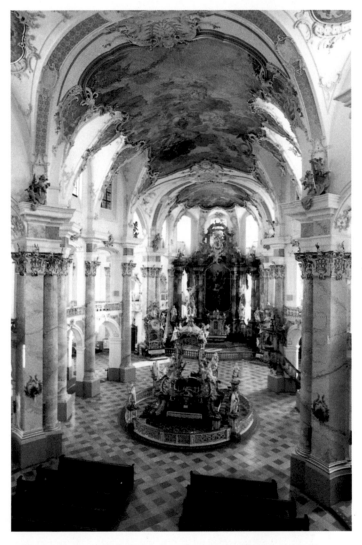

26-7. Interior, Church of the Vierzehnheiligen. 1743–72

Rococo decoration in Germany was as often religious as secular. One of the many opulent Rococo church interiors still to be seen in Germany and Austria is that of the Church of the Vierzehnheiligen (fig. 26-5), which was begun by Neumann in 1743 but was not completed until 1772, long after his death. The grand Baroque facade gives little hint of the overall plan (fig. 26-6), which is based on six interpenetrating oval spaces of varying sizes around a dominant domed ovoid center. The plan, in fact, recalls Borromini's design of the Church of San Carlo alle Quattro Fontane (see fig. 19-4). On the interior of the nave (fig. 26-7), the Rococo love of undulating surfaces and

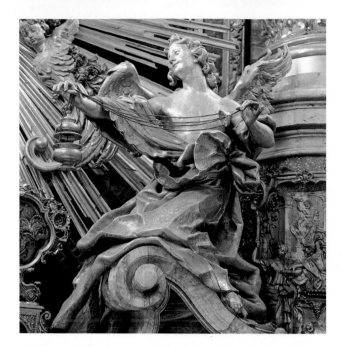

26-8. Egid Quirin Asam. *Angel Kneeling in Adoration*, part of a tabernacle on the main altar, Convent Church, Osterhofen, Germany. c. 1732. Limewood with gilding and silver leaf, height 6'6" (2 m)

gold and white of the interior. The foliage of the fanciful capitals is repeated here and there in arabesques, wreaths, and the ornamented frames of the irregular panels that line the vault. What Neumann had begun in the Kaisersaal at Würzburg he brought to full fruition here in the ebullient sense of spiritual uplift achieved by the complete integration of architecture and decoration.

Many sculptors as well as painters undertook church decoration, such as the sumptuous white, gold, and polychrome wood and plaster of the monastery at Melk (see fig. 19-31) and Vierzehnheiligen. Among the Bavarian artists of southern Germany, Egid Quirin Asam (1692–1750) was one of the best. He went to Rome in 1712 with his father, a fresco painter, and his brother, Cosmas Damian (1686–1739). There, they studied Bernini's works and the illusionistic ceilings of Annibale Carracci and others (see figs. 19-13 and 19-14). Back in Bavaria, the brothers often collaborated on interior decoration in the Italian Baroque manner, to which they soon added lighter, more fantastic elements in the French Rococo style. Cosmas specialized in fresco painting and Egid in stone, wood, and stucco sculpture. The Rococo spirit is evident in Egid's *Angel Kneeling in Adoration* (fig. 26-8), a detail of a tabernacle made about 1732 for the main altar of a church in Osterhofen for which Cosmas provided the altarpiece. Carved of limewood and covered with silver leaf and gilding, the over-lifesize figure appears to have landed in a half-kneeling position on a large bracket swinging a censer. Bernini's angel in the Cornaro Chapel (see fig. 19-9) was the inspiration for Asam's figure, but

overlays of decoration creates a visionary world where flat wall surfaces scarcely exist. Instead, the viewer is surrounded by clusters of pilasters and engaged columns interspersed with two levels of arched openings to the side aisles and large clerestory windows illuminating the

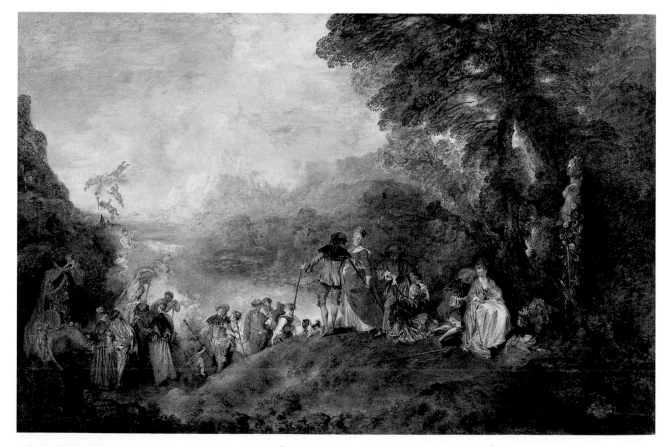

26-9. Jean-Antoine Watteau. *Le Pélerinage à l'Île de Cithère*. 1717. Oil on canvas, 4'3" x 6'4½" (1.3 x 1.9 m). Musée du Louvre, Paris

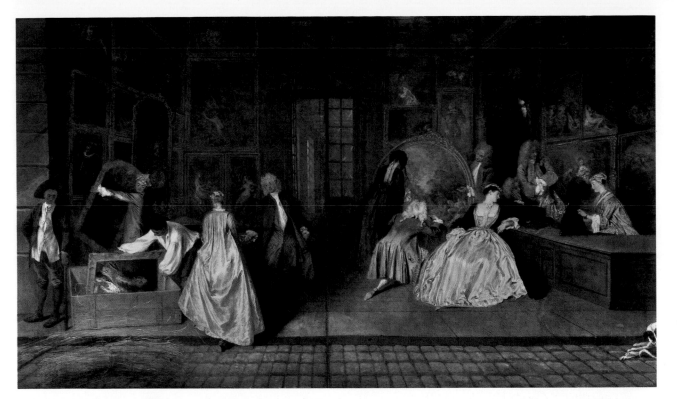

26-10. Jean-Antoine Watteau. *The Signboard of Gersaint*. c. 1721. Oil on canvas, 5'4" x 10'1" (1.62 x 3.06 m). Stiftung Preussische Schlössen und Gärten Berlin-Brandenburg, Schloss Charlottenburg

Watteau's sign painting was designed for the Paris art gallery of Edme-François Gersaint, who introduced the English idea of selling paintings by catalog. The systematic listing of works for sale gave the name of the artist and the title, medium, and dimensions of each work of art. The shop depicted on the signboard is not Gersaint's but an ideal gallery visited by elegant and cultivated patrons. The sign was so admired that Gersaint sold it only fifteen days after it was installed. Later it was cut down the middle and each half was framed separately, which resulted in the loss of some canvas along the sides of each section. The painting was restored and its two halves reunited in the twentieth century.

the Bavarian artist has taken the liveliness of pose to an extreme, and the drapery, instead of revealing the underlying forms, swirls about in an independent decorative pattern.

PAINTING IN FRANCE

In painting, the work of Jean-Antoine Watteau (1684–1721) epitomizes the French Rococo style. Watteau created a new type of painting when he submitted his official examination canvas, *Le Pélerinage à l'Île de Cithère* (fig. 26-9), for admission to membership in the Royal Academy of Painting and Sculpture in 1717 (see "Academies and Academy Exhibitions," page 934). The academicians accepted the painting in a new category of subject matter, the *fête galante*, or elegant outdoor entertainment. The painting, whose ambiguous French title may be translated either as *Pilgrimage to the Island of Cythera* (*Cithère* in French) or *Pilgrimage on the Island of Cythera*, depicts a dream world in which beautifully dressed couples, accompanied by *putti*, either depart for or take leave of the mythical island of love. The verdant landscape would never soil the characters' exquisite satins and velvets, nor would a summer shower ever threaten them. This kind of idyllic vision, with its overtones of wistful melancholy, had a powerful attraction in early-eighteenth-century Paris and soon charmed the rest of Europe.

Tragically, Watteau died from tuberculosis when still in his thirties. During his final illness, while staying with the art dealer Edme-François Gersaint, he painted a signboard for Gersaint's shop (fig. 26-10). The dealer later wrote that Watteau had completed the painting in eight days, working only in the mornings because of his failing health. When the sign was installed, it was greeted with almost universal admiration, and Gersaint sold it shortly afterward.

The painting shows an art gallery filled with paintings from the Venetian and Netherlandish schools that Watteau admired. Indeed, the glowing satins and silks of the women's gowns are homage to artists like Gerard Ter Borch (see fig. 19-65). The visitors to the gallery are elegant ladies and gentlemen, at ease in these surroundings and apparently knowledgeable about paintings. Thus, they create an atmosphere of aristocratic sophistication. At the left, a woman in shimmering pink satin steps across the threshold. Ignoring her companion's outstretched hand, she is distracted by the two porters packing. While one holds a mirror, the other carefully lowers into the wooden case a portrait of Louis XIV, which may be a reference to the name of Gersaint's shop, Au Grand Monarque ("At the Sign of the Great King"). It also suggests the passage of time, for Louis had died in 1715. A number of other elements in the work also gently suggest transience. On the left, the clock positioned directly over the king's portrait, surmounted by an allegorical figure of Fame and sheltering a pair of lovers, is a traditional **memento mori**, a reminder of mortality. The figures on it suggest that both love and fame are subject to the depredations of time. Well-established **vanitas**

ACADEMIES AND ACADEMY EXHIBITIONS

During the seventeenth century, the French government founded a number of royal **academies** for the support and instruction of students in literature, painting and sculpture, music and dance, and architecture. In 1667, the Royal Academy of Painting and Sculpture began to mount occasional exhibitions of the members' recent work. These exhibitions came to be known as **Salons** because they were held in the Salon d'Apollon (the Apollo Room) in the Palace of the Louvre. Beginning in 1737, the Salons were held every other year, with a jury of members selecting the works to be shown. Illustrated here is a view of the Salon of 1787, with its typical floor-to-ceiling hanging of paintings. As the only public art exhibitions of any importance in Paris, the Salons were enormously influential in establishing officially approved styles and in molding public taste, and they helped consolidate the Royal Academy's dictatorial control over the production of art.

In recognition of the importance of Rome as a training ground for artists, the French Royal Academy of Painting and Sculpture opened a branch there in 1666. The competitive **Prix de Rome**, or Rome Prize, was also established, which permitted the winners to study in Rome for three to five years. A similar prize was established by the French Royal Academy of Architecture in 1720.

Many Western cultural capitals emulated the French model and opened academies of their own. Academies were established in Berlin in 1696, Dresden in 1750, London in 1768, Boston in 1780, New York in 1802, and Philadelphia in 1805. The English Royal Academy of Arts was quite different from its French prototype; although chartered by George III, it was a private institution independent of any interference from the Crown. It had only two functions, to operate an art school and to hold two annual exhibitions, one of art of the past and another of contemporary art, which was open to any exhibitor on the basis of merit alone. The Royal

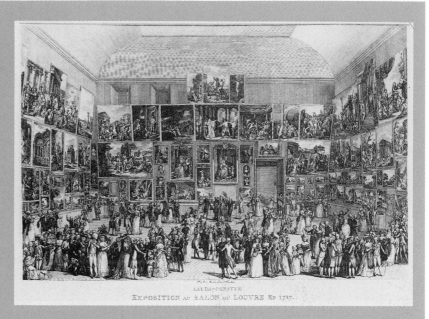

Piero Antonio Martini. *The Salon of 1787*. 1787. Engraving

Academy continues to function in this way to the present day.

In France, the Revolution of 1789 brought a number of changes to the Royal Academy. In 1791, the jury system was abolished as a relic of the monarchy, and the Salon was democratically opened to all artists. In 1793, all of the royal academies were disbanded and, in 1795, reconstituted as the newly founded Institut de France, which was to administer the art school—the École des Beaux-Arts—and sponsor the Salon exhibitions. The number of would-be exhibitors was soon so large that it became necessary to reintroduce some screening procedure, and so the jury system was revived. In 1816, with the restoration of the monarchy following the defeat of Napoleon, the division of the Institut dedicated to painting and sculpture was renamed the Académie des Beaux-Arts, and thus the old Academy was in effect restored.

Academic training, which had been established in the sixteenth-century to free the artist from the restraints of guild training, became during the late eighteenth and nineteenth centuries the chief obstacle to change and independent thinking of the sort promoted by the Enlightenment philosophes and practiced by

the Romantics. The academic premise was that the principles of excellence found in the classical works of antiquity and the Renaissance could be learned by systematic training of the mind and hand. In addition to learning the kinds of rules found in Joshua Reynolds's *Fifteen Discourses to the Royal Academy*, students studied from plaster casts of antique sculpture. Thus, when the student was finally allowed to work from the live model, he (women were not allowed to work from the nude) was expected to "correct" nature according to the higher conception of human form he had acquired from his studies.

Artists wishing to work according to their own standards of beauty and relevance increasingly came into conflict with the academies, especially in France. As we will see in the next chapter, the history of French art from about 1830 to the end of the century is largely that of the struggle between the conservative forces of the Academy and the rebellious innovations of those who became known as the **avant-garde**. The Academy's chief means of keeping artists in line were the officially appointed juries of the Salons. After 1830, the juries systematically rejected work that did not conform to the Academy's formal or thematic standards.

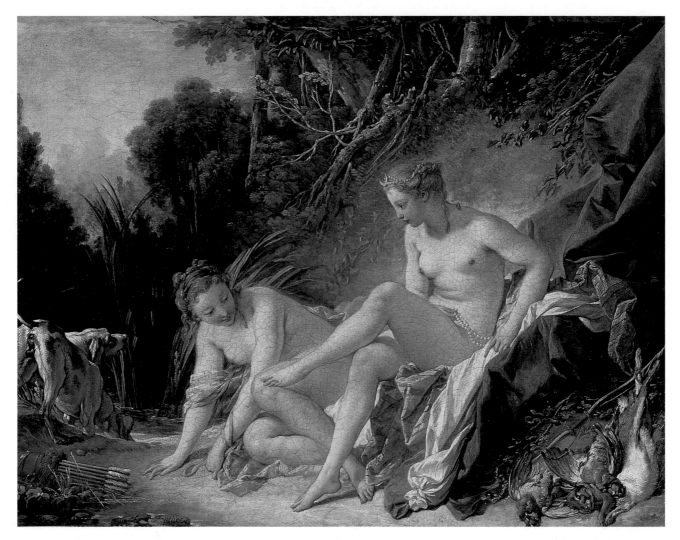

26-11. François Boucher. *Diana Resting after Her Bath*. 1742. Oil on canvas, 22 x 29" (56 x 74 cm). Musée du Louvre, Paris

emblems are the straw (in the foreground), so easily destroyed, and the young woman gazing into the mirror (set next to a vanity case on the counter), for mirrors and images of young women looking at their reflections were time-honored symbols of the fragility of human life. Watteau, dying, certainly knew how ephemeral life is, and no artist ever expressed the fleeting nature of human happiness with greater subtlety.

The artist most closely associated today with Parisian Rococo painting at its height is François Boucher (1703–70), who never met Watteau. In 1721, Boucher, the son of a minor painter, entered the workshop of an engraver to support himself as he attempted to win favor at the Academy. The young man's skill drew the attention of a devotee of Watteau, who hired Boucher to reproduce Watteau's paintings in his collection, an event that firmly established the direction of Boucher's career.

After studying at the French Academy in Rome from 1727 to 1731, Boucher settled in Paris and became an academician. Soon his life and career were intimately bound up with two women: The first was his artistically talented wife, Marie-Jeanne Buseau, who was a frequent model

as well as a studio assistant to her husband. The other was Louis XV's mistress, Madame de Pompadour, who became his major patron and supporter. Pompadour was an amateur artist herself and took lessons from Boucher in printmaking. After Boucher received his first royal commission in 1735, he worked almost continuously to decorate the royal residences at Versailles and Fontainebleau. In 1755, he was made chief inspector at the Gobelins Tapestry Manufactory, and he provided designs to it and to the Sèvres **porcelain** and Beauvais tapestry manufactories, all of which produced furnishings for the king. In 1765, Boucher became First Painter to the King.

While he painted a number of fine portraits and scenes of daily life, Boucher is best known for his mythological scenes, in which gods, goddesses, and *putti*—largely nude except for strategically placed draperies—frolic or relax in pastoral settings. Among the finest of Boucher's mythological paintings is *Diana Resting after Her Bath* (fig. 26-11), which was exhibited at the Salon of 1742. In the center of the picture, the Roman goddess of the hunt and her attendant assume complicated poses that appear natural and graceful due to Boucher's masterful orchestration of body

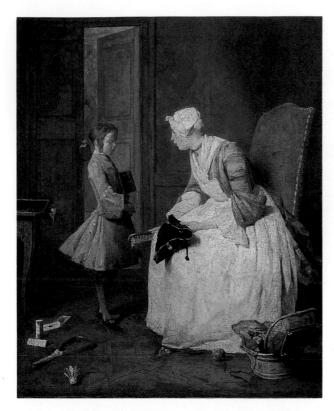

26-12. Jean-Siméon Chardin. *The Governess*. 1739.
Oil on canvas, 18⅛ x 14¾" (46 x 37.5 cm).
National Gallery of Canada, Ottawa

Chardin was one of the first European artists to
treat the lives of women and children with
sympathy and to honor the dignity of women's
work in his portrayals of young mothers,
governesses, and kitchen maids. Shown at the
Salon of 1739, *The Governess* was praised by
contemporary critics, one of whom noted "the
graciousness, sweetness, and restraint that
the governess maintains in her discipline of the
young man about his dirtiness, disorder, and
neglect; his attention, shame, and remorse; all
are expressed with great simplicity."

parts into a satisfying structure of vertical, horizontal, and
crossing diagonal masses. The cool greens of the forest
and the blue, white, and pink hues of the drapery behind
Diana throw into relief the appealing golden tones of her
flesh. Her nudity is emphasized by the crescent tiara in
her hair and the pearl necklace she dangles between her
hands. Subordinate details relating to the hunt—the dogs
and quiver at the left and the bow and dead game at the
right—provide a narrative context for the central subject
and demonstrate Boucher's skill as a painter of animals.

Paradoxically, many of the same royal and aristo-
cratic patrons who prized the erotic suggestiveness of
Boucher's mythological paintings also delighted in the
morally uplifting **genre** scenes painted by his contem-
porary Jean-Siméon Chardin (1699–1779). A painter
whose output was limited essentially to still lifes and
quiet domestic scenes, Chardin tended to work on a
small scale, meticulously and slowly. His early still lifes
consisted of a few simple objects that were to be

enjoyed for their subtle differences of shape and texture,
not for any virtuoso performance, complexity of compo-
sition, or moralizing content. But in the 1730s, Chardin
began to create moral genre pictures in the tradition of
seventeenth-century Dutch genre paintings, which
focused on simple, mildly touching scenes of everyday
middle-class life. One such picture, *The Governess* (fig.
26-12), shows a finely dressed boy, with books under his
arm, who listens to his governess as she prepares to
brush his tricorn (three-cornered) hat. Scattered on the
floor behind him are a racquet, a shuttlecock, and play-
ing cards, evoking the childish pleasures that the boy
leaves behind as he prepares to go to his studies and,
ultimately, to a life of responsible adulthood.

When the mother of young Jean-Honoré Fragonard
(1732–1806) brought her son to Boucher's studio around
1747–48, the busy court artist recommended that the
boy first study the basics of painting with Chardin.
Within a few months, Fragonard returned with some
small paintings done on his own, and Boucher gladly
welcomed him as an apprentice-assistant at no charge
to his family. Boucher encouraged the boy to enter the
competition for the **Prix de Rome**, the three-to-five-
year scholarship awarded to the top students in painting
and sculpture graduating from the French Academy's
art school. Fragonard won the prize in 1752 and spent
1756–61 in Italy, but not until 1765 was he finally
accepted into the Royal Academy. Fragonard catered to
the tastes of an aristocratic clientele, and he began to fill
the vacuum left by Boucher's death in 1770 as a decora-
tor of interiors.

Fragonard produced fourteen canvases commis-
sioned around 1771 by Madame du Barry, Louis XV's last
mistress, to decorate her château. These marvelously free
and seemingly spontaneous visions of lovers explode in
color and luxuriant vegetation. *The Meeting* (fig. 26-13)
shows a secret encounter between a young man and his
sweetheart, who looks anxiously over her shoulder to be
sure she has not been followed and clutches the letter
that arranged the tryst. The rapid brushwork that distin-
guishes Fragonard's technique is at its freest and most
lavish here. However, Madame du Barry rejected the
paintings as passé and commissioned another set in the
newly fashionable Neoclassical style. The Rococo world
was, indeed, ending, and Fragonard's erotic Rococo style
had become outmoded; he spent his last years living on a
small pension and the generosity of his highly successful
pupil Marguerite Gérard (1761–1837), who was his wife's
younger sister.

DECORATIVE ARTS AND SCULPTURE

In the eighteenth century, all media succumbed to the
enchantment of Rococo. Royal factories in every country
adopted the lively, elegant style in everything from chairs
and tables to tapestries, porcelain, and silverware. Not
only classical art but also the exotic art of the Far East
inspired artists—for example, Chinese motifs, known as
chinoiseries, became a decorative fantasy in *La Foire
Chinoise (The Chinese Fair)*, the tapestry from a six-piece

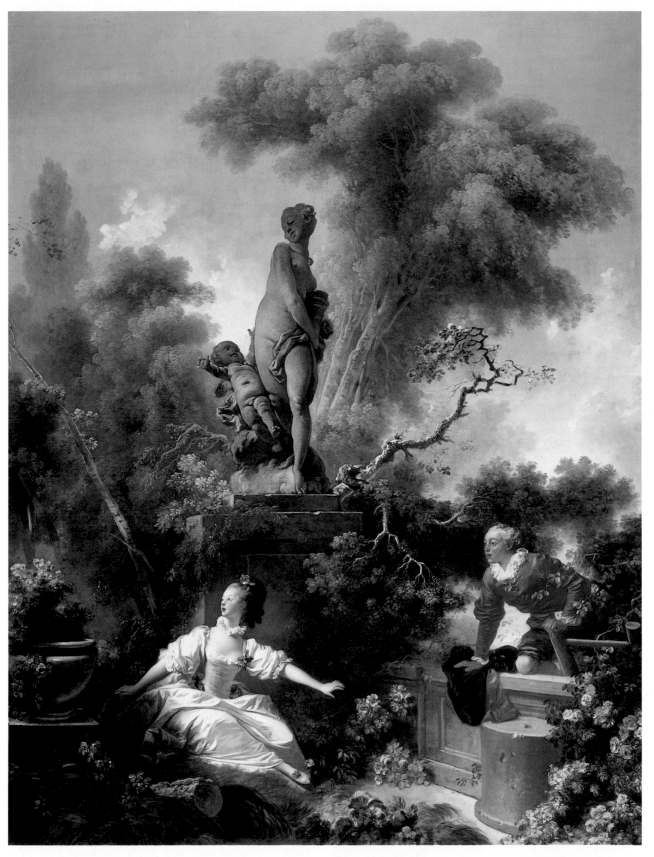

26-13. Jean-Honoré Fragonard. *The Meeting*, from *The Loves of the Shepherds*. 1771–73. Oil on canvas, 10'5¼" x 7'5⅝" (3.18 x 2.15 m). The Frick Collection, New York

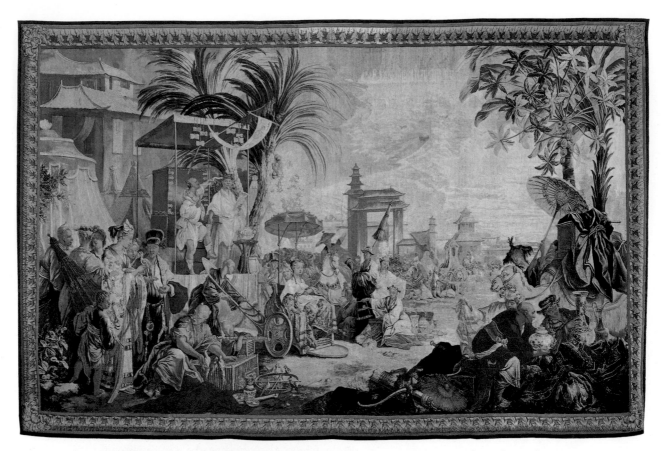

26-14. After a cartoon by François Boucher. *La Foire Chinoise (The Chinese Fair).* Designed 1743; woven 1743–75 at Beauvais, France. Tapestry of wool and silk, approx. 11'11" x 18'2" (3.63 x 5.54 m). The Minneapolis Institute of Arts
The William Hood Dunwoody Fund

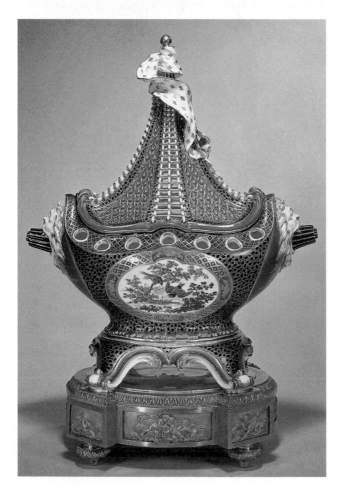

26-15. Potpourri jar, from Sèvres Royal Porcelain Factory, France. 1758. Soft-paste porcelain with polychrome and gold decoration, vase without base 14¾ x 13¾ x 6⅞" (37.5 x 34.6 x 17.5 cm). The Frick Collection, New York

suite done from designs by Boucher (fig. 26-14). Ten sets of the suite were woven between 1743 and 1775, most of them for the king. The artist used his imagination freely to invent a scene in a country he had never visited and probably knew little about beyond the imported Chinese porcelains. Boucher's goal was to create a mood of liveliness and exotic charm rather than an authentic depiction of China.

Europeans, especially Germans, had created their own version of hard-paste, or true, porcelain, of the type imported from China (see "The Secret of Porcelain," page 854). But many wares continued to be made in imitation of Chinese porcelain using soft paste, a cheaper clay mix containing ground glass, which can be fired at lower temperatures. A major production center of soft paste in France was the Royal Porcelain Factory at Sèvres, whose name today is synonymous with fine porcelain. Typical of its elegant creations for the court and other patrons able to afford such luxury items is a soft-paste potpourri jar in the shape of a boat (fig. 26-15), dated 1758, which is displayed on a base created for it. This rare technical masterpiece of sculpting and enamel painting is also a prime illustration of Rococo

26-16. Clodion. *The Invention of the Balloon*. 1784. Terra-cotta model for a monument, height 43½" (110.5 cm). The Metropolitan Museum of Art, New York

Rogers Fund and Frederick R. Harris Gift, 1944 (44.21a b)

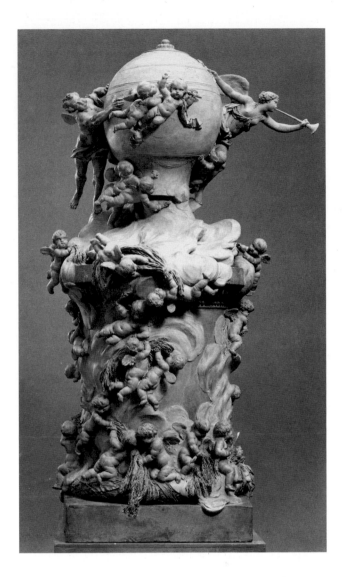

Clodion had a long career as a sculptor in the exuberant, Rococo manner seen in this work commemorating the 1783 invention of the hot-air balloon. During the austere revolutionary period of the First Republic (1792–95), he became one of the few Rococo artists to adopt successfully the more acceptable Neoclassical manner. In 1806, he was commissioned by Napoleon to provide the relief sculpture for two Paris monuments, the Vendôme Column and the Carrousel Arch near the Louvre.

taste. In a typical blend of realistic detail and sheer fantasy, the boat has gilded rope rigging and a rope ladder leading to the crow's nest at the top of the mast, around which curls a standard bearing the royal *fleurs-de-lis*. The portholes are actually open to the interior to allow the scent of the potpourri (aromatic herbs, rose petals, cinnamon bark, and the like) to escape. In emulation of Chinese vase decoration, the side of the boat is painted with birds and blossoms.

In the last quarter of the eighteenth century, French art generally moved away from Rococo style and toward the classicizing styles that would end in Neoclassicism. But one sculptor who clung to Rococo up to the threshold of the French Revolution in 1789 was Claude Michel, known as Clodion (1738–1814). His major output consisted of playful, erotic tabletop sculpture, mainly in uncolored **terra-cotta**. Typical of Clodion's Rococo designs is the terra-cotta model he submitted to win a 1784 royal commission for a large monument to the invention of the hot-air balloon (fig. 26-16). Although Clodion's enchanting piece may today seem inappropriate to commemorate a technological achievement, hot-air balloons then were elaborately decorated with painted Rococo scenes, gold braid, and tassels. Clodion's balloon, decorated with bands of classical ornament, rises from a columnar launching pad in billowing clouds of smoke, assisted at the left by a puffing wind god with butterfly wings and heralded at the right by a trumpeting Victory. A few *putti* are stoking the fire basket that provided the hot air on which the balloon ascended as others gather reeds for fuel and fly up toward them.

ART IN ITALY

From the late 1600s until well into the nineteenth century, the education of a young northern European or American gentleman (and increasingly over that period, gentlewoman) was completed on the Grand Tour, a prolonged visit to the major cultural sites of southern Europe. Accompanied by a tutor and an entourage of servants, the young man or woman began in Paris, moved on to southern France to visit a number of well-preserved Roman buildings and monuments there, then headed to Italy. Italy was the focus of the Grand Tour, repository of the classical and the Renaissance pasts and inspiration for the stylistic revival in the arts that would become Neoclassicism. There, the principal points of interest were Venice, Florence, Naples, and Rome.

ART OF THE GRAND TOUR

Wealthy northern European visitors to Italy often sat for portraits by artists such as Rosalba Carriera (1675–1757). Carriera, the leading portraitist in Venice during the first half of the eighteenth century, began her career designing lace patterns and painting miniature portraits on the ivory lids of snuffboxes. By the first years of the eighteenth century she was making portraits with **pastels**, crayons of pulverized pigment bound to a chalk base by weak gum water. A versatile medium, pastel can be employed in a sketchy manner to create a vivacious and fleeting effect or can be blended through rubbing to produce a highly finished image. Carriera's pastels earned her honorary membership in Rome's Academy of Saint Luke in 1705, and she later was admitted to the academies in Bologna and Florence. In 1720 she traveled to Paris, where she made a pastel portrait of the young Louis XV and was elected to the Royal Academy of Painting and Sculpture, despite the 1706 rule forbidding the

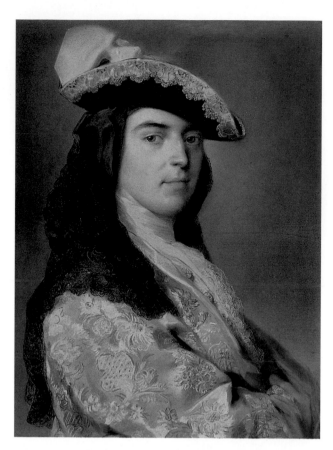

26-17. Rosalba Carriera. *Charles Sackville, 2nd Duke of Dorset*. c. 1730. Pastel on paper, 25 x 19" (63.5 x 48.3 cm). Private collection

admission of any more women (see "Women and Academies," below). Returning to Italy in 1721, Carriera spent much of the rest of her career in Venice, where she produced sensitive portraits of distinguished sitters such as the British aristocrat Charles Sackville (fig. 26-17).

Even more than portraits of themselves, visitors to Italy on the Grand Tour desired **vedute** (Italian for "views"; singular *veduta*), city views that they collected largely as fond reminders of their travels. These paintings were of two types. In one, known as the **capriccio** ("fanciful"), artists mixed actual features, especially ruins, into imaginatively pleasing compositions. The second, and by far the more popular type, featured naturalistic renderings of well-known tourist attractions—panoramic views that were meticulously detailed, topographically accurate, and populated with a host of contemporary figures engaged in typical activities. The Venetian artist Giovanni Antonio Canal, called Canaletto (1697–1768), became so popular among British clients for his scenes that his dealer arranged for him to work from 1746 to 1755 in England, where he painted topographic views of London and the surrounding countryside, giving impetus to a school of English landscape painting.

In 1762, the English king George III purchased Canaletto's *Santi Giovanni e Paolo and the Monument to Bartolommeo Colleoni* (fig. 26-18), painted probably in 1735–38. The Venetian square, with its famous fifteenth-century equestrian monument by Verrocchio (see fig. 17-54), is shown as if the viewer were in a gondola on a nearby canal. Immediately to the right is a perspectival

WOMEN AND ACADEMIES Although several women were made members of the European academies of art before the eighteenth century, their inclusion amounted to little more than honorary recognition of their achievements. In France, Louis XIV had proclaimed in the founding address of the Royal Academy that its intention was to reward all worthy artists, "without regard to the difference of sex," but this resolve was not put into practice. Only seven women gained the title of Academician between 1648 and 1706, the year the Royal Academy declared itself closed to women. Nevertheless, four more women had been admitted to the Academy by 1770, when the men became worried that women members would become "too numerous," and declared four women members to be the limit at any one time. Young women were not admitted to the Academy school nor allowed to compete for Academy prizes, both of which were nearly indispensable for professional success.

Women fared even worse at London's Royal Academy. After the Swiss painters Mary Moser and Angelica Kauffmann were named as founding members in 1768, no other women were elected until 1922, and then only as associates. Johann Zoffany's 1771–72 portrait of the London academicians shows the men grouped around a male nude model, along with the Academy's study collection of classical statues and plaster copies. Propriety prohibited the presence of women in this setting, so Zoffany painted Moser's and Kauffmann's portraits on the wall. In more formal portraits of the Academy, however, the two women were included.

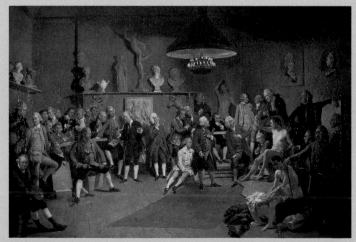

Johann Zoffany. *Academicians of the Royal Academy*. 1771–72. Oil on canvas, 47½ x 59½" (120.6 x 151.2 cm). The Royal Collection, Windsor Castle, Windsor, England
(RCON-400747, OM 1210 WC 431)

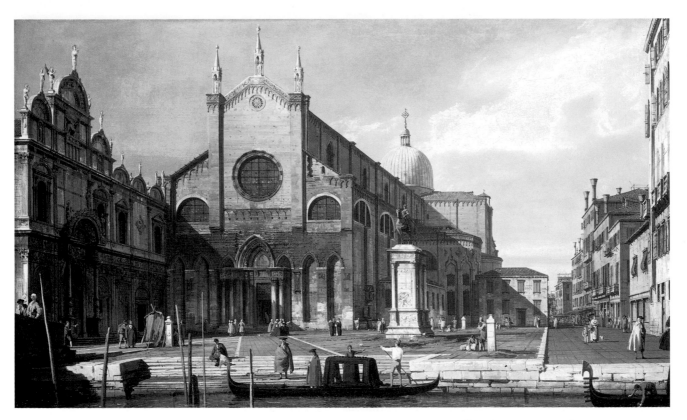

26-18. Canaletto. *Santi Giovanni e Paolo and the Monument to Bartolommeo Colleoni*. c. 1735–38. Oil on canvas, 18³/₈ x 30⁷/₈" (46 x 78.4 cm). The Royal Collection, Windsor Castle, Windsor, England

plunge down the street into the distance. Many of Canaletto's views, like this one, are topographically correct. In others he rearranged the buildings to tighten the **composition** (the arrangement of the painting's elements), even occasionally adding features to produce a *capriccio*.

Very different are the Roman views of Giovanni Battista Piranesi (1720–78), one of the century's greatest printmakers. Trained in Venice as an architect, Piranesi went to Rome in 1740. After studying etching, he began in 1743 to produce portfolios of prints, and in 1761 he established his own publishing house. Piranesi is best known for his views of ancient Roman ruins, such as *The Arch of Drusus* (fig. 26-19), published in 1748 in a portfolio of etchings called *Antichità Romane de' Tempi della Repubblica* (*Roman Antiquities from the Time of the Republic*). Such works are fine examples of the new taste for the **picturesque**, which contemporary British theorists defined as a landscape (actual or depicted) with an aesthetically pleasing irregularity in its shapes, composition, and lighting. But in other respects, Piranesi's views are early manifestations of Romanticism. These ruins are emotionally compelling reminders of the passage of time and of its sobering implications: All human achievements, even the great events memorialized in such triumphal arches, eventually come to ruin. The individual human, like those shown in the etching, is ultimately small and insignificant in relation to history and the cycle of birth and death.

Piranesi's and his patrons' interest in Roman ruins and in their symbolism was fueled by the discoveries made at Herculaneum and Pompeii, prosperous Roman towns near Naples that had been buried in 79 CE by the sudden eruption of Mount Vesuvius. In 1738, archaeologists began to

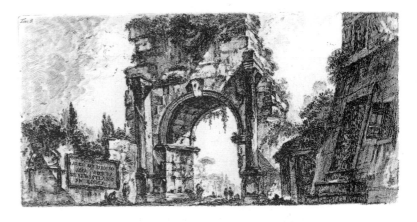

26-19. Giovanni Battista Piranesi. *The Arch of Drusus*. 1748. Etching, 14⁷/₁₆ x 28³/₄" (37 x 73 cm). Published in *Antichità Romane de' Tempi della Repubblica* (later retitled *Alcune Vedute di Archi Trionfali*), Rome, 1748. The Pierpont Morgan Library, New York
PML 12601

Piranesi's children carried on his publishing business after his death. Encouraged by Napoleon's officials, his sons Francesco and Piero moved the operation in 1799 to Paris, where between 1800 and 1807 they made and sold restrikes (posthumous impressions) of all of their father's etchings. Later Piranesi's plates were purchased by the Royal Printing House in Rome and reprinted again.

uncover evidence of the catastrophe at Herculaneum, and ten years later unearthed the remains of Pompeii. The extraordinary archaeological discoveries made at the two sites, published in numerous illustrated books, excited interest in classical art and artifacts and spurred the development of Neoclassicism.

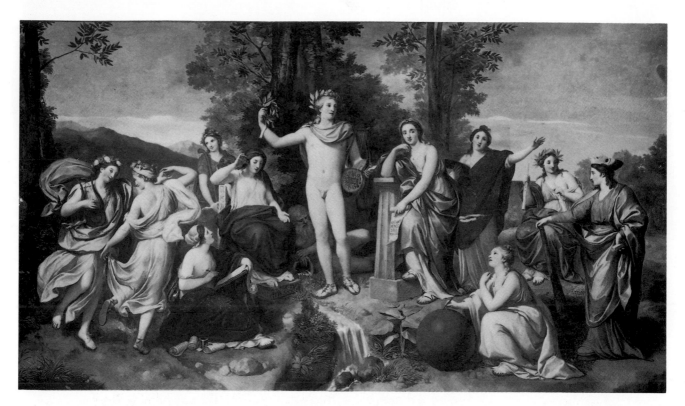

26-20. Anton Raphael Mengs. *Parnassus*, ceiling fresco in the Villa Albani, Rome. 1761

NEOCLASSICISM IN ROME

A notable sponsor of the classical revival was Cardinal Alessandro Albani (1692–1779), who amassed a huge collection of antique sculpture, **sarcophagi, intaglios, cameos**, and vases. In 1760–61, he built a villa just outside Rome to house and display his holdings. The Villa Albani became one of the most important spots on the Grand Tour. The villa was more than a museum, however; it was also a kind of shop, where many of the items he sold to satisfy the growing craze for antiquities were faked or heavily restored by artisans working in the cardinal's employ.

Albani's credentials as the foremost expert on classical art were solidified when he hired as his secretary and librarian Johann Joachim Winckelmann (1717–68), the leading theoretician of Neoclassicism. The Prussia-born Winckelmann had become an advocate of classical art while working in Dresden, where the French Rococo style he deplored was fashionable. In 1755, he published a pamphlet, *Thoughts on the Imitation of Greek Works in Painting and Sculpture*, in which he attacked the Rococo as decadent and argued that only by imitating Greek art could modern artists become great again. Winckelmann imagined that the temperate climate and natural ways of the Greeks had perfected their bodies and made their artists more sensitive to certain general ideas of what constitutes true and lasting beauty. Shortly after publishing this pamphlet, Winckelmann moved to Rome, where in 1758 he went to work for Albani. In 1764, he published the second of his widely influential treatises, *The History of Ancient Art*, which many consider the beginning of modern art history.

Winckelmann's closest friend and colleague in Rome was a fellow German, Anton Raphael Mengs (1728–79).

Largely as a result of their friendship, Winckelmann's employer, Cardinal Albani, commissioned Mengs to do a painting for the ceiling of the great gallery in his new villa. The *Parnassus* ceiling (fig. 26-20), from 1761, is usually considered the first true Neoclassical painting. The scene takes place on Mount Parnassus in central Greece, which the ancients believed to be sacred to Apollo (the god of poetry, music, and the arts) and the nine Muses (female personifications of artistic inspiration). At the center of the composition is Apollo, his pose modeled on that of the famous *Apollo Belvedere*, an ancient marble statue in the Vatican collection. Mengs's Apollo holds a lyre and a laurel branch, symbol of artistic accomplishment. Next to him, resting on a Doric column, is Mnemosyne, the mother of the Muses, who are shown in the surrounding space practicing the various arts. Inspired by relief sculpture he had studied at Herculaneum, Mengs arranged the figures in a generally symmetrical, pyramidal grouping parallel to the picture plane. Winckelmann, not surprisingly, praised the work for achieving the "noble simplicity and calm grandeur" that he had found in Greek originals.

The aesthetic ideals of the Albani-Winckelmann circle soon affected contemporary Roman sculptors, who remained committed to this paradigm for the next 100 years. The leading Neoclassical sculptor of the late eighteenth and early nineteenth centuries was Antonio Canova (1757–1822). Born near Venice into a family of stonemasons, Canova in 1781 settled in Rome, where under the guidance of the Scottish painter Gavin Hamilton (1723–98) he adopted the Neoclassical style and quickly became the most sought-after European sculptor of the period.

Canova specialized in two types of work: grand public monuments for Europe's leaders and erotic mythological

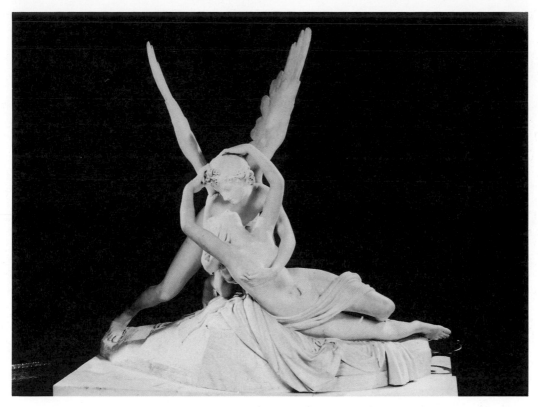

26-21. Antonio Canova. *Cupid and Psyche*. 1787–93. Marble, 6'1" x 6'8" (1.55 x 1.73 m). Musée du Louvre, Paris

subjects, such as *Cupid and Psyche* (fig. 26-21), for the pleasure of private collectors. *Cupid and Psyche* illustrates the love story of Cupid, Venus's son, and Psyche, a beautiful mortal who had aroused the goddess's jealousy. Venus casts Psyche into a deathlike sleep; moved by Cupid's grief and love for her, the sky god Jupiter (the Roman name for the Greek Zeus) takes pity on the pair and gives Psyche immortality. In this version of the theme (he did six), Canova chose the most emotional and tender moment in the story, when Cupid revives the lifeless Psyche with a kiss. Here Canova combined a Romantic interest in emotion with a more typically Neoclassical appeal to the combined senses of sight and touch. Because the lovers gently caress each other, the viewer is tempted to run his or her fingers over the graceful contours of their cool, languorous limbs.

REVIVALS AND ROMANTICISM IN BRITAIN

British tourists and artists in Italy became the leading supporters of Neoclassicism partly because they had been prepared for it by the architectural revival of Renaissance classicism in their homeland earlier in the century.

CLASSICAL REVIVAL IN ARCHITECTURE AND LANDSCAPING

Just as the Rococo was emerging in France, a group of British professional architects and wealthy amateurs led by the Scot Colen Campbell (1676–1729) took a stance against what they saw as the immoral extravagance of the Italian Baroque. As a moral corrective, they advocated a return to the austerity and simplicity found in the architecture of Andrea Palladio.

The most famous product of this group was Chiswick House (fig. 26-22, page 954), designed in 1724 by its owner, Richard Boyle, the third earl of Burlington (1695–1753). Burlington had visited Italy specifically to study Palladio's architecture, especially his Villa Rotunda (see fig. 18-63), which inspired his plan for Chiswick House. The building plan (fig. 26-23, page 954) shares the geometrical symmetry of Palladio's villa, although its central core is octagonal rather than round and there are only two entrances. The main entrance, flanked now by matching staircases, is a Roman temple front, a flattering reference to the building's inhabitant. Chiswick's elevation is characteristically Palladian, with a main floor resting on a basement, and tall rectangular windows with triangular pediments. The result is a lucid evocation of Palladio's design, with few but crisp details that seem perfectly suited to the refined proportions of the whole.

In Rome, Burlington had persuaded an English expatriate, William Kent (1685–1748), to return to London as his collaborator. Kent designed Chiswick's surprisingly ornate interior as well as the grounds, the latter in a style that became known throughout Europe as the English landscape garden. Kent's garden, in contrast to the regularity and rigid formality of Baroque gardens (see fig. 19-22), featured winding paths, a lake with a cascade, irregular plantings of shrubs, and other effects imitating the appearance of the natural rural landscape. The English landscape garden was another indication of the growing Enlightenment emphasis on the natural.

Following Kent's lead, **landscape architecture** flourished in the hands of such designers as Lancelot

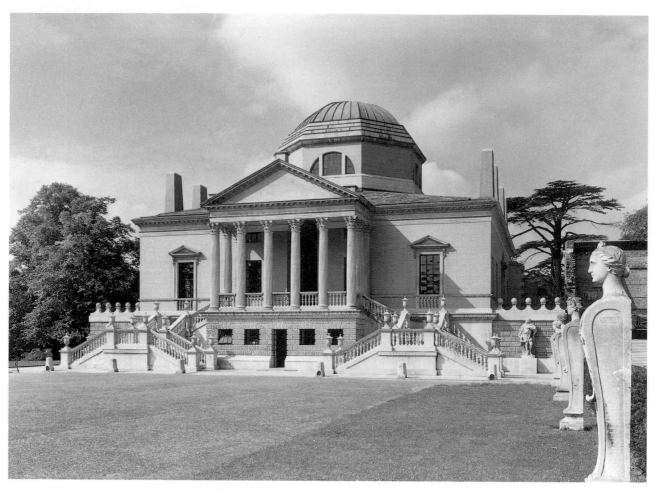

26-22. Richard Boyle, Lord Burlington. Chiswick House, West London, England. 1724–29. Interior decoration (1726–29) and new gardens (1730–40) by William Kent

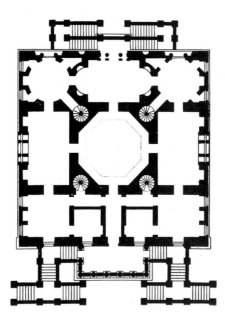

26-23. Plan of Chiswick House. 1724

("Capability") Brown (1716–83) and Henry Flitcroft (1697–1769). In the 1740s the banker Henry Hoare redid the grounds of his estate at Stourhead in Wiltshire (fig. 26-24) with the assistance of Flitcroft, a protégé of Burlington. The resulting gardens at Stourhead carried Kent's ideas much further. Stourhead is, in effect, an exposition of the picturesque, with orchestrated views dotted with Greek-

and Roman-style temples, grottoes, copies of antique statues, and such added delights as a rural cottage, a Chinese bridge, a Gothic spire, and a Turkish tent. In the view illustrated here, a replica of the Pantheon in Rome is just visible across a carefully placed lake. While the nostalgic evocation of an idyllic classical past recalls the work of the seventeenth-century French landscape painter Claude Lorrain (see fig. 19-28), who had found a large market in Britain, the exotic elements here are an early indication of the Romantic taste for the strange and the novel. The garden is therefore an interesting mixture of the Neoclassical and the Romantic.

Another example of the British taste for the classical that helped lay the ground for Neoclassicism was the work of John Wood the Elder (c. 1704–54), who dreamed of turning into a new Rome his native Bath—a spa town in the west near Wales, originally built by the Romans in the first century. On a large property near the town center, Wood began in 1727 to lay out a public meeting place, sports arena, and gymnasium. Much of his plan was never carried out, but in 1754 he began building the Circus (fig. 26-25), an elegant housing project that was completed in 1758 by his son, John Wood the Younger (d. 1782). The Circus was a circle of thirty-three town houses, all sharing a single three-story facade modeled on the exterior of the Roman Colosseum, with an attic to house the servants' quarters and steeply pitched roofs and large chimneys as a concession to English winters. The Woods' elegant Circus houses, with their handsome yet modestly scaled classical fronts,

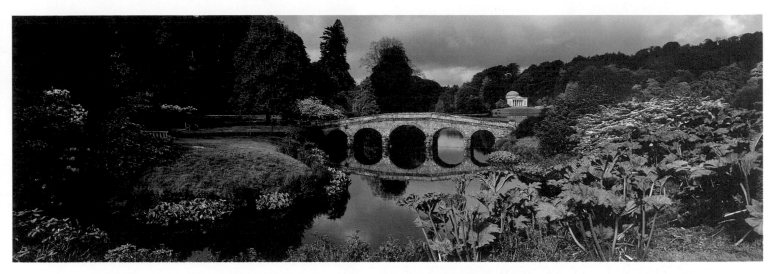

26-24. Henry Flitcroft and Henry Hoare. The Park at Stourhead, Wiltshire, England. Laid out 1743; executed 1744–65, with continuing additions

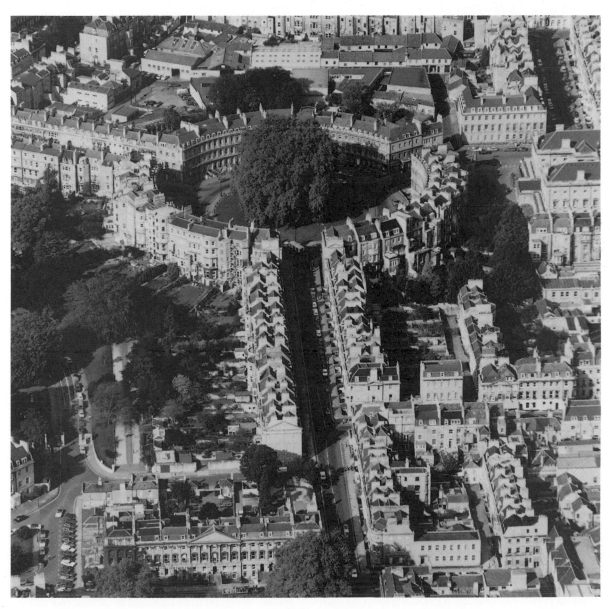

26-25. John Wood the Elder and John Wood the Younger. The Circus, Bath, England. 1754–58

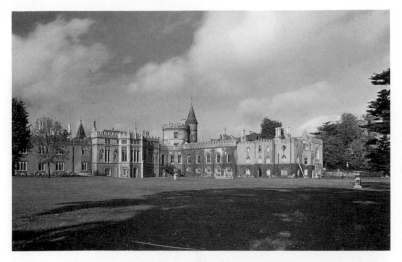

26-26. Horace Walpole and others. Strawberry Hill, Twickenham, England. 1749–76

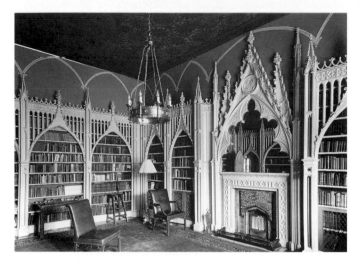

26-27. Horace Walpole, John Chute, and Richard Bentley. Library at Strawberry Hill. After 1754

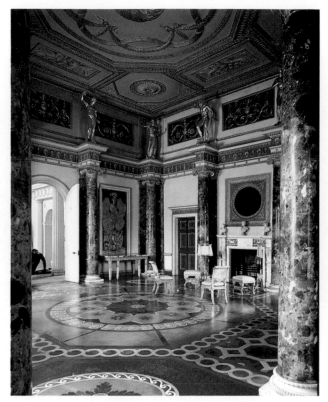

26-28. Robert Adam. *Anteroom*, Syon House, Middlesex, England. 1760–69

Adam's conviction that it was acceptable to modify details of the Classical orders was generally opposed by the British architectural establishment. As a result of that opposition, Adam was never elected to the Royal Academy.

were imitated enthusiastically in London and other British and American cities well into the nineteenth century.

GOTHIC REVIVAL IN ARCHITECTURE AND ITS DECORATION

Alongside the British classical revival of the mid-eighteenth century came a revival of the Gothic style, a manifestation of architectural Romanticism that spread to other nations after 1800 (see Chapter 27). Largely responsible for the Gothic revival was the conservative politician and author Horace Walpole (1717–97), who shortly before 1750 decided to remodel his house, called Strawberry Hill, in the Gothic manner (fig. 26-26). Gothic renovations were commonly performed in Britain before this date, but only to buildings that dated from the medieval period. Working with a number of friends and architects, Walpole spent nearly thirty years, from 1749 to 1776, transforming his home into a Gothic castle complete with **crenellated battlements**, **tracery** windows, and **turrets**.

The interior, too, was totally changed. One of the first rooms Walpole redesigned, with the help of amateurs John Chute (1701–76) and Richard Bentley (1706–82), was the library (fig. 26-27). Here the three turned for

inspiration to illustrations in the antiquarian books that the library housed. For the bookcases, they adapted designs from the old Saint Paul's Cathedral in London which had been destroyed in 1666. Prints depicting two medieval tombs inspired the chimneypiece. For the ceiling, Walpole incorporated a number of coats of arms of his ancestors—real and imaginary. The reference to fictional relatives offers a clue to Walpole's motives in choosing the medieval style. Walpole meant his house to suggest a castle out of the medievalizing Romantic fiction that he himself was writing. In 1764, he published *The Castle of Otranto*, a highly sensational novel set in the Middle Ages that helped launch the craze for the Gothic novel.

NEOCLASSICISM IN ARCHITECTURE AND THE DECORATIVE ARTS

The most important British contribution to Neoclassicism was a style of interior decoration developed by the Scottish architect Robert Adam (1728–92). On his Grand Tour in 1754–58, during which he became a member of Albani's circle of Neoclassicists, Adam largely ignored the civic architecture that had interested British classicists such as Wood and Burlington and focused instead on the applied ornament of Roman domestic architecture. When he returned to London to set up an architectural firm, he brought with him a complete inventory of decorative motifs, which he then modified in pursuit of a picturesque elegance. His stated aim to "transfuse the beautiful spirit of

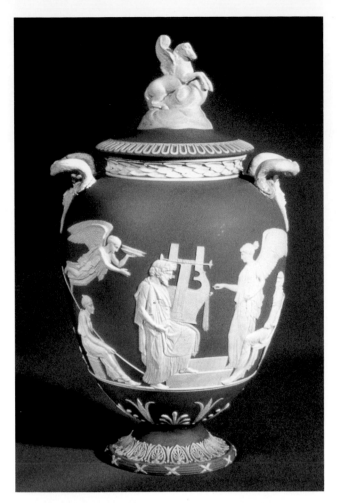

26-30. **Josiah Wedgwood. Vase**, made at the Wedgwood Etruria factory, Staffordshire, England. 1786. White jasper body with a mid-blue dip and white relief, height 18" (45.7 cm). Relief of *The Apotheosis of Homer* adapted from plaque by John Flaxman, Jr. 1778. Trustees of the Wedgwood Museum, Barlaston, Staffordshire, England

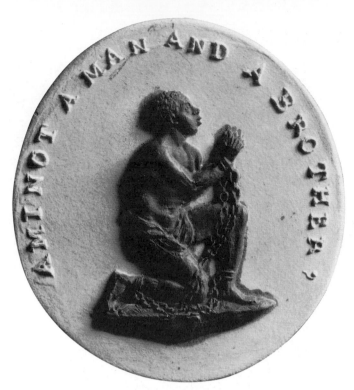

26-31. **William Hackwood, for Josiah Wedgwood.** *"Am I Not a Man and a Brother?"* 1787. Black and white jasperware, 1³/₈ x 1³/₈" (3.5 x 3.5 cm). Trustees of the Wedgwood Museum, Barlaston, Staffordshire, England

antiquity with novelty and variety" met with considerable opposition from the Palladian architectural establishment, but it proved ideally suited both to the evolving taste of wealthy clients and to the imperial aspirations of the new king, George III, whose reign began in 1760. In 1761, George appointed Adam and Adam's rival William Chambers (1723–96) as joint Architects of the King's Works.

Adam achieved worldwide fame for his interior renovations, such as those he carried out between 1760 and 1769 for the duke of Northumberland at his country estate, Syon, near London. The opulent colored marbles, gilded relief panels, classical statues, spirals, garlands, **rosettes**, and gilded moldings in the anteroom (fig. 26-28) are luxuriously profuse yet are restrained by the strong geometric order imposed on them and by the plain wall and ceiling surfaces. Adam's preference for bright pastel grounds and small-scale decorative elements, both inheritances from the Rococo (see fig. 26-7), also helped lighten the effect.

Such interiors were designed partly as settings for the art collections of British aristocrats, which included antiquities as well as a range of Neoclassical painting, sculpture, and decorative ware (fig. 26-29, "The Object Speaks: Georgian Silver", page 958). The most successful producer of Neoclassical decorative art was Josiah

Wedgwood (1730–95). In 1768, near Newcastle, he opened a pottery factory called Etruria after the ancient Etruscan civilization in central Italy known for its pottery. This production-line shop had several divisions, each with its own kilns (firing ovens) and workers trained in individual specialties. In the mid-1770s Wedgwood, a talented chemist, perfected a fine-grained, unglazed, colored pottery, which he called jasperware. The most popular of his jasperware featured white figures against a blue ground, like that in *The Apotheosis of Homer* (fig. 26-30). The relief on the front of the vase was designed by the sculptor John Flaxman, Jr. (1755–1826), who worked for Wedgwood from 1775 to 1787. Flaxman's scene of Homer being deified was based on a book illustration documenting a classical Greek vase in the collection of William Hamilton (1730–1803), a leading collector of antiquities and one of Wedgwood's major patrons. Flaxman's design simplified the original according to the prevailing idealized notion of Greek art and the demands of mass production.

The socially conscious Wedgwood—who epitomized Enlightenment thinking—established a village for his employees and cared deeply about every aspect of their living conditions. He was also active in the organized international effort to halt the African slave trade and abolish slavery. To publicize the abolitionist cause, Wedgwood asked the sculptor William Hackwood (c. 1757–1839) to design an emblem for the British Committee to Abolish the Slave Trade, formed in 1787. The compelling image created by Hackwood was a small medallion of black-and-white jasperware, cut like a cameo in the likeness of an African man kneeling in chains, with the legend "Am I Not a Man and a Brother?" (fig. 26-31). Wedgwood sent copies of the medallion to Benjamin Franklin, the president of the

THE OBJECT SPEAKS

GEORGIAN SILVER

Since ancient times, Europeans have prized silver for its rarity, reflectivity, and beautiful luster. At some times, its use was restricted to royalty; at others, to liturgical applications such as statues of saints, manuscript illuminations, and chalices. But by the Georgian period—the years from 1714 to 1830, when Great Britain was ruled by four kings named George—wealthy British families filled their homes with a variety of objects made of fine silver, utensils and vessels that they collected not simply as useful, practical articles but as statements of their own high social status.

British gentlemen employed finely crafted silver vessels, for example, to serve and consume punch, a potent alcoholic beverage that lubricated the wheels of Georgian society. Gentlemen took pride in their own secret recipes for punch, and a small party of drinkers might even pass around an elegant punch bowl as a communal vessel so that it, along with its contents, could be admired. Larger groups would drink from cups or goblets such as the simple yet elegant goblet by Ann and Peter Bateman, which has a gilded interior to protect the silver from the acid present in alcoholic drinks. (Hester Bateman's double beaker, also with a gilded interior, was made for use while traveling.) The punch would be poured into the goblets with a ladle such as the one shown here, by Elizabeth Morley, which has a twisted whalebone handle that floats, making it easy to retrieve from the punch bowl. Then, the filled goblets would be served on a flat salver like the one made by Elizabeth Cooke. Gentlemen also used silver containers to carry snuff, a pulverized tobacco that was inhaled by well-to-do members of both sexes. The fairly flat snuffbox, by Alice and George Burrows, has curved sides for easy insertion into the pockets of gentlemen's tight-fitting trousers.

All of the objects shown here bear the marks of silver shops run either wholly or partly by women, who played a significant role in the production of Georgian silver. While some women served formal apprenticeships and went on to become members of the goldsmiths' guild (which included silversmiths), most women became involved with silver through their relation to a master silversmith—typically a father, husband, or brother—and they frequently specialized in a specific aspect of the craft, such as engraving, **chasing**, or polishing. The widows of silversmiths often took over their husbands' shops and ran them with the help of journeymen or partners.

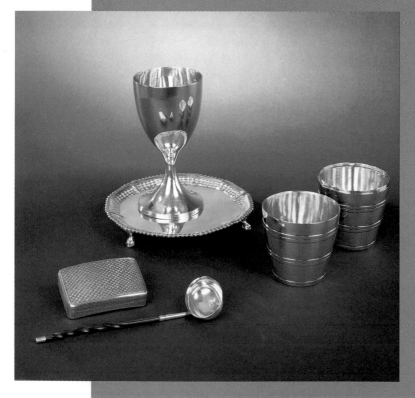

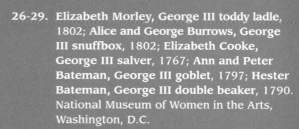

26-29. Elizabeth Morley, George III toddy ladle, 1802; Alice and George Burrows, George III snuffbox, 1802; Elizabeth Cooke, George III salver, 1767; Ann and Peter Bateman, George III goblet, 1797; Hester Bateman, George III double beaker, 1790. National Museum of Women in the Arts, Washington, D.C.

Silver Collection assembled by Nancy Valentine, purchased with funds donated by Mr. and Mrs. Oliver Grace and family

Hester Bateman (1708–94), the most famous woman silversmith in eighteenth-century Britain, inherited her husband's small spoon-making shop at the age of fifty-two and transformed it into one of the largest silver manufactories in country. Adapting new technologies of mass production to the manufacture of silver, Bateman marketed her well-designed, functional, and relatively inexpensive wares to the newly affluent middle class, making no attempt to compete with those silversmiths who catered to the monarchy or the aristocracy. She retired when she was eighty-two after training her daughter-in-law Ann and her sons and grandson to carry on the family enterprise. Both Hester's double beaker and Ann and Peter's goblet show the restrained elegance characteristic of Bateman silver.

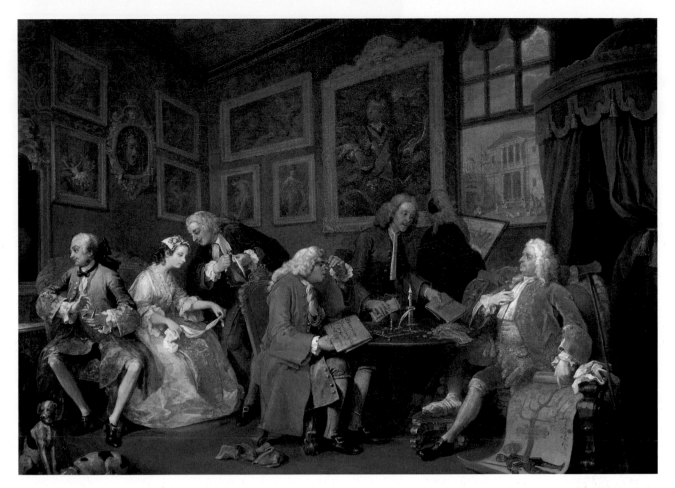

26-32. William Hogarth. *The Marriage Contract*, from *Marriage à la Mode*. 1743–45. Oil on canvas, 28 x 36" (71.7 x 92.3 cm). The National Gallery, London

Philadelphia Abolition Society, and to others in the abolitionist movement. Later, those active in the women's suffrage movement in the United States adapted the image by representing a woman in chains with the motto "Am I Not a Woman and a Sister?"

PAINTING

When the newly prosperous middle classes in Britain began to buy art, they wanted portraits of themselves. But taste was also developing for other subjects, such as moralizing satire and caricature, ancient and modern history, the British landscape and people, and scenes from English literature. Whatever their subject matter, many of the paintings that emerged in Britain reflected Enlightenment values, including an interest in social progress, an embrace of natural beauty, and faith in reason and science.

The Satiric Spirit. Following the discontinuation of government censorship in 1695, there emerged in Britain a flourishing culture of literary satire, directed at a variety of political and social targets. The first painter inspired by the work of these pioneering novelists and essayists was William Hogarth (1697–1764). Trained as a portrait painter, Hogarth believed art should contribute to the improvement of society. About 1730, he began illustrating

moralizing tales of his own invention in sequences of four to six paintings, which he then produced in sets of prints, both to maximize his profits and to influence as many people as possible.

Between 1743 and 1745, Hogarth produced the *Marriage à la Mode* suite, whose subject was inspired by Joseph Addison's 1712 essay in the *Spectator* promoting the concept of marriage based on love. The opening scene, *The Marriage Contract* (fig. 26-32), shows the gout-ridden Lord Squanderfield arranging the marriage of his son to the daughter of a wealthy merchant. The merchant gains entry for his family into the aristocracy, while the lord gets the money he needs to complete his Palladian house, which is visible out the window. The loveless couple who will be sacrificed to their fathers' deal sit on the couch. While the young Squanderfield stares admiringly at himself in the mirror, his unhappy fiancée is already being wooed by lawyer Silvertongue, who suggestively sharpens his pen. The next five scenes show the progressively disastrous results of such a union, culminating in the killing of Silvertongue by the young lord and the subsequent suicide of his wife.

Stylistically, Hogarth's works combine the additive approach of seventeenth-century Dutch genre painters with the nervous elegance of the Rococo. Hogarth wanted to please and entertain his audience as much as educate them. His work became so popular that in 1745

26-33. Joshua Reynolds. *Lady Sarah Bunbury Sacrificing to the Graces*. 1765. Oil on canvas, 7'10" x 5' (2.42 x 1.53 m). The Art Institute of Chicago
Mr. and Mrs. W. W. Kimball Collection, 1922. 4468

Lady Bunbury was one of the great beauties of her era. A few years before this painting was done, she had turned down a request of marriage from George III.

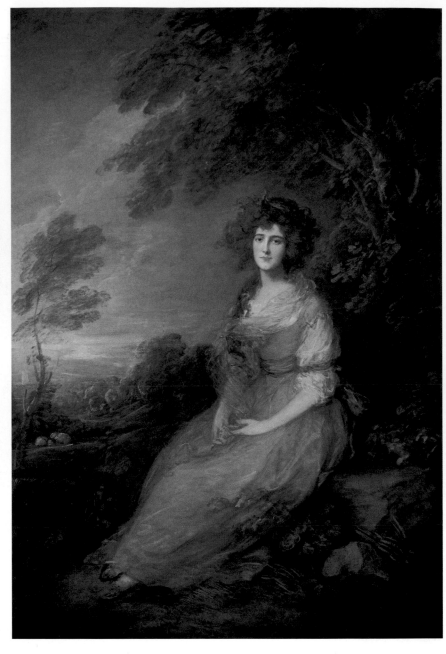

26-34. Thomas Gainsborough. *Portrait of Mrs. Richard Brinsley Sheridan*. 1785–87. Oil on canvas, 7'2½" x 5'½" (2.2 x 1.54 m). National Gallery of Art, Washington, D.C.
Andrew W. Mellon Collection

he was able to give up social portraiture, which he considered a deplorable form of vanity.

Portraiture. A generation younger than Hogarth, Sir Joshua Reynolds (1723–92) specialized in the very form of painting—social portraiture—that the moralistic Hogarth despised. After studying Renaissance art in Italy, Reynolds settled in London in 1753 and worked vigorously to educate artists and patrons to appreciate classical history painting. In 1768 he was appointed first president of the Royal Academy (see "Academies and Academy Exhibitions," page 944). Reynolds's *Fifteen Discourses to the Royal Academy* (1769–90) set out his theories on art: Artists should follow the rules derived from studying the great masters of the past, especially those who worked in the classical tradition;

art should generalize to create the universal rather than the particular; and the highest kind of art is history painting.

Because British patrons preferred portraits of themselves to scenes of classical history, Reynolds attempted to elevate portraiture to the level of history painting by giving it a historical or mythological veneer. A good example of this type of portraiture, a form of Baroque classicism that Reynolds called the **Grand Manner**, is *Lady Sarah Bunbury Sacrificing to the Graces* (fig. 26-33). Dressed in a classicizing costume, Bunbury plays the part of a Roman priestess making a sacrifice to the personifications of female Beauty, the Three Graces. The figure is further aggrandized through the use of the monumental classical arcade behind her, the emphatic classical **contrapposto** of her pose, and the large scale of the canvas. Such works were

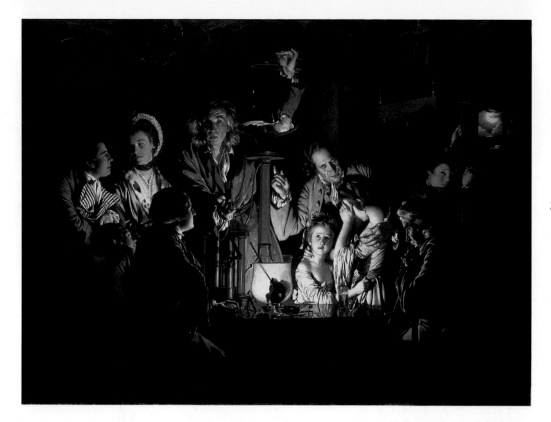

26-35. Joseph Wright. *An Experiment on a Bird in the Air-Pump*. 1768. Oil on canvas, 6 x 8' (1.82 x 2.43 m). The National Gallery, London

intended for the grand stairways of aristocratic residences.

A number of British patrons, however, remained committed to the kind of portraiture Van Dyck had brought to England in the 1620s, which had featured more informal poses against natural vistas. Thomas Gainsborough (1727–88) achieved great success with this mode when he moved to Bath in 1759 to cater to the rich and fashionable people who had begun going there in great numbers. A good example of his mature style is the *Portrait of Mrs. Richard Brinsley Sheridan* (fig. 26-34), which shows the professional singer (the wife of a celebrated playwright) seated informally outdoors. The sloping view into the distance and the use of a tree to frame the sitter's head seem to have been borrowed straight from Van Dyck (see fig. 19-48). But Gainsborough modernized the formula not simply through his lighter, Rococo palette and feathery brushwork but also by integrating the woman into the landscape, thus identifying her with it. The effect is especially noticeable in the way her windblown hair matches the tree foliage overhead. The work thereby manifests one of the new values of the Enlightenment: the emphasis on nature and the natural as the sources of goodness and beauty.

The Romance of Science. An Enlightenment concern with developments in the natural sciences is seen in the dramatic depiction of *An Experiment on a Bird in the Air-Pump* (fig. 26-35) by Joseph Wright of Derby (1734–97). Trained as a portrait painter, Wright made the Grand Tour in 1773–75 and then returned to the English Midlands to paint local society. Many of those he painted were the self-made entrepreneurs of the first wave of the Industrial Revolution, which was centered there in towns such as Birmingham. Wright belonged to the Lunar Society, a group of industrialists (including Wedgwood), mercantilists, and progressive nobles who met in Derby. As part of the society's attempts to popularize science, Wright painted a series of "entertaining" scenes of scientific experiments, including *An Experiment on a Bird in the Air-Pump*.

The second half of the eighteenth century was an age of rapid technological advances (see "Iron as a Building Material," page 962), and the development of the air pump was among the many innovative scientific developments of the time. Although it was employed primarily to study the property of gases, it was also widely used to promote the public's interest in science because of its dramatic possibilities. In the experiment shown here, air was pumped out of the large glass bowl until the small creature inside, a bird, collapsed from lack of oxygen; before the animal died, air was reintroduced by a simple mechanism at the top of the bowl. In front of an audience of adults and children, a lecturer is shown on the verge of reintroducing air into the glass receiver. Near the window at right, a boy stands ready to lower a cage when the bird revives. (The moon visible out the window is a reference to the Lunar Society.) By delaying the reintroduction of air, the scientist has created considerable suspense, as the reactions of the two girls indicate. Their father, a voice of reason, attempts to dispel their fears. The dramatic lighting not only underscores the life-and-death issue of the bird's fate but also suggests that science brings light into a world of darkness and ignorance. The lighting adds a spiritual dimension as well. During the Baroque era, such intimate lighting effects had been used for religious scenes (see fig. 19-27). Here science replaces religion as the great light and hope of humanity. This theme is emphasized through the devout expressions of some of the observers.

History Painting. European academies had long considered history painting—with subjects drawn from classical history and literature, the Bible, and mythology—as the highest form of artistic endeavor, but British patrons were reluctant to purchase such works from native artists.

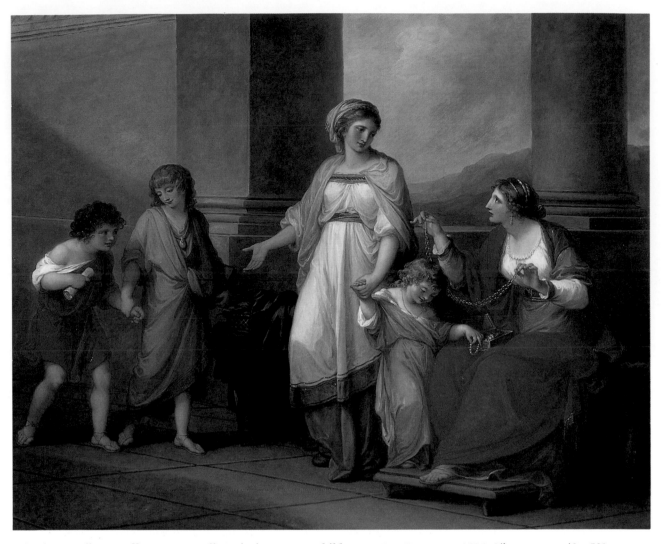

26-36. Angelica Kauffmann. *Cornelia Pointing to Her Children as Her Treasures*. 1785. Oil on canvas, 40 x 50"
(101.6 x 127 cm). Virginia Museum of Fine Arts, Richmond, Virginia
The Adolph D. and Wilkins C. Williams Fund

IRON AS A BUILDING MATERIAL In 1779, Abraham Darby III built a bridge over the Severn River at Coalbrookdale in England—a town typical of the new industrial environment, with factories and workers' housing filling the valley. The bridge itself is important because it represents the first use of structural metal on a large scale, with iron replacing the heavy, hand-cut stone **voussoirs** used to construct earlier bridges. Five pairs of cast-iron, semicircular arches form a strong, economical hundred-foot span. In functional architecture such as this bridge, the available technology, the properties of the material, and the requirements of engineering in large part determine form and often produce an unintended and revolutionary

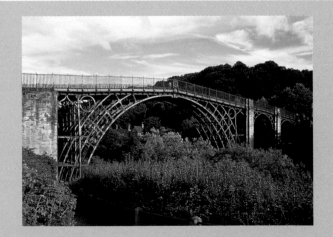

Abraham Darby III. Severn River Bridge, Coalbrookdale, England. 1779

new aesthetic. Here, the use of metal at last made possible the light, open, skeletal structure desired by builders since the twelfth century. Cast iron was quickly adopted by builders, giving rise to such architectural feats as the soaring train stations of the nineteenth century.

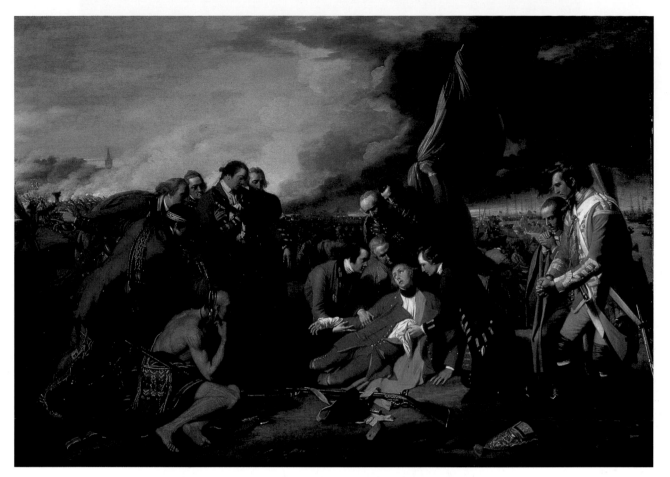

26-37. Benjamin West. *The Death of General Wolfe*. 1770. Oil on canvas, 4'11½" x 7' (1.51 x 2.14 m). The National Gallery of Canada, Ottawa

Gift of the Duke of Westminster, 1918

The famous Shakespearean actor David Garrick was so moved by this painting that he enacted an impromptu interpretation of the dying Wolfe in front of the work when it was exhibited by the Academy. The mid-eighteenth-century revival of interest in Shakespeare's more dramatic plays, in which Garrick played a leading role, was both a manifestation of and a major factor in the rise of a Romantic taste in Britain.

Instead, they favored Italian paintings bought on the Grand Tour or acquired through agents in Italy. Thus, the arrival in London in 1766 of the Italian-trained Swiss history painter Angelica Kauffmann (1741–1807) was a great encouragement to those artists in London aspiring to success as history painters. She was welcomed immediately into Joshua Reynolds's inner circle and in 1768 was one of two women artists named among the founding members of the Royal Academy (see "Women and Academies," page 950).

Kauffmann had assisted her father on church murals and was already accepting portrait commissions at age fifteen. She first encountered the new classicism in Rome, in the circle of Johann Winckelmann, whose portrait she painted, and where she had been elected to the Academy of Saint Luke. In a highly unusual move, she embarked on an independent career as a history painter. In London, where she lived from 1766 to 1781, Kauffmann produced numerous history paintings, many of them with subjects drawn from classical antiquity, such as *Cornelia Pointing to Her Children as Her Treasures* (fig. 26-36), which Kauffmann painted for an English patron after returning to Italy. The story takes place in the second century BCE, during the Republican era of Rome. A woman visitor has been showing Cornelia her

jewels and then requests to see those of her hostess. In response, Cornelia shows her two sons and says "These are my most precious jewels." Cornelia exemplifies the "good mother," a popular subject among later eighteenth-century history painters who, in the reforming spirit of the Enlightenment, often depicted subjects that would teach lessons in virtue. The value of Cornelia's maternal dedication is emphasized by the fact that under her loving care, the sons, Tiberius and Gaius Gracchus, grew up to be political reformers. Although the setting of Kauffmann's work is as severely simple as the message, the effect of the whole is softened by the warm, subdued lighting and by the tranquil grace of the leading characters.

Kauffmann's devotion to Neoclassical history painting was at first shared by her American-born friend Benjamin West (1738–1820), who, after studying in Philadelphia, traveled to Rome in 1759. There he met Winckelmann and became a student of Mengs. In 1763, West moved permanently to London, where he specialized in Neoclassical history paintings. In 1768, he became a founding member of the Royal Academy. Two years later, he shocked Reynolds and his other academic friends with his painting *The Death of General Wolfe* (fig. 26-37) because rather than

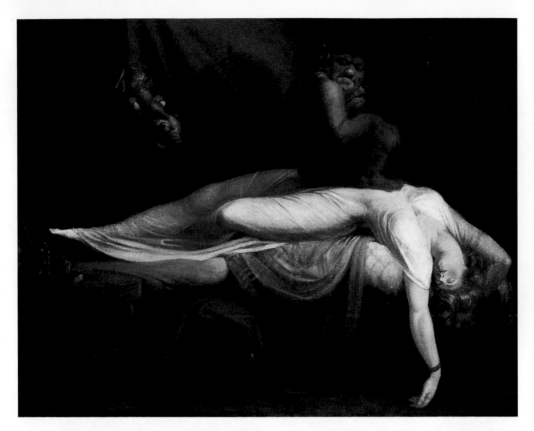

26-38. John Henry Fuseli. *The Nightmare*. 1781. Oil on canvas, 39³/₄ x 49¹/₂" (101 x 127 cm).
The Detroit Institute of Arts

Gift of Mr. and Mrs. Bert Smokler and Mr. and Mrs. Lawrence A. Fleischmann

Fuseli was not popular with the English critics. One writer said Fuseli's 1780 entry in the London Royal Academy exhibition "ought to be destroyed," and Horace Walpole called another painting in 1785 "shockingly mad, mad, mad, madder than ever." Even after achieving the highest official acknowledgment of his talents, Fuseli was called the Wild Swiss and Painter to the Devil. But the public appreciated his work, and *The Nightmare*, exhibited at the Academy in 1782, was repeated in at least six versions, all of which were sold to commercial engravers for reproduction in prints. One of these prints would one day hang in the office of the Austrian psychoanalyst Sigmund Freud, who believed that dreams were manifestations of the dreamer's repressed desires.

clothing the figures in ancient garb in accordance with the tenets of Neoclassicism, he chose to depict them in modern costumes. When Reynolds learned what West was planning to do, he begged him not to continue this aberration of "taste." George III informed West he would not buy a painting with British heroes in modern dress.

The painting shows an important event from the Seven Years' War (1756–63), whose main issue was the struggle between Britain and France for control of various overseas territories, including Canada. The decisive battle for Canada was fought at Quebec City in 1759. Although the British won, their leader, General James Wolfe, died just after receiving word that the French were in retreat. West offers the viewer a highly dramatized account of the event. Instead of showing Wolfe at the base of a tree surrounded by two or three attendants—as actually occurred—West chose to put him under a suitably dramatic sky. Beneath the flag that provides the apex of the asymmetrical triangular composition, West placed Wolfe at the center of an intensely concerned group of soldiers. For exotic interest and as an emblem of the natural, West added a Native American—a blatant fiction, since the Native Americans in this battle fought on the side of the French. The arrangement of the attendants and the posture of Wolfe were

meant to suggest a kind of Lamentation over the dead Christ (see fig. 17-15). Just as Christ died for humanity, Wolfe sacrificed himself for the good of the State.

The Death of General Wolfe enjoyed such an enthusiastic reception by the British public that Reynolds apologized to West, and the king was among five patrons to commission replicas. West's innovative decision to depict a modern historical subject in the Grand Manner established the general format for the depiction of contemporary historical events for all European artists in the later eighteenth and early nineteenth centuries. And the emotional intensity of his image helped launch the Romantic movement in British painting.

Romantic Painting. The Enlightenment's faith in reason and empirical knowledge, dramatized in such works of art as Joseph Wright's *Experiment on a Bird in the Air-Pump*, was countered by Romanticism's celebration of the emotions and subjective forms of experience. This rebellion against reason sometimes led Romantic artists to glorify the irrational side of human nature that the Enlightenment sought to deny. In Britain, one such artist was John Henry Fuseli (1741–1825). Born Johann Heinrich Füssli in Zurich, Switzerland, he was raised in an

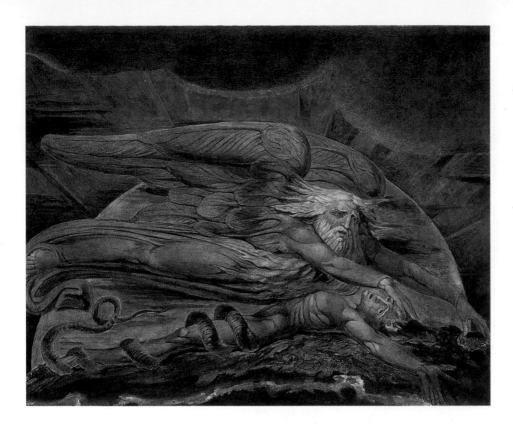

26-39. William Blake. *Elohim Creating Adam*. 1795. Color print finished in pen and watercolor, 17 x 21⅛" (43.1 x 53.6 cm). Tate Gallery, London

Made through a monotype process, Blake's large color prints of 1795 combine printing with painting and drawing. To make them, the artist first laid down his colors on heavy paperboard, likely using tempera, for he professed to despise oil paint. From the painted board Blake then pulled a few impressions, usually three, on separate sheets of paper. These impressions would vary in effect, with the first having fuller and deeper colors than the subsequent ones. Blake then finished each print by hand, using watercolor and pen and ink.

intellectual household where all things French, from the Rococo to the Enlightenment, were opposed. Instead of sensuality and rationality, those who gathered in his father's house celebrated intensity, originality, freedom of expression, and the imaginative power of the irrational. For their models of society and art, they looked to Britain. They were especially inspired by the contemporary emotional trend in British poetry and by the example of Shakespeare, whose dramatic plays were being revived there. It is not surprising that after studying between 1770 and 1778 in Rome—focusing on Michelangelo, not the ancients—Fuseli settled permanently in London and anglicized his name. At first, he supported himself as an illustrator and translator, including works by Shakespeare (into German) and Winckelmann (into English). By the early 1780s, he had begun to make a reputation as a Romantic painter of the irrational and the erotic with works such as *The Nightmare* (fig. 26-38).

The Nightmare is not a pure fantasy but is inspired by a popular Swiss legend of the Incubus, who was believed to sit on the chest of virgins while they sleep, causing them to have distressing erotic nightmares. The content of this sleeper's dream is suggested by the way the "night mare," on which the Incubus travels, breaks through the curtains of her room. This was the first of four versions of the theme Fuseli would paint, apparently for his own satisfaction. His motives are perhaps revealed by the portrait on the back of the canvas, which may be that of Anna Landolt. Fuseli had met her in Zurich in the winter of 1778–79 and had fallen in love with her. After she rejected his proposal of marriage, he returned to London, where he wrote to her that she could not marry another because they had made love in one of his dreams and she therefore belonged to him. The painting may be a kind of illustration of that dream.

Also opposed to the Enlightenment emphasis on reason was Fuseli's close friend William Blake (1757–1827),

a highly original poet, painter, and printmaker. Trained as an engraver, Blake enrolled briefly at the Royal Academy, where he was subjected to the teachings of Reynolds. The experience convinced him that all rules hinder rather than aid creativity, and he became a lifelong advocate of unfettered imagination. For Blake, imagination offered access to the higher realm of the spirit, while reason could only provide information about the lower world of matter.

Deeply concerned with the problem of good and evil, Blake developed an idiosyncratic form of Christian belief and drew on elements from the Bible, Greek mythology, and British legend to create his own mythology. The "prophetic books" that he designed and printed in the mid-1790s combined poetry and imagery dealing with themes of spiritual crisis and redemption. Their dominant characters include Urizen ("your reason"), the negative embodiment of rationalistic thought and repressive authority; Orc, the manifestation of energy, both creative and destructive; and Los, the artist, whose task is to create form out of chaos.

Thematically related to the prophetic books are an independent series of twelve large color prints that Blake executed for the most part in 1795, including the awe-inspiring *Elohim Creating Adam* (fig. 26-39). The sculpturesque volumes and muscular physiques of the figures reveal the influence of Michelangelo, whose works Blake admired in reproduction, and the subject invites direct comparison with Michelangelo's famous *Creation of Adam* on the ceiling of the Sistine Chapel (see fig. 18-13). But while Michelangelo, with humanist optimism, viewed the Creation as a positive act, Blake presents it in negative terms. In Blake's print, a giant worm, symbolizing matter, encircles the lower body of Adam, who, with an anguished expression, stretches out on the ground like the Crucified Christ. Above him,

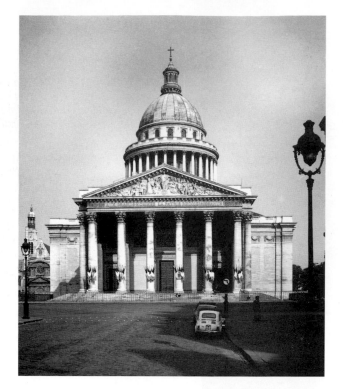

26-40. Jacques-Germain Soufflot. Panthéon (Church of Sainte-Geneviève), Paris. 1755–92

This building has a strange history. Before it was completed, the revolutionary government in control of Paris confiscated all religious properties to raise desperately needed public funds. Instead of selling Sainte-Geneviève, however, they voted in 1791 to make it the Temple of Fame for the burial of Heroes of Liberty. Under Napoleon I (ruled 1799–1814), the building was resanctified as a Catholic church and was again used as such under King Louis-Philippe (ruled 1830–48) and Napoleon III (ruled 1852–70). Then it was permanently designated a nondenominational lay temple. In 1851, the building was used as a physics laboratory. Here the French physicist Jean-Bernard Foucault suspended his now-famous pendulum on the interior of the high crossing dome and by measuring the path of the pendulum's swing proved his theory that the earth rotated on its axis in a clockwise motion. In 1995, the ashes of Marie Curie, who won the Nobel Prize in chemistry in 1911, were moved into this "memorial to the great men of France," making her the first woman to be enshrined there.

the winged Elohim ("Elohim" is one of the Hebrew names for God) appears anxious, even desperate—quite unlike the confident deity pictured by Michelangelo. For Blake, the Creation is tragic because it submits the spiritual human to the fallen state of a material existence. Blake's fraught and gloomy image challenges the viewer to recognize his or her fallen nature and seek to transcend it.

ART IN FRANCE During the seventeenth century, the French court had resisted the influence of the Italian Baroque and had opted instead for a more restrained classical style. Even during the Rococo period, the French Academy continued to promote classical principles. Consequently, French artists and architects of the late eighteenth century readily adopted the new classicism coming out of Italy. And because of their deep commitment to Neoclassicism, the French generally rejected the Romanticism arriving from England until the early nineteenth century (see Chapter 27).

ARCHITECTURE

French architects of the late eighteenth century generally considered classicism not one of many alternative styles but *the* single, true style. Such architects may be divided into two broad types, which we might call the traditionalists and the radical visionaries.

Representative of the traditionalists are Jacques-Germain Soufflot (1713–80) and his major accomplishment, the Church of Sainte-Geneviève (fig. 26-40), known today as the Panthéon. In this building, Soufflot attempted to integrate three traditions: the kind of Roman architecture he had seen on his trip to Italy in 1749; French and English Baroque classicism; and the Palladian style being revived at the time in England. The facade, with its huge **portico**, is modeled directly on ancient Roman temples. The dome, on the other hand, was inspired by several seventeenth-century examples, including Wren's Saint Paul's in London (see fig. 19-70). Finally, the radical geometry of its plan (fig. 26-41), a **central-plan** Greek cross, owes as much to Burlington's

26-41. Section and plan of the Panthéon (Church of Sainte-Geneviève)

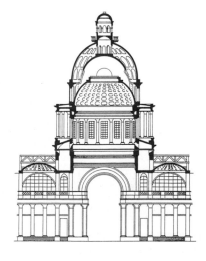 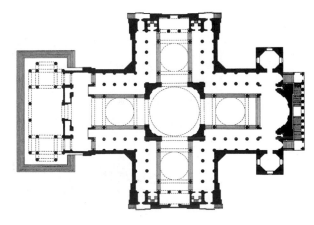

Chiswick House (see fig. 26-22) as it does to Christian tradition. Soufflot also seems to have been inspired by the plain, undecorated surfaces Burlington used in his home. The result is a building that attempts to maintain and develop the historical continuity of the classical tradition.

In the hands of the visionaries, however, classicism was stripped of its associations with the past and was remade as a vehicle of utopian Enlightenment aspirations—as can be seen in the mature work of Claude-Nicolas Ledoux (1736–1806). Early in his architectural career, Ledoux designed austere Neoclassical residences for the court of Louis XV and his last important mistress, Madame du Barry. During the 1770s and 1780s, inspired by the Enlightenment and supported by progressive government ministers, Ledoux turned his attention to town planning.

Ledoux's geometric plan for the city center of Chaux in southeastern France (fig. 26-42), which was never realized, organized a number of large private homes, a school, a church, an army barracks, two public baths, and various businesses around the city's two saltworks factories and their administrative headquarters, which occupy the very center. The different functions of the buildings are impossible to discern because all are in the same style—a stripped-down classicism. The applied decorations that to Ledoux indicated superfluous wealth were eliminated in favor of a more economical and egalitarian style. The plan indicates not only Ledoux's hopes for an orderly, homogenous, and rational future but also his assumption that industry—not the surrounding farms or the peripheral institutions of Church and State—would provide the foundation for that better future.

Another French architect known for his visionary projects was Étienne-Louis Boullée (1728–99), whose built work consisted mostly of homes for French aristocrats in a plain, simple brand of Neoclassicism. In 1782, he retired from private practice to devote himself to teaching, writing architectural theory, and designing visionary public buildings. Grandiose projects such as the **cenotaph** (funerary monument) for Isaac Newton (fig. 26-43) were never meant to be built but rather were intended to illustrate and extend the influence of Boullée's

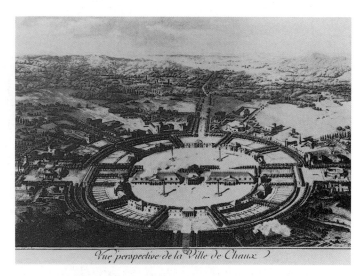

26-42. Claude-Nicolas Ledoux. Bird's-eye view of the town of Chaux (never built). Engraving, published 1804

theoretical ideas. By this point, Boullée had decided that copying and adapting classical designs were insufficient; architects needed to go beyond them in the use of the pure, geometric forms of nature. Although his monument for the great English scientist who had died in 1727 was inspired by round Roman tombs that were stepped and planted with trees, Boullée used a formal vocabulary of simple spheres instead of the Classical orders. Appropriately, the monument was meant to suggest a planet set within a series of circular orbits.

Although the project was eminently rational—and was meant to be read as such—its chief function was to appeal to the emotions. Boullée believed that architecture should be "poetic," by which he meant that it should engender feelings appropriate to the building's purpose. Here the desired effect is **sublime**, an awesome, nearly terrifying experience of the infinite described in Edmund Burke's influential essay of 1757, *A Philosophical Enquiry into the Origin of Our Ideas of the Sublime and the Beautiful*. Entering the cenotaph and discovering a monumental space—empty except for a small sarcophagus at lower center—would produce such an effect. The only

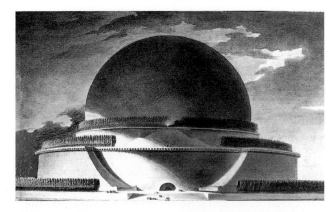

26-43. Étienne-Louis Boullée. Exterior and cross section of the cenotaph for Isaac Newton (never built). 1784. Ink and wash drawings, 15½ x 25½" (39.4 x 64.8 cm). Bibliothèque Nationale, Paris

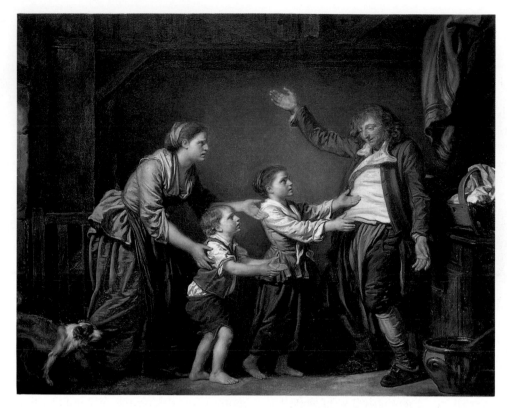

26-44. Jean-Baptiste Greuze. *The Drunken Cobbler*. Late 1770s. Oil on canvas, 29⅝ x 36⅜" (75.2 x 92.4 cm). Portland Art Museum, Portland, Oregon
Gift of Marion Bowles Hollis

In 1769, Greuze submitted a classical history painting to the Salon and requested the French Academy to change his official status from genre painter to the higher rank of history painter. The work and request were refused. Greuze was so angry that he thereafter boycotted the Salon, preferring to show his works privately.

light would come from small holes in the ceiling, meant to suggest stars in a night sky. Boullée wished the viewer to experience the overwhelming majesty not simply of the universe but also of the Supreme Being who had designed it.

PAINTING AND SCULPTURE

While French painters such as Boucher, Fragonard, and their followers continued to work in the Rococo style in the later decades of the eighteenth century, a strong reaction against the Rococo set in by the 1760s. A leading detractor of the Rococo was Denis Diderot (1713–84), an Enlightenment figure whom many consider the father of modern art criticism. Diderot's most notable accomplishment was editing the *Encyclopédie* (1751–72), a twenty-eight-volume compendium of knowledge and opinion to which many of the major Enlightenment thinkers contributed. In 1759, Diderot began to write reviews of the official Salon for a periodic newsletter for wealthy subscribers. Diderot believed that it was art's proper function to "inspire virtue and purify manners." He therefore admired artists such as Chardin (see fig. 26-12) and criticized the adherents of the Rococo.

Diderot's highest praise went to Jean-Baptiste Greuze (1725–1805)—which is hardly surprising, because Greuze's

major source of inspiration came from the kind of *drame bourgeois* ("middle-class drama") that Diderot had inaugurated with his plays of the late 1750s. In addition to comedy and tragedy, Diderot thought the range of theatrical works should include a "middle tragedy" that taught useful lessons to the public with clear, simple stories of ordinary life. Greuze's paintings, such as *The Drunken Cobbler* (fig. 26-44), of the late 1770s, became the visual counterparts of that new theatrical form, which later became known as melodrama. On a shallow, stagelike space and under a dramatic spotlight, a drunken father returns home to his angry wife and hungry children. The gestures of the children make clear that he has spent the family's grocery money on drink. In other paintings, Greuze offered wives and children similar lessons in how not to behave.

In sculpture, the first signs of the new Enlightenment values were evident in the art of those still working in the basic Rococo idiom. The leading sculptor in France during the middle of the century was Jean-Baptiste Pigalle (1714–85), who received commissions from the most prestigious clients, including Madame de Pompadour. In 1777, he produced a portrait bust of Diderot (fig. 26-45). The casual dress and pose are typically Rococo, although charm has here been sacrificed for intelligence. The thoughtful, faraway look in Diderot's face suggests he

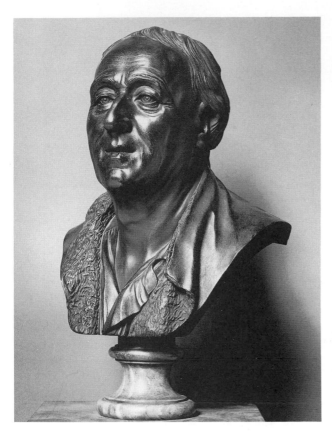

26-45. Jean-Baptiste Pigalle. *Portrait of Diderot*. 1777. Bronze, height 16¹/₂" (42 cm). Museé du Louvre, Paris

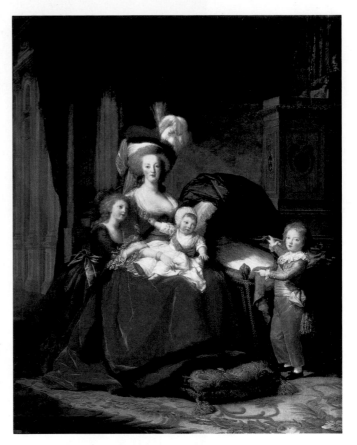

26-46. Marie-Louise-Élisabeth Vigée-Lebrun. *Portrait of Marie Antoinette with Her Children*. 1787. Oil on canvas, 9'1/₂" x 7'⁵/₈" (2.75 x 2.15 m). Musée National du Château de Versailles

As the favorite painter to the queen, Vigée-Lebrun escaped from Paris with her daughter on the eve of the Revolution of 1789 and fled to Rome. After a very successful self-exile working in Italy, Austria, Russia, and England, the artist finally resettled in Paris in 1804 at the invitation of Napoleon I and again became popular with Parisian art patrons. Over her long career, she painted about 800 portraits in a vibrant style that changed very little over the decades.

may be contemplating the better future he and his fellow philosophes imagined for humanity. Finally, the naturalism in Pigalle's handling of Diderot's aging features nicely underscores the sitter's own commitment to truth.

French portrait painting before the Revolution of 1789 may be characterized as a modified form of the Rococo. Elegant informality continued to be featured, but new themes were introduced, figures tended to be larger and more robust, and compositional arrangements were more stable. Many leading portraitists were women. The most famous was Marie-Louise-Élisabeth Vigée-Lebrun (1755–1842), who in 1779 became painter to Queen Marie-Antoinette. In 1787, she portrayed the queen with her children (fig. 26-46), in conformity with the Enlightenment theme of the "good mother," already seen in Angelica Kauffmann's painting of Cornelia (see fig. 26-36). The portrait of the queen as a kindly, stabilizing presence for her offspring was meant to counter her public image as selfish, extravagant, and immoral. The princess leans affectionately against her mother, proof of the queen's natural goodness. In a further attempt to gain the viewer's sympathy, the little dauphin—the eldest son and heir to a throne he would never ascend—points to the empty cradle of a recently deceased sibling. The image also alludes to the well-known allegory of Abundance, suggesting the peace and prosperity of society under the reign of her husband, Louis XVI (ruled 1774–92).

In 1783, Vigée-Lebrun was elected to one of the four places in the French Academy available to women (see "Women and Academies," page 950). Also elected that year was Adélaïde Labille-Guiard (1749–1803), who in 1790 successfully petitioned to end the restriction on women. Labille-Guiard's commitment to enlarging the number of women painters in France is evident in a self-portrait with two pupils that she submitted to the Salon of 1785. The monumental image of the artist at her easel was also meant to answer the sexist rumors that her paintings and those by Vigée-Lebrun had actually been painted by men. In a witty role reversal, the only male in her work is *her* muse—her father, whose bust is behind her. While the self-portrait flatters the painter's conventional feminine charms in a manner generally consistent with the Rococo tradition, a comparison with similar images of women by artists such as Fragonard (see fig. 26-13) reveals the more monumental

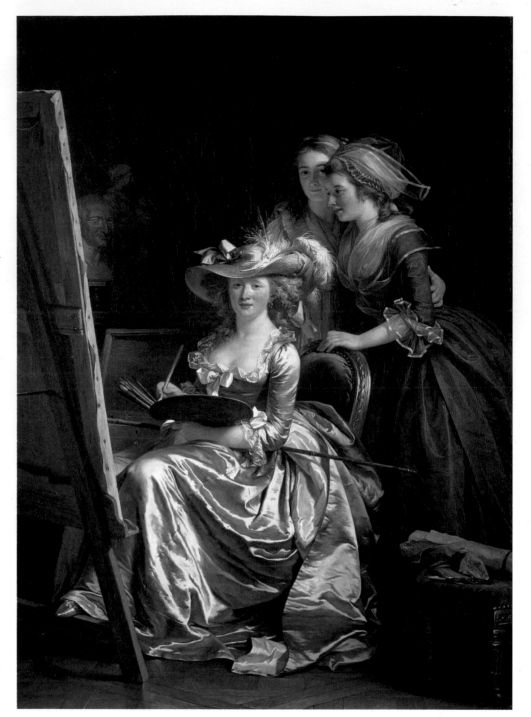

26-47. Adélaïde Labille-Guiard. *Self-Portrait with Two Pupils*. 1785. Oil on canvas, 6'11" x 4'11½" (2.11 x 1.51 m). The Metropolitan Museum of Art, New York

Gift of Julia A. Berwind, 1953 (53.225.5)

female type Labille-Guiard favored, in keeping with her conception of women as important contributors to national life, which is an Enlightenment impulse. The solid pyramidal arrangement of the three women adds to the effect (fig. 26–47).

The leading French Neoclassical painter of the era was Jacques-Louis David (1748–1825), who dominated French art during the Revolution and subsequent reign of Napoleon (see Chapter 27). In 1774, David won the Prix de Rome. David remained in Rome until 1780, assimilating the principles of Neoclassicism. After his return, he produced a series of severely undecorated, anti-Rococo paintings that extolled the antique virtues of stoicism, masculinity, and patriotism.

The first and most influential of these was the *Oath of the Horatii* (fig. 26-48), of 1784–85, which was a royal commission. In general, the work reflects the taste and

values of Louis XVI, who along with his minister of the arts, Count d'Angiviller, was sympathetic to the Enlightenment. Following Diderot's lead, d'Angiviller and the king believed art should improve public morals. Among his first official acts, d'Angiviller banned indecent nudity from the Salon of 1775 and commissioned a series of didactic paintings of French history. David's commission in 1784 was part of that general program.

David's painting was inspired by Pierre Corneille's seventeenth-century drama *Horace*, although the specific incident David records seems to have been his own invention. The story deals with the early Republican period of Roman history. Rome and Alba, a neighboring city-state, had been at war for some time when it was decided to settle the conflict by a battle to the death between the three best soldiers of each side. The three sons of Horace (the Horatii) were chosen to represent

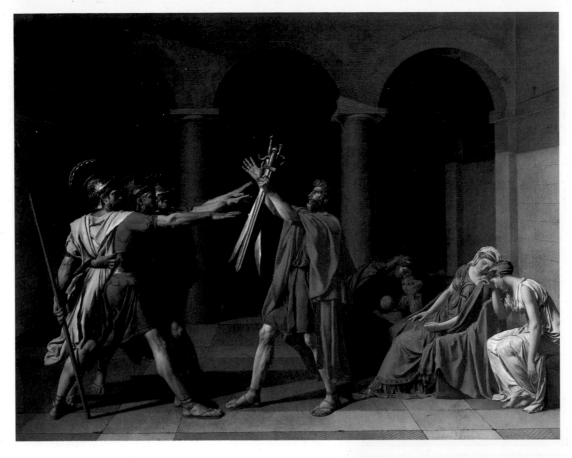

26-48. Jacques-Louis David. *Oath of the Horatii*. 1784–85. Oil on canvas, 10'8³/₄" x 14' (3.26 x 4.27 m). Musée du Louvre, Paris

26-49. Jacques-Louis David. *Death of Marat*. 1793. Oil on canvas, 5'5" x 4'2¹/₂" (1.65 x 1.28 m). Musées Royaux des Beaux-Arts de Belgique, Brussels

In 1793, David was elected a deputy to the National Convention and was named propaganda minister and director of public festivals. Because he supported Robespierre and the Reign of Terror, he was jailed after its demise in 1794. His estranged wife succeeded in winning his early release, an event he memorialized in a painting of 1799 showing a group of women stopping the battle between the Romans and the Sabines.

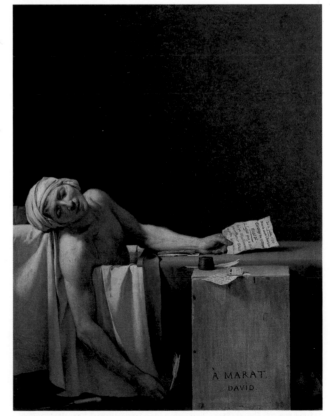

Rome against the Curatii, representing Alba. In David's painting, the Horatii are shown with their father, pledging an oath to the State. In contrast to the upright, muscular angularity of the men is a group of limp and weeping women and frightened children. The women are upset not simply because the Horatii might die but also because one of them (Sabina, in the center) is a sister of the Curatii, married to one of the Horatii, and another (Camilla, at the far right) is engaged to one of the Curatii. David's composition effectively contrasts the men's stoic willingness to sacrifice themselves for the State with the women's emotional commitment to family ties.

David's *Oath* soon became an emblem of the French Revolution of 1789. Its harsh lesson in republican citizenship effectively captured the mood of the new leaders of the French state who came to power in 1793—especially the Jacobins, egalitarian democrats who abolished the monarchy and presided over the Reign of Terror in 1793–94. Under the leadership of Robespierre (1758–94),

the Jacobin-dominated French Assembly ruthlessly executed all opponents, aristocratic or republican, killing some 40,000 people in the pursuit of democracy.

In 1793, the Jacobins commissioned from David a tribute to one of their slain leaders, Jean-Paul Marat (fig. 26-49). A radical pamphleteer, Marat was partly responsible for the 1792 riots in which hundreds of helpless political prisoners deemed sympathetic to the king were

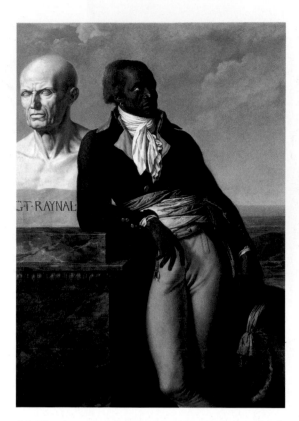

26-50. Anne-Louis Girodet-Trioson. *Portrait of Jean-Baptiste Belley*. 1797. Oil on canvas, 5'2½" x 3'8½" (1.59 x 1.13 m). Musée National du Château de Versailles

26-51. Jean-Antoine Houdon. *George Washington*. 1788–92. Marble, height 6'2" (1.9 m). State Capitol, Richmond, Virginia

The plow behind Washington alludes to Cincinnatus, a Roman soldier of the fifth century BCE who was appointed dictator and dispatched to defeat the Aequi, who had besieged a Roman army. After the victory, Cincinnatus resigned the dictatorship and returned to his farm. Washington's contemporaries compared him to Cincinnatus because, after leading the Americans to victory over the British, he resigned his commission and went back to farming rather than seeking political power. Just below Washington's waistcoat hangs the badge of the Society of the Cincinnati, founded in 1783 by the officers of the disbanding Continental Army who were returning to their peacetime occupations. Washington lived in retirement at his Mount Vernon, Virginia, plantation for five years before his 1789 election as the first president of the United States.

killed. A young supporter of the opposition party, Charlotte Corday d'Amont, decided that Marat should pay for his actions. Because Marat suffered from a painful skin ailment, he conducted his official business sitting in a medicinal bath. While Marat was signing a petition Corday had brought as a ruse to gain entry to his office, she stabbed him, then dropped her knife and fled. Instead of handling the event in a sensational manner as a Romantic might have, David played down the drama and showed us its quiet, still aftermath. Here David combined his reductive Neoclassical style with a Caravaggesque naturalism. Both stylistically and thematically, the *Death of Marat* is, in fact, quite similar to Spanish Baroque religious paintings such as Zurbarán's *Saint Serapion* (see fig. 19-35). The two peaceful martyrs are descriptively convincing and are brought close to the picture plane to make their respective sacrifices tangibly real and accessible for their disciples.

An influential teacher, David trained many of the important French painters who emerged in the 1790s and early 1800s. The lessons of David's teaching are evident, for example, in the *Portrait of Jean-Baptiste Belley* (fig. 26-50) by Anne-Louis Girodet-Trioson (1767–1824). Although Girodet also painted mythological subjects in a mode derived from Canova (see fig. 26-21), which annoyed his teacher, this noncommissioned portrait is in keeping with David's early stylistic and thematic principles. Stylistically, the work combines a graceful

sculptural pose with the kind of simplicity and descriptive naturalism found in David's *Marat*. The work also has a significant political dimension. Belley was a former slave sent by the colony of Saint-Dominique (now Haiti) as a representative to the French Republican Assembly. In 1794, he led the successful legislative campaign to abolish slavery in the colonies and grant black people full citizenship. Belley leans casually on a pedestal with the bust of the abbot Guillaume Raynal (1713–96), the French *philosophe* whose 1770 book condemning slavery had prepared the way for such legislation. (Unfortunately, in 1801 Napoleon reestablished slavery in the islands.) Girodet's portrait is therefore more of a tribute to the egalitarian principles of Raynal and Belley

than it is a conventional portrait meant to flatter a sitter.

Portraiture was the specialty of the leading Neoclassical French sculptor, Jean-Antoine Houdon (1741–1828), who had studied with Pigalle. Houdon lived in Italy between 1764 and 1768 after winning the Prix de Rome. Houdon's commitment to Neoclassicism began during his stay in Rome, where he came into contact with some of the leading artists and theorists of the movement. Houdon carved busts and full-length views of many important figures of his era, including foreigners. On the basis of his bust of the American ambassador to France, Benjamin Franklin, Houdon was commissioned by the Virginia state legislature to do a portrait of its native son George Washington. Houdon traveled to the United States in 1785 to make a cast of Washington's features and a bust in plaster. He then executed a lifesize marble figure in Paris (fig. 26-51). For this work, Houdon combined Pigalle's naturalism with the new classicism that many were beginning to identify with republican politics. Although the military leader of the American Revolution of 1776 is dressed in his general's uniform, Washington's serene expression and relaxed contrapposto pose derive from sculpted images of classical athletes. Washington's left hand rests on a *fasces*, a bundle of rods tied together with an axe face, used in Roman times as a symbol of authority. The thirteen rods bound together are also a reference to the union formed by the original states. Attached to the *fasces* are a sword of war and a plowshare of peace. Houdon's studio turned out a regular supply of replicas of such works as part of the cult of great men promoted by Enlightenment thinkers as models for all humanity.

ART IN NORTH AMERICA

Eighteenth-century art in North America remained largely dependent on the styles of the European countries— Britain, France, and Spain—that had colonized the continent. Throughout the century, easier and more frequent travel across the Atlantic contributed to the assimilation of the European styles, but in general North American art lagged behind the European mainstream. In the early eighteenth century, the colonies grew rapidly in population, and rising prosperity led to an increased demand among the wealthy for fine works of art and architecture. Initially this demand was met by European immigrants who came to work in the colonies, but by the middle of the century a number of native-born American artists were also achieving professional success.

ARCHITECTURE

The Palladian style, introduced to England by Inigo Jones in the seventeenth century (see fig. 19-68), continued to be popular in England and came to the British North American colonies in the mid-eighteenth century. One of the earliest examples, the work of English-born architect Peter Harrison (1716–75), is the Redwood Library (fig. 26-52), built in Newport, Rhode Island, in 1749. The fusion of the temple front with a colossal Doric order and a lower facade with a triangular pediment is not only typically

26-52. Peter Harrison. Redwood Library, Newport, Rhode Island. 1749

26-53. John Rawlins. Large dining room, Mount Vernon, Fairfax County, Virginia. 1786–87

Palladian (see fig. 18-63); it is, in fact, a faithful replica of a design by Palladio in his *Four Books on Architecture*. The elegant simplicity of this particular design made it a favorite of English architects for small pleasure buildings on the grounds of estates. The double temple front, used by Palladio for churches, is perfectly suited to a library.

During the Federal Period (1783–1830) following the colonies' victory in their War of Independence, Neoclassicism dominated American architecture. Despite the recent hostilities with Britain, American domestic architecture remained tied to developments in that country. With regard to interior design, the elegant Neoclassicism that Robert Adam had introduced to British society in the 1760s (see fig. 26-28) became the model for American designers such as John Rawlins. In 1786–87, he designed the large dining room at George Washington's home, Mount Vernon (fig. 26-53). As Adam himself had often done, Rawlins set delicate off-white

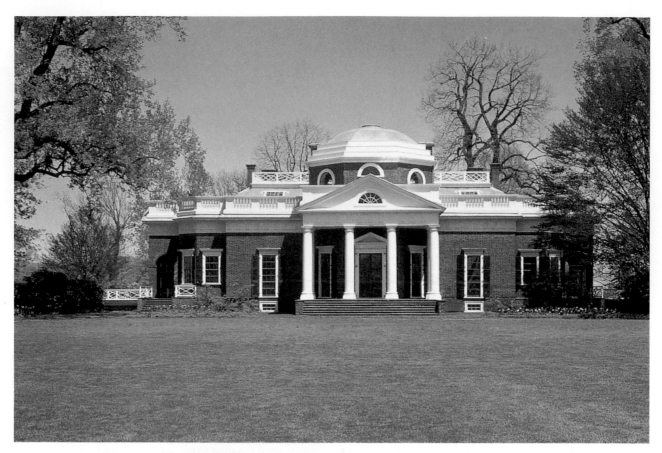

26-54. Thomas Jefferson. Monticello, Charlottesville, Virginia. 1770–84, 1796–1806

beadwork against a soft, monochromatic ground. Beneath a simple, classical cornice is the main decorative feature of the room, a Palladian or triumphal-arch window. Its pilasters are decorated with a design of modified Roman lamps. The overall effect is restrained, elegant, and restful.

Thomas Jefferson (1743–1826), principal author of the Declaration of Independence, designed his Virginia residence, Monticello, in a style much influenced by British examples. Jefferson was a self-taught architect who in the period before the American Revolution shared the British aristocratic taste for Palladio (see fig. 18-63). His first version of Monticello, built in the 1770s, was, like Harrison's early Redwood Library, based on a design in Palladio's *Four Books on Architecture*.

In 1784, Jefferson went to Paris and the next year became the American minister to France. There he discovered an elegant domestic architecture that made his home seem crude and provincial. After he returned in 1789 he completely redesigned Monticello, using French doors and tall narrow windows (fig. 26-54). Attempting to make his home appear to be a single story, in the French manner, he used a balustrade above the unifying cornice to mask the second floor. Despite these French elements and his stated rejection of the British Palladian mode, the building's simplicity and combination of temple front and dome remain closer to Burlington's Chiswick House (see fig. 26-22) than to contemporary French buildings. Compared with Burlington's residence, however, Jefferson's is less pretentious as a result of its humbler building materials (brick, wood, and stucco), its closer relation to the ground, and its smaller scale.

PAINTING

Just as British architects immigrated to the North American colonies before the Revolution, a few traditionally trained European artists crossed the ocean to satisfy the increasingly wealthy market's demand for portrait paintings. Probably the first such artist of stature to arrive was John Smibert (1688–1751), a Scot who had studied in London and spent considerable time in Italy. He arrived in the colonies in 1728 with one of his patrons, George Berkeley, an Anglican minister and philosopher, to be the art professor at the college Berkeley was planning to found in Bermuda. In 1729, while Berkeley and his entourage were in Newport, Rhode Island, to complete their arrangements for the project, Smibert painted a group portrait, *Dean George Berkeley and His Family*, commonly called *The Bermuda Group* (fig. 26-55). Berkeley, at the right, dictates to a richly dressed man at the table (John Wainwright, who commissioned the portrait but did not actually make the voyage). Seated between them are Berkeley's wife and child and their companion, a Miss Hancock. Standing behind the table are, from right to left, John James and Richard Dalton, two gentlemen adventurers who accompanied Berkeley, and Smibert himself, who looks out at the viewer.

Smibert's debt to Flemish painting, which was still favored in the English court at the time, is obvious in the

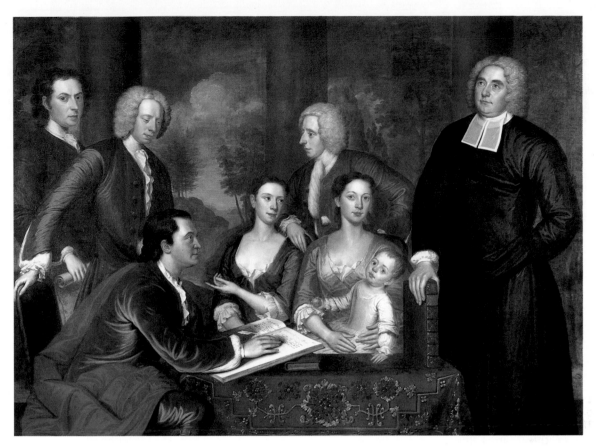

26-55. John Smibert. *Dean George Berkeley and His Family (The Bermuda Group)*. 1729. Oil on canvas, 5'9½" x 7'9" (1.77 x 2.4 m). Yale University Art Gallery, New Haven, Connecticut

Gift of Isaac Lathrop of Plymouth, Massachusetts

balanced but asymmetrical arrangement of figures and the great attention paid to representing textures of the costumes and the pattern of the Oriental rug on the table. The men's features are individualized likenesses, but the women's are idealized according to a convention of female beauty current in English portraiture—ovoid heads with large, plain features, columnlike necks, and tastefully exposed bosoms. The Bermuda project never went forward, and Smibert settled in Boston, working as a portrait painter, art-supply dealer, and printseller.

Among Smibert's friends was Peter Pelham, an English immigrant painter-engraver, who married a Boston widow with a tobacco shop in 1748. Pelham's stepson John Singleton Copley (1738–1815) grew up to be America's first native artist of genius. Copley's sources of inspiration were meager—Smibert's followers and his stepfather's engravings—but his work was already drawing attention when he was fifteen. Young Copley's canny instincts for survival in the colonial art world included an intuitive understanding of his upper-class clientele. They valued not only his excellent technique, which equaled that of European artists, but also his ability to dignify them while recording their features with unflinching realism, as seen in his powerful portrait of *Samuel Adams* (see fig. 26-1).

Copley's talents so outdistanced those of his colonial contemporaries that the artist aspired to a larger reputation. In 1766, he sent a portrait of his half brother, *Boy with a Squirrel*, to an exhibition in London. The critical

response was rewarding, and Benjamin West, the expatriate artist from Pennsylvania, encouraged Copley to study in Europe. At that time, he was kept from following the advice by family ties. But in 1773, revolutionary struggles hit close to home. Colonists dressed as Native Americans boarded a ship carrying tea and threw the cargo into Boston Harbor to protest the British East India Company's monopoly and the tax imposed on tea by the government—an event known as the Boston Tea Party. Copley was torn between two circles: his affluent in-laws and clients who were pro-British, and his radical friends, including Paul Revere, John Hancock, and Samuel Adams. Reluctant to take sides, Copley sailed in June 1774 for Europe, where he visited London and Paris, then Italy. In 1775, on the eve of the American Revolution, he settled in London, where his family joined him. Copley spent the rest of his life in London and there enjoyed moderate success as a portraitist and painter of modern history.

In 1780, the Connecticut-born John Trumbull (1756–1843) sailed to London to study under Benjamin West. The Harvard-educated son of the revolutionary governor of Connecticut, Trumbull had served as an officer in the War of Independence and been an aide-de-camp to General George Washington. At West's suggestion, and encouraged by Thomas Jefferson, then serving as the American minister to France, Trumbull in 1785 began a series of paintings depicting important events in the Revolutionary War. The first of these was *The Death of General Warren at*

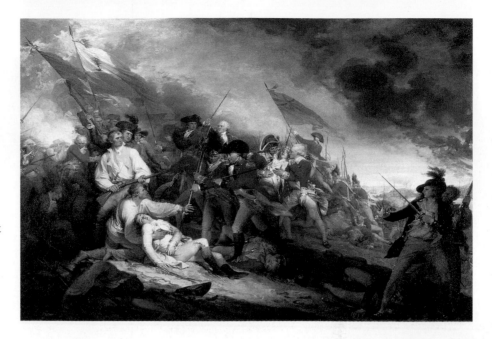

26-56. John Trumbull. *The Death of General Warren at the Battle of Bunker's Hill, June 17, 1775.* 1786. Oil on canvas, 25 x 34" (63.5 x 86.4 cm). Yale University Art Gallery; Trumbull Collection

the Battle of Bunker's Hill, June 17, 1775 (fig. 26-56). Completed in 1786, the canvas was praised by West as "the *best picture* of a modern battle that has been painted."

Trumbull had himself witnessed the smoke and fire of the Battle of Bunker Hill (called Bunker's Hill by the British) through field glasses from across Boston Harbor, where he was then stationed. The famous battle actually took place not on Bunker Hill but on nearby Breed's Hill, above the Charles River north of Boston. In an attempt to prevent the British from fortifying these high positions, the Americans occupied both hills on June 16, 1775. The next day, British troops launched two unsuccessful assaults on Breed's Hill. The third British attack succeeded because the Americans, running out of gunpowder, were forced to retreat. The British gained the hill but lost more than 1,000 men, nearly three times the losses suffered by the Americans.

Trumbull's painting represents the death of the American general Joseph Warren, who, having been shot, collapses into the arms of a comrade. In a noble gesture, the British major John Small attempts to save the dying Warren from being bayonetted by a grenadier. Behind Small, the British major John Pitcairn falls dying into the arms of his son. In the background, the British, led by their generals William Howe and Henry Clinton, storm up the hill from the right, while the Americans, under the command of General Israel Putnam, retreat at the left. In the extreme right foreground, Lieutenant Thomas Grosvenor of Connecticut, wounded in the chest and hand, is shown with his African-American servant, reacting with shock to General Warren's death.

Like all history paintings, Trumbull's depiction of this Revolutionary War contest is not an accurate record of the event but a dramatization of it, intended to tell the story of the battle and its heroes in an effective and memorable way. While clearly influenced by the example of West's *Death of General Wolfe* (see fig. 26-37), Trumbull's battle scene conveys a greater sense of excitement and spontaneity. For all of its drama West's composition, influenced by classical art, is relatively static and additive. The dying General Wolfe and his attendants are balanced on either side by groups of

mourning figures, ranged horizontally across a stage-like foreground. Trumbull's composition, inspired by Baroque art, is more dynamic and unified. The surging British soldiers and retreating colonial troops move from right to left and far to near in a powerful diagonal, emphasized by the wedge of dark smoke in the sky at the right, the tilting flags in the background, and the sword of Lieutenant Grosvenor. Compared to West's painting, Trumbull's also features looser brushwork, brighter colors, and stronger value contrasts, adding to its greater sense of immediacy.

Trumbull painted *The Death of General Warren* and several other Revolutionary battle pictures on a small scale because they were meant to serve as models for engravings. Following his return to the United States in 1789, Trumbull set out to sell subscriptions for his prints and sought support from his compatriots for a series of nationalistic history paintings on a grand scale. Due to pressing economic and political difficulties in the new republic, however, patronage was not forthcoming. Frustrated, between 1794 and 1800 Trumbull abandoned painting and served as an American diplomat in Europe. He resumed painting in 1800, but only in 1817 did he at last receive from Congress a commission to decorate the Rotunda of the United States Capitol with four large pictures of the American Revolution. *The Death of General Warren*, however, was not among the commissioned subjects, since it showed an American defeat.

Trumbull's *Death of General Warren* recorded an event in one of the political revolutions that complemented the technological and social revolutions of the eighteenth century. The Enlightenment's generally optimistic view that nature was good and that men and women would act to promote the happiness of others and the reformation of social institutions would continue to find artistic expression in the nineteenth century—especially in Neoclassicism. But at the turn of the century, Romanticism gained in force—partly in reaction to Neoclassicism—and the distinction between the two sometimes blurred, paving the way for the strong stream of realism that would arise during the nineteenth century.

PARALLELS

COUNTRY	EUROPEAN AND NORTH AMERICAN ART	ART IN OTHER CULTURES
FRANCE	26-9. **Watteau.** *Le Pélerinage à l'Île de Cithère* (1717)	23-19. **Taos Pueblo** (c. 1700), North America
	26-2. **Boffrand.** Salon de la Princesse, Paris (begun 1732)	21-12. **Shitao.** *Landscape* (c. 1700), China
	26-12. **Chardin.** *The Governess* (1739)	22-13. **Hakuin.** *Bodhidharma in the High Wind* (18th cent.), Japan
	26-11. **Boucher.** *Diana Resting after Her Bath* (1742)	
	26-40. **Soufflot.** Panthéon, Paris (1755–92)	
	26-13. **Fragonard.** *The Meeting* (1771–73)	22-14. **Rosetsu.** *Bull and Puppy* (18th cent.), Japan
	26-44. **Greuze.** *The Drunken Cobbler* (late 1770s)	
	26-45. **Pigalle.** *Portrait of Diderot* (1777)	22-15. **Harunobu.** *Geisha as Daruma Crossing the Sea* (mid-18th cent.), Japan
	26-48. **David.** *Oath of the Horatii* (1784–85)	24-12. **Parkinson.** Maori portrait (1769), New Zealand
	26-47. **Labille-Guiard.** *Self-Portrait with Two Pupils* (1785)	20-9. *Hour of Cowdust* (c. 1790), India
	26-46. **Vigée-Lebrun.** *Portrait of Marie Antoinette with Her Children* (1787)	23-13. **Mandan hide painting** (1797–1800), North America
	26-51. **Houdon.** *George Washington* (1788–92)	
	26-49. **David.** *Death of Marat* (1793)	
GERMANY	26-3. **Neumann.** Kaisersaal, Würzburg (1719–44)	
	26-8. **Asam.** *Angel Kneeling in Adoration* (c. 1732)	
	26-5. **Neumann.** Church of the Vierzehnheiligen, Staffelstein (1743–72)	
BRITAIN	26-22. **Lord Burlington.** Chiswick House (1724–29)	
	26-24. **Flitcroft & Hoare.** Stourhead Park, Wiltshire (begun 1743)	
	26-32. **Hogarth.** *The Marriage Contract* (1743–45)	
	26-26. **Walpole.** Strawberry Hill, Twickenham (1749–76)	
	26-28. **Adam.** Syon House, Middlesex (1760–69)	
	26-33. **Reynolds.** *Lady Sarah Bunbury Sacrificing to the Graces* (1765)	
	26-35. **Wright.** *An Experiment on a Bird in the Air-Pump* (1768)	
	26-37. **West.** *The Death of General Wolfe* (1770)	
	26-38. **Fuseli.** *The Nightmare* (1781)	
	26-36. **Kauffmann.** *Cornelia Pointing to Her Children as Her Treasures* (1785)	
	26-34. **Gainsborough.** *Portrait of Mrs. Richard Brinsley Sheridan* (1785–87)	
	26-39. **Blake.** *Elohim Creating Adam* (1795)	
NORTH AMERICA	26-1. **Copley.** *Samuel Adams* (c. 1770–72)	
	26-54. **Jefferson.** Monticello, Charlottesville (1770–84, 1796–1806)	
ITALY	26-17. **Carriera.** *Charles Sackville, 2nd Duke of Dorset* (c. 1730)	
	26-18. **Canaletto.** *Santi Giovanni e Paolo and the Monument to Bartolommeo Colleoni* (c. 1735–38)	
	26-21. **Canova.** *Cupid and Psyche* (1787–93)	

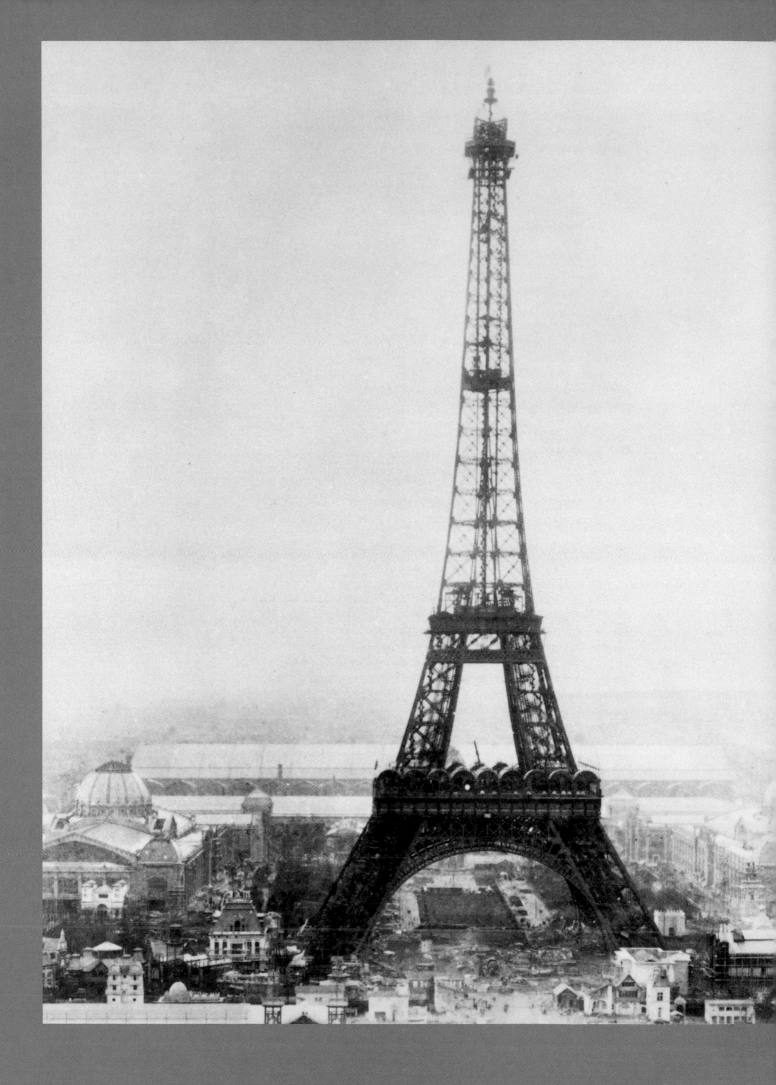

27-1. Gustave Eiffel. Eiffel Tower, Paris. 1887–89

27 Nineteenth-Century Art in Europe and the United States

"We writers, painters, sculptors, architects, and devoted lovers of the beauty of Paris . . . do protest with all our strength and all our indignation . . . against the erection, in the very heart of our capital, of the useless and monstrous Eiffel Tower, which public spitefulness . . . has already baptized, 'the Tower of Babel.'" With these words, published in Le Temps on February 14, 1887, a group of conservative artists announced their violent opposition to the immense iron tower just beginning to be built on the Seine River. The work of the engineer Gustave Eiffel (1832–1923), the 300-meter (984-foot) tower would upon its completion be the tallest structure in the world, dwarfing even the Egyptian pyramids and Gothic cathedrals.

The Eiffel Tower (fig. 27-1) was to be the main attraction of the 1889 Universal Exposition, one of several large fairs staged in Europe and the United States during the late nineteenth century to showcase the latest international advances in science and industry, while also displaying both fine and applied arts. But because Eiffel's marvel lacked architectural antecedents and did not conceal its construction, detractors saw it as an ugly, overblown work of engineering. For its admirers, however, it achieved a new kind of beauty derived from modern engineering and was an exhilarating symbol of technological innovation and human aspiration. One French poet called it "an iron witness raised by humanity into the azure sky to bear witness to its unwavering determination to reach the heavens and establish itself there." Perhaps more than any other monument, the Eiffel Tower embodies the nineteenth-century belief in the progress and ultimate perfection of civilization through science and technology.

TIMELINE 27-1. **The Nineteenth Century in the West.** The Industrial Revolution held sway, republics rose from revolutions, and the middle class swelled in numbers and influence.

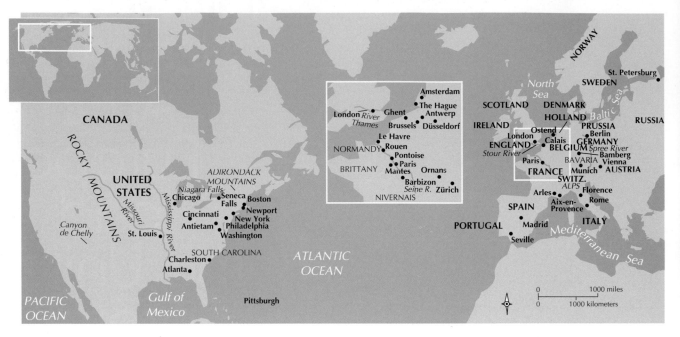

MAP 27-1.
Europe and North America in the Nineteenth Century. Europe took the lead in industrialization, and France became the cultural beacon of the Western world.

EUROPE AND THE UNITED STATES IN THE NINETEENTH CENTURY

The Enlightenment set in motion powerful forces that would dramatically transform life in Europe and the United States during the nineteenth century. Great advances in manufacturing, transportation, and communications created new products for consumers and new wealth for entrepreneurs, fueling the rise of urban centers and improving living conditions for many (see Map 27-1). But this so-called Industrial Revolution also condemned masses of workers to poverty and catalyzed new political movements that sought to reform society. Animating these developments was the widespread belief in "progress" and the ultimate perfectibility of human civilization—a belief rooted deeply in Enlightenment thought (Chapter 26).

The Industrial Revolution had begun in the eighteenth century in Britain, where the new coal-fed steam engine ran such innovations in manufacturing as the steam-powered loom. Increasing demands for coal and iron necessitated improvements in mining, metallurgy, and transportation. Subsequent development of the locomotive and steamship in turn facilitated the shipment of raw materials and merchandise, made passenger travel easier, and encouraged the growth of new cities (Timeline 27-1).

Continuing scientific discoveries led to the telegraph, telephone, and radio. By the end of the nineteenth century, electricity powered lighting, motors, trams, and railways in most European and American cities. Developments in chemistry created many new products, such as aspirin, disinfectants, photographic chemicals, and explosives. The new material of steel, an alloy of iron and carbon, was lighter, harder, and more malleable than iron and became the standard in heavy construction and transportation. In medicine and public health, Louis Pasteur's purification of beverages through heat (pasteurization) and the development of vaccines, sterilization, and antisepsis led to a dramatic decline in death rates all over the Western world.

Some scientific discoveries challenged traditional religious beliefs and affected social philosophy. Geologists concluded that the earth was far older than the estimated 6,000 years sometimes claimed for it by biblical literalists. Contrary to the biblical account of creation, Charles Darwin proposed that all life evolved from a common ancestor and changed through genetic mutation and natural selection. Religious conservatives attacked Darwin's account of evolution, which seemed to deny the divine creation of humans and even the existence of God. Some of Darwin's supporters, however, suggested that "survival of the fittest" had advanced the human race, with certain types of people—particularly

the Anglo-Saxon upper classes—achieving the pinnacle of social evolution. "Social Darwinism" provided a rationalization for the "natural" existence of a less "evolved" working class and a justification for British and American colonization of "underdeveloped" parts of the world.

The nineteenth century witnessed the rise of imperialism. To create new markets for their products and to secure access to cheap raw materials and cheap labor, European nations established colonies in most of Africa and nearly a third of Asia, and the United States did so in the Pacific. Colonial rule brought technological improvements to non-Western countries but also threatened traditional native cultures and suppressed the economic development of the colonized countries.

The availability of inexpensive labor closer to home had been crucial to the development of the Industrial Revolution in Britain. Displaced from their small farms and traditional cottage industries by technological developments in agriculture and manufacturing, the rural poor moved to the new factory and mining towns in search of employment, and industrial laborers—many of them women and children—suffered miserable working and living conditions. Although new government regulations led to improvements during the second half of the nineteenth century, socialist movements condemned the exploitation of laborers by capitalist factory owners and advocated communal or state ownership of the means of production and distribution. The most radical of these movements was communism, which called for the abolition of private property.

Paralleling the attempts to liberate workers were the struggles of feminists to improve the status of women and those of abolitionists to end slavery. In 1848—the same year that Karl Marx and Friedrich Engels published the *Communist Manifesto*, which predicted the violent overthrow of the bourgeoisie (middle class) by the proletariat (working class) and the creation of a classless society—the Americans Lucretia Mott and Elizabeth Cady Stanton held the country's first women's rights convention, in Seneca Falls, New York. They called for the equality of women and men before the law, property rights for married women, the acceptance of women into institutions of higher education, the admission of women to all trades and professions, equal pay for equal work, and women's suffrage (the right to vote, not fully achieved in the United States until 1920).

Some American suffragists of the mid-nineteenth century were also active in the abolitionist movement. Slavery in the United States was finally eliminated as a result of the devastating Civil War (1861–65), which claimed more American lives than all other wars in history combined. After the Civil War, the United States became a major industrial power, and the American northeast underwent rapid urbanization, fueled by millions of immigrants from Europe seeking economic opportunities.

EARLY-NINETEENTH-CENTURY ART: NEOCLASSICISM AND ROMANTICISM

For centuries, the major sources of artistic patronage in Europe had been Church leaders and secular nobility, but as the power of both the Church and the Crown declined in the nineteenth century, so did their influence over artistic production. In their place, the capitalist bourgeoisie, nations, and national academies became major patrons of the arts. Large annual exhibitions in European and American cultural centers took on increasing importance as a means for artists to show their work, win prizes, attract buyers, and gain commissions. Art criticism proliferated in mass-printed periodicals, helping both to make and to break artistic careers. And, in the later decades of the century, commercial art dealers gained in importance as marketers of both old and new art.

Both Neoclassicism and Romanticism (see Chapter 26) remained vital in early-nineteenth-century European and American art. Neoclassicism survived past the middle of the century in both architecture and sculpture. Romanticism took a variety of forms in the early decades. Many Romantic paintings and sculptures featured dramatic and intensely emotional subject matter drawn from literature, history, or the artist's own imagination. Some Romantic artists, however, painted humble images of the rural landscape infused with religious feeling. In architecture, Romanticism took the form of revivals of historical styles that expressed, among other things, an escapist fascination with other times and places.

LATE-NINETEENTH-CENTURY ART: REALISM AND ANTIREALISM

The second half of the nineteenth century has been called the positivist age, an age of faith in the positive consequences of close observation of the natural and human realms. The term *positivism* was used by the French philosopher Auguste Comte (1798–1857) during the 1830s to describe what he saw as the final stage in the development of philosophy, in which all knowledge would derive from science and scientific methods. In the second half of the century, the term *positivism* came to be applied widely to any expression of the new emphasis on objectivity.

In the visual arts the positivist spirit may be most obvious in the widespread rejection of Romanticism in favor of the accurate and apparently objective description of the ordinary, observable world. Positivist thinking is evident not simply in the growth of naturalism but also in the full range of artistic developments of the period after 1850—from the development of photography, capable of recording nature with unprecedented accuracy, to the highly descriptive style of academic art, to Impressionism's quasi-scientific emphasis on the

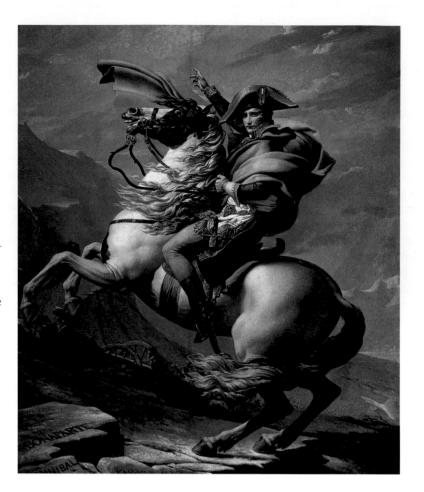

27-2. Jacques-Louis David. *Napoleon Crossing the Saint-Bernard*. 1800–01. Oil on canvas, 8'11" x 7'7" (2.7 x 2.3 m). Musée National du Château de la Malmaison, Rueil-Malmaison

David flattered Napoleon by reminding the viewer of two other great generals from history who had accomplished this difficult feat—Charlemagne and Hannibal—by etching the names of all three in the rock in the lower left.

optical properties of light and color. In architecture, the application of new technologies also led gradually to the abandonment of historical styles and ornamentation in favor of a more direct or "realistic" expression of structure and materials.

The late-nineteenth-century emphasis on realism did not go unchallenged, however. In the 1880s and 1890s a number of artists in both Europe and the United States rejected realistic styles, paving the way for the radically new nonrepresentational art forms that emerged shortly before World War I. Many of these artists used antirealist styles to express their personal feelings about their subjects or to evoke states of mystery or spirituality. Like the Romantic artists before them, they shunned the depiction of ordinary, modern life in favor of exploring artistically the realms of myth, fantasy, and imagination.

NEOCLASSICISM AND ROMANTICISM IN FRANCE

The undisputed capital of the nineteenth-century Western art world was Paris. The Paris École des Beaux-Arts attracted students from all over Europe and the United States, as did the **ateliers** (studios) of Parisian academic artists who offered private instruction. Virtually every ambitious nineteenth-century European artist, and many Americans, aimed to exhibit in the Paris Salon, to receive positive reviews from the Parisian critics, and to find favor with the French art-buying public.

Conservative juries controlled the Salon exhibitions, however, and from the 1830s onward they routinely rejected paintings and sculpture that did not conform to the academic standards of slick technique, mildly idealized subject matter, and engaging, anecdotal story lines. As the century wore on, progressive and independent artists ceased submitting to the Salon and organized private exhibitions to present their work directly to the public without the intervention of a jury. The most famous of these was the first exhibition of the Impressionists, held in Paris in 1874 (see page 1014). The institution of the Salon itself was democratized in 1884 with the inauguration of the Salon des Indépendants, which had no jury and awarded no prizes.

Audacious participants in such exhibitions came to think of themselves as enemies of convention and institutional authority—as pioneers of artistic expression every bit as revolutionary as the contemporary developments in science, technology, industry, and politics. Such artists, dedicated to radical artistic innovation, assumed the title of **avant-garde**, or vanguard, a term that in its original military usage denoted the foremost position of an advancing army.

DAVID AND HIS STUDENTS

Following Napoleon's rise to power in 1799, Jacques-Louis David (1748–1825), previously an ardent republican (see Chapter 26), switched his allegiance to the new dictator. David's new artistic task, the glorification of

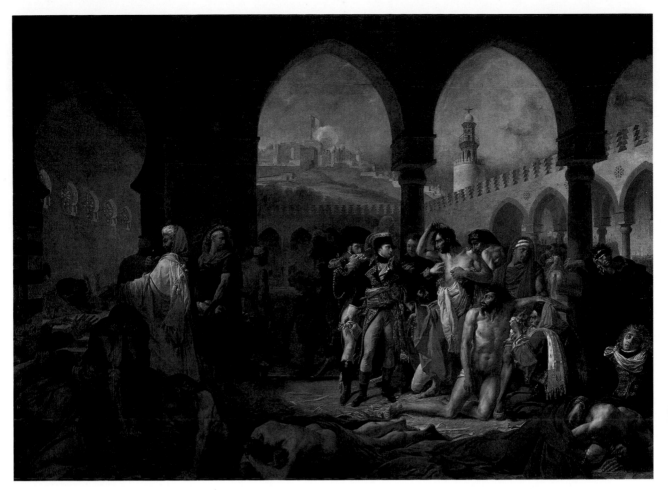

27-3. Antoine-Jean Gros. *Napoleon in the Plague House at Jaffa*. 1804. Oil on canvas, 17'5" x 23'7" (5.32 x 7.2 m). Musée du Louvre, Paris

Napoleon, appeared in an early, idealized account of Napoleon leading his troops across the Alps into Italy in 1800 (fig. 27-2). Napoleon—who actually made the crossing on a donkey—is shown calmly astride a rearing horse, exhorting us to follow him. His windblown cloak, an extension of his arm, suggests that Napoleon directs the winds as well. While Neoclassical in the firmness of its drawing, the work also takes stylistic inspiration from the Baroque—for example, in the dramatic diagonal **composition** used instead of the classical pyramid of the *Oath of the Horatii* (see fig. 26-48). When Napoleon fell from power in 1814, David moved to Brussels, where he died in 1825.

Antoine-Jean Gros (1771–1835), who began to work in David's studio as a teenager, eventually vied with his master for commissions from Napoleon. Gros also introduced elements of Romanticism into his work that proved influential for younger artists. Gros traveled with Napoleon in Italy in 1797 and later became an official chronicler of Napoleon's military campaigns. Gros's *Napoleon in the Plague House at Jaffa* (fig. 27-3) is an idealized account of an actual incident: During Napoleon's campaign against the Turks in 1799, bubonic plague broke out among his troops. Napoleon decided to quiet the fears of the healthy by visiting the sick and dying,

who were housed in a converted mosque. The format of the painting—a shallow stage and a series of arcades behind the main actors—is inspired by David's *Oath of the Horatii*. The overall effect is Romantic, however, not simply because of the dramatic lighting and the wealth of emotionally stimulating elements, both exotic and horrific, but also because the main action is meant to incite veneration, not republican virtue. At the center of a small group of soldiers and a doctor, Napoleon calmly reaches toward the sores of one of the victims, the image of a Christ-like figure healing the sick with his touch, consciously intended to promote him as semidivine. Not surprisingly, Gros gives no hint of the event's cruel historical aftermath: Two months later, Napoleon ordered the remaining sick to be poisoned.

Jean-Auguste-Dominique Ingres (1780–1867) thoroughly absorbed his teacher David's Neoclassical vision but reinterpreted it in a new manner. Inspired by Raphael rather than by antique art, Ingres emulated the Renaissance artist's precise drawing, formal **idealization**, classical composition, and graceful lyricism. Ingres won the **Prix de Rome** and lived in Italy from 1806 to 1824, returning to serve as director of the French Academy in Rome from 1835 to 1841. As a teacher and theorist, Ingres became the most influential artist of his time.

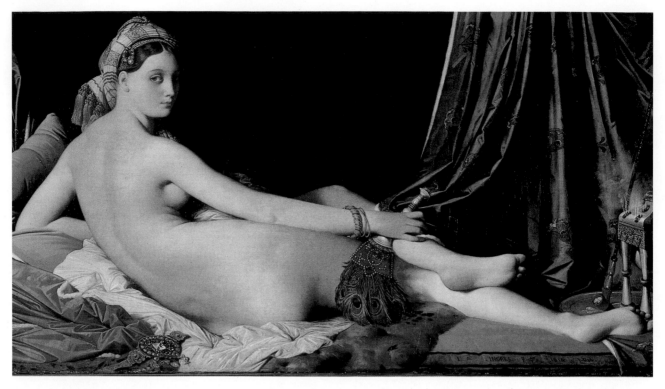

27-4. Jean-Auguste-Dominique Ingres. *Large Odalisque*. 1814. Oil on canvas, approx. 35 x 64" (88.9 x 162.5 cm). Musée du Louvre, Paris

During Napoleon's campaigns against the British in North Africa, the French discovered the exotic Near East. Upper-middle-class European men were particularly attracted to the institution of the harem, partly as a reaction against the egalitarian demands of women of their class that had been unleashed by the French Revolution.

Although Ingres, like David, fervently desired acceptance as a history painter, his paintings of literary subjects and contemporary history were less successful than his erotically charged portraits of women and female nudes, especially his numerous representations of the **odalisque**, a female slave or concubine in a sultan's harem. In *Large Odalisque* (fig. 27-4), the cool gaze this odalisque levels at her master, while turning her naked body away from what we assume is *his* gaze, makes her simultaneously erotic and aloof. The cool blues of the couch and the curtain at the right heighten the effect of the woman's warm skin, while the tight angularity of the crumpled sheets accentuates the languid, sensual contours of her form. Although Ingres's commitment to fluid line and elegant postures was grounded in his Neoclassical training, he treated a number of Romantic themes, such as the odalisque, in a highly personal, almost Mannerist fashion. Here the elongation of the woman's back (she seems to have several extra vertebrae), the widening of her hip, and her tiny, boneless feet are anatomically incorrect but aesthetically compelling.

Although Ingres complained that making portraits was a "considerable waste of time," he was unparalleled in rendering a physical likeness and the material qualities of clothing, hairstyles, and jewelry. In addition to polished lifesize oil portraits, Ingres produced—usually in just a day—small portrait drawings that are extraordinarily fresh and lively. The exquisite *Portrait of Madame Desiré Raoul-Rochette* (fig. 27-5) is a flattering yet credible interpretation of the relaxed and elegant sitter. With her gloved right hand Madame Raoul-Rochette has removed her left-hand glove, simultaneously drawing attention to her social status (gloves traditionally were worn by members of the European upper class, who did not work with their hands) and her marital status (on her left hand is a wedding band). Her shiny taffeta dress, with its fashionably high waist and puffed sleeves, is rendered with deft yet light strokes that suggest more than they describe. Greater emphasis is given to her refined face and elaborate coiffure, which Ingres has drawn precisely and modeled subtly through light and shade.

ROMANTIC PAINTING

Romanticism, already anticipated in French painting during Napoleon's reign, flowered during the royal restoration that lasted from 1818 to 1848, although it did not gain wide public acceptance until after 1830. French Romantic artists not only drew upon literary sources but also added the new dimension of social criticism. In general, Romantic painting featured loose, fluid brushwork, strong colors, complex compositions, powerful contrasts of light and dark, and expressive poses and gestures—all suggesting a revival of the more dramatic aspects of the Baroque.

Théodore Géricault (1791–1824) began his career painting Napoleonic military themes in a manner inspired

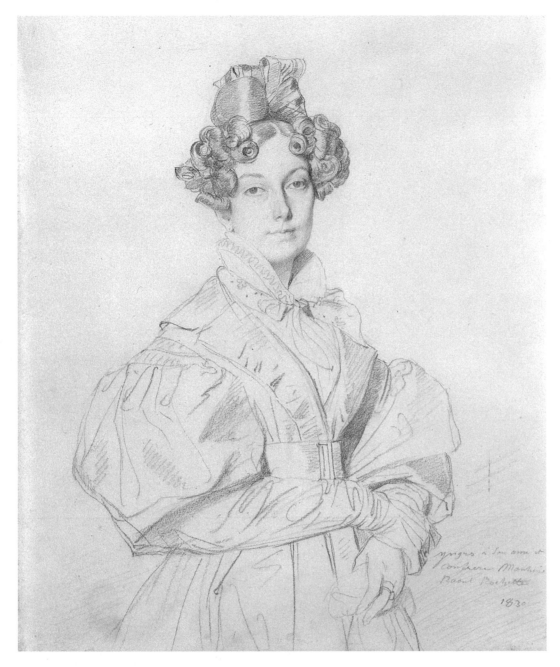

Madame Raoul-Rochette (1790–1878), née Antoinette-Claude Houdon, was the youngest daughter of the famous Neoclassical sculptor Jean-Antoine Houdon (see fig. 26-51). In 1810, at the age of twenty, she married Desiré Raoul-Rochette, a noted archaeologist, who later became the secretary of the Academy of Fine Arts and a close friend of Ingres. Ingres's drawing of Madame Rochette is inscribed to her husband, whose portrait Ingres also drew around the same time.

by Gros. After a brief stay in 1816–17 in Rome, where he discovered Michelangelo, Géricault returned to Paris determined to paint a great contemporary history painting. He chose for his subject the scandalous and sensational shipwreck of the *Medusa* (figs. 27-6, 27-7, 27-8, 27-9, "The Object Speaks", pages 986-7). In 1816, the ship of French colonists headed for Senegal ran aground near its destination; its captain was an incompetent aristocrat appointed by the newly restored monarchy for political reasons. Because there were insufficient lifeboats, a raft was hastily built for 152 of the passengers and crew, while the captain and his officers took the seaworthy boats. Too heavy to pull to shore, the raft was set adrift. When it was found thirteen days later, only fifteen people remained alive, having survived their last several days on human flesh. Géricault chose to depict the moment when the survivors first spot their rescue ship.

At the Salon of 1819, Géricault showed his painting under the neutral title *A Shipwreck Scene*, perhaps to downplay its politically inflammatory aspects and to encourage appreciation of its larger philosophical theme—the eternal and tragic struggle of humanity against the elements. Most contemporary French critics interpreted the painting as political commentary, however, with liberals praising it and royalists condemning it. Because the monarchy refused to buy the canvas, Géricault exhibited it commercially on a two-year tour of Ireland and England, where the London exhibition attracted more than 50,000 paying visitors.

While in Britain, Géricault turned from modern history painting in the **Grand Manner** to the depiction of the urban poor in a series of **lithographs** entitled *Various Subjects Drawn from Life and On Stone* (see "Lithography," page 989). *Pity the Sorrows of a Poor Old*

THE OBJECT SPEAKS

RAFT OF THE "MEDUSA"

Théodore Géricault's monumental history painting *Raft of the "Medusa"* (fig. 27-6) speaks powerfully through its composition, in which the victims' largely nude, muscular bodies are organized on crossed diagonals. The diagonal beginning in the lower left and extending to the waving figures registers their rising hopes. The diagonal that begins with the dead man in the lower right and extends through the mast and billowing sail, however, directs our attention to a huge wave. The rescue of the men is not yet assured. They remain tensely suspended between salvation and death. Significantly, the "hopeful" diagonal in Géricault's painting terminates in the vigorous figure of a black man, a survivor named Jean Charles, and may carry political meaning. By placing him at the top of the pyramid of survivors and giving him the power to save his comrades by signaling to the rescue ship, Géricault suggests metaphorically that freedom for all of humanity will only occur when the most oppressed member of society is emancipated.

Typical of history paintings of the day, Géricault's work was the culmination of extensive study and experimentation. An early pen drawing (fig. 27-7) depicts the survivors' hopeful response to the appearance of the ship on the horizon at the extreme left. Their excitement is set in relief by the mournful scene of a man grieving over a dead youth on the right side of the raft. A later pen-and-wash drawing (fig. 27-8) reverses the composition, creates greater unity among the figures, and establishes the modeling of their bodies through light and shade. These developments look ahead to the final composition of the *Raft of the "Medusa,"* but the study still lacks the figures of the black man and the dead bodies at the extreme left and lower right, which fill out the composition's base.

Géricault also made separate studies of many of the figures, as well as studies of actual corpses, severed heads, and dissected limbs (fig. 27-9) supplied to him by

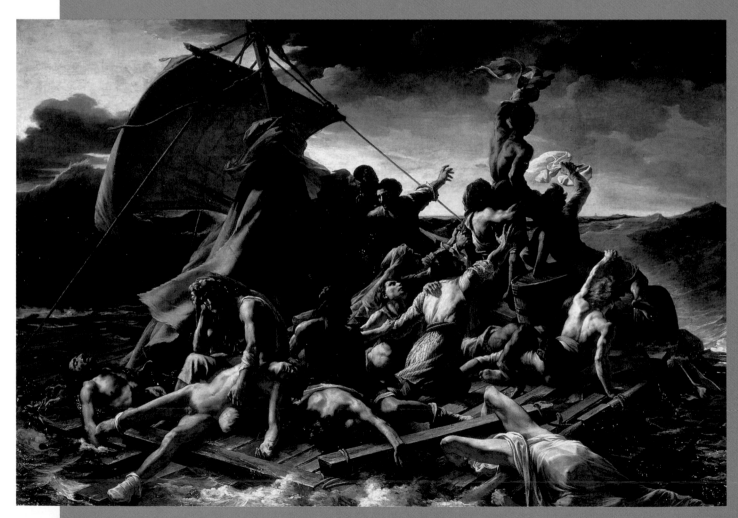

27-6. Théodore Géricault. *Raft of the "Medusa."* 1818–19. Oil on canvas, 16'1" x 23'6" (4.9 x 7.16 m). Musée du Louvre, Paris

friends who worked at a nearby hospital. For several months, according to Géricault's biographer, "his studio was a kind of morgue. He kept cadavers there until they were half-decomposed, and insisted on working in this charnel-house atmosphere. . . ." However, Géricault did not use cadavers directly in the *Raft of the "Medusa"*; to execute the final painting, he traced the outline of his composition onto a large canvas, then painted each body directly from a living model, gradually building up his composition figure by figure. He seems, rather, to have kept the corpses in his studio to create an atmosphere of death that would provide him with a more authentic understanding of his subject.

Nevertheless, Géricault did not depict the actual physical condition of the survivors of the raft: exhausted, emaciated, sunburned, and close to death. Instead, following the dictates of the Grand Manner, he gave his men athletic bodies and vigorous poses, evoking the work of Michelangelo and Rubens (see figs. 18-13 and 19-46). He did this to generalize and ennoble his subject, elevating it above the particulars of a specific shipwreck so that it could speak to us of more fundamental conflicts: humanity against nature, hope against despair, life against death.

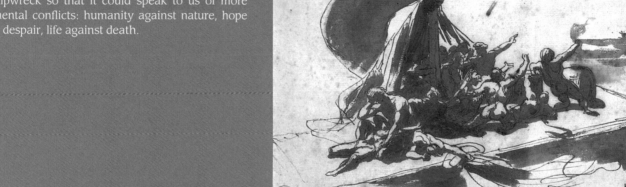

27-7. *The Sighting of the "Argus."* 1818. Pen and ink on paper, 13³/₄ x 16¹/₈" (34.9 x 41 cm). Musée des Beaux-Arts, Lille

27-8. *The Sighting of the "Argus."* 1818. Pen and ink, sepia wash on paper, 8¹/₈ x 11¹/₄" (20.6 x 28.6 cm). Musée des Beaux-Arts, Rouen

27-9. *Study of Hands and Feet.* 1818–19. Oil on canvas, 20¹/₂ x 25" (52 x 64 cm). Musée Fabre, Montpellier

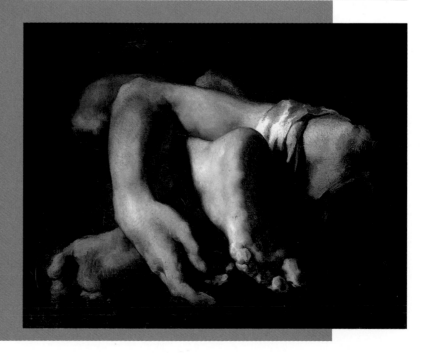

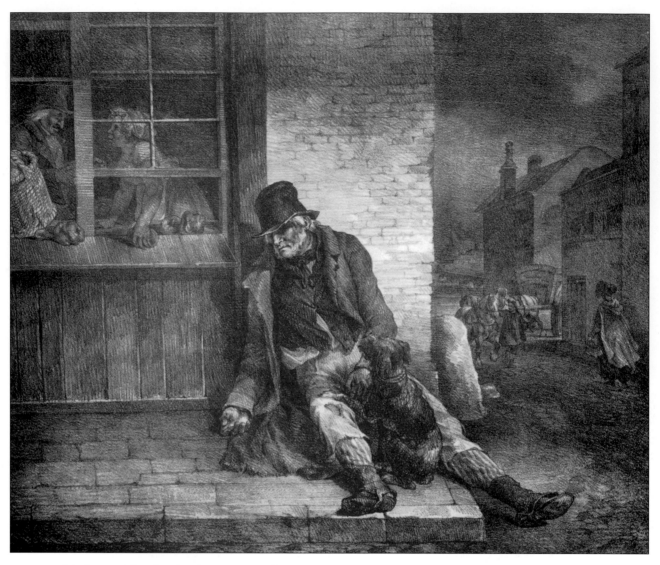

27-10. Théodore Géricault. *Pity the Sorrows of a Poor Old Man*. 1821. Lithograph, 12.5 x 14.8" (31.6 x 37.6 cm).

One of the first artists to use the recently invented medium of lithography to create fine art prints, Géricault published his thirteen lithographs of *Various Subjects Drawn from Life and On Stone* in London in 1821. The title of *Pity the Sorrows of a Poor Old Man* comes from a popular English nursery rhyme of the period that began: "Pity the sorrows of a poor old man whose trembling limbs have borne him to your door. . . ."

Yale University Art Gallery

Gift of Charles Y. Lazarus, B.A. 1936

Man (fig. 27-10) depicts a haggard beggar, slumping against a wall and limply extending an open hand. Through the window above him, we see a baker who ignores the hungry man's plight and prepares to pass a loaf of bread to a paying customer. Although the subject's appeal to the emotions can be considered Romantic, the print does not preach or sentimentalize. Viewers are invited to draw their own conclusions.

After Géricault's death, leadership of the French Romantic movement passed to his younger colleague Eugène Delacroix (1798–1863), who had modeled for the face-down figure at the center of the *Raft of the "Medusa."* Like Géricault, Delacroix depicted victims and antiheroes. One of his first paintings exhibited at a Salon was *Scenes from the Massacre at Chios* (fig. 27-11), an event even more terrible than the shipwreck of the *Medusa*. In

1822, during the Greeks' struggle for independence against the Turks, the Turkish fleet stopped at the peaceful island of Chios and took revenge by killing about 20,000 of the 100,000 inhabitants and selling the rest into slavery in North Africa. Delacroix based his painting on journalistic reports, eyewitness accounts, and study of Greek and Turkish costumes. The painting is an image of savage violence and utter hopelessness—the entire foreground is given over to exhausted victims awaiting their fate—paradoxically made seductive through its opulent display of handsome bodies and colorful costumes.

Although Delacroix generally supported liberal political aims, his visit in 1832 to Morocco seems to have stirred his more conservative side. As enthralled as Delacroix was with the brilliant color and dignified inhabitants of North Africa, his attraction to the patriarchal

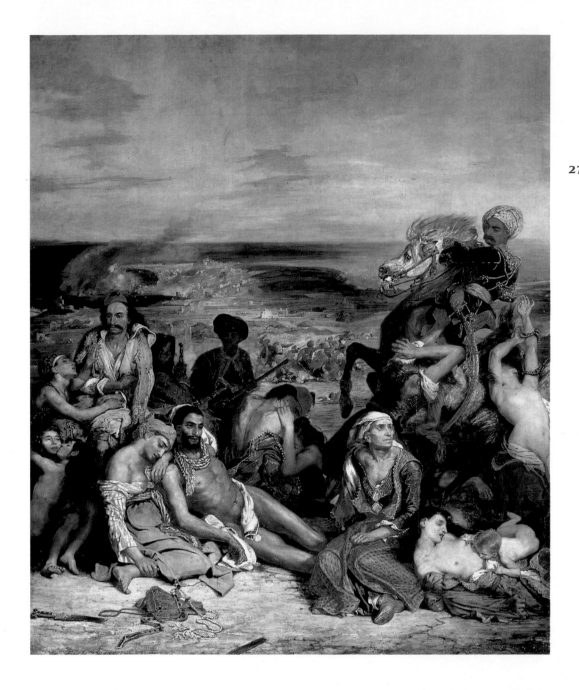

27-11. Eugène Delacroix. *Scenes from the Massacre at Chios.* 1822–24. Oil on canvas, 13'10" x 11'7" (4.22 x 3.53 m). Musée du Louvre, Paris

TECHNIQUE
LITHOGRAPHY

Lithography, invented in the mid-1790s, is based on the natural antagonism between oil and water. The artist draws on a flat surface—traditionally, fine-grained stone—with a greasy, crayonlike instrument. The stone's surface is wiped with water, then with an oil-based ink. The ink adheres to the greasy areas but not to the damp ones. A sheet of paper is laid facedown on the inked stone, which is passed through a flatbed press. Holding a scraper, the lithographer applies light pressure from above as the stone and paper pass under it, transferring ink from stone to paper, thus making lithography a direct method of creating a printed image. Francisco Goya, Théodore Géricault, Eugène Delacroix, Honoré Daumier, and Henri de Toulouse-Lautrec used the medium to great effect.

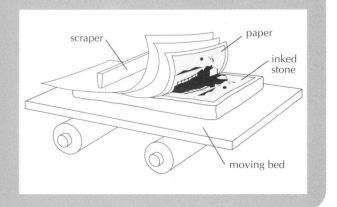

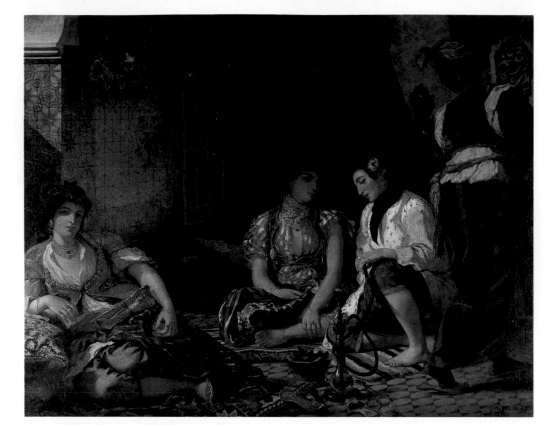

27-12. Eugène Delacroix. *Women of Algiers.* 1834. Oil on canvas, 5'10⅞" x 7'6⅛" (1.8 x 2.29 m). Musée du Louvre, Paris

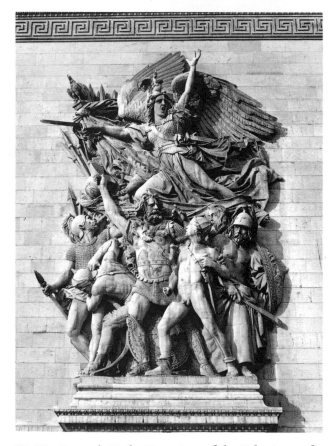

27-13. François Rude. *Departure of the Volunteers of 1792 (The Marseillaise).* 1833–36. Limestone, height approx. 42' (12.8 m). Arc de Triomphe, Place de l'Étoile, Paris

political and social system is also evident in paintings such as *Women of Algiers* (fig. 27-12). This image of hedonism and passivity countered the contemporaneous demands of many French women for property reform, more equitable child-custody laws, and other egalitarian initiatives.

ROMANTIC SCULPTURE

Romanticism gained general acceptance in France after 1830, when a moderate, constitutional monarchy under Louis-Philippe (the so-called July Monarchy, 1830–48) was established, bringing with it a new era of middle-class taste. This shift is most evident in sculpture, where a number of practitioners turned away from Neoclassical principles to more dramatic themes and approaches.

Early in the July Monarchy the minister of the interior decided, as an act of national reconciliation, to complete the triumphal arch on the Champs-Élysées in Paris, which Napoleon had begun in 1806. François Rude (1784–1855) received the commission to decorate the main arcade to commemorate the volunteer army that had halted a Prussian invasion in 1792–93. Beneath the violent exhortations of the winged figure of Liberty, the volunteers surge forward, some nude, some in classical armor (fig. 27-13). Despite such Neoclassical elements, the effect is Romantic. The crowded, excited grouping so stirred the patriotism of French spectators that it quickly became known as *The Marseillaise*, the name of the French national anthem written in the same year, 1792.

Another popular Romantic sculptor to emerge at the beginning of the July Monarchy was Antoine-Louis Barye (1796–1875), who specialized in scenes of violent animal combat. In addition to large works for wealthy patrons, including the king, Barye's studio produced

small, relatively inexpensive replicas, such as *Python Crushing an African Horseman* (fig. 27-14), for the middle-class market. Such unlikely scenes of exotic violence may have contributed to the popular view that nature was filled with hostile forces that required human control.

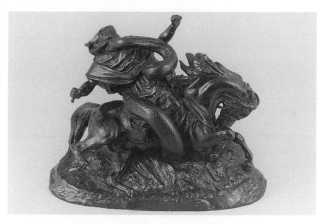

27-14. Antoine-Louis Barye. *Python Crushing an African Horseman*. 1845. Bronze, height 9" (22.8 cm). The Baltimore Museum of Art
George A. Lucas Collection

ROMANTICISM IN SPAIN

In eighteenth-century Spain, patrons had looked to foreign artists such as Giovanni Battista Tiepolo (see fig. 26 4) to fill major commissions. Not until late in the century were a native painter's achievements comparable to those of Velázquez. Francisco Goya y Lucientes (1746–1828), during the first half of his long career, chiefly produced formal portraits and Rococo genre pictures, but around 1800, the influence of Velázquez and Rembrandt led Goya to develop a more Romantic style of darker tonality, freer brushwork, and more dramatic presentation.

Goya's large portrait of the *Family of Charles IV* (fig. 27-15) openly acknowledges the influence of Velázquez's *Las Meninas* (see fig. 19-39) by placing the painter behind the easel on the left, just as Velázquez had. Goya's realistic rather than flattering depiction of the royal family has led some to see the painting as a cruel exposé of the sitters as common, ugly, and inept. Considering Goya's position at the time as principal court painter, however, it is difficult to imagine the artist deliberately mocking his most important patron. In fact, Goya made preparatory sketches for the painting, and the family apparently consented to his rendering of their faces. Viewers of the painting in 1800 would have found it striking not

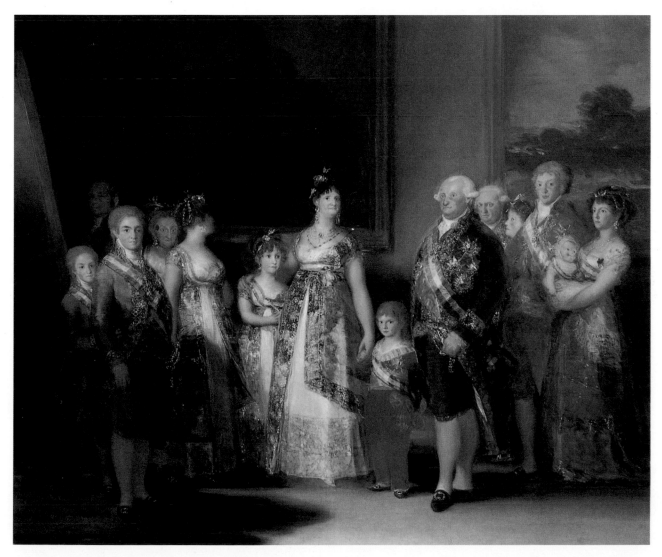

27-15. Francisco Goya. *Family of Charles IV*. 1800. Oil on canvas, 9'2" x 11' (2.79 x 3.36 m). Museo del Prado, Madrid

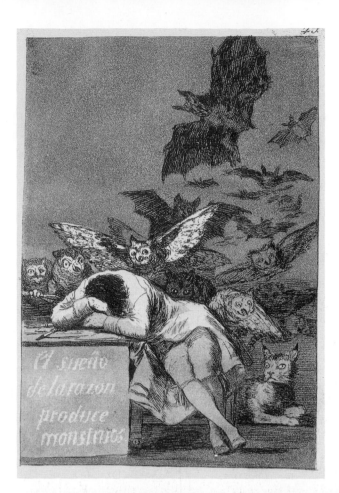

27-16. Francisco Goya. *The Sleep of Reason Produces Monsters*, No. 43 from *Los Caprichos (The Caprices)*. 1796–98; published 1799. Etching and aquatint, 8½ x 6" (21.6 x 15.2 cm). The Hispanic Society of America, New York

After printing about 300 sets of this series, Goya offered them for sale in 1799. He withdrew them from sale two days later without explanation. Historians believe that he was probably warned by the Church that if he did not he might have to appear before the Inquisition because of the unflattering portrayal of the Church in some of the etchings. In 1803 Goya donated the plates to the Royal Printing Office.

because it was demeaning but because its candid representation was refreshingly modern.

Goya belonged to a small but influential circle of Madrid intellectuals who subscribed to the liberal ideals of the French philosophes. After the early years of the French Revolution, however, Charles IV reinstituted the Inquisition, stopped most of the French-inspired reforms, and even halted the entry of French books into Spain. Goya responded to the new situation with *Los Caprichos (The Caprices)*, a folio of eighty **etchings** produced between 1796 and 1798 whose overall theme is suggested by *The Sleep of Reason Produces Monsters* (fig. 27-16). The print shows a slumbering personification of

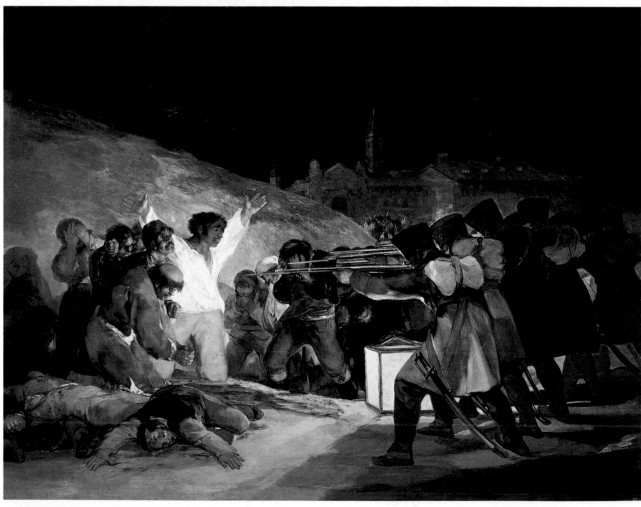

27-17. Francisco Goya. *Third of May, 1808*. 1814–15. Oil on canvas, 8'9" x 13'4" (2.67 x 4.06 m). Museo del Prado, Madrid

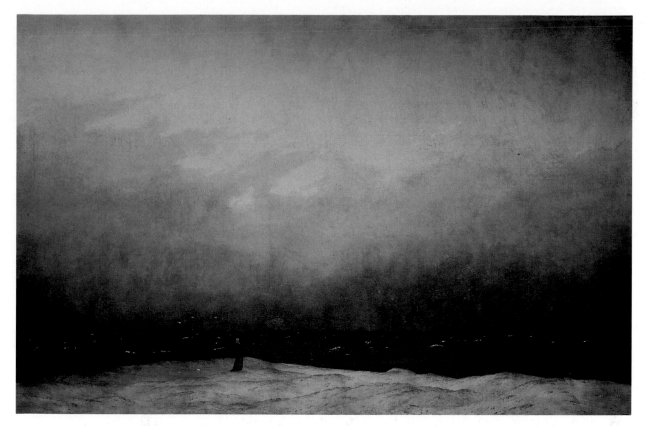

27-18. Caspar David Friedrich. *Monk by the Sea*. 1809–10. Oil on canvas, 43³/₈ x 67¹/₂" (110 x 171.5 cm). Schloss Charlottenberg, Berlin

Friedrich suffered a number of personal tragedies early in his life that even he admitted colored his work. When he was seven, his mother died. The following year, one of his sisters died; five years later, his older brother drowned while saving Caspar, who had fallen through the ice while skating; and another sister died two years later.

Reason, behind whom lurk the dark creatures of the night—owls, bats, and a cat—that are let loose when Reason sleeps. The rest of the *Caprichos* enumerate the specific follies of Spanish life that Goya and his circle considered monstrous. Goya hoped the series would show Spanish people the errors of their ways and reawaken reason. Despite the hopeful premise, however, the disturbing quality of Goya's portrait of human folly suggests he was already beginning to feel the despair that would dominate his later work.

In 1808 Napoleon conquered Spain and placed on its throne his brother Joseph Bonaparte. Many Spanish citizens, including Goya, welcomed the French because of the reforms they inaugurated, including a new, more liberal constitution. On May 2, 1808, however, a rumor spread in Madrid that the French planned to kill the royal family. The populace rose up, and a day of bloody street fighting ensued. Hundreds of Spanish people were herded into a convent, and a French firing squad executed these helpless prisoners in the predawn hours of May 3. Goya commemorated the event in a painting (fig. 27-17) that, like Delacroix's *Massacre at Chios* (see fig. 27-11), focuses on victims and antiheroes, the most prominent of which is a Christ-like figure in white. Goya's work is less an indictment of the French than of the faceless and mechanical forces of war itself, blindly destroying defenseless humanity. When asked why he painted such a brutal scene, Goya responded: "To warn men never to do it again."

Soon after the Spanish monarchy was restored, Ferdinand VII (ruled 1808; 1814–33) abolished the new constitution and reinstated the Inquisition, which the French had banned. In 1815 Goya was himself called before the Inquisition due to the alleged obscenity of an earlier painting of a female nude. Though found innocent, Goya gave up hope in human progress and retired to his home outside Madrid, where he vented his disillusionment in the series of nightmarish "black paintings" he did on its walls.

ROMANTIC LANDSCAPE PAINTING IN EUROPE

Romantic landscape painting generally took one of two forms. One—the dramatic—emphasized turbulent or fantastic natural scenery, often shaken by natural disasters such as storms and avalanches, and aimed to stir viewers' emotions and arouse a feeling of the **sublime**. The other—the naturalistic—presented closely observed images of tranquil nature, meant to communicate religious reverence for the landscape and to counteract the effects of industrialization and urbanization that were rapidly transforming it.

The leading German Romantic landscapist was Caspar David Friedrich (1774–1840), who felt, like many Romantics, that God was manifest in the landscape and that art was the ideal mediator between the divinity in nature and the individual. Friedrich expressed these sentiments in his powerful *Monk by the Sea* (fig. 27-18),

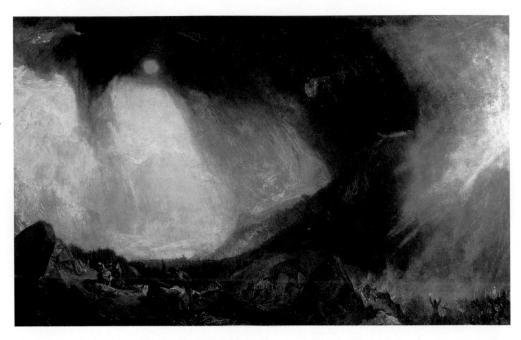

27-19. **Joseph Mallord William Turner.** *Snowstorm: Hannibal and His Army Crossing the Alps*. 1812. Oil on canvas, 4'9" x 7'9" (1.46 x 2.39 m). The Tate Gallery, London

painted during the painful Napoleonic occupation of northern Germany. The large canvas depicts a single monk on a desolate beach looking out over the cold Baltic Sea. The monk is shown from the rear, encouraging us to identify with his lonely quest to be at one with the infinite space of the universe. Friedrich emphasizes the sublime quality of that experience through the tiny scale of the monk in comparison to the expansive natural world that surrounds him, and by the absence of framing elements along the sides of the painting, suggesting an unending extension of beach, sea, and sky. The hopeful but uncertain effect Friedrich created here refers both to the national mood under the occupation and to his own, a result of the recent death of his father.

Friedrich's English contemporary Joseph Mallord William Turner (1775–1851) devoted much of his early work to the Romantic theme of nature as a cataclysmic force that overwhelms human beings and their creations. Turner entered the Royal Academy in 1789, was elected a full academician at the unusually young age of twenty-seven, and later became a professor in the Royal Academy school. During the 1790s, Turner helped revolutionize the British watercolor tradition by rejecting underpainting and topographic accuracy in favor of a freer application of paint and more generalized atmospheric effects. By the late 1790s, Turner was also exhibiting large-scale oil paintings of grand natural scenes and historical subjects.

Turner's *Snowstorm: Hannibal and His Army Crossing the Alps* (fig. 27-19) epitomizes the Romantic mood of sublime awe as an enormous vortex of wind, vapor, and snow threatens to annihilate the soldiers below it and even to obliterate the sun. Barely discernible in the distance is the figure of the brilliant Carthaginian general Hannibal, who, mounted on an elephant, led his troops through the Alps to defeat Roman armies in 218 BCE. Turner probably intended this painting as an allegory of the Napoleonic Wars—Napoleon himself had crossed the

Alps, an event celebrated in Jacques-Louis David's *Napoleon Crossing the Saint-Bernard* (see fig. 27-2). But while David's painting, which Turner saw in Paris in 1802, depicts Napoleon as a powerful figure who seems to command not only his troops but nature itself, Turner reduces Hannibal to a speck on the horizon and shows his troops threatened by a cataclysmic storm, as if foretelling their eventual defeat. In 1814, just two years after the exhibition of Turner's painting, Napoleon suffered a decisive loss to his European opponents and met final defeat at Waterloo in 1815.

The fall of the Napoleonic Empire exemplified a favorite Romantic theme of Turner's, "the course of empire"—the inevitable decline and death that comes to all great national extensions, from Rome to Spain to France, and even to his own Britain. Among Turner's many meditations on Britain's eventual fate is *The Fighting "Téméraire," Tugged to Her Last Berth to Be Broken Up* (fig. 27-20), of 1838. The *Téméraire*, the second-ranking British ship in a great naval victory over the Napoleonic fleet, thirty-three years later is being pulled to the scrap heap by one of the new steam-driven paddle vessels replacing the great sailing ships. The blazing sunset in the rear not only suggests the passing of the great ship but also suggests the decline of British imperial dominion, which depended on its rule of the sea. The broad and painterly treatment of the sky, which Turner laid down largely with a palette knife, hints at the abstraction of his late works of the 1840s, in which land, sea, and sky dissolve into vaporous bursts of color and light.

If Turner's works epitomize the theatrical side of Romantic landscape painting, those of his compatriot John Constable (1776–1837) exemplify the equally Romantic impulse toward naturalism as a form of personal devotion to nature. The son of a successful miller, Constable declared that the landscape of his youth in southern England had made him a painter even before he ever picked up a brush. Although he was trained at the

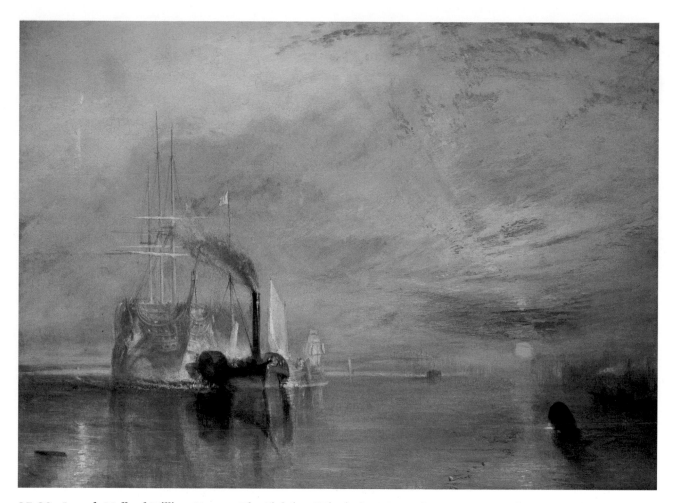

27-20. Joseph Mallord William Turner. *The Fighting "Téméraire," Tugged to Her Last Berth to Be Broken Up*. 1838. Oil on canvas, 35¼ x 48" (89.5 x 121.9 cm). The National Gallery, London

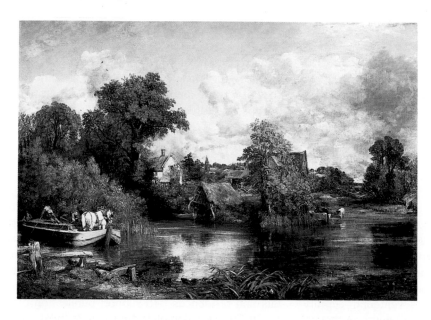

27-21. John Constable. *The White Horse*. 1819. Oil on canvas, 4'3¾" x 6'2⅛" (1.31 x 1.88 m). The Frick Collection, New York

Royal Academy—which considered naturalism an inferior art form—he was most influenced by the British topographic watercolor tradition of the late eighteenth century and by the example of seventeenth-century Dutch landscapists (see fig. 19-62). After moving to London in 1816, he dedicated himself to painting monumental views of the agricultural landscape of his youth.

The White Horse (fig. 27-21), a typical work of Constable's maturity, depicts a fresh early summer day in the Stour River valley after the passing of a storm. Sunlight glistens off the water and foliage, an effect Constable achieved through tiny dabs of white paint. In the lower left, a farmer and his helpers ferry a workhorse across the river. Such elements were never invented by Constable,

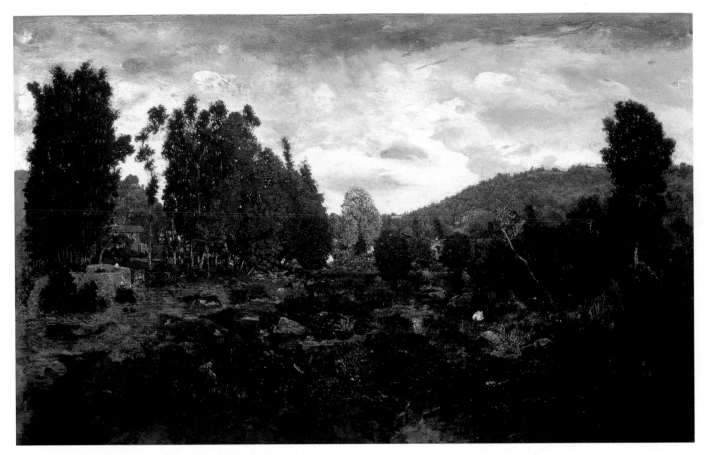

27-22. Théodore Rousseau. *The Valley of Tiffauge (Marais en Vendée)*. 1837–44. Oil on canvas, 25½ x 40½" (64.7 x 103 cm). Cincinnati Art Museum

Gift of Emilie L. Heine in memory of Mr. and Mrs. John Hauck (1940.1202)

Although this picture, with its informal composition and loose paint handling, looks as if it might have been painted directly on the spot, Rousseau in fact composed it in his studio and worked on it over several years. Not until the rise of Impressionism a generation later would artists routinely execute pictures on this scale outdoors, directly before the subject.

who insisted that art should be an objective record of things actually seen and who composed his paintings in the studio from sketches made on the site. Yet Constable made no reference to the region's ongoing economic depression and civil unrest. His idyllic images may have been in part a reaction against the blight attending England's industrialization.

Constable's first critical success came not in England but at the Paris Salon of 1824, where one of his landscapes won a gold medal. His example inspired a group of French landscape painters that emerged in the 1830s and became known as the Barbizon School because a number of them, including Théodore Rousseau (1812–67), lived in the rural town of Barbizon in the forest of Fontainebleau, near Paris. Trained at the academy, Rousseau turned to landscape around 1830, inspired by the works of Constable and the seventeenth-century Dutch landscapes he admired in the Louvre. Although Rousseau's first submission to the Salon in 1831 was accepted, his modest canvases of the French countryside were systematically refused between 1836 and 1841 because they were not idealized, were not peopled with biblical or classical figures, and seemed too sketchy and "unfinished." From 1842 to 1848 he did not submit to the Salon. As a result of his exclusion from the Salon,

Rousseau became known as *le grand refusé* ("the great refused one"). Like most works by Rousseau and his colleagues, *The Valley of Tiffauge* (fig. 27-22) invites the spectator to experience the soothing tranquillity of unspoiled nature.

NATURALISTIC, ROMANTIC, AND NEOCLASSICAL AMERICAN ART

Before the advent of photography, artists played an important role in circulating knowledge about the natural world. One of America's most celebrated scientific naturalists was John James Audubon (1785–1851), whose life's ambition was "to complete a collection of drawings of the Birds of our country, from Nature . . . and to acquire . . . a knowledge of their habitats and residences." To support publication of his *The Birds of America* (completed in 1839), Audubon sold paintings after his drawings. In *Common Grackle* (fig. 27-23), the birds are closely observed and in their natural habitat, and they are rendered in the combination of watercolor and drawing that Audubon favored to capture naturalistic detail. Audubon's concern for accuracy and effective sense of artistic design—the two grackles are opposing diagonals—raised his work above mere illustration.

27-23. John James Audubon. *Common Grackle*, for *The Birds of America*. 1826–39. Watercolor, graphite, and selective glazing, 23⁷/₈ x 18¹/₂" (61.2 x 47.4 cm). Collection of the New-York Historical Society, New York City (1863.17.007)

To create Audubon's *The Birds of America*, his watercolors, like this one of grackles, were copied by the London printmaker Robert Havell using the aquatint process. Broad areas of neutral color were inked on the plates and the rest added by hand on the prints themselves. This bird encyclopedia was Audubon's first successful business venture. The cost to him of the first issue was $100,000, and 2,000 sets were eventually sold at $1,000 each. Between 1840 and 1844, before his health and eyesight began to fail, he supervised the production of *Birds* with reduced-size illustrations.

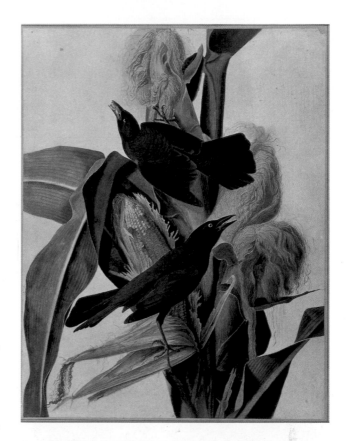

Audubon's counterpart in anthropology was George Catlin (1796–1872). After a brief law career, Catlin established himself as a portraitist in Philadelphia. Inspired by a visiting delegation of Native American chiefs, Catlin moved in 1830 to St. Louis, then a frontier city, and made five extended trips west of the Mississippi to study the life and customs of the Plains peoples. In contrast to some of his contemporaries' unflattering images of Native Americans as bloodthirsty savages, Catlin's portraits, such as *Buffalo Bull's Back Fat, Head Chief, Blood Tribe* (fig. 27-24), present their subjects as proud and dignified. In an encyclopedic style similar to Audubon's, Catlin described in his notes how his subjects' costumes were made and decorated. In 1837, he assembled an exhibition, called the "Indian Gallery," that included 200 scenes of Native American village life and hunting forays, 310 portraits of chiefs, and a collection of Native American art and artifacts. The exhibition toured the eastern United States before moving on to London and Paris. Catlin was unable to convince the U.S. government to purchase his life's work for a national museum, but seven years after his death, it was bought for the Smithsonian Institution.

LANDSCAPE AND GENRE PAINTING

America's foremost Romantic landscape painter in the first half of the nineteenth century was Thomas Cole (1801–48). He emigrated from England to the United States at seventeen and by 1820 was working as an itinerant portrait painter. On trips around New York City Cole sketched and painted the landscape, which quickly became his chief interest, and his paintings launched what became known as the Hudson River School.

With the help of a patron, Cole traveled in Europe between 1829 and 1831. In England he was impressed by Turner's landscapes, and in Italy the classical ruins aroused his interest in a subject that also preoccupied Turner: the course of empire. In the mid-1830s, while painting *The Course of Empire*, an epic account of a landscape from its primeval state through its architectural peak under an ancient empire to its final state of desolation, Cole went on a sketching trip that resulted in *The*

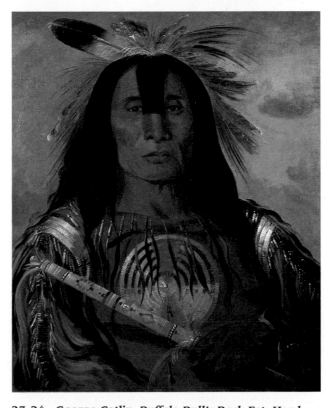

27-24. George Catlin. *Buffalo Bull's Back Fat, Head Chief, Blood Tribe*. 1832. Oil on canvas, 29 x 24" (73.7 x 60.9 cm). National Museum of American Art, Smithsonian Institution, Washington, D.C.

The title is Catlin's translation of this Blackfoot chief's name, which refers to the hump of fat on a male buffalo's back.

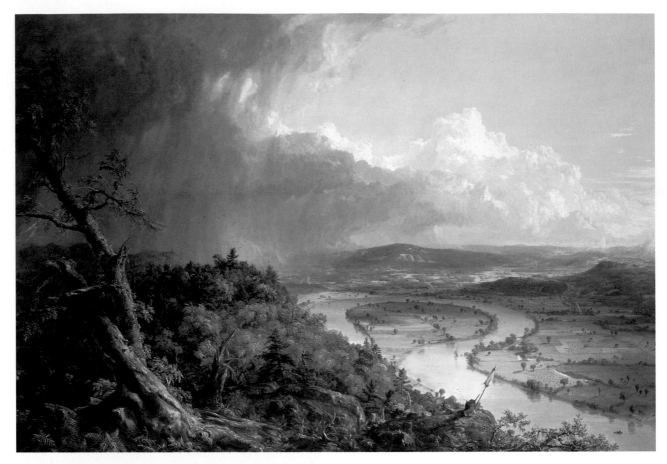

27-25. Thomas Cole. *The Oxbow*. 1836. Oil on canvas, 51½ x 76" (1.31 x 1.94 m). The Metropolitan Museum of Art, New York

Gift of Mrs. Russell Sage, 1908 (08.228)

Oxbow (fig. 27-25), which he painted for exhibition at the National Academy of Design in New York. Cole considered it one of his "view" paintings, which were usually small, although this one is monumental. The scale suits the dramatic view from the top of Mount Holyoke in western Massachusetts across a spectacular oxbow-shaped bend in the Connecticut River. To Cole, such ancient geological formations constituted America's "antiquities." Along a great sweeping arc produced by the departing dark clouds and the edge of the mountain, Cole contrasts the two sides of the American landscape: its dense, stormy wilderness and its congenial, pastoral valleys. The fading storm suggests that the wild will eventually give way to the civilized. Given Cole's current interest in the course of empire, however, he probably saw this development as merely an early phase of a larger, eventually tragic cycle.

Along with images of native scenery such as Cole's, pictures of everyday American life were also popular in the middle decades of the nineteenth century. A leading American genre painter was the Missouri artist George Caleb Bingham (1811–79), who after 1844 began to record scenes of traders and boatmen who traveled the Mississippi River and its tributaries. *Fur Traders Descending the Missouri* (fig. 27-26), originally titled *French Trapper and His Half-Breed Son*, shows two trappers with their pet bear cub in a dugout canoe, gliding peacefully through early-morning stillness.

The neatly dressed trappers gaze out at the viewer with thoughtful expressions—not at all the dirty and uncivilized types portrayed in contemporary literature. Bingham also idealized their environment: The image of the setting—the mirrorlike surface of the water, the misty background, the rosy glow filling the sky—is not only idealized but also nostalgic, for by now the independent French *voyageurs* who had opened the fur trade using canoes had been replaced by trading companies using larger, more efficient craft. Bingham's painting thus both records a vanished way of life and celebrates the early stages of white civilization and commerce on the frontier.

SCULPTURE

After the American Revolution, the demand for monumental sculpture in marble and bronze grew significantly in the United States. At first, patrons looked to European Neoclassicists, such as Canova (see fig. 26-21) and Houdon (see fig. 26-51), but they soon turned to Americans trained abroad in the Neoclassical style. Italy was the wellspring of Neoclassical inspiration in sculpture, as well as the source of the materials and skilled workers needed for large commissions in marble. The first American sculpture students began arriving in Italy around 1825, and by the 1840s they were flocking to the American artists' colonies in Florence and Rome.

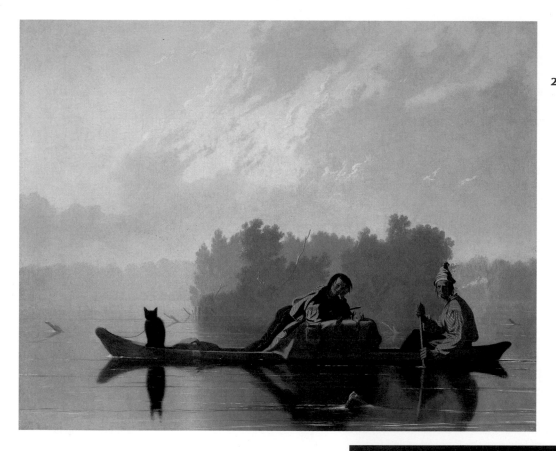

27-26. George Caleb Bingham. *Fur Traders Descending the Missouri*. c. 1845. Oil on canvas, 29 x 36" (73.7 x 91.4 cm). The Metropolitan Museum of Art, New York

Morris K. Jesup Fund, 1933 (33.61)

The most famous American Neoclassicist of his generation was Hiram Powers (1805–73), who called himself the "Yankee stonecutter." Born in Vermont, he grew up in Cincinnati, where as a young man he created lifesize wax figures for a historical museum. After some formal training with a local sculptor Powers went to Europe to study, and he settled permanently in Florence in 1837. Six years later Powers created the sculpture that gained him an international reputation, *The Greek Slave* (fig. 27-27). Inspired by the Greeks' struggle for independence against the Turks and by accounts of atrocities such as Delacroix recorded in his *Massacre at Chios* (see fig. 27-11), the sculpture portrays a beautiful Greek captive put up for sale in a Turkish slave market. According to

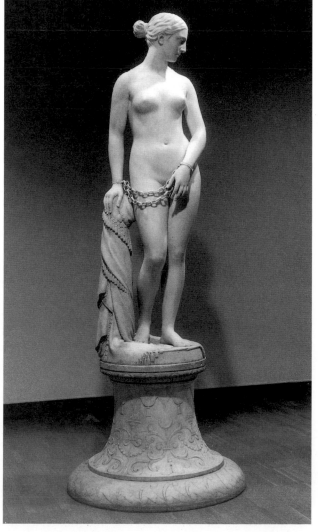

27-27. Hiram Powers. *The Greek Slave*. 1843. Marble, height 5'5½" (1.68 m). Yale University Art Gallery, New Haven, Connecticut

Olive Louise Dann Fund

In time-honored tradition, the creation of a large marble statue was rarely carried through from beginning to end by the artist who conceived it. By delegating the more time-consuming processes of execution to specialists, artists were able to accept and carry out more commissions, including replicas of popular works. *The Greek Slave* exists in seven authentic versions produced in Powers's Florence workshop. This statue put Powers in such demand that he was able to charge the then unheard-of price of $4,000 for each of its six replicas.

Powers's written description, "she stands exposed to the gaze of the people she abhors, and awaits her fate with intense anxiety, tempered indeed by the support of her reliance on the goodness of God." A sculpted locket and cross, evoking the woman's lost loved ones and her Christian faith, hang from the support beneath her right hand. To overcome any objections to *The Greek Slave's* nudity—potentially offensive to his Victorian audience—Powers issued an explanatory pamphlet that declared it was "not her person but her spirit that stands exposed." *The Greek Slave* was privately exhibited in London in 1845 and the following year in New York, where long lines of people paid 25 cents to view it. It gained international fame through its exhibition in the American section of the first World Exposition, held in London's Crystal Palace in 1851 (see fig. 27-38). Orders for full-size copies poured in, and miniatures in plaster, marble, and china decorated many American mantels.

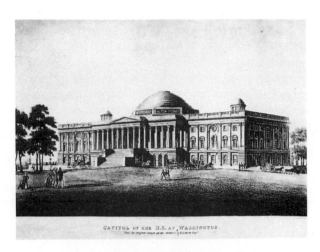

27-28. Benjamin Henry Latrobe. U.S. Capitol, Washington, D.C. c. 1808. Engraving by T. Sutherland, 1825. New York Public Library
I. N. Phelps Stokes Collection

REVIVAL STYLES IN ARCHITECTURE BEFORE 1850

Nineteenth-century architects were trained to work in a variety of historical modes, each of which was thought to have appropriate uses, depending on its historical associations. Neoclassicism, which evoked both Greek democracy and Roman republicanism, became the favored style for government buildings in the United States. In Europe, many different kinds of public institutions, including art museums, were built in the Neoclassical style.

A major Neoclassical edifice in Washington, D.C. was the U.S. Capitol, initially designed in 1792 by William Thornton (1759–1828), an amateur architect. His monumental plan featured a large dome over a temple front flanked by two wings to accommodate the House of Representatives and the Senate. In 1803, President Thomas Jefferson, also an amateur architect (see fig. 26-54), hired a British-trained professional, Benjamin Henry Latrobe (1764–1820), to oversee the actual construction of the Capitol. Latrobe modified Thornton's design by adding a grand staircase and Corinthian colonnade on the east front (fig. 27-28). After the building was gutted by the British in the War of 1812, Latrobe repaired the wings and designed a higher dome. Seeking new symbolic forms for the nation within the traditional classical vocabulary, Latrobe also created for the interior a variation on the Corinthian order by substituting indigenous plants—corn (fig. 27-29) and tobacco—for the Corinthian order's acanthus leaves (see fig. 6, Introduction). Latrobe resigned in 1817, and the reconstruction was completed under Charles Bulfinch (1763–1844). A major renovation begun in 1850 brought the building closer to its present form.

Many European capitals in the early nineteenth century erected museums in the Neoclassical style—which, being derived chiefly from Greek and Roman religious architecture, positioned the new buildings as temples of culture. The most influential of these was the Altes ("Old") Museum in Berlin, designed in 1822 by Karl Friedrich Schinkel (1781–1841) and built between 1824

27-29. U.S. Capitol. Corncob capital sculpted by Giuseppe Franzoni, 1809

27-30. Karl Friedrich Schinkel. Altes Museum, Berlin. 1822–30

27-31. Charles Barry and Augustus Welby Northmore Pugin. Houses of Parliament, London, England. 1836–60.
Royal Commission on the Historical Monuments of England, London

Pugin published two influential books in 1836 and 1841, in which he argued that the Gothic style of Westminster Abbey was the embodiment of true English genius. In his view, the Greek and Roman Classical orders were stone replications of earlier wooden forms and therefore fell short of the true principles of stone construction.

and 1830 (fig. 27-30). Commissioned to display the royal art collection, the Altes Museum was built on an island in the Spree River in the heart of the capital, directly across from the Baroque royal palace. The museum's imposing facade consists of a screen of eighteen Ionic columns, raised on a platform with a central staircase. Attentive to the problem of lighting art works on both the ground and the upper floors, Schinkel created interior courtyards on either side of a central rotunda, tall windows on the museum's outer walls to provide natural illumination, and partition walls perpendicular to the windows to eliminate glare on the varnished surfaces of the paintings on display.

Schinkel also created numerous Gothic architectural designs, which many Germans considered an expression of national genius. Meanwhile, the British claimed the Gothic as part of *their* patrimony and erected a plethora of Gothic revival buildings in the nineteenth century, the most famous being the Houses of Parliament (fig. 27-31). After Parliament's Westminster Palace burned in 1834,

27-32. Richard Upjohn. Trinity Church, New York City, 1839–46

the government opened a competition for a new building designed in the English Perpendicular Gothic style, to be consistent with the neighboring Westminster Abbey, the thirteenth-century church where English monarchs are crowned.

Charles Barry (1795–1860) and Augustus Welby Northmore Pugin (1812–52) won the commission. Barry was responsible for the basic plan, whose symmetry suggests the balance of powers of the British system; Pugin provided the intricate Gothic decoration laid over Barry's essentially classical plan. The leading advocate of Gothic architecture in his era, Pugin in 1836 published *Contrasts*, which unfavorably compared the troubled modern era of materialism and mechanization with the Middle Ages, which he represented as an idyllic epoch of deep spirituality and satisfying handcraft. For Pugin, Gothic was not a style but a principle, like classicism. The Gothic, he insisted, embodied two "great rules" of architecture: "first that there should be no features about a building which are not necessary for convenience, construction or propriety; second, that all ornament should consist of enrichment of the essential structure of the building."

In nineteenth-century Europe and the United States, many architects used the Gothic style because of its religious associations, especially for the Roman Catholic Church, the Anglican Church of England, and the Episcopalian churches of Scotland and the United States. The British-born American architect Richard Upjohn (1802–78) designed many of the most important Gothic revival churches in the United States, including Trinity Church in New York (fig. 27-32). With its tall spire, long nave, and squared-off **chancel**, Trinity quotes the early-fourteenth-century British Gothic style particularly dear to Anglicans and Episcopalians. Every detail is historically accurate, although the vaults are of plaster, not masonry.

The stained-glass windows above the altar were among the earliest in the United States.

EARLY PHOTOGRAPHY IN EUROPE

A prime expression of the new, positivist interest in descriptive accuracy spurred by Comte's philosophy was the development of photography. Photography as we know it emerged around 1840, but since the late Renaissance, artists and others had been seeking a mechanical method for exactly recording or rendering a scene. One early device was the **camera obscura** (Latin for "dark chamber"), which consists of a darkened room or box with a lens through which light passes, projecting onto the opposite wall or box side an upside-down image of the scene, which an artist can trace. By the seventeenth century a small, portable camera obscura, or camera, had become standard equipment for many landscape painters. Photography developed essentially as a way to fix—that is, to make permanent—the images produced by a camera obscura on light-sensitive material.

The first to make a permanent picture by the action of light was Joseph-Nicéphore Niépce (1765–1833), who, seeking a less cumbersome substitute for lithography (see "Lithography," page 989), successfully copied translucent engravings by attaching them to pewter plates covered with bitumen, a light-sensitive asphalt used by etchers. Niépce then tried this substance in the camera. Using metal and glass plates covered with bitumen, he succeeded around 1826 in making the first positive-image photographs of views from a window of his estate at Gras, France.

In 1829, Niépce formed a partnership with Louis-Jacques-Mandé Daguerre (1787–1851), a Parisian painter

27-33. Louis-Jacques-Mandé Daguerre. *The Artist's Studio*. 1837. Daguerreotype, 6½ x 8½" (17 x 22 cm). Société Française de Photographie, Paris

27-34. William Henry Fox Talbot. *The Open Door*. 1843. Salt-paper print from a calotype negative. Science Museum, London
Fox Talbot Collection

who, working with a lens maker, had developed an improved camera. After Niépce's death in 1833, Daguerre continued their research using copper plates coated with iodized silver, long known to be light-sensitive. In 1835 he was amazed to find an image on a copper plate he had left in a cupboard. He determined that the vapor of a few drops of spilled mercury from a broken thermometer had produced the effect. Thus Daguerre discovered that an exposure to light of only twenty to thirty minutes would produce a latent image on one of his silvered plates treated with iodine fumes, which could then be made visible through development with mercury vapor. By 1837 he had established a method of fixing the image by bathing the plate in a strong solution of common salt after exposure. The inventor's first such picture, a **daguerreotype**, was a still life of plaster casts, a wicker-covered bottle, a framed drawing, and a curtain (fig. 27-33). This arrangement, reminiscent of a still-life painting convention since at least the seventeenth century, indicates Daguerre's intention to emulate not only an optical reality but also an artistic tradition.

The 1839 announcement of Daguerre's invention prompted English scientist William Henry Fox Talbot (1800–77) to publish the results of his own work on what he later named the **calotype** (from the Greek term for "beautiful image"). Talbot's process, even more than Daguerre's, became the basis of modern photography because, unlike Daguerre's, which produces a single, positive image, Talbot's calotype is a negative image from which an unlimited number of positives can be printed. In *The Pencil of Nature* (issued in six parts, 1844–46), the first books to be illustrated with photographs, Talbot described the evolution of his process from his first experiments in the mid-1830s using paper impregnated with silver chloride. At first, he copied engravings, pieces of lace, and leaves in negative by laying them on chemically treated paper and exposing them to light. By the summer of 1835 he was using this paper in both large and small cameras. Then, in 1840, he discovered, independently of Daguerre, that latent images resulting from exposure to

the sun for short periods of time could be developed chemically. Applying the technique he had earlier used with engravings and leaves, he was able to make positive prints from the paper negatives.

One of the calotypes hand-pasted into *The Pencil of Nature* was *The Open Door* (fig. 27-34). The subject, like many by Talbot, is rural, a nostalgic evocation of an agrarian way of life that was fast disappearing. In the doorway of an old, time-worn cottage Talbot has placed a sturdy broom, whose handle is carefully positioned to parallel the shadows on the door. This is the kind of traditional, hand-crafted broom that mass production was beginning to make obsolete, but the use of photography itself also suggests that something made by mechanical means could have a genuine value, comparable to that of the hand-made. Talbot's "soliloquy of the broom," as his mother called it, gives evidence of his conviction that photography might offer a creative artistic outlet for those, like himself, without the manual talent to draw or paint.

The final step in the development of early photography was taken in 1851 by Frederick Scott Archer (1813–57), a British sculptor and photographer, who was one of many in western Europe trying to find a way to make silver nitrate adhere to glass. The result would be a glass negative, which would be reproducible, like Talbot's, and have the clarity of the daguerreotype. Archer's solution was collodion, a combination of guncotton, ether, and alcohol used in medicinal bandages. He found that a mixture of collodion and silver nitrate, when wet, needed only a few seconds' exposure to light to create an image. Although the wet-collodion process was more cumbersome than earlier techniques, it quickly replaced them because of its greater speed and the sharper tonal subtleties it produced. Moreover, it was universally available because Archer, unlike Daguerre and Talbot, generously refused to patent his invention. Thus the era of modern photography was launched (see "How Photography Works," page 1004). Once a practical photographic process had been invented, the question became how to use it. The real issue was whether photography, taken

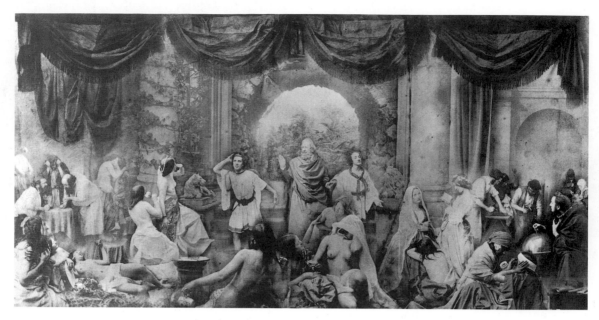

27-35. Oscar Rejlander. *The Two Paths of Life*. 1857. Combination albumen print, 16 x 31" (41 x 79.5 cm).
George Eastman House, Rochester, New York

on its own terms, could be considered a new art form.

Among the first photographers to argue for its artistic legitimacy was Oscar Rejlander (1813–75) of Sweden, who had studied painting in Rome, then settled in England. He first took up photography in the early 1850s as an aid for painting but was soon attempting to create photographic equivalents of the painted and engraved moral allegories so popular in Britain since the time of Hogarth (see fig. 26-32). In 1857 he produced his most famous work, *The Two Paths of Life* (fig. 27-35), by combining thirty negatives. This allegory of Good and Evil, work and idleness, was loosely based on Raphael's *School of Athens* (see fig. 18-7). At the center, an old sage ushers two young men into life. The serene youth on the right turns toward personifications of Religion, Charity, Industry, and other virtues, while his counterpart eagerly responds to the enticements of pleasure. The figures

on the left Rejlander described as personifications of "Gambling, Wine, Licentiousness and other Vices, ending in Suicide, Insanity, and Death." In the lower center, with a drapery over her head, is the hopeful figure of "Repentance." Although Queen Victoria purchased a copy of *The Two Paths of Life* for her husband, it was not generally well received as art. One typical response was that "mechanical contrivances" could not produce works of "high art," a criticism that would continue to be raised against photography.

Another pioneer of photography as art was Julia Margaret Cameron (1815–79), who received her first camera as a gift from her daughters when she was forty-nine. Cameron's principal subjects were the great men of British arts, letters, and sciences, many of whom had long been family friends. Cameron's work was more personal and less dependent on existing forms than

TECHNIQUE

HOW PHOTOGRAPHY WORKS

A camera is essentially a lightproof box with a hole, called an aperture, which is usually adjustable in size and regulates the amount of light that strikes the film. The aperture is covered with a lens, which focuses the image on the film, and a shutter, a kind of door that opens for a controlled amount of time, to regulate the length of time that the film is exposed to light—usually a small fraction of a second. Modern cameras also have a viewer that permits the photographer to see virtually the same image that the film will "see."

Photography is based on the principle that certain substances are sensitive to light and react to light by changing **value**. In early photography, a glass plate was coated with a variety of emulsions; in modern black-and-white photography, film is coated with an emulsion of silver halide crystals (silver combined with iodine, chlorine, or other halogens) suspended in a gelatin base. (Color photography uses a different light-sensitive emulsion.)

The film is then exposed. Light reflected off objects enters the camera and strikes the film. Pale objects reflect more light than do dark ones. The silver in the emulsion collects most densely where it is exposed to the most light, producing a "negative" image on the film. Later, when the film is placed in a chemical bath (developed), the silver deposits turn black, as if tarnishing. The more light the film receives, the denser the black tone created. A positive image is created from the negative in a darkroom; then the film negative is placed over a sheet of paper that, like the film, has been treated to be light-sensitive, and light is directed through the negative onto the paper. Thus, a multiple number of positive prints can be made from a single negative.

27-36. Julia Margaret Cameron. *Portrait of Thomas Carlyle*. 1863. Silver print, 10 x 8" (25.4 x 20.3 cm). The Royal Photographic Society, London

27-37. Nadar (Gaspard-Félix Tournachon). *Portrait of Charles Baudelaire*. 1863. Silver print. Caisse Nationale des Monuments Historiques et des Sites, Paris

The year this photograph was taken, Baudelaire published "The Painter of Modern Life," a newspaper article in which he called on artists to provide an accurate and insightful portrait of the times. The idea may have come from Nadar, who had been trying to do just that for some time. Although Baudelaire never wrote about the photographic work of his friend Nadar, he was highly critical of the vogue for photography and of its influence on the visual arts. In his Salon review of 1859 he said: "The exclusive taste for the True . . . oppresses and stifles the taste of the Beautiful. . . . In matters of painting and sculpture, the present-day *Credo* of the sophisticated is this: 'I believe in Nature . . . I believe that Art is, and cannot be other than, the exact reproduction of Nature. . . .' A vengeful God has given ear to the prayers of this multitude. Daguerre is his Messiah."

Rejlander's. Like all of Cameron's portraits, that of the famous British historian Thomas Carlyle is deliberately slightly out of focus (fig. 27-36). Cameron was consciously rejecting the sharp stylistic precision of popular portrait photography, which she felt accentuated the merely physical attributes and neglected a subject's inner character. By blurring the details she sought to call attention to the light that suffused her subjects—a metaphor for creative genius—and to their thoughtful, often inspired expressions. In her autobiography Cameron said: "When I have had such men before my camera my whole soul has endeavored to do its duty towards them in recording faithfully the greatness of the inner as well as the features of the outer man."

The Frenchman Gaspard-Félix Tournachon, known as Nadar (1820–1910) applied photography to an even more ambitious goal, initially adopting the medium in 1849 as an aid in realizing the "Panthéon-Nadar," a series of four lithographs intended to include the faces of all the well-known Parisians of the day. Nadar quickly saw both the documentary and the commercial potential of the photograph and in 1853 opened a portrait studio that became a meeting place for many of the great intellectuals and artists of the period. The first exhibition of Impressionist art was held there in 1874 (see page 1019).

A realist in the tradition inaugurated by Daguerre, Nadar embraced photography because of its ability to

capture people and their surroundings exactly: He took the first aerial photographs of Paris (from a hot-air balloon equipped with a darkroom), photographed the city's catacombs and sewers, produced a series on typical Parisians, and attempted to record all the leading figures of French culture. As can be seen in his portrait of the poet Charles Baudelaire (fig. 27-37), Nadar avoided props and formal poses in favor of informal ones determined by the sitters themselves. His goal was not so much an interpretation as a factual record of a sitter's characteristic appearance and demeanor.

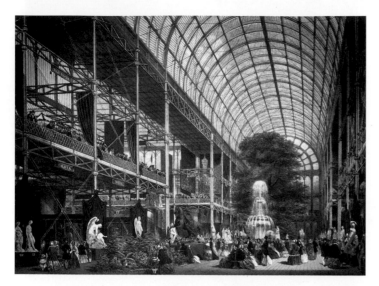

27-38. Joseph Paxton. Crystal Palace, London. 1850–51. Iron, glass, and wood.

After a competition that drew 245 entries failed to produce a design for a temporary edifice that could be completed in time for the London Great Exhibition, the commissioners approached Joseph Paxton, a professional gardener who had recently designed a number of impressive greenhouses, and asked him to submit a proposal. Paxton presented them with a design, scale drawings, and cost sheets for an exhibition hall that was, in effect, a greatly enlarged greenhouse. The commissioners, relieved but unenthusiastic, accepted his plan, and the structure was completed in the extraordinarily brief span of just over six months. After the exhibition, the Crystal Palace was dismantled and reconstructed in an enlarged form at Sydenham, where it remained until destroyed by a fire in 1936.

NEW MATERIALS AND TECHNOLOGY IN ARCHITECTURE AT MIDCENTURY

The positivist faith in technological progress as the key to human progress spawned world's fairs that celebrated advances in industry and technology. The first of these fairs, the London Great Exhibition of 1851, introduced new building techniques that ultimately contributed to the temporary abandonment in the twentieth century of **historicism**—the use of historically based styles—in architecture.

The revolutionary construction of the Crystal Palace (fig. 27-38), created for the London Great Exhibition by Joseph Paxton (1801–65), featured a structural skeleton of cast iron that held iron-framed glass panes measuring 49 by 30 inches, the largest size that could then be mass-produced. Prefabricated wooden ribs and bars supported the panes. The triple-tiered edifice was the largest space ever enclosed up to that time—1,851 feet long, covering more than 18 acres, and providing for almost a million square feet of exhibition space. The central vaulted transept—based on the new railway stations and, like them, meant to echo imperial Roman architecture—rose 108 feet to accommodate a row of elms dear to Prince Albert, the husband of Queen Victoria. Although everyone agreed that the Crystal Palace was a technological

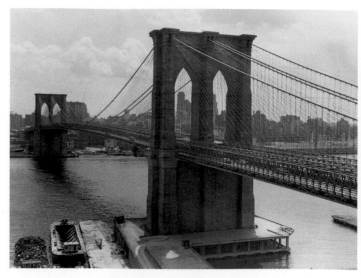

27-39. John Augustus Roebling and Washington Augustus Roebling. Brooklyn Bridge, New York City. 1867–83

marvel, most architects and critics considered it a work of engineering rather than legitimate architecture. Some observers, however, were more forward-looking. One visitor called it a revolution in architecture from which a new style would date.

Bridge designers had pioneered the use of cast iron, wrought iron, and then steel, as a building material; the first cast-iron bridge had been erected in England in 1779 (see "Iron as a Building Material," page 962). The most famous early steel bridge, the Brooklyn Bridge (fig. 27-39), was designed by John Augustus Roebling (1806–69), a German-born civil engineer who had invented twisted-wire cable, a great structural advance over the wrought-iron chains then used for suspension bridges. In 1867, Roebling was appointed chief engineer for the long-proposed Brooklyn–Manhattan bridge, whose main span would be the longest in the world at that time. He died two years later, and his engineer son Washington Augustus Roebling (1837–1926) completed the project.

The bridge roadbed, nearly 6,000 feet long, hangs beneath a web of stabilizing and supporting steel-wire cables (the heaviest of which is 16 inches in diameter) suspended from two massive masonry towers that rise 276 feet above the water. The roadbed and cables are purely functional, with no decorative adornment, but the granite towers feature projecting cornices over pointed-arch openings. These historicist elements allude both to Gothic cathedrals and to Roman triumphal arches. Rather than religion or military victories, however, Roebling's arches celebrate the triumphs of modern engineers.

A less reverent attitude toward technological progress can be seen in the first attempt to incorporate structural iron into architecture proper: the Bibliothèque Sainte-Geneviève (fig. 27-40), a library in Paris designed by Henri Labrouste (1801–75). Conventionally trained at the École des Beaux-Arts and employed as one of its professors, Labrouste was something of a radical in his desire to reconcile the École's conservative design principles with the technological innovations of industrial

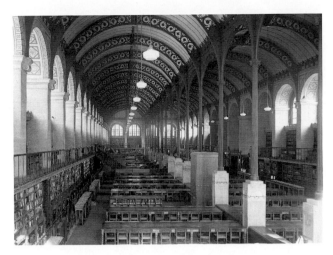

27-40. Henri Labrouste. Reading Room, Bibliothèque Sainte-Geneviève, Paris. 1843–50

architectural techniques. The exterior of the library features the most ancient of permanent building materials, cut stone, which was considered the only "noble" construction material—that is, suitable for a serious building. The columns in the entrance hall are solid masonry with cast-iron decorative elements. In the main reading room, however, cast iron plays a structural role. Slender iron columns—cast to resemble the most ornamental Roman order, the Corinthian—support two parallel **barrel vaults**. The columns stand on tall concrete pedestals, a reminder that modern construction technology rests on the accomplishments of the Romans, who refined the use of concrete. The design of the delicate floral cast-iron **ribs** in the vaults is borrowed from the Renaissance architectural vocabulary.

engineers. Although reluctant to promote this goal in his teaching, he clearly pursued it in his practice.

Because of the Bibliothèque Sainte-Geneviève's educational function, Labrouste wanted the building to suggest the course of both learning and technology. The window arches on the exterior have panels with the names of 810 important contributors to Western thought from its religious origins to the positivist present, arranged chronologically from Moses to the Swedish chemist Jons Jakob Berzelius. The exterior's stripped-down Renaissance style reflects the belief that the modern era of learning dates from that period. The move from outside to inside subtly outlines the general evolution of

FRENCH ACADEMIC ART AND ARCHITECTURE

The Académie des Beaux-Arts and its official art school, the École des Beaux-Arts, exerted a powerful influence over the visual arts in France throughout the nineteenth century (see "Academies and Academy Exhibitions," page 944). Academic artists controlled the Salon juries, and major public commissions routinely went to academic architects, painters, and sculptors.

Unlike Labrouste in the Bibliothèque Sainte-Geneviève, most later-nineteenth-century architects trained at the École des Beaux-Arts worked in historicist styles, typically using iron only as an internal support for conventional materials, as in the case of the Opéra, the Paris opera house (fig. 27-41) designed by Charles Garnier (1825–98). The Opéra was to be a focal point of a

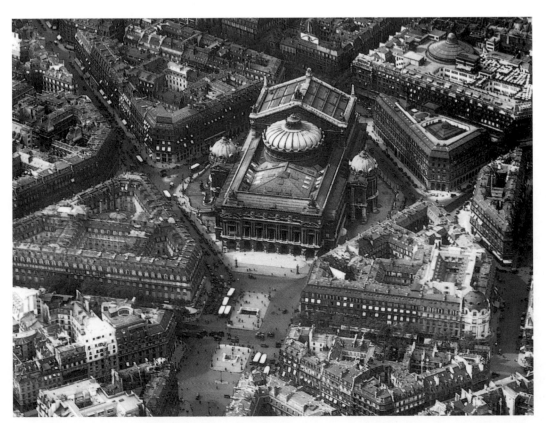

27-41. Charles Garnier. The Opéra, Paris. 1861–74.

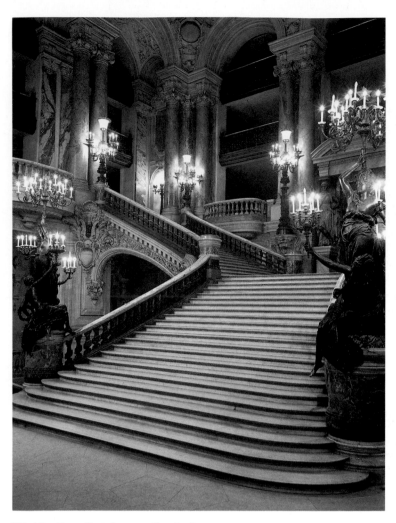

27-42. Grand staircase, the Opéra

The bronze figures holding the lights on the staircase are by Marcello, the pseudonym used by Adèle d'Affry (1836–79), the duchess Castiglione Colonna, as a precaution against the male chauvinism of the contemporary art world.

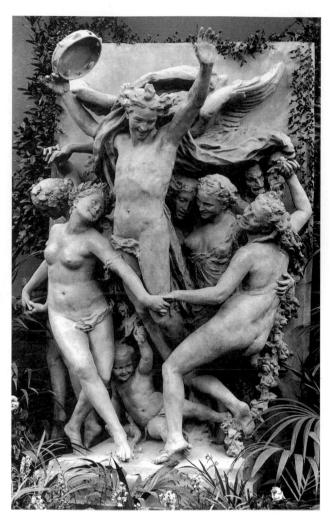

27-43. Jean-Baptiste Carpeaux. *The Dance*. 1867–68. Plaster, height approx. 23'3½" (7.1 m). Musée de l'Opéra, Paris

controversial urban redevelopment plan begun under Napoleon III by Georges-Eugène Haussmann (1809–91) in the 1850s. Garnier's design was selected in a competition despite Empress Eugénie's objection that it resembled no recognizable style. To her charge that it was "neither Louis XIV, nor Louis XV, nor Louis XVI," Garnier retorted, "It is Napoleon III." The massive facade, featuring a row of paired columns above an **arcade**, is essentially a heavily ornamented, Baroque version of the seventeenth-century wing of the Louvre, an association meant to suggest the continuity of French greatness and to flatter Emperor Napoleon III by comparing him favorably with King Louis XIV. The luxuriant treatment of form, in conjunction with the building's primary function as a place of entertainment, was intended to celebrate the devotion to wealth and pleasure that characterized the period. The ornate architectural style was also appropriate for the home of that most flamboyant musical form, the opera.

The inside of what some critics called the "temple of pleasure" (fig. 27-42) was even more opulent, with neo-Baroque sculptural groupings, heavy, gilded decoration, and a lavish mix of expensive, polychromed materials.

The highlight of the interior was not the spectacle onstage so much as the one on the great, sweeping Baroque staircase, where various members of the Paris elite—from old nobility to newly wealthy industrialists—could display themselves, the men in tailcoats accompanying women in bustles and long trains. As Garnier himself said, the purpose of the Opéra was to fulfill the most basic of human desires: to hear, to see, and to be seen.

Jean-Baptiste Carpeaux (1827–75), who had studied at the École des Beaux-Arts under the Romantic sculptor François Rude (see fig. 27-13), was commissioned to carve one of the large sculptural groups for the facade of Garnier's Opéra. In this work, *The Dance* (fig. 27-43), a winged personification of Dance, a slender male carrying a tambourine, leaps up joyfully in the midst of a compact, entwined group of mostly nude female dancers, embodying the theme of uninhibited Dionysian revelry. The erotic implication of this wild dance is revealed by the presence in the background of a satyr, a mythological creature known for its lascivious appetite.

Carpeaux's group upset many Parisians because he had not smoothed and generalized the bodies as

Neoclassical sculptors such as Canova had done (see fig. 26-21). Although the figures are idealized, their detailed musculature and bone structure (observe the knees and elbows, for example) make them appear not to be creatures of a higher, better world but to belong, instead, to the "real" world. Carpeaux's handling of the body and its parts has therefore been labeled realistic.

Carpeaux's unwillingness to idealize physical details was symptomatic of a major shift in French academic art in the second half of the nineteenth century. Although the influence of photography on the taste of the period has sometimes been cited as the probable cause of this change, both photography and the new exactitude in academic art were simply manifestations of the increasingly positivist values of the era. These values were particularly evident among the bankers and businesspeople who came to dominate French society and politics in the years after 1830. As patrons, these practical leaders of commerce were generally less interested in art that idealized than in art that brought the ideal down to earth.

The effect of this new taste on academic art is nowhere more evident than in the work of Adolphe-William Bouguereau (1825–1905), who became one of the richest and most powerful painters in France in the late nineteenth century by giving the public not only the subjects it wanted but also the factual detail it loved. In *Nymphs and a Satyr* (fig. 27-44), for example, four young and voluptuous wood nymphs attempt to drag a reluctant satyr into the water. The satyr's slight smile and the lack of real struggle suggest that this is good-natured teasing. The painting's power depends less on the subject than on the way Bouguereau was able to make it seem palpable and "real" through a highly detailed depiction of physical forms and textures. In order to produce a persuasive satyr Bouguereau made careful anatomical studies of horses' ears and of the hindquarters of goats. Furthermore, Bouguereau makes the scene not only real but accessible. The figure on the right appears to lead both the satyr and the viewer into the scene—the world of the viewer and that of the painting seem continuous, so we are invited to join in the romp.

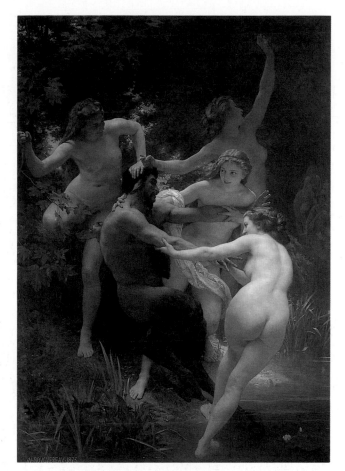

27-44. Adolphe-William Bouguereau. *Nymphs and a Satyr*. 1873. Oil on canvas, 9'3⅜" x 5'10⅞" (2.8 x 1.8 m). Sterling and Francine Clark Art Institute, Williamstown, Massachusetts

FRENCH NATURALISM

The kind of work produced in the 1830s and 1840s by the Barbizon School (see fig. 27-22) became increasingly popular with Parisian critics and collectors after 1850, largely because of the radically changed conditions of Parisian life. Between 1831 and 1851 the city's population doubled, then the massive renovations of the entire city led by Haussmann transformed Paris from a collection of small neighborhoods to a modern, crowded, noisy, and fast-paced metropolis. Another factor in the appeal of images of peaceful country life was the widespread uneasiness over the political and social effects of the Revolution of 1848, when workers overthrew the monarchy, and fear of further disruptions.

Soothing images of the rural landscape became a specialty of Jean-Baptiste-Camille Corot (1796–1875), who during the early decades of his career had painted not only historical landscapes with subjects drawn from the Bible and classical history, but also ordinary country scenes similar to those depicted by the Barbizon School. Ironically, just as popular taste was beginning to favor the latter kind of work, Corot around 1850 moved on to a new kind of landscape painting that mixed naturalistic subject matter with Romantic, poetic effects. A fine

FRENCH NATURALISM AND REALISM AND THEIR SPREAD

Although the European national academies continued to control both the teaching and the display of art in the second half of the nineteenth century, increasing numbers of artists rejected their precepts in favor of the naturalist credo that art should faithfully record ordinary life. What had been considered a marginal element in landscape painting of the second quarter of the century gradually came to dominate the work of independent-minded landscape and figure painters after 1850. Much of their art was labeled **realism**, a term invented to describe a kind of naturalism with a socialist political message. By 1860 the term *realism* had lost its political meaning and had become for most artists and critics simply a synonym for *naturalism*.

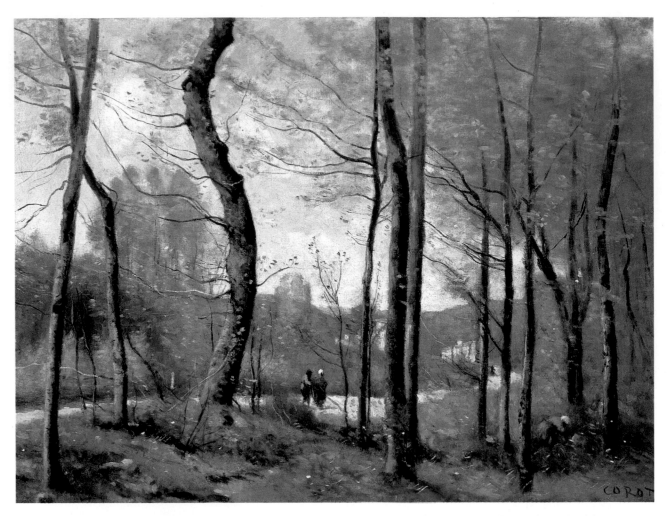

27-45. Jean-Baptiste-Camille Corot. *First Leaves, Near Mantes*. c. 1855. Oil on canvas, 13³⁄₈ x 18¹⁄₈" (34 x 46 cm).
The Carnegie Museum of Art, Pittsburgh
Acquired through the generosity of the Sarah Mellon Scaife Family (66.19.3)

example is *First Leaves, Near Mantes* (fig. 27-45), an idyllic image of budding green foliage in a warm, misty wood. The feathery brushwork in the grasses and leaves infuses the painting with a soft, dreamy atmosphere that is counterbalanced by the solidly modeled tree trunks in the foreground, which create a firm sense of structure. Beyond the trees, a dirt road meanders toward the village in the background. Two rustic figures travel along the road at the lower center, while another figure labors in the woods at the lower right. Corot invites us to identify with these figures and to share imaginatively in their simple and unhurried rural existence.

Among the period's most popular painters of farm life was Rosa Bonheur (1822–99), whose commitment to rural subjects was partly the result of her aversion to Paris, where she had been raised. Bonheur's success in what was then a male domain owed much to the socialist convictions of her parents, who belonged to a radical utopian sect founded by the Comte de Saint-Simon (1760–1825), which believed not only in the equality of women but also in a female Messiah. Bonheur's father, a drawing teacher, provided most of her artistic training.

Bonheur devoted herself to painting her beloved farm animals with complete accuracy, increasing her knowledge by reading zoology books and making detailed studies in stockyards and slaughterhouses. (To gain access to these all-male preserves, Bonheur got police permission to dress in men's clothing.) Her professional breakthrough came at the Salon of 1848, where she showed eight paintings and won a first-class medal. Shortly after, she received a government commission to paint *Plowing in the Nivernais: The Dressing of the Vines* (fig. 27-46), a monumental composition featuring one of her favorite animals, the ox. The powerful beasts, anonymous workers, and fertile soil offer a reassuring image of the continuity of agrarian life. The stately movement of people and animals reflects the kind of carefully balanced compositional schemes taught in the academy and echoes scenes of processions found in classical art. The painting's compositional harmony—the shape of the hill is answered by and continued in the general profile of the oxen and their handler on the right—as well as its smooth illusionism and conservative theme were very appealing to the taste of the times. Bonheur became so famous that in 1865 she received France's highest award, membership in the Legion of Honor, becoming the first woman to be awarded its Grand Cross.

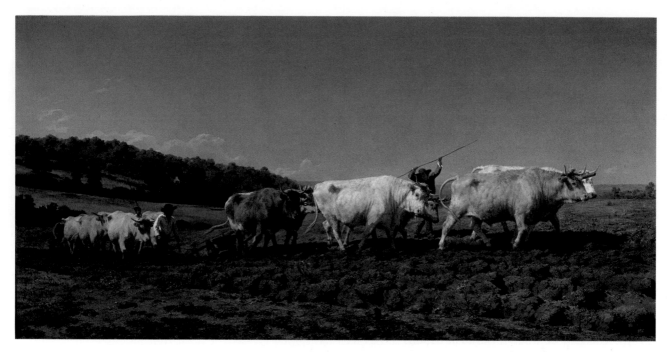

27-46. Rosa Bonheur. *Plowing in the Nivernais: The Dressing of the Vines*. 1849. Oil on canvas, 5'9" x 8'8" (1.8 x 2.6 m). Musée d'Orsay, Paris

Bonheur was often compared with Georges Sand, a contemporary woman writer who adopted a male name as well as male dress. Sand devoted several of her novels to the humble life of farmers and peasants. Critics at the time noted that *Plowing in the Nivernais* may have been inspired by a passage in Sand's *The Devil's Pond* (1846) that begins: "But what caught my attention was a truly beautiful sight, a noble subject for a painter. At the far end of the flat plough-land, a handsome young man was driving a magnificent team [of] oxen."

The most renowned of the French rural naturalists, Jean-François Millet (1814–75), grew up on a farm and, despite living in Paris between 1837 and 1848, never felt comfortable in the city. The Revolution's preoccupation with ordinary people led Millet to focus on peasant life, only a marginal concern in his early work, and his support of the Revolution earned him a state commission that allowed him to move from Paris to the village of Barbizon. After settling there in 1849, he devoted his art almost exclusively to the difficulties and simple pleasures of rural existence.

Among the best known of Millet's mature works is *The Gleaners* (fig. 27-47), which shows three women gathering grain at harvesttime. The warm colors and slightly hazy atmosphere are soothing, but the scene is one of extreme poverty. Gleaning, or the gathering of the grains left over after the harvest, was a form of relief offered to the rural poor. It required hours of back-breaking work to gather enough wheat to produce a single loaf of bread. When the painting was shown in 1857, a number of critics thought Millet was attempting to rekindle the sympathies and passions of 1848, and he was therefore labeled a realist. Yet Millet's intentions were actually quite conservative. An avid reader of the Bible, he saw in such scenes the fate of humanity, condemned since the Expulsion of Adam and Eve from the Garden of Eden to earn its bread by the sweat of its brow. Millet was neither a revolutionary nor a reformer but a fatalist who found the peasant's heroic acceptance of the human condition exemplary.

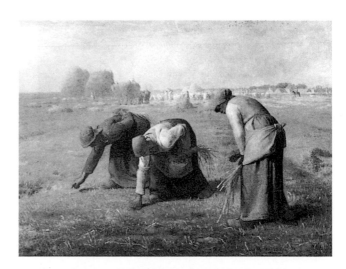

27-47. Jean-François Millet. *The Gleaners*. 1857. Oil on canvas, 33 x 44" (83.8 x 111.8 cm). Musée d'Orsay, Paris

FRENCH REALISM

Gustave Courbet (1819–77), like Millet, was inspired by the events of 1848 to turn his attention to poor and ordinary people. Born and raised in Ornans near the Swiss border and largely self-taught as an artist, he moved to Paris in 1839. The street fighting of 1848 seems to have radicalized him. He told one newspaper in 1851 that he was "not only a Socialist but a democrat and a Republican: in a word, a supporter of the whole Revolution." Courbet proclaimed his new political commitment in

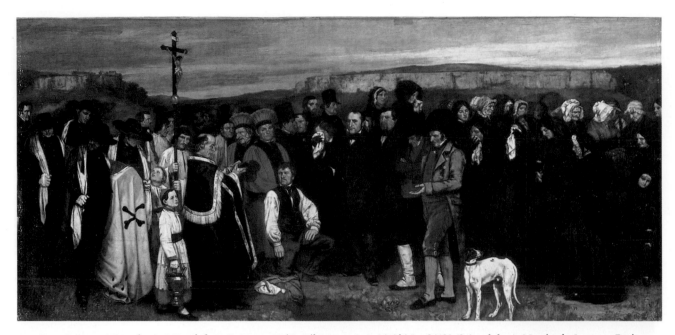

27-48. Gustave Courbet. *A Burial at Ornans*. 1849. Oil on canvas, 10'3¹/₂" x 21'9" (3.1 x 6.6 m). Musée du Louvre, Paris

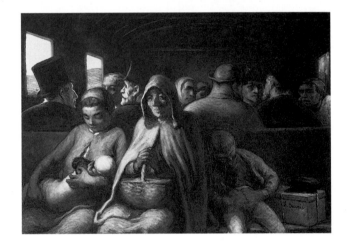

27-49. Honoré Daumier. *The Third-Class Carriage*.
c. 1862. Oil on canvas, 25³/₄ x 35¹/₂" (65.4 x 90.2 cm). The National Gallery of Canada, Ottawa

Although he devoted himself seriously to oil painting during the later decades of his life, Daumier was known to the Parisian public primarily as a lithographer whose cartoons and caricatures appeared regularly in the press. Early in his career he drew antimonarchist caricatures critical of King Louis-Philippe, but censorship laws imposed in 1835 obliged him to focus on social and cultural themes of a nonpolitical nature.

three large paintings he submitted to the Salon of 1850–51.

One of these, *A Burial at Ornans* (fig. 27-48), is a huge 10-by-21-foot canvas inspired by the funeral of Courbet's maternal grandfather, Jean-Antoine Oudot, who had died in 1848. Conservative critics hated the work for its focus on common people and for its disrespect for compositional standards: Instead of arranging figures in a pyramid that would indicate a hierarchy of importance, Courbet lined them up in rows across the picture plane—an arrangement he considered more democratic. His political convictions are especially evident in the individual attention and sympathetic treatment he accords the ordinary citizens of Ornans. Courbet's respect and affinity for "the people" is also expressed in the scale of the work— ordinarily reserved for major historical events—and in the way the mourners' genuine sorrow is contrasted with the apparent indifference of the two church officials dressed in red behind the officiating priest.

On a thematic level, the painting may record the fate of the Revolution of 1848. The July elections that year returned to power a conservative government, which undid the progressive legislation enacted by the revolutionaries. Courbet's grandfather had been involved in the French Revolution of 1789, and the two men to the right of the open grave—dressed not in contemporary but in late-eighteenth-century clothing—are also revolutionaries of Oudot's generation. The gesture of futility offered by the foremost of the pair suggests that they are burying not simply one of their colleagues but their political hopes as well.

Partly for convenience, Bonheur, Millet, Courbet, and the other country-life naturalists and realists who emerged in the 1850s are sometimes referred to as the generation of 1848. Because of his sympathy with working-class people, Honoré Daumier (1808–79) is also grouped with this generation. Unlike Courbet and the others, however, Daumier often depicted urban scenes, as in *The Third-Class Carriage* (fig. 27-49). The painting depicts the interior of one of the large, horse-drawn buses that transported Parisians along one of the new boulevards Haussmann had introduced as part of the city's

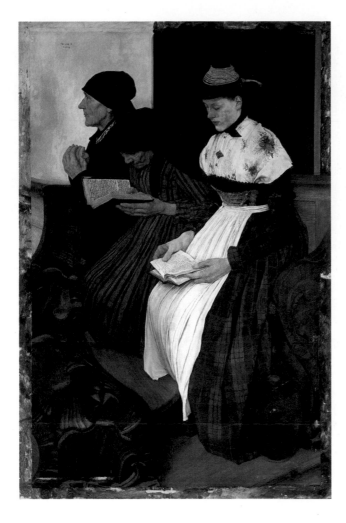

27-50. Wilhelm Leibl. *Three Women in a Village Church*. 1878–82. Oil on canvas, approx. 29 x 25" (73.7 x 63.5 cm). Kunsthalle, Hamburg

About this painting Leibl wrote to his mother in 1879: "Here in the open country and among those who live close to nature, one can paint naturally. . . . It takes great staying power to bring such a difficult, detailed picture to completion in the circumstances. Most of the time I have literally taken my life in my hands in order to paint it. For up to now the church has been as cold as a grave, so that one's fingers get completely stiff. Sometimes, too, it is so dark that I have the greatest difficulty getting a clear enough view of the part on which I am working. . . . Several peasants came to look at it just lately, and they instinctively folded their hands in front of it. . . . I have always set greater store by the opinion of simple peasants than by that of so-called painters."

redevelopment. Daumier places the viewer in the poor section of the bus, opposite a serene grandmother, her daughter, and her two grandchildren. Although there is a great sense of intimacy and unity among these people, they are physically and mentally separated from the upper- and middle-class passengers, whose heads appear behind them.

NATURALISM AND REALISM OUTSIDE FRANCE

Following the French lead, artists of other western European nations also embraced naturalism and realism in the period after 1850. Among them was the German painter Wilhelm Leibl (1844–1900), who worked in a conventional academic style until a decisive meeting with Courbet in 1869 that spurred him to travel to Paris and familiarize himself with its naturalist currents. After Leibl's return to Germany, he lived in Munich for several years before moving to rural Bavaria, in southern Germany, where he dedicated himself to peasant subjects.

Leibl used villagers as models for his best-known painting, *Three Women in a Village Church* (fig. 27-50), which contrasts the plain but fresh beauty of its foreground figure with the weathered faces of those behind her. More than a reverie on youthful beauty, however, the painting also extols the conservative customs and values of these traditionally dressed and ardently pious people.

Even the elaborately carved pews, which seem to date from the Baroque period, suggest a faithfulness to the past. The scene is rendered with a minute care that owes more to the example of Hans Holbein (see fig. 18-76) than to that of Courbet. Leibl thereby demonstrates his own devotion to time-honored artistic standards threatened by innovation and change.

In Russia, too, realism developed in relation to a new concern for the peasantry. In 1861 the czar abolished serfdom, emancipating Russia's peasants from the virtual slavery they had endured on the large estates of the aristocracy. Two years later a group of painters inspired by the emancipation declared allegiance to both the peasant cause and freedom from the St. Petersburg Academy of Art, which had controlled Russian art since 1754. Rejecting what they considered the escapist, "art for art's sake" aesthetics of the academy, the members of the group dedicated themselves to a socially useful realism. Committed to bringing art to the people in traveling exhibitions, they called themselves the Wanderers. By the late 1870s members of the group, like their counterparts in music and literature, had also joined a nationalistic movement to reassert what they considered to be an authentic Russian culture rooted in the traditions of the peasantry, rejecting the western European customs that had long predominated among the Russian aristocracy.

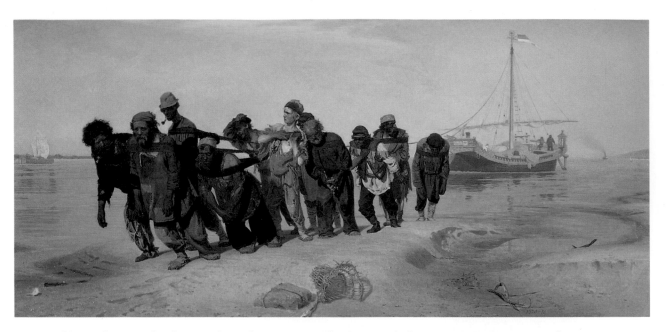

27-51. Ilya Repin. *Bargehaulers on the Volga*. 1870–73. Oil on canvas, 4'3¾" x 9'3" (1.3 x 2.81 m). Russian State Museum, St. Petersburg

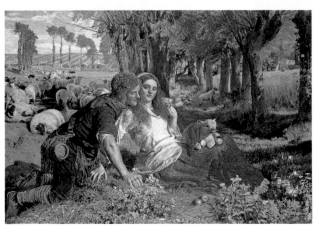

27-52. William Holman Hunt. *The Hireling Shepherd*. 1851. Oil on canvas, 30⅛ x 43⅛" (76.4 x 109.5 cm). Manchester City Art Gallery, England

Ilya Repin (1844–1930), who attended the St. Petersburg Academy and won a scholarship to study in Paris, joined the Wanderers in 1878 after his return to Russia. Repin painted a series of works illustrating the social injustices then prevailing in his homeland, including the *Bargehaulers on the Volga* (fig. 27-51). The painting features a group of wretchedly dressed peasants condemned to the brutal work of pulling ships up the Volga River. To heighten our sympathy for these workers, Repin placed a youth in the center of the group, a young man who will soon look as old and tired as his companions unless something is done to rescue him. In this way, the painting is a cry for action.

LATE-NINETEENTH-CENTURY ART IN BRITAIN

In 1848 seven young London artists formed the Pre-Raphaelite Brotherhood in response to what they considered the misguided practices of contemporary British art. Instead of the Raphaelesque conventions taught at the Royal Academy, the Pre-Raphaelites advocated the naturalistic approach of certain early Renaissance masters, especially those of northern Europe. They advocated as well a moral approach to art, in keeping with a long tradition in Britain established by Hogarth (see fig. 26-32).

The combination of didacticism and naturalism that characterized the first phase of the movement is best represented in the work of one of its leaders, William Holman Hunt (1827–1910), for whom moral truth and visual accuracy were synonymous. One of the best-known paintings of this academically trained artist is *The Hireling Shepherd* (fig. 27-52). Hunt painted the landscape portions of the composition outdoors, an innovative approach at the time, leaving space for the figures, which he painted in his London studio. The work depicts a farmhand neglecting his duties to flirt with a woman while pretending to discuss a death's-head moth that he holds in his hand. Meanwhile, some of his employer's sheep are wandering into an adjacent field, where they may become sick or die from eating green corn. Hunt later explained that he meant to satirize pastors who instead of tending their flock waste time discussing what he considered irrelevant theological questions. The painting can also be seen a moral lesson on the perils of temptation. The woman is cast as a latter-day Eve, as she feeds an apple—a reference to humankind's fall from grace—to the lamb on her lap and distracts the shepherd from his duty.

The other major members of the group, John Everett Millais (1829–96) and Dante Gabriel Rossetti (1828–82), were less inclined to this sort of moralizing and by 1852 had broken with Hunt, which led to the dissolution of the

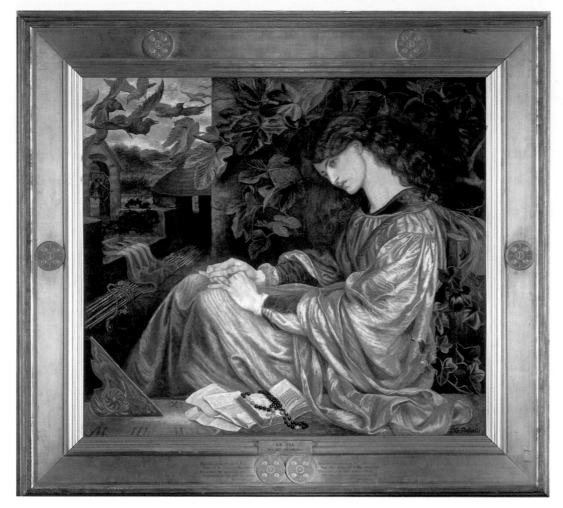

27-53. Dante Gabriel Rossetti. *La Pia de' Tolomei*. 1868–69. Oil on canvas, 41½ x 47½"
(105.4 x 119.4 cm). Spencer Museum of Art, University of Kansas, Lawrence

In addition to his work as a painter and poet, Rossetti created innovative and beautiful designs for picture frames, book bindings, wallpaper, and furniture, as well as architectural sculpture and stained glass. The gilded frames he designed for his pictures were intended to enhance their decorative effect and make their meaning clearer through inscriptions and symbols. The massive frame surrounding *La Pia de' Tolomei* features simple moldings on either side of broad, sloping boards, into which are set a few large roundels. The title of the painting is inscribed above the paired roundels at the lower center. On either side of them appear four lines from Dante's *Purgatory* spoken by the spirit of La Pia, in Italian at the left and in Rossetti's English translation at the right, which reads: "Remember me who am La Pia,—me/From Siena sprung and by Maremma dead./This in his inmost heart well knoweth he/With whose fair jewel I was ringed and wed."

group. In 1857 Rossetti, son of an exiled Italian poet and a poet himself, met two young Oxford students, William Morris (1834–96) and Edward Burne-Jones (1833–98), while working on a mural at the university. Their shared interest in the Middle Ages inaugurated the second, unofficial phase of Pre-Raphaelitism.

Morris's wife, Jane Burden, became Rossetti's favorite model. Her particular blend of physical beauty and sad, aloof spirituality perfectly suited Rossetti's vision of the Middle Ages and lent itself to his yearning for the spiritual beauty he found lacking in the modern world. After Rossetti and Burden became lovers, sometime in the 1860s, his images of her took on an added biographical dimension. *La Pia de' Tolomei* (fig. 27-53) uses an incident from Dante's *Purgatory* to articulate the artist's own unhappy romantic situation. La Pia ("Pious One"), locked up by her husband in a castle, was soon to die. The rosary and prayer book in front of her refer to her

piety, the banner lances of her husband on the ramparts suggest her captivity, and the sundial and ravens allude to her impending death. Her continuing love for her husband, author of the letters lying under the prayer book, is symbolized by the evergreen ivy behind her. However, the luxuriant fig leaves that surround her, traditionally associated with lust and the Fall, have no source in Dante's tale. Rossetti further personalizes the tale by showing her fingering her wedding ring, a captive not so much of her husband as of her marriage.

William Morris worked briefly as painter under the influence of Rossetti before turning his attention to interior design and decoration. Morris's interest in handcrafts developed in the context of a widespread reaction against the gaudy design of industrially produced goods that began with the Crystal Palace exhibition of 1851. Unable to find satisfactory furnishings for their new home after marrying Burden in 1859, Morris designed

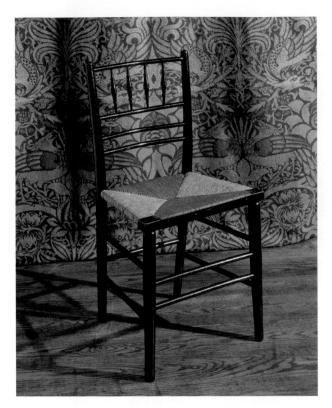

27-54. (foreground) **Philip Webb (?). Single chair from the Sussex range**. In production from c. 1865. Ebonized wood with rush seat, 32⁵/₈ x 16³/₈ x 14" (83.8 x 42 x 35.6 cm). Manufactured by Morris & Company. William Morris Gallery (London Borough of Waltham Forest)

(background) **William Morris. *Peacock and Dragon* curtain**. 1878. Handloomed jacquard-woven woolen twill, 12'10¹/₂" x 11'5⁵/₈" (3.96 x 3.53 m). Manufactured at Queen Square and later at Merton Abbey. Victoria and Albert Museum, London

Morris and his principal furniture designer, Philip Webb (1831–1915), adapted the Sussex range from traditional rush-seated chairs of the Sussex region. The handwoven curtain in the background is typical of Morris's fabric design in its use of flat patterning that affirms the two-dimensional character of the textile medium. The pattern's prolific organic motifs and soothing blue and green hues—the decorative counterpart to those of naturalistic landscape painting—were meant to provide relief from the stresses of modern urban existence.

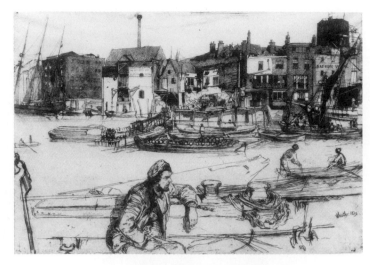

27-55. James Abbott McNeill Whistler. *Black Lion Wharf*. 1859. Etching, 5⁷/₈ x 8⁷/₈" (15 x 22.6 cm). The Metropolitan Museum of Art, New York
Harris Brisbane Dick Fund, 1917 (17.3.35)

A copy of this work can be seen on the wall in Whistler's most famous painting, the portrait of his mother, whose formal title is *Arrangement in Gray and Black, No. 1* (1871). That title communicates Whistler's priority in his later work of creating harmonious relationships of form and color over recording an accurate likeness of his subject.

and made them himself with the help of friends. He then founded a decorating firm to produce a full range of medieval-inspired objects. Although many of the furnishings offered by Morris & Company were expensive, one-of-a-kind items, others, such as the rush-seated chair illustrated here (fig. 27-54), were cheap and simple, intended to provide a handcrafted alternative to the vulgar excess characteristic of industrial furniture. Concerned with creating a "total" environment, Morris and his colleagues designed not only furniture but also stained glass, tiles, wallpaper, and fabrics, such as the *Peacock and Dragon* curtain seen in the background of figure 27-54.

Morris inspired what became known as the Arts and Crafts movement. His aim was to benefit not just a wealthy few but society as a whole. As he asked in the lectures he began delivering in 1877, "What business have we with art at all unless we can share it?" A socialist, Morris sought to eliminate the machine not only because he found its products ugly but also because of its deadening influence on the worker. With craftwork, he maintained, the laborer gets as much satisfaction as the consumer. Unlike his Pre-Raphaelite friends, who wished to escape into idealizations of the Middle Ages, Morris saw in that era the model for economic and social reform.

Not all of those who participated in the revival of the decorative arts were committed to improving the conditions of modern life. Many, including the American expatriate James Abbott McNeill Whistler (1834–1903), saw in the Arts and Crafts revival simply another way to satisfy an elitist taste for beauty. After failing out of West Point in the early 1850s, Whistler studied art in Paris, where he came under the influence of Courbet. His first important works were etchings, such as *Black Lion Wharf* (fig. 27-55), a naturalistic image of life along the Thames River. Although inspired by Courbet, Whistler's etching shows little of the French artist's interest in either the solid tangibility of things or the social significance of work. Because of its horizontal emphasis and the absence of a strong focal point, our eye scans the etching's registers, making a quick survey of its picturesque details before passing on and out of the frame. This approach to composition anticipates the French Impressionists. The work is important, too, because of Whistler's

THE PRINT REVIVALS

A number of Romantic artists, including Théodore Géricault and Eugène Delacroix, used **lithography** to produce fine art prints (see "Lithography," page 889). But as lithography was more commonly used by newspaper caricaturists such as Honoré Daumier, the medium became identified with the popular arts. Another art form, **etching**, was then used almost exclusively to produce cheap reproductions of well-known works, although Delacroix, Corot, and Millet had produced the occasional etching (see "Etching and Drypoint," page 808). The first of the nineteenth-century artists to devote himself to the medium was Charles-Émile Jacque (1813–94), a less well-known member of the Barbizon School, who as a student had studied and copied etchings by Rembrandt.

Inspired by the work of Jacque and by the amateur example of his brother-in-law, Francis Seymour Haden, James Abbott McNeill Whistler turned to etching in 1858, and his early work inaugurated a great age of etching. The interest it generated convinced an amateur French etcher and printer, Alfred Cadart, to organize the Society of Etchers in 1862. Cadart, who was also a print dealer, conceived the society as a way to bring before the public the kind of innovative work rejected by the Salon jury and to protest the growth and influence of photography. The Romantic poet and critic Théophile Gautier said in his preface to the first volume of etchings Cadart issued:

> In these times when photography fascinates the vulgar by the mechanical fidelity of its reproductions, it is needful to assert an artistic tendency in favor of free fancy and picturesque mood. The necessity of reacting against the positivism of the mirrorlike apparatus has made many a painter take to the etcher's needle. . . .

The critical response to Cadart's early volumes, issued annually, was so positive that even the conservative organizers of the Salon decided to dedicate an entire room to etchings at the exhibition of 1866. Cadart's efforts established a solid foundation for a tradition that eventually included the work of Edgar Degas, Mary Cassatt, and a host of French artists. Cadart contributed further to the spread of etching when he helped form the French Etching Club in New York in 1866.

A second phase in the print renaissance began around 1890 and lasted well into the next decade. It too was centered in Paris, but now the medium was chromolithography, which printed in color. The artist largely responsible for it was a poster designer, Jules Chéret (1836–1932), whose printing business employed chromolithography for a variety of commercial work, from menus to posters. Chéret's clever theater and café advertising posters of the late 1860s and 1870s attracted so much attention that in 1880 the critic Joris-Karl Huysmans advised his readers to ignore the paintings and prints at the Salon and to turn, instead, to the "astonishing fantasies of Chéret" that could be found plastered along any street.

By the end of the decade the poster vogue was in full flower, not only in France but throughout the West. Influenced by Japanese prints and Art Nouveau, with its commitment to beautifying the urban environment, a number of talented and ambitious young artists turned their attention to designing them. The most famous poster artist was Henri de Toulouse-Lautrec, who produced thirty between 1891 and his death in 1901 (see fig. 27-84).

Lithography also grew with a renewal of interest in book illustration spurred by the art dealer Ambroise Vollard, who asked artists to provide original lithographs for books. The best-known English book illustrator was Aubrey Beardsley (1872–98), whose work combined influences from Whistler, the second phase of the Pre-Raphaelite movement, and Japanese prints to form a beautifully "unnatural" style.

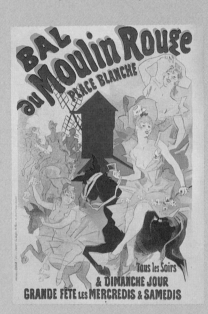

Jules Chéret. *Bal au Moulin Rouge*. 1889. Four-color lithograph, 23½ x 16½" (59.7 x 41.9 cm). Jane Voorhees Zimmerli Art Museum, Rutgers, The State University of New Jersey

crucial early place in the print revival of the later nineteenth century (see "The Print Revivals," above).

Whistler produced *Black Lion Wharf* soon after he moved, in 1859, to London, partly to distance himself from Courbet and his influence. The new vogue for the arts of Japan helped fuel in him a growing dissatisfaction with naturalism (see "Japonisme," page 1020). Whistler had been one of the first to collect Japanese art when it became available in curio shops in London and Paris after the 1853 reopening of that nation to the West. The simplified, elegant forms and subtle chromatic harmonies of Japanese art (Chapter 22) had a profound influence on his paintings of the early 1860s such as *Rose and Silver: The Princess from the Land of Porcelain* (see fig. 21, Introduction, showing the Peacock Room Whistler later designed to house it), which shows a Caucasian woman dressed in a Japanese robe and posed amid a collection of Asian artifacts. The work is Whistler's answer to the medieval costume pieces of the Pre-Raphaelites. What Whistler saw in Japanese objects was neither a preferable world nor a way to reform European decorative arts, but rather a model for painting. As the work's main title declares, Whistler attempted to create a formal and coloristic harmony similar to that of the objects

Édouard Manet had in his studio a copy of *The Pastoral Concert*, a work in the Louvre then attributed to Giorgione and now attributed to both Titian and Giorgione (see fig. 18-24). His *Déjeuner sur l'Herbe* (see fig. 27-56) was clearly inspired by *The Pastoral Concert*, a modern reply to its theme of ease in nature. Manet also adapted for his composition a group of river gods and a nymph from an engraving by Marcantonio Raimondi based on Raphael's *The Judgment of Paris*—an image that, in turn, looked back to Classical reliefs. Manet's allusion to the engraving was apparent to some observers at the time, such as the critic Ernest Chesneau, who specifically noted this borrowing and objected to it.

With its deliberate allusions to Renaissance art works, Manet's painting addresses not just the subject of figures in a landscape: It also addresses the history of art and Manet's relationship to it by encouraging the viewer to compare his painting with those that inspired it. To a viewer who has in mind the traditional perspective and the rounded modeling of forms of the two Renaissance works, the stark lighting of Manet's nude and the flat, cutout quality of his figures become all the more shocking. Thus, by openly referring to these exemplary works of the past, Manet emphasized his own radical innovations.

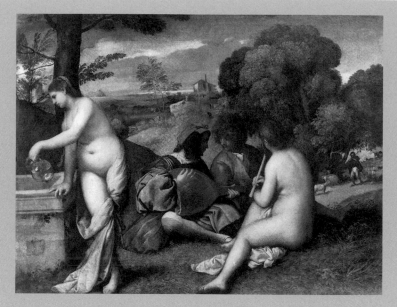

Titian and Giorgione. *The Pastoral Concert*. (formerly attributed to Giorgione). c. 1509–10. Oil on canvas, 43 1/4 x 54 3/8 (109.9 x 138.1 cm). Musée du Louvre, Paris

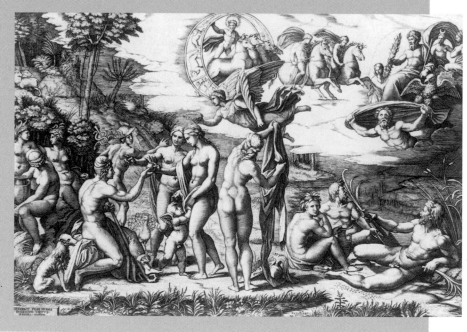

Marcantonio Raimondi, after Raphael's ***The Judgment of Paris***. c. 1520. Engraving. Yale University Art Gallery

Gift of Edward B. Greene, Yale 1990

displayed in the room. Thus, delicate organic shapes are shown against a rich pattern of colors orchestrated around silver and rose. By leaving his wet brushmarks visible, Whistler emphasized the paint itself over the depicted subject.

Whistler's growing commitment to "art for art's sake," or an art of purely aesthetic values, culminated in the highly abstracted nocturnes, or night scenes, he began to paint in the mid-1860s. In pictures such as *Nocturne: Blue and Gold—Old Battersea Bridge* (see "*Japonisme,*" page 1020), Whistler reduced his palette to a few subtle tones and simplified the elements of the scene into smudgy silhouettes, transforming the ugly banks of the industrialized Thames into a realm of evocative beauty and mystery.

IMPRESSIONISM

While British artists were moving away from the naturalism advocated by the original Pre-Raphaelite Brotherhood, their French counterparts were pushing the French realist tradition into new territory. Instead of themes of the working classes and rural life that had engaged Courbet, Corot, and the Barbizon painters, the generation that matured around 1870 was generally devoted to subjects of leisure, the upper middle class, and the city. Although many of these artists specialized in paintings of the countryside, their point of view was usually that of a city person on holiday.

In April 1874, a number of these artists, including Paul Cézanne, Edgar Degas, Claude Monet, Berthe Morisot, Camille Pissarro, and Pierre-Auguste Renoir,

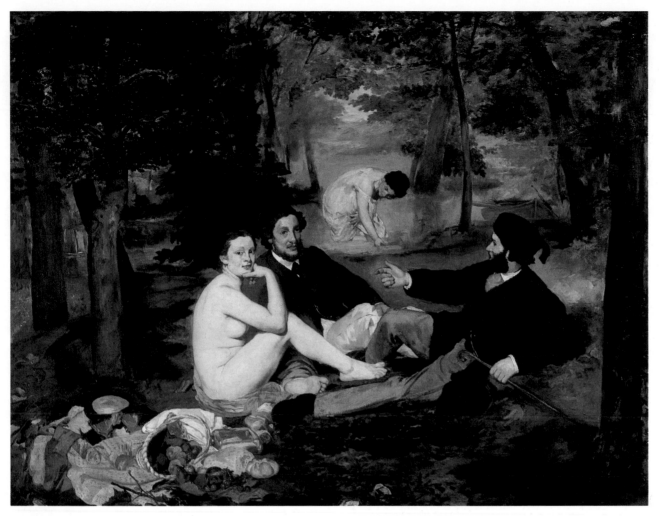

27-56. Édouard Manet. *Le Déjeuner sur l'Herbe (The Luncheon on the Grass)*. 1863. Oil on canvas, 7' x 8'8"
(2.13 x 2.64 m). Musée d'Orsay, Paris

exhibited together in Paris as the *Société Anonyme des Artistes Peintres, Sculpteurs, Graveurs, etc.* (Corporation of Artists Painters, Sculptors, Engravers, etc.). All thirty participants agreed not to submit anything that year to the Salon, which had in the past often rejected their works; hence, their exhibition was a declaration of independence from the academy and a bid to gain the attention of the public without the intervention of a jury. While the exhibition received some positive reviews, it was attacked by conservative critics. Louis Leroy, writing in the comic journal *Charivari*, seized on the title of a painting by Monet, *Impression, Sunrise* (1873), and dubbed the entire exhibition "impressionist." While Leroy used the word to attack the seemingly haphazard technique and unfinished look of some of the paintings, Monet and many of his colleagues were pleased to accept the label, which spoke to their concern for capturing an instantaneous impression of a scene in nature. Seven more Impressionist exhibitions followed between 1876 and 1886, with the membership of the group varying slightly on each occasion; only Pissarro participated in all eight shows. The exhibitions of the Impressionists inspired other artists to organize alternatives to the Salon, a development that by the end of the century ended the French Academy's centuries-old stranglehold on the display of art and thus on artistic standards.

Frustration among progressive artists with the exclusionary practices of the Salon jury had been mounting in the decades preceding the first Impressionist exhibition. Such discontent reached a crescendo in 1863 when the jury turned down nearly 3,000 works submitted to the Salon, leading to a storm of protest. In response, Napoleon III ordered an exhibition of the refused work called the Salon des Refusés ("Salon of the Rejected Ones"). Featured in it was a painting by Édouard Manet (1832–83), *Le Déjeuner sur l'Herbe* (fig. 27-56), which scandalized contemporary viewers and helped to establish Manet as a radical artist. Within a few years, many of the future Impressionists would gather around Manet and follow his lead in challenging academic conventions.

A well-born Parisian who had studied in the early 1850s with the progressive academician Thomas Couture (1815–79), Manet had by the early 1860s developed a strong commitment to realism, largely as a result of his friendship with the poet Baudelaire (see fig. 27-37). In his article "The Painter of Modern Life," Baudelaire called for an artist who would be the painter of contemporary manners, "the painter of the passing moment and all the suggestions of eternity that it contains."

JAPONISME

James Abbott McNeill Whistler's etchings and paintings of the 1850s and early 1860s show London's Old Battersea Bridge as it really was: a narrow, squat, aging bridge that carried pedestrian traffic. But in his *Nocturne: Blue and Gold—Old Battersea Bridge* of the early 1870s, Whistler greatly exaggerated the height and curve of the bridge and increased the span between its wooden pilings. He probably did so to make it resemble the Kyobashi Bridge depicted in a woodblock print from the *One Hundred Famous Views of Edo* by the nineteenth-century Japanese artist Hiroshige. Japanese art (Chapter 22) also inspired the spatial flattening, asymmetrical composition, and monochromatic palette of this and other Whistler paintings.

Whistler's interest in Japanese art was part of a widespread fascination with Japan and its culture that swept across the West in the last half of the nineteenth century. The vogue began shortly after the U.S. Navy forcibly opened Japan to Western trade and diplomacy in 1853. Soon, Japanese lacquers, fans, bronzes, hanging scrolls, kimonos, ceramics, illustrated books, and **ukiyo-e** (prints of the "floating world," the realm of geishas and popular entertainment) began to appear in western European specialty shops, art galleries, and even some department stores. French interest in Japan and its arts reached such proportions by 1872 that the art critic Philippe Burty gave it a name: **japonisme**.

Japanese art profoundly influenced Western painting, printmaking, applied arts, and eventually architecture. The tendency toward simplicity, flatness, and the decorative evident in much painting and graphic art in the West between roughly 1860 and 1900 is probably the most characteristic result of that influence. Nevertheless, its impact was extraordinarily diverse. What individual artists took from the Japanese depended on their own interests. Thus, Whistler found encouragement for his decorative conception of art, while Edgar Degas discovered both realistic subjects and interesting compositional arrangements (see fig. 27-62), and those interested in the reform of late-nineteenth-century industrial design found in Japanese objects both fine craft and a smooth elegance lacking in the West. Some, like Vincent van Gogh, saw in the spare harmony of Japanese art and wares evidence of an idyllic society, which he considered a model for the West. Perhaps the most strongly influenced were the new printmakers, like Mary Cassatt (fig. 27-67), who, lacking a strong tradition of their own, considered themselves part of the Japanese tradition more than the Western.

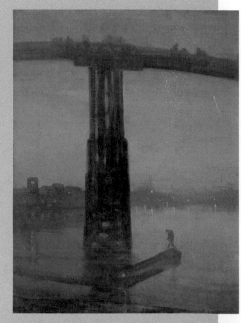

(above)
James Abbott McNeill Whistler. Nocturne: Blue and Gold—Old Battersea Bridge. 1872–75. Oil on canvas, 26¼ x 19¾" (66.7 x 50.2 cm). Tate Gallery, London

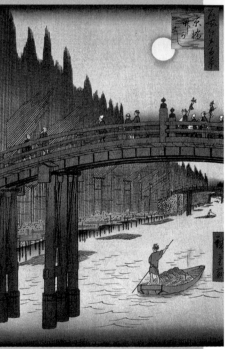

(below)
Utagawa Hiroshige. One Hundred Views of Edo: Bamboo Yards, Kyobashi Bridge. 1857. Color woodblock print. The Brooklyn Museum of Art

Manet seems to have responded to Baudelaire's call in painting *Le Déjeuner sur l'Herbe*, whose frank declaration of modernity was deeply offensive to both the academic establishment and the average Salon-goer. Most disturbing to contemporary viewers was the "immorality" of Manet's theme: a suburban picnic featuring a scantily clad bathing woman in the background and, in the foreground, a completely naked woman, seated alongside two fully clothed, upper-class men. Manet's scandalized audience assumed that these women were prostitutes and that the well-dressed men were their clients.

Manet apparently conceived of *Le Déjeuner sur l'Herbe* as a modern version of a famous Venetian Renaissance painting in the Louvre, the *Pastoral Concert*, then believed to be by Giorgione but now attributed to Titian (see fig. 18-24 and "Artistic Allusions in Manet's Art," page 1018). The intended meaning of *Le Déjeuner* remains a matter of considerable debate. Some see it as a portrayal of modern alienation, for the figures in Manet's painting fail to connect with one another psychologically. Although the man on the right seems to gesture toward his companions, the other man gazes off absently while the nude turns her attention away from them and to the viewer. Moreover, her gaze makes us conscious of our role as outside observers; we, too, are estranged. Manet's rejection of warm colors for a scheme of cool blues and greens plays an important role, as do his flat, sharply outlined figures, which seem starkly lit because of the near absence of modeling. The figures are not integrated with their natural surroundings, as in the Titian, but seem to stand out sharply against them, as if seated before a painted backdrop.

Shortly after completing *Le Déjeuner sur l'Herbe* Manet painted *Olympia* (fig. 27-57), whose title alluded to a socially ambitious prostitute of the same name in a novel and play by Alexandre Dumas *fils* (the younger). Like *Le Déjeuner sur l'herbe*, *Olympia* was based on a Venetian Renaissance source, Titian's *Venus of Urbino* (see fig. 18-26), which Manet had earlier copied in Florence. At first, Manet's painting appears to pay homage to Titian's in its subject matter (the Titian painting was then believed to be the portrait of a Venetian courtesan) and composition. However, Manet in effect made his modern counterpart the very antithesis of the Titian. Whereas Titian's female is curvaceous and softly rounded, Manet's is angular and flattened. Whereas Titian's looks lovingly at the male spectator, Manet's appears coldly indifferent. Our relationship with Olympia is underscored by the reaction of her cat, who—unlike the sleeping dog in the Titian—arches its back at us. Finally, instead of looking up at us, Olympia stares down on us, indicating that she is in the position of power and that we are subordinate, akin to the black servant at the foot of the bed who brings her a bouquet of flowers. In reversing the Titian, Manet subverted the entire tradition of the accommodating female nude. Not surprisingly, conservative critics vilified the *Olympia* when it was displayed at the Salon of 1865.

By this time Manet had become the unofficial leader of a group of progressive artists and writers who gathered at the Café Guerbois in the Montmartre district of Paris. Among the artists who frequented the café were Degas, Monet, Pissarro, and Renoir, who would soon exhibit together as the Impressionists. With the exception of Degas, who, like Manet, remained a studio painter, these artists began to paint outdoors, *en plein air*

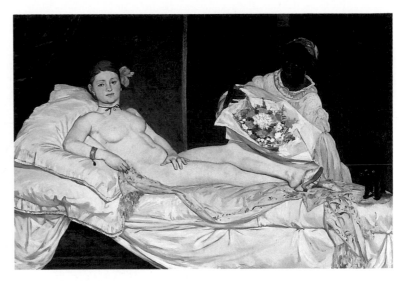

27-57. Édouard Manet. *Olympia*. 1863. Oil on canvas, 4'3" x 6'2¼" (1.31 x 1.91 m). Musée du Louvre, Paris

("in the open air"), in an effort to record directly the fleeting effects of light and atmosphere. (*Plein air* painting was greatly facilitated by the invention in 1841 of tin tubes for oil paint.)

Born in Paris but raised in the port city of Le Havre, the academically trained Claude Monet (1840–1926) made many of his earliest efforts at *plein air* painting along the Normandy coast in the late 1860s. In 1867 he painted several beach scenes at Sainte-Adresse, a small resort town just north of Le Havre, including *Terrace at Sainte-Adresse* (fig. 27-58). With its strong light, rich shadows, and bold colors, the painting conveys the sparkling freshness of a bright summer day on the seaside. Elegantly dressed members of the *haute bourgeoisie* (upper

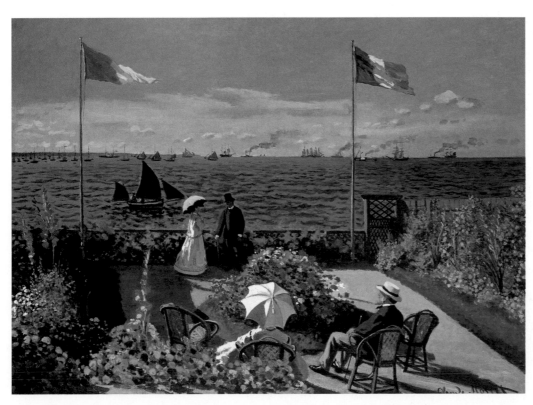

27-58. Claude Monet. *Terrace at Sainte-Adresse*. 1867. Oil on canvas, 38⅝ x 51⅛" (98.1 x 129.9 cm). The Metropolitan Museum of Art, New York

Purchased with special contribution and purchase fund given or bequeathed by friends of the museum, 1967 (67.241)

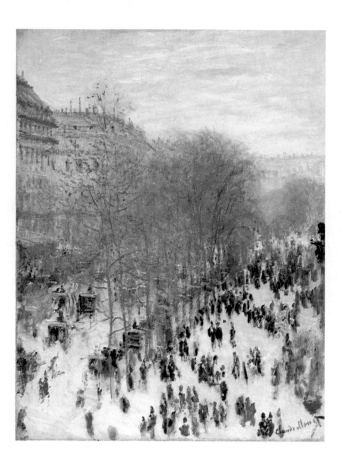

27-59. Claude Monet. *Boulevard des Capucines, Paris*. 1873–74. Oil on canvas, 31¼ x 23¼" (79.4 x 59.1 cm). The Nelson-Atkins Museum of Art, Kansas City, Missouri

Purchase: The Kenneth A. and Helen F. Spencer Foundation Acquisition Fund (F72–35)

middle class) enjoy the weather and relax on a terrace blooming with colorful flowers. The actual setting was the seaside villa of Monet's aunt, and the models for the painting were members of Monet's family, including his father, seated at the lower right. To contemporary viewers unaware of these facts, however, the figures would have appeared simply as well-to-do vacationers taking their leisure in pleasant surroundings.

Despite its informal subject, *Terrace at Sainte-Adresse* features a carefully calculated design, inspired by the Japanese prints that fascinated so many Western artists at this time (see "Japonisme," page 1020). The flagpoles and flags, fence, and horizon line form a geometric structure of verticals and horizontals, responding to the edges of the rectangular canvas and asserting the two-dimensionality of its surface. The high vantage point also serves to flatten out the picture's space, which seems to climb up the composition in horizontal bands rather than receding into depth. Equally assertive of the picture plane are the many discrete strokes and touches of pure color, intended to describe flowers, leaves, and waves, but also registering simply as marks of paint on the surface of the canvas.

Many of Monet's fully Impressionist pictures of the 1870s and 1880s, such as *Boulevard des Capucines*, Paris of 1873–74 (fig. 27-59), are made up almost entirely of these small dabs and blotches of paint. Monet used these discrete marks of paint to record the shifting play of light on the surface of objects and the effect of that light on the eye, without concern for the physical character of the objects being represented. The American painter Lilla

Cabot Perry (1848–1933), who befriended Monet in his later years, recalled him telling her:

> When you go out to paint, try to forget what objects you have before you—a tree, a house, a field, or whatever. Merely think, Here is a little square of blue, here an oblong of pink, here a streak of yellow, and paint it just as it looks to you, the exact color and shape, until it gives your own naive impression of the scene before you.

Perry also reported that Monet

> said he wished he had been born blind and then had suddenly gained his sight so that he could have begun to paint in this way without knowing what the objects were that he saw before him. He held that the first real look at the motif was likely to be the truest and most unprejudiced one. . . .

Two important ideas are expressed here. One is that a quickly painted oil sketch most accurately records a landscape's general appearance. This view had been a part of academic training since the late eighteenth century, but such sketches were considered merely part of the preparation for a finished work. In essence Monet attempted to raise these traditional "sketch aesthetics" to the same level as a completed painting. As a result, the major criticism at the time was that his paintings were not "finished." The second idea—that art benefits from a

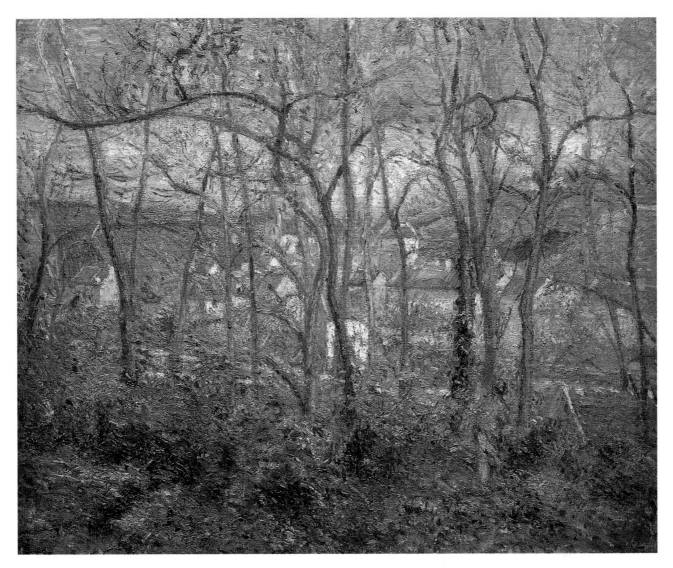

27-60. Camille Pissarro. *Wooded Landscape at l'Hermitage, Pontoise*. 1878. Oil on canvas, 18⁵/₁₆ x 22¹/₁₆"
(46.5 x 56 cm). The Nelson-Atkins Museum of Art, Kansas City, Missouri

Gift of Dr. And Mrs. Nicholas S. Pickard

naive vision untainted by intellectual preconceptions—belonged to both the naturalist and the realist traditions, from which Monet's work evolved.

Although he painted during the 1870s in a style similar to Monet's, Camille Pissarro (1830–1903) identified more strongly with peasants and rural laborers. Born in the Danish West Indies to a French family and raised near Paris, Pissarro studied art in that city during the 1850s and early 1860s. After assimilating the influences of both Corot and Courbet, Pissarro embraced Impressionism in 1870, when both he and Monet were living in London to escape the Franco-Prussian War. There they worked closely together, dedicating themselves, as Pissarro later recalled, to "*plein air* light and fugitive effects." The result, for both painters, was a lightening of color and a loosening of paint handling.

Following his return to France Pissarro settled in Pontoise, a small, hilly village northwest of Paris that retained a thoroughly rural character. There he worked for much of the 1870s in a style close to that of Monet, using high-keyed color and short brushstrokes to capture

fleeting qualities of light and atmosphere. Rather than the vacationer's landscapes that Monet favored, however, Pissarro chose agrarian themes such as orchards and tilled fields. In the late 1870s his painting tended toward greater visual and material complexity. *Wooded Landscape at l'Hermitage, Pontoise* (fig. 27-60) reflects the continuing influence of Corot (see fig. 27-45) in its composition of foreground trees that screen the view of a rural path and village and in its inclusion of a rustic figure at the lower right. Pissarro uses a brighter and more variegated palette than Corot, however, and he applies his paint more thickly, through a multitude of dabs, flecks, and short brushstrokes. The result is a dense, crusty surface of pigment that denies the academic conception of the picture plane as a transparent window and declares instead its actual status as a flat surface covered with paint.

More typical of the Impressionists in his proclivity for painting scenes of upper-middle-class recreation was Pierre-Auguste Renoir (1841–1919), who met Monet at the École des Beaux-Arts in 1862. Despite his early

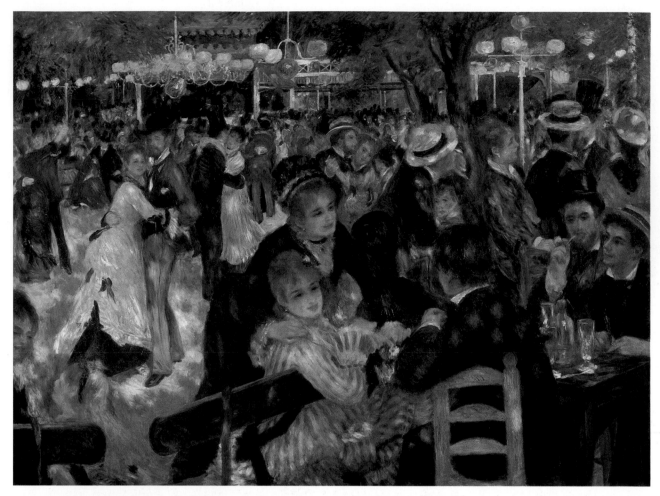

27-61. Pierre-Auguste Renoir. *Moulin de la Galette*. 1876. Oil on canvas, 4'3½" x 5'9" (1.31 x 1.75 m). Musée d'Orsay, Paris

predilection for figure painting in a softened, Courbet-like mode, Renoir was encouraged by his more forceful friend Monet to create pleasant, light-filled landscapes, painted outdoors. By the mid-1870s Renoir was combining Monet's style in the rendering of natural light with his own taste for the figure.

Moulin de la Galette (fig. 27-61), for example, features dancers dappled in bright afternoon sunlight. The Moulin de la Galette (the "Pancake Mill"), in the Montmartre section of Paris, was an old-fashioned Sunday afternoon dance hall, which during good weather made use of its open courtyard. Renoir has glamorized its working-class clientele by replacing them with his young artist friends and their models. Frequently seen in Renoir's work of the period, these attractive members of the middle class are shown in attitudes of relaxed congeniality, smiling, dancing, and chatting. The innocence of their flirtations is underscored by the children in the lower left, while the ease of their relations is emphasized by the relaxed informality of the composition itself. The painting is knit together not by figural arrangement but by the overall mood, the sunlight falling through the trees, and the way Renoir's soft brushwork weaves his blues and purples through the crowd and across the canvas. This idyllic image of a carefree age of innocence, a kind of paradise, nicely encapsulates Renoir's essential notion of art: "For

me a picture should be a pleasant thing, joyful and pretty—yes pretty! There are quite enough unpleasant things in life without the need for us to manufacture more."

Subjects of urban leisure also attracted Edgar Degas (1834–1917), but he did not share the *plein air* Impressionists' interest in outdoor light effects. Instead, Degas composed his pictures in the studio from working drawings—a traditional academic procedure. Degas had in fact received rigorous academic training at the École des Beaux-Arts in the mid-1850s and subsequently spent three years in Italy studying the Old Masters. Firm drawing and careful composition remained central features of his art for the duration of his career, setting it apart from the more spontaneously executed pictures of the *plein air* painters.

The son of a Parisian banker, Degas was closer to Manet than to other Impressionists in age and social background. Manet, whom he met in 1862, and his circle gradually persuaded Degas to turn from history painting to the depiction of contemporary life. After a period of painting psychologically probing portraits of friends and relatives, Degas turned in the 1870s to such Paris amusements as the racetrack, music hall, opera, and ballet. Composing his ballet scenes from carefully observed studies of rehearsals and performances, Degas, in effect, arranged his own visual choreography. *The Rehearsal on Stage* (fig. 27-62), for example, is not a

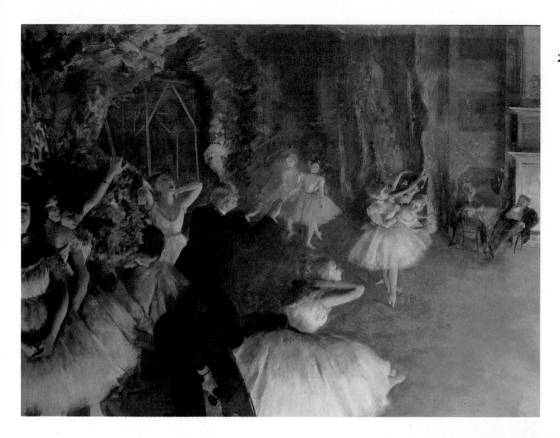

(left)

27-62. Edgar Degas. *The Rehearsal on Stage*. c. 1874. Pastel over brush-and-ink drawing on thin, cream-colored wove paper, laid on bristol board, mounted on canvas, 21 x 28½" (53.3 x 72.3 cm). The Metropolitan Museum of Art, New York

Bequest of Mrs. H. O. Havemeyer Collection, Gift of Horace Havemeyer, 1929 (29.160.26)

This is one of three versions of the same composition that Degas executed, with minor variations, around the time of the first Impressionist exhibition. It began as a brush-and-ink drawing on paper, over which Degas then drew in pastel. Finally, he redrew a number of details in ink, notably some of the faces and the arm of the seated dancer in the foreground. The combination of firmly drawn anatomy and more loosely sketched clothing and setting is typical of Degas's mature work.

(right)

27-63. Mary Cassatt. *Woman in a Loge*. 1879. Oil on canvas, 31⅝ x 23" (80.3 x 58.4 cm). Philadelphia Museum of Art

Bequest of Charlotte Dorrance Wright

Long known as *Lydia in a Loge, Wearing a Pearl Necklace*, this painting was believed to portray Cassatt's sister, Lydia, who came to live with her in 1877 and posed for many of her works. The young, red-haired sitter does not resemble the older, dark-haired Lydia, however, and was probably a professional model whose name has not been recorded. The painting is now known by the title it had when shown at the fourth Impressionist exhibition, in 1879.

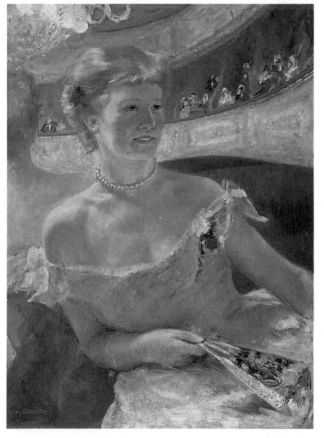

factual record of something seen but a careful contrivance, inspired partly by Japanese prints, intended to delight the eye. The rehearsal is viewed from an opera box close to the stage, creating an abrupt foreshortening of the scene emphasized by the dark scroll of the bass viol that juts up from the lower left.

Another artist who showed with the Impressionists was the American expatriate Mary Cassatt (1845–1926). Born near Pittsburgh to a well-to-do family, Cassatt studied at the Pennsylvania Academy of the Fine Arts in Philadelphia between 1861 and 1865 and then moved to Paris for further academic training. She lived in France for most of the rest of her life. The realism of the figure paintings she exhibited at the Salons of the early and middle 1870s attracted the attention of Degas, who invited her to participate in the fourth Impressionist exhibition, in 1879. Although she, like Degas, remained a studio painter, disinterested in *plein air* painting, her distaste for what she called the tyranny of the Salon jury system made her one of the group's staunchest supporters.

Cassatt focused her work on the world to which she had access: the domestic and social life of well-off women. One of the two paintings she exhibited in 1879 was *Woman in a Loge* (fig. 27-63). The painting's bright and luminous color, fluent brushwork, and urban subject were no doubt chosen partly to demonstrate her solidarity with

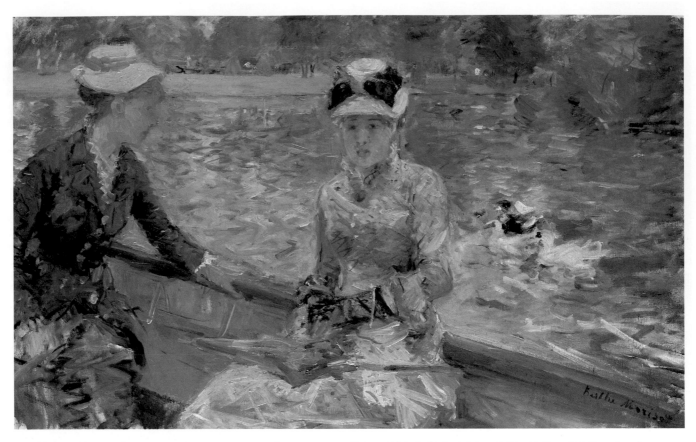

27-64. Berthe Morisot. *Summer's Day*. 1879. Oil on canvas, 17¹³/₁₆ x 29⁵/₁₆" (45.7 x 75.2 cm). The National Gallery, London
Lane Bequest, 1917

her new associates. (Renoir had exhibited a very similar image of a woman at the opera in 1874.) Reflected in the mirror behind the smiling woman are other operagoers, some with opera glasses trained not on the stage but on the crowd around them, scanning it for other elegant socialites. As Charles Garnier had noted, his new Opéra (see fig. 27-42) made an ideal backdrop for just this kind of display.

Cassatt decided early to have a career as a professional artist, but Berthe Morisot (1841–95) came to that decision only after years in the amateur role then conventional for women. Morisot and her sister, Edma, copied paintings in the Louvre and studied under several different teachers, including Corot, in the late 1850s and early 1860s. The sisters showed in the five Salons between 1864 and 1868, the year they met Manet. In 1869 Edma married and, following the traditional course, gave up painting to devote herself to domestic duties. Berthe, on the other hand, continued painting, even after her 1874 marriage to Manet's brother, Eugène, and the birth of their daughter in 1879. Morisot sent nine works to the first exhibition of the Impressionists in 1874 and showed in all but one of their subsequent exhibitions.

Like Cassatt, Morisot dedicated her art to the lives of bourgeois women, which she depicted in a style that became increasingly loose and **painterly** over the course of the 1870s. In works such as *Summer's Day* (fig. 27-64), Morisot pushed the "sketch aesthetics" of Impressionism

almost to their limit, dissolving her forms into a flurry of feathery brushstrokes. Originally exhibited in the fifth Impressionist exhibition in 1880 under the title of *The Lake of the Bois du Boulogne*, Morisot's picture is typically Impressionist in its depiction of modern urban leisure in a large park on the fashionable west side of Paris. As the women apparently ride in a ferry between tiny islands in the largest of the park's lakes, the viewer occupies a seat opposite them and is invited to share their enjoyment of the delicious weather and pleasant surroundings.

Although he never exhibited with the Impressionists, preferring to submit his pictures to the official Salon, Édouard Manet nevertheless in the 1870s followed their lead by lightening his palette, loosening his brushwork, and confronting modern life in a more direct manner than he had in *Le Déjeuner sur l'Herbe* and *Olympia* (see figs. 27-56 and 27-57), both of which maintained a dialogue with the art of the past. But complicating Manet's apparent acceptance of the Impressionist viewpoint was his commitment, conscious or not, to counter Impressionism's essentially optimistic interpretation of modern life with a more pessimistic one.

Manet's last major painting, *A Bar at the Folies-Bergère* (fig. 27-65), for example, contradicts the happy aura of works such as *Moulin de la Galette* (see fig. 27-61) and *Woman in a Loge* (see fig. 27-63). In the center of the painting stands one of the barmaids at the Folies-Bergère, a large nightclub with bars arranged around a

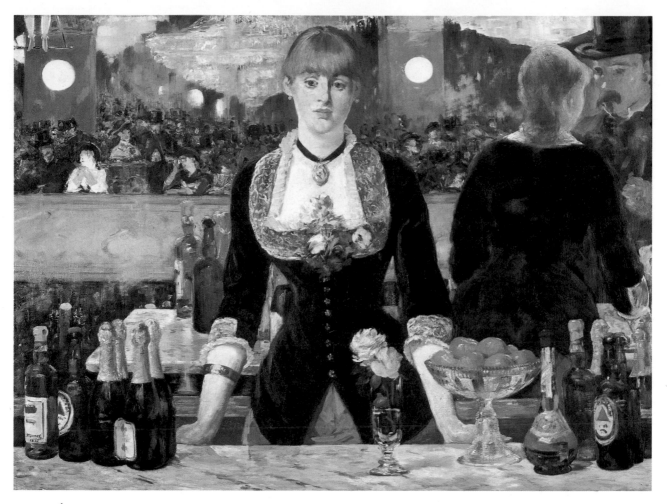

27-65. Édouard Manet. *A Bar at the Folies-Bergère*. 1881–82. Oil on canvas, 37³/₄ x 51¹/₄" (95.9 x 130 cm).
Courtauld Institute Galleries, London
Home House Collection

theater that offered circus, musical, and vaudeville acts. Reflected in the mirror behind her is some of the elegant crowd, who are entertained by a trapeze act. (The legs of one of the performers can be seen in the upper left.) On the marble bartop Manet has spread a glorious still life of liquor bottles, tangerines, and flowers, associated not only with the pleasures for which the Folies-Bergère was famous but also with the barmaid herself, whose wide hips, strong neck, and closely combed golden hair are echoed in the champagne bottles. The barmaid's demeanor, however, refutes these associations. Manet puts the viewer directly in front of her, in the position of her customer. She neither smiles at this customer, as her male patrons and employers expected her to do, nor gives the slightest hint of recognition. She appears instead to be self-absorbed and slightly depressed. But in the mirror behind her, her reflection and that of her customer tell a different story. In this reflection, which Manet has curiously shifted to the right as if the mirror were placed on a slant, the barmaid leans toward the patron, whose intent gaze she appears to meet; the physical and psychological distance between them has vanished. Exactly what Manet meant to suggest by this juxtaposition has been much debated. One possibility is that he

wanted to contrast the longing for happiness and intimacy, reflected miragelike in the mirror, with the disappointing reality of ordinary existence that directly confronts the viewer of the painting.

LATER IMPRESSIONISM

In the years after 1880, Impressionism underwent what historians have termed a "crisis," as many artists grew dissatisfied with their attempts to capture momentary perceptions through spontaneous brushwork and casual compositions. In response, they began to select subjects more carefully, work longer on their pictures, and develop styles that lent their imagery a greater sense of permanence and seriousness.

The artist most strongly affected by this crisis was Renoir, whose experience of the paintings of Raphael and other Old Masters on a trip to Italy in 1881 caused him to reconsider his commitment to painting modern life. Renoir became convinced that, unlike the enduring themes of Renaissance art, his records of contemporary life (see fig. 27-61) were too bound to their time to maintain the interest of future viewers. He therefore began to focus on the nude, a subject more difficult to locate in a

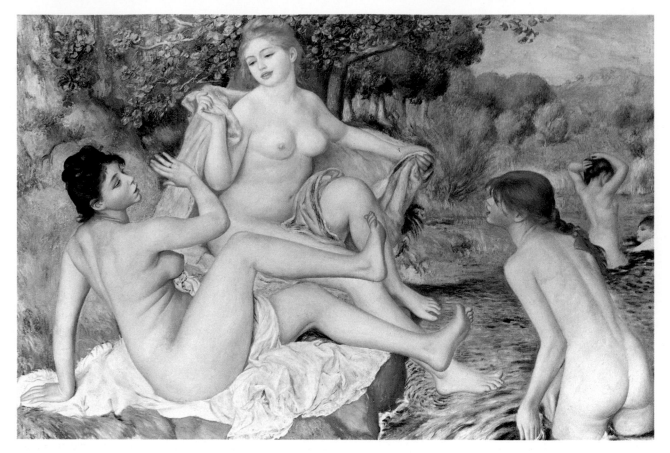

27-66. Pierre-Auguste Renoir. *Bathers*. 1887. Oil on canvas, 3'10³⁄₈" x 5'7¹⁄₄" (1.18 x 1.71 m). Philadelphia Museum of Art
Mr. and Mrs. Carroll S. Tyson Collection

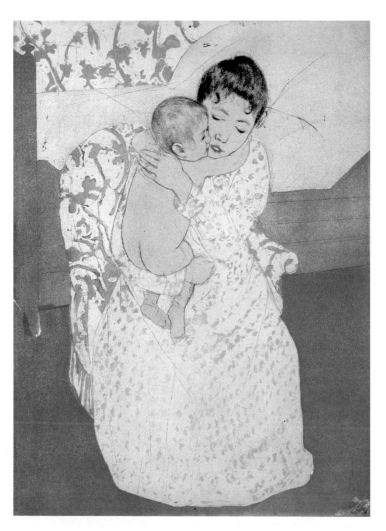

particular time and place. The stable, pyramidal grouping of his three female *Bathers* (fig. 27-66) was based on a seventeenth-century sculpture by François Girardon at Versailles (see fig. 19-25). This source clearly indicates Renoir's new commitment to the classical tradition of the female nude that originated in the Hellenistic period and was first adopted by French artists during the reign of Louis XIV. The work is perhaps closer to Bouguereau's *Nymphs and a Satyr* (see fig. 27-44) than to Renoir's own *Moulin de la Galette*. The women are shown from three different views—front, back, and side—a convention that had been established in countless paintings of the Three Graces. Their chiseled contours also reflect a move toward academicism. Only the more loosely brushed landscape, the high-key colors, and the women themselves, who look like they could be contemporary Parisians on the banks of the Seine, prevent the painting from being a wholesale rejection of Impressionism.

Cassatt, too, in the period after 1880 moved toward a firmer handling of form and more classic subjects. The shift is most apparent in her new focus on the theme of mother and child. In *Maternal Caress* (fig. 27-67), one of the many colored prints she produced in her later career, we see her sensitive response to the tradition of the Madonna and Child. Apparently fresh from the bath, the

27-67. Mary Cassatt. *Maternal Caress*. 1891. Drypoint, soft-ground etching, and aquatint on paper, 14³⁄₄ x 10³⁄₄" (37.5 x 27.3 cm). National Gallery of Art, Washington, D.C.
Rosenwald Collection

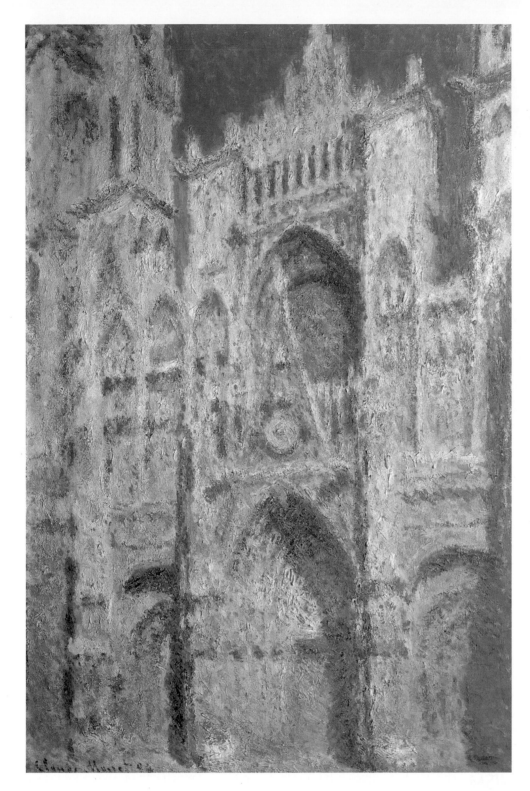

27-68. Claude Monet. *Rouen Cathedral: The Portal (in Sun)*. 1894. Oil on canvas, 39¼ x 26" (99.7 x 66 cm). The Metropolitan Museum of Art, New York

Theodore M. Davis Collection, Bequest of Theodore M. Davis, 1915 (30.95.250)

Monet painted more than thirty views of the facade of Rouen Cathedral. He probably began each canvas during two stays in Rouen in early 1892 and early 1893, observing his subject from a second-story window across the street. He then finished the whole series in his studio at Giverny. In these paintings Monet continued to pursue his Impressionist aim of capturing fleeting effects of light and atmosphere, but his extensive reworking of them in the studio produced pictures far more carefully orchestrated and laboriously executed than his earlier, more spontaneously painted *plein air* canvases.

plump infant shares a tender moment with its adoring mother. Their intimacy is underscored by the subtle harmony of apricots and browns. Even the pairing of decorative patterns reinforces the central theme. These patterns, like the work's simple contours and sharply sloping floor, derive from Japanese prints. Works such as *Maternal Caress* appear to be Cassatt's Western answer to the work of Japanese printmakers such as Utamaro (fig. 8, Introduction), aiming for not only the timeless but also the universal.

Even Monet, who initially appeared immune to the growing crisis of Impressionism, eventually responded to it in the 1890s by choosing themes such as haystacks and poplars that had strong associations with French history and culture (the poplar, for example, was during the French Revolution known as the Tree of Liberty). Monet's apparent desire to place Impressionism within the great traditions of French art is most evident in his famous series of paintings devoted to the play of light over the intricately carved facade of Rouen Cathedral (fig. 27-68). Monet apparently chose the subject primarily for its **iconographic** associations, for the building symbolizes the continuity of human institutions such as the Church and the enduring presence of the divine. In effect, *Rouen Cathedral: The Portal (in Sun)* seems to argue that beneath the shimmering, insubstantial veneer

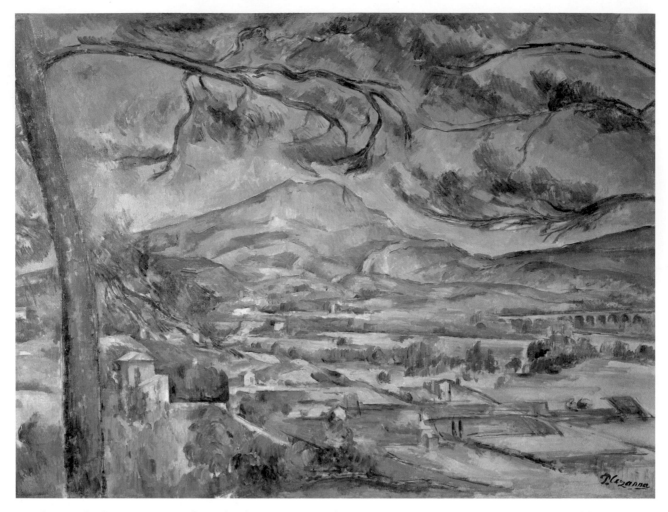

27-69. Paul Cézanne. *Mont Sainte-Victoire*. c. 1885–87. Oil on canvas, 25¹/₂ x 32" (64.8 x 81.3 cm). Courtauld Institute Galleries, University of London

of shifting appearances is a complex web of durable and expanding connections. Thus, while Renoir, Cassatt, and others were moving away from Impressionism, Monet was apparently trying to place it in a more enduring, coherent context. This pattern of rejection and reform is evident, as well, in the works of the next generation of French artists, the Post-Impressionists.

POST-IMPRESSIONISM

The English critic Roger Fry coined the term *Post-Impressionism* in 1910 to identify a broad reaction against Impressionism in avant-garde painting of the late nineteenth and early twentieth centuries. Art historians recognize Paul Cézanne (1839–1906), Paul Gauguin (1848–1903), Vincent van Gogh (1853–1890), and Georges Seurat (1859–1891) as the principal Post-Impressionist artists. Each of these painters moved through an Impressionist phase and continued to use in his mature work the bright Impressionist palette. But each came also to reject Impressionism's emphasis on the spontaneous recording of light and color and instead sought to create art with a greater degree of formal order and structure. This goal led the Post-Impressionists to depart from naturalism and develop more **abstract**

styles that would prove highly influential for the development of modernist painting in the early twentieth century (Chapter 28).

No artist had a greater impact on the next generation of modernist painters than Cézanne, who enjoyed little professional success until the last few years of his life, when younger artists and critics began to recognize the revolutionary qualities of his art. The son of a prosperous banker in the southern French city of Aix-en-Provence, Cézanne studied art first in Aix and then in Paris, where he participated in the circle of realist artists around Manet. Cézanne's early pictures, somber in color and coarsely painted, often depicted Romantic themes of drama and violence, and were consistently rejected by the Salon.

In the early 1870s Cézanne changed his style under the influence of Pissarro and adopted the bright palette, broken brushwork, and everyday subject matter of Impressionism. Like the Impressionists, with whom he exhibited in 1874 and 1877, Cézanne now dedicated himself to the objective transcription of what he called his "sensations" of nature. Unlike the Impressionists, however, he did not seek to capture transitory effects of light and atmosphere but rather to create a sense of

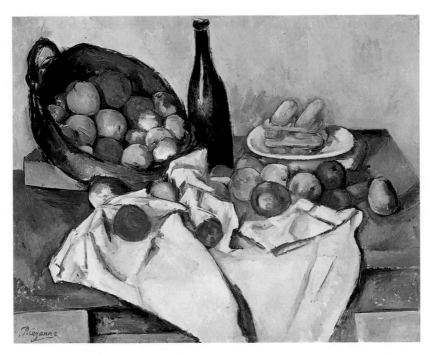

27-70. Paul Cézanne. _Still Life with Basket of Apples_. 1890–94. Oil on canvas, 24³/₈ x 31" (62.5 x 79.5 cm). The Art Institute of Chicago
Helen Birch Bartlett Memorial Collection

order in nature through a methodical application of color that merged drawing and modeling into a single process. His professed aim was to "make of Impressionism something solid and durable, like the art of the museums."

Cézanne's tireless pursuit of this goal is exemplified in his paintings of Mont Sainte-Victoire, a prominent mountain near his home in Aix that he depicted about thirty times in oil from the mid-1880s to his death. The version here (fig. 27-69) shows the mountain rising above the Arc Valley, which is dotted with houses and trees and is traversed at the far right by an aqueduct. Framing the scene at the left is an evergreen tree, which echoes the contours of the mountains, creating visual harmony between the two principal elements of the composition. The even lighting, still atmosphere, and absence of human activity in the landscape communicate a sense of timeless endurance, at odds with the Impressionists' interest in capturing a momentary aspect of the ever-changing world. Cézanne's paint handling is more deliberate and constructive than the Impressionists' spontaneous and comparatively random brushwork. His strokes, which vary from short, parallel hatchings to sketchy lines to broader swaths of flat color, not only record his "sensations" of nature but also weave every element of the landscape together into a unified surface design. That surface design coexists with the effect of spatial recession that the composition simultaneously creates, generating a fruitful tension between the illusion of three dimensions "behind" the picture plane and the physical reality of its two-dimensional surface. On the one hand, recession into depth is suggested by elements such as the foreground tree, a **_repoussoir_** (French for "something that pushes back") that helps

draw the eye into the valley and toward the distant mountain range, and by the gradual transition from the saturated greens and orange-yellows of the foreground to the softer blues and pinks in the mountain, which create an effect of **atmospheric perspective**. On the other hand, this illusion of consistent recession into depth is challenged by the inclusion of blues, pinks, and reds in the foreground foliage, which relate the foreground forms to the background mountain and sky, and by the tree branches in the sky, which rhyme with the contours of the mountain, making the peak appear nearer and binding it to the foreground plane.

Spatial ambiguities of a different sort appear in Cézanne's late still lifes, in which many of the objects seem incorrectly drawn. In S_till Life with Basket of Apples_ (fig. 27-70), for example, the right side of the table is higher than the left, the wine bottle has two different silhouettes, and the pastries on the plate next to it are tilted upward while the apples below seem to be viewed head-on. Such apparent inaccuracies are not evidence of Cézanne's incompetence, however, but of his willful disregard for the rules of traditional scientific perspective. Although scientific perspective mandates that the eye of the artist (and hence the viewer) occupy a fixed point relative to the scene being observed (see "Renaissance Perspective Systems," page 621), Cézanne studies different objects in a painting from slightly different positions. The composition as a whole, assembled from multiple sightings of its various elements, is complex and dynamic and even seems on the verge of collapse. The pastries look as if they could levitate, the bottle tilts precariously, the fruit basket appears ready to spill its contents, and only the folds and small tucks in the white

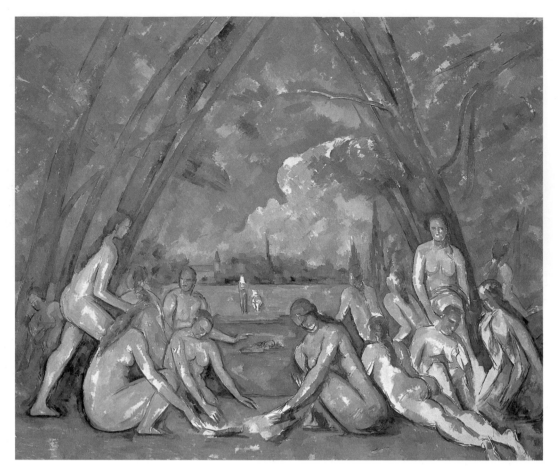

27-71. Paul Cézanne. *The Large Bathers*. 1906. Oil on canvas, 6'10" x 8'2" (2.08 x 2.49 m). Philadelphia Museum of Art

The W. P. Wilstach Collection

cloth seem to prevent the apples from cascading to the floor. All of these physical improbabilities are designed, however, to serve the larger visual logic of the painting as a work of art, characterized by Cézanne as "something other than reality"—not a direct representation of nature but "a construction after nature."

Toward the end of his life, Cézanne's constructions after nature became increasingly abstract, as seen in the monumental *The Large Bathers* (fig. 27-71), probably begun in the last year of his life, and left unfinished. This canvas, the largest Cézanne ever painted, culminated his involvement with the subject of nude bathers in nature, a theme he had admired in the Old Masters and had depicted on numerous earlier occasions. Unlike his predecessors, however, Cézanne did not usually paint directly from models but instead worked from earlier drawings, photographs, and memory. As a result, his bathers do not appear lifelike but have simplified, schematic forms. In *The Large Bathers*, the bodies cluster in two pyramidal groups at the left and right sides of the painting, beneath a canopy of trees that opens in the middle onto a triangular expanse of water, landscape, and sky. The figures assume motionless, statuesque poses (the crouching figure at the left quotes a Hellenistic *Crouching Venus* that Cézanne had copied in the Louvre) and seem to exist in a timeless realm, unlike the bathers of Manet and Renoir, who clearly inhabit the modern world. Emphasizing the scene's serene remoteness from everyday life, the simplified yet resonant palette of blues and greens, ochers and roses, laid down

in large patches over a white ground, suffuses the picture with light. Despite its unfinished state, *The Large Bathers* stands as a grand summation of Cézanne's art.

Another artist who, like Cézanne, adapted Impressionist discoveries to the creation of an art of greater structure and monumentality was Georges Seurat. Born in Paris and trained at the École des Beaux-Arts, Seurat became devoted to classical aesthetics, which he combined with a rigorous study of optics and color theory, especially the "law of the simultaneous contrast of colors," first formulated by Michel-Eugène Chevreul in the 1820s. Chevreul's law holds that adjacent objects not only cast reflections of their own color onto their neighbors but also create in them the effect of their **complementary color**. Thus, when a blue object is set next to a yellow one, the eye will detect a trace of purple, the complementary of yellow, and in the yellow object a trace of orange, the complementary of blue.

The Impressionists knew of Chevreul's law but had not applied it systematically. Seurat, however, calculated exactly which **hues** should be combined, in what proportion, to produce the effect of a particular color. He then set these hues down in dots of pure color, next to one another, in what came to be known by the various names of divisionism (the term preferred by Seurat), pointillism, and Neo-Impressionism. In theory, these juxtaposed dots would merge in the viewer's eye to produce the impression of other colors, which would be perceived as more luminous and intense than the same hues mixed on the palette. In Seurat's work, however,

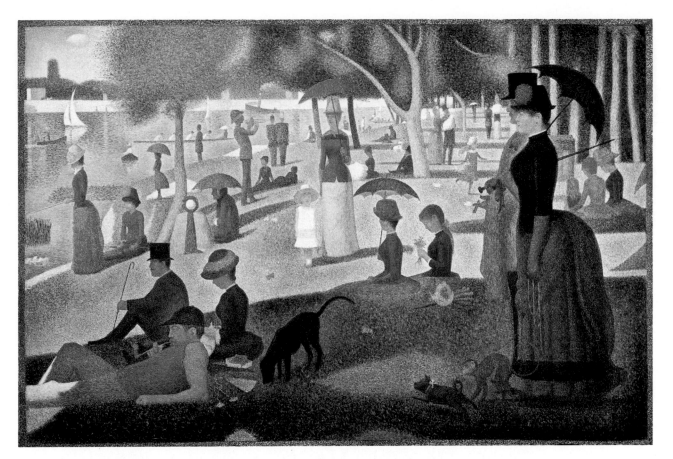

27-72. **Georges Seurat.** *A Sunday Afternoon on the Island of La Grande Jatte*. 1884–86. Oil on canvas, 6'9½" x 10'1¼" (2.07 x 3.08 m). The Art Institute of Chicago

Helen Birch Bartlett Memorial Collection

Although the painting is highly stylized and carefully composed, it has a strong basis in factual observation. Seurat spent months visiting the island, making small studies, drawings, and oil paintings of the light and the people he found there. All of the characters in the final painting, including the woman with the monkey, were based on his observations at the site.

this optical mixture is never complete, for his dots of color are large enough to remain separate in the eye, giving his pictures a grainy appearance.

Seurat's best-known work is *A Sunday Afternoon on the Island of La Grande Jatte* (fig. 27-72), which he first exhibited at the eighth and final Impressionist exhibition in 1886. The theme of weekend leisure is typically Impressionist, but the rigorous divisionist technique, the stiff formality of the figures, and the highly calculated geometry of the composition produce a solemn, abstract effect quite at odds with the casual naturalism of earlier Impressionism. Seurat's picture in fact depicts a contemporary subject in a highly formal style recalling much older art, such as that of the ancient Egyptians.

From its first appearance, *A Sunday Afternoon on the Island of La Grande Jatte* has generated conflicting interpretations. Contemporary accounts of the island indicate that on Sundays it was noisy, littered, and chaotic. By painting it the way he did, Seurat may have intended to show how tranquil it *should* be. Was Seurat merely criticizing the Parisian middle class, or was he trying to establish a social ideal for a more civilized way of life in the modern city? The key to Seurat's ideal may be the composure of the mother and child who stand as

the still point around which the others move. The child, in particular, is a model of self-restraint and may even represent the progress of human evolution, as obliquely suggested by the monkey in the right foreground.

Among the many artists to experiment with divisionism was the Dutch painter Vincent van Gogh. The oldest surviving son of a Protestant minister, van Gogh worked as an art dealer, teacher, and evangelist before deciding in 1880 to become an artist. After brief periods of study in Brussels, The Hague, and Antwerp, he moved in 1886 to Paris, where he discovered the work of the Impressionists and Neo-Impressionists. Van Gogh quickly adapted Seurat's divisionism, but rather than laying his paint down regularly in dots he typically applied it freely in multidirectional dashes of **impasto** (thick applications of pigment), which gave his pictures a greater sense of physical energy and a palpable surface texture.

During the last year and a half of his life van Gogh experienced repeated psychological crises that led to his going into a mental asylum and eventually committing suicide, in July 1890. He recorded his heightened emotional state in paintings that contributed significantly to the emergence of the **expressionistic** tradition, in which the intensity of an artist's feelings overrides fidelity

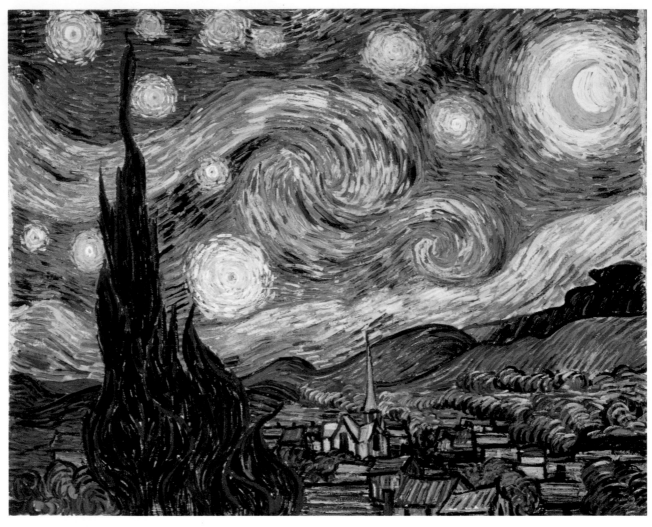

27-73. Vincent van Gogh. *The Starry Night*. 1889. Oil on canvas, 28³/₄ x 36¹/₂" (73 x 93 cm). The Museum of Modern Art, New York
Acquired through the Lillie P. Bliss Bequest

to the actual appearance of things. One of the earliest and most famous examples of expressionism is *The Starry Night* (fig. 27-73), which van Gogh painted from his window in the asylum at Saint-Rémy. Above the quiet town the sky pulsates with celestial rhythms and blazes with exploding stars. One explanation for the intensity of van Gogh's feelings is the then-popular theory that after death people journey to a star, where they continue their lives. Contemplating immortality in a letter, van Gogh wrote: "Just as we take the train to get to Tarascon or Rouen, we take death to reach a star." The idea is given visible form in this painting by the cypress tree, a traditional symbol of both death and eternal life, which dramatically rises to link the terrestrial and celestial realms. The brightest star in the sky is actually a planet, Venus, which is associated with love. Is it possible that the picture's extraordinary excitement also expresses van Gogh's euphoric hope of gaining the companionship that had eluded him on earth?

In painting from his imagination rather than from nature in *The Starry Night*, van Gogh was perhaps following

the advice of Gauguin, who had once counseled another friend, "Don't paint from nature too much. Art is an abstraction. Derive this abstraction from nature while dreaming before it, and think more of the creation that will result." Gauguin's own mature work was even more abstract than van Gogh's, and, like Cézanne's, it laid important foundations for the development of nonrepresentational art in the twentieth century. During the 1870s and early 1880s the Parisian-born Gauguin enjoyed a comfortable bourgeois life as a stockbroker and painted in his spare time under the tutelage of Pissarro. He exhibited in the final four Impressionist exhibitions, held between 1880 and 1886. In 1883, Gauguin lost his job during a stock market crash; three years later he abandoned his wife and five children to pursue a full-time painting career. Disgusted by what he considered the corruption of urban civilization and seeking more "primitive" existence, Gauguin lived for extended periods in the French province of Brittany between 1886 and 1891, traveled to Panama and Martinique in 1887, spent two months in Arles with van Gogh in 1888, then in 1891

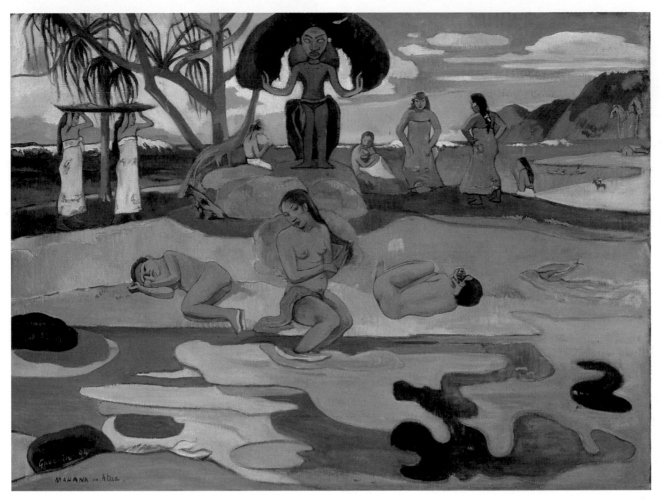

27-74. Paul Gauguin. *Mahana no atua (Day of the God)*. 1894. Oil on canvas, 27³/₈ x 35⁵/₈" (69.5 x 90.5 cm). The Art Institute of Chicago

Helen Birch Bartlett Memorial Collection (1926.198)

sailed for Tahiti, a French colony in the South Pacific. After a final sojourn in France in 1893–95, Gauguin returned to the Pacific, where he died.

Gauguin's mature style was inspired by such nonacademic sources as medieval stained glass, folk art, and Japanese prints and featured simplified drawing, flattened space, and antinaturalistic color. Gauguin rejected Impressionism because it neglected subjective feelings and "the mysterious centers of thought." Gauguin called his anti-Impressionist style synthetism, because it synthesized observation of the subject in nature with the artist's feelings about that subject, expressed through abstracted line, shape, space and color. Very much a product of such synthesis is *Mahana no atua (Day of the God)* (fig. 27-74), which, despite its Tahitian subject, was painted in France during Gauguin's return after two years in the South Pacific. Gauguin had gone to Tahiti hoping to find an unspoiled paradise where he could live and work cheaply and "naturally." What he discovered, instead, was a thoroughly colonized country whose native culture was rapidly disappearing under the pressures of Westernization. In his paintings, Gauguin ignored this reality and depicted the Edenic ideal in his imagination, as seen in *Mahana no atua*, with

its bright colors, stable composition, and appealing subject matter.

Gauguin divided *Mahana no atua* into three horizontal zones in styles of increasing abstraction. The upper zone, painted in the most realistic manner, centers around the statue of a god, behind which extends a beach landscape populated by Tahitians. In the middle zone, directly beneath the statue, three figures occupy a beach divided into several bands of antinaturalistic color. The central female bather dips her feet in the water and looks out at the viewer, while on either side of her two figures recline in fetuslike postures—perhaps symbolizing birth, life, and death. Filling the bottom third of the canvas is a strikingly abstract pool whose surface does not reflect what is above it but instead offers a dazzling array of bright colors, arranged in a puzzlelike pattern of flat, curvilinear shapes. By reflecting a strange and unexpected reality exactly where we expect to see a mirror image of the familiar world, this magic pool seems the perfect symbol of Gauguin's desire to evoke "the mysterious centers of thought." Like many of Gauguin's works, *Mahana no atua* is enigmatic and suggestive of unstated meanings that cannot be literally represented but only evoked indirectly through abstract pictorial means.

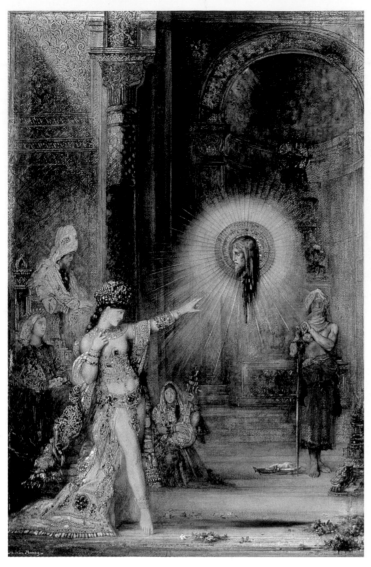

27-75. Gustave Moreau. *The Apparition*. 1874–76. Watercolor on paper, 41⁵⁄₁₆ x 28³⁄₁₆" (106 x 72.2 cm). Musée du Louvre, Paris

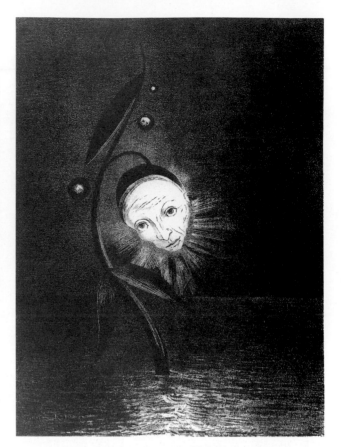

27-76. Odilon Redon. *The Marsh Flower, a Sad and Human Face*, plate 2 from *Homage to Goya*. 1885. Lithograph, 10⁷⁄₈ x 8" (27.5 x 20.3 cm). The Museum of Modern Art, New York

Abby Aldrich Rockefeller Purchase Fund

Fascinated by the science of biology, Redon based his strange hybrid creatures on the close study of living organisms. His aim, as he wrote in his journal, was "to make improbable beings live, like human beings, according to the laws of probability by putting . . . the logic of the visible at the service of the invisible."

SYMBOLISM IN PAINTING

Gauguin's suggestiveness is characteristic of Symbolism, an international movement in late-nineteenth-century art and literature of which he was a recognized leader. Like the Romantics before them, the Symbolists opposed the values of rationalism and material progress that dominated modern Western culture and instead explored the nonmaterial realms of emotion, imagination, and spirituality. Ultimately the Symbolists sought a deeper and more mysterious reality than the one we encounter in everyday life, which they conveyed not through traditional iconography but through ambiguous subject matter and formal stylization suggestive of hidden and elusive meanings. Instead of objectively representing the world, they transformed appearances in order to give pictorial form to psychic experience, and they often compared their works to dreams. It seems hardly coincidental that Sigmund Freud, who compared artistic creation to the process of dreaming, wrote his pioneering *The Interpretation of Dreams* (1900) during the Symbolist period.

A dreamlike atmosphere pervades the later work of Gustave Moreau (1826–98), an older academic artist whom the Symbolists recognized as a precursor. The Symbolists particularly admired Moreau's renditions of the biblical subject of Salome, the young Judaean princess who, at the instigation of her mother, Herodias, performed an erotic dance before her stepfather, Herod, and demanded in return the head of John the Baptist (Mark 6:21–28). In *The Apparition* (fig. 27-75), exhibited at the Salon of 1876, the seductive Salome confronts a vision of the saint's severed head, which hovers open-eyed in midair, simultaneously dripping blood and radiating holy light. Moreau depicts this macabre subject and its exotic architectural setting in elaborate linear detail with touches of jewel-like color. His style creates an atmosphere of voluptuous decadence that amplifies Salome's role as the archetypal *femme fatale*, the "fatal woman" who tempts and destroys her male victim—a fantasy that haunted the imagination of countless male Symbolists, perhaps partly in response to late-nineteenth-century feminism.

A younger artist who embraced Symbolism was Odilon Redon (1840–1916). Although he exhibited with

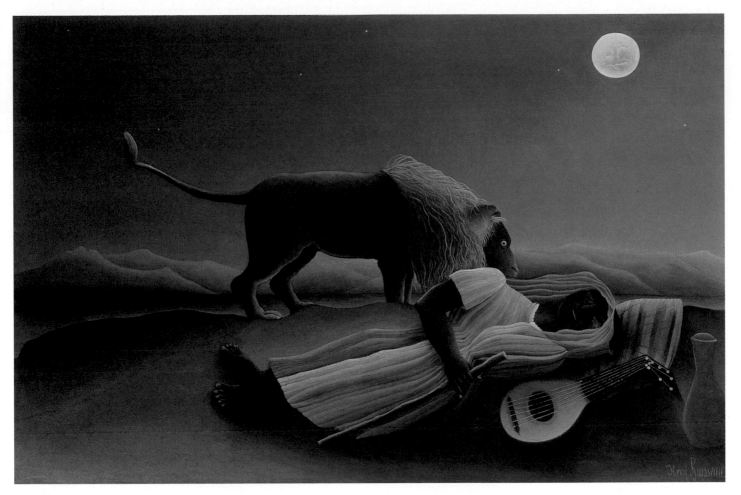

27-77. Henri Rousseau. *The Sleeping Gypsy*. 1897. Oil on canvas, 4'3" x 6'7" (1.3 x 2.03 m). The Museum of Modern Art, New York
Gift of Mrs. Simon Guggenheim

From 1886 until his death, Rousseau exhibited regularly at the Salon des Indépendants. While most critics dismissed his work for its stylistic naiveté, his pictures excited the admiration of a few progressive figures such as the playwright Alfred Jarry, who gave Rousseau his nickname, Le Douanier ("the customs official"). By the early twentieth century Rousseau had become a celebrity to the Parisian avant-garde, including the poet Guillaume Apollinaire and Pablo Picasso, who bought several of Rousseau's paintings and later donated them to the Louvre. In 1908 Picasso hosted a now-legendary banquet for Rousseau that confirmed his high standing among the younger generation of artists.

the Impressionists in 1886, he diverged from their artistic goals by using nature as a point of departure for fantastic visions tinged with loneliness and melancholy. For the first twenty-five years of his career, Redon, a graphic artist, created moody images in black-and-white charcoal drawings that he referred to as *Noirs* ("Blacks") and in related etchings and lithographs, such as *The Marsh Flower, a Sad and Human Face* (fig. 27-76), one of many bizarre human-vegetal hybrids Redon invented. Despite the supernatural appearance of this plant's sorrowful but radiant human face, it was inspired by contemporary Darwinian theories that posited a common ancestry for all forms of earthly life.

A contemporary of the Symbolists who shared their interest in poetic and dreamlike imagery was Henri Rousseau (1844–1910), a "naive," or untrained "primitive," painter. After a long career as a municipal toll collector in Paris, which earned him the nickname Le Douanier ("the customs official"), Rousseau retired in 1893 to devote his

full energies to painting. Rousseau admired academic painting and tried to emulate its polished style, but, lacking formal training, he failed to grasp academic rules of scale, perspective, modeling, and coloring. Working in a sincere but awkward manner, he painted with strong hues, gave his forms crisp outlines, posed his figures stiffly, and positioned them in flattened and airless spaces. As a result, his compositions have a stylized quality similar to that of the Post-Impressionists. Among Rousseau's most famous works is *The Sleeping Gypsy* (fig. 27-77), a haunting picture whose mood of nocturnal mystery and magic anticipates the twentieth-century Surrealists, who claimed Rousseau as a precursor.

Symbolism originated in France but had a profound impact on the art of other European countries, where it often merged with expressionist tendencies. Such a melding of Symbolism and Expressionism is evident in the work of the Belgian painter and printmaker James Ensor (1860–1949), who, except for four years of study at

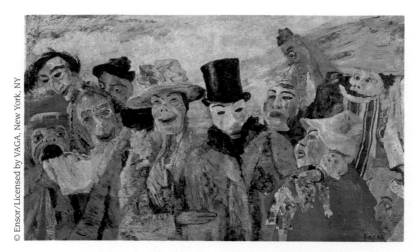

27-78. James Ensor. *The Intrigue*. 1890. Oil on canvas, 35¹⁄₂ x 59" (90.3 x 150 cm). Koninklijk Museum voor Schone Kunsten, Antwerp

the Brussels Academy, spent his life in the coastal resort town of Ostend. Like Redon, Ensor derived his weird and anxious visions from the observation of the real world—often grotesque papier-mâché masks that his family sold during the annual pre-Lenten carnival, one of Ostend's main holidays. In paintings such as *The Intrigue* (fig. 27-78), these disturbing masks seem to come to life and reveal rather than hide the character of the people wearing them—comical, stupid, and hideous. The acidic colors increase the sense of caricature, as does the crude handling of form. The rough paint is both expressive and expressionistic: Its lack of subtlety well characterizes the subjects, while its almost violent application directly records Ensor's feelings toward them.

The sense of powerful emotion that pervades Ensor's work is even more evident in that of his Norwegian contemporary Edvard Munch (1863–1944). Munch's most famous work, *The Scream* (fig. 27-79), is an unforgettable image of modern alienation that merges Symbolist suggestiveness with expressionist intensity of feeling. Munch recorded the painting's genesis in his diary: "One evening I was walking along a path; the city

27-79. Edvard Munch. *The Scream*. 1893. Tempera and casein on cardboard, 36 x 29" (91.3 x 73.7 cm). Nasjonalgalleriet, Oslo

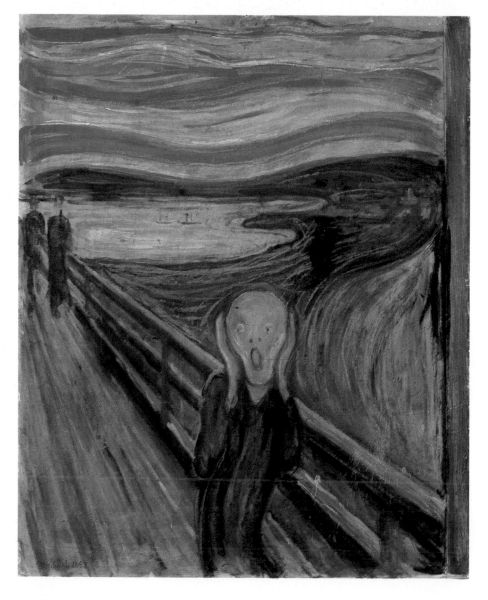

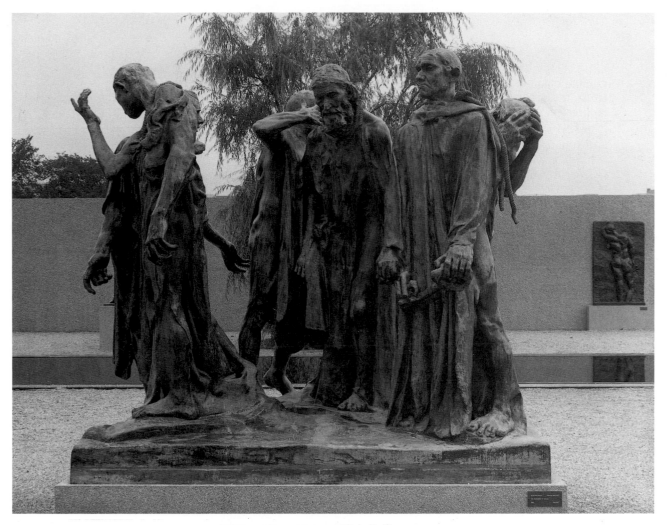

27-80. Auguste Rodin. *Burghers of Calais*. 1884–86. Bronze, 6'10½" x 7'11" x 6'6" (2.1 x 2.4 x 2 m). Hirshhorn Museum and Sculpture Garden, Smithsonian Institution, Washington, D.C.

was on one side, and the fjord below. I was tired and ill. . . . I sensed a shriek passing through nature. . . . I painted this picture, painted the clouds as actual blood." In the painting itself, however, the figure is on a bridge and the scream emanates from him. Although he vainly attempts to shut out its sound by covering his ears, the scream fills the landscape with clouds of "actual blood." The overwhelming anxiety that sought release in this primal scream was chiefly a dread of death, as the sky and the figure's skull-like head suggest, but the setting of the picture also suggests a fear of open spaces. The expressive abstraction of form and color in the painting reflects the influence of Gauguin and his Scandinavian followers, whose work Munch had encountered shortly before he painted *The Scream*.

LATE-NINETEENTH-CENTURY FRENCH SCULPTURE

The most successful and influential European sculptor of the late nineteenth century was Auguste Rodin (1840–1917). Born in Paris and trained as a decorative craftsperson, Rodin failed on three occasions to gain entrance to the École des Beaux-Arts and consequently spent the first twenty years of his career as an assistant

to other sculptors and decorators. After an 1875 trip to Italy, where he saw the sculpture of Donatello and Michelangelo, Rodin developed his mature style of vigorously modeled figures in unconventional poses, which were simultaneously scorned by academic critics and admired by the general public.

Rodin's status as a major sculptor was confirmed in 1884, when he won a competition for the *Burghers of Calais* (fig. 27-80), commissioned to commemorate an event from the Hundred Years' War. In 1347 Edward III of England had offered to spare the besieged city of Calais if six leading citizens (or burghers)—dressed only in sackcloth with rope halters and carrying the keys to the city—would surrender to him for execution. Rodin shows the six volunteers preparing to give themselves over to what they assume will be their deaths. The Calais commissioners were not pleased with Rodin's conception of the event. Instead of calm, idealized heroes, Rodin presented ordinary-looking men in various attitudes of resignation and despair. He exaggerated their facial expressions, expressively lengthened their arms, greatly enlarged their hands and feet, and swathed them in heavy fabric, showing not only how they may have looked but how they must have felt as they forced themselves to take

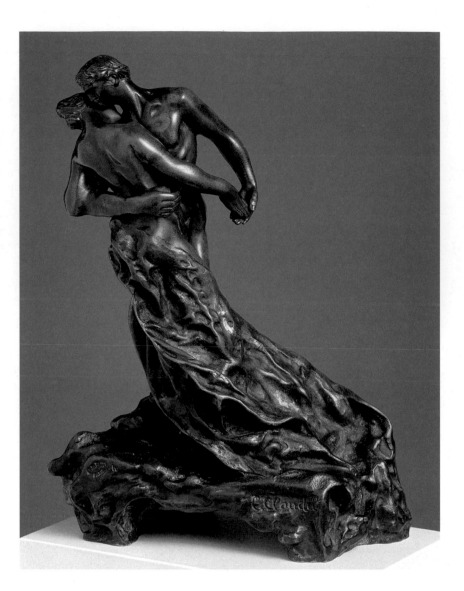

27-81. Camille Claudel. *The Waltz.* 1892–1905. Bronze, 9⁷/₈" (25 cm). Neue Pinakothek, Munich

French composer Claude Debussy, a close friend of Claudel, displayed a cast of this sculpture on his piano. Debussy acknowledged the influence of art and literature on his musical innovations.

one difficult step after another. Rodin's willingness to stylize the human body for expressive purposes was a revolutionary move that opened the way for the more radical innovations of later sculptors.

Nor were the commissioners pleased with Rodin's plan to display the group on a low pedestal. Rodin felt that the usual placement of such figures on an elevated pedestal suggested that only higher, superior humans are capable of heroic action. By placing the figures nearly at street level, Rodin hoped to convey to viewers that ordinary people, too, are capable of noble acts. Rodin's removal of public sculpture from a high to a low pedestal would lead, in the twentieth century, to the elimination of the pedestal itself and to the presentation of sculpture in the "real" space of the viewer (see fig. 29-33).

An assistant in Rodin's studio who worked on the *Burghers of Calais* was Camille Claudel (1864–1943), whose accomplishments as a sculptor were long overshadowed by the dramatic story of her life. Claudel began to study sculpture in 1879 and became Rodin's pupil four years later. After she started working in his studio, she also became his mistress, and their often stormy relationship lasted fifteen years. Both during and after her association with Rodin, Claudel enjoyed independent professional success, but she also suffered

from psychological problems that eventually overtook her, and she spent the last thirty years of her life in a mental asylum.

Among Claudel's most celebrated works is *The Waltz* (fig. 27-81), which exists in several versions made between 1892 and 1905. The sculpture depicts a dancing couple, the man unclothed and the woman seminude, her lower body enveloped in a long, flowing gown. In Claudel's original conception, both figures were entirely nude, but she had to add drapery to the female figure after an inspector from the Ministry of the Beaux-Arts found the pairing of the nude bodies indecent and recommended against a state commission for a marble version of the work. After Claudel added drapery, the same inspector endorsed the commission, but it was never carried out. Instead, Claudel modified *The Waltz* further and had it cast in bronze.

In *The Waltz*, Claudel succeeded in conveying an illusion of fluent motion as the dancing partners whirl in space, propelled by the rhythm of the music. The spiraling motion of the couple, enhanced by the woman's flowing gown, encourages the observer to view the piece from all sides, increasing its dynamic effect. Despite the physical closeness of the dancers there is little actual physical contact between them, and their facial expressions reveal

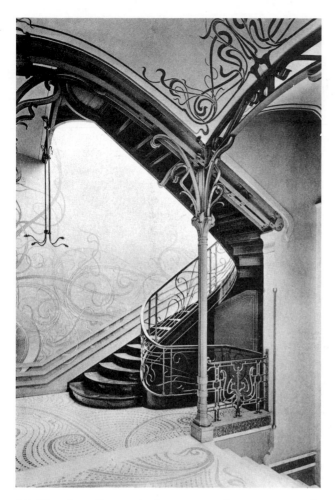

27-82. Victor Horta. Stairway, Tassel House, Brussels. 1892–93

no passion or sexual desire. After violating decency standards with her first version of *The Waltz*, Claudel perhaps sought in this new rendition to portray love as a union more spiritual than physical.

ART NOUVEAU

The swirling mass of drapery in Claudel's *Waltz* has a stylistic affinity with Art Nouveau (French for "new art"), a movement launched in the early 1890s that for more than a decade permeated all aspects of European art, architecture, and design. Like the contemporary Symbolists, the practitioners of Art Nouveau largely rejected the values of modern industrial society and sought new aesthetic forms that would retain a preindustrial sense of beauty while also appearing fresh and innovative. They drew particular inspiration from nature, especially from organisms such as vines, snakes, flowers, and winged insects, whose delicate and sinuous forms were the basis of their graceful and attenuated linear designs. Following from this commitment to organic principles, they also sought to harmonize all aspects of design into a beautiful whole, as found in nature itself.

The man largely responsible for introducing the Art Nouveau style in architecture and the decorative arts

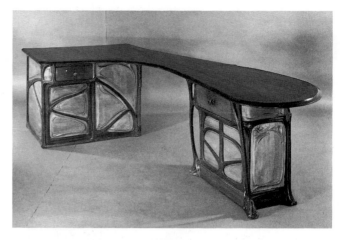

27-83. Hector Guimard. Desk. c. 1899 (remodeled after 1909). Olive wood with ash panels, 28³/₄ x 47³/₄" (73 x 121 cm). The Museum of Modern Art, New York
Gift of Madame Hector Guimard

was a Belgian, Victor Horta (1861–1947). Trained at the academies in Ghent and Brussels, Horta worked in the office of a Neoclassical architect in Brussels for six years before opening his own practice in 1890. In 1892 he received his first important commission, a private residence in Brussels for a Professor Tassel. The result, especially the house's entry hall and staircase (fig. 27-82), was strikingly original. The ironwork, wall decoration, and floor tile were all designed in an intricate series of long, graceful curves. Although Horta's sources are still a matter of debate, he apparently was much impressed with the stylized linear graphics of the English Arts and Crafts movement of the 1880s. Horta's concern for integrating the various arts into a more unified whole, like his reliance on a refined decorative line, derived largely from English reformers.

The application of graceful linear arabesques to all aspects of design, evident in the entry hall of the Tassel House, began a vogue that spread across Europe and acquired a number of regional names. In Italy it was called *Stile floreale* ("Floral Style") and *Stile Liberty* (after the Liberty department store in London); in Germany, *Jugendstil* ("Youth Style"); in Spain, *Modernismo* ("Modernism"); in Vienna, *Sezessionstil*, after the secession from the academy led by the painter Gustav Klimt (see page 1062); in Belgium, *Paling Style* ("Eel Style"); and in France, a number of names, including *moderne*. The name eventually accepted in most countries derives from a shop, La Maison de l'Art Nouveau ("The House of the New Art"), which opened in Paris in 1895.

In France Art Nouveau was also sometimes known as *Style Guimard* after its leading French practitioner, Hector Guimard (1867–1942). Guimard worked in an eclectic manner during the early 1890s but in 1895 met and was influenced by Horta. He went on to design the famous Art Nouveau–style entrances for the Paris Métro (subway) and devoted considerable effort to interior design and furnishings, such as the desk he made for himself (fig. 27-83). Instead of a static and stable object,

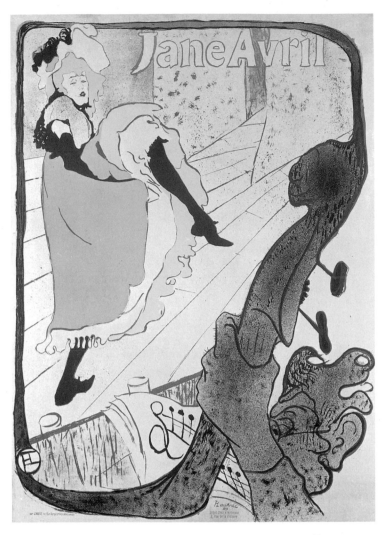

27-84. Henri de Toulouse-Lautrec. *Jane Avril*. 1893. Lithograph, 50½ x 37" (129 x 94 cm). San Diego Museum of Art

The Baldwin M. Baldwin Collection

Guimard handcrafted an asymmetrical, organic entity that seems to undulate and grow.

The Art Nouveau style also had a powerful impact on the graphic arts, including poster design, whose most innovative French practitioner in the 1890s was Henri de Toulouse-Lautrec (1864–1901). Born into an aristocratic family in the south of France, Lautrec suffered from a genetic disorder and childhood accidents that left him dwarfed and crippled. Extremely gifted artistically, he moved to Paris in 1882 and had private academic training before discovering the work of Degas, which greatly influenced his own development. He also discovered Montmartre, a lower-class entertainment district of Paris, and soon joined its population of bohemian artists. From the late 1880s Lautrec dedicated himself to depicting the social life of the Parisian cafés, theaters, dance halls, and brothels—many of them in Montmartre—that he himself frequented.

Among these images were thirty lithographic posters Lautrec designed between 1891 and 1901 as advertisements for popular night spots and entertainers

(see "The Print Revivals," page 1017). His portrayal of the café dancer Jane Avril (fig. 27-84) demonstrates the remarkable originality that Lautrec brought to an essentially commercial project. The composition juxtaposes the dynamic figure of Avril dancing onstage at the upper left with the cropped image of a bass viol player and the scroll of his instrument at the lower right. The bold foreshortening of the stage and the prominent placement of the bass in the foreground both suggest the influence of Degas, who employed similar devices (see fig. 27-62). Lautrec departs radically from Degas's naturalism, however, particularly in his imaginative extension of each end of the bass viol's head into a curving frame that encapsulates Avril and connects her visually with her musical accompaniment. Also antinaturalistic are the radical simplification of form, suppression of modeling, flattening of space, and integration of blank paper into the composition, all of which suggest the influence of Japanese woodblock prints (see "Japonisme," page 1020). Meanwhile, the emphasis on curving lines and the harmonization of the lettering with the rest of the design are characteristic of Art Nouveau.

ART IN THE UNITED STATES

The tension between an academic tradition imported from western Europe and an unbroken American tradition of realism marked the development of art in the United States during the second half of the nineteenth century. The advocates of realism had long considered it distinctively American and democratic; others, in contrast, saw the academic ideal as a link to a higher western European culture.

NEOCLASSICAL SCULPTURE

Immediately before and after the Civil War (1861–65), sculpture—especially in marble—remained the essential medium for those committed to "high," or European, culture. A new generation of sculptors continued the European Neoclassical tradition established in Rome by Antonio Canova (see fig. 26-21) and brought to the United States in the second quarter of the nineteenth century by artists like Hiram Powers. Most members of this new generation studied in Rome, including a number of women, whom the American author Henry James dubbed the "white, marmorean [marble] flock."

The most prominent of these women, Harriet Hosmer (1830–1908), moved to Rome in 1852 where she rapidly mastered the Neoclassical mode and began producing major exhibition pieces such as *Zenobia in Chains* (fig. 27-85), which she entered into an international exhibition in London in 1862 and then sent on tour around the United States. Like Powers's famous *The Greek Slave* (see fig. 27-27), another marble image of a chained woman, Hosmer's sculpture is Neoclassical in form but Romantic in content, representing an exotic historical subject calculated to appeal to the viewer's emotions. Zenobia, the ambitious third-century queen of the Syrian city of Palmyra, was captured by the Romans and forced to march through the streets of Rome in chains. Hosmer presents her as a noble

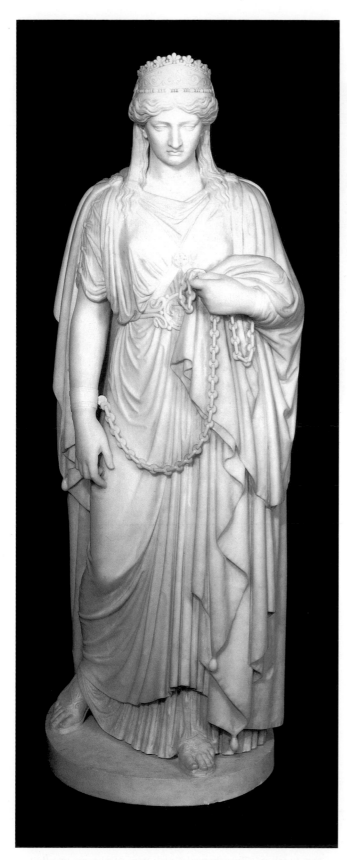

27-85. Harriet Hosmer. *Zenobia in Chains*. 1859. Marble, 4' (1.21 m). Wadsworth Atheneum, Hartford, Connecticut

Gift of Mrs. Josephine M. J. Dodge

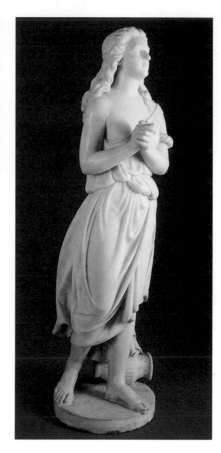

27-86. Edmonia Lewis. *Hagar in the Wilderness*. 1875. Marble, 52⁵⁄₈ x 15¼ x 17" (133.7 x 39.1 x 43.6 cm). National Museum of African Art, Smithsonian Institution, Washington, D.C.

and monumental figure, resolute even in defeat. "I have tried to make her too proud to exhibit passion or emotion of any kind," wrote Hosmer of *Zenobia*, "not subdued, though a prisoner; but calm, grand, and strong within herself." Thus, unlike Powers's *The Greek Slave*, *Zenobia* is not powerless but powerful, embodying an ideal of womanhood strikingly modern in its defiance of Victorian conventions of female submissiveness.

Another American woman who moved to Rome to become a sculptor was Edmonia Lewis (c. 1843/45–after 1911). Born in New York State to a Chippewa mother and an African-American father and originally named Wildfire, Lewis was orphaned at the age of four and raised by her mother's people. As a teenager, with the help of abolitionists, she attended Oberlin College, the first college in the United States to grant degrees to women, then moved to Boston. Her highly successful busts and medallions of abolitionist leaders and Civil War heroes financed her move to Rome in 1867, where she was welcomed into Hosmer's circle.

In Rome, Lewis continued to dedicate herself to the causes of human freedom, especially those involving women: "I have a strong sympathy for all women who have struggled and suffered," she said. *Hagar in the Wilderness* (fig. 27-86), for example, tells the story of the

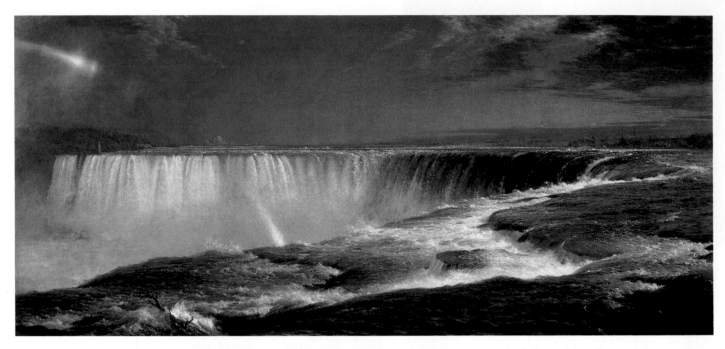

27-87. Frederic Edwin Church. *Niagara*. 1857. Oil on canvas, 3'6½" x 7'6½" (1.1 x 2.3 m). The Corcoran Gallery of Art, Washington, D.C.

Egyptian concubine of the biblical patriarch Abraham, given to him by his childless wife, Sarah, so that he might have a son. When Hagar's son, Ishmael, was in his teens, the elderly Sarah miraculously gave birth to a son, Isaac. Out of jealousy, she then demanded that Abraham drive Hagar and her son into the wilderness. When Hagar and Ishmael were dying from thirst, an angel led them to a well and told Hagar that her son's descendants would be a great nation (Genesis 16:1–16; 21:9–21). Because of her African origins, Hagar represented for Lewis the plight and the hope of her entire race.

LANDSCAPE PAINTING AND PHOTOGRAPHY

In contrast to the late Neoclassicism prevalent in sculpture, during the years before the Civil War American landscape painters shifted from the Romantic tradition of Thomas Cole (see fig. 27-25) toward a more factual naturalism. This transition is particularly evident in the work of Frederic Edwin Church (1826–1900), Cole's only student. Like Cole, Church favored the grand spectacles of nature, such as Niagara Falls (fig. 27-87). In its epic aspirations Church's *Niagara* remains Romantic in conception, but its Romanticism is tempered by a scientific eye to detail. The painting's magnificent spectacle, precarious vantage point, and large scale were designed to generate grand emotions, especially nationalistic pride. By including a rainbow—a traditional symbol of divine approval—over the falls, Church appealed to his compatriots' preconceptions about their national destiny.

Americans flocked to see *Niagara*, and more than a thousand visitors in New York City bought reproductions of the work.

Albert Bierstadt (1830–1902), born in Germany and raised in Massachusetts, specialized in paintings of the American West. After studying at the Düsseldorf Academy, Bierstadt in 1859 accompanied a U.S. Army expedition, led by Colonel Frederick Lander, mapping an overland route from St. Louis to the Pacific Ocean. Working from his sketches and photographs, he produced the paintings that made his fame. The first of these, *The Rocky Mountains, Lander's Peak* (fig. 27-88), attracted large crowds and sold for $25,000, the highest price an American painting had yet brought—more than forty times what a skilled carpenter or mason then earned per year. The huge canvas, intended for Eastern audiences only slightly familiar with Native Americans and even less familiar with the Rockies, combines a documentary approach to Native American life in the tradition of George Catlin (see fig. 27-24) with an epic, composite landscape in the tradition of Church. The painting is more than a geography lesson, however. As in the work of Church and Cole, it conveys an implicit historical narrative. From the Native American encampment in the foreground, with its apparent associations to the Garden of Eden, the eye is drawn into the middle ground by the light on the waterfall, then up to Lander's Peak. To Americans who believed that it was the divinely sanctioned Manifest Destiny of the United States to expand all the way to California, the composition's

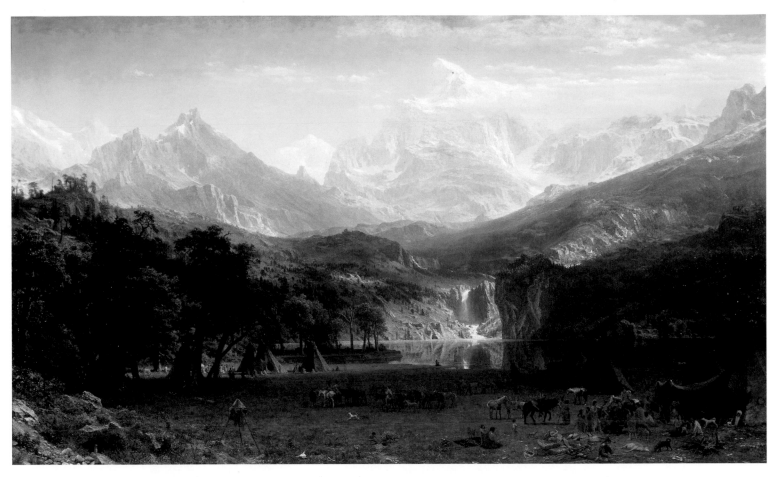

27-88. Albert Bierstadt. *The Rocky Mountains, Lander's Peak*. 1863. Oil on canvas, 6'1¼" x 10'3¾" (1.86 x 3 m).
The Metropolitan Museum of Art, New York
Rogers Fund, 1907 (07.123)

spatial progression must have appeared to map out their nation's westward and "upward" course. The painting seems virtually to beckon them into this paradise to displace the Native Americans already inhabiting it.

The photographer Timothy H. O'Sullivan (1840–82), like Bierstadt, accompanied survey expeditions. His most famous Western photograph, *Ancient Ruins in the Cañon de Chelley, Arizona* (fig. 27-89), while ostensibly a documentary image, is infused with a Romantic sense of awe before the grandeur of nature. The 700-foot canyon wall fills the composition, giving the viewer no clear vantage point and scant visual relief. The bright, raking sunlight across the rock face reveals little but the cracks and striations formed over countless eons. The image suggests not only the immensity of geological time but also humanity's insignificant place within it. Like the Classical ruins that were a popular theme in European Romantic art and literature, the eleventh- to fourteenth-century

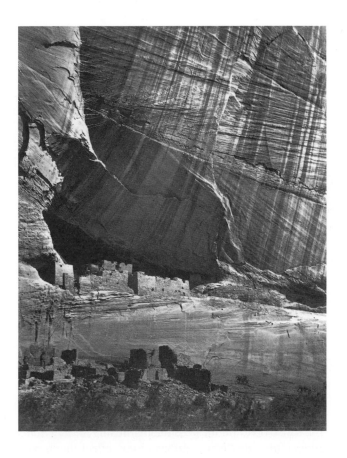

27-89. Timothy H. O'Sullivan. *Ancient Ruins in the Cañon de Chelley, Arizona*. 1873. Albumen print.
National Archives, Washington, D.C.

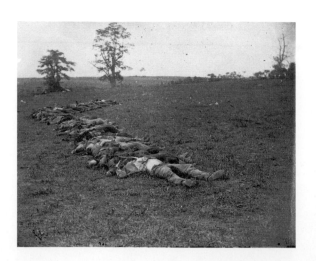

27-90. Alexander Gardner. *Confederate Dead Gathered for Burial, Antietam, September 1862*. 1862. Albumen silver print. Library of Congress, Washington, D.C.

An 1862 editorial in the *New York Times* commented that Mathew Brady and his assistants "bring home to us the terrible reality . . . of the war. If [they have] not brought bodies and laid them in our door yards . . . [they have] done something very like it."

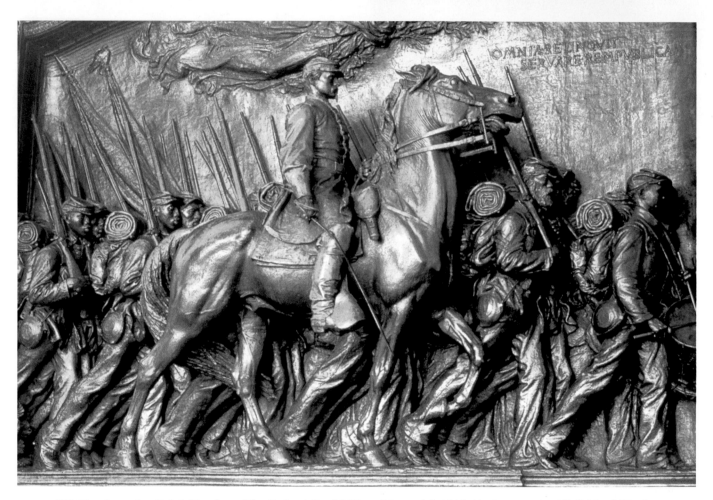

27-91. Augustus Saint-Gaudens. The Robert Gould Shaw Memorial. 1884–97. Bronze, 11 x 14' (3.35 x 4.27 m).
Boston Common, Boston, Massachusetts

Anasazi ruins suggest the inevitable passing of all civilizations. The four puny humans on the left, standing in this majestic yet barren place, reinforce the theme of human futility and insignificance.

CIVIL WAR PHOTOGRAPHY AND SCULPTURE

The sense of Romantic pessimism infusing *Ancient Ruins in the Cañon de Chelley, Arizona* may reflect the impact of the Civil War, which lasted four bloody years (1861–65) and cost nearly 620,000 American lives. Inspired by British war photographers in the 1850s, more than 300 American and foreign photographers eventually entered the battle zone with passes from the U.S. government.

The first photographer at the front was Mathew B. Brady (1823–96), who gained government permission to take a team and a darkroom wagon to the field of battle.

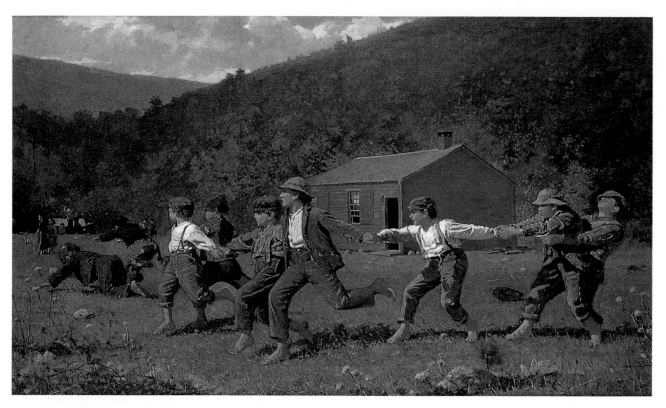

27-92. Winslow Homer. *Snap the Whip*. 1872. Oil on canvas, 22¼ x 36½" (55.9 x 91.4 cm). The Butler Institute of American Art, Youngstown, Ohio

After Brady himself was almost killed in an early battle, he left the photographing to his twenty assistants, among whom was Timothy O'Sullivan. Brady's Photographic Corps amassed more than 7,000 negatives documenting every aspect of the war except the actual fighting, because the cameras were still too slow to capture action scenes. Brady and his assistants took their most memorable images immediately after battles, before the dead could be buried. *Confederate Dead Gathered for Burial, Antietam, September 1862* (fig. 27-90), by Brady's most acclaimed assistant, Alexander Gardner (1821–82), shows the corpses of some of the more than 10,000 Confederate soldiers who had fallen in that battle. The grim evidence of carnage in such works made a powerful impression on the American public, cutting through the so-called glamour of war.

After the war, both the North and the South commissioned public sculpture to commemorate the dead and honor their heroes. Augustus Saint-Gaudens (1848–1907), the preeminent American sculptor of the late nineteenth century, created six Civil War memorials. Born in Ireland, Saint-Gaudens grew up in New York City, studied sculpture at the École des Beaux-Arts, and from 1870–75 worked in Rome before returning to the United States. Nine years later he began work on the Robert Gould Shaw Memorial (fig. 27-91), which pays tribute to the twenty-five-year-old white commander of the first African-American military corps in the North, the Massachusetts Fifty-fourth

Regiment. In July 1863, just two months after triumphantly marching through the streets of Boston to join the Union forces, Shaw and hundreds of his men died in an attack on Fort Wagner, near Charleston, South Carolina. In Saint-Gaudens's sculpture, the mounted Shaw and his infantrymen move resolutely toward their destiny, accompanied by an allegorical figure of Peace and Death. Nearly 180,000 African Americans eventually fought for the Union, and President Abraham Lincoln believed their contributions helped tip the scales toward the Union victory.

POST–CIVIL WAR REALISM

Saint-Gaudens's use of allegorical figures tied his art to an older European tradition of idealism that other American artists such as Winslow Homer (1836–1910) rejected, believing that unadorned realism was the more appropriate style for democratic values. Homer began his career in 1857 as a freelance illustrator for popular periodicals such as *Harper's Weekly*, which sent him to cover the Civil War in 1862. In 1866–67 Homer spent ten months in France, where the naturalist art he saw may have inspired the rural subjects he painted when he returned. Works like *Snap the Whip* (fig. 27-92), with its depiction of boys playing outside a one-room schoolhouse in the Adirondack Mountains on a glorious day in early fall, evoke the innocence of childhood and the

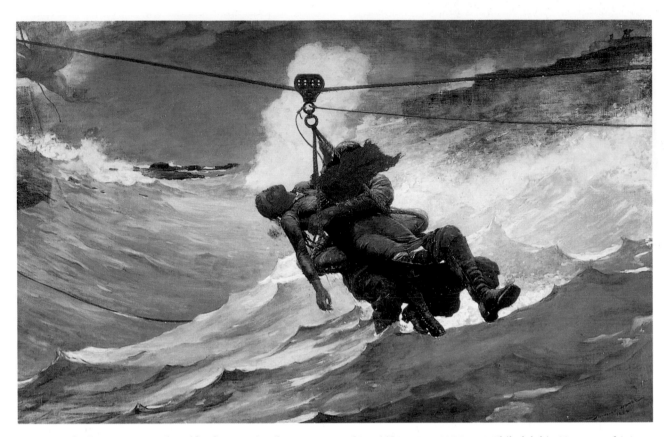

27-93. Winslow Homer. *The Life Line*. 1884. Oil on canvas, 28³/4 x 44⁵/8" (73 x 113.3 cm). Philadelphia Museum of Art
The George W. Elkins Collection

In the early sketches for this work, the man's face was visible. The decision to cover it focuses more attention not only on the victim but also on the true hero, the breeches buoy.

imagined charms of a preindustrial America for an audience that was increasingly urbanized. Many of these paintings were reproduced as wood engravings for illustrated books and magazines.

Homer's art changed significantly after he spent 1881–82 in a tiny English fishing village on the rugged North Sea coast. The strength of character of the people there so inspired him that he turned from idyllic subjects to more dramatic themes involving the heroic human struggle against natural adversity. In England, he was particularly impressed with the breeches buoy, a mechanical apparatus used to rescue those aboard foundering ships. During the summer of 1883 Homer made sketches of a breeches buoy imported by the lifesaving crew in Atlantic City, New Jersey. The following year Homer painted *The Life Line* (fig. 27-93), which depicts a coastguardsman using the breeches buoy to rescue an unconscious woman and is a testament not simply to human bravery but to its ingenuity as well.

The most uncompromising American realist of the era, Thomas Eakins (1844–1916), also celebrated the human mind. Born in Philadelphia, Eakins trained at the Pennsylvania Academy of the Fine Arts and the École des

Beaux-Arts, then spent six months in Spain, where he encountered the profound realism of Diego Velázquez and Jusepe de Ribera (see figs. 19-34, 19-37). After he returned to Philadelphia in 1870, he specialized in frank portraits and scenes of everyday life whose lack of conventional charm generated little popular interest.

One work did attract attention: *The Gross Clinic* (fig. 27-94) was severely criticized and was refused exhibition space at the 1876 Philadelphia Centennial. The painting shows Dr. Samuel David Gross performing an operation with young medical students looking on. The representatives of science—a young medical student, the doctor, and his assistants—are all highlighted. This dramatic use of light, inspired by Rembrandt and the Spanish Baroque masters Eakins admired, is not meant to stir emotions but to make a point: Amid the darkness of ignorance and fear modern science shines the light of knowledge. The light in the center falls not on the doctor's face but on his forehead—on his mind.

In the shadows along the right-hand side of *The Gross Clinic* Eakins included a self-portrait, testimony to his personal knowledge of the subject. Eakins had studied anatomy, an interest that led him to photography,

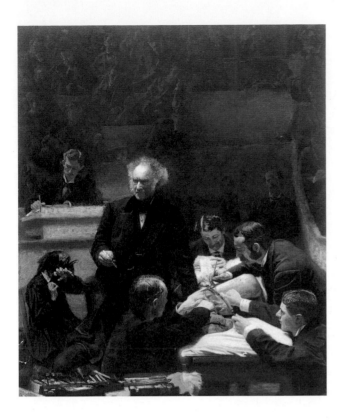

which he used both as an aid for painting and as a tool for studying the body in motion. He made a number of studies with the English-born American Eadweard Muybridge (1830–1904), a pioneer in motion photography. During the 1860s Muybridge made landscape photographs and worked for U.S. government geographic and military surveys. In 1872 he was hired by railroad owner and former California governor Leland Stanford, who wanted to prove that a running racehorse at one point in its stride has all four feet off the ground. Working with a fast new shutter developed by Stanford's engineer, Muybridge succeeded in 1878 in confirming Stanford's contention in *Sally Gardner Running* (fig. 27-95).

URBAN PHOTOGRAPHY

Muybridge and Eakins used photography as a scientific tool, but other late-nineteenth-century photographers continued the struggle begun by Europeans such as Rejlander and Cameron to win recognition for photography as an art form (see figs. 27-35 and 27-36). Their efforts led to the rise of an international movement known as Pictorialism, in which photographers sought to create images whose aesthetic qualities matched those of painting, drawing, and printmaking. While most European Pictorialists photographed traditional artistic subjects such as rural landscapes, genre scenes, and nudes, the leading American Pictorialist, Alfred Stieglitz (1864–1946), found picturesque subjects in the street life of New York City.

Born in New Jersey to a wealthy German immigrant family, Stieglitz was educated in the early 1880s at the Technische Hochschule in Berlin, where he discovered

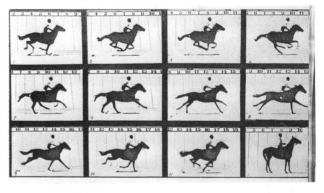

27-95. Eadweard Muybridge. *Sally Gardner Running at a 1:40 Gait, 19 June, 1878*. 1878. Wet-plate photography. Academy of Natural Sciences of Philadelphia

This image was produced by twelve cameras with shutter speeds, according to Muybridge, of "less than two-thousand part of a second." The cameras, spaced 21 inches apart, were triggered by electric switches attached to thin black threads stretched across the track. In order to maximize the light, the ground was covered with powdered lime and a white screen was set up along the rail, with its linear divisions corresponding to the spacing of the cameras.

photography and quickly recognized its artistic potential. In 1890 Stieglitz began to photograph New York City street scenes with one of the new high-speed, handheld cameras (the most popular of which, the Kodak, was invented by George Eastman in 1888), which permitted him to "await the moment when everything is in balance"

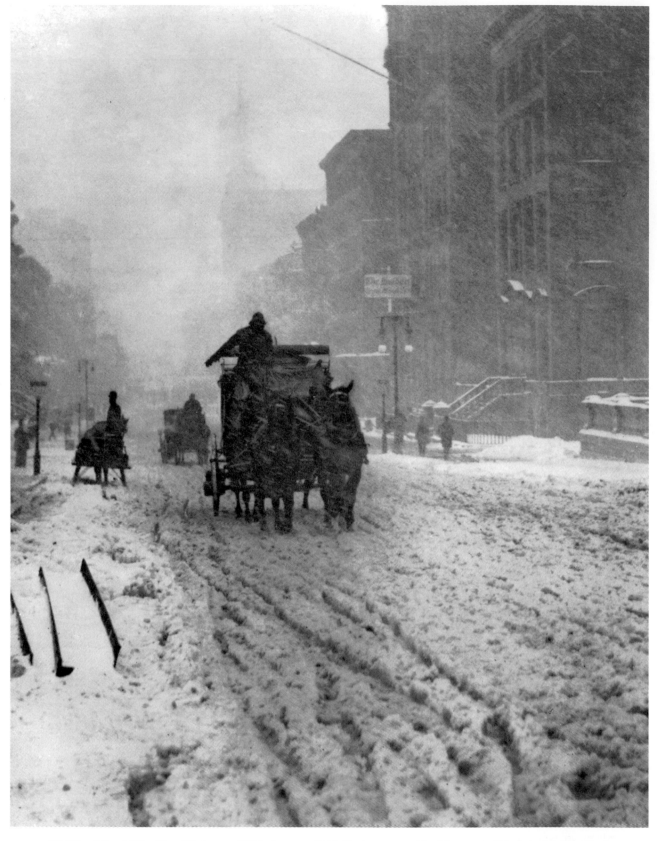

27-96. Alfred Stieglitz. *Winter on Fifth Avenue*. 1893. Photogravure. The Museum of Modern Art, New York

and capture it. For *Winter on Fifth Avenue* (fig. 27-96), Stieglitz waited three hours on a street corner in a fierce February snowstorm before taking the shot of the coach drawn by a team of four horses. He made a further selection in the darkroom by printing only the central section of the negative, thereby enlarging the motif of the coach and transforming what was originally a horizontal composition into a vertical one, which he found more aesthetically pleasing.

The urban photographs of Jacob Riis (1849–1914) offer a harsh contrast to the essentially aesthetic views of Stieglitz. A reformer who aimed to galvanize public concern for the unfortunate poor, Riis saw photography not as an artistic medium but a means of bringing about

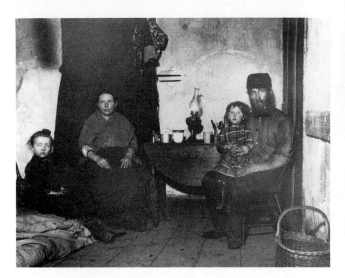

27-97. **Jacob Riis.** *Tenement Interior in Poverty Gap:*
An English Coal-Heaver's Home. c. 1889.
Museum of the City of New York
The Jacob A. Riis Collection

During the late nineteenth and early twentieth cen-
turies, American social and business life operated
under the British sociologist Herbert Spencer's
theory of Social Darwinism, which in essence held
that only the fittest will survive. Riis saw this theory
as merely an excuse for neglecting social problems.

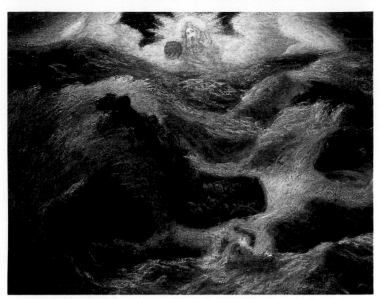

27-98. **Albert Pinkham Ryder.** *Jonah.* c. 1885. Oil on canvas,
mounted on fiberboard, 27¼ x 34⅜" (69.2 x 87.3 cm).
National Museum of American Art, Smithsonian Institution,
Washington, D.C.
Gift of John Gellatly

social change. Riis immigrated to New York City from
Denmark in 1870 and was hired as a police reporter for
the *New York Tribune*. He quickly established himself as a
maverick among his colleagues by actually investigating
slum life himself rather than merely rewriting police
reports. Riis's contact with the poor convinced him that
crime, poverty, and ignorance were largely environmen-
tal problems that resulted from, rather than caused, harsh
slum conditions. He believed that if Americans knew the
truth about slum life, they would support reforms.

Riis turned to photography in 1887 to document
slum conditions, and three years later published his pho-
tographs in a groundbreaking study, *How the Other Half
Lives*. The illustrations were accompanied by texts that
described their circumstances in matter-of-fact terms.
Riis said he found the poor, immigrant family shown here
(fig. 27-97) when he visited a house where a woman had
been killed by her drunken, abusive husband:

> The family in the picture lived above the rooms
> where the dead woman lay on a bed of straw,
> overrun by rats. . . . A patched and shaky stair-
> way led up to their one bare and miserable
> room. . . . A heap of old rags, in which the baby
> slept serenely, served as the common sleeping-
> bunk of father, mother, and children—two bright
> and pretty girls, singularly out of keeping in their
> clean, if coarse, dresses, with their surround-
> ings. . . . The mother, a pleasant-faced woman,
> was cheerful, even light-hearted. Her smile
> seemed the most sadly hopeless of all in the
> utter wretchedness of the place.

What comes through clearly in the photograph is the
family's attempt to maintain a clean, orderly life despite the
rats and the chaotic behavior of their neighbors. The broom
behind the older girl implies as much, as does the caring
way the father holds his youngest daughter. Riis shows that
such slum dwellers are decent people who deserve better.

RELIGIOUS ART

While Riis directly confronted the harsh conditions of
slum life, many American artists of the late nineteenth
century turned their backs on modern reality and, like
their European Symbolist counterparts, escaped into the
realms of myth, fantasy, and imagination. Some were
also attracted to traditional literary, historical, and reli-
gious subjects, which they treated in unconventional
ways to give them new meaning, as did Albert Pinkham
Ryder (1847–1917) in his highly expressive interpretation
of *Jonah* (fig. 27-98).

Ryder moved from Massachusetts to New York City
around 1870 and studied at the National Academy of
Design. Although he traveled to Europe four times
between 1877 and 1896, he seems to have been mostly
unaffected by old and modern works there. His mature
painting style was an extremely personal one, as were
his working methods. Ryder would paint and repaint the
same canvas over a period of several years, loading
glazes one on top of another to a depth of a quarter inch
or more, mixing in with his oils such substances as var-
nish, bitumen, and candle wax. Due to chemical
reactions between his materials and the uneven drying
times of the layers of paint, most of Ryder's pictures have
become darkened and severely cracked.

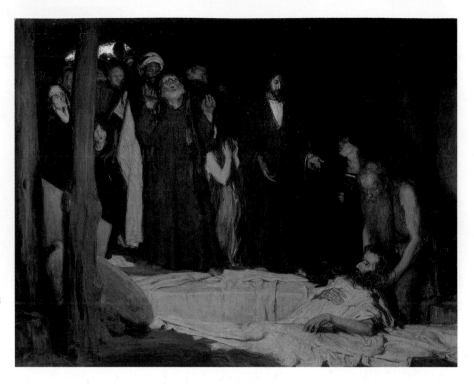

27-99. Henry Ossawa Tanner. *The Resurrection of Lazarus*. 1896. Oil on canvas, 37⅜ x 47¹³/₁₆" (94.9 x 121.4 cm). Musée d'Orsay, Paris

Tanner believed that biblical stories could illustrate the struggles and hopes of contemporary African Americans. He may have depicted the resurrection of Lazarus because many black preachers made a connection between the story's themes of redemption and rebirth and the Emancipation Proclamation of 1863, which freed black slaves and gave them a new life.

In *Jonah*, Ryder depicted the moment when the terrified Old Testament prophet, thrown overboard by his shipmates, was about to be consumed by a great fish. Appearing above in a blaze of holy light is God, shown as a bearded old man who holds the orb of divine power and makes a gesture of blessing, as if promising Jonah's eventual redemption. Both the subject—being overwhelmed by hostile nature—and its dramatic treatment through dynamic curves and sharp contrasts of light and dark are characteristically Romantic. The broad, generalized handling of the violent sea is particularly reminiscent of Turner (see figs. 27-19, 27-20), one of the few modern European artists whose work Ryder is known to have admired.

Biblical subjects became a specialty of Henry Ossawa Tanner (1859–1937), the most successful African-American painter of the late nineteenth and early twentieth centuries. The son of a bishop in the African Methodist Episcopal Church, Tanner grew up in Philadelphia, sporadically studied art under Thomas Eakins at the Pennsylvania Academy of the Fine Arts between 1879 and 1885, then worked as a photographer and drawing teacher in Atlanta. In 1891 he moved to Paris for further academic training. In the early 1890s Tanner painted a few African-American genre subjects but ultimately turned to Biblical painting in order to make his art serve religion.

Tanner's *The Resurrection of Lazarus* (fig. 27-99) received a favorable critical reception at the Paris Salon of 1897 and was purchased by the Musée du Luxembourg, the museum for living artists. The subject is the biblical story in which Jesus went to the tomb of his friend Lazarus, who had been dead for four days, and revived him with the words "Lazarus, come forth" (John 11:1–44). Tanner shows the moment following the miracle, as Jesus stands before the amazed onlookers and gestures toward Lazarus, who begins to rise from his tomb. The limited palette of browns and golds, strongly reminiscent of Rembrandt, is appropriate for the somber burial cave. It also has the expressive effect of unifying the astonished witnesses in their recognition that a miracle has indeed occurred.

ARCHITECTURE

The history of late-nineteenth-century American architecture is a story of the impact of modern conditions and materials on the still-healthy Beaux-Arts historicist tradition. Unlike painting and sculpture, where antiacademic impulses gained force after 1880, in architecture the search for modern styles occurred somewhat later and met with considerably more resistance. As the École des Beaux-Arts in Paris was rapidly losing its leadership in figurative art education, it was becoming the central training ground for both European and American architects.

Richard Morris Hunt (1827–95) in 1846 became the first American to study architecture at the École des Beaux-Arts. Extraordinarily skilled in Beaux-Arts eclecticism and determined to raise the standards of American architecture, he built in every accepted style, including Gothic, French classicist, and Italian Renaissance. After the Civil War, Hunt built many lavish mansions emulating aristocratic European models for the growing class of wealthy Eastern industrialists and financiers.

Late in his career, Hunt participated in a grand project with more democratic aims: He was head of the board of architects for the 1893 World's Columbian Exposition in Chicago, organized to commemorate the 400th anniversary of Columbus's arrival in the Americas. The board abandoned the metal-and-glass architecture of earlier world's fairs (see fig. 27-38) in favor of the appearance of what it called "permanent buildings—a dream city." (The buildings were actually temporary ones composed of staff, a mixture of plaster and fibrous materials.) To create a sense of unity for all the exposition's major buildings, the board designated a single, classical style associated with both the birth of democracy in

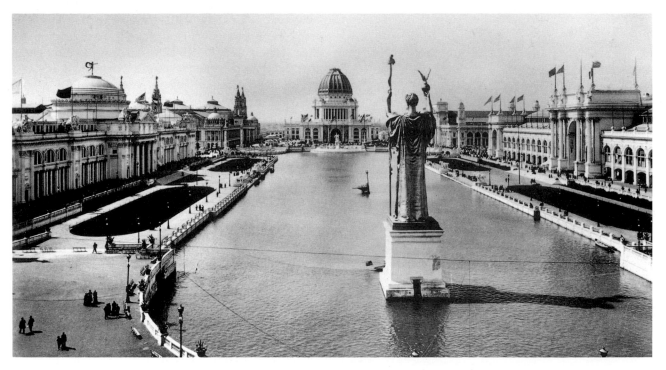

27-100. Court of Honor, World's Columbian Exposition, Chicago. 1893. View from the east

Surrounding the Court of Honor were, from left to right, the Agriculture Building by McKim, Mead, and White; the Administration Building by Richard Morris Hunt; and the Manufactures and Liberal Arts Building by George B. Post. The architectural ensemble was collectively called The White City, a nickname by which the exposition was also popularly known. The statue in the foreground is *The Republic* by Daniel Chester French.

ancient Greece and the imperial power of ancient Rome, reflecting United States's pride in its democratic institutions and emergence as a world power. Hunt's design for the Administration Building at the end of the Court of Honor (fig. 27-100) was in the Renaissance classicist mode used by earlier American architects for civic buildings (see fig. 27-28). It was also meant to communicate that the United States was cultivating a new, more democratic renaissance after the Civil War.

The World's Columbian Exposition also provided a model for the American city of the future—reassurance that it could be clean, spacious, carefully planned, and classically beautiful, in contrast to the ill-planned, sooty, and overcrowded American urban centers rapidly emerging in the late nineteenth century. Frederick Law Olmsted, the designer of New York's Central Park (see "The City Park," page 1055), was principally responsible for the landscape design of the Chicago exposition. He converted the marshy lakefront into lagoons, canals, ponds, and islands, some laid out formally, as in the Court of Honor, others informally, as in the section containing national and state pavilions. After the fair closed and most of its buildings were taken down, Olmsted's landscape art remained for succeeding generations to enjoy.

The second American architect to study at the École des Beaux-Arts was Henry Hobson Richardson (1838–86). Born in Louisiana and schooled at Harvard, Richardson returned from Paris in 1865 and settled in New York. Like Hunt, he worked in a variety of styles, but he became famous for a simplified Romanesque style known as Richardsonian Romanesque. His best-known building

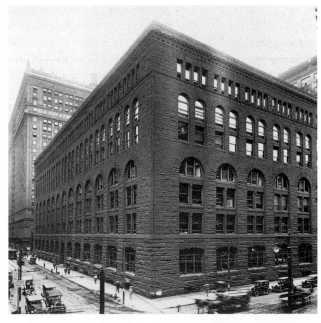

27-101. Henry Hobson Richardson. Marshall Field Wholesale Store, Chicago. 1885–87. Demolished c. 1935

was probably the Marshall Field Wholesale Store in Chicago (fig. 27-101). Although it is reminiscent of Renaissance palaces in form and of Romanesque churches in its heavy stonework and arches, it has no precise historical antecedents. Instead, Richardson took a fresh approach to the design of this modern commercial building. Applied ornament is all but eliminated in

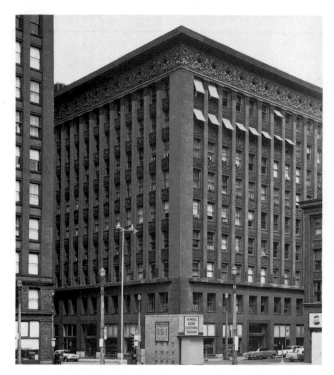

27-102. Louis Sullivan. Wainwright Building, St. Louis, Missouri. 1890–91

favor of the intrinsic appeal of the rough stone and the subtle harmony between the dark red granite facing of the base and the red sandstone of the upper stories. The solid corner piers, the vertical structural supports, give way to the regular rhythm of the broad arches of the middle floors, which are doubled in the smaller arches above, then doubled again in the rectangular windows of the attic. The integrated mass of the whole is completed in the crisp line of the simple cornice at the top.

Richardson's plain, sturdy building was a revelation to the young architects of Chicago then engaged in rebuilding the city after the disastrous fire of 1871 and helped shape a distinctly American architecture. About this time, new technology for making inexpensive steel (an alloy of iron, carbon, and other materials) brought architecture entirely new structural possibilities. The first structural use of steel in the internal skeleton of a building was made in Chicago by William Le Baron Jenney (1832–1907), and his example was soon followed by the younger architects who became known as the Chicago School. These architects saw in the stronger, lighter material the answer to both their search for an independent style and their clients' desire for taller buildings. Interest in tall buildings was sparked because the rapidly rising cost of commercial property made its more efficient use a major consideration, and the first electric elevator, dating from 1889, made them possible.

Equipped with steel and with the improved passenger elevators, driven by new economic considerations, and inspired by Richardson's departure from Beaux-Arts historicism, the Chicago School architects produced a

new kind of building, the skyscraper, and a new style (see "The Skyscraper," page 1088). A fine early example of their work, and evidence of its rapid spread throughout the Midwest, is Louis Sullivan's Wainwright Building in St. Louis, Missouri (fig. 27-102). The Boston-born Sullivan (1856–1924) had studied for a year at the Massachusetts Institute of Technology (MIT), home of the United States' first architectural program, and equally briefly at the École des Beaux-Arts, where he seems to have developed his lifelong distaste for historicism. He settled in Chicago in 1875, partly because of the building boom there that followed the fire of 1871, and in 1883 entered into a partnership with the Danish-born engineer Dankmar Adler (1844–1900).

Sullivan's first major skyscraper, the Wainwright Building, has a U-shaped plan that provides an interior light well for the illumination of inside offices. The ground floor, designed to house shops, has wide plate-glass windows for the display of merchandise. The second story, or mezzanine, also features large windows for the illumination of the shop offices. Above the mezzanine rise seven identical floors of offices, lit by rectangular windows. An attic story houses the building's mechanical plant and utilities. Forming a crown to the building, this richly decorated attic is wrapped in a foliate frieze of high-relief terra-cotta, punctuated by bull's-eye windows, and capped by a thick cornice slab.

The Wainwright Building thus features a clearly articulated, tripartite design in which the different character of each of the building's parts is expressed through its outward appearance. This illustrates Sullivan's philosophy of functionalism, summed up in his famous motto, "form follows function," which holds that the function of a building should dictate its design. But Sullivan did not design the Wainwright Building along strictly functional lines; he also took expressive considerations into account. The thick corner piers, for example, are not structurally necessary since the building is supported by a steel-frame skeleton, but they serve to emphasize its vertical thrust. Likewise, the thinner piers between the office windows, which rise uninterruptedly from the third story to the attic, echo and reinforce the dominant verticality. Sullivan emphasized verticality in the Wainwright Building not out of functional concerns but rather out of emotional ones. A tall office building, in his words, "must be every inch a proud and soaring thing, rising in sheer exultation."

In the Wainwright Building that exultation culminates in the rich vegetative ornament that swirls around the crown of the building, serving a decorative function very much like that of the foliated capital of a classical column. The tripartite structure of the building itself suggests the classical column with its base, shaft, and capital, reflecting the lingering influence of classical design principles even on an architect as opposed to historicism as Sullivan. It would remain for the modernist architects of the early twentieth century to break free from tradition entirely and pioneer an architectural aesthetic that was entirely new.

THE CITY PARK

Parks originated during the second millennium BCE in China and the Near East as enclosed hunting reserves for kings and the nobility. In Europe from the Middle Ages through the eighteenth century, they remained private recreation grounds for the privileged. The first urban park intended for the public was in Munich, Germany, laid out by Ludwig von Sckell in 1789–95 in the picturesque style of an English landscape garden (see fig. 26-24), with irregular lakes, gently sloping hills, broad meadows, and paths meandering through wooded areas.

Increased crowding and pollution during the Industrial Revolution prompted outcries for large public parks whose greenery would help purify the air and whose open spaces would provide city dwellers of all classes with a place for healthful recreation and relaxation. Numerous municipal parks were built in Britain during the 1830s and 1840s and in Paris during the 1850s and 1860s, when Georges-Eugène Haussmann redesigned the former royal hunting forests of the Bois de Boulogne and the Bois de Vincennes in the English style favored by the emperor.

In American cities before 1857, the only outdoor spaces for the public were small squares found between certain intersections, and larger gardens, such as the Boston Public Garden. Neither kind of space filled the growing need for varied recreational facilities. For a time, naturalistically landscaped suburban cemeteries became popular sites for strolling, picnicking, and even horseracing—an incongruous use that strikingly demonstrated the need for urban recreation parks.

The rapid growth of Manhattan spurred civic leaders to set aside parkland while open space still existed. The city purchased an 843-acre tract in the center of the island and in 1857 announced a competition for its design as Central Park. The competition required that designs include a parade ground, playgrounds, a site for an exhibition or concert hall, sites for a fountain and for a viewing tower, a flower garden, a pond for ice skating, and four east-west cross streets so that the park would not interfere with the city's vehicular traffic.

The latter condition was pivotal to the winning design, drawn up by architect Calvert Vaux (1824–95) and park superintendent Frederick Law Olmsted (1822–1903), who sank the crosstown roads in trenches hidden below the surface of the park and designed separate routes for carriages, horseback riders, and pedestrians. Central Park contains some formal elements, such as the stately tree-lined Mall leading to the classically styled Bethesda Terrace and Fountain, but its designers believed that the "park of any great city [should be] an antithesis to its bustling, paved, rectangular, walled-in streets."

Accordingly, Olmsted and Vaux followed the English tradition by designing Central Park in a naturalistic manner based on irregularities in topography and plantings. Where the land was low, they further depressed it, installing drainage tiles and carving out ponds and meadows. They planted clumps of trees to contrast with open spaces, and they emphasized natural outcroppings of schist to provide elements of dramatic, rocky scenery. They arranged walking trails, bridle paths, and carriage drives to provide a series of changing vistas. An existing reservoir divided the park into two sections. Olmsted and Vaux developed the southern half more completely and located most of the sporting facilities and amenities there, while they treated the northern half more as a nature preserve. Substantially completed by the end of the Civil War, Central Park was a tremendous success and launched a movement to build similar parks in cities across the United States and to conserve wilderness areas and establish national parks.

Frederick Law Olmsted and Calvert Vaux. Central Park, New York City.
1858. Revised and extended park layout shown in map of 1873

The rectangular water tanks in the middle of the park were later removed and replaced by a large, elliptical meadow known as the Great Lawn.

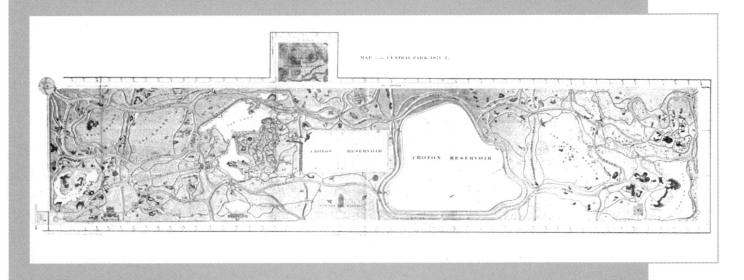

PARALLELS

COUNTRY	WESTERN ART	ART IN OTHER CULTURES

FRANCE

27-2. David. *Napoleon Crossing the St-Bernard* (1800–01)
27-3. Gros. *Napoleon in the Plague House at Jaffa* (1804)
27-4. Ingres. *Large Odalisque* (1814)

27-6. Géricault. *Raft of the "Medusa"* (1818–19)
27-11. Delacroix. *Scenes from the Massacre at Chios* (1822–24)
27-13. Rude. *Departure of the Volunteers of 1792* (1833–36)
27-22. T. Rousseau. *The Valley of Tiffauge* (1837–44)
27-40. Labrouste. Bibliothèque Ste-Geneviève, Paris (1843–50)
27-46. Bonheur. *Plowing in the Nivernais: The Dressing of the Vines* (1849)
27-48. Courbet. *A Burial at Ornans* (1849)
27-45. Corot. *First Leaves, Near Mantes* (c. 1855)
27-47. Millet. *The Gleaners* (1857)
27-41. Garnier. The Opéra, Paris (1861–74)
27-49. Daumier. *The Third-Class Carriage* (c. 1862)
27-37. Nadar. *Portrait of Charles Baudelaire* (1863)
27-56. Manet. *Le Déjeuner sur l'Herbe* (1863)
27-43. Carpeaux. *The Dance* (1867–68)
27-62. Degas. *The Rehearsal on Stage* (c. 1874)
27-61. Renoir. *Moulin de la Galette* (1876)
27-60. Pissarro. *Wooded Landscape at l'Hermitage, Pontoise* (1878)
27-63. Cassatt. *Woman in a Loge* (1879)
27-64. Morisot. *Summer's Day* (1879)
27-72. Seurat. *A Sunday Afternoon on the Island of La Grande Jatte* (1884–86)
27-80. Rodin. *Burghers of Calais* (1884–86)
27-76. Redon. *The Marsh Flower, a Sad and Human Face* (1885)
27-69. Cézanne. *Mont Ste-Victoire* (c. 1885–87)
27-1. Eiffel. Eiffel Tower, Paris (1887–89)
27-73. Van Gogh. *The Starry Night* (1889)
27-81. Claudel. *The Waltz* (1892–1905)
27-84. Toulouse-Lautrec. *Jane Avril* (1893)
27-68. Monet. *Rouen Cathedral: The Portal (in Sun)* (1894)
27-74. Gauguin. *Mahana no atua (Day of the God)* (1894)
27-77. H. Rousseau. *The Sleeping Gypsy* (1897)
27-83. Guimard. Desk (c. 1899)

ENGLAND

27-19. Turner. *Snowstorm: Hannibal and His Army Crossing the Alps* (1812)
27-21. Constable. *The White Horse* (1819)
27-31. Barry and Pugin. Houses of Parliament, London (1836–60)
27-38. Paxton. Crystal Palace, London (1850–51)

27-52. Hunt. *The Hireling Shepherd* (1851)
27-55. Whistler. *Black Lion Wharf* (1859)
27-36. Cameron. *Portrait of Thomas Carlyle* (1863)
27-53. Rossetti. *La Pia de' Tolomei* (1868–69)

ART IN OTHER CULTURES

23-13. **Mandan hide painting** (1797–1800), North America
25-17. **Ijo ancestor screen** (19th cent.), Nigeria
25-7. **Lobi spirit figure** (19th cent.), Burkina Faso
25-16. **Fang guardian** (19th cent.), Gabon
25-8. **Kongo figure** (19th cent.), Democratic Republic of Congo
24-10. **Queen's skirt** (1823-24), Hawaii
22-1. **Hokusai.** *The Great Wave* (c. 1831), Japan
23-16. **Tlingit screen** (c. 1840), North America
24-13. **Maori meetinghouse** (1842/43), New Zealand
24-11. **Kearny cloak** (c. 1843), Hawaii
23-11. **Delaware shoulder bag** (c. 1860), North America

COUNTRY	WESTERN ART

UNITED STATES

27-28. Latrobe. U.S. Capitol, Washington, D.C. (c. 1808)
27-23. Audubon. *Common Grackle* (1826–39)
27-24. Catlin. *Buffalo Bull's Back Fat, Head Chief, Blood Tribe* (1832)
27-25. Cole. *The Oxbow* (1836)
27-32. Upjohn. Trinity Church, New York City (1839–46)
27-27. Powers. *The Greek Slave* (1843)
27-26. Bingham. *Fur Traders Descending the Missouri* (c. 1845)
27-87. Church. *Niagara* (1857)

27-85. Hosmer. *Zenobia in Chains* (1859)
27-90. Gardner. *Confederate Dead Gathered for Burial, Antietam, September 1862* (1862)
27-88. Bierstadt. *The Rocky Mountains, Lander's Peak* (1863)
27-39. Roebling and Roebling. Brooklyn Bridge, New York City (1867–83)
27-92. Homer. *Snap the Whip* (1872)
27-94. Eakins. *The Gross Clinic* (1875)
27-86. Lewis. *Hagar in the Wilderness* (1875)
27-95. Muybridge. *Sally Gardner Running at a 1:40 Gait, 19 June, 1878* (1878)
27-91. Saint-Gaudens. The Robert Gould Shaw Memorial, Boston (1884–97)
27-98. Ryder. *Jonah* (c. 1885)
27-101. Richardson. Marshall Field Wholesale Store, Chicago (1885–87)
27-97. Riis. *Tenement Interior in Poverty Gap: An English Coal-Heaver's Home* (c. 1889)
27-102. Sullivan. Wainwright Building, St. Louis (1890–91)
27-96. Stieglitz. *Winter on Fifth Avenue* (1893)
27-100. Hunt. Court of Honor, World's Columbian Exposition, Chicago (1893)
27-99. Tanner. *The Resurrection of Lazarus* (1896)

OTHER EUROPE

27-17. Goya. *Third of May, 1808*, Spain (1814–15)

27-18. Friedrich. *Monk by the Sea*, Germany (1809–10)
27-30. Schinkel. Altes Museum, Germany (1822–30)
27-51. Repin. *Bargehaulers on the Volga*, Russia (1870–73)
27-78. Ensor. *The Intrigue*, Belgium (1890)
27-82. Horta. Tassel House, Belgium (1892–93)
27-79. Munch. *The Scream*, Norway (1893)
27-50. Leibl. *Three Women in a Village Church*, Germany (1878–81)
27-35. Rejlander. *The Two Paths of Life*, Sweden (1857)

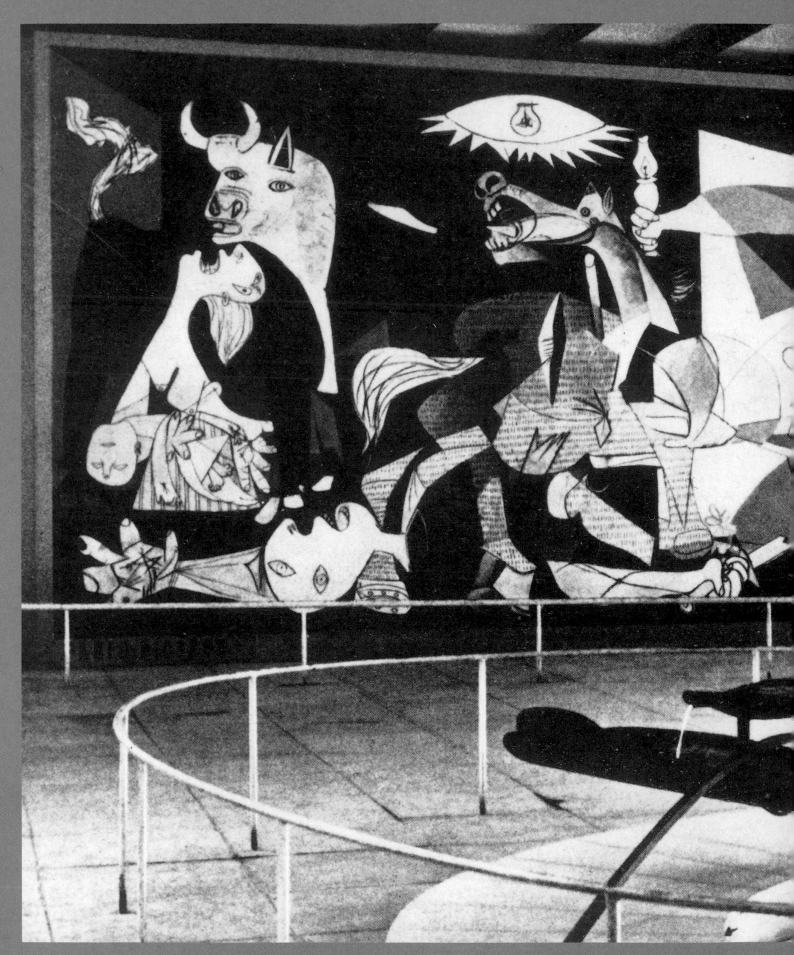

28-1. Pablo Picasso. *Guernica.* 1937. Oil on canvas, 11'6" x 25'8" (3.5 x 7.8 m). Museo Nacional Centro de Arte Reina Sofía, Madrid. On permanent loan from the Museo del Prado, Madrid. Shown installed in the Spanish Pavilion of the Paris Exposition, 1937. In the foreground: Alexander Calder's *Fontaine de Mercure.* 1937. Mercury, sheet metal, wire rod, pitch, and paint, 44" x 115" x 77" (122 x 292 x 196 cm). Fundacio Joan Miro, Barcelona

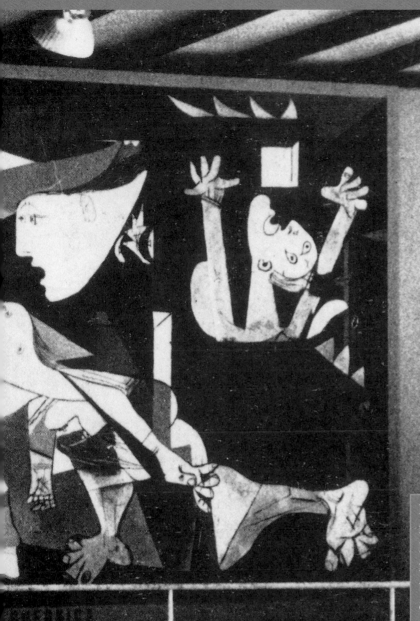

28
The Rise of Modernism in Europe and North America

In April 1937, during the Spanish Civil War, German pilots flying for Spanish fascist leader Franco targeted the Basque city of Guernica. This act, the world's first bombing of civilians, killed more than 1,600 people and shocked the world. The Spanish artist Pablo Picasso, living in Paris at the time, reacted to the massacre by painting *Guernica*, a stark, hallucinatory nightmare that became a powerful symbol of the brutality of war (fig. 28-1).

Picasso, focusing on the victims, restricted his palette to black, gray, and white—the tones of the newspaper photographs that publicized the atrocity. Expressively distorted women, one holding a dead child and another trapped in a burning house, wail in desolation at the carnage. A screaming horse, an image of betrayed innocence, represents the suffering Spanish Republic, while a bull symbolizes either Franco or Spain. An electric light and a woman holding a lantern suggest Picasso's desire to reveal the event in all its horror.

During World War II, a Nazi officer showed Picasso a reproduction of *Guernica* and asked, "Is that you who did that?" Picasso is said to have replied, "No, it is you."

1922 SOVIET UNION FORMED ▲

▲ 1914–1918 WORLD WAR I

TIMELINE 28-1. Europe and North America 1900–50. The first half of the twentieth century in the West was dominated by wars in Europe and Asia. The United States took sides in both world wars.

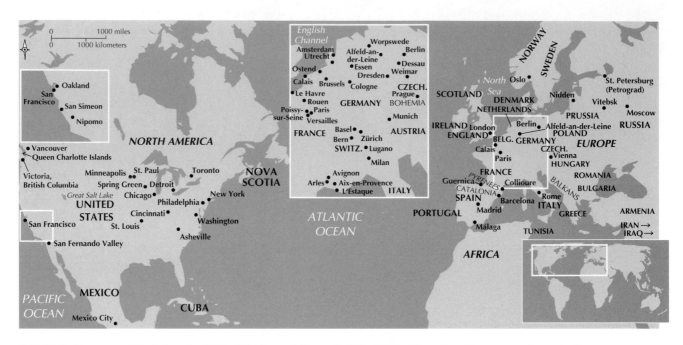

MAP 28-1. Europe and North America 1900–50. Through the end of World War II, western Europe was home to the many forms of modernism.

EUROPE AND THE UNITED STATES IN THE EARLY TWENTIETH CENTURY

Just as we must ponder *Guernica* within the context of the Spanish Civil War, so too must we consider the backdrop of politics, war, and technological change to understand other twentieth-century art. As that century dawned, many Europeans and Americans believed optimistically that human society would "advance" through the spread of democracy, capitalism, and technological innovation. By 1906 representative governments existed in the United States and every major European nation (see Map 28-1), and Western power grew through colonialism throughout Africa, Asia, the Caribbean, and the Pacific. The competitive nature of both colonialism and capitalism created great instability in Europe, however, and countries joined together in rival political alliances. World War I erupted in August 1914, initially pitting Britain, France, and Russia (the Allies) against Germany and Austria (the Central Powers). U.S. troops entered the war in 1917 and contributed to an Allied victory the following year.

World War I significantly transformed European politics and economics, especially in Russia, which became the world's first Communist nation in 1917 when a popular revolution brought the Bolshevik ("Majority") Communist party of Vladimir Lenin to power. In 1922 the Soviet Union, a Communist state encompassing Russia and neighboring areas, was created.

The United States emerged from the war as the economic leader of the West, and economic recovery followed in Western Europe, but the 1929 New York stock market crash plunged the world into the Great Depression. In 1933 U.S. President Franklin D. Roosevelt responded with the New Deal, an ambitious welfare program meant to provide jobs and stimulate the American economy, and Britain and France instituted state welfare policies during the 1930s. Elsewhere in Europe, the economic crisis brought to power right-wing totalitarian regimes: Benito Mussolini had already become the fascist dictator of Italy in the mid-1920s; he was followed in Germany in 1933 by the Nazi leader Hitler and in Spain in 1939 by General Francisco Franco. Meanwhile, in the Soviet Union, Joseph Stalin (who had succeeded Lenin in 1924) consolidated his authoritarian rule through the execution or imprisonment of millions of his political opponents.

German aggression led in 1939 to the outbreak of World War II, which initially pitted Germany, Italy, Japan, and the Soviet Union against Britain and France. The Soviet Union turned against Germany in 1941, and later that year the United States was drawn into the war by the Japanese attack on the U.S. naval base at Pearl Harbor, in Hawaii. The most destructive war in history, World War II claimed the lives of between 15 and 20 million soldiers and approximately 25 million civilians, including 6 million European Jews who perished in the Nazi Holocaust. It ended first in Europe in May 1945, then in the Pacific in August 1945 when the United States dropped atomic bombs on Hiroshima and Nagasaki, Japan, ushering in the

1930 1940 1950

▲ 1929 GREAT DEPRESSION BEGINS ▲ 1935 FIRST ANALOG AND DIGITAL COMPUTERS ▲ 1945 FIRST ATOMIC BOMB USED
 ▲ 1933 NEW DEAL IN U.S.; ▲ 1939–45 WORLD WAR II
 HITLER COMES TO POWER IN GERMANY

nuclear era, with its constant threat of global annihilation.

During the two world wars, technological innovations resulted in such deadly devices as the army tank, the fighter bomber, and the atomic bomb. Yet dramatic scientific developments and improvements transformed life in times of peace: in medicine, prevention and cure of disease; in agriculture, increased production to feed the world's booming population; in communication, the radio, wireless telegraph, radar, television, and motion picture; and in transportation, the automobile and airplane. Finally, the first analog and digital computers, designed to process mass amounts of data and perform advanced calculations, were introduced in the 1930s.

Accompanying the momentous changes in politics, economics, and science were equally revolutionary developments in art and culture, which historians have gathered under the label of *modernism*. Although *modern* simply means "up-to-date," the term *modernism* connotes a rejection of conventions and a commitment to radical innovation; animating modernism is the desire to "make it new" (in the words of poet Ezra Pound). Like scientists and inventors, modernist artists engage in a process of experimentation and discovery, seeking to explore new possibilities of creativity and expression in a rapidly changing world.

<div style="display:flex">
<div style="width:55%">

EARLY MODERNIST TENDENCIES IN EUROPE

</div>
<div style="width:45%">

After 1900 the pace of artistic innovation increased in a dizzying succession of movements, or "isms," including Fauvism, Expressionism, Cubism, Futurism, Dadaism, Suprematism, Constructivism,

</div>
</div>

Purism, Neoplasticism, and Surrealism. Each was led by charismatic artists who promoted their movement's unique philosophy through written statements, some of which took the form of **manifestos**. Although modernism is characterized by tremendous aesthetic diversity, several broad tendencies mark many modernist artists. Foremost is a tendency toward **abstraction**. While some modernists presented recognizable subject matter in a distorted manner, others created completely abstract, or **nonrepresentational**, art, which communicates exclusively through such formal means as line, shape, space, color, and texture. Modernist architecture too moved toward abstraction and rejected historical styles and ornamentation in favor of simple geometric forms and undecorated surfaces. A second feature of modernism is a tendency to emphasize physical processes through visible brushstrokes and chisel marks, for example, and the materials used; this is especially true in modernist architecture, which often reveals rather than conceals the inner structure of the building, giving it a quality of "honesty" seen in other forms of modernist art. A third feature is modernism's continual questioning of the nature of art itself

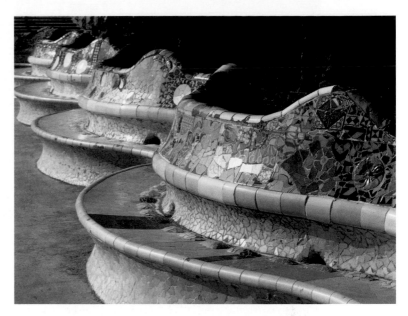

28-2. Antonio Gaudí. Serpentine bench, Güell Park, Barcelona. 1900–14

through the adoption of new techniques and materials, including ordinary, "nonartistic" materials that break down distinctions between art and everyday life.

The rise of European and American modernism in the early twentieth century was driven by such exhibitions as the 1905 Salon d'Automne ("Autumn Salon") in Paris, which launched the Fauve movement; the first exhibition of Der Blaue Reiter group in Munich in 1911; and the 1913 New York Armory Show, the first large-scale introduction of European modernism to American audiences. A key event in shaping the modernist canon was the 1929 opening of the Museum of Modern Art in New York, which rapidly assembled the world's finest modernist collection. State-supported museums dedicated to modern art also opened in other capitals, such as Paris, Rome, Brussels, and Madrid, signaling the transformation of modernism from an embattled fringe movement to officially recognized "high culture."

LATE-FLOWERING ART NOUVEAU

Originating in the 1890s (Chapter 27) and still flourishing in the early 1900s, Art Nouveau was the first international modernist movement of the twentieth century. In Spain, where the style was called *Modernismo*, the major practitioner was the Catalan architect Antonio Gaudí i Cornet (1852–1926). Gaudí attempted to integrate natural forms into his buildings and into daily life. For a public plaza on the outskirts of Barcelona, he combined architecture and sculpture in a continuous, serpentine bench that also is a boundary wall (fig. 28-2). Its surface is a

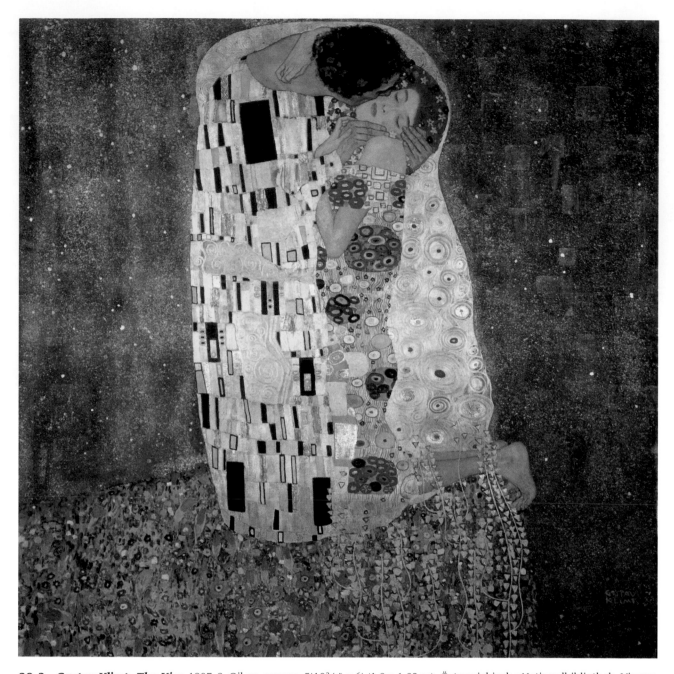

28-3. Gustav Klimt. *The Kiss*. 1907–8. Oil on canvas, 5'10¾" x 6' (1.8 x 1.83 m). Österreichische Nationalbibliothek, Vienna

The Secession was part of a generational revolt expressed in art, politics, literature, and the sciences. The Viennese physician Sigmund Freud, founder of psychoanalysis, may be considered part of this larger cultural movement, one of whose major aims was, according to the architect Otto Wagner, "to show modern man his true face."

glittering mosaic of broken pottery and tiles in homage to the long tradition of ceramic work in Spain.

In Austria, Art Nouveau was referred to as *Sezession-stil* because of its association with the Vienna Secession, one of several such groups formed in the late nineteenth century by progressive artists who seceded from conservative academic associations to form more liberal exhibiting bodies. The Vienna Secession's first president, Gustav Klimt (1862–1918), led a faction within the group dedicated to a richly decorative art and architecture that would offer an escape from the drab, ordinary world.

Between 1907 and 1908 Klimt perfected what is called his golden style, seen in *The Kiss* (fig. 28-3), where a couple embrace in a golden aura. The representational elements here are subservient to the decorative ones, which are characteristically Art Nouveau in their intricate, ornamental quality. Not evident at first glance is the tension in the couple's physical relationship, most noticeable in the way that the woman's head is forced uncomfortably against her shoulder. That they kneel dangerously close to the edge of a precipice further unsettles the initial impression for those willing to look behind the beautiful surface.

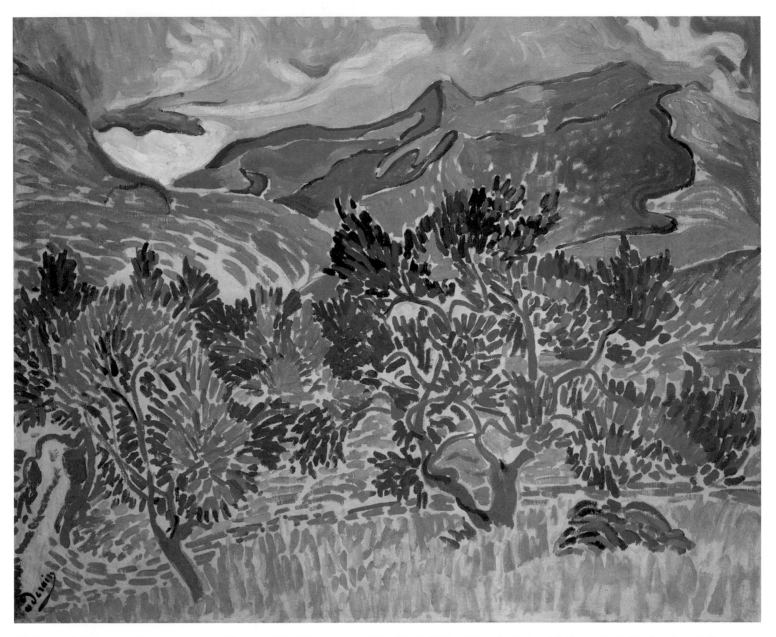

28-4. André Derain. *Mountains at Collioure*. 1905. Oil on canvas, 32 x 39¹/₂" (81.5 x 100 cm). National Gallery of Art, Washington, D.C. John Hay Whitney Collection

THE FAUVES

Reviewing the 1905 Salon d'Automne, critic Louis Vauxcelles referred to some young painters as *fauves* ("wild beasts")—a term that captured the explosive colors and impulsive brushwork that characterized their pictures. Their leaders—André Derain (1880–1954), Maurice de Vlaminck (1876–1958), and Henri Matisse (1869–1954)—had been trying to advance the colorist tradition in modern French painting, which they dated from the work of Eugène Delacroix (see figs. 27-8, 27-9) and which included that of the Impressionists, Neo-Impressionists, and Post-Impressionists such as Gauguin and van Gogh.

Among the first major Fauve works were paintings that Derain and Matisse made in 1905 in Collioure, a Mediterranean port. Derain's *Mountains at Collioure* (fig. 28-4) exemplifies so-called mixed-technique Fauvism, in which short strokes of pure color, derived from the work of van Gogh and the Neo-Impressionists (see fig. 27-70), are combined with curvilinear planes of flat color, inspired by Gauguin's paintings and Art Nouveau decorative arts (see figs. 27-71, 27-80). Derain's assertive colors, which he likened to "sticks of dynamite," do not record what he actually saw in the landscape but rather generate their own purely artistic energy. The stark juxtapositions of complementary hues—green leaves next to red tree trunks, red-orange

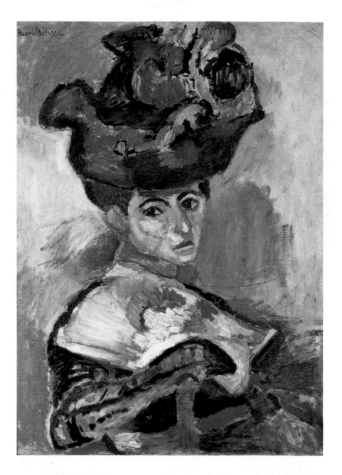

28-5. Henri Matisse. *The Woman with the Hat.* 1905.
Oil on canvas, 31¾ x 23½" (80.6 x 59.7 cm).
San Francisco Museum of Modern Art
Bequest of Elise S. Haas

Both *The Woman with the Hat* and *Le Bonheur de Vivre*
(fig. 28-6) were originally owned by the brother and
sister Leo and Gertrude Stein, important American
patrons of European avant-garde art in the early
twentieth century. They hung their collection in their
Paris apartment, where they hosted an informal salon
that attracted many leading literary, musical, and
artistic figures, including Matisse and Picasso. In
1913 Leo moved to Italy while Gertrude remained in
Paris, pursuing a career as a modernist writer and
continuing to host a salon with her companion,
Alice B. Toklas.

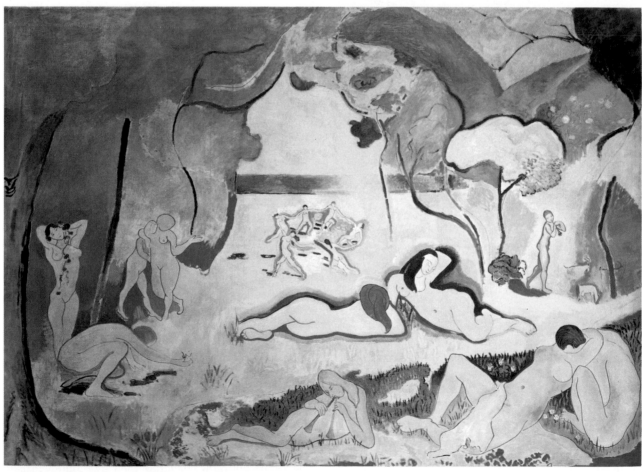

28-6. Henri Matisse. *Le Bonheur de Vivre (The Joy of Life).* 1905–6. Oil on canvas, 5'8½" x 7'9¾"(1.74 x 2.38 m).
The Barnes Foundation, Merion, Pennsylvania

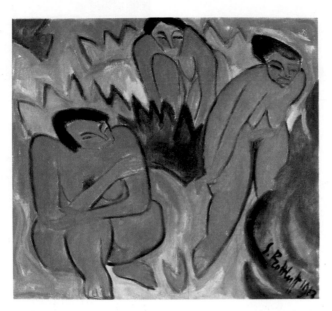

28-7. Karl Schmidt-Rottluff. *Three Nudes—Dune Picture from Nidden*. 1913. Oil on canvas, 38⅝ x 41¾" (98 x 106 cm). Staatliche Museen zu Berlin, Preussischer Kulturbesitz, Nationalgalerie

mountainsides against blue-shaded slopes—create what Derain called "deliberate disharmonies." Equally interested in such deliberate disharmonies was Matisse, whose *The Woman with the Hat* (fig. 28-5) sparked controversy at the 1905 Salon d'Automne—not because of its fairly conventional subject, but because of the way its subject was depicted: with crude drawing, sketchy brushwork, and wildly arbitrary colors that create a harsh and dissonant effect.

Matisse himself soon reacted against his early Fauve work by developing a style of greater stability and serenity. Signaling this change was a large canvas painted during the winter of 1905–6, *Le Bonheur de Vivre (The Joy of Life)* (fig. 28-6). Although the painting's genesis was a sketch made at Collioure the previous summer, the finished work is a response not to something seen but rather something imagined: a mythical earthly paradise where uninhibited, naked revelers dance, make love, and commune with nature. The vibrant colors, applied so roughly in *The Woman with the Hat*, are now laid down broadly and without any trace of nervous excitement. The brushwork, too, is softer and more careful, subservient to the pure sensuality of the color. The only movement is in the long, flowing curves of the trees and the sinuous contours of the nude bodies. These undulating rhythms, in combination with the relaxed poses of the two reclining women at the center, establish the quality of "serenity, relief from the stress of modern life," that Matisse wanted to characterize his work from this point. "What I dream of," wrote Matisse in 1908, "is an art . . . devoid of troubling or depressing subject matter . . . which might be for every mental worker, be he businessman or writer, like . . . a mental comforter, something like a good armchair in which to rest."

DIE BRÜCKE

In northern Europe, the expressionist tradition of artists like van Gogh and Ensor expanded as younger artists used abstracted forms and colors to communicate emotional and spiritual states. Prominent in German expressionist art were Die Brücke ("The Bridge"), which formed in Dresden in 1905 when four architecture students—Fritz Bleyl (1880–1966), Erich Heckel (1883–1970), Ernst Ludwig Kirchner (1880–1938), and Karl Schmidt-Rottluff (1884–1976)—decided to devote themselves to painting and to form an exhibiting group. Other German and European artists later joined Die Brücke, which endured until 1913.

Named for a passage in Friedrich Nietzsche's *Thus Spake Zarathustra* (1883) that spoke of contemporary humanity's potential to be the evolutionary "bridge" to a more perfect "superman" of the future, Die Brücke's members nevertheless demonstrated little interest in advancing the evolutionary process. Instead, their art suggests a Gauguinesque yearning to return to imaginary origins. Among their favorite motifs were women living harmoniously in nature, such as depicted in Schmidt-Rottluff's *Three Nudes—Dune Picture from Nidden* (fig. 28-7), which shows three simplified female nudes formally integrated with their landscape. The style is purposefully simple and direct, in keeping with the painting's evocation of the prehistoric and is a good example of modernist **primitivism**, which drew its inspiration from so-called primitive art of Africa, Pre-Columbian America, and Oceania, as well as the work of children, folk artists, "naive" artists such as Henri Rousseau (see fig. 27-74), and the mentally ill. The bold stylization typical of such art offered a compelling alternative to the sophisticated illusionism that the modernists rejected and provided

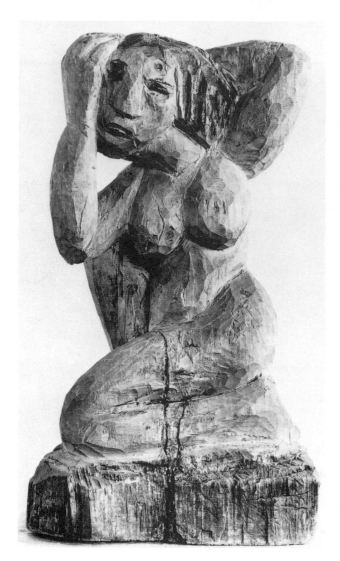

28-8. Erich Heckel. *Crouching Woman*. 1912. Painted linden wood, 11⁷/₈ x 6³/₄ x 3⁷/₈" (30 x 17 x 10 cm). Estate of Erich Heckel, Hemmenhofen am Bodensee, Germany

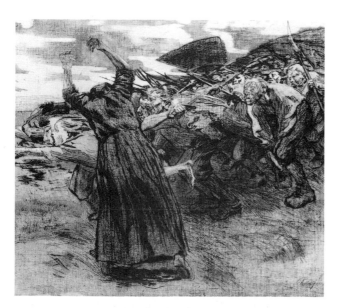

28-10. Käthe Schmidt Kollwitz. *The Outbreak*, from the Peasants' War series. 1903. Etching. Staatliche Museen zu Berlin, Preussischer Kulturbesitz, Kupferstichkabinett

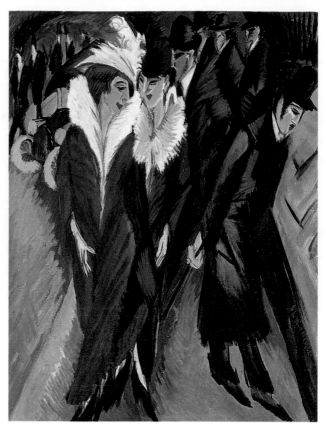

28-9. Ernst Ludwig Kirchner. *Street, Berlin*. 1913. Oil on canvas, 47¹/₂ x 35⁷/₈" (120.6 x 91 cm). The Museum of Modern Art, New York
Purchase

them formal models to adapt. Many modernists also believed that immersion in "primitive" aesthetics gave them access to a more authentic state of being, uncorrupted by civilization and filled with primal spiritual energies. Several Die Brücke members also made their own "primitive" sculpture. Heckel's *Crouching Woman* (fig. 28-8) is crudely carved in wood, rejecting the classical tradition of marble and bronze and suggesting the desire to return to nature depicted in Schmidt-Rottluff's *Three Nudes*.

During the summers, Die Brücke artists did return to nature, visiting remote areas of northern Germany, but in 1911 they moved to Berlin—perhaps preferring to imagine the simple life. Ironically, their images of cities, especially Berlin, offer powerful arguments against living there. Particularly critical of urban life are the street scenes of Kirchner, such as *Street, Berlin* (fig. 28-9). Dominating the left half of the painting, two prostitutes strut past well-dressed bourgeois men, their potential clients. The women and men appear as artificial and dehumanized figures, with masklike faces and stiff gestures. Their bodies crowd together, but they are psychologically distant from one another, victims of modern urban alienation. The harsh colors, tilted perspective, and angular lines register Kirchner's expressionistic response to the subject.

INDEPENDENT EXPRESSIONISTS

While Die Brücke sought to further their artistic aims collectively, many expressionists in German-speaking

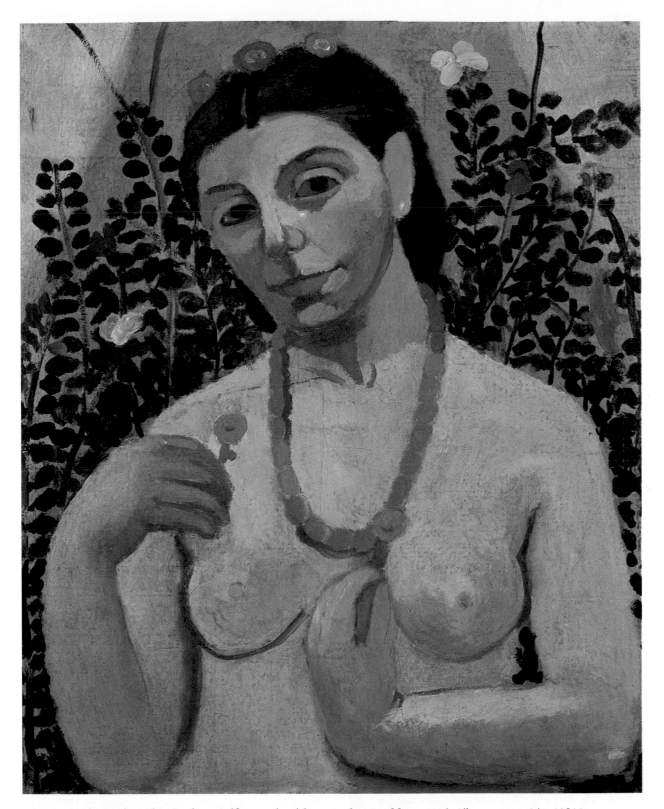

28-11. Paula Modersohn-Becker. *Self-Portrait with an Amber Necklace*. 1906. Oil on canvas, 24 x 19³⁄₄"
(61 x 50 cm). Öffentliche Kunstsammlung Basel, Kunstmuseum, Basel, Switzerland

countries worked independently. One, Käthe Schmidt Kollwitz (1867–1945), was committed to causes of the working class and pursued social change primarily through printmaking because of its potential to reach a wide audience. Between 1902 and 1908 she produced the Peasants' War series, seven etchings that depict events in a sixteenth-century rebellion. *The Outbreak* (fig. 28-10) shows the peasants' built-up fury from years of mistreatment exploding against their oppressors, a lesson in the power of group action. Kollwitz said that

she herself was the model for the leader of the revolt, Black Anna, who raises her hands to signal the attack.

Paula Modersohn-Becker (1876–1907), like Kollwitz, studied at the Berlin School of Art for Women, then moved in 1898 to Worpswede, a rustic artists' retreat in northern Germany. Dissatisfied with the Worpswede artists' naturalistic approach to rural life, after 1900 she made four trips to Paris to assimilate recent developments in Post-Impressionist painting. Her *Self-Portrait with an Amber Necklace* (fig. 28-11)

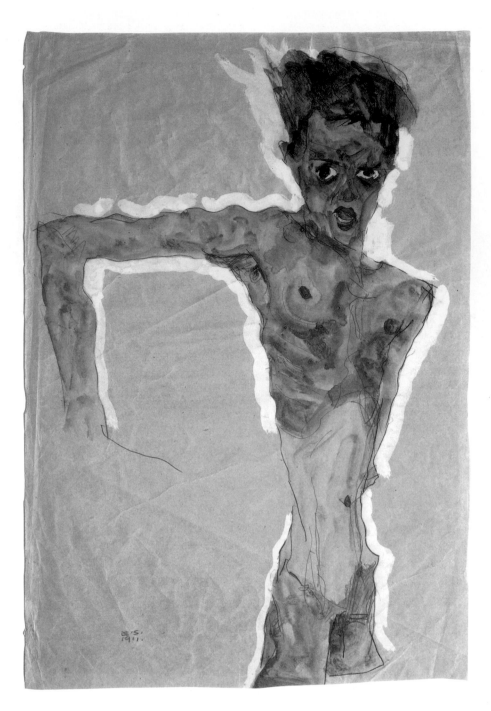

28-12. Egon Schiele.
Self-Portrait Nude. 1911. Gouache and pencil on paper, 20¼ x 13¾" (51.4 x 35 cm). The Metropolitan Museum of Art, New York

Bequest of Scofield Thayer, 1982 (1984.433.298)

testifies to the inspiration she found in Gauguin. Her simplified shapes and crude outlines are similar to those in Schmidt-Rottluff's *Three Nudes*, but her muted palette avoided his intense colors. By presenting herself against a screen of flowering plants and tenderly holding a flower that echoes the shape and color of her breasts, she appears as a natural being in tune with her surroundings, not an eroticized object of male design.

In contrast to Modersohn-Becker's gentle self-portrait, one by Austrian Egon Schiele (1890–1918) conveys physical and psychological torment (fig. 28-12). Schiele's father had suffered from untreated syphilis and died insane when Egon was fourteen, leaving his son with an abiding link between sex, suffering, and death. In numerous drawings and watercolors, Schiele represented women in sexually explicit poses that emphasize the animal nature of the human body, and his self-portraits reveal deep ambivalence toward the sexual

content of both his art and his life. In *Self-Portrait Nude*, the artist stares at the viewer with an anguished expression, his emaciated body stretched into an uncomfortable pose. The absent right hand suggests amputation, and the unarticulated genital region, castration. The missing body parts have been interpreted as the artist's symbolic self-punishment for indulgence in masturbation, then commonly believed to lead to insanity.

DER BLAUE REITER

The last major pre–World War I expressionist group, Der Blaue Reiter ("The Blue Rider"), was named for a popular image of Saint George on the city emblem of Moscow, which many believed would be the world's capital during Christ's thousand-year reign on earth following the Apocalypse prophesied by Saint John. Der Blaue Reiter formed in Munich around the painters Vasily Kandinsky

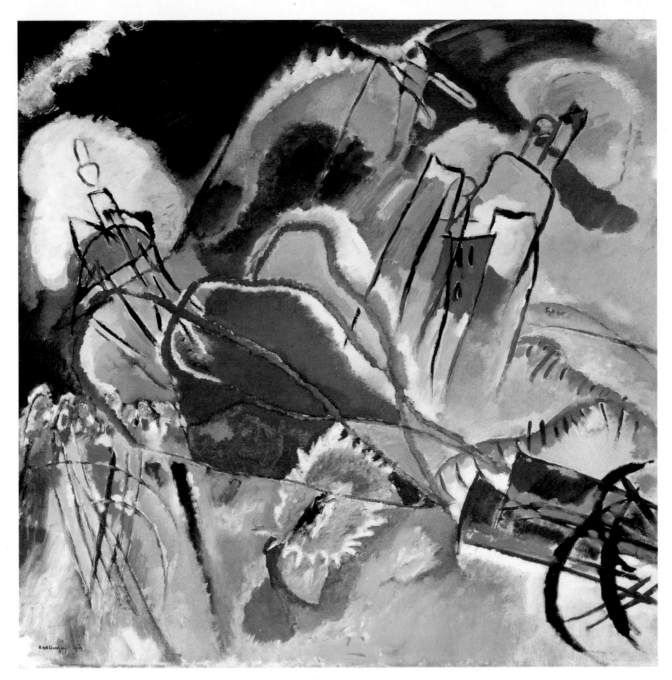

28-13. Vasily Kandinsky. *Improvisation No. 30 (Warlike Theme)*. 1913. Oil on canvas, 43¼ x 43¼" (109.9 x 109.9 cm).
The Art Institute of Chicago
Arthur Jerome Eddy Memorial Collection

(1866–1944), a Russian from Moscow, and Franz Marc (1880–1916), a native of Munich, who both considered blue the color of spirituality. Its first exhibition, in December 1911, featured fourteen very diverse artists, whose subjects and styles ranged widely, from the naive realism of Henri Rousseau to the radical abstraction of Kandinsky.

Millennial and apocalyptic imagery appeared often in Kandinsky's art in the years just prior to World War I. In *Improvisation No. 30 (Warlike Theme)* (fig. 28-13), the firing cannons in the lower right combine with the intense reds, blackened sky, and precariously leaning mountains to suggest a scene from the end of the world. Such paintings, sometimes thought to reflect fear of the coming war, may instead be ecstatic visions of the destructive prelude to the Second Coming of Christ. The schematic churches

on top of the mountains are based on the churches of Moscow.

Kandinsky never expected his viewers to understand his symbolism. Instead, he intended to awaken their spirituality and thus inaugurate "a great spiritual epoch" through the sheer force of color. As he explained in his influential book, *Concerning the Spiritual in Art* (1911): "[C]olor directly influences the soul. Color is the keyboard, the eyes are the hammers, the soul is the piano with many strings. The artist is the hand that plays, touching one key or another purposely, to cause vibrations in the soul."

During the early years of his career Marc moved from naturalism to a colorful form of expressionism influenced by the Fauves. By 1911 he was painting animals rather than people because he felt that animals enjoyed a

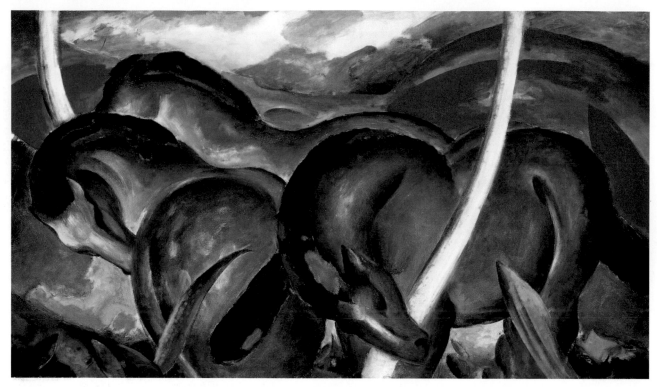

28-14. Franz Marc. *The Large Blue Horses*. 1911. Oil on canvas, 3'5⅜" x 5'11¼" (1.05 x 1.81 m). Walker Art Center, Minneapolis

Gift of T. B. Walker Collection, Gilbert M. Walter Fund, 1942

28-15. Paul Klee. *Hammamet with Its Mosque*. 1914. Watercolor and pencil on two sheets of laid paper mounted on cardboard, 8⅛ x 7⅝" (20.6 x 19.7 cm). The Metropolitan Museum of Art, New York

The Berggruen Klee Collection, 1984 (1984.315.4)

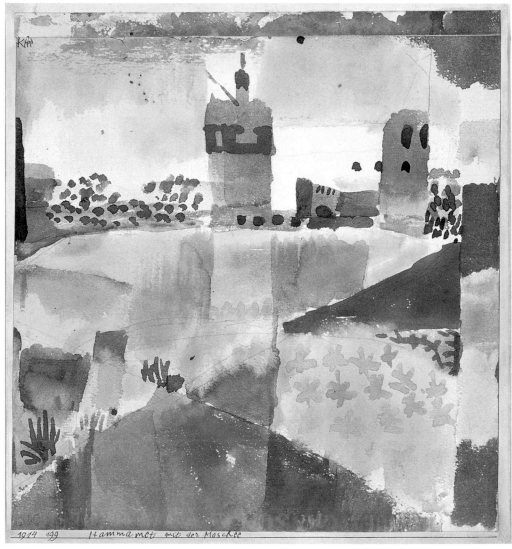

purer, more spiritual relationship to nature than did humans, and he rendered them in bold, primary colors. In his *The Large Blue Horses* (fig. 28-14) the animals merge into a homogenous unit, whose fluid contours reflect the harmony of their collective existence and rhyme with the lines of the hills behind them, suggesting that they are also in harmony with their surroundings. The pure, strong colors reflect their uncomplicated yet intense experience of the world as Marc enviously imagined it.

The Swiss-born Paul Klee (1879–1940) participated in the second Blaue Reiter exhibition of 1912, but his involvement with the group was never more than tangential. A 1914 trip to Tunisia, not Der Blaue Reiter, inspired Klee's interest in the expressive potential of color. On his return Klee painted watercolors based on his memories of North Africa, including *Hammamet with Its Mosque* (fig. 28-15). The play between geometric composition and irregular brushstrokes is reminiscent of Cézanne's work, which Klee had recently seen. The luminous colors and delicate **washes**, or applications of dilute watercolor, result in a gently shimmering effect. The subtle modulations of red across the bottom, especially, are positively melodic. Klee, who played the violin and belonged to a musical family, seems to have wanted to use color the way a musician would use sound, not to describe appearances but to evoke subtle nuances of feeling.

EARLY MODERNIST SCULPTURE

Developments in early modernist sculpture generally followed those in painting and the graphic arts, as we saw in Heckel's *Crouching Woman* (see fig. 28-8), which translates into three dimensions the subject and style of two-dimensional Die Brücke works. Many innovators of early-twentieth-century sculpture were trained as painters, and some—such as Matisse and Picasso—remained primarily painters.

Aristide Maillol (1861–1944) turned from painting to sculpture around 1900, when an eye disease caused him to turn to modeling in clay. His first major sculpture, exhibited at the 1905 Salon d'Automne, was *The Mediterranean* (fig. 28-16). The lifesize female bather sits in a relaxed pose, her body simplified into idealized forms inspired by ancient Mediterranean and Egyptian art as well as the late-nineteenth-century bathers of Renoir (see fig. 27-63). At the same time, the smooth modeling and closed, self-contained pose of *The Mediterranean* represent a deliberate rejection of the energetic handling and tortured poses favored by Rodin, the dominant sculptor of the previous generation (see fig. 27-77).

"Maillol, like the ancient masters, proceeded by volume," said his friend Henri Matisse. "I am concerned with the arabesque like the Renaissance artists." In *La Serpentine* (fig. 28-17), Matisse transformed sculptural volumes into linear **arabesques** of the kind he had previously explored in paintings such as *Le Bonheur de Vivre* (see fig. 28-6). Matisse derived the pose of *La Serpentine* from a photograph of a model, whose stocky proportions he elongated and transformed into flexible, ropelike forms. "I thinned and composed the forms," explained

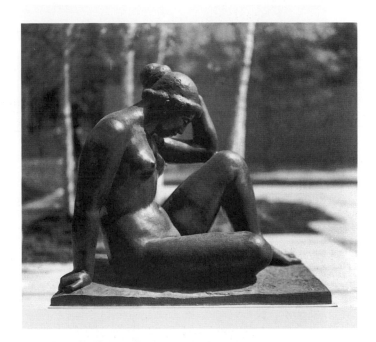

28-16. Aristide Maillol. *The Mediterranean*. 1902–5. Bronze, 41 x 45 x 29¾" at base (104.1 x 114.3 x 75.6 cm). The Museum of Modern Art, New York

Gift of Stephen C. Clark

28-17. Henri Matisse. *La Serpentine*. 1909. Bronze, 22¼ x 11 x 7½" (56.5 x 28.9 x 19 cm), including base. The Museum of Modern Art, New York

Gift of Abby Aldrich Rockefeller

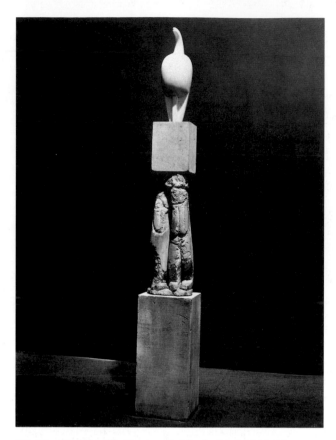

28-18. Constantin Brancusi. *Magic Bird*. 1908–12. White marble, height 22" (55.8 cm), on three-part limestone pedestal, height 5'10" (1.78 m), of which the middle part is the *Double Caryatid* (c. 1908); overall 7'8" x 12¾" x 10⅝" (237 x 32 x 27 cm). The Museum of Modern Art, New York

Katherine S. Dreier Bequest

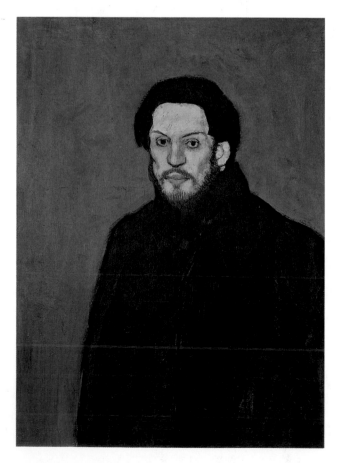

Matisse, "so that the movement would be completely comprehensible from all points of view." In the finished sculpture, this movement is created as much by the open spaces between the thinned-down elements as by the elements themselves.

The most original of the early modernist sculptors was Constantin Brancusi (1876–1957), who sought to portray "the essence of things" by distilling his subjects into smooth and purified forms. In 1904 Brancusi arrived in Paris from his native Romania and enrolled at the École des Beaux-Arts. After two months as an assistant to Rodin in early in 1907, Brancusi left and rejected Rodin's modeling method for the technique of direct carving in stone in a style that emphasized formal and conceptual simplicity. Motivating this change was Brancusi's interest in the ancient Greek philosophy of Plato, who held that all worldly objects and beings are imperfect imitations of their perfect models, or Ideas, which exist only in the mind of God.

Exemplary of Brancusi's quest for timeless essence is *Magic Bird* (fig. 28-18). The lower, limestone section has three parts, the middle one showing two rough-hewn figures (one of which has its face buried in the other's shoulder) representing the flawed world of ordinary human existence. The top section, carved in pure white marble, symbolizes the higher world of Ideas through the elegantly simplified form of a standing bird. The bird was apparently inspired by the hit of the 1910 Paris musical season, *The Firebird*, a ballet scored by the Russian composer Igor Stravinsky. But unlike the mythical magic birds that inspired the ballet, which always have dazzling plumage, the beauty of Brancusi's bird lies in its utter simplicity.

CUBISM IN EUROPE

Both the splintered shapes in Kirchner's *Street, Berlin* (see fig. 28-9) and the flattened space and geometric blocks of color in Klee's *Hammamet with Its Mosque* (see fig. 28-15) reflect the influence of Cubism, the most talked-about "ism" of twentieth-century art. Cubism was the joint invention of Pablo Picasso (1881–1973) and Georges Braque (1882–1963), built upon the foundation of Picasso's early work.

PICASSO'S EARLY ART

Picasso was born in Málaga, Spain, where his father taught in the School of Fine Arts. At fourteen Picasso entered the School of Fine Arts in Barcelona and two years later was admitted as an advanced student to the academy in Madrid. Picasso's involvement in the avant-garde began in the late 1890s, when he moved back to Barcelona. Beginning in 1900 he made frequent extended visits to Paris and moved there in early 1904.

During this time Picasso was attracted to the socially conscious nineteenth-century French painting

28-19. Pablo Picasso. *Self-Portrait*. 1901. Oil on canvas, 31⅞ x 23⅝" (81 x 60 cm). Musée Picasso, Paris

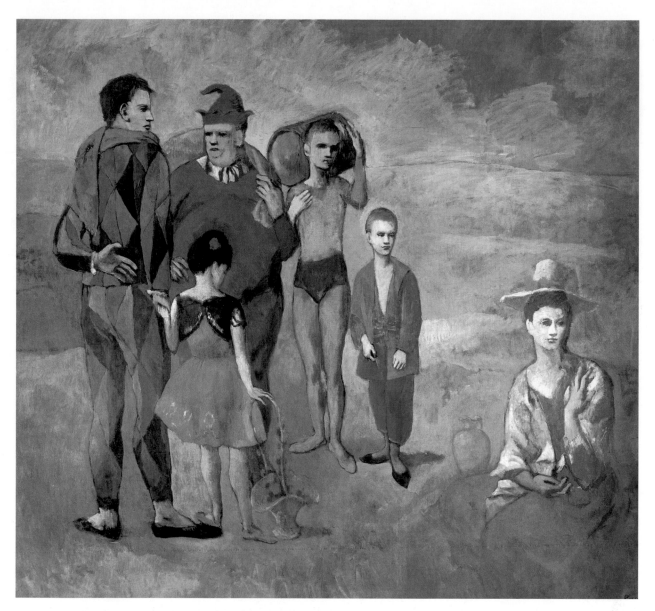

28-20. Pablo Picasso. *Family of Saltimbanques*. 1905. Oil on canvas, 6'11¾" x 7'6⅜" (2.1 x 2.3 m). National Gallery of Art, Washington, D.C.
Chester Dale Collection

that included Honoré Daumier (see fig. 27-46) and Toulouse-Lautrec (see fig. 27-81). In what is known as his Blue Period, he painted the outcasts of Paris and Barcelona in weary poses and a coldly expressive blue, likely chosen for its associations with melancholy. These paintings seem to have been motivated by Picasso's political sensitivity to those he considered victims of modern capitalist society, which eventually led him to join the Communist party. They also reflect his own unhappiness, hinted at in his 1901 *Self-Portrait* (fig. 28-19), which reveals his familiarity with cold, hunger, and disappointment.

After he settled in Paris, Picasso's personal circumstances greatly improved. He gained a large circle of supportive friends, and his work attracted several important collectors. His works from the end of 1904 through 1905, known collectively as the Rose Period because of the introduction of that color into his palette, show the last vestiges of his earlier despair. During the Rose Period, Picasso was preoccupied with the subject of traveling

acrobats, *saltimbanques*, whose rootless and insecure existence on the margins of society was similar to the one he too had known. Picasso rarely depicted them performing but preferred to show them at rest, as in *Family of Saltimbanques* (fig. 28-20). In this mysterious composition, six figures inhabit a barren landscape painted in warm tones of beige and rose sketchily brushed over a blue ground. Five of the figures cluster together in the left two-thirds of the picture while the sixth, a seated woman, curiously detached, occupies her own space in the lower right. All of the *saltimbanques* seem psychologically withdrawn and uncommunicative, as silent as the landscape they occupy is empty. Scholars have identified them as disguised portraits of members of Picasso's circle, including the dark-haired artist himself, who stands at the left in a motley costume.

In 1906 the Louvre installed a newly acquired collection of sixth- and fifth-century BCE sculpture from the Iberian region (modern Spain and Portugal). These

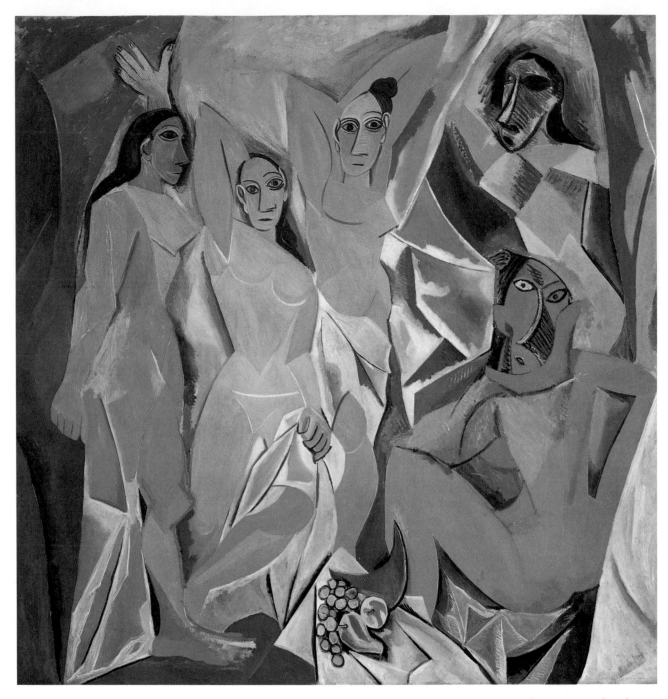

28-21. Pablo Picasso. *Les Demoiselles d'Avignon*. 1907. Oil on canvas, 8' x 7'8" (2.43 x 2.33 m). The Museum of Modern Art, New York

Acquired through the Lillie P. Bliss Bequest

ancient Iberian figures, which Picasso identified with the stoic dignity of the villagers in the province of his birth, became the chief influence on his work for the next year. Another important influence came from Gauguin's primitivist paintings and wood carvings, which Picasso also studied at this time.

Picasso's Iberian period culminated in 1907 in *Les Demoiselles d'Avignon* (fig. 28-21). The Iberian influence is seen specifically in the faces of the three leftmost figures, with their simplified features and wide, almond-shaped eyes. The faces of the two right-hand figures, painted in a radically different style, were inspired by another "primitive"

source—the African masks that Picasso saw in an ethnographic museum in Paris. With this painting Picasso responded to Matisse's recent *Le Bonheur de Vivre* (see fig. 28-6), and to the larger French classical tradition, which to Picasso was embodied in the harem paintings of Ingres, exhibited in a 1905 retrospective (see fig. 27-4). Picasso, however, substituted for the harem a bordello; the term *demoiselles*, meaning "young ladies," is a euphemism for "prostitutes," and *Avignon* refers not to the French town but to the red-light district of Barcelona.

In a preliminary study for the painting (fig. 28-22), Picasso included two men with the five women. Related

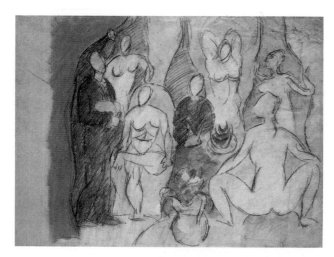

28-22. Pablo Picasso. Study for *Les Demoiselles d'Avignon*. 1907. Pastel on paper, 18¾ x 30" (47.6 x 63.7 cm). Öffentliche Kunstsammlung Basel, Kupferstichkabinett, Basel, Switzerland

preliminary drawings have led scholars to identify the man on the left holding a book as a student, and the seated man as a sailor, perhaps symbolizing, respectively, the contemplative and the active life. Picasso likely eliminated the men because the allegory they suggest detracts from the central issue of sexuality and because their confrontation with the women on display makes the viewer a mere onlooker. In the final painting, the viewer is a participant: The women look directly at us.

While the women in the sketch are conventionally rendered in soft curves, those in the painting are flattened and fractured into sharp curves and angles. The space they inhabit is equally fractured and convulsive. The central pair of *demoiselles* raise their arms in a traditional gesture of accessibility but contradict it with their hard, piercing gazes and firm mouths. Even the fruit displayed in the foreground, a symbol of female sexuality, seems hard and dangerous. Women, Picasso suggests, are not the gentle and passive creatures that men would like them to be. With this viewpoint he contradicts practically the entire tradition of erotic imagery since the Renaissance.

Picasso's friends were horrified by his new work. Matisse, for example, accused Picasso of making a joke of modern art and threatened to break off their friendship. But one artist, Georges Braque, responded positively, and he saw in *Les Demoiselles d'Avignon* a potential that Picasso probably had not fully intended. Picasso was not consciously trying to break with the Western pictorial tradition that dated back to the early fourteenth century painter Giotto. But what secured Picasso's place at the forefront of the Parisian avant-garde was the revolution in form that *Les Demoiselles d'Avignon* inaugurated. Braque responded eagerly to Picasso's formal innovations and set out, alongside Picasso, to develop them.

ANALYTIC CUBISM

Georges Braque was born a year after Picasso, near Le Havre, France, where he trained to become a house decorator like his father and grandfather. In 1900 he moved to Paris. The Fauve paintings in the 1905 Salon d'Automne so impressed him that he began to paint brightly colored landscapes, but it was the 1907 Cézanne retrospective that established his future course. Picasso's *Demoiselles* sharpened his interest in altered form and compressed space and emboldened Braque to make his own advances on Cézanne's late direction.

Braque's 1908 *Houses at L'Estaque* (fig. 28-23) reveals the emergence of early Cubism. Inspired by Cézanne's example, Braque reduced nature's many colors to its essential browns and greens and eliminated detail to emphasize basic geometric forms. Arranging the buildings into an approximate pyramid, he pushed those in the distance closer to the foreground, so the viewer looks *up* the plane of the canvas more than into it. The painting is less a Cézannesque study of nature than an attempt to translate nature's complexity into an independent, aesthetically satisfying whole.

Braque submitted *Houses at L'Estaque* to the progressive 1908 Salon d'Automne, but the jury, which included Matisse, rejected the painting—Matisse reportedly referring to Braque's "little cubes." In a review of Braque's November 1908 solo exhibition, critic Louis Vauxcelles, who had given the Fauves their name, borrowed Matisse's observation and wrote that Braque

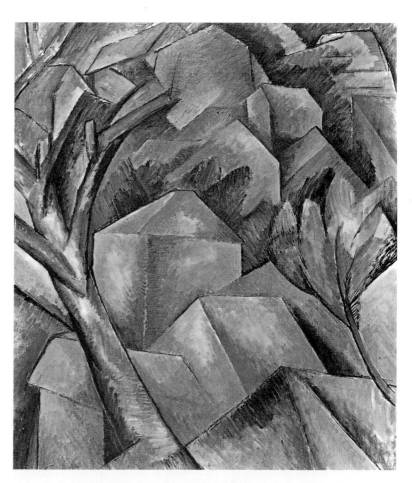

28-23. Georges Braque. *Houses at L'Estaque*. 1908. Oil on canvas, 36¼ x 23⅝" (92 x 60 cm). Kunstmuseum, Bern, Switzerland
Collection Hermann and Magrit Rupf-Stiftung

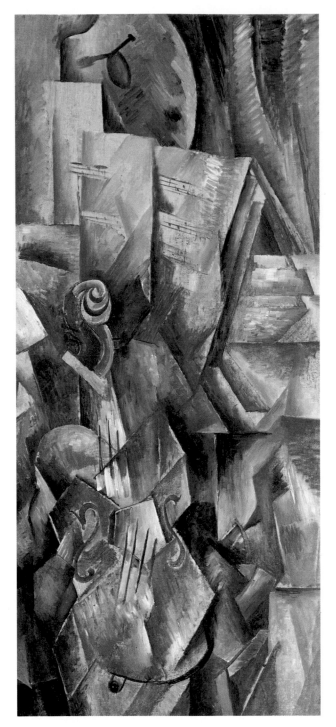

28-24. Georges Braque. *Violin and Palette*. 1909–10. Oil on canvas, 36¹/₈ x 16⁷/₈" (91.8 x 42.9 cm). Solomon R. Guggenheim Museum, New York

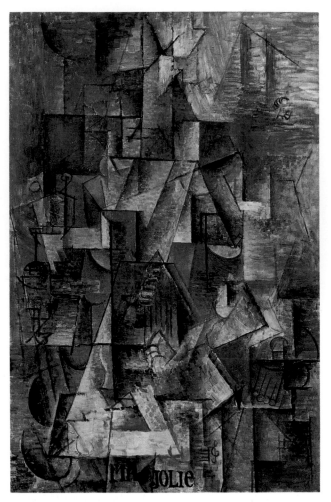

28-25. Pablo Picasso. *Ma Jolie*. 1911–12. Oil on canvas, 39³/₈ x 25³/₄" (100 x 65.4 cm). The Museum of Modern Art, New York

Acquired through the Lillie P. Bliss Bequest

In 1923 Picasso said, "Cubism is no different from any other school of painting. The same principles and the same elements are common to all. The fact that for a long time Cubism has not been understood . . . means nothing. I do not read English, [but] this does not mean that the English language does not exist, and why should I blame anyone . . . but myself if I cannot understand [it]?"

"reduces everything, places and figures and houses, to geometrical schemes, to cubes." Thus, the name *Cubism* was born.

Braque's early Cubist work helped point Picasso in a new artistic direction. By the end of 1908 the two artists had begun an intimate working relationship that lasted until Braque went off to war in 1914. "We were like two mountain climbers roped together," Braque later said. The two were engaged in a difficult quest for a new conception of painting as an arrangement of form and color on a two-dimensional surface. This arduous journey would require both Picasso's audacity and Braque's sense of purpose.

The move toward abstraction begun in Braque's landscapes in 1908 continued in moderately scaled still lifes the two artists produced over the next two and a half years. In Braque's *Violin and Palette* (fig. 28-24), the gradual elimination of space and recognizable subject matter is well under way. The still-life items are not arranged in illusionistic depth but are parallel to the picture plane in a shallow space. Using the **passage** technique developed by Cézanne, in which shapes closed on one side are open on another so that they can merge with adjacent shapes, Braque knit the various elements together into a single shifting surface of forms and colors. In some areas

of the painting, these formal elements have lost not only their natural spatial relations but their identities as well. Where representational motifs remain—the violin, for example—Braque has fragmented them to facilitate their integration into the whole.

In the still-discernible palette, sheet music, and violin, Braque reveals his and Picasso's new conception of painting. Critic and poet Guillaume Apollinaire wrote that the two were "moving toward an entirely new art which will stand, with respect to painting as envisaged heretofore, as music stands to literature. It will be pure painting, just as music is pure literature." As the musician arranges sounds to make music, Braque arranged forms and colors to make art.

Braque's and Picasso's paintings of 1909 and 1910 initiated what is known as Analytic Cubism because of the way the artists broke objects into parts as if to analyze them. The works of 1911 and early 1912 are also grouped under the *Analytic* label, although they reflect a different approach to the breaking up of forms. Instead of simply fracturing an object, Picasso and Braque picked it apart and rearranged its elements. Remnants of the subject Picasso worked from are evident throughout *Ma Jolie* (fig. 28-25), for example, but any attempt to reconstruct that subject—a woman with a stringed instrument—would be misguided because it provided only the raw material for a formal arrangement. *Ma Jolie* is not a representation of a woman, or of a place, or of an event, but simply a "pure painting." Again Picasso included a musical analogy—a G clef and the words *Ma Jolie* ("My Pretty One"), the title of a popular song—suggesting that the viewer should approach the painting the way one would a musical composition, either by simply enjoying the arrangement of its elements or by analyzing it, but not by asking what it represents.

A subtle tension between order and disorder is maintained throughout the painting. For example, the shifting effect of the surface, a delicately patterned texture of grays and browns, is given regularity through the use of short, horizontal brushstrokes. Similarly, with the linear elements, strict horizontals and verticals dominate, although many irregular curves and angles are also to be found. The combination of horizontal brushwork and right angles firmly establishes a grid that effectively counteracts the surface flux. Moreover, the repetition of certain diagonals and the relative lack of details in the upper left and upper right create a pyramidal shape. Thus, what at first may seem a random assemblage of lines and muted colors turns out to be a well-organized unit. The aesthetic satisfaction of such a work depends on the way chaos seems to resolve itself into order.

SYNTHETIC CUBISM

Works like *Ma Jolie* brought Picasso and Braque to the brink of total abstraction, but in the spring of 1912 they began to create works that suggested more clearly discernible subjects. This second major phase of Cubism is known as Synthetic Cubism because of the way the

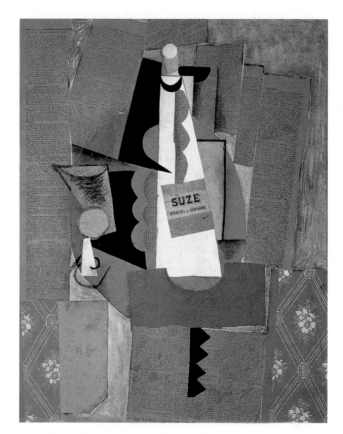

28-26. **Pablo Picasso.** *Glass and Bottle of Suze*. 1912. Pasted paper, gouache, and charcoal, 25³/₄ x 19³/₄" (65.4 x 50.2 cm). Washington University Gallery of Art, St. Louis, Missouri
University Purchase, Kende Sale Fund, 1946

artists created motifs by combining simpler elements, as in a chemical synthesis. Picasso's *Glass and Bottle of Suze* (fig. 28-26), like many of the works he and Braque created from 1912 to 1914, is a **collage** (from the French *coller*, "to glue"), a work composed of separate elements pasted together. At the center, newsprint and construction paper are assembled to suggest a tray or round table supporting a glass and a bottle of liquor with an actual label. Around this arrangement Picasso pasted larger pieces of newspaper and wallpaper. The elements together evoke not only a place—a bar—but also an activity: the viewer alone with a newspaper, enjoying a quiet drink.

The refuge from daily bustle that both art and quiet bars can provide was a central theme in the Synthetic Cubist works of Braque and Picasso. The two artists, however, used different types of newspaper clippings. Braque's clippings deal almost entirely with musical and artistic events, but Picasso often included references to political events that would soon shatter the peaceful pleasures these works evoke. In *Glass and Bottle of Suze*, for example, the newspaper clippings deal with the First Balkan War of 1912–13, which contributed to World War I.

Picasso soon extended the principle of collage into three dimensions to produce Synthetic Cubist sculpture,

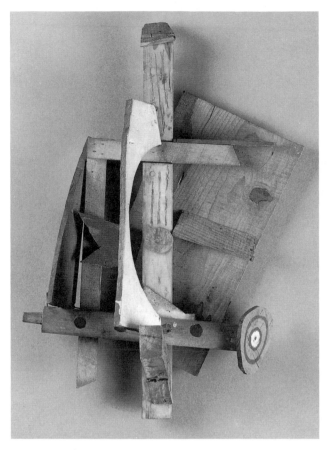

28-27. Pablo Picasso. *Mandolin and Clarinet*. 1913. Construction of painted wood with pencil marks, 22⅝ x 14⅛ x 9" (58 x 36 x 23 cm). Musée Picasso, Paris

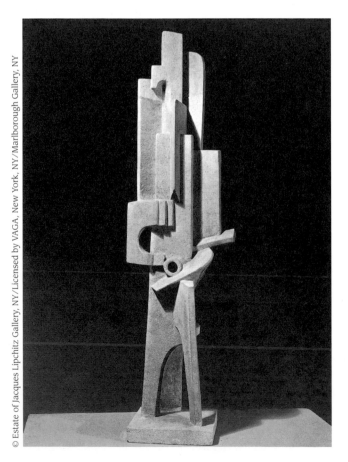

such as *Mandolin and Clarinet* (fig. 28-27). Composed of wood scraps, the sculpture suggests the typical Cubist subject of two musical instruments at right angles to each other. In works such as this Picasso introduced the revolutionary technique of **assemblage**, giving sculptors the option not only of carving or modeling but also of constructing their works out of found objects and unconventional materials. Another innovative feature of assemblage was its introduction of space into the interior of the sculpture and the consequent creation of volume through contained space rather than mass. This innovation reversed the traditional conception of sculpture as a solid surrounded by void—a conception retained even in such a daring work as Matisse's *La Serpentine* (see fig. 28-17).

RESPONSES TO CUBISM

As the various phases of Cubism emerged from the studios of Braque and Picasso, it became clear to the art world that something of great significance was happening. The radical innovations upset the public and most critics, but the avant-garde saw in them the future of art.

French Responses. Some artists, such as sculptor Jacques Lipchitz (1891–1973), incorporated these innovations in less radical art. Lipchitz, who came to Paris from his native Lithuania in 1909, assimilated both Analytic and Synthetic Cubism. *Man with a Guitar* (fig. 28-28), for example, is in the Synthetic Cubist mode, although it is carved rather than constructed. Like Picasso in *Mandolin and Clarinet*, Lipchitz combined curvilinear and angular shapes, in this case to evoke the familiar Cubist subject of a figure holding a guitar. The hole at the center of the work is a visual pun that suggests both the sound hole of the guitar and the figure's navel. The sculpture aims simply to create a pleasant symphony of shifting but ultimately stable forms.

At the other end of the spectrum was the radical painting of Robert Delaunay (1885–1941), who attempted to take monochromatic, static, and antisocial Analytic Cubism into a new, wholly different direction. Neo-Impressionism and Fauvism influenced Delaunay's early painting, and his interest in the spirituality of color led him to participate in Der Blaue Reiter exhibitions. Beginning in 1910 Delaunay attempted to fuse Fauvist color with Analytic Cubist form in works dedicated to the modern city and modern technology. One of these, *Homage to Blériot* (fig. 28-29), pays tribute to the French pilot who in 1909 was the first to fly across the English Channel. One of Blériot's early airplanes, in the upper right, and the Eiffel Tower were symbols of technological and social progress, and the crossing of the Channel was evidence of a new, unified world without national

28-28. Jacques Lipchitz. *Man with a Guitar*. 1915. Limestone, 38¼ x 10½ x 7¾" (97.2 x 26.7 x 19.7 cm). The Museum of Modern Art, New York Mrs. Simon Guggenheim Fund (by exchange)

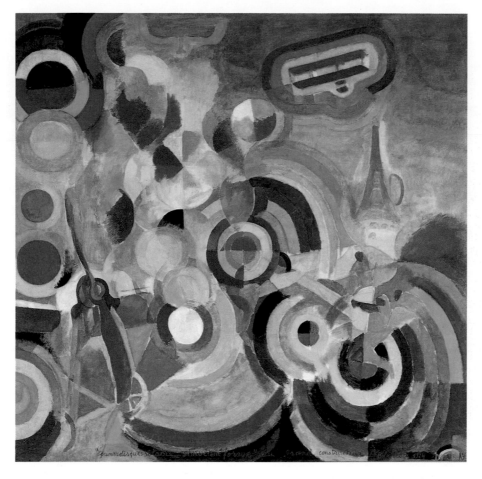

28-29. Robert Delaunay. *Homage to Blériot.* 1914. Tempera on canvas, 8'2½" x 8'3" (2.5 x 2.51 m). Öffentliche Kunstsammlung Basel, Kunstmuseum, Basel, Switzerland

Emanuel Hoffman Foundation

antagonisms. The brightly colored circular forms that fill the canvas suggest both the movement of the propeller on the left and the blazing sun, as well the great **rose windows** of Gothic cathedrals. By combining images of progressive science with those of divinity, Delaunay suggested that progress is part of God's divine plan. The ecstatic painting thus synthesizes not only Fauvist color and Cubist form but also conservative religion and modern technology.

The critic Apollinaire labeled Delaunay's style Orphism for its affinities with Orpheus, the legendary Greek poet whose lute playing charmed wild beasts, implying an analogy between Delaunay's painting and music. Delaunay preferred to think of his work in terms of "simultaneity," a complicated concept he developed with his wife, the Russian-born artist Sonia Delaunay-Terk (née Sonia Stern, 1885–1979), from Michel-Eugène Chevreul's law of the simultaneous contrast of colors (see page 1032). Simultaneity for Delaunay and his wife connoted the collapse of spatial distance and temporal sequence into the simultaneous "here and now," and the creation of harmonic unity out of elements normally considered disharmonious.

After marrying Delaunay in 1910, Delaunay-Terk produced paintings very similar to his, but she devoted much of her career to fabric and clothing design. Her greatest critical success came in 1925 at the International Exposition of Modern Decorative and Industrial Arts, for which she decorated a Citroën sports car to match one of her ensembles (fig. 28-30), suggesting that her bold geometric designs were an expression of the new automobile age.

Delaunay-Terk chose that particular car because it was produced cheaply for a mass market, and she had recently brought out inexpensive ready-to-wear clothing. Moreover, the small three-seater was specifically designed to appeal to the "new woman," who, like Delaunay-Terk, was less tied to home and family and less dependent on men than her predecessors.

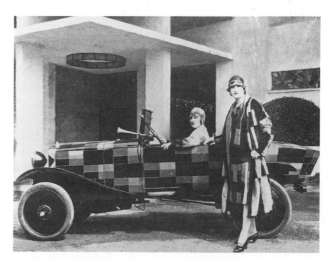

28-30. Sonia Delaunay-Terk. Clothes and customized Citroën B-12. From *Maison de la Mode*, 1925

The term *Art Deco* was coined at the 1925 International Exposition of Modern Decorative and Industrial Arts in Paris to describe the kind of geometric style evident in many of the works on display, including Delaunay-Terk's clothing and fabric designs.

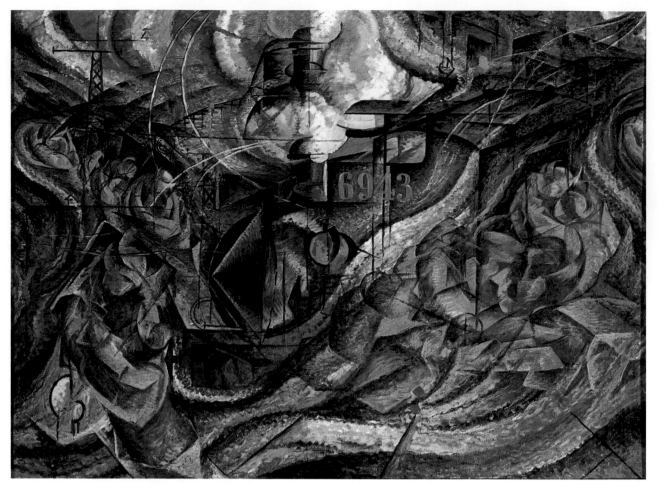

28-31. Umberto Boccioni. *States of Mind: The Farewells*. 1911. Oil on canvas, 27⅛ x 37⅞" (70.7 x 96 cm). The Museum of Modern Art, New York
Gift of Nelson A. Rockefeller

This painting is the first in the *States of Mind* trilogy of train station scenes, whose other two canvases depict *Those Who Go* and *Those Who Remain*. In each picture, Boccioni sought to capture "the rhythm specific to the emotion" of the subject as "*a state of form, a state of color*, each of which will give back to the viewer the 'state of mind' that produced it."

Italian Responses. Italian Futurism emerged on February 20, 1909, when a controversial Milanese poet and literary magazine editor, Filippo Marinetti (1876–1944), published his "Foundation and Manifesto of Futurism" in a Paris newspaper. An outspoken attack against everything old, dull, "feminine," and safe, Marinetti's manifesto promoted the exhilarating "masculine" experiences of warfare and reckless speed. Futurism aimed both to free Italy from its past and to promote a new taste for the thrilling speed, energy, and power of modern technology and modern urban life.

In April 1911 five Milanese artists issued the "Technical Manifesto" of Futurist painting, in which they boldly declared that "all subjects previously used must be swept aside in order to express our whirling life of steel, of pride, of fever, and of speed." The paintings of Umberto Boccioni (1882–1916), one of the manifesto's signers, celebrate the pulsating dynamism of the modern industrial city. *States of Mind: The Farewells* (fig. 28-31), for example, immerses the viewer in the crowded, exciting chaos of a train station. At the center,

with numbers emblazoned on its front, is a powerful steam locomotive. Pulsing across the top of the work is a series of bright curves meant to suggest radio waves emanating from the steel tower in the left rear. Adding to the complexity of the tightly packed surface are the longer, more fluid rhythms that seem to pull a crowd of metallic figures—or perhaps a single couple moving through space and time—from beneath the tower down and across the picture. Although the simplified, blocky forms were borrowed from Analytic Cubism, their sequential arrangement was inspired by time-lapse photography. Boccioni wanted to convey more than a purely physical sense of place. He wanted, as well, to evoke the sounds, smells, and emotions that made the train station the epitome of the noisy urban existence he and his colleagues loved.

In 1912 Boccioni took up sculpture and his *Technical Manifesto of Futurist Sculpture* called for a "sculpture of environment" in which closed outlines would be broken open and sculptural forms integrated with surrounding space. His major sculptural work, *Unique Forms of*

Continuity in Space (fig. 28-32), presents an armless nude figure in full, powerful stride. The contours of the muscular body flutter and flow into the surrounding space, expressing the figure's great velocity and vitality as it rushes forward, a stirring symbol of the brave new Futurist world.

Russian Responses. Since the time of Peter the Great (ruled 1682–1725), Russia's ruling classes had turned to Western Europe for cultural models. In 1898, two wealthy young men—Aleksandr Benois (1870–1960) and Serge Diaghilev (1872–1929)—who wanted not just to import Western innovations but also to make Russia for the first time a center of innovation, launched the magazine *World of Art*, dedicated to international art, literature, and music. The following year the World of Art group, centered in Russia's capital, St. Petersburg, held its first international art exhibition, including works by Degas, Monet, and Whistler. Diaghilev took an exhibition of contemporary Russian art to Paris in 1906 and three years later brought his ballet company, the Ballets Russes, to the French capital, where it enjoyed enormous success.

The World of Art group inspired a similar group in Moscow, the Golden Fleece. In 1906 it launched an art magazine by that name and in 1908 organized a major exhibition of Russian and French art, which included works by Rodin, Maillol, Toulouse-Lautrec, Gauguin, Cézanne, Matisse, Derain, and Braque. Among the young Russian artists in the first Golden Fleece exhibition were Mikhail Larionov (1881–1964) and Natalia Goncharova (1881–1962), who had met at a Moscow art school and became lifelong companions (they married in 1955). Exposed to French modernism, Larionov and Goncharova adopted the bright colors and simplified forms of the Fauves, which they combined with a strongly nationalistic interest in "primitive" Russian art forms such as **icon** paintings, signboards, and *lubki*, the cheap **woodblock prints** that decorated peasant homes. Larionov and Goncharova's Neo-Primitivist paintings of the early 1910s were boldly colored and crudely stylized genre scenes of Russian peasants intended to celebrate both native Russian artistic styles and the country's traditional agrarian way of life. Their slightly later works, however, such as Goncharova's *Aeroplane over Train* (fig. 28-33), reflect Western European art's promotion of modern technological progress, suggesting the conflict many Russians felt over the opposition of rural to urban, agrarian to industrial, and Russian to Western European.

Goncharova's painting combines two leading symbols of technological advance in a style derived from early Analytic Cubism and Futurism. Blocky Cubist shapes are closely packed in a dynamic Futurist rhythm across a surface also marked by sharp diagonals. Because knowledge of Analytic Cubism and Futurism arrived in Moscow almost simultaneously and they were superficially similar, artists such as Goncharova tended to link them. Thus, the style that evolved from them in 1912–14 is known as Cubo-Futurism, even though it had less to do with Cubist than with Futurist values.

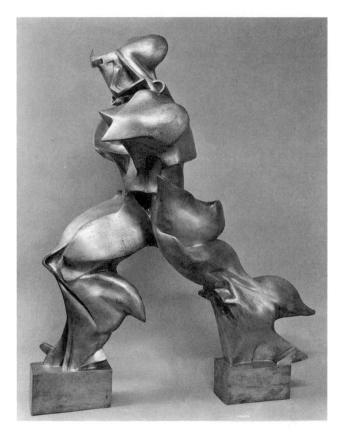

28-32. Umberto Boccioni. *Unique Forms of Continuity in Space*. 1913. Bronze, 43⁷⁄₈ x 34⁷⁄₈ x 15³⁄₄" (111 x 89 x 40 cm). The Museum of Modern Art, New York

Acquired through the Lillie P. Bliss Bequest

Boccioni and the Futurist architect Antonio Sant'Elia (see fig. 28-44) were both killed in World War I. The Futurists had ardently promoted Italian entry into the war on the side of France and England. After the war Marinetti's movement, still committed to nationalism and militarism, supported the rise of fascism under Benito Mussolini, although a number of the original members of the group rejected this direction.

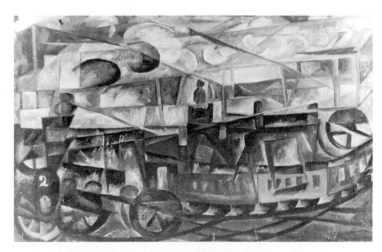

28-33. Natalia Goncharova. *Aeroplane over Train*. 1913. Oil on canvas, 21⁵⁄₈ x 32⁷⁄₈" (55 x 83.5 cm). Kazan-skil Muzej, Russia

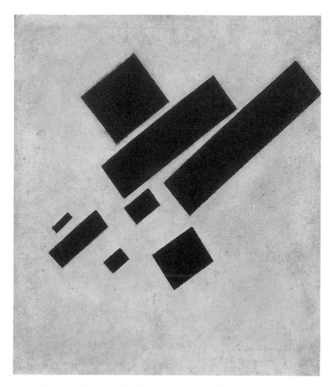

28-34. Kazimir Malevich. *Suprematist Painting (Eight Red Rectangles)*. 1915. Oil on canvas, 22½ x 18⅞" (57 x 48 cm). Stedelijk Museum, Amsterdam

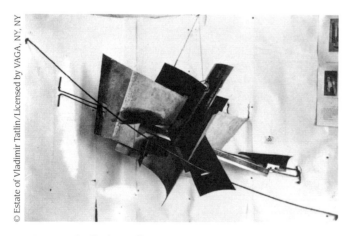

28-35. Vladimir Tatlin. *Corner Counter-Relief*. 1915. Mixed mediums, 31½ x 59 x 29½" (80 x 150 x 75 cm). Present whereabouts unknown

After Goncharova and Larionov left for Paris in 1915, their colleague Kazimir Malevich (1878–1935) emerged as the leading figure in the Moscow avant-garde. According to his later reminiscences, "in the year 1913, in my desperate attempt to free art from the burden of the object, I took refuge in the square form and exhibited a picture which consisted of nothing more than a black square on a white field." Malevich exhibited thirty-nine works in this radically new vein at the "Last Futurist Exhibition of Paintings: 0.10" exhibition in St. Petersburg in the winter of 1915–16. One work, *Suprematist Painting (Eight Red Rectangles)* (fig. 28-34), consists simply of eight

red rectangles arranged diagonally on a white painted ground. Malevich called this art Suprematism, short for "the supremacy of pure feeling in creative art" motivated by "a pure feeling for plastic [that is, formal] values." By eliminating objects and focusing entirely on formal issues, Malevich intended to "liberate" the essential beauty of all great art.

While Malevich was launching an art that transcended the present, Vladimir Tatlin (1885–1953) was opening a very different direction for Russian art, inspired by Synthetic Cubism. In April 1914 Tatlin went to Paris specifically to visit Picasso's studio. Tatlin was most impressed by Synthetic Cubist sculpture, such as *Mandolin and Clarinet* (see fig. 28-27), and began to produce innovative nonrepresentational relief sculptures constructed of various materials, including metal, glass, plaster, asphalt, wire, and wood. These Counter-Reliefs, as he called them, were based on the concept of ***faktura***, the conviction that each material generates its own repertory of forms and colors. Partly because he wanted to place "real materials in real space" and because he thought the usual placement on the wall tended to flatten his reliefs, he began at the "0.10" exhibition of 1915–16 to suspend them across the upper corners of rooms (fig. 28-35)—the traditional location for Russian icons. In effect, these Corner Counter-Reliefs were intended to replace the old symbol of Russian faith with one dedicated to respect for materials. But because his choice of materials increasingly favored the industrial over the natural, these modern icons were also incipient expressions of the post–World War I shift away from aestheticism and toward utilitarianism in Russia, a topic explored later in this chapter.

EARLY MODERNIST TENDENCIES IN THE UNITED STATES

Artistic modernism developed more slowly in the United States than in Europe because the still-vital American realist tradition was fundamentally opposed to the abstract styles of painters like Kandinsky, Delaunay, and Malevich. In the opening decade of the twentieth century, a vigorous realist movement coalesced in New York City around the charismatic painter and teacher Robert Henri (1865–1929). Speaking out against both the academic conventions and the impressionistic style then dominating American art, Henri told his students: "Paint what you see. Paint what is real to you."

In 1908, Henri organized an exhibition of artists who came to be known as The Eight, four of whom were former newspaper illustrators. The show was a gesture of protest against the conservative exhibition policies of the National Academy of Design, the American counterpart of the French École des Beaux-Arts. Because they depicted scenes of often gritty urban life in New York City, five of The Eight became part of what was later dubbed the Ashcan School.

Most characteristic of this school is John Sloan (1871–1951), whose *Backyards, Greenwich Village* (fig.

28-36), belies the Ashcan label, because, like the laundry in it, it seems fresh and clean—an effect that depends on both the wet look of the paint and the refreshing blues that dominate it. Balancing those cool tonalities are the warm yellows of the building and fence, which give the picture its emotional temperature. Beneath the laundry, which suggests the presence of caring parents, two warmly dressed children are building a snowman, while an alley cat looks on. Another observer is a little girl in the window at the right, a stand-in for the artist, who looks out with joy on this ordinary backyard and its simple pleasures.

An outspoken opponent of the Ashcan school aesthetic was the photographer Alfred Stieglitz (see fig. 27-93), who sought recognition for photography as a creative art form on a par with painting, drawing, and printmaking. Stieglitz promoted his views through an organization called the Photo-Secession, founded in 1902, and two years later opened a gallery at 291 Fifth Avenue, soon known simply as 291, which exhibited modern art as well as photography to help break the barrier between the two. Stieglitz's chief ally was another American photographer, Edward Steichen (1879–1973), who then lived in Paris and helped arrange exhibitions unlike any seen before in the United States, including works by Rodin (1908 and 1910), Matisse (1908 and 1912), Toulouse-Lautrec (1909), Henri Rousseau (1910), Cézanne (1911), Picasso (1911), and Brancusi (1914). Thus, in the years around 1910 Stieglitz's gallery became the American focal point not only for the advancement of photographic art but also for the larger cause of European modernism. Even more important, Stieglitz also exhibited young American artists beginning to experiment with modernist expression.

The turning point for modernist art in the United States was the 1913 exhibit known as the Armory Show. It was assembled by one of The Eight, Arthur B. Davies (1862–1928), to demonstrate how outmoded were the views of the National Academy of Design. Unhappily for the Henri group, the Armory Show also demonstrated how out of fashion their realistic approach was. Of the more than 1,300 works in the show, only about a quarter were by Europeans, but those works drew all the attention. Critics claimed that Matisse, Kandinsky, Braque, Duchamp (see fig. 28-64), and Brancusi were the agents of "universal anarchy." The academic painter Kenyon Cox called them mere savages. When a selection of works continued on to Chicago, civic leaders there called for a morals commission to investigate the show. Faculty and students at the School of the Art Institute were so enraged they hanged Matisse in effigy.

A number of younger artists, however, responded positively and sought to assimilate the most recent developments from Europe. The issue of realism versus academicism, so critical before 1913, suddenly seemed inconsequential. For the first time in their history, American artists at home began fighting their provincial status.

Among the pioneers of American modernism who exhibited at the Armory Show was Marsden Hartley (1877–1943), who was also a regular exhibitor at Stieglitz's 291 gallery. Between 1912 and 1915 Hartley lived mostly

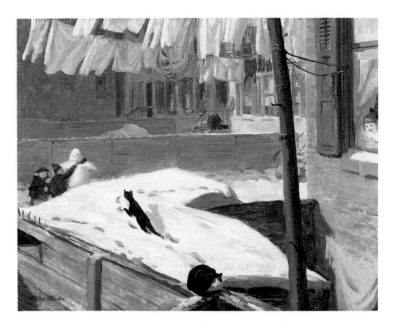

28-36. **John Sloan.** *Backyards, Greenwich Village*. 1914. Oil on canvas, 26 x 32" (66 x 81.3 cm). Whitney Museum of American Art, New York
Purchase

abroad, first in Paris, where he discovered Cubism, then in Berlin, where he was drawn to the colorful, spiritually oriented expressionism of Kandinsky. Around the beginning of World War I, Hartley merged these influences into the powerfully original style seen in his *Portrait of a German Officer* (fig. 28-37, page 1084, "The Object Speaks"), a tightly arranged composition of boldly colored shapes and patterns, interspersed with numbers, letters, and fragments of German military imagery that refer symbolically to its subject.

Another American artist influenced by European modernism was the photographer Paul Strand (1890–1976), who also exhibited at 291. Stimulated by the Armory Show and Stieglitz's exhibitions of Cézanne, Picasso, and Brancusi at 291, Strand in the summer of 1916 made an innovative series of abstract photographs derived from objects in the real world. *Chair Abstract, Twin Lakes, Connecticut* (fig. 28-38, page 1085), is a cropped view of the seat, back, and spindled arm of a chair, in whose structure Strand discovered a formal relationship to the geometries of Cubism. By turning his camera over 45 degrees and bringing it close to the chair, he created an abstract composition that has less to do with a piece of furniture than with geometric shapes, light and dark contrasts, flattened space, and the dynamism of the diagonal.

EARLY MODERN ARCHITECTURE

New industrial materials and advances in engineering enabled twentieth-century architects to create unprecedented architectural forms that responded to the changing needs of society. In formal terms, modernist architecture rejected historical styles and emphasized simple, geometric forms and plain, undecorated surfaces.

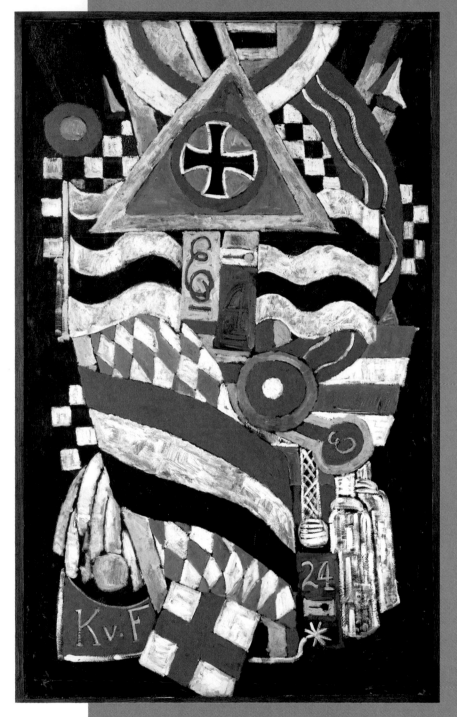

28-37. Marsden Hartley. *Portrait of a German Officer.*
1914. Oil on canvas, 68¼ x 41⅜" (1.78 x 1.05 m).
The Metropolitan Museum of Art, New York
The Alfred Stieglitz Collection, 1949 (49.70.42)

Marsden Hartley's modernist painting does not literally represent its subject but speaks symbolically of it through the use of numbers, letters, and fragments of German military paraphernalia and insignia. While living in Berlin in 1914, the homosexual Hartley became enamored of a young Prussian lieutenant, Karl von Freyburg, whom he later described in a letter to his dealer, Alfred Stieglitz, as "in every way a perfect being—physically, spiritually and mentally, beautifully balanced—24 years young. . . ." Freyburg's death at the front in October 1914 devastated Hartley, and he mourned the fallen officer through the act of painting.

The black background of the *Portrait of a German Officer* serves formally to heighten the intensity of its colors and expressively to create a solemn, funereal undertone. The symbolic references to Freyburg include his initials ("Kv.F"), his age ("24"), his regiment number ("4"), epaulettes, helmet cockades, and the Iron Cross he was awarded the day before he was killed. The cursive "E" may refer to Hartley himself, whose given name was Edmund.

Even the seemingly abstract, geometric patterns have symbolic meaning. The black-and-white checkerboard evokes Freyburg's love of chess. The blue-and-white diamond pattern comes from the flag of Bavaria. The black-and-white stripes are those of the historic flag of Prussia. And the red, white, and black bands constitute the flag of the German Empire, adopted in 1871.

28-38. Paul Strand. *Chair Abstract, Twin Lakes, Connecticut*. 1916. Palladium print, 13 x 9¹¹/₁₆" (33 x 24.6 cm).
San Francisco Museum of Modern Art
Purchase

Strand's pioneering abstract photographs were influenced by Cubist painting. In taking them, he said he "set out to find out what this abstract idea was all about and to discover the principles behind it. . . . I did not have any idea of imitating painting or competing with it but was trying to find out what its value might be to someone who wanted to photograph the real world."

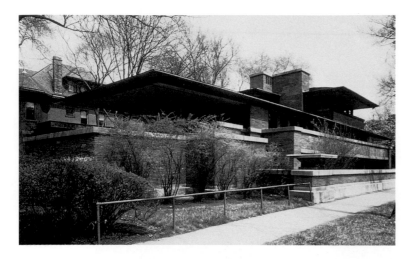

AMERICAN MODERNISM

Many consider Frank Lloyd Wright (1867–1959), a pioneer of architectural modernism, the greatest American architect of the twentieth century. His mother, determined that he would be an architect, had hung engravings of cathedrals over his crib. Summers spent working on his uncle's farm in Wisconsin gave him a deep respect for nature, natural materials, and agrarian life. After briefly studying engineering at the University of Wisconsin, Wright apprenticed for a year with a Chicago architect, then spent the next five years with Adler and Sullivan (see fig. 27-99), eventually becoming their chief drafter. In 1893, Wright opened his own office, specializing in domestic architecture. Seeking better ways to integrate house and site, he turned away from the traditional boxlike design and by 1900 was creating "organic" architecture that integrated a building with its natural surroundings.

This distinctive domestic architecture is known as the **Prairie Style** because many of Wright's early houses were built in the Prairie States and were inspired by the horizontal character of the prairie itself. Its most famous expression is the Frederick C. Robie House (fig. 28-39), which, typical of the style, is organized around a central chimney mass that marks the hearth as the physical and psychological center of the home. From the chimney mass, dramatically **cantilevered** (see "Space-Spanning Construction Devices," page 22, Starter Kit) roofs and terraces radiate outward into the surrounding environment,

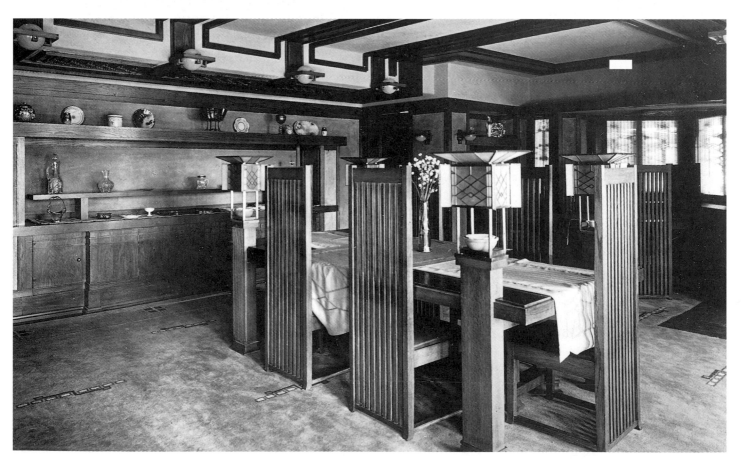

28-40. Dining room, Frederick C. Robie House

In 1897 Wright helped found the Chicago Arts and Crafts Society, an outgrowth of the movement begun in England by William Morris (Chapter 27). But whereas his English predecessors looked nostalgically back to the Middle Ages and rejected machine production, Wright did not. He detested standardization, but he thought the machine could produce beautiful and affordable objects. The chairs seen here, for example, were built of rectilinear, machine-cut pieces. Wright, a conservationist, favored such rectilinear forms in part because they could be cut with a minimum of wasted lumber.

echoing the horizontality of the prairie even as they provide a powerful sense of shelter for the family within. The windows are arranged in long rows and deeply embedded into the brick walls, adding to the fortresslike quality of the building's central mass.

The horizontal emphasis of the exterior continues inside, especially in the main living level—one long space divided into living and dining areas by a freestanding fireplace. The free flow of interior space that Wright sought was partly inspired by traditional Japanese domestic architecture, which uses screens rather than heavy walls to partition space (see "Shoin Design," page 865). In his quest to achieve organic unity among all parts of the house, Wright integrated lighting and heating into the ceiling and floor and designed built-in bookcases, shelves, and storage drawers. He also incorporated freestanding furniture of his own design, such as the dining room set seen in figure 28-40. The chairs feature a strikingly modern, machine-cut geometric design that harmonizes with the rest of the house. Their high backs were intended to create around the dining table the intimate effect of a room within a room. Wright also designed the table with a view to promoting intimacy: Because he felt that candles and large bouquets running down the center of the table formed a barrier between people seated on either side, he integrated lighting features and flower holders into the posts near each of the table's corners.

THE AMERICAN SKYSCRAPER

After 1900 New York City assumed leadership in the development of the skyscraper, whose soaring height was made possible by the use of the steel-frame skeleton for structural support and other advances in engineering and technology (see "The Skyscraper," page 1088). New York clients rejected the innovative style of Louis Sullivan and other Chicago architects for the historicist approach still in favor in the East, as seen in the Woolworth Building (fig. 28-41), designed by Cass Gilbert (1859–1934). When completed, at 792 feet and 55 floors, it was the world's tallest building. Its Gothic-style external details, inspired by the soaring towers of late-medieval churches, resonated well with the United States' increasing worship of business. Gilbert explained that he wished to make something "spiritual" of what others called his Cathedral of Commerce.

EUROPEAN MODERNISM

In Europe, a stripped-down and severely geometric style of modernist architecture arose, partly in reaction against the ornamental excesses of Art Nouveau. A particularly harsh critic of Art Nouveau (known in Austria as *Sezessionstil*) was the Viennese writer and architect Adolf Loos (1870–1933). In the essay "Ornament and Crime" (1913), he insisted, "The evolution of a culture is synonymous with the removal of ornament from utilitarian objects." For Loos, ornament was a sign of a degenerate culture.

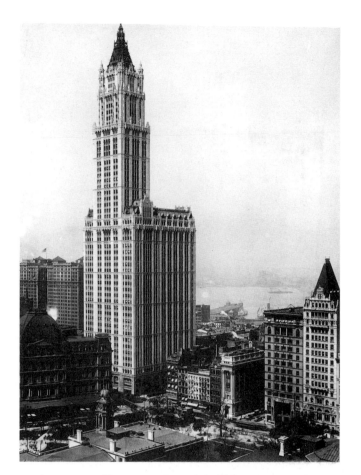

28-41. Cass Gilbert. Woolworth Building, New York.
1911–13 ©Collection of The New-York Historical Society, New York City
(46309)

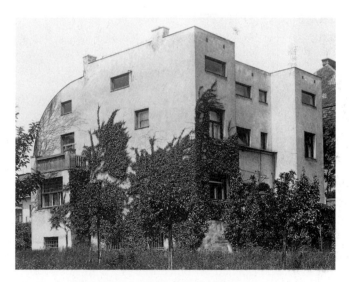

28-42. Adolf Loos. Steiner House, Vienna. 1910

Exemplary of Loos's aesthetic is his Steiner House (fig. 28-42), whose stucco-covered, reinforced-concrete construction lacks embellishment. The plain, rectangular windows are placed only according to interior needs. For Loos, an exterior was simply to provide protection from the elements. The curved roof allows rain and snow to run off but, unlike the traditional pitched roof, creates no wasted space.

The evolution of the skyscraper depended on the development of these essentials: metal beams and girders for the structural-support skeleton; the separation of the building-support structure from the enclosing layer (the cladding); fireproofing materials and measures; elevators; and plumbing, central heating, artificial lighting, and ventilation systems. First-generation skyscrapers, built between about 1880 and 1900, were concentrated in the Midwest, especially Chicago (see fig. 27-102). Second-generation skyscrapers, with more than twenty stories, date from 1895. At first the tall buildings were freestanding towers, sometimes with a base, like the Woolworth Building of 1911–1913 (see fig. 28-41). New York City's Building Zone Resolution of 1916 introduced mandatory setbacks—recessions from the ground-level building line—to ensure light and ventilation of adjacent sites. Built in 1931, the 1,250-foot, setback-form Empire State Building, diagrammed here, is thoroughly modern in having a streamlined exterior—its cladding is in Art Deco style—that conceals the great complexity of the internal structure and mechanisms that make its height possible. The Empire State Building is still one of the tallest buildings in the world.

masonry wall
girder
cladding
heat source
concrete slab flooring
beams
elevator shafts (layer two)
stairwells (layer one)
setbacks

The purely functional exteriors of Loos's buildings qualify him as a founder of European modernist architecture. Another was the German Walter Gropius (1883–1969), who opened an office in 1910 with Adolf Meyer (1881–1929). Gropius's lectures on increasing workers' productivity by improving the workplace drew the attention of an industrialist who in 1911 commissioned him to design the Fagus Factory (fig. 28-43). This building represents the evolution of modernist architecture from the engineering advances of the nineteenth century. Unlike the Eiffel Tower or the Crystal Palace (see figs. 27-1, 27-35), it was conceived not to demonstrate advances or solve a problem but to function as a building. With it Gropius proclaimed that modern architecture should make intelligent and sensitive use of what the engineer can provide.

To produce a purely functional building, Gropius gave the Fagus Factory facade no elaboration beyond that dictated by its construction methods. The slender brick piers along the outer walls mark the vertical members of the building's steel frame, and the horizontal bands of brickwork at the top and bottom, like the opaque panels between them, mark floors and ceilings. A **curtain wall**—an exterior wall that bears no weight but simply separates the inside from the outside—hangs over the frame, and it consists largely of glass. The corner piers standard in earlier buildings, here rendered unnecessary by the steel-frame skeleton, have been eliminated. The large windows both reveal the building's structure and flood the workplace with light. This building insists that good engineering is good architecture.

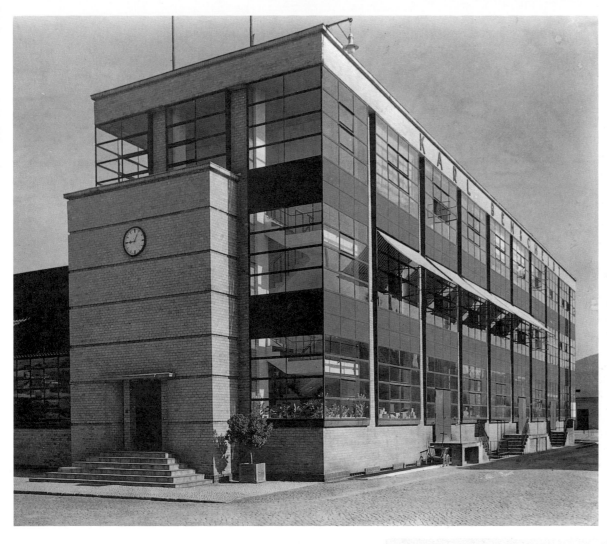

Just prior to World War I, an Italian Futurist architect, Antonio Sant'Elia (1888–1916), conceived a more dynamic and visionary solution to the search for a modern style in drawings for his theoretical *Città Nuova* ("New City") (fig. 28-44). His conception of the new city of steel, glass, and reinforced concrete was not based on advanced technology alone but also on the way it can emphasize the energy of modern life. The basic structure of Sant'Elia's new city would be the skyscraper, whose stepped-back design would not be functional but expressive of rapid movement. Cutting through and beneath the city would be a network of roads and subways extending in places to seven levels below the ground. The nerve center of this vast transportation system would be the colossal station for trains and airplanes pictured here. Sant'Elia's fantastic station functions as a giant futurist machine in which, as one critic noted, "traffic assumes a role analogous to that of water in a fountain." But water and all other natural features are banished from Sant'Elia's city.

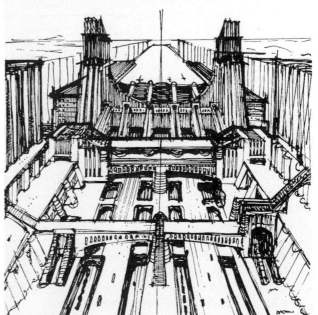

28-44. **Antonio Sant'Elia. Station for airplanes and trains**. 1914. Musei Civici, Como

"We are no longer the men of the cathedrals, the palaces, the assembly halls," Sant'Elia wrote in the 1914 *Manifesto of Futurist Architecture*, "but of big hotels, railway stations, immense roads, colossal ports, covered markets . . . demolition and rebuilding schemes. We must invent and build the city of the future, dynamic in all its parts . . . and the house of the future must be like an enormous machine."

MODERNISM IN EUROPE BETWEEN THE WARS

World War I had a profound effect on Europe's artists and architects. While many responded pessimistically to the unprecedented destruction, some sought in the war's ashes the basis for a new, more secure civilization. Some were utopian visionaries, while others captured in their art nightmarish visions; some sought stability in classical forms

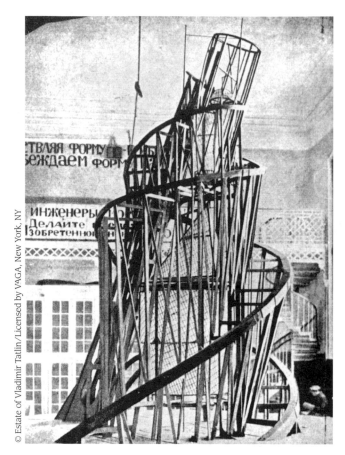

28-45. Vladimir Tatlin. Model for the Monument to the Third International. 1919–20. Wood, iron, and glass. Destroyed

of the past, yet others looked to the precision of new geometric and industrial forms to create order from chaos. And other European artists between the wars presented barbed social criticism, deeply personal self-expression, or whimsical works that defied convention.

UTILITARIAN ART FORMS IN RUSSIA

In the 1917 Russian Revolution, the radical socialist Bolsheviks overthrew the czar, took Russia out of the world war, and turned to winning an internal civil war that lasted until 1920. Most of the Russian avant-garde enthusiastically supported the Bolsheviks, who in turn supported them. Vladimir Tatlin's case is fairly representative. In 1919, as part of his work on a committee to implement Russian leader Vladimir Lenin's Plan for Monumental Propaganda, Tatlin devised the Monument to the Third International (fig. 28-45), a 1,300-foot-tall building to house the organization devoted to the worldwide spread of Communism. Tatlin's visionary plan combined the appearance of avant-garde sculpture with a fully utilitarian building, a new hybrid form as revolutionary as the politics it represented. In Tatlin's model, the steel structural support, a pair of leaning spirals connected by grillwork, is on the outside of rather than inside the building. Tatlin

combined the skeletal structure of the Eiffel Tower (which his tower would dwarf) with the formal vocabulary of the Cubo-Futurists to convey the dynamism of what Lenin called the "permanent revolution" of Communism. Inside the steel frame would be four separate spaces: a large cube to house conferences and congress meetings, a pyramid for executive committees, a cylinder for propaganda offices, and a hemisphere at the top, apparently meant for radio equipment. Each of these units would rotate at a different speed, from yearly at the bottom to hourly at the top. Although Russia lacked the resources to build Tatlin's monument, models displayed publicly were a symbolic affirmation of faith in what the country's science and technology would eventually achieve.

One of Tatlin's associates, Aleksandr Rodchenko (1891–1956), in 1921 helped launch a group known as the Constructivists, who were committed to quitting the studio and going "into the factory, where the real body of life is made." In place of artists dedicated to pleasing themselves, politically committed artists would create useful objects and promote the aims of the collective. Rodchenko came to believe that painting and sculpture did not contribute enough to practical needs, so after 1921 he gave up traditional "high art" painting and sculpture to make photographs, posters, books, textiles, and theater sets that would promote the ends of the new Soviet society.

In 1925 Rodchenko designed a model workers' club for the Soviet pavilion at the Paris International Exposition of Modern Decorative and Industrial Arts (fig. 28-46). Although Rodchenko said such a club "must be built for amusement and relaxation," the space was essentially a reading room dedicated to the proper training of the Soviet mind. Designed for simplicity of use and ease of construction, the furniture was made of wood because Soviet industry was best equipped for mass production in that material. The design of the chairs is not strictly utilitarian, however. Their high, straight backs were meant to promote a physical and moral posture of uprightness among the workers.

Not all modernists were willing to give up traditional high art forms. El Lissitzky (1890–1941), for one, attempted to fit the formalism of Malevich to the new imperative that art be useful to the social order. After the revolution, Lissitzky was invited to teach architecture and graphic arts at the Vitebsk School of Fine Arts and came under the influence of Malevich, who also taught there. By 1919 he was using Malevich's Suprematist vocabulary for propaganda posters and for the new type of art work he called the Proun (pronounced "pro-oon"), possibly an acronym for the Russian *"proekt utverzhdenya novogo"* ("project for the affirmation of the new"). Most Prouns were paintings or prints, but a few were spaces (fig. 28-47) that qualify as early examples of **installation** art. Lissitzky rejected conventional painting tools as too personal and imprecise and produced his Prouns with the aid of mechanical instruments. Their engineered look was meant to encourage precise thinking among the public. Like

many other Soviet artists of the late 1920s, Lissitzky grew disillusioned with the power of formalist art to communicate broadly and turned to more utilitarian projects—architectural design and typography, in particular—and began to produce, along with Rodchenko and others, propaganda photographs and **photomontages**, the combination of several photographs into one work.

The move away from abstraction was led by a group of realists, deeply antagonistic to the avant-garde, who banded together in 1922 to form the Association of Artists of Revolutionary Russia (AKhRR) to promote a clear, representational approach to depicting workers, peasants, revolutionary activists, and, in particular, the life and history of the Red Army. Their tendency to create huge, overly dramatic canvases and statues on heroic or inspirational themes established the basis for the Socialist Realism instituted by Stalin after he took control of the arts in 1932.

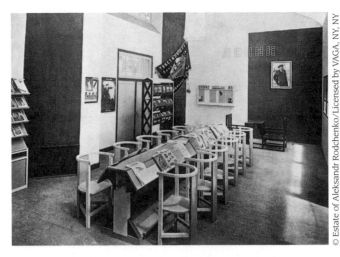

28-46. Aleksandr Rodchenko. View of the Workers' Club, exhibited at the International Exposition of Modern Decorative and Industrial Arts, Paris. 1925. Rodchenko-Stepanova Archive, Moscow

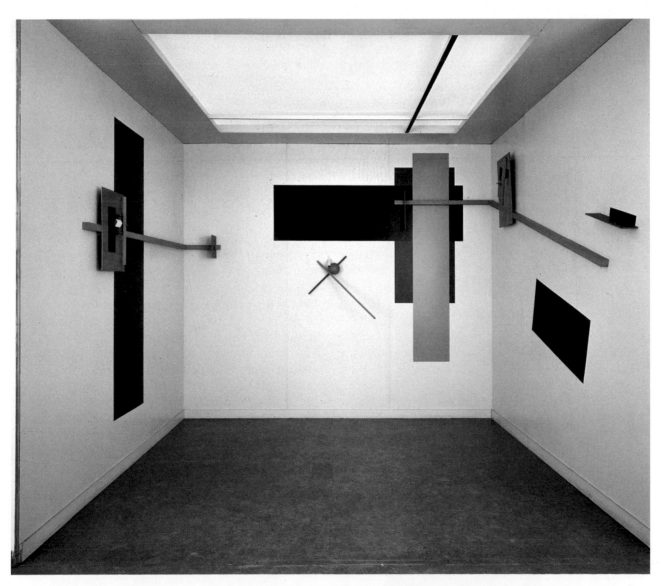

28-47. El Lissitzky. Proun space created for the Great Berlin Art Exhibition. 1923, reconstruction 1965. Stedelijk Van Abbemuseum, Eindhoven, the Netherlands

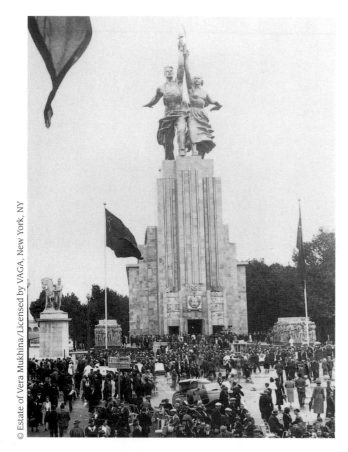

One of the sculptors who worked in this official style was Vera Mukhina (1889–1953), who is best known for her *Worker and Collective Farm Worker* (fig. 28-48), a colossal stainless-steel sculpture made for the Soviet Pavilion at the Paris Universal Exposition of 1937. The powerfully built male factory worker and female farm laborer hold aloft their respective tools, a hammer and a sickle, to mimic the appearance of these implements on the Soviet flag. The two figures are shown as equal partners striding purposefully into the future, their determined faces looking forward and upward. The dramatic, windblown drapery and the forward propulsion of their diagonal poses enhance the sense of vigorous idealism. Intended to convince an increasingly skeptical international audience of the continuing success of the Soviet system, after the exposition the work was relocated to Moscow, where it continued to serve the propagandistic needs of the state.

28-48. **Vera Mukhina. *Worker and Collective Farm Worker***, sculpture for the Soviet Pavilion, Paris Universal Exposition. 1937. Stainless steel, height approx. 78' (23.8 m)

RATIONALISM IN THE NETHERLANDS

In the Netherlands, the Dutch counterpart to the inspirational formalism of Lissitzky was provided by a group known as de Stijl ("the Style"), whose leading artist was Piet Mondrian (1872–1944). The turning point in Mondrian's life came in 1912, when he went to Paris and encountered Analytic Cubism. After assimilating its influence he gradually moved from radical abstractions of landscape and architecture to a simple, austere form of geometric art inspired by them. In the Netherlands during World War I, he met Theo van Doesburg (1883–1931), another painter who shared his artistic views. In 1917 van Doesburg started a magazine, *De Stijl*, which became the focal point of a Dutch movement of artists, architects, and designers. Mondrian contributed several articles to the magazine between 1917 and 1924 before breaking from the group in the latter year.

Animating the de Stijl movement was the conviction that there are two kinds of beauty: a sensual or subjective one and a higher, rational, objective, "universal" kind. In his mature works Mondrian sought the essence of the second kind, eliminating representational elements because of their subjective associations and curves because of their sensual appeal. From about 1920 on, Mondrian's paintings, such as *Composition with Yellow, Red, and Blue* (fig. 28-49), all employ the same essential formal vocabulary: the three primary hues (red, yellow, and blue), the three neutrals (white, gray, and black), and horizontal and vertical lines. The two linear directions are meant to symbolize the harmony of a series of opposites, including male versus female,

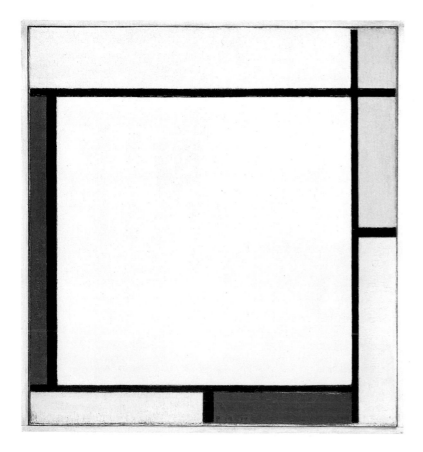

28-49. **Piet Mondrian. *Composition with Yellow, Red, and Blue***. 1927. Oil on canvas, 15 x 14" (38.5 x 35.9 cm). The Menil Collection, Houston.

Mondrian so disliked the sight of nature, whose irregularities he held largely accountable for humanity's problems, that when seated at a restaurant table with a view of the outdoors, he would ask to be moved.

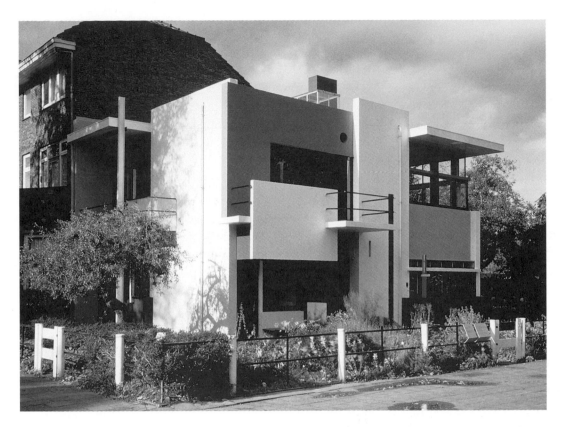

individual versus society, and spiritual versus material. For Mondrian the essence of higher beauty was resolved conflict, what he called dynamic equilibrium. Here, in a typical composition, Mondrian achieved this equilibrium through the precise arrangement of color areas of different size, shape, and "weight," asymmetrically grouped around the edges of a canvas whose center is dominated by a large area of white. The ultimate purpose of such a painting is to demonstrate a universal style with applications beyond the realm of art. Like Art Nouveau, de Stijl wished to redecorate the world. But Mondrian and his colleagues rejected the organic style of Art Nouveau, believing that nature's example encourages "primitive animal instincts." If, instead, we live in an environment designed according to the rules of "universal beauty," we, like our art, will be balanced, our natural instincts "purified." Mondrian hoped to be the world's last artist: He thought that art had provided humanity with something lacking in daily life and that, if beauty were in every aspect of our lives, we would have no need for art.

The major architect and designer of de Stijl was Gerrit Rietveld (1888–1964), whose Schröder House in Utrecht is an important example of the modernist architecture that came to be known as the International Style (see "The International Style," page 1094). Rietveld applied Mondrian's principle of a dynamic equilibrium to the entire house. The radically asymmetrical exterior (fig. 28-50) is composed of interlocking gray and white planes of varying sizes, combined with horizontal and vertical accents in primary colors and black. His "Red-Blue" chair is shown here in the interior (fig. 28-51), where sliding partitions allow modifications in the spaces used for sleeping, working, and entertaining. These innovative wall partitions

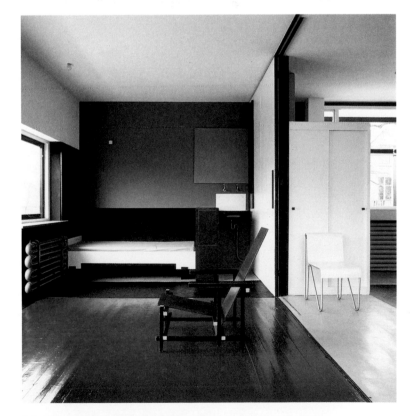

28-51. **Interior, Schröder House**, with "Red-Blue" chair

were the idea of the patron, Truus Schröder-Schräder (1889–1985), a widowed interior designer. Though wealthy, Schröder-Schräder wanted her home to suggest not luxury but elegant austerity, with the basic necessities sleekly integrated into a meticulously restrained whole.

ELEMENTS OF ARCHITECTURE

The International Style

After World War I, increased exchanges between modernist architects led to the development of a common formal language, transcending national boundaries, which came to be known as the International Style. The term gained wide currency as a result of a 1932 exhibition at The Museum of Modern Art in New York, "The International Style: Architecture since 1922," organized by the architectural historian Henry-Russell Hitchcock and the architect and curator Philip Johnson. Hitchcock and Johnson identified three fundamental principles of the style.

The first principle was "the conception of architecture as volume rather than mass." The use of a structural skeleton of steel and ferroconcrete made it possible to eliminate load-bearing walls on both the exterior and interior. The building could now be wrapped in a skin of glass, metal, or masonry, creating an effect of enclosed space (volume) rather than dense material (mass). Interiors could now feature open, free-flowing plans providing maximum flexibility in the use of space.

The second principle was "regularity rather than symmetry as the chief means of ordering design." Regular distribution of structural supports and the use of standard building parts promoted rectangular regularity rather than the balanced axial symmetry of classical architecture. The avoidance of classical balance also encouraged an asymmetrical disposition of the building's components.

The third principle was the rejection of "arbitrary applied decoration." The new architecture depended upon the intrinsic elegance of its materials and the formal arrangement of its elements to produce harmonious aesthetic effects.

The style originated in the Netherlands, France, and Germany, and by the end of the 1920s had spread to other industrialized countries. Important influences on the International Style included Cubism, the abstract geometry of de Stijl, the work of Frank Lloyd Wright, and the prewar experiments in industrial architecture of Germans such as Walter Gropius. The first concentrated manifestation of the trend came in 1927 at the Deutscher Werkbund's Weissenhofsiedlung exhibition in Stuttgart, Germany, directed by Mies van der Rohe. This permanent exhibition included modern houses by, among others, Mies, Gropius, and Le Corbusier. Its aim was to present models using new technologies and without reference to historical styles. All of the buildings featured flat roofs, plain walls, and asymmetrical openings, and almost all of them were rectilinear in shape.

The concepts of the International Style remained influential in architecture until the 1970s, particularly in the United States, where numerous European architects, including Mies and Gropius, settled in the 1930s. Even Frank Lloyd Wright, an individualist who professed to disdain the work of his European colleagues, adopted elements of the International Style in his later buildings such as Fallingwater (see fig. 28-82).

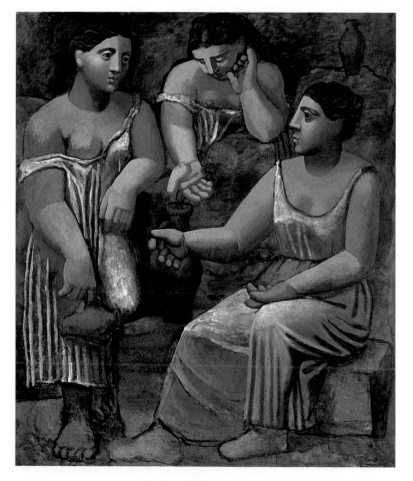

CLASSICISM AND PURISM IN FRANCE

De Stijl's pursuit of a utopian ideal of universal order and harmony was in part a response to the chaos and destruction of World War I. In France, by contrast, the desire for stability led some to reject the experimentation of the avant-garde. Numerous critics advocated a revival of the noble tradition of French classicism as a means of rebuilding French culture and society—a tendency summed up by the poet and playwright Jean Cocteau as a "call to order."

One artist who answered this call was Cocteau's close friend Picasso. While continuing to paint in the Synthetic Cubist style he had developed before World War I (see fig. 28-26), during the early 1920s Picasso also worked in a Neoclassical manner in paintings such as *Three Women at the Spring* (fig. 28-52). The large, powerfully modeled figures resemble living statues, while the treatment of the drapery suggests the **fluting** of classical columns. With their thickened limbs and bulky hands, Picasso's women lack the ideal proportions of classical Greek art, but they do embody the classical values of dignity and calm repose.

28-52. Pablo Picasso. *Three Women at the Spring*.
1921. Oil on canvas, 6'8¼" x 5'8½" (2.04 x 1.74 m).
The Museum of Modern Art, New York
Gift of Mr. and Mrs. Allan D. Emil

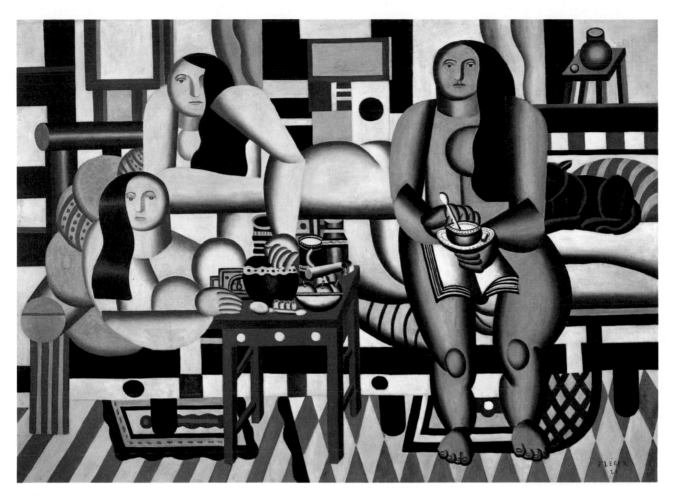

28-53. Fernand Léger. *Le Grand Déjeuner (The Large Luncheon)*. 1921. Oil on canvas, 6'1/2" x 8'3" (1.84 x 2.52 m). The Museum of Modern Art, New York
Mrs. Simon Guggenheim Fund

Another expression of the "call to order" in modern French art was Purism, whose leading figure was the Swiss-born Charles-Édouard Jeanneret (1887–1965). A largely self-taught and widely traveled architect and painter, Jeanneret moved to Paris in 1917, where he met the painter Amédée Ozenfant (1886–1966). Together they developed a highly disciplined form of painting, which, taking Synthetic Cubism as its starting point, emphasized the geometric purity, simplicity, and harmony of ordinary still-life objects. The Purist aesthetic was strongly inspired by the machine, whose streamlined products Ozenfant and Jeanneret saw as models of a new kind of classical beauty.

Like the Constructivists and the proponents of de Stijl, the Purists firmly believed in the power of art to change the world. In 1920 Jeanneret, partly to demonstrate his faith in the ability of individuals to remake themselves, renamed himself Le Corbusier. He and Ozenfant believed that they were producing a new and improved Cubism that would not only provide aesthetic pleasure but also, by inducing in its viewers an orderly frame of mind, promote social order.

One of the artists strongly influenced by Purism was Fernand Léger (1881–1955). In Paris before World War I, Léger had developed a dynamic, personal Analytic Cubism in which he attempted to reconcile traditional artistic subjects with his radical taste for industrial metal and machinery. In the early 1920s he briefly experimented with Purism in a series of paintings that included *Le Grand Déjeuner (The Large Luncheon)* (fig. 28-53). The painting is Léger's updated answer to the French odalisque tradition of Ingres and Delacroix (see figs. 27-4, 27-9). The women, arranged within a geometric grid, stare out blankly at us, embodying a quality of classical calm akin to that seen in Picasso's *Three Women at the Spring*. Léger's women have identical faces, and their bodies seem assembled from standardized, detachable metal parts. The bright, cheerful colors and patterns that surround them suggest a positive vision of an orderly industrial society.

Purism's most important contributions were not in painting or sculpture but in architecture. Although he never gave up painting, after the early 1920s Le Corbusier concentrated on architecture and urban planning. One of his

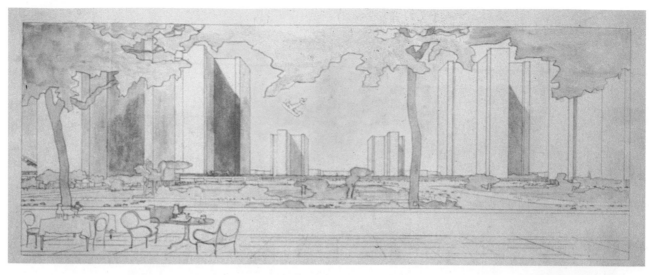

28-54. Charles-Édouard Jeanneret (Le Corbusier). Plan for a Contemporary City of Three Million Inhabitants. 1922

The skyscrapers Le Corbusier planned for the center of his city were intended to house offices, not residences. Residences would be in smaller suburban terraces of five-story houses around the periphery of the city. In 1925 Le Corbusier devised a similar plan for Paris, convinced that the center of the city needed to be torn down and rebuilt to accommodate automobile traffic. The Parisian street was a "Pack-Donkey's Way," he said. "Imagine all this junk . . . cleared off and carried away and replaced by immense clear crystals of glass, rising to a height of over six hundred feet!"

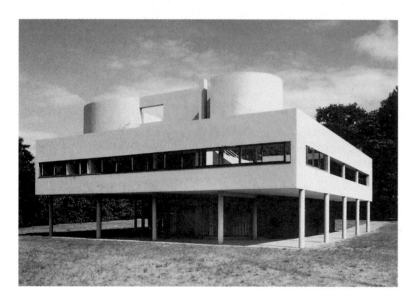

28-55. Le Corbusier. Villa Savoye, Poissy-sur-Seine, France. 1929–30

Located 30 miles outside of Paris, near Versailles, the Villa Savoye was designed as a weekend retreat. The owners, arriving from Paris, could drive right under the house, whose ground floor curves to accommodate the turning radius of an automobile and incorporates a three-car garage.

first mature projects was his conception for a Contemporary City of Three Million Inhabitants (fig. 28-54), exhibited in Paris in 1922. Le Corbusier hated the crowded, noisy, chaotic, and polluted places that cities had become in the late nineteenth century. What he envisioned for the future was a city of uniform style, laid out on a grid, and dominated, like Sant'Elia's (see fig. 28-44), by skyscrapers, with wide traffic arteries that often passed beneath ground level. Le Corbusier's city would differ from Sant'Elia's, however, in two fundamental respects. First, the buildings would be strictly functional, in the manner of Gropius and Meyer's Fagus Factory (see fig. 28-43). Second, nature would not be neglected. Set between the widely spaced buildings would be large expanses of parkland. The result, Le Corbusier thought, would be a clean and efficient city filled with light, air, and greenery. Le Corbusier's vision had a profound effect on later city planning, especially in the United States.

During the 1920s Le Corbusier designed a number of houses for private clients. The most well known, the Villa

Savoye (fig. 28-55), is an icon, like Rietveld's Schröder House, of the International Style (see "The International Style," page 1094). The last of his Purist villas, it culminated the so-called domino construction system begun in 1914, in which ferroconcrete (concrete reinforced with steel bars) slabs were floated on six freestanding steel posts (placed at the positions of the six dots on a domino playing piece). Over the next decade the architect explored the possibilities of this structure and in 1926 published "The Five Points of a New Architecture," which argued for elevating houses above the ground on *pilotis* (freestanding posts); making roofs flat for use as terraces; using curtain walls, as opposed to supporting walls, for exterior and interior walls to provide freedom of design; and using ribbon windows (windows that run the length of the wall).

Although none of these ideas was new, Le Corbusier applied them in a distinctive fashion that combined two apparently opposed formal systems: the Classical Doric architecture of ancient Greece and the clear precision of machinery. Such houses could be effectively placed in nature, as here, but they were meant to transcend it, as the elevation off the ground and pure white coloring suggest.

BAUHAUS ART IN GERMANY

The German counterpart to the total and rational planning envisioned by de Stijl and Le Corbusier was conceived between 1919 and 1933 at the Bauhaus

SUPPRESSION OF THE AVANT-GARDE IN GERMANY

The 1930s in Germany witnessed a serious political reaction against avant-garde art and, eventually, a concerted effort to suppress it. One of the principal targets was the Bauhaus (see fig. 28-58), the art and design school founded in 1919 by Walter Gropius, where Paul Klee, Vasily Kandinsky, Josef Albers, Ludwig Mies van der Rohe, and many other luminaries taught. Through much of the 1920s the Bauhaus had struggled against an increasingly hostile and reactionary political climate. As early as 1924 conservatives had accused the Bauhaus of being not only educationally unsound but also politically subversive. To avoid having the school shut down by the opposition, Gropius moved it to Dessau in 1925, at the invitation of Dessau's liberal mayor, but left soon after the relocation. His successors faced increasing political pressure, as the school was a prime center of modernist practice, and the Bauhaus was again forced to move in 1932, this time to Berlin.

After Adolf Hitler came to power in 1933, the Nazi party mounted an aggressive campaign against modern art. In his youth Hitler himself had been a mediocre academic painter, and he had developed an intense hatred of the avant-garde. During the first year of his regime, the Bauhaus was forced to close for good. A number of the artists, designers, and architects who had been on its faculty—including Albers, Gropius, and Mies—immigrated to the United States.

The Nazis also launched attacks against the German Expressionists, whose often intense depictions of German soldiers defeated in World War I and of the economic depression following the war were considered unpatriotic. Most of all, the treatment of the human form in these works, such as the expressionistic exaggeration of facial features, was deemed offensive. The works of these and other artists were removed from museums, while the artists themselves were subjected to public ridicule and often forbidden to buy canvas or paint.

As a final move against the avant-garde, the Nazi leadership organized in 1937 a notorious exhibition of banned works. The "Degenerate Art" exhibition was intended to erase modernism once and for all from the artistic life of the nation. Seeking to brand all the advanced movements of art as sick and degenerate, it presented modern art works as specimens of pathology; the organizers printed derisive slogans and comments to that effect on the gallery walls (see illustration). The 650 paintings, sculpture, prints, and books confiscated from German public museums were viewed by 2 million people in the four months the exhibition was on view in Munich and by another million during its subsequent three-year tour of German cities.

By the time World War II broke out, the authorities had confiscated countless works from all over the country. Most were publicly burned, though the Nazi officials sold much of the looted art at public auction in Switzerland to obtain foreign currency.

Among the many artists crushed by the Nazi suppression was Ernst Ludwig Kirchner, whose *Street, Berlin* (see fig. 28-9) was included in "Degenerate Art." The state's open animosity was a factor in his suicide in 1938. Other artists, such as John Heartfield, left the country to continue their work and to voice their opposition to the Nazis. In his scathing caricatures of Hitler (see fig. 28-62), Heartfield mocked him by using some of the modernist artistic innovations that Hitler had condemned.

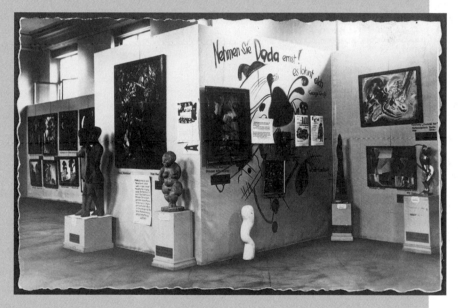

Room 3 of "Degenerate Art" exhibition, Munich, 1937

("House of Building"), the school that was the brainchild of Walter Gropius. Gropius admired the spirit of the medieval building guilds—the *Bauhütten*—that had built the great German cathedrals. He sought to revive and commit that spirit to the reconciliation of modern art and industry by synthesizing the efforts of architects, artists, and designers. The Bauhaus was formed in 1919, when Gropius convinced the authorities of Weimar, Germany, to allow him to combine the city's schools of art and craft. The Bauhaus moved to Dessau in 1925 and then to Berlin in 1932, where it remained for less than a year before Hitler, who detested the avant-garde, closed it (see "Suppression of the Avant-Garde in Germany," above).

Although Gropius's "Bauhaus Manifesto" of 1919 declared that "the ultimate goal of all artistic activity is the building," the school offered no formal training in architecture until 1927. Gropius thought students would be ready for architecture only after they had completed the required preliminary course and received full training in the crafts taught in the Bauhaus workshops. The preliminary, or foundation course, directed initially by the Swiss-born Johannes Itten (1888–1967), was designed, in the words of Gropius, "to liberate the individual by breaking down conventional patterns of thought in order to make way for personal experiences and discoveries." The workshops—which included pottery, metalwork, textiles, stained glass, furniture making, carving, and wall painting—were intended to teach both specific technical skills and basic design skills, based on the principle of learning through doing.

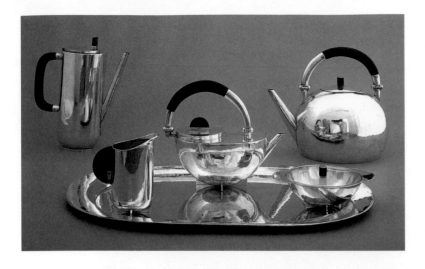

28-56. Marianne Brandt. Coffee and tea service. 1924. Silver and ebony, with Plexiglass cover for sugar bowl. Bauhaus Archiv, Berlin

The lid of Marianne Brandt's sugar bowl is made of Plexiglas, reflecting the Bauhaus's interest in incorporating the latest advances in materials and technology into the manufacture of utilitarian objects.

Between 1919 and 1923 many Bauhaus workshops, under the influence of Itten, promoted the creation of unique, handmade objects that reflected the individualism of their maker but conflicted with Gropius's view that art should serve a socially useful function. In 1922 Gropius implemented a new emphasis on industrial design, and the next year Itten was replaced by the Hungarian-born Laszlo Moholy-Nagy (1895–1946), who reoriented the workshops toward the creation of sleek, functional designs suitable for mass production. The elegant tea and coffee service by Marianne Brandt (1893–1983), for example (fig. 28-56), though handcrafted in silver, was a prototype for mass production in a cheaper metal such as nickel silver. After the Bauhaus moved to Dessau, Brandt designed several innovative lighting fixtures and table lamps that went into mass production, earning much-needed revenue for the school. After Moholy-Nagy's departure in 1928 (the same year Gropius left), she directed the metal workshop for a year before leaving the Bauhaus herself.

As a woman holding her own in the otherwise all-male metals workshop, Brandt was an exceptional figure at the Bauhaus. Although women were admitted to the school on an equal basis with men, Gropius opposed their education as architects and channeled them into workshops that he deemed appropriate for their gender, namely pottery and textiles. One of the most talented members of the textile workshop was the Berlin-born Anni Albers (née Annelise Fleischmann, 1899–1994), who arrived at the school in 1922 and three years later married Josef Albers (1888–1976), a Bauhaus graduate and professor. Obliged to enter the textiles workshop rather than training as a painter, Anni Albers set out to make "pictorial" weavings that would equal paintings as fine—as opposed to applied—art. Albers's wall hangings, such as the one shown in figure 28-57, were intended to aesthetically enhance the interior of a modern building in the same way an abstract painting would. The decentralized, rectilinear design reflects the influence of de Stijl, while acknowledging weaving as a process of structural organization.

Albers's intention was "to let threads be articulate . . . and find a form for themselves to no other end than their own orchestration." Numerous other Bauhaus works reveal a similarly "honest" attitude toward materials, including Gropius's design for the new Dessau Bauhaus, built in 1925–26. The building frankly acknowledges the reinforced concrete, steel, and glass of which it is built but is not strictly utilitarian. Gropius, influenced by de Stijl, used asymmetrical balancing of the three large, cubical structural elements to convey the dynamic

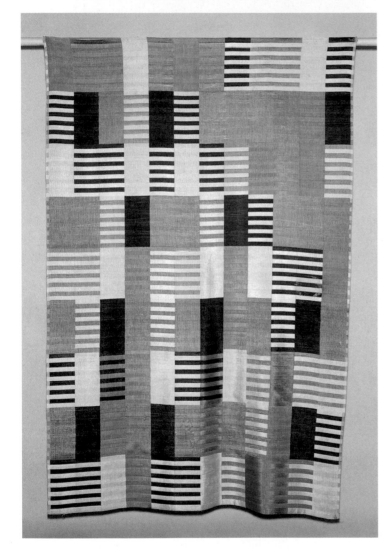

28-57. Anni Albers. Wall hanging. 1926. Silk, two-ply weave, 5'11⁵/₁₆" x 3'11⁵/₈" (1.83 x 1.22 m). Busch-Reisinger Museum, Harvard University Association Fund

Following the closure of the Bauhaus in 1933 by the Nazis, Anni Albers and her husband, Josef, emigrated to the United States, where they became influential teachers at the newly founded Black Mountain College in Asheville, North Carolina. Anni Albers exerted a powerful influence on the development of fiber art in the United States through her exhibitions, her teaching, and her many publications, including the books *On Designing* (1959) and *On Weaving* (1965).

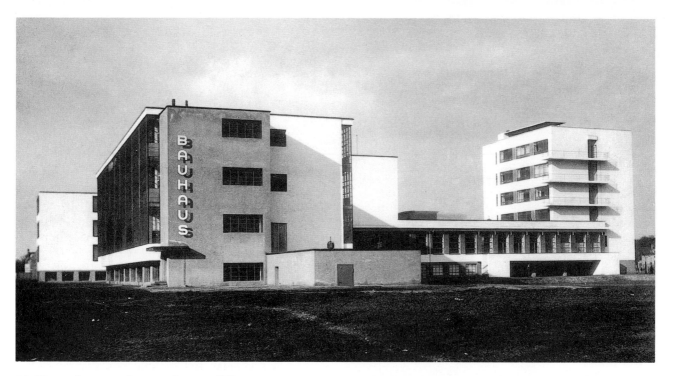

28-58. Walter Gropius. Bauhaus Building, Dessau, Germany. 1925–26

One of the enduring contributions of the Bauhaus was graphic design. The sans-serif letters of the building's sign not only harmonize with the architecture's clean lines but also communicate the Bauhaus commitment to modernity. Sans-serif typography (that is, a typeface without serifs, the short lines at the end of the stroke of a letter) had been in use only since the early nineteenth century, and a host of new sans-serif typefaces was created in the 1920s.

quality of modern life (fig. 28-58). The expressive glass-panel wall that wraps around two sides of the workshop wing of the building recalls the glass wall of the Fagus Factory (see fig. 28-43) and sheds natural light on the workshops inside. The raised parapet below the workshop windows demonstrates the ability of modern engineering methods to create light, airy spaces unlike the heavy spaces of past styles.

The director of the Bauhaus between 1930 and its closing in 1933 was the architect Ludwig Mies van der Rohe (1886–1969), whose well-known aphorism crystallized the views of his modernist colleagues: "Less is more." Mies's great passion was the subtle perfection of structure, proportion, and detail using sumptuous materials such as travertine, richly veined marbles, tinted glass, and bronze. His abilities and interests are evident in the elegantly simple entrance pavilion to the German exhibits that he designed for the 1929 International Exposition held in Barcelona (fig. 28-59). For its construction, Mies relied on the domino system developed by Le Corbusier. Slender piers support floor and ceiling slabs. Curtain walls divide and enclose the spaces. The interior, based on the de Stijl conception of harmoniously balanced rectangles, resembles a Mondrian painting (see fig. 28-49). Mies also designed for the pavilion a pair of elegantly simple, leather-upholstered, stainless-steel chairs for the king and queen of Spain to sit in during their official visit, as well as a number of ottomans for their entourage. Although the handmade originals were designed for ceremonial use, they were later mass-produced and are still a status symbol in many homes and offices today.

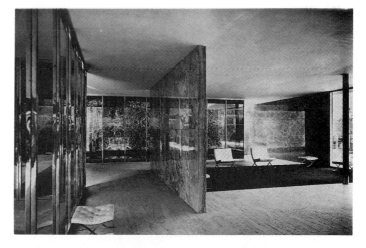

28-59. Ludwig Mies van der Rohe. Interior, German Pavilion, International Exposition, Barcelona. 1929

DADA

The emphasis on individuality and irrational instinct in the work of artists like Gauguin and many of the Expressionists did not die out entirely after World War I. It endured in the Dada movement, which began with the opening of the Cabaret Voltaire in Zürich, Switzerland, on February 5, 1916. The cabaret's founders, German actor and poet Hugo Ball (1886–1927) and his companion, Emmy Hennings (d.1949), a nightclub singer, had moved to neutral Switzerland after the war broke out. Their cabaret was inspired by the bohemian artists' cafés they had known in Berlin and Munich and attracted avant-garde writers and artists of various nationalities who shared their disgust with bourgeois culture, which they blamed for the war.

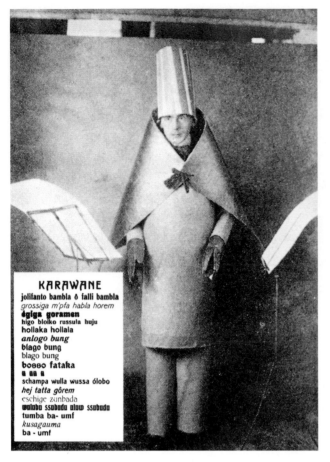

28-60. Hugo Ball reciting the sound poem "Karawane."
Photographed at the Cabaret Voltaire, Zürich, 1916

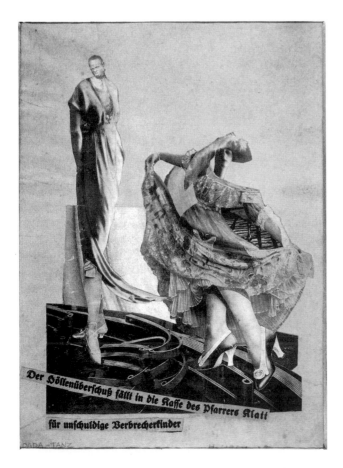

Ball's performance while reciting one of his sound poems, "Karawane" (fig. 28-60), reflects the iconoclastic spirit of the Cabaret Voltaire. His legs and body encased in blue cardboard tubes, his head surmounted by a white-and-blue "witch-doctor's hat," as he called it, and his shoulders covered with a huge, gold-painted cardboard collar that flapped when he moved his arms, he slowly and solemnly recited the poem, which consisted of nonsensical sounds. As was typical of Dada, this performance involved two both critical and playful aims. One goal was to retreat into sounds alone and thus renounce "the language devastated and made impossible by journalism." Another end was simply to amuse his audience by introducing the healthy play of children back into what he considered overly restrained adult lives. The flexibility of interpretation inherent in Dada extended to its name, which, according to one account, was chosen at random from a dictionary. In German the term signifies baby talk; in French it means "hobbyhorse"; in Romanian and Russian, "yes, yes"; in the Kru African dialect, "the tail of a sacred cow." The name and therefore the movement could be defined as the individual wished.

Early in 1917 Ball and the Romanian poet Tristan Tzara (1896–1963) organized the Galerie Dada. Tzara also edited a magazine, *Dada*, which soon attracted the attention of like-minded men and women in various European capitals. The movement spread farther when members of Ball's circle returned to their respective homelands. Richard Huelsenbeck (1892–1974) brought Dada to Germany, where he helped form the Club Dada in Berlin in April 1918. Following the example of some of his Zürich predecessors, Johannes Baader (1875–1955) took Dada out of the cabaret and into the streets. Among his many famous "actions" was an infiltration of the meeting of the Weimar National Assembly on July 16, 1919, where he distributed a leaflet demanding the replacement of the government by Dada, with himself as president.

One distinctive feature of Berlin Dada was the amount of visual art it produced, while Dada elsewhere tended to be more literary. Berlin Dada members especially favored photomontage, one of whose leading practitioners was Hannah Höch (1889–1978). Between 1916 and 1926 Höch worked for Berlin's largest publishing house, producing handiwork patterns and writing articles on crafts for a domestically oriented magazine, and many of her photomontages focus on women's issues. Although the status of women improved in Germany after the war and the "new woman" was much discussed in the German news media, Höch's contribution to this discussion was largely critical. In works such as *Dada Dance* (fig. 28-61), she seems to ridicule the way

28-61. Hannah Höch. *Dada Dance*. 1922. Photomontage, 12⅝ x 9⅛" (32 x 23 cm). Collection Arturo Schwartz, Milan

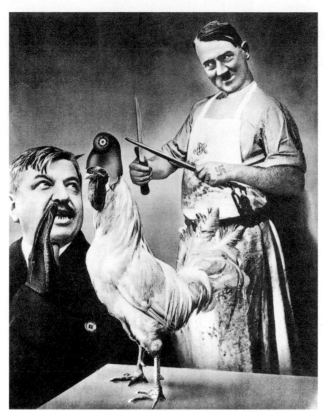

28-62. John Heartfield. *Have No Fear—He's a Vegetarian*. Photomontage in *Regards* no. 121 (153) (Paris), May 7, 1936. Stiftung Archiv der Akademie der Künste, Berlin

changing fashions establish standards of beauty that women, regardless of their natural appearance, must observe. On the right is an odd composite figure, wearing high-fashion shoes and dress, in a ridiculously elegant pose. The taller figure, with a small, black African head, looks down on her with a pained expression. For Höch, as for many in the modernist era, Africa represented what was natural, so Höch presumably meant to contrast natural elegance with its foolish, overly cultivated counterpart. The work's message is not immediately evident, however; nor is it spelled out clearly by the text, which reads: "The excesses of Hell fell into the cash box for innocent criminal catchers."

Because the precise meaning of such works is difficult to decipher, their power as social commentary is limited. One of the first artists to change his approach in recognition of this limitation was John Heartfield (1891–1968). Born Helmut Herzfelde near Berlin, he was drafted in 1914 but after a feigned nervous breakdown was released from the army to work as a letter carrier. He often dumped his mail deliveries to encourage dissatisfaction with the war, and he anglicized his name to protest the nationalistic war slogan "May God Punish England." After the war he joined Berlin Dada but spent most of his time doing election posters and illustrations for Communist newspapers and magazines. Recognizing the primacy of the message, he

developed a clear and simple approach to photomontage that might be called post-Dada.

Typical of his mature work is *Have No Fear—He's a Vegetarian* (fig. 28-62), a version of which appeared in a French magazine in 1936. The work shows Hitler sharpening a knife behind a rooster, the symbol of France. The warning being communicated is ironic, given that the whispering man is Pierre Laval, then the pro-German premier of France. Hitler, then rising to power in Germany on a program of nationalism, militarism, and hatred for Jews, would soon occupy France. Heartfield had left Germany in 1933, when the Nazis gained control and Hitler ordered his arrest. Heartfield literally jumped out his window to escape and moved to Czechoslovakia, then to England, where he produced his powerful anti-Hitler photomontages.

A leading French Dadaist, Marcel Duchamp (1887–1968) was influential in spreading Dada to the United States when he moved to New York in 1915 to escape the war in Europe. In Paris, Duchamp had experimented successfully with Cubism before abandoning painting, which he came to consider a mindless activity. By the time he arrived in New York, Duchamp believed that art should appeal to the intellect rather than the senses. Duchamp's cerebral approach is exemplified in his **readymades**, which were ordinary manufactured objects transformed

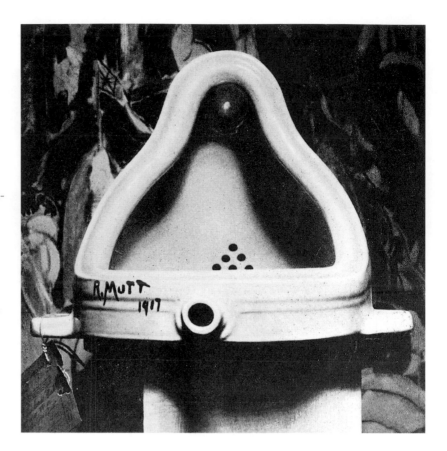

28-63. Marcel Duchamp. *Fountain*. 1917. Porcelain plumbing fixture and enamel paint, height 24⅝" (62.23 cm). Photograph by Alfred Stieglitz. Philadelphia Museum of Art

Louise and Walter Arensberg Collection

Stieglitz's photograph is the only known image of Duchamp's original *Fountain*, which mysteriously disappeared after it was rejected by the jury of the American Society of Independent Artists exhibition. Duchamp later produced several more versions of *Fountain* by simply buying new urinals and signing them "R. Mutt/1917."

into art works simply through the decision of the artist. The most notorious readymade was the *Fountain* (fig. 28-63): a porcelain urinal turned 90 degrees and signed with the pseudonym "R. Mutt," a play on the name of the fixture's manufacturer, the J. L. Mott Iron Works. Duchamp submitted the *Fountain* anonymously in 1917 to the first annual exhibition of the American Society of Independent Artists, which was committed to staging a large, unjuried show, open to any artist who paid a $6 entry fee. Duchamp, a founding member of the society and the head of the show's hanging committee, entered *Fountain* partly to test just how open the society was. A majority of the society's directors declared that the *Fountain* was not a work of art, and, moreover, was indecent, so the piece was refused. The decision did not surprise Duchamp, who immediately resigned from the society.

In a small journal he helped to found, Duchamp published an unsigned editorial on the Mutt case refuting the charge of immorality and wryly noting: "The only works of Art America has given are her plumbing and bridges." In a more serious vein, he added: "Whether Mr. Mutt with his own hands made the fountain or not has no importance. He CHOSE it. He took an ordinary article of life, placed it so that its useful significance disappeared under the new title and point of view—created a new thought for that object." Duchamp's philosophy of the readymade, succinctly expressed in these lines, would have a tremendous impact on later twentieth-century artists such as Jeff Koons (see fig. 29-71).

Duchamp's most intellectually challenging work is probably *The Bride Stripped Bare by Her Bachelors, Even* (fig. 28-64), usually called *The Large Glass*. He made his

first sketches for the piece in 1913 but did not begin work on it until he arrived in New York. At the most obvious level it is a pessimistic statement of the insoluble frustrations of male-female relations. The tubular elements encased in the top half of the glass represent the bride. She releases a large romantic sigh, which stimulates the bachelors below, represented by nine different moldlike forms attached to a waterwheel. The wheel resembles and is attached to a chocolate grinder, a reference to a French euphemism for masturbation. A bar separates the males from the female, preventing the fulfillment of their respective sexual desires. Duchamp reverses the conventional power roles of men and women by placing the female in the dominant position; the males merely react to her.

SURREALISM

The successor to Dada in opposing the rationalist tide of postwar art and architecture was Surrealism, a movement founded by the French writer André Breton (1896–1966). A participant in the Paris Dada movement after the war, Breton became dissatisfied with the playful nonsense activities of his colleagues and set out to make something more programmatic out of Dada's implicit desire to free human behavior. In 1924 he published his "Manifesto of Surrealism," outlining his own view of Freud's theory that the human psyche is a battleground where the rational, civilized forces of the conscious mind struggle against the irrational, instinctual urges of the unconscious. The way to achieve happiness, Breton argued, does not lie in strengthening the repressive forces of reason, as the Purists insisted, but in freeing the

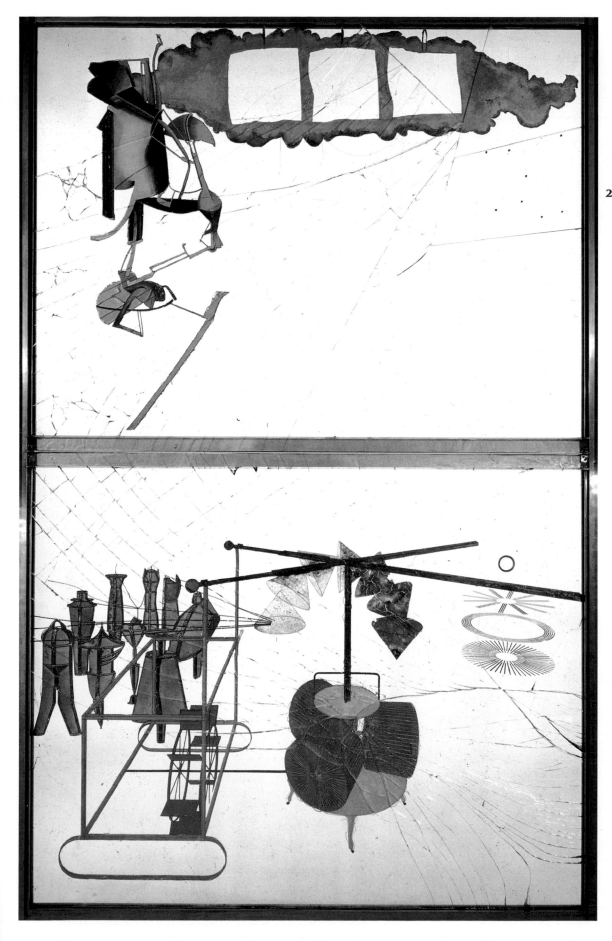

28-64. Marcel Duchamp.
The Bride Stripped Bare by Her Bachelors, Even (The Large Glass). 1915–23. Oil and lead wire on glass, 9'1¼" x 5'⅛" (2.77 x 1.76 m). Philadelphia Museum of Art

Bequest of Katherine S. Dreier

Duchamp declared *The Large Glass* "definitively unfinished" when he signed it in 1923, which seems appropriate to a work whose main theme is unfulfilled sexual desire. After the glass was broken in transit in 1926, Duchamp cheerfully accepted the accident as part of the work and in 1936 spent weeks painstakingly reassembling the pieces.

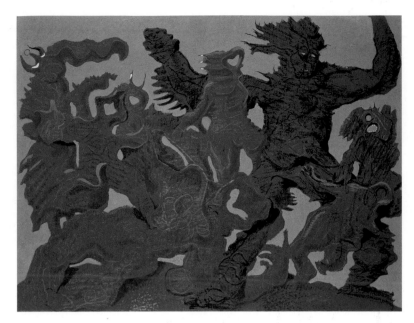

28-65. Max Ernst. *The Horde*. 1927. Oil on canvas, 44⅞ x 57½"
(114 x 146.1 cm). Stedelijk Museum, Amsterdam

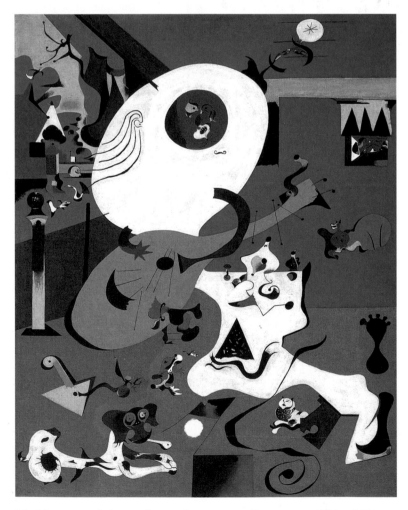

28-66. Joan Miró. *Dutch Interior I*. 1928. Oil on canvas, 36⅛ x 28¾"
(91.8 x 73 cm). The Museum of Modern Art, New York
Mrs. Simon Guggenheim Fund

individual to express personal desires, as Gauguin and Die Brücke had asserted. Breton and the group around him developed a number of techniques for liberating the individual unconscious, including dream analysis, free association, automatic writing, word games, and hypnotic trances. Their aim was to help people discover the larger reality, or "surreality," that lay beyond the narrow rational notions of what is real.

Surrealist painters employed a variety of manual techniques, known collectively as **automatism**, which were designed to produce new and surprising forms without conscious control. Particularly inventive in his use of automatism was Max Ernst (1891–1976), a self-taught German artist who helped organize a Dada movement in Cologne and later moved to Paris, where he joined Breton's circle. In 1925 Ernst discovered the automatist technique of *frottage*, in which the artist rubs a pencil or crayon across a piece of paper placed on a textured surface. The resulting imprints stimulated Ernst's imagination, and he discovered in them fantastic creatures, plants, and landscapes, which he articulated through additional drawing. Ernst adapted the *frottage* technique to painting through **grattage**, creating patterns by scraping off layers of paint from a canvas laid over a textured surface. He then would extract representational forms from the patterns through overpainting. One result of this technique is *The Horde* (fig. 28-65), a nightmarish scene of a group of monsters, seemingly made out of wood, who advance against some unseen opponent. Like much of Ernst's work of the period, this frightening image seems to resonate with the violence of World War I—which he experienced firsthand in the German army—and also to foretell the coming of another terrible European conflict.

By contrast, a blithe and playful spirit animates the painting of Joan Miró (1893–1983), a Spanish artist who in the 1920s divided his time among Paris, his native Barcelona, and nearby Montroig. In his early work Miró attempted to reconcile diverse French influences with his devotion to his native Catalan landscape. In 1923 he began to produce a fantastic brand of landscape and figure painting, inspired, he later claimed, by the hallucinations brought on by hunger and by staring at the cracks in his ceiling. Although Miró exhibited on numerous occasions with the Surrealists, he never officially joined the group or shared its theoretical interests.

Dutch Interior I (fig. 28-66) is Miró's imaginative paraphrase of Hendrik Maertensz Sorgh's *The Lutanist* (1661), a little-known Dutch painting of a male lute player serenading a young woman, with a dog and cat on the floor. Miró playfully translated elements from Sorgh's picture into a **biomorphic** language of curving shapes and lines that evoke organic forms and processes and seem to mutate before the viewer's eyes. The animated forms and cheerful colors create a giddy effect, counterbalanced by the crisply delineated shapes and tightly structured composition that reveal a high degree of formal control. Very much in the manner of a Renaissance artist, Miró carefully worked out the composition in preliminary drawings and then prepared a large **cartoon**, gridded for

transfer, that guided his execution of the final painting.

Even more carefully executed are the paintings Salvador Dalí (1904–89), a Catalan like Miró. Trained at the San Fernando Academy of Fine Arts in Madrid, where he mastered the traditional methods of illusionistic representation, Dalí traveled to Paris in 1928 and met Miró, who introduced him to the Surrealists. By the next year Dalí had converted fully to Surrealism and was welcomed officially into the movement by Breton. Dalí's contribution to Surrealist theory was the "paranoiac-critical method," in which the sane person cultivates the ability of the paranoiac to misread ordinary appearances and become liberated from the shackles of conventional thought. A well-known example is *The Persistence of Memory* (fig. 28-67), which is set in a landscape recalling a bay near Dalí's birthplace. According to Dalí, the idea of the soft watches came to him one evening after dinner while he was meditating on a plate of Camembert cheese. One of the limp watches drapes over an amoeba-like human head, its shape inspired by a large rock on the coast. The head, which Dalí identified as a self-portrait, first appeared in a 1929 painting entitled *The Great Masturbator*. It may symbolize the artist's lifelong obsession with masturbation—an obsession that caused him considerable anxiety. The limp watches express one aspect of that anxiety by suggesting the sexual impotence that Dalí feared could result from his indulgence in autoeroticism. Another image of anxiety is the ant-covered watchcase at the lower left, a bizarre *memento mori* inspired by Dalí's childhood memories of seeing dead and dying animals swarming with ants.

The absurd yet compelling image of ants feeding on a metallic watch typifies the Surrealist interest in unexpected juxtapositions of disparate realities. When created with

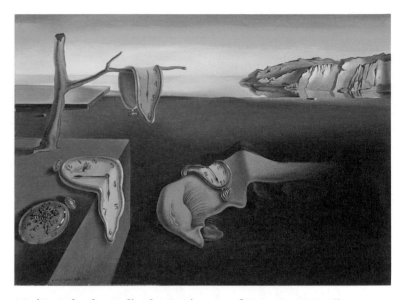

28-67. Salvador Dalí. *The Persistence of Memory*. 1931. Oil on canvas, 9¹⁄₂ x 13" (24.36 x 33.33 cm). The Museum of Modern Art, New York
Given anonymously

actual rather than represented objects and materials, the strategy produced disquieting assemblages such as *Object (Le Déjeuner en fourrure)* (fig. 28-68), by Meret Oppenheim (1913–85), a Swiss artist who was one of the few female participants in the Surrealist movement. Consisting of a cup, saucer, and spoon covered with the fur of a Chinese gazelle, Oppenheim's work transforms implements normally used for drinking tea into a hairy ensemble that simultaneously attracts and repels the viewer.

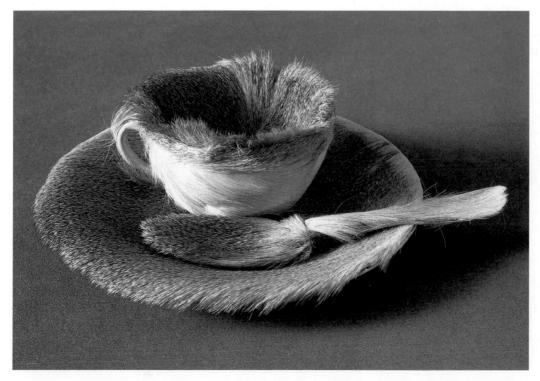

28-68. Meret Oppenheim. *Object (Le Déjeuner en fourrure) (Luncheon in Fur)*. 1936. Fur-covered cup, diameter 4³⁄₈" (10.9 cm); fur-covered saucer, diameter 9³⁄₈" (23.7 cm); fur-covered spoon, length 8" (20.2 cm); overall height, 2⁷⁄₈" (7.3 cm). The Museum of Modern Art, New York
Purchase

Oppenheim's *Object* was inspired by a café conversation with Picasso about her designs for jewelry made of fur-lined metal tubing. When Picasso remarked that one could cover just about anything with fur, Oppenheim replied, "Even this cup and saucer."

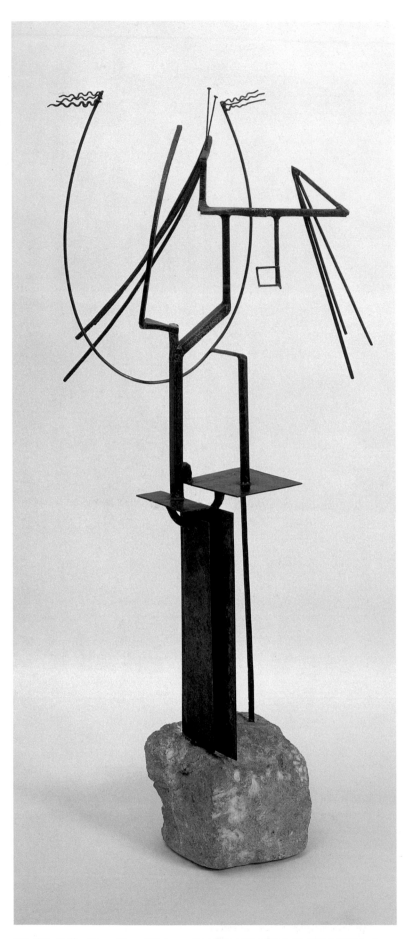

28-69. Julio González. *Woman Combing Her Hair II*. 1934. Welded iron, 47⅝ x 23¾ x 11⅜" (121 x 60 x 29 cm). Moderna Museet, Stockholm

MODERNISM IN SCULPTURE

Surrealist assemblages such as Oppenheim's *Object*, composed of manufactured objects and found materials, build on the tradition of the readymade that Duchamp inaugurated before World War I (see fig. 28-63). A new, more technically demanding medium of assemblage was welded metal, pioneered in the years around 1930 by the Catalan Julio González (1876–1942). A friend of Picasso who also left Barcelona for Paris in 1900, González supported himself by making jewelry and decorative metalwork. He turned to sculpture in the late 1920s when Picasso asked for his technical help in constructing several works in welded iron. Their collaboration marked the emergence of the modernist medium of "direct metal" sculpture, in which the artist composes the work directly by welding pieces of metal together. In the early 1930s González developed a style of extreme openness and linearity, using iron rods to "draw in space," as in *Woman Combing Her Hair II* (fig. 28-69). In this highly abstracted figure, space is used as a positive sculptural element, replacing the traditional sculptural emphasis on mass with an emphasis on spatial volumes defined by a linear framework.

Although equally innovative in his abstraction of the human body, the English sculptor Henry Moore (1898–1986) was more conservative than González in his devotion to the time-honored sculptural materials of stone, wood, and bronze, the established sculptural methods of carving and modeling, and the traditional sculptural emphasis on mass. After serving in World War I, Moore studied sculpture at the Leeds School of Art and the Royal College of Art in London. The African, Oceanic, and Pre-Columbian art he saw at the British Museum had a powerful impact on his developing aesthetic. In the simplified forms of these "primitive" art works he discovered an intense vitality that interested him far more than the refinement of the Renaissance tradition, as well as a respect for the inherent qualities of the stone or wood from which the work is fashioned. In most of his own works of the 1920s and 1930s, Moore practiced direct carving in stone and wood and pursued the ideal of truth to material.

A central subject in Moore's art is the reclining female figure, such as *Recumbent Figure* (fig. 28-70), whose massive, simplified forms recall Pre-Columbian art. The carving reveals Moore's sensitivity to the inherent qualities of the stone, whose natural striations harmonize with the sinuous surfaces of the design. While certain elements of the body are clearly defined, such as the head and breasts, supporting elbow and raised knee, other parts flow together into an undulating mass more suggestive of a hilly landscape than of a human body. An open cavity penetrates the torso, emphasizing the relationship of solid and void fundamental to Moore's art. "The hole connects one side to the other, making it immediately more three-dimensional," the sculptor wrote in 1937. "A hole can itself have as much shape-meaning as a solid mass." Moore also remarked on "the mystery of the hole—the mysterious fascination of caves in hillsides and cliffs," identifying

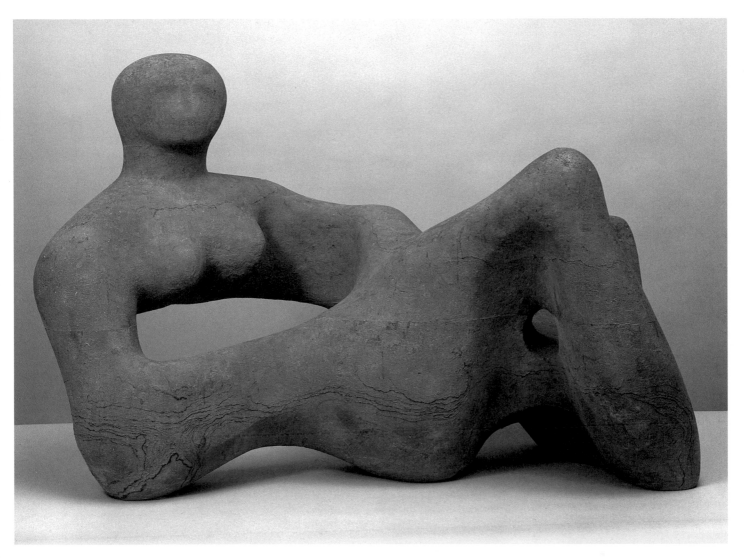

28-70. Henry Moore. *Recumbent Figure*. 1938. Hornton stone, length 55" (141 cm). Tate Gallery, London

Originally carved for the garden of the architect Serge Chermayeff in Sussex, Moore's sculpture was situated next to a low-lying modernist building with an open view of the gently rolling landscape. "My figure looked out across a great sweep of the Downs, and her gaze gathered in the horizon," Moore later recalled. "The sculpture had no specific relationship to the architecture. It had its own identity and did not *need* to be on Chermayeff's terrace, but it so to speak *enjoyed* being there, and I think it introduced a humanizing element; it became a mediator between modern house and ageless land."

the landscape as a source of inspiration for his hollowing out of the human body.

ART AND ARCHITECTURE IN THE UNITED STATES BETWEEN THE WARS

After World War I, the United States entered a period of isolationism that lasted until the bombing of Pearl Harbor in 1941. Accompanying this political isolationism was an emphasis on cultural nationalism, as artists and writers pursued what one critic called the "national spirit." Even Alfred Stieglitz, devoted in the prewar years to an international view of modernism, adopted a cultural nationalist position following the closing of 291 in 1917. Arguing against American art with a "French flavor," Stieglitz dedicated his new venues, the Intimate Gallery (1925–29) and An American Place (1929–46), exclusively to a select group of American artists.

During these years Stieglitz reserved his strongest professional and personal commitment for Georgia O'Keeffe (1887–1986). Born in rural Wisconsin, O'Keeffe studied and taught art sporadically between 1907 and 1915, when a New York friend showed Stieglitz some of O'Keeffe's abstract charcoal drawings. On seeing them, Stieglitz is reported to have said, "At last, a woman on paper!" Stieglitz included O'Keeffe's work in a small group show at 291 in spring 1916 and gave her a one-person exhibition the following year. One male critic wrote that O'Keeffe, with her organic abstractions, had "found expression in delicately veiled symbolism for 'what every woman knows' but what women heretofore kept to themselves." This was the beginning of much written criticism that focused on the artist's gender, to which O'Keeffe strongly objected. She wanted to be considered an artist, not a woman artist.

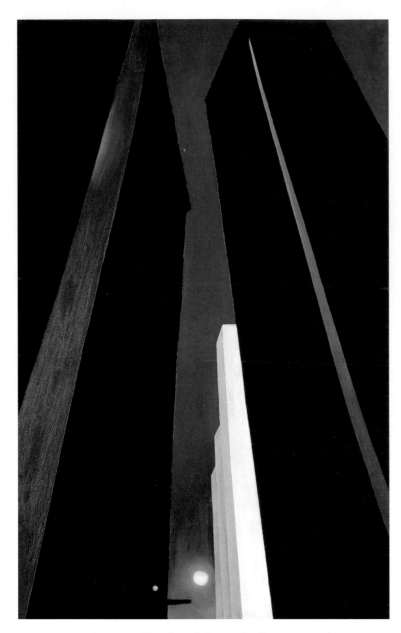

28-71. Georgia O'Keeffe. *City Night*. 1926. Oil on canvas, 48 x 30"
(123 x 76.9 cm). Minneapolis Institute of Arts

O'Keeffe went to New York in 1918, and she and Stieglitz married in 1924. In 1925 Stieglitz introduced O'Keeffe's innovative, close-up images of flowers, which remain among her best-known subjects (see fig. 4, Introduction). That same year, O'Keeffe began to paint New York skyscrapers, which artists and critics of the period recognized as an embodiment of American inventiveness and productive energy. O'Keeffe's skyscraper paintings are not unambiguous celebrations of lofty buildings, however. She often depicted them from a low vantage point so that they appear to loom ominously over the viewer, as in *City Night* (fig. 28-71), whose dark tonalities, stark forms, and exaggerated perspective may produce a sense of menace or claustrophobia. The painting seems to reflect O'Keeffe's own growing perception of the city as too confining.

PRECISIONISM

Despite their ambivalent attitude toward the city, O'Keeffe's skyscraper paintings share important thematic and formal similarities with the work of the Precisionists, a group of painters active in the 1920s and 1930s who devoted much of their art to urban and industrial subjects, and who tended to work with simplified forms, crisply defined edges, smooth brushwork, and unmodulated colors. An important influence on Precisionist painting was photography, which during these same decades also took as a subject the clean, abstract geometries of the factory and skyscraper.

The mature canvases of the leading Precisionist artist, Charles Sheeler (1883–1965), for example, were often based on his own photographs, many of which were made on commercial assignment. In 1927 Sheeler was hired to photograph the new Ford Motor Company plant at River Rouge, outside of Detroit. In 1930 he used the background of one of these photographs to make *American Landscape* (fig. 28-72), a panoramic scene of the River Rouge boat slip, ore storage bins, and cement plant that tells, among other things, about the transformation of raw materials into industrial goods. The title suggests that Sheeler was responding to the popular viewpoint that such factories were the new American churches, the sites of its new faith in a better future. That he painted the work a year after the great stock-market crash of 1929, which began the Great Depression, suggests that the painting may be a testament to Sheeler's continuing faith in American industry and in its fundamental stability.

AMERICAN SCENE PAINTING AND PHOTOGRAPHY

Sheeler's focus on a recognizable American subject, painted in a realistic style, allies his work to a broader tendency known as American Scene Painting, which flourished during the Great Depression. Struggling through economic distress and the agricultural catastrophe of the Dust Bowl, Americans turned their attention homeward; artists followed suit by painting indigenous subjects in an accessible realist style. The trend toward American Scene Painting was encouraged by several New Deal art programs that gave financial support to American artists and generally promoted American subject matter (see "Federal Patronage for American Art during the Depression," opposite). American Scene painters energetically documented the lives and circumstances of the American people and the American land. While some produced images that confronted the depressed conditions of the present, others celebrated the myths and traditions of the American past or crafted optimistic images to provide hope for the future.

A generally optimistic attitude pervades the works of the Regionalists, a group of Midwestern American Scene painters led by Grant Wood (1891–1942), Thomas Hart Benton (1889–1975), John Steuart Curry (1897–1946), who focused on the farms and small-town life of the

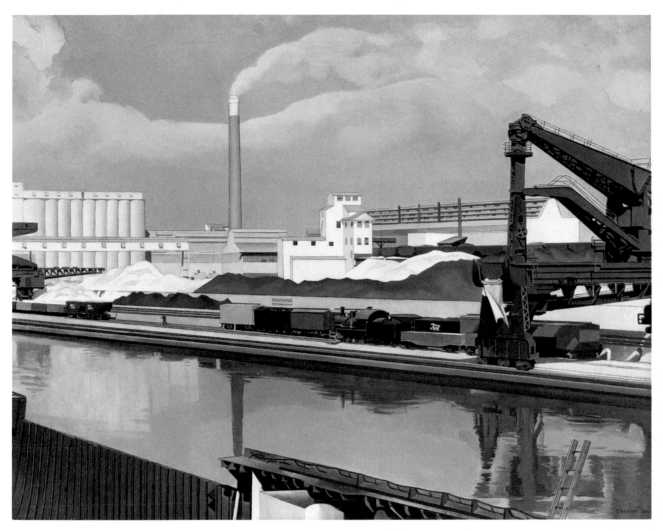

28-72. Charles Sheeler. *American Landscape.* 1930. Oil on canvas, 24 x 31" (61 x 78.7 cm). The Museum of Modern Art, New York

Gift of Abby Aldrich Rockefeller

FEDERAL PATRONAGE FOR AMERICAN ART DURING THE DEPRESSION President Franklin D. Roosevelt's New Deal, programs to provide relief for the unemployed and to revive the nation's economy, included several initiatives to give work to American artists. The Public Works of Art Project, set up in late 1933 to employ needy artists, was in existence for only five months, but supported the activity of 4,000 artists, who produced more than 15,000 works. The Section of Painting and Sculpture in the Treasury Department, established in October 1934 and lasting until 1943, commissioned murals and sculpture for public buildings but was not a relief program; artists were paid only if their designs were accepted. The Federal Art Project of the Works Progress Administration, which ran from 1935 to 1943, succeeded the PWAP in providing relief to unemployed artists. The most important work-relief agency of the depression era, the WPA employed more than 6 million workers by 1943. Its programs to support the arts included the Federal Theater Project and the Federal Writers' Project as well as the Federal Art Project. About 10,000 artists participated in the FAP, producing a staggering amount of art, including about 108,000 paintings, 18,000 works of sculpture, 2,500 murals, and thousands of prints, photographs, and posters. Because it was paid for by the government, all this art became public property. The murals and large works of sculpture, commissioned for public buildings such as train stations, schools, hospitals, and post offices, reached a particularly wide audience.

The Federal Art Project paid a generous average salary of about $20 a week (a salesclerk at Woolworth's earned only about $11), allowing painters and sculptors to devote themselves full-time to art and to think of themselves as professionals in a way few had been able to do before 1935. New York City's painters, in particular, began to develop a group identity, largely because they now had time to meet and discuss art in the bars and coffeehouses of Greenwich Village, the city's answer to the cafés that played such an important role in the art life of Paris. Finally, the FAP gave New York's art community a sense that high culture was important in the United States. The FAP's monetary support and its professional consequences would prove crucial to the artists later known as the Abstract Expressionists, who would shortly transform New York City into the art capital of the world (see Chapter 29).

28-73. Grant Wood. *American Gothic.* 1930. Oil on beaverboard, 29⅞ x 24⅞" (74.3 x 62.4 cm). The Art Institute of Chicago

American heartland (and overlooked the growing disaster of the Dust Bowl). Wood's *American Gothic* (fig. 28-73), the most famous Regionalist painting, is usually understood as a picture of a husband and wife but was actually meant to show an aging Iowa farmer and his unmarried daughter (posed by Wood's dentist and sister). Wood pictured the stony-faced couple standing in front of their house, built in a Victorian style known as "Carpenter Gothic" due to such details as the Gothic-style window in the gable, which suggests the importance of religion in their lives. The father's pitchfork signifies his occupation while giving him a somewhat menacing air. The daughter is associated with potted plants, seen behind her right shoulder, which symbolize traditionally feminine domestic and horticultural skills. Wood saw *American Gothic* as a sincerely affectionate portrayal of the small-town Iowans he had grown up with—conservative, provincial, religious Midwesterners, descendants of the pioneers—whom the artist characterized as "basically good and solid people."

The essentially positive image of agrarian life conveyed in Regionalist works ignored the growing economic problems of farmers during the depression. To build public support for federal assistance to those in need, the government, through the Resettlement Agency (RA) and Farm Securities Administration (FSA), hired photographers to document the problems of farmers, then supplied these photographs, with captions, free to newspapers and magazines. A leading RA/FSA photographer between 1935 and 1939 was the San Francisco–based Dorothea Lange (1895–1965). Many of her photographs document the plight of migrant farm laborers who had flooded California looking for work because of the Dust Bowl conditions on the Great Plains. *Migrant Mother, Nipomo, California* (fig. 28-74) pictures Florence Thompson, the thirty-two-year-old mother of seven children, who had gone to a pea-picking camp but found no work because the peas had frozen on the vines. The tired mother, with her knit brow and her hand on her mouth, seems to capture the fears of an entire population of disenfranchised people.

While the Regionalist painters and RA/FSA photographers focused on rural subjects, other American Scene artists documented city life. A major urban realist of the period was Edward Hopper (1882–1967), who had studied with Robert Henri between 1900 and 1906. Hopper

supported himself as a commercial illustrator until 1924, when a successful show of his watercolors allowed him to devote himself full-time to painting. From that point onward, Hopper depicted scenes of modern life that suggested isolation, alienation, and abandonment. His spare, realist style was characterized by solid forms, sober brushwork, tightly structured compositions, and bold contrasts of light and shadow. Hopper's *Nighthawks* (fig. 28-75), showing four people in an all-night diner, is a study in loneliness and boredom. The anonymous man with his back to us is utterly alone. The couple, too, is just as separate. While the man stares off into space, the woman examines her sandwich. They seem as cold as the fluorescent light that bathes them and as empty as the streets and stores outside. The viewer, placed on the street, is made to share in their condition.

A strong contrast to Hopper's bleak worldview is seen in the optimistic outlook of Norman Rockwell (1894–1978), whose wholesome, good-natured images of everyday life, widely circulated through the mass media, made him the most popular chronicler of the mid-twentieth-century American scene. Born in New York City, Rockwell quit high school to attend the National Academy of Design and the Art Students League, where he studied illustration and mastered the meticulous style of illusionism he would employ throughout his career. In 1916 he created his first of 322 covers for the *Saturday Evening Post* magazine.

While Rockwell greatly admired Picasso and other modern artists whose work often displeased the general public, his own aim was to paint pictures that "everybody would understand and like." Rockwell did not succeed in

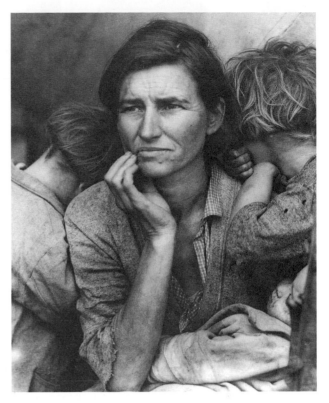

28-74. Dorothea Lange. *Migrant Mother, Nipomo, California*. February 1936. Gelatin-silver print. Library of Congress, Washington, D.C.

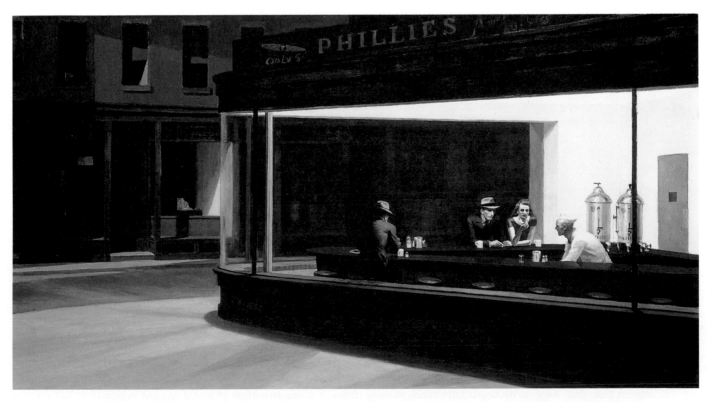

28-75. Edward Hopper. *Nighthawks*. 1942. Oil on canvas, 33 x 60" (83.8 x 152.4 cm). The Art Institute of Chicago

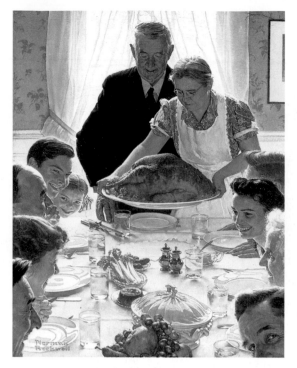

28-76. Norman Rockwell. *Freedom from Want*, story illustration, *Saturday Evening Post*, March 6, 1943. Oil on canvas, 45¾ x 35½" (117.3 x 91 cm). Collection of the Norman Rockwell Museum at Stockbridge, Massachusetts, Norman Rockwell Art Collection Trust

This is one of four images Rockwell made to illustrate the four freedoms that President Roosevelt had identified in his 1941 State of the Union address, with the implication that they would be objectives of World War II, which the United States entered later that year. (The other three were freedom of speech, freedom to worship, and freedom from fear.) Sent on a national tour by the Office of War Information and reproduced on posters for the Second War Loan Drive, Rockwell's *Four Freedoms* helped to raise $132 million in war bonds.

pleasing everybody—particularly modernist artists, critics, and art historians—but he undeniably created legible and vivid images, many of which have become icons of American popular culture. One is *Freedom from Want* (fig. 28-76), which for many is the ideal image of the traditional American Thanksgiving dinner. Dominating the composition is the stable, pyramidal group of the benign grandfather and nurturing grandmother, who prepares to set an enormous turkey on the graciously set table. The smiling members of the extended family and guests line either side of the table, and a welcoming face at the lower right invites us to join them. Despite its brilliant realism, we recognize *Freedom from Want* as an idealization, calculated, as were most of Rockwell's images, to reflect "life as I would like it to be."

THE HARLEM RENAISSANCE

Between the two world wars, hundreds of thousands of African Americans migrated from the rural, mostly agricultural South to the urban, industrialized North, fleeing racial and economic oppression and seeking greater social and economic opportunity. This transition gave rise to the so-called New Negro movement, which encouraged African Americans to become politically progressive and racially conscious. The New Negro movement in turn stimulated a flowering of black art and culture known as the Harlem Renaissance, because its capital was Harlem, the country's largest black population center. The intellectual leader of the Harlem Renaissance was Alain Locke (1886–1954), a critic and philosophy professor who argued that black artists should seek their artistic roots in the traditional arts of Africa rather than in those of white America or Europe. Because leading white modernists such as Picasso and the members of Die Brücke had looked to African art for inspiration, Locke's call offered black artists the possibility of both reclaiming their racial

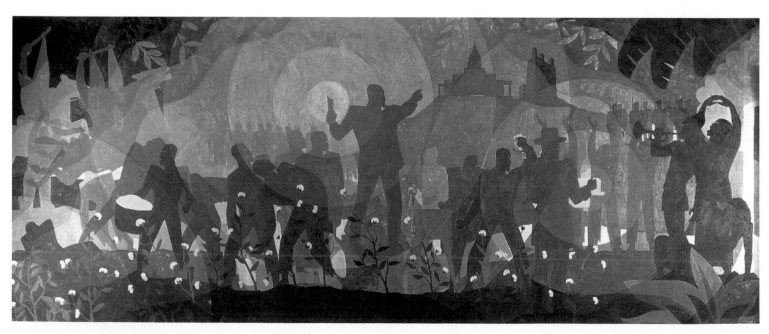

28-77. Aaron Douglas. *Aspects of Negro Life: From Slavery through Reconstruction*. 1934. Oil on canvas, 5' x 10'8" (1.5 x 3.25 m). Schomburg Center for Research in Black Culture, New York Public Library, Astor, Lenox, and Tilden Foundations

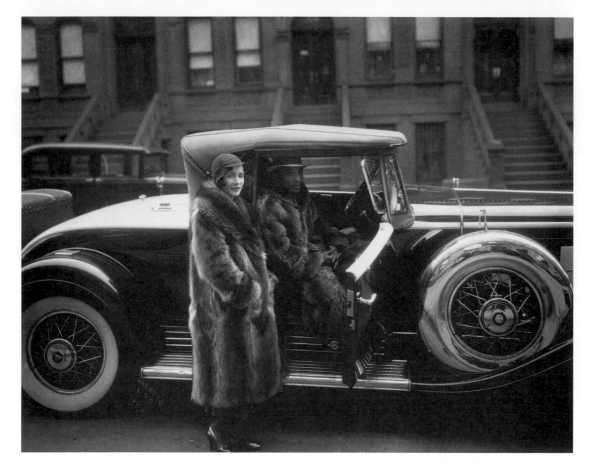

28-78. James VanDerZee. *Couple Wearing Raccoon Coats with a Cadillac, Taken on West 127th Street, Harlem, New York*. 1932. Photograph

heritage and participating in the already established history of Euro-American modernism.

The first black artist to answer Locke's call was Aaron Douglas (1898–1979), a native of Topeka, Kansas, who moved to New York City in 1925 and rapidly developed an abstracted style influenced by African art as well as the contemporary, hard-edged aesthetic of Art Deco. In paintings such as *Aspects of Negro Life: From Slavery through Reconstruction* (fig. 28-77), Douglas used schematic figures, silhouetted in profile with the eye rendered frontally as in ancient Egyptian reliefs and frescoes, and limited his palette to a few subtle hues, varying in value from light to dark and sometimes organized abstractly into concentric bands that suggest musical rhythms or spiritual emanations. This work, painted for the 135th Street branch of the New York Public Library under the sponsorship of the Public Works of Art Project, was intended to awaken in African Americans a sense of their place in history. At the right, Southern black people celebrate the Emancipation Proclamation of 1863, which freed the slaves. Concentric circles issue from the Proclamation, which is read by a figure in the foreground. At the center of the composition, an orator symbolizing black leaders of the Reconstruction era urges black freedmen, some still picking cotton, to cast their ballots in the box before him, while he points to a silhouette of the Capitol on a distant hill. Concentric circles highlight the ballot in his hand. In the left background, Union soldiers depart from the South at the close of Reconstruction, as the fearsome Ku Klux Klan, hooded and on horseback, invades from the left. Despite this negative image, the heroic orator at the center of Douglas's panel remains the focus of the composition, inspiring contemporary viewers to continue the struggle to improve the lot of African Americans.

Like Douglas, photographer James VanDerZee (1886–1983) created positive images of African Americans that conveyed the sense of racial pride and social empowerment promoted by the New Negro movement. The largely self-taught VanDerZee maintained a studio in Harlem for nearly fifty years and specialized in portraits of the neighborhood's middle- and upper-class residents. His best-known photograph, *Couple Wearing Raccoon Coats with a Cadillac, Taken on West 127th Street, Harlem, New York* (fig. 28-78), depicts the ideal New Negro man and woman: prosperous, confident, and cosmopolitan, thriving glamorously even in the midst of the depression.

ABSTRACTION

Although realism dominated American art in the period between the two world wars, some artists remained committed to modernist abstraction. One was Stuart Davis (1894–1964), a native of Philadelphia who studied in New York under Robert Henri between 1909 and 1912. He painted in the realistic Ashcan manner until 1913, when his discovery of European modernism at the Armory Show convinced him to move toward abstraction. By the 1920s, he had developed a personal mode of Synthetic Cubism. During the 1930s, Davis became politically active, serving as president of the Artists Union and as an officer of the American Artists Congress, a left-wing artistic organization that opposed the international spread of fascism. Davis rarely allowed overt political messages to enter his art, but nevertheless considered abstract painting to be "a progressive social force" because it gave "concrete artistic formulation to the new lights, speeds, and spaces which are uniquely real in our time."

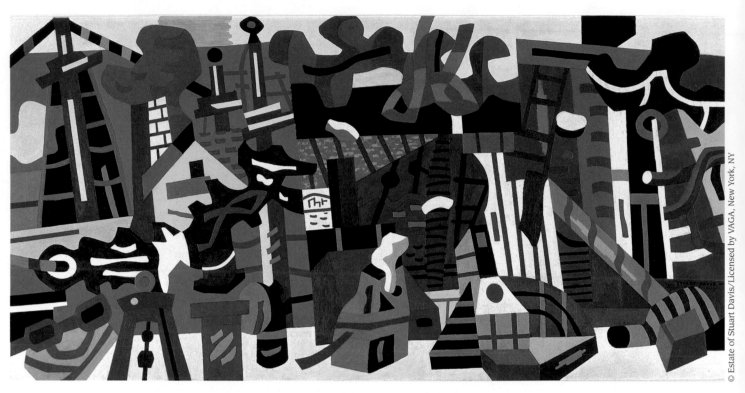

28-79. Stuart Davis. *Swing Landscape*. 1938. Oil on canvas, 7'1^{15}/$_{16}$" x 14'3^{5}/$_{16}$" (2.20 x 4.39 m). Indiana University Art Museum

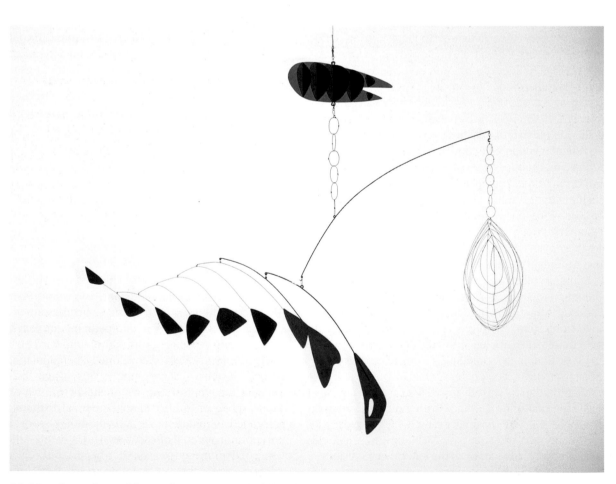

28-80. Alexander Calder. *Lobster Trap and Fish Tail*. 1939. Hanging mobile: painted steel wire and sheet aluminum, approx. 8'6" x 9'6" (2.6 x 2.9 m). The Museum of Modern Art, New York

Commissioned by the Advisory Committee for the stairwell of the Museum

An ambitious example of Davis's abstract style of the 1930s is *Swing Landscape* (fig. 28-79), a mural commissioned by the Federal Art Project for the Williamsburg Housing Project in Brooklyn, New York, but never installed there. The title alludes to swing music, from which Davis, a great lover of jazz, drew inspiration for his upbeat style of painting. The mural definitely "swings," with its bouncy yet tightly ordered arrangement of colorful shapes and lines that skip, squiggle, and clamber across its surface. Embedded within the complex design are representational elements that include a mast and rigging, a chimney, a yellow house, pulleys, ropes, and a ladder. Combined with the abstract stripes and blocks of color surrounding them, they evoke a waterfront pulsating with the "new lights, speeds, and spaces" of contemporary America.

While Davis's paintings only suggest motion, Alexander Calder (1898–1976) made works of sculpture that actually move. Calder's **kinetic** works unfix the traditional stability and timelessness of art and invest it with vital qualities of mutability and unpredictability. Born in Philadelphia and trained in both engineering and painting, Calder went to Paris in 1926 and became friendly with Surrealists such as Miró and abstractionists such as Mondrian. On a 1930 visit to Mondrian's studio, he was impressed by the rectangles of colored paper that the painter had tacked up everywhere on the walls. What would it look like, Calder wondered, if the flat shapes were moving freely in space, interacting in not just two but three dimensions? The question inspired Calder to begin creating sculpture with moving parts, known as **mobiles**. Calder's *Lobster Trap and Fish Tail* (fig. 28-80) features delicately balanced elements that spin and bob in response to shifting currents of air. At first, the work seems almost completely abstract, but Calder's title works on our imagination, helping us find the oval trap awaiting unwary crustaceans at the right and the delicate wires at the left that suggest the backbone of a fish. The work's whimsical spirit and biomorphic form reflect the influence of Miró. The term *mobile*, which in French means "moving body" as well as "motive," or "driving force," came from Calder's friend Marcel Duchamp, who no doubt relished the double meaning of the word.

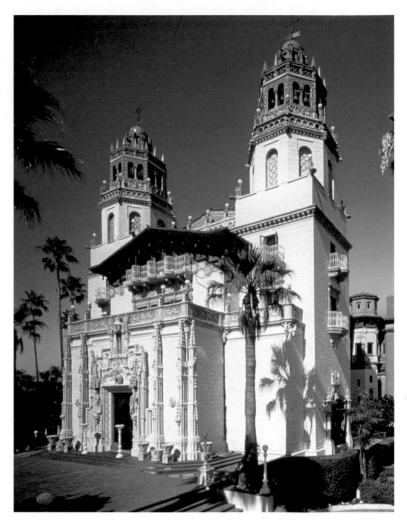

28-81. Julia Morgan. Front entrance, La Casa Grande, San Simeon, California. 1922–26

Morgan regularly commuted 200 miles from San Francisco to San Simeon to supervise the construction of William Randolph Hearst's estate overlooking the Pacific Ocean. Under construction between 1920 and 1937, the property included the main mansion and three guesthouses; outdoor and indoor swimming pools, tennis courts, and a 50-seat movie theater; a poultry farm, orchard, and vegetable gardens; and a private zoo containing more than 100 exotic species including giraffes, emus, and zebras.

ARCHITECTURE

In contrast to the revolutionary architectural developments in Europe that produced the International Style, American architecture in the interwar years was dominated by an academic eclecticism that in some ways paralleled the country's political isolationism. One successful academic architect of the period was Julia Morgan (1872–1957), one of the first women to sustain a productive architectural practice in the United States. A native of San Francisco, Morgan received an engineering degree in 1894 from the University of California, Berkeley. Although the École des Beaux-Arts did not accept women, she moved to Paris anyway and in 1896 enrolled in a private architectural studio. Two years of persistence paid off, and she was admitted to the École as its first female student. In 1904 she opened her own office in San Francisco, and over the course of her career designed more than 700 buildings. By 1927 she had a staff of fourteen architects, six of them women.

Morgan did much of her early work for friends and for women's organizations. At Mills College for women she designed several buildings in a revival of the increasingly popular Mission style, first introduced by Spanish settlers. She also designed numerous buildings throughout California for the Young Women's Christian Association (YWCA). Morgan's most important client was the newspaper magnate William Randolph Hearst, who in 1919 commissioned her to design a palatial estate in San Simeon, about 200 miles south of San Francisco. The main building, called La Casa Grande ("The Great House") (fig. 28-81), is a free interpretation of a Mission-style church built of reinforced concrete (see "Space-Spanning

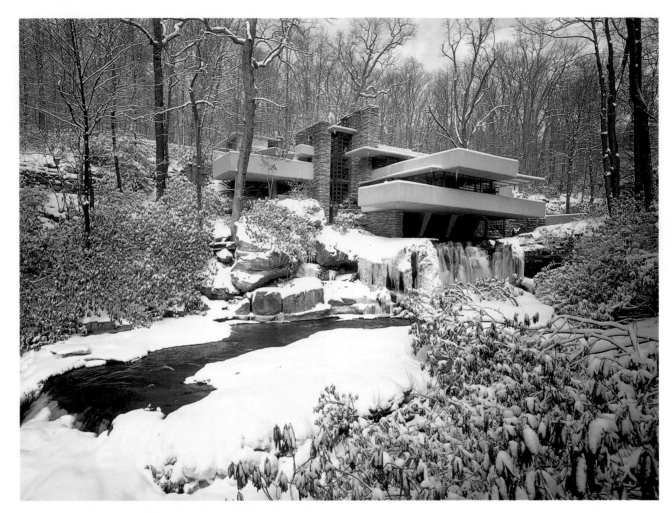

28-82. Frank Lloyd Wright. Edgar Kaufmann House, Fallingwater, Mill Run, Pennsylvania. 1935-37

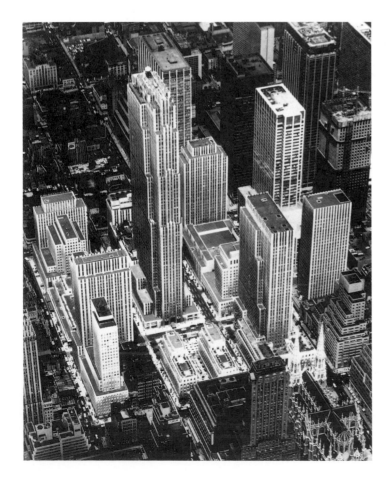

Construction Devices," page 22, Starter Kit). Above the single doorway and below the pair of wide, sturdy towers typical of such churches, Morgan added a house front to indicate the building's function. Since the Renaissance, the Greek temple had been adapted to domestic architecture, but similar domestic adaptation of the Christian church was rare. The elaborate decoration on the facade of the Casa Grande reflects the detailing throughout. Morgan employed a host of stonecutters, experts in ornamental plasters, wood carvers, iron casters, weavers, tapestry makers, and tile designers to copy or improvise from historical models the decorative arts that filled the estate's 127 rooms.

A very different sort of country house is Frank Lloyd Wright's Fallingwater (fig. 28-82), in rural Pennsylvania, perhaps the best-known expression of Wright's conviction that buildings ought to be not simply on the landscape but *in* it. The house was commissioned by Edgar Kaufmann, a Pittsburgh department store owner, to replace a family summer cottage whose site featured a waterfall into a pool where the family children played. To the Kaufmanns' great surprise, Wright decided to build the house into the cliff over the pool, allowing the waterfall

28-83. Reinhard & Hofmeister; Corbett, Harrison, & MacMurray; Hood & Fouilhoux. Rockefeller Center, New York. 1931–39

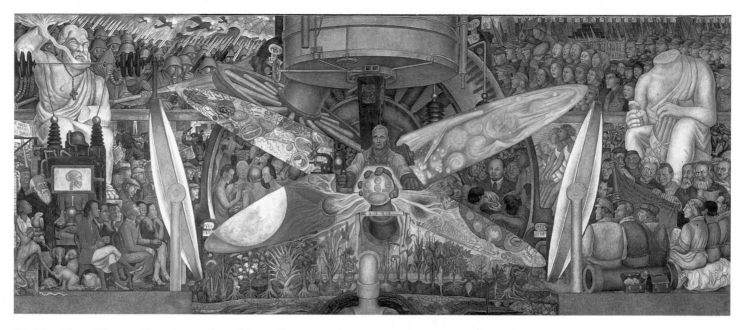

28-84. Diego Rivera. *Man, Controller of the Universe*. 1934. Fresco, 15'9 1/8" x 37'2 1/2" (4.85 x 11.45 m). Museo del Palacio de Bellas Artes, Mexico City

to flow around and under the house. A large boulder on which the family had sunbathed was built into the house as the hearthstone of the fireplace. In a dramatic move that engineering experts questioned, Wright cantilevered a series of broad terraces out from the cliffside, echoing the great slabs of rock below. The house is further tied to its site through materials. Although the terraces are poured concrete, the wood and stone used elsewhere are either from the site or in harmony with it. Such houses do not simply testify to the ideal of living in harmony with nature but declare war on the modern industrial city. When asked what could be done to improve the city, Wright responded: "Tear it down."

A more constructive approach to improving the city is represented by Rockefeller Center in New York City, one of the most ambitious urban designs of the twentieth century (fig. 28-83). The project, financed by millionaire John D. Rockefeller, Jr., was designed to house the young radio and television industries, with RCA, RKO, and NBC as its principal tenants. The fourteen original buildings of Radio City (as it was first named), constructed between 1931 and 1939, were designed by three leading firms of the era: Hood & Fouilhoux; Corbett, Harrison, & Mac-Murray; and Reinhard & Hofmeister. The centerpieces of the complex are the slender, 70-story RCA (now GE) Building and the Art Deco–style Radio City Music Hall. The center's amenities—many of them now standard features of urban commercial complexes—include a pedestrian mall, a sunken skating rink, roof gardens, underground walkways, garages, shops, theaters, and restaurants. Adorning the buildings are sculpture, mosaics, murals, metalwork, and enamels commissioned from some of the era's best-known artists and artisans. Many of these art works address the theme of "New Frontiers and the March of Civilization," devised to express the visionary idealism of this essentially commercial project.

ART IN MEXICO BETWEEN THE WARS

The Mexican Revolution of 1910 overthrew the thirty-five-year-long dictatorship of General Porforio Díaz and was followed by ten years of political instability. In 1921 the reformist president Alvaro Obregón came to power and restored political order. In an effort to promote Mexican cultural development and a sense of national identity, Obregón's government commissioned artists to decorate public buildings with murals celebrating the history, life, and work of the Mexican people.

Prominent in the new Mexican mural movement was Diego Rivera (1886–1957), a child prodigy who had enrolled in Mexico City's Academia de San Carlos at age eleven. From 1911 to 1919 Rivera lived in Paris, where he befriended Picasso and worked in a Synthetic Cubist style. In 1919 he met David Alfaro Siqueiros (1896–1974), another future Mexican muralist. They began to discuss Mexico's need for a national and revolutionary art. In 1920–21 Rivera traveled in Italy to study its great Renaissance frescoes, then began a series of monumental murals for Mexican government buildings, inspired by both Italian Renaissance and Pre-Columbian art of Mexico.

Between 1930 and 1934 Rivera worked in the United States, painting murals in San Francisco, Detroit, and New York. In 1932 the Rockefeller family commissioned him to paint for the lobby of the RCA Building in Rockefeller Center a fresco on the theme "Man at the Crossroads Looking with Hope and High Vision to the Choosing of a New and Better Future." When Rivera, a Communist, provocatively insisted on including a portrait of Lenin in the mural, the Rockefellers canceled his commission, paid him his fee, and had the unfinished mural destroyed. In response to what he called an "act of cultural vandalism," Rivera re-created the mural in the Palacio de Bellas Artes in Mexico City, under the new title Man, *Controller of the Universe* (fig. 28-84). At the center

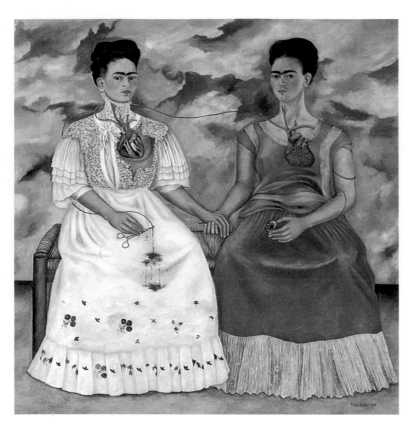

28-85. Frida Kahlo. *The Two Fridas*. 1939. Oil on canvas. 5'8½" x 5'8½" (1.74 x 1.74 m). Museo de Arte Moderno, Instituto Nacional de Bellas Artes, Mexico City

of the mural, the clear-eyed young figure in overalls represents Man, who symbolically controls the universe through the manipulation of technology. Crossing behind him are two great ellipses that represent, respectively, the microcosm of living organisms as seen through the microscope at Man's right hand, and the macrocosm of outer space as viewed through the giant telescope above his head. Below, fruits and vegetables rise from the earth as a result of his agricultural efforts. To Man's left (the viewer's right), Lenin joins the hands of several workers of different races. To Man's right, decadent capitalists debauch themselves in a nightclub, directly beneath the disease-causing cells in the ellipse. (Rivera vengefully included in this section a portrait of the bespectacled John D. Rockefeller, Jr.) The wings of the mural feature, to Man's left, the workers of the world embracing socialism, and, to Man's right, the capitalist world, which is cursed by militarism and labor unrest.

While Rivera and other muralists painted on walls to communicate public messages, other Mexican artists made more private, introspective statements through the medium of easel painting. One such artist was Frida Kahlo (1907–54), who was born in Mexico City of a German father and a Mexican mother. A nearly fatal trolley accident in 1925 left her crippled and in pain for the rest of her life. While convalescing from the accident, she taught herself to paint. Her work soon brought her into contact with Rivera, whom she later called her "second

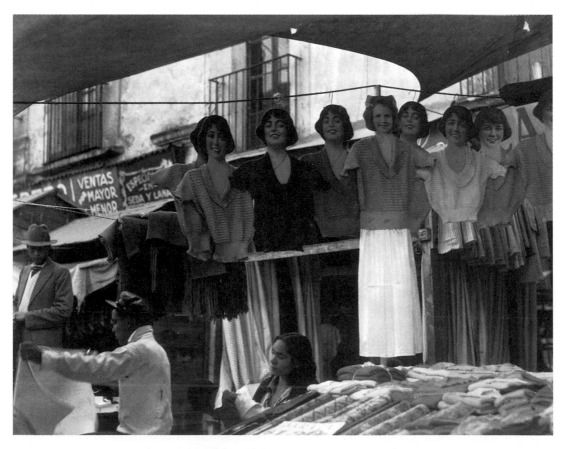

28-86. Manuel Alvarez Bravo. *Laughing Mannequins*. 1930. Gelatin-silver print, 7⁵⁄₁₆ x 9⁹⁄₁₆"
(18.6 x 24.3 cm). The Art Institute of Chicago
Julian Levy Collection, Gift of Jean Levy and the Estate of Julian Levy (1988.157.8)

accident." In 1929 they married, but their relationship was always stormy and they were divorced in 1939 (they remarried the next year). While the divorce papers were being processed, Kahlo painted *The Two Fridas* (fig. 28-85), a large work that dealt with her personal pain. Here she presents her two ethnic selves: the European one, in a Victorian dress, and the Mexican one, wearing a traditional Mexican peasant skirt and blouse. She told an art historian at the time that the Mexican image was the Frida whom Diego loved and the European one the Frida whom he did not. The two Fridas join hands, and they are intimately connected by the artery running between them. The artery begins at the miniature of Diego as a boy that the Mexican Frida holds and ends in the lap of the other Frida, who attempts without success to stem the flow of blood from it.

In 1938 André Breton, the leader of the Surrealists, traveled to Mexico City and there met Rivera and Kahlo. Breton was so impressed by Kahlo that he wrote the introduction to the catalog of her New York exhibition that fall and arranged for her to show in Paris the following year. Although Breton claimed her as a natural Surrealist, she herself said she was not: "I never painted dreams. I painted my own reality." Nevertheless, she willingly participated in Surrealist shows, including the international Surrealist exhibition in Mexico City in 1940.

Another participant in that exhibition was the photographer Manuel Alvarez Bravo (b. 1902), whom Breton had also met in 1938 and recognized as a Surrealist. Alvarez Bravo enjoyed the friendship of Rivera and other Mexican muralists, whose work he documented photographically. His principal subjects, however, were the indigenous Indian people of Mexico, both urban and rural, and the details of their everyday world. Like many other art photographers of the interwar decades, Alvarez Bravo was committed to the aesthetics of "straight," or pure, photography, in which the photographer finds a subject, brings it into sharp focus, carefully frames it in the viewfinder, then prints the resulting negative without any darkroom manipulation. Using this method, he discovered and photographed unexpected juxtapositions of objects that create a strange and haunting poetry of the kind Breton considered Surrealist. In *Laughing Mannequins* (fig. 28-86), for example, Alvarez Bravo captured the odd sight of a row of glamorous cardboard women dressed in real clothing, hovering in the air above shoppers and stall-keepers, and smiling out at the viewer. In this uncanny juxtaposition of the animate and the inanimate, the cardboard mannequins seem strangely more alive than the flesh-and-blood people on the street below.

EARLY MODERN ART IN CANADA

Canadian artists of the nineteenth century, like their counterparts in the United States, generally worked in styles derived from European art. A number of Canadians studied in Paris during the late nineteenth century, some of them mastering academic realism and painting figurative and genre subjects, others developing tame versions of Impressionism and Post-Impressionism

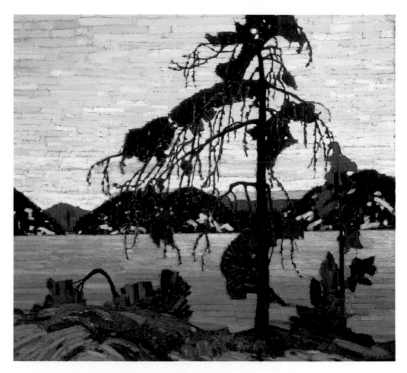

28-87. Tom Thomson. *The Jack Pine*. 1916–17. Oil on canvas, 49⅞ x 54½" (127.9 x 139.8 cm). National Gallery of Canada, Ottawa

Purchase, 1918.

that they applied to landscape painting. Back in Canada, several of the most advanced painters in 1907 formed the Canadian Art Club, an exhibiting society based in Toronto, Ontario.

In the early 1910s, a younger group of Toronto artists, many of whom worked for the same commercial art firm, became friends and began to go on weekend sketching trips together. They adopted the rugged landscape of the Canadian north as their principal subject and presented their art as an expression of Canadian national identity, despite its stylistic debt to European Post-Impressionism. A key figure in this development was Tom Thomson (1877–1917), who beginning in 1912 spent the warm months of each year in Algonquin Park, a large forest reserve 180 miles north of Toronto. There he made numerous small, swiftly painted, oil-on-board sketches that were the basis for full-size paintings he executed in his studio during the winter. A sketch made in the spring of 1916 led to *The Jack Pine* (fig. 28-87). The tightly orga-nized composition features a stylized pine tree rising from a rocky foreground and silhouetted against a luminous background of lake and sky, horizontally divided by cold blue hills. The glowing colors and thick brushwork suggest the influence of Post-Impressionism, while the sinuous shapes and overall decorative effect reveal a debt to Art Nouveau. The painting's arresting beauty and reverential mood, suggesting a divine presence in the lonely northern landscape, have made it an icon of Canadian art, and, for many, a symbol of the nation itself.

Three years after Thomson's tragic 1917 death by drowning in an Algonquin Park lake, several of his former

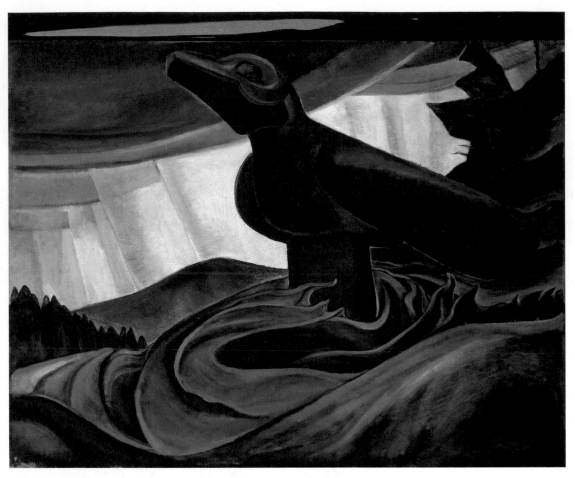

28-88. Emily Carr. *Big Raven*. 1931. Oil on canvas, 34 x 44⅝" (87.3 x 114.4 cm). The Vancouver Art Gallery
Emily Carr Trust

colleagues formed an exhibiting society called the Group of Seven. These artists traveled widely across Canada in search of pristine wilderness subjects, which they painted in styles generally influenced, as Thomson's had been, by Post-Impressionism. Overcoming initial conservative opposition to their use of simplified forms and bold color, the Group of Seven had by the late 1920s established themselves as the dominant school of Canadian painting. (The group disbanded in 1933, but continued to influence Canadian art through a larger successor organization, the Canadian Group of Painters.)

The Group of Seven regularly invited other like-minded artists to exhibit with them. One was the West Coast artist Emily Carr (1871–1945), who first met members of the group on a trip to Toronto in 1927. Born in Victoria, British Columbia, Carr studied art in San Francisco (1891–94), England (1899–1904), and Paris (1910–11), where she assimilated the lessons of Post-Impressionism and Fauvism. Between 1906 and 1913 she lived in Vancouver, where she became a founding member of the British Columbia Society of Art. On a 1907 trip to Alaska she was taken with the monumental carved poles of Northwest Coast Native Americans and resolved to document these "real art treasures of a passing race." Over the next twenty-three years Carr visited more than thirty native village sites across British Columbia, making drawings and watercolors as the basis for oil paintings.

After a commercially unsuccessful exhibition of her Native American subjects in 1913, Carr returned to Victoria and opened a boardinghouse. Running this business left little time for art, and for the next fifteen years she hardly painted. Her life changed dramatically in 1927 when she was invited to participate in an exhibition of West Coast art at the National Gallery of Canada in Ottawa, Ontario. It was on her trip east to attend the show's opening that she met members of the Group of Seven, whose example and encouragement rekindled her interest in painting.

Under the influence of the Group of Seven, Carr developed a dramatic and powerfully sculptural style full of dark and brooding energy. An impressive example of such work is *Big Raven* (fig. 28-88), which Carr based on a watercolor she made in 1912 in an abandoned village in the Queen Charlotte Islands. There she discovered a carved raven raised on a pole, the surviving member of a pair that had marked a mortuary house. While in her autobiography Carr described the raven as "old and rotting," in her painting the bird appears strong and majestic, thrusting dynamically above the swirling vegetation, a symbol of enduring spiritual power. Through its focus on a Native American artifact set in a recognizably northwestern Canadian landscape, Carr's *Big Raven* may be interpreted, like the paintings of the Group of Seven, as an assertion of national pride.

STYLE	WESTERN ART	ART OF OTHER CULTURES
LATE ART NOUVEAU	28-2. Gaudí. Serpentine bench, Barcelona (1900–14) 28-3. Klimt. *The Kiss* (1907–8)	23-12. **Blackfoot tepee** (c. 1900), North America 24-5. **Tamberan house** (20th cent.), Papua New Guinea 25-9. **Baule spirit spouse** (early 20th cent.), Côte d'Ivoire 25-15. **Dogon mask** (early 20th cent.), Mali 25-6. **Lega mask** (early 20th cent.), Democratic Republic of Congo 25-3. **Yoruba twins** (20th cent.), Nigeria 25-10. **Yoruba staff** (20th cent.), Nigeria 25-1. **Ashanti finial** (20th cent.), Ghana 25-11. **Ashanti** *kente* **cloth** (20th cent.), Ghana 23-14. **Kwakiutl dancers** (1914), North America 23-22. **Klah.** *Whirling Log* (c. 1925), North America 23-17. **Tlingit blanket** (before 1928), North America 23-20. **Martinez and Martinez. Blackware jar** (c. 1942), North America 23-21. **Velarde.** *Koshares* (1946–47), North America
FAUVE	28-4. Derain. *Mountains at Collioure* (1905) 28-5. Matisse. *The Woman with the Hat* (1905) 28-6. Matisse. *Le Bonheur de Vivre* (1905–6)	
DIE BRÜCKE	28-8. Heckel. *Crouching Woman* (1912) 28-7. Schmidt-Rottluff. *Three Nudes—Dune Picture from Nidden* (1913) 28-9. Kirchner. *Street, Berlin* (1913)	
INDEPENDENT EXPRESSIONISM	28-10. Kollwitz. *The Outbreak* (1903) 28-11. Modersohn-Becker. *Self-Portrait with an Amber Necklace* (1906) 28-12. Schiele. *Self-Portrait Nude* (1911)	
DER BLAUE REITER	28-14. Marc. *The Large Blue Horses* (1911) 28-13. Kandinsky. *Improvisation No. 30 (Warlike Theme)* (1913) 28-15. Klee. *Hammamet with Its Mosque* (1914)	
EARLY MODERNIST EUROPEAN SCULPTURE	28-16. Maillol. *The Mediterranean* (1902–5) 28-18. Brancusi. *Magic Bird* (1908–12) 28-17. Matisse. *La Serpentine* (1909)	
EARLY PICASSO	28-19. Picasso. *Self-Portrait* (1901) 28-20. Picasso. *Family of Saltimbanques* (1905) 28-21. Picasso. *Les Demoiselles d'Avignon* (1907)	
ANALYTIC CUBISM	28-23. Braque. *Houses at L'Estaque* (1908) 28-24. Braque. *Violin and Palette* (1909–10) 28-25. Picasso. *Ma Jolie* (1911–12)	
SYNTHETIC CUBISM	28-26. Picasso. *Glass and Bottle of Suze* (1912) 28-27. Picasso. *Mandolin and Clarinet* (1913)	
FRENCH CUBIST RESPONSES	28-29. Delaunay. *Homage to Blériot* (1914) 28-28. Lipchitz. *Man with a Guitar* (1915) 28-30. Delaunay-Terk. Clothes and customized Citroën B-12 (1925)	

STYLE	WESTERN ART
ITALIAN FUTURISM	28-31. Boccioni. *States of Mind: The Farewells* (1911) 28-32. Boccioni. *Unique Forms of Continuity in Space* (1913)
RUSSIAN CUBO-FUTURISM	28-33. Goncharova. *Aeroplane over Train* (1913)
RUSSIAN SUPREMATISM	28-34. Malevich. *Suprematist Painting* (1915)
RUSSIAN COUNTER-RELIEF	28-35. Tatlin. *Corner Counter-Relief* (1915)
AMERICAN ASHCAN	28-36. Sloan. *Backyards, Greenwich Village* (1914)
AMERICAN MODERNISM	28-37. Hartley. *Portrait of a German Officer* (1914) 28-38. Strand. *Chair Abstract, Twin Lakes, Connecticut* (1916)
AMERICAN MODERNIST ARCHITECTURE	28-39. Wright. Robie House, Chicago (1906–9) 28-41. Gilbert. Woolworth Building, New York (1911–13) 28-83. Rockefeller Center, New York (1931–39) 28-82. Wright. Fallingwater, Mill Run (1935–37)
AMERICAN ACADEMIC ARCHITECTURE	28-81. Morgan. La Casa Grande, San Simeon (1922–26)
EUROPEAN MODERNIST ARCHITECTURE	28-42. Loos. Steiner House, Vienna (1910) 28-43. Gropius and Meyer. Fagus Factory, Alfeld-an-der-Leine (1911–16) 28-44. Sant'Elia. Station for airplanes and trains (1914)
RUSSIAN UTILITARIANISM	28-45. Tatlin. Model for Monument to the Third International (1919–20) 28-47. Lissitzky. Proun space for Great Berlin Art Exhibition (1923) 28-46. Rodchenko. Workers' Club (1925) 28-48. Mukhina. *Worker and Collective Farm Worker* (1937)
DUTCH RATIONALISM	28-50. Rietveld. Schröder House, Utrecht (1924) 28-51. Rietveld. "Red-Blue" chair (1924) 28-49. Mondrian. *Composition with Yellow, Red, and Blue* (1927)
FRENCH CLASSICISM	28-52. Picasso. *Three Women at the Spring* (1921)
FRENCH PURISM	28-53. Léger. *Le Grand Déjeuner* (The Large Luncheon) (1921) 28-54. Le Corbusier. Plan for a Contemporary City of Three Million Inhabitants (1922) 28-55. Le Corbusier. Villa Savoye, Poissy-sur-Seine (1929–30)

PARALLELS

STYLE	WESTERN ART
GERMAN BAUHAUS	28-56. Brandt. Coffee and tea service (1924)
	28-58. Gropius. Bauhaus Building, Dessau (1925–26)
	28-57. Albers. Wall hanging (1926)
	28-59. Mies van der Rohe. German Pavilion (1929)
DADA	28-63. Duchamp. *Fountain* (1917)
	28-64. Duchamp. *The Bride Stripped Bare by Her Bachelors, Even* (1915–23)
	28-60. Ball reciting "Karawane" (1916)
	28-61. Höch. *Dada Dance* (1922)
	28-62. Heartfield. *Have No Fear—He's a Vegetarian* (1936)
SURREALISM	28-65. Ernst. *The Horde* (1927)
	28-66. Miró. *Dutch Interior I* (1928)
	28-67. Dalí. *The Persistence of Memory* (1931)
	28-68. Oppenheim. *Object (Le Déjeuner en fourrure) (Luncheon in Fur)* (1936)
	28-1. Picasso. *Guernica* (1937)
MODERNIST SCULPTURE	28-69. González. *Woman Combing Her Hair II* (1934)
	28-70. Moore. *Recumbent Figure* (1938)
AMERICAN PRECISIONISM	28-71. O'Keeffe. *City Night* (1926)
	28-72. Sheeler. *American Landscape* (1930)
AMERICAN SCENE	28-73. Wood. *American Gothic* (1930)
	28-74. Lange. *Migrant Mother, Nipomo, California* (1936)
	28-75. Hopper. *Nighthawks* (1942)
	28-76. Rockwell. *Freedom from Want* (1943)
HARLEM RENAISSANCE	28-78. VanDerZee. *Couple Wearing Raccoon Coats with a Cadillac, Taken on West 127th Street, Harlem, New York* (1932)
	28-77. Douglas. *Aspects of Negro Life: From Slavery through Reconstruction* (1934)
AMERICAN ABSTRACTION	28-79. Davis. *Swing Landscape* (1938)
	28-80. Calder. *Lobster Trap and Fish Tail* (1939)
MEXICAN MODERNISM	28-86. Alvarez Bravo. *Laughing Mannequins* (1930)
	28-84. Rivera. *Man, Controller of the Universe* (1934)
	28-85. Kahlo. *The Two Fridas* (1939)
CANADIAN MODERNISM	28-87. Thomson. *The Jack Pine* (1916–17)
	28-88. Carr. *Big Raven* (1931)

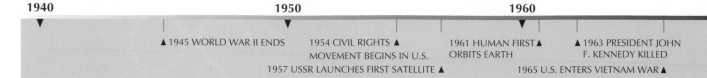

▲ 1945 WORLD WAR II ENDS 1954 CIVIL RIGHTS ▲ 1961 HUMAN FIRST ▲ ▲ 1963 PRESIDENT JOHN
MOVEMENT BEGINS IN U.S. ORBITS EARTH F. KENNEDY KILLED

1957 USSR LAUNCHES FIRST SATELLITE ▲ 1965 U.S. ENTERS VIETNAM WAR ▲

TIMELINE 29-1. The World since 1945. The second half of the twentieth century saw the widespread acceptance of the digital computer, the start of the Space Age, and major political realignments.

MAP 29-1. The World since 1945. The distribution of cultural sites expands to be fully global.

THE WORLD SINCE 1945

The United States and the Soviet Union emerged from World War II as the world's most powerful nations and soon were engaged in the "Cold War." The Soviets set up Communist governments in Eastern Europe and supported the development of communism elsewhere. The United States through financial aid and political support sought to contain the spread of communism in Western Europe, Japan, Latin America, and other parts of the developing world. A second huge Communist nation emerged in 1949 when Mao Tse-tung established the People's Republic of China. The United States tried to prevent the spread of communism in Asia by intervening in the Korean War (1950–53) and in the Vietnam War (1965–73).

The United States and the Soviet Union built massive nuclear arsenals aimed at each other, effectively deterring either from attacking for fear of a devastating retaliation. The Cold War ended in the late 1980s, when the Soviet leader Mikhail Gorbachev signed a nuclear-arms reduction treaty with the United States and instituted economic and political reforms designed to foster free enterprise and democracy. The dissolution of the Soviet Union soon followed and gave rise to numerous independent republics.

While the Soviet Union and the United States vied for world leadership, the old European states gave up their empires. The British led the way by withdrawing from India in 1947. Other European nations gradually granted independence to colonies in Asia and Africa, which entered the United Nations as a Third World bloc not aligned with either side of the Cold War. Despite the efforts of the United Nations, deep-seated ethnic and religious hatreds have continued to spark violent conflicts around the world—in countries such as Pakistan, India, South Africa, Somalia, Ethiopia, Rwanda, the former Yugoslavia, and states throughout the Middle East.

The formerly communist republics' turn to capitalism increased the economic interdependence among all nations, and wealthy countries like the United States saw increasing prosperity. Third World countries also experienced economic gains, but in many cases they were offset by tremendous population growth—brought about largely by economic development and improvements in agriculture and medicine. Despite this growth in population, the world seems smaller, thanks to remarkable advances in transportation and communication, including the Internet. With enhanced global communication has come increased awareness of the many grave problems that confront us at the dawn of the twenty-first century. Pollution, soil erosion, freshwater depletion, global warming, and other depredations threaten ecosystems everywhere. Only recently have the nations of the world begun to work together to address these global problems on whose solution the future of humanity surely depends.

▲ 1968 ROBERT F. KENNEDY AND
MARTIN LUTHER KING, JR., KILLED

▲ 1990 GERMANY REUNITED
▲ 1991 USSR DISSOLVED

2000 HUMAN ▲
GENOME SEQUENCE
DECODED

THE "MAINSTREAM" CROSSES THE ATLANTIC

The United States's stature after World War II as the most powerful democratic nation was soon reflected in the arts. American artists and architects assumed leadership in artistic innovation that by the late 1950s was acknowledged across the Atlantic, even in Paris. This dominance endured until around 1970, when the belief in the existence of an identifiable mainstream, or single dominant line of artistic development, began to wane (see "The Idea of the Mainstream," page 1128).

POSTWAR EUROPEAN ART

Despite the shift of critical focus away from Europe, several European artists received worldwide attention. One, Swiss-born Alberto Giacometti (1901–66), worked as a Surrealist sculptor until, around 1935, he returned to working directly from the model. The figures he produced were the antithesis of the classical ideal: small, frail and lumpy, their surfaces rough and crude. Shown alone or in groups, as in figure 29-2, Giacometti's anonymous men and women seemed to illustrate the bleaker side of existentialism espoused by his friend philosopher Jean-Paul Sartre (1905–80), who asserted that humans wander alone and aimlessly in a meaningless universe.

Another European who drew international attention was the English painter Francis Bacon (1909–92). While working as an interior decorator, Bacon taught himself to paint in about 1930 but produced few pictures until the early 1940s, when the onset of World War II crystallized his harsh view of the world. His style draws on the **expressionist** work of Vincent van Gogh (see fig. 27-70) and Edvard Munch (see fig. 27-76), as well as on Picasso's figure paintings. His subject matter comes from a wide variety of sources, including post-Renaissance Western art. *Head Surrounded by Sides of Beef* (fig. 29-3), for example, is inspired by Diego Velázquez's *Pope Innocent X*, a solid and imperious figure that Bacon transformed into an anguished, insubstantial man howling in a black void. The feeling is reminiscent of Munch's *The Scream*, but Bacon's pope is enclosed in a claustrophobic box that contains his frightful cries. The figure's terror is magnified by the sides of beef behind him, copied from a Rembrandt painting. (Bacon said that slaughterhouses and meat brought to his mind the Crucifixion.) Bacon's pope seems to respond, then, to the realization that humanity is merely mortal flesh.

The French painter Jean Dubuffet (1901–85) developed a distinctive form of expressionism inspired by what he called *art brut* ("raw art")—the work of children and the insane—which he considered uncontaminated by culture. Like artists as diverse as Gauguin and the Surrealists, Dubuffet thought that civilization corrupts innate human sensibilities. At times he applied paint

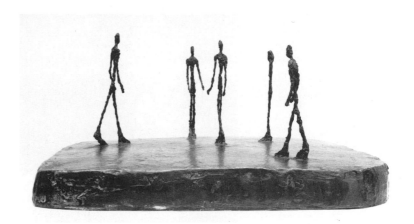

29-2. Alberto Giacometti. *City Square*. 1948. Bronze, 8¹/₂ x 25³/₈ x 17¹/₄" (21.6 x 64.5 x 43.8 cm). The Museum of Modern Art, New York
Purchase

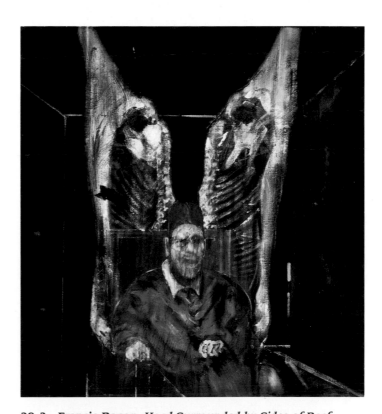

29-3. Francis Bacon. *Head Surrounded by Sides of Beef*. 1954. Oil on canvas, 50³/₄ x 48" (129 x 122 cm). The Art Institute of Chicago
Harriott A. Fox Fund

mixed with tar, sand, and mud, using his fingers and ordinary kitchen utensils, in a deliberately crude and spontaneous style that imitated *art brut*. In the early 1950s he began to mix oil paint with new, fast-drying industrial enamels, laying them over a preliminary base of still-wet oils. The result was a texture of fissures and crackles that suggests organic surfaces, like those of

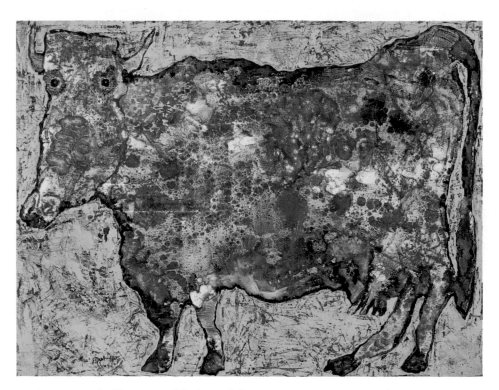

29-4. Jean Dubuffet. *Cow with the Subtile Nose*. 1954. Oil on enamel on canvas, 35 x 45³/₄" (89.7 x 117.3 cm). The Museum of Modern Art, New York

Benjamin Scharps and David Scharps Fund

THE IDEA OF THE MAINSTREAM

A central conviction of modernist artists, critics, and art historians was the existence of an artistic mainstream, the notion that some art works are more important than others—not by virtue of their aesthetic quality but because they participate in the progressive unfolding of some larger historical purpose. According to this view, the overall evolutionary pattern is what confers value, and any art that does not fit within it, regardless of its appeal, can be for the most part ignored.

Such thinking depended on two long-standing Western ideas about historical change. The first was the ancient Greek belief that history records the steady advance, or progress, of human learning and accomplishment. The second was the Judeo-Christian faith that humanity is passing through successive stages that will inevitably bring it to a final state of perfection on earth. The specifically modern notion of the mainstream arose from the reformulation of those old ideas by the Enlightenment philosopher Georg Wilhelm Friedrich Hegel (1770–1831), who argued that history is the gradual manifestation of divinity over time. It is, in other words, the process by which the divine reveals itself to us, and those who seem to shape events are only the vehicles by which the divine makes itself known. As one modern writer succinctly put it, history is "the autobiography of God." Hegel's conception of history as the record of great, impersonal forces struggling toward some transcendent end had a profound effect on succeeding generations of Western European philosophers, historians, and social theorists. Socialists in France assimilated and developed his ideas into their concept of the artistic avant-garde, a notion of artistic advance central to the rise of modernism.

The first significant discussions of what constituted the modernist mainstream emerged after World War II, shaped by the critical writings of Clement Greenberg (1909–94), whose thinking was grounded in a Hegelian concept of art's development. Greenberg argued that modern art since Édouard Manet (Chapter 27) involved the progressive disappearance of narrative, figuration, and pictorial space because art itself—regardless of what the artists may have thought they were doing—was undergoing a "process of self-purification" in reaction to a deteriorating civilization. Although members of the art world rejected Greenberg's concept of the mainstream during the Abstract Expressionist era, a powerful group of American critics and historians, the so-called Greenbergians, embraced it around 1960.

In the ensuing decades, belief in the concept of the mainstream gradually eroded, partly because of the narrow way it had been defined by Greenberg and his followers. Because their mainstream omitted so much of the history of recent art, observers began questioning whether a single, dominant mainstream had ever existed. The extraordinary proliferation of art styles and trends after the 1960s greatly contributed to those doubts, which were compounded by the decline of conviction in the concept of historical progress. Few historians today would disagree with the assessment of the art critic Thomas McEvilley: "History no longer seems to have any shape, nor does it seem any longer to be going any place in particular." Thus, the concept of the mainstream has been relegated to the status of another of modernism's myths.

29-5. Jean-Paul Riopelle. *Knight Watch*. 1953. Oil on canvas, 38 x 76'⁵/₈" (96.6 x 194.8 cm). The National Gallery of Canada, Ottawa
Purchased 1954

Cow with the Subtile Nose (fig. 29-4). Dubuffet observed that "the sight of this animal gives me an inexhaustible sense of well-being because of the atmosphere of calm and serenity it seems to generate." The animal seems completely content and focused on its "subtile" nose, which appears to twitch just slightly, perhaps at the scent of some grassy morsel.

Dubuffet's celebration of crude, basic forms of self-expression, including **graffiti**, contributed to the emergence of the most distinctive postwar European artistic approach: *art informel* ("formless art"), which was sometimes also called *tachisme* (French for "spot" or "stain"). *Art informel* was promoted by French critic Michel Tapié (1909–87), who opposed geometric formalism as the proper response to the horrors of World War II. He insisted that Dada and the two world wars had discredited all notions of humanity as reasonable, thus clearing the way for a new and more authentic concept of the species that locates the origins of human expression in the simple, honest mark.

One participant in this broad movement was the French Canadian painter Jean-Paul Riopelle (b. 1923), who settled in Paris in 1949. In his native Montreal, Riopelle had participated in the activities of *Les Automatistes* ("The Automatists"), who applied the Surrealist technique of **automatism** to the creation of abstract paintings. In the early 1950s he began to squeeze blobs of paint directly onto the canvas and then spread them with a palette knife to create an "all-over" pattern of bright color patches, suggestive of broken shards of stained glass, and often traversed, as in *Knight Watch* (fig. 29-5), by a network of spidery lines.

Another prominent exponent of *art informel* was the Spanish painter Antoni Tàpies (b. 1923), a native of Barcelona who traveled frequently to Paris in the 1950s. An important source of Tàpies's aesthetic was his fascination with "the graffiti of the street . . . a whole world of protest—

repressed, clandestine but full of life." In works such as *White with Graphism* (fig. 29-6), Tàpies did not communicate a particular message but recorded the fundamental human urge to self-expression. The white plasterlike surface (a mixture of sand and oil paint) with its crudely drawn and incised marks re-creates the look and feel of the city walls that inspired his work in this vein.

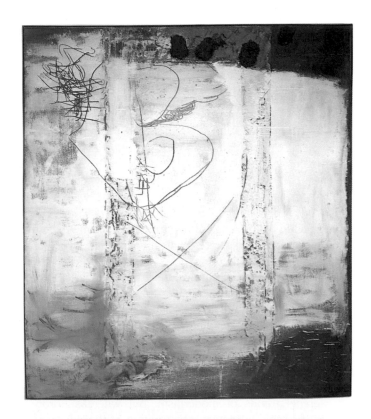

29-6. Antoni Tàpies. *White with Graphism*. 1957. Mixed mediums on canvas, 6'3⁷/₈" x 5'8³/₄" (1.93 x 1.75 m). Washington University Gallery of Art, St. Louis, Missouri
Gift of Mr. and Mrs. Richard Weil, 1963

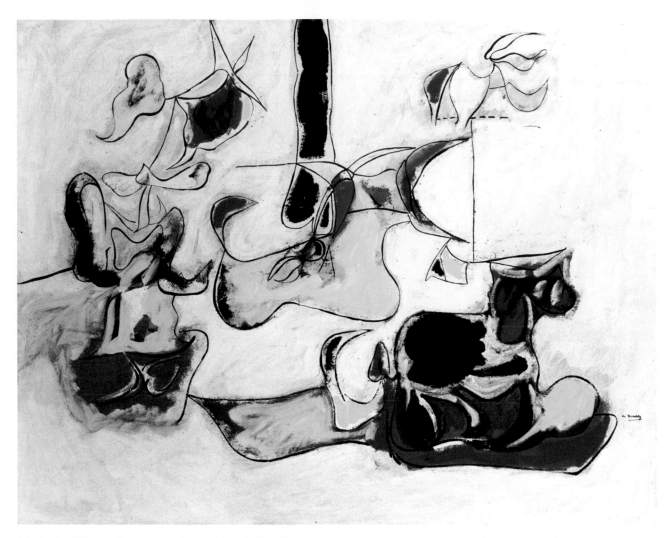

29-7. Arshile Gorky. *Garden in Sochi.* c. 1943. Oil on canvas, 31 x 39" (78.7 x 99.1 cm). The Muscum of Modern Art, New York

Acquired through the Lillie P. Bliss Bequest

Because of his commitment to Surrealism and to Ingres's linear elegance, Gorky was dubbed the Ingres of the Unconscious.

ABSTRACT EXPRESSIONISM

The rise of fascism and the outbreak of World War II led many leading European artists and writers to move to the United States. By 1940 André Breton, Salvador Dalí, Fernand Léger, Piet Mondrian, and Max Ernst were living in New York. American **abstract** artists were most deeply affected by the ideas of the Surrealists, from which they evolved Abstract Expressionism, a wide variety of work—not all of it abstract or expressionistic—produced in New York between 1940 and roughly 1960. Abstract Expressionism is also known as the New York School, a more neutral label many art historians prefer.

THE FORMATIVE PHASE

The earliest Abstract Expressionists found inspiration in Cubist formalism and Surrealist automatism, two very different strands of modernism. But whereas European Surrealists had derived their notion of the unconscious from Sigmund Freud, many of the Americans subscribed to the thinking of Swiss psychoanalyst Carl Jung (1875–1961). Jung's theory of the collective unconscious holds that beneath one's private memories lies a storehouse of feelings and symbolic associations common to all humans. Abstract Expressionists, dissatisfied with what they considered the provincialism of American art in the 1930s, sought the universal themes within themselves.

One of the first artists to bring these influences together was Arshile Gorky (1904–48), who was born in Armenia and emigrated to the United States in 1920 following Turkey's brutal eviction of its Armenian population, which caused the death of Gorky's mother. Converging in Gorky's mature work were his intense childhood memories of Armenia, which provided his primary subject matter; his interest in Surrealism; and his attraction to Jungian ideas. These factors came together in the early 1940s in three paintings inspired by Gorky's father's garden in Armenia, which Gorky called the Garden of Wish Fulfillment (fig. 29-7). In the garden was a rock upon which village women, including his mother, rubbed their bare breasts for the granting of wishes; above the rock stood a "Holy Tree" to which people tied strips of clothing. Gorky's painting includes the highly abstracted images of a bare-breasted woman at the left, a tree trunk at the upper center, and perhaps pennants of cloth at the

upper right. The out-of-scale yellow shoes below the tree may refer to a pair of slippers his father gave him. Knowledge of such autobiographical details is not necessary, however, for the fluid, **biomorphic** forms—derived from Miró (see fig. 28-66)—suggest vital life forces and signal Gorky's evocation of not only his own past but also an ancient, universal, unconscious identification with the earth. Despite their improvisational appearance, Gorky's paintings were based on detailed preparatory drawings—he wanted his paintings to touch his viewers deeply and to be formally beautiful, like the drawings of Ingres and Matisse.

Jackson Pollock (1912–56), the most famous of the Jung-influenced Abstract Expressionists, rejected this European tradition of aesthetic refinement—what he referred to as "French cooking"—for cruder, rougher formal values identified with the Wyoming frontier country of his birth. Pollock went to New York in 1930 and studied at the Art Students League with the Regionalist painter Thomas Hart Benton. Self-destructive and alcoholic, Pollock entered Jungian psychotherapy in 1939. Because Pollock was reluctant to talk about his problems, the therapist engaged him through his art, analyzing in terms of Jungian symbolism the drawings Pollock brought in each week.

The therapy had little apparent effect on Pollock's personal problems, but it greatly affected his work. He gained a new vocabulary of symbols and a belief in Jung's notion that artistic images that tap into primordial human consciousness can have a positive psychological effect on viewers, even if they do not understand the imagery. In paintings such as *Male and Female* (fig. 29-8), Pollock covered the surface of the painting with symbols he ostensibly retrieved from his unconscious through automatism. Underneath them is a firm compositional structure of strong vertical elements flanking a central rectangle—evidence, according to Pollock's therapist, of the healthy, stable adult psyche in which male and female elements are integrated. Such elements are balanced throughout the painting and within the forms suggesting two facing figures. Each figure combines soft, curving shapes suggestive of femininity with firmer, angular ones that connote masculinity. The sexual identity of both figures is therefore ambiguous; each seems to be both male and female. The painting and the two figures within it represent not only the union of Jung's anima (the female principle in the male) and animus (the male principle in the female) but also that of Pollock and his lover, Lee Krasner (1908–84), a painter (see fig. 29-11) with whom he had an intense relationship and whom he would marry in 1945.

ACTION PAINTING

In the second phase of Abstract Expressionism, which dates from the late 1940s, two different approaches to expression emerged—one based on fields of color and the other on active handling of paint. The second approach, known as action painting, or **gesturalism**, first inspired the label Abstract Expressionism. The term *action painting* was coined by art critic Harold Rosenberg

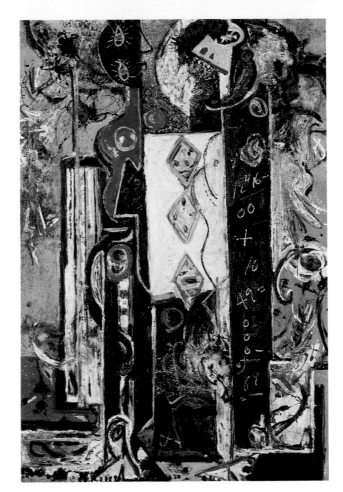

29-8. Jackson Pollock. *Male and Female*. 1942. Oil on canvas, 6'1¼" x 4'1" (1.86 x 1.24 m). Philadelphia Museum of Art

Gift of Mr. and Mrs. Gates Lloyd

The reds and yellows used here, like the diamond shapes featured at the center, were inspired by Southwestern Native American art. Native Americans, like other so-called primitive peoples, were believed to have direct access to the collective unconscious and were therefore much studied by Surrealists and early members of the New York School, including Pollock and his psychiatrist.

(1906–78) in his 1952 essay "The American Action Painters," in which he claimed: "At a certain moment the canvas began to appear to one American painter after another as an arena in which to act—rather than a space in which to reproduce, redesign, analyze, or 'express' an object, actual or imagined. What was to go on the canvas was not a picture but an event." Although he did not mention them by name, Rosenberg was referring primarily to Pollock and to Pollock's chief rival for leadership of the New York School, Willem de Kooning (1904–97).

Pollock began to replace painted images and symbols with freely applied paint as the central element of his work in the mid-1940s. After moving in 1945 to The Springs, a rural community near the tip of Long Island, New York, he created a number of rhythmic, dynamic paintings devoted to nature themes. From the fall of 1946 on he worked in a renovated barn, where he placed his canvases on the floor so that he could work on them from all four sides. Sometime in the winter of 1946–47, he also began to employ enamel house paints along with

conventional oils, dripping them onto his canvases with sticks and brushes, using a variety of fluid arm and wrist movements (fig. 29-9). As a student in 1936, he had experimented with spraying and dripping industrial paints in the New York studio of the visiting Mexican muralist David Alfaro Siqueiros. He may have been reminded of those experiments by the 1946 exhibition of small drip paintings of a self-taught painter, Janet Sobel (1894–1968), which he had seen in the company of his chief artistic adviser, the critic Clement Greenberg.

Greenberg's view that the mainstream of modern art was flowing away from representational easel painting toward mural-scale abstraction may have also influenced Pollock's formal evolution, but his shift in working method was grounded in his own continuing interests in both automatism and nature. The result over the next four years was graceful linear abstractions, such as *Autumn Rhythm (Number 30)* (fig. 29-10), in which Pollock seems to have felt that the free, unselfconscious act of painting was giving vent to primal, natural forces. Soon after he began the drip paintings, Pollock wrote: "On the floor I am more at ease [T]his way I can . . . literally be in the painting When I am in the painting I am not aware of what I am doing [T]here is pure harmony." These words suggest that while painting, Pollock took pleasure in the sense of being fully absorbed in action, which eliminated the anxiety of self-consciousness—the existential sense of estrangement between oneself and the world. Embodying this state of "harmony," the delicate skeins of paint in *Autumn Rhythm* effortlessly loop over and under one another in a mesmerizing pattern without beginning or end that spreads evenly across the surface of the canvas.

Lee Krasner, who had studied in New York with the German expatriate teacher and abstract painter Hans Hofmann (1880–1966), produced fully nonrepresentational work several years before Pollock did. After she began living with him in 1942, however, she virtually stopped painting to devote herself to the conventional role of a supportive wife. Following the couple's move to Long Island in 1945, she set up a small studio in a guest bedroom, where she produced small, tight, gestural paintings similar in

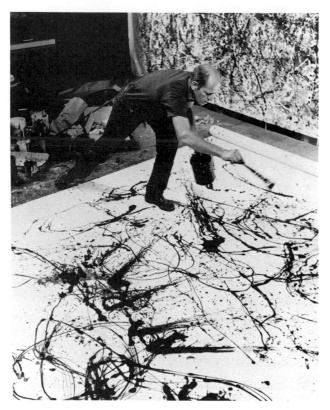

29-9. Hans Namuth. Photograph of Jackson Pollock painting, The Springs, New York. 1950

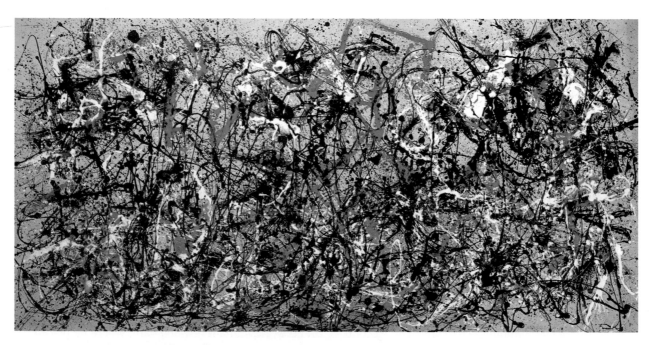

29-10. Jackson Pollock. *Autumn Rhythm (Number 30)*. 1950. Oil on canvas, 8'9" x 17'3" (2.66 x 5.25 m).
The Metropolitan Museum of Art, New York
George A. Hearn Fund, 1957 (57.92)

composition to Pollock's but lacking their sense of freedom. After Pollock's death in an automobile crash in 1956, Krasner took over his studio and produced large, dazzling gestural paintings, known as the *Earth Green* series, which marked her emergence from her husband's shadow. Works such as *The Seasons* (fig. 29-11) feature bold, sweeping curves that express not only her new sense of liberation but also her identification with the forces of nature in the bursting, rounded forms and springlike colors.

"Painting, for me, when it really 'happens' is as miraculous as any natural phenomenon," said Krasner, suggesting an attitude similar to that of Pollock, who found "pure harmony" in the act of painting. By contrast, Willem de Kooning insisted that "Art never seems to make me peaceful or pure." An immigrant from the Netherlands, de Kooning in the 1930s became friendly with several modernist painters, including Stuart Davis (see fig. 28-79) and Arshile Gorky, but resisted the shift to Jungian Surrealism. For him it was more important to record honestly and passionately his sense of the world around him, which was

never simple or certain. "I work out of doubt," he once remarked. During the 1940s he expressed his nervous uncertainty in the agitated way he handled paint itself.

After painting a series of biomorphic abstractions in the late 1940s, de Kooning shocked the art world by reintroducing figuration in paintings of women—also shocking because of the brutal way he depicted his subjects. The first, *Woman I* (fig. 29-12), took him almost two years

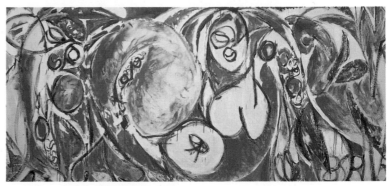

(above)
29-11. Lee Krasner. *The Seasons*. 1957. Oil on canvas, 7'8¾" x 16'11¾" (2.36 x 5.18 m). Whitney Museum of American Art, New York

Purchased with funds from Frances and Sydney Lewis (by exchange), the Mrs. Percy Uris Purchase Fund, and the Painting and Sculpture Committee

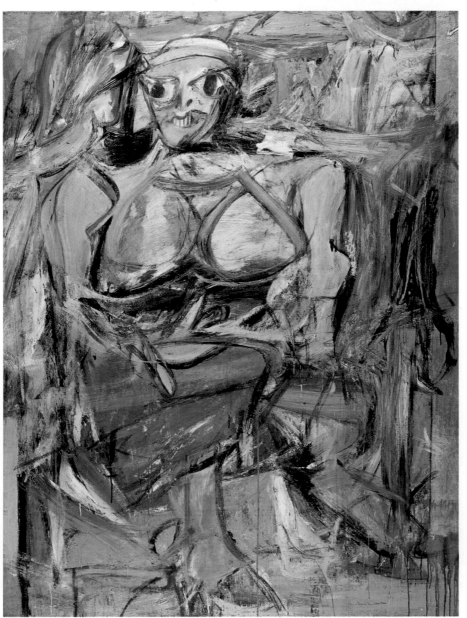

(left)
29-12. Willem de Kooning. *Woman I*. 1950–52. Oil on canvas, 6'3⅞" x 4'10" (1.93 x 1.47 m). The Museum of Modern Art, New York
Purchase

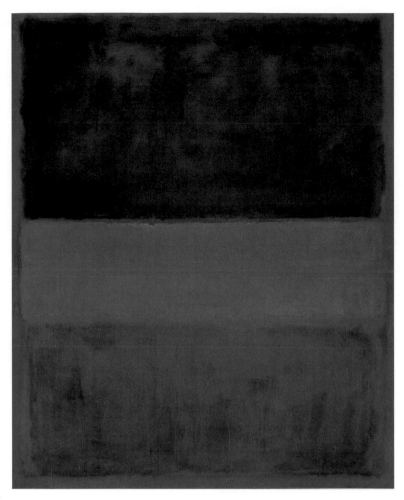

29-13. Mark Rothko. *Brown, Blue, Brown on Blue*. 1953. Oil on canvas, 9'7¾" x 7'7¼" (2.97 x 2.34 m). The Museum of Contemporary Art, Los Angeles

The Panza Collection

(1950–52) to paint. His wife, the artist Elaine de Kooning (1918–89), said that he painted it, scraped it, and repainted it at least several dozen times. Part of de Kooning's dissatisfaction stemmed from the way the images in these paintings veered away from the conventionally pretty women in advertising that inspired them. What emerged is not an elegant companion but a powerful adversary, more dangerous than alluring, a sister to Picasso's formidable *demoiselles* (see fig. 28-21). Only the bright primary colors and luscious paint surface give any hint of de Kooning's original sources, but these qualities are nearly lost in the furious slashing of the paint. Critics repeatedly questioned de Kooning's feelings toward women. "I *like* beautiful women," he explained, "in the flesh; even the models in the magazines. Women irritate me sometimes. I painted that irritation in the Woman series." But he added: "Maybe . . . I was painting the woman in *me*."

De Kooning, like Gorky, was committed to the highest level of aesthetic achievement historically set by great Western painters, and his paintings were a carefully orchestrated buildup of interwoven strokes and planes of color based largely on the example of Analytic Cubism (see figs. 28-23, 28-24, 28-25). "Liquefied Cubism" is the way one art historian described them. The deeper roots of de Kooning's work, however, lie in the coloristic tradition of artists such as Titian and Rubens, who superbly transformed flesh into paint.

COLOR FIELD PAINTING

An alternative to gestural paint handling is seen in the work of Abstract Expressionists Mark Rothko (1903–70) and Barnett Newman (1905–70), who by 1950 had evolved individual styles that relied on large rectangles of color to evoke transcendent emotional states. Because of

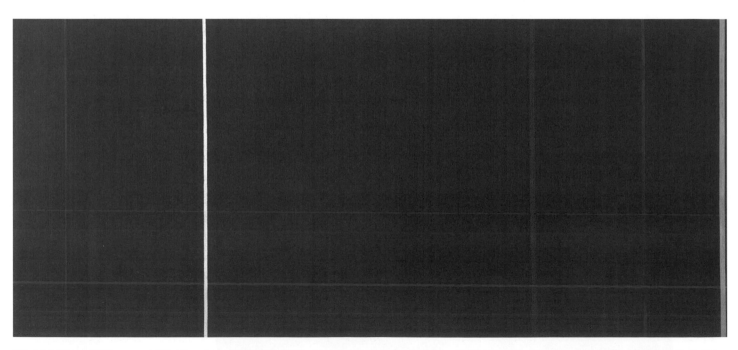

29-14. Barnett Newman. *Vir Heroicus Sublimis*. 1950–51. Oil on canvas, 7'11⅜" x 17'9¼" (2.42 x 5.41 m). The Museum of Modern Art, New York

Gift of Mr. and Mrs. Ben Heller

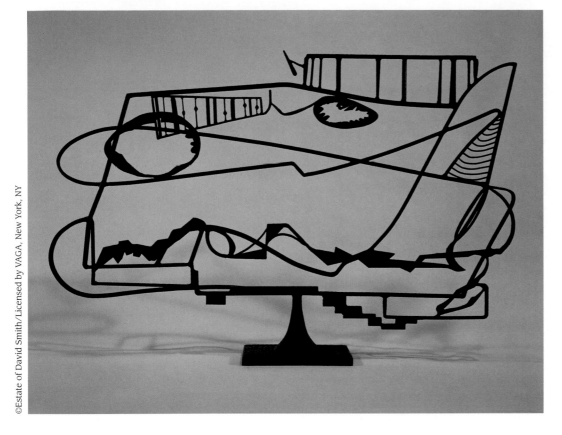

29-15. David Smith. *Hudson River Landscape*. 1951. Welded steel, 49 x 73³/₄ x 16¹/₂" (127 x 187 x 42.1 cm). Whitney Museum of American Art, New York Purchase

the formal and emotional similarities of their work, they, along with a third painter, Clyfford Still (1904–80), were soon referred to collectively as Color Field painters.

Rothko's mature paintings typically feature two to four soft-edged rectangular blocks of color hovering one above another against a monochrome ground. In works such as *Brown, Blue, Brown on Blue* (fig. 29-13) Rothko sought to harmonize into a satisfying unity the two divergent human tendencies that German philosopher Friedrich Nietzsche called the Dionysian and the Apollonian. The rich color represents the emotional, instinctual, or Dionysian element (after Dionysos, the Greek god of wine, the harvest, and inspiration), whereas the simple compositional structure is its rational, disciplined, or Apollonian counterpart (after Apollo, the Greek god of light, music, and truth). However, Rothko was convinced of Nietzsche's contention that the modern individual was "tragically divided," so his paintings are never completely unified but remain a collection of separate parts. What gives this fragmentation its particular force is that these elements offer an abstraction of the human form. In *Brown, Blue, Brown on Blue*, as elsewhere, the three blocks approximate the human division of head, torso, and legs. The vertical paintings, usually somewhat taller than the adult viewer, thus present the viewer with a kind of amplified mirror image of the divided self. The dark tonalities that Rothko increasingly featured in his work emphasize the tragic implications of this division. The best of his mature paintings maintain a tension between the harmony they seem to seek and the fragmentation they regretfully acknowledge.

Barnett Newman also developed a distinctive non-representational art to address modern humanity's existential condition, declaring his "subject matter" to be "[t]he self, terrible and constant." Newman specialized in monochrome canvases with one or more vertical lines, or "zips," dividing the surface, as in *Vir Heroicus Sublimis* (fig. 29-14), whose Latin title means "Man, Heroic and Sublime." The zips, like Rothko's rectangles, can be understood as extreme abstractions of the human figure, providing an element with which viewers can identify. Newman sought to contrast the small, finite vertical of the self with the infinite and sublime expanse of the universe, suggested by the monochromatic field that seems to extend beyond our vision. But unlike the late-eighteenth and nineteenth-century painters of the natural sublime such as Turner (see fig. 27-16), Newman meant to make the viewer feel exalted, not terrified or insignificant.

SCULPTURE OF THE NEW YORK SCHOOL

The New York School included talented and successful sculptors, the most famous of whom was David Smith (1906–65). Smith gained metalworking skills at nineteen as a welder and riveter at an automobile plant in his native Indiana. He first studied painting but turned to sculpture in the early 1930s after seeing reproductions of welded metal sculptures by Picasso and Julio González (see fig. 28-69). After World War II, Smith defied the traditional values of vertical, monolithic sculpture by welding horizontally formatted, open-form pieces that extended the tradition of "drawing in space" established by González. A fine example is *Hudson River Landscape* (fig. 29-15), whose fluent metal calligraphy, reminiscent of Pollock's poured lines of paint, was inspired by views

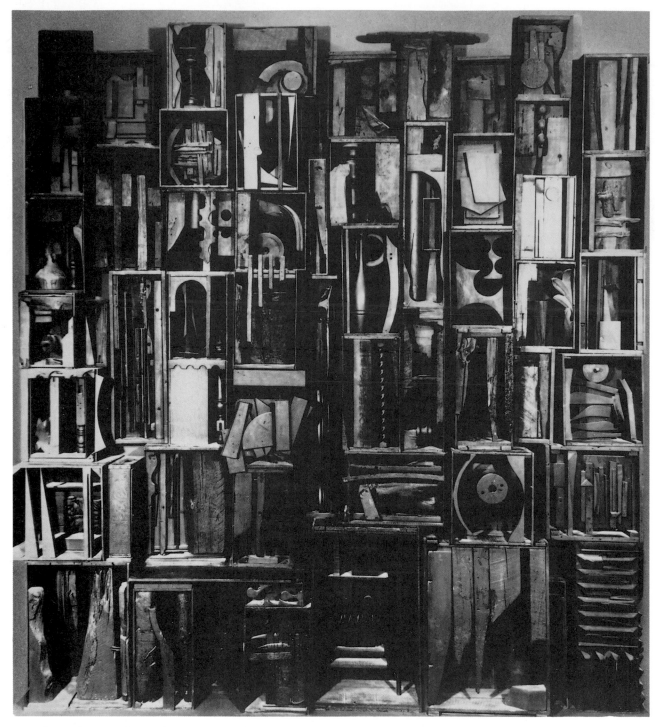

29-16. Louise Nevelson. *Sky Cathedral*. 1958. Assemblage of wood construction, painted black, 11'3½" x 10'¼" x 1'6" (3.44 x 3.05 x 0.46 m). The Museum of Modern Art, New York

from a train window of the rolling topography of upstate New York. Like many of his works from this period, the piece is meant to be seen from the front, like a painting.

During the last five years of his life, Smith turned from nature-based themes to formalism—a shift partly inspired by his "discovery" of stainless steel. Smith explored both its relative lightness and the beauty of its polished surfaces in the *Cubi* series, monumental combinations of geometric units inspired by and offering homage to the formalism of Cubism. Like the Analytic Cubist works of Braque and Picasso (see figs. 28-23, 28-24, 28-25), *Cubi XIX* (see fig. 5, Introduction) presents a finely tuned balance of elements that, though firmly

welded together, seems ready to collapse at the slightest provocation. The viewer's aesthetic pleasure depends on this tension and on the dynamic curvilinear patterns formed by the play of light over the sculpture's burnished surfaces. The *Cubi* works were meant to be seen outdoors, not only because of the effect of sunlight but also because of the way natural shapes and colors complement their inorganic ones.

While many sculptors of the New York School shared Smith's devotion to welded metal, some continued to work with more traditional materials, such as wood. Wood became the signature medium of Louise Nevelson (1899–1988), a Russian immigrant who gained intimacy

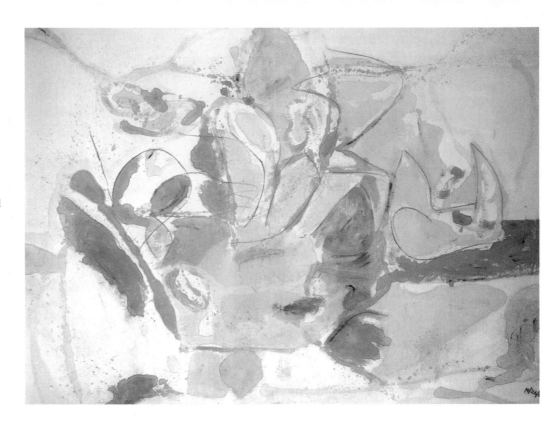

29-17. Helen Frankenthaler. *Mountains and Sea*. 1952. Oil on canvas, 7'2¾" x 9'8¼" (2.2 x 2.98 m). Collection of the artist on extended loan to the National Gallery of Art, Washington, D.C.

with the material as a child in Maine, where her father ran a lumberyard. After studying painting with Hans Hofmann, who introduced her to the formal language of Cubism, Nevelson turned to sculpture around 1940, working first in a mode reminiscent of Henry Moore (see fig. 28-70) before discovering her talent for evoking ancient ruins, monuments, and royal personages through **assemblage**, the joining together of disparate elements to construct a work of art.

Nevelson's most famous works are the wall-scale assemblages she began to produce in the late 1950s out of stacked packing boxes, which she filled with carefully and sensitively arranged Analytic Cubist–style compositions of chair legs, broom handles, cabinet doors, spindles, and other wooden refuse. She painted her assemblages a matte black to obscure the identity of the individual elements, to formally integrate them, and to provide an element of mystery. One of her first wall assemblages was *Sky Cathedral* (fig. 29-16), which Nevelson believed could transform an ordinary space into another, higher realm—just as the prosaic elements she worked with had themselves been changed. To add a further poetic dimension, Nevelson first displayed *Sky Cathedral* bathed in soft blue light, like moonlight.

THE SECOND GENERATION OF ABSTRACT EXPRESSIONISM

A second generation of Abstract Expressionists, most of whom took their lead from Pollock or de Kooning, emerged in the 1950s to produce the movement's last major phase. Among these artists were a number of women, including Joan Mitchell (1926–92), Grace Hartigan (b. 1922), and Helen Frankenthaler (b. 1928). Frankenthaler, like Pollock, worked on the floor, drawn

to what she described as Pollock's "dancelike use of arms and legs." She produced a huge canvas, *Mountains and Sea* (fig. 29-17), in this way, working from watercolor sketches she had made in Nova Scotia. Instead of using thick, full-bodied paint, as Pollock did, Frankenthaler thinned her oils and applied them in **washes** that soaked into the raw canvas, producing a watercolorlike effect. Clement Greenberg, who had introduced her to Pollock, saw in Frankenthaler's stylistic innovation a possible direction for avant-garde painting as a whole—a direction that many artists took after the waning of Abstract Expressionism at the end of the 1950s.

ALTERNATIVES TO ABSTRACT EXPRESSIONISM

In 1958–59 the Museum of Modern Art organized an exhibition of first-generation Abstract Expressionist work, "The New American Painting," which traveled to eight European capitals before its New York showing. But just when the Museum of Modern Art and many Europeans were finally acknowledging Abstract Expressionism as "the vanguard of the world," as one Spanish critic called it, the New York art world was growing increasingly skeptical about the group's right to such a title—primarily because Abstract Expressionism was no longer, in fact, new. Thus, by the end of the 1950s New York critics accused first-generation Abstract Expressionists, such as de Kooning, of faltering and dismissed the second-generation as "method actors" who faked genuine subjectivity. Amid the growing critical conviction that Abstract Expressionism had lost its innovative edge, they turned to the question of what would succeed it as the next mainstream development. A number of options quickly emerged.

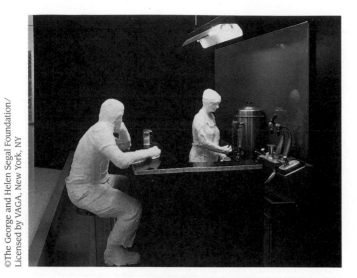

29-18. George Segal. *The Diner*. 1964–66. Plaster, wood, chrome, Formica, Masonite, fluorescent tubes, 8'6" x 9' x 7'3" (2.6 x 2.7 x 2.2 m). Walker Art Center, Minneapolis

Gift of the T. B. Walker Foundation

RETURN TO THE FIGURE

Although many American artists in the 1940s and 1950s had continued to work in a representational mode, their reputations had suffered because of the belief of critics such as Greenberg that modernist art could only advance by eliminating figuration and becoming increasingly abstract. The crisis of Abstract Expressionism, however, now freed some artists to follow their long-frustrated inclination to paint or sculpt the figure.

One participant in the revival of figurative art was the sculptor George Segal (1924–2000), who during the 1950s painted large canvases of nudes in a loose, improvisatory manner derived from action painting. He turned to sculpture in 1958, fashioning crude figures out of wood, chicken wire, burlap, and plaster—materials he was comfortable with, he said, because he had used them on his New Jersey chicken farm. In 1961 he began making casts of live models with plaster-soaked bandages. He then placed these frozen, white figures in real, three-dimensional settings, heightening the tension between artifice and reality. Drained of color and thus emotion, Segal's lonely figures, as in *The Diner* (fig. 29-18), are reminiscent of Hopper's (see fig. 28-75).

HAPPENINGS

Segal's placement of his figures in real environments reflects the influence of his friend Allan Kaprow (b. 1927), who, in turn, had been influenced by the composer and philosopher John Cage (1912–92). Opposed to the expressionist attitude typical of the New York School, Cage sought to extinguish his artistic ego by basing his work on chance and by embracing everyday experience as a source of aesthetic interest. Kaprow incorporated Cage's ideas, including the notion that art should move

toward theater, into an influential 1958 essay, "The Legacy of Jackson Pollock," his response to the emerging crisis of Abstract Expressionism. Kaprow argued that artists had two options: to continue working in Pollock's style or to give up making paintings altogether and develop the ritualistic aspects of Pollock's act of painting. He concluded that Pollock "left us at the point where we must become preoccupied with . . . the space and objects of our everyday life . . . chairs, food, electric and neon lights, smoke, water, old socks, a dog, movies . . . or a billboard selling Draino [sic]." For modernists this was a shocking statement, for these were precisely the ordinary things they aspired to transcend.

In 1958 Kaprow began to stage **Happenings**— loosely scripted, multimedia, "live" art works that took on the character of theatrical events. A particularly ambitious Kaprow Happening of the early 1960s was *The Courtyard* (fig. 29-19), staged on three consecutive nights in the skylight-covered courtyard of a run-down Greenwich Village hotel. At the center of the courtyard stood a 30-foot-high tar paper–covered "mountain." Spectators were handed brooms by two workers and invited to help clean the courtyard, which was filled with crumpled newspaper and bits of tin foil, the latter dropped from the windows above. The workers ascended ladders to dump the refuse into the top of the mountain, while a man on a bicycle rode through the crowd, ringing his handlebar bell. After a few moments, wild noises were heard from the mountain, which then erupted in an explosion of black crepe-paper balls. This was followed by a shower of dishes that broke on the courtyard floor, while noises and activity were heard from the windows above. Mattresses and cartons were lowered to the courtyard, which the workers carried to the top of the mountain and fashioned into an "altar-bed." A young woman, wearing a nightgown and carrying a transistor radio, then climbed to the top of the mountain and reclined on the mattresses. Two photographers entered, searching for the young woman. They ascended the ladder, took flash pictures of her, thanked her, and left. The happening concluded with an "inverse mountain" descending to cover the young woman.

Although Kaprow argued that Happenings lacked literary content, *The Courtyard* was for him richly symbolic—the young woman in the nightgown, for example, was the "dream girl," the "embodiment of a number of old, archetypal symbols. She is the nature goddess (Mother Nature) . . . and Aphrodite (Miss America)." Kaprow admitted that "very few of the visitors got these implications out of *The Courtyard*," but he believed that many sensed at some level "there was something like that going on."

In 1959 Kaprow learned that a Japanese group, the Gutai Bijutsu Kyokai (Concrete Art Association), had been producing **performance art** similar to what he was advocating, giving Kaprow and other artists in his circle a sense that they were participating in a truly international movement. Gutai had been formed in Osaka in 1954 by Jiro Yoshihara (1905–72), a leading prewar Japanese abstractionist, in an effort to revitalize Japanese art. Inspired by

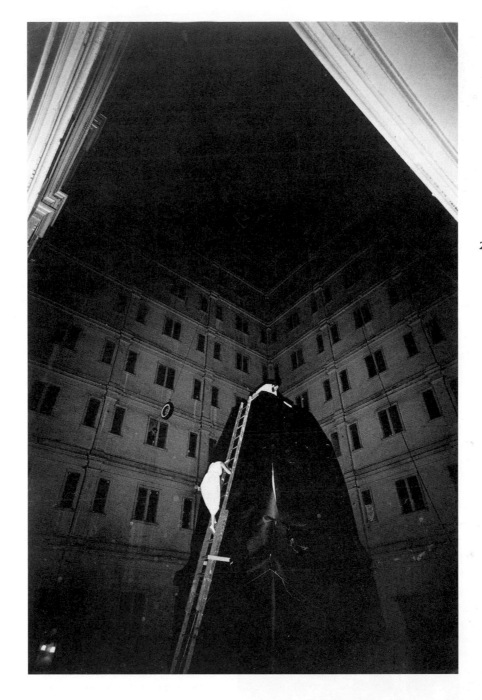

29-19. **Allan Kaprow.** *The Courtyard.* 1962. Happening at the Greenwich Hotel, New York

the rich heritage of the post–World War I Japanese Dada movement, Gutai organized outdoor installations, theatrical events, and dramatic displays of art making. At the second Gutai Exhibition, in 1956, for example, Shozo Shimamoto (b. 1928), dressed in protective clothing and eyewear, produced *Hurling Colors* (fig. 29-20) by smashing bottles of paint on a canvas laid on the floor, pushing Pollock's drip technique (see fig. 29-9) into new territory two years before Kaprow advocated doing so.

Four years later, a very different painting performance was staged in Paris by Yves Klein (1928–62), who was the leading member of the Nouveaux Réalistes ("New Realists") group that formed in 1960 around the critic Pierre Restany (b. 1930). The mystical Klein had since 1950 been making transcendent monochrome paintings of various hues, and in 1957 he turned to blue

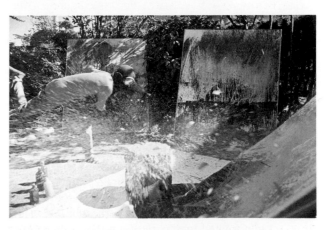

29-20. **Shozo Shimamoto.** *Hurling Colors.* 1956. Happening at the second Gutai Exhibition, Tokyo

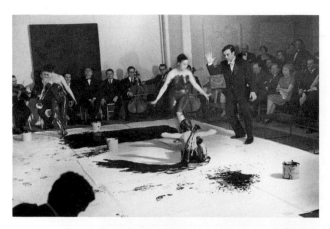

29-21. Yves Klein. *Anthropométries of the Blue Period*. 1960. Performance at the Galerie Internationale d'Art Contemporain, Paris

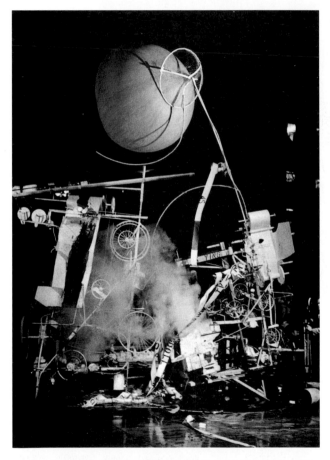

29-22. Jean Tinguely. *Homage to New York*. 1960. Self-destroying sculpture in the garden of the Museum of Modern Art, New York

alone, which he considered the most spiritual color, to free himself and the viewer from materiality and to evoke the infinite. Klein's desire to spiritualize humanity—to bring about what he called a "blue revolution"—was evident in his 1960 *Anthropométries of the Blue Period* (fig. 29-21): Klein invited members of the Paris art world to watch him direct three nude female models covered in blue paint press themselves against large sheets of paper. This attempt to spiritualize flesh was accompanied by Klein's *Monotone Symphony*—twenty minutes of a slow progression of single notes followed by twenty minutes of silence—which he considered to be the aural equivalent of the color blue.

ASSEMBLAGE

A third alternative to Abstract Expressionism was assemblage, exemplified by the kind of works that Louise Nevelson created (see fig. 29-16). In 1961 the Museum of Modern Art organized "The Art of Assemblage," whose exhibition catalog argued that assemblage was the work of artists brought up on Abstract Expressionism who sought to move beyond its tired formulas into new and unexplored terrain. Avant-garde critics were not convinced, however—partly because much of the work looked not like a new development but like a Dada revival; partly because it was mostly sculpture at a time when painting took pride of place; and partly because little of it seemed to transcend the ordinary materials from which it was composed.

Included in the exhibition was Swiss-born Jean Tinguely (1925–91), a member, like Klein, of the Nouveaux Réalistes. After producing abstract paintings, constructions of various materials, and a few edible sculptures made of grass, Tinguely moved to Paris in 1951 and gave up painting for **kinetic** sculpture, or sculpture made of moving parts. His awkward and purposely unreliable motor-driven works, which he called *métamatics*, were the very antithesis of perfectly calibrated industrial machines. Tinguely, an anarchist, wanted to free the machine, to let it play. Like his Dada forebears, he created art implicitly critical of an overly restrained and practical bourgeois mentality.

Tinguely's most famous work is *Homage to New York* (fig. 29-22), which he designed for a special one-day exhibition in the sculpture garden of the Museum of Modern Art. He assembled the work from yards of metal tubing, several dozen bicycle and baby-carriage wheels, a washing-machine drum, an upright piano, a radio, several electric fans, a noisy old Addressograph machine, a bassinet, numerous small motors, two motor-driven devices that produced abstract paintings by the yard, several bottles of chemical stinks, and various noise-makers—the whole ensemble painted white and topped by an inflated orange meteorological balloon. The machine was designed to destroy itself when activated. On the evening of March 17, 1960, before a distinguished group of guests, including New York governor Nelson A. Rockefeller, the work was plugged in. As smoke poured out of the machinery and covered the crowd, parts of the contraption broke free and scuttled off in various directions, sometimes frightening the onlookers. A device meant to douse the burning piano—which kept playing only three notes—failed to work, and firefighters had to be called in. They extinguished the blaze and finished the work's destruction—to boos from the crowd, who, except for the museum officials, had been delighted by the spectacle.

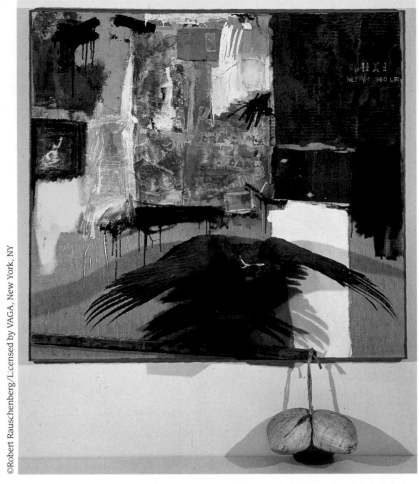

29-23. Robert Rauschenberg. *Canyon.* 1959. Combine painting: oil, pencil, paper, metal, photograph, fabric, wood on canvas, plus buttons, mirror, stuffed eagle, pillow tied with cord, and paint tube, 6'1" x 5'6" x 2'3/4" (1.85 x 1.68 x 0.63 m).
Collection Mr. and Mrs. Michael Sonnabend, on infinite loan at the Baltimore Museum of Art

A major American artist in the "Art of Assemblage" exhibition was Robert Rauschenberg (b. 1925), who in 1948 found a mentor in John Cage. Cage's interest in breaking down the barriers between art and the everyday world is reflected in Rauschenberg's statement "Painting relates to both art and life. Neither can be made. (I try to act in the gap between the two.)" Rauschenberg's desire to work in this "gap" found perfect expression in his "combines," which chaotically mix conventional artistic materials with a wide variety of ingredients gathered from the urban environment. *Canyon* (fig. 29-23), for example, features an assortment of family photographs (the boy with the upraised arm is Rauschenberg's son), public imagery (the Statue of Liberty, which echoes the boy's pose), fragments of political posters (in the middle), and various objects salvaged from trash (the flattened steel drum at upper right) or purchased (the stuffed eagle). The rich disorder challenges the viewer to make sense of it. In fact, Rauschenberg meant his work to be open to various readings, so he assembled material that each viewer might interpret differently. One could, for example, see the Statue of Liberty as a symbolic invitation to interpret the work freely. Or perhaps, covered as it is with paint applied in the manner of action painting, it symbolizes that distinctively American style. Following Cage's ideas, Rauschenberg created a work of art that was to some extent beyond his control—a work of **iconographic** as well as formal disarray. Rauschenberg cheerfully accepted the chaos and unpredictability of modern urban experience and tried to find artistic metaphors for it. "I only consider myself successful," he said, "when I do something that resembles the lack of order I sense."

Another American in "The Art of Assemblage" exhibition was Jasper Johns (b. 1930), who had come to New York from South Carolina in 1948 and met Rauschenberg six years later. Unlike Rauschenberg's works, Johns's are controlled, emotionally cool, and highly cerebral. Inspired by the example of Marcel Duchamp (see figs. 28-63, 28-64), Johns produced conceptually puzzling works that seemed to bear on issues raised in contemporary art. Art critics, for example, had praised the evenly dispersed, "nonhierarchical" quality of so much Abstract Expressionist painting, particularly Pollock's. The target

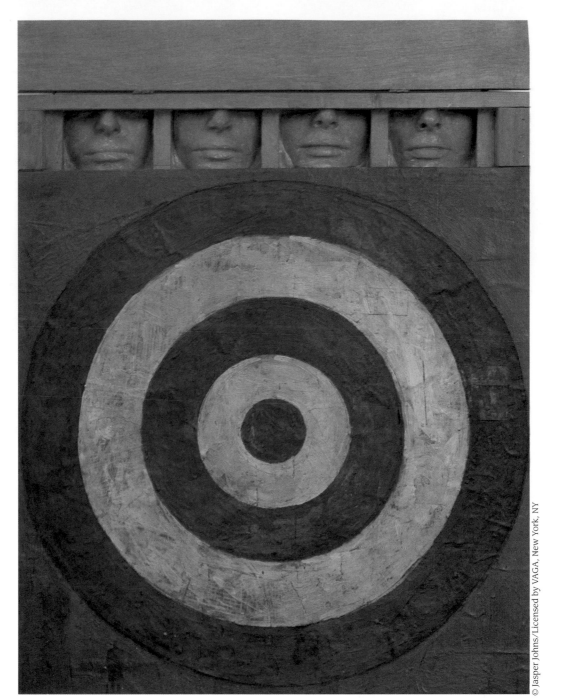

29-24. Jasper Johns. *Target with Four Faces.* 1955. Assemblage: encaustic on newspaper and cloth over canvas, surmounted by four tinted plaster faces in wood box with hinged front; overall, with box open, 33⅝ x 26 x 3" (85.3 x 66 x 7.6 cm). The Museum of Modern Art, New York

Gift of Mr. and Mrs. Robert C. Scull

in *Target with Four Faces* (fig. 29-24), an emphatically hierarchical, organized image, can be seen as a critical comment on this discourse. The image also raises thorny questions about the difference between representation and abstraction. The target, although arguably a representation, is flat, whereas two-dimensional representational art usually creates the illusion of three-dimensional space. The target therefore occupies a troubling middle ground between the two kinds of painting then struggling for dominance in American art.

Johns's works also had a psychological dimension, providing him with a way literally to cover certain personal anxieties and fears, some of which can be vaguely discerned in the **collage** materials partially buried beneath the thick **encaustic** paint. Here, for example, the outline of a lone man in a trench coat is discernible in the lower left. Johns's sense of loneliness and emptiness is perhaps also evident in the faces at the top of the work, which have been cut off at eye-level, a move that both depersonalizes them and prevents them from connecting with the viewer. Moreover, the faces are as blank and neutral as the target below. One historian suggested that Johns, as a homosexual in the homophobic climate of postwar New York, felt like a target.

Johns had a powerful effect on a number of artists who matured around 1960. The cool impersonality of his work contributed to the emerging Minimalist aesthetic, while his interest in Duchamp helped elevate that artist to a place of importance previously occupied by Picasso. Finally, Johns's conceptually intriguing use of subjects from ordinary life helped open the way for the most controversial development to emerge after Abstract Expressionism, Pop art.

POP ART

In 1961–62 several exhibitions in New York City featured art that drew on popular culture (comic books, advertisements, movies, television) for its style and subject matter

and came to be called Pop art. Many critics were alarmed by Pop, uncertain whether it was embracing or parodying popular culture and fearful that it threatened the survival of both modernist art and high culture—meaning a civilization's most sophisticated, not its most representative, products. Such fears were not entirely unfounded. The Pop artists' open acknowledgment of the powerful commercial culture contributed significantly to the eclipse, about 1970, of traditional modernism and thus, some argue, the very notion of "standards" that had kept "high culture" safely insulated from "low."

Pop art did not originate in New York but in London, in the work of the Independent Group (IG), formed in 1952 by a few members of the Institute of Contemporary Art (ICA) who resisted the institute's commitment to modernist art, design, and architecture. The IG's most prominent figures included the artists Richard Hamilton (b. 1922) and Eduardo Paolozzi (b. 1924), the architecture critic Reyner Banham (1922–88), and the art critic Lawrence Alloway (1926–90). At their first meeting Paolozzi showed slides of American ads, whose utopian vision of a future of contented people with ample leisure time to enjoy cheap and plentiful material goods was very appealing to those living amid the austerity of postwar Britain. Products of the American mass media and commercial culture—including Hollywood movies, Madison Avenue advertising, Detroit automobile styling, science fiction, and pop music—soon became the central subject matter of British Pop art such as $he (fig. 29-25), by London-born Richard Hamilton, who had once briefly worked in advertising. $he features a "cornucopic refrigerator" from an RCA Whirlpool ad, a pop-up toaster from a General Electric ad sprouting the tube of a Westinghouse vacuum cleaner, and a stylized image of a model, Vikky Dougan, who specialized in ads for backless dresses and bathing suits. Although Hamilton said he meant to counter the artistic image of women as timeless beings with the more down-to-earth picture of them presented in advertising, the somewhat mysterious result seems closer to traditional art than to the straightforward imagery of the advertisements on which it draws. In short, one of the primary imperatives of modern advertising—clarity of message—has here been sacrificed to those of avant-garde art: individuality and provocative invention.

Roy Lichtenstein (1923–97) was among the first American artists to accept the look as well as the subjects of popular culture. In 1961, while teaching at Rutgers University with Allan Kaprow, Lichtenstein began producing paintings whose imagery and style—featuring heavy black outlines, flat primary colors, and the **Benday dots** used to add tone in printing—were drawn from advertisements and cartoons. The most famous of these early works were based on panels from war and romance comic books, which Lichtenstein said he turned to for formal reasons. Although many assume that he merely copied from the comics, in fact he made numerous subtle yet important formal adjustments that tightened, clarified, and strengthened the final image. He said that the cartoonist intended to "depict" but he intended to "unify." Nevertheless, many of the paintings retain a sense of the cartoon plots they

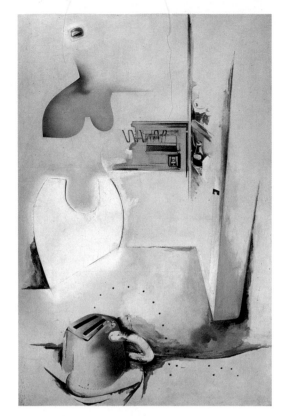

29-25. Richard Hamilton. *$he*. 1958–61. Oil, cellulose, collage on panel, 24 x 16" (61 x 40.6 cm). Tate Gallery, London

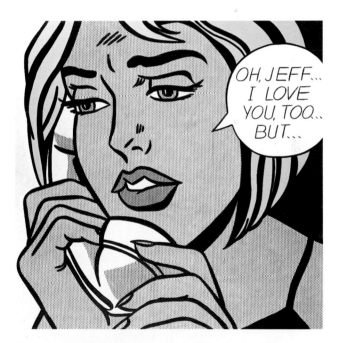

29-26. Roy Lichtenstein. *Oh, Jeff . . . I Love You, Too . . . But* 1964. Oil and Magna on canvas, 48 x 48" (122 x 122 cm)
Private collection

draw on. *Oh, Jeff . . . I Love You, Too . . . But . . .* (fig. 29-26), for example, compresses into a single frame the generic romance-comic story line, in which two people fall in love, face some sort of crisis, or "but," that temporarily threatens their relationship, then live happily ever after. Lichtenstein reminds us that this plot is only an adolescent fiction; real-life relationships like his own marriage, then in the process of dissolving, end, as here, with the "but."

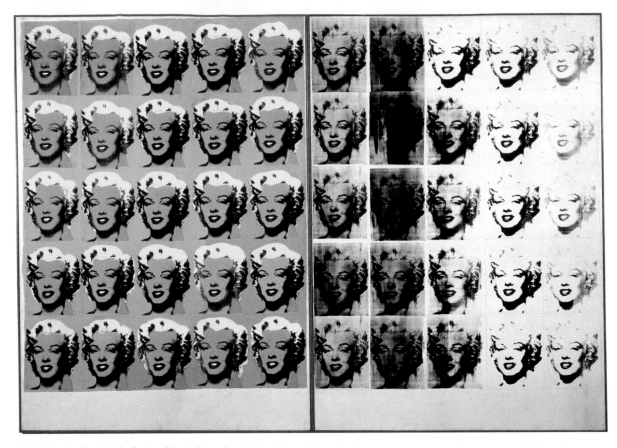

29-27. Andy Warhol. *Marilyn Diptych*. 1962. Oil, acrylic, and silk screen on enamel on canvas, 6'8⅞" x 4'9" (2.05 x 1.44 m). Tate Gallery, London

Warhol assumed that all Pop artists shared his affirmative view of ordinary culture. In his account of the beginnings of the Pop movement, he wrote: "The Pop artists did images that anybody walking down Broadway could recognize in a split second—comics, picnic tables, men's trousers, celebrities, shower curtains, refrigerators, Coke bottles—all the great modern things that the Abstract Expressionists tried so hard not to notice at all."

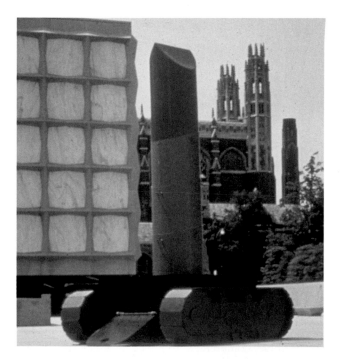

29-28. Claes Oldenburg. *Lipstick (Ascending) on Caterpillar Tracks*. 1969, reworked 1974. Installed at Beineke Plaza, Yale University, New Haven, Connecticut. Yale University Art Gallery

Gift of Colossal Keepsake Corporation

Another Pop artist who masked personal concerns behind the impersonal veneer of American popular imagery was Andy Warhol (1928–87). While extremely successful as a commercial illustrator in New York during the 1950s, Warhol decided in 1960 to pursue a career as an artist along the general lines suggested by the work of Johns and Rauschenberg. Drawing on popular and commercial culture was more than a careerist move, however; it also allowed him to celebrate the middle-class values he had absorbed growing up in Pittsburgh during the Great Depression. Such values may be discerned in the *Marilyn Diptych* (fig. 29-27), one of the first in which Warhol turned from conventional painting to the assembly-line technique of silk-screening photo-images onto canvas. The method was faster and quicker and thus more profitable, and Warhol could also produce many versions of the subject—all of which he considered good business. The subject of the work is also telling. Like many Americans, Warhol was fascinated by movie stars such as Marilyn Monroe, whose persona became even more compelling after her suicide in 1962, the event that prompted Warhol to begin painting her. The strip of pictures in this work suggests the sequential images of film, the medium that made Monroe famous. The face Warhol portrays, taken from a publicity photograph, is not that of Monroe the person but of Monroe the star, since Warhol was interested in her public mask, not in

her personality or character. He may have borrowed the **diptych** format from the **icons** of Christian saints he recalled from the Byzantine Catholic church he attended as a youth. By symbolically treating the famous actress as a saint, Warhol shed light on his own fascination with fame. Not only does fame bring wealth and transform the ordinary into the beautiful (Warhol was dissatisfied with his own looks), it also confers, as does holiness for a saint, a kind of immortality.

Swedish-born Claes Oldenburg (b. 1929) took both a more critical and a more humorous attitude toward his popular subjects than did Warhol and Lichtenstein. Oldenburg's humor—fundamental to his project to reanimate a dull, lifeless culture—is most evident in such large-scale public projects as his Lipstick Monument for his alma mater, Yale University (fig. 29-28). Oldenburg created this work at the invitation of a group of graduate students in Yale's School of Architecture, who requested a monument to the "Second American Revolution" of the late 1960s, which was marked by student demonstrations against the Vietnam War. By mounting a giant lipstick tube on tracks from a Caterpillar tractor, Oldenburg suggested a missile grounded in a tank and simultaneously subverted the warlike reference by casting the missile in the form of a feminine cosmetic with erotic overtones. Oldenburg thus urged his audience, in the vocabulary of the time, to "make love, not war." He also addressed the issue of "potency," both sexual and military, by giving the lipstick a balloonlike vinyl tip, which, after being pumped up with air, was meant to deflate slowly. (In fact, the pump was never installed and the drooping tip, vulnerable to vandalism, was soon replaced with a metal one, as seen in the illustration.) Oldenburg and the students provocatively installed the monument on a plaza fronted by the Yale War Memorial and the president's office. The university, offended by the work's irreverent humor, had Oldenburg remove it the next year. In 1974 he reworked *Lipstick (Ascending) on Caterpillar Tracks* in fiberglass, aluminum, and steel and donated it to the university, which this time accepted it for the courtyard of Morse College.

POST-PAINTERLY ABSTRACTION AND OP ART

During the 1960s, influential critic Clement Greenberg and his many followers considered post-painterly abstraction to be the legitimate heir to Abstract Expressionism and the only truly new event in the evolution of contemporary art. Greenberg coined the term *post-painterly* to describe the style that he believed had supplanted the "painterly," or gestural, abstraction of the New York School.

In 1953 Greenberg had introduced Morris Louis (1912–62), a painter from Washington, D.C., then working in a late Cubist style, to the work of Helen Frankenthaler (see fig. 29-17). Impressed with Frankenthaler's stain technique and apparently convinced by Greenberg's ideas on the inevitability of pure formalism (see "The Idea of the Mainstream," page 1128), Louis stepped "beyond" Abstract Expressionism by eliminating all extra-artistic meanings from his work. In paintings such as *Saraband*

29-29. Morris Louis. *Saraband*. 1959. Acrylic resin on canvas, 8'5¹/₈" x 12'5" (2.57 x 3.78 m). Solomon R. Guggenheim Museum, New York

(fig. 29-29) he purged not only the figural and thematic references found in the work of Frankenthaler but also the subjective, emotional connotations found in that of Pollock, de Kooning, Rothko, and Newman. Here, color does not represent emotion; it is simply color. The painting is simply a painting, not a metaphor for something beyond art. The luscious "veil" of blended colors in *Saraband*—which Louis created by tipping the canvas to allow the thinned acrylics to flow according to their inherent properties—offers pure delight to the eye.

In Canada, the leading practitioner of post-painterly abstraction was the Toronto-based Jack Bush (1909–77). He adopted the mode after a 1957 meeting with Clement Greenberg, who advised Bush to seek in his oils the pared-down effect he had achieved in his watercolors. After working with thinned down oils during the first half of the 1960s, Bush switched to acrylics in 1966, the year he painted *Tall Spread* (fig. 29-30, page 1146). In this large painting from Bush's Ladder series, a stack of color bars fills the right side of the canvas, held in place by a single brown vertical stripe at the left. While the bands of the ladder alternate in value between dark and light, Bush chose their hues not according to any systematic logic but rather intuitively. Similarly, he avoided geometric regularity by varying the width of each band and leaning its top and bottom edges slightly off the horizontal. Thus, for all its formalism, the painting retains a sense of unpredictability and a "hand-made" character that give it a deeply human quality.

Bush once characterized his art as "something to look at, just with the eye, and react." Greenbergian critics of the 1960s used the term *optical* to describe post-painterly abstractions because they appealed exclusively to the sense of sight. In the mid-1960s, the term *optical* was also applied in a different and narrower sense to a kind of nonobjective art that used precisely structured patterns of lines and colors to affect visual perception and, often, to create illusions of motion. Optical art, popularly known as Op art, achieved its greatest notoriety in the United States when it was featured in "The Responsive Eye," an international survey of "perceptual abstraction" staged in 1965 at the Museum of Modern Art in New York. Among the Op paintings included was *Current*

(fig. 29-31), by the English painter Bridget Riley (b. 1931). During the early 1960s Riley worked exclusively in black and white, using simple motifs such as squares, triangles, and circles, which she distorted and arranged in patterns that produced effects of fluctuating motion. In other paintings, such as *Current*, she used tightly spaced, parallel, curved lines, creating a swimming or billowing sensation. As with many Op works, staring at the pattern may produce discomfort.

MINIMALISM AND POST-MINIMALISM

In its emphasis on hard-edged geometry, Op art bore a formal relationship to Minimalism, which emerged in the mid-1960s as the dominant mode of abstraction in New York. Following Clement Greenberg's theory of modernism, Minimalists sought to purge their art of everything that was not essential to art. They banished subjective gestures and personal feelings; negated representation, narrative, and metaphor; and focused exclusively on the art work as a physical fact. They employed simple geometric forms with plain, unadorned surfaces and often used industrial techniques and materials to achieve an effect of complete impersonality.

The painter Frank Stella (b. 1936) inaugurated the Minimalist movement in the late 1950s through a series of large "Black Paintings," whose flat, symmetrical black enamel stripes, laid down on bare canvas with a house painter's brush, rejected the varied colors, spatial depth, asymmetrical compositions, and impulsive brushwork of gestural painters like de Kooning. In 1960 Stella created a series of "Aluminum Paintings," using a metallic paint normally applied to radiators. He chose this paint because it "had a quality of repelling the eye" and created an even flatter, more abstract effect than had the "soft" black enamel. While the Black Paintings featured straight bands that either echoed the edges of the rectangular canvas or cut across them on the diagonal, in the Aluminum Paintings, such as *Avicenna* (fig. 29-32), Stella arrived at a more consistent fit between the shape of the support and the stripes painted on it by cutting notches

29-30. Jack Bush. *Tall Spread*. 1966. Acrylic on canvas, 106 x 50" (271 x 127 cm). The National Gallery of Canada, Ottawa
Purchase, 1966

29-31. Bridget Riley. *Current*. 1964. Synthetic polymer on board, 58³⁄₈" x 58⁷⁄₈" (148 x 149 cm). The Museum of Modern Art, New York
Philip Johnson Fund

While the American popular media loved Op art, most avant-garde critics detested it. Lucy Lippard, for example, called it "an art of little substance," depending "on purely technical knowledge of color and design theory which, when combined with a conventional geometric . . . framework, results in jazzily respectable jumping surfaces, and nothing more." For Lippard and like-minded New York critics, Op was too involved with investigating the processes of perception to qualify as serious art.

29-32. Frank Stella. *Avicenna*. 1960. Aluminum paint on canvas, 6'2½" x 6' (1.91 x 1.85 m). The Menil Collection, Houston

out of the corners and the center of the canvas and making the stripes "jog" in response to these irregularities.

In these and subsequent series, Stella continuously developed the possibilities of the shaped canvas. He used thick stretchers (the pieces of wood on which canvas is stretched) to give his works the appearance of slablike objects, which his friend Donald Judd (1928–94) recognized as suggesting sculpture. By the mid-1960s Judd, trained as a painter, had decided that sculpture offered a better medium for creating the kind of pure, matter-of-fact art that he and Stella both sought. Rather than *depicting* shapes, as Stella did—which Judd thought still smacked of illusionism—Judd created *actual* shapes. In search of maximum simplicity and clarity, he evolved a formal vocabulary featuring identical rectangular units arranged in rows and constructed of industrial materials, especially anodized aluminum, stainless steel, and Plexiglas. *Untitled* (fig. 29-33) is a typical example of his mature work, which the artist did not make by hand but had fabricated according to his specifications. He faced the boxes with transparent Plexiglas to avoid any uncertainty about what might be inside. He arranged them in evenly spaced rows—the most impersonal way to integrate them—and avoided sets of two or three because of their potential to be read as representative of something other than a row of boxes. Judd provided the viewer with a set of clear, self-contained facts, setting the conceptual clarity and physical perfection of his art against the messy complexity of the real world.

Such messy complexity is exactly what the Post-Minimalists of the late 1960s allowed back into their art. While these artists retained the Minimalists' commitment

29-33. Donald Judd. *Untitled*. 1969. Anodized aluminum and blue Plexiglas, each 3'11½" x 4'11⅞" x 4'11⅞" (1.2 x 1.5 x 1.5 m); overall 3'11½" x 4'11⅞" x 23'8½" (1.2 x 1.5 x 7.2 m). The St. Louis Art Museum, St. Louis, Missouri
Purchase funds given by the Shoenberg Foundation, Inc.

to abstraction, they replaced the impersonal and timeless geometry of Minimalism with irregular forms that often suggested narrative or metaphorical content. And while the Minimalists favored hard, industrial materials, the Post-Minimalists often employed soft, flexible materials such as felt, string, latex, and rubber.

A leading Post-Minimalist was Eva Hesse (1936–70), whose brief career was cut tragically short by her death from a brain tumor at the age of thirty-four. Born in Hamburg to German Jewish parents, Hesse narrowly escaped the Nazi Holocaust by emigrating with her family to New

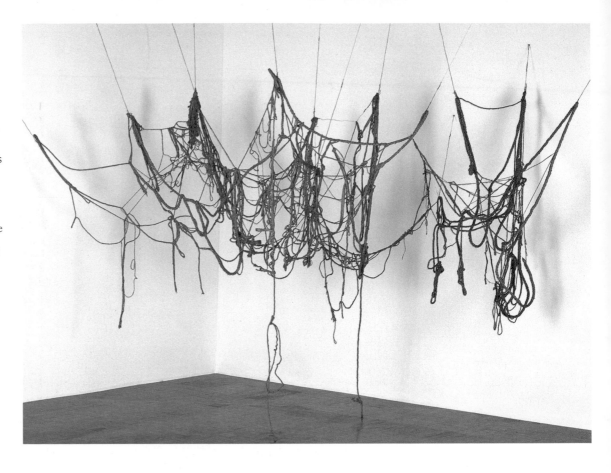

29-34. Eva Hesse. *Rope Piece*. 1970. Latex over rope, string and wire; two strands, dimensions variable. Whitney Museum of American Art, New York

Purchase, with funds from Eli and Edythe L. Broad, the Mrs. Percy Uris Purchase Fund, and the Painting and Sculpture Committee

York City in 1939. After graduating from the Yale School of Art in 1959, she painted darkly expressionistic self-portraits that reflected the emotional turbulence of her life. In 1964 she began to make nonobjective sculpture that adapted the vocabulary of Minimalism to a similarly self-expressive purpose. "For me . . .," said Hesse, "art and life are inseparable. If I can name the content . . . it's the total absurdity of life." In aesthetic terms, the "absurdity" that Hesse pursued in her last works was the complete denial of fixed form and scale, so vital to Minimalists like Judd. Her *Rope Piece* (fig. 29-34), for example, takes on a different shape and different dimensions each time it is installed. The work consists of several sections of rope, which Hesse and her assistant dipped in latex, knotted and tangled, and then hung from wires attached to the ceiling. The resulting linear web extends into new territory the tradition of "drawing in space" inaugurated by Julio González (see fig. 28-69) and advanced by David Smith (see fig. 29-15). Much more than a welded sculpture, Hesse's *Rope Piece* resembles a three-dimensional version of a poured painting by Jackson Pollock, and, like Pollock's work, it achieves a sense of structure despite its chaotic appearance.

CONCEPTUAL AND PERFORMANCE ART

While Hesse and other Post-Minimalists made art works whose mutability challenged the idea of the art object as static and durable, the artists who came to be known as Conceptualists pushed Minimalism to its logical extreme by eliminating the art object itself. Although the Conceptualists always produced something physical, it was often only a printed statement, a set of directions, or a documentary photograph. This shift away from the aesthetic object toward the pure idea was largely inspired by the growing reputation of Marcel Duchamp and his assertion that making art should be a mental, not a physical, activity. Deemphasizing the art object also kept art from becoming simply another luxury item, a concern raised by the booming market for contemporary art that rose during the 1960s.

The most prominent American Conceptual artist, Joseph Kosuth (b. 1945), abandoned painting in 1965 and began to work with language, under the influence of Duchamp and the linguistic philosopher Ludwig

29-35. Joseph Kosuth. *One and Three Chairs*. 1965. Wood folding chair, photograph of chair, and photographic enlargement of dictionary definition of chair; chair, 32³⁄₈ x 14⁷⁄₈ x 20⁷⁄₈" (82.2 x 37.8 x 53 cm); photo panel, 36 x 24¹⁄₈" (91.4 x 61.3 cm); text panel 24¹⁄₈ x 24¹⁄₂" (61.3 x 62.2 cm). The Museum of Modern Art, New York

Larry Aldrich Foundation Fund

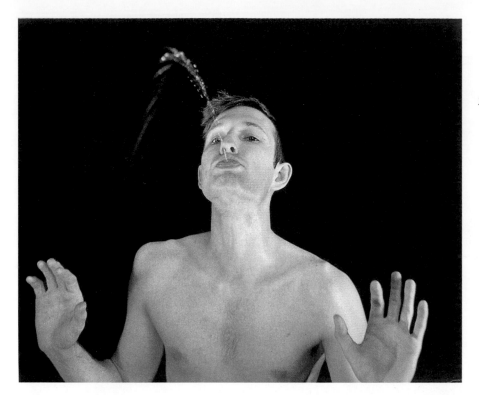

29-36. Bruce Nauman. *Self-Portrait as a Fountain*. 1966–7. Color photograph, 19¾ x 23¾" (50.1 x 60.3 cm).

Courtesy Leo Castelli Gallery, New York

Regarding his works of the later 1960s, Nauman observed, "I was using my body as a piece of material and manipulating it. I think of it as going into the studio and being involved in some activity. Sometimes it works out that the activity involves making something, and sometimes the activity itself is the piece."

Wittgenstein (1889–1951). Kosuth believed that the use of language would direct art away from aesthetic concerns and toward philosophical speculation. His *One and Three Chairs* (fig. 29-35) invites such speculation by presenting an actual chair, a full-scale black-and-white photograph of the same chair, and a dictionary definition of the word *chair*. The work thus leads the viewer from the physical chair to the purely linguistic ideal of "chairness" and invites the question of which is the most "real."

Many Conceptual artists used their bodies as an artistic medium and engaged in simple activities or performances that they considered works of art. Use of the body offered another alternative to object-oriented mediums like painting and sculpture, and it produced no salable art work unless the artist's activity was recorded on film or video. One artist who used his body as an artistic medium in the late 1960s was the California-based Bruce Nauman (b. 1941). In 1966–67 he made a series of eleven color photographs based on wordplay and visual puns. In *Self-Portrait as a Fountain* (fig. 29-36), for example, the bare-chested artist tips his head back, spurts water into the air, and, in the spirit of Duchamp, designates himself a work of art.

As we have already seen in the case of Yves Klein (see fig. 29-21) and Jannis Kounellis (see fig. 29-1), European artists of the period also engaged in conceptual and performance art. Among the most influential of them was the German Joseph Beuys (1921–86), who dedicated his highly unconventional art to promoting social change. A Nazi fighter pilot during World War II, Beuys was shot down over the Soviet Union in 1943 and was saved by nomadic Tatars, who, according to Beuys, saved him by wrapping him in fat and animal-hair felt to preserve his body warmth. Later, Beuys elaborated his rescue into a personal mythology of rebirth, which became central to his art. In 1962 Beuys joined Fluxus, an international movement founded largely by experimental musicians who, in the spirit of John Cage, advocated performance art as a

means of eliminating the barriers between art and life. From this point forward, Beuys produced performance art, or "actions," that communicated his concern with healing and rebirth. For his 1974 action *Coyote: I Like America and America Likes Me* (fig. 29-37), Beuys landed in New York, was wrapped in felt, and was taken by ambulance to a Manhattan gallery, part of which was cordoned off with industrial chain-link fencing. Inside was a live coyote, a symbol for Beuys of the Native American people traumatized by the European appropriation of their lands and of the American wilderness threatened with extinction by modern industrial society. For seven days Beuys and the coyote lived together. Beuys, wrapped in a felt tent from which a shepherd's crook protruded, silently followed the animal around, sometimes mimicking it. Beuys saw felt as a regenerative natural material, one capable of healing the sick. The crook is the Tatar shaman's symbol. The artist thus presented himself as the shaman, come to help save the native peoples and wildlife of the United States and in this way heal a sick nation.

29-37. Joseph Beuys. *Coyote: I Like America and America Likes Me*. 1974. Weeklong action staged in the René Block Gallery, New York

Courtesy Ronald Feldman Fine Arts, New York

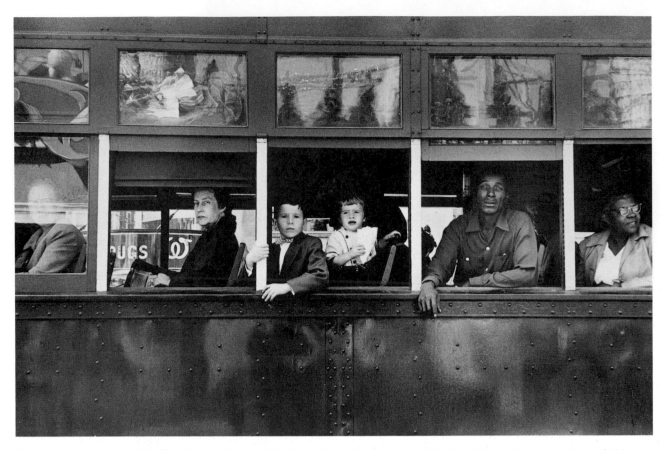

29-38. Robert Frank. *Trolley, New Orleans*. 1955–56. Gelatin-silver print, 9 x 13" (23 x 33 cm). The Art Institute of Chicago

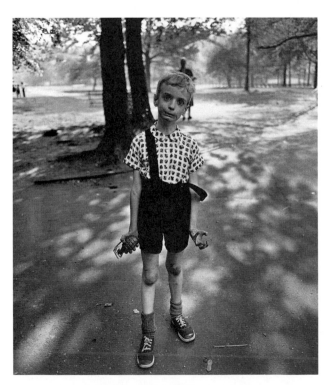

29-39. Diane Arbus. *Child with Toy Hand Grenade, New York*. 1962. Gelatin-silver print, 8¼ x 7¼" (21 x 18.4 cm). The Museum of Modern Art, New York
Purchase

POSTWAR AMERICAN PHOTOGRAPHY

Documentary photography, which flourished under New Deal patronage in the 1930s (see fig. 28-74), went into eclipse following the withdrawal of government support during World War II. Meanwhile, photojournalism, which burgeoned in the 1930s with the appearance of large-format picture magazines such as *Life*, grew in importance during the postwar decades. Fashion periodicals such as *Vogue* and *Harper's Bazaar* also provided work for professional photographers and stimulated the development of color photography.

Many photographers took on commercial assignments to earn a living while producing independent work more expressive of their personal concerns and aesthetic interests. An important noncommercial trend that emerged in the 1950s was a new form of documentary photography that rejected traditional aesthetic standards to survey in a raw and unsentimental manner what one writer called the "social landscape." The founder of this mode was the Swiss-born American photographer Robert Frank (b. 1924). Frustrated by the pressure and banality of news and fashion assignments, Frank applied successfully for a Guggenheim Fellowship in 1955 to finance a yearlong photographic tour of the United States. From more than 28,000 images, he selected 83 for a book published first in France as *Les Américains* in 1958 and a year later in an English-language edition as *The Americans*, with an introduction by the Beat writer Jack Kerouac (1922–69).

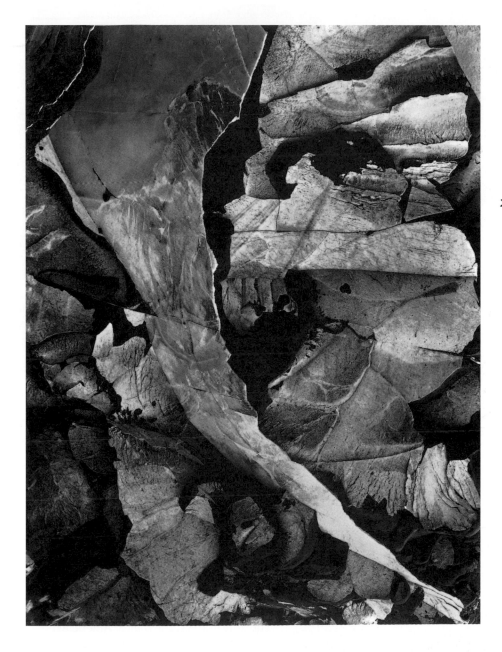

The book was poorly received by American critics, who were disturbed by Frank's often haphazard style. Frank, however, was capable of producing classically balanced and sharply focused images, but only when it suited his sense of the truth. The perfect symmetry of *Trolley, New Orleans* (fig. 29-38), for example, ironically underscores the racial prejudice of segregation that it documents. White passengers sit in the front of the trolley, African Americans in the back. At the same time, the rectangular frames of the trolley windows isolate the individuals looking through them, evoking a sense of urban alienation.

In her complete preoccupation with subject matter, Diane Arbus (1923–71), even more than Frank, rejected the concept of the elegant photograph, discarding the niceties of conventional art photography (fig. 29-39). She developed this approach partly in reaction to her experience as a fashion photographer during the 1950s—she and her husband, Allan Arbus, had been *Seventeen* magazine's favorite cover photographers—but mostly because she did not want formal concerns to distract viewers from her compelling, often disturbing subjects.

Other postwar American photographers remained largely aloof from the "social landscape" and continued the modernist tradition, taking "straight" photographs of natural and human-made subjects that possessed powerfully abstract qualities when translated into cropped, flattened, black-and-white images. A leading practitioner of this mode was Minor White (1908–76), whose aesthetically beautiful photographs were also meant to be forms of mystical expression, vehicles of self-discovery and spiritual enlightenment. Using a large-format camera, White focused sharply on weathered rocks (fig. 29-40), swirling waves, frosted windowpanes, peeling paint, and similar "found" subjects that, as enigmatic photographic images, can induce in the viewer a meditative state.

White's student Jerry N. Uelsmann (b. 1934) departed from his teacher's commitment to straight photography by creating composite images through the combination of several negatives, a practice initiated in the mid-nineteenth

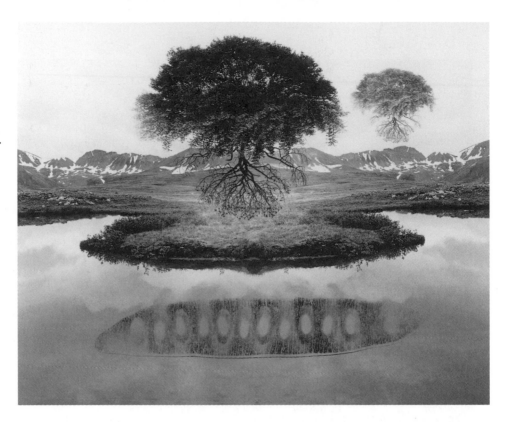

29-41. **Jerry N. Uelsmann.** *Untitled*. 1969. Gelatin-silver print. The Art Institute of Chicago

Restricted gift of the People's Gallery (1971.558)

century by photographic artists like Oscar Rejlander (see fig. 27-32). Uelsmann used sophisticated darkroom techniques to fuse disparate, incongruous images into a seamless, surreal whole that appears to be an objective record of the absurd (fig. 29-41).

THE RISE OF AMERICAN CRAFT ART

Since the Renaissance, Western critics and art historians have generally maintained a distinction between the so-called high or fine arts—architecture, sculpture, painting, the graphic arts, and, more recently, photography—and the so-called minor or decorative arts—such as pottery,

29-42. **Peter Voulkos.** *Untitled Plate*. 1962. Gas-fired stoneware with glaze, diameter 16¼" (41.3 cm). The Oakland Museum

Gift of the Art Guild of The Oakland Museum Association (62.87.4)

textiles, glassware, metalwork, furniture, and jewelry, which typically serve either a practical or an ornamental function. In the postwar decades, however, a number of artists began to push traditional craft mediums such as clay, fiber, glass, metal, and wood in new directions and to create new forms of expression that blurred the conventional distinctions between fine and decorative art, establishing a mode somewhere between the two that might best be called craft art.

A major innovator in the clay medium was the Montana-born Peter Voulkos (b. 1924), who after working briefly as a production potter came under the influence of de Kooning and other gestural painters on a visit to New York City in 1953. The radical American break from European and Asian traditions—sometimes called the "clay revolution"—began with the ruggedly sculptural ceramic works Voulkos produced in the mid-1950s, which resembled traditional pottery only in their retention of the basic form of a hollow container. By the late 1950s Voulkos had abandoned the pot form and was making large ceramic works spontaneously assembled from numerous wheel-thrown and slab-built elements, their surfaces often covered with bright, gesturally applied glazes or epoxy paint. In the early 1960s, Voulkos returned to traditional ceramic forms such as dishes (fig. 29-42), buckets, and vases but rendered them nonfunctional by tearing, gouging, and piercing them in the gestural fashion derived from Abstract Expressionism. Voulkos made many of these works, including the one illustrated here, at the workshop-demonstrations he gave throughout the country, where, much like a jazz musician, he worked improvisationally before an audience.

Despite resistance from conservative potters, the clay revolution spread rapidly across university art departments in the early 1960s. A comparable revolution in glass was initiated by Harvey Littleton (b. 1922), a

29-43. Harvey Littleton. *Implosion/Explosion*. 1964. Blown glass, height 7½" (19.2 cm). The Toledo Museum of Art, Ohio

Gift of Maurine B. Littleton and Carol Shay (1992.36)

In 1963, Littleton established the nation's first hot-glass studio program at the University of Wisconsin, and other glass programs soon sprang up around the country. Many of them were led by Littleton's former students, including Dale Chihuly (see fig. 16, Introduction), who established the famous Pilchuck Glass School in Seattle in 1971.

ceramics professor at the University of Wisconsin who turned to glassblowing in the 1960s. Paralleling the move that Voulkos had made in clay, Littleton abandoned the production of traditional, functional vessels for experimentation with nonfunctional, sculptural forms like *Implosion/Explosion* (fig. 29-43). Here Littleton violated the customarily painstaking discipline of glassblowing, smashing the blown-glass bubble and then reheating it to force the walls of the piece to bend outward while appearing to cave in. As with the gesturally handled clay-works of Voulkos, the expressionistic look of Littleton's glass piece bears comparison to the work of the New York School action painters.

A leading American innovator in the textile medium during this period was Lenore Tawney (b. 1907), who, like Voulkos and Littleton, willingly broke the traditional rules of her craft when she found them too confining. Starting in the early 1960s, Tawney rejected the traditional rectangular tapestry format by making shaped weavings (fig. 29-44), in which the strands of the **warp** are not parallel but angled or curved. Her use of an open, gauze-weave technique derived from Peruvian textiles gave her forms a sense of volume, while her invention of a special reed for the loom enabled her to vary the shape of the work as she wove it. With a series of elegantly tall and austerely beautiful tapestries that she called woven forms, Tawney transformed the surface-oriented medium of weaving into a three-dimensional art form and declared, "It is sculptural."

FROM MODERNISM TO POSTMODERNISM

The 1960s were a watershed period in the history of modern art. Outside of the work of Beuys, Kounellis, and a few other socially engaged avant-garde artists, little of the earlier modernist faith in the transformative power of art is evident in the works produced during the decade. Although the Minimalists continued to believe that the history of art had a coherent, progressive shape and that art represented a pure realm outside ordinary "bourgeois" culture, the purity, honesty, and clarity of their art were not meant to change the world but to retreat from it. To the next generation, by contrast, the concepts of artistic purity and the mainstream seemed naive. In fact, the generation that came to maturity around 1970 had little faith in either purity or progress. The optimism that had characterized the beginning of the modernist era and had survived both world wars gave way to a growing uncertainty about the future and about art's power to influence it. The decline of modernism in the arts was neither uniform nor sudden. Its gradual erosion occurred over a long period and was the result of many individual transformations. The many approaches to art that have emerged from the ruins of modernism are designated by the catchall term *postmodernism*.

29-44. Lenore Tawney. *Black Woven Form (Fountain)*. 1966. Linen, 8'7" x 1'3¼" (2.62 x 0.39 m). American Craft Museum, New York

29-45. **Ludwig Mies van der Rohe and Philip Johnson. Seagram Building, New York City**. 1954–58

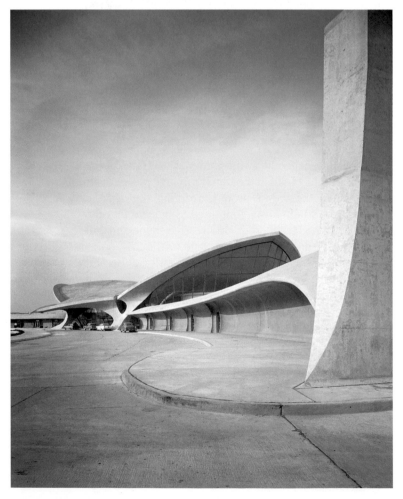

29-46. **Eero Saarinen. Trans World Airlines Terminal, John F. Kennedy Airport, New York**. 1956–63

ARCHITECTURE

As in painting and sculpture, modernism endured in architecture until about 1970. The stripped-down International Style pioneered by such architects as Walter Gropius (see figs. 28-43, 28-58) and Le Corbusier (see fig. 28-55) dominated new urban construction in much of the world after World War II. Many of the most famous examples of International Style architecture were built in the United States by German architects, such as Gropius and Mies van der Rohe, who during the Nazi era assumed prestigious positions at American schools of architecture.

Whether designing schools, apartments, or office buildings, Mies used the same simple, rectilinear industrial vocabulary. The differences among his buildings are to be found in their details. Because he had a large budget for the Seagram Building in New York City (fig. 29-45), for instance, he used custom-made bronze (instead of standardized steel) beams on the exterior, an example of his love of elegant materials. Mies would have preferred to leave the steel structural supports visible, but building codes required him to encase them in concrete. The ornamental beams on the outside thus stand in for the functional beams inside, much as the shapes on the surface of a Stella painting refer to the structural frame that holds the canvas (see fig. 29-32).

The dark glass and bronze were meant to give the Seagram Company a discreet and dignified image. The building's clean lines and crisp design seemed to epitomize the efficiency, standardization, and impersonality that had become synonymous with the modern corporation itself—which, in part, is why this particular style dominated corporate architecture after World War II. Such buildings were also economical to build. Mies believed that the industrial preoccupation with streamlined efficiency was the dominant value of the day and that the only legitimate architecture was one that expressed this modern spirit.

While Mies's pared-down, rectilinear idiom dominated skyscraper architecture well into the 1970s, other building types invited more adventuresome modernist designs that departed significantly from the principles of the International Style. A trend toward powerfully expressive, organic forms, for example, characterized the architecture of numerous buildings dedicated to religious or cultural functions. Expressionist designs sometimes appeared also in commercial architecture, as in the remarkable Trans World Airlines (TWA) Terminal at Idlewild (now John F. Kennedy) Airport in New York City, by the Finnish-born American architect Eero Saarinen (1910–61). Seeking to evoke the excitement of air travel, Saarinen gave his building dynamically flowing interior spaces and covered it with two broad, winglike canopies of reinforced concrete that suggest a huge bird about to take flight (fig. 29-46).

Modernist architects of the post–World War II decades also sought fresh solutions to the persistent challenge of urban housing, which had engaged pioneers of the International Style such as Le Corbusier. The desire for economy led to an interest in the use of standard,

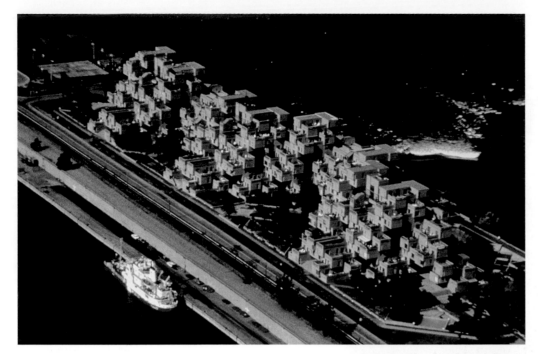

prefabricated elements for the construction of both individual houses and larger residential complexes. An innovative example of the latter is Habitat '67 (fig. 29-47) by the Israeli-born Canadian Moshe Safdie (b. 1938). Built as a permanent exhibit for the 1967 World Exposition in Montreal, the complex consists of three stepped clusters of prefabricated concrete units attached to a zigzagging concrete frame that provides a series of elevated streets and sheltered courtyards. By stacking units that contained their own support system, Safdie eliminated the need for an external skeletal frame and allowed for expansion of the complex simply through the addition of more units. An inspired alternative to the conventional high-rise apartment block, Habitat '67 offers greater visual and spatial variety, increased light and air to individual apartments, and a sense of community not often found in a big city housing project.

Postmodern Architecture. Historians trace the origin of postmodernism in architecture to the work of the Philadelphian Robert Venturi (b. 1925) and his associates, who rejected the abstract purity of the International Style by incorporating into their designs elements drawn from vernacular (meaning popular, common, or ordinary) sources. Parodying Mies van der Rohe's famous aphorism "Less is more," Venturi claimed "Less is a bore" in his pioneering 1966 book, *Complexity and Contradiction in Architecture*. The problem with Mies and the other modernists, he argued, was their impractical unwillingness to accept the modern city for what it is: a complex, contradictory, and heterogeneous collection of "high" and "low" architectural forms.

While writing *Complexity and Contradiction in Architecture*, Venturi designed a house for his mother (fig. 29-48) that illustrated many of his new ideas. The building is both simple and complex. The shape of the facade returns to the archetypal "house" shape—evident in children's drawings—that modernists from Rietveld to Safdie had rejected (see fig. 28-50). Its vocabulary of triangles, squares, and circles is also elementary, although

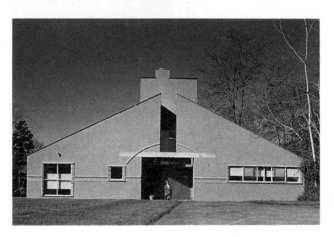

29-48. Robert Venturi. Vanna Venturi House, Chestnut Hill, Pennsylvania. 1961–64

29-49. Ground-floor plan of the Vanna Venturi House

the shapes are arranged in a complex asymmetry that skews the restful harmonies of modernist design. The most disruptive element of the facade is the deep cleavage over the door, which opens to reveal a mysterious upper wall (which turns out to be a penthouse) and chimney top. On the inside, too, complexity and contradiction reign (fig. 29-49). The irregular floor plan, especially evident in the odd stairway leading to the second floor, is further complicated by the unusual ceilings, some of which are partially covered by a barrel vault.

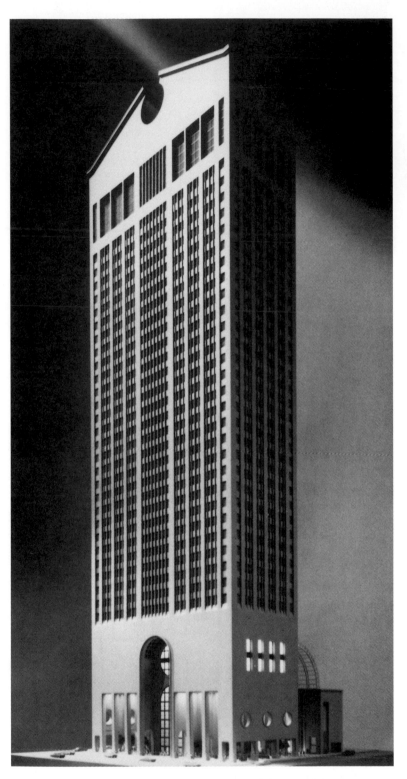

29-50. Philip Johnson and John Burgee. Model, AT&T Corporate Headquarters, New York. 1978–83

After collaborating on the Seagram Building (see fig. 29-45) with Mies, who had long been his architectural idol, Johnson grew tired of the limited modernist vocabulary. During the 1960s he experimented with a number of alternatives, especially a weighty, monumental style that looked back to nineteenth-century Neoclassicism. At the end of the 1970s he became fascinated with the new possibilities opened by Venturi's postmodernism, which he found "absolutely delightful."

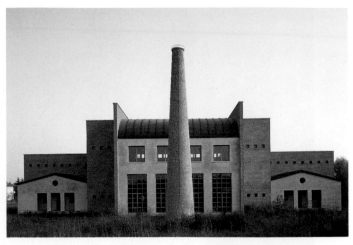

29-51. Aldo Rossi. North (rear) facade, New Town Hall, Borgoricco, Italy. 1983–88
Courtesy Aldo Rossi

The Vanna Venturi House makes reference to a number of other buildings, from Michelangelo's Porta Pia in Rome to a nearby house designed by Venturi's mentor, Louis Kahn (1901–74). Although such allusions to architectural history were lost on the general public, they provided many architects, including Philip Johnson (b. 1906), with a path out of modernism. Johnson's major contribution to postmodernism is the AT&T Corporate Headquarters (now the Sony Building) in New York City (fig. 29-50), an elegant, granite-clad skyscraper whose thirty-six oversized floors reach the height of an ordinary sixty-story building. The skyscraper makes gestures of accommodation to its surroundings: Its smooth, uncluttered surfaces match those of its International Style neighbors, while the classically symmetrical window groupings between vertical piers echo those in more conservative Manhattan skyscrapers built in the early to middle 1900s. What critics focused on, however, was the building's resemblance to a type of eighteenth-century furniture: the Chippendale highboy, a chest of drawers with a long-legged base. Johnson seems to have intended a pun on the terms *highboy* and *high-rise*. In addition, the round notch at the top of the building and the arched entryway at the base recall the coin slot and coin return on old pay telephones. Many critics were not amused by Johnson's effort to add a touch of humor to high architecture. His purpose, however, was less to poke fun at his client or his profession than to create an architecture that would amuse the public and at the same time, like a fine piece of furniture, meet its deeper aesthetic needs with a formal, decorative elegance.

A striking contrast to Johnson's playful postmodernism is the sober, formally reductive Neo-Rationalism of the Italian Aldo Rossi (1931–97). Rossi based his architecture on a return to certain premodernist building archetypes (**typologies**)—such as the church, the house, and the factory—stripped of all ornamentation and reduced to their geometric essentials, much as in the designs of Neoclassicists like Claude-Nicolas Ledoux and Étienne-Louis Boullée (see figs. 26-42, 26-43). He aimed

to achieve both historical continuity and universal time-lessness. To enrich the emotional impact of these rationally conceived typologies, Rossi believed that architects should use them in mysterious and evocative ways.

The New Town Hall Rossi built in Italy's industrial belt, in Borgoricco (fig. 29-51), near Venice, illustrates these concepts. The large windows, metal roof, and exhaust chimney derive from nineteenth- and early-twentieth-century factory designs (see fig. 28-43), whereas the temple fronts on the flanking wings, which evoke the building's civic function, are done in a style typical of the aristocratic Palladian housing in the surrounding countryside (see fig. 18-63). The result is a provocative and unexpected marriage of local forms and other European architectural types. The simple geometry and the building's rigorous symmetry give it a stable, timeless air.

High Tech Architecture. Even as postmodernism flourished in the later 1970s and 1980s, another new architectural trend, known as High Tech, challenged it as the dominant successor to an exhausted modernism. Characterized by the expressive use of advanced building technology and industrial materials, equipment, and components, High Tech found its defining monument in the Centre National d'Art et de Culture Georges Pompidou (fig. 29-52) in Paris, designed by Renzo Piano (b. 1937) of Italy and Richard Rogers (b. 1933) of England. Responding to the need for a large, flexible building that would house several different institutions—the French national museum of modern art, a public library, and centers for industrial design and for music and acoustic research—the architects chose to turn the structure inside out, placing its supporting steel frame on the exterior and leaving its vast internal floors uninterrupted by columns. The service and circulation functions are also placed on the exterior and brightly colored, with red designating the elevators, blue the air-conditioning ducts, green the water pipes, and yellow the electrical units. While some criticized the Centre Pompidou as too radical for its neighborhood, the design in fact makes reference to the origins of functional architecture in Paris, evoking both the glass-and-iron sheds that once stood in the historic market area adjacent to it and the most famous of the exposed-metal structures that gave birth to modernist architecture, the Eiffel Tower (see fig. 27-1).

Among the most spectacular examples of High Tech architecture is the HongKong & Shanghai Bank (fig. 29-53) by Norman Foster (b. 1935), a fellow Englishman and onetime architectural partner of Richard Rogers. Invited by his client to design the most beautiful bank in the world, Foster spared no expense in the creation of this futuristic forty-seven-story skyscraper. The rectangular plan features service towers at the east and west ends, eliminating the central service core typical of earlier skyscrapers such as the Seagram Building (see fig. 29-45). As in the Centre Pompidou, the load-bearing steel skeleton, composed of giant masts and girders, is on the exterior. The individual stories hang from this structure, allowing for uninterrupted facades and open working areas filled with natural light. The main banking hall, the lowest

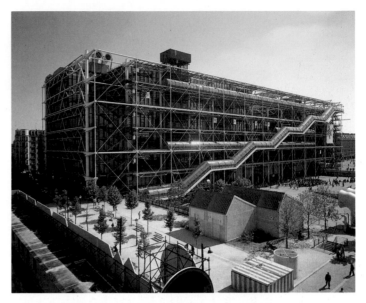

29-52. Renzo Piano and Richard Rogers. Centre National d'Art et de Culture Georges Pompidou, Paris. 1971–77

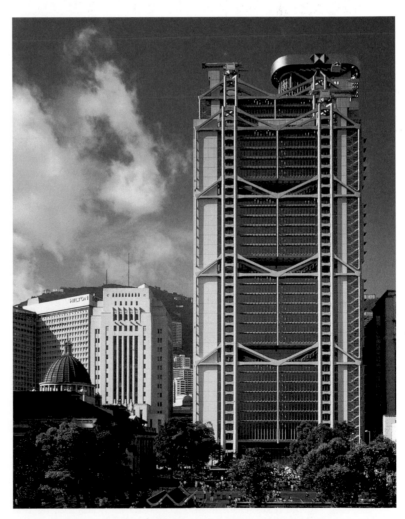

29-53. Norman Foster. HongKong & Shanghai Bank, Hong Kong. 1979–86

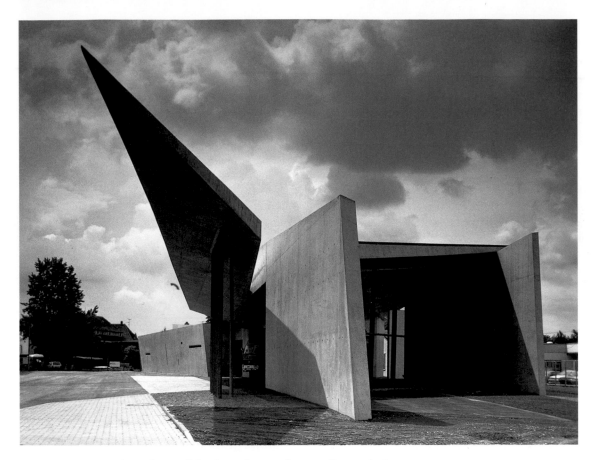

29-54. Zaha Hadid. Vitra Fire Station, Weil-am-Rhein, Germany. 1989–93

segment of the building, features a ten-story atrium space flooded by daylight refracted from motorized "sunscoops" at its apex, computer-programmed to track the sun and channel its rays into the building. The sole concession Foster's High Tech building makes to tradition are the two bronze lions that guard its public entrance—the only surviving elements from the bank's previous headquarters. A popular belief holds that touching the lions before entering the bank brings good luck.

Deconstructivist Architecture. "Deconstructivist Architecture," a 1988 exhibition at The Museum of Modern Art in New York, highlighted an international avant-garde tendency to disturb the traditional architectural values of harmony, unity, and stability through the use of skewed, distorted, and impure geometry—an aesthetic early-twentieth-century Russian Suprematist and Constructivist art and architectural design (Chapter 28) employed to convey a sense of formal dynamism and, in the case of politically committed Constructivism, the world-transforming energies of the Russian Revolution. Many architects since the 1980s have combined an awareness of these Russian sources with an interest in the theory of deconstruction developed by French philosopher Jacques Derrida (b. 1930). Concerned mostly with the analysis of verbal texts, Derridean deconstruction holds that no text possesses a single, intrinsic meaning but rather its meaning is always "intertextual"—a product of its relationship to other texts—and is always "decentered," or "dispersed" along an infinite chain of linguistic signs whose meanings are themselves unstable. Deconstructivist architecture is,

consequently, often "intertextual" in its use of design elements from other traditions, including modernism, and "decentered" in its denial of a unified and stable form.

A prime example of deconstructivist architecture is the Vitra Fire Station in Weil-am-Rhein, Germany (fig. 29-54), by the Baghdad-born Zaha Hadid (b. 1950), who studied architecture in London and established her practice there in 1979. Stylistically influenced by the Suprematist paintings of Kasimir Malevich (see fig. 28-34), the Vitra Fire Station features leaning, reinforced concrete walls that meet at unexpected angles and jut dramatically into space, denying any sense of unity while creating a feeling of dynamism appropriate to the building's function.

Represented, like Hadid, in the "Deconstructivist Architecture" show was the Toronto-born, California-based Frank O. Gehry (b. 1929), who achieved his initial fame in the late 1970s with his inventive use of vernacular forms and cheap materials set into unstable and conflicted arrangements. After working during the 1980s in a more classically geometrical mode, Gehry developed in the 1990s a powerfully organic, sculptural style, most famously exemplified in his enormous Guggenheim Museum in Bilbao, Spain (fig. 29-55). The building's complex steel skeleton is covered with a thin skin of silvery titanium that shimmers gold or silver depending on the light. Like the original Frank Lloyd Wright Guggenheim Museum in Manhattan (fig. 22, Introduction), Gehry's building resembles a living organism from most vantage points except the north, from which it resembles a giant ship, a reference to the shipbuilding so important to Bilbao. The inside features

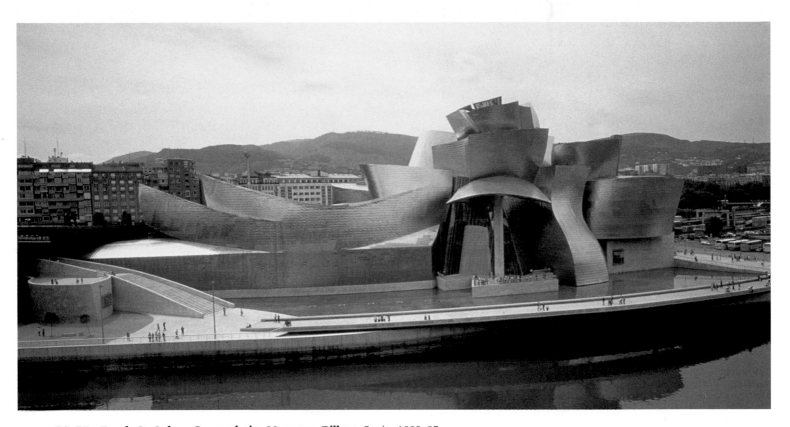

29-55. Frank O. Gehry. Guggenheim Museum, Bilbao, Spain. 1993–97

Philip Johnson, the dean of American architects, called the Guggenheim Museum in Bilbao the greatest building of the twentieth century.

a huge atrium, which both pays homage to Wright's famous one in New York (see fig. 29-90) and attempts to outdo it in size and effect. In competing with Wright, Gehry meant to provide for the needs of artists, who he claimed "want to be in *great* buildings."

EARTHWORKS AND SITE-SPECIFIC SCULPTURE

Among the many responses to Minimalism that shaped American avant-garde art of the late 1960s and 1970s was a movement to take art out of the marketplace and back to nature. A number of sculptors began to work outdoors, using raw materials found at the site to fashion **earthworks**. They pioneered a new category of art making called **site-specific sculpture**, which is designed for a particular location, often outdoors.

One of the leaders of the earthworks movement was Michael Heizer (b. 1944), the California-born son of a specialist in Native American archaeology. Heizer moved to New York in 1966 but, disgusted by the growing emphasis on art as an investment, began to spend time in the Nevada desert and to create works there that could not easily be bought and sold and that required a considerable commitment of time from viewers who wanted to see them. There, in 1969–70, Heizer hired bulldozers to produce his most famous work, *Double Negative* (fig. 29-56). Using a simple Minimalist formal vocabulary, he made two gigantic cuts on opposite sides of a canyon wall. To fully understand the work, the viewer needs to walk into the 50-foot-deep channels and experience their awe-inspiring scale. Through its creation of a pure, transcendent artistic

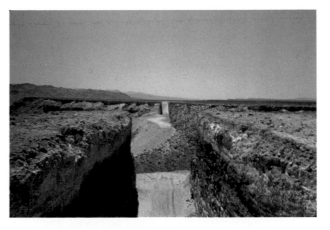

29-56. Michael Heizer. *Double Negative*. 1969–70. 240,000-ton displacement at Mormon Mesa, Overton, Nevada, 1,500 x 50 x 30' (457.2 x 15.2 x 9.1 m). Museum of Contemporary Art, Los Angeles
Gift of Virginia Dwan. Photograph courtesy the artist

alternative to commercialized, urban life, Heizer's work is more modernist than postmodernist.

More postmodern in intention was the work of another major earthworks artist, Robert Smithson (1938–73), a New Jersey native who first traveled to the Nevada desert with Heizer in 1968. In his mature work Smithson sought to illustrate the "ongoing dialectic" in nature between constructive forces—those that build and shape form—and destructive forces—those that destroy it.

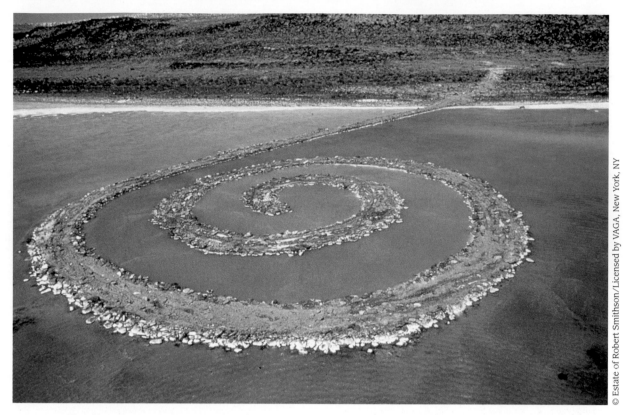

29-57. Robert Smithson. *Spiral Jetty*. 1969–70. Black rock, salt crystal, and earth spiral, length 1,500' (457 m). Great Salt Lake, Utah

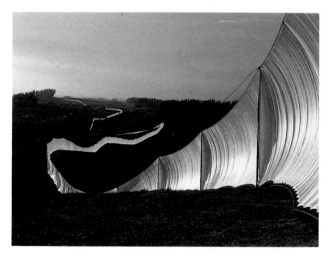

29-58. Christo and Jeanne-Claude. *Running Fence*. 1972–76. Nylon fence, height 18' (5.5 m), length 24½ miles (40 km). Sonoma and Marin counties, California

Spiral Jetty (fig. 29-57), a 1,500-foot spiraling stone and earth platform extending into the Great Salt Lake in Utah, expresses these ideas. Smithson chose the lake because it recalls both the origins of life in the salty waters of the primordial ocean and the end of life. One of the few organisms that live in the otherwise dead lake is an alga that gives it a red tinge, vaguely suggestive of blood. Smithson also liked the way the abandoned oil rigs that dot the lake's shores suggested both prehistoric dinosaurs and some vanished civilization. He used the spiral because it is the most fundamental shape in nature, appearing, for example, in galaxies, seashells, DNA molecules, and even

salt crystals. Finally, Smithson chose the spiral because, unlike modernist squares, circles, and straight lines, it is a "dialectical" shape, one that opens and closes, curls and uncurls endlessly. More than any other shape, it suggested to him the perpetual coming and going of things.

Strongly committed to the realization of temporary, site-specific art works in both rural and urban settings are Christo and Jeanne-Claude, both born on June 13, 1935. Christo Javacheff (who uses only his first name) emigrated from his native Bulgaria to Paris in 1958, where he met Jeanne-Claude de Guillebon, the Nouveaux Réalistes, and some of the Fluxus artists. His interest in "wrapping" (or otherwise defining) places or things in swaths of fabric soon became an obsession, and he began wrapping progressively larger items. Their first collaborative work, in 1961, was *Stacked Oil Barrels* and *Dockside Packages* at the Cologne, Germany, harbor. The pair moved to New York City in 1964. Among their works after this move, in 1968 Christo and Jeanne-Claude wrapped the Kunsthalle museum in Berne, Switzerland, and the following year wrapped 1 million square feet of the Australian coastline. These artists make clear that their first tenet is freedom, so they pay all their own expenses, never accepting sponsors but rather raising funds through the sale of preparatory drawings of the intended project.

Their best-known work, *Running Fence* (fig. 29-58), consisted of a 24½-mile-long, 18-foot-high nylon fence that crossed two counties in northern California and extended into the Pacific Ocean. The artists chose the location in Sonoma and Marin counties for purely aesthetic reasons, as well as to call attention to the link between urban, suburban, and rural spaces. This concern with aesthetics is common to all their work, in which

29-59. Richard Estes.
Prescriptions Filled
(Municipal Building).
1983. Oil on canvas,
3 x 6' (0.91 x 1.83 m).
Private collection

they reveal the joy and beauty in various spaces. At the same time, the conflict and collaboration between the artists and various social groups open the workings of the political system to scrutiny and invest their work with a sense of social space. For example, Christo and Jeanne-Claude spent forty-two months countering the resistance of county commissioners, half of whom were for the project from the outset, as well as social and environmental organizations, before they could create *Running Fence.* Meanwhile, the project forged a community of supporters drawn from groups as diverse as college students, ranchers, lawyers, and artists. In a way, the fence broke down the social barriers among those people.

SUPER REALISM

While some avant-garde artists abandoned the studio to work with materials in nature, others remained committed to pushing the traditional mediums of painting and sculpture in new directions. An important new tendency came to public attention in 1972 in the "Sharp Focus Realism" exhibition at the Sidney Janis Gallery in New York City. Although they featured recognizable subject matter, the paintings in the show had aesthetic ties to Minimalism. Instead of being personal, deliberately rough, and painterly, works of this kind, known as Super Realist, are impersonally executed with great technical precision. Often based on color photographs, they are so illusionistic that, when seen in reproduction, they can be mistaken for color photographs themselves.

A leading Super Realist painter is the American Richard Estes (b. 1936), who during the 1970s and early 1980s produced a series of paintings on the theme of reflections, including *Prescriptions Filled (Municipal Building)* (fig. 29-59). Estes always eliminated people when he transcribed his source photographs to canvas, emphasizing his interest in the aesthetic pleasures of refined compositional arrangements. The window reflection in *Prescriptions Filled,* for example, allows Estes to create a nearly perfect symmetry. The picture's formal tension comes from the subtle differences between the two halves, especially the point between the lamppost and the edge of the glass window at the very center of the painting. Without making any overt commentary on their subjects, Estes's cool, static, and closed paintings suggest that urban life is flat and empty.

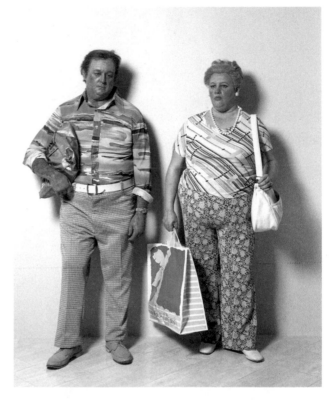

29-60. Duane Hanson. *The Shoppers.* 1976. Cast vinyl, polychromed in oil with accessories, lifesize. Collection the Nerman Family

Duane Hanson (1925–96), the major sculptor of the Super Realist movement, created astonishingly lifelike figures cast directly from live models in polyester resin and fiberglass, vinyl, or bronze, which he then painted and outfitted with hair, glass eyes, and real clothing and other accessories. His earliest works, which dealt with large social issues such as war, poverty, and racism, were highly dramatic, but about 1970 he turned to more mundane subjects. From that point on, Hanson held up an unflattering mirror to American society's work and leisure. *The Shoppers,* for example (fig. 29-60), shows two garishly dressed, overweight consumers carrying bags with their recent purchases. As their dazed expressions tell us, the material goods that are supposed to make them happy clearly do not.

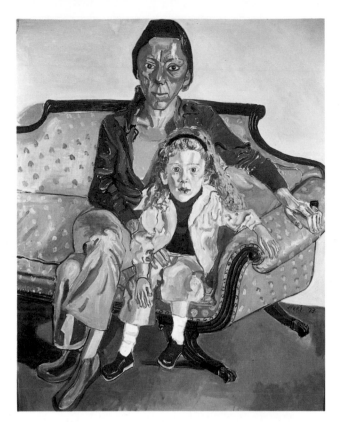

29-61. Alice Neel. *Linda Nochlin and Daisy*. 1973. Oil on canvas, 55½ x 44" (141 x 112 cm). Museum of Fine Arts, Boston

Seth K. Sweetser Fund

Nochlin, then a professor at Vassar College, helped inaugurate feminist art history with her 1971 essay "Why Have There Been No Great Women Artists?" In it, she argued that women had been denied the opportunity to achieve greatness by their exclusion from the male-dominated institutional systems of training, patronage, and criticism that set the standards of professional accomplishment.

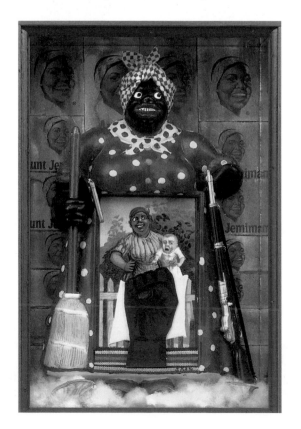

FEMINIST ART

Feminist art emerged in the context of the Women's Liberation movement of the late 1960s and early 1970s. A major aim of feminist artists and their allies was increased recognition for the accomplishment of women artists, both past and present. A 1970 survey revealed that although women constituted half of the nation's practicing artists, only 18 percent of commercial New York galleries carried works by women. Of the 143 artists in the 1969 Whitney Annual (now the Whitney Biennial), one of the country's most prominent exhibitions of the work of living artists, only eight were women. The next year, the newly formed Ad Hoc Committee of Women Artists, disappointed by the lukewarm response of the Whitney's director to their concerns, staged a protest at the opening of the 1970 Annual. To focus more attention on women in the arts, feminist artists began organizing women's cooperative galleries. While feminist art historians wrote in books and journals about women artists and the issues raised by their work, feminist curators and critics promoted the work of both emerging women artists and long-neglected ones, such as Alice Neel (1900–84), who had her first major museum retrospective at age seventy-four.

Reflecting a series of life crises, including the death in infancy of one of her children and the abduction of another by the child's father, Neel's early work featured distorted, expressionistic images of couples, mothers, and children. Her style softened after she moved from Philadelphia to New York in 1932 and began to specialize in frank and revealing images of the people she knew. She first received art world attention in the early 1960s with the revival of figurative painting, but her penetrating portraits were considered too subjective for the prevailing "cool" aesthetic. Her subjects now included well-known critics, curators, artists, and even the feminist art historian Linda Nochlin (fig. 29-61). Neel presents Nochlin as a warm, thoughtful woman, affectionately holding her daughter, a representative of all those other daughters whose future prospects Nochlin was devoted to enlarging.

Another artist who achieved widespread recognition only with the arrival of the feminist movement was the Los Angeles–based African-American sculptor Betye Saar (b. 1926). Inspired by the glass-fronted box assemblages of the American Joseph Cornell (1903–72), Saar began to construct her own boxes in which she juxtaposed found objects. Several early works in this medium reflect both feminist interests and the aims of the civil rights movement. Saar's best-known work, *The Liberation of Aunt Jemima* (fig. 29-62), **appropriates** the derogatory stereotype of the cheerfully servile "mammy" and transforms it into an icon of militant black feminist power. Set against a background papered with the smiling advertising image of Aunt Jemima, stands a note pad holder in the form of an

29-62. Betye Saar. *The Liberation of Aunt Jemima*. 1972. Mixed mediums, 11¾ x 8 x 2¾" (29.8 x 20.3 x 7 cm). Berkeley Art Museum, University of California

Purchased with the aid of funds from the National Endowment for the Arts

THE OBJECT SPEAKS

THE DINNER PARTY

A complex, mixed-medium **installation** that fills an entire room, Judy Chicago's *The Dinner Party* speaks powerfully of the accomplishments of women throughout history. Five years of collaborative effort went into the creation of the work, involving hundreds of women and several men who volunteered their talents as ceramists, needle-workers, and china painters to realize Chicago's designs. *The Dinner Party* is composed of a large, triangular table, each side stretching 48 feet, which rests on a triangular platform covered with 2,300 triangular porcelain tiles. Chicago saw the equilateral triangle as a symbol of the equalized world sought by feminism and also identified it as one of the earliest symbols of the feminine. The porcelain "Heritage Floor" bears the names of 999 notable women from myth, legend, and history. Along each side of the triangular table, thirteen place settings each represent a famous woman. Chicago chose the number thirteen because it is the number of men who were present at the Last Supper and also of witches in a coven, and therefore a symbol of occult female power. The thirty-nine women honored through the place settings include mythical ancient goddesses like Ishtar, legendary figures like the Amazon, and historical personages such as the Egyptian queen Hatshepsut, the Roman scholar Hypatia, the medieval French queen Eleanor of Aquitaine, the medieval French author Christine de Pisan (see fig. 20, Introduction), the Italian Renaissance noblewoman Isabella d'Este (see page 709), the Italian Baroque painter Artemesia Gentileschi (see figs. 19-20 and 19-21), the eighteenth-century English feminist writer Mary Wollstonecraft, the nine-teenth-century American abolitionist Sojourner Truth, and the twentieth-century American painter Georgia O'Keeffe (see figs. 4, Introduction, and 28-71).

Each place setting features a 14-inch-wide painted porcelain plate, ceramic flatware, a ceramic chalice with a gold interior, and an embroidered napkin, all set upon an elaborately decorated runner. The runners incorporate decorative motifs and techniques of stitching and weaving appropriate to the period with which each woman was associated. Most of the plates feature abstract designs based on female genitalia because, Chicago said, "that is all [the women at the table] had in common They were from different periods, classes, ethnicities, geographies, experiences, but what kept them within the same confined historical space" was the fact of their biological sex. Chicago thought it appropriate to represent the women through plates because they "had been swallowed up and obscured by history instead of being recognized and honored."

Chicago emphasized china painting and needle-work in *The Dinner Party* to celebrate craft mediums traditionally practiced by women and to argue that they should be considered "high" art forms on par with painting and sculpture. This argument complemented her larger aim of raising awareness of the many contributions women have made to history, thereby fostering women's empowerment in the present.

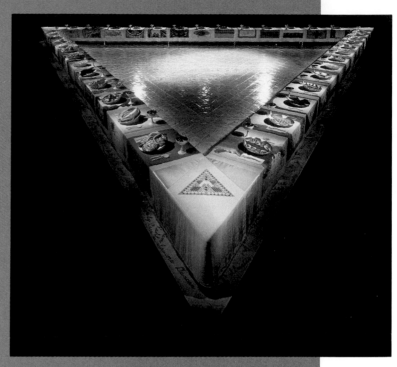

29-63. Judy Chicago. *The Dinner Party*. 1974–79. White tile floor inscribed in gold with 999 women's names; triangular table with painted porcelain, sculpted porcelain plates, and needlework, each side 48' (14.6 m)
Courtesy the artist

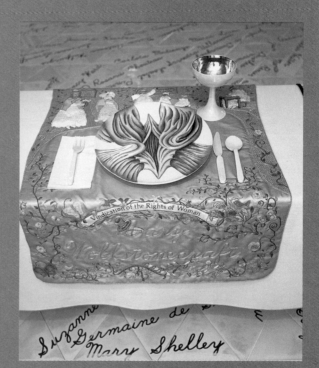

***Mary Wollstonecraft* place setting,** detail of *The Dinner Party*

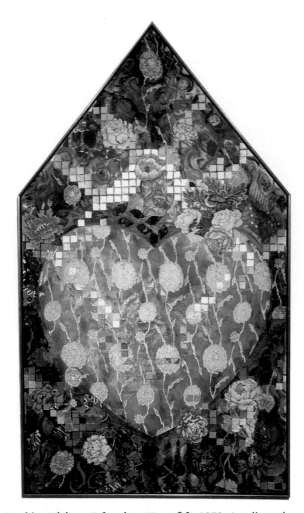

29-64. Miriam Schapiro. *Heartfelt.* 1979. Acrylic and fabric on canvas, 5'10" x 3'4" (1.8 x 1 m). Collection of the Morton G. Neumann Family

Courtesy Steinbaum Krauss Gallery, New York

After returning to New York from California in 1975, Schapiro became a leading figure in the Pattern and Decoration movement. Composed of both female and male artists, the movement sought to merge modernist abstraction with ornamental motifs derived from women's craft, folk art, and a variety of non-Western sources to break down hierarchical distinctions between them.

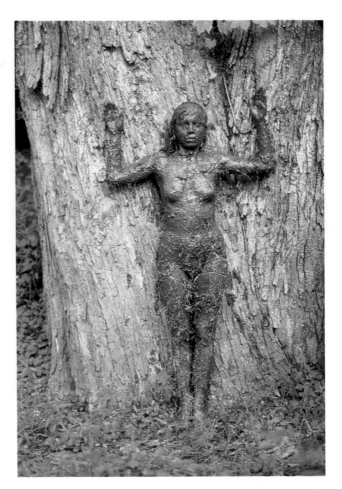

29-65. Ana Mendieta. Untitled work from the Tree of Life series. 1977. Color photograph, 20 x 13¼" (50.8 x 33.7 cm)

Courtesy Galerie Lelong, New York. © The Estate of Ana Mendieta

Aunt Jemima. She holds a broom (whose handle is actually the pencil for the note pad) and pistol in one hand and a rifle in the other. In the place of the note pad is a picture of another jolly mammy holding a crying child identified by the artist as a mulatto, or person of mixed black and white ancestry. In front of this pair is a large clenched fist—a symbol of "black power" signaling African Americans' willingness to use force to achieve their aims. Saar's armed Jemima liberates herself not only from racial oppression but also from traditional gender roles that had long relegated black women to such subservient positions as domestic servant or mammy.

A younger artist who assumed a leading role in the 1970s was Judy Chicago (b. 1939), whose *The Dinner Party* (fig. 29-63, "The Object Speaks") is perhaps the best-known work of feminist art created in that decade. Born Judy Cohen, she became Judy Gerowitz after her marriage and then in 1970 adopted the surname Chicago (from the

city of her birth) to free herself from "all names imposed upon her through male social dominance." Originally a Minimalist sculptor, Chicago in the late 1960s began to make abstracted images of female genitalia designed to challenge the aesthetic standards of the male-dominated art world and to validate female experience. In 1970 she established the first feminist studio art course at Fresno State College (now California State University, Fresno). The next year, she moved to Los Angeles and teamed up with the painter Miriam Schapiro (b. 1923) to establish at the new California Institute of the Arts (CalArts) the Feminist Art Program, dedicated to training women artists.

During the first year of the program, Chicago and Schapiro led a team of twenty-one female students in the creation of *Womanhouse* (1971–72), a collaborative art environment set in a run-down Hollywood mansion, which the artists renovated and filled with installations that addressed women's issues. Schapiro's work for *Womanhouse*, created in collaboration with Sherry Brody, was *The Dollhouse*, a mixed-medium construction featuring several miniature rooms adorned with richly patterned fabrics. Schapiro soon began to incorporate pieces of fabric into her acrylic paintings, developing a type of work she called femmage (from *female* and *collage*). Schapiro's

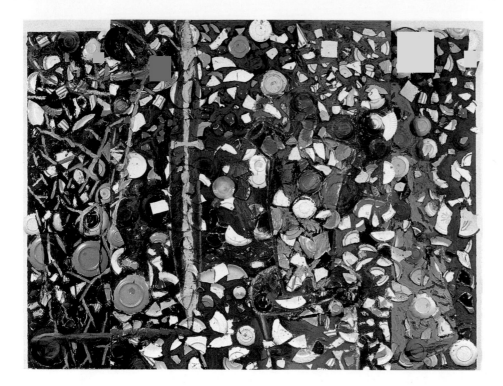

29-66. **Julian Schnabel.** *The Death of Fashion*. 1978. Oil and crockery on canvas and wood, 7'6" x 10' x 1'1" (2.29 x 3.05 x 0.33 m). Des Moines Art Center, Iowa

Purchased with funds from Roy Halston Frowick (1991.47)

Schnabel adapted the painting's title from a news headline about the death of a fashion model, but the work makes no apparent reference to the story. He thereby denied the title its traditional function of identifying the picture's subject matter, leaving the viewer to speculate freely on the relationship between the painting's imagery and the label attached to it.

femmages, such as *Heartfelt* (fig. 29-64), celebrate traditional women's craftwork. *Heartfelt* is shaped like a house, and the patterns in it suggest curtains, wallpapers, quilts, and other decorative forms women make or use in their domestic spaces. The title and heart shape at the center evoke an essential feature of female sensibility according to Schapiro and her circle: women's capacity for feeling. Both the formal and the emotional richness of *Heartfelt* were meant to counter the Minimalist aesthetic of the 1960s, which Schapiro and other feminists considered typically male.

Many feminists, including Cuban-born Ana Mendieta (1948–85), celebrated the notion that women have a deeper identification with nature than do men. By 1972 Mendieta had rejected painting for performance and body art. Inspired by Santería, an Afro-Caribbean religion emphasizing immersion in nature, she produced ritualistic performances on film, as well as about 200 earth-and-body works, called Silhouettes, which she recorded in color photographs. Some were done in Mexico, and others, like the Tree of Life series (fig. 29-65), were set in Iowa, where she moved after the 1961 Cuban Revolution. In this work, Mendieta stands covered with mud, her arms upraised like a prehistoric goddess, appearing at one with nature, her "maternal source."

POSTMODERNISM

Much of the art being made by the end of the 1970s was widely considered to be postmodern. Although there is no universal agreement on what the term *postmodern* means, it involves rejection of the concept of the mainstream and recognition of artistic **pluralism**, the acceptance of a variety of artistic intentions and styles. Many critics insist that pluralism applies to modernism as well and has been a characteristic of art since at least the Post-Impressionist era. Others argue that the art world's attitude toward pluralism has changed: Where critics and artists once searched for a historically inevitable mainstream in the midst of pluralistic variety, many now accept pluralism for what it probably always was—a manifestation of our culturally heterogeneous age.

Those who resist the term *postmodern* also point to the continued use of the term *avant-garde* to describe the most recent developments in art. But whereas *avant-garde* formerly indicated a significant newness, it now lacks that connotation. Indeed, many recent avant-garde styles implicitly acknowledge the exhaustion of the old modernist faith in innovation—and in what it implied about the "progressive" course of history—by reviving older styles. For this reason, the names of a number of recent styles in both art and architecture begin with the prefix *neo*, denoting a new and different form of something that already exists.

NEO-EXPRESSIONISM

A number of shows in leading New York art galleries in the late 1970s and early 1980s signaled the emergence of the first of the neos, Neo-Expressionism. The renewed interest in expressionism, long thought dead, was inspired partly by the emphasis on personal feeling in feminist art and by the example of the emotion-laden figurative work of such older American artists as Philip Guston (1913–80) and Leon Golub (b. 1922). Although six of the nineteen artists discussed in an early assessment of Neo-Expressionism in the magazine *Art in America* (December 1982–January 1983) were women, some of them never fit comfortably under the label Neo-Expressionist. Other women were soon dropped from the category when critics decided, perhaps prematurely, that the style was a male phenomenon, reasserting masculine values and viewpoints.

The most prominent American Neo-Expressionist was Brooklyn-born Julian Schnabel (b. 1951), who gained notoriety in 1979 for "plate paintings," such as *The Death of Fashion* (fig. 29-66). The idea for painting on crockery

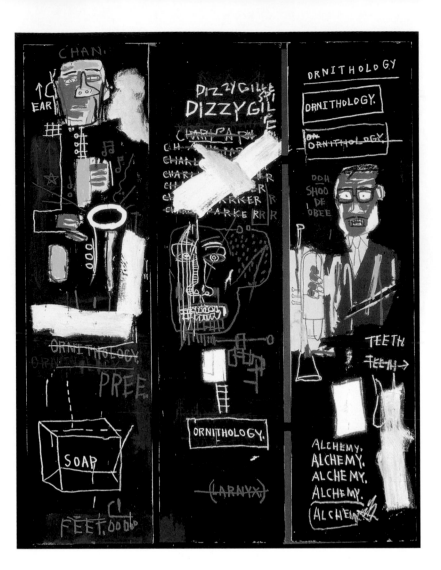

29-67. **Jean-Michel Basquiat.** *Horn Players*. 1983. Acrylic and oil paintstick on canvas, three panels, overall 8' x 6'5" (2.44 x 1.91 m). Broad Art Foundation, Santa Monica, California

APPROPRIATION During the late 1970s and 1980s, **appropriation** (the representation of a preexisting image as one's own) became a popular technique among postmodernists in both the United States and Western Europe. The borrowing of figures or compositions has been an essential technique throughout the history of art, but the emphasis had always been on changing or personalizing the source. A copy or reproduction was not considered a legitimate work of art until Marcel Duchamp changed the rules with his **readymades** (see fig. 28-63), insisting that the quality of an art work depends not on formal invention but on the ideas that stand behind it. Duchamp's own sort of appropriations first inspired the Pop artists Andy Warhol and Roy Lichtenstein, whose reuse of imagery from popular culture, high art, ordinary commerce, and the tabloids then helped point the way for the artists of the 1970s and 1980s.

Critics and historians now use the term *appropriation* to describe the activities of two distinct groups. To the first belong artists such as Sigmar Polke (see fig. 29-69) and Julian Schnabel (see fig. 29-66), who combine and shape their borrowings in personal ways. These artists, along with earlier ones such as Robert Rauschenberg (see fig. 29-23), might be called **collage** appropriators. "Straight appropriators," on the other hand, are those, such as Sherrie Levine (see fig. 29-72), who simply repaint or rephotograph imagery from commerce or the history of art and present it as their own.

The work of the latter is grounded not only in the Duchampian tradition but also in the ideas of French literary critics known as the Post-Structuralists. Of particular importance was their critique of certain basic and unexamined assumptions about art. In "The Death of the Author" (1968), for example, Roland Barthes argued that the meaning of a work of art depends not on what the author meant (which

Derrida and others argued was neither certain nor entirely recoverable) but on what the reader understands. Furthermore, Barthes questioned the modernist notion of originality, of the author as a creator of an entirely new meaning. The author merely recycles meanings from other sources; he said: A "text is a tissue of quotations drawn from the innumerable centers of culture." The work of Levine seems almost to illustrate such ideas.

Some straight appropriators have encountered legal problems. Levine's first high-art appropriations were photographic copies of Edward Weston originals. When the lawyers for the Weston estate threatened to sue her for infringement of copyright, she moved to the work Walker Evans produced during the 1930s for the Farm Security Administration (Chapter 28), which has no copyright. Others faced with the possibility of legal action, especially from owners of commercial trademarks, have taken the same cautious route.

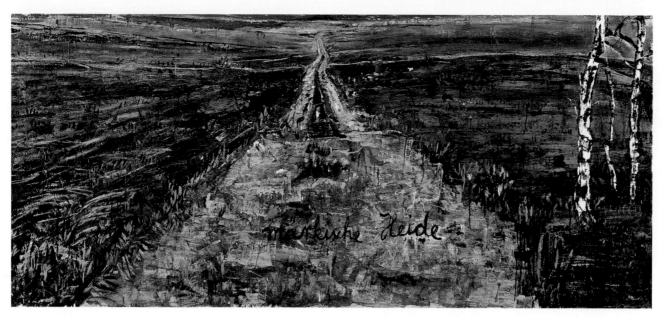

29-68. Anselm Kiefer. *Heath of the Brandenburg March*. 1974. Oil, acrylic, and shellac on burlap, 3'10½" x 8'4" (1.18 x 2.54 m). Stedelijk Van Abbemuseum, Eindhoven, the Netherlands

Kiefer often incorporates words and phrases into his paintings that amplify their meaning. Here, the words *märkische Heide* ("March Heath") evoke an old patriotic tune of the Brandenburg region, "Märkischer Heide, märkischer Sand," which Hitler's army adopted as a marching song.

came to Schnabel during a 1978 visit to Barcelona, where he saw the broken glazed tiles that Art Nouveau architect Antonio Gaudí had incorporated into his buildings and park benches (see fig. 28-2). On his return to New York, Schnabel constructed large wood-and-canvas supports to which he affixed whole and broken plates. Painting over this powerfully physical surface with thick, energetic strokes, he rendered crude images such as the large sword and mutilated torso in the central panel of *The Death of Fashion*. In their rough vitality, these images revive the spirit of Die Brücke and other early-twentieth-century expressionists (Chapter 28). Unlike these earlier artists, however, Schnabel typically appropriated his images from other sources (see "Appropriation," opposite), frequently combining images to create a sense of fragmentation, incompleteness, and ultimate lack of a coherent meaning, typical of much postmodern work.

Another American painter associated with the Neo-Expressionist movement was the tragically short-lived Jean-Michel Basquiat (1960–88), whose meteoric career ended with his death from a heroin overdose at age twenty-seven. The Brooklyn-born son of a Haitian father and a Puerto Rican mother, Basquiat was raised in middle-class comfort, against which he rebelled as a teenager. After quitting high school at seventeen, he left home to become a street artist, covering the walls of lower Manhattan with short and witty philosophical texts signed with the tag SAMO ©. In 1980 Basquiat participated in the highly publicized "Times Square Show," which showcased the raw and aggressive styles of subway graffiti artists. The response to Basquiat's contribution encouraged him to begin painting professionally. Although he was untrained and wanted to make "paintings that look as if they were made by a child," Basquiat was a sophisticated artist. He carefully studied the Abstract Expressionists, the late paintings of Picasso, and Dubuffet (see fig. 29-4), among others.

Basquiat's *Horn Players* (fig. 29-67) portrays jazz musicians Charlie Parker (at the upper left) and Dizzy Gillespie (at center right) and includes numerous verbal references to their lives and music. The urgent paint handling and scrawled lettering seem genuinely expressionist, conveying Basquiat's strong emotional connection to his subject (he avidly collected jazz records and considered Parker one of his personal heroes), as well as his passionate determination to make African-American subject matter visible to his predominantly white audience. "Black people," said Basquiat, "are never portrayed realistically, not even portrayed, in modern art, and I'm glad to do that."

In Germany, the revival of expressionism took on political connotations because the work of the original expressionists had been labeled degenerate and banned by the Nazis during the 1930s (see "The Suppression of the Avant-Garde in Germany," page 1097). The German Neo-Expressionist Anselm Kiefer (b. 1945) was born in the final weeks of World War II and in his work has sought to come to grips with his country's Nazi past— "to understand the madness." The burned and barren landscape in his *Heath of the Brandenburg March* (fig. 29-68) evokes the ravages of war that the Brandenburg area, near Berlin, has frequently experienced, most recently in World War II. The road that lures us into the landscape, a standard device in nineteenth-century landscape paintings, here invites us into the region's dark past.

Kiefer's determination to deal with his country's troubled past was shaped in part by his informal study under Joseph Beuys (see fig. 29-37) in the early 1970s. Another prominent Beuys student was Sigmar Polke (b. 1941), who grew up in Communist-controlled East Germany before moving at age twelve to West Germany. During the 1960s Polke made crude "capitalist realist" paintings that expressed a more critical view of consumer culture than did the generally celebratory work of the British and

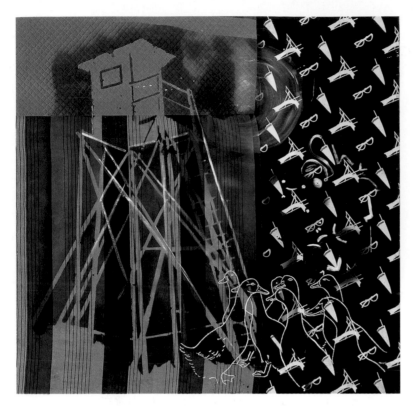

29-69. Sigmar Polke. *Raised Chair with Geese*. 1987–88. Artificial resin and acrylic on various fabrics, 9'5¹/₈" x 9'5¹/₈" (2.9 x 2.9 m). The Art Institute of Chicago

Restricted gift in memory of Marshall Frankel; Wilson L. Mead Endowment (1990.81)

29-70. Peter Halley. *Fire in the Sky*. 1993. Acrylic, Day-Glo acrylic, and Roll-a-Tex on canvas, 7'11¹/₂" x 7'3⁵/₈" (2.43 x 2.27 m). Des Moines Art Center

Purchased with funds from the Edmundson Art Foundation, Inc., and partial gift of Gagosian Gallery and the artist (1993.10)

American Pop artists. Like them, Polke appropriated his images from the mass media. Subsequently, Polke began to mix diverse images from different sources and paint them on unusual supports, such as printed fabrics, creating a complex, layered effect. *Raised Chair with Geese* (fig. 29-69), for example, juxtaposes the silhouette of a watchtower with outlined figures of geese and a printed pattern of sunglasses, umbrellas, and folding chairs. The motif of the elevated hut generates many dark associations, ranging from the raised chair used by German fowl hunters (reinforced by the presence of the geese), to a sentry post for soldiers monitoring the border between East and West Germany, to a concentration camp watchtower. Set next to the decorative fabric evocative of the beach, however, the tower also evokes the more pleasurable image of a raised lifeguard chair. Such lighter touches distinguish Polke's work in general from the unrelievedly serious efforts of Kiefer.

NEO-CONCEPTUALISM

In the United States, an analytic and often cynical mode emerged in the mid-1980s that seemed to be a reaction to both the emotionalism of Neo-Expressionism and the populism of graffiti art. Known as Neo-Conceptualism, it reflected the influence of the difficult and usually skeptical ideas on literature, philosophy, and society of a group of French intellectuals known as the Post-Structuralists— among them Derrida, Roland Barthes (1915–80), Jean Baudrillard (b. 1929), and Michel Foucault (1926–84)— who had become popular among American intellectuals in the late 1970s.

The ideas of Baudrillard and Foucault were particularly important to the artistic development of Peter Halley (b. 1953), the leading painter of the Neo-Conceptualist group. Baudrillard has argued that movies, television, and advertising have made ours the age of the simulacrum, or surrogate image that simulates reality. Simulacra, moreover, often seem hyperreal, or more real than the world they purport to reflect. The television stereotype of the average American family, for example, has replaced the social reality of family life, and advertising employs supersaturated colors to make products seem hyperreal. Halley realized that the fluorescent Day-Glo colors he had been using in his work were themselves signs of this new social phenomenon. He also began to question the Minimalist assertion that geometric forms are nonreferential; by the beginning of the 1980s, Halley was making abstract paintings with forms intended to be read as meaningful signs of the contemporary cultural phenomena described by Baudrillard and Foucault.

In *Fire in the Sky* (fig. 29-70), one of his so-called Neo-Geo (or new geometry) paintings, Halley applied hyperreal colors to the kind of simulated stucco used in suburban housing. This false stucco surface is itself a sign of the dominance of the simulacrum. The large central square, or cell, represents both the home and the brain (which is composed of cells). The rectangular forms that connect with it refer on one level to plumbing and electrical circuitry, on another to information reaching the brain through both

29-71. Jeff Koons. *The New Shelton Wet/Dry Triple Decker*. 1981. Vacuum cleaners in Plexiglas with fluorescent lights, 10'4½" x 2'4" x 2'4" (3.16 x 0.72 x 0.72 m). Des Moines Art Center, Iowa

Purchased with funds from Roy Halston Frowick (1991.46)

In the spirit of Duchamp's readymades (see fig. 28-63), Koons did not make but simply selected the displayed appliances, while their cases, like the Minimalist sculpture of Donald Judd (see fig. 29-33), were fabricated according to the artist's specifications. Koons's physical detachment from his work emphasizes its conceptual status. "It's information that's important to me," he said. "I like to push myself to the point where my work is done purely mentally without having any interaction with materials in process."

subconscious and conscious processes (represented by the lower and upper piping, respectively). The central cell has the further meaning of jail or imprisonment, a reference to Foucault's assertion that modern bureaucratic political regimes imprison the individual. The central square has therefore three referents: home, brain cell, and prison cell. Halley's intent is not to protest troubling social phenomena but to find a visually engaging way to illustrate them.

The most controversial Neo-Conceptualist is Jeff Koons (b. 1955), whose blatant careerism and artistic emphasis on consumerism, shocking to many critics, is informed by his admiration for Andy Warhol and his professional experience as a Wall Street commodities broker. Koons's first major series, called The New, featured brand-new vacuum cleaners encased in Plexiglas boxes and brilliantly lit by fluorescent tubes. Mimicking the display of merchandise that might be encountered in a department store, a sculpture such as *The New Shelton Wet/Dry Triple Decker* (fig. 29-71) is a commentary on the consumer's never-ending desire for the new as well as a frank declaration of art's status as a commodity under capitalism. To Koons, the work also addresses larger philosophical issues. The vacuum cleaners, though designed to suck up dirt, remain forever immaculate in their sealed cases and, in their purity, achieve a kind of immortality. "Maybe they'll die off as art," said Koons, "but they're equipped to out-survive us physically."

Sherrie Levine (b. 1947), another provocative Neo-Conceptualist, made her reputation by appropriating imagery from other artists. In 1981 she began making photographic copies of famous twentieth-century works by male artists as a way of attacking the predominantly male Neo-Expressionist movement. As she explained, "I felt angry at being excluded. As a woman, I felt there was not room for me The whole art system was geared to celebrating . . . male desire." *Untitled (After Aleksandr Rodchenko: 11)* (fig. 29-72) is not an homage to the Russian Constructivist (see fig. 28-46) but a critique of certain ideas associated with him and with modernism. Levine's work is inspired by the deconstructionism of Derrida, in which he unravels prevailing cultural assumptions, or "myths," by revealing them to contain self-conflicting messages. By appropriating images by men associated with innovation, Levine deconstructed those concepts and suggested that all art and thought are derivative.

29-72. Sherrie Levine. *Untitled (After Aleksandr Rodchenko: 11)*. 1987. Black-and-white photograph, 20 x 16" (50.8 x 40.6 cm)

Courtesy Marian Goodman Gallery, New York

29-73. Barbara Kruger. *We Won't Play Nature to Your Culture*. 1983. Photostat 6'1" x 4'1" (1.85 x 1.24 m)
Courtesy Mary Boone Gallery, New York

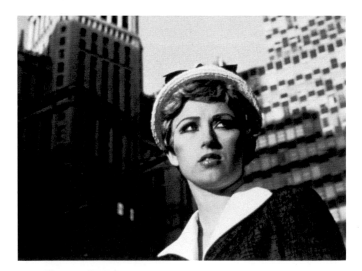

29-74. Cindy Sherman. *Untitled Film Still #21*. 1978. Black-and-white photograph, 8 x 10" (20.3 x 25.4 cm)
Courtesy Metro Pictures, New York

LATER FEMINIST ART

Levine can also be grouped with a second generation of feminist artists that emerged in the 1980s. These artists tended to believe that differences between the sexes are not intrinsic but are socially constructed to suit the needs of those in power. Thus, young women learn how to behave from role models promoted in magazines, movies,

and other sources of cultural coercion. The feminists considered resisting those cultural forces to be a major task of feminism and feminist art.

Barbara Kruger (b. 1945) is an important representative of this generation. Drawing on her experience as a designer and photo editor for women's magazines, she began in the late 1970s to create works that combined glossy high-contrast images, usually borrowed from old advertisements, and bold, easily readable, catchy texts. Her purpose was to undermine the media with its own devices, "to break myths, not to create them," but at times Kruger also seems to express a sense of futility. In *We Won't Play Nature to Your Culture* (fig. 29-73), for example, the voice is strong and defiant but the image is weak. The text declares that women will no longer accept the patriarchal definition of men as producers of culture and women as products of nature, but the woman lies passively on her back and is symbolically blinded by the leaves over her eyes.

One of the most critically acclaimed later feminists is Cindy Sherman (b. 1954), who, after moving to New York City in 1977, began creating black-and-white photographs that simulate stills from B-grade movies of the 1940s and 1950s. Each of the approximately seventy-five photographs in the series shows a single female figure, always Sherman in some guise. In *Untitled Film Still #21* (fig. 29-74), she poses as a perplexed young innocent apparently recently arrived in a big city, its buildings looming threateningly behind her. In the context of feminist film criticism's focus on movie representations of women as helpless creatures who need a man to care for them, Sherman's re-creation of such roles seems to be part of a critical, deconstructive agenda. She herself said she was "making fun" of the female role models from her childhood as well as engaging in a pure form of play that she had loved while growing up.

THE PERSISTENCE OF MODERNISM

Despite declarations of the death of modernism by postmodern artists and critics, many artists remained committed to its central values of formal innovation and personal expression. A leading modernist painter is the Chicago-born Elizabeth Murray (b. 1940), who moved to New York in 1967. Her artistic breakthrough came in the late 1970s, when she began to work on irregularly shaped canvases. During the 1980s her canvases, now stretched over thick plywood supports, became increasingly complex and three-dimensional physical presences over whose swelling surfaces she painted abstracted figures and familiar objects. Her bold and colorful style is inspired simultaneously by "high" modernist art and "low" popular culture: She employs Cubist-style fragmentation, Fauvist color, Surrealist biomorphism, and gestural, Abstract Expressionist paint handling, while also drawing inspiration from cartoons and animated films, which have fascinated her since childhood. *Chaotic Lip* (fig. 29-75) is an enormous, organically shaped canvas with rounded lobes that radiate out in several directions. Splayed across the painting's surface is an

animated green table, whose square top and rubbery legs evoke a cartoonish human figure. Constituting the figure's "head" is a squiggly red doughnut shape (the "chaotic lip"?), connected by a thin cord to a hole in the center of the table. The hole suggests a human profile and the cord and "doughnut," a cartoon speech balloon. The same motifs also suggest a vaginal opening and the flow of menstrual blood. Murray's work is characteristically modernist in its emphasis on ambiguous forms that generate a rich variety of possibilities.

Another artist devoted to the creation of evocative organic forms is the African-American sculptor Martin Puryear (b. 1941), whose early interest in biology marked an attraction to nature that would shape his mature aesthetic. As a Peace Corps volunteer in Sierra Leone on the west coast of Africa, Puryear studied the traditional, preindustrial woodworking methods of local carpenters and artisans. In 1966 he moved to Stockholm, Sweden, to study printmaking and learn the techniques of Scandinavian cabinetmakers. Two years later he began graduate studies in sculpture at Yale, where he encountered the work of a number of visiting Minimalist sculptors, including Richard Serra (see fig. 29-84). By the middle of the 1970s he had combined these formative influences into a distinctive personal style reminiscent, in its organic simplicity, of Constantin Brancusi (see fig. 28-18). Puryear's *Plenty's Boast* (fig. 29-76) does not represent anything in particular but suggests any number of things, including a strange sea creature or a fantastic musical instrument. Perhaps the most obvious reference is to the horn of plenty evoked in the sculpture's title. But the cone is empty, implying an "empty boast"—another reference to the title. Whatever associations one prefers, the beauty of the sculpture lies in its superb craft and its idiosyncratic yet elegant forms. Sounding like an early-twentieth-century modernist, Puryear said, "The task of any artist is to discover his own individuality at its deepest."

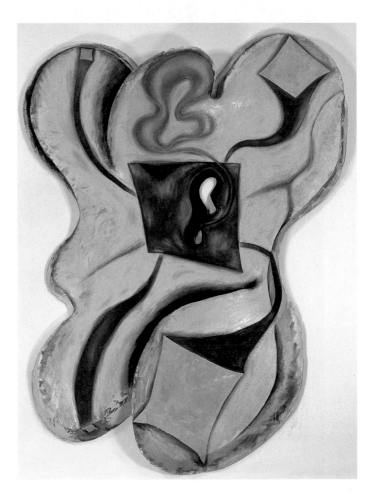

29-75. Elizabeth Murray. *Chaotic Lip*. 1986. Oil on canvas, 9'9½" x 7'2½" x 1' (3.01 x 2.22 x 0.31 m). Spencer Museum of Art, University of Kansas, Lawrence

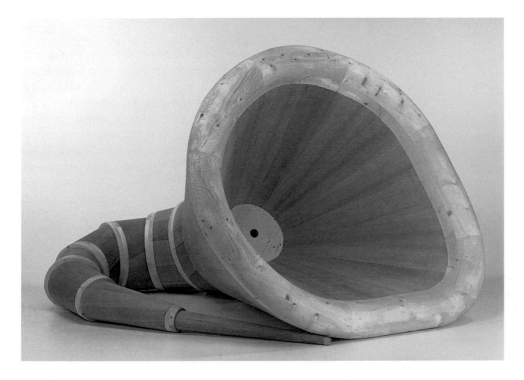

29-76. Martin Puryear. *Plenty's Boast*. 1994–95. Red cedar and pine, 5'8" x 6'11" x 9'10" (1.73 x 2.11 x 1.35 m). The Nelson-Atkins Museum of Art, Kansas City, Missouri

Purchase of the Renee C. Crowell Trust

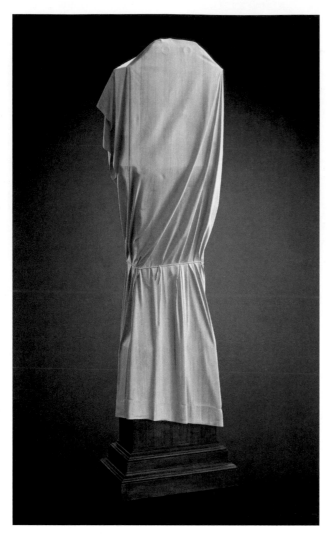

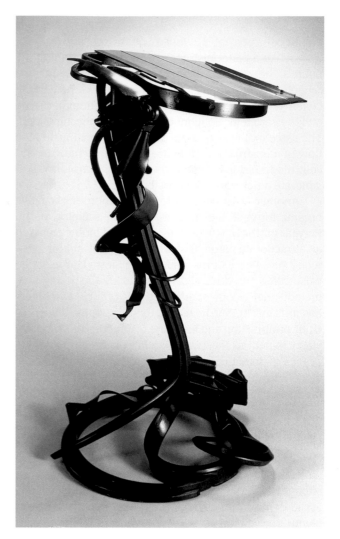

29-77. Wendell Castle. *Ghost Clock.* 1985. Mahogany and bleached Honduras mahogany, 7'2¼" x 2'½" x 1'3" (2.19 x 0.62 x 0.38 m). Renwick Gallery, Smithsonian American Art Museum, Washington, D.C.

Museum purchase through the Smithsonian Institution Collections Acquisition Program

29-78. Albert Paley. *Lectern.* 1989. Steel and brass, 45 x 37 x 25" (115 x 95 x 64 cm). American Craft Museum, New York

Museum purchase with funds provided by the Horace W. Goldsmith Foundation and the American Craft Museum Collectors Circle

RECENT CRAFT ART

Puryear's impressive woodworking skills link his sculpture to the contemporary American craft art movement that has flourished in recent decades. Another master of the medium of wood is Wendell Castle (b. 1932), who during the 1960s made highly original laminated wood furniture in an organic, sculptural style. His innovative furniture designs attracted not only praise but also numerous imitators, causing him in the late 1970s to change direction and begin carving technically demanding **trompe l'oeil** sculpture in wood. Related to the contemporary Super Realism of artists like Duane Hanson (see fig. 29-60), Castle's carvings represent everyday objects placed on or draped over furniture he built using traditional techniques. The impressively crafted *Ghost Clock* (fig. 29-77), which imitates an eighteenth-century clock borrowed from an antiques dealer, is covered by a *trompe l'oeil* sheet carved out of bleached mahogany. The sculpture's power comes not only from its astonishing

illusionism but also its haunting imagery, evoking an anthropomorphic presence forever hidden beneath the shroud.

A leading craft artist in the medium of metal is Albert Paley (b. 1944). In the early 1970s Paley gained a national reputation for his large and dramatic jewelry, a form of wearable sculpture. In the mid-1970s he turned to large-scale forged and fabricated architectural metalwork, producing ornamental gates, window grilles, railings, and other forms in a sinuous, organic style inspired by late-nineteenth-century Art Nouveau (see figs 27-82, 27-83). Paley also designs independent works of sculpture, traditionally considered "fine art," and furniture, considered "applied art." All of his efforts are characterized by an emphasis on formal innovation and virtuoso craft, as seen in his *Lectern* (fig. 29-78).

In contrast to the expansive quality of Paley's metalwork are the self-contained ceramic forms of Toshiko Takaezu (b. 1922), who was born in Hawaii to Japanese parents. Since the late 1950s she has closed the tops of

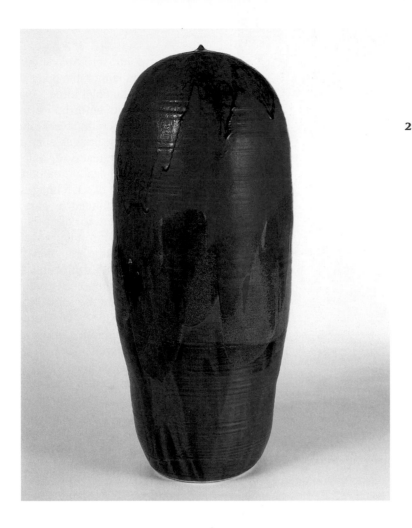

Like many craft artists, Takaezu
feels a strong physical and emo-
tional connection to her medium:
"One of the best things about clay
is that I can be completely free
and honest with it. When I make
it into a form, it is alive, and even
when it is dry, it is still breathing!
I can feel the response in my
hands, and I don't have to force
the clay. The whole process is an
interplay between the clay and
myself and often the clay has
much to say."

her vessels (leaving only a pinhole opening for the hot air
to escape during firing), rendering them nonfunctional
and emphasizing their status as abstract sculptural
forms rather than utilitarian objects. A virtuoso colorist,
she employs a rich variety of glazes to create sensuous
hues and surface effects. Among her favorite colors are
deep blues, purples, and blacks—seen, for example, in
Large Form (fig. 29-79)—which evoke for the artist the
beauty of her native Hawaii.

THE RETURN TO THE BODY

A great deal of recent avant-garde art has focused on the
human body, which numerous postmodern critics have
identified as an "object" subject to the operations of power
as well as a "site" for the display and definition of race,
class, gender, and sexual identity. One artist who has dealt
extensively with the vulnerable yet enduring body is the
Polish sculptor Magdalena Abakanowicz (b. 1930). In the
late 1960s she began producing large, woven, abstract
works of sculpture that soon gave way to figural pieces that
challenged the conventional distinctions between craft
and sculpture. Typical of her work is *Backs* (fig. 29-80), a
composition of eighty headless, limbless, genderless, and
hollow-front impressions made on a single mold over a
five-year period. The anonymous figures appear to be both
resigned and worshiping. "People ask me," she said, "is this
the concentration camp in Auschwitz or is it a religious cer-
emony in Peru . . . and I answer all these questions, 'yes,'
because it is . . . about existence in general."

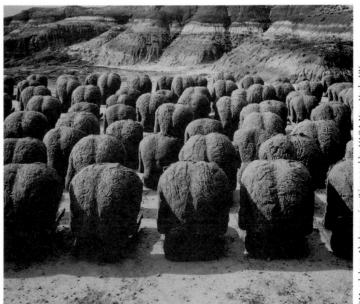

29-80. Magdalena Abakanowicz. *Backs.* 1976–80; shown installed
near Calgary. Canada, 1982. Burlap and resin, each piece approx.
25¾ x 21¾ x 23¾" (65.4 x 55.3 x 60.3 cm). Collection of Museum
of Modern Art, Pusan, South Korea

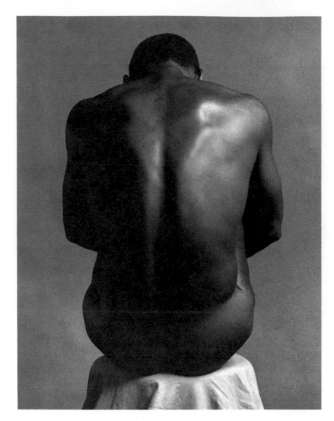

29-81. Robert Mapplethorpe. *Ajitto (Back)*. 1981.
Gelatin-silver print, 20 x 16" (50.8 x 40.6 cm).
The Robert Mapplethorpe Foundation, New York

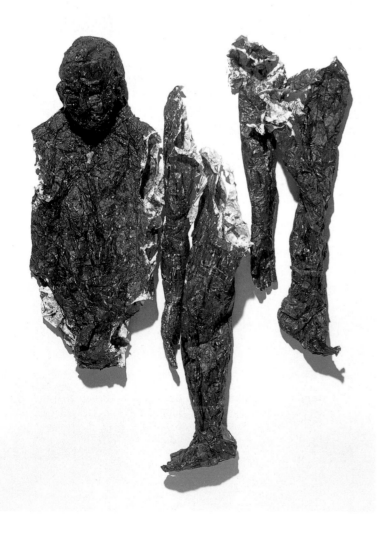

In sharp contrast to Abakanowicz's emphasis on the fragmented and vulnerable body, the American photographer Robert Mapplethorpe (1946–89) chose young, statuesque models whose physical perfection he celebrated in carefully crafted black-and-white photographs. While many of these images, such as *Ajitto (Back)* (fig. 29-81), are classically reserved, Mapplethorpe also made photographs of explicitly homoerotic subjects and sex acts. The inclusion of such images in his 1989–90 touring retrospective, funded in part by a grant from the National Endowment for the Arts, fueled a heated controversy over public funding for the arts in the United States—a matter that remains the subject of much debate (see "Recent Controversies over Public Funding for the Arts," opposite). The Contemporary Arts Center in Cincinnati presented the show in 1990, putting the controversial works in their own room with a clearly printed advisement. Cincinnati officials nevertheless charged the museum and its director with obscenity and put them on trial. The jury failed to find that the photographs "lack[ed] serious literary, artistic, political, or scientific value"—one of the criteria for obscenity set by the Supreme Court in a 1973 decision—and acquitted the museum and its director. The jury had decided, as one juror commented, "we may not have liked the pictures" but they were art. "We learned," he added, "that art doesn't have to be pretty."

A conscious rejection of the "pretty" has marked the production of numerous contemporary artists concerned with representing the base human body and its fluids, such as blood, vomit, and excrement. The American sculptor Kiki Smith (b. 1954) has thoroughly explored this territory in works such as *Untitled* (fig. 29-82). This disturbing sculpture, made of red-stained, tissue-thin gampi paper, represents the flayed, bloodied, and crumpled skin of a male figure, torn into three pieces that hang limply from the wall. The body, once massive and vigorous, is now hollow and lifeless. The exposure of its interior suggests the loss of boundaries between the body and the environment.

A related interest of contemporary artists has been gender ambiguity. Many postmodern theorists argue that gender—as opposed to anatomical sex—is not biologically determined but socially constructed. Thus, the supposedly natural boundaries between the masculine and the feminine are in fact artificial and subject to transgression. Deeply interested in such transgression is the Japanese photographer–performance artist Yasumasa Morimura (b. 1951), well-known for his re-creations of famous European paintings and, more recently, impersonations of European and Hollywood movie stars. Like Cindy Sherman (see fig. 29-74), Morimura poses for all the figures in his photographs, regardless of age, sex, or race, radically transforming his appearance through costumes

29-82. Kiki Smith. *Untitled*. 1988. Ink on gampi paper,
48 x 38 x 7" (121.9 x 96.5 x 17.8 cm).
The Art Institute of Chicago
Gift of Lannon Foundation (1997.121)

RECENT CONTROVERSIES OVER PUBLIC FUNDING FOR THE ARTS

Should public money support the creation or exhibition of art that some taxpayers might find indecent or offensive? This question became an issue of heated debate in 1989–90, when controversies arose around the work of the American photographers Robert Mapplethorpe and Andres Serrano (b. 1950), who had both received funding, directly or indirectly, from the National Endowment for the Arts (NEA). Serrano became notorious for a large color photograph, *Piss Christ* (1987), that shows a plastic crucifix immersed in the artist's urine. Although Serrano did not create that work using public money, he did receive in 1989 a $15,000 NEA grant through the Southeastern Center for Contemporary Art (SECCA), which included *Piss Christ* in a group exhibition. *Piss Christ* came to the attention of the Reverend Donald Wildmon, leader of the American Family Association, who railed against it as "hate-filled, bigoted, anti-Christian, and obscene." Wildmon exhorted his followers to flood Congress and the NEA with letters of protest, and the attack on the NEA was quickly joined by conservative Republican politicians.

Amid the Serrano controversy, the Corcoran Gallery of Art in Washington, D.C., decided to cancel its showing of the NEA-funded Robert Mapplethorpe retrospective (organized by the Institute of Contemporary Art [ICA] in Philadelphia), because it included homoerotic and sadomasochistic images. Congress proceeded to cut NEA funding by $45,000, equaling the $15,000 SECCA grant to Serrano and the $30,000 given to the ICA for the Mapplethorpe retrospective. It also added to the NEA guidelines a clause requiring that award decisions take into consideration "general standards of decency and respect for the diverse beliefs and values of the American public."

The decency clause was soon challenged as unconstitutional in federal court by a group of performance artists—Karen Finley, John Fleck, Holly Hughes, and Tim Miller, popularly dubbed the NEA Four—who in the summer of 1990 had been denied NEA grants due to the provocative nature of their work. Finley, the best known of the group, had sought funding for a performance in which she describes a sexual assault by stripping to the waist, smearing chocolate over her breasts, and shouting profanity. The artists, whose suit was joined by a coalition of free-speech and art-world organizations, argued that the decency clause violated the First Amendment right to freedom of expression. While lower courts sided with the plaintiffs, in the summer of 1998 the United States Supreme Court ruled in favor of the government. The court allowed the decency clause to stand because it was only "advisory" and did not establish a categorical requirement that art be decent.

During the years of legal battle, the NEA underwent major restructuring under pressure from the Republican-controlled House of Representatives, some of whose members sought to eliminate the agency altogether. In 1996 Congress cut the NEA's budget by 40 percent, cut its staff in half, and replaced its seventeen discipline-based grant programs with four interdisciplinary funding categories. It also prohibited grants to individual artists in all areas except literature, making it impossible for controversial figures like Serrano and Finley to receive grants.

Another major controversy over the use of taxpayer money to support the display of provocative art erupted in the fall of 1999, when the Brooklyn Museum of Art opened the exhibition "Sensation: Young British Artists from the Saatchi Collection" in defiance of a threat from New York City mayor Rudolph Giuliani to eliminate city funding and evict the museum from its city-owned building if it persisted in showing work that he called "sick" and "disgusting." Giuliani and Catholic leaders took particular offense at Chris Ofili's *The Holy Virgin Mary*, a glittering painting of a stylized African Madonna with a breast made out of elephant dung, surrounded by cutout photographic images of women's buttocks and genitalia. Ofili (b. 1968), a British-born black of Nigerian parentage who is himself Catholic, explained that he meant the painting to be a contemporary reworking of the traditional image of the Madonna surrounded by naked *putti*, and that the elephant dung, used for numerous practical purposes by African cultures, represents fertility. Giuliani and his allies, however, considered the picture sacrilegious.

When in late September the Brooklyn Museum of Art refused to cancel the show, Giuliani withheld the city's monthly maintenance payment to the museum of $497,554 and filed a suit in state court to revoke its lease. The museum responded with a federal lawsuit seeking an injunction against Giuliani's actions on the grounds that they violated the First Amendment. On November 1, the U.S. District Court for the Eastern District of New York barred Giuliani and the city from punishing or retaliating against the museum in any way for mounting the exhibition. While the mayor had argued that the city should not have to subsidize art that fosters religious intolerance, the court ruled that the government has "no legitimate interest in protecting any or all religions from views distasteful to them." Taxpayers, said the court, "subsidize all manner of views with which they do not agree," even those "they abhor."

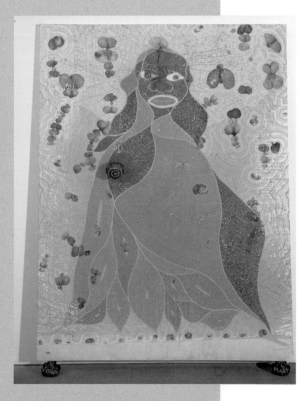

Chris Ofili. *The Holy Virgin Mary*. 1996. Paper collage, oil paint, glitter, polyester resin, map pins, and elephant dung on linen, 7'11" x 5'11⁵/₁₆" (2.44 x 1.83 m). The Saatchi Gallery, London

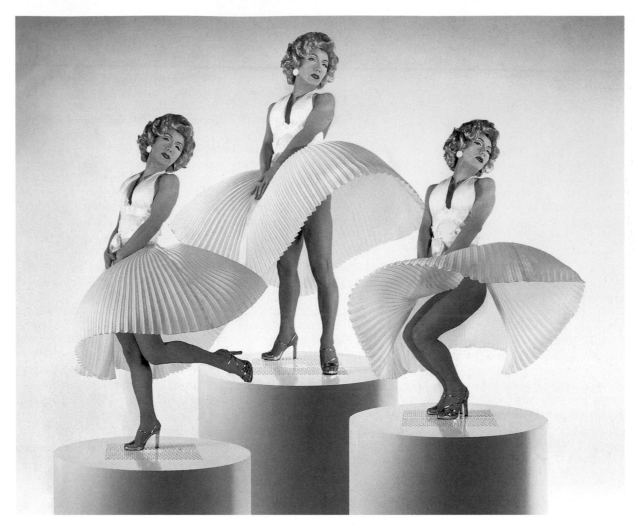

29-83. Yasumasa Morimura. *Self-Portrait (Actress)/White Marilyn*. 1996. Ilfochrome and acrylic sheet, 37¼ x 47¼" (94.6 x 120 cm)

Courtesy Luhring Augustine Gallery, New York

Known for his impersonations of male and female figures in famous Western paintings as well of actresses like Marilyn Monroe, Morimura extends the tradition of Japan's Noh and Kabuki theaters, in which men play all the roles, both male and female.

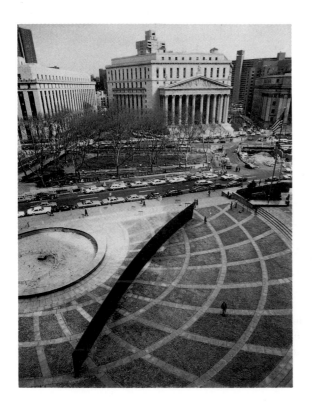

29-84. Richard Serra. *Tilted Arc*. 1981. Hot-rolled steel, height 12' (3.7 m), length 120' (36.58 m). Federal Plaza, Foley Square, New York; removed in 1989

In his 1989 article on what he termed the "destruction" of *Tilted Arc*, Serra argued that the perception that the majority of the public wanted its removal was untrue, an exaggeration by those who simply did not like the work. He pointed out that during a three-day hearing in 1985, some 122 people spoke in favor of retaining the sculpture and only 58 spoke for its removal. Moreover, a petition for removal presented at the hearing had 3,791 signatures, representing fewer than a quarter of the approximately 12,000 employees in the federal buildings at the site—and another petition against removal had 3,763 signatures.

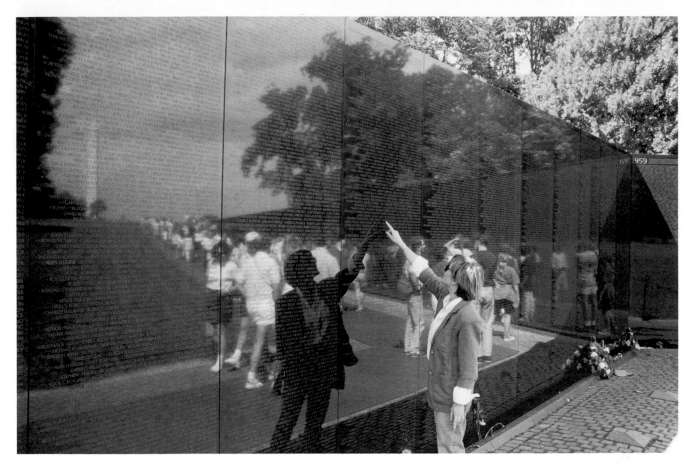

29-85. Maya Ying Lin. Vietnam Veterans Memorial. 1982. Black granite, length 500' (152 m). The Mall, Washington, D.C.

and makeup. Unlike Sherman, however, Morimura also uses digital computer-scanning technology to manipulate his compositions and, in some cases, to combine multiple self-images in a single photograph, as in *Self-Portrait (Actress)/White Marilyn* (fig. 29-83), which mimics Marilyn Monroe's famous skirt-blowing scene in *The Seven Year Itch*. The work represents a shift not only in gender but also in race, as an Asian actor impersonates a Caucasian star. It can be seen not only as a response to the capitalist media's global dissemination of celebrity images but also as an argument for what one critic has called a "post-national, postgendered, de-essentialized identity."

PUBLIC ART

Throughout history and across cultures, works of art have been placed in public spaces to address a broad audience. Prior to the modernist period, works of public art often served to honor a hero, commemorate an important event, or celebrate widely shared social or religious values and were normally readily understandable to the public. Modernist artists continued to make public art but typically worked in abstract styles that were difficult for untrained viewers to comprehend. In many cases, controversies ensued, pitting the conservative taste of the general public against the more adventuresome aesthetics of modernist artists and their supporters.

A particularly loud controversy arose over *Tilted Arc* (fig. 29-84), a Minimalist work by the American sculptor Richard Serra (b. 1939). A steel wall 12 feet high and 120 feet long that tilted 1 foot off its vertical axis, *Tilted Arc* was commissioned for the plaza of a federal government building complex in New York City. Typical of Serra's work, it was strong, simple, tough, and, given its tilt, fairly threatening. Some employees in the nearby buildings found the work objectionable. Calling it an "ugly rusted steel wall" that "rendered useless" their "once beautiful plaza," they petitioned to have it removed. The government agreed to do so, but Serra went to court to preserve his work. He eventually lost his case, and the sculpture was removed in 1989.

The Vietnam Veterans Memorial (fig. 29-85), now widely admired as a fitting testament to the Americans who died in that conflict, was also a subject of public controversy when it was first proposed due to its severely Minimalist style. In its request for proposals for the design of the monument, the Vietnam Veterans Memorial Fund—composed primarily of veterans themselves—stipulated that the memorial be without political or military content, that it be reflective in character, that it harmonize with its surroundings, and that it include the names of the more than 58,000 dead and missing. In 1981 they awarded the commission to Maya Ying Lin (b. 1960), then an undergraduate studying in the architecture department at Yale University. Her Minimalist-inspired design called for two 200-foot-long walls (later expanded to almost 250 feet) of polished black granite, to be set into a gradual rise in Constitution Gardens on the Mall in Washington, D.C., meeting at a 136-degree angle at the point where the walls and slope would be at their full 10-foot height. The names of the

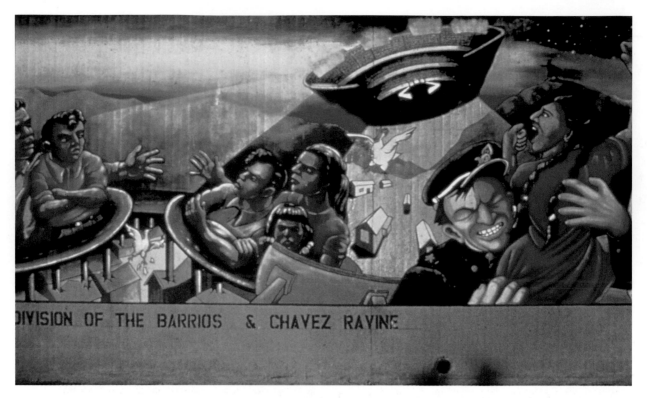

29-86. Judy Baca. *The Division of the Barrios*, detail from *The Great Wall of Los Angeles*. 1976–83. Height 13' (4 m), overall length approx. 2,500' (762 m). Tujunga Wash Flood Control Channel, Van Nuys, California

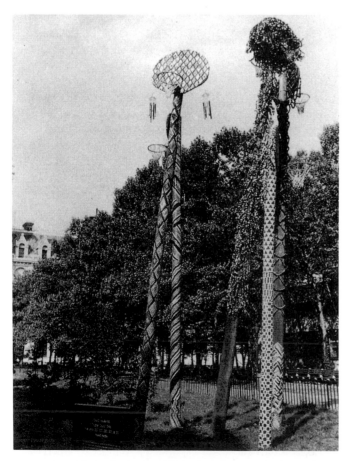

29-87. David Hammons. *Higher Goals*. 1982; shown installed in Brooklyn, New York, 1986. Five poles of mixed mediums, including basketball hoops and bottle caps, height of tallest pole 35' (10.6 m)

dead were to be incised in the stone in the order in which they died, with only the dates of the first and last deaths, 1959 and 1975, recorded.

Lin's memorial has become one of the most compelling monuments in the United States, largely because it creates an understated encounter between the living, reflected in the mirrorlike polished granite, and the dead, whose names are etched in its black, inorganic permanence. Quiet and solemn, the work allows visitors the opportunity for contemplation. Adding significantly to the memorial's intrinsic power are the many mementos, from flowers to items of personal clothing, that have been left below the names of loved ones by friends and relatives.

Although it lists their individual names, Lin's Vietnam Veterans Memorial integrates those it commemorates, without regard to their differences in age, sex, ethnicity, race, religion, or socioeconomic class. Beginning in the 1970s another, very different sort of public art in the United States took the opposite approach, concentrating on such differences as a way of acknowledging the **multiculturalism** of American society. Leaders in the creation of this type of public art were a number of Chicano artists in Los Angeles and other California cities who in the 1970s began to paint public murals, reviving a tradition started by Diego Rivera (see fig. 28-84) and other Mexican artists following the Mexican Revolution.

While the Chicano muralists most often worked in the barrios, one, Judy Baca (b. 1949), created her most ambitious work at a site in the white, suburban San Fernando Valley. Painted at the invitation of the U.S. Army Corps of Engineers, Baca's *Great Wall of Los Angeles* (fig. 29-86)

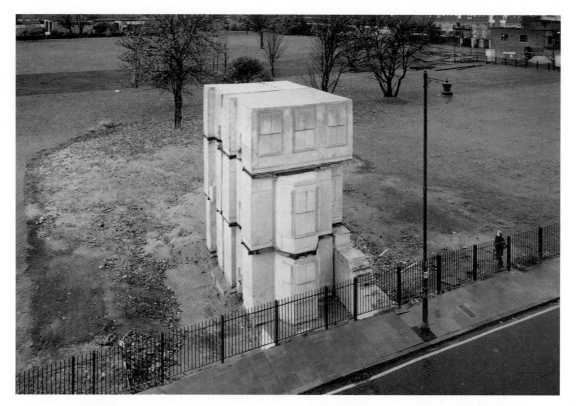

29-88. Rachel Whiteread. *House*. 1993. Sprayed concrete. Corner of Grove and Roman roads, London; destroyed in 1994
Commissioned by Artangel Trust and Beck's

extends almost 2,500 feet along the wall of a drainage canal, making it perhaps the longest mural in the world. Its subject is the history of California, with an emphasis on the role of racial minorities. The twentieth-century scenes include the deportation of Mexican-American citizens during the Great Depression, the internment of Japanese-American citizens during World War II, and residents' futile protests over the division of a Chicano neighborhood by a new freeway. The mural concludes with more positive images of the opportunities gained by minorities in the 1950s and 1960s. Typical of Baca's public work, *The Great Wall of Los Angeles* was a group effort, involving arts professionals and some 215 young people who painted the mural under Baca's direction.

Another socially minded artist strongly committed to the creation of public art is David Hammons (b. 1943), an outspoken critic of the gallery system who insists that art today is "like Novocaine. It used to wake you up but now it puts you to sleep." Only street art, uncontaminated by commerce, he maintains, can still serve the old function. Hammons for the most part aims his work at his own African-American community. His best-known work is probably *Higher Goals* (fig. 29-87), which he produced in several versions between 1982 and 1986. This one, temporarily set up in a Brooklyn park, has backboards and baskets set on telephone poles—a reference to communication—that rise as high as 35 feet. The poles are decorated with bottle caps, a substitute for the cowrie shells used not only in African design but also in some African cultures as money. Although the series may appear to honor the game, Hammons said it is "antibasketball sculpture." "Basketball

has become a problem in the black community because kids aren't getting an education It means you should have higher goals in life than basketball."

Works like *Higher Goals* have reinforced the notion that art is most effective as a social tool when it avoids an institutional setting, takes root in a specific community, and addresses locally important issues in straightforward language. Like environmental earthworks, socially conscious art seems to function best when it is site-specific, such as *House* (fig. 29-88), by the British sculptor Rachel Whiteread (b. 1963). Known for her sculptural casts of negative spaces, such as the inside of a wardrobe chest, Whiteread in this instance produced a sprayed-concrete cast of the inside of an entire East London house, the last remaining from a Victorian-era terrace that was being removed to create a new green space. Whiteread intended the work both as a monument to the idea of home and as a political statement about "the state of housing in England; the ludicrous policy of knocking down homes like this and building badly designed tower blocks which themselves have to be knocked down after 20 years." Immediately upon its completion, *House* became the focus of public debate over not just its artistic merits but also social issues such as housing, neighborhood life, and the authority of local planners. Intended to be temporary, Whiteread's work stood for less than three months before it, too, was demolished.

In their drive to bring about positive social change, some artists have created public works meant to provoke not only discussion but also tangible improvements. Notable examples are the *Revival Fields* of the Chinese-

29-89. Mel Chin. *Revival Field: Pig's Eye Landfill.* 1991–present. St. Paul, Minnesota

Although it serves the practical purpose of reclaiming a hazardous waste site through the use of plants that absorb toxic metals from the soil, Chin sought funding for his *Revival Field* series not from the Environmental Protection Agency but from the National Endowment for the Arts. In 1990 his grant application, which had been approved by an NEA panel, was vetoed by NEA chair John E. Frohnmayer, who questioned the project's status as art. Frohnmayer reversed his decision after Chin eloquently compared *Revival Field* to a work of sculpture: "Soil is my marble. Plants are my chisel. Revived nature is my product This is responsibility and poetry."

29-90. Jenny Holzer. *Untitled* **(Selections from** *Truisms, Inflammatory Essays, The Living Series, The Survival Series, Under a Rock, Laments* **and** *Mother and Child Text).* 1989–90. Installation at the Solomon R. Guggenheim Museum, New York, with extended helical tricolor LED electronic display signboard, 14" x 525'10" x 4" (36 cm x 161.8 m x 10 cm). Solomon R. Guggenheim Museum, New York
Partial gift of the artist, 1989

American artist Mel Chin (b. 1951), which are designed to restore the ecological health of contaminated land through the action of "hyperaccumulating" plants that absorb heavy metals from the soil. Chin created his first *Revival Field* near St. Paul, Minnesota, in the dangerously contaminated Pig's Eye Landfill (fig. 29-89). Chin gave the work the cosmological form of a circle in a square (representing heaven and earth in Chinese iconography), divided into quarters by intersecting walkways. He seeded the inside of the circle with hyperaccumulating plants and the outside with nonaccumulating plants as a control. Every year the plants are harvested and replanted and toxic metals removed from the soil. "Rather than making a metaphorical work to express a problem," said Chin, "a work can . . . tackle a problem head-on. As an art form it extends the notion of art beyond a familiar object-commodity status into the realm of process and public service."

29-91. Ann Hamilton. *Indigo Blue*. 1991. Installation for "Places with a Past," Spoleto Festival U.S.A., Charleston, South Carolina

INSTALLATION AND VIDEO ART

Many contemporary artists reject the traditional conception of a work of art as a portable object and instead make installations that are tied to a particular physical site, where they may exist permanently or for a limited time—typically, the duration of an exhibition. Contemporary installation art generally experiments with new forms, materials, and mediums, including light, sound, video, and computer technology.

A major installation artist is Ohio-born Jenny Holzer (b. 1950), who worked initially as a street artist in New York in the 1970s. In the mid-1970s in a course in the history of contemporary art, Holzer read a number of Post-Structuralist writers and then set out to rephrase their ideas as one-liners suited to the reading habits of Americans raised on advertising messages. She compiled these statements, called *Truisms*, in alphabetical lists, had them printed, and plastered them all over her neighborhood. With remarks reflecting a variety of viewpoints and voices, such as "Any Surplus Is Immoral" and "Morality Is for Little People," she hoped to "instill some sense of tolerance in the onlookers or the reader."

During the 1980s Holzer moved progressively into mediums that would address wider audiences—most notably, computer-controlled light-emitting diode (LED) machines, whose usual advertising function she subverted by programming them to display her provocative messages. Holzer often presented her works in public places, including on the Spectacolor board above Times Square in New York City. Meanwhile, increasing recognition from the art world brought her invitations to exhibit in museums. In a spectacular installation of 1989–90, Holzer wrapped her signboards in a continuous loop around three floors of the helical interior of Frank Lloyd Wright's Guggenheim Museum (fig. 29-90). The words moved and flashed in red,

green, and yellow colored lights, surrounding the visitor with Holzer's unsettling declarations ("You are a victim of the rules you live by") and disturbing commands ("Scorn Hope," "Forget Truths"). The installation also included, on the ground floor and in a side gallery, spotlighted granite benches carved with Holzer's texts. The juxtaposition of cutting-edge technology, lights, and motion with the static, hand carved benches, evocative of antiquity and mortality, created a striking contrast fundamental to the expressive effect of the whole.

Site-specific installations have assumed a prominent place in large-scale, regularly held international exhibitions of contemporary art such as the Venice Biennale and the Carnegie International in Pittsburgh. While many of these shows simply sample the diversity of current art, some are organized around themes, as was the 1991 Spoleto Festival U.S.A. exhibition in Charleston, South Carolina, entitled "Places with a Past." Eighteen artists were invited to find sites in the city for temporary works that would provide an "intimate and meaningful exchange" with the citizens of Charleston on issues from its history.

Ohio artist Ann Hamilton (b. 1956) originally planned to deal with slavery in her entry. When she found an abandoned automobile repair shop on Pinkney Street, however, she decided to treat an aspect of American life neglected by most historians. The street was named for Eliza Lucas Pinkney, who in 1744 introduced to the American colonies the cultivation of indigo, the source of a blue dye used for, among other things, blue-collar work clothes. The focal point of Hamilton's *Indigo Blue* (fig. 29-91) was a pile of about 48,000 neatly folded work pants and shirts. However, *Indigo Blue* was more a tribute to the women who washed, ironed, and folded such clothes—in this case, Hamilton and a few women helpers, including her mother—than to the men who worked in them. In front of the great mound of shirts and pants sat a woman

29-92. Nam June Paik. *Electronic Superhighway: Continental U.S.* 1995. Forty-seven-channel closed-circuit video installation with 313 monitors, neon, steel structure, color, and sound; approx. 15 x 32 x 4' (4.57 x 9.75 x 1.2 m). Courtesy the artist and Holly Solomon Gallery, New York

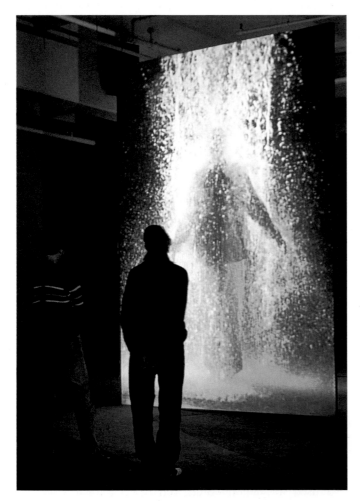

29-93. Bill Viola. *The Crossing.* 1996. Video/sound installation with two channels of color video projected onto 16-foot-high screens, 10½ minutes. View of one screen at 1997 installation at Grand Central Market, Los Angeles

Collection: Edition 1, Collection of the Solomon R. Guggenheim Museum, Gift of the Bohen Foundation; Edition 2, Collection of Pamela and Richard Kramlich, San Francisco; Edition 3, Dallas Museum of Art, Texas

erasing the contents of old history books—creating page space, Hamilton said, for the ordinary, working-class people usually omitted from conventional histories.

A number of installation artists work with video, either using the video monitor itself as a visible part of their work or projecting video imagery onto walls, screens, or other surfaces. The pioneer of video as an artistic medium was the Korean-born, New York–based Nam June Paik (b. 1931), who proclaimed that just "as collage technique replaced oil paint, the cathode ray tube will replace the canvas." Strongly influenced by John Cage, Paik made experimental music in the late 1950s and early 1960s and participated in the performance activities of Fluxus. He began working with modified television sets in 1963 and bought his first video camera in 1965. Since then, Paik has worked with live, recorded, and computer-generated images displayed on video monitors of varying sizes, which he often combines into sculptural ensembles such as *Electronic Superhighway: Continental U.S.* (fig. 29-92), a site-specific installation created for the Holly Solomon Gallery in New York. Stretching across an entire wall, the work featured a map of the continental United States outlined in neon and backed by video monitors perpetually flashing with color and movement and accompanied by sound. (Side walls featured Alaska and Hawaii.) The monitors within the borders of each state displayed images reflecting that state's culture and history, both distant and recent. The only exception was New York State, whose monitors displayed live, closed-circuit images of the gallery visitors, placing them in the art work and transforming them from passive spectators into active participants.

Paik's videos often use rapid cuts and fast motion to evoke the ceaseless flow of images and information carried by electronic communication systems. By contrast, the California-based video artist Bill Viola (b. 1951) often employs extreme slow motion to heighten sensory awareness and induce a state of contemplation at odds with the fast-paced images of the mass media. Inspired by both Eastern and Western religions, Viola frequently addresses themes relating to birth, death, and spirituality. In *The Crossing* (fig. 29-93), two videos, projected simultaneously on either side of a 16-foot-high screen, show a casually dressed white man on a dark set, approaching in slow motion. When his body almost fills the screen, he stops and stands impassively, facing the viewer. On one side of the screen, a small flame appears at the man's feet and gradually spreads to consume his entire body. On the other side, a trickle of water starts falling on his head, steadily increasing into a torrent that inundates him. Meanwhile, the amplified sounds of fire and water increase to a mighty roar. When the flames die down and the water subsides, the man has disappeared. What is perhaps most remarkable about this (illusionistic) annihilation is that the man does not physically resist but calmly accepts being engulfed by the elements, even stretching out his arms as if to welcome them. Viola's work dramatizes, among other things, the belief of many world religions—including Hinduism, Judaism, and Christianity—in the power of fire and water to purge and purify the human mind and soul.

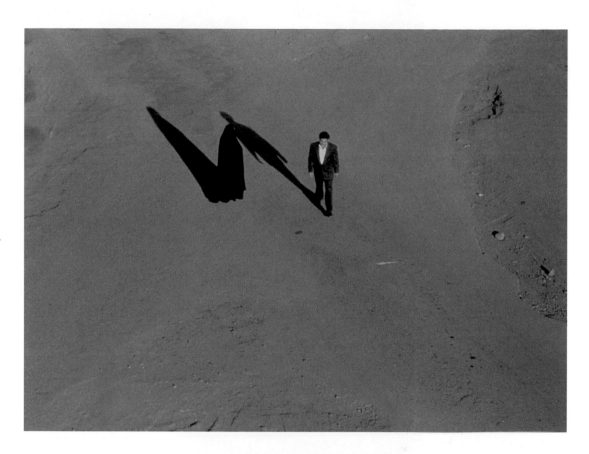

(right and below)
29-94. Shirin Neshat. Production stills from *Fervor*. 2000. Video/sound installation with two channels of black-and-white video projected onto two screens, 10 minutes. Courtesy Barbara Gladstone Gallery

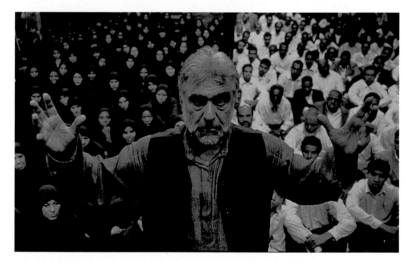

While Viola's works resonate within a wide variety of cultural traditions, the photographic and video artist Shirin Neshat (b. 1957) addresses universal themes within the specific context of modern-day Islamic society. Neshat was studying art in California when revolution shook her native Iran in 1979. Returning to Iran in 1990 for the first time in twelve years, Neshat was shocked by the extent to which fundamentalist Islamic rule had transformed her homeland, particularly through the requirement that women appear in public veiled from head to foot in a *chador*, a square of fabric. Upon her return to the United States, Neshat began using the black *chador* as the central motif of her work.

In the late 1990s Neshat began to make visually arresting and poetically structured videos that offer subtle critiques of Islamic society. *Fervor* (fig. 29-94), in Neshat's words, "focuses on taboos regarding sexuality and desire" in Islamic society that "inhibit the contact between the sexes in public. A simple gaze, for instance, is considered a sin" Composed of two separate video channels projected simultaneously on two large, adjoining screens, *Fervor* presents a simple narrative. In the opening scene, a black-veiled woman and jacket-wearing man, viewed from above, cross paths in an open landscape. The viewer senses a sexual attraction between them, but they make no contact and go their separate ways. Later, they meet again while entering a public ceremony where men and women are divided by a large curtain. On a stage before the audience, a bearded man fervently recounts (in Farsi, without subtitles) a story adapted from the Koran about Yusuf (the biblical Joseph) and Zolikha. Zolikha attempts to seduce Yusuf (her husband's slave) and then, when he resists her advances,

falsely accuses him of having seduced her. The speaker passionately urges his listeners to resist such sinful desires with all their might. As his tone intensifies and the audience begins to chant in response to his exhortations, the male and female protagonists grow increasingly anxious, and the woman eventually rises and exits hurriedly. *Fervor* ends with the man and woman passing each other in an alley, again without verbal or physical contact.

While Neshat concentrates on dualisms and divisions—between East and West, male and female, individual desire and collective law—the Shanghai-born artist Wenda Gu (b. 1955) dedicates his art to bringing people together. Trained in traditional ink painting at China's National Academy of Fine Arts, Gu in the 1980s began to paint pseudocharacters—fake, Chinese-looking ideograms

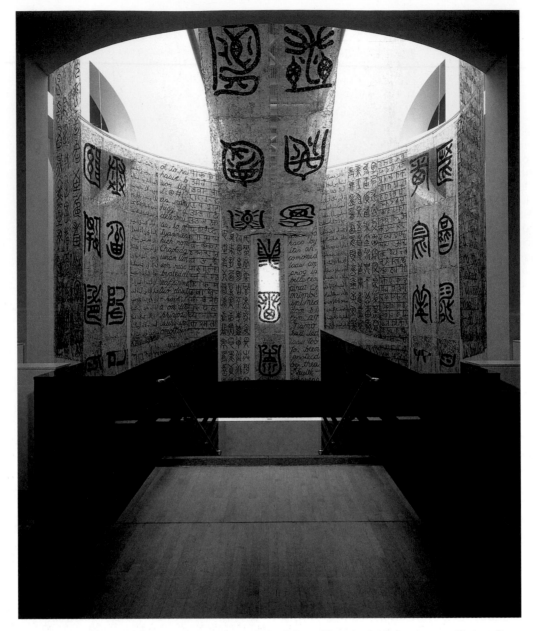

29-95. Wenda Gu. *United Nations: The Babel of the Millennium*. 1999. Site-specific installation made of human hair, height 75' (22.9 m), diameter 34' (10.4 m). San Francisco Museum of Modern Art

Fractional and promised gift of Viki and Kent Logan

of his own invention. Although he later claimed that his intent was simply to "break through the control of tradition," the Chinese authorities feared that his work contained hidden political messages and did not permit his first solo exhibition to open in 1986. The next year Gu emigrated to the United States and in 1993 began his *United Nations* series, which he describes as an ongoing worldwide art project. The series consists of site-specific installations or "monuments" made of human hair, which Gu collects from barbershops across the globe and presses or weaves into bricks, carpets, and curtains. Gu's "national" monuments—installed in such countries as Poland, Israel, and Taiwan—use hair collected within and address issues specific to that country. His "transnational" monuments address larger themes and blend hair collected from different countries as a metaphor for the mixture of races that the artist predicts will eventually unite humanity into "a brave new racial identity." Many of

Gu's installations, such as *United Nations: The Babel of the Millennium* (fig. 29-95), also incorporate invented scripts based on Chinese, English, Hindi, and Arabic characters that, by frustrating viewers' ability to read them, "evoke the limitations of human knowledge" and help prepare them for entry into an "unknown world."

In its ambitious attempt to address in artistic terms the issue of globalism that dominates discussions of contemporary economics, society, and culture, Gu's work is remarkably timely. Yet, like all important art, it is meant to speak not only to the present but also to the future, which will recognize it as part of the fundamental quest of artists throughout history to extend the boundaries of human perception, feeling, and thought and to express humanity's deepest wishes and most powerful dreams. "A great 'utopia' of the unification of mankind probably can never exist in our reality," admits Gu, "but it is going to be fully realized in the art world."

PARALLELS

STYLE	INTERNATIONAL AVANT-GARDE ART	OTHER POSTWAR ART
POSTWAR EUROPEAN	29-2. Giacometti. *City Square* (1948) 29-3. Bacon. *Head Surrounded by Sides of Beef* (1954) 29-4. Dubuffet. *Cow with the Subtile Nose* (1954) 29-5. Riopelle. *Knight Watch* (1953) 29-6. Tàpies. *White with Graphism* (1957)	23-21. Velarde. Santa Clara *Koshares* (1946–47), North America 20-10. Mathur, Jeanneret. **Gandhi Bhavan** (1959–61), India 24-3. Marika. *Wawalag Sisters* (1959), Australia 22-16. Ceramic vessels (after 1970), Japan 24-15. Tjapaltjarri. *Love Story* (1978), Australia 24-14. Kakalia. Hawaiian *Royal Symbols* (1978), North America
ABSTRACT EXPRESSIONISM	29-8. Pollock. *Male and Female* (1942) 29-7. Gorky. *Garden in Sochi* (c. 1943) 29-17. Frankenthaler. *Mountains and Sea* (1952)	24-7. *Tatanua* masks (1979), New Ireland 25-18. Guro mask (1983), Côte d'Ivoire 21-13. Wu. *Pine Spirit* (1984), China
ACTION PAINTING	29-10. Pollock. *Autumn Rhythm (Number 30)* (1950) 29-12. De Kooning. *Woman I* (1950–52) 29-11. Krasner. *The Seasons* (1957)	25-4. Bwa masks (1984), Burkino Faso 25-20. Odundo. *Angled Piece* (1990), Kenya 22-17. Fujii. *Untitled* (1990), Japan 23-23. Smith. **Salish-Cree-Shoshone Trade (Gifts for Trading Land with White People)** (1992), North America
COLOR FIELD	29-14. Newman. *Vir Heroicus Sublimis* (1950–51) 29-13. Rothko. *Brown, Blue, Brown on Blue* (1953)	
NEW YORK SCHOOL SCULPTURE	29-15. Smith. *Hudson River Landscape* (1951) 29-16. Nevelson. *Sky Cathedral* (1958)	
FIGURAL	29-18. Segal. *The Diner* (1964–66) 29-80. Abakanowicz. *Backs* (1976–80) 29-81. Mapplethorpe. *Ajitto (Back)* (1981) 29-82. Smith. *Untitled* (1988) 29-83. Morimura. *Self-Portrait (Actress)/White Marilyn*	
HAPPENINGS	29-20. Shimamoto. *Hurling Colors* (1956) 29-21. Klein. *Anthropométries of the Blue Period* (1960) 29-19. Kaprow. *The Courtyard* (1962)	
ASSEMBLAGE	29-24. Johns. *Target with Four Faces* (1955) 29-23. Rauschenberg. *Canyon* (1959) 29-22. Tinguely. *Homage to New York* (1960)	
POP	29-25. Hamilton. *$he* (1958–61) 29-27. Warhol. *Marilyn Diptych* (1962) 29-26. Lichtenstein. *Oh, Jeff . . . I Love You, Too . . . But . . .* (1964) 29-28. Oldenburg. *Lipstick (Ascending) on Caterpillar Tracks* (1969)	
POST-PAINTERLY/ OP	29-29. Louis. *Saraband* (1959) 29-31. Riley. *Current* (1964) 29-30. Bush. *Tall Spread* (1966)	

STYLE	INTERNATIONAL AVANT-GARDE ART
MINIMALISM/ POST-MINIMALISM	29-32. Stella. *Avicenna* (1960) 29-33. Judd. *Untitled* (1969) 29-34. Hesse. *Rope Piece* (1970)
CONCEPTUAL/ PERFORMANCE	29-35. Kosuth. *One and Three Chairs* (1965) 29-36. Nauman. *Self-Portrait as a Fountain* (1966) 29-1. Kounellis. *Untitled (12 Horses)* (1969) 29-37. Beuys. *Coyote: I Like America and America Likes Me* (1974)
POSTWAR U.S. PHOTOGRAPHY	29-38. Frank. *Trolley, New Orleans* (1955–56) 29-39. Arbus. *Child with Toy Hand Grenade, New York* (1962) 29-40. White. *Capitol Reef, Utah* (1962) 29-41. Uelsmann. *Untitled* (1969)
AMERICAN CRAFT ART	29-42. Voulkos. *Untitled Plate* (1962) 29-43. Littleton. *Implosion/Explosion* (1964) 29-44. Tawney. *Black Woven Form (Fountain)* (1966) 29-77. Castle. *Ghost Clock* (1985) 29-78. Paley. *Lectern* (1989) 29-79. Takaezu. *Large Form* (c. 1995)
MODERNIST ARCHITECTURE	29-45. Mies and Johnson. Seagram Bldg., New York City (1954–58) 29-46. Saarinen. TWA Terminal JFK Airport, New York (1956–62) 29-47. Safdie. Habitat '67, Montreal (1964–67)
POSTMODERNIST ARCHITECTURE	29-48. Venturi. Vanna Venturi House, Chesnut Hill, Pennsylvania (1961–64) 29-50. Johnson, Burgee. AT&T Bldg., New York (1978–83) 29-51. Rossi. New Town Hall, Borgoricco (1983–88)
HIGH TECH ARCHITECTURE	29-52. Piano, Rogers. Centre Pompidou, Paris (1971–77) 29-53. Foster. HongKong & Shanghai Bank, Hong Kong (1979–86)
DECONSTRUCTIVIST ARCHITECTURE	29-54. Hadid. Vitra Fire Station, Weil-am-Rhein (1989–93) 29-55. Gehry. Guggenheim Museum, Bilbao (1993–97)
EARTHWORKS/ SITE-SPECIFIC SCULPTURE	29-56. Heizer. *Double Negative* (1969–70) 29-57. Smithson. *Spiral Jetty* (1969–70) 29-58. Christo, Jeanne-Claude. *Running Fence* (1972–76)
SUPER REALISM	29-60. Hanson. *The Shoppers* (1976) 29-59. Estes. *Prescriptions Filled (Municipal Building)* (1983)
FEMINISM	29-62. Saar. *The Liberation of Aunt Jemima* (1972) 29-61. Neel. *Linda Nochlin and Daisy* (1973) 29-63. Chicago. *The Dinner Party* (1974–79) 29-65. Mendieta. Tree of Life series (1977) 29-74. Sherman. *Untitled Film Still #21* (1978) 29-64. Schapiro. *Heartfelt* (1979) 29-73. Kruger. *We Won't Play Nature to Your Culture* (1983)

PARALLELS

STYLE	INTERNATIONAL AVANT-GARDE ART
NEO-EXPRESSIONISM	**29-68.** Kiefer. *Heath of the Brandenburg March* (1974) **29-66.** Schnabel. *The Death of Fashion* (1978) **29-67.** Basquiat. *Horn Players* (1983) **29-69.** Polke. *Raised Chair with Geese* (1987–88)
NEO-CONCEPTUALISM	**29-71.** Koons. *The New Shelton Wet/Dry Triple Decker* (1981) **29-72.** Levine. *Untitled (After Aleksandr Rodchenko: 11)* (1987) **29-70.** Halley. *Fire in the Sky* (1993)
LATE MODERNISM	**29-75.** Murray. *Chaotic Lip* (1986) **29-76.** Puryear. *Plenty's Boast* (1994–95)
PUBLIC ART	**29-86.** Baca. *The Great Wall of Los Angeles* (1976–83) **29-84.** Serra. *Tilted Arc* (1981) **29-85.** Lin. Vietnam Veterans Memorial, Washington, D.C. (1982) **29-87.** Hammons. *Higher Goals* (1982) **29-89.** Chin. *Revival Field: Pig's Eye Landfill* (begun 1991) **29-88.** Whiteread. *House* (1993)
INSTALLATION/VIDEO	**29-90.** Holzer. *Untitled* (1989–90) **29-91.** Hamilton. *Indigo Blue* (1991) **29-92.** Paik. *Electronic Superhighway: Continental U.S.* (1995) **29-93.** Viola. *The Crossing* (1996) **29-95.** Gu. *United Nations: The Babel of the Millenium* (1999) **29-94.** Neshat. *Fervor* (2000)

Glossary

abacus The flat slab at the top of a **capital**, directly under the **entablature**.

absolute dating A method of assigning a precise historical date to periods and objects based on known and recorded events in the region as well as technically extracted physical evidence (such as carbon-14 disintegration). *See also* **radiometric dating, relative dating**.

abstract, abstraction Any art that does not represent observable aspects of nature or transforms visible **forms** into a pattern resembling the original model. Also: the formal qualities of this process.

academic art *See* academy, academician.

academy, academician An institution established to train artists. Most academies date from the Renaissance and later; they became powerful state-run institutions in the seventeenth and eighteenth centuries. Academies replaced **guilds** as the venue where students learned both the craft and the theory of art. Academies held exhibitions and awarded prizes; helped artists be seen as trained specialists, rather than craftspeople; and promoted the change in the social status of the artist. An academician is an official academy-trained artist whose work establishes the accepted style of the day.

acanthus A leafy plant whose foliage inspired architectural ornamentation, used in the **Corinthian** and **Composite orders** and in the relief scroll known as the *rinceau*.

acropolis The **citadel** of an ancient Greek city, located at its highest point and housing temples, a **treasury**, and sometimes a royal palace. The most famous is the Acropolis in Athens.

acroterion An ornament at the corner or peak of a roof.

acrylic A fast-drying synthetic paint popular since the 1950s.

adobe Sun-baked blocks made of clay mixed with straw. Also: the buildings made with this material.

adyton The back room of a Greek temple. At Delphi, the place where the **oracles** were delivered. More generally, a very private space or room.

aedicula (aediculae) A type of decorative architectural frame, usually found around a niche, door, or window. An *aedicula* is made up of a **pediment** and **entablature** supported by **columns** or **pilasters**.

aerial perspective. *See* perspective.

aesthetics The philosophy of beauty.

agora An open space in a Greek town used as a central gathering place or market. *See also* **forum**.

aisle Passage or open corridor of a church, hall, or other building that parallels the main space, usually on both sides, and is delineated by a row, or **arcade**, of **columns** or **piers**. Called side aisles when they flank the **nave** of a church.

album A book consisting of blank pages (leaves) on which typically an artist may sketch, draw, or paint.

alignment An arrangement of stones (**menhirs**) in straight rows.

allegory In a work of art, an image (or images) that illustrates an **abstract** concept, idea, or story, often suggesting a deeper meaning.

altar A tablelike structure where religious rites are performed. In Christian churches, the **altar** contains a consecrated slab of stone, the **mensa**, supported by the **stipes**.

altarpiece A painted or carved panel or **winged** structure placed at the back of or behind and above. The religious imagery is often specific to the place of worship for which it was made. *See also reredos; retablo*.

amalaka In Hindu architecture, the circular or square-shaped element on top of a spire *(shikhara)*, often crowned with a **finial**, symbolizing the cosmos.

ambulatory The passage (walkway) around the **apse** in a **basilican** church or around the central space in a **central-plan** building.

amphiprostyle Term describing a building, usually a temple, with **porticoes** at each end but without **columns** along the other two sides.

amphitheater An oval arena for athletic events and spectacles developed by ancient Roman architects from the idea of two theaters placed facing each other, with ascending tiers of seats for the audience.

amphora An ancient Greek jar for storing oil or wine, with an egg-shaped body and two curved handles.

Anastasis In the Byzantine Church, Christ's descent into hell to release and resurrect the worthy dead.

Andachtsbild (Andachtsbilder) German for "devotional image." A painting or sculpture that depicts themes of Christian grief and suffering, such as the *pietà*, intended to encourage meditation.

aniconic A symbolic representation without images of human figures, very often found in Islamic art.

animal interlace Decoration of interwoven animals or serpents, often found in Celtic and northern European art in the early medieval period.

animal style A type of imagery used in Europe and western Asia during the ancient and medieval periods, characterized by stylized, animal-like shapes arranged in intricate patterns or in combats.

ankh A looped cross signifying life, used by ancient Egyptians.

anta (antae) A rectangular **pilaster** found at the ends of the framing walls of a recessed **portico**.

antependium (antependia) The front panel of a **mensa** or **altar** table.

anticlassical A term designating any image, idea, or **style** that opposes the **classical** norm.

apotheosis Deification of an individual. In art, often shown as an ascent to Heaven, borne by angels, *putti*, or an eagle.

appliqué A piece of any material applied to another.

apprentice A student artist or craftsperson in training. In a system of artistic training established under the **guilds** and still in use today, master artists took on apprentices (who usually lived with the master's family) for several years. The apprentice was taught every aspect of the artist's craft, and he or she participated in the master's workshop or **atelier**.

appropriation An artist's practice of taking ideas or objects from another source for a new work of art. In previous centuries artists often copied one another's figures, **motifs**, or **compositions**, while in modern times the sources for appropriation extend from material culture to works of art.

apse, apsidal A large semicircular or polygonal (and usually **vaulted**) niche. In the Christian church, it contains the **altar**. *Apsidal* is an adjective describing the condition of having such a space.

aquamanile A vessel holding water used for washing hands, whether during the celebration of the Catholic Mass or before eating at a secular table. An aquamanile may have the form of a human figure or a grotesque animal.

aquatint A type of **intaglio** printmaking developed in the eighteenth century that produces an area of even **tone** without laborious **cross-hatching**. Basically similar in technique to an **etching**, the aquatint is made through use of a porous resin coating of a metal plate, which when immersed in acid allows an even, all-over biting of the plate. When printed, the end result has a granular, textural effect.

aqueduct A trough to carry water through gravity, if necessary supported by **arches**.

arabesque A type of **linear** surface decoration based on foliage and **calligraphic** forms, usually characterized by flowing lines and swirling shapes.

arcade A series of **arches**, carried by **columns** or **piers** and supporting a common wall or **lintel**. In a blind arcade, the **arches** and supports are engaged (attached to the wall) and have a decorative function.

arch In architecture, a curved structural element that spans an open space. Built from wedge-shaped stone blocks called *voussoirs*, which, when placed together and held at the top by a trapezoidal **keystone**, form an effective space-spanning and weight-bearing unit. Requires **buttresses** at each side to counter the outward thrust caused by the weight of the structure. **Corbel arch**: arch or vault formed by **courses** of stones, each of which projects beyond the lower course until the space is closed, usually with a **capstone**. **Horseshoe arch**: an arch with more than a half-circle shape; typical of western Islamic architecture. **Ogival arch**: a pointed arch created by **S** curves. **Relieving arch**: an arch built into a heavy wall just above a **post-and-lintel** structure (such as a gate, door, or window) to help support the wall above by transferring the load to the side walls.

Archaic smile The curved lips of an ancient Greek statue, usually interpreted as an attempt to animate the features.

architectonic Resembling or relating to the spatial or structural aspects of architecture.

architrave The bottom element in an **entablature**, beneath the **frieze** and the **cornice**.

Archivolt Curved moldings formed by the **voussoirs** making up an **arch**.

ashlar A highly finished, precisely cut block of stone. When laid with others in even **courses**, ashlar masonry creates a uniform face with fine joints. Often used as a facing on the visible exterior of a building, especially as a **veneer** for the **facade**. Also called **dressed** stone.

assemblage Artwork created by gathering and manipulating two and/or three-dimensional found objects.

astragal A thin convex decorative **molding**, often found on **Classical entablatures**, and usually decorated with a continuous row of beadlike circles.

atelier The studio or workshop of a master artist or craftsperson, usually consisting of junior associates and **apprentices**.

atmospheric perspective Variations in color and clarity caused by distance. *See also* **perspective**.

atrial cross The cross placed in the **atrium** of a church. In Colonial America, used to mark a gathering and teaching place.

atrium An unroofed interior courtyard or room in a Roman house, sometimes having a pool or garden, sometimes surrounded by columns. Also: the open courtyard in front of a Christian church; or an entrance area in modern architecture.

attic story The top story of a building. In **classical** architecture often decorated or carrying an inscription.

attribute The symbolic object or objects that identify a particular deity, saint, or personification in art.

automatism A technique whereby the usual intellectual control of the artist over his or her brush or pencil is forgone. The artist's aim is to allow the subconscious to create the artwork without rational interference. Also called automatic writing.

avant-garde In art, *avant-garde* (derived from the French military word meaning "before the group," or "vanguard)" denotes those artists or concepts of a strikingly new, experimental, or radical nature for the time.

axial Term used to describe a **plan** or design that is based on a symmetrical, **linear** arrangement of elements along a central axis. Bilateral symmetry.

axis Imaginary central line.

axis mundi A concept of an "axis of the world," which denotes a link between the human and celestial realms.

background Within the depicted space of an artwork, the area of the image at the greatest distance from the **picture plane**.

bailey The outermost walled courtyard of a castle.

baldachin A canopy (whether suspended from the ceiling, projecting from a wall, or supported by **columns**) placed over an honorific or sacred space such as a throne or **altar**.

balustrade A low barrier consisting of a series of short circular posts (called balusters), with a rail on top.

baptismal font A large open vessel or tank, usually of stone, containing water for the Christian ritual of baptism.

baptistry A building used for the Christian ritual of baptism, traditionally having a **central plan**.

bar tracery *See* **tracery**.

barbican An exterior defensive fortification of a gate or portal.

barrel vault *See* **vault**.

base Masonry supporting a statue or the **shaft** of a column.

basilica A large rectangular building. Often built with a **clerestory**, side **aisles** separated from the center **nave** by **colonnades**, and an **apse** at one or both ends. Roman centers for administration, later adapted to Christian church use. Constantine's architects added a transverse aisle at the end of the nave called a **transept**.

basilica plan A plan consisting of **nave** and side **aisles**, often with a **transept** and usually with an **apse**.

bas-relief Low-relief sculpture. *See also* **relief sculpture**.

battered A wall that slopes inward at the top for stability.

battlement The uppermost, fortified sections of a building or wall, usually including **crenellations** and other defensive structures.

bay A unit of space defined by architectural elements such as **columns, piers**, and walls.

beadwork Any decoration created with or resembling beads.

beehive tomb A **corbel**-vaulted tomb, conical in shape like a beehive, and covered by an earthen mound.

Benday dots In modern printing and typesetting, the individual dots that, together with many others, make up lettering and images. Often machine- or computer-generated, the dots are very small and closely spaced to give the effect of density and richness of **tone**.

bestiary A book describing characteristics, uses, and meaning illustrated by moralizing tales about real and imaginary animals, especially popular during the Middle Ages in western Europe. *See also* **herbal**.

bevel, beveling A cut made at any angle except a right angle. Also: the technique of cutting at a slant.

bi A jade disk with a hole in the center used in China for the ritual worship of the sky. Also: a badge indicating noble rank.

biomorphic Term used to describe forms that resemble or suggest shapes found in nature.

bird's-eye view A view from above.

black-figure A **style** or technique of ancient Greek pottery in which black figures are painted on a red clay ground.

blackware A ceramic technique that produces pottery with a primarily black surface. Blackware has both **matte** and glossy patterns on the surface of the wares.

blind Decorative elements attached to the surface of a wall, with no openings, used decoratively.

block printing A printed image, such as a **woodcut** or wood **engraving**, made from a carved woodblock.

bobbin A cylindrical reel around which a material such as yarn or thread is wound when spinning, sewing, or weaving.

bodhisattva A being who is far advanced in the journey of becoming a Buddha. The *bodhisattva* defers personal enlightenment to help all living beings emancipate themselves from the cycle of suffering.

boiserie Decoratively carved and/or painted wood paneling or wainscotting, usually applied to seventeenth- and eighteenth-century French interiors.

Book of Hours. A private prayer book, having a calendar, services for the canonical hours, and sometimes special prayers.

boss A decorative knoblike element. Bosses can be found in many places, such as at the intersection of a Gothic **vault rib**. Also button-like projections in decorations and metalwork.

bracket, bracketing An architectural element that projects from a wall to support a horizontal part of a building, such as beams or the eaves of a roof.

broken pediment *See* **pediment**.

bronze A metal made from copper alloy, usually mixed with tin or zinc. Also: any sculpture or object made from this substance.

buon fresco *See* **fresco**.

burin A metal instrument used in the making of **engravings** to cut lines into the metal plate.

bust A portrait depicting only the head and shoulders of the subject.

buttress, buttressing A type of architectural support. Usually consists of massive masonry with a wide **base** built against an exterior wall to brace the wall and strengthen the **vaults**. Acts by transferring the weight of the building from a higher point to the ground. Flying buttress: An **arch** built on the exterior of a building that transfers the thrust of the roof vaults at important stress points to a detached buttress **pier** leading to the wall buttress.

cairn A pile of stones or earth and stones that served as a prehistoric burial site and as a marker of underground tombs.

calligraphy A form of writing with pictures, as in the Chinese language.

calotype The first photographic process utilizing negatives and paper positives, invented by William Henry Fox Talbot in the late 1830s.

calyx krater *See* **krater**.

came A lead strip, **H**-shape in **section**, used in the making of leaded or **stained-glass** windows. Separate pieces of glass are fitted into the grooves on the sides to hold the design together.

cameo Gemstone, clay, glass, or shell having layers of color, carved in **low relief** to create an image and ground of different colors.

camera obscura An early cameralike device. A dark box (or room) with a hole in one side (sometimes fitted with a lens), the camera obscura operates when bright light shines through the hole, casting an upside-down image of an object outside onto the inside wall of the box. This image then can be traced.

campanile The Italian term for a freestanding bell tower.

canon Established rules or standards.

canon of proportions A set of ideal mathematical ratios in art based on measurements of the human body.

cantilever A beam or structure that is anchored at one end and projects horizontally beyond its vertical support, such as a wall or **column**. It can carry loads throughout the rest of its unsupported length. Or a bracket used to carry the **cornice** or extend the eaves of a building.

capital The sculpted top of a **column** forming a transition between the vertical **shaft** and the horizontal **lintel** or **entablature**. According to the conventions of the **orders**, capitals include different decorative elements. A historiated capital has narrative figures. *See also* **order**.

capriccio A painting or print of a fantastic, imaginary landscape, usually with architecture.

capstone The final, topmost stone in a **corbel arch** or **vault**, which joins the sides and completes the structure.

caricature An artwork that exaggerates individual peculiarities, usually with humorous or satirical intent.

cartoon A full-scale drawing used to transfer the outline of a design onto a surface (such as a wall, canvas, panel, or tapestry) to be painted or woven.

cartouche A frame for a **hieroglyphic** inscription formed by a rope design surrounding an oval space. Used to signify a sacred or honored name. Also: in architecture, a decorative device or plaque, usually with a plain center used for inscriptions or epitaphs.

caryatid A sculpture of a draped female figure acting as a **column** supporting an **entablature**.

casemate A vaulted chamber within the thickness of a fortified wall that provides storage space, usually for weapons or military equipment.

casement A window sash that opens on hinges at the side, swinging open the entire length.

catacomb An underground burial ground consisting of tunnels on different levels, having niches for urns and *sarcophagi* and often incorporating rooms (*cubiculae*).

cathedral the principal Christian church in a diocese, built in the bishop's administrative center and housing his throne (*cathedra*).

cella The principal interior room at the center of a Greek or Roman temple within which the cult statue was usually housed. Also called the **naos**.

cenotaph A funerary monument commemorating an individual or group buried elsewhere.

centaur In Greek mythology, a creature with the head, arms, and torso of a man and the legs and hind quarters of a horse.

centering A temporary structure that supports a masonry **arch** and **vault** or **dome** during construction until the mortar is fully dried and the masonry is self-sustaining.

central-plan building Any structure designed with a primary central space; may be surrounded by radiating elements as in the **Greek-cross** (equal-armed cross) **plan**.

ceramics A general term covering all types of **wares** made from fired clay, including **porcelain** and **terra-cotta**.

Chacmool In Mayan sculpture, a half-reclining figure, probably representing an offering bearer.

chaitya A type of Buddhist temple found in India. Built in the **form** of a hall or **basilica**, a *chaitya* hall is highly decorated with sculpture and usually is carved from a cave or natural rock location. It houses a sacred shrine or **stupa** for worship.

chakra Sanskrit term for "wheel"; (see *dharmachakra*)

chamfer The slanted surface produced when an angle is trimmed or **beveled**, common in building and metalwork.

champlevé An enamel technique in which the cells gouged out of the metal plate hold colored glass. *See also* **cloisonné**.

chancel The end of the church containing the **choir**, **ambulatory**, and radiating chapels. Also called **chevet**.

chasing Ornamentation made on metal by indenting the surface with a hammer.

château (châteaux) A French country house or castle. A château fort or military castle incorporates defensive fortifications such as **moats** and towers.

chattri (chattris) A decorative pavilion with an umbrella-shaped **dome** in Indian architecture.

cherub (cherubim) The second highest order of angels (*see* **seraph**). Popularly, an idealized small child, usually depicted naked and with wings.

chevet A French term for the area of a church beyond the **crossing** and including the **apse**, **ambulatory**, and radiating chapels.

chevron A decorative or heraldic **motif** of repeated **V**s; a zigzag pattern.

chiaroscuro An Italian word designating the contrast of dark and light in a painting, drawing, or print. Spatial depth and **volumetric forms** through slight gradations in the intensity of light and shadow are used to indicate three dimensions.

chinoiserie The decorative imitation of Chinese art and **style** common in the eighteenth century.

chip carving A type of decorative incision on wood, usually made with a knife or chisel, characterized by small triangular or square patterns.

chiton A thin sleeveless garment, fastened at waist and shoulders, worn by men and women in ancient Greece.

choir The section of a Christian church reserved for the clergy or the religious, either between the **crossing** and the **apse** or in the **nave** just before the crossing, screened or walled and fitted with stalls (seats). In convents, funeral chapels, and later Protestant churches, the choir may be raised above the nave over the entrance. Also: an area reserved for singers.

chromolithography A type of **lithographic** process utilizing color. A new stone is made for each color, and all are printed onto the same piece of paper to create a single, colorful lithographic image.

ciborium A canopy over the **altar** in Christian churches, usually consisting of a domed roof supported by **columns**. Also: the receptacle for the Eucharist in the Catholic Mass. *See also* **baldachin**.

circus A circular or oval arena built by ancient Romans and usually enclosed by raised seats for spectators.

citadel A fortress or defended city, if possible placed in a high, commanding location.

clapboard Horizontal planks used as protective siding for buildings, particularly houses in North America.

Classical When capitalized, a term referring to the culture, art, and architecture of the Classical period of ancient Greece, from about 480 BCE to about 320 BCE. *See also* **classical**.

Classical orders *See* **order**.

classical, classicism Any aspect of later art or architecture following the rules, canons, and examples of the art of ancient Greece and Rome. Also: in general, any art aspiring to the qualities of restraint, balance, and rational order exemplified by the ancient Greeks and Romans.

clerestory The topmost zone of a wall with windows in a **basilica** (secular or church), extending above the roofs of the **aisles**. Provides direct light into the central interior space, the **nave**.

cloisonné An enamel technique in which metal strips are affixed to the surface to form the design. The resulting areas (cloisons) are filled with colored glass.

cloister An open space, part of a monastery, surrounded by an **arcaded** or **colonnaded** walkway, often having a fountain and garden, and dedicated to nonliturgical activities and the secular life of the religious. Members of a cloistered order do not leave the monastery or interact with outsiders.

cloth of honor A piece of fabric, usually rich and highly decorated, hung behind a person of great rank on ceremonial occasions. Signifying the exalted status of the space before them, cloths of honor may be found behind thrones, **altars**, or representations of holy figures.

codex (codices) A book, or a group of **manuscript** pages (a gathering of folios), held together by stitching or other binding on one side.

coffer A recessed decorative panel that, repeated, is used to decorate ceilings or **vaults**. The use of coffers is called coffering.

coiling A technique in basketry. Coiled baskets are made from a spiraling structure held or sewn in place by another material.

collage A technique in which cutout forms of paper (including newsprint), cloth, or found materials are pasted onto another surface. Also: an image created using this technique.

colonnade A row of **columns**, supporting a straight **lintel** (as in a **porch** or **portico**) or a series of **arches** (an **arcade**).

colonnette A small **column**, usually found attached to a **pier** or wall. Colonnettes are decorative features that may reach into the **vaulted** sections of the building, contributing to the vertical effect.

colophon The data placed at the end of a book listing the book's author, publisher, illuminator, and other information related to its production.

colossal order *See* order.

column An architectural element used for support and/or decoration. Consists of a rounded or polygonal vertical **shaft** placed on a **base** topped by a larger, usually decorative **capital**. In classical architecture, built in accordance with the rules of one of the architectural **orders**. Columns can be freestanding or attached to a background wall (**engaged**).

column statue A **column** carved to depict a human figure.

complementary color The primary and secondary colors across from each other on the color wheel (red and green, blue and orange, yellow and purple). When juxtaposed, the intensity of both colors increases. When mixed together, they negate each other to make a neutral gray-brown.

Composite order *See* order.

composition The arrangement of elements in an artwork.

compound pier A **pier** or large **column** with **shafts**, **pilasters**, or **colonnettes** attached to it on one or more sides.

conch *See* half dome.

concrete A building material developed by the Romans, which is easily poured or molded when wet and hardens into a strong and durable stonelike substance. Made primarily from lime, sand, cement, and rubble mixed with water.

cone mosaic An early type of surface decoration created by pressing colored cones of baked clay into prepared wet plaster; associated with Sumerian architecture.

cong A square or octagonal jade tube with a cylindrical hole in the center. A symbol of the earth, it was used for ritual worship and astronomical observations in ancient China.

connoisseurship A term derived from the French word *connoisseur*, meaning "an expert," and signifying the study and evaluation of art based primarily on formal, visual, and stylistic analysis. A connoisseur studies the **style** and technique of an object to deduce its relative quality and possible maker. This is done through visual association with other, similar objects and styles the connoisseur has seen in his or her study. *See also* contextualism; formalism.

content When discussing a work of art, the term can include all of the following: its **subject matter**; the ideas contained in the work; the artist's intention; and even its meaning for the beholder.

contextualism A methodological approach in art history that focuses on the culture surrounding an art object. Unlike **connoisseurship**, contextualism utilizes the literature, history, economics, and social developments (among other things) of a period, as well as the object itself, to explain the meaning of an artwork. *See also* **connoisseurship**.

contrapposto A way of representing the human body so that its weight appears to be borne on one leg. Also: a twisting body position. *Contrapposto* first appears in sculpture from the ancient Greece.

corbel arch *See* arch.

corbel vault *See* vault.

corbel, corbeling An early roofing and **arch**ing technique in which each **course** of stone projects slightly beyond the previous layer (a corbel) until the uppermost corbels meet. Results in a high, almost pointed **arch** or **vault**. A corbel table is a ledge supported by corbels.

Corinthian order *See* order.

cornice The uppermost section of a **Classical entablature**. More generally, any horizontally projecting element of a building, usually found at the top of a wall. A **raking cornice** is formed by the junction of two slanted cornices, supporting or following the line of the roof.

course A horizontal layer of stone used in building.

cove A concave **molding**, or the area of ceiling where a wall and ceiling converge. A **cove ceiling** incorporates such moldings on all sides.

crenellation Alternating high and low sections of a wall, giving a notched appearance and creating permanent defensive shields in the walls of fortified buildings.

crockets Stylized leaves used in Gothic decoration.

cromlech In prehistoric architecture, a circular arrangement of upright stones (**menhirs**).

cross vault *See* groin vault.

cross-hatching A technique primarily used in printmaking and drawing in which parallel lines (hatching) are drawn across a previous set, but from a different angle. Cross-hatching gives a great density of **tone** and allows the artist to create the illusion of shadows.

crossing The part of a cross-shaped church where the **nave** and the **transept** meet, often marked on the exterior by a tower or **dome**.

cruciform A term describing anything that is cross-shaped, as in the cruciform **plan** of a church.

cruck One of a pair of curved timbers forming a principal support of a roof or wall.

crypt The **vaulted** underground space beneath the floor of a church, usually under the sanctuary, which may contain tombs and relics.

cubiculum (cubiculae) A private chamber for burial in the **catacombs**. The *sarcophagi* of the affluent were housed there in arched wall **niches**.

cuneiform An early form of writing with wedge-shaped marks impressed into wet clay with a **stylus**, primarily used by ancient Mesopotamians.

curtain wall A wall in a building that does not support any of the weight of the structure. Also: the freestanding outer wall of a castle.

cycle A series of images depicting a single story or theme intended to be displayed together.

cyclopean construction or **masonry** A method of building using huge blocks of rough-hewn stone. Any large-scale, **monumental** building project that impresses by sheer size. Named after the Cyclops, one-eyed giants of legendary strength in Greek myths.

cylinder seal A small cylindrical stone decorated with **incised** patterns. When rolled across soft clay or wax, a raised pattern or design (**relief**) is made, which served in Mesopotamian and Indus Valley cultures as an identifying signature.

dado (dadoes) The lower part of a wall, differentiated in some way (by a **molding** or different coloring or paneling) from the upper section.

daguerreotype An early photographic process that makes a positive print on a light-sensitized copperplate; invented and marketed in 1839 by Louis-Jacques-Mandé Daguerre.

Day-Glo A trademark name for fluorescent painted materials.

Deesis In Byzantine art, the representation of Christ flanked by the Virgin Mary and Saint John the Baptist.

demotic writing An informal **script** developed by the ancient Greeks in about the eighth century BCE and used exclusively for non-sacred texts.

dentil Small, toothlike blocks arranged in a continuous band to decorate a **Classical entablature**.

dharmachakra Sanskrit for "wheel" (*chakra*) and "law" or "doctrine" (*dharma*); often used in Buddhist iconography to signify the "wheel of the law."

di sotto in su Seen from below (worm's eye view), in Italian.

diorama A large painting made to create an environment, giving the viewer an impression of being at the site depicted. Usually hung on several walls of a room and specially lit, the diorama was a popular attraction in the nineteenth century and was sometimes exhibited with sculpted figures.

dipteral A building that is surrounded by two rows of **columns** (a double **peristyle**).

diptych Two panels of equal size (usually decorated with paintings or reliefs) hinged together.

dogu Small human figurines made in Japan during the Jomon period. Shaped from clay with exaggerated expressions and in contorted poses, *dogu* were probably used in religious rituals.

dolmen A prehistoric structure made up of two or more large upright stones supporting a large, flat, horizontal slab or slabs (called **capstones**).

dome A curved masonry **vault** theoretically consisting of an **arch** rotated on its **axis**. May be crowned by an open space (**oculus**) and/or an exterior **lantern** and may rest on a vertical wall (**drum**). When a dome is built over a square space, an intermediate element (a **pendentive** or a **squinch**) is required to make the transition to a circular drum or dome. A dome on pendentives incorporates arched, sloping intermediate sections of wall (spherical triangles) that carry the weight and thrust of the dome to heavily **buttressed** supporting **piers**. A dome on squinches uses an four beams supported by an arch built into the wall (**squinch**) in the upper corners of the space, converting the square plan to an octagon to carry the weight of the dome across the corners of the square space below.

donjon *See* keep.

Doric order *See* order.

dormer A vertical window built into a sloping roof. A dormer window has its own roof and side walls that adjoin to the body of the roof proper.

dressed stone *See* ashlar.

drillwork The technique of using a drill for the creation of shadows in sculpture.

drum The wall that supports a **dome**. Also: a segment of the circular **shaft** of a **column**.

drypoint An **intaglio** printmaking process by which a metal (usually copper) plate is directly inscribed with a pointed instrument (**stylus**). The resulting design of scratched lines is inked, wiped, and printed. Also: the print made by this process.

earthworks Artwork and/or sculpture, usually on a large scale, created by manipulating the natural environment. Also: the earth walls of a fort.

easel painting Any painting of small to intermediate size that can be executed on an artist's easel.

echinus A cushionlike circular element found below the **abacus** of a **Doric capital**. Also: a similarly shaped **molding** (usually with **egg-and-dart motifs**) between the **volutes** of an **Ionic capital**.

edition A single printing of a book or print. An edition can have a different number but includes only what is printed at a particular time by the same press by the same publisher or artist.

egg-and-dart A decorative **molding** made up of an alternating pattern of round (egg) and downward-pointing, tapered (dart) elements.

electron spin resonance techniques Method that uses magnetic field and microwave irradiation to date material such as tooth enamel and it surrounding soil.

elevation The arrangement, proportions, and details of any vertical side or face of a building. Also: an architectural drawing showing an exterior or interior wall of a building. A building's main elevation is usually its **facade**.

emblema (emblemata) In a mosaic, the elaborate central **motif** on a floor, usually a self-contained unit done in a more refined manner, with smaller *tesserae* of both marble and semiprecious stones.

embossing The technique of working metal by hammering from the back to produce a **relief**. *See also* **repoussé**.

embroidery The technique in needlework of decorating fabric by stitching designs and figures of colored threads of fine material (such as silk) into another material (such as cotton, linen, or wool). Also: the material produced by this technique.

enamel Glass bonded to a metal surface by heat. After firing, the glass forms an opaque or translucent substance that is fixed to the metal background in a decorative or narrative design. Also: an object created with enamel technique. *See also* **champlevé; cloisonné**.

encaustic A painting technique using pigments mixed with hot wax as a **medium**. Popular in Egypt, Greece, and Rome.

engaged column A **column** attached to a wall. *See also* **column**.

engraving An **intaglio** printmaking process of inscribing an image, design, or letters onto a metal or wood surface from which a print is made. An engraving is usually drawn with a sharp implement (**burin**) directly onto the surface of the plate. Also: the print made from this process.

entablature In the **Classical orders**, the horizontal elements above the **columns** and **capitals**. The entablature consists of, from bottom to top, an **architrave**, a **frieze**, and a **cornice**.

entasis A slight bulge built into the shaft of a Greek **column**. The optical illusion of entasis makes the **column** appear to be straight.

etching An **intaglio** printmaking process, in which a metal plate is coated with acid-resistant resin and then inscribed with a **stylus** in a design, revealing the plate below. The plate is then immersed in acid, which eats away the exposed metal. The resin is removed, leaving the design etched permanently into the metal and the plate ready to be inked, wiped, and printed.

Eucharist The central rite of the Christian church, from the Greek word "thanksgiving." Also known as the Mass or Holy Communion, the ritual was inspired by the Last Supper. According to traditional Catholic Christian belief, consecrated bread and wine become the body and blood of Christ; in Protestant belief, bread and wine symbolize body and blood.

exedra (exedrae) In architecture, a semicircular **niche**. On a small scale, often used as decoration, whereas larger *exedrae* can form interior spaces (such as an **apse**).

expressive When used in describing art, **form** that seems to convey the feelings of the artist and to elicit an emotional response in the viewer.

expressionism, expressionistic Terms describing a work of art in which **forms** are created primarily to evoke subjective emotions rather than to portray objective reality.

extrados The upper, curving surface of a **vault** or **arch**. *See also* *intrados*.

facade The face or front wall of a building.

faience Glazed **ceramic** that, upon firing, acquires a lustrous, smooth, impermeable texture.

faktura An idea current among Russian Constructivist artists and other Russian artists of the early twentieth century that referred to the inherent **forms** and colors suitable to different materials. Used primarily in their mixed-**medium** constructions of a **nonrepresentational** type.

fang ding A square or rectangular bronze vessel with four legs. The *fang ding* was used for ritual offerings in ancient China during the Shang dynasty.

fête galante A subject in painting depicting well-dressed people at leisure in a park or country setting, often associated with eighteenth-century French painting.

filigree Delicate, lacelike ornamental work.

fillet The flat surface between the carved out flutes of a **column shaft**. *See also* **fluting**.

finial A knoblike architectural or furniture decoration found at the top point of a spire, **pinnacle**, canopy, or **gable**.

flower piece Any painting with flowers as the primary subject. **Still lifes** of flowers became particularly popular in the seventeenth century in the Netherlands and Flanders.

fluting In architecture, evenly spaced parallel vertical grooves **incised** on **shafts** of **columns** or columnar elements (such as **pilasters**).

flying buttress *See* **buttress**.

folio A page or leaf in a **manuscript** or book. Also: a large sheet of paper or parchment, which, when folded twice and cut, produces four separate sheets; more generally, any large book.

foreground Within the depicted space of an artwork, the area that is closest to the **picture plane**.

foreshortening The illusion created on a flat painted or drawn surface in which figures and objects appear to recede or project sharply into space. Accomplished according to the rules of **linear perspective**.

form In speaking of a work of art or architecture, the term refers to purely visual components: line, color, shape, texture, mass, spatial qualities, and **composition**—all of which are called formal elements.

formal elements *See* **form**.

formalism, formalist An approach to the understanding, appreciation, and valuation of art based almost solely on considerations of **form**. This approach tends to regard an artwork as independent of its time and place of making. *See also* **connoisseurship**.

formline In Native American works of art, a line that defines and creates a space or **form**.

forum A Roman town center; site of temples and administrative buildings and used as a market or gathering area for the citizens.

four-iwan mosque *See* **iwan** *and* **mosque**.

freestanding An independent column or sculpture.

fresco A painting technique in which water-based pigments are applied to a surface of wet plaster (called *buon fresco*). The color is absorbed by the plaster, becoming a permanent part of the wall. *Fresco secco* is created by painting on dried plaster, and the color my flake off. **Murals** made by both these techniques are called frescoes.

frieze The middle element layer of an **entablature**, between the **architrave** and the **cornice**. Usually decorated with sculpture, painting, or **moldings**. Also: any continuous flat band with **relief sculpture** or painted decorations.

fritware A type of pottery made from a mix of white clay, quartz, and other chemicals that, when fired, produces a highly brittle substance.

frontispiece An illustration opposite or preceding the title page of a book. Also: the primary **facade** or main entrance **bay** of a building.

frottage A design produced by laying a piece of paper over a **relief** or **incised** pattern and rubbing with charcoal or other soft **medium**.

fusuma Sliding doors covered with paper, used in Japanese construction. *Fusuma* are often highly decorated with paintings and colored backgrounds.

gable The triangular wall space found on the end wall of a building between the two sides of a pitched roof. Also: a triangular decorative panel that has a gablelike shape.

gadrooning A form of decoration on architecture and in metalwork characterized by sequential convex **moldings** that curve around a circular surface; the opposite of **fluting**.

galleria In church architecture, the story found above the side **aisles** of a church, usually open to and overlooking the **nave**. Also: in secular architecture, a long room, usually above the ground floor in a private house or a public building used for entertaining, exhibiting pictures, or promenading. Also called **gallery**.

gallery A place where art is exhibited, specifically an art gallery. A gallery may be commercial, that is, a place where art is sold, or public or private, where it is not for sale. *See also galleria.*

garbhagriha From the Sanskrit word meaning "womb chamber," a small room or shrine in a Hindu temple containing a holy image.

genre A type or category of artistic form, subject, technique, **style**, or **medium**. *See also* genre painting.

genre painting A term used to loosely categorize paintings depicting scenes of everyday life, including (among others) domestic interiors, party scenes, inn scenes, and street scenes.

geoglyphs Earthen designs on a colossal scale, often created in a landscape as if to be seen from the air.

Geometric A period in Greek art from about 1100 BCE to 600 BCE. The pottery is characterized by patterns of rectangles, squares, and other **abstract** shapes. Also: lower-cased, any style or art using primarily these shapes.

gesso A ground made from glue, gypsum, and/or chalk forming the ground of a wood panel or the priming layer of a canvas that provides a smooth surface for painting.

gesturalism Painting and drawing in which the brushwork or line visibly records the artist's physical gesture at the moment the paint was applied or the lines laid down. Associated especially with expressive styles, such as Zen painting and Abstract Expressionism.

gilding The application of paper-thin **gold leaf** or gold pigment to an object made from another **medium** (for example, a sculpture or painting). Usually used as a decorative finishing detail.

giornata Adopted from the Italian term meaning "a day's work," a *giornata* is the section of a **fresco** that is plastered and painted in a single day.

glaze *See* glazing.

glazing In **ceramics**, a method of treating earthenwares with an outermost layer of vitreous liquid (glaze) that, upon firing, renders a waterproof and decorative surface. In painting, a technique particularly used with oil **mediums** in which a transparent layer of paint (glaze) is laid over another, usually lighter, painted or glazed area.

gloss A type of clay **slip** used in **ceramics** by ancient Greeks and Romans that, when fired, imparts a colorful sheen to the surface.

gold leaf Paper-thin sheets of hammered gold that are used in **gilding**. In some cases (such as Byzantine **icons**), also used as a ground for paintings.

golden section A line that when divided into two, the smaller part is the same proportion to the larger as the larger is to the whole. Said to be the ideal proportion, it was supposedly discovered by the ancient Greeks

Good Shepherd A man carrying a sheep or calf or with a sheep or calf at his side. In **classical** art, the god Hermes carrying a calf; in Christian art, Jesus Christ with a sheep (an image inspired by the Old Testament Twenty-third Psalm or the New Testament parable of the Good Shepherd).

gopura The towering gateway to an Indian Hindu **temple complex**. A temple complex can have several different *gopuras*.

gouache Opaque **watercolor** having a chalky effect.

graffiti Usually drawings and/or text of an obscene, political, or violent nature by anonymous persons; found in all periods and all **mediums**.

Grand Manner An elevated **style** of painting popular in the Neoclassical period of the eighteenth century in which an artist looked to the ancients and to the Renaissance for inspiration; for portraits as well as history painting, the artist would adopt the poses, **compositions**, and attitudes of Renaissance and antique models.

granulation A technique for decorating gold in which tiny balls of the precious metal are fused to the main surface.

graphic arts A term referring to art, whether drawn or printed, that utilizes paper as primary support.

graphic artist *See* graphic arts, graphic design.

graphic design A concern in the visual arts for shape, line, and two-dimensional patterning, often especially apparent in works including typography and lettering.

graphic designer *See* graphic arts, graphic design.

grattage A pattern created by scraping off layers of paint from a canvas laid over a textured surface. *See also frottage.*

Greek-cross plan *See* central-plan building.

Greek-key pattern A continuous rectangular scroll often used as a decorative border. Also called a meander pattern.

grid A system of regularly spaced horizontally and vertically crossed lines that gives regularity to an architectural **plan**. Also: in painting, a grid enables designs to be enlarged or transferred easily.

griffin An imaginary creature with the head, wings, and claws of an eagle and the body and hind legs of a lion.

grisaille A painting executed primarily in shades of gray.

groin vault *See* vault.

groundline The solid baseline that indicates the ground plane on which the figure stands. In ancient representations, such as those of the Egyptian, the figures and the objects are placed on a series of groundlines to indicate depth (space in **registers**).

grout A soft cement placed between the *tesserae* of a **mosaic** or of tiles to hold the pieces together.

guild An association of craftspeople. The medieval guild had great economic power, as it controlled the selling and marketing of its members' products, and it set standards and provided economic protection, group solidar-

ity, and training in the craft to its members.

half dome Semicircular dome that expands outward from a central dome, in Byzantine architecture to cover the **narthex** on one side and the **sanctuary apse** on the other. Also called conch.

half-timber construction A method of building, particularly in heavily timbered northern European areas, for vernacular structures. Beginning with a timber framework built in the **post-and-lintel** manner, the builder constructed walls between the timbers with bricks, mud, or **wattle**. The exterior could then be faced with plaster or other material.

hall church A church with a **nave** and **aisles** of the same height, giving the impression of a large, open hall.

halo The representation of a circle of light surrounding the head of deities, saints, or other holy beings. *See also* **mandorla**.

halos An outdoor pavement used by ancient Greeks for ceremonial dancing.

hammered gold Created by indenting a gold surface with a hammer.

handscroll A long, narrow, horizontal painting and/or text, common in ancient Roman, Chinese, and Japanese art, of a size intended for individual use. A handscroll is stored wrapped tightly around a wooden pin and is unrolled for viewing or reading.

hanging scroll In Chinese and Japanese art, a vertical painting or text mounted on sections of silk. At the top is a semicircular rod; at the bottom is a round dowel. Hanging scrolls are kept rolled and tied except for special occasions, when they are hung for display, contemplation, or commemoration.

haniwa Pottery forms, including cylinders, buildings, and human figures, that were placed on top of Japanese tombs or burial mounds.

Happening A type of art form incorporating performance and visual images developed in the 1950s. A Happening was organized without a specific narrative or intent; with audience participation, the event proceeded according to chance and individual improvisation.

header In building, a brick laid so that its end, rather than its side, faces out.

heliograph A type of early photograph created by the exposure to sunlight of a plate coated with light sensitive asphalt.

hemicycle A semicircular interior space or structure.

henge A circular area enclosed by stones or wood posts set up by Neolithic peoples. It was usually bounded by a ditch and raised embankment.

herbal A book describing the characteristics, uses, and meaning of plants. *See also* **bestiary.**

herm A statue that has the head and torso of a human but the lower part of which is a plain, tapering pillar of rectangular shape. Used primarily for architectural decoration.

hieratic In painting and sculpture, a formalized **style** for representing rulers or sacred or priestly figures.

hieratic scale The use of different sizes for significant or holy figures and those of the everyday world to indicate importance. The larger the figure, the greater the importance.

hieroglyphs Picture writing; words and ideas rendered in the form of pictorial symbols.

high relief Relief sculpture in which the image projects strongly from the background. *See also* **relief sculpture**.

himation In ancient Greece, a long loose outer garment.

historiated Bearing images or a narrative, as a historiated **capital** or initial.

historicism A nineteenth-century consciousness of and attention to the newly available and accurate knowledge of the past, made accessible by historical research, textual study, and archaeology.

history painting The term used to denote those paintings that include figures in any kind of historical, mythological, or biblical narrative. Considered from the Renaissance until the twentieth century as the noblest form of art, history paintings generally convey a high moral or intellectual idea and often are painted in a grand pictorial **style**.

hollow-casting *See* lost-wax casting.

horizon line A horizontal "line" formed by the implied meeting point of earth and sky. In **linear perspective**, the **vanishing point** or points are located on this line.

horseshoe arch *See* arch.

house-church A private home used as a Christian church.

house-synagogue A Jewish place of worship located in a private home.

hue Pure color. The saturation or intensity of the hue depends on the purity of the color. Its value depends in its lightness or darkness.

hydria A large ancient Greek and Roman jar with three handles (horizontal ones at both sides and one vertical at the back), used for storing water.

hypostyle hall Marked by numerous rows of tall, closely spaced **columns**. In ancient Egyptian architecture, a large interior room of a **temple complex** preceding the **sanctuary**.

icon An image in any material representing a sacred figure or event in the Byzantine, and later the Orthodox, Church. Icons were venerated by the faithful, who believed them to have miraculous powers to transmit messages to God.

iconoclasm The banning or destruction of images, especially **icons** and religious art. Iconoclasm in eighth- and ninth-century Byzantium and sixteenth- and seventeenth-century Protestant territories arose from differing beliefs about the power, meaning, function, and purpose of imagery in religion.

iconographic *See* iconography.

iconography The study of the significance and interpretation of the **subject matter** of art.

iconostasis The partition screen in a Byzantine Orthodox church between the **sanctuary** (where the Mass is performed) and the body of the church (where the congregation assembles). The iconostasis displays **icons**.

idealism *See* idealization.

idealization A process in art through which artists strive to make their forms and figures attain perfection, based on pervading cultural values and their own mental image of beauty.

ideograph A **motif** or written character that expresses an idea or symbolizes an action in the world. It is distinct from a **pictograph**, which symbolizes or represents an actual object, person, or thing. Egyptian **hieroglyphs** and Chinese **calligraphs** are examples of writing that consist of both ideographs and pictographs.

ignudi Heroic figures of nude young men.

illumination A painting on paper or **parchment** used as illustration and/or decoration for **manuscripts** or **albums**. Usually done in rich colors, often supplemented by gold and other precious materials. The illustrators are referred to as illuminators. Also: the technique of decorating manuscripts with such paintings.

illusionism, illusionistic An appearance of reality in art created by the use of certain pictorial means, such as **perspective** and foreshortening. Also: the quality of having this type of appearance.

impasto Thick applications of pigment that give a painting a palpable surface texture.

impost, impost block A block, serving to concentrate the weight above, imposed between the **capital** of a **column** and the lowest block (*voussoir*) of an **arch** above.

impression Any single printing of a print (woodcut, engraving, drypoint, or etching). Each and every impression of a print is by nature different, given the possibilities for variation inherent in the printing process, which requires the plate to be inked and wiped between every impression.

in antis Term used to describe the position of columns set between two walls, as in a **portico** or a **cella**.

incising A technique in which a design or inscription is cut into a hard surface with a sharp instrument.

ink painting A style of painting developed in China using only monochrome colors, usually black ink with gray washes. Ink painting was often used by artists of the **literati painting** tradition and is connected with Zen Buddhism.

inlay A decorative process in which pieces of one material (usually wood or metal) are set into the surface of an object fashioned from a different material.

installation *See* installation art.

installation art Artworks created for a specific site, especially a gallery or outdoor area, that create a total environment.

intaglio A technique in which the design is cut into the surface of an object, such as an engraved seal stone. In the **graphic arts**, intaglio includes **engraving**, **etching**, and **drypoint**—all processes in which ink transfers to paper from **incised**, ink-filled lines cut into a metal plate.

intarsia The decoration of wood surfaces with **inlaid** designs created of contrasting materials such as metal, shell, and ivory.

interlace A type of **linear** decoration particularly popular in ancient and early medieval art, in which ribbonlike serpents, vines, or animals or ribbons are interwoven.

interlacing *See* interlace.

intrados The curving inside surface of an **arch** or **vault**. *See also extrados*.

intuitive perspective *See* perspective.

Ionic order *See* order.

isometric projection A building diagram that represents graphically the parts of a building. Isometric projections have all planes of the building parallel to two established vertical and horizontal axes. The vertical axis is true, while the horizontal is drawn at an angle to show the effect of recession. All dimensions in an isometric drawing are proportionally correct. *See also* **plan**, **section**.

iwan A large, **vaulted** chamber in a **mosque** with a **monumental arched** opening on one side.

jamb In architecture, the vertical element found on both sides of an opening in a wall, such as a door or window.

japonisme A **style** in French and American nineteenth-century art that was highly influenced by Japanese art, especially prints.

joined-wood sculpture A method of constructing large-scale wooden sculpture developed in Japan. The entire work is constructed from smaller hollow blocks, each individually carved, and assembled when complete. The joined-wood technique allowed the production of larger sculpture, as the multiple joints alleviate the problems of drying and cracking found with sculpture carved from a single block.

ka The name given by ancient Egyptians to the human life force, or spirit.

kantharos A type of Greek vase or goblet with two large handles and a wide mouth.

keep The most heavily fortified defensive structure in a castle; a tower located at the heart of the castle complex.

kente A woven silk cloth made by the Ashanti peoples (men) of Africa. *Kente* cloth is woven in long, narrow pieces in complex and colorful patterns, which are then sewn together.

key block A key block is the master block in the production of a colored **woodcut**, which requires different blocks for each color. The key block is a flat piece of wood with the entire design carved or drawn on its surface. From this, other blocks with partial drawings are made for printing the areas of different colors.

keystone The topmost *voussoir* at the center of an **arch**—the last block to be placed. The pressure of this block holds the arch together. Sometimes of a larger size and/or highly decorated.

kiln An oven designed to produce enough heat for the baking, or firing, of clay.

kinetic Artwork that contains parts that can be moved either by hand, air, or motor.

kiva A structure in a Native American pueblo used for community gatherings and rituals.

kondo The main hall inside a Japanese Buddhist temple where the images of Buddha are housed.

kore (korai) An Archaic Greek statue of a young woman.

kouros (kouroi) An Archaic Greek statue of a young man or boy.

krater An ancient Greek vessel for mixing wine and water, with many subtypes that each

have a distinctive shape. **Calyx krater:** a bell-shaped vessel with handles near the base that resemble a flower calyx. **Volute krater:** a type of krater with handles shaped like scrolls.

kufic An ornamental, angular Arabic script.

kylix A shallow Greek vessel or cup, used for drinking, with a wide mouth and small handles near the rim.

lacquer A type of hard, glossy surface varnish used on objects in East Asian cultures, made from the sap of the Asian sumac or from shellac, a resinous secretion from the lac insect. Lacquer can be layered and manipulated or combined with pigments and other materials for various decorative effects.

lakshana Term used to designate the thirty-two marks of the historical Buddha. The *lakshana* include, among others, the Buddha's golden body, his long arms, the wheel impressed on his palms and the soles of his feet, and his elongated earlobes.

lamassu Supernatural guardian-protector of ancient Near Eastern palaces and throne rooms, often represented architecturally as a combination of the bearded head of a man, powerful body of a lion or bull, wings of an eagle, and the horned headdress of a god, and usually possessing five legs.

lancet A lancelike or blade shape. Also: a tall narrow window crowned by a sharply pointed **arch**, typically found in Gothic architecture.

landscape architecture, landscape gardening The creation of artificial landforms, lakes, and contrived planting to produce an ideal nature.

landscape painting A painting in which a natural outdoor scene or vista is the primary subject.

lantern A **turret**like structure situated on top of a dome, with windows that allow light into the space below.

Latin-cross plan A cross-shaped building plan, incorporating a long **nave** and shorter **transept** arms.

lectionary A book containing readings from Christian scripture arranged according to the Church calendar from which the officiant reads to the congregation during holy services.

lekythos (lekythoi) A slim Greek oil vase with one handle and a narrow mouth.

limner An artist, particularly a portrait painter, in England during the sixteenth and seventeenth centuries and in New England during the eighteenth and nineteenth centuries.

linear perspective *See* **perspective.**

linear, linearity A descriptive term indicating an emphasis on line, as opposed to mass or color, in art.

lingam **shrine** A place of worship centered on an object or representation in the form of a phallus (the *lingam*), which symbolizes the power of the Hindu god Shiva.

lintel A horizontal element of any material carried by two or more vertical supports to form an opening.

literati painting A **style** of painting that reflects the taste of the educated class of East Asian intellectuals and scholars. Aspects include an appreciation for the antique, smaller

scale, and an intimate connection between maker and audience.

lithograph A print made from a design drawn on a flat stone block with greasy crayon. Ink is applied to the wet stone, and when printed, adheres only to the open areas of the design. *See also* **chromolithography.**

lithograph *See* **lithography.**

loculus (loculi) A **niche** in a tomb or **catacomb** in which a *sarcophagus* was placed.

loggia Italian term for a covered open-air gallery.

lost-wax casting A method of casting metal, such as **bronze**, by a process in which a wax mold is covered with clay and plaster, then fired, melting the wax and leaving a hollow **form**. Molten metal is then poured into the hollow space and slowly cooled. When the hardened clay and plaster exterior shell is removed, a solid metal form remains to be smoothed and polished.

low relief **Relief** sculpture whose figures project slightly from the background. *See also* **relief sculpture.**

lozenge A decorative **motif** in the shape of a diamond.

lunette A semicircular shape; on a wall, often framed by an **arch** over a door or window.

lusterware **Ceramic** pottery decorated with metallic **glazes**.

madrasa An Islamic institution of higher learning, where teaching is focused on theology and law.

maenad In ancient Greece, a female devotee of the wine god Dionysos who participated in orgiastic rituals. She is often depicted with swirling drapery to indicate wild movement or dance. (Also called a Bacchante, after Bacchus, the Roman name of Dionysos.)

majolica Tin-**glazed** pottery.

maki-e In Japanese art, the effect achieved by sprinkling gold or silver powder on successive layers of **lacquer** before each layer dries.

mandala An image of the cosmos represented by an arrangement of circles or concentric geometric shapes containing diagrams or images. Used for meditation and contemplation by Buddhists.

mandapa In a Hindu temple, an open hall dedicated to ritual worship.

mandorla Light encircling, or emanating from, the entire figure of a sacred person. *See also* **halo.**

manifesto A written declaration of an individual's or group's ideas, purposes, and intentions.

manuscript A handwritten book or document.

maqsura A separate enclosure in a Muslim **mosque,** near the *mihrab*, designated for dignitaries.

martyrium (martyria) In Christian architecture, a church, chapel, or shrine built over the grave of a martyr or the site of a great miracle.

mastaba A flat-topped, one-story structure with slanted walls over an ancient Egyptian underground tomb.

mathematical perspective *See* **perspective.**

matte A smooth surface that is without shine or luster.

mausoleum A **monumental** building used as a tomb. Named after the tomb of Mausolos erected at Halikarnassos around 350 BCE.

meander *See* **Greek-key pattern.**

medallion Any round ornament or decoration. Also: a large medal.

medium, mediums, media In general, the material(s) from which any given object is made. In painting, the liquid substance in which pigments are suspended.

megaron The main hall of a Mycenaean palace or grand house, having a columnar porch and a room with a central fireplace surrounded by four **columns**.

memento mori From Latin terms meaning "reminder of death." An object, such as a skull or extinguished candle, typically found in a *vanitas* image, symbolizing the transience of life.

memory image An image that relies on the generic shapes and relationships that readily spring to mind at the mention of an object.

menhir A **megalithic** stone block, placed by prehistoric peoples in an upright position.

menorah A lamp stand with seven or nine branches; the nine-branched menorah is used during the celebration of Hanukkah. Representations of the seven-branched menorah, once used in the Temple of Jerusalem, are a symbol of Judaism.

mensa The consecrated stone of the **altar** in a Christian church.

metope The carved or painted rectangular panel between the **triglyphs** of a **Doric frieze**.

mezzanine The low intermediate story of a building inserted between two stories of regular size.

middle ground Within the depicted space of an artwork, the area that takes up the middle distance of the image. *See also* **foreground.**

mihrab A recess or **niche** that distinguishes the wall oriented toward Mecca (*qibla*) in a **mosque.**

minaret A tall tower next to a **mosque** from which believers are called to prayer.

minbar A high platform or pulpit in a **mosque.**

miniature Anything small. In painting, miniatures may be illustrations within **albums** or **manuscripts** or intimate portraits.

minuscule *See* **script.**

mirador In Spanish and Islamic palace architecture, a room with windows and sometimes balconies on three sides overlooking gardens and courtyards.

mithuna The amorous male and female couples in Buddhist sculpture, usually found at the entrance to a sacred building. The *mithuna* symbolize the harmony and fertility of life.

moat A large ditch or canal dug around a castle or fortress for military defense. When filled with water, the moat protects the walls of the building from direct attack.

mobile A sculpture made with parts suspended in such a way that they move in a current of air.

modeling In painting, the process of creating the illusion of three-dimensionality on a two-dimensional surface by use of light and

shade. In sculpture, the process of molding a three-dimensional form out of a malleable substance.

module A segment or portion of a repeated design.

molding A shaped or sculpted strip with varying contours and patterns. Used as decoration on architecture, furniture, frames, and other objects.

monastery The buildings housing a community of men (monks) or women (nuns) living under religious vows.

monolith A single stone, often very large.

Monophysitism The Christian doctrine stating that Jesus Christ has only one nature, both divine and human. Declared a heresy in the fifth century.

monoprint A single print pulled from a hard surface (such as a blank plate or stone) that has been prepared with a painted design. Each print is an individual artwork, as the original design is a transient one, lost in the printing process.

monstrance A liturgical vessel displaying a relic or the consecrated Host during the **Eucharist** rite.

monumental A term used to designate a project or object that, whatever its physical size, gives an impression of grandeur.

mortise-and-tenon joint A method of joining two elements. A projecting pin (tenon) on one element fits snugly into a hole designed for it (mortise) on the other. Such joints are very strong and flexible.

mosaic Images formed by small colored stone or glass pieces (*tesserae*), affixed to a hard, stable surface.

mosque An edifice used for communal Muslim prayers.

motif Any recurring element of a design or **composition**. Also: a recurring theme or subject.

movable-type printing A method of printing text in which the individual letters, cast on small pieces of metal (die), are assembled into words on a mechanical press. When each **edition** was complete, the type could be reused for the next project.

mudra A symbolic hand gesture in Buddhist art that denotes certain behaviors, actions, or feelings.

mullion A slender vertical element or **colonnette** that divides a window into subsidiary sections.

multiculturalism Recognition of all cultures and ethnicities in a society or civilization.

multiple-point perspective *See* perspective.

muqarna The complex **squinches** used in Islamic architecture to achieve the transition between walls and **vaults** or flat and rounded surfaces.

mural Wall-like. A large painting or decoration, done either directly on a wall or separately and affixed to it.

naos The principal room in a temple or church. In ancient architecture, the **cella**. In a Byzantine church, the **nave** and **sanctuary**.

narthex The vestibule or entrance **porch** of a church.

naturalism, naturalistic A **style** of depiction in which the physical appearance of the rendered image in nature is the primary inspiration. A naturalistic work appears to record the visible world.

nave The central aisle of a **basilica**, two or three stories high and flanked by **aisles**.

nave arcade *See* nave *and* arcade.

nave colonnade *See* nave *and* colonnade.

necking The **molding** at the top of the **shaft** of the **column**.

necropolis A large cemetery or burial area; literally a "city of the dead."

negative space Empty or open space within or bounded by the forms of a painting, sculpture, or architectural design.

niche A hollow or recess in a wall or other solid architectural element. Niches can be of varying size and shape and may be intended for many different uses, from display of objects to housing of a tomb.

niello A metal technique in which a black sulfur alloy is rubbed into fine lines engraved into a metal (usually gold or silver). When heated, the alloy becomes fused with the surrounded metal and provides contrasting detail.

nimbus A halo.

nishiki-e A multicolored and ornate Japanese print.

nocturne A night scene in painting, usually lit by artificial illumination.

nonobjective *See* nonrepresentational.

nonrepresentational **Abstract** art that does not attempt to reproduce the appearance of objects, figures, or scenes in the natural world. Also called **nonobjective art**.

obelisk A tall, four-sided stone **shaft**, hewn from a single block, that tapers at the top and is completed by a **pyramidion**. A sun symbol erected by the ancient Egyptians in ceremonial spaces (such as entrances to **temple complexes**). Today used as a commemorative monument.

oblique perspective *See* perspective.

oculus (oculi) In architecture, a circular opening. Oculi are usually found either as windows or at the apex of a **dome**. When at the top of a dome, an oculus is either open to the sky or covered by a decorative exterior **lantern**.

odalisque From the Turkish term for a woman in a harem. Usually represented as a reclining female nude shown among the accouterments of an exotic, luxurious environment by nineteenth- and twentieth-century artists.

ogival arch *See* arch.

oil painting Any painting executed with the pigments floating in a **medium** of oil. Oil paint has particular properties that allow for greater ease of working (among others, a slow drying time, which allows for corrections, and a great range of relative opaqueness of paint layers, which permits a high degree of detail and luminescence).

oil sketch An **oil painting**, usually on a small scale, intended as a preliminary stage for the production of a larger work. Oil sketches are often very **painterly** in technique

oinoche A Greek wine jug with a round mouth and a curved handle.

olpe Any Greek vase or jug without a spout.

one-point perspective *See* perspective.

onion dome A bulbous, unvaulted and therefore nonstructural dome found in Russia and Eastern Europe, usually in church architecture.

openwork Decoration, such as **tracery**, with open spaces incorporated into the pattern.

oracle A person, usually a priest or priestess, who acts as a conduit for divine information. Also: the information itself or the place at which this information is communicated.

orant A standing figure praying with outstretched arms and upraised hands.

order A system of proportions in **Classical** architecture. Doric: the **column shaft** of the Doric order can be **fluted** or smooth-surfaced and has no **base**. The Doric **capital** consists of an undecorated **echinus** and **abacus**. The Doric **entablature** has a plain **architrave**, a **frieze** with **metopes** and **triglyphs**, and a simple **cornice**. Tuscan: a variation of Doric characterized by a smooth-surfaced column shaft with a base, a plain architrave, and an undecorated frieze. Ionic: the column of the Ionic order has a base, a fluted shaft and a capital decorated with **volutes**. The Ionic entablature consists of an architrave of three panels, a frieze usually containing carved **relief** ornament, and a cornice with **dentils** and **moldings**. Corinthian: the most ornate of the orders, the Corinthian column includes a base, a fluted shaft with a bell-shaped capital elaborately decorated with **acanthus** leaf carvings. Its entablature consists of an architrave decorated with moldings, a frieze often containing sculptured reliefs, and a cornice with dentils. Composite: a combination of the Ionic and the Corinthian orders. The capital combines acanthus leaves with volute scrolls. A **colossal** order is any of the above built on a large scale, rising through several stories in height and often raised from the ground by a **pedestal**.

orthogonal Any line running back into the represented space of a picture perpendicular to the imagined **picture plane**. In **linear perspective**, all orthogonals converge at a single **vanishing point** in the picture and are the basis for a **grid** that maps out the internal space of the image. An orthogonal plan is any plan for a building or city that is based exclusively on right angles, such as the grid plan of many modern cities.

orthogonal plan *See* orthogonal.

overpainting A final layer of paint applied over a dry underlayer.

ovoid An adjective describing a rounded oval object or shape. Also: a characteristic **form** in Native American art, consisting of a rectangle with bent sides and rounded corners.

pagoda An East Asian temple in the form of a tower built with successively smaller, repeated stories. Each story is usually marked by an elaborate projecting roof.

painterly A **style** of painting, that emphasizes the techniques and surface effects of brushwork (also light and **shade**).

palace complex A group of buildings used for living and governing by a ruler and his supporters, usually fortified.

palette A handheld support used by artists for the storage and mixing of paint during the

process of painting. Also: the choice of a range of colors made by an artist in a particular work or typical of his or her **style**.

palisade A stake fence that forms a defensive barrier.

Palladian An adjective describing a style of architecture, or an architectural detail, reminiscent of the classicizing work of the sixteenth-century Italian architect Andrea Palladio.

palmette A fan-shaped ornament with radiating leaves.

panel painting Any painting executed on a wood support. The wood is usually planed to provide a smooth surface. A panel can consist of several boards joined together, normally covered with **gesso**.

Pantokrator Christ Almighty, represented holding a book and giving a blessing.

papyrus A native Egyptian river plant; a writing paper made from the stems; a popular decorative element in Egyptian architecture.

parapet A low wall at the edge of a balcony, bridge, roof, or other place from which there is a steep drop, built for the safety of onlookers. A parapet walk is the passageway, usually open, immediately behind the uppermost exterior wall or battlement of a fortified building.

parchment A writing surface made from treated skins of animals and used during antiquity and the Middle Ages.

Paris Salon The annual display of art by French artists in Paris during the eighteenth and nineteenth centuries. Established in the seventeenth century as a venue to show the work of members of the French **Academy**, the Salon and its judges established the accepted official **style** of the time. *See also* **salon.**

parterre An ornamental, highly regimented flowerbed. An element of the ornate gardens of seventeenth-century palaces and **châteaux**.

passage In painting, *passage* refers to any particular area within a work, often those where **painterly** brushwork or color changes exist. Also: a term used to describe Paul Cézanne's technique of blending adjacent shapes.

passage grave A prehistoric tomb under a **cairn**, reached by a long, narrow, slab-lined access passageway.

pastel Dry pigment, chalk, and gum in stick or crayon form.

pedestal A platform or base supporting a sculpture or other monument.

pediment A triangular **gable** found over the narrow ends of buildings. In the **Classical** Greek temple, formed by an **entablature** and the sloping roof or a **raking cornice**. The form may be used decoratively above a door or window, sometimes with a curved upper **molding**. A **broken pediment** has an open space at the center of the topmost angle and/or the horizontal **cornice**.

pendentive The concave triangular section of a wall that forms the transition between a square or polygonal space and the circular base of a **dome**.

pendentive dome *See* **dome.**

peplos A loose outer garment worn by women of ancient Greece. A cloth rectangle fastened on the shoulders and belted below the bust or at the waist.

performance art An artwork based on a live, sometimes theatrical performance by the artist.

peripteral A term used to describe any building (or room) that is surrounded by a single row of **columns**. When such columns are engaged instead of freestanding, called pseudo-peripteral.

peristyle A surrounding **colonnade** in Greek architecture. A peristyle building is surrounded on the exterior by a colonnade. Also: a peristyle court is an open colonnaded courtyard, often having a pool and garden.

perspective A system for representing three-dimensional space on a flat surface. Atmospheric perspective: A method of rendering the effect of spatial distance on a two-dimensional plane by subtle variations in color and clarity of representation. **One-point** and **multiple-point perspective** (also called **linear**, scientific, or **mathematical perspective**): A method of creating the illusion of three-dimensional space on a two-dimensional surface by delineating a **horizon line** and multiple **orthogonal** lines. These recede to meet at one or more points on the horizon (called **vanishing points**), giving the appearance of spatial depth. Called scientific or mathematical because its use requires some knowledge of geometry and mathematics, as well as optics. **Intuitive perspective:** A method of representing three-dimensional space on a two-dimensional surface by the use of **formal elements** that act to give the impression of recession. This impression, however, is achieved by visual instinct, not by the use of an overall system or program involving scientific principles or mathematics for depicting the appearance of spatial depth. **Oblique perspective**: An intuitive spatial system used in painting, in which a building or room is placed with one corner in the **picture plane**, and the other parts of the structure all recede to an imaginary **vanishing point** on its other side. Oblique perspective is not a comprehensive, mathematical system. **Reverse perspective**: A Byzantine perspective theory in which the orthogonals or rays of sight do not converge on a vanishing point in the picture, but are thought to originate in the viewer's eye in front of the picture. Thus, in reverse perspective the image is constructed with orthogonals that diverge, giving a slightly tipped aspect to objects.

petrograph A prehistoric drawing or painting on rock. Also called petroglyph.

photomontage A photographic work created from many smaller photographs arranged (and often overlapping) in a **composition**.

piazza The Italian word for an open city square.

pictograph A highly stylized depiction serving as a symbol for a person or object. Also: a type of writing utilizing such symbols.

picture plane The theoretical spatial plane corresponding with the actual surface of a painting.

picture stone A stone used in medieval northern Europe as a commemorative monument, which is carved or inscribed with ancient writing and representations of human figures, gods, ships, and serpents. *See also* **rune stone.**

picturesque A term describing the taste for the familiar, the pleasant, and the pretty, popular in the eighteenth and nineteenth centuries in Europe. When contrasted with the sublime, the picturesque stood for all that was ordinary but pleasant.

piece-mold casting A casting technique in which the mold consists of several sections that are connected during the pouring of molten metal, usually **bronze**. After the cast form has hardened, the pieces of the mold are then disassembled, leaving the completed object. Because it is made in pieces, the mold can be reused.

pier A masonry support made up of many stones, or rubble and **concrete** (in contrast to a **column shaft** which is formed a single stone or a series of drums), often square or rectangular in **plan**, and capable of carrying very heavy architectural loads. *See also* **compound pier.**

pietà Italian for "pity." A devotional subject in Christian religious art. After the Crucifixion, the body of Jesus was laid across the lap of his grieving mother, Mary. When others are present the subject is called the Lamentation.

pietra dura Italian for "hard stone." Semiprecious stones selected for color variation and cut in shapes to form ornamental designs such as flowers or fruit.

pietra serena A gray Tuscan limestone used in Florence.

pigment A substance that gives color to a material.

pilaster A rectangular, **engaged** columnar element that is used for decoration in architecture.

pillar In architecture, any large, freestanding vertical element. Usually functions as an important weight-bearing unit in buildings.

pinnacle In Gothic architecture, a steep pyramid decorating the top of another element such as a **buttress**.

plaiting The technique of weaving strips of fabric or other flexible substances under and over each other. Used in basketry.

plan A graphic convention for representing the arrangement of the parts of a building.

plasticity The three-dimensional quality of an object, or the degree to which any object can be modeled, shaped, or altered.

plinth The slablike **base** or **pedestal** of a **column**, statue, wall, building, or piece of furniture.

pluralism A social structure or goal that allows members of diverse ethnic, racial, or other groups to exist peacefully within the society while continuing to practice the customs of their own divergent cultures. Also: an adjective describing the state of having many valid contemporary **styles** available at the same time to artists.

podium A raised platform that acts as the foundation for a building. Most often used for Etruscan, Greek, and Roman temples.

polychrome *See* **polychromy.**

polychromy The multicolored painted decoration applied to any part of a building, sculpture, or piece of furniture.

polyptych An **altarpiece** constructed from multiple panels, sometimes with hinges to allow for movable **wings**.

popular culture The elements of culture (arts) that are recognized by the general public. Popular culture has the associations of something cheap, fleeting, and accessible to all.

porcelain A type of extremely hard and fine **ceramic** made from a mixture of kaolin and other minerals. Porcelain is fired at a very high heat, and the final product has a translucent surface.

porch The covered entrance on the exterior of a building. With a row of **columns** or **colonnade**, also called a **portico**.

portal A grand entrance, door, or gate, usually to an important public building, and often decorated with sculpture.

portcullis A fortified gate, constructed to move vertically and often made of metal bars, used for the defense of a city or castle.

portico In architecture, a projecting roof or **porch** supported by **columns**, often marking an entrance. *See also* **porch**.

post-and-lintel construction An architectural system of construction with two or more vertical elements (posts) supporting a horizontal element (**lintel**).

postern A side or back (often secret) exit from a fortified city or castle.

potassium-argon dating Technique used to measure the decay of a radioactive potassium isotope into a stable isotope of argon, an inert gas.

potsherd A broken piece of **ceramic ware**.

Prairie Style A type of domestic architecture, named after a design by Frank Lloyd Wright, popular in the Midwestern United States from 1900 to 1920. Prairie Style buildings are characterized by low-pitched roofs with wide overhanging eaves that emphasize the horizontality of the structure, large hearths, and the use of traditional materials.

predella The lower zone, or **base**, of an **altarpiece**, decorated with painting or sculpture related to the main **iconographic** theme of the altarpiece.

primary colors Blue, red, and yellow—the three colors from which all others are derived.

primitivism The borrowing of subjects or forms usually from non-Western or prehistoric sources by Western artists. Originally practiced by Western artists as an attempt to infuse their work with the naturalistic and expressive qualities attributed to other cultures, especially colonized cultures, primitivism also borrowed from the art of children and the insane.

Prix de Rome A prestigious scholarship offered by the French **Academy** at the time of the establishment of its Roman branch in 1666. The scholarship allowed the winner of the prize to study in Rome for three to five years at the expense of the state. Originally intended only for painters and sculptors, the prize was later expanded to include printmakers, architects, and musicians.

pronaos The enclosed vestibule of a Greek or Roman temple, found in front of the **cella** and marked by a row of **columns** at the entrance.

propylon (propylaia) A large, often elaborate gateway to a temple or other important building.

proscenium The stage of an ancient Greek or Roman theater. In modern theater, the area of the stage in front of the curtain. Also: the framing **arch** that separates a stage from the audience.

prostyle A term used to describe a **classical** temple with a **colonnade** placed across the entrance.

provenance The history of ownership of a work of art from the time of its creation to the present.

psalter In Jewish and Christian scripture, a book containing the songs attributed to King David.

pseudo-kufic Designs intended to resemble the script of the Arabic language.

pseudo-peripteral *See* **peripteral**.

punchwork Decorative designs that are stamped onto a surface, such as metal or leather, using a punch (a handheld metal implement).

putto (putti) A plump, naked little boy. Cupid in **classical** art; a **cherub** or baby angel in Christian art.

pylon A massive gateway formed by a pair of tapering walls of oblong shape. Erected by ancient Egyptians to mark the entrance to a **temple complex**.

pyramidion A pyramid-shaped block set as the finishing element atop an **obelisk**.

qibla The **mosque** wall indicating the direction of Mecca; includes the *mihrab*.

quadrant vault *See* **vault**.

quatrefoil A four-lobed decorative pattern common in Gothic art and architecture.

quillwork A Native American decorative craft. The quills of porcupines and bird feathers are dyed and attached to fabric, birch bark, or other material in patterns.

quincunx A building in which five **domed bays** are arranged within a square, with a central unit and four corner units. (When the central unit has similar units extending from each side, the form becomes a **Greek cross**.)

quoin A stone, often extra large or decorated for emphasis, forming the corner of two walls.

radiometric dating A method of dating prehistoric works of art made from organic materials, based on the rate of degeneration of radiocarbons in these materials. *See also* **relative dating, absolute dating**.

radiometry *See* **radiometric dating**.

raigo A painted image that depicts the Amida Buddha and other Buddhist deities guiding the soul of a dying worshiper to paradise.

raking cornice *See* **cornice**.

raku A type of **ceramic** pottery made by hand, coated with a thick, dark **glaze**, and fired at a low heat. The resulting vessels are irregularly shaped and glazed, and are highly prized. *Raku* **ware** is used in the Japanese tea ceremony.

rampart The raised walls or embankments used as primary protection in the fortification of a city or castle.

readymade An object from popular or material culture presented without further manipulation as an artwork by the artist.

realism In art, a term first used in Europe around 1850 to designate a kind of **naturalism** with a social or political message, which soon lost its didactic import and became synonymous with naturalism.

realistic Describes a style in which an artist attempts to depict objects as they are in actual, visible reality.

recto The right-hand page in the opening of a book or **manuscript**. Also: the principal or front side of a leaf of paper or parchment, as in the case of a drawing. The **verso** is the reverse side.

red-figure A **style** and technique of ancient Greek vase painting characterized by red clay-colored figures on a black background. (The figures are reversed against a painted ground and details are drawn, not engraved, as in **black-figure**.) *See also* **black-figure**.

refectory The dining hall for monks or nuns in a monastery or convent.

register A device used in systems of spatial definition. In painting and sculpture, a register indicates the use of differing **groundlines**, self-contained bands in a vertical arrangement, to differentiate distance within an image. In printmaking, the marks at the edges used to align the print correctly on the page, especially in multiple-block color printing; also called **registration marks**.

reintegration The process of adaptation and transformation of European techniques and styles by artists in colonial areas.

relative chronology A practice of dating objects in relation to each other when the **absolute dating** of those objects cannot be or has not been established. Also known as relative dating.

relative dating *See also* **absolute dating; relative chronology; radiometric dating**.

relief sculpture A three-dimensional image or design whose flat background surface is carved away to a certain depth, setting off the figure. Called **high** or **low** (bas) **relief** depending upon the extent of projection of the image from the background. Called **sunken relief** when the image is modeled below the original surface of the background, which is not cut away.

relieving arch *See* **arch**.

reliquary A container, often made of precious materials, used as a repository to protect and display sacred relics. *See also* **monstrance**.

replica A very close copy of a painting or sculpture, sometimes done by the same artist who created the original.

repoussé A technique of hammering metal from the back to create a protruding image. Elaborate reliefs are created with wooden **forms** against which the metal sheets are pressed and hammered.

repoussoir French for "something that pushes back." An object or figure placed in the immediate **foreground** of a **composition**, usually the left or right edge, whose purpose is to direct the viewer's eye into the background and suggest recession into depth.

representational Any art that attempts to depict an aspect of the external, natural world in a visually understandable way.

reredos A decorated wall or screen behind the **altar** of a church. *See also* **retablo**.

retablo Spanish for "altarpiece." The screen placed behind an **altar**. Often very a large scale, having many painted or carved panels.

reverse perspective *See* **perspective**.

revetment A covering of cut stone, fine brick, or other solid facing material over a wall built of coarser materials. Also: surface covering used to reinforce a retaining wall, such as an embankment.

revivalism The practice of using older **styles** and modes of expression in a conscious manner. Revivalism does not usually entail the same academic and historical interest as **historicism**.

rhyton A vessel in the shape of a figure or an animal, used for drinking or pouring liquids on special occasions.

rib Projecting band at the juncture of the curved surfaces, or cells, of a **vault** that is sometimes structural and sometimes purely decorative.

rib vault See **vault**.

ribbon interlace A **linear** decoration made up of interwoven bands, often found in Celtic and northern European art of the medieval period.

ridge rib A rib running the length of the **vault**.

ridgepole A longitudinal timber at the apex of a roof that supports the upper ends of the rafters.

rinceau A decorative foliage scroll, usually **acanthus**.

ring wall Any wall surrounding a building, town, or fortification, intended to separate and protect the enclosed area.

rock-cut tomb Ancient Egyptian multichambered burial site, hewn from solid rock and often hidden.

rood A crucifix.

rood screen In a church, a screen that separates the public **nave** from the private and sacred area of the **choir**. The screen supports a **rood** (crucifix).

roof comb In a Mayan building, a masonry wall along the apex of a roof that is built above the level of the roof proper and often highly decorated false **facades**.

rose window A round window, often filled with **stained glass**, with **tracery** patterns in the form of wheel spokes. Large, elaborate, and finely crafted, rose windows are usually a central element of the **facade** of French Gothic cathedrals.

rosette A round or oval ornament resembling a rose.

rotulus (rotuli) A scroll or **manuscripts** rolled in a tubular form.

rotunda Any building (or part thereof) constructed in a circular (or sometimes polygonal) shape, usually producing a large open space crowned by a **dome**.

round arch See **arch**.

roundel Any element with a circular format, often placed as a decoration on the exterior of architecture.

rune stone A stone used in early medieval northern Europe as a commemorative monument, which is carved or inscribed with runes, ancient German or Scandinavian writing.

running spirals A decorative **motif** based on the shape formed by a line making a continuous spiral.

rustication In building, the rough, irregular, and unfinished effect deliberately given to the exterior facing of a stone edifice. Rusticated stones are often large and used for decorative emphasis around doors or windows, or across the entire lower floors of a building, probably deriving from fortifications.

sacristy In a Christian church, the room in which the priest's robes and the sacred vessels are housed. Sacristies are usually located close to the sanctuary and often have a place for ritual washing as well as a private door to the exterior.

sahn The central courtyard of a Muslim mosque.

salon A large room, often used for intellectual gatherings and the exhibition of works of art. *See* **Paris Salon**.

sanctuary A sacred or holy enclosure used for worship. In Greece, includes one or more temples and an **altar**. In Christian buildings, the space around the altar in a church, usually at the east end (also called the chancel or presbytery).

sand painting Ephemeral religious art created with different colored sands by Native Americans of North America, Australian Aborigines, and other peoples in Japan and Tibet.

sanghati The robe worn by a Buddhist monk. Draped over the left shoulder, the robe is made from a single piece of cloth wrapped around the body.

sarcophagus (sarcophagi) A rectangular stone coffin. Often decorated with **relief sculpture**.

scarification Ornamental marks, scars, or scratches made on the human body.

school of artists An art historical term describing a group of artists, usually working at the same time and sharing similar **styles**, influences, and ideals. The artists in a particular school may not necessarily be directly associated with one another, unlike those in a workshop or atelier.

scientific perspective See **perspective**.

script Handwriting. Includes minuscule (as in lower-case type) and minuscule (capital letters). *See also* **calligraphy**.

scriptorium (scriptoria) A room in a monastery for writing or copying **manuscripts**.

scroll painting A painting executed on a rolled support. Rollers at each end permit the horizontal scroll to be unrolled as it is studied or the vertical scroll to be hung for contemplation or decoration.

sculpture in the round Three-dimensional sculpture that is carved free of any attaching background or block.

section A method of representing the three-dimensional arrangement of a building in a graphic manner. A section is produced when an imaginary vertical plane intersects with a building, laying bare all the elements that make up the (cross section of the) structure at that point. Also: a view of an element of an object as if sliced through. *See also* **elevation**.

segmental pediment A **pediment** formed when the upper **molding** is a shallow arc.

sepia An ink **medium** often used in drawing that has an extremely rich, dark brownish **tone**.

seraph (seraphim) An angel of the highest rank in the Christian hierarchy.

serdab In Egyptian tombs, the small room in which the *ka* statue was placed.

sfumato Italian term meaning "smoky," soft, and mellow. In painting, the effect of haze in an image. Resembling the color of the atmosphere at dusk, *sfumato* gives a smoky effect.

shade Any area of an artwork that is shown through various technical means to be in shadow. Also: the technique of making such an effect.

shaft The main vertical section of a **column** between the **capital** and the **base**, usually circular in cross section.

shater A type of roof used in Russia and the Near East with a steep pitch and tentlike shape.

shikhara In the architecture of northern India, a conical (or pyramidal) spire found atop a Hindu temple and often crowned with an *amalaka*.

shoin The architecture of the aristocracy and upper classes in Japan, built in traditional asymmetrical fashion and incorporating the traditional elements of residences, such as the *tokonoma* and *shoji* screens.

shoji A standing Japanese screen covered in translucent rice paper and used in interiors.

side aisle See **aisle**.

silversmith An artisan who makes silver wares.

sinopia The preparatory design or underdrawing of a **fresco**. Also: a reddish chalklike earth pigment.

site-specific sculpture A sculpture commissioned and designed for a particular spot.

slip A mixture of clay and water applied to a **ceramic** object as a final decorative coat. Also: a solution that binds different parts of a vessel together, such as the handle and the main body.

spandrel The area of wall adjoining the exterior curve of an **arch** between its springing and the **keystone**, or the area between two arches, as in an **arcade**.

speech scroll A scroll painted with words indicating the speech or song of a depicted figure.

springing The point at which the curve of an **arch** or **vault** meets with and rises from its support.

squinch An **arch** or **lintel** built across the upper corners of a square space, allowing a circular or polygonal **dome** to be more securely set above the walls.

stadium In ancient Greece, a race track with tiers of seats for spectators.

stained glass A decorative process in glass-making by which glass is given a color (whether intrinsic in the material or painted onto the surface). To fill windows, small pieces of differently colored glass are precisely cut and assembled into a design, held together by **cames**. Details of images may be painted on the colored glass to create symbols and narratives.

stele (stelai) A stone slab placed vertically and decorated with inscriptions or reliefs. Used as a grave marker or memorial.

stepped pyramid A **pyramid** consisting of successive levels of **mastaba** forms appearing to rise in staggered "steps" rather than in sloping triangular faces.

stereobate A foundation upon which a **Classical** temple stands.

stigmata The wounds of Christ; said to appear on the bodies of certain holy persons.

still life A type of painting that has as its subject inanimate objects (such as food, dishes, fruit, or flowers).

stipes The support structure of an **altar** which holds up the **mensa**, or top surface.

stoa In Greek architecture, a **portico** or promenade with long rows of **columns** used as a meeting place.

stockade A defensive fencelike wood fortification built around a village, house, or other enclosed area.

stretcher The wooden framework on which an artist's canvas is attached, usually with tacks, nails, or staples. Also: a reinforcing horizontal brace between the legs of a piece of furniture, such as a chair. Also: in building, a brick laid so that its longer edge is parallel to the wall.

stringcourse A continuous horizontal band, such as a **molding**, decorating the face of a wall.

stucco A mixture of lime, sand, and other ingredients into a material that can be easily molded or modeled. When dry, produces a very durable surface used for covering walls or for architectural sculpture and decoration.

stupa In Buddhist architecture, a bell-shaped or pyramidal religious monument, made of piled earth or stone, and containing sacred relics.

style A particular manner, **form**, or character of representation, construction, or expression typical of an individual artist or of a certain school or period.

stylization, stylized A manner of representation that conforms to an intellectual or artistic idea rather than to **naturalistic** appearances.

stylobate In **Classical** architecture, the stone foundation on which a temple **colonnade** stands.

stylus An instrument with a pointed end (used for writing and printmaking), which makes a delicate line or scratch. Also: a special writing tool for **cuneiform** writing with one pointed end and one triangular wedge end.

subject matter *See* **content**.

sublime A concept, thing, or state of exceptional and awe-inspiring beauty and moral or intellectual expression. The sublime was a goal to which many nineteenth-century artists aspired in their artworks.

sunken relief *See* **relief sculpture**.

swag A decorative device in architecture or interior ornament (and in paintings), in which a loosely hanging garland is made to look as if constructed of flowers or gathered cloth.

syncretism In religion or philosophy, the union of different ideas or principles.

tablinum A large reception room for family records and hereditary statues in an ancient Roman house, connected to the **atrium**.

talud-tablero A design characteristic of architecture at Teotihuacan in which a sloping *talud* at the base of a building supports a wall-like *tablero*, where ornamental painting and sculpture are usually placed.

taotie A mask with a dragon or animal-like face common as a decorative **motif** in Chinese art.

tapa A cloth made in Polynesia by pounding the bark of a tree, such as the paper mulberry. It is also known as bark cloth.

tapestry Multicolored pictorial or decorative weaving meant to be hung on a wall or placed on furniture.

tatami Mats of woven straw used in Japanese houses as a floor covering.

temenos A sacred enclosure. In **Classical** architecture, includes temples, treasuries, **altars**, and other buildings and spaces for ritual activities.

tempera A painting **medium** made by blending egg yolks with water, pigments, and occasionally other materials, such as glue. The technique was often used during the fourteenth and fifteenth centuries to paint **murals** and **panel paintings**.

temple complex A group of buildings dedicated to a religious purpose, usually located close to one another in a **sanctuary**.

tenebrism A term signifying the use of strong **chiaroscuro** and artificially illuminated areas to create a dramatic contrast of light and dark in a painting.

tepee A portable dwelling constructed from hides stretched on a structure of poles set at the base in a circle and leaning against one another at the top. Tepees were typically found among the nomadic Native Americans of the North American Plains.

terminal Any element of sculpture or architecture that functions as decorative closure. Terminals are usually placed in pairs at either end of an object (such as furniture) or **facade** (as on a building) to help frame the **composition**.

terra-cotta A **medium** made from clay fired over a low heat and sometimes left unglazed. Also: the orange-brown color typical of this medium.

tessera (tesserae) The small cube of stone, glass, or other object that is pieced together with many others to create a **mosaic**.

Theotokos In Byzantine art, the Virgin Mary as mother or "bearer" of God.

thermoluminescence dating A technique that measures the irradiation of the crystal structure of materials such as flint or pottery and the soil in which it is found, determined by luminescence produced when a sample is heated.

tholos A small, round building. Sometimes built underground, as in a Mycenaean tomb.

tierceron In **vault** construction, a secondary rib that arcs from a **springing** point to the rib that runs lengthwise through the **vault**, called the **ridge rib**.

tint The dominant color in an object, image, or pigment.

tokonoma A **niche** for the display of an art object (such as a scroll or flower arrangement) in a Japanese tearoom.

tomb effigy A carved portraitlike image of the deceased on a tomb or *sarcophagus*.

tondo A circular painting or relief.

tone The overall degree of brightness or darkness in an artwork. Also: saturation, intensity, or value of color and its effect.

torana In Indian architecture, an ornamented gateway **arch** in a temple, usually leading to the **stupa**.

torii The ceremonial entrance gate to a Japanese Shinto temple.

toron In West African **mosque** architecture, the wooden beams that project from the walls. Torons are used as support for the scaffolding erected annually for the replastering of the building.

torque A neckpiece, especially favored by the Celts, fashioned as a twisted metal ring.

tracery The thin stone or wooden bars in a Gothic window, screen, or panel, which create an elaborate decorative pattern while supporting the structure.

transept The arm of a **cruciform** church, perpendicular to the **nave**. The point where the nave and transept cross is called the **crossing**. Beyond the crossing lies the **sanctuary**.

travertine A mineral building material similar to limestone, typically found in central Italy.

treasury A building or room, for keeping valuable (and often holy) objects.

trefoil An ornamental design made up of three rounded lobes placed adjacent to one another.

triforium The element of the interior **elevation** of a church, found between the **nave arcade** or **colonnade** and the **clerestory**, covers the blind area created by the sloping roof over the aisles. The triforium can be made up of openings from a passageway or gallery, or can be wall supporting paintings or **mosaics**.

triglyph Rectangular blocks between the **metopes** of a **Doric frieze**. Identified by the three carved vertical grooves, which approximate the appearance of the ends of wooden beams.

trilithon Prehistoric structure composed of two upright **monoliths** supporting a third one laid horizontally.

triptych An artwork made up of three panels. The panels are often hinged together so the side segments (**wings**) fold over and protect the central area.

triumph In Roman times, a celebration of a particular military victory, usually granted to the commanding general upon his return to Rome. Also: in later times, any depiction of a victory.

triumphal arch A freestanding, massive stone gateway with a large central **arch**, built as urban ornament to celebrate military victories (as by the Romans).

trompe l'oeil A manner of representation in which the appearance of natural space and objects is re-created with the express intention of fooling the eye of the viewer, who may be convinced that the subject actually exists as three-dimensional reality.

trophy Captured military objects such as armor and weapons that Romans displayed in an upheld pole or tree to celebrate victory. Also: a similar grouping that recalls the Roman custom of displaying the looted armor of a defeated opponent.

trumeau A **column**, **pier**, or post found at the center of a large **portal** or doorway, supporting the **lintel**.

tug (tugra) The calligraphic imperial monograms used in Ottoman courts.

tunnel vault *See* **vault**.

turret A tall and slender tower.

Tuscan order *See* **order**.

twining A basketry technique in which short rods are sewn together vertically. The panels are then joined together to form a vessel.

tympanum In **classical** architecture, the vertical panel of the **pediment**. In medieval and later architecture, the area over a door enclosed by an **arch** and a **lintel**, often decorated with sculpture or **mosaic**.

types In theology, figures or examples of biblical events. *See also* **typology**.

typological See **typology**.

typology In Christian iconography, a system of matching Old Testament figures and events and even some classical and other secular sources to New Testament counterparts to which they were seen as prefigurements.

ukiyo-e A Japanese term for a type of popular art that was favored from the sixteenth century, particularly in the **form** of color **woodblock** prints. *Ukiyo-e* prints often depicted the world of the common people in Japan, such as courtesans and actors, as well as landscapes and myths.

undercutting A technique in sculpture by which the material is cut back under the edges so that the remaining **form** projects strongly forward, casting deep shadows.

underdrawing The original drawing, obscured by application of paint.

underglaze Color or decoration applied to a ceramic piece before **glazing**.

urna In Buddhist art, the curl of hair on the forehead that is a characteristic mark of a *buddha*. The *urna* is a symbol of divine wisdom.

ushnisha In Asian art, a round turban or tiara symbolizing royalty and, when worn by a *buddha*, enlightenment.

value The darkness or lightness of a color (**hue**).

vanishing point In a **perspective** system, the point on the **horizon line** at which **orthogonals** meet. A complex system can have multiple vanishing points.

vanitas An image, especially popular in Europe during the seventeenth century, in which all the objects symbolize the transience of life. *Vanitas* paintings are usually of **still lifes** or **genre** subjects.

vault An **arched** masonry structure that spans an interior space. **Barrel** or **tunnel vault**: an elongated or continuous vault, shaped like half a cylinder. **Quadrant vault**: a half-barrel vault. **Groin** or **cross vault**: a vault created by the intersection of two barrel vaults of equal size. **Rib vault**: ribs (extra masonry) demark the junctions of a groin vault. Ribs may function to reinforce the groins or may be purely decorative. **Corbel vault**: a vault made by projecting **courses** of stone. *See also* **corbeling**.

vaulting A system of space spanning using vaults.

veduta (vedute) Italian for "vista" or "view."

Paintings, drawings, or prints often of expansive city scenes or of harbors.

vellum A fine animal skin prepared for writing and painting. *See also* **parchment**.

veneer In architecture, the exterior facing of a building, often in decorative patterns of fine stone or brick. In decorative arts, a thin exterior layer for decoration laid over wooden objects or furniture. Made of fine materials such as rare wood, ivory, metal, and semi-precious stones.

verism A **style** in which artists concern themselves with capturing the exterior likeness of an object or person, usually by rendering its visible details in a finely executed, meticulous manner.

verso The (reverse) left-hand page of the opening of a book or **manuscript**. Also: the subordinate or back side of a leaf of paper, as in the case of drawings.

vignette A small **motif** or scene that has no established border.

vihara From the Sanskrit term meaning "for wanderers." A *vihara* is, in general, a Buddhist monastery in India. It also signifies monks' cells and gathering places in such a monastery.

villa A country house.

vimana The main element of a Southern Indian Hindu temple, usually in the shape of a pyramidal or tapering tower raised on a **plinth**.

volumetric A term indicating the concern for rendering the impression of three-dimensional volumes in painting, usually achieved through **modeling** and the manipulation of light and shadow (**chiaroscuro**).

volute A spiral scroll, most often decoration on an **Ionic capital**.

volute krater *See* **krater**.

votive figure An image created as a devotional offering to a god or other deity.

voussoirs The oblong, wedge-shaped stone blocks used to build an **arch**. The topmost center *voussoir* is called a **keystone**.

wall painting *See* **mural**.

ware A general term designating pottery produced and decorated by the same technique.

warp The vertical threads in a weaver's loom. Warp threads make up a fixed framework that provides the structure for the cloth and are thus often stronger than **weft** threads. *See also* **weft**.

wash A diluted **watercolor**. Often washes are applied to drawings or prints to add **tone** or touches of color.

watercolor A type of painting using water-soluble pigments that are floated in a water **medium** to make a transparent paint. The technique of watercolor is most suited to a paper support.

wattle-and-daub A wall construction method combining upright branches, woven with twigs (wattles) and plastered or filled with clay or mud (daub).

weft The horizontal threads in a woven piece of cloth. Weft threads are woven at right angles to and through the **warp** threads to make up the bulk of the decorative pattern. In carpets,

the weft is often completely covered or formed by the rows of trimmed knots that form the carpet's soft surface.

westwork The **monumental**, west-facing entrance section of a Carolingian, Ottonian, or Romanesque church. The exterior consists of multiple stories between two towers; the interior includes an entrance vestibule, a chapel, and a gallery overlooking the **nave**.

white-ground A type of ancient Greek pottery in which the background color of the object is painted with a **slip** that turns white in the firing process. Figures and details were added by painting on or **incising** into this slip. White-ground **wares** were popular in the **Classical** period as funerary objects.

wing A side panel of a **triptych** or **polyptych** (usually found in pairs), which was hinged to fold over the central panel. Wings often held the depiction of the donors and/or subsidiary scenes relating to the central image.

woodblock print A print made from a block of wood that is carved in **relief** or **incised**. *See also* **woodcut**.

woodcut A type of print made by carving a design into a wooden block. The ink is applied to the plate with a roller. As the ink remains only on the raised areas between the carved-away lines, these carved-away areas and lines provide the white areas of the print. Also: the process by which the woodcut is made.

x-ray style In Australian aboriginal art, a manner of representation in which the artist depicts a figure or animal by drawing its essential internal organs and bones, as well as its outline.

yaksha, yakshi The male (*yaksha*) and female (*yakshi*) nature spirits that act as agents of the Hindu gods. Their sculpted images are often found on Hindu temples and other sacred places, particularly at the entrances.

zeitgeist German for "spirit of the time," meaning the cultural and intellectual aspects of a period that pervade human experience and are expressed in all creative and social endeavors.

ziggurat In Mesopotamia, an artificial (human-made) mountain; a tall stepped tower of earthen materials, often supporting a shrine.

Bibliography

Susan Craig

This bibliography is composed of books in English that are appropriate "further reading" titles. Most items on this list are available in good libraries, whether college, university, or public institutions. I have emphasized recently published works so that the research information would be current. There are three classifications of listings: general surveys and art history reference tools, including journals and Internet directories; surveys of large periods (ancient art in the Western tradition, European medieval art, European Renaissance through eighteenth-century art, modern art in the West, Asian art, and African and Oceanic art and art of the Americas); and books for individual chapters 1 through 29.

General Art History Surveys and Reference Tools

Adams, Laurie Schneider. *Art across Time*. New York: McGraw-Hill, 1999.

Andrews, Malcolm. *Landscape and Western Art*. Oxford History of Art. Oxford: Oxford Univ. Press, 1999.

Barral I Altet, Xavier. *Sculpture From Antiquity to the Present*. 4 vols. London: Taschen, 1996.

Bazin, Germain. *A Concise History of World Sculpture*. London: David & Charles, 1981.

Brownston, David M., and Ilene Franck. *Timelines of the Arts and Literature*. New York: HarperCollins, 1994.

Chadwick, Whitney. *Women, Art, and Society*. 2nd ed, Rev. & exp. New York: Thames and Hudson, 1997.

Cole, Bruce, and Adelheid Gealt. *Art of the Western World: From Ancient Greece to Post-Modernism*. New York: Summit, 1989.

Crofton, Ian, comp. *A Dictionary of Art Quotations*. New York: Schirmer, 1989.

Dictionary of Art, The. 34 vols. New York: Grove's Dictionaries, 1996.

Encyclopedia of World Art. 16 vols. New York: McGraw-Hill, 1972–83.

Fleming, John, Hugh Honour, and Nikolaus Pevsner. *The Penguin Dictionary of Architecture and Landscape Architecture*. 5th ed. New York: Penguin, 1998.

Fletcher, Banister. *Sir Banister Fletcher's A History of Architecture*. 20th ed. Ed. Dan Cruickshank. Oxford: Architectural Press, 1996.

Gardner, Helen. *Gardner's Art through the Ages*. 10th ed. Ed. Richard G. Tansey and Fred S. Kleiner. Fort Worth: Harcourt Brace College, 1996.

Griffiths, Antony. *Prints and Printmaking: An Introduction to the History and Techniques*. 2nd ed. London: British Museum Press, 1996.

Hall, James. *Dictionary of Subjects and Symbols in Art*. Rev. ed. New York: Harper & Row, 1979.

Hartt, Frederick. *Art: A History of Painting, Sculpture, Architecture*. 4th ed. New York: Abrams, 1993.

Havercamp Begemann, Egbert, and Carolyn Logan. *Creative Copies: Interpretative Drawings from Michaelangelo to Picasso*. London: Sotheby's, 1988.

Heller, Nancy G. *Women Artists: An Illustrated History*. 3rd ed. New York: Abbeville, 1997.

Holt, Elizabeth Gilmore, ed. *A Documentary History of Art*. 3 vols. New Haven: Yale Univ. Press, 1986.

Honour, Hugh, and John Fleming. *The Visual Arts: A History*. 5th ed. New York: Abrams, 1999.

Hornblower, Simon, and Antony Spawforth. *The Oxford Classical Dictionary*. 3rd ed. Oxford: Oxford Univ. Press, 1996.

Hults, Linda C. *The Print in the Western World: An Introductory History*. Madison: Univ. of Wisconsin Press, 1996.

Janson, H. W., and Anthony F. Janson. *History of Art*. 6th ed. Rev. and Exp. New York: Abrams, 2000.

Jervis, Simon. *The Penguin Dictionary of Design and Designers*. London: Lane, 1984.

Jones, Lois Swan. *Art Information and the Internet: How to Find It, How to Use It*. Phoenix: Oryx Press, 1999.

Kemp, Martin. *The Oxford History of Western Art*. Oxford: Oxford Univ. Press, 2000.

Kostof, Spiro. *A History of Architecture: Settings and Rituals*. 2nd ed. Rev. Greg Castillo. New York: Oxford Univ. Press, 1995.

Livingstone, E. A. *The Concise Oxford Dictionary of the Christian Church*. Oxford: Oxford Univ. Press, 2000.

Mackenzie, Lynn. *Non-Western Art: A Brief Guide*. Upper Saddle River, NJ: Prentice Hall, 1995.

Mair, Roslin *Key Dates in Art History: From 600 BC to the Present*. Oxford: Phaidon, 1979.

McConkey, Wilfred J. *Klee as in Clay: A Pronunciation Guide*. 3rd ed. Lanham, MD.: Madison Books, 1992.

Preble, Duane, Sarah Preble, and Patrick Frank. *Artforms: An Introduction to the Visual Arts*. 6th ed. New York: Longman, 1999.

Roberts, Helene, ed. *Encyclopedia of Comparative Iconography: Themes Depicted in Works of Art*. 2 vols. Chicago: Fitzroy Dearborn, 1998.

Rotberg, Robert I., Theodore K. Rabb, and Jonathan Brown eds. *Art and History: Images and Their Meaning*. Cambridge: Cambridge Univ. Press, 1988.

Sed-Rajna, Gabrielle. *Jewish Art*. Trans. Sara Friedman and Mira Reich. New York: Abrams, 1997.

Slatkin, Wendy. *Women Artists in History: From Antiquity to the Present*. 3rd ed. Upper Saddle River, NJ: Prentice Hall, 1997.G

Stangos, Nikos, ed. *The Thames and Hudson Dictionary of Art and Artists*. Rev. exp. & updated ed. World of Art. New York: Thames and Hudson, 1994.

Steer, John, and Antony White. *Atlas of Western Art History: Artists, Sites and Movements from Ancient Greece to the Modern Age*. New York: Facts on File, 1994.

Sutton, Ian. *Western Architecture: From Ancient Greece to the Present*. World of Art. New York: Thames and Hudson, 1999.

Thacker, Christopher. *The History of Gardens*. Berkeley: Univ. of California Press, 1979.

Trachtenberg, Marvin, and Isabelle Hyman. *Architecture: From Prehistory to Postmodernity*. Upper Saddle River, NJ: Prentice Hall, 2001.

Walker, John A. *Design History and the History of Design*. London: Pluto, 1989.

West, Shearer, ed. *The Bulfinch Guide to Art History: A Comprehensive Survey and Dictionary of Western Art and Architecture*. Boston: Little, Brown and Co., 1996.

Wilkins, David G., Bernard Schultz, and Katheryn M. Linduff. *Art Past/Art Present*. 4th ed. Upper Saddle River, NJ: Prentice Hall, 2000.

Art History Journals: A Selected List

African Arts. Quarterly. Los Angeles
American Art. 3/year. Washington, D.C
American Journal of Archaeology. Quarterly. Boston
Antiquity. Quarterly. Cambridge
Apollo. Monthly. London
Architectural History. Annually. Farnham, Surrey, Eng.
Archives of American Art Journal. Quarterly. Washington, D.C.
Archives of Asian Art. Annually. New York
Ars Orientalis. Annual. Ann Arbor, MI.
Art Bulletin. Quarterly. New York
Artforum. Monthly. New York
Art History. 11/year. New York
Art in America. Monthly. New York
Art Journal. Quarterly. New York
Art News. Quarterly. Mumbai, India
Arts and the Islamic World. Annually. London
Asian Art and Culture. Triannually. Washington, D.C.
Burlington Magazine. Monthly. London
Flash Art International. Bimonthly. Milan
Gesta. Semiannually. New York
History of Photography. Quarterly. London
Journal of Design History. Quarterly. Oxford
Journal of Egyptian Archaeology. Annually. London
Journal of Hellenic Studies. Annually. London
Journal of Roman Archaeology. Annually. Portsmouth, RI
Journal of the Society of Architectural Historians. Quarterly. Chicago
Journal of the Warburg and Courtauld Institutes. Annually. London
Marg. Quarterly. 5/year. Mumbai, India
Master Drawings. Quarterly. New York
Oriental Art. Quarterly. Singapore
Oxford Art Journal. Semiannually. Oxford
Print Quarterly. Quarterly. London
Simiolus. Quarterly. Utrecht, Netherlands
Woman's Art Journal. Semiannually. Laverock, PA

Internet Directories for Art History Information

THE ART HISTORY RESEARCH CENTRE
http://www-fofa.concordia.ca/arth/ARHC/splash.html

Sponsored by Concordia University in Montreal, this directory includes the following divisions: search engines, newsgroups, mailing lists, library catalogues and bookstores, article indexes, universities, collections, other resources, and citing sources. There is also a link to an article by Leif Harmsen, "The Internet as a Research Medium for Art Historians."

ART HISTORY RESOURCES ON THE WEB
http://witcombe.sbc.edu/ARTHLinks.html

Authored by Christopher L. C. E. Witcombe of Sweet Briar College in Virginia, the site includes an impressive number of links for various art historical eras as well as links to research resources, museums, and galleries.

ART IMAGES FOR COLLEGE TEACHING (AICT)
http://www.mcad.edu/AICT/html

These images are the property of art historian and photographer Allan T. Kohl who offers them for nonprofit use. The images are organized into the following groupings: ancient, medieval era, Renaissance and Baroque, 18th–20th century, non-Western.

ART IN FLUX: A DIRECTORY OF RESOURCES FOR RESEARCH IN CONTEMPORARY ART
http://www.art.uidaho.edu/artnet/bsu/contemporary/artinflux/intro.html

Cheryl K. Shutleff of Boise State University in Montana has authored this directory, which includes sites selected according to their relevance to the study of national or international contemporary art and artists.

MOTHER OF ALL ART HISTORY LINKS PAGES
http://www.umich.edu/~hartspc/histart/mother/index.html

Maintained by the Department of the History of Art at the University of Michigan, this directory includes useful annotations and the URLs for each site included.

VOICE OF THE SHUTTLE: ART AND ART HISTORY PAGE
http://vos.ucsb.edu/shuttle/art.html

Sponsored by University of California, Santa Barbara, this is part of the larger directory which includes all areas of humanities. A very extensive list of links including general resources, museums, institutes and centers, galleries and exhibitions, auctions, artists and works by chronology, cartography, art theory and politics, cartography, design, architectural historical preservation, art and technology, image, slide and clip-art resources, image copyright and intellectual property issues, journals and zines, studio art depts. and programs, art history depts. and programs, conferences, calls for papers, deadlines, course syllabi and teaching resources.

YAHOO! ARTS>ART HISTORY
http://dir.yahoo.com/Arts/Art_History/

Another extensive directory of art links. Each listing includes the name of the site as well as a few words of explanation.

WORLD WIDE ARTS RESOURCES
http://www.wwar.com

Interactive arts gateway offering access to artists, museums, galleries, art, art history, education, and more.

ART MUSEUM NETWORK
http://www.amn.org

The official website of the world's leading art museums, the Art Museum Network offers links to the websites of countless museums worldwide, as well as links to the Art Museum Image Corsortium (AMICO) (www.amico.org), an illustrated search engine of more than 50,000 works of art available by subscription and ExCalendar (www.excalendar.net), the official exhibition calendar of the world's leading art museums, among other websites.

ARTMUSEUM.NET
http://www.artmuseum.net

ArtMuseum.net provides a forum for internet-based museum exhibitions around the country.

Ancient Art in the Western Tradition, General

Adam, Robert. *Classical Architecture: A Comprehensive Handbook to the Tradition of Classical Style*. New York: Abrams, 1991.

Amiet, Pierre. *Art in the Ancient World: A Handbook of Styles and Forms*. New York: Rizzoli, 1981.

Becatti, Giovanni. *The Art of Ancient Greece and Rome, from the Rise of Greece to the Fall of Rome*. New York: Abrams, 1967.

Dunabin, Katherine M.D. *Mosaics of the Greek and Roman World*. Cambridge: Cambridge Univ. Press, 1999.

Ehrich, Robert W., ed. *Chronologies in Old World Archaeology*. 3rd ed. Chicago: Univ. of Chicago Press, 1992.

Groenewegen-Frankfort, H. A., and Bernard Ashmole. *Art of the Ancient World: Painting, Pottery, Sculpture, Architecture from Egypt, Mesopotamia, Crete, Greece, and Rome.* Library of Art History. Upper Saddle River, NJ: Prentice Hall, 1972.

Huyghe, René. *Larousse Encyclopedia of Prehistoric and Ancient Art.* Rev. ed. Art and Mankind. New York: Prometheus, 1966.

Laing, Lloyd Robert, and Jennifer Laing. *Ancient Art: The Challenge to Modern Thought.* Dublin: Irish Academic, 1993.

Lloyd, Seton, and Hans Wolfgang Muller. *Ancient Architecture.* New York: Rizzoli, 1986.

Oliphant, Margaret. *The Atlas of the Ancient World: Charting the Great Civilizations of the Past.* New York: Simon & Schuster, 1992.

Powell, Ann. *Origins of Western Art.* London: Thames and Hudson, 1973.

Saggs, H. W. F. *Civilization before Greece and Rome.* New Haven: Yale Univ. Press, 1989.

Scranton, Robert L. *Aesthetic Aspects of Ancient Art.* Chicago: Univ. of Chicago Press, 1964.

Smith, William Stevenson. *Interconnections in the Ancient Near East: A Study of the Relationships between the Arts of Egypt, the Aegean, and Western Asia.* New Haven: Yale Univ. Press, 1965.

Stillwell, Richard, ed. *Princeton Encyclopedia of Classical Sites.* Princeton: Princeton Univ. Press, 1976.

European Medieval Art, General

Binski, Paul. *Painters.* Medieval Craftsmen. London: British Museum Press, 1992.

Brown, Michelle P. *Understanding Illuminated Manuscripts: A Guide to Technical Terms.* London: J. Paul Getty Museum, 1994.

Brown, Sarah, and David O'Connor. *Glass-painters.* Medieval Craftsmen. London: British Museum Press, 1992.

Calkins, Robert C. *Medieval Architecture in Western Europe: From A.D. 300 to 1500.* 1v. + laser optical disc. New York: Oxford Univ. Press, 1998.

———. *Monuments of Medieval Art.* New York: Dutton, 1979.

Camille, Michael. *The Gothic Idol: Ideology and Image-Making in Medieval Art.* Cambridge New Art History and Criticism. Cambridge: Cambridge Univ. Press, 1989.

———. *The Medieval Art of Love: Objects and Subjects of Desire.* New York: Abrams, 1998.

Cherry, John F. *Goldsmiths.* Medieval Craftsmen. London: British Museum Press, 1992.

Coldstream, Nicola. *Masons and Sculptors.* Medieval Craftsmen. London: British Museum Press, 1991.

Conant, Kenneth John. *Carolingian and Romanesque Architecture, 800–1200.* 3rd ed. Pelican History of Art. Harmondsworth, Eng.: Penguin, 1973.

De Hamel, Christopher. *Scribes and Illuminators.* Medieval Craftsmen. London: British Museum Press, 1992.

Duby, Georges. *Sculpture: The Great Art of the Middle Ages from the Fifth to the Fifteenth Century.* New York: Skira/Rizzoli, 1990.

Eames, Elizabeth S. *English Tilers.* Medieval Craftsmen. London: British Museum Press, 1992.

Fossier, Robert, ed. *The Cambridge Illustrated History of the Middle Ages.* 3 vols. Trans. Janet Sondheimer and Sarah Hanbury Tenison. Cambridge: Cambridge Univ. Press, 1986–97.

Hurlimann, Martin, and Jean Bony. *French Cathedrals.* Rev. & enl. London: Thames and Hudson, 1967.

Kenyon, John. *Medieval Fortifications.* Leicester: Leicester Univ. Press, 1990.

Labarge, Margaret Wade. *A Small Sound of the Trumpet: Women in Medieval Life.* London: Hamilton, 1990.

Larousse Encyclopedia of Byzantine and Medieval Art. London: Hamlyn, 1963.

Mâle, Emile. *Religious Art in France: The Late Middle Ages: A Study of Medieval Iconography and Its Sources.* Princeton: Princeton Univ. Press, 1986.

Pfaffenbichler, Matthias. *Armourers.* Medieval Craftsmen. London: British Museum Press, 1992.

Snyder, James. *Medieval Art: Painting-Sculpture-Architecture, 4th–14th Century.* New York: Abrams, 1989.

Staniland, Kay. *Embroiderers.* Medieval Craftsmen. London: British Museum Press, 1991.

Stoddard, Whitney. *Art and Architecture in Medieval France: Medieval Architecture, Sculpture, Stained Glass, Manuscripts. The Art of the Church Treasuries.* New York: Harper & Row, 1972.

Stokstad, Marilyn. *Medieval Art.* 2nd ed. New York: Westview, 2001.

Wieck, Roger S. *Painted Prayers: The Book of Hours in Medieval and Renaissance Art.* New York: Braziller, 1997.

Zarnecki, George. *The Art of the Medieval World: Architecture, Sculpture, Painting, the Sacred Arts.* New York: Abrams, 1975.

European Renaissance through Eighteenth-Century Art, General

Black, C. F., et al. *Cultural Atlas of the Renaissance.* New York: Prentice Hall, 1993.

Blunt, Anthony. *Art and Architecture in France, 1500–1700.* 5th ed. Rev. Richard Beresford. Pelican History of Art. New Haven: Yale Univ. Press, 1999.

Brown, Jonathan. *Painting in Spain: 1500–1700.* Pelican History of Art. New Haven: Yale Univ. Press, 1998.

Circa 1492: Art in the Age of Exploration. Washington, D.C.: National Gallery of Art, 1991.

Cole, Bruce. *Italian Art, 1250–1550: The Relation of Renaissance Art to Life and Society.* New York: Harper & Row, 1987.

Craske, Matthew. *Art in Europe, 1700–1830: A History of the Visual Arts in an Era of Unprecedented Urban Economic Growth.* Oxford History of Art. Oxford: Oxford Univ. Press, 1997.

Cuttler, Charles D. *Northern Painting from Pucelle to Bruegel: Fourteenth, Fifteenth and Sixteenth Centuries.* New York: Holt, Rinehart and Winston, 1973.

Graham-Dixon, Andrew. *Renaissance.* Berkeley: Univ. of California Press, 1999.

Harbison, Craig. *The Mirror of the Artist: Northern Renaissance Art in Its Historical Context.* Perspectives. New York: Abrams, 1995.

Hartt, Frederick. *History of Italian Renaissance Art: Painting, Sculpture, Architecture.* 4th ed. Rev. David C. Wilkins. New York: Abrams, 1994.

Huyghe, René. *Larousse Encyclopedia of Renaissance and Baroque Art.* Art and Mankind. New York: Prometheus, 1964.

Kubler, George, and Martin Soria. *Art and Architecture in Spain and Portugal and Their American Dominions, 1500–1800.* Pelican History of Art. Harmondsworth, Eng.: Penguin, 1959.

McCorquodale, Charles. *The Renaissance: European Painting, 1400–1600.* London: Studio Editions, 1994.

Minor, Vernon Hyde. *Baroque & Rococo: Art & Culture.* New York: Abrams, 1999.

Murray, Peter. *Renaissance Architecture.* History of World Architecture. Milan: Electa, 1985.

Roettgen, Steffi. *Italian Frescoes.* 2 vols. Trans. Russell Stockman. New York: Abbeville, 1996.

Stechow, Wolfgang. *Northern Renaissance, 1400–1600: Sources and Documents.* Upper Saddle River, NJ: Prentice Hall, 1966.

Summerson, John. *Architecture in Britain: 1530–1830.* 7th ed. Pelican History of Art. Harmondsworth, Eng.: Penguin, 1983.

Turner, Richard. *Renaissance Florence: The Invention of a New Art.* Perspectives. New York: Abrams, 1997.

Waterhouse, Ellis K. *Painting in Britain, 1530 to 1790.* 5th ed. Yale Univ. Press Pelican History of Art. New Haven: Yale Univ. Press, 1994.

Whinney, Margaret Dickens. *Sculpture in Britain: 1530–1830.* 2nd ed. Rev. by John Physick. Pelican History of Art. London: Penguin, 1988.

Modern Art in the West, General

Arnason, H. Harvard. *History of Modern Art: Painting, Sculpture, Architecture, Photography.* 4th ed. Rev. Marla Prather. New York: Abrams, 1998.

Baigell, Matthew. *A Concise History of American Painting and Sculpture.* Rev. ed. New York: Icon Editions, 1996.

Bjelajac, David. *American Art: A Cultural History.* Upper Saddle River, NJ: Prentice Hall, 2000.

Bowness, Alan. *Modern European Art.* World of Art. New York: Thames and Hudson, 1995.

Brettell, Richard R. *Modern Art, 1851–1929: Capitalism and Representation.* Oxford History of Art. Oxford: Oxford Univ. Press, 1999.

Brown, Milton W. *American Art: Painting, Sculpture, Architecture, Decorative Arts, Photography.* New York: Abrams, 1979.

Burnett, David G. *Masterpieces of Canadian Art from the National Gallery of Canada.* Edmonton, AB: Hurtig, 1990.

Chipp, Herschel Browning. *Theories of Modern Art: A Source Book by Artists and Critics.* California Studies in the History of Art. Berkeley: Univ. of California Press, 1984.

Clarke, Graham. *The Photograph.* Oxford History of Art. Oxford: Oxford Univ. Press, 1997.

Craven, Wayne. *American Art: History and Culture.* New York: Abrams, 1994.

———. *Sculpture in America.* An American Art Journal/Kennedy Galleries Book. Newark: Univ. of Delaware Press, 1984.

Eitner, Lorenz. *Neoclassicism and Romanticism, 1750–1850: An Anthology of Sources and Documents.* New York: Harper & Row, 1989.

Ferebee, Ann. *A History of Design from the Victorian Era to the Present.* New York: Van Nostrand Reinhold, 1980.

Frampton, Kenneth. *Modern Architecture: A Critical History.* 3rd ed. Rev. & enl. World of Art. New York: Thames and Hudson, 1992.

Greenough, Sarah, et al. *On the Art of Fixing a Shadow: One Hundred and Fifty Years of Photography.* Washington, D.C.: National Gallery of Art, 1989.

Hamilton, George Heard. *Painting and Sculpture in Europe, 1880–1940.* 6th ed. Pelican History of Art. New Haven: Yale Univ. Press, 1993.

Hammacher, A. M. *Modern Sculpture: Tradition and Innovation.* Enlg. ed. New York: Abrams, 1988.

Handlin, David P. *American Architecture.* World of Art. London: Thames and Hudson, 1985.

Harris, Ann Sutherland, and Linda Nochlin. *Women Artists: 1550–1950.* Los Angeles: Los Angeles County Museum of Art, 1976.

Harrison, Charles, and Paul Wood, eds. *Art in Theory, 1900–1990: An Anthology of Changing Ideas.* Cambridge: Blackwell, 1992.

Hitchcock, Henry Russell. *Architecture: Nineteenth and Twentieth Centuries.* 4th ed. Pelican History of Art. Harmondsworth, Eng.: Penguin, 1977.

Hughes, Robert. *The Shock of the New.* Rev. ed. New York: Knopf, 1991.

Hunter, Sam, and John Jacobus. *American Art of the 20th Century: Painting, Sculpture, Architecture.* New York: Abrams, 1973.

———, and Daniel Wheeler. *Modern Art: Painting, Sculpture, Architecture.* 3rd Rev. ed. New York: Abrams, 2000.

Kroeber, Karl. *British Romantic Art.* Berkeley: Univ. of California Press, 1986.

Lewis, Samella S. *African American Art and Artists.* Rev. ed. Berkeley: Univ. of California Press, 1994.

Lindsay, Jack. *Death of the Hero: French Painting from David to Delacroix.* London: Studio, 1960.

Lynton, Norbert. *The Story of Modern Art.* 2nd ed. Oxford: Phaidon, 1989.

McCoubrey, John W. *American Art, 1700–1960: Sources and Documents.* Upper Saddle River, NJ: Prentice Hall, 1965.

Mellen, Peter. *Landmarks of Canadian Art.* Toronto: McClelland and Stewart, 1978.

Middleton, Robin, and David Watkin. *Neoclassical and 19th Century Architecture.* 2 vols. History of World Architecture. New York: Electa/Rizzoli, 1987.

Murray, Joan. *Canadian Art in the Twentieth Century.* Toronto: Dundurn, 1999.

Newhall, Beaumont. *The History of Photography: From 1839 to the Present.* 5th ed. Rev. New York: Museum of Modern Art, 1997.

Patton, Sharon F. *African-American Art.* Oxford History of Art. Oxford: Oxford Univ. Press, 1998.

Powell, Richard J. *Black Art and Culture in the 20th Century.* World of Art. New York: Thames and Hudson, 1997.

Rosenblum, Naomi. *A World History of Photography.* 3rd ed. New York: Abbeville, 1997.

Roth, Leland. *A Concise History of American Architecture.* Icon Editions. New York: Harper & Row, 1979.

Russell, John. *The Meanings of Modern Art.* New York: Museum of Modern Art, 1991.

Schapiro, Meyer. *Modern Art: 19th and 20th Centuries.* New York: Braziller, 1978.

Sparke, Penny. *Introduction of Design and Culture in the Twentieth Century.* New York: Harper & Row, 1986.

Stangos, Nikos, ed. *Concepts of Modern Art: From Fauvism to Postmodernism.* 3rd ed. Exp. & updated. World of Art. New York: Thames and Hudson, 1994.

Stiles, Kristine, and Peter Howard Selz. *Theories and Documents of Contemporary Art: A Sourcebook of Artists' Writings.* California Studies in the History of Art; 35. Berkeley: Univ. of California Press, 1996.

Tafuri, Manfredo. *Modern Architecture.* 2 vols. History of World Architecture. New York: Electa/Rizzoli, 1986.

Tuchman, Maurice. *The Spiritual in Art: Abstract Painting 1890–1985.* Los Angeles: Los Angeles County Museum of Art, 1986.

Upton, Dell. *Architecture in the United States.* Oxford History of Art. Oxford: Oxford Univ. Press, 1998.

Weaver, Mike, ed. *The Art of Photography, 1939–1989.* New Haven: Yale Univ. Press, 1989.

Wilmerding, John. *American Art.* Pelican History of Art. Harmondsworth, Eng.: Penguin, 1976.

Woodham, Jonathan M. *Twentieth Century Design.* Oxford History of Art. Oxford: Oxford Univ. Press, 1997.

Asian Art, General

Barnhart, Richard M. *Three Thousand Years of Chinese Painting.* New Haven: Yale Univ. Press, 1997.

Blunden, Caroline, and Mark Elvin. *Cultural Atlas of China.* 2nd ed. New York: Checkmark Books, 1998.

Bussagli, Mario. *Oriental Architecture.* 2 vols. History of World Architecture. New York: Electa/Rizzoli, 1989.

Chang, Leon Long-Yien, and Peter Miller. *Four Thousand Years of Chinese Calligraphy*. Chicago: Univ. of Chicago Press, 1990.

Clunas, Craig. *Art in China*. Oxford History of Art. Oxford: Oxford Univ. Press, 1997.

Collcutt, Martin, Marius Jansen, and Isao Kumakura. *Cultural Atlas of Japan*. New York: Facts on File, 1988.

Craven, Roy C. *Indian Art: A Concise History*. Rev. ed. World of Art. New York: Thames and Hudson, 1997.

Dehejia, Vidya. *Indian Art*. Art & Ideas. London: Phaidon Press, 1997.

Ebrey, Patricia Buckley. *The Cambridge Illustrated History of China*. Cambridge Illustrated History. Cambridge: Cambridge Univ. Press, 1996.

Elisseeff, Danielle, and Vadime Elisseeff. *Art of Japan*. Trans. I. Mark Paris. New York: Abrams, 1985.

Fisher, Robert E. *Buddhist Art and Architecture*. World of Art. New York: Thames and Hudson, 1993.

Harle, James C. *The Art and Architecture of the Indian Subcontinent*. 2nd ed. Pelican History of Art. New Haven: Yale Univ. Press, 1994.

Heibonsha Survey of Japanese Art. 31 vols. New York: Weatherhill, 1972–80.

Japanese Arts Library. 15 vols. New York: Kodansha International, 1977–87.

Kramrisch, Stella. *The Art of India: Traditions of Indian Sculpture, Painting, and Architecture*. 3rd ed. London: Phaidon Press, 1965.

Lee, Sherman E. *A History of Far Eastern Art*. 5th ed. Ed. Naomi Noble Richards. New York: Abrams, 1994.

———. *China, 5000 Years: Innovation and Transformation in the Arts*. New York: Solomon R. Guggenheim Museum, 1998.

Loehr, Max. *The Great Painters of China*. New York: Harper & Row, 1980.

Louis-Frederic. *Buddhism*. Flammarion Iconographic Guides. Trans. Nissim Marshall. Paris: Flammarion, 1995.

Martynov, Anatolii Ivanovich. *Ancient Art of Northern Asia*. Urbana: Univ. of Illinois Press, 1991.

Mason, Penelope. *History of Japanese Art*. New York: Abrams, 1993.

Medley, Margaret. *Chinese Potter: A Practical History of Chinese Ceramics*. 3rd ed. Oxford: Phaidon, 1989.

Michell, George. *The Penguin Guide to the Monuments of India*. 2 vols. New York: Viking, 1989.

Paine, Robert Treat, and Alexander Soper. *Art and Architecture of Japan*. 3rd ed. Pelican History of Art. Harmondsworth, Eng.: Penguin, 1981.

Rowland, Benjamin. *Art and Architecture of India: Buddhist, Hindu, Jain*. Pelican History of Art. Harmondsworth, Eng.: Penguin, 1977.

Seckel, Dietrich. *Art of Buddhism*. Rev. ed. Art of the World. New York: Greystone Press, 1968.

Sickman, Lawrence, and Alexander Soper. *Art and Architecture of China*. Int. ed. Pelican History of Art. New Haven: Yale Univ. Press, 1992.

Stanley-Baker, Joan. *Japanese Art*. Rev. & exp. ed. World of Art. New York: Thames and Hudson, 2000.

Stutley, Margaret. *Harper's Dictionary of Hinduism: Its Mythology, Folklore, Philosophy, Literature and History*. New York: Harper & Row, 1977.

Sullivan, Michael. *The Arts of China*. 4th ed., Exp. & rev. Berkeley: Univ. of California Press, 1999.

Tadgell, Christopher. *The History of Architecture in India: From the Dawn of Civilization to the End of the Raj*. London: Architecture, Design, and Technology Press, 1990.

Thorp, Robert L., and Richard Ellis Vinograd. *Chinese Art & Culture*. New York: Abrams, 2001.

Tregear, Mary. *Chinese Art*. Rev. ed. World of Art. New York: Thames and Hudson, 1997.

Vainker, S. J. *Chinese Pottery and Porcelain: From Prehistory to the Present*. London: British Museum, 1991.

Varley, H. Paul. *Japanese Culture*. 4th ed., Updated & exp. Honolulu: Univ. of Hawaii Press, 2000.

African and Oceanic Art and Art of the Americas, General

Anderson, Richard L. *Art in Small-Scale Societies*. 2nd ed. Upper Saddle River, NJ: Prentice Hall, 1989.

Berlo, Janet Catherine, and Lee Ann Wilson. *Arts of Africa, Oceania, and the Americas: Selected Readings*. Upper Saddle River, NJ: Prentice Hall, 1993.

Blocker, H. Gene. *The Aesthetics of Primitive Art*. Lantham, MD: Univ. Press of America, 1994.

Coote, Jeremy, and Anthony Shelton, eds. *Anthropology, Art, and Aesthetics*. New York: Oxford Univ. Press, 1992.

D'Azevedao, Warren L. *The Traditional Artist in African Societies*. Bloomington: Indiana Univ. Press, 1989.

Drewal, Henry, and John Pemberton III. *Yoruba: Nine Centuries of African Art and Thought*. New York: Center for African Art, 1989.

Guidoni, Enrico. *Primitive Architecture*. Trans. Robert Eric Wolf. History of World Architecture. New York: Rizzoli, 1987.

Hiller, Susan, ed. & comp. *The Myth of Primitivism: Perspectives on Art*. London: Routledge, 1991.

Leiris, Michel, and Jacqueline Delange. *African Art*. Arts of Mankind. London: Thames and Hudson, 1968.

Leuzinger, Elsy. *The Art of Black Africa*. Trans. Ann Keep. New York: Rizzoli, 1976.

Mexico: Splendors of Thirty Centuries. New York: Metropolitan Museum of Art, 1990.

Murray, Jocelyn, ed. *Cultural Atlas of Africa*. Rev. ed. New York: Facts on File, 1998.

Phillips, Tom. *Africa: The Art of a Continent*. London: Prestel, 1996.

Price, Sally. *Primitive Art in Civilized Places*. Chicago: Univ. of Chicago Press, 1989.

Schuster, Carl, and Edmund Carpenter. *Patterns that Connect: Social Symbolism in Ancient & Tribal Art*. New York: Abrams, 1996.

Visonà, Monica Blackmun et al., *A History of Art in Africa*. New York: Abrams, 2000.

Willett, Frank. *African Art: An Introduction*. Rev ed. World of Art. New York: Thames and Hudson, 1993.

CHAPTER 1 Prehistory and Prehistoric Art in Europe

Anati, Emmanuel, and Tiziana Cittadini. *Valcomonica Rock Art: A New History for Europe*. English version ed. Thomas King and Jason Clairborne. Capo di Ponte, Italy: Edizioni del Centro, 1994.

Bahn, Paul G. *The Cambridge Illustrated History of Prehistoric Art*. Cambridge Illustrated History. Cambridge: Cambridge Univ. Press, 1998.

Bandi, Hans-Georg, et al. *Art of the Stone Age: Forty Thousand Years of Rock Art*. 2nd ed. Trans. Ann E. Keep. Art of the World. London: Methuen, 1970.

Beltrán Martínez, Antonio. *Rock Art of the Spanish Levant*. Trans. Margaret Brown. Cambridge: Cambridge Univ. Press, 1982.

Castleden, Rodney. *The Making of Stonehenge*. London: Routledge, 1993.

Chauvet, Jean-Marie, Eliette Brunel Deschamps, and Christian Hillaire. *Dawn of Art: The Chauvet Cave: The Oldest Known Paintings in the World*. Trans. Paul G. Bahn. New York: Abrams, 1996.

Chippindale, Christopher. *Stonehenge Complete*. New York: Thames and Hudson, 1994.

Forte, Maurizio, and Alberto Siliotti. *Virtual Archaeology: Re-Creating Ancient Worlds*. New York: Abrams, 1997.

Freeman, Leslie G. *Altamira Revisited and Other Essays on Early Art*. Chicago: Institute for Prehistoric Investigation, 1987.

Gowlett, John A. J. *Ascent to Civilization: The Archaeology of Early Humans*. 2nd ed. New York: McGraw-Hill, 1993.

Graziosi, Paolo. *Paleolithic Art*. New York: McGraw-Hill, 1960.

Laing, Lloyd. *Art of the Celts*. World of Art. New York: Thames and Hudson, 1992.

Leakey, Richard E. and Roger Lewin. *Origins Reconsidered: In Search of What Makes Us Human*. New York: Doubleday, 1992.

Leroi-Gourhan, André. *The Dawn of European Art: An Introduction to Paleolithic Cave Painting*. Trans. Sara Champion. Cambridge: Cambridge Univ. Press, 1982.

Lhote, Henri. *The Search for the Tassili Frescoes: The Story of the Prehistoric Rock-Paintings of the Sahara*. 2nd ed. Trans. Alan Houghton Brodrick. London: Hutchinson, 1973.

Marshack, Alexander. *The Roots of Civilization: The Cognitive Beginnings of Man's First Art, Symbol, and Notation*. New York: McGraw-Hill, 1971.

Megaw, Ruth, and Vincent Megaw. *Celtic Art: From Its Beginnings to the Book of Kells*. New York: Thames and Hudson, 1989.

O'Kelly, Michael J. *Newgrange: Archaeology, Art, and Legend*. New Aspects of Antiquity. London: Thames and Hudson, 1982.

Powell, T. G. E. *Prehistoric Art*. World of Art. New York: Oxford Univ. Press, 1966.

Price, T. Douglas, and Gray M. Feinman. *Images of the Past*. 3rd ed. Mountain View, CA: Mayfield, 2000.

Renfrew, Colin, ed. *The Megalithic Monuments of Western Europe*. London: Thames and Hudson, 1983.

Ruspoli, Mario. *The Cave of Lascaux: The Final Photographs*. New York: Abrams, 1987.

Sandars, N. K. *Prehistoric Art in Europe*. 2nd ed. Pelican History of Art. New Haven: Yale Univ. Press, 1995.

Sura Ramos, Pedro A. *The Cave of Altamira*. Gen. Ed. Antonio Beltran. New York: Abrams, 1999.

Sieveking, Ann. *The Cave Artists*. Ancient People and Places, vol. 93. London: Thames and Hudson, 1979.

Soffer, Olga. *The Upper Paleolithic of the Central Russian Plain*. Studies in Archaeology. Orlando, Fla.: Academic, 1985.

Torbrugge, Walter. *Prehistoric European Art*. Trans. Norbert Guterman. Panorama of World Art. New York: Abrams, 1968.

Ucko, Peter J., and Andree Rosenfeld. *Paleolithic Cave Art*. New York: McGraw-Hill, 1967.

CHAPTER 2 Art of the Ancient Near East

Akurgal, Ekrem. *The Art of the Hittites*. Trans. Constance McNab. New York: Abrams, 1962.

Amiet, Pierre. *Art of the Ancient Near East*. Trans. John Shepley and Claude Choquet. New York: Abrams, 1980.

Bienkowski, Piotr, and Alan Millard, eds. *Dictionary of the Ancient Near East*. Philadelphia: Univ. of Pennsylvania Press, 2000.

Bottero, Jean. *Mesopotamia: Writing, Reasoning, and the Gods*. Trans. Zainab Bahrani and Marc Van De Mieroop. Chicago: Univ. of Chicago Press, 1992.

Collon, Dominique. *Ancient Near Eastern Art*. Berkeley: Univ. Of California Press, 1995.

———. *First Impressions: Cylinder Seals in the Ancient Near East*. Chicago: Univ. of Chicago Press, 1987.

Downey, Susan B. *Mesopotamian Religious Architecture: Alexander through the Parthians*. Princeton: Princeton Univ. Press, 1988.

Ferrier, R. W., ed. *Arts of Persia*. New Haven: Yale Univ. Press, 1989.

Frankfort, Henri. *The Art and Architecture of the Ancient Orient*. 5th ed. Pelican History of Art. New Haven: Yale Univ. Press, 1996.

Ghirshman, Roman. *The Arts of Ancient Iran from Its Origins to the Time of Alexander the Great*. Trans. Stuart Gilbert and James Emmons. Arts of Mankind. New York: Golden, 1964.

Harper, Prudence, Joan Arz, and Françoise Tallon, eds. *The Royal City of Susa: Ancient Near Eastern Treasures in the Louvre*. New York: The Metropolitan Museum of Art, 1992.

Haywood, John. *Ancient Civilizations of the Near East and Mediterranean*. London: Cassell, 1997.

Kramer, Samual Noah. *History Begins at Sumer: Thirty-Nine Firsts in Man's Recorded History*. 3rd rev. ed. Philadelphia: Univ. of Pennsylvania Press, 1956.

———. *The Sumerians, Their History, Culture, and Character*. Chicago: Univ. of Chicago Press, 1963.

Lloyd, Seton. *Ancient Turkey: A Traveller's History of Anatolia*. Berkeley: Univ. of California Press, 1989.

Maisels, Charles Keith. *The Near East: Archaeology in the "Cradle of Civilization"*. The Experience of Archaeology. London: Routledge, 1993.

Oppenheim, A. Leo. *Ancient Mesopotamia: Portrait of a Dead Civilization*. Rev. ed. completed by Erica Reiner. Chicago: Univ. of Chicago Press, 1977.

Parrot, André. *The Arts of Assyria*. Trans. Stuart Gilbert and James Emmons. Arts of Mankind. New York: Golden, 1961.

———. *Sumer: The Dawn of Art*. Trans. Stuart Gilbert and James Emmons. Arts of Mankind. New York: Golden, 1961.

Porada, Edith. *The Art of Ancient Iran: Pre-Islamic Cultures*. Art of the World. New York: Crown, 1965.

Roaf, Michael. *Cultural Atlas of Mesopotamia and the Ancient Near East*. New York: Facts on File, 1990.

Roux, Georges. *Ancient Iraq*. 3rd ed. London: Penguin, 1992.

Russell, John Malcolm. *Sennacherib's Palace without Rival at Nineveh*. Chicago: Univ. of Chicago Press, 1991.

Saggs, H. W. F. *Everyday Life in Babylonia and Assyria*. New York: Dorset, 1987.

———. *Civilization before Greece and Rome*. New Haven: Yale Univ. Press, 1989.

Woolley, Leonard. *The Art of the Middle East including Persia, Mesopotamia and Palestine*. Trans. Ann E. Keep. Art of the World. New York: Crown, 1961.

CHAPTER 3 Art of Ancient Egypt

Aldred, Cyril. *Egyptian Art in the Days of the Pharaohs, 3100–320 B.C.* World of Art. London: Thames and Hudson, 1980.

Arnold, Dieter. *Temples of the Last Pharaohs*. New York: Oxford Univ. Press, 1999.

Baines, John, and Jaromír Málek. *Atlas of Ancient Egypt*. Rev. ed. New York: Facts on File, 2000.

Breasted, James Henry. *A History of Egypt from the Earliest Times to the Persian Conquest*. 2nd ed. Rev. London: Hodder & Stroughton, 1920.

Brier, Bob. *Egyptian Mummies: Unraveling the Secrets of an Ancient Art*. New York: Morrow, 1994.

David, A. Rosalie. *The Pyramid Builders of Ancient Egypt: A Modern Investigation of Pharaoh's Workforce*. London: Routledge, 1986.

Egyptian Art in the Age of the Pyramids. New York: Metropolitan Museum of Art, 1999.

The Egyptian Book of the Dead: The Book of Going Forth by Day: Being the Papyrus of Ani (Royal Scribe of the Divine Offerings). Trans. Raymond O. Faulkner. 2nd Rev. ed. San Francisco: Chronicle, 1998.

Grimal, Nicolas-Christophe. *A History of Ancient Egypt*. Trans. Ian Hall. Oxford: Blackwell, 1992.

Kozloff, Arielle P., and Betsy M. Bryan. *Egypt's Dazzling Sun: Amenhotep III and His World*. Cleveland: Cleveland Museum of Art, 1992.

Lehner, Mark. *The Complete Pyramids*. New York: Thames and Hudson, 1997.

Malek, Jaromir. *Egyptian Art*. Art & Ideas. London: Phaidon, 1999.

Manniche, Lise. *City of the Dead: Thebes in Egypt*. Chicago: Univ. of Chicago Press, 1987.

Martin, Geoffrey Thorndike. *The Hidden Tombs of Memphis: New Discoveries from the Time of Tutankhamun and Ramesses the Great*. London: Thames and Hudson, 1991.

Menu, Bernadette. *Ramesses II, Greatest of the Pharoahs*. Discoveries. New York: Abrams, 1999.

Montet, Pierre. *Everyday Life in Egypt in the Days of Ramesses the Great*. Trans. A. R. Maxwell-Hysop and Margaret S. Drower. Philadelphia: Univ. of Pennsylvania Press, 1981.

Pemberton, Delia. *Ancient Egypt*. Architectural Guides for Travelers. San Francisco: Chronicle, 1992.

Reeves, C. N. *The Complete Tutankhamun: The King, the Tomb, the Royal Treasure*. London: Thames and Hudson, 1990.

Robins, Gay. *The Art of Ancient Egypt*. Cambridge: Harvard Univ. Press, 1997.

Russmann, Edna R. *Egyptian Sculpture: Cairo and Luxor*. Austin: Univ. of Texas Press, 1989.

Smith, W. Stevenson. *The Art and Architecture of Ancient Egypt*. 3rd ed. Rev. William Kelly Simpson. Pelican History of Art. New Haven: Yale Univ. Press, 1998.

Strouhal, Eugen. *Life of the Ancient Egyptians*. Norman: Univ. of Oklahoma Press, 1992.

Tiradritti, Francesco, and Araldo De Luca. *Egyptian Treasures from the Egyptian Museum in Cairo*. New York: Abrams, 1999.

Wilkinson, Richard H. *Reading Egyptian Art: A Hieroglyphic Guide to Ancient Egyptian Painting and Sculpture*. London: Thames and Hudson, 1992.

Winstone, H. V. F. *Howard Carter and the Discovery of the Tomb of Tutankhamun*. London: Constable, 1991.

CHAPTER 4 Aegean Art

Barber, R. L. N. *The Cyclades in the Bronze Age*. Iowa City: Univ. of Iowa Press, 1987.

Castleden, Rodney. *The Knossos Labyrinth. A New View of the "Palace of Minos" at Knossos*. London: Routledge, 1990.

Demargne, Pierre. *The Birth of Greek Art*. Trans. Stuart Gilbert and James Emmons. Arts of Mankind. New York: Golden, 1964.

Dickinson, Oliver. *The Aegean Bronze Age*. Cambridge World Archaeology. Cambridge: Cambridge Univ. Press, 1994.

Doumas, Christos. *The Wall-Paintings of Thera*. 2nd ed. Trans. Alex Doumas. Athens: Kapon Editions, 1999.

Fitton, J. Lesley. *Cycladic Art*. 2nd ed. London: British Museum, 1999.

Higgins, Reynold. *Minoan and Mycenean Art*. Rev. ed. World of Art. New York: Thames and Hudson, 1997.

Immerwahr, Sara Anderson. *Aegean Painting in the Bronze Age*. University Park: Pennsylvania State Univ. Press, 1990.

Marinatos, Nanno. *Art and Religion in Thera: Reconstructing a Bronze Age Society*. Athens: Mathioulakis, 1984.

Marinatos, Spyridon, and Max Hirmer. *Crete and Mycenae*. New York: Abrams, 1960.

Matz, Friedrich. *The Art of Crete and Early Greece: Prelude to Greek Art*. Trans. Ann E. Keep. Art of the World. New York: Crown, 1962.

Morgan, Lyvia. *The Miniature Wall Paintings of Thera: A Study in Aegean Culture and Iconography*. Cambridge: Cambridge Univ. Press, 1988.

Preziosi, Donald, and Louise Hitchcock. *Aegean Art and Architecture*. Oxford History of Art. Oxford: Oxford Univ. Press, 1999.

Pellegrino, Charles R. *Unearthing Atlantis: An Archaeological Survey*. New York: Random House, 1991.

CHAPTER 5 Art of Ancient Greece

Akurgal, Ekrem. *The Art of Greece: Its Origins in the Mediterranean and Near East*. Trans. Wayne Dynes. Art of the World. New York: Crown, 1968.

Arias, Paolo. *A History of 1000 Years of Greek Vase Painting*. New York: Abrams, 1962.

Ashmole, Bernard. *Architect and Sculptor in Classical Greece*. Wrightsman Lectures. New York: New York Univ. Press, 1972.

Berve, Helmut, and Gottfried Gruben. *Greek Temples, Theatres, and Shrines*. New York: Abrams, 1963.

Biers, William. *The Archaeology of Greece: An Introduction*. 2nd ed. Ithaca: Cornell Univ. Press, 1996.

Blumel, Carl. *Greek Sculptors at Work*. 2nd ed. Trans. Lydia Holland. London: Phaidon, 1969.

Boardman, John. *Early Greek Vase Painting: 11th-6th Centuries B.C.: A Handbook*. World of Art. London: Thames and Hudson, 1998.

———. *Greek Art*. 4th ed., Rev. & exp. World of Art. London: Thames and Hudson, 1996.

———. *Greek Sculpture: The Archaic Period: A Handbook*. World of Art. New York: Oxford Univ. Press, 1991.

———. *Greek Sculpture: The Classical Period: A Handbook*. London: Thames and Hudson, 1985.

———. *Greek Sculpture: The Late Classical Period and Sculpture in Colonies and Overseas*. World of Art. New York: Thames and Hudson, 1995.

———. *Oxford History of Classical Art*. Oxford: Oxford Univ. Press, 1993.

———. *The Parthenon and Its Sculptures*. Austin: Univ. of Texas Press, 1985.

Buitron-Oliver, Diana, and Nicholas Gage. *The Greek Miracle: Classical Sculpture from the Dawn of Democracy: The Fifth Century B.C.* Washington, D.C.: National Gallery of Art, 1992.

Camp, John M. *The Athenian Agora: Excavations in the Heart of Classical Athens*. New York: Thames and Hudson, 1986.

Carpenter, Thomas H. *Art and Myth in Ancient Greece: A Handbook*. World of Art. London: Thames and Hudson, 1991.

Cartledge, Paul, ed. *The Cambridge Illustrated History of Ancient Greece*. Cambridge Illustrated History. Cambridge: Cambridge Univ. Press, 1998.

Charbonneaux, Jean, Robert Martin, and François Villard. *Archaic Greek Art (620–480 B.C.)*. Trans. James Emmons and Robert Allen. Arts of Mankind. New York: Braziller, 1971.

———. *Classical Greek Art (480–330 B.C.)*. Trans. James Emmons. Arts of Mankind. New York: Braziller, 1972.

———. *Hellenistic Art (330–50 B.C.)*. Trans. Peter Green. Arts of Mankind. New York: Braziller, 1973.

Durando, Furio. *Splendours of Ancient Greece*. Trans. Ann Ghitinghelli. London: Thames and Hudson, 1997.

Francis, E. D. *Image and Idea in Fifth-Century Greece: Art and Literature after the Persian Wars*. London: Routledge, 1990.

Fullerton, Mark D. *Greek Art*. Cambridge: Cambridge Univ. Press, 2000.

Havelock, Christine Mitchell. *Hellenistic Art: The Art of the Classical World from the Death of Alexander the Great to the Battle of Actium*. 2nd ed. New York: Norton, 1981.

Homann-Wedeking, Ernst. *The Art of Archaic Greece*. Trans. J. R. Foster. Art of the World. New York: Crown, 1968.

Hood, Sinclair. *Arts in Prehistoric Greece*. Pelican History of Art. Harmondsworth, Eng.: Penguin, 1978.

Human Figure in Early Greek Art, The. Washington, D.C.: National Gallery of Art, 1988.

Hurwit, Jeffrey M. *The Art and Culture of Early Greece 1100–480 B.C.* Ithaca: Cornell Univ. Press, 1985.

———. *The Athenian Acropolis: History, Mythology, and Archaeology from the Neolithic Era to the Present*. Cambridge: Cambridge Univ. Press, 1999.

Jenkins, Ian. *The Parthenon Frieze*. Austin: Univ. of Texas Press, 1994.

Lagerlof, Margaretha Rossholm. *The Sculptures of the Parthenon: Aesthetics and Interpretation*. New Haven: Yale Univ. Press, 2000.

Lawrence, A. W. *Greek Architecture*. 5th ed. Rev. R. A. Tomlinson. Pelican History of Art. New Haven: Yale Univ. Press, 1996.

Lullies, Reinhart, and Max Hirmer. *Greek Sculpture*. Rev. & enl. ed. Trans. Michael Bullock. New York: Abrams, 1960.

Martin, Roland. *Greek Architecture: Architecture of Crete, Greece, and the Greek World*. History of World Architecture. New York: Electa/Rizzoli, 1988.

Onians, John. *Art and Thought in the Hellenistic Age: The Greek World View 350–50 B.C.* London: Thames and Hudson, 1979.

Osborne, Robin. *Archaic and Classical Greek Art*. Oxford History of Art. Oxford: Oxford Univ. Press, 1998.

Papaioannou, Kostas. *The Art of Greece*. Trans. I. Mark Paris. New York: Abrams, 1989.

Pedley, John Griffiths. *Greek Art and Archaeology*. 2nd ed. New York: Abrams, 1998.

Pollitt, J. J. *Art and Experience in Classical Greece*. London: Cambridge Univ. Press, 1972.

———. *Art in the Hellenistic Age*. Cambridge: Cambridge Univ. Press, 1986.

———. *The Art of Ancient Greece: Sources and Documents*. Cambridge: Cambridge Univ. Press, 1990.

Powell, Anton, ed. *The Greek World*. London: Routledge, 1995.

Ridgway, Brunilde Sismondo. *The Archaic Style in Greek Sculpture*. 2nd ed. Chicago: Ares, 1993.

———. *Fifth Century Styles in Greek Sculpture*. Princeton: Princeton Univ. Press, 1981.

———. *Fourth Century Styles in Greek Sculpture*. Wisconsin Studies in Classics. Madison: Univ. of Wisconsin Press, 1997.

———. *Hellenistic Sculpture I: The Styles of ca. 331–200 B.C.* Wisconsin Studies in Classics. Madison: Univ. of Wisconsin Press, 1990.

Robertson, Martin. *Greek Painting: The Great Centuries of Painting*. Geneva: Skira, 1959.

Roes, Anna. *Greek Geometric Art: Its Symbolism and Its Origin*. London: Oxford Univ. Press, 1933.

Sacks, David, and Oswyn Murray. *Encyclopedia of the Ancient Greek World*. New York: Facts on File, 1995.

Schefold, Karl. *Classical Greece*. Trans. J. R. Foster. Art of the World. London: Methuen, 1967.

Scully, Vincent. *The Earth, the Temple, and the Gods: Greek Sacred Architecture*. Rev. ed. New Haven: Yale Univ. Press, 1979.

Smith, R. R. R. *Hellenistic Sculpture: A Handbook*. World of Art. New York: Thames and Hudson, 1991.

Spivey, Nigel. *Greek Art*. Art & Ideas. London: Phaidon Press, 1997.

Stewart, Andrew F. *Greek Sculpture: An Exploration*. 2 vols. New Haven: Yale Univ. Press, 1990.

Webster, T. B. L. *The Art of Greece: The Age of Hellenism*. Art of the World. New York: Crown, 1966.

CHAPTER 6 Etruscan Art and Roman Art

Andreae, Bernard. *The Art of Rome*. Trans. Robert Erich Wolf. New York: Abrams, 1977.

Bianchi Bandinelli, Ranuccio. *Rome: The Centre of Power: Roman Art to A.D. 200*. Trans. Peter Green. Arts of Mankind. London: Thames and Hudson, 1970.

———. *Rome: The Late Empire: Roman Art A.D. 200–400*. Trans. Peter Green. Arts of Mankind. New York: Braziller, 1971.

Bloch, Raymond. *Etruscan Art*. Greenwich, CT: New York Graphic Society, 1965.

Boethius, Axel, and J. B. Ward-Perkins. *Etruscan and Early Roman Architecture*. 2nd ed. Pelican History of Art. Harmondsworth, Eng.: Penguin, 1978.

Breeze, David John. *Hadrian's Wall*. 4th ed. London: Penguin, 2000.

Brendel, Otto J. *Etruscan Art*. 2nd ed. Pelican History of Art. New Haven: Yale Univ. Press, 1995.

Brilliant, Richard. *Roman Art: From the Republic to Constantine*. London: Phaidon, 1974.

Buranelli, Francesco. *The Etruscans: Legacy of a Lost Civilization from the Vatican Museums*. Memphis: Lithograph, 1992.

Christ, Karl. *The Romans: An Introduction to Their History and Civilisation*. Berkeley: Univ. of California Press, 1984.

Cornell, Tim, and John Matthews. *Atlas of the Roman World*. New York: Facts on File, 1982.

D'Ambra, Eve. *Roman Art*. Cambridge: Cambridge Univ. Press, 1998.

Elsner, Ja's. *Imperial Rome and Christian Triumph: The Art of the Roman Empire A.D. 100-450*. Oxford History of Art. Oxford: Oxford Univ. Press, 1998.

Grant, Michael. *Art in the Roman Empire*. London: Routledge, 1995.

Guillaud, Jacqueline, and Maurice Guillaud. *Frescoes in the Time of Pompeii*. New York: Potter, 1990.

Heintze, Helga von. *Roman Art*. New York: Universe, 1990.

Henig, Martin, ed. *A Handbook of Roman Art: A Comprehensive Survey of All the Arts of the Roman World*. Ithaca: Cornell Univ. Press, 1983.

Kahler, Heinz. *The Art of Rome and Her Empire*. Trans. J. R. Foster. Art of the World. New York: Crown, 1963.

Ling, Roger. *Roman Painting*. Cambridge: Cambridge Univ. Press, 1991.

L'Orange, Hans Peter. *The Roman Empire: Art Forms and Civic Life*. New York: Rizzoli, 1985.

MacDonald, William L. *The Architecture of the Roman Empire: An Introductory Study*. Rev. ed. 2 vols. Yale Publications in the History of Art. New Haven: Yale Univ. Press, 1982.

———. *The Pantheon: Design, Meaning, and Progeny*. Cambridge: Harvard Univ. Press, 1976.

———, and John A. Pinto. *Hadrian's Villa and Its Legacy*. New Haven: Yale Univ. Press, 1995.

Mansuelli, G. A. *The Art of Etruria and Early Rome*. Art of the World. New York: Crown, 1965.

Packer, James E., and Kevin Lee Sarring. *The Forum of Trajan in Rome: A Study of the Monuments*. 2 vols., portfolio and microfiche. California Studies in the History of Art; 31. Berkeley: Univ. of California Press, 1997.

Pollitt, J. J. *The Art of Rome, c. 753 B.C.–337 A.D.*: Sources and Documents. Upper Saddle River, NJ: Prentice Hall, 1966.

Quennell, Peter. *The Colosseum*. New York: Newsweek, 1971.

Ramage, Nancy H., and Andrew Ramage. *The Cambridge Illustrated History of Roman Art*. Cambridge: Cambridge Univ. Press, 1991.

———. *Roman Art: Romulus to Constantine*. 2nd ed. Upper Saddle River, NJ: Prentice Hall, 1996.

Rediscovering Pompeii. 4th ed. Rome: L'Erma di Bretschneider, 1992.

Spivey, Nigel. *Etruscan Art*. World of Art. New York: Thames and Hudson, 1997.

Sprenger, Maja, and Bartolini, Gilda. *The Etruscans: Their History, Art, and Architecture*. New York: Abrams, 1983.

Strong, Donald. *Roman Art*. 2nd ed. Rev. & annotated. Ed. Roger Ling. Pelican History of Art. New Haven: Yale Univ. Press, 1995.

Vitruvius Pollio. *Ten Books on Architecture*. Trans. Ingrid D. Rowland; Commentary Thomas Noble Howe, Ingrid D. Rowland, Michael J. Dewar. Cambridge: Cambridge Univ. Press, 1999.

Ward-Perkins, J. B. *Roman Architecture*. History of World Architecture. New York: Electa/Rizzoli, 1988.

———. *Roman Imperial Architecture*. Pelican History of Art. New Haven: Yale Univ. Press, 1981

Wheeler, Robert Eric Mortimer, Sir. *Roman Art and Architecture*. World of Art. New York: Oxford Univ. Press, 1964.

CHAPTER 7 Early Christian, Jewish, and Byzantine Art

Age of Spirituality: Late Antique and Early Christian Art, Third to Seventh Century. New York: Metropolitan Museum of Art, 1979.

Beckwith, John. *The Art of Constantinople: An Introduction to Byzantine Art 330–1453*. 2nd ed. London: Phaidon, 1968.

———. *Early Christian and Byzantine Art*. 2nd ed. Pelican History of Art. Harmondsworth, Eng.: Penguin, 1979.

Boyd, Susan A. *Byzantine Art*. Chicago: Univ. of Chicago Press, 1979.

Buckton, David, ed. *The Treasury of San Marco, Venice*. Milan: Olivetti, 1985.

Carr, Annemarie Weyl. *Byzantine Illumination, 1150–1250: The Study of a Provincial Tradition*. Chicago: Univ. of Chicago Press, 1987.

Christe, Yves. *Art of the Christian World, A.D. 200–1500: A Handbook of Styles and Forms*. New York: Rizzoli, 1982.

Cutler, Anthony. *The Hand of the Master: Craftsmanship, Ivory, and Society in Byzantium (9th–11th Centuries)*. Princeton: Princeton Univ. Press, 1994.

Demus, Otto. *Byzantine Art and the West*. Wrightsman Lectures. New York: New York Univ. Press, 1970.

———. *Byzantine Mosaic Decoration: Aspects of Monumental Art in Byzantium*. New Rochelle: Caratzas, 1976.

———. *The Church of San Marco in Venice: History, Architecture, Sculpture*. Washington, D.C.: Dumbarton Oaks, 1960.

Evans, Helen C., and William D. Wixom, eds. *The Glory of Byzantium*. New York: Abrams, 1997.

Ferguson, George Wells. *Signs and Symbols in Christian Art*. New York: Oxford Univ. Press, 1967.

Gough, Michael. *Origins of Christian Art*. World of Art. London: Thames and Hudson, 1973.

Grabar, André. *The Art of the Byzantine Empire: Byzantine Art in the Middle Ages*. Trans. Betty Forster. *Art of the World*. New York: Crown, 1966.

———. *Byzantine Painting: Historical and Critical Study*. Trans. Stuart Gilbert. New York: Rizzoli, 1979.

———. *Early Christian Art: From the Rise of Christianity to the Death of Theodosius*. Trans. Stuart Gilbert and James Emmons. Arts of Mankind. New York: Odyssey, 1969.

———. *The Golden Age of Justinian from the Death of Theodosius to the Rise of Islam*. Trans. Stuart Gilbert and James Emmons. Arts of Mankind. New York: Odyssey, 1967.

Hubert, Jean, Jean Porcher, and W. F. Volbach. *Europe of the Invasions*. Trans. Stuart Gilbert and James Emmons. Arts of Mankind. New York: Braziller, 1969.

Kitzinger, Ernst. *Byzantine Art in the Making: Main Lines of Stylistic Development in Mediterranean Art, 3rd–7th Century*. Cambridge: Harvard Univ. Press, 1977.

Krautheimer, Richard. *Early Christian and Byzantine Architecture*. 4th ed. Pelican History of Art. Harmondsworth, Eng: Penguin, 1986.

———. *Rome, Profile of a City, 312-1308*. Princeton: Princeton Univ. Press, 1980.

Mainstone, R. J. *Hagia Sophia: Architecture, Structure and Liturgy of Justinian's Great Church*. London: Thames and Hudson, 1988.

Lowden, John. *Early Christian and Byzantine Art*. Art & Ideas. London: Phaidon, 1997.

Mango, Cyril. *Art of the Byzantine Empire, 312–1453: Sources and Documents*. Upper Saddle River, NJ: Prentice Hall, 1972.

———. *Byzantine Architecture*. History of World Architecture. New York: Rizzoli, 1985.

Manincelli, Fabrizio. *Catacombs and Basilicas: The Early Christians in Rome*. Florence: Scala, 1981.

Mathew, Gervase. *Byzantine Aesthetics*. London: J. Murray, 1963.

Mathews, Thomas P. *Byzantium: From Antiquity to the Renaissance*. Perspectives. New York: Abrams, 1998.

Milburn, R. L. P. *Early Christian Art and Architecture*. Berkeley: Univ. of California Press, 1988.

Oakshott, Walter Fraser. *The Mosaics of Rome: From the Third to the Fourteenth Centuries*. London: Thames and Hudson, 1967.

Rice, David Talbot. *Art of the Byzantine Era*. New York: Praeger, 1963.

———. *Byzantine Art*. Harmondsworth, Eng.: Penguin, 1968.

Rodley, Lyn. *Byzantine Art and Architecture: An Introduction*. Cambridge: Cambridge Univ. Press, 1993.

Schapiro, Meyer. *Late Antique, Early Christian, and Mediaeval Art*. New York: Braziller, 1979.

Simson, Otto Georg von. *Sacred Fortress: Byzantine Art and Statecraft in Ravenna*. Chicago: Univ. of Chicago Press, 1948.

Stevenson, James. *The Catacombs: Rediscovered Monuments of Early Christianity*. Ancient Peoples and Places. London: Thames and Hudson, 1978.

Weitzmann, Kurt. *Late Antique and Early Christian Book Illumination*. New York: Braziller, 1977.

———. *Place of Book Illumination in Byzantine Art*. Princeton: Art Museum, Princeton Univ., 1975.

Wharton, Annabel Jane. *Art of Empire: Painting and Architecture of the Byzantine Periphery: A Comparative Study of Four Provinces*. University Park: Pennsylvania State Univ. Press, 1988.

CHAPTER 8 Islamic Art

Akurgal, Ekrem, ed. *The Art and Architecture of Turkey*. New York: Rizzoli, 1980.

Al-Faruqi, Ismail R, and Lois Lamya'al Faruqi. *Cultural Atlas of Islam*. New York: Macmillan, 1986.

Aslanapa, Oktay. *Turkish Art and Architecture*. London: Faber, 1971.

Atasoy, Nurhan. *Splendors of the Ottoman Sultans*. Ed. and Trans. Tulay Artan. Memphis, TN: Lithograph, 1992.

Atil, Esin. *The Age of Sultan Suleyman the Magnificent*. Washington, D.C.: National Gallery of Art, 1987.

———. *Art of the Arab World*. Washington, D.C.: Smithsonian Institution, 1975.

———. *Islamic Art and Patronage: Treasures from Kuwait*. New York: Rizzoli, 1990.

———. *Renaissance of Islam: Art of the Mamluks*. Washington, D.C.: Smithsonian Institution, 1981.

Blair, Sheila S., and Jonathan Bloom. *The Art and Architecture of Islam 1250–1800*. Pelican History of Art. New Haven: Yale Univ. Press, 1994.

Brend, Barbara. *Islamic Art*. Cambridge: Harvard Univ. Press, 1991.

Dodds, Jerrilynn D., ed. *al-Andalus: The Art of Islamic Spain*. New York: Metropolitan Museum of Art, 1992.

Ettinghausen, Richard, and Oleg Grabar. *The Art and Architecture of Islam: 650–1250*. Pelican History of Art. New Haven: Yale Univ. Press, 1994.

Falk, Toby, ed. *Treasures of Islam*. London: Sotheby's, 1985.

Frishman, Martin, and Hasan-Uddin Khan. *The Mosque: History, Architectural Development and Regional Diversity*. London: Thames and Hudson, 1994.

Glasse, Cyril. *The Concise Encyclopedia of Islam*. San Francisco: Harper & Row, 1989.

Grabar, Oleg. *The Alhambra*. Cambridge: Harvard Univ. Press, 1978.

———. *The Formation of Islamic Art*. Rev. ed. New Haven: Yale Univ. Press, 1987.

———. *The Great Mosque of Isfahan*. New York: New York Univ. Press, 1990.

———. *The Mediation of Ornament*. A. W. Mellon Lectures in the Fine Arts. Princeton: Princeton Univ. Press, 1992.

———, Mohammad al-Asad, Abeer Audeh, and Said Nuseibeh. *The Shape of the Holy; Early Islamic Jerusalem*. Princeton: Princeton Univ. Press, 1996.

Grube, Ernest J. *Architecture of the Islamic World: Its History and Social Meaning*. Ed. George Mitchell. New York: Morrow, 1978.

Hillenbrand, Robert. *Islamic Art and Architecture*. World of Art. London: Thames and Hudson, 1999.

Hoag, John D. *Islamic Architecture*. History of World Architecture. New York: Abrams, 1977.

Irwin, Robert. *Islamic Art in Context: Art, Architecture, and the Literary World*. Perspectives. New York: Abrams, 1997.

Jones, Dalu, and George Mitchell, eds. *The Arts of Islam*. London: Arts Council of Great Britain, 1976.

Khatibi, Abdelkebir, and Mohammed Sijelmassi. *The Splendour of Islamic Calligraphy*. Rev. and exp. ed. New York: Thames and Hudson, 1996.

Lentz, Thomas W., and Glenn D. Lowry. *Timur and the Princely Vision: Persian Art and Culture in the Fifteenth Century*. Los Angeles: Los Angeles County Museum of Art, 1989.

Papadopoulo, Alexandre. *Islam and Muslim Art*. Trans. Robert Erich Wolf. New York: Abrams, 1979.

Petsopoulos, Yanni, ed. Tulips, *Arabesques and Turbans: Decorative Arts from the Ottoman Empire*. New York: Abbeville, 1982.

Raby, Julian, ed. *The Art of Syria and the Jazira, 1100–1250*. Oxford Studies in Islamic Art. Oxford: Oxford Univ. Press, 1985.

Rice, David Talbot. *Islamic Art*. World of Art. New York: Thames and Hudson, 1965.

Robinson, Francis, ed. *The Cambridge Illustrated History of the Islamic World*. Cambridge Univ. Press, 1996.

Schimmel, Annemarie. *Calligraphy and Islamic Culture*. New York: New York Univ. Press, 1983.

Ward, R. M. *Islamic Metalwork*. New York: Thames and Hudson, 1993.

Welch, Anthony. *Calligraphy in the Arts of the Muslim World*. Austin: Univ. of Texas Press, 1979.

CHAPTER 9 Art of India before 1100

Allchin, Bridget, and Raymond Allchin. *The Rise of Civilization in India and Pakistan*. Cambridge World Archaeology. Cambridge: Cambridge Univ. Press, 1982.

Behl, Benoy K. *The Ajanta Caves: Artistic Wonder of Ancient Buddhist India*. New York: Abrams, 1998.

Berkson, Carmel. *Elephanta: The Cave of Shiva*. Princeton: Princeton Univ. Press, 1983.

Brooks, Robert R.R. , and Vishnu S. Wakakar. *Stone Age Painting in India*. New Haven: Yale Univ. Press, 1976.

Chandra, Pramod. *The Sculpture of India, 3000 B.C.–1300 A.D.* Washington, D.C.: National Gallery of Art, 1985.

Czuma, Stanislaw J. *Kushan Sculpture: Images from Early India*. Cleveland: Cleveland Museum of Art, 1985.

Dehejia, Vidya. *Art of the Imperial Cholas*. New York: Columbia Univ. Press, 1990.

———. *Early Buddhist Rock Temples*. Ithaca: Cornell Univ. Press, 1972.

Dessai, Vishakha N., and Darielle Mason, eds. *Gods, Guardians, and Lovers: Temple Sculptures from North India, A.D. 700–1200*. New York: Asia Society Galleries, 1993.

Dimmitt, Cornelia. *Classical Hindu Mythology*. Philadelphia: Temple Univ. Press, 1978.

Eck, Diana L. *Darsan. Seeing the Divine Image in India*. 3rd. ed. Chambersburg, PA: Anima, 1998.

Gupta, S. P. *The Roots of Indian Art: A Detailed Study of the Formative Period of Indian Art and Architecture, Third and Second Centuries B.C., Mauryan and Late Mauryan*. Delhi: B. T. Pub. Corp., 1980.

Harle, J. C. *Gupta Sculpture*. Oxford: Clarendon, 1974.

Huntington, Susan L. *The Arts of Ancient India: Buddhist, Hindu, Jain*. New York: Weatherhill, 1985.

———. *Leaves from the Bodhi Tree: The Art of Pala India (8th–12th Centuries) and Its International Legacy*. Dayton, OH: Dayton Art Institute, 1990.

Hutt, Michael. *Nepal: A Guide to the Art and Architecture of the Kathmandu Valley*. Boston: Shambala, 1995.

Knox, Robert. *Amaravati: Buddhist Sculpture from the Great Stupa*. London: British Museum, 1992.

Kramrisch, Stella. *The Art of Nepal*. New York: Abrams, 1964.

———. *Presence of Siva*. Princeton: Princeton Univ. Press, 1981.

Meister, Michael, ed. *Discourses on Siva: On the Nature of Religious Imagery*. Philadelphia: Univ. of Pennsylvania Press, 1984.

———. *Encyclopedia of Indian Temple Architecture*. 2 vols. in 7. Philadelphia: Univ. of Pennsylvania Press, 1983.

Flaherty, Wendy. *Hindu Myths*. Harmondsworth, Eng.: Penguin, 1975.

Pal, Pratapaditya, ed. Aspects of Indian Art. Leiden: Brill, 1972.

———. *The Ideal Image: The Gupta Sculptural Tradition and Its Influence*. New York: Asia Society, 1978.

Possehl, Gregory, ed. *Ancient Cities of the Indus*. Durham, NC: Carolina Academic, 1979.

———. *Harappan Civilization: A Recent Perspective*. 2nd ed. New Delhi: American Institute of Indian Studies, 1993.

Poster, Amy G. *From Indian Earth: 4,000 Years of Terracotta Art*. Brooklyn: Brooklyn Museum, 1986.

Rosenfield, John M. *The Dynastic Arts of the Kushans.* California Studies in the History of Art. Berkeley: Univ. of California Press, 1967.

Sankalia, H. D. *Prehistoric Art in India.* Durham, N.C.: Carolina Academic Press, 1978.

Shearer, Alistair. *Upanishads.* New York: Harper & Row, 1978.

Skelton, Robert, and Mark Francis. *Arts of Bengal: The Heritage of Bangladesh and Eastern India.* London: Whitechapel Gallery, 1979.

Thapar, Romila. *Asoka and the Decline of the Mauryas.* Rev. ed. Delhi: Oxford, 1997.

———, and Percival Spear. *History of India.* London: Penguin, 1990.

Weiner, Sheila L. *Ajanta: Its Place in Buddhist Art.* Berkeley: Univ. of California Press, 1977.

Williams, Joanna G. *Art of Gupta India, Empire and Province.* Princeton: Princeton Univ. Press, 1982.

CHAPTER 10 Chinese Art before 1280

The Art Treasures of Dunhuang. Hong Kong: Joint, 1981.

Barnhart, Richard. *Along the Border of Heaven: Sung and Yuan Painting from the C. C. Wang Family Collection.* New York: Metropolitan Museum of Art, 1983.

Billeter, Jean François. *The Chinese Art of Writing.* New York: Skira/Rizzoli, 1990.

Cahill, James. *Art of Southern Sung China.* New York: Asia Society, 1962.

———. *Index of Early Chinese Painters and Paintings: T'ang, Sung, and Yuan.* Berkeley: Univ. of California Press, 1980.

De Silva, Anil. *The Art of Chinese Landscape Painting: In the Caves of Tun-huang.* Art of the World. New York: Crown, 1967.

Fong, Wen, ed. *Beyond Representation: Chinese Painting and Calligraphy, 8th–14th Century.* Princeton Monographs in Art and Archaeology. New York: Metropolitan Museum of Art, 1992.

———. *The Great Bronze Age of China: An Exhibition from the People's Republic of China.* New York: Metropolitan Museum of Art, 1980.

Fong, Wen, and Marilyn Fu. *Sung and Yuan Paintings.* New York: New York Graphic Society, 1973.

Gridley, Marilyn Leidig. *Chinese Buddhist Sculpture under the Liao: Free Standing Works in Situ and Selected Examples from Public Collections.* New Delhi: International Academy of Indian Culture, 1993.

Ho, Wai-kam, et al. *Eight Dynasties of Chinese Painting: The Collections of the Nelson Gallery-Atkins Museum, Kansas City, and the Cleveland Museum of Art.* Cleveland: Cleveland Museum of Art, 1980.

James, Jean M. *A Guide to the Tomb and Shrine Art of the Han Dynasty 206 B.C.– A.D. 220.* Chinese Studies; 2. Lewiston: E. Mellen Press, 1996.

Juliano, Annette L. *Art of the Six Dynasties: Centuries of Change and Innovation.* New York: China House Gallery, 1975.

Karetzky, Patricia Eichenbaum. *Court Art of the Tang.* Lantham: Univ. Press of America, 1996.

Lawton, Thomas. *Chinese Art of the Warring States Period: Change and Continuity, 480–222 B.C.* Washington, D.C.: Freer Gallery of Art, Smithsonian Institution, 1982.

———. *Chinese Figure Painting.* Washington, D.C.: Smithsonian Institution, 1973.

Lim, Lucy. *Stories from China's Past: Han Dynasty Pictorial Tomb Reliefs and Archaeological Objects from Sichuan Province, People's Republic of China.* San Francisco: Chinese Culture Foundation, 1987.

Ma, Ch'eng-yuan. *Ancient Chinese Bronzes.* Ed. Hsio-Yen Shih. Hong Kong: Oxford Univ. Press, 1986.

Munakata, Kiyohiko. *Sacred Mountains in Chinese Art.* Champaign: Krannert Art Museum, Univ. of Illinois, 1991.

Paludan, Ann. *Chinese Spirit Road: The Classical Tradition of Stone Tomb Sculpture.* New Haven: Yale Univ. Press, 1991.

———. *Chinese Tomb Figurines.* Hong Kong: Oxford Univ. Press, 1994.

Powers, Martin J. *Art and Political Expression in Early China.* New Haven: Yale Univ. Press, 1991.

Rawson, Jessica. *Ancient China: Art and Archaeology.* London: British Museum, 1980.

———. *Mysteries of Ancient China: New Discoveries from the Early Dynasties.* London: British Museum Press, 1996.

Rhie, Marylin M. *Early Buddhist Art of China and Central Asia.* Handbuch der Orientalistik. Vierte Abteilung. China; 12. Leiden: Brill, 1999-.

Watson, William. *Ancient Chinese Bronzes.* 2nd ed. The Arts of the East. London: Faber and Faber, 1977.

———. *The Arts of China to AD 900.* Pelican History of Art. New Haven: Yale Univ. Press, 1995.

Weidner, Marsha, ed. *Latter Days of the Law: Images of Chinese Buddhism, 850–1850.* Lawrence: Spencer Museum of Art, Univ. of Kansas, 1994.

Whitfield, Roderick, and Anne Farrer. *Caves of the Thousand Buddhas: Chinese Art from the Silk Route.* London: British Museum, 1990.

Wu Hung. *Monumentality in Early Chinese Art and Architecture.* Stanford: Stanford Univ. Press, 1995.

CHAPTER 11 Japanese Art before 1392

Cunningham, Michael R. *Buddhist Treasures from Nara.* Cleveland: Cleveland Museum of Art, 1998.

Kidder, J. Edward. *Early Buddhist Japan.* Ancient People and Places. New York: Praeger, 1972.

———. *Early Japanese Art: The Great Tombs and Treasures.* Princeton: Van Nostrand, 1964.

———. *Japanese Temples: Sculpture, Paintings, Gardens, and Architecture.* London: Thames and Hudson, 1964.

———. *Prehistoric Japanese Arts: Jomon Pottery.* Tokyo: Kodansha International, 1968.

Kurata, Bunsaku. *Horyu-ji, Temple of the Exalted Law: Early Buddhist Art from Japan.* New York: Japan Society, 1981.

LaMarre, Thomas. *Uncovering Heian Japan: An Archaeology of Sensation and Inscription.* Asia-Pacific. Durham, NC: Duke Univ. Press, 2000.

Miki, Fumio. *Haniwa.* Trans. and adapted by Gino Lee Barnes. Arts of Japan, 8. New York: Weatherhill, 1974.

Mino, Yutaka. *The Great Eastern Temple: Treasures of Japanese Buddhist Art from Todai-ji.* Chicago: Art Institute of Chicago, 1986.

Murase, Miyeko. *Iconography of the Tale of Genji: Genji Monogatari Ekotoba.* New York: Weatherhill, 1983.

Nishiwara, Kyotaro, and Emily J. Sano. *The Great Age of Japanese Buddhist Sculpture, A.D. 60–1300.* Fort Worth, TX: Kimbell Art Museum, 1982.

Okudaira, Hideo. *Narrative Picture Scrolls.* Trans. Elizabeth ten Grutenhuis. Arts of Japan, 5. New York: Weatherhill, 1973.

Pearson, Richard J. *Ancient Japan.* Washington, D.C.: Sackler Gallery, 1992.

Rosenfield, John M., Fumiko E. Cranston, and Edwin A. Cranston. *The Courtly Tradition in Japanese Art and Literature: Selections from the Hofer and Hyde Collections.* Cambridge: Fogg Art Museum, Harvard Univ., 1973.

———. *Japanese Arts of the Heian Period: 794–1185.* New York: Asia Society, 1967.

Soper, Alexander Coburn. *Evolution of Buddhist Architecture in Japan.* Princeton Monographs in Art and Archaeology, no. 22. New York: Hacker Art, 1978.

Swann, Peter. *The Art of Japan: From the Jomon to the Tokugawa Period.* Art of the World. New York: Crown, 1966.

CHAPTER 12 Art of the Americas before 1300

Abel-Vidor, Suzanne. *Between Continents/Between Seas: Precolumbian Art of Costa Rica.* New York: Abrams, 1981.

Abrams, Elliot Marc. *How the Maya Built Their World: Energetics and Ancient Architecture.* Austin: Univ. of Texas Press, 1994.

Alcina Franch, José. *Pre-Columbian Art.* Trans. I. Mark Paris. New York: Abrams, 1983.

Anton, Ferdinand. *Art of the Maya.* Trans. Mary Whitall. London: Thames and Hudson, 1970.

Benson, Elizabeth P., and Beatriz de la Fuente. *Olmec Art of Ancient Mexico.* Washington, D.C.: National Gallery of Art, 1996.

Berrin, Kathleen, ed. *Feathered Serpents and Flowering Trees: Reconstructing the Murals of Teotihuacan.* San Francisco: Fine Arts Museums of San Francisco, 1988.

———, and Esther Pasztory. *Teotihuacan: Art from the City of the Gods.* New York: Thames and Hudson, 1993.

Brody, J. J. *The Anasazi: Ancient Indian People of the American Southwest.* New York: Rizzoli, 1990.

———. *Anasazi and Pueblo Painting.* Albuquerque: Univ. of New Mexico Press, 1991.

Coe, Michael D. *The Jacquar's Children: Pre-Classical Central Mexico.* New York: Museum of Primitive Art, 1965.

Coe, Ralph T. *Sacred Circles: Two Thousand Years of North American Indian Art.* London: Arts Council of Great Britain, 1976.

Donnan, Christopher B. *Ceramics of Ancient Peru.* Los Angeles: Fowler Museum of Cultural History, Univ. of California, 1992.

———. *Moche Art of Peru: Pre-Columbian Symbolic Communication.* Rev. ed. Los Angeles: Fowler Museum of Cultural History, Univ. of California, 1978.

Fash, William Leonard. *Scribes, Warriors, and Kings: The City of Copan and the Ancient Maya.* London: Thames and Hudson, 1991.

Fewkes, Jesse Walter. *The Mimbres: Art and Archaeology.* Albuquerque: Avanyu, 1989.

Frazier, Kendrick. *People of Chaco: A Canyon and Its Culture.* Rev. & updated ed. New York: Norton, 1999.

Herreman, Frank. *Power of the Sun: The Gold of Colombia.* Antwerp: City of Antwerp, 1993.

Heyden, Doris, and Paul Gendrop. *Pre-Columbian Architecture of Mesoamerica.* Trans. Judith Stanton. History of World Architecture. New York: Electa/Rizzoli, 1988.

Korp, Maureen. *The Sacred Geography of the American Mound Builders.* Native American Studies. Lewiston, NY: Mellen, 1990.

Kubler, George. *The Art and Architecture of Ancient America: The Mexican, Maya, and Andean Peoples.* 3rd ed. Pelican History of Art. New Haven: Yale Univ. Press, 1990.

———. *Esthetic Recognition of Ancient Amerindian Art.* Yale Publications in the History of Art. New Haven: Yale Univ. Press, 1991.

Longhena, Maria. *Ancient Mexico: The History and Culture of the Maya, Aztecs, and Other Pre-Columbian Peoples.* Trans. Neil Frazer Davenport. New York: Stewart, Tabori & Chang, 1998.

Miller, Mary Ellen. *The Art of Mesoamerica: From Olmec to Aztec.* Rev. ed. World of Art. New York: Thames and Hudson, 1996.

———. *Maya Art and Architecture.* World of Art. London: Thames and Hudson, 1999.

———, and Karl Taube. *The Gods and Symbols of Ancient Mexico and the Maya: An Illustrated Dictionary of Mesoamerican Religion.* New York: Thames and Hudson, 1993.

Moseley, Michael. *The Incas and Their Ancestors: The Archaeology of Peru.* London: Thames and Hudson, 1992.

Pang, Hildegard Delgado. *Pre-Columbian Art: Investigations and Insights.* Norman: Univ. of Oklahoma Press, 1992.

Pasztory, Esther. *Pre-Columbian Art.* Cambridge: Cambridge Univ. Press, 1998.

Paul, Anne. *Paracas Art and Architecture. Object and Context in South Coastal Peru.* Iowa City: Univ. of Iowa Press, 1991.

Schele, Linda, and David Freidel. *A Forest of Kings: The Untold Story of the Ancient Maya.* New York: Morrow, 1990.

Schele, Linda, and Mary Ellen Miller. *The Blood of Kings: Dynasty and Ritual in Maya Art.* New York: Braziller, 1986.

Stone-Miller, Rebecca. *Art of the Andes: From Chavin to Inca.* World of Art. New York: Thames and Hudson, 1996.

———. *To Weave for the Sun: Andean Textiles in the Museum of Fine Arts, Boston.* Boston: Museum of Fine Arts, 1992.

Townsend, Richard, ed. *The Ancient Americas: Art from Sacred Landscapes.* Chicago: Art Institute of Chicago, 1992.

———. *The Aztecs.* 2nd rev. ed. Ancient Peoples and Places. London: Thames and Hudson, 2000.

Wuthenau, Alexander von. *The Art of Terracotta Pottery in Pre-Columbian Central and South America.* Art of the World. New York: Crown, 1970.

CHAPTER 13 Art of Ancient Africa

Bassani, Ezio, and William Fagg. *Africa and the Renaissance: Art in Ivory.* New York: Center for African Art, 1988.

Ben-Amos, Paula. *The Art of Benin.* Rev. ed. Washington, D.C.: Smithsonian Institution Press, 1995.

———, and Arnold Rubin. *The Art of Power, the Power of Art: Studies in Benin Iconography.* Monograph Series, no. 19. Los Angeles: Fowler Museum of Cultural History, Univ. of California, 1983.

Cole, Herbert M. *Igbo Arts: Community and Cosmos.* Los Angeles: Fowler Museum of Cultural History, Univ. of California, 1984.

Connah, Graham. *African Civilizations: Precolonial Cities and States in Africa: An Archaeological Perspective.* Cambridge: Cambridge Univ. Press, 1987.

Eyo, Ekpo, and Frank Willett. *Treasures of Ancient Nigeria.* Ed. Rollyn O. Kirchbaum. New York: Knopf, 1980.

Ezra, Kate. *Royal Art of Benin: The Perls Collection in the Metropolitan Museum of Art.* New York: Metropolitan Museum of Art, 1992.

Fagg, Bernard. *Nok Terracottas.* Lagos: Ethnographica, 1977.

Garlake, Peter S. *Great Zimbabwe.* London: Thames and Hudson, 1973.

———. *The Hunter's Vision: The Prehistoric Art of Zimbabwe.* Seattle: Univ. of Washington Press, 1995.

Huffman, Thomas N. *Symbols in Stone: Unravelling the Mystery of Great Zimbabwe.* Johannesburg: Witwatersrand Univ. Press, 1987.

Lhote, Henri. *The Search for the Tassili Frescoes: The Story of the Prehistoric Rock-Paintings of the Sahara.* 2nd ed. Trans. Alan Houghton Brodrick. London: Hutchinson, 1973.

Shaw, Thurstan. *Unearthing Igbo-Ukwu: Archaeological Discoveries in Eastern Nigeria.* New York: Oxford Univ. Press, 1977.

Willcox, A. R. *The Rock Art of Africa.* London: Croon Helm, 1984.

Willett, Frank. *Ife in the History of West African Sculpture.* New York: McGraw-Hill, 1967.

CHAPTER 14 Early Medieval Art in Europe

Alexander, J. J. G. *Medieval Illuminators and Their Methods of Work.* New Haven: Yale Univ. Press, 1992.

Art of Medieval Spain, A.D. 500–1200, The. New York: Metropolitan Museum of Art, 1993.

Backes, Magnus, and Regine Dolling. *Art of the Dark Ages.* Trans. Francisca Garvie. *Panorama of World Art.* New York: Abrams, 1971.

Backhouse, Janet, D. H. Turner, and Leslie Webster. *The Golden Age of Anglo-Saxon Art, 966–1066.* Bloomington: Indiana Univ. Press, 1984.

Beckwith, John. *Early Medieval Art: Carolingian, Ottonian, Romanesque.* World of Art. New York: Oxford Univ. Press, 1974.

Cahn, Walter. *Romanesque Bible Illumination.* Ithaca: Cornell Univ. Press, 1982.

———. *Romaesque Manuscripts: The Twelfth Century.* 2 vols. A Survey of Manuscripts Illuminated in France. London: H. Miller, 1996.

Calkins, Robert G. *Illuminated Books of the Medieval Ages.* Ithaca: Cornell Univ. Press, 1983.

Davis-Weyer, Caecilia. *Early Medieval Art, 300–1150: Sources and Documents.* Upper Saddle River, NJ: Prentice Hall, 1971.

Dodds, Jerrilynn D. *Architecture and Ideology in Early Medieval Spain.* University Park: Pennsylvania State Univ. Press, 1990.

Dodwell, C. R. *Pictorial Art of the West 800–1200.* Yale Univ. Press Pelican History of Art. New Haven: Yale Univ. Press, 1993.

Eco, Umberto. *Art and Beauty in the Middle Ages.* Trans. Hugh Bredin. New Haven: Yale Univ. Press, 1986.

Evans, Angela Care. *The Sutton Hoo Ship Burial.* Rev. ed. London: British Museum, 1994.

Farr, Carol. *The Book of Kells: Its Function and Audience.* London: British Library, 1997.

Fergusson, Peter. *Architecture of Solitude: Cistercian Abbeys in Twelfth-Century England.* Princeton: Princeton Univ. Press, 1984.

Fernie, E. C. *The Architecture of the Anglo-Saxons.* London: Batsford, 1983.

Fitzhugh, William W. , and Elisabeth I. Ward, eds. *Vikings: The North Atlantic Saga.* Washington, D.C.: Smithsonian Institution Press, 2000.

Harbison, Peter. *The Golden Age of Irish Art: The Medieval Achievement, 600–1200.* London: Thames and Hudson, 1998.

Henderson, George. *Early Medieval.* Style and Civilization. Harmondsworth, Eng.: Penguin, 1972.

———. *From Durrow to Kells: The Insular Gospel-Books, 650–800.* London: Thames and Hudson, 1987.

Horn, Walter W., and Ernest Born. *Plan of Saint Gall: A Study of the Architecture and Economy of and Life in a Paradigmatic Carolingian Monastery.* 3 vols. California Studies in the History of Art. Berkeley: Univ. of California Press, 1979.

Hubert, Jean, Jean Porcher, and W. F. Volbach. *Carolingian Renaissance.* Arts of Mankind. New York: Braziller, 1970.

———. *Europe of the Invasions.* Trans. Stuart Gilbert and James Emmons. Arts of Mankind. New York: Braziller, 1969.

Lasko, Peter. *Ars Sacra, 800–1200.* 2nd ed. Pelican History of Art. New Haven: Yale Univ. Press, 1994.

Mayr-Harting, Henry. *Ottonian Book Illumination: An Historical Study.* 2 vols. 2nd rev. ed. London: Harvey Mlller, 1999.

Nordenfalk, Carl Adam Johan. *Early Medieval Book Illumination.* New York: Rizzoli, 1988.

Palol, Pedro de, and Max Hirmer. *Early Medieval Art in Spain.* Trans. Alisa Jaffa. London: Thames and Hudson, 1967.

Richardson, Hilary, and John Scarry. *An Introduction to Irish High Crosses.* Dublin: Mercier, 1990.

Stalley, R.A. *Early Medieval Architecture.* Oxford History of Art. Oxford: Oxford Univ. Press, 1999.

Tschan, Francis Joseph. *Saint Bernward of Hildesheim.* 3 vols. Notre Dame, IN: The Univ. of Notre Dame, 1942.

Verzone, Paola. *The Art of Europe: The Dark Ages from Theodoric to Charlemagne.* Art of the World. New York: Crown, 1968.

Williams, John. *Early Spanish Manuscript Illumination.* New York: Braziller, 1977.

Wilson, David M. *Anglo-Saxon Art: From the Seventh Century to the Norman Conquest.* London: Thames and Hudson, 1984.

———, and Ole Klindt-Jensen. *Viking Art.* 2nd ed. Minneapolis: Univ. of Minnesota Press, 1980.

CHAPTER 15 Romanesque Art

Armi, C. Edson. *Masons and Sculptors in Romanesque Burgundy: The New Aesthetics of Cluny III.* 2 vols. University Park: Pennsylvania State Univ. Press, 1983.

Barral I Altet, Xavier. *The Romanesque: Towns, Cathedrals and Monasteries.* Taschen's World Architecture. New York: Taschen, 1998.

Braunfels, Wolfgang. *Monasteries of Western Europe: The Architecture of the Orders.* Trans. Alastair Laing. New York: Thames and Hudson, 1993.

Busch, Harald, and Bernd Lohse. *Romanesque Sculpture.* London: Batsford, 1962.

Cahn, Walter. *Romanesque Bible Illumination.* Ithaca: Cornell Univ. Press, 1982.

Evans, Joan. *Cluniac Art of the Romanesque Period.* Cambridge: Cambridge Univ. Press, 1950.

Focillon, Henri. *The Art of the West in the Middle Ages.* 2 vols. Ed. Jean Bony. Trans. Donald King. London: Phaidon, 1963.

Forsyth, Ilene H. *The Throne of Wisdom: Wood Sculptures of the Madonna in Romanesque France.* Princeton: Princeton Univ. Press, 1972.

Gantner, Joseph, and Marvel Pobe. *Romanesque Art in France.* London: Thames and Hudson, 1956.

Grape, Wolfgang. *The Bayeux Tapestry: Monument to a Norman Triumph.* New York: Prestel, 1994.

Hearn, M. F. *Romanesque Sculpture: The Revival of Monumental Stone Sculptures in the Eleventh and Twelfth Centuries.* Ithaca: Cornell Univ. Press, 1981.

Jacobs, Michael. *Northern Spain: The Road to Santiago de Compostela.* Architectural Guides for Travelers. San Francisco: Chronicle, 1991.

Kennedy, Hugh. *Crusader Castles.* Cambridge: Cambridge Univ. Press, 1994.

Kubach, Hans Erich. *Romanesque Architecture.* History of World Architecture. New York: Electa/Rizzoli, 1988.

Kuhnel, Biana. *Crusader Art of the Twelfth Century: A Geographical, and Historical, or an Art Historical Notion?* Berlin: Gebr. Mann, 1994.

Kunstler, Gustav. *Romanesque Art in Europe.* Greenwich, CT: New York Graphic Society, 1969.

Little, Bryan D. G. *Architecture in Norman Britain.* London: Batsford, 1985.

Mâle, Emile. *Religious Art in France, the Twelfth Century: A Study of the Origins of Medieval Iconography.* Bollingen Series. Princeton: Princeton Univ. Press, 1978.

Nebosine, George A. *Journey into Romanesque: A Traveller's Guide to Romanesque Monuments in Europe.* Ed. Robyn Cooper. London: Weidenfeld and Nicolson, 1969.

Norton, Christopher, and David Park. *Cistercian Art and Architecture in the British Isles.* Cambridge: Cambridge Univ. Press, 1986.

Petzold, Andreas. *Romanesque Art.* Perspectives. New York: Abrams, 1995.

Radding, Charles M., and William W. Clark. *Medieval Architecture, Medieval Learning: Builders and Masters in the Age of Romanesque and Gothic.* New Haven: Yale Univ. Press, 1992.

Schapiro, Meyer. *Romanesque Art.* New York: Braziller, 1977.

———. *The Romanesque Sculpture of Moissac.* New York: Braziller, 1985.

Stones, Alison, and Jeanne Krochalis, Paula Gerson, and Annie Shaver-Crandell. *The Pilgrim's Guide: A Critical Edition.* 2 vols. London: Harvey Miller, 1998.

Swarzenski, Hanns. *Monuments of Romanesque Art: The Art of Church Treasures of North-Western Europe.* 2nd ed. Chicago: Univ. of Chicago Press, 1967.

Tate, Robert Brian, and Marcus Tate. *The Pilgrim Route to Santiago.* Oxford: Phaidon, 1987.

Wilson, David M. *The Bayeux Tapestry: The Complete Tapestry in Color.* New York: Random House, 1985.

The Year 1200. 2 vols. New York: Metropolitan Museum of Art, 1970.

Zarnecki, George. *Romanesque Art.* New York: Universe, 1971.

———, Janet Holt, and Tristam Holland. *English Romanesque Art, 1066–1200.* London: Weidenfeld and Nicolson, 1984.

CHAPTER 16 Gothic Art

Alexander, Jonathan, and Paul Binski, eds. *Age of Chivalry: Art in Plantagenet England, 1200–1400.* London: Royal Academy of Art, 1987.

Andrews, Francis B. *The Mediaeval Builder and His Methods.* New York: Barnes & Noble, 1993.

Armi, C. Edson. *The "Headmaster" of Chartres and the Origins of "Gothic" Sculpture.* University Park: Pennsylvania State Univ. Press, 1994.

Aubert, Marcel. *The Art of the High Gothic Era.* Rev. ed. Art of the World. New York: Greystone, 1966.

Binski, Paul. *Medieval Craftsmen: Painters.* London: British Museum, 1991.

Bony, Jean. *French Gothic Architecture of the 12th and 13th Centuries.* California Studies in the History of Art. Berkeley: Univ. of California Press, 1983.

Borsook, Eve, and Fiorella Superbi Gioffredi. *Italian Altarpieces, 1250–1550: Function and Design.* Oxford: Clarendon, 1994.

Branner, Robert. *Manuscript Painting in Paris during the Reign of Saint Louis: A Study of Styles.* California Studies in the History of Art. Berkeley: Univ. of California Press, 1977.

Camille, Michael. *Gothic Art: Glorious Visions.* Perspectives. New York: Abrams, 1996.

Coe, Brian. *Stained Glass in England, 1150–1550.* London: Allen, 1981.

Crosby, Sumner McKnight. *The Royal Abbey of Saint-Denis from Its Beginnings to the Death of Suger, 475–1151.* Yale Publications in the History of Art. New Haven: Yale Univ. Press, 1987.

Erlande-Brandenburg, Alain. *Gothic Art.* Trans. I. Mark Paris. New York: Abrams, 1989.

———. *Notre-Dame de Paris.* New York: Abrams, 1998.

Favier, Jean. *The World of Chartres.* Trans. Francisca Garvie. New York: Abrams, 1990.

Franklin, J. W. *Cathedrals of Italy.* London: Batsford, 1958.

Frisch, Teresa G. *Gothic Art, 1140–c. 1450: Sources and Documents.* Upper Saddle River, NJ: Prentice Hall, 1971.

Grodecki, Louis. *Gothic Architecture.* Trans. I. Mark Paris. History of World Architecture. New York: Electa/Rizzoli, 1985.

———, and Catherine Brisac. *Gothic Stained Glass, 1200–1300.* Ithaca: Cornell Univ. Press, 1985.

Mâle, Emile. *Religious Art in France, the Thirteenth Century: A Study of Medieval Iconography and Its Sources.* Princeton: Princeton Univ. Press, 1984.

Martindale, Andrew. *Gothic Art.* World of Art. London: Thames and Hudson, 1967.

McIntyre, Anthony. *Medieval Tuscany and Umbria.* Architectural Guides for Travellers. San Francisco: Chronicle, 1992.

Metropolitan Museum of Art, The. *The Secular Spirit: Life and Art at the End of the Middle Ages.* New York: Dutton, 1975.

O'Neill, John Philip, ed. *Enamels of Limoges: 1100–1350.* Trans. Sophie Hawkes, Joachim Neugroschel, and Patricia Stirneman. New York: Metropolitan Museum of Art, 1996.

Panofsky, Erwin. *Abbot Suger on the Abbey Church of St.-Denis and Its Art Treasures.* 2nd ed. Ed. Gerda Panofsky-Soergel. Princeton: Princeton Univ. Press, 1979.

———. *Gothic Architecture and Scholasticism.* Latrobe, PA: Archabbey, 1951.

Pevsner, Nikolas, and Priscilla Metcalf. *The Cathedrals of England.* 2 vols. Harmondsworth, Eng.: Viking, 1985.

Pope-Hennessy, John. *Italian Gothic Sculpture.* 3rd ed. Oxford: Phaidon, 1986.

Sauerlander, Willibald. *Gothic Sculpture in France, 1140–1270.* Trans. Janet Sandheimer. London: Thames and Hudson, 1972.

Scott, Kathleen L. *Later Gothic Manuscripts, 1390–1490.* 2 vols. A Survey of Manuscripts Illuminated in the British Isles; 6. London: H. Miller, 1996.

Simson, Otto Georg von. *The Gothic Cathedral: Origins of Gothic Architecture and the Medieval Concept of Order.* 3rd ed. Bollingen Series. Princeton: Princeton Univ. Press, 1988.

Smart, Alastair. *The Dawn of Italian Painting, 1250–1400.* Ithaca: Cornell Univ. Press, 1978.

White, John. *Art and Architecture in Italy, 1250 to 1400.* 3rd ed. Pelican History of Art. Harmondsworth, Eng.: Penguin, 1993.

Wieck, Roger S. *Time Sanctified: The Book of Hours in Medieval Art and Life.* New York: Braziller, 1988.

Williamson, Paul. *Gothic Sculpture 1140–1300.* Pelican History of Art. New Haven: Yale Univ. Press, 1995.

Wilson, Christopher. *The Gothic Cathedral: The Architecture of the Great Church, 1130–1530.* New York: Thames and Hudson, 1990.

CHAPTER 17 Early Renaissance Art in Europe

Alexander, J.J.G. *The Painted Page: Italian Renaissance Book Illumination, 1450–1550.* Munich: Prestel, 1994.

Ames-Lewis, Francis. *Drawing in Early Renaissance Italy.* New Haven: Yale Univ. Press, 1994.

———. *The Intellectual Life of the Early Renaissance Artist.* New Haven: Yale Univ. Press, 2000.

Baxandall, Michael. *Painting and Experience in Fifteenth-Century Italy: A Primer in the Social History of Pictorial Style*. Oxford: Clarendon, 1972.

Blum, Shirley. *Early Netherlandish Triptychs: A Study in Patronage*. California Studies in the History of Art. Berkeley: Univ. of California Press, 1969.

Campbell, Lorne. *Renaissance Portraits: European Portrait-Painting in the 14th, 15th, and 16th Centuries*. New Haven: Yale Univ. Press, 1990.

Cavallo, Adolph S. *The Unicorn Tapestries at the Metropolitan Museum of Art*. New York: The Museum, 1998.

Chastel, André. *The Flowering of the Italian Renaissance*. Trans. Jonathan Griffin. Arts of Mankind. New York: Odyssey, 1965.

———. *French Art: The Renaissance, 1430-1620*. Paris: Flammarion, 1995.

———. *Studios and Styles of the Italian Renaissance*. Trans. Jonathan Griffin. Arts of Mankind. New York: Odyssey, 1966.

Christianity and the Renaissance: Image and Religious Imagination in the Quattrocento. Syracuse, NY: Syracuse Univ. Press, 1990.

Christiansen, Keith, Laurence B. Kanter, and Carl Brandon Strehlke. *Painting in Renaissance Siena, 1420-1500*. New York: Metropolitan Museum of Art, 1988.

Christine, de Pisan. *The Book of the City of Ladies*. Trans. Rosalind Brown-Grant. London: Penguin Books, 1999.

Flanders in the Fifteenth Century: Art and Civilization. Detroit: Detroit Institute of Arts, 1960.

Gilbert, Creighton, ed. *Italian Art, 1400-1500: Sources and Documents*. Evanston: Northwestern Univ. Press, 1992.

Heydenreich, Ludwig Heinrich. *Architecture in Italy, 1400-1500*. Rev. Paul Davies. Pelican History of Art. New Haven: Yale Univ. Press, 1996.

Hind, Arthur M. *An Introduction to a History of Woodcut*. New York: Dover, 1963.

Huizinga, Johan. *The Autumn of the Middle Ages*. Trans. Rodney J. Payton and Ulrich Mammitzsch. Chicago: Univ. of Chicago Press, 1996.

Lane, Barbara G. *The Altar and the Altarpiece: Sacramental Themes in Early Netherlandish Painting*. New York: Harper & Row, 1984.

Levey, Michael. *Early Renaissance*. Harmondsworth, Eng.: Penguin, 1967.

Meiss, Millard. *French Painting in the Time of Jean de Berry: Muller, Theodor. Sculpture in the Netherlands, Germany, France, and Spain: 1400-1500*. Trans. Elaine and William Robson Scott. Pelican History of Art. Harmondsworth, Eng.: Penguin, 1966.

Pacht, Otto. *Early Netherlandish Painting: From Rogier van der Weyden to Gerard David*. Ed. Monika Rosenauer. Tran. David Britt. London: Harvey Miller, 1997.

Panofsky, Erwin. *Early Netherlandish Painting: Its Origins and Character*. 2 vols. Cambridge: Harvard Univ. Press, 1966.

Plummer, John. *The Last Flowering: French Painting in Manuscripts, 1420-1530, from American Collections*. New York: Pierpont Morgan Library, 1982.

Seymour, Charles. *Sculpture in Italy, 1400-1500*. Pelican History of Art. Harmondsworth, Eng.: Penguin, 1966.

Snyder, James. *Northern Renaissance Art: Painting, Sculpture, the Graphic Arts from 1350 to 1575*. New York: Abrams, 1985.

Welch, Evelyn S. *Art and Society in Italy, 1350-1500*. Oxford History of Art. Oxford: Oxford Univ. Press, 1997.

CHAPTER 18 Renaissance Art in Sixteenth-Century Europe

Baxandall, Michael. *The Limewood Sculptors of Renaissance Germany*. New Haven: Yale Univ. Press, 1980.

Bosquet, Jacques. *Mannerism: The Painting and Style of the Late Renaissance*. Trans. Simon Watson Taylor. New York: Braziller, 1964.

Chastel, André. *The Age of Humanism: Europe, 1480-1530*. Trans. Katherine M. Delavenay and E. M. Gwyer. London: Thames and Hudson, 1963.

Chelazzi Dini, Giulietta, Alessandro Angelini, and Bernardina Sani. *Sienese Painting: From Duccio to the Birth of the Baroque*. New York: Abrams, 1998.

Cole, Alison. *Virtue and Magnificence: Art of the Italian Renaissance Courts*. Perspectives. New York: Abrams, 1995.

Farmer, John David. *The Virtuoso Craftsman: Northern European Design in the Sixteenth Century*. Worcester, MA: Worcester Art Museum, 1969.

Freedberg, S. J. *Painting in Italy, 1500 to 1600*. 3rd ed. Pelican History of Art. New Haven: Yale Univ. Press, 1993.

Hayum, André. *The Isenheim Altarpiece: God's Medicine and the Painter's Vision*. Princeton Essays on the Arts. Princeton: Princeton Univ. Press, 1989.

Hollingsworth, Mary. *Patronage in Sixteenth Century Italy*. London: Murray, 1996.

Huse, Norbert, and Wolfgang Wolters. *Art of Renaissance Venice: Architecture, Sculpture and Painting, 1460-1590*. Trans. Edmund Jephcott. Chicago: Univ. of Chicago Press, 1990.

Klein, Robert, and Henri Zerner. *Italian Art, 1500-1600: Sources and Documents*. Upper Saddle River, NJ: Prentice Hall, 1966.

Kubler, George. *Building the Escorial*. Princeton: Princeton Univ. Press, 1982.

Landau, David, and Peter Parshall. *The Renaissance Print: 1470-1550*. New Haven: Yale Univ. Press, 1994.

Lazzaro, Claudia. *The Italian Renaissance Garden: From the Conventions of Planting, Design, and Ornament to the Grand Gardens of Sixteenth-Century Central Italy*. New Haven: Yale Univ. Press, 1990.

Lieberman, Ralph. *Renaissance Architecture in Venice, 1450-1540*. New York: Abbeville, 1982.

Lotz, Wolfgang. *Architecture in Italy, 1500-1600*. Pelican History of Art. Rev. Deborah Howard. New Haven: Yale Univ. Press, 1995.

Mann, Nicholas, and Luke Syson, eds. *The Image of the Individual: Portraits in the Renaissance*. London: British Museum Press, 1998.

Martineau, Jane, and Charles Hope. *The Genius of Venice, 1500-1600*. New York: Abrams, 1984.

Murray, Linda. *The High Renaissance and Mannerism: Italy, the North and Spain, 1500-1600*. World of Art. London: Thames and Hudson, 1995.

Olson, Roberta J. M. *Italian Renaissance Sculpture*. World of Art. New York: Thames and Hudson, 1992.

Osten, Gert von der, and Horst Vey. *Painting and Sculpture in Germany and the Netherlands, 1500-1600*. Pelican History of Art. Harmondsworth, Eng.: Penguin, 1969.

Paoletti, John T, and Gary M. Radke. *Art in Renaissance Italy*, 2nd ed. Upper Saddle River, NJ: Prentice Hall, 2001.

Pietrangeli, Carlo, et al. *The Sistine Chapel: The Art, the History, and the Restoration*. New York: Harmony, 1986.

Pope-Hennessy, Sir John. *Italian High Renaissance and Baroque Sculpture*. 3rd ed. Oxford: Phaidon, 1986.

———. *Italian Renaissance Sculpture*. 3rd ed. Oxford: Phaidon, 1986.

Rosand, David. *Painting in Cinquecento Venice: Titian, Veronese, Tintoretto*. Rev. ed. Cambridge: Cambridge Univ. Press, 1997.

Rowland, Ingrid D. *The Culture of the High Renaissance: Ancients and Moderns in Sixteenth Century Rome*. Cambridge: Cambridge Univ. Press, 1998.

Shearman, John. *Mannerism*. Harmondsworth, Eng.: Penguin, 1967.

Smith, Jeffrey Chipps. *Nuremberg, a Renaissance City, 1500-1618*. Austin: Huntington Art Gallery, Univ. of Texas, 1983.

Strong, Roy C. *Artists of the Tudor Court: The Portrait Miniature Rediscovered, 1520-1620*. London: Victoria and Albert Museum, 1984.

Vasari, Giorgio. *The Lives of the Artists*. Trans. Julia Conaway Bondanella and Peter Bondanella. New York: Oxford Univ. Press, 1991.

Verheyen, Egon. *The Paintings in the Studiolo of Isabella d'Este at Mantua*. Monographs on Archaeology and Fine Arts. New York: New York Univ. Press, 1971.

Williams, Robert. *Art, Theory, and Culture in Sixteenth-Century Italy: From Techne to Metateche*. Cambridge: Cambridge Univ. Press, 1997.

CHAPTER 19 Baroque Art in Europe and North America

Ackley, Clifford S. *Printmaking in the Age of Rembrandt*. Boston: Museum of Fine Arts, 1981.

Bazin, Germain. *Baroque and Rococo*. Trans. Jonathan Griffin. World of Art. New York: Praeger, 1964.

Berger, Robert W. *The Palace of the Sun: The Louvre of Louis XIV*. University Park: Pennsylvania State Univ. Press, 1993.

———. *Versailles: The Chateau of Louis XIV*. Monographs on the Fine Arts. University Park: Pennsylvania State Univ. Press, 1985.

Blunt, Anthony, et al. *Baroque and Rococo Architecture and Decoration*. New York: Harper & Row, 1982.

Boucher, Bruce. *Italian Baroque Sculpture*. World of Art. New York: Thames and Hudson, 1998.

Brown, Christopher. *Scenes of Everyday Life: Dutch Genre Painting of the Seventeenth Century*. London: Faber & Faber, 1984.

Enggass, Robert, and Jonathan Brown. *Italy and Spain 1600-1750: Sources and Documents*. Upper Saddle River, NJ: Prentice Hall, 1970.

Fuchs, R. H. *Dutch Painting*. World of Art. New York: Oxford Univ. Press, 1978.

Gerson, Horst, and E. H. ter Kuile. *Art and Architecture in Belgium, 1600-1800*. Pelican History of Art. Baltimore: Penguin, 1960.

Haak, Bob. *The Golden Age: Dutch Painters of the Seventeenth Century*. Trans. and ed. Elizabeth Willems-Treeman. New York: Abrams, 1984.

Held, Julius Samuel, and Donald Posner. *17th and 18th Century Art: Baroque Painting, Sculpture, Architecture*. Library of Art History. New York: Abrams, 1971.

Hempel, Eberhard. *Baroque Art and Architecture in Central Europe: Germany, Austria, Switzerland, Hungary, Czechoslovakia, Poland. Painting and Sculpture: 17th and 18th Centuries. Architecture: 16th to 18th Centuries*. Trans. Elisabeth Hempel and Marguerite Kay. Pelican History of Art. Harmondsworth, Eng.: Penguin, 1965.

Lagerlof, Margaretha Rossholm. *Ideal Landscape: Annibale Caracci, Nicolas Poussin, and Claude Lorrain*. New Haven: Yale Univ. Press, 1990.

Montagu, Jennifer. *Roman Baroque Sculpture: The Industry of Art*. New Haven: Yale Univ. Press, 1989.

Norberg-Schulz, Christian. *Baroque Architecture*. New York: Rizzoli, 1986.

———. *Late Baroque and Rococo Architecture*. History of World Architecture. New York: Rizzoli, 1985.

Rosenberg, Jakob, Seymour Slive, and E.H. Ter Kuile. *Dutch Art and Architecture 1600 to 1800*. Pelican History of Art. New Haven: Yale Univ. Press, 1977.

Slive, Seymour. *Dutch Painting 1600-1800*. Pelican History of Art. New Haven: Yale Univ. Press, 1995.

Stechow, Wolfgang. *Dutch Landscape Painting of the Seventeenth Century*. 3rd ed. Oxford: Phaidon, 1981.

Temple, R. C., ed. *The Travels of Peter Mundy in Europe and Asia, 1608-1667*. London: n.p., 1925.

Vlieghe, Hans. *Flemish Art and Architecture, 1585-1700*. Pelican History of Art. New Haven: Yale Univ. Press, 1998.

Wittkower, Rudolf. *Art and Architecture in Italy, 1600 to 1750*. 3 vols. 6th ed. Rev. Joseph Connors and Jennifer Montagu. Pelican History of Art. New Haven: Yale Univ. Press, 1999.

CHAPTER 20 Art of India after 1100

Asher, Catherine B. *Architecture of Mughal India*. New York: Cambridge Univ. Press, 1992.

Beach, Milo Cleveland. *Grand Mogul: Imperial Painting in India, 1600-1660*. Williamstown: Sterling and Francine Clark Art Institute, 1978.

———. *Imperial Image, Paintings for the Mughal Court*. Washington, D.C.: Freer Gallery of Art, Smithsonian Institution, 1981.

———. *Mughal and Rajput Painting*. New York: Cambridge Univ. Press, 1992.

Blurton, T. Richard. *Hindu Art*. Cambridge: Harvard Univ. Press, 1993.

Davies, Philip. *Splendours of the Raj: British Architecture in India, 1660 to 1947*. London: Murray, 1985.

Desai, Vishakha N. *Life at Court: Art for India's Rulers, 16th-19th Centuries*. Boston: Museum of Fine Arts, 1985.

Guy, John, and Deborah Swallow, eds. *Arts of India, 1550-1900*. London: Victoria and Albert Museum, 1990.

Khanna, Balraj, and Aziz Kurtha. *Art of Modern India*. London: Thames and Hudson, 1998.

Losty, Jeremiah P. *The Art of the Book in India*. London: British Library, 1982.

Miller, Barbara Stoller. *Love Song of the Dark Lord: Jayadeva's Gitagovinda*. New York: Columbia Univ. Press, 1977.

Mitchell, George. *The Royal Palaces of India*. London: Thames and Hudson, 1994.

Nou, Jean-Louis. *Taj Mahal*. Text by Amina Okada and M. C. Joshi. New York: Abbeville, 1993.

Pal, Pratapaditya. *Court Paintings of India, 16th-19th Centuries*. New York: Navin Kumar, 1983.

———, et al. *Romance of the Taj Mahal*. Los Angeles: Los Angeles County Museum of Art, 1989.

Tillotson, G. H. R. *Mughal India*. Architectural Guides for Travelers. San Francisco: Chronicle, 1990.

———. *The Rajput Palaces: The Development of an Architectural Style, 1450-1750*. New York: Oxford Univ. Press, 1999.

———. *The Tradition of Indian Architecture: Continuity, Controversy and Change since 1850*. New Haven: Yale Univ. Press, 1989.

Welch, Stuart Cary. *The Emperors' Album: Images of Mughal India*. New York: Metropolitan Museum of Art, 1987.

———. *India: Art and Culture 1300-1900*. New York: Metropolitan Museum of Art, 1985.

CHAPTER 21 Chinese Art after 1280

Andrews, Julia Frances. *Painters and Politics in the People's Republic of China, 1949-1979*. Berkeley: Univ. of California Press, 1994.

Barnhart, Richard M. *Painters of the Great Ming: The Imperial Court and the Zhe School*. Dallas: Dallas Museum of Art, 1993.

——. *Peach Blossom Spring: Gardens and Flowers in Chinese Painting*. New York: Metropolitan Museum of Art, 1983.

——, et al. *The Jade Studio: Masterpieces of Ming and Qing Painting and Calligraphy from the Wong Nan-p'ing Collection*. New Haven: Yale Univ. Art Gallery, 1994.

Beurdeley, Michael. *Chinese Furniture*. Trans. Katherine Watson. Tokyo: Kodansha International, 1979.

Billeter, Jean François. *The Chinese Art of Writing*. New York: Skira/Rizzoli, 1990.

Bush, Susan, and Hsui-yen Shih, eds. *Early Chinese Texts on Painting*. Cambridge: Harvard Univ. Press, 1985.

Cahill, James. *The Compelling Image: Nature and Style in Seventeenth-Century Chinese Painting*. Charles Norton Lectures 1978–79. Cambridge: Harvard Univ. Press, 1982.

——. *The Distant Mountains: Chinese Painting in the Late Ming Dynasty, 1580–1644*. New York: Weatherhill, 1982.

——. *Hills beyond a River: Chinese Painting of the Y'uan Dynasty, 1279–1368*. New York: Weatherhill, 1976.

——. *Parting at the Shore: Chinese Painting of the Early and Middle Ming Dynasty, 1368–1580*. New York: Weatherhill, 1978.

Chan, Charis. *Imperial China*. Architectural Guides for Travelers. San Francisco: Chronicle, 1992.

Clunas, Craig. *Pictures and Visualities in Early Modern China*. Princeton: Princeton Univ. Press, 1997.

Fang, Jing Pei. *Treasures of the Chinese Scholar: Form, Function and Symbolism*. Ed. J. May Lee Barrett. New York. Weatherhill, 1997.

Fong, Wen C., and James C. Y. Watt. *Possessing the Past: Treasures from the National Palace Museum, Taipei*. New York: Metropolitan Museum of Art, 1996.

In Pursuit of the Dragon: Traditions and Transitions in Ming Ceramics: An Exhibition from the Idemitsu Museum of Arts. Seattle: Seattle Art Museum, 1988.

Jenyns, Soame. *Later Chinese Porcelain: The Ch'ing Dynasty, 1644–1912*. 4th ed. London: Faber & Faber, 1971.

Keswick, Maggie. *The Chinese Garden: History, Art and Architecture*. New York: Rizzoli, 1978.

Knapp, Ronald G. *China's Vernacular Architecture: House Form and Culture*. Honolulu: Univ. of Hawaii Press, 1989.

Lee, Sherman, and Wai-Kam Ho. *Chinese Art under the Mongols: The Y'uan Dynasty, 1279–1368*. Cleveland: Cleveland Museum of Art, 1968.

Lim, Lucy. *Contemporary Chinese Painting: An Exhibition from the People's Republic of China*. San Francisco: Chinese Culture Foundation of San Francisco, 1983.

——, ed. *Wu Guanzhong: A Contemporary Chinese Artist*. San Francisco: Chinese Culture Foundation, 1989.

Liu, Laurence G. *Chinese Architecture*. New York: Rizzoli, 1989.

Ng, So Kam. *Brushstrokes: Styles and Techniques of Chinese Painting*. San Francisco: Asian Art Museum of San Francisco, 1993.

Polo, Marco. *The Travels of Marco Polo*. Trans. Teresa Waugh and Maria Bellonci. New York: Facts on File, 1984.

Shih-t'ao. *Returning Home: Tao-chi's Album of Landscapes and Flowers*. Commentary by Wen Fong. New York: Braziller, 1976.

Sullivan, Michael. *Art and Artists of Twentieth-Century China*. Berkeley: Univ. of California Press, 1996.

——. *Symbols of Eternity: The Art of Landscape Painting in China*. Stanford: Stanford Univ. Press, 1979.

Tsu, Frances Ya-sing. *Landscape Design in Chinese Gardens*. New York: McGraw-Hill, 1988.

Vainker, S. J. *Chinese Pottery and Porcelain: From Prehistory to the Present*. London: British Museum, 1991.

Walters, Derek. *Feng Shui: The Chinese Art of Designing a Harmonious Environment*. New York: Simon & Schuster, 1988.

Watson, William. *The Arts of China 900–1620*. Pelican History of Art. New Haven: Yale Univ. Press, 2000.

Weidner, Marsha Smith. *Views from Jade Terrace: Chinese Women Artists, 1300–1912*. Indianapolis, IN: Indianapolis Museum of Art, 1988.

Yu Zhuoyun, comp. *Palaces of the Forbidden City*. Trans. Ng Mau-Sang, Chan Sinwai, and Puwen Lee. New York: Viking, 1984.

CHAPTER 22 Japanese Art after 1392

Addiss, Stephen. *The Art of Zen: Painting and Calligraphy by Japanese Monks, 1600–1925*. New York: Abrams, 1989.

——. *Zenga and Nanga: Paintings by Japanese Monks and Scholars, Selections from the Kurt and Millie Gitter Collection*. New Orleans: New Orleans Museum of Art, 1976.

Baekeland, Frederick, and Robert Moes. *Modern Japanese Ceramics in American Collections*. New York: Japan Society, 1993.

Guth, Christine. *Art of Edo Japan: The Artist and the City 1615-1868*. Perspectives. New York: Abrams, 1996.

Hickman, Money L. *Japan's Golden Age: Momoyama*. New Haven: Yale Univ. Press, 1996.

Hiesinger, Kathryn B., and Felice Fischer. *Japanese Design: A Survey Since 1950*. Philadelphia: Philadelphia Museum of Art, 1994.

Meech-Pekarik, Julia. *The World of the Meiji Print: Impressions of a New Civilization*. New York: Weatherhill, 1986.

Merritt, Helen. *Modern Japanese Woodblock Prints: The Early Years*. Honolulu: Univ. of Hawaii Press, 1990.

——, and Nanako Yamada. *Guide to Modern Japanese Woodblock Prints: 1900–1975*. Honolulu: Univ. of Hawaii Press, 1995.

Michener, James A. *The Floating World*. New York: Random House, 1954.

Munroe, Alexandra. *Japanese Art after 1945: Scream Against the Sky*. New York: Abrams, 1994.

Murase, Miyeko. *Emaki, Narrative Scrolls from Japan*. New York: Asia Society, 1983.

——. *Masterpieces of Japanese Screen Painting: The American Collections*. New York: Braziller, 1990.

——. *Tales of Japan: Scrolls and Prints from the New York Public Library*. Oxford: Oxford Univ. Press, 1986.

Okakura, Kakuzo. *The Book of Tea*. Ed. Everett F. Bleiler. New York: Dover, 1964.

Okyo and the Maruyama-Shijo School of Japanese Painting. Trans. Miyeko Murase and Sarah Thompson. St. Louis: St. Louis Art Museum, 1980.

Seo, Aubrey Yoshiko. *The Art of Twentieth-Century Zen: Paintings and Calligraphy by Japanese Masters*. Boston: Shambala, 1998.

Singer, Robert T., with John T. Carpenter. *Edo, Art in Japan 1615–1868*. Washington, D.C.: National Gallery of Art, 1998.

Takeuchi, Melinda. *Taiga's True Views: The Language of Landscape Painting in Eighteenth-Century Japan*. Stanford: Stanford Univ. Press, 1992.

Thompson, Sarah E., and H. D. Harpptunian. *Undercurrents in the Floating World: Censorship and Japanese Prints*. New York: Asia Society Gallery, 1992.

Till, Barry. *The Arts of Meiji Japan, 1868-1912: Changing Aesthetics*. Victoria, BC: Art Gallery of Victoria, 1995.

CHAPTER 23 Art of the Americas after 1300

Archuleta, Margaret, and Rennard Strickland. *Shared Visions: Native American Painters and Sculptors in the Twentieth Century*. Phoenix: Heard Museum, 1991.

Baquedano, Elizabeth. *Aztec Sculpture*. London: British Museum, 1984.

Berdan, Frances F. *The Aztecs of Central Mexico: An Imperial Society*. New York: Holt, 1982.

Berlo, Janet Catherine, and Ruth B. Phillips. *Native North American Art*. Oxford History of Art. Oxford: Oxford Univ. Pres, 1998.

Bringhurst, Robert. *The Black Canoe: Bill Reid and the Spirit of Haida Gwaii*. Seattle: Univ. of Washington Press, 1991.

Broder, Patricia Janis. *American Indian Painting and Sculpture*. New York: Abbeville, 1981.

——. *Earth Songs, Moon Dreams: Paintings by American Indian Women*. New York: St. Martin's Press, 1999.

Coe, Ralph. *Lost and Found Traditions: Native American Art 1965–1985*. Ed. Irene Gordon. Seattle: Univ. of Washington Press, 1986.

Conn, Richard. *Circles of the World: Traditional Art of the Plains Indians*. Denver: Denver Art Museum, 1982.

Crandall, Richard C. *Inuit Art: A History*. Jefferson, NC: McFarland, 2000.

Dockstader, Frederick J. *The Way of the Loom: New Traditions in Navajo Weaving*. New York: Hudson Hills, 1987.

Feest, Christian F. *Native Arts of North America*. Updated ed. World of Art. New York: Thames and Hudson, 1992.

Haberland, Wolfgang. *Art of North America*. Rev. ed. Art of the World. New York: Greystone, 1968.

Hawthorn, Audrey. *Art of the Kwakiutl Indians and Other Northwest Coast Tribes*. Vancouver: Univ. of British Columbia Press, 1967.

Hemming, John. *Monuments of the Incas*. Boston: Little, Brown, and Co., 1982.

Highwater, Jamake. *The Sweet Grass Lives On: Fifty Contemporary North American Indian Artists*. New York: Lippincott and Crowell, 1980.

Jonaitis, Aldona. *Art of the Northern Tlingit*. Seattle: Univ. of Washington Press, 1986.

——, ed. *Chiefly Feasts: The Enduring Kwakiutl Potlatch*. Seattle: Univ. of Washington Press, 1991.

Kahlenberg, Mary Hunt, and Anthony Berlant. *The Navajo Blanket*. New York: Praeger, 1972.

Levi-Strauss, Claude. *Way of the Masks*. Trans. Sylvia Modelski. Seattle: Univ. of Washington Press, 1982.

MacDonald, George F. *Haida Art*. Seattle: Univ. of Washington Press, 1996.

Maurer, Evan M. *Visions of the People: A Pictorial History of Plains Indian Life*. Minneapolis: Minneapolis Institute of Arts, 1992.

McNair, Peter L., Alan L. Hoover, and Kevin Neary. *Legacy: Tradition and Innovation in Northwest Coast Indian Art*. Vancouver: Douglas and McIntyre, 1984.

Nicholson, H. B., and Eloise Quinones Keber. *Art of Aztec Mexico: Treasures of Tenochtitlan*. Washington, D.C.: National Gallery of Art, 1983.

Parezo, Nancy J. *Navajo Sandpainting: From Religious Act to Commercial Art*. Tucson: Univ. of Arizona Press, 1983

Pasztory, Esther. *Aztec Art*. New York: Abrams, 1983.

Penney, David. *Art of the American Indian Frontier: The Chandler-Pohrt Collection*. Detroit: Detroit Institute of Arts, 1992.

Peterson, Susan. *The Living Tradition of Maria Martinéz*. Tokyo: Kodansha International, 1977.

Smith, Jaune Quick-to-See, and Harmony Hammond. *Women of Sweetgrass: Cedar and Sage*. New York: American Indian Center, 1984.

Stewart, Hilary. *Totem Poles*. Seattle: Univ. of Washington Press, 1990.

Stierlin, Henri. *Art of the Aztecs and Its Origins*. New York: Rizzoli, 1982.

——. *Art of the Incas and Its Origins*. New York: Rizzoli, 1984.

Trimble, Stephen. *Talking with the Clay: The Art of Pueblo Pottery*. Santa Fe: School of American Research Press, 1987.

Wade, Edwin, and Carol Haralson, eds. *The Arts of the North American Indian: Native Traditions in Evolution*. New York: Hudson Hills, 1986.

Walters, Anna Lee. *Spirit of Native America: Beauty and Mysticism in American Indian Art*. San Francisco: Chronicle, 1989.

Wood, Nancy C. *Taos Pueblo*. New York: Knopf, 1989.

CHAPTER 24 Art of Pacific Cultures

Allen, Louis A. *Time before Morning: Art and Myth of the Australian Aborigines*. New York: Crowell, 1975.

Barrow, Terrence. *The Art of Tahiti and the Neighbouring Society, Austral and Cook Islands*. New York: Thames and Hudson, 1979.

——. *An Illustrated Guide to Maori Art*. Honolulu: Univ. of Hawaii Press, 1984.

Buhler, Alfred, Terry Barrow, and Charles P. Montford. *The Art of the South Sea Islands, including Australia and New Zealand*. Art of the World. New York: Crown, 1962.

Caruana, Wally. *Aboriginal Art*. World of Art. New York: Thames and Hudson, 1996.

Craig, Robert D. *Dictionary of Polynesian Mythology*. New York: Greenwood, 1989.

D'Alleva, Anne. *Arts of the Pacific Islands*. Perspectives. New York: Abrams, 1998.

Gell, Alfred. *Wrapping in Images: Tattooing in Polynesia*. Oxford Studies in Social and Cultural Anthropology. New York: Oxford Univ. Press, 1993.

Greub, Suzanne, ed. *Art of Northwest New Guinea: From Geelvink Bay, Humboldt Bay, and Lake Sentani*. New York: Rizzoli, 1992.

Guiart, Jean. *The Arts of the South Pacific*. Trans. Anthony Christie. Arts of Mankind. New York: Golden, 1963.

Hammond, Joyce D. *Tifaifai and Quilts of Polynesia*. Honolulu: Univ. of Hawaii Press, 1986.

Hanson, Allan, and Louise Hanson. *Art and Identity in Oceania*. Honolulu: Univ. of Hawaii Press, 1990.

Heyerdahl, Thor. *The Art of Easter Island*. Garden City, NY: Doubleday, 1975.

Jones, Stella M. *Hawaiian Quilts*. Rev. 2nd ed. Honolulu: Daughters of Hawaii, 1973.

Kaeppler, Adrienne Lois, Christian Kaufmann, and Douglas Newton. *Oceanic Art*. Trans. Nora Scott and Sabine Bouladon. New York: Abrams, 1997.

Layton, Robert. *Australian Rock Art: A New Synthesis*. New York: Cambridge Univ. Press, 1992.

Leonard, Anne, and John Terrell. *Patterns of Paradise: The Style and Significance of Bark Cloth around the World*. Chicago: Field Museum of Natural History, 1980.

Mead, Sydney Moko, ed. *Te Maori: Maori Art from New Zealand Collections*. New York: Abrams, 1984.

Morphy, Howard. *Ancestral Connections: Art and an Aboriginal System of Knowledge*. Chicago: Univ. of Chicago Press, 1991.

People of the River, People of the Trees: Change and Continuity in Sepik and Asmat Art. St. Paul: Minnesota Museum of Art, 1989.

Rabineau, Phyllis. *Feather Arts: Beauty, Wealth, and Spirit from Five Continents*. Chicago: Field Museum of Natural History, 1979.

Scutt, R. W. B., and Christopher Gotch. *Art, Sex, and Symbol: The Mystery of Tattooing*. 2nd ed. New York: Cornell Univ. Press, 1986.

Serra, Eudaldo, and Alberto Folch. *The Art of Papua and New Guinea*. New York: Rizzoli, 1977.

Sutton, Peter, ed. *Dreamings, the Art of Aboriginal Australia*. New York: Braziller, 1988.

Thomas, Nicholas. *Oceanic Art*. World of Art. New York: Thames and Hudson, 1995.

Wardwell, Allen. *Island Ancestors: Oceania Art from the Masco Collection*. Seattle: Univ. of Washington Press, 1994.

CHAPTER 25 Art of Africa in the Modern Era

Abiodun, Rowland, Henry J. Drewal, and John Pemberton III, eds. *The Yoruba Artist: New Theoretical Perspectives on African Arts*. Washington, D.C.: Smithsonian Institution, 1994.

Adler, Peter, and Nicholas Barnard. *African Majesty: The Textile Art of the Ashanti and Ewe*. New York: Thames and Hudson, 1992.

Astonishment and Power. Washington, D.C.: National Museum of African Art, Smithsonian Institution, 1993.

Bacquart, Jean-Baptiste. *The Tribal Arts of Africa*. New York: Thames and Hudson, 1998.

Barley, Nigel. *Foreheads of the Dead: An Anthropological View of Kalabari Ancestral Screens*. Washington, D.C.: National Museum of African Art, Smithsonian Institution, 1988.

——. *Smashing Pots: Feats of Clay from Africa*. London: British Museum, 1994.

Biebuyck, Daniel P. *Lega Culture: Art, Initiation, and Moral Philosophy among a Central African People*. Berkeley: Univ. of California Press, 1973.

Brincard, Marie-Therese, ed. *The Art of Metal in Africa*. Trans. Evelyn Fischel. New York: African-American Institute, 1984.

Cole, Herbert M., ed. *I Am Not Myself: The Art of African Masquerade*. Los Angeles: Fowler Museum of Cultural History, Univ. of California, 1985.

——. Icons: *Ideals and Power in the Art of Africa*. Washington, D.C.: National Museum of African Art, Smithsonian Institution, 1989.
. *Mbari, Art and Life among the Owerri Igbo*. Bloomington: Indiana Univ. Press, 1982.

Drewal, Henry John. *African Artistry: Technique and Aesthetics in Yoruba Sculpture*. Atlanta: High Museum of Art, 1980.

——, and Margaret Thompson Drewal. *Gelede: Art and Female Power among the Yoruba*. Bloomington: Indiana Univ. Press, 1983.

Fagg, William Buller, and John Pemberton III. *Yoruba Sculpture of West Africa*. Ed. Bryce Holcombe. New York: Knopf, 1982.

Gilfoy, Peggy S. *Patterns of Life: West African Strip-Weaving Traditions*. Washington, D.C.: National Museum of African Art, Smithsonian Institution, 1992.

Glaze, Anita. *Art and Death in a Senufo Village*. Bloomington: Indiana Univ. Press, 1981.

Heathcote, David. *The Arts of the Hausa*. Chicago: Univ. of Chicago Press, 1976.

Kasfir, Sidney Littlefield. *Contemporary African Art*. World of Art. London: Thames and Hudson, 2000.

Kennedy, Jean. *New Currents, Ancient Rivers: Contemporary Artists in a Generation of Change*. Washington, D.C.: Smithsonian Institution, 1992.

Laude, Jean. *African Art of the Dogon: The Myths of the Cliff Dwellers*. Trans. Joachim Neugroschell. New York: Brooklyn Museum, 1973.

Martin, Phyllis, and Patrick O'Meara, eds. *Africa*. 3rd ed. Bloomington: Indiana Univ. Press, 1995.

McEvilley, Thomas. *Fusion: West African Artists at the Venice Biennale*. New York: Museum for African Art, 1993.

McNaughton, Patrick R. *The Mande Blacksmiths: Knowledge, Power and Art in West Africa*. Bloomington: Indiana Univ. Press, 1988.

Neyt, François. *Luba: To the Sources of the Zaire*. Trans. Murray Wyllie. Paris: Editions Dapper, 1994.

Perrois, Louis, and Marta Sierra Delage. *The Art of Equatorial Guinea: The Fang Tribes*. New York: Rizzoli, 1990.

Picon, John, and John Mack. *African Textiles*. New York: Harper & Row, 1989.

Roy, Christopher D. *Art of the Upper Volta Rivers*. Meudon, France: Chaffin, 1987.

Schildkrout, Enid, and Curtis A. Keim. *African Reflections: Art from Northeastern Zaire*. Seattle: Univ. of Washington Press, 1990.

Sieber, Roy. *African Furniture and Household Objects*. Bloomington: Indiana Univ. Press, 1980.

——. *African Textiles and Decorative Arts*. New York: Museum of Modern Art, 1972.

——, and Roslyn Adele Walker. *African Art in the Cycle of Life*. Washington, D.C.: National Museum of African Art, Smithsonian Institution, 1987.

Thompson, Robert Farris, and Joseph Cornet. *The Four Moments of the Sun: Kongo Art in Two Worlds*. Washington, D.C.: National Gallery of Art, 1981.

Vogel, Susan. *Africa Explores: 20th Century African Art*. New York: Center for African Art, 1991.

CHAPTER 26 Eighteenth-Century Art in Europe and North America

(see the bibliography for Chapter 19 for additional information on Rococo art)

Age of Neoclassicism. London: Arts Council of Great Britain, 1972.

Boime, Albert. *Art in an Age of Revolution, 1750–1800*. Chicago: Univ. of Chicago Press, 1987.

Braham, Allan. *The Architecture of the French Enlightenment*. Berkeley: Univ. of California Press, 1980.

Clark, Kenneth. *The Romantic Rebellion: Romantic versus Classic Art*. New York: Harper & Row, 1973.

Crow, Thomas E. *Painters and Public Life in Eighteenth-Century Paris*. New Haven: Yale Univ. Press, 1985.

Denvir, Bernard. *The Eighteenth Century: Art, Design, and Society, 1689–1789*. London: Longman. 1983.

Fried, Michael. *Absorption and Theatricality: Painting and Beholder in the Age of Diderot*. Berkeley: Univ. of California Press, 1980.

Honour, Hugh. *Neo-Classicism*. Harmondsworth, Eng.: Penguin, 1968.

Kalnein, Wend von. *Architecture in France in the Eighteenth Century*. Trans. David Britt. Pelican History of Art. New Haven: Yale Univ. Press, 1990.

Levey, Michael. *Painting and Sculpture in France, 1700–1789*. Pelican History of Art. New Haven: Yale Univ. Press, 1993.

Montgomery, Charles F., and Patricia E. Kane, eds. *American Art, 1750–1800: Towards Independence*. Boston: New York Graphics Society, 1976.

Rosenblum, Robert. *Transformations in Late Eighteenth-Century Art*. Princeton, NJ: Princeton Univ. Press, 1967.

Summerson, John. *Architecture of the Eighteenth Century*. World of Art. New York: Thames and Hudson, 1986.

CHAPTER 27 Nineteenth-Century Art in Europe and North America

Adams, Steven. *The Barbizon School and the Origins of Impressionism*. London: Phaidon, 1994.

Art of the July Monarchy: France, 1830 to 1848. Columbia: Univ. of Missouri Press, 1989.

Barger, M. Susan, and William B. White. *The Daguerreotype: Nineteenth-Century Technology and Modern Science*. Washington, D.C.: Smithsonian Institution, 1991.

Baudelaire, Charles. *The Painter of Modern Life, and Other Essays*. 2nd ed. Trans. and ed. Jonathan Mayne. London: Phaidon, 1995.

Berger, Klaus. *Japonisme in Western Painting from Whistler to Matisse*. Trans. David Britt. Cambridge Studies in the History of Art. Cambridge: Cambridge Univ. Press, 1992.

Boime, Albert. *Art in an Age of Bonapartism, 1800–1815*. Chicago: Univ. of Chicago Press, 1990.

Brion, Marcel. *Art of the Romantic Era: Romanticism, Classicism, Realism*. World of Art. New York: Praeger, 1966.

Clark, T. J. *The Absolute Bourgeois: Artists and Politics in France, 1848–1851*. Berkeley: Univ. of California Press, 1999.

——. *Image of the People: Gustave Courbet and the 1848 Revolution*. Berkeley: Univ. of California Press, 1999.

——. *The Painting of Modern Life: Paris in the Art of Manet and His Followers*. Rev. ed. Princeton, NJ: Princeton Univ. Press, 1999.

Cooper, Wendy A. *Classical Taste in America 1800–1840*. Baltimore: Baltimore Museum of Art, 1993.

Cumming, Elizabeth, and Wendy Caplan. *Arts and Crafts Movement*. World of Art. New York: Thames and Hudson, 1991.

Denis, Rafael Cardoso, and Colin Trodd. *Art and the Academy in the Nineteenth Century*. New Brunswick, NJ: Rutgers Univ. Press, 2000.

Denvir, Bernard. *Post-Impressionism*. World of Art. New York: Thames and Hudson, 1992.

——. *The Thames and Hudson Encyclopedia of Impressionism*. World of Art. New York: Thames and Hudson, 1990.

Duncan, Alastair. *Art Nouveau*. World of Art. New York: Thames and Hudson, 1994.

Eisenman, Stephen. *Nineteenth Century Art: A Critical History*. London: Thames and Hudson, 1994.

Eitner, Lorenz. *An Outline of Nineteenth Century European Painting: From David to Cezanne*. 2 vols. New York: Harper & Row, 1987.

Gerdts, William H. *American Impressionism*. New York: Abbeville, 1984.

Goldwater, Robert John. *Symbolism*. Icon Editions. New York: Harper & Row, 1979.

Hemingway, Andrew, and William Vaughan. *Art in Bourgeois Society, 1790–1850*. Cambridge: Cambridge Univ. Press, 1998.

Herbert, Robert L. *Impressionism: Art, Leisure, and Parisian Society*. New Haven: Yale Univ. Press, 1988.

Hilton, Timothy. *Pre-Raphaelites*. World of Art. London: Thames and Hudson, 1970.

Holt, Elizabeth Gilmore, ed. *The Expanding World of Art, 1874–1902*. New Haven: Yale Univ. Press, 1988.

Honour, Hugh. *Romanticism*. London: Allen Lane, 1979.

Needham, Gerald. *19th-Century Realist Art*. New York: Harper & Row, 1988.

Nochlin, Linda. *Impressionism and Post-Impressionism, 1874–1904*: Sources and Documents. Upper Saddle River, NJ: Prentice Hall, 1966.

——. *Realism and Tradition in Art, 1848–1900: Sources and Documents*. Upper Saddle River, NJ: Prentice Hall, 1966.

Novotny, Fritz. *Painting and Sculpture in Europe, 1780–1880*. 2nd ed. Pelican History of Art. New Haven: Yale Univ. Press, 1995.

Pool, Phoebe. *Impressionism*. World of Art. New York: Praeger, 1967.

Post-Impressionism: Cross-currents in European and American Painting, 1880–1906. Washington, D.C.: National Gallery of Art, 1980.

Rewald, John. *The History of Impressionism*. 4th rev. ed. New York: Museum of Modern Art, 1973.

——. *Post-impressionism: From Van Gogh to Gauguin*. 3rd ed. New York: Museum of Modern Art, 1978.

Rosenblum, Robert, and H.W. Janson. *19th Century Art*. New York: Abrams, 1984.

Stansky, Peter. *Redesigning the World: William Morris, the 1880s, and the Arts and Crafts*. Princeton: Princeton Univ. Press, 1985.

Sutter, Jean, ed. *The Neo-Impressionists*. Greenwich, CT: New York Graphic Society, 1970.

Triumph of Realism. Brooklyn: Brooklyn Museum, 1967.

Vaughan, William, and Francoise Cachin. *Arts of the 19th Century*. 2 vols. New York: Abrams, 1998.

Vaughan, William. *Romanticism and Art*. World of Art. New York: Thames and Hudson, 1994.

Weisberg, Gabriel P. *The European Realist Tradition*. Bloomington: Indiana Univ. Press, 1982.

CHAPTER 28 The Rise of Modernism in Europe and America

Ades, Dawn. *Photomontage*. Rev ed. World of Art. New York: Thames and Hudson, 1986.

Art into Life: Russian Constructivism, 1914–32. New York: Rizzoli, 1990.

Baigell, Matthew. *The American Scene: American Painting of the 1930's*. New York: Praeger, 1974.

Banham, Reyner. *Theory and Design in the First Machine Age*. 2nd ed. Cambridge: MIT Press, 1980.

Barr, Alfred H., Jr. *Cubism and Abstract Art. Painting, Sculpture, Constructions, Photography, Architecture, Industrial Arts, Theatre, Films, Posters, Typography*. Cambridge, MA: Belknap, 1986.

Barron, Stephanie, ed. *Degenerate Art: The Fate of the Avant-Garde in Nazi Germany*. Los Angeles: Los Angeles County Museum of Art, 1991.

Bayer, Herbert, Walter Gropius, and Ise Gropius. *Bauhaus, 1919–1928*. New York: Museum of Modern Art, 1975.

Brown, Milton. *Story of the Armory Show: The 1913 Exhibition That Changed American Art*. 2nd ed. New York: Abbeville, 1988.

Corn, Wanda. *The Great American Thing: Modern Art and National Identity, 1915-1935*. Berkeley: Univ. of California Press, 1999.

Curtis, James. *Mind's Eye, Mind's Truth: FSA Photography Reconsidered*. Philadelphia: Temple Univ. Press, 1989.

Curtis, Penelope. *Sculpture 1900-1945: After Rodin*. Oxford History of Art. Oxford: Oxford Univ. Press, 1999.

Dachy, Marc. *The Dada Movement, 1915–1923*. New York: Skira/Rizzoli, 1990.

Davidson, Abraham A. *Early American Modernist Painting, 1910–1935*. New York: Harper & Row, 1981.

Dube, Wolf-Dieter. *Expressionists*. Trans. Mary Whittall. World of Art. New York: Thames and Hudson, 1998.

Freeman, Judi. *The Fauve Landscape*. Los Angeles: Los Angeles County Museum of Art, 1990.

Fry, Edward. *Cubism*. New York: McGraw-Hill, 1966.

Golding, John. *Cubism: A History and an Analysis, 1907–1914*. Cambridge, MA: Belknap, 1988.

Gordon, Donald E. *Expressionism: Art and Idea*. New Haven: Yale Univ. Press, 1987.

Gray, Camilla. *Russian Experiment in Art, 1863–1922*. New York: Abrams, 1970.

Green, Christopher. *Art in France: 1900-1940*. Pelican History of Art. New Haven: Yale Univ. Press, 2000.

Haiko, Peter, ed. *Architecture of the Early XX Century*. Trans. Gordon Clough. New York: Rizzoli, 1989.

Harrison, Charles, Francis Frascina, and Gill Perry. *Primitivism, Cubism, Abstraction: The Early Twentieth Century*. New Haven: Yale Univ. Press, 1993.

Haskell, Barbara. *The American Century: Art & Culture, 1900–1950.* New York: Whitney Museum of American Art, 1999.

Herbert, James D. *Fauve Painting: The Making of Cultural Politics.* New Haven: Yale Univ. Press, 1992.

Hulten, Pontus. *Futurism and Futurisms.* New York: Abbeville, 1986.

Jaffe, Hans L. C. *De Stijl, 1917–1931: The Dutch Contribution to Modern Art.* Cambridge, MA: Belknap, 1986.

Lane, John R., and Susan C. Larsen. *Abstract Painting and Sculpture in America 1927–1944.* Pittsburgh: Museum of Art, Carnegie Institute, 1984.

Lloyd, Jill. *German Expressionism: Primitivism and Modernity.* New Haven: Yale Univ. Press, 1991.

Overy, Paul. *De Stijl.* World of Art. New York: Thames and Hudson, 1991.

Picon, Gaetan. *Surrealists and Surrealism, 1919–1939.* Trans. James Emmons. New York: Rizzoli, 1977.

Rickey, George. *Constructivism: Origins and Evolution.* Rev. ed. New York: G. Braziller, 1995.

Rosenblum, Robert. *Cubism and Twentieth-Century Art.* Rev. ed. New York: Abrams, 1984.

Spate, Virginia. *Orphism: The Evolution of Non-Figurative Painting in Paris, 1910–1914.* Oxford Studies in the History of Art and Architecture. Oxford: Clarendon, 1979.

Stich, Sidra. *Anxious Visions: Surrealist Art.* New York: Abbeville, 1990.

Tisdall, Caroline, and Angelo Bozzolla. *Futurism.* World of Art. New York: Oxford Univ. Press, 1978.

Weiss, Jeffrey S. *The Popular Culture of Modern Art: Picasso, Duchamp, and Avant-Gardism.* New Haven: Yale Univ. Press, 1994.

Whitfield, Sarah. *Fauvism.* World of Art. New York: Thames and Hudson, 1996.

Whitford, Frank. *Bauhaus.* World of Art. London: Thames and Hudson, 1984.

Zurier, Rebecca, Robert W. Snyder, and Virginia M. Mecklenburg. *Metropolitan Lives: The Ashcan Artists and Their New York.* Washington, D.C.: National Museum of American Art, 1995.

CHAPTER 29 The International Avant-Garde since 1945

Alberro, Alexander, and Blake Stimson, eds. *Conceptual Art: A Critical Anthology.* Cambridge: MIT Press, 1999.

Andersen, Wayne. *American Sculpture in Process, 1930–1970.* Boston: New York Graphic Society, 1975.

Anfam, David. *Abstract Expressionism.* World of Art. New York: Thames and Hudson, 1996.

Archer, Michael. *Art Since 1960.* World of Art. London: Thames and Hudson, 1997.

Ashton, Dore. *American Art since 1945.* New York: Oxford Univ. Press, 1982.

———. *The New York School: A Cultural Reckoning.* Harmondsworth, Eng.: Penguin, 1979.

Atkins, Robert. *Artspeak: A Guide to Contemporary Ideas, Movements, and Buzzwords.* 2nd ed. New York: Abbeville, 1997.

Baker, Kenneth. *Minimalism: Art of Circumstance.* New York: Abbeville, 1988.

Battcock, Gregory. *Idea Art: A Critical Anthology.* New York: Dutton, 1973.

———. *Minimal Art: A Critical Anthology.* Berkeley: Univ. of California Press, 1995.

———, and Robert Nickas. *The Art of Performance: A Critical Anthology.* New York: Dutton, 1984.

Beardsley, John. *Earthworks and Beyond: Contemporary Art in the Landscape.* 3rd ed. New York: Abbeville, 1998.

Blake, Peter. *No Place Like Utopia: Modern Architecture and the Company We Kept.* New York: Knopf, 1993.

Bolton, Richard, ed. *Culture Wars: Documents from the Recent Controversies in the Arts.* New York: New, 1992.

Broude, Norma, and Mary D. Garrard. *The Power of Feminist Art: The American Movement of the 1970s, History and Impact.* New York: Abrams, 1994.

Castleman, Riva, ed. *Art of the Forties.* New York: Museum of Modern Art, 1991.

Chase, Linda. *Hyperrealism.* New York: Rizzoli, 1975.

Causey, Andrew. *Sculpture since 1945.* Oxford History of Art. Oxford: Oxford Univ. Press, 1998.

Collins, Michael, and Andreas Papadakis. *Post-Modern Design.* New York: Rizzoli, 1989.

Crow, Thomas. *The Rise of the Sixties: American and European Art in the Era of Dissent.* Perspectives. New York: Abrams, 1996.

De Oliveira, Nicolas, Nicola Oxley, and Michael Petry. *Installation Art.* Washington, D.C.: Smithsonian Institution Press, 1994.

Dormer, Peter. *Design since 1945.* World of Art. New York: Thames and Hudson, 1993.

Endgame: Reference and Simulation in Recent Painting and Sculpture. Boston: Institute of Contemporary Art, 1986.

Ferguson, Russell, ed. *Discourses: Conversations in Postmodern Art and Culture.* Documentary Sources in Contemporary Art. Cambridge: MIT Press, 1990.

———. *Out There: Marginalization and Contemporary Cultures.* Documentary Sources in Contemporary Art; 4. New York: New Museum of Contemporary Art, 1990.

Fineberg, Jonathan David. *Art Since 1940: Stategies of Being.* 2nd ed. New York: Abrams, 2000.

Ghirardo, Diane. *Architecture after Modernism.* World of Art. New York: Thames and Hudson, 1996.

Godfrey, Tony. *Conceptual Art.* Art & Ideas. London: Phaidon, 1998.

Goldberg, RoseLee. *Performance: Live Art Since 1960.* New York: Abrams, 1998.

Green, Jonathan. *American Photography: A Critical History since 1945 to the Present.* New York: Abrams, 1984.

Grundberg, Andy. *Photography and Art: Interactions since 1945.* New York: Abbeville, 1987.

Hays, K. Michael, and Carol Burns, eds. *Thinking the Present: Recent American Architecture.* New York: Princeton Architectural, 1990.

Henri, Adrian. *Total Art: Environments, Happenings, and Performance.* World of Art. New York: Oxford Univ. Press, 1974.

Hertz, Richard. *Theories of Contemporary Art.* 2nd ed. Upper Saddle River, NJ: Prentice Hall, 1993.

Hobbs, Robert Carleton, and Gail Levin. *Abstract Expressionism: The Formative Years.* Ithaca: Cornell Univ. Press, 1981

Hoffman, Katherine. *Explorations: The Visual Arts since 1945.* New York: HarperCollins, 1991.

Jencks, Charles. *Architecture Today.* 2nd ed. London: Academy, 1993.

———. *The New Moderns from Late to Neo-Modernism.* New York: Rizzoli, 1990.

———. *What Is Post-Modernism?* 4th rev., enl. ed. London: Academy Editions, 1996.

Joachimedes, Christos M., Norman Rosenthal, and Nicholas Serota, eds. *New Spirit in Painting.* London: Royal Academy of Arts, 1981.

Johnson, Ellen H., ed. *American Artists on Art from 1940 to 1980.* New York: Harper & Row, 1982.

Kaprow, Allan. *Assemblage, Environments & Happenings.* New York: Abrams, 1965.

Kingsley, April. *The Turning Point: The Abstract Expressionists and the Transformation of American Art.* New York: Simon & Schuster, 1992.

Kramer, Hilton. *The Age of the Avant-Garde: An Art Chronicle of 1956–1972.* New York: Farrar, Straus & Giroux, 1973.

Land and Environment Art. Ed. Jeffrey Kastner. Survey Brian Wallis. Themes and Movements. London: Phaidon Press, 1998.

Lippard, Lucy. *Pop Art.* World of Art. New York: Praeger, 1966.

Livingstone, Marco. *Pop Art: A Continuing History.* New York: Abrams, 1990.

Lucie-Smith, Edward. *Art in the Eighties.* Oxford: Phaidon, 1990.

———. *Art in the Seventies.* Ithaca: Cornell Univ. Press, 1980.

———. *Artoday.* London: Phaidon, 1995.

———. *Movements in Art since 1945: Issues and Concepts.* 3rd rev. & exp. ed. World of Art. London: Thames and Hudson, 1995.

———. *Sculpture since 1945.* Oxford: Phaidon, 1987.

———. *Super Realism.* Oxford: Phaidon, 1979.

Manhart, Marcia, and Tom Manhart, eds. *The Eloquent Object: The Evolution of American Art in Craft Media since 1945.* Tulsa: Philbrook Museum of Art, 1987.

Meisel, Louis K. *Photo-Realism.* New York: Abrams, 1989.

Meyer, James, ed. *Minimalism.* Themes and Movements. London: Phaidon, 2000. Phillips, Lisa. *The American Century: Art and Culture, 1950-2000.* New York: Whitney Museum of American Art, 1999.

Polcari, Stephen. *Abstract Expressionism and the Modern Experience.* Cambridge: Cambridge Univ. Press, 1991.

Risatti, Howard, ed. *Postmodern Perspectives: Issues in Contemporary Art.* 2nd ed. Upper Saddle River, NJ: Prentice Hall , 1998.

Rosen, Randy, and Catherine C. Brawer, comps. *Making Their Mark: Women Artists Move into the Mainstream, 1970–85.* New York: Abbeville, 1989.

Rush, Michael. *New Media in Late 20th-Century Art.* World of Art. London: Thames and Hudson, 1999.

Russell, John. *Pop Art Redefined.* New York: Praeger, 1969.

Sandler, Irving. *American Art of the 1960's.* New York: Harper & Row, 1988.

———. *Art of the Postmodern Era: From the Late 1960s to the Early 1990s.* New York: Icon Editions, 1996.

———. *The New York School: The Painters and Sculptors of the Fifties.* New York: Harper & Row, 1978.

———. *The Triumph of American Painting: A History of Abstract Expressionism.* New York: Harper & Row, 1976.

Sayre, Henry M. *The Object of Performance: The American Avant-Garde since 1970.* Chicago: Univ. of Chicago Press, 1989.

Shapiro, David, and Cecile Shapiro. *Abstract Expressionism: A Critical Record.* New York: Cambridge Univ. Press, 1990.

Shohat, Ella. *Talking Visions: Multicultural Feminism in a Transnational Age.* Documentary Sources in Contemporary Art; 5. New York: New Museum of Contemporary Art, 1998.

Skilled Work: American Craft in the Renwick Gallery, National Museum of American Art, Smithsonian Institution. Washington, D.C.: Smithsonian Institution Press, 1998.

Smith, Paul J., and Edward Lucie-Smith. *Craft Today: Poetry of the Physical.* New York: American Craft Museum, 1986.

Stich, Sidra. *Made in USA: An Americanization in Modern Art, the '50s & '60s.* Berkeley: Univ. of California Press, 1987.

Taylor, Brandon. *Avant-Garde and After: Rethinking Art Now.* Perspectives. New York: Abrams, 1995.

Taylor, Paul, ed. *Post-Pop Art.* Cambridge: MIT Press, 1989.

Waldman, Diane. *Collage, Assemblage, and the Found Object.* New York: Abrams, 1992.

———. *Transformations in Sculpture: Four Decades of American and European Art.* New York: Solomon R. Guggenheim Foundation, 1985.

Wallis, Brian, ed. *Art after Modernism: Rethinking Representation.* Documentary Sources in Contemporary Art; 1. New York: New Museum of Contemporary Art, 1984.

———. *Blasted Allegories: An Anthology of Writings by Contemporary Artists.* Documentary Sources in Contemporary Art; 2. New York: New Museum of Contemporary Art, 1987.

Wheeler, Daniel. *Art since Mid-Century: 1945 to the Present.* Upper Saddle River, NJ: Prentice Hall, 1991.

Wood, Paul. *Modernism in Dispute: Art Since the Forties.* New Haven: Yale Univ. Press, 1993.

Word as Image: American Art, 1960–1990. Milwaukee: Milwaukee Art Museum, 1990.

Zolberg, Vera L., and Joni Maya Cherbo, eds. *Outsider Art: Contesting Boundaries in Contemporary Culture.* Cambridge Cultural Social Studies. Cambridge: Cambridge Univ. Press, 1997.

Index

Illustration references are in *italic* type.

A

Aachen (Aix-la-Chapelle), Germany, 496–97; Palace Chapel of Charlemagne, 497–98, *497*, *498*
abacus, 163, 164, 378
Abakanowicz, Magdalena, 1173; *Backs*, 1173, *1173*
Abbasid caliphate, 345, 347–48, 353
Abbess Hitda and Saint Walpurga, presentation page, *Hitda Gospels*, manuscript, Ottonian, 512, *512*, 549
Abd ar-Rahman I, 347–48
Abd ar-Rahman III, 349
Abduction of Persephone, wall painting, Vergina, Macedonia, Greece, 170, *206*, 207
Abelam people, 903–4
Abonnema village, Nigeria, ancestor screen (*duen fobara*), Ijo culture, 930, *931*
Aborigines (Australian), 901, 911–12
Abraham, 72, 291, 300, 345
Abraham, Sarah, and the Three Strangers, *Psalter of Saint Louis*, 577, 582, *582*
absolute dating, 54, 131
Abstract Expressionism, 854, 1109, 1130–37, 1167; second generation, 1137; successors to, 1137–53
abstraction, 25, 29; African, 920; American, 1130; Byzantine, 314; Egyptian, pre-Dynastic, 95; Indian, 384; Islamic, 344; late Roman, 279–80; Medieval, 505; modernist, 1061, 1113–15; Neolithic art, 46–47; Post-Impressionist, 1030; Scandinavian, 488
Abu Bakr, 344, 349
Abul Hasan and Manohar, *Jahangir-nama*, manuscript, *Jahangir in Darbar* page, 830, *831*
Abu Simbel, Egypt, 117, 119
Temple of Rameses II, 116, *118*, 119; and Temple of Nefertari, 116, *118*, 119
Academicians of the Royal Academy (Johann Zoffany), *950*
academic tradition, 944, 1007–9
Académie des Beaux-Arts, 944, 1007
academies, 778, 944; women in, 949–50, 969
Academy of Saint Luke, 949
acanthus leaves motif, 164, 200, 211
Achaemenid Persians, 69, 89; art, 364
Achilles, 158, 175
Achilles Painter, 198; style of, *Woman and Maid*, vase, 198, *198*
acropolis, 185
Acropolis, Athens, Greece, 37, 155, 170–71, *170*, *171*, 185, *186*, 187–96, 211
Erechtheion, 187, 193–94, *193*; Porch of the Maidens, 193–94, *194*, 265
Parthenon, 85, 163, 187–93, *188*, *191*, 267; drawing by William Pars, 187, 189, *189*; friezes, 188, 190, 191–93, *191*, *192*, 243; pediment (Elgin Marbles), 85, 190, *190–91*
Temple of Athena Nike, 194–96, *194*, *195*, 203, 218
Actaeon, 184
action painting, 1131–34
A.D. (artist), 175
Adam, Robert, 956–57; Syon House, Middlesex, England, *956*, 957, 973
Adam and Eve (Albrecht Dürer), 717–18, *717*, 806
Adam and *Eve* panels, *Ghent Altarpiece* (Jan van Eyck), 631, 670–71, *670*
Adams County, Ohio, Great Serpent Mound, *466*, 467
Adena culture (North America), 466
Ad Hoc Committee of Women Artists, 1162
Adler, Dankmar, 1054
Adler and Sullivan, 1086

Admonitions of the Imperial Instructress to Court Ladies, scroll (Gu Kaizhi, attributed to), 412, *412*
adobe, 464, 480
Adoration of the Magi, altarpiece (Gentile da Fabriano), 667, *667*
Adoration of the Magi (in Christian art), 306
Adoration of the Shepherds (in Christian art), 306
"A.D." Painter, *Women at a Fountain House*, vase, 175, *175*, 186
adyton, 163, 165
aedicula, 667, 725, *725*
Aegean art, 129–51
Aegean civilization, 130 (map)
Aegina, Greece, Temple of Aphaia, pediment, 167–68, *167*, 187, 213
Aelst, Pieter van, shop of, *Miraculous Draft of Fishes*, Vatican Palace, Rome, Italy, after Raphael's Sistine tapestries, 693, *693*, 696
Aeneas, 144, 158, 242
Aeneid, 233
aerial perspective, 617
Aeroplane over Train (Natalia Goncharova), 1081, *1081*
Aeschylus, 211
Aesculapius, 158
Aesop, 161
aesthetics, 655
aesthetic sense, 48
Africa
ancient, 471–82, 472 (map)
art: contemporary, 931–34; influence on African American art, 1112–13; influence on Western art, 1074, 1101; traditional, 915–35
artists, 477
civilizations of, 917
colonialism in, 916–17, 932
modern, 916–19, 916 (map)
postcolonial, 1126
African American artists, 1112–13
Agamemnon, 144, 145, 158, 232
Agnolo. *See* Baccio d'Agnolo
Agony in the Garden (in Christian art), 306–7
agora, 185
Agora, Athens, Greece, 185–87, *185*, 198, 199
Agra, India, Taj Mahal, *824–25*, 825, 832–33, *833*
agriculture: Americas, 451; China, 402; Japan, 430; Neolithic, 53
Ah Hasaw, 458
Ain Ghazal, Jordan, 69–70, *69*; figure, 69–70, *69*
aisle, 296; Islamic, 346
Ajanta, Maharashtra, India, Cave I, 386–87, *387*, 397
Ajax, 158, 175
Ajitto (Back) (Robert Mapplethorpe), 1174, *1174*
Akbar, Indian ruler, 830
Akhenaten (Amenhotep IV), 117–22
Akhenaten and His Family, relief sculpture, Egyptian, 120, *120*
Akhetaten, Egypt (modern Tell el-Amarna, Egypt), 120
Akiode (Yoruba artist), 920; (?) twin figures (*ere ibeji*), 919, 920, *920*, 931
Akkad, *Stela of Naramsin*, 77, *77*, 85, 97
Akkad, Akkadians, 69, 76–77
Akrotiri, Thera, Greek island, 140–41; House Xeste 3, 140–41, *140*; *Landscape*, wall painting, 141, *141*; West House, *128*, 129, 140
al-, *names in*. *See next element of name*
Albani, Cardinal Allesandro, 952
Albarello, jar, Faenza, Italy, 665–66, *665*
Albers, Anni, 1098; wall hanging, 1098, *1098*
Albers, Joseph, 1097, 1098
Alberti, Leon Battista, 651, 655, 656, 661, 675–76, 701, 741; art theory of, 655; *De Pictura (On Painting)*, 621; Rucellai palace,

Florence, Italy, 655, *655*; Sant'Andrea church, Mantua, Italy, 656, *656*, *657*, 727, 737
album, 844
album leaves, 842, 844
Alcuin of York, 500
Alexander VI, Pope, 687
Alexander VII, Pope, 760
Alexander Severus, Emperor, 279
Alexander the Great, 90, 126, 155–56, 177, 198, 205–7, 210, 383
Alexander the Great, coin, Thrace, 206–7, *206*
Alexander the Great, statue (Lysippos), copy after, 205–6, *205*
Alexander the Great Confronts Darius III at the Battle of Issos (Philoxenos, possibly, or Helen of Egypt), 207–8, *207*, 209, 268
Alexandria, Egypt, 155, 156, 210, 292; lighthouse at, 104
Alfeld-an-der-Leine, Germany, Fagus Factory, 1088, *1089*, 1096, 1099, 1154
Alfonso X "the Wise," of Castile, 589, 590
Alfonso the Wise, page, *Cantigas de Santa Maria*, manuscript, Spanish Gothic, 590, *590*
Alhambra, Granada, Spain, Palace of the Lions, 352, 354–55, *354*, *355*
Ali, 344–45, 349
alignments (of menhirs), 57–58
Alkyoneos, 214
all'antica, 665
Allegories of the Five Senses, painting series (Jan Brueghel and Peter Paul Rubens), *Sight* from, 800, 801, *801*
allegory, 772
Allegory of Good Government in the City and *Allegory of Good Government in the Country*, frescoes (Ambrogio Lorenzetti), 606–7, *606–7*
Allegory of Peace, Ara Pacis, Rome, Italy, 244, *244*
Alloway, Lawrence, 1143
Alma-Tadema, Sir Lawrence, 37; *Pheidias and the Frieze of the Parthenon, Athens*, 37, *37*
alphabet, 155
Altamira, Spain, cave, 50–51
paintings, 48, 50, 52, 54; *Bison*, 50–51, *50*
altar, 297; Christian, 628, *628*
Altar of Zeus, Pergamon, Asia Minor (modern Turkey), 214–15, *214*, 237; frieze sculpture, 214, *214*
altarpiece, 507, 590, 628, *628*; Gothic, 590–92, 601
Altarpiece of Saint Vincent (Nuño Gonçalvez), panel, *Saint Vincent with the Portuguese Royal Family*, 646, *646*
Altarpiece of the Holy Blood (Tilman Riemenschneider), *Last Supper*, center piece, 712, *712*
Altar to Amitabha Buddha, China, Sui dynasty, 414–15, *414*, 416
Altdorfer, Albrecht, 721; *Danube Landscape*, 721, *722*, 744
Altes Museum, Berlin, Germany (Karl Friedrich Schinkel), 1000–1001, *1001*
Altneuschul, Prague, Bohemia (Czech Republic), 592–93, *593*
Alvarez Bravo, Manuel, 1119
amalaka, 381, 388
Amaravati School, 384–86
Amarna period (Egypt), 117–22
Amasis Painter, 172–75; *Dionysos with Maenads*, vase, 172–74, *173*
Amazon frieze, panel, Mausoleum, Halikarnassos (modern Bodrum, Turkey), 202, *202*
Amazons, 190
ambulatory, 300, 497, 519, *568*
Amenemhat I, 110, 112
Amenhotep III, 114, 120
Amenhotep IV. *See* Akhenaten

American art. *See* United States art
American Artists Congress, 1113
American Civil War, 981, 1046–47
American colonial art, 820–21, 973–76
American Gothic (Grant Wood), 1110, *1110*
American Landscape (Charles Sheeler), 1108, *1109*
American peoples (Native Americans), 877–97, 878 (map)
 art: contemporary, 895–96; "Indian" style, 893–94; influence on mainstream art, 1131
 crafts, 884–85
 Eastern Woodlands (U.S.), 884–88
 effect of European conquests, 794
 Northwest Coast (U.S.), 888–92
 prehistory, 879
 Southwest (U.S.), 468, 879, 892–95, 1131
American Place, 1107
American Pop art, 40, 1168
American Revolution (1776), 938, 975–76
American Scene painting, 1108–12
American Society of Independent Artists, 1102
Americas, the: about 1300 C.E., 878 (map); ancient, 450 (map)
Amida Buddha, 437, 443–44
Amida Buddha (Jocho), 438, *438*, 444
Amida Buddha, fresco, temple, Horyu-ji, Nara, Japan, 435, *435*
Amiens, Île-de-France, France, Notre-Dame cathedral, *570–73*, *571–78*, 579, 597
"Am I Not a Man and a Brother?" ceramic medallion (William Hackwood), for Josiah Wedgwood, 957–58, *957*
Amitabha Buddha, 376, 414–15, 427, 826
Ammit, 125
Amorites, 78
amphiprostyle temple, 163, 194
Amphitrite, 158
amphora, 172
Amsterdam, the Netherlands, 786, 802
Amun, 96, 114, 120
Analytic Cubism, 1075–77, 1080, 1081, 1092, 1134, 1136
Anang Ibibio people (Nigeria), 929
Anasazi culture, 449, 468, 879, 892
Anastaise (French artist), 36, 623
Anastasis, Church of the Monastery of Christ in Chora, Istanbul, Turkey, 338, *339*
Anastasis, the (in Christian art), 307
Anatolia (modern Turkey), 86–88, 353
Anavysos Kouros, statue, from Anavysos, near Athens, Greece, 169, *169*, 171, 230
ancestor screen (*duen fobara*), Abonnema village, Nigeria, Ijo culture, 930, *931*
ancestor worship, African, 929–31
Ancient Ruins in the Cañon de Chelley, Arizona (Timothy H. O'Sullivan), 1045–46, *1045*
Andachtsbilder (devotional statues), 596
Andean culture, 462–65
Andhra dynasty, 379–82, 383
Andrea del Castagno, 622, 672; *Last Supper*, fresco, Sant'Apollonia, Florence, Italy, 672, *673*, 689
Angelico, Fra (Guido di Pietro), 622, 672; *Annunciation*, fresco, San Marco monastery, Florence, Italy, 672, *672*
Angel Kneeling in Adoration, tabernacle (Egid Quirin Asam), 942–43, *942*
Angiviller, Count d', 970
Anglo-Saxons, 488–89, 542
Anguissola, Sofonisba, 733; *Child Bitten by a Crayfish*, 733, *733*
aniconic ornament, 344
animal interlace, 485, 505, 536
animals, domesticated, 53
animal style, 488, 525
Anjou, 622
ankh, 96, 112
Annunciation, the (in Christian art), 306
Annunciation, fresco (Fra Angelico), 672, *672*
Annunciation, panel from altarpiece (Simone Martini), 583, 603–4, *603*
Annunciation, The (Jan van Eyck), 631–32, *631*
Annunciation, Virgin and Child with Angels,

Resurrection panel, *Isenheim Altarpiece* (Matthias Grünewald), 713, 714–16, *715*
Annunciation, Visitation, Presentation in the Temple, and *Flight into Egypt*, altarpiece wings (Melchior Broederlam), 625–26, *626*, 629, 667
Annunciation and Virgin of the Rosary (Veit Stoss), 713, *713*
Annunciation and *Visitation*, Notre-Dame cathedral, Reims, Ile-de-France, France, 576–77, *576*, 583, 594
Annunciation to the Shepherds (in Christian art), 306
anta, 163, 166
antependium, 628, *628*
Anthemius of Tralles, 310–11
anthropologists, 38
Anthropométries of the Blue Period, performance (Yves Klein), 1140, *1140*, 1149
anti-Classical style, 212–18
Antigonus, 210
Antinous, 258
Antinous, Hadrian's Villa, Tivoli, Italy, *258*, 280
Antioch, 156, 292
Antiochus III, 216
antirealism, 981–82
Antonello da Messina, 680–83
Antoninus Pius, 246
Antwerp, Belgium, 745, 796; house of Peter Paul Rubens, 797, *797*
Anubis, 96, 125
Anu Ziggurat, Uruk (modern Warka, Iraq), 70–72, *70*
Apadana of Darius and Xerxes. *See* ceremonial complex, Persepolis, Iran
apartment block (*insula*), Ostia, Italy, 263, *263*
Aphrodite, 156, 158, 205
Aphrodite of Knidos (Praxiteles), 203–4, *203*, 218
Aphrodite of Melos (Venus de Milo), statue, Hellenistic, 218, *219*
Apocalypse, 291
Apollinaire, Guillaume, 1037, 1077, 1079
Apollo, 156, 157, 158, 177, 179, 226, 282
Apollo, statue, Temple of Apollo, Veii, Italy, 226–30, *227*
Apollo Attended by the Nymphs of Thetis (François Girardon), 782, *782*, 1028
Apollo Belvedere (Roman statue), 952
Apollodorus of Damascus, 247
Apollo with Battling Lapiths and Centaurs, pediment sculpture, Temple of Zeus, Olympia, Greece, *178*, 179, 191, 203
apostles, 291
apotheosis, 242, 460
Apparition, The (Gustave Moreau), 1036, *1036*
"Apple Cup" (Hans Krug, Workshop of), 711, *711*
appliqué, 907
apprenticeship, 33–34
appropriation, 1162, 1166
apse, 247, 296, 298, 382, 520, *568*, 702
apsidal chapel, *568*
aquamanile, 546
Aquamanile, griffin-shaped, Romanesque, 546, *547*, 593
aquatint process, 997
aqueduct, 235
Aquinas, Thomas, 558, 617
arabesque, 344, 833, 940, 1071
Arabic script, 343, 349–52, 356
Arabs, 473
Ara Pacis, Rome, Italy, 242–45, *243*, *244*, 255, 286
Arbus, Allan, 1151
Arbus, Diane, 1151; *Child with Toy Hand Grenade*, *1150*, 1151
arcade, 228, 237, 345, *568*, 704, *704*, 1008
Arcadius, 302
arch, 228
archaeology, archaeologists, 38; Aegean, 144, 149
Archaic period (Greek), 157, 161–77, 179–80
Archaic smile, 169, 226
Archangel Michael, icon, Byzantine, 334, *335*
Archangel Michael, panel, Byzantine, *320*, 321

Archer, Frederick Scott, 1003
architectural decoration: Austria and Germany, 940–43; French Renaissance, 739–42; modernist rejection of, 1087, 1094
architectural interiors, paintings of, 808
architectural orders. *See* orders of architecture
architectural sculpture: Baroque, 760–67; Early Renaissance, 666; Flamboyant, 626–27; French Gothic, 559–79; Gothic, 626; Greek, 165–68, 178–79, 199–202; Northern European, 536–37; Romanesque, 523–29
architecture
 beauty in, 29–30
 elements of, 55, 100, 163–64, 228, 229, 236, 298, 311, 324, 351, 352, 381, 418, 525, 561, 568, 587, 704, 725
 materials: concrete, 1096; iron, 962, 1006–7; masonry, 537–40; timber, 535–37
 periods and styles: 18th century, 966–68; academic, 1007–9; American, 1052–54, 1115–17; American colonial, 820–21, 973–74; Baroque, 760–67, 778–82, 786–88, 816–20; Buddhist, 381, 416–17; Byzantine, 323–33, 337–38; Chinese, 411, 413–14, 416–17, 848, 850; classical, 1094; classical revival, 953–56; deconstructivist, 1158–59; Early Renaissance, 650–60; Egyptian, 108–9; English, 753, 816–20; English Gothic, 584–87; Etruscan, 225–26, 229; expressionist, 1154; Flamboyant, 626–27; French, 739–42, 778–82, 966–68, 1007–9; French Gothic, 559–79, 589; German, 940–43; German Gothic, 592–93; Gothic, 492, 559–79, 584–87, 589–90, 592–93, 597, 786, 1001; Gothic revival, 956; Greek, 162–65, 199–202, 207; Hellenistic, 211–12; Hindu, 381; Imperial Christian, 297–308; Indian, 390, 417, 832; Inka, 882, 883; Islamic, 311, 345–49, 354–58, 493; Italian, 650–60, 701–10, 723–27, 734–38, 760–67; Italian Gothic, 597; Japanese, 431–32, 863, 865, 1087; Jewish and Early Christian, 294–97; Late Renaissance, 723–27; later Gothic, 579; Mayan, 458–59; Medieval, 497–99, 506; Mesopotamian, 68; Minoan, 135; modern (*see* modern architecture); modernist, 1061; Mughal, 832; Neoclassical, 956–59, 1156; Neolithic, 55–60; Northern European, 535–40; Oceania, 905–6; Paleolithic, 45; Peruvian, 463; postmodern, 1155–57; Renaissance, 653, 701–10, 739–42, 753; revival styles, 1000–1002; Roman, 164, 229, 235, 236, 237–39, 246–54, 260–69, 506, 516; Romanesque, 518–23, 544–45, 584, 597; Russian, 1158; Spanish, 354, 742, 786–88; Spanish colonial, 796; Spanish Gothic, 492, 589–90; United States, 189; Venetian, 734–38
architrave, 163, 164, 655, 700
archivolt, 524, 525, *525*
Arch of Constantine, Rome, Italy, 256, 282–83, *282*, 314
Arch of Drusus, The (Giovanni Battista Piranesi), 951, *951*
Arch of Titus, Rome, Italy, 229, 254–55, *254*, *255*, 283, 293
Ares, 156, 158
Arezzo, Italy, San Francesco church, Bacci Chapel, 658, 672–73, *673*
Argos, Greece, temple, model of, 160, *161*
Ariadne, 134
Arianism, 304–5
aristocracy, European, 938
Aristotle, 25, 177, 198, 558
Ark of the Covenant, 291, 293
armchair, China, Ming dynasty, 847, *847*
armor: English, 752; Japanese, 445, *445*
Armor of George Clifford (Jacob Halder), 752
Armory Show (1913), 1061, 1083
Arnolfo di Cambio, 597
Arpino, Cavaliere d', 774
Arras weaving center, 642
arriccio, 604

art: defined, 25; movements in ("isms"), 1061; need for, 30–32; public display of, 1179; religious, 758, 788–89; social and political functions of, 32, 39–40, 1179–80; theory of, 655; viewer's responsibility, 40, 760, 768
art brut ("raw art"), 1127–29
art deco, furniture, 918
Artemis, 134, 156, 158, 184
Artemis Slaying Actaeon, vase (Pan Painter), 184, *184*
"art for art's sake," 48, 1018
art history, 25, 37–40, 41; ancient writings on, 229
art informel ("formless art"), 1129
artisans, 33
artists, 32–35; anonymous, 477; livelihood of, Dutch, 803; names and nicknames, 617–18, 622; in the Renaissance, 687; social position of, 32–33, 218–20, 236, 460–61, 650, 687, 841–42; training of, 33–35; women (*see* women); workshops, 760
Artist's Studio, The (Louis-Jacques-Mandé Daguerre), 1003, *1003*
art market, 943, 1125; Dutch, 803
Art Nouveau, 1041–42, 1061–62, 1063, 1087, 1093, 1167, 1172
arts, major (fine) and minor (craft), 1152
Arts and Crafts Movement, 1016, 1041, 1086
art works: copies vs. originals, 760, 803, 1166; destruction or plunder of, 39, 85; names of, 47
Aryans, 376, 828
Asam, Egid Quirin, 942–43; tabernacle, Convent Church, Osterhofen, Germany, *Angel Kneeling in Adoration*, 942–43, *942*
Ascension, page, *Rabbula Gospels*, Syria, Early Christian, 322, *322*, 336, 530
Ascension, the (in Christian art), 307
Ashanti people (Ghana), 915, 926–27
Ashcan School, 1082–83
Ashikaga family, 858, 862
ashlar, 146
Ashoka, Indian ruler, 371, 377–78, 379, 828
Ashokan pillar, Lauriya, Nandangarh, India, *370–71*, 371
Ashvagosha, *Buddhacharita*, 385
Asia
 postcolonial, 1126
 South, 372; architecture, 381
 Southeast, 376
Asklepios, 158
Asmat ancestral spirit poles (*mbis*), Faretsj River, Irian Jaya, Indonesia, 904, *904*
Asmat people, 904
Aspects of Negro Life: From Slavery through Reconstruction (Aaron Douglas), *1112*, 1113
Assasif, Egypt, Funerary Stele of Amenemhat I, 110–12, *110*
assemblage, 31, 1078, 1106, 1137, 1140–42
Assisi, Italy: *Life of Saint Francis* cycle (Giotto), 609; St. Francis Basilica, 39, 609; Upper Church, 601, 609–10, *610*
assistants, artists', 628
Association of Artists of Revolutionary Russia (AKhRR), 1091
Assumption of the Virgin, fresco (Correggio), 705–6, *705*, 769
Assurbanipal, 71, 82
Assurbanipal and His Queen in the Garden, Nineveh (modern Kuyunjik, Iraq), 82, *82*
Assurnasirpal II, 80
Assurnasirpal II Killing Lions, Palace of Assurnasirpal II, Nimrud, Iraq, 80, *81*
Assyria, Assyrians, 69, 71, 80–83; city-states of, 67
Astarte (Ishtar), 205
astragal, 164, 211
Astronomy or *Venus Urania* (Giovanni da Bologna), 732, *733*, 741
Asuka period (Japan), 432–34, 859
Aswan High Dam, 119
Asymmetrical Angled Piece (Magdalene Odundo), 934, *934*
Atahualpa, 794
atelier, 830, 982
Aten, 120

Athanadoros, 215
Athena, 134, 156, 158, 179, 187, 193, 214
Athena, Herakles and Atlas, pediment sculpture, Temple of Zeus, Olympia, Greece, 179, *179*, 203
Athena Attacking the Giants, frieze sculpture, Altar of Zeus, Pergamon, Asia Minor (modern Turkey), 214, *214*
Athena Nike, 187
Athens, Greece, 36–37, 134, 155, 156, 161, 172, 178, 185, 188, 198, 199, 267
 Acropolis, 37, 155, 170–71, *170*, *171*, 185, *186*, 187–96, 211
 Erechtheion, 187, 193–94, *193*; Porch of the Maidens, 193–94, *194*, 265
 Parthenon, 85, 163, 187–93, *188*, *191*, 267; drawing by William Pars, 187, 189, *189*; friezes, 188, 190, 191–93, *191*, *192*, 243; pediment (Elgin Marbles), 85, 190, *190–91*
 Temple of Athena Nike, 194–96, *194*, *195*, 203, 218
 Agora, 185–87, *185*, 198, 199
 Dipylon Cemetery, 159–60, *159*
 Dipylon Gate, 191
 government, 186–87
 Painted Stoa, 198
 Panathenaic Way, 186
 Temple of the Olympian Zeus, 211–12, *211*, 267
Atlas, 179
atmospheric perspective, 271, 337, 621, 640, 1031
atrial cross, 794
Atrial cross, Basilica of Guadalupe, Mexico City, Mexico, 794–95, *794*
atrium, 225, 263–64, 298, 702, 794
Attack on the Castle of Love, jewelry casket lid, French Gothic, 580, *580*
Attalos I, 212
AT&T Corporate Headquarters, model for, New York, N.Y. (Philip Johnson), with John Burgee, 1156, *1156*
attic story, 251
attitude, 406
attribute (identifying symbol of a god), 170, 294, 526
Atum, 96
Audubon, John James, 996–97
Birds of America, 997; *Common Grackle* page, 996–97, *997*
Augustine, Saint, 489
Augustus Caesar (Octavian), 229, 234, 236–37, 241, 245
Augustus of Primaporta, statue, Roman, 241–42, *241*, 257
Aulus Metellus ("The Orator"), statue, Roman, *240*, 241, 242, 383
Aurora, 158
Aurora, ceiling fresco (Guido Reni), 771, *771*, 942
Australia, 900; Aboriginal art, 901–2, 911
Austria, 1060; *Woman from Willendorf*, figurine, paleolithic, 46, *46*, 47
Austrian art: architectural decoration, 940–43; Baroque, 785–86; modernist, 1062
automatism, 1104, 1129
Autumn Colors on the Qiao and Hua Mountains, handscroll (Zhao Mengfu), 842, *842–43*
Autumn Rhythm (Number 30) (Jackson Pollock), 1132, *1132*
Autun, Burgundy, France, 518
 Cathedral (originally abbey church) of Saint-Lazare, 157, 163, 165, 166–67, 524, 527–29, *527*; west portal, *526*, 527, 531, 540, 561, 564
Avalokiteshvara, 826–27
avant-garde, 36, 944, 982, 1099, 1165; Nazi suppression of, 1097; post-World War II, 1125
Avenue at Middelharnis (Meindert Hobbema), *810*, 811, 994–95
Avicenna (Frank Stella), 1146–47, *1147*, 1154
Avignon, France, 559, 597, 622
axial plan, 116, 237
axis mundi, 378, 381, 388–89, 418
Aztec empire and culture, 455, 794–95, 879–81

B

Baader, Johannes, 1100
Babur, Indian ruler, 829–30
baby carrier, Native American, Sioux, 885–86, *885*
Babylon, Mesopotamia (modern Iraq), 78–80, 83; Ishtar Gate, 83–85, *84*; reconstruction drawing of, 83, *83*, 104
Babylonians, 69, 78, 291
Baca, Judy, 1178–79; *The Division of the Barrios*, 1178–79, *1178*
Bacchus, 158, 286, 293, 302
Baccio d'Agnolo, 651
Backs (Magdalena Abakanowicz), 1173, *1173*
backstrap loom, 452
Backyards, Greenwich Village (John Sloan), 1083, *1083*
Bacon, Francis (16th-century English philosopher), 759
Bacon, Francis (20th-century English artist), 1127; *Head Surrounded by Sides of Beef*, 1127, *1127*
Bactria, 383
Baerze, Jacques de (wood carver), 625
Baghdad, 345, 353
Bahram Gur Visiting One of His Wives, an Indian Princess, color and gilt on paper, Indian, from a copy of Nizami's *Haft Paykar (Seven Portraits)*, 365, *366*
bailey, 539, *587*
Bal au Moulin Rouge (Jules Chéret), *1017*
Baldacchino (Gianlorenzo Bernini), 761–62, *761*
baldachin (*baldacchino*), 551, 608, 761
Balder, 487
Ball, Hugo, 1099–1100; Reciting "Karawane" (photograph), 1100, *1100*
ball game, ritual, Mesoamerican, 451
balustrade, 627, *704*, 725, 764
Bamana, Mali, jar, Mende culture, *933*
Banham, Reyner, 1143
banner, painted, China, Han dynasty, 407–9, *407*, 411
Banner of Las Navas de Tolosa, Spain, Islamic, *362*, 363
Baptism of Christ (in Christian art), 306
baptistry, 296, 298
Baptistry of the Orthodox, Ravenna, Italy, 305–8, *305*
Bar at the Folies-Bergère, A (Édouard Manet), 1026–27, *1027*
barbarians, 212, 496
Barbarossa, Frederick, 941
Barberini Harp, Italian Baroque, 768, *768*
Barberini Palace, Rome, Italy, 771–72, *772*
barbicans, *587*
Barbizon School, 996, 1009, 1018
Barcelona, Spain, San Francisco church, 591–92, *591*, *592*, *592*
Barcelona International Exposition (1929), German Pavilion, 1099, *1099*
Bardon, Geoff, 911
bargeboard, 910
Bargehaulers on the Volga (Ilya Repin), 1014, *1014*
bark cloth, 907
bark painting, 901
Barma and Postnik (architects), 338
Baroque art, 35, 757–823, 939; Austrian, 785–86; Dutch, 800–816; English, 816–20; Flemish, 796–800; French, 778–85; German, 785–86; influence of, 983; Italian, 760–78, 966; Spanish, 786–94, 1048
Barozzi, Giacomo. *See* Vignola
barrel vault, 226, 228, 300, 382, 1007
Barry, Charles, 1002; Houses of Parliament, London, England, with Augustus Welby Northmore Pugin, 1001, *1001*
bar tracery, 578
Barthes, Roland, 1166, 1168
Barye, Antoine-Louis, 990–91; *Python Crushing an African Horseman*, 991, *991*
bas-de-page scenes, 583
base, 162, 164, *704*

Basil II, 327
basilica, 235, 247, 297, 492, 518, 702
Basilica, Trier, Germany, 281, *281*, 299
Basilica of Guadalupe, Mexico City, Mexico, 794–95, *794*
Basilica of Maxentius and Constantine (Basilica Nova), Rome, Italy, 283–85, *283*, *284*, 656
basilica-plan church, 297–300, *298*, 347, 497
basilica synagogue, 296
Basilica Ulpia, Rome, Italy, 247, *247*, 283, 298, 299
basketry, 885, 888, 893; Native American, 885
Basquiat, Jean-Michel, 1167; *Horn Players*, *1166*, 1167
Bateman, Ann and Peter, 958
Bateman, Hester, 958
Bath, England, 954–56; Royal Crescent, 954–56, *955*
Bathers (Pierre-Auguste Renoir), 1028, *1028*
baths: Islamic, 367; Roman, 275–76
Baths of Caracalla, Rome, Italy, 275–76, *276*
Batlló Crucifix, Spain, Romanesque, 529–30, *529*
battered wall, 481
Battista Sforza and *Federico da Montefeltro*, pendant portraits (Piero della Francesca), 676–77, *677*
Battle between the Gods and the Giants, frieze sculpture, Siphnian Treasury, Sanctuary of Apollo, Delphi, Greece, *166*, 167
Battle between the Romans and the Barbarians, relief, *Ludovisi Battle Sarcophagus*, *278*, 279
battlements, 587
Battle of Centaurs and Wild Beasts, floor mosaic, Hadrian's Villa, Tivoli, Italy, 267, *267*
Battle of San Romano, The (Paolo Uccello), 614–15, *615*, 621
Battle of the Bird and the Serpent, page, *Commentaries* by Beatus and Jerome (Emeterius, and Ende), *494*, 494
Battle of the Nudes (Antonio del Pollaiuolo), 650, *650*, 665
battle-scene hide painting, Native American, Mandan, 887, *887*
Baudelaire, Charles, 1019–20; "The Painter of Modern Life" (newspaper article), 1005
Baudrillard, Jean, 1168
Bauhaus Building, Dessau, Germany (Walter Gropius), 1097, 1098–99, *1099*, 1154
Bauhaus school and movement, 1096–99
Baule people (Côte d'Ivoire), 924–25
Bavaria, 189
bay, 228, 417, 654, 816, 865
Bayeux Tapestry, Norman-Anglo-Saxon: *Bishop Odo Blessing the Feast*, 542, *542*, 544; *Messengers Signal the Appearance of a Comet (Halley's Comet)*, 540–42, 543, *543*
Baysonghur, Prince, 365
beadwork, 886, 974
beaker, Susa (modern Shush, Iran), 85–86, *85*
Bearing of the Cross (The Road to Calvary) (in Christian art), 307
Beatus, *Commentary on the Apocalypse*, 493–94
Beau Dieu, relief, Notre-Dame cathedral, Amiens, Ile-de-France, France, 573–75, *573*
beauty, defined, 25–30
Beaux-Arts historicist tradition, 1052
beehive tombs, 146
Beijing, China, 424; Forbidden City, 848, *848*, 930
Belarus, 326
Belgium, 745, 786
Bellini, Gentile, 680, 708; *Procession of the Relic of the True Cross before the Church of Saint Mark*, 680, *680*, 706
Bellini, Giovanni, 680–81, 708–9; *Saint Francis in Ecstasy*, 681, *681*, 706; *Virgin and Child Enthroned with Saints Francis, John the Baptist, Job, Dominic, Sebastian, and Louis of Toulouse*, San Giobbe church, Venice, Italy, 680–81, *681*, 706
Bellini, Jacopo, 680
Bellori, Giovanni, 775
bells, set of, China, Zhou dynasty, 406, *406*
Benday dots, 1143

Benedictine Monastery Church, Melk, Austria (Jakob Prandtauer), 786, *786*; interior, after designs of Prandtauer (Antonio Beduzzi, and Joseph Munggenast), 786, *787*, 942
Benedictines, 498–99, 517, 520, 786
Benedict of Nursia, *Rule for Monasteries*, 498–99
Beni Hasan, Egypt: rock-cut tombs, 110, *110*; Tomb of Khnumhotep, 110, *110*
Benin, 473, 477–79, 917; *General and Officers*, brass, *478*, 479; Head of an *oba* (king), 478, *478*; mask of an *iyoba*, 479, *479*; Memorial head, *477*, 478; periods of art, 478
Benois, Aleksandr, 1081
Bentley, Richard, 956
Benton, Thomas Hart, 1108, 1131
Bering Strait, 450–51
Berkeley, George, 974
Berlin, Germany, Altes Museum, 1000–1001, *1001*
Berlin Dada, 1100–1101
Berlin Kore, statue, Keratea (near Athens), Greece, 169–70, *169*
Bernard de Clairvaux, Abbot, 521, 524
Bernard de Soissons, 575
Bernini, Gianlorenzo, 702, 761–63, 765–68, 772, 818, 942; *Baldacchino*, Saint Peter's Basilica, Rome, Italy, 761–62, *761*; *David*, 760, 768, *768*; Piazza, Saint Peter's Basilica, Rome, Italy, 761, 762–63, *762*; Piazza Navona, Four Rivers Fountain, Rome, Italy, 764–66, *765*; *Saint Teresa of Ávila in Ecstasy*, 766–67, *767*, 942; Santa Maria della Vittoria, Cornaro Chapel, Rome, Italy, 766–67, *766*
Bernward of Hildesheim, Bishop, 507, 508
Berry, 622
Bertoldo di Giovanni, 694
bestiary, 584, 644
Betrayal, the (in Christian art) (The Arrest), 307
Betrayal and Arrest of Christ, page, *Book of Hours of Jeanne d'Evreux* (Jean Pucelle), 582–83, *583*
Beuys, Joseph, 1149, 1153, 1167; *Coyote: I Like America and America Likes Me*, 1149, *1149*, 1167
beveled, 882
Bhagavad Gita, 378
bhakti devotion, 397–98, 833
bi (jade piece), 409
Bible, 290, 297, 500, 718
Bierstadt, Albert, 1044–45; *The Rocky Mountains, Lander's Peak*, 1044–45, *1045*
Big Raven (Emily Carr), 1120, *1120*
Bihzad, Kamal al-Din, 365; *The Caliph Harun al-Rashid Visits the Turkish Bath*, miniature, 367, *367*
biiga dolls (Mossi), 919
Bilbao, Spain, Guggenheim Museum, 36, 1158–59, *1159*
Bingham, George Caleb, *Fur Traders Descending the Missouri*, 998, *999*
biomorphism, 1104, 1131
Bird, monolith, Great Zimbabwe, Zimbabwe, 482, *482*
Bird-Headed Man with Bison and Rhinoceros, cave paintings, Lascaux, France, 51–52, *51*
Bird's-eye View of the Town of Chaux (Claude-Nicolas Ledoux), 967, *967*, 1156
Birds of America, book (John James Audubon), *Common Grackle* page, 996–97, *997*
Birth of Mahavira, The, leaf, *Kalpa Sutra*, manuscript, Indian, 827–28, *827*, 830, 834
Birth of the Virgin (Pietro Lorenzetti), 604–6, *605*
Birth of Venus, The (Sandro Botticelli), 678, *679*
Birth tray of Lorenzo de' Medici (Giovanni di Ser Giovanni), 677, *677*
Bishop Odo Blessing the Feast, Bayeux Tapestry, Norman-Anglo-Saxon, 542, *542*, 544
bishops, 291–92
Bison, cave painting, Altamira, Spain, 50–51, *50*
Bison, relief sculpture, Le Tuc d'Audoubert, France, 52–53, *52*
Black Death, 584
black-figure pottery, 161, 172, 173

Black Lion Wharf (James Abbott McNeill Whistler), 1016–17, *1016*
Black Mountain College (Asheville, NC), 1098
blackware, 893
Black Woven Form (Fountain) (Lenore Tawney), *1153*
Blake, William, 965–66; *Elohim Creating Adam*, 965–66, *965*
blanket, Chilkat, Native American, Tlingit, 888–89, *889*
Blaue Reiter, Der (The Blue Rider), 1061, 1068–71, 1078
Blegen, Carl, 144
Bleyl, Fritz, 1065
blind arcade, 302, 506, 833
blind porch, 194
blind windows, 724
block books, 644
blolo bla and *bian* figures (Baule), 925
bloodletting rituals, 457
bobbin, 452
Boboli Gardens, the Great Grotto, Pitti Palace, Florence, Italy (Bernardo Buontalenti), *741*
Boccaccio, Giovanni, 617; *Concerning Famous Women*, book, page, *Thamyris*, 623
Boccioni, Umberto, 1080–81; *States of Mind: The Farewells*, 1080, *1080*; *Unique Forms of Continuity in Space*, 1081, *1081*
Bodhidharma, 870, 872
Bodhidharma Meditating (Hakuin Ekaku), 870, *870*
bodhisattva, 376, 388, 415, 826
Bodhisattva, wall painting, Cave I, Ajanta, Maharashtra, India, 386–87, *387*, 397
Bodhisattva Avalokiteshvara, The, India, Late Medieval, 826, *827*
body, the, in art, 1173–77
Boffrand, Germain, 939; Hôtel de Soubise, Paris, France, Salon de la Princesse, 939, *939*
Bois de Boulogne, 1055
Bois de Vincennes, 1055
Bologna. *See* Giovanni da Bologna
Bologna, Italy, 557
Bombay, India, 836
Bondone. *See* Giotto de Bondone
Bonheur, Rosa, 1010, 1011; *Plowing in the Nivernais: The Dressing of the Vines*, 1010, *1011*, 1073
Bonheur de Vivre, Le (The Joy of Life) (Henri Matisse), 1064, *1064*, 1065, 1071–72, 1074
Boniface IV, Pope, 254
Bonn museum, *Vesperbild*, 596, *596*
Bonsu, Kojo, 926; (?) finial of a spokesperson's staff (*okyeame poma*), 914–15, 915, 926
Bonsu, Osei, 926
book arts: French Gothic, 580–84, 588; Islamic, 365; Medieval, 493, 499–502, 510–13; Romanesque, 532–34, 540, 546–49; Spanish Gothic, 590
book covers, 502, 507
Book of Homilies, Romanesque, page, self-portrait of nun Guda, 549, *549*
Book of Hours of Jeanne d'Evreux (Jean Pucelle): page, *Betrayal and Arrest of Christ*, 582–83, *583*; page, *Fox Seizing a Rooster*, 584, *584*
Book of Kells, Hiberno-Saxon, 490–91; page, *Chi Rho Iota*, 484, 485, 491
Book of the Dead, Egyptian, 99, 125; *Judgment before Osiris*, 96, 99, *124*, 125, 527
books: Medieval, 490; origin of, 304; printed, 644
Books of the Hours (prayer books), 582
Bookstand with Gospels, mosaic, Mausoleum of Galla Placidia, Ravenna, Italy, *304*
Borgoricco, Italy, New Town Hall, *1156*, 1157
Borgund stave church, Sogn, Norway, 535, 536, *536*
Borrassá, Luis, 591–92; *Virgin and Saint George*, altarpiece, San Francisco church, Barcelona, Spain, 591–92, *591*; *Education of the Virgin*, 592, *592*

Borromini, Francesco, 763–64, 765; San Carlo alle Quattro Fontane church, Rome, Italy, 760, 763–64, 763, 764, 764, 941

Bosch, Hieronymus, 745–46; *Garden of Earthly Delights*, 745–46, 745

Boscoreale (near Pompeii), Italy, House of Publius Fannius Synistor, 270, 270; bedroom (reconstruction), 263, 269–70, 269

boss, 164, 491, 587

Boston Public Garden, 1055

boteba figure (Lobi), 922–23

Böttger, Johann Friedrich, 846

Botticelli, Sandro, 622, 656, 677–80, 696; *The Birth of Venus*, 678, 679; *Mystical Nativity*, 679–80, 679; *Primavera*, 678, 678

bottle, enameled and gilded, Syrian, 352, 360, 361

bottle, fish-shaped, Egyptian, 121–22, 121

Boucher, François, 945–46; *Diana Resting after Her Bath*, 945–46, 945; *La Foire Chinoise (The Chinese Fair)*, tapestry copy after, 946–48, 948

Bouguereau, Adolphe-William, 1009; *Nymphs and a Satyr*, 1009, 1009, 1028

bouleuterion, 186

Boulevard des Capucines, Paris (Claude Monet), 1022, 1022

Boullée, Étienne-Louis, 967; Cenotaph for Isaac Newton (never built), 967–68, 967, 1156

Bourbon dynasty, 798

Bourges, France, House of Jacques Coeur, interior courtyard, 627, 627

Bourgot (illuminator), 623

Bouts, Dirck, 637–38; *Justice of Otto III, Wrongful Execution of the Count* panel, 638, 638

bowl, painted, Chinese neolithic, 403, 403

bowl with kufic border, Uzbekistan, 352, 352

Boyle, Richard, Lord Burlington, Chiswick House, London, England, 953, 954, 967, 974

Boy with a Basket of Fruit (Caravaggio), 774, 774

bracket, 704, 704, 788

bracketing (East Asian architecture), 411, 418

Brady, Mathew B., 1046–47

Brahma, 390–91

Brahman, 376, 378, 389, 828

Bramante, Donato, 692, 701, 702, 724; San Pietro in Montorio church, Tempietto, Rome, Italy, 701, 701, 818

Brancusi, Constantin, 1072, 1083, 1171; *Magic Bird*, 889–92, 1072, 1072, 1171

Brandt, Marianne, 1098; coffee and tea service, 1098, 1098

Braque, Georges, 1072, 1075, 1081, 1083, 1136; *Houses at L'Estaque*, 1075, 1075, 1134, 1136; *Violin and Palette*, 1076, 1076, 1134, 1136

brass, 63; Egypt, 231–33; sculpture, 181, 404

Brassempouy, France, *Woman*, figurine, paleolithic, 46, 47, 47

Bravo, Manuel Alvarez, *Laughing Mannequins*, 1118, 1119

breakfast pieces, 800

Brescia, Italy, Saint Giulia church, 279, 495–96, 495, 529

Breton, André, 1102–4, 1105, 1119, 1130

Breuil, Abbé Henri, 48

Bride Stripped Bare by Her Bachelors, Even, The (The Large Glass) (Marcel Duchamp), 1083, 1102, 1103, 1141

bridges, 1006

Bridget, Saint, 641

Britain, 487–91, 1060; Hadrian's Wall, 261, 261; Roman, 487, 488

British art. *See* English art

British East India Company, 836

British Empire, 477–78, 836

Brody, Sherry, 1164

Broederlam, Melchior, 625–26; *Annunciation, Visitation, Presentation in the Temple*, and *Flight into Egypt*, altarpiece wings, Chartreuse de Champmol, Dijon, France, 625–26, 626, 629, 667

broken pediment, 250, 788

bronze, 63; Egypt, 231–33; sculpture, 181, 404

Bronze Age, 63; Aegean, 130, 131–33; China, 405–6; Crete, 133; Greece, 142

Bronze Foundry, A, vase (Foundry Painter), 177, 177

bronzes, small, Renaissance, 665

Bronzino (Agnolo Tori), 731–32; *Portrait of a Young Man*, 731–32, 731

Brooklyn Bridge, New York, NY (John Augustus Roebling), with Washington Augustus Roebling, 1006, 1006

Brooklyn Museum of Art, "Sensation" show (1999), 1175

Brown, Blue, Brown on Blue (Mark Rothko), 1134, 1135

Brown, Lancelot ("Capability"), 820, 953–54

Brücke, Die ("The Bridge"), 1065, 1071, 1104, 1167

Brueg(h)el family, 748

Bruegel, Pieter, the Elder, 746–48; *Carrying of the Cross*, 747–48, 747; *Return of the Hunters*, 748, 748

Brueghel, Jan, 748, 800, 801; *Allegories of the Five Senses*, painting series, *Sight*, and Peter Paul Rubens, 800, 801, 801

Brueghel, Pieter, the Younger, 748

Bruges, 641

Brunelleschi, Filippo, 597, 621, 650–52, 653, 655, 658, 669, 699; Capponi Chapel, Florence, Italy, Santa Felicità church, 729, 729; Cathedral (Duomo), Florence, Italy, 597, 598, 650–52, 651, 652, 764; Foundling Hospital, Florence, Italy, 652, 653, 653, 672; San Lorenzo church, Florence, Italy, 652–54, 652, 669, 699

brushcs, 869

brushstrokes, visibility of, 630

Brussels, Belgium, 642, 745; Tassel House, 1041, 1041, 1172

Brutus, Lucius Junius, 232

Buchan, Alexander, 910

buddha, marks of, and Buddhist iconography, 434

Buddha (Siddhartha Gautama, Shakyamuni), 376, 378–79, 385, 436, 828; representation of, 383, 384–85

Buddha and Attendants, India, Kushan period, 384, 384

Buddhism, 371; beliefs and branches of, 376; in China, 413–17, 841; iconography, 383, 434; in India, 375, 377–88, 394, 826–27, 828; in Japan, 427, 432–38, 859

Buffalo Bull's Back Fat, Head Chief, Blood Tribe (George Catlin), 997, 997, 1044

building. *See* architecture

Bulgars, 310

Bull and Puppy, detail, screen (Nagasawa Rosetsu), 871, 871

Bullfinch, Charles, 1000

Bull Leaping, wall painting, palace complex, Knossos, Crete, 142, 142

bull lyre, Ur (modern Muqaiyir, Iraq), 74–76, 75

bulls, 139

bull's-head rhyton, Knossos, Crete, 136, 139, 139

Bunsei, 860; *Landscape*, hanging scroll, 860, 860

buon fresco, 139, 604

Buoninsegna. *See* Duccio di Buoninsegna

Buontalenti, Bernardo, Pitti Palace, Florence, Italy, Boboli Gardens, the Great Grotto, 741

Burden, Jane, 1015

Burghers of Calais, bronze (Auguste Rodin), 1039–40, 1039, 1063

Burgos, Spain, 362; Santa Maria church, Quintanilla de las Viñas, 492–93, 492

Burgundy, 516, 517, 622, 628, 630, 646

Burial at Ornans, A (Gustave Courbet), 1012, 1012

burial chambers, Neolithic, 55

burial customs. *See* funerary customs

Burial of Count Orgaz (El Greco), 743–44, 743

burial ship, Oseberg, Norway, 504, 505, 536; post with animal figures, 505, 505, 536

burial ship, Sutton Hoo, England, 489, 489, 490

burin, 648, 808

Burke, Edmund, *A Philosophical Enquiry into the Origin of Our Ideas of the Sublime and the Beautiful*, 967

Burkina Faso, 919, 920–21, 922; doll (*biiga*), Mossi culture, 919, 919; spirit figure (*boteba*), Lobi culture, 922, 923, 923

Burne-Jones, Edward, 1015

Burrows, Alice and George, 958

Buseau, Marie-Jeanne, 945

Bush, Jack, 1145; *Tall Spread*, 1145, 1146

Busketos, 550

Bust of a Man, Mohenjo-Daro, India, 374, 374

buttress, 228, 313, 519, 627

Buxheim Saint Christopher, The, hand-colored woodcut, German Renaissance, 648–49, 649

bwami masks, 921–22

Bwa peoplc, 920–21

Byodo-in temple, Uji (near Kyoto), Japan, 437–38, 437

Byzantine (Eastern) Empire, 290 (map), 302, 310, 495, 517; fall of, 354

Byzantine art, 286, 309–10, 344, 530, 607, 681, 742–43; Early, 309–23; influence of, 601; Late, 309–10, 337–40; Middle, 309, 323–37

Byzantine style (Romanesque), 531–32

Byzantium, 309. *See also* Istanbul

C

caduceus, 751

Caen, France, Saint-Étienne church, 539–40, 539, 540, 561

caesaropapism, 310

Café Guerbois, 1021

Cage, John, 1138, 1141, 1149, 1182

Cahokia, Illinois, urban center and mounds, 467, 467, 468

Cairo, Egypt, Sultan Hasan mosque complex, 347, 357, 357

Calchas (Greek priest), 232–33

Calcutta, India, 836

Calder, Alexander, 1115; *Lobster Trap and Fish Tail*, 1114, 1115

calendrical systems, Mesoamerican, 451, 457, 458

Calf Bearer (Moschophoros), sculpture, Acropolis, Athens, Greece, 171, 171

Caliph Harun al Rashid Visits the Turkish Bath, The, miniature (Kamal al-Din Bihzad), 367, 367

caliphs, 344, 348

calligraph, 404

calligraphy, 343, 828, 842, 850–51; Chinese, 413; Islamic, 349–52, 365–68; Japanese, 438–40, 861

Calligraphy Pair (Ikkyu), 861, 861

calligraphy sample (Wang Xizhi), 413, 413

Calling of Matthew (in Christian art), 306

Calling of Saint Matthew (Caravaggio), 774–76, 775

calotype, 1003

Calvert, Frank, 144

Calvin, John, 719

calyx krater, 175

Cambridge, England, 557

Camel Carrying a Group of Musicians, earthenware, China, 415, 415

cameo, 245, 495, 952

camera obscura, 812–13, 1002

Cameron, Julia Margaret, 1004–5; *Portrait of Thomas Carlyle*, 1005, 1005, 1049

cames, 569, 570

campanile, 550, 606

Campbell, Colin, 953

Campin, Robert, 629–30, 633; *Mérode Altarpiece*, 620, 628, 629–30, 629; wing, *Joseph in His Carpentry Shop*, 620–22, 620, 718

Canaan, 291

Canadian art, 1119; of native peoples, 890

Canaletto (Giovanni Antonio Canal), 950; *Santi Giovanni e Paolo and the Monument to Bartolommeo Colleoni*, 950–51, 951

canon, as ideal, rejection of, 37

canon of proportions, 28, 202, 205; Egyptian, 98, 99, 108; of Polykleitos, 196–97; Vitruvian, 690

Canopus area. *See* Hadrian's Villa, Tivoli, Italy

Canova, Antonio, 952–53, 972, 998, 1042; *Cupid and Psyche*, 953, *953*, 972, 998, 1009, 1042

Cantigas de Santa Maria, manuscript, Spanish Gothic, page, *Alfonso the Wise*, 590, *590*

cantilever, 1086

canvas, painting on, 707

Canyon, combine (Robert Rauschenberg), 1141, *1141*, 1166

Capetian dynasty, 517

capital, 27, 102, 162, 164, 378, 654, *704*

Capitol Reef, Utah (Minor White), 1151, *1151*

Cap Morgiou, France, 48; Cosquer cave, *42–43*, 48

Capponi Chapel, Florence, Italy (Filippo Brunelleschi), Santa Felicità church, 729, *729*

capriccio, 950, 951

Caprichos (The Caprices), Los, print series (Francisco Goya y Lucientes), page, *The Sleep of Reason Produces Monsters*, 992–93, *992*, 1135

capstone, 57, 381, 394

Captain Frans Banning Cocq Mustering His Company (The Night Watch) (Rembrandt van Rijn), 803, 805–6, *805*, 807

Caracalla, 274–75

Caracalla, bust, Roman, 275, *275*

Caravaggio (Michelangelo Merisi), 622, 774–77, 778, 783, 788, 796, 802; *Boy with a Basket of Fruit*, 774, *774*; *Calling of Saint Matthew*, 774–76, *775*; *Entombment*, 776, *776*, 793

Caravaggism, 783, 788, 791, 798

carbon-14 (radiocarbon) dating, 54

Carnegie International, 1181

Caroline Books (Libri Carolini), 496

Carolingian Empire, 496–502, 535; artists of, 531

Carpeaux, Jean-Baptiste, 1008–9; *The Dance*, sculptural group, Opéra, Paris, France, 1008–9, *1008*

carpets, Islamic, 363–64, *364*

Carr, Emily, 1120; *Big Raven*, 1120, *1120*

Carracci, Annibale, 768, 769–71, 784, 796, 798, 942; ceiling, Farnese palazzo, Rome, Italy, with Michelangelo, 703, 768, *770*, 771, 780, 942

Carracci family, 771

Carriera, Rosalba, 949–50; *Charles Sackville, 2nd Duke of Dorset*, 950, *950*

Carrying of the Cross (Pieter Bruegel, the Elder), 747–48, *747*

Carthage, North Africa, 234

Carthusians, 625

cartoon, 689, 1104

cartouche, 112, 251, 704, *725*, 727, 764

carved portal, 524

carved vase, Uruk (modern Warka, Iraq), *72*, 73

caryatid, 166, 194

Casa Grande, La, front entrance, San Simeon, California (Julia Morgan), 1115, *1115*

Casino Rospigliosi, Rome, Italy, 771, *771*, 942

Cassatt, Mary, 1025–26, 1028–29, 1030; *Maternal Caress*, 1020, 1028–29, *1028*; *Woman in a Loge*, 1025–26, *1025*, 1071

Castagno. *See* Andrea del Castagno

casting, piece-mold, 404

cast iron, 962, 1006

Castle, Wendell, 1172; *Ghost Clock*, 1172, *1172*

castle-monastery-cathedral complex, Durham, Northumberland, England, 537–39, *537*

castles, Gothic, 587

catacomb, 239, 289

Catacomb of Commodilla, Rome, Italy, *288*, 289, 293

Catacomb of Saints Peter and Marcellinus, Rome, Italy, 293, *293*, 303, 322

Catalonia, 589

Catharina Hooft and Her Nurse (Frans Hals), 802, *802*, 821

cathedral, 292; Medieval, 557–58

Cathedrals. *See individual cities*

Catholicism. *See* Roman Catholic Church

Catlin, George, 997; *Buffalo Bull's Back Fat, Head Chief, Blood Tribe*, 997, *997*, 1044

Cattle Being Tended, rock art, Tassili-n-Ajjer, Algeria, 474, *474*

Cavallini, Pietro, 609

cave art, Paleolithic, 47–53, 54, 139

Cave I, Ajanta, Maharashtra, India, 386–87, *387*, 397

Cave-Temple of Shiva, Elephanta, Maharashtra, India, 391–92, *391*, 392, *392*, 398

Caxton, William, 644

ceiling painting, illusionistic, 768–73, 941

cella, 160, 163, 238

Cellini, Benvenuto, 732; *Saltcellar of Francis I*, 732, *732*

Celtic peoples, 64, 487; missionaries, 485

cemeteries, Roman, 289

Cennini, Cennino, 608; *Il Libro dell'Arte*, 602

cenotaph, 302, 832, 967

Cenotaph for Isaac Newton (never built; Étienne-Louis Boullée), 967–68, *967*, 1156

Centaur, Lefkandi, Euboea, Greece, 159, *159*

centaurs, 159, 179, 190

centering, 228, 652

Central America, 462

Central Park, New York, NY (Frederick Law Olmsted), with Calvert Vaux, 1055, *1055*

central-plan church, 298, *298*, 300–308, 656, 760, 966–67

central-plan mosque, 351, 358

Centre National d'Art et de Culture Georges Pompidou, Paris, France (Renzo Piano), with Richard Rogers, 1157, *1157*

Centula Monastery, France, Saint Riquier abbey church, *496*, 497, 540

Ceramic figures of man and woman, Cernavoda, Romania, paleolithic, 60, 61, *61*

ceramics: African, 932–34; Chinese, 368, 423–24; contemporary recognition of, as art, 1152; Greek, 159–60; Islamic, 352, 361; Italian Renaissance, 665–66; Japanese, 866–67, 873; Korean, 866; Minoan, 135, 139; Mycenaean, 150; Neolithic, 60–63; *see also* pottery

ceramic vessel (Miyashita Zenji), 873, *873*

ceramic vessel (Morino Hiroaki), 873, *873*

ceramic vessel (Ito Sekisui), 873, *873*

ceramic vessel (Tsujimura Shiro), 873, *873*

ceramic vessels, Denmark, Neolithic, 62, *62*

Cerberus, 231

ceremonial center, Teotihuacan, Mexico, 454, *455*

ceremonial centers: Mesoamerican, 451, 453; Neolithic, 57–60

ceremonial complex, Persepolis, Iran, *88*, 89–90, *90*; Apadana of Darius and Xerxes, *88*, 89

Ceres, 158

Cernavoda, Romania, ceramic figures of man and woman, paleolithic, 60, 61, *61*

Cerveteri, Italy, La Banditaccia, Etruscan cemetery, 230, *230*, 231, *231*; Tomb of the Reliefs, 230, *230*

Cézanne, Paul, 1018–19, 1030–32, 1071, 1075, 1076, 1081, 1083; *The Large Bathers*, 1032, *1032*, 1063; *Mont Sainte-Victoire*, *1030*, 1031; *Still Life with Basket of Apples*, 1031–32, *1031*, 1063, 1127

Chacmools, 462

Chaco Canyon, New Mexico, 468; Pueblo Bonito, *448–49*, 449, 468

chair (Philip Webb[?]), 710, 1016, *1016*

chair, Congo, Ngombe culture, *918*

Chair Abstract, Twin Lakes, Connecticut (Paul Strand), 1083, *1085*

Chair of Peter (in Saint Peter's Basilica), 762

chaitya, 382

chaitya hall, Karla, Maharashtra, India, *382*

chakra (Buddhist symbol), 378, *434*

Chalice of Abbot Suger of Saint-Denis, medieval, with Egyptian and French elements, *30*, 31

Chamber of King Roger. *See* Norman Palace, Palermo, Sicily

Chambers, William, 957

chamfered, 833

Champollion, Jean-François, 111

Chan (Zen) Buddhism, 423, 444, 849

chancel, 497, 1002

Chandella dynasty, 395

Chandigarh, India, Punjab University, Gandhi Bhavan, 836, *836*

Chang'an (Tang capital; present-day Xi'an), China, 415, 841, 848, 850

Chanhu-Daro, India, jar, painted, with birds, 375, *375*

Chaotic Lip (Elizabeth Murray), 1170–71, *1171*

chapel, *587*

characters, Chinese, 404

Chardin, Jean-Siméon, 946; *The Governess*, 946, *946*, 968

Charioteer, Sanctuary of Apollo, Delphi, Greece, 157, 181, *181*

Charlemagne (Charles the Great), 496–97, 501

Charlemagne Window, stained glass, Notre-Dame cathedral, Chartres, Île-de-France, France, 567–70, *569*

Charles I, of England, 693, 798, 799–800, 816, 818

Charles I at the Hunt (Anthony Van Dyck), 800, *800*, 961

Charles V, Emperor, 686–87, 709, 710–23, 739, 742, 785

Charles V of France, 623

Charles V Triumphing over Fury (Leone Leoni), 719, *719*; without armor, 719, *719*

Charles VI, Emperor, 785

Charles VII, of France, 646

Charles Sackville, 2nd Duke of Dorset (Rosalba Carriera), 950, *950*

Charlottesville, Virginia, Monticello, 974, *974*, 1000

Chartres, Île-de-France, France, Notre-Dame cathedral, *554*, 555, 557, *557*, 562, 563–71, *564*, *565*, *566*, *567*, *569*, 579, 586, 595; Royal Portal, 563–64, *563*

Chartreuse de Champmol, Dijon, France, 622, 625–26, *625*, *626*, 629, 667

Charvari (comic journal), 1019

chasing, 958

Chatal Huyuk, Anatolia, 70; shrine room, 70, *70*

Château of Fontainebleau, France, Chamber of the Duchess of Étampes, *740*, 741

châteaux, 739

chattri, 832–33

Chauvet cave, 47–48

Chavin de Huantar, Peru (Early Horizon period), 463

Chéret, Jules, *Bal au Moulin Rouge*, *1017*

cherub, 291, 794

Chesneau, Ernest, 1018

Chestnut Hill, Pennsylvania, Vanna Venturi House, 1155–56, *1155*

Chevalier, Étienne, 646

Chevreul, Michel-Eugene, 1032–33, 1079

chevron, 146, 539, 907

chiaroscuro, 689, 782

Chicago, Illinois: Frederick C. Robie House, 1086–87, *1086*, 1087; Marshall Field Wholesale Store, 1053–54, *1053*, 1088; World's Columbian Exposition, Court of Honor, 1053, *1053*

Chicago, Judy (Judy Cohen), 1163, 1164; *The Dinner Party*, 1163, *1163*, 1164

Chicago Arts and Crafts Society, 1086

Chicago School (architecture), 1054

Chicano muralists, 1178–79

Chichen Itza, Yucatan, Mexico, 451, 461; pyramid, with Chacmool in foreground, 461–62, *461*

Chihuly, Dale, 33, 1153; *Violet Persian Set with Red Lip Wraps*, 33, *33*, 35, 1153

Child Bitten by a Crayfish (Sofonisba Anguissola), 733, *733*

Child with Toy Hand Grenade (Diane Arbus), *1150*, 1151

Chilkat Tlingit people, 888

Chin, Mel, 1180; *Revival Field: Pig's Eye Landfill*, 1179–80, *1180*

China, 402 (map), 427, 432, 435, 436, 438, 444, 840 (map)

Chinese People's Republic, 1126

civilization, 841, 859
civil service and literati painters, 839, 845
dynasties, 841, 850
incense burner, Han dynasty, *408*, 409
influence on Japan, 859
modern period, 854
Neolithic period, 402–4
unattributed works from: Altar to Amitabha Buddha, Sui dynasty, 414–15, *414*, 416; armchair, Ming dynasty, 847, *847*; banner, painted, Han dynasty, 407–9, *407*, 411; bells, set of, Zhou dynasty, 406, *406*; *Camel Carrying a Group of Musicians*, earthenware, 415, *415*; *fang ding* bronze, Shang dynasty, 405–6, *405*; Guan Ware vase, Song dynasty, 424, *424*; model of a house, Han dynasty, 411, *411*, 417; porcelain flask, Ming dynasty, 846, *847*
Chinese art, 401–25, 839–55; iconography of, 411; influence on Japanese art, 868–69; influence on Western art, 946
chinoiseries, 946
Chios (?), Greek island, *Kore*, statue, *170*, 171
chip carving, 488
Chi Rho Iota, page, *Book of Kells*, manuscript, Hiberno-Saxon, *484*, 485, 491
chiton, 171
choir, 492, 520, *568*
Chola dynasty, 394, 396
Chrétien de Troyes, 558
Christian art, 283, 650; early, 292–87, iconography of, 294, 306–7
Christian house-church, Dura-Europos, Syria, 296–97, *297*
Christianity, 290, 345, in ancient Rome, persecution and later acceptance, 282, 285, 297; controversies and schisms, 304–5; conversion of barbarians to, 496, 503, 517; early, 236, 291–92; Medieval, 489; missionaries, 473, 485; in the Renaissance, 619; role of art in, 30–31, 496, 523–24; in Spanish colonial America, 794
Christine de Pisan, 35–36, 623, 1163; *Christine Presenting Her Book to the Queen of France*, 35–36, *36*, 627
Christ in Majesty, wall painting, San Clemente church, Tahull, Lérida, Spain, 531–32, *532*, 534
Christo (Javacheff), 1160–61; (with Jeanne-Claude), *Running Fence*, 1160–61, *1160*
Christ Pantokrator, mosaic, Church of the Dormition, Daphni, Greece, 330, *330*, 525, 531
Christus, Petrus, 635–37; *Saint Eloy (Eligius) in His Shop*, 627, 637, *637*
Christ Washing the Feet of His Disciples, page, *Gospels of Otto III*, manuscript, Ottonian, 511–12, *511*
Chrysaor, 166
Chryssolakkos (near Mallia), Crete, Pendant of gold bees, *136*, 137
Church, Frederic Edwin, 1044; *Niagara*, 1044, *1044*
Church, the. *See* Roman Catholic Church
churches
 Byzantine, 310–21, 323–24, 337–38
 decoration of, 312
 domed, 324
 facades, parts of, 725
 Gothic, 559, *568*
 plans: basilica plan, 297–300, *298*, 347, 497; central plan, 298, *298*, 300–308, 656, 760, 966–67; cruciform plan, 302, 519; Greek-cross plan, 298, 324, 658; Latin-cross plan, 298, *568*, 656
Church of the Dormition, Daphni, Greece, 330–31, *330*, *331*, 525, 531, 601
Church of the Monastery of Christ in Chora, Istanbul, Turkey, 338, *339*; funerary chapel, 337–38, *338*
Churrigueresque style, 788
Chute, John, 956
Cibola pottery, 449

ciborium, 298
Ci'en Temple, Xi'an, Shanxi, China, Great Wild Goose Pagoda, 417, *417*
Cimabue (Cenni di Pepi), 607–8, 609, 617; *Virgin and Child Enthroned*, 607, *608*
Cistercians, 517, 521–23, 534
citadel, 80, 144, 199, 374
citadel, Mycenae, Greece, 142–46, *143*
citadel, Tiryns, Greece, 147–48, *147*
citadel and palace complex of Sargon II, reconstruction drawing, Dur Sharrukin (modern Khorsabad, Iraq), 80–82, *81*
City Night (Georgia O'Keeffe), 1108, *1108*
city park movement, 1055
city planning: Chinese, 848, 850; Egyptian, 108–9, 199; Etruscan, 225–26; Greek, 199; Roman, 260–63
Cityscape, wall painting, House of Publius Fannius Synistor, Boscoreale (near Pompeii), Italy, 270, *270*
City Square (Alberto Giacometti), 1127, *1127*
city-states: Greek (*polis*), 155, 188; Italian, 542, 597; Mesopotamian, 68–69
Ciudadela, Teotihuacan plaza, 455–56
civilization, 373–75
clapboard, 820
"classic," "classical," 179, 799
Classical (Greco-Roman) art, 28, 126, 179; Christian adaptation of, 285–86, 308; Renaissance interest in, 650
classical (Greco-Roman) literature, 558; Renaissance interest in, 617
Classical Greek art. *See* Greek art, classical
Classical Style, Byzantine, 337
Classical Style, Hellenistic, 218–20
classicizing style, 594, 656, 704, 953–56, 1094–96; Baroque, 783–84
Classic period (Mesoamerica), 451–53
Classis (modern Classe), Italy, 302
Claudel, Camille, 1040–41; *The Waltz*, bronze, 1040–41, *1040*, 1073
Claude Lorrain (Claude Gellée), *Landscape with Merchants*, 784, *784*, 809, 954
clay, 62
clay revolution, 1152
Cleansing of the Temple (in Christian art), 306
Clement VII, Pope, 687, 723
Cleopatra, 210
clerestory, 115, 247, 298, 299, 498, 520, *568*, 654
Clodion (Claude Michel), 949; *The Invention of the Balloon*, model for monument, 949, *949*
cloisonné, 334
cloister, 497
cloth, African, 926
Clottes, Jean, 49
Clouet, Jean, 739; *Francis I*, 739, *739*
Cluniac monateries, 520–21
Cluny, Burgundy, France, 524, 534; Abbey (Cluny III), 517, 520–21, *521*, 523
Cluny Lectionary, Romanesque, page, *Pentecost*, 533–34, 533
Coalbrookdale, England, Severn River Bridge, *962*
Coatlicue, 794–95, 880, 881
Cocteau, Jean, 1094
codex, 304, 321; Mayan, 460–61
Codex Fejervary-Mayer, Aztec or Mixtec, 876–77, 877
Codex Mendoza, Aztec, page, *The Founding of Tenochtitlan*, 880, *880*
Coeur, Jacques, 627
coffee and tea service (Marianne Brandt), 1098, *1098*
coffer, 253, 669, 688, 763
Cogul, Lérida, Spain, *People and Animals*, 54–55, *54*
coiling (basketry), 885; basketry, 893
coin (daric), Persia (modern Iran), 90, *90*
coin minted by Croesus, king of Lydia, 89
coins, 89, 90, 155
Colbert, Jean-Baptiste, 778
Cold War, 1126
Cole, Thomas, 1044; *The Course of Empire*, 997–98; *The Oxbow*, 997–98, *998*, 1044

collage, 1077, 1142, 1166
collectors, 35–36; Renaissance, 665; Roman, 268
collodion, 1003
Cologne, Germany, Cathedral, 510, *510*, 529, 601
colonialism, 473, 916–17, 932, 1126
Colonna, Fra Francesco, *Hypnerotomachia Poliphili*, book, *Garden of Love* page, *644*
colonnade, 116, 157, 163, 702
colonnette, 571
colophon, 490, 493, 844
colophon page, *Commentaries* by Beatus and Jerome (Emeterius, and Senior), 490, 493–94, *493*
color: complementary, 1032; Egyptian, 108
Color Field painting, 1134–35
colossal head, La Venta, Mexico, 454, *454*
colossal order, 725, *725*, 727
Colossal statue of Rameses II, Temple of Rameses II, Luxor, Egypt, 116, 119, *119*
Colosseum, Rome, Italy, 250–51, *250*, *251*, *251*, 655
Colossus of Rhodes, 104
Columbus, 842
column, 102, 164, 228, 229, 345, 704; Egyptian, *102*
Column of Trajan, Rome, Italy, 247–49, *248*, 255–56, *255*
column statue, 564–65
Commentaries by Beatus and Jerome: illustrated by Emeterius and Ende, page, *Battle of the Bird and the Serpent*, 494, *494*; illustrated by Emeterius and Senior, colophon page, 490, 493–94, *493*
Commodus, 246, 259–60, 274
Commodus as Hercules, bust, Roman, 260, *260*
Common Grackle page, *Birds of America* (John James Audubon), 996–97, *997*
Communism, 1060, 1090, 1117–18, 1126
Comnenian dynasty, 323
complementary color, 1032
Composite order, 229, 659, 762
composition, 77, 951, 983
Composition with Yellow, Red, and Blue (Piet Mondrian), 1092–93, *1092*, 1099
compound pier, 520, *568*
Comte, Auguste, 981, 1002
Conceptualism, 1148–49
Concerning Famous Women (Giovanni Boccaccio), page, *Thamyris*, *623*
concrete, 236, 237; reinforced, 1096
condottieri, 662–63
cone mosaic, 72
Confederate Dead Gathered for Burial, Antietam, September 1862 (Alexander Gardner), *1046*, 1047
Confrérie de Saint-Jean, 582
Confucianism, 409–12, 416, 841; in Japan, 869
Confucius, 410, 841, 850
cong, 403, 404
cong, jade piece, Chinese neolithic, 403–4, *403*
Congo, 923–24
Congo, Democratic Republic of, 927; chair, Ngombe culture, *918*; portrait figure (*ndop*) of King Shyaam a-Mbul a-Ngwoong, Kuba culture, 927, *927*; power figure (*nkisi nkonde*), Kongo culture, 923, *923*
conical tower, Great Zimbabwe, Zimbabwe, 481, *481*
connoisseurship, 37, 41
Conques, France, 515, 518, 524; Sainte-Foy abbey church, *514*, 515, 518, 519–20, *519*, 520, 565
conservation, 183
Constable, John, 994–96; *The White Horse*, 995–96, *995*
Constantina, 300–302
Constantine I the Great, emperor, 256, 259, 282–85, 292, 293, 297, 305, 702
Constantine the Great, statue, Roman, 284, *284*
Constantinople, 292, 302, 309, 310–14, 323, 354, 368, 517, 558, 601; fall of, 338, 340
Constructivism, 1090, 1158
contrapposto, 196, 691, 960
controlled space, 67

Convent Church, Osterhofen, Germany, 942–43, *942*
Cook, James, 907, 908, 910
Cooke, Elizabeth, 958
cope, Flemish, of the Order of the Golden Fleece, 641–42, *642*
Copernicus, Nicolaus, 759
copies of artworks, 760, 803, 1166
Copley, John Singleton, 937, 975; *Boy with a Squirrel*, 975; *Samuel Adams*, *936*, 937, 975
Coppo di Marcovaldo, *Crucifix*, 601, *601*, 609
copyright protection, applied to art, 1166
corbel, *55*, 57, 545, 587
corbel arch, 226
corbel vault, 57, 146, 458
Corbett, Harrison, & MacMurray, 1117
Corcoran Gallery of Art, Washington, D.C., 1175
Córdoba, Spain, 348–49; Great Mosque, 348, 349, *350*, 351, 352, 493
Corinth, Greece, 155, 161, 172, 236; pitcher (olpe), 161, *161*
Corinthian engaged pilaster, *704*
Corinthian order, 28, 162, 164, 200, 211–12, 238, 519, 654
Cormont, Renaud de, 571
Cormont, Thomas de, 571–72
Cornalaragh, Ireland, openwork box lid, 64, *64*
Cornelia Pointing to Her Childen as Her Treasures (Angelica Kauffmann), *962*, 963, 969
Cornell, Joseph, 1162
Corner Counter-Relief (Vladimir Tatlin), 1082, *1082*
cornice, 162, 164, 229, 303, 394, 627, 696, 704, *704*, *725*, 766
Corot, Jean-Baptiste-Camille, 1009–10, 1018, 1023; *First Leaves, Near Mantes*, 1010, *1010*, 1023
Correggio (Antonio Allegri), 705–6, 730; *Assumption of the Virgin*, fresco, Cathedral, Parma, Italy, 705–6, *705*, 769
Cortés, Hernán, 794
Cortona, Pietro da (Pietro Berrettini), 771–72
Cosmati work, 551
cosmology, Chinese, 850
Cosquer, Henri, 43
Cosquer cave, Cap Morgiou, France, *42–43*, 43, 48, 54
Cossutius, 211
Costantine I, 291
Costa Rica, 462; *Shaman with Drum and Snake*, pendant, 462, *462*
Côte d'Ivoire, 924–25, 931–32; spirit mask, Guro culture, 932, *932*; spirit spouse (*blolo bla*), Baule culture, *924*, 925
Council of Chalcedon, 305
Council of Ephesus, 299
Council of Trent, 723
Councils of Nicaea: First, 305; Second, 309
Counter-Reformation, 723, 758, 760
Couple Wearing Raccoon Coats with a Cadillac, Taken on West 127th Street, Harlem, New York, photograph (James VanDerZee), 1113, *1113*
Courbet, Gustave, 1011–12, 1016, 1017, 1018, 1023; *A Burial at Ornans*, 1012, *1012*
Cour Carré. *See* Lescot, Pierre
course, 56–57, 146, 226, 481, 652, 905
court masques, English, 818
Court of Honor. *See* World's Columbian Exposition, Chicago, Illinois
court painting: China, 845–46; French ducal, 622–27
Court style (French Gothic), 578, 582, 583
Courtyard, The (Allan Kaprow), 1138, *1139*
Couture, Thomas, 1019
Cow with the Subtile Nose (Jean Dubuffet), 1127–29, *1128*, 1167
Cox, Kenyon, 1083
Coyolxauhqui, 881
Coyote: I Like America and America Likes Me (Joseph Beuys), 1149, *1149*, 1167
craft arts: American, 1152–53, 1172; post-World War II, 1172–73
craftspeople, 33

Cranach, Lucas, the Elder, 721; *Martin Luther as Junker Jörg*, 721, *721*
Creation and Fall, relief (Wiligelmus), 552, *552*
crenellated battlements, 956
crenellation, 83, 523, *587*
Crete, 131, 133–42, 149
crocket, *568*, 627
Croesus, king of Lydia, 89, 90; coin minted by, *89*
cromlech, 57
Cromwell, Oliver, 759–60
Cross, Saint Giulia church, Brescia, Italy, 279, 495–96, *495*, 529
cross (Christian symbol), forms of, 294, 302
crosses, Irish stone, 491
cross-hatching, 159, 901
crossing, 327, 519, 650
crossing pier, 762
cross vault, 228
Crouching Woman (Erich Heckel), 1066, *1066*, 1071
Crucifix (Coppo di Marcovaldo), 601, *601*, 609
Crucifixion, the (in Christian art), 307
Crucifixion, Lamentation panels, *Isenheim Altarpiece* (Matthias Grünewald), 713, 714–16, *714*
Crucifixion, mosaic, Church of the Dormition, Daphni, Greece, 330–31, *331*, 601
Crucifixion, page, *Rabbula Gospels*, Syria, Early Christian, 321–22, *321*, 330, 336, 530
Crucifixion with Angels and Mourning Figures, book cover, *Lindau Gospels*, Carolingian, 502, *503*, 510
cruciform plan, 302, 519
cruck, *535*
Crusades, 517, 527, 558, 578, 601
crypt, 298
Crystal Palace, London, England (Sir Joseph Paxton), 1000, 1006, *1006*, 1052
Crystal Palace exhibition (1851), 1015
cubicula, 239, 293
Cubiculum of Leonis, Catacomb of Commodilla, Rome, Italy, *288*, 289, 293
Cubism, 1072–82, 1083, 1094, 1130, 1137; influence of, 1078–82
Cubi XIX (David Smith), 27, *27*, 1136
Cubo-Futurism, 1081, 1090
culture, high and low, 1143
cuneiform writing, 70, 71, *71*
Cupid, 158, 242
Cupid and Psyche (Antonio Canova), 953, *953*, 972, 998, 1009, 1042
curators, 36
Current (Bridget Riley), 1146, *1146*
Curry, John Steuart, 1108
curtain wall, 1088
Curtis, Edward S., 890; Hamatsa dancers (photograph), 889, 890, *890*
Cuyp, Aelbert, 809; *Maas at Dordrecht*, 809, *809*
Cuzco, Peru, 881–82; Temple of the Sun (Inka), 794, 882, *882*
Cybele, 236
Cyclades, Greek islands, 129, 131–33; "frying pan" terra-cotta vessel, 132, *132*; *Seated Harp Player*, 132, *133*; women figurines, 132, *132*
cycles, 748
cyclopean construction, 146
cylinder seal, from Sumer, 76, *76*, 374
cylinder seals, Sumerian, 76
Cyrus the Great, 89, 178
Czech Republic, *Woman from Ostrava Petrkovice*, figurine, paleolithic, 46, *46*

D

Dada, 1099–1105, 1129; Japanese, 1139
Dada Dance (Hannah Höch), 1100–1101, *1100*
dado, 229, 272, 338, 579, 693
dagger blade, Mycenae, Greece, 136, 150, *150*
Daguerre, Louis-Jacques-Mandé, 1002–3; *The Artist's Studio*, 1003, *1003*
daguerreotype, 1003
Daitoku-ji, Kyoto, Japan, Juko-in, 864, *864*

Dalí, Salvador, 1105, 1130; *The Great Masturbator*, 1105; *The Persistence of Memory*, 1105, *1105*
Damascus, 345
Damian, Cosmas, 942
Dance, The, sculptural group (Jean-Baptiste Carpeaux), 1008–9, *1008*
dance staff depicting Eshu, Nigeria, Yoruba, 925, *925*
Dante, 617
Danube Landscape (Albrecht Altdorfer), 721, *722*, 744
Daoism, 411–12, 841
Daphni, Greece, Church of the Dormition, 330–31, *330*, *331*, 525, 531, 601
Darby, Abraham, III, 962; Severn River Bridge, Coalbrookdale, England, *962*
Darius I, 89, 155
Darius and Xerxes Receiving Tribute, ceremonial complex, Persepolis, Iran, 89–90, *90*
Darwin, Charles, 980–81
dating of art, 54, 130, 131
Daumier, Honoré, 40, 989, 1012–13, 1073; *Rue Transonain, Le 15 Avril 1834*, 40, *40*; *The Third-Class Carriage*, 1012–13, *1012*
David (Jewish hero), 336
David (Gianlorenzo Bernini), 760, 768, *768*
David (Donatello), 662, *663*, 695
David (Michelangelo), 695, *695*, 768
David, Jacques-Louis, 970–72, 982–84; *Death of Marat*, 971–72, *971*; *Napoleon Crossing the Saint-Bernard*, *982*, 983, 994, 1125; *Oath of the Horatii*, 970–71, *971*
David the Psalmist, page, *Paris Psalter*, Byzantine, 336–37, *336*
Davies, Arthur B., 1083
Davis, Stuart, 1113–15, 1133; *Swing Landscape*, *1114*, 1115, 1133
de, *names with. See in many cases, next element of name, or uninverted name*
Dean George Berkeley and His Family (The Bermuda Group) (John Smibert), 974–75, *975*
death masks, Roman, 239
Death of Fashion, The (Julian Schnabel), 1165–67, *1165*
Death of General Warren at the Battle of Bunker's Hill, June 17, 1775, The (John Trumbull), 976, *976*
Death of General Wolfe, The (Benjamin West), 963, *963*, 976
Death of Marat (Jacques-Louis David), 971–72, *971*
Death of Sarpedon, vase (Euphronios and Euxitheos), 175–77, *176*
deconstruction, 41
deconstructivist architecture, 1158–59
Decorated style (English Gothic), 579, 586
decorative arts: Chinese, 846; French, 946–49; Neoclassicism in, 956–59
Degas, Edgar, 1018–19, 1020, 1021, 1024–25, 1081; *The Rehearsal on Stage*, 1020, 1024–25, *1025*, 1042
Degenerate Art Exhibition (1937), Munich, Germany, 1097, *1097*
Deir el-Bahri, Egypt: funerary temple of Hatshepsut, 116, *117*, 157, 237; *Hatshepsut as Sphinx*, sculpture, *116*; tomb of Nefertari, 96, 121, 123, *123*, 124
Déjeuner sur l'Herbe, Le (The Luncheon on the Grass) (Édouard Manet), 1018, 1019–21, *1019*, 1026
de Kooning, Elaine, 1134
de Kooning, Willem, 1131, 1133–34, 1145, 1152; *Woman I*, 1133–34, *1133*
Delacroix, Eugène, 988–90, 1063, 1095; *Scenes from the Massacre at Chios*, 988, *989*, 993, 999; *Women of Algiers*, 990, *990*
Delaunay, Robert, 1078; *Homage to Blériot*, 1078–79, *1079*
Delaunay-Terk, Sonia, 1079
Delhi, India, 836
Delivery of the Keys to Peter (in Christian art), 306
Delivery of the Keys to Saint Peter, fresco (Pietro Perugino), 675–76, *675*, 690

Delphi, Greece
 Sanctuary of Apollo, 156–57, *156*, 157, *157*,
 181, *181*, 211; Siphnian Treasury, 157, 163,
 166–67, *166*, 167
 Sanctuary of Athena Pronaia, *tholos at*, 200,
 200, 211
De Materia Medica, manuscript (Pedanius
 Dioscorides), *Wild Blackberry*, *320*, 321
Demeter, 134, 158, 206
democracy, Greek, 155
Demoiselles d'Avignon, Les (Pablo Picasso),
 1074–75, *1074*, 1134; study for, 1074–75, *1075*
demotic writing, 111
Denial of Peter (in Christian art), 307
Denmark: ceramic vessels, Neolithic, 62, *62*;
 Gummersmark brooch, 488, *488*, 525
dentil, 164, 211
Deogarh, Uttar Pradesh, India, Vishnu Temple,
 388, 389, *389*, 390, *390*, 392, 395
*Departure of the Volunteers of 1792 (The
 Marseillaise)* (François Rude), 990, *990*, 1008
Deposition, altarpiece (Rogier van der Weyden),
 634, *634*, 964
Derain, André, 1063, 1081; *Mountains at
 Collioure*, 1063, *1063*
Derrida, Jacques, 41, 1158, 1166, 1168, 1169
Descartes, René, 759
Descent from the Cross (Deposition) (in
 Christian art), 307
Descent into Limbo (in Christian art), 307
Descent of the Amida Trinity, triptych, Japan,
 Kamakura period, 444, *444*
desk (Hector Guimard), 1041, *1041*, 1172
Dessau, Germany, Bauhaus Building, 1097,
 1098–99, *1098–99*, 1154
Deutscher Werkbund, exhibition (1927), 1094
Devi, 378, 393
dharma, 377
dharmachakra, 435
Dharmaraja Ratha, Mamallapuram, Tamil
 Nadu, India, 394, *394*, 397
Diaghilev, Serge, 1081
Diana, 158
Diana Resting after Her Bath (François
 Boucher), 945–46, *945*
Diary (Minidoka Series #3; Roger Shimomura),
 change to hash, 40, *40*
Diderot, Denis, 938, 968
Dijon, France, Chartreuse de Champmol, 622,
 625–26, *625*, *626*, 629, 667
Diner, The (George Segal), 1138, *1138*
Dinner Party, The (Judy Chicago), 1163,
 1163, 1164
Diocletian, 279–82
Dionysos, 158, 211, 218
Dionysos with Maenads, vase (Amasis Painter),
 172–74, *173*
Dionysus the Pseudo-Areopagite, 334
Dioscorides, Pedanius, *De Materia Medica*,
 manuscript, *Wild Blackberry*, *320*, 321
diptych, 285, 308, 507, 628, *628*, 635, 1145
Dipylon Cemetery, Athens, Greece,
 159–60, *159*
Diquis culture, 462
Discus Thrower (Diskobolos) (Myron), *152*, 153,
 182–83, 190, 268
dish, silver, British-Roman, 286, *286*
Disk of Enheduanna, Ur (modern Muqaiyir,
 Iraq), 76, *77*
Disputà (Raphael), 691, *691*
divination (prophecy), 232–33
divination bowl (Olowe of Ise), 31, *31*
diviners, African, 922–26
Division of the Barrios, The (Judy Baca),
 1178–79, *1178*
Djenné, Mali, 479, 917; Great Friday Mosque,
 480, *480*
Djoser, Egyptian king, 100
Djoser's funerary complex, Saqqara, Egypt,
 100–102, *100*, 101, *101*
documentary photography, 1150
Doesburg, Theo van, 1092
Dogon people (Mali), 929–30
dogu, 429–30

dogu earthenware figure, Japan, Jomon period,
 429, *429*
doll (*biiga*), Burkina Faso, Mossi culture, 919, *919*
dolmen, 57
dome, 228, 298, 380; on pendentives, *311*;
 on squinches, *311*
Dome of the Rock, Jerusalem, Palestine,
 345–47, *346*
domestic architecture, Roman, 263–67
Domitian, 254
Donatello (Donato di Niccolò Bardi), 622, 650,
 656, 662–65, 674, 1039; *David*, 662, *663*, 695;
 Equestrian monument of Erasmo da Narni
 (*Gattamelata*), 662, 664, *664*, 1125; *Feast of
 Herod*, panel of baptismal font, Cathedral
 Baptistry, Siena, Italy, 662, *662*; *Mary
 Magdalen*, 662, *663*
Dong Qichang, 849–51, 853, 869; *The Qingbian
 Mountains*, hanging scroll, 851, *851*
donors, depiction of, 630
door (Olowe of Ise), 927, *928*
Doors of Bishop Bernward. *See* Saint Michael
 abbey church, Hildesheim, Germany
doorway panels, church, Urnes, Norway,
 536–37, *537*
Dordogne, France, La Mouthe cave, 48, 53, *53*
Doric engaged column, *704*
Doric order, 162, 164, 189
Dormition of the Virgin, relief, Cathedral,
 Strasbourg, France, 594, *594*
Dossi, Burkina Faso, masks, Bwa culture, 920,
 921, 931
Double Negative (Michael Heizer), 1159, *1159*
double pediment, *725*
Doubting Thomas, relief, abbey church, Santo
 Domingo de Silos, Castile, Spain, 523, *523*
Douglas, Aaron, 1113; *Aspects of Negro Life:
 From Slavery through Reconstruction*,
 1112, 1113
dove (Christian symbol), 294
dragons (Chinese motif), 847
drawbridge, 587
Drawing Lesson, The (Jan Steen), 33–34, *34*
Dream of Henry I page, *Worcester Chronicle*
 (John of Worcester), 540, *541*
Dream Time (Australian Aboriginal), 901–2
dressed stone, 135, 380, 481
drum (architecture), 164, 228, 253, 311, 345,
 650, 701, 833
Drunken Cobbler, The (Jean-Baptiste Greuze),
 968, *968*
drypoint, 806, 808, *808*
du Barry, Madame, 946, 967
Dubuffet, Jean, 1127–29, 1167; *Cow with the
 Subtile Nose*, 1127–29, *1128*, 1167
Duccio di Buoninsegna, 601–3, 617
 Maestà Altarpiece, Cathedral, Siena, Italy,
 603, *603*; *Virgin and Child in Majesty* panel,
 602–3, *602*
Duchamp, Marcel, 1083, 1101–2, 1115, 1125,
 1141, 1142, 1148, 1166, 1169; *Bride Stripped
 Bare by Her Bachelors, Even, The (The Large
 Glass)*, 1083, 1102, *1103*, 1141; *Fountain*,
 1102, *1102*, 1106, 1125, 1141, 1166, 1169
duen fobara screens (Ijo), 930–31
Dunhuang, Gansu, China, *The Western Paradise
 of Amitabha Buddha*, wall painting, 416,
 416, 418
Dunn, Dorothy, 893–94
Dupérac, Étienne, *Piazza del Campidoglio,
 Rome*, print, 723, *723*
Dura-Europos, Syria, 294–97; Christian house-
 church, 296–97, *297*; synagogue, 295, *295*,
 296, *296*
Dürer, Albrecht, 621, 711, 716–18, 720–21, 778,
 808; *Adam and Eve*, 717–18, *717*, 806; *Four
 Apostles*, 720–21, *720*; *Four Horsemen of the
 Apocalypse*, 717, *717*, 806; house of,
 Nuremberg, Germany, 711, *711*; *Melencolia I*,
 718, *718*, 806; *Self-Portrait*, 716–17, *716*
Durga, 393
Durga as Slayer of the Buffalo Demon, relief,
 Mamallapuram, Tamil Nadu, India,
 393, *393*

Durham, Northumberland, England: castle-
 monastery-cathedral complex, 537–39, *537*;
 Cathedral, 537–39, *538*, 539, 566
Dur Sharrukin (modern Khorsabad, Iraq),
 80–82; citadel and palace complex of Sargon
 II, reconstruction drawing, 80–82, *81*;
 ziggurat at, 82
Dutch art: Baroque, 800–816; genre paintings,
 813, 946; Rationalism, 1092–93;
 Renaissance, 745–48
Dutch Interior I (Joan Miró), 1104, *1104*, 1131
Dutch Republic, 786, 800–802
Dyck, Anthony Van, 778, 799–800, 961;
 Charles I at the Hunt, 800, *800*, 961
*Dying Gallic Trumpeter, Chieftain and Wife, and
 Mother and Child* (Epigonos, attributed to),
 212–13, *213*, 268
Dying Warrior, pediment, Temple of Aphaia,
 Aegina, Greece, 167–68, *167*, 213

E

Eakins, Thomas, 1049; *The Gross Clinic*,
 1048–49, *1049*
Early Christian World, 290 (map)
Early Horizon period, 463
Early Renaissance, 641–83
earrings, Greek, *208*
earspool, Peru, Moche culture, 465, *465*
earth embankment, 587
earthenware, 62
earthenware soldiers, Qin emperor mausoleum,
 Lintong, Shaanxi, China, 400, 401, 407
earthworks: Celtic, 64; modern, 1159–61;
 Native American, 879, 884
East Africa, 473
Easter Island, Polynesia, 899, 900, 901, 906;
 moai ancestor figures, *898–99*, 899, 906
Eastern Church. *See* Orthodox Church
Eastern Empire. *See* Byzantine Empire
Eastern Woodlands (U.S.), 884–88
Eastman, George, 1049
Ebbo, archbishop of Reims, 501
Ebbo Gospels, manuscript, Carolingian,
 Matthew the Evangelist, 501, *501*, 531
echinus, 163, 164
École des Beaux-Arts, 944, 982, 1007, 1032,
 1039, 1052, 1054
Edict of Milan, 282, 297
Edirne, Turkey, Selimiye Cami (Mosque of
 Selim), 351, 358, *358*, *359*, 363
edition, 648
Edo (Tokyo), Japan, 866
Edo period (Japan), 866–73
Education of the Virgin, Virgin and Saint George,
 altarpiece (Luis Borrassá), 592, *592*
effigies, 429–30
egg-and-dart moldings, 257
Egypt, 155, 156, 159, 353, 357, 472–73, 917;
 Ancient, 94 (map); Early Dynastic period,
 95–99; Middle Kingdom, 108–13; neolithic
 and predynastic period, 94–95; New
 Kingdom, 113–25; Old Kingdom, 99–108
Egyptian art, 175, 279; influence of, 125–26;
 temples, 57
Eiffel, Gustave, 979
Eiffel Tower, Paris, France, *978–79*, 979, 1088,
 1090, 1157
Eight, The, 1082
Eighty Years War, 745
Einhard, 497
Eitoku, Kano, 863–64
Ekkehard and Uta, statues, Cathedral,
 Naumburg, Germany, 595–96, *596*
Ekpo masks, 929
Elam, 69, 85–86
Eleanor of Aquitaine, 559
Electronic Superhighway: Continental U.S.
 (Nam June Paik), 1182, *1182*
electron spin resonance dating, 54
Elephanta, Maharashtra, India, Cave-Temple
 of Shiva, 391–92, *391*, 392, *392*, 398
Eleusis, Greece, Sanctuary of Demeter and
 Persephone at, 206

elevations, 162
elevators, 1054
Elgin, earl of, 85, 190
Elizabeth I, of England, 750–51, 752
Elizabeth I as a Princess (Teerling, Levina
 Bening, attributed to), 750–51, *750*
Elohim Creating Adam (William Blake),
 965–66, *965*
emblemata, 267, 269
embroidery, 452, 540, 544, 589; Peruvian, 463–64
Emeterius and Ende (with the scribe Senior),
 Commentaries by Beatus and Jerome, 490,
 493–94, *493*, 494, *494*
emotion in art, 213
Emperor Justinian and His Attendants, mosaic,
 San Vitale, Ravenna, Italy, 317, *317*, 488
emperors: Japanese, 430; Roman, 234
Empire State Building, New York, N.Y., *1088*
Empress Theodora and Her Attendants, San
 Vitale, Ravenna, Italy, 317, *318*
encaustic painting, 126, 170, 1142
Encyclopédie, 968
Ende (illuminator), 494, 623
engaged column, 102, 238, 704
engaged half column, *725*
Engels, Friedrich, 981
England, 516, 535, 543, 559, 622, 646, 742,
 748, 816
English art: 18th century, 953–66; 19th century,
 1014–18; architecture, 753, 816–20; Baroque,
 816–20; classicism, 953–56; Gothic period,
 584–89; Gothic revival, 956; Neoclassicism,
 956–59; painting, 749–52; Renaissance,
 748–55; Romanticism, 953–66
English landscape architecture, 816–20,
 953–54, 1055
engraving, 644, 648–49, *648*, 717, 803;
 technique, 648
Enheduanna, 76
Enlightenment, 938–39
Ensor, James, 1037–38, 1065; *The Intrigue*,
 1038, *1038*
entablature, 162, 164, 226, 456, 700, 704, *704*,
 725, 761
entasis, 165
Entombment, the (in Christian art), 307
Entombment (Caravaggio), 776, *776*, 793
Entombment (Jacopo da Pontormo), 729–31,
 730, 744
Entry into Jerusalem (in Christian art), 306
Eos, 158
Ephesos, temple of the goddess Artemis, 104
Epic of Gilgamesh, 71
Epidauros, Greece: theater, *210*, 211; *tholos*,
 Corinthian capital, 27–28, *28*
Epigonos, 213–14; attributed to, *Dying Gallic
 Trumpeter, Chieftain and Wife, and Mother and
 Child*, 212–13, *213*, 268
Equestrian monument of Bartolommeo
 Colleoni (Andrea del Verrocchio), 664, *664*,
 665, 950, 1125
Equestrian monument of Erasmo da Narni
 (*Gattamelata*; Donatello), 662, 664, *664*, 1125
Equestrian statue of Marcus Aurelius, Roman,
 259, *259*, 279
Erasmo da Narni, 664
Erasmus, 718, 749
Erechtheion, Acropolis, Athens, Greece, 187,
 193–94, *193*; Porch of the Maidens, 193–94,
 194, 265
Erechtheus, 193
ere ibeji figure (Yoruba), 919–20
Ergotimos, 172; and Kleitias, *François Vase*,
 172, *172*
Ernst, Max, 1104, 1130; *The Horde*, 1104, *1104*
Eros, 158
Escorial, Madrid, Spain (Juan Bautista de
 Toledo), with Juan de Herrera, 742, *742*, 786
Eshnunna (modern Tell Asmar, Iraq), votive
 statues, 73–74, *73*
Eshu, 925–26
Esoteric Buddhism, art of, 436–37
Esquilache Immaculate Conception, The
 (Bartolomé Esteban Murillo), 793–94, *793*

Este, Isabella d', marchesa of Mantua, 709–10
Este family (Ferrara), 649
Estes, Richard, 1161; *Prescriptions Filled
 (Municipal Building)*, 1161, *1161*
etching, 806, 808, *808*, 992, 1017
Eternal Shiva, relief, Cave-Temple of Shiva,
 Elephanta, Maharashtra, India, 392, *392*, 398
Étienne Chevalier and Saint Stephen, wing,
 Melun Diptych (Jean Fouquet), 628, 646, *647*
Etruscan civilization, 224–33, 224 (map),
 231–32, 233, 236
Eucharist (Christian rite), 293, 302
Eumenes II, 214
Euphronios, 175–77; and Euxitheos, *Death of
 Sarpedon*, vase, 175–77, *176*
Euripides, 211
Europe: 16th century, 686–87; 17th century, 758
 (map); 18th century, 938 (map); 20th century,
 1060–61, 1060 (map); early Middle Ages, 486
 (map); Gothic, 556 (map); prehistoric, 44
 (map); Roman, 224 (map); Romanesque,
 516 (map)
European art: 18th century, 937–77; 19th
 century, 979–96, 1000–1042; Cubism,
 1072–82; Modernism, 1059–82, 1087–1107;
 post–World War II, 1127–29
Eusebius, 297
evangelists, Christian, symbols for, 294
Evans, Sir Arthur, 131, 133, 135, 137, 149
Evans, Walker, 1166
ewer, fritware, Persian, 361, *361*
exedra, 237, 253, 311, 315, 498
Exekias, 175; *The Suicide of Ajax*, vase, 165,
 174, 175
Experiment on a Bird in the Air-Pump, An
 (Joseph Wright), 961, *961*, 964
Exposition Internationale des Arts Décoratifs et
 Industriels Modernes (Paris, 1925), 918,
 1090; Workers' Club, *1091*, 1169
Expressionism, 1037–38, 1127; German,
 1065–71, 1097, 1167
expressionistic style, 26, 1033; contemporary,
 1167; Hellenistic, 213; Medieval, 501
Expulsion from Paradise, The (Masaccio),
 670–71, *670*
extrados, 228
Eyck, Jan van, 621, 622, 630–33, 635, 637, 640,
 645, 670–71, 693; *The Annunciation*, 631–32,
 631; *Ghent Altarpiece*, Saint-Bavo cathedral,
 Ghent, Flanders, *Adam* and *Eve* panels, 631,
 670–71, *670*; *Man in a Red Turban*, 632, *632*;
 *Portrait of Giovanni Arnolfini (?) and His Wife,
 Giovanna Cenami (?)*, 632–33, *633*, 637, 807–8

F

facade, 160, 655, 704
Face of King Senusret III, Egyptian, 112, *112*
factory buildings, 1157
Faenza, Italy, 666; *Albarello*, jar, 665–66, *665*
Fagus Factory, Alfeld-an-der-Leine, Germany
 (Walter Gropius), with Adolf Meyer, 1088,
 1089, 1096, 1099, 1154
faience, Egyptian, 112, 122
fakes, 145
faktura, 1082
Fallingwater, Edgar Kaufmann House, Mill
 Run, Pennsylvania (Frank Lloyd Wright),
 1094, 1116–17, *1116*
Fall of the Giants, fresco (Giulio Romano),
 703–5, *703*
family life, and African art, 919–22
Family of Charles IV (Francisco Goya y
 Lucientes), 991–92, *991*
Family of Saltimbanques (Pablo Picasso),
 1073, *1073*
Family of Vunnerius Keramus, portrait, Roman,
 277–78, *278*, 495
fang ding, 405
fang ding bronze, China, Shang dynasty,
 405–6, *405*
Fang people (West Africa), 930

Fan Kuan, 421; *Travelers among Mountains and
 Streams*, *420*, 421
Faretsj River, Irian Jaya, Indonesia, Asmat
 ancestral spirit poles (*mbis*), 904, *904*
Farm Security Administration (FSA), 1166
Farnese, Alessandro, 701
Farnese family, 704, 771
Farnese Gallery, Rome, Italy, 769, *769*
Farnese palazzo, Rome, Italy (Antonio da
 Sangallo), with Michelangelo, 703, *703*, 768,
 770, 771, 780, 942
fascism, 1060, 1081, 1130
Fauvism, 1063–65, 1069, 1075, 1078–79, 1081
Fayum portraits, 126, 275
Feast in the House of Levi (Veronese), 734–36,
 735, 941
Feast of Herod, panel of baptismal font
 (Donatello), 662, *662*
featherwork, Oceania, 907–8
February page, *Très Riches Heures*, manuscript
 (Limbourg brothers), 624–25, *624*, 630, 640,
 670–71, 748
Federal Art Project, 1109
Federal Period architecture, 973
feminist art, 41, 1162–65, 1170
Feminist Art Program (California Institute
 of the Arts), 1164
feminists, 19th century, 981
feng shui, 850
Ferrara, 649
Fertile Crescent, 68–69
fertility rituals and objects, 919
Fervor (Shirin Neshat), production stills,
 1183, *1183*
fête galante, 943
feudalism, 516–17; Japan, 862, 866
fiber arts, 86; Early Renaissance, 641–45;
 modern, 1098
*Fighting "Téméraire," Tugged to Her Last Berth to
 Be Broken Up, The* (Joseph Mallord William
 Turner), 994, *995*, 1052
figurative art: ban on, 343–44; Chinese, 418;
 Egyptian, 98–99; Islamic, 349; post–World
 War II, 1138
figure, Ain Ghazal, Jordan, 69–70, *69*
figurines: African, 922–30; Chinese, 407;
 Egyptian, 112; Japanese, 429–30
filigree, 136
fillets, 164
Finding of the Baby Moses, synagogue,
 Dura-Europos, Syria, 296, *296*
fine arts, 37
finial, 388, 480, 788, 833
finial of a spokesperson's staff (*okyeame poma*;
 Kojo), *914–15*, 915, 926
Finley, Karen, 1175
Fiorentino. *See* Rosso Fiorentino
Fiorentino, Rosso, 730
Fire in the Sky (Peter Halley), 1168–69, *1168*
firman, 368
First Leaves, Near Mantes (Jean-Baptiste-
 Camille Corot), 1010, *1010*, 1023
fish (Christian symbol), 294
Fishing in a Mountain Stream (Xu Daoning),
 421–22, *421*
Five Rathas (Hindu temples), 393–94
Flagellation, the (The Scourging) (in Christian
 art), 307
Flamboyant style (French Gothic), 579,
 626–27
Flanders, 786, 796; art of (*see* Flemish art);
 Monkey Cup, beaker, 645, *645*
Flaxman, John, Jr., 957
Fleck, John, 1175
Flemish art, 628–46, 974; Baroque, 796–800;
 influence of, 645–48
fleurs-de-lis, 949
Flight into Egypt (in Christian art), 306
Flitcroft, Henry, 954; Park at Stour, Wiltshire,
 England, with Henry Hoare, 954, *955*, 1055
Flood Tablet, from *The Epic of Gilgamesh*, 71, *71*
Florence, Italy, 601, 607, 612, 649–55, 656, 688
 Baptistry of San Giovanni, 650, 660–62, *661*;
 doors, 599–601, *600*, 660–62

Capponi Chapel, Santa Felicità church, 729, *729*
Cathedral (Duomo), 597, *598*, 650–52, *651*, *652*, 764
Early Renaissance architecture in, 650–55
Foundling Hospital, 652, 653, *653*, 672
Medici Chapel, Church of San Lorenzo, 699–700, *699*
Medici-Riccardi palace, 654–55, *654*
Orsanmichele, 658, 660, 666, *666*
Pitti Palace, Boboli Gardens, the Great Grotto, *741*
Rucellai palace, 655, *655*
San Lorenzo church, 652–54, *652*, 669, 699
San Lorenzo monastery, 693, 700–701, *700*
San Marco monastery, 672, *672*
Santa Maria del Carmine, Brancacci Chapel, 669, *669*–71, 670–71, 688
Santa Maria Novella, 667–69, *668*, 681
Sant'Apollonia, 672, *673*, 689
Santa Trinità church, 667, *667*; Sassetti Chapel, 676, *676*
"*Flotilla*," fresco, West House, Akrotiri, Thera, Greek island, *128*, 129, 140
flower piece, 26, 814; Dutch, 814–16
Flower Piece with Curtain (Adriaen van der Spelt), 25–26, *25*
Flower Still Life (Rachel Ruysch), 815, *815*
fluting, 102, 164, 392, 1094
Fluxus, 1149, 1160, 1182
flying buttress, 565
Foire Chinoise (The Chinese Fair), La, tapestry copy after (François Boucher), 946–48, *948*
folk art, 1035
Fontainebleau, France
 Château, 739; Chamber of the Duchess of Étampes, *740*, 741
 School of, 741
Fontana, Domenico, 760
Fontana, Lavinia, 733–34; *Noli Me Tangere*, 734, *734*
Fontenay, Burgundy, France, abbey church, 521–23, *522*, 584
Fontenelle, Bernard de, 938
footprints, prehistoric, 50
foot-washing ritual, 511–12
Forbidden City, Beijing, China, 848, *848*, 930
foreshortening, 177, 267, 621, 660
formalism, 1090, 1092, 1145
formline elements, 889
Fortuna, 234
forum, 235, 260
Foster, Norman, 1157–58; HongKong & Shanghai Bank, Hong Kong, 1157–58, *1157*
Foucault, Michel, 1168
Founding of Tenochtitlan, The, page, *Codex Mendoza*, Aztec, 880, *880*
Foundling Hospital, Florence, Italy (Filippo Brunelleschi), 652, 653, *653*, 672
Foundry Painter, 177; *A Bronze Foundry*, vase, 177, *177*
Fountain (Marcel Duchamp), 1102, *1102*, 1106, 1125, 1141, 1166, 1169
Fouquet, Jean, 646; *Melun Diptych*, wing, *Étienne Chevalier and Saint Stephen*, 628, 646, *647*
Four Apostles (Albrecht Dürer), 720–21, *720*
Four Crowned Martyrs (Nanni di Banco), 660, *661*, 662
Four Horsemen of the Apocalypse (Albrecht Dürer), 717, *717*, 806
four-*iwan* mosque, 351, 355–56
Four Noble Truths (Buddhism), 376
Four Rivers Fountain, Piazza Navona, Rome, Italy (Gianlorenzo Bernini), 765–66
Fox Seizing a Rooster, page, *Book of Hours of Jeanne d'Evreux* (Jean Pucelle), 584, *584*
Fragonard, Jean-Honoré, 946; *The Loves of the Shepherds*, series, *The Meeting*, 946, *947*, 969
France, 516, 556, 559, 778, 918, 1060, 1101; art (*see* French art); unattributed work from, *Woman from Brassempouy*, figurine, paleolithic, 46, 47, *47*
Francis, Saint, 610
Francis I, of France, 690, 739, 749–50
Franciscans, 609, 796

Francis I (Jean Clouet), 739, *739*
Franco, Francisco, 1059, 1060
François Vase (Ergotimos and Kleitias), 172, *172*
Frank, Robert, 1150–51; *The Americans*, 1150; *Trolley, New Orleans*, *1150*, 1151
Frankenthaler, Helen, 1137, 1145; *Mountains and Sea*, 1137, *1137*, 1145
Franklin, Benjamin, 938
Franks, 487, 496
Frederick II, Emperor, 597
Frederick Barbarossa, Emperor, 498
Frederick C. Robie House, Chicago, Illinois (Frank Lloyd Wright), 1086–87, *1086*; dining room, *1086*, 1087
Frederick Henry, prince, 802, 805
Frederick Leyland house, London, England, Peacock Room, 36, *36*
Freedom from Want (Norman Rockwell), 1112, *1112*
Freeman, Leslie G., 48
freestanding sculpture, Greek, 168–71, 179–83
French art
 architecture, 739–42, 778–82, 966–68, 1007–9
 painting, 739, 782–85, 943–46, 968–73, 984–90
 periods and styles: 18th century, 966–73; academic, 1007–9; Baroque, 778–85; classicism, 1094–96; Cubism, 1078–79; Flemish style, 646; Gothic, 559–84; naturalism, 1009–11; Neoclassicism, 946, 949, 982–91; Purism, 1095–96; realism, 1009–13; Renaissance, 739–42; Romanesque, 517–34; Romanticism, 982–91
 sculpture, 781–82, 946–49, 968–73, 990–91, 1039–41
French Revolution (1789), 625, 643, 938, 971
fresco, 386, 531, 604, 666, 688, 707; Early Renaissance in Italy, 667–76; Mesoamerican, 456
fresco secco, 139, 604
Freud, Sigmund, 41, 964, 1102, 1130; *The Interpretation of Dreams*, 1036
Frey, 487
Freya, 487
Friedrich, Caspar David, 993–94; *Monk by the Sea*, 993–94, *993*
frieze, 163, 164, 346
Frigg, 487
Frolicking Animals (Toba Sojo, attributed to), 440–42, *441*
frottage, 1104
Fry, Roger, 1030
"frying pan" terra-cotta vessel, Cyclades, Greek islands, 132, *132*
Fujii, Chuichi, *Untitled '90*, 874, *874*
Fujiwara Shunzei, 866
funerary architecture, Egyptian, 99–104
funerary art: Egyptian, 160; Greek, 160; Romanesque, 546
funerary customs: African, 929–31; Ancient Near East, 76; China, 405–6; Roman, 239, 279
Funerary Stele of Amenemhat I, Assasif, Egypt, 110–12, *110*
Funerary temple of Hatshepsut, Deir el-Bahri, Egypt, 116, *117*, 157, 237
furniture: African, 918; art deco, 918; Chinese, 846–47
Furrier's Shop, stained glass, Notre-Dame cathedral, Chartres, Ile-de-France, France, detail of *Charlemagne Window*, 567–70, *569*
Fur Traders Descending the Missouri (George Caleb Bingham), 998, *999*
Fuseli, John Henry (Johann Heinrich Füssli), 964–65; *The Nightmare*, *964*, 965
fusuma (Eitoku Kano), 864, *864*
fusuma sliding doors, 863–64, 865
Futurism, 1080–81

G

gable, 160, 164, 627, 725, *725*, 910
Gabon, reliquary guardian (*nlo byeri*), Fang culture, 930, *930*

gadrooning, 491
Gainsborough, Thomas, 961; *Portrait of Mrs. Richard Brinsley Sheridan*, *960*, 961
Galileo Galilei, 759
galleria, 769
gallery, 311, 498, 519
Gallic Chieftain Killing His Wife and Himself, Hellenistic, 212–13, *212*
Gandhara (Pakistan), *Standing Buddha*, 383, *383*, 435
Gandhara School, 383–84, 386, 435
Gandhi Bhavan. *See* Mathur, B. P.
Ganymede, 208
garbhagriha, 381, 388, 390
garden, Pompeii, Italy, wall niche, *266*
Garden and a Princely Villa, A, sketch for set design (Inigo Jones), *818*
garden carpet, Persian, 363, *363*, 364
Garden in Sochi (Arshile Gorky), 1130–31, *1130*
Garden of Earthly Delights (Hieronymus Bosch), 745–46, *745*
Garden of Love page, *Hypnerotomachia Poliphili*, book (Fra Francesco Colonna), *644*
Garden of the Cessation of Official Life, Suzhou, Jiangsu, China, *838–39*, 839, 847
gardens: Chinese, 847; English landscape, 816–20, 953–54, 1055; French Baroque, 780; Islamic, 354; Japanese, 861–62; Renaissance, 741–42; Roman, 266
Garden Scene, Villa of Livia, Primaporta, Italy, 266, 270, *270*, 293
Gardner, Alexander, 1047; *Confederate Dead Gathered for Burial, Antietam, September 1862*, *1046*, 1047
Garnier, Charles, 1007–8; Opéra, Paris, France, 1007, *1007*, 1008, *1008*, 1026
Gates of Paradise (East Doors) (Lorenzo Ghiberti), 650, 660–62, *661*
Gaucher de Reims, 575
Gaudí y Cornet, Antonio, 1061–62, 1167; serpentine bench, in Güell Park, Barcelona, Spain, 1061–62, *1061*, 1167
Gauguin, Paul, 906, 1030, 1034–35, 1036, 1063, 1068, 1074, 1081, 1104, 1127; *Mahana no atua (Day of the God)*, 1035, *1035*, 1065
Gaulli, Giovanni Battista (Baciccia), 772; *Triumph of the Name of Jesus*, ceiling fresco, Il Gesù church, Rome, Italy, 772, *773*
Gauls, 212
Ge, 158, 214
Geb, 96
Geese Aslant in the High Wind (Uragami Gyokudo), 869–70, *869*
Gehry, Frank O., 1158–59; Guggenheim Museum, Bilbao, Spain, 36, 1158–59, *1159*
Geisha as Daruma Crossing the Sea (Suzuki Harunobu), 872, *872*
Gemma Augustea, cameo, Roman, 245, *245*, 510
gender vs. sex, 1174
General and Officers, brass, Benin, 478, *479*
Genesis, manuscript, *Rebecca at the Well* page, 320, *321*
Genji paintings, 440–41
Genoa, Italy, 542
genre painting: American, 997–98; Baroque, 759; Chinese, 845; Dutch, 813, 946
Gentile da Fabriano, 666–67; *Adoration of the Magi*, altarpiece, Santa Trinità church, Florence, Italy, 667, *667*
Gentileschi, Artemisia, 777–78, 1163; *Judith and Maidservant with the Head of Holofernes*, 777, *777*; *La Pittura*, 777–78, *777*
geoglyphs, 464
geomancy, Chinese, 850
geometric design, 902
Geometric Period (Greek), 157, 159–60
George, Saint, 323
George III, of England, 957
George Clifford, 3rd Earl of Cumberland (Nicholas Hilliard), 751, *751*
George Washington (Jean-Antoine Houdon), *972*, 973, 985, 998
Gérard, Marguerite, 946

Géricault, Théodore, 984–88, 989; *Pity the Sorrows of a Poor Old Man*, 984–88, *988*; *Raft of the "Medusa,"* 985, 986–87, *986*; *The Sighting of the "Argus,"* 985, 986, *987*, 1063; *Study of Hands and Feet*, 985, 986, *987*, 1063, 1095; *Various Subjects Drawn from Life and On Stone*, 988

German art

architecture and architectural decoration, 940–43

painting, 714–18

printmaking, 714–18

sculpture, 711–13

styles: avant-garde, suppression of, 1097; Baroque, 785–86; Bauhaus, 1096–99; Expressionism, 1065–71, 1097, 1167; Flemish, 646; Gothic, 592–96; naturalism and realism, 1013; Renaissance, 710–23

German Pavilion, Barcelona International Exposition (1929; Ludwig Mies van der Rohe), 1099, *1099*

Germany, 1060, 1101; art (*see* German art); Nazi, 1060, 1097; Renaissance and Reformation, 710–23

Germany, Germans, 495, 516, 542, 556

Gernrode, Germany, Saint Cyriakus church, 506, *506*, *507*, 544

Gero, archbishop of Cologne, 510

Gero Crucifix, Cathedral, Cologne, Germany, 510, *510*, 529, 601

Gersaint, Edme-François, 943

gesso, 602, 630

gesturalism, 912, 1131

Gesù, Il, church, Rome, Italy (Vignola), with Giacomo della Porta, 723, 724–27, *725*, 761, 766, 772, *773*, 778, 987

Geta, 274–75

Ghana, 917, 926–27; *kente* cloth, Ashanti, 926, *926*

Ghent, Flanders, 641; Saint-Bavo cathedral, 631, 670–71, *670*

Ghent Altarpiece (Jan van Eyck), *Adam* and *Eve* panels, 631, 670–71, *670*

Ghiberti, Lorenzo, 660–61; Gates of Paradise (East Doors), Baptistry of San Giovanni, Florence, Italy, 650, 660–62, *661*

Ghirlandaio, Domenico, 622, 640, 676, 694, 696; altarpiece, Sassetti Chapel, Santa Trinità church, Florence, Italy, 676, *676*; *The Nativity with Shepherd*, 676

Ghost Clock (Wendell Castle), 1172, *1172*

Giacometti, Alberto, 1127; *City Square*, 1127, *1127*

Giants, 214

Gibla wall, 351

Gilbert, Cass, 1087; Woolworth Building, New York, NY, 1087, *1087*, 1088

gilding, 634

Gilgamesh, 71

Gilpin, Laura, Taos Pueblo (photograph), 893, *893*

Giorgione (Giorgio da Castelfranco), 706–9, 734, 1018; *The Tempest*, *706*, 707, 745

giornata, 604

Giotto di Bondone, 608–12, 617

frescoes, Scrovegni (Arena) Chapel, Padua, Italy, 617, *618*; *The Lamentation*, 612, *612*; *Last Judgment*, 610–12, *611*; *Marriage at Cana, Raising of Lazarus, Resurrection* and *Noli Me Tangere*, 617, *619*

Virgin and Child Enthroned, 608, *609*

Giovanni da Bologna, 732; *Astronomy* or *Venus Urania*, 732, *733*, 741

Giovanni di Ser Giovanni (lo Scheggia), 622, 677; Birth tray of Lorenzo de' Medici, 677, *677*

Girardon, François, 781–82; *Apollo Attended by the Nymphs of Thetis*, 782, *782*, 1028

Girodet-Trioson, Anne-Louis, 972; *Portrait of Jean-Baptiste Belley*, 972–73, *972*

Gislebertus, 527

Gita Govinda, manuscript, Indian, 833–34; page, *Krishna and the Gopis*, 834, *834*

Giuliani, Rudolph, 1175

Giulio Romano, 703–5, 730, 739

Palazzo del Tè, Mantua, Italy, 703–5, *703*; *Fall of the Giants*, fresco, Sala dei Giganti, 703–5, *703*

Giza, Egypt: The Great Sphinx, 24, *24*, 25, 35, 47, 104; *Khafra*, statue, 99, 104, *105*, 107, 112; pyramids, 102–4, *103*; temples and pyramids, model, 102, *103*; Valley Temple of Khafre, *55*

glass: colored, 569; Egyptian, 121, 122; Islamic, 360–61

Glass and Bottle of Suze (Pablo Picasso), 1077, *1077*, 1094

glassmaking, contemporary, 1152–53

glaze (ceramic), 416, 630, 760

glazed bricks, 83

glazing (painting), 531, 631, 846

Gleaners, The (Jean-François Millet), 1011, *1011*

gliding, 136

globalism, 1126, 1184

gloss, 161, 173

Glykera (legendary artist), 26, 208

Gnosis (artist), 208; *Stag Hunt*, mosaic, 208, *208*, 210

Gobelins Tapestry Manufactory, 945

Goddess, the, 828

Godescalc Evangelistary, Carolingian, *Mark the Evangelist*, 500–501, *500*

gods: Greek, 177; Hindu, 378, 390; Roman, 234; Scandinavian, 487

Goes, Hugo van der, 639–41; *Portinari Altarpiece*, 640, 642, 676, 679

Gogh, Theo van, 41

Gogh, Vincent van, 41, 1020, 1030, 1033–34, 1063, 1065, 1127; *Large Plane Trees*, 25, 41, *41*; *The Starry Night*, 1034, *1034*

Golden Fleece group (Moscow), 1081

gold leaf, 90, 136, 138, 863

gold work: Americas, 462; Greek, 208–10

Golub, Leon, 1165

Gonçalvez, Nuño, 645; *Altarpiece of Saint Vincent*, panel, *Saint Vincent with the Portuguese Royal Family*, 646, *646*

Goncharova, Natalia, 1081–82, *Aeroplane over Train*, 1081, *1081*

Gonzaga, Federigo, 703

Gonzaga, Ludovico, 656, 674

Gonzaga family (Mantua), 649

González, Julio, 1106, 1135, 1148; *Woman Combing Her Hair II*, 1106, *1106*, 1135, 1148

Good Shepherd (in Christian art), 293

Good Shepherd, Mausoleum of Galla Placidia, Ravenna, Italy, 303–4, *303*, 318

Good Shepherd, Orants, and Story of Jonah, Catacomb of Saints Peter and Marcellinus, Rome, Italy, 293, *293*, 303, 322

gopura, 829

gopura, Minakshi-Sundareshvara Temple, Madurai, Tamil Nadu, India, 829, *829*

Gorbachev, Mikhail, 1126

Gorgon and Medusa, pediment sculpture, Temple of Artemis, Korkyra (Corfu), Greece, 165, *165*

Gorgons, 165

Gorky, Arshile, 1130–31, 1133; *Garden in Sochi*, 1130–31, *1130*

Gospel Book of Durrow, manuscript, Hiberno-Saxon, *Lion*, 490, *490*

Gospels, 291

Gospels of Otto III, manuscript, Ottonian, page, *Christ Washing the Feet of His Disciples*, 511–12, *511*

Gothic architecture, *568*, 626, 786, 956, 1001, *1087*

Gothic art, 487, 555–612, 556 (map), 565

gouge, *648*

Goujon, Jean, 741

Governess, The (Jean-Siméon Chardin), 946, *946*, 968

government, African, 926–29

Goya y Lucientes, Francisco, 989, 991–93; *Caprichos (The Caprices), Los*, print series, page, *The Sleep of Reason Produces Monsters*, 992–93, *992*, 1135; *Family of Charles IV*, 991–92, *991*; *Third of May, 1808*, *992*, 993

Gozzoli, Benozzo, 621; *Saint Augustine Reading Rhetoric in Rome*, Sant'Agostino church, San Gimignano, Italy, *621*

graffiti art, 55, 1129, 1167

Granada, Spain, Alhambra, 354–55; Palace of the Lions, 352, 354–55, *354*, 355, *355*

Grand Déjeuner, Le (The Large Luncheon) (Fernand Léger), 1095, *1095*

Grand Manner, 960, 985

Grand Tour, 949–51

granulation, 136

graphic arts, Early Renaissance in, 648–83

grattage, 1104

Grave Stele of Hegeso, Greek, 163, 191, 197, *197*

Great Depression, 1060, 1108–10

Great Friday Mosque, Djenné, Mali, 480, *480*

Great Mosque, Córdoba, Spain, 348, 349, *350*, 351, 352, 493

Great Plains, 886–88

Great Pyramid and ball court, La Venta, Mexico, 453, *453*

Great Schism, 597, 675

Great Serpent Mound, Adams County, Ohio, Mississippian culture, *466*, 467

Great Sphinx, The, Giza, Egypt, 24, *24*, 25, 35, 47, 104

Great Stupa, Sanchi, Madhya Pradesh, India, 379–82, *379*, 434; gateway (*torana*), 380, *380*; *yakshi* bracket figure, *380*, 381

Great Temple of Amun, Karnak, Egypt, 114, *114*, *115*; flower and bud columns, *115*

Great Wall of China, 407

Great Wave, The, Thirty-Six Views of Fuji, print series (Katsushika Hokusai), 856–57, 857, 867, 872–73

Great Wild Goose Pagoda. *See* Ci'en Temple, Xi'an, Shanxi, China

Great Zimbabwe, Zimbabwe, 480–82, 917; *Bird*, monolith, 482, *482*; conical tower, 481, *481*

Greco, El (Domenikos Theotokopoulos), 742–45; *Burial of Count Orgaz*, 743–44, *743*; *View of Toledo*, 744–45, *744*

Greco-Roman art. *See* Classical (Greco-Roman) art

Greece, Greeks, 90, 224, 472; Byzantine period, 328–31; Mycenaean, 142–51

Greek art, classical, 57, 154–55, 157, 177–210, 235–36, 245

artists, 154–55, 177, 198; social position of, 218–20; women, 209

Classic period, 153–221, 154 (map)

Fifth Century B.C.E. ("High" or "Golden"), 185–98, 214–15

Fourth Century B.C.E., 198–210

historical divisions of, 157–59

transitional or early period, 178–84

Greek cross, 302, 701, 702

Greek-cross-plan churches, 298, 324, 658

Greek Revival style, 189

Greek Slave, The (Hiram Powers), 999–1000, *999*, 1042–43

Greenberg, Clement, 1128, 1132, 1137, 1145

Gregorian chant (plainchant), 520

Gregory of Nazianus, Saint, 286

Gregory the Great, Pope, 489, 496

Greuze, Jean-Baptiste, 968; *The Drunken Cobbler*, 968, *968*

grid (urban), 89, 261–62

Griffin, statue, Islamic, 359, *359*, 546, 550

grisaille, 569, 582, 627

Grizzly bear house-partition screen (Native American, Tlingit), Wrangell, Canada, 888, *888*, 890

groin, *561*

groin vault, 228, 251, *561*

Gropius, Walter, 1088, 1094, 1097–98, 1154; Bauhaus Building, Dessau, Germany, 1097, 1098–99, *1099*, 1154; Fagus Factory, Alfeld-an-der-Leine, Germany, with Adolf Meyer, 1088, *1089*, 1096, 1099, 1154

Gros, Antoine-Jean, 983; *Napoleon in the Plague House at Jaffa*, 983, *983*

Gross Clinic, The (Thomas Eakins), 1048–49, *1049*

Grotto of Thetis, The (Jean Lepautre), showing original setting of *Apollo Attended by the Nymphs of Thetis*, 782, *782*
groundline, 73, 98, 167
Group of Seven, 1120
group portraits, 638, 803, 805–6
Grünewald, Matthias, 714–16
Isenheim Altarpiece: Annunciation, Virgin and Child with Angels, Resurrection panel, 713, 714–16, *715; Crucifixion, Lamentation* panels, 713, 714–16, *714;* diagram of, 714–16, *715*
Gu, Wenda, 1183–84; *United Nations: The Babel of the Millennium*, 1184, *1184*
Guan Ware, 424
Guan Ware vase, China, Song dynasty, 424, *424*
Guanyin, 415
Gudea, 77–78
Guercino, Il (Giovanni Francesco Barbieri), 33, 774; *Saint Luke Displaying a Painting of the Virgin*, 33, *33*, 774
Guernica (Pablo Picasso), *1058–59*, 1059
Guggenheim Foundation and Museum, 36
Guggenheim Museum, Bilbao, Spain (Frank O. Gehry), 36, 1158–59, *1159*
Guild of Saint Luke, 628
guilds, 557, 623, 628, 1097
Guimard, Hector, 1041–42; desk, 1041, *1041*, 1172
Gu Kaizhi, attributed to, *Admonitions of the Imperial Instructress to Court Ladies*, scroll, 412, *412*
Gummersmark brooch, Denmark, 488, *488*, 525
Gupta dynasty, 386–88, 828
Guro people (Côte d'Ivoire), 931–32
Guston, Philip, 1165
Gutai Bijutsu Kyokai (Concrete Art Association), 1138–39
Gutenberg, Johann, 644
Guti, 77
Gyokudo, Uragami, 869; *Geese Aslant in the High Wind*, 869–70, *869*

H

Habitat '67, Montreal, Quebec, Canada (Moshe Safdie), 1155, *1155*
Habsburg Empire, 646
Hackwood, William, 957; *"Am I Not a Man and a Brother?"* ceramic medallion, for Josiah Wedgwood, 957–58, *957*
Hades, 158, 170, 206, 207
Hadid, Zaha, 1158; Vitra Fire Station, Weil-am-Rhein, Germany, 1158, *1158*
Hadith, 348
Hadrian, 211, 234, 246, 247, 256–57, 258, 265–67
Hadrian Hunting Boar and Sacrificing to Apollo, reliefs, now on Arch of Constantine, Roman, 256, *256*, 282
Hadrian's Villa, Tivoli, Italy, *258*, 265, *265*, 267, *267*, 280; Canopus area, 265, *265*, 281
Hadrian's Wall, Britain, 261, *261*
Hagar in the Wilderness, marble (Edmonia Lewis), 1043–44, *1043*
Hagenauer, Nikolaus, 713; *Isenheim Altarpiece*, shrine, *Saint Anthony Enthroned between Saints Augustine and Jerome* panel, 625, 713, *713*, 714
Hagesandros, 215
Hagesandros, Polydoros, and Athanadoros of Rhodes, *Laocoön and His Sons*, 38, 39, *39*, 215, *215*, 268, 759, 761
Hagia Sophia, Istanbul, Turkey, 310–13, *310*, 311, *312*, 313, 324, 325, 351, 357–58
Hagia Triada, Crete, *Harvester Vase*, 136, 138, *138*
Haida people, 888
al-Hakam II, 349
Hakuin Ekaku, 870; *Bodhidharma Meditating*, 870, *870*
Halder, Jacob, Armor of George Clifford, 752
Halikarnassos (modern Bodrum, Turkey), Mausoleum, 104, 200–202, *201*, *202*, 205
Hall, Edith, 149

hall church, 592–93
Halley, Peter, 1168–69; *Fire in the Sky*, 1168–69, *1168*
Hall of Bulls, Lascaux, France, 51, *51*
Hall of Mirrors. *See* Hardouin-Mansart, Jules
halos, 157
Hals, Frans, 802, 804, 814; *Catharina Hooft and Her Nurse*, 802, *802*, 821; *Officers of the Haarlem Militia Company of Saint Adrian*, 802, *803*
Hamatsa dancers (photograph) (Edward S. Curtis), 889, 890, *890*
Hamatsa masks, 889, 890
Hamilton, Ann, 1181 82; *Indigo Blue*, installation, 1181–82, *1181*
Hamilton, Gavin, 952
Hamilton, Richard, 1143; *he*, 1143, *1143*
Hamilton, William, 957
Hammamet with Its Mosque (Paul Klee), *1070*, 1071, 1072
hammam Islamic bathhouse, 367
Hammons, David, 1179; *Higher Goals*, *1178*, 1179
Hammurabi, 78, 79
Hampton, James, *Throne of the Third Heaven of the Nations' Millennium General Assembly*, 31, *31*
Hamza-nama, manuscript, Indian, page, *Hamza's Spies Scale the Fortress*, 830, *830*
hand mirror, Egyptian, 122, *122*
handprints, prehistoric, 50
handscroll, Chinese, 412–13, 421–22, 842, 844
Han dynasty, 401, 407–11, 841
Hanging Gardens of Babylon, 85
hanging scrolls, 842, 844
Hangzhou, 423
haniwa, 430–31
haniwa earthenware figure, Japan, Kofun period, 430, *430*
Hanson, Duane, 1161, 1172; *The Shoppers*, 1161, *1161*, 1172
Happenings, 1138–40
Harappa, India, *Torso*, *374*, 375
Harappan civilization, 373–74
Harbaville Triptych, devotional piece, Christian, *334*
Hardouin-Mansart, Jules, 778–80; Palais de Versailles, Versailles, France, Hall of Mirrors, with Charles Le Brun, 780, *781*, 940
Hardwick Hall, Shrewsbury, England (Robert Smythson), High Great Chamber, 753, *753*
Harlem Renaissance (1920s), 1112–13
Harmony in Blue and Gold (James Abbott McNeill Whistler), 36, *36*
Harrison, Peter, 973; Redwood Library, Newport, Rhode Island, 973, *973*
Hartigan, Grace, 1137
Hartley, Marsden, 1083, 1084; *Portrait of a German Soldier*, 1083, *1084*
Harunobu, Suzuki, 872; *Geisha as Daruma Crossing the Sea*, 872, *872*
Harvester Vase, Hagia Triada, Crete, 136, 138, *138*
Harvesting of Grapes, Santa Costanza, Rome, Italy, 302, *302*
Hasan, sultan, 357
Haterius family tomb, Rome, Italy, *256*, 257
Hathor, 96
Hatshepsut, 116
Hatshepsut as Sphinx, sculpture, Deir el-Bahri, Egypt, *116*
Hattushash (near modern Boghazkeui, Turkey), 86; Lion Gate, 86–88, *87*
Haussmann, Baron Georges-Eugène, 1008, 1009, 1055
Havell, Robert, 997
Have No Fear—He's a Vegetarian (John Heartfield), 1097, 1101, *1101*
Hawaiian Islands, 900, 901, 906–8, 910
Hawara, Egypt, Mummy wrapping of a young boy, 126, *126*
Hawes, Harriet Boyd, 149, *149*
Head, Nigeria, Nok culture, 475, *475*
header course, 906

Head of a king, Ife, Nigeria, 476, *476*
Head of a Man, bronze head, Etruscan or Roman, perhaps Lucius Junius Brutus, 232, *233*
Head of an *oba* (king), Benin, 478, *478*
Head of Lajuwa (?), Ife, Nigeria, Yoruba, 471, 476, *476*
Head Surrounded by Sides of Beef (Francis Bacon), 1127, *1127*
Hearst, William Randolph, 1115
Heartfelt (Miriam Schapiro), *1164*, 1165
Heartfield, John (Helmut Herzfelde), 1097, 1101; *Have No Fear—He's a Vegetarian*, 1097, 1101, *1101*
Heath of the Brandenburg March (Anselm Kiefer), 1167, *1167*
Hebrews. *See* Jews
heb sed festival, 95
Heckel, Erich, 1065; *Crouching Woman*, 1066, *1066*, 1071
Hector, 158
Hegel, Georg Wilhelm Friedrich, 1128
Heian-kyo (Kyoto), Japan, 859
Heian period (Japan), 436–42, 859
Heizer, Michael, 1159; *Double Negative*, 1159, *1159*
Helen, Saint, 282
Helen of Egypt, 208, 209
Helios, 158
Helladic period (Bronze Age Greece), 142–51
Hellenistic art, 157–58, 210–20, 279; artists, 210–11; influence on Indian art, 383–84
Hellenistic Ruler, statue, Hellenistic, 218, *220*
Hellmouth, manuscript, English, *Winchester Psalter*, 540, *541*, 588
Hellmouths, 541
Hemessen, Caterina van, 746; *Self-Portrait*, 746, *746*
Hemessen, Jan Sanders van, 746
hemicycles, 724
Hennings, Emmy, 1099–1100
Henri, Robert, 1082, 1110, 1113
Henri IV, of France, 778, 799
Henri IV Receiving the Portrait of Marie de' Medici (Peter Paul Rubens), *798*, 799
Henry VIII, of England, 719, 748, 749–50, 753
Henry VIII (Hans Holbein, the Younger), 749–50, *749*, 1013
Hephaistos, 158
Hera, 156, 158
Herakleitos, 268; *The Unswept Floor*, mosaic, Roman copy of Greek original, 268, *268*, 269
Herakles (Hercules), 158, 179, 205–6, 226, 260
Herat, Iran, 365
Hercules and Antaeus (Antonio del Pollaiuolo), 650, 665, *665*
Hermes, 158, 176
Hermes and the Infant Dionysos (Praxiteles), 202–3, *203*
Herodotus, 94, 95, 474
Herod the Great, 291
Herrera, Juan de, 742
Hesse, Eva, 1147–48; *Rope Piece*, 1148, *1148*
Hestia, 158
Hiberno-Saxon style, 489–91
hidden symbols, 629–30
Hideyoshi, Toyotomi, 862
Hierakonpolis, Egypt, 95; jar, 95, *95*, 132; *Palette of Narmer*, 96–98, *97*
hieratic scale, 73, 97
hieratic style, Christian, 314
hieratic writing, 111
hieroglyphs, 111, 112
high and low culture, 1143
Higher Goals (David Hammons), *1178*, 1179
High Great Chamber. *See* Smythson, Robert
high relief, 52–53, 76, 165, 384, 648
High Renaissance, 687–710
high tech architecture, 1157–58
Hildegard of Bingen, 546–48

Hildegard's Vision, manuscript, Romanesque, *Liber Scivias*, 546–48, *548*

Hildesheim, Germany, Saint Michael abbey church, Doors of Bishop Bernward, 507, 508, *508*, 531; schematic diagram of the message of, 507, 508, *509*

Hilliard, Nicholas, 751; *George Clifford, 3rd Earl of Cumberland*, 751, *751*

himation, 171

Himeji Castle, Hyogo, near Osaka, Japan, 863, *863*

Hindu art, India, 828–29

Hinduism, 375, 377, 378, 386, 394–95, 828–29; temples, 388–97

Hippodamos of Miletos, 199

Hippopotamus, statue, tomb of Senbi, Meir, Egypt, 112, *113*, 122

Hireling Shepherd, The (William Holman Hunt), 1014, *1014*

Hiroshige, Utagawa, 872; *One Hundred Views of Edo: Bamboo Yards, Kyobashi Bridge*, 1020, *1020*

historicism, 1006

history, idea of progress in, 1128, 1165

history painting, 939, 960, 961–64, 976, 986

Hitchcock, Henry-Russell, 1094

Hitda Gospels, manuscript, Ottonian, presentation page, *Abbess Hitda and Saint Walpurga*, 512, *512*, 549

Hitler, Adolf, 1060, 1097, 1101

Hittites, 69, 86–88, 116

Hobbema, Meindert, 811; *Avenue at Middelharnis*, 810, 811, 994–95

Höch, Hannah, 1100–1101; *Dada Dance*, 1100–1101, *1100*

Hofmann, Hans, 1132, 1137

Hogarth, William, 959–60; *Marriage à la Mode*, print series, *The Marriage Contract*, 959, *959*, 1004, 1014

Hohlenstein-Stadel, Germany, *Lion-Human*, figurine, 45–46, *45*, 52

Hohokam culture, 892; ritual ball game, 468

Hokhokw mask (Seaweed, Willie, attributed to), 889, 890, *891*

Hokusai, Katsushika, 857, 872; *Thirty-Six Views of Fuji*, print series, *The Great Wave*, 856–57, 857, 867, 872–73

Holbein, Hans, the Younger, 749–50; *Henry VIII*, 749–50, *749*, 1013

Holland, 745, 800

hollow-casting, 181

Holy Roman Empire, 505, 516, 542–49, 646, 686–87, 785; Gothic period, 592–96

Holy Virgin Mary, The (Chris Ofili), 1175, *1175*

Holzer, Jenny, 1181; *Untitled*, installation at Guggenheim Museum, 1159, *1180*, 1181

Homage to Blériot (Robert Delaunay), 1078–79, *1079*

Homage to New York, assemblage (Jean Tinguely), *1140*

Homer, 144, 145, 149, 172

Homer, Winslow, 1047–48; *The Life Line*, 1048, *1048*, 1083; *Snap the Whip*, 1047–48, *1047*

HongKong & Shanghai Bank, Hong Kong (Norman Foster), 1157–58, *1157*

Honorius, 302

Hood & Fouilhoux, 1117

Hopewell culture (North America), 466

Hopi, 468

Hopper, Edward, 1110–11; *Nighthawks*, 1111, *1111*, 1138

Horde, The (Max Ernst), 1104, *1104*

horizontal log construction, *535*

Horn Players (Jean-Michel Basquiat), *1166*, 1167

Horse and Sun Chariot, bronze, Trundholm, Zealand, Denmark, 63, *63*, 488

Horsemen, Procession, Parthenon, friezes, Acropolis, Athens, Greece, 188, 192, *192*

horseshoe arch, 348, 352, 493

Horta, Victor, 1041; Tassel House, Brussels, Belgium, 1041, *1041*, 1172

Horus, 96, 97

Horyu-ji, Nara, Japan, temple, 413, 432, *432*, 433–34, *433*, 435, *435*; Tamamushi Shrine, 433, *433*

Hosmer, Harriet, 1042–43; *Zenobia in Chains*, marble, 1042–43, *1043*

Hôtel de Soubise, Paris, France (Germain Boffrand), Salon de la Princesse, 939, *939*

Houdon, Jean-Antoine, 973, 998; *George Washington*, *972*, 973, 985, 998

Hour of Cowdust, manuscript, India, Mughal period, 834–35, *835*

Hours of Mary of Burgundy (Mary of Burgundy Painter), page, *Mary at Her Devotions*, 627, 641, *641*

house
Chinese, Han dynasty, model of, 411, *411*, 417
Egyptian, model of, with garden, 109, *109*
Etruscan, 225
Greek, 187
Neolithic, 55–57
Roman, 263–67; typical plan of, 263–64, *263*

House (Rachel Whiteread), 1179, *1179*

house (Abelam culture), Sepik River, Papua New Guinea, 903, *903*

house-church (Christian), 295, 296–97

house interior, Skara Brae, Orkney Islands, Scotland, *56*, 57

House of Jacques Coeur, Bourges, France, interior courtyard, 627, *627*

House of Julia Felix, Pompeii, Italy, 272, *272*

House of M. Lucretius Fronto, Pompeii, Italy, 272–73, *273*

House of Publius Fannius Synistor, Boscoreale (near Pompeii), Italy, 270, *270*; bedroom (reconstruction), 263, 269–70, *269*

House of the Silver Wedding, Pompeii, Italy, 264, *264*

House of the Vettii, Pompeii, Italy, peristyle garden, 264, *264*, 266

Houses at L'Estaque (Georges Braque), 1075, *1075*, 1134, 1136

Houses of Parliament, London, England (Charles Barry), with Augustus Welby Northmore Pugin, 1001, *1001*

house-synagogue (Jewish), 295

House Xeste 3, Akrotiri, Thera, Greek island, 140–41, *140*

Hudson River Landscape (David Smith), 1135–36, *1135*, 1148

hue, 1032

Huelsenbeck, Richard, 1100

Hugh de Semur, 520

Hughes, Holly, 1175

Hughes, Robert, 31

Huineng, 849

Huitzilopochtli, 879

Huizong, Emperor, 418, 422; attributed to, *Ladies Preparing Newly Woven Silk*, handscroll, 418, *419*

human beings, prehistory of, 44–45

human figure. *See* body, the, in art; figurative art

Human-Headed Winged Lion (Lamassu), Palace of Assurnasirpal II, Nimrud, Iraq, 66, 67, 80, 291

humanism, 616–22, 632

Hundreds of Birds Admiring the Peacocks, hanging scroll (Yin Hong), 845–46, *845*

Hundred Years' War, 559, 579, 584, 622, 646

Hungry Tigress Jataka, panel, Tamamushi Shrine, temple, Horyu-ji, Nara, Japan, 433, *433*

Hunt, Richard Morris, 1052–53

Hunt, William Holman, 1014; *The Hireling Shepherd*, 1014, *1014*

hunting, 108

Hunt of the Unicorn, tapestry series, French Renaissance, *Unicorn at the Fountain*, 642–43, *643*

Hurling Colors, happening (Shozo Shimamoto), 1139, *1139*

hydria, 175

Hyksos, 113

Hyogo, near Osaka, Japan, Himeji Castle, 863, *863*

Hypatius of Ephesus, 312

Hypnerotomachia Poliphili, book (Fra Francesco Colonna), *Garden of Love* page, *644*

Hypnos, 176

hypostyle, 348

hypostyle hall, 114, 351

I

Iberian peninsula, spread of Flemish style in, 645–46

Ibn Muqla, 351

Ice Age, 44, 53, 450

icon, 1081, 1082, 1145

iconoclasm, 309, 322–23, 496, 710, 720

iconographic images, 826, 1029

iconography, 37, 1141; Buddhist, 383; Christian, 306–7; Roman, 229

iconostasis, 313

icons, 313, 322, 334, 340, 496; worship of, 309

Ideal City with a Foundation and Statues of the Virtues (anonymous North Italian painter), 620–22, *620*

idealism (idealization), 25, 27–28, 217, 477, 635, 983

ideograph, 404

Ieyasu, Tokugawa, 862, 866

Ife, Nigeria, 475–77; Head of a king, 476, *476*; Head of Lajuwa (?), Yoruba, 471, 476, *476*; ritual vessel, *470*, 471

Ignatius of Loyola, 723, 724, 743

ignudi, 696

Iguegha, 477

Ijo people (Nigeria), 930–31

Ikere, Nigeria, royal palace, 927, *928*

Ikkyu, 861; *Calligraphy Pair*, 861, *861*

Iktinos, 177, 187, 188

Île-de-France, France, 516, 556, 559

Iliad, 149, 150, 176

illuminated manuscripts. *See* manuscripts

illusionism, 317

illusionistic fresco painting, 768–73, 941

illustrations, book, 304

Imhotep, 100–102

impasto, 760, 1033

Imperial Forums, Rome, Italy, 246–47, *246*

imperialism, 981

Imperial Procession, Ara Pacis, Rome, Italy, 243, *244*, 255, 286

Implosion/Explosion (Harvey Littleton), 1153, *1153*, 1157

impost, 228, 305

impost block, 493, 654

Impressionism, 996, 1018–30; Later, 1027–30

Improvisation #30 (Warlike Theme) (Vasily Kandinsky), 1069, *1069*

in antis, 163, 166–67

incense burner, China, Han dynasty, *408*, 409

incised designs, 902

incising, 62, 76, 429; cave art, 50; clay, 132; stone, 384

Incredulity of Thomas (in Christian art), 307

Independent Group (IG), 1143

India, 372–73, 372 (map), 826 (map)
art, 370–99, 825–37; architecture, 832; early medieval period, 394–95; Late Medieval, 826–29; modern, 836; Mughal, 829–35; temples (*see* temples); Vedic period, 375–77
British in, 836
civilization, 828
Muslims in, 398
unattributed works from: *The Bodhisattva Avalokiteshvara*, Late Medieval, 826, *827*; *Buddha and Attendants*, Kushan period, 384, *384*; *Hour of Cowdust*, Mughal period, 834–35, *835*; Lion capital, 378, *378*; *Shiva Nataraja*, sculpture, Chola dynasty, 398, *398*; *Siddhartha in the Palace*, relief, Andhra period, 385, *385*; *Standing Buddha*, Gupta period, 386, *386*, 398; *Yakshi Holding a Fly Whisk*, Maurya period, 377, *377*, 381

"Indian" style (American), 893–94

Indigo Blue, installation (Ann Hamilton), 1181–82, *1181*
individualist painting (China), 853–54
Indonesia, 903
Indra, 376
industrial design, 1098
Industrial Revolution, 938, 980, 1055
Indus Valley (Harappan) civilization, 373, 828
Ingres, Jean-Auguste-Dominique, 983–84, 1074, 1095; *Large Odalisque*, 984, *984*, 1074, 1095; *Portrait of Madame Désiré Raoul-Rochette*, 984, *985*
Initiation Rites of the Cult of Bacchus (?), wall painting, Villa of the Mysteries, Pompeii, Italy, 271–72, *271*
initiation rituals and objects, 920–22
ink, Chinese, 869
Inka Empire, 794, 879, 881–84
ink painting, 869; Japanese, 859–61
inlay, 73, 136, 868
Innocent X, Pope, 760, 764, 765
Inquisition, 723, 735, 759, 992
inscriptions, 648
installations, 1090, 1163, 1181–82
Institut de France, 944
Institute of American Indian Arts (AIA) (Santa Fe), 895–96
intaglio, 648, 952
intarsia, 660
International Exhibition of Modern Decorative and Industrial Arts (Paris, 1925), 1079
International Exposition (Barcelona, 1929), 1099
International Gothic style, 556, 604, 612, 622, 625–26, 630, 646, 666–67
International Style (modern architecture), 1093, 1094, 1154, 1155, 1156; in India, 836
Intimate Gallery, 1107
intonaco, 604
intrados, 228
Intrigue, The (James Ensor), 1038, *1038*
intuitive perspective, 270, 621
Invention of the Balloon, The, model for monument (Clodion), 949, *949*
Investiture Controversy, 550
Investiture of Zimrilim, wall painting, Mari (modern Tell Hariri, Iraq), 78–80, *80*
Iona, 485, 490, 491, 502
Ionia, 178
Ionic order, 162, 164, 193, *704*
Iphigenia, 232
Iran. *See* Persia
Ireland, 487, 489–91
Irene, Empress, 309
Irian Jaya, 903, 904
iron, 64; in construction, 962
Iron Age, 64
Isabeau, Queen of France, 623
Isabella d'Este (Titian), *709*
Isabella of Portugal, 631
Ise, Japan, shrine, 431, *431*
Isenheim Altarpiece (Matthias Grünewald): *Annunciation, Virgin and Child with Angels, Resurrection* panel, 713, 714–16, *715*; *Crucifixion, Lamentation* panels, 713, 714–16, *714*; diagram of, 714–16, *715*; shrine (Nikolaus Hagenauer), *Saint Anthony Enthroned between Saints Augustine and Jerome* panel, 625, 713, *713*, 714
Isfahan, Iran, Masjid-i Jami (Great Mosque), 352, 356–57, *356*, 357
Ishiyama-gire, album leaf, Japanese, 438–40, *439*
Ishtar, 78, 205
Ishtar Gate, Babylon, Mesopotamia (modern Iraq), 83–85, *84*
Isidorus of Miletus, 310–11
Isis, 96, 236
Islam, Muslims, 290, 309, 398, 473, 480, 517, 518, 549, 569, 589, 916–17; beliefs of, 345; contemporary, 1183; early, 344, 344 (map); later, 353–68
Islamic art, 343–69, 525, 526–27; role of artists in, 351
Istanbul, Turkey, 354

Church of the Monastery of Christ in Chora, 338, *339*; funerary chapel, 337–38, *338*
Hagia Sophia, 310–13, *310*, 311, *312*, 313, 324, 325, 351, 357–58
Italian art
architecture, 650–60, 701–10, 723–27, 734–38, 760–67
painting, 666–83, 703–10, 774–78
periods and styles: 18th century, 949–53; Baroque, 760–78; Cubism, 1080–81; Early Renaissance, 649–83; Gothic, 597–612; High Renaissance, 687–710; Late Renaissance, 723–38; Neoclassicism, 952–53
printmaking, 649
sculpture, 660, 768
Italy, 314, 516, 542, 686–87, 701, 1060
Itten, Johannes, 1097–98
Itza (Mayan), 461–62
Ivan IV the Terrible, 338
ivories, Byzantine, 321, 333–36
iwan, 351, 355–57, 833

J

Jack Pine, The (Tom Thomson), 1119, *1119*
jade, 404
Jahangir, Indian ruler, 830–32
Jahangir-nama, manuscript (Abul Hasan and Manohar), *Jahangir in Darbar* page, 830, *831*
Jain art, India, 827–28
Jainism, 375, 377, 381, 828
jakshana, 383
jamb, 228, 389, 525, *525*
James, Henry, 1042
James I, 799, 816, 818
Jane Avril (Henri de Toulouse-Lautrec), 1017, 1042, *1042*
Janus, 234
Japan, 376, 415, 428 (map), 858 (map), 1060
civilization, 859
modern period, 873
prehistoric, 428
unattributed works from: *Descent of the Amida Trinity*, triptych, Kamakura period, 444, *444*; *dogu* earthenware figure, Jomon period, 429, *429*; *haniwa* earthenware figure, Kofun period, 430, *430*; *Night Attack on the Sanjo Palace*, scroll, Kamakura period, 442–43, *442*, 445; vessel, Jomon period, 429, *429*; Womb World mandala, Heian period, 434, *436*, 437
Japanese art, 857–75, 1017; before 1392, 427; influence of Chinese art on, 859, 868–69; influence on Western art, 873; theater, 1176; woodblock prints, 40, 857, 871–72, *871*, 1020, 1022, 1035, 1042
Japonisme, 873, 1017, 1020, 1022
jar, Bamana, Mali, Mende culture, *933*
jar, blackware storage (Maria Montoya and Julian Martinez), 893, *893*
jar, fragments, Melanesian, Lapita culture, 902, *902*
jar, Hierakonpolis, Egypt, 95, *95*, 132
jar, painted, with birds, Chanhu-Daro, India, 375, *375*
Jarry, Alfred, 1037
Jashemski, Wilhelmina, 266
jataka tales, 433
Jean, Duke of Berry, 623
Jean de Marville, 625
Jean le Noir, 623
Jeanne-Claude (de Guillebon), 1160–61
Jeanneret, Pierre, 836
Jefferson, Thomas, 239, 938, 974; Monticello, Charlottesville, Virginia, 974, *974*, 1000
Jenghiz Khan, 353, 840
Jenney, William Le Baron, 1054
Jericho, 69
Jerome, Saint, 297
Jerome's *Explanatio in Isaiam*, manuscript, Romanesque, *The Tree of Jesse*, 534, *534*, 567
Jerusalem, 156, 292
Dome of the Rock, 345–47, *346*

First Temple (of Solomon), 229, 291, 311, 345
pilgrimages to, 518
Second Temple, 291; destruction by Romans, 254
Jesuits, 723, 724, 796
Jesus among the Doctors (in Christian art), 306
Jesus and the Samaritan Woman at the Well (in Christian art), 306
Jesus before Pilate (in Christian art), 307
Jesus Crowned with Thorns (in Christian art) (The Mocking of Jesus), 307
Jesus of Nazareth, 290, 291; iconography of, 306–7
Jesus Walking on the Water (in Christian art), 306
Jesus Washing the Disciples' Feet (in Christian art), 306
jewelers, 136
jewelry, Oceania, 909
jewelry, from tomb of Queen Yabay, Nimrud, Iraq, 82, *82*, 137
Jewish art, 292–86
Jewish Bride, The (Rembrandt van Rijn), *807*, 808
Jewish Cemetery, The (Jacob van Ruisdael), *810*, 811
Jewish World, 290 (map)
Jews, 290, 291, 345, 589, 592–93; in the Netherlands, 809; Scriptures (Old Testament), 290; *see also* Judaism
Jiangzhai, China, 402–3
Jiaxiang, Shandong, China, Wu family shrine, 410–11, *410*
Joan of Arc, 646
Jocho, 438; *Amida Buddha*, 438, *438*, 444
John, Saint, 291, 294
John F. Kennedy Airport. *See* Saarinen, Eero
John of the Cross, Saint, 743
John of Worcester, *Worcester Chronicle, Dream of Henry I* page, 540, *541*
Johns, Jasper, 1141–42; *Target with Four Faces*, 1142, *1142*
Johnson, Philip, 1094, 1156; AT&T Corporate Headquarters, New York, N.Y., with John Burgee, 1156, *1156*
joined wood: construction, 438; sculpture, 440
Jomon period (Japan), 428–30, 859
Jonah, 293
Jonah (Albert Pinkham Ryder), 1051, *1051*
Jonah Swallowed and *Jonah Cast Up*, statuettes, Christian, 294, *295*
Jones, Inigo, 816–18; *A Garden and a Princely Villa*, sketch for set design, *818*; Whitehall Palace, London, England, 816, *816*, 973
Joseph in His Carpentry Shop, wing, *Mérode Altarpiece* (Robert Campin), 620–22, *620*, 718
Joseph Master (Master of the Smiling Angels), 577
Josephus, Flavius, 254; *Jewish Wars*, 229
Joshua Roll, Byzantine, page, *Joshua Leading the Israelites*, 337, *337*
Judaism, 236, 290, 291, 309; places of worship, 295–96; *see also* Jews
Judd, Donald, 1147, 1169; *Untitled*, 1040, 1147, *1147*, 1169
Judgment before Osiris, Book of the Dead, Egyptian, 96, 99, *124*, 125, 527
Judgment of Paris, The (Raphael), engraving by Marcantonio Raimondi, *1018*
Judith and Maidservant with the Head of Holofernes (Artemisia Gentileschi), 777, *777*
Jugendstil ("Youth Style"), 1041
Juko-in, Daitoku-ji, Kyoto, Japan, 863
Julia Domna, 274
Julian the Apostate, 285
Julian the Apostate, coin, Roman, 285, *285*
Julio-Claudian dynasty, 234, 242, 246
Julius II, Pope, 685, 687, 690–92, 695, 698, 701, 702, 718
Julius Caesar, 234
Jung, Carl, 1130
Juno, 158
junzi, 410
Jupiter, 158

Juran, 853
Justice of Otto III (Dirck Bouts), *Wrongful Execution of the Count* panel, 638, *638*
Justinian Code, 310
Justinian I, Emperor, 310, 314

K

ka, 99
Kaaba, 348
kabuki theater, 872
kachinas, 894
kahili, 910
Kahlo, Frida, 1118–19; *The Two Fridas, 1118*, 1119
Kahn, Louis I., 1156
Kahun (near modern el-Lahun), Egypt, 108–9; town plan, 109, *109*, 199
Kakalia, Deborah (Kepola) U., 910; *Royal Symbols*, quilt, 910, *911*
Kallikrates, 187, 188
Kalpa Sutra, manuscript, Indian, leaf, *The Birth of Mahavira*, 827–28, *827*, 830, 834
Kamakura period (Japan), 442–46, 859
Kamares Ware, 135–37
Kamares Ware jug, Phaistos, Crete, 135, *135*, 139
kanaga masks, 829–30
Kandariya Mahadeva temple, Khajuraho, Madhya Pradesh, India, 395, *395*, 396
Kandinsky, Vasily, 1068–69, 1083, 1097; *Improvisation #30 (Warlike Theme)*, 1069, *1069*
Kanishka, Indian king, 383, 828
Kano, Eitoku, *fusuma*, Juko-in, Daitoku-ji, Kyoto, Japan, 864, *864*
Kano school of painting (Japan), 863–64
Kant, Immanuel, 938
kantharos, 174
Kao Ninga, 445, 446; attributed to, *Monk Sewing*, 445, 446, *446*
Kaprow, Allan, 1138, 1143; *The Courtyard*, 1138, *1139*
Karla, Maharashtra, India, chaitya hall, *382*
Karnak, Egypt, 96, 114–15
 Great Temple of Amun, 114, *114*, *115*; flower and bud columns, *115*
Kashan, Persia, 361
Katholikon. *See* Monastery of Hosios Loukas, Stiris, Greece
Kauffmann, Angelica, 950, 963; *Cornelia Pointing to Her Childen as Her Treasures*, 962, 963, 969
Kearny Cloak, the, feather, Hawaiian, 908, *908*
keep (*donjon*), 539, *587*
Kekrops, 193
Kells, 485
Kent, William, 953
kente cloth, 926–27
kente cloth, from Ghana, Ashanti, 926, *926*
Kepler, Johannes, 759
Keratea (near Athens), Greece, *Berlin Kore*, statue, 169–70, *169*
Kerouac, Jack, 1150
key block, 871
keystone, 228
Khafra, 102, 104
Khafra, statue, Giza, Egypt, 99, 104, *105*, 107, 112
Khajuraho, Madhya Pradesh, India, 395; Kandariya Mahadeva temple, 395, *395*, 396
Khnumhotep, 110
Khons, 96, 114
Khufu, 102
Kiefer, Anselm, 1167, 1168; *Heath of the Brandenburg March*, 1167, *1167*
Kiev, Ukraine, 326–28; Santa Sophia Cathedral, 324, *326*, 327, *327*
Kievan Rus, 326–27
kilim, 364
kiln, 62, 173, 846
kinetic sculpture, 1115, 1140
King Henry III Supervising the Works, page from illustrated manuscript, English, *586*
kings, ceremonial, 67

Kino, Eusebio, 796
Ki no Tsurayuki, 438
Kirchner, Ernst Ludwig, 1065, 1097; *Street, Berlin*, 1066, *1066*, 1072, 1097
Kiss, The (Gustav Klimt), 1062, *1062*
kiva, 468
Klah, Hosteen, 895; *Whirling Log Ceremony*, sand painting, woven by Mrs. Sam Manuelito, 895, *895*
Klee, Paul, 1071, 1097; *Hammamet with Its Mosque*, *1070*, 1071, 1072
Klein, Yves, 1139–40, 1149; *Anthropométries of the Blue Period*, performance, 1140, *1140*, 1149
Kleitias, 172
Klenze, Leo von, 189
Klimt, Gustav, 1041, 1062; *The Kiss*, 1062, *1062*
Knight Watch (Jean-Paul Riopelle), 1129, *1129*
Knossos, Crete, 131, 133, 135, 137, 141, 149; bull's-head rhyton, 136, 139, *139*; palace complex, *134*, 135, 137, *137*, 142, *142*, 149; *Woman or Goddess with Snakes*, 137–38, *138*
knotted carpets, 364
koan, 870
Koetsu, Hon'ami, 867; *Mount Fuji*, teabowl, *866*, 867
Kofun period (Japan), 430–31, 859
Kollwitz, Käthe Schmidt, 1067; *Peasants' War*, *1066*, 1067
kondo, 432
Kongo people (Zaire), 923–24
Koons, Jeff, 1169; *The New Shelton Wet/Dry Triple Decker*, 1102, 1169, *1169*
Koran, 290, 343, 348, 349–52
Koran, Egyptian, manuscript page, 365, *365*
Koran, Syria, manuscript page, *342–43*, 343, 351
Korea, 376, 415, 427, 430, 432, 435, 436
Korean art, 866, 868
Korean War, 1126
kore statue, 168, 169–71
Kore statue, Chios (?), Greek island, *170*, 171
Korin, Ogata, 867–68; lacquer box for writing implements, 868, *868*, 869
Korkyra (Corfu), Greece, Temple of Artemis, 165, *165*
koru pattern, 910
Koshares of Taos (Pablita Velarde), 894, *894*
Kosho, 442–43; *Kuya Preaching*, painted wood, 414, *426–27*, 437, 442–43, 446
Kosuth, Joseph, 1148–49; *One and Three Chairs*, 1148, 1149
Kounellis, Jannis, 1125, 1149, 1153; *Untitled (12 Horses)*, *1124–25*, 1125, 1149
kouros statue, 168–69, 179–80
Krasner, Lee, 1132–33; *The Seasons*, 1131, 1133, *1133*
Krishna, 833–35
Krishna and the Gopis, page, *Gita Govinda*, manuscript, Indian, 834, *834*
Kritian Boy, statue, Greek, 179–81, *180*, 196
Kritias, Athenian ruler, 198
Kritios (artist), 180
Krug, Hans, 711; Workshop of (?), "Apple Cup," 711, *711*
Kruger, Barbara, 1170; *We Won't Play Nature to Your Culture*, 1170, *1170*
Kuba people (Zaire), 927
Kublai Khan, 424, 840, 842
kufic script, 351–52, 356
Kushan period (India), 377, 383–86, 417, 828
Kuya, 427, 446
Kuya Preaching, painted wood (Kosho), 414, *426–27*, 437, 442–43, 446
Kwakiutl people, 888, 890
kylix, 177
Kyoto, Japan, 435, 850, 859, 861; Daitoku-ji, Juko-in, 864, *864*; Myoki-an Temple, Tai-an tearoom, 864–65, *865*; Ryoan-ji, garden, stone and gravel, 861–62, *862*

L

La Banditaccia, Etruscan cemetery, Cerveteri, Italy, 230, *230*, 231, *231*; Tomb of the Reliefs, 230, *230*

Labille-Guiard, Adélaïde, 969–70; *Self-Portrait with Two Pupils*, 970, *970*
Labrouste, Henri, 1006–7; Sainte-Geneviève, Bibliothèque, Paris, France, Reading Room, 1006–7, *1007*
Labyrinth, 137
lacquer box for writing implements (Ogata Korin), 868, *868*, 869
lacquerware, 868
Lactantius, 297
Ladies Preparing Newly Woven Silk, handscroll (Huizong, Emperor, attributed to), 418, *419*
Lady Sarah Bunbury Sacrificing to the Graces (Joshua Reynolds), 960–61, *960*
La Fayette, Madame de, 939
Lagash (modern Telloh, Iraq), 77; votive statue of Gudea, 78, *78*, 80
Lakshmi, 393
lamassus, 67
Lamb or Sheep (Christian symbol), 294
Lamentation, The, frescoes (Giotto di Bondone), 612, *612*
Lamentation, the (in Christian art), 307
Laming-Emperaire, Annette, 48
lamps, prehistoric, 53
lamp with ibex design (Paleolithic), La Mouthe cave, Dordogne, France, 48, 53, *53*
lancet, 565
Landscape, album (Shitao), 853–54, *853*
Landscape, hanging scroll (Bunsei), 860, *860*
Landscape, wall painting, Akrotiri, Thera, Greek island, 141, *141*
landscape design: Baroque, 816–20; English, 816–20, 953–54, 1055
landscape painting: American, 997–98, 1044–46; Chinese, 412, 420–23, 850; Dutch, 808–13; Japanese, 872–73; Roman, 270–71; Romantic, 993–96
Landscape with Merchants (Claude Lorrain), 784, *784*, 809, 954
Landscape with Rainbow (Peter Paul Rubens), 799, *799*
Landscape with Saint John on Patmos (Nicolas Poussin), 784, *785*
Lange, Dorothea, 1110; *Migrant Mother, Nipomo, California*, 1110, *1111*, 1150
Langobards, in Italy, 495–96
lantern, 652, 724
lantern tower, 520
Laocoön, 215
Laocoön and His Sons (Hagesandros, Polydoros, and Athanadoros of Rhodes), 38, 39, *39*, 215, *215*, 268, 759, 761
Laozi, 841
La Pia de' Tolomei (Dante Gabriel Rossetti), 708, 1015, *1015*
Lapita culture, 901, 902, 909
Lapith Fighting a Centaur, metopes, Parthenon, Acropolis, Athens, Greece, 190, *191*, 192
Lapiths, 179, 190
Larbro Saint Hammers, Gotland, Sweden, pictured stone, *504*, 505
Large Bathers, The (Paul Cézanne), 1032, *1032*, 1063
Large Blue Horses, The (Franz Marc), *1070*, 1071
Large Form (Toshiko Takaezu), 1173, *1173*
Large Odalisque (Jean-Auguste-Dominique Ingres), 984, *984*, 1074, 1095
Large Plane Trees (Vincent van Gogh), 25, 41, *41*
Larionov, Mikhail, 1081–82
Lascaux, France
 cave paintings, 48, 51; *Bird-Headed Man with Bison and Rhinoceros*, 51–52, *51*
 Hall of Bulls, 51, *51*
 plan of, *50*, 51
Last Judgment, frescoes (Giotto di Bondone), 610–12, *611*
Last Judgment, relief, Gislebertus, Saint-Lazare cathedral, Autun, Burgundy, France, *Weighing of Souls*, 524, 527, *527*
Last Judgment, wall fresco (Michelangelo), 696, 726, 727

Last Judgment Altarpiece (Rogier van der Weyden), 628, 635, *635*
Last Supper (in Christian art), 306
Last Supper, center piece, *Altarpiece of the Holy Blood* (Tilman Riemenschneider), 712, *712*
Last Supper, fresco (Andrea del Castagno), 672, *673*, 689
Last Supper, The (Leonardo da Vinci), 34–35, *35*, 688–89, *688*, 736
Last Supper, The (Rembrandt van Rijn), after Leonardo da Vinci's fresco, 34–35, *34*, 805
Last Supper, The (Tintoretto), 736–37, *736*
La Tène style, 64
Late Renaissance, 723–38; architecture, 723–27
Latin America, colonial period, 786
Latin cross, 702
Latin-cross church plan, 298, *568*, 656
La Tour, Georges de, 782–83; *Magdalen with the Smoking Flame*, 783, *783*, 961
Latrobe, Benjamin Henry, United States Capitol, Washington, D.C., 1000, *1000*, 1053; corncob capitals, 1000, *1000*
Laughing Mannequins (Manuel Alvarez Bravo), *1118*, 1119
Laurana, Luciano, 659; Ducal Palace, Urbino, Italy, 659, *659*, 704
Lauriya, Nandangarh, India, Ashokan pillar, *370–71*, 371
La Venta, Mexico, 453–54; colossal head, 454, *454*; Great Pyramid and ball court, 453, *453*
Le Brun, Charles, 778, 780–81
Le Corbusier (Charles-Édouard Jeanneret), 189, 1094, 1095–96, 1099, 1154–55; Plan for a Contemporary City of Three Million Inhabitants, 1096, *1096*; Villa Savoye, Poissy-sur-Seine, France, 1096, *1096*, 1154
Lectern (Albert Paley), 1172, *1172*
lectionary, 533
Ledoux, Claude-Nicolas, 967; *Bird's-eye View of the Town of Chaux*, 967, *967*, 1156
Leeuwenhoek, Antoni van, 759
Lefkandi, Euboea, Greece, *Centaur*, 159, *159*
legalism, 407
Lega people (East Africa), 921–22
Léger, Fernand, 1095, 1130; *Grand Déjeuner, Le (The Large Luncheon)*, 1095, *1095*
Legrain, Pierre, 918
Leibl, Wilhelm, 1013; *Three Women in a Village Church*, 1013, *1013*
lekythos, 197–98
Le Loup, Jean, 575
Lenin, Vladimir, 1060, 1090
Le Nôtre, André, 778, 780
Leo III, Emperor, 309
Leo III, Pope, 496
Leo X, Pope, 687, 690, 693, 698–99, 721
Leo X with Cardinals Giulio de' Medici and Luigi de' Rossi (Raphael), *692*, 693
Leonardo da Vinci, 33, 621, 622, 692, 707, 729, 778; career, 688–90, 739; *The Last Supper*, wall painting, Santa Maria delle Grazie, Milan, Italy, 34–35, *35*, 688–89, *688*, 736; *Mona Lisa*, 689–90, *689*; opinions of, 26–27; *Virgin and Saint Anne with the Christ Child and the Young John the Baptist*, 689, *689*; *Vitruvian Man*, *690*
Leoni, Leone, 719; *Charles V Triumphing over Fury*, 719, *719*; without armor, 719, *719*
Lepautre, Jean, *The Grotto of Thetis*, showing original setting of *Apollo Attended by the Nymphs of Thetis*, 782, *782*
Leroi-Gourhan, André, 48
Lescot, Pierre, 741; Louvre, Palais du, Paris, France, Cour Carré, *740*, 741
"Less is more," 1099
Leto, 158
Le Tuc d'Audoubert, France, *Bison*, relief sculpture, 52–53, *52*
Le Vau, Louis, 778, 781; Palais de Versailles, Versailles, France, with André Le Nôtre and Jules Hardouin-Mansart, 778–82, *779*, *780*, 819, 953
Levine, Sherrie, 1166, 1169, 1170; *Untitled*

(After Aleksandr Rodchenko: 11), 1166, 1169, *1169*
Lewis, Edmonia, 1043–44; *Hagar in the Wilderness*, marble, 1043–44, *1043*
Leyster, Judith, 802–4; *Self-Portrait*, 804, *804*
li, 410, 419–20
Liang Wu Di, 413
Liangzhu culture, 403–4
Liberation of Aunt Jemima, The (Betye Saar), 1162–64, *1162*
Libergier, Hughes, 586
Liber Scivias, Hildegard's Vision, manuscript, Romanesque, 546–48, *548*
Libyan Sibyl, ceiling frescoes (Michelangelo), *698*
Lichtenstein, Roy, 1143, 1166; *Oh, Jeff . . . I Love You, Too . . . But . . .*, 1143, *1143*
Liège, Belgium, 593
Life Line, The (Winslow Homer), 1048, *1048*, 1083
Life of John the Baptist (Andrea Pisano), 599–601, *600*, 660–62
Life of the Prophet, manuscript (al-Zarir), *Prophet Muhammad and His Companions Traveling to the Fair* page, *349*, 368
"Life of the Virgin," vestments, English, 589, *589*
light source, 630, 961
Limbourg, Paul, Herman, and Jean (brothers), 622–25, 630; *Très Riches Heures*, manuscript, *February* page, 624–25, *624*, 630, 640, 670–71, 748
limner, 821
Lin, Maya Ying, 1177–78; *Vietnam Veterans Memorial*, Washington, D.C., 1177–78, *1177*
Linda Nochlin and Daisy (Alice Neel), 1162, *1162*
Lindau Gospels, Carolingian, book cover, *Crucifixion with Angels and Mourning Figures*, 502, *503*, 510
Lindisfarne, 485, 502
lingam, 392
lintel, 55, 57, 389, *525*
Lintong, Shaanxi, China, Qin emperor mausoleum, *400*, 401, 407
Lion, Gospel Book of Durrow, manuscript, Hiberno-Saxon, 490, *490*
Lion capital, India, 378, *378*
Lion Gate, Hattushash (near modern Boghazkeui, Turkey), 86–88, *87*
Lion Gate, Mycenae, Greece, 144, *144*, 149
Lion-Human, figurine, Hohlenstein-Stadel, Germany, 45–46, *45*, 52
Lions and Prophet Jeremiah (?), relief, south portal, Saint-Pierre priory church, Moissac, Toulouse, France, *524*, 525
Lipchitz, Jacques, 1078; *Man with a Guitar*, 1078, *1078*
Lippard, Lucy, 1146
Lippi, Filippino, 669, 677
Lipstick (Ascending) on Caterpillar Tracks (Claes Oldenburg), *1144*, 1145
Lissitzky, El, 1090–91; Proun space, 1090, *1091*
lists (knightly), 587
literati, Chinese, 839, 841–42, 861, 869; painting style, 842–44, 848–51, 853
lithography, 40, 544, 985, 988, 989, 1017
Littleton, Harvey, 1152–53; *Implosion/Explosion*, 1153, *1153*, 1157
Liuthar (Aachen) Gospels, Ottonian, *Otto III Enthroned*, 510–11, *511*
Liuthar School, 510
Livia, bust, Roman, 242, *242*
Livia (wife of Augustus), 241, 242
Loango, Africa, 479
Lobi people (Burkina Faso), 922
Lobster Trap and Fish Tail (Alexander Calder), *1114*, 1115
Locke, Alain, 1112
loculi, 293
lodge books, 580
log construction, *535*
loggia, 654, 703, 704, *704*
London, England: Chiswick House, 953, *954*, 967, 974; Crystal Palace, 1000, 1006, *1006*, 1052; Frederick Leyland house, Peacock

Room, 36, *36*; Houses of Parliament, 1001, *1001*; Saint Paul's Cathedral, 818–19, *819*, 966; Whitehall Palace, 798, 816–18, *816*, *817*, 973
London Great Exhibition (1851), 1006
Loos, Adolf, 1087–88; Steiner House, Vienna, Austria, 1087, *1087*
looting, 70, 92, 99
Lorblanchet, Michel, 49
Lorenzetti, Ambrogio, 604, 606–7; frescoes, Palazzo Pubblico, Siena, Italy, *Allegory of Good Government in the City* and *Allegory of Good Government in the Country*, 606–7, *606–7*
Lorenzetti, Pietro, 604–6, 609; *Birth of the Virgin*, 604–6, *605*
Lorrain, Claude (Claude Gellée), 783–85, 809, 954
lost-wax casting process, 136, 209, 406, 462, 476
Lot, 300
lotus flower (Buddhist symbol), 378, 434, *434*
lotus throne (Buddhist symbol), *434*
Louis, Morris, 1145; *Saraband*, 1145, *1145*
Louis IX, of France (Saint), 578, 580–82
Louis IX and Queen Blanche of Castile, page, Moralized Bible, French Gothic, 581, *581*, 590
Louis XIII, of France, 778, 798
Louis XIV (Hyacinthe Rigaud), *756*, 757, 778, 781, 785
Louis XIV, of France, 757, 778, 781–82, 939, 950
Louis XV, of France, 780
Louis XVI, of France, 780, 969
Louvre, Palais du, Paris, France (Pierre Lescot), Cour Carré, *740*, 741
Loves of the Shepherds, The, series (Jean-Honoré Fragonard), *The Meeting*, 946, *947*, 969
low relief, 230, 378, 404
Luanda, Africa, 473, 479
Ludovisi Battle Sarcophagus, relief, *Battle between the Romans and the Barbarians*, *278*, 279
Luke, Saint, 33, 291, 294, 774
Lunar Society, 961
lunette, 293, 520, 654, 695, 698
Luther, Martin, 718, 720, 721
Luxor, Egypt, 96, 114–15, 119; Temple of Amun, Mut, and Khons, Pylon of Rameses II, 115, *115*, 119; Temple of Rameses II, 116, 119, *119*
luxury arts: Byzantine, 333–36; early Renaisssance, 641–45
Lydia, 89, 90
Lysippos, 205–6, 218, 256; *Alexander the Great*, statue, copy after, 205–6, *205*; *The Scraper (Apoxyomenos)*, *204*, 205, 218

M

Maas at Dordrecht (Aelbert Cuyp), 809, *809*
Maat, 125
Mabel of Bury Saint Edmunds, 589
Macedonia, 155, 198
machine esthetic, 1095
Machu Picchu, Peru, 882, 883, *883*
MacLaren, Charles, 144
Maderno, Carlo, 702, 760–61, 763, 766
Madonna and Child with Lilies (Luca della Robbia), 658, 660, 666, *666*
Madonna with the Long Neck (Parmigianino), 730, *730*, 741
Madras, India, 836
madrasa, 351, 356
Madrid, Spain: Escorial, 742, *742*, 786; San Fernando, Hospicio de, Portal, 788, *788*, 796
Madurai, Tamil Nadu, India, Minakshi-Sundareshvara Temple, 829, *829*
maenads, 172
Maestà Altarpiece (Duccio di Buoninsegna), 603, *603*; *Virgin and Child in Majesty* panel, 602–3, *602*

Magdalen with the Smoking Flame (Georges de La Tour), 783, *783*, 961
Magdeburg, Germany, Cathedral, 594–95, *595*
Magdeburg Ivories, German, *Otto I Presenting Magdeburg Cathedral to Christ*, 507, *507*
Magi Asleep, The, relief, Saint-Lazare cathedral, Autun, Burgundy, France, 527–29, *527*
magic, sympathetic, 48
Magic Bird (Constantin Brancusi), 889–92, 1072, *1072*, 1171
Maguey Bloodletting Ritual, fresco, Teotihuacan, Mexico, 456–58, *457*
Magyars, 505
Mahana no atua (Day of the God) (Paul Gauguin), 1035, *1035*, 1065
Mahavira, 376–77, 827–28
Mahayana Buddhism, 376, 383, 432, 826–27, 828
Maillol, Aristide, 1071, 1081; *The Mediterranean*, 1071, *1071*
mainstream, concept of, in art, 1127, 1128, 1153, 1165
Maison Carrée, Nîmes, France, 238–39, *238*
Maison de la Mode, clothes and customized Citroën B-12 (Paris Exposition, 1925), 1079, *1079*
Maison de l'Art Nouveau, La (Paris), 1041
Maitreya, 376
majolica, 629, 666
Ma Jolie (Pablo Picasso), *1076*, 1077, 1134, 1136
maki-e, 868
malanggan ceremonial art, 904
Male and Female (Jackson Pollock), 1131, *1131*
Malevich, Kazimir, 1082, 1090, 1158; *Suprematist Painting (Eight Red Rectangles)*, 1082, *1082*, 1158
Mali, 917, 929–30; mask, *kanaga*, Dogon culture, 929–30, *929*
Malinalco, Mexico, Rock-cut sanctuary, 881, *881*
Mallorca, 589
Mamallapuram, Tamil Nadu, India, 393; Dharmaraja Ratha, 394, *394*, *397*; *Durga as Slayer of the Buffalo Demon*, relief, 393, *393*
Mamluk dynasty, 353, 361
mammoth-bone house, reconstruction drawing of, Ukraine, 45, *45*
Man, Controller of the Universe, fresco (Diego Rivera), 1117–18, *1117*, 1178
Man and Centaur, statuette, Olympia, Greece, perhaps, 160, *160*
Manchu peoples, 851
mandala (Buddhist symbol), 380, 390, *434*, 437
mandapa, 381, 395
Mander, Karel van, 802
Mandolin and Clarinet (Pablo Picasso), 1078, *1078*, 1082
mandorla, 313, 495
Manet, Édouard, 1018, 1019–21, 1024, 1026–27, 1128; *A Bar at the Folies-Bergère*, 1026–27, *1027*; *Le Déjeuner sur l'Herbe (The Luncheon on the Grass)*, 1018, 1019–21, *1019*, 1026; *Olympia*, 1021, *1021*, 1026
Manet, Eugène, 1026
manifestos, 1061
Man in a Red Turban (Jan van Eyck), 632, *632*
Mannerism, 723, 729–32
Mansart, François, 778
Man's Love Story (Clifford Possum Tjapaltjarri), 911–12, *912*
Mantegna, Andrea, 674–75, 680, 703; frescoes, Camera Picta, Ducal Palace, Mantua, Italy, *674*, 675, 703, 760
Mantle with bird impersonators, Peru, Paracas culture, 452, *463*, 464
Mantua, Italy, 649, 655, 656–60, 674–75, 796
 Ducal Palace, Camera Picta, *674*, 675, 703, 760
 Palazzo del Tè, 703–5, *703*; Sala dei Giganti, 703–5, *703*
 Sant'Andrea church, 656, *656*, *657*, 727, 737
 manuscripts, 304
 Byzantine, 321, 336–37
 illuminated, 304; Celtic, 485; early Medieval,

489–91, 500–502, 510–13; Early Renaissance, 622–25, 629, 641; Gothic, 580–84; Islamic, 365–68; Romanesque, 540
Manutuke Poverty Bay, New Zealand, Te-Hau-ki-Turanga (Maori meetinghouse), 909, *909*
Manuzio, Aldo (Aldus Manutius), 644
Man with a Guitar (Jacques Lipchitz), 1078, *1078*
Manyoshu (Japanese poetry anthology), 435
Maon (Menois), France, mosaic synagogue floor, 296, *296*
Maori, 908–10
Mapplethorpe, Robert, 1174, 1175; *Ajitto (Back)*, 1174, *1174*
maqsura, 347
Marat, Jean-Paul, 971–72
marble, 132, 181
Marburg, Germany, Saint Elizabeth church, 592, *592*
Marc, Franz, 1069–71; *The Large Blue Horses*, *1070*, 1071
Marcovaldo, Coppo di, 601
Marcus Aurelius, 246, 259, 282
Marduk Ziggurat, 85
marginalia, 588
Mari (modern Tell Hariri, Iraq), 78; *Investiture of Zimrilim*, wall painting, 78–80, *80*
Marie Antoinette, Queen, 780, 969
Mariette, Auguste, 107
Marika, Mawalan, 902; *The Wawalag Sisters and the Rainbow Serpent*, 902, *902*
Marilyn Diptych (Andy Warhol), 1144, *1144*
Marine Style (Minoan), 139
Marinetti, Filippo Tommaso, 1080, 1081
Mark, Saint, 291, 294
Market Gate, Miletos, Asia Minor (modern Turkey), 249–50, *250*
Markets of Trajan, Rome, Italy, 249, *249*
Mark the Evangelist, Godescalc Evangelistary, manuscript, Carolingian, 500–501, *500*
Marquesas Islands, Polynesia, 906; war club, 906, *907*
Marriage à la Mode, print series (William Hogarth), *The Marriage Contract*, 959, *959*, 1004, 1014
Marriage at Cana, Raising of Lazarus, Resurrection and *Noli Me Tangere*, frescoes (Giotto di Bondone), 617, *619*
Marriage of the Emperor Frederick and Beatrice of Burgundy, The, fresco (Giovanni Battista Tiepolo), *940*, 941, 991
Mars, 158
Marshall Field Wholesale Store, Chicago, Illinois (Henry Hobson Richardson), 1053–54, *1053*, 1088
Marshals and Young Women, Procession, Parthenon, friezes, Acropolis, Athens, Greece, 188, 192, *192*, 243
Marsh Flower, a Sad and Human Face, The (Odilon Redon), *1036*, 1037, 1127
Martinez, Julian, 893
Martinez, Maria Montoya, 893; (and Julian) jar, blackware storage, 893, *893*
Martini, Piero Antonio, *The Salon of 1787*, 944
Martini, Simone, 603–4, 609; *Annunciation*, panel from altarpiece, Cathedral, Siena, Italy, 583, 603–4, *603*
Martin Luther as Junker Jörg (Lucas, the Elder Cranach), 721, *721*
Martyrdom of Saint Bartholomew (Jusepe), 789, *789*, 1048
Martyrdom of Saint Lawrence, Mausoleum of Galla Placidia, Ravenna, Italy, 303, *303*, 304
Martyrdom of Saint Ursula, Saint Ursula reliquary (Hans Memling), 639, *639*
martyrium, 298, 302, 497, 656, 702
Maruyama-Shijo school (Japan), 870–71
Marx, Karl, 41, 981
Marxist art critics, 41
Mary at Her Devotions, page, *Hours of Mary of Burgundy* (Mary of Burgundy Painter), 627, 641, *641*
Mary Magdalen (Donatello), 662, *663*
Mary of Burgundy Painter, 641; *Hours of Mary of Burgundy*, page, *Mary at Her Devotions*,

627, 641, *641*
Marys at the Tomb (The Holy Women at the Sepulcher) (in Christian art), 307
Masaccio (Maso di Ser Giovanni di Mone Cassai), 622, 667–72; *The Expulsion from Paradise*, Brancacci Chapel, Santa Maria del Carmine, Florence, Italy, 670–71, *670*; *Tribute Money*, fresco, Brancacci Chapel, Santa Maria del Carmine, Florence, Italy, 671, *671*; *Trinity with the Virgin, Saint John the Evangelist, and Donors*, fresco, Santa Maria Novella, Florence, Italy, 667–69, *668*, 681
Masjid-i Jami (Great Mosque), Isfahan, Iran, 352, 356–57, *356*, 357
mask, *bwami*, Zaire, Lega culture, 922, *922*
mask, *Ekpo*, Nigeria, Anang Ibibio culture, 929, *929*
mask, *kanaga*, Mali, Dogon culture, 929–30, *929*
mask, *nowo*, Sierra Leone, Mende culture, 921, *921*
"Mask of Agamemnon" (funerary mask), Mycenae, Greece, 136, 144, *145*, 149, 150
mask of an *iyoba*, Benin, 479, *479*
masks: African, 920–22, 928–30; Bwa, 920–21
masks, Dossi, Burkina Faso, Bwa culture, 920, *921*, 931
Masolino, 669
masonry, Inka, 883
masons, 580, 586
Massacre of the Innocents (in Christian art), 306
mass production, 1098
mastaba, 99–100, *100*
master builders, 586
Master of Buli, 477
Master of Flémalle, 629–30, 633
materials, "honest," 1098
Maternal Caress (Mary Cassatt), 1020, 1028–29, *1028*
Mathur, B. P., 836; Punjab University, Chandigarh, India, Gandhi Bhavan, with Pierre Jeanneret, 836, *836*
Mathura School, 383, 384
Matisse, Henri, 918, 1063, 1064, 1065, 1071–72, 1074, 1075, 1081, 1083; *Bonheur de Vivre, Le (The Joy of Life)*, 1064, *1064*, 1065, 1071–72, 1074; *La Serpentine*, 1071, *1071*, 1078; *Woman with the Hat, The*, 1064, *1064*, 1065
Matsushima screens (Tawaraya Sotatsu), *866–67*, 867
matte, 791, 893
Matthew, Saint, 291, 294
Matthew the Evangelist, Ebbo Gospels, manuscript, Carolingian, 501, *501*, 531
Maurya dynasty, 377–79, 828
mausoleum, 201, 407, 497, 829
Mausoleum, Halikarnassos (modern Bodrum, Turkey), 104, 200–202, *201*, *202*, 205
Mausoleum of Galla Placidia, Ravenna, Italy, 302–3, *302*, 303–4, *303*, 304, *304*, 318
Mausoleum under Construction, relief, Haterius family tomb, Rome, Italy, *256*, 257
Mausolos, prince of Karia, 200
Mausolos (?), statue, Mausoleum, Halikarnassos (modern Bodrum, Turkey), 201, *201*
Maxentius, 282, 283
Maya
 art, 457–62; Classic period, 458–61
 people and civilization, 879
Mayapan, Mexico, 462
Mazarin, Cardinal, 778
mbis (New Guinea spirit poles), 904
McEvilley, Thomas, 1128
McKim, Mead, and White, Pennsylvania Railroad Station, New York, N.Y., waiting room, interior, 276, *277*
meander, 245
meaning in art, 27, 30–31
Mecca, 343, 344, 345, 347, 348
medallion, 293
Medes, 83
Medici, Catherine de, 741

Medici, Cosimo de', the Elder, 649–50, 654, 677
Medici, Lorenzo de' ("the Magnificent"), 656, 677, 694
Medici, Marie de', 778, 798–99, 814
Medici Chapel, Florence, Italy, Church of San Lorenzo, 699–700, 699
Medici family, 649–50, 652, 693, 698–99
Medici-Riccardi palace, Florence, Italy (Michelozzo di Bartolommeo), 654–55, 654
Medici Venus, statue, Roman copy of Greek original, 28, 28
Medina, 344, 348
Mediterranean, 233
Mediterranean, The (Aristide Maillol), 1071, 1071
Medusa, 158, 165–66
Meeting, The, The Loves of the Shepherds, series (Jean-Honoré Fragonard), 946, 947, 969
megalith, 144
megalithic architecture, Neolithic, 57–60
megaron, 147–48, 160
Meiji period (Japan), 873–74
Meir, Egypt, tomb of Senbi, 112, 113, 122
Melanesia, 900, 902–5, 906
Meleager, 172
Melencolia I (Albrecht Dürer), 718, 718, 806
Melk, Austria, Benedictine Monastery Church (Jakob Prandtauer), 786, 786; interior, after designs of Prandtauer, Antonio Beduzzi, and Joseph Munggenast, 786, 787, 942
Melun Diptych (Jean Fouquet), wing, Étienne Chevalier and Saint Stephen, 628, 646, 647
memento mori, 943–45
Memling, Hans, 638–39; Saint Ursula reliquary, 639, 639; Martyrdom of Saint Ursula, 639, 639
Memmi, Lippo, 603
Memorial head, Benin, 477, 478
memory images, 47, 177
Mende people (Sierra Leone), 921, 933
Mendieta, Ana, 1165; Tree of Life series (photographs), 1164, 1165
Ménec, Carnac, France, menhir alignments, 57, 58
Menelaus, 144
Mengs, Anton Raphael, 952, 963; Parnassus, 952, 952
menhir, 57–58; statue, 60
menhir alignments, Ménec, Carnac, France, 57, 58
menhir statue of a woman, Montagnac, France, 60, 60
Meninas (The Maids of Honor), Las (Diego Velázquez), 760, 792–93, 792, 991
Menkaura, 102, 104
Menkaura and a Queen, statue, Egyptian, perhaps his wife Khamerernebty, 104–5, 105, 125, 132, 168
menorah, 255, 293
Menorahs and Ark of the Covenant, Villa Torlonia, Rome, Italy, 293, 293
mensa, 628, 628
men's hand (Japanese), 440
Mentuhotep II, 108
Mercury, 158
Merian, Maria Sibylla, 814; The Metamorphosis of Insects of Surinam, book, 814, 814
Mérode Altarpiece (Robert Campin), 620, 628, 629–30, 629; wing, Joseph in His Carpentry Shop, 620–22, 620, 718
Merye-ankhnes, Queen, 106
Mesoamerica: ancient, 451–62; art, chronology of, 451–53; civilization, 879; symbolism of, 794–95
Mesopotamia (modern Iraq), 68–69, 353
Messengers Signal the Appearance of a Comet (Halley's Comet), Bayeux Tapestry, Norman-Anglo-Saxon, 540–42, 543, 543
metal, in construction, 962, 1106
metal plate (engraving), 648
metalwork: Aegean, 136, 137; Africa, 474–75; Ancient Near East, 74; Byzantine, 334; Celtic, 491; early European, 63; Early Renaissance, 649; German, 492, 593–94; Greek, 160, 177; Islamic, 359–60; Mesoamerican, 462; Minoan, 135; Modernist, 1106; Mycenaean,

150; nomadic, 495; Peruvian, 464; Romanesque, 546
métamatics (Tinguely), 1140
Metamorphosis of Insects of Surinam, The, book (Maria Sibylla Merian), 814, 814
Metochites, Theodore, 337
metopes, 163, 164
Meuse Valley (Mosan), 546, 593; metalwork, 577
Mexican art: colonial architecture, 788; Modernism, 1117–19; mural movement, 1117–18, 1118
Mexico, 794, 879–81; Revolution of 1910, 1117
Mexico City, Mexico, Basilica of Guadalupe, 794–95, 794
Meyer, Adolf, 1088
Michael, Archangel, 334
Michel, Claude, 949
Michelangelo Buonarroti, 622, 661, 671, 692, 702, 703, 704, 730, 733, 736, 742, 747, 778, 965, 1039
 career, 39, 694–701, 723–24, 727–29
 David, 695, 695, 768
 Moses, Tomb of Julius II, San Pietro in Vincoli, Rome, Italy, 698, 699
 Pietà (Rondanini Pietà), 700, 727–28, 727
 Pietà (Vatican), 694–95, 694, 727
 Porta Pia, 1156
 Saint Peter's Basilica, Rome, Italy, 687, 698, 701–2, 718, 724, 724, 760–63
 San Lorenzo monastery, Florence, Italy, 693, 700–701, 700
 Sistine Chapel, Vatican Palace, Rome, Italy, frescoes, 685, 696, 697, 727, 768, 776, 965, 987; Last Judgment, 726; Libyan Sibyl, 698
 sonnet in hand-writing of, with self-portrait, 684, 685
 Tombs of Giuliano and Lorenzo de' Medici, Church of San Lorenzo, Medici Chapel, Florence, Italy, 699–700, 699
Michelozzo di Bartolommeo, 654; Medici-Riccardi palace, Florence, Italy, 654–55, 654
Micronesia, 900, 905–6
Middle-Aged Flavian Woman, bust, Roman, 257, 258, 258, 577
Middle Ages, 486–87, 623
middle class, European, 938
Middle Kingdom (China), 402
Middlesex, England, Syon House, 956, 957, 973
Mieris, Frans van, 25–26
Mies van der Rohe, Ludwig, 1094, 1097, 1099, 1154, 1155; German Pavilion, Barcelona International Exposition (1929), 1099, 1099; Seagram Building, New York, NY, with Philip Johnson, 1154, 1154, 1156, 1157
Migrant Mother, Nipomo, California (Dorothea Lange), 1110, 1111, 1150
mihrab, 347, 351
Milan, Italy, 302, 545, 649, 688–89; Santa Maria delle Grazie, 34–35, 35, 688–89, 688, 736; Sant'Ambrogio church, 539, 545, 545; Station for airplanes and trains, proposed (Antonio Sant'Elia), 1089, 1089, 1096
Miletos, Asia Minor (modern Turkey), 199; Market Gate, 249–50, 250; plan of, 199, 199
Millais, John Everett, 1014
Miller, Tim, 1175
Millet, Jean-François, 1011; The Gleaners, 1011, 1011
Mill Run, Pennsylvania, Fallingwater, Edgar Kaufmann House, 1094, 1116–17, 1116
Mills, Robert, 189
mimesis (imitation), 25, 229
mimis, 901
Mimis and Kangaroo, rock art, Oenpelli, Arnhem Land, Australia, 901, 901
Minakshi-Sundareshvara Temple, Madurai, Tamil Nadu, India, 829, 829
Minamoto Yoritomo, 859
minaret, 347, 832–33
minbar, 345, 347
Minerva, 158
Ming dynasty (China), 845–51, 853
miniatures, 304; Islamic, 365

Minimalism, 1142, 1146–48, 1153, 1161
Minoan civilization, 133–42, 149; art, 148–49, 175; dating of, 131; Late Period, 141–42; Old Palace Period, 135–37; Second Palace Period, 137–41
Minos, king of Crete, 133, 134, 139, 149, 158
Minotaur, 134, 139
Miracle of the Crib at Greccio (Saint Francis Master), 601, 609–10, 610
Miraculous Draft of Fish, altarpiece (Konrad Witz), 647–48, 647
Miraculous Draft of Fishes (shop of Pieter van Aelst), after Raphael's Sistine tapestries, 693, 693, 696
mirador, 355
Miró, Joan, 1104–5, 1115; Dutch Interior I, 1104, 1104, 1131
mirror, Etruscan, 232, 233
mirrors, 632
missionaries, Christian, 794, 917
Mission style, 1115–16
Mississippian culture (North America), 467
Mitchell, Joan, 1137
Mithras, 236, 282
mithuna couples, 382, 389
Miyashita Zenji, 873; ceramic vessel, 873, 873
Mnesikles, 193
moai ancestor figures, Easter Island, Polynesia, 898–99, 899, 906
moat, 430, 539, 587
mobiles, 1115
Moche culture (Peru), 464–65
Moche Lord with a Feline, ceramic, Peru, 464–65, 465
Model for the Monument to the Third International (Vladimir Tatlin), 1090, 1090
modeling, 52, 208
models, nude, 1049
Modena, Italy, Cathedral, 551, 552, 552
modern architecture, 1083–89, 1095–97; American, 1086–87, 1154–55; European, 1087–89; International Style, 1094
modernism, 1061; decline of, 1143, 1153; persistence of, 1170–71; sculpture, 1071, 1106–7
Modernismo (Modernism), 1041, 1061
Modersohn-Becker, Paula, 1067–68; Self-Portrait with an Amber Necklace, 1067–68, 1067
Mogollon culture (American Southwest), 468
Mohenjo-Daro, India, 374; Bust of a Man, 374, 374
Moholy-Nagy, Laszlo, 1098
Moissac, Toulouse, France, Saint-Pierre priory church, 524; south portal, 524–27, 524, 525, 531, 564
molding, 245, 395, 627, 704, 704, 727
Momoyama period (Japan), 862–65
Mona Lisa (Leonardo da Vinci), 689–90, 689
Monastery of Hosios Loukas, Stiris, Greece, Katholikon, 328–30, 329
Monastery of Saint Catherine, Mount Sinai, Egypt, 313–14, 313, 322–23, 323
monastic communities, 309, 498–99, 517
Mondrian, Piet, 1092–93, 1115, 1130; Composition with Yellow, Red, and Blue, 1092–93, 1092, 1099
Monet, Claude, 1018–19, 1021–23, 1029–30, 1081; Boulevard des Capucines, Paris, 1022, 1022; Rouen Cathedral: The Portal (in Sun), 1029–30, 1029; Terrace at Sainte-Adresse, 1021–22, 1021
Mongols, 353, 354, 408, 424, 840–41, 842
Monk by the Sea (Caspar David Friedrich), 993–94, 993
Monkey Cup, beaker, Flanders, 645, 645
monks, Buddhist, 446
Monk Sewing (Kao Ninga, attributed to), 445, 446, 446
monograms (Christian symbols), 294
monolith, 482
Monophysitism, 304–5
monotheism, 290
Monroe, Marilyn, 1144

Montagnac, France, menhir statue of a woman, 60, *60*

Montbaston, Jeanne and Richart de, 623

Montefeltro, Federico da, 659–60

Montefeltro family, 649

Monticello, Charlottesville, Virginia (Thomas Jefferson), 974, *974*, 1000

Montreal, Quebec, Canada, Habitat '67, 1155, *1155*

Mont Sainte-Victoire (Paul Cézanne), *1030*, 1031

monumental narrative relief, 391–93

monumental sculpture, 78, 161

monumental tombs, Greek, 200–201

Moon Goddess Coyolxauhqui, The, stone disk, Aztec, *880*, 881

Moore, Henry, 1106–7, 1137; *Recumbent Figure*, 1106, *1107*, 1137

Moorish architecture, 786

Mora, Paolo and Laura, 124

Moralized Bible, French Gothic, page, *Louis IX and Queen Blanche of Castile*, 581, *581*, 590

Moreau, Gustave, 1036; *The Apparition*, 1036, *1036*

Morgan, Julia, 1115–16; La Casa Grande, front entrance, San Simeon, California, 1115, *1115*

Morimura, Yasumasa, 1174–77; *Self-Portrait (Actress)/White Marilyn*, *1176*, 1177

Morino Hiroaki, 873; ceramic vessel, 873, *873*

Morisot, Berthe, 1018–19, 1026; *Summer's Day*, 1026, *1026*

Morisot, Edma, 1026

Morley, Burrows, Cooke, Bateman families, silverware, 957, *958*

Morris, William, 1015–16, 1086; *Peacock and Dragon* curtain, 710, 1016, *1016*

mortise-and-tenon joint, 59, 847

mosaic: Byzantine, 313–14, 328; Greek, 207–8; Imperial Christian, 299–300; Jewish, 296; Mesopotamian, 70; Roman, 267–69; Romanesque, 550–51

mosaic synagogue floor, Maon (Menois), France, 296, *296*

Mosan region. *See* Meuse Valley

Moscow, Russia, Saint Basil the Blessed, 324, *324*, 338, *339*

Moser, Mary, 950

Moses, 291, 296

Moses (Michelangelo), 698, *699*

mosque, 345, 347, 480, 829

Mossi people (Burkina Faso), 919

Mother Goddess Coatlicue, The, statue, Aztec, 794, 881, *881*

motif, 698, 704, 884, 932

Mott, Lucretia, 981

Moulin de la Galette (Pierre-Auguste Renoir), 1024, *1024*, 1026, 1027–28

mound builders, North America, 466–68

Mountains and Sea (Helen Frankenthaler), 1137, *1137*, 1145

Mountains at Collioure (André Derain), 1063, *1063*

Mount Fuji, teabowl (Hon'ami Koetsu), *866*, 867

Mount Olympos, 156, 158

Mount Sinai, Egypt, Monastery of Saint Catherine, 313–14, *313*, 322–23, *323*

Mount Vernon, Fairfax County, Virginia, 973–74, *973*

Mount Vesuvius, 229

movable wing, *628*

Mozarabic art, 493, 531

Mrs. Freake and Baby Mary, painting, American colonial, 821, *821*

Mshatta, Jordan, palace, 347, *347*; facade of, 347, *347*

mudra, 384, *385*, 435

Mughal rulers (India), 825, 829–30, 832; art and architecture of, 829–35

Muhammad, the Prophet, 290, 343, 344, 345; life of, 348–49

Mukhina, Vera, 1092; *Worker and Collective Farm Worker*, 1092, *1092*

al-Mulk, pen box of (Shazi), 359, *359*

al-Mulk al-Muzaffar, Majd, 359

mullions, 578

multiculturalism, 1178

mummies, 92, 99

mummy wrapping of a young boy, Hawara, Egypt, 126, *126*

Munch, Edvard, 1038–39, 1127; *The Scream*, 1038–39, *1038*

Munich, Germany, Degenerate Art Exhibition (1937), *1097*

muqarna, 311, 352, 355

murals: Mexican, 1117–18, 1178; *see also* wall painting

Murasaki, Lady, *Tale of Genji*, 436, 440; scroll, Japanese, 440, *441*

Murillo, Bartolomé Esteban, 793–94; *The Esquilache Immaculate Conception*, 793–94, *793*

Muromachi period (Japan), 858–62

Murray, Elizabeth, 1170–71; *Chaotic Lip*, 1170–71, *1171*

Museum of Modern Art, NY, 1061
exhibitions: "The Art of Assemblage" (1961), 1140; "Deconstructivist Architecture" (1988), 1158; "The New American Painting" (1958–59), 1137; "The Responsive Eye" (1965), 1145–46

museums, 36–37, 193, 1061

music, Chinese, 406, 869

Musicians and Dancers, wall painting, Tomb of the Lionesses, Tarquinia, Italy, 231, *232*

Muslims. *See* Islam

al-Mustasim, Yaqut, 352

Mut, 96, 114

Muybridge, Eadweard, 1049; *Sally Gardner Running at a 1:40 Gait, 19 June 1878*, 1049, *1049*

Mycenae, Greece, 141–42, 145, 149; citadel, 142–46, *143*; Lion Gate, 144, *144*, 149; "Mask of Agamemnon" (funerary mask), 136, 144, *145*, 149, 150; *tholos* ('Treasury of Atreus'), 146, *146*, 199; *Two Women with a Child*, figurine, 149, *149*; *Warrior Vase*, 150, *150*

Mycenaean civilization, 142–51

Myoki-an Temple, Kyoto, Japan (Sen no Rikyu), Tai-an tearoom, 864–65, *865*

Myron, 182–83; *Discus Thrower (Diskobolos)*, *152*, 153, 182–83, 190, 268

mystery plays (liturgical dramas), 541

mystery religions, 206, 236, 271–72, 289

Mystical Nativity (Sandro Botticelli), 679–80, *679*

mythocentric age, China, 407

N

Nadar (Gaspard-Félix Tournachon), 1005; *Portrait of Charles Baudelaire*, 1005, *1005*, 1019

Namuth, Hans, Photograph of Jackson Pollock painting, 1132, *1132*, 1139

Nanchan Temple, Wutaishan, Shanxi, China, 417, *417*

Nanga (Southern) school (Japan), 868–70

Nan Madol, Pohnpei, Micronesia, royal mortuary compound, 905–6, *905*

Nanna Ziggurat, Ur (modern Muqaiyir, Iraq), 72–73, 72

Nanni di Banco, 660; *Four Crowned Martyrs*, 660, *661*, 662

naos, 160, 163, 298, 311

Naples, Kingdom of, 786, 788

Napoleon Crossing the Saint-Bernard (Jacques-Louis David), *982*, 983, 994, 1125

Napoleonic Wars, 776

Napoleon in the Plague House at Jaffa (Antoine-Jean Gros), 983, *983*

Nara, Japan, 434–35, 850, 859; Todai-ji temple, 435

Nara period (Japan), 434–35, 859

Narmer, 96

narrative art, Indian, 391–93

narthex, 296, 298, 497, *568*

Nashville, Tennessee, Parthenon, 189

National Academy of Design (New York), 1083

National Endowment for the Arts (NEA), 35; and public funding for art, 1174, 1175

Native Americans. *See* American peoples

Nativity, the (in Christian art), 306

Nativity, pulpit (Giovanni Pisano), 599, *599*

Nativity, pulpit (Nicola Pisano), 597–99, *599*

naturalism, 25–26, 218, 476, 617, 759–60, 1013–14; American, 996–1000; Chinese, 415–16; French, 1009–11; Gothic, 594; Indian, 384

nature, 938–39, 1096; rejection of, 1093

Nauman, Bruce, 1149; *Self-Portrait as a Fountain*, 1149, *1149*

Naumburg, Germany, Cathedral, 595–96, *596*

Navajo people, 892, 894–95

nave, 247, 296, 298, *568*, 652, 702, 760

nave arcade, 299

nave colonnade, 298

Naxos, Greek island, 132

Nazca culture (Peru), 463–64

Nazca lines, Peru, 464, *464*

Naziism, 1060, 1097

ndop figures (Kuba), 927

Near East, ancient, 67–91; map, *68*

Nebuchadnezzar II, King, 83, 291

necking, 164

necropolis, 100, 239

Neel, Alice, 1162; *Linda Nochlin and Daisy*, *1162*, 1162

Nefertari, 117; tomb of, 123–25

Nefertiti, 120–21, 131

Nefertiti, head, Egyptian, *121*

negative spaces, 160

Neo-Babylonia, 83–85

Neoclassicism, 939; 19th century, 981; American, 996–1000, 1042–44; in architecture, 956–59, 1156; British, 956–59; French, 946, 949, 982–91; Italian, 952–53

Neo-Conceptualism, 1168–69

Neo-Confucianism, 419–20, 423, 866, 870

Neo-Expressionism, 1165–68

Neo-Geo, 1168

Neo-Impressionism, 1063, 1078

Neolithic period, 53–63; cities, 69–70; Japan, 428–30

Neoplatonism, 649–50

Neo-Primitivism, 1081

Nephthys, 96

Neptune, 158

Neri, Filippo, 774

Nero, 234, 246, 250

Nerva, 246

Neshat, Shirin, 1183; *Fervor*, production stills, 1183, *1183*

Netherlandish painting, 628–29

Netherlands, 742, 745, 786, 809. *See also* Dutch art

Neumann, Johann Balthasar, 940; Vierzehnheiligen, Church of the, Staffelstein, Germany (near), 941–42, *941*, 957

Nevelson, Louise, 1136–37, 1140; *Sky Cathedral*, *1136*, 1137, 1140

New Deal, 1060, 1108, 1109, 1150

New Delhi, India, 836

Newgrange, Ireland, tomb interior, 57, *57*, 146

New Guinea, 900, 903–4

New Ireland, Papua New Guinea, 904–5; *tatanua*, mask dance, 904–5, *905*

Newman, Barnett, 1134–35, 1145; *Vir Heroicus Sublimus*, *1134*, 1135

New Negro movement, 1112–13

Newport, Rhode Island, Redwood Library, 973, *973*

New Shelton Wet/Dry Triple Decker, The (Jeff Koons), 1102, 1169, *1169*

New Testament, 291

New Town Hall, Borgoricco, Italy (Aldo Rossi), *1156*, 1157

New York, NY
art scene, 1109, 1130
buildings and structures: AT&T Corporate Headquarters, model for, 1156, *1156*; Brooklyn Bridge, 1006, *1006*; Central Park, *1055*; Empire State Building, *1088*;

Pennsylvania Railroad Station, waiting room, interior, 276, *277*; Rockefeller Center, *1116*, 1117; Seagram Building, 1154, *1154*, 1156, 1157; Solomon R. Guggenheim Museum, 36, *37*, 1158; Trans World Airlines Terminal, John F. Kennedy Airport, 1154, *1154*, 1152; Trinity Church, 1002, *1002*, 1152; Woolworth Building, 1087, *1087*, 1088

New York Kouros, kouros statue, Greek, 168, *168*

New York School, 1130; sculpture, 1135–37

New Zealand, 901, 908–10

Ngombe people, 918

Ngongo ya Chintu, 477

Niagara (Frederic Edwin Church), 1044, *1044*

niche, 725, *725*

Nicholas of Verdun, 593; *Shrine of the Three Kings*, reliquary, 577, 593–94, *594*

niello, 136, 546

Niépce, Joseph-Nicéphore, 1002–3

Nietzsche, Friedrich, 1135

Nigeria, 475, 917, 919, 927–29, 930, 932, 933–34; dance staff depicting Eshu, Yoruba, 925, *925*; head, Nok culture, 475, *475*; mask, *Ekpo*, Anang Ibibio culture, 929, *929*

Night Attack on the Sanjo Palace, scroll, Japan, Kamakura period, 442–43, *442*, 445

Nighthawks (Edward Hopper), 1111, *1111*, 1138

Nightmare, The (John Henry Fuseli), *964*, 965

Nike, 158, 214

Nike (Victory) Adjusting Her Sandal, relief sculpture, Temple of Athena Nike, Acropolis, Athens, Greece, 194–96, *195*, 203, 218

Nike (Victory) of Samothrace, Samothrace, Macedonia, 216–17, *216*

Nile River, 94, 96

Nîmes, France: Maison Carrée, 238–39, *238*; Pont du Gard, 235, *235*

Nimrud, Iraq, 67, 80; Palace of Assurnasirpal II, *66*, 67, 80, *81*, 291; tomb of Queen Yabay, 82, *82*, 137

Nineteenth-Century art, 979–1057

Nineveh (modern Kuyunjik, Iraq), 71, 82; *Assurbanipal and His Queen in the Garden*, 82, *82*

nishiki-e, 872

Nizami, 365

Ni Zan, 842–44; *The Rongxi Studio*, hanging scroll, 843, *843*, 849

nkisi and *nkisi nkonde* figures (Kongo/Songye), 923–24

nlo byeri figures (Fang), 930

Nobunaga, Oda, 862

Nochlin, Linda, 1162; "Why Have There Been No Great Women Artists?" (essay), 1162

Nocturne: Blue and Gold - Old Battersea Bridge (James Abbott McNeill Whistler), *1020*

Nok Culture (Ouattara), 932, *932*

Nok culture (Nigeria), 475, 917

Noli Me Tangere (Lavinia Fontana), 734, *734*

Noli Me Tangere ("Do Not Touch Me") (in Christian art), 307

nonfinito, 700

nonrepresentational (nonobjective) art, 27, 1061

Normandy, France, 503, 516

Norman Palace, Palermo, Sicily, Chamber of King Roger, 333, *333*

Normans, 331, 503, 542

Norns, 487

Norse, 487

North Africa, 917

North America, 938 (map), 1060 (map); Pre-European, 465–68; Vikings in, 503

North American art: 18th century, 937–77; Modernism, 1059–61, 1082–87, 1107–20; *see also* United States art

Northern European art, 625–26

North Italian painter, anonymous, *Ideal City with a Foundation and Statues of the Virtues*, 620–22, *620*

North Sea, 534–35

Northwest Coast peoples (U.S.), 888–92

Notre-Dame cathedral, Amiens, Île-de-France, France, *570*, 571–75, *571*, *572*, *573*, 579, 597

Notre-Dame cathedral, Chartres, Île-de-France, France, *554*, 555, 557, *557*, *562*, 563–70, *564*, *565*, *566*, *567*, *569*, 579, 586, 595; Royal Portal, 563–64, *563*

Notre-Dame cathedral, Paris, France, 574, *574*, 575

Notre-Dame cathedral, Reims, Île-de-France, France, 575–77, *575*, *576*, *577*, 583, 586, 594

Nouveaux Réalistes (New Realists), 1139–40, 1160

nowo masks, 921

Nubia, Egypt, 125, 472; Temple T, Kawa, 125, *125*

nude in art, 168–69, 202, 203–5, 650, 662, 695–96, 710, 719, 727, 944, 946, 950, 984, 1049

Numumusow potters, 933

Nuremberg, Germany, 710–11, 721; house of Albrecht Dürer, 711, *711*

Nut (sky), 96

Nymphs and a Satyr (Adolphe-William Bouguereau), 1009, *1009*, 1028

O

Oath of the Horatii (Jacques-Louis David), 970–71, *971*

obelisk, 115, 760

Object (Le Déjeuner en fourrure; Luncheon in Fur) (Meret Oppenheim), 1105, *1105*

observation of nature, 177, 218

Oceania: peopling of, 900–901; recent art in, 910–12; traditional art of, 902–9

Octopus Flask, Palaikastro, Crete, 139, *139*

oculus, 228, 253, 311, 652, 818

odalisque, 984

Odin, 487, 505

Odundo, Magdalene, 934; *Asymmetrical Angled Piece*, 934, *934*

Odysseus, 144, 158, 175

Odyssey, 149

Oenpelli, Arnhem Land, Australia, *Mimis and Kangaroo*, rock art, 901, *901*

Officers of the Haarlem Militia Company of Saint Adrian (Frans Hals), 802, *803*

Ofili, Chris, 1175; *The Holy Virgin Mary*, 1175, *1175*

Oh, Jeff . . . I Love You, Too . . . But . . . (Roy Lichtenstein), 1143, *1143*

oil painting, 630, 631, 666, 680–83, 687, 706–7; Early Renaissance in Italy, 676–83

O'Keeffe, Georgia, 27, 41, 1107–8, 1163; *City Night*, 1108, *1108*; *Red Canna*, 26, 27, 1108

Okyo, Maruyama, 870–71

Olbrechts, Frans, 477

Oldenburg, Claes, 1145; *Lipstick (Ascending) on Caterpillar Tracks*, *1144*, 1145

Old Masters, Roger de Piles's grading of, 778

Old Saint Peter's, Rome, Italy, 297–98, *297*, 497

Old Testament, 336

Old Testament Trinity (Three Angels Visiting Abraham), The (Andrey Rublyov), 340, *340*

Old Woman, statue, Hellenistic, 217–18, *217*

Olmec culture, 453–54, 458

Olmsted, Frederick Law, 1053, 1055; Central Park, New York, N.Y., with Calvert Vaux, *1055*

Olodumare, 925

Olowe of Ise, 31, 927; divination bowl, 31, *31*; door, royal palace, Ikere, Nigeria, 927, *928*

olpe, 161

Olympia (Édouard Manet), 1021, *1021*, 1026

Olympia, Greece: (perhaps from) *Man and Centaur*, statuette, 160, *160*; Sanctuary of Hera and Zeus, 156; statue of Zeus, 104; Temple of Hera, 202; Temple of Zeus, 178–79, *178*, 179, *179*, 190, 191, 203

Olympian Games (ancient), 153, 156, 179

Olympic Games (modern), 153, 156, 179

One and Three Chairs (Joseph Kosuth), 1148, 1149

One Hundred Views of Edo: Bamboo Yards, Kyobashi Bridge (Utagawa Hiroshige), *1020*

one-point perspective, 688

Onjo-ji monastery, Shiga prefecture, Japan, Guest Hall, *865*

Op art, 1145–46

Open Door, The, The Pencil of Nature, series (William Henry Fox Talbot), 1003, *1003*

openwork, 64, 488

openwork box lid, Cornalaragh, Ireland, 64, *64*

Opéra, Paris, France (Charles Garnier), 1007, *1007*, 1008–9, *1008*, 1026

opithodomos, 163

Oppenheim, Meret, 1105; *Object (Le Déjeuner en fourrure; Luncheon in Fur)*, 1105, *1105*

opus anglicanum, 589

opus incertum, 236

opus reticulatum, 236

opus testaceum, 236

oracle, 157

oracle bones, 405

Orange, France, Roman theater, 239, *239*

Orange, House of, 800–802

orant figures, 293

Orbais, Jean d', 575

orders of architecture, 164, 229, 655

Orientalizing period (Greek), 157, 161

Orphism, 1079

Orsanmichele, Florence, Italy, 658, 660, 666, *666*

Orthodox (Eastern) Church, 292, 338

Orthodox painting, Chinese, 853

orthogonal city plan, 199

orthogonals, 621

Oseberg, Norway, burial ship, *504*, 505, 536; post with animal figures, 505, *505*, 536

Osiris, 96, 125, 236

Osterhofen, Germany, Convent Church, 942–43, *942*

Ostia, Italy, 262–63; apartment block (*insula*), 263, *263*

Ostrava Petrkovice, Czech Republic, *Woman*, figurine, paleolithic, 46, *46*

Ostrogoths, 302, 314, 487

O'Sullivan, Timothy H., 1045–46, 1047; *Ancient Ruins in the Cañon de Chelley, Arizona*, 1045–46, *1045*

Otto I, Emperor, 505

Otto I Presenting Magdeburg Cathedral to Christ, Magdeburg Ivories, German, 507, *507*

Otto III, Emperor, 510–11

Otto III Enthroned, Liuthar (Aachen) Gospels, Ottonian, 510–11, *511*

Ottoman Empire, 354, 357–58

Ottoman Turks, 338, 351, 353–54, 367–68

Ottonian dynasty, 505, 510–11, 542

Ouattara, 932, 934; *Nok Culture*, 932, *932*

Our Lady of Guadalupe (Sebastian Salcedo), 795, *795*

Ovid, 229, 274

Oxbow, The (Thomas Cole), 997–98, *998*, 1044

Oxford University, England, 557

Ozenfant, Amédée, 1095

P

Pacal, Lord, 459

Pacific peoples, 899–913, 900 (map)

Padua, Italy, 656; Sant' Antonio church, 664–65; Scrovegni (Arena) Chapel, 610–12, *611*, 612, *612*, 617, *618*, *619*

Paestum, Italy, 162; Temple of Hera I, 162, *162*, 163–65

paganism, 285

pagoda, 417, 418, 432; stone, 418; wooden, 418

Paik, Nam June, 1182; *Electronic Superhighway: Continental U.S.*, 1182, *1182*

painted pottery cultures (China), 403

painterly style, 1026

painting
 grading of Old Masters, 778
 periods and styles: 16th century, 714–18; 18th century, 968–73; American colonial, 821, 974–76; Australian Aborigine, 901–2; Baroque, 774–78, 782–85, 788–94; British,

959–66; Buddhist, 435; Chinese, 412–13, 841–46, 869; Dutch, 745–48, 802–16; Early Christian, 293–94; Early Renaissance in Italy, 666–83; Egyptian, 107, 108, 124; English, 749–52; French, 739, 782–85, 943–46, 968–73, 984–90; Germany, 714–18; Gothic, 591, 601–12; Greco-Roman, 126; Greek, 161, 197–98; Indian, 386, 832, 833–35; International Gothic, 666–67; Italian, 601–12, 666–83, 703–10, 774–78; Jewish, 293–94, 296; mannerist, 729–32; Mayan, 460–61; Mughal, 830–32; Renaissance, 703–10, 739, 742–52; Romantic, 984–90; Spanish, 742–45, 788–94; Venetian, 734–38; Zen, 870
 status of, 655, 690, 841–42
palace, Mshatta, Jordan, 347, *347*; facade of, 347, *347*
palace, Pylos, Greece, megaron of, 148, *148*, 160
Palace Chapel of Charlemagne, Aachen (Aix-la-Chapelle), Germany, 497–98, *497*, 498, *498*
palace complex, 81
palace complex, Knossos, Crete, *134*, 135, 137, *137*, 142, *142*, 149
Palace of Assurnasirpal II, Nimrud, Iraq, 66, 67, 80, *81*, 291
Palace of Diocletian, Split, Croatia, 280–81, *280*, 281
Palace of the Lions. *See* Alhambra, Granada, Spain
palaces: Byzantine, 324–25; Islamic, 347, 354; Minoan, 135; Renaissance, 704
Pala dynasty (India), 394, 826–27
Palaikastro, Crete, *Octopus Flask*, 139, *139*
Palais de Versailles, Versailles, France (Louis Le Vau and Jules Hardouin-Mansart), 778–82, *779*, 819, 953; Hall of Mirrors (Charles Le Brun), 780, *781*, 940; plan (André Le Nôtre), *780*
Palatine Chapel, Palermo, Sicily, 332, *332*
Palazzo del Tè, Mantua, Italy (Giulio Romano), 703–5, *703*; Sala dei Giganti, 703–5, *703*
Palazzo Ducale, Venice, Italy, Council Chamber, 32, *32*, 35, 734
Palazzo Pubblico, Siena, Italy, 606–7, *606–7*
Palenque, Mexico, 459; Temple of the Inscriptions, 459–60, *459*, 460, *460*
Paleolithic period: Americas, 450–51; Europe, 44–53
Palermo, Sicily: Norman Palace, Chamber of King Roger, 333, *333*; Palatine Chapel, 332, *332*
Palestine, 291
Palestrina, Italy, Sanctuary of Fortuna Primigenia, model of, 237, *237*
palette, 97
Palette of Narmer, Hierakonpolis, Egypt, 96–98, *97*
Paley, Albert, 1172; *Lectern*, 1172, *1172*
Paling Style ("Eel Style"), 1041
Palissy, Bernard, 741–42; (attributed to) plate, "style rustique," 742, *742*
Palissy-style works, 742
Palladio, Andrea, 737, 778, 953; *Four Books of Architecture*, 738, 816, 973, 974; San Giorgio Maggiore church, Venice, Italy, 736, 737, *737*, 778, 816; Villa Rotunda (Villa Capra), Vicenza, Italy, 738, *738*, 778, 816, 953, 973, 974, 1157
Pallava dynasty, 393, 394
Palma, Mallorca, Spain, Cathedral, 589–90, *590*
palmette, 175
Pan, 158
Panathenaic festival, 191, 193
panel, 630
panel painting: Byzantine, 322–23; Early Renaissance, 629; Flemish, 629–41; Gothic, 601; technique, 602, 630
Pan Painter, 183–84; *Artemis Slaying Actaeon*, vase, 184, *184*
Pantheon, Rome, Italy, 228, 252–54, *252*, 253,

253, 298, 738; dome, 228, *253*, 311
Panthéon (former Church of Sainte-Geneviève), Paris, France (Jacques-Germain Soufflot), 966–67, *966*
Pantokrator type, 534
Paolozzi, Eduardo, 1143
papacy. *See* popes
paper, 351–52; painting on, Indian, 832
Papua New Guinea, 903–4
Papunya cooperative, 911
papyrus, 97
Paracas culture (Peru), 463–64
parapet, 194, *587*
parapet walk, *587*
parchment, 304, 490, 494
Paris, France, 557, 741–42; Bibliothèque Sainte-Geneviève, Reading Room, 1006–7, *1007*; Centre National d'Art et de Culture Georges Pompidou, 1157, *1157*; Eiffel Tower, *978–79*, 979, 1088, 1090, 1157; Hôtel de Soubise, Salon de la Princesse, 939, *939*; Louvre, Palais du, Cour Carré, 740, 741; Métro, 1041–42; Notre-Dame cathedral, 574, *574*, 575; Opéra, 1007, *1007*, 1008–9, *1008*, 1026; Panthéon (former Church of Sainte-Geneviève), 966–67, *966*; Sainte-Chapelle, 578–79, *578*, 582; Tuileries Palace, 741–42
Paris (hero), 158
Paris Exposition (1925), 1079, *1079*
Paris Psalter, Byzantine, page, *David the Psalmist*, 336–37, *336*
Park at Stour, Wiltshire, England (Henry Flitcroft), with Henry Hoare, 954, *955*, 1055
Parkinson, Sydney, 908, 910; *Portrait of a Maori*, 906, *908*, 910
parks, 1055
Parma, Italy, Cathedral, 705–6, *705*, 769
Parmigianino (Francesco Mazzola), 730; *Madonna with the Long Neck*, 730, *730*, 741
Parnassus (Anton Raphael Mengs), 952, *952*
Paros, Greek island, 132
Parrhasios, 25
Parson Capen House, Topsfield, Massachusetts, 820–21, *820*
parterre, 780
Parthenon, Acropolis, Athens, Greece, 85, 163, 187–93, *188*, *191*, 267; drawing by William Pars, 187, 189, *189*; friezes, 188, 190, 191–93, *191*, *192*, 243; pediment (Elgin Marbles), 85, 190, *190–91*
Parting of Lot and Abraham, Santa Maria Maggiore church, Rome, Italy, 299–300, *300*
passage, 1076
passage graves, 57
pastels, 949
Pasteur, Louis, 980
Pastoral Concert, The (Titian and Giorgione), 707–8, *707*, 1018, *1018*, 1020
Patroclus, 158, 172, 176
patrons of art, 35–37; city governments, 628; in Italy, 649; merchant and middle-class, 757, 758–59, 802, 866, 871–72; popes, 687; private individuals, 35–36, 601, 745; public, 36–37, 1175; religious, 720, 753; in the Renaissance, 687; Roman, 218; women, 709; *see also* collectors
Paul (Saul), Saint, 291
Paul III, Pope, 687, 703, 704, 723–24, 727
Paul V, Pope, 760
Pausanias, 202, 229, 267
Pausias (legendary artist), 26, 208
Pavement period (Ife), 471
Paxton, Sir Joseph, Crystal Palace, London, England, 1000, 1006, *1006*, 1052
Peacock and Dragon curtain (William Morris), 710, 1016, *1016*
Peasants' War, 716
Peasants' War (Käthe Schmidt Kollwitz), *1066*, 1067
Pech-Merle cave, France: cave at, 48–50, 52; *Spotted Horses and Human Hands*, cave paintings, 48–50, *49*
pectoral, Scythian, 209, *209*
Pedanius Dioscorides, 321

pedestal, 167, 229, *704*
pediment, 162, 704, 724, *725*, 761
pediment sculpture, Temple of Zeus, Olympia, Greece, *178*, 179, 190
Peeters, Clara, 800; *Still Life with Flowers, Goblet, Dried Fruit, and Pretzels*, 800, *800*, 801
Pegasus, 166
Pélerinage à l'Île de Cithère, Le (Jean-Antoine Watteau), *942*, 943
Peleus, 172
Pelham, Peter, 975
Peloponnesian Wars, 185
Pencil of Nature, The, series (William Henry Fox Talbot), *The Open Door*, 1003, *1003*
Pendant of gold bees, Chryssolakkos (near Mallia), Crete, *136*, 137
pendentive, 302, 311
pendentive dome, 302, 653
Pennsylvania Railroad Station, New York, N.Y. (McKim, Mead, and White), waiting room, interior, 276, *277*
Pentecost, page, *Cluny Lectionary*, Romanesque, 533–34, *533*
People and Animals, Cogul, Lérida, Spain, 54–55, *54*
"People of the Book," 345
peplos, 170
Peplos Kore, sculpture, Acropolis, Athens, Greece, 170, *170*
Pepy II, 106
Pepy II and His Mother, Queen Merye-ankhnes, statue, Egyptian, 106, *106*
performance art, 1138, 1149
Pergamene Style, 212–18
Pergamon, Asia Minor (modern Turkey), 156, 212–16
 Altar of Zeus, 214–15, *214*, 237; frieze sculpture, 214, *214*
Pericles, 36–37, 155, 185, 187, 188, 193
peripteral temple, 162, 163, 238
peristyle, 162, 163
peristyle court, 115
Perpendicular style (English Gothic), 753, 1002
Perry, Lilia Cabot, 1022
Persephone, 158, 170, 206, 207
Persepolis, Iran, 89, 156
 ceremonial complex, *88*, 89–90, *90*; Apadana of Darius and Xerxes, *88*, 89
Perseus, 158, 165
Persia, Persians, 69, 88–90, 155–56, 177, 178, 294, 344, 353, 363; Empire, 310
Persia (modern Iran), coin (daric), 90, *90*
Persian painting style, 830
Persian Wars, 155, 171, 178
Persistence of Memory, The (Salvador Dalí), 1105, *1105*
personification, 381
perspective, 655, 760, 870; Chinese, 421–22; Renaissance systems of, 621; shifting, 421–22
Peru: colonial architecture, 788; earspool, Moche culture, 465, *465*; Mantle with bird impersonators, Paracas culture, 452, *463*, 464; *Moche Lord with a Feline*, ceramic, 464–65, *465*; Nazca lines, 464, *464*
Perugia, Italy, Porta Augusta, 225–26, *225*, 251–52
Perugino, Pietro, *Delivery of the Keys to Saint Peter*, fresco, Vatican Palace, Rome, Italy, 675–76, *675*, 690
Perugino (Pietro Vannucci), 675–76, 696
Pesaro Madonna (Titian), *708*, 709
Petrarch, 616–17
Petronius, 268
Phaistos, Crete, 135; Kamares Ware jug, 135, *135*, 139
phantasia (imagination), 229
pharaoh (Egyptian ruler), 113
Pheidias, 37, 187, 188, 202, 220; statue of Athena, 187, 188, 190
Pheidias and the Frieze of the Parthenon, Athens (Lawrence Alma-Tadema), 37, *37*
Philadelphia, Pennsylvania, Second Bank of the United States, 187, 189, *189*

Philip II, 719, 742–43, 745, 751, 785
Philip II of Macedon, 155, 207
Philip IV, of Spain, 798
Philip the Arab, 276–77
Philip the Arab, bust, Roman, 276–77, *277*
Philip the Bold, duke of Burgundy, 623, 625–26
Philip the Good, duke of Burgundy, 631, 645
philosophes, 938, 944
philosophy: Chinese, 406, 409–11, 419–20, 841; Greek, 198–99
Philoxenos, possibly, or Helen of Egypt, *Alexander the Great Confronts Darius III at the Battle of Issos*, 207–8, *207*, 209, 268
Philoxenos of Eretria, 208
Phoebus, 158
Phoenicia, Phoenicians, 224, 472
Photograph of Jackson Pollock painting (Hans Namuth), *1132*, *1132*, 1139
photography, 26; American, 1044–47, 1049–51, 1083, 1108–12, 1150–51; documentary, 1150; early, 1002–5; post-World War II, 1150–51; "straight," 1119; technique, 1004
photojournalism, 1150
photomontage, 1091, 1100–1101
Photo-Secession group, 1083
Piano, Renzo, 1157; Centre National d'Art et de Culture Georges Pompidou, Paris, France, with Richard Rogers, 1157, *1157*
piano mobile, *704*
piazza, 704, 760
Piazza del Campidoglio, Rome, print (Étienne Dupérac), 723, *723*
Piazza Navona, Rome, Italy (Gianlorenzo Bernini), Four Rivers Fountain, 764–66, *765*
Piazza of St. Peter's, Rome, Italy (Gianlorenzo Bernini), 761, 762–63, *762*
Picasso, Pablo, 134, 918, 1037, 1059, 1064, 1071, 1072–78, 1082, 1083, 1094, 1135, 1136, 1167
 Les Demoiselles d'Avignon, 1074–75, *1074*, 1134; study for, 1074–75, *1075*
 Family of Saltimbanques, 1073, *1073*
 Glass and Bottle of Suze, 1077, *1077*, 1094
 Guernica, 1058–59, *1059*
 Ma Jolie, *1076*, 1077, 1134, 1136
 Mandolin and Clarinet, 1078, *1078*, 1082
 Self-Portrait, *1072*, 1073
 Three Women at the Spring, 1094, *1094*
Picaud, Aymery, 518
pictograph, 71, 96, 404
Pictorialism, 1049
Picts, 490
picture plane, 317, 630, 688
picturesque, 951
picture stone, 505
picture stone, Larbro Saint Hammers, Gotland, Sweden, *504*, 505
piece-mold casting, 404, 405, 406
pier, 228, 313, 345, 493, 525
Piero della Francesca, 656, 672–73; *Battista Sforza* and *Federico da Montefeltro*, pendant portraits, 676–77, *677*; frescoes, Bacci Chapel, San Francesco church, Arezzo, Italy, 658, 672–73, *673*
Pietà (in Christian art), 307, 694–95
Pietà (Titian), 728, *728*
Pietà (*Rondanini Pietà*) (Michelangelo), 700, 727–28, *727*
Pietà (Vatican) (Michelangelo), 694–95, *694*, 727
pietra dura, 833
pietra serena, 652–54
Pigalle, Jean-Baptiste, 968–69; *Portrait of Diderot*, 968–69, *969*
pilaster, 226, 646, 696, 700, 704, *725*, 761, 816
Pilchuck Glass School, 1153
Piles, Roger de, 760, 778
pilgrimages, Christian, 515, 518, 518 (map)
pillar, 163; Indian monolithic, 378
Pine Spirit (Wu Guanzhong), 854, *854*
pinnacle, 627
Pipe with beaver effigy, Hopewell culture, Illinois, 466, *466*
Piranesi, Giovanni Battista, 951; *The Arch of Drusus*, 951, *951*

Pisa, Italy, 359, 542, 549–50, 649
 Baptistry, 597–99, *598*, *599*
 Cathedral, 599, *599*; complex, 550, *550*, 597
Pisano, Andrea, 597–98, 599; *Life of John the Baptist*, doors, Baptistry of San Giovanni, Florence, Italy, 599–601, *600*, 660–62
Pisano, Bonanno, 550
Pisano, Giovanni, 599; pulpit, Cathedral, Pisa, Italy, *Nativity*, 599, *599*
Pisano, Nicola, pulpit, Baptistry, Pisa, Italy, 597, *598*; *Nativity*, 597–99, *599*
Pissarro, Camille, 1018–19, 1021, 1023, 1030; *Wooded Landscape at l'Hermitage, Pontoise*, 1023, *1023*
pitcher (olpe), Corinth, Greece, 161, *161*
Pitti Palace, Florence, Italy (Bernardo Buontalenti), Boboli Gardens, the Great Grotto, *741*
Pittura, La (Artemisia Gentileschi), 777–78, *777*
Pity the Sorrows of a Poor Old Man (Théodore Géricault), 984–88, *988*
Pius VII, Pope, 776
Pizarro, Francisco, 794, 884
plague, 559, 579
plaiting (basketry), 885
Plan for a Contemporary City of Three Million Inhabitants (Le Corbusier), 1096, *1096*
Plantagenet dynasty, 559, 584
plaques, ivory, 507
plate, "style rustique" (Bernard Palissy, attributed to), 742, *742*
Plato, 27–28, 177, 198, 1072
plein air painting, 1021, 1023, 1025
Plenty's Boast (Martin Puryear), 1171, *1171*
plinth, 229
Pliny the Elder, 168, 181, 207, 209, 215, 229, 239, 241, 270–71; *The Natural History*, 229
Plotinus, *Enneads*, 229
Plowing in the Nivernais: The Dressing of the Vines (Rosa Bonheur), 1010, *1011*, 1073
plundering of art, 39
pluralism, 1165
Plutarch, 206, 218–20, 229
Pluto, 158
podium, 186, 226
Poet on a Mountain Top, handscroll (Shen Zhou), 849, *849*, 861
poetry, Japanese, 438–40
Pohnpei, Micronesia, 905
pointed arch, 352, 522, *561*, *568*, 650
Poissy-sur-Seine, France, Villa Savoye, 1096, *1096*, 1154
Polke, Sigmar, 1166, 1167–68; *Raised Chair with Geese*, 1166, 1168, *1168*
Pollaiuolo, Antonio del, 622, 650, 665; *Battle of the Nudes*, 650, *650*, 665; *Hercules and Antaeus*, 650, 665, *665*
Pollock, Jackson, 1131–33, 1138, 1139, 1141, 1145; *Autumn Rhythm (Number 30)*, 1132, *1132*; *Male and Female*, 1131, *1131*
Polo, Marco, 842, 846
Polybius, house of, 266
polychrome, 871
Polydoros, 215
Polygnotos of Thasos, 198
Polykleitos of Argos, 177, 196–97, 199, 202, 205, 220; *Spear Bearer (Doryphoros)*, 196–97, *196*, 202, 205, 242, 268
Polynesia, 900, 901, 906–10
polyptych, 628, 635
Pomona, 234
Pompadour, Madame de, 945, 968
Pompeii, Italy, 229, 260–61, 264, 266, 951; garden, wall niche, *266*; House of Julia Felix, 272, *272*; House of M. Lucretius Fronto, 272–73, *273*; House of the Silver Wedding, 264, *264*; House of the Vettii, peristyle garden, 264, *264*, 266; plan of, 261, *261*; Villa of the Mysteries, 271–72, *271*; *Young Woman Writing*, wall painting, 272, *272*
Pont du Gard, Nîmes, France, 235, *235*
Pontius Pilate, 291
Pontormo, Jacopo da, 729–30, 731; *Entombment*, 729–31, *730*, 744

Pop Art, 1142–45; American, 40, 1168
popes, papacy, 297, 309, 310, 495, 511, 517, 534, 542, 559, 597, 687, 701; patronage of, 760; title of, 292
Popol Vuh, Book of (Mayan), 461
popular art and culture, 37, 1142–43
porcelain, 62, 846, 945, 948; Chinese, 846; European, 846
porcelain flask, China, Ming dynasty, 846, *847*
porch, 160
Porta, Giacomo della, 702, 704, 724, 765
Porta Augusta, Perugia, Italy, 225–26, *225*, 251–52
Portable altar of Saints Killian and Liborius (Roger of Helmarshausen), 546, *547*
portable arts, Islamic, 358–64
portal, 298, 519, 568, 788; Romanesque, 525
portal sculpture, 520; Romanesque, 551–52
portcullis, *587*
portico, 109, 163, 266, 763, 966
Portinari, Tommaso, 639–41
Portinari Altarpiece (Hugo van der Goes), *640*, 642, 676, 679
portrait figure (*ndop*) of King Shyaam a-Mbul a-Ngwoong, Democratic Republic of Congo, Kuba culture, 927, *927*
Portrait of a German Soldier (Marsden Hartley), 1083, *1084*
Portrait of a Lady (Rogier van der Weyden), 635, *636*
Portrait of a Maori (Sydney Parkinson), 906, *908*, 910
Portrait of a Young Man (Bronzino), 731–32, *731*
Portrait of Charles Baudelaire (Nadar), 1005, *1005*, 1019
Portrait of Diderot (Jean-Baptiste Pigalle), 968–69, *969*
Portrait of Giovanni Arnolfini (?) and His Wife, Giovanna Cenami(?) (Jan van Eyck), 632–33, *633*, 637, 807–8
Portrait of Jean-Baptiste Belley (Anne-Louis Girodet-Trioson), 972–73, *972*
Portrait of Lord Pacal, Temple of the Inscriptions, Palenque, Mexico, 460, *460*
Portrait of Madame Desiré Raoul-Rochette (Jean-Auguste-Dominique Ingres), 984, *985*
Portrait of Marie Antoinette with Her Children (Marie-Louise-Élisabeth Vigée-Lebrun), 969, *969*
Portrait of Mrs. Richard Brinsley Sheridan (Thomas Gainsborough), *960*, 961
Portrait of Thomas Carlyle (Julia Margaret Cameron), 1005, *1005*, 1049
portrait sculpture, Roman, 104–7, 257–60, 284
portraiture
 group, 638, 803, 805–6
 periods and styles: Baroque, 757; British, 960–61; Dutch, 802–8; Egyptian, 112; French, 968–69; Hellenistic, 217; Neoclassical, 973; Renaissance, 617; Roman, 239–41, 277–79
 photographic, 1005
 social, 960
Portugal, 473, 477, 645–46, 786
Portuguese Synagogue, Amsterdam (Emanuel de Witte), 808–9, *809*
Poseidon, 156, 158, 193
positivism, 981–82, 1002, 1006
Possum Tjapaltjarri, Clifford, 911–12; *Man's Love Story*, 911–12, *912*
post-and-lintel construction, *55*, 57, 162, 395
post-and-lintel cruck construction, *535*
postern, *587*
Post-Impressionism, 1030–42, 1063, 1067
Post-Minimalism, 1146–48
postmodernism, 1153, 1165–84; architecture, 1155–57
post-painterly abstraction, 1145–46
Post-Structuralism, 1166, 1168
post with animal figures, burial ship, Oseberg, Norway, 505, *505*, 536
potassium-argon dating, 54
potpourri jar (Sèvres Royal Porcelain Factory), 948–49, *948*

potsherd, 62, 207

potter's wheel, 62

pottery: African, 932–34; American Southwest, 468; Ancient Near East, 74, 85–86; Chinese, 403, 423–24; Greek, 157; Japan, 428–31; Native American, 449, 468; Neolithic, 62–63, 403; Oceania, 902; Peruvian, 464; Pueblo, 893; *see also* ceramics

Pound, Ezra, 1061

Poussin, Nicolas, 778, 781, 783–85; *Landscape with Saint John on Patmos*, 784, *785*

poussinistes, 778

power figure (*nkisi nkonde*), Democratic Republic of Congo, Kongo culture, 923, *923*

Powers, Hiram, 999–1000, 1042; *The Greek Slave*, 999–1000, *999*, 1042–43

Prague, Bohemia (Czech Republic), Altneuschul, 592–93, *593*

Prairie style (Native American), 1086–87

Prandtauer, Jakob, 786; Benedictine Monastery Church, Melk, Austria, 786, *786*; interior, after designs of Prandtauer (Antonio Beduzzi, and Joseph Munggenast), 786, *787*, 942

Prato, Italy: Early Renaissance architecture in, 656–60; Santa Maria delle Carceri, 656–59, *658*

Praxiteles, 202–5, 218, 256; *Aphrodite of Knidos*, 203–4, *203*, 218; *Hermes and the Infant Dionysos*, 202–3, *203*

Precisionism, 1108

predella, 628, *628*, 712

prehistoric art, 43–65; cave paintings, 48, 49

Pre-Raphaelite Brotherhood, 1014

Prescriptions Filled (Municipal Building) (Richard Estes), 1161, *1161*

Presentation in the Temple (in Christian art), 306

press, *648*

Priam, 158

Priapus, 234

Priene, Asia Minor (modern Turkey), city plan, 199

Priestess of Bacchus (?), panel, Roman, 285–86, *285*

Primaporta, Italy, Villa of Livia, 266, 270, *270*, 293

Primaticcio, Francesco, 724, 739–41; stucco and wall painting, Chamber of the Duchess of Étampes, Château, Fontainebleau, France, *740*, 741

Primavera (Sandro Botticelli), 678, *678*

"primitive" art, 918, 1065–66, 1074

primitive art, 473

primitivism, 1065–66

printing, 644, 648, 718

printmaking, 648–49, *648*, 806; German, 714–18

Prix de Rome, 785, 944, 946, 983

Procession, Parthenon, friezes, Acropolis, Athens, Greece: *Horsemen*, 188, 192, *192*; *Marshals and Young Women*, 188, 192, *192*, 243

Procession of the Relic of the True Cross before the Church of Saint Mark (Gentile Bellini), 680, *680*, 706

Procopius of Caesarea, 311

pronaos, 160

Prophet Muhammad and His Companions Traveling to the Fair page, *Life of the Prophet*, manuscript (al-Zarir), *349*, 368

Prophets and Ancestors of Christ, relief, Notre-Dame cathedral, Chartres, Île-de-France, France, 564, *564*

Propylaia, Athens, Greece, Acropolis, 187, 193

proscenium, 211

Proserpina, 158

Prosse Edda, 504

prostyle, 238

Protestantism, 718–22, 742, 753, 758, 816

Protestant Reformation, 585, 745, 758, 785; and the arts, 718–22; in Germany, 710–23

Proto-Geometric style, 159

Proun art, 1090–91

Proun space (El Lissitzky), 1090, *1091*

provenance, 41

Psalm 1 (Beatus Vir), *Windmill Psalter*, English, 588, *588*

Psalm 23, page, *Utrecht Psalter*, Carolingian, 502, *502*, 507, 540

Psalter of Saint Louis, *Abraham, Sarah, and the Three Strangers*, 577, 582, *582*

psalters, illustrated, 336, 540

pseudo-kufic inscriptions, 530

Ptah, 96

Ptolemaic dynasty, 156

Ptolemaic theory, 759

Ptolemy, 126, 210

Ptolemy V, 111

public art, contemporary, 1177–80

public funding of art, 1174, 1175

Public Works of Art Project, 1109

Pucelle, Jean, 582

Book of Hours of Jeanne d'Evreux: page, *Betrayal and Arrest of Christ*, 582–83, *583*; page, *Fox Seizing a Rooster*, 584, *584*

Pueblo Bonito, Chaco Canyon, New Mexico, *448–49*, 449, 468

Pueblo peoples, 879, 892–94

pueblos, 468

Pugin, Augustus Welby Northmore, 1001, 1002; *Contrasts* (book), 1002

pulpit (Giovanni Pisano), *Nativity*, 599, *599*

pulpit (Nicola Pisano), 597, *598*; *Nativity*, 597–99, *599*

punchwork, 603

Punic Wars, 234

Punitavati (Karaikkalammaiyar), statue, Indian, 29, *29*

Punjab University, Chandigarh, India (B. P. Mathur), Gandhi Bhavan, with Pierre Jeanneret, 836, *836*

Pure Land Buddhism, 427, 437–38, 442–44, 446, 859

Purism, 1095–96, 1102

purse cover, burial ship, Sutton Hoo, England, 489, *489*, 490

Puryear, Martin, 1171; *Plenty's Boast*, 1171, *1171*

putti, 302, 675, 696, 762, 940

pylon, 114

Pylon of Rameses II. *See* Temple of Amun, Mut, and Khons, Luxor, Egypt

Pylos, Greece: palace, megaron of, 148, *148*, 160; palace at, 148

pyramid: Egyptian, *100*, 102–4; Mesoamerican, 455

pyramid, Chichen Itza, Yucatan, Mexico, with Chacmool in foreground, 461–62, *461*

pyramidion, 116

Pyramid of Djoser, Saqqara, Egypt, 101, *101*

pyramids, Giza, Egypt, 102–4, *103*

Pyramids of the Sun and Moon (Peru), 464

Pythian Games, 157, 181

Python Crushing an African Horseman (Antoine-Louis Barye), 991, *991*

Q

qi, 412, 419–20

qibla wall, 347

Qin dynasty (China), 401, 407

Qin emperor mausoleum, Lintong, Shaanxi, China, *400*, 401, 407

Qingbian Mountains, The, hanging scroll (Dong Qichang), 851, *851*

Qing dynasty (China), 841, 851–54

Qiu Ying, 846; *Spring Dawn in the Han Palace*, handscroll, 846, *846*

quatrefoils, 573

Queen Nefertari Making an Offering to Isis, wall painting, tomb of Nefertari, Deir el-Bahri, Egypt, 96, 121, 123, *123*, 124

Queen Tiy, head, Egyptian, 120, *121*

Quetzalcoatl, 880–81

quillwork, 885

quilt, Hawaiian, 910–11

quincunx, 327

Quintanilla de las Viñas. *See* Santa María church, Burgos, Spain

quoins, 704, *704*

R

Ra (or Re), 95

Ra (Ra-Atum), 96

Rabbula Gospels, Syria, Early Christian: page, *Ascension*, 322, *322*, 336, 530; page, *Crucifixion*, 321–22, *321*, 330, 336, 530

Radha, 833–34

radiometric dating, 54, 131, 467

rafter, *535*

Raft of the "Medusa" (Théodore Géricault), 985, 986–87, *986*

raigo, 443–44

Raimondi, Marcantonio, engraving after Raphael's *The Judgment of Paris*, 1018

Rainaldi, Girolamo and Carlo, 765

Raised Chair with Geese (Sigmar Polke), 1166, 1168, *1168*

Raising of Lazarus (in Christian art), 306

Raising of the Cross, The (Peter Paul Rubens), 797–98, *797*

Rajaraja I, 396, 397

Rajaraja I and His Teacher, wall painting, Rajarajeshvara Temple to Shiva, Thanjavur, Tamil Nadu, India, 397, *397*

Rajarajeshvara Temple to Shiva, Thanjavur, Tamil Nadu, India, 396–97, *396*, 397, *397*

Rajput painting, 833–35

raking cornices, 162

raku ware, 867

Ramesses II, 114, 115, 116–17, 119

ramparts, *587*

Raoul-Rochette, Desiré, 985

Raoul-Rochette, Madame (née Antoinette-Claude Houdon), 985

Raphael (Raffaello Sanzio), 690–94, 696, 701, 702, 729, 730, 778, 799; *Disputà*, Stanza della Segnatura, Vatican Palace, Rome, Italy, 691, *691*; *The Judgment of Paris*, engraving by Marcantonio Raimondi, *1018*; *Leo X with Cardinals Giulio de' Medici and Luigi de' Rossi*, 692, *693*; *School of Athens*, fresco, Stanza della Segnatura, Vatican Palace, Rome, Italy, 692–93, *692*, 1004; *The Small Cowper Madonna*, 690, *691*, 701

Rationalism, Dutch, 1092–93

Rauschenberg, Robert, 1141, 1166; *Canyon*, combine, 1141, *1141*, 1166

Ravenna, Italy, 302–8, 310, 314–21, 495; Baptistry of the Orthodox, 305–8, *305*; Mausoleum of Galla Placidia, 302–3, *302*, 303–4, *303*, 304, *304*, 318; Sant'Apollinare in Classe, 314, 318, *318*, *319*; San Vitale, 298, 314–15, *314*, 315, *315*, *316*, 317, *317*, *318*, 488, 497

Rawlins, John, 973–74; dining room, Mount Vernon, Fairfax County, Virginia, 973–74, *973*

Rayonnant style (French Gothic), 578

readymades, 1101–2, 1166

realism, 760, 775, 981–82; American, 1047–49, 1082; Chinese, 420; French, 1009–13; Gothic, 577; Greco-Roman, 217, 218

Rebecca at the Well page, *Genesis*, manuscript, 320, 321

Reciting "Karawane" (photograph; Hugo Ball), 1100, *1100*

Recumbent Figure (Henry Moore), 1106, *1107*, 1137

"Red-Blue" chair (Rietveld), *1093*

Red Canna (Georgia O'Keeffe), *26*, 27, 1108

red-figure vase painting, 173, 175

Redon, Odilon, 1036–37; *The Marsh Flower, a Sad and Human Face*, *1036*, 1037, 1127; *Noirs*, 1037

Redwood Library, Newport, Rhode Island (Peter Harrison), 973, *973*

Reformation. *See* Protestant Reformation

Regionalists, 1108–10

register, 73, 160, 391, 617

registration mark, 871

Regnaudin, Thomas, 782

Rehearsal on Stage, The (Edgar Degas), 1020, 1024–25, *1025*, 1042

Reid, Bill, 889–92; *The Spirit of Haida Gwaii*, 892

Reims, Île-de-France, France, 575, 594; Notre-Dame cathedral, 575–78, *575*, 576–77, *576*, 577, *577*, 583, 586, 594
Reinach, Salomon, 48
Reinhard & Hofmeister, 1117; Rockefeller Center, New York, NY, with Corbett, Harrison & MacMurray; Hood & Fouilhoux, *1116*, 1117
reintegration, 886, 910
Rejlander, Oscar, 1004, 1152; *The Two Paths of Life*, 1004, *1004*, 1049, 1088
relative dating, 54, 131, 254
relics, 628
relief sculpture, 507; Chinese, 404; Egyptian, 107, 108, *108*; Etruscan, 230; Greek, 165, 167; high, 52–53, 76, 165, 384; Indian, 378, 384, 391–93; Italian, 662; low, 230, 378, 404; Medieval, 507; Mesopotamia, 76; Neolithic art, 52; Roman, 241, 254–57
relieving arch, 144, 254
religion: African, 922–26; Egyptian, 95–96; Etruscan, 226, 230; Greek, 156–57, 158, 226, 236; India, 375–77; Mesopotamian, 68–69, 70, 73–74, 226; prehistoric, 48; role of art in, 30–31; Roman, 158, 236
religious art, 758, 788–89, 1051–52
reliquary: Buddhist, 379; Christian, 515, 639, 762
reliquary guardian (*nlo byeri*), Gabon, Fang culture, 930, *930*
Rembrandt van Rijn, 34, 778, 804–8, 1048; *Captain Frans Banning Cocq Mustering His Company (The Night Watch)*, 803, 805–6, *805*, 807; *Christ Healing the Sick* ("Hundred-Guilder Print"), 803; *The Jewish Bride*, *807*, 808; *The Last Supper*, after Leonardo da Vinci's fresco, 34–35, *34*, 805; *Self-Portrait*, 807, *807*; *Three Crosses*, 806, *806*
ren, 410
Renaissance, 612, 616–22, 641–83; architectural decoration, 739–42; architecture, 653, 701–10, 739–42, 753; artists in, 33; England, 748–55; France, 739–42; German, 710–23; Italian, 687–710; Netherlands, 745–48; Northern Italy, 703–10; painting, 739, 742–48, 749–52; Spain, 742–45; women artists in the, 623, 733–34
Reni, Guido, 771; *Aurora*, ceiling fresco, Casino Rospigliosi, Rome, Italy, 771, *771*, 942
Renoir, Pierre-Auguste, 1018–19, 1021, 1023–24, 1027–28, 1071; *Bathers*, 1028, *1028*; *Moulin de la Galette*, 1024, *1024*, 1026, 1027–28
Repin, Ilya, 1014; *Bargehaulers on the Volga*, 1014, *1014*
replicas, 196
repoussé, 136, 142, 502, 593
repoussoir, 1031
representation. *See* figurative art
Resettlement Agency (RA)/Farm Securities Administration (FSA), 1110
Residenz, Würzburg, Bavaria, Germany, Kaisersaal (Imperial Hall), 940–41, *940*, 941, 991
Restany, Pierre, 1139
restoration, 38–39, 203, 585
Resurrection, the (in Christian art), 307
Resurrection and Angel with Two Marys at the Tomb, panel, Christian, 308, *308*
Resurrection of Lazarus, The (Henry Ossawa Tanner), 1052, *1052*
retablo, 591, 788
Return of the Hunters (Pieter Bruegel, the Elder), 748, *748*
reverse perspective, 314, 318
Revett, Nicholas, 189
Revival Field: Pig's Eye Landfill (Mel Chin), 1179–80, *1180*
revival styles, 1000–1002
Reynolds, Joshua, 960; *Fifteen Discourses to the Royal Academy*, 944; *Lady Sarah Bunbury Sacrificing to the Graces*, 960–61, *960*
Rhine Valley, 546, 593
Rhodes, 215–16

rhyton, 138
Riace *Warrior A*, statue, Greek, 181–82, *182*, 183, *183*, 197
rib, 519, *561*, 650, 1007
ribbon interlace, 490
Ribera, Jusepe (José) de (Lo Spagnoletto), 788–89, 1048; *Martyrdom of Saint Bartholomew*, 789, *789*, 1048
Ribera, Pedro de, 788, 796; San Fernando, Hospicio de, Madrid, Spain, Portal, 788, *788*, 796
rib vault, *568*
Richardson, Henry Hobson, 1053–54; Marshall Field Wholesale Store, Chicago, Illinois, 1053–54, *1053*, 1088
Richardsonian Romanesque, 1053
Richelieu, Cardinal de, 778
ridgepole, 226, *535*
Riemenschneider, Tilman, 711–12, 720; *Altarpiece of the Holy Blood, Last Supper*, center piece, 712, *712*
Rietveld, Gerrit, 1093; Schröder House, Utrecht, Netherlands, 1093, *1093*, 1155
Rigaud, Hyacinthe, 757, 785; *Louis XIV*, *756*, 757, 778, 781, 785
Riis, Jacob, 1050–51; *How the Other Half Lives*, 1051; *Tenement Interior in Poverty Gap: An English Coal-Heaver's Home*, 1051, *1051*
Riley, Bridget, 1146; *Current*, 1146, *1146*
Rimpa school, 867–68
ring wall, 144, 185
Riopelle, Jean-Paul, 1129; *Knight Watch*, 1129, *1129*
Ripa, Cesare, 778
ritual bronzes, China, 405–6
rituals, African, 919–22
ritual vessel, Ife, Nigeria, Yoruba, *470*, 471
Rivera, Diego, 1117–19, 1178; *Man, Controller of the Universe*, fresco, 1117–18, *1117*, 1178
roads and bridges, Roman, 235
Robbia, Andrea della, 653, 666
Robbia, Luca della, 666; *Madonna and Child with Lilies*, Orsanmichele, Florence, Italy, 658, 660, 666, *666*
Robert, Hubert, 782
Robert de Luzarches, 571
Robert Gould Shaw Memorial, The (Augustus Saint-Gaudens), *1046*, 1047
Robespierre, 971
Robusti, Manetta, 737
rock art: Neolithic, 53–55; Saharan, 473–74
rock-cut caves: Buddhist, 386–87; China, 413–14; Egyptian, 110; India, 382
rock-cut sanctuary, Malinalco, Mexico, 881, *881*
rock-cut tombs, Beni Hasan, Egypt, 110, *110*
Rockefeller, John D., Jr., 1117, 1118
Rockefeller Center, New York, N.Y. (Reinhard & Hofmeister), with Corbett, Harrison & MacMurray; Hood & Fouilhoux, *1116*, 1117
Rockwell, Norman, 1111–12; *Freedom from Want*, 1112, *1112*
Rocky Mountains, Lander's Peak, The (Albert Bierstadt), 1044–45, *1045*
Rococo style, 939–49, 952, 966, 968–69
Rodchenko, Aleksandr, 1090, 1169; Exposition Internationale des Arts Décoratifs et Industriels Modernes, Paris, 1925, Workers' Club, 1090, *1091*, 1169
Rodin, Auguste, 1039–40, 1071, 1072, 1081, 1083; *Burghers of Calais*, bronze, 1039–40, *1039*, 1063
Roebling, John Augustus, 1006; Brooklyn Bridge, New York, NY, with Washington Augustus Roebling, 1006, *1006*
Roebling, Washington Augustus, 1006
Roger II, count of Sicily, 331–32
Roger of Helmarshausen, Portable altar of Saints Killian and Liborius, 546, *547*
Rogers, Richard, 1157
Roman art, ancient, 236, 344, 577; classicizing style, 300; copies of Greek art, 268; influence of, 549–52
Roman Catholic Church (Western Church, "the Church"), 292; in England, 816; in Medieval

Europe, role of, 487, 517; post-Reformation, 758; in the Renaissance, 619; in Spanish colonial America, 794
Roman Empire, 224 (map), 225, 233, 246; army, 261–62; decline and fall of, 487, 495, 616; division into eastern and western empires, 302; late, 274–86; trade with China, 408
Romanesque art, 487, 515–53, 516 (map), 556
Roman-German style, 496
Romano. *See* Giulio Romano
Roman Republic, 225, 233–34; in Egypt, 126
Romans, ancient: origin of, 144, 233–34; as patrons, 218
Romans Crossing the Danube and Building a Fort, Column of Trajan, Rome, Italy, 255, *255*
Roman theater, Orange, France, 239, *239*
Romanticism, 939, 944, 984–96; 19th century, 981; American, 996–1000, 1044; British, 953–66; French, 982–91; Italian, 951; Spanish, 991–93
romantic love, 558
Rome, Italy
 ancient plan of, 246
 architecture, 723–27
 buildings and structures
 Ara Pacis, 242–45, *243*, 244, *244*, 255, 286
 Arch of Constantine, 256, 282–83, *282*, 314
 Arch of Titus, 229, 254–55, *254*, 255, *255*, 283, 293
 Barberini Palace, 771–72, *772*
 Basilica of Maxentius and Constantine (Basilica Nova), 283 85, *283*, 284, *284*, 656
 Basilica Ulpia, 247, *247*, 283, 298, 299
 Baths of Caracalla, 275–76, *276*
 Casino Rospigliosi, 771, *771*, 942
 Catacomb of Commodilla, *288*, 289, 293
 Catacomb of Saints Peter and Marcellinus, 293, *293*, 303, 322
 Colosseum, 250–51, *250*, 251, *251*, 655
 Column of Trajan, 247–49, *248*, 255–56, *255*
 Farnese Gallery, 769, *769*
 Farnese palazzo, 703, *703*, 768, *770*, 771, 780, 942
 Il Gesù church, 723, 724–27, *725*, 761, 766, 772, *773*, *778*, 987
 Haterius family tomb, *256*, 257
 Imperial Forums, 246–47, *246*
 Markets of Trajan, 249, *249*
 Old Saint Peter's, 297–98, *297*, 497
 Pantheon, 228, 252–54, *252*, 253, *253*, 298, 738; dome, 228, *253*, 311
 Piazza Navona, Four Rivers Fountain, 764–66, *765*
 Saint John Lateran, 297
 Saint Peter's Basilica, 687, 698, 701–2, 718, 724, *724*, 760–63, *761*, *762*
 San Carlo alle Quattro Fontane church, 760, 763–64, *763*, 764, *764*, 941
 San Clemente church, 550–51, *551*
 San Pietro in Montorio, Church of, Tempietto, 701, *701*, 818
 San Pietro in Vincoli, Tomb of Julius II, 698, *699*
 Santa Costanza, 300–302, *300*, *301*, 302, *302*, 315
 Santa Maria della Vittoria, Cornaro Chapel, 766–67, *766*
 Santa Maria Maggiore church, 299–300, *300*
 Santa Sabina, 299, *299*
 Temple of Neptune, possibly, *240*, 241
 Temple perhaps of Portunus, 237–38, *238*
 Vatican Palace, 675–76, *675*, 690, 693, *693*, 696; Sistine Chapel, 685, 693, 695–98, *696*, *697*, *698*, 726, 727, 768, 776, 965, 987; Stanza della Segnatura, 691, *691*, 692–93, *692*, 1004
 Villa Farnesina, 271, *271*, 293
 Villa Torlonia, 293, *293*
 founding of, 223, 233
 Late Renaissance, 723–27
 Medieval, decline of, 310
 Medieval Church in, 292, 302
 pilgrimages to, 518
 Romanesque architecture in, 550
 Sack of, 687

Romulus and Remus legend, 223, 233
Rongxi Studio, The, hanging scroll (Ni Zan),
 843, *843,* 849
rood screen, 601
roof, *568*
roof comb, 459
Roosevelt, Franklin Delano, 1060
Rope Piece (Eva Hesse), 1148, *1148*
Rosenberg, Harold, 1131
Rosetsu, Nagasawa, 871; screen, detail, *Bull
 and Puppy,* 871, *871*
Rosetta Stone, Egyptian, 85, 111, *111*
rosette, 161, 164, 254, 347, 525, 957
rose window, *568,* 1079
Rossetti, Dante Gabriel, 1014–15; *La Pia de'
 Tolomei,* 708, 1015, *1015*
Rossi, Aldo, 1156–57; New Town Hall,
 Borgoricco, Italy, *1156,* 1157
Rosso Fiorentino, 739
Rothenburg ob der Tauber, St. James
 church, 712
Rothko, Mark, 1134–35, 1145; *Brown, Blue,
 Brown on Blue, 1134,* 1135
rotunda, 300, 497
Rouen, France, Saint-Maclou church,
 626–27, *627*
Rouen Cathedral: The Portal (in Sun) (Claude
 Monet), 1029–30, *1029*
round arch, 226, 228
roundel, 86, 226, 334, 632
Rousseau, Henri, 1037, 1065, 1069, 1083; *The
 Sleeping Gypsy,* 1037, *1037,* 1071
Rousseau, Jean-Jacques, 938
Rousseau, Théodore, 996; *The Valley of Tiffauge
 (Marais en Vendée),* 996, *996,* 1009
Royal Academy of Architecture (France), 778
Royal Academy of Arts (England), 944,
 950, 960
Royal Academy of Painting and Sculpture
 (France), 778, 943, 944, 949–50
Royal Crescent, Bath, England (John Wood),
 with John Wood the Elder, 954–56, *955*
royal mortuary compound, Nan Madol,
 Pohnpei, Micronesia, 905–6, *905*
royal palace, Ikere, Nigeria, 927, *928*
Royal Portal. *See* Chartres, Notre-Dame
 cathedral
Royal Symbols, quilt (Deborah), 910, *911*
rubbing, Wu family shrine, Jiaxiang, Shandong,
 China, 410–11, *410*
rubénistes, 778
Rubens, Peter Paul, 693, 778, 791, 796–99, 801,
 805, 818, 1134; ceiling painting, Whitehall
 Palace, London, England, 798, 816–18, *817;
 Henri IV Receiving the Portrait of Marie de'
 Medici, 798,* 799; house of, Antwerp,
 Belgium, 797, *797; Landscape with Rainbow,*
 799, *799; The Raising of the Cross,*
 797–98, *797*
Rublyov, Andrey, 340; *The Old Testament Trinity
 (Three Angels Visiting Abraham),* 340, *340*
Rucellai, Giovanni, 649
Rucellai palace, Florence, Italy (Leon Battista
 Alberti), 655, *655*
Rude, François, 990; *Departure of the Volunteers
 of 1792 (The Marseillaise),* 990, *990,* 1008
Rudolf of Swabia, tomb effigy of, 546, *546*
Rue Transonain, Le 15 Avril 1834 (Honoré
 Daumier), 40, *40*
ruins, 951
Ruisdael, Jacob van, 811; *The Jewish Cemetery,
 810,* 811
Rukupo, Raharuhi, 909–10; Te-Hau-ki-Turanga
 (Maori meetinghouse), Manutuke Poverty
 Bay, New Zealand, 909, *909*
rune stones, 503
Running Fence (Christo and Jeanne-Claude),
 1160–61, *1160*
running spirals, 146
Russia, 45, 310, 323, 326, 338, 503, 1060, 1081
Russian art: architecture, 1158; Cubist,
 1081–82; naturalism and realism, 1013–14;
 utilitarian, 1090–92
rusticated, 655, 704, 778

Ruysch, Rachel, 814–16; *Flower Still Life,*
 815, *815*
Ryder, Albert Pinkham, 1051–52; *Jonah,*
 1051, *1051*
Ryoan-ji, Kyoto, Japan, garden, stone and
 gravel, 861–62, *862*

S

Saar, Betye, 1162; *The Liberation of Aunt
 Jemima,* 1162–64, *1162*
Saarinen, Eero, 1154; Trans World Airlines
 Terminal, New York, NY, John F. Kennedy
 Airport, 1154, *1154*
sacrifice: Aztec, 880–81; Chinese, 405; Peru,
 465; Viking, 505
sacristy, 652
Safavid dynasty, 365
Safdie, Moshe, 1155; Habitat '67, Montreal,
 Quebec, Canada, 1155, *1155*
Sahara, 473–74, 479, 917
sahn, 351
*Saint Anthony Enthroned between Saints
 Augustinc and Jerome* panel, *Isenheim
 Altarpiece,* shrine (Nikolaus Hagenauer), 625,
 713, *713,* 714
Saint Augustine Reading Rhetoric in Rome
 (Benozzo Gozzoli), *621*
Saint Basil the Blessed, Moscow, Russia, 324,
 338, *339*
Saint-Bavo cathedral, Ghent, Flanders, 631,
 670–71, *670*
Saint Cyriakus church, Gernrode, Germany,
 506, *506, 507,* 544
Saint-Denis, Île-de-France, France, abbey
 church, 31, 555, 560–62, *560,* 561, 563, 575,
 579–80, *579,* 583
Sainte-Chapelle, Paris, France, 578–79,
 578, 582
Sainte-Foy abbey church, Conques, France,
 514, 515, 518, 519–20, *519,* 520, 520, 565
Sainte-Geneviève, Bibliothèque, Paris, France
 (Henri Labrouste), Reading Room,
 1006–7, *1007*
Sainte-Geneviève church. *See* Panthéon, Paris,
 France
Saint Elizabeth church, Marburg, Germany,
 592, *592*
Saint Eloy (Eligius) in His Shop (Petrus Christus),
 627, 637, *637*
Saint-Étienne church, Caen, France, 539–40,
 539, 540, *540,* 561
Saint Foy, reliquary statue, Sainte-Foy
 abbey church, Conques, France, *514,* 515,
 518, 519
Saint Francis in Ecstasy (Giovanni Bellini), 681,
 681, 706
Saint Francis Master, 609; *Miracle of the Crib at
 Greccio,* Upper Church, Assisi, Italy, 601,
 609–10, *610*
Saint Gall, Switzerland, Abbey of, 499, *499*
Saint-Gaudens, Augustus, 1047; The Robert
 Gould Shaw Memorial, *1046,* 1047
Saint Giulia church, Brescia, Italy, 279, 495–96,
 495, 529
Saint James cathedral, Santiago de
 Compostela, Spain, 29–30, *30,* 519
Saint Joseph, relief, Notre-Dame cathedral,
 Reims, Île-de-France, France, 576, 577
Saint-Lazare cathedral, Autun, Burgundy,
 France, 157, 163, 165, 166–67, 524, 527–29,
 527; west portal, *526,* 527, 531, 540, 561, 564
St. Louis, Missouri, Wainwright Building, 1054,
 1054, 1086
Saint Luke Displaying a Painting of the Virgin
 (Il Guercino), 33, *33,* 774
Saint-Maclou church, Rouen, France,
 626–27, *627*
Saint Maurice, sculpture, Cathedral,
 Magdeburg, Germany, 594, *595*
Saint Michael abbey church, Hildesheim,
 Germany, Doors of Bishop Bernward, 507,
 508, *508,* 531; schematic diagram of the
 message of, 507, 508, *509*

Saint Paul's Cathedral, London, England
 (Christopher Wren), 818–19, *819,* 966
Saint Peter's Basilica, Rome, Italy (Bramante,
 Sangallo, Michelangelo, della Porta,
 Maderno, Bernini), 687, 698, 701–2, 718, 724,
 724, 760–63, *761,* 762–63, *762*
St. Petersburg, Russia, Academy of Art, 1013
Saint-Pierre priory church, Moissac, Toulouse,
 France, south portal, 524–27, *524,* 525,
 531, 564
Saint Riquier abbey church, Centula
 Monastery, France, *496,* 497, 540
Saint-Savin-sur-Gartempe, Poitou, France,
 abbey church, *530,* 531, *531*
Saint Serapion (Francisco de Zurbarán), 789,
 789, 972
Saint-Simon, Comte de, 1010
Saint Stephen and *Saint Theodore,* relief, Notre-
 Dame cathedral, Chartres, Île-de-France,
 France, 565, *565,* 595
Saint Teresa of Avila in Ecstasy (Gianlorenzo
 Bernini), 766–67, *767,* 942
Saint Ursula reliquary (Hans Memling),
 639, *639; Martyrdom of Saint Ursula,*
 639, 639
Saint Vincent with the Portuguese Royal Family,
 panel, *Altarpiece of Saint Vincent* (Nuño
 Gonçalvez), 646, *646*
Salcedo, Sebastian, 795; *Our Lady of
 Guadalupe,* 795, *795*
Salian dynasty, 542
Salisbury, Wiltshire, England, Cathedral,
 584–86, *585*
Salisbury Plain, England, Stonehenge, 57,
 58–60, *59,* 144
*Sally Gardner Running at a 1,40 Gait, 19 June
 1878* (Eadweard Muybridge), 1049, *1049*
Salon, French, 939, 944, 982, 1019
Salon d'Automne (1905), 1061, 1063–65, 1075
Salon de la Princesse. *See* Boffrand, Germain
Salon des Indépendants, 982, 1037
Salon des Refusés ("Salon of the Rejected
 Ones"), 1019
Salon of 1787, The (Piero Antonio Martini), *944*
salons, private, 939
Saltcellar of Francis I (Benvenuto Cellini),
 732, *732*
Samarkand ware, 352
Samarra, Iraq, 345
Samath Gupta style, 386
Samoa, 901
Samothrace, Macedonia, 216; *Nike (Victory)
 of Samothrace,* 216–17, *216*
samsara, 376, 378
Samuel Adams (John Singleton Copley), 936,
 937, 975
samurai, 442, 445, 858–59, 866
San Carlo alle Quattro Fontane church, Rome,
 Italy (Francesco Borromini), 760, 763–64,
 763, 764, 764, 941
Sánchez Cotán, Juan, 790–91; *Still Life with
 Quince, Cabbage, Melon, and Cucumber,*
 790, 790
Sanchi, Madhya Pradesh, India, Great Stupa,
 379–82, *379,* 434; gateway (*torana*), 380, *380;
 yakshi* bracket figure, *380,* 381
San Clemente church, Rome, Italy, 550–51, *551*
San Clemente church, Tahull, Lérida, Spain,
 531–32, *532,* 534
San Clemente Master, 531–32
sanctuaries, 156, 520, *568*
Sanctuary of Apollo, Delphi, Greece, 156–57,
 156, 157, *157,* 181, *181,* 211; Siphnian
 Treasury, 157, 163, 166–67, *166,* 167
Sanctuary of Athena Pronaia, Delphi, Greece,
 tholos at, 200, *200,* 211
Sanctuary of Fortuna Primigenia, model of,
 Palestrina, Italy, 237, *237*
Sand, George, *The Devil's Pond,* 1011
sand painting: Australian, 911; Navajo, 895
San Fernando, Hospicio de, Madrid, Spain
 (Pedro de Ribera), Portal, 788, *788,* 796
San Francesco church, Arezzo, Italy, Bacci
 Chapel, 658, 672–73, *673*

San Francisco church, Barcelona, Spain, 591–92, *591*, 592, *592*

Sangallo, Antonio da, the Younger, 702, 704, 724; Farnese palazzo, Rome, Italy, with Michelangelo, 703, *703*

Sangallo, Giuliano da, 656; Santa Maria delle Carceri, Prato (near Florence), Italy, 656–59, *658*

sanghati, 383

San Gimignano, Italy, Sant'Agostino church, *621*

San Giobbe church, Venice, Italy, 680–81, *681*, 706

San Giorgio Maggiore church, Venice, Italy (Andrea Palladio), 736, 737, *737*, 778, 816

San Giovanni baptistry, Florence, Italy, 650, 660–62, *661*; doors, 599–601, *600*, 660–62

San Lorenzo, Mexico (Olmec center), 453

San Lorenzo church, Florence, Italy (Filippo Brunelleschi), 652–54, *652*, 669, 699

San Lorenzo monastery, Florence, Italy (Michelangelo), 693, 700–701, *700*

San Marco cathedral, Venice, Italy, 302, *324*, 325–26, *325*, 680

San Marco monastery, Florence, Italy, 672, *672*

San Pietro in Montorio, Church of, Rome, Italy (Donato Bramante), Tempietto, 701, *701*, 818

San Pietro in Vincoli, Rome, Italy, Tomb of Julius II, 698, *699*

San Simeon, California, La Casa Grande, front entrance, 1115, *1115*

Sanskrit, 376, 828

Santa Costanza, Rome, Italy, 300–302, *300*, *301*, 302, *302*, 315

Santa Fe Indian School, 893–94

Santa Felicità church, 729, *729*

Sant'Agostino church, San Gimignano, Italy, *621*

Santa Maria church, Burgos, Spain, Quintanilla de las Viñas, 492–93, *492*

Santa Maria del Carmine, Florence, Italy, Brancacci Chapel, 669, *669*, 670–71, *670*, 671, *671*, 688

Santa Maria della Vittoria, Rome, Italy (Gianlorenzo Bernini), 766–67, *766*

Santa Maria delle Carceri, Prato (near Florence), Italy (Giuliano da Sangallo), 656–59, *658*

Santa Maria delle Grazie, Milan, Italy, 34–35, *35*, 688–89, *688*, 736

Santa Maria Maggiore church, Rome, Italy, 299–300, *300*

Santa Maria Novella, Florence, Italy, 667–69, *668*, 681

Sant'Ambrogio church, Milan, Italy, 539, 545, *545*

Sant'Andrea church, Mantua, Italy (Leon Battista Alberti), 656, *656*, 657, 727, 737

Sant'Apollinare in Classe, Ravenna, Italy, 314, 318, *318*, 319

Sant'Apollonia, Florence, Italy, 672, *673*, 689

Santa Sabina, Rome, Italy, 299, *299*

Santa Sophia Cathedral, Kiev, Ukraine, 324, *326*, *327*

Santa Trinità church, Florence, Italy, 667, *667*; Sassetti Chapel, 676, *676*

Sant'Elia, Antonio, 1081, 1089, 1096; Station for airplanes and trains, Milan, Italy, 1089, *1089*, 1096

Santeria (religion), 1165

Santiago de Compostela, Spain, 518; Saint James cathedral, 29–30, *30*, 519

Santi Giovanni e Paolo and the Monument to Bartolommeo Colleoni (Canaletto), 950–51, *951*

Santo Domingo de Silos, Castile, Spain, abbey church, 523, *523*

San Vitale, Ravenna, Italy, 298, 314–15, *314*, 315, *315*, *316*, 317, *317*, *318*, 488, 497

San Xavier del Bac Mission, Tucson, Arizona (near), 788, 796, *796*

Sappho, 161

Saqqara, Egypt: Djoser's funerary complex, 100–102, *100*, 101, *101*; Pyramid of Djoser, 101, *101*; *Sculptors at Work*, relief, 98–99, *98*; Tomb of Ti, 107–8, *107*

Saraband (Morris Louis), 1145, *1145*

sarcophagus, 100, 231, 279, 952

sarcophagus, La Banditaccia, Etruscan cemetery, Cerveteri, Italy, 231, *231*

sarcophagus lid, Temple of the Inscriptions, Palenque, Mexico, 459–60, *460*

Sarcophagus of Junius Bassus, Christian, 308–9, *309*

Sargon I, 76

Sargon II, 80

Sarpedon, 158, 176

Sartre, Jean-Paul, 1127

Sassanian Persia, 344, 353

satire, British, 959–60

Saturn, 234

Saussure, Ferdinand de, 41

Savonarola, Fra Girolamo, 678, 680, 694

Saxons, 487

Saxony, 546

scaffold, 568

Scandinavia, 487–88; medieval, 502–5; myths, 537

scarification patterns, 476

Scarlet Ware, 74

Scarlet Ware vase, Tutub (modern Tell Khafajeh, Iraq), 74, *74*

Scenes from the Massacre at Chios (Eugène Delacroix), 988, *989*, 993, 999

Schapiro, Meyer, 1164–65

Schapiro, Miriam, *Heartfelt*, *1164*, 1165

Schiele, Egon, *Self-Portrait Nude*, 1068, *1068*

Schinkel, Karl Friedrich, 1000 1001; Altes Museum, Berlin, Germany, 1000–1001, *1001*

Schliemann, Heinrich, 144, 145, 149, 150

Schliemann, Sophia, 149

Schmidt-Rottluff, Karl, 1065, 1068; *Three Nudes—Dune Picture from Nidden*, 1065, *1065*

Schnabel, Julian, 1165–67; *The Death of Fashion*, 1165–67, *1165*

Scholasticism, 558, 566–67, 617

Schongauer, Martin, 649, 717; *Temptation of Saint Anthony*, 649, *649*, 717

school (artistic), 814

School of Athens, fresco (Raphael), 692–93, *692*, 1004

School of Fontainebleau, 741

School of the Mind, 423

Schröder House, Utrecht, Netherlands (Gerrit Rietveld), 1093, *1093*, 1155

Schröder-Schräder, Truus, 1093

science, 1061; 17th century, 759–60; Baroque period, 814; as subject, 961

scientific illustration, 814

Sckell, Ludwig von, 1055

Scotland, 189, 816

Scraper (Apoxyomenos), The (Lysippos), *204*, 205, 218

Scream, The (Edvard Munch), 1038–39, *1038*

screen (Nagasawa Rosetsu), detail, *Bull and Puppy*, 871, *871*

scribes, Egyptian, 106

scriptorium, 321, 489–90, 493, 533, 588; Medieval, 490, 499–502

scroll: Chinese, 844; Greco-Roman, 304

Scrovegni (Arena) Chapel, Padua, Italy, 610–12, *611*, 612, *612*, 617, *618*, 619

sculpted face of woman, Uruk (modern Warka, Iraq), *72*, 73

Sculptors at Work, relief, Saqqara, Egypt, 98–99, *98*

sculpture
 materials of, "direct metal," 1106
 periods and styles: 16th century, 711–13; 18th century, 968–73; African, 475, 482, 917; American, 998–1000, 1042–44, 1046–47, 1135–37; Buddhist, 386; Cubist, 1077–78; Early Renaissance, 660; Egyptian, 98–99, 104–7, 112, 168–69, 231–33; French, 781–82, 946–49, 968–73, 990–91, 1039–41; German, 711–13; German Gothic, 593–96; Gothic, 579–80; Greek, 160, 196–97, 199–207; Hellenistic, 212–20; Imperial Christian, 308–9; Indian, 386; Italian, 660, 768; Italian Futurist, 1080–81; Italian

Gothic, 597–601; Japanese, 874; Jewish and Early Christian, 293–94; Mannerist, 732; Mayan, 459–60; Medieval, 507–10; Mesopotamian, 73–74; Minoan, 137–38; Modernist, 1071, 1106–7; Mycenaean, 148–49; Neolithic, 60–63; Northern European, 625–26; Northwest Coast peoples, 889; Oceania, 906; Olmec, 454; Paleolithic, 45–47; Roman, 239–40; Romanesque, 529–30; Romantic, 990–91
 status of, 690
 types: relief, 45, 662; in the round, 45, 132, 231, 454, 579–80

S-curve pose, 580

Scythians, 209–10

Seagram Building, New York, NY (Ludwig Mies van der Rohe), with Philip Johnson, 1154, *1154*, 1156, 1157

seals, 413; Indian, 373

seals, Indus Valley civilization, 373, *373*, 374

seal script (China), 413

Seascape, wall painting, Villa Farnesina, Rome, Italy, 271, *271*, 293

Seasons, The (Lee Krasner), 1131, 1133, *1133*

Seated Buddha, sculpture, Yungang, Shanxi, China, 414, *414*

Seated Harp Player, Cyclades, Greek islands, 132, *133*

Seated Scribe, statue, Egyptian, 106–7, *106*

Seaweed, Willie, 890, 891; (attributed to) Hokhokw mask, 889, *890*, *891*

Second Bank of the United States, Philadelphia, Pennsylvania (William Strickland), watercolor by A. J. Davis, 187, 189, *189*

seed jar, Anasazi culture, 468, *468*

Segal, George, 1138; *The Diner*, 1138, *1138*

segmental pediments, 816

Sekisui, Ito, 873; ceramic vessel, 873, *873*

Selene, 158

Seleucus, 210

Self-Portrait (Albrecht Dürer), 716–17, *716*

Self-Portrait (Caterina van Hemessen), 746, *746*

Self-Portrait (Judith Leyster), 804, *804*

Self-Portrait (Pablo Picasso), *1072*, 1073

Self-Portrait (Rembrandt van Rijn), 807, *807*

Self-Portrait (Actress)/White Marilyn (Yasumasa Morimura), *1176*, 1177

Self-Portrait as a Fountain (Bruce Nauman), 1149, *1149*

Self-Portrait Nude (Egon Schiele), 1068, *1068*

Self-portrait of nun Guda, page, Book of Homilies, Romanesque, 549, *549*

Self-Portrait with an Amber Necklace (Paula Modersohn-Becker), 1067–68, *1067*

Self-Portrait with Two Pupils (Adélaïde Labille-Guiard), 970, *970*

Selimiye Cami (Mosque of Selim), Edirne, Turkey (Sinan), 351, 358, *358*, *359*, 363

Seljuk Turks, 353, 355–57

semiotics, 41

Senbi, tomb of, Meir, Egypt, 112, *113*, 122

Senenmut, 116

Senior (artist), 493–94

Sen no Rikyu, 864–65; Myoki-an Temple, Kyoto, Japan, Tai-an tearoom, 864–65, *865*

Senusret II, 108–9, 112; pectoral of, 112–13, *113*

Senusret III, 112

Sepik River, Papua New Guinea, house (Abelam culture), 903, *903*

Septimius Severus, 274–75

Septimius Severus, Julia Domna, and Their Children, Caracalla and Geta, painting, Roman, *274*, 275

seraphim, 681

serdab, 99, *100*

Serlio, Sebastiano, 748

Serpentine, La (Henri Matisse), 1071, *1071*, 1078

serpentine bench, in Güell Park (Antonio Gaudí), 1061–62, *1061*, 1167

Serra, Richard, 1171, 1177; *Tilted Arc*, 1171, *1176*, 1177

Serrano, Andres, *Piss Christ*, 1175
Sesshu, 860–61; *Winter Landscape, 860,* 861
Seth, 96
Sety I, 115
Seurat, Georges, 1030, 1032–33; *A Sunday Afternoon on the Island of La Grande Jatte,* 1033, *1033*
Seven Wonders of the World, 104
Severan dynasty, 274–76, 279
Severe Style, 181
Severn River Bridge, Coalbrookdale, England (Abraham Darby), *962*
Sévigné, Madame de, 939
Sèvres Royal Porcelain Factory, 948–49; potpourri jar, 948–49, *948*
sexism, in art, 1174
Sezessionstil, 1041, 1062, 1087
Sforza family (Milan), 649, 688–89
sfumato, 690
shaft, 162, 164, 378, *704*
Shah Jahan, Indian ruler, 825, 830, 832
Shaka Triad (Tori Busshi), 433–34, *433*
Shakespeare, William, 134, 816, 965
shakti, 393
shamanism, 52, 430, 454, 462, 859, 888, 922
Shaman with Drum and Snake, pendant, Costa Rica, 462, *462*
Shangdi (Chinese deity), 405
Shang dynasty (China), 841
shater, 338
Shazi, al-Mulk, pen box of, 359, *359*
$he (Richard Hamilton), 1143, *1143*
Sheeler, Charles, 1108; *American Landscape,* 1108, *1109*
Shen Zhou, 848–49, 861; *Poet on a Mountain Top,* handscroll, 849, *849,* 861
Sherman, Cindy, 1170; *Untitled Film Still #21,* 1170, *1170,* 1174
She-Wolf, statue, Etruscan, *222–23,* 223, 231, 233
Shiga prefecture, Japan, Onjo-ji monastery, Guest Hall, *865*
Shihuangdi, Emperor of China, 401, 407
Shiite Muslims, 345, 349
shikhara, 381, 388
Shimamoto, Shozo, 1139; *Hurling Colors,* happening, 1139, *1139*
Shimomura, Roger, 40; *Diary* (Minidoka Series #3), 40, *40*
Shinto, 431–32, 435, 859
Shitao, 853–54; *Landscape,* album, 853–54, *853*
Shiva, 378, 391–92, 397–98, 828
Shiva Nataraja, 397–98
Shiva Nataraja, sculpture, India, Chola dynasty, 398, *398*
shogun, 859, 873
shoin architecture, 865
shoji screens, 865
Shona people (Great Zimbabwe), 480–82, 917
Shoppers, The (Duane Hanson), 1161, *1161,* 1172
Shotoku, Prince, 432
shoulder bag, Native American, Delaware, 886, *886*
Shrewsbury, England, Hardwick Hall, High Great Chamber, 753, *753*
shrine, Ise, Japan, 431, *431*
Shrine of the Three Kings, reliquary (Nicholas of Verdun), 577, 593–94, *594*
shrine room, Chatal Huyuk, 70, *70*
Shu, 96
Shubun, 859–60
Shuhda (artist), 351
Shunga dynasty, 379–82
Shute, John, 748
Sicily, 331–33, 542
Siddhartha in the Palace, relief, India, Andhra period, 385, *385*
side aisles, *568*
Sidney Janis Gallery, "Sharp Focus Realism" (New York, 1972), 1161
Siena, Italy, 583, 601–7, 612; Cathedral, 583, 602–4, *602, 603;* Cathedral Baptistry, 662, *662;* Palazzo Pubblico, 606–7, *606–7*

Sierra Leone, 921; mask, *nowo,* Mende culture, 921, *921*
Sight, from *Allegories of the Five Senses,* series (Jan Brueghel and Peter Paul Rubens), 800, 801, *801*
Sighting of the "Argus," The (Théodore Géricault), 985, 986, *987,* 1063
signatures, artists', 161, 172
Signboard of Gersaint, The (Jean-Antoine Watteau), 943–45, *943*
silk, painting on, 412–13, 844
Silk Road, 407, 408, 415
silver, 360; British, 958
silverware (Morley, Burrows, Cooke, Bateman families), 957, *958*
Sinan, 358; Selimiye Cami (Mosque of Selim), Edirne, Turkey, 351, 358, *358, 359,* 363
sinopia, 604, 672
Siphnian Treasury. *See* Sanctuary of Apollo, Delphi, Greece
Siqueiros, David Alfaro, 1117, 1132
Sistine Chapel. *See* Vatican Palace, Rome, Italy
site-specific sculpture, 1159–61, 1176, 1179
Sithathoryunet, 112
Six Dynasties (China), 411
Sixtus III, Pope, 300
Sixtus V, Pope, 248, 763
Skara Brae, Orkney Islands, Scotland: house interior, *56,* 57; village plan, 56–57, *56*
sketchbook, page (Villard de Honnecourt), 580, *581*
skirt of Queen Kamamalu, Hawaiian, 907, *907*
Skopas, 205
Sky Cathedral (Louise Nevelson), *1136,* 1137, 1140
skyscraper, 1054, 1087, 1088, 1154
slavery, 972, 981
slave trade, 917, 957–59
Slavs, 310, 326
Sleeping Gypsy, The (Henri Rousseau), 1037, *1037,* 1071
Sleep of Reason Produces Monsters, The, page, *Caprichos (The Caprices), Los,* print series (Francisco Goya y Lucientes), 992–93, *992,* 1135
slip (pottery), 159, 173, 893, 902
Sloan, John, 1082–83; *Backyards, Greenwich Village,* 1083, *1083*
Sluter, Claus, 625, 629; Well of Moses, Chartreuse de Champmol, Dijon, France, 622, 625, *625*
Small Cowper Madonna, The (Raphael), 690, *691,* 701
Smibert, John, 974–75; *Dean George Berkeley and His Family (The Bermuda Group),* 974–75, *975*
Smith, David, 27, 1135–36, 1148; Cubi series, 1136; *Cubi XIX,* 27, *27,* 1136; *Hudson River Landscape,* 1135–36, *1135,* 1148
Smith, Jaune Quick-to-See, *Trade (Gifts for Trading Land with White People),* 896, *896*
Smith, Kiki, 1174; *Untitled,* 1174, *1174*
Smithson, Robert, 1159–60; *Spiral Jetty,* 1160, *1160*
Smythson, Robert, 753; Hardwick Hall, Shrewsbury, England, High Great Chamber, 753, *753*
Snap the Whip (Winslow Homer), 1047–48, *1047*
Snowstorm: Hannibal and His Army Crossing the Alps (Joseph Mallord William Turner), 994, *994,* 1052
Sobel, Janet, 1132
Social Darwinism, 981
Socialist Realism (U.S.S.R.), 1091–92
Société Anonyme des Artistes Peintres, Sculpteurs, Graveurs, etc., 1019
Socrates, 199
Sogn, Norway, Borgund stave church, *535,* 536, *536*
Solomon, King, 291
Solomon R. Guggenheim Museum, New York, NY (Frank Lloyd Wright), 36, *37,* 1158
Solon, 155
Song dynasty, 419–24; northern, 420–23; southern, 423

Song dynasty (China), 839, 840, 841
Songye people (Zaire), 923–24
Sophocles, 177, 211
Sorel, Agnès, 646
Sorgh, Hendrik Maertensz, 1104
Sosos of Pergamon, 268
Sotatsu, Tawaraya, 867; Matsushima screens, *866–67,* 867
Soufflot, Jacques-Germain, 966–67; Panthéon (former Church of Sainte-Geneviève), Paris, France, 966–67, *966*
South America, 881–84; pre-European, 462–65
South Cross of Ahenny, Tipperary, Ireland, 491, *491,* 493
south porch, *568*
south portal, *568*
Southwest, American, 468. *See* American peoples
Soviet Union, 1060, 1090–92, 1126
Spain, 348, 353, 645–46, 786, 1059, 1060
 art. *See* Spanish art
 Christian, 492
 Golden Age, 786
 Gothic, 589–92
 Islamic, 354–55, 361–67, 493
 Romanesque, 518
 unattributed works from: Banner of Las Navas de Tolosa, Islamic, *362,* 363; *Batlló Crucifix,* Romanesque, 529–30, *529*
spandrel, 228, 298–99, 525, *525,* 653, 695, 833
Spanish Armada, 742
Spanish art
 architecture, 742, 786–88
 painting, 742–45, 788–94
 styles: Baroque, 786–94, 1048; modern, 1061–62; Renaissance, 742–45; Romanticism, 991–93
Spanish colonial art, 788, 794–96
Sparta, Greece, 144, 155, 178, 185, 198; *Vapheio Cup,* 136, 142, *143*
Spear Bearer (Doryphoros) (Polykleitos of Argos), 196–97, *196,* 202, 205, 242, 268
speech scroll, 457
Spelt, Adriaen van der, 25–26; *Flower Piece with Curtain,* 25–26, *25*
Speyer, Germany, Cathedral, 544, *545,* 566
Sphinx of Taharqo, Temple T, Kawa, Nubia, Egypt, 125, *125*
Spiral Jetty (Robert Smithson), 1160, *1160*
spire, *568*
spirit figure (*boteba*), Burkina Faso, Lobi culture, 922, 923, *923*
spirit mask, Côte d'Ivoire, Guro culture, 932, *932*
Spirit of Haida Gwaii, The (Bill Reid), *892*
spirit spouse (*blolo bla*), Côte d'Ivoire, Baule culture, 924, 925
spirit world, in African art, 922–26, 929–31
Split, Croatia, Palace of Diocletian, 280–81, *280,* 281
Spoils from the Temple of Solomon, Jerusalem, relief, Arch of Titus, Rome, Italy, 229, 255, *255,* 293
Spoleto Festival U.S.A. (Charleston, SC, 1991), "Places with a Past," 1181
spolia, 299
sponsor, civic, 36–37
Spotted Horses and Human Hands, cave paintings, Pech-Merle cave, France, 48–50, *49*
Spring and Autumn period (China), 406
Spring Dawn in the Han Palace, handscroll (Qiu Ying), 846, *846*
Spring Festival on the River (Zhang Zeduan), 422–23, *422*
springing, 228
squinch, 311, 328, 352, 355, 520
Sri Lanka, 376
stadium, 156, 235
Staël, Madame de, 939
Staffelstein, Germany (near), Vierzehnheiligen, Church of the, 941–42, *941,* 957
stage design, English, 818
Stag Hunt, mosaic (Gnosis), 208, *208,* 210

stained glass, 561, 567, 578, 582; windows, 569
Stalin, Joseph, 1060, 1091
Stamatakis, Christos, 146
Standing Buddha, Gandhara (Pakistan), 383, *383*, 435
Standing Buddha, India, Gupta period, 386, *386*, 398
Stanton, Elizabeth Cady, 981
Starry Night, The (Vincent van Gogh), 1034, *1034*
States of Mind: The Farewells (Umberto Boccioni), 1080, *1080*
Station for airplanes and trains, Milan, Italy (Antonio Sant'Elia), 1089, *1089*, 1096
statues: architectural, 564–65; Greek, 169–71, 177, 179–80; monumental, 78; neolithic, 60; wood, 529, 596
Statuette of a llama, Inka, 884, *884*
stave churches, 536
steel, 980, 1006, 1054
Steen, Jan, 33, 814; *The Drawing Lesson*, 33–34, *34*
Steichen, Edward, 1083
Stein, Gertrude, 1064
Stein, Leo, 1064
Steiner House, Vienna, Austria (Adolf Loos), 1087, *1087*
Stela of Hammurabi, Susa (modern Shush, Iran), 78, 79, *79*, 85
Stela of Naramsin, Akkad, 77, *77*, 85, 97
stele, 77, 110, 197, 384; Mayan, 457–58
Stella, Frank, 1146–47; *Avicenna*, 1146–47, *1147*, 1154
stereobate, 163, 164
Stieglitz, Alfred, 1049–50, 1083, 1084, 1107–8; *Winter on Fifth Avenue*, 1050, *1050*
stigmata, 681
Stijl, de ("the Style"), 1092–94, 1098, 1099
Stile floreale ("Floral Style"), 1041
Stile Liberty, 1041
Still, Clyfford, 1135
still life, 26; Dutch, 814–16; Roman, 271–72
Still Life, wall painting, House of Julia Felix, Pompeii, Italy, 272, *272*
Still Life with Basket of Apples (Paul Cézanne), 1031–32, *1031*, 1063, 1127
Still Life with Flowers, Goblet, Dried Fruit, and Pretzels (Clara Peeters), 800, *800*, 801
Still Life with Quince, Cabbage, Melon, and Cucumber (Juan Sánchez Cotán), 790, *790*
stipes, 628
Stiris, Greece, Monastery of Hosios Loukas, Katholikon, 328–30, *329*
stoa, 157, 186
stockade, 467, *587*
stone (as construction material), 1007
Stonehenge, Salisbury Plain, England, 57, 58–60, *59*, 144
stoneware, 62, 846
stone work, Neolithic, 56–57
Stoss, Veit, 712; *Annunciation and Virgin of the Rosary*, 713, *713*
"straight" photography, 1119
Strand, Paul, 1083, 1085; *Chair Abstract, Twin Lakes, Connecticut*, 1083, *1085*
Strasbourg, France, Cathedral, 594, *594*
Stravinsky, Igor, 1072
Strawberry Hill, Twickenham, England (Horace Walpole), 956, *956*; Library (with John Chute and Richard Bentley), 956, *956*
Street, Berlin (Ernst Ludwig Kirchner), 1066, *1066*, 1072, 1097
stretcher course, 906
Strickland, William, 189; Second Bank of the United States, Philadelphia, Pennsylvania, watercolor by A. J. Davis, 187, 189, *189*
stringcourse, 540, 704, *704*, 741
structuralism, 41
Stuart, James, 189
Stuart dynasty, 798
stucco, 187, 230
stucco and wall painting (Francesco Primaticcio), *740*, 741
Studiolo of Federico da Montefeltro, Ducal Palace, Urbino, Italy, 660, *660*

Studio School (Native American art), 894
Study of Hands and Feet (Théodore Géricault), 985, 986, *987*, 1063, 1095
stupa, 379–82, *381*, 417, 418; Central Asia, 418; Indian, 418
Sturluson, Snorri, 504
Style Guimard, 1041–42
styles, 25
stylization, 29, 73, 131
stylobate, 162, 163, 164
stylus, 70, 71, 173
subject matter of art, 27
sublime, 967–68, 993
Sub-Saharan civilizations, 474–82
Succulent (Edward Weston), 26, *26*
Sudan, 474, 917
suffragists, 959, 981
Sufism, 355
Suger, Abbot of Saint-Denis, 31, 555, 560–61
Suicide of Ajax, The, vase (Exekias), 165, *174*, 175
Sui dynasty (China), 414–15
Suitor's Visit, The (Gerard Ter Borch), 813–14, *813*, 943
Suleyman "the Magnificent," 358, 368
Sullivan, Louis, 1054, 1087; Wainwright Building, St. Louis, Missouri, 1054, *1054*, 1086
Sultan Hasan mosque complex, Cairo, Egypt, 347, 357, *357*
Sumer, cylinder seal, 76, *76*, 374
Sumer, Sumerians, 69, 70–76
Summer's Day (Berthe Morisot), 1026, *1026*
sumptuary laws, 654
Sunday Afternoon on the Island of La Grande Jatte, A (Georges Seurat), 1033, *1033*
sunken relief, 120
Sunni Muslims, 345
Super Realism, 1161
Supper at Emmaus (in Christian art), 307
Suprematism, 1082, 1090, 1158
Suprematist Painting (Eight Red Rectangles) (Kazimir Malevich), 1082, *1082*, 1158
Surrealism, 1102–5, 1119, 1127, 1130
Surrender at Breda, The (Diego Velázquez), 791–92, *791*
Susa (modern Shush, Iran), 85–86; beaker, 85–86, *85*; *Stela of Hammurabi*, 78, 79, *79*, 85; *Woman Spinning*, 86, *87*
sutra, 435
Sutton Hoo, England, 489; burial ship, 489, *489*, 490
Suzhou, Jiangsu, China, Garden of the Cessation of Official Life, 838–39, *839*, 847
swag, 243, 788
Swahili, 473, 917
Swing Landscape (Stuart Davis), *1114*, 1115, 1133
Switzerland, Dada art in, 1099–1100
swords, Japanese, 445
Symbolism (movement), 1036–39
symbols in art, 26; Christian, 566–67; Egyptian, 96; hidden, 629–30; and invention of writing, 70
synagogue, 295–96, 592–93
synagogue, Dura-Europos, Syria, 295, *295*, 296, *296*
syncretism, 258, 293
Synthetic Cubism, 1077–78, 1082, 1095
Syon House, Middlesex, England (Robert Adam), *956*, 957, 973
Syria
Koran, manuscript page, *342–43*, 343, 351
Rabbula Gospels, Early Christian: page, Ascension, 322, *322*, 336, 530; page, Crucifixion, 321–22, *321*, 330, 336, 530

T

tabernacle (Egid Quirin Asam), *Angel Kneeling in Adoration*, 942–43, *942*
tablinum, 264
tachisme, 1129
Taharqo, Egyptian ruler, 125

Tahull, Lérida, Spain, San Clemente church, 531–32, *532*, 534
Tai-an tearoom. *See* Sen no Rikyu
Taj Mahal, Agra, India, *824–25*, 825, 832–33, *833*
Takaezu, Toshiko, 1172–73; *Large Form*, 1173, *1173*
Taking of the Roman Census, frieze, Temple of Neptune, possibly, Rome, Italy, *240*, 241
Talbot, William Henry Fox, 1003; *The Pencil of Nature*, series, *The Open Door*, 1003, *1003*
Tall Spread (Jack Bush), 1145, *1146*
talud-tablero construction, 456
Tamamushi Shrine, Horyu-ji, Nara, Japan, 432–33
tamberan house (Abelam culture), Sepik River, Papua New Guinea, 903, *903*
tamberan houses, 903–4
Tang dynasty, 415–18, 435, 841, 846
Tanner, Henry Ossawa, 1052; *The Resurrection of Lazarus*, 1052, *1052*
Tantric Buddhism, 826–27
Taos Pueblo, New Mexico, 893
Taos Pueblo (photograph; Laura Gilpin), 893, *893*
taotie, 404
tapa, 907
tapestry, 364; Andean, 452; Anglo-Norman, 540; Early Renaissance, 629; Flemish, 642–45; Peru, *452*; Renaissance, 693, 745
Tapié, Michel, 1129
Tàpies, Antoni, 1129; *White with Graphism*, 1129, *1129*
Target with Four Faces (Jasper Johns), 1142, *1142*
Tarquinia, Italy: kings, *233*; Tomb of the Lionesses, 231, *232*; tombs at, 231
Tassel House, Brussels, Belgium (Victor Horta), 1041, *1041*, 1172
Tassili-n-Ajjer, Algeria, *Cattle Being Tended*, rock art, 474, *474*
tatami mats, 864, *865*
tatanua, mask dance, New Ireland, Papua New Guinea, 904–5, *905*
tatanua masks, 904–5
Tatlin, Vladimir, 1082, 1090; *Corner Counter-Relief*, 1082, *1082*; Model for the Monument to the Third International, 1090, *1090*
tattooing, 909
Tawney, Lenore, 1153; *Black Woven Form (Fountain)*, *1153*
tea ceremony (*cha no yu*), 864–67
Teerling, Levina Bening, 750; (attributed to) *Elizabeth I as a Princess*, 750–51, *750*
Tefnut, 96
Te-Hau-ki-Turanga (Maori meetinghouse), Manutuke Poverty Bay, New Zealand (Raharuhi Rukupo), 909, *909*
temenos (Greek temple complex), 156–57
tempera, 173, 197, 602, 630, 631, 666, 707; Early Renaissance in Italy, 676–83
Tempest, The (Giorgione), 706, 707, 745
Tempietto. *See* Bramante, Donato
temple complexes, India, 828–29
Temple of Amun, Mut, and Khons, Luxor, Egypt, Pylon of Rameses II, 115, *115*, 119
Temple of Aphaia, Aegina, Greece, pediment, 167–68, *167*, 187, 213
Temple of Apollo, Veii, Italy, 226–30, *227*
Temple of Artemis, Korkyra (Corfu), Greece, 165, *165*
Temple of Athena Nike, Acropolis, Athens, Greece, 194–96, *194*, *195*, 203, 218
Temple of Hera I, Paestum, Italy, 162, *162*, 163–65
Temple of Neptune, possibly, Rome, Italy, *240*, 241
Temple of Rameses II, Abu Simbel, Egypt, 116, *118*, 119; and Temple of Nefertari, 116, *118*, 119
Temple of Rameses II, Luxor, Egypt, 116, 119, *119*
Temple of the Feathered Serpent, Teotihuacan, Mexico, 456, *456*

Temple of the Inscriptions, Palenque, Mexico, 459–60, *459*, 460, *460*
Temple of the Olympian Zeus, Athens, Greece, 211–12, *211*, 267
Temple of the Sun (Inka), Cuzco, Peru, 794, 882, *882*
Temple of Zeus, Olympia, Greece, *178*, 179, *179*, 190, 191, 203
Temple perhaps of Portunus, Rome, Italy, 237–38, *238*
temples
 Egyptian, 102, *103*, 114–17
 Etruscan, 226, *226*
 Greek, 160, *161*, 162–65
 Hindu, 828–29
 Indian, 381, *381*, 388–97; early northern, 388–93; early southern, 393–94; monumental northern, 395–96; monumental southern, 396–97; temple complexes, 828–29
 Japanese, 432, 435
 Mesoamerican, 456–60
 Oceania, 906
 Sumerian temple complexes, 69
temples and pyramids, model, Giza, Egypt, 102, *103*
Temple T, Kawa, Nubia, Egypt, 125, *125*
Temptation of Saint Anthony (Martin Schongauer), 649, *649*, 717
tenebrism, 774, 775
Tenement Interior in Poverty Gap: An English Coal-Heaver's Home (Jacob Riis), 1051, *1051*
Teotihuacan, Mexico, 454–57, 879; ceremonial center, 454, *455*; *Maguey Bloodletting Ritual*, fresco, 456–58, *457*; Pyramid of the Sun and Pyramid of the Moon, 455; Temple of the Feathered Serpent, 456, *456*
tepees (photograph), Native American, Blackfoot, 887, *887*
Ter Borch, Gerard, 813–14; *The Suitor's Visit*, 813–14, *813*, 943
Teresa of Avila, Saint, 743, *766*
Terminus, 234
Terrace at Sainte-Adresse (Claude Monet), 1021–22, *1021*
terra-cotta, 131, 226, 227, 374, 653, 665, 949; African, 476
tesserae, 267, 300
Tetrarchs, The, statue group, Roman, 279, *279*, 284
textiles, 86; African, 926–27; Andean, 452, 463–64; Bauhaus, 1098; contemporary, 1153; early Renaisssance, 641–45; Hawaiian, 910; Inka, 882–84; Islamic, 352–53, 361–64, 530; Navajo, 894–95; Northwest Americas, 888–89; Oceania, 907; Peruvian, 463–64
Textile with elephants and camels, Persian, 352–53, *353*, 361
Thamyris, 623
Thamyris, page, *Concerning Famous Women* (Giovanni Boccaccio), *623*
Thanatos, 176
Thanjavur, Tamil Nadu, India, Rajarajeshvara Temple to Shiva, 396–97, *396*, 397, *397*
thatch, *535*
theater, Epidauros, Greece, *210*, 211
theaters: English, 818; Greek, 211; Hellenistic, 211; Japanese, 1176; Roman, 239
Thebes, Egypt, 92, 108, 114, 120, 122; map of district, 114, *114*, 116
Theodora, Empress, 309, 310
Theodore, Saint, 323
Theodoros (architect), 200
Theodosius I, Emperor, 179, 302
Theophilus, 309; *On Diverse Arts*, 547
Thera (Santorini), Greek island, 129, 131, 140
Theravada Buddhism, 376
thermoluminescence dating, 54
Theseus, 158
Thetis, 172
Third-Class Carriage, The (Honoré Daumier), 1012–13, *1012*
Third of May, 1808 (Francisco Goya y Lucientes), *992*, 993

Third World bloc, 1126
Thirty-Six Immortal Poets (Japanese anthology), 438–40
Thirty-Six Views of Fuji, print series (Katsushika Hokusai), *The Great Wave*, *856–57*, 857, 867, 872–73
tholos, 186–87, 199–200, 237, 300, 656
tholos, Epidauros, Greece, Corinthian capital, 27–28, *28*
tholos ('Treasury of Atreus'), Mycenae, Greece, 146, *146*, 199
Thomson, Tom, 1119; *The Jack Pine*, 1119, *1119*
Thor, 487
Thornton, William, 1000
Thoth, 124, 125
Thousand Peaks and Myriad Ravines, A, hanging scroll (Wang Hui), *852*, 853
Thrace, *Alexander the Great*, coin, 206–7, *206*
Three Crosses (Rembrandt van Rijn), 806, *806*
Three Nudes - Dune Picture from Nidden (Karl Schmidt-Rottluff), 1065, *1065*
Three Women at the Spring (Pablo Picasso), 1094, *1094*
Three Women in a Village Church (Wilhelm Leibl), 1013, *1013*
Throne of the Third Heaven of the Nations' Millennium General Assembly (James Hampton), 31, *31*
Throne of Wisdom type, 529
Thutmose (artist), 121
Thutmose I, 114, 116
Thutmose II, 116
Thutmose III, 113, 114, 116
Ti, 107
Tian (Heaven), 406
Tiberius, 234, 242, 245
Tibet, 376
Tiepolo, Giovanni Battista, 941
 fresco, Kaisersaal (Imperial Hall), Residenz, Würzburg, Bavaria, Germany, 940–41, *940*; *The Marriage of the Emperor Frederick and Beatrice of Burgundy*, *940*, 941, 991
tiercero, 587
Tikal, Guatemala, 458–59; temples, 458–59, *458*
tiki figures, 909
Tilted Arc (Richard Serra), 1171, *1176*, 1177
tilts (jousts), 752
timber construction, 535, 820–21
"Times Square Show" (1980), 1167
Timgad, modern Algeria, 262, *262*; plan of, 262, *262*
Timurid dynasty and style, 365
Tinguely, Jean, 1140; *Homage to New York*, assemblage, *1140*
Tintoretto (Jacopo Robusti), 736–37, 743; *The Last Supper*, 736–37, *736*
Tipperary, Ireland, South Cross of Ahenny, 491, *491*, 493
Tiryns, Greece, citadel, 147–48, *147*
Titans, 158
Titian (Tiziano Vecelli), 687, 707, 708–10, 728–29, 734, 736, 743, 771, 778, 1134; and Giorgione, *The Pastoral Concert*, 707–8, *707*, 1018, *1018*, 1020; *Isabella d'Este*, 709; *Pesaro Madonna*, *708*, 709; *Pietà*, 728, *728*; *Venus of Urbino*, 710, *710*, 1021
Titus, 229, 254, 291
Tivoli, Italy, 265
Hadrian's Villa, *258*, 265, *265*, 267, *267*, 280; Canopus area, 265, *265*, 281
Ti Watching a Hippopotamus Hunt, Tomb of Ti, Saqqara, Egypt, 107–8, *107*
Tiy, Queen of Egypt, 120–21
Tlaloc, 880
Tlingit people, 888
Toba Sojo, 440; attributed to, *Frolicking Animals*, 440–42, *441*
tokonoma, 865, *865*
Tokugawa family, 866, 873
Tokyo, Japan, 866, 873
Toledo, Juan Bautista de, 742, 743; Escorial, Madrid, Spain, with Juan de Herrera, 742, *742*, 786
Toledo, Spain, 518

tomb effigies, Romanesque, 546
Tomb II, so-called Tomb of Philip, Vergina, Macedonia, Greece, *206*, 207
Tomb of Khnumhotep, Beni Hasan, Egypt, 110, *110*
Tomb of Nefertari, Deir el-Bahri, Egypt, 96, 121, 123, *123*, 124
Tomb of the Lionesses, Tarquinia, Italy, 231, *232*
Tomb of the Reliefs. *See* La Banditaccia, Etruscan cemetery, Cerveteri, Italy
Tomb of Ti, Saqqara, Egypt, 107–8, *107*
tombs: Egyptian, 107–8, 109–12; Etruscan, 230–31; Helladic, 144–46; Japanese, 430; Mycenaean, 150; Neolithic, 57–60; Roman, 239, 289; Romanesque, 546
Tombs of Giuliano and Lorenzo de' Medici (Michelangelo), 699–700, *699*
tondo, 272, 305
Tonga, 901
Topsfield, Massachusetts, Parson Capen House, 820–21, *820*
torana, 380, 381
Tori Busshi, 433–34; *Shaka Triad*, temple, Horyu-ji, Nara, Japan, 433–34, *433*
torii, 431
toron, 480
torque, 209
Torso, Harappa, India, *374*, 375
totalitarianism, 1060
Toulouse-Lautrec, Henri de, 989, 1042, 1073, 1081, 1083; *Jane Avril*, 1017, 1042, *1042*
Tournai weaving center, 642
tower, 568, 587
Tower of Babel, wall painting, abbey church, Saint-Savin-sur-Gartempe, Poitou, France, 531, *531*
towns: Medieval, 557; Neolithic, 55–57; planning (*see* city planning)
tracery, 568, 571, 626, 956
trade, Silk Road, 408
Trade (Gifts for Trading Land with White People) (Jaune Quick-to-See Smith), 896, *896*
Traini, Francesco, *Triumph of Death*, 559
Trajan, 234, 246, 247, 256, 282
transept, 298, 492, 497, 519, 568, 652, 702
Transfiguration, the (in Christian art), 306
Transfiguration of Christ, Monastery of Saint Catherine, Mount Sinai, Egypt, 313–14, *313*, 322
Transfiguration of Christ with Saint Apollinaris, First Bishop of Ravenna, The, Sant'Apollinare in Classe, Ravenna, Italy, 318, *319*
Trans World Airlines Terminal, New York, NY (Eero Saarinen), John F. Kennedy Airport, 1154, *1154*
Traoré, Ismaila, 480
Travelers among Mountains and Streams (Fan Kuan), *420*, 421
travertine, 765
Tree of Jesse (in Christian art), 534
Tree of Jesse, page from Jerome's *Explanatio in Isaiam*, Romanesque, 534, *534*, 567
Tree of Jesse, stained glass, Notre-Dame cathedral, Chartres, Ile-de-France, France, 567, *567*
Tree of Life series, photographs (Ana Mendieta), *1164*, 1165
trefoil, 374–75, 568, 572
Très Riches Heures, manuscript (Paul, Herman, and Jean Limbourg), *February* page, 624–25, *624*, 630, 640, 670–71, 748
Tribute Money, fresco (Masaccio), 671, *671*
Trier, Germany, Basilica, 281, *281*, 299
triforium, 299, 565, *568*
triglyph, 163, 164
Trinity Church, New York, N.Y. (Richard Upjohn), 1002, *1002*, 1152
Trinity with the Virgin, Saint John the Evangelist, and Donors, fresco (Masaccio), 667–69, *668*, 681
triptych, 604, 625, 628, *628*, 797
Trissino, Giangiorgio, 737

triumphal arch, 228, 254
Triumph of Death (Francesco Traini), *559*
Triumph of the Barberini, ceiling fresco, Pietro da Cortona, Barberini Palace, Rome, Italy, 771–72, *772*
Triumph of the Name of Jesus, ceiling fresco (Gaulli, Giovanni Battista), 772, *773*
Triumph of Venice, The, fresco (Veronese), 32, *32*, 35, 734
Trojan War, 144, 158, 175, 215, 233
Trolley, New Orleans (Robert Frank), *1150*, 1151
trompe l'oeil, 338, 659–60, 769, 1172
troubadours, 558
Troy, 144, 149, 190, 233
Trumbull, John, 975–76; *The Death of General Warren at the Battle of Bunker's Hill, June 17, 1775*, 976, *976*
trumeau, 524, 525, *525*, 573
Trundholm, Zealand, Denmark, *Horse and Sun Chariot*, bronze, 63, *63*, 488
Tsujimura Shiro, 873; ceramic vessel, 873, *873*
Tucson, Arizona (near), San Xavier del Bac Mission, 788, 796, *796*
tugra, 368
tugra of Sultan Suleyman, manuscript, Turkish, 368, *368*
tunic, Inka, 884, *884*
turf, *535*
Turkey, 363
Turks, 517, 827, 829
Turner, Joseph Mallord William, 994; *The Fighting "Téméraire," Tugged to Her Last Berth to Be Broken Up*, 994, *995*, 1052; *Snowstorm: Hannibal and His Army Crossing the Alps*, 994, *994*, 1052
turret, *587*, 741, 956
Tuscan order, 226, 229
Tutankhamun (Tutankhaten), 92, 122–23; coffin of, 92, 123, *123*; funerary mask of, 92, *92*, *93*; tomb of, 122–23
Tutub (modern Tell Khafajeh, Iraq), Scarlet Ware vase, 74, *74*
Twelth-century Renaissance, 517
Twelve Views from a Thatched Hut (Xia Gui), 422–23, *423*
Twickenham, England, Strawberry Hill, 956, *956*; Library (with John Chute and Richard Bentley), 956, *956*
twin figures (*ere ibeji*; Akiode), 919, 920, *920*, 931
twining (basketry), 885
Two Fridas, The (Frida Kahlo), *1118*, 1119
291 Gallery (New York), 1107
Two Paths of Life, The (Oscar Rejlander), 1004, *1004*, 1049, 1088
Two Women with a Child, figurine, Mycenae, Greece, 149, *149*
tympanum, 520, 525, *525*, 627
typography, 1099
typological exegesis, 308, 508
typology, 617, 1156
Tzara, Tristan, 1100

U

Uccello, Paolo, 621, 656; *The Battle of San Romano*, *614–15*, 615, 621
Uelsmann, Jerry N., 1151–52; *Untitled*, 1152, *1152*
uffalo-hide robes, 887–88
Uji (near Kyoto), Japan, Byodo-in temple, 437–38, *437*
ukiyo-e prints, 40, 857, 871, *871*, 872–73, 1020, 1022, 1035, 1042
Ukraine, 45, 310, 323, 326; mammoth-bone house, reconstruction drawing of, 45, *45*
Ulu Burun, off Turkey, shipwreck discovery at, 131
Ulysses, 158
Umar, 344
Umayyad dynasty, 345, 347–49
undercut, 660
underglaze, 846
Unicorn at the Fountain, *Hunt of the Unicorn*, tapestry series, French Renaissance, 642–43, *643*

Unique Forms of Continuity in Space (Umberto Boccioni), 1081, *1081*
United Nations: The Babel of the Millennium (Wenda Gu), 1184, *1184*
United Silla period, 435
United States, 907, 1060, 1126
United States art
 architecture, 1052–54, 1086–87, 1115–17, 1154–55
 craft arts, 1152, 1172
 Federal patronage, 1109
 periods and styles: 19th century, 979–82, 996–1002, 1006–7, 1042–55; 20th century, 1060–61; abstraction, 1130; Civil War period, 1046–47; colonial period, 820–21, 973–76; genre painting, 997–98; Harlem Renaissance, 1112–13; landscape painting, 997–98, 1044–46; Modernism, 1059–61, 1082–87, 1107–17; Modernist, 1083; naturalism, 996–1000; Neoclassicism, 996–1000, 1042–44; Pop Art, 1168; realism, 1047–49, 1082; religious art, 1051–52; Romanticism, 996–1000
 photography, 1044–47, 1049–51, 1083, 1108–12, 1150–51
 sculpture, 998–1000, 1042–44, 1046–47, 1135–37
United States Capitol, Washington, D.C. (Benjamin Henry Latrobe, after William Thornton), 1000, *1000*, 1053; corncob capitals, 1000, *1000*
Universal Exposition (Paris, 1889), 979
universities, 517, 557
Unswept Floor, The, mosaic (Herakleitos), Roman copy of Greek original, 268, *268*, 269
Untitled (Jenny Holzer), installation at Guggenheim Museum, 1159, *1180*, 1181
Untitled (Donald Judd), 1040, 1147, *1147*, 1169
Untitled (Kiki Smith), 1174, *1174*
Untitled (Jerry N. Uelsmann), 1152, *1152*
Untitled (12 Horses) (Jannis Kounellis), *1124–25*, 1125, 1149
Untitled (After Aleksandr Rodchenko: 11) (Sherrie Levine), 1166, 1169, *1169*
Untitled '90 (Chuichi Fujii), 874, *874*
Untitled Film Still #21 (Cindy Sherman), change to hash, *1170*, 1174
Untitled Plate (Peter Voulkos), 1152, *1152*
Upanishads, 376, 828
Upjohn, Richard, 1002; Trinity Church, New York, NY, 1002, *1002*, 1152
Ur (modern Muqaiyir, Iraq), 72–73; bull lyre, 74–76, *75*; *Disk of Enheduanna*, 76, *77*; Nanna Ziggurat, 72–73, *72*
Urban II, Pope, 517
Urban VIII, Pope, 760, 761–62, 768
urban center and mounds, Cahokia, Illinois, 467, *467*, 468
urban design, Baroque, 760–67
Urbino, Italy, 649; Ducal Palace, 659, *659*, 660, *660*, 704; Early Renaissance architecture in, 656–60
urna, 383
Urnes, Norway, church, 536–37, *537*
Urnes style, 537
Ursula, Saint, 639
Uruk (modern Warka, Iraq), 70–72; Anu Ziggurat, 70–72, *70*; carved vase, *72*, 73; sculpted face of woman, *72*, 73
ushnisha, 383
Utamaro, Kitagawa, 28–29; *Woman at the Height of Her Beauty*, 29, *29*, 33, 1029
Uthman, 344
utilitarianism, Russian, 1090–92
Utrecht, Netherlands, 809; Schröder House, 1093, *1093*, 1155
Utrecht Psalter, Carolingian, 501–2; page, *Psalm 23*, 502, *502*, 507, 540
Uzbekistan, bowl with kufic border, 352, *352*

V

Valhalla, 487
Valkyries, 487
Valley of the Golden Mummies, 92

Valley of Tiffauge, The (Marais en Vendée) (Théodore Rousseau), 996, *996*, 1009
value (optical), 1004
van, von, *names with. See in many cases, next element of name*
Vanbrugh, John, 819; Blenheim Palace, Woodstock, Oxfordshire, England, *819*, 820
VanDerZee, James, 1113; *Couple Wearing Raccoon Coats with a Cadillac, Taken on West 127th Street, Harlem, New York*, photograph, 1113, *1113*
vanishing point, 621, 662
vanitas painting, 813, *814*, 943 45
Vanna Venturi House, Chestnut Hill, Pennsylvania (Rauch & Scott Brown Venturi), 1155–56, *1155*
Vapheio, Sparta, Greece, tomb at, 142
Vapheio Cup, Sparta, Greece, 136, 142, *143*
Vasari, Giorgio, 556, 608, 654, 695; *Lives of the Most Excellent Italian Architects, Painters, and Sculptors*, 37, 687
vase, Dipylon Cemetery, Athens, Greece, 159–60, *159*
Vase (with *Apotheosis of Homer* by John Flaxman, Jr.; Josiah Wedgwood), 957, *957*
Vase Painter and Assistants Crowned by Athena and Victories, A, vase, Greek, *209*
vase painting: Greek, 161, 172–77, 183–84; Mayan, 461
Vatican Palace, Rome, Italy, 675–76, *675*, 690, 693, *693*, 696; Sistine Chapel, 675, 685, *693*, 695–98, *696*, *697*, *698*, *726*, *727*, 768, 776, 965, 987; Stanza della Segnatura, 691, *691*, 692–93, *692*, 1004
vault, 228, 519, 561, 650
Vaux, Calvert, 1055
Vauxcelles, Louis, 1063, 1075–76
Vedas, 375–77, 378, 828
vedute, 950
Veii, Italy, Temple of Apollo, 226–30, *227*
Veiled and Masked Dancer, statue, Hellenistic, 217, *217*
Velarde, Pablita, 894; *Koshares of Taos*, 894, *894*
Velázquez, Diego, 788, 791–93, 1048; *Las Meninas (The Maids of Honor)*, 760, 792–93, *792*, 991; *Pope Innocent X*, *1127*; *The Surrender at Breda*, 791–92, *791*; *Water Carrier of Seville*, 790, 791, 1048
Velderrain, Juan Bautista, 796
vellum, 304, 321, 351, 490
veneer, 99, 236, 237
Venice, Italy, 323, 325–26, 542, 649, 656, 941; architecture, 734–38; painting, 680–83, 734–38; Palazzo Ducale, Council Chamber, 32, *32*, 35, 734; San Giobbe church, 680–81, *681*, 706; San Giorgio Maggiore church, 736, 737, *737*, 778, 816; San Marco cathedral, 302, *324*, 325–26, *325*, 680
Venice Biennale, 1181
Venturi, Rauch & Scott Brown, Vanna Venturi House, Chestnut Hill, Pennsylvania, 1155–56, *1155*
Venturi, Robert, 1155–56; *Complexity and Contradiction in Architecture*, 1155
Venus, 158
"Venus figures," 47
Venus of Urbino (Titian), 710, *710*, 1021
Verdun, 593
Vergina, Macedonia, Greece: *Abduction of Persephone*, wall painting, 170, *206*, 207; Tomb II, so-called Tomb of Philip, *206*, 207
verism, 239, 258
Vermeer, Jan, 811–13; *View of Delft*, 811–12, *811*; *Woman Holding a Balance*, *812*, 813
Veronese (Paolo Caliari), 32, 734–36, 743, 771, 778; *Feast in the House of Levi*, 734–36, *735*, 941; *The Triumph of Venice*, fresco, Council Chamber, Palazzo Ducale, Venice, Italy, 32, *32*, 35, 734
Verrocchio, Andrea del, 665, 677, 688; Equestrian monument of Bartolommeo Colleoni, 664, *664*, 665, 950, 1125

Versailles, France, 778–82, 786
 Palais de Versailles, 778–82, *779*, *780*, 819, 953; Hall of Mirrors, 780, *781*, 940
 Trianon palace, 780
Vespasian, 234
Vesperbild, Bonn museum, 596, *596*
Vesperbild (Christian art form), 307, 596
vessel, Japan, Jomon period, 429, *429*
vessel, painted, Mayan, 461, *461*
vessels: Neolithic, 60–63; standard shapes, Greek, 172, *172*
Vesta, 158
Vézelay, Burgundy, France, Sainte-Madeleine church, 518, 524
Vicenza, Italy, Villa Rotunda (Villa Capra), 738, *738*, 778, 816, 953, 973, 974, 1157
video art, 1182–84
Vienna, Austria, Steiner House, 1087, *1087*
Vienna Secession, 1062
Vierzehnheiligen, Church of the, Staffelstein, Germany (near; Johann Balthasar Neumann), 941–42, *941*, 957
Vietnam Veterans Memorial, Washington, D.C. (Maya Ying Lin), 1177–78, *1177*
Vietnam War, 1126
viewer, as participant in work of art, 760, 768
View of Delft (Jan Vermeer), 811–12, *811*
View of the Farnese Gallery, engraving (Giovanni Volpato), with Michelangelo, 769, *769*
View of Toledo (El), 744–45, *744*
Vigée-Lebrun, Marie-Louise-Élisabeth, 969; *Portrait of Marie Antoinette with Her Children*, 969, *969*
vignette, 321
Vignola (Giacomo Barozzi), 724–27, 742, 778; Il Gesù church, Rome, Italy, with Giacomo della Porta, 723, 724–27, *725*, 761, 766, 772, 778, 987
vihara, 381, 382
Vijayanagar, Indian kingdom, 828–29
Vikings, 485, 502–5, 534–35
Villa Farnesina, Rome, Italy, 271, *271*, 293
village plan, Skara Brae, Orkney Islands, Scotland, 56–57, *56*
Villa of Livia, Primaporta, Italy, 266, 270, *270*, 293
Villa of the Mysteries, Pompeii, Italy, 271–72, *271*
Villard de Honnecourt, sketchbook, page, 580, *581*
Villa Rotunda (Villa Capra), Vicenza, Italy (Andrea Palladio), 738, *738*, 778, 816, 953, 973, 974, 1157
Villa Savoye, Poissy-sur-Seine, France (Le Corbusier), 1096, *1096*, 1154
Villa Torlonia, Rome, Italy, 293, *293*
vimana, 381, 394, 829
Viola, Bill, 1182; *The Crossing*, 1182, *1182*
Violet Persian Set with Red Lip Wraps (Dale Chihuly), 33, *33*, 35, 1153
Violin and Palette (Georges Braque), 1076, *1076*, 1134, 1136
Viollet-le-Duc, Eugène-Emmanuel, 574
Virgil, 144, 229, 233
Virgin and Child, sculpture, abbey church, Saint-Denis, Ile-de-France, France, 579–80, *579*, 583
Virgin and Child, sculpture, French Romanesque, *528*, 529
Virgin and Child Enthroned (Cimabue), 607, *608*
Virgin and Child Enthroned (Giotto di Bondone), 608, *609*
Virgin and Child Enthroned with Saints Francis, John the Baptist, Job, Dominic, Sebastian, and Louis of Toulouse (Giovanni Bellini), 680–81, *681*, 706
Virgin and Child in Majesty panel, *Maestà Altarpiece* (Duccio di Buoninsegna), 602–3, *602*
Virgin and Child with Saints and Angels, icon, Monastery of Saint Catherine, Mount Sinai, Egypt, 322–23, *323*

Virgin and Saint Anne with the Christ Child and the Young John the Baptist (Leonardo da Vinci), 689, *689*
Virgin and Saint George, altarpiece (Luis Borrassá), 591–92, *591*; *Education of the Virgin*, 592, *592*
Virgin Mary, 291, 299–300, 322–23, 527, 534, 793–94, 795
Virgin of Vladimir, icon, Christian, 328, *328*, 534
Vir Heroicus Sublimus (Barnett Newman), *1134*, 1135
Virtues and Vices, relief, Notre-Dame cathedral, Amiens, Ile-de-France, France, 573, *573*
Visconti family (Milan), 649
Vishnu, 378, 389–91, 828, 833
Vishnu Narayana on the Cosmic Waters, relief, Vishnu Temple, Deogarh, Uttar Pradesh, India, 390, *390*, 392
Vishnu Temple, Deogarh, Uttar Pradesh, India, *388*, 389, *389*, 390, *390*, 392, 395
Visigoths, 348, 487, 492, 495
Visitation, the (in Christian art), 306
Vitra Fire Station, Weil-am-Rhein, Germany (Zaha Hadid), 1158, *1158*
Vitruvian Man (Leonardo da Vinci), 690, *690*
Vitruvius, Marcus Pollio, 226, 690, 701, 724, 778; *On Architecture*, 655; *Ten Books of Architecture*, 229, 235
Vladimir, Grand Prince, 326–27
Vlaminck, Maurice de, 1063
Volpato, Giovanni, *View of the Farnese Gallery*, engraving, Farnese Gallery, Rome, Italy, with Michelangelo, 769, *769*
Volto Santo Medieval sculpture, 529
volute, 164, 659, 700, 725, *725*, 788, 940
volute krater, 172
votive figures, 73–74, 133, 226
votive statue of Gudea, Lagash (modern Telloh, Iraq), 78, *78*, 80
votive statues, Eshnunna (modern Tell Asmar, Iraq), 73–74, *73*
Voulkos, Peter, 1152; *Untitled Plate*, 1152, *1152*
voussoir, 226, 228, 348, 524, 525, *525*, 962
Vulca (artist), 227
Vulcan, 158

W

Wainwright Building, St. Louis, Missouri (Louis Sullivan), 1054, *1054*, 1086
wall hanging (Anni Albers), 1098, *1098*
wall painting: Ancient Near East, 78–80; Gothic, 591; Greek, 207–8; Mesoamerican, 456; Minoan, 139–41; Roman, 269–173; Romanesque, 530–32
wall painting, House of M. Lucretius Fronto, Pompeii, Italy, 272–73, *273*
Wall with horses, Cosquer cave, Cap Morgiou, France, *42–43*, 48
Walpole, Horace, 956, 964
 Strawberry Hill, Twickenham, England, 956, *956*; Library (with John Chute and Richard Bentley), 956, *956*
Waltz, The, bronze (Camille Claudel), 1040–41, *1040*, 1073
wampum, 885
Wang Hui, 853; *A Thousand Peaks and Myriad Ravines*, hanging scroll, *852*, 853
Wang Xizhi, 413; calligraphy sample, 413, *413*
war club, Marquesas Islands, Polynesia, 906, *907*
wares (ceramic), 60, 85
Warhol, Andy, 1144–45, 1166, 1169; *Marilyn Diptych*, 1144, *1144*
Wari Empire, 882
warp, 364, 452, 885, 888, 926, 1153
Warring States period (China), 406
Warrior Vase, Mycenae, Greece, 150, *150*
wash, 1071, 1137
Washington, D.C.
 United States Capitol, 1000, *1000*, 1053; corncob capitals, 1000, *1000*
 Vietnam Veterans Memorial, 1177–78, *1177*
Washington, George, 972, 973

watchtower, China, 418
Water Carrier of Seville (Diego Velázquez), *790*, 791, 1048
watercolor paints, 648
Watteau, Jean-Antoine, 943–45; *Le Pélerinage à l'Île de Cithère*, *942*, 943; *The Signboard of Gersaint*, 943–45, *943*
wattle-and-daub, 55–56, *535*, 820
Wawalag Sisters and the Rainbow Serpent, The (Mawalan Marika), 902, *902*
Webb, Philip, 1016; (?) chair, 710, 1016, *1016*
wedding basket, Pomo, *885*
Wedgwood, Josiah, 957–59; Vase (with *Apotheosis of Homer* by John Flaxman, Jr.), 957, *957*
wedjat (Egyptian symbol), 96
weft, 364, 452, 926
Weickman, Christopher, 482
Weighing of Souls, Last Judgment, relief, Gislebertus, Saint-Lazare cathedral, Autun, Burgundy, France, 524, 527, *527*
Weil-am-Rhein, Germany, Vitra Fire Station, 1158, *1158*
Weil, Benjamin, 963–64, 975; *The Death of General Wolfe*, 963, *963*, 976
Western art: African influence on, 917–18; in Japan, 870
Western Church. *See* Roman Catholic Church
Western Empire. *See* Roman Empire
Western Paradise of Amitabha Buddha, The, wall painting, Dunhuang, Gansu, China, 416, *416*, 418
Western Pure Land, 376, 414, 427, 437, 826
West House, Akrotiri, Thera, Greek island, *128*, 129, 140
Weston, Edward, 26, 1166; *Succulent*, 26, *26*
westwork, 497
wet-collodion process, 1003
We Won't Play Nature to Your Culture (Barbara Kruger), 1170, *1170*
Weyden, Rogier van der, 633–35, 638, 640; altarpiece, *Deposition*, 634, *634*, 964; *Last Judgment Altarpiece*, 628, 635, *635*; *Portrait of a Lady*, 635, *636*
Whirling Log Ceremony, sand painting (Hosteen Klah), woven by Mrs. Sam Manuelito, 895, *895*
Whistler, James Abbott McNeill, 36, 1016–18, 1081; *Black Lion Wharf*, 1016–17, *1016*; *Harmony in Blue and Gold*, Peacock Room, Frederick Leyland house, London, England, 36, *36*; *Nocturne: Blue and Gold—Old Battersea Bridge*, 1018, 1020, *1020*; *The Princess from the Land of Porcelain*, 36
White, Minor, 1151; *Capitol Reef, Utah*, 1151, *1151*
white-ground vase painting, 173, 197
Whitehall Palace, London, England (Inigo Jones), 798, 816–18, *816*, *817*, 973
White Horse, The (John Constable), 995–96, *995*
Whiteread, Rachel, 1179; *House*, 1179, *1179*
White with Graphism (Antoni Tàpies), 1129, *1129*
Wild Blackberry, De Materia Medica, manuscript (Pedanius Dioscorides), *320*, 321
Wildmon, Donald, 1175
Wiligelmus, 551–52; *Creation and Fall*, relief, Cathedral, Modena, Italy, 552, *552*
Willendorf, Austria, *Woman*, figurine, paleolithic, 46, *46*, 47
William and Mary, of England, 816
William of Orange, 800
William of Sens, 584, 586
William the Conqueror, 535, 539, 541, 543
Wiltshire, England, Park at Stour, 954, *955*, 1055
Winchester Psalter, Hellmouth, manuscript, English, 540, *541*, 588
Winckelmann, Johann Joachim, 963; *The History of Ancient Art*, 952; *Thoughts on the Imitation of Greek Works in Painting and Sculpture*, 952

Windmill Psalter, English, *Psalm 1 (Beatus Vir)*, 588, *588*

wings, 625

Winter Landscape (Sesshu), *860*, 861

Winter on Fifth Avenue (Alfred Stieglitz), 1050, *1050*

Witte, Emanuel de, 808–9; *Portuguese Synagogue, Amsterdam*, 808–9, *809*

Wittenberg, 721

Wittgenstein, Ludwig, 1149

Witz, Konrad, 647–48; altarpiece, *Miraculous Draft of Fish*, 647–48, *647*

Wölfflin, Heinrich, *Principles of Art History*, 799

Woman and Maid, vase (style of Achilles Painter), 198, *198*

Woman at the Height of Her Beauty (Kitagawa Utamaro), 29, *29*, 33, 1029

Woman Combing Her Hair II (Julio González), 1106, *1106*, 1135, 1148

Woman from Brassempouy, figurine, France, paleolithic, 46, 47, *47*

Woman from Ostrava Petrkovice, figurine, Czech Republic, paleolithic, 46, *46*

Woman from Willendorf, figurine, Austria, paleolithic, 46, *46*, 47

Woman Holding a Balance (Jan Vermeer), *812*, 813

Womanhouse (Judy Chicago and Miriam Schapiro), 1164

Woman I (Willem de Kooning), 1133–34, *1133*

Woman in a Loge (Mary Cassatt), 1025–26, *1025*, 1071

Woman or Goddess with Snakes, Knossos, Crete, 137–38, *138*

Woman Spinning, Susa (modern Shush, Iran), 86, *87*

Woman with the Hat, The (Henri Matisse), 1064, *1064*, 1065

Womb World mandala, Japan, Heian period, 434, *436*, 437

women

artists: 20th century, 1162–65; in academies, 949–50, 969; African, 933; American, 1107; Medieval, 549; Middle Ages, 622, 623; Renaissance, 623, 687, 733–34; Surrealist, 1105

in cultures: contemporary, 1170; Greek, 197; Japanese, 440; Muslim, 348; Roman, 263, *274*

depiction of, 28–29, 981, 1075, 1134

as patrons of art, 709, 939

Women at a Fountain House, vase ("A.D." Painter), 175, *175*, 186

women figurines, Cyclades, Greek islands, 132, *132*

Women of Algiers (Eugène Delacroix), 990, *990*

women's hand (Japanese), 440

Women's Liberation movement, 1162

women's suffrage movement, 959, 981

Wood, Grant, 1108; *American Gothic*, 1110, *1110*

Wood, John, the Elder, 954

Wood, John, the Younger, 954; Royal Crescent, Bath, England, with John Wood the Elder, 954–56, *955*

woodblock prints, 28, 648; Japanese, 40, 857, 871, *871*, 872, 1020, 1022, 1035, 1042; Russian, 1081; technique, *648*

woodcuts, 644, 648–49, *648*

Wooded Landscape at l'Hermitage, Pontoise (Camille Pissarro), 1023, *1023*

wood sculpture, 438, 440, 529, 596

Woodstock, Oxfordshire, England, Blenheim Palace, *819*, 820

Woolworth Building, New York, N.Y. (Cass Gilbert), 1087, *1087*, 1088

Worcester Chronicle (John of Worcester), *Dream of Henry I* page, 540, *541*

Worker and Collective Farm Worker (Vera Mukhina), 1092, *1092*

Workers' Club. *See* Rodchenko, Aleksandr

workshops, artists', 33, 760, 799

Works Progress Administration (WPA), 1109

World, the, contemporary, 1126–27, 1126 (map)

World of Art group, 1081

World's Columbian Exposition (Chicago, 1893), 1052; Court of Honor, 1053, *1053*

World Tree, 794

World War I, 1060, 1089, 1099, 1104

World War II, 1060–61, 1097, 1130, 1150

Worpswede group, 1067

Wrangell, Canada, Grizzly bear house-partition screen (Native American, Tlingit), 888, *888*, 890

Wren, Christopher, 818–19; Saint Paul's Cathedral, London, England, 818–19, *819*, 966

Wright, Frank Lloyd, 1086–87, 1094, 1116–17 Fallingwater, Edgar Kaufmann House, Mill Run, Pennsylvania, 1094, 1116–17, *1116* Frederick C. Robie House, Chicago, Illinois, 1086–87, *1086*; dining room, *1086*, 1087 Solomon R. Guggenheim Museum, New York, N.Y., 36, *37*, 1158

Wright of Derby, Joseph, 961; *An Experiment on a Bird in the Air-Pump*, 961, *961*, 964

writing: Chinese, 403, 404, 405, 435, 841, 1183–84; Egyptian, 111; invented, 1184; Japanese, 435, 436, 438–40, 859; Mayan, 458; Medieval script, 500; Mesopotamia, 70–71; Minoan, 134

Wrongful Execution of the Count panel, *Justice of Otto III* (Dirck Bouts), 638, *638*

wrought iron, 1006

Wu, emperor, 410

Wu family shrine, Jiaxiang, Shandong, China, 410–11, *410*

Wu Guanzhong, 854; *Pine Spirit*, 854, *854*

Würzburg, Bavaria, Germany, Residenz, Kaisersaal (Imperial Hall), 940–41, *940*, 941, 991

Wutaishan, Shanxi, China, Nanchan Temple, 417, *417*

Wyatt, James, the Destroyer, 585

X

Xerxes I, 89

Xia dynasty (China), 405

Xia Gui, 423, 424; *Twelve Views from a Thatched Hut*, 422–23, *423*

Xi'an, Shanxi, China, Ci'en Temple, Great Wild Goose Pagoda, 417, *417*

Xie He, 412

Xi River, 402

x-ray style, 901

Xuande, emperor, 846

Xuanzang, 417

Xu Daoning, 421–22; *Fishing in a Mountain Stream*, 421–22, *421*

Y

Yabay, Queen, tomb of, Nimrud, Iraq, 82, *82*, 137

yaksha, 377, 384

yakshi, 377

Yakshi Holding a Fly Whisk, India, Maurya period, 377, *377*, 381

Yangshao culture, 403

Yangzi River, 402

Yayoi period (Japan), 430–31, 859

Yellow River, 402

Yggdrasil, 487

Yin Hong, *Hundreds of Birds Admiring the Peacocks*, hanging scroll, 845–46, *845*

Yongle, emperor, 848

Yoritomo, Minamoto Yoritomo, 442

Yoruba Ife, Nigeria, 471, 476

Yoruba people, 31, 917, 919–20, 925–26, 927, 931, 933–34

Yoshihara, Jiro, 1138

Young, Thomas, 111

Young Flavian Woman, bust, Roman, 257–58, *257*, 577

Young Girl Gathering Crocus Flowers, wall painting, House Xeste 3, Akrotiri, Thera, Greek island, 140–41, *140*

Young Woman Writing, wall painting, Pompeii, Italy, 272, *272*

Yuan dynasty, 424, 840, 841–44

Yungang, Shanxi, China, *Seated Buddha*, sculpture, 414, *414*

Z

Zaire, mask, *bwami*, Lega culture, 922, *922*

Zappi, Gian Paolo, 733

al-Zarir, *Life of the Prophet*, manuscript, *Prophet Muhammad and His Companions Traveling to the Fair* page, *349*, 368

Zen Buddhism, 423, 444–45, 858–61, 866; and tea ceremony, 864

Zenobia in Chains, marble (Harriet Hosmer), 1042–43, *1043*

Zen painting, 870

Zeus, 156, 158

Zeuxis, 25

Zhang Xuan, 418

Zhang Zeduan, 422; *Spring Festival on the River*, 422–23, *422*

Zhao Mengfu, 842; *Autumn Colors on the Qiao and Hua Mountains*, handscroll, 842, *842–43*

Zhou dynasty (China), 406, 410; Eastern, 841, 850

Zhuangzi, 841

ziggurat, 70, 101

Zimrilim, 78

Zoffany, Johann, 950; *Academicians of the Royal Academy*, 950

Zuni, 468

Zurbarán, Francisco de, 788, 789–90, 794; *Saint Serapion*, 789, *789*, 972

Credits